1970
WHO'S WHO IN
AMERICAN ART

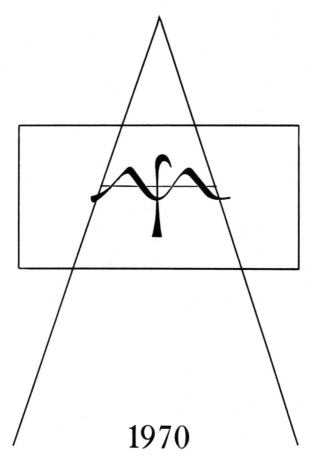

1970

The American Federation of Arts

WHO'S WHO IN AMERICAN ART

Edited by Dorothy B. Gilbert

R. R. BOWKER COMPANY, NEW YORK & LONDON

Published by the R. R. Bowker Company
(A XEROX COMPANY) 1180 Avenue of the Americas,
New York, New York 10036
Copyright © 1970 by Xerox Corporation.
Standard Book Number: 8352-0284-4
Library of Congress Catalog Number: 36-27014

CONTENTS

PREFACE

With this edition, WHO'S WHO IN AMERICAN ART has been redesigned in a new format while the content, in general, remains the same as in previous volumes of the series which began, as a one-volume edition, in 1947. However, the coverage continues to be expanded to include those active in various phases of the art field. New names have been added through the cooperation of Miss Betty Chamberlain, Founder and Director of Art Information, Inc., New York City, who served as Adviser and the resources of her extensive art files have helped to broaden the scope of the book.

As in previous volumes, data on the activities of entrants has been edited from returned questionnaires. Occasionally, the address of a biographee will appear with only city and state. This is not a typographical error—it is at the request of the biographee. A number of distinguished leaders of the art and educational fields have retired and they are omitted at their request. Photographers and architects are also omitted, unless they are active in other creative art fields, as their organizations publish membership lists and have biographical information in their files.

The Geographical Index, compiled by state and city with professional classifications following the names of more than 5,000 biographees, the Canadian Section with information similar to the American Section, Obituaries from the years 1966-1969 and National and Regional Open Exhibitions are again included.

The Editor wishes to express her deep appreciation to Mrs. Anne J. Richter, Editor-in-Chief and to Mr. David Biesel, Managing Editor of the Book Editorial Department of the R. R. Bowker Company and to others of the staff for their assistance and personal time devoted to this book. Also my thanks to the many art gallery directors, art organizations, art and educational experts throughout the country for their suggestions and assistance. The R. R. Bowker Company uses every effort to include relevant material submitted but has no legal responsibility for accidental omissions or errors in these listings. Corrections and new names of qualified artists and others in affiliated fields will always be welcome.

November, 1969

Dorothy B. Gilbert
Editor

ABBREVIATIONS

Professional Classifications

C.—Craftsman
Cart.—Cartoonist
Comm. A.—Commercial Artist
Cr.—Critic
Cur.—Curator
Des.—Designer

E.—Educator in Col. or Univ.
Eng.—Engraver
Et.—Etcher
Gr.—Graphic Artist
I.—Illustrator
L.—Lecturer

Lith.—Lithographer
P.—Painter
S.—Sculptor
Ser.—Serigrapher
T.—Teacher in Elem. or H.S.
W.—Writer

Entries Not Abbreviated

Art Dealers
Art Editors

Collectors
Conservators

Photographers
Scholars

Addresses And Symbols

First address is studio or business.
h.—Home address (if more than one address)
s.—Summer address.

w.—Winter address.
*—No information from artist this year.
†—Death notice received too late to
omit name.

Museums

AGAA—Addison Gallery of American Art, Andover, Mass.
AIC—Art Institute of Chicago.
BM—Brooklyn Museum.
BMA—Baltimore Museum of Art.
BMFA—Boston Museum of Fine Arts.
CAL.PLH—California Palace of the Legion of Honor, San Francisco, Cal.
CAM—City Art Museum of St. Louis.
CGA—Corcoran Gallery of Art.
CM—Cincinnati Museum Association.
CMA—Cleveland Museum of Art.
DMFA—Dallas Museum of Fine Arts.
FMA—Fogg Museum of Art.
LC—Library of Congress.
MMA—Metropolitan Museum of Art.
MModA—Museum of Modern Art.

NCFA—National Collection of Fine Art, Washington, D.C.
NGA—National Gallery of Art, Washington, D.C.
PC—Phillips Collection, Washington, D.C.
PMA—Philadelphia Museum of Art.
SAM—Seattle Art Museum.
SFMA—San Francisco Museum of Art.
VMFA—Virginia Museum of Fine Arts, Richmond, Va.
WAC—Walker Art Center, Minneapolis, Minn.
WMA—Worcester Museum of Art, Worcester, Mass.
WMAA—Whitney Museum of American Art.

Associations, Expositions, Schools

AAMus—American Association of Museums.

AAPL—American Artists Professional League.

AAUP—American Association of University Professors.

AAUW—American Association of University Women.

A.Dir. Cl.—Art Directors Club, New York, N.Y.

AEA—Artists Equity Association, New York, N.Y.

AFA—American Federation of Arts, New York, N.Y.

AIA—American Institute of Architects.

AIID—American Institute of Interior Designers.

AIGA—American Institute of Graphic Arts.

ANA—Associate of the National Academy of Design, New York, N.Y.

Arch. Lg—Architectural League of New York, N.Y.

ASL—Art Students League of New York, N.Y.

ASMP—American Society of Miniature Painters, New York, N.Y.

AWS—American Watercolor Society of New York, N.Y. (formerly AWCS)

BAID—See Nat. Inst. for Arch. Edu.

CAA—College Art Association of America, New York, N.Y.

CUASch—Cooper Union Art School, New York, N.Y.

FAP—Federal Art Project, Works Projects Administration.

GGE1939—Golden Gate Exposition, San Francisco, Cal., 1939.

IDSA/SA—Industrial Designers Society of America.

IGAS—International Graphic Arts Society.

MIT—Massachusetts Institute of Technology, Cambridge, Mass.

NA—Academician of National Academy of Design, New York, N.Y.

NAC—National Arts Club, New York, N.Y.

NAD—National Academy of Design, New York, N.Y.

Nat. Inst. for Arch. Edu.—National Institute for Architectural Education.

NAEA—National Art Education Association.

NAWA—National Association of Women Artists, New York, N.Y.

NSMP—National Society of Mural Painters, New York, N.Y.

NSS—National Sculpture Society, New York, N.Y.

PAFA—Pennsylvania Academy of Fine Arts, Philadelphia, Pa.

PBA—Public Buildings Administration, U.S. Treasury Dept., Washington, D.C.

PIASch—Pratt Institute Art School, Brooklyn, N.Y.

PMSchIA—Philadelphia Museum School of Industrial Art, Philadelphia, Pa. (now PMCol.A.)

R.I.Sch.Des.—Rhode Island School of Design, Providence, R.I.

SAGA—Society of American Graphic Artists, New York, N.Y. (formerly SAE)

SC—Salmagundi Club, New York, N.Y.

SI—Society of Illustrators.

SSAL—Southern States Art League.

General Abbreviations

A—Art, Arts, Artist.

AA—Art Association (preceded or followed by city).

AC or A.Cl.—Art Club (preceded or followed by city).

Ann.—Annual.

Arch.—Architect, Architectural.

Assn.—Association

Assoc.—Associate, Associated.

Asst.—Assistant.

B.—Born.

B.A.—Bachelor of Arts.

B.Arch.—Bachelor of Architecture.

Balt.—Balitmore, Md.

B. of E.—Bachelor of Education.

B.F.A.—Bachelor of Fine Arts

B.P.—Bachelor of Painting.

Chm.—Chairman.

Cl.—Club.

Col.—College.

Coll.—Collection.

Com.—Committee.

Comm.—Commission.

Cur.—Curator.

D. or d.—Died.

Dec.—Decorator.

Deg.—Degree.

Dir.—Director.

Ed.—Editor.

Edu.—Educated, Education.

Exh.—Exhibited, Exhibition.

Exec.—Executive.

Exp.—Exposition.

F.—Fellow (used with organizations).

F.A.—Fine Arts.

Fed.—Federation.

Fnd.—Foundation.

Gal.—Gallery.

Gld.—Guild.

Gr.—Graver, Graphic.

Grad.—Graduate, Graduated.

Hon.—Honorary member.

Illus.—Illustrated, Illustration.

Indp.—Independent.

Indst.—Industry, Industrial.

Inst.—Institute.

Instr.—Instructor.

Int.—International.

Let.—Letters.

Lg.—League.

Los A.—Los Angeles, Cal.

M.A.—Master of Arts.

Mem.—Memorial.

M.F.A.—Master of Fine Arts.

Min.—Miniature.

Mod.—Modern.

Mun.—Municipal.

Mus.—Museum.

Nat.—National.

N.Y.—City of New-York, N.Y.

Phila.—Philadelphia, Pa.

Publ.—Publication, Publisher.

Pr.M.—Printmakers (preceded or followed by city).

San F.—San Francisco, Cal.

Sc.—Science.

Sch.—School.

Soc.—Society.

Un.—Union, United.

USPO—United States Post Office.

WC—Watercolor.

AMERICAN
BIOGRAPHIES

AMERICAN BIOGRAPHIES

AACH, HERBERT H.—Painter, E., W., L.
404 E. 14th St.; h. 523 E. 14th St., New York, N.Y. 10009
B. Cologne, Germany, Mar. 24, 1923. Studied: Art Acad., Cologne with Ludwig Meidner; PIASch.; BM Sch.A. with Tamayo, Ferren, Dickinson, Gonzales and Osver; Stanford Univ., and in Mexico. Member: CAA; Eastern AA; Nat. Art Edu. Assn; Intersociety Color Council. Awards: prizes, Hazleton A.Lg., 1956, 1963; Roberson Mem. Center, 1959. Work: Everhart Mus. A., Scranton, Pa.; BMFA; William Penn Mem. Mus.; Birla Acad. A. & Culture, Calcutta, India. Exhibited: WMAA, 1952, 1956; BM, 1953, 1956-1958; PAFA, 1957-1962; Art U.S.A., 1958; Illinois Biennial, 1961; Brooklyn Soc. A., 1948-1950; Creative Gal., N.Y., 1950, 1952-1954; Hazleton A. Lg., 1956-1965; Buck Hill Falls, 1956; Everhart Mus. A., 1956, 1958, 1960, 1962; Roberson Memorial, 1957, 1959, 1961; Avant Garde Exh., 1958; Jacques Seligmann Gal., N.Y., 1965, 1966, 1968; Pace Col., 1966; Lehigh Univ., 1965-1967, 2-man, 1968; Fordham Univ., 1967; Kent State Univ., 1967; Capricorn Gal., 1967 (2); Cranbrook Acad.A., 1966; Essex County Exh., 1969; Art Direction, 1958, 1959 and others; one-man: Creative Gal., N.Y., 1951; Everhart Mus. A., 1959; Stroudsburg, Pa., 1957; Landry Gal., N.Y., 1961; Pa. State Univ., 1962; Lehigh Univ., 1968; Howard Wise Gal., N.Y., 1967; Jacques Seligmann Gal., N.Y., 1964, 1968. Positions: Tech. Dir., Am. Artists Color Works (15 years); Contrib. Ed., "Color Engineering"; Instr. Queen's College Branch of City University of New York. Memb. Standing Comm., U.S. Govt. Commercial Standards governing Artists' Oil Paints.

AARONS, GEORGE—Sculptor
Eagle Rd., Gloucester, Mass. 01930
B. Russia, Apr. 6, 1896. Studied: BMFA Sch.; BAID. Member: NSS. Awards: prizes, Boston Inst. Contemporary A., 1945; Rockport AA, 1953; Arch. Lg., 1958; Beverly Farms, Mass., 1961. Work: groups, memorials, monuments, reliefs: Old Harbor Village, Boston; USPO, Ripley, Miss.; Telephone Bldg., Cincinnati; West End House, Boston; Hilles Library, Radcliffe College, Cambridge, Mass.; Brandeis Univ., Waltham, Mass.; Hillel House, Univ. Connecticut; Baltimore Hebrew Congregation; Hillel House, Boston Univ.; Fitchburg Art Museum, Mass.; Musee de St. Denis, France; Combined Jewish Philanthropies of Boston. Exhibited: Inst. Contemporary A., Boston; BMFA; Busch-Reisinger Mus., Cambridge, Mass.; AGAA; WMAA; Sc. Center, New York, N.Y.; PAFA; A. Alliance, Phila., Pa.; PMA, 1940, 1949; DMFA; CMA; AAG; CGA; DeCordova Museum, Lincoln, Mass.; Cayuga Museum of History and Art, Auburn, N.Y., Brandeis Univ.; Ein Harod Mus., Israel.

ABBELL, SAMUEL—Art Patron
59 E. Van Buren St. 60605; h. 6918 S. Euclid Ave., Chicago, Ill. 60649
B. Chicago, Ill., Jan. 4, 1925. Studied: Harvard Univ.; Univ. Chicago, B.S. Member: Metropolitan Museum of Art (Life); AIC (Life).*

ABELES, SIGMUND M.—Sculptor, E., Gr., L.
137 Langley Rd., Newton Center, Mass. 02181
B. New York, N.Y., Nov. 6, 1934. Studied: PIASch.; Univ. South Carolina, A.B.; ASL; Skowhegan Sch. Painting & Sculpture (Scholarship); BMSch. A. (Scholarship); Columbia Univ., M.F.A. Awards: Fresco prize (first) Skowhegan Sch., 1955; Grant, Nat. Inst. A. & Lets., 1965. Work: Columbia Mus. A.; Columbia Univ.; Fresco panel, South Solon, Me., Meeting House; Bowdoin Col. Mus.; Boston Pub. Lib.; Dartmouth Col.; deCordova and Dana Mus.; R.I. Sch. Des. Mus.; Colgate Univ.; LC; Monclair A. Mus.; Mus. MModA; Museo de Arte, Ponce, Puerto Rico; PAFA; Wellesley Col.; Phila. Free Lib.; Univ. Colorado. Exhibitions: PAFA, 1957; Soc. Wash. PrM, 1957, 1964, 1965; Norfolk Mus. A., 1957, 1963; Cal. PLH, 1961, 1964; Skowhegan Prize-winners, 1957; PAFA, 1965; Phila. Pr. Cl., 1965; deCordova Mus., 1964; Boston A. Festival, 1964; WMAA, 1967; 28 American Printmakers, Amsterdam, Holland; AAA Gal., N.Y. One-man: Columbia Mus. A., 1961; Wheaton Col., 1964; Roten Gal., Baltimore, 1965; Wellesley Col. Mus., 1966; Tragos Gal., Boston, 1966; Kalamazoo A. Center, 1968; Kentmore Gal., Phila., 1968; Block Gal., St.

Louis, 1968; State Univ. of New York, Potsdam, 1969. Positions: Instr., Drawing and Printmaking, Swain School of Design, New Bedford, Mass., 1961-64; Res. Artist and Instr., Wellesley College, Mass., 1964-1969; Asst. Prof. Drawing, Boston University, Boston, Mass. as of Sept., 1969.

ABLOW, JOSEPH—Painter, E., L., W.
16 Monmouth Court, Brookline, Mass. 02146
B. Salem, Mass., Aug. 16, 1928. Studied: BMFA Sch. A.; Bennington Col., B.A.; Harvard Univ., M.A., and with Oskar Kokoschka, Jack Levine, Ben Shahn. Awards: Paige Traveling Scholarship, BMFA, 1951; Fulbright Grant (Paris) 1958-1959; prize, Rhode Island A. Festival, 1961. Exhibited: AIC, 1957; Brandeis Univ., 1954; Silvermine Gld. of A., 1955; Boston A. Festival, 1953-1956, 1958, 1962, 1963; Middlebury College, 1968; Kunstsalon Wolfsberg, Zurich, Switzerland. Lectures: Renaissance to Modern Painting, Sculpture, Design and Architecture to numerous museums and art organizations. Positions: Instr., Bard College, Middlebury College, Wellesley, Chm. Div. of Art, School of Fine & Applied Art, Boston University, Boston, Mass., 1964-1967; Assoc. Prof., Div. of Art, 1968- .

ABRAMOVITZ, MR. AND MRS. MAX—Collectors
431 E. 85th St., New York, N.Y., 10028

ABRAMS, HARRY N.—Publisher, Collector
6 W. 57th St. 10019; h. 33 E. 70th St., New York, N.Y., 10021
B. London, England, Feb. 23, 1905. Studied: National Acad. Design; Art Students League. Collection: mainly American and French 20th Century Paintings. Positions: Pres., Harry N. Abrams, Inc., New York, N.Y.*

ABRAMS, RUTH—Painter
18 W. 10th St., New York, N.Y. 10011
B. New York, N.Y. Studied: Columbia Univ. (Fine Arts); ASL (Sculpture); New Sch. for Social Research; Workshops: Zorach, Archipenko, Harrison. Work: Carnegie Inst. Tech.; Smith Col. Mus. A.; Rose A. Mus., Brandeis Univ.; N.Y. Univ. Art Coll.; Univ. of Caracas; Mus. Fine Arts, Caracas, Venezuela; Cornell Univ. A. Mus.; and in private colls. U.S. and South America. Exhibited: CGA, 1947; Riverside Mus., N.Y.; Art: USA, 1958; Critics Choice, 1960; Poindexter Gal., 1961; East Hampton Gal., 1963, all New York City; DMFA, 1963. One-man: ACA Gal., 1940, 1943, 1949; Roko Gal., 1956, 1959; Camino Gal., 1957, 1958, D'Arcy Gal., 1962, all in New York City; Mus. of Fine Arts, Caracas, 1963; MIT Faculty Cl., Cambridge, Mass., 1964, 1969; Columbia Univ. Avery Lib., 1967, 1968 (on loan); Shepherd Gal., 1968. Position: Art Dir., New Sch. for Social Research Assn., 1966. Illustrated in publications Ekistics, Athens, Greece; Arena-Interbuild, London, England, 1967.

ACHEPOHL, KEITH—Etcher, T.
Pacific Lutheran University, Parkland, Tacoma, Wash. 98447
B. Chicago, Ill., Apr. 11, 1934. Studied: Knox Col., B.A.; Univ. Iowa, M.F.A. Awards: purchase prizes—LC, 1959, 1961; SAM, 1967; SAGA, 1969, and the Lynd Ward prize 1967; Springfield Mus. A., 1959, 1960, 1966; Nat. Drawing and Print Exh., Oklahoma A. Center, 1966; Olivet Col., 1969; Tiffany Fnd. grant for printmaking, 1965. Work: AIC; LC; PMA; N.Y. Public Library; William Rockhill Nelson Gal. A., Kansas City; SAM; Free Library of Philadelphia; USIA; Univ. Iowa; Ohio Univ.; Univ. Missouri; Bucknell Univ.; Achenbach Fnd. for Graphic A., San Francisco; Springfield A. Mus., and others. Exhibited: LC, 1959, 1961, 1963, 1969; SAM, 1961, 1964, 1967, 1968; AIC, 1963, 1965, 1966, 1968; PAFA, 1967; Boston Pr.M., 1959, 1966, 1967, 1969; Washington Pr.M., 1960, 1962; Nat. Drawing and Print Exh., Houston, 1965; BM, 1960, 1968; Joslyn Mus. A., 1960, 1966; Silvermine Gld., 1960, 1962, 1966, 1968; SAGA, 1967, 1969; LC (USIA) to Orient, 1961-1962 and Europe, 1961, 1966; Olivet Col., 1966, 1967, 1969; Nat. Print and Drawing, Potsdam, N.Y., 1967; Phila. Pr. Cl., 1962, 1968; Univ. Kentucky, 1968. Posi-

tions: Instr., Printmaking, Univ. Iowa, 1960-1962; Hope Col, Holland, Mich., 1966-1969; A.-in-Res., Pacific Lutheran University, Tacoma, Wash., 1969- .

ACKERMAN, GERALD MARTIN—Scholar, W.
 3200 Kipling St., Palo Alto, Calif. 94306
B. Alameda, Cal., Aug. 21, 1928. Studied: Univ. of California at Berkeley, B.A.; Univ. of Munich (1956-1958); Princeton Univ., M.F.A., Ph.D. Field of research: Art Theory; 19th Century Masters, in particular Gerome. Author: "Elements of Art History," 1970. Articles contributed to: Art Bulletin, Gazette des Beaux Arts, Art News. Positions: Instr., Bryn Mawr College, Bryn Mawr, Pa., 1960-64; Asst. Prof., Dept. of Art, Stanford Univ., 1964- .

ACQUAVELLA, NICHOLAS—Art dealer
 Acquavella Gallery, 18 E. 79th St., New York, N.Y. 10021*

ACTON, ARLO C.—Sculptor
 3556 23rd St., San Francisco, Cal. 94132*

ADAMS, ALICE (GORDY)—Sculptor, C., T.
 246 Bowery 10012; h. 328 E. 89th St., New York, N.Y. 10028
B. New York, N.Y., Nov. 16, 1930. Studied: Columbia Univ., B.F.A.; L'Ecole National d'Art Decoratif, Aubusson, France. Member: Am. Abstract A. Awards: French Government Fellowship; Fulbright Travel Grant, 1953-1954 to Aubusson, France; MacDowell Colony grant, 1966. Work: Univ. Nebraska Coll. Exhibited: Riverside Mus., N.Y., 1966-1968; Victoria and Albert Mus., London, England, 1961; Mus. Contemp. Crafts, N.Y., 1958, 1963, 1966; USIS traveling exh., 1966-1967; Fischbach Gal., N.Y., 1966; Loeb Center, N.Y. Univ., 1967; North Carolina Mus. A., Releigh, 1968. Contributor to Crafts Horizons. Positions: Instr., Sculpture, Textiles, Manhattanville Col.; California State Col. at Los Angeles.

ADAMS, CLINTON—Painter, Lith., E.
 University of New Mexico, Albuquerque, N.M. 87105
B. Glendale, Cal. Dec. 11, 1918. Studied: Univ. Cal., Los Angeles, Ed.B., M.A. Member: CAA; AAUP; Int. Council Fine Arts Deans (chm. 1966). Exhibited: One-man: UCLA, 1950; Landau Gal., 1952, 1955, 1958, 1961, 1965; Pasadena A. Mus., 1954; Louisville A. Center, 1956; Univ. Texas, 1957; Univ. Florida, 1957; Jonson Gal., Albuquerque, 1961, 1963, 1968; Arizona State Univ., 1962; Delgado Mus. A. (two-man), 1963. Work: AIC; BM; BMFA; MModA; Los A. Mus. A.; La Jolla Mus. A.; Achenbach Fnd. Gr. A.; UCLA A. Gal., Mus. New Mexico, and others. Positions: Asst. Prof. A., UCLA, 1946-54; Prof. A., Hd. A. Dept., University of Kentucky, Lexington, Ky., 1954-1957; Prof. A., Hd. A. Dept., University of Florida, Gainesville, Fla., 1957-1960; Assoc. Dir. Tamarind Lithography Workshop, 1960-61; Dean, College of Fine Arts, University of New Mexico, Albuquerque, N.M., 1961- .

ADAMS, (MOULTON) LEE—Painter, I., L.
 4243 St. Johns Ave.; h. 1436 Avondale Ave., Jacksonville, Fla. 32205
B. Jacksonville, Fla., July 15, 1922. Studied: Univ. North Carolina and special work in botany at Rollins Col., A.B. Member: Audubon Soc.; Assoc. member, AID; Assoc., AWS. Awards: Montgomery Palm Medal, Rollins College; prizes, Jacksonville A. Festival, 1961-1963. Work: many botanical watercolors and oils in private collections; Fairchild Tropical Gardens, Coral Gables; Garden Club of America Headquarters, New York City; United Fruit Co.; Hunt Botanical Lib., Carnegie-Mellon Univ.; Jacksonville A. Mus.; Central offices, ACL Railroad; First National Bank, Orlando. Murals: St. Vincent's Hospital, River Club, Timuquana Country Club, and Sears Roebuck Co., all Jacksonville, Fla.; Ribault Club; 10 murals, N.Y. Worlds Fair, 1964-65; I., series of prints "Fifty Wildflowers of Northeastern America" (Nat. Audubon Soc., 1951); illustrations, Audubon Nature Encyclopedia; series of folios illus. tropical fruit of the world under direction of David Fairchild. Cover des. for Horticulture magazine and others. Lectures on expeditions made for subject matter. Exhibited: nationally; one-man: Nat. Audubon Soc. Hdqtrs., New York City; Kennedy Galleries, New York; Mus. Natural History, Buffalo; Baylor Univ.; Cornell Univ.; Fairchild Tropical Gardens, Miami; Garden Club of America, New York; Horticultural Hall, Boston; International House, New Orleans; Los A. Mus. A.; Miami Beach A. Center; Morehead Gal., Univ. North Carolina; N.Y. Botanical Gardens; Phi Beta Kappa Hall, College of William & Mary; Wilmington Soc. Fa.; Univ. Georgia; Garden Symposium, Williamsburg, Va.; Norton Gal. A., West Palm Beach; Cummer Gal. A., Jacksonville; Tryon Gallery, London England, 1968. Group Shows: rep. U.S.A. in "Flower Artists of the World," London Eng., 1968; Exhibition, 20th Century Botanical Art and Illustration, Worldwide Exhibition; Hunt Botanical Library; Am. Watercolor Society, N.Y., 1963-66.

ADAMS, MARK—Painter, Des.
 3816 22nd St., San Francisco, Cal. 94114
B. Fort Plain, N.Y., Oct. 27, 1925. Studied: Syracuse Univ.; Colum-

bia Univ.; and with Hans Hofmann; Jean Lurcat, France. Awards: San F. Art Commission award, 1956. Work: DMFA; San F. Pub. Lib.; SFMA; Chase Manhattan Bank; Crown Zellerbach Bldg., San F.; Bank of California; Firestone Baptistry, Carmel, Cal. Architectural commissions include tapestries, painted murals, mosaics and stained glass. Exhibited: Mus. Contemp. Crafts, 1956, 1957, 1962, 1965, 1968; SFMA, 1953, 1958, 1959, 1961, 1962, 1965; Pasadena A. Mus., 1962, 1965, 1968; CAM, 1964; Intl. Biennial of Tapestry, Lausanne, Switzerland, 1962, 1965; one-man: deYoung Mus., 1959; Portland (Ore.) Mus. A., 1961; CAL.PLH, 1961; SFMA, 1962; French & Co., 1964; Hansen Gal., 1965, 1968. Positions: Instr., Design, San Francisco Art Institute, 1960-61; Artist-in-Residence, American Academy in Rome, 1963.

ADAMS, MRS. MARK. See Van Hoesen, Beth

ADAMS, PAT—Painter, E.
 Bennington College, Bennington, Vt. 05201
B. Stockton, Cal., July 8, 1928. Studied: Univ. California at Berkeley, B.A.; Brooklyn Mus. A. Sch. Member: Artists Cl. Awards: Yaddo Fellowship, 1954, 1964, 1969; Fulbright Grant for painting in France, 1956-1957; MacDowell Fellowship, 1968; Nat. Council on the Arts Grant, 1968; purchase award, "Americans in Europe," Bordighera, Italy, 1952. Work: Hirschhorn Coll; WMAA; Univ. Michigan; Middlebury Col.; Univ. North Carolina, Greensboro. Ex-Hibited: MModA traveling exh. to France, 1956-1957; WMAA, 1956, 1958, 1961; Stable Gal., N.Y., 1956; AFA, 1957, 1959; PAFA, 1959; Illinois Wesleyan Univ., 1962; Joslyn Mus., Omaha, 1958; Finch Col. Mus., N.Y., 1968; one-man: Zabriskie Gal., N.Y., 1954, 1956, 1957, 1960, 1962, 1964, 1965, 1967. Positions: Instr., A., Faculty, Bennington College, Bennington, Vt., at present.

ADAMS, PHILIP RHYS—Museum Director, L., W.
 Cincinnati Art Museum, Cincinnati, Ohio 45202
B. Fargo, N.D., Nov. 19, 1908. Studied: Ohio State Univ., B.A.; N.Y. Univ., M.A.; hon. deg., Litt. D., Miami Univ.; D.F.A., Wittenberg Col., Springfield, Ohio; Litt. D., Conservatory of Music, Cincinnati; Doctor of Humane Letters, Univ. of Cincinnati, 1964; L.H.D. Hebrew Union College, Jewish Institute of Religion, Cincinnati, 1967; Princeton University; The Sorbonne, and with Cook, Robinson, Mather. Member: Assn. A. Mus. Dir.; Trustee, AFA; AAMus.; Taft Mus. Comm. of the Inst. FA; AID (Hon.). Author: "The Sculpture of Erwin F. Frey," 1940; "Rodin," 1945; "The Exhibition," UNESCO Manual for Museums, 1960; "Walt Kuhn," 1960; "Mary Callery," 1961. Contributor to art magazines. Positions: Instr., L., Newcomb Col., 1931-34; Asst. Dir. 1934-36, Dir., 1936-45, Columbus (Ohio) Gal. FA; Dir., Cincinnati Mus. Assn., Cincinnati, Ohio, 1945- .

ADAMS, ROBERT DAVID—Designer, P., T., I., Comm., L., S.
 215 Rose Dr., Cocoa Beach, Fla. 32931
B. Nelsonville, N.Y., Feb. 6, 1925. Studied: Pratt Institute, N.Y. (Grad.). Member: Dutchess County AA (Bd. of Dirs. 1959-61); Creative Contemp. A. Group; Type Directors Club of New York City; Int. Center Typographic Arts; Aspen Design Conference; IBM (Pres. 1959-61) Art Club. Awards: prizes, IBM A. Cl., 1957-1959; Watson Trophy Show, 1958, 1959; Dutchess County AA, 1958, 1960 (2). Exhibited: IBM Research Lab. Gal., 1958, 1959; Hyde Park, N.Y., 1958; Bennett Jr. Col., 1958; IBM Country Club; Ahda Artzt Gal., N.Y., 1960; Art Depot, LaGrangeville, N.Y.; Dutchess Community College, 1966; Vassar College Alumni House, 1966, 1967, and others; One-man: Hyde Park, N.Y., 1962; Art Depot, 1964; Marist College, 1962, 1964, etc. Positions: Art Director, Periodical House, N.Y.; McFadden Publications, N.Y.; Design Consultant; Senior Graphic Designer, IBM.

ADAMS, WILLIAM HOWARD—Art Administrator, Patron, Collector
 The National Gallery of Art 20565; h. 2820 P St., N.W., Washington, D.C. 20007.
B. Jackson County, Mo. Studied: University of Missouri; Washington and Lee University, LL.B. Author: "Politics of Art," 1967; Editor, "The Community and the Arts," 1964. Collection: Contemporary and Primitive Art. Positions: Trustee, Kansas City Art Institute, 1956-1962; Chairman, Missouri Council of the Arts, 1963-1965; Member, International Council, Museum of Modern Art; Assistant Administrator, National Gallery of Art; Member, Truman Library Board; Editorial Board, "Cultural Affairs."

ADDAMS, CHARLES—Cartoonist
 c/o New Yorker Magazine, 25 W. 43rd St., New York, N.Y. 10036
B. Westfield, N.J. Studied: Univ. of Pennsylvania; Grand Central Art School. Work: Contributor to New Yorker Magazine; Collections (books) of cartoons: Drawn and Evil; Addams and Evil; Monster Rally; Homebodies; Night Crawlers; Black Maria; The Groaning Board. Exhibited: MMA Print Exhibition; Mus. of the City of N.Y. (original Drawings).*

ADLER, A. M.—Art Dealer
Hirschl & Adler Galleries, 21 E. 67th St., New York, N.Y. 10021 B. New York, N.Y. Sept. 2, 1902. Studied: Yale Col.; Yale Arch. Sch.; Inst. of FA, New York Univ. Positions: Past Pres., Art & Antique Dealers Assn.; Past Pres., Confederation Internationale Negociants Objets d'Art.

ADLER, SAMUEL M.—Painter, E., L.
27 East 22nd St. 10010; h. 45 Christopher St., New York, N.Y. 10014
B. New York, N.Y., July 30, 1898. Studied: NAD. Awards: J. Henry Schiedt Memorial prize, PAFA, 1951; purchase award, Univ. Illinois, 1952 and WMAA, 1952; Audubon A. Patron's Award, 1956, medal of honor, 1960; purchase award, Staten Island Inst. of Arts & Sciences, 1962; elected Assoc. Member Center for Advanced Study, Univ. of Illinois, 1964; Ford Grant Artist-in-Residence, Krannert A. Mus. of the Univ. of Illinois, 1965; prizes, Am. Soc. Contemp. A., 1967, 1968. Work: Univ. Illinois; Munson-Williams-Proctor Inst.; Clearwater Mus. A.; WMAA; Glicenstein Mus., Safad, Israel; Butler Inst. of Am. Art; Loeb Coll., New York Univ., Norfolk Mus. A. & Sciences; Slater Mem. Mus., Norwich, Conn.; Illinois Wesleyan Univ.; Univ. of Notre Dame. Exhibited: AIC, 1948, 1952, 1957; Chicago Soc. for Contemp. Am. A., 1940, 1952; PAFA, 1948, 1951-1953; Nebraska AA, 1949, 1952, 1953; CGA, 1949; NAD, 1949, 1951; Dallas AI, 1949; Dayton AI, 1949, 1950; Univ. Illinois, 1949-1953, 1955, 1957; Des Moines Art Center, 1949, 1954; Museum of Cranbrook Academy, 1949, 1953; MMA, 1950, 1952; WMAA, 1951-1955, 1956; CAM, 1951, 1953; Norton Mus. and Gal. A., 1952, 1955; VMFA, 1954, 1956; Univ. Mississippi, 1953; Sarasota AA, 1952, 1956; Clearwater Art Center, 1953, 1956; Audubon A., 1953, 1954, 1956, 1957; Columbus Gal. FA, 1953; Los Angeles County Mus., 1945; Key West Art & Hist. Soc., 1952, 1955; Denver A. Mus., 1955, 1956; N.Y. Univ., 1955-1958; Univ. Georgia, 1949, 1953, 1954, 1956; Univ. Washington, 1952; SFMA, 1952; Stanford Univ., 1952; Woodstock AA, 1952, 1953, 1955; Jewish Mus., N.Y., 1949; Telfair Acad., 1953, 1956; Staten Island Inst. A. & Sc., 1956, 1957; DeCordova & Dana Mus., 1955; Illinois Wesleyan Col., 1955; Grand Rapids A. Gal., 1957; "75 Living Americans," France, Italy and Germany, 1956, 1957, and many others. One-man: Luyber Gal., New York City, 1948; Univ. Indiana, 1950; Louisville Art Center 1950; Mint Mus. A., 1951; Phila. A. Alliance, 1954; Borgenicht Gal., New York City, 1952, 1954; Grand Central Moderns, 1961; Retrospective, Univ. of Illinois, 1960; Babcock Gal., New York City, 1962; Krannert Mus. A., Univ. of Illinois, 1964; Univ. of Notre Dame Mus. A., 1965; Rose Fried Gal., New York City, 1965; Univ. Iowa, 1966; Univ. Georgia, 1967; Rippon College, 1968. Lectures at art associations, museums and schools. Positions: Washington Square College of Arts & Sciences, and Div. of General Education, 1948- ; Private Instruction, 1935- ; Prof. FA, New York University, N.Y.; Visiting Prof., Univ. of Illinois, 1959-60; Univ. Georgia, 1968-69.

ADLER, SEBASTIAN JOSEPH, JR.—Museum Director
Contemporary Arts Museum, 6945 Fannin St. 77025; h. 15 Knipp Rd., Houston, Tex. 77024
B. Chicago, Ill., Sept. 11, 1936. Studied: Winona State Col., B.S.; Univ. Minnesota. Member: Western Assn. A. Mus.; AAMus.; CAA; Northwood Inst. Positions: Fndr.-Dir., The Nobles County Art Center, 1958-1960; Dir., Sioux Falls Art Center, 1960-1962; Asst. Dir., 1963-1964, Dir., 1965-1966, Wichita Art Museum, Wichita, Kans.; Dir., Contemporary Arts Museum, 1966- , Houston, Tex.

ADLMANN, JAN ERNST von—Museum Director, Des.
Wichita Art Museum, 619 Stackman Dr., Wichita, Kans. 67203
B. Rockland, Me., Sept. 18, 1936. Studied: Univ. Vienna, Austria; Free Univ. West Berlin; N.Y. Univ. Inst. FA, M.A.; Univ. California, Berkeley, Ph.D. Member: AAMus.; CAA; Southeastern Mus. Conf.; Florida A. Mus. Dirs. Assn. Awards: Salzburg Austro-American Soc. Fellowship, 1960; Austrian Government Fellowship, 1961; Fellowship, Federal Republic of West Germany, 1963; Alumni Assn. Travel Grant, N.Y. Univ. Inst. FA, summer 1960. Author, Des., catalogues: "Religious Art: From Byzantium to Chagall," 1964; "Los Angeles-New York Drawings of the 1960's," 1967; "The Art of Venice," 1967; "40 Now California Painters," 1968 (co-author); "Robert Gordy," 1969. Contributor article, "The Gauguin (Carved) Coconuts," in Gallery Notes, Albright-Knox A. Gal., Buffalo, N.Y. summer, 1965. Positions: Curatorial Asst., Albright-Knox A. Gal., 1964-1965; Instr., A. Hist., State Univ. of New York, Buffalo 1965; Visiting Asst. Prof., Univ. of Colorado; Dir., Tampa Bay A. Center, Fla., 1967-1969; Dir., Wichita A. Mus., Wichita, Kans., 1969 (Sept.)- .

ADRIAN, BARBARA—Painter
304 E. 73rd St., New York, N.Y. 10021
B. New York, N.Y., July 25, 1931. Studied: ASL with Reginald Marsh; Hunter Col.; Columbia Univ. Sch. Gen. Studies. Member: ASL; Pen & Brush Cl. Awards: Altman prize, NAD, 1968. Work: Sumner Fnd.; Mayor's office, San Juan, P.R.; Butler Inst. Am. Art;

Univ. So. Illinois. Exhibited: Portland (Me.) Mus. A., 1958; Butler Inst. Am. A., 1963, 1964, 1965, 1968; New York City Festival, 1957; Workshop Gal., 1958; G Gallery, N.Y., 1955, 1959; Lane Gal., Cal., 1962, 1963; Museum Gal., Lubbock, Tex., 1962-1964; Gal. 777, N.Y., 1963; NAD, 1963; Vendome Gal., Pittsburgh, 1964, 1965; Grippi Gal., 1960, 1963; Banfer Gal., N.Y., 1964, 1965, 1966, 1969; Akron AI, 1968; Childe Hassam Fund Exh., 1968; Univ. Miami, 1967; Univ. Maryland, 1966, 1967; BMA, 1966, 1967; CGA, 1966, 1967; Silvermine Gld., 1967. Illus. for Cosmopolitan magazine. Positions: Instr., Art Workshop, Jamaica, N.Y., 1958-1959; private classes, 1960; A. Consultant to Macy, Saks and other stores, 1959-1960; Instr., Art Students' League, New York.

ADRIANI, BRUNO—Collector, Scholar, W.
Rte. 2, Box 370; h. Valley View Ave., Carmel, Cal. 93921
B. Werne, Westfalen, Germany, Aug. 18, 1881. Studied: Universities of Munich, Kiel, Berlin, Germany; studied art and aesthetics with Prof. Woelfflin and Prof. Simmel. Member: MMA (Hon.); Fellow, Cal. Palace of the Legion of Honor, San Francisco. Collection: Pre-Columbian Sculpture from Olmec to Huastec; Graphics: Durer, Rembrandt, Canaletto, Picasso, Villon, Renoir, Manet, Daumier, Goya, Cezanne, and others. Author: "Problems of the Sculptor," 1943 (and in German, Spanish and French translations, 1948, 1949, 1961); "Pegot Aering," 1945. Positions: Hd. Dept. for Art in Government, Berlin, 1923-1930; Hd., Dept. for Modern Art in Ministry for Art and Education, Berlin, 1930.

AGHA, MEHEMED FEHMY—Writer
140 W. 57th St., New York, N.Y. 10019; h. Hillview Rd., R.D. #2, Malverne, Pa.*

AGOOS, HERBERT M.—Collector
209 South St. 02111; h. 11 Kennedy Road, Cambridge, Mass. 02138
B. Boston, Mass., Dec. 12, 1915. Studied: Harvard Col., A.B.; Fine Arts Museum Course with Paul Sachs. Collection: 20th Century Modern.*

AGOSTINELLI, MARIO—Painter, S.
440 E. 79th St., New York, N.Y. 10021
B. Arequipa, Peru. Studied: In Argentina, Brazil, France and Italy. Awards: prizes, All. A. Am.; Berkshire Mus., Pittsfield, Mass.; Conn. Acad. FA, Hartford; NAC; Painters & Sculptors Soc. of New Jersey; Springfield Mus. A.; Sociedad des Artistes Escritores de Buenos Aires; Samuel Morse Medal, NAD; gold medal, Knickerbocker Artists; gold medal, Salon of Watercolor, Lima, Peru; gold medal, Rio de Janeiro; silver medal, Societe des Artistes Francaises, Paris, France. Work: Academia de Bellas Artes, Buenos Aires; Mus. Mod. A., Rio de Janeiro; Springfield (Mass.) Mus. A. Exhibited: All. A. Am.; Butler Inst. Am. Art; Conn. Acad FA; Knickerbocker A.; Miami, Fla.; NAD; NAC; Painters & Sculptors of New Jersey; New York State Expo.; Norfolk Mus. A.; Ringling Mus. A., Sarasota; Silvermine Gld. A.; Springfield Mus. A.; Berkshire Mus.; Sao Paulo Bienal. Numerous one-man exhibitions—Chicago, Detroit, Dallas, Los Angeles, San Francisco, Boston, New York City and others; also in Europe and Latin America.*

AGOSTINI, PETER—Sculptor
613 E. 12th St., 10009; h. 151 Avenue B, New York, N.Y. 10009
B. New York, N.Y., Feb. 13, 1913. Studied: Leonardo da Vinci Sch. A., N.Y. Awards: Brandeis Univ. Creative Arts Award, 1964; Longview Fnd. purchase award, 1960-1962. Work: Univ. of Texas; Univ. of Cal; Univ. of So. Cal.; Int. Ladies Garment Workers Union; WMAA. Exhibited: WMAA, 1964; Radich Gal., 1960, 1968; Richard Gray Gal., Chicago, and others. Positions: Lectures and summer courses at Columbia Univ., 1961; Wagner Col., 1968.

AHLSKOG, SIRKKA—Craftsman, T., S.
414 East 83rd St., New York, N.Y. 10028
B. Finland, Apr. 15, 1917. Studied: Suolahden Kansanopisto (Weaving School), Finland; Craft Students League, N.Y. Member: Pen & Brush Cl.; Artist-Craftsmen of New York (Bd. Memb.); Awards: Pen & Brush Cl., 1957-1961, 1963. Work: (tapestries) Atlanta AA Mus.; Norfolk Mus. Arts & Sciences. Exhibited: Pen & Brush Cl., 1957-1960, 1963; Women's Intl. Exh., N.Y.; Augusta, Ga.; Wichita AA, 1959; Craft Students Lg. Gal., 1959 (one-man); Chautauqua AA, 1959; Cooper Union Mus., 1960, 1961, 1963; Georg Jensen, Inc., 1960; Design Center, N.Y., 1960, 1962; Princeton AA, 1964; Guild Hall, East Hampton, N.Y., 1967; one-man: Winston-Salem, N.C., 1956; Norfolk Mus. A.; Manchester Inst. A. & Sc.; Columbia (S.C.) Mus. A., 1961; Atlanta AA, 1962. Position: Instr., Tapestry Weaving, Penland School of Handicrafts, 1956-1957; L., Tapestry Weaving.

AHYSEN, HARRY JOSEPH—Painter, Gr., L., E.
Art Dept, Sam Houston State College; h. 2215 Ave. P, Apt. A, Huntsville, Tex. 77340
B. Port Arthur, Tex., Sept. 6, 1928. Studied: Tulane Univ., New

Orleans; Univ. Houston, B.F.A.; Univ. Texas, M.F.A. Member: San Antonio WC Soc.; Beaumont FA Soc.; Houston A. Lg.; Texas A. Edu. Assn.; Louisiana Crafts Council. Awards: Beaumont A. Mus., 1963; Tri-State Exh., Galveston, 1962; City of New Orleans Award of Merit, 1963; Research grant into Painting with Movement and Light. Work: Univ. Texas, Austin; Big Three Welding Co., Houston; Texas Co., New York; Gulf Co., Dallas; mural, Buccaneer Hotel; Pressuer Royalties Corp., Houston; murals, Flagship Hotel, Galveston, 1967-1968; paintings, Huntsville Nat. Bank and Huntsville Savings & Loan, 1969; Brown School, Austin; cover for "The Texaco Star." Exhibited: Miss. Nat. Exh., Jackson, 1962; Juried Arts Exh., Waco, 1963; Newport, R.I., WC Exh., 1964; Witte Mem. Mus., San Antonio, 1964; DMFA, 1962, 1964; Beaumont A. Mus., 1966; Univ. Texas; Galveston A. Exh., 1962; Contemp. AA, Houston, 1964; Houston A. Lg., 1964, 1965; Laguna Gloria Mus., Austin, 1966; Bute Gal., Houston, 1966; Jewish Community Center, Houston, 1967; one-man: Newport, R.I.; Burch-Wademan Gal., Houston, 1964; Univ. Texas, 1962; Carriage House, Austin, 1962; Downtown Gal., New Orleans; Houston A. Lg., 1965; Herzog Gal., Houston, 1965; Sam Houston State College, Huntsville, 1964-65; Houston Library; Chanticleer Gal., Huntsville, 1966; Doss Music Center, Houston, 1969. Positions: Prof. Design and Painting, Univ. Texas; Orleans Parish School Distr.; Sam Houston State College, Huntsville, at present.

AKSTON, JOSEPH JAMES—Collector, Art Patron, Publisher
 Art Digest, Inc., 60 Madison Ave., New York, N.Y. 10010; h.
 Hotel Pierre, New York, N.Y. 10021 and 246 Wells Rd., Palm
 Beach, Fla. 33480
Studied: Georgetown Univ. Sch. of Foreign Service, Washington, D.C. Member: Bd. of Overseers, Brandeis Univ. (Art Program), Waltham, Mass.; Bd. of Dirs., Whitney Museum of American Art Council, New York, N.Y.; Memb. of the National Council and Trustee of the Museum of African Art, Washington, D.C.; Memb. of Four Arts Society, Palm Beach, Fla. Position: President and Editor: Arts Magazine, Art Voices Magazine, Art Digest Newsletter, New York, N.Y.

ALAJALOV, CONSTANTIN—Painter, I.
 140 West 57th St., New York, N.Y. 10019; h. Ox Pasture Rd.,
 Southampton, N.Y. 11958
B. Rostov, Russia, Nov. 18, 1900. Studied: Gymnasium, Rostov, Russia; Univ. of Petrograd. Work: BM; PMA; Mus. City of New York; MModA; Societe Anonyme; DMFA; Sterling & Francine Clark AI, Williamstown, Mass. In 1964 Syracuse University's Manscripts Collections opened a file on Alajalov's paintings, drawings, books, manuscripts, etc. Murals for S.S. "America." Completed a large composition of "The Hands of Leonard Bernstein" conducting, 1967. Sets for Michael Mordkin's Ballet and posters for many theatrical productions. Collection of paintings reproduced in "Alajalov, Conversation Pieces." Illus: George Gershwin's "Song Book"; Alice Duer Miller's "Cinderella"; Cornelia Otis Skinner & Emily Kimbrough's "Our Hearts Were Young and Gay"; Cornelia Skinner's "Nuts in May," "Bottoms Up" and others. Contributor to The New Yorker, Saturday Evening Post, Life, Vogue, Fortune, Vanity Fair, Harper's Bazaar, House & Garden, Town & Country and other national magazines. Lectured on Composition at Parsons Sch. of Des., N.Y.; Instr., Composition & Drawing at Archipenko's Ecole des Beaux Arts and Phoenix Sch. of Des., both New York City. Exhibited: nationally. One-man: Hollywood, Cal., New York City, Dallas, Tex.

ALBEE, GRACE (THURSTON) (ARNOLD) (Mrs. Percy F.) —
 Engraver, L.
 84-43 123rd St., Kew Gardens, N.Y. 11415
B. Scituate, R.I., July 28, 1890. Studied: R.I.Sch. Des.; wood engraving with Paul Bornet in Paris. Member: NA; Albany Pr. Cl.; Print Council of Am.; AAPL; Old Bergen Art Gld.; Springfield A. Lg.; Life Fellow, MMA; Audubon A.; Academic A.; Springfield, Mass.; Providence A. Cl.; Providence WC Cl.; Boston Pr. M. Awards: prizes, NAD; Providence AC; SAGA, 1951; Conn. Acad., 1955, 1958; Hunterdon County A. Center, 1958; Boston Pr. M.; Pr. Cl. of Albany, N.Y., 1959, purchase prize, 1964; medals: Audubon A.; Artists Fellowship; Grand National Gold Medal, AAPL 1961, prize 1965; R.I. Sch. Des., 1965; Providence A. Cl., 1965; Woodmere A. Gal. (Pa.), 1965; Pratt Center for Gr. A., 1966, 1968; Albany Pr. Cl. (purchase) 1967; N.Y. Univ.; 1968; Helen Gould Kennedy Award, Academic Artists, 1968. Work: MMA; Carnegie Inst.; CMA; Okla. A&M Col.; John Herron AI; R.I.Sch. Des.; LC; Nat. Mus., Stockholm; NAD; PMA; Cleveland Pr. Cl.; Marblehead AA; N.Y. Pub. Lib.; Boston Pub. Lib.; Culver Military Acad.; Nat. Mus., Israel; Coll. of King Victor Emmanuel, Italy; Melrose Pub. Lib.; Nat. Mus., Rosenwald Coll., Wash. D.C.; Frontispiece port, engr., Duc de la Rochefoucauld for "A Little Book of Aphorisms" and frontispiece for "Unicorns and Tadpoles." Exhibited: Salon d'Automne, Beaux Arts, Am. Lib., Paris: NAD, 1934-1968; AIC, 1935; PAFA, 1936, 1944; Sweden, 1937; 50 Am. Prints, AIGA, 1945, 1946, 1951; Providence AC; Albany Pr. Cl.; LC; AFA traveling exh.; CGA; Carnegie Inst.; New Jersey State Mus.; Phila. Pr. Cl., 1938-1946; CMA, 1943; MMA, 1942; England,

France, Austria, Germany, Italy, Switzerland, Israel, 1953-1958; Indonesia, Iran, Iraq, Pakistan, New Zealand, Australia, 1958-1960. Donated, in memory of Percy F. Albee, prints, drawings & pastels to Trenton, N.J. Museum and prints to Norton Museum, West Palm Beach, Fla.; oil portrait & bas relief to R.I. Mus. A.

ALBERS, ANNI—Designer, C., E., W., L., Gr.
 8 North Forest Circle, New Haven, Conn. 06515
B. Berlin, Germany. Studied: Bauhaus (Diploma), Weimar & Dessau. Awards: Gold Medal, AIA, 1961; Citation, Philadelphia Col. of Art, 1962; DABA Citation, the Decorative Arts Book Award, 1965; Fellowship, Tamarind Lithography Workshop, 1964. Work: MModA; Busch-Reisinger Mus., Harvard Univ.; BMA; Cranbrook Acad. A.; Currier Gal. A.; Kunstgewerbemuseum, Zürich; Neu Sammlung, Munich; Bauhaus Archives, Darmstadt; Memorial (commissioned) for Nazi victims, The Jewish Mus., N.Y.; BM; Victoria & Albert Museum, London. Exhibited: MModA one-man traveling exhibition, 1949-1953; other one-man: Wadsworth Atheneum, 1953; Honolulu Acad. A., 1954; MIT; BMA; Yale Univ. A. Gal.; Carnegie Inst.; Contemporary Arts Assn., Houston. Author: "Anni Albers: On Designing," 1959 2nd ed. 1962; "Anni Albers: On Weaving," 1965. Contributor to Encyclopaedia Britannica with article on Hand-weaving. Lectures: museums and universities in the U.S. and abroad.

ALBERS, JOSEF—Painter, Gr., Des., E., L., W.
 8 North Forest Circle, New Haven, Conn. 06515
B. Bottrop, Germany, Mar. 19, 1888. Studied: Royal A. Sch. Berlin; Sch. Applied A., Essen; A. Acad., Munich; Bauhaus, Weimar. Member: Am. Abstract A.; Print Council of Am.; Hon. Memb., AIGA; Nat. Inst. A. & Lets. Awards: Ada Garrett prize, AIC, 1954; William A. Clark prize, CGA, 1957; German Federal Republic, 1957, 1967; D.F.A., University of Hartford, 1958; Conrad von Soest prize, Germany, 1959; Ford Fnd. Grant, 1959; D.F.A., Yale Univ., 1962; D.F.A., California Col. A. & Crafts, Oakland, 1964; Medal, Am. Inst. Graphic Arts, 1964; Fellowship & Grant, Graham Fnd., 1962; Carnegie Inst. Technology, 1967; Grand Prix, third Biennale, Santiago, Chile, 1968; Grand Prix, Nordheim-Westfalen, West Germany, 1968; other honorary degrees: Univ. Connecticut, LL.D., 1966; Univ. North Carolina, D.F.A.; Ruhr Univ., Bochum, W. Germany, Ph.D., 1967; Univ. Illinois, D.F.A., 1969; Minneapolis A. Sch., D.F.A., 1969; Kenyon Col., D.F.A., 1969. Work: Yale Univ. A. Gal.; AGAA; CM; BM; Springfield (Mass.) Mus.; Busch-Reisinger Mus.; Munson-Williams-Proctor Inst.; Los A. Mus. A.; Pan Am. Bldg., N.Y.; NGA; Rosenwald Coll.; Graduate Center, Harvard Univ.; MMA; WMAA; Solomon R. Guggenheim Mus. A.; Corning Glass Bldg.; Time & Life Bldg., N.Y.; AIC; Wadsworth Atheneum; Portland (Ore.) A. Mus.; PMA; CGA; Univ. Michigan Mus. A.; Carnegie Inst.; Rochester Inst. Technology; Iowa State T. Col.; Brooks Mem. Gal.; BMA; MModA; Lyman Allyn Mus., and in many colleges & universities. Museu de Arte Moderno, Rio de Janeiro, Brazil and in museums in cities of Germany and Switzerland. Exhibited: North and South America, Europe, Japan, Australia. More than 100 one-man exhibitions, U.S. and abroad. Many group shows to 1965. Various group shows including Sao Paolo, Brazil, 1957; first Biennale, Mexico, 1958; Brussels Worlds Fair, 1958. Lectures extensively in leading universities, colleges and art schools including Mexico, 1949; Cuba, 1952; Chile, Peru, Germany, 1953, 1956, 1960; Hawaii, 1954; Germany, 1953, 1955, 1960. Positions: Hd. A. Dept., Black Mountain (N.D.) College; Chm., Dept. Design, Yale Univ., New Haven, Conn., 1950-1959; Visiting Critic, Yale Sch. Fine A., 1959-1960.

ALBERT, CALVIN—Sculptor, E.
 325 W. 16th St., New York, N.Y.; h. 222 Willoughby Ave., Brooklyn, N.Y. 11205
B. Grand Rapids, Mich., Nov. 19, 1918. Studied: AIC; Inst. Des., Chicago, with Moholy-Nagy; Archipenko Sch. FA. Awards: prizes, Audubon A., 1955, 1957; American prizewinner "Unknown Political Prisoner" competition, London, 1953; Haas prize, Detroit Inst. A., 1944; Fulbright Grant (Italy) 1961-62; Tiffany Fnd. Grant, 1963, 1965; Guggenheim Fellowship, 1966. Work: Detroit Inst. A.; WMAA; MMA; AIC; Univ. Nebraska; Park Ave. Synagogue, New York City; BM; Chrysler Mus.; Temple Israel, Tulsa, Okla.; Nelson Gal. A.; St. Paul's Church, Peoria. Ill. Exhibited: AIC, 1941, 1945, 1952, 1954; VMFA, 1946; Detroit Inst. A., 1945; PAFA, 1949, 1953; WMAA, 1953-1955, 1956-1957; Stable Gal., 1953-1955, 1959 (one-man), 1965 (one-man); MModA, 1953, 1954, 1956; MMA, 1952; Univ. Nebraska, 1955; Walker A. Center, 1954; Denver A. Mus., 1954; Univ. Illinois, 1957; BM, 1957; one-man: Theobold Gal., Chicago, 1941; Grand Rapids A. Gal., 1943; Puma Gal., 1944; AIC, 1945; Cal. PLH, 1946; Laurel Gal., 1950; Grace Borgenicht Gal., 1952, 1954, 1956, 1957; one-man traveling exh., 1957, to Des Moines A. Center, Univ. Michigan, Grand Rapids A. Gal., Michigan State Univ.; Retrospective exh., Jewish Mus., N.Y., 1960; Galleria George Lester, Rome, 1962 (one-man); Sculpture Biennale, Carrara, Italy, 1962. Position: Prof. of Art, Pratt Institute, Hd. of Graduate Sc. program, Brooklyn, N.Y. Co-author: "Figure Drawing Comes to Life," 1957.

ALBIN, EDGAR A.—Educator, P., L., W.
1332 South Rogers, Springfield, Mo. 65804
B. Columbus, Kans., Dec. 17, 1908. Studied: Univ. Tulsa, B.A.; State Univ. Iowa, M.A. and with Grant Wood, Philip Guston and Donald Mattison. Member: AAUP; Mo. Edu. Assn.; Delta Phi Delta; Kappa Delta Pi; Theta Alpha Phi; National Collegiate Players, Sigma Phi Epsilon and honorary AIA. Awards: Fulbright Research Scholar to India, 1954-55; panel member Seminar on American Culture, Bangalore, India, 1955. Visiting prof. Stetson Univ., Summer, 1950, 51 and 52, consultant for Monett, Mo., Title III program in the Arts, 1965-67 and Russellville, Arkansas, Title III program in Humanities, 1966-69. Exhibited: in U.S.A. since 1936. Lectured widely throughout U.S.A. and India; co-author of Humanities syllabus and Fine Arts syllabus, Univ. of Arkansas; articles in College Art Journal, Artrends (India) and numerous articles and feature stories. Positions: Prof. and Head, Dept. of Art, Southwest Missouri State College, Springfield, Mo.

ALBRIGHT, IVAN—Painter
55 E. Division St., Chicago, Ill. 60610*

ALBRIGHT, MALVIN MARR—Painter, S.
3500 Vista Park, Fort Lauderdale, Fla; 1500 Lake Shore Dr., Chicago, Ill. 60610
B. Chicago, Ill., Feb. 20, 1897. Studied: Univ. Illinois (Arch.); AIC; PAFA. Awards: Altman prize, NAD, 1942, 1962; Brower prize, 1943, M. R. French Medal, 1935, both AIC; Gold Medal, Chicago Soc. A., 1934; W. A. Clarke Award; Corcoran Silver Medal, Wash., D.C.; Palmer Mem. Prize, NAD; Dana Medal, PAFA, 1965. Member: NA; F., Royal Soc. Arts, London; Int. Inst. A. & Lets.; NSS; Phila. WC Cl.; F., PAFA. Work: CGA; Fine Arts Gal. of San Diego; Toledo Mus. A.; Butler Inst. Am. A.; Univ. Georgia; IBM; PAFA. Exhibited: NAD; WMAA; MModA; PAFA; Carnegie Inst.:CGA; AIC; CMA; Detroit Inst. A.; BM; CAM; Denver Mus. A.; SFMA; Cal. PLH; PMA; Milwaukee AI and others nationally.

ALBRIZIO, HUMBERT—Sculptor
1627 33rd St., San Diego, Cal. 92102
B. New York, N.Y., Dec. 11, 1901. Studied: BAID; New Sch. Social Research. Member: NSS; S. Gld.; Audubon A. Awards; med., NSS, 1940; prizes, Walker A. Center, 1945, 1946, 1951; Des Moines, Iowa, 1946; Denver Mus. A., 1947; Audubon A., 1947; Joslyn A. Mus., 1949; Des Moines A. Center, 1960. Work: Walker A. Center; USPO, Hamilton, N.Y.; State Univ. Iowa; Joslyn A. Mus., Worcester Mus. A.; Iowa State Teachers Col.; Univ. Wisconsin;Springfield (Mo.) Mus. A.; Montclair College (N.J.); Colby College, Watertown, Me.; WAC; Denver A. Mus; Arizona State Col.; Des Moines A. Center. Exhibited: MMA; WMAA; BM; NAD; PMA; Carnegie Inst.; PAFA; Albany Inst. Hist. & A.; AIC; Denver A. Mus.; WAC; Univ. Nebraska; VMFA; Munson-Williams-Proctor Inst.; DMFA, and others.

ALCALAY, ALBERT—Painter
c/o Krasner Gallery, 1061 Madison Ave., New York, N.Y. 10028
B. Paris, France, 1917. Awards: Guggenheim Fellowship, 1951; prize, Boston A. Festival, 1960. Work: Inst. Contemp. A., Boston; Phillips Acad., Andover, Mass.; Colby Col.; Harvard Univ.; De Cordova & Dana Mus.; MModA; Univ. Rome; Simmons Col. Exhibited: Univ. Illinois, 1955, 1957, 1959; WMAA, 1956, 1958, 1960; Inst. Contemp. A., Boston, 1960; PAFA, 1960; MModA, 1955; One-man: Krasner Gal., N.Y., 1959, 1961-1963; De Cordova & Dana Mus., 1954; Phila. A. Cl., 1951; Swetzoff Gal., Boston, 1952-1956, 1958; Pace Gal., Boston, 1961, 1962; Mickelson Gal., 1964.

ALCOPLEY, L.—Painter, Gr., Des., I., W., L.
50 Central Park West, New York, N.Y. 10023
B. Germany, June 19, 1910. Studied: In Dresden; Atelier 17, New York City. Member: Am. Abstract Artists; Groupe Espace, Paris, France. Work: MModA; National Mus. of Modern Art, Tokyo; Stedelijk Mus., Amsterdam; Musée d'Art et d'Industrie, Saint-Etienne, France; Art Museum Elath, Israel; Kunst Museum, Wuppertal, Germany; National Gallery of Art, Reykjavik, Iceland; Israel Mus., Jerusalem; Univ. A. Mus., Univ. Cal., Berkeley. Mural, Univ. of Freiburg, Germany. Exhibited: Am. Abstract Artists annually, 1948-68; Musée d'Art Moderne de la Ville de Paris, Salon des Réalités Nouvelles, Salon de Mai, Comparaisons, all Paris, France; 1953-60; Stedelijk Mus., Amsterdam, 1955, and an exhibition of textile designs (with Matisse, Picasso, Chagall and Miro), 1956; Rose Fried Gal., New York, N.Y., 1955, 1956; American and Japanese Abstract Artists in museums in Japan and Honolulu, 1955-56; International Exhibition of Stained windows at Cathedral of Louvain-Leuven, Belgium, 1958; MModA, 1962, 1963; AFA Traveling Exh., 1962-1964; Int. Watercolor Biennial, BM, 1963, and others. One-man: Passedoit Gal., 1950; U.S. State Dept., Frankfurt and Wiesbaden, Germany, 1952; Am. Cultural Centers, Kyoto and Tokyo, Japan, 1955; in museums and galleries in France, Belgium, Germany, Holland, England and Japan, 1956-1960; Louis Alexander Gal., New York City, 1962; Stedelijk Mus., Amsterdam, 1962; Oslo, Norway and Wuppertal, Germany, 1963; Byron Gal., New York City, 1964; Yamada Gal., Kyoto, 1967; Goethe House, N.Y., 1967; Israel Mus., Jerusalem, 1969. Author: "Einsichten, Drawings by Alcopley to Poems by S.E. Broese," 1959; "You Don't Say," 1962; "Alcopley - Listening to Heidegger and Hisamatsu," 1969. Books about: Ecritures - Dessins d'Alcopley," (Michael Seuphor), 1954; "Alcopley - Structures for Organ and Piano," (Otto Gmelin), 1969. Portfolios: "Structures of Travel," 1962; "Little Promenades With My Friend Will," 1967. Contributor to Cimaise (Paris), Bokubi (Kyoto), Typographica 3 (London). Leonardo (Oxford), and numerous other publications. Co-editor: "Leonardo, International Journal of the Contemporary Artist," 1968. Lectures: Chinese and Japanese Calligraphy, Stedelijk Mus., Amsterdam, 1955.

ALDRICH, LARRY—Collector, Patron
Larry Aldrich Associates, 530 7th Ave., New York, N.Y. 10018
President and Founder, The Larry Aldrich Museum of Contemporary Art, Ridgefield, Conn., with changing exhibitions of contemporary art maintains permanent sculpture park; library. Collection: Contemporary Painting and Sculpture.

ALEXANDER, ROBERT SEYMOUR—Industrial Designer, E., P.
Art Dept., Michigan State University, East Lansing, Mich.; h. 5040 Algonquin Way, Okemos, Mich. 48864
B. Pittsburgh, Pa., Feb. 1, 1923. Studied: Shrivenham Am. Univ., England; Carnegie Inst. Tech.; Univ. Illinois, B.F.A.; Cranbrook Acad. A., M.F.A. Member: Indst. Des. Soc. of America; Soc. Arch. Historians. Awards: prize, Furniture-Des. competition, New York, N.Y., 1958; other awards in design and photography. Work: Designs and design consultation for business firms and Government including ANSCO, FMC, Beaver Furniture, Capitol Storage, Michigan State Univ.; U.S. Air Force; ROTC; U.S.O.E. Instructional Materials Center for Handicapped Children and Youth; Design for Education Workshop, sponsored by CBS and Creative Playthings. Exhibited: Kresge A. Center, Michigan State Univ. 1956, 1960, 1966-1969; The Little Gallery, Birmingham, Mich., 1968; Kalamazoo Art Center. Positions: Des., Ford Motor Co., 1952-1953; Des. Consultant, 1954- ; in charge Indust. Des., Dept. of Art, Michigan State University, East Lansing, Mich., 1954- . Commissioner, Michigan Cultural Commission, 1960-1962.

ALLEN, CLARENCE CANNING—Painter, Des., I., W., L.
1645 E. 17th Place, Tulsa, Okla. 74120
B. Cleveland, Ga. Studied: Southeastern State Col., Oklahoma; ASL; San Antonio A. Acad, with Bridgman, Neilson, Arpa, Gonzalez, Guion, Steinke, Taylor and Romanovsky. Member: AAPL; NSMP; SI; The Mission Group of Artists, Tucson; Nat. Cartoonists Soc. Awards: Six national awards of Freedoms Foundation. Work: Port. of Will Rogers in Memorial Hospital, Saranac Lake, N.Y. and many other portraits and sketches of prominent Oklahomans. Designed the new World-Tribune Mechanical Bldg. and murals for same. Murals for Tulsa Press Club and Tulsa's new City Hall. Author: "Sketching"; "Tulsa Churches";"Let's Talk About You"; "Who's Who in Tulsa" 1949-51; "Are You Fed Up With Modern Art?" and other books. Contributor to national and regional publications. Exhibited: Witt Memorial Museum, San Antonio, Tex.; Philbrook Art Center, Tulsa; World's Fair, Montreal; Verona, Italy and MMA; New York. In permanent collections of Oklahoma Hist. Soc.; William Allen White Fnd., Kansas; Univ. Missouri; Univ. Mississippi; in the libraries of Presidents Eisenhower, Truman, Johnson and in many private collections.

ALLEN, COURTNEY—Illustrator, S., C.
County Rd., North Truro, Mass. 02666
B. Norfolk, Va., Jan. 16, 1896. Studied: Corcoran Sch. A.; NAD, and with Charles W. Hawthorne. Member: Provincetown AA; SI; All. A. Am. Exhibited: All A. Am.; Provincetown AA; Chrysler A. Mus.; Provincetown Historical Mus. Positions: Pres., Provincetown AA, 1956-58; Trustee, Chrysler A. Mus., Provincetown, Mass., 1960-1968; Pres., Truro (Mass.) Historical Soc., 1969.

ALLEN, LORETTA B. (Mrs. Clarence)—Painter, Des., Comm., I., T.
1645 E. 17th Place, Tulsa, Okla. 74120
B. Caney, Kans. Studied: Univ. Oklahoma with Marshall Lackey (sculpture); Grace Chadwick, Oklahoma City; Federal Arts Schs., Minneapolis; Famous Artists Schools and with Molly Guion and Dimitri Romanofsky, New York. Member: AAPL. Work: Illus. Children's books; fashion design; fashion illus. for local publications. Exhibited: Oklahoma City Art Center; Tulsa Studio Group, 1961, 1962; Osage County Historical Museum, 1969 and others.

ALLEN, MARGARET PROSSER—Educator, P.
119 Briar Lane, Newark, Del. 19711
B. Vancouver, B.C., Jan. 26, 1913. Studied: Univ. Washington, B.A., M.F.A., and with Alexander Archipenko, Amedee Ozenfant. Member:

AAUP. Awards: prize, Wilmington Soc. FA, 1949; University research grant for work on Indian architectural ornament, 1967-1968. Work: Wilmington Soc. FA; Univ. Delaware Coll. Exhibited: Wilmington Soc. FA, 1942-1945, 1947-1949, 1951, 1953-1964; Univ. Delaware, 1946 (one-man); Northwest Exh., 1938, 1941, 1943, 1945, 1947, 1948; Weyhe Gal., 1947; Rehoboth A. Gal., 1952 and group shows in Delaware area. Photographic exhibition "The Carvings of Sanchi," circulated by Smithsonian Institution for three years beginning spring of 1968. Positions: Instr. A., 1942-48, Asst. Prof. A., 1949- , Univ. Delaware, Newark, Del.

ALLEN, MARGO (Mrs. Harry Hutchinson Shaw)—Sculptor, P., L., W.
 501 Sloop Lane, Sarasota, Fla. 33577; s. Cohasset, Mass.
B. Lincoln, Mass., Dec. 3, 1895. Studied: BMFA Sch.; Naum Los Sch., British Acad., Rome, Italy. Member: NSS. Awards: prizes, (2) Delgado Mus. A. Work: Port., busts, bas-reliefs: U.S. Frigate "Constitution"; HMS "Dragon"; Cohasset War Mem.; church, Winchester, Mass.; Butler AI; CM; Mus., New Mexico, Santa Fe; Cal. PLH; Nat. Mus., Mexico; Dallas Mus. FA; First Nat. Bank, Lafayette, La.; New Iberia Bank, La.; Stanford Univ. Exhibited: NAD; PAFA; Cal.PLH; Phila. A. All.; AGAA; Paris, France, 1961; Cambridge, England, 1962; Bryna Gal., Mexico, D.F.; Misrachi, Mex.; Sarasota AA; Friends Gallery, Sarasota, Fla.; Longboat Key Art Center, Fla.; Columbia Art Museum, S.C.; Meridian Art Museum, Miss.; Manatee A. Lg.; Longboat AA, Florida; one-man: Mus. FA of Houston; Dallas Mus. FA; SAM; Joslyn A. Mus.; Currier Gal.; Clearwater A. Mus.; San Diego FA Soc.; DeYoung Mus.; Delgado Mus. A., 1953; Beaumont (Tex.) Mus. A.; Lafayette (La.) Mus. A.; AAUW, Lafayette, La.

ALLEN, PATRICIA (Patricia Burr Bott)—Painter, S., Gr., W., L.
 151 Carroll St., City Island, Bronx, N.Y. 10464
B. Old Lyme, Conn., Mar. 17, 1911. Studied: Rollins Col.; ASL, and with George B. Burr, Malcolm Fraser, Ivan Olinsky, Harry Sternberg. Member: Catherine Wolfe A. Cl.; Gotham Ptrs.; New Jersey P. & Sc.; Fndr.- Memb. Animal Artists; Bronx A. Gld.; NAC; AAPL; Nat. Lg. Am. Pen Women; Orlando AA; AEA; NAWA. Awards: med., Fla. Fed. A., 1944; prize, Gotham Ptrs. Work: Massillon Mus. A.; Riveredge Fnd. Mus., Calgary, Canada; work permanently on view at Grand Central Galleries, New York, N.Y.; Greenville (S.C.) Mus. A.; Hickory (N.C.) Mus. A.; Statesville (N.C.) Mus. A. & Sc. Exhibited: Fla. Fed. A., 1934; AEA, 1955; Riverside Mus., 1954; Yonkers Mus., 1953; NAD, 1950; Brygider Gal.; Louisiana State Graphic Exh.; Yorktown Heights, N.Y.; High Plains Gal., Amarillo, Tex.; Collectors Corner Gal., Wash. D.C.; Studio 17, Leonardo, N.J.; High Mus. A., Atlanta, Ga.; Massillon Mus. A., Ohio; Farnsworth Mus., Rockland, Me.; Greenville (S.C.) Mus. A.; Hickory (N.C.) Mus. A.; Parrish Museum, L.I., N.Y.; Soc. of Animal Artists; Dord Fitz Gal., Amarillo, Tex.; Original Graphics; Statesville (N.C.) Mus. A. & Sc; N.Y. World's Fair, 1965. One-man: Orlando, Fla. 1934; Burr Gal., 1955, 1958. Position: Dir., Burr Gallery, New York, N.Y. Innovator of Plasmics, a media of plastic, oil and collage. 2nd Vice-Pres. Soc. of Animal Artists; Bd. Member, Original Graphics; Pub. Rels. and Sales, Grand Central Galleries, New York, N.Y., at present.

ALLING, CLARENCE (EDGAR)—Museum Director, T., C.
 Waterloo Municipal Galleries, 225 Cedar St. 50704; h. 200 Parkview Blvd., Waterloo, Iowa 50702
B. Dawson County, Neb., Jan. 28, 1933. Studied: Washburn Univ., Topeka, B.F.A; Ohio State Univ., Columbus, with Edgar Littlefield; Univ. Kansas, Lawrence, M.F.A., with Sheldon Carey. Awards: Merit Award, Sioux City, 1965; purchase award, Ceramic Natl., Everson Mus., Syracuse, N.Y., 1960; prizes, Designer-Craftsman Show, Lawrence, Kans., 1959-1961. Exhibited: Ceramic Natl., Syracuse, 1960, 1962; Young Americans, N.Y., 1962; Fiber-Clay-Metal Exh., 1962, St. Paul; Decorative Arts & Ceramics, Wichita, Kans., 1958, 1960-1962; Annual Jewelry Makers, Plattsburg, N.Y., 1962; Area Artists, Sioux City, 1963, 1965; Des Moines, 1964; Midwest Designer-Craftsman, Kalamazoo, Mich., 1962; same, biennial, Omaha, 1961; Kansas Designer-Craftsman, Lawrence, Kans., 1956, 1958-1962; one-man: Mulvane A. Center, Topeka, 1963; Sioux City A. Center, 1963; 2-man: L'Atelier, Cedar Falls, Iowa, 1965. Work: Excelsior Ins. Co. of New York. Positions: Dir., Waterloo Municipal Galleries, Waterloo, Iowa, at present.

ALLOWAY, LAWRENCE—Museum Curator
 330 W. 20th St., New York, N.Y. 10011
B. London, England, Sept. 17, 1926. Awards: Second Foreign Critic's Prize, 30th Venice Biennale. Author: "9 Abstract Artists," 1954; "Ettore Colla," 1960; "Metallisation of the Dream," 1963. "The Venice Bienalle, 1895-1968," 1968; Contributor to Art News, N.Y., 1953-57; Art International, Lugano, since 1957. Arranged numerous exhibitions for Institute of Contemporary Art, London, 1954-60; at Guggenheim Museum: Francis Bacon, 1963; Guggenheim International Award, 1964. Positions: Deputy Dir., Institute of Contemporary Art, London, 1954-1960; Instr., Bennington College, 1961-62; Cur. Guggenheim Museum, New York, N.Y., 1962-1966; Prof. of Art, State University of New York at Stony Brook, 1968- .

ALONZO, JACK J.—Art Dealer, Collector
 26 E. 63rd St., 10021; h. 31 E. 12th St., New York, N.Y. 10003
B. Brooklyn, N.Y., July 3, 1927. Studied: Brooklyn College; New York University. Specialty of Gallery: Contemporary paintings, drawings, prints and sculpture. Positions: Director, Alonzo Gallery, 1965- .

ALPS, GLEN E.—Educator, Gr.
 University of Washington; h. 6523 Fortieth Ave., N.E., Seattle, Wash. 98115
B. Loveland, Colo., June 20, 1914. Studied: Colorado State College, B.A.; Univ. of Washington, M.F.A.; Univ. of Iowa (Grad. Study). Member: CAA; AFA; Phila. Print Club; Northwest Printmakers. Awards: Ford Foundation Grants, 1961, 1965; purchase awards: Pasadena A. Mus.; N.Y. State Univ. Col. at Oswego, 1968; Col. of the Pacific, Stockton, Cal., 1969; SAM; Otis AI, Los Angeles; California State College, Long Beach. Work: LC; CM; PMA; SAM; Portland A. Mus.; National Gallery, Stockholm, Sweden; Pasadena A. Mus.; Free Library, Philadelphia, Pa.; Victoria and Albert Museum, London, England; Bibliotheque Nationale, Paris, France and numerous college, university and private collections. Sculpture: Dec. fountain, Seattle Municipal Bldg; metal screen, Seattle Pub. Lib.; metal wall sculpture, Seattle Magnolia Branch Lib. Exhibited: Northwest Printmakers, 1961-1969; BM, 1962, 1964, 1966; Pasadena A. Mus., 1962, 1964; Portland A. Mus., 1964; Invitational Print Shows: Kansas City AI & Sch. of Design, 1962; Frank H. McClung Mus. A., Knoxville, Tenn., 1962; Traveling exhibition, circulated by Am. Craftsmen's Council, New York, 1962; Brooks Mem. A. Gal., 1962; Seattle World's Fair, 1962 (2); "Tamarind Artists" exhibition circulated by UCLA, 1962; "Tamarind Fellows of the Northwest," Marylhurst Col., Portland, Ore., 1963; Univ. of Puget Sound, 1963; Univ. of Oregon, 1963, 1964; Otis AI, Los Angeles, 1963; "Graphic Arts, U.S.A.," circulated by U.S.I.S. touring Russia and Eastern Europe, 1963; Cal. State College at Long Beach, 1964; Circulating exhibition by Smithsonian Institution, 1964; Univ. of Kansas, 1964; Oklahoma City A. Center, 1966, 1967; SAGA, 1967, 1968; Int. Triennial of original Colored Graphics, Grenchen, Switzerland and Frederickstad, Norway, 1967; N.Y. State Univ. Col. at Oswego, 1968; Univ. of the Pacific, Stockton, Cal., 1969; Kansas State Univ., Manhattan, 1966; Florida State Univ., Tallahassee, 1967; Assoc. Am. A., N.Y., 1968; Eastern Michigan Univ., Ypsilanti, 1968; Hofstra Univ., 1968, circulated by Pratt Center for Graphic A.; Bradley Univ., Peoria, Ill., 1968. One-man: Henry A. Gal., Seattle; Hanga Gal., Seattle; Larson Gal., Yakima Jr. Col., Washington; Panaca Gal., Bellevue, Wash.; Montana State Col.; Kittredge Gal., Univ. of Puget Sound, Tacoma; San Francisco State Col., 1966; Univ. California, 1966; Utleg Gal., Seattle, 1967. Circulating exhibition of Collagraph prints and plates, sponsored by Western Assn. Mus., 1964-. Positions: Prof. of Art, Chm. Div. of Printmaking, Univ. of Washington, Seattle, Wash., 1945- .

ALSDORF, JAMES W.—Collector, Patron
 3200 W. Peterson St., Chicago, Ill. 60645; h. 301 Woodley Rd., Winnetka, Ill. 60093
B. Chicago, Ill., Aug. 16, 1913. Studied: University of Pennsylvania, Wharton School of Finance and Commerce. Collection: Modern Drawings, Paintings and Sculpture; also, American 19th Century Trompe l'oeil School; Early Americana and Folk Art, Archaic and Classical Art. Position: Vice President, Mem. Executive Committee, Trustee, The Art Institute of Chicago, Chairman: Comm. on Oriental Art, Comm. on Primitive Art, Comm. on Exhibitions; Vice Chairman, Comm. on Buildings, Comm. on Buckingham Fund and Acquisitions; Member, Comm. on 20th Century Paintings and Sculpture, Comm. on Prints and Drawings; Member, National Comm., University Art Museum, Univ. of California, Berkeley, California; Advisory Council, Univ. Art Gallery, Univ. of Notre Dame, Notre Dame, Ind., The American Federation of Arts, Museum of Contemporary Art, Chicago, Ill., Field Museum, Chicago, Ill.; Gov. Life Member, Chicago Historical Society; Associate, Archives of American Art; Benefactor, Art Association of Indianapolis, John Herron Art Gallery. President, Alsdorf Foundation, Chicago, Ill., 1949- .

ALSTON, CHARLES HENRY—Painter, S., T.
 555 Edgecombe Ave., New York, N.Y. 10032; h. 1270 Fifth Ave., New York, N.Y. 10029
B. Charlotte, N.C., Nov. 28, 1907. Studied: Columbia Univ., B.A., M.A. Member: NSMP (Bd. Dirs.); Spiral (art organization). Awards: Dow F., Columbia Univ., 1930; Rosenwald F., 1939-40, 1940-41; grant, Nat. Inst. A. & Lets., 1958; prizes, Atlanta Univ., 1941; Dillard Univ., 1942; Joe and Emily Lowe award, 1960, Work: MMA; WMAA; Butler AI; Detroit Inst. A.; Ford Coll.; IBM; Waddell Coll., Atlanta Univ.; Jamestown (Va.) Mus. A.; Tougaloo College (Miss.); murals, Golden State Mutual Life Ins. Co., Los Angeles; Lincoln H.S., Brooklyn, N.Y.; Am. Mus. of Natural History; Harriet Tubman Schl, New York City; Perry Schneider Memorial Room, City Col., N.Y.; Harlem Hospital; portrait, Louis T. Wright Mem. Lib., Harlem Hospital, N.Y. Exhibited: MMA, 1950; WMAA, 1952-1953; PAFA, 1952, 1953, 1954; High Mus. A., 1938; BMA, 1937;

Downtown Gal., 1942; MModA, 1937, 1958, 1968; Brussels World Fair, 1958; CGA, 1938; ASL, 1950-1952; John Heller Gal., 1953, 1955, 1956, 1958; Feingarten Gal., N.Y., 1960; Gal. Mod. A., N.Y.; retrospective, Fairleigh Dickinson Univ., 1969. Illus. for leading publishers. Contributor illus. to Fortune, New Yorker, Reporter, and other magazines. Positions: Instr., ASL, New York, N.Y., 1949- ; Joe and Emily Lowe A. Sch., New York, N.Y., 1949-1957; faculty, City College, N.Y., Dept. Fine Arts; Faculty, New School for Social Research, New York City, N.Y., 1963-64; Advisory Com., Nat. Council for the Arts, 1968.

ALTMAN, HAROLD—Etcher, P., E.
 Box 57, Lemont, Pa., 16851
B. New York, N.Y., Apr. 20, 1924. Studied: ASL; Cooper Union Sch. A.; Academie de la Grande Chaumiere, Paris, France. Member: SAGA. Awards: 2 Guggenheim Fellowships, 1960-1961, 1961-1962; Nat. Acad. A.&Lets., N.Y., 1963 (cash award); Fulbright Research Fellowship, 1964-1965 and numerous other awards. Work: MModA; WMAA; BMFA; PMA; MMA; Detroit Inst. A.; CMA; AIC; Los Angeles County A. Mus.; Royal Mus. Fine Arts, Copenhagen; WAC; NGA; Wadsworth Atheneum; PAFA; Albright-Knox A. Gal., Buffalo; Milwaukee A. Center; Norfolk Mus. A.; CalPLH; Yale Univ.; Princeton Univ.; LC; Bibliotheque Nationale, Paris; Newark Mus. A.; Smithsonian Institution; Univ. Kentucky; Syracuse Univ.; N.Y. Pub. Lib. and many other collections. Exhibited: Nationally and internationally. More than 150 one-man exhs. including, AIC, 1960; SFMA, 1962; Escuela Natl. des Artes Plasticas, Mexico City, 1962; Milwaukee AI; Everson Mus. A., Syracuse, N.Y. 1969; Sagot Le Garrec Gal., Paris, France, 1968; throughout Europe, Japan, Israel and others. Position: Prof. Drawing and Painting, Pennsylvania State University, University Park, Pa. at present.

ALTMAYER, JAY P.—Collector
 75 St. Michael St. 36601; h. 55 S. McGregor St., Mobile, Ala. 36608
B. Mobile, Ala., Mar. 1, 1915. Studied: Tulane Univ., B.A. LL.B. Collection: American paintings mostly dealing with plantation life and workers; also paintings by William Aiken Walker, Sully, Rembrandt Peale, Gilbert Stuart, Severn Rosen, Jarvis, and others; large collection of precious metal and jewelled historical American presentation swords. Author: "American Presentation Swords." *

ALTSCHUL, ARTHUR GOODHART—Collector, Patron
 55 Broad St. 10004; h. 993 Fifth Ave., New York, N.Y. 10028
B. New York, N.Y., Apr. 6, 1920. Studied: Yale University, B.A. Collections: The American Eight; The Nabis and other Post-Impressionists. Positions: Trustee, Whitney Museum of American Art; Trustee, Yale University Art Gallery; Trustee, American Federation of Arts.

AMATEIS, EDMOND—Sculptor, E., W., I.
 1620 Fifth St., Clermont, Fla. 32711
B. Rome, Italy, Feb. 7, 1897. Studied: BAID; Julian Acad., Paris; Am. Acad. in Rome. Member: NA; NSS (Pres. 1942-44); University Cl., Winter Park, Fla.; A. Fellowship; Nat. Inst. A. & Let. Awards: F., Am. Acad. in Rome, 1921-1924; prizes, Arch. L., 1929; PAFA, 1933; Morris prize, NSS; Government comp. for Typhus Comm. medal; Government comp. for Asiatic-Pacific Theatre medal. Work: Brookgreen Gardens, S.C.; Baltimore & Kansas City war mems.; William M. Davidson Mem., Pittsburgh; USPO, Ilion, N.Y.; Commerce Bldg., Wash., D.C.; portraits: Hall of Am. Artists, New York; reliefs, garden sculpture, portraits, sc. groups, etc.: Buffalo Hist. Soc.; Rochester Times-Union; private estates; USPO, Philadelphia, Madison Square Branch; Acacia Life Bldg., Wash., D.C.; George Washington Univ.; Metropolitan Housing Project; Kerckhoff Mausoleum, Cal.; medal for Soc. Medalists; figure, U.S. Government Cemetery Draguignan, France; American Red Cross; "The Polio Wall of Fame," Ga. Warm Springs Fnd., Warm Springs, Ga., 1958, and many others, Illus. "Rhododendrons of the World" by David Leach. Exhibited: PAFA; NAD, 1969; NSS. Author of articles on sculpture.

AMBERG, H. GEORGE—Writer, E., L.
 University of Minnesota; h. 2208 Irving Ave., South, Minneapolis, Minn. 55405
B. Halle, Germany, Dec. 28, 1901. Studied: Univ. Munich, Kiel, Cologne, Germany, Ph.D. Member: Am. Soc. for Aesthetics; Theatre Lib. Assn.; Am. Soc. for Theatre Research; Am. Fed. of Film Societies; Creative Film Fnd.; British Film Inst.; AAUP; Int. Film Seminars (Trustee); F., Royal Soc. Arts; CAA; Soc. of Cinematologists. Author: "Art in Modern Ballet," 1946; "The Theatre of Eugene Berman," 1947; "Ballet in America," 1949; article on Ballet in Encyclopedia of the Arts; article on Ballet Design in Encyclopedia of the Dance; Contributing Ed. to Fund & Wagnall Standard Encyclopedia, 1958- ; Many articles to Graphis, Interiors, Theatre Arts, Wesleyan Univ. Press, Saturday Review, Minnesota Review and other publications. Lectures: Theatre, Art, Aesthetics, Film. Positions: Prof., Univ. Minnesota, Minneapolis, Minn. 1956- ; Prof.

Minneapolis School of Art, 1956-1963; Dir., "Louisiana Story" Study Film, under grant from the Louis W. and Maude Hill Family Foundation, 1960-1963; Producer, Dir., The "Captive Eye," six one-hour films on the art of the film, in cooperation with KYCA-TV under a grant from the above Foundation, 1963- .*

AMBROSE, CHARLES EDWARD—Painter, E., S.
 University of Southern Mississippi; h. Box 175 Southern Station, Hattiesburg, Miss. 39401
B. Memphis, Tenn., Jan. 6, 1922. Studied: Univ. Alabama, B.F.A., M.A. Member: New Orleans AA; Alabama WC Soc.; Mississippi AA; Mississippi Edu. Assn.; AAUP; South Miss. AA (Pres.). Awards: prize, New Orleans AA, 1954; Mississippi AA, 1955, 1967; Edgewater Tri-State prize, 1966, 1969; Biloxi, Miss., 1967; Sear's Regional, Hattiesburg, 1964 (2). Work: portraits, Science Hall and Lawrence Hall, William Carey College; Grace Christian School, and Latin Am. Inst., both Hattiesburg; Federal Savings & Loan, First Presbyterian Church, Hattiesburg; portrait plaques: (3) Student Union, Mississippi Southern College; large restoration for Jefferson Davis shrine (Beauvoir), Biloxi, Miss. Exhibited: New Orleans AA, 1952, 1954, 1957; Mississippi AA, 1953, 1954; Birmingham, Ala., 1949; Alabama WC Soc., 1955, 1957; one-man: Univ. Alabama, 1950; Lauren Rogers Mus., 1952, 1954; Gulf Coast A. Workshop; Meridian AA; Women's Club, Mobile, Ala., 1960; (and lecture); Gulf Coast Theatre of Arts, Gulfport, Miss., 1961; Jackson, Miss., 1964, 1968; Biloxi, Miss., 1969; Greenwood, Miss., 1969. Lecturer, Art History, Art Appreciation and Art Forms. Positions: Instr. A., University of Southern Mississippi 1950-51; Asst. Prof. A., 1951-1963, Assoc. Prof., 1963- .

AMEN, IRVING—Engraver, P., S.
 295 Seventh Ave., New York, N.Y. 10001; h. 120 E. 90th St., New York, N.Y. 10028
B. New York, N.Y., July 25, 1918. Studied: ASL; PIASch.; Acad. Grande Chaumiere, Paris; L'Accademia Fiorentina delle arti del disegno. Member: International Soc. of Wood Engravers; Audubon A; Am. Color Pr. Soc.; Boston Pr. M.; SAGA; AEA. Awards: F. H. Anderson Mem. prize, 1950; Erickson award, 1952, 1954. Work: MMA; LC; MModA; Smithsonian Inst.; U.S. Nat. Mus.; PMA; Pennell Collection; N.Y. Pub. Lib.; Bibliotheque Nationale, Paris; Bibliotheque Royal, Brussels; BMA; FMA; CM, Bezalel Nat. Mus., Jerusalem; Stadtische Mus., Wilberfeld, Germany; Victoria and Albert Mus., London; Brooks Mem. A. Gal.; CGA; deCordova & Dana Mus.; BMFA; Albertina Mus., Vienna, and in many colleges and universities. Exhibited: one-man: (1959-1961 and prior), New York City; Wash., D.C.; Pennsylvania; Cincinnati; Greensboro, N.C.; Los Angeles, Cal.; Mass.; Cape Cod; Jerusalem, Israel and in many universities. 14 International Group Exhibitions in Europe and the Far East, 1953-1958; Int. Assn. Plastic Arts; National Group shows: MModA, 1949, 1953; MMA, 1955; Univ. Illinois, 1956; Univ. Wisconsin; Art: U.S.A., New York, 1958. Annual National Group Shows: LC; BM; NAD; Phila. Pr. Cl.; Am. Color Pr. Soc.; Boston Pr. M.; Wash. Pr. M.; deCordova Mus., 1961; Audubon A.; SAGA.*

AMES, ARTHUR FORBES—Painter, C., Des., E.
 4094 Olive Hill Dr., Claremont, Cal. 91711
B. Tamaroa, Ill., May 19, 1906. Studied: Cal. Sch. FA, San Francisco, Cal. Member: Am. Craftsmen's Council. Awards: prizes, AIA (So. Cal. Br.) 1956, 1958 for distinguished decoration; Ceramic National Exh., Syracuse, N.Y., 1949, 1951, 1954; Wichita Decorative Arts Nat. Exh., 1953, 1954; Cal. State Fair, 1948, 1949, 1951; San Gabriel Exh., Pasadena Purchase Award, 1961. Work: Syracuse Mus. FA; Wichita AA; Pasadena A. Mus.; enamel panels, (24) Emanuel Temple, Beverly Hills, Cal.; Home Savings & Loan Bldg., Beverly Hills; 6 murals, No. Hollywood Presbyterian Church (mosaic, tile & enamel); Altar & Tabernacle, St. Paul the Apostle Church, Westwood, Cal.; 2 mosaic murals, Mission Valley Shopping Center, San Diego; tapestries: Garrison Theatre, Claremont (Cal.) College; California Fed. Savings. & Loan Co., Los Angeles. Exhibited: Univ. of Illinois, 1952, 1953; Smithsonian Traveling Exh., 1953, 1956, 1957; Am. Craftsmen's Exh., sponsored by State Dept., to Europe, and Asia, 1952; Brussels World Fair, 1957, 1958. Position: Prof. and Hd. Design, Otis Art Institute, Los Angeles, Cal.

AMES, JEAN GOODWIN—Designer, P., C., E.
 4094 Olive Hill Dr., Claremont, Cal. 91711
B. Santa Ana, Cal., Nov. 5, 1903. Studied: Pomona Col., Claremont, Cal.; AIC; Univ. Cal. at Los Angeles, B.E.; Univ. So. Cal., M.F.A. Awards: prizes, Syracuse Ceramic Exh., 1951; Wichita Ceramic Exh., 1952; California Fashion Creators award for ceramic achievement, 1952; AIA (So. Cal. Branch), 1956, 1958; Los Angeles Times "Woman of the Year in Art," 1958. Work: decorations in enamel, ceramics, mosaics, tapestry: Newport Harbor Union H.S.; Claremont Community Church; Emanuel Temple, Beverly Hills; St. Paul's Church, Westwood, Los Angeles; Guarantee Savings & Loan Assn., Fresno; murals: San Diego Civic Center; North Hollywood First Presbyterian Church; Rose Hills Mem. Park; Garrison Theatre, Claremont (Cal.) College;

Cal. Fed. Savings & Loan Co., Los Angeles. Exhibited: nationally. Positions: A. T., Scripps and Claremont Colleges, Cal., 1940- ; Prof. A., Claremont Graduate Sch.

AMES, LEE J.—Illustrator
44 Lauren Ave., Deer Park, N.Y. 11729
B. New York, N.Y. Studied: Columbia Univ., with Carnohan. Illustrated many juvenile books, 1947-1956, plus many text books, Golden Books, book jackets, etc. Contributor of cartoons and illus. to Boy's Life. Lectures "Book Illustration: Techniques and Methods." Author: "Draw, Draw, Draw," 1962. Positions: Instr., Cartoonists & Illustrators Sch., New York, N.Y., 1947-1948; A. Dir., Weber Assoc., 1947-52; Pres., Ames Advertising Co., New York, N.Y., 1953-54; Artist-in-Residence, Doubleday & Co., 1957-1962.

AMES, (POLLY) SCRIBNER—Painter, S., W., L.
5834 Stony Island Ave., Chicago, Ill. 60637
B. Chicago, Ill. Studied: AIC; Univ. Chicago, with Jose de Creeft, Hans Hofmann and with Schwegerle in Munich. Member: AEA; Chicago A. Cl. (Bd. Dirs.); Renaissance Soc.; Chicago AI Rental Gal. Work: Hudson Walker Gal.; Illinois State Museum (Sc.) 1961; and in private collections, in U.S. and abroad. Portrait of Cooper D. Schmitt in Schmitt Dormitory, Univ. of Tennessee, 1958; 5 panel wood carving, Univ. of Chicago H.S., 1961; ms. on Marsden Hartley in Archives Am. Art; port. of Povla Frijsh presented to Town Hall, N.Y.C., 1961; port. of Mrs. e. e. cummings, 1968; port. of Geraldine Page, hung in Martin Beck Theatre and exhibited at Poindexter Gal., N.Y., 1960; port. of Maureen Ting-Klein, costumier of Metropolitan Opera Co., 1968. Exhibited: One-man exhibitions nationally; Knoedler Gal., N.Y.; Chicago A. Cl.; MModA; Bonestell Gal., 1939; WFNY, 1939; Kalamazoo AI, 1939; Puma Gal., 1943; Creative Arts Gal., Charlottesville, Va., 1947; Carroll-Knight Gal., St. Louis, 1948, 1949; Renaissance Soc., Chicago, 1956-1965; Cromer-Quint Gal., Chicago, 1957, 1958; Chicago A. Cl., 1958; Chicago Navy Pier Jury Selection, 1958; Illinois State Fair, 1958; Poindexter Gal., N.Y., 1960; recent one-man exhibitions: Closson Gal., Cincinnati; 1961; Chicago Pub. Lib., 1961; Bresler Gal., Milwaukee, 1962; Model Rooms, Carson Pirie Scott & Co., Chicago, 1964; Carsons, Peoria, Ill. 1965; Arts Festival, McCormack Place, Chicago, 1962; Univ. of Chicago, 1962-1964; Lincoln Center, Urbana, Ill. 1968; one-man exhibitions abroad: Culture Center, N.W.I., 1947; Galerie Chardin, Paris, France, 1949; Esher-Surrey Gal., The Hague, 1950; Cercle Universitaire, Aix-en-Provence, 1950. Contributor of articles to magazines and lectures on art and artists; also on Greece, TV, Chicago, 1964.

AMINO, LEO—Sculptor, Des., T.
58 Watts St., New York, N.Y. 10013
B. Formosa, Japan, June 26, 1911. Studied: N.Y. Univ.; Am. A. Sch. Work: Grand Rapids A. Gal.; AGAA; Univ. Nebraska; Texas State Col. for Women; Des Moines A. Center; WMAA; MModA. Massillon Mus., Ohio; State Teachers Col., Muncie, Ind.; Chrysler Mus. A., Provincetown, Mass.; Olsen Fnd., New Haven., Conn. Exhibited: WFNY 1939; AIC; MMA; MModA; WMAA; PAFA; Worcester A. Mus.; Munson-Williams-Proctor Inst.; Nebraska AA; VMFA; State Univ. Iowa; Grand Rapids A. Gal.; Newark Mus.; Cranbrook Acad.; Columbus GA. FA; one-man: Montross Gal., 1940; Artists Gal., 1940, 1943; Clay Club Gal., 1941; Bonestell Gal., 1945; Sculptor's Gal., 1946-1959; Grand Rapids A. Gal., 1948; Memphis Acad. A., 1948; Decatur A. Center, 1948; Univ. Nebraska, 1949; Texas State Col. for Women, 1949; Univ. North Carolina, 1949; George Walter Vincent Smith A. Gal., 1949; Cornell Univ. 1949; Indiana State T. Col., 1950; Sculpture Center, 1951, 1952, 1954; Phila. A. All., 1951; Sculpture Center, 1957; East Hampton Gallery, New York, 1969. Position: Instr., Cooper Union A. Sch., New York, N.Y., 1952- .

ANARGYROS, SPERO—Sculptor
2503 Clay St., San Francisco, Cal. 94115
B. New York City, N.Y., Jan. 23, 1915. Studied: (Scholarship) ASL; Master Institute of United Arts, New York. Member: ASL (Life); NSS; F., Intl. Inst. A. & Lets. Awards: St. Gaudens Medal, 1934; Academic A., 1959. Work: Bas-relief Portrait of Gen. Simon Bolivar Buckner, Jr., Rotunda, State Capitol of Kentucky, 1949; Port. plaque Gaetano Merola, San Francisco Opera House, 1953; Bronze bas-relief Main Office, First Western Bank, San Francisco, 1957; Hawaii Statehood Medallion, 1959; Granite Seal of City & County of San Francisco, Hall of Justice, 1960; Port. plaque Physics Laboratory, Stanford Univ., 1962; 25th Anniversary Commemorative Medallion for Golden Gate Bridge, 1962; Heroic size port. of Benjamin Franklin for Franklin Savings & Loan Co., San Francisco, 1964; Bronze relief, lobby Crocker Bank, San Mateo; life-size bronze lions, Chinatown branch of Hong Kong Bank, San Francisco, 1967; port. bust of Dr. Jesse Carr, lobby San F. Genl. Hospital; Alaska Centennial coin, 1967; San Diego-Coronado Bay Bridge commemorative medallion, 1969. Exhibitions: NAD, 1938-1940, 1953-1956, 1959; Arch. Lg., New York, 1959; PAFA, 1940; Cal. State Fair, 1952, 1953; DeYoung Mem. Mus.,

1953, 1962-1963; San Francisco Art Festivals, 1952-1955; one-man: Houston and Corpus Christi, Tex., 1968; San Francisco, 1969; Egyptian Mus., San Jose, Cal., 1969.

ANDERSEN, ANDREAS STORRS—Educator, P.
2401 Wilshire Blvd. 90057; h. 6661 Maryland Dr., Los Angeles, Cal. 90048.
B. Chicago, Ill., Oct. 6, 1908. Studied: Carnegie Inst. Technology: Acad. di Belli Arti, Rome, Italy; AIC; British Acad. Fine Arts, Rome. Member: AAUP; CAA; NEA; NAEA; Pacific AA; Los Angeles County A. Mus. (Hon.); Univ. So. Cal. Art Gallery (Hon.); Beta Theta Pi. Awarded grant by National Foundation for the Arts and Humanities for study of certain British and European schools of art. Work: IBM; Univ. of Arizona and in private colls. Editor: Signs and Symbols in Christian Art, 1954. Exhibited: MMA; WMAA; CGA; M.H. De Young Mus., San Francisco. Positions: Prof. A. and Hd. Art Dept., 1940-1962, Dir., Univ. Art Gallery, 1949-1956, Faculty, 1935-1961, University of Arizona, Tucson; Co-Dir., Southwestern Indian Art Project, 1960-1962; Dir., Otis Art Institute, Los Angeles, Cal., 1962- .

ANDERSEN, ROBERT W.—Painter, T., C., L.
511 W. Menomonee St. 60614; h. 1651 N. Harding Ave., Chicago, Ill. 60647
B. Chicago, Ill., May 29, 1933. Studied: AIC, B.F.A.; Univ. Chicago and De Paul Univ. (concurrent); Summer School of Painting, Saugatuck, Mich. Member: Chicago Soc. A. (Pres. 1962-63, 1963-64); Renaissance Soc. of Univ. of Chicago. Awards: Broadus James Clarke Award, AIC, 1958; William H. Bartels Prize, AIC, 1960. Work: In private colls. Exhibited: Momentum Midcontinental, 1953, 1955; Artists of Chicago and Vicinity, 1958-1960; 22 Chicago Painters, Tacoma, Wash., 1963; Western Mus. traveling exh., 1964-1965. Lectures on painting and sculpture, primitive and contemporary art to art associations and organizations. Positions: Instr., History of Art, Schools of the Art Institute of Chicago; painting, Old Town Art Center, Chicago; Asst. Dept. of Museum Edu., Art Institute of Chicago, 1959-1962.*

ANDERSON, BRAD(LEY) J.—Cartoonist
P.O. Box 1418; h. 1316 York Dr., Vista, Cal. 92063
B. Jamestown, N.Y., May 14, 1924. Studied: Syracuse Univ., B.F.A. Member: Magazine Cartoonist Gld.; Newspaper Comics/Council. Work: Albert T. Reid Coll.; William Allen White Fnd., Univ. Kansas, Syracuse University Manuscripts Library, A Complete Collection of "Grandpa's Boy," original comic strips. Exhibited: San Diego Fair Fine Arts & Cartoon Exh.; Punch (British-American Exh.) 1954; Cartoon Exhibition "The Selected Cartoons of 14 Saturday Evening Post Cartoonists"; "Cartoon Americana" (Overseas Exh.) Illus. "Marmaduke," 1955 (a collection of reprints from Anderson's syndicated panel "Marmaduke"); "Marmaduke Rides Agin"; "Marmaduke Rides Again" (first printing 1968). Contributor cartoons to: Sat. Eve. Post; Look; N.Y. Times Book Review; TV Guide; Better Homes & Gardens; McCalls; Good Housekeeping, and others. "Marmaduke" internationally syndicated in daily newspapers; "Grandpa's Boy" in weekly newspapers. Book, "More About Marmaduke," 1962. Positions: A. Dir., Graphic A. Dept., Syracuse Univ., N.Y., 1950-1952.

ANDERSON, DOUG—Illustrator, Comm. A.
35 East 63rd St., New York, N.Y. 10021
B. New Hampshire, Oct. 2, 1919. Studied: New School, N.Y.; ASL. Illus.: New Yorker Magazine, Fortune, Good Housekeeping, Reader's Digest, Gourmet, Seventeen, This Week, Theatre Arts and others; New York Times, New York Herald Tribune, Saturday Review. Illus. some 40 books. Author: "How to Draw with the Light Touch"; "New Things to Draw & How to Draw Them"; "Let's Draw a Story"; "Humorous Drawing Made Easy."

ANDERSON, GUY—Painter
Box 217, La Conner, Wash. 98257
B. Edmonds, Wash., Nov. 20, 1906. Studied: Tiffany Fnd., N.Y. Awards: Tiffany Fnd. Scholarship; Award of Merit, for Art in Architecture, Seattle Chptr. AIA, 1965; Governor's Award " Man of the Year," 1969; prizes, Anacortes (Wash.) A. Festival, 1964. Work: Murals: Edmonds Pub. Library; Hilton Inn, Seattle Airport; Opera House, Seattle; work in collections: SAM; Munson-Williams-Proctor Inst., Utica, N.Y., Mus. of Victoria, B.C.; Washington State Univ. Mus.; Univ. Oregon Mus.; Tacoma A. Mus., and in private colls. Exhibited: MMA, 1952; SAM, 1953 (4-man); USIA, Europe and Asia, 1956-1957; Seattle World's Fair, 1962; Washington Governor's Invitational, 1964-1969; Anacortes A. Festival, 1963-1965; Frye Mus., Seattle, 1965; AFA, 1967-1968; and other group exhibitions in prior years. One-man: SAM, 1945, 1960; Otto Seligmann Gal., Seattle, 1954, 1957, 1959, 1963, 1965; Col. of Puget Sound, 1954; Tacoma A. Lg., 1960; Smolin Gal., N.Y., 1962; Thomas Gal., San Diego, 1962; Orris Gal., San Diego, 1962; Kenmore Gal., Philadelphia, 1963; Tacoma A. Mus., 1968.

ANDERSON, GWEN(DOLYN) (ORSINGER) —Painter, T., C., L.
1361 Wisconsin Ave., Georgetown, Washington, D.C.; h.
6520 Ivy Hill Dr., McLean, Va. 22101
B. Chicago, Ill., May 31, 1915. Studied: UCLA; Univ. Illinois, B.S.;
AIC; Norton Gal. & Sch. A.; Corcoran Sch. A. and with Eliot O'Hara.
Member: Palm Beach A. Lg.; Kiln Club of Wash. D.C.; Georgetown
A. Group; Corcoran A. Lg.; Charter Memb. Falls Church-Arlington
Br., Nat. Lg. of Am. Pen Women (Vice-Pres., 1956-58, Pres.,
1958-60, Va. State A. Chm., 1960-62); World Crafts Council; Vir-
ginia Craftsmen's Council. Awards: prizes, Norton Gal., 1946;
Metropolitan State A. Comp., 1953; Harvest Festival, Alexandria,
Va., 1953, 1955, 1957, 1958, 1961; Nat. A. Week, 1955; Georgetown
A. Group, 1955, 1956; Nat. Fed. Women's Cl., 1953, 1955; Smith-
sonian Inst., 1956, 1958, 1962, 1963, 1966; Nat. Lg. of Am. Pen
Women, 1956, 1958, 1961, 1963-1965, 1968; Md. Religious Show,
1958: Md. Art Festival, 1958; Va. State A. Show (2) 1961, 1963
(2): A. Festival, Wash., D.C. (2) 1960, 1961; Arlington A. Fes-
tival, 1959, 1960, 1961; Creative Crafts exh., Smithsonian Inst.,
1962; St. Andrews Religious Art Exh., 1964, 1965, 1967; Norfolk
Mus. A. & Sciences, 1966. Work: Am. Lg. Am. Pen Women, Wash.,
D.C. Exhibited: AIC; Norton Gal. A.; Palm Beach A. Lg.; Corcoran
Gal. A.; Washington WC Cl.; Rehoboth Cottage Tour, 1955, 1964;
NCFA, 1948, 1949, 1953-1955; Smithsonian Inst., 1956, 1958, 1960,
1961; Georgetown A. Group, 1956; Nat. Lg. of Am. Pen Women,
1956, 1958; CGA, 1957; Md. Religious Show and Md. A. Festival,
1958; Denver A. Mus., 1964; VMFA, 1963; Artists Mart, Wash. D.C.,
1962 (one-man); 20th Century Gal., Williamsburg, Va., 1968; rental
gal., Norfolk Mus. A. & Sciences, 1968-1969; World Crafts Exh.,
Lima, Peru, 1968. Recent one-man exhs.: enamels, Artists' Mart,
Wash., D.C., 1962-1966; Va. Handicrafts of Lynchburg, 1968; Gal.
Greif, Baltimore, 1969; Univ. Virginia, Charlottesville, 1969; 5-
man exh. of Virginia Enamelists, Richmond, 1966. Positions: Part-
ner, The Artists Mart, Washington, D.C. Gen. Chm., 9th Intl. Ce-
ramic Exh., Smithsonian Inst., 1963. Instr., Enameling, Thousand
Islands Museum, Summer Craft School, 1966, 1967; American Arts
Associates Craft School, Washington, D.C., 1968, 1969; Richmond
Polytechnic Craft Workshop, 1968.

ANDERSON, HOWARD BENJAMIN—Lithographer, P., Comm. A.
2725 Devon Ave., Chicago, Ill. 60645
B. Racine, Wis., June 26, 1905. Studied: Univ. Wisconsin, B.S.; AIC
with Chapin, Ritman, Kahn; CGA Sch., with Eugen Weiss. Member:
Chicago Soc. A.; SAGA. Awards: Univ. Wisconsin, 1951. Exhibited:
Univ. Wisconsin, 1950-1954; 1957; Oakland A. Mus., 1948-1952; SAM,
1949-1952, 1954; Wichita AA, 1949, 1950, 1952-1954; Joslyn A. Mus.,
1949; Phila. Pr. Cl., 1949, 1952, 1959; BM, 1950, 1953; SAGA, 1950-
1955, 1956, 1957, 1959, 1960, 1967, 1968; Bradley Univ., 1952; AIC,
1948, 1949, 1952; Denver A. Mus., 1951, 1952; PAFA, 1952, 1953,
1957, 1961; LC, 1953, 1956; SFMA, 1954; Portland (Me.) Mus. A., 1953,
1955; BMFA, 1954; NAD, 1956; Soc. Washington Pr. M., 1956-1958;
Portland (Me.) Mus. A., 1956, 1957; Washington WC Cl., 1956, 1957;
Los A. County Fair Assn., 1956; American-Japanese Print Exh., To-
kyo, 1967; Chicago A., 1957, 1958, 1963, 1966; one-man: Wustum A.
Mus., Racine, Wis.; State T. Col., Kutztown, Pa., 1957; Pr. Cl. of Al-
bany, 1960; Oklahoma Pr. M. Soc., 1959.

ANDERSON, JEREMY RADCLIFFE—Sculptor, E.
534 Northern Ave., Mill Valley, Cal. 94941
B. Palo Alto, Cal., Oct. 28, 1921. Studied: Cal. Sch. FA, with David
Park, Clyfford Still, Mark Rothko, William Hayter and Robert
Howard. Member: San F. AI. Work: Redwood sculpture, SFMA;
Pasadena Mus. A.; Univ. California Museum, Berkeley; MModA,
New York. Exhibited: San F. AA, 1948, 1949, 1951-1953, 1958, 1959,
1963; WMAA, 1956, 1964; "American Sculpture of the Sixties," Los
Angeles, 1967; "Funk Show" Univ. California, Berkeley, 1967;
"West Coast Now," Portland, Ore., Seattle, Wash., Los Angeles,
Cal., 1968; "California Sculpture," Visual Arts Gal., New York,
1969; one-man: Allan Frumkin Gal., Chicago, 1954; Stable Gal., New
York, 1954; Dilexi Gal., San F., 1960-1962; Los Angeles, 1962; Re-
trospective exhibition, SFMA and Pasadena Mus. A., 1966 and 1967.
Positions: Instr., Sculpture, San Francisco Art Institute, 1958- .

ANDERSON, JOHN—Sculptor
c/o Allan Stone Gallery, 48 E. 86th St., New York, N.Y. 10028
Exhibited: WMAA, 1964, 1966, 1968, 1969.

ANDERSON, LENNART —Printmaker, T.
877 Union St., Brooklyn, N.Y. 11215
B. Detroit, Mich., Aug. 22, 1928. Studied: AIC, B.F.A.; Cranbrook
Acad. A., M.F.A. Awards: Tiffany Fnd. Grant, 1957, 1961; Prix de
Rome, 1958-1961. Work: Detroit Inst. A.; WMAA; Hudson Co., De-
troit. Exhibited: WMAA, 1963, 1964; Boston Univ., 1964; Carnegie
Int., 1964; Silvermine Gls. A., 1963; IBM, 1963; one-man: Tanager
Gal., 1962; Graham Gal., N.Y., 1963; Nelson Gal. A., Kansas City,
1964 (2-man). Positions: Instr., Pratt Institute, Brooklyn, N.Y., at
present.*

ANDRADE, EDNA (WRIGHT)—Painter, Des., Ser., E.
415 S. Carlisle St., Philadelphia, Pa. 19146
B. Portsmouth, Va. Jan. 25, 1917. Studied: PAFA; Barnes Fnd.;
Univ. Pennsylvania, B.F.A. Member: AEA; F., PAFA; Philadelphia
Pr. Cl.; Philadelphia WC Cl. Awards: Cresson European Traveling
Scholarship (2), PAFA; Mary Butler prize, F., PAFA, 1964; Mary
Smith prize, PAFA, 1968; Eyre Medal, Philadelphia WC Cl., 1968;
Childe Hassam Fund purchase, Am. Acad. A. & Lets., 1967, 1968.
Work: PMA. PAFA; Norfolk Mus. A. & Sciences; McNay A. Inst.;
Montclair A. Mus.; City of Philadelphia; Philadelphia Pr. Cl.;
PMA; Univ. California, Berkeley; Univ. Massachusetts; BMA;
AGAA; Brooklyn Col.; LC. Commissions: Reredos: Church of the
Good Samaritan, Paoli, Pa.; mosaic mural, Columbia Branch Li-
brary, Philadelphia; banner, Westinghouse Corp.; marble intarsia
mural, Welsh Road Library, and others. Exhibited: Philadelphia A.
All. 1965; PAFA, 1961, 1963, 1969; Ft. Worth A. Center, 1965; Nat.
Council on Church Architecture, 1965; Fordham Univ., 1965; South-
ampton Col., 1966; Ohio State Univ.; Univs. of Iowa, Purdue, South-
ern Illinois, 1965-1966; Des Moines A. Center, 1966; Am. Acad. A.
& Lets., 1967, PAFA, 1968; Philbrook A. Center, Tulsa, Okla., 1968;
Am. Color Print Soc., 1968, 1969. Positions: Prof., Painting, Draw-
ing, Design, Beaver Col., Glenside, Pa., 1963-1964; Philadelphia
Col. Art, 1957- .

ANDRÉ, CARL—Sculptor
Box 540, Cooper Sta., New York, N.Y. 10003
B. Quincy, Mass., Sept. 16, 1935. Studied: With Patrick Morgan and
Frank Stella. Member: Art Workers Coalition. Awards: Nat. En-
dowment for the Arts award, 1968. Work: Brandeis Univ.; Inst. Con-
temp. A., Chicago; WAC; Haus Lange, Krefeld, Germany. Exhibited:
Sculpture of the '60s, Los Angeles and Philadelphia, 1967; Primary
Structure, New York City, 1966; Art of the Real, New York City,
1968; Minimal Art, The Hague, Dusseldorf, Paris and Berlin, 1968;
also exhibited in galleries in Dusseldorf, 1967; Munchen, 1968; Ant-
werp, 1968; Tibor de Nagy Gal., N.Y., 1965, 1966; Dwan Gal., Los
Angeles, 1968 and New York City, 1967, 1969; Blum Gal., Los Ange-
les, 1968. Lectures on Metals.

ANDREWS, BENNY—Painter, S., T., I.
31 Beekman St., New York, N.Y. 10038
B. Madison, Ga., Nov. 13, 1930. Studied: Fort Valley (Ga.) State
Col.; Sch. of the Art. Inst. of Chicago, B.F.A.; Univ. Chicago.
Awards: John Hay Whitney Fellowship, 1965-1966. Work: Norfolk
Mus. A. & Sciences; Mus. African Art, Washington, D.C.; Butler
Inst. Am. A.; Chrysler Mus., Provincetown, Mass.; Wisconsin
State Univ.; Stout State Univ. (Wis.); Hirschlorn Coll.; Later Mem.
Mus., Norwich, Conn. Exhibited: Detroit Inst. A., 1959; PAFA,
1960; Chrysler Mus., Provincetown, Mass., 1966; BM, 1963; Am.
Acad. A. & Lets., 1966; Butler Inst. Am. A., 1967; Minneapolis
Inst. A., 1968; High Mus., Atlanta, 1968; Flint Inst. A., 1968; Ev-
erson Mus. A., Syracuse, N.Y., 1969; Graham Gal., N.Y.; Forum
Gal., N.Y., 1962, 1964, 1966 (one-man); ACA Gal.; Riverside Mus.,
N.Y., 1968; New Sc., N.Y.; Brooklyn Col.; ASL; N.Y. Worlds Fair.
Illus.: "I Am the Darker Brother," 1968. Positions: Instr., Paint-
ing and Drawing, New School for Social Research, N.Y.; Queens
College, N.Y.

ANDREWS, OLIVER —Sculptor, E.
408 Sycamore Rd., Santa Monica, Cal. 90402
Studied: Univ. Southern California; Stanford Univ., B.A; Univ. Cali-
fornia, Santa Barbara, and with Jean Helion in Paris, France.
Awards: prizes, Los A. County Mus. A., 1957, 1961; Univ. California
at Los A., Research Grant, 1961-1968; Inst. Creative A., Univ. Cali-
fornia, 1963, 1967. Exhibited: Los A. County Mus. A., 1959, 1961;
Alan Gal., N.Y., 1955, 1957-1965; WMAA, 1956, 1962; Santa Barbara
Mus. A., 1957, 1959, 1968; Frank Perls Gal., Los A., 1958, 1961,
1962; Univ. California, Los A., 1959, 1963; MModA, 1959; Galerie
Grimaud, N.Y., 1960; San Jose State Col., 1960; Wadsworth Athe-
neum, 1960; Providence A. Cl., 1960; SFMA, 1960-1963, 1966; Long
Beach State Col., 1960, 1963; A. Center in La Jolla, 1960, 1961;
Univ. So. California, 1961; Municipal A. Gal., Los A., 1961; Pomona
Col., 1962, 1967; Guggenheim Mus. A., N.Y., 1962; Albright-Knox
Gal., Buffalo, N.Y., 1963; Newport Beach A. Patrons, Balboa, Cal.,
1964; David Stuart Ga., Los A., 1965(2), 1966, 1967; Los A. AA,
1965; Esther Bear Gal., Santa Barbara, 1965-1967; Los A. Valley
Col., 1964, 1965; Muncipal A. Gal., Los A., 1965, 1968; Univ. Hawaii,
1965; San Fernando Valley State Col., 1966; Univ. Calif., Santa Bar-
bara, 1966; Southwestern Col., Chula Vista, Calif., 1966, 1968;
Southern Calif. Exp., San Diego, 1967; Southern Assn. of Sculp-
tors traveling exh., 1967-1968; Calif. State Col. Los A., 1967.
One-man: Santa Barbara Mus. A., 1950, 1956, 1963; Stanford
Univ. A. Gal., 1952, 1960 (3-man); Alan Gal., N.Y., 1961, 1966
(2-man); Los A. County Mus. A., 1963; Perls Gal., Beverly
Hills, 1960, 1961; Gallery Eight, Santa Barbara, 1961; Municipal
A. Gal., Los A. 1963 (2-man). David Stuart Gal., Los A., 1967;
Palomar Col., San Marcos, 1967. Work: Sculptural lighting fixture,

Yale Univ.; bronze fountain, West Valley Professional Center, San Jose, Cal.; Stage Design: Theatre Group's "King Lear" UCLA, 1964 and Hollywood Pilgrimage Theatre, 1964; and in private collections. Lectures on sculpture at museums, schools, art, student and faculty groups and on radio, television, 1959-1969. Positions: Asst. Prof., Drawing & Sculpture, Univ. of California, Los Angeles, 1957- ; Assoc. Prof., Sculpture, San Fernando Valley State College, 1962- .

ANDRUS, J. ROMAN—Educator, Lith.
Brigham Young University; h. 1765 North 651 East, Provo, Utah 84601
B. St. George, Utah, July 11, 1907. Studied: Otis AI, with Eduard Vysekal, Roscoe Shrader; ASL; Columbia Univ., T. Col.; Brigham Young Univ., M.A.; Colorado Springs FA Center; Univ. Colorado, Ed. D. Member: Assoc. Utah A.; Utah State Curriculum Comm.; ASL; Utah Acad. A. Sc. & Let. Bd. Memb: Central Utah Arts Council 1969-- Awards: prizes, Otis AI, 1939; Brigham Young Univ., 1940-1942; Utah State Inst. FA, 1945, 1950. Distinguished Service Award, Utah Academy of Science, Arts, and Letters, 1968. Work: Utah State Capitol Coll.; Dixie Jr. Col.; Brigham Young Univ. Exhibited: Cal. State Fair, 1939; Otis AI, 1938, 1939; Assoc. Utah A., 1940-1945; Springville Exh., 1939-1955; Cedar City, 1943-1955; Dixie Jr. Col., 1939-1955. Positions: Instr. A., 1943-46; Asst. Prof. A., 1947-1952; Assoc. Prof. A., 1952-1958; Prof. A. 1958- ; Chm., A., Dept., 1954- , Brigham Young Univ., Provo, Utah; Bd. Memb., Utah State Inst. FA, 1962-65.

ANDRUS, VERA—Painter, Lith., W., T., L., I.
17 Parker St., Rockport, Mass. 01966
B. Plymouth, Wis. Studied: Univ. Minnesota; Minneapolis Inst. A.; ASL, with Boardman Robinson, George Grosz. Member: NAWA; Rockport AA. Awards: prizes, Minneapolis Inst. A., 1928; Westchester Fed. Womens Cl., 1954; Albert H. Wiggins Mem. prize, Boston Pr. M., 1954; med., NAWA, 1941; Hudson Valley AA, 1941, 1943, 1944; Rockport AA, 1957, 1961, 1962; Brockton AA, 1962. Work: MMA; Minneapolis Inst. A.; LC; Smithsonian Inst.; BMFA; Boston Pub. Lib.; Univ. Minnesota; Univ. Maine. Exhibited: WMAA; Carnegie Inst.; PAFA; AIC; MMA; Boston A. Festival, 1959; one-man: Smithsonian Inst.; Univ. Maine; Am. Mus. Natural Hist.; Rockport AA; Concord (Mass.) AA; Gulf Coast A. Center, Clearwater, Fla.; Carlisle Gal., Carlisle, Mass. Author, I., "Sea-Bird Island," 1939; "Sea Dust," 1955; "Black River; a Wisconsin Story," 1967. Positions: Formerly Staff Member, MMA, 1931-1957; T., City Col., Adult Education Program, New York, N.Y.

ANGEL, RIFKA—Painter
79-81 MacDougal St., New York, N.Y. 10018
B. Calvaria, Lithuania, Sept. 16, 1899. Studied: ASL, with Boardman Robinson; Moscow A. Acad. Member: AEA; F.I.A.L. Awards: prizes, AIC, 1933; Des. for Democratic Living Exh., 1948; Chicago A. Soc., 1934; CAM, 1945. Work: AIC; Honolulu Acad. A.; William Rockhill Nelson A. Gal.; Brandeis Univ. Exhibited: AIC, 1931, 1933, 1935, 1939; MModA., 1934; WMAA; BM; CAM; de Aenlle Gal., N.Y., 1959; one-man: Honolulu Acad. A.; Nelson A. Gal.; Findlay Gal.; Knoedler Gal.; Diana Court Gal.; Breckenridge Gal.; Carl Fischer Gal.; Roullier Gal., Chicago; ACA Gal., 1947; Van Dieman-Lilienfeld Gal., 1954 (Retrospective); de Aenlle Gal., N.Y., 1959; Park Avenue Gal., N.Y., 1963 Retrospective of 40 years work; Jason Gal., N.Y., 1965; Waddington Gals., Montreal, Canada, 1965; Galeries d'Ange, N.Y., 1965.

ANGELINI, JOHN MICHAEL—Painter, Des.
139 Pine Tree Rd., Bloomingdale, N.J. 07403
B. New York, N.Y., Nov. 18, 1921. Studied: Newark Sch. F. & Appl. A.; special studies in Europe, 1961. Member: All. A. Am.; P. & S. Soc. of New Jersey; Assoc. A. of New Jersey; New Jersey WC Soc.; AWS; Audubon A. Awards: Medal of Honor, Audubon A., 1963; Silver Medal, N.J. WC Soc., 1963; Medal of Honor, NAC, 1964; P. & S. Soc., 1964. Other awards: Art Centre of the Oranges, N.J., 1966, 1968; Morristown Mennen Show, N.J., 1966, 1968; Plainfield A. Festival, 1967; The Mall, Short Hills, N.J., 1968; Best in Show, "Art in the Park, " Paterson, N.J., 1968; Beinfang Award, New Jersey WC Soc., 1968. Work: St. Vincent Col., Latrobe, Pa.; Overlook Hospital, N.J.; Bamberger's, Newark; Bloomfield Col., Paterson Lib., Parsippany Lib., First Presbyterian Church, Livingston, all in New Jersey. Exhibited: Audubon A., 1966-1969; Watercolor, U.S.A., 1966; AWCS, 1966-1968; New Jersey P. & S. Soc., 1966-1969; All. A. Am., 1966-1968; New Jersey WC Soc., 1966-1968; N.Y. State Mus., Trenton, 1966; Barr Gal., Maine, 1967; Springfield Mus. A., Mass., 1967; Butler Inst. Am. A., 1968; Montclair (N.J.) A. Mus., 1967-1969; NAD, 1968; one-man: Bloomfield Col., New Jersey, 1968; Heritage A. Gal., New Jersey, 1967; Argus Gal., 1966. Medal of Honor Watercolor "Autumn" reproduced on cover of "Prize Winning Watercolors, Book II." Position: Art Dir., Package Design, 1950- .

ANGELO, EMIDIO—Cartoonist, P., Film Maker
1510 Crest Rd., Penn Wynne, Pa.
B. Philadelphia, Pa., Dec. 4, 1903. Studied: PMSch. Indst. A. Mem-

ber: Da Vinci All.; PAFA Fellowship; Nat. Cartoonist Soc.; American Editorial Cartoonists. Awards: PAFA European Scholarships, 1927, 1928; Da Vinci award, 1945, silver medal, 1958, 1960 and bronze medal, 1961, silver medal, 1968; Freedom Fnd. award, 1951; Charles K. Smith prize, Woodmere A. Gal., 1960; gold medal, Phila. Sketch Cl., 1969. Exhibited: PAFA; Da Vinci A. All., 1930-1952; Author of five cartoon books: "Just Be Patient"; "The Time of Your Life"; "Emily and Mabel," and others. Positions: Instr., Advanced Art Class, Samuel S. Fleisher Art Memorial, Philadelphia, Pa.; Editorial Cartoonist, the Main Line Times. Produced short color film of Alighieri's "The Inferno," 1967.

ANGELOCH, ROBERT (HENRY)—Painter
Glasco Turnpike, Woodstock, N.Y. 12498
B. Richmond Hill, N.Y., Apr. 8, 1922. Studied: ASL; Acad. FA, Florence, Italy and with Fiske Boyd. Member: ASL; Woodstock AA. Awards: McDowell Traveling Scholarship, 1951; Emily Lowe Award, 1954; Kleinert Award, 1955; Woodstock Fnd. Award, 1956; Berkshire Mus.: Warner Prize, 1955; Berkshire Eagle Prize, 1956; Tyringham Gal., 1957; Crane Award, 1963; Albany Inst. Hist. & Art: prizes, 1957, 1960, 1961, 1964; Purchase award, Woodstock AA, 1964; Jane Peterson Prize, All. A. Am., 1964; 1st prize, Springfield Mus. of FA, 1968. Work: Munson-Williams-Proctor Inst.; ASL. Ilus., Author "Rillet," "Monhegan," (Books of drawings) 1965. Positions: Supv., Woodstock Summer School, ASL., 1960-1968; Instr., Woodstock School of Art, 1968-1969; ASL, Woodstock, 1964-1969.

ANSPACH, ERNST—Collector
42 Wall St., 10005; h. 118 W. 79th St., New York, N.Y., 10024
B. Glogau, Germany, Feb. 4, 1913. Studies: Univs. of Munich, Berlin and Breslau; Breslau, Ph.D. Collection: African Tribal Sculpture. Exhibited: Museum of Primitive Art, New York, November 1967- February, 1968; University of Notre Dame, February 1968-April 1968. Fellow in Perpetuity, Metropolitan Museum of Art, New York; Fellow, University Museum, Philadelphia, Pa. General partner, Loeb, Rhoades & Co, investment bankers.

ANTHONY, LAWRENCE K.—Sculptor, P., E.
Southwestern College; h. 1666 Forrest Ave., Memphis, Tenn. 38112
B. Florence, S.C., May 27, 1934. Studied: Washington & Lee Univ., A.B.; Univ. of Georgia, M.F.A. Work: Sc., Gibbes Mus. A., Charleston, S.C.; Univ. So. Carolina, Columbia; Columbia College, Columbia, S.C.; Arkansas State College, Jonesboro; Southwestern College, Memphis, Tenn.; Florence Mus., Florence, S.C.; Mississippi State Col. for Women; U.S. Embassies in Bern, Switzerland and Tokyo, Japan; Univ. Georgia, Athens; Brooks Mem. A. Gal., Memphis; Jewish Community Center, Memphis. Positions: Assoc. Prof. Art (Sc. & Hist. of Art), Southwestern College, Memphis Tenn.

ANTONAKOS, STEPHEN—Sculptor
435 W. Broadway, New York, N.Y. 10013
B. Greece, Nov. 1, 1926. Studied: BM Sch. A. Work: WMAA (Lipman Fnd.); Larry Aldrich Mus., Ridgefield, Conn.; Finch Col. Mus., N.Y.; Miami Mus. Mod. A.; Univ. Maine; Milwaukee A. Center; Weatherspoon A. Gal., Univ. North Carolina, and in private colls. Exhibited: Miami Mus. Mod. A., 1958; Martha Jackson Gal., N.Y., 1960; Allan Stone Gal., 1961, 1962, 1964; Byron Gal., 1963, 1964; PVI Gal., N.Y., 1964, 1965; Visual Arts Gal., 1965; WMA, 1965, 1967; Van Bovenkamp Gal., 1965; Finch Col. Mus., 1966; WMAA, 1966 (2), 1968, 1969; Westmoreland County Mus., Greensburg, Pa., 1966; Stedelijk Mus., Eindhoven, Holland, 1966; Nelson Gal. A., Kansas City, Mo., 1966; Flint Inst. A., 1966; BM A. Sch., (Faculty Exh.) 1966, 1968; Georgia Mus. A., Athens 1967; N.J. State Mus., Trenton, 1967; Los A. County Mus., 1967; PMA, 1967; Carnegie-Mellon Mus., Pittsburgh, 1967; Newark Col. Engineering, 1968; AFA traveling exh., 1968; Univ. North Carolina, 1968; R. I. Sch. Des., 1969; UCLA A. Gal., 1969; one-man: Univ. Maine, 1958; Avant-Garde Gal., N.Y., 1958; Byron Gal., 1964; Miami Mus. Mod. A., 1964; Schramm Gal., Ft. Lauderdale, Fla., 1964; Fischbach Gal., N.Y., 1967-1969. Positions: Instr., Painting and Sculpture, Univ. North Carolina, Greensboro; Yale Univ. Seminars.

ANTREASIAN, GARO ZAREH—Painter, Lith., E., L.
1300 Morningside Dr., Albuquerque, N.M. 87110
B. Indianapolis, Ind., Feb. 16, 1922. Studied: John Herron AI, B.F.A. Awards: prizes, MModA, 1953; Bradley Univ. Prints, 1955; William Rockhill Nelson Gal.; Prints & Drawings Exhs.: Wichita AA; DMFA; Olivet Col., 1966-1967; Albion Col.; Northern Illinois Univ.; N.Y. State Univ. at Potsdam, 1968; Nat. Lithography Exh., Univ. of Fla., 1969. Work: U.S. Coast Guard, New London, Conn.; Herron AI; Phila. Pr. Cl.; Bradley, Indiana, Syracuse, Florida State, Michigan, So. Illinois; Notre Dame, and Minnesota universities; Smith, Albion, and Reed colleges; Ill. Inst. Tech.; U.S. Embassy Coll.; Indiana State Office Bldg.; Indiana Nat. Bank; BMFA; PMA; NGA; BM; LC; Guggenheim Mus.; MModA; MMA; SAM; Los A. Mus.

A.; DMFA; Smithsonian Inst., and others. Exhibited: Indiana A. Cl., 1950, 1953; Life Magazine exh., MMA, 1950; AFA traveling Exh., 1950-1952, 1953; BMFA; PMA; N.Y. Pub. Lib.; USIA European traveling exh., 1959, 1963, 1964 (2); Art:USA, 1959; Print Council, 1959, 1960; SAM; Western Mich. Univ.; LC; Peabody Col.; The White House, Wash., D.C., 1966; Temple Univ.; Otis AI; Eastern Mich. Univ.; Hofstra Univ., N.Y., 1967; Univ. Kentucky, 1969; SFMA, 1968; MModA, 1969; one-man: Tulane Univ.; Notre Dame; Stephens Col.; Kalamazoo AI; Swope A. Gal., 1962; Purdue Univ., 1963; Little Rock A. Center, 1964; Prints in UNESCO traveling exh.; Washburn Univ.; Sheldon Mem. Gal.; Univ. Nebraska, 1967; Martha Jackson Gal., N.Y., 1969. Positions: Tech. Dir., Tamarind Lithography Workshop, Los Angeles, Cal., 1960-61; Prof., Dept. Art, Univ. of New Mexico, Albuquerque, N.M.

ANUSZIEWICZ, RICHARD J.—Painter
R.F.D. Frenchtown, N.J. 08825
B. Erie, Pa., May 23, 1930. Studied: Cleveland Inst. A.; Kent State Univ., B.S. in Edu.; Yale Univ., M.F.A. Work: Akron A. Inst.; Allentown (Pa.) A. Mus.; Albright-Knox A. Gal., Buffalo; AIC; CMA; CGA; MModA; WMAA; Yale Univ.; Butler Inst. Am. A. Exhibited: Tate Gal., London, 1964; Janis Gal., N.Y., 1964, 1965; Pollock, 1967; Univ. Illinois, 1961, 1963; N.Y. Univ., 1961; PAFA, 1962; WMAA, 1962 (traveling), 1963; Univ. Minnesota, 1962; Silvermine Glad. A., 1962, 1963; Allentown A. Mus., 1963; De Cordova & Dana Mus., Lincoln, Mass., 1963; MModA traveling exh., 1963-1964; Washington Gal. Mod. A., 1963; Carnegie Int., 1964.*

APGAR, NICOLAS ADAM—Painter, Lith., T.
Virginia Commonwealth University, 901 W. Franklin St., 23220; h. 2207 Buford Rd., Richmond, Va. 23235
B. Gaillon, France, Dec. 8, 1918. Studied: Syracuse Univ., M.F.A. Member: Albany A. Group. Exhibited: Albany State T. Col., 1958 (one-man); Munson-Williams-Proctor Inst., Utica, 1957, 1958; Syracuse Mus. A., 1959-1961; Cooperstown, N.Y., 1961; Norfolk Mus. A., 1963; Ball State T. College, 1964; Butler Inst. Am. Art, 1964. Work: Syracuse Univ., Munson-Williams-Proctor Inst; Fresco, State Univ. of N.Y. at Syracuse, Medical collection. Positions: Instr., A & Anatomy, Syracuse Univ., 1960, 1961; F., Univ. of Virginia (Asian Studies) 1964; Asst. Prof. Design, Academic Services Division, Virginia Commonwealth University at present.

APOSTOLIDES, ZOE—Painter
c/o Capricorn Gallery, 11 W. 56th St., New York, N.Y. 10019
Studied: Cal. Sch. FA, San Francisco; Univ. California, Berkeley; N.Y. Univ., Inst. FA; ASL; Hans Hofmann Sch. A. Work: In private colls., U.S. and abroad. Awards: prizes, Virginia Artists Mart Gal., 1957; BMA, 1958, 1959; Virginia Intermont Col., 1958; Exhibited: San Francisco A. Festival, 1955; Kanegis Gal., Boston, 1955; Boston Indp. A., 1956; Virginia Artists Mart Gal., Washington, D.C., 1957; Pittsburgh Plan for Art; BMA; Virginia Intermont Col., 1958; BMA, 1959; AFA, 1959; Howard Univ., 1959; City Center Gal., N.Y., 1960; Artists Gal., N.Y., 1961; Allan Stone Gal., N.Y., 1962; Sindin Gal., Hartsdale, N.Y., 1963; Inst. Contemp. A., Boston, 1963; Bridge Gal., N.Y., 1964, 1965; Chelsea A. Festival, N.Y., 1965; Hilton Hotels A. Gal., New York and Athens, Greece, 1965; MModA, lending coll.; Pittsburgh Plan for Art, 1965; Hartford Arts Fnd., 1966; Palma de Mallorca and Corfu, 1967; one-man: Beryl Lush Gal., Provincetown, Mass., 1954; Tivoli Gal., Canal Zone, Panama, 1956; Panama City, 1957; Origo Gal., Washington, D.C., 1959; Nova Gal., Boston, Mass., 1961; Bridge Gal., N.Y., 1963; Town Wharf Gal., 2-man, 1965; Capricorn Gal., N.Y., 1966, 1969.

APPEL, KEITH KENNETH—Painter, Pr.M., E.
4705 Malibu Dr., Anchorage, Alaska 99503
B. Bricelyn, Minn., May 21, 1934. Studied: Mankato State College, Minn., B.A., B.S., M.S. Member: Alaska A. Gld (Pres.); NAEA (State Rep.). Awards: Landkammer Juried Show, Mankato, Minn., 1960; Fur Rendezvous Exh., Anchorage, 1961-1965; Alaska Centennial, 1967. Exhibited: Landkammer Show, 1960; Fur Rendezvous, 1962-1965; All Alaska Exhibition, 1961, 1964-1969; Festival of Music, 1963-1967; Alaska Centennial, 1967; one-man, 1964, 1965. Positions: Instr. Art, East High School, Anchorage, Alaska. Art Consultant, Anchorage School District, 1968-1969.

ARAKAWA, SHUSAKU—Painter
c/o Dwan Gallery, 29 W. 57th St., New York, N.Y. 10019; h. 124 W. Houston St., New York, N.Y. 10012*

ARBEIT, ARNOLD A.—Painter, E., C., I., S., W., L.
116 Fox Meadow Rd., Scarsdale, N.Y. 10583
B. New York, N.Y., Oct. 1, 1916. Studied: BAID; Columbia Univ.; N.Y. Univ., B.Arch. M.Arch., M.A.; MIT; Georgetown Univ., and with Hale Woodruff, William Armstrong, Lloyd Morgan. Member: AIA; N.Y. Soc. Arch.; NIAE (Vice-Chm. & Trustee) CAD. Awards: Armstrong Mem. medal; N.Y. Soc. Arch., 1967. Work: Columbus

(Ga.) Mus. Arts & Crafts, Exhibited: N.Y. Univ. traveling exh., 1950-52; CAD, 1951, 1952; Laurel Gal., 1949; Isaac Delgado Mus. A., 1945; Tucson A. Exh., 1949; BM, 1942, 1948; NAD, 1942, 1943; N.Y. Univ., 1948-1952; one-man, NYC, 1960, 1966; Scarsdale, N.Y., 1963-1965, 1967-1969. Contributor to Architectural Forum; Museum News. Lectures on Art and its Relation to Architecture. Lobby paintings & sculpture in several public buildings, New York City. Positions: Instr. & Cr., Senior Arch. Des., The Cooper Union, New York, N.Y., 1947-1967; Vice-Pres., NYU Alumni Assn., Sch. of Arch. & Fine Arts; Prof. Arch., City Univ. of New York, City College. Col., U.S. Army Res. Civil Affairs; Fine Arts, Munuments & Archives, Chief; Exh., Art Schools U.S.A., 1953; Dir., Col. Programming Service, 16 N.Y.C. colleges, 1967- .

ARENBERG, ALBERT L.—Collector
20 N. Wacker Dr., Chicago, Ill. 60606; h. 1214 Green Bay Rd., Highland Park, Ill. 60035
B. Des Moines, Iowa, Nov. 16, 1891. Studied: Illinois Institute of Technology, B.S., E.E. Collection: Includes works by Miro, Giacometti, Soulages, Kline, and others.

ARKUS, LEON ANTHONY—Museum Director
Museum of Art, Carnegie Institute, 4400 Forbes Ave.; h. 420 Coventry Rd., Pittsburgh, Pa. 15213
B. New Jersey, May 6, 1915. Exhibitions and Collections arranged: "Exotic Art from Ancient and Primitive Civilizations" (1959); "Retrospective Exhibition of Paintings in Pittsburgh Internationals (1958); "Paintings by Alberto Burri" (1957); "Paintings from the Fifties" (AFA, 1964-1965); "Tour of Paintings and Drawings by Vincent Van Gogh" (1962-63); "Pittsburgh Collects" (1963); "Three Self-Taught Pennsylvania Artists: Edward Hicks, John Kane, Horace Pippin" (1966); "Five Years of Collecting" (1967); "Retrospective Exhibition of Paintings, Watercolors, and Drawings by Carl-Henning Pedersen" (1968); "Sculpture We Live With" (1968); "The Discerning Eye" (1969); "Art of Black Africa" (1969); print exhibitions and one-man shows. Member: Associated Artists of Pittsburgh (Hon.); American Association of Museums; AAID (Hon.); Pittsburgh Council for the Arts; Advisory Committee for School of Contemporary Arts, Northwood Institute, Cedar Hill, Texas. Positions: Director, Museum of Art, Carnegie Institute, Pittsburgh, Pa.; Board of Governors, Pittsburgh Plan for Art (1958-); Executive Committee, Three Rivers Arts Festival.

ARMSTRONG, ROGER—Painter, Cart., W., L., T.
483 Jasmine St., Laguna Beach, Cal. 92651
B. Los Angeles, Cal., Oct. 12, 1917. Studied: Pasadena City Col.; Chouinard A. Inst. Member: Cal. Nat. WC Soc.; Laguna Beach AA (Life); Los Angeles AA. Awards: prizes, Orange County A. Exh., 1963; purchase prize, Pio Pico A. Festival, Pico Rivera, Cal. Work: City of Santa Fe Springs, Cal.; City of Pico Rivera. Cartoonist: "Ella Cinders," United Feature Syndicate, 1950-1960; "Napoleon and Uncle Elby," Times Mirror Syndicate, 1951-1961. Exhibited: Cal. Nat. WC Soc., Annual and Traveling, 1964-1969; FA Gal. of San Diego, 1965, 1966; Long Beach A. Mus. traveling, 1964-1966; All-City Exh., Laguna Beach AA, 1966-1968; Festival of Arts, Laguna Beach, 1963-1967 Lectures: History of Cartooning. Arranged exhibitions: "West Coast Figurative," 1964; First Annual West Coast Sculpture Exhibition, 1964; Three Man Exhibition - Keith Finch, Edgar Ewing, Robert Frame-, 1963, and others.

ARNASON, H. HARVARD—Art Historian
1075 Park Ave., New York, N.Y. 10028
B. Winnipeg, Man., Canada, April 24, 1909. Studied: Univ. Manitoba; Northwestern Univ., B.S., M.A.; Princeton Univ., M.F.A. Member: AAUP; Archaeological Inst. of Am.; CAA; AAMus; AFA (trustee); T. B. Walker Foundation (Trustee); Solomon R. Guggenheim Foundation (Trustee). Awards: Fulbright Fellow, 1955-56, Chevalier de l'Ordre des Arts et des Lettres, République de France. Positions: Instr., Dept. Art, Northwestern Univ., 1936-38; L., Frick Coll., 1938-42; Senior Field Rep., OWI, Iceland, 1942-44; Asst. Deputy Dir. for Europe, OWI, 1944-45; Actg. Chief, Program Planning and Evaluation Unit, Office of International Information and Cultural Affairs, Dept. of State, 1946-47; Alternate U.S. Representative, Preparatory Comm. of UNESCO, London and Paris, 1946; Tech. Adv. to U.S. Delegation, First General Conference of UNESCO, Nov., Dec., 1946; Visiting Assoc. Prof., College of the Univ. of Chicago, 1947; Prof. and Chm., Dept. of Art, Univ. of Minnesota, 1947-1960; Dir., Walker Art Center, Minneapolis, Minn., 1951-60; Carnegie Visting Prof., Univ. of Hawaii, 1959; Vice President for Art Administration, The Solomon R. Guggenheim Foundation, 1960-1969. Author: Books, monographs, articles on Stuart Davis, Philip Guston, Conrad Marca-Relli, Jacques Lipchitz, modern sculpture, Jean-Antoine Houdon, etc., articles on early Christian art, 18th century and modern art. Recent books: Alexander Calder (with Pedro Guerrero), 1966; History of Modern Art, 1968; Alexander Calder (with Ugo Mulas), 1969.

ARNEST, BERNARD PATRICK—Painter
c/o Kraushaar Gallery, 1055 Madison Ave., New York, N.Y. 10022
B. Denver, Colo., Feb. 19, 1917. Studied: Colorado Springs FA Center. Awards: Guggenheim F., 1940; Chief, War Artists, Hist. Sec., ETO, 1944-45; State Dept. grantee, Afghanistan, 1960. Member: AEA; Assn. Univ. Prof. Work: War Dept. Permanent Coll.; Minneapolis Inst, A.; Univ. Georgia; WAC; Fla. Gulf Coast A. Center; Univ. Nebraska; Colo. Springs FA. Center. Exhibited: WMAA, 1948-1951; CGA; Carnegie Inst., 1952; Univ. Minnesota, 1951; Univ. Nebraska; PAFA; Univ. Illinois; WAC; Toledo Mus. A.; Des Moines A. Center; one-man: SFMA; Univ. Minnesota; Colorado Springs FA Center, and others. Positions: Instr., Minneapolis Sch. A., 1947-49; Assoc. Prof. A., Univ. Minnesota, 1949-1957; Prof., Hd. Sch. A., Colorado College & Colorado Springs A. Center, 1957- .

ARNHEIM, RUDOLF—Educator, W.
Carpenter Center for the Visual Arts, Harvard University, 19 Prescott St., Cambridge, Mass. 02138
B. Berlin, Germany, July 15, 1904. Studied: Univ. Berlin, Ph.D. Member: CAA; Am. Soc. for Aesthetics; Am. Psychological Assn. Awards: Guggenheim F., 1941, 1942. Contributor to Journal of Aesthetics; Psychological Review; "Aspects of Form"; "Poets at Work"; "Essays in Teaching"; "Education of Vision," and others. Author: "Art and Visual Perception"; "Film As Art," 1957; "Picasso's Guernica," 1962; "Toward a Psychology of Art," 1966. Positions: Visiting Prof., New School for Social Research, New York, N.Y., 1943-1968; Former Pres., Division on Aesthetics, Am. Psychological Assn.; Prof., Psychology of Art, Sarah Lawrence College, Bronxville, N.Y., 1943-1968; Carpenter Center for the Visual Arts, Harvard Univ., Cambridge, Mass., 1968- .

ARNHOLD, MR. AND MRS. HANS—Collectors
Ritz-Tower Hotel, Park Ave. at 57th St., New York, N.Y. 10022*

ARNOLD, NEWELL HILLIS—Sculptor. C., E.
Monticello College, Godfrey, Ill. 62035; h. 1412 Shands Court, Kirkwood, Mo., 63122
B. Beach, N.D. Studied: Univ. Minnesota, B.A.; Minneapolis Sch. A.; Cranbrook Academy, with Carl Milles. Member: St. Louis A. Gld.; Sculptors Gal., St. Louis; Professional Artists Assoc. of St. Louis. Work: Walker A. Center; Monticello Col.; St. Patrick's Church, Walnut, Kans.; monument for fountain, Westport Indst. Recreation Center, St. Louis; Wood Carving for Visitors Center at Jefferson National Expansion Memorial,St. Louis; Hand of God for fountain, Madison, Wis.; Racine Pub. Lib.; Univ. Minnesota; Minn. Dept. Health; World War II Mem.,St. Louis; St. Anne's Church, Normandy, Mo.; Ressurection Church, Bishop DuBourg H.S., Aquinas H.S., Ladue Jr. H.S., St. Louis; Rockhurst Col., Kansas City; Large Statues of Christus Rex at Lutheran Churches of St. Louis & Florissant, Mo.; St. Mary's Church, Hannibal, Mo.; Cardinal Ritter's Chapel & Garden, St. Louis, Mo.; Interparish H.S., Jefferson City, Mo.; Presbyterian Church, Alton, Ill.; Presbyterian Church, Normandy, Mo.; St. Joseph's Hospital, St. Paul, Minn.; Adolphus Gustavus Lutheran Church, St. Paul, Minn. and private commissions for homes and gardens. Exhibited: Arch. Lg., 1937; WFNY 1939; CAM; Wichita, Kans.; A. Gld.; Plastic Exh.—U.S.A., in Russia, 1960; Contemp. Religious Art, Birmingham, Mich., 1961; Natl. Church Architectural Conf. (2nd award), 1960; Nat. Ecclesiastical A. Exh., Chicago, 1965. Positions: Prof. of Sculpture & Ceramics, Monticello College, Godfrey, Ill., 1938- .

ARNOLD, PAUL B.—Educator, P., Gr.
Allen Art Museum; h. 396 Morgan St., Oberlin, Ohio 44074
B. Taiyuanfu, China, Nov. 4, 1918. Studied: Oberlin Col., A.B., M.A.; Univ. Minnesota, M.F.A. Member: CAA; Oberlin City Public Arts Com.; Midwest Col. A. Conference. Work: Allen A. Mus.; Canton AI; SAM; LC; Univ. Minnesota; Butler Inst. Am. Art; CMA; Wadsworth Atheneum, Hartford, Conn.; BMA; Dayton AI; Brooks Mem. A. Gal.,Memphis;De Pauw Univ. A. Center. Awards: F., Faculty Fellowship Program, Ford Fnd., 1951-52; purchase prizes, Canton AI, 1951; Joslyn A. Mus., 1952; LC, 1953; Print Exh., Dallas, Tex.; Dayton AI, 1959, 1960; De Pauw Univ., 1961; prizes, Audubon A.; Canton AI, 1955; Audubon A., prize, 1956, medal, 1957; Grant, Great Lakes Colleges Assn., 1965-66. Exhibited: Portland Soc. A., 1948, 1951, 1953; Ohio WC Soc., 1949-1952, 1956; Midwest A., 1950; Canton AI, 1951, 1953, 1955, 1959; Butler AI, 1952; SAGA, 1951, 1953, 1954, 1957, 1959, 1960; Joslyn A. Mus., 1952; Am. Color Pr. Soc., 1952, 1957; Northwest Pr. M., 1952, 1953, 1957; LC, 1952, 1954; Phila. Pr. Cl., 1952; Audubon A., 1953-1955, 1956, 1957, 1959, 1967; Ohio Pr. M., 1953, 1955-1960, 1963; Albany Pr. Cl., 1953, 1955; Massillon Mus. A., 1953; Ohio State Univ., 1953, 1956 (one-man); Denison Univ., 1954; Youngstown, Ohio, 1954; Dallas, Tex., 1954; Bradley Univ., 1955; Ohio WC Soc., 1956; Phila. A. All., 1957; Silvermine Gld. A., 1958; Pasadena A. Mus., 1958; Pratt Contemporaries, N.Y., 1959; CMA, 1961, 1963, 1966; Women's City Cl.,

Cleveland, 1959; Wise Gal., 1960; N.Y.U., 1960-61; Mansfield, Ohio, A. Gld., 1961, 1963; Soc. Washington Pr. M., 1964; Ohio Univ., 1964; Olivet Col., 1964; Jewish Center, Columbus, Ohio, 1964, 1969; One-man: Lafayette (Ind.) AA, 1959; Allen A. Mus., Oberlin, 1967, 1968; Purdue Univ., 1959; Univ. Montana, 1959; Bluffton Col., 1960; Jersey City State Col., 1966; Mount Hermon (Mass.) Sch., 1967; Northfield (Mass.), 1967; Mayfair Gal., Cleveland, 1967; Col. of Wooster, 1967; Lorain County Community Col., 1968; Miami Univ., Oxford, Ohio, 1968; Laurel Sch., Cleveland, 1969. I., "General Chemistry," 1955: "Laboratory Experiments in General Chemistry," 1955; Co-author, "The Humanities at Oberlin," IGAS, 1956-57. Positions: Prof. FA, Oberlin College, Oberlin, Ohio, 1941-42, 1946-51, 1952-1956; Assoc. Prof., 1956-1959, Prof., 1959- ; Acting Chm., Dept. A., 1967-1968; Dir., Oberlin Col., East Asian Language and Area Studies Center, 1967-1968; Member, Oberlin City Council; Chm., City Hall Bldg. Com., 1968; Peace Corps Training Program Project Director, 1964, 1965.

ARNOLD, RICHARD R.—Designer, P., E.
Design Division, Minneapolis School of Art, 200 E. 25th St.; h. 4419 Fremont Ave., S., Minneapolis, Minn. 55409
B. Detroit, Mich., July 14, 1923. Studied: Southwestern Univ.; Wayne Univ., B.F.A.; Cranbrook Acad. Art, M.F.A., with Zoltan Sepeshy; Tulane Univ.; Univ. Michigan. Member: CAA; Work: Cranbrook Mus. A.; Northwestern Nat. Life Ins. Coll.; mural, Essex Bldg., Minneapolis; Des. for: Chrysler Corp.; American Motors; General Mills Coll.; General Electric; American Standard; General Motors; Ford Motor Co.; Michigan Bell Telephone Co.; Xerox, etc. Exhibited: AFA "Communication Through Art," Pakistan, Turkey, Iran; White Mus., Cornell Univ. 1956 (one-man); Univ. Wisconsin, 1950 (one-man); CalPLH, 1960; other exhs. in Detroit, Mich.; Madison, Wis.; Chicago, Ill.; New York City; San Francisco, Cal.; Ithaca, N.Y.; Rochester and Syracuse, N.Y. and others. Lectures: "Mass Production and Architecture," Univ. Toronto, Canada; "Interior Architecture," Univ. Massachusetts. Positions: Instr., Univ. of Wisconsin, 1948-1951; Asst. Prof., Cornell Univ., 1953-1956; Asst. Prof., San Jose State College, 1958-1960; Assoc. Prof., Rochester Institute of Technology, 1960-1964; Prof., Head, Design Division, Minneapolis School of Art,Minneapolis, Minn., 1964- . Visiting Professor Summer 1968 Univ. of Victoria, B.C.

ARON, KALMAN—Painter
921 N. Westmount Dr., Los Angeles, Cal. 90069
B. Riga, Latvia, Sept. 14, 1924. Studied: Acad of Art., Riga; Acad. FA, Vienna, B.A. Member: Los A. AA. Awards: Ahmanson Award, Bronze Medal, Los Angeles County Museum, 1962. Work: CGA; La Jolla Mus. A. Port., Henry Miller, Chancellor Spieth, Univ. of California, Riverside, Cal. Exhibited: Denver A. Mus., 1960; Los A. County Mus., 1956; Mus. FA of Houston, 1962; CalPLH.; O'Hana Gal.. London, 1963; Feingarten Gal., Los Angeles, 1964.

ARONSON, BORIS—Painter, Des., S., Gr., I., W., C.
310 W. 86th St. 10024; h. 1 West 89th St., New York, N.Y. 10024
B. Kiev, Russia, Oct. 15, 1900. Studied: in Russia, Germany, France; State A. Sch., Kiev; Sch. of the Theatre, Kiev, with Alexandra Exter; Herman Struch, Berlin; special training with Ilya Mashkov, Sch. Mod. Painting, Moscow. Member: United Scenic A. Union; German A. Soc. Awards: Guggenheim F., 1950; American Theatre Wing award, 1950, 1951; Ford Fnd. Grant. Work: sets for more than 100 stage productions including Pictures at an Exhibition; The Great American Goof; The Snow Maiden (ballets); Awake and Sing; Cabin in the Sky; Detective Story; The Crucible; The Rose Tattoo; The Diary of Anne Frank; The Firstborn; J.B.; Fiddler on the Roof; Incident at Vichy; Judith; Cabaret; Zorba; Mourning Becomes Electra (Metropolitan Opera); The Price, etc.; Des., interior for Temple Sinai, Wash., D.C. including sculptured wood carving, silver and ceramic tile, metalwork in bronze, and designed furniture in wood; des., "Coriolanus" for Shakespeare Mem. Theatre, Stratford, England. Exhibited: AIC; WMAA; MModA; Provincetown AA; New School; PMA; Cincinnati Mod. A. Soc.; Wright/Webster/Hepburn Gal.; one-man: New Art Circle; Guild A. Gal., N.Y.; WMAA; Steimatsky Gal., Jerusalem;Tel-Aviv Mus.;Boyer Gal., Phila.;Babcock Gal.;Stendahl Gal., Los A.; Bertha Schaefer Gal.; Nierendorf Gal., and others. Retrospective exhibition, Storm King A. Center, Mountainville, N.Y.; Saidenberg Gal., N.Y. Author: "Marc Chagall," 1923; "Modern Graphic Art," 1924; Illus., "The Theatre in Life"; various children's books. (Biog.) "Boris Aronson et l'art du théatre" by Waldemar George, Paris, 1928. Contributor to Theatre Arts, Show, Vogue, Interior Magazines. Positions: Instr., Stage Designing, PIA Sch., 1957.

ARONSON, DAVID—Painter
Brimstone Lane, Sudbury, Mass. 01776
B. Shilova, Lithuania, Oct. 28, 1923. Studied: BMFA Sch. Awards: prizes, Inst. Contemp. A., Boston, 1944; VMFA, 1946; Boston A.

Festival, 1952-1954; Tupper A. Fund Competition, 1954; grant, Nat. Soc. A. & Sets., 1958; Guggenheim F., 1960; purchase prize, Nat. Soc. A. & Lets., 1961-1963; NAD, 1967; PAFA, 1967(purchase). Work: VMFA; AIC; Bryn Mawr Col.; BMFA; Portland (Me.) Mus. A.; CGA; MModA; Colby Col.; Atlanta Univ.; WMAA; Univ. New Hampshire; Brandeis Univ.; de Cordova & Dana Mus.; Univ. Nebraska; Atlanta AA; Krannert A. Mus., Univ. Illinois; Smithsonian Inst.; Milwaukee A. Inst.; PAFA; William Lane Fnd., Leominster, Mass.; Stone Fnd., Newton, Mass.; The Johnson Fnd., Racine, Wisc.; Utica, N.Y. Exhibited: AIC; VMFA; Univ. Illinois; MMA; Inst. Contemp. A., Boston; BMFA; WMAA; Bridgestone Gal., Tokyo; Royal Academy of Art, London; Mus. of Mod. A., Paris; Palazzo Venezia, Rome; Congresse Halle, Berlin; Charlottenborg, Copenhagen; Palais des Beaux Arts, Brussels. One-man: Niveau Gal., N.Y., 1945, 1956; Mirsky Gal., Boston, 1951, 1959, 1964; Downtown Gal., N.Y., 1954; Nordness Gal., N.Y., 1960, 1963; MModA, 1946; Rex Evans Gal., Los Angeles, 1961; Zora Gal., Los Angeles, 1965; J. Thomas Gal., Provincetown, Mass., 1964; Hunter Gal., Chattanooga, Tenn., 1965; Kovler Gal., Chicago, 1966; Verle Gal., West Hartford, Conn., 1969. Positions: Instr., BMFA Sch. FA, Boston, Mass., 1943-55; Chm., Div. A. Assoc. Prof. A., Sch. Fine & Applied A., 1955-1963; Prof. A., 1962- , Boston University.

ARONSON, IRENE—Designer, P., Gr., T., I., W.
63-20 Haring St., Rego Park, Long Island, N.Y.
B. Dresden, Germany, Mar. 8, 1918. Studied: Eastbourne Sch. A. & Crafts, England; Slade Sch. FA., Univ. London; Ruskin Sch. Drawing, Oxford Univ.; Parsons Sch. Des., New York; Columbia Univ., B.F.A.; Teachers Col., Columbia Univ., M.A. Member: NAWA; AEA; United Scenic A.; Am. Color Pr. Soc.; Chicago Et. Soc.; Phila. Pr. Cl. Awards: gold medal, Eastbourne Sch. A. & Crafts; prizes, Slade Sch. Des.; Knickerbocker A., 1958; NAWA, 1954, 1957. Work: Mus. City of N.Y.; Ringling Bros. Mus.; N.Y. Pub. Lib.; Mus. A., Providence, R.I.; MModA; MMA; Bezalel Mus., Israel; Bibliotheque Nationale, Paris, France; Royal Lib., Brussels; Benjamin Franklin Lib., Paris, France; Free Lib., Phila., Pa.; Victoria & Albert Mus.; British Mus.; Tokyo Mus. Mod. A.; Rosenwald Coll.; BMFA; Davison A. Center, Middletown, Conn. Illus. for Theatre Arts, Country Book, Tomorrow, Encore, and other magazines; Ballet Russe de Monte Carlo "Souvenir Book"; Vienna Choir Boys "Souvenir Book"; jackets and illus. for leading publishers. Costumes for "The Spectacle of Toys." Barnum & Bailey's Circus, 1946; "Front Page" and "Laura"); cover for Programme Book for "Russian Festival," Madison Square Garden, 1959. Contributed articles to Design magazine, 1951, 1955, 1959-1961; The Artist, 1961, 1965, 1967; Am. Artist magazine, 1964, 1968. Exhibited: Wakefield Gal.; Am.-British A. Center; Bonestell Gal.; MModA; Chicago SE; Univ. So. Cal.; Phila. Pr. Cl.; Creative Gal.; Weyhe Gal., 1952 (one-man); Smithsonian Inst., 1954 (one-man); Brooks Mem. Gal., Memphis, 1955 (one-man); Weyhe Gal., 1956 (one-man); Contemporaries; NAD; PAFA; BMFA; NCFA; BM, 1958; Argent Gal., 1959 (2-man); Rome, Italy; NAWA, 1962-1968; Museo Nacional de Arte Moderno, Mexico City, 1959 (one-man); Eastbourne, England, 1961 (one-man), group exh., 1968; City Hall Mus. Art, Hong Kong, 1964. Position: Asst. Instr. Painting, Walden School, New York; Instr., A. & Des., Evening Div., City Col. for Adult Edu., New York, 1948-1951; Instr., Painting & Drawing, N.Y. Bd. Edu., Adult Edu., evening classes.

ARONSON, JOSEPH—Designer, W.
118 East 37th St., New York, N.Y. 10016
B. Buffalo, N.Y., Dec. 22, 1898. Studied: Univ. Buffalo; Columbia Univ. Sch. Arch., B. Arch. Member: V.Pres., Victorian Society; Arch.L.; Soc. Arch. Hist. Author: "Furniture & Decoration," 1936, (revised, 1952); "Encyclopedia of Furniture," 1938, rev. 1965. Contributor to: Popular Science magazine; Dictionary of the Arts; Book of Knowledge; Encyclopedia Americana; Formerly Cr., Design, Pratt Institute, Brooklyn, N.Y.

ARTHUR, REVINGTON—Painter, E., Gr., L.
Box 276, Glenbrook, Conn. 06906
B. Glenbrook, Conn. Studied: ASL; Grand Central Sch. A., with George Luks, George P. Ennis; Eastport Summer Sch. A., with Arshile Gorky; Columbia Univ. Ext. Member: Audubon A.; Silvermine Gld. A.; Conn. Acad. FA; New Orleans AA; Conn. WC Soc. Awards: prizes, Conn. Acad. FA, 1955; New Haven P. & C., 1948, 1955; Stonehenge award, New England Exh., 1953; Conn. WC Soc., 1951; Silvermine Gld. A., 1944. Work: BM; Telfair Acad. A.; Walker A. Center; Wilmington Soc. FA; Fla. Southern Col.; Rollins Col.; Ford Motor Co. Exhibited: 16 one-man exhs., New York, N.Y., 1932-1955; 21 one-man exhs. elsewhere, 1947-1955. Lectures: "Art Today and Yesterday," Chautauqua, 1956; "History of Graphics," Silvermine Gld., 1955; "The Art of the World," series of 8 talks, Chautauqua, Lecture-Demonstrations. Positions: Dir., Chautauqua A. Center, 1944- ; Assoc. Dir., Silvermine A. Sch., 1951- ; Dir., The New England Exh., 1950- ; Dir., 1st Nat. Pr. Exh., Sil-

vermine Gld., 1956- ; Instr., Syracuse Univ. courses at Chautauqua A. Center, 1953- ; Instr., Silvermine Sch. A., 1951- ; Instr., New York Univ. courses at Chautauqua, 1944-1952.*

ARTIS, WILLIAM ELLISWORTH—Educator, C., S., Gr., L., P.
Mankato State College; h. 1904 Warren St., Mankato, Minn. 56001
B. New York, N.Y., Feb. 2, 1919. Studied: N.Y. State Univ. Col. of Ceramics, Alfred Univ.; Syracuse Univ.; Chadron State Col.; Pa. State Univ. Member: Am. Ceramic Soc.; NSS; CAA; NAEA. Awards: Rosenwald F., 1947; Atlanta Univ. purchase award, 1944, 1945, 1947, 1951, 1952, 1959, 1962, 1963, 1965. Work: WAC; IBM; Slater Mem. Mus., Norwich, Conn.; Howard Univ.; Trevor Arnett Gal., Wash. D.C.; National Portrait Gallery, Wash., D.C.; Joslyn A. Mus., Omaha, Neb.; Goodall A. Gal., Doane College, Crete, Neb.; ceramic tile room divider, men's dormitory, Chadron State Col.; work illus. in "American Negro Art," (N.Y. Graphic Soc.). Exhibited: NAC, 1940; NSS; WMAA; Great Hall, City College, 1967; Creighton Univ., Omaha, Neb., 1969; Syracuse Mus. FA, Nat. Ceramic Exh., 1940, 1947-1951; Pa. State Univ., Hetzel Union Bldg., 1956-1961, Joslyn A. Mus., 1962. Positions: Assoc. Prof. of Art, Mankato State College, Mankato, Minnesota, at present.

ARTSCHWAGER, RICHARD—Painter, S.
20 E. Broadway, New York, N.Y. 10001
B. Washington, D.C., Dec. 26, 1924. Studied: Cornell Univ., A.B., and with Ozenfant. Awards: Casandra Fnd. Award, 1969. Work: WMAA; MModA; William Rockhill Nelson Mus. A., Kansas City, Mo.; Milwaukee A. Center. Exhibited: WMAA, 1966, 1968; MModA, 1967; AFA, 1969; Documenta IV, Kassel, Germany; Kunsthalle, Bern, Switzerland, 1969; Avignon, Stockholm and London, 1969; "Pop Art," Nat. Arts Council, London, England, 1969. Contributor to Arts magazine, 1967. Positions: Instr., painting, Univ. Cal., Davis; Sch. Visual Arts, N.Y.; A.-in-Res., Univ. Wisconsin, 1968.

ARTZ, FREDERICK B.—Scholar, Writer, Collector
157 N. Professor St., Oberlin, Ohio 44074
B. Dayton, Ohio, Oct. 19, 1894. Studied: Oberlin Col., A.B.; Harvard Univ., Ph.D. Awards: Litt.D., Oberlin College, 1966. Author: "From the Renaissance to Romanticism, Trends in Style in Art, Literature and Music," 1962; "Mind of the Middle Ages," 3rd edition, 1965. Positions: Prof., Oberlin College, 1924-1966.

ASAWA, RUTH (LANIER)—Sculptor, Gr.
1116 Castro St., San Francisco, Cal. 94114
B. Norwalk, Cal., Jan. 27, 1926. Studied: Milwaukee State T. Col., with Robert von Neumann; Black Mountain Col., with Josef Albers. Awards: Purchase award, Oakland Mus. A., 1959; Tamarind Fellowship, 1965; purchase award, San Francisco A. Festival, 1966; Dymaxion award, 1966. Exhibited: MModA, 1958; Sao Paulo, 1955; San F. AA, 1952, 1957; WMAA, 1955, 1956, 1958; AIC, 1955, 1957; New Haven, Conn., 1953; Design Research, Cambridge, Mass., 1956; SFMA, 1954 (4-man), (3-man) 1963; Ankrum Gal., Los Angeles, 1962 (2-man); Peridot Gal., N.Y., 1954, 1956, 1958 (one-man); de Young Mem. Mus., San Francisco, 1960 (one-man); Pasadena Mus. A., 1965 (one-man); Capper Gal., San Francisco, 1969 (one-man); Los Angeles County Fair, 1969. Positions: Member, San Francisco A. Comm., 1968-1970.

ASCHENBACH, PAUL—Sculptor
Charlotte, Vt. 05445
B. Poughkeepsie, N.Y., May 25, 1921. Studied: R.I. Sch. Des. Work: de Cordova & Dana Mus., Lincoln, Mass.; Rochester (N.Y.) Mem. Mus.; Bundy A. Gal., Waitsfield, Vt.; Fleming Mus., Univ. of Vermont. Sculpture: Trinity College Chapel, Burlington, Vt.; Univ. Vermont Lib.; College of Mount St. Josephs, Cincinnati, Ohio, 1965. Exhibited: one-man: Fleming Mus., Univ. of Vermont, 1954, 1968; Moore Gal., Cambridge, Mass., 1955; Sculpture Center, N.Y., 1957, 1961. Positions: Asst. Prof., Sculpture, University of Vermont, Burlington, Vt.; Dir. Vt. Int. Sculptors Symposium, 1968; Participant, Symposium, St. Margarethen, Austria, 1969.

ASCHER, MARY G. (Mrs. David)—Painter, C., Gr., L.
336 Central Park West, New York, N.Y. 10025
B. Leeds, England. Studied: Col. City of New York, B.A.; N.Y. Univ., M.A.; N.Y. Sch. App. Des.; Grand Central Sch. A.; Famous Artists Sch.; ASL; Sch. Chinese Brushwork. Member: NAWA, AAUW; ASL; AFA; F., Royal Soc. A., London, England; Nat. Lg. Am. Pen Women; Am. Soc. Contemp. A.; Int. Platform Assn. Nat. Soc. A. & Lets. Awards: gold medal of honor, P. & S. Soc. of New Jersey, 1958; NAWA Tucker award, 1960; Hartford Fnd. F., 1961; Nat. Lg. Am. Pen Women, 1962; New England Exh., 1967; Medallion and Plaque Career Achievement Award, Baruch Alumni Soc. of City Col., N.Y., 1968. Work: Bat Yam Mus., Israel; Ein Harod Mus., Israel; Nat. Mus. of Sports; NCFA; Norfolk Mus. A. & Sciences;

Interchurch Center Library, N.Y., Fordham Univ., N.Y. Exhibited. Art: USA, 1958, 1959; NAWA 1958-1960, 1963-1965, France, 1967, 1969, Canada, 1969, N.Y. Bank for Savings, 1967, 1968; Lever House, N.Y., 1967, 1968; other exhs.: Interchurch Center, 1966; Fordham Univ., 1968; Advertising Cl., N.Y., 1968; (all one-man); Province-town A. Festival, 1958; Riverside Mus., N.Y., 1960; Tokyo, Japan, 1960 (exchange exh. with women artists of Japan); also in England, Scotland, Latin America. Church Arch. Gld. of America; 50 one-man traveling exhibitions, Old Testament and Apocrypha, in U.S., 1966-1969. Author, I., "Poetry-Painting" 1958; Limited Folio Edition of Lithographs of "Twelve Women of the Old Testament and Apocrypha" with original script by the artist, 1963. Position: Editor, NAWA News Letter, 1961- .

ASHER, DR. AND MRS. LEONARD—Collectors
 12921 Marlboro St., Los Angeles, Cal. 90049*

ASHER, LILA OLIVER—Painter, Des., T., S., Gr.
 4100 Thornapple St., Chevy Chase, Md. 20015
B. Philadelphia, Pa., Nov. 15, 1921. Studied: PMSchA., and with Frank B. A. Linton. Member: Soc. Wash. A. (Pres., 1962-1964). Awards: prizes, Metropolitan State A. Exh., 1949, 1950; CGA, 1956; Chevy Chase A. Fair, 1957, 1958; prize (graphics) Univ. Virginia, 1963. Work: Howard Univ.; Barnett Aden Gal.; CGA; Univ. Virginia; Sweet Briar Col.(Va.); City of Wolfsburg, Germany. Exhibited: PAFA, 1941; Barnett Aden Gal., 1951 (one-man); Soc. Wash. A., 1949, 1952; CGA, 1947, 1949-1960; Wash. Ceramic Show, 1948; Am. Vet. Exh., 1948; Metropolitan State A. Exh., 1948, 1950; A. Cooperative, 1948; Whyte Gal., 1949, 1950; Woodmere A. Gal., Phila. Pa., 1949, 1950; Wash. WC Soc., 1949; Soc. Wash. Pr. M., 1949-1968; Pan-American Union, 1953; LC, 1954; Wm. C. Blood Gal., 1955, Phila. (one-man); A. Cl., Wash., D.C., 1957 (one-man); Collectors Gal., 1959 (one-man); Univ. Maine, 1960; Va. Intermont Col., 1958, 1959; BMA, 1959; Burr Gal., New York City, 1963 (one-man); Gallery 222, El Paso, Tex., 1965; AEA, Massillon, Ohio; one-man: Thomson Gallery, N.Y., 1968; B'nai Brith Gallery, Wash. D.C., 1969. Executed 3600 portraits of servicemen in Army & Navy Hospitals for USO. Position: Instr., Dept. A., Howard Univ., Washington, D.C., 1948-1951, Asst. Prof. at present; Instr., Wilson T. Col., Washington, D.C., 1952-1954. Guest artist, City of Wolfsburg, Germany, Summer of 1968.

ASHTON, DORE—Critic, W., E., L.
 217 E. 11th St., New York, N.Y. 10003
B. Newark, N.J., May 21, 1928. Studied: Univ. of Wisconsin, B.A.; Harvard Univ., M.A. Award: Mather Award for Art Criticism. Author: "The Unknown Shore"; "A View of Contemporary Art," 1962; "Modern American Sculpture," 1968; "Richard Lindner," 1969; "Modern American Painting," 1969; "A Reading of Modern Art," 1969. Positions: Hd., Art History Dept., The Cooper Union, New York, N.Y.; Contributing Editor, "Studio International."

ASKEW, R. KIRK, JR.—Art Dealer, Collector
 Durlacher Brothers, 538 Madison Ave., New York, N.Y.
 10022; h. R.D. No. 1, East Greenville, Pa. 18041
B. Kansas City, Mo., Nov. 19, 1903. Studied: Massachusetts Inst. Tech. (Architecture); Harvard Univ., B.S. and Grad. School of Fine Arts. Collection: personal. Gallery specialty: Old and Modern Paintings and Drawings. Positions: American Representative of Durlacher Bros., 1927-1937; Owner, Durlacher Bros., New York, N.Y., 1937- .*

ASKIN, ARNOLD SAMUEL—Collector
 Time & Life Bldg., Rockefeller Center, New York, N.Y.
 10020; h. Cross River Road, Katonah, N.Y. 10536
B. Utica, N.Y., Aug. 21, 1901. Studied: Yale Univ., B.A. Collection: Impressionist and Post-Impressionist Paintings.*

ASMAR, ALICE—Painter, Des., T., L., Gr.
 P.O. Box 1965, Hollywood, Cal., 90028
B. Flint, Mich., Mar. 31, 1929. Studied: Lewis & Clark Col., Portland, Ore., B.A.; Univ. Washington, M.F.A., with Edward Melcarth; Ecole Nationale Superieure des Beaux-Arts, Paris, France. Member: Centro Studi e Scambi Internazionale, Rome; Intl. Platform Assn.; Desert A. Center, Palm Springs, Cal. Awards: A. Schol. from Portland (Ore.) A. Mus. & Oregon Bd. of Edu.; Schol., Lewis & Clark Col.; prizes, SAM, 1952; (firsts) Annual Oregon State Fairs, 1955-1957; Western Regional award, Am. Crayon Co., 1957; Harriett Hale Wooley Grant, for study in Paris, 1958-1959; Spoleto, Italy, 1959; F., MacDowell Colony, 1959-1960; F. Huntington Hartford Fnd., 1960, 1961, 1964; All-City Art Festival Medal, 1963; So. California Exposition, 1964; Nat. Orange Show Silver Medal, 1966; Intl. Platform Assn., first place, 1967; Ancona, Italy, Biennale Medal of Honor, 1968-69. Work: Gal. Mod. A., N.Y.; Roswell Mus., N.M.; and in private collections. Exhibited: Portland A. Mus., annually, 1948-1958; Lewis & Clark Col., annually, 1948-1958; Reed Col., annually, 1948-1958; Washington State traveling exh., 1952-1953; SAM, 1952-1954; Oakland A. Mus., 1954; Marylhurst Col., Marylhurst, Ore., 1958; Art; USA,

N.Y., 1958; Drawings: U.S.A., St. Paul A. Center; Galleria Pascal, Toronto, Canada; Lyman Allyn Mus., New London, Conn.; Feingarten Gal., Los Angeles; Pasadena A. Mus. All-City A. Festival, Los A., Cal., 1961; Los A. County Mus.; Frye Mus. A., Seattle, 1961, and many others; one-man: Peeble's & Fole-Myers Gal., Portland, Ore., annually, 1952-1958; Uitti Gal., Seattle, 1953; Portland Symphony Civic Auditorium, 1958; Salem A. Mus., 1958 (retrospective); Gallerie de Fondation des Etats-Unis, Paris, France, 1959; Gladstone and Portland, Ore., Venice, Cal.; Sabersky Gal., Los Angeles; Pasadena A. Mus.; Santa Monica Lib., 1964; Bednarz Gal., Los A., 1965; Downey (Cal.) Mus., 1966; Saddleback Inn, Santa Ana, Cal., 1966 and Phoenix, Ariz., 1967; Gardner's House Beautiful, Laguna Beach, 1967; Old Town Gal., San Diego, 1967; Jamison Gal., Santa Fe, 1968, 1969; Roswell Mus., 1968; New Mexico A. & Crafts Center, 1968; Burbank Lib., 1968; Little Gal., Santa Ana, 1969.

ATKIN, MILDRED TOMMY (Mrs. Fisher Winston)—Painter
 710 Park Ave., New York, N.Y. 10021
B. New York, N.Y. Studied: Metropolitan A. Sch., and with Arthur Schweider. Member: NAWA; AEA; Am. Soc. Contemp. A.; P. & S. of New Jersey; Pen & Brush Cl.; N.Y. Soc. Women A.; Nat. Soc. of Painters in Casein; Audubon A. Awards: Pen & Brush Cl., 1958, 1960; Marion K. Halderstein Mem. prize, 1963; Jeannette Genius Prize, 1964; NAWA, 1959; Medal of Honor, P. & S. Soc. of New Jersey, 1966. Work: Washington County Mus. FA, Hagerstown, Md.; Robert Hull Fleming Mus., Burlington, Vt.; Georgia Mus. A., Athens, Ga.; St. Vincents College; Mus. of the City of New York; Norfolk Mus. Arts & Sciences; Tweed Gal., Univ. of Minnesota, Duluth; Regar Mus., Anniston, Ala.; East Central Oklahoma Mus.; Wheaton Col.; NYU Medical Center. Exhibited: Montross Gal., 1935, 1937-1939; Bonestell Gal., 1944, 1945 (one-man); NAD, 1948, 1950-1955; WMAA, 1951; Stedelijke Mus., Amsterdam, Holland, 1956; Brussels, Belgium, 1956; Bern, Switzerland, 1957; Chase Gal., 1957, 1958; other one-man exhs: Bodley Gal. N.Y., 1968; Sidney (Ohio) Lib.; Wustum Mus. FA, Racine, Wis.; Appleton (Wis.) Pub. Lib.; State Univ., LaCrosse, Wis.; Butler Inst. Am. Art; Inst. Tech., Platteville, Wis.; St. Vincent's Col., Latrobe, Pa.; Regar Mus., Anniston, Ala. and in South America, France, Canada, England, Scotland, Japan. 36 one-man exhs. to date. Painting reproduced with article in "Prize Winning Art, Book 7." Positions: Instr. Painting including portrait painting, New York City; Dir., N.Y. Chapter, AEA, 1952-1955, 1956-1958, 1962-1966; Exec. Bd., NAWA, 1952-1954, 1955-1957, Treas., 1957-1959, 1964-1965; Bd. Dirs., Nat. Soc. of Painters in Casein; Delegate to U.S. Comm. of Intl. Assn. of Art, 1963-1969, Bd. Dirs., Am. Soc. of Contemp. A., 1967-1969.†

ATKINSON, TRACY—Museum Director
 Milwaukee Art Center, 750 N. Lincoln Memorial Dr., Milwaukee 53202; h. 14000 N. Birchwood Lane, Mequon, 1 W, Wis. 53092
B. Middletown, Ohio, Aug. 10, 1928. Studied: Ohio State Univ., B.F.A.; Univ. Pennsylvania, M.A. Member: AAMus.; AFA; Wisconsin Arts Fnd. & Council; Landmarks Comm., Milwaukee; Assn. A. Mus. Dirs.; Wisconsin Midwest Mus. Conference (Vice-Pres.). Awards: Harrison Fellow, Univ. Pennsylvania, 1955. Lectures: Contemporary Art, to schools, clubs and art groups. Exhibitions arranged: Antique Lustre, Buffalo; Contemporary Painting, German Expressionism, at Columbus, Ohio; Heritage Milwaukee, Wisconsin Collects, Pop Art and the American Tradition, Options, Aspects of a New Realism, at Milwaukee, each exhibition with full catalogue. Positions: Curatorial Asst., Albright A. Gallery, Buffalo, N.Y., 1956-1959; Asst. Dir., Columbus Gallery of Fine Arts, (Ohio), 1959-1962; Dir., Milwaukee Art Center, 1962- .

ATKYNS, (WILLIE) LEE (JR.)—Painter, T., Gr., S., L., I., E.
 4712 Wisconsin Ave., Washington, D.C. 20016; s. Lee Atkyns
 Puzzletown Art Studio, Duncansville, Pa.
B. Washington, D.C., Sept. 13, 1913. Member: Soc. Wash. A.; Wash. WC Cl.; Puzzletown A. Gld.; All. A. Johnstown; Indiana (Pa.) AA; Wash. AC; Am. A. Lg.; Intl. Inst. A. & Lets.; Landscape Cl., Wash.; AEA; Intl. Platform Assn. Awards: prizes, Soc. Wash. A., 1947, 1954; Wash. AC, 1946; All. A. Johnstown, 1947, 1948, 1949, 1950, 1953; Landscape Cl., Wash., 1954, 1956, 1960, 1962, 1968; Indiana AA, 1954; Interdenominational Religious Exh., Wash., D.C., 1957; Metropolitan AAPL, 1954; Rockville (Md.) A. Lg., 1961. Exhibited: Butler AI; Carnegie Inst.; Univ. Chicago; AWS; NAD; Wash. AC; Smithsonian Inst.; CGA; Phillips. Mem. Gal.; Whyte Gal.; Toledo Mus. A.; Springfield AA; L.D.M. Sweat Mem. A. Mus.; Utah State Inst.; Terry AI; Catholic Univ.; Indiana State T. Col.; BMA, and 24 one-man exhs. to date. Work: Phillips Mem. Gal.; Talladega Col., Alabama; All. A. Johnstown; Altoona (Pa.) H.S.; Hospital, Lexington, Ky.; private coll. U.S. and abroad. Position: Dir., Lee Atkyns Studio-Gallery & Sch. A., Washington, D.C. & Duncansville, Pa.

ATWELL, ALLEN—Painter, E.
 Department of Art, Cornell University, Ithaca, N.Y. 14850
B. Pittsburgh, Pa., Oct. 19, 1925. Studied: Cornell Univ. B.F.A., M.F.A.; Univ. Pennsylvania. Awards: Grad. Fellowship, 1949-51,

Grad. Assistantship, 1951, Cornell Univ.; Ford Fnd. Fellowship, (India) 1953-1954; Fulbright Research Grant (India), 1961-1962; Rockefeller Research Grant (Southeast Asia), 1962. Exhibitions: MModA; Artists Gal., N.Y.; Passedoit Gal., N.Y.; Munson-Williams-Proctor Inst., Ithaca, N.Y.; Andrew Dickson White Mus. A., Cornell Univ.; Syracuse Univ.; Addison Gal. of Am. Art, Andover, Mass.; Nationally circulated exh., AFA; Makler Gal., Philadelphia; Cogate Univ. Work: in private collections. Positions: Instr., Dept. of Art, 1951-1955, Asst. Prof. Art, 1955-1958, Assoc. Prof. A., 1958- , Cornell University, Ithaca, N.Y. Visiting Prof., Eastern Montana College of Education, 1959 (summer).*

AUBIN, BARBARA—Painter, T., L.
Loyola University, Lewis Towers Fine Arts Department, 820 N. Michigan Ave., 60611; h. 1925 N. Hudson Ave., Chicago, Ill. 60614
B. Chicago, Ill., Jan. 12, 1928. Studied: Carleton Col., B.A.; Sch. of the Art Institute, Chicago, B.A.E., M.A.E. Member: Chicago Soc. A.; CAA; AAMus; AAUP; Ill. A. Edu. Assn.; Mich. WC Soc. Awards: prizes, Chicago Tribune Comp., 1952; Old Northwest Territory Exh., 1954; Eugenie Mayer Award, Wisconsin Salon of Art, Madison, 1957; WAC (purchase) 1958; Illinois State Fair, 1960; Oppenheimer Purchase Prize, Artists of Chicago & Vicinity, 1961; George D. Brown Foreign Travel F., 1955; Buenos Aires Convention Act Grant to Haiti, 1958-59, 1959-60; Atwater-Kent Award, 1962; Ball State Teachers Col, Muncie, Ind., 1962 (purchase). Mich. WC Soc., 1965; Union Lg. Purchase award, Chicago, 1965; Huntington Hartford Fnd. grant, 1963; New Horizons in Painting, Chicago, 1968. Work: AIC; Centre D'Art, Port-au-Prince, Haiti; Ball State T. Col.; Union Lg. Cl., Chicago. Exhibited: Butler Inst. Am. A., 1961-1962; Ball State T. Col., 1961, 1962, 1964; PAFA, 1953, 1961; Art: USA, N.Y., 1958; All. A. Am., 1954; Momentum Midcontinental, 1954; AWCS, 1957; AIC, 1953, 1955, 1960, 1961, 1964, 1968; Illinois State Fair, 1956-1958, 1960; Ravinia Festival of the Arts, 1958; Miss. Valley A., 1964; Graphic Arts Exh., Wichita, 1963; Wash. WC Assn., Smithsonian Inst., 1962, 1963; PAFA, 1961; Fairweather-Hardin Gal., 1963; Grand Rapids A. Mus., Grand Rapids, Mich., 1963, 1965; Okla. A. Center, 1964, 1968; Gal. Arkep, N.Y., 1966; Univ. S. Dak., 1966; Mich. WC Soc., 1966, 1968; Newport AA, Newport, R.I., 1967; Drawings: USA, St. Paul A. Center (and traveling), 1968; Ill. State Fair, 1968. One-man: AIC, 1967; La Grange A. Lg., 1968; and others in Chicago area and in Haiti; six one-man exhs. in Chicago and Haiti. Positions: Instr., Dept. A., Univ. Wisconsin, Milwaukee, 1957-58; Centre D'Art, Port-au-Prince, Haiti, 1959-60; Instr., Watercolor, Painting & Drawing, School of the Art Institute, Chicago, Ill., 1960-1964; Instr., Wayne State Univ., Detroit, 1964-1965; Instr., Figure Drawing, Chicago Academy of Fine Arts, 1965-1966; Asst. Prof., Art Inst. of Chicago, 1965-1968. Asst. Prof., Loyola University, 1969- .

AULT, LEE ADDISON—Collector, Publisher, Art Patron
635 Madison Ave. 10022; h. 435 E. 52nd St., New York, N.Y. 10022
B. Cincinnati, Ohio, Sept. 30, 1915. Studied: Princeton Univ. Collection: 20th Century Painting, Sculpture and Primitive Art. Positions: Pres., Quadrangle Press (art books), 1947-1951; Publisher of Art in America, 1957-1969; Trustee, American Federation of Arts, 1954- , Treas., 1957-1960; Advisory Council, Princeton University Art Museum, 1963- ; Trustee, Friends of the Whitney Museum of American Art; Trustee, Skowhegan School of Painting and Sculpture.

AUSTIN, DARREL—Painter
c/o Perls Galleries, 1016 Madison Ave., New York, N.Y. 10021; h. R.D. 3, New Fairfield, Conn. 06810
B. Raymond, Wash., June 25, 1907. Studied: Univ. Oregon; Univ. Notre Dame. Work: MMA; MModA; Detroit Inst. A.; Nelson Gal. A.; Rochester Mem. A. Gal.; Albright-Knox A. Gal.; Smith Col. Mus.; BMFA; Clearwater A. Mus.; PMG; PAFA; Portland Mus. A.; Encyclopaedia Britannica Coll.; Sarah Lawrence Col. Mus.; IBM Coll.; Hebrew Univ.; Montclair Mus. A., New Jersey; Rollins Col., Winter Park, Fla.; mural, Medical Col., Portland, Ore. Awards: Walter Lippincott Award, PAFA, 1950. Exhibited: National exhibitions annually, 1941- ; One-man: Perls Galleries, New York, 1940-1945, 1947, 1948, 1950, 1953, 1955, 1957, 1960-1962, 1964; Univ. Notre Dame; Harmon Gal., Naples, Fla., 1964; Newport AA, 1962; Jeffress Gal., London, England, 1963.*

AUVIL, KENNETH WILLIAM—Serigrapher, E., W.
Art Department, San Jose State College, San Jose, Cal. 95114; 605 Olson Rd., Santa Cruz, Cal. 95060
B. Ryderwood, Wash., Dec. 18, 1925. Studied: Univ. Washington, B.A., M.F.A. Awards: prizes, Wichita AA, 1956, 1961; Northwest Pr. M., 1953; Pacific Northwest A. & Crafts Fair, Bellevue, Wash., 1953-1956, 1958, 1959, 1961; Cal. Soc. Et., 1959, 1961; Northwest Printmakers Int. Exh., 1962; Exh. of FA Graphics, Olivet Col., Olivet, Mich., 1964; Nat. Gr. A. and Drawing Exh., Wichita, Kan., 1965; BMFA, 1966. Work: prints: U.S. Information Service; Victoria

& Albert Mus., London, England; Bibliotheque Nationale, Paris, France; Wichita AA; Henry Gallery, Seattle; Arizona State College; Marin County Civic Center, Cal.; Portland (Ore.) A. Mus.; Mills College, Oakland, Cal; Rockefeller Center, N.Y.; SAM; De Cordova and Dana Mus., Boston; Melrose Public Lib., Mass; State Col. at Boston; Univ. of N. H.; Pine Manor Jr. Col.; Art in Embassies Program. Exhibited: 4th Biennale, Italy, 1956; SFMA, 1956; Northwest Pr. M., 1953, 1954, 1957-1968; Wichita AA, 1955-1965; Oakland A. Mus., 1958, 1959; LC, 1959, 1963, 1966; Oklahoma City Nat. Print Exh., 1959; Nat. Serigraph Soc., 1959; Cal. Soc. Et., 1959-1961, 1962, 1964; Denver A. Mus., 1959; BMFA, 1959; Philadelphia Print Fair, 1960; Smithsonian Inst., 1960, 1962; Oklahoma Printmakers, 1962, 1963, 1965, 1966; Knoxville A. Center, 1962; BMFA, 1962, 1964; BM, 1964, 1966; Olivet, Mich., 1964; NGA, 1964; SAGA, 1962; Pasadena A. Mus., 1960; Prints 1965, Potsdam, N.Y. Author: "Serigraphy," 1965. Positions: Tech. Illustrator, Boeing Aircraft Co., 1953-56; Visiting Prof., Univ. Washington, 1961; Prof., Printmaking, San Jose State College, San Jose, Cal., at present.

AVEDISIAN, EDWARD—Painter, T.
c/o Robert Elkon Gallery, 1063 Madison Ave., New York, N.Y. 10028
B. Lowell, Mass., 1936. Studied: Boston Mus. Sch. A. Exhibited: Tibor de Nagy Gal., N.Y.; Hansa Gal., N.Y.; BMA; Mus. Mod. A., Wash., D.C.; WMAA, 1963, 1965, 1967; Dayton Art Intl., 1964; Kasmin Gal., London, 1964; "Young America" WMAA, 1965; MModA, 1965; CGA, 1966; The Harry Abrams Collection, Jewish Mus., N.Y., 1966; The John Powers Collection, Larry Aldrich Mus., 1966; Robert Rowan Collection, SFMA, 1967; Paintings from Expo '67, Montreal; Boston Institute of Contemporary Art, 1967-1968; "Painters Under 40," WMAA, 1968; one-man: Boyston Print Center Gal., Cambridge, Mass., 1957; Hansa Gal., 1958; Tibor de Nagy Gal., 1959, 1960; Robert Elkon Gal., N.Y., 1962, 1964-1968; Galerie Zigler, Zurich, 1964; Nicholas Wilder Gal., Los A., 1966, 1968, 1969; Kasmin Gal., London, 1966, 1967. Work: Guggenheim Mus., N.Y.; WMAA; MMA; Los A. Mus. A.; Pasadena Mus. A.; Larry Aldrich Mus. A.; Wadsworth Atheneum, Hartford; Chrysler Mus. A., Provincetown, Mass. Positions: A.-in-Res., Univ. Kansas, Feb., 1969-June, 1969; Instr., School of Visual Arts, New York, 1969-1970.

AVERY, RALPH H.—Painter, Comm. A.
60 North Fitzhugh St., 14614; h. 11 Livingston Park, Rochester, N.Y. 14608
B. Savannah, Ga., Sept. 3, 1906. Studied: Rochester Inst. Technology; Louis Comfort Tiffany Fnd., Oyster Bay, N.Y. Member: ANA; AWS; Rochester A. Cl.; F., Rochester Mus. A. & Sciences. Awards: Herbert L. Pratt purchase award, AWS, 1954; M. Grumbacher purchase prize and Rudolf Lesch purchase prize, AWS, 1957; Citation, American Artist Magazine, 1954; Ranger Fund Purchase, NAD, 1961. Work: Rochester Mem. A. Gal.; Charles and Emma Frye A. Mus., Seattle, Wash. Exhibited: NAD, 1956, 1958; AWS, 1952-1955, 1957, 1958; Roberson Mem. Center, 1957; N.Y. State Fair, 1958; Rochester A. Cl., 1946-1958; Rochester-Finger Lakes Exhs., 1946-1958; one-man: Smithsonian Inst., 1944; Arnot A. Gal., Elmira, N.Y., 1953; Telfair Acad., Savannah, 1952. Cover Paintings for Reader's Digest, Mar. & Apr., 1957, Jan., Apr. & Dec., 1958. Illus., "The Instructor" magazine.

AVLON-DAPHNIS, HELEN—Painter, T.
400 West 23rd St., New York, N.Y. 10011
B. New York, N.Y., June 18, 1932. Studied: Hunter Col., B.F.A., M.A. Member: Com. on A. Edu., MModA. Awards: Scholarships, BMSch.; Colo. Springs FA Center; Hunter College Achievement Award, 1963. Exhibited: Colo. Springs FA Center, 1953; N.Y. City Center, 1952; Contemp. A., 1953; Forum, 1954; Panoras Gal., 1954, 1955; Silvermine Gld. A., 1955; BM, 1953; Provincetown AA; Schenectady Mus. A., 1957; Rochester Mem. A. Gal.; Ohio Univ., Athens, Ohio, 1958; Northern Illinois State T. Col.; Saginaw Mus. A.; Rockford AA; BM, 1958; Phoenix Gal., N.Y., 1959 (2-man), 1960 (one-man), 1961 (group); New Gal., Provincetown, Mass., 1960 (2-man), 1961 (2-man); Duo Gal., N.Y., 1961; Provincetown Golden Am. Exh., 1964; Gal. East, N.Y., 1964-65 (one-man), 1968, 1969; Bertha Schaefer Gal., N.Y., (2-man) 1963; Thomas Gal., Provincetown, 1964; Core-Graham Gal., 1965; Chrysler Art Show, 1960; Hyannis, Mass., 1960; Hudson Gld.; Chelsea A. Exh., 1968, 1969; St. Peter's Church, N.Y.; United Fed. Teachers A. Gal., 1968-1969 (one-man). Positions: A.T., Adults and children, Painting & Drawing: Washington Irving Adult Art Edu.; BM children's Div.; Horace Mann Sch. and Haaren H.S., Brooklyn College, Walt Whitman Jr. H.S., New York, N.Y. and Brooklyn, N.Y.; Dir., "Paint In," Chelsea Park, 1968.

AVNET, LESTER—Collector, Art Patron
Time & Life Bldg., Rockefeller Center, New York, N.Y. 10020; h. 188 Kings Point Rd., Kings Point, L.I., N.Y. 11024
B. New York, N.Y., Nov. 12, 1912. Studied: New York Univ. Collection: Impressionist and Post-Impressionist Cubist Paintings and

Drawings; Old Master Drawings; Sculpture, including works of Moore, Maillol, Rodin, Archipenko, Gauguin and Contemporaries. Positions: Trustee, American Federation of Arts; Assoc., Guggenheim Museum; Life Member, Metropolitan Museum of Art; Bd. of Trustees of Friends of the Whitney Museum of American Art; Trustee, Jewish Museum, N.Y.; Patron, Museum of Modern Art, N.Y.

AXTON, JOHN T. III— Painter
University of California, Berkeley, Cal.; h. 701 Vermont St., San Francisco, Cal. 94107
B. Fort Leavenworth, Kans., June 28, 1922. Studied: Georgia Sch. Tech.; Kansas City AI, B.F.A.; Yale Univ. Sch. FA, M.F.A. Exhibited: Cal.PLH, 1964; San F. Mus. A., 1965; 2-man; San F. Mus. A., 1964. Positions: Instr. Design, Univ. of California, Berkeley, Cal. at present.*

AYASO, MANUEL— Painter, S., Gr.
127 New York Ave., Newark, N.J. 07105
B. La Coruna, Spain, Jan. 1, 1934. Studied: Newark Sch. Fine & Indst. A. Awards: Trubeck award, 1960, Russell Mount award, 1961, both Montclair A. Mus., New Jersey; purchase prize, Newark Mus., 1961; purchase, Drawings:USA, St. Paul's Gal., 1961; Tiffany Fnd. Scholarship award, 1962; New Jersey Tercentenary Exh., Jersey City, 1964; Ford Fnd. purchase prize, 1964; Essex County Artists, 1966; purchase awards, New Jersey State Museum, 1966-1968. Work: WMAA; Newark Mus.; Butler Inst. Am. A.; New Jersey State Mus.; St. Paul's Gal. & Sch. A.; Illinois Wesleyan Univ.; Univ. Massachusetts; Amherst; PAFA; WMA; Slater Mem. Mus., Norwich, Conn. Exhibited: PAFA, 1961, 1963-1967; Drawings:USA, St. Paul's Gal., 1961, 1963; Nat. Inst. A. & Lets., 1962-1964; Drawings:USA traveling exh., 1962, 1964, 1965; Butler Inst. Am. A., 1965; Drawing Soc., 1965, 1966; WMAA, 1963; Montclair Mus., 1960, 1961; Newark Mus., 1961, 1963, 1964, 1968; New Jersey State Mus., 1966, 1968; Int. Watercolor Exh., BM, 1963; El Neohumanismo, USA-Italy-Mexico, Univ. Mexico City, 1963.

AYLING, MILDRED S.— Painter, L.
7212 River Rd., Oakdale, Cal. 95361
B. Hesper, Iowa, Jan. 24, 1912. Studied: San Miguel de Allende, Mexico, and privately. Member: Central Cal. A. Lg. (Fndr., Past Pres.); Mother Lode AA; Soc. Western A.; Stanislaus County Arts Council (Dir.). Awards: numerous, including Soc. Western A., 1968; Cal. State Savings & Loan Assn., purchase, 1967; Mother Lode AA, 1968. Work: Haggin Gals., Stockton, Cal.; Crocker A. Gal., Sacramento, and others. Exhibited: Soc. Western A., de Young Mem. Mus., San Francisco, 1968; Univ. Cal., Medical Sch., 1968; Crocker A. Gal., 1968; one-man: Villa Palette Cultural Center, 1963-1965; San Miguel de Allende, Mexico, 1966; Winblad Gal., San Francisco, 1966; Stanislaus and Merced colleges, 1967; Haggin Gal., 1967; Crocker A. Gal., 1967; Hunter Gal., San Francisco, and others.

AYMAR, GORDON CHRISTIAN— Portrait Painter
Flat Rock Rd., RFD No. 1, South Kent, Conn. 06785
B. East Orange, N.J., July 24, 1893. Studied: Yale Univ., A.B.; Yale Sch. FA; BMFA Sch. Member: A. Dir. Cl., N.Y. (former Pres. & on Adv. Bd.); Nat. Soc. A. Dir. (Charter Pres., Adv. Bd.): AWS. Awards: prizes, Nat. Soc. A. Dir., 1951; A. Dir. Cl., 1954; Prout's Neck, Me.; Yale Cl., N.Y.; Conn. Classic Arts; Darien A. Festival. Work: MModA; Union Theological Seminary; Madison Ave. Presbyterian Church, N.Y.; Am. Cyanamid Co., N.Y.; Pitney Bowes, Stamford, Conn.; Yale Univ.; Brooklyn Pub. Lib., and in private colls. Exhibited: One-man: Dayton AI; Montreal Mus. FA; Portraits, Inc.; and in Stamford, Greenwich, Rowayton, Noroton, New Canaan, and Wilton, Conn.; Berkshire, Mass.: NAC; Darien Pub. Lib.; Century Assn., N.Y.; AWS; Bridgeport Mus. A., Science & Indst.; Canton AI; Baldwin-Wallace Col., Berea, Ohio; Boise AA; Frye Mus., Seattle; Abilene Mus. FA; Orlando (Fla.) AA; Columbia (S.C.) Mus. A.; Davenport Mun. A. Gal.; Moore Col. Art, Philadelphia, Pa.; Arnot A. Gal., Elmira, N.Y.; Brooks Mem. Mus., Memphis, Tenn.; Royal Society of Painters in Watercolour. Author: "An Introduction to Advertising Illustration"; "Bird Flight"; "Yacht Racing Rules and Tactics"; "A Treasury of Sea Stories"; "Start 'Em Sailing"; Co-author: "Second Book on Sailing"; "Michael Sails the Mud Hen"; "The Art of Portrait Painting."

AZUMA, NORIO— Serigrapher
14 Greene St. 10013; h. 276 Riverside Dr., New York, N.Y. 10025
B. Kinagashima-cho, Mie, Japan, Nov. 23, 1928. Studied: Kanazawa A. Sch., Japan; Chouinard A. Inst., Los Angeles; ASL. Member: American Color Pr. Soc.; The Print Cl.; SAGA. Awards: prizes, Int. print exh., SAM, 1960; American Color Pr. Soc., 1960, 1963; SAGA, 1966, 1968. Work: Serigraphs-BM; CMA; PAFA; PMA; NCFA; AIC; WMAA; LC; Univ. California. Massachusetts Inst. Tech.; SAM; USIA, and others. Paintings: Chouinard A. Inst.; Butler

Inst. Am. A. Exhibited: CGA, 1963; 30 Contemporary Prints, 1964; The White House, Washington, D.C., 1966; WMAA, 1966; SAGA; Triennial of Original Colored Graphics, Grenchen, Switzerland, and others.

BABER, ALICE— Painter
597 Broadway 10012; h. 73 Bedford St., New York, N.Y. 10014
B. Charleston, Ill., Aug. 22, 1928. Studied: Indiana Univ., B.A.; Indiana Univ. Grad. Sch.; Fontainebleau Sch. A., France. Work: MModA; SFMA; N.Y. Univ.; WMA; Fordham Univ.; Marinotti Coll., Italy; NCFA; Geigy Chemical Corp.; United Tanker, Ltd., N.Y.; Manchester Mus., England; Peter Stuyvesant Coll., Amsterdam; Oinacotheca Cutai, Osaka, Japan; Univ. California, Berkeley; CGA; Univ. Notre Dame; Brandeis Univ., Waltham, Mass.; Cornell Univ., Ithaca, N.Y.; National Mus., Israel; Swope Gal. A.; White House Loan Coll., Washington, D.C.; U.S. Embassy Madrid, Spain and New Delhi, India; Art for Am. Embassies, State Dept., Washington, D.C. Exhibited: Stable Gal., N.Y., 1957; Deuxieme Biennale de Paris, 1961; Am. Embassy, USIS, London, 1961; Edinburgh, Scotland, 1962; Int. Graphics, New Vision Centre Gal., London, 1963; Peter Stuyvesant Coll. "Art in Industry," world traveling, Holland, 1964 permanent exh., 1966; WMA, 1964; Mulvane A. Center and Washburn Univ., Topeka, Kans., 1965; Le Havre Int. Exh., 1966-1967; Am. Embassy, Paris, 1966; Kent State Univ., Ohio, 1968. One-man: Galerie de la Librairie Anglaise, Paris, 1963; New Vision A. Centre, London, 1963; A.M. Sachs Gal., N.Y., 1965, 1966, 1969; Cologne Mus., Germany, 1966; Bernard M. Baruch Col., N.Y., 1968; other exhs., Karl Flinker Gal., Paris, 1962 (4-man); Osaka, Japan (2-man), 1964; Manchester, England, (5-man), 1965.

BACH, OTTO KARL— Museum Director, P., Cr., E., W., L., C.
Denver Art Museum; h. 140 Krameria St., Denver, Colo. 80220
B. Chicago, Ill., May 26, 1909. Studied: Dartmouth Col.; Univ. Paris; Univ. Chicago, M.A. Member: AA Mus.; Western Assn. A. Mus. Dir.; CAA; International Soc. for the Conservation of Museum Objects. Awards: Hon. degree, Doctor of Humanities, Univ. Denver, 1955; Extraordinary Services certif., City and County of Denver, 1955; American Creativity award, 1961; Chevalier Des Arts Et Des Lettres, 1969. Author: "A New Way to Paul Klee"; "Life in America"; "Under Every Roof," and others. Originator, Living Arts Center pilot educational programs, 1959- . Positions: Dir., Grand Rapids A. Gal., 1934-44; Dir., Denver A. Mus., Denver, Colo. 1944- .

BACHRACH, GLADYS WERTHEIM— Painter
305 East 72nd St. 10021; h. Millbrook, N.Y. 12545
B. New York, N.Y., June 10, 1909. Studied: Columbia Univ. Member: AEA; Boston Soc. Indp. A.; Provincetown AA. Awards: Fla. Southern Col. 1952. Work: Fla. Southern Col. and in private collections national and international. Exhibited: Norfolk Mus. A. & Sc., 1951, 1952; Fla. Int. Exh., 1952; Ohio Wesleyan Univ., 1950; Gal. St. Etienne, 1951; Berkshire A. Center, 1951, 1952; Shore Studios, Provincetown, 1951, 1952; Cambridge AA, 1951; Contemporaries, 1952; AFI Gal., New York, 1952 (one-man); J. Myers Fnd., 1952; one-man: Gal. St. Etienne, 1949; Mint Mus. A., 1951; Loring A. Gal., Wickford, R.I., 1952; Massillon Mus., (Ohio), 1953; Neville Pub. Mus., Green Bay, Wis., 1953; Cayuga Mus. Hist. & Art, Auburn, N.Y., 1953; South Bend AA, 1954; Univ. Kentucky, 1954; Roosevelt Field A. Center, 1958; Condon Riley Gal., 1958 (one-man), drawings (one-man) 1960. Work and study in Greece, Turkey, Egypt and Spain, 1962-65.

BACIGALUPA, ANDREA— Painter, C., Muralist
Studio of Gian Andrea, 626 Canyon Rd., Santa Fe, N.M. 87501
B. Baltimore, Md., May 26, 1923. Studied: Am. Univ., Biarritz, France (U.S. Army sponsorship); Maryland Inst. FA, with Jacques Maroger; ASL (Woodstock) with Arnold Blanch, Sigmund Menkes; Accademia di Belli Arti, Florence, Italy, with Ottone Rosai; Alfred Univ., with Daniel Rhodes. Awards: Bronze medallion, Maryland Inst. FA, 1950. Work: Private colls. U.S.A., Europe and Orient; liturgical and secular commissions in churches, public buildings and residences in the U.S. Exhibited: One-man, traveling, and group shows throughout the U.S. and France. Positions: President of Marelli-Lee, Inc., Milan-based specialists in liturgical arts; New Mexico and Arizona area representative for Gabriel Loire, stained-glass master of Chartres.

BACKUS, STANDISH, JR.— Painter, I., Des., Gr.
2626 Sycamore Canyon, Santa Barbara, Cal. 93103
B. Detroit, Mich., Apr. 5, 1910. Studied: Princeton Univ., A.B.; Univ. Munich. Member: Cal. WC Soc.; AFA; AEA; AWS; Los Angeles AA; F., Int. Inst. A. & Lets.; Santa Barbara AA. Awards: prizes, Cal. WC Soc., 1940; Oakland A. Gal., 1939; Cal. State Fair, 1948, 1949. Work: Santa Barbara Mus. A.; Utah State Col.; San Diego FA Soc.; mural, Beckman Instrument, Inc., 1955; Cal. WC Soc.; Los A. Mus. A.; U.S. Navy Dept., Wash., D.C.; mosaic mural, Pacific War Memorial, Corregidor Island, Manila Bay, R.P., 1967-1968. Exhib-

ited: AIC, 1940; Los A. Mus. A., 1938-1940; Navy Combat Exh., 1945, 1946; BM; Denver A. Mus.; one-man: Santa Barbara Mus. A.; Detroit AI, and in Salt Lake City, San Francisco. Positions: Naval Combat A., Pacific area & Japan, 1945; Instr., Univ. California Extension; official Navy artist, Byrd Expedition to South Pole, 1955-56.

BACON, PEGGY (BROOK) — Painter, Gr., I., Cart., W.
Cape Porpoise, Me. 04014
B. Ridgefield, Conn., May 2, 1895. Studied: N.Y. Sch. F. & App. A.; ASL. Member: NAD; SAGA; Nat. Inst. A. & Let. Awards: Guggenheim F. 1934; award, Nat. Acad. A. & Let., 1944; prize, Butler Inst. Am. A., 1955. Work: MMA; WMAA; BM; MModA, etc. Exhibited: nationally. Author of 18 books and illustrator of 64 books. Contributor to New Yorker, Town & Country, Vanity Fair and other national magazines.

BADER, FRANZ — Gallery Director, Collector
2124 Pennsylvania Ave., N.W. 20037; h. 5622 Massachusetts Ave., N.W., Washington, D.C. 20016
B. Vienna, Austria, Sept. 19, 1903. Studied: in Europe. Awards: Golden Badge of Honor for Cultural Contributions to the Republic of Austria, 1964; the Bundesverdienstkreuz First Class of the Federal Republic of Germany for Cultural Contributions, 1965. Positions: Vice-Pres. and General Mngr., Whyte Gallery, Washington, D.C., 1939-1953; Pres., Franz Bader Gallery, Washington, D.C., 1953- . Specialty of the Gallery: Paintings, Sculpture, Ceramics, Original Prints by Area Artists; Original Prints by leading American and European Masters.

BAGERIS, JOHN — Painter, E.
132 E. 28th St., New York, N.Y. 10016
B. Fremont, Ohio, May 11, 1924. Studied: AIC, B.F.A., M.F.A. (painting with Boris Anisfeld); Acad. FA, Munich, Germany; Univ. Chicago; Wayne Univ. Awards: Fulbright Fellowship, 1953-54; prizes in regional shows; scholarships. Work: MModA; WMAA; Detroit Inst. A.; BM. Exhibited: Fulbright Traveling Exh., Europe, 1954; WMAA, 1958, 1960; RoKo Gal., 1957, 1961 (one-man); Werbe Gal., Detroit, 1955; Souza Gal., Mexico City, 1958, 1959 (one-man); AIC, 1947, 1948, 1950, 1951; Detroit Inst. A., 1943, 1950, 1951-1953, 1959; Smithsonian Inst., 1959; Inst. Contemp. A., Lima, Peru, 1961; MModA, 1962; one-man, Osborne Gal., New York City, 1964. Positions: Instr., Painting & Drawing, School of Visual Arts, New York, N.Y. at present.

BAHM, HENRY — Painter
755 Beacon St. 02159; h. 131 Wallace St., Newton, Mass. 02161
B. Boston, Mass., Feb. 26, 1920. Studied: Massachusetts Sch. A.; BMFA Sch. A. Member: Provincetown AA. Awards: prizes, Jordan Marsh Co., 1966; Cooperstown AA, 1967; Springfield Mus. FA, 1967. Work: Las Vegas AA; Univ. North Carolina; Norfolk Mus. A. & Sciences; Berwick A. Center. Exhibited: Columbia Mus. A., 1957; Los Angeles County Mus.; Audubon A., 1967; Univ. North Carolina, 1965; Norfolk Mus. A. & Sciences, 1965; Copperstown AA; De Cordova & Dana Mus.; Springfield A. Lg.; Boston A. Festival, 1961-1965.

BAILEY, JAMES ARLINGTON, JR. — Painter, Restorer
3421 Main Highway, Coconut Grove, Fla. 33133; h. 7719 S.W. 69th Ave., S. Miami, Fla. 33143
B. Ft. Lauderdale, Fla., May 26, 1932. Studied: Univ. Florida; Univ. Denver; Univ. Maryland Overseas Ext.; Georgetown Univ. B.S., F.S. and in Grad. Sch. Awards: purchase award, Weatherspoon Mus., Univ. North Carolina, 1967; Work: Norton Gal. A., W. Palm Beach; Ft. Lauderdale Mus. A.; Mus. Contemp. A., Houston; Columbus Mus. A.; Univ. North Carolina, Greensboro; Princeton Univ. Exhibited: Univ. North Carolina, 1967; Purdue Univ., 1967, 1969; R.I. A. Festival, 1968; Soc. Four A., Palm Beach, 1969; Mus. Contemp. A., Houston, 1966; Gulf Coast Regional, Mobile, Ala., 1966-1968; Bass Mus. A., Miami Beach, 1967, 1968; Columbia (S.C.) Mus., 1966; Mirell Gal., Coconut Grove, Fla., 1962-1969.

BAILEY, WORTH — Museum Curator, E., Des.
8029 Washington Rd., Alexandria, Va. 22308
B. Portsmouth, Va., Aug. 23, 1908. Studied: William & Mary Col.; Univ. Pennsylvania, B.A. Member: AAMus.; Am. Soc. Arch. Historians. Awards: Norfolk Soc. A., 1926-1928; Fellowship, Brookings Institution Center for Advanced Study, 1962. Work: Univ. Pennsylvania; Valentine Mus. A.; Col. of William & Mary. Exhibited: Norfolk, Williamsburg, Richmond, Va., 1928-1938. Contributor to Encyclopedia Americana and to art, antique and history magazines. Illus., "Christmas with the Washingtons"; "Seaport in Virginia: George Washington's Alexandria." Des., Christmas card series; Alexandria Commemorative Stamp, 1949. Author: "Safeguarding a Heritage," 1963. Positions: Cur., Jamestown Archeological Project, 1933-38; Cur., Mount Vernon, Va., 1938-51; Curatorial Consultant, National Trust for Historic Preservation, Washington, D.C., 1951-56. Con-

sultant, "Our Town 1749-1865," special exh., Alexandria Assn., 1956; Cur., Alexander Hamilton Bicentennial Exh., U.S. Treasury, 1957; Arch. Hist., Historic American Buildings Survey, National Park Service, Washington, D.C., 1958-1966; Editor, "Historic American Buildings Survey Catalogue Supplement," 1959; Hist. (Am) Bldgs. Survey, "Wisconsin Architecture"; Fine Arts Committee, "Sully Plantation." Fairfax County, 1963-1969.

BAILIN, HELLA — Painter
829 Bishop St., Union, N.J. 07083
B. Dusseldorf, Germany, Oct. 17, 1915. Studied: Berlin Acad.; Reimann Sch. Berlin; Newark Sch. Fine & Indst. Arts. Member: N.J. WC Soc.; All. A. Am.; Assoc. A. of New Jersey; AWS; Portraits, Inc. Awards: Walter Margetts award, AAPL, 1964; Prize, Westfield, N.J. State Exh.; prizes, Fairlawn (N.J.) AA, 1967, 1968; AAPL, 1966-1968; New Jersey WC Soc., 1968. Work: Painting, Marshall School, South Orange, N.J.; murals: Mennen Products, Morristown, N.J.; Consolidated Gas Co., Metuchen, N.J.; Marshall Sch., South Orange, N.J.; Temple Beth Ahm, Springfield, N.J. Exhibited: NAD, 1964, 1965; Audubon A., 1962, 1963; All. A. Am., 1961-1964; AWCS, 1960, 1963; Watercolor: USA, 1963; AAPL, 1961; Montclair A. Mus., 1959, 1961-1964, 1967, 1969; Newark Mus. A., 1959, 1961; Jersey City Mus., 1959, 1960, 1963; Westfield AA, 1964, 1965; AAPL, 1961, 1964; Monmouth Col., 1962, 1963.

BAIRD, JOSEPH ARMSTRONG, JR. — Educator, W., L.
Department of Art, University of California, Davis, Cal. 95616
B. Pittsburgh, Pa., Nov. 22, 1922. Studied: Oberlin Col. (B.A.); Harvard Univ. (M.A., Ph.D.). Member: CAA; Soc. Arch. Historians; Nat. Trust for Hist. Preservation. Contributor to Art Bulletin, Journal of the Society of Architectural Historians, Journal of Aesthetics and Art Criticism, Handbook of Latin American Studies. Author of "The Churches of Mexico," 1962 and "Time's Wondrous Changes: San Francisco Architecture: 1776-1915" (Cal. Hist. Soc., 1962); also various monographs-catalogues of California artists. Lectures: Baroque Architecture in Mexico; American Architecture; Research Methods; Connoisseurship and Museum Training. Positions: Instr., Art History and Archaeology; Univ. Toronto, 1949-53; Asst. & Assoc. Prof. of Art History, and Curator of Collections, University of California, Davis, Cal., 1953-1961; Lecturer, 1961- . Cur. Art, Cal. Hist. Soc., San Francisco, 1962-1963; Cur., Bancroft Library, Univ. California, Berkeley, 1964-1965.

BAKANOWSKY, LOUIS J. — Educator, S., Arch.
1000 Massachusetts Ave., Cambridge, Mass. 02138; h. 234 Pleasant St., Arlington, Mass.
B. Norwich, Conn., Oct. 8, 1930. Studied: Syracuse Univ., B.F.A.; Yale Univ.; Harvard Univ., B. Arch. Member: American Institute of Architects, Boston Society of Architects. Positions: Asst. Prof. Arch., Cornell University, 1962; Assoc. Prof. Arch., and Design, Harvard University, Cambridge, Mass., 1964- .

BAKER, ANNA P. — Painter, Gr.
Barton, Vt. 05822
B. London, Ont., Canada, June 12, 1928. Studied: Univ. of Western Ontario, B.A.; AIC, B.F.A., M.F.A. Member: Canadian Painters, Etchers & Engravers. Awards: Mr. and Mrs. Frank G. Logan prize and medal, AIC, 1956; prizes, Cleveland Inst. A., 1956, 1958; Ball State T. Col., 1959 (2), 1962; Lyman Allyn Mus., 1960; Wash. WC Soc., 1963; Wash. WC Exhibition, 1963; Canada Council Grant for Printmaking, 1968. Work: L.C; London Publ. Lib. and A. Mus.; CMA; Ball State T. Col; Univ. Western Ontario. Exhibited: Phila. Pr. Cl., 1953-1956; Northwest Pr. M.; Albany Pr. Cl.; Bradley Univ.; Boston Soc. Indp. A.; Portland, Me.; CM, 1954, 1956, 1958; Silvermine Gld. A., 1951; Wichita Print Exh., 1956; Butler Inst. Am. A., 1956; Norfolk Mus. A.; Boston Pr. M.; Alabama WC Soc.; San F. Mus. A.; "Art-USA," 1958; AIC, 1953, 1955, 1956, 1957; Cleveland May Show, 1955, 1956, 1957; Western Ontario, 1952-1958, 1968 (one-man); Young Contemp. of Canada, 1956-1958; Canadian Painters, Etchers & Engravers, 1955-1957, 1960; PAFA; Wash. WC Exh., 1963; Wash. WC Soc., 1962; Ball State T. Col., 1962 and prior; Lyman Allyn Mus.; Conn. Acad., 1960; Brockton, Mass.; Audubon A., 1960; Boston A. Festival, 1959; N.E. Vermont A., 1961; Portland A. Festival, 1961; St. Paul, 1962; Phila. A. All.; Oklahoma Printmakers, 1963; DeCordova & Dana Mus.; Goddard Col., Vt.; Los Angeles, 1966.

BAKER, CHARLES EDWIN — Editor, Hist., W.
New York Historical Society; h. 4652 Manhattan College Parkway, New York, N.Y. 10471
B. Harlan, Iowa, Dec. 16, 1902. Studied: State Univ. Iowa, B.A., M.A.; Columbia Univ. Member: Am. Assn. State & Local Hist.; N.Y. State Hist. Assn.; Soc. Am. Historians. Contributor to art magazines; Editor of books on the history of American art. Author: "The American Art Union," 1953; co-director, 1945-57, "Dictionary of Artists in America, 1564-1860," Yale Univ. Press, 1957. Positions: Ed, Hist. Records Survey, New York City, 1937-41; New-York Hist. Soc., 1944- .

BAKER, GEORGE P.—Sculptor, T.
3305 N. Olive Ave., Altadena, Cal. 91001
B. Corsicana, Texas, Jan. 23, 1931. Studied: College of Wooster
(Ohio); Occidental College, Los Angeles, A.B.; Univ. of Southern
California, M.F.A. Awards: prizes, Los A. Mus. A., 1959; Cal.
State Fair, 1959; Nat. Orange Show, Riverside, Cal., 1961; City
Festival, Los Angeles, 1963, 1964; purchase prize, La Jolla Mus.
A., 1962. Work: La Jolla Mus. A.; Lytton Financial Corp. of Los
Angeles and Oakland, Cal.; Howard Lipman Fnd., New York; bronze
fountain, Sch. of Arch., Univ. So. California, 1960; wall relief, Regis
Development Co., Los Angeles, 1965. Exhibited: SFMA, 1959-1961;
Denver A. Mus., 1962; Cal. State Fair, 1959-1961; La Jolla Mus. A.,
1960-1963; Los A. Mus. A., 1959, 1960; one-man: Landau Gal., Los
Angeles, 1960, 1964; Springer Gal., West Berlin, Germany, 1965.
Positions: Instr., Sculpture, University of Southern California, 1960-
1964; Occidental College, Los Angeles, 1964- .*

BAKER, MILDRED (Mrs. Jacob)—Associate Museum Director
The Newark Museum, 43-49 Washington St. 07101; h. 569 Mt.
Prospect Ave., Newark, N.J. 07104
B. Brooklyn, N.Y., Aug. 14, 1905. Studied: Univ. Rochester. Member:
AAMus.; AFA; Cosmopolitan Cl. Positions: Asst. to Exec. Dir., CAA,
1929-32; Asst. to Dir., and Asst. Dir., Federal Art Project, 1935-43;
Asst. to Dir., 1944- , Asst. Dir., 1949, Assoc. Dir., 1953- , The Ne-
wark Museum, Newark, N.J.; Assembled many important exhibitions
including Decorative Arts Today, 1948; annual exhibition of objects of
good design and the triennial exhibition of works by New Jersey Art-
ists. Vice-Chm., Governor's Commission for the Study of the Arts in
New Jersey. Appointed to New Jersey State Council on the Arts, 1966.

BAKER, RICHARD BROWN—Collector
118 W. 79th St., New York, N.Y. 10024
B. Providence, R.I., Nov. 5, 1912. Studied: Yale University, B.A.; Ox-
ford University, B.A., M.A.; ASL; Hans Hofmann Sch. FA. Author:
"Notes on My Collection," published in Art International, 1961. Col-
lection: Contemporary Art, International in scope. Exhibitions based
upon the Richard Brown Baker Collection: Museum of Art, Rhode Is-
land School of Design, 1959; Staten Island Institute of Arts and Sci-
ences, 1960; Drew University, 1960, 1962; Walker Art Center, 1961;
Jewett Art Center, Wellesley College, 1963; Yale University Art Gal-
lery, 1963; University of Rhode Island, Kingston, 1964; Museum of
Art, Rhode Island School of Design, 1964; The Larry Aldrich Museum,
Ridgefield, Conn., 1965; Oakland Univ. Art Gallery, Rochester, Mich.,
1966; Art History Gallery, Univ. of Wisconsin, Milwaukee, 1967; Univ.
of South Florida, Tampa, 1967; U.S. representation, sponsored by the
Smithsonian Institution, Museo de Arte Moderno, Mexico City, 1968;
Art Gallery, Univ. of Notre Dame, Indiana, 1969; Univ. of South Flor-
ida, Tampa, 1969.

BAKER, MR. and MRS. WALTER C.—Collectors
555 Park Ave., New York, N.Y. 10022*

BAKKE, LARRY—Painter, E., W.
University of Syracuse; h. B-20 #6 New Slocum Heights,
Syracuse, N.Y., 13210
B. Vancouver, B.C., Canada, Jan. 16, 1932. Studied: Univ. Wash-
ington, B.A., M.F.A.; post-graduate study, Syracuse Univ., with
Laurence Schmeckebier. Member: AAUP; NAEA. Awards: prizes,
Woessner Gal., Seattle, 1958, 1960; SAM, 1962, 1963; Spokane-
Northwest Annual, 1963; Renton (Wash.) A. Festival, 1963; Kinorn
Gal., Seattle, 1963; Western Washington Col., 1963; Center Exh.,
Syracuse, N.Y., 1965. Work: Syracuse Univ.; Everett (Wash.) Col.
Exhibited: Northwest Artists, 1960, 1961; Vancouver A. Gal., 1955-
1960, 1962; Woessner Gal., Seattle, 1960, 1962; Western Wash. Fair,
1960, 1962; A. of Puget Sound, Henry Gal., Univ. Washington, 1960-
1962; SAM, 1961-1963; Western Washington State Col., 1963; An-
chorage, Alaska, 1963; Purdue Univ., 1964; Syracuse Univ. Faculty
exhs., 1964, 1965 (2), 1966-1968; N.Y. State Expo., Syracuse, 1964; Ro-
chester Mem. Mus., 1964, 1969; NAD, 1964; Everson Mus. A., 1964;
"The Painter and The Photograph," traveling exh. organized by the
Staff of the A. Gal. of Univ. New Mexico, 1964-1965; Center Exh.,
Syracuse, 1965; Munson-Williams-Proctor Instr., Utica, N.Y., 1965,
1967-1969; Appleton Gal., Syracuse, 1966; Roberson Center, Bing-
hamton, N.Y., 1968; One-man Retrospective, Lowe Gal., Univ. Syra-
cuse, 1969. Contributor, "Aspects of Space," Creative Crafts, 1963;
co-author, "The Goal Is Visual Literacy," Washington Education,
1962. Positions: Instr., A. Hist., Drawing, Painting, Everett Col.,
Everett, Wash., 1959-1963; Prof., Painting, Drawing, Art Education,
Syracuse Univ., N.Y., 1963- ; Visiting Prof., Univ. Victoria (B.C.),
1958-1967; Visiting Prof., (summer 1969), Villa Giglucci, Florence,
Italy.

BALDWIN, JOHN L.—Director
Edward W. Root Art Center, Inc., Hamilton College, Clinton,
N.Y. 13323*

BALLATOR, JOHN R.—Painter, E., Lith.
Hollins College, Va. 24020
B. Portland, Ore., Feb. 7, 1909. Studied: Portland Mus. A. Sch.;
Univ. Oregon; Yale Univ., B.F.A. Work: Murals, USPO, Portland,
Ore.; Dept. Justice, Wash., D.C.; Menninger Sanatorium, Topeka,
Kan. Positions: Prof. A., 1938- , Hd. A. Dept., Hollins Col., Va.,
1941- .*

BALLINGER, HARRY RUSSELL—Painter, T., W., L.
R.F.D., New Hartford, Conn. 06057
B. Port Townsend, Wash., Sept. 4, 1892. Studied: Univ. California;
ASL; Academie Colorossi, Paris. Member: SC; All. A. Am.; Audu-
bon A.; Conn. Acad. FA; Kent AA; AWS; North Shore AA; Rockport
AA. Awards: prizes, SC, 1944, 1952, 1954, 1958 (2), 1959-1961,
1964; Conn. Acad. FA, 1944, 1956; Conn. WC Soc., 1944, 1945, 1954;
Meriden A. & Crafts, 1944, 1952, 1957, 1961; New Haven Paint &
Clay Cl., 1956, 1962; Jordan Marsh, Boston, 1953, 1960; Springfield,
Mass., 1952, 1953, 1955, 1962, 1964; North Shore AA, 1964; Hudson
Valley AA, 1958, 1961; AAPL, 1961; Rockport AA, 1953, 1955, 1960
(2), 1963. Work: Wadsworth Atheneum; New Britain Mus. Am. A.;
Springfield Mus. A.; murals, Plant H.S., West Hartford, Conn. Ex-
hibited: SC; NAD; Audubon A.; All. A. Am.; AWS (London, England),
AWS traveling exhs., and others. Author: "Painting Surf and Sea";
"Painting Boats and Harbors"; "Painting Landscapes." Positions:
Instr. A., Connecticut Central College, 1945-59.*

BALOSSI, JOHN—Educator
Dept. di Bellas-Artes, Humanities Div. Univ. of Puerto Rico,
Rio Piedras, P.R.*

BAND, MAX—Painter, W., S., L.
6401 Ivarene Ave., Hollywood, Cal. 90028
B. Naumestis, Lithuania, Aug. 21, 1900. Studied: Acad. A., Berlin,
and in Paris. Member: hon. memb., Cal. A. Cl.; F.I.A.L. Work:
Musée de Luxembourg, Petit Palais, Paris, and other European mu-
seums; French AI, Phila.; Riverside Mus.; PMG; Los A. Mus. A.;
Mus. Mod. A., Paris; deYoung Mem. Mus., San F.; Cal.PLH; Santa
Barbara Mus. A.; Parliament of Israel, Jerusalem; sculpture of F. D.
Roosevelt, The White House, Wash. D.C. Exhibited: extensively in
U.S. and Europe; one-man; Wildenstein Gal., 1948; Galerie Delisée,
Paris, 1949; Vigiveno Gal., Los Angeles, 1952, 1955; AIC (group),
1954; Musée du Petit Palais, Paris, 1955; Cal.PLH, 1956; also Marl-
borough Gal., London, 1956; B'nai B'rith Mus., Wash., D.C., 1958;
Acosta Gal., Beverly Hills, Cal., 1959; Jewish Community Center,
Long Beach, Cal., 1961; Michel Thomas Gal., Beverly Hills, Cal.,
1963. Author: "History of Contemporary Art," 1935; "Themes from
the Bible." Positions: Artist-in-Res., Univ. of Judaism, Los Angeles,
Cal., 1964.

BANISTER, ROBERT BARR—Educator, P., C., Gr., W.
13911 Perris Blvd., Sunnymead, Cal. 92388
B. Sheridan, Oregon, May 10, 1921. Studied: Univ. Oregon, B.S.,
M.A.; Rochester Inst. Tech.; Western Washington College; Armed
Forces Inst; Portland State College. Member: Cal. A. Edu. Assn.;
Pacific A. Edu. Assn.; NAEA; Oregon WC Soc.; Intl. Men of Art Gld.;
Riverside AA. Awards: Dept. of Army Citation, Ft. Sam Houston,
Tex., 1961; 5th Army Hqdtrs. Commanding General Award, 1957; pur-
chase awards: Witte Mem. Mus., San Antonio, 1961; Lincoln County
(Oregon) A. Center, 1962; Ford Motor Co. Painting Coll. Exhibitions:
U.S. Army Exh., Miami, Fla., 1961; Oregon Annuals, 1951, 1952, 1961,
1963; Ford Motor Traveling Exhs., 1948, 1952, 1954, 1962-1964; Men
of Art Gld., 1960, 1961; Texas Annual, 1961; So. California Annual,
1964; Seattle World Fair, 1962; Henry Gal., Univ. of Washington, 1959;
Portland (Ore.) A. Mus., 1948, 1950; La Sierra College, Cal., 1964;
Incarnate Word College, Texas, 1961. Contributor to Ford Times;
Western A. Edu. Assn. Bulletins; Pacific A. Bulletins; and educational
publications of the Armed Forces. Positions: A. Director, 4th and 5th
Hqdtrs. and 15th AF (SAC); Univ. Oregon Summer Program; A. Cur.,
Klamath Falls A. Center; Chm. & Founder, Moreno Valley Allied Arts
Center, Sunnymead, Cal.; Art Supv., Moreno Valley Unified School
District, Moreno Valley, Cal., and Riverside County Schools; Workshop
Dir. for teachers, San Diego State College, at present.

BANKS, VIRGINIA—Painter
3879 51st Ave., N.E., Seattle, Wash. 98105
B. Norwood, Mass., Jan. 12, 1920. Studied: Smith Col., B.A.; Butera
Sch. FA; State Univ. Iowa, M.A.; Colorado Springs FA Center.
Awards: prizes, SFMA, 1947; Wash. State Fair, 1949; Audubon A,
1951; Hallmark award, 1949; Smith Tower Gal., Seattle, Wash., 1960;
SAM purchase award, 1962. Work: SAM; IBM; Davenport Mun. Gal.;
Springfield (Mo.) A. Mus.; Univ. Illinois; Plattsburg State Col.; State
Univ. Iowa; SFMA; Cornell University; University of Notre Dame;
Univ. Oregon A. Gal. Exhibited: nationally since 1946; including AIC;
PAFA; BM; WMAA; Carnegie Inst.; Audubon A.; NAD; VMFA; SAM,
1962-1964; Governor's Invitational, Olympia, Wash., 1968-69; Cheney

Cowles Mus., Spokane, 1964; A. Gal of Victoria, B.C., 1964, 1965; FA Pavillion, World's Fair, Seattle, 1962; Philbrook A. Center, Tulsa, Okla., 1965; MMA; Weyhe Gal.; Alaska; Paris; Tokyo and Osaka, Japan; one-man: Grand Central Moderns, New York, 1950, 1952, 1956, 1959, 1965; Dusanne Gal., Seattle, 1952, 1958; Collector's Gal., Bellevue, Wash., 1965. Included in MModA lending service. Positions: T., Shady Hill Sch., Cambridge, Mass., 1941-51; State Univ. Iowa; Univ. Buffalo; Univ. Washington Ext. Div., 1950; AAG and Cornish A. Sch., Seattle, Wash. 1950-51.

BANNARD, WILLIAM DARBY—Painter
c/o Tibor de Nagy Gallery, 29 W. 57th St., New York, N.Y. 10019*

BANTA, E(THEL) ZABRISKIE (SMITH)—Painter, T., C.
223 Shore Dr., Ozona Shores, Fla. 33560; also, 9 Ocean Ave., Pigeon Cove, Mass.
B. Philadelphia, Pa. Studied: Cornell Univ.; ASL. Member: Florida A. Group; Phila. WC Soc.; Washington WC Soc.; Rockport AA; Bradenton AA; Fed. of Women A.; Maine WC Cl.; Tarpon Springs AA; North Shore AA; Cape Ann Mod. A.; Nat. Lg. Am. Pen Women; Fla. Gulf Coast A. Center. Awards: prizes, Mineola, N.Y., 1942 (2); Fla. Fed. A., 1954, 1959-1961; Mineola, N.Y., 1942, 1943; Pinellas, Fla., 1955, 1956, 1957, 1953-60, 1962, 1964; Florida State Fair, 1956; Gulf Coast A. Center, 1959-1962, 1966; Gold Trophy, Am. A. Soc.; Clearwater A. Group, 1968. Work: First Nat. Bank, Tarpon Springs; Pub. Lib., and Woman's Cl., Tarpon Springs, Fla., and Federal Savings & Loan, Tarpon Springs; Univ. Iowa; Mural, All Saints Episcopal Church, Tarpon Springs; Buena Vista Col., Storm Lake, Iowa. Exhibited: Fla. Artists, 1952-1958, 1959-1961, 1962 (traveling); NAD, 1957; Emily Lowe A. Gal., 1955; PAFA, 1947-1951; Sarasota AA, 1950-1952; All. A. Am., 1948, 1949; Wash. WC Cl., 1946-1950; Rockport AA, 1946-1958, 1959-1961; North Shore AA, 1946-1950; Cape Ann Mod. A., 1956, 1959-1961; Portland Mus. A., 1947-1950; Rockland, Me., 1947-1950; A. All., Rhode Island 1946, 1947; Fed. Women Painters, 1948, 1949; Elmira, N.Y., 1950; Woodmere A. Gal., Phila. Pa., 1947, 1948; Winter Haven Mar. 1954; Vero Beach, Fla., 1955; Norton Gal. A., 1961; Napier Gal. A., 1960; Palette Gal., 1960; Belleair A. Center, 1960; Cape Ann Festival of Arts, 1959-1961; Fla. Fed. A., 1959 traveling exh; Copley Soc., 1963, 1964; Petit Gal., Palm Beach, Fla. Positions: Pres., Tarpon Springs AA, 1955-56; Dir. of A., Tarpon Springs AA, 1957-58; Dir. Stonehenge Gallery, Pigeon Cove, Mass., 1946- ; Dir., Gallery in the Woods, Pigeon Cove, Mass.

BARANIK, RUDOLF—Painter
97 Wooster St., New York, N.Y. 10012
B. Lithuania, Sept. 10, 1920. Studied: AIC; ASL; Academie Julien, Paris; Academie Fernand Leger, Paris. Member: AEA. Awards: Joseph W. Beatman and Charles Shipman Payson awards, Silvermine Gld. A., 1958; Raymond Speiser Mem. award, PAFA, 1964; Childe Hassam purchase prize, Am. Acad. A. & Lets., 1969. Work: Living Arts Fnd.; WMAA; Univ. Massachusetts; NYU; Ball State T. Col.; Jacksonville Mus. A.; Peabody Mus., Nashville, Tenn.; MModA; Nat. Mus., Stockholm, Sweden; State Univ. N.Y. At Binghamton; Slater Mem. Mus., Norwich, Conn.; Hampton Col. Mus. and private colls. Exhibited: PAFA, 1954; Brandeis Univ., 1954; Univ. Nebraska, 1954, 1960; MModA circulating exh., 1954-55; Illinois Wesleyan Univ., 1954; Art:USA, 1958; Provincetown A. Festival, 1958; WMAA, 1958, 1960; Critics Choice 1960; Butler Inst. Am. A., 1959-1961; Silvermine Gld. A., 1957, 1958; BM, 1958; Am. Painting & Sculpture, 1958; Nat. Inst. A. & Lets.; PAFA, 1964; RoKo Gal., 1962; Am. Acad. A. & Lets., 1969; Anti-War Internat. Exh., Tokyo, 1968; Hampton Col. Mus., Va., 1966; N.Y. Univ. 1967; Sch. of Visual A., 1967; AAA Gal., N.Y., 1968; one-man; ACA Gal., 1953, 1955; RoKo Gal., 1958, 1961, 1964; Rena Gal., Princeton, N.J., 1961; Katonah (N.Y.) Gal., 1961; Miami, Fla., 1958; Galerie 8, Paris, France, 1951; Ball State T. Col., 1963; Pratt Inst., 1967; Ten Downtown Gal., N.Y., 1969. Positions: Lecturer, Queens College, L.I., N.Y.; Faculty of Pratt Inst., City Col. of N.Y. and Art Students Lg.

BARBEE, ROBERT THOMAS—Painter, Gr., E.
University of Virginia; h. 1521 Rugby Rd., Charlottesville, Va. 22903
B. Detroit, Mich., Sept. 25, 1921. Studied: Cranbrook Acad. A., B.A., M.F.A.; Centenary College, and in Mexico. Awards: prizes, Irene Leach Mem. Exh., Norfolk Mus. A. & Sciences, 1962; Thalheimer's Invitational Exh., Richmond, 1963; Norfolk Mus. A. Sciences, 1964. Work: Butler Inst. Am. Art, Youngstown, Ohio; Cranbrook Acad. A., Bloomfield Hills, Mich. Exhibited: Mus. A. of Ogunquit (Me.), 1962, 1963; Norfolk Mus. A. & Sciences, 1960; AFA, 1965; VMFA, 1953, 1955, 1957, 1961, 1965 and traveling exh., 1958, 1962; Birmingham Mus. A., 1959; Springfield Mus. FA, 1957; Rehn Gal., New York City, 1962, 1964. Positions: Instr., Painting & Drawing, University of Virginia, Charlottesville, Va.*

BARBER, MURIEL V. (Mrs. J. S. Barber, Sr.)—Painter, C., S., T., Cr.
1921 Field Rd., Sarasota, Fla. 33581
B. West Orange, N.J. Studied: Fawcett A. Sch., Newark; Wayman Adams Sch. A., and with Hubert DeGroat Main, Michael Lenson, Stanley Marc Wright, and others. Member: AAPL; Verona-West Essex AA; Essex WC Soc.; South Orange-Maplewood AA; Maplewood WC Cl.; Art Center of the Oranges, and others. Awards: prizes, Maplewood, 1959-1961; Douglass Col., 1959; A. Gal. of Maplewood, 1959, 1964; citation, AAPL, 1959; Essex WC Cl., 1963; Maplewood WC, 1963-1965; Fairleigh Dickinson Univ., 1964; Seton Hall Univ., 1964; Newark Mus. A., 1964. Work: Davis Elkins Coll., W. Va., and in private collections. Exhibited: Drew Univ., 1959; AAPL, 1959-1964; N.J. Fed. WC, 1959; A. Center of the Oranges, 1959, 1960; A. Gal. of Maplewood, 1959; Paramus, N.J., 1959; Newark Lib., 1960; Douglass Col., New Brunswick, N.J. 1960; Maplewood Women's Cl., 1960, 1963-1965; Newark Mus., 1960, 1964; Papermill Playhouse, 1965; Sarasota AA, 1967, 1968; Seton Hall Univ., 1964; Smithsonian Inst., 1961; Salmagundi Cl., N.Y., 1961; 19 one-man exhs. Positions: State Dir., Am. Art Week, New Jersey, 1957, 1958. Trustee, Nat. Bd. AAPL, 1956-1965.

BARBOUR, ARTHUR J.—Painter, T., I.
46 Voorhees Place, Erskine Lakes, Ringwood, N.J. 07456
B. Paterson, N.J., Aug. 23, 1926. Studied: Newark Sch. Fine & Indst. Arts, and with Avery Johnson, Syd Brown and James Carlin. Member: AWCS; Knickerbocker A.; P & S. Soc. of New Jersey; New Jersey WC Soc. (Traveling Exh. Chm.); AAPL. Awards: Elsie J. Royle award, West Milford, N.J. Annual, 1957; Grumbacher Award, Seton Hall Univ., 1958; Art Centre of the Oranges, 1959, 1960, 1962; Montclair A. Mus., 1963; Cherry Blossom Festival, Wash. D.C., 1961; New Jersey WC Soc., 1963; Wyckoff (N.J.) Outdoor Exh., 1964; Urban Farms Exh., 1964; Grumbacher Award, New Jersey WC Soc., 1964; Plainfield AA, 1964. Work: Watercolors-Woman's Day Magazine; Ford Motor Company Coll.; Essex Chemical Corp. (and mural); American Artists Christmas Card Group. Exhibited: AWCS; Audubon A.; All. A. Am.; Knickerbocker A.; Watercolor: USA; NAC; Grand Central Gal.; Montclair, Jersey City and Newark Mus. A.; New Jersey WC Soc.; P. & S. Soc. of New Jersey; AAPL; Art Centre of the Oranges; Hunterdon County Exh.; Summit AA; Plainfield AA, and others. One-man: Beaumont Mus. A., Texas, 1965. Positions: Instr. Watercolor Painting, Ringwood School of Art, Ringwood, N.J.*

BARDIN, J(ESSE) (REDWIN), Jr.—Painter, C., T.
Richland Art School of the Columbia Museum, 1112 Bull St.; h. 1723 Devine St., Columbia, S.C. 29201
B. Elloree, S.C., Mar. 26, 1923. Studied: Univ. South Carolina, B.A. & Certif.; ASL, with Will Barnet, Harry Sternberg, Vytlacil and Byron Browne. Ceramics with Mary Barber, Richland A. Sch. Member: Am. Craftsmen's Council; ASL; Columbia AA; Gld. of South Carolina A.; Carolina AA. Awards: prizes, Sarasota AA, 1961; Chattanooga AA, 1960-1963; Ford Fnd. purchase, 1960; Jacksonville, 1959; Springs Mills purchase, 1960-1963; Miami National, 1963; South Carolina Annual, 1963; Piedmont Belks purchase, 1959; Webbs A. Center, Columbus Mus., 1959; South Carolina Gld. A., purchase, 1958; Carolina AA, 1958; Southeastern Annual, Atlanta, 1957; Carolina Engraving Co. award, 1957; South Carolina State Fair, 1954-1960, and others. Work: Pa. State Univ.; Mint Mus.; Columbia Mus. A.; Furman Univ.; Louisiana State Univ.; Univ. of Southern Florida; Williams College, Williamstown, Mass.; Carolina AA; Gibbes A. Gal.; Univ. South Carolina; North Carolina Mus. A. and in private colls. Exhibited: BM, 1953; Berlin Acad. A., Germany; Butler Inst. Am. A., 1953, 1959, 1961; Ringling Mus. A., 1959, 1960, 1961; Soc. Four A., Palm Beach, 1959; Hunter Gal., 1960; Columbia Mus. A., 1957, 1959-1969; DMFA, 1955; Mississippi AA, 1958; Riverside Mus., N.Y., 1953; PAFA, 1953; Atlanta AA, 1954-1957, 1959, 1961; Paintings of the Year, Atlanta, 1961; Birmingham Mus. A., 1959; Mint Mus., 1959-1965; Jacksonville Mus. A., 1959; Winston-Salem Gal. FA, 1956-1958, 1960; Telfair Acad. A. & Sc., 1959-1960; Gibbes A. Gal., 1955-1965; Florence Mus., 1957-1959; Greenville Mus.; New Arts Gal., Atlanta, 1959; Mus. Dirs. Choice traveling exh., 1958-1960; one-man: Arnold Finkel Gal., Phila., 1960; Gibbes A. Gal., 1960; Columbia Col., 1959; Bob Jones Univ., 1959; Greenville Mus., 1959; Queens Col., 1959; Univ. South Carolina, 1958; Florence Mus., 1955; Mint Mus. A., 1963; Hunter Gal., 1964; Oak Ridge A. Center, 1964; North Carolina State Univ., 1963; Univ. Pennsylvania, 1965; Blacksburg AA (Va.), 1965; Canton AI, 1966; Decatur A. Center, 1966; El Paso Mus. A., 1966; Temple Univ., Phila., Pa., 1967; Alabama State College, 1967; Univ. North Carolina, 1968; Univ. Utah, 1968; No. Arizona Univ., Flagstaff, 1968 and others. Positions: Supv., Richland A. Sch. of the Columbia Museum of Art, Columbia, S.C.

BAREFOOT, CARL—Editor
Museum News, American Association of Museums, 2306 Massachusetts Ave., N.W., Washington, D.C. 20008*

BAREISS, WALTER—Collector
　　60 East 42nd St., New York, N.Y. 10017
B. Tuebingen/Wttbg., West Germany, May 24, 1919. Studied: Yale University, B.S.; Columbia Law School. Collection: 20th Century Art; Greek Vases, 6th & 5th Century B.C. Positions: Trustee, Museum of Modern Art, New York; Trustee, Associates in Fine Arts, Yale University; Member, Visiting Committee, Department of Greek and Roman Art, Metropolitan Museum, New York; Member, "Purchasing Commission for 20th Century Art," Bavarian State Museums, Munich; Chairman, Gallery Association, Bavarian State Museums, Munich; Vice-Chairman of Board, Stuttgart Gallery Association, Stuttgart, Germany.

BARETSKI, CHARLES ALLAN — Archivist, W., L., E., A. Libn.
　　Newark Public Library, Van Buren Branch, 140 Van Buren St.; h. 229 Montclair Ave., Newark, N.J. 07104
B. Mount Carmel, Pa., Nov. 21, 1918. Studied: N.Y. Univ., with Demetrios Tselos; Newark Univ. (merged with Rutgers), B.A.; Columbia Univ., B.S.L.S., M.S.L.S.; American Univ., Wash., D.C., Archival Dipl. and Dipl., Advanced Archival Admin.; Notre Dame Univ., M.A., Ph.D.; N.Y. Univ., M.A., Ph.D. Member: Am. Soc. for Aesthetics; Soc. of Am. Archivists; Polish A. Cl., Newark; Polish Univ. Cl. of New Jersey. Awards: Archival Interneship, Nat. Archives, Wash., D.C., 1951; Edna M. Sanderson Scholarship, Columbia Univ., 1945-46; (2) Louise Connolly Scholarships, Newark Pub. Lib., 1945-46; Research F., Univ. Notre Dame, 1956-57. Editor & Compiler: "The Polish Pantheon: A Roster of Men and Women of Polish Birth or Ancestry Who Have Contributed to American Culture and World Civilization," 1958; Ed., Publ., "Ironbound Counselor," community newspaper, Newark, 1965. Contributor to Art in America. College Art Journal. Journal of the American Institute of Architects, School and Society, The Polish Arts Club of Buffalo Bulletin, and others. Lectures on 19th Century American Painting; Historical School of Polish Painting in 19th Century; European Folk Art of 19th and 20th Centuries, etc. Founded and directed The Institute of Polish Culture, Seton Hall Univ., 1953-54. Positions: Sr. Lib. Asst., A. Dept., 1945-47, Sr. Libn., A. Dept., 1948-54, Branch Libn., 1954-56, 1957-, Newark Pub. Library; Archivist, Am. Council of Polish Culture Clubs, 1954-,, Vice-Pres., 1959-1961, 1967-1968, Assoc. Ed., 1964-1965; Research Asst., Univ. Notre Dame, 1956-57; Asst. Ed., Polish Am. Hist. Assn. Bulletin, 1959-1961, Nat. Ed., 1961-1965; Chm. Edu. Needs & Sch. Requirements Comm. of the Assoc. Community Councils of Newark, N.J., 1961-1962; Pres., 1969-1970; Ed. & Compiler "Higher Horizons," Edu. Program in New York City, N.Y., publ. 1961; Historian, Polish-Am. Unity League of New Jersey, 1965-1967; Chm., Academic Freedom Dept., Middle States Council for the Social Studies, 1965-1966.

BARILE, XAVIER J.—Painter, Gr., I., T., L.
　　180 West End Ave., Apt. 25N, New York, N.Y. 10023
B. Tufo, Italy, Mar. 18, 1891. Studied: CUASch; ASL, and with Victor Perard, William DeL. Dodge, Luis Mora, John Sloan and others. Member: FA Soc., Pueblo, Colo.; Am. Monotype Soc.; Audubon A.; St. Augustine AC; AAPL; P. & S. Soc., N.J.; AEA; ASL; Nat. A. Edu. Assn.; Nat. Soc. Painters in Casein; SC. Exhibited: NAD, 1943; Am. Monotype Soc. traveling exh., 1940, 1944; Mus. New Mexico, 1944 (one-man); NAC; LC; Soc. Indp. A.; Denver A. Mus.; Colorado Springs FA Center; Audubon A.; Newark Mus. A.; WMAA; Studio Cl.; AAPL (prize, 1956); AEA; SC; Nat. Soc. Painters in Casein; New Jersey Soc. P. & S.; Union Square Savings Bank, N.Y., 1958. Illus., magazine stories and covers; portraits of prominent persons. Lectures on oil, watercolor and casein painting and monotypes to colleges, art centers, galleries and clubs. Positions: Dir., Barile A. Sch., 1919-39; Hd., A. Dept., Pueblo Jr. Col., 1939-45; Instr. St. Augustine, Fla., 1945-46, Pan America A. Sch., 1948-49, Catan Rose Inst. FA., 1948-50; Dir., Instr., Barile Art Group, 180 W. End Ave., New York, N.Y.

BARINGER, RICHARD E.—Painter, Des., Arch.
　　1-D Church St. Christiansted, St. Croix, V.I. 00820
B. Elkhart, Ind., Dec. 3, 1921. Studied: Inst. of Design, Chicago, B.A.; studied painting with Moholy-Nagy and Emerson Woelffer and Architecture with Serge Chermayeff; Harvard Univ., Grad. Sch. of Design, B. Arch., M. Arch.; studied architecture with Walter Gropius. Awards: Rome prize, Am. Acad. in Rome, 1951; Sheldon Traveling Fellowship, Harvard Univ., 1951-1952; prize, Kalamazoo AI, 1942; Progressive Architecture award, Progressive Arch. Magazine, 1957; award for residential design, AIA: 1958; Architectural Record award, 1958. Work: Busch-Reisinger Mus., Harvard Univ.; Cooperative Ins. Co., Manchester, England; Farmers Elevator Ins. Co., Des Moines, Iowa; Pacific Indemnity Co., Los Angeles; Univ. of Massachusetts; MModA. Exhibited: Cal. PLH, 1947; Univ. Illinois, 1948; Inst. Contemporary Art, Boston; Univ. Ill. Annual, 1962; Gal. of Modern Art, Wash., D.C., 1963; Albright-Knox A. Gal., Buffalo, N.Y., 1963; MModA, New York City; Fort Worth Art Center, Tex.; Finch Col., N.Y., 1967; Colgate Univ., 1968; One-man: Margaret Brown Gal., Boston; Little Gal., Chicago; M.I.T., Cambridge, Mass., 1950; Segno

Gal., Winnetka, Ill., 1955; Ricardo Gal., Chicago, 1956; Bertha Schaefer Gal., N.Y.C., 1962, 1963, 1965; Nelson Taylor Gal., Easthampton, N.Y., 1962; Columbia Univ., 1963; Notre Dame Univ., 1966; Dwan Gal., N.Y.C. 1967. Many group shows. Author, designer, subject of articles in Progressive Architecture, Architectural Record, House and Home, Zodiac, Habitare, magazines. Position: Assoc. Prof. Arch., Inst. of Design of Illinois Inst. of Tech., 1955-1960; Asst. Prof. Arch., Columbia University, N.Y., 1962-1963; private practice in Architecture since 1955.

BARKAN, MANUEL—Scholar, Writer, Educator
　　128 N. Oval 43210; h. 395 E. Torrance Rd., Columbus, Ohio 43214
B. New York, N.Y., June 30, 1913. Studied: Teachers College, Columbia University, B.Sc., M.A.; Ohio State University, Ph.D. Also studied with George Grosz. Awards: Faculty Fellow, Fund for the Advancement of Education, 1951; Art Educator of the Year, National Art Education Association, 1967. Field of Research: Theory and Curriculum in Art Education. Author: "A Foundation for Art Education," 1955; "Through Art to Creativity," 1960. Currently Editor, "Studies in Art Education." (National Art Education Association). Positions: Director, Phase I, Aesthetic Education Curriculum Program of the Central Midwestern Regional Educational Laboratory, at present; Professor and Chairman, Division of Art Education, Ohio State University, Columbus, Ohio.

BARKER, WALTER—Painter, S.
　　c/o Betty Parsons Gallery, 24 W. 57th St., New York, N.Y. 10019*

BARNES, CATHERINE J.—Illustrator, Des.
　　Wenonah Ave., Mantua, N.J. 08051
B. Philadelphia, Pa., June 6, 1918. Studied: PMSchIA; ASL; & with Eliot O'Hara. Member: Phila. WC Cl.; PAFA; Phila. A. All. Exhibited: PAFA; AIC; BM; Montclair A. Mus.; Butler AI; Phila. A. All. (one-man). I., "Infant of Prague"; "Saints for Girls"; "Night Before Christmas"; "Cinderella," & other books. Illus., national travel & fashion magazines; Christmas cards for Am. A. Group. Official child's book, N.Y. World's Fair, 1964-65.*

BARNES, HALCYONE D.—Painter
　　Summit, Miss. 39666
B. Dallas, Tex., Mar. 31, 1913. Studied: Allisons A. Colony, Way, Miss.; Univ. Texas, and with Karl Zerbe, Fred Conway, Lamar Dodd, Richard Zellner, Andrew Bucci, and others. Member: Mississippi A. Colony; Delgado Mus. A. Assn.; Nat. WC Soc.; Provincetown AA; Mississippi AA. Awards: prizes, Nat. WC Show, Jackson, Miss., 1956, 1957, 1960; Allisons A. Show, 1956-1960; Mid-South Exh., Memphis, 1959, 1960; Nat. WC Exh., Birmingham, Ala.; Miss. A. Colony, Stafford Springs, Miss.; La Font Exh., Pascagoula, Miss. Work: Brooks Mem. Mus.; AGAA; Mississippi AA; Miss. State Col. for Women, Columbus; Miss. State Univ., Starkville, and in private colls. Murals: First Nat. Bank, McComb, Miss.; Delta Electric Co., Greenwood, Miss.; Hankins Corp., Magnolia, Miss. Exhibited: Birmingham WC Soc., 1956-1958, 1960; Mississippi AA, 1956, 1957; Atlanta, Ga., 1958-1961; Delgado Mus. A., New Orleans, 1955-1960; Mid-South Exh., Memphis, 1956-1961; Allisons A. Colony, 1955-1960; Provincetown AA, 1959, 1960; Morris Gal., N.Y., 1959; Jackson, Miss., 1956-1960; Delta A. Annual, Little Rock, 1958-1960; Hunter Gal., Chattanooga, 1960; Masur Mus., Monroe, La.; Univ. Miss.; Miss. AA, Jackson; 3-man exhs.: Louisiana A. Comm., Baton Rouge, 1955-1958; Mun. A. Gal., Jackson, 1957; Columbus, Miss., 1955-1961; Univ. Chattanooga, 1959; Southwest Miss. Jr. Col., Summit, 1958-1961; Mississippi Col., Clinton, 1959; Mary Buie Mus., Oxford, Miss., 1961; Dilfin Gals., Birmingham, 1960 (group); Le Petit Theater, New Orleans, 1965; La Font Inn, Pascagoula, Miss., 1965; Allisons Wells, Way, Miss.; Lauren Rogers Museum, Laurel, Miss.; Univ. Southern Mississippi, Hattiesburg; Mary Chilton Gal., Memphis; Ahda Artzt Gal., N.Y., 1964; Burr Gal., N.Y.; group show, Little Carnegie, N.Y., 1964; Soc. Four Arts, Palm Beach, Fla.; Edgewater Plaza, Biloxi, Miss.; Dixie Annual, Montgomery; Miss. A. Colony, and many others.

BARNES, ROBERT M.—Painter, E.
　　c/o Allan Frumkin Gallery, 32 East 57th St., New York, N.Y. 10022
B. Washington, D.C., Sept. 24, 1934. Studied: AIC, B.F.A.; Univ. of Chicago, B.F.A.; Columbia Univ.; Hunter College; Univ. of London, Slade Sch. A. (Fulbright Grant). Work: MModA; WMAA; AIC; Pasadena A. Mus. Awards: Copley Fnd. Award, 1961; Fulbright Grant, 1961-62, 1962-63. Exhibitions: Momentum Exh., Chicago, 1952-1955; AIC, 1955, 1958, 1960, 1961, 1963, 1964; Univ. Chicago, 1956; Rockford Col., 1956; Boston A. Festival, 1958; Univ. Colorado, 1961; Univ. Iowa, 1960; AFA Traveling Exhibition, 1961; David Herbert Gal., N.Y., 1961; Univ. Indiana, 1961; Galerie Du Dragon, Paris, France, 1962; WMAA, (2) 1962; Yale Univ., 1962; Allan Frumkin

Gal., N.Y., 1959-1963, one-man 1963, 1965; Allan Frumkin Gal., Chicago, 1963, one-man 1964; Kansas City AI, 1962, 1963; SFMA, 1963; MModA, 1963. Positions: Instr. Grad. Painting, 1960-61, Kansas City AI, Visiting Artist, 1963-64; Asst. Prof., Painting & Drawing, Indiana University, Bloomington, Ind., 1965- .*

BARNET, HOWARD J.—Collector
1000 Stewart Ave., Garden City, N.Y. 11530; h. Barker's Point Rd., Sands Point, N.Y.
B. New York, N.Y., Mar. 8, 1924. Studied: New York University, B.S.

BARNET, WILL—Painter, T., Gr.
215 West 57th St., 10019; h. 43 W. 90th St., New York, N.Y. 10024
B. Beverly, Mass., May 25, 1911. Studied: BMFA Sch.; ASL. Member: Phila. Pr. Cl.; Am. Abstract A.; Fed. Modern P. & S.; SAGA. Awards: CGA, 3rd prize & purchase, 1960, prize, 1961. Work: BMFA; WMAA; MMA; FMA; LC; PC; PMA; SAM; BM; N.Y. Pub. Lib.; Montana State Col.; Inst. Contemp. A., Boston; CGA; CM; Univ. A. Mus., Univ. California, Berkeley; Sara Roby Fnd. Coll.; Univ. Notre Dame A. Gal. Exhibited: Am. Abstract A.; Exchange Exh., Mus. Tokyo, Japan, 1955; BM, 1955-56; Yale Univ., 1955; Minneapolis Inst. A., 1945-1957; Retrospective Exh., Tweed Gal. A., Univ. Minnesota, 1958; Retrospective, Inst. Contemp. A., Boston, 1961; one-man: Walker A. Center, 1938; Galerie St. Etienne, 1943; Bertha Schaefer Gal., 1948-1951, 1953, 1955, 1961, 1962; DMFA, 1950; Stephens Col., 1950; AFA traveling exh., 1952-53; Boris Mirskie Gal., Boston, 1954; Esther Robles Gal., 1957; Krasner Gal., 1958; Galleria Trastevere, Rome, Italy, 1961; Mary Harriman Gal., Boston, Mass., 1964, 1965; Grippi & Waddell Gal., N.Y.C., 1965, 1966, 1968; Peter Deitsch Gal., N.Y.C., 1962, 1963. Positions: Instr., ASL, 1936- ; CUASch., 1945- , in N.Y.; Summer Instr., Montana State Col., 1951; Cornell Univ., 1968, 1969; Visiting Cr., Yale Univ., 1952, 1953; Guiding Faculty, Famous Artists Schs., 1954- ; Summer Instr., Univ. Ohio, Univ. Minnesota, Duluth, 1958; Univ. Washington, Spokane, 1963; Des Moines A. Center, Iowa, 1965; Pennsylvania State Univ., 1965.; Instr., PAFA, 1967- .

BARNETT, EARL D.—Designer, P., Comm. A.
2221 Prairie Ave., Glenview, Ill. 60025
B. Nov. 9, 1917. Studied: Cleveland Sch. A. (Grad.). Awards: purchase award, Butler Inst. Am. A., Youngstown, Ohio, 1965. Work: Portraits of Past Presidents of Benefit Trust Life Ins. Co., Chicago, and others for industrial and business organizations. Exhibited: All. A. Am.; Butler Inst. Am. A.; Cooperstown, N.Y.; Union Lg., Chicago, Ill.

BARNETT, HERBERT PHILLIP—Educator, P., L.
Art Academy of Cincinnati; h. 3 Moyer Place, Cincinnati, Ohio 45226
B. Providence, R.I., July 8, 1910. Studied: BMFA Sch., and in Europe. Awards: prizes, Manchester, N.H.; PAFA; Hallmark Award. Work: WMA; PAFA; Univ. Arizona; Amherst Col.; Randolph-Macon Col.; CM. Exhibited: (1952-1961) one-man: WMA; Fleming Mus. A.; Phila. A. All.; Fitchburg A. Center; Grace Horne Gal., Boston; Marie Harriman Gal.; Contemporary A.; Mortimer Levitt Gal., N.Y.; CM, 1952; Wittenberg Col., 1957; Miami Univ., 1957; CM; Dayton AI. Interior Valley Exh.; U.S. Exh., France; Corcoran Biennial; Hallmark International. Lectures to Natl. Assn. of Schools of Art, 1957, 1960. Positions: Instr., P., Univ. Vermont, 1943; Norfolk A. Sch., Yale Univ., 1948; Dir., Norfolk A. Sch., 1949; Hd., WMA Sch., 1940-51; Assoc. Prof. A. (affiliate) Clark Univ., 1946-51; Dean, Art Acad. Cincinnati, at present. Prof. A. (Adjunct) Univ. Cincinnati, 1959- .

BARR, ROGER TERRY—Sculptor, P., E., Gr., I., L.
261 Blvd. Raspail, Paris, 14; h. 30, rue de Citeaux, Paris 12e, France
B. Milwaukee, Wis., Sept. 17, 1921. Studied: Univ. Wisconsin; Nat. Univ. of Mexico; Pomona Col., B.A.; Claremont Col., M.F.A.; Jepson AI, Atelier 17. Member: CAA; AFA. Awards: prizes, Arizona State Fair, 1948; Cal. WC Soc., 1955; Oakland A. Mus., 1955; Stanford Univ., 1956 (purchase); Catherwood Fnd. F., 1956. Work: NAD; VMFA; Pasadena A. Mus.; Claremont Col.; Museu del Arte Moderna, Sao Paulo, Brazil; Stanford Univ.; BMFA; A. Mus. of Göteborg, Sweden, and in private colls. Exhibited: MMA, 1950; Univ. Illinois, 1948; BMA, 1954; Los A. Mus. A., 1948-1952; Santa Barbara Mus. A., 1955; Cal. PLH, 1956; SFMA, 1956; Downtown Gal., N.Y., 1955; Stockholm, Sweden, 1953; Redfern and Waddington Gals., London, 1957-1959; Intl. Sculpture Exh., Musee Rodin, 1966, Musee de Toulouse, 1967, Paris; Intl. Sculpture Symposium "Forma Viva," Yugoslavia, 1967; one-man: Scripps Col., 1949; Landau Gal., Los Angeles, 1952, 1954, 1956; deYoung Mem. Mus., 1956; Galerie Philadelphie, Paris, 1958, 1960; Esther Robles Gal., Los A., 1959, 1961; Feingarten Gal., N.Y., 1961. Positions: Instr., Univ. Cal. at Los Angeles, 1950-52; Cal. Sch. FA, San Francisco, 1954-56; Founding Dir., College Art Study Abroad, American Center for Students and Artists, Paris XIV, France, 1958- .

BARRETT, H. STANFORD—Painter, E.
Department of Fine Arts, University of the South, Sewanee, Tenn. 37375
B. Binghamton, N.Y., 1909. Studied: ASL; Beaux Arts Acad., N.Y.; Univ. London; The Slade School, London; Heatherly's, London; Acad. Julian, Paris, France; Grande Chaumiere, Paris, with Leger; study travel in Italy, Greece and Spain. Awards: prize, Hoosier A. Show, Hammond, Ind. Work: in galleries in California, Michigan, Indiana and in private colls. Exhibited: U.S. and abroad. Position: Artist-in-Residence, Dir. Univ. A. Gal., Instr., A. Hist. & Appreciation, Chm. A. Dept., University of the South, Sewanee, Tenn., at present.

BARRETT, OLIVER O'CONNOR—Sculptor, I., E., W.
313 W. 57th St., New York, N.Y. 10019
B. London, England, Jan. 17, 1908. Studied: Fircroft Col., England. Member: S. Gld.; F.I.A.L. Awards: prizes, Audubon A., 1948, medal, 1950; medal, Knickerbocker A., 1953. Work: Birmingham City Mus., England. Exhibited:PAFA, 1945; Royal Acad., London, 1933; Audubon A., 1946, 1948, 1950; New Orleans A. Lg., 1942, 1943; one-man: Sculpture Center, 1953, 1962; Potsdam State Univ., 1953; Norton Gal. & Sch. A., 1956, 1959; Potsdam Festival of Arts, 1955; "Sculpture Continuum," WMAA, 1962. Commissioned, 1963, by the Chunky Corporation, to make the Barrett Continuum Playground for the New York World's Fair. This is a sculpture continuum occupying a large outdoor space and based on the model previously shown at the Whitney Museum of American Art, New York. Illus. "Anything For a Laugh"; Author: "Little Benny Wanted a Pony," 1951. Contributor to Town & Country and other magazines. Writer of television Series on Art, sponsored by Palm Beach A. Lg., 1956. Positions: Instr. S., CUASch., MModA, New York, N.Y.*

BARRETT, THOMAS R.—Painter, T.
St. Paul's School, Concord, N.H. 03301
B. Woodhaven, N.Y., Feb. 7, 1927. Studied: Wesleyan Univ., B.A.; Brooklyn Mus. A. Sch.; Univ. of New Hampshire, M.A. Member: New Hampshire AA. Awards: prizes, Currier Gal. A., 1960, 1962; City of Manchester, N.H., 1965. Work: De Cordova & Dana Mus., Lincoln, Mass. Exhibited: AWS, 1952; Farnsworth Mus. A., Rockland, Me., 1952; Portland A. Festival, 1956-1960; Boston A. Festivals, 1952-1961; De Cordova & Dana Mus., 1965, 1968; Currier Gal. A., 1960-1969. Positions: Pres., New Hampshire AA, 1968-1969; Instr., A. History, St. Paul's School, Concord, N.H.

BARRIE, ERWIN S.—Painter
40 Vanderbilt Ave., New York, N.Y. 10017; h. Greenwich, Conn. 06830
B. Canton, Ohio, June 3, 1886. Studied: AIC. Member: Chicago AC; NAC; Greenwich A. Soc. Work: specializes in painting golf courses. In permanent coll. United States Golf Assn., Metropolitan Golf Assn.; private coll.; Pres. D. D. Eisenhower; Robert Jones, Jr.; Richard D. Tufts, Pres. U.S. Golf. Assn. Permanent one-man exhibition at Pinehurst, N.C. Position: Dir. & Manager, Grand Central A. Gal., and Grand Central Moderns, New York, N.Y.

BARRON, HARRIS—Sculptor
30 Webster Place, Brookline, Mass. 02146
B. Boston, Mass., Nov. 15, 1926. Studied: Vesper George Sch. A.; Kerr Sch. A.; Mass. Sch. A., B.F.A. Awards: Portland Mus. A. Festival, 1958; Art in America, 1960; prize (first) Art in Architecture, Everson Mus. A., 1962; prize (first) Margaret Brown Award, Inst. of Contemp. Art, Boston, Mass., 1964. Work: Architectural commissions: Temple Adath Yeshurun, Manchester, N.H.; and others; AGAA; Portland Mus. A.; St. Paul Gal. A.; relief wall, Sears Roebuck, Saugus, Mass.; bronze sc., Temple Facade, Leominster, Mass.; bronze sc., Temple Israel, Columbus, Ohio; wood relief, Alper-Wellesley Trust Bldg., Brookline, Mass; relief-frieze, West Hartford Community Centre; group in granite, Parkside Sch., Columbus, Ind.; relief, Washington Park, Y.M.C.A., Boston; relief, Fitchburg, Mass. Savings Bank; bronze, Marine Midland Trust Co., New York. Exhibited: Boston A. Festival, 1955-1957, 1960; Silvermine Gld. A., 1957; Smithsonian Inst., 1957; Wichita AA, 1955; St. Paul A. Gal., 1955; Inst. Contemp.*

BARRON, ROS—Painter
30 Webster Place, Brookline, Mass. 02146
B. Boston, Mass., July 4, 1933. Studied: Mass. Sch. A., B.F.A., and with Carl Nelson. Awards: prizes, Fiber, Clay & Metal Exh., 1956; Ceramic Nat., 1956; deCordova & Dana Mus., 1953; R.I. Arts Festival, 1964; Everson Mus. A., 1962; citation and prize, Sheraton Competition, Boston, 1964; Art in America (New Talent); Rep. of U.S.A., in UNESCO, Art in Architecture, Rotterdam, Holland, 1962. Work: AGAA; St. Paul Gal. A.; Arch. commissions: Choate Sch., Wallingford, Conn.; Temple Adath Yeshurun, Manchester, N.H.; wall painting, YMCA, Washington Park, Roxbury, Mass., 1964; tapestry, Temple Israel, Natick, Mass., WMA; Sheraton Corp., and others; relief wall, Sears Roebuck, Saugus, Mass.; 2 Ark doors,

Temple Beth Eloyhim, Wellesley, Mass.; wood relief, Alper-Wellesley Trust Co., Brookline, Mass. Exhibited: Boston A. Festival, 1955, 1956, 1957, 1964; Ceramic Nat., 1954, 1956; Wichita AA, 1955; America House, 1953, 1955, 1956; St. Paul Gal. A., 1955; Inst. Contemp. A., Boston, 1955; deCordova Mus., 1955; Silvermine Gld. A., 1957; Smithsonian Inst., 1957; Brussels World Fair, 1958; Ceramic International, 1958; Arch. Lg., 1958; Des.-Craftsmen, USA, 1960; USIA traveling exh. Europe, 1960-62; AFA traveling exh., 1960; Mus. Contemp. Crafts, N.Y., 1962; "Turn Toward Peace" exh., Boston, 1963; Fitchburg A. Mus., 1964; deCordova & Dana Mus., 1963; Stanhope Gal., Boston, 1964; Rhode Island A. Festival, 1964; one-man: deCordova & Dana Mus., 1956; Bonniers, N.Y., 1956; Kanegis Gal., Boston, 1958, 1963; Cummington Sch. A., 1958; Mus. Contemp. Craft, N.Y., 1960; Ward-Nasse Gal., Boston, 1964. Positions: Instr., deCordova & Dana Mus., Lincoln, Mass., 1956-1958.*

BARRON, MRS. S. BROOKS—Collector
19631 Argyle Crescent, Detroit, Mich. 48203
B. Hartford, Conn., Sept. 6, 1902. Studied: Connecticut College for Women, B.A. Collection: Contemporary Art.

BARR-SHARRAR, BERYL—Painter, E., W.
32 Union Square, New York, N.Y. 10003
B. Norfolk, Va., Apr. 22, 1935. Studied: Mount Holyoke Col., B.A.; Univ. of California, Berkeley, M.A.; Radcliffe Col., Cambridge, Mass; New York Univ. Awards: Fellowships: Yale Univ. Sch. of Design, Yale-Norfolk Summer Sch.; Skinner Fellowship 1956, '57, '58. Prix LeFranc pour la Jeune Peinture, Paris, 1964. Selected exhibitions: since 1962: "Forces Nouvelles," Paris, 1962; "Seven Americans of Paris," Am. Cultural Center, U.S. Embassy, Paris, 1962; Lausanne, Switzerland, 1965; Galerie Lutéce, Paris, 1966 and '67; Maisons de la Culture d'Amiens, Bourges, Musées d'Avignon, Besançon, Montpellier, Nancy, and Sainte-Etienne, 1967; Galerie Lucian Durand, Paris, 1967; Musées de Bordeaux, Menton, and le Havre, 1968; Mount Holyoke College, 1969. Publications: "The Artists' and Writers' Cookbook," Contact Editions, 1961; "Wonders, Warriors, and Beasts Abounding"; "How the Artist Sees His World" (A book for young people), 1967. Positions: Co-founder, College Art Study Abroad, American Center for Students and Artists, Paris, 1961; Associate Director, College Art Study Abroad, 1961-1968. Visiting Lecturer, Mount Holyoke College, 1968-69.

BARRY, EDITH CLEAVES—Painter, S., Des.
116 East 66th St., New York, N.Y. 10021; s. 24 Summer St., Kennebunk, Me. 04043
B. Boston, Mass. Studied: ASL; Paris, France; Rome, Italy. Member: NAWA; All. A. Am.; NSMP; Conn. Acad. FA; NAC; AAPL. Work: portraits in public bldgs., in New Jersey, Massachusetts, Maine. Murals in Maine and New York. Positions: Founder, Brick Store Museums, Kennebunk, Me. Dir., Workshop of the Brick Store Museum.†

BARSCHEL, H(ANS) J(OACHIM)—Graphic Designer, Photog., W.
Rochester Institute of Technology, College of Fine & Applied Art, 65 Plymouth Ave., South (8); h. 1 Lomb Memorial Dr., Rochester, N.Y. 14623
B. Berlin-Charlottenburg, Germany, Feb. 22, 1912. Studied: Mun. A. Sch., Acad. Free & App. A., Berlin, M.A. Awards: prize, AIGA, 1938. Work: MModA.; N.Y. Pub. Lib.; LC. Exhibited: AIGA, 1938; A. Dir. Cl., 1938, 1939, 1950; A-D Gal., 1946; Bevier Gal., Rochester Inst. Tech., 1954, 1965 (one-man); Faculty Art Exhs., 1957, 1959, 1961. Contributor to international art magazines: "Gebrauchsgraphic." Germany, 1952; "Art & Industry," London, 1954; "Publimondial," Paris, 1955; "Productionwise," New York, 1955. Des. book jackets, covers for Fortune, Steel Horizons, Seminar, Ciba Symposia, Town & Country, etc. Created graphic arts program brochure for Rochester Inst. Tech. Positions: Assoc. A. Dir., Great Lakes Press Corp., Rochester, N.Y., 1952-53; Assoc. A. Dir., John P. Smith Co., Rochester, N.Y., 1953-54; Des., Graphic A. Research Dept., 1954- ; Prof. Graphic Communication, Instr., Adv. Des., Des. for Reproduction & Creative Dwg., Rochester Inst. of Tech., Rochester 8, N.Y.; A. Dir. of "Matrix" an experimental Journal, RIT, Exec. memb. Rochester Arts Council. Author: "A Plea for Substantialism"; "Personal Reflections on My Era," 1964.

BARTLE, ANNETTE—Painter, Comm., I.
231 E. 76th St., New York, N.Y. 10021
B. Warsaw, Poland. Studied: Sorbonne, Paris, France, B.A.; Elmira Col., B.A.; ASL, with Robert Hale, Louis Bouche, R. Johnson, Menkes, Paul Fiene, John Carroll. Awards: Scholarship, ASL; Pan-American Traveling Scholarship; East Hampton Gld., N.Y. Work: Lincoln (Neb.) Life Insurance Co. Coll.; Woodside (N.Y.) Savings & Loan Assn.; C. V. Starr Co.; Union Carbide; mural in Top of the Fair Bldg., N.Y. World's Fair. Exhibited: Butler Inst. Am. A., 1957, 1959; Detroit AI, 1959; Miami A. Center, 1959, 1960; Univ. Nebraska, 1959-1960; Nebraska AA, 1959, 1960; CM, 1959, 1960; Columbus Gal. FA, 1958-

1960; St. Gaudens Mus., 1961; Springville AA, 1959; Art: USA, 1958; N.Y. Bd. of Edu. traveling exh., 1959-1960; IBM, 1960; United Nations Natl. Council of Women, 1959, 1960; U.S.I.A., 1963-1965; Univ. Colorado, 1964; WMFA, 1963; New York Univ., 1964; Bass Mus. A., 1964; Philbrook A. Center, 1964, 1965; Am. Acad. A. & Lets., 1964; one-man: Midtown Gal., N.Y., 1958, 1960, 1963, 1966. Contributor illus. to Esquire and Look magazines; Connecticut Mutual Life Ins. Co. publications. Published by American Artist's group 1966, 67, 68. Cited by U.S. 90th Congress, Jan. 23, 1968 (Volume 114, no. 7).

BARTLETT, FRED STEWART—Museum Director, T., W.
30 West Dale St.; h. 41 West Cache La Poudre, Colorado Springs, Colo. 80908
B. Brush, Colo., May 15, 1905. Studied: Univ. Colorado, A.B.; Univ. Denver; Harvard Univ.; Carnegie Fellowship. Member: AAMus.; Western Assn. A. Mus.; Assn. A. Mus. Directors. Contributor to art publications; lectures on art history, art appreciation. Positions: Dir. Edu., Asst. to Dir., Denver A. Mus., 1935-43; Cur., Paintings, Colorado Springs FA Center, 1945-55; Dir., 1955- . Chm., Air Force Academy Art Panel, Colorado Springs, Colo.

BARTLETT, PAUL—Painter, T.
University of Santa Barbara, Santa Barbara, Cal. 93118
B. Taunton, Mass., July 8, 1881. Studied: Harvard Univ., A.B.; Julian Acad., Paris, and with John Sloan. Member: Gld. of Charlotte A. Awards: medal, Chicago Soc. A., 1920; Temple medal, PAFA, 1932; Hartford Fnd., 1960; Montalvo Fnd., 1961; Carnegie Fnd., 1962. Work: Luxembourg Mus., Paris; CMA; WMAA; Mint Mus. A. Exhibited: PAFA; CGA; AIC; Carnegie Inst., and many others; one-man: Kraushaar Gal.; Wildenstein Gal., New York; Chester Johnson Gal., Chicago; Retrospective exh. "Fifty Years of Painting," Mint Mus. A., 1959. The Paul Bartlett Hacienda Collection comprises 230 pen and ink drawings of the haciendas from Sonora to Tabasco depicting their residences, churches, chapels, mills, artifacts, sculpture, furnishings and details. 160 haciendas are included. The collection has been exhibited in: Atlanta A. Mus.; Bancroft Library; Georgia Inst. Tech.; Mexico City; Los Angeles County Mus.; N.Y. Pub. Library; Univ. California, Santa Barbara; Univ. Texas; Univ. Virginia; Brooks Mem. Mus.; DMFA; Neiman-Marcus; Richmond A. Inst., Witte Mus. A., and others. Position: Editor of Publications, Univ. California, Santa Barbara, at present.

BARTLETT, ROBERT W.—Painter, Des., Comm., I.
57 Center Drive, Camp Hill, Pa. 17011
B. Chicago, Ill., Dec. 14, 1922. Studied: AIC; ASL. Member: Harrisburg AA (Bd. Trustees); Washington County Mus. FA. Awards: prizes, Olmstead Air Force Base, Middletown, Pa., 1953; Washington County Mus. FA, Hagerstown, Md., 1954, 1961, 1963; Motorola Natl. Comp., 1955; "Century of Service" comp. sponsored by Patriot-News, Harrisburg, 1954 (co-winner); Harrisburg AA, 1962, (co-winner, 1965). Work: Grumbacher Coll.; Washington County Mus. FA; William Penn H.S., Harrisburg; Pangborn Co. Coll.; Phoenix Galleries, Baltimore; murals Sullivan H.S., Chicago; State of Pa., 1961, and private commissions. Rep. in 1964 ed. "Prize Winning Paintings," and in "Visual Persuasion." Exhibited: Carnegie Mus., Pittsburgh, 1951; Army Air Force, Middletown, Pa., 1953; Century of Service Comp., Harrisburg, 1954; Motorola Comp., 1955; Harrisburg AA, 1955, 1956, 1959, 1960, 1962, 1964, 1965 (and one-man, 1965); Washington County Mus. FA, 1953, 1954, 1957-1965; Phoenix Galleries, Baltimore, Md., 1964. Positions: A. Dir., Johnstone & Cushing, N.Y., 1943-49; The McCarty Co., Pittsburgh, 1949-52; Michener & O'Connor, 1952-57; Owner, Harrisburg Ad-Art, 1958- .

BARTON, AUGUST CHARLES—Designer, P., E., L.
110 W. 40th St., New York N.Y. 10018.; h. Louises Lane, New Canaan, Conn. 06840
B. Szekesfehervar, Hungary, Nov. 15, 1897. Studied: Royal Hungarian Univ. Tech. Sciences; Royal Hungarian Col. Indst. A.; ASL. Member: AWS; Textiles Des. Gld.; Hudson Valley AA; Silvermine Gld. A. Work: Fabric Designs, U.S. and Europe. Samples of designs in Costume Inst., MMA; BM. Exhibited: AWS; Hudson Valley AA; Silvermine Gld. A.; Bronxville Women's Cl.; Moore Inst., Phila. Contributor to Women's Wear Daily. Lectures on fabric designing and fashions. Positions: Prof. A., Dress Fabric Des., Moore College of Art, Philadelphia, Pa., 1945-1962; Member of Faculty, Silvermine College of Art, New Canaan, Conn., 1958-1961; Prof. A., Philadelphia College of Textiles and Science, 1962- ; Consultant, Moore College of Art, Philadelphia, Pa., 1967- . Pres., Barton Studios, Inc.

BARTON, ELEANOR DODGE—Educator
Sweet Briar College, Sweet Briar, Va. 24595
B. Willsborough, N.Y., Jan. 23, 1918. Studied: Vassar Col., B.A.; N.Y. Univ., M.A.; Radcliffe Col. Grad. Sch, Ph.D. Member: CAA; Renaissance Soc. of Am.; Archaeological Inst. of Am.; AAUW (Shirley Farr Fellow); Phi Beta Kappa. Contributor to: Marsyas; Collier's Encyclopedia; Encyclopedia of World Art; New Catholic Encyclo-

paedia, Renaissance Quarterly. Lectures on Modern and Baroque Sculpture. Positions: Teaching F., Instr., Asst. Prof., Smith College, 1942-1953; Visiting L., Wellesley College, 1956-57; Prof. Chm. Dept. A., Sweet Briar College, Sweet Briar, Va., 1953- .

BARTON, JOHN MURRAY—Painter, Gr., L.
 11 West 18th St., New York, N.Y. 10011; h. 59 W. 12th St., New York, N.Y. 10011
B. New York, N.Y., Feb. 8, 1921. Studied: ASL, with George Bridgman, Frank Dumond, William von Schlegell; Tschacbasov Sch. A. Member: AEA. Work: BM; N.Y. Pub. Lib.; PMA; Butler Mus. Am. Art, Youngstown, Ohio; Yale Univ. Gal.; Newark Pub. Lib.; MMA; Mus. Modern A., Haifa, Israel; murals, Riverdale Jr. H.S., N.Y.; Polyclinic Hospital, N.Y.; South Carolina State Bank, Columbia, S.C.; ceramic, Manhattan Pub. Sch. #41. Exhibited: one-man: Fantasy Gal., Wash., D.C., 1958, 1960; Mack Gal., Philadelphia, Pa., 1957; Hudson Gld., N.Y., 1959. Other exhs.: Galerie Norval, N.Y.; Assoc. Am. A.; F.A.R. Gal.; Loring Gal., Cedarhurst, N.Y.; Merrick (N.Y.) A. Gal.; Picture House, N.Y.; Georgetown (D.C.) Graphics; Waller Gal., Chicago; Little Gal., Philadelphia; Philadelphia Pr. Cl. Lectures to art associations and clubs. Contributor woodcuts of space technologies for Space Aeronautics.

BARUCH, MR. and MRS. JOSEPH M.—Collectors
 Doubling Rd., Greenwich, Conn. 06832*

BARUZZI, PETER B.—Painter, E., L.
 Skidmore College; h. 107 Regent St., Saratoga Springs, N.Y.
B. Fredericktown, Pa., Dec. 3, 1924. Studied: Memphis Acad. A., B.F.A.; Memphis State T. Col.; Syracuse Univ., M.F.A.; State Univ. of Iowa, and with Mauricio Lasansky. Exhibited: PAFA, 1954; Chicago, Ill., 1954; AGAA, 1954; Memphis, 1948; Joslyn A. Mus., 1951; Va. Intermont Col., 1952; Brooks Mem. Mus., 1948-1954; Union Col., Schenectady, N.Y., 1955; Skidmore Col., 1964 (one-man); State Univ. of New York at Albany; Graham Gallery, New York City; Munson-Williams Proctor Inst., Utica, N.Y. Positions: Instr., Memphis Acad. A., 1951-54; Asst. Prof. A., Skidmore Col., Saratoga Springs, N.Y., 1954- . Dir., Chautauqua AA, 1960; Lecturer in Art, Union College, Schenectady, N.Y., 1963, 1964.

BARZUN, JACQUES—Educator, W., Hist., Cr., L.
 110 Low, Columbia University, N.Y. 10027; h. 1170 Fifth Ave., New York, N.Y. 10028
B. Creteil, France, Nov. 30, 1907. Studied: Lycee Janson de Sailly, Paris; Columbia Univ., B.A., A.M., Ph.D. Member: Am. Hist. Assn.; Soc. Am. Hist.; Authors Gld. Am.; Century Assn.; Nat. Inst. A. & Let.; Am. Acad. A. & Sciences; Acad. Delphinale, Grenoble; Fellow, Royal Soc. of Arts. Awards: F. Am. Council Learned Soc., 1933-34; Guggenheim F., 1945; Legion of Honor, 1956. Author: "Of Human Freedom," 1939; "Darwin, Marx, Wagner." 1941; "Romanticism and the Modern Ego," 1943; "Berlioz and the Romantic Century," 1950; "The House of Intellect," 1959; "Classic, Romantic, and Modern," 1961; "Science: The Glorious Entertainment," 1964; "The American University," 1968, and others. Positions: Instr., Columbia Col., Columbia Univ., 1928-37; Asst. Prof., Columbia Univ., 1938-42; Assoc. Prof., 1942-45; Prof. Columbia Univ., 1945- ; Dean of the Graduate Faculties, 1955-58; Dean of Faculties and Provost, 1958-1967; University Professor, 1967-; Special Assistant to the President on the Arts, 1967- . Seth Low Prof. of History, Columbia Univ, 1960- ; Extraordinary Fellow at Churchill College, Cambridge, 1961.

BASHOR, JOHN WILLIAM—Painter, E., C., Gr.
 Art Department, Bethany College; h. 217 Normal St., Lindsborg, Kans. 67456
B. Newton, Kans., Mar. 11, 1926. Studied: Washburn Univ., A.B.; State Univ. Iowa, M.F.A., and with Howard Church. Member: Kansas SA; Kansas Fed. A. (Pres. 1959-60). Awards: Harrison S. Morgan award, Missouri Valley annual, 1951, 1952; purchase award, Mid-America annual, Nelson Gal. A., 1952; purchase award, Springfield, Mo., 1957; Kansas State Col., 1952, 1956; Kansas State T. Col., 1957; Kansas Free Fair, Topeka, 1952; Iowa A. Salon, Des Moines, 1950. Work: State Univ. Iowa; Kansas State College; Kansas State T. College; Wm. Rockhill Nelson Gal. A.; St. Benedict's Col., Springfield, Mo.; Hutchinson Jr. Col.; mural, Kaw Valley Citizen's State Bank, Topeka, 1964. Exhibited: AWS, 1948; Magnificent Mile, 1956; Mid-America Exh., 1952, 1955; Joslyn Mus. A., 1957; Missouri Valley, 1951, 1952; Joslyn Mus. A., Biennial, 1957; Univ. Nebraska, 1957; circulating one-man exh., 1957; Veerhoff Gals., Wash. D.C. (one-man); traveling one-man-exh., State of Pennsylvania, 1962. Positions: Hd., Art Dept., Bethany College, Lindsborg, Kans., 1956- .*

BASKERVILLE, CHARLES—Painter
 130 W. 57th St., New York, N.Y. 10019
B. Raleigh, N.C., Apr. 16, 1896. Studied: Cornell Univ.; ASL; Julian Acad., Paris. Member: NSMP (Pres., 1957-59); AAPL. Work: mu-

rals, S.S. "America," murals, S.S. "Santa Magdalena," Graceline, 1963; Engelhard House, Johannesburg, So. Africa; 72 official portraits, AAF, Pentagon, Washington, D.C.; Nat. Portrait Gal., and Nat. Coll. of Fine Arts, Wash., D.C; Museum of the City of New York. Many portraits of noted persons including the King of Nepal and Prime Minister Nehru, 1949. Exhibited: Carnegie Inst., 1941; WMAA, 1936; CGA, 1940; Soc. Four A., Palm Beach, Fla., 1938, 1940; NGFA; Albright A. Gal.; deYoung Mem, Mus., San Francisco; MMA; Retrospective exh., Cornell Univ. Mus., 1954; one-man: Palm Beach A. Gal., 1961, 1963, 1965, 1967, 1969. Positions: Dir., Chrysler Corp. "Battle Art" Coll., 1945-47.

BASKIN, LEONARD—Sculptor, Gr., T.
 Fort Hill, Northampton, Mass. 01060
B. New Brunswick, N.J., Aug. 15, 1922. Studied: Yale Univ. Sch. FA; The New School; in Paris, and with Maurice Glickman. Awards: Tiffany Fnd. F. 1947; Guggenheim F., 1953; Medal, AIGA, 1965. Work: MMA; MModA.; BM; NGA; FMA; BMFA; WMA; SAM, PMA; CAM; LC. Exhibited: BM, 1949, 1952-1955; LC; Phila. Pr. Cl.; SAGA, 1952, 1953; New Sch. N.Y., 1967; Borgenicht Gal., N.Y., 1967, 1968; Kouler Gal., Chicago; Sao Paulo, Brazil; Musee de L'Art Moderne, Paris; Yugoslavia; Zurich, Switzerland, etc. Positions: Prof., S. & Gr. A., Smith College, Northampton, Mass., 1953- .

BASS, MR. and MRS. JOHN—Collectors, Patrons
 2100 Collins Ave., Miami Beach, Fla. 33139; also 200 Central Park, S., New York, N.Y. 10019
Collection: Paintings, Sculpture, Vestments, Tapestries, and other objects of art. John and Johanna Bass donated their collection to the City of Miami Beach, which provided a building to house the collection and which is now known as the Bass Museum of Art. There are many masterpieces in the collection, and one is Peter Paul Ruben's "St. Anne and the Holy Family." This work was on loan to the Royal Museum of Beaux Arts of Belgium, for an international Rubens Exposition in late 1965. Other works owned by Mr. and Mrs. Bass have been acquired by The Tate Gallery, London, Princeton University, Currier Gallery of Art, and others. Mr. and Mrs. Bass made substantial donations of art treasures to Hunter College, Finch College and Columbia University, New York, as well as to the State of Israel Museum. Positions: Mr. and Mrs. Bass are Trustees of the Bass Museum of Art and Mr. Bass is Director.

BATE, NORMAN ARTHUR—Etcher, W., I., E., P.
 Locust Ridge Farm, Melvin Hill Rd., R.D. 2, Geneva, N.Y. 14456
B. Buffalo, N.Y., Jan. 3, 1916. Studied: Buffalo AI; Pratt Inst. A., B.F.A.; Univ. Illinois, M.F.A. Member: Rochester Pr. Cl.; Canadian Soc. Painter-Etchers. Awards: prizes, purchase awards: Youngstown (Ohio) Univ.; Northwest Pr. M., 1957; Boston Soc. Indp. A., 1957, 1958; Paul Sachs award. FMA, 1958; Wichita AA, 1957; Silvermine Gld. A., 1958; John Taylor Arms Medal, Audubon A., 1959; Pennell Award, LC, 1960; Greene award, Albright-Knox Gal. A., Buffalo, N.Y., 1960. Work: (prints): FMA; Rochester Mem. A. Gal.; Middlebury (Vt.) Col.; deCordova & Dana Mus.; Youngstown Univ.; Northwest Pr. M.; Silvermine Gld. A.; Wichita AA; IGAS, 1958; AAA; FMA; N.Y. Pub. Lib., and private colls. Exhibitions: AIGA Exh., "50 Best Children's Books," MMA, 1955; BM, 1958, 1959, 1960; Audubon A., 1958, 1959, 1960, 1961, 1962; LC, 1957, 1959-1962; Silvermine Gld. A., 1958; Boston Pr. M., 1957, 1958, 1959-1961; Wichita AA, 1958; Bay Pr. M. (Oakland, Cal.), 1957; Northwest Pr. M., 1957; Phila. Pr. Cl., 1957, 1958; Canadian Soc. Painter-Etchers, 1959-1963; one-man: Univ. Maine, 1961; Nazareth Col., Rochester, 1965; incl. in "50 American Printmakers," 1961; Chicago Review, 1959; Revue des Arts, Paris, 1961, and others. Author, I., "Who Built the Highway?," 1953; "Who Built the Bridge?," 1954; "Who Fishes for Oil?," "Who Built the Dam?," 1958; "Vulcan," 1960; "What a Wonderful Machine is the Submarine," 1961; "When Cave Men Painted," 1963. Positions: Prof., Illus. and Graphics, College of Fine and Applied Arts, and the Graduate College, Rochester Inst. of Technology, Rochester, N.Y., 1957- .

BATES, GLADYS EDGERLY—Sculptor
 Stonecroft, Mystic, Conn. 06355
B. Hopewell, N.J., July 15, 1896. Studied: CGA; PAFA, with Charles Grafly. Member: NSS; NAWA; Mystic AA; Pen & Brush Cl.; Conn. Acad. FA. Awards: med., PAFA, 1931; NAWA, 1934; prizes, PAFA, 1920; Conn. Acad. FA, 1933; AIC, 1935; Pen & Brush Cl., 1944; NAWA, 1948; MMA, 1942; Clinton AA, 1959. Work: MMA; PAFA; N.J. State Mus. Exhibited: Century Progress, 1934; Texas Cent., 1936; AIC, 1939; Carnegie Inst., 1938; PMA, 1949; AGAA, 1941-1951; NAWA, 1965 and prior; Conn. Acad. FA, 1964 and prior; PAFA, 1950 and prior; Lyman Allyn Mus. A., 1952; New Jersey State Mus., 1953; Phila. A. All.; Mystic AA, 1925-1963; Madison A. Gal., 1958-1964; Eastern States Exh., 1963; Rowayton A. Center, 1964; Pen & Brush Cl., 1965.

BATES, KENNETH—Painter
 Stonecroft, Mystic, Conn. 06355
b. Haverhill, Mass., Oct. 28, 1895. Studied: ASL; PAFA. Member:

NA; New Haven Paint & Clay Cl.; Mystic AA; Conn. Acad. FA. Awards: prizes, PAFA, 1920; AIC, 1926; New Haven Paint & Clay Cl., 1929, 1953; Meriden A. & Crafts Assn., 1956; Conn. Acad. FA, 1927, 1950; medal, PAFA, 1928; Famous Artists Sch. award, Mystic AA, 1965. Exhibited: WFNY 1939; Carnegie Inst., 1944, 1945; CGA; PAFA; AIC; Toledo Mus. A.; Contemporary A. Gal.; Grand Central A. Gal., (one-man); Conn. Acad. FA; NAD; Mystic AA; Ogunquit A. Center; (all regularly to date), and others. Work: IBM; PAFA; Slater Mem. Mus., Norwich, Conn.; Woodmere A. Gal., Phila., Pa.; Beach Mem. Coll., Storrs, Conn. Author: "Brackman, His Art and Teaching," 1951.

BATES, KENNETH FRANCIS—Craftsman, T., L., W.
 11441 E. Blvd., Cleveland, Ohio; h. 7 E. 194th St., Euclid, Ohio 44119
B. North Scituate, Mass., May 24, 1904. Studied: Mass. Sch. A., B.S., in Edu.; and abroad, 1931-54. Member: F.I.A.L. Awards: prizes, CMA, 1929-1964; Wichita Natl. Ceramic Exh., 1951; Butler Inst. Am. A., 1954; special honor award. Mid-West Des.-Craftsmen, 1957; silver medal, CMA, 1949, 1957, 1966; Syracuse Natl. Ceramic Exh., 1946, 1960; Fine Arts Award of Cleveland, 1963; First Faculty Grant, 1965, study abroad. Work: CMA; Butler Inst. Am. A.; WFNY, 1939; GGE, 1940; Brussels World Fair, 1958. Murals: Campus Sweater Co., Cleveland; Lakewood Pub. Lib.; ecclesiastical enamels, Wash. D.C., Bethesda, Md., Youngstown, Ohio, Univ. Notre Dame; Indiana State T. Col.; Univ. Michigan, Univ. Tennessee; Birmingham Mus. A. Exhibited: Contemp. Am. Ceramics, 1937; Denmark, Sweden, Finland, 1938; CMA, 1928-1961; Cooper Union, N.Y., 1940; Boston Soc. A. & Crafts; Toledo Mus. A., 1938; Columbus Gal. FA; Univ. Pittsburgh; Art: USA, 1959; Mus. Contemp. Crafts, N.Y., 1959; European traveling exhs.; Smithsonian traveling exh.; Natl. Syracuse traveling exh.; one-man: Cleveland, New York, BM, AIC, 1961. Author: "Enameling, Principles and Practice," 1951, "The Enamelist," 1967, "Basic Design, Principles and Practice," 1960. Author articles on enameling. Contributor to Design Magazine, Ceramics Monthly, Craft publications, Encyclopaedia of the Arts and Encyclopaedia Britannica, Jr. Position: Instr. & Lecturer, Cleveland Institute of Art, Cleveland, Ohio, 1927- .

BATTCOCK, GREGORY—Writer, Critic
 Fairleigh Dickinson University, Teaneck, N.J.; h. 317 West 99th St., New York, N.Y. 10025
B. New York, N.Y., July 2, 1939. Studied: Michigan State Univ.; Hunter Col.; Accademia di Belle Arti, Rome; New York Univ. Editor: "The New Art," "The New American Cinema," "Minimal Art," "The New Music." Correspondent for Arts magazine; contributor to The Art Journal, Journal of Art Education, Art and Artists, and Film Culture.

BAUER, WILLIAM—Painter, I., Gr.
 7741 General Sherman Lane, St. Louis Mo. 63123
B. St. Louis, Mo., June 13, 1889. Studied: Washington Univ. Sch. FA. Member: St. Louis A. Gld.; F.I.A.L.; AFA; Two Thousand Men of Achievement-1969 (London). Awards: St. Louis A. Gld., 1921, 1923, 1927, Citation, 1960; Mid-Western A. purchase prize, Kansas City AI, 1924; State of Missouri purchase, 1949; St. Louis A. Lg., purchase, 1927; Independent A., purchase, 1931; First prize, St. Louis County Fair, 1947; Cal. A. Cl., 1948; State Fair, 1926, 1947, 1949, 1950, 1951; Missouri Fed. Women's Cl. purchase, 1949; Delgado Mus. A., 1953; Ill. State Mus. purchase prize, 1963; purchase prize, Annual "Scada" Show, Springfield, Ill., 1967. Work: Kansas City AI; Governor's Mansion, Jefferson City, Mo.; St. Louis Pub. Lib.; Illinois State Mus.; Waverly (Mo.) Pub. Lib.; Pittman Sch., Kirkwood, Mo.; Color Assoc., Inc.; Joslyn Mus. A. Color Slide Dept.; Color reproduction Book 4 "Prize Winning Paintings." Exhibited: CAM; St. Louis A. Gld.; Carnegie Inst.; Butler Inst. Am. A.; Knoxville A. Center; Joslyn Mus., Omaha; Mulvane A. Center, Topeka; All. A. Am., N.Y.; Brooks Mem. Mus., Memphis; Las Vegas A. Lg.; Oklahoma A. Center; Springfield (Mo.) Mus. A.; State Fair, Springfield, Ill.; Illinois State Museum. Article and reproductions in La Review Modern Art, Paris, France, 1961. Position: Bd. Governors, St. Louis A. Gld., 1960; Exec. Com. of Art Section, 1961.

BAUERMEISTER, MARY—Painter, S.
 119 Ridgewood Ave., Madison, Conn. 06443
B. Frankfurt, Germany, 1934. Work: MModA; Aldrich Mus. Contemp. A.; Guggenheim Mus., N.Y.; WMAA; Stedelijk Mus., Amsterdam; Flint Inst. A.; BM; Albright-Knox A. Gal., Buffalo; New Jersey State Mus., Trenton; Chase Manhattan Bank, and in private colls. Exhibited: WMAA, 1964-1969; Albright-Knox A. Gal., 1965; Aldrich Mus. Contemp. A., 1964-1966; Kent (Ohio) State Univ., 1967; Fairleigh Dickinson Univ., Madison, N.J., 1963; Riverside Mus., N.Y., 1963; MacMillan Theatre, Toronto, Canada, 1964; Staempfli Gal., N.Y., 1965; Byron Bal., N.Y., 1965; Univ. Texas, Austin, 1965; Ft. Worth A. Center, 1965; Newark Mus., 1965, 1966; Norfolk Mus. A.

& Sciences, 1966; VMFA, 1966; Guggenheim Mus., 1966; Finch Col., Mus., N.Y., 1966; Rigelhaupt Gal., Boston, 1966; Grippi & Waddell Gal., N.Y., 1966; Akron A. Inst., 1967; Ohio State Univ., 1967; other exhs. in Germany, Holland and Switzerland. One-man: Stedelijk Mus., Amsterdam, 1962; Galeria Bonino, N.Y., 1964, 1965, 1967.

BAUER-NILSEN, OTTO—Sculptor
 6703 Madison Rd., Cincinnati, Ohio 45227*

BAUM, WILLIAM—Painter
 195 Lafayette St., Williston Pk., L.I. N.Y. 11596
B. New York, N.Y., Oct. 30, 1921. Studied: Design Laboratories, and with Theodore Roszak, I. Rice Pereira. Awards: Berkshire AA, 1963; Larry Aldrich Award, Silvermine Gld. A., 1964. Exhibited: PAFA, 1962; Silvermine Gld. A., 1960, 1961, 1963, 1964; BM, 1960; Hudson River Mus., 1961; Berkshire Mus., 1963; Salpeter Gal., N.Y., 1960; Denker Gal., Woodmere, N.Y., 1964; one-man: Vassos Gal., 1964.

BAUMAN, LIONEL R.—Collector
 33 E. 70th St., New York, N.Y. 10021*

BAUMBACH, HAROLD—Painter
 278 Henry St., Brooklyn, N.Y. 11201
B. New York, N.Y., Jan. 18, 1905. Studied: PIASch. Member: Fed. Mod. P. & S. Work: BM; Albright A. Gal.; Univ. Arizona; Univ. Georgia; Univ. Iowa; Parrish A. Mus., Southampton, N.Y.; N.Y. Univ. Coll. R. I. Sch. Des.; Samuel S. Fleischer Mem., Phila., Pa.; WMAA; Chrysler Mus.; Stephen C. Clark Coll. Exhibited: PAFA, 1945, 1952; AIC, 1942; Carnegie Inst., 1944, 1945; Univ. Iowa, 1946; Univ. Nebraska, 1952; Univ. Illinois, 1952; Wildenstein Gal.; one-man: Contemporary A. Gal., 1937-1952; Salpeter Gal., 1954, 1955; 3 one-man, Barone Gal.; Mayer Gal., N.Y., 1960; Thibaut Gal., 1962; Rose Fried Gal., N.Y., 1964. Position: L., Instr., Vocational Studies, Brooklyn Col.

BAUR, JOHN I. H.—Museum Director, L., W.
 Whitney Museum of American Art, 945 Madison Ave., New York, N.Y. 10021; h. Mt. Holly Rd., Katonah, N.Y. 10536
B. Woodbridge, Conn., Aug. 9, 1909. Studied: Yale Univ., B.A., M.A. Author: "An American Genre Painter, Eastman Johnson," 1940; "John Quidor," 1942; "Theodore Robinson," 1946; "Revolution and Tradition in Modern American Art," 1951; "American Painting in the Nineteenth Century, Main Trends and Movements," 1953; "Loren MacIver and I. Rice Pereira," 1953; "George Grosz," 1954; "ABC for Collectors of American Contemporary Art," 1954; "The New Decade: 35 American Painters and Sculptors" (ed), 1955; "Charles Burchfield," 1956; "Bradley Walker Tomlin," 1957; "Nature in Abstraction," 1958; "William Zorach," 1959; "Philip Evergood," 1960; "Bernard Reder," 1961; co-author (with Lloyd Goodrich): American Art of Our Century," 1961; "Joseph Stella" (in prep). Contributor to art magazines. Lectures: American Art. Positions: Supv. Edu., 1934-36, Cur., Brooklyn Museum of Art, 1936-52; Cur., Whitney Museum of American Art, 1952-1958, Assoc. Dir. 1958-1968, Director 1968- . Visiting L., Yale Univ., 1951-52.

BAVINGER, EUGENE A.—Painter, T.
 Rt. #4, Norman, Okla. 73069
B. Sapulpa, Okla., Dec. 21, 1919. Studied: Univ. Oklahoma, B.F.A.; Instituto de Allende, Mexico, M.F.A. Awards: Over 30 awards in painting and drawing from regional and national exhibitions. Work: Mulvane A. Center; Joslyn Mus. A.; Denver A. Mus.; Nelson Gallery-Atkins Mus.; DMFA; Univ. of Denver; Oklahoma A. Center; AAGA; Masur Mus., Louisiana; Philbrook A. Center; Univ. Oklahoma; Kansas State College, Pittsburg; Colorado Springs FA Center. Exhibited: Nationally. Included in Book II, 1962 and Book IV, 1964 of "Prize Winning Painting"; Book III, "Prize Winning Graphics." Positions: Prof., Painting, Drawing and Design, Univ. of Oklahoma, Norman, Okla., 1947- .

BAYER, HERBERT—Painter, Des.
 P.O. Box B, Aspen, Colo. 81611
B. Haag, Austria, Apr. 5, 1900. Studied: The Bauhaus, Weimar, Germany. Member: Alliance Graphique Internationale; Am. Abstract A.; Design and Visual Arts Visiting Com. Harvard Univ.; Int. Des. Conference, Aspen, Colo. Awards: prizes, U.S. and Europe. Work: Paintings; Landes Mus., Linz; Albertina Mus., Vienna; Mus. Stuttgart; Mus. Mod. A., Rome; other mus. and galleries in Duisburg, Nurnberg; Dortmund; Hannover; Koln; Saarbrucken; Weisbaden; Darmstadt, and others. Also in SFMA; MModA; Smith Col.; Ft. Worth A. Center; Denver A. Mus.; Oklahoma A. Center; FMA; Joslyn Mus.; Univ. Michigan; Vassar Col.; Guggenheim Mus., etc. Mural, Bauhaus Bldg., Weimar; Commons Bldg., Grad. Center, Harvard Univ.; Elementary Sch., Bridgewater, Mass.; Health Center, Aspen, Colo.; map murals, Colonial Williamsburg, Va.; Sgraffito, Seminar Bldg., Aspen (Colo.) Inst. Buildings: Plants & offices for

Container Corp. of America; lodges, restaurant bldgs., health center and Seminar Bldg. for Aspen Inst. (Colo.); Air Force Museum, Wright-Patterson AFB, Ohio, 1959-60; Auditorium for Aspen Inst., 1961. Exhibited: Bauhaus Exh., MModA, 1938; Sao Paulo, 1957; Zurich, 1961; Marlborough, London, 1962; Howard Wise Gal., N.Y., 1965; Bauhaus Exh., Stuttgart, London, Amsterdam, Paris and the U.S., 1968-1969; one-man: Retrospective, Munich, 1956-1957; Schaeffer Gal., N.Y., 1953; Ft. Worth, 1958; Dusseldorf, 1960, 1967; Dortmund, 1960; Darmstadt, 1961; Duisburg, 1962; Morris Gal., N.Y., 1963; Byron Gal., N.Y., 1965; Munich, 1967; Aachen, 1967; Marlborough Gal., London, 1968. Contributor articles to Gebrauchsgraphik; College Art Journal; Bauhaus Magazine; Linea Grafica. Author, Des., "Herbert Bayer-Visual Communication, Architecture, Painting," 1967 and German edition, 1967. Positions: A. Dir., Vogue, Germany; Dir., Dorland Studio, Berlin; A. Dir., Dorland International, N.Y.; Consultant A. Dir., J. Walter Thompson, N.Y.; Consultant Des., Aspen Inst.; Chm., Dept. Design, Container Corp. of America; Consultant, Atlantic Richfield Co.

BEACH, WARREN—Museum Director, P.
Fine Arts Gallery of San Diego, Balboa Pk.; h. 3740 Pio Pico St., San Diego, Cal. 92106
B. Minneapolis, Minn., May 21, 1914. Studied: Phillips Acad., Andover, Mass.; Yale Univ., B.F.A.; Univ. Iowa, M.A.; Harvard Univ., M.A. Member: AGAA; AAMus.; CAA; AAMD; Western Assn. Mus. Dir. Work: AGAA; Columbus Gal. FA. Exhibited: Minneapolis AI; Art & Artists Along the Mississippi, 1941; Minnesota State Fair, 1941; Columbus A. Lg., 1948; one-man; Harriet Hanley Gal., Minneapolis, 1943; Grace Horne Gal., Boston, 1945. Positions: Dir. Ext. Services, WAC, 1940-41; Asst. Dir., Columbus (Ohio) Gal. FA, 1947-55; Dir., FA Gal. of San Diego, Cal., 1955- .

BEALL, LESTER THOMAS—Industrial Designer, P., I.
Dumbarton Farm, Brookfield Center, Conn. 06805
B. Kansas City, Mo., Mar. 14, 1903. Studied: Univ. of Chicago, Ph.B. Member: All. Graphique Internationale; AIGA; AIID; Package Des. Council; Soc. Typographic Arts; A. Dir. Cl., N.Y.; SI; Indst. Des. Soc. of America. Awards: Many honors and more than 100 awards. Exhibited: England: Dagenham, Manchester and Birmingham, also Victoria and Albert Mus., London; Central Hall, Westminster; RBA Galleries, Pall Mall; in Paris: Int. Exp. 1937; Palais du Louvre, Pavillon de Marsan; in Sweden: Royal Library, Stockholm and in Gothenburg and at Orebro; other exhibitions in Copenhagen, Oslo, Helsinki, Amsterdam, Stuttgart; Australia, Japan, Canada, and several cities in Russia. Exhibited in U.S. nationally in museums, galleries, universities and colleges; many one-man exhibitions. Contributor to periodicals: Advertising and Selling; The American Printer; Direct Advertising; Art in Advertising; Print. Lectures on Layout, Design, Typography, Color and Art in Advertising, Illustration, Advertising Layouts, Package Design, etc., to Typographic Societies, Advertising Clubs, Art Directors' Clubs, museums, colleges, universities, art societies and others, nationally and internationally. Visiting Critic, Pratt Institute, N.Y., Parsons School of Design, N.Y., Yale University, New Haven, Conn.*

BEALMER, WILLIAM—Educator
State of Illinois Office of Public Instruction 62706; h. 2201 W. Lawrence St., Springfield, Ill. 62704
B. Atlanta, Mo., Sept. 9, 1919. Studied: Northeast Missouri State Teachers College, B. Sc.; University of Colorado, M.F.A.; other study at Chicago Institute of Design; Des Moines Art Center; University of Iowa. Member: NAEA; International Society for Education Through Art; Illinois Education Association; National Education Association; American Craftsmen's Council; Illinois Art Education Association. Exhibited: Univ. Colorado Art Center; Des Moines Art Center; Sioux City Art Center; Joslyn Art Museum, Omaha; Art Department, Grinnell College and Iowa State College. Positions: Special Consultant to many universities, schools, filmmakers, television, art conferences and other organizations and institutions; President-elect, 1967-1969, President, 1969-1971, National Art Education association; Assistant Superintendent and State Supervisor of Art Education, Springfield, Illinois.

BEAM, PHILIP CONWAY—Educator, Administrator
Bowdoin College; h. 41 Spring St., Brunswick, Me.
B. Dallas, Tex., Oct. 7, 1910. Studied: Harvard Col., A.B.; Harvard Univ., M.A., Ph.D.; Courtauld Inst., London. Member: Am-Assn. Univ. Prof.; AAMus.; Maine A. Comm., 1946-55, Chm., 1954-55. Contributor to Art Journal; New England Quarterly. Contributing Ed., Dictionary of the Arts, 1944. Author: "The Language of Art," 1958; "The Art of John Sloan," 1962; "Winslow Homer At Prouts Neck," 1966. Positions: Dir., Bowdoin Col. Mus. A., Brunswick, Me., 1939-1964; Asst. Prof. A., 1939-1946; Assoc. Prof., 1946-1949; Prof. & Chm. Dept. A., 1949- . Henry Johnson Prof. A. & Archaeology, Bowdoin College, 1958- ; Consultant: "The World of Winslow Homer," 1966, Time-Life Books. Curator, Winslow Homer Collection, Bowdoin College Museum of Art, 1967- .

BEAMAN, RICHARD BANCROFT—Educator, Des., P.
5718 Fifth Ave., Pittsburgh, Pa. 15232
B. Waltham, Mass., June 28, 1909. Studied: Harvard Univ., S.B.; Union Theological Seminary (Columbia), B.D.; grad. study. Univ. of California, Berkeley and at Mass. Inst. Tech., with Kepes. Member: Assoc. A. Pittsburgh; Pittsburgh Plan for Art. Awards: Carnegie Inst. purchase award, 1959; Tiffany Award in Stained Glass, 1965; Artist of the Year, Pittsburgh A. & Crafts Center, 1969. Work: Carnegie Inst.; fused stained glass murals, Pittsburgh Hilton hotel; 4 fused stained glass windows, Wayne State Univ.; fused stained glass window, Presbyterian Church, E. Liverpool, Ohio, and others; painting, Westmoreland Mus. A., Greensburg, Pa.; fused stained glass wall, Provident Inst. for savings, Prudential Center, Boston. Exhibited: Carnegie Int., 1958; Grand Rapids American Annual, 1961; with Phila., New York, and Washington Watercolor Societies; Assoc. A. of Pittsburgh, 1957-1961; Los Angeles & Vicinity, 1948. Author: "Cubist Witch," 1949, in South Atlantic Quarterly. Positions: Instr., A. Dept., University of Redlands (Cal.), 1939-55; Painting and History, Carnegie Institute of Technology, Pittsburgh, Pa., at present. Pres., Pittsburgh Plan for Art.

BEAN, JACOB—Museum Curator
Metropolitan Museum of Art, Fifth Ave. at 82nd St., New York, N.Y. 10028
B. Stillwater, Minn., Nov. 22, 1923. Studied: Harvard Univ. Author: "Les Dessins Italiens de la Collection Bonnat," 1960; "One Hundred European Drawings in the Metropolitan Museum of Art," 1964; "Italian Drawings in the Art Museum, Princeton University," 1966. Co-Author: "Drawings from New York Collections I. The Italian Renaissance," 1965; "Drawings from New York Collections II. The 17th Century in Italy," 1967. Exhibitions arranged; "Les Dessins de la Collection Baldinucci," Paris, Rome, 1959; "Dessins Romains de XVII Siecle," Paris, 1959; "Dessins Francais de XVII Siecle," Paris, 1959. Positions: Chargé de Mission, Cabinet des Dessins, Musée du Louvre, Paris, 1957- ; Assoc. Editor, Master Drawings magazine, 1963- ; Curator of Drawings, Metropolitan Museum of Art, New York, N.Y. at present. Adjunct Professor of Fine Arts, Institute of Fine Arts, New York University, 1967- .

BEARD, MARION L. PATTERSON (Mrs. Francis E.)—
Educator, P., L.
300 N. Sixth St.; h. Route 1, Vincennes, Ind. 47591
B. Knox County, Ind., Nov. 3, 1909. Studies: Indiana State T. Col., B.S.; Syracuse Univ., M.F.A. Member: Intl. Platform Assn.; Indiana State T. Assn.; NEA; Hoosier Salon; Hoosier Salon Patrons Assn.; NAWA; Indiana A. Cl.; Vincennes T. Assn.; Western AA; Nat. A. Edu. Assn.; Indiana A. Edu. Assn.; Indianapolis AA; Am. Assn. Univ. Women; Vincennes T. Fed. Awards: prizes, Hoosier Salon, 1942, 1948; Wabash Valley A., 1948, 1950. Exhibited: AWS, 1941; NAWA, 1943-1945, 1949, 1950, 1951; Swope A. Gal., 1948-1951; Indiana A. Cl., 1948; Hoosier Salon, 1942-1958; Hoosier A. Gal., 1942; Indiana A., 1942, 1944, 1945, 1951; Hoosier Salon traveling exh., 1946; Syracuse Univ., 1942 (one-man); Vincennes Fortnightly Cl., 1946 (one-man); Ogunquit A. Center, 1954; Nelson Wilson Mem. Exh., Evansville, 1955; Wabash Valley A., 1947, 1948, 1950, 1951; Lieber Gal., Indianapolis, Ind., one-man, 1967. Positions: Supv., Art Edu., Vincennes City Sch., Vincennes, Ind., 1936- ; Faculty, Adult Edu., A. Dept., Vincennes Univ., Indiana Univ., 1951- ; Prof. Oil Painting, Vincennes Univ. Edu. Center; Western AA and NAEA Membership Chm. for State of Indiana, 1952-53, 1953-54; Memb. Adv. Bd., So. Indiana Reg. Scholastic A. Exh., 1955-56; A. Cr., T., Indiana State T. Col., 1957- ; A. Cr., T., Indiana Univ., 1960-61.

BEARDEN, ROMARE HOWARD—Painter
357 Canal St. 10013; h. 351 W. 114th St., New York, N.Y. 10026
B. Charlotte, N.C., Sept. 2, 1914. Studied: N.Y. Univ., B.S.; ASL. Awards: Am. Acad. A. & Lets. painting award, 1966; Cranbrook Acad. A. award, 1969. Work: MMA; MModA; Albright-Knox Gal., Buffalo, N.Y.; Williams Col. Mus.; Howard Univ. Mus. Exhibited: WMAA, 1947-1955; Carnegie Inst., 1961; MMA, 1950; MModA, 1961, and Homage to Dr. Martin Luther King, Jr. Exh., 1968; WMAA, 1969; "30 Black Artists," traveling exh., 1968-1969. Co-author (with Carl Holty): "The Painter's Mind," 1969. Contributor to Leonardo magazine, 1969. Lectures: "The Negro in American Art," Pratt Inst., Williams Col., Spelman Col., N.Y. Univ., and others.

BEASLEY, BRUCE—Sculptor
322 Lewis St., Oakland, Cal. 94607
B. Los Angeles, Cal., May 20, 1939. Studied: Dartmouth Col.; Univ. California, Berkeley, B.A. Work: MModA; Los Angeles County Mus. A.; Guggenheim Mus., N.Y.; University of Cal. at Los Angeles; San Francisco Art Commission; Univ. of Kansas; Marin Art Museum; Musee d'Art Moderne, Paris, France. Exhibited: MModA, 1961, 1962; Biennale de Paris, 1963; SFMA; Oakland A. Mus.; La Jolla A. Mus.; Richmond Mus. A.; Guggenheim Museum N.Y.; Univ. of Illinois.

BEATTIE, GEORGE—Painter, T., L.
 90 Fairlie St., N.W., 30303; h. 857 Woodley Dr., N.W., Atlanta, Ga. 30318
B. Cleveland, Ohio, Aug. 2, 1919. Studied: Cleveland Inst. A. Awards: Nat. Inst. A. & Let., N.Y., 1955; Fulbright Grant (Italy) 1956; prizes, Southeastern Annual, 1949; Assn. Georgia A., 1951, 1954; CMA, 1952; Mead-Atlanta Painting of the Year annual, 1959; Audubon A. Stern Medal, 1955. Work: WMAA; High Mus. Mem. A. Center, Atlanta AA; Columbus Mus. A.; Atlanta Univ.; Montclair (N.J.) Mus. A.; murals: State of Georgia Agricultural Bldg., and murals in Federal P.O. Bldg., Macon, Ga. Exhibited: MMA, 1952; Munson-Williams-Proctor Inst., 1955; Int. Drawing Annual, Uffizi Loggia, Florence, Italy, 1957; Fulbright Exh., Rome, 1957; Smithsonian Traveling Exh., 1955, 1958-59 and Archaeological Exh., 1961; Art-USA, 1959; Southeastern Annual, 12 years; Assoc. A. Georgia, 1951, 1954; Mead-Southeast Ann., 1955-1961; one-man: Grand Central Moderns, N.Y., 1954; Hirschl-Adler Gal., N.Y., 1961; Atlanta AA, 1950, 1961; Georgia Tech., 1954; Columbus Mus. A., 1956, 1963; Univ. Virginia Mus., 1956. Incl. in "Prize Winning Paintings," publ. 1960. Contributor Drawings to Life Magazine and American University Religious Guide, 1961. Lectures, student, civic, art and docent groups. Positions: A., with Link Marine Archaeological Expedition to Israel, 1960, and to Sicily, 1962; Instr., Creative drawing, Ga. Tech. Architectural School; Pres., Atlanta Arts Festival, 1965. Member, North American Assembly of State and Prov. Art Agencies, Vice-Chm., 1968-1969; Exec. Director, Georgia Commission of the Arts (on leave from Georgia Inst. of Technology).

BECHTLE, C. RONALD—Painter, L.
 1205-A Presidential Apts., Philadelphia, Pa. 19131
B. Philadelphia, Pa., Nov. 14, 1924. Studied: East Tennessee Univ.; Tyler Sch. FA, Temple Univ.; Fleisher Mem. A. Fnd. Member: Philadelphia WC Cl.; AEA. Work: Akron A. Inst.; Burpee Gal. A., Rockford, Ill.; Ft. Worth A. Center; Herron Mus., Indianapolis; High Mus. A., Atlanta; Miami Mus. Mod. A.; Munson-Williams-Proctor Inst.; Santa Barbara A. Mus.; Springfield Mus. FA; Universities of Maine, Nebraska, Minnesota, Kansas and Wisconsin. Exhibited: since 1962: PMA. PAFA, Moore Col. A., Philadelphia A. All.; Fleisher Mem., 1959-1969; Philadelphia Civic Center, 1968; Ruth White Gal., N.Y., 1961; Nat. Des. Center, N.Y., 1967; Parma Gal., N.Y., 1960; one-man: Fleisher Mem., 1958, 1963; Panoras Gal., N.Y., 1966; Santa Barbara A. Mus., 1967; Miami Mus. Mod. A., 1968.

BECK, MARGIT—Painter, T., L.
 22 Florence Ave., Great Neck, L.I., N.Y. 11050
B. Tokay, Hungary. Studied: Inst. of FA, Oradea Mare, Roumania; ASL. Member: AEA (Bd. Dirs.); Audubon A. (V.Pres.). Awards: Medal of Honor 1956, prizes, 1958, 1963, 1964, NAWA; Brooklyn Soc. A. (now Am. Soc. Contemp. A.), 1958, 1961, 1962, 1964; Audubon A., 1965, 1967, Medal of Honor, 1969; Silvermine Gld., 1963, 1964; NAD Ranger Fund purchase, 1966; Am. Acad. A. & Lets. purchase 1968; Nominated, Nat. Inst. A. & Lets. grant 1960, 1967, 1968; MacDowell Fnd. Res. Fellowship, 1956, 1957, 1959, 1960. Work: J. B. Speed A. Mus., Louisville, Ky.; Morse Mus., Winter Park, Fla.; Peabody Mus., Cambridge, Mass.; Norfolk Mus. A.: Glichtenstein Mus., Israel; NAD; CGA Lending Lib.; Hofstra Col.; WMAA; Miami Univ., Oxford, Ohio; Hunter Col., N.Y.; Mansfield (Pa.) State Col.; Lending Libs.: MModA, PMA. Exhibited: CGA, 1965; WMAA, 1956, 1959, 1960; AIC, 1959-1960; Butler Inst. Am., 1955, 1956-1958; BM, 1955, 1957, 1959, 1961, 1963; Dayton AI, 1955, 1956; Ringling Mus. A., 1957, 1958, 1960, 1961; PAFA, 1957, 1966-1968; Univ. Nebraska, 1957, 1959; Springfield Mus. A., 1957; AFA, (Whitney Selection), 1961; AFA U.S. Embassy, Denmark 1964-1967; CGA traveling exh., 1965, 1966, 1967; Univ. Georgia, 1956-1961; Columbia (S.C.) Mus. A., 1956-1961; Forum Gal., N.Y. 1963; Am. Acad. A. & Lets., 1960, 1964, 1967, 1968; Nat. Inst. A. & Lets., 1960, 1967, 1968; Davenport Mun. Mus., 1963; Mus. Mod. A., Sao Paulo, 1960; Lehigh Univ., 1963-1968; Pennsylvania State Col., 1965; 16 one-man exhs. Positions: Instr. A., North Shore Community A. Center; Art in America Sch. of Painting; Hofstra Sch. Ptg.; N.Y. Univ. at present.

BECK, ROSEMARIE (PHELPS)—Painter, T.
 6 E. 12th St., New York, N.Y. 10003
B. New York, N.Y., July 8, 1924. Studied: Oberlin College, B.A.; N.Y. Univ., Inst. FA; Award: Ingram-Merrill Grant, 1967. Work: WMAA; Mural, Rotron Mfg. Co., and work in private colls. Exhibited: Kootz Gal., 1950; PAFA, 1954, 1966; AIC, 1954-1961; WMAA, 1955, 1957, 1958; Univ. Michigan, 1956; Allen A. Mus., Oberlin, 1957; BM, 1957; Abstract Impressionists, England, 1958; one-man: Peridot Gal., 1953, 1955, 1956, 1959, 1960, 1963, 1965, 1968; Wesleyan Univ., 1960; N.Y. State Univ., New Paltz, N.Y., 1962; Vassar Col., 1957, 1961; Walters A. Gal., 1965; Nat. Inst. A. & Lets., 1968, 1969. Positions: Lecturer, Painting, Vassar College, 1957-1964; Middlebury Col., 1958-1960, 1963; Parsons Sch. Des., New York City, 1965; Queens College, N.Y., 1968- .

BECKER, CHARLOTTE (Mrs. Walter Cox)—
 Illustrator, P., Comm., W.
 Pine Plains, N.Y. 12567
B. Dresden, Germany, Mar. 31, 1907. Studied: CUASch.; ASL. Author, Illus., fourteen books for children; Illus. for leading publishers. Member of N.Y. Camera Cl. Over one thousand calendars, art prints and magazine covers published in the U.S. with world-wide distribution, all of children, for Kitterlinus Co., Louis F. Dow Co., McKettrick Co., Brown & Bigelow, Toronto Star Magazine, McCalls Magazine, etc. Positions: Dir., Art Gallery, Pine Plains, N.Y.; Restorer of paintings.

BECKER, MARTIN—Collector
 2 Sutton Place South, New York, N.Y. 10022*

BECKER, MAURICE—Painter, Cart.
 237 East 10th St., New York, N.Y. 10003
B. Russia, Jan. 4, 1889. Studied: with Robert Henri, Homer Boss. Member: Indp. A ; AEA (Bd. Dir.); Audubon A.; Fed. Mod. P. & S. Awards: AFA, 1950. Work: Woods A. Mus., Montpelier, Vt.; Jefferson Sch. Soc. Science, New York; Holbrook Col.; Univ. Georgia; Chrysler Mus.; N.Y. Hist. Soc.; Pennsylvania Hist. Soc.; Ringling Mus. A.; Ain Harod & Tel Aviv Mus., Israel. Mural, Worcester (Mass.) Acad. Exhibited: San F. AA, 1916 (one-man); Whitney Studio Cl., 1924 (one-man); Mexico City, 1922 with (Orozco, Siqueiros, and Rivera); J. B. Neumann Gal., 1925-1929; Macbeth Gal., 1942, 1945; WMAA, 1924-1939, 1945, 1946; MMA, 1942, 1952, 1953; NAD, 1944, 1945; Carnegie Inst., 1945; Berkshire Mus., 1946 (one-man); AIC; John Heller Gal., 1951; AEA; A. Lg. Am., 1949; Fed. Modern P. & S., 1951-1961; A.F.I. Gal., 1952; Fed. Modern P. & S. traveling exh., 1955-56; Greenwich Gal., N.Y., 1957; 50th Anniversary Exh. of original 1913 Armory Show, 1962. One Man: Hartert Gal., 1954, 1955, 1957; Art of Today Gal., 1955; Nicholas Gal., 1964, 1965; Tina Netzer Gal., 1963; CCC Gal., Brighton Beach, N.Y., 1963.*

BECKMANN, HANNES—Painter, T., L.
 207 E. 17th St., New York, N.Y. 10024
B. Stuttgart, Germany, Oct. 8, 1909. Studied: Bauhaus, Dessau and with Kandinsky, Paul Klee, Josef Albers. Work: Busch-Reisinger Mus., Cambridge, Mass.; Newark Mus. A., Newark, N.J.; BMFA; Bauhaus Archives, West Germany; Chase Manhattan Bank, N.Y., and in private collections. Exhibitions: Riverside Mus., N.Y., 1960; VMFA, 1962; de Cordova and Dana Mus., Lincoln, Mass., 1963; Newark Mus. A., 1964; "The Responsive Eye," MModA and four other museums, 1965; Univ. of Texas Mus., 1965; Art for U.S. Embassies traveling exh., 1966; "Fifty Years of Bauhaus," Stuttgart, traveling exh. in U.S., Europe, Netherlands and Japan, 1968; Harvard Univ., 1969; one-man: Mus. Non-Objective Painting, 1949; Kanegis Gal., Boston, Mass., 1962, 1964, 1965, 1966, 1968; Lectures: Dartmouth Col., 1968; Harvard Univ., 1969. Positions: Instr., Color Theory & Design, Cooper Union Sch. of Art & Arch., New York City, 1952- ; Visiting Critic, Dept. FA, Yale University, New Haven, Conn., 1960-1961. Adjunct Prof., courses in Psychology of Perception, Cooper Union Sch. of A. & Arch., 1967-1968.

BEDFORD, HELEN DE WILTON—Educator, C.
 Southeast Missouri State College; h. 1030 Merriweather St., Cape Girardeau, Mo. 63701
B. Columbia, Mo., Nov. 12, 1904. Studied: Univ. Missouri, B.S. in Edu.; T. Col., Columbia Univ., M.A.; Univ. New Mexico. Member: Western AA; Missouri State T. Assn.; Kappa Pi; Southeast Mo. Art Edu. Assn.; NAEA; Missouri State A. T. Contributor to Missouri Art Magazine. Positions: Dir., Southeast Missouri State Col., Dept. FA, Cape Girardeau, Mo. Sponsor and Member, Scholarship Committee for the Kappa Pi national honorary art fraternity.

BEDNO, EDWARD—Designer, T.
 5009 S. Ellis Ave., Chicago, Ill. 60626
B. Chicago, Ill., Mar. 8, 1925. Studied: AIC, B.F.A.; Inst. Des., Chicago, M.S. in Visual Des.; Northwestern Univ.; Univ. Chicago. Member: Soc. Typographic A.; A. Gld.; AIGA. Awards: Midwest Film Festival. Exhibited: A. Dir. Cl., Chicago; Soc. Typographic A.; Contemp. Des. Exh., Los Angeles; Midwest Book Clinic; AIGA; Type Dir. Cl.; Graphis; A. Dir. Cl., N.Y.; A. Gld., Chicago (one-man des. exh.); 500 D Gal., (one-man). Contributor of photographic essay in American Heritage Magazine, 1964. Positions: Instr., Northwestern Univ., Evanston, Ill., 1951-52; Instr., Inst. of Design, 1957, Lecturer, 1960-1964, Asst. Prof., 1964- ; Pres., Bedno Associates, Chicago, Ill.

BEELKE, RALPH G.—Educator
 Purdue University; h. 304 Hollowood Dr., W. Lafayette, Ind. 47906
B. Buffalo, N.Y., Dec. 16, 1917. Studied: Albright A. Sch., Buffalo; Univ. of Buffalo, Ed. B.; Teachers Col., Columbia Univ., M.A., Ed. D. Member: NAEA; NEA; AAUP. Awards: Art Educator of the Year,

1963 (NAEA); Member, U.S. Delegation to Soviet Union, 1961, to study Arts Education. Exhibited: Nat. Serigraph Soc.; Western New York Artists; Maryland Artists; CGA. Author: "Curriculum Materials in Art Education," 1963; Editor: Art Education, 1958-61; Eastern Arts Assn. Bulletin, 1951-1958; Western Arts Bulletin, 1963-1965. Positions: Hd. Dept. Art, State University, Fredonia, N.Y., 1948-1953; Specialist, Education in Arts, U.S. Office of Education, 1953-1956; Exec. Sec., NAEA, 1956-1962; Hd., Dept. Art & Design, Purdue University, West Lafayette, Ind., 1962-65; Head, Dept. of Creative Arts, Purdue Univ. 1965- .

BEERMAN, HERBERT—Painter, T., S., L.
 162 Stuyvesant Ave., Newark, N.J.; h. 130 Passaic Ave., Livingston, N.J. 07039
B. Newark, N.J., Nov. 8, 1926. Studied: Rutgers Univ.; Univ. Miami, A.B.; Yale Univ., Sch. Des., with Josef Albers, B.F.A. Awards: MacDowell F., 1958, 1959, 1961; Yaddo Fellowship, 1963, 1964; prize, Saratoga Centennial, 1963. Member: AEA. Exhibited: Artists Gal., N.Y., 1957, (one-man) 1958, 1960; Camino Gal., N.Y., 1957, 1958; Newark Mus., 1961 Krasner Gal., N.Y., 1963 (one-man); Pratt Inst. A. Lib., 1963; Seton Hall Univ., So. Orange, N.J., 1964 (one-man); Yaddo Gal., Saratoga Springs, N.Y. 1964 (one-man); Fairleigh Dickinson Univ., Madison, N.J. 1964; Plainfield, N.J. Outdoor Show, 1964. Lectures: Contemp. A., Rutgers Univ.; Seton Hall Univ., 1964; Cornell Univ., 1964. Positions: Instr., Color Theory, 2-D Des., Pratt Institute, Brooklyn, N.Y. 1960- ; Instr., Painting, Arts Workshop, Newark Museum, Newark, N.J., 1959- .*

BEERMAN, MIRIAM—Painter
 25 Eastern Parkway, Brooklyn, N.Y. 11238
B. Providence, R.I., Nov. 11, 1923. Studied: R.I. Sch. Design; ASL; New Sch. for Social Research, N.Y.; Atelier 17, Paris, France. Awards: Fulbright Fellowship to Paris with renewal; ASL Scholarship; McDowell Colony Fellowship, Peterborough, N.H.; Ives prize, R.I. Sch. Design; Providence A. Cl. award. Work: Andrew Dickson White Mus., Cornell Univ.; Squibb Bldg., Minneapolis; New Sch. for Social Research, N.Y.; WMAA; Downtown Gal., N.Y.; Chelsea Gal., N.Y. Exhibited: American Embassy, Paris; BM (prints) and circulated by the American Federation of Arts; Boston A. Festival; State Capitol, Albany, N.Y.; PAFA, 1967; New Sch. for Social Research A. Gal., 1968; Chelsea Gal., N.Y., 1969 (one-man); Inst. of Int. Edu., 1968; R.I. Sch. Design Mus.; Nat. Gal. of Canada, Ottawa; Jacques Seligmann Gal., N.Y.; Downtown Gal., N.Y.; Dartmouth Col.; J. B. Speed A. Mus., Louisville, Ky.; Long Island Univ., N.Y., and others.

BEETZ, CARL HUGO—Lithographer, P., E., W.
 266-27th Ave., San Francisco, Cal. 94121
B. San Francisco, Cal., Dec., 25, 1911. Studied: Cal. Sch. FA, with Spencer Macky; ASL, with George Bridgman; Chouinard AI, with Pruett Carter. Member: Cal. WC Soc.; Cal. Soc. Et. Awards: Redlands A. Gld., 1941. Work: SFMA. "Drawings and Lithographs of Carl Beetz," Am. Artist Magazine, 1960. Exhibited: Pomona, Cal., 1937; AIC, 1941; Riverside Mus., 1940, 1944; San Diego, 1941; Lib. Cong., 1944, 1945; Phila. Pr., 1944; Indianapolis Pr. Show, 1946; Springfield Pr. Show, 1946; Cal. WC Soc., 1937, 1939, 1940, 1942, 1943; San F. AA. 1941, 1943, 1946; Fnd. Western A., Los A., 1937, 1938, 1940, 1942, 1944; Utah State Agri. Col., 1947; Oakland A. Mus., 1950, 1956; SFMA, 1951; Cal. Soc. Et., 1954, 1956; San F., Sacramento, Cal.; one-man: Los A. Mus. A., 1942; M.H. deYoung Mus., 1944, 1957; Jepson AI, 1949; SFMA, 1946 (4-man). Positions: Instr., Chouinard AI, 1935-44; Cal. Col. A. & Crafts, Oakland, Cal., 1944-58; Acad. Adv., San Francisco, 1944-53; Prof. A., Cal. Col. A. & Crafts, Oakland; City Col. of San Francisco, 1945- .

BEGG, JOHN (ALFRED)—Sculptor, P., Des.
 137 S. Broadway, Hastings-on-Hudson, N.Y. 10706
B. New Smyrna, Fla., June 23, 1903. Studied: Columbia Univ., B.S., and with Arthur Wesley Dow, Ossip Zadkine. Work: Indiana Mus. Mod A.; Print Coll., N.Y. Pub. Lib.; AGAA. Awards: Brandeis Creative Festival sc. award; Yonkers Mus., 1957, 1958, 1964. Exhibited: WMAA, 1945, 1950; BM, 1935, 1937; Buchholz Gal., 1943, 1945; Wakefield Gal., 1942 (one-man); Nierndorf Gal., 1945; New Sch. Social Research, 1948, 1949; WMA, 1948; AWS, 1952, 1960; Hudson River Mus. Retrospective Exh., 1967; Westchester A. Soc., 1965-1967; Albany Inst. of History & Art, 1965; State Univ. at Albany, 1967; Riverside Mus., 1965. Positions: Dir. Des. & Production, Oxford Univ. Press., 1939-1968; Vice-Pres., 1960-1968. L., Typography & Des., N.Y. Univ., 1950-58; Bd. Dirs., AIGA, 1942-44, 1951-54.

BEGGS, THOMAS MONTAGUE—Fine Arts Consultant, P.
 Smithsonian Institution, Wash., D.C.; h. 6540 Hitt Ave., McLean, Va. 22101
B. Brooklyn, N.Y., Apr. 22, 1899. Studied: PIASch.; ASL; Yale Univ., B.F.A.; Ecole des Beaux-Arts, Fontainebleau, France. Member: AAMus. Awards: med., Sch. A. Lg., 1917; BAID, 1923; Carnegie F. to FMA, 1928-1929; Grant from Federal Republic of Germany (for travel in Germany to museums and art schools), 1954. Work: Redlands Univ., Redlands, Cal.; murals, H.S., Brooklyn, N.Y.; Pacific Bldg., Miami, Fla. Author, I., magazine and newspaper articles. Positions: Hd., A. Dept., Pomona Col., 1926-47; Asst. Dir., Nat. Coll. Fine Arts, Smithsonian Inst., Washington, D.C., 1947-48, Dir., 1948-1964; Special Assistant to the Secretary for Fine Arts, 1964-65; Smithsonian Inst. Representative on Cultural Presentations Committee, O.C.B., 1957-1960. Fine Arts Consultant, U.S. Dept. of the Treasury, 1966- .

BEHL, MARJORIE—Painter
 7332 Elvin Ct., Norfolk, Va. 23505
B. Pocahontas, Ark., Mar. 8, 1908. Studied: Collins Sch. of A., Tampa, Fla.; Cal. Col. of Arts & Crafts, with George Post; Col. of William & Mary, Norfolk, with Charles Sibley. Member: Soc. Western A; Virginia Beach AA; Tidewater AA; Sarasota AA. Awards: prizes, Arkansas State Mus., 1957; Virginia Beach Boardwalk Exh., 1963, 1964; Tidewater Annual, Norfolk Mus., 1957, 1965. Work: Univ. Virginia, Charlottesville, (purchased for permanent coll.); Valentine Mus. A., Richmond; Florence Crittenden Home for Girls, Norfolk; Loan Coll., Virginia State Mus.; Norfolk Mus.; Virginia Nat. Bank, Charlottesville, (purchase); school collections in Oakland, Cal., Richmond and Norfolk, Va. Exhibited: Virginia State Artmobile, 1957, 1959; Gibbes Gal., 1957, 1958; Norfolk Mus. A., 1959; de Young Mus., San F., 1957; Little Rock Mus. A., 1958; VMFA, 1957, 1959, 1960; Irene Leache Mem. Exh., 1945, 1957, 1960, and others; Winston-Salem Gal. FA, 1958; Williamsburg, Va. (under VMFA), 1960-61; Valentine Mus. A., Richmond, Tidewater A., Norfolk Mus., 1956-1958, 1960; VMFA Loan Coll.; Norfolk Mus. Loan Coll.; 3-man traveling exh., VMFA, 1960; 2-man exh.,·Norfolk Mus., 1966. Lectures on Contemp. A. to clubs and other organizations.

BEHL, WOLFGANG—Sculptor, T.
 15 Girard Ave.; h. 179 Kenyon St., Hartford, Conn. 06105
B. Berlin, Germany, Apr. 13, 1918. Studied: Acad. FA, Berlin, Germany; R.I. Sch. Des. Awards: Eisendrath prize, AIC, 1944; Milwaukee AI, 1945; Springfield A. Lg., 1955; Conn. Acad., 1961, 1963, 1964; Nat. Inst. A. & Lets., 1963; A. Festival, Hartford, 1964. Work: AGAA; Lowe Gal., Univ. Miami, Fla.; port., Elihu Buritt Lib., New Britain, Conn.; Stations of the Cross, & 12 ft. bronze Cross, St. Timothy Church. W. Hartford, Conn.; sc. wall, Univ. Hartford; Woodcarving, Lobby of Conn. General Ins. Co., Bloomfield, Conn., 1967. Exhibited: Univ. Illinois, 1957; Bertha Schaefer Gal., annually (one-man) 1946-1968; AIC, 1943, 1944; Milwaukee AI, 1945; Virginia Mus. A., 1946, 1947, 1948, 1949, 1951; Boston A. Festival, 1946, 1957; Silvermine Gld. A., 1946, 1947; Wadsworth Atheneum, 1957; Katonah, N.Y., 1958; Plastics-USA, sponsored by USIS, traveling exh., to Russia, 1960; Mus. Contemp. A., 1962; Carnegie Inst., 1962, 1964; PAFA, 1964 (purchased by Ford Fnd. for PAFA permanent coll.); one-man: Mint Mus. A., 1949, 1950, Hollins Col.; Randolph-Macon Col., 1951; Sweet Briar Col., 1951; Town & Country Cl., Hartford, 1962; Verle Gal., Hartford, 1964; Slater Mem. Mus., Norwich, Conn., 1964; Univ. of Conn., 1965; Bucknell Univ., 1965; New Haven A. Festival, 1965; Retrospective exhibition "A Decade of Sculpture," New Britain (Conn. Mus. Am. A., 1969. "America Houses" in Schweinfurt, Wurzberg & Munich, Germany, 1952; 3 man: VMFA, 1948. Illus. "Aphrodite and Adonis," (10 woodcuts). Positions: Assoc. Prof., Sc. & Drawing. Layton Sch. A., Milwaukee, 1944-45; Richmond Professional Inst. of the College of William & Mary, 1945-1953; Hartford A. Sch., of Univ. of Hartford, Hartford, Conn., 1946- . Guest Lecturer: Rinehart Sch. of Sculpture, Maryland Inst., 1963; Rhode Island Sch. Des., 1963.

BEHNCKE, ETHEL BOUFFLEUR (Mrs. Nile J.)—
 Educator, Des., L.
 545 Algoma Blvd., Oshkosh, Wis. 54901
B. Tacoma, Wash. Studied: Univ. Washington, B.E.; Univ. Chicago, M.A.; Chicago Acad. FA, and with Nile Behncke, and others. Awards: Julia Piatt F., AAUW, for European study. Member: AAUW (life); NEA; Wisconsin A. Edu. Assn.; NAEA; Nat. Assn. for Higher Edu.; Wisconsin Acad. A. & Lets.; Bd. Memb. & Program Chm., Paine A. Center. Contributor to Design Magazine. Lectures: Modern Art, Interior Design, Art Education, History of Art; Supv., Fed. A. Project for N.E. Section of Wisconsin. Positions: Iowa State College, Ames, Iowa; Chm. A. Dept.; Prof., Wisconsin State University, Oshkosh, Wis.

BEHNCKE, NILE JURGEN—Museum Director, P.
 545 Algoma Blvd., Oshkosh, Wis. 54901
B. Oshkosh, Wis., June 4, 1894. Studied: Oshkosh State Col.; George Enness A. Sch. Member: Wisconsin P. & S.; Bd., Paine A. Center. Awards: Wisconsin Fed. Women's Cl.; Wisconsin P. & S.; Wisconsin State prize; Northeast A. Work: Madison Pub. Sch.; Nurses Hospital, Victoria, B.C.; Oklahoma A. Center; Neville Pub. Mus.; Kenosha, Wis., A. Gal.; Manitowoc Mus.; Allis A. Lib., Milwaukee; Paine A. Center; Casper (Wyo.) A. Center; Kohler (Wis.) Pub. Sch.; Ripon Col.; Ft. Dodge A. Gal.; AIC; Colburn Co.; Oshkosh Pub. Mus.; Oshkosh State Col.; Oshkosh H.S.; Bergstrom Mus.; and in private coll.

Exhibited: Wisconsin P. & S.; PAFA; AIC; CGA; AWS; Paine A. Center; Ill. State Mus.; Bergstrom Mus.; Peninsula AA; one-man: Tour of Wisconsin Museums. Positions: Dir., Cur. A., Oshkosh Pub. Museum, Oshkosh, Wis.; T., A. & Mus. classes.

BEINECKE, FREDERICK WILLIAM—Collector
 330 Madison Ave., 10017; h. 888 Park Ave., New York, N.Y. 10021
B. New York, N.Y., Apr. 12, 1887. Studied: Yale University, Ph.B.; Sheffield Science School. Collection: French Impressionists.*

BEINEKE, J. FREDERICK (Dr.)—Collector
 1115 Fifth Ave., New York, N.Y. 10028
B. Decatur, Ind., Apr. 5, 1927. Collection: African and South Pacific Art; Japanese Woodblock Prints.

BEITTEL, KENNETH R. —Educator
 268 Chambers Bldg., Pennsylvania State University, University Park, Pa. 16802*

BEITZ, LESTER U.—Painter, I., W.
 Packsaddle Press; h. 2407 Audubon Pl., Austin, Tex. 78741
B. Buffalo, N.Y., May 11, 1916. Studied: A. Inst. of Buffalo; and with Charles S. Bigelow. Work: in private collections. Also, murals: Officer's Club, Royal Air Force Station, Fairford, England; Enlisted Men's Club, Schilling Air Force Base, Salina, Kans., 1962. Specializes in the portrayal of the American West. Author, Illus. "A Treasury of Frontier Relics." Contributor, articles, illus. and features on Frontier Americana in leading Western media—Real West, Desert, Western Digest, Argosy, Ford Times and various other magazines.

BELINE, GEORGE—Painter, S.
 370 Central Park West, New York, N.Y. 10025; s. Delaware River Dr., Frenchtown, N.J. 08825
B. Minsk, Russia, July 23, 1887. Studied: NAD; Lycee Charlemagne, Ecole des Beaux-Arts, Ecole Superieure des Places de Vosges, Paris, France. Member: All. A. Am.; Hudson Valley AA; SC; AAPL; Hunterdon County A. Center (N.J.). Awards: prizes, AAPL; SC, Louis Lilly prize, 1967; medals NAD. Exhibited: NAD; PAFA; Mun. A. Gal.; AAPL; AWS; BM; NAC; PC; Ogunquit A. Center; Springville, Utah; Washington, D.C.; Oakland (Cal.) Mus. A.; Springfield (Mass.) Academic A. Represented in public and private collections; NAD; Treasurer, All. A. Am., 1961-1964.

BELING, HELEN (Mrs. Lawrence R. Kahn)—Sculptor, T., L.
 287 Weyman Ave., New Rochelle, N.Y. 10805
B. New York, N.Y., Jan. 1, 1914. Studied: Col. City of N.Y.; NAD; ASL. Member: Audubon A.; NAWA; S. Gld. (Sec.); N.Y. Soc. Women A.; New Rochelle AA. Awards: prizes, Audubon A., 1952, 1959, 1963, Medal of Honor, 1965; NAWA, 1951, 1962, Medal of Honor, 1958; Medal of Honor-1968; Silvermine Gld. A., 1957, 1960; Sabena Comp. (Intl.), 1953. Work: Butler Inst. Am. A., Youngstown, Ohio; Syracuse Univ. Mus. A.; Norfolk Mus. A.; Television Acad. of A. & Sciences; Jewish Community Center, White Plains, N.Y.; Temple Israel, Waterbury, Conn.; Congregation B'nai Jacob, Woodbridge, Conn. Pleasantvalley home, West Orange, N.J.; Temple Emanu-el Yonkers, N.Y. Exhibited: MMA; NAD; PAFA; Audubon A.; NAWA; Syracuse Mus. FA; WMAA; Ohio Univ.; Univ. Illinois; City Art Mus., St. Louis, Mo.; London, England; Brussels, Belgium; U.S.I.A. sc. show, Dacca, Pakistan, 1961; Mexico; Bryant Park N.Y.; Lever House, N.Y.; Everson Mus. & traveling exh.; one-man: John Heller Gallery, 1952, 1954; Krasner Gal., N.Y., 1959, 1961, 1964; 1967, 1969; Hudson River Mus., 1961.

BELL, CLARA LOUISE (Mrs. Bela Janowsky)—Painter
 52 West 57th St., New York, N.Y. 10019
B. Newton Falls, Ohio. Studied: Cleveland Sch. A.; ASL, and with Henry G. Keller. Member: ASMP; NAWA; (Memb. Jury, 1962-63; Exh. jury, 1964-65). Awards: prizes, CMA, 1919, 1923, 1925, 1926; NAWA, 1949, 1961, 1964, medals, 1930, 1952, 1959. Exhibited: ASMP, 1926-1958; MMA, 1950; NAWA, 1928-1964; Argent Gal., 1950; All. A. Am., 1954, 1960, 1963; Royal Soc. Min. P., London, England, 1958; Greenbriar, White Sulphur Springs, W.Va., 1933 (one-man); Butler Inst. Am. A., 1939; Newport, R.I., 1932 (one-man); Copley Gal., Boston, 1914 (one-man); Clinton Acad., Easthampton, N.Y. (2-man) 1930; Chester A. Gld.(Vt.), 1960-1964; Rehoboth A. Lg., Del., 1960. Work: MMA; BM; Masonic Temple, Youngstown, Ohio; Butler Inst. Am. A.; Coast Guard Acad., Hamilton Hall, New London, Conn.; Smithsonian Inst., Washington, D.C.; Longyear Fnd., Boston. Work reproduced in Art Digest, 1951, American Artist, 1958.

BELL, ENID (Mrs. Enid Bell Palanchian)—Sculptor, C., T., I., W., L., W.
 277 Walton St., Englewood, N.J. 07631
B. London, England, Dec. 5, 1904. Studied: in England & Scotland; &

with Sir W. Reid Dick, London; ASL. Awards: Med., Paris Int. Exh., 1937; AAPL, 1934; New Mexico State Fair, 1940, 1941; Newark AC, 1933; N.J. Exh., 1949, 1951. Work: Congressional med. for Lincoln Ellsworth; Carved wood murals, Robert Treat Sch., Newark, N.J.; Beth Israel Hospital, Newark, N.J.; USPO, Mt. Holly, Boonton, N.J.; Hereford, Tex.; carved wood portrait reliefs, Armenian Cultural Fnd., Boston. Exhibited: PAFA; NAD; WFNY 1939; Paris Int. Exp.; MMA; BM; Mus. New Mexico, Santa Fé; Ferargil Gal., 1929 (one-man); Arden Gal., 1934 (one-man); Argent Gal., 1949; NSS; Illinois State Mus., Springfield, 1957 (one-man); Columbus (Ga.) Mus. A. & Crafts, 1957 (one-man). Author: "Tincraft as a Hobby"; "Practical Woodcarving Projects"; "Arts and Crafts" filmstrips. Positions: Instr., S. Newark Sch. F. & Indst. A., Newark, N.J., 1944-1968. Contributor to American Artist magazine.

BELL, LELAND—Painter
 241 W. 16th St., New York, N.Y. 10011
B. Cambridge, Md., 1922. Exhibited: Schoelkopf Gal., 1963, 1964; Knoedler Gal., 1963; Manhattanville Col., 1963; Univ. Nebraska, 1963; PAFA, 1963; one-man: Hansa, Poindexter, Zabriskie, Jane Street Galleries, all New York City.*

BELLAMY, RICHARD—Art dealer
 Goldowsky Gallery, 1078 Madison Ave., New York, N.Y. 10028*

BENDIG, WILLIAM C.—Painter, T.
 Hollycroft, Ivoryton, Conn. 06442
B. Corry, Pa., Dec. 1, 1927. Studied: Trinity Col., Hartford, Conn.; Univ. London, Chelsea Sch. A., (London) with Ceri Richards; private study in Greece and Italy. Member: Essex AA (Vice-Pres., 1959-1961); Mediaeval Acad. of Am. Work: Trinity Col. Exhibited: Provincetown, Mass., 1957; Ogunquit, Me., 1953; Springfield Mus. A., 1953; Mystic AA, 1957-58, 1961; N.Y. City Center, 1957; Lyme AA, 1956; Springfield A. Lg., 1957; Essex AA, 1956-1961; Riverside Mus., N.Y., 1960. Lectures: Trinity College, 1965; Art History, Mediaeval Art, Architecture, etc. Frequent judging of exhibitions: recently - Silvermine (Conn.), Chautauqua (N.Y.), Virginia Beach Regional. Positions: Instr., Painting, Drawing, Art History, Brunswick Sch., Greenwich, Conn., Cheshire Acad. (Conn.); Publisher of the magazine The Art Gallery, 1957- .

BENEKER, KATHARINE—Museologist, Designer Exh., P.
 American Museum of Natural History; h. 110 Sunset Lane, Tenafly, N.J. 07670; also Truro, Cape Cod, Mass. 02666
B. Brooklyn, N.Y., May 11, 1909. Studied: PMSchIA; Mass. Sch. A., and with Richard Miller, Charles W. Hawthorne. Member: AAMus. Exhibited: AWS, 1942-1945; NAWA, 1943, 1944; Provincetown AA, 1938-1941. Positions: T., Brewster, Mass., 1932-34-36; Supv. Exh., Am. Mus. Natural Hist. New York, N.Y., 1940-52, Hd. Dept. Preparation & Exhibition, 1952-1954; Exh. Co-ordinator, 1954-1955; Asst. to Chm. of Exhibition & Graphic Arts, 1955- .*

BENGERT, ELWOOD G.—Stained Glass Designer, P.
 814 High Mountain Rd., Franklin Lakes, N.J.; h. 375 Dorothy Lane, Wyckoff, N.J. 07481
B. Clifton, N.J., Dec. 16, 1921. Studied: Newark Sch. Fine & Indst. Arts; Parsons Sch. Design, N.Y. and in Paris. Member: AAPL; New Jersey WC Soc. Awards: prizes, AWS, 1955; NAD, 1958; Montclair Mus. A., 1960; Knickerbocker A., 1960; New Jersey WC Soc. Work: Franklin Lakes National Bank and in churches and public bldgs. Exhibited: AWS, 1955; NAD, 1958; Montclair Mus. A., 1955, 1960; Knickerbocker A., 1960; New Jersey WC Soc., 1955-1958; AAPL, 1960, 1961, 1964; Worlds Fair, N.Y., New Jersey Pavilion, 1964-65; traveling exhibitions. Positions: Stained Glass Designer, Hiemer & Co., Clifton, N.J.; Payne-Spiers Studios, Paterson, N.J. Owner, Bengert Art Co., Franklin Lakes, N.J.

BENGSTON, BILLY—Painter
 Artist Studio, 110 Mildred Ave., Venice, Cal. 90291
B. Dodge City, Kans., June 7, 1934. Awards: Nat. Fnd. for the Arts Grant, 1967; Tamarind Lithography Workshop Fellowship, 1968. Exhibited: Oakland A. Mus., 1963; Los Angeles County Mus., 1963; Sao Paulo Bienal, 1965; SAM, 1966; Gallery Reese Palley, San Francisco, 1969; Janie Lee Gal., Ft. Worth, Tex., 1968; Jewish Mus., N.Y., 1968; WMAA, 1962, 1968; Univ. California at Irvine, 1967; Milwaukee A. Center, 1964. One-man: Ferus Gal., Los Angeles, 1957, 1958, 1960-1963; Martha Jackson Gal., N.Y., 1962; SFMA, 1968; Pasadena A. Mus., 1969; Los Angeles County Mus., retrospective, 1968 (traveled to the Washington Gal. Mod. A., and the Vancouver A. Gallery). Work: Larry Aldrich Mus. Contemp. A., Ridgefield, Conn.; AFA; Los Angeles County Mus.; MModA; Pasadena A. Mus.; WMAA; Univ. California at Los Angeles. Contributor to Artforum. Positions: Instr., Chouinard A. Inst., 1961; Lecturer, Univ. California at Los Angeles 1962-1963; Guest Artist, Univ. Oklahoma, Norman, 1967, and Univ. Colorado, Boulder, 1969.

BENJAMIN, KARL STANLEY—Painter
675 W. 8th St., Claremont, Cal. 91711
B. Chicago, Ill., Dec. 29, 1925. Studied: Northwestern Univ.; Univ.
Redlands (Cal.), B.A.; Claremont Grad. Sch., M.A. Work: WMAA;
Los Angeles County Mus.; SFMA; Santa Barbara Mus. A.; Pasadena
A. Mus.; Long Beach Mus.; La Jolla Mus. A.; FA Gal. of San Diego;
Univ. Redlands; Mus. Mod. A., Israel; Pomona Col.; Scripps Col.;
Univ. California, Berkeley, Mus.; Salk Inst., La Jolla, Cal. Exhi-
bited: CGA, 1967; MModA, 1965-1966, and traveling; Mead Corp.,
1965-1967 and traveling; SFMA, 1965; J. B. Speed Mus., Louisville,
1965; Denver Mus. A., 1965; Colorado Springs FA Center, 1964;
Amon Carter Mus. Western A., Ft. Worth, 1962-1963; Painting of
the Pacific, U.S., Japan, Australia, New Zealand, 1961-1963; WMAA,
1962 and traveling; AFA traveling exh., 1959-1961; USIS, Inst.
Contemp. A., London, England and Queen's Col., Belfast, Ireland,
1960; Four Abstract Classicists, organized by Los Angeles County
Mus. and SFMA, 1959-1961, shown at many institutions in the U.S.;
Pasadena A. Mus., 1961-1962; Carnegie Inst., 1961; one-man: Henri
Gal., Washington, D.C., 1968; Hollis Gal., San Francisco, 1964,
1966; Esther Robles Gal., Los Angeles, 1959, 1960, 1962, 1964,
1965; Jefferson Gal., La Jolla, 1965; Santa Barbara Mus. A., 1962,
1968; Bolles Gal., San Francisco, 1961; La Jolla Mus., 1961;
Scripps Col., 1960; Long Beach Mus., 1958 and others.

BENN, BEN—Painter, T.
110 W. 96th St., Apt. 4A, New York, N.Y. 10025
B. Russia, Dec. 27, 1884. Studied: NAD. Member: AEA; Fed. Mod.
P. & S. Awards: Schiedt award, PAFA, 1952, and the Carol H. Beck
Gold Medal, 1966. Work: MMA; WMAA; Walker A. Center; Newark
Mus. A.; Albany Inst. Hist. & A.; Mus. City of New York; Watkins Gal.,
American Univ., Wash., D.C. Exhibited: PAFA; WMAA; MMA; Butler
AI, Youngstown, Ohio; Intl. Assn. of the Plastic Arts, traveling exh.,
Europe, 1956; BMA; Knoxville (Tenn.) A. Center; Kroller-Müller
Mus., The Hague, Holland; WMA; Jewish Community Center, Detroit;
CGA; Rochester Mem. A. Gal.; Fed. Mod. Painters & Sculptors; To-
ledo Mus. A.; Berkshire Mus. A., Pittsfield, Mass.; Philbrook A. Cen-
ter, Tulsa, Okla.; Nebraska AA Art Galleries, Univ. of Nebraska; Intl.
A. Festival, Madrid, Spain; Critics' Choice, Providence, R.I.; Museum
Cantini, Marseilles, France; Jewish Mus., New York City; Decade of
the Armory Exhibition, WMAA; Am. Acad. A. & Lets.; State Mus.,
Biro-Bidjan, Russia; Bicentennial Brown Univ., Providence, R.I.,
1965; Jewish Mus., N.Y., 1965 (one-man).

BENNEY, ROBERT—Painter, I., W., L.
50 W. 96th St., New York, N.Y. 10025; also, Haviland Apts., Rt.
9-G, Hyde Park, N.Y. 12538
B. New York, N.Y., July 16, 1904. Studied: CUASch.; ASL; NAD;
Grand Central Sch. A. Member: SI; AEA; ASL; A. & Writers Assn.;
Appraisers Assn. of Am.; F.I.A.L. Awards: prizes, PMA; med. A.
Dir. Cl. (Abbott Lab.), 1945; CUASch. Work: Shell Oil Co.; RCA-
Victor, Abbott Lab.; U.S. Navy; U.S. Army; U.S. Air Force; Standard
Oil Co., New Jersey; Chrysler Corp.; United Aircraft Corp.; de-
Young Mus. A.; IBM; Am. Sugar Refining Co.; American Tobacco
Co.; General Foods Corp.; Western Electric Corp.; SAM; CGA;
Mariners Mus., Newport News, Va.; Fort Sam Houston, Tex.; MDW
Pentagon, Wash., D.C.; Chaplain Sch., Fort Slocum, N.Y.; Army
Medical Center, Fort Totten, N.Y.; SI U.S.A.F. project; Paintings &
Drawings, French Morocco, No. Africa; produced Visual Story of
Sugar. Exhibited: NAD; CGA; Currier Gal., 1940; VMFA, 1940;
BMFA, 1944; AIC, 1944; Inst. Mod. A.; NGA, 1943, 1945; MMA,
1943; Carnegie Inst., 1945; BM; Montreal AA; deYoung Mem. Mus.,
1945; Dallas Mus. FA, 1945; Portland Mus. A., 1945; Arch. Lg.,
N.Y.; N.Y. Pub. Lib.; Newspaper A. Exh., 1938; San Diego FA Soc.;
La Jolla A. Center; SAM; Norfolk Mus. A. & Sc.; Springfield (Mass.)
Mus. FA; MMA; SI; U.S.A.F. Acad., Denver; U.S.A.F., Bolling Field,
Wash., D.C.; Los A. County Fair, 1960; Smithsonian Inst., 1967;
Albany Inst. of History and A., 1968; State Univ. of N.Y., 1969. Many
portraits of prominent persons, I., "Naval Aviation," 1944; Contri-
butor: "Men Without Guns" (as told to DeWitt Mackenzie); "Life of
Joshua," 1959. Contributor to "Our Flying Navy"; "Pictures,
Painters and You," 1949; Life's Picture History of World War II,
1950; American Artist magazine, 1956; True Magazine, Reader's
Digest, and others. Lectures: "Art in Industry," "Spanish Paint-
ing," "Impressionist Painting," Dutchess County AA, "Art in In-
dustry," N.Y. Bd. Edu., Sch. A. Lg., "Art in the School Yearbook,"
Columbia Schol. Press Assn., N.Y.; "Visual Communication," Over-
seas Press Cl.; "Contemporary Techniques in Painting and Illustra-
tion," I.B.M. A.A., Poughkeepsie, N.Y.; "Art for Industry and Agri-
culture," Rotary Club, Hyde Park. Visiting Prof. A., Dutchess Com-
munity College, Poughkeepsie, N.Y.

BENSING, FRANK C.—Portrait Painter, I., Des.
1 West 67th St., New York, N.Y. 10023; s. Woodstock, N.Y.
12498
B. Chicago, Ill., Oct. 29, 1893. Studied: AIC. Member: AWS; SI; SC;
A. Gld.; A. Fellowship; Dutch Treat Club; Allied Artists. Awards:

Gold Medal of Honor, NAC, 1969. Exhibited: NAD; All. A. Am.; SC;
AWS; AIC, I., national magazines. Work: Bryn Mawr Col.; State Office
Bldg., Albany, N.Y.; Joseph P. Kennedy Mem. Hospital, Boston, Mass.;
Univ. Delaware; Earlham Col., Richmond, Ind.; Univ. Notre Dame;
Spaulding House, Harvard Univ.; St. Luke's Hospital, N.Y.; Douglass
Col., New Brunswick, N.J.; Union College, Schenectady, N.Y.; Colum-
bia Univ.; Children's Hospital, Boston; Univ. of Miami, Coral Gables,
Fla.; College of St. Thomas, St. Paul, Minn.; Yale Univ. Engineer's
Club; Wilson College; Middlebury College; Upsala Col., West Orange,
N.J.; Duke Univ., Durham No. Carolina; Cleveland Clinic Fnd.; Amer-
ican Bible Soc.; Univ. Pennsylvania; McCallie Sch., Chattanooga, Tenn.

BENSINGER, B. EDWARD III—Collector
Bensinger Enterprises, 499 North Canon Dr.; h. 613 North
Canon Dr., Beverly Hills, Cal. 90210
B. Chicago, Ill., Nov. 27, 1929. Studied: Yale University, B.A.; Uni-
versity of Southern California, Grad. School of Business, M.B.A.
Collection: Beckmann and Corot. Positions: Bensinger Enterprises,
Beverly Hills, Cal.; Brunswick Corporation, Chicago.

BENSON, EMANUEL—Educator, W., Cr., L.
P.O. Box 754, Bridgehampton, L.I., N.Y. 11932
B. New York, N.Y., Oct. 22, 1904. Studied: Dartmouth College, B.A.;
Columbia Univ. Contributor to: Parnassus; Saturday Review; N.Y.
Sun; Creative Art; American Magazine of Art; monographs on John
Marin; Problems of Portraiture. Positions: Chief, Div. Edu., Phila-
delphia Museum of Art, 1936-1953; Dean Philadelphia Col. A., 1953-
1965; Consultant Philadelphia College of Art; Critic-in-Res., Nassau
Community Col.; Dir., Summer Art Program, Southampton Col.;
Dir., Benson Gal., Bridgehampton, L.I., since 1965.

BENSON, GERTRUDE A.—Art Critic, Feature Writer, Ed.
1530 Locust St., Philadelphia, Pa. 19102
Studied: Hunter Col., B.A.; N.Y. Univ., M.A. Awards: Carnegie F.,
1929-30, 1930-31. Contributor to Art Bulletin; Parnassus; New York
Times; Philadelphia Evening & Sunday Bulletin; Philadelphia In-
quirer. Positions: A. Editor, Phila. Inquirer, 1950-57; Asst. Prof.
Phila. Mus. Col. of Art, Dept. of Humanities, 1960-1963; Asst. Dir.,
Public Relations, Drexel Institute of Technology, Philadelphia, Pa.,
1964- .

BENTLEY, CLAUDE—Painter, T., L.
c/o Ronald L. Barnard, Suite 815, 134 S. La Salle St., Chicago,
Ill. 60603
B. New York, N.Y., June 9, 1915. Studied: Northwestern Univ.; AIC.
Awards: Mural Comp., Taxco, Mexico, 1949; MMA, 1952; AIC, 1955,
John G. Curtis, Jr. Award, 1963; Old Orchard Art Fair, 1963;
Brotherhood Week Exh., Chicago, 1959; purchase awards: Univ. Illi-
nois, 1949; Denver A. Mus., 1954, 1960; Sarasota AA, 1959; Village
Art Fair, Oak Park, Ill., 1959; Illinois State Mus., 1963; Work: Univ.
Illinois; MMA; Denver A. Mus.; AIC; Illinois State Mus.; Santa Bar-
bara Mus. A.; Intl. Mineral & Chemical Corp.; Layton Sch. A., Mil-
waukee; murals, 3600 Lake Shore Dr. Bldg., Chicago. Exhibited:
1956-61; CGA; SFMA; Santa Barbara Mus. A.; AIC; Sarasota AA;
Denver A. Mus.; PAFA; WMAA; Univ. Illinois; Carnegie Inst.; BM;
Univ. Wisconsin; LC; Univ. Nebraska, and others; one-man: Duveen-
Graham, N.Y.; AIC, 1959; Fiengarten Gal. (Chicago & N.Y.), 1960.
Lectures: "Contemporary Painting with Sumi Ink," Milwaukee A.
Center, Fort Wayne A. Sch.

BENTON, FLETCHER—Sculptor
c/o Bonino Gallery, 7 W. 57th St., New York, N.Y. 10019
Exhibitions: Gump's Gal., San Francisco, Cal., 1964; Galeria Bo-
nino, N.Y., 1968; WMAA, 1968.*

BENTON, THOMAS HART—Painter
3616 Belleview Ave., Kansas City, Mo. 64111
B. Neosho, Mo., Apr. 15, 1889. Studied: AIC; & abroad. Awards:
Med., Arch. L., 1933; gold medal, AIA. Work: MMA; Wanamaker
Gal. Coll.; MModA; BM; murals, State Capitol, Jefferson, Mo.; In-
diana State Univ.; New Sch. Social Research; Harry Truman Library,
Independence, Mo; Power Authority of the State of New York; WMAA.
Author: "An Artist in America," "An American in Art," 1969.

BENTON, WILLIAM (Senator)—Collector
Encyclopaedia Britannica, 342 Madison Ave., New York, N.Y.
10017; h. Sasco Hill Rd., Southport, Conn. 06490
B. Minneapolis, Minn., Apr. 1, 1900. Studied: Carleton College;
Yale University, A.B. Collection: Contemporary American Painting
and Sculpture. Positions: Trustee, Friends of the Whitney Museum
of American Art; Member, Advisory Committee, Poses Institute of
the Fine Arts, Brandeis University; Fellow (Life), Metropolitan
Museum of Art; Member, International Council at the Museum of
Modern Art; Committee for a National Advisory Council on the Arts;
Advisory Committee on the Arts, National Cultural Center.

BEN-ZION—Painter, Gr., T.
58 Morton St., New York, N.Y. 10014
B. Ukraine, Russia, July 8, 1897. Work: MModA; Newark Mus. A.; AIC; Phillips Coll.; N.Y. Pub. Lib.; Tel Aviv Mus., Israel; AIC; William Rockhill Nelson Mus. A.; Ball State Col.; Bezalel Mus., Jerusalem. Exhibited: PAFA, 1940; Carnegie Inst., 1945; WMAA, 1946; Willard Gal.; Buchholz Gal.; Jewish Mus., N.Y., 1948, 1952; annual exhibition, Bertha Schaefer Gal.; one-man: BMA; Portland (Ore.) Mus.; Taft Mus., Cincinnati; SFMA; Univ. Iowa; CAM; Duveen-Graham Gal., N.Y.; a 25 year (1933-1959) Retrospective Exh., Jewish Mus., N.Y., 1959, and many others. Publications: 3 portfolios of etchings on Biblical Themes—Biblical Themes, Prophets, Ruth, Job, Song of Songs; Fourth Volume of Biblical etchings "Judges and Kings," 1964; Fifth volume, "The Life of a Prophet," 1965, Limited Editions Club; drawings to "The Wisdom of the Fathers," publ. N.Y.*

BERD, MORRIS—Painter, E.
R.D. No. 2, Media, Pa. 15163
B. Philadelphia, Pa., Mar. 12, 1914. Studied: Phila. Graphic Sketch Cl.; Phila. Mus. Col. of Art; in Mexico and Europe. Awards: Gimbels Mural Comp., 1952; Silver Medal, Jubilee Show YMHA; Katzman prize, Phila. Pr. Cl., 1962. Exhibited: PAFA, 1939, 1941, 1946, 1948-1961; Traveling Art, Inc., 1957-1959; Phila. A. All.; Gal. 1015, Wyncote, Pa., 1957-1965; Penn Center, Phila., Pa., 1961; Cheltenham A. Center; PMA; Beloit Col.; Phila. Pr. Cl.; Franklin Inst. and others; one-man: Carlin Gal., 1951; Pa. Mus. Col. of Art, 1952; PAFA, 1953; Phila. A. All., 1957, 1967; Haverford Sch., 1958; Wallingford A. Center, 1959; Haddonfield, N.J., 1960; Newman Gal., 1961; Gal. 1015, 1965; Pa. Military Col., 1964; Warehouse Gal., Arden, Del., 1954-1969. Work: Barnes Fnd.; Lyman Allyn Mus. A.; Mus. FA of Houston; PAFA; Phila. Col. A.; Franklin Inst. Positions: Prof., Chm., Painting & Drawing Dept., Philadelphia Museum College of Art; Instr., Adult Classes, Philadelphia Museum College of Art, at present.

BERENSTAIN, STANLEY—Cartoonist, W.
644 Stetson Rd., Elkins Park, Pa. 19117
B. Philadelphia, Pa., Sept. 29, 1923. Studied: PMSch. Indust. A.; PAFA. Member: Nat. Cartoonists Soc.; Author's Lg. Awards: NEA's School Bell Award, 1960, for illustrated article "How to Undermine Junior's Teacher." Author, I., "Berenstain's Baby Book," 1948; "Tax-Wi$e," 1952; "Marital Blitz," 1955; "Baby Makes Four," 1956; "Lover Boy," 1958; "It's All in the Family," 1958; "It's Still in The Family," 1961; "The Big Honey Hunt," 1962; "The Facts of Life For Grown Ups," 1963; "The Bike Lesson," 1964; "Flipsville-Squaresville," 1965; "The Bears' Picnic," 1966; "The Bear Scouts," 1967; "Mr. Dirty vs. Mrs. Clean," 1967; "The Bears-Vacation," 1968; "Inside Outside Upside Down," 1968; "Bears on Wheels," 1969, (all in collaboration with Janice Berenstain); "Bedside Lover Boy," 1960; "And Beat Him When He Sneezes," 1960; "Call Me Mrs.," 1961. Contributor to: Look, McCall's, This Week, Better Homes and Gardens, True, etc. Work: Albert T. Reid Coll., Univ. Kansas; Farrell Lib. Coll., Kansas State Univ.; the Stanley and Janice Berenstain Coll., Syracuse Univ. (est. 1966). Cartoons by The Berenstains featured in advertising campaigns and brochures. Monthly cartoon feature, "It's All in the Family," for McCall's. Calendars and Greeting Cards for Hallmark, 1962- .

BERG, PHIL—Collector, Patron
10939 Chalon Rd., Los Angeles, Cal., 90024
B. New York, N.Y., Feb. 15, 1902. Studied: College of Textiles & Science of Pennsylvania, B.S. Archaeological activities includes excavations in Meso-America, Mesopotamian Valley, etc. Collection: Includes material starting with Mohenjo-Daro and Sumerian figures through history of art of man until Miró. Several hundred pieces presently being donated to the Los Angeles County Museum. Positions: Trustee, Southwest Museum and Los Angeles County Museum.

BERGAMO, DOROTHY JOHNSON—Painter, Lith., T., L.
8828 N. 17th Ave., Phoenix, Ariz. 85021; s. Box 672, Pinetop, Ariz. 85935
B. Chicago, Ill., Feb. 1, 1912. Studied: Univ. Chicago, Ph.B.; AIC, B.F.A.; Northwestern Univ., M.A.; Arizona State Col.; Univ. Colorado. Awards: F., AIC, 1937; prizes, AIC, 1943; Arizona State Fair, 1950, 1952, purchase, 1965; Texas WC Soc., 1952; Tucson FA Assn., 1955; Arizona, purchase prize, 1964, first prize WC, 1966. Work: Pub. Health Service Hospital, Lexington, Ky.; Witte Mus. A.; Marion Koogler McNay AI; Agricultural & Tech. H.S., San Antonio, Tex.; Mun. Coll., City of Phoenix, Ariz.; Grand Canyon Col., Phoenix; Olsen Fnd., Guilford, Conn.; Valley Nat. Bank Coll. of Am. Art. Exhibited: AIC; San Antonio A. Exh.; Texas FA Assn.; Contemp. A. Gal.; one-man: Witte Mus. A., San Antonio, 1944; Bright Shawl Gal., San Antonio, 1945; Phoenix Little Theatre, 1951; Phoenix A. Center, 1951; Phoenix Woman's Cl., 1954. Positions: Instr., San Antonio AI, 1943-46; Jr. Col., Bergen County, N.J., 1946-47; Shurtliff Col.,

Alton, Ill., 1947-48; Arizona State Col., Tempe, 1948-51; Dir., Phoenix A. Center, Phoenix, Ariz., 1951-56. Hd. A. Dept., Carl Hayden H.S., Phoenix, Ariz., 1957- . Consultant, A. Educ., Phoenix Union High Sch. System.

BERGEN, SIDNEY L.—Art Dealer
ACA Gallery, 25 E. 73rd St. 10021; h. 275 Central Park West, New York, N.Y. 10024
B. New York, N.Y., Sept. 27, 1922. Studied: Alfred University. Specialty of Gallery: Contemporary and Early 20th Century American Art. Positions: Owner-Director, ACA Gallery, New York, N.Y.

BERGER, JASON—Painter
2884 Main St., Buffalo, N.Y. 14214
B. Malden, Mass., Jan. 22, 1924. Studied: BMFA Sch.; Univ. Alabama; Ossip Zadkine Sch. A., Paris, France. Awards: BMFA Sch., Paige Scholarship for study abroad, 1957; prize, Boston A. Festival, grand prize, 1955, first prize, 1961; Traveling F., BMFA Sch.; purchase prize, Sheraton-Boston Hotel, 1965. Work: MModA; Chase Manhattan Bank, New York City; Smith Col. Mus. A.; Guggenheim Mus. A. Exhibited: Inst. Mod. A., Boston, 1943; Boris Mirsky Gal., Boston, 1943-1947; Downtown Gal., N.Y., 1947; Berkshire Mus. A., 1947; Swetzoff Gal., Boston, 1949-1958; Galerie LeGrip, Rouen, France, 1950; AIC, 1952, 1954; Salon de la Jeune Sculpture, Musee Rodin, Paris, France, 1952; Inst. Contemp. A., Boston, 1952, 1956, 1960, 1961; Boston A. Festival, 1952-1957, 1961; AGAA, 1953-54 (traveling exh., auspices of AFA); Brandeis Univ., 1953; Tufts Col., 1953; Boston Indp. A., 1953; BMFA, 1953-1957, WMA, 1954; Carnegie Inst., 1954; LC, 1954; MModA (toured U.S. and Europe), 1954, drawings, 1957; Deerfield Acad., 1954 (one-man); Silvermine Gld. A.; Collector's Show, Dallas, Tex.; Fitchburg A. Mus., 1955; Swetzoff Gal., 1956 (one-man); Peridot Gal., N.Y., 1956, 1957, 1958, 1961 (one-man); Pace Gal., 1961; Gal. 10, Boston, 1960; Nova Gal., Boston, 1960 (one-man); Joan Peterson Gal., Boston, 1962, 1968 (one-man); Dana Coll. exhibition, Inst. Contemp. A., Boston, 1962. Illus., "Foundation Course in French," 1956. Positions: Instr., Painting, BMFA Sch., Boston, Mass., 1955-1969; Assoc. Prof. A., State Univ. of N.Y. at Buffalo, 1969- .

BERGER, KLAUS—Educator, W.
Department Art History, University of Kansas; h. 700 Indiana St., Lawrence, Kans. 66044
B. Berlin, Germany, Mar. 24, 1901. Studied: Univs. of Munich, Berlin, Heidelberg, Germany; Univ. Goettingen, Ph.D.; Ecole du Louvre, Paris. Member: Renaissance Soc. Am.; AAUP; Société de l'Histoire de l'Art français. Awards: Fulbright F., 1954 (guest Prof. Univ. of Cologne, Germany); Am. Council of Learned Societies, 1958; Guggenheim Fellow, 1966. Author: "Géricault, Drawing and Watercolors," 1946; "French Master Drawings of the Nineteenth Century," 1950 (also German edition); "Géricault and His Work," 1952 (also French & German eds.); "Odilon Redon, Fantasy and Color," 1965 (also German ed.). Contributor to Art News; Art Quarterly; College Art Journal; Gazette des Beaux-Arts; Renaissance News, and others. Positions: Prof., Northwestern Univ.; Biarritz U.S. Army Univ.; Univ. Kansas City; Prof. of Art History, Univ. of Kansas, Lawrence, Kans., at present.

BERGER, SAMUEL A.—Collector
56 Pine St., 10005; h. 1095 Park Ave., New York, N.Y. 10028
B. New York, N.Y., Sept. 29, 1884. Studied: City College, New York; A.B.; New York Law School, LL.B. Collection: Impressionist, Post-Impressionist and Avant-garde American. Positions: Former Vice-President, Association of the Bar, New York, N.Y., 1960-61, 1961-62.

BERGERE, RICHARD—Illustrator, P., Comm.
143-28 41st Ave., Flushing, N.Y. 11355
Studied: N.Y. Univ., B.S.; Columbia Univ., M.A.; ASL; Parsons Sch. Des. Illus: "A Tree Grows in Brooklyn," 1948; "Balloons Fly High," 1960; "From Stones to Skyscrapers," 1960; "This Too Was Thomas Jefferson," 1961; "When Will My Birthday Be?," 1961; "Automobiles of Yesteryear," 1961; "Homes of the Presidents," 1962; "Paris in the Rain," 1963; "Jonathan Visits the White House," 1964; "The Story of St. Peter's," 1966.

BERGLING, VIRGINIA C.—Writer
(Mail) P.O. Box 523, Coral Gables, Fla. 33134; h. 3230 S. W. 79th Ave., Miami, Fla. 33155
B. Chicago, Ill., Nov. 6, 1908. Member: Miami A. Lg.; AFA; Heraldic Societies. Work: Bergling publications in leading art museums and libraries internationally. Editor, 1966 edition Heraldic Designs & Engravings Manual, 1967 (9th ed.). Art Alphabets & Lettering, 1964. Edits Art Monograms and Lettering and Ornamental Designs and Illustrations by the late J. M. Bergling. Positions: Editor, Publisher, Dealer in rare books on genealogy and art.

BERGMAN, MR. and MRS. LOUIS B.—Collectors
110 Riverside Drive, New York, N.Y. 10024*

BERKMAN, AARON—Painter, T., L., W.
Bercone Studio Gallery, 1305 Madison Ave. 10028; h. 230 E.
88th St., New York, N.Y. 10028
B. Hartford, Conn., May 23, 1900. Studied: Hartford A. Sch.; BMFA
Sch. Member: AEA; Audubon A. Awards: F., Yaddo Fnd., 1957; Huntington Hartford Fnd., 1958. Exhibited: BM, 1941; Avery Mem.,
Hartford, 1936; AWS, 1944; Audubon A., 1954-1958, and others. One-
man: Grace Horne Gal., Boston, 1926, 1927; Wadsworth Atheneum,
1926, 1927; Babcock Gal., 1928, 1951; ACA Gal., 1932, 1934; Erich-
Newhouse Gal., 1937; Assoc. Am. A., 1943; Kaufman A. Gal., 1946,
1950, 1960, 1965; BM, 1932; Bercone Gal., 1969. Author: "Art and
Space," 1949; "The Functional Line in Painting," 1955-61. Monthly
column "Amateur Standing," in Art News; Contributor to Encyclo-
pedia Americana, 1964, article on Symmetry in Art. Positions: T.
Lecturer, Art Hist., Dir., YM-YWHA A. Center, New York, N.Y.,
1940-1968; Dir., Bercone Gallery, New York, N.Y., 1968- .

BERKON, MARTIN—Painter, T.
51-25 Van Kleeck St., Elmhurst, N.Y. 11373
B. Brooklyn, N.Y., Jan. 30, 1932. Studied: Brooklyn Col., B.A.;
N.Y. Univ., M.A.; also study at Pratt Institute, Brooklyn. Member:
CAA; AAUP. Awards: Patrons prize, Nat. Soc. Painters in Casein,
1965. Exhibited: Nat. Soc. Painters in Casein, 1960, 1965; Oklahoma
Pr.M., 1963, 1965; Ohio Univ., 1964; Ball State Univ., 1965; Wes-
leyan Col., 1965; Butler Inst. Am. A., 1965, 1967, 1969; Morris Gal.,
N.Y., 1957; BM, 1958; Silvermine Gld. A., 1963; one-man: Smolin
Gal., 1962 and 20th Century West Gal., 1967, both New York City.
Positions: Instr., Elements of Des., Fairleigh Dickinson Univ.;
Painting, Nassau Community Col., and City Col., New York.

BERKOWITZ, LEON—Painter
2003 Kalorama Rd., N.W., Washington, D.C. 20009
B. Philadelphia, Pa., Sept. 14, 1915. Studied: Univ. Pennsylvania,
B.F.A.; George Washington Univ., M.A.; ASL; CGA Sch. A.; Mexico
City Univ.; Grande Chaumiere, Paris, France; Academia delle Bella
Arti, Florence, Italy. Work: CGA; NCFA; Oklahoma A. Center, Ok-
lahoma City; Phoenix Mus. A.; James Michener Coll., Univ. Texas,
Austin; Larry Aldrich Mus., Ridgefield, Conn.; and others. Exhib-
ited: CGA, 1967, 1969; AFA traveling exhibition, 1967-1969; Larry
Aldrich Mus., 1968-1969; A.M.Sachs Gal., N.Y., 1969 (one-man);
New A. Center, London, England, 1963 (one-man); Smithsonian Inst.,
1967. Positions: Instr., CGA Sch. A.; American Univ.; Catholic
Univ. of America, Washington, D.C.; Escuela Bellas Artes, Barce-
lona, Spain; Hd. Dept. Painting, CGA Sch. A., at present; A. Dir. and
co-founder, Workshop Center of the Arts, Washington, D.C.

BERLIND, ROBERT ELLIOT—Painter, T.
Minneapolis School of Art, 200 E. 25th St. 55404; h. 2412
Aldrich Ave., Minneapolis, Minn. 55405
B. New York, N.Y., Aug. 20, 1938. Studied: Columbia College, B.A.;
Yale School of Art & Architecture, B.F.A., M.F.A. Positions: Instr.,
Foundation Design & Drawing, Minneapolis School of Art, at present;
Lecturer, Positano Art Workshop, Positano, Italy, 1961.*

BERMAN, EUGENE—Painter, Des., Scenic Des., Gr., I.
107 Via del Plebicito, Rome, Italy 00186
B. St. Petersburg, Russia, 1899. Studied: Russia, Germany, Switzer-
land, France and Italy. Awards: Guggenheim F., 1947, 1949; Work:
Musee d'Art Moderne, Paris; Mod. Gal., Venice; Albertina Mus.,
Vienna; MMoDA; MMA; AIC; CM; CMA; Hartford Atheneum; CAM;
Denver Mus. A.; Smith Col.; FMA; BMFA; Vassar Col.; Univ. Neb-
raska; Univ. Illinois (Urbana); Columbia Mus. FA; Albright A. Gal.;
Univ. Iowa; Santa Barbara Mus. A.; Los A. Mus. A., etc. Designed
many productions for the New York Metropolitan Opera, the Scala in
Milan, the Philharmonic Academy, Rome, and others. Exhibited:
many one-man shows in the U.S. and abroad including Rome, Milan,
Turin, Paris, Palermo. Retrospective exh., Inst. Mod. A., Boston,
1941, circulated to leading museums; MMoDA, 1945. Lithographic
work and illus. for numerous books. Scenic work: Music Festival,
Hartford Atheneum, 1936; ballets: Ballet Russe de Monte Carlo; Bal-
let Theatre; American Ballet Caravan; Sadler's Wells Ballet, Lon-
don; Scala Ballet, Milan; opera Theatre de l'Etoile, Paris, Metro-
politan Opera, N.Y.; New York City Center Opera, 1952; N.B.C. Tel-
evision premiere, 1951; inauguration of the Italian XVIII century
Theatre at Ringling Museum, Sarasota, Fla., 1952.

BERMAN, DR. MURIEL M. (Mrs. Philip) — Collector, Patron, L.
20 Hundred Nottingham Rd., Allentown, Pa. 18103
B. Pittsburgh, Pa. June 21, 1924. Studied: Carnegie Inst. Technol-
ogy; University of Pittsburgh; Pa. College of Optometry; Muhlenberg
Col.; Cedar Crest Col., Allentown. Member: Art Collectors Club of
America, New York; Friends of the Whitney Museum of American
Art; American Federation of Arts; Archives of American Art, De-

troit; Museum of Modern Art; Museum of Primitive Art, N.Y.;
Allentown Art Museum; Historical Soc., Lehigh County, Pa.; Reading
Art Museum, Jewish Museum, N.Y. Collection: Early 20th Century
American; Modern, Pop and Op Art. World-wide collector of art in-
cluding Eskimo, Japanese, Aboriginal Australian, American, French,
African. Lecturer to clubs, colleges and schools. Loan exhibitions
to universities, colleges, public buildings and schools for educa-
tional purposes. Some loan exhibitions of personal collections in-
clude Lehigh University, Moravian College, Corcoran Gallery Art,
Art in the Embassies Program, American Federation of Arts, Whit-
ney Museum of American Art and Trout Hall, Historical Site, Allen-
town (Benjamin West's). Founder and donor "Carnegie-Berman"
College Art Slide Library Exchange. Positions: Allentown Art Mu-
seum Auxiliary (Art appreciation Dir.); Lehigh County Community
College, Bd. Trustees and Secretary, Bd. Directors; Baum Art
School Bd. Trustees; Non-Governmental Organization, UNICEF;
Lehigh Art Alliance; Treas. and Bd. Trustees, Kutztown College,
Pa., and numerous other government, civic and educational posi-
tions.

BERMAN, PHILIP—Collector, Patron
20 Hundred Nottingham Rd., Allentown, Pa. 18103
B. Pennsburg, Pa., June 28, 1915. Studied: Ursinus College. Mem-
ber: Friends of the Whitney Museum of American Art; Museum of
Modern Art; Art Collectors Club; American Federation of Arts;
Allentown Art Museum; Museum of Primitive Art; Aspen Center of
Contempory Art; Lehigh Art Alliance: Archives of American Art;
Philadelphia Museum of Art; American Association of Museums,
and others. Collection: American, French and Japanese Art, A num-
ber of these collections are on traveling exhibitions in the United
States on temporary loan; many paintings are on permanent loan to
civic and educational institutions in the Lehigh Valley area; Partici-
pant in Art in the Embassies Program. Institutions having perman-
ent exhibits from the Berman Collection include Lehigh University;
Moravian College, Cedar Crest College; Muhlenberg College, the
Allentown City Hall, the Allentown School District and Perkiomen
Prep. School. Positions: Exec. Bd. & Chm. of Finance Committee,
Cedar Crest College; Memb. Bd. & Finance Committee, Lehigh Val-
ley Educational TV; Bd. Associates, Muhlenberg College and Memb.
Bd. & Exec. Committee, Baum Art School, all Allentown, Pa. Many
other positions in business, banking, educational civic, govern-
ment, and art activities.

BERNARD, DAVID E.—Graphic Printmaker, E., S.
Wichita State University; h. 2243 N. Yale Ave., Wichita, Kans.
67220
B. Sandwich, Ill., Aug. 8, 1913. Studied: Univ. Illinois, B.F.A.;
Univ. Iowa, M.F.A.; studied with Mauricio Lasansky, Humbert
Albrizio. Member: SAGA; Cal. Soc. Etchers; Wichita A. Mus.; Wich-
ita A. Gld. Work: prints, Nelson Mus. A., Atkins Mus., Kansas City,
Mo.; Pennell Coll., Library of Congress; Joslyn A. Mus., Omaha;
Wichita A. Mus.; Wichita AA; Sandzen Mem. Gal., Lindsborg, Kans.;
DePauw Univ., Greencastle, Ind.; Pub. Lib., Phila., Pa.; Otis AI, of
Los Angeles County; Minnesota Mining & Mfg. Co., St. Paul; Denison
Univ., Granville, Ohio; Univ. Nebraska; Kansas State Univ., Manhat-
tan, Kans. Exhibited: In national and regional print exhs., since
1950; recent exhs. include: Inst. Cultural, Guadalajara, Mexico, 1963
1950; recent exhs. include: Inst. Cultural, Guadalajara, Mexico,
1963; SFMA, 1965; SAM, 1964; Atkins Mus., Kansas City, 1964;
Univ. Kansas, Lawrence, 1964; Wichita AA, 1965; Springfield (Mo.)
Mus. A., 1964, 1965, 1967, 1968; Wichita Mus. A., 1965-1968; SAGA,
annually; America-Japan Contemp. Print Exchange, Tokyo, 1967;
Eastern Michigan Univ., 1967; one-man: Wichita A. Mus., 1964;
Amarillo (Tex.) Col.: 1965; Philbrook A. Center, Tulsa, 1967; Wich-
ita AA, 1968; Birger Sandzen Mem. Gal., Lindsborg, Kans., 1968;
Fort Hays State Col., Hays, Kans., 1969; 2-man Univ. Texas at
El Paso, 1969. Illus., "A West Wind Rises", 1962; "Sun City,"
1964, both by Bruce Cutler. Prints published in Kansas Magazine,
Artists Proof and Motive. Positions: Assoc. Prof. A., Wichita State
University, Wichita, Kans., 1949- .

BERNE, GUSTAVE MORTON—Collector
9 Beech Lane, Great Neck, N.Y. 11024
B. New York, N.Y., Mar. 4, 1903. Studied: Columbia College, A.B.;
Columbia Law School, LL.B. Collection: French Impressionists.
Positions: Pres., Long Island (N.Y.) Jewish Medical Center.

BERNSTEIN, BENJAMIN D.—Collector
2224 N. 10th St. 19133; h. 1824 Delancey St., Philadelphia, Pa.
19103
B. New York, N.Y., June 24, 1907. Member: Buten Museum of Wedg-
wood; Fellow, Philadelphia Museum of Art; Life Member, American
Federation of Arts; Member, University of Pennsylvania Museum,
Pennsylvania Academy of Fine Arts, Museum of Modern Art, New
York; Hon. Member, Art Guild of Texas; Society Arti et Amicitiae
of Amsterdam. Collection: Contemporary Art, mainly Expression-

ist; large collection of oils, gouache, drawings, sculpture and lithographs. Positions: Jury, Art Commission for Tercentenary; served on juries for Fine Arts Commission, Art Alliance, Philadelphia; Board Director, Philadelphia Art Alliance.

BERNSTEIN, GERALD—Painter, Former Mus. Cur., T., Restorer
1639 Richmond Rd., Staten Island, N.Y. 10304
B. Indianapolis, Ind., Aug. 25, 1917. Studied: John Herron AI; ASL; N.Y. Univ., B.A.; N.Y. Univ. Inst. FA, M.A. Exhibited: Staten Island Mus., 1950-1961, 1965 (one-man); Pietrantonio Gal., N.Y.; Wagner Col., Staten Island. Awards: Staten Island Mus. A., 1958, 1959, 1960, 1961, 1963, 1964. Lectures: History of Art, Art Appreciation to associations, clubs, schools and colleges. Mus. Exhs. arranged or assembled: "The Artist Looks at Nature," 1952; "Two Hundred Years of American Art," 1954; "American Art Today," 1954; "Modern Realism." 1956, etc. Position: Cur. A., Staten Island Inst. Arts & Sciences, 1950-1956; Pres., Section of Art, Staten Island Mus., 1956-58; Owner, Island Art Center Gallery, 1958- . A.-in-Res., and Instr., Staten Island Community College.

BERNSTEIN, SYLVIA—Painter
8 Circle Rd., Scarsdale, N.Y. 10583
B. Brooklyn, N.Y., Apr. 11, 1920. Studied: NAD, with Arthur Covey, Gifford Beal, Sidney Dickinson. Member: AEA; Knickerbocker A.; AWS; NAWA; N.Y. Soc. Women Artists; P. & S. of New Jersey; Audubon A.; Phila. WC Soc. Awards: prizes, Jane C. Stanley Mem. award, NAWA, 1954, 1957; Samuel Mann Mem. award, 1960; New Haven R.R. Painting Comp., 1956; Grumbacher award, Silvermine Gld. A., 1957; same at Chautauqua, N.Y., 1958; gold medal, NAC, 1957; Laura M. Gross Mem. Award, Silvermine, 1959; Soc. Four Arts, 1960, and Channing Hare award, 1961; also Zimmerman Award; NAWA Medal of Honor; Alfred Khouri Mem. Award; Dawson Mem. Medal. Work: N.Y. Univ.; WMAA; Wadsworth Atheneum, Hartford; Ball State T. Col.; Norfolk Mus. A.; Hudson River Mus., N.Y.; Columbia (S.C.) Mus. A.; Butler Inst. Am. A.; PAFA; Denver A. Mus.; BM; Munson-Williams-Proctor-Inst., Utica, N.Y.; Springfield (Mo.) A. Mus.; Adlai E. Stevenson Mem. Inst., Chicago, Ill. Article and painting publ. in "Award Winning Watercolors." Exhibited: Butler Inst. Am. A., 1957, 1958, 1968; AWS, 1958; Audubon A., 1957; Portland (Me.) Mus. A., 1957; Columbia (S.C.) Mus. A., 1956, 1966 (one-man); Exchange exh., Berlin, Germany, Galerie Boss-Petrides, Paris, France; Silvermine Gld. A., 1957, 1958, 1959; Chautauqua Inst., 1958; Ruth White Gal., N.Y., (one-man) 1956, 1959, 1960; Am. Acad. A. & Lets.; Galerie Irla Kerk, Canada; PAFA, 1969; "200 Years of Watercolor Painting in America," MMA, 1967. Position: Bd. Dirs., NAWA.

BERNSTEIN, THERESA F. (Mrs. William Meyerowitz)—
Painter, Et., Lith., T., W., A. Hist.
54 West 74th St., New York, N.Y. 10023; s. 44 Mt. Pleasant Ave., East Gloucester, Mass. 01930
B. Philadelphia, Pa. Studied: PAFA, ASL. Member: NAWA; North Shore AA; Audubon A.; Am. Color Pr. Soc.; Cape Ann Soc. Mod. A.; All. A. Am. Awards: med., Phila. Plastic Cl.; French Inst. A. & Sc.; prizes, NAWA, 1949, 1951, 1955, 1964; SAGA, 1953; LC (purchase), 1953; North Shore AA; Am. Color Pr. Soc.; Phila. Pr. Cl.; Knickerbocker A., 1956. Work: Boston Pub. Library; PMA; AIC; LC; BM; Cushing Acad.; etching, Laramie (Wyo.) Univ.; Princeton Univ.; Harvard Univ.; Dayton AI; Fitchburg (Mass.) Mus. A.; WMAA; Bezalel Mus., Jerusalem; Tel Aviv and Ain Harod Mus., Israel; MMA. Portraits of former Chief Justice Harlan Stone; Owen J. Roberts; Felix Frankfurter and others in private colls. Exhibited: AIC; Carnegie Inst.; MMA; CGA; PAFA; NAD; Dayton AI; WMAA; BMFA; BM; WMA; Fitchburg (Mass.) Mus.; Nat. Inst. A. & Lets., 1963; NAWA, 1965-1968; North Shore AA, 1967; Rockport AA, 1967; Ogunquit A. Center, 1966; one-man, N.Y., 1960; Bar Harbor A. Gal., 1966-1968; Ogunquit A. Center, 1968; Columbus (Ga.) Mus., and others. Contributor to newspapers and museum bulletins. Positions: Dir., Summer Art Course, East Gloucester, Mass.; Chmn., Cape Ann A. Festival Exh., Mem. & Retrospective Group, 1954, 1956, 1961; Jury, NAWA, 1957-59, All. A. Am., 1961; Nominating Comm. & Publicity Comm., NAWA, 1964-1966. Elected Hon. Director, New York Society, 1968.

BERRESFORD, VIRGINIA—Painter
Vineyard Haven, R.D., Mass. 02568
B. New York, N.Y. Studied: T. Col., Columbia Univ.; ASL; with Ozenfant, Paris and New York. Work: WMAA; Detroit Inst. A. Exhibited: WMAA; CM; Detroit Inst. A.; Albright-Knox A. Gal., Buffalo; Carnegie Int.; PAFA; MModA; BM; AIC; Minneapolis Inst. A.; Soc. Four Arts, Palm Beach, Fla.; CGA; Provincetown AA; Silvermine Gld. A.; one-man: Mortimer Levitt Gal., N.Y. 1950, 1952; Stuart A. Gal., Boston, 1949; Bodley Gal., N.Y., 1957, 1958; Dunbarton Gal., Boston, 1963; Studio West, Tucson, 1964; Jacques Seligmann Gal., N.Y., 1969. Positions: Dir., Berresford Gallery, Menemsha, Mass. (summers).

BERTOIA, HARRY—Sculptor, Des., P., C.
Main St., Bally, Pa.; h. R.D. #1, Barto, Pa. 19504
B. San Lorenzo, Italy, Mar. 10, 1915. Studied: A. & Crafts Sch., Detroit; Cranbrook Acad. A. Awards: Gold Medal, Arch. Lg.; Gold Medal, AIA; Graham F., 1957. Work: MIT Chapel, Cambridge, Mass.; Dallas Pub. Lib.; MGM Technical Center; St. Louis Airport; bronze panel, Dulles Int. Airport.*

BESS, FORREST CLEMENGER—Painter, L.
1701 Ave. E, Bay City, Tex. 77414
B. Bay City, Tex., Oct. 5, 1911. Studied: Texas A. & M. Col.; Univ. Texas. Awards: Prize, Witte Mem. Mus., 1946. Work: Museum of FA of Houston; Brandeis Univ.; BMFA; Univ. St. Thomas, Houston, Tex. Exhibited: CGA, 1940; Mus. FA of Houston, 1939, 1940; San Antonio A., 1946; Dallas Mus. FA, 1946; A. West of the Mississippi, Colo. Springs FA Center; Contemp. Arts Assn., Houston, 1963, 1964; New Arts, Houston, 1963; one-man: Mus. FA of Houston, 1951; Dallas Mus. FA, 1951; Witte Mem. Mus., (retrospective); Betty Parsons Gal., 1951, retrospective, 1961; Philbrook A. Center, 1952; Oklahoma A. Center, 1952; Texas Southern Univ., 1951; Mus. Contemp. A., Houston, 1957; Emmerich Gal., Houston, 1958; Stanford Univ., 1958; deYoung Mem. Mus., San F., 1958; Dord Fitz Gal., Amarillo, Tex., 1958; Hemisfair, San Antonio; Witte Mem. Mus., San Antonio, Tex., 1967 (one-man). Lectures on Design, Photography; Cartier-Bresson, Eve Arnold, Oliver Baker, Sumio Kuwabara.

BESSEMER, AURIEL—Painter, E., I., W., L.
Seaire Motel, 2811 N. Ocean Blvd., Ft. Lauderdale, Fla. 33308
B. Grand Rapids, Mich., Feb. 27, 1909. Studied: Western Reserve Acad.; Columbia Univ.; Master Inst.; NAD. Member: Intl. Platform Assn. Awards: Scholarships, Columbia Univ. Cl.; Western Reserve Acad.; Master Inst. Work: PC; Western Reserve Acad.; murals: Amalgamated Meat Cutters Exec. ofc., N.Y.; United Wire, Metal & Machine Health Center Fund, N.Y.; Michael's Cl., Wash., D.C.; Citizens Comm. for Army & Navy; Wabash Railroad; Pennsylvania Railroad; Volco Brass & Copper Co.; USPO, Hazelhurst, Miss., Arlington, Va., Winnsboro, S.C.; mosaics: Church of St. Clement, Alexandria, Va.; many portraits. Exhibited: PC; CGA; Wash., D.C. Pub. Lib.; one-man: Asheville, N.C.; Raleigh A. Center; Currier Gal., A.; Bowdoin Col.; Roerich Mus., N.Y.; Arch. Lg., 1961; Springfield (Mo.) State Teachers Col.; St. Louis Pub. Lib., and museums in Ohio, Fla., New York, etc. Lecturer to schools, colleges, women's clubs and art groups. Author, I., "Aurielartograph," 1947. Contributor (author) articles, poems & book reviews to The Beacon, Voice Universal (Sussex, England); Aesthetics (Bombay, India); Cyclo-Flame (Alpine, Tex.) etc.

BESSER, LEONARD—Sculptor, P., T., Gr.
49 Wilton Rd.; h. 4 Prospect Rd., Westport, Conn. 06880
B. Philadelphia, Pa., May 16, 1919. Studied: Phila. Gr. Sketch Cl.; Kann Inst., Los Angeles, Cal.; seminars with Dong Kingman, Ben Shahn and Fletcher Martin. Member: AWS; Silvermine Gld. A. Awards: prizes, Am. Legion Veterans A. Festival, Los A., 1950, 1951, 1952; purchase prize, Bridgeport (Conn.) Mus. of A. & Sciences, 1961; Lily B. Starr Mem. award, Silvermine Gld. A., 1964; New Canaan, Conn., Ann. Exh., 1964. Work: National Archives, Wash., D.C. Exhibited: Audubon A., 1954-1956; AWS, 1954-1957; Los A. Mus. A., 1951, 1952; San Bernardino Orange Show, 1951, 1952; N.Y. City Center, 1953, 1954; Portland AA, 1957; 2 one-man, Kessler Gal., Provincetown, Mass., 1960, 1961; Wadsworth Atheneum, Hartford, 1961; Bridgeport Mus. A. & Sciences, 1961; one-man: Art Galleries, Ltd., Wash. D.C., 1962; Vincelette Gal., Westport, Conn., 1964. Positions: Asst. Dir., Instruction Dept., Famous Artists School, Westport, Conn.*

BETHEA, F. ELIZABETH—Educator, P.
Louisiana Polytechnic Institute; h. 709 North Trenton St., Ruston, La. 71270
B. Birmingham, Ala., May 11, 1902. Studied: Newcomb Col., Tulane Univ., B. Des.; Columbia Univ., M.A.; Univ. Chicago; N.Y. Univ. Member: Southeastern AA; Com. on A. Edu., MModA; CAA; Southeastern Col. AA; Am. Craftsmen's Council; AID (Assoc.); Int. Des. Conference; NAEA. Positions: Prof., Hd. Dept. A., Louisiana Polytechnic Inst., Ruston, La., 1926- . Teaching: Design, A. Hist., Painting, A. Edu.*

BETSBERG, ERNESTINE (Mrs. Arthur Osver)—Painter
465 Foote St., St. Louis, Mo. 63119
B. Bloomington, Ill., Sept. 6, 1909. Studied: AIC, with Boris Anisfeld. Awards: Raymond Traveling F., AIC. Exhibited: AIC, 1936, 1938, 1939, 1941, 1942; VMFA, 1946; NAD, 1945; N.Y., 1956, 1958, 1959; St. Louis, Mo., 1960; PAFA, 1962, 1968; one-man: Syracuse Univ., 1949; Grand Central Moderns, 1950, 1952; Japan, 1951; Paris, France, 1953; Rome, Italy, 1953, 1958; Univ. Florida, 1955; PAFA, 1951-1953; Univ. Nebraska; Munson-Williams-Proctor Inst., 1955; WMAA, 1955; Monday Club, St. Louis, 1964; Schweig Gal., St. Louis, 1965, 1967; 4-man show, Artists Gld., St. Louis, 1963.

BETTMANN, OTTO L.—Graphic Historian
136 E. 57th St.; h. 25 Sutton Place, South, New York, N.Y.
10022
B. Leipzig, Germany, Oct, 15, 1903. Studied: Univ. of Leipzig, Ph.D.
Positions: Editor, C. F. Peters Music Publs., Leipzig; Editor, Axel
Juncker Editors, Berlin; Cur., Rare Books, State Art Library, Ber-
lin, 1930-1933; Founder, Director, Bettmann Archive, Inc., 1935- ;
Author of graphic histories: "Pictorial History of Medicine," 1956;
"Our Literary Heritage" (with Van Wyck Brooks), 1956; "Pictorial
History of Music" (with Paul Henry Lang), 1960; "The Bettmann
Portable Archive," 1967. The Bettmann Archive, Inc., is an art li-
brary topically arranged to form pictorial History of Civilization.

BETTS, EDWARD H.—Painter, E.
804 Dodds Dr., Champaign, Ill. 61820
B. Yonkers, N.Y., Aug. 4, 1920. Studied: Yale Univ., B.A.; Univ. Il-
linois, M.F.A.; ASL. Member: NA; AWS; Audubon A.; Phila. WC Cl.;
ASL; Ogunquit AA. Awards: medal, Audubon A., 1952; AWS, 1953,
silver medal, 1959; Phila. WC Cl., 1954, 1955; prizes, NAD, 1953,
1954; Altman award, 1957, 1959, 1966; Butler AI, 1953 (purchase);
AWS, 1950, 1966, 1968; All. A. Am., 1951; Audubon A., 1951; Cal.
WC Soc., 1951, 1954, 1955, 1957, 1959 (purchase); Ball State T. Col.,
1960 (purchase). Work: Univ. Rochester; Davenport Mun. A. Gal.;
Springfield (Mo.) A. Mus.; Butler AI; Ball State T. Col.; VMFA; Cal.
WC Soc.; Ogunquit A. Mus.; Walter Chrysler, Jr., Collection; FMA;
Atlanta Univ.; St. Lawrence Univ.; Upjohn Pharmaceutical Co.; La
Jolla A. Center; NAD; New Britain (Conn.) Mus. A.; Kansas State
Univ.; USIA (Prints in Embassies Program). Exhibited: CGA, 1947,
1951, 1955, 1957, 1959; MMA, 1950; BM, 1953, 1955, 1960; WMAA,
1958; SFMA, 1958; Provincetown, Mass., 1958; Boston A. Festival,
1956, 1958-1960; Art-USA, 1959; Univ. Nebraska, 1953, 1955; PAFA,
1953-1955, 1960, 1961, 1965; Denver A. Mus., 1954, 1955, 1957,
1960; one-man: New York, N.Y., 1953, 1955, 1956, 1959, 1961, 1965,
1968; Chicago, Ill., 1954, 1956, 1957; Phila., Pa., 1955, 1957; Iowa
Wesleyan Univ., 1961; Hassam Purch. Fund Exh., Nat. Inst. A. &
Lets., N.Y., 1961, 1963, 1965; Colby Col., Waterville, Me., 1964;
Sheldon Swope A. Gal., 1966; Lamont Gal., Phillips Exeter Acad.,
1968. Author article, "Painting in Polymer and Mixed Media,"
American Artist Magazine, 1964. Positions: Prof. A., Univ. Illinois,
1949- . Assoc. Memb., Center for Advanced Study, Univ. Ill., 1968-
69.

BIANCO, PAMELA (RUBY) (Mrs. Georg T. Hartmann)—Illustrator,
P., Lith., W.
428 Lafayette St., New York, N.Y. 10003
B. London, England, Dec. 31, 1906. Member: AEA. Awards: Gug-
genheim F., 1930. Work: Queens Col., N.Y. Exhibited: Leicester
Gal., London, England; Anderson Gal., N.Y.; Print Rooms, San F.,
Cal.; Knoedler Gal.; Ferargil Gal.; Los A., Cal.; Boston,
Mass.; Chicago, Ill.; one-man David Herbert Gal., N.Y., 1961; In-
ternational Gal., Baltimore, Md., 1964; Graham Gal., N.Y., 1969.
Work: Mus. Mod. A., N.Y., and in private colls. I., "The Skin
Horse," 1927; "The Birthday of the Infanta," 1929; "Three Christ-
mas Trees," 1930; "The Easter Book of Legends and Stories,"
1947; Author, I., "The Starlit Journey," 1933; "Playtime in Cherry
Street," 1948; "Paradise Square," 1950; "Little Houses Far Away,"
1951; "The Look-Inside Easter Egg," 1952; "The Doll in the Win-
dow," 1953; "The Valentine Party," 1954; "Toy-Rose," 1957, and
many others.

BICHLER, LUCILLE MARIE PARIS (DR.)—Painter
155 N. 12th St., Paterson, N.J. 07502
B. Cleveland, Ohio, Apr. 8, 1928. Studied: Univ. California, Berke-
ley, B.A., M.A.; Atelier 17, Paris, France. Member: San F AA.
Awards: Charles Renwick award, Richmond, Cal., 1953; Butterfield
Purchase award, Ball State, 1956; Chicago Momentum Exh., 1956;
Monmouth Col., 1965; Bainbridge award, Argus Gal., N.J., 1963;
Taussig Traveling Fellowship, 1950-51 and McEnerney Grad. Fel-
lowship, 1952, Univ. California. Exhibited: AGAA; SFMA, 1950,
1951, 1953-1955, 1961, 1962; San F. Women A., 1952, 1953, 1956-
1958; Oakland A. Mus., 1952-1954; Jack London Exh., Oakland,
1954; Richmond A. Gal., 1952, 1953, 1955; Ball State Natl., 1956;
Contemp. A. Group, N.Y., 1957; Argus Gal., 1963, 1964; 16 Artists-
Bay Area Graphics, 1964, (on tour); Univ. Minnesota Gal., 1965;
Monmouth Col., 1964, 1965, 1968; New Jersey State Mus., 1968;
One-man: Aegis Gal., N.Y., 1965. Positions: Prof., Painting, Graphics,
Ball State, Univ., Muncie, Ind., 1955-57; Paterson (N.J.) State
College, 1959-1969.

BICKFORD, GEORGE PERCIVAL—Collector, L.
1144 Union Commerce Bldg. 44115; h. 2247 Chestnut Hills
Drive, Cleveland, Ohio 44106
B. Berlin, N.H., Nov. 28, 1901. Studied: Harvard College, A.B.,
Harvard Law School, LL.B. Member: American Association of
Museums; American Oriental Society; American Council for Asian

Studies. Collection: East Indian Antiquities. Positions: Vice-Pres-
ident and Trustee, Cleveland Museum of Art, 1957- ; Cleveland
Institute of Art, 1955- ; Trustee, American Committee on South
Asian Art.

BIDDLE, GEORGE—Painter, Gr., W., C., S., L.
Croton-on-Hudson, N.Y. 10520
B. Philadelphia, Pa., Jan. 24, 1885. Studied: Harvard Univ., B.A.
Member: NSMP; Mural A. Gld.; SAGA; Am. A. Congress; AEA.
Work: murals: Dept. Justice, Wash., D.C.; Nat. Lib., Rio de Janeiro;
Supreme Court, Mexico City; USPO, New Brunswick, N.J.; in collec-
tions of: MMA; Mus. Mod. A., Tokyo; Bridgestone Mus., Tokyo; Nat.
Mus., Tel-Aviv; WMAA; MModA; PAFA; PMA; BMFA; Birmingham
Mus. FA; Phoenix A. Mus.; Brandeis Univ.; SFMA; San Diego FA
Soc.; Los A. Mus. A.; LC; N.Y. Pub. Lib.; NCFA, Carnegie Inst.;
Joslyn A. Mus.; Portland AA; FMA; Museo Arte Moderna, Venice;
Kaiser Friedrich Mus., Berlin; Nat. Gal., Canada; more than 90 one-
man exhs., U.S. and abroad. Author: "Adolphe Borie"; "Boardman
Robinson"; "Green Island"; "Artist at War"; "George Biddle's War
Drawings"; "Yes and No of Contemporary Art"; "Indian Impres-
sions," "Tahitian Journal," 1968, etc. Contributor to national maga-
zines. Positions: Chm, War Dept. A. Com., 1943; A. Memb. Nat.
Comm. FA, 1950; Dir., 1950, Nat. Dir., AEA; Pres., NSMP, 1934,
Mural A. Gld., 1934-36; Inst. of A. & Lets.; Vice-Pres., SAGA, 1935;
Nat. Dir., Am. A. Congress.

BIDDLE, JAMES—Preservationist, Patron, Collector, Writer
748 Jackson Pl., 20006; h. 2425 Wyoming Ave., Washington,
D.C. 20008
B. Philadelphia, Pa., July 8, 1929. Studied: Princeton University
(Art & Archaeology). Positions: Curator, The American Wing,
Metropolitan Museum, 1963-1967; President, National Trust for
Historic Preservation, 1967- ; President, The Drawing Society;
Trustee, The American Federation of Arts.

BIDNER, ROBERT D. H.—Painter, Des.
559 First St., Brooklyn, N.Y. 11215
B. Youngstown, Ohio, Mar. 14, 1930. Studied: Cleveland Inst. A.,
B.F.A. Awards: medals, Cleveland Inst. A., 1952; Audubon A., 1966;
prizes, Silvermine Gld., 1968; Butler Inst. Am. A. (2); NAD, 1952;
purchase prizes, Ranger Fund, NAD; Canton Mus. A.; Friends of Am.
A., Ohio. Work: Canton Mus. A.; James Michener Coll.; Xerox
Corp.; Cornell Univ.; Notre Dame Univ.; Fordham Univ.; NAD; Col-
orado Springs FA Center; Butler Inst. Am. A.; MModA rental; Bd.
Edu., New York; Ivest Corp., Boston, and in private colls. Many
portrait, graphic art and mural commissions: Eastman Bolton Schol-
arship for travel. Exhibited: CGA, 1957; Westmoreland County Mus.,
Greensburg, Pa., 1969; NAD, 1956-1958; All. A. Am., 1955, 1959,
1961; Audubon A., 1956, 1966; Sarasota AA, 1952; Butler Inst. Am.
A., 1952, 1953, 1955-1958; Univ. North Carolina, 1967; Artists for
Scholarships, Education and Defense Fund, CORE, 1967, 1968; Amel
Gal., 1962-1964; Contemporaries Gal., 1964, 1965, Alan Stone Gal.,
1966, A.M. Sachs Gal., 1967, 1968, AFA, 1964-1965, all of New York
City; Mickelson Gal., Washington, D.C., 1967, 1968; CMA, 1949-
1953, 1955, 1956; Canton Mus. A.; Ohio WC Soc. One-man: Amel
Gal., 1963; A.M. Sachs Gal., 1967, 1969; Butler Inst. Am. A., 1948
(2-man); Mickelson Gal., 1967 (3-man). Positions: A. Dir., Fuller,
Smith and Ross, Inc., 1958-1966; Ted Bates and Co., 1966- , both
New York City.

BIEDERMAN, KAREL JOSEPH—Sculptor, Writer, Historian
Route 2, Red Wing, Minn. 55066
B. Cleveland, Ohio, Aug. 23, 1906. Studied: Art Inst., Chicago.
Awards: Sikkens Award, Stedelijk Mus., Amsterdam, Holland, 1962;
Ford Foundation Award, WAC, 1964, Donors Award. 1966; Nat. Coun-
cil on the Arts Award, 1966; Minn. State Arts Council Award, 1969.
Work: MModA; PMA; WAC. Three Structurist works Interstate
Clinic, Red Wing, Minn.; Tate Gal., London; Kroller-Muller Mus.,
Otterlo, Holland; Des Moines A. Center. Exhibited: Matisse Gal.,
New York, 1936; Albright A. Gal., Buffalo, 1936; Reinhardt Gal., New
York, 1936; Arts Club, Chicago, 1941; Carnegie International, 1964;
WMAA, 1964, 1966; St. Paul Sch. of Art, 1954; Stedeiijk Mus., Am-
sterdam, 1962; Kunstgewerbe Mus., Zurich, 1962; Columbia Univ.
Sch. of Arch., 1963; Georgia Inst. Technology, Atlanta, 1963; Marl-
borough-Gerson Gal., New York, 1964; WAC, 1964, 1965, 1966; Ro-
chester (Minn.) A. Center, 1967; Marlborough New London Gal., Lon-
don, 1966; Mus. Contemp. A., Chicago, 1968; Hayward Gal., London,
1969, and in Paris. Author: "Art as the Evolution of Visual Knowl-
edge," 1948; "Letters on the New Art," 1951; "The New Cezanne,"
1958, and others. Contributor to Parnas, Amsterdam, 1958; Struc-
ture, Amsterdam, 1958-1960, 1962, 1964; The Structurist, 1960-
1962; Studiekamraten and Horizont, both Stockholm, 1961, 1964,
1965; Main Currents, 1962; Artforum, 1965, Form, 1966, 1967,
Studies in the 20th Century, 1968, D.A.T.A., 1968, and other publica-
tions.

BIER, ELMIRA—Assistant to Museum Director
 1600-21st St.; h. 4311 North Glebe Rd., Arlington, Va. 22207
B. Baltimore, Md. Studied: Goucher Col., A.B.; Harvard Univ.;
American Univ.; Univ. Wisconsin. Positions: Asst. to Dir., Phillips
Collection, in charge of music, Washington, D.C., 1923- .

BIER, JUSTUS—Museum Director, W., L.
 North Carolina Museum of Art, 107 East Morgan St., Raleigh,
 N.C. 27601
B. Nurnberg, Germany, May 31, 1899. Studied: Univ. Munich,
Erlangen, Jena, Bonn, Zurich, Ph.D. Member: CAA; Chm., Comm.
on regional societies, 1951, 1952, mem., nominations com., 1952;
Am. Soc. for Aesthetics, Ed. Council, 1952-54, chm. session, 1954;
Midwestern Col. A. Conference, Pres., 1951-52; Southeastern Col.
A. Conference, Chm. session on A. Hist., 1951, 1958, 1959, chm.
nominations com., 1952; Assoc. memb., Int. Assn. A. Cr., Am. Sec-
tion; AFA; AAUP; A. Center Assn., Louisville, Ky., membr. Bd.
Dir., 1949-53, 1954-56, 1957-60; Prof. Advisor, Junior League of
Louisville, 1945-60. Awards: Albrecht Durer med., City of Nurn-
berg, 1928; traveling F., publication grant Notgemeinschaft der
Deutschen Wissenschaft, 1928, 1930; August Kestner med., Kestner-
Gesellschaft, Hannover, 1938; Guggenheim F., 1953-54, 1956-57;
Institute for Advanced Study, Princeton, N.J., research grant, 1953-
54; Fulbright Award, 1960-61. Author: Tilmann Riemenschneider
(3 vols.) and other books published in Germany and Austria, 1922-
1948; contributor to Art Bulletin, Art in America, Art Quarterly,
Studio, Gazette des Beaux-Arts, Munchner Jahrbuch der bildenden-
Kunst, and others. Lectures: Tilmann Riemenschneider; Franconian
Sculpture; Twentieth Century Sculpture. Positions: Docent, Instr.,
A. Hist., Municipal Univ., Nurnberg, 1925-30; Dir., Cur., Kestner-
Gesellschaft AI, Hannover, 1930-36; Fnd., Dir., Mus. fur das
vorbildliche Serienprodukt, Hannover, 1930-36; Asst. Prof. A. Hist.,
Actg. Hd., Dept. FA, Univ. Louisville, 1937-41; Assoc. Prof., 1941-
46, Prof., 1946-60; Dir., Allen R. Hite AI, 1946-60; Cr. & A. Ed.,
The Courier-Journal, Louisville, Ky., 1944-53, 1954-56; Visiting
Prof., Free University of Berlin, 1956, Univ. So. Cal., 1959, Univ.
Wurzburg, 1960-61; Director, North Carolina Museum of Art,
Raleigh, N.C., 1961- .*

BIER, MRS. JUSTUS. See Bier, Senta Dietzel

BIER, SENTA DIETZEL (Mrs. Justus Bier)—Educator, W., Cr.
 107 East Morgan St., Raleigh, N.C. 27601
B. Nurnberg, Germany, Oct. 12, 1900. Studied: Univ. Munich,
Zurich, Bonn, Ph.D. Member: Southeastern Col. A. Conference.
Author: Furttenbachs Gartenentwurfe. Positions: Asst. to A. Libn.,
Vereinigte Staatsschulen fur freie und angewandte Kunst, Berlin,
1928-29; Asst., Bavarian State Museums, Munich, 1929-31; Cur.
Museum fur das vorbildliche Serienprodukt, Kestner-Gesellschaft,
Hannover, 1932-36. Lecturer in German, 1946-47, Instr. German,
1947-48, Lecturer in A. Hist., 1948-53, Asst. Prof. A. Hist. (part-
time), 1953-54, 1955-58, Univ. of Louisville. Cr. & A. Ed., The
Courier-Journal, Louisville, Ky., 1953-60. Lecturer in Art History,
Bellarmine College, Louisville, Ky., 1958-60.*

BILECK, MARVIN—Etcher, Eng., I., T.
 302 E. 3rd St., New York, N.Y. 10009
B. Passaic, N.J., Mar. 2, 1920. Studied: Cooper Union Sch. of Art.
Awards: Fulbright Grant to France, 1958; Runner-up for Caldecott
Medal, 1964. Work: Books illustrated included in Fifty Books of
the Year, AIGA, 1953; Children's Best Books, AIGA, 1954, 1956,
1962; N.Y. Times Best Illustrated Books, 1964. Illus: "A Walker in
the City" (Kazin); "The Penny That Rolled Away" (MacNeice); "The
Country Doctor and Other Stories" (Turgenev); "Sugarplum" (Jo-
hanna Johnson); "Nobody's Birthday" (Ann Colver); "The Dream of
Alcestis" (Morrison); "Rain Makes Applesauce." Illustrations in
New York Times, The Reporter Magazine, Harpers, New Republic.
Positions: Instr., Drawing, Graphics, Calligraphy and Art of the
Book, Philadelphia College of Art, Pa.*

BILLINGS, HENRY—Painter, Des., I., W.
 Box 1014, Sag Harbor, N.Y. 11963
B. Bronxville, N.Y., 1901. Studied: ASL. Work: WMAA; murals,
Music Hall, N.Y.; WFNY 1939; USPO, Lake Placid, Wappinger Falls,
N.Y.; Columbia, Tenn.; Medford, Mass.; American Export Lines,
1950. Exhibited: Midtown Gal.; NAD; WMAA. Positions: Instr., ASL,
Woodstock, N.Y., 1963-1965; Pres., AEA, 1951-52; Memb., Nat.
Comm. for UNESCO I., children's books. Trustee of the Long Island
Chapter of Nature Conservancy.

BILLMYER, JOHN EDWARD—Craftsman, E., P., L.
 1519 East Mexico St., Denver, Colo. 80210
B. Denver, Colo., Aug. 17, 1912. Studied: Univ. Denver; Kirkland
Sch. A.; Western Reserve Univ., B.A., M.A., and abroad. Member:
AAUP; Am. Ceramic Soc.; CAA. Work: CMA; Denver A. Mus. Ex-
hibited: Syracuse Mus. FA., 1948, 1950, 1952, 1953, 1956; Wichita

Mus. A., 1951, 1955, 1957; Denver A. Mus., 1947-1968; Metropolitan
Show, Denver A. Mus., 1952-1967; CMA, 1933-1942; Colorado
Springs FA Center, 1960; one-man, (pottery) Commercial Gal., Den-
ver, 1960. Position: Prof., Graphics, and History of Romanesque
and Baroque Architecture, University of Denver, Denver, Colo.

BINAI, PAUL FREYE—Painter, E.
 The Detroit Institute of Arts, 5200 Woodward Ave., 48202; h.
 1941 McNichols Rd., Highland Park, Mich. 48203
B. Lancaster, Pa., June 3, 1932. Studied: Indiana Univ., A.B.,
M.F.A., with Alton Pickens, Leo Steppat; Yale Univ.; John Herron AI;
Ecole Fontainebleau, Paris. Member: CAA; AAMus. Awards: Pur-
due Univ. Research Fnd. Grant, 1961; Walter Damrosch Fellowship
for study in painting at the Fontainebleau School of FA, 1962. Work:
Purdue Univ. A. Center; Miami Mus. Mod. A. Exhibited: Kansas
City AI, 1954; J. B. Speed Mus., Louisville, 1954; John Herron AI,
1953, 1955, 1957, 1958, 1961; South Bend A. Center, 1954; Evans-
ville A. Mus., 1955; FA Center, Indiana Univ., (one-man), 1954; Pur-
due Univ. A. Gal. (one-man), 1960; San Francisco AI, 1963; Madison
Gal., New York, 1963; Palais de Fontainebleau, France, 1962; AFA,
1964-1965; Akron AI (with Robert Liikala), 1964; One-man: Miami
Mus. A., 1964; Ligoa Duncan Gal., New York City, 1964; Raymond
Duncan Gal., Paris, 1964. Positions: Instr., Dept. Art & Design,
Purdue University, Lafayette, Ind., 1960-1964; Instr., Akron Art In-
stitute, Akron, Ohio, 1964-1968; Asst. Dir., Project "Outreach,"
Detroit Institute of the Arts, 1968- .

BINFORD, JULIEN—Painter, S., E.
 Route 2, Powhatan, Va. 23139
B. Richmond, Va., 1909. Studied: Emory Univ., Ga.; AIC. Awards:
Ryerson F., AIC; F., VMFA, 1940; Rosenwald F., 1943; prize, Buck
Hill Falls, Pa.; Va. State Library Natl. Mural Comp.; Springfield
Mus. A. Work: Murals: Shiloh Baptist Church, Fine Creek, Va.;
H.S., Richmond, Va.; 57th St. Branch, Greenwich Savings Bank, N.Y.;
14th St. Branch, Greenwich Savings Bank, N.Y.; Post Office, Forrest,
Miss. Permanent collections of: PMG; IBM; BMFA; New Britain
Mus.; Springfield Mus. A.; Oberlin College, Ohio; Univ. Nebraska;
William Rockhill Nelson Gal. A.; Univ. Georgia; State Mus. of Wash-
ington; Munson-Williams-Proctor Inst.; AGAA; VMFA; Mary Wash-
ington College; Univ. Virginia; Longwood Col., Va. Exhibited: Salon
d'Automne, Paris; AIC; Carnegie Inst.; Pittsburgh International, and
many national exhs. One-man: Galerie Jean Charpentier; Galeries
Jeanne Castel, both Paris, France; VMFA; Midtown Gal., N.Y.; Ober-
lin College; Univ. Virginia. Position: Prof. A., Drawing and Paint-
ing, Mary Washington College, Fredericksburg, Va.

BINGHAM, MRS. HARRY PAYNE—Collector
 834 Fifth Ave., New York, N.Y. 10021*

BINGHAM, LOIS A.—Art Administrator, L.
 National Collection of Fine Arts, Smithsonian Institution,
 20001; h. 1221 Massachusetts Ave., N.W., Washington, D.C.
 20005
B. Iowa Falls, Iowa, July 8, 1913. Studied: Oberlin Col., Ohio, B.A.,
M.A.; Yale Univ. Sch. FA; Univ. Paris, Institut d'Art & Archeologie.
Awards: Scholarship, Oberlin Col.; Fellowship, Carnegie Grant for
grad. study, Univ. Paris; Scholarship, Yale Univ. Sch. FA. Author:
"How to Look at Works of Art," (National Gallery of Art); "High-
lights of American Painting," (CARE), N.Y.; contributor to "Favor-
ite Paintings from The National Gallery of Art." Lectures given,
National Gallery of Art: "The Medici: Patrons of Art"; "The Index
of American Design"; "Dutch Painting"; "Manuscripts of the Mid-
dle Ages"; "Duccio's Maestra." Exhibitions arranged: More than
200, arranged and supervised, including Moscow exhibition "Modern
Painting and Sculpture," 1959; Biennial exhibitions: at Sao Paulo,
Venice, Santiago, New Delhi, Paris, 1961- ; "Nation of Nations,"
to inaugurate Berlin Congress Hall, 1954; numerous others of
painting, sculpture and crafts. Positions: National Gallery of Art,
1943-1954, Associate Curator for Education, 1948-1954; Chief, Fine
Arts Division, Exhibition Branch, United State Information Agency,
1954-1965; Chief, International Art Program, Smithsonian Institu-
tion, National Collection of Fine Arts, Washington, D.C., 1965- .

BIRILLO, BEN—Sculptor
 498 Fifth St., Brooklyn, N.Y. 11215*

BIRMELIN, AUGUST ROBERT—Painter, Et., E.
 547 Riverside Drive, New York, N.Y. 10027
B. Newark, N.J., Nov. 7, 1933. Studied: Cooper Union A. Sch.; Yale
Univ., B.F.A., M.F.A.; Slade Sch., Univ. of London; and with Gabor
Peterdi, Rico Lebun, Bernard Chaet, Josef Albers. Awards: Pur-
chase prize, Silvermine Gld. A., 1960; Schiedt Award, PAFA, 1962;
Nat. Inst. A. & Lets., 1968. Work: Prints—MMoA; WMA; AGAA;
BMFA; Drawings—WMAA; Newark Mus. A.; BM; MMoA; Sara Roby
Fund; Paintings—WMA; Chase Manhattan Bank, N.Y.; Worcester
Mus. (Mass.); Mus. of Contemp. A., Nagaoka, Japan. Exhibited:

PAFA, 1962; CGA, 1965; WMAA, 1962, 1963; BM, 1960; Univ. Illinois, 1965; deCordova Mus., 1968; and others; Rome, 1964; Milan, 1962; one-man: Stable Gal., N.Y., 1967; Alpha Gal., Boston, 1968. Positions: Instr.,Printmaking, Yale Summer Sch., Norfolk, Conn., 1960; Instr., painting, Skowhegan Sch. of Painting, summer, 1967. Assoc. Prof., A. Dept., Queens Col., N.Y., 1964-1969.

BIRO, IVAN —Sculptor
c/o Bertha Schaefer Gallery, 41 E. 57th St., New York, N.Y. 10022*

BISACCIO, PHILIP—Editor, Cr., W., P.
101 W. 78th St., New York, N.Y. 10024
B. New York, N.Y., Mar. 15, 1927. Studied: ASL with Reginald Marsh. Member: ASL; AAPL. Contributor to National Sculpture Review; Rosicrucian Digest. Positions: Editor, The Art Times.*

BISCHOFF, ELMER NELSON— Painter, E.
Art Dept., University of California, 94720; h. 2571 Shattuck Ave., Berkeley, Cal. 94704
B. Berkeley, Cal., July 9, 1916. Studied: Univ. California, B.A., M.A. Awards: prizes, SFMA, 1941, 1946; Richmond (Cal.) A. Center, 1955, 1956; Oakland A. Mus., 1957; AIC, 1964; grants: Ford Fnd., 1959; Nat. Acad. A. & Lets., 1963. Exhibited: San F. AA, 1941-1958; AIC, 1947, 1959, 1964; Los A. Mus. A., 1951; Art:U.S.A., 1957; Am. Paintings, 1945-1957; Minneapolis Inst. A., 1957; New Talent: U.S.A., 1958; AFA "West Coast Artists," 1958; WMAA, 1959, 1961, 1965; MModA, 1962-1964; CGA, 1963, 1965; Tate Gal., London, 1964; one-man: Paul Kantor Gal., Los A., 1955; San F. AA, 1956; De Young Mus., San F., 1961; Staempfli Gal., N.Y., 1960, 1962, 1964; Crocker Gal., Sacramento, Cal., 1964; Henry Gal., Univ. of Washington, 1968; Richmond A..Gal., 1969. Positions: Instr., Chm., Fine Arts Dept., and Graduate Program, California School of the Fine Arts, San Francisco, Cal., 1956-1963; Prof. Art, University of California, Berkeley, Cal., 1963- .

BISGARD, J. DEWEY (Dr.)—Collector, Patron
542 Doctors Bldg.; h. 402 J.E. George Blvd.,Omaha, Neb. 68132
B. Harlan, Iowa, Apr. 17, 1898. Collection: Contemporary Art. Positions: Trustee, Joslyn Art Museum, Omaha, Neb., 1954- ; Chm., Accession Committee Board of Trustees, Joslyn Art Museum. Member, Art Consulting Committee, Sheldon Mem. Art Gallery, University of Nebraska, 1963- .

BISHOP, ISABEL (Mrs. Harold G. Wolff)—Painter, Et.
857 Broadway, New York, N.Y. 10003; h. 355 West 246th St., Riverdale, N.Y. 10471
B. Cincinnati, Ohio, Mar. 3, 1902. Studied: ASL; N.Y.Sch. App. Des. Member: NA; Nat. Inst. A. & Let.; SAGA; Benjamin Franklin Fellow, Royal Society of Arts, London, 1964; Phila. WC Soc.; Audubon A. Awards: prizes, NAD, 1936, 1943, 1945, 1955, 1964, 1967; SAGA, 1939; Butler AI, 1941; PAFA, 1953; med., CGA, 1945; LC, 1946; Hon. D.F.A., Moore Inst. A., Sc. & Industry, Phila., Pa. Work: WMAA; VMFA; MMA; PAFA; AGAA; Springfield Mus. A.; Butler AI; PMG; BMA; CAM; N.Y. Pub. Lib.; Phillips Acad., Andover, Mass.; LC; CGA; mural, USPO, New Lexington, Ohio; Cranbrook Acad. A.; John Herron AI; Munson-Williams-Proctor Inst.; Newark Mus.A.; New Britain A. Mus.; Tel-Aviv Mus., Israel; Des Moines Art Center. Exhibited: Carnegie Inst.; VMFA; CGA; WFNY 1939; GGE, 1939; AIC; WMAA; CAM; Berkshire Mus., Pittsfield, Mass., 1957 (one-man); Midtown Gal., N.Y., (one-man) 1959; VMFA (with Richard Lippold), 1960; Art U.S.A., 1962; Gallery of Modern Art, New York, 1965; Rochester Mus. A. & Sciences; Univ. Illinois; six one-man exhs., New York, and many others. Contributor to art magazines.

BISHOP, JAMES —Painter
c/o Fischbach Gallery, 29 W. 57th St., New York, N.Y. 10019*

BISSELL (CHARLES) PHIL(IP)—Cartoonist, I.
Worcester Evening Gazette, 20 Franklin St., Worcester, Mass. 01601; h. 162 W. Main St., Box 155, Westboro, Mass. 01581
B. Worcester, Mass., Feb. 1, 1926. Studied: Sch. Practical A., Boston; Art Instruction, Minneapolis, Minn. Originator, Boston Patriots' Insignia. Work: Naismith Basketball Hall of Fame, Springfield, Mass.; Dwight D. Eisenhower Mus., Abilene, Kans. Exhibited: So. California Expo., 1964. Positions: Cartoonist, Worcester Evening Gazette.

BITTERS, STAN —Sculptor
5616 N. Forkner St., Fresno, Cal. 93705*

BITTLEMAN, ARNOLD (IRWIN)—Painter
R.D. Eagle Bridge, N.Y. 12057
B. New York, N.Y., July 4, 1933. Studied: Rhode Island Sch. Des.;

Yale Univ., B.F.A., M.F.A. Awards: Prize, Metropolitan Young Artists Show, N.Y.C., 1959; Alice K. English Traveling Fellowship, Yale Univ., 1956-1957. Work: MModA; WMAA; BM; FMA; AGAA; BMFA; Rose Mus., Brandeis Univ., Waltham, Mass.; Munson-Williams-Proctor Inst., Utica, N.Y. Exhibited: WMAA, 1958-59, 1962-63; MModA, 1959, 1965; PAFA, 1959; BM; Mus. Contemp. Art, Houston, Tex., 1960; Univ. Michigan, Ann Arbor, 1965; Yale Sch. Art, 1963; AFA traveling Exh., 1958, 1960; Borgenicht Gal., New York, 1960; one-man: Kanegis Gal., Boston, 1958, 1961, 1965. Articles with reproductions of work, Art In America; Artists at Work. Positions: Instr., Drawing, Color, Parsons School of Design, New York City; Yale Univ. School of Art and Architecture, New Haven, Conn.; painting, printmaking, Skidmore College, Saratoga, N.Y.; Artist-in-Residence and Lecturer in the Arts, Union College, Schenectady, N.Y.

BLACK, MARY CHILDS—Museum Director, W., E., L.
Museum of American Folk Art, 49 W. 53rd St. 10019; h. 270 West End Ave., New York, N.Y. 10023
B. Pittsfield, Mass. Studied: George Washington Univ., Washington, D.C., M.A.; Univ. of North Carolina, Greensboro, B.A.; Catholic Univ., Washington, D.C. Member: AAM; AFA; SPNEA; Planning Committee, South Street Seaport, Inc.; Advisory Council, Historical Society of Early American Decoration, Inc. Lectures: at leading museums, historical societies and clubs. Films: Assistant producer of a series of films on folk art subjects including Folk Artist of the Blue Ridge and Around the World in Eighty Feet (Colonial Williamsburg). Author: "American Folk Painting" (with Jean Lipman), 1967; "Ammi Phillips: Portrait Painter, 1788-1865" (with Barbara and Lawrence Holdridge), 1969; "Erastus Field 1805-1900" (Abby Aldrich Rockefeller Folk Art Collection), 1963; articles in American Heritage, Antiques, Art in America, Arts in Virginia, Craft Horizons and Curator. In preparation Limners of the Upper Hudson (Syracuse Univ. Press). Positions: Registrar, (1957-1958), Curator (1958-1964), Director, (1961-1964) of the Abby Aldrich Rockefeller Folk Art Collection, Williamsburg, Va.; Director, Museum of American Folk Art, New York, N.Y. 1964- ; Visiting lecturer, Univ. of Vermont and Shelburne Museum, "American Art and Design—The Folk Tradition," 1965.

BLACK, WENDELL H.—Educator, Pr. M., P.
Department of Fine Arts, University of Colorado; h. 2088 Alpine Dr., Boulder, Colo. 80302
B. Moline, Ill., Mar. 22, 1919. Studied: State Univ. of Iowa, B.F.A., M.F.A. Awards: Faculty Fellowship (Creative Research Grant), Univ. of Colorado for 1965-1966 (awarded 1964); Tamarind Artist-Teacher Fellow, summer 1963 at Herron School of Art, Indianapolis. Work: Bibliotheque Nationale, Paris, France; Victoria and Albert Mus., London; Achenbach Fnd. Graphic Art, CalPLH; LC; Mus. Mod. A., Youngstown, Ohio; Butler Inst. Am. A.; Universities of Minnesota, Illinois, Colorado, Alaska; Illinois Wesleyan Univ.; Oklahoma City Univ.; Brigham Young Univ., Provo, Utah; Univ. Nebraska, Hall Collection; Ohio State Univ., and others. Exhibited: (1962-64) Ohio State Univ.; Univ. Colorado; (one-man); Joslyn A. Mus., Omaha (one-man); Tweed Gal., Duluth, Minn.; Washington and Jefferson College, Washington, Pa.; St. Louis A. Gld.; Denver A. Mus.; Univ. Kansas A. Mus., Lawrence, Kans.; J. B. Speed A. Mus., Louisville; Jewish Community Center, Long Beach, Cal.; Univ. Alaska A. Mus.; Gallerie Nees Morphes, Athens Greece, and others. Positions: Prof. Printmaking, University of Colorado, Boulder, Colo.*

BLACKBURN, LENORA W. (Mrs. Willis C.)—Collector
4505 N. Sunset Drive, Mobile, Ala. 36608
B. Midland, Texas, Aug. 21, 1904. Studied: Univ. Texas, B.A. Collection: (collected with Willis C. Blackburn): Old Masters including: Titian; Ghirlandaio; Rubens; Hals; Van der Helst; Rembrandt; Bol; Turner; Constable; Van Dyck; Watteau; Ingres; Vigée-Lebrun; Angelica Kaufmann; Richard Wilson; Benjamin West; Bonington; Alma-Tadema; Rousseau; Daubigny; Inness; Sully; Eakins; Charles Wilson Peale; William Marshall (Lincoln's portrait of which Marshall made an engraving); Blakelock; Robert Chailloux; Gainsborough; Vanderlyn; Franz van Mieris; Robert Henri, and many others.

BLACKBURN, MORRIS—Painter, Gr., T., L.
2104 Spring St., Philadelphia, Pa. 19103
B. Philadelphia, Pa., Oct. 13, 1902. Studied: PAFA, and with Arthur B. Carles. Member: Phila. A. All.; Phila. Pr. Cl.; Nat. Ser. Soc.; Phila.WC Cl. (Bd.); AWS; All. A. Am.; Audubon A. Awards: Guggenheim F., 1952-53; Phila. Pr. Cl.; med., PAFA, and Thornton Oakley prize, 1955; Zimmerman prize, 1959; Art Merit Award, Ocean City, N.J., 1968; Medal, Phila. WC Cl., 1969. Work: PMA; PAFA; Capehart Coll.; U.S. State Dept.; Brooks Mem. A. Gal.; Pa. State Univ.; Fleisher A. Mem.; LC; Woodmere A. Gal.; Phila. Pub. Lib.; Univ. Montana; U.S. Information Service; New Jersey State Mus.; Butler Inst. AM. A.; Friends Central School, Phila.; Port., Hon. Thomas J. Clary, U.S. District Court, Philadelphia. Exhibited: PAFA, 1937-

1956; NAD; AIC; WMAA; MMA; Toledo Mus. A.; three exhs. in France, sponsored by U.S. Embassy; Venice Biennale; Santa Barbara Mus. A.; Montclair A. Mus.; Springfield A. Mus.; Gimpel Fils, London; Kunsthaller Gallerie, Zurich; PMA; Phila. Pr. Cl.; Phila A. All. Exhs. 1962-64; PMA; PAFA; AWS; Audubon A.; Watercolors USA, Springfield, Mo.; LC; Locust Club; Mus. of New Mexico, Santa Fe; Phila. A. All.; Phila. "Tradition" traveling exh. throughout U.S.A. Museums, 34 one-man shows. Author, I., of article in "How Paintings Happen," by Ray Bethers; "The Artist Teacher," AEA Newsletter, 1955. Subject of a motion picture, "Portrait of a Painter" by Emidio Angelo, Coll. of Phila. Mus. Art. Positions: Instr., Painting, PMA; Instr., Graphic A., & Painting, PAFA, Philadelphia, Pa.

BLACKETER, JAMES (RICHARD) — Painter, Des., T.
2260 Glenneyre St., Laguna Beach, Cal. 92651
B. Laguna Beach, Cal., Sept. 23, 1931. Studied: Santa Ana College. Member: Laguna Beach AA; Festival of A. Assn.; Am. Inst. FA; Laguna Beach A. Gld. Awards: Nat. Scholastic award, 1950; (2) Festival of Arts, 1959; prize, Ebell Cl., Los Angeles, 1961; various prizes and awards, Laguna Beach AA, 1953- . Exhibited: Carnegie Inst., 1950; Laguna Beach AA, 1953-1969; Laguna Beach Festival A., 1953-1969; Long Beach A. Mus.; Los A. County Fair, 1961. Positions: A. Dir. & Des., Federal Sign and Signal Corp., 1953-1969; Sec., Bd. Dir., Laguna Beach AA, 1960-1961; Memb. Bd. Dirs., 1960-61. Instr., oil painting class and privately.

BLACKWELL, JOHN VICTOR — Scholar, Educator
University of Nebraska at Omaha, 60th and Dodge Sts.; h. 10522 Poppleton St., Omaha, Neb.
B. Yale, Okla., Oct. 25, 1919. Studied: James Millikin Univ., B.A.; State Univ. of Iowa, M.A., M.F.A., Ph.D. Awards: numerous. Field of Research: Medieval Art History.

BLADEN, RONALD — Sculptor
182 Fifth Ave., New York, N.Y. 10010
B. Vancouver, B.C., Canada, July 13, 1918. Studied: Vancouver A. Sch.; California Sch. FA. Awards: Rosenberg Fellowship, National Arts Council, San Francisco. Work: MModA; Los Angeles County Mus. A. Exhibited: WMAA, 1966, 1968; Guggenheim Mus. A., 1967; Minimal Art, The Hague, 1968; Documenta Kassel, 1968; CGA, 1967; Jewish Mus., New York, 1966.

BLAGDEN, THOMAS P. — Painter, T.
Lime Rock Rd., Lakeville, Conn. 06039
B. Chester, Pa., Mar. 29, 1911. Studied: Yale Col., B.A.; PAFA and with Henry Hensche, George Demetrios. Member: Conn. WC Soc.; Century Assn. Awards: prizes, Conn. WC Soc.; Berkshire AA. Work: Albany Inst. Hist. & Art; Addison Gal. Am. Art, Andover, Mass.; Chrysler Mus. A.; Wadsworth Atheneum; Berkshire Mus.; Amherst Col.; Univ. Georgia. Exhibited: CGA, 1937, 1941; PAFA, 1938, 1940, 1967; Albany Inst. Hist. & A., 1939-1955; Conn. WC Soc., 1940-1958; MMA, 1950; Am. Acad. A. & Lets., 1960, 1961, 1965; one-man: Berkshire Mus., 1950, 1958; Milch Gal., 1951, 1954, 1957, 1959, 1962, 1964, 1966; Saint-Gaudens Mus., Cornish, N.H., 1964; Boston Univ., 1965; Bristol (R.I.) Mus., 1967; New Britain (Conn.) Mus. Am. A., 1968; Univ. New Hampshire, 1969. Positions: A. Instr., Hotchkiss School, Lakesville, Conn., 1935-56.

BLAI, BORIS — Sculptor, E.
Fourth & High Aves., Melrose Park, Philadelphia Pa. 19126
B. Rovnow, Russia, July 24, 1890. Studied: Kiev Imperial Acad. FA; Imperial Acad. FA, Leningrad; Ecole des Beaux-Arts, Paris, France; Apprentice to Auguste Rodin; Fla. Southern Col., D.F.A. Member: Phila. A. All.; PMA; Grand Central A. Gal. Awards: Page One Award from Newspaper Guild of Greater Philadelphia, 1960; Phila. Art Alliance Medal, 1960; Samuel S. Fels Medal, 1962. Work: Sculpture: PMA; Temple Univ.; Long Beach Island Fnd. A. & Sc.; Lessing Rosenwald Coll.; many portrait commissions; Samuel Fels medal, 1957; Sherr Mem., Beth Sholom Center, Elkins Park, Pa.; Assoc. with R. Tait McKenzie in work for Canadian Mem., Edinburgh, Scotland and statue of General Wolfe, London; statue of Gen. Meade, New Jersey State Park; statue of Johnny Ring, Temple Univ.; Mem. for David Weber, Har Zion Synagogue, Wynnefield, Pa., 1960. Exhibited: PAFA, 1924, 1925; Intl. Sculpture Exh., PMA, 1949; Detroit Inst. A., 1934; one-man: Grand Central A. Gal., 1934; Phila. A. All.; Woodmere A. Gal.; AIC; Long Beach Fnd. Contributor to American Magazine; Reader's Digest. Lectures, demonstrations on portrait sculpture, art education, etc. Positions: Hd. A. Dept., Oak Lane Sch., 1927-35; Fndr. & Dean, Tyler Sch. FA, Temple Univ., 1935-1960 (now Dean Emeritus); Fndr. & Vice-Pres., Long Beach Island Fnd. for A. & Sc., 1948- .

BLAINE, NELL — Painter, Gr., Des., T.
210 Riverside Dr., New York, N.Y. 10025
B. Richmond, Va., July 10, 1922. Studied: Richmond Professional Inst.; Richmond Sch. A.; Atelier 17 and with Hans Hofmann. Member: Jane St. Group; Am. Abstract A.; F., Macdowell Colony & Yaddo Fnd. Awards: F. VMFA, 1943, 1956; Norfolk Mus. A., 1946; Ingram Merrill Grant, 1962, 1964, 1966; Longview Fnd. Grant, 1964. Work: 2 murals in Revlon, Tishman Bldg., New York, N.Y.; VMFA; Colgate Univ.; WMAA; Univ. So. Illinois; Chase Manhattan Bank Coll.; N.Y. State Univ. T. Col.; Hallmark Coll.; WMA; Riverside Mus., N.Y.; Longwood College, Farmville, Va.; Hirschhorn Fnd. Coll.; MModA; A. Mus., Univ. Cal.; Georgia Mus. A., Athens; Taconic Fnd., N.Y.; Weatherspoon Gal., Univ. N.C.; Knoedler Gal., N.Y.; Exhibited: AIC, 1944; Am. Abstract A., 1945-1957; Art of this Century, 1945; Am-British A. Gal.; traveling exh., sponsored by State Dept. in Paris, Rome, Munich, Copenhagen, 1950; Mus. Mod. A., Japan, 1955; Stable Gal., 1954, 1955; AIC; PAFA; MModA, 1956; MModA traveling, 1967; WMAA, 1956; Spoleto, Italy, 1958 "Festival of 2 Worlds"; MModA (lending); New School, N.Y.; Art-USA, 1959; Frumkin Gal., N.Y.; Knoedler Gal. N.Y., 1963; Artists for CORE, N.Y., 1962-1966; Zabriskie Gal., N.Y., 1963; Albright-Knox A. Gal., Buffalo, N.Y., 1963; Kansas City AI, 1963; "Hofmann and His Students," MModA traveling exhibition, 1963; Finch College Gal., 1962; Schoelkopf Gal., N.Y.; Peridot Gal., 1967; Art in the White House program, 1966-1969; Art in the Embassies program, 1966-1969; one-man: Jane St. Gal., 1945, 1948; VMFA, 1947; Univ. So. Illinois, 1949; Tibor de Nagy Gal., 1953, 1954; Yaddo, 1961; Phila. A. All., 1961; Stewart Rickard Gal., San Antonio, 1960; Poindexter Gal., N.Y., 1956, 1958, 1960, 1966, 1968; XXth Century Gal., Williamsburg, Va., 1962; Longwood College, Va., 1963; Zabriskie Gal., Provincetown, Mass., 1963; 3-man: VMFA, 1955. Book: "Prints, Nell Blaine — Poems, Kenneth Koch," 1953; Filmed in "Nell Blaine" by Bolotowsky; "Nell Blaine Paints a Picture," Art News, 1959; "Women Artists in Ascendance," Life Magazine, 1957; reproductions, Art News, 1968; illus. "In Memory of my Feelings," by Frank O'Hara, 1968. Positions: A. Dir., United Jewish Appeal, 1950; Instr., Painting, Great Neck Pub. Sch., L.I., N.Y., 1956-57, Adult Program.

BLAIR, CARL RAYMOND — Painter, T.
34408 Bob Jones University, Greenville, S.C. 29614
B. Atchison, Kans., Nov. 28, 1932. Studied: Univ. Kansas, B.F.A.; Kansas City AI and Sch. of Des., M.F.A. Member: Gld. of South Carolina A.; Southeastern College A. Conference; Int. Platform Assn. Awards: Gld. of South Carolina A., 1959, 1960, 1962, 1964, 1966-1968; 1st purchase award, Peidmont Painting & Sculpture Exh., 1965; Merit Award, Calloway Gardens Exh., 1967; 1st Award for painting "Appalachian Corridors I" exh., 1968; award, Int. Platform Assn., 1968. Work: in collections of universities, museums, businesses and private. Exhibited: William Rockhill Nelson Gal. A., Kansas City, 1954; Gld. of South Carolina A., 1957-1968; Telfair Acad. A., Savannah, 1960; Ringling Museum of A., Sarasota, 1963; Isaac Delgado Mus. A., New Orleans, 1963; Montgomery (Ala.) Mus. A., 1965-1968; Mead Packaging Co., Atlanta, 1965; Soc. Four A., Palm Beach, 1965; The Parthenon, Nashville, Tenn., 1966-1968; Comins Gal., Comins, Mich., 1967 (3-man); Springs Cotton Mills, N.Y., 1967, 1968; Butler Mus. Am. A., 1968; Charleston, W.Va., ("Appalachian Corridors I"), 1968; Int. Platform Assn., Wash., D.C., 1966; George Hunter Gal., Chattanooga, 1969 (3-man); California State Col., California, Pa., 1969; Lycoming Col., Williamsport, Pa., 1969; South Carolina Invitational I, Columbia, S.C., 1969. Positions: Prof. Art, Drawing & Painting, Graduate and Under-Graduate, Bob Jones University, 1957- ; Summer School: Kansas City AI, 1962, 1964-1966; Greenville, S.C., Mus. A., 1968, 1969.

BLAIR, ROBERT N. — Painter, S., Gr., E., I.
R.D. #1, Olean Rd., Holland, N.Y. 14080
B. Buffalo, N.Y., Aug. 12, 1912. Studied: BMFA Sch. Member: Buffalo Soc. A.; Pattern Soc. Awards: prizes, Albright-Knox A. Gal., 1940, 1944, 1947, 1951, 1963, 1965; AIC, 1948; Buffalo Soc. A., 1951, 1954, 1955, 1956-59, silver medal, 1962, 1968, gold medal, 1968; Alabama WC Soc., 1947; medal, Buffalo Soc. A., 1947, 1950; Guggenheim F., 1946, 1951; Butler AI, 1953; Baltimore WC Soc., 1953; Silvermine Gld. A., 1955, 1958; 1965; Kenmore A. Soc., 1960; Chautauqua Natl., 1963. Work: MMA; Butler AI; Bryn Mawr AA; Ford Motor Co.; Munson-Williams-Proctor Inst.; Colgate Univ.; Dubuque AA; murals, chapel and hospital, Ft. McClellan, Ala.; Bethlehem Steel Co., Lackawanna; Olean House, Olean, N.Y.; Unitarian Church, East Aurora, N.Y.; Lakeview, N.Y. Book covers for Lowell Thomas's "St. Lawrence Seaway"; "Under Three Flags." Exhibited: BM, 1939; AIC, 1942-1944, 1948; NCFA, 1942; MMA; Riverside Mus.; Albany Inst. Hist. & A., 1934-1948; BMA; Alabama WC Soc.; Albright A. Gal., 1942 (one-man); Buffalo Mus., Sch., 1942 (one-man); Alabama Polytechnic Inst., 1944; Univ. Alabama, 1944; Colgate Univ., 1939, 1941; one-man: Morton Gal., 1939-1941; Ferargil Gal., 1953; Buffalo, N.Y., 1937, 1938, 1944-1948, 1953, 1955; New Masters Gal., N.Y., 1962, 1967; Buffalo, N.Y., 1965. I., "Captain and Mate," 1940 and other children's books. Article and reproduction of paintings, American Artist magazine, 1966. Positions: Dir., Buffalo AI, 1946-49; Instr., Univ. Buffalo, Buffalo, N.Y.

BLAIR, WILLIAM McCORMICK—Art Patron
135 S. La Salle St. 60603; h. 1416 Astor St., Chicago, Ill. 60610
B. Chicago, Ill., May 2, 1884. Studied: Yale University, B.A. Awards: Honorary Doctor of Laws, Northwestern University, 1964; Honorary Doctor of Literature, Lake Forest College, 1963. Positions: President, Board of Trustees, The Art Institute of Chicago, 1958- ; Trustee, University of Chicago, Chicago Natural History Museum; Trustee, American Federation of Arts.*

BLAKE, LEO B.—Painter, T., L., I.
Blake Studios, Cheshire, Mass. 01225
B. Galesburg, Ill., July 7, 1887. Studied: AIC; & with Alfred East, W. J. Reynolds, Birge Harrison. Member: SC; North Shore AA; Conn. Acad. FA; Grand Central A. Gal.; New Haven Paint & Clay Cl. Awards: New Haven Paint & Clay Cl., 1942; Conn. Acad. FA, 1939; SC, 1942; Mass. Fed. Women's Cl., 1943, 1944; Vixseboxes Gal., Cleveland; Meriden A. & Crafts, 1952, 1958 (hon. mention), Best Port. award, 1960, prize 1963; Jordan Marsh, Boston, 1957, 1959, 1960. Work: Rochester Inst. Tech.; Ill. Acad. FA; Foxhollow Sch.; Bavier Gal.; Lee, Adams and Meriden Savings Banks. Exhibited: AIC, 1910, 1911; Chicago SA; North Shore AA; SC; Syracuse Univ.; Conn. Acad. FA; Williams Col.; Berkshire Mus. A.; Springfield A. Lg.; Phila. A. All.; Grand Central A. Gal.; Jordan Marsh Co., Boston, 1957; Meriden A. & Crafts Assn. (Conn.), 1957, 1958, 1963.

BLAKE, PETER JOST—Writer, Critic, Architect
810 Carnegie Hall 10019; h. 108 E. 81st St., New York, N.Y. 10028
B. Berlin, Germany, Sept. 20, 1920. Studied: Univ. London; Regent Street Polytechnic School of Architecture; University of Pennsylvania School of Architecture; Pratt Institute School of Architecture, B. Arch. Awards: Fellow, Graham Foundation for Advanced Studies in the Fine Arts, 1962; Ford Foundation Grant, to design an ideal off-Broadway theatre (in collaboration with David Hays), 1960; Howard Myers Award for Architectural Journalism, 1960; Citation, American Institute of Architects for design of American Architecture Exhibit sent to Iron Curtain countries, 1958; Contemporary Achievement Medal from Pratt Institute, 1967; Special Citation, American Institute of Architects, 1967. Positions: Editor, Architectural Forum; Partner, James Baker & Peter Blake, Architects, New York; Member of Committee on Aesthetics, 1965-1966 and Juror for the Medal of Honor and Award of Merit, 1968-1969, American Institute of Architects; Vice-President for Architecture, 1966-1968 and Member of Scholarship and Awards Committee, 1968-1969, The Architectural League of New York; Board of Directors, 1965-1970, Int. Design Conference, Aspen, Colo.; Urban Design Committee, 1969, American Institute of Architects; Member, Committee on the Second Regional Plan, Regional Plan Association.

BLANC, PETER (WILLIAM PETERS BLANC)—Painter, E., W.
161 West 75th St., New York, N.Y. 10023
B. New York, N.Y., June 29, 1912. Studied: Harvard Univ., B.A.; St. John's Univ., L.L.B.; Corcoran Sch. A.; American Univ., M.A. Member: Spiral Group; AEA, (Bd. Dirs. 1963-1969; A. Gld., Washington, (Pres. 1951-1953); Soc. Washington A.; Proto V. Awards: prizes, CGA, 1949; Soc. Wash. A., 1951; Wash. WC Cl., 1952. Work: VMFA; Fort Worth A. Center; Tweed Gal., Univ. Minnesota; N.Y. Univ. Exhibited: WMAA, 1952; CAM, 1951; Nebraska AA, 1951; Wash. WC Cl., 1949, 1951, 1952; CGA, 1948-1951; Riverside Mus., 1950, 1954, 1956, 1958, 1964; New Sch. for Social Research, 1955; Springfield Mus. A., 1952; Passedoit Gal., 1951, 1953 (one-man), 1958 (one-man); NCFA, 1953; BMA, 1953; BM, 1955; Colorado Springs FA Center, 1955; La Galeria Escondida, Taos, N.M., 1955 (one-man); Artists Gal., N.Y., 1957; Univ. Nebraska, 1958; FMA, 1959; N.Y. Univ., 1960; East Hampton Gld., 1960-1968; Albert Landry Gal., N.Y., 1960 (one-man); St. Paul (Minn.) Gal., 1961; Hudson River Mus., 1965 (one-man); Poindexter Gal., 1962; Fort Worth A. Center, 1963, 1966 (one-man); Daniels Gal., N.Y., 1964; Benson Gal., Bridgehampton, N.Y., 1966, 1967, 1969 (three-man); Book Gal., White Plains, N.Y., 1967; Iona Col., 1967; Westchester A. Soc., White Plains, N.Y., 1967; Southampton Gal., Long Island, N.Y., 1967-1969; Wichita Falls AA, Tex., 1968; Tweed Gal., Duluth, 1968; other one-man exhs.; Assoc. A. Gal., Wash. D.C., 1962; Amel Gal., N.Y., 1964; Hudson River Mus., 1965; Thomson Gal., N.Y., 1969. Positions: Instr., American Univ., Washington, D.C., 1950-53.

BLANCHARD, CAROL—Painter, Gr., E.
375 Bleecker St., New York, N.Y. 10014
B. Springfield, Mass., Aug. 29, 1918. Studied: Colby Jr. College; ASL; Painter's Workshop, Boston, Mass. Awards: Carnegie Inst. A., 1951-1953, 1959; A. Dir. Cl., 1955, 1956; Scarsdale AA, 1950-1960; Benedictine Art Award in Creative Arts, 1967, 1968. Work: murals, Pasangrahn, St. Martin, B.W.I., 1959; Bay Roe, Jamacia, B.W.I., 1963; San Miguel de Allende, Mexico, 1965; paintings in private collections. Exhibited: Vigivino Brentwood Gal., 1949; Albright-

Knox A. Gal., Buffalo, 1952; WAC, 1960; Carnegie Inst., Pittsburgh, 1951-1959; Univ. Ill., 1953; CAM, 1949, 1951; A. Inst., Zanesville, Ohio, 1950; Kalamazoo Inst. A., Mich.; Yonkers AA, Yonkers, N.Y.; Scarsdale AA, Scarsdale, N.Y. I., "Always Ask A Man,"; seven books by Mary Stolz; Christmas cards for United Nations. Illustrations in Village Voice, Woman's Wear Daily, and other newspapers.

BLANKFORT, DOROTHY (Mrs. Michael)—Collector
1636 Comstock Ave., Los Angeles, Cal. 90024
Studied: Bates College; Cornell University. Collection: Chiefly Contemporary American. Member: Exec. Bd., Contemporary Art Council of the Los Angeles County Museum.

BLANKFORT, MICHAEL—Collector
1636 Comstock Ave., Los Angeles, Cal. 90024
Studied: University of Pennsylvania; Princeton University. Member: Exec. Bd., Contemporary Council, and Exhibitions Committee of the Los Angeles County Museum. Collection: Contemporary American Art.

BLATTNER, ROBERT HENRY—Designer, I., T., P., W., L.
200 Park Ave., New York, N.Y. 10017; h. Loch Lane, Port Chester, N.Y. 10573
B. Lynn, Mass., Dec. 8, 1906. Studied: Mass. Col. A., B.S. in Edu. Member: AIGA; A. Dir. Cl.; SI. I., Christian Science Monitor, Reader's Digest. Lectures: Design; Advertising Illustration. Positions: A. Dir., Marschalk & Pratt, 1944-45; Assoc. A. Dir., Reader's Digest, 1945- .*

BLAUSTEIN, ALFRED—Painter, Gr., T.
141 E. 17th St., New York, N.Y. 10003
B. New York, N.Y., Jan. 23, 1924. Studied: CUASch.; Skowhegan Sch. A. Awards: Prizes, Prix de Rome, 1954-1957; LC, 1956; Guggenheim F, 1958, 1961-62; Am. Acad. A. & Lets., 1958. Work: WMAA; LC; PAFA; Wadsworth Atheneum; Butler Inst. Am. A. Mural, South Solon Meeting House, South Solon, Me.; commissioned: drawings of African Life, 1948-1949. Exhibited: MMA, 1950; PAFA, 1951; Albright A. Gal., 1952; WMAA, 1953, 1957; Carnegie Inst., 1952; Butler Inst. Am. A., 1952; Univ. Illinois, 1957; AFA "Art in America," 1958; LC, 1956; Acad. A. & Lets., 1957; BM, 1957; Buffalo, N.Y., 1950, 1951, 1952; Downtown Gal., 1956; Am. Acad. in Rome, Italy, 1955-1957; Nordness Gal., N.Y., 1959 (one-man); PAFA, 1960; Butler Inst. Am. A., 1961. Contributor to The Reporter, Spectrum, Natural History Magazine. Positions: Instr., Des., Drawing & Painting, Albright A.Sch., Buffalo, N.Y.; CUASch., N.Y.; Yale Summer A. Sch., Norfolk, Conn.; Pratt Inst.; Visting Lecturer, Yale Univ.

BLEIFELD, STANLEY—Sculptor, P., Gr., T.
Spring Valley Road, Weston, Conn., 06880
B. Brooklyn, N.Y., Aug. 28, 1924. Studied: Tyler Sch. FA of Temple Univ., B.F.A., B.S. Ed., M.F.A.; Barnes Fnd., Merion, Pa. Member: NSS. Awards: John Gregory Award, NSS, 1964; F, Tyler Sch. FA, 1964. Tiffany Fellowships 1965, 1967. Work: Bas-relief, Vatican Pavilion, N.Y. World's Fair, 1964-65. Illus. "A Day at the County Fair"; "Elly the Elephant." Article on work in Life Magazine, 1963. Exhibitions: AFA, 1966-1967; one-man: Kenmore Gal., Phila. Pa., 1967; Fairfield Univ., Fairfield, Conn., 1967; IFA Gal., New York, 1968; Peridot Gal., New York, 1968. Positions: Instr., New Haven State Teachers College, 1953-1955; Danbury State College, 1955-1963; Silvermine College of Art, 1964- .

BLEY, ELSA W.—Painter, T.
Main St., Dorset, Vt.; w. National Arts Club, 15 Gramercy Park, New York, N.Y. 10003
B. New York, N.Y., Mar. 10, 1903. Studied: ASL; Grand Central Sch. A., and with George Luks, George Pearse Ennis, Wayman Adams, Henry B. Snell. Member: NAC; Pen & Brush Cl.; Southern Vt. A.; Scarsdale AA; NAWA. Awards: med., Sch. A. Lg., 1919; Scarsdale AA, 1936, 1938, 1944, 1945. Exhibited: Wash. WC Cl., 1936; AWS, 1931, 1937; Montross Gal., 1933-1942; Scarsdale AA, 1931-1946; NAC, 1936-1939, 1962-1965; Southern Vt. A., 1938-1965; NAWA, 1948-1963; AAPL, 1963; Bronxville Pub. Lib., 1956; Stedelijke Mus., Amsterdam, 1956; 3 nat. traveling exhs., and in Canada, 1953-1955; traveling exh., Belgium & Switzerland, 1956-57; NAC, 1961; Pen & Brush Cl., 1959-1965; traveling exh., Japan, 1960; Riverside Mus., 1960; one-man: So. Vermont A. Center, 1963; Weathersfield A. Center, 1964. Positions: Founder, Dir., Scarsdale A. Gld., 1934-45; Instr., Southern Vt. A. Center, 1951-1958, 1963-1965; Garden City Community Cl., 1957-58; Chm., WC Jury, NAWA, 1959-61.*

BLIZZARD, ALAN—Painter, E.
Scripps College; h. 650 Marylind Ave., Claremont, Cal. 97111
B. Boston, Mass., Mar. 25, 1929. Studied: Mass. Sch. A., Boston, with Lawrence Kupferman; Univ. Arizona, with Andreas Andersen; Univ. Iowa, with Stuart Edie, James Lechay, and Byron Burford.

Work: BM; Univ. Iowa; UCLA; MMA; AIC; Denver A. Mus.; La Jolla Mus. A.; Scripps College and Claremont Graduate School. Exhibited: many exhibitions in leading museums, colleges, universities and art centers. Positions: Visiting Asst. Prof., Univ. Oklahoma; Asst. Prof., Univ. California, Los Angeles; Assoc. Prof., Scripps College and Claremont Graduate School, Claremont, Cal.

BLOCH, E. MAURICE—Educator, L., Mus. Cur. & Dir., W., P.
2253 Veteran Ave., Los Angeles, Cal., 90064
B. New York, N.Y. Studied: N.Y. Univ., B.F.A.; N.Y. Univ. Inst. FA, M.A., Ph.D.; Harvard Univ.; NAD, with Gifford Beal, Charles C. Curran; ASL, with Robert Brackman. Member: Am. Assn. Univ. Prof.; CAA; Art Historians of So. California; Manuscript Soc.; State Historical Soc. of Missouri. Awards: Fellowship, N.Y. Univ., 1944, 1945, 1947; C.R.B. Fellowship, Belgium, 1951; Founders Day Award of Achievement, New York Univ., 1958; ACLS Grant-in-Aid, 1962; Western Heritage Center Award, 1968. Contributor to scholarly periodicals on art including Gazette des Beaux-Arts; Art in America; The Connoisseur; New-York Historical Society Quarterly; and others. Author: "George Caleb Bingham: The Evolution of an Artist and a Catalogue Raisonne," 2 volumes, 1967, Berkeley and Los Angeles, University of California Press. Positions: Instr., Univ. Missouri, 1943-1944; L., N.Y. Univ., 1945-1946; Univ. Minnesota, 1946-1947; Asst. Prof., Keeper of Drawings and Prints, The Cooper Union, New York, 1949-1955; Prof., Art History, Cur., Graphic Arts, Director, Grunwald Graphic Arts Fnd., Univ. California, Los Angeles, Cal., 1956- . Other professional positions: Bd. Dirs., Tamarind Lithography Workshop, Los Angeles; Bd. Dirs., UCLA Art Council; Regional Editor, Journal of the West; Bd. Dirs., Print Council of America.

BLOCK, ADOLPH—Sculptor, T., W.
400 West 23rd St.; h. 319 West 18th St., New York, N.Y. 10011
B. New York, N.Y., Jan. 29, 1906. Studied: BAID; Fontainebleau, France, and with Hermon MacNeil, Sterling Calder. Member: ANA; F., NSS; All. A. Am.; Arch. Lg.; Fontainebleau Alumni Assn. Awards: prizes, BAID (Paris prize), 1927; F., Fontainebleau, 1927; F. Tiffany Fnd., 1926; Fontainebleau Alumni Assn., 1932, 1934, 1938; medal, BAID; 1926; Hon. men., Arch. Lg., 1955, 1956; prize, All. A. Am., 1956, gold med., 1958, Lindsay Morris prize, 1963, Therese Richard prize, 1964; NSS, 1958; Silver Medal, 1967; Newington award, 1959; Hering Mem. medal for work on Nat. Shrine, Wash., D.C.; Herbert Adams Mem. medal & citation, NSS; Mayor award, AAPL; Gold medal of Honor, Hudson Valley AA, 1961; Acad. of Achievement gold plate award, 1961. Work: Morris, Bryant H.S., New York; Bayonne (N.J.) Pub. Lib.; Queens Vocational H.S., N.Y.; Beth-El Hospital, Brooklyn, N.Y.; port. busts & medal des., Am. Chemical Soc.; Am. Tel. & Tel. Co.; Am. Inst. of Physics; Tobacco Indst., Hall of Fame, N.Y.; William Allen Mem. medal, Am. Soc. Human Genetics; 1961 issue of medal for Soc. of Medalists; bronze plaque, Beth-El Hospital, Brooklyn, N.Y.; panels for Nat. Shrine of the Immaculate Conception, Wash., D.C.; Designed bronze memorial portrait panel, Dr. Franz J. Kallmann for Columbia-Presbyterian Medical Center, N.Y., 1967; Des., Washington Irving Medal for N.Y. Univ. Hall of Fame, 1968. Exhibited: NAD; PAFA; Arch. Lg.; NSS; WMAA; NAC; Argent Gal.; French & Co.; SC; All. A. Am.; Jewish Mus.; religious sculpture; Barbizon Plaza Hotel, N.Y. Positions: Rec.-Sec., 1953-1955, Sec., 1956-58, 1st Vice-Pres, 1959-62, Pres., 1963-1965, NSS; Ed., Nat. Sculpture Review, 1958- ; Dir., FA Fed. of New York, 1954-62; Delegate to FA Fed., 1954-60; NSS Delegate, Int. Council of Plastic Arts, 1958-1962; Vice-Pres., 1960-63, Pres., 1964-1965; Dir., All. A. Am., 1961-64; Chm. Memb. Comm., NSS, 1956-62; Instr. S., NAD, 1959- .

BLOCK, AMANDA ROTH (Mrs.)—Painter, Gr.
5250 Woodside Dr., Indianapolis, Ind. 46208
B. Louisville, Ky., Feb. 20, 1912. Studied: Smith College; Univ. Cincinnati; Art Acad. of Cincinnati; ASL; Herron Sch. Art, Indianapolis. Member: Assn. Professional A. of Indiana; SAGA; Print Council of Am.; Phila. Pr. Cl.; AFA. Awards: Fifty Indiana Prints Exh., purchase prizes, 1960, 1964; Wabash Valley Exh., 1963, 1965; De Pauw Univ. Natl. Print Exh., purchase, 1963; Indiana Artists, Catherine Mattison Award, 1963. Work: Indiana State Col.; De Pauw Univ.; Indiana State Medical Assn.; Sheldon Swope A. Gal., Terre Haute; Boston Pub. Lib.; USIS prints for Embassies; Lafayette (Ind.) A. Center; Lippman Associates, Indianapolis; J. B. Speed A. Mus.; PMA. Exhibited: Butler Inst. Am. Art, 1960, 1962; Burr Gal., N.Y., 1962; Hanover College, 1963; De Pauw Univ., 1963, 1964; John Herron Mus. A., 1958-1969; South Bend Mus. A. & Sciences, 1964; SAGA, at Assoc. Am. A. Gallery, N.Y., 1965-1969; Sheldon Swope A. Gal., 1963, 1965; Purdue Univ., Ind., 1966; Isetan Gal., Tokyo, Japan, 1967; Phila. Pr. Cl., 1968; PAFA, 1969; one-man: 1444 Gal., Indianapolis, 1962; Swope A. Gal., 1963; Revel Gal., N.Y., 1964 (2-man); Harriet Crane Gal., Cincinnati, 1965; Talbot Gal., Indianapolis, 1967; Merida Gal., Louisville, 1967.

BLOCK, IRVING ALEXANDER—Painter, E.
c/o Ankrum Gallery, 910 N. La Cienega Blvd., Los Angeles, Cal.; h. 3880 Carpenter Ave., Studio City, Cal. 91604
B. New York, N.Y. Studied: N.Y. Univ., B.S.; NAD; Grand Chaumiere, Paris, France. Member: Motion Pictures Acad. A. & Sciences. Awards: prizes, Cal. WC Soc., 1949; Women of St. Albans, 1964; Venice Film Festival, 1956; Joseph H. Hirshhorn Grant, 1969. Work: San Fernando State Col.; MMA; Los Angeles Pub. Lib.; Galveston, Tex., Pub. Lib. Exhibited: Many group shows. One-man: Ankrum Gal., Los Angeles, 1963; Gallery de Ville, Los Angeles, 1962; Chabot Gal., Los Angeles, 1955; ACA Gal., N.Y., 1950; Los Angeles County Mus.; Phoenix A. Mus., 1964; Colorado Springs FA Center, 1963; La Jolla A. Mus., 1965 and others. Art Films produced, directed and written: "Goya," 1955; "World of Rubens," 1957; "Rembrandt, Poet of Light," 1953. Lectures: Spanish Painting; Psychology of Art; Film as Art at Univ. California at Los Angeles, Santa Cruz, and Irvine, Cal. Positions: Pres., Sceptre Productions, Inc. (Documentaries, Film Producer, Art Dir., etc.). Prof. FA, San Fernando Valley State College, Northridge, Cal., at present.

BLOCK, MR. and MRS. LEIGH B.—Collectors
1260 Astor St., Chicago, Ill. 60610
(Mr. Block): B. Chicago, Ill., Apr. 7, 1905. Studied: Univ. Chicago. Positions: Vice-President in charge of purchases, 1939- , Director, 1948- , Inland Steel Co.; Director, National Scholarship Service and Fund for Negro Students, Medical Research Institute of Michael Reese Hospital; Trustee, Northwestern University, Chicago; Trustee, Art Institute of Chicago, and other positions in cultural organizations.*

BLOCK, MRS. LOU. See Nay, Mary Spencer

BLOEDEL, LAWRENCE HOTCHKISS—Collector
Sloan Road, Williamstown, Mass. 01267
B. Bellingham, Wash., Mar. 21, 1902. Studied: Williams College, B.A.; Columbia University, B.S. Collection: 20th Century American Art. Positions: 2nd Vice-President, The American Federation of Arts, at present.

BLOOM, DON(ALD) S.—Painter, T., L.
Piscataway Board of Education, Piscataway, N.J. 08854; h. 31 Dexter Rd., East Brunswick, N.J. 08816
B. Roxbury, Mass., Sept. 3, 1932. Studied: Massachusetts Col. A., Boston, B.F.A.; Inst. de Allende, San Miguel, Mexico, M.F.A.; Rutgers Univ. Sch. of Ed. Member: Assoc. A., New Jersey; New Jersey A. Edu. Assn.; NAEA. Work: Guggenheim Fnd.; Fairleigh Dickinson Univ.; Upsala Col.; New Brunswick Pub. Library; Broadway Bank of Paterson, N.J. Awards: prizes, Silvermine Gld., 1963; medal, Audubon A., 1963; Guggenheim Fellowship, 1960-1961; Hartford Fnd. Fellowship, 1964, 1965; other prizes, Atlantic City, 1966, 1967; Boston A. Festival, 1955; So. Orange Exh., 1962, 1965, 1966; Eatontown, N.J., 1961; Passaic, N.J., 1964; Rutherford, N.J., 1967; Bloomfield, 1967; Hunterdon County A. Center, 1967; So. Orange A. Gal., 1967; Plainfield AA, 1964, 1967, and others. Exhibited: WMAA, 1959; PAFA, 1964; Audubon A., 1963-1965; Butler Inst. Am. A., 1959, 1961-1964; Nat. Mus. of Sports, 1965; Springfield (Mo.) Mus., 1965; Atlantic City, 1962, 1965-1967; Boston A. Festival, 1953-1956; Silvermine Gld., 1963; N.J. State Mus., Trenton, 1965, 1966; Newark Mus., 1955, 1961, 1965; NAD, 1966; Montclair Mus. A., 1955, 1958, 1959, 1962-1964, and others. One-man: Lawrence Gal., Kansas City, 1964 (2); Newton Centre, Mass., 1965; Aspen, Colo., 1965; Col. Mt. Joseph, Cincinnati, 1966; Old Bergen A. Gld., traveling exh., 1962-1963; Highgate Gal., Montclair, 1960, 1963, 1965, 1967; Gld. Creative A., Shrewsbury, 1960. Positions: Chm., K-12 Art Program, Piscataway, N.J., 1966- .

BLOS, MAY—Illustrator, C., P.
29 Live Oak Rd., Berkeley, Cal. 94705
B. Sebastopol, Cal., May 1, 1906. Studied: Univ. California, A.B., and in Europe. Work: Hunt Botanical Lib., Carnegie Inst. Tech., Pittsburgh. Exhibited: Oakland A. Mus.; Hunt Botanical Lib., Carnegie Inst. Tech., 1964; Biology Lib., Univ. California, Berkeley, 1963. Illus. "Mammals of Nevada"; "Nicotiana," 1955; "Cactus & Succulent Journal," 1953-1964; Field Museum, 1956-1964; Madrono, 1956; Univ. California, Paleontology Dept., 1958-1969; Museum displays in Paleontology Museum, 1962-1969, Seismology Dept., 1969; illus. for research in volcanology and earthquakes, Anthropology Dept., 1968-1969; cactus and succulent drawings, Huntington Botanical Gardens, San Marino, Cal., 1966-1969.

BLOS, PETER W.—Painter, E., Gr.
29 Live Oak Rd., Berkeley, Cal. 94705
B. Munich, Germany, Oct. 29, 1903. Studied: with Herman Groeber, Franz von Stuck, in Munich. Member: East Bay AA; Soc. Western A.; Oakland Mus. Assn.; Oakland AA. Awards: More than 100, in-

cluding Soc. Western A., 1968; Jack London Festival, 1966 and prior; Lodi Grape Festival, 1966-1968 and prior; Springville, Utah, 1967. Work: NAD; portraits at Univ. California and throughout the U.S., paintings in private colls. Exhibited: 1966-1968: DeYoung Mus., San Francisco; Oakland A. Mus.; St. Mary's Col.; San Jose State Col.; Univ. Santa Clara; Sacramento; Springville (Utah) Annual; Univ. Cal. Medical Center, San Francisco, and many others prior to 1966. Positions: Instr., figure and portrait painting, Walnut Creek Civic A. Center, Walnut Creek, Cal., 1966-.

BLUHM, NORMAN — Painter
333 Park Ave. South; h. 39 Gramercy Park, New York, N.Y. 10010
B. Chicago, Ill., Mar. 28, 1920. Studied: Illinois Inst. Tech.; Ecole des Beaux-Arts, Paris; Grand Chaumiere, Paris, and Architecture with Mies van der Rohe. Awards: Longview Fnd. Fellowship. Work: WMAA; PC; BMA; Mass. Inst. Tech.; Univ. Massachusetts; Dayton A. Inst.; Albright-Knox A. Gal., Buffalo; Chrysler Mus., Provincetown; Nelson-Atkins Mus., Kansas City, Mo.; Inst. Contemp. A., Dallas; Vassar Col.; N.Y. Univ.; Reed Col., Portland, Ore.; Phoenix A. Mus.; Melbourne Mus., Australia; Norfolk Mus. A. & Sciences; Nat. Mus. of Wales, and in private colls. U.S. and abroad. Exhibited: Stockholm, Sweden, 1955; Martha Jackson Gal., N.Y., 1956; Carnegie Int., 1958; Documenta II, Kassel, Germany, 1959; Inst. Contemp. A., Boston, 1959 (traveling to Europe); Arthur Tooth and Sons, London, 1959-1962; WAC, 1960; Columbus Mus. FA, 1960; WMAA, 1960; AIC, 1960, 1968; Guggenheim Mus., N.Y., 1961 (2), 1964; Torino, Italy, 1962; Anderson-Mayer, Paris, 1962; Salon de Mai, Paris, 1964; MModA traveling to Europe and Far East, 1964, 1966, 1968; Jewish Mus., N.Y., 1967; Los Angeles County Mus., 1968. One-man: Leo Castelli Gal., N.Y., 1957, 1960; Torino, Italy, 1961; Holland-Goldowsky Gal., Chicago, 1961; Graham Gal., N.Y., 1961; David Anderson Gal., N.Y., 1962, 1965; Galerie Huber, Zurich, 1963; Am. Gal., N.Y., 1963; Anderson-Mayer Gal., Paris, 1963; Brussels, 1964; Galerie Stadler, Paris, 1968; CGA, 1969.

BLUM, SHIRLEY NEILSEN—Scholar, E.
Dept. of Art, University of California, Riverside, Cal. 92502; h. 1123 Sunset Hills Rd., Los Angeles, Cal. 90069
B. Petaluma, Cal., Oct. 14, 1932. Studied: Stockton College, A.A.; University of Chicago, M.A.; University of California, Los Angeles, Ph.D. Awards: Distinguished Teaching Award, University of California, Riverside, 1969. Author: "Jawlensky and the Serial Image"; "Early Netherlandish Triptychs," 1969. Positions: Associate Professor, Art History, University of California, Riverside, at present.

BLUMBERG, RON—Painter, T.
10930 Le Conte Ave., 90024; h. 974 Teakwood Rd., Los Angeles, Cal. 90049
B. Reading, Pa., May 16, 1908. Studied: ASL; NAD; Academie Grande Chaumiere, Paris, France. Member: Cal. WC Soc.; Los A. AA. Work: Los A. Mus. A. Awards: prizes, Texas State Fair; Westwood AA, 1953, 1955; Cal. WC Soc., 1954, 1956; Los A. Mus. A purchase, 1958; Madonna Festival, Los Angeles, 1960, 1961; Tucson A. Center, 1962; Newport Beach AA, 1963; Downey (Cal.) A. Mus., 1967; St. Albans Annual, Los A., purchase prize, 1967. Exhibited: nationally in galleries and museums since 1931. One-Man: Robles Gal., Los A., 1959; Univ. of Redlands, 1959; Monrovia, Cal., 1960; Burr Gals., Los A., 1962, 1963; Ryder Gal., Los A., 1965; other one-man exhs., New Orleans, La.; Tulsa, Okla.; Houston, Tex.; New York, N.Y.; Los Angeles, Cal., and others. Positions: private instruction, 1951- .

BLUME, PETER—Painter
Sherman, Conn. 06784
B. Russia, Oct. 27, 1906. Studied: ASL; Edu. All. Sch. A., N.Y.; Beaux-Arts. Member: ANA; Nat. Inst. A. & Let.; Am. Acad. A. & Lets. Awards: Guggenheim F., 1932, 1936; prizes, Carnegie Inst., 1934; Grant, Nat. Inst. A. & Let., 1947. Work: BMFA; Columbus Gal. FA; MModA; MMA; WMAA; PMA; Wadsworth Atheneum; Randolph-Macon Col.; AIC; Mus. FA of Houston; Addison Gal. Am. A., Andover, Mass.; Newark Mus. A.; Williams Col.; murals, USPO, Cannonsburg, Pa.; Rome, Georgia; Geneva, N.Y. Exhibited: BMFA; WMAA; MMA; MModA and many others.

BLUMENTHAL, MARGARET M.—Designer
10 West 93rd St., New York, N.Y. 10025
B. Latvia, Sept. 7, 1905. Studied: in Berlin, with B. Scherz, Bruno Paul. Exhibited: Monza, Italy, 1927; MMA, 1930; Pratt Inst. Gal., 1935. Positions: Indst. & Textile Des., 1943- . Freelance Des. & Stylist for Libbey-Owens Co.; Fallani & Cohn Co.; Drulane Co.; Toscony Fabrics; Franco Mfg. Co.; Colortex Co.; Astorloid Co.

BOARDMAN, JEANNE (Mrs. Lester Knorr)—Painter, C.
2012 E. Reservoir Blvd., Peoria, Ill. 61614
B. Chambersburg, Pa., June 1, 1924. Studied: Indiana State College,

B.S. in Art Edu.; Columbia Univ., M.A.; ASL; Ohio State Univ., Ph.D. Member: AWS; Texas WC Soc.; Peoria A. Center. Awards: prizes, Washington County Mus. FA, Hagerstown, Md., 1949; ASL Scholarship, 1949-50; Ohio State Univ. Grad. Fellowship, 1953-1954; Texas WC Soc., 1958, 1959; Peoria A. Center, 1961; Lakeview Center A. & Science, Peoria, 1969. Work: Dallas Theological Seminary; Decorator Center, Dallas, Tex.; Regional A. Gal., N.Y.C.; Ohio State Univ.; Bradley Univ.; Collectors Gal., Amer. House, N.Y.C. and work in private colls. Exhibited: International House, N.Y., 1949-1950; NAD, 1955; Morris Gal., N.Y., 1955; Contemp. A. Gal., 1956; Laguan Gloria A. Mus., Austin, Tex., 1956-1957; Witte Mem. Mus., (2-man) 1958, 1959, 1962; DMFA, 1957; Texas Fine A. Assn. traveling exhs., 1956-1958; Peoria A. Center, 1960-1962; Eureka Col., Eureka, Ill., 1962; Springfield A. Mus. (Mo.), 1962; Feingarten Gal., Chicago, 1961, 1962; Univ. Illinois, 1965; Milwaukee, Wis., 1966; Bertha Schaefer Gal., traveling exh. textiles, 1966-1969; Religious Art exh., Cranbrook Acad. A., 1966; Sloan Gal., Valparaiso Univ. (2-man), Ind., 1966; Knox Col. (2-man), Galesburg, Ill., 1968; Madison AA, Wisc., 1968; Indiana Univ., 1968; Northern Ill. Univ., De Kalb, 1969; Albion Col., Mich., 1969; Springfield AA, 1969; Sherbeyn Gal. (2-man), Chicago, 1969; one-man: Washington County Mus. FA, 1956; State Teachers Col., Indiana, Pa., 1949; Ohio State Univ., 1956; Regional A. Gal., N.Y., 1956-1957; Southwest Texas State Col., San Marcos, 1957; Contemp. A. Gal., N.Y., 1961; Bradley Univ., 1960-1963; Sherman Gal., Chicago, 1969. Positions: Supv. A., Public Schs., Waynesboro, Pa., 1946-1949; Instr., State Univ. of New York at Buffalo, 1950-1953; Ohio State Univ., 1954; Asst. Prof., New Haven State Teachers College, 1955-1956; Faculty, School of Art, Bradley University, Peoria, Ill., 1961-1963.

BOARDMAN, SEYMOUR — Painter
234 W. 27th St. 10001; h. 334 E. 30th St., New York, N.Y. 10016
B. Brooklyn, N.Y., Dec. 29, 1921. Studied: City Col., N.Y., B.S.S.; ASL; Ecole des Beaux Arts, Paris; Academie de la Grande Chaumiere, Paris and with Fernand Leger, Paris. Awards: Longview Fnd., 1963. Work: WMAA; Guggenheim Mus.; WAC; Santa Barbara Mus. A.; N.Y. Univ.; Newark Mus.; Wagner Col., Staten Island, N.Y.; Geigy Chemical Corp.; Union Carbide, N.Y.; Brandeis Univ., Rose A. Mus.; Cornell Univ. and in private colls. Exhibited: WMAA, 1955, 1967; Albright-Knox Gal., Buffalo, 1967; Santa Barbara A. Mus., 1964; Basel, Switzerland, 1964; Nebraska AA, 1956; Butler Inst. Am. A., 1955; SFMA, 1955; Carnegie Inst., 1955; Salon de Mai, Paris, 1951; one-man: A. M. Sachs Gal., N.Y., 1965, 1967, 1968; Esther Robels Gal., Los Angeles, 1965; Stephen Radich Gal., Los Angeles, 1960-1962; Dwan Gal., Los Angeles, 1960; Martha Jackson Gal., N.Y., 1955, 1956; Galerie de Mai, Paris, 1951.

BOAZ, WILLIAM G.—Educator, S., P.
Chapman College; h. 346 N. Center St., Orange, Cal. 92666
B. Hickory, Ky., July 6, 1926. Studied: Murray State Col., with Clara Eagle; Univ. Louisville with Wilkje and Krause; Univ. Georgia, M.A. in Art Edu., with Lamar Dodd, Ferdinand Warren, Sibyl Browne; Hans Hofmann Sch. A., Provincetown, Mass.; Post-Grad., New York Univ., with Margaret Naumburg and Teachers Col., Columbia Univ., with Edwin Ziegfeld; Research in Japan on Haniwa sculpture. Awards: Chevalier Medal of the Royal Cambodian Government, 1962. Member: California A. Edu. Assn.; Orange County A. Edu. Assn. Exhibited: Louisville A. Center, 1952, 1956, 1957; H.C.E. Gal., Provincetown, 1956; Purcell Gal., Orange, Cal., 1963; Oxford, Miss., 1956, 1957; N.Y. Univ., 1963. Positions: A. Edu., Univ. Georgia, Athens, Ga.; Supv. A., Gainesville, Ga.; Asst. Prof. Sc. & A. Edu., Murray State Col., Murray, Ky.; Art Edu., consultant for the Cambodian government under auspices of U.S. Operations Mission, Unitarian Service Committee; Prof. A. Edu., and Sculpture, Chapman College, Orange, Cal., at present.*

BOBBITT, VERNON L.—Painter, E.
Albion, Mich. 49224
B. Pella, Iowa, July 27, 1911. Studied: State Univ. Iowa, B.F.A., M.A.; Denison Univ.; Columbia Univ. Member: Michigan Comm. on the Arts; Am. Assn. Univ. Prof.; Midwestern Col. AA; CAA. Exhibited: nationally. One-man Weyhe Gal., N.Y., 1956; Lowe Art Gal., Univ. Miami, 1964; Ft. Lauderdale, Fla., FA Gal., 1965; Battle Creek, Mich. Civic A. Center, 1965. Positions: Chm., A. Dept., Albion Col., Albion, Mich., 1946- .

BOBLETER, LOWELL STANLEY—Painter, E., Gr., L., W., Des.
School of the Associated Arts; h. 2040 Berkeley Ave., St. Paul Minn. 55105
B. New Ulm, Minn., Dec. 24, 1902. Studied: St. Paul Gal. & Sch. A. Member: SAGA; Chicago SE; Am. Assn. Mus. Dir.; Am. Assn. Univ. Prof.; Minnesota AA; AFA; Nat. Soc. Int. Des.; Int. Des. Educators Council. Awards: Prizes, Minneapolis State Fair, 1931, 1933, 1934, 1935, 1936, 1938; Minneapolis Inst. A., 1933, 1935-1937, 1939, 1940, 1942, 1943, 1945; Minneapolis Women's Cl., 1940, 1941; Prints

chosen by Walker A. Center, St. Paul Gal. & Sch. A., Collectors of Am. A., for "Presentation Print Prizes." Work: Smithsonian Inst.; Cal. State Lib.; SAGA; Chicago SE; Parkersburg FA Center; Minneapolis Inst. A.; PAFA; N.Y. Pub. Lib; Lib. Cong.; Walker A. Center; NGA; Flint AI; Hamline Univ.; Minn. Fed. Women's Cl.; MMA. Exhibited: SAE, 1931-1964; Chicago SE; NAD; Lib. Cong.; PAFA; 50 Prints of the Year; 100 Best Prints; regularly in national and international exhs. Numerous one-man exhs., 1941-1961. Lectures: Art History. Positions: Dir., St. Paul Gallery & School of Art, 1940-42; Dir. FA, Minn. State Fair, 1941-48; Minn. A. Comm., 1942- ; Prof. A., Chm. Sch. FA, Hamline Univ., 1942-48; Pres., Lowell Bobleter & Assoc., 1958- ; Pres., School of the Assoc. Arts, St. Paul, Minn., 1948- . Pres., Trustee, School of the Associated Arts Fnd., 1965- .

BOCCIA, EDWARD EUGENE—Painter, C., E.
600 Harper Ave., Webster Groves, Mo. 63119
B. Newark, N.J., June 22, 1921. Studied: PIASch.; ASL; Columbia Univ., B.S., M.A. Awards: prizes, Italian Government Fellowship Award for research and painting in Italy, 1958-1959; Bronze Medal, Temple Israel, St. Louis, Mo., 1962. Work: CAM; St. Louis A. Gld.; Metropolitan Church Federation, St. Louis; Kansas State College; Nelson Gal. A.; Lowe Gal., Univ. Miami; Temple Israel, St. Louis; stained glass, Clayton Inn, Mo.; Four Wall Paintings, First National Bank, St. Louis; Stations of the Cross, Old Cathedral, St. Louis; mural, Stations of the Cross and stained glass windows, Newman Chapel, Washington Univ., St. Louis; religious drawings, Temple Brith Sholom Kneseth Israel, St. Louis; paintings and drawings, Bel-Air Motel, St. Louis; Seton Hall Univ., So. Orange, N.J. Other work: Denver A. Mus.; Univ. Massachusetts; Drury College, Springfield, Mo.; St. Louis Univ. Exhibited: City A. Mus., St. Louis, 1951-1958, 1960, 1961; William Rockhill Nelson Gal. A., 1951, 1953, 1957, 1958, 1964, 1965; Washington Univ., St. Louis, 1956; Grand Rapids A. Gal., 1961; Retrospective (1945-1960), St. Louis Univ.; Jewish Community Center, St. Louis, 1963 (one-man); Webster College, Webster Groves, (one-man) 1963; Natl. Liturgical Art Show, St. Louis, 1964; Drury College, (one-man), 1965; Traveling Exhibition, sponsored by the Missouri State Council in the Arts, 1968 and others. Contributor to St. Louis Post-Dispatch and Washington University magazines. Positions: Dean, Columbus A. Sch., Columbus, Ohio, 1948-1951; Guest Instr., Univ., Saskatchewan, Canada, Summer Session, 1960; Webster Groves (Mo.) College, Summer Session, 1965; Prof. FA, Washington University, St. Louis, Mo., at present.

BOCK, VERA—Illustrator, Des.
318 W. 105th St., New York, N.Y. 10025
B. St. Petersburg, Russia. Studied: in Europe. Exhibited: N.Y. Pub. Lib.; Woodmere A. Gal., Phila., Pa.; A. Dir. Club, N.Y.; William Farnsworth Mus., Rockland, Me., 1952 (one-man), 1957. Work: Extensively represented in the Kerlan Collection, Univ. of Minnesota Library. Illus., and designs books for leading publishers. Illus., Life, Coronet magazines.

BODIN, PAUL—Painter
225 West 86th St., New York, N.Y. 10024
B. New York, N.Y., Oct. 30, 1910. Studied: NAD; ASL, with Boardman Robinson. Awards: special distinction award, Art:USA, 1958; Longview Fnd., 1958. Work: Dallas AA; Univ. W. Va.; Albright A. Gal. Exhibited: Audubon A., 1954; MMA, 1952; BM, 1949, 1959; Phila. A. All., 1949; Santa Barbara Mus. A., 1949; Ohio Wesleyan Univ., 1949; Yale A. Gal., 1949; Grand Central A. Gal.; Rose Fried Gal., 1958; Am. British A. Center, 1943-1945; Chas. Egan Gal., 1946; Parsons Gal., 1947, 1948; Argent Gal., 1950; Korman Gal., 1955; Spiral Group, 1951-1958; Springfield Mus. A., 1952; Univ. Maine, 1956; Art-USA, 1959; one-man: Playhouse Gal., 1936; Kohn Gal., 1937; Artists Gal., 1942; Laurel Gal., 1948, 1950; New Gallery, 1952; Betty Parsons Gal., 1959, 1961.

BOESE, ALVIN WILLIAM—Research, Collector
3 M Company, 2501 Hudson Rd. 55119; h. 803 Lincoln Ave., St. Paul, Minn. 55102
B. St. Paul, Minn., Mar. 24, 1910. Collection: Mainly Contemporary American Art, all media except sculpture. Positions: Mngr., Dept. devoted to research and development of improved surfaces for artists, 3 M Company, St. Paul, Minn.*

BOGART, GEORGE A.—Painter, E.
932 Ishler St., Boalsburg, Pa. 16827
B. Duluth, Minn., Oct. 30, 1933. Studied: Univ. Minnesota, Duluth, B.A.; Univ. Washington, Seattle, M.F.A., and with Fletcher Martin, Philip Evergood, Dong Kingman. Awards: Purchase prize, Witte Mem. Mus., San Antonio, 1960; purchase prize, Delgado Mus. A., New Orleans, 1964; purchase prize, Illinois State Univ., 1969; Teaching Excellence Award, Univ. Texas, Austin, 1962, 1965. Work: Witte Mem. Mus.; Delgado Mus. A. Exhibited: SAM, 1957-1959; Woessner Gal., Seattle, 1958, 1959; Minneapolis Inst. A.; Pacific Northwest Arts & Crafts Fair, Bellevue, Wash.; Western Washington State Fair, 1958; SFMA, 1958; A. Acad. Cincinnati, 1958; Cleveland Inst. A., 1958; Akron AI, 1958; Mass. Sch. A., Boston, 1958; PIASch., 1958; Atlanta AI, 1958; Memphis Acad. A., 1958; Henry Gal., Univ. Washington, 1959; Waco Art Forum, Tex., 1960; Witte Mem. Mus., 1960, 1962, 1963; Oklahoma A. Center, 1960; Beaumont A. Mus., 1960, 1961, 1963; Laguna Gloria Gal., Austin, 1960, 1961; Delgado Mus. A., 1961, 1964; Denver A. Mus., 1961, 1962; Arch. Lg., N.Y., 1961; DMFA, 1964, 1965; Mus. Contemp. A., Dallas, 1963; Mus. FA of Houston, 1963; Univ. of Texas Mus., 1963; New York World's Fair, 1964; Illinois State Univ., Normal, 1969; 2-man: Mobarus Gal., San Antonio, 1959; Univ. of Texas, 1967; 3-man: Valley House Gal., 1960; one-man: Univ. of Texas, 1962, also 1965; Midwestern Univ., Wichita Falls, 1965; Pa. State Univ., 1969; Pa. State Univ., Altoona Campus, 1969. Contributor to "Southwestern Art." Illus. "George Bogart Drawings and Paintings," 1967. Positions: Instr., Univ. Washington, Seattle; Prof. A., Univ. of Texas, Austin; Prof. A., Pa. State Univ., State College, Pa., at present.

BOGGS, FRANKLIN—Painter, E., S.
Beloit College; h. 2542 Hawthorne Dr., Beloit, Wis. 53511
B. Warsaw, Ind., July 25, 1914. Studied: Ft. Wayne A. Sch.; PAFA. Awards: Two Cresson Scholarships, Chas. Tappan award, PAFA; Gimbels Wisconsin Exh., prize, 1952; prize, Milwaukee Journal "Freedom of the Press" exh.; Fulbright research grant to Finland, 1958. Work: Abbott Laboratories Coll.; U.S. War Dept.; USPO, Newton, Miss.; murals, A. S. Aloe Bldg., New Orleans, La.; Mayo Clinic, Rochester, Minn., 1953; Corral Restaurant, Beloit, Wis.; Meyer Assoc., Milwaukee; Merchants & Savings Bank, Janesville, Wis.; tryptich, Marquette Univ., Milwaukee, Wis., 1954; mural, Crippled Children's School, Helsinki, Finland, 1958-59; Supervised assembling of American Indian exh., circulated & lectured on it, Finland & Sweden, 1958-59; mural, Alonzo Aldrich Jr. H.S., Beloit, 1960-61; Vocational Sch., Janesville, Wis., 1961; Concrete Murals: Yates American Machine Co., 1961, Univ. Wisconsin Math. Bldg., 1962, Cancer Research Bldg., 1963, all Madison, Wis.; Univ. Wisconsin-Milwaukee, 1964; Cutler-Hammer Office Bldg., Milwaukee, 1965. Exhibited: PAFA, 1939, 1950. Illus., "Men Without Guns," Army medical paintings reproduced in art magazines. Series of paintings for Trostel Tanneries, Brussels, exhibited nationally and published. Positions: I., T.V.A., 1940-44; War Artist, 1944; Chm. A. Dept., Beloit Col., 1955- ; Artist-in-Residence, Beloit Col., 1945- .*

BOGHOSIAN, VARUJAN—Sculptor, E.
Dartmouth College; h. 14 Valley Rd., Hanover, N.H. 03755
B. New Britain, Conn., June 26, 1926. Studied: Vesper George Sch. A., Boston; Yale Univ. Sch. A. & Architecture, B.F.A., M.F.A. Awards: Fulbright Grant to Italy, 1953; Howard Fnd. Fellowship, 1967; Sculptor-in-Residence, Am. Acad. in Rome, 1967. Work: WMAA; MModA; AGAA; WMA; R.I. Sch. Des. Mus.; New Britain (Conn.) Mus. American A. Exhibited: WMAA, 1963, 1964, 1966, 1968; one-man: Stable Gal., N.Y., 1963-1966; Cordier & Ekstrom Gal., N.Y., 1969. Positions: Prof., Sculpture, Dartmouth College, Hanover, N.H. at present. Also taught at Univ. of Florida; Pratt Institute, Brooklyn, N.Y.; Cooper Union, New York City; Brown Univ.; Drawing, Yale Sch. Architecture.

BOHAN, PETER—Scholar, Art Gallery Director
Art Gallery, State University College, New Paltz, N.Y.; h. 10 Huguenot St., New Paltz, N.Y. 12561
B. New York, N.Y. Studied: Univ. Bristol, England; Rensselaer Polytechnic Inst., B. Eng.; Columbia Univ.; Yale Univ., M.A., Ph.D. Awards: Fulbright Scholar, England, 1958-1959; Yale Univ. Fellowships, 1955-1960; State Univ. of New York Research Grant, 1964. Author: American Gold, 1700-1860. Field of Research: Architectural History, especially 18th and 19th Cent. British. Positions: Dir., Colonial Arts Foundation; Pres., Ninety Miles Off Broadway (Theatre Company); Prof. History of Art, Art Gallery Dir., State University College, New Paltz, N.Y.*

BOHNERT, ROSETTA (Mrs. Herbert)—Painter, W., T., L.
243 South Broadway, Hastings-on-Hudson, N.Y. 10706
B. Brockton, Mass. Studied: Univ. Rhode Island; Sch. App. Des., N.Y., and with Olaf Olesen, Maud Mason, Walter Farndon. Member: Contemp. Cl., Greenwich, Conn.; Academic A., Springfield, Mass.; AAPL; Hudson Valley AA (Past Pres.); All. A. Am.; Catherine Lorillard Wolfe A. Cl. Work: Brueckner Mus. Awards: prizes, Hudson Valley AA, Gold medal & citation, 1961; NAC; Wolfe A. Cl., and others. Exhibited: traveling exh., Studio A. Gld.; AAPL; NAC; All. A. Am.; Hudson Valley AA; Wolfe A. Cl. Positions: Dir. Natl. Bd., AAPL.; Vice-Pres., Hudson Valley AA; Nat. Dir., Council of Am. Art Soc.

BOHROD, AARON—Painter
4811 Tonyawatha Trail, Madison, Wis. 53716
B. Chicago, Ill., Nov. 21, 1907. Studied: Crane Col., Chicago; AIC;

ASL; Ripon (Wis.) College, Honorary D.F.A., 1961. Member: NA. Awards: prizes, AIC, 1933 (2), 1934 (2), 1935, 1937, 1945, 1947; GGE, 1939; Carnegie Inst., 1939; Cal. WC Soc., 1940; PAFA; MMA; CGA, 1943; Ill. State Fair, 1955; Old Northwest Territory Exh., 1954; NAD, 1961, 1965; Guggenheim F., 1936, 1937. Work: MMA; WMAA; AIC; BM; BMA; PAFA; CGA; Detroit Inst. Arts; Swope Gal. A.; Walker A. Center; Butler AI; Telfair Acad. A.; Cranbrook Acad. A.; Witte Mem. Mus.; Davenport AI; Springfield Mus. A.; Norton Gal. A.; New London, Conn.; Bergstrom A. Center, Appleton, Wis.; Oshkosh (Wis.) Pub. Museum; Evansville (Ind.) AI; Universities of Neb., Ariz., Ill., Ohio, Wis., Mo.; Lawrence Col.; Ripon Col.; Syracuse Univ.; ceramics (with F. Carlton Ball) CMA; Detroit Inst. A.; Univ. Illinois; murals, USPO, Vandalia, Clinton, and Galesburg, Ill. Author: "A Pottery Sketchbook," 1959; "A Decade of Still Life," 1965. Positions: A.-in-Residence, So. Illinois Univ., 1941-42; A., War Correspondent, Life Magazine, 1942-45; A.-in-Residence, Univ. Wisconsin, 1948- ; Instr., Ohio Univ. (summer), 1949, 1954; Ball State T. Col. (summer), 1952; No. Michigan Col. (summer), 1953.

BOLLES, JOHN—Art Dealer
 Bolles Gallery, 729 Sansome St., San Francisco, Cal. 94111*

BOLLEY, IRMA (SAILA)—Painter, Des.
 79 Redmont Rd., Watchung, N.J. 07060
B. Turku, Finland, Aug. 28, 1909. Studied: Massachusetts Col. of Art, and with F. Douglas Greenbowe and Joe Jones. Member: NAWA; New Jersey WC Soc.; Hunterdon A. Center; Summit (N.J.) A. Center. Designer-Consultant for McCall Needlework & Crafts Pubs., specializing in stitchery paintings and rugs; travel assignments to Europe and South America to research design and crafts for the magazine, 1950- . Other work (freelance) in applied art, crafts and interior decor. First prize mixed media (stitchery painting) Summit (N.J) A. Center, 1967. Work in private collections.

BOLLINGER, WILLIAM—Sculptor
 c/o Bykert Gallery, 24 E. 81st St., New York, N.Y. 10019*

BOLOMEY, ROGER (HENRY)—Sculptor, P., E., L.
 Wingdale, N.Y. 12594
B. Torrington, Conn., Oct. 19, 1918. Studied: Univ. Lausanne, Arch. Des.; Acad. FA, Florence, Italy; Cal. Col. A. & Crafts, Oakland, and with Alfredo Cini, in Switzerland. Member: San Francisco A. Inst.; AFA. Awards: prizes, San Jose State Col., 1962; Int. Sculpture Comp., Bundy Gal., Waitsfield, Vt., 1963; San Francisco A. Inst., 1965; "New Talents" Arts in America, 1966; Sculpture Comp., Nassau County, N.Y., 1967; Finalist, CGA Playground Sculpture Comp., 1967. Work: MModA; WMAA; Los Angeles County Museum; Oakland Mus.; Univ. California, Berkeley; Larry Aldrich Mus., Ridgefield, Conn.; Bundy A. Gal.; Chase Manhattan Bank Coll.; CGA. Mural, San Jose State Col.; fountain sculpture, Milwaukee; sculptures for New York State Office Bldgs., Albany, in process. Exhibited: Salon de Mai, Paris, France, 1963, 1964; New Acquisitions, WMAA, 1964; Sculpture Annual, WMAA, 1964, 1966; Larry Aldrich Mus., 1964, 1965, 1967; Carnegie Int., 1964; Switzerland, 1966; Amerikanische Kunst aus Schweizer Besitz, St. Gallen, Switzerland, 1966; Univ. Illinois, 1967; Hemisfair, San Antonio, Tex. Lectures: History of 20th Century Sculpture, Survey of Today's Art at Herbert H. Lehman College (formerly Hunter College). Positions: Prof., Herbert H. Lehman Col., New York.

BOLOTOWSKY, ILYA—Painter, T., S., W., L.
 Southampton College of Long Island University, Southampton, L.I.; h. John St., Sag Harbor, L.I., N.Y. 11963
B. Petrograd, Russia, July 1, 1907. Studied: Col. St. Joseph, Constantinople, Turkey; NAD. Member: Am. Abstract A.; Fed. Mod. P. & S. Awards: prize, NAD, 1924-25, 1929-1930; Tiffany & Yaddo Fnd. scholarships, 1929, 1930, 1934; Guggenheim F., 1942; Univ. Wyoming Grad. Sch. Grant, for experimental and creative film work, 1953, 1954; first prize, experimental film "Metanoia," Midwest Film Festival, 1963. Work: PMA; PMG; Guggenheim Mus.; WMAA; MModA; Chase Manhattan Bank; Lyman Allyn Mus. A.; Union Carbide; Continental Grain Co., and in France and Sweden; Munson-Williams-Proctor Inst.; Yale Univ. Gal. A.; Brandeis Univ.; Frederick Olsen Fnd.; Rock Springs (Wyo.) H.S.; Univ. Wyoming College of Agriculture; murals, Williamsburgh Housing Project; WFNY, 1939; Cinema I, New York City, N.Y.; Theodore Roosevelt H.S.; Hospital for Chronic Diseases, N.Y.; Phillips Steel Co., Pittsburgh, Pa.; SFMA; Sheldon Mem. Gal., Univ. Neb.; Albright-Knox A. Gal.; Larry Aldrich Mus. of Contemp. A. Exhibited: Carnegie Inst., 1946-1948; MModA, 1939-1961; WMAA, 1938, 1950, 1952-1961; CGA, 1934; SFMA; Riverside Mus.; New Art Circle (one-man), 1946, 1952; Pinacotheca (one-man), 1947; Rose Fried Gal. (one-man), 1950; Grace Borgenicht Gal. (one-man), 1954, 1956, 1958, 1959, 1961, 1963, 1966, 1968; Realites Nouvelles Salon, Paris, 1947, 1949, 1952; Mus. Mod. A., Tokyo, Japan, 1955; N.Y. State Univ., Stony Brook, (one-man),

1968; retrospective, State Univ. of Wisconsin, Whitewater, 1967; Contemp. Am. Painting, Paris and other cities in France, 1956-57; Western Germany, 1956-57; Hawaii, Latin America & many others in U.S. Positions: Actg. Hd., Dept. A., Black Mountain Col. (N.C.), 1946-48; Asst. Prof. A., 1948, Assoc. Prof. A., 1953, Univ. of Wyoming, Laramie, Wyo. (On leave from Univ. Wyoming 1954-56; teaching Brooklyn Col. Dept. A., Brooklyn, N.Y.); Prof. A., State University of New York, State T. College, New Paltz, N.Y., 1957- ; Chm. FA Dept., Southampton College, Southampton, L.I. N.Y.; Adjunct Prof., Hunter College, New York, N.Y. 1963-64. Film seminar, Wisconsin Univ., Whitewater, 1968; visiting Prof. A., Univ. New Mexico, Albuquerque. Ed. Comm., "World of Abstract Art," 1957; Articles in "Realities Nouvelles," 1947, 1949, 1952; Article-interview in "Naum Gabo," 1958. Article and play published in "Leonardo," 1969 and "The Quest," 1968; three portfolios of serigraph prints. Books: "Russian-English Dictionary of Art," 1962.

BOLSTER, ELLA S. (Mrs. H. G.)—Craftsman, L.
 6391 E. Printer Udell, Tucson, Ariz. 85710
B. Helena, Montana, Dec. 8, 1906. Studied: Montana State Col.; Colorado State Col., with Alexander Bick; weaving, with Mary M. Atwater, Montana State Univ.; hand-weaving of Gold Brocades, National College, Tehran, Iran; pottery, with Pieter Gruenfeldt, The Hague, Holland; weaving, with Anni Albers, Haystack Mountain Sch. Crafts, Liberty, Me. Member: Des-Weavers of Washington (Hon. Life Memb.); Natl. Lg. Am. Pen Women (State Pres., 1968-70, Branch Art Chairman, 1966-69). Awards: prizes, Smithsonian Inst., 1954, 1956, 1958; Wichita A. Mus., 1955 (purchase); St. Paul Gal. A., 1955; CGA, 1955; Norfolk Mus. A., 1956; Nat. Lg. Am. Pen Women, 1957, 1964, 1st in SW Region, 1967; Women's Intl. Expo., New York City, 1957 (3 firsts); 1958, 1959, (2 firsts & 1 second), 1960 (2 firsts), 1961 (2); Arlington A. Festival, 1958-1960, 1961, 1962; State Fair, Richmond, 1958-1960, 1961; Merit Award, Arizona Crafts, 1966 (Tucson Art Center). Work: St. Mary's Episcopal Church, Arlington, Va.; Wichita AA Gallery. Exhibited: Intl. Textile Exch., Women's Col., Greensboro, N.C., 1954; Wichita A. Mus., 1955; St. Paul A. Gal., 1955; Women's Intl. Expo., 1957-1961; Nat. Lg. Am. Pen Women, 1957-1964; Univ. Nebraska, 1959-1961 (exh. toured 8 other museums, 1959); Univ. Southwestern Louisiana, 1961; Chesapeake Area Exh. of Crafts, 1954, 1956, 1958; Creative Crafts, Smithsonian Inst., 1954, 1956, 1958, 1960, 1962; CGA, 1954-1959; Virginia Artists, Richmond, 1955; BMA, 1957; State Fair, Richmond, 1958-1961; Arlington A. Festival, 1958-1962; one-man: Pen-Arts Bldg., Wash. D.C.; Artists' Mart; Domino Gal.; Studio Gal., Wash., D.C.; Miami Design Derby, 1961; Watkins Gal., Wash. D.C., 1962; Ariz. State Fair, 1964; Tucson A. Center, 1965, 1967-1969; Arizona Crafts, Tucson, 1965. Author: Vol. 2, 1961, "Practical Weaving Suggestions," publ. by Lily Mills Co.; article on Exhibiting, in Handweaver & Craftsman Magazine, 1961. Lectures: Hand Weaving as a Creative Art; Good Design in Hand Weaving, etc. Positions: Instr., Creative Stitchery, Univ. Arizona, 1967- .

BOLTON, MIMI DUBOIS—Painter, L., T.
 12504 Rolling Rd., Potomac, Md. 20854
B. Gravlotte, France, Dec. 12, 1902. Studied: Marquette Univ.; Corcoran Sch. A.; Phillips Mem. Sch., and with Richard Lahey, Karl Knaths. Member: Wash. Soc. A.; Wash. Gld. A.; NAWA; AEA. Awards: prizes, Wash. Soc. A., 1951, 1952 (2), 1958, 1960, Alonzo Aden prize 1962; CGA, 1954; BMA, 1952; Nat. Jury Show, Tyler, Tex.; Chautauqua, 1961. Work: CGA; The White House, Wash., D.C. Exhibited: BMA, 1952, 1954, 1955, 1961, 1962; BMFA, 1955; Toledo Mus. A., 1957; Butler Inst. Am. A., 1952, 1965; Audubon A., 1954; New York City Center, 1955; NAWA, 1954, 1955; AFA traveling exh., 1956-1957; Acad. A. & Sc., Richmond, Va., 1949; U.S. State Dept. traveling exh. to Vienna and Central Europe auspices of Franz Bader Gal., 1959- ; U.S. State Dept. exh. to Turkey, 1958- ; Wash. Soc. A., 1940-1961; Wash. A. Gld., 1950-1959; CGA, 1949-1963; Pan Am. Union, 1955; Franz Bader Group Shows, 1950-1969; Wilson T. Col., 1957, 1958; Terre Haute Mus. A., 1949; American Univ., 1958; Turkish Embassy, 1958; Barnet Aden Gal., Wash. D.C., 1955-1961; Sarasota AA, 1959, 1960; Chautauqua Nat., 1960-1964; George Washington Univ., 1965, and many local exhs., 1938-1969; One-man: Miami, Fla., 1959; CGA, 1956, 1963; BMA, 1952, 1961; Henry Thompson Gal., N.Y.; 1950; Silver Spring (Md.) A. Center, 1950; A. Cl., Wash. D.C., 1945; Alexandria (Va.) Library, 1949; Bader Gal., 1960, 1966, and 1968; Avant-Garde Gal., N.Y., 1959; Bridge Gal., N.Y., 1966, and others locally. Author: children's book, "Merry-Go-Round Family," 1954; Art In Embassies Program, State Dept., 1967-68-69.

BOMAR, BILL—Painter
 Hotel Chelsea, 222 West 23rd St., New York, N.Y. 10010; h. 1503 Hillcrest St., Fort Worth, Tex. 76107
B. Fort Worth, Texas. Work: BM; Mus. FA of Houston; Fort Worth A. Center; DMFA; Des Moines A. Center. Exhibited: 6 one-man exhs., Weyhe Gal., New York City most recent, 1964.*

BOND, ROLAND S.—Collector
2600 Republic National Bank Bldg. 75201; h. 4600 Brookview Dr., Dallas, Texas 75220
B. Van Alstyne, Tex., Dec. 25, 1898. Collection: Contemporary French Artists. Positions: Trustee, Dallas Museum of Fine Arts.

BONGART, SERGEI—Painter, T., L.
533 W. Rustic Rd., Santa Monica, Cal. 90402
B. Kiev, Russia, Mar. 15, 1918. Studied: Kiev Acad. Arts (Grad.). Member: AWS; Royal Soc. Arts, England; NAD; Nat. Soc. Painters in Casein. Awards: prizes, Mid-South Exh., 1952; Nat. Am. Exh., Los Angeles, 1955 (2); AAPL, 1959; Cal. State Fair 1959 (2); Cal. AC, 1957; Laguna Beach AA, 1962; Los Angeles County Fair, 1961; Frye Mus. A., Seattle, Wash., 1962, 1964; AWS, 1965, silver medal, 1969. Medals: Painters & Sculptors Club, Los A., 1957, 1958; (gold medal, 1955); Valley Artists Gld., 1956; Nat. Orange Show, 1958; Grand Nat. Medal, AAPL, 1959; Soc. Western A. award, 1968; Int. WC Exh., San Diego, 1967; Work: Kanev Mus., Kanev, Russia; Theatre Mus., Kiev, Russia; Sacramento, Cal., State Fair Coll.; Frye Mus., Seattle, Wash.; NAD; Laguna Beach AA. Exhibited: Brooks Mem. Gal., Memphis; Los A. Mus. A.; NAD; Laguna Beach A. Gal.; Oakland A. Mus.; Frye Mus. A.; Univ. So. Cal., Fisher Gals., Univ. of Santa Clara Gal.; Cowie Gal.; Hatfield Gal., both Los A.; Santa Cruz A. Lg.; All-California Exh., Laguna Beach; Cal. State Fair; AWS traveling exhs.; NAD, 1965; MMA; Mus. of Ukranian A. and Ukranian Acad., Kiev, Russia; AWS; PAFA; M.H. de Young Mem. Mus., San F.; Butler Inst. Am. A.; Oklahoma City A. Center; Watercolor: U.S.A., Springfield, Mo.; one-man: Cowie Gal., Los A., 1958, 1967, 1968; Frye Mus. A., 1962, 1964; Laguna Beach A. Mus., 1959; Laguna Beach A. Gal., 1964, 1968; Simon Patrick Gal., Los Angeles, 1967, 1968; Ventura A. Forum Gal., 1967; Oklahoma City A. Center, 1968. Positions: Instr., Bongart Sch. of Art; Laguna Beach Sch. of A. & Des.; Sch. of Art, Seattle, Wash.

BONGIORNO, LAURINE MACK (Mrs.)—Educator
19 North Park St., Oberlin, Ohio
B. Lima, Ohio, Apr. 17, 1903. Studied: Oberlin Col., A.B.; Radcliffe Col., Ph.D. Member: CAA. Contributor to: College Art Bulletin; Allen Mem. A. Mus. Bulletin. Positions: Asst. Prof. A., 1930-42, Assoc. Prof. A., Wellesley (Mass.) College, 1942-44; Lecturer in Fine Arts, Oberlin College, 1956-1966; Ed., Allen Mem. A. Mus. Bulletin, Oberlin, Ohio, 1950-1967.

BONINO, ALFREDO—Art dealer
Bonino Gallery, 7 West 57th St., New York, N.Y. 10019*

BONSIB, LOUIS WILLIAM—Painter
Bonsib Advertising Agency, 927 South Harrison St.; h. 3322 N. Washington Rd., Ft. Wayne, Ind. 46804
B. Vincennes, Ind., Mar. 10, 1892. Studied: Indiana Univ., A.B.; Vincennes Univ.; Univ. Illinois; Univ. Cincinnati. Member: Indiana AA; Hoosier Salon; Ft. Wayne A. Sch. & Mus. Assn.; "The Twenty" Club; Brown County AA; Northern Indiana AA; Van Wert (Ohio) AA. Work: Indianapolis and Ft. Wayne Pub. Schs.; Veterans Hospital, Marion, Ind.; Lincoln Natl. Life Ins. Co. (7 paintings in home office bldg.) Indiana Inst. Technology (52 paintings); Ft. Wayne State Sch., Ft. Wayne; Indiana Univ.; Hanover Univ.; Fed. Women's Cl.; Gary (Ind.) Pub. Schs; 25 paintings in main office and branches of Lincoln Natl. Bank & Trust Co. of Fort Wayne; Allen County Nursing Home. Exhibited: Ogunquit AA, 1949, 1950; Tate Gal., Terre Haute; South Bend AA; Ft. Wayne AA; Hoosier Salon (over 20 years); No. Indiana A. Salon (annually); Ft. Wayne Woman's Cl.; Indiana AA, annually, and many one-man exhs. and awards. Positions: Pres., Bd. Dir., Ft. Wayne Art School & Museum Assn., 1949-1952.

BONTECOU, LEE, (Miss)—Sculptor
c/o Leo Castelli Gallery, 4 E. 77th St., New York, N.Y. 10021
B. Providence, R.I., Jan. 1931. Studied: ASL. Awards: Fulbright F., Rome, 1957-1958; Tiffany Fnd. Award, 1959; CGA, 1963. Exhibited: WMAA; Lincoln Center, N.Y.; Pasadena A. Mus., 1964; Spoleto, Italy, 1958; one-man: Gallery G., N.Y., 1959; Leo Castelli Gal., N.Y., 1960, 1962.*

BOOKATZ, SAMUEL—Painter
2700 Que St., N.W., Washington, D.C. 20007
B. Philadelphia, Pa., Oct. 3, 1910. Studied: John Huntington Inst., Cleveland, Ohio; Cleveland Sch. A.; BMFASch.; Grande Chaumiere, Paris, Am. Acad. in Rome. Member: NSMP. Awards: F., BMFASch.; prizes, CMA; Hallmark award, 1949, 1952, CGA, 1952, 1953, 1955, 1956, 1959; Birmingham Mus. A., 1956; Butler Inst. Am. A., 1958; Soc. Wash. A., 1957; Wash. WC Cl., 1959; Scholarship, Instituto de Allende, San Miguel, Mexico, 1954; XXI Am. Drawing Biennial, 1964. Work: CGA; PC; Barnet Aden Gal.; Smithsonian Inst.; CMA; Milwaukee AI; LC; PAFA; Rochester Mus. A.; Birmingham Mus. A.; Butler Inst. Am. A.; Municipal Court Art Trust, Wash. D.C.; Amherst Col.; Norfolk Mus. A. & Sciences; Court of Appeals,

Wash. D.C.; Franklin Roosevelt Mem. Lib., Hyde Park N.Y.; murals & portraits, Navy Hospitals, Phila., Pa., Wash., D.C., Norfolk, Va., Bethesda, Md. Work also in private coll. & indst. firms. Exhibited: CGA, 1944, 1953-1955; PAFA, 1947-1960; CMA, 1930-1946; VMFA, 1940; Univ. Illinois, 1953; Butler AI, 1955; BMA, 1955; Ill. State Fair, 1948; one-man: Paris, France, 1938; Cleveland Inst. A., 1940; CGA, 1948; U.S. Nat. Mus., Wash. D.C., 1950. Positions: Instr., Dir., Samuel Bookatz Gal. A., Washington, D.C. and Upperville, Va.

BOOKBINDER, JACK—Painter, Lith., E., L., W.
323 South Smedley St., Philadelphia, Pa. 19103
B. Odessa, Ukraine, Jan. 15, 1911. Studied: Univ. Pennsylvania, B.F.A. in Edu.; PAFA, with Henry McCarter, Daniel Garber; Tyler Sch. FA, M.F.A., and European study. Member: AEA; Phila. A. All.; Phila. WC Cl.; Audubon A.; Phila. Pr. Cl.; NAEA; Eastern AA; Pr. Council of Am.; AWS. Awards: F., Barnes Fnd., 1938, 1939, F., Pa. Sch. Social Work, Univ. Pa., 1935-36; prizes, PAFA, 1947, 1952, 1953; LC, 1951; Tyler Sch. FA, 1950, 1951, 1955; Rochester Pr. Cl., 1948; Phila. A. T. Assn., 1950; DaVinci All., 1949, 1964, silver med., 1952; Pennell Mem. medal, Phila. WC Cl., 1957; F., Tyler Sch. FA, Temple Univ., 1958, prize, 1964; Mong Q. Lee Mem. award, AWS, 1961; William Church Osborn Memorial Award, 1968. Work: PAFA; LC; PMA; Yale Univ.; Tyler Sch. FA; Woodmere A. Gal.; New Britain Inst.; Lessing J. Rosenwald Coll.; Kutztown State. T. Col. (Pa.); Converse Col. (S.C.); and in private colls. Exhibited: annually PAFA, 1944- ; annually Phila. A. All., 1948- ; LC, 1945, 1946, 1949, 1951, 1964; Phila. Pr. Cl., 1944-1963; DaVinci All., 1944-1955; Woodmere A. Gal., annually 1944- ; CGA, 1945, 1951, 1953, 1957; Albany Inst. Hist. & A., 1945; PMA, 1946, 1955, 1961, 1964; Assoc. Am. A., 1946; SAM, 1947; Rochester Pr. Cl., 1948; Carnegie Inst., 1949; Phila. Sketch Cl., 1949-1957; BM, 1949; Phila. WC Cl., annually 1947- ; Contemporary A. Assn., 1950, 1951; Tyler Sch. FA, annually 1947- ; Butler AI, 1955, 1956, 1958, 1961; AWS, 1956; Traveling Art, Inc., 1955, 1956, 1957; Royal Acad., London, 1962; U.S. State Dept., abroad, 1962; Mus. FA, Abilene, Tex.; Reading (Pa.) Mus. A. MMA, 1966; Fifty American Watercolorists, Mexico City, 1968. One-man: PAFA, 1953; Phila. A. All., 1954, 1964; Woodmere A. Gal., 1955; Atlantic City, 1958; Hager Gal., Lancaster, Pa., 1958; Nessler Gal., N.Y.C., 1961. Positions: L. Barnes Fnd., 1936-44; Pa. State Col., 1950; Univ. Pa., 1947-1959; PAFA, 1949-1961; Consultant Edu. Div., PMA, 1944-45; Asst. to Dir. A., Bd. Edu., Phila., Pa., 1945-1959; Dir. A. Edu., Bd. of Edu., Phila., Pa., 1959- ; Producer & Moderator of series of television programs on art over Philadelphia stations. Contributor to: Compton's Encyclopedia, 1955; American Artist magazine, NAEA Journal, Nat. A. Educ. Assn. Yearbook, Eastern AA Research Bulletin, School Arts Magazine. Author booklets: "Invitation to the Arts," 1944; " The Gifted Child—His Education in the Philadelphia Public Schools"; "Art in the Life of Children," 1957.

BOPP, EMERY—Educator, P., S., Des.
Bob Jones University, Greenville, S.C. 29614; s. Hillsdale, Route 2, N.Y. 12529
B. Corry, Pa., May 13, 1924. Studied: PIASch.; Yale Univ., Sch. Painting & Design, B.F.A., with Josef Albers, William de Kooning; N.Y. Univ.; Rochester Inst. Tech., M.F.A. Member: Southeastern College A. Conf.; Gld. South Carolina A. (Treas, 1961-62, V.-Pres. 1963-64, Pres. 1964-65); CAA; Intl. Platform Assn. Exhibited: Hunter Gal. A., Chattanooga (purchase award), 1965; Invitational Exh., Butler Inst. Am. A., 1966; Birmingham Mus. A., 1966; Southeastern Exh., Atlanta (merit award), 1967; Greenville County Mus. A. (purchase award), 1968; Bob Jones Univ., 1962-1964. Work: Addison Gal. Am. A., Andover, Mass.; George T. Hunter Gal., Chattanooga, Tenn.; Greenville County Mus. A., Greenville, S.C. Positions: Chm. Division of Art, Bob Jones University, Greenville, S.C. 1955- .

BORGATTA, ISABEL CASE—Sculptor, L.
320 Clinton Ave., Dobbs Ferry, N.Y. 10522
B. Madison, Wis., Nov. 21, 1921. Studied: Smith Col.; Yale Univ. Sch. FA, B.F.A.; ASL, and with Jose de Creeft. Awards: prizes, Village A. Center, 1946; NAWA, 1952; sc. award, Village A. Center, 1951; Silvermine Gld. A., 1959, 1960; Hudson River Mus., 1960; Yonkers AA, 1960; Jacques Lipchitz Award, Hudson River Mus., 1963; MacDowell Colony Fellowship, 1968. Work: Wadsworth Atheneum, Hartford, Conn.; Norfolk Mus. A., Norfolk, Va. Exhibited: PAFA, 1950-1952, 1954; WMAA, 1954; Audubon A., 1947-1961; NAD, 1949; NAWA, 1952, 1953; Riverside Mus., 1949, 1950, 1953; Laurel Gal., 1949, 1950; RoKo Gal., 1947-1950; LaVista Gal., 1950; Van Loen Gal., 1950, 1951; Penthouse Gal., 1951; New Haven Paint & Clay Cl., 1943, 1944; Village A. Center, 1946, 1947, 1951; Silvermine Gld. A., 1954, 1955, 1959, 1960; New Jersey P. & S., 1945, 1947; Hudson River Mus., 1959-1961; Knoedler Gal., 1960; Scarborough, N.Y., 1965; one-man: Village A. Center, 1947; Peoria (Ill.) Pub. Lib., 1951; Galerie St. Etienne, 1954; Tyringham (Mass.) Gal.,

1955; Gallery 10, 1960; Exhibits Unlimited, 1963; Frank M. Rehn Gal., 1968. Article & repro. in Life, 1954. Positions: L., Art Dept., City College of New York, at present.

BORGATTA, ROBERT E.—Painter, E., S.
320 Clinton Ave., Dobbs Ferry, N.Y. 10522
B. Havana, Cuba, Jan. 11, 1921. Studied: NAD; N.Y. Univ. Sch. of Architecture & Allied Arts, B.F.A.; Yale Univ. Sch. FA, M.F.A.; N.Y. Univ. Inst. FA. Member: Audubon A.; Yonkers AA; AWS; Nat. Soc. Painters in Casein. Awards: N.Y. Univ. Chancellor's F., 1939; Tiffany F., 1942; Emily Lowe award, 1957; Chautauqua AA, 1955; Silvermine Gld. A., 1954, 1956; Nat. Soc. Painters in Casein, 1961, 1969; Audubon A. 1959, 1969; Brooklyn Soc. A., 1959; Tarrytown, N.Y., 1964. Work: Ford Fnd.; Norfolk Mus. A. Exhibited: PAFA, 1957; WMAA, 1954; CGA, 1940, 1965-1969; All. A. Am., 1946, 1951-1965; Audubon A., 1953-1969; AWS, 1955, 1957, traveling exh., 1961, 1964; Nat. Soc. Painters in Casein, 1957, 1958-1969; Schettini Gal., Milan, 1957; Associated Gal., Detroit, 1955, 1956; Los A. AA, 1952; Ft. Worth Mus. A., 1950; Riverside Mus., N.Y., 1956, 1958, 1960; Kaufman Gal., N.Y., 1955; RoKo Gal., N.Y., 1950; Weyhe Gal., 1945; Chautauqua AA, 1954; Ross Gal., White Plains, N.Y., 1957, 1958; New Sch. for Social Research, N.Y., 1957; Brooklyn Soc. A., 1957-1964; Eggleston Gal., 1957; Schanen Stern Gal., 1960; Yonkers AA, 1958-1960; Hilda Carmel Gal., 1959; Babcock Gal., N.Y., 1964-1969; Bass Mus., Miami, Fla., 1964; N.Y. Worlds Fair, 1964; Norfolk Mus. A., 1963; Gillary Gal., Jericho, L.I., N.Y., 1962-1964; MIT, 1962; PMA, 1966, 1968; MModA, (lending), 1966, 1968; Grumbacher traveling exh., 1968-1969; one-man: Wellons Gal., 1954; Tyringham (Mass.) Gal., 1954, 1955; Peoria (Ill.) Pub. Lib., 1954; City Col., N.Y., 1958; Babcock Gal., 1964, 1969; Exhibits Unlimited, Ardsley, N.Y., 1963. Positions: Assoc. Prof., City College of New York.

BORGHI, GUIDO RINALDO—Painter, S., T.
335 Fordham Pl., City Island, N.Y. 10464
B. Locarno, Switzerland, Mar. 29, 1903. Studied: Europe and New York. Member: Soc. Animal Artists; Soc. Indp. A. Awards: prize, Yorktown Heights Exh., 1957. Work: mural, Lexington Sch. for Deaf & Dumb Children, N.Y.; Minadoka County Grange, Idaho; Adamo Restaurant, N.Y.; East River Savings Bank; Rockefeller Center Bank. Exhibited: CGA, 1939; NAD, 1940; Roerich Mus., 1936; Salon of America, 1934; Boise Mus. A., 1941; Soc. Indp. A., 1937; Mun. A. Gal., N.Y.; Contemporary A. Gal.; Heyburn AI (Idaho); Gramercy Gal.; Hudson (N.Y.) Pub. Lib.; Yonkers Mus. A.; Burr Gal., N.Y.; Lever House, N.Y.C., 1964; Kennedy Gal., N.Y.C.; Mus. Science & Natural History, St. Louis, Mo., 1969; Manufacturers Nat. Bank of Detroit, 1969; Boston Mus. of Science, 1969. Positions: A. Instr., Shell Oil Art Class, 1959-61; Equitable Life Ins. Co. art classes, Recreation Art & Sculpture classes, Radio City, N.Y., 1962- .

BORGZINNER, JON—Writer, Cr.
Jericho Lane, East Hampton, L.I., N.Y. 11937
B. New York, N.Y., Jan. 14, 1938. Studied: Yale Univ., B.A.; Institute d'Art et d'Archeologie, Univ. of Paris (Fulbright Grant). Member: Municipal A. Soc.; consultant, Anonymous Arts Recovery Soc., 1964- . Awards: Bausch & Lomb Medal for outstanding criticism of optical art, 1964; The Chaddford Society's prize for essays on contemporary British graphics, 1965; The Daumier Society award for research in contemporary posters, 1968. Positions: Art Editor, Time Magazine, New York, N.Y., 1963-1967; Assoc. Editor, Life Magazine, 1967-1969; Freelance writer and critic.

BORHEGYI de, STEPHAN—Museum Director, E., W.
c/o Milwaukee Public Museum, 800 West Wells St., Milwaukee, Wis. 53233
B. Budapest, Hungary, Oct, 17, 1921. Studied: Péter Pázmány Univ., Budapest, Ph.D.; Yale Univ., Post doctoral research F. Member: Am. Anthropological Assn.; Soc. for Am. Archaeology; AAMus.; Spanish Colonial Arts Soc.; Royal Anthropological Soc. of Great Britain and Ireland (F.); Oklahoma Anthropological Soc.; Mountain Plains Mus. Assns.; Oklahoma Acad. Science, and many others. Awards: Diploma of Merit by the Guatemalan Govt. for reorganization of the Guatemalan National Museum, 1951. Articles contributed: "Installation of Archaeological and Ethnological Material in the Guatemalan National Museum" in "Museum," a quarterly publ. by UNESCO, 1954; "American University Museums," Museums Journal, 1956; "The Spanish Colonial Art Museum of Guatemala," "Museum," 1956; "The Public Relations Function in American Colleges and University Museums," The Museologist, 1956; "Aqualung Archaeology," Natural History Magazine, 1598; "A Primitive Art Exhibit" publ. by "Curator," Vol. IV, No. 1, 1960, and others. Lectures: Pre-Columbian Art; Folk Art; Maya Art and Architecture. Arranged exhibitions: Cyprus Exhibit, Hungarian Nat. Mus., 1947; Maya Art & Archaeology Exh., Guatemalan Nat. Mus., 1950; Spanish Colonial Art, Colonial Art Mus., Guatemala, 1951; American Handicrafts (U.S. State Dept.), Guatemala City, 1950; Primitive Art, Univ. Oklahoma, 1957; African Art, Univ. Oklahoma, 1957; Primitive Art, Milwaukee, 1960; Pre-Columbian Arts of Peru, Milwaukee, 1961; Art in Ivory, Milwaukee; Underwater Archaeology traveling exh., 1963; Polish Folk Art, 1963; Arts of the Ancient Mayas, 1964. Positions: Asst. Cur., Hungarian Nat. Mus. of Science & History, 1947-48; Prof. Anthropology, San Carlos Univ., Guatemala, 1949-51; Dir., Stovall Mus., Univ. Oklahoma, Norman, Okla., 1954-59; Asst. Prof. Anthropology, Univ. Oklahoma, 1954-59; Dir., Milwaukee Public Museum, 1959- ; Lecturer & Prof. Anthropology, Univ. Wisconsin at Milwaukee; Marquette Univ.

BORIS, BESSIE (KLEIN)—Painter
444 W. 20th St., New York, N.Y. 10011
B. Johnstown, Pa., June 6, 1920. Studied: Pratt Inst., Brooklyn, N.Y.; ASL. Awards: prizes, VMFA, 1946; Butler Inst. Am. A., 1947; Missouri Valley A., 1951; Dana Award, PAFA, 1961; purchase prizes, Missouri Valley A., 1950; Kansas State T. Col., 1952. Work: Norfolk Mus. A. & Sciences; New York Univ.; Slater Mem. Mus., Norwich, Conn.; Mulvane A. Center, Washburn Univ., Topeka. Exhibited: Denver Mus. A.; VMFA; Butler Inst. Am. A.; Colorado Springs FA Center; Joslyn Mem. Mus.; CGA, 1950; Inst. Contemp. A., Boston, 1951, circulated by AFA; Cober Gal., N.Y., 1960; PAFA, 1961, 1963, 1969; Silvermine Gld. A., 1963; Fairleigh Dickinson Univ., 1964; One-man: Mulvane A. Center, 1950; Mills Gal., N.Y., 1960; Cober Gal., N.Y., 1960, 1961, 1963, 1965.

BOROS, BILLI—Publisher, P., W., Cr.
The Art Times, 101 W. 78th St., New York, N.Y. 10024; h. same.
B. New York, N.Y. Studied: ASL, with Edwin Dickinson, Reginald Marsh, Iver Rose; Aviano Acad. of Art. Member: AAPL; ASL (life memb.). Awards: Wolfe A. Cl., 1969. Exhibited: City Center A. Gal.; Caravan House; Burr Gal.; Studio 41, the Cortile; NAC, 1965; AAPL, 1965-1967; Nat. A. Lg., 1969; Wolfe A. Cl., 1966, 1969. Work in private collections. Positions: Published "The Art Times," and wrote column "Boros' Hall," 1958-1960, 1963-1964.

BORZEMSKY, BOHDAN—Painter, Gr.
211 Oakdene Ave., Teaneck, N.J. 07666
B. Kolomya, Ukraine, July 7, 1923. Studied: Art Sch. & Art Acad., Lviv, Western Ukraine; Cooper Union A. Sch., N.Y. and with Edwin Dickinson, Robert Gwathmey. Member: Ukrainian Art & Literary Cl.; Ridgewood (N.J.) AA. Awards: prizes, Cooper Union (2). Work: Ukrainian Inst. of America; St. Peters Col. Library, Jersey City, N.J. Exhibited: Montclair A. Mus.; Jersey City Mus. A.; New Britain Mus. Am. A., Conn.; LC; NAD; NAC; Fairleigh Dickinson Univ., Teaneck, N.J.; Ohio Univ. A. Gal.; Brockton (Mass.) AA.; Boston Pr.M.

BOSCH, GULNAR KHEIRALLAH—Art Historian
Department of Art, Florida State University 32306; h. 1501 Hilltop Dr., Tallahassee, Fla. 32303
B. Lake Preston, S.D., Oct. 31, 1909. Studied: AIC, B.A. in Edu.; N.Y. Univ., M.A.; Oriental Inst., Univ. Chicago, Ph.D. Member: CAA; Southeastern College Art Conference (Vice-Pres., 1956-57, Pres., 1957-58); Am. Oriental Soc. Contributor to Journal of Near Eastern Studies; Islamic Review; Muslim Digest; Art Bulletin; Ars Orientalis. Lectures: Islamic Art and Contemp. Art: "Booktrade Practices Indicated by Islamic Bookbindings of the 14th and 15th Centuries"; "Space in Persian Miniature Painting," etc. Positions: (Art History)—Asst. Prof., Florida State College for Women; Prof., Fla. State Univ., Tallahassee; Prof., Wesleyan College, Macon, Ga.; Prof., Louisiana State Univ., Baton Rouge, La.; Research Asst. at Oriental Inst., Univ. Chicago; Hd. A. Dept., Wesleyan College; Chm. Art Dept., Louisiana State University; Hd. A. Dept., Florida State University, at present.

BOSIN, F. BLACKBEAR—Painter, Comm., Des.
1032 West 13th St., Wichita, Kans. 67203
B. Cement, Okla., June 5, 1921. Member: Wichita A. Gld. (V.-Pres. 1964-66, Bd. Dirs, 1964-66); F.I.A.L.; Wichita Hist. Mus.; Am. Mus. Natural Hist.; Advertising A. Assn. Awards: prizes, Philbrook A. Center, 1953-1961, 1964, 1967; deYoung Galleries, 1953; Denver A. Mus., 1953 (purchase, 1954); Santa Fe, N.M., 1958; Am. Research Fnd. award, Gal. of Indian Art 1958; Sheridan, Wyo., 1960, 1964; Scottsdale, Wyo., 1964. Work: Philbrook A. Center; Gilcrease Fnd., Wichita AA; Dept. of Interior, Wash., D.C., and in private coll. Exhibited: Philbrook A. Center (one-man) 1963; group exh., 1964; Gilcrease Fnd.; J. Graham Gal.; deYoung Gal.; Denver A. Mus.; Wichita AA (one-man); Smithsonian Inst.; Great Plains Gal.; Heard Mus. A., Phoenix, 1964 (one-man); Wichita A. Mus., 1965 (one-man); Whitney Gal. of Western Art, Cody, Wyo., 1965 (one-man); Am. Indian A. Center, N.Y., 1967 (one-man). Owner, Great Plains Studio, Commercial & Fine Arts, Arts & Crafts of the American Indian, Wichita, Kans., 1960- .

BOSTICK, WILLIAM ALLISON—
Painter, C., Cart., I., Lith., L., E., W.
The Detroit Institute of Arts; h. 9340 W. Outer Dr., Detroit, Mich. 48219
B. Marengo, Ill., Feb. 21, 1913. Studied: Carnegie Inst. of Tech., B.S.; Cranbrook Acad. A., with Zoltan Sepeshy; Detroit Soc. A. & Crafts; Wayne Univ., MA. Member: Scarab Cl., Detroit (Past Pres.). Awards: Prizes: Detroit Inst. A., 1943, 1945, 1963; Scarab Cl. gold medal exh., 1960, 1961, 1962 (gold medal), 1963, 1966, 1967, 1968 (gold medal); Mich. WC Soc., 1961; Michigan Acad., 1961. Work: Cranbrook Acad. A.; Detroit Inst. A. Evansville Mus. A. & Sciences. Exhibited: Audubon A., 1945; Pepsi-Cola, 1945; Detroit Inst. A., 1936-1963; Detroit WC Cl., 1946; Michigan WC Soc., 1948-1964; Scarab Cl., 1938-1969; Domesday Press Exh., 1945; Fifty Books of the Year, 1948, 1960. Author, I., "England Under G.I.'s Reign," 1946; I., "Art in the Armed Forces," "Many a Watchful Night"; Des. & Illus., "Mysteries of Blair House," 1948; Des., "For Modern Living" catalogue. Des., all books & catalogs publ. by Detroit Inst. A. since 1946; various books publ. by Wayne State Univ. Press. Contributor articles to Navy publications; Museum News. Positions: Sec., and Administrator, Detroit Inst. A.; Former Exec. Sec., Detroit Mus. A. Founders Soc.; Bd. Past Pres., Midwest Museums Conference; Past Ed., Midwest Museums Quarterly; Bd. Memb. The Book Club of Detroit; Regional Vice-Pres., AIGA. Former part-time Instr., Italic Handwriting, Univ. Center for Adult Edu.; part-time Inst., History of the Book, Wayne State Univ. Grad. School. Former part-time Instr., Calligraphy, Detroit Soc. A. & Crafts.

BOSTWICK, MR. and MRS. DUNBAR W.—Collectors
778 Park Ave., New York, N.Y. 10021*

BOTERF, CHESTER A., JR.—Painter, T.
46 MacDougal St., New York, N.Y. 10012
B. Ft. Scott, Kans., Apr. 27, 1934. Studied: Univ. Kansas, B.A.; Columbia Univ., M.F.A.; ASL; Hunter Col. Work: MModA; Des Moines A. Center; Aldrich Mus. Contemp. A.; Fordham Univ.; Columbia Univ.; Chase Manhattan Bank; Interchemical Corp.; Treadwell Corp. Exhibited: Des Moines A. Center, 1968; Aldrich Mus., 1968; Herron Mus. A., Indianapolis, 1969; one-man: De Nagy Gal., N.Y., 1967, 1968. Positions: Instr., Design and Drawing, Hunter College, New York, 1965- .

BOTHMER, BERNARD V.—
Museum Curator, Vice Director, E., W., L.
The Brooklyn Museum, Eastern Parkway and Washington Ave. 11238; h. Brooklyn Heights, Brooklyn, N.Y. 11201
B. Germany, Oct. 13, 1912. Studied: University of Berlin; University of Bonn. Member: College Art Association; American Research Center in Egypt; Archaeological Institute of America; Egypt Exploration Society; Compagnie de la Toison d'Or. Awards: Fulbright Research Fellowship (Egypt) 1954-1955, 1955-1956, 1963-1964. Author: "Egyptian Sculpture of the Late Period, 700 B.C. to A.D. 100 (Brooklyn Museum), 1960. Contributor to: The Journal of Egyptian Archaeology; American Journal of Archaeology; Bulletin of the Museum of Fine Arts, Boston; Brooklyn Museum Bulletin; Brooklyn Museum Annual; Kemi; La Revue des Arts; Journal of Near Eastern Studies; The Connoisseur, and other periodicals. Lectures: Extensively on Ancient Egyptian Art and Archaeology; Sites in Egypt. Exhibitions arranged: "Five Years of Collecting Egyptian Art," 1956-1957; "Egyptian Scultpure of the Late Period," 1960-1961, both at The Brooklyn Museum. Positions: Assistant, Egyptian Department, Berlin State Museum, 1932-1938; Assistant Curator, Museum of Fine Arts, Boston, 1946-1956; Director, American Research Center in Cairo, 1956-1957; Adjunct Professor of Fine Arts, Graduate School of Arts and Sciences, Institute of Fine Arts, New York University, 1960- ; Project Director, Mendes Expedition, New York University, 1963- ; Assistant Curator, Associate Curator, Curator of Ancient Art, The Brooklyn Museum, 1956- .

BOTHWELL, DORR—Painter, Gr., T., L.
P.O. Box 27, Mendocino, Cal. 95460
B. San Francisco, Cal., May 3, 1902. Studied: Cal. Sch. FA; Univ. Oregon. Member; San F. AI. Awards: prizes, San F. Soc. Women A., 1929, 1942; San Diego A. Gld., 1932; San F. AA, 1944; Rosenberg Traveling Scholarship, 1949-50; Cal. PLH; Nat. Ser. Soc., 1952, 1955; BM, 1948. Work: San Diego FA Gal.; Los A. Mus. A.; SFMA; Crocker A. Gal., Sacramento; Santa Barbara Mus. A.; MModA; BM; Nelson Gal. A.; Univ. Wisconson; Victoria & Albert Mus., London, England; Bibliotheque Nationale, Paris, France; WMAA; MMA; FMA. Co-Author: "NOTAN, The Principle of Dark-Light Design" (Dorr Bothwell & Marlys Frey), 1968. Exhibited: GGE, 1939; Cal. PLH, 1946-1952, 1962, 1964; SFMA, 1940-1951; Los.A. Mus. A.; CGA; NGA; Eric Locke Gal., San F., 1959; Brunn Gal., San F.; Univ. California Ext., San F., Mendocino A. Center; Denver A. Mus.; WMAA; Foundation des Etats-Unis, American Embassy, Paris,

1950, 1951; Universidad de Chile, 1950; Circulo de Bellas Artes, La Palma, Mallorca, 1952; Carnegie Inst., 1952, 1955; Museu de Arte Moderna, Sao Paulo, Brazil, 1955; Art: USA, 1958; Smithsonian Inst., 1952; one-man: Rotunda Gal., San F., 1946, 1949, 1952; Cal. PLH, 1947; Serigraph Gal., N.Y., 1948, 1952; Nat. Serigraph Soc., 1954; DeYoung Mem. Mus., 1957, 1963; Meltzer Gal., N.Y., 1958. Positions: Instr., University of California Extension summer session in Mendocino, Color and Design, at Mendocino Art Center.

BOTKIN, HENRY—Painter, Cr., W., L.
56 West 11th St., New York, N.Y. 10011
B. Boston, Mass., April 5, 1896. Studied: Mass. Sch. A.; ASL, and abroad. Member: AEA. Awards: prizes, Audubon A., 1945, 1950; Pepsi-Cola, 1947. Member: Fed. Mod. P. & S.; Audubon A.; Provincetown AA; FA Assoc. Gal. Work: in 39 museums including MMA; MModA; PMG; Univ. Nebraska; Newark Mus. A.; Univ. Oklahoma; Walker A. Center; Denver A. Mus.; Akron AI; BM; Modern Mus., Munich, Germany; Butler Inst. Am. A.; Wadsworth Atheneum, Hartford, Conn.; Rochester Mem. A. Gal.; Walter Chrysler, Jr., Coll.; DMFA; BMFA; WMAA; Smith Col.; Tel-Aviv Mus. A. and many others; also in private coll. in U.S. and abroad. Contributor to Archives of Am. Art. Exhibited: CGA; PAFA; Carnegie Inst.; AIC; WMAA; MMA; BMA; Denver A. Mus.; Harriman Gal. (one-man); Los A. Mus. A.; SFMA; Chicago AC; PMG; BMFA; Kansas City AI; Rehn Gal., N.Y., 1965 (one-man), 1968; SFMA; De Young Mem. Mus., San Francisco; BM; Nat. Inst. A. & Lets., N.Y.; Detroit Inst.; Mus. Mod. A., Tokyo; State Mus., Munich, Germany; Bonn Mus., Germany; MModA; museums in Canada, Yugoslavia, Israel, Great Britain, and many more. Downtown Gal., N.Y.; 51 one-man exhs. Positions: Organized many art exhs. U.S. and abroad, including first American abstract show in Japan; Pres., Am. Abstract A., 1954-55; Pres., AEA, 1951-52; Pres., Fed. Mod. P. & S., 1957-61.

BOTT, PATRICIA BURR. See Allen, Patricia

BOUGHTON, WILLIAM HARRISON—Painter, T.
4625 Corkwood Lane, Beaumont, Tex. 77706
B. Dubuque, Iowa, Feb. 19, 1915. Studied: Univ. Iowa, B.A. with Grant Wood, Fletcher Martin; Univ. California, M.A., with Erle Loran, Shaeffer Zimmern. Member: AAUP; CAA; AEA; Nat. Ser. Soc. Awards: Phelan Scholar, Univ. California, 1945-46. Work: American Color Slide Library. Exhibited: SFMA, 1945; Serigraphies Americaines, Paris, France; 10 Am. Painters of Today, France; American Watercolorists, France; Salade Exposiones De La Universidad de Chile; Student Union, Lamar State College. Positions: Prof., Hd. Dept. A., Lamar State Col., Beaumont, Texas.

BOURAS, HARRY—Sculptor, L., E.
540 N. Lake Shore Dr., 60611; h. 850 Castlewood Terr., Chicago, Ill. 60640
B. Rochester, N.Y., Feb. 13, 1931. Studied: Univ. Rochester, B.A.; Univ. Chicago (Post-grad.). Member: Cliffdwellers; Art Club of Chicago. Awards: Logan Medal and the Pauline Palmer Prize, AIC. Since 1965 has had a weekly program of Art Criticism, "Critics Choice," Station WFMT Chicago. Lectures widely in colleges and universities throughout the Midwest. Exhibited: 11 one-man exhibitions during the last three years in Chicago, New York City, London, Tokyo, Paris and elsewhere. Positions: A.-in-Res., Univ. of Chicago, 1963-1965; Faculty, 1959-1965 and A.-in-Res., Columbia College, Chicago, 1964- .

BOURGEOIS, LOUISE—Sculptor, Eng.
347 W. 20th St., New York, N.Y. 10011
B. Paris, France, Dec. 25, 1911. Studied: Ecole des Beaux-Arts, Paris; ASL, and with Fernand Leger. Awards: prize, MModA, 1943. Work: Albright A. Gal.; MModA; WMAA; Rhode Island School of Design; New York Univ. Exhibited: MModA, 1941, 1951, 1969; LC; MMA, 1962; WMAA, 1945, 1946, 1953-1955, 1957, 1960, 1962, 1963, 1968; Los A. Mus. A., 1943; SFMA, 1944; Cal. PLH, 1950; Walker A. Center, 1954; Univ. Illinois, 1954; Boston A. Festival, 1956; Univ. Illinois, 1957; Allen Mem. A. Mus., Oberlin, Ohio, 1958; DMFA, 1960; Andrew Dickson White Mus., Cornell Univ., 1959; Rhode Island School of Design, 1966; BMA, 1969; La Biennale de Carrara, 1969.

BOWER, ANTHONY—Editor
Art in America, 635 Madison Ave., New York, N.Y. 10022*

BOWMAN, DOROTHY (LOUISE)
(Mrs. Howard Bradford)—Serigrapher, P.
Big Sur, California 93920
B. Hollywood, Cal., Jan. 20, 1927. Studied: Chouinard AI, with Dan Lutz, Richard Haines, Jean Charlot; Jepson AI, with Rico Le Brun. Member: Western Serigraph Inst.; Am. Color Pr. Soc. Awards: prizes, Los A. County Fair, 1952, 1953; purchase prizes: Nat. Ser. Soc., 1952; BM, 1954; LC, 1954; Univ. Illinois, 1956; Boston Pr. M.,

1956, 1958; California A., 1957; Wichita, Kans., 1957; Am. Color Print Soc., Stern award, purchase, 1965. Work: N.Y. Pub. Lib.; Immaculate Heart Col., Los Angeles; BM; Crocker A. Gal., Sacramento, Cal.; MMA; LC; San Jose State College; BMFA; deCordova & Dana Mus.; Boston Pub. Lib.; Rochester Mem. A. Gal.; Univ. Wisconsin, Milwaukee. IGAS commission for 210 serigraphs, 1957; Presentation Artist, Boston Pr. M., 1960. Exhibited: BM; 1950-1956, 1958; Nat. Ser. Soc., 1950, 1951, 1953, 1954; LC, 1951-1953, 1955-1958; AFA traveling exhs., 1955-1958; Los A. Mus. A., 1947-1953, 1957.*

BOWMAN, JEAN—Portrait Painter, I., T.
 Middleburg, Va., 22117; Studio: 33 W. 67th St., New York, N.Y. 10023
B. Mt. Vernon, N.Y., Sept. 27, 1917. Studied: Grand Central A. Sch.; NAD; Scott Carbee Sch. A., and with Jonas Lie, Jerry Farnsworth, Leon Kroll. Member: Grand Central A. Gal.; Animal Artist Soc. Awards: prize, Grand Central A. Sch., 1936. Work: many equestrian portraits for private collectors including H.M. Queen Elizabeth, II. port. in permanent exh. at National Museum of Racing; Commissions: Germany, 1960; France, 1961-62; Canada, 1963, 1965, England, 1968, Ireland, Scotland, 1967, and in many states of the U.S. Exhibited: Knoedler Gal., 1949; One-man: Scott & Fowles, 1952; Vose Gal., 1940; Grand Central A. Gal., 1953, 1954; Nat. Museum of Racing, 1958. I., for various equestrian publications including British Race Horse, The Blood Horse; covers for The Chronicle, a weekly horse publication on hunting, steeple chasing, racing & polo. Commissions in England and Ireland, 1958.

BOWMAN, RICHARD—Painter, Gr.
 178 Springdale Way, Redwood City, Cal. 94062
B. Rockford, Ill., Mar. 15, 1918. Studied: AIC, B.F.A.; Univ. Iowa, M.F.A. Awards: Ryerson traveling fellowship (painting in Europe), AIC, 1942; William Franch Mem. Gold Medal, AIC, 1945; prizes, Iowa State Fair, 1948; Montreal, Canada, 1952; Winnipeg A. Gal., 1953, and others. Work: SFMA; Oakland Mus.; Stanford Univ.; Univ. Texas Mus.; Santa Barbara A. Mus.; deYoung Mem. Mus., San Francisco, and in private colls. Exhibited: AIC, 1944, 1945, 1947; Joslyn Mem. Mus., Omaha, 1948, 1949; Laguna Beach, Cal., 1948; Phila. Pr. Cl., 1949; SFMA, 1949, 1956 (2); WAC 1949, BM, 1949; Sao Paulo Biennale, 1953; other exhs., 1950-1960. Recent exhs., WMAA, 1962; Carnegie Int., 1963; Rockford AA (Ill.), "50 California Artists," 1965 (selected for AFA circulating exh., 1966-1968). Canadian Exhs.: Montreal, 1951, 1952; Winnipeg A. Gal., 1951, 1953; Richardson Gal., Winnipeg, 1952; Canadian Soc. Gr. A., Toronto, 1952; A. Gal. of Toronto, 1954; Western Canadian A. Circuit, 1952, 1953; Nat. Gal., Ottawa, 1953; Vancouver A. Gal., 1953; Royal Ontario Mus., Toronto, 1954, and others. One-man: Ras-Martin Gal., Mexico City, 1943; Pinacotheca Gal., N.Y. (now Rose Fried Gal.), 1945; AIC, 1945; Milwaukee A. Inst., 1946; Univ. Illinois, 1947; Burpee A. Gal., 1947; Swetzoff Gal., Boston, 1949; Sausalito, Cal., 1949; Stanford Univ., 1950 (2); Retrospectives, Stanford Univ., 1956 and SFMA, 1961.

BOWMAN, RUTH—Curator, L., W., E.
 New York University, 10003; h. 139 E. 63rd St., New York, N.Y. 10021
B. Denver, Colo., June 14, 1923. Studied: Bryn Mawr College, A.B.; Columbia Univ. Sch. Architecture; N.Y. Inst. FA. Member: AAMus.; CAA; Visual Arts Committee, New York City Cultural Council. Positions: Asst. Cur., The Jewish Museum, N.Y. 1962-1963; Visiting Lecturer, The Museum of Modern Art, N.Y., 1964-1969; Staff Lecturer, Gallery Passport, Ltd., 1962-1968; Adjunct Professor of Art History, New York University, School of Continuing Education, 1965- ; Curator, New York University Art Collection, 1963- ; Weekly radio and television art programs WNYC, 1967- ; Nat. Exhibitions Committee, American Federation of Arts; Advisory Bd., Museum of American Folk Art.

BOYCE, GERALD GLADWIN—Educator, P., C., L.
 Indiana Central College, 4001 South Otterbein Ave.; h. 1260 Morgan Dr., Indianapolis, Ind. 46227
B. Embarrass, Wis., Dec. 29, 1925. Studied: Milwaukee State T. Col.; Milwaukee AI; State Univ. of Iowa; Indiana Univ.; Americano-Guatemalteco Instituto, Guatemala City, and with Karl G. Hansen, Denmark. Study & research—Europe, Egypt, Turkey. Member: CAA; Mid-west College A. Conference; Indiana College AA. Awards: numerous awards in competitions. Work: MModA and in private colls. Exhibited: AIC; Toledo Mus. A.; Wadsworth Atheneum; Los A. Mus. A.; Colo. Springs FA Center; J.B. Speed Mus. A.; SFMA; DePauw Univ.; MModA; Wichita A. Mus.; Des Moines A. Center; St. Paul Gal. A.; Ball State T. Col.; Bradley Univ.; Indiana Univ.; South Bend A. Center; Univ. Iowa; Univ. Michigan; Ohio State Univ.; Univ. Wisconsin; Milwaukee AI; Wisconsin State Coll; Univ. Illinois; one-man: Bethel Col., Minn.; Wabash Col.; H. Lieber Gal., Arts Crest Gal., both Indianapolis; Little Gal., Nashville; Indiana Centenary

Col. Positions: Prof. A., Chm. FA Dept., Indiana Central College, Indianapolis, Ind., 1950- . State Rep. to Nat. Crafts Council. Sec.-Treas., North Central Region of Am. Craftsmen's Council; Pres., Indiana Artist-Craftsmen, 1965.*

BOYCE, RICHARD—Sculptor, T.
 The Alan Gallery, 766 Madison Ave., New York, N.Y. 10021
B. New York, N.Y., June 11, 1920. Studied: ASL; BMFA Sch., with Karl Zerbe. Member: AEA. Awards: BMFA Grant for study in Europe, 1949-51; Bartlett Grant for work in Mexico, 1960-61. Work: Worcester Mus. A.; Mus. of the Rhode Island Sch. of Des.; Andover Gal.; De Cordova & Dana Mus.; Jewett A. Center, Wellesley College; Harvard Univ.; WMAA. Exhibited: AIC, 1961; Sweat Mem. Mus., Portland, Maine, 1959; De Cordova Mus., 1960; Boston A. Festival, 1960; WMAA, 1962; PAFA, 1964; Univ. Illinois, 1965; one-man: Boris Mirsky Gal., 1951 (in Europe); Swetzoff Gal., Boston, 1953, 1959; Zabriskie Gal., N.Y., 1961, 3-man, 1960; 3-man, Johns Hopkins Univ., 1948. Positions: Instr., Painting, SFMA, 1946-47; Cambridge Center for Adult Edu., 1948-49; Instr., A., Wellesley College, 1954, Asst. Prof. A., 1959; Instr. Advanced Design, Boston University School of Fine Arts, 1959. Visiting Hd. Sculpture, UCLA, Los Angeles, Cal., 1963-1964.*

BOYD, E. (Miss)—Writer, Mus. Cur., P., L.
 Museum of New Mexico, Santa Fe, N.M. 87501
B. Philadelphia, Pa., Sept. 23, 1903. Studied: PAFA. Member: Intl. Inst. for Conservation of Museum Objects; Spanish Colonial A. Soc.; New Mexico Archaeological Soc. Work: renderings of regional folk art, Index of American Design; restoration and preservation of interior paintings of regional colonial churches; conservation of altarpieces, in missions at Laguna Pueblo, N.M.; Ranchos de Taos; San Miguel, Santa Fe; San Jose Church, Hernandez, N.M. Author: "Saints and Saintmakers," 1946; Section on New Mexican Spanish colonial material in "The Concise Encyclopedia of American Antiques," 1958; "Popular Arts of Colonial New Mexico," 1969. Contributor to Arts & Architecture; Antiques; Hobbies; House & Garden; Southwest Review and other publications. Lectures on New Mexican arts and crafts. Arranged rooms, DMFA, "Religious Art of the Western World," 1958; Exhibition, "Popular Arts of Colonial New Mexico," Mus. of International Folk Art, Santa Fe, N.M., 1959; "Santeros of New Mexico," Museum of International Folk Art, Santa Fe, N.M., 1969. Positions: Registrar, Los A. Mus. A., 1949-51; Cur., Spanish Colonial Dept., Museum of New Mexico, Santa Fe, 1951-1969.

BOYER, JACK K.—Museum Director, Cur.
 Kit Carson Home & Museum, Kit Carson St.; h. Canon Rd., Taos, N.M. 87571
B. Van Houten, N.M., Sept. 2, 1911. Member: AAMus.; Archaeological Soc. of New Mexico; New Mexico State Hist. Soc.; Clearing House for Western Museums. Contributor to newspapers and other publications. Collected and arranged all exhibits in the Kit Carson Home & Museum. Positions: Dir., Cur., Kit Carson Home & Museum, Taos, N.M., 1954- .

BOYER, MRS. RICHARD C.—Collector, Patron
 6237 Jefferson Highway, Baton Rouge, La. 70806
B. New York, N.Y., Mar. 5, 1917. Studied: Barnard College, B.A. Collection: Louisiana Artists.

BOYLE, JAMES M.—Educator
 Art Department, Univ. of Wyoming, Laramie, Wyo. 82070*

BOYNTON, JAMES W.—Painter, Lith.
 3723 Albans St., Houston, Tex. 77005
B. Ft. Worth, Tex., Jan. 12, 1928. Studied: Texas Christian Univ., Ft. Worth, Tex., B.F.A., M.F.A. Awards: purchase awards and prizes, Denver Mus. A., 1952, 1954, 1958; Texas FA Assn., 1952, 1957; Texas State Fair, 1953, 1964; Ft. Worth, 1951, 1952, 1954, 1955; Houston, Tex., 1955; Texas WC Soc., 1951, 1953-1964; Underwood-Neuhaus Comp., 1957; Butler Inst. Am. A., 1957; Feldman award, Dallas, 1956, 1958, 1959; Art: USA, 1959; SFMA, 1962; Mus. Contemp. A., Houston, 1965; Beaumont A. Mus., 1968; Oklahoma City A. Center, 1968; Tamarind Workshop Fellowship, 1967. Work: DMFA; Mus. FA, Houston; Witte Mem. Mus.; Texas FA Assn.; Ft. Worth A. Center; Butler Inst. Am. A.; Inland Steel Co., Chicago; Underwood-Neuhaus, Houston; Denver Mus. A.; Wadsworth Atheneum; Guggenheim Mus., N.Y.; Mus. Contemp. A., Dallas; WMAA; MModA; Tamarind Lithography Workshop; Los A. Mus. A.; UCLA Grunwald Collection; La Jolla Mus. A.; Pasadena Mus. A.; PMA; Amon Carter Mus., Ft. Worth; D.D. Feldman Fnd., and in many private colls. Exhibited: Ft. Worth annuals, 1950-1955; DMFA and circuit, 1950-1958; Texas WC Soc., 1951-1956; Texas FA Assn., 1951, 1952, 1954, 1957; Mus. FA, Houston, 1955, 1957, 1964; Mus. New Mexico, Santa Fe, 1957; Knoedler Gal., N.Y., 1952; SFMA, 1952, 1962; 1969; Delgado Mus. A., 1951, 1952, 1954, 1958,

1967; Colorado Springs FA Center, 1953, 1954, 1957, 1965; Denver A. Mus., 1952, 1954-1956, 1958, 1963; Guggenheim Mus., N.Y., 1954; Carnegie Inst., 1955; MModA., 1956, 1962, 1969; Mus. FA, Houston, 1956, 1957, 1964; AFA circulating exh., 1956, 1957; Columbia Mus. A., 1957; DMFA & AFA circulating exh., 1957; Butler Inst. Am. A., 1957; Mus. Contemp. A., Houston, 1957, 1961, 1965; WMAA, 1957, 1958, 1967-68; AIC, 1957, 1958; Stanford Univ., 1958; VMFA, 1958; Brussels World's Fair, 1958; CalPLH, 1962; deYoung Mem. Mus., San F., 1962; Mus. Contemp. A., Dallas, 1959, 1960; Los A. Mus. A., 1969; Texas Pavillion, San Antonio, 1968; Yale Univ.; Chrysler Mus. A., Provincetown; De Waters A. Center, Flint, Mich.; Univ. Michigan, 1965; Columbia (S.C.) Mus. A. one-man: Ft. Worth A. Center, 1955; La Galeria Escondido, Taos, N.M.; Emmerich Gal., Houston, 1957; Fairweather-Hardin Gal., Chicago, 1958; Barone Gal., N.Y., 1958, 1959; Bolles Gal., San F., 1959, 1962; Staempfli Gal., N.Y., 1961; Calhoun Gal., Dallas, 1960, 1962; Louisiana Gal., Houston, 1964, and other regional and national shows. Positions: Instr., Univ. Houston, 1955, 1957; San Francisco AI, 1960, 1962; Univ. New Mexico, Albuquerque, (Summer) 1963.

BRACH, PAUL (HENRY)—Painter, Lith., E.
California Institute of the Arts, Los Angeles 90057; h. 2621 Inyaha Lane, La Jolla, Cal. 92037
B. New York, N.Y., Mar. 13, 1924. Studied: State Univ. Iowa, B.F.A., M.F.A. Member: CAA. Awards: Tamarind Fellowship, 1964. Work: MModA; WMAA; Los Angeles County Mus.; N.Y. Public Library; Smith Col.; Joslyn A. Mus.; Albion Col.; Univ. Arizona; Univ. New Mexico, and others. Exhibited: CAM, 1950; Stable Gal., N.Y., 1950-1955; Tanager Gal., N.Y., 1954, 1955; MModA, 1954, 1965, 1966 and traveling exh. to Africa, 1966, Tamarind Exh., 1969; Sidney Janis Gal., 1956; CGA, 1959; R.I. Sch. Des. Mus., 1959; WMAA, 1960, 1963, 1964; Saidenberg Gal., 1960; AIC, 1961; Jewish Mus., N.Y., 1963, 1965, 1969; Emmerich Gal., N.Y., 1964; Rose A. Mus., Brandeis Univ., 1964; Univ. Illinois, 1965; Cordier-Ekstrom Gal., 1965; Finch Col., N.Y., 1965; SFMA, 1965; one-man: Leo Castelli Gal., N.Y., 1957, 1958; Union Col., Schenectady, N.Y., 1958; Dwan Gal., Los Angeles, 1960; Cordier-Ekstrom Gal., N.Y., 1962, 1964; Univ. A. Mus., Albuquerque, N.M., 1965; Loeb Student Center, N.Y. Univ., 1966; Kornblee, Gal., N.Y., 1968. Positions: Prof. A., N.Y. Univ., Div. Gen. Edu., 1954-1967; Parsons Sch. Des., N.Y., 1956-1967; Cooper Union, N.Y., 1960-1962; Chm., Visual A. Dept., Univ. California at San Diego, 1967-1969; Dean, Sch. A., California Institute of the Arts, Los Angeles, 1969- .

BRACKMAN, ROBERT—Painter
Noank, Conn. 06340
B. Odessa, Russia, Sept. 25, 1898. Studied: Francisco Ferer Sch.; NAD, and with George Bellows, Robert Henri. Member: NA; All. A. Am.; Audubon A.; Conn. Acad. FA; Royal Soc. A., London, England; Int. Soc. A. & Lets.; Mystic AA; New Haven Paint & Clay Cl.; AWS. Awards: Thomas B. Clarke prize, 1932; AIC, 1929; NAD, 1941, 1960; Noel Flagg prize, 1936; Conn. Acad. FA, 1947; gold medal, NAC, 1950; prize, Laguna Beach A. Festival, 1952; med., All. A. Am., 1952; Beck gold med., PAFA, 1958; purchase prizes, Audubon A., 1960; Buckhill Co., Pa., 1960; Springville, Iowa, 1960; Andrew Carnegie prize, NAD, 1965; Ford Fnd. Grant, Artist-in-res., (museum), 1965. Work: BM; R.I.Sch. Des.; Conn. Agricultural Col.; Honolulu Acad. A.; Pasadena AI; MMA; Newark Mus. A.; Montclair A. Mus.; High Mus. A.; New Haven (Conn.) Lib.; Wilmington Soc. A.; Minneapolis Inst. A.; WMAA; Butler Inst. Am. Art; Canajoharie Mus.; Norton A. Gal.; Rockford AA; Encyclopaedia Britannica; IBM; New Britain Inst.; Mus. FA of Houston; Brooks Mem. Gal.; Univ. Georgia; Davenport Mem. A. Gal.; Toledo Mus. A.; Yale Univ.; Princeton Univ.; Harvard Coll.; Pentagon Bldg., Wash., D.C.; U.S. State Dept.; West Point Acad.; Conn. Life Insurance Co.; Bryn Mawr Coll.; Rochester Mem. A. Gal.; Univ. Chicago; RCA; Milton Acad.; Dupont Coll.; Colonial Williamsburg and many portraits of prominent persons. Work also in a large number of university and college colls. Exhibited: nationally and internationally. Positions: Instr., ASL, 1934- ; American A. Sch., New York, N.Y., 1951- ; Guest Instr., Minneapolis AI.

BRADFORD, HOWARD—Serigrapher, P., T.
417 Cannery Row, Monterey, Cal. 93940
B. Toronto, Ont., Canada, July 14, 1919. Studied: Chouinard AI; Jepson AI, with Rico LeBrun. Member: Am. Color Print Soc. Awards: purchase awards and prizes, SFMA, 1950; Los A. Mus. A., 1950; Bradley Univ., 1951; Serigraph Soc., N.Y., 1951, 1952; Am. Color Pr. Soc., 1951, 1952, 1959; Northwest Pr. M., 1951; LC, 1951, 1956, 1957; Print Exh., Pomona, Cal., 1951; Cal. State Fair, 1951, 1952, 1956; Nat. Pr. Exh., Peoria, Ill., 1952; Pacific A. Festival, Oakland, Cal., 1952; New Britain Pr. annual, 1953; Los A. Art Festival, 1953; Nat. Pr. annual, Dallas, 1953; Graphic A. Exh., Wichita, Kans., 1955; Univ. Illinois, 1957; Monterey Peninsula Mus., 1965, 1968; Guggenheim F., 1960. Work: paintings—Los A. Mus. A.; Cal. State Fair Coll.; serigraphs—DMFA; MModA; SAM; LC; FA

Center, San Diego; N.Y. Pub. Lib.; Crocker A. Gal., Sacramento; MMA; High Mus. A., Atlanta; New Britain Mus. A. (Conn.); BMA; PMA; Univ. Wisconsin; Univ. Illinois; Bradley Univ.; Univ. New Hampshire; Norton Gal. A., Palm Beach, Fla. and others. Exhibited: Dallas Pr. Soc., MModA., 1953; U.S. Information Service, Europe, 1956-1958; 60 American Printmakers, Europe, 1956; Nat. Pr. Exh., Pomona, Cal. 1948-1953; SFMA, 1950, 1956; Northwest Pr. M., 1951; Bradley Univ., 1951, 1952; LC, 1951-1955, 1957, 1958; BM, 1950-1952, 1954, 1955, 1958; Boston Pr. M., 1956, 1957; AIC, 1956, 1957; Santa Barbara Mus. A., 1955, 1957; Los A. Mus. A., 1950-1953; Cal. State Fair, 1950-1958; Am. Printmakers, Bordighera, Italy, 1957; AIC, 1957; Univ. Illinois, 1956; Denver A. Mus., 1958; Townhouse, Ventura, Cal., 1967 (one-man), and others. Positions: Instr., Lith., Painting, Ser., Jepson AI, Los Angeles, Cal., 1950-53; summer Guest Instr., Univ. Utah, 1958. Owner, Serigraphs, Ltd., a gallery workshop, Monterey, Cal.

BRADFORD, MRS. HOWARD. See Bowman, Dorothy (Louise)

BRADLEY, MRS. HARRY LYNDE — Collector
136 W. Greenfield Ave., Milwaukee, Wis 53204*

BRADSHAW, GLENN R(AYMOND)—Educator, P., W.
906 Sunnycrest St., Urbana, Ill. 61801
B. Peoria, Ill., Mar. 3, 1922. Studied: Kenyon College; Illinois State Normal Univ., B.S.; Univ. Illinois, M.F.A. Member: AWS; Cal. WC Soc.; Nat. Soc. Painters in Casein. Awards: prizes, Washington WC Assn., 1962; Oklahoma Nat., Oklahoma City, 1962; 6th & 7th North Dakota Nat., 1962, purchase, 1963; Illinois State Fair, 1962, 1964, 1966; Cal. WC Soc., 1962, 1965; Springfield A. Mus. (Mo.), 1963; purchase, Henry Ward Ranger Fund, NAD, 1963; Old Testament Nat. Art Comp., Temple Israel, St. Louis, 1963, 1964; Mid-States Exh., Evansville Mus. A., 1963; Drawings: USA, St. Paul A. Center, 1963; Director's Prize, Nat. Soc. Painters in Casein, N.Y., 1964, 1966; American Artist Medal, AWS, 1964; other purchase awards: Univ. Tennessee, 1966; Las Vegas, Nev., 1966; Sun Carnival, El Paso, 1966; Union Lg., Chicago, 1967; Mun. A. Lg., Waterloo, Iowa, 1967; Watercolor:USA, 1967; Decatur A. Center, 1968; Swope Gal., Terre Haute, 1968; Chicago A. Gld., 1969. Work: Illinois State Normal Univ.; Birmingham Mus. A.; Mississippi AA, Jackson; Nelson Gal. A., Kansas City; M. Grumbacher Co., N.Y.; Cal. WC Soc.; Pasadena A. Mus.; Butler Inst. Am. Art; Evansville Mus. Arts & Sciences; Univ. North Dakota; Springfield (Mo.) A. Mus.; San Diego Mus. A.; Temple Israel, St. Louis; Univ. Illinois, Urbana. Exhibited: Washington WC Soc.; Oklahoma City; North Dakota Nat. Exh., Grand Forks; Illinois State Fair; AWS; Cal. WC Soc.; Albuquerque, N.M.; Evansville Mus., MMA, 1967, and others. One-man: Illinois State Normal Univ., 1947, 1950, 1961; Cedar Falls AA, 1951; Schermerhorn Gal., Beloit, Wis., 1956, 1957, 1959; Millikin Univ., Decatur, 1955; Flint (Mich) A. Center, 1957; Old Orchard Bank, Skokie, Ill., 1959; Illini Union, Univ. Ill., 1960; Haslem Gal., Madison, 1966; Wisconsin Center for Adult Edu., Madison, 1966; St. Louis (Mo.) Gal., 1967; Gilman Gal., Chicago, 1963, 1965; other exhs. (2 and 4-man), 1966-1968. Positions: Cr., A.T., Univ. Illinois, 1947-50; Instr. A., Iowa State T. Col., 1950-52; Prof. A., University of Illinois, Urbana, Ill., 1952- .

BRADSHAW, ROBERT GEORGE—Educator, P.
Douglass College, Rutgers University, New Brunswick, N.J.; h. 48 Hilltop Blvd., East Brunswick, N.J. 08816
B. Trenton, N.J., Mar. 13, 1915. Studied: Princeton Univ., A.B.; Columbia Univ., M.A. Member: CAA; New Jersey WC Soc.; Hunterdon County A. Center; New Jersey A. Edu. Assn. Awards: honors, Art & Archaeology, Princeton Univ., 1937; prize, Montclair (N.J.) A. Mus., 1963; New Jersey WC Soc., 1959. Exhibited: AWS, 1955; NAC, 1952, 1953, 1955; BMFA, 1954; Princeton A. Mus., Alumni Exhs.; Newark Mus. A.; N.J. State Mus.; Montclair A. Mus.; New Jersey P. & S.; North Shore AA; Cape Ann Festival; Cape Ann Soc. Mod. A.; N.Y. World's Fair, 1965; one-man: Contemporary Cl.; Univ. Vermont; West Side Gal., New York City; Douglass Col. Gal. Lectures: Art Appreciation and History. Positions: Prof., Douglass Col. of Rutgers Univ., Art Dept., 1946, Acting Chm., 1964-65.

BRAINARD, OWEN D.—Educator, P., Ser., L., W.
321 Kresge Art Center, Michigan State University; h. 850 Tarleton Ave., East Lansing, Mich. 48823
B. Kingston, N.Y., Sept. 6, 1924. Studied: Syracuse Univ., B.F.A., M.F.A.; Columbia Univ.; N.Y. State Univ., Col. for Teachers, Albany, N.Y., and with Stephen Peck, Dong Kingman. Member: CAA; AEA; AAUP; NAEA; Western A. Edu. Assn. Awards: prizes, Des Moines A. Center, 1953, 1955; Northeast Iowa A. Exh., Cedar Falls, 1957; Des Moines Women's Club, 1956; Iowa State Fair, 1953, 1955, 1957 (purchase). Work: Ford Coll. Am. Art; Iowa A. Edu. Assn.; Ford Times; mosaic mural, Everett H.S., Lansing, Mich. Exhibited: PAFA, 1953; LC, 1958; Art: USA, 1958; Nelson Gal. A., Kansas City, 1952, 1955; Hudson Valley, 1950; Schenectady, N.Y.,

1950; WAC, 1953; Joslyn A. Mus., 1953, 1956; AEA traveling exh., 1956; Regional Art Today, Joslyn Mus. A., 1957; Univ. Nebraska Gal., 1957; Cornell College, 1952; Sioux City A. Center, 1952, 1954; Kansas City AI, 1953; Central Col., 1953; Grinnell Col., 1954; Univ. Nevada, 1955; Midland, Mich., 1957; Little Gallery, Jackson, Mich., 1957; Detroit Inst. A., 1962; Silvermine Gld. A. (Conn.), 1962; Flint Inst. A., 1964; Kalamazoo Inst. A., 1964; one-man: Albany Inst. Hist. & Art, 1951; Schenectady A. Mus., 1951; Des Moines A. Center, 1955; Kresge A. Center, E. Lansing. Positions: Supv., Elem. Art, Bethlehem Central Schs., Delmar, N.Y., 1949-51; Asst. Prof., Drake Univ., Dept. Art, 1952-57; Prof., Michigan State Univ., East Lansing, Mich., 1959- . Exec. Bd., Midwest College A. Conf.

BRANDON, WARREN EUGENE—Painter, T., W.
2441 Balboa St. 94121; h. 719 Bay St., San Francisco, Cal. 94109
B. San Francisco, Cal., Nov. 2, 1916. Studied: Milligan Col., Tenn.; and with Raymond Brose, Jack Feldman, Jack Davis and Eliot O'Hara. Member: A. Advisory Council for State of California (Sec.); co-founder, Artists' Cooperative of San Francisco; Marin Soc. A. (Chm. A. Council & Bd. Dirs.); AEA; Southwest A.; A. Guild of Am.; F., Royal Soc. A., London. Awards: Diablo A. Festival; Marin Soc. A.; Bayfair (Cal.) Annual; Southwestern Painters, Tucson, Ariz.; Palo Alto Prof. A.; Frye Mus. Annual Prize, Seattle; San Francisco Annual, 1963; San Mateo Annual; Tucson A. Festival. Work: 7 paintings, Kaiser Bldg., Oakland, Cal.; Milligan College; Kaiser Center, Oakland, and in many private collections. Exhibited: SFMA, 1960; Nat. A. Roundup, Las Vegas, Nev., 1960, 1961, 1963, 1964; Denver A. Mus., 1961; Cal. PLH, 1961; DeYoung Mem. Mus., San F., 1959, 1960, 1961; West Coast Oil Painters, Frye Mus. A., Seattle, Wash., 1961; Oakland A. Mus.; Knickerbocker A., 1964; Cal. State Fair, 1962, 1963 (one-man), 1964-1969; A. Gld. of America, 1961 (one-man); Frye Mus. A. (one-man). Author: "Six Paintings in Search of an Artist," 1961. Lectures on art to women's art and civic clubs. Position: Private classes in San Francisco. Summer teaching tours in Canada, Seattle, Wash., Reno, Nev., Carmel, Cal., etc. Annual art tours to various countries. Judge, Juror, Cal. State Fair (2 yrs).

BRANDT, GRACE BORGENICHT—Art Dealer, Collector
1018 Madison Ave. 10021; h. 138 E. 95th St., New York, N.Y. 10028; also Water Mill, L. I., N.Y. 11976
B. New York, N.Y., Jan. 25, 1915. Studied: Columbia University, M.A.; André L'Hote, Paris, France. Specialty of Gallery: Contemporary American Painting and Sculpture. Collection: Contemporary American Painting and Sculpture; French Drawings. Positions: Director, Grace Borgenicht Gallery, New York, N.Y., 1951- .

BRANDT, REX(FORD)—Painter, I., W., L., T., Des.
405-407 Goldenrod Ave., Corona del Mar, Cal. 92625
B. San Diego, Cal., Sept. 12, 1914. Studied: Univ. California, A.B.; Stanford Univ.; Redlands Univ. Member: ANA; Laguna Beach AA; AWS; Cal. WC Soc.; and others. Awards: prizes, Los. A. Mus. A., 1937, 1945; Oakland A. Mus., 1937, 1942; San Diego FA Gal., 1939, 1942; So. Cal. Fair, 1936-1939; Laguna Beach, 1936, 1937, 1941, 1944, 1948, 1949, 1952, 1956-1960; Cal. WC Soc., 1938, 1941, 1945, 1952, 1956; Orange Show, 1949; Cal. State Fair, 1934; Univ. Cal., 1935; Univ. Cal., Berkeley, 1936; Los A. County Fair, 1936-1939, 1960; Ebell Cl., Los A., 1938; Santa Paula 1943; Riverside FA Gld., 1941, 1943; Newport H.S., 1946; San Dimas, Cal., 1946; AWS, 1952, 1954, Newcastle award, 1965, Saportas award, 1968; Obrig prize, NAD, 1961, Morse Medal, 1968; N. Western A. Dirs., 1955; Paramount H.S., 1952; de Young Mem. Mus., 1953; medals, Oakland A. Mus., 1940, 1942; City of Los Angeles, 1951; citation, A. Dir. Cl., Los A., 1955; Work: Los A. Mus. A.; Crocker A. Gal.; San Diego FA Soc.; Chaffey AA; Cole of California; Riverside Polytechnic H.S.; Ford Motor Co.; Newport Union H.S.; Bonita H.S.; Paramount H.S.; Automobile Cl. of So. Cal.; U.S. Maritime Service; Orange Coast College; U.S. Treasury Dept.; SFMA; murals, San Bernardino and Chemawa H.S. Exhibited: AIC; CGA; Chaffey AA; Los A. AA; AGAA; Haggin Mem. Gal.; NCFA; Chicago A. Cl.; St. Paul Acad. (Minn.); DMFA; Los A. County Fair; Denver A. Mus.; San Diego FA Gal.; Museo de la Acuarele, Mexico City, 1968; Currier Mus. A.; Faulkner Gal. A.; Monticello Col.; Univ. So. Cal.; Riverside Mus.; Laguna Beach AA; Yellowstone A. Center; John Herron AI; Pasadena AI; Long Beach A. Center, and many others; one-man: Cal. PLH; Crocker A. Gal.; Santa Barbara Mus. A.; Los A. Mus. A.; Coronado AA; Fleming Mus. A.; So. Methodist Univ.; Univ. of Redlands; Pasadena Col.; Padua Hills Gal., Chaffey Col.; Courvoisier Gal.; San F.; Allan Hancock Col., and others. I., Fortune and Life magazines. Author: "Watercolor Technique in Fifteen Lessons"; "Watercolor Landscape"; "The Artist's Sketchbook and Its Uses"; "Composition of Landscape Painting," moving picture lectures for Ford Motors, Grumbacher Co., USIS, and others. Po-

sitions: Dir., Rex Brandt Sch., Corona del Mar, Cal.; Instr. Chouinard AI, Los Angeles, Cal., 1947-1959; V.-Pres., AWS, 1965-1969.

BRANDT, WARREN—Painter, E.
138 E. 95th St., New York, N.Y. 10028
B. Greensboro, N.C., Feb. 26, 1918. Studied: PIASch.; ASL; Washington Univ., St. Louis, Mo., B.F.A.; Univ. North Carolina, M.F.A. Member: CAA. Awards: John T. Millikin Traveling F., Washington Univ., 1948. Exhibited: Holland-Goldowsky Gal., 1960; MMA; AFA; WMAA; BM; one-man: Nonogan Gal., 1959; American Gal., 1961; Memphis State Univ., 1960; New Gal., Provincetown, 1960; Michigan State Univ., Oakland, Mich., 1961; Stuttman Gal., Provincetown, 1962; Grippi Gal., N.Y., 1963, 1964; Obelisk Gal., Wash., D.C., 1963; A. M. Sachs Gal., New York, N.Y., 1966-1968; Benson Gal., Bridgehampton, N.Y., 1967; Barnes Gal., Los Angeles, 1968; Cora Gal., Southampton, N.Y., 1968; Agra Gal., Wash., D.C., 1969; Grand Ave. Gal., Milwaukee, 1969; Mercury Gal., London, England, 1969; Univ. North Carolina, 1967; Reed Col., Portland, Ore., 1967; Eastern Ill. Univ., 1968; Salem Col., Winston-Salem, N.C., 1968; Retrospective exhibition, Allentown (Pa.) Mus. A., 1969. Work: Wash. Mus. Mod. A.; Chrysler Mus.; Mich. State Univ. Mus.; So. Illinois Univ.; Rochester Mus. A. & Sciences; New Mexico State Mus.; Smithsonian Inst.; NCFA; Guild Hall, East Hampton, N.Y.; Michener Fnd.; Joseph Hirshhorn Coll. Positions: Hd., Dept. Art, Salem College, Winston-Salem, N.C., 1949-50; Instr., Pratt Institute Art Sch., Brooklyn, N.Y., 1950-52; Chm., Dept. Art, Univ. of Mississippi, University, Miss., 1957-59; Chm., Dept. A., Southern Illinois University, Carbondale, Ill., 1959-61; Supv. A. Acquisitions, So. Illinois Univ., 1961-62; Instr. Drawing, School of Visual Arts, New York, N.Y., 1962-63; Chm., N.Y. Sch. Painting & Drawing, 1966- .

BRANNER, ROBERT—Scholar
Columbia University, New York, N.Y.; h. 440 Riverside Drive, New York, N.Y. 10027
B. New York, N.Y., Jan. 13, 1927. Studied: Yale Univ., B.A., Ph.D. Member: Nat. Committee for the History of Art, 1969- . Awards: John Simon Guggenheim Memorial Fellow, 1963; Alice Davis Hitchcock Award for the most distinguished book on the history of architecture for 1963. Books published: "Gothic Architecture" (New York) 1961; "Burgundian Gothic Architecture" (London) 1960; "La Cathédrale de Bourges" (Paris) 1963; "Saint Louis and the Court Style" (London) 1965. Field of Research: Mediaeval Art and Architecture. Positions: Chm. & Prof., Dept. of Art History; Prof., Columbia University, New York, N.Y., 1968- .

BRANSOM, (JOHN) PAUL—Painter, I., Et., T.
15 West 67th St., New York, N.Y. 10023
B. Washington, D.C., July 26, 1885. Member: AWS; SC; Soc. Animal Artists; AAPL. Exhibited: Retrospective Exh., Woodmere A. Gal., Chestnut Hill, Philadelphia, Pa., 1963. Illus., forty-five books, including, "The Call of the Wild," "The Wind in the Willows," "An Argosy of Fables," "Animals of American History," "Hunters Choice," "Wilderness Champion," "Wahoo Bobcat," "Phantom Deer," "Zoo Parade," and others.

BRAUNER, ERLING B.—Educator, P.
Michigan State University, East Lansing, Mich.; h. 2527 Arrowhead Rd., Okemos, Mich. 48864
B. Ithaca, N.Y., Apr. 16, 1906. Studied: Cornell Univ., B.F.A., M.F.A. Work: Denison Univ. Lib. Exhibited: Flint AI, 1950, 1952; Birmingham Little Gal.; Detroit Inst. A., 1953; South Bend AA, 1954, 1960; Ohio State Univ., 1956; Wooster College, 1956; Detroit Inst. A., 1956; Grand Rapids AI, 1956; Saginaw Mus. A., 1958. Positions: Instr., 1935-40, Asst. Prof., 1940-42, Assoc. Prof., 1942-58, Prof., 1958- , Chm., Dept. of Art, 1962- , Michigan State Univ., East Lansing, Mich. Exec. Com., Chm., Visual Arts Com., Michigan State Council for the Arts, 1966-1969.

BRAZEAU, WENDELL PHILLIPS—Educator, P., Gr.
University of Washington; h. 2631 29th Ave., West, Seattle, Wash. 98199
B. Spokane, Washington, May 19, 1910. Studied: Univ. Washington, B.A., M.F.A.; Archipenko Sch. FA. Member: San F. AA. Awards: prizes, Northwest WC Exh., 1950; Henry Gal., 1952; Western Wash. Fair; SAM, 1956. Exhibited: SAM, annually (one-man, 1957); Northwest Pr.M.; Oakland A. Gal.; Portland (Ore.) A. Mus.; Kaufman Gal., N.Y.; Northwest WC Soc.; Henry Gal. (one-man); Butler Inst. Am. A., 1957; Santa Barbara Mus. A., 1957. Work: SAM, and in private colls. Positions: Prof. A., Univ. Washington, Seattle, Wash.*

BREASTED, JAMES H(ENRY), JR.—Lecturer, Hist.
Kent School, Kent, Conn.; Mail: P.O. Box 276, Kent, Conn. 06757
B. Chicago, Ill., Sept. 29, 1908. Studied: Princeton Univ., A.B.;

Heidelberg Univ.; Oxford Univ.; Univ. Chicago, A.M.; Inst. for Advanced Study, Princeton. Member: Egypt Exploration Soc.; Soc. for Italic Handwriting; Archaeological Inst. Am.; CAA; Officier de l'Academie Francaise. Author: "Arab Nationalism in the Near East," in publ., "Africa; The Near East and The War," 1943; Egyptian Servant Statues (Bollingen Fnd., 1948). Contributor to professional journals. Positions: Instr., A. & Archaelogy, Colorado College, Colorado Springs, 1937-39; Visting L. in art Hist., Hunter College, N.Y., 1941; Asst. Prof., Art Hist., UCLA, Los Angeles, Cal., 1941-46; Dir., Los A. Mus. A., 1946-51; L., Art Hist., and Master, Kent Sch., Kent, Conn., 1952- ; Chm. Dept. A. & Art History, Kent Sch., Kent, Conn., 1963- ; Dir., Olcott Damon Smith Gallery, Kent School, 1964- . Memb. Screening Comm., 3rd Intl. Art-film Festival, MMA, 1957. Chairman of the Jury, Annual Italic Handwriting Competition, 1963-67; Chairman, Independent Schools Art Instructors Assn., 1965-67; Member, Bd. of Dir., The Barnstormers, Inc., 1966- ; Chairman, 1967- . Personal coll. of over 12,000 color-slides of architecture, sculpture and painting in Holland, Belgium, France, Italy, Spain, Austria, Switzerland and Germany; also art museums in New York City and New England.

BRECHER, SAMUEL—Painter, T.
124 West 23rd St.; h. 425 East 78th St., New York, N.Y. 10021
B. Austria, July 4, 1897. Studied: CUASch.; NAD, and with Charles Hawthorne. Member: Audubon A.; Nat. Soc. Casein Painters; All. A. Am; Painters & Sc. of New Jersey. Awards: prizes, SC, 1950, 1951; N.Y. State Fair, 1951; Fla. Southern Col., 1952 (citation); A. Lg. Long Island, 1954; Audubon A., 1953, 1956; Fla. Intl. Exh., 1952; All. A. Am., 1960; Nat. Soc. Ptrs. in Casein, 1962. Work: MMA; Walker A. Center; Newark Mus. A.; Tel-Aviv and Ain Harod Mus., Israel; Fla. Southern Col.; Staten Island Inst. A. & Sciences, 1961. Exhibited: WFNY 1939; GGE 1939; PAFA, 1936, 1943, 1957; Phila. WC Cl., 1958; Silvermine Gld. A., 1958; Butler Inst. Am. A., 1958; NAD, 1924, 1927, 1931, 1936, 1937, 1945, 1946; Carnegie Inst., 1941, 1944; AIC, 1936, 1938; AFA, 1931, 1944; Walker A. Center, 1943; Dayton AI, 1936, 1951, 1952; VMFA, 1944; BM, 1944; CM, 1939; SFMA, 1942; N.Y. State Fair, 1951; Rochester Mem. A. Mus., 1951-1955; Fla. Southern Col., 1952; Riverside Mus., 1954; CGA, 1953; New Britain A. Mus., 1951; Staten Island Mus. A. & Sci., 1956; one-man: ACA Gal., 1935; Hudson Walker Gal., 1938, 1940; Kraushaar Gal., 1942, 1944; Babcock Gal., 1949, 1951; Merrill Gal., N.Y., 1962; Bergen County Y.M.H.A., 1966. Positions: Instr., Painting, Newark Sch. F. & Indst. A., Newark, N.J.

BRECKENRIDGE, JAMES D.—Scholar, Educator
Department of Art, Northwestern University; h. 2420 Harrison St., Evanston, Ill. 60201
B. New York, N.Y., Aug. 8, 1926. Studied: Cornell University, B.A.; Princeton University, M.F.A., Ph.D. Advanced study: Dumbarton Oaks Research Library, Harvard University, Washington, D.C.; University of Paris (Sorbonne); Warburg Institute, University of London. Positions: Curator, Corcoran Gallery of Art, 1952-1955; Curator, Baltimore Museum Art, 1955-1960; Visiting Associate Professor, University Pittsburgh, 1960-1961; Board of Directors, College Art Association, 1967- ; Advisory Board, International Center of Mediaeval Art, 1966- ; Associate Professor, Northwestern University, 1961-1966, Professor, 1966- , Chairman, Department of Art, 1964- . Field of Research: History of Portraiture.

BREER, ROBERT—Filmmaker, P.
c/o Galeria Bonino, 7 W. 57th St., New York, N.Y. 10019
B. Detroit, Mich., 1926. Studied: Stanford Univ. Awards: Stanford Painting Award. Exhibited: Int. Expo. of Art in Motion, Amsterdam, Stockholm and Copenhagen, 1961; Film Retrospective, Charles Cinema, New York City, 1963; other films—Washington Gal. Mod. A.; MModA; "Breathing," film selected for New York Film Festival, Lincoln Center, 1964; Film Series, Gal. Mod. A., N.Y., 1964; Judson Hall, N.Y., 1964; N.Y. and London Film Festivals, 1965; one-man: Bonino Gal., N.Y., 1966, 1967. Designed Pepsi-Cola Pavilion, Osaka World's Fair, 1970.

BREESKIN, ADELYN DOHME (Mrs.)—
Lecturer, Former Museum Director, A. Consultant
Room 617, National Collection of Fine Arts, Smithsonian Institution, Washington, D.C. 20025; h. 1254 31st St., N.W., Washington, D.C. 20007
B. Baltimore, Md., July 19, 1896. Studied: Bryn Mawr Col.; Radcliffe Col.; Sch. FA, Crafts & Dec. Des., Boston. Awards: Doctor of Letters, Goucher Col., 1953; "Star of Solidarity," Italian Government, 1954, for promoting intercultural betterment; D.F.A., Washington Col., 1961; Wheaton College, 1963 (D.F.A.); Hood College, Frederick, Md., 1966; Morgan State College, Baltimore, Md., 1966. U.S. Commissioner in charge of the American Pavillion of the 30th Venice Biennale Exh., 1960. Author: "The Graphic Work of Mary Cassatt," 1948; Baltimore Museum "News" articles; contributor to "L'Oeil" and to other art publications, Europe and U.S. Lectures in

U.S. and abroad. Television and radio. Positions: Staff, Johns Hopkins Univ., McCoy College, Art Dept., 1937-1950; Cur. Prints & Drawings, 1930- , General Cur., 1938, Actg. Dir., 1942, Dir., 1947-1962, Baltimore Museum of Art; Sec.-Treas., 1953-56, Pres., 1956-57, AAMus. Dirs.; Sec., Print Council of America; Memb. Jury of Selection, Intl. Graphic Arts Soc., 1955-1964; Trustee, AFA, 1960- . Has served on many juries for selection for exhibitions shown in U.S. and abroad. American Specialist Lecture Tour of the Orient under the State Dept., Nov. 1964- March, 1965. Art Consultant and Curator of Contemporary Art, 1966- , National Collection of Fine Arts, Smithsonian Institution.

BREGER, DAVE (DAVID)—Cartoonist
King Features Syndicate, New York, N.Y.; h. 26 Smith Ave., South Nyack, N.Y. 10960
B. Chicago, Ill., Apr. 15, 1908. Studied: Univ. Illinois; Northwestern Univ., B.S. Member: Nat. Cartoonists Soc.; Newspaper Comics Council. Awards: Award of Merit, Northwestern Univ., 1946; Certif. of Honor, Am. Nat. Red Cross, 1947; Award of Merit, U.S. Treasury Dept., 1950, 1958. Author: "Private Breger," 1942; "Private Breger's War," 1944; "Private Breger in Britain," 1944; "G.I. Joe," 1945; "How To Draw and Sell Cartoons," 1966; creator syndicated cartoon, "Mr. Breger"; Editor, "But That's Unprintable," 1955. Instr., Cartooning, New York University, General Education Division, 1961-1963.

BREININ, RAYMOND—Painter, S., T.
48 West 20th St., New York, N.Y. 10011
B. Vitebsk, Russia, Nov. 30, 1910. Studied: Chicago Acad. FA; and with Uri Penn. Awards: prizes, AIC (7); MMA; PAFA (2); Univ. Illinois; Ecclesiastical A. Gld., Detroit; Art,USA, 1958; Bloomington AA. Work: MMA; MModA; BM; AIC; PC; BMFA; FMA; SFMA; San Diego FA Soc.; Newark Mus. A.; Cranbrook Acad. Art; Zanesville A. Mus.; John Herron AI; Williams Col.; Univ. Illinois; Am. Acad. A. & Lets.; State Dept., U.S. Govt.; Encyclopaedia Britannica; Capehart Coll.; E. Lilly Co.; Nat. Gal., Scotland; costumes and settings for Ballet Theatre's "Undertow"; murals, Winnetka (Ill.) H.S.; State Hospital, Elgin, Ill.; USPO, Wilmette, Ill.; Pump Room, Ambassador East Hotel, Chicago; Jade and Emerald rooms Sherman Hotel, Chicago. Positions: A-in-Res., Univ. Southern Illinois; Instr. A., Univ. Minnesota; Breinin Sch. A., Chicago, Ill.; Instr., painting & drawing, Art Students League, New York, N.Y.*

BREITENBACH, EDGAR—Chief, Print Division
Library of Congress, Washington, D.C. 20540
Positions: Chief, Prints and Photograph Division, Library of Congress, Washington, D.C.

BREITENBACH, WILLIAM J.—Painter, E.
Box 2023, Sam Houston College Station, Huntsville, Tex. 77340
Studied: Univ. of Wisconsin, B.S., M.S. in A. Edu.; Ed. D. program at the Univ. of Houston, Houston, Tex. Member: NAEA; Texas A. Edu. Assn.; Print Council of Am.; Pratt Center for Contemp. Pr.M.; Exhibited: Ball State Univ., Muncie, Ind., 1963, 1964; Drawings: USA, St. Paul A. Center, St. Paul, Minn., 1963; Neville Pub. Mus., Green Bay, Wis., 1965; Jewish Community Center, Houston, Tex., 1965-1967; Troup Gal., Dallas, 1965; James Bute Gal., Houston, 1966; Mount St. Paul Col., Waukesha, Wisc., 1967. One-man: Univ. Wisc., 1963, 1964(2); Eau Claire State Col., Eau Claire, Wis., 1963; Fredericks Gal., Milwaukee, 1964; Pensacola A. Center, Pensacola, Fla., 1966; Northwestern State Col. of La., Nacogdoches, Tex., 1966; Hanover Col., Hanover, Ind., 1966; Cultural Exchange Comm., Puebla, Mexico, 1967; Col. of Southern Utah, Cedar City, Utah, 1967; George Peabody Col., Nashville, Tenn., 1967; Northern Montana Col., Havre, Mont., 1967. Positions: Instr., Sam Houston State College, Huntsville, Tex.

BREITHAUPT, ERWIN M., JR.—Educator, P.
Ripon College; h. 844 Ransom St., Ripon, Wis. 54971
B. Columbus, Ohio, Nov. 12, 1920. Studied: Miami Univ., Oxford, Ohio, B.F.A.; Ohio State Univ., M.A., Ph.D. Member: CAA. Awards: Rockefeller Fnd. Fellowship, 1952-1953; Severy award, 1965; Obrig award, NAD, 1969. Co-Author, "Creativity and the Arts," 1961. Contributor of articles: "A New Approach to Art Education" (Education, 1956); "The Basic Art Course at Georgia" (College Art Journal, 1957); "An Institutional Approach to Aesthetics" (Southwestern Louisiana Journal, 1959). Positions: Prof. A., Ripon College, Ripon, Wis.

BRENDEL, OTTO J.—Scholar, Educator
Columbia University; h. 315 Riverside Drive, New York, N.Y. 10025
B. Nuremberg, Germany, Oct. 10, 1901. Studied: Heidelberg, Germany, Ph.D. Member: Fellow, American Academy in Rome; Life member, German Archaeological Institute. Field of Research: Art,

especially painting and sculpture: Greek, Etruscan, Roman, Classical survivals in later Art including Contemporary. Contributor to books and periodicals, U.S. and abroad, 1924- . Positions: Prof., Dept. of Art History and Archaeology, Columbia University, New York, N.Y.

BRENNAN, FRANCIS EDWIN—
Art Editor, Collector, Writer
40 E. 62nd St., New York, N.Y. 10021
B. Maywood, Ill., July 14, 1910. Studied: University of Wisconsin; Art Institute of Chicago. Awards: Ordre de Mérite Commercial, France, 1950; Legion of Honour, France, 1960. Positions: Secretary, American Federation of Arts.

BRENNAN, HAROLD JAMES—Educator, C., L., W.
College of Fine and Applied Arts, Rochester Institute of Technology, 1 Lomb Memorial Dr., Rochester, N.Y. 14623
B. Indianapolis, Ind., Oct. 25, 1903. Studied: Carnegie Inst., B.A., M.A.; Harvard Univ.; Univ. of Paris. Member: Com. on A. Edu., Am. Inst. AA; Midwest Des-Craftsmen. Awards: Scholarship, Inst. of International Edu., Univ. Paris, 1938; Grogan prize, Assoc. A. of Pittsburgh, 1938. Exhibited: Assoc. A. Pittsburgh, Contributor to Craft Horizons; Handweaver & Craftsman; Journal of Am. Indst. AA. Lecturer, Arts Program of the Assn. of Am. Colleges, 1934-53, on "Contemporary Design for Living"; "The Designer-Craftsman in Modern Society," etc. Positions: Prof. A., 1933-46, Chm. Div. of the Arts, 1946-48, Westminster Col.; Dir., Sch. for Am. Craftsmen, Rochester Inst. Tech., 1948- ; Chm. Div. Arts, 1953- , Dean, College of Fine & Applied Arts, 1959- .

BREWER, DONALD J.—Educator, W., Cr., L.
Fresno State College, N. Maple & Shaw Ave.; h. 653 E. San Bruno St., Fresno, Cal. 93726
B. Los Angeles, Cal., July 22, 1925. Studied: Univ. California, Santa Barbara, B.A.; special training at Santa Barbara Mus. A., with Donald J. Bear. Member: AFA; AAMus.; Western Assn. A. Mus. (V. Pres. 1962). So. Cal. A. Hist. Assn. Lectures: "Modern Art," La Jolla Mus. A.; Univ. California Extension. Arranged following exhs.: "The Art of Negro Africa"; Marc Chagall 75th Anniversary Exh.; The Work of Henry Moore; George Rouault, Paintings and Graphic Work; The Work of Louis I. Kahn. Positions: Dir., La Jolla Museum of Art, La Jolla, Cal., 1960-1968; Dir., Art Exhibitions & Prof. Art, Fresno State College, Fresno, Cal.

BREWINGTON, MARION VERNON—Museum Director, W.
The Kendall Whaling Museum, Sharon, Mass. 02067
B. Salisbury, Md., June 23, 1902. Studied: Univ. Pennsylvania, B.S. Member: Soc. for Nautical Research; Salem Marine Soc; Mass. Hist. Soc.; Maryland Hist. Soc.; American Antiquarian Soc. Awards: Guggenheim F., 1958. Author: "Chesapeake Bay, A Pictorial Maritime History," 1953; "Shipcarvers of North America," 1962; "Navigating Instruments," 1963; "Kendall Whaling Museum Paintings," 1965; "The Marine Paintings in the Peabody Museum," 1968. Contributor of many articles to The American Neptune; Maryland Magazine of History; Pennsylvania Magazine of History; U.S. Naval Inst. Proceedings, etc. Positions: Cur., Naval Hist. Fnd., 1946-48; Cur., Maritime History, Md. Hist. Soc., 1954-55; Cur., Kendall Whaling Mus., 1956-66; Asst. Dir. & Cur. Maritime History, The Peabody Mus., Salem Mass. 1956-66; Director, Kendall Whaling Museum, Sharon, Mass. 1966- .

BREZIK, HILARION, C.S.C.—Painter, I., Exhibit Dir.
St. Edward's University, Austin, Tex. 78704
B. Houston, Tex., Aug. 5, 1910. Studied: Univ. Notre Dame, B.F.A. Member: Texas FA Assn. Work: 3-wall mural, St. Charles Boys Home, Milwaukee, Wis. Exhibited: Brothers of the Holy Cross National Exh., 1960, 1963, 1965; Wisconsin Exh., 1941-1943; Texas FA Assn., 1961, 1962, 1963. Illus.: "That Boy"; "The Boy Who Sailed Around the World"; "The Dragon Killer"; "The Happy Heart." Contributor articles to Catholic Art Association Quarterly; Illus, to Associate of St. Joseph. Positions: Instr., Art, Hd. A. Dept., Cathedral H.S., Indianapolis, Ind; Superior & Dir., St. Charles Boys Home, Milwaukee, Wis.; Boysville of Michigan, Clinton, Mich; Variety Boys Ranch, Bedford, Texas. Fine Arts Exhibit Dir., Instr. A., St. Edward's University, Austin, Texas.

BRICE, WILLIAM—Painter, E.
427 Beloit St., Los Angeles, Cal. 90049
B. New York, N.Y., Apr. 23, 1921. Studied: Chouinard AI; ASL. Member: AEA. Awards: Los Angeles, 1947; Los Angeles City Exh., 1951. Work: MMA; WMAA; MModA; Los A. Mus. A.; Santa Barbara Mus. A. Exhibited: Carnegie Inst., 1948, 1949, 1954; WMAA, 1947, 1950, 1951; Santa Barbara Mus. A., 1945; Los A. Mus. A., 1947-1951; Cal. PLH, 1951-1952; Sao Paulo, Brazil. Positions: Prof., Dept. A., Univ. California at Los Angeles, 1953- .*

BRIGGS, AUSTIN—Collector, Illustrator
Chestnut Woods Rd., West Redding, Conn. 06896
B. Humboldt, Minn., Sept. 8, 1908. Studied: Wicker Art School, Detroit, Mich.; Art Students League, New York. Member: Founding Faculty, "Famous Artists Schools," Westport, Conn.; Players; SI. Awards: More than 60 awards, including gold medals, from Society of Illustrators; Art Directors Club and others; "Hall of Fame," Soc. Illustrators. Collection: Modern Sculpture—Henry Moore, Nadelman, Bernard Meadows, Alexander Calder, Leonard Baskin, etc.

BRIGGS, ERNEST—Painter
128 W. 23rd St., New York, N.Y. 10011
B. San Diego, Cal., Dec. 24, 1923. Studied: Cal. Sch. FA, San Francisco. Work: Carnegie Inst., Pittsburgh; Michigan State Univ., East Lansing; Rockefeller Inst., New York; WMAA; SFMA, and in private colls. Exhibited: WMAA, 1955, 1956, 1961; MModA, 1956; CGA, 1961; SFMA, 1962, 1963; San Francisco AA, 1948, 1949, 1953; CalPLH, 1953; Stable Gal., New York, 1955; Museum Contemp. A., Dallas, 1962; Allan Frumkin Gal., Chicago, 1953; one-man: Stable Gal., 1954, 1955; Cal. Sch. FA, San Francisco, 1956; Howard Wise Gal., New York, 1960. Positions: Instr., Drawing & Painting, Univ. Florida, 1958; Pratt Institute, New York, 1961- .*

BRILL, WILLIAM W.—Collector, Patron
7 Cornelia St., New York, N.Y. 10014
B. New York, N.Y., Aug. 26, 1918. Studied: Yale University, B.A. Collection: Primitive Art, particularly African. Exhibit of collection at New York Public Library, Milwaukee Public Museum, St. Paul A. Center, Tweed Gallery, University of Minnesota. Donor of primitive art to various museums.

BRITSKY, NICHOLAS—Painter, E.
University of Illinois, Champaign, Ill. 61820; h. 1410 South Vine St., Urbana, Ill. 61801
B. Ukraine, Dec. 11, 1913. Studied: Yale Univ., B.F.A.; Columbia Univ.; Syracuse Univ. Member: CAA; AFA. Awards: Traveling F., Yale Univ., 1938; Fulbright F., 1956-57, 1965-1966 to Portugal; Univ. Illinois Faculty grant, 1968; prizes, Ohio Univ., 1951; Old Northwest Territory Exh., 1954; Ill. State Mus., 1959; Illinois State Fair, 1964; Evansville (Ind.) Mus. A., 1964. Work: Bell Telephone Bldg., Waterloo, Iowa; Galesburg Jr. H.S. Contributor to Encyclopaedia Slovanica. Lectures: Contemporary Art; Mural Decoration. Exhibited: Butler AI, 1953, 1955, 1959; Illinois State Mus., 1958-1961; Ill. State Fair, 1959, 1962, 1964, 1967, 1968; Ohio Univ., 1959, 1960; NAD, 1963; Evansville Mus., 1961, 1963, 1964, 1967; Stephen's Col., 1965; Ford Motor Co., 1964; Rosary Col., 1962. Positions: Prof. A., Univ. Illinois, Champaign, Ill., 1946- .

BRITTIAN, W. LAMBERT—Educator
College of Home Economics, Cornell University, Ithaca, N.Y. 14850*

BROADD, HARRY ANDREW—Educator, P., L., A. Hist.
University of Tulsa; h. 3166 East 40th St., Tulsa, Okla. 74105
B. Chicago, Ill., Feb. 17, 1910. Studied: Univ. Chicago, Ph.B.; Columbia Univ., A.M.; Univ. Michigan, Ph.D.; Northwestern Univ.; AIC. Member: AAUP; CAA; NAEA. Exhibited: AIC, 1932, 1933, 1936, 1937; Laguna Beach AA, 1945; Univ. Chicago, 1932, 1933; Century Gal., Chicago, 1935; Detroit Inst. A., 1946; Philbrook A. Center, 1947-1958. Contributor to Design Magazine; articles on art to World Book Encyclopedia. Lectures: History of Art, Philbrook A. Center, 1950-54. Positions: Instr., Indiana Univ., 1935-37; Asst. Prof. A., Mich. State Normal Col, Ypsilanti, Mich., 1937-1947; Assoc. Prof. A., 1947-54, Prof. A., 1954- , Univ. Tulsa, Tulsa, Okla.*

BROCHSTEIN, I. S.—Collector
2322 Braeswood Blvd., Houston, Tex. 77025*

BRODERSON, MORRIS—Painter
Ankrum Gallery, 657 N. La Cienega Blvd., Los Angeles, Cal. 90069; also, Downtown Gallery, 465 Park Ave., New York, N.Y. 10022
B. Los Angeles, Cal., 1928. Studied: Univ. Southern California. Work: BMFA; Container Corp. of Am.; Honolulu Acad. A.; Kalamazoo Inst. A.; Los A. Mus. A.; WMAA; Joslyn A. Mus.; Omaha, Neb.; Palm Springs Desert Mus.; Phoenix A. Mus.; James A. Michener Fnd. Coll.; Marion Koogler McNay AI, San Antonio, Tex.; FA Gal., San Diego; SFMA; Santa Barbara Mus. A.; Univ. So. Florida, Tampa; Stanford Mus. A., Stanford, Cal., and work in private colls. Exhibited: Group exhibitions, 1966-1969: Carnegie Intl., Pittsburgh; Krannert A. Mus., Univ. Illinois; 43rd Anniversary Exhibition, Downtown Gallery, New York, N.Y.; Amon Carter Mus., Fort Worth, Tex.; Univ. of Georgia; Univ. of North Carolina; Univ. of Connecticut Mus. A. Special exhibitions at Ankrum Gallery since 1961, and

at the Downtown Gallery since 1963. Retrospective exhibition at Fine Arts Gallery of San Diego, Cal., 1969.

BRODERSON, ROBERT—Painter
 Mountain Road, Woodbury, Conn. 06798
B. West Haven, Conn., July 6, 1920. Studied: Duke Univ.; State Univ. Iowa, M.F.A.; and in Mexico and Europe on research grants from Duke Univ. Awards: Nat. Inst. A. & Lets., grant, 1962; Duke Univ. Summer Research Fellowship, 1963; Guggenheim Fellowship, 1964; Childe Hassam Purchase, 1968; prizes, Winston-Salem, 1949; Des Moines A. Center, 1951; North Carolina State A. Gal., 1953; Eastern Carolina College, 1954; Painting of the Year, Atlanta, 1958; Southeastern Annual, Atlanta, 1960; and others. Work: Nat. Inst. A. & Lets., N.Y.; WMAA; Wadsworth Atheneum, Hartford; Colorado Springs FA Center; Art Mus., Princeton Univ. Exhibited: North Carolina State A. Gal., 1949, 1952, 1953, 1960; Southeastern Exh., Atlanta, 1950, 1954, 1960; Butler Inst. Am. Art, 1951, 1953; Des Moines A. Center, 1951; Kansas City, 1951; PAFA, 1951, 1953, 1962; MMA, 1952; CGA, 1953, 1957, 1962; MModA, 1962; CMA, 1962; CAM, 1962; Krannert A. Mus., Univ. Illinois, 1963, 1965; Univ. Colorado, 1963; Denver A. Mus., 1963; Illinois Wesleyan Univ., 1963; Duke Univ., 1963; Nebraska AA, 1964; Carnegie Intl., 1964; one-man: Mint Mus., Charlotte, 1951; Allied Arts, Durham, 1955; North Carolina State A. Gal., 1957, 1960; Catherine Viviano Gal., New York, N.Y. 1961, 1963, 1964, 1965; Terry Dintenfass Gal., New York, N.Y., 1966, 1968.

BRODEY, STANLEY C.—Painter
 424 Woodmere Blvd., Woodmere, N.Y. 11598
B. New York, N.Y., Sept. 17, 1920. Studied: Pratt Inst., N.Y.; A. Lg., Long Island; John Pike WC Sch. Member: Prof. A. Lg.; AAPL; Hudson Valley AA; Nat. A. Lg.; A. Lg. Nassau County; Malverne A.; Suffolk County A. Lg.; Huntington Township A. Lg.; Long Beach AA. Awards: Heckscher A. Mus., 1965; A. Lg., Long Island, 1964; Pierce Trowbridge Wetter Mem. Award, 1963; A. Lg. Nassau County, 1966-1968; Awixa Pond A. Center, 1966, 1967; Lake A. Center, 1967, 1968; Syosset A. Gld. & Gal., 1968; Kiwanis Cl. Travel Award, 1968; Suffolk County A. Lg., 1966-1969. Work: State Col. of Virginia; Sayville Pub. Lib.; Awixa Pond A. Center. Exhibited: Audubon A., 1965; NAC, 1962-1964, 1966-1968; Knickerbocker A., 1962-1964; AAPL, 1962, 1966, 1967, 1969; All. A. Am., 1961; A. Lg., Long Island, 1961-1964; N.Y. World's Fair, 1964; Heckscher Mus. A., 1965; Long Island A., 1965; Hofstra Univ., 1965; Univ. Missouri, 1966; Harding Col., 1966; Fla. Gulf Coast A. Center, 1966; Massillon Mus., 1966; Hudson Valley AA, 1966-1968; A. Lg. Nassau County, 1966-1969; AWS, 1968; Adelphi Univ., 1969; Wisconsin State Univ., 1969; St. Ambrose Col., 1969; W. Va. Wesleyan Univ., 1969; North Dakota State Col., 1969.

BRODIE, GANDY—Painter, T., Des., C., L.
 West Townsend, Vt. 05359
B. New York, N.Y., May 20, 1924. Studied: Columbia Univ.; Hans Hofmann Sch. FA. Awards: Cultural Enrichment grant, State of Washington; Title III, A.-in-Res., Hollins Col., 1968; Ingram Merrill Fnd. Award, 1962; Nat. Arts Council Award. Work: MModa; WMAA; PC; BMA; Chrysler Mus., Provincetown, Mass.; Massachusetts Inst. Tech.; Sarah Lawrence Col.; Gloria Vanderbilt Mus.; Longview Fnd.; Jewish Mus., N.Y.; Mint Mus. A., Charlotte, N.C.; Park Ave. Synagogue; Norfolk Mus. A. & Sciences. Exhibited: one-man: Kootz Gal., 1951, Urban Gal., 1954, Durlacher Gal., 1955, 1957, 1959, 1961, 1963, Zabriskie Gal., 1967, Saidenberg Gal., 1964, all in New York City; also, Obelisk Gal., Boston, 1965; Richard Gray Gal., Chicago, 1967.

BRODY, MR. and MRS. SIDNEY F.—Collectors
 360 S. Mapleton Dr., Los Angeles, Cal. 90024*

BROMBERG, MR. and MRS. ALFRED L.—Collectors
 3201 Wendover Road, Dallas, Tex., 75214*

BRONER, ROBERT—Etcher, Eng., P., E., Cr.
 18244 Parkside, Detroit, Mich. 48221
B. Detroit, Mich., Mar. 10, 1922. Studied: Wayne Univ., B.F.A., M.A.; Detroit Soc. A. & Crafts; Atelier 17, N.Y., with S. W. Hayter. Awards: prizes, Los A. Art Week, 1948; Michigan A. Annual, 1961, 1966; purchase award, BM, 1964; SAGA, 1969; Wayne State Univ. Faculty Research Fellowship, 1965; Probus Achievement award, 1969. Work: MModa; BM; Guggenheim Mus ; N.Y. Pub. Lib.; PMA; Natl. Gal., Smithsonian Inst., Wash., D.C.; WAC; CM; Detroit Inst. A.; AIC; Los A. Mus. A.; MMA; Boston Pub. Lib.; FMA. Exhibited: Print Council, 1960; AFA 14 Painter-Printmakers, 1960, 1961; MModa, 1954; MMA, 1953; BM, 1951, 1953, 1958, 1960, 1964, 1966, 1968; PAFA, 1959, 1960; New Forms Gal., Athens, Greece, 1965; Otis A. Inst., 1962; Pasadena A. Mus., 1962; SAGA, 1962, 1963, 1969; USIS traveling exh., 1967-1969; British Int. Prints, 1969; Inst. Contemp. A., London, 1969; FA Gal., San Diego, 1969; Salon

de Mai, Paris 1969. One-man: Phila. A. All., 1956; Wellons Gal., N.Y., 1955; Werbe Gal., 1953; Garelick's Gal., 1957, 1961; Michigan State Univ., 1957; Carmel, Cal., 1960; Feingarten, Los A., 1961 Contributor to Art in America; Craft Horizons; Pictures on Exhibit. Positions: Instr., Auburn University, 1948-49; Dir., Montclair Sch Fine & Comm. A., 1951-52; Instr., Robert Blackburn's Creative Graphics, New York, 1953-56; Instr., Detroit Soc. A. & Crafts, 1957-1963; Instr., Life drawing, Lecturer, Eastern Michigan University, 1961-1962 Instr. A. & Art History, New York City Community College, 1963-1964; Assoc. Prof., Humanistic Studies, Monteith Col., Wayne State Univ., Detroit, Mich.

BROOK, ALEXANDER—Painter
 "Point House," Sag Harbor, L.I., N.Y. 11963
B. Brooklyn, N.Y., July 14, 1898. Member: NAD; Nat. Inst. A. & Let. Awards: Med. & prize, AIC, 1929; Carnegie Inst., 1930, 1939; med., PAFA, 1931; Guggenheim F., 1931; WMA; gold med., PAFA, 1948; Los A. Mus., 1934; med., Paris Exp., 1937; med., San F. AA, 1938; 2nd Altman prize, NAD, 1957. Work: MMA; WMAA; MModa; BM; Newark Mus.; AIC; Albright A. Gal.; CGA; Nelson Gal. A.; Toledo Mus. A.; SFMA; Univ. Nebraska; BMFA; Detroit Inst. A.; CAM; Carnegie Inst.; Wadsworth Atheneum, Hartford, Conn.; Michigan State Univ.; deYoung Mem. Mus., San Francisco, etc.*

BROOK, MRS. ALEXANDER. See Knee, Gina

BROOKS, CHARLES M., JR.—Educator
 Art Department, Lawrence College, Appleton, Wis. 54911
B. East Orange, N.J., 1908. Studied: Yale Univ., M.F.A. Member: Am. Soc. Architectural Historians. Awards: 6-time Medalist, B.A.I.D.; prize, Fontainebleau, 1933. Author: "Texas Missions, Their Romance and Architecture"; "Vincent van Gogh. A Bibliography." Positions: Hd., Art Dept., Lawrence College, Appleton, Wis.; Dir. John Nelson Bergstrom A. Center, Neenah, Wis.*

BROOKS, JAMES—Painter, T.
 500 West Broadway, New York, N.Y. 10012; also 128 Neck Path, The Springs, East Hampton, N.Y. 11937
B. St. Louis, Mo., Oct. 18, 1906. Studied: Southern Methodist Univ.; ASL, with K. Nicolaides, Boardman Robinson. Awards: prizes, Carnegie Inst., 1952; Logan prize, AIC, 1957. Work: BM; WMAA; MModa; Albright A. Gal., Buffalo, N.Y.; MMA; Guggenheim Mus.; Nebraska Univ.; Tate Gal., London; Wadsworth Atheneum, Hartford, Conn.; WAC. Exhibited: Univ. Nebraska, 1951, 1952; Univ. Minnesota, 1951, 1957; BM, 1951; WMAA, 1950-1952, 1953, 1955-1958; "Vanguard American Painters," Japan, 1950, Paris, 1951; Univ. Illinois, 1952, 1953, 1955-1960; Guggenheim Mus., 1954; Carnegie Inst., 1952, 1955, 1958, 1961; MModa, 1951, 1956; Sidney Janis Gal., 1950; "New American Painting," Basle, Milan, Brussels, Barcelona, Paris, London and Berlin, 1958; São Paulo, 1957; CGA, 1958; Tokyo, 1958; Kassel, Germany, 1959; Mexico City, 1960; one-man: Peridot Gal., 1949-1953; Miller-Pollard Gal., Seattle, 1952; Grace Borgenicht Gal., 1954; Stable Gal., N.Y. 1956, 1959; Kootz Gal., N.Y., 1961, 1962, 1964; Arte Nuova, Turin, 1959; Martha Jackson Gal., New York, N.Y., 1968; Berenson Gal., Miami, Fla., 1969. Retrospective Exhibition: WMAA; Brandeis Univ.; BMA; Walker A. Center; Washington Gal. Mod. A., Washington, D.C.; Univ. California, Los Angeles, (Feb. 12, 1963-Feb. 9, 1964). Positions: Instr., drawing, Columbia Univ., 1946-48; Instr., Lettering, PIASch, 1948-59; Visiting Cr., Yale Univ., 1955-56, 1957-60; Visiting Artist, New College, Sarasota, Fla., 1965; Prof. A., Queens College, New York, N.Y., 1968-69.

BROOKS, LOUISE CHERRY (Mrs.)—Collector, Ceramist
 3604 Narrow Lane Road, Montgomery, Ala. 36106
B. Phoenix City, Ala., Aug. 28, 1906. Studied: with Kelly Fitzpatrick and Charles Shannon. Awards: Alabama Art League; Nat. Society of Arts & Letters. Collection: Early English Staffordshire Figures. Personally specializes in and produces ceramic bird groups. Positions: Member Board of Trustees, Montgomery Museum of Fine Arts and Montgomery Art Guild.*

BROSE, MORRIS—Sculptor, T.
 1437 Randolph St. 48226; h. 65 McLean St., Highland Park, Mich. 48203
B. Wyszkow, Poland, May 16, 1914. Studied: Detroit Inst. A. & Crafts; Wayne State Univ., Detroit; Cranbrook Acad. A., Bloomfield Hills, Mich. Awards: prizes, purchase prize, Detroit Inst. A., 1958; Detroit Soc. Women Painters & Sculptors, 1959; Leon and Joseph Winkleman Fnd. prize, 1959; Michigan Artists Founders Prize, 1962. Work: Detroit Inst. A.; Grosse Pointe, Mich., Library; Chase Manhattan Bank Coll., New York, Zieger Osteopathic Hospital, Detroit; J. L. Hudson Eastland Center, Michigan; Wayne State Univ.; Cranbrook Acad. A.; Livonia Mall, Livonia, Michigan. Exhibited: PAFA,

1953, 1954, 1960; WMAA, 1960; Nebraska Univ. A. Gal., 1960; CM, 1961; John Herron Mus. A., Indianapolis, 1961; AIC, 1961; MModA, 1961; Spoleto Festival, Italy, 1961; Galleria 88, Rome, 1961; Michigan Artists annually, 1954- ; Peridot Gal., N.Y., 1960, 1962, 1964; Kasle Gal., Detroit, 1967 (one-man); Chicago, Ill., 1966 (one-man); Westminster sculpture exh., 1969; Cranbrook Acad. A. Alumni exh., 1968. Lectures: Contemporary Sculpture at Detroit Inst. A.; TV; Wayne State Univ.; Montieth Col.; Detroit Inst. A., and others. Positions: Instr., Sculpture, Cranbrook Acad. A.; Soc. A. & Crafts; Oakland University, Rochester, Michigan.

BROUDO, JOSEPH DAVID—Educator, C., P., L.
Endicott Junior College; h. 5 Gary Ave., Beverly, Mass. 01915
B. Baltimore, Md., Sept. 11, 1920. Studied: Alfred Univ., B.F.A.; Boston Univ., M. Edu. Member: Boston Soc. A. & Crafts; Mass. Assn. Craft Groups. Awards: prizes, Eastern States Expo. (Crafts), Storrowton, Mass., 1946; Sarasota, Fla., 1953; DeCordova & Dana Mus. (ceramics), 1954; Lowe Gal. A. (ceramics), 1955. Work: International Mus. Ceramics, Faenza, Italy; Mills College, Oakland, Cal. Exhibited: Syracuse Mus. A., 1947, 1950, 1954, 1956, 1960; Eastern States Exh., 1946, 1947; Lowe Gal. A., 1955, 1957; Nat. Dec. A. & Ceramics, Wichita, Kans., 1955; America House, N.Y., 1950; Boston A. Festival, 1952, 1953, 1955, 1956, 1957, 1961; Sarasota A. & Crafts, 1953; Doll & Richards Gal., Boston, 1952, 1956 (one-man); Roka Gal., Newton, Mass., 1951 (one-man); Tyringham Gal.; Lenox Gal.; Intl. Exh., Ostend, Belgium, 1960; New Delhi, India, 1960. WMA, 1948, 1952; BMFA, 1952-1954; DeCordova Mus., 1953, 1954; Inst. Contemp. A. Boston, 1955; G.W.V. Smith Mus., 1955; Berkshire Mus., Pittsfield, Mass., 1958 (one-man); Marblehead A. Gld., 1958 (one-man); Craftsmen of the Eastern States, 1964; Smithsonian Inst. traveling exh., 1965; Ceramic Nat., Everson Mus., Syracuse, N.Y., 1964, 1966-1968; Des.-Craftsmen Exh., 1967. Contributor to A. Edu. Bulletin; Eastern A. Assn.; Mass. Craft Bulletin. Positions: Bd. Dir., Mass. Assn. of Craft Groups, 1955-65; Pres. Gld. of Beverly A., 1949-51, Bd. Dir., 1952-57; Bd. Dirs., Boston Soc. A. & Crafts, 1961; Hd. Dept. A., Endicott Junior Col., Beverly, Mass., 1946- ; Instr., State Adult Edu. Program; Summer Dir., Ceramic Workshop, Lenox, Mass.; Member Statewide Adv. Committee on Craft Edu.

BROUDY, MIRIAM L.—Painter
Cloverly Circle, East Norwalk, Conn. 06855
B. Altoona, Pa., Sept. 30, 1905. Studied: PIASchA.; Academie Colorossi, Paris; ASL, with Kuniyoshi. Member: Silvermine Gld. A. (Exec. VP., 1957-61); NAWA; Meriden A. & Crafts; AEA. Awards: prizes, Penrose award, Conn. Acad. FA, 1956; New England Exh., 1957, 1961; NAWA, 1963; bronze medal, Silvermine Gld. A., 1958; Ranger purchase award, NAD, 1961. Work: Scranton Mus. A. Exhibited: NAWA, 1952-1956, 1958, 1960, 1961, 1964-1968; Silvermine Gld. A., 1950-1961; Terry AI, 1952; Riverside Mus., 1949; Meriden A. & Crafts, 1952; New Haven Paint & Clay Cl., 1954-1958; BMA, 1954; NAD, 1953, 1956, 1961; Conn. Acad. FA, 1954, 1956, 1961; Chautauqua, N.Y., 1955; Art: USA, 1958; Springfield Mus. A., 1958, 1967; New England Exh., 1964-1968; Fairfield Univ., Fairfield, Conn., 1967; Elmira (N.Y.) Col., 1968; Nassau Col., 1969; Knickerbocker A., 1961; one-man: Silvermine Gld. A., 1951, 1954, 1957, 1960, 1964, 1968; Blair County A. Fnd., Altoona, Pa., 1963; Gallery 14, Palm Beach, Fla., 1963.

BROUGH, RICHARD BURRELL—
Educator, P., Des., Comm., A., I.
Art Department, Univ. of Alabama; h. 17 Elmira Dr., Tuscaloosa, Ala. 35401
B. Salmon, Idaho, May 31, 1920. Studied: Grande Chaumiere, Paris; San Antonio AI; Chouinard AI. Member: Texas WC Soc.; AAUP; Alabama WC Soc.; Mississippi AA; Birmingham AA. Awards: prizes, Mississippi AA, 1954; Alabama A. Lg., 1954; Texas WC Soc.; Ala. State Fair, 1st Award, 1966. Work: Mississippi AA; Birmingham AA. Exhibited: Alabama WC Soc., 1948-1958; BMA, 1949, 1950; Butler AI, 1952; Oakland A. Mus., 1950, 1951; MMA, 1950; Audubon A., 1951; Birmingham AA, 1949-1955; New Orleans AA, 1949, 1950; Southeastern Ann., 1949-1952, 1955; Alabama A. Lg., 1949-1952; Texas WC Soc., 1950, 1951; DMFA, 1952; USIS traveling exh., Near East & South America, 1960-61; N.Y. Worlds Fair—Ford Exh. I., for Ford Motor Co. Publications: Birmingham News Sunday magazine; Paintings reproduced in World Book-Alabama Section; jacket des., Univ. Alabama Press, 1953-1955; 31 one-man exhs. to date. Positions: Prof. A., Univ. Alabama, at present.

BROUILLETTE, T. GILBERT—Art Dealer, Consultant-Research
27 Main St. (P.O. Box 550) Falmouth, Mass. 02541
B. Warrensburg, Mo., Aug. 2, 1906. Studied: Westminster College, Fulton, Mo., B.A.; Harvard University, Grad. School Architecture; Harvard University, Museum Direction under Prof. Paul J. Sachs. Specializing: Paintings by Old Masters; French & American Impressionists; American 19th Century Masters.

BROUSSARD, JAY REMY—Museum Director, P.
State of Louisiana Art Commission, 208 Old State Capitol, Baton Rouge, La. 70801; h. 3640 Marigold Ave., Baton Rouge, La. 70808
B. New Iberia, La., Dec. 20, 1920. Studied: Louisiana State Univ.; Univ. Southwestern Louisiana. Member: Southeastern Mus. Conf. (Past Pres.); Southern Art Museums Directors' Assn.; AAMus.; Nat. Trust for Historic Preservation. Awards: Silver Medal, 1st Nat. Amateur Painters Exh., Art News Magazine, 1950; prize, Delgado Mus. A., 1950; Special mention, Southeastern Annual, Atlanta, 1952. Exhibited: CGA, 1951; PAFA, 1952, 1953; Butler Inst. Am. A., 1952, 1953; Florida Intl., Lakeland, 1952; Southeastern Annuals, Atlanta, 1951-1953; Denver Mus. A., 1953; New Orleans AA, 1947-1953. Positions: Member Fine Arts Faculty, Louisiana State Univ., 1949-1956; Juror of selections and awards for many major regional and national art exhibitions including Texas General; Univ. Miami, Lowe Gallery Annuals; Jacksonville Mus. Annuals; Miss. AA Annuals; Beaumont A. Mus., and others; Dir., State of Louisiana Art Commission, Baton Rouge, 1947- .

BROWN, BO (ROBERT FRANKLIN)—Cartoonist
218 Wyncote Rd., Jenkintown, Pa. 19046
B. Philadelphia, Pa., July 2, 1906. Studied: Univ. Pennsylvania, A.B. Member: Nat. Cartoonists Soc.; Magazine Cartoonists Guild. Exhibited: Treasury Dept., 1948; A. Dir. Exh., Phila., 1943-1947. Author, I., "Bo Brown Abroad." Work: Cartoons in leading U.S. and foreign magazines.

BROWN, DAN(IEL) Q(UILTER)—Cartoonist, P.
930 West Adams St., Sandusky, Ohio 44870
B. Fremont, Ohio, Oct. 17, 1911. Exhibited: Am. Soc. Magazine Cart. War Show, 1943; Butler AI, 1940; Mansfield (Ohio) A. Cl., 1941; Sandusky, Ohio, 1944. Contributor cart., Sat. Eve. Post, American Weekly, Wall Street Journal, King Features Syndicate, Phila. Inquirer, Ladies Home Journal, Town Journal, and many other publications, both here and abroad. Works published in many books and anthologies.

BROWN, HARRY JOE, JR.—Collector, W., Critic
952 Fifth Ave., New York, N.Y. 10021; h. 622 Roxbury, Beverly Hills, Cal. 90210
B. Los Angeles, Cal., Sept. 1, 1935. Studied: Stanford Univ.; Yale Univ., B.A.; Oxford Univ., M.A. Contributor to Nation and New Republic periodicals. Collection: Modern Expressionist. Positions: Pres., Renaissance House Foundation for the Arts.*

BROWN, JAMES M. III—Museum Director
Virginia Museum of Fine Arts, Boulevard & Grove St., Richmond, Va. 23221
B. Brooklyn, N.Y., Oct. 7, 1917. Studied: Amherst Col., B.A., M.A. (hon.); Harvard Univ., M.A. Member: Council, AAMus.; CAA; AFA. Awards: Hon. degree, Amherst Col., 1954. Contributor to: College Art Journal; Art Forum; Saturday Review; Positions: Asst. to the Dir., Inst. Contemp. A., Boston, Mass., 1942; Asst. to Dir., Dumbarton Oaks Research Lib. & Coll., Wash., D.C., 1946; Asst. Dir., Inst. Contemp. A., Boston, 1946-48; Dir., William A. Farnsworth Mus., Rockland, Me., 1948-1951; Dir., Corning Glass Center, Corning, N.Y., 1951-1963; Pres., Corning Glass Works Fnd., 1961-1963; Treas., Am. Assn. of Museums; Vice-Pres., United States Committee—ICOM; Dir., Oakland Museum, Oakland, Cal., 1964-1967; Dir., Norton Simon, Inc., Museum of Art, Fullerton, Cal., Jan. 1968-Sept., 1969; Director, Virginia Museum of Fine Arts, Richmond, Va., Oct. 1969- .

BROWN, JOHN—Art dealer
23 W. 56th St., New York, N.Y. 10019*

BROWN, J(OHN) CARTER—Museum Director, L., W., Cr.
National Gallery of Art, Washington, D.C. 20565; h. 3330 Reservoir Rd., N.W., Washington, D.C. 20007
B. Providence, R.I., Oct. 8, 1934. Studied: Harvard College, A.B.; Harvard Graduate School of Business Administration, M.B.A.; Inst. Fine Arts, New York Univ., M.A. with thesis in Dutch 17th Century painting. Member: Architectural Historians: AAMus.; AFA; CAA. Author and Director—Films: "The American Vision," 1965; "Conquerors of the Wilderness"; "America in Transition." Contributor to Museum News and Washington Sunday Post. Lectures: American art; Baroque painting; Widener Collection; American Museums, at Art Institute of Chicago, The National Gallery of Art, Commercial Club, Chicago, the Virginia Museum of Fine Arts, Lake Forest College, and others. Positions: Asst. Director, and Asst. to the Director, National Gallery of Art, Washington, D.C., 1964- .*

BROWN, JOSEPH—Sculptor, E.
Princeton University; h. 31 Edwards Pl., Princeton, N.J. 08540
B. Philadelphia, Pa., Mar. 20, 1909. Studied: Temple Univ., B.S.,

and with R. Tait McKenzie. Member: NSS; AAUP; Franklin Inn Cl. Awards: med., Montclair A. Mus., 1941; prize, NAD, 1944. Work: MacCoy Mem., Princeton, N.J.; Leroy Mills Mem.; Rosengarten Trophy; Firestone Lib.; PAFA; Clarence Irvine Mem., Collingwood, N.J.; Lehigh Univ.; A.A.U. Swimming Monument, Yale Univ.; St. Barnabas, Phila., Pa.; two heroic bronze statues, Johns Hopkins Univ.; port. bust of Robert Frost, Detroit Public Library; Medallion, Russell Callow, U.S. Naval Academy; heroic bronze hands, Overlook Hospital, Summit, N.J.; Monument, Temple Univ.; Many portraits of prominent persons. Designer of Play Communities in London, Tokyo, Phila., Pa., N.J. Neuro-Psychiatric Inst. Contributor to Architectural Record; Editorial-Domus; Home Economics Journal, and others. Exhibited: NAD, 1934, 1935, 1940, 1944; AIC, 1941; PAFA, 1934-1944; Arch. Lg., 1935, 1937; Montclair A. Mus., 1941, 1942; Phila. Pub. Lib., 1949-1951; PMA, 1949; Firestone Lib., Princeton, N.J.; Woodmere A. Gal., 1950; one-man: Yale Univ.; Univ. Virginia; Bucknell Univ.; Lehigh Univ.; Univ. Bridgeport; Springfield Col.; Expo '67, Montreal; XIX Olympiad, Mexico City; Buffalo & Erie County Mus., N.Y.; Time & Life Bldg., N.Y.; Phila. Free Lib. Lectures in universities, colleges and museums, Radio-TV programs. Positions: Prof., S. & Arch., Princeton Univ., Princeton, N.J., 1939- .

BROWN, JUDITH—Sculptor
c/o Kanegis Gallery, 123 Newbury St., Boston, Mass. 02116
B. New York, N.Y., Dec. 17, 1932. Studied: Sarah Lawrence Col., B.A. Awards: Frank J. Lewis award, Univ. Illinois, 1959; Silvermine Gld. A., 1964. Work: Memorial A. Gal., Rochester, N.Y.; Evansville Mus. A.; Riverside Mus., New York; Larry Aldrich Museum; Cathedral of Cuernavaca, Mexico; Jewish Mus., New York; Congregation Beth-El, South Orange, N.J.; Congregation Sharay Tefilo, East Orange, N.J.; mural sculpture, Lobby, Radio Station WAVE, Louisville; sculpture for Electra Film Productions, New York; wall sculpture, Youngstown (Ohio) Research Center, and other commissions. Exhibited: Mus. Contemp. Crafts, New York, 1957; DMFA, 1958; Jewish Mus., 1958; Christocentric A. Festival, Univ. Illinois, 1959; Detroit Inst. A., 1959; PAFA, 1959; Boston A. Festival, 1960, 1964; Nat. Acad. A. & Lets., 1962; Arkansas A. Center, Little Rock, 1963; Manchester, N.H., A. Festival, 1963; Bundy Art Gal., Waitsfield, Vt., 1963; Esther Robles Gal., Los Angeles, 1964; Jefferson Gal., La Jolla, Cal., 1964; DMFA, 1964; PVI Gal., New York, 1964; Silvermine Gld. A., 1963, 1964; Riverside Mus., 1964; Hopkins A. Center, Dartmouth Col., 1964; one-man: Cushman Gal., Houston, Tex., 1962; Albert Landry Gal., N.Y., 1962, 1963; Galeria de Antonio Souza, Mexico City, 1963; Newport AA, 1963; Hopkins A. Center, Dartmouth College, 1964.*

BROWN, RICHARD F(ARGO)—Museum Director
Kimbell Foundation, Forth Worth, Tex. 76102
B. New York, N.Y., Sept. 20, 1916. Studied: Bucknell Univ., A.B.; New York Univ. Institute of Fine Arts; Harvard Univ., M.A., Ph.D. Member: CAA (Pres.); Sec.-Treas. Assn. A. Mus. Directors; Member of the Council, AAMus. Awards: Phi Beta Kappa; Decoration of Arts & Letters, Republic of France, 1962. Positions: Teaching Fellow, Art History, Harvard Univ., 1947-49; Visting Prof., 19th Century French Painting, Harvard Univ., 1954; Research Scholar and Lecturer, The Frick Collection, New York, N.Y., 1949-1954; Dir., Los Angeles County Art Museum, Los Angeles, Cal., to 1965; Director, Kimbell Art Foundation, Fort Worth, Texas, 1966- .

BROWN, W(ILLIAM) F(ERDINAND) II—
Cartoonist, I., W.
Grahampton Lane, Greenwich, Conn. 06830
B. Jersey City, N.J., Apr. 16, 1928. Studied: Montclair (N.J.) Acad.; Princeton Univ., A.B. Member: National Cartoonists Soc.; Nat. Acad. Television A. & Sc.; A. & Writers Soc.; Writers Guild of America, East; ASCAP. Work: Author, I., "Tiger, Tiger," 1950; "Beat, Beat, Beat," 1959; "The Girl in the Freudian Slip," 1959; "The Abominable Showmen," 1960; "The World Is My Yo-Yo," 1963. Illus., "Dear Folks," 1959; "Dear Mr. Congressman," 1960; "Dear Man of Affairs," 1961; "Those Crazy Mixed-Up Kids," 1961; "The Complete Cookbook for Men," 1961. Contributor cartoons to: Sat. Eve. Post, Collier's, True, Esquire, Sports Illustrated, and other publications and cartoon anthologies in U.S. and abroad. Writer, network TV shows for NBC, CBS, ABC.

BROWN, WILLIAM THEO(PHILUS)—Painter, T.
3854 Rambla Orienta, Malibu, Cal. 90265
B. Moline, Ill., Apr. 7, 1919. Studied: Yale Univ., B.A.; Ozenfant Sch. A.; Univ. California, Berkeley, M.A., and with Leger. Awards: prize, Barnsdal Park, Los Angeles, 1962. Work: Oakland A. Mus.; SFMA; CalPLH; Davenport Municipal A. Gal. Exhibited: Minneapolis AI, 1945-1957; West Coast Artists traveling exh.; SFMA; Santa Barbara Mus. A., 1957, 1959; Univ. of Illinois, Urbana, 1969; one-man: (2) Kornblee Gal., New York; (5) Landau Gal., Los Angeles; SFMA; Landau-Alan Gal., New York, N.Y., 1968 (one-man). Contrib-

utor to Life Magazine of color reproductions of football paintings, 1956. Positions: Instr., Drawings and Painting, Univ. California, Berkeley; Univ. California, Davis Campus; San Francisco Inst. A.; Stanford Univ.

BROWNE, ROBERT M. (DR.)—Collector
2260 Liliha St. 96817; h. 3625 Anela Place, Honolulu, Hawaii 96822
B. Brooklyn, N.Y., Apr. 12, 1926. Studied: University of Rochester, A.B.; Johns Hopkins University School of Medicine, M.D. Collection: Primitive Art; Hawaiiana; Japanese (Mingei) Ceramics.

BROWNE, SYD—Painter, Lith., Et., T.
Winter Harbor, Me. 04693
B. Brooklyn, N.Y., Aug. 21, 1907. Studied: ASL, and with Eric Pape, Frank DuMond. Member: ANA; AWS; SAGA; Southern Pr. M.; SC; Audubon A.; Baltimore WC Cl.; All.A.Am.; Conn. Acad. FA; ASL; Phila. WC Cl.; Grand Central A. Gal. Awards: Conn. Acad. FA; SC; Audubon A.; AWS; med., All.A.Am.; Stanton & Catherine Woodman Prize, Ogunquit, Me., 1960, 1964; Council of American Artists award, 1967 and Philip J. Ross prize, 1968, both Salmagundi Club, New York, N.Y. Work: N.Y. Hist. Soc.; Fairleigh-Dickinson Univ., Rutherford, N.J.; N.Y. Univ.; LC; New Britain Inst.; Staten Island Inst.; Prentiss Hall Coll. Exhibited: Paris Int. Exp., 1937; WFNY, 1939; AIC, 1939; NAD; PAFA; CGA; Montclair A. Mus.; New Britain Inst.; Sweat Mem. Mus.; Farnsworth Mus. A. Positions: Instr., Newark Sch. F. & Indust. A., Newark, N.Y., 1946- ; Guest Instr., Norton Gal. & Sch. A., West Palm Beach, Fla., 1956.

BROWNING, COLLEEN—Painter, I.
100 La Salle St., New York, N.Y. 10027
B. Fermoy, County Cork, Eire, May 16, 1929. Studied: Slade Sch. A., London, England. Member: N.A. Awards: Anna Lee Stacey Scholarship; Edwin Austin Abbey Scholarship; Tupperware; prizes, Slade Sch. A.; Carnegie Inst., 1952; NAD; Butler AI, 1945; AWS, 1953; Nat. Inst. A. & Let.; Emily Lowe award; Rochester Fingerlakes Exh.; Metamold, Cedarburg, 1953; F. MacDowell & Yaddo Fnd.; Los A. County Fair; Stanford Univ. Work: Cal. PLH; Butler AI; Williams Col.; Detroit Inst. A.; Rochester Mem. A. Gal.; Spaeth Fnd.; Friends of Am. A. Assn.; Williamstown (Mass.) Mus. A.; Columbia (S.C.) Mus. A.; murals, Grinkle Hall, Yorkshire, England; Services Canteen, Salisbury, England; Sibley, Lindsay & Curr, Rochester, N.Y. Exhibited: WMAA; MModA; Carnegie Inst.; Nat. Inst. A. & Let.; AIC; Butler AI; Walker A. Center; Brandeis Univ.; Flint Inst. A.; Rochester Mem. A. Gal.; AWS; Wisconsin Union; WMA; NAD; Springfield Mus. A.; DMFA; Audubon A.; Univ. Illinois; Cortland Fair; N.Y. State Fair; Easthampton Religious A. Exh.; Metamold Exh.; PAFA; Newark Mus. A.; Gal. Mod. A., N.Y. 1968; Detroit Inst. A., 1969; Bienal Interamericana, Mexico; Spoleto, Italy; Los Angeles County Fair; and in England; one-man: Little Gal., London 1949; Edwin Hewitt Gal., 1952, 1954, 1957; Lane Gal., Los Angeles; Robert Isaacson Gal., 1960, 1962; Main St. Gal., Chicago, 1960; Jacques Seligmann Gal., N.Y., 1965; Kennedy Gal., N.Y., 1969; Rochester, N.Y. Illus., Doubleday Junior DeLuxe Editions; Doubleday Zenith Books; "Sugar and Spice"; "Portrait of a Lady," Limited Editions Club, 1966; Turck & Reinfeld book jacket award, 1958, 1964. Lecturer in art, City College, New York, N.Y.

BRUCKER, EDMUND—Painter, E.
John Herron Art School; h. 545 King Dr., Indianapolis, Ind. 46260
B. Cleveland, Ohio, Nov. 20, 1912. Studied: Cleveland Inst. A., and with Henry G. Keller, Rolf Stoll. Member: Indiana A. Cl.; Hoosier Salon. Awards: prizes, CMA, 1937-1939, 1942, 1945, 1948, 1951; Hoosier Salon, 1961-1967; John Herron AI., 1941-1943, 1946-1948, 1953-1955, 1963; Butler AI, 1937; Indiana A. Cl., 1967, 1968; Indiana State Fair, 1966-1968; Illinois State Fair, 1953, 1958, 1959; Indiana Pr. Exh., 1945-1947, 1951; Michiana regional 1955, 1957, 1958; Chicago Magnificent Mile, 1955; L.S. Ayers Exh., 1947; "500" Festival of the Arts, 1966-1968; Wabash Valley regional, 1967; Glendale A., Festival, 1966. Work: City of Cleveland Coll.; John Herron AI; CMA; Butler AI; Darmouth Col.; U.S. Govt.; De Pauw Univ.; Evansville Mus. A.; Sheldon Swope A. Gal.; Indiana Univ. Mem. Union. Exhibited: CMA; Hoosier Salon; PAFA; Univ. Illinois; Butler AI; Ohio Valley A.; John Herron AI; Michiana regional; MMA; Carnegie Inst.; MModA. NAD; LC; Los Angeles County Mus.; Evansville Mus. A.; Swope A. Gal. Positions: Instr., Cleveland Inst. A., 1936-38; Instr., John Herron A. Sch., Indianapolis, Ind., 1938-1967. Assoc. Prof., Herron Sch. of A., Indiana Univ., at present.

BRUMBAUGH, THOMAS B.—Educator, L.
Vanderbilt University, Box 1648, Sta. B, Nashville, Tenn., 37203
B. Chambersburg, Pa., May 23, 1921. Studied: State Col., Indiana, Pa., B.S.; Biarritz American Univ.; Univ. Iowa, M.A.; Ohio State Univ., Ph.D.; Harvard Summer Sch.; F., East Asian Studies, Har-

vard Univ., 1959-60; Fulbright Scholar (India), summer, 1961.
Member: Am. Soc. for Aesthetics; CAA; Japan Soc.; Archaeological
Inst. Am. Contributor to Art Journal; Art News; Art Quarterly; Com-
mentary; and other publications. Lectures 19th Century and Oriental
Art to art organizations and study groups. Positions: Actg. Hd., A. •
Dept., Hood College, Frederick, Md., 1950-53; Instr., Ohio State Univ.,
1953-54; Asst. Prof. A., Emory Univ., Atlanta, Ga., 1954-61; Prof.,
1961-1963; Prof., Vanderbilt University, Nashville, Tenn., 1964- .

BRUMER, SHULAMITH—Sculptor
 Sculpture Center, 167 E. 69th St. h. 473 Franklin D.
 Roosevelt Dr., New York, N.Y. 10002
B. Kiev, Russia, July 5, 1924. Studied: Columbia Univ., with Mal-
darelli; Sculpture Center with Dorothea Denslow. Member: All. A.
Am.; ASL; Sculpture Center; Knickerbocker A. Awards: prizes,
Knickerbocker A., 1957; Audubon A., 1958, 1963; All. A. Am., 1960;
American Veterans Society Award, 1966. Exhibited: NAD, 1963,
1964; Audubon A., 1958-1965; All A. Am., 1956-1964; Silvermine
Gld. A., 1959, 1962; Knickerbocker A., 1957-1960; Riverside Mus.,
N.Y., 1957; Sculpture Center, 1965, 1968 (one-man).

BRUNDAGE, AVERY—Collector
 10 N. La Salle St. 60602; h. 229 Lake Shore Drive, Chicago, Ill.
 60611
B. Detroit, Mich., Sept. 28, 1887. Studied: Univ. Illinois. Collection:
Oriental Art given to the City of San Francisco which has built a new
wing on the M. H. de Young Memorial Museum to house it and has
appointed an Independent Committee to develop a Center of Asian Art
and Culture. Positions: Trustee, The Art Institute of Chicago; Hon-
orary Trustee, M. H. de Young Memorial Museum, San Francisco,
Cal.

BRUNER, LOUISE (Mrs. Raymond A.)—Critic, W., L.
 Toledo Blade (4); h. 2244 Scottwood Ave., Toledo, Ohio 43610
B. Cleveland, Ohio, June 13, 1910. Studied: Denison Univ., B.A.;
Western Reserve Univ.; Univ. Florida; Univ. Toledo. Member: To-
ledo A. Cl.; Toledo Mod. A. Group; Archaeological Inst. of Am.
Awards: APA-Nat. Council of Awards for Workshop in art criticism,
1968; Ohio Newspaper Women's Assn., 1964-1968, for critical re-
views. Contributor to Grolier Encyclopedia; American Artist; Arts;
St. Louis Post Dispatch. Author: "Directory of Museums and Art
Exhibits," Toledo Blade, 1956. Positions: Critic, Cleveland (Ohio)
News, 1940-50; Toledo Blade, 1952- . Midwest Correspondent, The
Art Gallery, at present. Lecturer, Univ. Florida, 1963-1964.

BRUNO, PHILLIP A.—Art Dealer, Collector, W.
 Staempfli Gallery, 47 E. 77th St. 10021; h. 419 E. 57th St., New
 York, N.Y. 10022
B. Paris, France. Studied: Columbia College (History of Fine Arts
& Architecture), B.A.; New York University Institute of Fine Arts.
Member: (Hon. Life) St. Paul A. Center; First Hon. Member, Ten-
nessee Fine Arts Center at Cheekwood, Nashville, Tenn.; Dukes
County Historical Society, Edgartown, Mass.; National Trust for His-
toric Preservation. Organized first one-man exhibition in Europe of
Jose Luis Cuevas, Paris, 1955; Organized first one-man show in the
South of works of Elmer Livingston Macrae, Nashville, 1963; first
retrospective exhibition of Ralph Rosenborg, Wash., D.C., 1952; Re-
stored 17th century house on Martha's Vineyard, Mass., 1964. Col-
lection: mainly mid-20th century American watercolors and draw-
ings, ranging from Marin to Gatch. Among artists represented:
Lachaise, Demuth, Arthur B. Davies, Tobey, Kline, Corbett. Part of
the collection has been exhibited at the Krannert Art Museum, 1961
and at the Tennessee Fine Arts Center, Cheekwood, 1962. Finch
College Museum of Art, N.Y., Nov. 23, 1965-Jan. 9, 1966; The Saint
Paul Art Center, St. Paul, Minn., March 3-May 15, 1966. Positions:
Associated with Weyhe Gallery, New York, 1950-51; co-founder,
Grace Borgenicht Gallery and Assoc. Director, 1951-55; Dir., World
House Galleries, New York, 1956-60; Dir. American Exhibitions for
La Napoule Fnd., New York and France; Co-Director, Staempfli Gal-
lery, New York, 1960- .

BRYAN, WILHELMUS B.—Educator
 3171 Ridgewood Rd., N.W., Atlanta, Ga. 30327
B. Washington, D.C., Oct. 9, 1898. Studied: Princeton Univ., B.A.,
M.A.; Univ. Minnesota; Macalester Col., L.H.D. Member: Nat.
Assn. of Schs. of Art (Pres.); Soc. A. & Art Dir. Lectures to
schools, colleges, church and art education groups. Positions: Dean,
Macalester College, St. Paul; Dir., Blake School, Minneapolis; Dir.,
Westminster Fnd., Princeton Univ.; Dir., Emeritus, Minneapolis
Sch. A., Minneapolis, Minn.; Dir., Atlanta Art Association; Chm.,
Georgia State Art Commission, at present.

BRYANT, OLEN LITTLETON—Sculptor
 Austin Peay University, Clarksville, Tenn. 37040
B. Cookieville, Tenn., May 4, 1927. Studied: Murray State Col.,
Murray, Ky., B.S.; Cranbrook Acad. A., Bloomfield Hills, Mich.,

M.F.A.; Instituto Allende, San Miguel, Mexico; Cleveland Institute
of Art. Member: Nashville A. Gld.; Am. Craftsmens Council; CAA.
Awards: prizes, Purchase prize, Tennesse A. Festival, 1960; prize,
Mid South Exh., Brooks Mem. Mus., Memphis, 1965. Work: Tennes-
see Fine Arts Center; sculpture relief, St. Scholastica Convent,
Fort Smith, Ark. Exhibited: Syracuse (N.Y.) Ceramic National,
1951, 1964; Atlanta A. Festival, 1964; Huntsville A. Center, 1964;
Woman's Exchange, Memphis, 1965; one-man: Nashville A. Gld.,
1962, 1964; Tennessee Fine Arts Center, Nashville, Tenn., 1969.

BUCHER, GEORGE ROBERT—Educator, P., Des., L., S., I.
 Susquehanna University, Selinsgrove, Pa. 17870
B. Sunbury, Pa., Oct. 14, 1931. Studied: Univ. Pennsylvania &
PAFA, M.F.A., B.F.A.; Barnes Fnd., with Violette de Mazia. Mem-
ber: CAA; Am. Craftsmen's Council. Work: Civic Fine Arts Center
and Sioux Falls Col., Sioux Falls, S.D. Exhibited: PAFA, 1956,
1957; Phila. A. All., 1961; Norval Gal., N.Y., 1962; Minneapolis
AI, 1963; Univ. Nebraska, 1963; Civic Fine Arts Center, Sioux Falls,
1965; William Penn Mus., Harrisburg, Pa., 1966; Little Gal., Phila.,
Pa., 1967; Woodstock (N.Y.) Theater, 1967; Gal. Unique, Hartsdale,
N.Y.; Gal. Internationale, New York, N.Y. Arranged exh., Univ. of
Pennsylvania Museum: Philadelphia Artists, 1959; Ruins of Rome,
1961; Coptic Art, 1960; Mayan Art, 1958; Phrygian Art, 1959; De-
signed permanent North American Art Section, Univ. Pa. Museum,
1961; Wistar Institute of Anatomy Mus. medical exhs., 1955; Student
art exhibits for Sioux Falls College, 1963-1965. Lectures: Concept
of a Picture; String Instruments for Vision; Asymmetric Orienta-
tions in Art at Fine Arts Center, Sioux Falls; Children and Art, Tri-
State Christian Teachers Assn., Ireton, Iowa. Positions: Instr.,
Painting, Univ. of Pennsylvania; Univ. Pennsylvania Museum; Salem
H.S.; Wistar Institute of Anatomy; Assoc. Prof. Drawing, painting,
design, crafts and history of art, Sioux Falls College, Sioux Falls,
S.D. to 1965; Susquehanna Univ., Selinsgrove, Pa. 1965- .

BUCK, RICHARD DAVID—Museum Conservator, L.
 Intermuseum Laboratory, Dudley Peter Allen Memorial Art
 Museum; h. Oberlin, Ohio 44074
B. Middletown, N.Y., Feb. 3, 1903. Studied: Harvard Univ., S.B.,
A.M. Member: Int. Inst. for Conserv. of Mus. Objects (Am. Group
Chm., 1959-61). Contributor: Studies in Conservation, Museum.
Positions: Dept. Conservation, Fogg Mus. A., Harvard Univ., 1937-
52; Conservator, 1949-52; L., in FA, 1950-52; Advisor on Conser-
vation, Nat. Gal., London, 1949-50 (on leave from Fogg Museum);
Chief Conservator, Intermuseum Conservation Assn., & Dir., Inter-
museum Laboratory, Lecturer, Oberlin College, Oberlin, Ohio,
1952- . Seminars on Properties of Wood Objects: Conservation
Center, N.Y. Univ., 1964, 65, 67; Mexico City (Auspices of UNESCO),
July, 1966. CRIA Consultant, Florence, Italy, April, 1967.

BUCKLEY, CHARLES EDWARD—Museum Director
 City Art Museum of St. Louis; h. 665 S. Skinker St., St. Louis,
 Mo. 63110
B. South Hadley Center, N.H., Apr. 29, 1919. Studied: Sch. of the Art
Inst. of Chicago, B.F.A.; Harvard Univ., M.A. Member: AAMus.
Dirs.; Soc. Arch. Historians; AAMus.; CAA. Contributor to: Con-
noisseur, Art Quarterly, Art Bulletin, Antiques. Lectures: American
Art 17th to 20th Century; 18th Century American Decorative Art; En-
glish Painting 18th to 20th Century. Positions: Teaching Fellow,
Dept. FA, Harvard Univ.; Loomis School, Windsor, Conn.; Hartford
Col. Keeper, W. A. Clark Collection, Corcoran Gallery of Art, 1949-
1951; General Cur., Wadsworth Atheneum, Hartford, Conn., 1951-
1955; Dir., Currier Gal. A., 1955-1964; Dir., City Art Museum, St.
Louis, Mo., 1964- .

BUDD, DAVID—Sculptor, P.
 c/o Goldowsky Gallery, 1078 Madison Ave., New York, N.Y.
 10028; h. Chez Cameo, Place Nationale, Antibes, A.M.*

BUECHNER, THOMAS S.—Museum Director
 The Brooklyn Museum, Eastern Parkway, Brooklyn, N.Y.
 11238
B. New York, N.Y., Sept. 25, 1926. Studied: Princeton Univ.; ASL;
L'Ecole des Beaux-Arts, Fontainebleau; L'Ecole des Beaux-Arts,
Paris; Inst. Voor Pictologie, Amsterdam. Member: CAA; AAMus.;
AFA; Archaeological Inst. Am.; Am. Assn. Mus., Dirs.; Circle of
Glass Collectors, London. Editor of "Glass Studies." Contributor to:
Archaeology; Antiques; Art News Annual; Interiors; Connoisseur
Yearbook; Encyclopaedia Britannica, etc. Positions: Faculty Mem-
ber, Corning Community College, 1958-60; Trustee, M. M. van
Dantzig Mem. Fnd., Amsterdam, 1960; Dir., Corning Museum of
Glass, Corning, N.Y., 1950-60; Dir., Brooklyn Museum, Brooklyn,
N.Y., 1960- . Other positions: Dir., The Victorian Society in Amer-
ica; Councilor, L.I. Historical Society; Advisor, South St. Seaport
Museum; Advisor, Arts in Edu. Comm.; Bank St. College of Educa-
tion; Trustee, Corning Museum of Glass; Bd. of Dir., N.Y. Cultural
Showcase Foundation; Int. Council of Museums, N.Y. Conference
Comm.; National Committee, Drawing Society.

BULLARD, EDGAR JOHN, III—Museum Curator
The National Gallery of Art 20565; h. 2527 Q St., N.W., Washington, D.C. 20007
B. Los Angeles, Cal., Sept. 15, 1942. Studied: University of California at Los Angeles, B.A., M.A., in art history. Member: CAA; AAMus; Archives of Am. Art. Awards: Samuel Kress Foundation Fellow, National Gallery of Art, 1967-1968. Author: "John La Farge at Tautira, Tahiti," National Gallery Report and Studies in the History of Art, Vol. 2, 1968; "Luks and Glackens in Cuba," Art of the Americas Bulletin IV, 1969. Exhibitions arranged: "The Artist Looks at Himself: Self Portraits by Graphic Artists," University of California at Los Angeles Art Galleries, 1966. Positions: Museum Curator specializing in American Art and in exhibition organization, The National Gallery of Art, Washington, D.C., at present.

BULTMAN, FRITZ—Sculptor, P., T., W., L.
176 E. 95th St., New York, N.Y. 10028
B. New Orleans, La., Apr. 4, 1919. Studied: New Bauhaus, Chicago; Hans Hofmann Sch. FA. Awards: prize, AIC, 1964; Italian Government Grant, work in Italy, 1950-51; Fulbright Research Grant, Paris, 1964-65. Work: WMAA; Rockefeller A. Gal., Seal Harbor, Me.; Museum of Art, Rhode Island School of Design. Exhibited: United States, Paris, Cologne, Turino, Milan and Japan. Contributor of article on Hans Hofmann, Art News, 1963. Lectures—universities, colleges, art clubs and museums. Positions: Instr., Painting, Hunter College and Pratt Institute, New York, N.Y.; Instr., FA Work Center, Provincetown, Mass., A.-in-Res., 1968-1970.

BUNKER, EUGENE FRANCIS, JR.—Educator, C., P., S.
Asheville-Biltmore College, Department of Art & Music; h. 1 Fairmont Rd., Asheville, N.C. 46218
B. Bozeman, Mont., Aug. 11, 1928. Studied: Montana State Col. Bozeman, B.S.; Mills Col., Oakland, Cal., M.A. Member: Am. Craftsmen's Council. Awards: prizes, Cal. State Fair, 1955; North Montana State Fair, 1952, 1957; Northwest Ceramic Exh., Portland, Ore., 1952; Midwest Des.-Craftsmen, 1957; Northwest Craftsmen, Henry Gal., Seattle, 1952, 1953; purchase award, Fiber-Clay-Metal Exh., St. Paul Gal. A., 1954; Dec. Arts Ceramic Exh., Wichita, Kans.; Winter Park, Fla. (sculpture), 1963; Daytona Beach, Fla. (crafts), 1964; N.Y. World's Fair, 1964; Asheville Bank Exh. (sculpture), 1965. Work: stoneware: Portland (Ore.) Mus. A.; U.S. State Dept. Traveling Exh. Coll.; St. Paul Gal. A.; Cal. State Fair Coll.; fountain bowls for Wilbur School, Wilbur, Wash.; Altar appointments for 4 churches in Winter Park, Fla. and many commissions for private colls. Exhibited: Syracuse Nat., Everson Mus., 1954, 1960; Young Americans, 1953; Nat. Dec. A. Ceramic Exh., 1952-1955, 1957; Fiber-Clay-Metal, 1954; Miami Nat., 1959; Midwest Des.-Craftsmen, 1957; U.S.A. Des.-Craftsmen, 1953; Cal. State Fair, 1955; North Montana State Fair, 1952, 1957; Northwest Ceramics, 1952; Northwest Craftsmen, 1952, 1953; one-man: AIC, 1961 Asheville-Biltmore Col. (ceramics, jewelry, painting); Hendersonville, N.C.; Barzansky Gal., N.Y. Author: Laboratory Text for Ceramics Classes, Stetson Univ. Press, 1960. 4 articles for World Book Encyclopedia. Positions: Prof. A. Dept., Instr. of Ceramics, Jewelry, A. Edu., etc., Stetson University, 1959-1964; Community Consultant and A. Dir., Dept. of Community Development, Southern Illinois University, Carbondale, Ill.; Research Tech., Harper Ceramics, Ft. Lauderdale; Mngr., Pottery, Archie Bray Fnd., Helena, Mont.; Prof., Hd. Dept. Art and Music, Asheville-Biltmore College, Asheville, N.C., 1964- .*

BUNSHAFT, MR. and MRS. GORDON—Collectors
200 E. 66th St., New York, N.Y. 10021*

BURCH, CLAIRE—Painter, W.
30 Bethune St., New York, N.Y. 10014
B. New York, N.Y., Feb. 19, 1925. Studied: New York Univ., B.A. Member: Guild Hall, Easthampton, N.Y.; Silvermine Gld. A. Awards: prizes, North Shore Community A., Center, 1962; Lond Island Artists, Hofstra Univ., 1963; Guild Hall, 1963; Hutton Award, Parrish A. Mus., 1963; Village A. Center, 1963. Work: N.Y. Univ.; Berkshire Mus. A.; Sterling & Francine Clark AI; Williams Col.; Gloucester AI; Butler Inst. Am. A.; Guild Hall Mus.; Southampton Col.; Nassau Community Col.; Heckscher Mus. A., and others. Exhibited: Silvermine Gld. A., 1961, Galerie L'Antipoete, Paris, 1961; North Shore Community A. Center, Roslyn, N.Y., 1961; Nordness Gal., N.Y., 1961; Village A. Center; Guild Hall, 1961; Exh. for benefit of Brandeis Lib. at Brickman Handler Estate, Kings Point, N.Y.; one-man: North Shore Unitarian Church, Manhasset, N.Y., 1961; Ruth White Gal., N.Y., 1961; Paul Kessler Gal., Provincetown, 1962; RoKo Gal., N.Y., 1964; Berlitz Gal., 1963; Southampton Col., 1964; Valley Bank, Easthampton, 1964; 4-man exh. Galerie L'Antipoete, Paris, 1962. Articles and verse in Saturday Review, Life, McCalls, Good Housekeeping, Redbook, New Republic, The Humanist and other publications.

BURCHESS, ARNOLD—Painter, E.
227 West 27th St., New York, N.Y.; h. 195-14 90th Ave., Hollis, N.Y. 11423; s. South Harpswell, Me.
B. Chicago, Ill., June 7, 1912. Studied: City Col., N.Y., B.S.S., and with George W. Eggers, Robert Garrison. Member: Alabama WC Soc.; Springfield A. Lg.; Audubon A.; F.I.A.L.; AWS; New Orleans AA; Cal. WC Soc. Awards: prize, Birmingham Mus. A., 1954. Work: Sc., with Robert Garrison, walls of Radio City (Music Hall Bldg.), 1934-35; Fashion Inst. Tech., N.Y. Article and illus. on "Water Color," American Artist magazine, 1959; included in "100 Watercolor Techniques," 1969. Exhibited: Riverside Mus., 1955; AWS, 1955-1967; Butler AI, 1955; G.W.V. Smith Mus., Springfield, Mass., 1955; Contemp. A. Gal., 1955; Birmingham Mus. A., 1955; Cal. WC Soc., 1955; Assoc. Am. A., 1955; Delgado Mus. A., 1957; Westchester A. Center, 1958; U.S. Natl. Mus., 1958; PAFA, 1958, 1961-1963; N.Y. City Center, 1958; MModA, 1958; Audubon A., 1956-1969; NAC, 1956-1958; Howard Col., 1957; Long Beach (Cal.) Mun. A. Center, 1957; Cal. PLH, 1957; Mobile AA, 1957; Shorter Col. 1957; Alabama Polytechnic Col., 1957; Alabama State T. Col., 1957; Jacksonville (Fla.) Mus. A., 1957; Lauren Rogers Mus. A., Laurel, Miss., 1957; NAD, 1959-1967; Hollis Gal., 1960, 1963, 1966-1968; Fashion Inst. of Technology, 1960-1965; one-man: Van Dimant Gal., Southhampton, 1957; Whitestone Gal., 1959, 1960. Lectures: Metropolitan Mus. A., N.Y., Sculpture; Shapes in Clay, etc. Positions: Prof. Fine Arts, Co-ordinator of Fine Arts and Acting Chm., Fashion Inst. Technology, New York, N.Y., 1959- ; Co-ordinator, Fashion Inst. Technology Design Laboratory and Library, 1964-1966.

BURDEN, CARTER—Collector
527 Madison Ave. 10022; h. 1140 Fifth Ave., New York, N.Y. 10028
B. Los Angeles, Cal., Aug. 25, 1941. Studied: Harvard University; Columbia University Law School. Member: Executive Committee, Junior Council of the Museum of Modern Art, New York; Collections and Acquisitions Committee and of the International Council, Museum of Modern Art; Founder and President, The Studio Museum in Harlem, New York, N.Y. Collection: Works of the Contemporary Period, mainly American Abstract Paintings since 1950.

BURGARD, RALPH—Director of Arts Councils
1564 Broadway, New York, N.Y. 10036; h. 2575 Palisade Ave., Riverdale, N.Y. 10463
B. Buffalo, N.Y., June 22, 1927. Studied: Dartmouth Col., A.B. Positions: Dir., The Arts Council of Winston-Salem, North Carolina and the St. Paul Council of the Arts and Sciences. In St. Paul, directed the building of a three million dollar Arts and Science Center and organized an annual united cultural fund campaign; Board Member, National Council on the Arts and Government, the Dartmouth Arts Council, the urban Arts Corps and the Cunningham Dance Fnd. Founding Member of Community Arts Councils, Inc.; Member Advisory Committees for the Institute of International Education and the New York City Cultural Council. In 1965, became first Executive Director of Associated Councils of the Arts (formerly Arts Councils of America) a nonprofit, national association of state and community arts councils. Author of numerous articles and a book "Arts in the City."

BURKE, E. AINSLIE—Painter, T., Lith.
Syracuse University School of Art; h. 300 Lennox Ave., Syracuse, N.Y. 13210
B. Omaha, Neb., Jan. 26, 1922. Studied: Maryland Inst. FA; Johns Hopkins Univ.; McCoy Col.; ASL; San Miguel Allende, Mexico. Member: Woodstock AA (Chm. 1962); AAUP; ASL (Life). Awards: Baltimore Sun award, 1947; Woodstock Fnd.; Kleinert Award; Fulbright Fellowship, 1957-1958; purchase award, Springfield Mus. FA, 1955. Work: Columbia Univ. Student Center; Springfield (Mass.) Mus. FA; Storm King A. Center, Mountainville, N.Y.; Lowe A. Mus., Syracuse Univ.; Lamont A. Mus., Exeter, N.H.; Lehigh Univ.; Gen. Elec. Co. Exhibited: Syracuse Univ., 1962-1969; Woodstock AA, 1962-1966; Maine A. Gal., 1965; PMA, 1966; Stamford (Conn.) Mus., 1966; Springfield Mus., 1966, 1967; CGA, 1966; Columbia (S.C.) Mus., 1965; Sarasota AA, 1965; Maine Coast A., 1968; Schuman Gal., Rochester, N.Y., 1969; PAFA, 1969; Marietta Col., 1969; Kraushaar Gal., N.Y., 1955-1969; one-man: Assoc. Am. A., 1953; Kraushaar Gal., 1960, 1963, 1967; Mari Gal., Woodstock, 1959; L.I. Univ., 1961; Polari Gal., Woodstock, 1964; Lamont Mus., Exeter, N.H., 1964; Storm King A. Center, 1964; Albany Inst. Hist. & A., 1964; Lehigh Univ., 1965; Univ. Maine, 1968. Positions: Visiting Artist, Exeter Acad., N.H., 1964; Prof. A., Painting & Drawing, Syracuse Univ. Sch. A., N.Y., 1962-1969.

BURKHARDT, HANS GUSTAV—Painter, E., Gr.
1914 Jewett Dr., Los Angeles, Cal. 90046
B. Basel, Switzerland, Dec. 20, 1904. Studied: CUASch.; Grand Central Sch. A., and with Gorky. Member: AFA; Los A. AA.

Awards: prizes, Los A. Mus. A., 1946, 1954, 1957; Cal. State Fair, 1954, 1958, 1959, 1962; Terry AI, 1951; Los Angeles All-City Exh., 1957, 1960, 1961 (purchase awards); Santa Barbara Mus. A., 1957; Cal. WC Soc., 1959, 1961. Work: Los A. Mus. A.; Santa Barbara Mus. A.; City Los Angeles Coll.; Pasadena Mus. A.; Columbia (S.C.) Mus. A.; Emily & Joe Lowe A. Gal., Coral Gables, Fla.; Mus. Mod. A., Eilat, Israel; Mus. A., Tel-Aviv; Downey Mus.; Long Beach Mus. A.; La Jolla Mus. A.; Joslyn A. Mus., Omaha, Neb.; FA Gal. of San Diego; Moderna Museet, Stockholm; Kunsthaus, Lucerne, Switzerland; Kunstmuseum, Basel, Switzerland. Exhibited: Los A. Mus. A., 1945, 1946, 1953-1955, 1957; Cal. State Fair, annually; Cal. PLH, 1946, 1947; deYoung Mem. Mus., San Francisco, 1950; SFMA, 1955-1957; Santa Barbara Mus. A., (Pacific Coast Biennial, on tour), 1957; Denver Mus. A., 1949, 1953, 1954; Univ. Nebraska, 1957; "Art of Southern California, II," on extended tour at present; AIC, 1947, 1951; Univ. Illinois, 1951; PAFA, 1951-1953; MMA, 1951; Terry AI, 1951; Butler Inst. Am. A., 1955; Art:USA, 1958; United Nations Tenth Anniversary, San Francisoo, 1955; WMAA, 1951, 1955, 1958; CGA, 1947, 1951, 1953; AFA circulating exh., 1951-52; Sao Paulo Biennial, 1955; 40 year retrospective, FA Gal. of San Diego, 1966; one-man: Yearly at Los Angeles galleries since 1939; Los A. Mus. A., 1945; Univ. Oregon, 1948; Mus. of Guadalajara, Mexico, 1950; Occidental Col., Los A., 1955; Instituto Allende, Mexico, 1956; Pasadena Mus. A., 1958; Ankrum Gal., Los A., 1961, 1962, 1964; Retrospective, 1931-61; Santa Barbara Mus. A., 1961; Cal. PLH, 1961; Los A. Municipal A. Gal., 1962; FA Gal. of San Diego, 1968. Positions: Asst. Prof. A., Long Beach State Univ.; Prof. A., Univ. Southern California, Los Angeles, Cal; Assoc. Prof. A., San Fernando Valley State Col. 1963- .

BURKHART, DR. ROBERT C.—Educator
State University College of Buffalo, 1300 Elmwood Ave., Buffalo, N.Y. 14222*

BURNETT, CALVIN—Graphic Artist, P., T., W.
20 Braemore Rd., Brighton, Mass. 02135
B. Cambridge, Mass., July 18, 1921. Studied: Boston Univ., M.F.A.; BMFA Sch. A.; Mass. Sch. A., B.S., in Edu. Member: Cambridge AA; Boston Pr. M. (Bd. Dir.). Awards: prizes, Atlanta Univ., 1947, 1948, 1956, 1961, 1963, 1966, 1968; Cambridge Centennial Exh., 1946; Cambridge AA, 1949; Germanic Mus., Cambridge, 1946; Wharton Settlement, Phila., Pa., 1953 (purchase); Busch-Reisinger Mus., 1949; Howard Univ., 1949 (purchase); Assoc. Am. A., 1959; Boston Printmakers, 1965; Beverly Farms Regional, 1963; Wichita, Kans., 1963; New Orleans, La., 1963; 1st prize, Jordan Marsh Co., 1968. Work: Howard Univ.; Wharton House, Phila., Pa.; Atlanta Univ.; Lewis Sch., Boston; Nat. Bezalel Mus., Jerusalem; Inst. Contemp. A. (AEA slide coll.); Boston Pr.M. Presentation Print, 1958; BMFA; Fogg Mus.A.; Boston Pub. Lib. Author: "Objective Drawing Techniques," 1966. Exhibited: Inst. Mod. A., Boston, 1943, 1944; Boris Mirski Gal., 1943-1953; Int. Pr. Soc., N.Y., 1944; Oakland Mus. A., 1944; NAD, 1944-1946; Jordan Marsh Co., 1944, 1947, 1949, 1954, 1955, 1958; Wellesley Col., 1944, 1950; Atlanta Univ., 1944-1953, 1956-1961; Boston Pub. Lib., 1944-1955; AFA traveling exh., 1945-1948, 1956-1957; Kiel Auditorium, St. Louis, Mo., 1946; San F. AA, 1946; Taller de Graphico, Mexico; Cambridge AA, 1946-1955; Downtown Gal., 1946-1955; Children's A. Center, Boston, 1947, 1953; State Dept. traveling exh., 1957-58; Inst. Contemp. A., 1955; LC, 1948, 1949; Howard Univ., 1949; Boston Univ., 1951, 1953; Arthur Wood Gal., Boston, 1954, 1955 and many others. One-man: Boris Mirski Gal., 1946; Cambridge AA, 1953; Children's A. Gal., 1947, 1953; Lewis Sch. FA, 1950; Arthur Wood Gal., 1955; Marlboro Col., 1955; Gropper Gal., 1956; Village Studio, 1957; AGAA, 1955 (traveling, 1955-56). Positions: Comm. & Ed. Illus. & Adv. Art for many firms and publications; Instr., Gr. A., deCordova & Dana Mus., Lincoln, Mass., 1953-56; Assoc. Prof., Mass. College A., Boston, Mass., 1956- .

BURNETT, MRS. LOUIS A. See Moore, Martha E.

BURNETT, LOUIS ANTHONY—Painter, T.
4 Hoffman Rd., High Bridge, N.J. 08829; s. 17 Dock Square, Rockport, Mass. 01966
B. New York, N.Y. Studied: ASL. Member: ASL (Bd. Control); AEA; AAPL; All. A. Am.; Rockport AA; Cape Ann Mod. A. Awards: prizes, Village A. Center, 1948, 1949; Washington Square Outdoor Show, 1949; Madison Square Garden, 1952; A. Lg. of Long Island; Guild Hall, Easthampton, N.Y.; Atlantic City, N.J., Grand Prize, 1968 purchase prize, 1969; Ranger Fund purchase, NAD, 1969. Work: in private coll. U.S., Canada, and South America; Friars Cl., N.Y. Exhibited: WMAA; Riverside Mus.; Jersey City Mus. A.; NAD; NAC; New Jersey P. & S.; Long Island A. Lg.; Portraits, Inc.; All. A. Am.; Town Hall Cl., N.Y.; Gloucester, Mass.; Springfield Mus. A.; WMAA; Montclair A. Mus.; Parrish Mus., Southampton, N.Y., and others.

BUROS, LUELLA (Mrs. Oscar K.)—Painter, Des., Publ.
220 Montgomery St., Highland Park, N.J. 08904
B. Canby, Minn. Studied: Rutgers Univ.; T. Col., Columbia Univ.; Ohio State Univ. Member: AEA; Assoc. A. New Jersey (Dir., 1958-1960); NAWA; New Brunswick A. Center (Dir., 1952-1960); New Jersey WC Soc.; Phila WC Cl.; A. Council of New Jersey. Awards: prizes, Columbus A. Lg., 1935; AAPL, 1938, 1940; Asbury Park Soc. FA, 1938; New Jersey Gal., 1938, 1940; Montclair A Mus., 1938, 1940-1; Springfield A. Lg., 1941; Norfolk Mus. A. & Sc., 1944, 1945; Wash. WC Cl., 1945; A. Council New Jersey, 1949, 1952; Plainfield AA, 1950-1951; Rahway A. Center, 1951-1952; Newark A., 1940, 1953; NAWA (med. honor), 1953; Old Mill Gal., 1954; Hunterdon County A. Center, 1955. Work: Montclair A. Mus.; Newark Mus. A.; City of Cape May, and in private colls. Exhibited: AIC; CGA; Nat. Exh. Am. A.; GGE, 1939; MMA; AWS; NAWA; Audubon A.; NAC; All. A. Am.; Phila. WC Cl.; Wash. WC Cl.; traveling exhs., AFA, AIC, NAWA, Montclair A. Mus. in U.S. and abroad. Typographical Des., "Mental Measurements Yearbooks" series. Publ., The Gryphon Press, 1940- ; Sec., The Buros Fnd., 1966- .

BURROWS, SELIG S.—Collector, Patron
514 W. 49th St. 10019; h. 96 Merrivale Rd., Great Neck, N.Y. 11020; also 6 W. 56th St., New York, N.Y. 10019
B. New York, N.Y., June 1, 1913. Studied: Fordham University; New York University School of Law. Collection: Late 19th Century and 20th Century American Art. Positions: Member, Board of Directors of the Council of the Whitney Museum of American Art; Member, Advisory Board of the Skowhegan School of Painting and Sculpture; Chairman, Arts Council of Great Neck, N.Y.; Trustee, Long Island Theatre Society.

BURWASH, NATHANIEL—Sculptor
8 Dana St., Cambridge, Mass. 02138*

BUSH, BEVERLY—Painter, S.
229 Broadway East 98122; h. 3521 E. Spruce St., Seattle, Wash. 98102
B. Kelso, Wash. Studied: Univ. Washington, B.A.; NAD Sch. FA; ASL. Member: AEA. Awards: Youth Friends Assn. Scholarship, NAD, 1954-1955; Joseph Isador Merit Scholarship, 1955-1956, 1956-1957. Exhibited: Art: USA, 1959; Audubon A., 1959; NAWA, 1958; City Center, N.Y., 1958; Studio Gal., N.Y., 1959 (one-man); SAM, 1964; Otto Seligman Gal., Seattle, 1960-1965. Positions: Editor, Natl. News Letter and Exec. Secretary, Artists Equity Assn., 1958- .

BUSH, LUCILE ELIZABETH—Educator, P.
Wheaton College, Norton, Mass. 02766; h. 425 North Maysville St., Mt. Sterling, Ky. 40353
B. Mt. Sterling, Ky., July 26, 1904. Studied: Univ. Kentucky, A.B.; T. Col., Columbia Univ., M.A.; Columbia Univ., Ph.D., ASL, and with Leger, L'Hote and Marcoussis, Paris, France. Member: CAA; AAUP; Mediaeval Acad.; Renaissance Soc.; Soc. Architectural Historians. Awards: Carnegie Scholarship, 1930; Elizabeth Avery Colton F., 1945-46, AAUW. Work: Skidmore Col., Saratoga Springs, N.Y.; portraits in private coll.; scenery & costume design for Harwich (Mass.) Junior Theatre. Exhibited: one-man exhs. in Saratoga Springs, Schenectady and Glens Falls, N.Y. Author: "Bartolo di Fredi, Sienese Painter of the late 14th Century," 1950 (microfilm only). Lectures: Various aspects of Mediaeval Iconography. Positions: Instr. A., Skidmore Col., 1928-43; Instr., A. Dept., Chm. A. Dept., Wheaton Col., Norton, Mass., 1947-1965; Dir., Watson Gallary, 1962-1966; Teaching, 1966- .

BUSH-BROWN, ALBERT—Writer, Educator, L.
115 Bowen St., Providence, R.I. 02906
B. West Hartford, Conn., Jan. 2, 1926. Studied: Princeton Univ., A.B., M.F.A., Ph.D.; Society of Fellows, Harvard Univ., 1950-53. Member: CAA; Soc. Architectural Historians; Hon. AIA; Hon. Assoc., Rhode Island Chptr. AIA. Awards: Woodrow Wilson Fellow in Art & Archaeology, Princeton Univ., 1947-1948; Howard Fnd. Fellow, Brown Univ., 1959-1960; Ford Fnd. F., 1968-1969. Work: Editor: "Architecture and Planning," The Encyclopaedia Britannica, 1955-1969; Journal of Architectural Education, 1957-1961; Journal of Aesthetics and Art Criticism, 1958-1961 (Advisor). Author: "Louis Sullivan," 1960; (with John E. Burchard) "The Architecture of America: A Social Interpretation," 1961; "Books, Bass, Barnstable," 1967; "Theory for Modern Architecture" (in prep.). Author of many articles (1952-1965) on Architecture, Architectural Design and Education and related fields for encyclopaedias, art and architectural journals, magazines, newspapers, etc. Positions: Nat. Council on The Arts (White House), 1964-1970; Nat. Advisory Comm., Archives of American Art, 1962; Providence City Plan Comm., 1962, reappointed 1965 for 5 years; Hon. Life Trustee, Trinity Square Playhouse, 1962; Chm., Research & Design Center, Inc., Providence, 1964; Dir.-at-

Large, Nat. Council of the Arts in Education, 1965 for 6 year term; and other organizations. Career: in other fields—Instr. A. & Archaeology, Princeton Univ., 1949-50; Asst. Prof., A. & Architecture, Western Reserve Univ., 1953-54; Asst. Prof., Architecture, MIT, 1958-1962; Exec. Officer, Architecture, MIT, 1958-62; Pres., Rhode Island School of Design, Providence, R.I., 1962-1968; Bemis Visiting Prof., MIT, 1968-69; Fellow, Joint Center Urban Studies, Harvard-MIT, 1968-69; Fellow, Kennedy Inst. of Politics, Harvard, 1968-1969; Dir., Council Urban and Regional Studies, State Univ. of N.Y. at Buffalo, 1968.

BUSHMILLER, ERNEST PAUL (ERNIE)—Cartoonist
United Features Syndicate, 220 East 42nd St., New York, N.Y.; h. Haviland Rd., Stamford, Conn. 06903
B. New York, N.Y., Aug. 23, 1905. Studied: NAD. Member: SI; Nat. Cartoonists Soc.; Dutch Treat Cl.; A. & Writers Assn. Author, I., several books on comic strip "Nancy." Positions: Cart., comic strip "Nancy" and Sunday comic "Fritzi Ritz," syndicated by United Features.*

BUTLER, JOSEPH G.—Museum Director, E., P.
The Butler Institute of American Art, 524 Wick Ave., Youngstown, Ohio 44502; h. 1915 Walker Mill Rd., Poland, Ohio 44514
B. Youngstown, Ohio, Sept. 5, 1901. Studied: Dartmouth Col. Member: Archives of Am. Art; AEA. Awards: prizes, Massillon Mus. A., 1941; Arizona State Fair, 1946; Mississippi AA, 1948-49; Ohio State Fair, 1949, 1950, 1956; Ohio WC Soc., 1952; A. Festival, Bloomfield, Mich., 1954-55; Canton AI, 1957; Chautauqua A. Assn., Patron of American Art Award, 1962. Work: Columbus (Ohio) Mus. A.; Dartmouth Col.; Kalamazoo Inst. A.; Massillon Mus.; Phillips Exeter Acad., Exeter, N.H. Arranged Nat. Annual Midyear Shows, 1938- ; "Ohio Painters of the Past"—David G. Blythe, 1947, Wm. T. Richards and Anna Richards Brewster, 1954; "Art of the Carrousel," 1961. Positions: Dir., Butler Inst. American Art, Youngstown, Ohio.

BUTLER, JOSEPH THOMAS—Museum Curator, W., L.
Sleepy Hollow Restorations, Tarrytown, N.Y. 10591; h. 269 Broadway, Dobbs Ferry, N.Y. 10522
B. Winchester, Va., Jan. 25, 1932. Studied: Univ. Maryland, B.S.; Ohio Univ., M.A.; Univ. Delaware, M.A. Member: NAC; Advisory Council, Mus. of Early American Folk Arts, N.Y. Awards: Winterthur F., 1955-57. Contributor to Antiques; Encyclopaedia Britannica; Connoisseur (American Editor, 1967-); Encyclopedia Americana; articles on various aspects of the American decorative arts with emphasis on 19th Century. Lectures: 17th, 18th and 19th century decorative arts to museum groups. Author: "American Antiques, 1800-1900" (1965); "Candleholders in America, 1650-1900" (1967); "The Family Collections at Van Cortlandt Manor" (1967). Positions: Curator, Sleepy Hollow Restorations, Tarrytown, N.Y., 1957- .

BUTTON, JOHN—Painter
c/o Kornblee Gallery, 58 E. 79th St., New York, N.Y., 10021
B. San Francisco, Cal., 1929. Studied: Univ. California at Berkeley; California School of Fine Arts. Work: Columbia Univ.; AIC; and in private collections. Exhibited: David Herbert Gal.; Hirschl & Adler Galleries; Tibor de Nagy Gal., and Tanager Gal., all New York City. One-man: Tibor de Nagy Gal., 1957; Kornblee Gal., 1963, 1965.*

BUTTS, PORTER FREEMAN—Educator, W.
Memorial Union Bldg.; h. 2900 Hunter Hill, Shorewood Hills, Madison, Wis. 53705
B. Pana, Ill., Feb. 23, 1903. Studied: Univ. Wisconsin, B.A., M.A. Member: Madison AA. Author: "Art in Wisconsin: The Art Experience of the Middle West Frontier," 1936; "State of the College Union Around the World," 1967; "Planning College Union Facilities for Multiple-Use," 1966. Editor, "Bulletin of Assn. of College Unions," 1936- ; script for color-sound film, "Arts Center and Living Room of the University." Contributor to: art magazines; "The College Union as a Cultural Center," in 1961 Proceedings of the Assn. of College Unions; "The College Union Story," Journal of the Am. Inst. Arch., 1964. Planning Consultant, Milwaukee War Mem. Cultural Center and 115 college community centers in U.S., Canada, Puerto Rico, and Pakistan. Member building committee, Elvehjem Art Center, Univ. of Wisconsin. Positions: Prof., Division of Social Education, Univ. Wisconsin, 1928- .

BUZZELLI, JOSEPH ANTHONY—
Painter, Lith., Ser., C., T., L., Enamelist.
608 N. Casey Key, Osprey, Fla. 33559
B. Old Forge, Pa., May 6, 1907. Studied: ASL; Univ. So. California; Columbia Univ.; Beaux-Arts and Grande Chaumiere, Paris, France. Member: ASL; AEA; Huntington Hist. Soc.; Huntington A. Lg. (Bd. Memb.); AFA; Am. Craftsmen's Council. Awards: prizes, Butler

AI, 1940, 1941; Parkersburg FA Center, 1945, 1946; All. A., Johnstown, 1941; Advertising Cl., N.Y., 1942; Emily Lowe Award, Eggleston Gal., 7th annual; Guild Hall, East Hampton, 1958, 1959, 1961. Work: N.Y. Mem. Hospital; New York City Fed. Detention House; Wiltwyck Sch., Esopus, N.Y. Exhibited: San Diego FA Soc.; AIC; MMA; Denver A. Mus.; LC; Carnegie Inst.; Syracuse Mus. FA; Phila. A. All.; SAM; Everhart Mus. A.; WMAA; Birmingham Mus. A.; Atlanta AA; Columbia (S.C.) Mus. A.; Columbus (Ga.) Mus. A.; Sioux City A. Center; Davenport Mun. A. Gal.; Lowe Gal.; Tannenbaum Gal., N.Y.; America House, N.Y.; Univ. Delaware; Massillon Mus. A.; Philbrook A. Center; Jacksonville A. Mus.; Univ. Georgia; Guild Hall, East Hampton, N.Y.; Hampton Gal., Amagansett, N.Y.; and many others including one-man exhs.; MMA; CM; CMA; Butler AI; Ferargil Gal.; AWS; San F. AA; Rochester Mem. A. Gal.; Dartmouth Col.; Currier Gal. A.; Sweat Mem. Mus.; Kent State Col.; Akron AI; Dayton AI; CAM; William Rockhill Nelson Mus. A.; Oklahoma A. Center; Explorer A. Gal., N.Y., 1961; Parrish A. Mus., Southampton, N.Y., 1965 (one-man). Positions: Founded Vendome A. Gal.; 1936-43; Established Long Beach A. Center, 1939; Dir., Jabu Enamel Art Gal., New York, N.Y.

BYE, RANULPH (de BAYEUX)—Painter, E.
R. D. 2, Doylestown, Pa. 18901
B. Princeton, N.J., June 17, 1916. Studied: Philadelphia Mus. College of Art; ASL, with Frank V. DuMond and William C. Palmer. Also with Henry C. Pitz. Member: AWS; Phila. WC Cl.; SC; All. A. Am.; Grand Central A. Gal. Awards: prizes, SC, 7 awards since 1958; Grumbacher purchase prize, AWS, 1964, prize, 1966; Gold Medal, NAC, 1963, prize, 1966. Work: Moore Col. A.; Woodmere A. Gal., Phila.; Ford Motor Co.; Reading Pub. Mus.; Munson-Williams-Proctor Inst. A., Utica, N.Y.; BMFA; Cover paintings for "Prevention" magazine; Calendar paintings for Equitable Life Assurance Soc.; the Connecticut Mutual Life Insurance Co.; New York Life Insurance Co. Des. Christmas cards for Am. A. Group; Map of Bucks County. Pa. in color showing points of interest; Art assignment with U.S. Navy Mine Force, Charlestown, S.C., 1963. Exhibited: Widely in U.S. including NAD, 1969; AWS; Audubon A.; All. A. Am.; Phila. WC Cl.; PAFA, 1969; PAFA; one-man: Grand Central Gals., 1953, 1956, 1958, 1962, 1964; Smithsonian Inst., 1968. Recent exhs. in Philadelphia, William Farnsworth A. Mus., Rockland, Me., 1963, and others. Author article on railroad stations, publ. by American Heritage, 1965. Contributor to American Artist magazine; Included in "Seascapes and Landscapes in Watercolor," 1956. Positions: Assoc. Prof. A., Moore College of Art, Philadelphia, Pa., 1948- .

BYRD, D. GIBSON—Painter, E.
Department of Art, University of Wisconsin; h. 5905 Hammersley Rd., Madison, Wis. 53711
B. Tulsa, Okla., Feb. 1, 1923. Studied: Univ. Tulsa, B.A.; State Univ. of Iowa, M.A. Work: Philbrook A. Center, Tulsa; Kalamazoo Inst. A.; Wright A. Center, Beloit Univ.; Wisconsin State Col., LaCrosse; Univ. Wisconsin Fox River Ext. Center; Butler Inst. Am. A., Youngstown, Ohio, and in private colls. Exhibited: Delgado Mus. A., New Orleans; Butler Inst. Am. A.; Philbrook A. Center; Denver Mus. A.; WAC; Grand Rapids A. Center; Joslyn Mus. A.; Oklahoma A. Center, and others. One-man: Tulsa, Okla., Kalamazoo, Mich., Milwaukee, Wis., etc. Positions: Dir., Kalamazoo A. Center, 1952-1955; Lecturer, Univ. Michigan Ext., 1952-1954; Prof. A. Edu., Drawing and Painting, Univ. Wisconsin, Madison, 1955- , Chm. Dept. A., 1967- .

BYRNES, JAMES BERNARD—Museum Director
Isaac Delgado Museum of Art, City Park; h. 1243 Bourbon St., New Orleans, La. 70116
B. New York, N.Y., Feb. 19, 1917. Studied: Univ. Perugia, Italy; Instituto Meschini, Rome; Am. Mus. Natural Hist. (Mus. Edu. Methods); ASL; Am. A. Sch.; NAD. Member: Western Assn. A. Mus. Dirs.; Am. Mus. Assn; Am. Soc. for Aesthetics; Spanish Colonial Arts Soc.; Southeastern A. Mus. Dirs. Assn. (Council Memb.); Committee Memb., for Standards for Small Museums, Southeastern Mus. Conference. Author various museum catalogs, monographs, popular and scholarly articles on painting and sculpture. Positions: Mus. Docent, Field Activity Program, N.Y.C. Board of Edu., 1935-40; Indst. Des., 1940-41; U.S. Navy, Audio-Visual Training Aids Specialist, 1942-45; Docent, in Art, and Cur., Los A. Mus. A., 1946; Cur. A., Los A. Mus. A., 1946-53; Dir., Colorado Springs FA Center, 1954-Oct. 1955; Assoc. Dir., 1955-1957, Acting Dir., 1957-1960, Dir., 1960-1962, North Carolina Mus. A., Raleigh, N.C.; Dir., Isaac Delgado Museum of Art, New Orleans, La., 1962- . Visiting Lecturer; Univ. Southern California "20th Century Art," 1950; Univ. Florida, Gainesville, 1961; Tulane University, Dept. A. History, "Schools of 20th Century Art," 1962.*

BYRON, CHARLES ANTHONY—Art Dealer
1018 Madison Ave., 10021; h. 25 E. 83rd St., New York, N.Y. 10028
B. Istanbul, Turkey, Dec. 15, 1920. Studied: Ecole Libre des Sci-

ences Politiques, Paris, France; Paris University, Harvard University, B.A., LL.B., M.A. Specialty of Gallery: Contemporary and Surrealist Art.

BYWATERS, JERRY—
Fine Arts Center Director., E., W., P., L.
School of the Arts, Southern Methodist University; h. 3625 Amherst St., Dallas, Tex. 75225
B. Paris, Tex., May 21, 1906. Studied: Southern Methodist Univ., A.B.; ASL. Awards: prizes, Dallas Mus. FA, 1933, 1937, 1939, 1942; Houston Mus. FA, 1940; Corpus Christi, 1947. Work: Dallas Mus. FA; Texas State Col. for Women; Southern Methodist Univ.; Princeton Univ. Pr. Cl.; OWI; murals, USPO, Houston, Farmersville, Trinity, Quannah, Tex. Lecturer: American and Mexican subjects. Contributor to: Art in America, 1955, Southwest Review (A.Ed.); Ed., "Twelve From Texas," 1952. Author monographs on Otis Dozier (1956); Andrew Dasburg (1957); Everett Spruce (1958); Andrew Dasburg (1959 for AFA). Positions: A. Cr., Dallas News, 1933-1939; Dir., Dallas Mus. FA, 1943-1964; Prof. A., 1936- . Dir., Pollock Galleries, Owen Fine Arts Center, 1966- , Southern Methodist University, Dallas, Tex.

CABOT, HUGH—Painter, W.
Box 1222, Taos, N.M. 87571; h. Boston, Mass.
B. Boston, Mass., Mar. 22, 1930. Studied: Vesper George Sch. A.; BMFA Sch. A.; Mexico City Col.; Oxford Univ., England. Member: Assoc. Am. A. Work: Official Navy Combat Artist, Korean War, with work in the Navy office of History & Records. Other work represented, Humble Oil & Refining, Midland, Tex.; Phillips Oil Co., Bartlesville, Okla.; Wilco Bldg., Midland, Tex. Presently working on Mexican Frontier historical paintings and drawings. Exhibited: First Exh. combat art, Navy sponsored, Tokyo, 1953; USN "Operation Palette" traveling exh. Combat art "Korea by Cabot," 1953. Illus. for Nippon Times, and Boston Globe. Illus., "The Mountain of Gold." Contributor to Life and Fortune magazines. Author-Painter, limited edition portfolio depicting Southwestern Americana. Positions: A.-in-Res., (summer) Taos, N.M. and, winter, Taxco, N.M.

CADDELL, FOSTER—Painter, T., I., Lith.
Route 49, Voluntown, Conn. 06384
B. Pawtucket, R.I., Aug. 1921. Studied: R.I. Sch. Des.; and with Peter Helck, Robert Brackman, Guy Wiggins. Member: Academic AA; Providence A. Cl.; AAPL; 50 Am. A. Awards: prizes, Norwich Acad. A., 1947; Ogunquit A. Center 1949; AAPL, 1953; Conservative Painters of Rhode Island, 1962; Academic A. of Am., 1968. Work: paintings, Church of England and Mormon Church, Utah; many illustrations for other religious denominations. Portrait of U.S. Senator Thomas Dodd for Washington, D.C.; Port. of government officials, educators and business executives. Feature article, "Foster Caddell, Painter and Teacher," in American Artist Magazine, 1968. Exhibited: Ogunquit A. Center, 1948-1958; AAPL, 1950-1954; Academic AA, 1963-1969; Providence A. Cl., 1947-1969; one-man: Providence A. Cl., 1948, 1963, and other regional exhs. in Connecticut and Rhode Island. Illustrated many books, fiction and non-fiction and others for educational purposes. Conducts private school of painting.

CADMUS, PAUL—Painter, Et.
128 Remsen St., Brooklyn, N.Y. 11201
B. New York, N.Y., Dec. 17, 1904. Studied: NAD; ASL. Member: SAGA. Awards: prize, AIC, 1945; grant, Nat. Inst. A. & Lets., 1961; purchase prize, Norfolk Mus. A. & Sciences, 1967. Work: MModA; Sweet Briar Col.; Am. Embassy, Ottawa, Can.; MMA; WMAA; AGAA; Cranbrook Acad. A.; Lib. Cong.; AIC; BMA; N.Y. Pub. Lib.; SMA; Wadsworth Atheneum; Williams Col.; Milwaukee AI, and others; mural, Parcel Post Bldg., Richmond, Va. Exhibited: WMAA, 1934, 1936-1938, 1940, 1941, 1945, 1963, 1964; BM, 1935; AIC, 1935; London, Eng., 1938; SAE, 1938; GGE, 1939; PAFA, 1941; Carnegie Inst., 1944, 1945; MModA, 1942, 1943, 1944 and many others; Am. Exh., Florence, Italy. Publication: Paul Cadmus/Prints and Drawings, 1922-1967, by the Brooklyn Museum, 1968.

CAESAR, DORIS—Sculptor
Litchfield, Conn. 06759
B. New York, N.Y., 1892. Studied: ASL; Archipenko Sch. A., and with Rudolph Belling. Member: Fed. Mod. P. & S.; Sculptors Gld.; Arch. Lg., N.Y.; N.Y. Soc. Women A.; NAWA; Audubon A. Work: sculpture: AGAA; Albion Col.; Atlanta AA; Brooks Mem. Mus.; Busch Reisinger Mus., Harvard Univ.; CMA; Colby Col.; Colo. Springs FA Center; Connecticut Col.; Dayton AI; Farnsworth Mus.; Ft. Worth AA; Grand Rapids A. Gal.; Howard Univ.; Huntington Gals.; La Casa del Libro, San Juan; Lawrence Mus., Williams Col.; Minneapolis Inst. A.; Newark Mus.; N.Y. State Univ.; PAFA; PMA; Phoenix Mus. A.; Portland Mus. A.; St. Bernard's Church, Hazardville, Conn.; St. John's Abbey, Collegeville, Minn.; Univs. of Delaware, Indiana, Iowa, Minnesota; Utica Pub. Lib.; Wadsworth Atheneum; WMAA; Nelson Gal. A., Kansas City; Father Judge Mission

Seminary, Lynchburg, Va. Exhibited: MMA, 1955; Sc. Int., Phila., 1940-1950; New Burlington Gal., London, 1956; AFA traveling exh., 1953-1954; Salzburg Festival of Religious Art, 1958-1959; WMAA traveling exh., 1959; Brooks Mem. Mus., Memphis, 1960, and many others; one-man: Weyhe Gal., N.Y., 1933, 1935, 1937, 1947, 1953, 1957, 1959, 1961; Curt Valentin Gal., 1943; Petit Palais, Paris, France, 1950; Margaret Brown Gal., Boston, 1956; WMAA, 1959; Wadsworth Atheneum, Hartford, 1960.*

CAGGIANO, VITO—Educator, Art Administrator
Drury College, Springfield, Mo. 65802*

CAHILL, JAMES FRANCIS—Museum Curator, E.
Department of Art, University of California 94720; h. 2422 Hillside Ave., Berkeley, Cal. 94704
B. Fort Bragg, Cal., Aug. 13, 1926. Studied: Univ. California, B.A.; Univ. Michigan, M.A., Ph.D. Member: CAA; Assn. for Asian Studies. Author: "Chinese Painting," 1960; "Fantastics and Eccentrics in Chinese Painting," 1968. Positions: Advisory Council, Asia House, New York City; Prof., Chinese and Japanese Art, Cur., Oriental Art, Univ. Mus., Univ. California, Berkeley, Cal.

CAIN, JAMES FREDERICK, JR.—Printmaker, Mus. Cur.
Alverthorpe Gallery; h. 1046 Kingsley Rd., Jenkintown, Pa. 19046
B. Philadelphia, Pa., June 24, 1938. Studied: Assumption Col., Worcester, Mass., A.B.; Tyler Sch. A., Temple Univ., Philadelphia, Pa., M.A.; also studied at Laval Univ., Quebec City, Canada; Harvard Univ. Member: English Speaking Union; Philobiblon Cl.; Philadelphia Pr. Cl. Awards: English Speaking Union Grant for study at British Museum, 1968; Ford Fnd. Curatorial Training Grant, Tamarind Lithography Workshop, Los Angeles, 1967. Work: prints- MModA; Los Angeles County Mus.; AIC; Pasadena A. Mus.; Mus. FA of San Diego; La Jolla A. Center; Amon Carter Mus. Western A.; Grunwald Graphic A. Fnd., Univ. California at Los Angeles; Rosenwald Coll. Designed the illustration section for the National Gallery of Art's catalogue "Fifteenth Century Engravings of Northern Europe," 1967. Exhibited: In most major exhibitions of prints including numerous international exhibits in which items from the National Gallery's collections were included. Positions: Curator for the National Gallery of Art, assigned to the Lessing J. Rosenwald Collection of Graphic Arts, Alverthorpe Gallery, Jenkintown, Pa., 1966- .

CAIN, JO(SEPH) (LAMBERT)—Painter, E., Lith.
University of Rhode Island, Kingston, R.I. 02881
B. New Orleans, La., Apr. 16, 1904. Studied: Chicago Acad. FA; AIC; ASL; & in Paris. Member: Am. Assn. Univ. Prof.; Contemporary A. Group. Awards: F., Carnegie Inst.; F. & med., Tiffany Fnd. Work: murals, N.Y. State Training Sch., Warwick, N.Y. Exhibited: PAFA; NAD; AGAA; Fleming Mus.; R.I. Sch. Des.; WMAA; MModA. Author: "Art is the Artist." Positions: Prof., Hd. A. Dept., Univ. Rhode Island, Kingston, R.I. Co-Dir. with Matene Rachotes Cain, Summer Art Workshop.*

CAIN, JOSEPH A.—Painter, E., Cr., W.
402 Troy Dr., Corpus Christi, Tex. 78412
B. Henderson, Tenn., May 27, 1920. Studied: Tennessee State Col.; Univ. California, B.A., M.A. Member: Nat. Soc. Painters in Casein; F., Royal Soc. A., London; Nat. Platform Assn.; Texas WC Soc.; South Texas A. Lg.; Corpus Christi A. Fnd.; Texas FA Assn.; NEA; Texas Classroom T. Assn.; F.I.A.L.; AFA; Cal. WC Soc.; Texas Assn. of Schs. of A. Awards: prizes, South Texas A. Lg. (many); Vista (Cal.) A. Gld., 1960; T. Corpus Christi A. Fnd., South Texas Fair; Texas WC Soc., 1951, 1958, 1960, 1965, 1969; Texas FA Assn., 1954; PAFA, 1965, 1966; Grumbacher award, Nat. Soc. Ptrs. in Casein, 1965; Coca-Cola purchase award, Corpus Christi A. Fnd., 1965; Texas FA Assn., purchase, 1964; Prix de Paris, 1963; Butler Inst. Am. A., 1966; Southwestern Regional WC Soc., Dallas, 1969; Tri-Group Show, Corpus Christi, 1969, and many others. Work: Marine Corps Combat Art Coll., Wash., D.C.; Seton Hall Univ.; Ford Times; Goliad Lib., Goliad, Tex.; mural, Chamber of Commerce, 1960; Mosaic, Spohn Hospital, Corpus Christi, 1961; Buccaneer Bowl, 1961, and in many private colls. Exhibited: Radio City Music Hall, Marine Combat Art, 1952; Grand Central A. Gal., 1955, 1956, 1964; Los A. Mus. A., 1955; Santa Barbara Mus. A., 1955; DMFA, annually; Witte Mem. Mus., annually; Butler Inst. Am. A., 1957; Ball State T. Col., 1957, 1958; Denver Mus. A., 1955, 1958; Brooks Mem. A. Gal., 1956-1958; St. Augustine AA; Richmond (Cal.) A. Center, 1951; Saranac Lake, N.Y., 1958; Laguna Gloria Gal., Austin, Tex., annually; Centennial Mus., Corpus Christi, annually; D.D. Feldman Coll. Contemp. Texas Art, Dallas and national circuit; Grumbacher Coll. Am. Watercolors; Delgado Mus. A., annually; Alabama WC Soc.; Texas WC Soc., 1950-1965; Wash. WC Cl., 1952, 1953; Cal. WC Soc., 1953-1958; South Texas A. Lg.; Corpus Christi A. Fnd., 1949-1965; Beaumont (Tex.) Mus.; El Paso AA; Mus. New Mexico, 1957; Seton Hall Univ., 1958; Provincetown A. Festival,

1958; Petite Gal., N.Y.; 1957; Sarasota AA, 1960; Contemp. Pr.M., 1960; Oklahoma A. Center, 1961; Miss. AA, 1961; PAFA; one-man: Texas Col. of A. & Indst., Kingsville, 1953; Little Theatre, Corpus Christi, 1955; Rosenberg Gal., Galveston, 1955; Connors Jr. Col., Okla., 1955; Univ. Corpus Christi; Laguna Gloria A. Gal., 1957; Parkdale Grill, Corpus Christi, 1958; Beaumont Mus., 1960; Louisiana A. Comm., Baton Rouge, 1960; San Antonio A. Center, 1960; South Western Univ., 1961; Corpus Christi FA Colony (Artist of the Month) exh., 1961; Incarnate Word Col., San Antonio, 1961; Univ. Oregon, 1964; Willimantic State Col., 1965; Macalester Col., 1965; Ligoa Duncan Gal., N.Y., 1963; Univ. of Texas, Corpus Christi, 1969; Lubbock Tex. AA, 1969; Sam Houston State Col., 1969; San Diego State Col., 1969; Texas Christian Univ., 1969; traveling exh., sponsored by Old Bergen A. Gld., 2 yrs. and others. Contributor to Ford Times; Arts & Activities and Texas Trends. Work reproduced in Prizewinning Watercolors, 1964 and in Prizewinning Art, 1966. Positions: A. Ed., Corpus Christi Caller-Times, 1960- . Asst. Prof. & Chm. A. Dept. Del Mar College, Corpus Christi, Tex. Member of Municipal Art Council, Corpus Christi, 1967- .

CAJORI, CHARLES—Painter, T.
 205 West 14th St., New York, N.Y. 10011
B. Palo Alto, Cal., Mar. 9, 1921. Studied: Colorado Springs FA Center; Cleveland Sch. A.; Columbia Univ. Member: CAA. Awards: Fulbright F., 1952-53; Yale award for painting, 1959; Longview Fnd. purchase award, 1962. Exhibited: CGA, 1959; WMAA, 1957; Univ. Nebraska, 1958; Vanguard A., WAC, 1955; Univ. Texas, 1966, 1968; New Sch. Social Research, 1967, 1968; Univ. Washington, 1967; one-man: New York City, 1956, 1958, 1961, 1963; Wash., D.C., 1955; Stable Gal., 1954-1957; Cornell Univ., 1961; Univ. Washington, 1964; Bennington Col., 1969. Work: WMAA; WAC; Kalamazoo AI. Positions: Instr. Painting, Notre Dame of Maryland, 1949-1955; American Univ., 1955, 1956; PMA Sch. A., 1956; CUASch., 1956-1965. Visiting A., Univ. Calif., Berkeley, 1959; Visiting Cr., Cornell Univ., 1961; Univ. Washington, 1964; Colo. Springs FA Center, 1964; Visiting Critic, Yale Univ., 1963. Instr., New York Studio Sch., 1964- ; Queens Col., 1965- .

CALAPAI, LETTERIO—Painter, Eng., Et., L., E.
 82 West 3rd St., New York, N.Y. 10012
B. Boston, Mass., Mar. 29, 1904. Studied: Mass. Sch. A.; Sch. FA & Crafts; ASL; Am. A. Sch., and with Robert Laurent, Ben Shahn, Stanley Hayter. Member: NSMP; Atelier 17, New York & Paris; Western N.Y. Pr. M.; SAGA; AEA; Phila. Pr. Cl; Boston Pr. M.; AFA; Pr. Council of Am.; Audubon A.; Cal. Soc. Et. Awards: prizes, Am. in the War Exh., 1943; Fifty Prints of the Year, AIGA, 1944; Boston Pr. M., 1948; LC, 1950, 1951; Tiffany Fnd. grant, 1959; 100 Prints of the Year, SAGA, 1962; N.Y. Worlds Fair, 1964-65; Hunterdon City A. Center, 1964; Free Lib., Phila., 1964; Howard Univ., 1961; Rosenwald Fnd., 1960. Work: MMA; FMA; BMFA; BM; Houghton Lib., Harvard Univ.; LC; N.Y. Pub. Lib.; Bibliotheque Nationale, Paris; Princeton Univ. Lib., and in coll. in the U.S. and abroad. Exhibited: Smithsonian Inst., 1947; Kenyon Col., 1948; Boston Pub. Lib., 1948; Univ. Maine, 1951; Petit Palais, Paris, 1949; London (England) Gal., 1948; Mus. FA, Zurich, 1949; Berlin Festival, 1951; Royal Ontario Mus., 1952; LC, 1948-1952; Carnegie Inst., 1950, 1951; AIC; CGA; BM; CM; Denver A. Mus.; Stanford Univ.; SFMA; Honolulu Acad. A.; VMFA; N.Y. Pub. Lib.; Phila. Pr. Cl.; SAGA; Boston Pr. M.; Northwest Pr. M.; Western N.Y. Pr. M.; traveling exh.: America in the war exhs., 1944; AIGA European exh., 1945-1946; OWI, European tour of prints, 1944-1965; Paris, Exp. Int. de la Gravure Contemporaine, 1949-50, 1951-52; one-man: Montross Gal., 1934; Tricker Gal., 1939; Norlyst Gal., 1945; George Binet Gal., 1946; Peter Deitsch Gal., 1960. Positions: Hd., Gr. A. Dept., Albright A. Sch., 1949-55; L., N.Y. Univ., Sch. of Art Edu. & Div. Genl. Studies; Visiting Assoc. Prof. FA, Brandeis Univ., 1964-65. Dir., The Intaglio Workshop for Advanced Printmaking, New York, N.Y.*

CALAS, NICOLAS—Critic, E.
 Fairleigh Dickinson University, Teaneck, N.J. 07666; h. 210 E. 68th St., New York, N.Y. 10021
B. Lausanne, Switzerland, 1907. Studied: School of Law and Political Science, University of Athens, Greece. Author: "Confound the Wise," 1942; Co-author: (with Margaret Mead) "Primitive Heritage," 1953; (with Elena Calas) "The Peggy Guggenheim Collection of Modern Art," 1966; "Art in the Age of Risk," 1968. Contributor to Arts magazine and Art International. Positions: Associate Professor, Art History, Fairleigh Dickinson University, Teaneck, N.J.

CALCAGNO, LAWRENCE—Painter
 215 Bowery, New York, N.Y. 10002
B. San Francisco, Cal., Mar. 23, 1916. Studied: Cal. Sch. FA, and in France and Italy. Awards: prizes, Military Personnel Exh., NGA, 1944, 1945; purchase prize, SFMA, 1949; Albright A. Gal.; Buffalo,

1957. Work: Carnegie Inst.; Albright A. Gal.; WMAA; BMFA; Houston Mus. FA; CAL.PLH; Nat. Coll. of Am. A., Smithsonian Inst.; WAC; Honolulu Academy of Arts, and in private colls. Exhibited: Henry Gal., Univ. Wash., Seattle, 1949; Galerie Craven, Paris, 1953; SFMA, 1954; Martha Jackson Gal., N.Y., 1954, 1956; Butler Inst. Am. A., 1957; Brussels Worlds Fair, 1958; WMAA, 1957, 1965-1967; Mus. FA of Houston, 1957; MModA. traveling exh. to France, 1956; one-man: Labaudt Gal., 1947; Florence, Italy, 1951, 1952; Milan, Madrid, Paris, 1955; Martha Jackson Gal., N.Y., 1955, 1958, 1960-1962; Albright A. Gal., 1957; Lima, Peru, 1957; Karliss Gal., Provincetown, 1962-1964; Osborne Gal., N.Y., 1964; Siden Gal., Detroit, 1965, 1967-1969; Houston Mus. FA, 1965; retrospective, Westmoreland County Mus.; 1967; Honolulu Academy of Arts, 1968-1969. Positions: Asst. Prof. A., Univ. Alabama, 1955-56; Asst. Prof. A., Albright A. Sch., Univ. of Buffalo, N.Y., 1956-57; A.-in-Res., Univ. Illinois, 1958-59; N.Y. Univ., 1960, 1961; Andrew Mellon Prof., Carnegie-Mellon Univ., 1965-1968; Visiting A.-in-Res., Honolulu Academy of Arts, 1968.

CALCIA, LILLIAN ACTON—Educator
 301 Rea Ave. Extension, Hawthorne, N.J. 03104
B. Paterson, N.J., Mar. 28, 1907. Studied: Montclair State Normal; Columbia Univ., T. Col., B.S., M.A.; N.Y. Univ., Sch. Edu., Ed. D. Member: NEA (Life); New Jersey Edu. Assn.; Assn. Supv. & Curriculum Dirs.; New Jersey A. Edu. Assn.; Eastern AA.; Nat. A. Assn.; CAA. Positions: Instr. A. Elementary, Passaic, N.J., 1925-28; A., Elem. & Jr. H.S., Paterson, N.J., 1928-35; A., Newark State T. Col., 1935-55; A., Montclair State Col., 1955- ; Chm. A. Dept., Newark State T. Col., 1949-55; Chm. A. Dept., Montclair State Col., 1955- . Founder, Past-Pres., New Jersey Art Edu. Assn.

CALDER, ALEXANDER—Sculptor, P., I.
 Painter Hill Rd., Roxbury, Conn. 06783
B. Philadelphia, Pa., July 22, 1898. Studied: Stevens Inst. Technology, M.E.; ASL. Member: Am. Acad. A. & Lets. Awards: prizes, Plexiglas Comp., 1938; AV, 1942, first prize sculpture, Int. Exh. Contemp. Painting & Sculpture, Pittsburgh, 1958. Work: MModA; MMA; Berkshire Mus. A.; Smith Col.; Wadsworth Atheneum; Chicago AC; Mus. Western A., Moscow; Washington Univ.; CAM; PMA.; Guggenheim Mus.; Paris Exp., 1937. Exhibited: Dunkelman, Toronto, 1968; Perls Gal., 1967; Martha Jackson, 1967; Findlay, 1967. One-man exhibitions in leading museums nationally. I., "Fables of Aesop," 1931; "Three Young Rats," 1944.

CALDWELL, HENRY BRYAN—Museum Director
 Norfolk Museum of Arts & Sciences, Yarmouth & The Hague; h. 920 Graydon Ave., Norfolk, Va. 23507
B. Larchmont, N.Y., June 22, 1918. Studied: Harvard Univ., A.B.; N.Y. Univ., M.A. Positions: Asst. Dir., Corcoran Gal. A., Washington, D.C., 1950-54; Dir., Fort Worth A. Center, Fort Worth, Tex., 1955-60; Dir., Norfolk, Mus. A. & Sciences, 1960- .

CALFEE, WILLIAM H.—Sculptor
 4817 Potomac Ave., N.W., Washington, D.C. 20007; also, Dorset, Vt.
B. Washington, D.C., Feb. 7, 1909. Studied: Ecole des Beaux-Arts, Paris, with Paul Landowski; Cranbrook Acad. A., with Carl Milles. Work: PMG; MMA; Cranbrook Acad. A.; Philbrook A. Center; BMA; murals, public bldgs.; Font, altar and candlesticks, St. Augustine Chapel, Wash., D.C., 1969. Exhibited: PAFA; MMA; WMAA, 1966; traveling exh. sculpture, auspices of Santa Barbara Mus. A. to West Coast museums, 1959-60; Graham Gal., N.Y. (one-man); Southern Vermont Art Center, Manchester, Vermont, (one-man) 1969. Collaborator on and Introduction to: "Tradition and Experiment in Modern Sculpture," text by Charles Seymour. Positions: Chm. Dept. Painting & Sculpture, American Univ., Wash., D.C., 1945-1953, Adjunct Prof., at present, and will teach sculpture, 1969. Co-Owner, Jefferson Place Gallery, Washington, D.C.

CALKIN, CARLETON IVERS—Educator, P., L.
 265 Matanzas Blvd., St. Augustine, Fla. 32084
B. Grand Rapids, Mich., July 27, 1914. Studied: Univ. South Dakota, B.F.A.; Minneapolis Inst. A. Sch.; Chouinard A. Inst.; Ohio Univ., M.A.; Univ. California, Ph.D.; Univ. Michoacan, Mexico; Inter-Am. Univ., Panama. Member: CAA; Am. Archaeological Soc. Work: Ports. of Indian Chiefs, So. Dakota Hist. Mus., Vermillion, S.D.; ports., Texas Christian Univ., Ft. Worth; Hist. mural, Ohio Univ.; War murals, Rio Hato Air Base, Panama. Exhibited: Regional exhs., Ft. Worth, Tex.; Local, regional and State Fair Shows, Indiana. Contributor, Latin American Art section to Encyclopaedia Britannica, 1957. Lectures: Pre-Columbian, Latin American Archaeology; Colonial and Contemp. Latin American Art. Positions: Instr., A., Ohio Univ., Univ. California, Texas Christian Univ.; Hd., A. Dept., Purdue Univ., Lafayette, Ind., 1955-1962; Prof. A. Hist., 1962-66; Cur., St. Augustin Historical Commission.

CALLAHAN, JACK—Portrait Painter, T.
 Bearskin Neck, Rockport, Mass. 01966
B. Somerville, Mass. Studied: Vesper George Sch. A.; Mass. Sch.
A.; ASL. Member: Boston WC Soc.; Academic A., Springfield; Por-
traits, Inc., N.Y.; Portrait A. of New England; Copley Soc., Boston;
Springfield AA; Gld. Boston A.; All. A. Am.; Hudson Valley AA;
Rockport AA; North Shore AA. Awards: Carl R. Matson Mem.
Award, Rockport AA, 1958, 1962, 1964, and hon. men., Rockport AA,
1953, 1954, 1958, 1959, 1963, 1964; Copley Soc., Boston, 1962; Man-
chester (Conn.) Herald Award, Lions A. Festival, 1962 (2); Spring-
field Academic A., 1961-1962; Richard Mitton Mem. Gold Medal,
Jordan Marsh, Boston, Mass., 1963; Archer M. Huntington Award,
Hudson Valley AA, 1963; Henry Wisewood Mem. Award, North Shore
AA, Gloucester, Mass., 1963; Hatfield Award of Merit, Boston Soc.
WC Painters, 1965. Work: Port., Univ. Massachusetts, and in many
private colls. Exhibited: Academic A., Springfield; BMFA, 1961;
AGAA, 1963; Columbus (Ga.) Mus. A.; Endicott Jr. College; Doll &
Richards Gal., Boston, 1963; NAD, 1963; Smith Mus. FA, Spring-
field; AWCS; one-man: Rockport AA (2); Copley Soc., Boston. Con-
ducted demonstrations at: North Shore AA; Rockport AA; Eastern
States Exh., Springfield; Lexington (Mass.) A. & Crafts. On Juries
for North Shore AA, 1959, 1962; Rockport AA, 1961. Positions:
Instr. FA, Vesper George Sch. A. Maintains studio and gallery,
Rockport, Mass., year round.*

CALLAHAN, KENNETH—Painter, W.
 Long Beach, Wash.; also 117 E. 57th St., New York, N.Y.
 10022
B. Spokane, Wash., Oct. 30, 1906. Awards: Guggenheim F., 1954-
55. Work: in more than 40 public collections including SAM; SFMA;
MMoDA; MMA; PAFA; PMA; BM; AGAA; Wichita Mus. A.; Phelps
Mem. Gal.; Walker A. Center; Am. Acad. A. & Let.; Springfield
Mus. A.; Portland A. Mus.; Henry Gal., Seattle; murals, USPO, An-
acortes, Centralia, Wash; Rugby, N.D.; Marine Hospital, Seattle,
Wash.; Wash. State Lib., Olympia, Wash.; Syracuse (N.Y.) Univ.
Exhibited: International shows, Europe, Japan, Brazil, etc. & nation-
ally, 1946-1961; WMAA; MMA; MModA; PAFA; Maynard Walker
Gal., N.Y. (12 one-man) in New York, and many others.*

CALLAN, ELIZABETH PURVIS—Painter, Comm., T., L.
 626 James St., Pelham Manor, N.Y. 10803
B. Hamilton, Ont., Canada, Sept. 17, 1918. Studied: Vesper George
Sch. A.; Jackson Von Ladau Sch. of Fashion, Boston, and ext.
courses at PIA.Sch.; ASL; NAD; watercolor painting with Edgar
Whitney and Mario Cooper. Member: AWS; All. A. Am.; Hudson
Valley AA; Catherine L. Wolfe AA. Awards: Many for watercolor
nationally and regionally. Exhibited: AWS, 1958, 1961-1965; All. A.
Am., 1962-1964; traveling exhs., AWS past three years; Hudson Val-
ley AA; Wolfe A. Cl.; New Rochelle AA; Mexico; England, and
others. Positions: Fashion Illus. and Commercial illus., 1940-1945.
Lectures and demonstrations (watercolor). Corr. Sec., AWS 1961-
1964, Dir. and Chm. of Demonstrations, currently.

CALLERY, MARY—Sculptor
 168 East 68th St., New York, N.Y. 10021
B. New York, N.Y., June 19, 1903. Studied: ASL. Member: AEA.
Work: MModA; Toledo Mus. A.; SFMA; AGAA; CM; Detroit Inst. A.;
Aluminum Co. of America; Roosevelt P.S., N.Y.; Wingate P.S.,
Brooklyn, N.Y., and in private collections. Exhibited: one-man:
Curt Valentin Gal., 1944, 1947, 1949, 1950, 1952, 1955; Galleria Mai,
Paris, 1949; A. Cl., Chicago, 1945; Margaret Brown Gal., Boston,
1951; Brussels World's Fair, 1958; Knoedler Gal., 1957, 1961, 1965;
Knoedler Gal., Paris, France, 1962.*

CALLISEN, STERLING—Educator
 10 Ridgecrest West, Scarsdale, N.Y. 10583
Positions: Prof., Hist. of Art, Pace Col., N.Y.

CAMPBELL, DOROTHY BOSTWICK—Painter, S., Ceramist
 3111 Woodland Drive, N.W., Washington, D.C. 20008
B. New York, N.Y., Mar. 26, 1899. Studied: with Eliot O'Hara.
Member: Cooperstown AA; Sarasota AA; Long Boat Key AA; Am. A.
Lg., Wash., D.C. Awards: prize, Collector's Corner, Georgetown,
D.C.; Cooperstown AA. Work: Cooperstown AA; Mystic (Conn.) Sea-
port Mus., in private collections, France, England and Portugal as
well as the United States and Canada. Member: Pioneer Gallery and
American Art League of Washington, D.C.; member and Director of
the Cooperstown Art Association. Exhibited: Chosen for the One-
Man Show for 1965 at Cooperstown 30th Annual Art Exhibition; Sara-
sota AA; Pioneer Gal., Cooperstown; several exhs., Wash., D.C.

CAMPBELL, KENNETH—Sculptor, P., T.
 79 Mercer St., New York, N.Y. 10012
B. West Medford, Mass., Apr. 14, 1913. Studied: Mass. Sch. of A.,
with Ernest Major, Cyrus Darlin, Richard Andrews, William Porter;

NAD, with Leon Kroll, Gifford Beal; ASL, with Arthur Lee. Mem-
ber: Artists Club (Treas. & Bd. Memb., 1953-61); ASL; Sculptors
Gld. (Bd. Mem.); Audubon A.; Boston Soc. Indp. A. (Bd. Dir.).
Awards: prize & gold medal, New England Painters, 1949; prize,
New England P. & S., 1949; Longview Fnd. awards (2), 1962; Silver-
mine Gld. A., 1963; Ford Fnd. purchase awards, 1963, 1964; Richard
Davis Mem. Award, Audubon A., 1965; Guggenheim F., 1965. Work:
Kalamazoo AI; WAC; WMAA. Exhibited: WMAA, 1960, 1962, 1964,
1966; Inst. Contemp. A., 1949; BMFA, 1952; Guggenheim Mus., 1948,
1952; WMA, 1960, 1962, 1964; Stable Gal., N.Y., 1960; PAFA, 1964;
Silvermine Gld. A., 1963, 1964; Audubon A. 1964, 1965; Sculptors
Gld., N.Y., 1964, 1965, 1967; AIC, 1964; Parke-Bernet Gal., N.Y.,
1964-1965; Univ. Illinois, 1965; Univ. N.C., 1966; retrospective exh.,
Univ. Ky., 1967; one-man: Smith Gal., Boston, 1947; Norlyst Gal.,
N.Y., 1949; Camino Gal., N.Y., 1960; Margaret Brown Gal., 1952;
Provincetown, Mass., 1953; Dennis (Mass.) A. Center, 1952; Pro-
vincetown AA; Grand Central Moderns, N.Y., 1960, 1962, 1963, 1966;
Queens College, 1964. Positions: Instr., Drawing, Painting, Sculp-
ture, Studio Five, Boston & Provincetown, 1947-51; Erskine Sch.,
Boston, 1947-48; Instr., Silvermine College of Art, 1962, 1963;
Queens College, Flushing, N.Y., 1963-1966. A.-in-Res., Univ. Ky.,
1966; Univ. R.I., 1967; Lecturer, Columbia Univ. & Univ. Md., 1968-
1969.

CAMPBELL, (JAMES) LAWRENCE—Painter, Cr., E., W., Des.
 340 W. 56th St. 10019; h. 215 W. 98th St., New York, N.Y.
 10025
B. Paris, France, May 21, 1914. Studied: London Central Sch. A.;
Academie de la Grande Chaumiere, Paris; ASL. Member: Int. Assn.
A. Critics, American Section; Fed. Mod. P. & S. Work: Joseph
Hirshhorn Coll., Wash., D.C. Exhibited: Weatherspoon Gal., Univ.
North Carolina, 1966; PAFA, 1950, 1952; AFA traveling Exh., 1955-
1956; one-man: Contemp. A., New York City, 1951; 3-man: Tanager
Gal., N.Y., 1961; Kornblee Gal., N.Y., 1964; many groups and local
"theme" exhs.; traveling exh. circulated to branches of the N.Y.
State Univ., 1969. Author: "Thomas Sills," 1965. Contributor to
encyclopedias and yearbooks; article in "The Mosaics of Jeanne
Reynal," Reviews and articles to Art News since 1949; also articles
to Craft Horizons, Vogue, Cosmopolitan, Washington Post, Journal of
Aesthetic Criticism. Lectures: "John Ruskin," "The Gallery Scene
Today," "Turner," "American Painting" at galleries, museums and
on TV. Positions: Assoc. Prof., Brooklyn College Art Dept.; Pratt
Institute, Brooklyn; Director Publications, Editor and Designer, cat-
alogues and books of the Art Students League, 1950- .

CAMPBELL, MALCOLM—Scholar
 G-23 New Fine Arts Bldg., University of Pennyslvania, Phila-
 delphia, Pa. 19103; h. 4514 Chester Ave., Philadelphia, Pa.
 19143
B. Hackensack, N.J., May 12, 1934. Studied: Princeton Univ., A.B.,
M.F.A., Ph.D. Contributor to Art Bulletin; Burlington Magazine;
Rivista d'Arte. Field of Research: 17th Century Italian Art.

CAMPBELL, MARJORIE DUNN—Educator, P.
 Arts & Industries Bldg., Iowa State Teachers College; h. 713
 Main St., Cedar Falls, Iowa 50613
B. Columbus, Ohio, Sept. 14, 1910. Studied: Ohio State Univ., B.S.
in Edu., M.A.; Claremont Col. Grad. Inst. A.; T. Col., Columbia
Univ., and with Hans Hofmann, Emil Bisttram, Millard Sheets.
Member: A. Edu. of Iowa; Int. Soc. for Edu. through Art; Western
AA; Nat. A. Edu. Assn. Contributor to School Arts, Art Education
Journal, Everyday Art magazines. Positions: Instr., App. A., Univ.
Missouri, 1942-45; Asst. Prof. FA, Ohio State Univ., 1945-49; Asst.
Prof. A., State Col. of Iowa, Cedar Falls, Iowa, 1949- .*

CAMPBELL, ORLAND—Portrait Painter
 1 West 67th St., New York, N.Y. 10023
B. Chicago, Ill., Nov. 28, 1890. Studied: George Washington Univ.;
Corcoran A. Sch.; PAFA, with Henry McCarter. Member: Century
Assn. Work: U.S. Capitol Bldg., Wash., D.C.; Canajoharie Mus.;
U.S. Military Acad., West Point, N.Y.; MIT; Univ. Chicago; Rens-
selaer Polytechnic Inst.; Mus. City of N.Y.; Southern Vermont A.
Center. Exhibited: CGA, 1923; CAM, 1924; Arch. L., 1926; Wilden-
stein Gal.; one-man: So. Vermont A. Center, 1960; Century Assn.,
N.Y., 1960; Macbeth Gal.; Knoedler Gal.; Glenn Hodges Gal. (Palm
Beach); Amherst Col., 1959; Century Assn., N.Y., 1960; South Ver-
mont A. Center, 1960; Adelphi Univ., 1965. Contributor to American
Heritage, 1958. Author: "The Lost Portraits of Thomas Jefferson
by Gilbert Stuart," 1965. Trustee, Southern Vermont Art Center.

CAMPBELL, RICHARD HORTON—Painter
 16551 Sunset Blvd., Pacific Palisades, Cal. 90272
B. Marinette, Wis., Jan. 11, 1921. Studied: Cleveland Sch. A.; A.
Center Sch., Los A. Member: Cal. WC Soc.; Los A. AA; Westwood
AA; F.I.A.L. Awards: prizes, Los A. City Exh.; CMA; Los A. Fes-

tival A.; Currier Gal. A., Manchester, N.H.; Tucson A. Center; Long Beach City College; Otis AI; State Fairs, Cal., San Diego, Orange County; Westwood AA. Exhibited: Butler Inst. Am. A.; Denver A. Mus.; Oakland A. Mus.; Cal. WC Soc.; CMA; Los A. Mus. A.; Old Northwest Territory Exh.; Los A. AA; Westwood AA; Cal. State Fair; Orange County Show; Sarasota AA; Crocker A. Gal.; Rochester Mem. Mus.; Pittsburgh Plan for Art; Esther Robles Gal., Los A.; Kent State Univ.; Loyola Univ.; Occidental Col.; St. Lawrence Univ.; Col. of Puget Sound; Laguna Beach Festival A.; Los A. All-City Exh.; Madonna Festival; 1st Unitarian Church of Los A.; one-man: deYoung Mem. Mus., San F.; Santa Monica A. Gal.; Whittier AA; Comara Gal.; Lighthouse Gal. Positions: Bd. Dirs., Santa Monica A. Gal.*

CAMPBELL, VIVIAN—Writer, Collector
 Art Department, Life Magazine, Rockefeller Center 10020;
 h. 408 W. 20th St., New York, N.Y. 10011
B. Belmont, Mass., May 20, 1919. Studied: Fogg Museum, Harvard University; special studies, Ecole du Louvre and University of Paris. Collection: General, but with some emphasis on Contemporary American art. Author, "A Christmas Anthology of Poetry and Painting," 1947; also articles for various American and French publications on painting and sculpture. Positions: Asst. Keeper, X-rays and Research Asst. to Dr. Alan Burroughs, Fogg Museum of Art, Harvard University, 1939-42; Dir., Harry Stone Gallery, New York, 1942-44; Art Dir., Woman's Press, 1944-47; Dir., Art Catalogs, UNESCO, 1949-50; Reporter and Editor in Art Department, Life Magazine, 1950- .*

CAMPBELL, WILLIAM P.—Museum Curator
 National Gallery of Art, Smithsonian Institution, Washington, D.C. 20565
Positions: Asst. Chief Curator, National Gallery of Art.*

CAMPOLI, COSMO PIETRO—Sculptor, E.
 Contemporary Art Workshop, 542 W. Grant St. 60614; h. 5307 S. University Ave., Chicago, Ill. 60615
B. South Bend, Ind., Mar. 21, 1922. Studied: AIC. Awards: Raymond Traveling Fellowship, AIC, 1950; Ford Fnd. Grant, 1960; purchase prize, MMoDA, 1959; other prizes, Chicago Area Exh., Hyde Park A. Center, 1958 (2). Work: MMoDA; VMFA; Univ. Southern Illinois, Carbondale; Unitarian Church, Chicago; Exchange Nat. Bank, Chicago. Exhibited: MMoDA, 1959; Chicago Area Exhs. since 1943; USIS exh., Moscow and Petrograd; Galerie du Dragone, Paris; Spoleto, Italy; Carnegie Int. Exh., Pittsburgh, Pa. Positions: Assoc. Prof., Hd. Dept. Sculpture, Inst. Des., Illinois Inst. Tech., 1952-1967; Visiting Prof., Sculpture Dept., Univ. Chicago, 1964-1969; Co-Director, Contemporary Art Workshop, Chicago, Ill.

CANADAY, JOHN E.—Critic, Writer
 New York Times, 229 W. 43rd St., New York, N.Y. 10036
B. Ft. Scott, Kans., Feb. 1, 1907. Studied: Univ. Texas, B.A.; Yale Univ., M.A. and Certif. in Painting. Author: "Metropolitan Seminars in Art" (publ. by Metropolitan Mus.); "Culture Gulch"; "Lives of the Painters," both 1969; "Mainstreams of Modern Art"; "Embattled Critic"; "Keys to Art" (with Katherine Canaday); also seven mystery novels under pseudonym Matthew Head. Positions: Art Critic, New York Times, New York, N.Y.

CANDELL, VICTOR—Painter, T., L.
 22 E. 10th St., New York, N.Y. 10003
B. Budapest, Hungary, May 11, 1903. Studied: in Paris, Budapest, New York. Member: Audubon A.; AEA; F., Edward MacDowell Assn.; F.I.I.A.L; AAUP. Awards: prizes, MMoDA, 1940; U.S. Treasury Dept., 1942; Emily Lowe award; Lamont Prize, Audubon A., 1961; Silvermine Gld. A., 1962; New England Exh., 1968. Work: WMAA; MMA; Nat. Inst. A. & Let.; Montclair A. Mus.; Univ. Nebraska; Carnegie Inst.; Munson-Williams-Proctor Inst.; Brandeis Univ.; CGA; N.Y. Univ.; Newark Mus. A.; Krannert Mus, Urbana, Ill.; CGA; Syracuse Univ., N.Y. Exhibited: WMA; Audubon A.; MMA; WMAA; AIC; Univ. Illinois; CGA; Carnegie Inst.; Des Moines A. Center; PAFA; one-man: Grand Central Moderns, 1952, 1954, 1959, 1964, 1966; Hofstra Col., 1959. Positions: Instr., Brooklyn Mus. Sch. A., 1946-54; Cooper Union, 1954-1968; N.Y. Univ., 1969- ; Fndr., Co-Dir., (with Leo Manso), Provincetown Workshop (summers), 1959- ; Guest Critic, Columbia Sch. Painting, 1952-53, 1955-56; Ohio Univ. Sch. A., 1957; Syracuse Sch. A., 1952-53; Cranbrook Acad., 1958; Silvermine Gld. A., 1960-61; Faculty, Silvermine College of Art, 1960- ; Seminars, Cape Cod A. Group, Hyannis, Mass., 1959-61; Larchmont Artists Group, 1969- ; Cutter Mill Group, Great Neck, N.Y., 1968- ; Greenwich A. Center Group, 1968- .

CANIFF, MILTON A.—Cartoonist, I., W., L.
 c/o King Features, 235 E. 45th St., New York, N.Y. 10017
B. Hillsboro, Ohio, Feb. 28, 1907. Studied: Ohio State Univ., B.A.; Atlanta Law Sch., Hon. LL.D.; Rollins Col., Hon. D.F.A. Member:

Natl. Cartoonists Soc.; Natl. Press Cl.; Overseas Press Cl.; Aviation Writers Assn.; Players Cl.; SI; Newspaper Comics Council; Military Collectors & Historians. Awards: Billy DeBeck Mem. award, 1947; Sigma Delta Chi Distinguished Service award, 1949; Air Force Assn. Medal of Merit, 1952; Air Force Assn. A. & Lets. Trophy, 1953; Treasury Dept. Citation, 1953; Ohio Career Medal, 1954; USAF Exceptional Service award, 1957; Ohio Governor's award for outstanding Ohioan, 1957; 1969 George Washington Honor Medal Award from Freedoms Foundation for "You Are The Flag" mural in new Boy Scout Building at Flag Plaza, Pittsburgh, Pa. Work: Producing features "Dickie Dare" and "Gay Thirties" for Assoc. Press, N.Y., 1932; created "Terry and The Pirates," Chicago Tribune-N.Y. Daily News Syndicate, 1934; started "Steve Canyon" strip for Chicago Sun-Times-Daily News Syndicate (now Publishers Newspaper Syndicate) in 1947; weekly GI strip "Male Call" for service publications, WW II.

CANTEY, SAM III—Collector
 First National Bank, P.O. Box 2260; h. 1220 Washington Terrace, Fort Worth, Tex., 76107
B. Fort Worth, Tex., Apr. 18, 1914. Studied: Washington & Lee Univ., B. A. Collection: 20th Century watercolors, drawings and prints; School of Fontainebleau, prints and drawings. Positions: Executive Vice-President and Board Member, Past President, Fort Worth Art Association; Founding Chairman Advisory Council, Fine Arts College, University of Texas.

CANTINI, VIRGIL D.—Sculptor, C., E.
 205 South Craig St., Pittsburgh, Pa. 15213
B. Italy, Feb. 28, 1919. Studied: Manhattan Col.; Carnegie Inst. Tech., B.F.A.; Alfred Univ.; Cleveland Inst. A.; Univ. Pittsburgh, M.A.; Skowhegan Sch. P. & S. Member: Assoc. A. Pittsburgh (Pres.); A. & Crafts Center, Pittsburgh (Bd. Dir.); Pittsburgh Plan for Art; Craftsmen's Gld. Western Pa.; CAA; Sc. Soc. of Western Pa. Awards: prizes, Assoc. A. Pittsburgh, 1946-1952, 1954, 1955, 1957-1959, 1963; Craftsmen's Gld., Pittsburgh, 1954, 1957, 1959, 1960; Pittsburgh Soc. Sculptors, 1956; Sculptures of Western Pa., Exh., 1957; also Pittsburgh Chamber of Commerce & Time Magazine, 1950; Carnegie Inst., 1954; Newspaper Gld., Pittsburgh, 1955; Pittsburgh Jr. Chamber of Commerce, 1955; A. & Crafts Center, 1956 (Artist of the Year); Guggenheim F., 1957-58; Bishop Wright Award and Pope Paul VI for outstanding contemporary art particularly liturgical art, 1964. Da Vinci Medal, ISDA Cultural Heritage Fnd., 1967. Work: Stations of the Cross, church furnishings, doors, enamels, etc., for many churches in Pittsburgh, Lancaster, Greenville, McKees Rocks, Sewickley, Greenfield, Washington, and Greensburg, all in Pennsylvania; Campbell, Toledo and Canton, Ohio; Episcopal Students Chapel, Carnegie Inst.; United Steelworkers of America; Pittsburgh Plate Glass Co.; Univ. Pittsburgh; cloisonne enamel panel commissioned by Notre Dame Univ. for presentation to Dwight D. Eisenhower, 1960; sc. mosaics, Urban Redevelopment Authority, Pittsburgh, 1964; wrought iron sc., Gateway Towers, Pittsburgh, 1964; Y.M.C.A., New Castle, Pa., 1964; steel & bronze sc., Joseph Horne Co., Pittsburgh, 1964-65. Sculptures, Grad. Sch. of Public Health, Univ. of Pittsburgh, 1966; Liogonier Pub. Lib., 1968; New Kensington Citizen General Hospital, 1968; Shadyside Presbyterian Church, 1968; Hillman Library, 1969; Township Elementary Sch. (wall sculpture), 1969; Urban Redevelopment Authority for East Liberty Mall, 1969. Exhibited: Assoc. A. Pittsburgh, 1943-1956; Syracuse Mus. FA, 1949; Univ. Pittsburgh, 1943-1956; Syracuse Mus. FA, 1949; Univ. Pittsburgh, 1950; Wichita A. Mus., 1952; Univ. Illinois, 1952; Iowa State T. Col., 1955; Grand Rapids, 1956; Carnegie Inst., 1956; Brooks Mem. Mus., Memphis, 1956; Mus. Contemp. Crafts, N.Y., 1957; Int. Exh., Carnegie Inst., 1958, 1964-65; Brussels Fair, 1958; Art: USA, 1959; Mus. Contemp. Crafts, 1959; Smithsonian Inst., 1959; one-man: Allegheny Col., 1951; Pittsburgh Playhouse, 1952; Center, Pittsburgh, 1956; Ohio State Univ., 1955; A. & Crafts Center, Pittsburgh, 1956; Univ. West Va., 1960; Pittsburgh Plan for Art, 1962; Westmoreland County Mus. A., Greensburg, Pa., 1963; Pittsburgh Int., 1967. Positions: Instr., Pittsburgh Pub. Schs., 1948-52; Instr., 1952-56, Asst. Prof., 1954-57, Assoc. Prof., 1957-60, Prof., 1960- , Chm. Studio Arts Dept. & A. Educ., 1968- , Univ. Pittsburgh. Consultant to Special Educ. Dept., Diocese of Pittsburgh, 1968.

CANTOR, ROBERT LLOYD—Educator, Des., C., Cr., W., L.
 15 Gulf Rd., Lawrence Brook, East Brunswick, N.J. 08816
B. New York, N.Y., Aug. 14, 1919. Studied: N.Y. Univ., Ph.D. Member: Eastern AA; Nat. Edu. Assn.; Indst. A. Assn.; Com. on A. Edu.; MMoDA; Soc. Plastic Engr. Exhibited: Charleston A. Gal. (one-man). Author: "History of Art Workbook"; "Plastics for the Layman"; also training film scenarios, manuals, textbooks. Contributor to art, educational and political journals; New Leader, etc. Positions: Prof. F. & Indst. A., West Virginia Inst. Tech., Montgomery, W. Va.; Exec. Dir., AEA, New York; Ed. Dir., Am. Craftsman Sch., New York, N.Y.; Instr., N.Y. Univ., City Col., Fashion Inst. Tech., Columbia Univ., New York, N.Y.

CAPARN, RHYS (Mrs. Rhys Caparn Steel)—Sculptor, T.
939 8th Ave.; h. 333 West 57th St., New York, N.Y. 10019
B. Onteora Park, N.Y., July 28, 1909. Studied: Bryn Mawr Col.;
Ecole Artistique des Animaux, Paris, France; Archipenko Sch. A.,
N.Y. Member: Fed. Mod. P. & S.; Sculptors Gld.; Am. Abstract
A.; NAWA; New Sculpture Group; F.I.A.L.; (Pres.) Fed. Mod. P. &
Sc., 1944-45, 1961-64. Awards: prizes, MMA, 1951; N.Y. State Fair,
1958; NAWA, 1944, 1945, medal of honor, 1960, 1961. Work: CAM;
Colorado Springs FA Center; CGA; Dartmouth Col.; FMA; La Jolla
A. Center; North Carolina State Mus.; Butler Inst. Am. A.; River-
side Mus., N.Y.; WMAA; Norfolk Mus. A.; Bryn Mawr College; Sculp-
ture & drawings for entrance lobby, Barnard Col. Library. Exhib-
ited: MMoA traveling exh., 1941; WMAA, 1941, 1953, 1954, 1956,
1960; Petit Palais, Paris, 1950; PAFA, 1951-1953, 1960; U.S.I.A.
exh. Europe, 1956-57; Europe and Far East, 1957-58; Mus. Nat.
Hist., Animals in Sculpture Exh., 1958; Munson-Williams-Proctor
Inst., 1956, 1958; Syracuse Univ., 1956; Silvermine Gld. A., 1956;
VMFA, 1958; Old Westbury, N.Y., 1960; IBM Gal., N.Y., 1960;
Claude Bernard Gal., Paris, 1960; Newark Mus. A., 1965; Nat. Inst.
A. & Lets., 1968; one-man: Delphic Studios, N.Y., 1933, 1935; 2-man
exh., Sculptors Gld. Gallery, 1969; Arch. Lg., 1941; N.Y. Zoological
Park, 1942; Wildenstein Gal., N.Y., 1944-1947; Dartmouth Col., 1949,
1955; Heller Gal., N.Y., 1953; Meltzer Gal., 1956, 1959, 1960; River-
side Mus., N.Y., 1961; Provincetown, Mass., 1961.

CAPONI, ANTHONY—Sculptor, E.
Art Department, Macalester College 55101; h. Rt. No. 1,
County Rd. 30, St. Paul, Minn. 55111
B. Pretare, Italy, May 7, 1921. Studied: Univ. Flore, Italy; Cleve-
land Sch. A.; Walker A. Center; Univ. Minnesota, B.S., M. Ed. Mem-
ber: AEA; Soc. Minn. Sculptors. Awards: Ford Fnd. Grant, prizes,
Minneapolis Inst. A., 1947, 1948, 1949, 1953, 1959; Minnesota State
Fair, 1948, 1950, 1955; 1957, 1959, 1965; St. Paul Gal. A., 1949,
1955. Work: Minneapolis Inst. A.; sc., columns, figures: St. Joseph
Sch., Red Lake Falls, Minn.; St. Mary's Church, Warroad, Minn.;
St. Johns Church, Rochester, Minn.; Trinity Lutheran Church, Roch-
ester; Immaculate Conception Church, Minneapolis, Minn.; Macales-
ter Col., St. Paul; Convent of St. Clare, Minneapolis; wax models
for all bronze motifs in Eisenhower Lib., Abilene. Produced art
film "Form that Lives and Forms," 1959, Univ. Minn.; two bronze
relief sculptures, Ascoli, Italy. Exhibited: WAC, 1947-1958; Iowa
State T. Col., 1958; St. Paul Gal. A., 1947-1958; Minneapolis AI
annually. Co-Dir., film "Sculpture in Minnesota," 1950. Positions:
Pres., Minn. Sculpture Group, 1952; Vice-Pres., Minn. Soc. Sculp-
tors, 1958; Prof. A., Hd. A. Dept., 1958- , Chm. FA Div., 1967- ,
Macalester College, St. Paul, Minn.

CAPP, AL—Cartoonist
Capp Enterprises, 122 Beacon St., Boston, Mass. 02116
B. New Haven, Conn., Sept. 28, 1909. Author syndicated comic, Lil
Abner.

CAREWE, SYLVIA—Painter, Pr. M., Tapestry Des.
500 E. 83rd St., New York, N.Y. 10028
B. New York, N.Y. Studied: Columbia Univ.; New School and with
Kuniyoshi and Hans Hofmann, and abroad. Member: AEA; Brooklyn
Soc. A.; AWS; Phila. Pr. Cl.; N.Y. Soc. Women A.; NAWA; Atelier
17. Work: Brandeis Univ.; Butler AI; Howard Univ.; Musee de l'Arte
Moderne, Paris, France; Richmond (Ind.) AA; Tel-Aviv Mus.;
MMoA; WMAA; Nationale de Jakarta, Indonesia, and in private col-
lections. Color story and cover in American Illustrated, 1962; Arts
Illustrated, 1966; Review Moderne, Paris, 1960. Awards: ACA Gal.
Comp., 1947. Exhibited: MMoA.; WMAA; BMFA; BM; Audubon A.; BM;
Brooklyn Pub. Lib.; Riverside Mus.; Vassar Col.; Phila. Pr. Cl.;
Smith Mus., Springfield, Mass.; Columbia Mus. A. (S.C.); Georgia
Mus. A., Athens; High Mus. A., Atlanta, Ga.; Colo. Springs FA Cen-
ter; one-man: Three Arts, Poughkeepsie, N.Y., 1947, 1952, 1954,
1958; ACA Gal., 1947, 1953, 1954 (4-man) 1956, 1958, 1961; French
& Co., N.Y., 1960-1962, tapestries; Community Church, tapestries,
1964 and tapestries and banners, 1969; Barnett Aden Gal., Wash.,
D.C., 1950; Richmond AA, 1955; Univ. Indiana, 1955; Ball State T.
Col., Muncie, 1955; Decatur A. Center, 1955; Butler AI, 1955, 1959;
Galerie Granoff, Paris, France, 1957; Univ. North Carolina, 1958;
North Carolina Col. Union, Raleigh, 1958; Community Church, N.Y.,
1964. Positions: Pres., Am. Soc. Tapestry Designers.

CAREY, EDWARD F. (TED)—Collector, Designer, Teacher
320 E. 57th St., New York, N.Y. 10022
B. Chester, Pa., June 3, 1932. Studied: Philadelphia Museum School
of Art, B.F.A. Collection: Contemporary Paintings, Sculpture and
Drawings. Positions: Textile Designer, Free Lance Illustrator, and
Instr., Pratt Institute, Brooklyn.

CAREY, JAMES SHELDON—Educator, C.
University of Kansas; h. 2122 Owens Lane, Lawrence, Kans.
66044
B. Bath, N.Y., July 28, 1911. Studied: N.Y. State Col. of Ceramics,
Alfred Univ., B.S. in Ceramic Art; T. Col., Columbia Univ.; A.M. in
F. & Indust. A. Member: F., Am. Ceramic Soc.; AAUP; Am. Craft-
men's Council (Trustee); Sertoma Int. Awards: prize, 9th Ann.
Exh., Hendersonville, N.C., 1951; CAM, 1948, 1953, 1959; Nat. Ce-
ramic exh., Wichita, 1958; Syracuse Mus. FA, 1958; Springfield (Mo.),
1960. Work: MMA; Nelson Gal. A.; Joslyn A. Mus.; Everson Mus.,
Syracuse; Springfield (Mo.) Mus. A.; Wichita AA; Univ. Kansas. Ex-
hibited: Nationally. In addition, international traveling exhs., AFA,
Smithsonian Inst., Am. Craftsmen's Council; Int. Ceramic, Ostend,
Belgium, 1959; Int. Cultural Exchange, Geneva, 1960 (work given to
Finland); recent group exhs.: St. Cloud (Minn.) Col., 1968; Univ.
New Mexico, 1968; Wichita AA, 1968; Lima, Peru, 1968; Syracuse
Nat. Ceramics Exh., 1969; one-man: Univ. South Florida, Tampa,
1966; Univ. Texas, Austin, 1967; Southwest State Col., 1967. Con-
tributor to Am. Ceramic Soc. Bulletin; Edu. & Tech. Des. Magazine;
Arts & Activities. Lectures and demonstrations, TV, 1956-60. Po-
sitions: Instr. Ceramics, T. Col., Columbia Univ., 1940-42; R.I. Sch.
Des., 1942-43; Univ. Kansas, 1944-45; Asst. Prof., Univ. Kansas,
1945-48; Assoc. Prof. Ceramics, 1948-53; Prof., 1953- ; Adv. Ed.
Ceramics Monthly, 1953-55; Bd. Dirs., Nat. Council on Edu. for the
Ceramic Arts.

CAREY, JOHN THOMAS—Educator, Historian
University of West Florida, Pensacola, Fla. 32504; h. 412
Sunnydale Lane, Cantonment, Fla. 32533
B. Wilmont, Minn., Aug. 23, 1917. Studied: Milwaukee State Teach-
ers College, B.S.; University Wisconsin, M.S.; Ohio State Univer-
sity, Ph.D. Member: College Art Association; Southeast College
Art Association; Florida Art Education Association. Field of Re-
search: American Art and History of Prints and Graphic Processes.
Author, book reviews, Journal of the Art Education Journal. Posi-
tions: Chairman, Professor Art, Northern Illinois University, De-
Kalb, 1956-1966; Instr., Humanities Program for Junior Executives,
Motorola Corp., Chicago, 1960-1966; Visiting Professor of Art His-
tory, Rollins College, Winter Park, Fla., 1967; Chairman, Faculty of
Art, University of West Florida, Pensacola, 1968- ; Visiting Profes-
sor of Art History, Chapman College, Orange, California, Spring,
1969.

CARIOLA, ROBERT—Painter, S., Gr., T.
c/o Merrick Art Galleries, 8 Merrick Ave., Merrick, L.I.,
N.Y. 11566
B. Brooklyn, N.Y., Mar. 1927. Studied: Pratt Inst. A. Member:
Hon. memb., Catholic FA Soc. Awards: prizes, Operation Democ-
racy, Locust Valley, L.I., 1958; Hofstra Col. (prize and purchase
award); Security Natl. Bank Award; Heckscher Mus.; Country A.
Gal.; Baldwin Center Creative A.; SAGA; Knoxville A. Center pur-
chase, 1961; Emily Lowe Award, 1962; Tiffany Fnd. Grant, 1964-65;
Roosevelt Raceway Award, 1963. Exhibited: Hofstra Col., 1958;
Barbizon Plaza, N.Y.; ACA Gal.; Hall of Art; Contemp. A.; Newman
Gal., Phila. Pa.; Assoc. Am. A.; CGA; PAFA; NAD; Parke-Bernet
Gal.; Madison Gal., N.Y.; Country A. Gal., Westbury, N.Y.; Heck-
scher Mus.; North Shore Community A. Center; Whitney Estates
Exh.; Print Cl. of Albany; BMFA; Silvermine Gld. A.; Ohio Univ.;
Phila. Free Lib.; Washington Soc. Printmakers; Wesleyan College;
Long Beach, N.Y., AA; American Art Today, N.Y. Worlds Fair; Con-
temp. Christian A. Gal., N.Y. (three-man), 1968; Springfield Mus.,
1969; Cranbrook Acad. A., Bloomfield Hills, Mich., 1969; one-man:
Vatican Pavilion, N.Y. Worlds Fair, 1964; Hall of Art; Little Gal.,
Phila.; Hofstra College; Baldwin Center; Calderon Theatre, Hemp-
stead, N.Y.; Kenmore Gal., Phila.; Merrick A. Gals., Merrick, N.Y.;
Lazuk Gal., Cold Spring Harbour, N.Y. Work: Topeka Pub. Lib.;
College of Wooster (Ohio); Hofstra College; F. & W. Publ. Co., Cin-
cinnati; Our Lady of Angels Seminary, Albany, N.Y.; St. Hubert's
H.S., Phila.; stained glass windows, Trinity Lutheran Church, N.J.;
metal sc. in various churches on east coast, since 1965; and in pri-
vate collections. Work reproduced (cover) in "Writer's Annual,"
1958. Paintings reproduced by American Playing Card Co. Lectured,
"The Metaphor in Art," & presented film, produced with William
Rouleau, "Tempo, Now, the Word," at Marymount Col., Caldwell
Col. & Dominican Cols., 1968-1969.

CARLIN, JAMES—Painter, T.
73 Cathedral Ave., Nutley, N.J. 07110
B. Belfast, North Ireland, June 25, 1909. Studied: Belfast Mun. Col.,
Ireland, and with Beaumont, in London, England. Member: AWS;
Phila. WC Cl.; SC; N.J. WC Soc.; Audubon A.; All. A. Am. Awards:
AWS, 1943, 1947; Audubon A., 1947; Montclair A. Mus., 1941, 1942,
1946, 1949, Silver Medal of Honor, 1969; All. A. Am., 1945; P. & S.
Soc., N.J., 1946; A. Council of N.J., 1948; SC, 1950; N.J. State Exh.,
1952; SC, 1952; NAD, 1951. Work: stained glass windows (in collab-
oration) Londonderry Guild Hall; memorial windows in several
churches in Ireland. Exhibited: PAFA; NAD; MMA; BM; Denver A.
Mus.; N.Y. Hist. Soc.; Newark Mus.; one-man: Grand Central A.
Gal.; Miami Beach A. Center. Positions: Hd. Dept. FA, Newark Sch.
F. & Indst. A., Newark, N.J.

CARMACK, PAUL R.—Cartoonist
 1 Norway St., Boston, Mass. 02115; h. Longwood Towers, Brookline, Mass. 02116
B. Madisonville, Ky., Dec. 18, 1895. Studied: AIC. Member: Am. Assn. Editorial Cartoonists. Awards: Freedoms Fnd. Hon. Medal, 1951, 1953, 1956, 1958, 1959, 1960-1962. Author, I., "The Diary of Snubs, Our Dog" (4 vols.); I., "Huttee Boy, the Elephant." Positions: Staff Cart., The Christian Science Monitor, 1925-1961.*

CARMEL, HILDA—Painter, C.
 3210 Fairfield Ave., Riverdale, N.Y. 10463
B. New York, N.Y. Studied: City College of N.Y.; N.Y. Univ.; ASL. Member: Lg. of Present Day Artists; AEA; Composers, Authors & Artists of Am.; Bronx Council on the Arts; Int. Platform Assn.; Soc. of Italic Handwriting; Centro Studi E Scambi Internazionali. Work: Jewish Mus., N.Y.; Evansville (Ind.) A. Mus.; Sholom Asch Museum, Bat Yam Mus., both Israel; Long Island Univ. Exhibited: Riverside Mus., N.Y.; Phila. A. All.; Rochester Mem. Gal.; DMFA; CMA; Albright A. Gal., Buffalo; United Nations A. Gal., 1964; Lever Bros., 1966-1969; Pace Col. 1967; Traveling Show 1967-1969; P. & S. of N.J., 1968; N.Y. Univ., 1966-1968; Brooklyn Col., 1969; and others; one-man: in Florida, Illinois, New York. Assembled portfolio of sixteen original lithographs, publ. 1960. Arranged numerous exhibitions; assembled 30 works which were donated to the Sholom Asch Mus. in Israel, 1962; assembled and exhibited in her gallery works by 65 artists and sent to Israel for later exhibition in a new gallery in Safad, Israel. Positions: Dir., Hilda Carmel Gallery, N.Y., 1959-1963; Founded Gallery 84 in 1963,(now honorary member). Dir., AEA, 1967- ; Exh. Chm., Lg. of Present Day Artists; Co-chm. & sec., Group 3, AEA.

CARMICHAEL, JAE (Jane Grant Giddings)—Painter, Gr., T., L.
 985 San Pasqual St., Pasadena, Cal. 91106; also 21032 Eastman Way, Laguna Beach, Cal. 92652
B. Hollywood, Cal., Aug 22, 1925. Studied: Univ. So. California, B.A., with Francis deErdely; Claremont Col., M.F.A., with Millard Sheets, Phil Dike; Mills Col., with Roi Partridge, Raymond Puccinelli, Dong Kingman, William Gaw. Member: Cal. WC Soc.; Pasadena Soc. A.; Women Painters of the West; Laguna Beach AA; NAC. Awards: prizes, Pasadena Soc. A., 1955; Pasadena A. Mus., 1954; Julia Ellsworth Ford award, 1956; Laguna Beach A. Festival, 1957, 1959-1961. Work: Mills Col.; Scripps Col.; mural, Crippled Children's Soc., Canoga Park, Cal., 1955; Frye Mus., Seattle; Long Beach (Cal.) Mus.; Networks Electronics Corp.; Computer Measurement Corp. Exhibited: Pasadena A. Mus., 1956; Cal. WC Soc., 1953, 1955, 1956, 1959-1961; Los A. AA, 1956-1958; Pasadena Soc. A., 1950-1958; Women Painters of the West, 1956-1958; Los A. Mus. A., 1957, Madonna Festival, Adrian, Mich., 1958; Bodley Gal., N.Y., 1958; Newport Beach, Cal., 1954, 1958, 1960; AWS, 1958; Ligoa Duncan Gal., N.Y., 1958; Denver A. Mus., 1953, 1958, 1959-1961; Butler Inst. Am. A., 1958; Prix de Paris Exh., Duncan Gal., N.Y., 1958; Scripps Col., 1958; Laguna Beach A. Gal., 1958, 1962; Hansen Gal., San F., 1965; Rivas Gal., Los Angeles, 1963, 1964; Wooden Horse Gal., Laguna Beach, 1965; Dobson Gal., Fresno, 1965; one-man: Pasadena A. Mus., 1955; Palos Verdes Gal., 1954, 1955 (2-man), 1958 (2-man); La Canada (Cal.) Lib., 1956; Westridge Sch., Pasadena, 1957, 1960; Manhattan Gal., Pasadena, 1961. Positions: Instr., Jr. Mus., Pasadena A. Mus., 1953- ; Pasadena Sch. FA, 1953, 1955, 1957, (Dir. 1969); adult classes, Pasadena A. Mus., 1956-57, Sch. FA, 1956-58; Seymour Sch., Pasadena, 1957; Westridge Sch. for Girls, 1957-58. Dir., Wooden Horse Gal., Laguna Beach, 1961-1965; Lecturer, A. Hist. & Cinema, Pasadena City Col., 1968-1969; Instr., drawing & painting, Palos Verdes Community AA., 1966-1969; Bd. Dir., Los Angeles AA., 1965-1969.

CARO, FRANK—Art Dealer
 41 E. 57th St., New York, N.Y. 10022
B. Gouezec, Finistere, France, July 17, 1904. Specialty of Gallery: Chinese Antique Arts and Contemporary Chinese Painters; Arts of India and Southeast Asia; Pre-Columbian Arts.

CARPENTER, GILBERT FREDERICK—Painter, E.
 Art Department, University of North Carolina, Greensboro, N.C.; h. 2505 W. Market St., Greensboro, N.C. 27403
B. Billings, Mont., July 14, 1920. Studied: Stanford Univ., A.B.; Chouinard AI, Los Angeles; Ecole des Beaux Arts, Paris; Grad. work, Art History, Columbia Univ. Member: CAA; AAUP; Am. Archaeological Assn; North Carolina State A. Soc. Work: Sheldon Mem. Mus.; Honolulu Acad. A. Exhibited: Honolulu Acad. A., 1951, 1959, 1960, 1961; CAL.PLH, 1952; Joslyn Mus., 1952; Rice Gal., N.Y., 1959; VMFA, 1966; Weatherspoon Gal., Univ. of North Carolina, 1968. Positions: Art Critic, Honolulu Star Bulletin, 1961-1962; Hd., Art Dept., University of Hawaii, 1960-1962; Hd., Art Dept., University of North Carolina, Greensboro, N.C., at present.

CARPENTER, HARLOW—Museum Director
 Bundy Art Gallery, Waitsfield, Vt. 05673; h. Warren, Vt. 05674
B. California, Oct. 20, 1926. Studied: Harvard Univ. Sch. of Des., B. Arch. Positions: Dir., Bundy Art Gallery, Waitsfield, Vt.*

CARPENTER, JAMES M.—Educator
 Colby College; h. 1 Edgewood St., Waterville, Me. 04901
B. Glens Falls, N.Y., Dec. 7, 1914. Studied: Harvard Univ., A.B., Ph.D. Contributor to the Art Bulletin. Author of section of book "Maine and Its Role in American Art." Member: Maine State Commission on Arts and Humanities. Positions: Prof., Chm. A. Dept., Colby College, Waterville, Me.

CARREL, CLAUDIA—Painter, S., Gr.
 25 Eastern Parkway, Brooklyn, N.Y. 11238
B. Paris, France, Jan. 11, 1921. Studied: BMFA Sch. FA; ASL; Pratt Graphic A. Center, N.Y.; Hans Hofmann Sch. A. Awards: prizes, NAD, 1962; Grumbacher Award, Audubon A., 1963. Work: Rose A. Mus.; Brandeis Univ.; Andrew Dickson White Mus., Cornell Univ.; BMFA; Norfolk Mus. A. & Sciences; Columbia Univ. A. Coll.; Finch Col., N.Y.; Long Island Univ., N.Y. Exhibited: American Federation of Arts traveling exh., 1968; Fine Arts Fnd., Hartford, Conn.; Parrish A. Mus., Southampton, N.Y., and others. 7 one-man exhs., New York City.

CARROLL, ROBERT JOSEPH—Painter, I., Des.
 327 W. 11th St., New York, N.Y. 10014
B. Syracuse, N.Y., Oct. 11, 1904. Studied: Crouse Col. F. A. of Syracuse Univ.; Parsons Sch. of Des., N.Y. Exhibited: BM; Syracuse Mus. FA; Albright A. Gal., Buffalo; Rochester Mus. A.; and in the following New York galleries: Harriman, Ferargil, Balzac, Chase, Schoneman, Norval, Jansen. Work: Illus. for Vogue, Harpers Bazaar, McCalls magazines; jackets for Doubleday Publ.; record covers for various companies.

CARSON, SOL KENT—Painter, E., Pr. M.
 312 College Ave., Lancaster, Pa. 17603
B. Philadelphia, Pa., June 7, 1917. Studied: Barnes Fnd.; Temple Univ., B.F.A., B.S. in Ed., M.Ed.; Milan, Italy, Ph. D.; grad. study, N.Y. Univ.; Zecker-Hahn Acad., Phila., Pa. Member: Eastern AA; NAEA; AAUP. Awards: Scholarships & Fellowships, Tyler Sch. FA, Temple Univ.; Zecker-Hahn Acad.; Barnes Fnd.; prize, Int. Lg. for Peace and Freedom. Work: Free Lib., Phila., Pa.; Temple Univ., Tyler Gal.; Temple Univ., Sch. Theology; Cornwells Heights, Pa.; bronze bust, Morris Harvey Col., Charleston, W. Va. Exhibited: WFNY, 1939; MModA; Dublin Gal.; Federal A. Gal.; PAFA; Cheltenham AA; Woodmere A. Gal.; Free Lib., Phila., Pa.; Temple Univ., Tyler Gal.; Eastern AA traveling exh.; Oklahoma A. Center; Civic Center Mus., 1968; A. All., 1967; William Penn Mem. Mus., Harrisburg, Pa., 1967; Millersville State Col., 1966-1968. Lectures: Art; Restorative Art; Color Concepts to educational clinics, State Boards and other groups. Positions: Mus. Consultant, Univ. Pennsylvania, 1945-1946; Dir., Prof. A., Dept. of Art, Temple University, 1946-1955, Dir., Dept. of Visual Edu., Temple University Professional Schools, 1944-1947; Art Consultant, Bristol Township School System, 1956-1966. Summers: Visiting Prof., Wisconsin State Univ., Superior, 1965-1967. Assoc. Prof. A., Millersville State Col., 1966- .

CARTER, ALBERT JOSEPH—Museum Curator, T.
 6337 16th St., Washington, D.C. 20011
B. Washington, D.C., Apr. 20, 1915. Studied: Howard Univ., B.S.; Columbia Univ., T. Col., M.A. in art and art edu. Fellow, Corning Mus. of Glass (N.Y.), 1957; D.H.L. in Education, Teamer Schools of Education, Charlotte, N.C., 1968. Member: AAMus. Exhibitions assembled and arranged: Ceramics, Textiles, Metals & Wood, 1947-48; Japanese Wood Block Color Prints, 1947-48; Contemporary Indian Paintings, 1947-48; Expressionism in Graphic Arts, 1948-49; Miniatures for Illuminated Books of the Middle Ages, 1949-50; Contemporary American Paintings, 1949-50; New Vistas in American Art, 1961. Positions: Cur., Howard Univ. Art Gallery, Washington, D.C.; Instr. Comm. A., G.I. Sch., Letchers A. Center, Washington, D.C., 1946-59.

CARTER, CLARENCE HOLBROOK—Painter, E., L., Des.
 Spring Mills, Milford, N.J. 08848
B. Portsmouth, Ohio, Mar. 26, 1904. Studied: Cleveland Sch. A., and with Hans Hofmann. Member: ANA; Delaware Valley AA (Pres. 1962-63); AWS (Bd. Dirs. 1961-62, Vice-Pres., 1962). Awards: prizes, Cleveland A. & Crafts, 1927-1939; Cleveland Pr. M., 1931; Butler Inst. Am. A., 1937, 1940, 1943, 1946; Carnegie Inst., 1941, 1943, 1944. Work: MMA; MModA; IBM; San Diego FA Gal.; Upjohn Mus., Kalamazoo, Mich.; WMAA; BM; FMA; CMA; Toledo Mus. Al.

Butler Inst. Am. A.; Oberlin Col.; Nelson Gal. A.; Swope A. Gal.; Rochester Mem. A. Gal.; Arnot A. Gal.; Wooster Col. Mus.; Univ. Ohio; City of Portsmouth, Ohio; Univ. Nebraska; Lehigh Univ.; Jefferson Sch., Maplewood, N.J.; Pittsburgh Pub. Schs.; USPO, Portsmouth, Ravenna, Ohio; Cleveland Pub. Auditorium. Contributor to College Art Journal, American Artist. Author of Chapter in "Work for Artists." Exhibited: Carnegie Inst.; PAFA; CGA; AIC; BM; CMA; VMFA; Detroit Inst. A.; Toledo Mus. A.; Nebraska AA; Nelson Gal. A.; Swope Gal. A.; DMFA; CGE, 1939; deYoung Mem. Mus.; Cal. PLH; WMAA; MModA; MMA; Arch. Lg.; Albright A. Gal.; Ft. Worth A. Center; Montclair Mus. A.; Musee de Moderne Arte, Paris; Zurich, Switzerland; Museo di Moderno Arte, Rome; Tate Gal., London; Museo de Arte Moderno, Barcelona; Belgrade, Yugoslavia and in many South American and Canadian museums; one-man: Butler Ins. Am. A.; Finley Gal.; Milwaukee A. Inst.; Sarasota AA; Grand Central A. Gal.; Ferargil Gal.; Suffolk Mus., Stony Brook, L.I.; Cleveland Inst. A.; Minneapolis Inst. A.; "Clarence Carter Week," Portsmouth, Ohio, 1950; Univ. Louisville; Arnot A. Gal., 1951, 1963; High Mus. A., 1957; Palm Beach, Fla., 1957; New Brunswick, N.J., 1957; New Hope, Pa., 1958; Buffalo, N.Y., 1958; Lafayette Col., 1956-59, 1962-1964; Allentown A. Mus., 1959; D'Arcy Gal., N.Y., 1961; St. Vincent Col., Latrobe, Pa., 1962; Stover Mill, Bucks County, Pa., 1963; Scofield Gal., Doylestown, Pa., 1964; Mickelson Gal., Wash. D.C., 1965; Newsweek Magazine, N.Y., 1965. Positions: Asst. Prof., Carnegie Inst., 1938-44; Dir. A., Chautauqua Inst., N.Y. Univ., 1943; Dir., FAP for Northeastern Ohio, 1937-38; Guest Instr., Ohio Univ.; Cleveland Inst. A.; Minneapolis Sch. A.; Lehigh Univ.; Atlanta A. Inst.; lectures on art in museums, colleges and art schools. Visiting L., 1961, A.-in-Res., 1961-1965, Lafayette Col., Easton, Pa.*

CARTER, DEAN—Sculptor, E.
 Virginia Polytechnic Institute; h. Blacksburg, Va. 24060
B. Henderson, N.C., Apr. 24, 1922. Studied: Corcoran Sch. A.; American Univ., B.A.; Univ. Indiana, M.F.A.; Ogunquit Sch. P. & S.; Ossip Zadkine Sch. A., Paris, France. Member: Soc. Wash. A.; So. Highlands Handicrafts Gld.; Indianapolis AA; Blacksburg AA; Southern Sculptors Assn. (V.-Pres.); Springfield A. Lg.; P. & S. of New Jersey; Boston Soc. Indp. A. Awards: Scholarship, American Univ., 1941; Sleicher award, 1947; Brick Store Mus., 1948; Detroit Inst. A., 1949; Huckleberry Mountain, N.C., 1950; Winston-Salem Gal.; P. & S. of New Jersey, 1951; Wash. Sculptors Group, 1951; Santa Monica, Cal., 1951; Wichita AA, 1953 (purchase); Cini Fellowship, Venice, Italy, 1964. Work: Mary Baldwin Col.; Radford Col.; Student Union Bldg., Univ. Indiana; Cranbrook Acad. A.; Wesley Fnd. Bldg., Blacksburg, Va.; Providence Bldg., Falls Church, Va. and Seven Corners, Va.; Hollins Col.; Wichita AA. Exhibited: Wash. Sculptors Group, 1948-1955; Virginia Highlands Festival, 1954; Springfield Mus. A., 1953; BMFA, 1953; PAFA, 1954; Carnegie Inst., 1955; Sculpture Center, 1955; Smithsonian circulating exh., 1969-1971; one-man: Hunter Gal., Chattanooga; Schneider Gal., Rome, Italy; Blacksburg, Va.; Weatherspoon Gal., Greensboro, N.C.; Univ. Virginia; The Contemporaries, N.Y.C.; Artists Mart, Wash., D.C.; Washington & Lee Univ.; Workshop Originals; Albuquerque, N.M.; New Mexico Mus. FA; VMFA, 1961; Taos, N.M.; Mary Baldwin Col., Staunton, Va.; Radford Col., Va.; Cini Fnd., Venice; Greer Gal., N.Y. Contributor to Virginia Record, 1965. Positions: Prof. and Chm., Art Program, Va. Polytechnic Inst., Blackburg, Va. 1950- .

CARTER, GRANVILLE W.—Sculptor
 625 Portland Ave., Baldwin, L.I., N.Y. 11510
B. Augusta, Me., Nov. 18, 1920. Studied: Portland Sch. Fine & Appl. A.; NAD; N.Y. Sch. Indst. A.; Grande Chaumiere, Paris, France, and in Rome, Italy. Also with Hinton, Waugh, Flanagan, Link, Haseltine and others. Member: NSS; ANA; AAPL; Inst. Platform Assn. Awards: prize, NAD, 1946; Tiffany Fnd. Fellowship, 1954, 1955; Lindsey Morris Mem. award, 1966; Henry Hering Arch. Sculpture Medal. Work: Hall of Fame, N.Y. Univ.; NAD; Washington National Cathedral; capitals, Hofstra Col.; medals: Am. Inst. Chemical Engineers; Am. Welding Soc.; Churchill Gold Medal, Pilgrim Soc. of U.S.A.; Tower Dedication Medal, Washington National Cathedral; Canadian American Centennial Medal; George Washington Medal, Hall of Fame; Jane Addams Medal, Hall of Fame; figures, Washington National Cathedral; 31 clerestory keystones, Nave, Washington National Cathedral; James Fenimore Cooper Medal and Thomas A. Edison Medal, both in N.Y. Univ. Hall of Fame; Jane Addams port. bust, Hall of Fame, N.Y. Univ.; port. placques of Thomas Edison, Thomas Edison Nat. Historical Site and Museum, East Orange, N.J.; heroic Archangels, South Transept, Washington National Cathedral; bronze port. bust, Alexander T. Stewart, Garden City, N.Y.; many other works in private collections. Exhibited: NAD; Arch. Lg.; Am. Acad. in Rome; Lever Bros. House, Dime Savings Bank, the Coliseum, Design Center, Nat. Arts Club, all New York City; also Adelphi Col.; N.Y. Univ.; Schoneman Gal., N.Y.; Presbyterian Center, Ridgewood, N.J.; traveling exh., NSS; Smithsonian Inst.; Int.

Exh. Medals, Paris, 1967, Prague, 1969, and others. Positions: Council, Nat. Sculpture Soc., 1960-1969; Rec. Sec., NSS, 1963, 1964, 1965.

CARTLEDGE, RACHEL H.—Painter
 1933 Guernsey Ave., Abington, Pa. 19001
B. Philadelphia, Pa. Studied: Univ. Pennsylvania, B.F.A.; Temple Univ., M.F.A.; and privately with Henry Snell, Earle Horter, Arthur B. Carles, Ernest Thurn, and Hans Hofmann. Awards: Gold and Silver Medals from the Plastic Cl.; Award of Merit, Phila. Art Teachers annual exhibition and the Gertrude Rowan Capolino Prize at Woodmere Art Gallery. Exhibited: Regularly at PAFA, Edu. & Tech. Des. Magazine; Arts & Activities. Lectures and demonstrations, TV, 1956-60. Positions: Instr. Ceramics, T. Col., Columbia Univ., 1940-42; R.I. Sch. Des., 1942-43; Univ. Kansas, 1944-45; Asst. Prof., Univ. Kansas, 1945-48; Assoc. Prof. Ceramics, 1948-53, Prof., 1953- ; Adv. Ed. Ceramics Monthly, 1953-55.*

CASARELLA, EDMOND—Graphic Artist, P., S., T., Comm.
 83 E. Linden Ave., Englewood, N.J. 07631
B. Newark, N.J., Sept. 3, 1920. Studied: Cooper Union A. Sch.; Brooklyn Mus. A. Sch., with Peterdi. Member: S.Gld; SAGA; Print Council. Awards: Fulbright Grant to Italy, 1951-1952; Tiffany Fnd. award, 1955; Guggenheim Fellowship, 1960; prizes, Print Council, 1959; LC, 1955, 1956, 1958; Bay Print Makers, Oakland, Cal., 1955, 1957; Phila. Pr. Cl., 1956; Soc. Contemp. A., 1957; Univ. Illinois, 1954, 1956; Boston Pr. M., 1957; Northwest Pr. M., 1956; N.Y. State Fair, 1958; SAGA, 1962, 1963 (2). Work: BM; LC; Victoria & Albert Mus., London, England. Exhibited: group shows: The Contemporaries, N.Y., 1955, 1956; Cooper Union, 1956; Phila. Pr. Cl., 1956; Phila. Curators Print Choice, 1956; Phila. A. All., 1960; Brooks Mem. Mus., Memphis, 1960-1962; Univ. Kentucky, 1958, 1959, 1961, 1962; Assoc. Am. A., 1962; Birmingham Graphics, 1963; N.Y. Fnd. for the USIA, 1963; Los A. AI, 1963; Zabriskie Gal., 1954-1956; Il Camino Gal., Rome, 1952; I.F.A. Gal., Wash. D.C., 1958; Columbia Univ., 1957; Am. Acad. in Rome, 1960, 1961; Grippi Gal., N.Y., 1963; Riverside Mus., N.Y., 1963; Roko, I.B.M., Nordness Gals., all N.Y.; Yale Univ. Gal., 1960; New Jersey State Mus., 1959; Bundy A. Gal., Waitsfield, Vt., 1963; Jewish Mus., N.Y., 1964; N.Y. World's Fair, 1964, 1965; J. L. Hudson A. Gal., Detroit, 1964. National and International: MModA, 1953, 1954; BM, 1953-1960, 1962, 1964; PAFA, 1953, 1959, 1963; CGA, 1955, 1956, 1958; BMFA, 1957; LC, 1955, 1956, 1958, 1959, 1963; Salzburg, Austria, 1952, 1958; Bordighera, Italy, 1957; France, 1957, 1958; WMAA, 1959-1963; Am. Graphics, Netherlands, 1953; AWS, 1957-1959; Univ. Illinois, 1954, 1956, 1958; Soc. Wash. Pr.M., 1957, 1958; Grenchen, Switzerland, 1958; Mexico, 1958; Univ. Utah, 1958; others-Russia, 1963-64; Romania, 1964; Poland, 1965; Yugoslavia, 1959, 1961; Amsterdam, 1964, etc. One-man: Zabriskie Gal., N.Y., 1953, 1956; Obelish Gal., Wash., D.C., 1956, 1961; Univ. Louisiana, 1957; Univ. Mississippi, 1957; Univ. Kentucky, 1964; Rutgers Univ.; retrospective Print Shows: Skopje and Bitola, Yugoslavia, 1967; retrospective Sculpture: YMHA, Hackensack, N.J., 1969. Positions: Instr., Gr., & Sc., BM Graphic Workshop, 1956-1960; also, N.Y. Univ., Columbia Univ. T. Col., Hunter Col., Yale Univ., Rutgers Univ., Pratt Institute, Art Students League, N.Y., The Cooper Union, N.Y.

CASCIERI, AREANGELO—Educator, P.
 500 Concord Ave., Lexington, Mass. 02173*

CASE, ANDREW W.—Educator, P., L.
 450 Roosevelt Ave., York, Pa. 17404
B. Tipton, Ind., July 19, 1898. Studied: PIASch; Pennsylvania State Univ., B.S., M.A. Member: Scarab Cl.; AAUP; Liturgical Arts Soc.; Catholic Comm. on Intellectual & Cultural Affairs. Work: Pa. State Univ., and in private colls. Exhibited: Nationally. Contributor to America; Amer-Ecclesiastical Review; Catholic Digest; Catholic World; The Lamp. Positions: Prof., FA (Emeritus) Pennsylvania State University, University Park, Pa.; Dean, York Academy of Arts, York, Pa.

CASEY, ELIZABETH T.—Museum Curator
 Rhode Island School of Design Museum of Art, 224 Benefit St., Providence, R.I. 02903; h. 89 Ingleside Ave., Edgewood, R.I. 02905
B. Providence, R.I. Studied: Pembroke Col. Work: Completely illustrated catalog with text of the Aldrich Collection of 18th Century European Porcelain Figures, 1966. Positions: Cur., Aldrich Collection and of Oriental Art, Rhode Island School of Design Museum, Providence, R.I.

CASTEEL, HOMER, JR.—Painter, S., Lith.
 1827 35th Ave., Meridian, Miss. 39301
B. Canton, Miss., July 25, 1919. Studied: George Washington Univ.; Univ. Mississippi, B.A.; AIC, M.F.A. Work: murals, Jackson, Meri-

dian, Miss.; Coyoacan, Mexico; Stafford Springs; bas-reliefs: Jackson, McComb, Brookhaven and Meridian, Miss.; Greenville, Ala. Pensacola, Fla.; Little Rock, Ark. Exhibited: one-man: Chicago, Ill.; Mexico City; Jackson, Miss; Meridian, Miss.; Vicksburg, Miss. Author, Illus., "The Running Bulls." Positions: Hd. A. Dept., Meridian Junior College, Meridian, Miss.

CASTELLI, LEO—Art Dealer
4 E. 77th St. 10021; h. 965 Fifth Ave., New York, N.Y. 10021 B. Trieste, Italy, Sept. 4, 1907. Studied: Univ. Milan, Italy (law degree); Columbia Univ. grad. work in History. Gallery Specialty: American Vanguard Painting and Sculpture.

CASTELLON, FREDERICO—Painter, Gr., S., E., I.
98 Remsen St., Brooklyn, N.Y. 11201
B. Almeria, Spain, Sept. 14, 1914. Member: NA; SAGA; Nat. Inst. A. & Lets. Awards: F., Spanish Republic, 1934-36; Guggenheim F., 1941, 1950; Nat. Inst. A. & Let. Grant, 1950; prizes, AIC, 1938; PAFA, 1940; Assoc. Am. A., 1946; LC, 1949; SAGA, 1964, 1966; Mary Collins prize, Phila. Print Club, 1964. Work: WMAA; PAFA; MModA; PMA; MMA; BM; AIC; N.Y. Pub. Lib.; LC; Newark Pub. Lib.; Princeton Univ. Exhibited: Weyhe Gal., 1934, 1936-1940; AFA traveling exh., 1937; AIC, 1937-1940; WMAA, 1938-1945; PAFA, 1938-1942; Carnegie Inst., 1942; one-man: Assoc. Am. A., 1952; Paris, France, 1952; Bombay, India, 1952; in 1953: Venezuela, Colombia, Peru, Chile, Bolivia, Uruguay, Argentina, Paraguay, with lectures in each under auspices of State Dept. Specialist Div., of I.E.S.; Gallery 10, 1961; Dintenfass Gal., N.Y., 1963; Phila. Pr. Cl., 1964; Hudson Gld. A., 1964; Great Neck, L.I., 1964; Slater Mem. Mus., 1968-1969; Los Angeles County Mus., 1968; Storm King A. Center, Mountainville, N.Y., 1969. I., "Shenandoah," 1941; "I Went into the Country," 1941; "Bulfinch's Mythology," 1948; "The Story of Marco Polo," 1954; "The Man Who Changed China," 1954; "The Story of J. J. Audubon," 1955; "The Little Prince," 1954; "The Life of Robert L. Stevenson," 1954. Reproduction of paintings on "The Sumerian Civilization" for Life's series "The Epic of Man," 1956; 15 paintings on "The History of Medicine" for MD magazine, 1960-61; "The Story of Madame Curie," 1960; "Hundred Years of Music in America," 1961; Recent published work: "France-Italy," portfolio of 12 etchings for Assoc. Am. A., 1966; "Poe," portfolio of 16 3-color lithographs for Roten Gallery, 1968; "Caprices-No.1," portfolio of 12 etchings; 1969; "Caprices-No.2," 12 etchings (both for Artist); "Poems of Norman Rosten," 6 etchings, 1969, and others. Positions: Instr., T. Col., Columbia Univ., New York, N.Y., 1946-1961; Pratt Inst., Brooklyn, N.Y., 1952-1961; New Sch. for Social Research, N.Y.

CASTLE, MRS. ALFRED L.—Art Patron
P.O. Box 3349, Honolulu, Hawaii
B. Honolulu, Hawaii, Apr. 23, 1886. Studied: Bryn Mawr College.*

CATALDO, JOHN WILLIAM—
Scholar, Graphic Designer, Writer, Sculptor
Philadelphia College of Art, Broad & Pine Sts., Philadelphia, Pa. 19102; h. 114 West Riding Dr., Cherry Hill, N.J. 08034 B. Boston, Mass., Nov. 28, 1924. Studied: Massachusetts College of Art, B.S. in Edu.; Teachers College, Columbia University, M.A., ED. D. Also study at University of California, Los Angeles, University of Buffalo and School for American Craftsmen. Awards: Art Directors Awards, 1964, 1965, Boston; NEA Citation for Graphic Design, 1964; Sculpture and Print Awards, Albright-Knox Art Gallery, Buffalo, 1958. Author and graphic designer of: "Lettering"; "Graphic Design and Visual Communication"; "Words and Calligraphy for Children," 1958 (4th ed. 1964), 1966, 1969. Positions: Associate Editor, Journal of the National Art Education Association, 1960-1962; Editor, School Arts magazine, 1963-1968; Chairman, Curriculum in the Arts for the Public Schools of Pennsylvania, 1968-1969; Professional Standards Committee of the NAEA, 1968-1969; President, Eastern Regional of the National Art Education Association, 1968-1970.

CATAN-ROSE, RICHARD—Painter, T., Et., Lith., S., L., I.
72-72 112th St., Forest Hills, L.I., N.Y. 11375
B. Rochester, N.Y., Oct. 1, 1905. Studied: Royal Acad. FA, Italy, M.F.A.; St. Andrews Univ., London, England, LL.D.; CUASch; & with Pippo Rizzo, Antonio Quarino, J. Joseph, A. Shulkin. Member: AFA. Work: Our Lady Queen of Martyrs Church, Forest Hills, L.I., N.Y.; Royal Acad. FA, Italy. Exhibited: All. A.Am., 1939, 1940; Vendome Gal., 1939, 1940, 1941; Forest Hills, L.I., N.Y., 1944-1946 (one-man); Argent Gal., 1946 (one-man); & in Europe. Positions: Pres., Catan-Rose Inst. A., Jamaica, L.I., N.Y.

CATER, HAROLD DEAN—Historian, W., E., L.
Mackinac College, Mackinac Island, Mich. 49757
B. Syracuse, N.Y., Aug. 5, 1908. Studied: Syracuse Univ., A.B.; Columbia Univ., Ph.D. Member: AAMus.; Nat. Assn. for State and Lo-

cal History; Nat. Trust for Historic Preservation. Author: "Modern Study Guide for American History," 1941; "Henry Adams and His Friends," 1947; "Washington Irving and Sunnyside," 1957. Positions: Instr. History, 1934-1946; Historian, Historical Div., War Dept. Special Staff, Pentagon, Wash., D.C., 1946-48; Dir., Minnesota Hist. Soc., St. Paul, 1948-55; Exec. Dir., Sleepy Hollow Restorations, Tarrytown, N.Y., 1955-61; Expert Consultant on the Arts, Office of Edu., Dept. Health, Education & Welfare, Wash., D.C., 1961-1962; Consultant on the Arts, Prof. of History and Director of Admissions & Financial Aid, C. W. Post College, 1963-1968; Senior Fellow, Mackinac College, Mackinac, Mich., 1968- .

CATLIN, STANTON L.—Museum Director, L., W.
Center for Inter-American Relations, 680 Park Ave., New York, N.Y. 10021; h. 83 Knob Hill Dr., Mt. Carmel 18, Conn.
B. Portland, Ore., Feb. 19, 1915. Studied: Oberlin Col., A.B.; Acad. FA, Prague, Czechoslovakia; Am. School Classical Studies, Athens, Greece; Fogg Mus. F., in Modern A.; N.Y. Univ. Inst. FA, M.A. Member: Grolier Cl. Author: "La Peinture Mexicaine," 1952; contributor to: Minneapolis Inst. A. Bulletin; Art News; N.Y. Times, New Yorker; Yale Review; Art in America, and others. Positions: Asst. to Dir., Circulating Exhs., MModA, 1939; Sec. to Com. on Art, Coordinator of Inter-American Affairs, 1941-42; Supv., Exh. of Contemp. American Painting sent to South and Central America, by MModA, 1941; Prof of North American Art, Faculty of FA, Univ. of Chile, 1942-43; Exec. Dir., AIGA, 1946-50; Editor, then Cur. of American Art, Minneapolis Inst. Arts, 1952-58; Asst. Dir., Yale Univ. A. Gallery, New Haven, Conn., 1958-1967; Lecturer, Dept. Hist. & Art, Yale Univ., 1962-1964; Dir., Art of Latin America Since Independence, Yale Univ.-Univ. Texas, 1965, 1967; Dir., Art Gallery, Center for Inter-American Relations, N.Y., 1967- .

CAVALLI, DICK—Cartoonist
Sleepy Hollow Rd., New Canaan, Conn. 06840
B. New York, N.Y., Sept. 28, 1923. Member: Nat. Cartoonists Soc. Exhibited: Punch exh. of Humor, London, England, 1953. Contributor to: Sat. Eve. Post, Collier's, Look, This Week, True, Wall Street Journal, Sports Illustrated, American Weekly and to many foreign magazines. Cartoons have appeared in numerous books, anthologies and cartoon collections. NEA Service syndicated comic strip, "Morty Meekle." Assisted in preparation of text books for Famous Cartoonists Course, Famous Artists Schools.*

CAVALLITO, ALBINO—Sculptor
261 Mulberry St., New York, N.Y. 10012
B. Cocconato, Italy, Feb. 24, 1905. Studied: Trenton (N.J.) Sch. Indst. A.; BAID; Fontainebleau Sch. FA, with Jose de Creeft. Member: F., NSS; S. Gld.; Audubon A.; All. A. Am. Awards: prizes, Nat. Inst. A. & Let., 1953; NAD, 1954; Arch. Lg., 1954; Hudson Valley AA, 1955; NSS, 1957; Audubon A., 1956; gold med., All. A. Am., 1954. Work: AGAA; mural, USPO, Kenovia, W. Va. Exhibited: NAD; AIC; WMAA; DMFA; BM; MMA; S. Gld.; Nat. Inst. A. & Let.; Arch. Lg.; Hudson Valley AA; Audubon A.; All. A. Am.*

CAVALLON, GIORGIO—Painter
178 E. 95th St., New York, N.Y. 10028
B. Sorio, Province of Vicenza, Italy, Mar. 3, 1904. Studied: NAD; and with Hans Hofmann and Charles Hawthorne. Member: Am. Abstract A.; Artists' Club. Awards: Tiffany Fnd. Scholarship, 1929; Guggenheim Fellowship, 1966-1967. Work: Albright Knox A. Gal., Buffalo, N.Y.; Continental Grain Co., N.Y.; Solomon R. Guggenheim Mus., N.Y.; James A. Michener Foundation; Singer Mfg. Co.; Union Carbide Co., N.Y.; N.Y. Univ.; Geigy Chemical Corp., Ardsley, N.Y.; WMAA; MModA; Tishman Corp., N.Y.; Chase Manhattan Bank, N.Y.; Univ. A. Mus., Berkeley, Cal. Exhibited: MModA, 1951, 1963; MMA, 1952; Univ. Nebraska, 1955; Univ. North Carolina, 1956; Carnegie Inst., 1959, 1961, 1962; Documenta II, Kassel, Germany, 1959; AIC, 1959, 1961; WMAA, 1959, 1961, 1965-1968; Guggenheim Mus., 1961; Ringling Mus. A., Sarasota, Fla., 1962; SFMA, 1963; Washington (D.C.) Mus. Mod. A., 1963; Finch Col. Mus., 1968; Univ. Tex. A. Mus., Austin, 1964, 1968; AFA, 1968, 1969; Jewish Mus., N.Y., 1967; Yale Univ. A. Gal., 1967; PAFA, 1966; Mus. Mod. A., Bogota, Colombia, 1963, 1964; Univ. Ill., 1963; WAC, 1960; one-man: Egan Gal., N.Y., 1946, 1948, 1951, 1954; Stable Gal., N.Y., 1957, 1959; Kootz Gal., N.Y., 1961, 1963, 1965; A.M. Sachs Gal., N.Y., 1969 and others including Italy, France, Japan, Germany. Positions: A.-in-Res., University of North Carolina, Greensboro, N.C., 1964. Visiting critic: Yale Univ., 1967 and Columbia Univ., summer 1969.

CAVANAUGH, TOM—Painter, E.
Department Fine Arts, Louisiana State University; h. 3365 Tyrone Dr., Baton Rouge, La. 70808
B. Danville, Ill., July 19, 1923. Studied: Univ. Illinois, B.F.A., M.F.A. Awards: McLellan Traveling F., Univ. Illinois, 1950; Fulbright F. to Italy, 1956; purchase prizes: Nelson Gal. A., Kansas City, 1952; Joslyn Mus. A., 1954; Mulvane A. Center, Topeka, 1955;

Kansas State Col., Manhattan, 1956; Delgado Mus. A., 1959; Arkansas A. Center, 1961; Louisiana State Exh., 1966; Lucille Lortel award, Silvermine Gld. A., 1956; special jury commendation and purchase, Painting of the Year, Atlanta, 1959. Work: Nelson Gal. A.; Joslyn Mus. A.; Washburn Univ., Topeka; Louisiana State Exh., 1966; Kansas State Col.; Delgado Mus. A.; Kansas City AI; Arkansas A. Center. Exhibited: Univ. Illinois, 1948; MMA, 1950; WMAA, 1951; Portland A. Festival, 1958; Provincetown A. Festival, 1958; Fulbright Painters, WMAA, 1958; CGA, 1959, 1961; Sarasota Annual, 1960; Old Northwest Territory Exh., 1947-1952; New England Annual Exhs., 1951, 1955; Mid-America, 1953-1955; Boston A. Festival, 1952, 1955; Univ. of Nebraska, 1954; CAM, 1953, 1954, 1956; Southeastern Annual, Atlanta, 1958-1961; Delgado Mus. A., 1958-1961; South Coast Exh., Ringling Mus., 1961; VMFA, 1962; "Maine: 100 Artists of the 20th Century," Colby College, 1964. Included in "Prize Winning Oil Paintings," vol. 1, 1960; vol. 7, 1967; "Artist and Advocate," 1967. Positions: Dir., Instr., Springfield AA, 1947-49; Kansas City AI, 1952-55; Washington Univ., Sch. of Fine Arts, 1955-56; Assoc. Prof., Louisiana State University, Baton Rouge, La., 1957- . Dir., The Bay Street Studio, Boothbay Harbor, Me. (summers) 1950- .

CECERE, ADA RASARIO—Painter, Lith., T.
41 Union Sq.; h. 240 Waverly Pl., New York, N.Y. 10014
B. New York, N.Y. Studied: ASL; NAD; BAID. Member: NAWA; AWS; Audubon A.; Pen & Brush Cl.; All. A. Am.; Knickerbocker A. Awards: Treas. Dept. mural for S.S. Pres. Jackson, 1941; prizes, NAWA, 1943, 1946, 1950, 1951, 1953, 1958, 1960, 1961, 1964, 1967, 1968; All. A. Am., 1959, 1967; Pen & Brush Cl., 1950, 1951, 1953, 1955, 1962, 1964, 1965, 1967, 1968; Knickerbocker A., 1957-1963. Work: murals, Hyde Park Restaurant; Broadway Central Hotel; Hotel Newton; Norfolk Mus. A.; Ohio Univ., Athens, Ohio. Exhibited: BM, 1936, AWS, 1928-1933, 1946, 1952-1958, 1960, 1962, 1965-1967; NAWA, 1930-1969; Arch. Lg., 1928-1933; Ferargil Gal.; Argent Gal., 1930-1958; Newport AA, 1944; Dayton AI, 1945; Audubon A., 1948-1969; Albright A. Gal., 1951; Pen & Brush Cl., 1953-1959, 1961; NAD, 1959-1961, 1967; VMFA; Norfolk Mus.; Oklahoma A. Center; BM, and others. Represented in many private collections. Positions: Dir., Audubon A., 1962-1964; 1968, 1969. Advisory Bd., NAWA, 1959, 1960, 1962, 1964, 1968.

CECERE, GAETANO—Sculptor, E., L.
41 Union Square 10003; h. 240 Waverly Pl., New York, N.Y. 10014
B. New York, N.Y., Nov. 26, 1894. Studied: NAD; BAID; Am. Acad. in Rome. Member: NA; NSS. Awards: prizes, NAD, 1924; AIC, 1927; PAFA, 1930; Garden Cl. of Am., 1929, 1930; NSS, 1935; F., Am. Acad. in Rome; Knickerbocker Artists, 1963; Colgate W. Darden, Jr. medal, Mary Washington Col. of Univ. of Virginia. Work: MMA; Numismatic Mus., N.Y.; Norfolk Mus. A.; plaques, U.S. Capitol, Wash., D.C.; reliefs, Fed. Reserve Bank, Jacksonville, Fla.; Brookgreen Gardens, S.C.; Norton Gal., West Palm Beach, Fla.; War mem., Clifton, Plainfield, Princeton, N.J.; port. monuments, Lincoln Mem. Bridge, Milwaukee, Wis.; State of Texas; State of Montana. Exhibited: NAD, 1924-1969; PAFA, 1924-1958; AIC, 1924-1927; WMAA, 1934; MMA, 1935, 1951; CAM, 1942-1946; Arch.L., 1924-1933; NSS, 1924-1958; All. A. Am., 1962-1964; Audubon A., 1962, 1964, 1965; Knickerbocker A., 1962-1964. Lectures: Contemporary & Ecclesiastical Sculpture.

CELENDER, DONALD D.—Painter, S. Historian
Macalester College; h. 15 Duck Pass Rd., St. Paul, Minn. 55110
B. Pittsburgh, Pa., Nov. 11, 1931. Studied: Carnegie Inst. Tech., B.F.A.; Univ. Pittsburgh, M. Ed., Ph.D. Member: CAA; Soc. Arch. Historians; AAMus.; Minnesota Arts Forum; Assoc. A. Pittsburgh; Soc. Sculptors; Craftsmen's Gld.; Pittsburgh Plan for Art; Minneapolis Soc. Arts. Awards: prizes, Assoc. A. of Pittsburgh, 1956; Best Craftsmanship, (Sculpture) Art for Mount Lebanon, 1959 (and for Painting) 1959; American Artist Award, 1951; Univ. Pittsburgh Henry Clay Frick Galleries, 1961; "Man of the Year in Art" Pittsburgh Jaycees, 1961; A. W. Mellon Scholar, Henry Clay Frick Dept. of Fine Arts, 1960-1963; John Dougherty Mem. Scholarship, 1953; Carnegie Inst. Alumni Scholarship, 1954-1956; Faculty Foreign Fellowship for study in the Orient; Faculty Research Grant for Experimental Sculpture. Work: General Mills, Minneapolis; WAC; murals: Minneapolis Central Library and East Branch Library; stabile Nokomis Branch Library, Minneapolis; stained glass panels, St. James Lutheran Church, Crystal, Minn.; mosaics: Children's Hospital, Pittsburgh, Pa.; Latrobe (Pa.) Mus. (painting); mosaics, Ellis School, Pittsburgh; other work in private collections U.S. and abroad. Exhibited: WAC, 1964; Associated A. Pittsburgh, 1956-1963; Arts & Crafts Center, Pittsburgh, 1962; Univ. Pittsburgh, 1963; Craftsmen's Gld., 1956-1960; Augsburg Col., 1969; Macalester Col., 1969; St. Olaf's Col., 1969; one-man:

Minneapolis Inst. A., 1964; Univ. Minnesota, 1965; Macalester College, 1965; Pittsburgh Playhouse Gal., 1962; Pittsburgh Press Club, 1961; Washington A. Gal., 1961; Ogelbay Inst., 1961; Unitarian Center, Minneapolis, 1964, and others. Author: Articles on George Bellows; Caneletto, Duccio, Pieter DeHooch; Matthias Grünewale; Edouard Manet; William Turner, National Gallery of Art; Musical Instruments in Art; Dissertation: Precisionism in Twentieth Century American Painting. Lectures: Twentieth Century American Painting, Sculpture, Architecture; Sienese Painting; Seventeenth Century Dutch Painting; Oriental Art; Modern Art. Positions: Lecturer, National Gallery of Art, 1961-1963; Dir. Education and Public Activities, Minneapolis Institute of Arts, 1964; 8 lectures on Modern Art and Architecture over KTCA-TV, St. Paul, 1968. Art Historian, Macalester College, St. Paul, 1965- . Guest Lecturer, Minneapolis Inst. Arts, 1965.

CELENTANO, FRANCIS M.—Painter
1919½ 2nd Ave., Seattle, Wash. 98101
B. New York, N.Y., May 25, 1928. Studied: N.Y. Univ., B.A.; N.Y. Univ. Inst. FA, M.A.; Acad. FA, Rome, Italy. Awards: Fulbright Fellowship in Painting, Rome, Italy, 1958. Work: MModA; N.Y. Univ.; Columbia Broadcasting Co.; Albright-Knox A. Gal., Buffalo, N.Y.; Rose A. Mus., Brandeis Univ.; SAM; Stedelijk Mus., Amsterdam, Holland; Henry Gal., Univ. Wash., Seattle. Exhibited: MModA, 1965, 1966; WMAA, 1965, 1967; Albright-Knox A. Gal., Buffalo, 1968; Northwest A., SAM, 1966-1968. Positions: Assoc. Prof., Design, Drawing and Painting, Univ. of Washington, Seattle, at present.

CHAET, BERNARD R.—Painter, E.
141 Cold Spring St., New Haven, Conn. 06511
B. Boston, Mass., Mar. 7, 1924. Studied: BMFA Sch.; Tufts Col., B.S. in Edu. Awards: Sabbatical grant, Nat. Council on the Arts and Humanities, 1966-1967; prizes, Silvermine Gld. A., 1955; New Haven A. Festival, 1958; Sharon (Conn.) A. Fnd., 1958; Senior Faculty Fellowship, Yale Univ., 1962-63 (Visiting Artist, Am. Acad. in Rome); prize, "Drawings USA, 1963," St. Paul A. Center. Work: FMA; BMFA; R.I.Sch.Des. mus. A.; Yale Univ.; Universities of Mass., Conn., N.Y.; Hopkins A. Center, Dartmouth Col.; WMA; BM; Brandeis Univ. DeCordova & Dana Mus.; AGAA; UCLA. Exhibited: Los A. Mus. A., 1945; Inst. Mod. A., Boston, 1943; Detroit Inst. A., 1949; Springfield Mus. A., 1950; Univ. Illinois, 1951, 1953, 1962; Cornell Univ., 1951, 1961; Ft. Worth Mus. A., 1951; MIT, 1951; Inst. Contemp. A., Boston, 1954, 1957, 1958; MModA, 1956; Univ. Arkansas, 1955; BM, 1955, 1957; Wadsworth Atheneum, Hartford, 1960; Currie Gal. A., 1960; PAFA, 1962; CGA, 1963; Drawing Soc. of Am. traveling exh., 1965; one-man: Boris Mirski Gal., N.Y., 1946, 1951, 1955, 1957, 1960, 1965; Bertha Schaefer Gal., 1954; Stable Gal., N.Y., 1959, 1961, 1967; Alpha Gal., Boston, 1968; White Mus., Cornell Univ., 1961. Catalogue and Selection for "20th Century Drawings"—An Exhibition, Yale Univ. A. Gal., 1955. Author: "Artists at Work," 1961; "The Art of Drawing," 1969. Lectures on Art: Minneapolis A. Inst.; Brown Univ.; Smith College; Cleveland Inst. A; Yale Univ.; Cornell Univ.; Minneapolis Sch. A. Positions: Assoc. Prof. Painting, 1951- & Chm. Dept. Art, 1959-1962 Yale University, New Haven, Conn.; Dir., Art Div., Yale Summer School of Music & Art, 1960- .

CHALIAPIN, BORIS—Painter
38 Central Park South, New York, N.Y. 10019
Member: SI.*

CHALK, MR. and MRS. O. ROY—Collectors
1010 Fifth Ave., New York, N.Y. 10028*

CHAMBERLAIN, BETTY—Art Information Director, W.
11 W. 56th St. 10019; h. 850 Second Ave., New York, N.Y. 10017
B. Feb. 10, 1908. Studied: Smith Col., A.B.; Sorbonne, Paris, graduate studies with Henri Focillon. Member: AAMus. Contributor of articles and art reviews to art magazines. Author: "Artists' Guide to His Market," 1969. Positions: Metropolitan Museum, N.Y., 1929-1932; Philadelphia Museum of Art, 1938-1940; OWI Domestic Graphic Program, 1942-1943; Museum of Modern Art, N.Y., Publicity Dir., 1948-1954; Mng. Editor, Art News, 1954-1956; Publicity and Community Development Dir., Brooklyn Museum, 1956-1959; Founder, Dir., Art Information Center, Inc., New York, N.Y., 1959- . Member, Advisory Council, Mus. of Am. Folk Art, N.Y.

CHAMBERLAIN, ELWYN—Painter
222 Bowery, New York, N.Y. 10012
B. Minneapolis, Minn., May 19, 1929. Studied: Minneapolis Sch. A.; Univ. Idaho, B.A.; Univ. Wisconsin, M.S., B.A., M.A. Work: Sarah Roby Fnd.; WMAA; Johnson Wax Co.; "Art USA Now," 1965. Exhibited: PAFA, 1953; Walker A. Center, 1951, 1954; WMAA, 1955; Edwin Hewitt Gal., 1954, 1957 (one-man); DeCordova & Dana Mus.,

1954; Colorado Springs FA Center, 1955; Denver A. Mus., 1955; Yale Univ. Gal., 1955, 1957; Phila. A. All.; R.I. Sch. Des.; Deerfield Acad.; Provincetown A. Festival; Spoleto Festival of Two Worlds, Spoleto, Italy, 1958; Gallery G. 1959 (one-man); Nordness Gal., N.Y., 1961 (one-man); Art: USA, 1963; Dwan Gal., Los Angeles; Fischbach Gal., N.Y. (one-man), 1965.*

CHAMBERLAIN, JOHN ANGUS—Sculptor
53 Greene St., New York, N.Y. 10013
B. Rochester, Ind., Apr. 16, 1927. Studied: AIC; Univ. Illinois; Black Mountain Col. Exhibited: Sao Paulo, 1961; Carnegie Inst. Int., 1961; MModA, 1959, 1961; Momentum Exh., Chicago, 1953, 1954, 1959; Wells St. Gallery, Chicago, 1957 (one-man); Hansa Gal., N.Y., 1958; Martha Jackson Gal., N.Y., 1958.*

CHAMBERLAIN, SAMUEL—Etcher, Lith., W., E., L., Des.
5 Tucker St., Marblehead, Mass. 01946
B. Cresco, Iowa, Oct. 28, 1895. Studied: Univ. Washington; MIT; Royal Col. A., London; & with Edouard Leon, Paris. Member: NA; SAGA; Am. Acad. A. & Sc.; Chicago SE. Awards: Guggenheim F., 1926; Kate W. Arms prize. Work: Lib. Cong.; N.Y. Pub. Lib.; MMA; BMFA; AIC; Bristish Mus., London; Victoria & Albert Mus., London; Bibliotheque Nationale, Paris. Exhibited: NAD, annually; various etching exh. Author, I., "France Will Live Again," 1940; "Fair is Our Land," 1942; "Bouquet de France," 1952; "Soft Skies of France," 1954; "Nantucket," 1955; "Italian Bouquet," 1958; "The New England Image," 1962; "British Bouquet," 1963; "Etched In Sunlight," 1968; "New England In Color," 1969. Contributor to Gourmet Magazine regularly.

CHAMBERLAIN, WESLEY—Printmaker
c/o Perls Gallery, 350 N. Camden Dr., Beverly Hills, Cal. 90210*

CHANDLER, ELISABETH GORDON —Sculptor
Mill Pond Lane, Old Lyme, Conn. 06371
B. St. Louis, Mo., June 10, 1913. Studied: The Lenox Sch.; sculpture with Walter Russell, Edmondo Quattrocchi. Member: F., NSS; Pen & Brush Cl.; All. A. Am.; F.I.A.L.; NAC; Catherine Lorillard Wolfe A. Cl.; Lyme AA; F., AAPL. Awards: prizes, Brooklyn War Mem. Comp., 1945; Catherine L. Wolfe A. Cl., 1951, 1958, sc. prize, 1963, Huntington Gold Medal, 1969; Pen & Brush Cl., 1954, gold medal, 1963, Am. Heritage prize, 1968; Proctor prize, NAD, 1956; Greer prize NAD, 1960; gold medal, Hudson Valley AA, 1956; Medal of Honor, Pen & Brush Cl., 1957, 1961; NAC, 1959, 1960, 1962; gold medal, 1960, 1962 prize 1961, Arts & Crafts of Meriden, 1962, sc. award, 1969. Work: The Lenox Sch., N.Y.; Aircraft Carrier "U.S.S. Forrestal"; James L. Collins Parochial Sch.; Woodstock Cemetery; Kensico Cemetery, N.Y.; Storm King A. Center, N.Y.; James Forrestal Research Center and Woodrow Wilson Sch. for Public & Int. Affairs, Princeton Univ.; Columbia Univ. Sch. of Law; Mid-Georgia Regional Lib., and in private collections. "Barkers for Britain" medal, 1941; Forrestal Mem. Medal, 1954; Timoshenko Medal for Applied Mechanics, 1957; Benjamin Franklin Medal, N.Y. Univ. Hall of Fame, 1962; Tonkin Gulf Mem. Plaque for U.S.S. Forrestal, etc. Exhibited: NAD, 1950-1952, 1956, 1957, 1960, 1966-1969; NSS, 1953-1957, 1966-1969; All. A. Am., 1952-1960; Pen & Brish Cl., 1950-1961, 1966-1969; AAPL, 1950, 1951, 1953, 1954, 1957, 1958-1961, 1966-1969; NAC, 1948-1961, 1966-1969; Catherine L. Wolfe A. Cl., 1951, 1954-1960, 1966-1969; Hudson Valley AA, 1956, 1966-1969; Lyme AA, 1956-1961, 1966-1969; Mattituck Mus., Waterbury, Conn., 1953; Academic A., 1960; Smithsonian Inst. Am. Numismatic Assn., 1966-1969.

CHANDLER, JOHN WILLIAM—Educator
2 Coolidge Ave., Concord, N.H.; w. Lycoming College, Williamsport, Pa. 17701
B. Concord, N.H., Sept. 28, 1910. Studied: Exeter Sch. A., Boston; Manchester (N.H.) Inst. A. & Sc.; St. Anselm's Col., A.B.; Boston Univ., M.E.; further study at Harvard, Columbia Univs., and abroad; and with Aldro T. Hibbard. Member: New Hampshire AA; Pa. Gld. of Craftsmen; Williamsport Arts Council; CAA. Awards: prize, Currier Gal. A., 1947. Exhibited: Pasadena AI, 1946; New Hampshire AA, 1941-1945; New England Prep. Schools, 1950-51; Keene T. Col., Keene, N.H., 1951 (one-man); Jordan-Marsh, Boston, 1944, 1945; Currier Gal. A., 1947; de Cordova & Dana Mus., 1952; Symphony Hall, Boston; Bucknell Univ.; BMFA; Nebraska Wesleyan, 1958; Everhart Mus. A., 1958; Mid-Penn A., 1960, 1961. Lectures on Design; Folk Art; to civic and church groups. Contributor articles to Hobbies magazine. Positions: Instr. & Exec. Dir., 1933-46, Dept. FA, Manchester Inst. A. & Sc., Manchester, N.H.; Acting Dir., Currier Gal. A., 1946; Assoc. Prof., Dept. A., Lycoming Col., 1952- . Co-Chm., Williamsport (Pa.) A. Festival, 1962. Exhibition Chm., James Brown Library, 1967; Pres., Mid-State Artists, 1967-1968; Chm., A. Dept., Lycoming Col. (Pa.) and Dir. of Art Center, at present.

CHAPIN, LOUIS (LE BOURGEOIS), JR.—Critic, W.
The Earl Rowland Foundation, 8 E. 62nd St. 10021; h. 444 E. 20th St., New York, N.Y. 10009
B. Brooklyn, N.Y., Feb. 6, 1918. Studied: Principia Col., B.A.; Boston Univ., A.M. (Fine Arts). Positions: Instr., Art Appreciation, The Principia College, Elsah, Ill., 1946-1960; Christian Science Monitor Staff, 1960-1966. Freelance writer, critic, 1966- ; Dir., The Earl Rowland Fnd., New York, N.Y., engaged in producing and writing sound filmstrips documenting major art exhibits, 1967- .

CHAPMAN, DAVE—Industrial Designer
35 East Wacker Dr.; h. 568 Hawthorne Pl., Chicago, Ill. 60613
B. Gilman, Ill., Jan. 30, 1909. Studied: Armour Inst. Tech., B.S. in Arch. Member: F., Am. Soc. Indst. Des. (Bd. Dirs., Past Pres.); AIC (Life); Soc. Typographic Arts; F., Royal Soc. of Arts; F.I.A.L. Awards: Des. award medal, IDI, 1954, 1960; numerous awards and citations, AIGA, STA, ADC. Exhibited: Phila. A. All., 1945, 1946, 1960; Int. Council of the Societies of Indst. Des., Venice, 1959, 1961; Interplas '61, London, England. Lectures on phases of industrial design. Positions: Hd., Products Des. Div., Montgomery Ward & Co., 1934-36; Pres., Dave Chapman, Goldsmith & Yamasaki, Inc., Industrial Design, 1936- . Pres., Design Research, Inc., 1955- .*

CHAPMAN, MRS. GILBERT—Collector, Patron
1 Sutton Place South, New York, N.Y. 10022
Studied: Atelier Julian, Paris, France; Art Institute of Chicago. Collection: Modern Art; Polynesian Art and some Pre-Columbian Art. Positions: Pres., Arts Club of Chicago, 1931-1941; Director, International Council of the Museum of Modern Art and Member of the Executive Committee.

CHAPMAN, HOWARD EUGENE—Designer, Cart., A. Dir.
3213 Wessynton Way, Alexandria, Va. 22309
B. Martinsburg, W. Va., Dec. 20, 1913. Studied: Corcoran Sch. A., with Richard Lahey; George Washington Univ., B.S. in Edu.; Tiffany Fnd., with Hobart Nichols. Awards: bronze med., Wash. A. Cl., 1948; scholarship, Tiffany Fnd.; prize, Washington County Mus. FA, Hagerstown, Md., 1939. Work: CGA. Positions: A.Dir., Congressional Quarterly Service, Inc., Wash., D.C.; Creator, Dir., Association Art Aids, Alexandria, Va.; Creator daily comic panel, "Federal Fidgets," self-syndicated; Editorial cartoons & Caricatures. Designer: publications, editorial graphics, book covers, direct mail promotion.

CHAPPELL, WARREN—Illustrator, Des., Gr.
James St., Norwalk, Conn. 06850
B. Richmond, Va., July 9, 1904. Studied: Univ. Richmond, B.A.; Colorado Springs FA Center, and in Germany. With Boardman Robinson, Allen Lewis and Rudolf Koch. Awards: Hon. D.F.A., Univ. of Richmond (Va.), 1969. Author: "The Anatomy of Lettering," 1935; Illus., "Tom Jones"; "The Tragedies of Shakespeare"; "The Complete Novels of Jane Austen"; "The Borzoi Music Classics for Children," 1940-1969, and others. Author, I., "They Say Stories." Contributor to The Dolphin; Virginia Quarterly Review; The Horn Book. Designer: Lydian and Trajanus type. Former Instr., Graphic Arts, ASL and Colorado Springs Fine Arts Center. Des. and/or Illus. approx. 250 books.

CHARLES, CLAYTON (HENRY)—Sculptor, E., P., L.
University of Miami, Coral Gables, Fla.; h. 5835 Southwest 87th Ave., Miami, Fla. 33243
B. Goodman, Wis., Sept. 11, 1913. Studied: Univ. Wisconsin, B.A., M.A., with Wolfgang Stechow, Oskar Hagen, John Kienitz, James Watrous. Awards: Milwaukee AI, 1950; Wisconsin Salon, 1947; Assoc. Fla. Sculptors, 1961; Wisconsin Ann., 1939. Work: IBM; City of Milwaukee; Univ. of Wisconsin; Beloit Col.; Gimbel's Wisconsin Coll.; North Carolina State A. Soc.; Arch. Sc., South Florida State Hospital; Miami Jai Alai; Southern Medical Group Clinic; East Ridge Retirement Village. Exhibited: Grand Central A. Gal., 1947; AIC, 1949; Wis. Salon, 1939-1942, 1948-1950; Milwaukee AI, 1939-1942, 1947; Gimbels, 1949. Positions: Edu. Dir., Milwaukee AI, 1946-47; Assoc. Prof., 1947-49, Chm. Dept. A., 1949-51, Beloit Col.; Prof., Dept. A., Univ. Miami, Coral Gables, Fla., 1951- .

CHARLOT, JEAN—Painter, Gr., E., I., W., L.
University Hawaii Art Department; h. 4956 Kahala Ave., Honolulu, Hawaii 96815
B. Paris, France, Feb. 7, 1898. Studied: Lycee Condorcet, Paris. Member: P. & S. of Hawaii; SAGA; Pr. M. of Hawaii. Awards: Guggenheim F., 1945-1947; Grant, National council on the Arts, 1968; Hon. Deg., D.F.A., Grinnell Col., 1946; Hon. Deg. LL.D., St. Mary's Col., 1956; Ryerson L., Yale Univ., 1948; prizes, Los A. County Fair, 1949; Honolulu Acad. A., and many others. Work: MModA; Rochester Mem. A. Gal.; DMFA; SMFA; Honolulu Acad. A.;

MMA; AIC; San Diego FA Soc., and abroad; frescoes: Mexican Govt.; Naiserelagi, Fiji, 1962-1963; Church of St. Bridgit, Peapack, N.J.; Univ. Georgia FA Bldg.; Arizona State Col.; Univ. Hawaii; First Hawaiian Bank, Waikiki, Hawaii; churches in Kohala, Honolulu, Lincoln Park, Mich.; two series of The Way of the Cross in tile, in churches in Honolulu and Kauai, Hawaii; frescoes, FA Bldg., St. Mary's Col., Notre Dame, Ind., Univ. Notre Dame, South Bend, Ind.; murals, Des Moines FA Center; St. Catherine's Church, Kauai; Hawaiian Village Hotel, Waikiki; Grace Episcopal Church, Hoolehua, Molokai; Jefferson Hall, East West Center, Honolulu; St. Leonard Friary, Centerville, Ohio; Tradewinds Apts., Waikiki, 1961. Exhibited: principal museums in the U.S. and abroad. Author: "Art from the Mayans to Disney"; "Charlot Murals in Georgia"; "Mexican Art and the Academy of San Carlos, 1875-1915," Univ. Texas, 1962; "Mexican Mural Renaissance," Yale Univ., 1963; "Three Plays of Ancient Hawaii," Univ. Hawaii, 1963; "Jean Charlot: Posada's Dance of Death," Pratt Graphic Art Center, 1964; "Dance of Death"; "Art-Making From Mexico to China." Illus., "Book of Christopher Columbus"; "Characters of the Reformation"; "Pageant of the Popes"; "Carmen"; "El Indio"; "Henry the Sixth," Part 3; "Conversational Hawaiian"; "The Bridge of San Luis Rey," Thornton Wilder, Limited Editions Club, 1962; children's books: "Sun, Moon and Rabbit"; "Tito's Hats"; "Two Little Trains"; "Fox Eyes"; "Secret of the Andes"; "A Hero by Mistake"; "Martin de Porres, Hero"; "The Poppy Seeds"; "Our Lady of Guadalupe"; "Sneakers"; "Dumb Juan," and many others. Portfolios of lithographs and woodcuts published. Positions: Emeritus Senior Professor, Univ. Hawaii, Senior Scholar, East West Center, 1967.

CHASE, ALICE ELIZABETH—Educator, L., W.
 Yale University Art Gallery 06520; h. 324 Willow St., New Haven, Conn. 06511
B. Ware, Mass., Apr. 13, 1906. Studied: Radcliffe Col., B.A., with G.H. Edgell, P.J. Sachs; Yale Univ., M.A., with Henri Focillon, Sumner Crosby, G.H. Hamilton. Awards: Hon. Phi Beta Kappa, 1963; Citation, Wilson Col., 1969; Citation, Radcliffe Col., 1969. Member: Soc. Architectural Historians; Archaeological Inst. of America; CAA. Lectures: Iconography and other history of art subjects. Instr., "Introduction to Iconography." Author: "Famous Paintings, An Introduction to Art for Young People," 1951, rev. ed. 1961; "Famous Artists of the Past," 1964; "Looking at Art," 1966. Positions: Docent, 1931- ; Asst. Prof. Hist. A., 1946- , Yale Univ., New Haven, Conn., Cur. Edu., Brooklyn Museum, 1946-47.

CHASE, DORIS TOTTEN —Sculptor, P., L.
 7217 57th St., N.E., Seattle, Wash. 98115
B. Seattle, Wash., Apr. 29, 1923. Studied: Univ. Washington, and with Mark Tobey. Awards: AEA, 1952; Press Club Exh., 1955; Pacific Northwest A. & Crafts Fair, 1956, 1958, 1962, 1963, 1966-1968; Puget Sound Oil Exh., 1959; West Coast Exh., 1965; SAM, 1967, 1968. Fellowship, Huntington Hartford Fnd. 1955, 1956, 1960. Work: SAM; Frye Mus. A.; Seattle Pub. Lib.; Lincoln First Federal Bank; Northwest Bank and in Japan, Battelle Inst., Seattle Comm. Col.; Finch Col. Mus. Exhibited: Smithsonian Inst. traveling exh., 1958, 1959; SAM; Pacific Northwest Exh., Spokane; Henry Gal., Frye Mus. A., Seattle; Kauffman Gal., N.Y.; Univ. British Columbia, Vancouver; Speed Mus. A.; Stanford A. Gal., Cal.; Veterans Mem., Helena, Mont.; Davenport, Iowa; The Gallery, Honolulu, Hawaii; Galleria Castello, San Marino and Int. Abstract Exh., Florence, Italy; Syracuse Univ. Mus.; Chas. Feingarten Gal., Los Angeles; Denver A. Mus.; Univ. Oregon. One-man: Otto Seligmann Gal., 1956, 1959; Hall-Coleman Gal., 1960-1962; Galleria Numero, Rome, Italy, 1962-1966; Int. Gal., Bologna and Parma, Italy, 1962; Formes Gal., Tokyo, Japan, 1963; Center Gal., Bangkok, Thailand, 1963; Collectors Gal., Seattle, 1965, 1968; Smolin Gal., N.Y., 1965; Ruth White Gal., N.Y., 1967, 1969; Bolles Gal., San Francisco, 1964; Tacoma A. Mus., 1967.

CHAVEZ, EDWARD—Painter, S., C., Gr., E.
 32 Plochman Lane, Woodstock, N.Y. 12498
B. Wagonmound, N.M., Mar. 14, 1917. Awards: Tiffany Fnd. Award, 1948; Fulbright Grant, 1951 (Italy); Childe Hassam Purchase Award, 1953. Exhibited: MMA; PAFA; AIC; Univ. Illinois; NAD; WMAA; Carnegie Inst. Tech.; SFMA; CGA; Nat. Inst. A. & Lets.; One-man: Denver A. Mus.; Assoc. Am. A., N.Y., 1948, 1949; Ganso Gal., N.Y., 1950, 1952-1954; Il Camino Gal., Rome, 1951; Mus. New Mexico, 1954; Rabow Gal., San Francisco, 1954; Anna Werbe Gal., Detroit, 1957; John Heller Gal., N.Y., 1955-1960; N.Y. State Col. for Teachers, Albany, 1960. Work: LC; Watkins Gal., Wash. D.C.; Newark Mus. A.; MModA; Print Club of Albany; Grand Rapids Mus. A.; Abbott Laboratories Coll.; Roswell Mus. A., New Mexico; Mus. New Mexico; Detroit Inst. A.; Butler Inst. Am. A.; Murals: USPO Center, Texas, Geneva, Nev., Glenwood Springs, Colo.; West H.S., Denver; Recreation Hall, Fort Warren, Wyoming; 200th Station Hospital, Recife, Brazil. Positions: Instr., Art Students League, N.Y., 1954; same-Summer School, 1955-1958; Visiting Prof. A., Colorado College Art Dept., Colorado Springs Fine Arts Center, 1959 and Sum-

mer School, 1960-1962; Prof. A., Syracuse University, 1960-1962; Instr. A., Dutchess County Community College, Poughkeepsie, 1963; A.-in-Res., Ogden City School System, Ogden, Utah, 1968.

CHEN, CHI —Painter
 15 Gramercy Park, 10003; h. 23 Washington Square North, New York, N.Y. 10011
B. Wusih, Kiangsu, China, May, 1912. Studied: in China. Member: NA; AWS; Audubon A.; All. A. Am; SC; Phila. WC Cl.; NAC. Awards: prizes, AWS, 1953, 1955, 1962, 1963, 1965, 1966, 1969; NAD, 1955, 1961, 1963, 1967, 1969 (gold medal of merit); Butler Inst. Am. A., 1955; Chautauqua AA, 1954; Phila. WC Cl.; Silvermine Gld. A.; Grant, Nat. Inst. A. & Lets., 1960; medals: (2) NAC; Knickerbocker A.; Audubon A., 1956, 1963, 1968; All. A. Am., 1960; PAFA, 1961; Watercolor USA, 1962, 1966, 1968. Exhibited: 1948-1969; AWS, 1948-1969; NAD, 1953-1969; Audubon A.; All. A. Am.; Phila. WC Cl.; PFA; Butler Inst. Am. A.; WMAA, 1954, 1956, 1960, 1963; CGA; NAC; Univ. Illinois; Silvermine Gld. A.; Utah State Univ.; Los A. Mus. A.; Contemp. Chinese American A.; Pa. State T. Col.; Pa. State Univ.; Am. Acad. A. & Lets.; San Diego A. Festival; IBM; BM; PAFA; MMA; Art:USA, N.Y., 1959; BM, 1963; Watercolor:USA, 1962, 1963, 1965-1969; Rosequist Gal., Ariz., 1968; Northern Ariz. Univ., 1968; CMA, 1968; Norfolk Mus. A. & Sciences, 1969; Oklahoma Mus. A., 1969; Springville (Utah) Mus. A., 1965-1969. One-man: Arch. Lg., 1947; Rodman Gal., Fitzwilliam, N.H., 1947-1950; Arnot A. Gal., Elmira, N.Y.; Portland (Me.) Mus. A., 1948; Mus. FA of Houston, 1948; Ferargil Gal., N.Y., 1948; United Nations Cl., Wash., D.C., 1948; Witte Mem. Mus., San Antonio, 1949, 1953, 1964; DMFA, 1949; Mus. New Mexico, 1949; Newport AA, 1950; Delgado Mus. A., 1951; Wilmington A. Center, 1951; Miami Beach A. Center, 1952, 1954, 1958; Gump's San F., 1952; La Jolla A. Center, 1953; Key West Hist. Soc., 1954, 1956; Grand Central A. Gal., 1954, 1956, 1958, 1963, 1965, 1969; Frye A. Mus., Seattle, 1955; Gallery 10, New Hope, Pa., 1960; Allentown (Pa.) A. Mus., 1963; Stewart Rickard Gal., San Antonio, 1963; Fort Worth A. Center, 1965, and others. Work: MMA; PAFA; Acad. A. & Lets.; NAD; Butler Inst. Am. A.; Witte Mus.; Mus. FA of Houston; DMFA; Portland (Me.) Mus. A.; Delgado Mus.; Frye Mus. A.; Arnot A. Gal.; Wilmington A. Center; Univ. Utah; Univ. Arizona; Smithsonian Inst.; Allentown Mus. A. Contributor to many national magazines. On jury of awards and selections of many organizations. Publications: "Watercolor by Chen Chi" (Shanghai, China); "Paintings-Chen Chi" (Switzerland). Positions: Visiting Prof., Pa. State Univ., (Summers), 1959, 1960. A.-in-Res., Ogden, Utah, 1967.

CHENEY, SHELDON—Writer, Cr.
 12 Stony Hill Rd., New Hope, Pa. 18938
B. Berkeley, Cal., June 29, 1886. Studied: Univ. California, A.B.; Cal. Col. A. & Crafts; Harvard Univ. Member: Authors Lg. Am.; Soc. Am. Hist. Awards: Hon. F., Union College, 1937-40; Benjamin Franklin Fellow, Royal Soc. A., London. Author: "The Story of Modern Art," 1958; "Expressionism in Art," rev. ed. 1958; "A New World History of Art," 1956; "Sculpture of the World," 1968; and other books. Contributor to art magazines and Encyclopaedia Britannica, etc.

CHERMAYEFF, IVAN—Designer, P., Gr., L., I.
 830 Third Ave., 10022; h. 347 E. 62nd St., New York, N.Y. 10021
B. London, England, June 6, 1932. Studies: Harvard Inst. Des.; Mass. Inst. Technology; Yale Univ., B.F.A. Member: Alliance Graphique International; AIGA; Fellow, Royal Soc. A. Award: Industrial Arts Medal, AIA., 1967. Positions: Pres., Am. Inst. of Graphic Arts, 1965-1967; Vice-Pres., Intl. Design Conference, Aspen, Colo.; Trustee, Museum of Modern Art; Pres., Chermayeff & Geismar Assoc., Inc.; Partner, Seven Associates; Editorial Bd., Architectural Forum; Visiting Committee, Yale Univ. School of Art & Architecture.

CHERNER, NORMAN—Designer, T., L., I., W.
 293 Saugatuck Ave., Westport, Conn. 06880
B. New York, N.Y., June 7, 1920. Studied: N.Y. Sch. F. & App. A.; Columbia Univ., B.S., M.A. Exhibited: Four one-man exhs., American House, New York, N.Y.; traveling exhibition sponsored by Am. Craftsmen's Assn.; Good Design Exh., 1951-1953; MModA; Inst. Contemp. A., Boston; Akron AI; Mus. FA of Houston; BMA; work selected by Interiors magazine as one of best commercial interiors of the year; traveling exh. arch. interiors, AFA-Arch. Lg., 1961. Author: "Make Your Own Modern Furniture"; "How To Build Children's Toys & Furniture," 1954; "How To Build Under $5,000," and "Fabricating Houses from Component Parts," 1957. Lecturer, City Col. and N.Y. Pub. Lib. Positions: Des. Consultant for Helekon Furniture Corp.; Instr., MModA. & Fieldston Sch. Indst. Des., 1946-49; T. Col., Columbia Univ., 1949-1953; Dir. Norman Cherner Associates, New York, N.Y., and Norwalk, Conn., 1946- ; Des. House for Int. Trade Fair, U.S. Dept. Commerce in Vienna, 1958; Des. Consul-

tant, Remington-Rand Lib. Bureau. Also for Gift & Art Center, New York City; Pilgrim Glass Corp., West Virginia Pavilion, N.Y. Worlds Fair, 1964-65; Continual Program Furniture Design, Robert Benjamin Co., Inc.; Marriott Motor Motel Gift Shops, and other corporate branches for offices and merchandise environments for firms in the furnishings and gift industries.

CHESNEY, LEE (R., Jr.) —Graphic-Printmaker, P., E.
Department of Fine Arts, University of Southern California; h. 14601 Westfield Ave., Pacific Palisades, Cal. 90272
B. Washington, D.C., June 1, 1920. Studied: Univ. Colorado, B.F.A., with James Boyle; State Univ. of Iowa, M.F.A., with Mauricio Lasansky, James Lechay; Universidad de Michoacan, Mexico, with Alfred Zalce. Member: Midwest Col. AA; CAA; SAGA; Japanese Pr. Assn. Awards: prizes, PMA, 1953; DMFA, 1953; John Taylor Arms award, 1955; LC, 1954, 1958; SAM, 1959, 1961; Silvermine Gld. A., 1959; Butler Inst. Am. A., 1959; Pasadena Mus., 1960; Oklahoma City A. Center, 1960; Pr.M. Oklahoma, 1961; Logan Medal & Prize, AIC, 1962, 1966. Centennial Exh. of Am. Assn. of Land Grant Colleges & Universities, Kansas City, Mo., Nelson Gal., 1962; SAGA, 1961, Concora Fnd. prize, 1963; Vera List purchase prize, 1965; Cal. Soc. Etchers, 1961; purchase awards: BM, 1953, 1956; Univ. So. California, 1953, 1954; DMFA, 1953, 1954; Denver Mus. A., 1954, 1959-1961; Bradley Univ., 1953, 1969; Youngstown Col., 1954; Washington Univ., 1955; Texas Wesleyan Univ., 1955; Michigan State Univ., 1956; Oakland A. Mus., 1957; Am. Color Pr. Soc., Phila., 1968; Los Angeles Pr.M. Soc., Long Beach, Cal., 1968; Am. Pr.M., DePauw Univ., 1968; Eastern Mich. State Univ., 1969; Fulbright award, 1956-1957; Univ. Illinois Research Grant, 1963-1964. Work: prints and paintings — Mus. Mod. A., Tokyo; Tokyo Univ. of Arts; Nat. Gal. A., Stockholm, Sweden; Tate Gal., London, England; Bibliotheque Nationale, Paris; Victoria & Albert Mus., London; SAM; NGA; Milwaukee-Downer Col.; Ohio State Univ.; MModA; BM; LC; PMA; Denver A. Mus.; DMFA; Oakland A. Mus.; Illinois Mus. Natural History; USIA (State Dept.); Albion Col.; Bradley Univ.; Illinois Wesleyan Univ.; Michigan State Univ.; Butler Inst. Am. A.; AIC; Otis AI; Wadsworth Atheneum; Univ. Nebraska; Texas Wesleyan Univ.; Univ. Alaska; Univ. Utah; Baylor Univ.; N.J. State Mus.; Univ. Wisconsin; Wash. State Univ.; N.Y. State Univ. at Oneonta, and others. Exhibited: BM, 1948, 1950, 1952-1956, 1958, 1960, 1962, 1968; LC, 1950, 1954, 1956, 1958, 1960, 1962; Phila. Pr. Cl., 1947, 1949, 1950, 1953-1955, 1958; SAM, 1947-1951, 1953-1956; SFMA, 1949, 1950, 1953, 1954; Bradley Univ., 1950, 1952-1955; Northwest Pr.M., 1948, 1950, 1952-1956; 1958-1960, 1962, 1965, 1967; SAGA, 1954, 1955, 1958, 1963, 1965, 1968; Japanese Pr. Assn., 1957-1969; plus many other national annuals and group shows; paintings—Denver A. Mus., 1949, 1952, 1955, 1956; Des Moines A. Center, 1947-1950; WAC, 1949; 1st Biennial, Tokyo, Japan, 1957; 4th Biennial, Bordighera, Italy, 1957; American Cultural Center, Paris, France, 1964. Arranged the following biennial national print exhs. for Univ. Illinois: "Graphic Arts—USA," 1954; "50 Contemporary American Printmakers," 1956; "Recent American Prints," (1947-1957), 1958. Articles in College Art Journal, 1959-1960 and Japan Print Quarterly, 1966-1967. Positions: Prof. A., Univ. of Illinois, Urbana, Ill., 1950-1967, Assoc. Dean of FA, Univ. of Southern Cal., 1967- .

CHETHAM, CHARLES —Museum director
Smith College Museum of Art, Northampton, Mass. 10160*

CHEW, PAUL ALBERT—Museum Director
Westmoreland County Museum of Art, 221 North Main St.; h. 208 North Maple Ave., Greensburg, Pa. 15601
B. Norristown, Pa., Apr. 22, 1925. Studied: Univ. Pittsburgh, B.A., M.A.; Manchester Univ., England, Ph.D. Member: CAA; AAMus.; Soc. Arch. Historians. Awards: Fellowship, Univ. Manchester, 1955-56, 1957-58; Grad. Assistantship, Henry Clay Frick FA Dept., Univ. Pittsburgh, 1950-51. Genl. Editor, "250 Years of Art in Pennsylvania," Univ. Pittsburgh Press, 1959. Visiting Scholar at Seton Hill College and St. Vincent College; lecturer at University of Pittsburgh, Greensburg Campus. Contributor to Carnegie Magazine; Journal of the School of Architecture, Univ. Manchester, England; Perspectives, Washington Univ. Lectures: History of Art. Positions: Exec. to the Dir., Circulating Exhibitions, MModA; Dir., Westmoreland County Mus. A., Greensburg, Pa., at present.

CHIARA, ALAN R. —Painter, Des., T.
Chiara and Assoc., Fine Arts and Interiors, 1005 Huron Rd., 44115; h. 16305 Woodbury, Cleveland, Ohio 44135
B. Cleveland, Ohio, May 5, 1936. Studied: Cooper Union Sch. A.; Cleveland Inst. A. Member: AWS. Awards: U.S.A. Watercolor Exh., Springfield, Mo., 1964, 1965, 1968; Butler Inst. Am. Art, 1964; AWS, 1964, silver medal, 1966; Bloomingdale Mem. award, 1969; Mississippi AA, 1964; NAD, 1967; American Greeting Card Corp. Exh., 1960-1965, and in local and regional exhibitions. Work: Springfield A. Mus.; Butler Inst. Am. Art; Mount Sinai Hospital. Contributor of cover designs for pictorial magazine of Cleveland Plain Dealer. Ex-

hibited: AWS, 1964-1969; Missouri Watercolor Exh., 1964; USA: Watercolors, 1964-1968; Chautauqua AA, 1962-1965; Nat. Soc. Painters in Casein, 1964; Butler Inst. Am. A., 1962-1968; Cleveland May Show, 1961-1964, 1967-1968; Park Synagogue, 1963-1965; Am. Greeting Card Co., 1960-1965; Oklahoma A. Center, 1969; Miss. AA, 1964-1969; NAD, 1966-1968; one-man: Guenther Maddox Gal., Cleveland, 1967; Canton A. Inst., 1968. Positions: Design Specialist American Greeting Card Corporation, Cleveland, Ohio, 7 years.

CHIEFFO, CLIFFORD TOBY—Painter, E., Ser.
5412 Nevada Ave., N.W., Washington, D.C. 20015
B. New Haven, Conn., July 23, 1937. Studied: Southern Conn. State Col., B.S.; Teachers Col., Columbia Univ., M.A. Member: Am. Soc. for Aesthetics and A. Criticism; CAA. Awards: Berkshire Mus., Pittsfield, Mass., purchase, 1963; Teaching Fellowship, Italy, 1963; A.-in-Res., AFA Grant, Colorado, 1965; A.-in-Res., Missouri Council on the Arts, 1967. Work: BMA; Berkshire Mus. A.; Georgetown Univ.; U.S. State Dept., Art in Embassies program; NCFA; USIA. Exhibited: Washington Gal. Mod. A., 1968; Munson-Williams-Proctor Inst., Ithaca, N.Y., 1968; BMA, 1965, 1966; Omaha, Neb., 1966; Univ. Maryland, 1966; CGA, 1963, 1965, 1967; Berkshire Mus., 1964; Colorado State Col., 1965; Castellane Gal., New York City, 1969; George Washington Univ., 1965; Boston A. Festival, 1964; New Hampshire A. Festival, 1964; Columbia Univ., 1963; Four American Printmakers, American Embassy, Ireland, 1968. Author: "Silk-Screen As a Fine Art," 1968. Positions: Instr., painting, drawing, silk-screen, Univ. Maryland; Corcoran Sch. A.; Chm., Dept. FA, Georgetown Univ., Washington, D.C., at present.

CHILLMAN, JAMES, JR.—Educator, L., Mus. Dir., W.
2242 Stanmore Dr., Houston, Tex. 77019
B. Philadelphia, Pa., Dec. 24, 1891. Studied: Univ. Pennsylvania, B.S. in Arch., M.S. in Arch.; PAFA; Am. Acad. in Rome. Member: F., AIA; Soc. Arch. Hist.; AA Mus.; Texas FA Assn. Awards: F., Am. Acad. in Rome, 1919-1922; F., Univ. Pennsylvania, 1913, 1914; F., Carl Schurz Fnd., 1936; Star of Solidarity, Italy. Contributor to: Encyclopedia of the Arts; art & architectural magazines. Lectures: Western Art & Architecture. Positions: Instr., Asst. Prof., Prof. Arch., Trustee, Prof. Fine Arts, The Rice Univ., Houston, Tex., 1916-19, 1923- ; Dir., Mus. FA of Houston, 1924-53; Dir. Emeritus, 1953- ; Chm., Arch. Com., Texas Medical Center, Houston, Tex.

CHINN, YUEN YUEY—Painter, Gr.
Kraushaar Galleries, 1055 Madison Ave., New York, N.Y. 10021
B. Kwantung, China, Dec. 24, 1922. Studied: Columbia Univ., B.F.A., M.F.A. Member: F.I.A.L. Awards: Brevoort Eickemeyer F., Columbia Univ., 1952-53; Fulbright Award, 1954-55; John Hay Whitney F., 1956-57. Work: Columbia Univ.; FMA; Mus. Mod. A. & Nat. Mus., Stockholm. Exhibited: BMFA, 1954; Young American Printmakers, 1953; CGA, 1957; LC, 1958; WMAA, 1958, 1959; Sweden, 1960; Paris, France, 1961; one-man: Numero Gal., Florence, Italy, 1955; Galleria D'Arte, Ascona, Switzerland, 1955; Gallerie Arnaud, Paris, France; Gallery Beno, Zurich, Switzerland, 1956; Franz Bader Gal., 1957; Salon de Mai, Paris, 1961; Karl Flinker Gallery, Paris, 1964, (4-man) 1962; Comparaisons 65, Paris, 1965; group exh., Haus am Waldsee, "9 Europaische Kunstler," Berlin-Zehlendorf, Germany, 1963.*

CHINNI, PETER A.—Sculptor
389 Broome St., New York, N.Y. 10012
B. Mt. Kisco, N.Y., Mar. 21, 1928. Studied: ASL; Academia di Belle Arti, Rome, Italy and with Roberto Melli, Felice Casorati, and Emilio Sorini, Italy. Member: Sculptors Gld. Awards: prizes, Stone Mem. Prize, Silvermine Gld. A., 1961; Artists of Northern Westchester, 1958-1960; purchase prize, Denver A. Mus. 1961. Work: Denver A. Mus.; CAM. Exhibited: Carnegie International, 1964, 1965; WMAA, 1960, 1962, 1963-1965; New Sch. for Social Research, N.Y., 1964; Milan, Italy, 1962; Denver A. Mus., 1959-1962; Silvermine Gld. A., 1959, 1961; Bundy A. Gal., 1963; Festival of Two Worlds, Spoleto, Italy, 1960; Lever House, N.Y., 1963, 1964; CGA, 1962; Audubon A., 1958-1962; Art: USA, 1958; one-man: Janet Nessler Gal., N.Y., 1959, 1961; Royal Marks Gal., N.Y., 1964; Rome, Italy, 1955-1957.*

CHIPP, HERSCHEL BROWNING—Educator, Mus. C., W., L., Cr.
Department of Art, University of California; h. 822 Santa Barbara Rd., Berkeley, Cal. 94707
B. New Hampton, Mo., Nov. 9, 1913. Studied: Univ. California, Berkeley, B.A., M.A.; Columbia Univ., Ph.D.; Université de Paris. Member: CAA; Société de l'histoire de l'art Francais. Awards: Fulbright Fellowship to France, 1951-1952; Belgian-American Educational Foundation Fellowship, 1952. Work: Contributor art reviews to Art News (1956-1960), New York Times and Art magazine; articles in Art Bulletin, Journal of Aesthetics and Art Criticism, Art Journal, Art Forum; numerous exhibition catalogues. Author:

"Viennese Expressionism," 1963; "Jugendstil and Expressionism in German Posters," 1965; "Theories of Modern Art," 1968; "Friedrich Hundertwasser," 1969. Field of Research: Twentieth Century Painting and Sculpture. Positions: Dir., American Exhibition, Paris Biennale, 1963; Dir., College Art Association of America, 1961-1965; Dir., University Art Gallery, Chm., A. Dept., University of California; Berkeley, 1961- .

CHRISTENSEN, ERWIN OTTOMAR—Museum Curator, E., W., L.
Lanham, Md. 20801
B. St. Louis, Mo., June 23, 1890. Studied: Univ. Illinois, B.S.; Harvard Univ., M. Arch., M.A.; AIC. Contributor to psychological and art journals. Lectures: American (U.S.) Folk Art; History of European Art; History of Architecture, etc. Author: "Popular Art in the United States," 1948; "The Index of American Design," 1950; "Early American Wood-carving," 1952; "Primitive Art," 1955; "A History of Western Art," 1959; "A Pictorial History of Western Art," 1964; "American Crafts and Folk Arts," 1964; "A Guide to Art Museums in The U.S.," 1968. Ed., Museums Directory, US & Canada, 1961. Positions: Instr., Syracuse Univ., 1934-36; Univ. Pennsylvania, 1937-39; Carl Schurz Fnd., 1939-40; Cur., Index of Am. Des. & Dec. A., NGA, Washington, D.C., 1946-1960; Instructor for Coe and Monmouth Colleges in Art Seminars, National Gallery of Art, 1963-1969; Dir. Publications, AAMus., 1960- ; Consultant, American Assn. Museums, 1964- .

CHRISTENSEN, GARDELL DANO—Painter, S., W., Des.
320 Knoll Dr., San Pedro, Cal. 90731
B. Shelley, Idaho, Aug. 31, 1907. Studied: sculpture with Alice Craze, Max Kalish. Member: AAMus.; SC. Work: African Hall, North American Hall and Boreal Hall, of the American Mus. Natural Hist., N.Y.; Mus. of Okmulgee Nat. Park, Macon, Ga.; Custer Battle Field, Montana; Colonial Mus., Nairobi, British East Africa. Exhibited: NAD; Georg Jensen Co., 1939. Illus., "Wapiti the Elk," "Animals of the World," "Monkeys," "Big Cats". Author, I., "The Fearless Family"; "Mr. Hare"; "Buffalo Kill"; "Buffalo"; "Colonial New York," 1969, and others. Contributor of articles and illus. to Era, Audubon and other nature magazines. Positions: Exhibits Des., Am. Mus. Natural Hist., 1928-41; Asst. Prod. Mngr., McArthur 3-Dimensional Adv. Corp., 1947-49; Sculptor, Nat. Park Mus. Laboratories, 1950-51; Exh. Des., Montana Historical Soc., 1952-53; A. Dir., Hagstrom Map Co., 1954-55; Exhibits Des., Hagley Mus., Wilmington, Del., 1956-59; Cur. Exhibits, Schenectady Mus., 1959-62; Sr. Mus. Technician, Dept. Hist. & Archives, in charge of exhibits for Historic Sites for State of New York, Albany, N.Y., 1962-1968; Exhibits designer, Cabrillo Beach (Cal.) Marine Museum.

CHRISTENSEN, HANS (JORGEN)—Craftsman, Des., T.
h. 119 Faircrest Rd., Rochester, N.Y. 14623
B. Copenhagen, Denmark, Jan. 21, 1924. Studied: Denmark and Norway. Member: Am. Craftsmens Council; F.I.A.L. Awards: several prizes in the United States and Europe. Exhibited: participates in numerous group exhibitions yearly. Several one-man exhs. in U.S. Positions: Silversmith, Georg Jensen's Solvsmedie, Copenhagen, 1944-54; Instr., Kunsthaandverkersholen, Copenhagen, 1953-54; Prof., Metalcraft, Sch. for American Craftsmen, Rochester Inst. Tech., Rochester, N.Y., 1954- .

CHRISTIAN, STEPHAN L.—Art Patron
201 11th St. 25701; h. 1251 12th St., Huntington, W.Va. 25701
B. Huntington, W.Va., Apr. 17, 1926. Studied: Princeton University, A.B.; Yale University, M.F.A. Positions: Member of the Board of The Huntington Galleries, Huntington, W.Va.

CHRISTIANA, EDWARD I.—Painter, T.
310 Genesee St., Utica, N.Y.; h. 6 Steuben St., Holland Patent, N.Y. 13354
B. White Plains, N.Y., May 8, 1912. Studied: PIASch; Munson-Williams-Proctor Inst., with William C. Palmer; Utica, Sch. A. & Sc. Member: Cooperstown AA; AWS. Awards: prizes, Utica, N.Y., 1945; Cortland, N.Y., 1947, 1950, 1951; AWS, 1949, 1952; Cooperstown AA, 1953, 1954, 1961; Syracuse Ann., 1954, 1956; Albany Inst. Hist. & A., 1956. Work: Munson-Williams-Proctor Inst.; Manchester (N.H.) Mus. A.; Columbus Mus. FA; Cary Mem. Lib., Lexington, Mass. Exhibited: AIC, 1942, 1944; Mississippi AA, 1946; AWS, 1945-1947, 1949-1951; Munson-Williams-Proctor Inst., 1939-1964; Cortland, N.Y., 1947-1951; BMA, 1949; N.Y. State Fair, 1950, 1951, 1957, 1958; Audubon A., 1950; PAFA, 1952; Acad. A. Syracuse, 1952; Hartwick Col., Oneonta, N.Y., 1963; one-man: Munson-Williams-Proctor Inst., 1946, 1955, 1957; Cazenovia Jr. Col., 1949; Colgate Univ., 1946, 1969; Utica Pub. Lib., 1950; Utica Col., 1951; Syracuse Mus. FA, 1939; Cooperstown, N.Y., 1957; Cushman Gal., Houston, Tex., 1957; Albany Inst. Hist. & A., 1956, 1958; Fifth Ave. Gal., Ft. Worth, 1959; Bresler Gal., Milwaukee, 1959; Upstairs Gal., Toronto, 1960; Utica (N.Y.) Col., 1961; Hartwick Col., 1963; Cary Mem. Lib.,

1965; Appleton Gal., Syracuse, N.Y., 1965; N.Y. State Univ. at Morrisville, N.Y., 1967; Edward W. Root A. Center, Hamilton Col., 1968; Herkimer County Community Col., 1968. Positions: Instr., Children's classes, Munson-Williams-Proctor Inst., 1941-46, and Instr. Ptg., Drawing & Des., 1954- ; Instr., Cazenovia Jr. Col., 1948-49; Utica Col., 1953-54; A. Dir., Cooperstown AA.

CHRIST-JANER, ALBERT WILLIAM—Educator, W. P.
Pratt Institute Manhattan Center, 46 Park Ave., New York, N.Y. 10016
B. Appleton, Minn., June 13, 1910. Studied: St. Olaf Col., B.A.; AIC, B.F.A.; Yale Univ., M.A.; Harvard Univ.; Fogg Mus.; Lake Erie Col., D.F.A.; St. Olaf Col., A.F.D., 1963. Awards: Guggenheim F., 1950, 1960; Rockefeller Award, 1955; NAD, Ranger purchase award, 1969; Am. Phil. Soc. grant, 1968; Arthur Judson grant, 1968; Phila WC Cl., 1967; SAGA, purchase, 1968; Pr. Cl., purchase, 1968, 1969; CM, purchase, 1968; NAC, bronze medal, 1968. Exhibited: CAM; Detroit Inst. A.; Kansas City AI; AIC; BM; NAD; PAFA, 1959, 1963, 1965, 1968. Work: In most major museums across the country, and in numerous private colls. Author: "George Caleb Bingham," 1940; "Boardman Robinson," 1946; "Eliel Saarinen," 1948; "Art in Child Life," 1959; "Forms," 1968; "Modern Church Architecture," 1961 (with Mary Mix Foley). Positions: Hd. A. Dept., Stephens Col., 1936-42; Michigan State Univ., 1942-45; Dir., Cranbrook Acad. Mus. & Lib., 1945-47; Dir., Humanities Div., Univ. Chicago, 1947-52; Dir., Arts Center, New York Univ., 1952-1956; Dir., Sch. A., Pennsylvania State Univ., 1956-58; Dean. A. Sch., Pratt Inst., Brooklyn, N.Y., 1958-1968. Dir., Pratt Inst. Manhattan Center, 1968- .

CHRISTOPHER, WILLIAM R.—Painter, C., T.
Hartland, Vt. 05048
B. Columbus, Ga., Mar. 4, 1924. Studied: Sorbonne, Paris; Academie Julian, Paris; Fontainebleau, France, and with Zadkine, Hofmann, Ozenfant. Awards: Rosenthal Fnd. awards, 1953, 1955; Frank Kirk Mem. prize, NAD, 1968; purchase, Carroll Reece Mus., Univ. Tennessee; Nat. Inst. A. & Lets. grant, 1969; purchase, Childe Hassam Fund, Am. Acad. A. & Lets., 1968; gold medal, Boston A. Festival, 1964. Work: BMFA; WMAA; DeCordova & Dana Mus., Lincoln, Mass.; Boston Univ. Libraries; Dartmouth Col.; AGAA; Reece Mus.; Chase Manhattan Bank; SAM; Wichita A. Mus. Exhibited: Roko Gal., N.Y., 1949-1953, 1966; BM, 1954, 1956, 1958, 1960; Silvermine Gld. A., 1958, 1960; Terrain Gal., N.Y., 1955-1959; WMAA, 1961; BMFA, 1963-1965; DeCordova & Dana Mus., 1962-1968; CGA, 1961, 1963, 1965; Inst. Contemp. A., Boston, 1959-1967; Boston Univ., 1960-1964; AFA traveling exh., 1963, 1967; Smithsonian Inst., traveling, 1960-1961, 1965; VMFA, 1962; Art for Embassies, 1965-1968; FMA, 1967; Norfolk Mus. A. & Sciences, 1967; Dartmouth Col., 1969; PAFA, 1969; Nat. Inst. A. & Lets., 1969, and others. One-man: Roko Gal., 1952; Nexus Gal., Boston, 1957, 1958, 1960; Joan Peterson Gal., Boston, 1961, 1962, 1965; Amel Gal., N.Y., 1961; Dartmouth Col., 1964-1966; Boston Univ., 1964; AGAA, 1966; Larcada Gal., N.Y., 1968; Drew Univ., 1968.

CHRYSLER, MR. and MRS. WALTER P., JR.—Collectors
14 E. 75th St., New York, N.Y. 10021*

CHRYSSA, V.—Sculptor, P.
863 Broadway, New York, N.Y. 10003
B. Athens, Greece, 1933. Studied: Grande Chaumiere, Paris; Cal. Sch. FA. Work: MMoA; WMAA; Chase Manhattan Bank; Albright-Knox A. Gal. Exhibited: MMoA, 1963; Seattle World's Fair, 1962; Boston A. Festival; WMAA; Martha Jackson Gal., N.Y., 1960; Carnegie Inst.; David Herbert Gal.; Pace Gal., 1967, 1968; Dunkelman Gal., 1968; one-man: Cordier & Ekstrom Gal., N.Y., 1962, 1963; Robert Fraser Gal., London, 1962; Betty Parsons Gal., N.Y., 1961.

CHUBB, FRANCES FULLERTON—Educator, P.
University of Puget Sound; h. 235 Broadway #405, Tacoma, Wash. 98402
B. St. Mary's, Idaho, Oct. 6, 1913. Studied: Univ. Puget Sound, B.F.A.; Univ. Washington, M.F.A., and with George Z. Heuston. Member: Tacoma A. Mus.; Women Painters of Washington; Washington AA. Awards: prize, Olympia Ann., 1953, 1957; Tacoma AA, 1940. Exhibited: Seattle and Tacoma Galleries, 1939- . Illus., "Lumber Industry in Washington," 1939. Positions: Instr., A., A. Appreciation, Painting, A. Hist., Univ. Puget Sound, Tacoma, Wash., 1942-53; Asst. Prof., 1953-58, Assoc. Prof., 1958-1968, Prof., 1968- .

CHUEY, ROBERT ARNOLD—Painter, T.
2460 Sunset Plaza Dr., Los Angeles, Cal. 90069
B. Barberton, Ohio, Nov. 15, 1921. Studied: Art Center Sch., Los Angeles; Otis AI; Jepson AI., Los Angeles. Awards: prizes, All-City Exh., Mus. Mod. A., Beverly Hills, 1949; special award, Malibu AA,

1954. Work: CAM, and in private collections. Exhibited: Sao Paulo Bienal, 1955; PAFA, 1958; Reed Col., Portland, Ore., 1964; Los A. Mus. A., 1949, 1951-1953, 1956, 1957, 1958, 1960; Fleischer-Anhalt Gal., Los Angeles, 1966; Univ. California, Santa Barbara, 1966; Newport Harbor, California, 1968; Alumni Exh., Otis A. Inst., 1968; Los Angeles Mun. Exh., 1968. One-man: Frank Perls Gal., Los Angeles, 1951, 1954, 1957, 1961, 1963; Fleischer-Anhalt Gal., Los Angeles, 1967, 1968. Contributor: "Drawing, A Search for Form," (Mugnaini), 1966 and "Painting Techniques," (Mungnaini), 1969. Contributor reproductions to "Realm of Contemporary Still Life," 1963. Positions: Drawing & Painting, Chouinard AI, 1958-1963 and Univ. California at Los Angeles, 1963-1965, 1968-1969; Univ. California, Santa Barbara, 1965-1967.

CHUMLEY, JOHN WESLEY—Painter
4024 Fairfax Ave., Ft. Worth, Tex. 76116
B. Rochester, Minn., Sept. 12, 1928. Studied: Univ. Kentucky; Ringling Sch. A., Sarasota, Fla.; PAFA. Member: AWS; Phila. WC Cl. Awards: prizes, Florida Fed. A., 1954; Manatee A. Lg., 1954; Knoxville A. Center, 1955; Phila. WC Cl., 1957; Audubon A., 1957; Feldman Coll., 1959; NAD, 1959; Tarrant County Exh., 1959, 1960; Texas Annual (purchase), 1960. Work: PAFA; N.Y. Hospital; Utica (N.Y.) Hospital; Everhart Mus.; Feldman Coll.; West Texas Mus.; Amon Carter Mus. Exhibited: AWS, 1957-1960; Phila. WC Cl., 1959; Univ. Nebraska, 1959; Tarrant County, 1959; Feldman Coll., 1959; NAD, 1960; Am. Acad. A. & Lets., 1960; Wadsworth Atheneum, 1960; Texas Annual, 1960; Audubon A., 1957; PAFA, 1957, 1958; Fla. Fed. A., 1954; Ft. Lauderdale Fnd., 1955; Knoxville A. Center, 1955; Atlanta, Ga., 1954; Alabama WC Soc., 1954; Sarasota AA, 1954, 1955; Manatee A. Lg., 1954, 1955.*

CHURCH, C. HOWARD—Educator, P., Gr., S.
Michigan State University; h. 271 Lexington Ave., East Lansing, Mich. 48823
B. Sioux City, Neb., May 1, 1904. Studied: AIC, B.F.A., with Boris Anisfield and with John Norton, William P. Welsh; Univ. Chicago, B.A.; Ohio State Univ., M.A. Member: CAA; Mich. Acad. Sc., A. & Let. (Art Program Chm., 1953-54, 1954-55, Chm. FA Section, 1956-59, Pres., 1959-60); Midwest College AA (V.-Pres. 1959-60, Pres. 1960-61). Awards: prizes, Joslyn Mus. 1941, 1942; Fine Arts Medal, Michigan Acad. of Science, Arts & Letters, 1963; purchase award members exh., Mich. Acad. Science, Arts & Lets., 1966. Work: murals, 1932-36, Morgan Park Military Acad., Chicago. Exhibited: widely since 1932. One-man: Mulvane A. Mus.; Thayer Mus. A.; Univ. Nebraska; Joslyn A. Mus; Kresge A. Center, East Lansing, Mich. Positions: Dir., Morgan Park Sch. A., Chicago, Ill., 1933-36; Dir., Mulvane A. Mus., Hd. A. Dept., Washburn Univ., Topeka, Kans., 1940-45; Hd. A. Dept., Michigan State Univ., East Lansing, Mich., 1945-60, Prof., 1961- .

CHURCH, ROBERT M.—Educator, Mus. D.
San Francisco State College, 1600 Holloway St. 94124; h. 425 Greenwich St., San Francisco, Cal. 94133
B. Junction City, Kans., Mar. 30, 1924. Studied: Univ. Michigan; Univ. California, B.A.; Notre Dame Univ.; Columbia Univ.; Cornell Univ. Member: CAA; AAMus. Work: SFMA; Philbrook A. Center. Contributor to College Art Journal, Western Arts Quarterly, San F. AA Bulletin, and others. Lectures on Art History, Contemporary Art and Architecture. Positions: Asst. Cur., Cur., SFMA, 1945-50; Dir., Philbrook A. Center, Tulsa, Okla., 1950-1955; Asst. to the President, Cal. Col. of Arts & Crafts, Oakland, Cal., 1955-1957; Dir., A. Gal., Univ. Arizona, Tucson, Ariz., 1957-61 Dir. Gallery Lounge & Coordinator of the Interdisciplinary Program for the Creative Arts, San Francisco State College, 1962- .*

CICERO, CARMEN LOUIS—Painter
355 Mountain Rd., Englewood, N.J. 07631
B. Newark, N.J., Aug. 14, 1926. Studied; Newark State T. Col., B.S.; Hunter Col., and with Hans Hofmann, Robert Motherwell. Awards: Guggenheim F., 1958; Ford Fnd. purchase award, 1962. Work: Newark Mus. A.; Guggenheim Mus.; MModA; Toronto Mus. A.; WMAA; Larry Aldrich Mus.; Cornell Univ.; N.Y. Univ.; Sara Roby Fnd.; Univ. Michigan; Univ. Nebraska; BM; WMA; Museum Boymans -Van Beuningen, Rotterdam, Netherlands; Stedelijk Museum, Schiedam, Netherlands, and in many private collections. Exhibited: CGA, 1953; WMAA, 1955, 1957; MModA, 1953, 1955; AFA traveling exh., 1956; Stable Gal., 1956; Nebraska AA, 1957; AIC, 1957; Rome, Italy, 1958; WMA, 1958; Peridot Gal., N.Y., 1956, 1957, 1959, 1961; Am. Acad. A. & Lets.; BM; Newark Mus. A.; PAFA; Univ. Colorado; Univ. Nebraska and others.

CIKOVSKY, NICOLAI—Painter, Lith., T.
500 West 58th St., New York, N.Y. 10019
B. Russia, Dec. 10, 1894. Studied: in Vilna, Penza, Moscow. Member: ANA. Awards: med. & prize, AIC, 1931, 1932; prize, WMA, 1933, 1937; Soc. Wash. A., 1941; NAD, 1959 (purchase). Work:

MModA; BM; AIC; PAFA; CAM; WMA; Los A. Mus. A.; PC; Nelson Gal. A.; WMAA; Univ. of Syracuse; Buffalo Univ.; Smithsonian Institution, Washington, D.C.; murals, Dept. Interior, Wash., D.C.; USPO, Towson, Silver Spring, Md. Exhibited: Toledo Mus. A.; MModA; AIC, 1960, 1961; Newark Mus. A.; Glasgow Mus.; Walker A. Center; Carnegie Inst.; PC; CGA; BM; BMFA; PMA; WMA; CAM; Los A. Mus. A.; NAD, 1959, and others.

CIPRIANO, ANTHONY GALEN—Sculptor
24 W. 56th St. 10019; h. 46 Bank St., New York, N.Y. 10007
B. Buffalo, N.Y., Sept. 30, 1937. Studied: Notre Dame Univ. with Ivan Mestrovic; ASL with George Grosz; Int. Summer Sch. A. with Kokoschka. Member: SC. Awards: prizes, Michigan-Indiana Exh., 1956; SC, 1965. Work: Bass Mus., Miami, Fla.; Gal. of Mod. A., N.Y.; numerous portrait busts. Exhibited: Encore Gal., Buffalo, N.Y., 1956; Greenwich Gal., 1968; Portraits, Inc., N.Y., 1969; Bass Mus., 1965, 1969. Positions: Instr., Sculpture privately.

CITRON, MINNA (WRIGHT)—Painter, Gr., T., W., L.
32 Union Square; h. 145 4th Ave., New York, N.Y. 10003
B. Newark, N.J., Oct. 15, 1896. Studied: Brooklyn Inst. A.&Sc.; N.Y. Sch. App. Des.; ASL; Col. City New York; and with K. Nicolaides, Kenneth Hayes Miller; Atelier 17. Member: SAGA; AFA; A. Lg. Am.; NAWA; ASL; Boston Pr.M.; Am. Color Pr. Soc.; AEA; Assoc. A. of New Jersey; Soc. Indp. A., Boston; Provincetown AA. Awards: prizes, N.Y. Sch. App. Des., 1926; SAGA, 1942, 1943, 1969; Am. Color Pr. Soc., 1948, 1950, 1967; Norton Gal. A., 1948; Phila. Pr. Cl., 1948; Boston Soc. Pr.M., 1949, 1961; Boston Soc. Indp. A., 1949; Brooklyn Soc. A., 1950; Soc. Four A., 1951; DMFA, 1953; Cal. Soc. Pr.M., 1956, 1961; Hunterdon County A. Center (N.J.), 1958; Montclair A. Mus., 1960; Guild Hall, Easthampton, 1959; N.J. State Mus., Trenton, 1968; Ford Fnd., A.-in-Res., Roanoke, Va., 1965. Work: MMA, WMAA; Norfolk Mus. A. & Sc.; Newark Mus. A.; CGA; AIC; LC; N.Y. Pub. Lib.; New Jersey Pub. Lib.; Detroit Inst. A.; MModA; Worcester A. Mus.; R.I. Sch. Des.; Howard Univ.; FMA; BMA; Rosenwald Coll.; NGA; Bibliotheque Nationale, Paris; Instituto Nacional de Cuba; murals, USPO, Manchester and Newport, Tenn., etc. Exhibited: CGA; WMAA; Newark Mus. A.; Carnegie Inst.; PAFA; AIC; Amsterdam, Holland; FMA; BMA. One-man: ACA Gal., 1944, 1946, 1947; Midtown Gal., 1935, 1937, 1939, 1941, 1943; Lynchburg, Va., 1938; Havana, Cuba, 1949, 1952; Smithsonian Inst., 1949; Galerie Conti, Paris, 1947; Salon des Realites Nouvelles, 1947-48; Delgado Mus. A., 1947; Howard Univ., 1947; Museu de Arte Moderna, Sao Paulo, Brazil, 1952; Rio de Janeiro, 1952; San Miguel de Allende, Mexico, 1955; Gal. Arnaud, Paris, 1958; Waddington Gal., London, 1959; 4 one-man exhs. Yugoslavia, auspices USIA, 1960; Elberfeld, West Germany, 1961; U.S. Embassy, London, 1967 (one-man). Lecturer. Positions: Instr., Brooklyn Mus., Brooklyn, N.Y., 1943-46; Paris correspondent, Iconograph magazine, 1946- ; Lecturer, (tour), South America, 1952.

CLAGUE, JOHN (ROGERS)—Sculptor, T.
Cleveland Institute of Art, 11141 East Blvd. 44106; h. 11625 County Line Rd., Gates Mills, Ohio 44040
B. Cleveland, Ohio, Mar. 14, 1928. Studied: Cleveland Inst. A., B.F.A. (sculpture with William McVey). Awards: prizes, Cleveland Mus. A., 1955-1966. Work: Cleveland Mus. A.; Larry Aldrich Mus.; Univ. Massachusetts; reliefs, Cleveland Recreation Centers; bronze figure, Jewish Community Center, Cleveland, 1961. Exhibited: WMAA, 1964-1965; Cleveland Mus. A., 1955-1968; one-man: Waddell Gal., N.Y., 1966; Larry Aldrich Mus., 1967. Positions: Instr. Sculpture, Oberlin College (Ohio), 1957-1961; Visiting A., Ball State Teachers College, 1960; Instr. Sculpture, Cleveland Inst. Art, 1957- .

CLANCY, JOHN—Art Dealer
Frank Rehn Gallery, 36 E. 61st St., New York, N.Y. 10021*

CLARE, ELIZABETH—Art Dealer
M. Knoedler & Company, 14 E. 57th St., New York, N.Y. 10022*

CLARE, STEWART (DR.)—Research Artist, Des., E., L., W.
4000 Charlotte St., Kansas City, Mo. 64110
B. Montgomery City, Mo., Jan. 31, 1913. Studied: Kansas Univ., B.A.; Iowa State Univ., M.S.; Univ. Chicago, Ph.D.; Advanced Study-research in Color and Design, Kansas City AI & Univ. of Missouri, Kansas City. Member: Am. Fed. Artists; Fed. Canadian A.; NEEA; NEA; Western AA; Int. Soc. for Edu. through Art; Nat. Council of Arts & Govt.; Inter-Soc. Color Council; Assn. Higher Edu; AAUP; Scientific Research Soc. Am., and others. Awards: Scholastic Awards for Scientific Illustrations, Univ. Missouri; William Volker Fund Scholarship, 1932-1935; Univ. of Kansas, Rockefeller and University Teaching Fellowships, 1935-1940; Research Grants and Awards from various academic institutions, 1958-1965. Work: in private collections, U.S. and Canada. Exhibited: Univ. Missouri;

Univ. Alberta, Canada Art Faculty Exh., 1950-1952; London (Can.) Pub. Lib. & Mus., 1951; Trans-Canada traveling exh., 1951-1952; Calgary, 1951, 1952; Edmonton, 1952; Alberta Soc. A., 1952; Alberta Visual Arts Board Exh., 1953; traveling, 1953-1954; Western AA, Minneapolis AI, 1964; one-man: Univ. Alberta, 1950-1952; Edmonton A. Mus., 1953; Rutherford Lib., Univ. Alberta, 1951-1953; Broadway A. Gal., Kansas City, 1953; Univ. Kansas City, 1953; Univ. Adelaide, Australia, 1954; Private exh., Gezira Research Station, Wad Medani, Sudan, North Africa, 1955-56; Union Col., Barbarourville, Ky., 1958-1960; Science of Color-Design Exhs., Adirondack Science & Art Camp, Twin Valleys, Lewis, N.Y., 1962, 1963, 1964, 1965, 1966; Kansas City Mus. Science, 1965; Kansas Union Gal., Univ. Kansas, 1965-1966; Univ. Missouri, 1966; Univ. Western Kentucky, 1967; Laughlin-Lewis Library, Col. of Emporia (Kans.), 1968. Author articles on Theory of Color and Design and Scientific Subjects (see Leaders in American Science). Contributor scientific illus. to various periodicals and textbooks. Lectures: Science and Art of Pigment Colors; Abstractions in Color and Design; the Pigment Colors and The Science of Color, a series of lectures given in Science for Teachers at Union College, 1958-1960 and The Adirondack Science Camp, 1962-1965, all illus. lectures. Positions: Lecturer-Instr., Theory of Color & Des., Dept. FA, Univ. Alberta, 1950-1953; Lecturer, Science of Color & Design, Col. A. & Sciences, State Univ. N.Y at Plattsburgh, 1962-1966 (and see other lectures above); Color Consultant, Private and Volunteers for International Technical Assistance; numerous positions in scientific research and teaching (see Am. Men of Science and Who's Who in American Education). Prof., Biology, Col. of Emporia, Emporia, Kans., at present.

CLARK, ANTHONY MORRIS—Collector, Museum Director, Scholar
 The Minneapolis Institute of Arts, 201 E. 24th St., Minneapolis, Minn. 55404
B. Chestnut Hill, Pa., Oct. 12, 1923. Studied: Harvard Univ. Collection: 18th Century Roman Art. Various scholarly studies published in United States, Great Britain, Germany, Italy, etc. Field of Research: 18th Century Roman Art. Positions: Faculty Asst., Salzburg Seminar of Harvard University, 1950; Field Worker, The Byzantine Institute, Istanbul, 1954; Sec., The Museum of Art, Rhode Island School of Design, 1955-1959; David E. Finley Fellow, The National Gallery of Art, 1959-1961; Curator, Painting & Sculpture, 1961-1963, Acting Director, 1963, Director, 1963-, The Minneapolis Institute of Arts.

CLARK, ELIOT (CANDEE)—Painter, W., L., E., Cr.
 Rio Rd., R.D. 5, Charlottesville, Va. 22901
B. New York, N.Y., Mar. 27, 1883. Studied: ASL; & with John Twachtman, Walter Clark. Member: NA; NAC; Intl. Inst. A. & Lets.; NSS (hon.); SC (hon.); Century Assn.; Conn. Acad. FA; AWS (Permanent Hon. Pres., 1968-); All. A. Am. Awards: Prizes, NAD; Witte Mem. Mus., San Antonio, Tex.; Bush prize, All. A. Am., 1950. Work: NAD; NAC; Dayton AI; Muncie (Ind.) AA; MMA; Witte Mem. Mus.; Ft. Worth AA; Wichita Falls, Ft. Worth, San Antonio Women's Clubs. Exhibited: NAD; CGA; Carnegie Inst.; PAFA; Albright A. Gal.; CAM; R.I. Sch. Des.; AIG; VMFA; NAC; SC; AWCS; Retrospective Exh., Mus. FA, Univ. Virginia, 1963. Author: "Alexander Wyant," 2 vols., 1916; "John Twachtman," 1924; "J. Francis Murphy," 1926; "History of the National Academy of Design," 1954. Contributor to: Art magazines; Cr.; Studio of London (reviews of N.Y. Exhs.). Positions: Bd. Governors, NAC, 1943-; Member, Council, NAD, 1945-, First Vice-Pres., 1955, Pres., 1958-, Bd. Dir., N.Y. City Center Gal.; Staff L., Asia Inst., New York, N.Y.; Trustee (Ex-officio) MMA.

CLARK, G. FLETCHER—Sculptor
 1360 Lombard St., San Francisco, Cal. 94109
B. Waterville, Kans., Nov. 7, 1899. Studied: Univ. California, B.A.; BAID, and in Europe. Work: Wood Mem. Gal., Montpelier, Vt., and in private colls. U.S. and abroad. Exhibited: Cal. PLH, 1933 (one-man); Avant-Garde Gal., 1959; Gal. Contemporary Christian Art, New York, 1963; Gilbert Gal., San F., 1968.

CLARK, MARK ALAN—Museum Curator
 The Dayton Art Institute, 405 Riverview Ave. 45405; h. 225 Belmonte Park East, Dayton, Ohio 45405
B. Dayton, Ohio, Jan. 20, 1931. Lectures: French Furniture of the 17th and 18th Century, to art museums and various organizations. Positions: Cur. Decorative Arts and Museum Registrar, The Dayton Art Institute, Dayton, Ohio at present.

CLARKE, RUTH ABBOTT (Mrs.)—Painter, E.
 1023 Spring Garden St., Greensboro, N.C. 27403
B. Greensboro, N.C., Dec. 10, 1909. Studied: Univ. North Carolina at Greensboro, A.B., M.F.A.; Hans Hofmann Sch. A.; ASL; T. Col.; Columbia Univ. Member: Assoc. A. of North Carolina (Bd. Dirs.). Awards: prizes, Assoc. A. North Carolina, 1961; Winston-Salem Gal. FA, 1961, 1963, 1964; Great Barrington, Mass., 1957; Greens-

boro A. Lg., 1964. Work: Wake Forest Col.; Elliott Hall Coll., Univ. North Carolina at Greensboro; Wachovia Bank Coll. Exhibited: Knoxville A. Center, 1961; Nat. Soc. Painters in Casein, 1956; Mint Mus. A., 1964, 1965; Drawing Soc. of America, Atlanta, 1965; Southeastern Annual, Atlanta, 1964; Winston-Salem Gal. FA, 1958, 1965; Hunter Gal., Chattanooga, 1960, 1961; Norfolk Mus. A., 1960, 1964; North Carolina A., 1956, 1957, 1960; Assoc. A. North Carolina, 1960, 1961, 1963-1965; Assoc. A. North Carolina traveling exhs., 1961-62, 1962-63, 1963-64, 1964-65; Mus. New Mexico, 1962, traveling 1963-64; one-man: North Carolina Col., Raleigh, 1961; Univ. North Carolina, 1964; Attic Gal., Greensboro, 1964; Garden Gal., Raleigh, 1965; Reidsville A. Center, 1965; Mint Mus. A., Charlotte, 1965; Winston-Salem Gal. FA (2-man) 1964 and other exhibitions. Positions: Prof. A., Univ. North Carolina at Greensboro, 1954-1956; Meredith College, Raleigh, 1957-1961; Specialist, A. Edu., Frederick County, Md., 1961-1962; A. Edu. Greensboro College, 1965.*

CLAWSON, REX MARTIN—Painter
 78 Third Ave., New York, N.Y. 10003
B. Dallas, Tex., Nov. 2, 1930. Studied: Colorado Springs FA Center, with William Johnstone. Awards: Texas F., 1948; prize, DMFA, 1951. Exhibited: DMFA, 1947-1951; Texas Ann., 1951-1953; Knoedler Gal., 1952; Edwin Hewitt Gal., 1955 (one-man); Royal Athena II Gal., N.Y., 1963, 1964 (both one-man).*

CLEARY, FRITZ—Sculptor, Cr.
 205 Grassmere Ave.; h. 209 Windermere Ave., Interlaken, N.Y. 14847
B. New York, N.Y., Sept. 26, 1914. Studied: St. John's Univ.; NAD; Beaux Arts Inst., with Alexander Finta. Member: All. A. Am. Awards: Warren prize, AAPL; Gold Medal, All. A. Am., 1967; Prize, Oakland A. Mus. Work: World War II Memorial, Point Pleasant, N.J.; John F. Kennedy Memorial, Asbury Park, N.J.; Robert Mount Memorial, Monmouth (N.J.) College. Exhibited: NAD; PAFA; Oakland A. Mus.; in college museums—Princeton, Amherst, Connecticut College for Women and museums of Brooklyn, N.Y., Newark, Trenton and Montclair, N.J.; Southern Vermont Artists and with numerous New Jersey art groups and galleries. Author, Illus., "Sixty Days Around the World," 1956. Positions: Art Critic, Asbury Park Press, Asbury Park, N.J., with weekly column, 1945-1962 then as a Sunday Feature, 1962- to date.

CLENDENIN, EVE—Painter, Gr.
 150 Central Park South, New York, N.Y. 10019; (studio) 31 Columbus Ave., New York, N.Y. 10019
B. Baltimore, Md. Studied: Banff Sch. FA, with H. G. Glyde, and with Eliot O'Hara, Hans Hofmann. Member: NAWA; Am. Abstract A.; Provincetown AA; AEA; Cape Cod AA. Awards: prizes, NAWA, 1957; BM, 1958; Cape Cod AA, 1962, 1965. Exhibited: New York City Center, 1953; Eola Gal., Orlando, Fla., 1954 (one-man); Cape Cod AA, 1953-1958, 1962; NAWA traveling and annual exhs., 1945-1962; Provincetown AA, 1946-1957, 1962; Riverside Mus., 1954-1968; Realities Nouvelles, Paris, 1955; Nat. Mus. Mod. A., Tokyo, Japan, 1955; Gallery 251, Provincetown, 1954; H-C Gal., Provincetown, 1955; Provincetown AA, 1946-1961; Argent Gal., N.Y., 1945 (one-man); Eola Gal., Orlando, Fla., 1945 (one-man); Vose Gal., Boston, 1946; Seligmann Gal., N.Y., 1946; Dayton AA, 1947; Am. Abstract A., 1953-1963; New York City Center, 1953; Soc. Four Arts, 1957; James Gal., N.Y., 1957, 1958; Art: USA, 1958; BMA, 1958; NAWA print exh., 1957; PAFA, 1959; NGA, 1960; Lyman Allyn Mus., 1960; N.Y. World's Fair, 1965; Karlis Gal., Provincetown, Mass., 1960, 1961, 1962, 1963; Christopher Cross Assoc., New York, 1963; East End Gal., Provincetown, Mass., 1963; Chrysler Mus., Provincetown; Stedelijk Mus., Amsterdam, 1956; Maison des Arts, Brussels, 1956; Kunst Mus., Bern, Switzerland, 1957; Cianu Gal., Lugano, Switzerland, 1957; Municipal Mus., Tokyo, 1960; Westchester A. Soc., 1967; North Carolina Mus. A., 1969.

CLERK, PIERRE—Painter
 186 Bowery, New York, N.Y. 10012
B. Atlanta, Ga., Apr. 26, 1928. Studied: Montreal Sch. A. & Des.; Academy Julien, Paris, France; McGill Univ., Montreal. Work: MModA; Guggenheim Mus.; Nat. Gal. of Canada, Ottawa, and in private colls. Exhibited: Venice Biennale, 1956, 1958; MModA, 1956; Canadian Biennale, 1957; Carnegie Intl., 1959; A. Gal. of Toronto, 1968; one-man: Numero Gal., Florence, Italy; Beho Gal., Zurich, Switzerland; Montreal Mus. FA; New Gal., N.Y.; Il Cavallino, Venice, Italy; Siegelaub Gal., N.Y., 1966, 1967.

CLIFFORD, HENRY—Museum Curator
 Philadelphia Museum of Art, Philadelphia, Pa.; h. Radnor, Pa. 19087
B. Newcastle, Me., May 24, 1904. Awards: Hon. degree, D.F.A., Villanova Univ., 1965. Arranged and organized exhs.: Mexican Art Today, 1943; Jose Maria Velasco, 1944; Henri Matisse, Retrospec-

tive Exh. of Paintings, Drawings and Sculpture (in collaboration with the artist), 1948; Toulouse-Lautrec, 1955; Picasso, 1958; Courbet, 1959-60; World of Flowers, 1963; Franklin Watkins Retrospective, 1964. Positions: Cur. Painting, Philadelphia Museum of Art, Philadelphia, Pa.*

CLIFT, JOHN RUSSELL—Illustrator, P., T., Gr., Comm.
355-A Newbury St., Boston, Mass. 02115
B. Taunton, Mass., Nov. 13, 1925. Studied: Boston Mus. Sch. FA. Member: Alumni Assn. of the Boston Mus. Sch. FA. Awards: Traveling Fellowships, Boston Mus. Sch. FA, 1952-1953, 1958-1959. Work: Ford Motor Co.; Alcan Aluminum Co., Cleveland; Bethlehem Steel Co. of Pennsylvania. Exhibited: Various print shows throughout the U.S. including MModA; DeCordova & Dana Mus., Lincoln, Mass.; Mirski Gal., Boston, 1963 (one-man). Illus. for Fortune, Ford Times and Lamp-Standard Oil Co. magazines. Positions: Instr. Drawing & Illustration, Boston Mus. School of Fine Arts, at present.*

CLOAR, CARROLL—Painter, Lith.
235 S. Greer St., Memphis, Tenn. 38111
B. Earle, Ark., Jan. 18, 1913. Studied: Southwestern Col., A.B.; Memphis Acad. A.; ASL. Member: AEA. Awards: McDowell F., 1940; Guggenheim F., 1946; prizes, LC; Rochester Mem. A. Gal.; BM; Butler Inst. Am. A., 1956. Work: MMA; MModA; BM, Newark Mus. A.; Butler Inst. Am. A.; Brooks Mem. Gal.; Columbia (S.C.) Mus. A.; Brandeis Univ.; Abbott Labs.; WMAA; Wadsworth Atheneum; CGA; St. Petersburg Mus. A.; LC; Atlanta AA; Mus. A., Science & Indst., Bridgeport, Conn.; Southwestern College; Uniontown (Pa.) Friends of Art; Chase Manhattan Bank, N.Y.; Tennessee FA Center, Nashville; State Univ. of N.Y., Albany. Exhibited: Carnegie Inst., 1955, 1958; Univ. Illinois, 1957, 1959, 1963, 1965; WMAA; PAFA; Butler Inst. Am. A.; Univ. Nebraska, 1958; Mid-South Exh., Memphis, 1956; one-man: Brooks Mem. A. Gal., 1955, 1957, 1960 (retrospective) 1962; Little Rock FA Center, 1956, 1961; Alan Gal., N.Y., 1953, 1956, 1960, 1962, 1964; Atlanta AA, 1960; Washington Federal, Miami Beach, 1961; Fort Worth A. Center, 1963; Retrospective exh., State Univ. of N.Y., Albany, 1968. Contributor to Life, Horizon, Delta Review magazines.

CLOWES, ALLEN WHITEHILL—
Collector, Patron, Museum Administration
250 E. 38th St. 46205; h. 3744 Spring Hollow Road, Indianapolis, Ind. 46208
B. Buffalo, N.Y., Feb. 18, 1917. Studied: Harvard Univ., B.S. Fine Arts; Fogg Museum, Harvard Univ., Art History with Chanler Post, Benjamin Rowland, Leonard Opdyke, Kuhn, and Paul Sachs; Harvard Grad. School of Business Administration, M.B.A. Awards: Hon. D.F.A., Franklin College, Franklin, Ind., 1964. Collection: The Clowes Fund Collection of Paintings by the Old Masters was originally formed by the late Dr. G. H. A. Clowes, scientist and patron of the arts, and now belongs to the Clowes Fund, Inc. Included are paintings by Bellini, Bosch, Bruegel, Caravaggio, Clouet, Constable, Cranach, Duccio, Durer, El Greco, Goya, Hals, Holbein, Rembrandt and Rubens. The dates of the collection span five centuries, from the 14th to 19th. Positions: President and Director, The Clowes Fund Collection of Old Masters, 3744 Spring Hollow Rd., Indianapolis, Ind. (open Thurs. and Sun. 2-6 p.m.).

CLUTZ, WILLIAM—Painter
485 Central Park West, New York, N.Y. 10025
B. Gettysburg, Pa., Mar. 19, 1933. Studied: Mercersburg (Pa.) Acad.; Univ. Iowa; B.A. Work: Chase Manhattan Bank, N.Y.C.; Newark Mus. A.; Washington County Mus. A.; Mercersburg Acad.; St. Paul A. Center; N.Y. Univ.; Ball State T. Col.; Guggenheim Mus.; Addison Gal. Am. A.; Univ. Nebraska; FMA; MModA; Univ. Massachusetts. Exhibited: "Recent Drawings: USA," MModA, 1956 and "Recent Painting: USA," 1962; McNay AI, San Antonio, 1963; David Herbert Gal., 1960, 1962; AFA traveling exhibition, 1960-1961; Mus. Contemp. A., Houston, 1961; PAFA, 1964; Art Dealers Assn. of America 1964; St. Paul A. Center, 1964; Ball State T. Col., 1964. One-man: Bertha Schaefer Gal., N.Y., 1963, 1964, 1966, 1969; David Herbert Gal., 1962; Condon Riley Gal., N.Y., 1959. Positions: A.-in-Res., Bucknell Univ., Bucknell, Pa., 1957; Visiting Instr., Univ. of Minnesota, Duluth, 1967-68.

CLYMER, JOHN F.—Painter, I.
Route 1, Bridgewater, Conn. 06752
B. Ellensburg, Wash., Jan. 29, 1907. Studied: Vancouver (B.C.) Sch. A.; Ontario Col. A.; Wilmington Acad. A.; Grand Central A. Sch., with George Southwell, H. Varley, J. W. Beatty, Frank Schoonover, N.C. Wyeth, Harvey Dunn. Member: Soc. Animal Artists; SC; Ontario Soc. A.; Hudson Valley AA. Awards: Dr. Byron Kenyon award, 1962 and Grumbacher award, 1964, both Hudson Valley AA. Work: Glen Bow Fnd., Calgary, Canada; Montana Hist. Soc., Helena and in many private collections. Exhibited: Royal Canadian Acad., 1933-1935; NAD, 1936; Soc. Animal Artists, 1962-1965; Hudson Valley

AA, 1962-1965. Contributor illus. to Saturday Eve. Post, Field & Stream; advertising illus. for Chrysler, Ford, New England Life, Goodyear, American Cyanamide, and others.*

COATES, ROBERT M.—Writer, Cr.
New Yorker Magazine, 25 West 43rd St., New York, N.Y. 10036; h. Old Chatham, N.Y. 12136
B. New Haven, Conn., Apr. 6, 1897. Studied: Yale Univ., B.A. Member: Nat. Inst. A. & Lets. Author: "The Eater of Darkness," 1929; "The Outlaw Years," 1930; "Yesterday's Burdens," 1933; "All The Year Round," 1943; "The Bitter Season," 1946; "Wisteria Cottage," 1948; "The Farther Shore," 1955; "The Hour After Westerly," 1957; "The View from Here," 1960; "Beyond the Alps," 1961. Positions: A. Cr., W., New Yorker Magazine.

COBB, RUTH (Mrs. Lawrence Kupferman)—Painter
38 Devon Rd., Newton Centre, Mass. 02159
B. Boston, Mass., Feb. 20, 1914. Studied: Mass. Col. A. Member: Boston Soc. WC Painters; AWS; All. A. Am. Awards: Butler Inst. Am. A., purchase, 1966; All. A. of Am., Vassileff award, 1966, gold medal of honor, 1968; PAFA, 1967; AWS, 1968; NAD, purchase, 1968; Audubon A., Winsor Newton medal, 1969. Work: VMFA; Wheaton College (Mass.); Univ. Massachusetts; BMFA; Munson-Williams-Proctor Inst.; AGAA; Brandeis Univ.; Fitchburg (Mass.) Mus. A.; DeCordova & Dana Mus.; Portland (Me.) Mus. A.; Butler Inst. Am. A.; AGAA; VMFA; Tufts Univ. Exhibited: PAFA, 1967, 1969; Butler Inst. Am. A., 1966; Watercolor:USA, Springfield, Mo., 1966; McNay Mus., 1966; Witte Mem. Mus., 1967; AWS, 1968; All. A. Am., 1968; NAD, 1969; Audubon A., 1967.

COBURN, BETTE LEE (Mrs. Marvin)—Painter
Henderson Rd., Greenville, S.C. 29605
B. Chicago, Ill., July 31, 1921. Studied: Grinnell Col., Iowa; Evanston (Ill.) A. Center; AIC; N.C. State Univ. Member: AEA; Gld. of South Carolina A.; Am. Pen Women; Greenville AA (Bd. Dirs.); NAWA. Awards: "Woman of the Year in Art," Greenville, 1962; prizes, Gld. S.C. Artists, 1959, 1962; Gibbes Gal., Charleston, 1961-1963, 1967; Greenville Mus., 1958, 1960-1964, 1967, 1968; Greenville Ad Club, 1962, 1963; Asheville, N.C., Bank award, 1961; County Fair, 1964. Work: U.S. Army Air Corps: Maremounts Saco-Lowell Collection, Easley, S.C.; Greenville Mus. A.; Spartanburg Pub. Lib.; Fidelity Fed. Bank, Hendersonville, N.C.; Governor's Mansion. Exhibited: Hunter A. Gal., Chattanooga, 1961; Spring Mill Annual, Lancaster S.C., 1961-1964; Gibbes Gal., Charleston, 1961-1964, 1967; Clemson (S.C.) College, 1963; Atlanta AA, 1961, 1962; Converse College, 1963; Mint Mus. A., Charlotte, 1965; High Mus. A., Atlanta, 1968; Univ. North Carolina, 1969; NAWA, Cannes, France, 1969; London (Ont., Canada) A. Mus., 1969; La Napoule, France, 1969; Emerald Gal., Hollywood, Fla. One-man: Greenville Mus. A.; Asheville Mus. A.; Columbia Mus. A.; Atlanta Decorative Arts Center; Flat Rock Playhouse, Hendersonville; Silo Theatre, Black Mountain, N.C.; Greenville-Spartanburg Jetport; Erskine College; Peoples Nat. Bank, Greenville, and others. Des., covers, brochures and programs for Greenville A. Festival, Greenville Chamber of Commerce and American Pen Women.

COCHRAN, GEORGE MCKEE—Painter, Cart., I., W., L.
358 West 7th Ave., Eugene, Ore. 97401
B. Stilwell, Okla., Oct. 5, 1908. Member: Am. Indian A. Festival; Northwest Cart. & Gag Writers Soc.; Congress of Am. Indians; Cherokee Fnd. of Oklahoma. Awards: prizes, Oregon State Fair, 1951, 1952; American Indian A. Exh., Sheridan, Wyo., 1961; American Indian A. Festival, LaGrande, Ore., 1960, 1961. Work: Haskell Inst., Lawrence, Kans.; Truman Library, Mo.; Seattle Pub. Lib.; Oregonian, Portland, Ore.; Desert News and other newspaper colls. murals: Church of Latter Day Saints, Eugene, Ore.; work reproduced in many magazines and periodicals. Exhibited: American Indian Exh., Sheridan, Wyo.; Indian A. Festival, LaGrande, Ore.; Hotel Utah Gal.; Hollywood Park (Cal.) Gal.; Meier & Frank Gal., Portland, Ore.; Univ. of Oregon; Hollywood Municipal Gal., and in many state and county fairs. Author, I., "Indian Portraits of the Pacific Northwest," 1959. Contributor articles, cartoons and illustrations to many magazines and newspapers. Positions: Chm., Northwest Cartoonist & Gag Writers Gld.; Memb. Bd. Dirs., American Indian A. Festival.*

COES, KENT DAY—Painter, Des., I.
463 Valley Rd., Upper Montclair, N.J. 07043
B. Chicago, Ill., Feb. 14, 1910. Studied: N.Y. Univ.; Grand Central A. Sch., with George Ennis, Grant Reynard, Edmund Graecen, and others; ASL, with Frank DuMond, George Bridgman. Member: ANA; AWS; New Jersey WC Soc. (Fndr-Memb.); All. A. Am.; SC; Academic AA; Knickerbocker A.; Artists Fellowship; Montclair AA; Hudson Valley AA; Baltimore WC Cl. Awards: prizes, All. A. Am., gold medal, 1959; Academic AA, 1956, 1960; New Jersey WC Soc., 1960, 1964, 1967; Balt. WC Cl., 1958, 1965; American Artist magazine medal of honor 1957; SC, 1961, 1968; Hudson Valley AA, gold

medal, 1959. Work: Montclair A. Mus.; Univ. Pennsylvania; Univ. Wyoming; Frye Mus. A., Seattle; Norfolk Mus. A. & Sciences; Holyoke Mus. of A., Mass.; St. Vincent's Col., Latrobe, Pa. Exhibited: AWS, 1948-1969; All. A. Am., 1950-1969; Audubon A., 1950-1960; NAD, 1950, 1957, 1960-1969; Academic AA, 1953-1969; New Jersey State Exh., 1930-1964; New Jersey WC Soc. 1939-1969; Knickerbocker A., 1959-1969. Positions: Bd. Dirs., Artists Fellowship, 1960-1966; Vice-Pres., All. A. Am., 1961-1964, Dir., 1964-1966; Dir., of Publ., AWS, 1956-, Dir., 1964-.

COGGESHALL, CALVERT—Painter
969 Lexington Ave., New York, N.Y. 10021
B. Utica, N.Y., 1907. Studied: Univ. Pennsylvania; ASL, and in Europe. Work: BMFA; Union Carbide Bldg., and in private collections. Exhibited: MModA, 1951, 1956; Toledo Mus. A., 1954; one-man: Betty Parsons Gal., New York, 1951, 1952, 1955, 1957, 1961, 1965, 1967-1969.

COGSWELL, DOROTHY McINTOSH—Educator, P., L.
Mount Holyoke College; h. 23 Jewett Lane, South Hadley, Mass. 01075
B. Plymouth, Mass., Nov. 13, 1909. Studied: Yale Sch. FA, B.F.A., M.F.A. Member: Springfield A. Lg; CAA; AAMus. Awards: prizes, Eastern States Exh, 1941; Fulbright Grant for Lectureship, National A. Sch., Sydney, Australia, 1957-58. Work: Springfield A. Mus.; Newport AA; Wisteriahurst, Mt. Holyoke Mus.; mural, Mt. Holyoke Col. (2) 1961, 1963. Exhibited: WFNY, 1939; AWS, 1933, 1934, 1941; New Haven Paint & Clay Cl., 1930-1952; Conn. Acad. FA, 1937, 1940-1945; Springfield A. Lg., 1940-1954, 1968; Boston Soc. Indp. A., 1946-1960; one-man: Albany Inst. Hist. & A., 1941-1946; G.W.V. Smith Mus. A., 1946; Elmira Col., 1950, 1952; Univ. Massachusetts, 1951; Rutgers Univ., 1952; Oklahoma A. & M. Col., 1953; Nebraska State Col., 1954; Georgia Mus. A., Columbus, Ga., 1955; Portland A. Mus., 1964; Wisteriahurst, Mt. Holyoke, 1967. Lectures: Modern Painting at Sydney Univ. and Nat. A. Gal., of New South Wales, Australia; Mexican Art at Univ. of New South Wales. Positions: Instr. A., 1939-44, Asst. Prof., 1944-47, Assoc. Prof., 1947-1958, Prof., 1958-, Chm. Dept. A., 1960-, Mount Holyoke Col., South Hadley, Mass.; Chm., Mount Holyoke Friends of Art, 1948-1960.

COGSWELL, MARGARET P.—Museum Administrator
National Collection of Fine Arts, Smithsonian Institution 20560; h. 2929 Connecticut Ave., N.W., Washington, D. C. 20008
B. Evanston, Ill., Sept. 15, 1925. Studied: Wellesley Col., B.A.; Pratt Inst.; Sch. of the Art Inst. of Chicago; Columbia Univ.; ASL. Member: AAMus. Awards: Gold Medal for printmaking, American Artist magazine, 1953. Editor: The American Poster, 1968; Sao Paulo 9, 1967; The Cultural Resources of Boston, 1964; The Ideal Theater: Eight Concepts, 1963; The Armory Show—50th Anniversary Exhibition, 1963; General Editor: The American Artists Series, 1959-1963, and others. Exhibitions arranged: "Communication Through Art," 1964; "God and Man in Art," 1957; "Today's Religious Art," 1958; "The New Landscape in Art and Science," 1959; "Structural Steel in Today's Architecture," 1959; "The American Poster," 1968. Positions: Chm., 50 Books of the Year, American Institute of Graphic Arts, 1964; Trustee, Ben and Abby Grey Foundation, St. Paul, Minnesota; Committee, List Art Poster Program; Head. Dept. of Publications, American Federation of Arts, 1955-1966; Deputy Commissioner, 34th Venice Bienale, American Exhibition, 1968; Deputy Chief, International Art Program, National Collection of Fine Arts, 1966-.

COHEN, MR. and MRS. ARTHUR A.—Collectors
160 E. 70th St., New York, N.Y. 10021
Mr. Cohen—: B. New York, N.Y., June 25, 1928. Studied: Univ. of Chicago, B.A., M.A. Organizer of opening exh. of the Jewish Mus., "The Hebrew Bible in Christian, Jewish and Muslim Art," 1963. Positions: Managing editor, "The Documents of 20th Century Art," Viking Press, 1968-. Collection: Primitive and ancient arts; modern painting and sculpture.

COHEN, GEORGE—Painter, S.
c/o Feigen Gallery, 27 E. 79th St., New York, N.Y. 10021
Work: La Jolla Mus. A. Exhibited: Feigen Gal., N.Y., 1960, 1965.*

COHEN, H. GEORGE—Painter, Des., E., L.
Hillyer Bldg., Smith College; h. 15 Washington Ave., Northampton, Mass. 01060
B. Worcester, Mass., Sept. 14, 1913. Studied: WMA Sch.; Inst. Des., Chicago, and with Herbert Barnett, Kenneth Shopen. Member: Springfield A. Lg.; Soc. Cinematologists; CAA; AAUP; Am. Film Inst.; University Film Assn.; New England Screen Educ. Assn. Awards: prizes, Springfield A. Lg., 1945-1949, 1951-1958, 1960; Berkshire AA, 1959; Columbia (S.C.) Mus. A., 1957; Conn. WC Soc., 1957; Macdowell F., 1958; Wadsworth Atheneum; Westfield State Col. A. Exh. Work: Mt. Holyoke Col. Mus.; Univ. Massachusetts; de-

Cordova & Dana Mus. A.; Slater Mem. Mus., Norwich, Conn.; Loeb Center, N.Y. Univ.; Worcester A. Mus.; AGAA; Smith Col.; Chase Manhattan Bank, N.Y.; AFA; Ford Motor Co. Exhibited: NAD, 1943; AWS, 1942-1944; AIC, 1945, 1954; SFMA, 1944; Springfield A. Lg., 1942-1958, 1960, 1961; WMA, 1940, 1941, 1943, 1944, 1946, 1950; Boston Arts Festival, 1954, 1955, 1956, 1957, 1960, 1961; MMA, 1952; Provincetown AA, 1948-1955; Mt. Holyoke Col., 1954; Smith Col. Mus., 1955, 1958, 1959; Deerfield Acad., 1953, 1957 (one-man); G.W.V. Smith Mus. (one-man) 1967; AFA traveling exh., 1953-54; Ford Motor Co. traveling exh., 1952-53, 1954-55, 1955-56; Boris Mirski Gal., 1955-56, 1957 (one-man); Wadsworth Atheneum 1964 & prior; Radcliffe Grad. Center, 1958; Columbia (S.C.) Mus. A., 1957; Berkshire AA, 1959; Lyman Allyn Mus., 1960; State Univ., Potsdam, N.Y., 1960; New Haven Festival A., 1960; Inst. Contemp. A., Boston, 1961; VMFA, 1961; Angeleski Gal., N.Y., 1960 (one-man); BM, 1964; deCordova & Dana Mus., 1964, 1968; Brockton A. Mus., 1968; Amherst Col., 1968; Ward-Nasse Gal., Boston, 1966-1968, and many other exhs. Lectures: Modern Painting, Modern Art, Art of Film, Kinetic Art. Contributor to Lincoln Times; Ford Times (illus.). Positions: Instr., 1942-1946, Prof. A., 1946-1962, Prof., 1962-. Smith Col., Northampton, Mass.

COHEN, HAROLD LARRY—Educator, Des., L.
Institute for Behavioral Research, 2429 Linden Lane, Silver Spring, Md. 20902
B. Brooklyn, N.Y., May 24, 1925. Studied: PIASch.; Northwestern Univ.; Inst. Design, B.A. in Product Des. Member: F.I.A.L.; Am. Assn. for the Advancement of Science. Awards: winner of five Good Design Awards, with Davis Pratt; MModA, 1949-1953; Des. of chair selected by U.S. Govt. for traveling exh. of one hundred leading U.S. products. Lectures: "Educating the Architect"; "On Furniture"; "Creative Thinking," etc. Positions: Prof. Des., Chm., Dept. Des., Dir., Des. Research & Development Southern Illinois Univ., Carbondale, Ill.; Executive Director, Institute for Behavioral Research, Silver Spring, Md., at present.

COHEN, HY—Painter
166 West 72nd St., New York, N.Y. 10023
B. London, England, June 13, 1901. Studied: NAD; City Col. of N.Y., BS. Member: AEA (Pres. 1963-); AWS (Life memb.). Exhibited: CGA; BM; AWS; Washington Univ.; AIC; MMA; Carnegie Inst.; PAFA; CAM; Los Angeles County Mus.; WAC; NAD; Audubon A.; Drawings: U.S.A.-St. Paul and others. One-man: ACA Gal., N.Y., 1932, 1933, 1935, 1937, 1938, 1940, 1944, 1946, 1947, 1949, 1952, 1958, 1962; West Newbury, Mass. 1949-1950; Adam A. Center, 1964. Organized and moderated "Let's Talk About Art," a radio program on WNYC, weekly, 1945-1946.

COHEN, WILFRED P.—Collector, Patron
1290 Ave. of the Americas, New York, N.Y. 10019; h. 28 Nassau Dr., Great Neck, L.I., N.Y. 11021
B. New York, N.Y., Aug. 24, 1899. Studied: New York University; City College, New York. Collection: Giacometti; Arps; California Painters. Exhibited collection at Country Art Gallery, Westbury, Long Island and at Galerie Chassaing, Paris, France. Awards: National Conference of Christians and Jews, 1964.

COINER, CHARLES T.—Painter, W., L., Des.
Mechanicsville, Bucks County, Pa. 18934
B. Santa Barbara, Cal., Aug. 20, 1898. Studied: Chicago Acad. FA; AIC. Member: N.A.; A. Dirs. Cl., New York and Philadelphia; AEA; Phila. A. All. Awards: prizes, A. Dir. Cl.; Phillips Mill Exh., 1962. Work: Designer, government, civilian defense insignia and posters; Philadelphia Conservationists; Philadelphia Children's Hospital and Philadelphia Orchestra. Paintings in collection of PMA; PAFA; NAD; Davenport (Iowa) Mus.; WMAA. Exhibited: in most national open shows as well as regional exhibitions in Pennsylvania. Contributor articles to Esquire on Sporting Art.

COKE, VAN DEREN—Educator, Mus. Dir., Photographer, Cr.
Department of Art, University of New Mexico; h. 1412 Las Lomas St. N.E., Albuquerque, N.M. 87106
B. Lexington, Ky., July 4, 1921. Studied: Univ. Kentucky, A.B.; Indiana Univ., M.F.A.; Harvard Univ. Studied photography with Ansel Adams and Nicholas Haz. Member: CAA; AFA; AAMus.; George Eastman House Associates; Nat. Bd. Dirs., Soc. for Photographic Education. Awards: Major awards in U.S. Camera, Modern Photography, Popular Photography International Competitions. Art in America "New Talent USA," Creative Photography, 1960. Work: MModA; George Eastman House; Smithsonian Inst.; SFMA. Sheldon Mem. Gal., Univ. of Nebraska; AGAA; Bibliotheque Nationale, Paris, France. Exhibited: One-man: George Eastman House, Rochester, N.Y., 1956, 1961; Carl Siembab Gal., Boston, 1962; de Cordova & Dana Mus.; Louisville A. Center; Limelight Gal. and Photographer's Gal., both New York City; University galleries: Cornell, Tulane, Nebraska, Florida, Texas, Arizona State and Wesleyan; Phoenix A.

Mus., 1963; Florida State Univ., 1963; Univ. New Hampshire, 1967; Focus Gal., San Francisco, 1969. Photographic exhs.: Milan, Italy, 1960; De Cordova & Dana Mus., 1962, 1967; Paris, France, 1962; Sheldon Mem. Mus., Univ. Nebraska, 1966; MModA, 1965; N.Y. State Council on the Arts, 1966; Pratt Inst., Brooklyn, N.Y., 1969. Author: "Taos and Santa Fe the Artist's Environment 1882-1942" (publ. 1962); "Kenneth M. Adams," 1963; "Raymond Jonson," 1963; "The Painter and the Photograph," 1964; "Impressionism in America," 1965; "The Drawings of Andrew Dasburg," 1966; "Young Photographers," 1968; "John Marin in New Mexico," 1968. Contributor to: Art News Annual, 1965; Art in America; Art Journal; Infinity; Aperture and other photographic publications. Lectures: "The Art of New Mexico," Univ. Nebraska; "Meaning in Contemporary Photography," Univ. Arizona; "The Influence of Painting on Photography," Brandeis Univ.; "The Use of Brady's Photographs by 19th Century Portrait Painters," George Eastman House; Arranged exhibitions: Art Since 1889; Impressionism in America; The Painter and the Photograph; Taos and Santa Fe the Artist's Environment: 1882-1942. Positions: Instr., Creative Photography, 19th & 20th Century Art History, Sculpture: Indiana Univ., Univ. Florida, Arizona State Univ., Univ. of New Mexico; Asst. Prof., Univ. Florida; Assoc. Prof., Arizona State Univ.; Chm., Dept. Art Univ. of New Mexico, Albuquerque, N.M., at present.

COLBY, VICTOR—Educator, S.
The Foundry, Cornell University, Ithaca, N.Y.; h. R.D. No. 1, Groton, N.Y. 13073
B. Frankfort, Ind., Jan. 5, 1917. Studied: Corcoran Sch. A., with Robert Laurent; Indiana Univ., A.B.; Cornell Univ., M.F.A., with Kenneth Washburn. Awards: prize, Munson-Williams-Proctor Inst., 1961. Work: Munson-Williams-Proctor Inst.; Phillips Hall, Cornell Univ.; St. Lawrence Univ., Canton, N.Y.; sculpture for Wilson Synchroton Laboratory, Cornell Univ.; State Univ. College, Cortland, N.Y. Exhibited: Central N.Y. Artist, 1950-1961; Allan Stone Gal., N.Y., 1964; PVI Gal., N.Y., 1965; Syracuse Univ., 1967 (2); Mus. Contemp. Crafts, N.Y., 1967; Ithaca Col., N.Y., 1968; Smithsonian Inst. traveling exh., 1968; one-man: Hewitt Gal., 1958; Cornell Univ., 1952, 1958, 1963, 1967; Roberson Mem., Binghampton, N.Y., 1963; State Univ. College, Cortland, N.Y., 1964; Elmira (N.Y.) College, 1965; Munson-Williams-Proctor Inst., 1957; Oneonta State T. Col., 1960; The Contemporaries Gal., N.Y., 1966; St. Lawrence Univ., Canton, N.Y., 1968. Positions: Prof. Sculpture, Cornell Univ., Ithaca, N.Y.; Actg. Chm., Dept. A., Cornell Univ., 1964.

COLE, ALPHAEUS P.—Painter, I., T., Des., W.
222 W. 23rd St., New York, N.Y. 10011; s. R.F.D., Beaver Brook Rd., Old Lyme, Conn. 06371
B. Hoboken, N.J., July 12, 1876. Studied: Julien Acad., Paris; Ecole des Beaux-Arts, Paris, and with Benjamin Constant, Jean Paul Laurens. Member: NA; SC; NAC; Lyme (Conn.) AA; All. A. Am.; Hudson Valley AA. Awards: prizes, SC, 1943, 1969 (2); NAC, 1934, 1937, 1939; med., AAPL, 1934; Conn. Acad. FA, 1920; Montclair Soc. A., 1934; Hudson Valley AA, 1956-1958, 1967; All. A. Am., 1966. Work: Nat. Port. Gal., London; BM; Univ. Virginia; Univ. Alabama; Fordham Univ. Law Sch.; Univ. Col., London, England; Museum of Art, Newcastle-on-Tyne, England. Exhibited: Paris Salon, 1900, 1901, 1903; Royal Acad., London, 1904-1910; NAD, 1910-1919, 1953-1955; AWS, 1953-1955 and prior; All. A. Am., 1953-1961; Hudson Valley AA, 1953-1961; Old-Lyme AA; NAC, 1953-1960; SC, 1953-1955; San Diego, Cal. Co-author (with Margaret Cole) "Timothy Cole, Wood Engraver."

COLE, SYLVAN, JR.—Art Dealer and Administrator, Writer
Associated American Artists, 663 Fifth Ave., 10022; h. 1112 Park Ave., New York, N.Y. 10028
B. New York, N.Y., Jan. 10, 1918. Studied: Cornell University, B.A. Specialty of Gallery: Original Etchings, Lithographs and Woodcuts. Author: "Raphael Soyer, Fifty Years of Printmaking," 1967. Positions: Member: Print Council of America, 1958- ; Art Museum Associates, Andrew Dickson White Museum, Cornell University; Advisory Committee, Pratt Center for Contemporary Printmaking, 1964- ; Art Dealers Association of America, 1963- ; Board of Directors, 1966- ; Vice-President, 1968- ; Associated American Artists, 1946- , President and Director, 1958- .

COLE, THOMAS CASILEAR—Painter, L., E., I.
939 Eighth Ave., New York, N.Y. 10019
B. Staatsburgh, N.Y., July 23, 1888. Studied: Harvard Univ.; BMFA Sch., with Philip Hale, Frank W. Benson, and Edmond C. Tarbell; Julian Acad., Paris, with Laurens. Member: Rockport AA; Am. Veterans Soc. A. Work: Fed. Court, N.Y.; Vt. State Capitol; N.Y. Bar Assn.; Brooklyn Pub. Lib.; Battle Abbey Mus., Richmond, Va.; U.S. Naval Acad.; Queens Pub. Lib., L.I., N.Y.; Mass. Supreme Court; L.I. Col. Hospital; Duke Univ.; Tennessee Supreme Court; Butler Inst. Am. A.; Hispanic Soc. Am., N.Y.; N.Y. Hist. Soc.; Tenn. Hist.

Soc., Nashville; Genealogical & Biographical Soc., N.Y.; Newton Theological Seminary, Mass.; Long Island Col. Hospital; Brooklyn 9th Reg. Armory; Cornell Med. Col., N.Y.; Kings County Medical Soc., N.Y., etc. Exhibited: NAD; PAFA; BMFA; AIC; SFMA; Albright A. Gal.; All. A. Am.; Paris Salon, 1923; Knoedler Gal. (one-man). Lectures on art. Illus.: "Gunston Hall." Positions: Former Instr. port. painting, Phoenix Sch. A., Traphagen Sch. A., Sch. F. & Indst. A., all New York, N.Y.

COLESCOTT, WARRINGTON—Painter, E.
Art Dept., University of Wisconsin, Madison, Wis. 53706
B. Oakland, Cal., Mar. 7, 1921. Studied: Univ. California, A.B., M.A.; Grande Chaumiere, Paris, France; Slade School of Art, London, England. Awards: Fulbright Fellow, Slade Sch. A., London, England, 1957; Guggenheim Fellow, 1965-1966; prizes, Wisconsin Salon, 1949, 1951, 1955, 1960, 1962-1964; Am. Color Print Soc., 1951, 1952, 1956, 1964; Wisconsin State Fair, 1958-1960; Wisconsin P. & S., 1960; SAGA, 1963, purchase, 1964; purchase prizes: BM, 1955; LC, 1960; North Dakota Pr. M., 1961, 1963; Oklahoma Pr. M., 1961, 1964, 1968. Work: Univ. Wisconsin; N.Y. Pub. Lib.; USIS; MMA; MModA.; Univ. Nebraska; Smith Col.; BM; NGA; CMA. Exhibited: PAFA, 1950, 1952, 1959, 1960, 1964; WAC, 1949, 1953, 1957, 1959; BM, 1953, 1957, 1969; Am. Color Pr. Soc., 1953-1969; WMAA, 1954, 1956, 1957; Silvermine Gld. A., 1957, 1960; Am. Pr. Council, 1959; PMA. Positions: Prof., Dept. of A., University of Wisconsin, Madison, Wis.

COLETTI, JOSEPH ARTHUR—Sculptor, L., W.
Fenway Studios, 30 Ipswich St., Boston, Mass. 02115
B. San Donato, Italy, Nov. 5, 1898. Studied: Harvard Univ., A.A.; Am. Acad. in Rome, and with John Singer Sargent. Member: F., NSS; Mass. State A. Comm.; North Shore AA; Medieval Acad. Am.; Arts Center Comm., Univ. Virginia; Boston Hist. Conservation Comm.; Trustee, New England Conservatory of Music. Awards: Traveling scholarship, FMA, 1923, 1924-1925; F., Harvard Univ.; med., Boston Tercentenary FA Exh., 1932; hon. Phi Beta Kappa, Harvard Univ., 1948; Henry Hering medal, NSS, for sculpture on Baltimore Cathedral; decorated: Cavaliere Ufficiale "nell' Ordine al Merito della Repubblica Italiana." Work: FMA; Lyman Allyn Mus.; Brookgreen Gardens, S.C.; Gagnon Mem., Quebec, Canada; Quincy (Mass.) Pub. Lib.; Harvard Glee Club medal; Deedy Mem., Mass. State House; Gagnon Mem., Lafayette Park, Manchester, N.H.; Washburn Mem., Cambridge, Mass.; font, St. John's Episcopal Church, Westwood, Mass.; Lt. William Callahan Mem., Callahan Tunnel, Boston; Paderewski Medallion, Cathedral of Wavel Castle, Cracow, Poland; St. Theresa of Avila statue, Washington Cathedral; Lafayette Park, Salem, Mass.; sculpture on Facade and 11 panels for interior of Cathedral of the Assumption, Balt., Md.; Boston A. Festival medal; Nat. Gal. Contemp. A., Florence, Italy; Sen. Walsh statue, Esplanade, Boston; Gen. Logan statue, Logan Airport, East Boston; Father McGivney statue, Waterbury, Conn.; Bibliotheque Nationale, Paris, France; Vatican Library, Rome; Orpheus fountain, Atrium, Lowell (Mass.) State Col. Music Bldg.; two panels facade, Harvard Grad. Sch. of Bus. Admin. Exhibited: Cal. PLH, 1929; PAFA, 1929-1931; MModA, 1933; WFNY 1939; PMA, 1939; MMA, 1942; WMAA, 1940; FMA, 1928 (one-man); Boston Inst. Mod. A., 1940-1942; Audubon A., 1946. Lectures: Contemporary Sculpture. Author: Foreword to catalog "Maillol," Inst. of Modern Art, Boston; Articles on "Sculpture Techniques"; "Stone Carving"; "Stone-Carving Tools," Encyclopedia Britannica. Article: "Government and the Arts: a Program," in Boston Forum, 1966. Biography by Alan Priest, "The Sculpture of Joseph Coletti," 1968. Positions: Chm., Massachusetts State Art Commission, 1961-1966.

COLIN, GEORGIA TALMEY (Mrs. Ralph F.)—
Collector, Interior Designer
22 E. 66th St., 10021; h. 941 Park Ave., New York, N.Y. 10028
B. Boston, Mass. Studied: Smith College; Univ. of Grenoble; Sorbonne. Member: AIID; Nat. Soc. of Interior Designers. Collection: Mainly School of Paris painting and sculpture of the first forty years of the twentieth century with some later American and European painting and sculpture. Positions: Pres., Talmey, Inc.—Interior Designers, New York, N.Y., 1928- ; Member of Visiting Committee to the Department of Fine Arts, Smith College, 1952- ; Chm. of Committee, 1954-1957.

COLIN, RALPH F.—Collector
575 Madison Ave. 10022; h. 941 Park Ave., New York, N.Y. 10028
B. New York, N.Y., Nov. 18, 1900. Studied: College of the City of New York, B.A.; Columbia University Law School, LL.B. Collection: Mainly School of Paris painting and sculpture of the first forty years of the twentieth century with some later American and European painting and sculpture. Positions: Trustee, The Museum of Modern Art, 1954- , Vice-Pres., 1963- ; Founder, Administrative Vice-President and General Counsel, Art Dealers Association of America,

Inc. 1962- ; Trustee and Vice-Chairman, The International Council of the Museum of Modern Art, 1956- ; Trustee, The American Federation of Arts, 1946-1956; Member, Visiting Committee for the Department of Fine Arts and the Fogg Museum, Harvard University, 1951- ; Member, Advisory Committee on the Arts Center Program, Columbia University; Director and Trustee, The Philharmonic Symphony Society of New York, Inc., 1942-1956, Vice-President, 1951-1956; Director, The Provincetown Theatre and the Greenwich Village Theatre in the early 1920's with Eugene O'Neill, Robert Edmond Jones, Kenneth MacGowan, etc.; Director, Parke-Bernet Galleries, Inc., 1959-1964; Organizer and Administrative Vice-President of Art Dealers Association of America, Inc., 1962- .

COLKER, ED.—Painter, Gr., E.
 R. D. #1, Hampton, N.J. 08827
B. Philadelphia, Pa.; Jan. 5, 1927. Studied: Philadelphia Col. A. (Grad.); N.Y. Univ. (Grad.). Member: CAA; AIGA; Pr. Council of America. Awards: Guggenheim Fellow, 1961; Rosenwald prize, 1963, Philadelphia; New Jersey State Mus., prizes, 1967, 1969. Work: Portfolio works and graphics—MModA; PMA; Nat. Mus., Stockholm; N.Y. Public Library; New Jersey State Mus. Commissions: Editions for Int. Graphic A. Soc., 1966, 1969. Exhibited: Smithsonian Inst., 1966; "Stampe de due Mundi," Rome-U.S.A., 1967; PAFA, 1968; New Jersey State Mus., 1967-1969. One-man: Amel Gal., N.Y., 1964; East Hampton Gal., N.Y., 1969. Positions: Instr., Drawing, Graphics, Philadelphia Col. A.; Visual Communication, Cooper Union, N.Y.; Assoc. Prof. FA, Grad. Sch. FA, Univ. Pennsylvania, at present.

COLLINS, GEORGE R.—Scholar, Writer
 Department of Art History, Columbia University, 10027; h. 448 Riverside Dr., New York, N.Y., 10027
B. Springfield, Mass., Sept. 2, 1917. Studied: Princeton Univ., B.A., M.F.A. Award: Guggenheim Fellowship, 1962-1963. Field of Research: Modern Architecture and City Planning; Spanish Art. Works Published: "Antonio Gaudi" N.Y. 1960, Milan, 1960, Barcelona, 1961, Ravensburg, Germany, 1962; (with wife, Christiane C. Collins), "Architecture of Fantasy" (translation and revision of "Phantastische Architektur"), 1960; Camillo Sitte, "City Planning According to Artistic Principles" (translation), New York & London, 1965; "Camillo Sitte and the Birth of Modern City Planning," New York & London, 1965. (With Carlos Flores): "Arturo Soria y la Ciudad Lineal," Madrid & Milan, 1968; numerous articles in journals. Positions: Prof. Art History, Columbia University, New York, N.Y., at present. Visiting Scholar in Modern City Planning, Vassar College, Fall, 1967; General Editor, Cities & Planning Series, N.Y.

COLLINS, KREIGH—Illustrator
 Ada, Mich. 49301
B. Davenport, Iowa, Jan. 1, 1908. Studied: Cincinnati A. Acad.; Cleveland A. Sch. Work: murals, East Grand Rapids H.S., Ottawa Hills H.S., East Congregational Church, all in Grand Rapids, Mich.; portraits and landscapes in private collections. Murals in city auditorium at Newberry, Mich. Exhibited: Grand Rapids A. Gal., 1930, 1933. I., "Marconi," 1943; "Perilous Island," 1942; "World History," 1946; & others. Creator Sunday feature, "Up Anchor!" Author, I., "Tricks, Toys and Tim," 1934; "Christopher Columbus," 1958; "David Livingstone," 1961. Many teaching pictures for publishers. Regular contributor of articles and illus. to "Yachting." Illustrations regularly for Methodist Publ. House, Southern Baptist Convention; "Motor Boating," and "Lakeland Boating."

COLLINS, LOWELL DAUNT—Painter, E., L., Gr., S., I.
 2903 Saint St.; h. 3825 Meadow Lake, Houston, Tex. 17027
B. San Antonio, Tex., Aug. 12, 1924. Studied: Mus. FA Sch., Houston, with Ruth Uhler, Robert Preusser; Colorado Springs FA Center, with Boardman Robinson; ASL, with Harry Sternberg; Univ. Houston, B.F.A., M.L. Awards: prizes, Texas FA Assn., 1948; Houston A. Exh., 1952, 1957 (purchase); Feldman A. Exh., Dallas, 1956; Easter A. Exh., Houston, 1954, 1957; Southwestern Prints & Drawings, 1961 purchase prize, Texas P. & S. Exh., San Antonio, 1962. Work: U.S. Information Service; Nelson Fnd.; Mus. FA of Houston. Exhibited: New Zealand Exchange Exh., 1948; Houston Int. Exh., 1956; AFA exh., Dallas, 1948, 1957; Knoedler Gal., 1952; Downtown Gal., 1952; Nat. WC Exh., Jackson, Miss., 1956, 1959; Columbia Biennial, 1957; Provincetown A. Festival, 1958; Houston A. Exh., 1947-1960; Texas FA Assn., 1948, 1949, 1957; D. D. Feldman Exh., 1956, 1958; Texas Print & Drawing, Dallas, 1957; Texas WC, Dallas, 1957; Texas Painting & Sc., 1958; Columbia, S.C., 1959; Texas Pavilion, New York Worlds Fair, 1964; Denver A. Mus., 1959; New Orleans AA, 1959, 1960; Northwest Pr. M., 1961; Hemisfair, San Antonio, Tex., 1968; Am. Soc. Appraisers, 1969; one-man: Mus. of FA, Houston, 1952; Cushman Gal., Houston, 1958; Austin, Tex., 1961; Beaumont Mus. A., 1965. Illus., "Houston: Land of the Big Rich," 1951; "Galveston Era," 1961; "Houston: The Feast Years," 1963; "The Unhappy Medium," 1965. Positions: Instr., Drawing & Painting, Mus.

FA Houston; Des. & Painting, Univ. Houston; Dean, A. Sch., Mus. FA, Houston, Tex.; Dir., Lowell Collins Sch. of A., Houston, Tex., 1966.

COLLINS, WILLIAM C.—Painter, T.
 Washington University, School of Fine Arts, St. Louis, Mo. 63130; h. 304 Edgewood Dr., Clayton, Mo. 63105
B. Cambridge, Mass., Jan. 18, 1925. Studied: Rhode Island Sch. Des., Providence, B.F.A.; Univ. Illinois, Urbana, M.F.A. Awards: Fulbright Grant, 1957-1959; Morton D. May purchase prize, CAM, 1956; prize, Interior Valley Exh., Cincinnati, 1961. Work: Mural, St. Johns Unitarian Church, Cincinnati, 1961. Exhibited: WMAA, 1964; Butler Inst. Am. A., 1960-1963; Albright-Knox A. Gal., Buffalo, 1952, 1953; Rhode Island Sch. of Des., A. Mus., 1948, 1949; Univ. Illinois, 1950, 1951; CAM; Nelson Gal., Kansas City; Amerika Haus, Munich, Germany, 1958; CM, 1960-1965; Dayton AI, 1960, 1964; one-man: Flair Gal., Cincinnati, 1967; Miami Univ., Oxford, Ohio, 1968. Positions: Instr., Drawing, Albright A. Sch., Buffalo, 1951-1953; Drawing and Painting, Washington Univ., St. Louis, 1955-1957; Drawing and Painting, Cincinnati A. Acad., 1959-1967; Visiting Prof. FA, Grad. Painting Program, Washington Univ., St. Louis, Mo., 1967-1969.

COLSON, CHESTER E.—Painter, E.
 Wilkes College, Wilkes Barre, Pa.; h. 538 Meadowland Ave., Kingston, Pa. 18704
B. Boston, Mass., June 17, 1917. Studied: Massachusetts Sch. A., B.S.; Columbia Univ., M.A.; and with Charles Curtis Allen. Member: Phila. WC Cl.; NAEA; Eastern AA; Wyoming Valley A. Lg., CAA; Pa. A. Educ. Assn. Awards: prizes, Royal House Hist. Soc., 1943; Alabama traveling exh., 1953; Champlain Valley, Vt., 1948; Hazleton, Pa. regional shows, 1959, Sordoni Prize, 1962. Work: Wilkes College, Wilkes Barre, Pa.; Everhart Mus., Scranton, Pa. Exhibited: Phila. WC Cl., 1964; Nat. Soc. Painters in Casein, N.Y., 1964, 1968; one-man: Everhart Mus., Scranton, Pa., 1966; Hazleton, Pa. A. Lg., 1967; Bucknell Univ., 1967. Positions: Prof. A., Chicago Teachers College, Meredith College, Raleigh, N.C.; Prof. A. and Chairman A. Dept., Wilkes College, Wilkes Barre, Pa., at present.

COLT, JOHN N.—Painter, E.
 Art Department, University of Wisconsin; h. 2224 E. Ivanhoe Pl., Milwaukee, Wis. 53202
B. Madison, Wis., May 15, 1925. Studied: Univ. Wisconsin, B.S., M.S. Awards: more than 40 prizes including Milwaukee A. Center, Medal of Honor, 1959; Ford Fnd. Award, WAC, 1962, 1964. Work: WMAA; Milwaukee A. Center; Le Centre d'Art, Port-au-Prince, Haiti; Grand Rapids A. Mus.; Ball State T. Col., Muncie, Ind.; Marquette Univ.; Univ. Wisconsin; Milton Col.; Beloit Col. Mural, Teatro Maria, Marquette Univ.; Subject of film "Passages, the Paintings of John Colt," produced by Milwaukee A. Center TV, 1967. Exhibited: LC, 1950; WMAA, 1958; WAC, 1962, 1964; PAFA, 1965; AIC; Denver A. Mus.; Wisconsin P. & S., 1950-1965; one-man: Milwaukee A. Center, 1969; Minneapolis Inst. A., 1969. Positions: Prof. A., Layton A. Sch., Univ. Saskatchewan, Ball State T. Col., Univ. So. California. Prof. A., University of Wisconsin, Milwaukee, Wis. at present.

COLT, PRISCILLA C.—Museum Curator, W., L.
 330 West Schantz Ave., Dayton, Ohio 45419
B. Kalamazoo, Mich., Oct. 15, 1917. Studied: Kalamazoo Col., A.B.; Western Reserve Univ., M.A.; Harvard Univ., Inst. FA, New York Univ. Lectures: European and American Painting & Sculpture. Contributor articles to Art Journal and Art International, 1964-65. Arranged special exhibitions and conducted research on collections, Portland A. Mus. Positions: Asst., Junior Mus., MMA, 1943-44; Asst. & Cur., Edu., VMFA, 1944-1947; Ed., Cur., Minneapolis Inst. A., 1948-49; Research Asst., Portland A. Mus., Portland, Ore., 1949-56. Instr., History of Art and Art Theory, School of the Dayton Art Institute, Dayton, Ohio, 1958-1969; Consultant, Contemporary Art, Dayton A. Inst., 1967- .

COLT, THOMAS C., JR.—Museum Director
 Dayton Art Institute 45405; h. 330 West Schantz Ave., Dayton, Ohio 45419
B. Orange, N.J., Feb. 20, 1905. Studied: Dartmouth Col., B.S.; Columbia Univ.; Cambridge, England. Member: AAMus.; Assn. Art Mus. Dir.; Am. Soc. for Aesthetics. Ed., "C.S. Price, 1874-1950"; "Prehistoric Stone Sculpture of the Pacific Northwest"; "Samuel H. Kress Collection of Paintings of the Renaissance," "Fifty Treasures of the Dayton Art Institute," and others. Award: Star of Solidarity, Italian Govt., 1953. Positions: Dir., VMFA, Richmond, Va., 1935-42; Armed Forces, 1942-45; Resumed Directorship, VMFA, 1945-48; Dir., Portland (Ore.) A. Mus., 1948-56; Dir. Dayton Art Institute, Dayton, Ohio, 1957- ; Pres., Intermuseum Conservation Assn., 1968- .

CONANT, HOWARD S.—Educator, W., L., P.
New York University, New York, N.Y.; h. 81 Stony Run, New Rochelle, N.Y. 10804
B. Beloit, Wis., May 5, 1921. Studied: Univ. Wisconsin, Milwaukee, B.S. in Edu.; ASL, with Yasuo Kuniyoshi; Univ. Wisconsin, Madison, M.S. in A. Edu.; Univ. Buffalo, Ed. D. Member: Institute for the Study of Art in Education (Pres., 1966-1968, Member, Board of Governors, 1968-); NAEA; Eastern AA; N.Y. State A.T. Assn. Awards: Distinguished Alumnus Award, University of Wisconsin-Milwaukee, 1968; 25th Anniversary Medal and Stipend for Distinguished Service to Education in Art, National Gallery of Art, Washington, D.C., 1966. Exhibited: Milwaukee AI, 1943, 1946, 1947, 1951; Layton A. Gal., 1945; NAD, 1946; SFMA, 1946; Albany Inst. Hist. & A., 1947; Hofstra Col., 1949; Ithaca (N.Y.) AA, 1950; State Univ. of N.Y. traveling exh., 1951-52, 1954-55; one-man: International Gal., Wash., D.C., 1945, 1946; Alexandria Pub. Lib., 1946; Wash., D.C. Pub. Lib., 1946; New-Age Gal., 1948; Junior League, Buffalo, 1955; College Union, Buffalo, 1955. Author: "Art as the Communication of Human Values" (Chap. 6, 1953 Yearbook) of NAEA; "Art in Education" (With Arne Randall), 1959 (revised 1963); "Masterpieces of the Arts," New Wonder World Encyclopedia, Parents Magazine, 1959; "Art Workshop Leaders Planning Guide," 1959; "Art Education," Center for Applied Research in Education, Wash., D.C., 1964; "Seminar on Elementary and Secondary School Education in the Visual Arts" N.Y. Univ., 1965 (report of U.S. Office of Education research project). Contributor of articles to art and educational publications. Lectures: Moderator of TV program "Fun to Learn" series, 1951-55, Color telecast on Modern Art, 1955; Author of Foreword, "Discovering Art" series, 1969-1970. Consultant & program participant, to NBC—TV and Girl Scouts of America; "Adventuring in the Hand Arts," 1958-59; Panelist, "Modern Art," on Invitation to Art, NBC—TV, 1961. Positions: Chm., Dept. A. Edu., Hd., Div. of Creative Arts, N.Y. Univ., 1955; Chm., N.Y.U. Art Collection Committee.

CONDIT, (ELEANOR) LOUISE (Mrs. Frederic G. M. Lange)—
Museum Supervisor
Metropolitan Museum of Art, Fifth Ave. & 82nd St., New York, N.Y. 10028; h. 1203 Emerson Ave., Teaneck, N.J. 07666
B. Baltimore, Md., May 7, 1914. Studied: Vassar Col., A.B.; Columbia Univ., M.A. Member: AAMus.; N.Y. Film Council; Councillor, AAMus., 1957-1963, Vice-Pres., 1960-1963; Incorporator, Bergen Community Mus., 1956; AIA; ICOM; Mus. Council of N.Y. (Sec.-Treas., 1960-1964). Awards: Carnegie Grant, 1939. Author: "Paul Revere," Metropolitan Museum Picture Book, 1944 and articles in professional journals. Positions: Supv. Edu., Brooklyn Children's Mus., 1935-42; Supv., The Junior Museum, MMA, New York, N.Y., 1943- , Asst. Dean, in charge of the Junior Mus., 1961-1967, Assoc. Dean, 1968- .

CONE, JANE HARRISON (Mrs.)—Critic
The Fogg Art Museum, Harvard University 02138;
h. 12 Arnold Circle, Cambridge, Mass. 02139
B. Essex, England, Oct. 1, 1939. Studied: Harvard Univ., M.A. in Fine Arts. Arranged Exhibition: "David Smith, 1906-1965" and compiled catalogue, Fogg Museum of Art. Positions: Critic, Arts Review, London, 1961-1962; London Correspondent for Arts magazine, 1962-1963; Contributing Editor, Arts magazine, 1963-1964; Contributing Editor, Artforum, 1967- . Freelance work: Articles for Art International.

CONGDON, WILLIAM—Painter
c/o Betty Parsons Gallery, 24 West 57th St., New York, N.Y. 10019; also, Galleria Cadario, via Spiga 7, Milan, Italy; h. Subiaco (Rome), Italy
B. Providence, R.I., Apr. 15, 1912. Studied: Yale Univ., B.A.; Demetrios Sch. Sc.; Cape Sch. A., with Henry Hensche; PAFA. Awards: Temple gold med., PAFA, 1951; prizes, R.I. Mus. A., 1949, 1950; CGA, 1953; Univ. Illinois, 1952 (purchase); gold medal, Sacred Art Exh., Trieste, 1961. Work: CAM; Univ. Illinois; Detroit Inst. A.; R.I. Mus. A.; BMFA; PC; AGAA; Wadsworth Atheneum; Rochester Mem. Mus.; Iowa State T. Col.; MModA; WMAA; MMA; Toledo Mus. A.; Mus. Mod. A., Venice; Carnegie Inst.; Mus. Contemp. A., Houston; Peggy Guggenheim Mus., Venice. Exhibited: NAD, 1939; PAFA, 1937-39, 1950-53, 1956, 1958, 1960; Carnegie Inst., 1940, 1952, 1958; WMAA, 1941, 1951, 1952, 1955, 1956, 1958; R.I. Mus. A., 1948, 1949; AGAA, 1941; AIC, 1952; Toledo Mus. A., 1952; Albright A. Gal., 1952; CAL.PLH, 1952; Contemp. A., Boston, 1951; Univ. Michigan, 1951; Univ. Illinois, 1952; Los A. Mus. A., 1951; Venice Biennale, 1952, 1958; MMA, 1950, 1953; Wildenstein Gal., 1952; Hallmark Comp., 1955; Betty Parsons Gal., N.Y., 1962-1964; one-man: Betty Parsons Gal., 1949, 1950, 1952-1954, 1956, 1959, 1962-1964, 1967; Margaret Brown Gal., 1951, 1956; Duncan Phillips Gal., 1952; Contemp. A., 1951; Chicago A. Cl., 1954; Obelisco Gal., Rome, Italy, 1954, 1958; Denver A. Mus., 1957; Mich. State Univ., 1959; Tokyo, 1952; Peggy Guggenheim Mus., Venice, 1957; Pro-Civitate, Assisi, Italy, 1961; Arthur Jeffres Gal., London, 1958; Palazzo Reale, Milan,

1962; William Congdon traveling exhibit in USA, 1964-1965; Vatican Pavilion, N.Y. Worlds Fair, 1964-1965; Rhode Island Mus. A., 1965; Cambridge Univ., England, 1967; Galleria Cadario, Milan, 1969. Lecture: "Artist in Search of his Origin," Coe Col., Cedar Rapids, Iowa, 1964. Contributor of articles to Italian magazines "Ovest," "Botteghe Oscure." Illus. for Life magazine and others. Author: "In My Disc of Gold," 1962; "Congdon," 1969.

CONNAWAY, INA (Mrs. Charles E.)—Painter, S., Gr., E.
308 S. St. Asaph St., Alexandria, Va. 22314
B. Cleburne, Tex., Dec. 27, 1929. Studied: Baylor Univ.; Famous Artist Course; Univ. Alaska; George Washington Univ.; Corcoran Art Sch. Member: AAPL; Nat. Soc. A. & Lets.; Int. Platform Assn. Awards: prizes, Beaux Arts Ball, 1963, Artist of the Month (Alaska A. Gld.), 1963, American Art Week, 1963, all Anchorage, Alaska; Alaska State Fair, Palmer, Alaska, 1964. Work: Alaska State Museum; John F Kennedy Elem. Sch., Ft. Richardson, Alaska; Chateau, Elemendorf AFB, Alaska; P. E. Wallace Sr. High Sch., Mt. Pleasant, Texas; Cora Kelly Elem. Sch., Alexandria, Va.; Christ Church, Alexandria, Va.; many portraits in public and private collections. Exhibited: West Point (N.Y.) Mus., 1961; Fort Leavenworth Post Art Exh., 1961; Alaska Fur Rendezvous Exh , Anchorage, 1963, 1964; Alaska State Fair, Palmer, 1963; Loussac Library Portrait Exh., Anchorage, 1963; Alaska Festival of Music Art Exh., 1963, 1964; Am. Art Week, Anchorage, 1964; Alaskan Arts & Crafts, Juneau, 1964; Alaskan Artists, Fairbanks, 1964; AAPL, N.Y., 1966; Austrian Exh., State Dept., Wash., D.C., 1967; Fairfax County Cultural Assn., 1967; Christ Church, 1968; Fisher Gal., Wash., D.C., 1968, 1969; Int. Platform Assn., Wash., D.C., 1967, 1968; Episcopal Church, Fredericksburg, Va., 1967; Lynn Kottler Gal., N.Y., 1966, 1968, 1969; one-man; Anchor Gal., 1963, Westward Hotel, 1965, both Anchorage; Hotel Baranof, Juneau, 1963; Officers Wives Club, Fort Richardson, Alaska, 1964; Lynn Kottler Gal., N.Y., 1966

CONNAWAY, JAY HALL—Painter, T., L.
Pawlet, Vt. 05761
B. Liberty, Ind., Nov. 27, 1893. Studied: ASL, with Bridgman, Chase, Julien Acad., Paris, with Laurens, NAD; Ecole des Beaux-Arts, Paris. Member: NA; All. A. Am.; SC; NAC; Audubon A.; CAA; Meriden A. & Crafts. Awards: prizes, Hoosier Salon, 1926, 1947; Ogunquit A. Center, 1949; Meriden A. & Crafts, 1950; NAD, 1926; NAC, 1928; New Haven Paint & Clay Cl., 1944; All. A. Am., 1945; Boothbay Harbor, Me., 1947; North Shore AA, 1959; So. Vermont A. Center, 1962; Cracker Barrel Bazaar, Newbury, Vt., 1964. Work: John Herron AI; Sweat Mus. A.; BMFA; Canajoharie A. Mus.; Springville (Utah) A. Gal.; Charleston AA; BMFA; New Haven Paint & Clay Cl.; Farnsworth Mus.; So. Vermont A.; Cal. PLH; White Mus.; Cornell Univ.; Indiana Univ.; South Vermont A. Center, Manchester; Kennedy Gal., N.Y. Exhibited: CGA; PAFA, 1926-1943; NAD, 1924-1946; AIC, 1928-1946; Toledo Mus. A., 1937; Clearwater, Fla., 1939, 1940; All. A. Am.; Albright A. Gal.; Macbeth Gal.; Grand Central A. Gal.; Colby Col., 1965; AFA traveling exh., 1964-1966; one-man: Macbeth Gal., 1926-1940; Milch Gal., 1929, 1941, 1944, 1949; Vose Gal., Boston 1940, 1948; Doll & Richards Gal., 1948, 1949, 1951, 1953, 1954, 1957, 1960; Oberlin Col., 1939; Dayton AI, 1939; John Herron AI, 1939, 1965; Currier Gal. A.; Montclair A. Mus., 1946; Manchester, Vt., 1951, 1952; So. Vermont A., 1953-1957; Cayuga Mus. A., 1955; Utica Pub. Lib., 1955; Westerly, R.I., 1956; Kennedy Gal., N.Y., 1957, 1962; Wiley Gal., Hartford, 1959; So. Vermont A. Center, 1961; Galaxy Gal., Phoenix, Ariz., 1963; Long Gal., Houston, 1963; Marlboro Col., Vt., 1965; "Connaway Retrospective Exh. 1903-1968," N.Y. State Univ. Mus. at Binghamton, 1969, and many others, Lectures & demonstrations: Techniques and Art History at museums and art centers. Positions: Trustee, Southern Vt. A. Center, 1954- .

CONNER, BRUCE—Illustrator
c/o Foss, 77 Carl St., San Francisco, Cal. 94117
B. Pyramid Lake, Nev., Nov. 18, 1938. Work: MModA; AGAA; WMA; SFMA; Los A. Mus. A.; Pasadena A. Mus.; Rose A. Mus., Brandeis Univ., and others.*

CONNERY, RUTH (McGRATH)—Painter, T.
141 Beacon Lane, Jupiter Inlet Colony, Jupiter, Fla. 33458
B. New York, N.Y. Mar. 2, 1916. Studied: Mills Col.; ASL with Frank Du Mond, William Von Schlegell, Boris Lubin. Member: ex-officer NAWA; Norton Gallery at West Palm Beach; New Rochelle A.A. Awards: prizes, New Rochelle A.A., 1954, 1955; Larchmont A.A., 1954; Hudson River Museum, 1960. Work: numerous private collections; Henry Bruckner High School, Bronx, N.Y.; First National Bank of Rye. Exhibited: NGA, 1951; NAWA, 1952-1968; NAD; Int. Woman's exhibit at Cannes, 1966; Anne Ross Gal., White Plains, N.Y.; Forley & Wren Gal., N.Y., 1966 (one-man show); Lever Bros. Gal., Lever Bros. Bldg.; Argent Gal., 1960; Pen & Brush Cl.; Contemporary Art Gal., 1957; Jersey City Museum 1960-1961; Brandeis Exh., at County Center, White Plains, N.Y. Positions: Instruc-

tor in Art in Adult Education program offered by County of Westchester, N.Y., and in a similar program of West Palm Beach as instructor in Techniques in Contemporary Art 1969.

CONNOLLY, JEROME—Painter, I.
55 Cambridge Rd., Stamford, Conn. 06902
B. Minneapolis, Minn., Jan. 14, 1931. Studied: Univ. Minnesota, B.S. in A. Edu. Member: Soc. of Animal Artists. Awards: Delta Phi Delta annual award, 1955. Work: Exhibits and backgrounds: Smithsonian Inst.; Pennsylvanis State Mus.; Illinois State Mus.; Buffalo Mus. Science; and in Junior Museums of Corpus Christi, Tex., Morristown, N.J., Tallahassee, Fla., McKinney, Tex., Westport and New Canaan, Conn., and others. Exhibited: Illinois State Fair, 1957; Mississippi Valley Exh., 1957, 1958; Soc. of Animal Artists, N.Y., 1963-1968; Hudson Valley AA, 1963, 1966, 1967; Ill. and Pa. State Museums, 1967; Crossroads of Sports, N.Y. Illustrated: "Study of Fishes Made Simple," 1962; "Lives of an Oak Tree," 1962; "Naming Living Things," 1963; "Face of North America," 1963, (children's edition, 1964); "Travels of Monarch X," 1966; "Last Trumpeters," 1967; "Butterfly and Moth," 1969; "Adelbert the Penquin," 1969; "Cheers for Chippie," 1969. Contributor illus. to Audubon Magazine. Positions: Exhibits Artist, Illinois State Museum, 1956-1959; Exhibits Artist, Nature Centers for Young America, 1959-1961; Supervisor of Exhibits, Natural Science for Youth, 1961-1964. Freelance, 1964- .

CONOVER, ROBERT FREMONT—Printmaker, P., T.
162 E. 33rd St., New York, N.Y. 10016
B. Trenton, N.J., July 3, 1920. Studied: PMA Sch. A.; ASL; BMSch. A. Member: SAGA; Am. Abstract A. Awards: prizes, Phila. Pr. Cl.; purchase, SAGA, 1967; BM, 1951, 1956; McDowell Colony Fellowship. Work: WMAA; BM; Graphic Div., Nat. Gal. A., Wash., D.C.; MModA, Tokyo; CM; Univ. Illinois; PMA; New Jersey State Mus., Trenton; Smithsonian Inst. (NCFA), and many others. Commissions: Int. Graphic A. Soc., 1958, 1962; Hilton Hotel, 1963; Assoc. Am. A. Gal., N.Y., 1967; ASL Graphic Edition, 1969. Exhibited: BM, 1950-1968; WMAA, 1950, 1951, 1953, 1954, 1956, 1967; LC, 1955, 1969; SAGA, 1965-1969; Int. Graphic A., Zagreb, Yugoslavia; PAFA; Carnegie Int.; Phila. Pr. Cl.; and others. Positions: Instr., Painting and Graphics, New School for Social Research, New York City; Brooklyn Museum, painting and drawing.

CONSTABLE, ROSALIND—Art Writer, Collector
360 W. 22nd St., New York, N.Y. 10011
B. England. Collection: Contemporary paintings, lithographs, drawings and sculpture. Positions: Researcher, Fortune magazine, 1930-1947; Cultural Correspondent of Time, Inc. publications, 1948-1967. Contributor to: Life, New Yorker, Book Week, New York and other publications. Freelance writer specializing in covering the art scene.

CONSTABLE, WILLIAM GEORGE—Museum Advisor, A. Hist.
23 Craigie St., Cambridge, Mass. 02138
B. Derby, England, Oct. 27, 1887. Studied: Cambridge Univ., M.A.; Slade Sch., London, with Wilson Steer, Havard Thomas. Member: F. Soc. Antiquaries; A. Workers Gld., London; Goldsmiths Co., London; Am. Acad. A. & Sc.; F., Int. Inst. Conservation (Past Pres.); Renaissance Soc. of America (Past Pres.); AFA (Trustee); Royal Acad. A. & Sc., Belgium (Hon.); Chevalier, Legion of Honor; Commendatore of the Crown of Italy; officier, Ordre des Arts et Lettres, France. Author: "Flaxman: English Painting 17th & 18th Centuries"; "Richard Wilson"; "The Painters Workshop"; "Canaletto"; "Art Collecting in the U.S.," and others. Contributor to: Art magazines & bulletins. Positions: Asst. Dir., Nat. Gal., London; Dir., Courtauld Inst. A., Univ. London; Slade Prof., Univ. Cambridge; Cur. Paintings, BMFA, Boston, Mass.; L., Yale Univ., New Haven, Conn.

CONSTANT, GEORGE—Painter
187 East Broadway, New York, N.Y, 10002
B. Greece, Apr. 17, 1892. Studied: Washington Univ., St. Louis, Mo.; AIC, and with Charles Hawthorne, George Bellows. Member: Fed. Mod. P. & S.; Audubon A. Awards: Scholarship, 1917, prize and med., 1943, AIC; Schilling purchase prize, 1939, 1945, 1957; LC, 1947 (purchase); Audubon A., 1946, 1968; Parrish Mus., Southampton, L.I., 1950, 1951, 1966; Guild Hall, 1962, 1963, 1966. Awarded the "Phoenix Cross of the Taxiarchs," by the late King Paul of Greece, 1963. Work: MMA; BM; Detroit Inst. A.; Dayton AI; SFMA; Walker A. Center; Delgado Mus. A.; LC; Stedelijk Mus., Amsterdam, Holland; Alabama Polytechnic Inst.; AGAA; Tel-Aviv Mus., Israel; State Dept., Wash., D.C.; PAFA; PMA; BMA; Butler Inst. Am. Art; Univ. Nebraska; N.Y. Univ.; Norfolk Mus. A. & Sci.; Smithsonian Inst.; Ball State Univ., Muncie, Ind.; Joseph Hirshhorn Mus. Coll., and others. Exhibited: CGA; Carnegie Inst.; AIC; MMA; BM; WMAA; MModA; PAFA; SFMA; Los A. Mus. A.; Rollins Col.; Amsterdam, Holland; VMFA; Wadsworth Atheneum; Musée d'Art Moderne, Paris, France; Munich, Germany; Victoria & Albert Mus.,

London; Mexico Univ., Mexico City; CAM; Cultural Div., U.S. Embassy, Paris, 1954-55 and many others. Over 31 one-man exhs., U.S. and abroad. Reproductions in "The Art Museum in America," Walter Pach; "The Naked Truth and Personal Vision," Bartlett H. Hayes, Jr.; "Twentieth Century Highlights of American Painting," State Dept. USIA. Publications: "George Constant," (Arts, Inc.), 1961; "George Constant," (Argonaut, Athens, Greece) 1968.

CONWAY, FRED—Painter, E., L.
Washington University, Art School, St. Louis, Mo. 63130
B. St. Louis, Mo., 1900. Studied: St. Louis Sch. FA; Julian Acad., Acad. Moderne, Paris, France. Member: St. Louis A. Gld.; A. Dir. Cl.; Arch. Lg. Awards: prizes, CAM, 1944, 1945, 1949; St. Louis A. Gld., 1928-1931, 1938-1948; Joslyn Mem. A. Mus., 1947; Univ. Illinois, 1949; CGA, 1949; Hallmark Comp., 1949; Springfield, Mo., 1944; Rolla, Mo., 1940; Y.M.H.A., St. Louis, 1941, 1942; Pepsi-Cola Exh., 1945, 1947, 1948; 48 States Comp., 1940; Denver A. Mus., 1947; Mulvane A. Mus., 1947, 1949; gold medal, Arch. Lg., 1956; Sesnan Gold Medal, PAFA; silver medal, CGA, 1949; Arch. Lg., 1956; A. Dirs. Cl., awards, Chicago and New York 1953. Work: CAM; Pepsi-Cola Co.; Springfield Mus. A.; Univ. Missouri; Denver A. Mus.; Joslyn Mem. A. Mus.; Univ. Illinois; CGA; Mulvane A. Mus.; Hallmark Coll.; Illinois Wesleyan Univ.; Washington Univ.; Container Corp.; IBM; murals, First Nat. Bank, Tulsa, Okla.; Mayo Clinic, Rochester, Minn.; Barnes Hospital, St. Louis, Mo.; Brown Shoe Co., St. Louis, Mo.; Peabody Coal Co., St. Louis; Federal Bldg., Kansas City, Mo.; Ch. 9, T.V., St. Louis, Mo.; U.S. Embassies, Europe. Exhibited: CAM; St. Louis A. Gld.; Denver A. Mus.; NAD; VMFA; PAFA; AIC; Carnegie Inst.; CMA; AGAA; Rochester Mem. Mus.; Toledo Mus. M.; WMAA; Butler AI; Wildenstein Gal.; Philbrook A. Center; Los A. Mus. A.; Des Moines A. Center; Univ. Oklahoma; Bowdoin Col.; Utica Pub. Lib., and many others including numerous one-man exhibitions. Positions: Prof., Painting, Washington Univ., St. Louis, Mo. 1923- .

COOK, AUGUST—Educator, P., Eng.
h. 438 South Fairview Ave., Ext., Spartanburg, S.C. 29302; Studio: R.R. 3, Chesnee, S.C. 29323
B. Philadelphia, Pa., Mar. 15, 1897. Studied: Harvard Univ.; PAFA, and with Garber, Hale, Carles. Member: F.I.A.L.; Boston Pr. M.; Gld. of South Carolina A; F. PAFA. Awards: prizes, Cresson traveling scholarship and Toppan prize, PAFA; Mint Mus. A.; Gibbes A. Gal.; Gld. South Carolina A. Work: Carnegie Inst.; Gibbes A. Gal.; LC; Furman Univ., Greenville, S.C.; Bethel (Vt.) Pub. Lib.; Butler Inst. Am. A.; Columbia Mus. A.; La Salle Col., Phila., Pa. Exhibited: BM; Carnegie Inst.; LC; Boston Pr. M.; Albany Inst. Hist. & A.; Buffalo Print exh.; SAGA; Audubon A.; Bradley Univ.; Phila. Pr. Cl.; Univ. California; Gibbes A. Gal.; Laguna Beach AA; New Britain Mus.; Newport, R.I.; Northwest Pr.M.; USIS, 1961-62, etc.

COOK, GLADYS EMERSON—Illustrator, P.
32 Union Square, West; h. Hotel Wolcott, 4 West 31st St., New York, N.Y. 10001
B. Haverhill, Mass., Nov. 7, 1901. Studied: Skidmore Col., B.S.; Univ. Wisconsin, M.S.; ASL, with Anthony Thieme, Yarnall Abbott. Member: F., Royal Soc. A., London; SAGA; SI; Circus Fans of Am.; AAUW; Wisconsin Alumni Assn. Awards: Artist of the Year, Albany Pr. Cl. Work: CM; N.Y. Pub. Lib.; MMA; PMA; LC. Created print "Queenie and Her Cubs," Ringling Bros. Exhibited: NAD, 1943, 1944, 1945; LC, 1943-1945; N.Y. Pub. Lib., 1942; NAC; SI, 1945 (one-man): Grand Central Gal., 1946; MMA, 1944 (one-man); Abercrombie & Fitch, N.Y. (one-man); Smithsonian Institution, Wash., D.C.; Nat. Horse Show, N.Y. (one-man); Bronx Zoological Park, 1941 (one-man). Author, I.; "Hiram and Other Cats," 1941; "American Champions," 1945; "How to Draw the Cat"; Portfolio of Champion Dogs; Portfolio of Cats; "How to Draw Horses"; "Circus Clowns on Parade"; "How to Draw Dogs," and others. I.; "We Lived with Peter"; "My Favorite Cat Stories" (James Mason); "Big Book of Cats"; "My Dog," Illus. book on Champion dogs; portfolio of four plates of Lipizzaner horses from the Spanish Riding School; 4 ports. of U.S. Equestrian Team, and others. Motion picture work on "The Yearling," "Thunderhead," "Rhubarb"; "Douglas—a Labrador Retriever." Contributor to newspapers with animal illus. Carter's Ink cat advertisements. Drawing cats on TV for Puss n' Boots products. Lectured on Drawing the Cat at MMA.

COOK, HOWARD—Painter, Gr., E., S.
c/o Grand Central Moderns Gallery, 1018 Madison Ave., New York, N.Y.; h. Ranchos de Taos, N.M. 87557
B. Springfield, Mass., July 16, 1901. Studied: ASL, and in Europe. Member: ASL; NAD "Graphics Class," Awards: Guggenheim F., 1931-32, 1934-35; gold med., Arch. Lg., 1937; AV, 1942; Tucson A. Festival, 1958; DMFA; Mus. New Mexico; Samuel F.B. Morse Gold Medal, NAD, 1963; purchase award, Tupperware; Oklahoma A. Center. Work: ModA; MMA; Oklahoma A. Center; Georgia Mus. A.;

WMAA; Santa Barbara Mus. A.; deYoung Mem. Mus.; PMA; Minneapolis Inst. A.; Denver A. Mus.; Dartmouth Col.; murals, Fed. Bldgs., Springfield, Mass.; Pittsburgh, Pa.; San Antonio, Tex.; Corpus Christi, Tex.; Mayo Clinic, Rochester, Minn. Exhibited: WMAA, AIC, 1934-1946; BM; Cal. WC Soc.; Springfield Mus. A.; Phila. Pr. Cl.; Phila. A. All.; Weyhe Gal. (4 one-man shows); Rehn Gal., 1945, 1949; Kennedy Gal., 1945; Grand Central Moderns, 1951, 1952, 1956, 1960, 1964 (one-man); other one-man exhs.: Rosequist Gal., Tucson, Ariz., 1962; Raymond Burr Gal., Beverly Hills, Cal., 1962; Retrospective exh., Roswell (N.M.) Mus. and A. Center, 1965. Author, I., "Sammi's Army," 1943. Contributor to art magazines. Position: Guest Prof. A., Univ. Texas, 1942-43; Minneapolis Sch. A., 1945, 1950; Univ. California, Berkeley, 1948; Scripps Col., 1951; Colo. Springs FA Center, 1949- ; Washington Univ., St. Louis, Mo., 1954; Highlands Univ., N.M., 1957- ; Univ. New Mexico, 1947, 1960; A.-in-Res., Roswell (N.M.) Mus. and A. Center, 1967-1968.

COOKE, C. ERNEST—Educator, W., Cr., L., P.
502 Harmeling St.; Virginia Intermont College, Bristol, Va. 19083
B. Owensboro, Ky., June 3, 1900. Studied: Univ. Richmond, A.B.; Harvard Univ., M.A.; Oxford & London Univ.; & with Robert Brackman. Exhibited: Norfolk Mus., 1945-1956; Intermont Exh., 1945-1956; East Tenn. State Col.; New York. Lectures: Renaissance & Contemporary Art. Author: "El Greco," 1961. Positions: Hd., Hist. A. Dept., Virginia Intermont Col., Bristol, Va., 1940- ; Instr., A. Hist., King Col., Bristol, Tenn., 1948- .*

COOKE, DONALD EWIN—Designer, I., Comm., L., W.
Edraydo, Inc., 34 West Ave.; h. 106 Oakford Circle, Wayne, Pa. 19087
B. Philadelphia, Pa., Aug. 5, 1916. Studied: PMSchIA, with Henry C. Pitz. Member: Phila. Sketch Cl.; Pa. Hist. Soc.; A. Gld. of Phila. Exhibited: PAFA. I., "The Nutcracker of Nuremberg," 1938; "The Firebird," 1939; "The Sorcerer's Apprentice," 1946; "Story-Teller Poems," 1948; "Miss Pickett's Secret," 1952; "Island Fortress," 1952, and others. Author: "Little Wolf Slayer," 1952; "Powder Keg," 1953; "The Narrow Ledge of Fear," 1954; "Johnny-on-the-Spot," 1955; "Valley of Rebellion," 1955; "Color by Overprinting," 1955; "The Romance of Capitalism," 1958; "Men of Sherwood," 1961; "Marvels of American Industry," 1962; "Atlas of the Presidents," 1964; "For Conspicuous Gallantry," 1966; "Presidents in Uniform," 1969; "Fathers of American Freedom," 1969. Author-I., "The Silver Horn of Robin Hood," 1956. Illus. of children's stories for "Child Life," "Jack and Jill," etc. Positions: Pres., Edraydo, Inc.

COOKE, HEREWARD LESTER, JR.—
Museum Curator, W., P.
National Gallery of Art, Washington, D.C. 20565
B. Princeton, N.J., Feb. 16, 1916. Studied: Oxford Univ., England, M.A.; ASL, with George Bridgman; Yale Univ. Sch. FA; Princeton Univ. Grad. Sch., Ph.D. Awards: Yates-Thompson award, England, 1935; prize, Beaux-Arts Comp., 1941; F., Princeton Univ., 1947-48; Fulbright award, France, 1951-52; Prix de Rome, 1952-53, 1953-54; F., Am. Philosophical Soc., 1954; Order of Merit, Italian Government, 1964. Author: "Painting Lessons from the Great Masters," 1967. Exhibited: nationally. One-man: Philadelphia, Princeton and Washington, D.C. Contributor articles on art to American and foreign journals. Positions: Cur., Painting, National Gallery of Art, Wash., D.C., 1961- .

COOLIDGE, JOHN PHILLIPS—Museum Director
Fogg Art Museum, Harvard University; h. 24 Gray Gardens West, Cambridge Mass. 02138
B. Cambridge, Mass., Dec. 16, 1913. Studied: Harvard Univ., A.B.; New York Univ., Ph.D. Member: CAA; Soc. Arch. Historians; Am. Acad. A. & Sciences. Author: "Mill and Mansion," 1943. Positions: Dir., Fogg A. Mus., Harvard Univ., Cambridge, Mass. (resigned, 1968); Trustee, BMFA, 1948- ; Asst. Prof. FA, Univ. Pennsylvania, 1946-47; Prof. FA, Harvard Univ., 1947- .

COONEY, BARBARA (Mrs. C. Talbot Porter)—Illustrator, W.
Pepperell, Mass. 01463
B. Brooklyn, N.Y., Aug. 6, 1917. Studied: Smith Col.; ASL. Awards: Caldecott Medal, 1959. Work: Illus. for various magazines and anthologies and in the past 25 years, illus. over 60 books. Caldecott Medal was awarded for "Chanticleer and the Fox."

COONEY, JOHN—Museum curator
Egyptian & Classical Dept., Cleveland Museum, 11150 East Blvd., Cleveland, Ohio 44106*

COOPER, MARIO—Painter, S., E., I., W.
54 W. 74th St., New York, N.Y. 10023
B. Mexico City, D.F., Nov. 26, 1905. Studied: Otis AI; Chouinard

AI; Grand Central Sch. A.; Columbia Univ. Member: NA; AWS; Audubon A.; All. A. Am.; Knickerbocker A.; Brooklyn Soc. A.; Cal. WC Soc.; Texas WC Soc.; New Jersey P.&S.; A. Lg., Long Island; SI; NSS; SC (Hon.); N.Y. Artists Gld.; Fellow, Royal Soc. A., London. Awards: prizes, med., Knickerbocker A., 1952, 1955; A. Lg., Long Island, 1950; New Jersey P.&S., 1949; Nassau A. Lg., 1949; prizes, All. A. Am., 1950, 1956; Hendersonville, N.C.; Indiana (Pa.) State T. Col.; AWS, 1955, 1956, 1961-1964; Brooklyn Soc. A., 1955; Audubon A., 1961; medal, 1961; NAD, 1956; Morse medal, 1967; Citation, 1967, medal, 1969, prizes, 1967-1969, AWS. Work: MMA; Coll. of U.S. Air Force; Processional Cross, Chapel of Intercession, and St. Martin's, New York, N.Y.; Butler Inst. Am. A.; St. Lukes Hosp., Denver, Colo.; painting of Atlas ICBM and planes, USAF, Marianas Hall, Armed Services Staff Col., Norfolk, Va.; commissioned by U.S. Air Force to paint the Capitals of Europe, 1960. Invited by National Gallery to document the flight of Apollo 10 for NASA, May, 1969. Illus., short stories of P.G. Wodehouse, Quentin Reynolds, Gouverneur Morris, Clarence Buddington Kelland, Eric Remarque's "Arch of Triumph," and others. Represented in "Forty Illustrators and How They Work"; "Introduction to Cartooning and Illustrating"; "The U.S. Air Force, A Pictorial History," 1966; "One Hundred Watercolor Techniques," 1968; "History of the American Watercolor Society," 1969, and others. Author: "Flower Painting in Watercolor," 1966; "Painting and Drawing the City," 1967. Exhibited: PMA, 1949; BM, 1952; NAD, 1947, 1948, 1950, 1951; PAFA, 1948, 1951, 1952; Indiana (Pa.) State T. Col.; Arch. Lg., 1951; AWS; Cal. WC Soc.; Audubon A.; All. A. Am.; WFNY 1939; Sarasota AA; Conn. Acad. FA; first nat. exh., USAF art, Smithsonian Inst., 1960, and in Japan, London, Mexico, etc.; one-man: New York, N.Y., 1953; Phila., Pa., 1953; Oklahoma A. Center; Lehigh Univ. (Pa.); Queens Col., N.Y., and others. Contributor to national magazines. Positions: Delegate to U.S. Comm. for IAPA, 1954- ; Pres., Audubon A., 1954-1958; Official A., for paintings of opening of U.S. Air Force Acad., in Far East, 1954; temp. duty, Alaska, USAF, 1956; in charge of team of four artists to Japan, Korea, Okinawa, 1956, for USAF; in charge team of five artists to Japan, 1957, for USAF. Instr., ASL, 1957- . A. Consultant, USAF, 1960; Pres., AWS, 1959- ; Instr., NAD Sch. FA, City Col., 1961-1968, New York.

COOPER, MRS. MARIO. See Meyers, Dale

COPELAND, LAWRENCE G.—Craftsman, Des., E.
442 Hamilton Place, Hackensack, N.J. 07601
B. Pittsburgh, Pa., Apr. 12, 1922. Studied: Royal F., Univ. Stockholm; Ohio State Univ., B.F.A., and with Baron Eric Fleming, Stockholm, Sweden; Emeric Gomery, Paris, France; Cranbrook Acad. A., M.F.A. Member: Am. Craftsmen's Council; AAUP; York State Craftsmen. Awards: med., Cranbrook Acad. A., 1951; Court of Honor, York State Crafts Fair, 1955, prize, 1961; Purchases by U.S. State Dept. for U.S. Int. Exh., 1953. Work: NGA; altar silver, Grace Presbyterian Church, Rochester, N.Y.; Annual awards for "Better Downtown Contest," Gannett Newspapers, Rochester, N.Y. Exhibited: Wichita Nat., 1950-1952; Finger Lakes Exh., annually; Mus. Contemp. Crafts, 1956-1958; York State Craft Fair, annually; one-man: Davidson A. Center, Middletown, Conn., 1955; Essex AA, 1955; York State Crafts Fair, 1961. Contributor to Craft Horizons. Lectures: Metalcraft, to craft and school groups and N.Y. Pub. Lib. Edu. Series. Design Consultations for City Col. of N.Y.; Reinauer Petroleum Co., and others. Positions: Instr., metalcrafts and Counselor, Sch. for Am. Craftsmen, Rochester Inst. Tech., Rochester, N.Y., 1951-1959. Des., Oneida, Ltd., Oneida, N.Y., 1959-1964. Asst. Prof., A. Dept., 1963-1967, Assoc. Prof., 1967- , Chm. Dept. A., 1968- , City College of New York. Bd. Member, York State Craftsmen, and Artist-Craftsmen of New York.

COPLAN, KATE M.—Exhibits Designer
3404 Rosedale Rd., Baltimore, Md. 21215
B. Baltimore, Md., Dec. 25, 1901. Studied: Johns Hopkins Univ. Member: Maryland Lib. Assn.; Am. Lib. Assn.; Baltimore Pub. Relations Council. Awards: prize, gold, silver & bronze meds., "Display Worlds" International window display comp., 1950; one of Baltimore's "10 Women of Achievement, 1950"; Baltimore's Hadassah's award, 1967. Contributor to Library Journal, Publisher's Weekly. Author: "Effective Library Exhibits: How to Prepare and Promote Good Displays," 1958; "Poster Ideas and Bulletin Board Techniques: For Libraries and Schools," 1962; "The Library Reaches Out," (with Edwin Castagna), 1965. Positions: Chief, Exhibits & Publ., Enoch Pratt Free Pub. Library, Baltimore, Md., 1935-1963.

COPLANS, JOHN (RIVERS)—Museum Curator
Pasadena Art Museum, 46 North Los Robles Ave., Pasadena, Cal. 91101
B. London, England, June 24, 1920. Awards: Guggenheim Fellowship, 1969. Author: "Cézanne Watercolors," 1967; "Serial Imagery," 1968; "Ellsworth Kelly" scheduled for publication 1970. Contributor to Artforum, Art News, Art in America, Art International

and others. Positions: Editor-at-Large, Artforum Magazine 1962-1966, Associate Editor 1966- ; Director, Art Gallery, University of California, Irvine 1965-1968; Curator, Pasadena Art Museum, 1967- .

COPLEY, WILLIAM N.—Painter
54 E. 72nd St.; h. 150 E. 69th St., New York, N.Y. 10021
B. New York, N.Y., Jan. 24, 1919. Studied: Phillips Acad., Andover, Mass.; Yale Univ. Work: Tate Gal., London, England; MModA. Also in many private collections, U.S. and abroad. Exhibited: Craven Gal., Paris, 1953; Int. Exposition, Tokyo, Japan, 1956; Salon de Mai, Paris, 1957, 1959, 1961-1963; Int. Surrealist Exh., N.Y., 1960; Stockholm, Sweden, 1961; Am. Chess Fnd., 1961; Musee des Arts Decoratifs, Louvre, 1962; Vienna, 1962; Oakland A. Mus., 1963; Galerie Schmidt, Paris, 1963; Salon des Realites Nouvelles, Paris, 1963; Selections from the L.M. Asher Coll., Art Gal., Univ. New Mexico, 1964; Brandeis Univ., 1964; Maremont Coll., Washington Gal. of Mod. A., 1964; Dwan Gal., Los Angeles, 1965; Heckscher Mus. A., Huntington, N.Y., 1965; Tamarind Lithography Workshop (at Otis AI), Los Angeles, 1965; Cordier Ekstrom Gal., N.Y. Exh. for the Am. Chess Fnd. for the Duchamp Fund. 1966. One-man: Galerie Davsset, 1953, Galerie de Dragon, 1956; Galerie Furstenberg, 1959, Galerie Iris Clert, 1961, 1962, all Paris, France; Galerie Mone Napoleaone, 1954, Galerie Naviglio, 1960, both Milan, Italy; Galerie Cavalino, Venice, Italy, 1960; Inst. Contemp. A., London, 1961; Hanover Gal., London, 1962; David Stuart Gal., Los Angeles, 1964; Louisiana Gal., Houston, Tex., 1965; Southwestern College, Chula Vista, Cal., 1965. Contributor to Art News and Art News Portfolio.*

COPPIN, JOHN STEPHENS—Painter
4301 Echo Rd., Bloomfield Hills, Mich. 48013
B. Mitchell, Ont., Canada, Sept. 13, 1904. Studied: Stratford Collegiate Inst., Ontario, Can.; John P. Wicker A. Sch., Detroit, Mich., and in Europe. Member: F.I.A.L.; Am. Fed. Artists; Mich. Acad. Science, Arts & Lets.; Prismatic Cl.; Acanthus Cl.; St. Dunstan's Gld. of Cranbrook. Awards: prizes, Detroit Inst. A., 1933, 1939, 1946, 1950; Scarab Cl. Gold Medals, 1941, 1944, 1946; Carl F. Clarke Award, 1953. Work: Detroit Inst. A.; Detroit City-County Bldg.; Univ. Michigan Lib.; Detroit Hist. Soc.; Automobile Club of Michigan; Dearborn Inn; Detroit Edison Co.; Blue Cross-Blue Shield Bldg.; Thos. J. Watson Coll. of famous Inventors and Scientists, New York; Stratford Shakespearean Festival Theatre, Ontario; Nat. Hist. Mus., Frederiksborg, Denmark; six historical paintings for Michigan State Univ.; murals: Detroit Central H.S.; Detroit Gas Co.; Adam Strohm Hall in Detroit Main Public Lib., 1965; Ports. and murals of over 150 prominent persons. Author, "Selected Work of John S. Coppin." Positions: A. Dir., Michigan Motor News, 1928- ; Art Instruction, 1928- ;

CORBETT, MRS. EDWARD. See Tirana, Rosamond

CORBETT, EDWARD M.—Educator, P.
3500 35th St., N.W., Washington, D.C. 20016; also Provincetown, Mass. 02657
B. Chicago, Ill., Aug. 22, 1919. Studied: California Sch. FA. Awards: Rosenberg F., 1951-52; Irene Leach Mem., Norfolk, Va., 1968; Nat. Inst. A. & Lets., 1968. Work: AIC; MModA; WMAA; SFMA; Tate Gal., London; Mount Holyoke Col.; NCFA; Univ. California (Berkeley); AGAA. Exhibited: CGA, 1955, 1964, 1966-1968; WMAA, 1953-1955, 1962, 1964, 1967, 1968; Sao Paulo, 1954; Univ. Illinois, 1955; Carnegie Inst., 1955; MModA, 1952, 1962, 1963; AIC, 1948, 1953, 1954; MModA traveling exh., Paris & Grenoble, France, 1954; Stable Gal., 1954, 1955; WAC, 1961; Henry Gal., Seattle; Tokyo, 1961; Rome, 1961; Grace Borgenicht Gal., N.Y., (one-man) 1956, 1959, 1961-1965, 1966-1969; Cal. PLH; Univs. Illinois, Nebraska; Sophie Newcomb Col., 1958; Tulane Univ.; VMFA; Herron Mus. A.; Highland Center, Tenn.; Wash. Gal. Mod. A., 1963, 1964; Inst. Contemp. A., Wash. D.C., 1964; UCLA Gal., 1965; NCFA, 1967, 1968; Quay Gal., San Francisco, (one-man) 1967; Retrospective exh., SFMA, 1969, and others. Positions: Instr., Cal. Sch. FA, 1947-50; Asst. Prof., Painting, Mount Holyoke Col., South Hadley, Mass., 1953- ; Dir., Taos Field Sch. of A., Univ. New Mexico, 1955; Visiting A., Univ. Minnesota, 1960-61; Visiting Critic, American Univ., Washington, D.C., 1966-1967; Prof., Painting, Univ. California at Santa Barbara, 1967-1968; A.-in-Res., Northwood Inst., Cedar Hill, Texas, 1969.

CORCOS, LUCILLE—Painter, I., Des.
167 South Mountain Rd., New City, N.Y. 10956
B. New York, N.Y., Sept. 21, 1908. Studied: ASL. Member: Audubon A.; AEA (Dir. 1964-66). Awards: Pepsi-Cola, 1944; Grumbacher award, 1956. Work: WMAA; U.S. Gypsum Co.; Upjohn Pharmaceutical Co.; Columbia Broadcasting System; Mus. A., Tel-Aviv; mural, North Shore Hospital, Manhasset, N.Y.; Life Magazine; mural, Waldorf-Astoria, New York; Des., illus., Multimedia Program for Instruction in Library Skills, "Libraries Are for Children,"

1967. Exhibited: WMAA, 1936, 1938, 1939, 1941, 1942, 1944, 1947, 1949-1954; AIC, 1939-1944; BM; MMA, 1941, 1942, 1950, 1951; Carnegie Inst., 1941, 1944, 1945, 1946, 1948, 1949; Rockland Fnd., 1954 (one-man); PMG, 1942; Rockland County A., 1964; Rockland Community College, 1964, 1965; Audubon A., 1946-1957, 1965; Columbus Gal. FA, 1952; Grand Central Moderns, (one-man) annually; traveling exh., South America, Great Britain; Exchange Exh., Paris, 1953-54; Am-Embassy, Paris, 1953-54; U.S.I.S., Rome, Italy, The Netherlands, 1957. I., "Treasury of Gilbert & Sullivan," 1941; "Treasury of Laughter," 1946; "Little Lame Prince," 1946; "Follow the Sunset," 1952; "Songs of the Gilded Age," 1960 (Book of the Month Cl.); Limited Editions Club, "Chichikov's Journey," 1944; "The Picture of Dorian Gray," 1957; 4-vol. ed. "Grimm's Fairy Tales" (Limited Editions Club), 1962. Author, I., "Joel Gets a Haircut," 1952; "Joel Spends His Money," 1954; "Joel Gets a Dog," 1958; "From Ungskah 1 to Oyaylee 10," 1965. Work reproduced in American Weekly, 1957, 1958; Life, 1954; Fortune, 1955-1958. Painting Commission: "This is Macy's," R. H. Macy Co., 1956, 1957, 1959, 1960; Painting, full color, House Beautiful, 1962; Series color illus., Good Housekeeping, 1963-64; Paintings for Upjohn Co., 1965.

CORDICH, JOHN—Painter
74 Pigeon Hill St., Rockport, Mass. 01966
B. Dubrovnik, Yugoslavia, 1898. Studied: ASL, and privately with Gregorieff, McNulty and Corbino. Work: in private collections. Exhibited: Rockport AA, 1956-1962; Cape Ann Soc. Modern A., 1956-1962; New School for Social Research, N.Y., 1957; Washington Irving Gal., N.Y., 1958, 1959; CGA, 1962; one-man: Rockport AA, 1955, 1958; Ripon College, Wis., 1958, 1961; Community Church, Boston, 1960; Verle Gal., Hartford, Conn., 1962; Babcock Gal., N.Y.*

CORMIER, ROBERT JOHN—Painter, L., T.
30 Ipswich St., Boston, Mass. 02115
B. Boston, Mass., May 26, 1932. Studied: R.H. Ives Gammell Studios, and in Europe. Member: Provincetown AA; AAPL; Academic A.; Copley Soc., Boston; Gld. Boston A.; North Shore AA; SC; Hudson Valley AA. Awards: prizes, All. A. Am., 1955; Ogunquit A. Center, 1957, 1958, 1960; AAPL, 1958, 1960, 1962, 1963; Ogunquit AA nat. exh., 1958; New England A., 1957, 1958, 1963, 1965, gold medal, 1961; Copley Soc., 1960; Grand prize, Boston A. Festival, 1962; prize, Hudson Valley AA; gold medal, Council of Am. Artist Societies, 1966. Work: Boston Col. Lib.; Maryhill (Wash.) Mus.; Middlesex Superior Court, Boston, and in private colls. Exhibited: All. A. Am., 1955; Ogunquit A. Center, 1956-1968; NAC, 1958; AAPL, 1958-1961; New England A., 1956-1967; Academic A., 1957; Chrysler Mus. A., 1958; Copley Soc., 1957-1968; Concord AA, 1957-1965; Maryhill Mus., 1958, 1960; Oregon Soc. A., 1958; Wash. State Hist. Mus., Tacoma, 1958; SAM, 1958 and other West Coast exhs.; North Shore AA, 1959; Provincetown AA, 1958-1960; Lyman Allyn Mus., 1960; Galerie Internationale, 1960; Portraits Inc., N.Y., 1961; Gld. Boston A., 1960-1969; Northwestern Univ., 1966, 1967. Positions: Instr., L., Vesper George Sch. A., Boston; Bd. Governors, Copley Soc., Boston; Dir., Mass. Chptr. AAPL.

CORNELIUS, FRANCIS DuPONT—Conservator, P.
Cincinnati Art Museum, 45202; h. 8400 Blome Rd, Cincinnati, Ohio, 45243.
B. Pittsburgh, Pa., Oct. 19, 1907. Studied: Univ. Pennsylvania, B. Arch.; Univ. Pittsburgh, M.A. Member: AAMus.; Bd. Trustees, Spanish Colonial A. Soc., Santa Fe, 1964- ; F., Int. Inst. for the Conservation of Mus. Objects. Exhibited: Assoc. A. Pittsburgh, annually. Author: "Frick Pieta Panels"; "Further Developments in the Treatment of Fire-blistered Oil Paintings," 1966; and "Movement of Wood and Canvas for Paintings in Response to High and Low RH Cycles," 1968. Lectures: "Conservation Methods," at universities and colleges. Positions: Research F., in Conservation, 1944-45; F., in Conservation, MMA, 1945-52; Tech. Advisor, 1952-55, Restorer, 1955-68, Colorado Springs FA Center; Conservator, Mus. New Mexico A. Gal., 1955-1961; Univ. Nebraska A. Gal., 1958- ; El Paso Mus. A., 1960- ; private studio for preservation of works of art, Colorado Springs, Colo., 1952-68. Participated in British Council course on Conservation, London, 1956. Research findings on surface films and disintegration of canvas supports exhibited at ICOM meeting, Amsterdam, Holland, 1957. Lecturer in Conservation of Art, Colorado College, 1961-68. Conservator of Cincinnati Art Museum, 1968- .

CORNELIUS, MARTY (Miss)—Painter, E., I., Cr., L., W.
P.O. Box 134, Pittsburgh, Pa., 15230; h. "Phoenix Nest," Ligonier, Pa. 15658
B. Pittsburgh, Pa., Sept. 18, 1913. Studied: Carnegie Inst., B.A., and with Reginald Marsh, Alexander Kostellow. Member: F.I.A.L.; Int. Platform Assn. Awards: prizes, Assoc. A. Pittsburgh, 1939, 1945, 1953; Martin Leisser Sch. Des., 1946-1949; Allegheny County, 1947, 1948, 1955; Butler Inst. Am. A., 1948; CGA, 1941, 1947; Kappa Kappa Gamma, 1952; Pittsburgh Playhouse, 1958. Exhibited: Car-

negie Inst., 1938-1969; WMAA, 1949; CGA, 1941, 1947; N.Y. Mun. Exh., 1936; Cal. PLH, 1946; Assoc. A. Pittsburgh, 1936-1968; Univ. Ohio, 1957; Ogunquit A. Center, 1957; Three Rivers Show, 1962, 1963; Int. Platform Assn., Wash., D.C., 1968; Westmoreland County Mus. A., Greensburg, Pa.; Carnegie-Mellon Univ. Work: Mercy Hospital, Pittsburgh; Latrobe (Pa.) H.S.; Pittsburgh Pub. Schs.; 2 illus. in "The Story of Pittsburgh," Stefan Lorant, 1958. Positions: Instr. A., Veteran's Hospitals, Pittsburgh, Pa.; A. Des., Aluminum Co. of Am., New Kensington, Pa., 1950-51; Instr. Drawing, Carnegie Inst. Tech., FA College, Pittsburgh, Pa., 1959-1961; Instr., Painting & Sc., Westmoreland County Mus. A., Greensburg, Pa. (Oct-Nov., 1964).

CORNELL, JOSEPH—Sculptor
 3708 Utopia Parkway, Flushing, N.Y. 11358
B. 1903. Exhibited: WMAA, 1964.*

CORNIN, JON—Painter, E., Des.
 812 Northvale Road, Oakland, Cal. 94610
B. New York, N.Y., Mar. 24, 1905. Studied: N.Y. Univ.; ASL, and with Raphael Soyer. Member: San F. AI; East Bay AA. Exhibited: Univ. Seattle; Gump's Gal., San F.; St. Botolph's Cl., Doll & Richards, Boston; Arizona State Fair; Cal. PLH; NAD; SFMA; Cal. State Fair, Pasadena AI; Oakland A. Gal.; Cal. WC Soc., traveling exh.; Univ. Alabama; Alabama WC Soc.; traveling exh.; Albright A. Gal.; Fresno A. Lg.; Denver Mus. A.; Los A. Mus. A.; Phila. Pr. Cl.; Kennedy Gal.; J.B. Speed Mus. A.; deYoung Mem. Mus.; Philbrook A. Center; Montross Gal.; Mus. New Mexico; Flint Inst. A.; Saginaw (Mich.) Mus. A.; Michigan State Col.; Slaughter Gal., San F. (one-man); Terry AI; Portland (Me.) Mus. A.; Henry Gal., Seattle; Laguna Beach A. Festival; San Joaquin & Haggin A. Gal., Stockton, Cal.; Butler Inst. Am.; Oakland A. Mus.; Art: USA, 1958; Mills College, Oakland, Cal.; Springfield (Mass.) Mus. A.; Fukuoka, Japan; Frye Mus. A.; Seattle, and many others. Work: in many private colls. Positions: Instr., Painting & Drawing in own school, Oakland, Cal.

CORR, MRS. PHILIP J. See Snow, Mary Ruth

CORSAW, ROGER D.—Ceramic Craftsman, E.
 University of Oklahoma, School of Art; h. 725 Juniper Lane, Norman, Okla. 73069
B. Ithaca, N.Y., Nov. 27, 1913. Studied: New York State Col. of Ceramics, Alfred Univ., B.S.; Inst. Des., Chicago, M.F.A. Awards: prizes, Nat. Ceramic Exh., Syracuse, N.Y., 1937; purchase award, Nat. Acad. A., Smithsonian Inst., 1955; Annual Western Art, Denver Mus. A.; Springfield, Mo. Work: Everson Mus. A., Syracuse; Wichita A. Gal.; Denver A. Mus.; Springfield, (Mo.) A. Mus. (all in ceramic colls.); Nat. Acad. A., Smithsonian Inst.; Mus. Contemp. Crafts, New York City. Exhibited: Nat. Ceramic, Syracuse, 1937, 1940, 1947-1949, 1954, 1958, 1960, 1962; Wichita A. Mus., 1947-1952, 1954, 1956, 1959, 1960, 1962; 2nd Intl. Ceramics, Ostend, Belgium, 1959; Intl. Cultural Exh., Switzerland, 1960; Designer-Craftsmen USA, 1960; Fiber-Clay-Metal, St. Paul, 1962; Craftsmen of Central States, Ft. Worth, 1962; 3rd Regional Crafts, San Antonio, 1962. Positions: Prof., Ceramic Art, 3D Des., University of Oklahoma, Norman, Okla. at present. Chm., Membership Committee and member Honors Committee, Nat. Council on Education for the Ceramic Arts.

CORTLANDT, LYN—Painter, Gr.
 1070 Park Ave., New York, N.Y. 10028
B. New York, N.Y. Studied: Chouinard AI; Jepson AI; ASL; PIASch.; Columbia Univ. Sch. Painting & Sculpture; Hans Hofmann Sch. A.; China Inst. in America. Member: F., Int. Inst. A. & Lets.; F., Royal Soc. A., London, England; All A. Am.; Int. Platform Assn.; P. & S. Soc. of New Jersey; Phila. WC Cl.; Pen & Brush Cl.; Nat. Trust for Historic Preservation. Work: MMA; BMFA; FMA; AIC; BM; Boston Pub. Lib.; BMA; CM; N.Y. Pub. Lib.; Musée Nationale d'Art Moderne, Paris; Springfield Mus. A.; Stedelijk Mus., Amsterdam, Holland and in other important public and private colls. Exhibited: PAFA; BM; and in many other national exhs.; also in Belgium, Greece, Italy, Japan, Portugal, Holland, Switzerland and France. Several one-man exhs. incl. New York City. Moderator radio panel forums: "Where is Abstract Art Leading Us?" and "Contemporary Styles of Painting." Lectures on Contemporary Arts.

COSLA, O. K. (Dr.)—Collector, Writer
 325 Front St., Berea, Ohio 44017
B. Rumania, May 21, 1899. Studied: Berlin, Germany, with Wilhelm von Bode. Collection: French, German, Dutch, Flemish, English Paintings, 12th Century-20th Century. Paintings from the Cosla Collection are in the museums of the Brigham Young University, Provo, Utah; Furman University, Greenville, S.C.; Baldwin Wallace College, Berea, Ohio; Montclair State College, Upper Montclair, N.J.; Mills College, Oakland, Cal.*

COSTIGAN, JOHN EDWARD—Painter
 Orangeburg-Hunt Rds., Orangeburg, N.Y. 10962
B. Providence, R.I., Feb. 29, 1888. Member: NA; NAC; SC; SAGA; AWS. Awards: prizes, NAD (purchase) 1961 and prior; AIC; SC, 1954 and prior; NAC (gold med., 1954 and prior); med., AWS, prize, 1958, medal, 1968; SAGA; LC, 1942, 1944, 1946; Ogunquit A. Center, 1955. Work: N.Y. Pub. Lib.; Brigham Young Univ.; Rochester Mem. A. Gal.; MMA; AIC; Los A. Mus. A.; Cranbrook Acad. A.; LC; Davenport Mun. A. Gal.; Frye Mus. A., Seattle; Utah State Univ.; murals, USPO, Girard, Ohio; Rensselaer, Ind.; Stuart, W. Va.; PC; BMFA; Smithsonian Inst. traveling exh., 1968-1970. Exhibited: nationally.

COTSWORTH, STAATS—Painter, I.
 360 East 55th St., New York, N.Y. 10022
B. Oak Park, Ill, Feb. 17, 1908. Studied: PMSchIA, and with Thornton Oakley, Herbert Pullinger; ASL, with Reginald Marsh. Member: Phila. WC Cl.; SC; Am. Soc. Painters in Casein; AWS; Audubon A. Awards: prizes, Conn. Acad. FA, 1954; Knickerbocker A., 1955. Work: Norfolk Mus. FA.; murals in private homes and public buildings. Exhibited: PAFA; CGA; Phila. WC Cl.; NAC; Am-British A. Center, 1948 (one-man); Hammer Gal., 1953 (one-man); WMAA, 1954. I., "A Bacchic Pilgrimage"; "Deep Water Days." Positions: Chm. & Custodian, Art Collection of the Players, New York, N.Y.

COTT, PERRY BLYTHE—Museum Curator
 National Gallery of Art; h. 3039 University Terrace, N.W., Washington, D.C. 20015
B. Columbus, Ohio, Mar. 27, 1909. Studied: Princeton Univ., A.B., Ph.D.; Univ. Paris. Member: CAA. Awards: Med., CAA, 1929. Author: "Siculo-Arabic Ivories," 1939. Contributor to: Art magazines. Positions: Chief Cur., National Gallery of Art, Washington, D.C.

COUCH, URBAN—Painter, E., L.
 The Minneapolis School of Art, 200 E. 25th St. 55404; h. 4100 Garfield Ave. South, Minneapolis, Minn. 55409
B. Minneapolis, Minn., Apr. 27, 1927. Studied: Minneapolis Sch. A., B.F.A.; Cranbrook Acad. A., Bloomfield Hills, Mich., M.F.A.; Skowhegan (Me.) Sch. Painting & Sculpture. Member: AEA; North Central Assn. Colleges & Secondary Schools (Consultant and Evaluator). Awards: prizes, purchase award, WAC, 1961. Work: Minneapolis Inst. A.; WAC; Univ. Minnesota; Cranbrook Mus. A.; General Mills; Col. of St. Theresa, Minnesota; Sioux A. Center, Iowa, and in private colls. Exhibited: Ravinia Invitational, Chicago, Ill.; Univ. Minnesota; WAC; Minneapolis Inst. A.; 39 group shows and 9 one-man shows over 18 years. Positions: Instr., Minneapolis Sch. A., 1955-1958; Painting, WAC, 1957-1961; Minnetonka A. Center, 1959-1960; Kingswood Sch., Bloomfield Hills, Mich., 1958-59; Chm., Foundation Program, Minneapolis Sch. A., 1959-1962; Leadership Training Program, North Central Assn., Chicago, 1962-63; Examiner & Consultant, North Central Assn., Chicago, 1963- ; Administrator of Education, Minneapolis Sch. A., 1962-63; Asst. Dir., Minneapolis Sch. A., 1963-64 A.-in-Res., Minnesota Junior Colleges, summers, 1967-1969.

COVEY, MRS. ARTHUR. See Lenski, Lois

COVI, DARIO A.—Educator, Mus. Dir.
 University of Louisville; h. 1361 S. First St., Louisville, Ky. 40202
B. Livingston, Ill., Dec. 26, 1920. Studied: Eastern Illinois State T. Col., B.Ed.; State Univ. of Iowa, M.A.; Warburg Inst., Univ. London; N.Y. Univ., Ph.D., and in Italy. Member: CAA; Renaissance Soc. of Am.; AAUP; Southeastern Col. A. Conference. Awards: Fulbright award, 1949-50, 1968-1969; Metropolitan Mus. A. F., 1951-52; Brussels Seminar F., 1952; Am. Phil. Soc. awards, 1959, 1962; Fulbright Grant for travel, 1946-65; Am. Council of Learned Soc. Fellowship, 1964-65. Contributor to Marsyas; Art Bulletin; Renaissance News; MMA Bulletin; McGraw-Hill Dictionary of Art; Burlington Magazine; North Carolina Museum of Art Bulletin. Positions: Prof. FA, 1964- , Hd. Dept. FA, 1963-1967; Dir., Allen R. Hite Art Inst., 1963-1967, Univ. of Louisville, Ky. Member, Exec. Committee, Kentucky Arts Commission, 1965- .

COVINGTON, HARRISON W.—Educator, P.
 University of South Florida; h. 11102 Carrollwood Dr., Tampa, Fla. 33618
B. Plant City, Fla., Apr. 12, 1924. Studied: Univ. Florida, B.F.A., M.F.A. Member: CAA; Southeastern Col. A. Conference; AFA; AAMus. Awards: Guggenheim Fellowship, 1964; prizes, Soc. Four A., 1960; Fla. State Fair, 1962; Research Grant, Univ. Fla. Research Council; Mead Corp. purchase award, 1962; Florida Artists Group, 1963, and many others. Work: Everson Mus. A.; John Herron Mus. A.; Ringling Mus. A.; Jacksonville Mus. A.; Univ. of Florida; Univ. of South Florida; Massachusetts State Col.; Ohio Univ.; Tampa Cham-

ber of Commerce, State of Florida; Peninsular Life Insurance Co.; Tampa Pub. Lib.; City of Gainesville, Florida. Exhibited: MModA; N.Y. Worlds Fair; 20 one-man exhibitions; Florida 17 Invitational Show, Wa'shington, D.C.; all major Southeastern regionals. Positions: Prof. Division Dean, Division of Fine Arts, University of South Florida, Tampa, Fla., at present.

COWAN, WOOD—Cartoonist, W., I., L.
Godfrey Rd., Weston-Westport, Conn. 06880
B. Algona, Iowa, Nov. 1, 1889. Studied: Univ. Iowa; AIC, with Vanderpoel, Dunn. Member: A. & W. Assn.; Westport A. Cl. Award: 1960 award for Best Cartoon, Nat. Fnd. for Highway Safety. Contributor to: New Yorker, Argosy, & other magazines of cartoons, comics. Lectures: Cartooning; Cartoon History. Co-author & Illustrator, "Famous Figures of the Old West." Positions: Cart., for newspapers in Chicago, Wash., D.C., & others. Pres., Artists & Writers Service, Weston, Conn.; Ed. Cart., Evening Register, New Haven, Conn.

COWDREY, (MARY) BARTLETT—
Historian, W., Cr., Archivist
33 Randolph St., Passaic, N.J. 07055
B. Passaic, N.J., June 16, 1910. Studied: Rutgers Univ., A.B., Litt. D.; Research student, London Univ., 1934-35. Member: AAMus.; CAA; N.Y. Hist. Soc.; N.Y. State Hist. Assn.; SAH. Author: "National Academy of Design Exhibition Record, 1826-1860," 2 vols. 1944; "George Henry Durrie," 1947; "The Mount Brothers," 1947; "Winslow Homer: Illustrator," 1951; "American Academy of Fine Arts and American Art Union, 1816-1852," 2 vols. 1953. Co-author: "William Sidney Mount, 1807-1868, An American Painter," 1944. Contributor to American Collector; Antiques; Dictionary of American Biography; Art in America; New York Hist. Soc. Quarterly; New York History; Panorama; Portfolio. Positions: Registrar, BM, 1940-42; Cur. Prints, N.Y. Hist. Soc., 1943; Cur. Paintings, H.S. Newman Gal., New York, 1943-49; Cur., 1949-52; Asst. Dir., 1952-55, Actg. Dir., 1954-55, Smith Col. Mus. A.; Archivist, New York Area, Archives of Am. A., (Detroit Inst. A.), 1955-1961.

COWEN, IRVIN—Painter
3163 N. Pine Grove Ave., Chicago, Ill. 60657
B. Chicago, Ill., May 2, 1922. Studied: AIC, and in Mexico. Exhibited: AIC, 1961; Oehlschlaeger Gal., Chicago, 1958- .

COWING, WILLIAM R.—Painter, T., L.
Westminster School; h. 30 Great Pond Rd., Simsbury, Conn. 06070
B. Hartford, Conn., Nov. 8, 1920. Studied: Univ. Hartford, B.F.A.; Grad. study, Univ. Mexico. Member: Conn. WC Soc.; Conn. Acad. FA; Springfield (Mass.) A. Lg. Awards: prizes, Hallmark award, 1952; Conn. WC Soc., 1952; Allen award, 1961; Conn. Acad. FA, 1960; Silvermine Gld. A., 1954. Work: New Britain Mus.; Springfield Mus. A.; Dayton AI. Exhibited: Butler Inst. Am. A., 1952, 1956, 1957; AWS, 1949; Hallmark Exh., 1952; Birmingham Mus. A., 1954; Conn. Acad. FA, 1941-1965; Springfield A. Lg., 1949-1965; Eastern States Exh., 1951, 1961, 1962; Silvermine Gld. A., 1951, 1952, 1954, 1955; New Haven Paint & Clay Cl., 1948; Boston A. Festival, 1955, 1956; Conn. WC Soc., 1948-1965. Positions: Instr., Westminster School, Simsbury, Conn.; Connecticut Acad. Council, 1962- ; Conn. Watercolor Soc., Bd. Dir., 1952-53, 1962-64; Pres., 1964-66; Housatonic AA Pres., 1960-64.*

COWLES, CHARLES—Publisher, Collector
Artforum Magazine, 667 Madison Ave., New York, N.Y. 10021
B. Santa Monica, Cal., Feb. 7, 1941. Studied: Stanford University. Collection: Contemporary. Positions: Publisher, Artforum magazine; Trustee, Studio Museum in Harlem, New York City.

COWLES, MR. and MRS. GARDNER—Collectors
740 Park Ave., New York, N.Y. 10021*

COWLES, RUSSELL—Painter
c/o Kraushaar Gallery, 1055 Madison Ave., New York, N.Y.; h. New Milford, Conn., also 179 E. 70th St., New York, N.Y. 10021
B. Algona, Iowa, Oct. 7, 1887. Studied: Dartmouth Col., A.B.; NAD; ASL; Am. Acad. in Rome; Century Assn. Awards: Med., AIC, 1925; Hon. Deg., D.H.L., Dartmouth Col., 1951; D.F.A., Grinnell Col., 1945; D.F.A., Cornell Col., 1958; prizes, Denver A. Mus., 1936; Santa Barbara Mus. A., 1943. Work: Denver A. Mus.; Terre Haute Mus.; Encyclopaedia Britannica Coll.; Murdock Coll., Univ. Wichita; Dartmouth Col.; Minneapolis Inst. A.; PAFA; Des Moines A. Center; Blanden Mem. A. Gal.; AGAA; New Britain (Conn.) Mus. Am. A.; Santa Barbara Mus. A.; VMFA. Exhibited: Nationally. One-man: Des Moines A. Center, 1955; Dartmouth Col., 1963; Kraushaar Gal., N.Y., 1939, 1941, 1944, 1946, 1948, 1950, 1954, 1959, 1965.

COWLEY, EDWARD P.—Educator, P.
State University of New York at Albany, N.Y.; h. Altamont, N.Y. 12009
B. Buffalo, N.Y., May 29, 1925. Studied: Albright A. Sch.; Buffalo State T. Col., B.S.; Columbia Univ., M.A. Awards: Ford Fnd. F., for study in Ireland, 1955; State Univ. of N.Y. Research Fnd. Grant, 1965. Work: paintings: Smith Col. Mus.; Berkshire Mus. A.; Albany Inst. Hist. & A.; Colgate Univ. Gal.; Schenectady Mus. A.; Munson-Williams-Proctor Inst.; Outdoor Hillside Exhibits, 1966-69. Positions: Prof., Chm. A. Dept., State Univ. of New York at Albany; Bd. Dirs., Albany Lg. A.

COX, ALLYN—Painter, T., L., W.
165 E. 60th St., New York, N.Y. 10022
B. New York, N.Y., June 5, 1896. Studied: NAD; ASL; Am. Acad. in Rome, Member: NA; NSMP (Pres. 1960-63); FA Fed. of N.Y.; Mun. A. Soc.; AAPL; Arch. Lg. Awards: Prix de Rome, 1916; med., Los A. Mus. A., 1926; gold med., Arch. Lg., 1954; AAPL, 1945; Triennial Gold Medal, Royal Arch Masons, for service to the arts. Work: Princeton Mus.; Parrish Mus. A., Southampton, N.Y.; murals, Clark Mem. Lib., Los A., Cal.; Univ. Virginia; U.S. Grant Memorial, N.Y., 1966; Dumbarton Oaks; mosaics, U.S. Military Cemetery Chapel, Luxembourg; mosaics, St. Paul's Hospital, Dallas, Tex.; George Washington Masonic Nat. Mem., Alexandria, Va.; S.S. "America"; Norfolk Naval Hospital; rotunda frieze, Nat. Capitol, Wash., D.C.; stained glass, St. Bartholomew's Church, N.Y., 1964-1967. Exhibited: NAD; AAPL; Arch. Lg.; Butler Inst. Am. A., and others. Lectures. Contributor of articles to various publications. Positions: Nat. Pres., AAPL, 1952-54; Instr., ASL and NAD.

COX, E. MORRIS—Collector
1700 Mills Tower 94104; h. 2361 Broadway, San Francisco, Cal. 94115
B. Santa Rosa, Cal., Feb. 5, 1903. Studied: Univ. California, A.B.; Harvard Univ., Graduate School of Business, M.B.A. Collection: Contemporary sculpture and painting. Positions: Pres., Dodge & Cox, Investment Managers; Trustee, San Francisco Museum of Art (Pres. 1955-60); Chairman, Board of Trustees, Treasurer (1963-1967), California Academy of Sciences; Dir., Bay Area Educational Television Assn.(KQED).

COX, GARDNER—Painter
88 Garden St., Cambridge, Mass. 02138
B. Holyoke, Mass., Jan. 22, 1906. Studied: Harvard Col.; MIT; BMFA Sch. Member: Century Assn.; Am. Acad. A. & Sciences; Nat. Inst. A. & Lets.; NAD (Assoc.); Massachusetts FA Comm. Awards: prizes, Inst. Mod. A., Boston, 1945; AIC, 1949, 1951. Work: Harvard Univ.; BMFA; AGAA; Wadsworth Atheneum; Yale Univ.; Wabash Col.; Wellesley Col.; Univ. Michigan; U.S. Dept. State; U.S. Army; U.S. Dept. Labor; Harvard Club, N.Y.; Dept. Defense, U.S. Army; NGA; Brandeis Univ.; Soc. of the Cincinnati, Wash., D.C.; U.S. Air Force; NASA. Exhibited: Carnegie Inst., 1941; VMFA, 1946, 1962; Inst. Contemp. A., Boston; MMA; AIC; Univ. Illinois, 1950, 1951; Pepsi-Cola, 1948. Positions: Hd. Dept. Painting, Boston Mus. FA. Sch., 1954- . Trustee, American Academy in Rome; Dir., Boston A. Festival.

COX, J. HALLEY—Painter, E.
University of Hawaii; h. 3279 F Beaumont Woods Place, Honolulu, Hawaii 96822
B. Des Moines, Iowa, May 20, 1910. Studied: San Jose State Col., A.B.; Univ. California, M.A. Member: Hawaii P. & S. Awards: prizes, Honolulu Pr.M., 1951, 1955; A. of Hawaii, 1951, 1952. Work: BMFA; Honolulu Acad. A.; Univ. Hawaii; Bloomfield AA; State T. Col., Baltimore, Md. Exhibited: Cal. PLH, 1945 (one-man); San F. AA, 1939-1945; SFMA, 1949; Honolulu Acad. A., 1948-1965; Honolulu Pr.M., 1948-1955; one-man: Gump's Gal., San F., 1949, 1951; Honolulu Acad. A., 1951; Gimas Gal., Honolulu, 1967; The Gallery, Honolulu, 1956; Santa Barbara Mus. A., 1955; Contemp. A. Gal., Honolulu, 1962, 1965; Hawaii P. & S., 1959-1964; Hawaii P. & S., 1959-1969; Honolulu Acad. A., 1966-1969 (group exhs.); Bloomfield AA, 1960; State T. Col., Baltimore, 1961. Positions: Prof. A., Univ. Hawaii, Honolulu, Hawaii; Exhibit Des., Bishop Mus., Honolulu, Hawaii, 1959-1962; Pres., Hawaii P. & S. Lg., 1958-59.

COX, JAN—Painter
22 Evans Way, Boston, Mass. 02115
B. The Hague, Holland, Aug. 27, 1919. Studied: Higher Inst. FA, Antwerp; Univ. Ghent. Work: Musée Royale des Beaux-Arts, Brussels; Koninklijk Museem voor Schone Kunsten, Antwerp; BMFA; CM; BM; MModA. Exhibited: one-man: Venice Biennale, 1956; BMFA, 1957; Smithsonian Inst. Traveling Exh., 1958-1959, 1961; Nova Gal., Boston, 1959; Catherine Viviano Gal., N.Y., 1960, 1962; Pace Gal., Boston, 1962. National and international exhs. include: Salon de Mai, Paris, 1959, 1960, 1964; Djakarta, Indonesia, 1951;

Liege, Belgium, 1952; Museum of Curacao, 1954; Sao Paulo Bienal, 1954; Guggenheim Int. Award Exh., N.Y., 1956; Biennale Internationale de Gravure, Tokyo, 1957; Inst. Contemp. A., Boston, 1958, 1960, 1962; Belgian Art at World's Fair, Brussels, 1958; Carnegie Inst., 1958; Boston A. Festival, 1959; Parke-Bernet Galleries, N.Y., 1960; Musée de l'Art Moderne, Paris, 1961; Musée de Castres, France, 1961; Phila-Pr. Cl., 1963; Prix Marzotto Traveling Exh., 1964; Acad. of Antwerp, 1964; Utrecht, 1964; Arnot A. Gal., Elmira, N.Y., 1964; AIC, 1965. Positions: Hd. Dept. of Painting, School of the Museum of Fine Arts, Boston, Mass., 1956- .*

COX, J(OHN) W(ILLIAM) S(MITH)—Painter, T.
 543 Boylston St., Boston, Mass. 02116
B. Yonkers, N.Y., May 18, 1911. Studied: PIASch; Academie Colorossi, Paris, with Othon Friesz; Boston Univ.; Eliot O'Hara Sch. A. Awards: Scholarship, O'Hara Sch. A.; prizes, Rockport, Mass., 1951, 1960; Wash. WC Cl., 1957. Work: BMFA; Ford Publications. Exhibited: Audubon A.; AWS; Alabama WC Soc.; Mississippi WC Soc.; Springfield A. Lg.; BM; Wash. WC Cl.; Rockport AA (annually); L.D.M. Sweat Mem. Mus.; Boston A. Festival; Marblehead AA, 1958; Golden Cod Gal., 1958; Cox Gal., 1958; deCordova & Dana Mus., 1955 (one-man); WAC, 1957 (2-man); New Britain Mus., 1958 (one-man). Contributor articles and illus. to Christian Science Monitor. Positions: Pres., New England Sch. of Art, 1961- .

COX, JOSEPH H.—Painter, E.
 School of Design, North Carolina State College, Raleigh, N.C. 27607
B. Indianapolis, Ind., May 4, 1915. Studied: John Herron AI, B.F.A., with Donald Mattison, Eliot O'Hara; Univ. Iowa, M.F.A., with Jean Charlot, Philip Guston. Awards: prizes, Indiana A., 1939; Hoosier Salon, 1942; Memphis Biennial, 1951; Knoxville A. Center, 1952; Atlanta Paper Co., "Painting of the Year" Exh., 1955, 1956; Southeastern Exh., Atlanta, 1956, 1958; purchase award, Norfolk Mus. A., 1957. Work: Atlanta Paper Co. Coll.; North Carolina State Mus.; Ford Motor Co. Coll. (with reproductions in Ford Times); Norfolk Mus. A.; Atlanta AA; N.C. Mus. A., Raleigh; Mint Mus. A., Charlotte; murals, USPO, Garret, Ind.; Alma, Mich.; six murals for TVA, Tenn., 1948-53; exterior murals, Carousel Theatre, Knoxville; North Greenville Jr. Col., Tigerville, S.C.; mosaic, Am. Oil Co., Yorktown, Va.; Catholic Church, Lexington, N.C.; mural, Woman's College, Greensboro, N.C.; Branch Banking & Trust Co., Raleigh; North Carolina Nat. Bank, Raleigh. Exhibited: Carnegie Inst., 1941; VMBA, 1942; Indiana A., 1938, 1939; Hoosier Salon, 1940, 1942; Kansas City AI, 1942; Univ. Iowa; Univ. Illinois; Joslyn A. Mus.; Weyhe Gal.; Denver A. Mus.; traveling exh. "10 Southern Artists"; High Mus. A., 1950, 1952-54; John Herron AI; Memphis, Tenn., 1951, 1953; Madison Gal., N.Y., 1962 (one-man); Univ. Kentucky; State A. Exh., Raleigh, N.C.; Norfolk Mus. A.; High Mus. A., and others. Positions: Instr. A. to 1942, Asst. Prof., 1945-48, Univ. Iowa; Univ. Tennessee, 1948-54; Assoc. Prof. Des., Sch. Des., North Carolina State Col., Raleigh, N.C., 1954- .*

COX, MRS. WALTER. See Becker, Charlotte

COX, WARREN EARLE—Craftsman, P., Des., W.
 6 East 39th St.; h. 140 East 40th St., New York, N.Y. 10016
B. Oak Park, Ill., Aug. 27, 1895. Exhibited: NAD. Contributor to national art magazines. Lectures: Decorations & Craftsmanship. Author: "Pottery & Porcelain"; "Chinese Ivory Sculpture"; "Lighting and Lamp Design"; "Some Master Painters of Early Chinese Ceramics," Connoisseur Year Book, 1955. Positions: Pres., Warren E. Cox Associates, New York, N.Y.; A. Dir., A. Ed., 14th Edition, Encyclopaedia Britannica, 1929-1939.*

COZE, PAUL (JEAN)—Painter, W., I., L., E., S.
 4040 East Elm St., Phoenix, Ariz. 85018
B. Beirut, Lebanon, July 29, 1903. Studied: Lycee Janson de Sailly; Ecole des Arts Decoratifs, Paris, France; and with J. F. Gonin. Member: Societe Nationale des Beaux-Arts. Awards: Chevalier de la Legion d'Honneur; Chevalier du Merite Touristique; silver medal, Paris; prizes, Pasadena; Arizona State Fair, etc. Work: Victoria Mus., Ottawa, Canada; Southwest Mus., Los A., Cal.; Heard Mus., Phoenix; Mesa Verde Mus. (Colo); Casa Grande Mus. (Ariz.); Montezuma Castle (Ariz.); Koshares Mus., La Junta, Colo.; Read Mullan Indian Mus., Phoenix; many nat. monuments in Arizona and New Mexico; murals, in pub. bldgs., Arizona; Stations of the Cross and Altars, St. Thomas Apostle, Phoenix, mural, Air Terminal Bldg., 1961; Phoenix City Hall; Prescott City Hall; Arizona Title Bldg.; Arizona State Coliseum; Heard Mus. (diorama); mural, Golden Door, Escondido, Cal.; sc. screen and fountain, U.S. Indian Medical Center, Phoenix, Ariz. Exhibited: Pasadena AI; Los Angeles A. Mus., Mus. New Mexico, Santa Fe; Tucson & Phoenix, Ariz., and in France and Canada. Author: "Moeurs et Histoire des Peaux-Rouges"; "Quatre Feux" and other books. W., I., "L'Illustration," "Les Enfants de France," "Tatler," "Arizona Highways Magazine,"

"Nat. Geographic Magazine," and other publications. Positions: Instr. A., Pasadena AI, 1942-46; Dir., Studio Workshop, Pasadena, 1944-51; Tech. Dir., Twentieth Century Fox, Universal and Warner Bros. Studios, Hollywood, Cal.; Dir., Expedition for Musee de l'Homme, Paris, in North Canada; conducted TV program and art column; Dir., "Miracle of the Roses," Scottsdale, Ariz.; French Consul (Hon.) for Arizona; Dir., Studio Paul Coze, Phoenix, Ariz.

CRAFT, JOHN RICHARD—Museum Director
 Columbia Museum of Art, Senate & Bull Sts., 29201; h. 712 Kipling Dr., Columbia, S.C. 29205
B. Uniontown, Pa., June 15, 1909. Studied: Yale Univ.; ASL; Sorbonne, Paris; Am. Sch. Classical Studies, Athens; Johns Hopkins Univ., M.A., Ph.D. Member: AAMus; AFA; Archaeological Inst. Am.; Intl. Council Mus.; South Carolina State Arts Commission; AID. Positions: Dir., Washington County Mus. FA, Hagerstown, Md., 1940-1950; Dir., Columbia Mus. A., Columbia, S.C., 1950- ; Pres., Southeastern Museums Conference, 1953-55; Chm., Southern Art Mus. Dir. Assn., 1955-1956.

CRAIG, EUGENE—Cartoonist, L.
 The Columbus Dispatch, Columbus, Ohio 43215; h. 73 East Kramer St., Canal Winchester, Ohio 43110
B. Fort Wayne, Ind., Sept. 5, 1916. Member: Am. Assn. Editorial Cart.; Nat. Cartoonists Soc. Awards: Many Freedoms Foundation awards, 1950, 1951, 1953, 1959, 1960, 1962 (top award). Work: Designed "Battle of Brooklyn" U.S. Postage Stamp, 1951. Positions: Cartoonist, Fort Wayne News-Sentinel, 1934-1951; Brooklyn Eagle, 1951-1955; Columbus Dispatch, 1955- . Chalk talks: "How to Draw Cartoons," to Journalism Clinics, Service Clubs, etc.*

CRAIG, MARTIN—Sculptor, T., P.
 235 7th Ave. 10011; h. 305 East 10th St., New York, N.Y. 10009
B. Paterson, N.J., Nov. 2, 1906. Studied: Col. City of N.Y., B.S. Member: A. Cl.; Sculptors Gld. Awards: prizes, MModA, 1940, 1955; Longview Fnd. award, 1962. Work: sc., Temple Mishkan Telfila, Newton, Mass.; Temple Israel, New Rochelle, N.Y.; Fifth Avenue Synagogue, N.Y.; Temple Beth-El, Providence, R.I.; Federal Housing Comm.; WFNY 1939; Kalamazoo Inst. A.; Montreal Gazette. Exhibited: Salon de Mai, Paris, 1952-1954; Salon de la Jeune Sculpture, Paris, 1950-1954; U.S. Embassy, Paris, 1953; Summer A. Festival, Belgium, 1952; MModA, 1955; WMAA; Mus. Contemp. A., Houston, Tex.; Stable Gal., N.Y.; Matisse Gal., N.Y.; Bryant Park and Lever House, New York, N.Y., 1967-1969; one-man: Galerie du Siecle, Paris, 1949; Galerie Colette Allendy, Paris, 1954. Positions: Instr. S., Sarah Lawrence Col., Cooper Union, Brooklyn Col., N.Y. Univ. & Pratt Inst., Brooklyn, N.Y.; Instr., New Sch., New York City, at present.

CRAMER, A(BRAHAM)—Cartoonist, Comm., P.
 1909 Quentin Rd., Brooklyn, N.Y. 11229
B. Russia, Aug. 25, 1903. Studied: Kiev Sch. FA, Russia; Acad. FA, Mexico City, Mexico. Work: murals and portraits in Mexico City and private colls. Exhibited: Soc. Indp. A. Contributor cartoons to: Sat. Eve. Post, Red Book, New Yorker, Ladies Home Journal, King Features Syndicate, Esquire, True, and others.

CRAMER, RICHARD CHARLES—Painter, E.
 39 N. 10th St., Philadelphia, Pa. 19107
B. Appleton, Wis., Aug. 14, 1932. Studied: Layton Sch. A., B.F.A.; Univ. Wisconsin, Milwaukee, B.S., Madison, M.S., M.F.A. Member: CAA. Awards: prizes, Milwaukee A. Inst., 1954; Wis. P. & S.; Syracuse All. A., 1964; Munson-Williams-Proctor Inst., Utica, N.Y., 1965. Work: PAFA; Everhart Mus., Scranton, Pa.; Everson Mus., Syracuse, N.Y.; Univ. Wisconsin; Southern Univ., New Orleans; Whitewater (Wis.) State Univ.; Layton Sch. A., Milwaukee. Exhibited: LC, 1952; PAFA, 1959; St. Paul Gal., 1961; Pasadena A. Mus., 1962; Ball State Univ., 1962; drawing biennial, Norfolk Mus. A., 1965; drawings, Smithsonian Inst., traveling exh., 1965; Wisconsin Prints, 1952-1954, 1958; Wisconsin Salon, 1953, 1957-1959, 1961; Syracuse Regional, 1963-1965; Printmakers, N.Y., 1966; Philadelphia A. Festival, 1967. Positions: Instr., Drawing & Design, Univ. Wisconsin, 1960-1962; Painting & Drawing, Elmira Col., Elmira, N.Y., 1962-1966; Painting & Drawing, Tyler Sch. A., Philadelphia, Pa., 1966- .

CRAMPTON, ROLLIN—Painter, T.
 147 Tinker St., Woodstock, N.Y. 12498
B. New Haven, Conn. Studied: Yale Univ. Sch. A.; ASL. Member: Woodstock AA; Member Conference Committee National Arts Conference. Work: MModA; WMAA; Massachusetts Inst., Tech.; Univ. Texas; Kalamazoo A. Center; Louisiana State Univ.; New York State Univ.; Albright-Knox A. Gal.; WAC; Rome-New York A. Fnd.; Univ. Syracuse; Univ. Rochester, and others. Exhibited: One-man: Wood-

ber of Commerce, State of Florida; Peninsular Life Insurance Co.; Tampa Pub. Lib.; City of Gainesville, Florida. Exhibited: MModA; N.Y. Worlds Fair; 20 one-man exhibitions; Florida 17 Invitational Show, Washington, D.C.; all major Southeastern regionals. Positions: Prof. Division Dean, Division of Fine Arts, University of South Florida, Tampa, Fla., at present.

COWAN, WOOD—Cartoonist, W., I., L.
 Godfrey Rd., Weston-Westport, Conn. 06880
B. Algona, Iowa, Nov. 1, 1889. Studied: Univ. Iowa; AIC, with Vanderpoel, Dunn. Member: A. & W. Assn.; Westport A. Cl. Award: 1960 award for Best Cartoon, Nat. Fnd. for Highway Safety. Contributor to: New Yorker, Argosy, & other magazines of cartoons, comics. Lectures: Cartooning; Cartoon History. Co-author & Illustrator, "Famous Figures of the Old West." Positions: Cart., for newspapers in Chicago, Wash., D.C., & others. Pres., Artists & Writers Service, Weston, Conn.; Ed. Cart., Evening Register, New Haven, Conn.

COWDREY, (MARY) BARTLETT—
 Historian, W., Cr., Archivist
 33 Randolph St., Passaic, N.J. 07055
B. Passaic, N.J., June 16, 1910. Studied: Rutgers Univ., A.B., Litt. D.; Research student, London Univ., 1934-35. Member: AAMus.; CAA; N.Y. Hist. Soc.; N.Y. State Hist. Assn.; SAH. Author: "National Academy of Design Exhibition Record, 1826-1860," 2 vols. 1944; "George Henry Durrie," 1947; "The Mount Brothers," 1947; "Winslow Homer: Illustrator," 1951; "American Academy of Fine Arts and American Art Union, 1816-1852," 2 vols. 1953. Co-author: "William Sidney Mount, 1807-1868, An American Painter," 1944. Contributor to American Collector; Antiques; Dictionary of American Biography; Art in America; New York Hist. Soc. Quarterly; New York History; Panorama; Portfolio. Positions: Registrar, BM, 1940-42; Cur. Prints, N.Y. Hist. Soc., 1943; Cur. Paintings, H.S. Newman Gal., New York, 1943-49; Cur., 1949-52; Asst. Dir., 1952-55, Actg. Dir., 1954-55, Smith Col. Mus. A.; Archivist, New York Area, Archives of Am. A., (Detroit Inst. A.), 1955-1961.

COWEN, IRVIN—Painter
 3163 N. Pine Grove Ave., Chicago, Ill. 60657
B. Chicago, Ill., May 2, 1922. Studied: AIC, and in Mexico. Exhibited: AIC, 1961; Oehlschlaeger Gal., Chicago, 1958- .

COWING, WILLIAM R.—Painter, T., L.
 Westminster School; h. 30 Great Pond Rd., Simsbury, Conn. 06070
B. Hartford, Conn., Nov. 8, 1920. Studied: Univ. Hartford, B.F.A.; Grad. study, Univ. Mexico. Member: Conn. WC Soc.; Conn. Acad. FA; Springfield (Mass.) A. Lg. Awards: prizes, Hallmark award, 1952; Conn. WC Soc., 1952; Allen award, 1961; Conn. Acad. FA, 1960; Silvermine Gld. A., 1954. Work: New Britain Mus.; Springfield Mus. A.; Dayton AI. Exhibited: Butler Inst. Am. A., 1952, 1956, 1957; AWS, 1949; Hallmark Exh., 1952; Birmingham Mus. A., 1954; Conn. Acad. FA, 1941-1965; Springfield A. Lg., 1949-1965; Eastern States Exh., 1951, 1961, 1962; Silvermine Gld. A., 1951, 1952, 1954, 1955; New Haven Paint & Clay Cl., 1948; Boston A. Festival, 1955, 1956; Conn. WC Soc., 1948-1965. Positions: Instr., Westminster School, Simsbury, Conn.; Connecticut Acad. Council, 1962- ; Conn. Watercolor Soc., Bd. Dir., 1952-53, 1962-64; Pres., 1964-66; Housatonic AA Pres., 1960-64.*

COWLES, CHARLES—Publisher, Collector
 Artforum Magazine, 667 Madison Ave., New York, N.Y. 10021
B. Santa Monica, Cal., Feb. 7, 1941. Studied: Stanford University. Collection: Contemporary. Positions: Publisher, Artforum magazine; Trustee, Studio Museum in Harlem, New York City.

COWLES, MR. and MRS. GARDNER—Collectors
 740 Park Ave., New York, N.Y. 10021*

COWLES, RUSSELL—Painter
 c/o Kraushaar Gallery, 1055 Madison Ave., New York, N.Y.; h. New Milford, Conn., also 179 E. 70th St., New York, N.Y. 10021
B. Algona, Iowa, Oct. 7, 1887. Studied: Dartmouth Col., A.B.; NAD; ASL; Am. Acad. in Rome; Century Assn. Awards: Med., AIC, 1925; Hon. Deg., D.H.L., Dartmouth Col., 1951; D.F.A., Grinnell Col., 1945; D.F.A., Cornell Col., 1958; prizes, Denver A. Mus., 1936; Santa Barbara Mus. A., 1943. Work: Denver A. Mus.; Terre Haute Mus.; Encyclopaedia Britannica Coll.; Murdock Coll., Univ. Wichita; Dartmouth Col.; Minneapolis Inst. A.; PAFA; Des Moines A. Center; Blanden Mem. A. Gal.; AGAA; New Britain (Conn.) Mus. Am. A.; Santa Barbara Mus. A.; VMFA. Exhibited: Nationally. One-man: Des Moines A. Center, 1955; Dartmouth Col., 1963; Kraushaar Gal., N.Y., 1939, 1941, 1944, 1946, 1948, 1950, 1954, 1959, 1965.

COWLEY, EDWARD P.—Educator, P.
 State University of New York at Albany, N.Y.; h. Altamont, N.Y. 12009
B. Buffalo, N.Y., May 29, 1925. Studied: Albright A. Sch.; Buffalo State T. Col., B.S.; Columbia Univ., M.A. Awards: Ford Fnd. F., for study in Ireland, 1955; State Univ. of N.Y. Research Fnd. Grant, 1965. Work: paintings: Smith Col. Mus. A.; Berkshire Mus. A.; Albany Inst. Hist. & A.; Colgate Univ. Gal.; Schenectady Mus. A.; Munson-Williams-Proctor Inst.; Outdoor Hillside Exhibits, 1966-69. Positions: Prof., Chm. A. Dept., State Univ. of New York at Albany; Bd. Dirs., Albany Lg. A.

COX, ALLYN—Painter, T., L., W.
 165 E. 60th St., New York, N.Y. 10022
B. New York, N.Y., June 5, 1896. Studied: NAD; ASL; Am. Acad. in Rome, Member: NA; NSMP (Pres. 1960-63); FA Fed. of N.Y.; Mun. A. Soc.; AAPL; Arch. Lg. Awards: Prix de Rome, 1916; med., Los A. Mus. A., 1926; gold med., Arch. Lg., 1954; AAPL, 1945; Triennial Gold Medal, Royal Arch Masons, for service to the arts. Work: Princeton Mus.; Parrish Mus. A., Southampton, N.Y.; murals, Clark Mem. Lib., Los A., Cal.; Univ. Virginia; U.S. Grant Memorial, N.Y., 1966; Dumbarton Oaks; mosaics, U.S. Military Cemetery Chapel, Luxembourg; mosaics, St. Paul's Hospital, Dallas, Tex.; George Washington Masonic Nat. Mem., Alexandria, Va.; S.S. "America"; Norfolk Naval Hospital; rotunda frieze, Nat. Capitol, Wash., D.C.; stained glass, St. Bartholomew's Church, N.Y., 1964-1967. Exhibited: NAD; AAPL; Arch. Lg.; Butler Inst. Am. A., and others. Lectures. Contributor of articles to various publications. Positions: Nat. Pres., AAPL, 1952-54; Instr., ASL and NAD.

COX, E. MORRIS—Collector
 1700 Mills Tower 94104; h. 2361 Broadway, San Francisco, Cal. 94115
B. Santa Rosa, Cal., Feb. 5, 1903. Studied: Univ. California, A.B.; Harvard Univ., Graduate School of Business, M.B.A. Collection: Contemporary sculpture and painting. Positions: Pres., Dodge & Cox, Investment Managers; Trustee, San Francisco Museum of Art (Pres. 1955-60); Chairman, Board of Trustees, Treasurer (1963-1967), California Academy of Sciences; Dir., Bay Area Educational Television Assn.(KQED).

COX, GARDNER—Painter
 88 Garden St., Cambridge, Mass. 02138
B. Holyoke, Mass., Jan. 22, 1906. Studied: Harvard Col.; MIT; BMFA Sch. Member: Century Assn.; Am. Acad. A. & Sciences; Nat. Inst. A. & Lets.; NAD (Assoc.); Massachusetts FA Comm. Awards: prizes, Inst. Mod. A., Boston, 1945; AIC, 1949, 1951. Work: Harvard Univ.; BMFA; AGAA; Wadsworth Atheneum; Yale Univ.; Wabash Col.; Wellesley Col.; Univ. Michigan; U.S. Dept. State; U.S. Army; U.S. Dept. Labor; Harvard Club, N.Y.; Dept. Defense, U.S. Army; NGA; Brandeis Univ.; Soc. of the Cincinnati, Wash., D.C.; U.S. Air Force; NASA. Exhibited: Carnegie Inst., 1941; VMFA, 1946, 1962; Inst. Contemp. A., Boston; MMA; AIC; Univ. Illinois, 1950, 1951; Pepsi-Cola, 1948. Positions: Hd. Dept. Painting, Boston Mus. FA. Sch., 1954- . Trustee, American Academy in Rome; Dir., Boston A. Festival.

COX, J. HALLEY—Painter, E.
 University of Hawaii; h. 3279 F Beaumont Woods Place, Honolulu, Hawaii 96822
B. Des Moines, Iowa, May 20, 1910. Studied: San Jose State Col., A.B.; Univ. California, M.A. Member: Hawaii P. & S. Awards: prizes, Honolulu Pr.M., 1951, 1955; A. of Hawaii, 1951, 1952. Work: BMFA; Honolulu Acad. A.; Univ. Hawaii; Bloomfield AA; State T. Col., Baltimore, Md. Exhibited: Cal. PLH, 1945 (one-man); San F. AA, 1939-1945; SFMA, 1949; Honolulu Acad. A., 1948-1965; Honolulu Pr.M., 1948-1955; one-man: Gump's Gal., San F., 1949, 1951; Honolulu Acad. A., 1951; Gimas Gal., Honolulu, 1967; The Gallery, Honolulu, 1956; Santa Barbara Mus. A., 1955; Contemp. A. Gal., Honolulu, 1962, 1965; Hawaii P. & S., 1959-1964; Hawaii P. & S., 1959-1969; Honolulu Acad. A., 1966-1969 (group exhs.); Bloomfield AA, 1960; State T. Col., Baltimore, 1961. Positions: Prof. A., Univ. Hawaii, Honolulu, Hawaii; Exhibit Des., Bishop Mus., Honolulu, Hawaii, 1959-1962; Pres., Hawaii P. & S. Lg., 1958-59.

COX, JAN—Painter
 22 Evans Way, Boston, Mass. 02115
B. The Hague, Holland, Aug. 27, 1919. Studied: Higher Inst. FA, Antwerp; Univ. Ghent. Work: Musée Royale des Beaux-Arts, Brussels; Koninklijk Museem voor Schone Kunsten, Antwerp; BMFA; CM; BM; MModA. Exhibited: one-man: Venice Biennale, 1956; BMFA, 1957; Smithsonian Inst. Traveling Exh., 1958-1959, 1961; Nova Gal., Boston, 1959; Catherine Viviano Gal., N.Y., 1960, 1962; Pace Gal., Boston, 1962. National and international exhs. include: Salon de Mai, Paris, 1959, 1960, 1964; Djakarta, Indonesia, 1951;

Liege, Belgium, 1952; Museum of Curacao, 1954; Sao Paulo Bienal, 1954; Guggenheim Int. Award Exh., N.Y., 1956; Biennale Internationale de Gravure, Tokyo, 1957; Inst. Contemp. A., Boston, 1958, 1960, 1962; Belgian Art at World's Fair, Brussels, 1958; Carnegie Inst., 1958; Boston A. Festival, 1959; Parke-Bernet Galleries, N.Y., 1960; Musée de l'Art Moderne, Paris, 1961; Musée de Castres, France, 1961; Phila-Pr. Cl., 1963; Prix Marzotto Traveling Exh., 1964; Acad. of Antwerp, 1964; Utrecht, 1964; Arnot A. Gal., Elmira, N.Y., 1964; AIC, 1965. Positions: Hd. Dept. of Painting, School of the Museum of Fine Arts, Boston, Mass., 1956- .*

COX, J(OHN) W(ILLIAM) S(MITH)—Painter, T.
 543 Boylston St., Boston, Mass. 02116
B. Yonkers, N.Y., May 18, 1911. Studied: PIASch; Academie Colorossi, Paris, with Othon Friesz; Boston Univ.; Eliot O'Hara Sch. A. Awards: Scholarship, O'Hara Sch. A.; prizes, Rockport, Mass., 1951, 1960; Wash. WC Cl., 1957. Work: BMFA; Ford Publications. Exhibited: Audubon A.; AWS; Alabama WC Soc.; Mississippi WC Soc.; Springfield A. Lg.; BM; Wash. WC Cl.; Rockport AA (annually); L.D.M. Sweat Mem. Mus.; Boston A. Festival; Marblehead AA, 1958; Golden Cod Gal., 1958; Cox Gal., 1958; deCordova & Dana Mus., 1955 (one-man); WAC, 1957 (2-man); New Britain Mus., 1958 (one-man). Contributor articles and illus. to Christian Science Monitor. Positions: Pres., New England Sch. of Art, 1961- .

COX, JOSEPH H.—Painter, E.
 School of Design, North Carolina State College, Raleigh, N.C. 27607
B. Indianapolis, Ind., May 4, 1915. Studied: John Herron AI, B.F.A., with Donald Mattison, Eliot O'Hara; Univ. Iowa, M.F.A., with Jean Charlot, Philip Guston. Awards: prizes, Indiana A., 1939; Hoosier Salon, 1942; Memphis Biennial, 1951; Knoxville A. Center, 1952; Atlanta Paper Co., "Painting of the Year" Exh., 1955, 1956; Southeastern Exh., Atlanta, 1956, 1958; purchase award, Norfolk Mus. A., 1957. Work: Atlanta Paper Co. Coll.; North Carolina State Mus.; Ford Motor Co. Coll. (with reproductions in Ford Times); Norfolk Mus. A.; Atlanta AA; N.C. Mus. A., Raleigh; Mint Mus. A., Charlotte; murals, USPO, Garret, Ind.; Alma, Mich.; six murals for TVA, Tenn., 1948-53; exterior murals, Carousel Theatre, Knoxville; North Greenville Jr. Col., Tigerville, S.C.; mosaic, Am. Oil Co., Yorktown, Va.; Catholic Church, Lexington, N.C.; mural, Woman's College, Greensboro, N.C.; Branch Banking & Trust Co., Raleigh; North Carolina Nat. Bank, Raleigh. Exhibited: Carnegie Inst., 1941; VMBA, 1942; Indiana A., 1938, 1939; Hoosier Salon, 1940, 1942; Kansas City AI, 1942; Univ. Iowa; Univ. Illinois; Joslyn A. Mus.; Weyhe Gal.; Denver A. Mus.; traveling exh. "10 Southern Artists"; High Mus. A., 1950, 1952-54; John Herron AI; Memphis, Tenn., 1951, 1953; Madison Gal., N.Y., 1962 (one-man); Univ. Kentucky; State A. Exh., Raleigh, N.C.; Norfolk Mus. A.; High Mus. A., and others. Positions: Instr. A. to 1942, Asst. Prof., 1945-48, Univ. Iowa; Univ. Tennessee, 1948-54; Assoc. Prof. Des., Sch. Des., North Carolina State Col., Raleigh, N.C., 1954- .*

COX, MRS. WALTER. See Becker, Charlotte

COX, WARREN EARLE—Craftsman, P., Des., W.
 6 East 39th St.; h. 140 East 40th St., New York, N.Y. 10016
B. Oak Park, Ill., Aug. 27, 1895. Exhibited: NAD. Contributor to national art magazines. Lectures: Decorations & Craftsmanship. Author: "Pottery & Porcelain"; "Chinese Ivory Sculpture"; "Lighting and Lamp Design"; "Some Master Painters of Early Chinese Ceramics," Connoisseur Year Book, 1955. Positions: Pres., Warren E. Cox Associates, New York, N.Y.; A. Dir., A. Ed., 14th Edition, Encyclopaedia Britannica, 1929-1939.*

COZE, PAUL (JEAN)—Painter, W., I., L., E., S.
 4040 East Elm St., Phoenix, Ariz. 85018
B. Beirut, Lebanon, July 29, 1903. Studied: Lycee Janson de Sailly; Ecole des Arts Decoratifs, Paris, France; and with J. F. Gonin. Member: Societe Nationale des Beaux-Arts. Awards: Chevalier de la Legion d'Honneur; Chevalier du Merite Touristique; silver medal, Paris; prizes, Pasadena; Arizona State Fair, etc. Work: Victoria Mus., Ottawa, Canada; Southwest Mus., Los A., Cal.; Heard Mus., Phoenix; Mesa Verde Mus. (Colo); Casa Grande Mus. (Ariz.); Montezuma Castle (Ariz.); Koshares Mus., La Junta, Colo.; Read Mullan Indian Mus., Phoenix; many nat. monuments in Arizona and New Mexico; murals, in pub. bldgs.; Arizona; Stations of the Cross and Altars, St. Thomas Apostle, Phoenix, mural, Air Terminal Phoenix, 1961; Phoenix City Hall; Prescott City Hall; Arizona Title Bldg.; Arizona State Coliseum; Heard Mus. (diorama); mural, Golden Door, Escondido, Cal.; sc. screen and fountain, U.S. Indian Medical Center, Phoenix, Ariz. Exhibited: Pasadena AI; Los Angeles A. Mus. A., Mus. New Mexico, Santa Fe; Tucson & Phoenix, Ariz., and in France and Canada. Author: "Moeurs et Histoire des Peaux-Rouges"; "Quatre Feux" and other books. W., I., "L'Illustration," "Les Enfants de France," "Tatler," "Arizona Highways Magazine,"

"Nat. Geographic Magazine," and other publications. Positions: Instr. A., Pasadena AI, 1942-46; Dir., Studio Workshop, Pasadena, 1944-51; Tech. Dir., Twentieth Century Fox, Universal and Warner Bros. Studios, Hollywood, Cal.; Dir., Expedition for Musee de l'Homme, Paris, in North Canada; conducted TV program and art column; Dir., "Miracle of the Roses," Scottsdale, Ariz.; French Consul (Hon.) for Arizona; Dir., Studio Paul Coze, Phoenix, Ariz.

CRAFT, JOHN RICHARD—Museum Director
 Columbia Museum of Art, Senate & Bull Sts., 29201; h. 712 Kipling Dr., Columbia, S.C. 29205
B. Uniontown, Pa., June 15, 1909. Studied: Yale Univ.; ASL; Sorbonne, Paris; Am. Sch. Classical Studies, Athens; Johns Hopkins Univ., M.A., Ph.D. Member: AAMus; AFA; Archaeological Inst. Am.; Intl. Council Mus.; South Carolina State Arts Commission; AID. Positions: Dir., Washington County Mus. FA, Hagerstown, Md., 1940-1950; Dir., Columbia Mus. A., Columbia, S.C., 1950- ; Pres., Southeastern Museums Conference, 1953-55; Chm., Southern Art Mus. Dir. Assn., 1955-1956.

CRAIG, EUGENE—Cartoonist, L.
 The Columbus Dispatch, Columbus, Ohio 43215; h. 73 East Kramer St., Canal Winchester, Ohio 43110
B. Fort Wayne, Ind., Sept. 5, 1916. Member: Am. Assn. Editorial Cart.; Nat. Cartoonists Soc. Awards: Many Freedoms Foundation awards, 1950, 1951, 1953, 1959, 1960, 1962 (top award). Work: Designed "Battle of Brooklyn" U.S. Postage Stamp, 1951. Positions: Cartoonist, Fort Wayne News-Sentinel, 1934-1951; Brooklyn Eagle, 1951-1955; Columbus Dispatch, 1955- . Chalk talks: "How to Draw Cartoons," to Journalism Clinics, Service Clubs, etc.*

CRAIG, MARTIN—Sculptor, T., P.
 235 7th Ave. 10011; h. 305 East 10th St., New York, N.Y. 10009
B. Paterson, N.J., Nov. 2, 1906. Studied: Col. City of N.Y., B.S. Member: A. Cl.; Sculptors Gld. Awards: prizes, MModA, 1940, 1955; Longview Fnd. award, 1962. Work: sc., Temple Mishkan Telfila, Newton, Mass.; Temple Israel, New Rochelle, N.Y.; Fifth Avenue Synagogue, N.Y.; Temple Beth-El, Providence, R.I.; Federal Housing Comm.; WFNY 1939; Kalamazoo Inst. A.; Montreal Gazette. Exhibited: Salon de Mai, Paris, 1952-1954; Salon de la Jeune Sculpture, Paris, 1950-1954; U.S. Embassy, Paris, 1953; Summer A. Festival, Belgium, 1952; MModA, 1955; WMAA; Mus. Contemp. A., Houston, Tex.; Stable Gal., N.Y.; Matisse Gal., N.Y.; Bryant Park and Lever House, New York, N.Y., 1967-1969; one-man: Galerie du Siecle, Paris, 1949; Galerie Colette Allendy, Paris, 1954. Positions: Instr. S., Sarah Lawrence Col., Cooper Union, Brooklyn Col., N.Y. Univ. & Pratt Inst., Brooklyn, N.Y.; Instr., New Sch., New York City, at present.

CRAMER, A(BRAHAM)—Cartoonist, Comm., P.
 1909 Quentin Rd., Brooklyn, N.Y. 11229
B. Russia, Aug. 25, 1903. Studied: Kiev Sch. FA, Russia; Acad. FA, Mexico City, Mexico. Work: murals and portraits in Mexico City and private colls. Exhibited: Soc. Indp. A. Contributor cartoons to: Sat. Eve. Post, Red Book, New Yorker, Ladies Home Journal, King Features Syndicate, Esquire, True, and others.

CRAMER, RICHARD CHARLES—Painter, E.
 39 N. 10th St., Philadelphia, Pa. 19107
B. Appleton, Wis., Aug. 14, 1932. Studied: Layton Sch. A., B.F.A.; Univ. Wisconsin, Milwaukee, B.S., Madison, M.S., M.F.A. Member: CAA. Awards: prizes, Milwaukee A. Inst., 1954; Wis. P. & S.; Syracuse All. A., 1964; Munson-Williams-Proctor Inst., Utica, N.Y., 1965. Work: PAFA; Everhart Mus., Scranton, Pa.; Everson Mus., Syracuse, N.Y.; Univ. Wisconsin; Southern Univ., New Orleans; Whitewater (Wis.) State Univ.; Layton Sch. A., Milwaukee. Exhibited: LC, 1952; PAFA, 1959; St. Paul Gal., 1961; Pasadena A. Mus., 1962; Ball State Univ., 1962; drawing biennial, Norfolk Mus. A., 1965; drawings, Smithsonian Inst., traveling exh., 1965; Wisconsin Prints, 1952-1954, 1958; Wisconsin Salon, 1953, 1957-1959, 1961; Syracuse Regional, 1963-1965; Printmakers, N.Y., 1966; Philadelphia A. Festival, 1967. Positions: Instr., Drawing & Design, Univ. Wisconsin, 1960-1962; Painting & Drawing, Elmira Col., Elmira, N.Y., 1962-1966; Painting & Drawing, Tyler Sch. A., Philadelphia, Pa., 1966- .

CRAMPTON, ROLLIN—Painter, T.
 147 Tinker St., Woodstock, N.Y. 12498
B. New Haven, Conn. Studied: Yale Univ. Sch. A.; ASL. Member: Woodstock AA; Member Conference Committee National Arts Conference. Work: MModA; WMAA; Massachusetts Inst., Tech.; Univ. Texas; Kalamazoo A. Center; Louisiana State Univ.; New York State Univ.; Albright-Knox A. Gal.; WAC; Rome-New York A. Fnd.; Univ. Syracuse; Univ. Rochester, and others. Exhibited: One-man: Wood-

stock A. Gal.; Stable Gal., N.Y., 1961, 1964; Krasner Gal., N.Y., 1960, etc. Positions: Instr., Parnassus Square Sch. of A., Woodstock, N.Y.

CRANE, JAMES—Educator, P., Cart.
Florida Presbyterian College; h. 7326 Demen Drive, South, St. Petersburg, Fla. 33712
B. Hartshorne, Okla., May 21, 1927. Studied: Albion Col., B.A.; State Univ. Iowa, M.A.; Michigan State Univ., M.F.A. Awards: Ford Fnd. Purchase, at WAC, 1961; Mead Corp. "Painting of Distinction" award, 1962; Jacksonville A. Festival, 1963, 1965; Fla. State Fair, 1965; Fla. A. Group 1965; Soc. Four Arts, Palm Beach, 1967. Author: "What Other Time," 1953; "On Edge," 1965 (Satirical cartoons); "The Great Teaching Machine," 1966; "Inside Out," 1967. Illus., "A Funny Thing Happened on the Way to Heaven," 1969. Positions: Prof. of Art, Florida Presbyterian College, St. Petersburg, Fla., at present.

CRANE, ROY(STON) (CAMPBELL)—Cartoonist, W.
5585 Jessamine Lane, Orlando, Fla. 32809
B. Abilene, Tex., Nov. 22, 1901. Studied: Hardin-Simmons Univ.; Univ. Texas; Chicago Acad. F.A. Member: Nat. Cart. Soc.; Cart. Cl; Nat. Comics Council. Awards: Cited, U.S. Navy, as War Correspondent, 1946; "Cartoonist of the Year," 1950, Best Story Strip Cartoonist, 1965, Nat. Cart. Soc.; Hon. Deg., Doctor of Humane Letters, Rollins Col., 1957; U.S. Navy gold medal for Distinguished Public Service, 1957; Banshee's "Silver Lady" award, outstanding Newspaper Artist of the Year, 1961. Work: Letters, papers, drawings, bound files in Carnegie Lib., Syracuse Univ. Drawings in Smithsonian, Univ. Kansas, Kansas State, Texas Univ., Rollins Col. and in Nat. Cart. Soc. exhs. in the Louvre, Smithsonian and many other places. Positions: A., W., NEA Service, newspaper strip "Wash Tubbs," "Captain Easy," 1924-1943; King Features Syndicate, newspaper strip "Buzz Sawyer," (appearing in 563 newspapers) 1943- .

CRAVEN, ROY C., JR.—Painter, E., Des., S., W., L.
Dept. of Art, University of Florida; h. 413 Northwest 36th Dr., Gainesville, Fla. 32601
B. Cherokee Bluffs, Ala., July 29, 1924. Studied: Univ. Chattanooga, B.A.; ASL, with Kuniyoshi, Grosz, Browne, Piening; Univ. Florida, M.F.A. Member: Southeastern College AA; CAA; Asia Soc.; AA Mus. Awards: prizes, VMFA, 1950 (purchase); AIGA, 1950; Brooks Mem. A. Gal., 1952; purchase & award, Ringling Mus. A., 1961; Fulbright Senior Research Scholar, India, 1962-63. Work: VMFA, Esso Standard Oil Co. of N.J.; Ryder Corp. Coll., Miami; arch. relief, Jacksonville Auditorium; facade, FA Bldg., Jacksonville Univ.; facade, Medical Bldg., Welsey Manor Retirement Village, St. Johns County, Fla. Exhibited: MMA, 1952; AFA traveling exh., 1956-58, 1961-62; Soc. Four Arts, 1956, 1957, 1959, 1960; Sarasota AA, 1956, 1957, 1960, 1961; Southeastern annual, Atlanta, 1953, 1957, 1964; Painting of the Year, Atlanta, 1956, 1958, 1961; Lowe Comp., 1950; New Orleans AA, 1957; Norfolk Mus., 1954; Director's Choice, 1956, 1957; Jacksonville A. Mus., 1959, 1960 (2-man); Tennessee FA Center, Nashville, 1960; Univ. Florida, 1960 (2-man), 1961 (one-man); Danforth Fnd., Atlanta, 1960; Ringling Mus., 1961; Atrium Gal., Jacksonville, 1961 (one-man); Jacksonville Univ., 1961; 14 Florida Artists, Nixon Gal., New Orleans, 1961; Coral Gables, Fla., 1963; Sarasota AA, 1965; Chattanooga, Tenn., 1965, and others. Lectures: Contemporary Painting; Indian Art. Author: "Indian Sculpture in the John and Mable Ringling Museum of Art," 1961; Author, Des., 32 page catalog for international exhibition, "Ten Contemporary Painters from India," selected by Craven to tour U.S. and Asian Art Centers, 1963-64. Contributor to: Bulletin of the North Carolina Mus. A., 1958; Living magazine, 1959; Span Magazine, New Delhi, 1964. Positions: Prof. A., & Dir. Univ. Gallery, Univ. Florida, Gainesville, Fla., 1954- .

CRAWFORD, JOHN M., JR.—Collector, Patron
46 E. 82nd St., New York, N.Y. 10028
B. Parkersburg, W. Va., Aug. 6, 1913. Studied: Brown University, A.B.; Harvard University School of Education. Awards: Hon. Litt. D., Brown University, 1964; Hon. L.H.D., Syracuse Univ., 1967. Collection: Chinese Calligraphy and Painting; William Morris and the Kelmscott Press (catalogue published 1960). Chinese Calligraphy and Painting in the Collection of John M. Crawford, Jr. (catalogue published 1962) was exhibited at The Morgan Library, New York, N.Y., 1962; Fogg Art Museum, Harvard University, Cambridge, Mass., 1963; William Rockhill Nelson Gallery of Art, Kansas City, Mo., 1963; Victoria and Albert Museum, London, England, 1965. Additional collections: Medieval Manuscripts; Early Printed Books; Other Printed Masterpieces; Modern Printing. William Morris Collection shown: Brown University, Providence, R.I., 1959; Grolier Club, New York, N.Y., 1964; National Gallery; Stockholm, Sweden, 1965; Musée Cernuschi, Paris, France, 1966. Positions: Member, Council of the Friends of Columbia University Libraries, 1967- ; Library Committee, Brown University, 1958- ; Grolier Club; Council, 1958- , Chairman Exhibition Committee, Century Association, 1965; Fellow, 1950, Life Fellow, 1959, Council of Fellows, 1961-1964, Morgan Library, New York City; Trustee, Syracuse University Library; Trustee, Asheville (N.C.) School, 1950; Visiting Committee, Fogg Art Museum, Harvard University, 1961-1964.

CRAWFORD, RALSTON—Painter, Lith., Photog., I., T., L.
10 East 23rd St. 10010; h. 60 Gramercy Park, New York, N.Y. 10010
B. St. Catherines, Ontario, Canada, Sept. 25, 1906. Studied: Otis AI; PAFA; Barnes Fnd.; Breckenridge Sch.; Columbia Univ., and in Europe. Awards: Wilmington Soc. FA, 1933; F., Tiffany Fnd., 1931; MMA, 1942. Work: MMA; Munson-Williams-Proctor Inst.; WMAA; Albright A. Gal.; PMG; LC; Mus. of FA of Houston; Flint Inst. A.; CM; Toledo Mus. A.; Walker A. Center; Univ. Minnesota; Honolulu Acad. A.; Univ. Oklahoma; Howard Univ.; Butler AI; MacMurray Col.; Hamline Univ.; Louisiana State Univ.; Louisiana State A. Comm.; Hofstra Col.; MModA; Milwaukee A. Center; SFMA; Univs. of Georgia, Nebraska, Alabama, Kentucky, Illinois, Michigan; Alabama Polytechnic Inst.; Vassar Col.; Duke Univ., and many others. Exhibited: CGA; MMA; WMAA; AIC; CM; PMG; PAFA; Albright A. Gal.; Cal. PLH; Dallas Mus. FA; Denver A. Mus.; Cornell Univ.; Lafayette Col.; Univ. Indiana; Rochester Mem. A. Gal.; Santa Barbara Mus. A.; deYoung Mem. Mus.; SAM; Portland (Ore.) A. Mus.; Downtown Gal.; CAM; Univ. Minnesota; Louisiana State Univ.; Univ. Colorado; AIC; Nordness Gal.; Weyhe Gal., and many others in U.S. and abroad, 44 one-man exhibitions. Retrospective Exhs.: Univ. of Illinois, 1966; Creighton Univ., Omaha, Neb., 1968. Illus., "Stars: Their Facts and Legends," 1940; covers and articles for Fortune magazine, 1944-46. A. Press Rep., at Bikini Atom Bomb test, 1946; photographs in Le Figaro, British Jazz Journal, Le Jazz Hot, Modern Photography and other publications. Photographic covers, New Orleans; records publ. by Riverside. Photographic research Consultant, Tulane Univ. Archive of New Orleans Jazz. Lectures: Modern Art. Positions: Instr., Cincinnati A. Acad., 1940, 1949; Buffalo Sch. FA, 1941-42; Guest Dir., Honolulu Sch. A.; A. Sch. of BM, 1948; Univ. Minnesota, 1949; Louisiana State Univ., 1950; Univ. Colorado, 1952, 1958; New Sch. for Social Research, New York, 1952-1957; Univ. So. Cal., 1960; Univ. Kentucky H.S. Week, 1960; Univ. Minn., 1961; Hofstra Col., 1960-1962; Visiting Artist, Sheldon A. Gal., Univ. Nebraska, under Ford Fnd. and AFA grant, 1965; Visiting Artist, Univ. Illinois, 1966.

CRAWFORD, WILLIAM H. (BILL)—Cartoonist, S., I., L.
Newspaper Enterprise Association, 230 Park Ave., New York, N.Y. 10017; h. Prospect Rd., Atlantic Highlands, N.J. 07716
B. Hammond, Ind., Mar. 18, 1913. Member: Nat. Cartoonists Soc. (Pres., 1960-61); Assn. of Am. Editorial Cartoonists. Studied: Chicago Acad. FA; Ohio State Univ., B.A.; Grande Chaumiere, Paris. Awards: Prize, CMA, 1934; Best Editorial Page Cartoonist, Nat. Cart. Soc., 1956, 1957, 1958, 1966. I., "Barefoot Boy with Cheek," 1943; "Zebra Derby," 1946; & others. Contributor to: national magazines. Positions: Ed. Cart., Newark (N.J.) Evening News, 1938-1961; Chief Editorial Cartoonist, Newspaper Enterprise Assn., New York, N.Y.

CRAWLEY, WESLEY V.—Sculptor, E.
School of Art, East Carolina University, Greenville, N.C. 27834
B. 1922. Studied: Univ. Arizona; Univ. Oregon, A.B., M.S. Awards: Scholarship, AIC, 1937; Teaching F., Univ. Oregon, 1951-52, 1958-59. Prizes, Oregon State Sculptors, 1956, 1957; Cal. State Ceramic Exh., 1953; purchase prizes, Southern Assn. Sculptors, 1968; Pembroke Col., 1968. Member: Southern Assn. Sculptors (Founding member); North Carolina AA. Work: Bronze figure, Peoples Bank & Trust Co., Rocky Mount, N.C. Exhibited: North Carolina AA traveling exh., 1966-1968; one-man: North Carolina AA; North Carolina Mus. A., Raleigh; Southern Assn. Sculptors, and others. Positions: Instr. Sculpture, Univ. Oregon, Eugene, Ore., 1948-1959; Prof., East Carolina College, Greenville, N.C., 1959- .

CREESE, WALTER LITTLEFIELD—Educator
Dept. of Architecture, University of Illinois, Urbana, Ill. 61801
B. Danvers, Mass., Dec. 19, 1919. Studied: Brown Univ., A.B.; Harvard Univ., M.A., Ph.D.; Columbia Univ. European study. Member: Soc. Architectural Hist. (Pres., 1958-59); AIA (Hon.) 1963; CAA. Awards: Arch. Lg., 1951; Faculty F., Am. Council of Learned Soc., 1951-52; Fulbright F., in Planning, Univ. Liverpool, England, 1955-56; Rehmann Fellow, AIA, 1960; Am. Council of Learned Soc. Grant-in-aid, 1968-69; Smithsonian Fellow, 1969. Positions: Instr. & Teaching F., Harvard Univ., 1944-45; Instr., Wellesley Col., 1945; Instr., 1946-47, Asst. Prof., 1947-52, Assoc. Prof., 1952-55, Prof., 1956-58, Univ. Louisville, Ky.; Chm., Louisville & Jefferson County Planning & Zoning Com., 1954-55; Ed., Journal of Soc. Arch. Hist., 1950-53; Ed. Advisor, College Art Journal. Prof., Univ. Illinois, Urbana, Ill., 1958-1963; Visiting Prof., Summer School, Harvard

Univ., 1961-1963; Dean, School of Architecture & Allied Arts, University of Oregon, Eugene, Ore., 1963-1968; Prof., Univ. of Illinois, Urbana, Ill., 1968- .

CREIGHTON, MRS. THOMAS H. See Lux, Gwen

CREMEAN, ROBERT—Sculptor
 c/o Felix Landau Gallery, 702 N. La Cienega Blvd., Los Angeles, Cal. 90069
B. Toledo, Ohio, Sept. 28, 1932. Studied: Alfred Univ., N.Y.; Cranbrook Acad. A., B.A.; M.F.A. Awards: Fulbright Scholarship to Italy, 1954-1955; Tamarind Lithography grant, 1966-1967. Work: CAM; Detroit Inst. A.; Santa Barbara Mus. A.; Univ. Nebraska; Univ. Miami; UCLA; Los A. Mus. A.; NCFA, Smithsonian Inst.; Nat. Gal. of Victoria, Melbourne, Australia, and in many private collections. Exhibited: Toledo Mus. A., 1955; Schneider Gal., Rome, Italy, 1955; Fontanella Gal., Rome, 1955; Cranbrook Acad. A., 1955; Detroit Inst. A., 1956; Contemporary Arts Mus., Houston, 1957; Santa Barbara Mus. A., 1957, 1961; La Jolla A. Center, 1957; Univ. Nebraska, 1958; Esther Robles Gal., 1960-1963; AIC, 1960, 1961; Traveling exh., 1961; SFMA, 1961; Ball State T. Col., 1961; Univ. Illinois, 1961, 1963; Arts of So. California (sculpture) traveling exh., 1961; CAL.PLH, 1961; WMAA, 1961, 1962; 50 California Painters organized by SFMA and Los A. Mus. A., for WMAA, WAC, Albright-Knox A. Gal., and Des Moines A. Center, 1962-63; West Coast, an exh. presented by the Amon Carter Museum of Western Art, Forth Worth in collaboration with UCLA and Oakland A. Mus., 1962-63; State Univ. Iowa, 1964; Newport Harbor, 1964; Denver Mus. A., 1964; Venice Biennale, 1968; Smithsonian traveling exh. in Europe and South America, 1968-1969, and many others. One-man: Universities of Nebraska, Texas, Colorado, Illinois; Fort Worth A. Center; State Univ. Iowa; Los Angeles Municipal Gal., circulating, 1964, 1965, 1966. Positions: Instr., Detroit Inst. A.; Univ. California at Los Angeles, 1956-57; Art Center in La Jolla, 1957-58.

CREO, LEONARD—Painter, S., Gr.
 Leys Hill, Walford, Ross on Wye, Herefordshire, England
B. New York, N.Y., Jan. 10, 1923. Studied: Mexico City Col., B.S., M.A., ASL, and with Pietro Annigoni. Work: paintings—Washington County Mus. A., Hagerstown, Md.; Georgia Mus. FA, Athens; Long Beach Mus. A., Cal.; Lyman Allyn Mus. A., New London, Conn.; Univ. Maine, Orono; Amherst Col., Mass.; Col. of St. Theresa, Winona, Minn.; Syracuse Univ. Sch. FA, Syracuse, N.Y. Exhibited: One-man: Carter Gal., Los Angeles, 1961, 1963, 1965, 1967, 1969; A.C.A. Gal., N.Y., 1965-1967, 1969; Chase Gal., N.Y., 1958-1963; Portal Gal., London, 1965, 1968, Galeria 51A, 1956, 1957; Galeria La Felucca, 1957, Galeria Toro Seduto, 1958, 1959, A.C.A. Gal., 1964, 1965, all in Rome, Italy; Galeria Santa Trinita, 1954, 1955, Florence, Italy; Galeria degli Artisti, Milan, Italy, 1954, 1956.

CRESPI, PACHITA—Painter, I., Des., L., W.
 1153 Madison Ave., New York, N.Y. 10028
B. Costa Rica, Aug. 25, 1900. Studied: N.Y. Sch. F. & App. Des.; ASL, with Henri, Luks. Member: NAWA; Pan-Am. Women's Soc.; Lg. Present-Day A. Work: WMAA; Univ. Arizona. Exhibited: one-man exh.: Beaux-Arts, London, England, 1934; Univ. Panama, 1943; Nat. Theatre, Costa Rica, 1945; Milch Gal., 1931; Morton Gal., 1929; Pinacotheca, 1942; Argent Gal., 1945; Nat. Mus., Wash., D.C., 1942; BMA, 1945; group exh.: Mem. Mus., Memphis, Tenn., 1943; Four Arts Cl., Palm Beach, Fla., 1943; Am.-British A. Center, 1943, 1944; Wildenstein Gal., 1943; NAWA, 1943-1946; Lg. Present-Day A., 1945. Author, I., "Manulito of Costa Rica," 1940; "Cabita's Rancho," 1942; "Wings Over Central America"; "Mystery of the Mayan Jewels"; "Gift of the Earth." Contributor to: The Horn Book; Holiday magazine. Positions: Dir., Pachita Crespi A. Gal., 1153 Madison Ave., New York, N.Y.*

CRESS, GEORGE AYRES—Painter, E.
 University of Chattanooga; h. 414 East View Dr., Chattanooga, Tenn. 37404
B. Anniston, Ala., Apr. 7, 1921. Studied: Emory Univ.; Univ. Georgia, B.F.A., M.F.A. Member: Southeastern College Conference (Pres. 1965-66); CAA. Awards: prizes, Assoc. Ga. A., 1943, 1954; A. of Chattanooga and Vicinity, 1952-1954; Alabama WC Soc., 1953; Southeastern A., 1954; Memphis Biennial 1955; Mid-South Annual; Birmingham Mus. A.; Soc. Four Arts; Winston-Salem Gal.; Columbus Square Annual; Mint Mus. A.; Atlanta A. Festival. Work: Emory Univ.; Birmingham Mus. A.; Brooks Mem. Gal.; Univ. Georgia; High Mus. A.; murals, TVA, Tenn.; Ford Motor Co.; Mead Corp.; Tenn. FA Center. Exhibited: CGA; BMA; Nashville AA; Delgado Mus. A.; Norfolk Mus. A.; Alabama WC Soc.; AGAA; Southeastern "Painting of the Year" exh., 1955; Columbia Biennial; Provincetown Annual; Detroit Inst. A.; PAFA; Chautauqua Annual; Springfield WC annual; one-man: Atlanta, Savannah, Knoxville, Washington, Staten Island and Chattanooga and Memphis; Univ. Georgia; Grand Central Moderns, N.Y. Positions: Instr., Judson Col., Marion, Ala., 1945-46; Mary

Baldwin Col., Staunton, Va., 1946-47; Univ. Maryland, 1947-48; Univ. Georgia, 1949, 1965, 1969; Univ. Tenn., 1949-51; Ontario Dept. of Educ., 1963; Univ. of South Carolina, 1967, Hd., A. Dept., Univ. Chattanooga, 1951- . Chm., Tenn. Col. A. Council, 1966-1968.

CRESSON, MARGARET FRENCH—Sculptor, W.
 "Chesterwood," Stockbridge, Mass. 01262
B. Concord, Mass. Member: NA; NSS; Arch. L. Awards: prizes, NAD, 1927; Stockbridge A. Exh., 1929; med. Soc. Wash. A., 1937; Dublin Hill A. Exh., 1939, 1944; gold medal, AAPL, 1959. Work: Berkshire Mus., Pittsfield, Mass.; CGA; N.Y. Univ.; Monroe Shrine, Fredericksburg, Va.; Rockefeller Inst.; Mass. State Normal Sch.; Prince Mem., Harvard Medical Lib.; etc. Exhibited: NAD, 1921, 1924, 1926, 1927, 1929, 1936, 1940, 1941, 1943, 1944; PAFA, 1922, 1925, 1927, 1928, 1929, 1937, 1940, 1941, 1942; AIC, 1928, 1929, 1937, 1940; Paris Salon, 1938; WFNY 1939; Carnegie Inst., 1941; Concord AA, 1923; Phila. A. All., 1927, 1928; WMAA, 1940. Contributor to: N.Y. Times, American Artist, American Heritage, Reader's Digest, articles on art & war memorials. Author: "Journey into Fame," life of Daniel Chester French; "Laurel Hill." Vice-Pres., Arch. Lg., 1944-46; Sec., NSS, 1941-42. Founder, "Chesterwood Studio Museum." Transferred to National Trust for Historic Preservation, in 1969.

CRIMI, ALFRED DI GIORGIO—Painter, T., I., W., L.
 227 West 13th St. 10011; h. 1975 Bathgate Ave., New York, N.Y. 10457
B. San Fratello, Italy, Dec. 1, 1900. Studied: NAD; Beaux-Arts Inst.; Scuola Preparatoria alle Arti Ornamentali, Rome. Member: Arch. Lg.; NSMP; AWS; Audubon A; CAA; SC; A. Fellowship (Bd. Dir.); All. A. Am.; New York City A. Commission, 1958-61 (Life F.); Painters & Sc. of New Jersey. Awards: medal, All A. Am., 1946, 1949, Emily Lowe award, 1964; gold medal, NAC, 1954; silver medal, A. Lg. of Long Island, 1954, special award, 1962; prizes, N.Y. State Fair, 1951; All. A. Am., 1956, 1960; A. Lg. of Long Island, 1954-1956, 1958; Emily Lowe award, 1956; Knickerbocker A., 1957, 1959, 1964; Wash. WC Cl., 1959; AWS, 1968; Audubon A., 1962; Springfield, (Mo.) Mus. (purchase), 1967. Work: murals, Forbes Lib., Northampton, Mass.; Aquarium, Key West, Fla.; Harlem Hospital; Rutgers Presbyterian Church, Christian Herald Bldg.; P.S. #5, P.S. #110, J.H.S. #131, all of New York; Holyoke (Mass.) Mus.; Columbia (S.C.) Mus. A.; Sperry Gyroscope Co. Archives, Long Island, N.Y. USPO, Northampton, Mass., Washington, D.C., Wayne, Pa.; Springfield (Mo.) Mus.; Norfolk (Va.) Mus.; Staten Island Mus.; Syracuse Univ. Exhibited: NAD; Audubon A; BM, MMA, WMAA; Acad. A. & Lets.; AIC; and in Paris; Rome and Bologna, Italy; 1st Int. Liturgical Arts, Trieste, Italy, 1961; Springfield Mus., 1967; Marietta Col., Ohio, 1967-1969. One-man: Babcock Gal., 1928; Portland (Ore.) Mus. A., 1932; de Young Mem. Mus., 1932; Binet Gal., 1947; Ferargil Gal., 1949; Ward Eggleston Gal., 1957; Selected Artists Gal., N.Y., 1959; Holyoke Mus., 1962; Bethlehem Univ., 1963; Fordham Univ., 1966; Temple Emeth, Teaneck, N.J., 1969. Contributor articles on fresco, mural techniques and mosaic art to art magazines including American Artist and Liturgical Arts magazines. Produced and narrated color film, "The Making and Fascination of Fresco Painting," 1961. Positions: Instr., Pratt Inst., Brooklyn, N.Y., 1948-49; City Col. of N.Y., 1948-1956; Guest instructor & lecturer, Pa. State University, 1963; private classes.

CRIST, RICHARD—Painter, I., W.
 Woodstock, N.Y. 12498
B. Cleveland, Ohio, Nov. 1, 1909. Studied: Carnegie Inst. Tech.; AIC. Member: Assoc. A. Pittsburgh; Woodstock AA (Exec. Bd.). Awards: American Traveling Scholarship, AIC; prizes, Carnegie Inst., 1940; Assoc. A. Pittsburgh; Berkshire Mus. A., 1957, 1968, and others. Work: Mineral Industries College; Pa. State Univ.; Public Schools colls., Pittsburgh, Somerset and Latrobe, Pa.; Mary Washington Col., Univ. Va. Mural, Prospect Sch., Pittsburgh, Pa. Exhibited: AIC, 1934; MModA, 1934; CM, 1935, 1936; WFNY 1939; Butler Inst. Am. A., 1941; Carnegie Inst., 1941; PAFA, 1947, 1949; Guggenheim Mus. A., 1950; WMAA, 1956, 1957; CGA; Assoc. A. Pittsburgh, annually; Phila. A. All.; New Hope, Pa.; Somerset, Pa.; Johnstown, Pa.; Berkshire A.; Pittsfield, Mass.; Woodstock, N.Y.; Albany Inst. Hist. & A., 1957; N.Y. State Col. for Teachers, Albany, 1957; Pa. State Univ.; Audubon A., 1967; Rensselaer Polytechnic Inst., Troy, N.Y., 1969; one-man: Washington Irving Gal., N.Y., 1958; Marist Col., Poughkeepsie, N.Y., 1967. Author, I., "Excitement in Appleby Street," 1950; "Chico," 1951 (award, Best Designed Book); "Good Ship Spider Queen," 1953; "The Cloud Catcher," 1956; "Secret of Turkeyfoot Mountain," 1957 (Jr. Literary Gld. Selection); "Broken Horse Chimneys" (Jr. Lit. Gld. Selection), 1960; "The Queekup Spring," 1961. Illus. in Natural History Magazine.

CRITE, ALLAN ROHAN—Painter, I., L., W., C.
 2 Dilworth St., Boston, Mass. 02118
B. Plainfield, N.J., Mar. 20, 1910. Studied: BMFA Sch.; Mass. Sch.

A.; Boston Univ., C.B.A.; Harvard Univ. Extension Studies, B.A. Member: Boston Soc. Indp. A.; Boston Inst. Mod. A.; Alum. Bd., BMFA Sch.; Bd., Children's Art Centre, Boston; Archaeological Inst. Am. Awards: BMFA Sch.; Seabury Western Theological Seminary, 1952. Work: BMFA; Spellman Col., Atlanta, Ga.; PMG; AGAA; Marine Hospital, Carville, La.; Villanova Col. (Pa.); Smith Col.; Insignia for USS "Wilson"; Mount Holyoke Col.; Newton Col. of Sacred Heart; churches, Wash., D.C.; Boston, Roxbury, Mass.; Norwich, Vt.; Wilmington, Del.; MIT Chapel, Cambridge, Mass.; Detroit, Mich.; Storrs, Conn.; Brooklyn, N.Y.; mural, Grace Church, Martha's Vineyard, Mass.; Stations of the Cross, Holy Cross Church, Morrisville, Vt., 1957, and many others. Exhibited: CGA; AIC; WFNY, 1939; Boston Soc. Indp. A.; Boston Inst. Mod. A.; Boston Pub. Lib.; New England Contemporary A.; Liturgical Arts exh., Trieste, Italy, 1961; Religious Art Festival, Brandon, Vt., 1961; Festival of Arts, Ecumenical Youth Assembly of North America, Ann Arbor, Mich., 1961; one-man: Grace Horne Gal.; Margaret Brown Gal.; Children's A. Center, Boston; BMFA; FMA; Farnsworth Mus. A.; Bates Col.; Topeka A. Cl.; Concord AA; libraries in Concord, Andover, Mass.; Nashua, N.H.; St. Augustine Col.; Univ. Maine; Boston Atheneum, 1968; Gordon Col., Wenham, Mass., 1969; exh. and lecture, Air Force Base, Westover, Mass., 1969. Author, I., of many religious books and articles; recent booklet, "Cultural Heritage of the United States," 1968; contributor to magazines and bulletins. Lectured on Christian Art, Oberlin (Ohio) Col., 1958; Regis. Col., Weston, Mass.

CROFT, L(EWIS) SCOTT—Painter
651 West 171st St., New York, N.Y. 10032
B. Chester Basin, N.S., Canada. Studied: with M. Denton Burgess; A. W. Allen, Vancouver, B.C., and with William S. Schwartz, Chicago. Member: AAPL. F.I.A.L.; Nova Scotia Soc. A.; All. A. Am.; Int. Platform Assn.; Int. Inst. A. & Let.; Awards: prizes, A. Festival Exh., Fla., 1958 and in regional shows. Work: American Univ., Cairo; Booklyn Col.; Univ. Colorado; Columbia Univ.; Cornell Univ., Andrew Dickson White Mus. A.; Fordham Univ.; Pace Col., N.Y.C.; Princeton Univ. A. Mus.; Virginia State Col.; Canadian Consulate, N.Y.; Chas. Pfizer & Co. Inc., N.Y.; FA Gal. of San Diego; E.B. Crocker A. Gal., Sacramento, Cal., and in private colls. Exhibited: AAPL, 1957, 1958; ACA Gal., N.Y.; Collectors Gal., N.Y.; Little Studio, N.Y.; Brooklyn Soc. A.; Delgado Mus. A.; Tampa AI; Fla. State Fair; Contemp. A. Gal., Fla. one-man: Contemp. A. Gal., Fla., 1959; Assoc. A. Gal., New Orleans, 1960; Brooklyn, 1960; Brooklyn Col., N.Y.; Pace Col., N.Y.C.; Caravan Gal., N.Y.; Elliott Mus., Stuart, Fla.; Borenstein Gal., New Orleans, and widely in Canada.

CRONBACH, ROBERT M.—Sculptor, E., L.
170 Henry St., Westbury, L.I., N.Y. 11590
B. St. Louis, Mo., Feb. 10, 1908. Studied: St. Louis Sch. FA; PAFA; & in Europe. Member: S. Gld.; AEA; Mun. A. Soc., N.Y.; Arch. Lg.; Artist-Craftsmen of N.Y.; Fed. Mod. P. & S.; Century Assn. Awards: Cresson traveling scholarship, PAFA, 1929, 1930; prizes, Rosenthal Potteries, 1931; FAP, 1940; Reynolds Metals sculpture trophy, 1961; sculpture, for Meditation Room, UN Bldg., N.Y. Work: sculptural decorations, CAM; Social Security Bldg., Wash., D.C.; St. Louis Mun. Auditorium; Willerts Park Housing Project, Buffalo, N.Y.; fountain, lobby of Federal Bldg., St. Louis; Pub. Library, Charleston, W.Va.; fountain, Ward Sch., New Rochelle, N.Y., and Trinity Lutheran Sch., Hicksville, N.Y.; sculpture, Temple Chizuk Amuno, Baltimore and Temple Israel, St. Louis, Mo.; fountain, 240 Central Park South, New York, bronze screen, Dorr-Oliver Bldg., Stamford, Conn., 1958; PMA. Exhibited: PMA, 1940; Hudson Walker Gal., 1940 (one-man); S. Gld., 1938, 1939, 1941, 1942, 1948, 1950-1955; PAFA; WMAA; ACA Gal., Colby Col., 1960-61; Springfield (Mo.) Mus. A.; MModA; CAM; Bertha Schaefer Gal. (2-man) 1964, 1967 & others prior; Mus. FA of Houston; Denver A. Mus.; Nat. Inst. A. & Lets., 1965. Positions: Bd. Governors, Skowhegan Sch. A. Lecturer, Haverford Col., Pa.

CROSBY, RANICE (Mrs. Jon C.)—Medical Illustrator, E., I.
Johns Hopkins Medical School; h. 3926 Cloverhill Rd., Baltimore, Md. 21218
B. Regina, Saskatchewan, Canada, Apr. 26, 1915. Studied: Connecticut Col., A.B.; Johns Hopkins Medical Sch., with Max Broedel; and with Robert Brackman. Member: Assn. Medical Illustrators; AAUP. Illus., medical textbooks. Contributor of: illus. for Medical Journals. Positions: A. to Dr. N.J. Eastman, Johns Hopkins Hospital; Asst. Prof. & Dir., Dept. A. as Applied to Medicine, Johns Hopkins Medical Sch., Baltimore, Md., 1944- .

CROSBY, SUMNER McKNIGHT—Educator
Department History of Art, Yale University, New Haven, Conn. 06520; h. Fairgrounds Rd., Woodbridge, Conn.
B. Minneapolis, Minn., July 29, 1909. Studied: Yale Univ., B.A., Ph.D.; Univ. Paris. Member: AFA; CAA; Archaeological Inst. Am.; Mediaeval Acad. Am.; Century Assn.; Membre Correspondent, So-

ciété Nationale des Antiquaires de France, 1946- ; Chevalier, Legion d'Honneur, 1950; D.F.A. (Hon.), Minneapolis Soc. of Fine Arts and School of Art; (Hon.) Int. Com. of the History of Art. Author: "The Abbey of St.-Denis" Vol. 1, 1942; "L'Abbaye Royale de Saint-Denis," 1952. Editor: "Art Through the Ages," 4th ed.; F. Mâle, "Religious Art in France in the Thirteenth Century," and others. Contributor to art magazines. Lectures: Mediaeval Art. Positions: Dir. Excavations in Abbey Church of Saint-Denis, France, 1938, 1939, 1946-48; Pres., 1941-45, Bd. Dir., 1940-45, 1946-51, CAA; Bd. Trustees, 1941-44, 1947-1955, AFA; Adv. Com., AGAA, 1946- ; Trustee, Textile Mus., Wash., D.C., 1943-47; Prof. Hist. of Art, 1950- , Chm., Hist. A. Dept., 1947-53, 1962-65; Chm. Audio-Visual Center, 1950-1955; Cur., Medieval A., 1947- , Yale Univ., New Haven, Conn. Exec. Com., Medieval Acad., 1962-1968; Pres., International Center of Romanesque Studies, 1965-1968; Trustee, Archeological Institute of America.

CROSS, WATSON, JR.—Painter, E., L.
Chouinard Art School, California Institute of the Arts, 2404 W. 7th St., Los Angeles, Cal. 90057; h. 1238 East Workman Ave., West Covina, Cal. 91790
B. Long Beach, Cal., Oct. 10, 1918. Studied: Chouinard AI, with Henry Lee McFee, Rico Lebrun. Member: Cal. WC Soc. Exhibited: Los A. Mus. A., 1945, 1952; Cal. WC Soc., 1941-1961; Pasadena AI, 1956, 1957, 1960; Chaffee Col., Ontario, Cal., 1960; U.S. Air Force Exhs., 1964, 1965. Positions: Instr. A., Chouinard AI, Los Angeles, Cal., 1944- . Special assignment, Air Force Pictorial Arts Division, to document bases in Alaska.

CROSSGROVE, ROGER LYNN—Painter, E.
23 Hillside Circle, Storrs, Conn. 06268
B. Farnam, Neb., Nov. 17, 1921. Studied: Kearney State T. Col.; Univ. Nebraska, B.F.A.; Univ. Illinois, M.F.A.; Universidad de Michoacan, Mexico. Member: CAA; AAUP; AWS; Am. Soc. Contemp. A.; Kappa Pi. Awards: Des Moines A. Center, 1954(purchase); Emily Lowe Award, Ward Eggleston Gal., 1951; Am. Soc. Contemp. A., 1957, 1959, 1960, 1964; AWS, 1964, 1967; Silvermine Gld., A. 1957; Village A. Center, 1958; Yaddo Fnd., 1957-1959, 1961, 1963; Butler Inst. Am. A., 1965(purchase); NAC, 1963, 1967(gold medal); Saratoga A. Fair, 1963. Exhibited: Terry AI, 1952; Joslyn A. Mus., 1949; BM, 1952, 1958, 1960; WMAA, 1956; Ward Eggleston Gal., 1951, 1953-1958; Des Moines A. Center, 1953, 1958; NAD, 1960; PAFA, 1965; Fleischer Mem., Phil., 1961; Phila. A. All., 1961; Audubon A., 1963, 1968; Saratoga A. Fair, 1963; AWS, 1960, 1964, 1966-1968; Am. Soc. Contemp. A., 1958-1968; AWS, 1960, 1964, 1966-1968; Galeria San Miguel, Mexico, 1966; Group Gal., Jacksonville, Fla., 1965-1968; Krannert A. Mus., Univ. Ill., 1963 and prior; NAC, 1958, 1960; Pratt Inst., Brooklyn, N.Y., 1959, 1961, 1966; Staten Island Mus., N.Y., 1961; Southern Vermont A. Center, 1963; Loan exh., U.S. Embassy, Copenhagen, 1964-1967 (under auspices of AFA). One-man: Fleischer A. Mem., Phila., 1961; El Centro Cultural "Ignacio Ramirez," San Miguel de Allende, Mexico, 1966; Instituto Mexicano Norteamericano de Relaciones Culturales, Mexico City, 1966; Instituto Cultural Mexicano Norteamericano de Michoacan, Morelia, Mexico, 1966. Positions: Assoc. Prof., Painting, & Assoc. Chm., Dept. Graphic Arts, Pratt Inst., Brooklyn, N.Y., 1952-1968. Prof., and Head, A. Dept., Univ. Conn., Storrs, Conn., 1969- .

CROWN, KEITH (ALLAN) JR.—Painter, E., L.
University of Southern California, Los Angeles, Cal. 90007; h. 943 First St., Manhattan Beach, Cal. 90266
B. Keokuk, Iowa, May 27, 1918. Studied: AIC, B.F.A. Member: Cal. WC Soc. (1st V. Pres., 1958-59, Pres., 1959-60). Awards: bronze star, U.S. Army, 1945; prize, Cal. WC Soc., 1956, 1960, 1963, 1964, 1965; Los A. All-City, 1961; Cal. State Fair, 1957, 1961; Whittier Col., 1963; Newport Beach, Cal., 1963. Research Grants, 1959, 1961, 1962; José Drudis Fnd. Grant, 1967; Downey Mus. A., 1967. Work: Ackland Mem. A. Mus., Chapel Hill, N.C.; Univ. of Mass., Amherst; Long Beach Mus. A., Cal.; Univ. of Calgary, Alberta, Canada; San Bernardino Valley Col., Cal.; Eastern Oregon Col., La Grande; Whittier Col., Cal.; Ahmanson Coll., Los Angeles. Exhibited: galleries and Museums of Canada, Mexico and U.S., including one-man shows: AIC; de Young Mus. A.; Pasadena Mus. A.; Oakland Mus. A.; Los A. County Mus. A.; Univ. of Southern California, 1967; Long Beach Mus. A., Cal., 1966; Univ. of Calgary, Alberta, Canada, 1967; San Bernardino Valley Col., Cal., 1967; Univ. of Mass., Amherst, 1967; Univ. of Texas, Austin, 1968; Fleischcer-Anhalt Gallery, Los Angeles, 1968; Doane Col., Crete, Nebraska, 1969. Positions: Instr., Luther Col., Decorah, Iowa, 1940-41; AIC, 1946; Prof. FA, Univ. Southern California, 1946- . Visiting Prof., Univ. of Wisconsin, Madison, 1960; Univ. Wis., Milwaukee, 1964; Univ. of Calgary, Canada, 1967; Univ. of North Carolina, 1968.

CRUTCHFIELD, WILLIAM RICHARD—
Printmaker, P., Des., I., T., W.
8212½ Melrose Ave., Los Angeles, Cal. 90046.
B. Indianapolis, Ind., Jan. 21, 1932. Studied: Herron Sch. A., India-

napolis, B.F.A.; Tulane Univ., M.F.A., and in Germany. Awards: Milliken award for travel in Europe, Herron Sch. A., 1956; Fulbright Award for study in Germany, 1960-1961; prizes, Herron Mus. A., 1956, 1966; purchase, Ball State Univ., Muncie, Ind., 1968. Work: Purdue Univ.; South Bend AA; Delgado Mus., New Orleans; R.I. Sch. Des., Providence; Herron Mus. A.; Leverett House, Harvard Univ.; Wabash Col., Crawfordsville, Ind.; La Jolla Mus. A.; Minneapolis Inst. A.; Pasadena A. Mus. Exhibited: Fulbright Artists, USIS traveling in Germany, 1962-1963; Tamarind Coll., Univ. California, Los Angeles, 1964; Arkansas A. Center, Little Rock, 1964; Otis A. Inst., 1967; American Embassy, Nepal, 1967; General Mills, Minneapolis, 1967; Minneapolis A. Inst., 1967; Humboldt State Col., Arcata, Cal., 1969; one-man: Arnheim, Holland, 1962; Hamburg, Germany, 1962; Indianapolis A. Lg. Fnd., 1964; Wabash Col., 1966; Minneapolis Inst. A., 1967; Stevens Gal., Detroit, 1967; Swihart Gal., Tucson, 1968; Giraffe Gal., Los Angeles, 1968. Positions: Instr , Drawing, Painting & Design, Herron School of Art, Indianapolis, 1962-1965; Asst. Prof., Chm., Div. of Foundation Studies, Minneapolis School of Art, 1965-1967; Guest Lecturer, School of Architecture, Univ. Minnesota, 1967; Humboldt State College, Arcata, Cal., 1969.

CSOKA, STEPHEN—Painter, Gr., E.
 85-80 87th St., Woodhaven, N.Y. 11421
B. Gardony, Hungary, Jan. 2, 1897. Studied: Budapest Royal Acad. A. Member: NA; SAGA; Audubon A. Awards: med., Barcelona Int. Exh., 1929; City of Budapest, 1930, 1933; SAGA; 1942, 1945, 1952; LC, 1944, 1946; Soc. Brooklyn A., 1944, 1949; Phila. WC Cl., 1945; La Tausca Pearls Comp., 1945; PAFA, 1945; (purchase) Ball State T. Col., 1958; Assoc. Am. A., 1947, 1953, 1958; Am. Acad. A. & Lets., 1948; NAD, 1950. Work: Budapest Mus. A.; LC; British Mus. A.; MMA; Norfolk Mus. A.; Ball State T. Col.; Peabody Mus., Cambridge, Mass.; Encyclopaedia Britannica Coll.; Princeton Pr. Cl.; N.Y. Pub. Lib.; Dayton AI; Columbus Mus. FA.; IBM; Delgado Mus. A.; Carnegie Inst.; Bezalel Nat. Mus., Jerusalem; Hunter & City Colleges, N.Y.C.; Reading (Pa.) Public Mus. Exhibited: CGA, 1945; Carnegie Inst., 1943-1945; NAD, 1940-1945; Contemporary A., 1940, 1943, 1945 (one-man); Phila. A. All., 1943 (one-man); Minnesota State Fair, 1943 (one-man); Contemp. A. Gal., N.Y., 1956, 1957 (one-man); Merrill Gal., N.Y.C., 1963; Pacem in Terris Gal., N.Y., 1968 (one-man). Author: "Pastel Painting." Positions: Instr., Fashion Inst. of Technology, Nat. Acad. Design, School of Fine Arts, all New York, N.Y.

CULLER, GEORGE D.—Educator, P., Gr.
 Philadelphia College of Art, Broad & Pine Sts., Philadelphia, Pa. 19102
B. McPherson, Kans., Feb. 27, 1915. Studied: Cleveland Inst. A.; Western Reserve Univ., B.S. in Edu. (Sch. Edu.), M.A. in Aesthetics & A. Hist. (Grad. Sch.). Exhibited: Midwestern exhibitions, Kansas City; May Shows, Cleveland; New Years Exhs., Butler Inst. Am. A., and others. Positions: Instr., Asst. Prof., Dept. A., Kansas State T. Col., Emporia, 1939-42; Hd. Illustrator, Dept. Production Illustration, Boeing Aircraft Co., Wichita, 1942-45; Instr., Painting, Cleveland Inst. A., 1946; Supv., Asst. Cur. of Edu., CMA, 1946-49; Dir., Akron AI, 1949-55; Dir., Mus. Edu., AIC, 1955-58; Assoc. Dir., 1958, Dir., 1961-65 San Francisco Museum of Art, San Francisco, Cal.; Pres., Philadelphia College of Art, Philadelphia, Pa., 1965- .

CUMING, BEATRICE—Painter, T.
 130 State St., New London, Conn.; h. Massapeag Rd., Uncasville, Conn. 06832
B. Brooklyn, N.Y., Mar. 25, 1903. Studied: PIASch; and in France. Member: AWS; Mystic AA; Conn. WC Soc.; Am. A.; Essex AA. Awards: prizes, Hartford, Conn., 1939, 1941; Springfield, Mass., 1936; Bok Fnd. F., 1939, 1940; F., MacDowell Colony, N.H., 1934, 1938, 1943, 1944, 1946, 1952; F., Yaddo Fnd., 1950-51, 1953, 1955; Huntington Hartford Fnd., 1953, 1956, 1959. Work: Lyman Allyn Mus.; Syracuse Mus. FA; Conn. College; LC. Exhibited: CGA, 1937; PAFA, 1932, 1953; AIC, 1930, 1942; WMAA, 1938, 1953; WFNY, 1939; Syracuse Mus. FA, 1945; Four Arts Cl.; Springfield Mus. FA, 1946; Hartford Atheneum, 1939, 1940; Mystic AA; Lyman Allyn Mus., 1959, 1960 & prior; Univ. Nebraska, 1946, 1948; WMA, 1946; Silvermine Gld. A., 1951, 1952, 1953, 1955; Riverside Mus., 1960; South Am. tour from Contemp. A. Gal., 1960; Am. A., Phoenix, 1959-1961; Essex AA, 1962-1967 and prior; Conn. Acad. A., 1962; Hartford Soc. Women Painters; Mystic AA, 1962-1967; Clinton AA, 1961; Univ. Nebraska, 1946, 1948; one-man: Guy Mayer Gal., 1942; Contemporary A., 1946; Lyman Allyn Mus., 1952-1968; New Gal., 1952; Westerly, R.I., 1954; Norwich (Conn.) Theatre, 1954; Springfield State Fair, 1957; New Haven Festival A., 1958; Mystic AA, 1956 (one-man); Hartford Audio Workshop, 1955. Positions: Dir., Young People's A. Program and Adult Painting Classes, Lyman Allyn Mus., New London, Conn.; Vice-Pres., Mystic AA, 1955, Pres., 1960 Council Essex A. Lg.; Council, Lyman Allyn Mus.

CUMMING, GEORGE BURTON—
 Editor Art Books, T., L., W.
 140 Greenwich Ave., Greenwich, Conn. 06830; h. 6 Ledgemore Lane, Westport, Conn. 06880
B. Waterbury, Conn., Oct. 12, 1909. Studied: Amherst Col., A.B.; Harvard Univ. Grad Sch. FA. Awards: Sachs F., 1939-40. Lectures, radio and TV programs on art. Catalogues: "John Stuart Curry," 1946; "Six States Photography," 1950; "Highlights of American Painting," 1954. Contributor of articles on art to magazines and newspapers. Positions: Instr., Institut du Rosey, Rolle, Switzerland, 1932-33; South Kent (Conn.) Sch., 1933-38; Asst. Dir., Albany Inst. Hist. & A., 1940-42; Dir., Milwaukee AI, 1942-43; Lt. U.S.N.R., 1943-46; resumed Directorship, Milwaukee AI, 1946-50; Dir., American Federation of Arts, Washington, D.C. and New York City, 1951-54. Dir., La Napoule A. Fnd., 1955; Dir. of Publications, and Editor, Art Book Dept., New York Graphic Soc., Greenwich, Conn., 1956-1968, Editor-in-Chief, 1968- . Memb., Amherst Col. Advisory Comm. on Modern Art, 1956- ; Trustee, Vergilian Society, 1965- .

CUMMINGS, NATHAN—Collector, Patron
 Waldorf Towers 28A, 100 E. 50th St., New York, N.Y. 10022
B. St. John, N.B., Canada, Oct. 14, 1896. Studied: Economist Training School, New York, N.Y. Awards: Hon. Doctor of Humanities, Southern College of Florida; Hon. Doctor of Laws, The Citadel Military College of South Carolina; Chevalier of the Legion of Honor, France; Cavalier of the Order of Merit, Italy; Commendador of the Order of Merit, Peru; Hon. Doctor of Laws, University of New Brunswick. Collection: Impressionists and Post-Impressionists, principally the latter. Positions: Member, New York State Chamber of Commerce; Governing Life Member, The Art Institute of Chicago; Benefactor, Metropolitan Museum of Art; Patron, Montreal Museum of Fine Arts; Patron and Governing Member, Minneapolis Society of Fine Arts; Member, Citizens Board, University of Chicago; Member, Religious Committee of the City of Chicago; Life Governor, Jewish Hospital, Montreal; Director, Rothschild Enterprises, Inc., Consolidated Foods Corp., Associated Products, Inc., Society National Bank of Cleveland; Patron, Lincoln Center for the Performing Arts, New York, N.Y.

CUMMINGS, WILLARD WARREN—Painter, T.
 R.F.D. 4, Skowhegan, Me. 04976
B. Old Town, Me., Mar. 17, 1915. Studied: Julien Acad., Paris; Yale Sch. FA; ASL, and with Wayman Adams, Robert Laurent. Awards: prize, Oakland A. Mus., 1940; Hon. Doctorate, Colby Col., 1960. Work: War Dept., Wash., D.C.; Newark Mus.; Racing Mus., Saratoga, N.Y.; Colby Col.; Univ. Maine; Yale Law Sch.; Britannica Films. Exhibited: AIC, 1941; CGA, 1940; Oakland A. Mus., 1940; MModA, 1938-1942; Smith Col. Mus., 1940 (one-man); Sweat A. Mus., 1940; Marie Harriman Gal., 1939; Margaret Brown Gal., Boston, 1951 (one-man); WMAA, 1954, 1955; Katonah Gal., 1956 (one-man); Maynard Walker Gal., 1957, 1961 (one-man). Positions: Fndr., Pres., Bd. of Trustees, Skowhegan Sch. Painting & Sculpture, Skowhegan, Me.*

CUNNINGHAM, BEN(JAMIN) (FRAZIER)—Painter, T.
 44 Carmine St., New York, N.Y. 10014
B. Cripple Creek, Colo., Feb. 10, 1904. Studied: Univ. Nevada; Cal. Sch. FA (now San Francisco Art Inst.). Member: Fed. Mod. P. & S. Work: MModA; Guggenheim Mus.; Ft. Worth A. Center; SFMA; Morgan State Col., Baltimore; Univ. Minnesota, Duluth; Birla Acad., Calcutta, India; Cooper-Hewitt Mus. of Design; Smithsonian Inst.; Michener Coll., Univ. Texas, Austin. Exhibited: Yale Univ. A. Gal., 1957; Morgan State Col., 1960; Cooper Union, 1960; MModA, 1965; Univ. Texas Mus., 1965; WMAA, 1965; Aldrich Mus. Contemp. A., 1966; Georgia Mus. A., 1967; PAFA, 1968; Detroit Inst. A., 1969. Positions: Instr., Newark Sch. Fine and Indst. A., 1945-1960; Pratt Inst., Brooklyn, N.Y., painting, 1965-1966; design, Cooper Union, 1960-1968; painting, ASL, 1967- .

CUNNINGHAM, CHARLES C.—Museum Director, Collector, Scholar, W.
 513 Sheridan Rd., Kenilworth, Ill. 60043
B. Mamaroneck, N.Y., Mar. 7, 1910. Studied: Harvard Col., A.B.; London Univ., B.A.; Harvard Univ.; Hon. D.F.A., Univ. Hartford. Awards: O.M., Republic of Italy. Member: AFA (Trustee); CAA; AAMus. (Council); U.S. Comm., Int. Council of Museums; Chicago Landmarks and Historical Comm.; Visiting Com. for Harvard Univ. and Smith Col.; A. Mus. Dir. Assn. (Pres., 1958); Archaeological Soc. Am.; Conn. Comm. on the Arts (Chm. 1964-1965); Benjamin Franklin Fellow, Royal Soc. A., London; Hon. Memb., A.I.A.; Hon. Memb. A.I.D. Ed., "Art in New England," 1939. Lectures: American Painting; French Painting, 19th & 20th Centuries; Dutch and Flemish Painting, 17th Century. Contributor to Art magazines, Mus. Bulletins and Catalogues. Nature of Art Collection: Dutch, French, American Painting and Sculpture. Works Published: "The Medicine

Man"; "The Pierpont Morgan Treasure"; "The Romantic Circle"; "Pictures within Pictures." Positions: Asst. Cur., Boston Museum of Fine Arts, 1935-41; Dir., Wadsworth Atheneum, Hartford, Conn., 1946-1966; Dir., Art Institute, Chicago, Ill., 1966- .

CUNNINGHAM, FRANCIS—Painter, T., I., L.
789 West End Ave., New York, N.Y. 10025
B. New York, N.Y., Jan. 18, 1931. Studied: Harvard Col., A.B.; ASL, with Dickinson and Hale. Member: ASL; AEA. Awards: Public Mem. award, 1965, purchase award, 1968, Berkshire Mus. A. Work: private collections. Exhibited: Contemporaries #1, Gallery of Mod. A., N.Y., 1965; Westerly Gal., 1964; PAFA, 1966; NAD, 1967, 1969; Butler Inst. Am. A., 1967; Flint, Mich., 1966; one-man, Waverly Gal., 1964; Salpeter Gal., N.Y., 1966; Hirschl & Adler Gal., N.Y., 1968; Berkshire Mus., Pittsfield, Mass., 1969. I., "Fundamentals of Roentgenology," 1964. Contributor to Art Quarterly, 1962. Lectures: "Greek to Contemporary"; "Proportions in Greek Sculpture," etc., at N.Y. Pub. Lib., 1962-1965. Positions: Instr., Painting & Drawing, Brooklyn Mus. Art School, 1962- ; Art History, City College of New York, 1962-1965; Instr., BM Sch. A., 1962- .

CURRIER, STEPHEN R.—Collector
666 Fifth Ave., New York, N.Y. 10019*

CURTIS, PHILIP C.—Painter
109 Cattle Track, Scottsdale, Ariz. 85251
B. Jackson, Mich., May 26, 1907. Studied: Albion Col., A.B.; Univ. Michigan (Law); Yale Sch. FA. Member: Royal Soc. A., London. Work: Phoenix A. Mus.; Arizona State Univ.; Des Moines A. Center. Exhibited: One-man: SFMA, 1949; Phoenix A. Mus., 1961, 1963; Knoedler Gal., N.Y., 1964; CAL.PLH, 1966; Fiengarten Gal., Los Angeles, 1966; No. Ariz. Univ., Flagstaff, 1967; Galerie Krugier, Geneva, Switzerland, 1967. Color reproductions of many works, Arizona Highways magazine. Positions: Established Phoenix A. Center (Dir.), 1936-39, now the Phoenix Art Museum.

CUSHING, GEORGE—Industrial Designer, L., T.
101 Park Ave., New York, N.Y. 10017; h. 9 Burnside Dr., Short Hills, N.J. 07078
B. Plainfield, N.J., Oct. 14, 1906. Studied: Rutgers Univ.; N.Y. Univ. Member: IDI; Soc. Industrial Des. Awards: Modern Plastic Award, 1939; Electrical Manufacturing Award, 1940; IDI, 1951. (These awards received in collaboration with Thomas G. Nevell, partner). Lectures: Industrial Design at N.Y. Univ.; Pratt Inst.; Newark Sch. F. & Indst. A.; Museum of the City of New York. Positions: Partner, Cushing & Nevell, 1933- , Partner, Cushing & Nevell, Ltd., Toronto, Canada, Pres., Cushing & Nevell, Inc. of California; Chm. Bd., Cushing & Nevell Tech. Des. Corp.; Chm. Bd. & Past Pres., Nat. Tech. Services Assn.

CUSUMANO, STEFANO—Painter, E.
170 W. 73rd St., New York, N.Y. 10023
B. Tampa, Fla., Feb. 5, 1912. Studied: Metropolitan A. Sch. and with Arthur Schwieder. Awards: Ford Fnd. purchase award, WMAA, 1962; Childe Hassam purchase award, Am. Acad. A. & Lets., 1968. Work: NGA; MMA; WMAA; BM; PMA; Newark Mus. A.; Pensacola A. Mus.; Univ. Illinois; Wesleyan Univ. Mus.; Johns Hopkins Univ. Mus.; Joslyn A. Mus., Omaha, Neb. Exhibited: MModA; WMAA; Univ. Illinois; PAFA; CGA; Carnegie Inst.; Am. Acad. A. & Lets., Butler Inst. Am. A.; Drawings USA, St. Paul A. Center, 1968, and many others. One-man: Montross Gal., 1942; George Binet Gal., 1946-1950; Passedoit Gal., 1953, 1956, 1957, 1959; Gallery 63, 1963, 1964, all in New York City; also, Philadelphia A. All., 1948; Woodmere A. Gal., 1950; Mari Gal., Woodstock, N.Y., 1962; Tampa AI, 1949; Oregon State Univ., 1951; Washington State Univ., 1951 and in Rome, Italy, 1964; Terry Dintenfass Gal., N.Y., 1968. Positions: Adjunct Assoc. Prof. A., N.Y. Univ. and Instr., Cooper Union Sch. of Art & Architecture, N.Y.

CUTHBERT, VIRGINIA (Mrs. Philip C. Elliott)—Painter, T., L.
147 Bryant St., Buffalo, N.Y. 14222
B. West Newton, Pa., Aug. 27, 1908. Studied: Syracuse Univ., B.F.A.; Carnegie Inst.; Chelsea Polytechnical Inst.; Univ. London, and with George Luks. Member: The Patteran, Buffalo, N.Y. Awards: F., Syracuse Univ., for European study; prizes, Carnegie Inst., 1934, 1935, 1957; Assoc. A. Pittsburgh, 1938, 1939; Butler Inst. Am. A., 1940; Albright A. Gal., 1944, 1946, 1965; Pepsi-Cola, 1946; Cortland State Fair, 1949, 1951, 1953; Albright-Knox A. Gal., 1950, 1952, 1955, 1958; Nat. Inst. A. & Let. grant, 1954; Chautauqua, N.Y., 1955; Buffalo, N.Y., 1956, 1957. Work: Albright-Knox A. Gal.; Princeton Mus. A.; One Hundred Friends of Pittsburgh Art; State Univ. of N.Y., Buffalo; Nat. Gypsum Co.; Mfg. & Traders Bank, Buffalo; Butler Inst. Am. A. Exhibited: Carnegie Inst., 1937-1940, 1943-1945, 1949; VMFA, 1940, 1942, 1946; PAFA, 1935, 1941, 1942, 1944, 1948-1952, 1953, 1958; MMA, 1943, 1944, 1951; Pepsi-Cola, 1946; AIC, 1938-1940, 1942, 1946, 1950, 1951, 1953; WMAA, 1946,
1948, 1950, 1953, GGE, 1939; Butler Inst. Am. A., 1938 (one-man); 1940, 1941, 1954, 1955, 1957, 1958, 1959, 1962, 1963 (one-man), 1964, R.I. Sch. Des., 1945; AFA traveling exh., 1937-1938, 1950-1951; Syracuse Mus. A., 1939 (one-man), Syracuse Univ., 1944 (one-man); Contemporary A. Gal., 1945, 1949, 1953 (all one-man); Albright A. Gal., 1942-1946, 1948-1958, 1959, 1960, 1963 (one-man), 1964, 1965; A. Dir. Cl. traveling exh., 1952-53; Carnegie Inst., 1952; CGA, 1949, 1951; Univ. Illinois, 1951; Cal.PLH, 1950, 1951; Walker A. Center, 1949, 1954; Nebraska Exh., 1949, 1950; Cortland State Fair, 1949, 1951; N.Y. State Fair, 1951, 1958; AIC, 1953, 1957; Western N.Y. exh., 1953-1955, 1959; A. Dir. Cl., 1953; Am. Acad. A. & Let., 1954; VMFA, 1954; Des Moines A. Center, 1954; Chautauqua A. Center, 1955, 1958, 1960, 1962; MModA, 1956; Rehn Gal., 1956-1958, 1959, 1966; DMFA, 1957; WMA, 1957; CMA, 1957; Provincetown A. Festival, 1958; Sarasota, 1959; Ft. Worth, 1959; Nelson Gal., Kansas City, 1959; N.Y. State Col. for T., Albany, 1959 (one-man); traveling exh. to Brazil, 1960; N.Y. State Fair, 1962; Cayuga Mus. Hist. & Art, 1963 (one-man); Silvermine Gld. A., 1964; Milwaukee A. Center, 1965, and many others. Positions: Instr., Painting, Albright A. Sch., 1948- ; N.Y. State T. Col., Buffalo, N.Y., 1950-52; L., Instr., Univ. Buffalo, 1948-52; L. Instr., Albright A. Sch. of Univ. Buffalo, 1954-1965.

CUTTLER, CHARLES DAVID—Historian, P., E.
1691 Ridge Rd., Iowa City, Iowa 52240
B. Cleveland, Ohio, Apr. 8, 1913. Studied: Ohio State Univ., B.F.A., M.A.; N.Y. Univ.; in Europe, Ph.D. Member: CAA; Renaissance Soc. of Am.; AAUP; C.R.B. F., Brussels, Belgium, 1953-54. Awards: Research Professorship, Univ. of Iowa, 1965-66; Fulbright Research Scholar for Belgium, 1965-66. Exhibited: PAFA; CMA; Columbus A. Lg. Author (in part) of "An Introduction to Literature and the Fine Arts," 1950; "Northern Painting from Pucelle to Bruegel," 1968. Contributor to Art Bulletin; Art Quarterly; Art Journal; Bulletin de l'Institut royal du patrimoine artistique, Brussels. Lectures on Bosch; Brussels, Oslo, Stockholm, Uppsala, 1966. Positions: Asst. Prof., Mich. State Univ. to 1957; Assoc. Prof., Univ. of Iowa, 1957, Prof., 1965- . Fields: Northern Renaissance: Medieval Art.

CYRIL, (RUTH)—Engraver, Et., Des., P., C.
800 West End Ave., New York, N.Y. 10025
B. New York, N.Y. Studied: N.Y. Univ.; New School, N.Y.; The Sorbonne, Paris, France; Member: La Guilde de la Gravure, Paris; SAGA. Awards: Fulbright Fellowship, to The Sorbonne, Paris. Work: Massillon Mus.; Smithsonian Inst.; Corning Glass Mus.; Bergstrom A. Center & Mus., Neenah, Wis.; New State Dept. Bldg., Washington, D.C.; Bibliotheque Nationale, Paris; LC; Alverthorpe Gal., Rosenwald Mus., Pennsylvania; MMA; Victoria & Albert Mus., London; FMA; DMFA; Delgado Mus. A., New Orleans; Rochester (N.Y.) Inst. Tech.; Wright A. Center, Beloit Col.; Georgia Mus. A., Athens; AGAA; McNay A. Inst., San Antonio; Henry Gal., Univ. Washington; Brooks Mem. Mus., Memphis and in many college and university museum collection. Exhibited: One-man: La Guilde de la Gravure, Paris, 1958, 1962, 1967; Brooks Mem. Mus., 1962; Portland (Me.) Mus. A., 1962; McNay A. Inst., 1962; AGAA, 1962; Monmouth Col., Ill., 1962; Georgia Mus., 1962; Assoc. Am. A., New York, 1960, 1962; Grosvenor Gal., London, 1962; Wright A. Center & Mus., 1963; Beloit Col., 1963; Rochester Inst. Tech., 1963; Smithsonian Inst., 1963; State of Louisiana A. Comm., 1963, circulating one year; Corning Glass Mus., 1964, 1966, 1967; Kansas State AA, 1964, circulating three months; Ripon Col., 1964; Bergstrom A. Center, 1964; Furman Univ., South Carolina, 1965; Univ. South Carolina, 1965; Ft. Wayne A. Inst., 1966; Massillon Mus., 1966, and others.

CZURLES, STANLEY A.—Educator, P., W., L., Des.
244 Wardman Rd., Kenmore, N.Y. 14217
B. Elizabeth, N.J., Sept. 14, 1908. Studied: Syracuse Univ., B.F.A., M.F.A.; Univ. Iowa, Ph.D. Member: NEA; Council member NAEA; Eastern AA (Pres. 1962-64). Exhibited: Albright A. Gal.; Syracuse Mus. FA; Buffalo Town Club (one-man). Contributor to art education magazines and bulletins. Author: "The Art Process and Learning: in the Child and the Articulated Curriculum," 1968. Positions: Asst. Prof. A., 1941-46; Dir. A. Edu., Prof., 1946- , Dir. Visual Edu., 1943- , State Univ. Col., Buffalo, N.Y.; Advisor to N.Y. State Council on the Arts; Consultant to N.Y. State Art Teachers Assn.

D'AGOSTINO, VINCENT—Painter
129 N. Clark Dr., Beverly Hills, Cal. 90211
B. Chicago, Ill, April 7, 1898. Studied: AIC, and with Charles Hawthorne, George Bellows. Member: AEA; NSMP; Assoc., Los A. Scenic A. Awards: Tiffany Fnd. scholarship. Work: WMAA; Tilden H.S., Brooklyn, N.Y.; murals, USPO, Gloucester, N.J.; Mt. Loretto Inst., Staten Island, N.Y.; Riccardo's Restaurant, Chicago, Ill.; Los A. County Fair, 1961. Exhibited: PAFA, 1931; Newark, N.J.; AIC, 1934, 1935; WFNY, 1939; Whitney Studio, 1929 (one-man); Milwaukee AI; Riccardo's Restaurant, Chicago; Oshkosh Mus. A.; Univ. Oklahoma; Mus. FA of Houston, 1934; Anthan Gal., Los A., 1950;

Pasadena AI, 1951; Los A. Home Show, 1953; Los A. County Fair, 1953; Los A. Mus. A., 1954; Constant Gal., 1959 (one-man); Retrospective exh., Bognar Gal., Hollywood, Cal., 1968; Beverly Hills Women's Cl., 1969 (one-man). Positions: Prof. A., Woodbury College, 1950-1954.

DAHILL, THOMAS HENRY, JR.—Painter, T., L.
Emerson College, 130 Beacon St., Boston, Mass. 02116; h. 223 Broadway, Arlington, Mass. 02174
B. Cambridge, Mass., June 22, 1925. Studied: Tufts Col., B.S.; Sch. of the Mus. FA, Boston; Skowhegan Sch. Painting & Sculpture; resident, Max Beckmann Gesellschaft, Murnau, Germany, 1956. Member: Inst. Contemp. A., Boston; MacDowell Colonists; Alumni Assn., Sch. of the Mus. FA, Boston. Awards: Fellowship (Abbey Memorial) to Am. Acad. in Rome, 1955-56, 1956-1957. Work: Mural, Unitarian Church, Brockton, Mass., 1958; Film strips of series of paintings on Old and New Testaments, 1961-62; Film strip of Life of George Washington Carver, 1961. Exhibited: USIS traveling exh., Near and Far East, 1958-1959; Int. Bienale of Religious Art, Salzburg, 1958-1959; Boston A. Festival, 1955, 1956, 1963; Arch. Lg.; N.Y., 1958; Downtown Gal., N.Y., 1956; Siembab Gal., Boston, 1959, 1961, 1962; Botolph Group, Boston, 1959; Mary Harriman Gal., 1964; Emerson College, 1964, 1967; Grover Cronin, Waltham, Mass., 1957, 1962, 1965; Drawings of North Africa exhibited through the Museum of Fine Arts Boston to galleries of New England Preparatory Schools, 1967-1969. Lectures: General Art History; Contemporary Use of Art in Churches, etc. Positions: Instr., History of Art, Tufts University, 1954-1955, 1960-1965; Dept. of Drawing, School of the Museum of Fine Arts, Boston, 1958-1965; Chm., FA Dept., Emerson College, Boston, Mass., 1967- .

DAHL, FRANCIS W.—Cartoonist
The Boston Herald, Boston, Mass. 02106; h. 47 Central Ave., Newtonville, Mass. 02160
B. Wollaston, Mass., Oct. 21, 1907. Author, I., "Left Handed Compliments"; "Dahl's Cartoons"; "Dahl's Boston"; "Dahl's Brave New World"; Birds, Beasts and Bostonians." Positions: Cart., The Boston Herald, 1930- .

DAHLBERG, EDWIN LENNART—Painter, I.
6 South Boulevard, Nyack, N.Y. 10960
B. Beloit, Wis., Sept. 20, 1901. Studied: AIC. Member: AWS (Bd. of Dir., 1965-1967); All. A. of Am. Awards: Adams traveling scholarship, AIC, 1924; Ranger purchase award, NAD, 1958; Pauline Law award, 1959 and Mrs. John J. Rodgers Memorial award, 1961, Hudson Valley AA, 1965; Digby Chandler award, All. A. Am., 1963, 1965; New Rochelle Women's Cl., 1966. Work: Wesleyan Univ.; Frye Mus. A., Seattle. Exhibited: AIC; PAFA; AWS, 1954-1961, and traveling exhs., 1956, 1961, 1963, 1964; Grand Central Gals.; NAC; Hudson Valley AA; AAPL; Eastern States Expo.; All. A. Am.; Baltimore WC Cl.; one-man, MF Gal., Nyack, N.Y., 1964; Rockland Community Col., 1966, 1967; Nyack Hospital, 1968. Article: "Edwin L. Dahlberg Seeks Mood in a Motif," American Artist, 1965. Represented in Norman Kent's "One Hundred Watercolor Techniques," 1968. Positions: Freelance painter and illustrator, 1930- .

DAHLIN, ED—Cartoonist
15 W. 72nd St., New York, N.Y. 10023
B. Chicago, Ill., Oct. 7, 1928. Studied: Chicago Acad. FA. Work: in "Best Cartoons of the Year," 1956-1960; "Cartoon Laffs for TRUE," 1958; "The Saturday Evening Post Carnival of Humor," 1958; "You've Got Me in the Nursery," 1958; "A Treasury of Sports Cartoons," 1957. Contributor to: Saturday Evening Post; True; Ladies Home Journal; American Legion; Better Homes and Gardens; Successful Farming; King Features Syndicate; McNaught Syndicate; McCalls; Pictorial Review; Sport; Argosy; Wall Street Journal; Parade; Cavalier; Christian Science Monitor and in worldwide foreign publications.*

DAILEY, JOSEPH CHARLES—
Painter, Des., Ser., C., T.
25 Columbia Court, Columbus, Ohio 43202
B. Reynoldsville, Pa., Mar. 4, 1926. Studied: Youngstown Univ., A.B., with Margaret Evans, David P. Skeggs, John Naberezny and Robert Elwell. Member: F.I.A.L.; Midwest Mus. Conf. Awards: prizes, Mahoning County, 1951; Trumble County, 1950; Youngstown College Purchase award, 1952; Iowa Artists annual (purchase). Work: Youngstown College; Westmar College; Sioux City A. Center; Missouri Synod; Des Moines A. Center; Sioux City Lib., and in numerous private colls. Exhibited: Butler Inst. Am. A., 1952, 1953; Massillon Mus. A., 1953; Canton AI; Akron AI; Siouxland WC Exch., 1955-1957; Six-State Exh., 1955-1958; Springfield Mus. A., 1956; Life of Christ Show (Iowa), 1957, 1958; Des Moines A. Center; Univ. Nebraska; Blanden Mem. Mus.; Univ. Kansas City; Stephens Col.; Cedar Falls AI; Sanford Mus., Cherokee, Iowa; Iowa State Fair, 1955, 1956; Laas-George Gal., San F., 1961; one-man: Youngstown

College; Youngstown Lib., 1953; Westmar College, 1951; Morningside College, 1957; Sioux City Lib., 1957; Iowa Unitarian Convent, 1956. Des. and Edited numerous brochures, catalogs, publications for Sioux City A. Center; art reviews for Sioux City Journal; TV art education series. Positions: Des., Crest Johnson Studios, Youngstown, Ohio, 1953; Staff Artist, Warren, Ohio, 1954; Asst. Dir., Sioux City A. Center, 1957-1961. Arts & Crafts Co-ordinator, Central Community Center, Columbus, Ohio, 1964-1968; Freelance, 1969.

DAINGERFIELD, MARJORIE (Mrs. Arthur E. Howlett)—
Sculptor, T., L.
1 West 67th St., New York, N.Y. 10023; s. Blowing Rock, N.C.
B. New York, N.Y. Studied: Sch. Am. S.; Grand Central Sch. A.; & with Solon Borglum, James Fraser, Edmond Amateis. Member: NSS; Pen & Brush Cl.; Catherine L. Wolfe A. Cl. Awards: Huntington award, Pen & Brush Cl., 1956, silver medal, 1964. Work: Sch. Tropical Medicine, San Juan, Puerto Rico; Hobart Col., Geneva, N.Y.; Ovens Auditorium and Queens Col., Charlotte, N.C.; statuette-emblem for Girl Scouts of America; bronze head of Dr. Bailey K. Ashford, Georgetown Univ., 1957; many portrait heads. Exhibited: NAD, since 1920; Arch. L., 1945; NSS, 1944, 1945; Mint Mus. A.; Norton A. Gal.; Wildenstein Gal.; Grand Central A. Gal.; Duke Univ.; Audubon A.; Pen & Brush Cl. Lectures: Sculpture—modelling heads. Pres., Blowing Rock AA, 1958. Author: "The Fun and Fundamentals of Sculpture," 1964.

DALTON, FRANCES L.—Painter, T.
70 Chestnut St., Andover, Mass. 01810
B. Amesbury, Mass., Dec. 28, 1906. Studied: Ecole des Beaux-Arts, Paris; BMFA Sch., with Philip Hale. Member: Gld. of Scholars (BMFA Sch.); AAPL; Boston Soc. Indp. A.; Andover A. Group; Mass. State Group on Nat. A. Ed.; NAEA; Eastern AA; North Andover FA Soc.; Alumni Assn., BMFA. Awards: prize and med., Jordan Marsh Co., 1944; traveling scholarship BMFA Sch.; Lawrence (Mass.) Centennial Exh., 1953. Work: portraits, Royal Hawaiian Hotel, Hawaii; Andover (Mass.) H.S. Exhibited: Jordan Marsh Co., 1954, 1959, 1960; Whistler House; Springfield Mus. A.; Woodstock A. Gal.; AGAA, 1959, 1960; Terry AI, 1952; Silvermine Gld. A.; Boston Soc. Indp. A.; Boston A. Festival, 1955; traveling exh., Boston Soc. Indp. A., 1954; John Esther Gal., Andover, 1955, 1961, 1962 (one-man); Brooks Sch., No. Andover, 1954; Copley Soc., Boston, 1957; Portland A. Mus., 1957; Andover Inn, 1958; St. Gaudens Mem., Cornish, N.H., 1958; H.S. Art Festival, 1958 (Chm. 1959-1964); Andover FA Soc., 1956-1958; BMFA Sch. Alumni exh., 1960; Lowell AA, 1962-1964; Edna Hibel Gal., Boston, 1964; BMFA Collectors Exh.

DALTON, HARRY L.—Collector
1212 Wachovia Bank Bldg., Charlotte, N.C. 28202
B. Winston-Salem, N.C., June 13, 1895. Studied: Duke Univ., A.B.; N.Y. Univ.; College of Technology and Owens College, Manchester, England. Awards: Hon. D.H.L., Duke University. New art galleries at Agnes Scott College, Decatur, Ga., called "The Dalton Galleries." Collection: Various schools, trends and movements in European and American art. Gifts and loans to colleges and museums have been made. Positions: Pres., Mint Museum of Art, Charlotte, N.C.; Bd. Memb. North Carolina Art Assn.; Dir. and Vice-Pres., Witherspoon Art Gallery of University of North Carolina; North Carolina Arts Council, appointed by the Governor; North Carolina State Art Society; Burnside Dalton Galleries, Wingate, North Carolina.

DALY, NORMAN DAVID—Painter, E., S., Des.
110 North Quarry St., Ithaca, N.Y. 14850
B. Pittsburgh, Pa., Aug. 9, 1911. Studied: Univ. Colorado, B.F.A.; Ohio State Univ., M.A.; N.Y. Univ. Awards: purchase prize, Syracuse Council of Arts, 1962; Everson Mus. A., 1963; Jurors' Show award, Rochester, 1963; Sculpture award, Rochester, 1964. Other prizes in prior years. Work: Oberlin Mus. FA; Wooster Col.; Munson-Williams-Proctor Inst.; White Mus. A., Cornell Univ.; St. Paul's Gal. A.; Univ. Washington; Rochester Mem. Gal.; WAC; N.Y. State Univ., Cortland; Everson Mus. A.; Ithaca College. Exhibited: WMAA, 1947, 1948, 1950; Carnegie Inst., 1948, 1949; AIC, 1943, 1944, 1951; PAFA, 1948-1950; Univ. Illinois, 1950; CGA, 1960; CAM, 1951; MMA, 1952; one-man: White A. Mus., Cornell Univ., 1961, 1965; Rochester Mem. Gal., 1963; Roberson A. Center, 1964; N.Y. State Univ., Cortland, 1963, Albany, 1964. Positions: Prof. A., Cornell Univ., Ithaca, N.Y., 1942- . Lectures & demonstrations: N.Y. State A.T. Assn. Conf., Albany & Schenectady, 1960, Corning, N.Y., 1961.

DAMAZ, PAUL F.—Writer, Architect, Collector
1010 Third Ave. 10021; h. 302 E. 88th St., New York, N.Y. 10028
B. Porto, Portugal, Nov. 8, 1918. Studied: St. Louis Col., Lyon, France; Ecole Speciale d'Architecture, Paris, France; Institut of Urbanism, Sorbonne, Paris, France. Awards: Arnold Brunner

Award, 1958. Member: AIA. Author: "Art in European Architecture," 1956; "Art in Latin American Architecture," 1964. Lecturer on Integration of Art and Architecture. Positions: Vice-President, Architectural League, N.Y., 1964-1966; Chairman, National Sub-Committee on Collaborative Arts, AIA; Art Adviser to New York State Council on Architecture.

DAME, LAWRENCE—Critic, W.
P.O. Box 2392, Palm Beach, Fla.; s. Maidstone, P.O., Jamaica
B. Portland, Me., July 2, 1898. Studied: Harvard Univ.; Univ. of Paris; Univ. Grenoble, France; Instituto de Burgos, Spain. Author: "New England Comes Back," 1940; "Yucatan," 1941; "Joys Beyond Pleasure," 1969; "Maya Mission," 1968; Co-author: "Boston Murders." Contributor to Saturday Evening Post; Reader's Digest; American Mercury; Magazine Digest; Arts magazine; N.Y. Times; Pictures on Exhibit, Art Voices, etc. Lectures: On art; ruins and relics of Yucatan. Reviewer of art books and other publications. Positions: Dir., News Office, Harvard Univ., 1943-44, 1950-53; A. Editor, Boston Herald, 1944-54; Contrib. Ed., Art Digest, 1950-54; Contrib. Columnist, Rome (Italy) Daily American, 1955; A. Ed., Sarasota Herald-Tribune, 1955-1962; A. Critic, The Palm Beacher, The Social Pictorial, The Palm Beach Illustrated, 1962-1965, New York Times, Nassau Tribune, Gleaner of Jamaica. Dir., Galerie Romancet-Vercel, 1965.

D'AMICO, AUGUSTINE A.—Collector, Patron
191 Exchange St.; h. 201 Broadway, Bangor, Me. 04401
B. Lawrence, Mass., May 15, 1905. Studied: Colby College; B.S., M.A. Member: AFA; Mus. Modern Art; Fellow, Colby College; Lg. of New Hampshire A. & Crafts; Patron of Fine Arts, Univ. Maine; American Craftsmen's Council. Collection: Paintings, Graphics, Ceramics. Collections exhibited: Paintings & Graphics, Univ. Maine, 1961; Contemporary Ceramics, Univ. Maine, 1963; Paintings & Graphics, Bixler Art Museum, Colby College, 1963; Contemporary Ceramics, Lincoln County Museum, Wiscasset, Me., 1965. Positions: Former Trustee, Colby College; Fellow, Colby College; Art Advisory Committee, Colby College; Trustee, Haystack Mountain School of Crafts, Deer Isle, Maine; Fine Arts Advisory Committee, City of Bangor, Me.; Member, World Craft Council.

D'AMICO, VICTOR—Art Educator
The Museum of Modern Art, 11 W. 53rd St., New York, N.Y. 10019; h. 30 Palmer Ave., White Plains, N.Y. 10603
B. New York, N.Y., May 19, 1904. Studied: The Cooper Union, New York; Pratt Institute, Brooklyn, N.Y.; Teachers College, Columbia University, B.S., M.A. Awards: Hon. Degree D.F.A., Philadelphia Museum College of Art, 1964; Medal of Honor, National Gallery of Fine Arts, Washington, D.C. for "outstanding service in the field of Art Education," 1966; Citation of Merit, State University of New York College at Buffalo, 1964. Positions: Founder, National Committee on Art Education, 1942, Exec. Dir., 1960-1965; Pres., Inst. Modern A., 1960- ; Dir., Dept. Education, MModA., 1937- ; Dir., Kearsarge A. Center, Long Island, N.Y., 1962- ; Instr., Dept. FA, Southampton Col., N.Y., 1967- .

d'ANDREA, ALBERT PHILIP—Educator, S., P.
2121 Bay Ave., Brooklyn, N.Y. 11210
B. Benevento, Italy, Oct. 27, 1897. Studied: Col. City of N.Y., A.B.; Univ. Rome. Member: Soc. Contemp. A.; Audubon A.; CAA; Benjamin Franklin F., Royal Soc. A., England; Hon. Academician, Accademia di Belle Arti, Perugia; NSS; Pres. (1965-1966), Gamma Chptr., N.Y., Phi Beta Kappa. Awards: prizes, Col. City of N.Y., 1933; LC, 1944; med. Ingenieurs professionals Francais, 1954; Townsend Harris award, N.Y., 1957; Lindsey Morris award, NSS, 1963. Work: LC; City Col. of N.Y.; Mus. City of N.Y.; N.Y. Hist. Soc.; Smithsonian Inst.; Accademia di Belle Arti, Perugia; Biblioteca Apostolica Vaticana; Royal Soc. A.; Bibliotheques Nationale, Dept. des Medailles; Jewish Mus., New York City; Hyde Park Mem. Lib.; Nat. Port. Gal., Wash., D.C. Exhibited: NSS, 1951, 1952, 1957, 1959-1969; NAD; Audubon A.; 1953, 1954, 1956-1967. Positions: Dir. Arch. & Engineering Unit of Bd. Edu., New York, 1947-51; Prof. A., Chm., Dept., Dir., Planning & Des., City Col. of New York, 1948-1968; Prof. Emeritus A., 1968. Author, "On Portraiture," NSS "Review," 1963. Creator of the following medals: David B. Steinman, Bernard M. Baruch, Jonas E. Salk, George M. Sarton, Thomas A. Edison award, Dr. Arthur Kornberg, Pres. Buell G. Gallagher, City College, N.Y.; James K. Hackett medal; Grover Cleveland Medal of the Hall of Fame, Gen. Douglas MacArthur, Andreas Vesalius, Dr. Martin Luther King, Dr. Sidney Farber, 1964-1969.

DANE, WILLIAM JERALD—Art Librarian
Newark Public Library; h. 25 Clifton Ave., (D-1612), Newark, N.J. 07104
B. Concord, N.H., May 8, 1925. Studied: Univ. New Hampshire, B.A.; Drexel Inst. Technology, M.L.S.; Harvard Univ.; N.Y. Univ. Inst. FA;

Univ. Paris (Sorbonne); Univ. Nancy, France; Attingham Park Summer Sch., England. Member: Grolier Club, N.Y.; Victorian Soc. of Am. (Chm., Publications Com., 1967-1969). Author: "Picture Collection Subject Headings," 1968. Positions: Supervising Art & Music Libr., Newark Public Lib., Newark, N.J. Chm., Art Sub-section of Am. Lib. Assn., 1964-1966.

DANENBERG, B.—Art dealer
Danenberg Gallery, 1000 Madison Ave., New York, N.Y. 10021*

DANES, GIBSON—Educator, L., Cr.
State University of New York, College at Purchase, Purchase, N.Y. 10577; h. Sawmill Rd., Newtown, Conn. 06470
B. Starbuck, Wash., Dec. 13, 1910. Studied: Univ. Oregon, with Michael Mueller; AIC, B.F.A., with Boris Anisfeld; Northwestern Univ., B.S., M.A.; Yale Univ., Ph.D. Member: CAA; Hon. Memb. Conn. Chptr. AIA. Awards: F., Northwestern Univ., 1937; Carnegie Scholarship, 1938; F., Yale Univ., 1946; Rockefeller Post-War F., 1946; Ford Fnd. F., 1951. Exhibited: Missouri State Exh., Jefferson City; Univ. Exh., Austin, Tex.; South County AA, Kingston, R.I. Contributor to art magazines, college journals. Author: "Looking at Modern Painting." Positions: Prof. A., Univ. Texas, Austin, Tex.; Prof. A., Ohio State Univ., 1948-52; Chm. Dept. A., Univ. California, Los Angeles, Cal., 1952-58; Dean, Sch. A. & Architecture, Yale Univ., New Haven, Conn., 1958-1968; Dean, Visual Arts, State Univ. of N.Y., College at Purchase, N.Y., 1968- .

DANIELS, DAVID—Collector
4 Sutton Place, New York, N.Y. 10022
B. Evanston, Ill., April 10, 1927. Studied: Yale University; Curtis Institute of Music, Philadelphia, Pa. Collection: Drawings and Sculpture. A catalogue "Drawings from the David Daniels Collection," was compiled by Agnes Mongan and Mary Lee Bennett, of the Fogg Museum of Art, for a traveling exhibition of the drawings shown at the following museums, 1968-1969: Minneapolis Institute of Arts, Art Institute of Chicago, Atkins Museum, Kansas City, Missouri; and the Fogg Art Museum, Harvard University, Cambridge, Massachusetts; and Colby College Art Museum. Positions: Trustee, Skowhegan School of Art; Trustee and Member, Acquisitions Committee, Minneapolis Institute of Arts; Member, National Committee, of the Drawing Society.

DANSON, EDWARD B.—Museum Director, W.
Museum of Northern Arizona, Fort Valley Road, Flagstaff, Ariz. 86001
B. Glendale, Ohio, Mar. 22, 1916. Studied: Univ. Arizona, B.A.; Harvard Univ., M.A., Ph.D. (Anthropology). Member: Southwestern Monuments Assn. (Bd. Trustees); Flagstaff Science Advisory Bd.; Advisory Comm., Multiple Use Management, Coconino Nat. Forest Service; Soc. for Am. Archaeology; F., Am. Anthropology Assn.; F., Am. Assn. for the Advancement of Science; F., Arizona Acad. of Science; Soc. for Am. Archaeology; Soc. for Historical Archaeology; Western Mus. Lg.; Southwest Advisory Bd., Sierra Club, 1966- ; Arizona Historical Assn., 1967- ; Bd. Dirs., Shrine of the Ages, Grand Canyon, 1964- . Advisory Council, 1964- . Advisory Board, 1958-1964, Nat. Park Service. Author: "New Dimensions in Hopi Ceramic Crafts"; "Last of the Frontier Merchants" (Nat. Parks Magazine); "An Important Archaeological Gift" (Palteau); co-author: "A Petrographic Study of Gila Polychrome" (American Antiquity); and numerous small papers and reviews. Positions: Asst. Prof., Anthropology, Colorado, 1948-1950, Arizona, 1950-1956; Asst. Dir., Archaeological Field School, 1952-1953; Acting Dir., 1954; Asst. Dir., 1956-1958, Dir., 1959- , Museum of Northern Arizona, Flagstaff, Ariz.

DAPHNIS, NASSOS—Painter
400 West 23rd St., New York, N.Y. 10011; also, 11 Bangs St., Provincetown, Mass. 02657
B. Krokeai, Greece, July 23, 1914. Member: Am. Abstract A. Awards: Ford Fnd, 1962; Nat. Fnd A. & Humanities, 1966. Work: BMA; Albright A. Gal.; Providence Mus. A.; WMAA; MModA; Tel-Aviv Mus., Israel; Chrysler Mus., Provincetown, Mass.; Norfolk Mus., Norfolk, Va.; Munson-Williams-Proctor Inst., Utica, N.Y., Univ. Mich. Exhibited: Carnegie Inst., 1946, 1947, 1952, 1955, 1958, 1959, 1961; Am. Abstract A., 1958, 1961; WMAA, 1959, 1961-1963, 1965, 1967. Guggenheim Mus., 1961; Seattle Worlds Fair, 1962 Wash. (D.C.) Gal. Mod. A., 1963; WAC, 1961; Minneapolis, Minn., 1962; Provincetown, Mass., Golden Anniversary Show, 1964; Salon de Mai, Paris, 1951; Osaka Exh. (Am. Sec.), 1958, 1959; CGA, 1959, 1963, 1969; Musee Cantonal des Beaux-Arts, Lausanne, Switzerland, 1963; De Cordova Mus., Lincoln, Mass., 1965; Castelli Gal., N.Y. 1967. One-man: Contemp. A., 1938, 1947, 1948; Mint Mus. A., Charlotte, N.C., 1949; Galerie Colette Allendy, Paris, France, 1950; Castelli Gal., N.Y., 1958-1961, 1963, 1965, 1968; Toninelli Gal., Milan,

Italy, 1961; Iris Clert Gal., Paris, 1962; Siden Gal. Detroit, 1967; retrospectives, Albright-Knox A. Gal., Buffalo, N.Y. 1969; Everson Mus., Syracuse, N.Y. 1969. Positions: Instr., Horace Mann Sch., New York, N.Y., 1953- .

D'ARCANGELO, ALLAN—Painter, Gr., T.
76 W. 69th St., New York, N.Y. 10023
B. Buffalo, N.Y., June 16, 1930. Studied: Univ. Buffalo, B.A.; City Col. of New York; American Univ. of Mexico. Work: Municipal Mus., The Hague, Holland; MModA; mural, Transportation & Travel Pavilion, N.Y. World's Fair; poster, Paris Review, 1965. Exhibited: Mexico City; Thibaut Gal., N.Y., 1963; Sarah Lawrence Col., 1963; Staten Island Mus. A. & Sciences, 1963; "Pop Art USA," Oakland A. Mus., 1963; Inst. Contemp. A., London, England, 1963; Univ. Massachusetts, 1963; Inst. Contemp. A., London, England, 1963; Univ. Massachusetts, 1963; Albright-Knox A. Gal., Buffalo, 1963; Des Moines A. Center, 1963; AGAA, 1963; Betty Parsons Gal., N.Y., 1963; Cordier & Ekstrom Gal., N.Y., 1964; Holland, Belgium and Germany, 1964; Riverside Mus., N.Y., 1964; Paris, France, 1964; MModA traveling exh., U.S. and to Spoleto, Italy, 1964; Byron Gal., 1964; Univ. Ohio, 1964; Dwan Gal., Los Angeles, 1964, 1965; WMA, 1965; Milwaukee A. Mus., 1965; Cornell Univ., 1965; Graham Gal., N.Y., 1965; School of Visual Arts, N.Y., 1965; one-man: Long Island Univ., 1961; Thibaut Gal., N.Y., 1963; Fischbach Gal., N.Y., 1964, 1965, 1969; Sonnabend Gal., Paris, France, 1965; Noyendorf Gal., Hamburg, Germany, 1965; Tokyo, Japan, 1967; Lambert, Paris, France, 1969; Siden Gal., Detroit, Mich., 1969; Zwirner Gal., Cologne, Germany (2-man with John Chamberlain), 1965; and others. Positions: Instr., Painting, Drawing, Design, School of Visual Arts; Art, New York City Public School System. Visiting Artist, Cornell Univ., 1968; Yale Univ., 1969.

D'ARISTA, ROBERT—Painter, E.
3125 Quebec Place, N.W., Washington, D.C. 20008
B. New York, N.Y., July 2, 1929. Studied: N.Y. Univ.; Columbia Univ.; Am. A. Sch.; Grande Chaumiere, Paris, France. Awards: Fulbright award, 1955. Work: Yale Univ. A. Gal.; Toledo Mus. A., and in private collections. Exhibited: PAFA, 1954, 1960; Solomon Guggenheim Mus., 1954; WMAA, 1954, 1955, 1957, 1958, 1959; Detroit Inst. A.; Carnegie Inst., 1955, 1958; Univ. Illinois, 1955; Univ. Nebraska, 1955-1957, 1964; AIC; BM, 1957; DMFA; Illinois Wesleyan Univ.; Art: USA, and others; one-man: Alan Gal., N.Y., 1955, 1956, 1959; Grippi Gal., 1962; Nordness Gal., 1964, 1968; Jefferson Place Gal., Wash., D.C., 1962. Positions: Lecturer, Univ. No. Carolina, 1964 (summer); Assoc. Prof., American University, Washington, D.C., 1961- .

DARRICARRERE, ROGER DOMINIQUE—Sculptor, C., Des., E.
1937 San Fernando Rd., Los Angeles, Cal. 90065
B. Bayonne, France, Dec. 15, 1912. Studied: Beaux-Arts, Bayonne, France; École Nationale Superieure des Décoratifs de Paris (Grad.); Institute des Metiers, Paris. Member: Southern California Des.-Craftsmen; Gld. for Religious Arch. Awards: Leon Bonat prize, Bayonne, France, 1931; AIA awards for FA and Craftsmanship, 1958, 1959, 1961, 1963; first prize, National Competition for stained glass panel for N.Y. World's Fair, 1964-1965; Nat. merit award, Craftsman USA, 1966, in architectural category-stained glass. Work: Lytton Center of Visual Arts; commissions: Spatial Kaleidoscope at Lytton Center, Los Angeles, 1959; revolving steel and glass sculpture depicting the moving picture industry; leaded glass window wall, World's Fair Contest winner, now at St. Stephen's Lutheran Church, Granada Hills, Cal.; Columbia Savings & Loan Assn., Los Angeles, 1966; University Lutheran Chapel and Student Center, 1966; massive bronze sculpture, "Atlantis," Lytton Savings and Loan Assn. of Northern California, Oakland, 1967. Exhibited: N.Y. World's Fair, 1964-1965; Mus. Contemp. Crafts, New York City, 1966; Craftsman USA, 1966, at Los Angeles County Mus., 1966; Corning Mus. of Glass, N.Y.; Pasadena A. Mus., 1959-1963 and later; Scripps Col., Claremont, Cal., 1959; Otis A. Inst., 1961-1965; Long Beach Mus. A.; Long Beach Col.; Univ. California at Los Angeles; Southern California Des.-Craftsmen; Palos Verdes Library, and others. Positions: Instr., Int. Des., and Painting, Coe College, Iowa, 1948-1951; "Glass in Architecture" Workshop Prof., California State College, at Long Beach, 1968, 1969; Lecturer, "Stained Glass and Sculpture," Mount St. Mary's College, Los Angeles, spring, 1969.

DARROW, WHITNEY, JR.—Cartoonist
Box 212, Saugatuck, Westport, Conn.; h. 331 Newtown Turnpike, Wilton, Conn. 06897
B. Princeton, N.J., Aug. 22, 1909. Studied: Princeton Univ., A.B.; ASL, and with Thomas Benton, Kimon Nicolaides. Author, I., "You're Sitting on My Eyelashes," 1943; "Please Pass the Hostess," 1949, collected cartoons; "Hold It Florence," collected cartoons, 1954; "Stop Miss!," collected cartoons, 1957; "Give Up," collected cartoons, 1966. Illus. "What Dr. Spock Didn't Tell Us," 1959; "The Snake Has All the Lines," 1960; "Kids Sure Rite Fun-

ny," 1962; "A Child's Guide to Freud," 1963; "Europe Without George," 1964; "Happiness is a Dry Martini," 1965; "Misery Is a Blind Date," 1967; "Whitney Darrow, Jr's Unidentified Flying Elephant," (story by R. Kraus) 1968; "Whitney Darrow Jr's Animal Etiquette," (story by R. Kraus) 1969; "Sex and the Single Child," (Sam Levenson) 1969. Contributor to New Yorker and other magazines; cartoons for national advertisers. Contributor: Famous Artists Schools Cartoon Course.

DASBURG, ANDREW MICHAEL—Painter, T.
Ranchos de Taos, N.M. 87557
B. Paris, France, May 4, 1887. Studied: ASL. Awards: prizes, Pan-Am. Exp., 1925; Carnegie Inst., 1927, 1931; Guggenheim F., 1932; Grant, Ford Fnd.; Nat. Fnd. for the Arts award, 1967. Work: WMAA; Denver A. Mus.; Los A. Mus. A.; Cal. PLH; Dallas Mus. FA; CM; MMA. Exhibited: Retrospective Exh., Ford Fnd.

DASH, ROBERT—Painter, Set Des., W.
302 Elizabeth St., New York, N.Y. 10012
B. New York, N.Y., June 8, 1932. Studied: Univ. New Mexico, B.A. Awards: State scholarship, Univ. of the State of N.Y., 1949. Work: MModA Lending Service; CGA Lending Service; Chase Manhattan Bank; First Nat. Bank, Memphis; N.Y. Univ. Exhibited: Silvermine Gld. A., 1961; Katonah, N.Y. Gal., 1961; East Hampton Gal., 1961; Yale Univ., 1961; DeAenlle Gal., 1960; Esther Stuttman Gal., 1960; David Herbert Gal., 1960; Barone Gal., 1961 (one-man); Kornblee Gal., 1963; Queens Col., 1963; RoKo Gal., BM, 1963; East Hampton Guild Hall, 1963; PVI Gal., N.Y., 1963; Graham Gal., 1964; MModA traveling exh., 1964; one-man: Kornblee Gal., 1962, 1963; Osborne Gal., 1964. Contributor critical articles to Arts, Art News, Transatlantic Review, New Mexico Quarterly. Des. sets for initial offering of American Theatre for Poets. Positions: Asst. Ed., New Mexico Quarterly, 1953-55; Assoc. Ed., Arts, 1957; Assoc. Ed., Art News, 1958; Asst. Ed., Noon Day Press, 1959.*

DATUS, JAY—Painter, T., W.
3801 North 30th St., Phoenix, Ariz. 85016
B. Jackson, Mich., Mar. 24, 1914. Studied: Worcester Mus. Sch.; Yale Univ. Sch. FA. Member: Phoenix FA Assn. (Bd. Trustees & 1st V.-Pres.); F., Royal Soc. Arts, London. Work: Univ. Wisconsin; Beloit Col.; Arizona State Capitol Bldg. Murals, Arizona State Capitol Bldg.; 1st Natl. Bank, Phoenix; Southern Arizona Bank & Trust Co., Tucson, Ariz. Exhibited: AIC; O'Brien Gal., Chicago (one-man); Phoenix FA Center (one-man). Author: "The Paint Box" art column in Arizona Republic newspaper (2 years). Positions: Dir. & Fndr., Kachina School of Art, Phoenix, Ariz., 1948- . Memb., Bd. Trustees, Heard Museum of Art, Phoenix, Ariz.

DAUGHERTY, JAMES HENRY—
Painter, Lith., W., I., L.
Westport, Conn. 06880
B. Asheville, N.C., June 1, 1889. Studied: Corcoran Sch. A.; PAFA. Member: Silvermine Gld. A. Awards: Newbery med., 1939. Work: Yale Mus. FA; N.Y.Pub.Lib.; Wilmington Pub. Lib.; Achenbach Fnd.; Cal. PLH; MModA; WMAA; murals, Stamford H.S.; Loew's Theatre, Cleveland, Ohio. Exhibited: Silvermine Gld. A.; Macbeth Gal.; Arch. Lg.; Bridgeport A. Lg.; Knoedler Gal.; Fairfield (Conn.) Univ.; Univ. Minnesota; N.Y.Pub.Lib.; Lib. of the Univ. Oregon. Author, I., "Daniel Boone"; "Andy and the Lion"; "A. Lincoln," "The Picnic" and other titles. Illus. over 50 books. Contributor to: magazines & periodicals.

d'AULAIRE, EDGAR PARIN—Painter, Et., Lith., W.
Lia Farm, Wilton, Conn. 06897; also, South Royalton, Vt. 05068
B. Campo Blenio, Switzerland, Sept. 30, 1898. Studied: Academi Scandinave; Academie Moderne, Paris; art schools in Florence and Rome; and with Andre L'Hote, Hans Hofmann. Awards: Caldecott medal, 1940. Work: many books in coll. of LC; The White House, Wash., D.C., and in European and American schools, libraries and print rooms. Exhibited: BMFA graphic art traveling exhibition; in Italy and major cities of U.S.A. Lectures: Art and literature for children on Radio and TV. Books in collaboration with Ingri Parin d'Aulaire: Magic Rug; Ola, Ola and Blakken; Conquest of the Atlantic; Lord's Prayer; George Washington; East of the Sun, West of the Moon; Children of the Northlights; Don't Count Your Chicks; Star Spangled Banner; Animals Everywhere; Wings for Per; Pocahontas; Too Big—Two Cars; Benjamin Franklin; Lief the Lucky; Nils, Buffalo Bill; Columbus; Magic Meadow; The Book of Greek Myths, 1962; Abraham Lincoln; Foxie; Norse Gods and Giants, 1967. Books translated into German, French, Norwegian, Turkish, Japanese, Korean, Burmese and also in Braille.

d'AULAIRE, INGRI MORTENSON PARIN—Writer, I., Lith., P.
Lia Farm, Wilton, Conn. 06897; also, South Royalton, Vt. 05068
B. Kongsberg, Norway, Dec. 27, 1905. Studied: Kunstindustriskolen, Oslo, Norway; Hans Hofmann, Munich; Andre L'Hote, Per Krogh, Acadamie Moderne, Paris. Awards: Caldecott medal, 1940. Work:

many books in coll. of LC; The White House, Wash., D.C., and in European and American schools. (For list of books, in collaboration with Edgar Parin d'Aulaire, see entry above.)

DAUTERMAN, CARL CHRISTIAN—
 Museum Curator, T., L., W.
 The Metropolitan Museum of Art, Fifth Ave. at 82nd St. 10028;
 h. 1326 Madison Ave., New York, N.Y. 10028
B. Newark, N.J., July 25, 1908. Studied: Newark Mus. Apprentice Training Course; Newark Sch. Fine & Indst. A.; N.Y. Univ., B.A.; Columbia Univ., M.A. Lectures on American and European Decorative Arts. Frequent contributor to The Metropolitan Museum Bulletin; Antiques, Connoisseur and other periodicals. Author (with J. Parker and E. Standen) "Decorative Arts at The Metropolitan Museum of Art" (Phaidon, London, 1964); "Checklist of American Silversmiths' Work 1650-1850 in Museums in the New York Metropolitan Area" (Metropolitan Museum of Art, 1968); also "Sevres" (Walker & Co., New York, 1969). Conducted weekly column, The Collector's Answer Box, N.Y. World-Telegram & Sun., 1953-1967. Positions: Curatorial Staff, Newark Museum, 1930-1938; Cooper Union Museum, 1938-1946; Catalogue Writer, decorative arts, Parke-Bernet Galleries, N.Y., 1946-1953; Administrative Consultant, The Metropolitan Museum of Art, 1953-1956, Assoc. Cur., Western European Arts, 1956-1968, Cur., 1968- . Lecturer in Art History, Columbia Univ., Adjunct Assoc. Prof., 1951-1969, Adjunct Prof., 1969- . Consultant, New York State Council on the Arts, 1962- .

DAVES, DELMER—Collector
 107 N. Bentley Ave., West Los Angeles, Cal. 90049*

DAVIDEK, STEFAN—Painter
 G5391 West Coldwater St., Flint, Mich. 48504
B. Flint, Mich., May 15, 1924. Studied: Flint Inst. A., with Jaroslav Brozik; ASL, with Morris Kantor, Howard Trafton; Cranbrook Acad. A., with Fred Mitchell. Member: Mich. Acad. of Science, Arts & Letters. Awards: prizes, Flint Inst. A., 1948, 1950, 1953, 1955, 1957, 1960, 1963, 1966; Louise Keeler award, Grand Rapids, 1956; Founders prize and Lou R. Maxon prize, Detroit, 1961; Best of Show award, Grand Rapids, 1961; South Bend, 1962. Work: Detroit Inst. A.; Flint Inst. A.; Mott Children's Clinic, Flint, Mich.; Hackley Gal., Muskegon, Mich.; North Muskegon Community Col.; mosaic, St. Luke's Church, Flint. Represented in "Prize Winning Paintings," 1966. Exhibited: Butler Inst. Am. A.; Youngstown, 1959; PAFA, 1959; Flint A. Show, 1940-1964; Michigan A. Annual 1945-1963; Grand Rapids, 1958-1963; Milwaukee Inst. A., 1964; Flint Inst. A., 1968, 1969; One-man: Detroit Gal., Whitehall, Mich., 1968. One-man: Detroit Inst. A. 1962; Flint Inst. A., 1963; Whitehall, Mich., 1963; Univ. Maine, Orono, 1966; Tadlow Gal., Whitehall, Mich., 1966; Hackley Gal., Moskegon, Mich., 1967. Positions: Instr., Flint Institute of Arts, 1962-1964; Haystack Mountain Sch. of Crafts, Deer Isle, Maine, 1966; Wayne State Univ., Detroit, 1967.

DAVIDSON, ALLAN A.—Painter, W., L., S.
 8 Dean Rd., Rockport, Mass.; also, 53 State St., Boston, Mass.;
 h. 8 Dean Rd., Rockport, Mass. 01966
B. Springfield, Mass., Feb. 24, 1913. Studied: Sch. Mus. FA, Boston; Ecole des Beaux-Arts, Paris; BA, Fogg Mus., Harvard Univ.; Maitre des Arts. Member: All. A. Am.; AWS; AAPL; Boston WC Soc.; Cape Ann Soc. Mod. A. (Pres.); North Shore AA; Provincetown AA; Rockport AA; SC. Awards: Lawson Mem. Award; Charpentier Award, Paris; Rockport AA (4); AAPL, 1961; SC, 1963; Benson-Hayes-Stuart award; Chase Mem. prize; Hendy Gold Medal. Work: in private collections. Exhibited: AWS; All. A. Am.; AAPL; Jordan Marsh Annual; Boston Symphony Annual; Boston WC Soc. Annual; SC; one-man: Berkshire Mus. A.; Fitchburg A. Mus.; Univ. Massachusetts; Rockport AA; Cape Ann Soc. Mod. A.; Nat. Acad.; PAFA, and others. Positions: Member, Commonwealth of Mass. Art Commission, 1961- ; Pres., Cape Ann Soc. Mod. A.; Set Des., South Shore Playhouse, Cohasset, Mass., 1941; Correspondent, "Stars & Stripes" and INS Art Critic; lectures at various schools and colleges.

DAVIDSON, HERBERT—Painter
 2145 N. Sedgewick St., Chicago, Ill. 60614
B. Green Bay, Wis., Sept. 6, 1930. Studied: AIC; Accademia de Belli Arte, Firenze, Italy. Awards: Anna L. Raymond Traveling Scholarship, AIC, 1956; Ill. State Fair, 1958-1962; N.Y. Art Directors, 1959; Am. Jewish A. Cl., 1961; Chicago Art Directors, 1962. Exhibited: Butler Inst. Am. Art, 1962; AIC; Sioux City A. Center; Ill. State Mus.; Haifa, Israel, 1961; Oehlschlaeger Gal., Chicago, Sarasota, Fla.; Babcock Gal., N.Y.*

DAVIDSON, J. LEROY—Scholar
 Art Department, Univ. of California at Los Angeles 90024; h.
 140 Acari Drive, Los Angeles, Cal. 90049
B. Cambridge, Mass., Mar. 16, 1908. Studied: Harvard Univ., A.B.; N.Y. Univ. Inst. FA, M.A.; Yale Univ., Ph.D. Awards: Fulbright

Research Fellow, 1952-53. Author: Numerous books and articles on Oriental Art. Field of Research: Oriental Art. Positions: Chm. Dept. A., University of California at Los Angeles.

DAVIDSON, MARSHALL BOWMAN—
 Editor, W., L., Cr.
 140 E. 83rd St., New York, N.Y. 10028
B. New York, N.Y., April 26, 1907. Studied: Princeton Univ., B.S. Awards: Carey-Thomas award for creative publishing ("Life in America," 1951). Work: MMA. Contributor to art, history and other magazines and MMA Bulletin. Lectures: American Decorative, Graphic and Fine Arts. Author: "Life in America," 1951; "American Heritage History of Colonial Antiques," 1967; "American Heritage History of American Antiques, 1784-1860," 1968; "American Heritage History of Antiques, 1865-1917," 1969. Positions: Asst. Cur., 1935-41, Assoc. Cur., 1941-47, Am. Wing; Ed. Publications, 1947-1960, MMA, New York, N.Y.; Editor, Horizon Books, 1961-1964; Editor, Horizon Magazine, 1964-1966, Senior Editor, 1966- , publ. by American Heritage Pub. Co., Inc., 551 Fifth Ave., New York, N.Y. 10017.

DAVIDSON, MORRIS—Painter, W., L., T.
 h. 7 Orchard Terrace, Piermont, N.Y. 10968; s. Miller Hill
 Rd., Provincetown, Mass. 02657
B. Rochester, N.Y., Dec. 16, 1898. Studied: AIC, and in Paris. Member: Provincetown AA. Work: BMA; Sarah Lawrence College; N.Y. Univ.; Bezalel Mus., Jerusalem; Univ. North Carolina, Greensboro. Exhibited: one-man: San Diego Mus. A.; BMA; PAFA; Passedoit Gal., Kleeman Gal., Galerie Internationale, 1964, and many others in New York; Univ. North Carolina, Raleigh, 1968. Author: "Understanding Modern Art," 1931; "Painting for Pleasure," 1938; "An Approach to Modern Painting," 1948; "Painting with Purpose," 1964. L., PMA; Carnegie Inst.; New Sch. Soc. Research. Positions: A. Consultant, Schenectady Pub. Sch.; Dir., Morris Davidson Sch. Modern Painting, Provincetown, 1935- .

DAVIDSON, SUZETTE MORTON (Mrs. Eugene A.)—
 Collector, Patron, Typographic Designer
 1301 Astor St., Chicago, Ill. 60610
B. Chicago, Ill., Aug. 24, 1911. Studied: Vassar College, A.B.; School of Art Institute of Chicago. Awards: AIGA (five), 1941-1965; Hon. L.H.D., Lake Forest College, 1966. Collection: 17th century paintings; 19th century English painting and drawing; Pre-Columbian and African gold; Ashanti gold weights. Positions: President, Women's Board, 1960-1963, Honorary Trustee, 1964- , AIC; Designer of publications, 1950-1960, AIC; Trustee, American Federation of Arts; Owner-proprietor, The Pocahontas Press, 1937- .

DAVIES, KEN(NETH) (SOUTHWORTH)—Painter, E.
 376 Valley Brook Rd., Orange, Conn. 06477
B. New Bedford, Mass., Dec. 20, 1925. Studied: Mass. Sch. A.; Yale Sch. FA, B.F.A. Member: Silvermine Gld. A.; Conn. Acad. FA. Awards: Tiffany Scholarship, 1950; Springfield Mus. A. purchase award. Work: Wadsworth Atheneum; Springfield Mus. A.; Univ. Nebraska; Berkshire Mus., Pittsfield, Mass.; Union Carbide Bldg., N.Y.; Detroit Inst. A. Exhibited: London, England, 1950; Carnegie Inst., 1952; PAFA, 1950; NAD, 1950, 1965; Univ. Illinois, 1951, 1952; WMA, 1952; Univ. Nebraska, 1953; Detroit Inst. A., 1952; WMA, 1952, 1953; Toledo Mus. A., 1953; Conn. Acad. FA; Silvermine Gld. A.; New York, N.Y., 1951, 1965, 1969 (one-man). Contributor advertising illus., to Life, Time, Fortune, Sat. Eve. Post, Look, Collier's, and other national magazines; illus., Nat. Geographic Magazine; covers for Fortune, Collier's, Family Circle. Positions: Dean, Paier Sch. A., New Haven, Conn.

DAVIS, ALICE—Educator, P.
 Iowa State University; h. 810 Gaskill Drive, Ames, Iowa 50010
B. Iowa City, Iowa, Apr. 1, 1905. Studied: Univ. Iowa, B.A., M.A.; NAD. Member: CAA; NAEA; Mid-West Col. Art Assn. Exhibited: Kansas City AI; Joslyn A. Mus. Positions: Prof. A., Hd. Dept., Lindenwood Col., St. Charles, Mo., 1945-47; Asst. Prof. A., Grinnell Col., Grinnell, Iowa, 1947-51; Assoc. Prof. App. A., Iowa State Univ., Ames, Iowa, 1951- .

DAVIS, DOUGLAS M.—Critic, Writer
 3523 O St. N.W., Washington, D.C. 20007
B. Washington, D.C., Apr. 11, 1934. Studied: Abbott Art School, Washington, D.C.; Rutgers University, M.A.; American University, Washington, D.C., B.A. Awards: American University Honor Society, 1956; Women's Guild Fellowship, 1955-1956; Rutgers Graduate Scholarship, 1956-1957; Funk & Wagnalls Fellowship, in Prose, 1967. Author of many articles and essays on art and related forms to art magazines, including The National Observer; The American Scholar, 1967, 1969; Art in America, 1967, 1968, 1969; Arts; Arts in Society, 1968; Evergreen Review, 1968; and others. Book reviews in Life, Holiday, New Republic, Washington Free Press; Paper for the Smithsonian Institution, "Juan Downey." Editor, "The World of Black

Humor," 1966. Many Lectures at N.Y. University, University of Wisconsin, Milwaukee Art Center, Smithsonian Institution, and others. Happenings and Events in New York and Washington, D.C., 1967, 1968, 1969. Positions: Art Critic, The National Observer, 1965- ; Contributing Editor, Art in America, 1967- ; Washington Correspondent, Arts, 1968- .

DAVIS, ESTHER—Painter, S.
10 Park Ave., New York, N.Y. 10016
B. Brunswick, Ga., Aug. 10, 1893. Studied: Parsons Sch. Des.; ASL; New School for Social Research, and privately. Awards: prizes, New School., 1961-1968; other awards in group exhs., 1962-1969. Member: AEA; All. A. Am.; AFA. Work: Colby Col.; Drew Univ.; Syracuse Mus. FA; Gal. Mod. A., N.Y.; Community Church, N.Y. Exhibited: Many New York groups; N.Y. World's Fair, 1965; one-man: New Sch., N.Y.; Bodley Gal., N.Y.; Roko Gal., N.Y., 1968. Positions: A. Consultant, Chm. of A. Gal., Community Church, N.Y.

DAVIS, GENE—Painter
1736 Pennsylvania Ave., N.W. 20006; h. 2480 16th St., N.W., Washington, D.C. 20009
B. Washington, D.C., Aug. 22, 1920. Studied: Maryland Univ.; Wilson Teachers Col., Wash., D.C. Awards: Nat. Council on the Arts grant, 1967; Bronze medal and William A. Clark Award, CGA, 1965. Work: Washington Gal. Mod. A.; CGA; MModA; MIT; Tate Gal., London; SFMA; NCFA; Brandeis Univ.; Oklahoma A. Center; Des Moines A. Center; Woodward Fnd., Washington, D.C. Exhibited: Brandeis Univ. and traveling exh., 1964; MModA, 1965, 1967; CGA, 1965, 1967; Wash. Gal. Mod. A., 1963; "Post-Painterly Abstraction," 1964, at Los A. Mus. A., WAC, Toronto A. Gal.; MModA traveling exh. to Tokyo and Kyoto, Japan, New Delhi Mus. A., Australia and New Zealand, 1966; Detroit Inst. A., 1967; Jewish Mus., N.Y., 1967; WMAA, 1968; Milwaukee A. Center, 1968; Mus. Contemp. A., Chicago, 1968; one-man: Bader Gal., Washington, D.C., 1956; Jefferson Place Gal., Washington, D.C., 1959, 1961, 1963, 1967; CGA, 1964; Kassel, Germany, 1967; SFMA, 1968; Washington Gal. Mod. A., 1968; Jewish Mus., N.Y., 1968.

DAVIS, GEORGE—Cartoonist, I., P.
108 Charles St., New York, N.Y. 10014
B. Newark, N.J., Feb. 6, 1914. Contributor cartoons to Collier's, Sat. Eve. Post, Look, American, Cavalier, Kings Features, Today's Health, Medical Economics, True, Best Cartoons of 1955, 1956, Extension, Ladies Home Journal, McNaught Syndicate, Wall St. Journal, Boy's Life, Cosmopolitan, Argosy and other national magazines and European publications. Positions: Medical illus., Medical Illustration Div., Veteran's Admin., 1950-52. Freelance Cartoonist, 1959- .

DAVIS, GERALD VIVIAN — Painter, E., Gr.
86 Elm St., Summit, N.J. 07901
B. Brooklyn, N.Y., Sept. 8, 1899. Studied: Ecole des Beaux-Arts, Julian Acad., Paris. Member: Societe Nationale Independents; Awards: purchase award, Contemp. N.J. Artists, 1959; prize, New Jersey State Exh., 1960. Work: Paintings for Ove Arup Partners, London, 1963; Univ. Kansas; Tiffany Fnd.; and in private collections in U.S. and Europe. Exhibited: London, Copenhagen, Salon Nationale des Beaux-Arts, Paris, 1929-1939; Salon d'Automne, 1930-1939; Soc. Gr. A., London, 1938, 1939; NAD, 1941, 1946; AIC; AWS, 1941, 1942, 1946; All. A. Am., 1940, 1941; Montclair A. Mus., 1957, 1958, 1959, 1960-1963 and prior; Riverside Mus.; Newark Mus. A., 1958, 1959, and prior; Princeton Univ.; Univ. Illinois; Nelson Gal. A.; Mulvane A. Mus.; and numerous New Jersey Regional and State exhibitions. One-man: Marquie Gal., 1941; Univ. Kansas Arch Lg., 1954; Contemp. N.J. Artists, 1964; Fairleigh Dickinson Univ., 1967; Gait's Gal., Chatham, 1967; Rabin & Krueger Gal., Newark, 1968.

DAVIS, HARRY ALLEN — Painter, E.
Herron School of Art of Indiana University, 1701 N. Pennsylvania St. 46202; h. 6315 Washington Blvd., Indianapolis, Ind. 46220
B. Hillsboro, Ind., May 21, 1914. Studied: John Herron AI, B.F.A.; Am. Acad. in Rome, F.A.A.R. Member: Indianapolis AA; Am. Acad. in Rome; Indiana A. Cl. (Dir.); Grand Central A. Gal.; Assn. Prof. A. (Vice-Pres.); Herron Alumni Assn. Awards: Prix de Rome, 1938; 85 prizes in juried shows including Chautauqua Nat., 1961; Ball State Nat., 1960, 1962; Butler Inst. Am. A., 1961; Watercolors: USA, 1965, 1966, 1968; Mainstreams Int., 1968; Michiana Regional, 1957; Tippecanoe Regional, 1963, 1967; Tri-State Regional, 1968; "500" Festival, 1966, 1968; numerous awards in Indiana A. Exhs., Indiana A. Cl. and Indiana State Fair Exhs. Work: Historic Properties Sect., Wash. D.C.; DePauw Univ.; Herron AI; Butler Inst. Am. A.; Ball State Univ.; Tri Kappa Coll.; Indiana State Univ.; LaFayette A. Center; Union City Lib.; Alpha Chi Omega Nat. Hdqtrs. Bldg., Indianapolis; Springfield (Mo.) Mus.; Southwest Missouri Mus. Assn.; American Fletcher Nat. Bank, Indianapolis. Exhibited: Many

nat., juried, one-man and group shows including Chautauqua Nat.; Ball State; Indiana A.; Grand Central Founders' Exh.; Indiana A. Cl. annually; Herrington College; CGA; PAFA; NAD; Painters in Casein; Butler Inst. Am. A.; All.A.Am.; Mainstreams Int., 1968, 1969, and others. Positions: A.-in-Res., Beloit College (Wis.) 1941-42; Instr., John Herron A. School, Indianapolis, Ind., 1946-1967, Assoc. Prof., 1967- .

DAVIS, JAMES EDWARD—Film-Maker, S., P., E.
1150 Fifth Ave., New York, N.Y. 10028
B. Clarksburg, W. Va., June 4, 1901. Studied: Princeton Univ., A.B., and with Andre L'Hote, Paris. Awards: for films: "Light Reflections," Brussels, 1949; "Analogies No. 1," Am. Film Assembly, 1954; "Color Dances No. 1" and "Reflections No. 11," Salerno, Italy, 1954; Graham Fnd. F. grant, Chicago, 1957 for work in experimental films. Work: numerous experimental films including "Analogies No. 1," 1953 (on program "50 Annees de Cinema Americain," sent to Paris, 1955, by MModA); "Shadows and Light Reflections," 1948, circulated by MModA, and other films on John Marin and Frank Lloyd Wright; film "Evolution," 1956, in MModA film library; two films shown at Int. Festival of Experimental Films, Brussels Fair, 1958; Still color photographs used by Steichen in lecture "Experimental Color Photography," MModA., 1957; plexiglas des. for terrace, Plaza Hotel, Cincinnati, Ohio; AGAA; Yale Univ.; MModA; Princeton Univ.; films: Kansas City Pub. Lib.; AGAA; U.S. State Dept., Wash., D.C. Exhibited: plastic sc., Walker A. Center, 1947; AGAA, 1949, 1954; Princeton Univ., 1949; Los A. Mus. A., 1950; SFMA, 1950; Phila., Pa., 1952; Univ. Iowa, 1952; paintings: MModA; 67 Gal., 1945 (one-man); Ferargil Gal., 1945 (one-man). Lectures: "Film as an Art Medium." Positions: Instr., Lawrenceville Sch., 1933-36; Asst. Prof., Princeton Univ., Dept. A. & Archaeology, 1936-42.*

DAVIS, JERROLD — Painter
66 Twain Ave., Berkeley, Cal. 94708
B. Chico, Cal., 1926. Studied: Univ. California at Berkeley, B.A., M.A. Awards: Sigmund Heller Traveling Fellowship, Univ. of California, (Europe) 1953-1954; Guggenheim Fellowship, 1958-1959; AFA.Ford Fnd. Artist-in-Residence, Flint, Mich., 1964; prizes, CalPLH, 1960, 1962; Legion of Honor, San Francisco, 1960, 1962. Work: Carnegie Inst., Pittsburgh; Santa Barbara Mus. A.; Los A. Mus. A.; Flint Inst. A.; Oakland Mus. A.; Bank of Am. World Headquarters, San Francisco. Exhibited: Sao Paulo Bienale, 1951; CalPLH, 1957, (one-man); Carnegie Inst., 1958; Univ. Illinois, 1959, 1961, 1963; (winter invitational) CalPLH, 1960-1964; Carmen Waugh Gal., Santiago, Chile, 1962; Flint Inst. A., 1964; La Jolla, 1965; "Especially for Children," Los Angeles County Mus., 1965; Art in the Embassies Program; Univ. Ariz., 1967; Lytton Center, Los Angeles, 1967, 1968; One-man: G.O.M.A., Scottsdale, Ariz., 1965; Quay Gal., San Francisco, 1967, 1968; Fleischer Anhalt Gal., Los Angeles, 1968, and other gallery and museum exhibitions.

DAVIS, JOHN HAROLD — Collector, Illus., P., Des., T.
Instituto Centro de Arte, Alameda Ricardo Palma 246 Miraflores, Lima, Peru; h. 2500 East Shorewood Blvd., Milwaukee, Wis. 53211
B. Milwaukee, Wis., Feb. 8, 1923. Studied: Layton Sch. Art; Milwaukee State Teachers College. Awards: Civic Gold Medal, Miraflores, 1963; Diploma of Honor from District Govt. of Miraflores, 1959; Two Awards of Excellence from Am. Inst. A., 1951. Member: Fndg. Memb., Renovavi, Peru World Craftsmen Council (Peruvian representative); Int. Institute for Conservation of Historic & Artistic Works. Exhibited: Jacques Seligmann Gal., N.Y.; AIC; Smithsonian Inst., Nat. Pr. Assn. Phila.; Milwaukee A. Center; Munson-Williams- Proctor Inst.; Syracuse Univ.; Centro Cultural Peruano Norteamericano, Lima; Museo de Arte, Lima; George Jensen, N.Y.; Art Center, Miraflores, Lima; Neiman-Marcus, Tex. Illustrations for books published in U.S., Peru & Spain. Collection: 20th century paintings & drawings and Peruvian Arts and Crafts. Positions: Director, Instituto Centro de Arte, Lima, Peru; Pres., Peruvian Foundation for Art & Education. South American Dir., World Crafts Council, 1966-1970.

DAVIS, LEROY — Art dealer
Davis Gallery, 231 E. 60th St., New York, N.Y. 10021*

DAVIS, MARIAN B.—Educator, Gallery Dir.
2701 Wooldridge Dr., Austin, Tex. 78703
B. St. Louis County, Mo., Sept. 24, 1911. Studied: Washington Univ., A.B., M.A.; Radcliffe Col., M.A., Ph.D. Member: CAA; Am. Assn. Univ. Prof.; Soc. Arch. Hist.; Archaeological Inst. America; Renaissance Soc. Am. Awards: Carnegie scholarship, 1937; F., Radcliffe Col., 1939; Univ. Texas, 1951. Positions: Asst. FA, Radcliffe Col., 1939-40; Instr., WMA, 1941-44; Asst. Prof. A., 1946-50, Assoc. Prof., 1950-1960, Prof., 1960- , Cur. and Edu. Dir., 1963-66; Chief Cur. and Acting Dir., 1966- , Teaching Gallery, Univ. Texas, Austin, Tex.; Dir., CAA, 1951-55; Ed. Bd., College Art Journal, 1955-1960.

DAVIS, ROBERT TYLER—Museum Assistant Director, E., W.
National Collection of Fine Arts of the Smithsonian Institution
20560; h. 3701 Massachusetts Ave., N.W., Washington, D.C.
20016
B. Los Angeles, Cal., Aug. 11, 1904. Studied: Univ. California at
Los Angeles; Harvard Col., A.B.; Harvard Univ., M.A. Member:
AAMus.; CAA. Author: "Native Arts of the Pacific Northwest," 1949.
Positions: Instr., Univ. Rochester, 1929-33; Dir. Edu., Albright
A. Gal., 1934-39; Dir. Portland (Ore.) Mus. A., 1939-47; Dir., Mon-
treal Mus. FA, Montreal, Canada, 1947-52; Prof. FA, McGill Univ.,
Montreal, 1947-52; Interim Dir., Lowe Gal., Univ. Miami, Coral
Gables, Fla., 1955-56; Dir., Vizcaya-Dade County A. Mus., Miami,
Fla., 1953-1957, Instr., 19th and 20th Century European Art, Honors
Course in Humanities, Univ. Miami, 1957-59; Museum Consultant,
French & Co., New York City, 1960-1968; Asst. Dir., National Col-
lection of Fine Arts, 1968- .

DAVIS, RONALD—Painter
3650 W. Pico Blvd., Los Angeles, Cal. 90019
B. Santa Monica, Cal., June 29, 1937. Studied: San Francisco A.
Inst.; Yale Norfolk Summer Sch. Music & Art. Awards: Nat. Fnd.
for the Arts, 1968. Work: Los Angeles County Mus.; MModA; Tate
Gal., London, England; Oakland Mus. A. Exhibited: One-man: Nich-
olas Wilder Gal., 1965, 1967, 1969; Leo Castelli Gal., 1968; Kasmin
Gal., 1968; Tibor de Nagy Gal., 1966, New York City; CGA, 1969.

DAVIS, MR. and MRS. WALTER—Collectors
Malter International, 545 Magazine St. 70130; h. 1819 Octavia
St., New Orleans, La. 70115
Studied: (Mrs. Marjorie Fry Davis)—Newcomb Art School; (Mr.
Walter Davis)—Tulane University Law School. Collection: Drawing
collections include Mary Cassatt, Modigliani, Louis Valtat, Xavier
de Calletay, Braunstein; Paintings include Maeda, Rouault; Sculpture
by Rosenblum, Bristow, Henry Moore; pre-columbian pieces; also
watercolors by Jean Dufy, oil by Raoul Dufy. Positions: (Mrs. Da-
vis) Women's Board Volunteer Committee, Delgado Museum of Art,
New Orleans.

DAVISON, AUSTIN L.—Decorative Designer, I., T.
Windy Moor, Stockton, N.J. 08559
B. Center Bridge, New Hope, Pa. Studied: State T. Col., Edinboro,
Pa. Work: Index of Am. Design, NGA; Tech. Illus. for RCA Victor;
Longines-Wittnauer Watch Co.; Johns Hopkins Univ.; mural, Atwater
Kent Mus., Phila., Pa. Work reproduced in following publications:
Index of American Design; Pennsylvania German Folk Art; Folk Art
of Rural Pennsylvania; Decorative Arts of Victoria's Era; Pennsyl-
vania German Art, and other books. Positions: Instr., New Orleans
Acad. Adv. A.; Instr., private studio at present.*

DAVISON, ROBERT—Painter, Des., Comm.
21-18 45th Ave., Long Island City, N.Y. 11101
B. Long Beach, Cal., July 17, 1922. Studied: Los Angeles City Col.
Work: Springfield (Mass.) Mus. FA (the James Philip Gray Coll.).
Exhibited: Instituto de Allende, Mexico, 1950; Hewitt Gal., N.Y.,
1955; NAD, 1948; Witte Mem. Mus., San Antonio, 1958; CGA, 1959;
PMA, 1959; Sarasota AA, 1959; AWS, 1959; Boston A. Festival,
1959; Eastern States Exh., Springfield, Mass., 1959; All. A. Am.,
1959; "The Life of Christ" Exh., Birmingham, Mich., 1960; Banfer
Gal., N.Y., 1962; one-man: Dept. FA, Univ. Cal. at Los Angeles,
1944; Hewitt Gal., N.Y., 1954; Janet Nessler Gal., N.Y., 1958. Des.
Scenery and Costumes for the Theatre; "Eighty Days Around the
World" (scenery), 1946; "Galileo," Hollywood, 1947; "Cirque de
Deaux" for Ballet Russe de Monte Carlo, 1948; "Constanzia," Ballet
Theatre, 1951; "La Barca di Venetia per Padova," Festival dei Due
Mondi, Spoleto, Italy, 1963; "Natalia Petrovna," Opera Soc. of
Washington, 1965.

DAWSON, BESS PHIPPS—Painter, T.
Summit, Miss. 39666
B. Tchula, Miss., Nov. 25, 1916. Studied: Belhaven Col., Jackson,
Miss., and with Ralph Hudson, Karl Zerbe, Fred Conway, Lamar
Dodd, Stuart Purser and others. Member: Mississippi AA. Awards:
prizes, Allison's A. Colony, 1953-1963; Mississippi AA, 1957; Miss.
A. Colony, 1963, 1964, 1966, 1967; Nat. WC Exh., Jackson, 1963,
1964; Festival of A., Meridian, 1964; Hattiesburg, 1965; Edgewater
Plaza, Gulfport, 1965; Montgomery, 1966; Jackson A. Festival, 1966;
Ala. WC Soc., 1967; Biloxi, Ala., 1968; McComb, Miss., 1969.
Work: Progressive Bank Bldg., Summit, Miss.; Delta Power & Light
Co., Greenwood, Miss.; 1st Nat. Bank, McComb, Miss.; Hankins
Container Corp., Magnolia, Miss. and Dallas, Tex.; painting, Miss.
Valley Gas Co., Jackson; Southwest Miss. Jr. Col., Summit, Miss.;
State Col. for Women, Columbus; Municipal A. Gal., Jackson, Miss.
AA; Miss. State Univ. Exhibited: Mississippi AA, 1954, 1956-1960;
McComb, Miss., 1953 (3-man); Southwest Miss. Jr., Col., 1954;
Mississippi State Col. for Women, 1955, 1961; Allison's Wells, Way,
Miss., 1955, 1959-1961; 331 Gallery, New Orleans, 1957, 1961; Art

Commission Gal., Baton Rouge, 1958; New Orleans AA, 1955, 1957,
1958, 1959; Southeastern annual, Atlanta, Ga., 1956, 1959; Knoxville
A. Center, 1961; Atlanta, 1961; Mid-South, Memphis, 1961; Chautau-
qua (N.Y.) AA, 1961; Univ. Chattanooga, 1961 (3-man); Miss. Col-
lege, Clinton, 1961; Buie Mus., Oxford, 1961; Miss. Southern Univ.;
Municipal Gal., Jackson; Lauren Rogers Mus., Laurel, Miss.; Mary
Chilton Gal., Memphis, Tenn.; Delgado Mus., New Orleans; A. Cen-
ter, Little Rock; Brooks Gal., Memphis; Univ. Alabama; Little Car-
negie, N.Y.; one-man: Miss. AA, Jackson; Ahda Artzt Gal., N.Y.,
1964 and others. Lectures: Contemporary Art. Positions: Bd.
Dirs., Miss. A. Colony, 1953- ; A. Supv., Pub. Schs., McComb,
Miss.

DAY, CHON (CHAUNCEY ADDISON)—Cartoonist
22 Cross St., Westerly, R.I. 02891
B. Chatham, N.J., Apr. 6, 1907. Studied: ASL, with Boardman Rob-
inson, John Sloan. Member: Magazine Cartoonists Gld.; Nat. Car-
toonists Soc. Awards: Best Gag Cartoonist of 1956, 1961, Nat. Car-
toonists Soc. Exhibited: MMA, 1942; PAFA. Author, I., "I Could Be
Dreaming," 1945; "What Price Dory," 1955; "Brother Sebastian,"
1957; "Brother Sebastian Carries On," 1959; "Brother Sebastian at
Large," 1961. Contributor cartoons to New Yorker, Good House-
keeping, Ladies Home Journal, True, Look, This Week.

DAY, HORACE TALMAGE—Painter, E.
113 N. Fairfax St., Alexandria, Va. 22314
B. Amoy, China, July 3, 1909. Studied: ASL; Tiffany Fnd. Award:
Purchase prize, XXI Drawing Biennial, Norfolk Mus. A. & Sciences,
1965. Work: VMFA; AGAA; Yale Univ. A. Gal.; Canajoharie A. Gal.;
King Col., Bristol, Va.; Nelson Gal. A.; Fleming Mus. A., Burling-
ton, Vt.; Univ. of Virginia; Longwood College, Va.; Southern Vt. A.
Center; mural, USPO, Clinton, Tenn.; Western State Hospital, Staun-
ton, Va. Exhibited: WMAA, 1944, 1945; Carnegie Inst., 1941; Pepsi-
Cola, 1943; VMFA, 1942-1944, 1949 (one-man), 1954; Macbeth Gal.
(one-man); Gibbes Mus. A., 1954; Telfair Acad., 1954; Memphis
Acad. A., 1954; Bodley Gal., N.Y., 1958 (one-man); Norfolk Mus. A.
& Sciences; Southern Vt. A. Center, Manchester (one-man). Work
reproduced in "Art in the Armed Forces," 1944; folio of drawings,
"Staunton in the Valley of Virginia," publ. Positions: Dir., Herbert
Inst. A., Augusta, Ga., 1936-41; Prof. A., Mary Baldwin Col., Staun-
ton, Va., 1941-1964; Dir., Saint-Memin Gal., Alexandria, Va.

DAY, MARTHA B. WILLSON (Mrs. Howard D.)—
Collector, Miniaturist
88 Congdon St., Providence, R.I. 02906
B. Providence, R.I., Aug. 16, 1885. Studied: R.I. Sch. Des.; Julian
Acad., Paris; & with Lucia F. Fuller. Member: Providence AC;
ASMP; Pa. Min. P. Soc. Awards: prize, PAFA, 1932; McCarty
Medal, Pa. Min. P. Soc. Work: PMA; Smithsonian Inst., both min-
iatures. Exhibited: ASMP, annually; Pa. Min. Soc. P., annually.
Lectures: Miniatures.

DAY, ROBERT JAMES—Cartoonist
11 Cornwell St., Rockville Centre, N.Y. 11570
B. San Bernardino, Cal., Sept. 25, 1900. Studied: Otis A. Inst., Los
Angeles. Exhibited: Many cartoon exhibitions throughout U.S. and in
Europe. Author, I., "All Out for the Sack Race," 1945 (book of Car-
toons); Illus., "We Shook the Family Tree," 1946; Reader's Digest
"Fun Fare," 1949; Arthur Godfrey's "Stories I Like to Tell," 1952;
"Little Willie," 1953; "Any Old Place With You," 1957; "Seen Any
Good Movies Lately?," 1958; "The Mad World of Bridge," 1960;
"Over the Fence is Out," 1961; "What Every Bachelor Knows,"
1961. Contributor to New Yorker, This Week, Sat. Review, Look.

DAY, WORDEN (Miss)—Sculptor, Gr.
285 Claremont Ave., Montclair, N.J. 07042
B. Columbus, Ohio, June 11, 1916. Studied: Randolph-Macon Col.,
B.A.; N.Y. Univ., M.A.; ASL, and with Maurice Sterne, Vaclav
Vytlacil, Stanley William Hayter and others. Member: ASL (Life);
Print Council of Am.; Soc. Int. Gr. A., Zurich. Awards: Traveling
F., VMFA, 1940-42; Rosenwald F., 1942-44; Guggenheim F.,
1952-53, 1961-62; prizes, VMFA, 1943; Norfolk Mus. A., 1944; CAM;
1948; BM, 1949, 1950; LC, 1960. Work: VMFA; NGA; MModA;
WMAA; MMA; LC; CAM; Yale Univ.; BM; PMA; BMA; Carnegie
Inst.; N.Y. Pub. Lib.; Sao Paulo Mus. Mod. A.; Montclair A. Mus.
Exhibited: Phila. A. All., 1937; VMFA, 1942, 1944; Perls Gal., 1940;
WMAA, 1941, 1948, 1952; LC, 1945, 1950; PMG, 1944; AIC, 1946-
1948, 1951; SFMA, 1946; CAM, 1946, 1951; Bertha Schaefer Gal.,
1947, 1948, 1951; BM, 1948-1952; AFA, 1948-1952; MModA, 1951;
MMA, 1950; Univ. Illinois 1950; SAM, 1949, 1950; Carnegie Inst.;
traveling exh. nat. & int.; Paris Exp., 1951-52, and other national
and international shows. One-man: Perls Gal., 1940; VMFA, 1940;
Bertha Schaefer Gal., 1948, 1951; Smithsonian Inst., 1951; Phila. A.
All., 1954; Norfolk Mus. A.; Ohio Univ., Athens; Krasner Gal., New
York City, 1959; Montclair A. Mus., 1959; Grand Central Moderns.
Positions: Instr., New School, N.Y.C.; ASL.

DAYTON, BRUCE B.—Collector
 700 Nicollet Ave., Minneapolis, Minn. 55402*

DEADERICK, JOSEPH—Painter, E., Et., S., Des.
 2462 Park St., Laramie, Wyo. 82070
B. Memphis, Tenn., Jan. 17, 1930. Studied: Univ. Georgia, B.F.A.;
Cranbrook Acad. A., M.F.A. Work: Kalamazoo Col.; ceramic tile
mural, Univ. Wyoming, 1968; faceted glass window, Lutheran Stu-
dent Center, Laramie, 1968. Exhibited: Conn. Acad. FA, Hartford,
1960; BM, 1964; Mississippi AA, 1965; Drawings:USA, St. Paul,
Minn., 1966, 1968, also traveling; Kansas State Univ., 1965; Okla-
homa A. Center, 1966; Univ. Montana, 1969; 8-States Arts Councils
traveling exhs., 1967-1969; one-man: Antioch Col., Ohio, 1965;
Earlham Col., 1965; Hope Col., Michigan, 1966; Wooster Col., 1966;
Colorado Springs FA Center, 1967; Univ. Missouri, 1968. Positions:
Prof. A., Instr., Design, 1956-1959, Drawing, Painting, Adv. Design,
1959- , Univ. Wyoming, Laramie, Wyo.

DEAK-EBNER, ILONA (ILONA E. ELLINGER)—Educator, P., L.
 Trinity College, Michigan Ave., N.E.; h. 2800 Woodley Rd.,
 N.W., Washington, D.C. 20008
B. Budapest, Hungary, June 12, 1913. Studied: Royal Hungarian
Univ. Sch. A., M.F.A.; Royal Swedish A. Acad.; Johns Hopkins Univ.,
Ph.D., with David M. Robinson, W. F. Albright; Univ. Freiburg,
Germany. Member: Soc. Wash. A.; Archaeological Inst. Am. Exhib-
ited: PAFA, 1942; Whyte Gal., 1944 (one-man); Soc. Wash. A.; Am.-
British A. Center, George Washington Univ., 1950 (one-man); Silver
Spring A. Gal., 1951; CGA, 1958. Positions: Prof., Hd. A. Dept.,
Trinity Col., Washington, D.C., 1943- ; Fulbright Prof. History of
Art & Architecture, Nat. College of Arts, Lahore, W. Pakistan, 1963-
64; Lecturer on American Art for USIS at Lahore, Rawalpindi,
Dacca.*

DEAN, ABNER—Cartoonist, I.
 New York, N.Y.
B. New York, N.Y., Mar. 18, 1910. Studied: NAD; Dartmouth Col.,
A.B. Member: SI. Author, I., "It's a Long Way to Heaven," 1945;
"What Am I Doing Here?," 1947; "And on the Eighth Day," 1949;
"Come As You Are," 1952; "Cave Drawings for the Future," 1954;
verse & cartoons: "Wake Me When It's Over," 1955; "Not Far from
the Jungle," 1956; "Abner Dean's Naked People," 1963.

de ANGELI, MARGUERITE LOFFT—Illustrator, W.
 2601 Parkway, Apt. 445, Philadelphia, Pa. 19130
B. Lapeer, Mich., Mar. 14, 1889. Member: Phila. A. All. Awards:
Newbery medal, 1950 ("The Door in the Wall"); Citation for
"Bright April," both from Am. Lib. Assn.; Citation for "Yonie
Wondernose," from Assn. for Childhood Edu.; awarded the Regina
Medal from Catholic Library Assn.; 1968. Author, I., "Black Fox of
Lorne," 1956; Selected & illus., Old Testament (King James Ver-
sion), 1960; "Book of Nursery & Mother Goose Rhymes," and many
others.

DEATON, CHARLES—Sculptor, Des.
 9935 W. 25th Ave., Denver, Colo. 80215; h. Genesee Mountain,
 Golden, Colo. 80401
B. Clayton, N.M., Jan. 1, 1921. Work: Buildings as sculpture—Wy-
oming Nat. Bank, Casper; Key Savings & Loan Asn., Englewood,
Colo.; Charles Deaton residence, Genesee Mountain, Colo. Contrib-
utor to "Art in America" featured article with photographs of the
above sculptured buildings. Lectures: Sculpture, Architecture, In-
dustrial Design and Graphics given at Interior Design Educators
Council of Chicago, Colorado State University, and Northeastern Ju-
nior College, Sterling, Colo.

de BOTTON, JEAN—Painter, S., Gr., L., T.
 930 Fifth Ave., New York, N.Y. 10021
B. Paris, France. Studied: Sorbonne, Ecole des Beaux-Arts, Paris.
Studied art with Antoine Bourdelle, Bernard Naudin, Paul Baudouin.
Member: Jury, Salon d'Automne, Salon des Tuileries, Salon des In-
dependents, Salon des Humoristes; Chef d'Atelier, Academie Mont-
marte, Paris. Exhibitions: (murals) Salon des Beaux-Arts; (fres-
coes) Palais de la Marine, Paris; Carnegie Inst.; Tokyo; Geneva;
Brussels and Antwerp. One-man: Harriman and Carstairs Galleries,
N.Y.; Leger Gal., London; SAM; Gal. FA of San Diego; Grace Gal.,
Boston; Perls Gal., Hollywood; Knoedler Gal., N.Y.; CalPLH; Arts
Club, Chicago; Atlanta AA, 1961; Fort Worth, Texas, 1962; Palm
Beach, 1962, 1964, 1968; Southampton, N.Y., 1963; J.L. Hudson Co.,
Detroit, 1964; Cologne Mus., Germany, 1964; Salzburg, 1965; Weiner
Secession Gal., 1965; Gal. Passeur, Paris, 1966; Doll & Richards,
Boston, 1966; Morgan Knott, Dallas, 1967; Locust Valley, N.Y. 1967;
Univ. of Maine, 1967; Adelphi Univ., 1967; Mus. Municipal de Nice,
France, 1968; Mus. de St Paul de Vence, France, 1968; Palm
Springs, 1969; Southampton, 1969. Awards: numerous awards,
Paris, 1921-1923; Laureat Beaux Arts de France; Laureat de l'In-
stitute de France. Work: Official Painter of Coronation of H.M.

King George VI, 1937. In collections of Musée National d'Art Mod-
ern, Paris; Musée de Versailles; Musée du Luxembourg, and others;
also, Chester Dale Collection; MMA; Phoenix A. Mus. Wallraff-Rich-
ards Mus., Koln, Germany; Albertina Mus., Vienna. Books: Mono-
graph, preface by Frank Elgar, ed. G. Fall, Paris, 1968.

de BRUN, ELSA—Painter
 161 E. 81st., New York, N.Y. 10028
B. Sweden, Oct. 11, 1896. Studied: Anna Sanstrom Sch., Stockholm,
Sweden, and independently. Member: James Joyce Soc. Work: Univ.
of Texas, Austin; Carnegie Endowment of International Peace, New
York. Exhibited: WMAA, 1949, 1950, 1955; Am. Acad. A. & Lets.,
1961-1963, 1965; Union Theological Seminary Religious Art Exh.,
1953; AFA traveling exh., 1949; Rose Fried Gal., Knoedler Galleries,
N.Y. Worlds Fair, 1964; Westerly Gal., 1964; NCFA, 1968; Sympo-
sium-Film, Exhibition, Congress for Advancement of Science, Dallas,
Tex., 1968-1969; Iconography in Art, New York City, 1969; one-man:
Carstairs Gal., Kleeman Gal., Passedoit Gal., all New York City;
SAM; Univ. Oregon; Lyman Allyn Mus. A., New London, Conn.;
Pacem In Terris Gal., N.Y., 1967.

DE CESARE, SAM—Painter, S., C., T., I.
 9-05 150th St., Whitestone, N.Y. 11357
B. New York, N.Y., May 31, 1920. Studied: New York Univ., B.S. in
Ed., M.A. in Admin.; and with Ruth Canfield, Oliver Connor Barrett.
Member: Indst. Arts, N.Y. (Chm.); Assn. Supv. & Administrators.
Awards: Soc. of Four Arts, Palm Beach, 1944; Springfield Mus. A.,
1945 (purchase); Grumbacher award, Long Island Univ., 1963. Work:
Springfield (Mo.) Mus. A.; War Memorial Murals, John Jay H.S.,
N.Y., 1967-1969. Exhibited: Springfield Mus. A., 1954; Conn. Acad.
FA, 1945; All. A. Am., 1947, 1948; Audubon A., 1952; Soc. Four
Arts, 1944; Pan-American Gal., N.Y., 1946; YMHA, N.Y., 1947,
1948; Laurel Gal., N.Y., 1949; ACA Gal., N.Y., 1949-1951; Medical
Benefit Fund Exh., Flower Fifth Ave. Hospital, 1963; one-man:
Panoras Gal., N.Y., 1944, 1952, 1959; Jens Risom Showroom, 1959-
1965. Co-Author technical manuals for USNR, 1942-45; General
Crafts Course of Study, N.Y. Bd. Edu., 1948. Lectures on Sculpture;
Art Appreciation. Positions: Chm., Indst. A., New York Secondary
Schools; Tech. Advisor (Des.), Yorkville Housing Comm., N.Y.,
1956-57; Memb. Comm. on Indst. Arts, Bd. Edu., N.Y., 1957-58;
Chm., Standing Advisory Com. on Industrial Arts, New York City,
1960-62.

DECKER, LINDSEY—Sculptor, T.
 506 W. Broadway, New York, N.Y. 10012
B. Lincoln, Neb., Jan. 24, 1923. Studied: Iowa State Teachers Col.;
Am. Acad. A., Chicago; State Univ. of Iowa, B.F.A., M.F.A.; and in
Rome, Italy. Awards: prizes, purchase prize, Detroit Inst. A., 1953,
1956; Italian Government Grant, 1957-58, 1958-59; Fulbright Fellow-
ship (Italy), 1957-58, 1958-59; Research Grant, Michigan State Univ.,
1954-55, 1960-61, 1962-63. Work: Detroit Inst. A.; Cranbrook Mus.
A.; Albion College (Mich.) and sculpture for Eastland Center, De-
troit, Mich. Work in many private colls., U.S., Mexico, England and
France. Exhibited: Sao Paulo Bienal, 1963; "Ten American Sculp-
tors" traveling exh., 1964; AFA traveling exhs., 1961-62, 1962-63,
1963-64; WMAA, 1956, 1960-1962, 1964, 1965; MModA, 1959, 1960;
Hanover Gal., London, England; PMA; Mus. Contemp. A., Houston;
Los A. Mus. A.; BMFA; AIC, and others. One-man: Zabriskie Gal.,
N.Y., 1959-60, 1962; Gray Gal., Chicago, 1964; Forsythe Gal., Ann
Arbor, Mich., 1961, and others. Positions: Instr., Sculpture, Cooper
Union, Queens Col., Columbia Univ., N.Y. and Michigan State Univ.,
Univ. of Wisconsin.*

DECKER, RICHARD—Cartoonist, Comm., Des., I.
 Lockwood & Crescent Rds., Riverside, Conn. 06878
B. Philadelphia, Pa., May 6, 1907. Studied: PMSchIA. Contributor
to New Yorker magazine, Look magazine, Sat. Eve. Post. Adver-
tisements for Phila. Evening Bulletin series, 1939- . Set designs
for 7 major plays for Connecticut Playmakers, Inc.*

de COUX, JANET—Sculptor
 Gibsonia, Pa. 15044
B. Niles, Mich. Studied: Carnegie Inst.; N.Y. Sch. Indst. Des.;
R.I. Sch. Des.; AIC, with C. P. Jennewein, A.B. Cianfarani, Alvin
Meyer, James Earl Fraser. Member: ANA; NSS; Pittsburgh Assoc.
A. Awards: Guggenheim F., 1938-39, 1939-40; Widener med., 1942;
Carnegie award, Pittsburgh; prize, NSS; Am. Acad. A. & Let. grant.
Work: Col. of New Rochelle; Soc. Medalists; USPO, Girard, Pa.; St.
Mary's Church, Manhasset, N.Y.; Sacred Heart Sch., Pittsburgh;
Liturgical A. Soc.; St. Vincent's, Latrobe, Pa.; St. Scholastica,
Aspinwall, Pa.; Crucifixion Group, Lafayette, N.J.; doors, St. Ann,
Palo Alto, Cal.; altar, St. Margaret's Hospital Chapel, Pittsburgh;
Christ King Church of Advent, Pittsburgh; Charles Martin Hall Mem.,
Thompson, Ohio; Brookgreen Gardens, S.C. Exhibited: one-man:
Carnegie Inst.; Pittsburgh A. & Crafts Center. Positions: Res. A.,
Cranbrook Acad. A., 1942-45.*

deCREEFT, JOSE—Sculptor, T.
551 Hudson St., New York, N.Y.; h. Kirby Lane North, Rye, N.Y. 10580; s. R.F.D. 1, Hoosick Falls, N.Y. 12090
B. Guadalajara, Spain, Nov. 27, 1884. Studied: Julian Acad., Ecole des Beaux-Arts, Maison Greber, Paris, and in Madrid. Member: ANA; Palm Beach A. Lg.; AEA; Audubon A.; NSS; S. Gld.; Fed. Mod. P. & S.; Nat. Inst. A. & Let. Awards: prizes, Julian Acad., 1906; MMA, 1942; PAFA, 1945; gold med., Audubon A., 1953; Ford Fnd. traveling retrospective exh. (2 yrs.), 1960; NSS, 1969. Work: MMA; WMAA; MModA; Wichita Mus. A.; Norton Gal. A.; Univ. Nebraska; BM; IBM; Fairmount Park, Phila., Pa.; Munson-Williams-Proctor Inst.; PMA; war. mem., Sauges, France; 200 pieces of sculpture at Fortress in Majorca, Spain; commissioned—"Alice in Wonderland," Central Park, New York City, 1959; mosaic mural, Nurses Residence and school, Bronx Municipal Hospital, 1965; bronze relief, Bellvue Hospital, Public Health Laboratory, New York, N.Y., 1966; Film: "Jose de Creeft (by Bob Hanson), 1966. Exhibited: Salon d'Automne, Salon de Tuileries, Salon des Artistes Independents, Societe Nationale des Beaux-Arts, France; MMA, 1942; PAFA, 1944-1955; WMAA (retrospective, 1960) and prior exhs.; Antwerp, Belgium, 1949; Mus. Sao Paulo, Brazil, 1950; AIC, 1951; 18 one-man shows in U.S., 1929-1965. Positions: Instr., ASL; New Sch. for Social Research, New York; Skowhegan (Me.) A. Sch., 1948-49; Norton Gal. A., West Palm Beach, Fla., 1948-52. Contributor article on sculpture to "7 Arts."

deCREEFT, MRS. LORRIE. See Goulet, Lorrie

de DIEGO, JULIO—Painter, Gr., I., C., T.
Box 702, Woodstock, N.Y. 12498
B. Madrid, Spain, May 9, 1900. Studied: in Madrid. Awards: prizes, AIC, 1935, 1940, 1944; Milwaukee AI, 1944; New Orleans, La., 1948; Birmingham Mus. A., 1954; Ford Fnd. Grant, 1964. Work: Walker A. Center; Encyclopaedia Britannica; IBM; AIC; Milwaukee AI; SFMA; Santa Barbara Mus. A.; MMA; PC; U.S. State Dept.; Montclair A. Mus.; San Diego FA Soc.; Washington Univ., St. Louis; Abbott Laboratories; Capehart Coll.; Newark Mus. A.; Birmingham Mus. A.; Univ. Denver; Clearwater, Fla., etc.; work reproduced in Time Magazine, 1962; des. many shows and decorations for hotels and clubs; Exhibited: AIC; Mulvane A. Mus.; Cal. WC Soc.; WFNY 1939; WMAA; Culver Military Acad.; Bonestell Gal.; Nierndorf Gal.; PAFA; CGA; Carnegie Inst.; Inst. Mod. A., Boston; Durand Ruel Gal.; VMFA; CAM; Univ. Iowa; CM; MModA; Tate Gal., London; Passedoit Gal.; John Heller Gal.; Assoc. Am. A.; Philbrook A. Center; AFA traveling Exh.; MMA; Mili-Jay Gal., Woodstock, N.Y., 1961; Art: USA, 1959; PAFA, 1959, 1960; Riverside Mus., N.Y., 1959, 1960; New Sch. for Social Research, N.Y., 1960; WMAA, 1961; Coral Gables and Miami, Fla., 1961; Mus. Mod. A., Miami, 1962; Clearwater Civic Center, 1962; Univ. Tampa, 1962; Bradenton A. Lg., 1962; Gladstone Gal., Woodstock, N.Y., 1962, 1963 (both one-man); one-man: Maverick Gal., Woodstock, 1966; Landry Gal., N.Y., 1966; Oehlschlaeger Gals., Sarasota, Fla. and Chicago, 1968, 1969; Picture of the Month, Lotos Cl., N.Y., 1963; Retrospective Exh., Art Lg. of Bradenton, McNay AI, San Antonio, Gal. Mod. A., Scottsdale, Ariz., 1964. I., "Rendezvous with Spain"; "Jewelry-Gold, Silver," 1969; "Our Wonderful World," 1969 and illus. for Young Scott Books, 1966; many paintings and cover designs for national magazines.

DEDINI, ELDON—Cartoonist
P.O. Box 1630, Monterey, Cal. 93940
B. King City, Cal., June 29, 1921. Studied: Chouinard AI. Member: Nat. Cartoonists Soc. Awards: Best Gag Cartoonist, 1958, 1961, 1964, Nat. Cart. Soc. Work: Story Dept., Walt Disney Studios. Exhibited: Cartoons, Richmond (Cal.) A. Mus., 1968. Contributor to New Yorker, Playboy, Punch, and other national magazines. Author: "The Dedini Gallery," 1961 (an album of cartoons).

DEEM, GEORGE—Painter
61 W. 74th St., New York, N.Y. 10023
B. Vincennes, Ind., Aug. 18, 1932. Studied: Vincennes Univ.; AIC; Univ. Chicago, B.F.A. Work: BMA; Albright-Knox Gal., Buffalo; Singer Sewing Machine Collection. Exhibited: AIC; Albright-Knox A. Gal.; Barnard Col., Columbia Univ.; MMA; CGA; Silvermine Gld. A.; one-man: Allan Stone Gal., N.Y., 1963, 1964, 1965, 1968, 1969. Positions: Instr., Painting, Leicester, England, 1967, 1968; Univ. Pa., 1969.

DEERING, ROGER (L.)—Painter, L., T.
Ocean Ave., Kennebunkport, Me.; w. The Carolina Hotel, Pinehurst, N.C. 04046
B. East Waterboro, Me., Feb. 2, 1904. Studied: Grad. Sch. FA, Portland Mus. A.; and with Wayman Adams, Penrhyn Stanlaws, Aldro Hibbard, Anson Cross, George Elmer Browne, Jay Connaway. Member: Rockport AA; Grand Central A. Gal.; Copley Soc., Boston; SC; AAPL; Artists' Fellowship, Inc., N.Y. Awards: prizes, Portland Soc. A., 1924; Brick Store Mus., 1945, 1958, 1960; AAPL, 1958; York (Me.) AA, 1959-1961; Rockport AA, 1960, 1961, 1962, 1963; paintings selected for reproduction on calendar of prize winning paintings, 1961, 1962, 1968, by N.Y. Life Ins. Co.; Copley Soc. of Boston, 1963. Work: Irving Trust Co., N.Y.; Gorham (Me.) State T. Col.; Woodsfords Congregational Church, Portland, Me.; murals, Portland, Scarboro Beach; Ennis Lib., Farmington, Me.; Newcomen Soc. of England in North America; Tamasee (S.C.) D.A.R. Sch.; Champlain Col., Burlington, Vt. Exhibited: L.D.M. Sweat Mus. A., 1926-1954; SC, 1952-1969; Jordan Marsh Co., 1965; NAC, 1953, 1954; AAPL, 1953-1958, 1965, 1968; Copley Soc., 1956-1958; Farnsworth Mus. A., 1946-1958 (one-man, 1947), 1960; Gorham State T. Col.; WFNY 1939; Montclair Woman's Cl., 1946 (one-man); Nasson Col., Springvale, Me., 1950 (one-man); traveling exh., Florida, 1955 (one-man); Doll & Richards Gal., Boston, 1961 (one-man); Univ. Maine A. Dept. traveling exhs., 1964-1969; Univ. Maine Gal., 1967-1969; Rockport AA, 1959-1969; Columbus (Ohio) Gal. A., 1961, 1962; Old Bergen A. Gld., (N.J.), traveling exh., 1969-1970; other one-man exhs.: Bronxville Pub. Lib., N.Y., 1961; Martellow Mus., Key West, Fla., 1962; Grand Central A. Gals., N.Y., 1963. Lectures: Marine Painting, Past and Present. Positions: Maine State Chptr. Chm., AAPL, 1938- , Memb. Adv. Bd.; Dir. T., Roger Deering Studio-Gallery & School of Outdoor Painting. Taught Marine & Landscape painting, Kennebunkport, Maine (summers) and at Pinehurst, N.C.

DEFENBACHER, DANIEL S.—Designer, E., W., L.
Raychem. Corp., Oakside at Northside, Redwood City, Cal. 94063
B. Dover, Ohio, May 22, 1906. Studied: Carnegie Inst.; Indiana Univ. Awards: F., Carnegie Inst., 1929-1930; Hon. deg., D.F.A., Lawrence Col., 1950. Ed., "American Watercolor and Winslow Homer," 1945; "Jades," 1944; Author, "Watercolor—U.S.A." Contributor to: School Arts; Better Design; Everyday Art Quarterly. Positions: Asst. to Nat. Dir., FAP, 1936-39; Dir., Walker A. Center, Minneapolis, Minn., 1939-51; Dir., Fort Worth (Tex.) A. Center, 1951-54; Exec. Com., Int. Des. Conference, 1951- ; Pres., Cal. Col. A. & Crafts, Oakland Cal., 1954-1957; Mgmt. Consultant in Des., Associate, Victor Gruen Assoc., Architect, Beverly Hills, Cal., 1957-59; Dir., Des. & Communications, Raychem. Corp., Redwood City, Cal., 1959- .

DE FOREST, JULIE MORROW (Mrs. Cornelius W.)—Painter
Vernon Manor Hotel, Suite 303, Oak & Burnet Sts., Cincinnati, Ohio 45219
B. New York, N.Y. Studied: Wellesley Col., A.B.; Columbia Univ., A.M.; & with Jonas Lie, Charles Hawthorne, John Carlson. Member: All.A.Am.; NAC; Professional A. of Cincinnati; Cincinnati Mus. Assn.; AAPL; F., Royal Soc. A., London, England (Life). Awards: Medallion, Women's Theodore Roosevelt Mem. Assn.; 2 poetry awards, College Cl., Cincinnati; prize, CM, 1958. Work: Farnsworth Mus., Wellesley Col.; Am. Fed. Women's Cl. Exhibited: CGA; CM, 1958; PAFA; NAD; All.A.Am.; NAC; WFNY, 1939; Professional A., Cincinnati; BM; Kansas City AI; Staten Island Mus. A.; Cincinnati MacDowell Soc.; one-man exh.: Marie Sterner Gal.; Milch Gal.; Farnsworth Mus.; Jersey City Mus. Assn.; Loring Andrews Gal., Cincinnati; Woman's A. Cl., Cincinnati; Newhouse Gal., New York; Chm., College Scholarship Com., Cincinnati Chapter DAR.

DE FOREST, ROY DEAN—Painter
1700 Bissell, Richmond, Cal. 94801*

de GRAAFF, MR. and MRS. JAN—Collectors, Patrons
Dodge Park near Gresham, Ore. 97030; (mail) P.O. Box 529
Collection: Structurist, Barbizon Paintings and Sculpture.

de HELLEBRANTH, BERTHA—Sculptor, P., C., I., L.
109 South Frankfort Ave., Ventnor, N.J. 08406
B. Budapest, Hungary. Studied: Budapest Acad. FA; Julian Acad., Grande Chaumiere, Paris, France. Member: Hungarian AA; CAA; Audubon A; Phila. WC Cl.; AEA; Wash. WC Cl.; Stained Glass Assn.; Phila. A. All.; PAFA; Royal Soc. A.; NSS; World Fed. A. (Bd. Governors); Silvermine Gld. A.; AWS. Awards: prize and med., Budapest; AAPL; Montclair A. Mus.; All. A. Am.; purchase prize, Springfield A. Mus.; gold med., Audubon A.; citation of merit, Fla. Southern Col.; S. Tesser Mem. award, 1965; prize, Jersey City Mus.; All. A. Am., and others. Work: BM; Fordham Univ.; Malvern (Pa.) Retreat House; Scranton Univ.; Fla. Southern Col.; Cistercian Abbey, Trappist, Ky.; Putnam A. Center, Newton, Mass.; Mem. Hospital, N.Y.; James Ewing Hospital, N.Y.; Franciscan Retreat House, DeWitt Mich.; Sacred Heart Convent, Phila. Pa., and in private collections. Exhibited: Stockholm, Konsthall; BM; NGA; MMA; PAFA; AIC; Phila. A. All; CAA traveling exh.; Amherst Col.; Springfield (Mass.) Mus. A.; Goucher Col.; DMFA; Illinois State Mus.; Worcester A. Center; NAD; Cal. PLH; Appleton, Wis.

de HELLEBRANTH, ELENA MARIA—Painter, T., L., W., I.
109 South Frankfort Ave., Ventnor, N.J. 08406
B. Budapest, Hungary. Studied: Acad. FA, Budapest; Julian Acad., Grande Chaumiere, Paris, France. Member: AWS; AEA; Audubon A; Wash. WC Cl.; Atlantic City A. Center; New Jersey P. & S. Soc.; AFA; AAPL; CAA; Hungarian AA; Phila. A. All.; PAFA; F., Royal Soc. A., London; World Fed. A. Awards: prize and med., Budapest, Hungary; Audubon A. (purchase prize); Ogunquit A. Center; citation, Fla. Southern Col.; Jersey City Mus. A., Montclair A. Mus.; Ida Wells Stroud award, AWS; Zimmerman prize, Phila. WC Soc.; prize, Nassau, B.W.I. Work: IBM; BM; Fla. Southern Col.; Scranton Mus. A.; Ventnor (N.J.) Hospital; Scranton Univ.; Hungarian Legation, Wash., D.C.; Putnam A. Center, Newton, Mass.; Fordham Univ.; Scranton (Pa.) Univ., and in private collections. Exhibited: AFA; WMA; Springfield Mus. A.; BM; Silberman Gal.; PAFA; Grand Rapids A. Gal.; NAD; All. A. Am.; AIC; Montclair A. Mus.; New Jersey State Mus.; U.S. Nat. Mus. Wash., D.C.; WFNY 1939; Toledo A. Mus.; Stockholm A. Mus.; St. Botolph Cl., Boston; Audubon A.; Ogunquit A. Mus.; Riverside Mus.; AWS; Phila WC Soc.; DMFA; Cal. PLH; Nassau, B.W.I., and others. Illus. (with Bertha de Hellebranth) "The Unwilling Satellite." Radio lectures on art, Philadelphia and New York City and Atlantic City AA. Other art lectures for the Dominican Congress in New York City. Author numerous articles on Art and Religion.

DEHNER, DOROTHY (Mrs. Ferdinand Mann)—
Sculptor, Pr.M., P., L.
33 Fifth Ave., New York, N.Y. 10003
B. Cleveland, Ohio. Studied: Univ. California at Los Angeles; ASL, with Kimon Nicolaides; Skidmore Col., B.S., and with Kenneth Hayes Miller, Jan Matulka, Boardman Robinson. Member: S. Gld.; Fed. Am. P. & S. Awards: prize, Audubon A., 1947; Art: USA, 1959; Florence Brevoort Kane Mem. Exh., Providence, R.I., 1962; Fellowship, Tamarind Workshop, Los Angeles, 1965. Work: BMA; MModA; MMA; Munson-Williams-Proctor Inst.; Columbus Gal. FA; Cummer Gal., Jacksonville; Phila. Free Lib.; Hemisphere Cl., N.Y.; Skidmore Col.; Univ. North Carolina; Univ. Wis.; Birla Acad. of A., Calcutta, India; Great Southwest Industrial Park, Atlanta, Ga.; Columbia Univ.; Waddington Gal., London. U.S. Embassies abroad and in private colls. Exhibited: Audubon A., 1945, 1947; SFMA; 1944; Albany Inst. Hist. & A.; Butler Inst. Am. A.; Carlebach Gal.; Delius Gal.; WMAA, 1960, 1962-63; and prior; MModA, 1959, 1960 and prior, and traveling exhs., 1958-1965; AFA traveling exhs., 1956-1961; BM, 1954, 1955; BMA; Colorado Springs FA Center; Skidmore Col.; SAM; Willard Gal.; Stable Gal.; Mus. Contemp. A. of Houston; Des Moines A. Center, 1957; CAM; DMFA; Riverside Mus., N.Y.; Los A. Mus. A. Carnegie Inst.; Guggenheim Mus., 1962; Betty Parsons Gal., N.Y., 1963; Rome-America Fnd., Rome, Italy; Waddington Gal., London, 1962; Bundy A. Gal., Waitsfield, Vt., 1963; Bernard Gal., Paris, 1960; Wadsworth Atheneum, 1962; Univ. Illinois, 1965; New Sch. for Social Research, 1960, 1961, 1963; Sculptors Gld., Lever House, N.Y., 1959-1965; Fed. Mod. P. & S., 1959-1965; Mus. Contemp. A., Dallas, 1963; Worlds Fair, N.Y., 1964; Bryant Park, N.Y. and Cummer Gal. A., Jacksonville, Fla. Triannale, Milan, Italy, 1964. In Italy, France, Greece, Holland, Belgium, etc. Nationally and with traveling exhs. of U.S. State Dept. in U.S. and abroad, 1954-58; one-man: Rose Fried Gal., N.Y., 1952; AIC, 1955; Wittenborn, N.Y., 1956, Skidmore Col., 1958; Glens Falls, N.Y., 1954; Clearwater, Fla., 1959; Gres Gal., Wash., D.C., 1959; Willard Gal., N.Y., 1955, 1957, 1959, 1961, 1963, 1966; Columbia Univ., 1962; Jewish Mus., N Y., 1965; Phila. A. All., 1962; Univ. Michigan, 1964; Cornell Univ., 1964; Hyde Coll., Glens Falls, N.Y., 1967. Foreword for John Graham's "System and Dialectics of Art," 1969. Article for "Architectural Forum." Positions: Lecturer, Parson's Sch. Des., N.Y., 1967 and Cummer Gal. of A., Jacksonville, Fla.

DEHNER, WALT(ER) LEONARD—Painter
142 West 44th St., New York, N.Y. 10036
B. Buffalo, N.Y., 1898. Studied: Univ. Michigan; Univ. Illinois; Ohio State Univ.; Harvard Univ.; Columbia Univ.; ASL, with Bellows, Rosen, Speicher, Sternberg, Grosz, Fogarty, Hale, Greene; PAFA with Breckenridge, Garber, BMFA Sch. A. Awards: Hassam Fund purchase award, NAD. Work: Colorado Springs FA Center; Wichita Mus. A.; Witte Mem. Mus., San Antonio; Toledo Mus. A. Exhibited: AIC; MMA; WMAA; CGA; BM; Clearwater, Fla.; Cal. WC Soc.; PAFA; Delgado Mus. A.; SAM; SFMA; Los A. Mus. A.; galleries in New York City: Kraushaar, Midtown, Milch, Maynard Walker, Salpeter; Wickersham Gal.; AWS; one-man: Babcock, Seligmann and Kraushaar Gals., N.Y. City; Actors Gal., N.Y. Positions: Dir. A., Univ. Puerto Rico, 1928-48; A.-in-Res., Bowling Green State Univ. (Ohio), 1946.

de HOYOS, LUIS—Collector
Synfleur Scientific Laboratories, Inc., 33 Oakley Ave.; h. 30 Lake St., Monticello, N.Y. 12701
B. New York, N.Y., Mar. 6, 1921. Studied: Colgate Univ., B.A. Col-

lections: Contemporary Latin American Paintings; Lithographs of Orozco, Rivera, Siqueiros; Paintings and Drawings of Covarrubias of primitive art objects (exhibited at the Museum of Primitive Art, New York, 1964); Guerrero stone sculpture (being circulated by the American Federation of Arts, 1966-1968). All collections available for exhibit by museums and universities.

DEITSCH, PETER—Art Dealer
24 E. 81st St. 10028; h. 1136 Fifth Ave., New York, N.Y. 10028
B. New York, N.Y., Aug. 16, 1924. Studied: Haverford Col.; Columbia Univ. Gallery Specialty: Original, rare prints and drawings, particularly of the 19th and early 20th century. Positions: Dealer Advisory Bd. of the Print Council of America, 1964-65; Member, Art Dealers' Association of America.

de JONG, GERRIT, JR.—Educator, W.
Brigham Young University; h. 640 North University Ave., Provo, Utah 84601
B. Amsterdam, Holland, Mar. 20, 1892. Studied: Univ. Munich, Germany; Univ. Utah, A.B., A.M.; Nat. Univ. of Mexico, Mexico City; Stanford Univ., Ph.D. Member: F., Utah Acad. Sciences, Arts & Lets.; Am. Musicological Soc.; Internationale Gesellschaft für Musikwissenschaft. Awards: Distinguished Service award, Utah Acad. Sciences, Arts & Lets., 1953; Univ. F., Stanford Univ., 1931-32; Distinguished Teacher award, Brigham Young Univ., 1960. Contributor article in Brazil, Portrait of Half a Continent, "Brazilian Music and Art," 1951. Lectures: "An Approach to Modernity in Art" "Candido Portinari," Utah Acad. Sciences, Arts & Lets., 1950; "Art, good and bad?" 1963. Also lectures on Aesthetics. Positions: Organized the College of Fine Arts at Brigham Young Univ., Provo, Utah, and was Dean, 1925-1959, Dean Emeritus, 1959- .

de JONG, HUBERT—Collector, Patron
306 Main St. 47708; h. 640 College Highway, Evansville, Ind. 47714
B. Evansville, Ind., Apr. 28, 1901. Collection: Paintings by artists of the School of Paris. Positions: Board of Directors, Evansville Museum of Arts & Sciences, 1954- .*

DeKAY, JOHN—Painter
251 E. 51st St., New York, N.Y. 10022
B. Ithaca, N.Y., Apr. 8, 1932. Studied: Ithaca Col., B.S. in Edu. Awards: Maurice Fromkes Scholarship for Segovia, Spain, 1961. Exhibited: Athens, Greece; Paris, France; Madrid, Spain; Spoleto, Italy; Palm Beach, Fla.; one-man: Wickersham Gal., New York and others. Work: National Archives, Washington, D.C.; John F. Kennedy Library Coll.; Painting of President Johnson's Inauguration, now in the Johnson private collection; portrait of Gen. Eisenhower in the President's Museum, Abilene, Kans.; Pope Paul portrait, Vatican City; Martin Luther King portrait, (Mrs. King); murals, Sterling Forest Conference Center.

DEKNATEL, FREDERICK BROCKWAY—Scholar
Fogg Art Museum, Harvard University; h. 146 Brattle St., Cambridge, Mass. 02138
B. Chicago, Ill., Mar. 9, 1905. Studied: Princeton University, A.B.; Harvard University, Ph.D. Awards: Knight, First Class, Order of St. Olaf, Norway, William Door Boardman Professor of Fine Arts, Harvard University. Author: "Edward Munch," 1950. Field of Research: XIX and XX Century Painting.*

de KNIGHT, AVEL—Painter, Critic
81 Perry St., New York, N.Y. 10014
B. New York, N.Y., 1925. Studied: Pratt Institute, N.Y.; Grande Chaumiere, Paris; Ecole des Beaux Arts and Julian Academy, Paris. Awards: Bodley Gal., N.Y. Comp., 1957; Palmer Mem. Prize and Ranger Fund purchase, NAD, 1958; Emily Lowe award, AWS, 1958; Childe Hassam Fund Purchase, American Acad. A. & Lets., 1960; Grumbacher Award, AWS, 1962; Karpick Mem. Award, Audubon A., 1961; Lena Mason Prize, and Ranger Fund purchase, NAD, 1963, 1964; Audubon A., 1964; U.S. State Dept. Cultural Exchange Grant (Soviet Union), 1961 (lectures, watercolor demonstrations in major cities of USSR). Work: WAC; Springfield (Mo.) Mus. A.; Massillon Mus. A.; Miles College, Birmingham, Ala. Exhibited: The Contemporaries, N.Y., 1963-1965. Positions: A. Critic, France-Amerique, 1959- .*

de KOLB, ERIC—Collector, Patron, Indst. Des., W.
694 Third Ave., 10017; h. 1175 Park Ave., New York, N.Y. 10028
B. Vienna, Austria, Mar. 10, 1916. Studied: Academy of Art, Vienna; Graphic Institute; Architectural Academy, Vienna. Member: AIGA. Awards: Welsh Award for best Graphic Package, 1953, 1955; prizes, Package Design Council, 1954, 1955. Collection: Romanesque, African, Greek and Etruscan Art. A collection of Romanesque Madonnas. Book on collection published 1962; author of two recent books:

"Soothsayer Bronzes of the Senufo," 1968; "Ashanti Goldweights," 1967, both publ. by Hautbarr. Positions: Eric de Kolb Industrial Designing Company, New York; Pres. AIGA, 1960.

de KOONING, ELAINE MARIE CATHERINE—
Painter, W., Cr., L.
c/o Graham Gallery, 1014 Madison Ave., New York, N.Y. 10021
B. New York, N.Y., Mar. 12, 1920. Studied: Leonardo da Vinci A. Sch.; Am. A. Sch.; and with William de Kooning. Awards: Hallmark Award, 1960. Work: MModA. Portrait of Pres. John F. Kennedy presented to the Truman Library, 1965; many other portraits of prominent persons in private collections. Exhibited: Carnegie Inst., 1956; Kootz Gal., N.Y., 1950; Contemp. A. of Houston, 1958, 1962; Univ. of California at Davis, 1963-64; MModA; AFA traveling exh., 1957; Jewish Mus., N.Y., 1957; WMAA, 1963; PAFA, 1964; AIC, 1964; Wildenstein Gal. (Hallmark), 1960; WAC, 1960; one-man: Stable Gal., N.Y., 1954, 1956; Tibor de Nagy Gal., N.Y., 1957; Univ. New Mexico, 1958; Mus. New Mexico, Santa Fe, 1958; Gump's, San F., 1959; Lyman Allyn Mus., New London, Conn., 1959; Howard Wise Gal., 1960; Holland Goldowsky Gal., Chicago, 1960; Ellison Gal., Ft. Worth, 1960; Graham Gal., N.Y., 1960, 1961, 1963, 1965; De Aenlle Gal., N.Y., 1961; Elmira Col., 1961; Tanager Gal., N.Y., 1960; Dord Fitz Gal., Amarillo, Tex., 1959; A. Gal. Unlimited, San Francisco, 1964; Univ. Nevada, 1964; Kansas City AI, 1965. Many other gallery exhs. nationally. Contributor many articles to Art News, 1949-59, and to other publications. Positions: Instr. A., Univ. New Mexico, 1958; Penn State Univ., 1959; Bartscht-Kelley Studios, Dallas, Tex., 1960; Yale Univ., 1967. Lectures on art to museums, colleges and universities, 1959-60. Visiting Professor: Univ. New Mexico, 1959; Pa. State Univ., 1960; Contemp. A. Assn., Houston, 1962; Univ. California at Davis, 1963-64.

deKOONING, WILLEM —Painter
Woodbine Drive, The Springs, East Hampton, L.I., N.Y. 11973
B. Rotterdam, Holland, Apr. 24, 1904. Many awards, including Holland's Talens Prize Int. Award, 1968. Work: in major museums and private collections. Exhibited: WMAA; Brussels World's Fair, 1958; Poindexter Gal., N.Y.; Venice Biennale; Albright-Knox Gal.; MModA; Stedelijk Mus., Amsterdam, 1968; Allan Stone Gal., N.Y.; J. L. Hudson Gal., Detroit, 1968; Knoedler Gal., N.Y., 1968, 1969 (one-man), and many others; one-man: Janis Gal., N.Y., 1953, 1956, 1959; Martha Jackson Gal., 1955; Allan Stone Gal., N.Y., 1962, 1963, and others.

DELAP, TONY—Sculptor, E.
225 Jasmine St., Corona del Mar, Cal. 92625
B. Oakland, Cal., Nov. 4, 1927. Studied: Claremont (Cal.) Grad. Sch. Member: San Francisco AA. Awards: Sullivan award, San Francisco A. Inst., 1964; AFA-Ford Fnd. grant, 1966; Appointed to Univ. Cal. Creative A. Inst., 1968. Work: WMAA; WAC; Larry Aldrich Mus.; Oakland Mus.; SFMA; MModA; Tate Gal., London, England; Arizona State Univ., Tempe. Exhibited: SFMA, 1958, 1960, 1961, 1963; Carnegie Inst., 1964, 1967; WMAA, 1964, 1966, 1968; MModA, 1965, 1967; The Jewish Mus., N.Y., 1966; U.C.I., 1966, 1967, 1969; SAM, 1966; Los Angeles County Mus., 1967; Stadler Gal., Paris, 1967; Portland A. Mus., 1967; Larry Aldrich Mus., 1965, 1968; one-man: Richmond (Cal.) A. Center, 1954; Oakland Mus., 1960; Dilexi Gal., San Francisco, 1963, 1967; Elkon Gal., N.Y., 1965-1967; Landau Gal., Los Angeles, 1966, 1969. Positions: Prof. A., Univ. California, Irvine, at present.

DeLAWTER, MR. AND MRS. HILBERT H.—Collectors, Patrons
2081 West Valley Rd., Bloomfield Hills, Mich. 48013
Mrs. DeLawter: Executive Board, Friends of Modern Art: Founders Society, Detroit Institute of Art; Acquisitions Committee on Modern Art, Detroit Institute of Arts; Nominating Committee, Executive Board, Friends of Modern Art; Member of the Board, Cranbrook Academy of Art and Acquisitions Committee, Galleries Committee; Organizer, Founding Member and Past Board Member, Bloomfield Art Association. Dr. DeLawter: Studied: Indiana University, B.S.; Indiana University School of Medicine, M.D. Positions: Primitive Acquisitions Committee, 1966- , Executive Board, African Art Gallery Committee, 1967- , Detroit Institute of Arts; Board Member, Wayne State University Press, Detroit, 1967. Collection: African Art; Modern Art-the colorists Louis, Noland, Olitski, and others. The collection has been exhibited as follows: "World Primitive Art," 1965, Oakland University Gallery, Rochester, Michigan; "An Exhibition of African Negro Sculpture and Afro-American Painting," Oakland University; "African Sculpture," Galleries of Cranbrook Academy of Art, Bloomfield Hills, April & May and the Detroit Artists Market, 1967. Dr. and Mrs. DeLawter on executive committee and sponsors of the first Arts Symposium at Oakland University.

DE LEEUW, CATEAU—Writer, L., P., I., Gr.
1763 Sleepy Hollow Lane, Plainfield, N.J. 07060
B. Hamilton, Ohio, Sept. 22, 1903. Studied: Metropolitan A. Sch.;

ASL; Grande Chaumiere, Paris. Member: PBC; Plainfield AA (Hon.); AAPL. Awards: Citation, Ohioana Library, for distinguished service to Ohio through writings for Children, 1958; Laura E. Hayford prize Pen & Brush Cl., 1934. Exhibited: AWCS, 1931; NAWA, 1933, 1934; Maplewood (N.J.) Woman's Cl.; Montclair A. Mus., 1933, 1934, 1944; New Britain Inst., 1930 (one-man); New Jersey Col. for Women, 1938, 1942 (one-man); New Jersey State Mus., 1953, 1954. Author: numerous books including "Give Me Your Hand," 1960 (Jr. Lit. Gld.); "Fear in the Forest," 1960 (Weekly Reader Children's Book Club); "The Turn in the Road," 1961; "Against All Others," 1961; "Where Valor Lies," 1959 (Catholic Youth Book Club)*; "Love is the Beginning," 1960*; "Nurses Who Led the Way," 1961.* (* in collaboration with Adele De Leeuw), and others; I., "Gay Design," 1942; "Linda Marsh," 1943; "Future for Sale," 1946; & others. Contributor to: Travel & juvenile magazines. Lectures: Art of Batik; Women in Art, etc.

DeLEEUW, LEON—Painter, S.
Montclair State College, Upper Montclair, N.J.; h. 201 Inwood Ave., Upper Montclair, N.J. 07043
B. Paris, France, May 5, 1931. Studied: ASL, with Will Barnet; Hans Hofmann Sch. FA; N.Y. Univ., with Philip Guston. Work: Newark Mus. A. Exhibited: U.S.I.S. Gallery, Florence, Italy, 1963; Newark Mus. A., 1957; Montclair Mus., 1968; N.J. State Mus., 1968; one-man: Phoenix Gal., N.Y., 1961, 1963, 1965; Montclair State Col., 1966, 1968; Wilson Col., Chambersburg, Pa., 1960; Muhlenberg Col., Allentown, Pa., 1961. Illus., "A Scraggly Tree, A Big Rock and a Toadstool," 1965. Positions: Prof., Painting & Sculpture, Montclair State College, Montclair, N.J., 1963- .

DELEVANTE, SIDNEY—Painter, T., L.
517 W. 113th St., New York, N.Y. 10025
B. Kingston, Jamaica, West Indies, Dec. 4, 1894. Studied: ASL, with Bridgman, Fogarty, DuMond, Rittenberg, Lewis C. Daniel, Hans Hofmann, and Luks. Member: (Life) ASL; Fed. of Modern P. & S. Work: Chaffee A. Gal. Mus., Rutland, Vt.; PMA; Evansville Mus. A., Indiana, and in many private collections. Exhibited: Canadian traveling exh., 1957-58; Univ. Kentucky, 1958; Riverside Mus., N.Y., 1958, 1960, 1964; Art:USA, 1959; Hudson River Mus., 1959; Audubon A., 1960, 1963, 1964; Loeb A. Center, N.Y. Univ., 1960, 1964; Jersey City Mus., 1960; Nordness Gal., N.Y., 1960, (three-man) 1961; Shore Studio Gal., Boston, 1961; Boston A. Festival, 1961; Am. Acad. A. & Lets., 1967; New Jersey State Mus., Trenton, 1967; one-man: Fleischman Gal., N.Y., 1959; Obelisk Gal., Wash. D.C., 1959, Collectors Gal., Chicago, 1961; Brill Gal., Cleveland, 1962; Smolin Gal., N.Y., 1962; A.C.A. Gal., N.Y., 1963; Manhattan Col., N.Y., 1964; Dorsky Gal., N.Y., 1965; A. Center of North New Jersey, 1967. Lectures at many galleries and colleges, 1950-1968. Positions: Instr., FA, Cooper Union, N.Y., 1938-1960; Columbia Univ., 1960-1964 (summer sessions), Fall-Spring term, 1961-1962; A. Center of Northern New Jersey, 1959- ; New York Univ., spring 1965, summer 1966; N.Y.C. Community Col., Brooklyn, 1967-1968.

DELLA-VOLPE, RALPH—Painter, Gr., E., L.
Bennett College, Millbrook, N.Y. 12545
B. New Jersey, May 10, 1923. Studied: NAD; ASL. Member: ASL. Awards: prizes, LC; Berkshire Mus. A.; ASL; Wichita AA, all purchase prizes; MacDowell Fellowship. Work: Chase Manhattan Bank, N.Y.; Mansfield State Col., Mansfield, Pa.; LC; ASL; Wichita AA; Slater Mem. Mus., Norwich, Conn., and in private collections. Exhibited: widely throughout the U.S. including PAFA; LC; Nat. Inst. A. & Lets., 1963, 1964; Butler Inst. Am. A., 1964; McNay AI, San Antonio; Mus. FA of Houston; Wadsworth Atheneum; Sweat Mem. Mus., Portland, Me.; Norfolk Mus. FA; J. M. Speed Mus., Louisville; Flint Inst. A.; Wichita AA; SAM; Chicago Soc. Etchers; Soc. Am. Etchers; Print Cl., Phila.; BM; Am. Color Print Soc.; Boston Pr.M.; Bradley Univ.; Vassar Col.; State T. Col., Albany, N.Y.; Lehigh Univ., and many others; one-man: Babcock Gal., N.Y., 1960, 1962, 1963; Artists Gal., N.Y., 1959; Bennett College, (Dec.) 1968-(Jan.) 1969; State Univ. of N.Y. at Cobleskill, 1968; Tyringham Gals. (Mass.); Lehigh Univ.; Berkshire Mus., Pittsfield, Mass.; Mansfield State Col., Pa., 1964. Work reproduced in many art magazines and the New York Times, 1962-1964. Positions: Prof. Drawing & Painting, Bennett College, Millbrook, N.Y., at present.

DEL MAR, MRS. W. A. See Ochtman, Dorothy

DeLONGA, LEONARD A.—Sculptor, P., E.
c/o Kraushaar Galleries, 1055 Madison Ave., New York, N.Y. 10028; h. 23 Woodbridge St., South Hadley, Mass. 01075
B. Canonsburg, Pa., Dec. 18, 1925. Studied: Univ. Miami, B.A., with Richard Merrick, Darnion Fink; Univ. Georgia, M.F.A., with Lamar Dodd, James J. Sweeney, Ferdinand Warren; N.Y. Univ., with Howard Conant, Hale Woodruff. Member: Georgia AA; Southeastern College AA. Awards: prizes, Ft. Worth, Tex., 1956; Georgia, 1952; Ball State Gal., Muncie, Ind., 1964. Work: Mount Holyoke Col.; Cornell Univ.; Univ. Missouri; Presidential Realty Co., Boston;

Ball State T. Col.; sculpture: Wilmington Soc. FA; Living Arts Fnd.; Nat. Broadcasting Co.; painting: Georgia Mus. A.; graphics: Texas Christian Univ.; Texas Wesleyan College. Exhibited: PAFA, 1960; Wadsworth Atheneum, 1960; BMA, 1961; Nat. Inst. A. & Lets., 1961; Columbia Mus. A., 1961; Collectors Choice, St. Paul, 1961; Colorado, 1961; Painting of the Year, Atlanta, 1957, 1958; Georgia Artists, 1951, 1952, 1957, 1961; Ft. Worth, Tex., 1955, 1956; Dallas, State Fair, 1955, 1956; Root A. Center, Hamilton Col., 1962; Vassar Col., 1962; Toledo Mus. A., 1962; Washington (Conn.) AA, 1963; Univ. Nebraska, 1962; Montclair State Col., 1964; Valley House, Dallas, 1964; Marion Koogler McNay AI, San Antonio, 1964, and many others; one-man: Kraushaar Gal., N.Y., 1961, 1964, 1967; Allentown (Pa.) Mus., 1965; Mount Holyoke Col., 1965; Texas Christian Univ.; N.Y. Univ.; Austin, Texas, 1956. Lectures on sculpture and sculptors to art associations. Positions: Hd. A. Dept., Texas Wesleyan Col., 1954-56; Instr. Sculpture & Painting, A. Dept., Univ. of Georgia, Athens, Ga., 1956-1962, Asst. Prof., 1962-1964; Assoc. Prof., Mount Holyoke Col., South Hadley, Mass., 1964- .

DE LUE, DONALD—Sculptor
 82 Highland Ave. Leonardo, N.J. 07737
B. Boston, Mass., Oct. 5, 1900. Studied: BMFA Sch. Member: ANA; NSS; Nat. Inst. A. & Lets.; Arch Lg.; All. A. Am.; AAPL; Am. Inst. Commemorative Art (Hon.). Awards: prizes, All. A., 1942, gold medal, 1951; NSS, gold medal, 1942, 1946; Guggenheim F., 1943-44; Nat. Inst. A. & Lets. Grant, 1945; gold medal, All. A. Am., 1946; prize, Meriden, Conn., 1953, 1957; Hering Mem. gold medal (2), 1960; AAPL gold medal; and other awards. Work: panels, fountains, memorials, figures, medals: Court House, Phila., Pa.; Univ. Pennsylvania; American Exporter Mem., New York, N.Y.; chapels at West Point and Arlington, Va.; Harvey Firestone Mem.; Fed. Reserve Bank, Boston and Phila.; U.S. Military Cemetery Mem., Omaha Beach, St. Laurent, Normandy, France; Science & Eng. Bldg., Carnegie Tech., Pittsburgh; Mem. chapel, Va. Polytechnic Inst., Blacksburg, Va.; Loyola Jesuit Seminary, Shrub Oak, N.Y.; U.S. Naval Acad., Annapolis, Md.; Sacred Heart Shrine, Hillside, Ill.; Brookgreen Gardens, S. C.; City Hall, Stockholm, Sweden; Anniversary Medal in Bibliotheque Nationale, Paris, France; George Washington port. statue, New Orleans; Sisters of St. Joseph chapel, Toronto; Nat. Science Fnd. gold medal; Hall of Fame for Great Americans gold medal; "The Rocket Thrower," bronze sculpture, Plaza of the Astronauts, N.Y. World's Fair, 1964-65 (figure reproduced on the Fair's Federal Stamp). Boy Scout Memorial Tribute, bronze, located on the Ellipse, Wash. D. C., 1964; Confederate Memorial, Gettysburg, Pa., 1964-65, and many others. Positions: Chm., Art Committee, Hall of Fame for Great Americans, New York Univ.; Adv. Ed., American Artist Magazine.

de MARCO, JEAN—Sculptor, C., Gr., T.
 131 Christopher St., New York, N.Y. 10014
B. Paris, France, May 2, 1898. Studied: Ecole Nationale des Arts Decoratifs, Paris. Member: ANA; NSS; All. A. Am.; Nat. Inst. A. & Let. Awards: med., New Rochelle AA, 1940; Am. Acad. A. & Lets., 1958; NAD, 1946; Arch. Lg., 1958; NSS, 1954, Henry Hering Medal, 1964; All. A. Am., Daniel Chester French award, 1961; prizes, NSS, 1945, 1948; Audubon A., 1948; Nat. Inst. A. & Let., 1950; NAD, 1956. Work: Whitemarsh Park Mem., Prospectville, Pa.; War Dept., Bldg., Wash., D.C.; USPO, Weldon, N.C.; Danville, Pa.; Nat. Shrine of Immaculate Conception, Wash. D.C.; U.S. Capitol, Wash., D.C.; Joslyn Mem. Mus.; Mem., Notre Dame Univ.; MMA; BM; House of Theology, Centerville, Ohio; Schiervier Hospital, Bronx, N.Y.; reliefs, Cathedral of the Assumption, Baltimore, Md.; S., war mem., Presidio, San Francisco BM (sculpture); MMA (graphics). Exhibited: PAFA, 1938, 1940, 1942-1946; AIC, 1938, 1941-1943; NAD, 1942, 1944, 1945; WFNY 1939; Fairmount Park, Phila., Pa., 1940; MMA, 1942; S. Gld., annually; Marie Sterner Gal., 1936; Buchholz Gal., 1941, 1943, 1945; one-man: Boyer Gal., 1940; Clay Cl., New York, 1946; Phila. A. All., 1948; BMFA Sch., 1948. Positions: Instr., S., BMFA Sch., Boston, Mass., 1948-52; summers—Columbia Univ., New York, N.Y.; Treas., S. Gld., 1940-51; Instr. S., Iowa State Univ., 1960, 1961; Instr. S., National Academy of Design, N.Y., 1960- .*

DE MARIA, WALTER—Sculptor
 27 Howard St., New York, N.Y. 10013
B. Albany, Cal., Oct. 1, 1935. Studied: Univ. California, Berkeley, B.A., M.A. Awards: Guggenheim Fellowship, 1969. Work: MModA; WMAA. Exhibited: Documenta IV, Kassel, Germany, 1968; WMAA, 1967, 1969; Los Angeles County Mus., 1967.

DE MARTINI, JOSEPH—Painter
 103 West 27th St., New York, N.Y. 10001
B. Mobile, Ala., July 20, 1896. Member: ANA; Audubon A. Awards: prize, Pepsi-Cola, 1944; Univ. Illinois, 1948 (purchase); Guggenheim F., 1951; prize, NAD, 1950; gold med., PAFA, 1952. Work: PMG; AGAA; CAM; BMFA; MModA; MMA; Brooks Mem. Mus.,

Memphis, Tenn.; Univ. Arizona; Walker A. Center; Rochester Mem. Mus.; Farnsworth Mus., Rockland, Me.; Wichita A. Mus.; New Britain Inst.; Canajoharie A. Gal.; State Dept., Wash., D.C.; Pepsi-Cola Coll.; IBM; Nebraska AA; WMAA. Exhibited: MModA, 1941-1943; Carnegie Inst., 1941, 1943, 1944, 1946; WMAA, 1934, 1942-1945; CGA, 1941, 1943, 1945; CAM, 1938, 1941, 1942, 1946; PAFA, 1940, 1942-1945; AIC, 1941, 1942; WFNY 1939; WMA, 1945; de Young Mem. Mus., 1941, 1943; PMG, 1942, 1943; Critics Choice, New York, N.Y., 1945; VMFA, 1942, 1944, 1946; Colorado Springs FA Center, 1942; BM, 1943; John Herron AI, 1945; Nebraska AA, 1945, 1946. Positions: A.-in-Res., Univ. Georgia, 1952-53.*

DE MENIL, JOHN—Collector
 3363 San Felipe Road, Houston, Tex. 77019*

DEMETRIOS, GEORGE—Sculptor
 Folly Cove, Gloucester, Mass. 01930
Member: ANA.*

DE NAGY, EVA—Painter
 462 Commercial St., Provincetown, Mass.; h. 52 Georgian Court, Elizabeth, N.J. 07208
B. Hungary. Studied: Academie Royal des Beaux-Arts, Brussels. Member: Provincetown AA; Cape Cod AA; AAPL (Publ. Chm., New Jersey Chptr.); P. & S. Soc. of New Jersey (Treas.). Work: Color slides, Gld. Lib. of Church Architectural Gld. of Am., Wash., D.C. Awards: prizes, Academie Royal des Beaux-Arts, 1929, 1930; First Presbyterian Church Art Exh., Perth Amboy, 1954; New Jersey State Fed. Women's Cl., 1954, 1959; bronze medal, Seton Hall Univ., 1956; New Jersey State Medical Assn. Convention Art Exh., 1958, 1960. Exhibited: Park Lane Gal., Glen Rock, N.J., 1948 (one-man); A. Council of New Jersey, 1948; U.S. Trust Co., Paterson, N.J., 1950; Morris County AA, 1950, 1951; First Presbyterian Church, Perth Amboy, 1954, 1963; New Jersey State Fed. Women's Cl., 1954-1960; Seton Hall Univ., 1956-1957; NAD, 1957, 1958; Knickerbocker A., 1958; AAPL, 1958, 1959; Ahda Artzt Gal., N.Y., 1958; Gloucester AI, 1960; Provincetown AA, 1960, 1961; Ecclesiastical Crafts Exh., Pittsburgh, 1961, 1962; P. & S. Soc. of New Jersey, 1961, 1962; Am.-Hungarian AA, New York City, 1962, 1963; Catherine L. Wolfe A. Cl., 1962, 1964; one-man: First Presbyterian Church, Trenton, 1961; Princeton Theological Seminary, 1961; Somerville Reformed Church, 1963; First Presbyterian Church, Ridgewood, N.J., 1963; Perth Amboy Pub. Lib., 1964. Positions: Owner-Dir., Eva de Nagy Gallery, Provincetown, Mass. State A. Chm., N.J. Fed. Women's Clubs, 1960, 1962; Memb., A. Comm., Trenton State Museum, 1960, 1962; Chm., Roebling-Boehm A. Scholarship, 1962, 1964.

DE NIRO, ROBERT—Sculptor, P.
 447 10th Ave., New York, N.Y. 10001
B. Syracuse, N.Y., May 3, 1922. Studied: Black Mountain Col., N.C.; and with Hans Hofmann. Awards: Guggenheim Fellowship, 1968; purchase, Longview Fnd. Exhibited: WMAA; Stable Gal., N.Y.; Jewish Mus., N.Y.; Inst. Contemp. A., Boston; Nebraska AA, 1960; AFA, circulating exh., 1960-1961; Ball State Univ.; Colorado Springs FA Center, 1961; MModA, 1962-1963; Kornblee Gal., N.Y., 1962; Illinois Wesleyan Univ., 1962; New School, N.Y., 1965; one-man: Egan Gal., N.Y., 1950, 1952, 1954; Poindexter Gal., N.Y., 1955, 1956; Zabriskie Gal., N.Y., 1958, 1960, 1962, 1965, 1967, 1968; State Univ. of N.Y., Buffalo, 1967; Reese Palley Gal., San Francisco and Atlantic City, 1968; Bard Col., 1969; Ellison Gal., Ft. Worth, 1959 (2-man); Felix Landau Gal., Los Angeles, 1960 (6-man); Knoedler Gal., N.Y., 1963 (5-man). Positions: Instr., School of Visual Arts and New School for Social Research, both New York City.

DENNIS, CHARLES H.—Cartoonist
 P.O. Box 816; h. 1831 Magnolia Way, Walnut Creek, Cal. 94597
B. Springfield, Mo., Nov. 11, 1921. Studied: San Francisco Acad. Adv. Art; A. Lg. of California. Work: Syracuse Univ. Exhibited: Smithsonian Institution; Univ. Cal. at Berkeley. Contributor cartoons to Look, True, Blue Book, Esquire, Playboy, Christian Science Monitor, Successful Farming and other national publications.

DENNIS, ROGER WILSON—
 Painter, Lith., T., Conservator
 Columbus Ave., Niantic, Conn. 06357
B. Norwich, Conn., Mar. 11, 1902. Studied: ASL, and with Guy Wiggins, Allen Cochran, Emile Gruppe, Robert Brackman. Member: Lyme AA; Conn. Acad. FA; Int. Inst. of Conservation (London and America). Awards: prize, Meriden, Conn. Exhibited: Conn. Acad. FA; Lyme AA; North Shore AA; Gloucester, Mass. Positions: Conservator, Lyman Allyn Mus. A., New London, Conn., 1950- .

DENNISON, DOROTHY D. (BUTLER)—Painter, Lith.
 1915 Walker Mill Rd., Poland, Ohio 44514
B. Beaver, Pa., Feb. 13, 1908. Studied: PAFA. Awards: prizes, PAFA; Butler Inst. Am. A.; Syracuse AA; Cooperstown AA; Cresson

traveling scholarship, PAFA, and other prizes. Work: Butler Inst. Am. Art; Massillon Mus. A.; Olsen Fnd.; Grumbacher Coll.; McKinley Memorial, Niles, Ohio; PAFA; Columbus Gal. FA; Canton A. Inst.; public buildings, Youngstown, Ohio; Pub. Lib., Struthers, Ohio. Exhibited: CM; CGA; PAFA; Newport AA; Butler Inst. Am. A.; Cooperstown AA; Canton AI; Massillon Mus. A.; Northwest Territory Exhs.; Portland, Me.; one-man: Butler Inst. Am. A.; Gallerias Costa, Mallorca, Spain; Hiram College; Carriage House, Germantown, Pa.; Canton AI; Govt. House, Antigua, B.W.I.; Syracuse Univ.; Kennedy Gal., N.Y. Positions: Instr., Drawing, Syracuse Univ.; Drawing & Painting, Russell Sage College; Butler Inst. Am. A.; Hd. A. Dept., Knox College, Galesburg, Ill.

DENSLOW, DOROTHEA HENRIETTA—Sculptor, T.
167 East 69th St., New York, N.Y. 10021
B. New York, N.Y., Dec. 14, 1900. Studied: ASL. Member: Conn. Acad. FA. Work: Mem. plaque, Beth Moses Hospital, Brooklyn, N.Y.; Brookgreen Gardens, S.C. Exhibited: Syracuse Mus. FA, 1938; Conn. Acad. FA, 1914-1944; BM, 1936; Springfield (Mass.) Mus. FA, 1936; Rochester Mem. A. Gal., 1940; Plainfield AA, 1943; Newark Mus., 1944; Clay Cl., 1934, 1949; Berkshire Mus. A., 1941; Lyman Allyn Mus., 1939; Sculpture Center, 1953. Positions: Founder & Dir., Sculpture Center, New York, N.Y., 1928 to present.*

DENTZEL, CARL SCHAEFER—Museum Director, W., L.
Southwest Museum, Highland Park, Los Angeles, Cal. 90042; h. Box 101, Northridge, Cal. 91324
B. Philadelphia, Pa., Mar. 20, 1913. Studied: Univ. California at Los Angeles; Univ. Berlin; Univ. Mexico. Member: Univ. Cal. at Los Angeles A. Council; Los A. Mus. A., Exec. Com., Mus. Assn. Lectures: "American Frontier Art"; "California Artists"; "Pre-Columbian Art"; "Aboriginal American Art"; "Art Aesthetics and Americans"; Art of the Southwest and Mexican 19th Century Art; "California Artists"; "California's Cultural Crisis"; Southwest Mus.; Pomona Col., Claremont, Cal. Author: "The Drawings of John Woodhouse Audubon, Illustrating His Adventures Through Mexico and California, 1849-50," 1957; "A Note on the Kicking Bear Pictograph of the Sioux Encounter at the Battle of the Little Big Horn with the 7th Cavalry Regiment under Lt. Colonel George Armstrong Custer," 1957; "Diary of Titian Ramsay Peale: Oregon to California, Overland Journey September and October, 1841" (Introduction & Bibliography by Carl Dentzel), 1957; "Cinco de Mayo—An Appraisal," 1960; "The Universality of Local History," 1960; "The Art of Leon Gaspard. Introduction in the Catalog of a Memorial Exhibition of Paintings and Sketches by Leon Gaspard," 1964; "Edward H. Davis and the Indians of the Southwest United States and Northwest Mexico. Introduction by C. S. Dentzel," 1965, and many other publications and introductions. Positions: Pres., Los A. County Museum Assn.; Memb. Bd., U.C.L.A. Art Council; Pres., Western Mus. Conf., 1957-58; Dir., Southwest Museum, Los Angeles, Cal. Pres., Cultural Heritage Board, City of Los Angeles, 1963-64.*

DE PAUW, VICTOR—Painter, W.
East Hampton, L.I., N.Y. 11937
B. Belgium, Jan. 21, 1902. Studied: Cal. Sch. FA; ASL. Awards: Southampton Col., L.I., N.Y., 1969 (purchase). Work: MModA. N.Y. Pub. Lib.; BM; CMA; Parrish A. Mus., Southampton, L.I., N.Y.; Cooper Union, N.Y.; Smithsonian Inst., Wash., D.C., and in private colls. U.S. and abroad. Exhibited: First one-man exh. in New York City, Clayton Gal., 1935, others: Morgan Gal., Fifteen Gal.; Passedoit Gal., 1954; Nessler Gal., 1954; Retrospective Exh. (30 years) Eastside Gal., N.Y.C., 1965; Parrish A. Mus., Southampton, L.I., N.Y., 1965; Pace Col., New York; Instituto de Estudios Norteamericanos, Barcelona, Spain. Positions: Instr., ASL; Peoples A. Center, MModA; Country Art Sch., Westbury, N.Y. art reviews for East Hampton Star. Illus., special edition, "The Spirit of Christmas," and illus. for other books. Lectures on Modern Art and Art of the American Indian, Southampton Col. of Long Island Univ., 1964.

DE POL, JOHN—Printmaker, Des., I.
280 Spring Valley Rd., Park Ridge, N.J. 07656
B. New York, N.Y., Sept. 16, 1913. Studied: ASL; Sch. of Tech., Belfast, Ireland. Member: ANA; ASL (Life); SAGA; Albany Pr. Cl. Awards: prizes, Richard Comyn Eames purchase prize, 1952; Kate W. Arms Mem. prize, 1955-56; Mrs. Norman William purchase prize, 1959; Albany Pr. Cl. (purchase), 1967; John Taylor Arms Memorial Prize, N.A.D. 1968; NAC, 1968. Work: Permanent coll. of various museums and libraries. Major collection of books and prints in Syracuse Univ. Lib. Executed Presentation Prints for Woodcut Soc., 1952; Miniature Pr. Soc., 1953; Albany Pr. Cl. 1958. Exhibited: nationally. One-man exhibitions: Albany Pr. Cl., 1957; Lycoming Col., 1958; Bucknell Univ. 1958; retrospective exh., N.Y. State Univ. at Binghamton, 1969. Illustrated many books. Numerous limited editions and ephemera for private presses, principally Pickering; Hammer Creek; Golden Hind; Between-Hours, and others.

DERGALIS, GEORGE—Painter, Critic, L., T.
188 Church St., Newton, Mass. 02158
B. Athens, Greece, Aug. 31, 1928. Studied: Academia de Belle Arti, Rome, Italy, M.A.; BMFA Sch. FA. Member: Museum of Fine Arts Alumni Assn. Awards: Rome Prize, Italy, 1951; William Paige Traveling Scholarship, BMFA, 1958. Work: Boston Mus. Sch. FA; DeCordova & Dana Mus., Lincoln, Mass. Exhibited: Springfield Mus. A., 1962, 1963; Fall River (Mass.) Nat. Exh., 1963, 1964; Boston A. Festival, 1961, 1964. Lectures: Painting Techniques; Contemporary Painting at public libraries, art centers, art associations. Positions: Instr., Painting, Boston Mus. Sch. FA and DeCordova & Dana Museum, Lincoln, Mass.*

DER HAROOTIAN, KOREN—Sculptor, P.
R.F.D. 9-W, Castle Rd., Orangeburg, N.Y. 10962
B. Ashodavan, Armenia, Apr. 2, 1909. Studied: WMA Sch. Awards: prize, Springfield A. Lg., 1945; Audubon A., 1950, med., 1949; gold med., PAFA, 1954; Am. Acad. A. Let. grant, 1954; Medal of Honor, Florence, Italy, 1962. Work: MMA; WMA; PAFA; Arizona State Col. Mus., Tempe; marble eagle, U.S. Pavilion, Brussels World's Fair, 1958; 13 ft. figure of Christ and four Christian Armenian Martyrs for facade of Diocesan House, Armenian Cathedral & Cultural Center, N.Y., 1959; sculpture, Bezalel Mus., Jerusalem, WMA; WMAA; Newark Mus. A.; Bernard Baruch City Col., N.Y.; and in private colls.; Fairmount Park Assn., Phila., Pa. Exhibited: Leicester Gal., Goupils Gal., Zwemmer Gal., London, England, 1938-39, 1964; WMAA, 1956 (and prior); PAFA, 1946-1956; AIC, 1951, 1954; Univ. Nebraska; Detroit Inst. A., 1960; Cranbrook Acad. A.; Univ. Iowa; Des Moines A. Center; Fairmount Park; PMA, 1949; Royal Acad., London, 1964; Royal Glasgow Inst. FA, 1964; USIS Gal., Florence, Italy, 1963; one-man: Caz-Delbos Gal., N.Y.; WMA; Morton Gal.; Mus. of Jamaica, B.W.I., 1942; Kraushaar Gal., 1945; Washington Square, 1948; Phila. A. All., 1950. 2-man (with Vytlacil) Gal. 10, Mt. Vernon, N.Y., 1959; Baruch City Col., 1960; The Contemporaries Gal., N.Y., 1967; Chakrian Gal., N.Y., 1969.

DE RIVERA, JOSE—Sculptor
40-40 24th St., Long Island City, N.Y. 11101
B. New Orleans, La., Sept. 18, 1904. Studied: With John W. Norton, Chicago, and in Europe. Member: S. Gld. Awards: Watson F. Blair prize, AIC, 1957; Nat. Inst. A. & Lets. Grant, 1959; Ford Fnd. Retrospective Exh., traveling, 1960. Work: MMoDA; AIC; MMA; WMAA; Blanden Memorial A. Gal., Fort Dodge, Iowa; CAM; Munson-Williams-Proctor Inst., Utica, N.Y.; Newark Mus. A.; BM; Carnegie Inst. Tech.; Rochester (N.Y.) Memorial A. Gal.; SFMA; VMFA; Annenberg Fnd., Phila., Pa.; commissions: N.Y. World's Fair, 1964-65; American Iron & Steel Institute, 1965; Smithsonian Inst., 1967. Exhibited: MMA, 1951, MMoDA, 1956; WAC, 1957 (one-man); Carnegie Inst., 1958, 1961; PAFA, 1958; Detroit Inst. A., 1958; Brussels World's Fair, 1958; AIC, 1959; American Exh., Moscow, 1959; Nat. Inst. A. & Lets., N.Y., 1959; AFA "Collector's Choice," 1959, 1962; MMoDA (and traveling), 1959-60; DeCordova & Dana Mus., 1960; WMAA, 1960; Zurich A. Mus., Switzerland, 1960; Mus. Mod. A., Stockholm, 1961; Stedelijk Mus., Amsterdam, 1961; Seattle World's Fair, 1962; Gal. of Mod. A., Wash. D.C., 1963; Battersea Park, London, 1963; Universities: Harvard, 1945; Yale, 1946; Illinois, 1953; Minnesota, 1954; Lehigh, 1955; Indiana, 1960; Colleges: Oberlin, 1958; Smith, 1960; Mt. Holyoke, 1960; Morgan State, 1960, and many other exhibitions, U.S. and abroad. One-man: Grace Borgenicht Gal., N.Y., 1952-1967. Positions: Instr., Sculpture, Brooklyn College, 1953; Critic, Sculpture, Yale Univ., 1953-1955; School of Design, North Carolina State College, Raleigh, 1957-1960.

DERUJINSKY, GLEB W.—Sculptor, C.
29 W. 65th St., Apt. 2D, New York, N.Y. 10023
B. Smolensk, Russia, Aug. 13, 1888. Studied: Univ. & FA Acad., Petrograd. Member: NA; NSS; AAPL; All. A. Am. Awards: Med., Russia, 1916; Phila. Sesquicentennial Exp., 1926; World's Fair, Paris, 1937; NAD, 1938, 1968; medal, NAC, 1961, 1964; 2 Henry Hering mem. medals; Lindsey Mem. prize, 1954, 1965; Meriden AA, 1954, 1960; AAPL, 1957, 1958; Daniel French prize, All. A. Am., 1958, gold medal, 1966. Work: MMA; busts, New Sch. for Social Research; Hyde Park, N.Y.; Memphis Mus.; Cranbrook Acad. A.; USPO, Wash., D.C.; group, Brookgreen Gardens; St. Mary's Church, Flushing, N.Y.; marble & teakwood figures in San Diego, Cal.; Toledo, Ohio; Pittsburgh & Philadelphia, Pa.; Mem. bust of Theodore Roosevelt, Panama Canal Zone; John F. Kennedy, St. Mary's Church, Flushing, N.Y.; Statue, Jesuit Mission, Mocameh, India; Chapel of the Holy Child, Summit, N.J.; statues, Washington Cathedral. Exhibited: PAFA; MMA; Royal Acad., England; Royal Acad., Belgium; Knoedler Gal., London, 1928 (one-man).

DE RUTH, JAN (Mr.)—Painter, W.
1 West 67th St., New York, N.Y. 10023
B. Karlsbad, Czechoslovakia, July 31, 1922. Studied: Rotter A. Sch.,

Prague; Ruskin Sch. Drawing, Oxford Univ., England; ASL; Taubes-Pierce A. Sch.; New School, N.Y. Member: Artists Fellowship; All. A. Am.(Vice-Pres.); Knickerbocker A.; AAPL; Conn. Acad. FA; Audubon A. Awards: Gold Medal, NAC. Work: Butler Inst. Am. A. (purchase); Audubon A. (purchase). Exhibited: 31 national juried exhs.; 14 museum one-man exhs.; 36 gallery one-man exhs. Author: "Portrait Painting"; "Painting the Nude." Contributor articles to The Artist magazine.

DESHAIES, ARTHUR—Printmaker
Art Department, Florida State University; h. 1314 Dillard St., Tallahassee, Fla. 32303
B. Providence, R.I., 1920. Studied: Cooper Union A. Sch., New York; Indiana Univ., M.F.A. Awards: Fulbright Fellowship to France; Tiffany Fnd. Grant; Guggenheim Fellowship in Creative Printmaking. Exhibited: Nationally and Internationally. Work: in many important museums in U.S. and Europe and in university, and private collections. Work reproduced in American Prints Today Catalogue, 1962.*

DESKEY, DONALD—Industrial Designer
575 Madison Ave. 10022; h. 222 Central Park South, New York, N.Y. 10019
B. Blue Earth, Minn., Nov. 23, 1894. Studied: Univ. California; Mark Hopkins A. Sch.; AIC; ASL; Grande Chaumiere, Paris, France. Member: BAID; F., Am. Soc. Indst. Designers; A. Dir. Cl.; AIGA; Package Des. Council (Dir.); Benjamin Franklin F., Royal Soc. A., London; Arch. Lg. Awards: Grand Prix, Gold Medal, for Indst. Des., Paris Exp., 1937; prizes, Pittsburgh Plate Glass Co.; A. Dir. Cl., 1961 (and others); AIGA, 1961. Exhibited: MMA, 1931, 1934, 1940; BM, 1931; Detroit Inst. A.; Chicago World's Fair, 1933; WFNY 1939; Paris Exp., 1937; Phila. A. All., 1945; Am. Des. Gal., 1929, 1930; MModA, 1937; N.Y. A. All., 1927-1930; Seattle World's Fair, 1962; WFNY 1964; U.S. Pavilions, Int. Trade Fairs in Salonika, Greece, 1960 and Zagreb, Yugoslavia, 1961; and in Germany, Sweden, Italy, Spain, Switzerland, England, etc. Dept. Agriculture Fairs in Verona, Milan, Madrid, Manchester, Cologne; Exhibit for Union Carbide in Moscow. Lectures: Industrial Design. Positions: Pres., Donald Deskey Assoc., Indst. Des. Consultants, 1927- ; Pres., Shelter Industries, Inc., 1939- ; Pres., Special Projects, Inc., N.Y.; Indst. Des. Consultant to various exhibitors N.Y. World's Fair, 1964-65; Seattle World's Fair, 1962; Adv. Bd., Soc. Plastic Engineers, Inc. of U.S.A.; Chm. Bd., Airport Cargo Center, Inc., Bohemia, N.Y.; Dir., Half Moon Bay, Ltd., Montego Bay, Jamaica; Dir., Donald Deskey Associates, Ltd., England; Dir., Sculley, Deskey & Scott, Inc. Author, Lecturer on Industrial Design.*

de TOLNAY, CHARLES—Educator, W.
Casa Buonarroti, Florence, Italy
B. Budapest, Hungary, May 27, 1899. Studied: Univ. Vienna, Ph.D., and in Germany. Member: CAA; Atheneum; Accademia del Disegno, Florence (Hon.). Awards: Laureat de l'Academie des Inscriptions et Belles-Lettres, Institute de France, 1937; Guggenheim and Bollingen Fellow; Hon. Degree, Rome Univ., 1964. Author: "History and Technique of Old Master Drawings," 1943; "The Sistine Ceiling," 1945, and many other books on art. Positions: Memb., Inst. for Advanced Study, Princeton, N.J., 1939-1948; Visiting Prof., Columbia Univ., New York, N.Y., 1953-1964; Dir., Casa Buonarroti, Florence, Italy.

DETORE, JOHN E.—Painter
811 Grant Blvd., Syracuse, N.Y. 13203
B. Syracuse, N.Y., Sept. 14, 1902. Member: AWS; Audubon A.; F. Royal Soc. A. Awards: prizes, Rochester-Finger Lakes Exh., 1959-1963; Roberson Mem. Mus., Binghamton, N.Y., 1959; Cooperstown AA, 1959, 1961-1963; Audubon A., 1961-1963; Munson-Williams-Proctor Inst., 1961 (3); AWS, 1960, 1962, 1963; Butler Inst. Am. A., 1964; Chautauqua AA, 1961; N.Y. State Expo., 1962 (purchase); Watercolor: USA, Springfield, Mo. Mus., 1963; Everson Museum of A., 1964. Work: Springfield (Mo.) Mus. A.; N.Y. State Univ. Col., Oswego; Princeton Univ.; Munson-Williams-Procotr Inst.; NAD; Rochester Mem. A. Gal.; Everson Mus. A.; Springfield (Mass.) Mus. FA; many works for Niagara Mohawk Power Co. Exhibited: AWS, 1960-1969; Audubon A., 1961-1968; Butler Inst. Am. A., 1960-1968; Chautauqua AA, 1961; Cooperstown AA, 1959-1968; Everson Mus. A., 1964 (one-man); Munson-Williams-Proctor Inst., 1961-1966; N.Y. State Expo., 1962; Roberson Mem. Center, Binghamton, N.Y., 1959, 1968; Rochester-Finger Lakes Exhs., 1959-1966; Watercolor: USA, 1963; Allis-Chalmers Nat. Exh., 1964; Grand Central Gals., N.Y., 1965, 1967 (one-man).

DEVERELL, TIMOTHY—Painter
53 W. 29th St., New York, N.Y. 10001
B. Regina, Sask., Canada, 1939. Studied: Univ. Saskatchewan, Regina Sch. A.; ASL. Awards: Allen Tucker Merit Scholarship: Edward MacDowell Traveling Scholarship, 1963. Exhibited: Mus. FA of Houston, 1961; Yale Univ. A. Gal., 1962; 7th Biennial of Canadian

Painting, National Gallery, Ottawa, 1968. One-man: Kornblee Gal., 1961, 1692; ASL, 1965, New York City.

DE VINNA, MAURICE (AMBROSE, JR.)—Critic, E.
Tulsa World 74101; h. 232 North Santa Fe Ave., Tulsa, Okla. 74127
B. Tulsa, Okla., Apr. 12, 1907. Studied: Harvard Univ., A.B.; Institut d'Art Contemporaine, Paris; and with Jacques Loutschansky. Paris; Institute of A. & Archaeology of the Univ. of Paris: Brevet d'Art de la Sorbonne; Harvard Grad. Sch. Member: Press Assoc., AID; Library Committee, Gilcrease Inst. Am. History & Art; Bd. Trustees, Oklahoma A. Center. Awards: Gilcrease Inst. History & Art Certif. of Merit; Citation, Univ. Tulsa Art Dept. Weekly Art & Music page, Tulsa World; Positions: L., Art History, Tulsa Ext. Center, Univ. Oklahoma, 1932-33; Asst. State Dir., WPA Art Program, 1936-42; Monuments, Fine Arts & Archives Section, OMGUS, 1946-47; special lecturer, Benedictine Heights Col., Tulsa, 1956- ; Fine Arts Editor, Tulsa World, Tulsa, Okla., 1934- .

deVIS-NORTON, MARY M. (Mrs. Howard)—
Museum Curator
Honolulu Academy of Arts; h. 2552 Sonoma Pl., Honolulu, Hawaii 96822
B. Vancouver, Wash., Aug. 22, 1914. Studied: Univ. California at Los Angeles, B.E. in Art; Univ. Hawaii (grad. study in art and education). Member: N.A.E.A. Positions: Museum Instr., 1941-53, Dir., Education, 1953-1963, Curator of Junior Education, 1963- , Honolulu Academy of Arts, Honolulu, Hawaii.

DE VITIS, MRS. H. BELLA. See Schaefer, Henri-Bella.

DE VITIS, THEMIS—Painter, Des., T., Cr.
111 Bank St., New York, N.Y. 10014
B. Lecce, Puglia, Italy, Nov. 3, 1905. Studied: Acad. Beaux-Arts, Rome, Venice and Milan, Italy; Fashion Inst. Tech., N.Y. (Certif.). Member: AEA; Kappa Pi (Hon. Member). Awards: Scholarship, Lecce, Italy, 1922; Nat. award, Beaux-Arts, Venice, 1927. Work: Mus. A., Province Bldg., and Municipal Bldg., Lecce, Italy; Univ. of Ciudad Trujillo, Dominican Republic; Norfolk Mus. A. & Sciences; Butler Inst. Am. A., Youngstown, Ohio; and in private collections; murals, port., des., for Thibaut, Renverne Originals, Louis Bowen and others; murals in Italy. Exhibited: Bari, Italy, 1930 (one-man), and other one-man exhs. in Italy and France; Palais d'Exposition, Rome, 1931; Salon des Tuileries, Paris, 1931, 1934, 1935; Beaux-Arts, Florence, Italy, 1933; Salon des Independents, Paris, 1935; Salon Art des Murals, AEA, 1951, 1952, 1954; AFA, 1955; Adirondack Annual, 1962, 1963; Mayorga Gal., N.Y., 1964 (one-man); Norfolk Mus. A. & Sciences, 1966, 1968. Contributor art criticisms to French and Italian publications. Memb. Welfare Com., AEA, N.Y. Chptr., 1952- , Dir. Exec. Bd., 1960-62.

DE VITO, FERDINAND A.—Painter, E.
141 E. Third St., New York, N.Y. 10009
B. Trenton, N.J., Jan. 4, 1926. Studied: Cleveland Inst. A., B.F.A.; Yale Univ., M.F.A.; Univ. Denver; PMSch. A. Studied painting with Josef Albers and Conrad Marca-Relli; graphics with Gabor Peterdi. Awards: Mary C. Page award, Cleveland, Ohio. Exhibited: Retrospective, Univ. A. Gal., Binghamton, N.Y., 1968; AFA, 1968, 1969; three-man: Mickelson Gal., Washington, D.C., 1966; one-man: East Hampton Gal., N.Y., 1965, and numerous selected and group shows. Positions: Asst. Prof. A., State Univ. of New York at Binghamton.

DEW, JAMES EDWARD—Educator, P., C.
Art Department, School of Fine Arts, University of Montana; h. 531 East Sussex Ave., Missoula, Mont. 59801
B. Barnesville, Ohio, Sept. 15, 1922. Studied: Oberlin Col., A.B., A.M.; Univ. Alabama. Member: CAA; AAUP; NAEA. Exhibited: Invitational 3rd Intermountain Biennial Painting & Sculpture, Salt Lake City, Utah, 1967. Many other exhibitions in U.S. on prior dates. One-man: DeMolay Gal., Great Falls, 1968; Cartwheel Gal., Missoula, 1969; Jaid Gal., Richland, Mont., 1969. Positions: Prof. A., Sch. FA, Univ. Montana, Missoula, Mont., 1947- .

de WELDON, FELIX WEIHS—Sculptor, P., T., L.
219 Randolph Pl., N.E.; h. 2132 Bancroft Pl., N.W., Washington, D.C. 20008; s. "Beacon Rock," Harrison Ave., Newport, R.I.
B. Vienna, Austria, Apr. 12, 1907. Studied: Marchetti Col., B.A.; Univ. Vienna, M.A., M.S., Ph.D.; & in Italy, France, England. Member: AFA; Sc. Memb., Nat. Comm. FA, appt. by President, 1950, re-appt. by Pres. Eisenhower, 1955, 1959. Awards: prizes, Vienna, Austria, 1925, 1927; Awarded Medal of Honour by the Government of Austria, for Arts and Sciences, 1937; St. Andrews, Canada, 1939. Work: busts, King George V & King George VI, London; Mus. City of Vienna; Nat. Port. Gal., London; American Embassy, Canberra, Australia; Naval War Col., Newport, R.I.; White House, Wash., D.C.;

State Capitol, Little Rock, Ark.; Dallas, Tex.; St. Augustine, Fla.; Mus., Brisbane, Australia; U.S. Naval Acad., Annapolis, Md.; many port. busts of prominent officials in Scotland, England & U.S. Groups, mem., monuments, reliefs: U.S. Marine Corps War Mem., Wash., D.C.; Commodore Perry statue, Tokyo, Japan; Marine mon., Belleau Wood, France; Iwo Jima Flag Raising statue, Quantico, Va.; Dealey mon., Dallas, Tex.; fountain, Ottawa, Can.; George Washington bust, Canberra, Australia; bronze statue of Speaker Rayburn, Bonham, Tex.; equestrian statue, Bolivar, Wash., D.C.; Red Cross Monument, Wash., D.C.; Monument to Admiral Richard E. Byrd, Arlington, Va.; bronze statue of Sam Rayburn, Wash., D.C.; Truman Memorial, bronze statue, Athens, Greece; Inaugural Medal for President Lyndon B. Johnson; bronze bust, President John F. Kennedy in Cabinet Room, White House; Revolutionary War Monument (Marine Corps), New Hall, Philadelphia, Pa.; National Guard Monument, Washington, D.C.; equestrian statue of Garcia, Havana, Cuba; Nat. War Mem., Kuala Lumpur, Federation of Malay. Exhibited: Vienna, 1925-1928; Paris Salon, 1929, 1930; Cairo, Egypt, 1932, 1933; Royal Acad., London, 1934-1937; Montreal Mus. A., 1938; Arch. L., N.Y., 1939. Lectures: History of Painting, 12th to 19th Century; etc.

DEWEY, MR. and MRS. CHARLES S., JR.—Collectors
435 E. 52nd St., New York, N.Y. 10022*

DICE, ELIZABETH JANE—Educator, C., P.
134 King St., Mississippi State College for Women, Columbus, Miss. 39701
B. Urbana, Ill., Apr. 3, 1919. Studied: Univ. Michigan, B. of Des., M. of Des.; Int. Sch. A., Mexico; Instituto Allende, Mexico; T. Col., Columbia Univ.; Indiana Univ., M.A. (Art History), 1967; Norfolk A. Sch., and with Jerry Farnsworth. Member: Miss. AA; Miss. Edu. Assn.; Southeastern Col. A. Conf.; Am. Craftsmens Council; AAUP. Awards: Prizes, Jackson, Miss., 1946, 1951; Memphis, Tenn.; Canton H.S. (Miss.), 1955; Miss. River Craft Exh., 1963. Exhibited: Nat. WC Show, Jackson, 1951; SAGA, 1951; Nat. Crafts Exh., Wichita, 1950; Mississippi AA, 1948-1951, 1967, 1968; Friends of Am. A.; Grand Rapids, 1950; Memphis Garden Cl., 1952; Starkville (Miss.) Craft Exh., 1954; New Orleans AA, 1955; one-man: Allison's Wells, Miss., 1953, 1958; Miss. State Col. for Women, 1953; Jackson AA, 1958; Meridian AA, 1958. Positions: Vice-Pres., 1954, Pres., 1955, Sec.-Treas., 1960, Art Section, Mississippi Edu. Assn.; Chm., State Pres., Southeastern AA, 1954-55; Assoc. Prof. A., Miss. State Col. for Women, Columbus, Miss., 1945-..

DICKERSON, DANIEL JAY—Painter, T.
104 High St., Leonia, N.J. 07605
B. Jersey City, N.J., Dec. 22, 1922. Studied: CUASch.; with Delevante, Gwathmey, Kantor; Cranbrook Acad. A., M.F.A., with Sepeshy. Awards: prizes, Springfield A. Lg., 1953; Silvermine Gld. A., 1954; ACA Gal., N.Y. annual comp., 1956; McDowell Colony Fellowship, 1954; Fulbright Grant to India, 1954; Emily Lowe award, Audubon A., 1964. Work: Cranbrook Acad. A.; Joseph Hirshhorn Coll.; Adelphi Univ. Mus.; Illinois Wesleyan Univ., Bloomington, Ill. Exhibited: WMAA, 1948; PAFA, 1946, 1947, 1953; Univ. Illinois, 1948; Art: USA, 1959; Am. Acad. A. & Lets., 1960, 1964; Michigan Artist Annual, 1946, 1947; 3-man: Phila. A. All.; one-man: ACA Gal., 1958, 1961, 1964; Springfield (Mo.) A. Festival, 1965; Calcutta, India, USIS, 1954; Bombay A. Gld., 1954; Dintenfass Gal., 1968. Positions: Instr., Oklahoma Univ. A. Sch., 1951; Visiting Artist, Smith College, 1952-53; Manhattanville Col., Purchase, N.Y., 1964-1968; Instr., 1956-1961, Chm. A. Dept., Finch Col., New York, N.Y., 1969- .

DICKERSON, WILLIAM J.—Painter, Lith., T.
9112 E. Central Ave. 67206; h. 509 North Martinson St., Wichita, Kan. 67203
B. El Dorado, Kan., Oct. 29, 1904. Studied: AIC; & with Bolton Brown, B.J.O. Nordfeldt. Member: Phila. WC Cl.; Prairie WC Painters; Wichita A. Gld.; Soc. Canadian Painters, Etchers & Engravers. Awards: prizes, Kansas City AI, 1939, 1940; Joslyn Mem., 1944; Wichita A. Mus., 1968. Work: Wichita AA; Kansas State Col.; Kansas Univ.; Wichita Univ.; gift print edition, Kansas Fed. A., 1969, and other editions for art societies; work also in private collections. Exhibited: AIC, 1931, 1932; PAFA, 1937, 1940; Rockefeller Center, 1936, 1937; Lib.Cong., 1943; Palace Legion Honor, 1946; Kansas City AI, 1930-1950; Joslyn Mem., 1944-1946, 1951; MMA, 1952 Annual one-man exhs., Wichita AA, 1952- . Positions: Dir., Sch. of the Wichita AA, Wichita, Kan., 1930- . Acting Dir., Wichita AA Galleries, 1963- .

DICKINSON, EDWIN—Painter, T.
Box 793, Wellfleet, Mass. 02667; 420 West 119th St., New York, N.Y. 10027
B. Seneca Falls, N.Y., Oct. 11, 1891. Studied: PIASch.; ASL; & with William M. Chase, Charles W. Hawthorne. Member: Fed. Mod. P. &S.; NAD; Patteran Soc., Buffalo; Am. Acad. A. & Lets; Nat. Inst.

A. & Let.; Century Assn.; ASL. Awards: prize, NAD, 1929, 1949; med., Century Assn., 1955; Nat. Acad. A. & Lets. grant, 1954. Work: MMA; Albright A. Gal.; MModA; WMAA; AIC; BM; ASL; Univ. Nebraska; Mus. A., Montpelier, Vt.; Mulvane Mus., Washburn Univ., Topeka, Kans. Bowdoin Col.; Cornell Univ.; Sprinflield (Mass.) Mus. FA. Exhibited: BMFA; MModA; WMA; PMA; VMFA; Witte Mem. Mus.; FA of Houston; Pasadena AI; Los A. Mus. A.; SFMA; Portland (Ore.) Mus. A.; CAM; AIC; Toledo Mus. A.; Albright A. Gal.; Luxembourg Mus., Paris; Carnegie Inst.; Rochester Mem. A. Gal.; NAD; Soc. Indp. A.; Senior U.S. Representative at 34th Biennale, Venice, 1968, with 21 oils, and other leading museums and organizations, since 1916. One-man: Albright A. Gal.; Rochester Mem. A. Gal.; Farnsworth Mus.; Wellesley Col.; MModA; Passedoit Gal. Lecturer: Hartford, Boston, and Columbia Universities. Positions: Instr. A., ASL, 1922-23, 1945-1965; CUASch, New York, N.Y., 1945-1950; BM, 1949-1953.

DICKINSON, MRS. NEVILLE S. See Feldman, Hilda

DICKINSON, WILLIAM STIRLING—
Educator, P., W., L.
Instituto Allende; h. "Los Pocitos," San Miguel de Allende, Guanajuato, Mexico
B. Chicago, Ill., Dec. 22, 1909. Studied: Princeton Univ., B.A.; AIC; Fontainebleau, France. Exhibited: AIC; and in Mexico. Co-author and I.: "Mexican Odyssey," 1935; "Westward from Rio," 1936; "Death is Incidental," 1937; Illus., "Imperial Cuzco" (trans. from the Spanish). Lectures: Survey of Mexico: series covering major aspects of Mexican life and culture. Positions: Assoc. Dir., Escuela Universitaria de Bellas Artes, 1938-51; Dir., Instituto Allende, San Miguel de Allende, Guanajuato, Mexico, 1951- .

DICKSON, HAROLD EDWARD—Educator, W.
206 Hartswick Ave., State College, Pa. 16801
B. Sharon, Pa., July 18, 1900. Studied: Pennsylvania State Univ., B.S.; Harvard Univ., M.A., Ph.D. Member: CAA; Am. Assn. Univ. Prof.; Soc. Arch. Hist.; Scarab Cl. Ed., "Observations on American Art; Selections from the Writings of John Neal (1793-1876)," 1943. Contributor to: Art magazines with articles on American art. Author: "A Working Bibliography of Art in Pennsylvania," 1948; "John Wesley Jarvis, American Painter," 1949; "A Hundred Pennsylvania Buildings," 1954; "Pennsylvania Painters," 1955; "George Grey Barnard," 1964; "Arts of the Young Republic," 1968. Positions: Prof. Hist. Art, Pennsylvania State Univ., Pa., 1923-1964, Emeritus, 1964- . Visiting Prof. Hist. A., Univ. North Carolina, 1965-1967.

DIEBENKORN, RICHARD—Painter
334 Amalfi Dr., Santa Monica, Cal. 90402
B. Portland, Ore., 1922. Studied: Stanford Univ.; Univ. of California; Cal. Sch. FA. Member: Nat. Council on A., 1966-1969; Am. Acad. A. & Lets. Awards: Albert Bender Grant, San Francisco. Work: in many major museums, and in private collections. Exhibited: CAL.PLH, 1960; MModA, 1960; PC, 1958, 1961; Carnegie Inst., 1955; 1958, 1961; WMAA, 1955, 1958, 1961; Los A. Mus. A., 1952, 1954, 1957, 1960; Brussels Worlds Fair, 1958; Oakland A. Mus., 1957; Guggenheim Mus., 1954; Venice Biennale, 1968; one-man: Poindexter Gal., N.Y., 1955, 1958, 1961, 1963, 1964, 1966, 1969; Paul Kantor Gal., Los Angeles, 1952, 1954, deYoung Mem. Mus., San Francisco, 1963; Washington Gal. A., 1964; Jewish Mus., 1965; Newport Beach Pavilion, 1965; Los Angeles County Mus., 1969. Positions: Prof. A., Univ. Cal. at Los Angeles, 1966- .

DIENES, SARI—Painter, Gr., Des., T., S.
Willow Grove Rd., Stony Point, N.Y.
B. Hungary, Oct. 8, 1899. Studies: Ozenfant Sch. FA; and with Andre L'Hote, Fernand Leger in Paris; Henry Moore in London. Awards: F., MacDowell Colony, 1952-1954; Atelier 17, 1952; Huntington Hartford Fnd., 1954; Yaddo Fnd., 1953; Ford Fnd. grant, 1966. Work: BM; MModA., figures for David Behrman's "Questions from the Floor," Buffalo, N.Y.; Electric Circus, N.Y.; Carnegie Recital Hall, N.Y., and in many private collections. Exhibited: BM A. Sch., 1946-1948; BM, 1948-1951; Salon des Realities Nouvelles, Paris, 1951; Ninth St. Exh. P. & S. 1951; WMAA, 1952; Univ. Illinois, 1953; MModA, 1954, 1961, 1962 and traveling; AFA taveling exh., 1953-1955, 1959, 1963-1964; 1963-1965; Wadsworth Atheneum, 1962, 1963; Rockland Fnd., 1963; P.V.I. Gal., N.Y., 1964; Byron Gal., N.Y., 1965; John Daniels Gal., 1965; Assoc. Am. Artists, 1962; Martha Jackson Gal., N.Y., 1960; Fischbach Gal., N.Y.; Rhode Island Sch. of Des. Mus., Providence; one-man: New Sch. for Social Research, 1942; Parsons Sch. Des., 1944; Carlebach Gal., 1948; Wittenborn Gal., 1949; Univ. Montana, 1952; Mills Col., N.Y., 1955, 1956, 1957; Betty Parsons Gal., 1950, 1954, 1955, 1959; Gump's, San F., 1957; Tokyo, Japan, 1958; Contemporaries Gal., N.Y. 1959; Yamada Gal., Kyoto, Japan, 1958; Smolin Gal., N.Y., 1964; Wesleyan Univ., Middletown,

Conn., 1968. Positions: Asst. Dir., Ozenfant Sch. FA, 1936-41; Instr., Parsons Sch. Des., 1944-45; Instr., BM A. Sch., 1946-49. Guest Artist, Stout State Univ., Menomonie, Wis., 1967.

DIERINGER, ERNEST—Painter, T.
299 Riverside Dr., New York, N.Y. 10025
B. Chicago, Ill., July 6, 1932. Studied: AIC. Work: Dayton AI; Montana Hist. Soc. Exhibited: AIC, 1955, 1964; Exh. Momentum, Chicago, 1955-1957; Hyde Park A. Center, Chicago, 1959; Montana Hist. Soc., 1961; Fairweather-Hardin Gal., Chicago, 1963; Contemp. AA, Houston, 1963-1964; Dayton AI, 1964; Post Painterly Abstraction traveling exh., 1964; Parke-Bernet Gal., N.Y. (Art Dealers Assn.) 1964; Riverside Mus., N.Y., 1964; Daniels Gal., N.Y., 1965; Champaign-Urbana, Ill., 1965; one-man: Wells St. Gal., Chicago, 1959; Poindexter Gal., N.Y., 1962, 1964, 1966.

DIKE, PHIL(IP) (LATIMER)—Painter, Des., C., E., Gr.
3110 Forbes Ave., Claremont, Cal. 91711
B. Redlands, Cal., Apr. 6, 1906. Studied: Chouinard AI, with Chamberlin, Hinkle; ASL, with DuMond, Luks, Bridgman; Am. Acad., Fontainebleau, with St. Hubert. Member: NA; Cal. WC Soc.; Phila. WC Cl.; AWS; West Coast WC Soc. (V.-Pres. 1964-65). Awards: prizes, Cal. WC Soc., 1931, 1935, 1939, 1945, 1946, 1952, 1953, 1956, 1957; Los A., Mus. A., 1931, 1934, 1945, 1947; Pasadena AI, 1933; NAD, 1950, 1958; Cal. State Fair, 1933, 1948, 1951, 1955, 1956, 1959; GGE, 1939; Arizona State Fair, 1931, 1950; Santa Cruz A. Lg., 1932, 1934; Los A. County Fair, 1932, 1949; Butler Inst. Am. A., 1959; Ebell Cl., 1933; Los A. Nat. Exh., 1934; Newport Harbor H.S., 1948; Coronado A. Fair, 1949; San Gabriel Valley A., 1951; Nat. Orange Show, 1951; med., Pepsi-Cola, 1947; Southwest Expo., 1928; AWS, 1965, Paul Remmy Mem. Prize, 1962 and John Ernst award, 1965; Laguna Beach A. Festival, 1962; British Nat. WC Soc., London, 1962; Certif. Merit, NAD, 1963; Illustration West, Certif. Merit, 1963; medal, Los Angeles Festival, 1963; Cal. Nat. WC Soc., 1965 and Brugger prize, 1966; purchase award, Springfield Mus., 1967; purchase prize, St. Alban's exh., Beverly Hills, Cal. Work: Wood Mus., Montpelier, Vt.; MMA; Santa Barbara Mus. A.; Andrew M. Dike Mem. Chapel, Redlands, Cal; tile dec., Scripps Col. Exhibited: Carnegie Inst.; Paris Salon; AIC; NAD; Phila. WC Cl.; Ferargil Gal.; Los A. Mus. A.; Fnd. Western A.; San Diego FA Soc.; Cal. PLH; Biltmore Gal., and others. I. & contributor to national magazines. Positions: Instr., Chouinard AI, Los Angeles, Cal., 1929-30, 1931-34, 1937-38, 1945-50; Instr., Color and Composition, Walt Disney Productions, 1935-45; Rex Brandt-Phil Dike Summer Sch., Corona del Mar, Cal., 1947-55; Prof. A., Scripps Col. and Claremont Grad. Sch., Claremont, Cal., 1950-1969.

DILLER, MARY BLACK—Painter, I., W., Des., T.
220 Cabrini Blvd., New York, N.Y. 10033
B. Lancaster, Pa. Studied: Carnegie Inst., with Petrovits; PAFA, with McCarter, Garber, Carles; ASL, with Thomas Fogarty; Metropolitan A. Sch., with Jacobs. Member: Audubon A.; Lancaster County AA (Fndr. & 1st Pres., 1937-39); Eastern AA; Tiffany Fnd.; AAPL; Heights AC; F., Nat. Hon. A. Soc. of Kappa Pi; Studio Cl. Awards: prizes, Studio Cl., 1923; Lancaster, Pa., 1925; Ogunquit A. Center, 1940; purchase award, St. Vincent Col., Latrobe, Pa., 1964. Work: Albany Inst. Hist. & A.; Tiffany Fnd.; Fla. Southern Col.; Columbia (S.C.) Mus. A. Exhibited: Audubon A., 1940-1962; PAFA, 1939-1941 (traveling exh.); ASL Veteran's Exh., 1944; Tiffany Fnd.; Newhouse Gal.; Am-British A. Center; Number 10 Gal.; N.Y.Pub.Lib. (one-man); Reading & Lancaster, Pa. (one-man). Author: "Drawing for Children"; "A Child's Adventures in Drawing"; special contributor of "How To Draw," Book of Knowledge, 1955; "Holiday Drawing Book," 1954; "Drawing for Young Artists," 1955; "Young Artists Go to Europe," 1958; "Drawing the Circus for Young Artists," 1960. Contributor to: newspapers & magazines; contributing editor to Every Childs Magazine; Design magazine; Illus., Jack & Jill magazine, 1960-61; Lancaster (Pa.) Sunday News. Positions: Pennsylvania State Dir., Am. A. Week.

DILLON, C. DOUGLAS—Patron, Collector
767 Fifth Ave., New York, N.Y. 10022; h. Far Hills, New Jersey 07931
B. Geneva, Switzerland, Aug. 21, 1909. Studied: Harvard University, A.B. Collection: French Impressionist Painting; 18th Century Continental and British Porcelain; 18th Century French Furniture and Decorative Objects. Positions: Trustee, 1951- , Vice President, 1967- , Chairman, Acquisitions Committee, 1967- , The Metropolitan Museum of Art, New York, N.Y.

DILLON, MILDRED MURPHY (Mrs. James F.)—
Printmaker, Et., Ser., R.
309 East Highland Ave., Philadelphia, Pa. 19118
B. Philadelphia, Pa., Oct. 12, 1907. Studied: PMSch. A.; PAFA; Barnes Fnd., with Earl Horter, and in Europe. Member: Am. Color Pr. Soc.; Phila. Pr. Cl.; AEA; Phila. A. All.; F., PAFA. Awards: prize, PAFA, 1953; Am. Color Pr. Soc., 1955 (Presentation Print);

Lear prize, Woodmere A. Gal., 1958; Klein prize, Phila. Pr. Cl., 1967. Work: PMA; Woodmere A. Gal.; Canadian P. & Et.; Phila. Pr. Cl.; Barnes Fnd.; Atwater Kent Mus.; Phila. Free Library. Exhibited: PAFA; NAD; Nat. Ser. Soc.; Phila. Pr. Cl.; LC; DMFA; Smith Mus., Springfield; Phila. A. All.; Royal Ontario Mus., Canada; Caracas, Venezuela; Tokyo, Japan; Univ. of Alaska. Exhibition Lecture, PAFA, 1955; demonstrations in schools—serigraphs for Prints in Progress, 1961- . Positions: Pres. Phila. A. Lg., 1940-1946; Pres., Am. Color Pr. Soc., 1950-52; Vice-Pres. Am. Color Pr. Soc., Philadelphia, Pa., 1952- ; Chm. Rittenhouse Square Outdoor A. Exh., Phila., Pa., 1958-1968, Vice-Chm., 1968- ; Bd. Dirs., Phila. Art Alliance, 1964- .

DIMONDSTEIN, MORTON—Sculptor, P., Gr., T., L.
530 N. La Cienaga Blvd., Los Angeles, Cal. 90069
B. New York, N.Y., Nov. 5, 1920. Studied: Am. A. Sch.; ASL; Los Angeles A. Inst. Member: Boston Pr.M.; Taller di Grafica Popular, Mexico; SAGA. Awards: AGA Gal., Los Angeles (one-man show competition), 1951; Los Angeles Festival, 1956; Boston Pr.M., 1961; purchase prizes, Northwestern Pr.M., 1961; Wichita AA, 1963. Work: Capital Record Co., Hollywood; Pushkin Stage Mus., Moscow; SAM; LC; Wichita AA; Am. Air Publication, and World Bank, both Washington, D.C., and work in private colls. Exhibited: LC; Carnegie Int.; Los Angeles County Mus.; MMA; 3rd Nat. Sculpture Biennial, Carrara, Italy; Lytton Center of the Visual Arts, Los Angeles; Portland (Ore.) Mus. A.; Louisiana State Mus.; Am. Acad. A. & Lets.; PAFA; Santa Barbara Mus. A.; and in Rome, London, Mexico City. One-man: ACA Gal., N.Y., 1952; Zeitgeist Gal., 1958, Streeter Blair Gal., 1959; Lewinson Gal., 1960, Carter Gal., 1964, Fleischer Anhalt Gal., 1967-1969, OGL, 1969, all in Los Angeles; also, ACA Gal., 1964 and Galleria Penelope, 1961, both in Rome, Italy; Galleria Gian Ferrari, Milan, 1963; Lorenz Gal., Bethesda, Md., 1969; World Bank, Washington, D.C., 1969; 2-man: Pasadena A. Inst., 1960; Koslow Gal., Encinco, Cal., 1965. Positions: Instr., A., New Sch. A., 1956-1957, Sch. FA, 1957-1969 and 1964-1968, Univ. Southern California, 1964-1968, all Los Angeles

DINE, JIM—Painter, Gr., E.
Sidney Janis Gal., 15 E. 57th St., 10022; h. 470 West End Ave., New York, N.Y. 10024
B. Cincinnati, Ohio, June 16, 1936. Studied: Ohio Univ., B.F.A.; Boston Mus. Sch. FA. Awards: AIC, 1964. Work: MModA; WMAA; Guggenheim Mus. A.; Jewish Mus., N.Y.; DMFA; Rose Art Mus.; Brandeis Univ.; Albright-Knox A. Gal., Buffalo. Exhibited: Venice Biennale, 1964, 1968; Carnegie Int., 1964; Buenos Aires, 1965; Gulbenkian Int., 1964; Pop Art, The Hague, Holland; Stockholm, Sweden; MModA; American Drawings, WMAA, 1965; Martha Jackson, 1960, 1962, 1968; Sonnabend, 1967; Pollock Gal., 1967; Judson, 1958, 1959; Reuben, 1960; Janis Gal., 1962-1966; Robert Fraser, London, 1965, 1966; Galleria Dell 'Ariete, Milan, 1962; Palais des Beaux-Arts, Brussels, 1963, and others. Teaching: Six seminar lectures on "The Object," Yale Grad. School of Art & Architecture, 1965. Illus., "The Poet Assasinated." Positions: A-in-Res., Oberlin Col., 1965; A-in-Res., Cornell Univ., 1966-1967; Instructor, Royal Col. of Art, London, 1967-1968.*

DINTENFASS, TERRY—Art Dealer
18 E. 67th St.; h. 130 E. 67th St., New York, N.Y. 10021
B. Atlantic City, N.J., Apr. 4, 1920. Studied: Philadelphia Mus. Col. Specialty of Gallery: Contemporary American Art. Positions: Director, Terry Dintenfass Gallery, New York, N.Y. 1960- .

DI SUVERO, MARK—Painter
Univ. of California, Berkeley, Cal. 94720; also, 195 Front St., New York, N.Y. 10038*

DIX, GEORGE EVERTSON—Art Dealer
39 E. 72nd St. 10021; h. 19 E. 55th St., New York, N.Y. 10022
B. Evanston, Ill., Apr. 6, 1912. Studied: Yale College, B.A., Yale University, M.A. Specialty of Gallery: Paintings and Drawings before 1900. Positions: Assistant Director, American-British Art Center, N.Y., 1946-1947; Owner of George Dix Gallery, 1947-1948; Co-owner, Durlacher Brothers, N.Y., 1948-1967; Private dealer, George Dix Gallery, N.Y., 1967- .

DOBBS, JOHN BARNES—Painter
250 W. 82nd St., New York, N.Y. 10021
B. Passaic, N.J., Aug.2, 1931. Studied: R.I. Sch. Des.; Brooklyn Mus. A. Sch.; Skowhegan Sch. Painting. Awards: Emily Lowe Award, Audubon A., 1965; Ranger Fund Purchase Prize, Audubon A., 1965; Tiffany Fnd. Grant, 1966. Exhibited: MModA, 1956; WMAA, 1962; NAD, 1965; Audubon A, 1965; Salon Populiste, Paris, 1963; Salon des Independents, Paris, 1962, 1963; one-man: New York, N.Y., 1958, 1959, 1964, 1966, 1967; Paris, France, 1963; Los Angeles, Cal., 1964. Author, Illus., "Drawings of a Draftee," 1959. Positions: Instr., Painting & Drawing, Brooklyn Mus. A. Sch., 1956-1959; New School for Social Research, New York, N.Y., 1964- .

DOBKIN, ALEXANDER—Painter, I., W., L., Gr., T.
737 Greenwich St., New York, N.Y. 10014
B. Genoa, Italy, May 1, 1908. Studied: Col. City of N.Y., B.S.; T. Col., Columbia Univ., M.A.; ASL. Member: AEA. Award: Purchase award, Am. Acad. A. & Lets., 1957, 1964. Work: U.S. Govt., Wash., D.C.; LC; Butler Inst. Am. A.; Newark Mus. A.; Tel-Aviv Mus., Israel; Phoenix FA Assn.; MModA; PMA. Exhibited: AIC; BM; CGA; PAFA; MModA; Carnegie Inst.; ACA Gal. (6 one-man). Illus., "Child's Garden of Verses," 1945; "Two Years Before the Mast," 1946; Whitman's "Selected Poems," "King Arthur and His Knights"; "Songs for Patricia." Author: "Principles of Figure Drawing." Contributor to: N.Y. Times with art criticisms. Lectures: Appreciation & History of Art. Positions: Dir., Art Sch. of the Educational Alliance, New York, N.Y., at present.

DOCKSTADER, FREDERICK J.—Museum Director, C.
Museum of the American Indian, Broadway at 155th St. 10032; h. 165 W. 66th St., New York, N.Y. 10023
B. Los Angeles, Cal., Feb. 3, 1919. Studied: Arizona State Col., A.B., M.A.; Western Reserve Univ., Ph.D. Awards: prizes, CMA, 1950, 1951; F., Cranbrook Inst. Science; Rochester Mus. A. & Science, American Anthropological Assn. Work: Silversmithing, CMA. Exhibited: CMA, 1949-1951; Cranbrook Acad. A., 1948. Author, I., "The Kachina and the White Man," 1954; "Indian Art in America," 1961; "Indian Art in Middle America," 1964; "Indian Art in South America," 1967. Contributor articles on Arts and Crafts to various publications. Lectures: Silversmithing; American Indian Art; Arts and Crafts. Specialized in exhibit installation and reorganization at Cranbrook Inst. Science, Dartmouth College Mus., Mus. of the American Indian. Positions: Staff Ethnologist, Cranbrook Inst. Science, Bloomfield Hills, Mich., 1946-53; Cur. Anthropology, Dartmouth College Mus., 1953-56; Asst. Dir., Mus. of the American Indian, New York, N.Y., 1956-1959, Dir., 1959- ; Commissioner, U.S. Indian Arts & Crafts Board, 1956-1968, Chm. 1961-1968; Instr., Silversmithing, Cranbrook Acad. A., New Hampshire Lg. A. & Crafts; Prof., Dept. A. & Archaeology, Columbia Univ., N.Y., 1961-1964, Member, Advisory Council, 1961- .

DODD, LAMAR—Painter, E., L.
University of Georgia; h. 590 Springdale Ave., Athens, Ga. 30601
B. Fairburn, Ga., Sept. 22, 1909. Studied: Georgia Inst. Tech.; ASL, with Boardman Robinson, George Bridgman, John Steuart Curry, Jean Charlot, George Luks, and others. Member: ANA; CAA; Com. on A. Edu.; Southeastern AA; Assn. Georgia A.; Athens AA; Atlanta AA; Audubon A.; Georgia Edu. Assn; A. Comm., of Georgia; Athens Rotary. Awards: prizes, SSAL, 1931, 1940; Alabama A. Lg., 1936; AIC, 1936; WFNY 1939; IBM; Telfair Acad., 1941; Pepsi-Cola, 1947, 1948; Assn. Georgia A., 1941, 1948, 1953; VMFA, 1948; Southeastern AA, 1949, 1953; PAFA (purchase), 1958; WMAA (purchase), 1958; Nat. Inst. A. & Let., 1950; Fla. International, 1951; Terry AI, 1951; NAD, 1953; NAC, 1954. Work: Atlanta AI; AIC; IBM; MMA; Montclair A. Mus.; Telfair Acad.; PAFA; WMAA; Univ. Georgia; Rochester Mem. A. Gal.; VMFA; Wilmington Soc. A.; Cranbrook Acad. Exhibited: Am. Acad. A. & Let.; AFA; AIC; AWS; BM; CGA; Delaware A. Center; NAD; N.Y. WC Cl.; PAFA; Syracuse Mus. FA Walker A. Center; WMAA; PC; Audubon A.; MMA; Dayton A. Center; Delgado Mus. A.; Grand Central A. Gal.; John Herron AI; Montclair A. Mus.; Univ. Illinois; MModA; NAC; Univ. Nebraska; Philbrook A. Center; Santa Barbara A. Mus.; CAM, Toledo Mus. A., etc. Illus. (Rivers of America Series), The Savannah and The Santee. Contributor to College Art Journal, Book of Knowledge, and other publications; Lectures: USA; Denmark; Germany; Turkey; Italy; Austria; Greece; United Chapters Phi Beta Kappa Lecturer, 1967-68. Positions: Regents Prof. A., Hd. Dept. of A., Univ. Georgia, Athens, Ga. Pres., CAA, 1954-56; Memb. U.S. Dept. of State Com. on the Arts Tour of India, Thailand, Belgium, Japan, Korea, Manila, etc., 1958. NASA Artist: Apollo 7 and 10, 1968-1969.

DODGE, ERNEST STANLEY—Museum Director, W., L.
Peabody Museum, 161 Essex St., Salem, Mass.; h. 161 Essex St., Salem, Mass. 01970
B. Trenton, Me., Mar. 18, 1913. Studied: Harvard Univ. Member: Am. Acad. A. & Science; Am. Anthropological Assn.; Mass. Hist. Soc.; Colonial Soc. of Mass.; Club of Odd Volumes; Am. Folklore Soc.; Am. Ethnological Soc.; Grolier Club. Awards: Guggenheim Fellowship, 1961; Hon. M.A., Marlboro College, Marlboro, Vt., 1962. Work: Peabody Mus. of Salem. Author: "Gourd Growers of the South Seas"; "Northwest by Sea"; "New England and the South Seas." Editor: The American Neptune (Quarterly Journal of Maritime History). Contributor of many articles to learned publications. Lectures: Primitive Art; Art of the North American Indians and of the South Seas. Positions: Mus. Asst., 1931, Asst. Cur., 1937, Cur., 1943, Asst. Dir., 1946, Dir., 1950- , Peabody Museum of Salem, Mass. Lowell Lecturer, 1962.

DOHANOS, STEVAN—Illustrator, P., Gr.
279 Sturges Highway, Westport, Conn. 06880
B. Lorain, Ohio, May 18, 1907. Studied: Cleveland Sch. A. Member: SI (Pres., 1961-1963); AWS. Awards: med., Phila. WC Cl., 1934; A. Dir. Cl., 1936; prize, Cleveland Pr. M., 1934. Work: WMAA; Cleveland Pr. Cl.; Avery Mem., Hartford, Conn.; New Britain Inst.; Dartmouth Col.; murals, Charlotte Amalie, St. Thomas, Virgin Islands; Forest Service Bldg., Elkins, W. Va.; USPO, West Palm Beach, Fla. I., national magazines. Positions: Founding Faculty Member, Famous Artists Sch., Westport, Conn.*

DOLE, GEORGE—Cartoonist, P.
823 Main St., Westbrook, Me.; h. 6 David Rd., Portland, Me. 04105
B. New York, N.Y., July 24, 1920. Studied: NAD; PIA Sch.; ASL. Member: Magazine Cartoonists Guild. Contributor cartoons to Playboy, True, Parade magazines and others. Work: "Best Cartoons of the Year," 1940-1956; "You've Got Me in Stitches," etc. Author, booklet, "Space Concepts in Art." Exhibited: Sixth International Salon of Cartoons, Montreal, Canada, 1969. The George Dole manuscript collection at Syracuse (N.Y.) University (permanent); also permanent collection in Farrell Library at Kansas State University, Manhattan, Kans.

DOLE, WILLIAM—Painter, E.
340 E. Los Olivos, Santa Barbara, Cal. 93105
B. Angola, Ind., Sept. 2, 1917. Studied: Olivet Col., A.B.; Univ. California, M.A. Work: Amherst Col.; Phoenix Mus. A.; Santa Barbara Mus. A.; Mills Col.; Rockefeller Inst.; FMA; Long Beach Mus. A.; PAFA; St. Paul A. Center; WAC. Exhibited: Cal. PLH, 1947, 1952; SFMA, 1948-1951; PAFA, 1950; Hallmark award, 1953; Cal. WC Soc., 1950-1952; Denver A. Mus., 1948; Cal. State Fair, 1950, 1951; Los A. County Fair, 1951; Santa Barbara Mus. A., 1955, 1957; Los A. Mus. A., 1958; Downtown Gal., N.Y., 1969; one-man: Santa Barbara Mus. A., 1951, 1958, 1968; deYoung Mem. Mus., 1951; Mills Col., 1951; Geddis-Martin Studios, Santa Barbara, 1952; La Jolla A. Center, 1954; Rotunda Gal., San F., 1954; Galerie Springer, Berlin, 1956, 1964; Locke Gal., San F., 1956; Sagittarius Gal., Rome, 1957; Duveen-Graham Gal., N.Y., 1958, 1960; Univ. California A. Gal., Santa Barbara, 1958; Lewinson Gal., Los A., 1959; Bear Gal., Santa Barbara, 1960, 1966; Mexico City, 1961; Rex Evans Gal., Los A., 1961, 1964, 1965, 1966, 1968; Thacher Sch., Ojai, Cal., 1961; La Jolla Mus., 1964; McRoberts & Tunnard Gal., London, 1966; Marion Koogler McNay Inst. A., San Antonio, 1969; Cowell Coll. Gal., Univ. Cal., Santa Cruz, 1969. Positions: L., Univ. California, 1947-49; Instr. A., 1949-51, Asst. Prof. A., 1951-58; Assoc. Prof. & Chm. A. Dept., 1958-1962, Prof. 1962- , Univ. California, Santa Barbara, Cal. mail: Univ. California at Santa Barbara.

DOLPH, CLIFFORD R.—Museum Director
Maryhill, Wash.
B. Chicago, Ill., July 29, 1901. Studied: Univ. Chicago; Univ. Colorado. Member: Western Assn. A. Mus. Editor, general & special exhibition catalogs, Maryhill Mus. FA. Positions: Dir., Maryhill Mus. FA, Maryhill, Wash., 1938- .

DOMAREKI, JOSEPH T.—Painter, S.
1482 Fox Trail, Mountainside, N.J. 07092
B. Newark, N.J., May 17, 1914. Studied: Faucett A. Sch., Newark; Newark Sch. Fine & Indst. A.; Newark State Col., B.A.; Univ. Iowa, M.A.; N.Y. Univ. (grad. work in A. Edu.). Member: NAEA; Audubon A. (Pres. 1963-1967); SC; Nat. Soc. Painters in Casein (Pres.); Assoc. A. of New Jersey; N.J. WC Soc.; Hunterdon AA; New Jersey A. Edu. Assn.; Knickerbocker A.; (Hon.) Nat. Soc. A. & Lets. Awards: prizes, Hunterdon AA, 1957; N.J. WC Soc., 1954, 1960, 1963; Montclair A. Mus.; Newark A. Cl.; A. Center of the Oranges; medal, Knickerbocker A., 1955, 1963; medal, Audubon A., 1961, 1964, purchase prize, 1960; NAC, 1964; J. J. Newman Mem. Medal, Nat. Soc. Ptrs. in Casein; Westfield AA. Work: Univ. Iowa; Pentagon Bldg., Wash., D.C.; Columbia (S.C.) Mus. A.; Newark State Col.; N.Y. Univ., A. Dept.; Seton Hall Univ.; Norfolk Mus. FA; Sinclair Research Center, Tulsa, Okla.; St. Lukes Church, Haworth, N.J.; Broad Nat. Bank, Newark, N.J.; Columbia H.S., Maplewood, N.J.; Niagara (N.Y.) Univ.; Union County Court House, Elizabeth, N.J.; Monmouth Col. Exhibited: Butler Inst. Am. A., 1950-1952; NAD, 1949, 1953; AWS, 1952; Audubon A., 1949, 1950, 1952, 1958, 1959-1969; Knickerbocker A., 1954-1969; Pittsburgh Plan for Art, 1957; Univ. Iowa, 1957; Art: USA, 1958; Univ. Nebraska, 1952; Newark Mus. A., annually; Nat. Soc. Painters in Casein, 1955-1961; Brazil, 1959-1960 (exh. selected by MModA, N.Y.); Montclair A. Mus., annually; Trenton State Mus.; N.Y. World's Fair, 1964; Gallery 64, Worlds Fair, N.Y.; Silvermine Gld. A., 1963; Festival of A., Princeton; one-man: Louisiana State Mus., 1954; Contemporary Arts, New York, N.Y., 1949, 1952, 1954, 1957; Ohrbach's N.Y., 1960; Castellane Gal., N.Y., 1960; Seton Hall Univ., 1965; Watercolors: USA, 1967. Positions: Combat A., U.S. Navy, Pacific Area; Hd. A. Dept., South Orange, N. J. Pub. Schs.

DOMBEK, BLANCHE—Sculptor
c/o The MacDowell Colony, Peterborough, N.H., 03458
B. New York, N.Y. Studied: Grad. Training Sch. for Teachers. Awards: F., MacDowell Colony, 1957; Huntington Hartford Fnd., 1958, 1960, 1962; Yaddo Fnd., 1969. Work: BM; Randolph-Macon Woman's Col.; and in private colls. Exhibited: WMAA, 1947, 1948, 1950, 1952, 1955; BM, 1947; PAFA, 1947; PMA, 1949; WMA, 1951; S. Center, 1946-1950; Tanager Gal., Camino Gal., The Contemporaries, Am. Abstract A., S. Gld., Riverside Mus., S. Gld., 1961, 1963, 1964, all New York City; Scarborough-on-Hudson, 1958, and group shows in France and Germany; one-man: Pinacotheca Gal., 1945; Wellons Gal., N.Y.; Colette Allendy Gal., Paris, France, 1954; Pasadena A. Mus., 1960; Draco Fnd., 1965; San Marin Mus., Frank Lloyd Wright Civic Center, San Rafael, Cal., 1965. Positions: Instr., A., Chadwick Sch., Rolling Hills, Cal.; sculpture, Univ. of Cal., at Riverside.

DOMINIQUE, JOHN A.—Painter
216 N. Pueblo Ave., R.R. 3, Ojai, Cal. 93023
B. Sweden, Oct. 1, 1893. Studied: Cal. Sch. Des.; Van Sloun Sch. Painting, San Francisco, and with Colin Campbell Cooper. Member: Ventura AA; Cal. WC Soc. Awards: prizes, Oregon State Fair, 1940, 1941; Glendale AA, 1950. Exhibited: Portland (Ore.) A. Mus., 1936; Oakland A. Mus., 1941; Los A. Mus. A., 1944; Cal. A. Cl., 1950, 1955-1959, 1962, 1963, 1965; Santa Paula Chamber of Commerce, 1950, 1951, 1959-1961, 1964, 1965; Ojai A. Center, 1961, 1962, 1965; Otis AI Alumni Assn., 1960-1965; Cal. WC Soc., 1961, 1965, traveling 1961, 1963; Ventura AA, 1964; Frye Mus. A., Seattle, 1962; Nat. WC Soc., 1969; and traveling exh., 1969-1970.

DONAHUE, KENNETH—Museum Director
Los Angeles County Museum of Art, 5905 Wilshire Blvd., Los Angeles 90036; h. 245 S. Westgate Ave., Los Angeles, Cal. 90049
B. Louisville, Ky., Jan. 31, 1915. Studied: Univ. Louisville, A.B.; N.Y. Univ. Inst. FA, A.M. Member: Assn. A. Mus. Dirs.; AAMus. (Council 1968-); CAA (Bd. of Directors 1967-); ICOM. Awards: Grant, Am. Council Learned Soc., 1942-43; Research F., Am. Council Learned Soc., Italy, 1947-1949. Contributor articles to professional journals. Exhibition Catalogues. Positions: L., MModA, 1938-43; L., & Curatorial Asst., Frick Collection, N.Y., 1949-53; Cur., 1953-57, Dir., 1957-1964, Ringling Museum of Art, Sarasota, Fla; Deputy Dir., Los Angeles County Museum, Los Angeles, Cal., 1964-1966; Director, 1966- .

DONATI, ENRICO—Painter, S.
222 Central Park West 10019; h. 953 Fifth Ave., New York, N.Y. 10021
B. Milan, Italy, Feb. 19, 1909. Studied: Univ. of Pavia, Italy. Member: Advisory Bd., Brandeis Univ., 1956- ; Jury of the Fulbright Scholarship Program, 1954 to 1956, and 1963; President's Council for Arts & Architecture of Yale Univ. Work: MModA; WMAA; CAM; Mus. FA of Houston; Albright-Knox A. Gal., Buffalo; Detroit Inst. A.; Univ. of Michigan; BMA; Newark Mus. A.; Michener Fnd.; Univ. Texas, Austin; Olsen Fnd., Guilford, Conn.; IBM; MIT; Chase Manhattan Bank, Rockefeller Inst., New York; J. L. Hudson Co.; Johns Hopkins Hospital, Baltimore; Anderson Clayton Co., Houston, and others. Exhibited: Carnegie Inst., 1950, 1952, 1954, 1956, 1958, 1961; MModA, 1953-1954; AIC, 1954, 1957, 1960; WMAA, 1954, 1956, 1958, 1959, 1961-1964; Guggenheim Mus., 1955, 1961; SFMA, 1955; CGA, 1956, 1960; WAC, 1960; Birmingham Mus., 1962; AFA, 1959; CM, 1964; Nebraska AA, 1964; Univ. Illinois, 1965, and many others including Europe, South America; one-man: Betty Parsons Gal., N.Y., 1954, 1955, 1957, 1959, 1960; Staempfli Gal., N.Y., 1962, 1963, 1966, 1968; Mass. Inst. Tech., 1964; J. L. Hudson Co., Detroit, 1964, 1966, 1969; Neue Galerie, Munich (Retrospective), 1952; Syracuse Univ.; Paul Rosenberg, N.Y.; Iolas Gal., N.Y.; Obelisk Gal., Wash., D.C.; also in Paris, Rome, Milan, Brussels, Venice, and others.

DONATO, LOUIS NICHOLAS—Painter, Des., T.
P.O. Box 158, Shelter Island, N.Y. 11964
B. New York, N.Y., Oct. 23, 1913. Studied: CUASch. Member: NAEA; A. Dir. Cl.; AIGA; Foreign Correspondents Cl., Hong Kong. Awards: Art Directors Exh., 1965 (painting). Work: PMG; CBS, New York; cover painting, Science & Technology magazine. Exhibited: WFNY 1939; PMG, 1940; BM, 1941; PAFA, 1941, 1942, 1946, 1954; Carnegie Inst., 1941, 1945; CGA, 1943, 1945; VMFA, 1942, 1946; AFA, traveling exh., 1943-1944, 1955-56; Lillienfeld Gal. (one-man); Am.-British A. Center; Artists Gal. (one-man) 1955; Art:USA, 1958; Retrospective Exh., International Gal., N.Y., 1961. Contributor article, Printers Ink magazine. Positions: Consulting A. Dir., Will, Folsom & Smith, New York, N.Y., 1944- ; Former Instr. CUASch., New York, N.Y.; Chm. Edu. & Scholarship Com., A. Dir. Cl. Lecture series, Young & Rubicam, New York, N.Y.; Vice-Pres., A. Dirs. Cl. Scholarship Fund; Former Chm. Adv. Des. Dept., Vice-Pres., Planning & Development, School of Visual Arts, New York, N.Y.

DONNESON, SEENA—Painter, Gr.
319 Greenwich St., New York, N.Y. 10013; h. 41 Saddle Lane, Roslyn Heights, N.Y. 11577
B. New York City, N.Y. Studied: Pratt Inst. A.; ASL. Member: AEA; NAWA; Prof. Artist Gld.(Pres., 1968-1969). Awards: MacDowell Fnd. Fellowship, 1963, 1964; prizes, Suffolk Museum, 1956; Heckscher Museum, 1965; Kansas State Univ., 1966; Ball State Univ., 1967; Tamarind Fellowship, 1968. Work: Andrew Dickson White Mus., Ithaca, N.Y.; Washington County Mus. A., Hagerstown, Md.; Jacksonville A. Mus.; VMFA; Lyman Allyn Mus. A., New London, Conn.; McCarter Theatre, Princeton Univ.; Univ. Oklahoma Mus. A.; Norfolk Mus. Arts & Sciences; Los Angeles County Mus.; MModA; Smithsonian Inst.; Mus. Graphic A., N.Y.; N.Y. Pub. Library; BM; USIA Art in Embassies Program; Finch Col., N.Y.; Long Island Univ.; Grunewald Graphic A. Fnd., Univ. California at Los Angeles; Pasadena A. Mus. Exhibited: All. A. Am., 1956-1958; Audubon A., 1957, 1958; Suffolk Mus., N.Y., 1956; Delgado Mus. A., New Orleans 1957; Knickerbocker A., 1957; ACA Gal., N.Y., 1957, 1958; NAWA, 1957-1960, 1962-1964; Art:USA, 1958; IBM Gal., 1958; Heckscher Mus., N.Y., 1959; North Shore Community A. Center, 1958, 1959, 1961, 1962; Contemporary Arts Gal., N.Y., 1961; NAWA traveling exh. to numerous museums, 1961-1962; Pietrantonio Gal., Southampton, 1962; Pen & Brush Cl., 1962; Norfolk Mus. A. & Sciences, 1963; Karen Horney Clinic, N.Y., 1963; Conn. Acad. FA, 1963; DeCordova & Dana Mus., 1963; Silvermine Gld. A., 1963; Pietrantonio Gal., Westhampton Beach, L.I., 1963; USIS, State Dept., American Gallery of U.S. Embassy, Athens and Salonika, Greece, 1957, 1958; U.S. Embassy, Brussels Worlds Fair, 1957, 1958; Municipal A. Mus., Tokyo, Japan and on tour throughout Japan, 1960-1961; Argentina (NAWA Exchange Exh.); Buenos Aires, 1962-1963; PAFA, 1968; Butler Inst. Am. A., 1968; Silvermine Gld., 1968; BM, 1966; Pratt Inst., 1966, 1968; Biennale of color graphics, Switzerland, 1967; one-man: Chase Gal., N.Y., 1957; Terrain Gal., N.Y., 1966; Pietrantonio Gal., N.Y., 1961-1963; McCarter Theatre, Princeton Univ., 1962; traveling exh. to numerous colleges and universities, 1962-1963, including universities of California, Oklahoma, Alabama, Oregon, George Washington, Stetson Univ., Kansas State Univ., Montana State College, Portland (Ore.) Mus. A., Brooks Mem. Mus., Memphis, Swope Gal. A., Terre Haute, Ind.; Nat. Print Exh., sponsored by AFA, 1966-1968; Int. Min. Print Exh., sponsored by New Jersey State Council on Fine Arts, 1966, 1968, and others. Positions: Art Staff, N.Y. University Liberal Arts Extension Program, 1961, 1962.

DONOHOE, VICTORIA—Critic
34 Narbrook Park, Narberth, Pa. 19072
Studied: Rosemont College, A.B.; University of Pennsylvania, Graduate School of Fine Arts, M.F.A.; Graduate Study, Villa Schifanoia (Pius XII Institute of Fine Arts), Florence, Italy. Member: Soc. Architectural Historians; Mediaeval Academy of America. Positions: Co-Chairman (with Monsignor John G. McFadden) of the 1963 National Liturgical Week art exhibition, sponsored by the Philadelphia Archdiocese; Art Critic, Catholic Standard & Times, Philadelphia, 1959-1962; Art Critic, Philadelphia Inquirer, 1962- .

DONSON, JEROME ALLAN—
Arts Center Director, S., E., Cr., W., L.
136 Main St., Evanston, Ill. 60202
B. New York, N.Y., Mar. 20, 1924. Studied: City Col., N.Y.; Univ. So. Cal., B.A., M.S.; American Graduate Sch., Denmark; Univ. California, Berkeley, M.A.; New Sch., N.Y. Member: Nat. Com. on A. Edu.; AAUP; AAMus.; Western Assn. A. Mus. Dir.; CAA; Chm., Com. on standards & films, Western Assn. A. Mus. Dirs.; Long Beach AA (Hon.); Gld. Florence (S.C.) Arts Council (Bd. Memb.); NEA. Awards: prizes, Gld. South Carolina A., 1955; AAPL, 1954, 1955; Scholarship to Am. Graduate Sch., Denmark. Contributor to Florence Morning News and other South Carolina newspapers, 1954-56; weekly column on museum news; contributor to, College Art Journal; Clearing House for Western Museums; Design; Ceramics Monthly; Curator, and other publications. Occasional TV programs; Hd., Univ. California Extension Course "Looking at Modern Painting." Exhibitions arranged: Traveling exh. series on Arts of Southern California: I: Architecture; II: Painting; III: Art in Film; IV: Indian Art, 1958; V: Prints, 1959; VI: Ceramics; VII: Photography; VIII: Drawing, 1960; IX: Interior Design; X: Collage, 1961. Also, Fifteen American Painters, 1957; Art in Long Beach Private Collections, 1957; Art of the Sepik River, 1957; Primitive Art, 1959-60; The Exodus Group, 1960; Landscape, Past and Present, 1960. Positions: Archeologist-Art Hist., Nat. Mus., Copenhagen, Denmark, 1950-51; Preparator, Mus. Authropology, Univ. California, Berkeley, 1953-54; Dir., Florence (S.C.) A. Mus., 1954-56; Dir. Long Beach Mus. A., Long Beach, Cal., 1956-1962. Chm. Training & Prof. Standards, Vice-Pres., Western Museums Lg.; A. Hist. Instr., Univ. Cal. Ext.; American Art Specialist, U.S. Dept. of State, In charge traveling painting exhibition "American Vanguard" in England, Austria, Germany and Yugoslavia; lectured on Art throughout Europe, etc., 1961-62; Dir. of Arts, Assoc. Prof. FA, Chm. A. Dept., Fairleigh Dickinson Univ., 1962-1963; Exec. Dir., office Cultural Affairs, City

of New York, conducted weekly TV program, "World of the Arts," 1963-64; Art News Ed., The Art Journal (CAA), 1964- ; Arts Consultant, Long Island Univ., co-ordinator of art exhs., architectural projects, Prof., 1965-1966.

DOOLEY, HELEN BERTHA — Educator, L., P.
Dooley Gallery, Box 5577, Carmel, Cal. 93921
B. San Jose, Cal., July 27, 1907. Studied: San Jose State Col.; Chouinard AI; Claremont Grad. Sch. with Millard Sheets; Univ. Cal., Berkeley; T. Col., Columbia Univ.; Cal. Col. FA, with Maurice Sterne. Member: Soc. Western A.; Carmel AA. Awards: Monterey County Fair, 1951, 1955, 1959: deYoung Mem. Mus., 1951, 1956; Mother Lode AA, 1959, 1960; Kingsley A. Annual, 1956; Stockton A. Lg., 1957, 1960, 1963, 1964; Lodi AA, 1962; Religious Art Exh., Carmel, Cal., 1962; AWS, 1963; Monterey Peninsula Mus. AA, 1967; Seaside A. Festival (2), 1968. Work: Shimizy A. Gal., Japan. Exhibited: Cal. State Fair; Cal. PLH; Oakland A. Mus.; PAFA, 1938, 1943, 1945; Madonna Festival, Los A., 1952; 15 California Painters, Monterey, 1956; Laguna Beach Festival of A., 1956, 1957; Carmel AA, 1955-1958, 1965; Aptos A. Center Gal., 1967, 1968, one-man: San Jose State Col. Lib., 1955, 1956; Haggin Mem. Mus., 1962; Carmel A. Gld., 1958, 1965; Skylight Gal., Stockton, 1959; Univ. of the Pacific, 1960, 1963; San Jose A. Lg., 1962; A. Gld., Carmel, 1962; Haggin Mus., Stockton, 1962; 7 Arts Gal., Bakersfield, 1963-64; Bakersfield A. Lg., 1965; Carmel AA, 1965; Seaside City Hall, 1968; Lord & Taylor Gal., N.Y., 1969. Author: "Art for Elementary Schools," 1942; "Elementary Crafts in a Nutshell," 1963; Illus., Laurel Handwriting Series, 1935; Represented in article in Revue Moderne, Paris, 1964. Positions: Prof., A. Edu., Univ. of the Pacific, Stockton, Cal., 1948-1968; Dir., Dooley Gal., Carmel, Cal. Private painting classes.

DOOLITTLE, WARREN FORD, JR.—Educator, P.
115 West Pennsylvania Ave., Urbana, Ill. 61801
B. New Haven, Conn., April 3, 1911. Studied: Yale Sch. FA, B.F.A.; Syracuse Univ., M.F.A. Member: Midwestern Col. AA; Awards: Ford Fnd. F., 1953-54; Wash. WC Cl., 1960. Exhibited: AIC, 1944, 1946; Cal. PLH, 1946; Northwest Pr. M., 1946; Pepsi-Cola, 1946; Arizona A. Exh., 1946; CGA, 1947; MMA, 1950; Springfield, Ill., 1950, 1951; Univ. Washington (D.C.), 1951; Wash. WC Cl., 1960; Butler AI, 1952; Denver A. Mus., 1955, 1960; Conn. Acad. FA, 1954; one-man: Urbana, Ill., 1954; Bloomington, Ill., 1955; Decatur, Ill., 1956; Univ. Illinois, 1958; Traveling Exh., Krannert A. Mus., 1965; European Traveling Exh., Ben & Abby Grey Fnd., 1965; Stephens Col., 1966; "Artists Who Teach" Exh., Springfield, Ill., 1969. Studio Gal., Geneva, Ill. Positions: Prof. A., Dir. of Painting Option 1948-1968, Chm. Grad. Programs in Art, Art Dept., Univ. Illinois, 1948-

DORMAN, MARGARET—
Gallery Director, P., S., T., I., L.
150 West 9th St., Apt. 2, Claremont, Cal. 91711
B. Budapest, Hungary, Aug. 24, 1910. Studied: Univ. Michigan, A.B. in Art & Lib. Science; Univ. New Mexico; School of Am. Research in Archaeology; Yale Univ.; Univ. Indiana, M.A.; with Fairbanks, Chapin at Univ. Mich.; Robert Henri, in New Mexico; Robert Eberhardt at Yale; Victor Meeks and Gizella Richter (research at MMA). Member: Am. Assn. Univ. Women; Am. Lib. Assn.; Women Painters of Michigan; Am. Archaeological Soc. Awards: Teaching F., Univ. New Mexico, 1931-32; F., Sch. Am. Research in Anthropology, Santa Fe., 1932-33; F., Claremont Col., 1932-33; FA F., Yale Univ., Teaching F., Indiana Univ., Bloomington. Work: Univ. Michigan Law Law Sch.; Univ. Colorado; Univ. New Mexico; Central Catholic H.S., Toledo; St. Joseph's Parish, Tiffin, Ohio; Heidelberg Col., Tiffin, Ohio; Oberlin Col.; and in private colls., U.S. and abroad. Exhibited: Univ. Michigan; Yale Univ.; Univ. New Mexico; Univ. So. California; MModA; Am. Assn. Univ. Women; Women Painters of Michigan; Palais Mont Calm, Quebec; Santa Fe and Taos, N.M.; galleries in Prague and the Univ. of Brazil. Author: "Watercolor Paintings of the Pueblo Indians of New Mexico" (State Dept. of N.M.); "Geometric Foundations of 5th and 4th century Greek Sculpture." Lectures: History of Western Art, Europe and America. Positions: Libn., Henry E. Huntington Lib., San Marino, Cal., 1933-36; LC, 1936-38; Ohio State Univ., Columbus; Univ. Illinois, 1946-47; Organized The Children's International Art Gallery, Claremont, Cal., 1948- . Represents all nations with children's drawings and paintings, ages 6 to 18 years.

DORN, CHARLES MEEKER—
Art Association Executive, Scholar, Writer
National Art Education Association, 1201 16th St., Washington, D.C. 20036; h. 2113 Mason Hill Dr., Alexandria, Va. 22306
B. Minneapolis, Minn., Jan. 17, 1927. Studied: George Peabody College for Teachers, Nashville, Tenn., B.A., M.A.; University of Texas, Austin, Ed.D. Member: National Education Association; National Art Education Association of America; College Art Association; International Society for Education Through Art. Awards: 25th Anniversary Award for Distinguished Service to Education in Art,

National Gallery of Art, 1966. Contributor of articles to: National College of Education Journal, 1960; The Bulletin, National Association of Secondary School Principals, 1963; NEA Journal, 1964; Illinois Journal of Education, 1965; Biiku Bunka, Tokyo, Japan, 1967; The Sketch Book of Kappa Pi, 1968, and many more. Exhibited: Faculty Exhs., Northern Illinois University; Memphis State University; Union University; Beloit State College. Positions: Many positions in Research and Development in Art Education; Assistant Prof. Art, Union University, Jackson, Tenn., 1950-1954; Instructor of Art and Education, Memphis State University, 1954-1957; Head, Department of Art, National College of Education, Evanston, Ill., 1959-1960; Associate Prof., Northern Illinois University, DeKalb, 1961-1962; Executive Secretary and Treasurer, National Art Education Association, 1962- ; Board of Directors, National Council of Arts in Education, 1962-1969.

DORR, WILLIAM SHEPHERD—Collector, P.
Liaison Films, Inc., 432 W. 45th St., New York, N.Y. 10036
B. Augusta, Ga., Nov. 10, 1925. Studied: Emory Univ.; Univ. Georgia (art with Lloyd Miller). Awards: prizes, Assn. of Georgia Artists, 1948; Southern Artists Exh., 1949. Collection: Contemporary American Art, including Arakawa, Calder, Chamberlain, Conner, Dine, Johns, Lindner, Oldenburg, Rivers, Rauschenberg, etc.*

DORRA, HENRI—Educator, Former Mus. Dir.
University of California, Santa Barbara, Cal. 93106
B. Jan. 17, 1924. Studied: London Univ., B. Sc.; Harvard Univ., M.S., M.A., Ph.D. Awards: Bowdoin prize, Harvard Univ., 1949; MMA Student F., 1951-52. Author: "Gauguin," MMA, 1953; "Seurat," Les Beaux-Arts, Paris, 1960; "The American Muse," N.Y., 1961. Contributor to: Gazette des Beaux-Arts; MMA Bulletin; Smith Col. Mus. Bulletin; Burlington Magazine; Arts; Art in America, etc. Lectures: Art History. Exhibitions organized: "Years of Ferment," UCLA; "Visionaries and Dreamers," "Ryder," CGA, SFMA, Cleveland Mus. A., 1955-60. Positions: Student F., MMA, 1951-52; Asst. Dir., Corcoran Gal. A., Washington, D.C., 1954-61; Asst. Dir., Philadelphia Mus. A., 1961-1962; Exec. Vice-Pres., Indianapolis AA, 1962-1963; Prof., Univ. of California, Santa Barbara, Cal., 1963- .

DOUGLAS, EDWIN PERRY—Painter
P.O. Box 13, Essex, N.Y. 12936
B. Lynn, Mass., June 18, 1935. Studied: BMFA Sch; R.I. Sch. Design, B.F.A.; San Francisco Art Inst., M.F.A. Work: Dayton A. Mus.; CM. Exhibited: San Francisco Art Inst. traveling exhibition, 1963; Montreal Mus. FA, 1964; London and Sarnia, Ont., Canada, 1964; Canadian Soc. Gr. Arts, Kingston, 1964; Canadian Soc. Painters, Etchers & Engravers, Toronto, 1964; Dayton Art Inst., 1965; Miami Univ., Ohio, 1966; CM, 1968. Positions: Painting & Drawing, Art Acad. of Cincinnati, 1964-1968.

DOWDEN, ANNE-OPHELIA (TODD)—
Illustrator, W., Des.
205 W. 15th St., New York, N.Y., 10011
B. Denver, Colo., Sept. 17, 1907. Studied: Univ. Colorado; Carnegie Inst., B.A.; ASL; Beaux Arts Inst. Design. Award: Tiffany Fellowship. Work: Hunt Botanical Library, Pittsburgh; Newark Mus. A. (Textile Coll.). Exhibited: GRD Gal., N.Y.; Carnegie Inst.; WMAA; MMA; Newark Mus. A.; Silvermine Gld. A.; Cooper Union Mus., N.Y., (Design); Brooklyn Botanic Garden; Hunt Botanical Library, Pittsburgh, 1964, 1968 and one-man, 1965. Author, I.: CUAS 8, "The Little Hill," 1961; "Look At A Flower," 1963; "The Secret Life of the Flowers," 1964; "Roses," 1965; Illus.: Life, 1952, 1955, 1957; House Beautiful, 1958, 1960; Natural History Magazine, 1959, 1961; Audubon Magazine, 1968; "Wild Flowers of the United States," title pages, 5 vols., 1966-1971; "Shakespeare's Flowers," 1969.

DOWLING, DANIEL BLAIR—Cartoonist
Kansas City Star, 1729 Grand Ave., Kansas City, Mo. 64108
B. O'Neil, Neb., Nov. 16, 1906. Studied: Univ. California, Berkeley; Chicago Acad. FA. Member: Assn. American Editorial Cartoonists. Awards: Christopher medal, 1955, 1956; Freedoms Fnd. Awards, 1954, 1956, 1957; Sigma Delta Chi, 1960. Positions: Syndicated editorial cartoonist, Hall Syndicate.

DOWLING, ROBERT W.—Association Chairman
Federal Hall Memorial Associates, Sub-Treasury Bldg., Wall & Nassau Streets, New York, N.Y. 10005*

DOWNING, GEORGE ELLIOTT—Educator, P.
Brown University; h. 144 Power St., Providence, R.I. 02906
B. Marquette, Mich., June 19, 1904. Studied: Univ. Chicago, Ph.B.; Harvard Univ., M.A., Ph.D. Positions: Instr. A., Univ. Chicago, 1926-30; Asst. Prof. A., 1932-46, Assoc. Prof. A., 1946-1953, Prof. A., 1953- , Brown Univ., Providence, R.I.*

DOYLE, EDWARD A.—Architectural Illustrator, P., Des.
150 Hornbine Rd., Swansea, Mass. 02777
B. Cranston, R.I., May 22, 1914. Studied: R.I. Sch. Des. Member: Fall River AA. Awards: Warren A. Festival, 1966; Fall River A. Assn., 1967, 1969. Exhibited: R.I. Artists; Providence A. Cl., 1958; Fall River AA, 1963, 1964, 1965; Jordan Marsh Annual, 1965; one-man, Attleboro Mus., 1968. Positions: Architectural Illustrator, 1946- ; Instr., figure drawing, Fall River A. Assn., 1966-1969.

DOYLE, TOM—Sculptor
135 Bowery, New York, N.Y. 10002
B. Jerry City, Ohio, May 23, 1928. Studied: Miami Univ., Oxford, Ohio; Ohio State Univ., Columbus, B.F.A., M.A. Exhibited: Carnegie Inst., 1961; Martha Jackson Gal., N.Y., 1960; Los Angeles County Mus., 1967; PMA, 1967, 1968; WMAA, 1967, 1968; BM, 1968; Inst. Contemp. A., Boston, 1969; one-man: Allan Stone Gal., N.Y., 1961; 3-man: Oberlin Col., Oberlin, Ohio, 1961; Dwan Gal., N.Y., 1966, 1967; Jewish Mus., N.Y., 1966.

DOZIER, OTIS—Painter, Lith.
7019 Dellrose Dr., Dallas, Tex. 75214
B. Forney, Tex., Mar. 27, 1904. Awards: Dallas All. A., 1932, 1946; Southwestern AA, 1948; New Orleans A. & Crafts, 1948; Denver A. Mus., 1943. Work: Univ. Nebraska; Dallas Mus. FA; Denver A. Mus.; MMA; Wadsworth Atheneum; Newark Mus.; murals, USPO, Arlington, Giddings, Fredericksburg, Tex. Exhibited: WMAA, 1945; Carnegie Inst., 1946; Pasadena, Cal., 1946; Dallas All. A., 1946; Witte Mem. Mus., 1948 (one-man); DMFA, 1956 (one-man). Positions: Instr., Dallas Mus. FA, Dallas, Tex., 1945- .*

DRABKIN, STELLA (Mrs.)—Painter, Mosaicist, Gr., Des.
2404 Pine St., Philadelphia, Pa. 19103
B. New York, N.Y., Jan. 27, 1906. Studied: NAD; Phila. Graphic Sketch Cl., and with Earl Horter. Member: SAGA; AEA; Phila. A. All.; Am. Color Pr. Soc.; Audubon A.; Phila. Pr. Cl. Awards: prizes, Am. Color Pr. Soc., 1944; N.J. State Mus., purchase award; Phila. Pr. Cl., 1955, 1967. Work: PAFA; PMA; NGA, Rosenwald Coll.; MMA; Pa. State Col.; LC; Phila. A. All.; Boston Pub. Library; N.J. State Mus.; Yale Univ. Library; color print included in UNICEF Calendar, 1966; Atwater Kent Mus.; Am. Color Pr. Soc. Presentation Print, 1949; Tel-Aviv Mus., Israel; Dagania Mus., Bezelel Mus., Jerusalem and in many private colls. Exhibited: nationally and internationally. Included in Am. A. Festival, Berlin, 1951; Phila. Pr. Cl., 1960; exhibited 1962-64: Am. Color Pr. Soc.; SAGA; Audubon A.; PAFA; PMA; one-man: Carlen Gal., 1938, 1939; Mus. New Mexico, 1947; Phila. A. All., 1944, 1950, 1969 (one-man); PAFA, 1952. Author: "Pennsylvania: Painting in Pennsylvania," included in "Printing With Monotype." Positions: (Chm.) Pr., Phila. A. All.; Council, Am. Color Pr. Soc., V.-Pres., Am. Color Pr. Soc., 1965- .

DRAPER, LINE BLOOM (Mrs. Glen C.)—Painter
4210 Corey Rd., Toledo, Ohio 43623
B. Belgium. Studied: Ecole des Arts Decoratifs, Verviers; Academie Royale des Beaux-Arts de Tournai; Bowling Green Univ., Ohio; Skowhegan Sch. A. Member: Toledo A. Cl. (Pres. 1963-1966); Toledo Fed. A. Soc.; Athena A. Soc. (Pres.); Women's A. Lg. Toledo; Port Clinton A. Cl. Awards: prizes, Lucas County A. Exh., 1962, 1968; "Midwest," Montpelier, Ohio, 1954, 1956, 1957, 1962, 1968; Nat. Bank, Toledo, 1967; N.W. Ohio Garden Show, 1956, 1957, 1960, 1965, 1966; Port Clinton, 1957, 1966, 1967(2), 1968; Toledo Mus. A., 1955, 1956, 1958-1960; Gold Medal and special award for Outstanding Achievement, 1964 and "Artist of the Year" 1964; Toledo A. Cl.; Wood County Exh., 1954 (4), 1962, 1963 (2), 1968 (2); Toledo Fed. A. Soc., 1964, 1966. Exhibited: One-man: Toledo Mus. A., 1956; Town Gal., 1954, 1956-1958; Westwood A. Theatre, 1950, 1960; Unitarian Church, Toledo, 1950, 1960, 1963; Toledo A. Cl., 1956, 1961, 1962; Cinema I and II, 1966, 1968; Park Lane, Toledo, 1966, 1967; Bowling Green Library, 1957, 1959; Fostoria A. Lg., 1959, 1960, and others.

DRAPER, ROBERT SARGENT—Art Dealer, P., W., L.
Mirell Gallery, 3421 Main Hwy. 33133; h. 7719 S. W. 69th Ave., Miami, Fla. 33143
B. Rutland, Vt., Feb. 18, 1920. Studied: Univ. Florida, B.A.; Norton Gallery & School of Art; Hans Hofmann School of Art. Member: Blue Dome Fellowship, Miami; AEA; Florida Artists Group. Awards: prizes, Miami Art League, 1948, 1950, 1951, 1955; Artists & Writers Soc., 1949; Society of the Four Arts, Palm Beach, 1954; American Artists Professional League, 1955. Work: Norton Gallery of Art; Lowe Museum, Coral Gables; Columbus (Ga.) Museum of Arts & Crafts; Emory University, Atlanta; American School of Madrid Museum, Spain, and in private collections. Exhibited: Riverside Museum, N.Y., 1958; Hirschel & Adler Gallery, N.Y., 1962; Fort Lauderdale, Fla., 1958; Norton Gallery, 1958; Springfield Museum of Fine Arts, 1956; Ringling Museum, Sarasota, 1955; Lowe Art Museum, 1953-1955; Florida Artists Group, 1961-1963, 1965, 1967, 1969; Society of the Four Arts, 1950-1954. Lectures: Pre-Columbian Art; Contemporary Art; Classical Art of the French 17th Century. Positions: President, Miami Art League, 1954-1955; Blue Dome Fellow-

ship, 1957-1958, 1960-1961, 1967-1969; President, Miami Artists Association, 1954-1955, 1956-1959. Owner, Mirell Gallery, Miami, Fla.

DRAPER, WILLIAM FANKLIN—Painter
535 Park Ave.; h. 160 East 83rd St., New York, N.Y. 10028
B. Hopedale, Mass., Dec. 24, 1912. Studied: Harvard Univ.; NAD; ASL; & with Jon Corbino, Leon Kroll, Zimmerman. Member: SC: Century Assn. Work: U.S. Navy, combat art; ports.; Harvard Univ.; Vassar Col.; Phillips Exeter Acad.; Lawrenceville Sch.; murals, U.S. Naval Acad., Annapolis, Md.; portraits of prominent naval commanding officers; recent portraits include: Pres. John F. Kennedy (1962-from life); Pres. Sarah Blanding, Vassar; Gov. Almond of Virginia; Gov. Meyner, New Jersey; Pres. Goheen of Princeton Univ., Pres. Pusey of Harvard, and others. Exhibited: NAD, 1934, 1941; AIC, 1941; MMA, 1945; NGA, 1945; CGA, 1943; Inst. Mod. A., Boston, 1940; BMFA, 1942; Nat. Gal., London, 1944. Author: "The Navy at War," 1943 (illus. by combat artists); Illus., "5000 Miles to Tokyo." Contributor: war paintings to Nat. Geographic magazine; Collier's; American Magazine.*

DREISBACH, C(LARENCE) I(RA)—Painter, Des., T., L.
916 North St. Lucas St., Allentown, Pa.
B. Union Hill, Pa., Jan. 28. 1903. Studied: Baum A. Sch., Allentown, Pa., and with Orlando G. Wales. Member: AAPL; Lehigh A. All.; St. Augustine AA; Lancaster County AA; Woodmere A. Lg.; Lansdale A. Lg.; Buck Hill AA; Pocono Mt. A. Group; A. Guild, Palm Beach A. Inst.; North Palm Beach A. Soc.; Lake Worth A. Lg. Awards: prizes, St. Augustine AA, 1953, 1956; Lansdale AA, 1935; Call-Chronicle exhs., 1954, 1955; Pocono Mt. regional; popular award, Lancaster Exh., 1961. Work: Allentown A. Mus.; Reading Pub. Mus.; Raub Jr. H.S.; Bethlehem H.S.; Bucks County Pub. Schs.; Call-Chronicle Pub. Co.; Quakertown H.S., and others. Exhibited: Fla. Southern Col., 1952; St. Augustine AA, 1953-1958; Ogunquit A. Center, 1955, 1957; Buck Hill AA, 1949-1951, 1957; Boston Indp. A. AAPL, 1957, 1958; Allentown A. Mus.; Pa. State Mus.; Reading Pub. Mus.; Lehigh Univ.; Woodmere A. Gal.; one-man: Allentown A. Mus., 1949; Lancaster County AA, 1958; Bucks County Sch. Service Center, 1957. Contributor illus. to "Ideals." Positions: Former Instr., Baum A. Sch., Allentown Community College and private classes; Conducts own gallery and art classes in Mountainhome, Pa., from June to Nov. Gives extensive lectures and demonstrations of landscape painting to various organizations.

DREITZER, ALBERT J.—Collector
600 Madison Ave.; h. 45 Sutton Place South, New York, N.Y. 10022
Collection: French Impressionists and Post-Impressionists.

DRERUP, KARL—Craftsman, P., E., Gr.
Thornton, N.H., P.O. Campton, N.H. 03223
B. Borghorst-Westphalia, Germany, Aug. 26, 1904. Studied: in Germany and Italy. Awards: prizes, Syracuse Mus. FA; Wichita, Kans., Nat. Decorative A. Exh.; Medal of Honor, Wichita AA, 1961; Hon. D.F.A., Univ. New Hampshire, 1968. Work: BMA; CM; DMFA; Los A. Mus. A.; Manchester, N.H.; Newark Mus. A.; MMA; San Diego FA Soc.; WMA. Exhibited: Brussels World's Fair, 1958; Syracuse Mus. FA; Wichita, Kans.; Designer-Craftsmen Exh.; Mus. Contemp. Crafts, N.Y., 1959 (3 Americans in Retrospect); BM, 1961; Wichita AA, and others; one-man: DMFA; Tulsa, Okla.; Detroit Inst. A.; San Diego FA Soc.; Manchester Mus. A.; Springfield (Mass.) Mus. A.; Palm Beach, Fla.; New England Crafts, WMA, 1955. Illus. "Carmen," 1930. Positions: Prof. FA, Plymouth T. Col., Plymouth, N.H., 1947-1968.

DRESSER, LOUISA—Museum Curator, L., W.
Worcester Art Museum, 55 Salisbury St. 01608; h. 65 Wachusett St., Worcester, Mass. 01609
B. Worcester, Mass., Oct. 25, 1907. Studied: Vassar Col., B.A.; FMA Sch.; Courtauld Inst., Univ. London. Member: Am. Antiquarian Soc., 1964- . "Seventeenth Century Painting in New England," 1935; "Early New England Printmakers," 1939; "Likeness of America," 1949; Co-author: "Maine and Its Role In American Art," 1963. Contributor to Art in America (monographs on Christian Gullager, 1949, and Edward Savage, 1953); WMA Annual and Bulletin; Antiques magazine. John Simon Guggenheim F., 1956-57. Positions: Assoc. in Decorative A., Cur., Decorative A., 1932-49; Acting Dir., 1943-46; Cur., 1949- ; Ed., WMA Annual, 1958- , WMA, Worcester, Mass. Trustee, Craft Center, Worcester, 1964-1968; Treas., Massachusetts Assn. Craftsmen, 1963-1967. Curatorial and Exhibits Committee, Old Sturbridge Village, 1961- ; Exec. Bd., Worcester Historical Society.

DREW, JOAN—Printmaker, S., L.
19 Elmwood Ave., Rye, N.Y. 10580
B. Indianapolis, Ind., Dec. 21, 1916. Studied: Mass. College of Art; ASL, graphics with Sternberg. Member: Boston Printmakers.

Work: serigraphs & woodcuts, relief prints & wood constructions.; Rochester Mem. A. Gal.; PMA; Lyman Allyn Mus. A.; N.Y. Pub. Lib.; Princeton Univ.; Mus. A., R.I.Sch.Design; CMA. Exhibited: Art in Embassies, 1964-65; MModA, 1957, 1958, 1960; Boston Printmakers, BMFA, 1957-1968; Albright-Knox A. Gal., 1964; Byron Gal., N.Y., 1965; One-man: Lyman-Allyn Mus., 1959; FAR Gal., N.Y., 1960; Yellowstone A. Center, Billings, Mont., 1966; Mayer Gal., Cleveland, 1967, and others. Contributor to New York Times of cover for children's book section, 1960 (serigraph). Included in "Prize-Winning Graphics II," 1964. Lectures, with slides, on serigraph-collage, etc.

DREW-BEAR, LOTTE — Art dealer
 Chicago Feigen Gallery, 226 E. Ontario St., Chicago, Ill. 60611*

DREWELOWE, EVE — Painter, S.
 Studio: 2025 Balsam Drive, Boulder, Colo. 80302
B. New Hampton, Iowa. Studied: Univ. Iowa, A.B., A.M.; Univ. Colorado. Member: Boulder A. Gld.; AEA; Prairie WC Assn. Awards: prize, Colorado State Fair, 1931, 1932, 1950; Springfield Mus. A., Denver A. Mus., 1932; Tri-State Exh., Cheyenne, Wyo., purchase award, 1958; Canon City, Col., 1961; Boulder AA, 1963. Work: Univ. Iowa; Univ. Colorado; Crippled Children's Sch., Jamestown, N.D.; Harkness House, London, Eng.; H.S., Agricultural Col., Cedar City, Utah; Included in tape-recording film, "Colorado Artists," 1966-1967. Exhibited: Nat. Exh. Am. A., N.Y., 1938; WFNY, 1939; PAFA, 1936; AIC, 1939; NAWA, 1939-1944, 1946; Denver A. Mus., 1926, 1931, 1933, 1936, 1938, 1941, 1945, 1959, 1960, 1964, 1965; Univ. Colorado, 1937; Cornell Univ., 1942; Henderson Gal., 1943, 1949 (one-man); Univ. Oklahoma, 1935; Kansas City AI, 1935, 1937, 1940, 1942, 1960; Joslyn Mem., 1934, 1936-1939, 1942, 1944, 1956, 1960, 1962; Boulder A. Gld., 1925-1966; Prairie WC Assn., 1936-1961; Boulder A. Gld. traveling exh., 1954-1956; Arizona State Fair, 1950; Cedar City, Utah, 1944-1966; UNESCO traveling exh., England, 1949; Central City Opera Festival, 1957, 1958, 1964; Nelson Gal.-Atkins Mus., 1960; Canon City, Colo., 1944-1961; Boulder Pub. Lib. Gal., 1965 (one-man); Univ. Arizona, Tucson, 1967. Illus. in "Denim and Broadcloth," 1953. Positions: Pres., Boulder Chpts. AEA, 1963-1968; Pres., Boulder A. Gld., 1962-63; Art Adv. Comm., Boulder Pub. Lib., 1964-1969; Juried Hallmark Colorado School Comp., 1964.

DREWES, WERNER — Painter, Gr.
 Point Pleasant, Pa. 18950
B. Canig, Germany, July 27, 1899. Studied: in Germany, with Klee, Kandinsky. Work: MModA; Honolulu Acad. A.; City of Frankfurt, Germany; FMA; AGAA; AIC; PAFA; SFMA; CAM; SAM; BM; Springfield, Mo.; Springfield, Ill.; State Mus., Trenton, N.J.; WMA; BMA; Guggenheim Mus., N.Y.; Rosenwald Mus., Jenkintown, Pa.; R.I. Sch. Des.; Wash. Univ., St. Louis; Univ. Urbana, Ill.; Bennington Col.; Wells Col.; Mills Col., Oakland, Cal.; Yale Univ.; Univ. Alabama; LC; Newark Pub. Lib.; Boston Pub. Lib.; N.Y. Pub. Lib.; MMA; BMFA; Bush-Reisinger Mus.; Los Angeles County Mus.; Tel Aviv Mus., Israel; Bibliotheque Nat., Paris; Victoria and Albert Mus., London. Exhibited: Carnegie Inst.; AIC; MMA, and many other group shows in U.S., and traveling exhs. abroad. One-man: Van Dieman-Lilienfeld; Kleemann; Nierndorf; Sch. for Social Research; also, Smithsonian Inst.; CMA; Mus. of Legion of Honor, San Francisco; Washington Univ., St. Louis, Mo.; Joslyn A. Mus., Omaha; Everhart Mus., Scranton, Pa.; Trenton State Col., N.J.; and in Europe and South America. Positions: Instr. A., Columbia Univ., 1936-39; Dir., Graphic A. Project, U.S. Federal A. Program, 1940-41; Instr., Brooklyn Col., 1944; Inst. Des., Chicago, 1945; Instr., Des., & Dir. First Year Program, Sch. FA, Washington Univ., St. Louis, Mo., 1946-1965, Prof. Emeritus, 1965.

DREXLER, ROSLYN — Painter
 c/o Kornblee Gallery, 58 E. 79th St., New York, N.Y. 10021; h. 319 W. 14th St., New York, N.Y. 10011*

DREXLER, SHERMAN — Painter
 c/o Graham Gallery, 1014 Madison Ave., New York, N.Y. 10021*

DRIESBACH, DAVID FRAISER — Painter, Pr.M., E.
 Art Department, Northern Illinois University; h. 520 Kendall Lane, DeKalb, Ill. 60115
B. Wausau, Wis., Oct. 7, 1922. Studied: Univ. Illinois; Beloit Col.; Univ. Wisconsin; PAFA; State Univ. of Iowa, B.F.A., M.F.A. Awards: prizes, Iowa State Fair, 1950; Yonkers prize, Des Moines, Iowa, 1950; All Arkansas annual, 1952; Memphis, Tenn., 1953; Sioux City, Iowa, 1953; All Iowa annual, 1953; Central Ill. Valley, 1955; Oakland A. Mus., 1958; Ohio Univ. purchase, 1960-1963; Dayton AI, 1962; Columbus (Ohio) Gal. FA, 1962, 1963; Cal. State Col., Long Beach, 1964; Univ. Kansas, 1964; Wesleyan Col.; Macon, Ga., 1965;

Conn. Acad. FA, 1964. Ford Fnd. purchase prize, 1960; Soc. Am. Gr. A., 1966, 1967; Lincoln Col., 1967. Member: Midwest College Arts Conf.; Cal. Soc. Etchers. Work: State Univ. Iowa; Des Moines A. Center; De Pauw Univ.; Starr King Sch., Oakland, Cal.; Columbus AI; Dayton AI; Beloit Col.; Univ. Kansas; Wesleyan Col.; Olivet Col.; Univ. Cal., Long Beach; No. Illinois Univ.; Mulvane Mus., Washburn Univ.; Kalamazoo Inst. A.; State Univ. N.Y. at Oswego and Oneonta; Miami Univ., Ohio; Bradley Univ.; Carleton Col.; Auburn Univ.; Ohio Northern Univ.; Ohio State Univ.; Waterloo Mun. Gal., Iowa; Peabody Col., Texas. Private port. commissions. Exhibited: Butler Inst. Am. A., 1950; WAC, 1950-1952; AIC, 1951, 1968; Denver A. Mus., 1951, 1958, 1962, 1964, 1966, 1967; MModA, 1952; MMA, 1952; SAM, 1953, 1961, 1964, 1966, 1968; Oakland A. Mus., 1958, 1963; Burpee Gal., Rockford, Ill., 1947-1949; Iowa State Fair, 1950-1952; Central Ill. Valley, 1954-1957; LC, 1960; Boston Pr.M., 1959, 1965, 1966; CMA, 1955; PAFA, 1956, 1958, 1961, 1965, 1967, 1968; Auburn Univ., 1962, 1966; Cal. Soc. Etchers, 1964, 1965; Dayton A. Inst., 1966, 1967; Soc. Am. Gr. A., 1966, 1967; Phila Pr. Cl., 1966, 1968; LC, 1966; Ohio Univ., 1966, 1967, 1968; Kutztown, Pa., 1966; Dulin Gal., Tenn., 1966; Orange Coast, Cal., 1966; Luther Col., 1966, 1967; Neb. Wesleyan, 1967; Beloit Col., 1967, 1968; Wichita AI, 1967; Lincoln Col., 1967; Springfield (Mass.) Col.; 1967; Peoria A. Center, 1967; Okla. A. Center, 1968, and others. Positions: Chm. A. Dept., Hendrix College, 1952-53; Instr., Graphics, Iowa State T. College, 1953-54; Chm., A. Dept., Prof. A., Millikin Univ., Decatur, Ill., 1954-59; Assoc. Prof. Painting, Ohio University, 1959-1964; Assoc. Prof., Northern Ill. University, 1964- .

DRIESBACH, WALTER CLARK, JR. — Sculptor
 2541 Erie Ave., Cincinnati, Ohio 45208
B. Cincinnati, Ohio, July 3, 1929. Studied: Dayton A. Inst. Sch.; A. Academy of Cincinnati. Awards: prizes, Garden Center, Cincinnati, 1956; Memphis Fellowship Exh., 1956; Fleischmann purchase award, Zoo Arts Festival, 1964; Ohio State Fair, 1966, 1968. Work: reliefs, monuments, figures, statues, etc., in churches, convents, and high schools in Dayton, Cincinnati, New Burlington, Middletown, Norwood, Milford, Springfield, all in Ohio. Exhibited: Herron Mus., Indianapolis, 1950; Columbus A. Lg., 1950; CM, 1949, 1950, 1955, 1958-1960, 1963, 1965; Dayton A. Inst., 1959-1961; Zoo Art Festival, 1962-1967; Univ. Cincinnati, 1968; Garden Center, 1967; Canton A. Inst., 1960; Memphis Acad. Faculty Show, 1957; A. Acad., Cincinnati Faculty Show, 1960; Wilmington Col., 1964, 1965 (2-man), and one-man in 1963; Antioch Col., 1966 (2-man); Cincinnati Mens A. Cl., 1967; Jewish Community Center, Cincinnati, 1967, 1969 (both one-man), and 1968.

DRISCOLL, EDGAR JOSEPH, JR. — Critic, W.
 The Boston Globe, 135 Wm. T. Morrissey Blvd. 02171; h. 75 Hancock St., Boston, Mass. 02114
B. Boston, Mass., Sept. 1, 1920. Studied: Cambridge School of Weston; Univ. Iowa, with Grant Wood; Yale Univ. Sch. FA. Member: St. Botolph Club; Yale Club; Harvard Club. Served on many juries of art shows and panels and lectured to various groups on art. Positions: Art Critic, The Boston Globe.*

DRISKELL, DAVID CLYDE — Painter, E., Gr., L.
 Art Department, Fisk University; h. 1601 Phillips St., N., Nashville, Tenn. 37208
B. Eatonton, Ga., June 7, 1931. Studied: Howard Univ., Wash., D.C., A.B. in Fine Arts; Catholic Univ. M.F.A.; Skowhegan (Me.) Sch. of Painting & Sculpture. Member: CAA; Nat. Conf. of Artists. Member, Tennessee Arts Commission's Visual Arts Panel; Board of Advisors, The Museum of African Art, Washington, D.C.; Board of Trustees of the American Federation of Arts. Awards: Skowhegan Fellowship, 1953; Scholastic award in Fine Arts, Howard Univ., John Hope award, Atlanta Univ.; Danforth Fnd. F., 1961; Rockefeller Fellowship, 1964, 1967 (faculty grant); Fellowship, Netherlands Institute for Art History, The Hague, 1964; Harmon Fnd. Award, 1964; Museum Donor Purchase Award, 1963, 1964. Work: Barnett Aden Gal., Howard Univ., Catholic Univ., all Wash., D.C.; Skowhegan Sch. A.; Savery Coll., Talladega College. Rhodes Nat. Gal., Salisbury, So. Rhodesia; Portland (Me.) Mus. A. Arranged and directed exhibitions: "Modern Masters," 1956 (Guggenheim Mus. loan); "26 Prints by Modern Masters," 1959 (Guggenheim Mus. loan) and 1961, and others from Nat. Gallery, Georgia Mus., etc. Positions: Prof. and Chm., Dept. of Art, Fisk University, Nashville, Tennessee.

DRIVER, MORLEY (BROOKE LISTER) —
 Collector, Writer, Critic
 8127 Agnes Ave., Detroit, Mich. 48214
B. London, England, Jan. 13, 1913. Studied: Slade School, London; Univ. California, B.A., M.A. and with Roger Fry and Bernard Berenson. Member: Phi Beta Kappa, Theta Sigma Phi, Kappa Kappa Gamma. Author: A series of articles on art for beginners printed in book form as a public service with no financial return to newspaper or author. Contributor of articles for magazines, television,

book reviews, etc. Collection: all media—Impressionists, Braque to Giacometti, Shahn, Baskin, Piper, Moore, Robert Parker, Picasso, Matisse, and others. Positions: Writer, Critic, Detroit Free Press; Ward's Quarterly.

DRUDIS, JOSÉ—Painter, L.
 5455 Wilshire Blvd., Los Angeles, Cal. 90036
B. Alvinyo, Spain, Dec. 15, 1890. Studied: Sch. FA, Barcelona; Univ. Barcelona. Awards: prizes, Barcelona, Spain; Traditional A. Exh., 1955; Friday Morning Cl., Los A., 1955; Pacific Coast Cl., Long Beach, Cal., 1955; gold med., Cal. A. Cl., 1955 (2), 1959; Ebell Cl., Los A., 1956; Les Palmes Academiques, Republic of France; Commander Cross, Grand Prix Humanitaire Belge, Belgium; gold medal, City of Mataró, Spain; Medal of Honor, Scandinavian-American A. Soc., Los Angeles, 1950, 1959; gold medal, Home Show, Pan-Pacific Auditorium, 1969. Work: Los A. Mus. A.; Royal Palace Mus., Madrid; Phoenix A. Center; Los A. City Hall Mus.; Pasadena A. Mus.; Los A. Mus. A.; Circulo de Bellas Artes de Madrid; Carson Estates; Del Amo Fnd., Los A.; Clarethian Seminary, Compton, Cal., and in private colls. U.S. and abroad. Exhibited: one-man: Los A. Mus. A.; Univ. Cal. at Los Angeles; Middlebury Univ., Vt.; Ralston A. Gal., N.Y.; City Cl., Boston; Arch. Cl., Boston; O'Bryan A. Gal., Chicago, Ill.; J.J. Guillespie Gal., Pittsburgh; Santa Barbara A. Lg.; Evanston (Ga.) Hotel; Dalzell Hatfield Gal., 1958; Whittier (Cal.) A. Mus., and others. Positions: Fndr. & Pres., José Drudis Foundation, Los Angeles, Cal.; Fellow, and Chm., Am. Inst. FA, Los Angeles, Cal.; Vice-Pres., Carson Estate Co.; Founder, Asociacion de Acuarelistas Catalanes.

DRUMM, DON—Sculptor, C.
 110 Corson Ave., Akron, Ohio 44302
B. Warren, Ohio, Apr. 11, 1935. Studied: Hiram Col.; Kent State Univ., B.F.A., M.A. Member: Ohio Des.-Craftsmen; Am. Craftsmens Council. Awards: prizes, Nat. Soc. Interior Des., 1965; CMA, purchase, 1964; Columbus Gal. FA. Work: Akron A. Inst.; CMA; Wooster Col.; Columbus Gal. FA; Massillon Mus.; Kent State Univ.; Bowling Green Univ.; reliefs, walls, steel sculpture, fountains for Alcoa Co., Pittsburgh; Galleries III, Charlottesville, Va.; Newton Falls Methodist Church; Kent State Univ.; City of Akron, and other commissions. Exhibited: Mus. Contemp. Crafts, N.Y., 1964, 1965, traveling exh. circulated by AFA, 1965-1967; Mus. West, San Francisco, 1965; Berea Col., 1965; CMA, 1964-1968; Butler Inst. Am. A., 1960; Columbus Gal. FA, 1966, 1967. Positions: Instr., Sculpture, Akron A. Inst.; A.-in-Res., Bowling Green Univ., 1966- .

DRUMMOND, MRS. CHARLES HAWKINS. See Grafly, Dorothy

DRUMMOND, SALLY HAZELET—Painter
 1 Wilton Rd. East, Ridgefield, Conn. 06877
B. Evanston, Ill., June 4, 1924. Studied: Rollins Col., Fla.; Columbia Univ., B.S.; Inst. Des., Chicago; Univ. Louisville, M.A. Awards: Fulbright Grant, Venice, 1952-1953; Guggenheim Fellowship, 1967-1968. Work: MModA; WMAA; J. B. Speed Mus., Louisville, Ky.; Hirshhorn Coll. Exhibited: Kentucky-Indiana Exh., 1951; Mus. FA of Houston, 1959; WMAA, 1960, 1964; AFA traveling exh., 1962-1963; MModA, 1964; New Jersey State Mus., Trenton (2-man),1967; J. B. Speed Mus., 1967.

DRYFOOS, NANCY PROSKAUER—Sculptor
 301 E. 47th St., New York, N.Y. 10017
B. New Rochelle, N.Y. Studied: Sarah Lawrence Col.; Columbia Univ. Ext.; ASL, and with Jose de Creeft. Member: NAWA; Knickerbocker A.; Brooklyn Soc. A.; Am. Soc. Contemp. A.; NSS; Audubon A.; All. A. Am.; Lg. of Present Day A.; N.Y. Soc. Women A.; P. & S. Soc. New Jersey. Awards: prizes, NAC, 1947; New Jersey P. & S., Soc., 1950, 1957; Village A. Center, 1950; Westchester A. & Crafts Gld., 1950, 1951; Knickerbocker A., 1953, 1958; NAWA, 1953; Hudson Valley AA, 1953; Silvermine Gld. A., 1953; gold medal, All. A. Am., 1953, 1967; Brooklyn Soc. A., 1955; Am. Soc. Contemp. A., 1968. Work: Brandeis Univ.; Sarah Lawrence Col.; N.Y. Univ.; Evanston Mus. A.; and in private colls. Exhibited: PAFA; Syracuse Mus. FA; BM; Riverside Mus.; Jersey City Mus. A.; NAD; Westchester County A. Center; Silvermine Gld. A.; NAC; Phila. A. All.; DMFA; CGA; Albright Gal. A.; YMHA, N.Y., 1952, and others. One-man: Contemporary A., 1952; Dime Savings Bank, Brooklyn, 1967; Silvermine Gld. A., 1954; Wellons Gal., 1956; Bodley Gal., 1958; Collectors Gal., Wash., D.C., 1960. Des. and executed medal for Am. Jewish Tercentenary, 1954; medallion, Dickenson College; 12 brass plaques for Kingsbridge House; Naomi Lehman Mem. Award; Joseph M. Proskauer Award; Alice Proskauer Award; Mildred Goetz Mem. Plaque.

DUBANIEWICZ, PETER PAUL—Painter, T., L.
 Cleveland Institute of Arts, 11141 East Blvd. 44106; h. 3289 Fairmount Blvd., Cleveland, Ohio 44118
B. Cleveland, Ohio, Nov. 17, 1913. Studied: Cleveland Inst. A.; BMFA Sch. A. Member: Cleveland Soc. A.; AWS; AAUP. Awards:

prizes, Cleveland May Show awards, 1942-1960; Alabama WC Soc., 1951-1953; Chautauqua, N.Y.; Ranger Fund, NAD, 1956; Ohio State Fair, Illinois State Fair; prize, Int. Platform Assn., Washington, D.C., 1966, and others. Work: City of Cleveland; Willoughby (Ohio) School System; East Cleveland Pub. Lib.; CMA; Butler Inst. Am. A.; and in churches, banks and hospitals in Ohio. Mural: Third Federal Savings Bank, Cleveland; mural, chancel wall, (Redeemer Lutheran Church, Brook Park, Ohio), 1968. Exhibited: CGA; PAFA; MMA; Butler Inst. Am. A.; Springfield (Mass.) Mus. FA; CMA; Art: USA; Watercolor U.S.A., 1968, and in galleries and museums in U.S. Positions: Instr., Cleveland Institute of Arts, Cleveland, Ohio, at present.

DUBIN, RALPH——Painter, T., Gr.
 2770 W. Fifth St., Brooklyn, N.Y. 11224
B. New York, N.Y., Sept. 2, 1918. Studied: City Col., N.Y., BMSch. A. Work: PAFA. Exhibited: WMAA, 1948; AIC, 1954; VMFA, 1954; Am. Inst. A. & Let., 1955, 1961; Butler Inst. Am. A., 1956; MModA, 1956; Springfield Mus. FA, 1956; BM; Des Moines A. Center; Edw. Root A. Center, Hamilton Col., 1961; one-man: RoKo Gal., 1947; Charles Fourth Gal., 1948, 1949; Kraushaar Gal., 1954, 1957, 1961, 1963, 1968. Positions: Instr. painting & drawing, children's classes, Brooklyn Mus. A., at present. Also Instr. A., N.Y. Community College and Queens College, N.Y.

DUBLE, LU—Sculptor
 17 E. 9th St., New York, N.Y. 10003
B. Oxford, England, Jan. 21, 1896. Studied: ASL; NAD; CUASch., and with Archipenko, deCreeft, Hofmann. Member: ANA, NSS; S. Gld.; Audubon A. Awards: Guggenheim F., 1937, 1938; F., Inst. Int. Edu.; prize, NAWA, 1937; Audubon A., 1950, gold medal, 1958; Nat. Acad. A. & Let., 1952; med., Audubon A., 1947. Work: Newark Mus. A.; WMAA. Exhibited: PMA, 1940; Carnegie Inst.; Montclair A. Mus., 1941; MMA, 1942, 1952; PAFA, 1942-1946; WMAA, 1946, 1947; NAD, annually; Audubon A. annually; S. Gld.; NAWA, annually; Marie Sterner Gal., 1938 (one-man); Toledo Mus. A., 1939; Riverside Mus. Positions: Vice-Pres., Audubon A., 1950-55; Instr. S., Greenwich House, New York, N.Y., at present.*

DUCA, ALFRED MILTON—Painter, S., E., Des., W., L.
 8 Arlington St., Annisquam, Gloucester, Mass. 01930
B. Milton, Mass., July 9, 1920. Studied: Pratt Inst., Brooklyn; BMFA Sch. A. Awards: prizes, Independent A., Boston, 1954; Boston A. Festival, 1957; Rockefeller Grant, 1959, 1960; Ford Fnd. Grant, 1961. Work: WMA; FMA; Addison Gal. Am. Art; Munson-Williams-Proctor Inst., Utica, N.Y.; BMFA; Brandeis Univ.; Temple Emanuel, Swampscott, Mass; Prudential Center, Boston, Mass.; sculpture, Castle Square Housing, Boston, 1966; John F. Kennedy Post-office, Boston, 1968. Exhibited: one-man: Downtown Gal., N.Y., 1961; Springfield (Mass.) Mus. FA, 1954, DeCordova & Dana Mus., 1952; Boston Gallery, 1947, 1949, 1950, 1951, 1954, 1957, 1958, 1961, 1967; Brockton A. Center Mus., 1952; in France and Italy; numerous traveling group shows. Author: The Polymer Tempera Process for Painting and Sculpture; The Foam Vaporization Process for Sculptors. Contributor to technical journals. Positions: Research Assoc., 1960-1962, Visiting Scholar, 1964, Research Affiliate, Mass. Inst. Technology, 1965- ; Member, Mass. Council on the Arts and Humanities; Special Governor's Comm. to investigate for an Arts Council, 1966 which was established; was elected member and re-appointed, 1967; Member, Community Educational Planning, 1960-1969; Consultant to Boston Museum of Fine Arts, 1966, Curriculum Development of Boston Museum School; Cultural Fnd. of Boston, 1966, and many other civic and professional organizations.

DUFOUR, PAUL ARTHUR—Painter, Gr., E.
 Louisiana State University 70803; h. 975 Aberdeen Ave., Baton Rouge, La. 70808
B. Manchester, N.H., Aug. 31, 1922. Studied: Univ. New Hampshire, B.A.; Yale Univ., B.F.A.; Univ. Tokyo; Kyoto Univ. Fine Arts. Member: Southeastern College Art Conf.; CAA; AAUP. Awards: Yale Achievement Award, 1952; Currier Gallery Award, 1952; Beaumont Art Mus.; Masur Mus. award and purchase, 1968; Grad. Council Research Grant to Japan, 1964; Louisiana State Univ. Council on Research awards, 1964, 1965, 1968, 1969. Work: stained glass window, Capital Bank & Trust Co., Baton Rouge; Caldwell Bank & Trust, Columbia, La.; Crucifix, Our Lady of the Lake Hospital and St. Joseph Academy, Baton Rouge; painting, Louisiana National Bank and American Bank & Trust Co., Baton Rouge; Chapel, Greenwell Springs Hospital, 1968; silvered bronzed Monstrance, St. Aloysius Church and St. Charles Borromeo Church; bronze doors, Bishop's Chapel and St. Joseph's Prep School Chapel. Work also in private collections. Exhibited: Yale Univ. A. Gal.; Currier Gal. Art, Manchester, N.H.; Carpenter Gal., Dartmouth Col.; Lamont Gal., Phillips Exeter Acad.; Fitchburg Mus. A.; Brick Store Mus., Kennebunk, Me.; Boston A. Festival; WAC; Catholic Univ. of Am., Wash. D.C.; Delgado Mus. A.; Southeast and Southwest Annual of Am. Art, At-

lanta, Ga. and Norman, Okla.; Lake Charles Regional; Louisiana Art Commission Annual, Baton Rouge; Delta Annual, Little Rock; others, 1962-64 include Beaumont A. Mus.; Liturgical Art Exhibition, Nat. Biennial Drawings; DMFA; Nat. Graphic Arts & Drawings Exh.; Tokyo Univ.; Kyoto Univ. of Fine Arts; Retrospective exh., Louisiana State Univ., 1966; Masur Mus. A.; Weatherspoon Gal., Univ. North Carolina, and others. Positions: Supv. Educ., Currier Gallery of Art; Dir., Currier Art Center; Asst. Prof., St. John's Univ., Collegeville, Minn.; A.-in-Res., Viterbo Col., La Crosse, Wis., 1968; Asst. Prof., Assoc. Prof., Prof., Louisiana State University, Baton Rouge, La., at present.

DUGMORE, EDWARD—Painter
100 West 14th St., New York, N.Y. 10011
B. Hartford, Conn., Feb. 20, 1915. Studied: Hartford A. Sch. (Scholarship); Cal. Sch. FA, San F., with Clyfford Still; Univ. Guadalajara, Mexico, M.A. Awards: Kohnstamm Award, AIC, 1962; A.F.A.-Ford Fnd. sponsored A-in-Res., Montana Inst. of the Arts, Great Falls, 1965; Guggenheim Fellowship, 1966-1967. Work: Museum purchase fund, New York City, 1954; Albright-Knox A. Gal., Buffalo; Univ. Southern Illinois, Carbondale; WAC; Housatonic Community Col., Stratford, Conn.; Geigy Chemical Corp., and in private colls. U.S. and Europe. Exhibited: Carnegie Inst., 1955; WAC, 1955; Albright A. Gal., Buffalo, 1956; Albright-Knox A. Gal., 1961; MModA traveling Exh., France, 1956; AIC, 1961; Guggenheim Mus., 1961; SFMA, 1963; Univ. Texas, Austin, 1964, 1968; one-man: Metart Gal., San F., 1949; Stable Gal., New York, 1953, 1954, 1956; Holland-Goldowsky Gal., Chicago, 1959; Howard Wise Gal., New York, 1960-61, 1963; Howard Wise Gal., Cleveland, 1960. Positions: Instr., Painting & Drawing.(part-time), Pratt Inst., Brooklyn, N.Y.

DUHME, H. RICHARD, JR.—Sculptor, E.
St. Louis School of Fine Arts, Washington University; h. 8 Edgewood Rd., St. Louis, Mo. 63124
B. St. Louis, Mo., May 31, 1914. Studied: PAFA; Univ. Pennsylvania; Barnes Fnd.; Washington Univ., B.F.A.; Am. Sch. Classical Studies, Athens, Greece. Member: All. A. Am.; NSS. Awards: Cresson award, PAFA, 1935; Rome prize, 1937; Ware F., 1938; Hon. mention, Prix de Rome, 1939; PAFA, 1941; A. Gld., St. Louis, 1948; Vassar Col., 1949; St. Louis Festival of Religion & the Arts, 1955. Work: Fountain, Overbrook, Pa.; port. mem., Centralia, Mo.; Granite City, Ill., St. Louis, Mo.; Graham Medal; fountain, Clayton (Mo.) YWCA; fountain group, Carondolet Bldg., Clayton, Mo.; plaque, Wash. Univ. Sch. of Dentistry; figure, St. Louis Priory Sch., 1957; Aviation Safety award, Monsanto Chemical Co., 1958; Plaque, Ralston Purina Co., 1958; Nat. Council Churches medal; Concordia Seminary medal; American Baptist Peach Plaque; sc., Nat. Humane Edu. Center, Waterford, Va.; Family and Children's Service Bldg., St. Louis, Mo.; fountain, Mycenae, Greece. Exhibited: PAFA, 1938-41, 1950; MMA, 1942; CAM, 1936-1939, 1947-1952, 1961; St. Louis A. Gld., 1948, 1949; Cosmopolitan Cl., Phila., 1940; Phila. A. All., 1939-1941; People's A Center, St. Louis, 1952, 1961; All A. Am., 1956, 1959-1961; NAD, 1957, 1960, 1961; Providence A. Cl., 1958; Chautauqua A. Center, 1958, 1959, 1961; John Herron AI, 1961. Positions: Assoc. Prof., Sculpture, Washington Univ., St. Louis, Mo., 1947- ; Instr. (summer) Syracuse Univ., Chautauqua Center, N.Y., 1953- .

Du JARDIN, GUSSIE (Mrs. Elmer Schooley)—
Painter, S., Gr.
Montezuma, N.M. 87731
B. San Francisco, Cal., Feb. 19, 1918. Studied: Univ. Colorado, B.F.A.; State Univ. Iowa, M.A. Awards: Roswell Mus. A., N.M.; purchase, New Mexico Biennial, 1960, 1962, 1964. Work: New Mexico Highlands Univ. (Collaborated) fresco, Las Vegas (N.M.) Hospital. Exhibited: Mus. of New Mexico traveling exh., 1953, 1954, 1956, 1957, 1960-1965, 1968; annual graphic art exh., Mus. New Mexico, 1952-1955; New Mexico A., 1953, 1954; New Mexico State Fair, 1951-1954; Fiesta Exh., 1951-1963; Mississippi Nat. Oil Exh., 1961; Butler Inst. Am. A., 1961; Southwestern A. Festival, Tucson, Ariz., 1969.

DUNBAR, GEORGE B.—Painter, T.
Box 524, Slidell, La. 70458
B. New Orleans, La., Sept. 20, 1927. Studied: Tyler Sch. FA, Philadelphia; Grande Chaumiere, Paris, France. Awards: prizes, Tyler Sch. FA; Delgado Mus. A., 1965; Brandeis Univ.; Tri State South painting exh. (purchase); Edgewater A. exh. Work: Lykes Bros. Co., New Orleans; Hilton Inn, New Orleans. Exhibited: Temple Univ.; Delgado Mus. A.; Parma Gal., N.Y.; Dubin-Lush Gal., Philadelphia; Denver A. Mus.; Riverside Mus., N.Y.; Bressler Gal., Milwaukee; Birmingham Mus. A.; Pensacola A. Center, and in Tokyo, Manila, Hong Kong, Vienna, etc. Positions: Instr., Tulane Univ., New Orleans, La.

DUNCALFE, W. DOUGLAS—Painter, E., Des., L.
224 Willoughby Ave., Brooklyn, N.Y. 11205
B. Vancouver, B.C. Canada, Sept. 11, 1909. Studied: ASL; Shaw Sch.

of Toronto, Can.; PIASch., B.F.A.; New Sch. Social Research, and with Robert B. Hale. Exhibited: SFMA, 1942, 1943; Oakland A. Mus., 1942; Vancouver (B.C.) A. Gal., 1934-1938; ACA Gal., 1947; AWS, 1946, 1947; Audubon A., 1947, 1948; MMA, 1948; WMAA, 1948; Fairleigh Dickinson Col., Rutherford, N.J., 1953 (one-man); City Col. of N.Y., 1953; Little Gal., Hudson Park Branch of N.Y. Pub. Lib., 1955 (one-man); pictures and textile exh., of City College at N.Y. Pub. Lib., 1955, BM, 1960; Pratt Inst., 1960, 1966 (one-man), and others. Lectures extensively to universities, art assns. and on television. Positions: Instr., Art Career Sch., N.Y., 1947-55; Traphagen Sch. of Fashion, N.Y., 1947-55; City Col. of New York, Ext. Div., 1951-54; Jamesine Franklin Sch. Prof. A., N.Y., 1952-55; Fairleigh Dickinson Univ., 1953; N.Y. Univ., 1956; Assoc. Prof. A., & Assoc. Chm., Dept. of Foundation A., Chm. Evening A. Dept. Pratt Inst., Brooklyn, 1953-.

DUNN, ALAN (CANTWELL)—Cartoonist, W., P.
c/o New Yorker Magazine, 25 West 43rd St., New York, N.Y. 10036
B. Belmar, N.J., Aug. 11, 1900. Studied: NAD; Tiffany Fnd.; Fontainebleau, France; Columbia Univ.; Visiting F., Am. Acad. in Rome. Member: Author's Gld. of the Author's Lg. Work: Works in various museums; comprehensive collections in Lib. of Congress & Alan Dunn manuscript coll. at Syracuse Univ. Paintings and cartoons exh. in nat. and internat. exhs. Author: "Rejection," 1932; "Who's Paying for this Cab?," 1945; "The Last Lath," 1947; "East of Fifth," 1948; "Should It Gurgle?," 1957; "Is There Intelligent Life on Earth?," 1960; "A Portfolio of Social Cartoons by Alan Dunn," 1968. Positions: Staff Contributor to New Yorker and Architectural Record magazines. Contributes to other magazines and newspapers.

DUNN, CAL(VIN) (E.)—Painter, Film-maker
Cal Dunn Studios, 141 West Ohio St., Chicago, Ill. 60610; h. 2920 Orange Brace, Riverwoods, Ill. (c/o Deerfield P.O.) 60015
B. Georgetown, Ohio, Aug. 31, 1915. Studied: Cincinnati A. Acad.; Central Acad. Comm. A. Member: AWS; Chicago A. Gld.; Acad. TV Arts & Sciences; Chicago Assn. Commerce & Industry; Bd. Dirs., Nat. Acad. Television Arts & Sciences; Directors Gld. of America. Awards: prizes, Chicago A. Gld., 1948-1951, 1955; Chicago "Magnificent Mile" A. Festival, 1952, 1953; Union Lg., Chicago, 1955; Visual Presentation Comp. (Sales Motion Picture), 1956; bronze medal, American Artist Magazine, 1956; TV Commercial exh., Chicago A. Gld., 1957; Nat. Offset & Litho. Comp., 1957; Defensive Driving Series (six, 10 min. motion pictures), Nat. Comm. For Films on Safety Comp., 1957; bronze plaque (10 min. animated motion picture), Nat. Comm. for Films on Safety, 1957; merit award, Nat. Safety Council, 1959; A. Gld. Chicago, 1959, 1960, 1961, 1962 (purchase); merit award, TV Commercial, Chicago Fed. Adv. Exh., 1961; color movie selected for showing at Am. Film Festival, 1960, and others. Work: Ford Motor Co. coll.; Allstate Insurance Co., Am. A. Group and in many private colls. Watercolor story assignments, Ford Times magazine, 1950-58; Life Insurance Assn. award, 1964. Exhibited: AWS, annually; Butler Inst. Am. A., 1954-1958; AWS traveling exh., 1957; Ford Times traveling exh., 1950-1958; Des Moines Assn. FA, 1939; Cornell Col, 1940; Davenport A. Gal., 1939; Am.-British A. Center, N.Y., 1941; Cincinnati Mod. A. Soc., 1941, 1942; Riverside Mus., 1942; AIC, 1946, 1950, 1951; CM, 1941, 1942; Union Lg., Chicago, 1955, 1956, Lake Geneva, 1954-1956; Magnificent Mile, 1952-1954; Chicago A. Gld., 1942-1958; Royal Gal., London, 1963; one-man: Davenport, Iowa, 1940; Cincinnati, Ohio, 1942; Chicago, Ill., 1952-1954; Evanston, Ill., 1956. Positions: Cartoons for Esquire, Ford Times, New Yorker, Post, Life, etc.; Animation A. Dir., Training Films, USAF, Wright Field, Dayton, Ohio, 1944-47; A. Dir., Sarra, Inc., Training Films, U.S. Navy; Dir., Cal Dunn Studios, producing cartoons for advertising, slidefilms and motion pictures for sales and training and TV commercials, at present.

DUNN, NATE—Painter, T.
490 Carley Ave., Sharon, Pa. 16146
B. Pittsburgh, Pa., July 4, 1896. Studied: Carnegie Inst. Tech., and with Arthur Sparks, G. Sotter, C. J. Taylor and others. Member: Buckeye A. Cl., Youngstown, Ohio; F., Royal Soc. Arts, London, England. Awards: prizes, Butler Inst. Am. A., 1952; St. John's Biblical Exh., Sharon, Pa.; Midland, Pa.; Conneaut Lake, Pa., 1959, 1960; Steubenville (Ohio) Annual, 1964, 1969; Jewish Community Center, Youngstown, Ohio, 1969. Work: Pa. State Col., and in many private colls. Exhibited: Midyear and New Year exhs., Butler Inst. Am. A., annually; Assoc. A., Pittsburgh; Conneaut Lake, Pa.; Canton, Ohio, 1951; one-man: Playhouse, Pittsburgh, 1958; Butler Inst. Am. A.; Canton, Ohio, 1960; Mansfield (Pa.) T. Col., 1961; Thiel Col., Greenville, Pa., 1961.

DUNN, O. COLEMAN—Collector
917 Kearns Bldg., 136 S. Main St. 84101; h. 633 North 1st West St., Salt Lake City, Utah 84116
B. Raymond, Alta., Canada, Mar. 27, 1902. Collection: British and

American Paintings and Drawings; European Old Masters. Exhibited collection of Paintings, Salt Lake City Art Center, 1963; Paintings and Drawings, Salt Lake Art Center, 1964.

DUNNINGTON, MRS. WALTER GREY—
Collector, Patron, Mus. President
Parrish Art Museum, Jobs Lane, Southampton, N.Y.; h. 960 Fifth Ave., New York, N.Y. 10021
B. Long Branch, N.J., Aug. 17, 1910. Studied: Smith College, B.A.; Bryn Mawr College, Post-Grad. in History. Collection: Furniture, Porcelain, Painting; Drawing. Positions: Treas., Women's Committee, Philadelphia Museum of Art, 1938-41; Pres., Bd. Trustees, Parrish Art Museum, Southampton, N.Y.; Dir., N.Y. Horticultural Society.

DUNWIDDIE, CHARLOTTE—Sculptor
35 East Ninth St., New York, N.Y. 10003
B. Strasbourg, France, June 19, 1907. Studied: with Dr. Wilhelm Otto, Acad. Art, Berlin; Mariano Benlluire y Gil, Madrid, and with Alberto Lagos, Buenos Aires. Member: Fellow, NSS; NAC; Pen & Brush Cl.; All. A. Am.; Fellow, Royal Soc. A., London, England; Hudson Valley AA; AAPL; Soc. Women Geographers. Awards: prizes, Pen & Brush Cl., 1958 (2), Gold Medal, 1962; Wolfe A. Cl., 1962, 1964; Gold Medal, 1966; AAPL, 1963; All. A. Am., 1962, 1964; Medal of Honor, NAC, 1964; Silver Medal, NSS, 1966; Ellin Speyer prize, NAD. Work: Marine Corps Mus., Wash., D.C.; Church of Santa Maria, Cochabamba, Bolivia (monument); Church of the Good Shepherd, Lima, Peru (monument); Throne Room of the Cardinal's Palace, Buenos Aires (port, bust); Bank of Poland, Buenos Aires (bas relief); Aqueduct Clubhouse, N.Y.; Mount St. Alfonsus, Suffield, Conn. Sculpture in Europe, South America and the United States. Positions: Pres., Pen & Brush Club, 1966– ; Sec., Nat. Sc. Soc., 1966-1969; Dir., Council of American Art Societies; Dir., AAPL.

Du PEN, EVERETT GEORGE—Sculptor, E.
University of Washington 98105; h. 1231 20th Ave., East, Seattle, Wash. 98102
B. San Francisco, Cal., June 12, 1912. Studied: Univ. So. California; Chouinard AI; Yale Univ. Sch. FA, B.F.A., and with Gage, Lukens, Sample, Snowden. Awards: Tiffany Scholarship, 1935-36; European F., 1937-38; Music & Art Fnd. award, 1950; Univ. Washington Grad. Sch. Grant, 1954; Saltus gold medal, NAD, 1954; Bellevue A. & Crafts Fair, 1957; European travel & Univ. Grant, 1964. Member: Research Soc. of Univ. Wash.; Municipal A. Comm. of City of Seattle; All. A. Am.; Northwest Sculpture Inst. (Pres., 1957); NSS (Fellow); All. A. of Seattle; Am. Craftsmens Council. Work: bronze fountain, State Lib., Olympia, Wash.; carvings, bronzes, churches, cathedrals and seminaries in Tacoma, Seattle and Longview, Wash., 1958-61; steel relief, Georgia Hotel, Vancouver, B.C.; fountain, Seattle Worlds Fair, 1962; carved wall and crucifix, St. John's Episcopal Church, Seattle; Baptismal Font, Emmanuel Episcopal Church, Seattle; Municipal Bldg., Seattle (carved screen), and others. Exhibited: Am. Acad. in Rome, 1937; NAD, 1954, 1956-1959; CAM, 1939-1942; San F. AA, 1943, 1954; Northwest Annual, 1945-1960; NSS, 1949; PAFA, 1950, 1958; Sculpture Center, 1951-1953; SAM, 1952 (one-man); Detroit Inst., 1958; Portland (Ore.) A. Mus., 1958; Bellevue A. & Crafts, 1950-1960; Henry Gal., Seattle, 1955-1961; Northwest Inst. Sc., 1955-1961; Wash. AA, 1957, 1958; Art:USA, 1958; Frye Mus. A., 1958-1961; Oregon Ceramic, Portland; SFMA, 1959, and others.*

DU PRE, GRACE ANNETTE—Portrait Painter
Studios: 361 Mills Ave. 29302, also, 3025 S. Pine St., Spartanburg, S.C. 29302
B. Spartanburg, S.C. Studied: Converse Col.; Grand Central A. Sch., and with Wayman Adams, Frank DuMond. Member: All. A. Am.; NAC; Grand Central A. Gal.; AAPL (Nat. Bd.); Carolina AA; Portraits, Inc.; Catherine L. Wolfe Cl. Awards: prizes, Ogunquit A. Center, 1951; AAPL, 1953; Wolfe A. Cl., 1955, and others. Work: White House; U.S. Supreme Court, Wash., D.C.; ports. 13 active Judges: U.S. Court of Appeals, Seventh Circuit, Chicago; State Capitol, S.C.; Law Bldg., Univ. Indiana; port., U.S. Senator Strom Thurmond; Law Lib., Columbia Univ.; Lib. Univ. of the South, Tenn.; Medical Col. & City Hall A. Gal., Charleston, S.C.; other Federal courts and pub. bldgs.; Clemson Col.(S.C.); The Citadel, Charleston; State Sch. for the Deaf and Blind, S.C.; port. coll., The Church of the Ascension, New York, N.Y.; official port. coll., New York City Main Post Office. Many portraits of prominent persons in South Carolina, including South Carolina's Chief Justice Taylor; Port. of Hon. James F. Byrnes for new library at The Citadel, Charleston; Justice Tom Clark, U.S. Supreme Court, 1968; Governor McNair, Governor's Mansion, Columbia, S.C., 1968; many others of lawyers and industrialists in South Carolina, 1967-1969. Exhibited: nationally; many one-man exhs.

DURCHANEK, LUDVIK—Sculptor, P.
Wassaic, N.Y. 12592
B. Vienna, Austria, Aug. 29, 1902. Studied: Worcester Art Museum; ASL, and with Romero, Corbino. Awards: prize, Silvermine Gld. A., 1963. Work: MModA; St. Paul Gal. A.; Storm King Art Centre, Mountainville, N.Y., and in many private collections. Exhibited: WMAA, 1963, 1965; MModA, 1959; R.I. Sch. Des., Providence; Silvermine Gld. A., 1963; Denver A. Mus., 1959; Los A. Mus. A., 1960; CAM, 1960; BMFA, 1960, etc.*

DUREN, TERENCE ROMAINE—Painter, I., L.
Shelby, Neb. 68662
B. Shelby, Neb., July 9, 1907. Studied: AIC; Fontainebleau, France; & in Vienna. Member: NSMP; F.I.A.L.; Int. Platform Assn. Awards: prizes, AIC, 1928; CMA, 1933, 1934, 1936; Joslyn Mem., 1943; Springfield (Mass.) Mus. A.; Pepsi-Cola, 1946; Terry AI, 1952; Fla. Southern Col., 1952; Franklin County (Neb.), 1952; Lincoln A. Gld., 1952. Work: AIC; CMA; CGA; Carnegie Inst.; Joslyn Mem.; Butler AI; murals, Pub. Bldgs., Cleveland, Columbus, Ohio. Exhibited: AIC, 1927, 1928; CMA, 1930-1941; Joslyn Mem., 1942-1946; Carnegie Inst., 1945, 1946; Los A. Mus. A., 1945; SFMA; Dallas Mus. FA; New Orleans, La.; Prairie WC Painters, 1944-1946; Cowie's Gal., Los A., 1952 (one-man); Grand Central A. Gal., 1945, 1946, 1950, 1955; Art:USA, 1958; Galerie Internationale, N.Y., 1961. I., cover drawings for "Panoramic Review," World Herald, Omaha, Neb.; Fortune & other publications; Illus. for "The American West" (Lucius Beebe), 1955; The World Books, 1960-61; Funk & Wagnall's Encyclopedias, 1960-61.*

DURIEUX, CAROLINE (Mrs.)—Lithographer, P.
772 West Chimes St., Baton Rouge, La. 70802
B. New Orleans, La., Jan. 22, 1896. Studied: Newcomb Col., Tulane Univ., B.A.; Louisiana State Univ., M.A.; PAFA with Henry McCarter. Member: Phila. WC Cl.; Baton Rouge Gal.; New Orleans AA; Audubon A. Awards: prizes, Delgado Mus. A., 1944; LC (purchase) 1944, 1946, 1952; 50 Prints of the Year, 1944; 50 Books of the Year, 1949. Work: MModA; PMA; N.Y.Pub.Lib.; VMFA; Bibliotheque Nationale, Paris; Gibbes A. Gal.; Brooks Mem. Gal.; AGAA; Atomic Mus., Oak Ridge, Tenn., Rosenwald Coll., NGA; LC. Exhibited: MMA; PMA; NAD, and others; one-man: Galleria Central, Mexico City; Delgado Mus. A.; VMFA; Witte Mem. Mus.; Mus. FA of Houston; Anglo-American Mus., Louisiana State Univ., 1968; Greenville County Mus., 1966; Retrospective, Louisiana State Univ. Library, Alexandria, La., 1969. Univ. Tulsa; FA Club of Chicago; Burlington Mus.A. Developed "Electron Printing" from radioactive drawing in collaboration with Dr. Harry Wheeler. Developed color Clichés-Verre Techniques in collaboration with Dr. Christman of the Louisiana State University Chemistry Dept. Positions: Prof. FA, Louisiana State Univ., Baton Rouge, La. (Emeritus, 1964- .)

DUTTON, BERTHA P.—Museum Director, E., W., L.
Museum of Navaho Ceremonial Art, Inc., Box 5153, Santa Fe, N.M. 87501
B. Algona, Iowa, Mar. 29, 1903. Studied: Univ. Nebraska; Univ. New Mexico, B.A., M.A.; Columbia Univ., Ph.D. Member: No. Arizona Soc. of Science and Art; Arizona Archaeological & Hist. Soc.; Bd., Southwestern Assn. on Indian Affairs; Archaeological Soc. of New Mexico; Southwest Anthro. Assn.; Soc. for Am. Archaeology; Sociedad Mexicano de Antropologia; Congress of Americanista (Intl.). Awards: Alice Fletcher Traveling Fellowship, 1935; Sch. of Am. Research Scholarship, 1936; Sch. Am. Research Grant-in-Aid, 1950; AAIW Fellowship, 1953-54; Wenner-Gren Fnd. Grant, 1962; Nat. Science Fnd. Grant-in-Aid, 1962-63; Columbus Explorations Fund Grant, 1964, 1965, 1968. Certificate of Appreciation, Indian Arts and Crafts Board, U.S. Dept. of the Interior, 1967. Author, I., "Leyit Kin, a Small House Ruin, Chaco Canyon, N.M.," 1938; "Excavations at Tajumulco, Guatemala" (with H. R. Hobbs), 1943; "The Pueblo Indian World" (with E. L. Hewett), 1945; Ed., "Pajarito Plateau and Its Ancient People," 1953; "Indians of the Southwest," 1965; "Sun Father's Way," 1963; "Friendly People, the Zuñi Indians," 1968 2nd ed.; "Navaho Weaving Today," 1968 4th ed.; "Indians of New Mexico," 1968; "Let's Explore! Indian Villages Past and Present," 1970, plus other monographs and articles (some 200 titles in all). Contributor to: El Palacio; Archaeology; American Antiquity; New Mexico Quarterly; Santa Fe New Mexican, etc. Lectures: Archaeology and Ethnology; Indian Arts & Crafts, to schools, clubs, civic organizations, etc. Planned and supervised remodeling of a building which became the Hall of Ethnology, Mus. of N.M., and prepared and installed new exhibitions. Positions: Instr., Anthropology, Univ. New Mexico TV course and adult classes at Taos, N.M., 1947-57; St. Michael's Col., Santa Fe, 1965 (Anthro.); Dept. Sec., Dept. of Anthropology, Univ. New Mexico, 1933-36; Cur., Ethnology, Museum of New Mexico, Santa Fe, N.M., 1938-1959; Cur., Interpretation, 1960-1962; Cur., Div. of Research, 1962-1965. Director, Museum of Navaho Ceremonial Art, Inc., 1966- .

DUVOISIN, ROGER A.—Illustrator, W.
 Gladstone, N.J. 07934
B. Geneva, Switzerland, Aug. 28, 1904. Studied: Col. Moderne, Ecole
des Arts et Metier, Ecole des Beaux-Arts, Geneva, Switzerland.
Awards: AIGA, 50 Best Books of the Year, 1933, 1938, 1939, 1948,
1950, 1957, 1958-1960; 50 Best Children's Books, 1945-1950, 1953,
1954, 1965-1966, 1967-1968; Caldecott med., 1948; Herald Tribune
award, 1944-1952; N.Y. Times (Ten Best), 1954, 1955, 1965; West
German Govt. first prize for Juvenile Books, 1956; Rutgers Univ.
Bi-Centennial award, 1966. Exhibited: MModA; Phila. A. All.;
WMA; Mus. City of N.Y.; Bratislava Bienniale of illustration, 1967;
U. of Minnesota, 1967; in various museums and colleges, and abroad.
Author, I., 42 juvenile books; I., 100 juvenile & adult books. Con-
tributor to New Yorker and other magazines.

DWIGHT, EDWARD H.—Museum Director
 Munson-Williams-Proctor Institute, 310 Genesee St., Utica,
N.Y. 13502
B. Cincinnati, Ohio, Aug. 2, 1919. Studied: Yale Univ.; Cincinnati
A. Acad.; St. Louis Sch. FA. Awards: F., Ford Fnd. for research
on J.J. Audubon, 1961. Member: AAMus. Dirs. Contributor to Print;
Antiques; Art in America; Art News; Canadian Arts. Exhibitions
arranged: "Juan Gris," 1948; "Paintings by the Peale Family,"
1954; "Rediscoveries in America Art," 1955; "Still Life Painting
Since 1470," 1956; "El Greco, Rembrandt, Goya, Cézanne, Van
Gogh, Picasso," 1957; "Ralston Crawford," 1958; "American Paint-
ing, 1760," 1960; "Masters of Landscape: East and West," 1963;
"Audubon Watercolors and Drawings," 1965. Positions: Dir.,
Cincinnati A. Mus., 1954-55; Dir., Milwaukee A. Center, & Cur. Lay-
ton Coll., 1955-1962; Dir., Museum of Art, Munson-Williams-Proc-
tor Institute, Utica, N.Y., at present.

DYCK, PAUL—Painter, L.
 Box 127, Camp Verde, Ariz. 86322
B. Chicago, Ill., Aug. 17, 1917. Studied: with Johann von Skramlik in
Prague, Florence, Rome and Paris. Work: Phoenix A. Mus.; Mus.
of Northern Ariz., and private colls. in U.S., Canada, England, Nor-
way & Italy. Exhibited: One-man: Cowie Gal., Los Angeles, 1955-
1957, 1959; O'Brien Gal., Phoenix, 1955-1960; Gilday Gal., San
Francisco, 1960; Southwest Mus., Los Angeles, 1960; Phoenix A.
Mus., 1961. Other one-man exhs. 1962-1965: Chicago Mus. Natural
History; Montana Hist. Soc.; Camelback Gals., Scottsdale, Ariz.;
Rosequist Gal., Tucson, Ariz. (1962-1965); Swarthe-Burr Gals.,
Beverly Hills, Cal.; Raymond Burr Gal., Beverly Hills, Cal.; Mus.
Northern Arizona, Flagstaff; Stable Gals., Scottsdale (1964, 1965);
Heard Mus., Phoenix; Ariz. State Mus., 1966; Rosequist Gal., Tuc-
son, 1966-1969; Gal. Mod A., N.Y., 1966, 1969; Yuma FA Assn. &
Hist. Soc. Mus., 1969. Lectures extensively on "American Indian
Culture." Painter of the American Indian Series of "The Indians of
the Overland Trail." Author: "Brulé Sioux," 1969.

DZUBAS, FRIEDEL—Painter
 147 Wooster St., New York, N.Y. 10012
B. Berlin, Germany, Apr. 20, 1915. Awards: Guggenheim Fellow-
ship, 1966; John Simon Guggenheim Memorial Fnd. Fellowship, 1966,
1968. Work: BMA; Guggenheim Mus. A.; Yale Univ.; Phil-
lips Collection, Wash., D.C.; Dayton AI; Aldrich Coll., Ridgefield,
Conn.; Cornell Univ.; CAM; N.Y. Univ.; Rose A. Mus., Brandeis
Univ.; Manufacturers Hanover Trust Co., N.Y.; Chase Manhattan
Bank; Woodward Fnd., Wash., D.C. Exhibited: AIC, 1942-1944;
Kootz Gal., N.Y., 1950; Stable Gal., N.Y., 1957; WMAA, 1958, 1959,
1963; Guggenheim Mus. A., 1961; CGA, 1963, 1967, 1968; Dayton AI,
1963; Los A. Mus. A., 1964; Inst. Contemp. A., Boston, 1967-1968;
Expo '67, Montreal; Wash. Gal. Mod. A., 1967; Univ. Illinois, 1967;
Detroit Inst. A., 1967; Los Angeles County Mus., 1964; Jewish Mus.,
N.Y., 1964; Carnegie Inst., 1961; Toronto, Canada, 1964; one-man:
Tibor de Nagy Gal., N.Y., 1952; Leo Castelli Gal., N.Y., 1958;
French & Co., N.Y., 1959; Dwan Gal., Los Angeles, 1960; Robert
Elkon Gal., N.Y., 1961-1963, 1965; Kasmin, Ltd., London, England,
1964, 1965; Emmerich Gal., N.Y., 1966-1968; Wilder Gal., Los An-
geles, 1966. Positions: A.-in-Res., Dartmouth College, 1962; Visit-
ing Artist, University of South Florida; Artist Member, symposium
on art education, N.Y. University, 1964; A. Critic, Cornell Univ.,
1967.

EAGLE, CLARA M.—Educator, C., Des., Serigrapher
 Murray State College, Division of Art, 1206 Olive Blvd.,
Murray, Ky. 42072
B. Columbus, Ohio, June 16, 1908. Studied: Ohio State Univ., B.S. in
Edu., M.A.; Sch. for Am. Craftsmen, and with John Huntington.
Member: AAUP; Am. Assn. Univ. Women; CAA; Western AA (Ken-
tucky Rep.); Southeastern Col. AA; Kentucky Edu. Assn.; Kentucky
A. Edu. Assn.; Kentucky Gld. A. & Craftsmen; NEA; NAEA; Louis-
ville A. Center Assn.; Am. Craftsmens Council; Kappa Delta Pi.
Awards: prize, Louisville, Ky.-Indiana Annual, 1961; hon. men.,

Silversmithing, Evansville Tri-State, 1959. Exhibited: Am. Crafts-
men's Council Show, Gatlinburg, 1960; Evansville Tri-State, 1959,
1965; Louisville-Indiana Annual, 1959, 1960; Mississippi River Craft
Show, 1965; Louisville Kentuckiana Exh., 1965. Positions: A. Supv.,
Mayfield Heights, Ohio, 1930-36, Mt. Vernon, Ohio, 1936-44, Ashta-
bula, 1944-45, Findlay, 1943-46, Rio Grande Col. (summer), 1946;
Hd., Div. Art, Murray State Col., Murray, Ky., 1946- . Ky. State A.
Chm.; AAUW, 1958-62; Pres., 1954-55, 1961-62, Ky. A. Edu. Assn.
Served Ed. Bd. for A. Edu. Curriculum Guide, Ky. Dept. of Edu.
Sponsor, Kappa Pi.*

EAMES, JOHN HEAGAN—Printmaker, P.
 Boothbay Harbor, Me. 04538
B. Lowell, Mass., July 19, 1900. Studied: Harvard Col., B.A.;
Royal Col. A., London, and with Robert Austin, Malcolm Osborne.
Member: ANA; SAGA; Assoc., Royal Soc. of Painter-Etchers, Lon-
don, England (1969). Awards: prizes, SAGA, Kate W. Arms award,
1952, 1954, 1957; John Taylor Arms award, 1953; Henry B. Shope
award, 1957; purchase prize, Albany Inst. Hist. & Art, 1957. Work:
LC; MMA, and in private colls. Exhibited: Venice, Italy, 1940;
Royal Acad., London, 1940; PAFA, 1940; NAD, annually to 1965;
AAPL, 1940, 1941; LC, 1942, 1945; Carnegie Inst., 1945; East Hamp-
ton, N.Y., 1946; Albany Inst. Hist. & A., annually; BM, 1950; Albright
A. Gal., 1951; Sweat Mus. A., 1952, 1957; SAGA, annually; Am. Acad.
A. & Let., 1953; Smithsonian Inst. traveling exh., 1954; SAGA ex-
change exh., England, 1954; Oakland (Cal.) Mus. A., 1958; Contemp.
Graphic Art-Overseas, USIS, 1960.

EAMES, MRS. RICHARD COMYN. See Parish, Betty Waldo

EASBY, DUDLEY T., JR.—Museum Executive
 The Metropolitan Museum of Art, 10028; h. 110 East End Ave.,
New York, N.Y. 10028
B. Lock Haven, Pa., Dec. 3, 1905. Studied: Princeton Univ., B.S.;
University of Pennsylvania Law School, LL.B. Awards: Research
Grant from the American Philosophical Society for study of pre-Co-
lumbian metalwork in Mexico, 1959; Hon. Fellow (Life), Archaeolog-
ical Inst. of America; Hon. Member, Hopi Cultural Center; Com-
mander, Peruvian Order of Merit; Officer, Peruvian Order of the
Sun. Contributor articles and lectures on Pre-Columbian metal-
lurgy and metalworking. Positions: Consulting Fellow, Univ. Penn-
sylvania Museum; Trustee, American Federation of Arts, Louis
Comfort Tiffany Foundation, Allen Tucker Memorial. Past Presi-
dent, Institute of Andean Research.

EASLEY, LOYCE (Mrs. Mack)—Painter, T.
 523 East Yucca Dr., Hobbs, N.M.88240
B. Weatherford, Okla., June 28, 1918. Studied: Univ. Oklahoma,
B.F.A. with major in Art Edu. & grad. work with Leonard Good;
Grad. work, Eastern New Mexico Univ., for major in Elem. Edu.
Also studied with Frederic Taubes. Member: New Mexico A. Lg.
(honorary life mbr.). Awards: prizes, Annual Fiesta, Mus. New
Mexico, 1961, 1963; El Paso Artists, 1961; South Plains A. Gld.,
1959. Roswell Mus.; Midland Mus.; Llano Estacado Exh. Work:
First Nat. Bank of Santa Fe Coll.; Office of Sec. of State, N.M.;
Rental-Sales Dept., Mus. N.M. Gallery; El Paso Mus. A.; Roswell
Mus. A.; Col. of Sante Fe; Texas Tech. Col.; U.S.Air Force Acad-
emy, Colorado Springs, Colo. Exhibited: Ford Fnd. Comp., 1959;
Sun Carnival, El Paso, 1957, 1963; El Paso Mus., 1961; included in
group shows from 1960, 1963 Biennial at Mus. of New Mexico; and
Santa Fe Rodeo Exh., 1958 which traveled nationally; Roswell Mus.,
1955-1958; Mus. New Mexico Rodeo Exh., 1955-1958; Fiesta Show,
1958, 1960, 1961; New Mexico Artists, 1958, 1960; 7 States Southwes-
tern A. Biennial, 1959, 1960, 1962; Nat. Exh. Univ. Arts, Seattle,
1964; Panhandle South Plains Fair, Lubbock, 1958; Univ. Oklahoma
A. Sch., 1963; Selected Artists Gal., N.Y., 1963; All-Oklahoma Exh.,
1964; Botts Mem. Gal., Albuquerque; NAD; Oklahoma A. Center;
Mus. New Mexico, 1961-1969(traveling exh.), and others. One-man:
Mus. New Mexico, 1959, 1961, 1963; Maude Sullivan Gal., El Paso;
Hobbs Pub. Lib., 1956; Hobbs Country Club, 1961; El Paso Mus.;
Texas Tech. Col.; New Mexico State Univ.; and others. 2-man: Mus.
New Mexico, 1957. Positions: Inst. A., Okmulgee, Okla. schools,
1946-47; Hobbs, N.M. schools, 1947-49; workshops and individual
instruction for children and adults.

EATON, MYRWYN L.—Educator, P., L., W.
 1633 Canyonwood Court, Walnut Creek, Cal. 94595
B. Strawberry Point, Iowa, July 30, 1904. Studied: State Univ. Iowa,
B.A.; Harvard Univ., M.A.; Chicago Acad. A.; AIC, and special
training with Arthur Pope, Harvard Univ. Member: AAUP. Awards:
Harvard Univ. Scholarships: Townsend, 1930-31; Bacon, 1933-34;
European Travel Grant, 1938. Exhibited: WMAA, 1952; Carnegie
Inst., 1955; Nat. Soc. Painters in Casein; Riverside Mus.; one-man:
Laguna Beach, 1947; George Binet Gal., N.Y., 1947, 1948, 1950;
United Nations Cl., Wash., D.C., 1950; Andre Maurice Gal., Paris,
1949; Worth Gal., Palm Beach, 1952; Hofstra Col., 1948; Houston,

Tex., 1957; Gal. Contemp. A., N.Y. Univ.; Walnut Creek, Cal., 1967 (one-man). Positions: Instr. A., North Dakota State Col.; Harvard Univ.; Radcliffe Col.; Prof. A., New York Univ., New York, N.Y., 1938-1964; Co-ordinator of Studio Courses, Div. of Gen. Edu., New York Univ.

EAVES, WINSLOW BRYAN—Sculptor
 Winslow Eaves Art Works, P.O. Potter Place, N.H. 03265
B. Detroit, Mich., Sept. 8, 1922. Studied: Cranbrook Acad. A., with Marshall Fredericks, Carl Milles; ASL, with William Zorach; Academie Beaux-Arts, Paris, France. Awards: prizes, Rome Comp., 1942; Fulbright grant, 1949-50; Syracuse Mus. FA, 1947; Manchester (N.H.) A. Festival, 1954; N.Y. State Fair, 1957; Finger Lakes-Rochester Exh., 1956; and others. Work: Cranbrook A. Mus.; Northwestern H.S.; Munson-Williams-Proctor Inst.; Dartmouth Col.; Univ. New Hampshire; Syracuse Univ.; monument, Melvin Village, N.H.; Eagle Mountain House, Jackson, N.H.; Univ. Vermont Medical Bldg.; Mechanics Nat. Bank, Concord, N.H.; Cornwall (N.Y.) Central H.S.; Color TV program, "The World and Work of Winslow Eaves," Northeast Networks, 1968. Exhibited: WMAA, 1948, 1949; MMA, 1951; Phila. A. All., 1947; Syracuse Mus. FA. ceramic exh., 1947-1950; Michigan A., 1940-1942; A. of Central N.Y., 1946-1949, 1956; one-man: Utica, N.Y.; 3 in New York City and 1 in France. Contributed chapter on welded sculpture in William Zorach's book, "Zorach Explains Sculpture." Positions: Instr., S., & Ceramics, Munson-Williams-Proctor Inst., Utica, N.Y., 1946-49; Visiting Sculptor, Dartmouth Col., 1953-55; Instr., S., Syracuse Univ., N.Y., 1955-1958. Asst. Prof., in Art, Dartmouth Col., 1958-1968.

EBERMAN, EDWIN—Designer, E., P.
 Famous Artists Schools, Westport, Conn. 06880; h. Wahackme Rd., New Canaan, Conn. 06840
B. Black Mountain, N.C., Feb. 20, 1905. Studied: Carnegie Inst., B.A. Member: A. Dir. Cl.; SI; AIGA. Co-author: "Technique of the Picture Story," 1945; Author, I., "Nantucket Sketch Book," 1946. Contributor to Arts & Decoration and Look magazines. Positions: A. Dir., Lord & Thomas Adv. Agency, 1937-41; Look Magazine, 1941-47; Sec. & Dir., Famous Artists Schools, Westport, Conn., 1947- .

ECKE, GUSTAV—Museum Curator
 Honolulu Academy of Arts, 900 South Beretania St., Honolulu, Hawaii 96814
Positions: Cur., Chinese Art, Honolulu Academy of Arts; Prof. Oriental Art, University of Hawaii.*

ECKER, DR. DAVID W.—Educator
 Dept. of Art Education, New York Univ., Washington Square, New York, N.Y. 10003*

ECKERT, WILLIAM DEAN—Educator, P., Gr.
 Dept. of Art, Lindenwood College; h. 620 Yale Blvd., St. Charles, Mo. 63301
B. Coshocton, Ohio, Oct. 10, 1927. Studied: Ohio State Univ., M.A., B.A., B.F.A.; State Univ. Iowa, Ph.D. Member: CAA; MCAC, AAUP; A. Com., Schenectady Mus. (vice-chm, 1967-1968). Awards: prizes, Akron AI, 1954 (2); Ohio State Fair, 1956; Strawn Art Center, Jacksonville, Ill. (2), 1964. Work: Butler Inst. Am. A. Exhibited: Sarasota AA, 1956, 1957; Ringling Mus. A., 1956; Ohio State Fair, 1956; Fla. Fed. A., 1956; Ohio Univ., Athens, 1957; State Univ. Iowa, 1958; others 1959-1965: Decatur A. Center; Quincy A. Center; Bradley Univ.; Western Illinois Univ.; Culver-Stockton Col., Canton, Mo.; Strawn Art Center; Albany Inst. A., 1966-1967; Schenectady Mus., 1966, 1967; Cooperstown A. Assn., 1966. Juror: Upper Hudson Valley Regional, Albany Inst. A., 1968. Positions: Instr. A., College of Wooster, Wooster, Ohio, 1953-54; Fla. Southern College, Lakeland, 1954-57; Grad. Asst., State Univ. Iowa, 1957-59; Asst. Prof., Western Illinois Univ., Macomb, Ill., 1959-1965; Assoc. Prof., Union College, Schenectady, N.Y., 1965-1968. Assoc. Prof., Lindenwood Col., St. Charles, Mo.

ECKSTEIN, JOANNA—Collector, Patron
 802 33rd St. East, Seattle, Wash. 98102
B. Seattle, Wash., July 28, 1903. Studied: Goucher College, Baltimore, Md., B.A. Collection: Contemporary Paintings including works by Tobey, Appel, Jenkins, Callahan and others. Positions: Curator, USIA exhibition of American paintings and sculpture, England and France, 1957-1958; Trustee and Docent, Seattle Art Museum.

EDGERLY, BEATRICE (Mrs. J. Havard Macpherson)—
 Painter, Lith., I., T., Cr., W.
 6161 E. Pima Ave. & Wilmot Rd. 87516; (mail) P.O. Box 4182, University Station, Tucson, Ariz.
B. Washington, D.C. Studied: Corcoran Sch. A.; PAFA; & abroad. Member: Phila. A. All.; NAWA; Mystic AA; Author's Gld.; Tucson Press Cl. Awards: F., PAFA; prizes, PAFA, 1921; NAWA, 1937;

Tucson FA Assn., 1938, 1939. Work: PAFA. Exhibited: PAFA; NAD; CGA; Tucson FA Assn.; Mystic AA, 1953 (2-man exh. with J. Havard Macpherson); Tucson, Ariz., 1954 (one-man); Milwaukee Pub. Lib., "Music & Art Exh.," 1954 (book & illus. of "From the Hunter's Bow"); Arizona State Col., 1955. Author, I., "Ararat Cocktail," 1939; "From the Hunter's Bow," 1942. Contributor to American Artist magazine; Arizona Highways magazine; Flying Magazine; AOPA Pilot's Magazine.

EDIE, STUART CARSON—Painter, E.
 111 South Summit St., Iowa City, Iowa 52240; s. Marfil, Guanajuato, Mexico
B. Wichita Falls, Tex., Nov. 10, 1908. Studied: Kansas City AI; ASL. Member: Woodstock AA. Awards: Joslyn Mem. Mus.; WAC; Des Moines A. Center; Mid-America annual; Minn. Centennial; Sioux City A. Center; Mulvane A. Center; A. of Miss. Valley. Work: MMA; WMAA; Davenport Mus. A.; Grinnell College; Tarkio College, Tarkio, Mo.; BM; Syracuse Mus. FA; Newark Mus.; Univ. Iowa; Univ. Georgia; mural, USPO, Honeoye Falls, N.Y.; Toledo Mus. A.; Joslyn Mem. Mus.; Kansas City AI; ASL; Des Moines A. Center; Mulvane A. Center; State Col. of Iowa. Exhibited: MModA; Carnegie Inst.; WMAA; PAFA; NAD; AIC; BM; John Herron AI. Positions: Prof. Painting, Univ. Iowa, Iowa City, Iowa.

EDMONDSON, LEONARD—Painter, Et., E.
 714 Prospect Blvd., Pasadena, Cal. 91103
B. Sacramento, Cal., June 12, 1916. Studied: Univ. California, Berkeley, A.B., M.A. Member: Los Angeles Printmaking Soc.(Pres. 1966), CAA; Bd. Memb., Pasadena A. Mus.; Pasadena Soc. A.(Pres. 1967). Awards: Tiffany Fnd. grant, 1952, 1955; Guggenheim F., 1960; prizes, SFMA, 1946, 1949, 1951-1953, 1957; Los A. Mus. A., 1957; Los A. County Fair, 1950-1953, 1956; James Phelan awards, San F., 1951, 1953; Cal. State Fair, 1951, 1952, 1962; BM, 1951, 1956; SAM, 1952-1954, 1959; Oakland A. Mus., 1952-1955, 1958; Pasadena A. Mus., 1952, 1954, 1957, 1958, 1962; Bradley Univ., 1952, 1955; MMA, 1952; Cal. WC Soc., 1953, 1955-1958; Univ. Illinois, 1954, 1955; DMFA, 1954; SAGA, 1957; LC, 1957, 1963; Cal. State Col., Long Beach, 1964, 1965; Am. Color Pr. Soc., 1954, 1955; VMFA, 1958; Otis A. Inst., 1962, 1963; Miracle Mile of A., Los Angeles, 1966-1968; Gold Crown Award for Outstanding Leadership in the Visual Arts from Pasadena Arts Council & Cultural Affairs, 1968; City of Los Angeles, All-City Festival, bronze medal and hon. mention, 1962-1964, and prize 1967; Los Angeles Pr.M. Soc., 1968, and others. Cal. State Col. at Los Angeles grant, 1965, 1967. Work: SFMA; Bibliotheque Nationale, Paris; Victoria & Albert Mus.; NGA; State of California; SAM; N.Y. Pub. Lib.; UCLA; Art Council, Pakistan, Karachi; Los A. Mus. A.; Pasadena A. Mus.; Univ. Illinois; LC; DMFA; Oakland A. Mus.; PMA; MMA; VMFA; BM; De Cordova & Dana Mus.; Rosenwald Coll.; Univ. North Dakota; Otis A. Inst.; USIA, and in many universities and colleges. Exhibited: AIC, 1948, 1957; MMA, 1952; Los A. Mus. A., 1947-1958; BM, 1950-1958, 1968; Denver A. Mus., 1947-1958; PAFA, 1951-1969; WMAA, 1952, 1953, 1955, 1956, 1958; Univ. Illinois, 1953-1969; Sao Paulo, Brazil, 1955; Guggenheim Mus., 1954; Carnegie Inst., 1955, 1959; VMFA, 1958; CGA, 1953, 1956, 1959; Print Council of America, 1959, 1962; Int. Graphics Exh., Switzerland, 1964; N.Y. Worlds Fair, 1964; Laguna Beach Gal., 1966; Tokyo, Japan, 1964; Univ. North Carolina, 1965; Carleton Col., 1966; Temple Univ., 1967; Long Beach Mus., 1963, 1965, 1966, 1969; one-man: deYoung Mem. Mus., 1952; Pasadena A. Mus., 1953; Santa Barbara Mus. A., 1953, 1966; Cal. Sch. FA, 1956; Landau Gal., Los Angeles, 1950-1953, 1955, 1958, 1960; The Gallery, Denver, 1963; Comara Gal., Los Angeles, 1963; Adele Bednarz Gal., Los Angeles, 1965, 1968; Laguna Beach Gal., 1964; Oklahoma City Univ., 1964; DeCordova & Dana Mus., 1967; SFMA, 1967; Swihart Int. Gal., 1968; Ventura (Cal.) Col., 1969; Heath Gal., Atlanta, Ga., 1969. Included in "Prize Winning Oil Paintings," 1960; "Prize Winning Graphics," 1963; " 11 Prints by 11 Printmakers," 1963. Positions: Prof. Pasadena City Col., 1947-1954, 1956- ; Chm., Des., Los Angeles County AI, 1954-1956; Instr., Summer Sessions, Univ. So. California, 1957.

EDWARDS, ETHEL (Mrs. Xavier Gonzalez)—Painter
 222 Central Park South, New York, N.Y. 10019
B. New Orleans, La. Studied: Newcomb Col. A. Sch., New Orleans, and with Xavier Gonzalez. Member: McDowell Colony Alumni. Awards: prizes, Larry Aldrich prize, Silvermine Gld.; Watercolor: USA, Springfield, Ill., 1967; Ball State Univ., Muncie, Ind., 1967. Work: IBM; Chase Manhattan Bank, N.Y.; Commerce Trust Bank, Kansas City, Mo.; BMFA; Springfield Mus. A.; Univ. Nebraska. Exhibited: Butler Inst. Am. A., Youngstown, Ohio, 1964-1969; Hartford Atheneum, 1967, 1968; Watercolor:USA, 1967-1969; Cape Cod AA, 1969; WMAA, 1964, 1965.

EDWARDS, KATE F(LOURNOY)—Portrait Painter
 The Darlington, Apt. 1105, 2025 Peachtree Rd., Northeast, Atlanta, Ga. 30309
B. Marshallville, Ga. Studied: AIC; Grande Chaumiere, Paris, and

with Charles Hawthorne. Member: Atlanta AA. Awards: prizes, Southeastern Fair Exh., 1916; Atlanta AA, 1921. Work: The Capitol, Wash., D.C.; First Nat. Bank, and Aidmore Children's Hospital, Atlanta, Ga.; Georgia Sch. Tech.; Mercer Univ.; Wesleyan Col., Macon, Ga.; Univ. Georgia; Wake Forest (N.C.) Col.; Governor's Palace, Puerto Rico; Court House, Atlanta, Ga.; High Mus. A.; Headquarters Bldg., Ft. Benning, Ga.; City Lib., Dayton, Wash.; Westminster Sch., Atlanta, Ga.; Fourth Nat. Bank, Columbus, Ga.; Court House, New Bern, N.C.; Univ. Illinois; Federal Reserve Bank, Atlanta; Calhoun Mem. Lib., Atlanta; Johnson Sch., Columbus, Ga.; Decatur-DeKalb Lib., Decatur, Ga.; Columbia Theological Seminary, Decatur; McCall Hospital, Rome, Ga.; Tinsley School, Macon, Ga.; Georgia Indst. Home, Macon; Georgia Federated Mutual Ins. Bldg., Atlanta; Oglethorpe Univ., Atlanta; Rome Bank & Trust Co., Rome, Ga.; Davenport House, Savannah; Willington Sch., Macon; Telephone Bldg., Dalton, Ga.; Lovett Sch., Atlanta, Ga.; U.S. District Court, Northern District of Georgia.

EGAN, CHARLES—Art Dealer
 Egan Gallery, 41 E. 57th St., New York, N.Y. 10022
B. Philadelphia, Pa., June 29, 1911. Specialty of Gallery: Modern American Art.

EGRI, TED—Sculptor, P., L., T.
 Taos, N.M. 87571
B. New York, N.Y., May 22, 1913. Studied: Master Inst., Roerich Mus., N.Y.; Hans Hofmann Sch. A. Member: AEA; Taos AA. Awards: prizes, Audubon A., 1946; Mus. New Mexico, 1965. Work: Wm. Rockhill Nelson Gal. A.; Mus. New Mexico; Jewish Community Center, Scranton, Pa.; Baylor Theater, Waco, Tex.; Northern Iowa Univ.; Mt. Sinai Temple, El Paso, Tex.; Executive Life Bldg., Beverly Hills, Cal.; Christ Luthern Church, Meridian, Miss.; Temple Emanuel, Denver; Public Park, Albuquerque, N.M. Exhibited: PAFA, 1953; Birmingham, Ala., 1954; Univ. Ill., 1952, 1953, 1955, 1961; Denver A. Mus., 1949, 1953, 1954, 1962; DMFA, 1958, 1960; Colo. Springs F.A. Center, 1950, 1952; Mus. New Mexico, 1951-61, 1963, 1965, 1966, 1968; SFMA, 1960; Santa Barbara Mus. A., 1956; Univ. of Judaism, Los Angeles; St. Luke's Methodist Church, Oklahoma City, 1968; Rocky Mountain Liturgical Arts Assn., Denver, 1966, 1967, 1969. Lectures: Understanding Modern Art; The Creative Process; Synthetics in Art; Abstraction in Art. Positions: Instr., Kansas City A.I., 1948-50; Philbrook A. Center, Tulsa, Okla., 1956, 1957; Visiting L., Univ. Wyo., 1959-60; Univ. Ill., 1960-61; Northern Iowa Univ., summers 1963, 1964; College of Santa Fe, 1968.

EHRENREICH, EMMA—Painter, Wood Eng., Et., L.
 817 Broadway; h. 55 Park Ave., New York, N.Y. 10016
B. New York, N.Y., Sept. 19, 1906. Studied: NAD; BMSch.; New Sch. for Social Research; City Col., N.Y.; Long Island Univ.; Grad. Sch., Hunter Col., and with Abraham Rattner, Morris Davidson. Member: NAWA: Am. Soc. Contemp. A.; Audubon A.; Hunterdon County A. Center; AEA; N.Y. Soc. Women A.; Nat. Soc. Painters in Casein; Provincetown AA. Awards: Prizes, NAWA, 1950, 1955, 1962, 1963, 1966, 1968; Am. Soc. Contemp. A., 1951, 1952, 1954, 1957, 1958, 1959, 1964 (2), 1965 (2); Riverside Mus. (purchase award), 1960; Audubon A. 1962, 1968; Nat. Soc. Painters in Casein, 1968. Work: Denver A. Mus.; Brandeis Univ.; Gouverneur Hospital; Riverside Mus.; Time & Life; Glickenstein Mus., Safed, Israel; Norfolk Mus. A.; Lawrence White Fnd; Slater Mus., Norwich, Conn. and in private collections. Exhibited: Brooklyn Soc. A., 1951, 1952; BM, 1953, 1957, 1959, 1961; Butler AI, 1954, 1957, 1958; Denver A. Mus., 1955; Fed. Mod. A. traveling exh., 1954, 1958; Nat. Exh., Jewish Tercentenary, 1955; BM, 1955; CGA; PAFA; Dayton Inst. A.; NAWA traveling exh., Greece, Belgium, 1958, Holland, Sweden, 1956-57; Japan, 1960; Rio de Janeiro, 1960; Sao Paulo, 1960; Buenos Aires, 1962 traveling shows, 1963-1969, to South America, India, France & Canada. One-man: Silvermine Gld. A., 1958; in many museums in U.S. and New York galleries; Contemporary A., 1953, 1955-1959, 1962, 1964, 1966; Temple Gates Gal., Utica, N.Y., 1963; Beryl Mills Gal. N.Y., 1964, 1969; Vendome Gal., Pittsburgh, 1966. Included in "Prize Winning Watercolors," 1963. Positions: Memb. Bd., Am. Soc. Contemp. A.; NAWA; N.Y. Soc. Women A.; Nat. Soc. Ptrs. in Casein; NSPC; Memb. Bd. & Publicity Chm., AEA.

EHRMAN, FREDERICK L.—Collector
 1 William St., New York, N.Y. 10004; h. Woodheath Farm, Armonk, N.Y. 10504
B. San Francisco, Cal., Jan. 3, 1906. Studied: Univ. California, A.B. Collection: Paintings, Sculptures (various). Positions: Dir. Beckman Instruments; Dir., The Greyhound Corporation; Dir., Playskool Mfg. Company; Dir., Lehman Corporation.*

EICHENBERG, FRITZ—Printmaker, Eng., Lith., I., T., W.
 University of Rhode Island, Kingston, R.I. 02881; h. 142 Oakwood Dr., Peace Dale, R.I. 02879
B. Cologne, Germany, Oct. 24, 1901. Studied: State Acad. Graphic

A., Leipzig, and with H. Steiner-Prag. Member: Royal Soc. A., London; SAGA; NA; AIGA; Awards: prizes, LC, 1943-1948, 1951; PAFA, medal, 1944; NAD, 1946; Distinguished service award, Limited Editions Cl., 1950. Work: N.Y. Pub. Lib.; LC; AIC; Univ. Minnesota Lib.; Rosenwald Coll.; Carnegie Inst.; BM; MMA; Spencer Coll., N.Y. Pub. Lib.; Hermitage, Leningrad; Bibliotheque-Nationale, Paris. Exhibited: PAFA, 1940-1952; NAD, 1938-1952; LC, 1943-1952; Carnegie Inst., 1943-1952; AIGA, 1938, 1940, 1944; SAGA; Xylon Int.; U.S. State Dept. Foreign Embassies Program, Graphics Exh., USSR, 1963; traveling in India, Southeast Asia, Japan, for the John D. Rockefeller III, Fund Graphics Survey, 1968; one-man: N.Y. Pub. Lib., 1949; Phila. A. All., 1949; New School, 1949; Univ. Maine, 1950; Cornell Univ., 1964; Brandeis Univ., 1964; one-man retrospective, Assn. Am. Artist, N.Y., 1967. Illus., "Richard III"; "Eugene Onegin," "War and Peace"; "Brothers Karamazov," 1949; " Jane Eyre"and "Wuthering Heights," 1943; "Crime and Punishment," 1938-48; "Reynard the Fox"; "The Idiot"; "The Possessed," 1960; Tolstoy's "Resurrection," 1963. Author-I., "Ape in a Cape," "Dancing in the Moon," and many other children's books. Author: Pendle Hill pamphlet "Art and Faith." Contributor to Horn Book, Print Magazine, Graphis Magazine; Penrose Annual; etc. Lectures: Book Illustration; Graphic Arts at various schools and colleges. Positions: Instr., Gr. A., New School for Social Research, 1935-40; Memb. Council, NAD, 1953-56; Dir. Emeritus and Founder, Pratt Inst. Graphic A. Centre, Dir. & Vice-Pres., AIGA, 1964-65; Prof. Arts, Chm., Dept. Graphic Arts, The Art School, Pratt Inst., Brooklyn, N.Y., 1956-1963; Ed., "Artist's Proof," an annual for Printmakers. Memb. Pennell Committee, Library of Congress, 1960-1967. Chm., A. Dept., Univ. Rhode Island, Kingston, 1966- .

EIDE, PALMER—Educator, P., S.
 2025 Austin Drive, Sioux Falls, S.D. 57105
B. Minnehaha County, S.D., July 5, 1906. Studied: Augustana Col., B.A.; AIC; Harvard Univ.; Yale Univ.; Cranbrook Acad. A. Member: AAUP; Com. on A., Nat. Council of Churches of Christ in America; CAA; Am. Oriental Soc. Awards: Scholarships, Harvard Univ., 1936-1937; F., Yale Univ., 1940, 1941; prizes, Sioux City A. Center, 1966; Augustana Alumni Award for Distinguished Service; Hon. D.F.A., Saint Olaf College, 1968. Work: S., City Hall, Broadcasting Station KSOO, Sioux Falls, S.D.; Trinity Lutheran Church, Rapid City, S.D.; First Lutheran Church, Sioux Falls, S.D.; Jehova Lutheran Church, St. Paul; St. Philip's Lutheran Church, Minneapolis; Trinity Lutheran Church, Spencer, Iowa; mosaics: First Presbyterian Church, Sioux Falls; chapel, Our Saviors Lutheran Church, Sioux Falls. Exhibited: 1959-61: Sioux City A. Center; Sioux Falls Civic A. Center; 4-man, Dakota Weslyan Univ., Mitchel, S.D.; Univ. South Dakota, Vermillion, S.D. Positions: Prof. A., Augustana Col., Sioux Falls, S.D., 1931- . Instr., (School year of 1964-65) The National College of Arts, Lahore, West Pakistan, under the Fulbright program.

EIDLITZ, DOROTHY MEIGS (Mrs. Ernest F.)—
 Patron, Photographer
 289 Trisman Terr., Winter Park, Fla. 32789; also, 4 E. 62nd St., New York, N.Y. 10021; s. "Sunbury Shores," St. Andrews, N.B., Canada
B. New Haven, Conn. Studied: Vassar College, A.B.; Univ. Pennsylvania (Grad. study); Columbia Univ.; New School for Social Research. Photography with Ansel Adams and Berenice Abbott and the late Konrad Cramer. Member: F., Royal Photographic Society of Great Britain; F., Photographic Society of America; MMA; MMoDA; American Federation of Arts; American Craftsmen's Council; Philadelphia Art Alliance; Friends of the Beaverbrook Art Gallery, Fredericton, N.B., Canada. Awards: numerous medals, and purchases. Exhibited: in many art galleries in the U.S. Work represented in books, "Poet's Camera," etc. Collection: Chiefly 20th Century American Painting, Sculpture, Ceramics. Japanese, both antique and contemporary. Positions: Founder, Hon. Pres., "Sunbury Shores Arts and Nature Centre, Inc.," St. Andrews, N.B., Canada; A.-in-Res., Research Studio Art Center, Maitland, Fla., 1961 (photography); Bd. Member, Orlando Art Assn., and Loch Haven Art Center, Orlando, Fla., 1965. President, The Dorothy Meigs Eidlitz Foundation, Inc.

EILERS, ANTON FREDERICK—Portrait Painter, Indst. Des., T.
 h. 2140 E. Chandler Ave., Evansville, Ind. 47714; s. Morattico, Va. 22523
B. Wilmington, N.C., Nov. 7, 1909. Studied: College of William & Mary, B.S.; Richmond Professional Institute. Member: Am. Soc. Industrial Designers. Awards: Bronstein purchase award, Evansville Mus. A., 1960; Merit Award, Hoosier Salon, 1950; Master Design Award, Product Engineering Magazine, 1964. Work: Paintings: Evansville Museum of Art; Evansville College; St. Mary's Hospital, Citizens Bank, Permanent Savings, all Evansville; Mechanics Bank, McComb, Miss. Exhibited: Tri-State Exh., Evansville Mus. A.; Hoosier Salon, Indianapolis; Evansville College; Ohio Valley Watercolor Exh., Athens, Ohio; one-man: Evansville Mus. A.; Hoosier Salon; Evansville College; Risley Galleries, Evansville; Thor Gal.,

Louisville, Ky.; Gal. A., Kilmarnock, Va.. Positions: Bd. Dirs., Evansville Museum; Instr. Port. Painting and Figure Drawing, Univ. Evansville.

EISENBERG, MARVIN—Scholar, T.
Department Art History, University of Michigan; h. 2200 Fuller Rd., Apt. 1201, Ann Arbor, Mich. 48105
B. Philadelphia, Pa., Aug. 19, 1922. Studied: University of Pennsylvania, A.B.; Princeton University, M.F.A., Ph.D. Member: CAA; Renaissance Soc. Am.; Mediaeval Acad. of America; Michigan Acad. Arts, Sciences and Letters. Awards: Phi Beta Kappa (Univ. Pa.); Fellow, Art & Archaeology, Princeton Univ.; Phi Kappa Phi (Univ. Michigan); Guggenheim Fellow, 1959-1960; Italian Government Decoration. Star of Solidarity II, 1961. Contributor of articles on Lorenzo Monaco, Spinello Aretino, Mariotto di Nardo, Neri di Bicci to Art Quarterly, Art Bulletin, Bollettino d'arte, as well as to museum bulletins. Fields of Research: Italian late mediaeval and Renaissance painting. Guest lecturer in American and Canadian museums. Positions: Bd. of Dirs., 1965- , Pres., 1968-1969, CAA; Prof. Dept. of History of Art, University of Michigan, Ann Arbor, Mich., (Chm.) 1961-1969.

EISENSTAT, BENJAMIN—Painter, I., E., W., L.
438 Camden Ave., Moorestown, N.J. 08057
B. Philadelphia, Pa., June 4, 1915. Studied: Fleisher Art Memorial; Albert Barnes Foundation; PAFA. Member: F., PAFA; Phila. A. All.; AWS; Phila. WC Soc.; AEA. Awards: prizes, Harrison Morris watercolor prize, PAFA (3); Medal of Achievement, Phila. WC Club, and Thornton Oakley Award; Award, Phila. A. Dirs. Annual. Work: PMA; Fleisher A. Memorial; U.S. Maritime Commission. Mural, Provident Mutual Life Ins. Co., Phila., 1965; Phila. Branch of First Camden National Bank, 1960; Official painting of nuclear submarine "Savannah" for U.S. Maritime Commission, 1959; First painting for "Collegia Medica" series of the Squibb Company program. Exhibited: MMA; PAFA; AWS; NAD; all Philadelphia exhibitions. Author, Illus., N.Y. Times (Sunday); Philadelphia Inquirer (Sunday) and Ford Times. Positions: Prof. A., and Assoc. Dir., Illustration Dept., Philadelphia College of Art.

EISENSTEIN, JULIAN—Collector
82 Kalorama Circle, N.W., Washington, D.C. 20008*

EISLER, COLIN—Scholar
Institute of Fine Arts, New York University, 1 E. 78th St., New York, N.Y. 10021*

EISNER, ELLIOT WAYNE—Scholar
School of Education, Stanford University; h. 820 Tolman Dr., Stanford, Cal. 94305
B. Chicago, Ill., Mar. 10, 1933. Studied: Roosevelt University, B.A, Art and Education; Illinois Institute of Technology, Institute of Design, M.S. in Art Education; University of Chicago, M.A. in Education, Ph. D., Education. Awards: The Palmer O. Johnson Memorial Award, American Educational Research Association, 1967; John Simon Guggenheim Fellowship, 1969-1970. Field of Research: The study of artistic learning in children and adults, the assessment of artistic creativity and the development of curriculum theory in the field of Art Education. Positions: Editor, "Studies in Art Education," 1963-1965, Co-Editor, 1962-1963; Chairman, Research Committee, National Art Education Association, 1965-1967, member, 1967-1972; Member, Editorial Board, "Music Educators Journal," 1968-1972; Member, Editorial Board, "Review of Educational Research," 1969-1971; Member, Board of Advisors of the Council for the Study of Mankind, 1964- .

EITEL, CLIFFE DEAN—Designer, P., I., Gr.
8 South Michigan Ave., Chicago, Ill. 60603; h. 1819 Oakwood Rd., Northbrook, Ill. 60062
B. Salt Lake City, Utah, June 18, 1909. Studied: NAD; AIC; Sch. Design, and with Hubert Ropp, Gyorgy Kepes, Joseph Binder. Awards: prizes, A. Gld. of Chicago, 1945. Work: SAM: ceramic murals, Mercy Hospital, Canton, Ohio; Tampa Municipal Hospital, Fla.; Mary Queen of Heaven Church, Elmhurst, Ill.; Augustinian Seminary, Olympia Fields, Ill.; Ravenswood Tile Co., Lincolnwood, Ill.; El Lago Apts., Chicago; mosaic tile murals, St. Mary's Hospital, Kankakee, Ill.; mural, Flavaroma Products, Inc., Northfield, Ill.; Graphic Pharmaceutical Designs used in many countries; Illustrations used in 1963 Year Book (World Book Encyclo.); Graphic Illus. at N.Y. World's Fair, 1964-65 for Equitable exhibit. Exhibited: Phila. Pr. Cl.; NAD; LC; Chicago A. Gld., Cliff Dwellers Cl., Renaissance Soc., Exh. Momentum, Hull House, Benjamin Gal., A. Dir. Cl., Soc. Typographical A., Magnificent Mile Exh., all in Chicago; SAM; BM; Laguna Beach AA; WAC; Mint Mus.; Newport AA; Wichita AA; Akron AI; in Germany with U.S. State Dept. Exh., 1951; Dir., Northbrook A. Lg., 1965-1966.

EITELJORG, HARRISON—Collector, Patron, Sponsor
2850 N. Meridian St. 46208; h. 9950 Spring Mill Rd., Indianapolis, Ind. 46290
B. Indianapolis, Ind., Oct. 1, 1904. Studied: Indiana Univ. Law School. Collection: Abstract and Modern American Art; School of Paris; also 'Western' Paintings. Positions: Trustee, Art Association of Indianapolis; Member, Fine Arts Advisory Committee and Member of Art School Committee, both of the Art Association of Indianapolis; Member, Contemporary Art Society of Indianapolis. Sponsor, Museum of Western Art, Steamboat Springs, Colorado: Western Paintings, Sculpture and Artifacts.

EITNER, LORENZ—Scholar, Writer, Art Historian
Dept. of Art and Architecture, Stanford University, Stanford, Cal. 94305
B. Brunn, Czechoslovakia, Aug. 27, 1919. Studied: Duke University, A.B.; Princeton University, M.F.A., Ph.D. Author: "The Flabellum of Tournus"; "Gericault Sketchbooks at the Chicago Art Institute"; "Introduction to Art"; "Neo-Classicism and Romanticism," 1969; Co-author, "The Arts in Higher Education," 1966. Field of Research: History of 19th Century Art. Positions: Prof. Art History, Univ. Minnesota, 1949-1963; Executive Head, Department of Art and Architecture, Stanford University, Stanford, Cal., 1963- , Dir., Stanford Museum; Dir., College Art Association of America, 1956-1963.

EKSTROM, ARNE H.—Art dealer
Cordier-Ekstrom Gallery, 980 Madison Ave., New York, N.Y. 10021*

ELAM, CHARLES HENRY—Museum Curator
The Detroit Institute of Arts, 5200 Woodward Ave. 48202; h. 25 E. Palmer St., Detroit, Mich. 48202
B. Ashland, Ky., Feb. 13, 1915. Studied: Univ. Cincinnati, Col. of Liberal Arts, A.B.; N.Y. Univ. Inst. FA, A.M.; Grad. work, Courtauld Inst., Univ. London, England. Member: AAMus.; CAA. Contributor to Museum Bulletins; Catalogued and assisted in assembling exhs.: "Rendezvous for Taste," Peale Museum, Baltimore, 1956; "French Paintings 1789-1929 from the Collection of Walter P. Chrysler, Jr.," Dayton Art Institute, 1960. Positions: Archivist, The Peale Museum, Baltimore, Md., 1954-1959; Chief Cur. The Dayton Art Institute, Dayton, Ohio, 1959-1964; Cur., American Art, The Detroit Institute of Arts, 1964- .*

ELIAS, HAROLD JOHN—Painter, C., Des., I., L.
1800 McCann Rd., Longview, Tex. 75601
B. Cleveland, Ohio, Mar. 12, 1920. Studied: AIC, B.F.A., M.F.A., with John Rogers Cox, Kathleen Blackshear; De Paul Univ.; Michigan State Univ. Member: Mich. Acad. Science, A. & Let.; Mich. WC Soc.; F.I.A.L.; Cultural Com., Univ. Michigan; Chicago Soc. A. Awards: prizes, Magnificent Mile, Chicago, 1952; Western Mich. A., 1953; AAUW, 1958-1960; Dr. Shiller Award, Michiana Exh., 1965. Work: Univ. Idaho, Moscow, Idaho; Ill. State Mus.; Massillon Mus. A., and in private colls. Exhibited: Alabama WC Soc., 1950; PAFA, 1950, 1952; Exh. Momentum, 1950, 1951, 1952; Creative Gal., N.Y., 1950; Esquire Theatre exh. of Chicago Art, 1950; MMA, 1950; NAD, 1951; Denver A. Mus., 1951; Magnificent Mile, 1951, 1952; Grand Rapids A. Gal., 1950-1952, 1954; Univ. Michigan, 1952; Michigan State Fair, 1952, 1954; Artists, Des., & Manufacturers Exh., Grand Rapids, 1952; BMFA, 1952; Detroit Inst. A., 1952; Sabena's sculpture comp., Brussels, 1953; Springfield, Ill., 1954; Massillon Mus. A., 1954; Michiana, 1955; one-man: Esquire Theatre, Chicago, 1951; Hackley A. Gal., 1951; Albion Col., 1953; Saginaw Mus., 1953; Univ. Mich., 1953; Neville Pub. Mus., 1953; Univ. Tulsa, 1953; Univ. Idaho, 1954; Univ. New Mexico, 1954; Racine AA, 1954; Olivet Col. 1954; State Col., Wash., 1954; Univ. Oklahoma, 1954; Kenosha Pub. Mus., 1954; Ball State T. Col., 1955; Oklahoma A. & M., 1955; Texas Christian Univ., 1955; Eastern N.M. Univ., 1955; Lafayette (Ind.) AA, 1955; Oklahoma A. Center, 1955; Stephen Austin State Col., 1955; Coos Bay A. League (Ore.), 1955; Sanford Mus., Cherokee, Iowa, 1955; Western Mich. Univ., 1958; Central Mo. State Col., 1958; East Carolina Col., 1958; Cornell Col., Mt. Vernon, Iowa, 1958; City Lib. Assn., Springfield, Mass., 1958; Cargill Theatre, 1968; LeTourneau Col., (with lecture), 1968, Longview, Tex.; Kilgore (Tex.) Col. (with lecture), 1969. One-man traveling exh., 1956-57 to major colleges, libraries, galleries and museums. Smithsonian Inst. traveling exh. "Midwest Designers," 1958. Positions: Instr., Muskegon Community Col., Adult Edu., 1952- ; Asst. to Dir., Hackley A. Gal., Muskegon, Mich.; Supervisor, Indst. A. Dept., Clark Equipment Co., Benton Harbor, Mich.; Instr., Adult Edu., St. Joseph, Mich.; Chm., Berrien County (Mich.) Cultural Com., Univ. Michigan, 1960; Sec. Cultural Com., State of Michigan, 1961; Chm., FA Festival, Southwestern Michigan, 1961; Exh. Chm., Benton Harbor Library; Chm., Twin Cities Cultural Committee; Member, State Council for the Arts, Michigan. Faculty, Lake Michigan College, Benton Harbor, Mich., 1965-1967. Member Education Com. and Civic Center Com., Longview, Tex.

ELIASOPH, PAULA—Painter, Gr., W., L., T.
　148-25 89th Ave., Jamaica, L.I., N.Y. 11435
B. New York, N.Y., Oct. 26, 1895. Studied: PIASch.; Univ. of the State of New York (Teacher's Certif.); ASL; Columbia Univ. Member: AWS; Nat. Lg. Am. Pen Women; ASL; Long Island A. Lg.; Fed. Mod. P. & S.; Inst. for the Study of Art Education, Museum of Modern Art. Awards: prizes, Queensboro YWCA, 1943; med., Long Island A. Lg., 1950. Work: BM; MMA; LC; Wash. (D.C.) Pub. Lib.; F.D. Roosevelt Lib.; N.Y. Pub. Lib.; murals, Hillside Hollis Center, Jamaica, L.I.; YMHA, Jamaica, L.I.; etching, Moreno Inst., New York, N.Y. Exhibited: LC, 1943; SAGA, 1944; Phila. Soc. Et.; AIC, 1931; BM, 1931; deYoung Mem. Mus.; AFA traveling exh., 1955-1957; Fed. Mod. P. & S., 1948, 1955, 1966, 1967, 1968; NAC, 1949 1951; PAFA; NAD; AWS, 1966, 1967; Wadsworth Atheneum; Riverside Mus., 1955-1964; Inst. Mod. A., Boston; Rochester Mem. A. Gal., 1946; Grand Central A. Gal., 1956; Art: USA, 1958; ASL, 1959, 1960; Silvermine Gld. A., 1958; Assoc. Am. A., 1955; Lever House, N.Y.C., 1965 and others. One-man: Clayton Gal., N.Y., BM; Belle & Fletcher Gal., Boston; Kew Gardens A. Center, L.I., 1952; Forest Hills, N.Y.; 1952; Guild Hall, East Hampton, L.I.; Montross Gal.; Argent Gal.; Easthampton Gal., N.Y.C., 1964, etc. Author: "Etchings and Drypoints of Childe Hassam." Contributor to Monks Pond magazine and art magazines. Slide lectures to P.T.A.s, 1966-1969. Positions: Chm., Queens Botanical Gardens A. Festival, 1949-1955; A. Chm. Golden Jubilee, Queens; A. Supv., Instr., Yeshiva of Central Queens, Elem. and Jr. H.S., 1949-　; Instr., Adult Sch. of Study, Forest Hills, N.Y., 1951-　; Lecturer, Queens Col. Lectures to PTA Societies.

ELISCU, FRANK—Sculptor
　Redding, Conn. 06875
B. New York, N.Y., July 13, 1912. Studied: BAID; Pratt Inst. Member: F., NSS; NA. Awards: prizes, Bennet prize for sculpture, 1953, Moore prize, 1950; Arch. Lg., 1955; silver medal, 1958. Work: busts, Aeronautical Hall of Fame; fountain, Brookgreen Gardens, S.C.; fountain, 100 Church St., New York, N.Y.; "Atoms for Peace" figure, Ventura, Cal.; war mem., Cornell Medical Col.; St. Francis for Steuben Glass Co.; heroic horses in slate, Bankers Trust Bldg., N.Y.; Stations of the Cross, Seminary in Virgin Islands. Author: "Sculpture: Three Techniques-Wax, Slate, Clay"; "Direct Wax Sculpture." Exhibited: NAD, 1935-1955; PAFA; Conn. Acad. FA; CMA; Springfield Mus. A.; Detroit Inst. A.; one-man in Mexico, sponsored by U.S. Govt. Positions: Pres., NSS.

ELISOFON, ELIOT—Collector, Writer, Painter, Photographer
　Time-Life Building, Rockefeller Center, 10020; h. 145 E. 27th St., New York, N.Y. 10016
B. New York, N.Y., April 17, 1911. Studied: Fordham University. Award: Peabody Fellow, Harvard University. Exhibited: (watercolors) one-man: Durlacher Gal., New York City; Gekkoso Gal., Tokyo; works in several U.S. museums. Collection: Primitive Art, especially African Art. Work published: "The Nile," color photography; "Java Diary"; "The Hollywood Style" (with Knight); "Art of Indian Asia" (with Zinser). Photographer, Life magazine, 1937-　.

ELKON, ROBERT—Art dealer
　Elkon Gallery, 1063 Madison Ave., New York, N.Y. 10028*

ELLINGER, ILONA E. See Deak-Ebner, Ilona

ELLIOTT, JAMES HEYER—Museum Director
　Wadsworth Atheneum, Hartford, Conn. 06103
B. Medford, Ore., Feb. 19, 1924. Studied: Willamette Univ., Salem, Ore., B.A.; Harvard University, M.A. Member: CAA; AAM; Western Assn. of Art Museums; I.C.O.M. Author: (title essay) "Bonnard and His Environment," 1964, Museum of Modern Art. Art Critic, New York Herald Tribune, European Edition, 1952-53. Positions: Curator, Actg. Dir., Walker Art Center, Minneapolis, Minn., 1953-1956; Asst. Chief Curator and Curator of Modern Art, 1956-1961, Chief Curator, 1962-1966, Los Angeles County Museum of Art; Director, Wadsworth Atheneum, Hartford, Conn., 1966-　. Trustee, AFA; Assoc. F., Trumbull Col., Yale Univ.; Assoc. Prof., graduate program in Mus. Admin., Hunter Col., N.Y.; Exec. Com., Friends of Hill-Stead Mus.; Founding Trustee, Horace Bushnell Mem. Hall; Founding Trustee, Simon Rodia's Tower in Watts; Chancellor's A. Advisory Com., Temple Univ.

ELLIOTT, MRS. PHILIP C. See Cuthbert, Virginia

ELLIOTT, PHILIP CLARKSON—Painter, E., W., L.
　147 Bryant St., Buffalo, N.Y. 14222
B. Minneapolis, Minn., Dec. 5, 1903. Studied: Univ. Minnesota; Yale Univ., B.F.A. Member: The Patteran; CAA; Nat. Assn. Schools of Art. Awards: Chaloner Fnd. Paris prize, 1929-1933; Pepsi-Cola, 1948; Western N.Y. Exh., 1965; Springville, N.Y., 1962; Albright A.

Gal., 1949, 1952. Work: murals, Univ. Pittsburgh; Albright-Knox A. Gal., and in private collections. Exhibited: PAFA, 1944; Carnegie Inst., 1943, 1945; MModA., 1952; Pepsi-Cola, 1948; N.Y. State Fair, 1962; Springville, N.Y., 1962; Albright-Knox A. Gal., 1962-1968 and prior; Western New York Exh., 1962-1968. Lectures: Techniques of Painting. Positions: Asst. Prof. FA, Univ. Pittsburgh, 1934-40; Dir., Albright A. Sch., Buffalo, N.Y., 1941-54; Prof. A., Chm. A. Dept., State Univ. of N.Y. at Buffalo, 1954-　.

ELLIOTT, RONNIE—Painter
　68 E. 7th St., New York, N.Y. 10003
B. New York, N.Y. Member: A. Lg. Am. Work: N.Y. Univ.; Carnegie Inst.; Wellesley Univ.; Farnsworth Mus. A.; MModA; WMAA; Andrew Dickson White Mus., Cornell Univ.; BMA; Musée d'Art et d'Industrie, St. Etienne, France; Birla Academy of A. & Culture, Calcutta, India. Exhibited: Carnegie Inst., 1941; CGA, 1939; NAD, 1941; Bennington Col., 1943; SFMA, 1945, 1946; Art of this Century, 1943-1945; MMA, 1942; Mus. Non-Objective Painting, 1946, 1947; MModA, 1948; Galerie Creuze, Paris, 1948 (one-man), 1957; Realities Nouvelles, Paris, 1948-1951; La Galerie Colette Allendy, Paris, 1952 (one-man); Galerie Arnaud, Paris, 1954; Rose Fried Gal., 1956-1958; Mus. Contemp. A., Houston, Tex., 1958; Galerie Mayer, N.Y., 1960; Newport, R.I., 1961; Art Assn. of Newport, 1961; WMAA, 1964; Collage Group: Sheldon Mem. Mus., Univ. Nebraska, 1964; Columbus A. Gal., (Ohio), 1964; Musée des Arts Decoratif, Louvre, Paris, 1964; Collage International, St. Etienne Musée, St. Etienne, France, 1964; Rochester Mem. A. Gal., N.Y. 1965; N.Y. Univ., N.Y., 1965; AFA, 1968; Finch Col., N.Y., 1968. One-man: Grand Central Moderns, New York, 1963; Granville Gallery, New York, N.Y., 1964. Rose Fried Gal., N.Y., 1957, 1967; Brooklyn Col., N.Y., 1968.

ELLIS, CARL EUGENE—Museum Curator, Assoc. Mus. Dir., T., L.
　Everhart Museum, Nay Aug Park 18510; h. 708 N. Main Ave., Scranton, Pa. 18504
B. Oklahoma City, Okla., Oct. 12, 1932. Studied: Univ. Arkansas, B.A. in Fine Arts and Art History; Univ. Arkansas Graduate School; Harvard Univ. Graduate School. Member: AAMus.; Northeastern Museum Assn.; Nat. Early American Glass Club. Arranged exhibitions: John Willard Raught, 1857-1931, A Retrospective Exhibition, 1961; Northeastern Pennsylvania Collectors Choice, A Loan Exhibition, 1962; American Jewelry Today, A National Competition, 1963; American Jewelry Today (A national Competition), 1963, 1965, 1967, 1969; Regional Art Competition, 1964, 1966, 1968; Drawings and Prints by Peter Takal, 1967; Dorflinger Glass Gallery (permanent), 1969. Prepared catalogs for all exhibitions listed, all at Everhart Museum. Positions: Asst. Cur. of Exhibitions and Instr., Art History, Akron Art Institute, 1958-1959; Curator of Art, Everhart Museum, 1959-　; Assoc. Dir., Everhart Museum, Scranton, Pa., 1966-　.

ELLIS, EDWIN CHARLES—Educator, Gr.
　207 Broad St., Warrensburg, Mo. 64093
B. Iowa City, Iowa, May 29, 1917. Studied: State Univ. Iowa, B.F.A., M.A., M.F.A. Member: AAUP; NEA; Missouri State T. Assn. Positions: Hd., Dept. A., Central Missouri State College, Warrensburg, Mo.

ELLIS, FREMONT F.—Painter
　553 Canyon Rd., Santa Fe, N.M. 87501
B. Virginia City, Mont., Oct. 2, 1897. Studied: ASL. Awards: Henry E. Huntington award Los Angeles County Mus.; Adele Hyde Morrison prize and bronze medal, Oakland Mus. A.; purchase prize, Springville, Utah Mus. Work: El Paso Mus. A.; Mus. New Mexico, Santa Fe; Thomas Gilcrease Inst. of American History and A., Tulsa, Okla.; Art Inst., Lubbock, Tex.; Univ. California at Los Angeles. Mural, S.S. America.

ELLIS, GEORGE RICHARD—Museum Curator
　2000 Eighth Ave., North 35203; h. 1108 S. 28th St., Apt. 7, Birmingham, Ala. 35205
B. Birmingham, Ala., Dec. 9, 1937. Studied: Univ. Chicago, B.A., M.F.A. Member: NAEA; Alabama A. Edu-Assn. (Vice-Pres.); Birmingham AA; Alabama WC Soc. (Vice-Pres., 1964-65, Pres., 1965-　). Positions: Art Supv., Jefferson County Schools, 1962-1964; Curator, Birmingham Museum of Art, at present.*

ELLISON, J. MILFORD—Teacher, P., L., Gr.
　2335 Chatsworth Blvd., San Diego, Cal. 92106; h. 7421 Via Capri, La Jolla, Cal. 92037
B. Sioux City, Iowa, Sept. 16, 1909. Studied: Chicago Acad. FA; Am. Acad. A., Chicago; Chouinard AI, Los A.; San Diego State Col., A.B.; Univ. Colorado; Univ. So. Cal.; Banff Sch. FA; Mexico City Col., M.A. Member: La Jolla AA; San Diego T. Assn.; Cal. T. Assn.; San Diego AI.; San Diego WC Soc. (Pres. 1964-65); San Diego City-County A. Edu. Assn. Awards: prizes, Army Spec. Services A. Exh.,

Paris, 1945; Banff Sch. FA, 1949; San Diego A. Gld., 1951; San Diego County Fair & So. Cal. Expo., 1951, 1954, 1955; San Diego AI, 1954, 1955, 1959, 1965; La Jolla AA, 1959-1961; Fiesta Del Pacific, 1959; La Jolla A. Festival, 1963. Work: San Diego FA Soc.; First Presbyterian Art Collection; San Diego City Hall; San Diego AI; Cal. Western Univ. Exhibited: AWS, 1946; San Diego Int. Exh., 1935; San Diego A. Gld., 1931-1950; San Diego FA Soc., 1944-1946, 1948, 1952, 1957, 1958, 1960-1963; La Jolla A. Center, 1945, 1954, 1955, 1959, 1960; La Jolla AA, 1954, 1955, 1957, 1959, 1961, 1962-1964; Laguna Beach AA, 1946, 1948-1956, 1961; Laguna Beach A. Festival, 1961; Los A. County Fair, 1961; San Diego Lib., 1958-1961; Oakland A. Mus., 1946; New Orleans AA, 1946; City of Paris, San F., 1946; San Diego County Fair, 1954, 1955, 1958, 1959, 1961; Foothills AA, 1953-1955, 1959, 1963; Mexico City Col., 1953; Grand Central Gal., N.Y., 1958. Positions: Instr., Univ. Ext., Univ. Cal., 1949-54, 1958; Chm. A. Dept., Point Loma H.S., San Diego, 1946- ; Instr., WC, California Western University, San Diego, 1954- .*

ELOUL, KOSSO—Sculptor, Gr.
 2237 N. New Hampshire Ave., Los Angeles, Cal. 90027
B. Mourom, Russia, Jan. 22, 1920. Studied: AIC. Member: Accademia Tiberina, Rome, Italy. Work: Nat. Memorial Mus., Jerusalem; Brandeis Univ., Rose A. Mus.; Storm King A. Center, Mountainville, N.Y.; and in private colls. Commissions: J. Patrick Lannan Fnd., Palm Beach, Fla.; Storm King A. Center; fountain, Beverly Woods, Los Angeles, Cal. Exhibited: Sculpture- Jewish Mus., N.Y., 1966; Carnegie Int., Pittsburgh, 1964, 1967; Antwerp, Middlheim Park Int., 1959; Spoleto, Italy, 1962; Salon de la Jeune, Rodin Mus., Paris, 1965; Cal. Sculpture, 1965; Stuart Gals., 1965, 1968; Alliata Gal., Rome, 1962; Morris Gal., Toronto, 1968. Graphics- 3rd Bienal, Tokyo, 1962; Tamarind Guest printing, 1965; Gemini print series, 1966; Smithsonian Inst., 1967. Positions: Instr., Sculpture, Cal. State Col. at Long Beach, 1965, and A.-in-Res., 1965.

ELSEN, ALBERT EDWARD—Scholar, Collector, W., E.
 Art Dept., Stanford University; h. 723 Alverado Row, Stanford, Cal. 94305
B. New York, N.Y., Oct. 11, 1927. Studied: Columbia College, A.B.; Columbia University, M.A., Ph.D. Awards: Fulbright Grant, Paris, France, 1949-50; American Council of Learned Societies Grants, 1952, 1960; Clark Foundation Award, 1962 (Paris); Guggenheim Fellowship, 1966-1967, England. Collection: Modern and Old Master painting, sculpture, prints and drawings. Author: "Rodin's Gates of Hell"; "Purposes of Art"; "Rodin" (Mus. Modern Art); "Rodin: Readings on His Life and Work"; "Seymour Lipton"; "The Sculpture of Matisse." Field of Research: 19th-20th Century Painting and Sculpture, European and American. Positions: Prof., Carleton College, 1952-1958; Prof., Art History, Indiana University, Bloomington, Ind., 1958-1968; Visiting Prof. Art History, Stanford University, Cal., 1963-1964, Prof., 1968- . Director, College Art Association, 1966-1967.

EMBRY, NORRIS—Painter, Gr.
 206 E. Chase St., Baltimore, Md. 21202
B. Louisville, Ky., Jan. 14, 1921. Studied: Academy of Fine Arts, Florence, Italy. Work: Guggenheim Mus. Exhibited: "100 American Drawings," Museum of Modern Art, New York, N.Y., 1965; Inst. Contemp. Art, Boston, 1957; Rochester Mem. A. Gal.; one-man: Robert Elkon Gallery, N.Y.C., 1963, 1965.

EMERSON, EDITH—Painter, I., L., W., Mus. Cur., T.
 Woodmere Art Gallery, 9201 Germantown Ave. 19118; h. 627 St. George's Rd., Philadelphia, Pa. 19119
B. Oxford, Ohio. Studied: AIC; PAFA; & with Cecilia Beaux, Hugh Breckenridge, Emil Carlsen, Violet Oakley, Henry McCarter. Member: NSMP; Phila. WC Cl.; F., PAFA; Am. Soc. Bookplate Collectors & Designers; Germantown Hist. Soc. Awards: Cresson traveling scholarships, PAFA, 1914, 1915; prizes, F., PAFA, 1919; Bryn Mawr Col., 1920; Granger prize, F., PAFA, 1957; Medal of Honor, Phila. WC Cl., 1964. Work: murals, Plays & Players Theatre, Phila.; Army & Navy triptychs; Chapel, Sisters of St. Joseph Convent; Church of the Nativity of the Blessed Virgin, Phila., Pa.; Temple Keneseth Israel, Elkins Park, Pa.; Haverford Prep Sch., Pa.; Bryn Mawr Col.; Vanderpoel Coll.; Woodmere A. Gal.; Convent Sisters of the Holy Rosary, Villanova, Pa.; PMA. Exhibited: PAFA, 1916-1957; CGA, 1924; AIC; NAD; Newport AA, 1941; PMA; Hartford Atheneum; Carnegie Inst.; Florence, Italy; Conn. Acad. FA, 1938; Arch. L.; Woodmere A. Gal., 1940-1965; Phila. Pr. Cl.; Phila. A. All.; F., PAFA, 1966. Illus., "The Song of Roland," 1938; "The Pageant of India's History," 1948. Contributor to: Art magazines & newspapers. Lectures: History of Art. Positions: Instr. A., Agnes Irwin Sch., 1916-27; PMSchIA, 1929-36; Cur., Woodmere A. Gal., 1946- , all in Philadelphia, Pa.; Chm., Regional Council of Community Art Centers (15 groups, 5000 members), 1950- . Chm., Regional Groups, Philadelphia A. Festival, 1959. Pres., Violet Oakley Mem. Foundation, 1961- .

EMERSON, STERLING DEAL—Museum Director
 Shelburne Museum, Inc., Shelburne, Vt.
B. St. Albans, Vt., May 21, 1917. Studied: Champlain College. Member: Nat. Trust for Historic Preservation in the U.S.; Early Am. Industries Assn. (Dir.); Vermont Hist. Soc.; Green Mountain Folklore Soc.; Newcomen Soc. in North America; AAMus. Lectures: museum collections; Historical meetings throughout New England. Dir. of cataloguing Shelburne Mus. collections; with Staff assembled exhibitions of the collections. Positions: Dir., Shelburne Museum, Shelburne, Vt.; Pres., Vermont Attractions Assoc.; Member, Advisory Committee, Museum of American Folk Arts, New York, N.Y.; Vice Pres., Shelburne Enterprises, Inc.; Sec. & Treas., New England Heritage, Inc.

EMERY, LIN (Miss)—Sculptor
 7520 Dominican St., New Orleans, La. 70118
B. New York, N.Y. Studied: Sorbonne, Paris; Sculpture Center, N.Y.; and with Ossip Zadkine, Paris. Member: NAWA; Sculpture Center; New Orleans AA. Work: Chrysler Mus. A.; Pensacola A. Center; Statues, exterior sculpture, fountains, fonts, Stations of the Cross, wall reliefs; etc., St. James Major Church, Holy Cross H.S., St. Catherine of Siena Church, Grace Episcopal Church, Mossy Home, all in New Orleans; St. Scholastica Acad. Covington, La.; St. Gertrude's Catholic Church, Des Allemands, La.; Father Judge Mission Seminary, Lynchburg, Va.; Imperial House Restaurant, Tampa, Fla.; Columbia (S.C.) Mus. A.; Delgado Mus. A.; St. Michael's Church, Biloxi, Miss.; Joske's of Texas, San Antonio; Germantown Savings Bank, Phila.; Civic Center, New Orleans (des, park, sculptured fountain and monument, 1964-67); De Waters A. Center; Norton Gal.; Huntington, West Va. Gal.; Columbia (S.C.) Mus. Exhibited: Pasadena Mus. A., 1946; PAFA, 1960, 1964; New Orleans AA, annually; NAWA, annually; AFA traveling Exhs., 1955, 1958, 1962, 1965; VMFA, 1956; Sculpture Center, N.Y., 1952, 1953; Univ. North Carolina, 1957; Denver A. Mus., 1958, 1960; Riverside Mus., 1958; Univ. Southwestern Louisiana, 1961; DeWaters A. Center, Flint, Mich., 1965; International House traveling exh., Tokyo, Philippine A. Center, Manila; USIS Library, Hong Kong. One-man: Delgado Mus. A., 1954, 1962, 1964; Birmingham Mus. A., 1955; Hunter Gal., Chattanooga, 1955; Columbia, S.C., 1955; Norton Gal., West Palm Beach, 1956; Sculpture Center, N.Y., 1957, 1962; Pensacola A. Center, 1958, 1962; Lyceum, Havana (USIS), 1958; Orleans Gal., New Orleans, 1960, 1962, 1964, 1968; Tennessee FA Center, 1962; Marble Arch Gal., Miami, 1963; Valley House Gal., Dallas, 1963; Royal Athena II, N.Y.C., 1964; Gal. Mod. A., Scottsdale, Ariz., 1965; Mus. of New Mexico, 1966; Centennial Mus., Corpus Christi, 1967; Kiko Gal., Houston, 1967. Positions: Visiting critic, Tulane Sch. of Architecture, 1967-1968.

EMIL, ALLAN D.—Collector, Patron
 575 Madison Ave. 10022; h. 60 Sutton Place South, New York, N.Y. 10021
B. New York City, N.Y., Mar. 25, 1898. Member: Metropolitan Museum of Art (Member in Perpetuity); Patron, Museum of Modern Art; Honorary Member, Friends of The Tate Gallery, London, England. Collection: Ancient and Modern Sculpture; Impressionist, Abstract and Modern Art. Positions: Trustee, American Federation of Arts; Trustee and Chairman of the Board, Friends of The Whitney Museum of American Art.

EMIL, ARTHUR D.—Collector
 32 E. 57th St. 10022; h. 47 E. 88th St., New York, N.Y. 10028
B. New York, N.Y., Dec. 29, 1924. Studied: Yale University; Columbia Law School. Collection: Modern Painting; Ancient Sculpture. Positions: Secretary, Junior Council of The Museum of Modern Art.*

EMMERICH, ANDRÉ—Art Dealer, Writer
 41 E. 57th St. 10022; h. 1060 Fifth Ave., New York, N.Y. 10028
B. Oct. 11, 1924. Studied: Oberlin College, B.A. Specialty of Gallery: Contemporary Art; Pre-Columbian Art; Classical Antiquities. Author: "Art Before Columbus," 1963; "Sweat of the Sun and Tears of the Moon" (Gold and Silver in Pre-Columbian Art), 1965. Writer, Editor (1944-1954) for publications including Time, N.Y. Herald Tribune, Réalitiés (Paris), World. Free-lance writing; contributed widely to magazines; columnist (regular) Greenwich Village Voice and Harper's Junior Bazaar. Positions: Memb. Bd. Directors, Art Dealers Association of America, 1967- ; Member, Visual Arts Advisory Committee to UNESCO, 1948-49; Director, André Emmerich Gallery, New York, N.Y., 1954- .

ENDRICH, FREDERICK C., JR.—Sculptor, Eng., T., P.
 846 Middlesex Turnpike, Old Saybrook, Conn. 06475
B. Middletown, Conn., July 14, 1930. Studied: Tyler School of Art, Temple University, B.F.A., B.S. Edu.; Cal. College of Arts & Crafts, Oakland, M.F.A. Member: Wadsworth Atheneum, Hartford; Lyman Allyn Mus., New London, Conn.; Essex (Conn.) AA; MModA; CAA; Mystic AA. Awards: prizes, Essex AA, 1959; Assistantship,

Cal. Col. Arts & Crafts, 1960. Work: John Bolles Gal., San Francisco; Hellenic-American Union, Athens, Greece; American Univ. of Beirut, Lebanon; Lyman Allyn Mus., New London, Conn; Austin A. Center; Trinity Col., Hartford and in private colls. Exhibited: San Francisco AA, 1960; Cal. State Fair, 1960; Bolles Gal., San Francisco, 1960; Am. Univ. of Beirut, Faculty exh., 1962-1964; New Haven and Waterbury A. Festivals, 1968; Univ. of Conn., Storrs, 1965-1969; one-man: Gal. Clio, Hydra, Greece, 1961; Hellenic-American Union Gal., Athens, Greece, 1962; Beirut Carlton Gal., 1964; Lyman Allyn Mus., New London, Conn., 1964; Trinity Col., 1965, 1967, and others here and abroad. Positions:Asst. Instr., Cal. Col. of Arts & Crafts, 1960-1961; Instr., American University, Beirut, Lebanon, 1961-1964; Instr., Trinity College, Hartford, Conn., and Hartford Branch, Univ. of Connecticut, 1965-1966. Instr., Univ. Conn., Storrs, 1966-1967; Asst. Prof., Waterbury Branch, Univ. Conn., 1967-1969; Cooper Union, N.Y., 1969- .

ENGEL, HARRY—Painter, E., L.
Indiana University, Bloomington, Ind. 47401
B. Roumania, June 13, 1901. Studied: Notre Dame Univ., A.B.; Columbia Univ., and in Paris, with Maurice Denis. Member: Indiana A. Cl.; Assoc. Am. A. Gal.; CAA. Work: John Herron AI. Awards: Carnegie F., 1929; prizes, Hoosier Salon, 1931, 1950; Indiana A. Cl., 1931, 1945, 1946; Temple Israel purchase award, 1960; Milwaukee AI, 1946; Audubon A.; John Herron AI, 1951, 1952, 1954, 1955-1960. Work: Indiana Univ. Union Bldg., Indiana Univ. Union Club; John Herron AI. Exhibited: PAFA, 1939, 1950, 1952; AIC, 1940; Detroit Inst. A., 1936; Milwaukee AI, 1946; John Herron AI, 1933 (one-man), 1951, 1952; Audubon A., 1950, 1952, 1954; WMAA, 1948-1951; Indiana A., 1948-1952; Provincetown AA, 1948-1952, 1955; Franz Bader Gal., Wash., D.C., 1958 (one-man); Provincetown A. Festival, 1958; retrospective exh., Indiana Univ., 1955. Positions: Prof. Painting & Drawing, Indiana Univ., Bloomington, Ind.

ENGEL, MICHAEL (MARTIN) II—Painter, Des., Lith., W.
22 Lee St., Huntington, L.I., N.Y. 11743
B. New York, N.Y., Mar. 20, 1919. Studied: ASL, with Kimon Nicolaides, George Picken, and with Katchemakoff. Member: SC; Kappa Pi; Artists Fellowship; Wall Street AA; Life Fellow, Royal Soc. Arts, London; Huntington A. Lg.; ASL; Audubon A. Awards: prize, Suburban A. Lg., L.I., N.Y., 1964; Wall St. AA. Work: Antioch Col.; Parrish A. Mus., Southampton, N.Y.; U.S. Navy Combat Art Coll. Exhibited: Audubon A., annually; Clayton-Liberatore Gal., N.Y.; Hofstra Col., 1959; Parrish A. Mus., 1960; Syosset A. Gal. One-man: Cayuga Mus., 1962. Positions: Vice-Pres., 1958-60, Sr. Vice-Pres., 1961, Pres., 1962-63, Historian, Audubon A., New York, N.Y.; Vice-Pres., Marsh & McLennan, Inc., 1964- ; Governor, Wall St. AA, 1964; Trustee, Artists Fellowship, 1963-1964.

ENGELHARD, MR. and MRS. CHARLES—Collectors
Waldorf Towers, 50th St. & Park Ave., New York, N.Y. 10022*

ENGGASS, ROBERT—Scholar, Writer
Art History Department, Pennsylvania State University, University Park, Pa.; h. 318 E. Prospect St., State College, Pa. 16801; also: via dell' Arancio 56, Rome, 00186, Italy
B. Detroit, Mich., Dec. 12, 1921. Studied: Harvard University, A.B.; Univ. Michigan, M.A., Ph.D. Awards: American Council of Learned Societies Grant-in-Aid, 1958; Fulbright Research Scholar, Rome, 1963-1964. Field of Specialization: 17th and 18th Century Italian Painting. Author: "Baciccio, Giovanni Battista Gaulli, 1639-1709" (1964). Articles in: Art Journal, Art Bulletin, Art Quarterly, Burlington Magazine, Paragone, Gazette des Beaux-Arts, Commentari, Arte antica e moderna, Bollettino d'arte, Revue du Louvre, Dizionario biografico degli Italiani, Encyclopedia of World Art, Palatino, L'Urbe.

ENGLAND, PAUL—Painter, S., E., Gr.
91 Christopher St., New York, N.Y. 10014; (studio): 512 Hudson St., New York, N.Y. 10014; also, 1181 North Boston Ave., Tulsa, Okla. 74106
B. Hugo, Okla., Jan. 12, 1918. Studied: Univ. Tulsa, M.A.; Carnegie Inst., A.B.; Grad. study, N.Y. Univ.; ASL, with George Grosz, William Zorach, Cameron Booth, Morris Kantor, Jose de Creeft, and in Paris, with Ossip Zadkine. Member: AEA; ASL. Awards: Philbrook A. Center, 1957, 1958; Joslyn A. Mus., 1957. Exhibited: PAFA, 1947, 1952, 1953; Contemporary A. Gal., 1944-1946; Philbrook A. Center, 1943-1958, 1963-1965; one-man: Le Centre d'Art, Port-au-Prince, Haiti, 1947; RoKo Gal., 1948; Galerie Creuze, Paris, 1949; Bodley Gal., 1950; Hugo Gal., 1951; La Galeria, Torremolinos, Spain, 1955; Grand Central Moderns, N.Y., 1955; Philbrook A. Center, 1958; Nicole Gal., N.Y., 1964; Benevy Gal., N.Y., 1967. Work: Williams Col. A. Mus.; Philbrook A. Center; Joslyn Mus. A.; Staten Island Mus. A. & Sciences; Adelphi University, Long Island, N.Y.; N.Y. Pub. Lib. Print Coll. Contributor to New Yorker magazine.

Positions: A. Cr., France-Amerique, New York, N.Y., 1955-57; Asst. Prof., Fine Arts Dept., Hofstra University, Hempstead, N.Y. 1959- .

ENGLANDER, GERTRUD—Craftsman, T.
345 East 52nd St., New York, N.Y. 10022
B. Germany. Studied: Cologne, Germany; Craft Students Lg., N.Y.; N.Y. Univ. Member: Artist-Craftsmen of N.Y. Work: Bertha Schaefer Gal.; America House; Brentano's, N.Y.; Georg Jensen Co., N.Y.; Rosenthal-Schwadron, New York, N.Y. Exhibited: Wichita, 1961; Designer-Craftsmen, 1960; Craftsmen of the Eastern States, 1963; Interchurch, N.Y., 1967-1969; Artist-Craftsmen of N.Y., 1965-1969. Positions: Instr. Ceramics, Craft Students League, N.Y., 1952- .

EPPINK, HELEN BRENAN (Mrs. N. R.)—Painter, Ed.
912 Union St., Emporia, Kans. 66801; s. Wild Rose, Wis.
B. Springfield, Ohio, Aug. 19, 1910. Studied: Cleveland Sch. A.; John Huntington Polytechnic Inst. Member: Kansas State A. T. Assn. Assn.; Kansas Fed. A.; NAEA; AAUP; Emporia Friends of A. (Vice-Pres. 1968-1969). Awards: CMA, 1933, 1935, 1937; Kansas City AI, 1939; Prairie WC Painters, 1954; Wichita, 1956; Kansas State Univ., 1954, 1965; Topeka A. Gld., award, 1967. Work: Kansas Fed. Women's Cl; Wichita A. Mus.; College of Emporia; Emporia Pub. Schools; Kansas State Univ. Exhibited: CMA, 1932-1938; Kansas City AI, 1939, 1940, 1942; Butler AI, 1941; Kansas Printmakers, 1949; Derby, England, 1948; Kansas Painters, 1949, 1951, 1952, 1956, 1958, 1960, 1963-1965; Nelson Gal. A., 1949; Mid-Am. A., 1954, 1955; Wichita, Kans., 1955, 1956, 1957, 1961; Kansas State T. Col., 1957 (one-man); Joslyn A. Mus., 1956; Kansas Cent. Exh., 1961; Kansas Fed. A., 1959, 1960, 1963, 1964; Hutchinson AA, 1964 (2-man). Positions: Instr. A., Ottawa Univ., Ottawa, Kans., 1948-51; Instr., A. Dept., College of Emporia, Kans., 1944-48, 1949-53; Kansas State T. Col., 1951, 1952, 1960-61; Assoc. Prof. A., Hd. Dept. A., College of Emporia, 1961- .

EPPINK, NORMAN R.—Educator, P., Gr.
912 Union Ave., Emporia, Kans. 66801; s. Wild Rose, Wis.
B. Cleveland, Ohio, July 29, 1906. Studied: Cleveland Sch. A., B.E.A.; John Huntington Polytechnic Inst.; Western Reserve Univ., M.A. Member: Am. Assn. Univ. Prof.; Kansas Fed. A. (Trustee, 1968-1969); AIGA; Kansas A. Edu. Assn. Awards: CMA, 1931, 1932, 1934, 1935, 1936, 1953-1955; Kansas City AI, 1938; Kans. Pr. M., 1947; Manhattan, Kans., 1952; Kansas Painters, Pittsburgh, 1949, 1951, 1952; Wichita, 1955; Prairie WC Painters, 1954; Hutchinson AA, 1955; Topeka A. Gld., 1953, 1955, 1956, 1967, 1968; Work: CMA; Cleveland Mun. Coll.; Kansas Fed. Women's Cl.; Emporia Women's City Cl.; Manhattan State Col.; Pittsburg State T. Col.; Ft. Scott H.S.; Wichita A. Mus. Exhibited: Butler AI, 1941; Topeka, 1942 (one-man); Wichita A., 1944 (one-man), 1947, 1959, 1960; Pittsburg, Kans., 1949, 1951, 1952; Manhattan, Kans., Mulvane Mus., 1954 (2-man); Denver A. Mus., 1953, 1955; Walker A. Center, 1954; Kans. Cent., 1961; Derby, England, 1948; Nelson Gal. A., 1949; Mid-Am. A., 1951, 1955; Pratt Graphic A. Center, N.Y., 1966, 1968; one-man: Cleveland Pub. Library, 1967 Univ. Denver, 1968. Author, I., "101 Prints," (original prints) circulated nationally by Nat. Gal. Art, 1968-1969. Limited eds. in Colls. of British Mus.; AIC; CAM; CMA; Denver Univ. Library; Houghton Library, Harvard Univ.; William Allan White Library, Emporia, Kans.; LC; Los Angeles County Mus.; MMA; N.Y. Pub. Library; Joslyn A. Mus., 1956; SAGA, 1954, 1955. Lectures: Prints and Printmaking. Positions: Prof. Art History, Kansas State T. Col., Emporia, Kans., 1937- .

ERBE, JOAN (Mrs. Joan Erbe Udel)—Painter
5603 Wexford Rd., Baltimore, Md. 21209
B. Baltimore, Md., Nov. 1, 1926. Member: AEA. Awards: prizes, CGA, 1960, 1962; AEA, 1960, 1961; Peale Mus., 1960; Baltimore A. Festival, 1961; BMA, 1963, 1964, 1966. Work: Municipal Court, Washington, D.C.; Peale Mus., Baltimore; BMA; Morgan College. Exhibited: Butler Inst. Am. A., 1960, 1961; LC, 1948; Smithsonian Inst., 1956; Berkshire A. Festival, 1953; Peale Mus., Baltimore 1951-1961; CGA, 1957-1960; BMA, 1954, 1956, 1958-1961, 1965; Salpeter Gal., N.Y., 1961 (one-man); IFA, Wash., D.C., 1958-1962, 1964-1966, 1968 (all one-man); Phila. A. All., 1962.

ERDMAN, R. H. DONNELLEY—Collector, Patron, Architect
80 Broad St. 02110; h. 50 River St., Boston, Mass. 02108
B. Pasadena, Cal., Jan. 19, 1938. Studied: Princeton University, B.A. (Arch.), M.F.A. (in Arch.); Ph.D. (Arch.); University of California, B. Arch.*

ERICSON, BEATRICE—Painter
14 Watkins Ave., Middletown, N.Y. 10940
B. Paris, France, Oct. 26, 1909. Studied: with Morris Davidson. Member: Provincetown AA; Creative Contemporaries. Work: Mi-

ami Mus. Mod. A.; N.Y. Univ.; Marist Col., Poughkeepsie, N.Y. Exhibited: Provincetown AA, 1952-1955; Contemporary A. Gal., N.Y., 1954, 1955; City Center, N.Y., 1956, 1958; Caravan Gal., N.Y., 1953; Dutchess AA, 1953-1958; Albany Inst. Hist. & Art, 1952-1955; Woodstock AA, 1955; Parnassus Gal., 1953, 1954; Berkshire Mus., 1953; Knickerbocker A., 1954; Silvermine Gld. A., 1960; Norfolk Mus. A. & Sciences; one-man: Albany Inst. Hist. & Art, 1955; Panoras Gal., N.Y., 1957; Avant Gal., N.Y., 1959; Angeleski Gal., N.Y., 1960; Paul Kessler Gal., Provincetown, Mass., 1967; Brata Gal., New York City, 1967; Temple Emeth, Teaneck, N.J., 1968.

ERICSON, DICK—Cartoonist, W., I., L.
 Roxbury, Conn. 06783
B. New York, N.Y., Apr. 12, 1916. Member: Nat. Cartoonists Soc. Awards: ENIT Trophy in Cartoon category, 13th Intl. Humor Festival, Bordighera, Italy, 1960; Special award, Nat. Automobile Dealers Pub. Rel. Committee for outstanding public relations achievements, 1954. Work: Nat. Cartoonists Soc. Coll.; LC. Contributor cartoons to numerous anthologies including "Best Cartoons of the Year," for 20 years. Also to Sat. Eve. Post; True; Playboy; Ladies Home Journal; Redbook; Saturday Review; Argosy; Sports Illustrated; This Week; Banking; King Features Syndicate; McNaught Syndicate and many more. Lectures on cartooning and advertising to schools, service clubs, business conventions, etc. Pioneered humor in the financial field with cartoons being syndicated by American Bankers Assn., Thrifticheck Service Corp., and by own syndicate under personal name. Positions: Advertising and public relations consultant, writer and illustrator; Vice-Pres., Bd. Governors (4 years), Chm. ACE Awards Committee, Public Relations Committee, Slide Shows, Overseas Tours, National Cartoonists Society. Creator of: Newspaper features "Citizen Sibley" and "Trixie the Trader," Syndicated by Al Smith Features; "Imagene," published by Banking; "Stewart the Steward" published in two children's papers used by many churches in the U.S.

ERICSON, ERNEST—Illustrator, Des., P., E.
 Kenyon & Eckhardt, 200 Park Ave.; h. 305 East 86th St., New York, N.Y. 10028
B. Boston, Mass. Studied: BMFASch.; AIC; ASL; Grande Chaumiere, Paris. Member: SI. Exhibited: Detroit Inst. A.; N.Y. WC Soc.; PAFA; SI. Positions: Instr., Adv. Des. Dept., School of Visual Arts, New York, N.Y., 1956- ; Illustrator, Kenyon & Eckhardt, New York, N.Y., 1955- .

ERIKSON, D. ERIK—Stained Glass Artist-Designer
 40 E. Sumner Ave., Roselle Park, N.J. 07204
B. New York, N.Y., Mar. 30, 1933. Studied: Pratt Institute, N.Y.; Cooper Union, N.Y.; Wimbledon School of Art, England; Cleveland Institute of Art. Awards: prizes, National Comp. sponsored by the Stained Glass Association of America; winning design for the Christian Witness Pavilion, Seattle World's Fair, 1961-62; Tiffany Grant in Stained Glass, 1964-65. Exhibited: Stained Glass Assn. of Am., 1956; Cleveland May Show, 1956; Newark Mus. A., 1959; American Craftsmen's Council, 1962; Museum of Contemporary Crafts, N.Y. (circulated by American Federation of Arts), 1962; Princeton, N.J., 1962; New Jersey Designer-Craftsmen, 1963; WMA, 1963 (circulated by Smithsonian Inst.); Newark Mus. A., 1965. Work: Cleveland State Hospital; Wickliffe (Ohio) Seminary; St. Patrick's Church, Canonsburg, Pa.; Church of St. Perpetua, McKeesport, Pa.; Church of St. Luke the Evangelist, Roselle, N.J., Henry Street Settlement, and in private residences. Positions: Pres., New Jersey Designer-Craftsmen, 1964-65; Vice-Pres., Northeast Regional Assembly of the American Craftsmen's Council, 1964-65; Appointed by the Governor of New Jersey to the Sub-Committee for Painting and Sculpture of the Commission to Study the Arts in the State of New Jersey, 1964-65.*

ERLANGER, ELIZABETH N.—Painter, Lith., T., L.
 156 W. 86th St., New York, N.Y. 10024
B. Baltimore, Md., Oct. 23, 1901. Studied: Ralph M. Pearson, ASL; Umberto Romano, Jean Liberte, Hans Hofmann. Member: NAWA; Audubon A.; Am. Color Pr. Soc.; N.Y. Soc. Women A.; Wash. Pr. M.; AEA; SAGA; Nat. Soc. Ptrs. in Casein; Acad. FA, Hartford, Conn.; N.J. Soc. P. & S. Awards: prizes, NAWA, 1952, 1953, 1956, 1958, 1961, 1963; Am. Soc. Contemp. A., 1953, 1955, 1958, 1960, 1963; N.J. Soc. P. & S., 1959, 1963; Nat. Soc. Ptrs. in Casein, 1963; Recipient of first special citation given by Governor Rockefeller to a woman for outstanding civic achievement in the arts, 1966. Work: Fla. Southern Col.; MMA; N.Y. Pub. Lib.; Univ. Maine; Colby Col.; Evansville Mus. A.; Richmond (Ind.) Mus. A.; Lehigh Univ.; St. Vincent Col.; Birmingham Mus. A.; Peabody Mus.; Joslyn Mus. A.; Brandeis Univ.; Riverside Mus., N.Y.; N.Y. Univ.; Collectors of Contemp. A.; Norfolk Mus. A., and in private collections. Exhibited: NAWA, 1946-1965; Audubon A., 1949-1965; Am. Soc. Contemp. A., 1950-1965; Nat. Soc. Ptrs. in Casein, 1953-1965; Wash. Pr. M., 1958-1965; SAGA, 1959-1965; Am. Color Pr. Soc., 1959-1965; Pasa-

dena A. Mus.; Delgado Mus. A.; BM; Riverside Mus.; NAD; NAC; Conn. Acad. FA; Silvermine Gld. A.; Smithsonian Inst.; Honolulu Acad. FA; Provincetown A. Gal., 50th Anniv., 1964; Jewish Mus., 1964; Worlds Fair, N.Y., 1964; traveling exhs.: U.S., Canada, Greece, France, Switzerland, Scotland, Japan, Buenos Aires, 1953-1965. One-man: Mus. New Mexico, 1948; New York City, 1948, 1949, 1951, 1957, 1959, 1963; Univ. Maine, 1955; Fairleigh Dickinson Univ., 1960; Silvermine Gld., 1960; Asheville, N.C., 1961 and traveling one-man in U.S. 1965; 8 one-man shows in New York. Positions: Pres., Am. Soc. Contemp. A., 1963-65; Bd. Memb., NAWA, N.Y. Soc. Women A.; Delegate to U.S. Comm. of Int. Assn. of Art, 1956-1963. Liaison Officer from U.S. Comm. of IAA to U.S. Nat. Comm. for UNESCO, 1964-1968. Demonstrations and lectures for School Art League, 1958-1965.

ERNST, JAMES A.—Painter, E., L.
 Crescent Coves, Bozman, Md. 21612
B. New York, N.Y., Aug. 5, 1916. Studied: PIASch.; Grand Central A. Sch. Member: CAA; A. Gld.; Md. Fed. of A.; Baltimore WC Cl. Awards: first prize, Dorchester A. Exh., Cambridge, Md., 1966; Md. Fed. of A., 1967, 1968; Acad. of A., Easton, Md., 1967; Land of Pleasant Living Exh., Baltimore, 1969. Exhibited: AWS, 1953-1955, 1958; Audubon A., 1958, 1961; Drawings-U.S.A., 1961-1966; one-man: Barzansky Gal., 1951-1958; Tedesco Gal., Paris, France, 1952, 1955; Smith Gal., St. Thomas, V.I., 1953; N.Y. Pub. Lib., 1959-1962; Casa de Portugal, N.Y., 1960-1962; Talbot County Lib., Easton, Md., 1965, 1968; Painting in Portugal, 1960, Azores, 1961 at invitation of Portuguese Govt. Lectures and demonstrations. City Col. and N.Y.Pub. Lib. Positions: Assoc. Supv. N.Y. Pub. Lib. A. Project, New York, N.Y., 1957-1962; Instr., City College of New York, 1950-62; Staff A., Batten, Barton, Durstine & Osborn, N.Y., 1951-62; Vice-Pres. A. Gld., 1961-1962. Memb. Joint Ethics Com., 1960-1969; Bd. Mem., Md. Fed. of A., 1968-1969. Author: "Drawing the Line," 1962.

ERNST, JIMMY—Painter, E.
 891 Ponus Ridge, New Canaan, Conn. 06840
B. Cologne, Germany, June 24, 1920. Studied: Cologne-Lindenthal Real-Gymnasium; Altona A. & Crafts Sch. Awards: prizes, Norman Wait Harris award, AIC, 1954; Creative Arts award, Brandeis Univ., 1957; Guggenheim grant, 1961. Work: MMA; WMAA; BM; Wadsworth Atheneum; AIC; Solomon Guggenheim Mus. A.; Albright A. Gal.; Toledo Mus. A.; Mus. of FA, Houston; VMFA; Toronto (Canada) A. Mus.; Munson-Williams-Proctor Inst.; Univ. Colorado; Washington Univ.; Lehigh Univ.; Cranbrook Acad. A.; Am. Acad. A. & Lets.; Pasadena A. Mus.; N.Y. Univ.; Finch Col.; Mitchener Fnd.; CGA; Norton Gal. A.; Detroit Inst. A.; Univ. So. Illinois; Wallraf-Richartz Mus., Cologne, and others; Exec. dining room, G.M. Tech. Center, 1956; painting, Abbott Laboratories, 1955; painting, Fortune Magazine, 1955, 1961; sculpture, N.B.C. Producer's Showcase, 1954; murals: USS Adams, 1956; Continental Bank, Lincoln, Neb., 1958-59. Exhibited: AIC, 1954, 1956; BM, 1952-1956; Univ. Illinois, 1952, 1953, 1957; WMAA, 1953-1958; PAFA, 1953, 1955, 1957, 1965; Carnegie Inst., 1955; Univ. Nebraska, 1953-1957; Venice Biennale, 1956; American Painting, Japan, 1955; American Drawing, Europe, 1954; American Bldg., Brussels World Fair, 1958; State Dept. Cultural Exchange Mission to Russia, 1961; Cologne, 1963; Bielefeld Mus., Germany, 1964; Berlin, 1965; one-man: Grand Rapids Mus. A., 1968; Chicago A. Cl., 1968. Lectures: Contemporary Art. Lectured for USIS, 1963 in USSR and Germany; also lectured at art associations and museums in the U.S. Positions: Visiting Artist, Univ. Colorado, 1954, 1965; Mus. FA, Houston, Tex., 1956; Prof., Dept. Art, Brooklyn College, 1951- .

ERPF, ARMAND G.—Collector
 42 Wall St. 10005; h. 550 Park Ave., New York, N.Y. 10021
B. New York, N.Y., Dec. 8, 1897. Collection: Modern Painting and Sculpture. Positions: Trustee, The American Federation of Arts; Trustee, The Whitney Museum of American Art; Member of Advisory Council, Institute of Fine Arts, New York University. Former President, Friends of the Whitney Museum of American Art.

ESHERICK, WHARTON—Sculptor, Des., C., Gr.
 Paoli, Pa. 19301
B. Philadelphia, Pa., July 15, 1887. Studied: PMSchA.; PAFA. Member: AEA. Awards: prizes, PAFA, 1951; PMSchA., 1957; one of eleven winners in Intl. Sculpture Comp., for "The Unknown Political Prisoner" (awarded 2 prizes); gold medal, Arch. Lg., 1954. Work: PAFA; AGAA; Casa del Libro, San Juan, P.R.; WMAA; PMA; Univ. Pennsylvania; woodcut illus.; "Song of Solomon"; "Song of the Broad Axe"; Altar pieces for Chapel, St. Thomas Episcopal Church, Whitemarsh, Pa.; Sc., Philadelphia Branch Public Library. Exhibited: WFNY, 1939; 20th Cent. Sculpture Show, 1952-53; Mus. Contemp. Crafts, N.Y., 1957, Retrospective exh., Dec. 1958 thru Feb. 1959; Brussels World Fair, 1958; PMA; PAFA; WMAA; Phila. A. All.; MModA, 1953; Tate Gal., London, England, 1953; BM, 1961;

Wilmington Soc. FA, 1963; Philadelphia A. All., 1964; AGAA, 1964; Triennale di Milano, 1964; Smithsonian Inst. traveling exh., 1964-65; USIA traveling exh., Latin America, 1964-65; Retrospective Exhs.; Franklin & Marshall Col., Lancaster, Pa., 1968; PAFA (paintings, sculpture, furniture and prints), 1968.

ESHOO, ROBERT—Painter, T.
1015 Chestnut St., Manchester, N.H. 03104
B. New Britain, Conn., Apr. 27, 1926. Studied: Sch. Mus. FA of Boston (Dipl., Grad. Asst.); Syracuse Univ., B.F.A., M.F.A. Awards: prizes, Boston A. Festival, 1954; Munson-Williams-Proctor Inst., Utica, N.Y., 1957; L.M.D. Sweat Mus. A., Portland, Me., 1957, 1958. Work: Brandeis Univ.; de Cordova & Dana Mus.; Sweat Mus. A.; AGAA; Currier Gal. A.; Munson-Williams-Proctor Inst.; BMFA; Wadsworth Atheneum, Hartford, Conn.; St. Anselm's Col., Manchester, N.H. Exhibited: MModA, 1956; AFA, 1956; AIC, 1957, 1961; WMAA, 1957; Univ. Illinois, 1957, 1959; VMFA, 1962; CGA, 1963; Boston A. Festival, 1953-1962; ICA, Boston, 1959; De Cordova & Dana Mus., 1962; Munson-Williams-Proctor Inst., 1957; Sweat Mem. Mus., 1957-1960; AGAA Retrospective Exh., 1962. Positions: Instr., Syracuse Univ.; Phillips Acad., Andover, Mass., Currier Art Center; Supv., Children's Art Classes, Currier Art Center, Manchester, N.H., 1958- . Hd. A. Dept., Derryfield Preparatory Sch., Manchester, N.H. 1965- .

ESMAN, BETTY (Betty Esman Samuels)—Painter
1230 Park Ave., New York, N.Y. 10028
B. New York, N.Y. Studied: Syracuse Univ. Col. FA; NAD; Ecole des Beaux-Arts, Paris, and elsewhere in Europe and South America. Member: NAWA; Brooklyn Soc. A.; Nat. Soc. Painters in Casein; P. & S. Soc. of New Jersey; AEA. Awards: prizes, NAWA, 1955, 1959; Brooklyn Soc. A., 1955, 1959. Work: Fla. Southern Col.; Brandeis Univ.; Ball State T. Col.; Univ. South Carolina; Peabody Mus.; Norfolk Mus. FA; Six U.S. Embassies, and in private coll. Exhibited: AIC; SFMA; Albright A. Gal.; CGA; Mus. FA of Houston; Wildenstein Gal.; Miami Univ.; Univ. Cincinnati; PAFA, 1952; NAWA, annually; WMAA; Phila. A. All.; Montclair (N.J.) Mus. A.; Peabody Mus., and many others; Brooklyn Soc., A., 1954, 1955; N.Y. World's Fair, 1964, 1965; U.S. Embassy, Paris, France; Musée des Beaux Arts, Dijon, France, 1954; Musée Ingres, Montauban, France; Sallé Franklin Bordeaux Musée Paul Dupuy, Toulouse, France, and others; USIS traveling exhs. to Holland & Yugoslavia; Mexico, 1965-1966. One-man: New York, 1950, 1952; Ball State T. Col., 1956; Bucknell Univ., 1957; Saranac Lake, N.Y., 1958; RoKo Gal., N.Y., 1960.*

ESSERMAN, RUTH (Mrs. Norman)—Painter, E.
433 Vine St.; h. 284 Prospect Ave., Highland Park, Ill. 60035
B. Chicago, Ill., May 21, 1927. Studied: Univ. Illinois, B.A., M.A.; AIC; Univ. Mexico. Member: Illinois A. Edu. Assn.; NAEA; Arts Club, Chicago; Illinois Edu. Assn. Awards: prizes, McCurry purchase award, Deerpath A. Lg., 1957; North Shore A. Lg., 1958; Old Orchard Festival, 1961; Evanston A. Fair, 1962, 1963; Eisendrath award, AIC, 1960. Exhibited: Denver A. Mus., 1959, 1960; AIC, 1958-1960, 1963; St. Paul, 1960; Minneapolis Inst. A., 1960; Chicago Sun Times Comp., 1960-1962; New Horizons, 1958; Roosevelt Univ. PanAmerican Exh., 1957; Hyde Park Comp., 1957, 1958. Positions: Instr., 1957- , Chm. A. Dept. 1960- , Highland Park High School; Pres.-Elect, Illinois A. Edu. Assn., 1964-65, Pres., 1965-66; Art Advisor to U.S. Office of Edu., 1967-1968.

ESTHER, SISTER (NEWPORT)—Educator, P., L., W.
Foley Hall, St. Mary-of-the-Woods, Ind. 47876
B. Clinton, Ind., May 17, 1901. Studied: AIC, B.A. in Edu.; St. Mary-of-the-Woods Col., A.B.; Syracuse Univ., M.F.A. Awards: LL.D., St. Mary's College, Notre Dame; prize, Hoosier Salon, 1937, 1939, 1942. Exhibited: MMA (illuminated mss.), 1944; Lakeside Press Gal., (book illus.), 1933; Hoosier Salon, 1933, 1937, 1939, 1940, 1942; John Herron AI, 1938; Int. Exp. of Sacred Art, Rome, 1950; Contemporary Religious Art, Tulsa, Okla., 1949. Contributor to Liturgical Arts magazine; Journal of Arts & Letters, St. Paul; Catholic Art Quarterly; Church Property Administration; The Catholic Educator, New Catholic Encyclopaedia "Art Education," 1965, and other magazines. Author: 90 picture studies for Barton Cotton's Picture Series; Jr. A. Hist. section of CAA Course of Study for Art in Elementary Grades; Art Section of "Self Evaluative Criteria for Elem. Schools" (Catholic Edu. Assn.), 1965. Lectures: Modern, Creative, Plastic Art and Art Edu. Positions: Founder, Catholic AA, 1936; Dir., 1936-40, Bd. Advisors, 1940-58; Founder, Ed., Catholic Art Quarterly, 1937-40; Hd. A. Dept., St. Mary-of-the-Woods, 1937-1964; Assembled U.S. Section of Int. Exp. Sacred Art, Rome, 1950; Chm., U.S. Comm. for the Holy Year Exhibit, 1949-51; Dir., A. Workshop, Catholic Univ., 1954, 1958, 1959; Staff, 1952-57. Ed., "Creative Art," 1955; "Catholic Art Education, New Trends," 1959; "Reevaluating Art in Education," 1960. Author: Art Section of "Report of Everett Curriculum Workshop," 1956; "Art Teaching Plans" (3 books), 1960, "Art Appreciation and Creative Work,"

1961; Art Consultant, 1956, and Nat. Liturgical Week, 1957. Collecting Committee for Children's Art Exh. for Vatican Pavillion, Brussels World Fair, 1958. Fndr., Gen. Chm., Conf. of Catholic A. Educators, 1958-1961. Permanent Exec. Sec., 1960-1963. Dir. A. Sect. of Nat. Catholic Charities Jubilee Program, 1958-60. Art Supv., Sisters of Providence, 1962- ; Board of Education, 1962-68. Dir., Summer Inst. of Art Education, Chicago, 1965; Speaker and Consultant on Elem. Art Edu. at NCEA convention, New York, N.Y., 1965.

ETNIER, STEPHEN MORGAN—Painter
c/o Midtown Gallery, 11 E. 57th St., New York, N.Y. 10022; h. Old Cove, South Harpswell, Me. 04079
B. York, Pa., Sept. 11, 1903. Studied: Yale Sch. FA; PAFA. Awards: prize, Butler AI; Altman prize, 1956, gold medal, NAD, 1955, 1956, 1964; Member: NA. Work: MMA; BMFA; Vassar Col.; PAFA; PC; New Britain Mus. A.; Farnsworth Mus. A.; Wadsworth Atheneum; Toledo Mus. A.; Bowdoin Col.; IBM; Gettysburg Col.; DMFA; Marine Mus., Searsport, Me.; Los A. Mus. A.; Parrish A. Mus., Southampton, N.Y.; Fairleigh Dickinson Col., Rutherford, N.J.; York (Pa.) Hist. Soc.; Butler AI; Yale Univ.; Brigham Young Univ.; Ogunquit Mus. A.; Martin Mem. Lib., York, Pa.; murals, USPO, Everett, Mass.; Spring Valley, N.Y. Exhibited: nationally.

ETS, MARIE HALL (Mrs. Harold)—Illustrator, W.
c/o Viking Press, 625 Madison Ave., New York, N.Y. 10022; h. Morningside Gardens, 501 West 123rd St., (Apt. 11-H), New York, N.Y. 10027
B. North Greenfield, Wis., Dec. 16, 1895. Studied: N.Y. Sch. F. & App. A.; Univ. Chicago, Ph.B.; AIC; & with Frederick V. Poole. Awards: Hans Christian Andersen award for "Play With Me," Stockholm, Sweden, 1956; also for same book, AIGA, 1958-1960; Caldecott Award, 1960. Work: Kerlan Collection, Univ. Minnesota Libraries; Iowa City Pub. Lib.; Milwaukee Pub. Lib.; set of illustrations for "Childcraft"; the "How and Why" Library. Exhibited: AFA 1st annual exh. selected books for children, 1945; Original drawings, Library Exhibit Gallery, T. College, Columbia Univ., 1963 (one-man); Albright-Knox Gallery of Art (with others) 1964. Author, I., "Mister Penny," 1935; "The Story of a Baby," 1939; "In the Forest," 1944; "Oley, the Sea Monster" (Herald-Tribune prizewinner) 1947; "Mr. T.W. Anthony Woo," 1951; "Another Day," 1953; "Play With Me," 1955; "Mr. Penny's Race Horse," 1956; "Cow's Party," 1958; "Mr. Penny's Circus," 1961, and others. Co-Author: "My Dog Rinty," 1946; Co-Author, I., "Nine Days to Christmas," 1959; "Gilberto and the Wind," 1963 (Honor book: N.Y. Herald-Tribune); "Automobiles for Mice," 1964 (Jt. Lit. Gld.); "Just Me," 1965; "Bad Boy, Good Boy," 1967; "Talking Without Words," 1968, and many others.

ETTENBERG, EUGENE M.—Book Designer, T., W., L., Cr.
Upland Lane, RFD 174, Croton-on-Hudson, N.Y. 10520
B. Westmount, Quebec, Canada, Oct. 21, 1903. Studied: T. Col., Columbia Univ. Ed.D., M.A.; PIASch., B.F.A. Member: AIGA; Type Dir. Cl. (Pres.); Authors Lg.; Columbia Faculty Cl.; Typophiles (Pres.); AAUP. Awards: Carey-Thomas Award, 1959; Golden Keys Award. Exhibited: AIGA, 1935-1941, 1948-1952; Morgan Lib., 1940. Author: "Type for Books and Advertising," 1937. Ed., "Advertising and Production Year Book," 1936-1940; "News Letter" of AIGA, 1935-1941, 1948-1952; Morgan Lib., 1940. Author: "Print," Gazette des Beaux-Arts (Paris), "Art of the Book," Publisher's Weekly, Times Literary Supplement (London), and other trade publications. Lectures: Typography. Positions: Manager, A. Dir., Typographer, The Gallery Press, New York, N.Y., 1954-1960; Vice-Pres., Marbridge Press, New York, N.Y., 1960-1967; Instr., Typography, Publ. Des., Adv. Des., PIASch., 1947- ; Dir. & V. Pres., AIGA, 1950- ; Tech. Ed., American Printer, 1950- ; Ed., "Portfolio," 1950- . Contr. Ed., American Artist magazine, 1951- ; Contrib. Ed., Inland Printer, 1967- ; Lecturer, Columbia Univ. Dept. Gr. A., 1952- ; Oklahoma State Univ. Sch. of Journalism, 1958- ; Radcliffe Col., 1960; Advisory Bd., Sch. of Continuing Edu., N.Y. Univ., 1968- .

ETTER, RUSS—Art Editor
Craft Horizons, 44 W. 53rd St., New York, N.Y. 10019*

ETTING, EMLEN—Painter, Des., I., E., W., L.
c/o Midtown Galleries, 11 East 57th St., New York, N.Y. 10022; h. 1927 Panama St., Philadelphia, Pa. 19103; (studio) 1921 Manning St., Philadelphia, Pa. 19103
B. Philadelphia, Pa., 1905. Studied: Harvard Univ.; Acad. de la Grande Chaumiere, Paris, and with Andre Lhote, Paris. Work: WMAA; PAFA; Atwater Kent Mus.; AGAA; murals, Market St. National Bank and Italian Consulate, Philadelphia. Awards: Italian Star of Solidarity; Chevalier, Legion d'Honneur. Exhibited: Fla. Southern Col.; VMFA; NAD; Audubon A.; PAFA; CAM; Phila. AA; Butler AI; Dayton AI; Bloomington AA; Illinois Wesleyan Univ.;

GGE, 1939; CGA; Norton Gal. A.; one-man: Midtown Gal.; Inst. Contemp. A., Boston, and in Cleveland, Philadelphia, Phoenix, and abroad. Translator, Illus., Paul Valery's "Cimetiere Marin," 1932. Author: "Drawing the Ballet," 1944; Illus., "Amerika" by Kafka, "Ecclesiastes"; "Born in a Crowd," by Gloria Braggiotti. Contributor to Art News, Fortune, Town & Country, Atlantic Monthly, This Week. Recording: The Liberation of Paris. Positions: Hon. Pres., Artists Equity Assn.; Hon. Pres., Alliance Francaise of Phila., Pa.

ETTINGHAUSEN, RICHARD—Museum Curator, W., L., Historian
Freer Gallery of Art, Washington, D.C. 20025
B. Frankfort-on-Main, Germany, Feb. 5, 1906. Studied: Univ. Frankfort, Ph.D.; & in England. Member: CAA; Am. Oriental Soc.; Asia House, N.Y.; Am. Res. Center in Egypt. Ed.: Ars Islamica, 1938-1951; Co-Ed., Ars Orientalis, 1951-1958; ed. bd., Ars Orientalis; Art Bulletin; Kairos. Author: "Studies in Muslim Iconography"; "Paintings of Emperors and Sultans of India," 1961. Contributor to: Ars Islamica, Ars Orientalis, Bulletin of Iranian Institute, Gazette des Beaux-Arts; Encyclopedia of World Art. Lectures: Persian Miniatures; Art of the Islamic Book; Near Eastern Pottery; The Arts of the Muslim East, etc. Positions: Research Assoc., Iranian Inst., N.Y., 1934-37; L., N.Y. Univ., 1937-38; Assoc. Prof. Hist. of Islamic A., Univ. Michigan, 1938-44; Assoc. in Near Eastern A., Freer Gal. A., Washington, D.C., 1944-1958, Cur. Near Eastern Art, 1958-1961; Hd. Cur., Near Eastern Art, 1961- ; Research Prof. Islamic Art, Univ. Michigan, 1948; Adjunct Prof., N.Y. Univ. Inst. FA, 1961-67; Prof., 1967- ; Consultative Chm., Islamic Dept., The Metropolitan Museum of Art, New York, N.Y., 1969- .

EVANS, BRUCE HASELTON—Museum Curator, W.
Dayton Art Institute, Forest & Riverview Aves. 45401; h. 334 Marathon Ave., Dayton, Ohio 45406
B. Rome, N.Y., Nov. 13, 1939. Studied: Amherst College, B.A.; N.Y. University Inst. FA, M.A. Member: AAMus; CAA; I.I.C. Author: "Fifty Treasures of the Dayton Art Institute," 1969. Contributor to museum bulletins, exhibition catalogues. Positions: Curatorial Asst. to the Director, Dayton Art Institute, Dayton, Ohio, 1965-1967; Chief Curator, 1968- .

EVANS, RICHARD—Painter, E., Gr.
Art Department, University of Wyoming; h. 519 S. 11th St., Laramie, Wyo. 82070
B. Chicago, Ill., Oct. 1, 1923. Studied: Otis A. Inst., Los Angeles; Cal. Col. A. & Crafts, B.A. Edu.; Univ. Wyoming, M.A. Awards: San Francisco A. Festival, 1950, 1951; Cedar City, Utah, purchase, 1965; Otis A. Inst., 1968; Stacey Fellow, 1947; Tiffany Fellow, 1948, 1950; Univ. Wyoming Grad. Council Fellow, 1965, 1969. Work: San Francisco FA Coll.; Univ. Wyoming; Col. of Southern Utah; numerous portraits. Exhibited: Otis A. Inst., 1966, 1968; Artist-Teacher USA exh., 1968; States' Arts Conferences traveling exh., 1968, 1969; Nat. A. tour, 1966; Survey '69; LC; Northwest Pr. M.; Art:USA, 1958; SAGA, 1960; Wyoming A. Council traveling exh., 1968, 1969; Colo. Springs FA Center, 1962. Contributor to American Artist magazine, 1962. Positions: Dir., Evening Sch., Cal. Col. A. & Crafts; Asst. Prof., Assoc. Prof. A., Univ. Wyoming since 1953, Prof., 1965- .

EVERGOOD, PHILIP—Painter, Gr., W., L., Des., I.
Route 67A, RFD No. 1, Bridgewater, Conn. 06752
B. New York, N.Y., Oct. 26, 1901. Studied: Cambridge Univ., Slade Sch., England; ASL; Julian Acad., Paris. Member: An Am. Group; AEA; Nat. Inst. A. & Let. Awards: prizes, AIC, 1935, 1946; AV, 1942; Carnegie Corp. grant, 1940-1942; Pepsi-Cola, 1944; Carnegie Inst., 1945; Schilling Purchase Award, 1946; La Tausca Comp., 1949; Hallmark Award, 1950; Carnegie Inst., 1950; CGA, 1951; Terry AI, 1952; Gold Med., PAFA, 1950, 1958; Nat. Inst. A. & Lets. grant, 1956; Ford Fnd. purchase award, 1962. Work: Encyclopaedia Britannica Coll.; Pepsi-Cola Coll.; MMA; MModA; WMAA; BMFA; Arizona State Univ.; Denver A. Mus.; BMA; BM; Kalamazoo AI; Nat. Gal., Melbourne, Australia; Geelong Gal., Victoria B. C.; Los A. Mus. A.; FMA; AIC; murals, Richmond Hill (L.I., N.Y.) Pub. Lib.; USPO, Jackson, Ga.; Kalamazoo Col. Exhibited: Carnegie Inst., 1938, 1939; La Pintura Contemporanea Norte Americana, 1941; WFNY 1939; WMA, 1942; Am-British Goodwill Exh., 1944; loan exh., Tate Gal., London, England, 1946; American Exh., Moscow, 1959; Retrospective Exh., WMAA, 1960. I., Fortune, Time magazines. Illus., Short Stories by Gogol, 1950. Lectures: Art & Aesthetics.*

EVERTS, CONNOR—Painter
4507 Spencer St., Torrance, Cal. 90503
B. Bellingham, Wash., Jan. 24, 1928. Studied: Chouinard A. Inst., Los Angeles; Univ. Washington; Mexico City Col., B.A.; Courtauld Inst., Univ. of London. Member: AEA; Los Angeles Printmaking

Soc. Awards: prize, Los Angeles County Mus. Art, 1955. Work: AIC; Gruenwald Fnd.; LC; Long Beach Mus. A.; Los Angeles County Mus. A.; MModA; Pasadena Mus. A.; Rosenwald Print Coll.; FA Gal. of San Diego; Smithsonian Inst.; Washington (D.C.) Gal. Mod. A.; Mus. Mod. A., Tokyo; SFMA, and in private colls., U.S., Europe, and Japan. Commission—El Camino Col. Art Bldg. installation, 1970. Exhibited: Pacific Coast Biennial, 1953; SFMA, 1951, 1955; Los Angeles County Mus. A., 1955, 1962; Nat. Drawing Exh., 1965; Int. Young Artists Exh., Tokyo, 1967; Tamarind Lithography Exh., MModA, N.Y., 1969, and other major juried exhs. One-man: 13 exhibitions including, London, England, 1953; Long Beach Mus. A., 1958; Santiago de Chile, 1959; Michael Walls Gal., San Francisco, 1957, 1959; Bertha Lewison Gal., 1959; Pasadena A. Mus., 1960; Comara Gal., Los Angeles, 1961, 1962; Eric Locke Gal., San Francisco, 1962; Nordness Gal., N.Y., 1963; and others. Traveling Exhs: Arts of Southern California II, V, VIII, X; Vortex: a survey of Los Angeles and San Francisco art; Hitchcock Coll., presently touring Canada; Cal. Printmakers, touring Europe; The Tamarind Lithography Workshop; The Exodus Group; Five by Five exh.; Self Portraits exhs., 1945-1969. Work reproduced in Art in America, Arts and Architecture, Art Forum, Frontier, Art News and other publications. Organized two exhibitions of Japanese Art, 1968, 1969 now traveling. Positions: Lecturer, Contemporary Art in America and in Japan-; Printmaking, at Univ. Illinois, 1968; Geomonic and Gutai Painting, Osaka, 1968; Lytton Visual Arts Center, 1965. Chm., Graphics Dept., Chouinard A. Inst., 1962-1965; Guest Artist, San Francisco A. Inst., 1965; Visiting Prof., Univ. So. Cal., 1967-1969; Chm., Advisory Bd., Los Angeles Municipal Art Dept., 1968.

EVETT, KENNETH WARNOCK—Painter, E.
Department Art & Architecture, Cornell University; h. 402 Oak Ave., Ithaca, N.Y. 14850
B. Loveland, Colo., Dec. 1, 1913. Studied: Colorado State College, A.B.; Colorado College, M.A.; Colorado Springs FA Center. Works: Montclair (N.J.) Mus. A.; Wichita Mus. A.; Joslyn Mus. A.; Fla. Gulf Coast A. Center; Munson-Williams-Proctor Inst.; Univ. Arizona; Univ. Colorado; Colorado Springs FA Center; Newark Mus. A.; N.C. State A. Soc., and in private colls.; murals, Rotunda, Nebraska State Capitol, Lincoln. Exhibited: WMAA; CGA, 1953; PAFA, 1952, 1954, 1964; MMA, 1952; AIC, 1952, 1954; VMFA; Kraushaar Gal., N.Y., 1948, 1952, 1954, 1957, 1960, 1964, 1969; Univ. Illinois; Toledo Mus. A.; Cal. PLH; Univ. Nebraska; Montclair A. Mus.; Inst. Contemp. A., Wash., D.C.; Munson-Williams-Proctor Inst.; Dartmouth Col.; Illinois Wesleyan Col., and others. Positions: Member Cornell Univ. Council for the Creative and Performing Arts; Advisory Committee, White Museum, Cornell Univ.; Prof. FA, Cornell Univ., Ithaca, N.Y., at present.

EWALD, LOUIS—Painter, Des.
Fetters Mill Rd., Bryn Athyn, Pa. 19009
B. Minneapolis, Minn., Dec. 19, 1891. Studied: Minneapolis Sch. A.; PMSchIA. Member: Church Arch. Gld. of Am.; NSMP. Work: paintings and dec. work in churches in Philadelphia, New York, Baltimore, Washington, D.C., York, Pa.; paintings and polychrome on altar reredos in St. Andrews R.C. Church, Drexel Hill, Pa.; ceiling and reredos in Chapel of the Christ Child, Christ Church, Wilmington, Del.; mural and inscriptions in chapel at Wittenberg Col., Springfield, Ohio; color and ornament painting in Grace Lutheran church, Pottstown, Pa.; decorative pages in Bibles publ. by Winston Publ. Co.; polychrome and gilding, Beth Sholom Synagogue, Elkins Park, Pa.; murals, Historic Trinity Lutheran Church, Reading, Pa.; painting on fabric, English Lutheran Church, Carey, Ohio; gilding the Fremiet statue of Jeanne d'Arc, PMA; symbols coloring etc., Church of Atonement, Wyomissing, Pa. and Abington (Pa.) Presbyterian Church; inscriptions, gilding and polychrome work in more than 60 churches; chapel and entrance ceiling, St. Mark's Episcopal Church, Phila., Pa.; color, symbols, inscriptions, Chapel of Christian Unity, Trinity Church, Princeton, N.J.

EWING, CHARLES KERMIT—Educator, P., L.
Art Department, University of Tennessee, Knoxville, Tenn. 37916
B. Bentleyville, Pa., May 27, 1910. Studied: Carnegie Inst., B.A., M.A., with Alexander Kostello; Iowa Univ., with Jean Charlot; Harvard Univ. Member: Assoc. A., Pittsburgh (Pres.); Prof. Affiliated Artists Assn., Atlanta. Awards: prizes, Assoc. A., Pittsburgh, 1940, 1943, 1945, 1956; Parkersburg, W. Va., 1942, 1943; Springfield, Mass., 1941; Southeastern Annual, Atlanta, 1950; Mid-South Annual, Memphis, 1963; Mead Co. "Painting of the Year," Atlanta. Work: Pittsburgh Pub. Schools; State College, Pa.; Univ. Pittsburgh; High Mus. A., Atlanta; Univ. Georgia Museum, Athens; murals, New Johnsonville (Tenn.) Steam Plant. Exhibited: NAD; Butler AI; Carnegie Inst.; Parkersburg, W. Va.; All. A. of Philadelphia; Assoc. A. Pittsburgh, 1938-1965; 3 one-man exhs., 1964-1965. Positions: A. Consultant, TVA.

EWING, EDGAR— Painter
University of Southern California; h. 4222 Sea View Lane, Los Angeles, Cal. 90065 and Odos Piraeus 6, Athens, Greece
B. Hartington, Neb., Jan. 17, 1913. Studied: AIC, with Boris Anisfeld; Univ. Chicago, and in Europe. Member: Cal. WC Soc.; Am. Assn. Univ. Prof.; AFA; Pacific AA; Los. A. County AI Assn.; Los Angeles AA. Awards: Ryerson F., 1935-37; Tiffany Fnd. grant, 1948-49; prizes, AIC, 1943; City of Los Angeles, 1950; Arizona State Fair, 1950; Chaffey Community AA, 1951; Los A. Mus. A., 1952; Cal. WC Soc., 1952-1955; Nat. Orange Show, 1953; Long Beach Mus. A., 1955; Cal. State Fair, 1956; San Jose State Col., 1957; Sierra Madre AA; Samuel Goldwyn award, Los. A. Mus. A., 1957; Ahmanson Award, City of Los Angeles Exh., 1962; José Drudis Fnd. award, 1967. Exhibited: AIC, AFA traveling exh.; Butler Inst. Am. A.; Carnegie Intl.; CM, Cal.PLH; Crocker A. Gal., Sacramento; CGA; Colo. Springs FA Center; DMFA; Detroit Inst. A.; Denver A. Mus.; de-Young Mem. Mus.; Fine Arts Soc. of San Diego; Frye Mus., Seattle; Fresno State College; Fort Worth A. Center; La Jolla A. Center; Los A. Mus. A.; Long Beach Mus. A.; Milwaukee AI; MMA; Minneapolis Inst. A.; Nelson Gal. A.; North Carolina Mus. A.; Oakland Mus. A.; Otis Art Inst., Los Angeles; Pasadena A. Mus. A.; PAFA; Portland A. Mus.; Va. Mus. FA; Smithsonian Inst.; SAM; SFMA; Sao Paulo, Brazil (Intl.) Santa Barbara Mus. A.; universities of: California at Los Angeles, Illinois, Nebraska, Utah; Wichita A. Mus. One-man: Santa Barbara Mus. A., 1952; Pasadena AI, 1952; College of Puget Sound, 1953; SAM, 1953; Dalzell Hatfield Gal., Los Angeles, 1954; deYoung Mem. Mus., 1955; Carnegie Inst., 1955; Dalzell Hatfield Gal., 1956, 1958, 1961, 1965; Long Beach Mus. A., 1960; Carnegie Inst., 1961; Esther Bear Gal., 1967; Carnegie-Mellon Univ., Pittsburgh, 1968, and many others of previous dates. Positions: Instr., AIC, 1937-1943; Summer Session Faculty, Univ. Michigan, 1946; Visiting Prof. FA, Univ. Oregon (Summer), 1950; Prof. FA, University of Southern California, Los Angeles, 1964-1969 (sabbatical leave, 1964—Italy and Greece); Mellon Prof. Painting, Carnegie-Mellon Univ., 1968-69.

FABE, ROBERT— Painter, E.
4235 Rose Hill Ave., Cincinnati, Ohio 45229
B. Chicago, Ill., May 24, 1916. Studied: Art Acad. of Cincinnati; ASL, and with Raphael Soyer, Arnold Blanch. Member: McDowell Soc. (Vice-Pres.); Cincinnati Prof. Artists; Cincinnati A. Cl.; Southwestern Ohio Prof. Artists. Awards: Emily Lowe Award, 1958; Dayton AI purchase award. Work: CM; Dayton AI; Butler Inst. Am. Art; First Nat. Bank, Cincinnati; Lipton Tea Co.; Cincinnati Enquirer; murals, restaurant in Dayton and Highland Towers, Cincinnati. Exhibited: CGA; PAFA; AIC; Butler Inst. Am. A., 1940-1944, 1949, 1950, 1960; Cincinnati A. & Vicinity, 1938-1965; Dayton AI, 1950-1964. Positions: Assoc. Prof. of Art, College of Design Architecture & Art, University of Cincinnati; Art Academy of Cincinnati.

FABRI, RALPH— Painter, Et., W., Cr., E.
54 West 74th St., New York, N.Y. 10023
B. Budapest, Hungary, Apr. 23, 1894. Studied: Royal State Gymnasium, B.A.; Royal Inst. Tech., Royal Acad. FA, M.A., Budapest. Member: NA (Council, 1949-52, Rec. Sec., 1952-55, Treas. 1961-1968); SAGA (Treas. 1946-48); Brooklyn Soc. A.; Wash. Pr. M.; Audubon A. (Pres. 1948-51, 1952-54, Hon. Life Pres. 1954-); Nat. Soc. Ptrs., in Casein (Pres. 1955-57, 1959-61, Hon. Life Pres. 1961-); Knickerbocker A.; Ptrs. & Sc. Soc. New Jersey; Providence WC Cl.; Boston Pr. M.; AAUP; Benjamin Franklin Fellow, Royal Soc. A., London; AWS; All. A. Am. (Dir., 1965-1968). Awards: J. T. Arms prize, 1942; LC, 1943-1945; Denver A. Mus., 1944; Conn. Acad. FA, 1945; NA, 1950; Fla. Southern Col., 1950; Applebaum prize, N.Y., 1952; A. Lg. Long Island; Hunterdon A. Center, N.J.; Walter E. Meyer prize, 1959; J. J. Newman Medal, N.Y., 1963; Medal of Honor, New Jersey, 1964; Grumbacher award, N.Y., 1965; Bainbridge award, Jersey City; Block award, Providence, R.I.; Oakes on the Hill award, Providence; Butler Inst. Am. A., purchase; Karl Davis award, Chester, Vt.; medal, NAC. Work: LC; Honolulu Acad. A.; Vanderpoel Coll.; Newark Pub. Lib.; Massillon Mus. A.; Attleboro Mus. A.; Univ. Maine; Rochester Mem. Mus.; Budapest Mus. FA; NAD; Smithsonian Inst.; Currier Gal. A.; Fla. Southern Col.; New York Pub. Lib.; Seton Hall Univ.; Rosenwald Coll.; Butler Inst. Am. A.; PMA; Oklahoma A. Center. Exhibited: AIC, 1932, 1935, 1939; NA since 1936; SAGA since 1935; SFMA, 1944, 1945; Northwest Pr. M., 1941-1952; Oakland AA, 1941-1951; PAFA, 1941, 1942, 1951; AWS, 1941, 1957, 1960; Conn. Acad. FA, 1942-1956; Audubon A., since 1945; LC, 1943-1952; Portland Soc. A., 1952; Carnegie Inst., 1949, 1950, 1951; Wichita AA, 1951; Reading Pub. Mus.; Norfolk Mus. A. & Sciences; Albany Pr. Cl., 1951; Newport AA, 1948-1951; Brooklyn Soc. A., since 1950; one-man: Smithsonian Inst., 1942; Honolulu Acad. A., 1943; Phila. A. All., 1943; New York, 1945, 1947, 1949, 1952, 1955, 1957; Univ. Maine, 1948, 1951, 1959; Albany Mus. Hist. & A., 1959, etc. Internationally: Italy, France, England, Scotland, Sweden, Norway, Finland, Turkey, India, Egypt and many others. Author: "Learn to Draw," 1945; "Oil Painting, How-to-do-

it," 1953; Sculpture in Paper; Guide to Polymer Painting, 1966; Color, A Complete Guide for Artists, 1967; Flower Painting, A Complete Guide, 1968; History of the American Watercolor Society; Painting Outdoors, 1969. Positions: Cr., Pictures on Exhibit, 1940-61; Assoc. Ed., "Today's Art"; A. Ed., Funk & Wagnall's Univ. Standard Encyclopedia, 1958-60; Chm., NAD Sch. FA, 1950-51; Assoc. Prof., CCNY (retired 1967); Instr., NAD School of Fine Arts.

FACCI, DOMENICO (AURELIO)— Sculptor, C., Des., L., E.
248 West 14th St., New York, N.Y. 10011
B. Hooversville, Pa., Feb. 2, 1916. Studied: Roerich Acad. A., and with Pietro Montana, Louis Slobodkin. Member: AEA (Bd. Dir., 1956-57, 1960-61, 1965-66, 1968-1969, V.Pres., 1958-59); Knickerbocker A.; Am. Soc. Contemp. A. (Pres. 1961-62, Bd. & Dir., 1963-1965, 1967-1970); Silvermine Gld. A.; P. & S. Soc. of New Jersey; Audubon A. (Bd. Dirs, Exec. V.P., 1963-64, Pres. 1967-1970); Lg. of Present Day A. (Treas.); NSS. Awards: prizes, Village A. Center, 1949-1953, 1955, 1956; Silvermine Gld. A., 1953-1955 (one-man), 1956, 1958; Am. Soc. Contemp. A., 1955, 1957, 1960, 1968; P. & S. Soc. of New Jersey, medal, 1955, prize, 1961; Fla. Southern Col., 1951, 1952; Audubon A., 1956, 1961, 1966; Knickerbocker A., 1959. Work: Fla. Southern Col.; Am. Cyanamide Co.; Bd. Edu., N.Y.; B'nai B'rith; bronze eagle, U.S. Pavilion, N.Y. World's Fair, 1964-65; wood sculptures, Americana Hotel, N.Y.; bronze portrait reliefs, Baseball Hall of Fame, Cooperstown, N.Y.; Freedom House, N.Y.; Norfolk Mus. A.; 8 ft. bronzes in Baltimore, Hagerstown, Md. and Guam. Exhibited: AEA, 1950; WMAA, 1951; Village A. Center, 1949-1955; NAD, 1936, 1944, 1953, 1954; ACA Gal., N.Y., 1952; BM, 1953; Silvermine Gld. A., 1953, 1954, 1955 (one-man), 1958, 1959, 1961; Pittsburgh A. & Crafts Center, 1954, 1955; Audubon A., 1955-1965; Am. Soc. Contemp. A., 1955-1965; Knickerbocker A., 1955-1965; Butler Inst. Am. A., 1964; N.Y. World's Fair, 1964. Exhibits annually with all membership societies. Positions: Instr. S., Roerich Acad. A., 1939-41; City Col. of N.Y., Ext. Div., 1953-54; Scarsdale Workshop, 1959-61; Ridgewood Village (N.J.) A. Sch., 1961-1965. Instr., YWCA, Craft Student's Lg., 1967- .

FACTOR, DONALD— Collector, Editor
701 N. Maple Dr., Beverly Hills, Cal. 90210
B. Los Angeles, Cal., Sept. 1, 1934. Studied: Univ. of Southern Cal. Contributor of articles and reviews to Artforum, Nomad and other publications. Collection: Contemporary American. Positions: Trustee, Pasadena Art Museum; Exec. Comm., Contemporary Art Council of Los Angeles County Museum of Art.*

FAGG, KENNETH S.— Sculptor, P., I.
Creative Director, Geo-Physical Dept., Rand McNally Co., Westerly Rd., Ossining, N.Y. 10562; h. 29 Deepwood Dr., Chappaqua, N.Y. 10514
B. Chicago, Ill., May 29, 1901. Studied: Univ. Wisconsin, B.A.; AIC; ASL. Member: SI; Am. Geographical Soc.; Assn. Am. Geographers; Arctic Inst. of America; AAAS; Geological Soc. of America. I., Holiday, Sat. Eve. Post, Life and Look magazines; Nat. Geographic Magazine. Work: Designed, sculptured & painted six-foot Geo-Physical Relief Globes of Earth and Moon for many museums, universities, business firms and the U.S. Government.

FAGGI, ALFEO— Sculptor, L.
Woodstock, N.Y. 12498
B. Florence, Italy, Sept. 11, 1885. Studied: Academia Belle Arti, Florence, Italy. Awards: prize & med., AIC, 1942. Work: AIC; AGAA; WMAA; Mus. New Mexico, Santa Fé; Phillips Acad.; BM; Univ. Chicago; Rosary Col., River Forest, Ill., Ogunquit Mus. A.; PAFA; Princeton Univ.; High Mus. A.; Scott Mem. Gal., Atlanta; Minneapolis Inst. A.; SAM; Albright A. Gal.; Columbus (Ohio) Mus. A.; PMG; Michigan State Univ.; St. Thomas Church, Chicago; mem. & busts, New York, N.Y.; Wash., D.C.; Chicago, Ill., etc. Exhibited: AIC, 1942, 1943; Albright A. Gal., 1941 (one-man); Fairmount Park AA (Phila.), 1940, 1949; WMAA, 1942, 1943; PAFA, 1943, 1948-1951, 1955-1957; SAM; Honolulu Acad. A.; PMG; BM; Gulf Coast A. Center; Argent Gal., 1944; Woodstock AA, 1961 and prior; Little Gal., Woodstock, N.Y., 1946; Univ. Chicago; Weyhe Gal., 1951, 1954 (one-man), 1957 (one-man), 1960; Atlantic City, 1951 (one-man); Ft. Worth A. Center, 1954; AFA traveling exh.; Christ Church, Greenwich, Conn., 1957, 1958; AGAA; Southern Ill. Univ. Carbondale, 1953 (one-man); Trieste, Italy, 1961; WMA, 1959. Lectures: "The Sculptor."*

FAHLSTROM, OYVIND— Painter
c/o Janis Gallery, 15 E. 57th St., New York, N.Y. 10022*

FAILING, FRANCES E(LIZABETH)— Painter, T.
5103 57th St. North, St. Petersburg, Fla. 33709
B. Canisteo, N.Y. Studied: PIASch.; Western Reserve Univ., B.S.; Columbia Univ., M.A.; Rochester Inst. Technology; Alfred Univ.; Cape Cod Sch. A.; Indiana Univ.; Butler Univ. Member: Plymouth

(England) A. Cl.; NAWA; Delta Kappa Gamma. Work: Herron Mus. A., Indianapolis, Ind.; Civic Center A. Coll., Phoenix, Ariz.; Plymouth (England) Mus. A., and in private colls. Awards: prizes, Indiana AA, 1934, 1951, 1952; Hoosier Salon, 1947; NAWA, 1937; Arizona State Fair (purchase), 1956, 1957, 1958. Exhibited: CM, 1934, 1936, 1937; PAFA, 1936; AIC, 1937; BM, 1937; NAWA, 1936-1938, 1941; CGA, 1937; N.Y. WC Cl., 1936; John Herron AI, 1933-1935, 1937, 1938, 1940-43, 1951; Hoosier Salon, 1934-1936; Indiana A. Cl., 1932-1934, 1936; Univ. Nevada, 1958; Phoenix Gal., 1956-1958; Phoenix A. Mus., 1960-61; Arizona State Univ., 1961; Southwestern States Exh., Tucson, 1958; Kansas City AI, 1938; Univ. of Arizona, Tucson, 1961; one-man: Witte Mem. Mus., 1936; Dallas Mus. FA, 1938; Mus. FA of Houston, 1939; Baylor Univ., FA, 1938; Ball State A. Gal.; Indiana State T. Col., 1952; Phoenix, Ariz., 1956; Ariz. State Univ., 1956; Yares Gal., Scottsdale, Ariz., 1965, and abroad. Positions: Chm., Dept. A., Washington H.S., Indianapolis, Ind., 1935-56; Asst. Prof. A., Arizona State Univ., Tempe, Ariz., 1956-1963.

FAIRWEATHER, SALLY H. (Mrs. Owen)—Art Dealer
Fairweather Hardin Gallery, 101 Ontario St., Chicago, Ill. 60611; h. 59 Hawthorne Rd., Barrington, Ill. 60010
B. Chicago, Ill., Sept. 28, 1917. Studied: Art Institute of Chicago, B.A.; Art Students League, N.Y.; and further study with Archipenko, Chicago. Specialty of the Gallery: Contemporary American Art. Positions: Instr., Katherine Lord's Studio, Evanston, Ill., 1938-1942; Member, Art Dealers Association of America, 1963- , Board of Directors, 1964-1965; Co-founder, Chicago Art Dealers Association, 1964, Board of Directors, 1969.

FAISON, S(AMSON) LANE, JR.—Educator, W., L., Cr.
Williams College Museum of Art; h. Scott Hill Rd., Williamstown, Mass. 01267
B. Washington, D.C., Nov. 16, 1907. Studied: Williams Col., A.B.; Harvard Univ., M.A.; Princeton Univ., M.F.A. Member: CAA (Pres. 1952-54, Dir., 1952-56, 1964-66); AAMus.; Mass. Council on Arts & Humanities. Awards: Chevalier de la Legion d'Honneur; Guggenheim Fellow, 1960-1961. Author: "Daumier's Third Class Carriage," 1946; "Manet," 1953; "Great Paintings of the Nude," 1953; "A Guide to the Art Museums of New England," 1958; "Art Tours and Detours in New York State," 1964. Contributor to N.Y. Times; Sat. Review; The Nation (A. Cr., 1952-55); Art Bulletin; Art in America; College Art Journal. Lectures: Contemporary Painting; German Baroque Architecture; Manet; Daumier; Nazi Art Looting Activities. Positions: Instr., Asst. Prof., Yale Univ., 1932-36; Dir., Central Collecting Point, Munich (State Dept.), 1950-51; Exec. Sec., Com. on Visual Arts, Harvard Univ., 1954-55; Asst. Prof., 1936- , Chm. Dept. A., 1940- , Amos Lawrence Professor, 1947- , Dir., Williams College Museum of Art, 1948- , Williamstown, Mass.

FALKENSTEIN, CLAIRE—Sculptor
719 Ocean Front Walk, Venice, Cal. 90291
B. Coos Bay, Ore. Studied: Univ. California, Berkeley. Work: AGAA; BMA; BMFA; Guggenheim Mus.; Los A. Mus. A.; Mills College A. Gal., Oakland, Cal.; MModA; SFMA; Southern Illinois Univ.; other works: floor to ceiling stair railing for Gallery Sapzio, Milan, Italy and Galerie Stadler, Paris, France; fire-screen designed for Louis VI fireplace in Baron de Rothschild's chateau; exhibited at the Louvre in group show "Art for Use," 1962; fountain, Wilshire Blvd., Los Angeles, 1964; other fountains, gates, murals for private residences, U.S. and abroad. Exhibited: 7 major U.S. exhibitions, 1958-59; also, Inst. Contemp. A., Boston, 1959; Il Segno Gallery, Rome, 1958; Carnegie Inst., 1964; WMAA, 1964; Martha Jackson Gal., N.Y., 1965 (one-man).*

FALTER, JOHN—Illustrator
R.D. 2, Lansdale, Pa. 19446
B. Plattsmouth, Neb., Feb. 28, 1910. Studied: Kansas City AI; ASL; Grand Central Sch. A. Member: SI; NAC; A. & W. Cl. Illus., "A Ribbon and a Star," 1946; "The Horse of Another Color," 1946. Contributor of: covers to Saturday Evening Post.*

FARBER, GEORGE W.—Collector
160 Fremont St. 01603; h. 138 Newton Ave., Worcester, Mass. 01609
B. Southbridge, Mass., July 11, 1901. Studied: Clark University. Collection: Graphics.

FARMER, EDWARD McNEIL—Painter
3635 Lupine Ave., Palo Alto, Cal. 94303
B. Los Angeles, Cal., Feb. 23, 1901. Studied: Stanford Univ., A.B., M.A.; Rudolph Schaeffer Sch. Des.; ASL. Member: Soc. Arch. Historian (Pres. Pacific Section, 1956-57); CAA; Col. Art Administrators Assn. (permanent Sec., Pres., 1954-55). Exhibited: AIC; Riverside Mus.; N.Y. WC Cl.; AWS; GGE, 1939; CM; California State Fair; PAFA; CGA; Grand Central A. Gal.; and in local exhs. Lectures: Painting & Architecture; Development of the American House; The

Arts at Mid-Century. Positions: Actg. Instr., Graphic A., 1923-25, Instr., 1925-32, Actg. Asst. Prof., 1932-36, Asst. Prof., 1936-40, Assoc. Prof., 1946, Prof., A. & Arch., 1946- , Actg. Exec. Hd., Dept. A. & Arch., 1961- , Emeritus, 1964- , Stanford Univ., Stanford, Cal.; in Germany, Beutelsbach bie Stuttgart, West Germany, 1958, in Florence, Italy, 1962. Ed., Stanford Art Series; Native Arts of the Pacific Northwest; 45 Contemporary Mexican Artists, 1951.

FARNSWORTH, MRS. HELEN SAWYER. See Sawyer, Helen

FARNSWORTH, JERRY—Painter, T.
3482 Flamingo, Sarasota, Fla. 33581
B. Dalton, Ga., Dec. 31, 1895. Studied: Corcoran Sch. A.; & with Charles W. Hawthorne. Member: NA; NAC; SC; Wash. Soc. A.; Provincetown AA. Awards: prize, NAD, 1925, 1927, 1933, 1935, 1952, med., 1936, prize, 1938; NAC, 1941; Los A. Mus. A., 1945; High Mus. A., 1946; Grand Central Gal., 1928. Work: Mus. FA of Houston; Toledo Mus. A.; PAFA; New Britain Mus.; MMA; Dayton AI; Vanderpoel Coll.; Delgado Mus. A.; WMAA, etc. Exhibited: nationally & internationally. Author: "Painting with Jerry Farnsworth"; "Learning to Paint in Oil"; "Portrait and Figure Painting." Positions: A. in Residence, Univ. Illinois, 1942-43; Dir., Farnsworth Sch. A., Sarasota, Fla.

FARR, FRED WHITE—Sculptor, C., E.
155 Ridge St., New York, N.Y. 10002
B. St. Petersburg, Fla., Aug. 9, 1914. Studied: Portland (Ore.) A. Mus. Sch.; Univ. Oregon; ASL. Member: AEA; McDowell Colonists. Awards: prize, Portland A. Mus., 1949; silver med., Port-au-Prince, 1950; purchase, Krannert A. Mus., Univ. Ill., 1959. Work: Portland A. Mus.; Ball State T. Col.; Detroit Inst. A.; PMG; Krannert A. Mus.; mural, Social Security Bldg., Wash., D.C.; SS Argentina. Exhibited: extensively in museums throughout the U.S.; Stable Gal., 1954, 1955; Bertha Schaefer Gal., 1955 (one-man); Paul Rosenberg Gal., N.Y., 1957-1961, 1964 (one-man); Art:USA, 1959, 1960. Author: "Jewelry," Collier's New Encyclopedia.

FARRELL, BILL JOHN—Craftsman, Gallery Director
Fine Arts Gallery, Purdue University; h. R.R. No. 9, Lafayette, Ind. 47906
B. Phillipsburg, Pa., Nov. 6, 1936. Studied: Indiana State College, Indiana, Pa. Member: Am. Craftsman Council; AFA; Assoc. A. Pittsburgh; Craftsman Gld. of Pittsburgh; Indiana Artist Craftsmen; Nat. Ceramic Soc.; NEA; Western Arts. Awards: prizes, Indiana AA, 1960-1963; Pittsburgh Craftsman Gld., 1961-1964; Assoc. A., Pittsburgh, 1962, 1963, 1965; Indiana (Pa.) AA, 1965. Exhibited: Assoc. A. Pittsburgh, 1959-1965; Indiana (Pa.) AA, 1959, 1960, 1961, 1963; Pittsburgh Craftsman Gld., 1961, 1963, 1964; Hanover Col., 1962; Michiana Regional, 1964; Midwest Exh., Evansville, 1964; Syracuse Nat. Traveling Exh., 1962, 1964; Butler Inst. Am. A., 1963; Ball State, Muncie, Ind., 1963, 1964; Craftsmen of Eastern States, Smithsonian Inst. Traveling Exh., 1963; Nat. Dec. A. Show, Wichita, 1964; Purdue Univ., 1964; Westmoreland County Mus. A., Greensburg, Pa., 1964; one-man: Art Dept. Gal., Penn State University, 1960; Bates Gal., Edinboro Col., 1961; Westmoreland County Mus. A., 1962; Purdue University, 1963; Anderson Col., Anderson, Ind., 1964; Eastern Illinois Univ., 1964; Univ. Wisconsin, 1965. Positions: Dir., Fine Arts Gallery, Instr., Pottery, Purdue University, Lafayette, Ind.*

FARRELL, PATRIC—
Museum Director, Writer, Lecturer, Collector
161 E. 81st St., New York, N.Y. 10028; s. Southfield, Mass.
B. New York, N.Y., July 22, 1907. Studied: Privately. Collection: Zorn, Goya, Rembrandt Etchings; Oriental, Irish, Modern Art. Author, Editor: Catalogues of Exhibitions of "AE" (George Russell); Jack B. Yeats; Sir William Orpen; John Keating. Critic: Saturday Review; New York Times. Lectures: Irish Art; Non-Objective Art; The John Quinn Collection, to clubs, universities and cultural organizations. Also lectures over U.S. and European radio and television. Arranged exhibitions: Jack B. Yeats, Sir John Lavery, "AE," Sean Keating, Power O'Malley, Memorial Exhibition Sir William Orpen, and others; also arranged exhibitions at leading art galleries in New York City and at Seattle Museum of Art, Lyman Allyn Museum, New London, Conn., Univ. Texas, Univ. Oregon and others. Positions: Director, The Museum of Irish Art, New York, N.Y., 1930- .

FARRIS, JOSEPH G.—Cartoonist, P.
Long Meadow Lane, Bethel, Conn. 06801
B. Newark, N.J., May 30, 1924. Studied: ASL; Biarritz Univ.; Whitney Sch. A. Member: Magazine Cartoonists Gld. Contributor cartoons to Sat. Eve. Post; True; American Legion; American Weekly; Ladies Home Journal; Playboy; This Week; Redbook; Look; New Yorker; Punch, and other national magazines. Illus., "Slave Boy in Judea"; book jackets for others. Advertising cartoons & decorative murals. Paintings in private collections. Exhibited: Emily Lowe

Award (one-man show) Ward Eggleston Gal., New York City. Author, Illus., "UFO Ho Ho," (book of cartoons).

FARRUGGIO, REMO MICHAEL—Painter
47 West 28th St., New York, N.Y. 10001
B. Palermo, Italy, Mar. 29, 1906. Studied: NAD; Edu. All. Indst. A. Sch., with Bogdonov. Member: AEA. Awards: prize, Detroit Inst. A., 1946; Butler Inst. Am. A., 1956. Work: MMA; Portland (Ore.) A. Mus.; Butler AI; St. Paul Mus. A.; DMFA; Mus. of New Mexico, Santa Fe; Musgrove Gal., London; Belanca Aircraft Corp., Detroit, and in private colls. Exhibited: MMA; WMAA; VMFA; Detroit Inst. A.; PAFA; NAD; CAM; Univ. Illinois; Delgado Mus. A.; BM; one-man: Schneider Gal., Rome, 1957; John Heller Gal., N.Y., 1959; Feingarten Gal., N.Y., 1962; Julian Levy Gal., Salpeter Gal., RoKo Gal., all New York City; Portland Mus. A., and in Mexico.*

FASANO, CLARA—Sculptor, T.
131 Christopher St., New York, N.Y. 10014
B. Castellaneta, Italy, Dec. 14, 1900. Studied: CUASch.; ASL; Adelphi Col., Brooklyn, N.Y.; Colorossi & Julian Acads., Paris, and with Arturo Dazzi, Rome. Member: F.; NSS; Audubon A.; S.Gld.; NAWA. Awards: Scholarship abroad, 1922-1923; prize, NAWA, 1945, 1950, medal, 1955; Audubon A., 1952; Medal of Honor, 1956; Nat. Inst. A. & Let., 1952; Daniel Chester French Medal, NAD, 1965. Work: S. reliefs, USPO, Middleport, Ohio; Technical H.S., Brooklyn, N.Y.; Port Richmond, Staten Island, N.Y., H.S.; many ports. of prominent persons. Included in Syracuse Univ. manuscript coll.; Norfolk Mus. A. & Sciences. Exhibited: PAFA, 1940, 1942-1961, 1962-1964; AIC, 1941, 1942; NAD, 1935, 1939, 1941, 1943, 1962-1964; WMAA, 1940, 1946; WFNY 1939; Fairmount Park AA, 1940; AV, 1941; Audubon A., annually; Arch. Lg., 1954, 1959; NSS, 1955, 1959, 1962-1964; NAWA, 1945, 1946; Buchholz Gal., 1941, 1943, 1945; S. Gld., 1941, 1942, 1959, 1962-1964; Selected Artists Gal., N.Y.; in Italy, France & England and major museums in U.S.A. Contributor article to National Sculpture Review, 1964. Positions: A. Instr.; Dalton Sch., New York, N.Y., 1940; Former Instr., Sc., Adult Edu., Bd. Edu., New York, N.Y.; Instr. Sc., Manhattanville College, Purchase, N.Y., at present. Adv. Bd., NAWA and Audubon A; Council, NSS.*

FASBENDER, WALTER—Museum Executive Director
Vanderbilt Museum, Centerport, N.Y. 11721
Positions: Exec. Dir., Vanderbilt Museum.

FASTOVE, AARON (Fastovsky)—Painter, I.
2720 Bronx Park East, Bronx, N.Y. 10467
B. Kiev, Russia, 1898. Awards: Municipal A. Gal., 1939, Special mention for contribution to first Index of American Design, 1942. Member: AFA. Work: NGA. Exhibited: NGA; WFNY, 1939; MMA, 1941, 1942; WMAA, 1950; Contemp. A. Gal., N.Y.; Mus. Nat. Hist.; Municipal A. Gal., N.Y.; Pa. German A. & Crafts traveling exhs.; Rockefeller Center; Univ. Colorado, 1958; Everhart Mus., Scranton, Pa., 1958; Rochester (Minn.) A. Center, 1959; Hallmark Cards, Kansas City, 1963; Univ. Notre Dame, 1964; NAD, 1963; two one-man exhs., New York City; Exposition Intercontinental, Monaco, 1966, 1968; Prix de Paris, Raymond Duncan Gal., Paris, France, 1967, and others. Contributor to Magazines.

FAULKNER, KADY B.—Painter, Et., Lith., Ser., E.
Kemper Hall, Kenosha, Wis. 53140
B. Syracuse, N.Y., June 23, 1901. Studied: Syracuse Univ., B.F.A., M.F.A.; ASL; & with Hans Hofmann, Boardman Robinson, Henry Varnum Poor. Member: Nat. Serigraph Soc.; Phila. Color Pr. Soc.; NAWA; Prairie Pr.M;; AEA; Northwest Pr.M. Awards: prizes, Joslyn Mem., 1945; Springfield, Mo., 1946; Madison, Wis., 1953; Kenosha A., 1961; Kenosha A. Fair, 1959; Zion (Ill.) A. Fair, 1969. Work: Kenosha Pub. Mus.; IBM; mural, USPO, Valentine, Neb.; altar piece, St. Mary's Episcopalian Church, Mitchel, Neb., and St. John's Church, Racine, Wis.; mural, Chapel Union Col., Lincoln, Neb.; mosaic mural, Kenosha, Wis., 1964. Exhibited: NAWA, 1940-1943, 1953-1957; AWCS, 1944, 1945; Springfield, Mo., 1945, 1946; Phila. Color Pr. Soc., 1944-1946; SFMA, 1945, 1946; Lincoln A. Gld., 1940-1946; Joslyn Mem., 1940-1945; Denver A. Mus., 1943, 1944; Racine A.; Wisconsin annuals, 1953-1955-1958; Wisconsin P. & S., 1961; Kenosha AA, 1961; Norfolk Mus. A., 1958, 1959; Beloit Annuals, 1962-1964; Ball State T. Col., 1958-1964. Positions: Hd. A. Dept., Kemper Hall, Kenosha, Wis.

FAULKNER, RAY (NELSON)—Educator, W., Mus. Dir.
Dept. of Art & Architecture, Stanford University, Stanford, Cal. 94305
B. Charlevoix, Mich., June 3, 1906. Studied: Univ. Michigan, A.B.; Harvard Univ., M.L.A.; Univ. Minnesota, Ph.D. Member: CAA; Pacific AA; Am. Soc. for Aesthetics. Awards: prize, Sch. Arch., Harvard Univ., 1929. Exhibited: Minneapolis Inst. A., 1935-1937; Ohio WC Soc., 1932. Co-Author: "Art Today," 1969; "Teachers Enjoy the Arts," 1943; "Inside Today's Home," 1968. Contributor to: Educational journals with articles on various aspects of college teaching of art. Lectures: Contemporary American Art. Positions: Pres., Dept. A. Edu., NEA, 1941-42; Council, Pacific AA, 1948-50; Instr., Assoc. Prof. A., Univ. Minnesota, 1932-39; Hd., Dept. F. & Indst. A., Prof. FA, T. Col., Columbia Univ., New York, N.Y., 1939-1946; Exec. Hd., Dept. A. & Arch., and Dir. A. Gal. and Mus. Stanford Univ., Stanford, Cal., 1946-61, Prof. A., 1961- .

FAUNCE, SARAH CUSHING—
Museum Curator, Scholar, Critic, Writer
The Brooklyn Museum, Eastern Pkwy. & Washington Ave., Brooklyn, N.Y. 11238; h. 66 E. 93rd St., New York, N.Y. 10028
B. Tulsa, Okla., Aug. 19, 1929. Studied: Wellesley College, B.A.; Washington University, M.A.; Columbia University. Field of Research: Modern Painting. Positions: Reviewer, Art News, 1962-1965; Lecturer, Barnard College, 1964; Curator of Art Collections, Columbia University, 1965-1969; Curator of Painting and Sculpture, Brooklyn Museum, Brooklyn, N.Y., 1969- .

FAURE, MRS. RENE B. See Greacen, Nan

FAUSETT, (WILLIAM) DEAN—Painter, Et., Lith.
1 West 67th St., New York, N.Y. 10023; h. Hill Rd., Dorset, Vt. 05251
B. Price, Utah, July 4, 1913. Studied: Brigham Young Univ.; ASL; BAID; Colorado Springs FA Center. Member: NSMP; Southern Vermont AA. Awards: F., Tiffany Fnd., 1932, 1933, 1935; prizes, Carnegie Inst., 1942; Durand-Ruel Gal., 1944; Guggenheim F., 1943-1944-1945; prize, NSMP, 1945; SC, 1946. Work: murals, USPO, Augusta, Ga.; West New York, N.J.; Rosenburg, Tex.; Grant's Tomb, N.Y.; YM-YWHA, Pittsburgh; Bldg. for Brotherhood, New York, N.Y.; Randolph Field, Tex.; U.S. Air Acad., Colorado Springs, Colo.; "Global Power" U.S. Air Forces, Armed Forces Comm. Room, U.S. Capitol, Wash. D.C.; State of New Jersey Dept. of Education new bldg., Trenton, N.J.; Fort Legonier (Pa.) Mus. Also represented in MMA; MModA; WMAA; Toledo Mus. A.; New Britain Mus.; WA; Bennington Mus. A.; Witte Mem. Mus.; AIC; Univ. Nebraska; Univ. Arizona; Smith College; Brigham Young Univ.; White House, Wash., D.C.; Williams Col.; Princeton Univ.; Am. Acad. A. & Let. Exhibited: WMAA, 1932, 1940, 1941, 1943-1946; Carnegie Inst., 1941-1946; AIC, 1935, 1943-1945; CGA, 1941, 1942, 1944, 1945; MMA, 1941; VMFA, 1942, 1944, 1946; NAD, 1935, 1941; BM, 1935, 1941; Toledo Mus. A., 1939, 1940; Durand-Ruel, 1943; Witte Mem. Mus., 1943-1945; John Herron AI, 1945, 1946; Southern Vermont A., 1940-1943, 1954-55 (one-man); Univ. Utah, 1960, 1968; Deeley Gal., Manchester, Vt., 1964 (one-man). Other one-man shows: Lamp-Post Gallery, 1967; Brigham Young Univ., Provo, Utah, 1968-69; Col. of Eastern Utah, Price, 1968; Springville A. Mus., Springville, Utah, 1968; Eccles Community A. Center, Ogden, Utah, 1968; Weber State Col., Ogden, Utah, 1968; Dixie State Col., St. George, Utah, 1969; Arizona State Univ., Tempe, 1969; Obergfel Gal., Palm Desert, Calif., 1969; Gold Key Gal., Scottsdale, Ariz., 1969; Cowie-Wilshire Gal., Los Angeles, 1969.

FAUSETT, LYNN—Painter
1105 Parkway Ave., Salt Lake City, Utah 84106
B. Price, Utah, Feb. 27, 1894. Studied: Brigham Young Univ.; Univ. Utah; ASL; & in France. Member: NSMP; ASL (Life). Awards: Meritorious Service Award, for work as Art Dir., Special Service, World War II. Work: murals, City Hall, Price, Utah; Univ. Wyoming; White Pine H.S., Ely, Nev.; L.D.S. Ward Chapel, Farmington, Utah and Salt Lake City; Kennecott Copper Corp., New York, N.Y.; Harmon Cafe, Salt Lake City, Utah (5 murals); Utah State Pioneer Park, Salt Lake. Exhibited: Univ. Utah (one-man); Utah Hist. Soc. (one-man) 1961; Old Supreme Court Chamber, Nat. Capitol, 1962.*

FAX, ELTON CLAY—Illustrator
51-28 30th Ave., Woodside, N.Y. 11377
B. Baltimore, Md., Oct. 9, 1909. Studied: Crouse Col., Univ. Syracuse, B.F.A. Member: Museo de la Caricatura Severo Vaccaro, Buenos Aires, Argentina. Awards: gold med., Cooperative Women's Civic Lg., Baltimore, 1932, 1933. Work: Virginia State Col.; Museo de la Caricatura, Buenos Aires. Exhibited: CGA; NGFA; Fisk Univ., 1968 (one-man). Books illus.: "Famous Harbors of the World," 1953; "Trumpeter's Tale," 1955; "Genghis Khan and The Mongol Horde," 1954; "Sitting Bull," 1946; "Melinday's Medal," 1945; "Terrapin's Pot of Sense," 1957. Author: "West Africa Vignettes," book of drawings & commentary, publ. by Am. Soc. of African Culture, N.Y. & Lagos, Nigeria, 1960; Author of "Four Rebels in Art" published in 1967 in International Library of Negro Life and History (The Negro In Music and Art). Positions: Specialist Grantee of Intl. Exchange Div., U.S. State Dept., 1955, 1964 touring 5 East African Countries and United Arab Republic. Leader of Friends World College Round-The-World Tour, 1969.

FEARING, KELLY—Painter, Et., E., W., L.
University of Texas; h. 1315 West 9th St., Austin, Tex. 78703
B. Fordyce, Ark., Oct. 18, 1918. Studied: Louisiana Polytechnic
Inst., B.A.; Columbia Univ., M.A. Member: NEA; N.A.E.A.; Western
AA; Texas FA Assn.; Texas State T. Assn. Awards: prizes, Texas
Annual, 1953-1955; Texas FA Assn., 1953-1955; Texas State Fair
purchase award, 1956; D. D. Feldman award, 1956, 1958. Work:
Fort Worth A. Mus.; DMFA; Mus. FA of Houston; Inst. Contemp. A.,
Boston; Vancouver (B.C.) A. Mus.; Texas FA Assn., and in private
coll. Exhibited: Perls Gal., Los A., 1953; Santa Barbara Mus. A.,
1953 (one-man); SFMA, 1953; Miami A. Center, 1953; PAFA, 1954;
DMFA, 1953; Margaret Brown Gal., Boston, 1954; Catholic Univ.,
Wash., D.C., 1954; Texas Annual, 1953-1955, 1959, 1960; Texas FA
Assn., 1953-1955; Mus. FA of Houston, 1955 (2-man); Henry Clay
Frick Mem. Gal., Univ. Pittsburgh, 1955 (one-man); Univ. Pitts-
burgh, 1955; AFA Traveling Exh., 1953-54, 1955-56; Fort Worth A.
Center, 1955 (2-man), 1959, 1968 (one-man); Carnegie Inst., 1955;
Hewitt Gal., N.Y.; Valley House, Dallas, 1958, 1961 (one-man); Colo.
Springs FA Center, 1961; Little Rock Mus. FA, 1961; DMFA, 1959,
1960; D. D. Feldman Exh., Dallas, 1959; McNey AI; Witte Mem. Mus.
1968 (one-man); Univ. Illinois; Louisiana Polytechnic Inst., 1966
(one-man); Univ. Texas, 1967 (2-man). Co-Author: "Our Expanding
Vision: Art Series for Children," 1959; "The Creative Eye," 1969.
Positions: Prof. A., Univ. Texas, Austin, Tex.

FeBLAND, HARRIET—Painter, C., T.
270 Soundview Ave., White Plains, N.Y. 10606
B. New York, N.Y. Studied: Am. Artists Sch.; New Sch. for Social
Research; ASL; Pratt Inst., N.Y.; New York Univ., B.A., and with
Barnett, Sternberg, Kuniyoshi, Gross and others. Member: AEA
(V.-Pres., Program Dir.); Lg. Present Day A.; NAWA; CAA. Work:
Hubert Wilkins Mus.; Hempstead; Bank of Long Island Coll.; Tweed
Gal., Univ. Minnesota; Emily Lowe Gal., Univ. Miami; Mann Sch.
Coll., and others. Exhibited: MMA, 1944, 1952; Carnegie Inst., 1956;
Drian Gal., London, 1963; Jersey City Mus., 1964, 1965; Hudson
River Mus., 1965-1969; Newark State Col., 1955; N.Y. World's Fair,
1965; Katonah (N.Y.) Gal., 1966, 1968; N.Y. Univ., Loeb Center,
1966, 1968; BM, 1968; 20 one-man exhs. including N.Y. Univ., 1968;
Spectrum Gal., N.Y., 1967; Rutgers Univ., 1969; Galerie Interna-
tional, N.Y., 1961; Pietrantonio Gal., N.Y., 1958, 1959; Seton Hall
Univ., N.J., 1967; Chatham Col., Pittsburgh; Emory Univ., Ga.; Riv-
erside Museum, N.Y., 1963. Work featured in "Plastics as an Art
Form," and included in Encyclopedia of Polymer Science and Tech-
nology." Positions: Faculty, Westchester (N.Y.) Art Workshop, at
present.

FEDER, BEN—Designer, P.
50 Rockefeller Plaza; h. 175 E. 62nd St., New York, N.Y.
10021
B. New York, N.Y., Feb. 1, 1923. Studied: Parsons Sch. Des.;
Veterans Center, Museum of Modern Art, with Prestopino. Member:
Int. Center for the Typographic Arts. Exhibited: Stamford (Conn.)
Mus. A., 1960; Bodley Gal., N.Y., 1964; Instituto de Allende, San
Miguel Allende, G.T.O. Mex. Lectures: Design; Typography. Posi-
tions: Des., for major book publishers, U.S. and abroad; books and
book jackets; Designer and Graphic Arts Consultant for The New
Book of Knowledge published by Grolier, Inc. Pres., Ben Feder,
Inc., New York, N.Y.

FEIGEN, RICHARD L.—Art Dealer, Collector, Writer, Patron
226 E. Ontario St., Chicago, Ill. 60611; also, 27 E. 79th St.,
New York, N.Y. 10021
B. Chicago, Ill., Aug. 8, 1930. Studied: Yale University, B.A.; Har-
vard University, Graduate School of Business Administration,
M.B.A. Member: Board of Directors, Arts Assembly, Adult Educa-
tion Council, Chicago, 1959-1961; Member Art Dealers Association
of America, 1965- ; Faculty Member, University for Presidents,
Young Presidents Organization National Convention, Phoenix, Ari-
zona, 1966 (taught courses, "Art for Your Business," and " Art
for the Private Collector"). Collection: 20th Century Paintings
(emphasis on Beckmann, Grosz and Dubuffet); 16th and 17th Century
Flemish and Dutch mannerist paintings; constructions by Joseph
Cornell; Kandinsky, Beckmann, Dubuffet, Grosz; Vanguard Ameri-
cans and British. Contributor to miscellaneous magazine articles
(Arts, Office Design, etc.). Specialty of Gallery: Impressionists
and post-impressionists; 20th century masters (primarily paintings
and sculpture); the Vanguard Generation. Positions: President,
Richard L. Feigen & Company, Inc., New York and Chicago; Richard
L. Feigen Gallery, Inc., New York and Chicago; Art for Business,
Inc., New York, N.Y.

FEIN, STANLEY—Painter, Cart., Des.
250 Warren St., Brooklyn, N.Y. 11201
B. New York, N.Y., Dec. 21, 1919. Studied: Parsons Sch. Des.; New
York Univ. Awards: A. Dirs. Club, 1957, Certif. Merit, 1960. Work:
N.Y. Univ. Coll. of Paintings. Illus., novel by Harry Pesin, "Why Is

a Crooked Letter?" Exhibited: Camino Gal., ACA Gal., A. Dirs.
Club, all New York City; one-man: Phoenix Gal., N.Y., 1961, 1962,
1964. Positions: Instr., Figure Drawing, Design, Color, Pratt Insti-
tute, Evening School, Brooklyn, N.Y.

FEININGER, T. LUX—Painter, T.
22 Arlington St., Cambridge, Mass. 02140
B. Berlin, Germany, June 11, 1910. Studied: in Germany. Member:
AEA. Work: MModA; FMA; Busch-Reisinger Mus., Harvard Univ.
Exhibited: Carnegie Inst., 1932 1933, 1935, 1936, 1938, 1946, 1947,
1948; AIC, 1940; MModA, 1943; Julien Levy Gal., 1947; U.N. Cl.,
Wash., D.C., 1949; Hewitt Gal., 1950; Behn-Moore Gal., Cambridge,
1955 (all one-man); Retrospective, Busch-Reisinger Mus., Harvard
Univ., 1962; Cambridge AA, 1965 (one-man); Trinity Col., Hartford,
Conn., 1967 (one-man); WMAA, 1951; BM, 1951; Mass. Inst. Tech.,
1953-54; Mint Mus. A., Charlotte, N.C. (with Lyonel Feininger),
1955-56; Sao Paolo Biennale, 1957; Albright A. Gal., 1959-1961;
Putney (Vt.) School, 1960; Mus. A. of Ogunquit, Me., 1961. Article:
"The Bauhaus: Evolution of an Idea" in Criticism, Wayne State
Univ., 1960. Text (book) "Lyonel Feininger; City at the Edge of the
World," 1965. Lectures: "The Intimate World of Lyonel Fein-
inger," Busch-Reisinger Mus., 1963; "The Working Methods of
Lyonel Feininger," Busch-Reisinger Mus., 1964. Positions: Instr.,
Des., Sarah Lawrence Col., New York, N.Y., 1950-52; Fogg Mus.
Fellow and Lecturer & Instr., Drawing & Painting, Harvard Univ.,
Cambridge, Mass., 1953-1962; Instr., Painting, Boston Mus. School
FA, 1962- .

FELDMAN, EDMUND BURKE—Scholar, Writer, Educator
University of Georgia; h. 140 Chinquapin Pl., Athens, Ga. 30601
B. Bayonne, N.J., May 6, 1924. Studied: Newark School of Fine &
Industrial Arts; Syracuse University, Painting; B.F.A.; University of
California at Los Angeles, M.A. in Art History; Columbia University,
Ed. D. in Fine Arts Education. Author: "Art as Image and Idea,"
1967; "Aesthetic Education: Foundations of Learning Through Art,"
1970. Contributor articles to: Arts in Society, Arts & Architecture,
College Art Journal, Saturday Review: Aesthetic Education Journal,
Carnegie Alumnus, Harvard Educational Review, School Review, and
many other educational publications. Positions: Board of Governors,
Pittsburgh Plan for Art, 1958-1960; Curator, Paintings & Sculpture,
Newark Museum, 1953; Assoc. Prof., Department Painting, Sculp-
ture & Design, Carnegie Institute of Technology, 1956-1960; Chair-
man, Art Division, State University of New York, 1960-1966; Prof.
Art, The University of Georgia, Athens, 1966- .

FELDMAN, HILDA (Mrs. Neville S. Dickinson)—Painter, T.
507 Richmond Ave., Maplewood, N.J. 07040
B. Newark, N.J., Nov. 22, 1899. Studied: Fawcett Sch., Newark,
N.J.; PIASch., with Anna Fisher. Member: AWS; NAWA; Gal. of So.
Orange & Maplewood, N.J.; N.J. WC Soc. Awards: prizes, NAWA,
1955, 1958. Work: Seton Hall Univ.; Reading Mus. A., and in private
collections. Exhibited: AWS, 1929, 1930, 1932, 1936, 1938, 1939,
1943-1946, 1947-1949, 1953, 1968; N.Y. WC Cl., 1935; NAWA, 1930,
1931, 1936, 1937, 1939, 1941-1946, 1947-1951, 1954-1960, 1962,
1964; Essex WC Cl.; 15 Gal.; Rabin & Krueger Gal.; Univ. Newark
(one-man); Orange Women's Cl.; Padawer Gal., 1961 (one-man);
Maplewood (N.J.) Women's Cl.; Argent Gal. (one-man); So. Orange,
Maplewood A. Gal., 1964 (one-man); in Belgium, Holland, Japan and
Switzerland, and others in U.S. and Canada. Positions: Instr. A.,
Newark Sch. F. & Indst. A., Newark, N.J., 1923- ; Instr., Milburn
Adult Sch., Milburn, N.J., 1946-1963; Exec. Bd., 1953-1960, Chm.
WC Jury, 1955-57, NAWA, Chm. Membership Jury, 1958-1960.

FELDMAN, LILIAN—Painter, T.
214-12 16th Ave., Bayside, N.Y. 11360
B. Brooklyn, N.Y., July 8, 1916. Studied: Cooper Union; Pratt In-
stitute, N.Y., and with Harry Sternberg. Member: Prof. A. Gld. of
Long Island. Awards: prize, Art Unlimited, Syosset, L.I., 1957.
Work: Nassau Community Col.; murals in private homes and small
businesses and in private colls. Exhibited: Hofstra Univ., 1957,
1958, 1960, 1961, 1963; Heckscher Mus., 1958, 1960, 1962, 1963; Art:
USA, 1958; Douglaston A. Gal., 1959; NAC, 1959; Manhasset A, 1960,
1963; Panoras Gal., N.Y., 1959, 1963; Sea Cliff, L.I., 1964; Nassau
Community College, 1964, 1967, 1968; Molloy College, 1965; Adelphi
Univ., 1965; Long Island A. Festival, 1966; Baiter Gal., Huntington,
N.Y., 1968; Brooklyn Col., 1968; Queensborough AA, 1969, and
others.

FELDMAN, WALTER—Painter, Gr., E.
Art Dept., Brown University; h. 224 Bowen St., Providence,
R.I. 02906
B. Lynn, Mass., Mar. 23, 1925. Studied: BMFA Sch.; Yale Univ.,
Sch. FA, B.F.A.; Yale Sch. Des., M.F.A. Awards: prizes, Alice
English traveling fellowship, Yale Univ., 1950; MMA, 1952; Fulbright
award, 1956-1957; Gold Palette Award, Milan, Italy, 1957; Am. Color
Pr. Soc., 1958; Am. Acad. A. & Lets., purchase, 1960; Howard Fnd.

award, 1961; R.I. Festival A., 1961, 1963; Boston A. Festival, 1964; Childe Hassam Fund purchase award, NAD, 1959; Hon. M.A., Brown Univ., 1959. Work: Yale Univ. A. Gal.; MMA; LC; Allentown (Pa.) A. Mus.; Bezalel Mus., Israel; Brown Univ.; IBM Coll.; Lehigh Univ.; Univ. Massachusetts; MModA; Phoenix A. Mus.; Princeton Univ.; Rensselaer County Hist. Soc. and Polytechnic Inst.; Univ. So. Cal.; USIA and others. Mosaic and mosaic murals, Temple Beth-El, Temple Emmanu-El, Providence; mural, Pembroke Col.; stained glass windows, Sugarman Mem. Chapel, Providence, R.I. Exhibited: Am. Acad. A. Lets., PAFA; LC; BM; SAM; MMA; MModA; Bradley Univ.; Norfolk Mus. A. & Sciences; Inst. Contemp. A., Boston; R.I. Sch.Des.; CGA; Yale Univ. A. Gal., 1950-1960; Lyman Allyn Mus. A., 1960; Nat. Inst. A. & Lets., 1961; De Cordova & Dana Mus., 1961, 1964; also, Brandeis Univ.; Butler Inst. Am. A.; Cornell Univ.; Currier Gal. A., Rockland, Me.; Iowa State Univ.; Lehigh Univ.; Univ. Nebraska; Springfield Mus. FA; WMA; Toledo Mus. A.; and others. One-man: Kraushaar Gal., N.Y., 1958, 1961, 1963; Witte Mus. A., San Antonio; Univ. Maine; Bates College; Mexican-American Inst., Mexico City, 1962; Inst. Contemp. A., London, 1968; Obelisk Gal., Boston, 1967; Brown Univ. (4-man), 1963; De Cordova & Dana Mus., 1964. Positions: Prof. A., Brown University, Providence, R.I.; Visiting Prof., drawing, painting, printmaking, Harvard Univ., 1968 and Univ. Cal., Riverside, 1969.

FELT, MR. and MRS. IRVING MITCHELL—Collectors
911 Park Ave., New York, N.Y. 10021*

FENCI, RENZO—Sculptor, E.
Otis Art Institute, 2401 Wilshire Blvd. 90057; h. 3206 Deronda Dr., Los Angeles, Cal. 90028
B. Florence, Italy, Nov. 18, 1914. Studied: Royal Institute of Art, Florence, Italy, degree Maestro d'Arte. Awards: Gold medal, Florence, Italy, 1934; prizes, Sacramento State Fair, 1942, 1949, 1950; San Bernardino Cal., 1952; Tri-County Exh., Santa Barbara, 1952; Los A. Mus. A., 1955. Work: Santa Barbara Mus. A.; Gallery of Modern Art, Florence, Italy; sculptured reliefs, monuments, portrait heads, USPO, Islas, So. Carolina; Home Savings & Loan Co., Beverly Hills; Encino, Arcadia, Los Angeles, La Mirada, Buena Park, Burbank, Compton, Cal.; Dr. Charles L. Lowman Memorial for Los Angeles Orthopaedic Hospital, 1968; Medal for Stanford Univ. called "Stanford Athletic Board Distinguished Achievement Medal." Half-hour TV program "Dialogues in Art" in color KNBC Los Angeles, in cooperation with Univ. Extension, UCLA and the Los Angeles County Mus. A. Exhibited: Natl. Exh. Contemp. A., Pomona, Cal., 1956; Wisconsin Salon, Madison, 1941; AIC; Sacramento State Fair; Santa Barbara Mus. A., 1955 (one-man); Otis AI, 1958, 1960, 1961, 1964. Positions: Prof., Sculpture and Drawing, University of California at Santa Barbara, 1946-1954; Prof. Sculpture, Head of Sculpture Dept., Otis Art Institute, Los Angeles, Cal., 1954- .

FENICAL, MARLIN EDWARD—Painter, Comm. A., I., W.
Dept. of the Army, The Pentagon, Washington, D.C.; h. 3192 Key Blvd., Arlington, Va. 22201
B. Harrisburg, Pa., July 22, 1907. Studied: Wellfleet Sch. A., and with Xavier Gonzales, Ben Wolff. Member: Soc. Wash. A.; Wash. WC Cl.; Franklin Technical Soc.; Rehoboth A. Lg. Awards: prizes, Washington A. Fair, 1946; AAPL, 1956, 1957; Wash. WC Cl., 1953; A. Lg. of Northern Virginia, 1958; Wash. Landscape Cl., 1955; Chevy Chase, Md., 1958; Rehoboth A. Lg., 1959, 1961; Waterford, 1959; Am. A. Lg., 1959. Work: Univ. Detroit; Rehoboth A. Lg. Exhibited: Wash. WC Cl., 1953-1958, 1960, 1961; Wash. A. Fair, 1946; CGA, 1955, 1956; Soc. Wash. A., 1957; A. Lg. of Northern Virginia, 1954, 1958; AAPL, 1956, 1957; Rehoboth Cottage Tour, 1958; Rehoboth A. Lg., 1959-1961; Atlanta, Ga., 1960; Rehoboth Cottage Tour, 1968; VMFA, 1965; one-man: Wash. A. Cl., 1956, 1959, 1961; Roumanian Inn, Wash., D.C., 1958; Chevy Chase, Md., 1958; Montgomery AA, 1961; Waterford, 1959; Artists Showcase, Virginia Beach, Va., 1968; Illus., U.S. Army training, technical and recruiting publications. Positions: Chief A. Dir., Dept. of the Army, Washington, D.C., 1947- . Publ., Author, I., "A Picture Tour of Historic Harpers Ferry," 1961.

FENTON, ALAN—Painter
333 Fourth Ave., New York, N.Y. 10010
B. Cleveland, Ohio, July 29, 1927. Studied: Cleveland Sch. A.; Pratt Institute, B.F.A., with Tworkov; ASL, with Gottlieb. Awards: prizes, CMA, 1960, 1961. Work: BMA; N.Y. State Mus.; M. Stoller & Co.; Richlan Corp.; Westport (Conn.) Savings; H. E. Laufer Corp. Exhibited: Art: USA, 1958; SFMA, 1963; CMA, 1959-1961; Pace Gal., Boston, 1964; one-man: Pace Gal., 1964; Larry Aldrich Mus., 1968; American Inst., Mexico City, 1967.

FENTON, BEATRICE—Sculptor
311 West Duval St. 19144; h. 621 Westview St., Philadelphia, Pa. 19119
B. Philadelphia, Pa., July 12, 1887. Studied: PAFA; PMSchIA.

Member: Phila. A. All.; F., NSS. Awards: F., PAFA; Percy M. Owens Mem. prize, F., PAFA, 1967; Cresson traveling scholarship, 1909-10; med., PAFA, 1922; Plastic Cl., 1922; Sesquicentennial Exp., Phila., 1926; Hon. deg., D.F.A., Moore Inst. A., Sc., & Indst., 1954; Violet Oakley Mem. Prize, 1962. Work: fountains, tablets, memorials, groups: Fairmount Park (2 fountains, erected 1964), Wister Park, Phila. Pa.; Danbury Park, Wilmington, Del.; Brookgreen Gardens, S.C.; Acad. Music, Phila.; Children's Hospital, Phila.; Penn Club., Phila.; Johns Hopkins Univ., Baltimore; Univ. Pennsylvania; Hahnemann Medical Col., Phila.; Pratt Free Lib., Balt.; Rittenhouse Square, Phila.; winning design for Alben W. Barkley Congressional Medal. Exhibited: Phila. A. All., 1924-1952, 1957, 1965; F. PAFA, 1920-1952, 1956, 1959-1961, 1964-1968; PAFA, 1948, 1951, 1952, 1954; NSS; Woodmere A. Gal., 1958, 1959-1964; DaVinci All., 1957; Woodmere Gal., 1965-1968. Positions: Instr. S., Moore Inst. A., Sc. & Indst., Philadelphia, Pa., 1942-53.

FENTON, HOWARD—Painter, E.
University of California; h. 750 Hot Springs Rd., Santa Barbara, Cal. 93103
B. Toledo, Ohio, 1910. Studied: Chouinard AI, Los A.; UCLA and Univ. California, Berkeley, M.A. Exhibited: Rome, London, San Francisco, Los Angeles, Santa Barbara Mus. and other galleries and museums. Positions: Prof. of drawing & painting, University of California, Santa Barbara, Cal.

FENTON, JOHN NATHANIEL—Painter, Et.
19 William St., Mt. Vernon, N.Y. 10552
B. Mountaindale, N.Y., June 29, 1912. Studied: ASL, with Kenneth Hayes Miller, Allen Lewis, Samuel Adler. Awards: Joseph Isador gold medal, NAD, 1958; Hassam purchase, Am. Acad. A. & Lets., 1958; Pratt Inst., Brooklyn, 1968. Work: BM; N.Y. Pub. Library; Assoc. Am. A. editions of prints; Pratt Contemp. Print Center. Exhibited: NAD, 1958; Columbus Mus. FA, 1958; Butler Inst. Am. A., 1958; Illinois Wesleyan Univ., 1958; Babcock Gal., N.Y., 1955, 1958, 1961 (one-man); AIC, 1961; Audubon A., 1961. Produced film short on basis of 50 paintings, done personally, on Poe's "The Black Cat," shown in theatres throughout U.S., & was invited for showing at Cannes Film Festival, 1961. Positions; Instr. A., Adult Edu., N.Y. Univ.; Goddard Col., Plainfield, Vt.; Scarsdale (N.Y.) H.S. and Adult Edu. Program.

FERBER, HERBERT—Sculptor, P., C.
41 Fifth Ave., New York, N.Y. 10003
B. New York, N.Y., Apr. 30, 1906. Studied: Col. City of N.Y.; Columbia Univ., B.S. Awards: prize, MMA, 1942; Guggenheim Fellowship, 1969-1970. Work: MMA; WMAA; Williams College; Detroit Inst. A.; Cranbrook Acad. A.; Albright A. Gal.; MModA; Brandeis Univ.; Grand Rapids A. Gal.; Bennington Col.; N.Y. Univ.; Newark Mus.; Univ. of Vt.; WAC; Yale Univ.; Rutgers Univ.; Univ. Ind.; N.Y. State Bldg. Complex; Kennedy Office Bldg., Boston. Exhibited: WMAA, 1941-1946; MModA., 1969; PAFA; BMFA. Positions: Visiting Prof., sculptor, Rutgers Univ., 1965-1967; Assoc. F., Morse Col., Yale Univ., 1967- .

FERDINAND, THOMAS—Art Dealer, Collector
Banfer Gallery, Inc., 23 E. 67th St., New York, N.Y. 10021
B. New York, N.Y., Mar. 11, 1923. Studied: Duke Univ., B.S.; Univ. North Carolina, M.S. Collection: Contemporary American Paintings and Drawings; Americana. Specialty of Gallery: Contemporary American Paintings and Drawings. Positions: Director, Banfer Gallery, Inc., New York, N.Y., 1962- .

FERGUSON, CHARLES B.—Museum Director, P., Gr., E., L.
56 Lexington St., New Britain, Conn. 06052; h. 114 Bloomfield Ave., Hartford, Conn. 06105
B. Fishers Island, N.Y., June 30, 1918. Studied: Williams College, A.B.; ASL with special training (painting) with Frank Dumond and (graphics) with Harry Sternberg; Trinity College, M.A. Work: murals, Williston Acad., Easthampton, Mass. (3); Renbrook School, West Hartford; and in Farmington, Conn. Positions: Owner, Red Barn Studio, Fishers Island N.Y.; lecturer, Art History, Demonstrator of painting and graphics; Sage Allen Prize, Conn. Academy of Fine Arts, 1969. Director, New Britain Museum of American Art, 1965- .

FERGUSON, EDWARD R., JR.—Painter, Gr.
Ferguson Art Shop, Buckham & West 2nd St., Flint, Mich. 48503; h. G8052 North Bray Rd., Mt. Morris, Mich. 48458
B. Pueblo, Colo., Mar. 21, 1914. Studied: Flint Inst. A. Member: F.I.A.L.; Boston Pr. M.; Hunterdon A. Center; Michigan Pr. M.; Flint Inst. A. Awards: prizes, Flint Inst. A., 1955, 1958; Michiana Regional, 1962; Hunterdon A. Center, 1963. Work: Detroit Inst. A.; Flint Inst. A.; ports., Genessee County Court House, and in private coll. Exhibited: Flint Inst. A., 1933-1942, 1953, 1954, 1956, 1958, 1959-1961, 1967; PAFA, 1941; Phila. A. All., 1940; Oklahoma A.

Center, 1940, 1941; Detroit Inst. A., 1934-1941, 1955, 1956, 1959, 1960; Wichita AA, 1955, 1956, 1958, 1960, 1961, 1963; LC, 1956-1958; Phila. Pr. Cl., 1957, 1959; Portland (Me.) Mus. A., 1958; South Bend AA, 1957, 1958; Okla. Pr. M., 1959; Soc. Wash. Pr. M., 1960, 1962, 1964; Northwest Pr. M., 1960, 1962, 1964; BM, 1960; Silvermine Gld. A., 1960, 1962; Hunterdon A. Center, 1960-1964, 1965, 1967; Ohio Univ., 1961, 1962; Bradley Univ., 1960, 1962; LC, 1960; Contemp. Gr. A. Overseas Exh., 1960; Bay Pr. M., 1960; Boston Pr. M., 1962, 1964, 1965; Grand Rapids A. Mus., 1965; Wichita AA, 1967; Hanover College, 1963; Knoxville A. Center, 1962; Fla. State Univ., 1964; South Bend A. Center, 1962, 1964.

FERGUSON, THOMAS REED, JR.—Educator, P.
 Pennsylvania State University, State College, Pa.; h. 512 West Hillcrest Ave., State College, Pa. 16801
B. Lancaster County, Pa., May 11, 1915. Studied: Pennsylvania State Univ., B.S. in A. Edu.; Univ. Pennsylvania; Harvard Univ., and with Charles W. Dawson, Hobson Pittman. Exhibited: Lehigh Univ., 1945; Lehigh County AA, 1945; Pa. State Univ. summer exh. Positions: Asst. Prof., Pennsylvania State Univ., State College, Pa., 1946- ; Dir., Univ. Relations, 1958-1969, Vice-Pres. for Public Affairs, 1969- .

FERN, ALAN M.—Museum Curator, Historian, Writer
 Library of Congress, Washington, D.C. 20540; h. 3605 Raymond St., Chevy Chase, Md. 20015
B. Detroit, Mich., Oct. 19, 1930. Studied: Univ. Chicago, A.B., M.A., Ph.D.; Courtauld Inst. Art, Univ. of London (Fulbright Scholar 1954-55). Member: CAA; Print Council of America (Bd. Dirs.); Special Libraries Assn.; AIGA (Bd. Dirs.). Author: "A Note on the Eragny Press," 1957; "Art Nouveau" (co-author, Mus. Mod. A., N.Y.) 1960; "Word and Image," 1969. Contributor articles and reviews to scholarly journals and Encyclopaedia Britannica on Modern Art, Printmaking, Typography and Architecture. Lectures: 19th and 20th Century Art; History of Graphic Art, at Art Inst., Chicago, Metropolitan Museum of Art, Univ. of Virginia and others. Exhibitions and Collections arranged: Art Nouveau (Museum Modern Art, 1960 with Selz, Constantine, Daniel and Hitchcock); many exhibitions of prints at Library of Congress, 1961 to present; Midway Gardens of Frank Lloyd Wright (Univ. Chicago), 1960. Positions: Faculty member, Univ. Chicago, 1953-1961; lecturer at various times at Art Inst. Chicago and Pratt Institute, N.Y. Asst. Chief, Prints & Photographs Division, Library of Congress at present.

FERREN, JOHN—Painter, S., Des., Gr., T.
 615 Fireplace Rd. Springs, East Hampton, L.I., N.Y. 11937
B. Pendleton, Ore., Oct. 17, 1905. Studied: Sorbonne, Paris; Univ. Florence, Italy; Univ. Salamaca, Spain. Work: MModA; WMAA; Univ. Nebraska; Yale Univ.; Joseph Hirshhorn Fnd.; Santa Barbara Mus. A.; Los Angeles County Mus.; High Mus. A., Atlanta; Crocker A. Gal., Sacramento, Cal.; Rose A. Mus., Brandeis Univ.; George Washington Univ.; Wadsworth Atheneum; PMA; SFMA; Detroit Inst. A.; Scripps Col.; Guggenheim Mus., N.Y. Awards: prize, Provincetown A. Festival, 1958; U.S. State Dept. grant, Beirut, Lebanon (Artist-in-Residence), 1963-64. Exhibited: CGA, 1937; PAFA, 1937, 1940, 1945; Cal. PLH, 1944, 1945; Detroit Inst. A., 1946; CAM, 1946; Kleemann Gal., 1947-1949; Mus. New Mexico, 1950; Santa Barbara Mus. A., 1952; SFMA, 1952; Stanford Univ., 1952; one-man: Matisse Gal., 1936-1938; Willard Gal., 1941; Minneapolis Inst. A., 1936; SFMA, 1937; Putzel Gal., Hollywood, Cal., 1936; Iolas Gal., 1953; Stable Gal., 1954, 1955, 1957, 1958; Pasadena Mus. A., 1955; Rose Fried Gal., N.Y. 1965-1968. Beirut, Lebanon, 1964; American Embassy Gallery, London, 1965. Contributor to Arts & Architecture; Art News; Canadian Arts; Arts Magazine. Positions: Assoc. Prof., Queens Col., New York, N.Y.

FERRIS, EDYTHE (Mrs. Raymond H.)—Painter, Gr., T., W., L.
 240 South 45th St., Philadelphia, Pa. 19104
B. Riverton, N.J., June 21, 1897. Studied: Phila. Sch. Des. for Women: and with Henry B. Snell. Member: Phila. Pr. Cl.; Phila. WC Club; Am. Color Pr. Soc. (Council Memb.); Int. Platform Assn.; AEA. Awards: Morris F., 1919, 1920; J. Lessing Rosenwald prize, 1955; med., Gimbels, 1932. Work: Phila. A. All.; Phila. Sch. Des. for Women Alumnae Coll.; St. Luke's Church, Kensington, Phila.; PMA; Free Lib. of Phila.; Soc. Canadian P. & Et.; Randolph-Macon Woman's College, and in private collections. Exhibited: NAD; PAFA; AWS; Phila. WC Cl.; NAWA; Wash. WC Cl.; A.All., 1967, 1969; AEA, 1968; Norfolk Drawing XXI, 1965; St. Paul Drawing Biennial, 1963, one-man: W. Phila. Br. Free Lib. of Phila.; Randolph-Macon Woman's College; Univ. Pennsylvania, Wanamakers, Phila.; Barnegat Light Gal.; prints widely exhibited U.S. and Canada. Contributor to School Arts & Crafts; Am.-German Review magazines; lecturer, Art Appreciation. Positions: Art Advisor, Carl Schurz Mem. Fnd., 1953-1967. Founder, University City A. Lg., 1965. Teaches private classes.

FERRIS, (CARLISLE) KEITH—Illustrator, P., Historian, L.
 50 Moraine Road, Morris Plains, N.J. 07950
B. Honolulu, Hawaii, May 14, 1929. Studied: Texas A. & M. College; George Washington Univ.; Corcoran School of Art. Awards: Citation of Merit, SI, 1966. Member: N.Y. Soc. Illustrators. Work: Paintings in USAF Documentary Art Coll.; series of paintings for Pratt & Whitney Aircraft, appearing in National Geographic (1963-1964); Illus. for Sperry Gyroscope Adv. 1958- ; painting series for Chandler Evans Div., Colt, Ind.; Editorial and Advertising Art for Flying and Aviation magazines. Exhibited: USAF exhibitions—N.Y. Soc. Illus., 1961-1969; N.Y. World's Fair, 1964; permanent exh., USAF Hg., The Pentagon, Washington, D.C. Positions: Chm., Air Force Art Committee, SI, 1968-1970.

FERRITER, CLARE (Mrs. John T. Hack)—Painter, T.
 4722 Rodman St., N.W., Washington, D.C.
B. Dickinson, N.D., June 18, 1913. Studied: Massachusetts Sch. A., Boston; Yale Univ., B.F.A.; Stanford Univ., M.A. Member: Soc. Wash. A.; Wash. WC Assn.; NAWA; AEA (Pres. Wash. chapter, 1967-1969). Awards: prizes, CGA, 1958; Butler Inst. Am. A., 1959; Delaware A. Center, 1960, 1964; Wash. WC Assn., 1961; NAWA, 1963, 1966; Soc. Wash. A., 1964, 1966; BMA, 1966. Work: Harvard Univ.; Cosmos Club, Wash., D.C.; Butler Inst. Am. A.; Dist. of Columbia Court Collection; Massillon (Ohio) Mus.; Int. Monetary Fund; George Washington Univ.; Univ. Delaware; AGAA. Exhibited: CGA, 1959; Butler Inst. Am. A., 1959, 1963, 1968; Soc. Four Arts, Palm Beach, 1959; Chautauqua Nat., 1961; BMA, 1957, 1963, 1965, 1966, 1967, 1968; Delaware A. Center, 1959-1963; CGA Area Artists, 1952-1962, 1964; Soc. Wash. A., 1966; NAWA, 1966, 1967; George Washington Univ., 1967; Univ. Del., 1969; Massillon Mus., 1969; Art in Am. Embassies program. One-man: Artists Mart, Georgetown, 1960; Mus. of Univ. of Puerto Rico, 1962; CGA, 1963; Franz Bader Gal., Wash., D.C., 1964; Bridge Gal., N.Y., 1964; Massillon Mus., 1966; Catholic Univ., 1966; St. Joseph Col., Emmitsburg, Md., 1968; Warehouse Gal., Arden, Del., 1968. Contributor illustrations to Manila Sunday Tribune and covers for Philippine Magazine. Positions: Grad. Workshop, St. Joseph's Col., Emmitsburg, Md., 1968. Assoc. Prof. A., Catholic Univ. of America, summer sessions, 1967-1969.

FIELD, RICHARD S.—Assistant Curator
 Philadelphia Museum of Art, Parkway at 26th St., Philadelphia, Pa., 19101
Studied: Harvard Univ., Ph.D. Positions: Asst. Curator, Graphic Arts (Rosenwald Collection), National Gallery of Art, Washington, D.C. Cur., Prints, Philadelphia Mus. A., Philadelphia, Pa., at present.

FIFE, MARY E. (Mr. Edward Laning)—Painter, T.
 82 State St., Brooklyn, N.Y. 11201
B. Canton, Ohio. Studied: Carnegie Inst., B.A.; NAD; CUASch.; ASL; Tiffany Fnd., and in Paris. Member: NAWA; Pen & Brush Cl. Awards: prizes, Butler Inst. Am. A.; 13 major prizes since 1962 including NAWA, 1964; Altman Prize, NAD, 1967; Pen & Brush Cl., 1968. Exhibited: AIC; Carnegie Inst.; PAFA; WMAA; Butler Inst. Am. A.; CAM; William Rockhill Nelson Gal. A.; New York City Center; NAWA, NAD 1967; Pen & Brush Cl. (one-man); and others. Positions: Instr., Hd. A. Dept., Birch-Wathen School, New York, N.Y., 1961- .

FILLMAN, JESSE R.—Collector
 2 S. State St. 02109; h. 16 Lime St., Boston, Mass. 02108
B. Pittsburgh, Pa., May 5, 1905. Studied: Amherst College, B.A.; Columbia University, LL.B. Collection: Mostly American Paintings and Sculpture.

FILMUS, TULLY—Painter, L., T.
 17 Stuart St., Great Neck, N.Y. 11023
B. Otaki, Russia, Aug. 29, 1908. Studied: PAFA; N.Y. Univ.; ASL. Member: AEA; Audubon A. Awards: Cresson traveling scholarship, PAFA, 1927, prize, 1948; SC, 1969. Work: WMAA; N.Y. Hist. Soc.; Kings County Hospital; Temple Beth-El, New York, N.Y.; Gayle Inst., Haifa; Syracuse Univ.; Tel-Aviv Mus., Ein-Herod Mus., Israel; Ports: Medical Center, N.Y.; Harvard Cl., N.Y.; Mass. Inst. Tech.; Yeshiva Univ.; Sholom Aleichem Inst.; Dwight A. Mem., Mt. Holyoke Col., South Hadley, Mass.; many portraits of Army and Navy officials and of prominent citizens; murals, Brookwood, N.Y. (6). Exhibited: WMAA, 1940-1946; CGA, 1942; PAFA, 1941-1946; AIC, 1941; Denver A. Mus., 1942; Carnegie Inst., 1941-1946; Am. A. Congress, 1935-1939; Audubon A., 1945, 1963, 1964; Phila. A. All., 1935; Toledo Mus. A.; BM; North Shore AA, 1957; Hirschel Adler Gal., N.Y., 1958; AFA traveling exh.; Los A. Mus. A.; ACA Gal., N.Y.; ACA Gal., Rome, Italy; High Gal., Lenox, Mass.; Israeli Pavilion, N.Y. World's Fair, 1964 and Pavilion of Fine Arts, 1964; Queens Col., 1963; Am. Acad. A. & Lets., 1963-1964; Nat. Inst. A. & Lets., 1963-1964; NAD, 1964; one-man: ACA Gal., New York City, 1967;

Kenmore Gal., Philadelphia, Pa., 1968. Positions: A. Instr., CUA-Sch., New York, N.Y., 1938-1949. Radio lectures on "Traditional & Contemporary Art." Establishment of a "Tully Filmus" Collection at Syracuse University includes working drawings, manuscripts of articles and letters. Subject of an art book "Tully Filmus," text by Dr. Alfred Werner, 1963.

FILTZER, HYMAN—Sculptor, Restorer
　　Metropolitan Museum of Art, New York, N.Y. 10028; h. 1639 Fulton Ave., Bronx, N.Y. 10457
B. Zitomir, Russia, May 27, 1901. Studied: Yale Sch. FA; BAID; & with Gutzon Borglum, Paul Manship. Member: All. A. Am.; F., NSS. Awards: prize, Nat. Aeronautic Assn., Wash., D.C., 1922. Work: S., Pub. Sch., N.Y., Bronx, & Queens; Bellevue Hospital, N.Y.; Ft. Wadsworth, N.Y.; Russell Sage Fnd.; U.S. Army Soldier's Trophy. Exhibited: NAD, 1926, 1936, 1940; PMA, 1940; WFNY 1939; Arch. L., 1938; WMAA, 1940; MMA, 1942; N.Y. Hist. Soc., 1943; PAFA, 1953; All. A. Am., 1953-1955. Positions: Senior Restorer of Sculpture, MMA, New York, N.Y., 1945- . (restored the Aphrodite, the large Assyrian sculptures and works of all periods owned by the Metropolitan Museum of Art).*

FINCH, KEITH—Painter
　　c/o Landau Gallery, 702 N. La Cienega, Los Angeles, Cal. 90069*

FINCK, FURMAN J.—Painter, T., W.
　　285 Central Park West, New York, N.Y. 10024; h. R.F.D. 3, Saint Johnsbury, Vt. 05819
B. Chester, Pa., Oct. 10, 1900. Studied: PAFA; Ecole des Beaux-Arts, Academie Julian, Paris, France. Member: SC; 25 Year Cl., Temple Univ.; Dutch Treat; St. George's Soc. of N.Y. Awards: Hon. DFA, Muhlenberg Col., Allentown, Pa., 1954; Cresson Award travelling scholarship, PAFA, 1924; Carnegie Award, NAD, 1943; American Academy, Rome, 1967; prizes WMA, 1945; SC, 1954; NAD, 1955. Work: Univ. Vermont; State House, Montpelier, Vt.; Mass. General Hospital; Harvard Univ.; State Capitol, Hartford, Conn.; Yale Univ.; Lyman Allyn Mus. A; Long Island Univ.; Nat. Democratic Club, N.Y.; Hospital Special Surgery; Hospital Joint Diseases, N.Y.; American Civil Liberties Union; Horace Mann Sch.; English-Speaking Union, N.Y.; Abington Mem. Hospital, Abington, Pa.; Muhlenberg Col.; State Capitol, Harrisburg, Pa.; The Evening Bulletin, Phila.; The Union League Cl.; Temple Univ. and Medical Sch.; Temple Medical Center; Phila. College Pharmacy; Drexel Institute; Univ. of Pennsylvania; Pennsylvania Institute; Doctors' Hospital, Phila.; Wyeth Laboratories, Wayne, Pa.; Anne Arundel Col., Severna Pk.; Western Maryland Col., Westminster, Md.; Farragut Medical Bldg., Doctors' Hospital, Wash., D.C.; Univ. North Carolina; Univ. of Georgia; Fla. Southern Col.; Toledo Mus. A.; Univ. of Iowa; University of Utah; Wash. State Univ.; Berliz Col., Zurich; Weinberger Col., Geneva; Dartmouth House, London, and in private colls. Many portraits of government officials, including two presidents of the U.S.A. A series of portraits of deans of the colleges of pharmacy throughout the U.S.; also a series of medical portraits including the "Babcock Clinic," containing 34 portraits; "The Churchill Clinic," "The Chamberlain Clinic," and "The Burnett Clinic," each containing 7 portraits. Author: "The Artist and the Architect," Journal American Inst. of Architecture; "The Meaning of Art in Education," "The Artist as Teacher"; "A Complete Guide to Portrait Painting." Exhibited: nationally and internationally. Position: Emeritus Prof. Painting, Tyler Col. FA., Temple Univ., Phila., Pa.; Tutorial counselor, Fordham Univ.

FINDLAY, DAVID—Art dealer
　　Findlay Gallery, 11 E. 57th St., New York, N.Y. 10022*

FINDLAY, HELEN T.—Art Dealer
　　Wally F Findlay Galleries, 320 S. Michigan Ave., Chicago, Ill. 60604
B. Kansas City, Mo., July 21, 1909. Studied: Vassar Col., A.B. Awards: Named one of "Nine Women of the Year" by Chicago Municipal Art League, 1959. Positions: President, Junior League of Kansas City, Mo., 1935-1936; Art Secretary, Association of Junior Leagues of America, 1936-1939; fund raising, National Recreation Association, 1939-1943; Secretary and Manager of Wally F Findlay Galleries, Chicago, Ill., 1962- ; Board Member, Chicago Vassar Club.

FINE, PERLE—Painter, W., Gr., L., E., Cr.
　　58 Third Ave., New York, N.Y. 10003; and The Springs, Easthampton, L.I., N.Y.
B. Boston, Mass., May 1, 1908. Member: Fed. Mod. P. & S.; Am. Abstract A.; Provincetown AA. Awards: Silvermine Gld. A., (3); purchase prize, BM. Work: WMAA; Smith Col. Mus.; Rutgers Univ.; Munson-Williams-Proctor Inst.; Los A. Mus. A.; Guggenheim Mus. A.; The Miller Company Coll.; Brandeis Univ.; BM; N.Y. Univ.;

Univ. California, Berkeley, and in private colls. Exhibited: Illinois Annual of Am. A., 1951; AIC; VMFA; SFMA; BM; MModA; MMA; Inst. Contemp. A., Boston; Newark Mus., 1965; WMAA; AGAA; Los A. Mus. A.; Réalités Nouvelle, Paris; Tanager Gal.; Stable Gal.; Guild Hall, Easthampton; Carnegie Inst.; 1958-59, 1961; Easthampton Gal., Easthampton; six one-man exhs., Parsons Gal.; Tanager Gal. (3 one-man); Graham Gal., N.Y., (6 one-man); Cornell Univ., 1961 (one-man). Monographs in the "New Iconography": Challenge of Modern Art; Painting Towards Architecture; Michael Seuphor's "Dictionary of Abstract Art" and "Piet Mondrian"; John I.H. Baur's "Nature in Abstraction"; "The World of Abstract Art"; "Contemporary American Painting," Univ. Illinois; Paris Review; and in "It Is" and "Art International," 1961; Harold Rosenberg's "The Anxious Object." Positions: Visiting Prof. A., Cornell University; Assoc. Prof. FA, Hofstra University, Long Island, N.Y.

FINE, STAN(LEY) M.—Cartoonist
　　2201 Bryn Mawr Ave., Philadelphia, Pa. 19131
B. Pittsburgh, Pa., May 24, 1922. Studied: Dobbins Art Vocational Sch., Philadelphia, Pa.; PMSchIA. Top sales to True, Man's Magazine, Philadelphia Bulletin, Crestwood Publications. Contributor to "Best Cartoons of the Year," 1966, 1967, 1968; True Cartoon Parade. Self syndicated panel, "Homedingers" appearing weekly, 1966 to present, in the Philadelphia Bulletin, Oakland Tribune, Washington Star, Toledo Blade, and others. Illustrated "The Franklin Mint," orientation Filmslide presentation, 1969; Illus., album cover for Laurie Record Co., "Snoopy's Christmas," 1968.

FINGESTEN, PETER—Sculptor, E., W., L.
　　Pace College, 41 Park Row; h. 339 E. 18th St., New York, N.Y. 10003
B. Berlin, Germany, Mar. 20, 1916. Studied: FA Col., Berlin, M.F.A.; PAFA. Member: CAA; Am. Soc. for Aesthetics; Accademia del Mediteranéo, Rome, (Bd. Dirs.), 1960). Awards: Tiffany Fnd. grant, 1948; prize, Milan, 1938. Work: port., Glycerine Corp. of America. Exhibited: PAFA; Audubon A., 1952; Argent Gal., 1951; Lehigh Univ., 1957 (one-man); 17 one-man exhs., U.S. and 23 in Europe. Author: "East is East," 1956; "Private Dictionary of the Arts," 1958 (limited, illus. edition); "Games Without Rules," 1964 (limited edition—drawings and collages); "The Eclipse of Symbolism," 1969. Contributor to College Art Journal; Sat. Review; Art Quarterly; American Artist; Journal of Aesthetics & Art Criticism; Oriental Art, London; Ismeo, Rome; and other magazines. Lectures: Magic and Art; Prehistoric Art; Modern Art, etc. Positions: Instr., Hist. of Art & Arch., Manhattan Col., 1946-50; Prof. A., Pace Col., New York, N.Y., 1950- . Chm. A. Dept., 1965- .

FINK, DON—Painter
　　38 rue Hippolyte Maindron, Paris 14e, France
B. Duluth, Minn., Sept. 1, 1923. Studied: ASL. Work: Modern Mus., Paris; WMAA; BM; Munson-Williams-Proctor Inst., Utica, N.Y.; Mus. A., Haifa, Israel; Mus. A., Tel Aviv.

FINK, HERBERT LEWIS—Painter, E., Gr., Des.
　　Art Department, Southern Illinois University; h. 1003 W. Hillcrest Drive, Carbondale, Ill. 62901
B. Providence, R.I., Sept. 8, 1921. Studied: Carnegie Inst. Tech.; R.I. Sch. Des., B.F.A.; Yale Univ., M.F.A.; ASL; and with John Frazier, Gabor Peterdi, Arshile Gorky, Rico Lebrun. Awards: Guggenheim Fellowship, 1965-1966; Chaloner Prize, 1951-52, 1952-53; Tiffany award, 1958; Ford Fnd. purchase award, 1959; purchase prizes: Am. Graphic A., 1959; LC, 1959; PMA, 1959; other prizes: College Pr. Annual, Ohio, 1959; Midwest Exh., Omaha, 1958; Am. Color Pr. Soc., 1959; A. Dir. Annual, 1959. Work: Univ. Michigan; Univ. Iowa; BMA; Maryland Inst.; Brown Univ.; LC; BMFA; Smith Col., Yale Univ. Gal. A.; Joslyn Mem. Mus.; R.I. Sch. Des.; mural, R.I. Postoffice Lobby, Providence, 1959; Sen. Green Airport, 1960 (metal sculpture); arch. screen, Hartford Bank & Trust Bldg. Exhibited: College print annual, Ohio, 1959; Midwest Exh., Omaha, 1958; Am. Color Pr. Soc., 1959; Am. Graphic A., 1959; A. Dirs, Annual, 1959; LC, 1959; PMA, 1959. Positions: Instr., Painting & Drawing, Rhode Island School of Design, Providence, 1951-1961; Yale University, New Haven, Conn., 1956-1961; Chm., A. Dept., Southern Illinois University, Carbondale, Ill., 1961- . Print Editor, IGAS, 1960; Trustee, Tiffany Fnd.

FINKELSTEIN, MAX—Sculptor
　　621 N. Curson Ave., Los Angeles, Cal. 90036
B. New York, N.Y., June 15, 1915. Studied: Los Angeles City Col.; Sculpture Center, New York, N.Y.; Cal. Sch. A., Los Angeles; Univ. California at Los Angeles. Awards: prizes, Long Beach Mus., 1965, 1967; Krannert Mus., Univ. Illinois, purchase, 1967. Other purchase awards: Los Angeles Municipal Gal., 1965; Long Beach Mus., 1965, 1967; Jewish Mus. N.Y., 1958, 1961. Work: Joseph Hirshhorn Coll.; Jewish Mus., N.Y.; Krannert Mus., Univ. Illinois; Univ. California Mus., Berkeley; Michener Fnd.; Santa Barbara

Mus. A. Exhibited: Univ. California Mus., Berkeley, 1967; Aldrich Mus. Contemp. A. (Conn.), 1968; Krannert Mus., Univ. Illinois, 1967; Univ. Arizona, 1967; Westside Jewish Community Center, Los Angeles, 1966; La Jolla Mus. A., 1966; SFMA, 1965, 1966; Los Angeles Municipal A. Gal., 1965; Long Beach Mus., 1965, 1967; AFA circulating exh., 1962-1963; Los Angeles County Mus., 1961; Jewish Mus., N.Y., 1958, 1961; one-man: La Jolla Mus., 1968; Santa Barbara Mus. A., 1968; A. M. Sachs Gal., N.Y., 1968; Feigen/Palmer Gal., Los Angeles, 1966; Adele Bednarz Gal., Los Angeles, 1965; Fresno A. Mus., 1964. Positions: Instr., Sculpture, Univ. Judaism, Los Angeles, Cal.

FINKLE, MR. and MRS. DAVID—Collectors
 480 Park Ave., New York, N.Y. 10022*

FINLEY, DAVID EDWARD—Former Museum Director
 1616 H St., N.W. 20006; h. 3318 O St., N.W., Washington, D.C. 20007
B. New York, S.C., Sept. 13, 1890. Studied: Univ. South Carolina, A.B.; George Washington Law Sch., LL.B. Member: AAMus. (Pres. 1945-49); Chm., U.S. National Comm. on International Cooperation Among Museums, 1945-49; V.Pres., Int. Council of Mus., 1946-49; V. Chm., American Comm. for Protection and Salvage of Artistic and Historic Monuments in War Areas, 1943-46; Smithsonian A. Comm. Awards: hon. deg., Doctor FA, Yale Univ., 1946; D.Litt., Univ. South Carolina, 1950; L.L.D., George Washington Univ., 1960; Doctor of Humane Letters, Georgetown Univ., 1960; Theodore Roosevelt Distinguished Service Medal, 1957; Henry Medal, Smithsonian Institute, 1967. Positions: Dir., National Gallery of Art, Washington, D.C., 1938-July 1, 1956; Chm., Commission of Fine Arts, 1950-1963; Chm. National Trust for Historic Preservation, 1949-1962. Member, National Portrait Gallery Commission, Smithsonian Institution; Member, National Collection of Fine Arts Commission, Smithsonian Institution; Trustee, Corcoran Gallery of Art.

FISCHBACH, MARILYN COLE (Mrs. Herbert)—
 Art Dealer, Collector
 39 W. 57th St. 10019; h. 303 E. 57th St., New York, N.Y. 10022
B. New York City, N.Y. Studied: New York University; New York School of Interior Design, and painting with Nicolas Takis, Victor D'Amico. Collection: Contemporary. Specialty of Gallery: Avante Garde. Positions: Owner, Thibaut Gallery, 1962, name changed to Fischbach Gallery, 1964, New York, N.Y.

FISCHER, JOHN—Painter, S.
 83 Leonard St., New York, N.Y. 10013
Exhibited: Allan Stone Gal., N.Y., 1964.

FISCHER, MILDRED (GERTRUDE)—Craftsman, Des., P., E.
 College of Design, Architecture & Art, University of Cincinnati 45221; h. 1306 Michigan Ave., Cincinnati, Ohio 45208
B. Berkeley, Cal., Sept. 15, 1907. Studied: Mount Holyoke Col., A.B.; Design study in Vienna; AIC; Cranbrook Acad. A.; tapestry technique with Martta Taipale in Finland, and Else Halling in Norway; Certif. from Wetterhoff Inst. Handicrafts, Finland. Member: Bd. of Review, Ohio Designer-Craftsmen, 1963-1967. Awards: numerous awards in painting and textiles including purchase award, Int. Textile Exh., Greensboro, N.C., 1947; weaving award, Nat. Dec. Arts Exh., Wichita, Kans.; Midwest Designer-Craftsmen, Milwaukee AI, 1956; tapestry award, Ohio-Designers, Columbus A. Mus., 1962; Contemp. A. Center, CM, 1961; Des.-Craftsmen of Ohio craft award, 1967. Work: Mus. Contemp. Crafts, N.Y.; Stephens Col., Columbia, Mo.; South Bend AA. Exhibited: Victoria and Albert Mus., London, traveling exh., 1962-1963; Univ. Nebraska A. Gal., 1961; AFA traveling exh. of crafts and Smithsonian Institution traveling exh., Designer-Craftsmen U.S.A., 1960. Eleven invitational one-man exhibitions including Mills College, N.Y., 1958 and Mus. of Contemp. Crafts, N.Y., 1959, and others in U.S. and Great Britain. Contributor article to Craft Horizons, 1959. Positions: Assoc. Prof. Design, University of Cincinnati.

FISHER, ETHEL—Painter, Et., Lith.
 30 E. 14th St.; h. 4 E. 89th St., New York, N.Y. 10028
B. Galveston, Tex., June 7, 1923. Studied: Univ. Texas, with Howard Cook, Everett Spruce, B.J.O. Nordfelt; Washington Univ., with Fred Conway; ASL, with Morris Kantor, Will Barnet. Member: AEA; San F. AA. Awards: prizes, Lowe Gal. A., Coral Gables, Fla., 1953; Fla. A. Group, 1956, 1957; Four Arts Soc., 1958-1960; Tiffany Fnd. Grant, 1965. Work: Norton Gal. A., West Palm Beach; Lowe Gal. A.; Peabody Mus., Nashville. Exhibited: Art: USA, 1958; Sarasota AA, 1957; Four Arts Soc., 1955, 1956; Phila. Pr. Cl., 1944; Fla. A. Group nat. Circuit, 1956 and 1957; Boston A. Festival, 1960; San F. AA traveling exh., 1962; Sachs Gal., N.Y., 1965; Castagno Gal., N.Y., 1965; one-man: National Mus., Havana, Cuba, 1957; High Mus. A., Atlanta, 1958; Norton Gal. A., 1958; Riverside Mus.,

1958; Angeleski Gal., N.Y., 1960; Dean Gal., San F., 1961; Lowe Gal. A., 1954. Positions: Memb. Fla. Arts Commission, 1960; Treas., AEA, 1961.*

FISHER, LEONARD EVERETT—Painter, Illustrator, Author
 7 Twin Bridge Acres Road, Westport, Conn. 06880
B. New York, N.Y., 1924. Studied: ASL with Reginald Marsh; Brooklyn College with Serge Chermayeff; Norfolk A. Sch. of Yale Univ.; Yale Univ. A. Sch., B.F.A., M.F.A. Member: AIGA; New Haven Paint & Clay Club, (Pres. 1968-); The Authors Gld. and The Authors League of America; Westport-Weston A. Council, (Dir., 1969-1972); Arts Council of Greater New Haven, (Dir. Ex-Officio, 1968); Silvermine Gld. A.; Soc. Conn. Craftsman. Awards: prizes, U.S. Army Exh., Hawaii, 1945; Weir Prize, Yale Univ., 1947; Winchester Fellowship, Yale Univ., 1949; Pulitzer Fellow, Columbia Univ. and Nat. Acad. Des., 1950; Outstanding textbook Citation, AIGA, 1958; Outstanding Children's Book (2), AIGA, 1963; Ten Best Pictures Award (children's books), N.Y. Times, 1964; Graphics prize, 5th Int. Book Fair, Premio Grafico, Bologna, Italy, 1968; New Haven P. & Clay Cl., 1969. Work: LC; Kerlan Coll. of the Univ. Minnesota; Elmira College, N.Y.; Atkinson Coll. of the Milwaukee Pub. Lib.; Children's Coll., Cedar Rapids Pub. Lib.; American Red Cross; Author's Room Coll., Wilmington, Del.; mural, Military Hospital, Oahu, Hawaii; U.S. Dept. of Interior, Nat. Park Service (collaborative mural) main lobby, Washington Monument, Wash., D.C., 1963; L. E. Fisher Archive, Univ. Oregon; Fairfield Univ., Conn.; Univ. of Southern Miss.; Housatonic Community Col., Conn.; Free Lib. of Phila., and others. Illustrated more than 150 children's books, and miscellaneous design projects in juvenile field. Author and illustrator of 18 of the 150 books with all material published 1955-1969. Exhibited: Seligmann Gal., N.Y., 1947-1949; New Haven Paint & Clay Cl., 1948, 1955-1969; Edwin Hewitt Gal., N.Y., 1950-1962, one-man 1952; WMAA, 1951; Springfield (Mass.) Mus. FA, 1952; AFA national tours, 1948, 1949, 1954, 1955, 1956; Emily Lowe Fnd. tours, 1951, 1952; Rochester Inst. Tech., 1953 (one-man); Silvermine Gld., 1965-1969, one-man, 1968; Southern New England Int., Fairfield Univ., 1967; Pa. State Univ., 1968, and others. Positions: Instr., Design Theory, Yale Univ. Art School, 1949-1950; Composition, 1951-1953, Dean, 1951-1953, Whitney School of Art, New Haven, Conn. Instr., painting & book illustration, Paier Sch. A., Hamden, Conn.

FISHKO, BELLA (Mrs.)—Art Dealer
 Forum Gallery, 1018 Madison Ave. 10021; h. 14 E. 75th St., New York, N.Y. 10021
B. Odessa, Russia, July 7, 1913. Studied: Hunter College; New School, N.Y.; N.Y. Univ. Institute of Fine Arts. Member: Art Dealers Assn. of America. Specialty of Gallery: Contemporary American Painting and Sculpture. Positions: Director, Forum Gallery, New York, N.Y.

FITCH, GEORGE HOPPER—Collector, Patron
 1960 Broadway, San Francisco, Cal. 94109
B. New York, N.Y., Nov. 29, 1909. Studied: Yale University, B.A. Collection: American watercolors of the 20th Century; Indian Miniatures. Positions: Director, deYoung Memorial Museum Society; Trustee, American Federation of Arts; Fellow, Pierpont Morgan Library; First Vice-President, American Federation of Arts, 1955-1964; President, Municipal Art Society, N.Y., 1958-1960; Chairman, Art Collectors Club of America, 1957-1964; Art Commission, New York City, 1964-1968, Vice-President, 1966-1968.

FITE, HARVEY—Sculptor, E., L., W.
 High Woods, Saugerties, N.Y. 12477
B. Pittsburgh, Pa., Dec. 25, 1903. Studied: St. Stephen's Col., and with Corrado Vigni, Florence, Italy. Member: Woodstock AA; AEA. Awards: Yaddo Fnd., 1954; Asia Fnd. grant for Cambodia, 1956. Work: in public and private colls. in U.S. and private colls. abroad. Exhibited: nationally and internationally with one-man shows in Rome, Paris, and New York. Reconstructor of Mayan Sculpture, Copan, Honduras, for Carnegie Inst. of Washington. Lectures: History and Theory of Sculpture during Italian Renaissance and Mayan Civilization; The Art of the Maya; Hindu and Khmer Stone Carving. Positions: Prof. Sculpture, Bard College, Annandale-on-Hudson, N.Y., 1933- .

FITZPATRICK, FRANK G.—Collector
 25 Mostyn St., Swampscott, Mass. 01907
B. West Newton, Mass., Apr. 28, 1878. Studied: Harvard College, A.B.; Harvard University, A.M. Member: The Society of Arts and Crafts, Boston; The National Early American Glass Club, Boston. Collection: Pottery; Ceramics; Ancient Roman Glass; Stiegel Wine Glasses and other 18th century glasses; Jacobite Glasses; American Flasks. Positions: President, The National Early American Glass Club, 1941 and 1942.*

FITZSIMMONS, JAMES JOSEPH—Painter
308 Enfield St., Thompsonville, Conn. 06082
B. Springfield, Mass., July 8, 1912. Studied: Pratt Institute, Sch. Architecture, Brooklyn, N.Y. Member: Essex AA; Academic AA; Springfield A. Lg.; Valley WC Soc. Awards: prizes, Am. Artist Magazine, 1954; Mus. FA of Springfield purchase award, 1955; Academic AA, 1963; Berkshire AA, 1963; Connecticut A. Festival, Travelers Ins. Co. purchase award, 1965. Work: Springfield Mus. FA; Travelers Ins. Co. Exhibited: Eastern States Exh., 1959-1963; NAD, 1963; Audubon A., 1962; So. Vermont A. Center, 1957; Knickerbocker A., 1963; Conn. WC Soc., 1963; Academic A., 1959, 1960, 1961, 1964; Springfield A. Lg., 1962, 1968.

FJELDE, PAUL—Sculptor, E.
161 Emerson Pl., Brooklyn, N.Y. 11205
B. Minneapolis, Minn., Aug. 12, 1892. Studied: Minneapolis Sch. A.; ASL; BAID; Royal Acad., Copenhagen; Grande Chaumiere, Paris, France. Member: F., NSS; NA; Eastern AA. Awards: F., Am.-Scandinavian Fnd.; AAPL; All. A. Am.; NSS. Work: monuments, Lier & Oslo, Norway; Hillsboro, N.D.; Madison, Wis.; St. Paul Hist. Soc.; arch. s., schools & bldgs., Pittsburgh, Pa.; New York, N.Y.; Boston, Mass.; Springfield, Mass.; Brookgreen Gardens, S.C.; Mus. of Hispanic Soc., N.Y.; numerous medals designed; mem. tablets and busts; Wendell Willkie memorials in State House, Indianapolis, Ind., and Bryant Park, New York, N.Y. Positions: Prof. A., PIASch., Brooklyn, N.Y., 1929- , Prof. Emeritus (Retired); Sec. NSS, 1950-53; Editor, Nat. Sculpture Review, 1951-55. Instr., Sculpture, Nat. Acad. Sch. Fine Arts, New York, N.Y.*

FLAGG, MR. and MRS. RICHARD B.—Collectors
624 W. Oregon St. 53204; h. 7170 North River Road, Milwaukee, Wis. 53217
B. Frankfurt am Main, Germany, Feb. 8, 1906 (Mr. Flagg). Studied: Academy of Arts in Vienna, Austria and special sculpturing training under Professor Joseph Heu in Vienna (Mr. Flagg). Collection: European wood sculpture of the 15th, 16th and 17th century; European furniture—Gothic, Renaissance and Baroque; Silver and metalcraft of the same periods; Important private collection of European clocks with emphasis on the early 16th and 17th centuries.*

FLAX, SERENE (Mrs. Don)—Painter
268 Moraine Rd., Highland Park, Ill. 60035
B. Chicago, Ill., May 25, 1926. Studied: Chicago Academy FA; AIC. Member: Cal. WC Soc.; AWS; Renaissance Soc. of Univ. of Chicago. Awards: prizes, Cal. WC Soc. (Bruggers Award), 1965; purchase award, Watercolor:USA, 1966 and traveling exh., 1967-1968; Illinois State Mus. (purchase), 1968; prize, Chicago Mun. A. Lg., 1969. Exhibited: Springfield (Mo.) A. Mus., 1963; St. Paul A. Center, 1964; All. A. Am., 1964; Audubon A., 1964; AWS, 1965; Butler Inst. Am. A., 1964; Illinois Regional, 1964; Cal. WC Soc., 1964; AWS and Cal. WC Soc. traveling exhs. to museums and universities, 1964-1965; Old Orchard A. Festival, 1964. Featured artist, American Artist magazine, 1967.

FLEISCHMAN, LAWRENCE A.—Collector, Patron, Art Gallery Director
Kennedy Gallery, 20 E. 56th St. 10022; h. 870 United Nations Plaza, New York, N.Y. 10017
B. Detroit, Mich., Feb. 14, 1925. Studied: University of Detroit, B.S. Collection: American and European Old Masters; Greek Vases. Awards: Citation from Detroit Mayor and Council, 1966; Merit Award, Lotus Club, 1966. Positions: President, Detroit Arts Commission, 1962-1966; President, Archives of American Art, 1959-1966; Board of Directors, Mannes School of Music, Editor, American Art Journal; Vice-President, Kennedy Art Gallery, New York, N.Y.

FLEMING, DEAN—Sculptor, P., E., Cart., L.
Libre St., Gardner, Colo. 81040
B. Santa Monica, Cal., Oct. 1, 1933. Studied: Santa Monica Col.; Mexico City Col.; Cal. Sch. FA, B.F.A., M.F.A. Awards: Papados "Artist of the Year," Greece, 1964; Oakland, Cal. award, 1961. Work: Aldrich Mus. Contemp. A.; Lannan Mus.; Los Angeles County Mus.; Univ. Texas A. Gal.; Michener Coll.; Cranbrook Acad. A.; City of Denver, 1968. Exhibited: SFMA, 1956, 1961; Oakland Mus., 1961; VMFA, 1960; Park Place Gal., 1962, 1967; Guggenheim Mus., 1967; Jacksonville, 1966, 1967; N.Y. Univ., 1967; Denver, 1967; CGA, 1968; Aspen, Colo., 1969. Positions: Instr., Painting, San Francisco A. Inst.; A. Hist., N.Y. State Univ.; Design, Carnegie Inst.; Painting, Pratt Inst., Brooklyn. Co-Dir., Six Gal., San Francisco, 1956-1961; Park Place Gal., 1962-1967. Member, Bd. Dirs., Libre, Inc., 1968-1969.

FLEXNER, JAMES THOMAS—Writer, Cr., L.
530 East 86th St., New York, N.Y. 10028
B. New York, N.Y., Jan. 13, 1908. Studied: Lincoln Sch.; T. Col.,

Columbia Univ.; Harvard Col., B.S. Member: F., Soc. Am. Historians; Authors Lg. Am.; P.E.N. Cl. (Pres. 1954-55); Century Association; Benjamin Franklin Fellow, Royal Society of Arts (Great Britain); Advisory Committee, The George Washington Papers. Awards: Lib. Cong. Grant-in-Aid for Studies in the History of Am. Civilization, 1945; Life in America prize, Houghton Mifflin, 1946; Guggenheim Fellowship, 1953; Parkman Prize, 1962. Lowell Lecturer, 1952. Lecturer, Columbia Univ., 1955. Author: "Doctors on Horseback," 1937; "America's Old Masters," 1939; "Steamboats Come True," 1944; "American Painting: First Flowers of Our Wilderness," 1947; "John Singleton Copley," 1948; "A Short History of American Painting" (also publ. as the Pocket History of American Painting), 1950; "The Traitor and the Spy," 1953; "American Painting: The Light of Distant Skies," 1954; "Gilbert Stuart," 1955; "Thomas Eakins," 1956; "Mohawk Baronet," 1959; "American Painting: That Wilder Image," 1962; "George Washington: The School of Experience, 1732-1755" (1965); "George Washington in the American Revolution" (1968). Co-Author: "William Henry Welch and the Heroic Age of American Medicine," 1941. Contributor of: Articles, book reviews, criticisms, stories to national, art & historical magazines. Lectures: "American Colonial Portraiture"; America's Nineteenth Century Native Painting School, etc.

FLINSCH, HAROLD, JR.—Collector, Patron, Cr.
Box 577, Newberry, S.C. 29108; h. Rt. 1, Box 117, Lexington, S.C. 29072
B. Minneapolis, Minn., Mar. 4, 1938. Studied: Mississippi State University; University of Minnesota; University of South Carolina. Collection: J. Bardin, E. Yaghjian, Chagall, Baskin, Parker, Whistler, Buffet, Abeles, Van Hook, Chitty and others. Positions: Past Vice President and Trustee, Columbia (S.C.) Art Association; Director, Newberry Arts Association, at present.

FLINT, LEROY W.—Educator, P., L., S.
Kent State University, School of Art, Kent, Ohio 44240; h. 2910 14th St., Cuyahoga Falls, Ohio 44223
B. Ashtabula, Ohio, Jan. 29, 1909. Studied: Cleveland Inst. A.; Cleveland College; Western Reserve Univ.; Univ. Minnesota. Member: AAMus.; Am. Soc. for Aesthetics; CAA; Akron Soc. A. Awards: prizes, Cleveland Inst. A., 1936, 1937, 1939, 1941, 1947, 1950, 1954, 1955, 1956. Work: CMA; Akron AI; Butler Inst. Am. A.; Columbus Mus. A.; CM; LC; mobile, Akron Pub. Lib.; murals, Cleveland Metropolitan Housing Authority; Cleveland Heights Pub. Schs.; Innes Jr. H.S., Akron; Akron Pub. Lib.; stained glass window, Fairview Park Hospital, Cleveland. Exhibited: Columbus, Ohio, 1953; Houston, Tex.; Butler Inst. Am. A.; CMA, 1936-1941; 1947-1956; Akron Art Inst., 1951-1958. Positions: Instr., CMA Edu. Dept.; Akron AI Sch. Des., 1950-53; Cur. Edu., Akron AI, 1954-56; Assoc. Prof. & Gallery Dir., Kent State University, Kent, Ohio at present.

FLOCH, JOSEPH—Painter
54 West 74th St.; h. 61 W. 74th St., New York, N.Y. 10023
B. Vienna, Austria, Nov. 5, 1895. Studied: State Acad. FA, Vienna. Member: NA; Fed. Mod. P. & S.; AFA; Salon d'Automne, Paris, France. Awards: prize, PAFA, 1944; Nat. Inst. A. & Lets., 1951; Brevoort-Eickemeyer prize, Columbia Univ., 1955; medal, Int. Exh. Paris, France, 1937; William Palmer Mem. award, NAD, 1960; Chevalier of the French Order of Arts and Letters; Isidor Mem. Gold Medal, NAD, 1963; Obrig Prize, NAD, 1964; Springfield (Mass.) Mus. FA, 1966. Work: MMA; WMAA; deYoung Mem. Mus., San F.; Toledo Mus. A.; MModA, Paris; Jeu de Paume, Paris; W.R. Nelson Gal. A., Kansas City; Albertina Mus., Vienna; Mus. of Lille, France; Mus. Grenoble, France; Belvedere Mus., Vienna; Mus. of the City of Vienna; Mus. City of Paris, France; Springfield Mus. A.; Montclair A. Mus.; Mus. in Tel Aviv and Jerusalem; Smithsonian Inst.; Butler Inst. Am. A., Youngstown, Ohio; Herron Mus. A., Indianapolis; Finch Col. Mus., N.Y. and others. Exhibited: Assoc. Am. A.; WMAA; PAFA; Wash. County Mus. FA; Toledo Mus. A.; CGA; AIC; N.Y. World's Fair, 1964-65; Forum Gal., N.Y., 1964 (one-man); PAFA, 1964; Carnegie Inst.; and many others. Contributor articles and reproductions in leading newspapers in U.S. and Europe. Positions: Faculty, New School of Social Research, New York, N.Y., at present.

FLOETHE, RICHARD—Illustrator, Des., Gr., T., L.
1391 Harbor Dr., Sarasota, Fla. 33579
B. Essen, Germany, Sept. 2, 1901. Studied: in Germany. Member: Sarasota AA. Awards: prizes, Limited Editions Club, 1934 ("Tyl Ulenspiegl"); 1936 ("Pinocchio"). Illus., "Street Fair," 1936; "Circus Shoe," 1939; "Smoky House," 1940; "Robinson Crusoe," 1945; "Picture Book of Astronomy," 1945; "Valley of Song," 1952; "Mr. Bell Invents the Telephone," 1953; "Picture Book of Electricity," 1953; "Family Shoes," 1954; "Venus Boy," 1955; "Ting-a-Ling Tales," 1955, and many others. In collaboration with Louise Lee Floethe: "If I Were Captain," 1956 (Junior Literary Club selection); "The Farmer and His Cows," 1957; "The Winning Colt,"

1956; "A Year to Remember," 1957; "Terry Sets Sail," 1958; "The Cowboy on the Ranch," 1959; "The Indian and His Pueblo," 1960; "Sara," 1961; "The Fisherman and His Boat," 1961; "Triangle X," 1960; "Blueberry Pie," 1962; "The Story of Lumber," 1962; "Sea of Grass," 1963; "The Islands of Hawaii," 1964; "The New Roof," 1965; "Fountain of the Friendly Lion," 1966; "1000 and One Buddhas," 1967; "Floating Market," 1969. Work: PMA; MMA; CAM; N.Y. Pub. Lib.; LC; Univ. Minnesota; Univ. Oregon; Univ. of South Florida; Columbia Univ.; Phila. Pub. Lib.; Univ. Southern Mississippi. Exhibited: Sarasota AA, 1955. Contributor to the Horn Book. Note on illustrating "All's Well That Ends Well," Limited Editions Club. Positions: Former Instr., Comm. Des., CUASch.; Former Instr., Illus., Ringling Sch. A., Sarasota, Fla.

FLORSHEIM, RICHARD A.—Painter, Gr., E., L.
 Studio F, 5 East Ontario St., Chicago, Ill. 60611; s. 651 Commercial St., Provincetown, Mass. 02657
B. Chicago, Ill., Oct. 25, 1916. Studied: Univ. Chicago, and with Aaron Bohrod. Member: Provincetown AA (trustee); Audubon A.; AEA; ANA; SAGA; Illinois A. Council. Awards: prizes, LC, 1959; Silvermine Gld. A., 1959. Work: Musée du Jeu de Paume, Paris; Mills Col., Oakland, Cal.; AIC; MMoDA; Birmingham Mus. A.; Univ. Minnesota; MMA; PMA; N.Y. Pub. Lib.; Dartmouth Col.; Idaho State Col.; Bibliotheque Nationale, Paris; La Napoule A. Fnd.; Musée Nationale d'Art Moderne, Paris; Victoria & Albert Mus., London; Royal Scottish Mus., Edinburgh; Glasgow A. Gal.; National Mus., Stockholm; Museo de Arte Moderna, Milan; Palacio de Bellas Artes, Mexico City; National Gal. of Canada; National Lib. of Ireland, Dublin; Detroit Inst. A.; LC, and in many other museums in U.S., Europe and South America. Exhibited: AIC; MMoDA; Birmingham Mus. A.; SAGA; Univ. Illinois; Wm. R. Nelson Gal. A.; BM; CAM; LC; Des Moines A. Center; Dayton AI; Columbus Mus. A.; Hunter Gal. A., Chattanooga; NAD; CGA; Butler Inst. Am. A.; DMFA; NGA; Norton Gal. A.; Universities of Chicago, Minneapolis, Columbia, Princeton, Cornell and others; Rochester Mem. A. Gal.; PAFA; SFMA; Phila. Pr. Cl.; Delgado Mus. A.; Chicago Pub. Lib.; Milwaukee AI; WMAA; PC, and many others. One-man: The Contemporaries, N.Y., 1953; Galerie Gerald Cramer, Geneva, Switzerland, 1953; Landau Gal., Los A., 1954; Jacques Seligmann Gal., 1955, 1957; Phila. A. All., 1955; Ohio State Univ., 1957; AIC, 1958; Babcock Gal., N.Y., 1959, 1961, 1964; Garelick's, Detroit, 1958, 1960, 1962, 1965, 1968; Oehlschlager Gal.,, Chicago, 1958, 1960, 1962, 1964, 1968, 1969; Assoc. Am. A., 1960, 1963, 1966 (30 year Retrospective); Shore Gal., Boston, 1961; Birmingham (Ala.) Mus. A., 1966; Univ. Maine, 1968; Cedar Rapids A. Center, 1968, and many others in prior years. Illus., "Exploring Life Through Literature," 1951. Contributor to College Art Journal; Art League News; Chicago Sun-Times. Lectures universities and colleges; Adult Edu. Council of Greater Chicago, 1949- . Positions: Instr., Layton Sch. A., Milwaukee, Wis., 1949-50; Pres. AEA, 1954-55; Instr., Painting, Contemporary Art Workshops, Chicago, Ill., 1953-1963. Artist-in-Residence, Atlanta Museum Art, AFA-Ford Fnd. Grant, 1963; U.S. Delegate to 4th Intl. Congress, I.A.P.A.

FLORY, ARTHUR L.—Graphic, P., T., I.
 1814 Beech Ave., Melrose Park, Pa. 19126
B. Lima, Ohio, Aug. 14, 1914. Studied: PMSchIA; NAD. Member: Phila. Pr. Cl.; AEA; Pr. Council Am.; Boston Pr.M.; AAUP; Am. Color Pr. Soc. Awards: prizes, AEA, Phila, 1951; Albany Pr. Cl., 1951; Ohio Pr. M., 1955; medal, Phila. WC Cl., 1955; Japan Soc. grant, 1960-61 (to establish Lithography workshop, Tokyo); Walker Lithography Prize, Phila. Pr. Cl., 1968. Work: U.S. Marine Hospital, Carville, La.; Wm. R. Nelson Gal. A.; Albany Inst. Hist. & A.; PMA; Bibliotheque Nationale, Paris; Dayton AI; Butler AI; Phila. Pub. Lib.; Princeton Univ.; New Britain Mus.; Phila. Pr. Cl.; Logan County Schs., Logan, W. Va.; PAFA; NGA; Rosenwald Coll.; Tel-Aviv Mus. A.; Bridgestone Gal., Nat. Mus. Western A., Nat. Mus. Mod. A., all Tokyo, Japan; A. Gal. of New South Wales, Sydney, Australia; Kamakura (Japan) Mus. Mod. A.; Fleisher Mem., Phila.; Pennell Coll., LC; and in museums in England & France. Exhibited: nationally and internationally. Author, I., "Where are the Apples?" 1945; "Animal Mother Goose," 1946; "Our Daily Bread," 1946; Co-Author: "Cow in the Kitchen," 1946, and other children's books. Positions: Instr., Graphics, Painting & Drawing, Stella Elkins Tyler Sch. FA, Temple Univ., Philadelphia, Pa., 1950-1968. Advisor in lithography, Phila. Col. A.

FOGEL, SEYMOUR—Painter, Muralist, Sculptor, W., L.
 243 Canal St., New York, N.Y. 10013; h. 20 Sue Terr., Westport, Conn. 06880
B. New York, N.Y., Aug. 25, 1911. Studied: NAD. Member: F., Int. Inst. A. & Lets. Awards: Winner, 48 State Comp., 1940; Social Security Bldg., Comp., 1941; prizes, Texas FA Assn., 1952; Mus. of FA of Houston, 1953; Dallas State Fair, 1955; Feldman Coll. award,

1955, 1956, 1958; Gulf Caribbean Int., 1956; silver medal, Arch. Lg., 1958. Work: DMFA; Mus. FA of Houston; WMAA; CAM; Michigan State Univ.; Edward Bruce Mem. Coll.; Univ. Missouri; Ft. Worth A. Center; Univ. Maryland; murals, Am. Nat. Bank, Austin; Univ. Texas Dental Branch, Houston; First Nat. Bank, Waco, Tex.; Abraham Lincoln H.S., N.Y.; Federal Bldg., Safford, Ariz.; Social Security Bldg., Wash., D.C.; Federal Bldg., Ft. Worth; P.S. #306, Brooklyn, N.Y.; U.S. Customs Court, Foley Square, New York, N.Y.; USPO, Cambridge, Minn.; Baptist Youth Center, Austin; Petroleum Cl., Houston, Tex.; First Christian Church, Houston; Ohio Wesleyan Univ.; Brooklyn Hospital; Hoffmann-La Roche Bldg., Nutley, N.J. Exhibited: All national exhibitions. One-man: Kendall Gal., San Angelo, Tex., 1954; Betty MacLean Gal., Dallas, 1954; Ft. Worth A. Mus., 1955; Headliner's Cl., Austin, 1955; Laguna Gloria Mus., Austin, 1956; Duveen-Graham Gal., N.Y., 1956; Mus. FA Houston, 1951; Santa Barbara Mus. A., 1957; McNay AI, 1958; Knoedler Gal., 1958; Michigan State Univ., 1961; Park Gal., Detroit, 1961; Allan Stone Gal., N.Y., 1963; Springfield (Mo.) Mus. A., 1964; Amel Gal., N.Y., 1965; Westport, Conn., 1966. Contributor to College Art Journal. Author articles on art and architecture to: Architecture & Engineering News; AIA Journal; National Journal of AIA; Liturgical Arts; Art in America. Positions: Asst. Prof., Univ. Texas, Austin, Tex., 1946-54. Visiting Prof., Painting, Michigan State Univ., 1961; Vice-Pres., Architectural League, N.Y., 1961-1962; Artist-in-Res., Springfield (Mo.) A. Mus., 1964.

FOLDS, THOMAS McKEY--Educator, L., Des., Cr.
 Dept. of Education, Metropolitan Museum of Art, 5th Ave. at 82nd St.; h. 535 East 86th St., New York, N.Y. 10028
B. Connellsville, Pa., Aug. 8, 1908. Studied: Yale Col., B.A.; Yale Sch. FA, B.F.A. Member: CAA. Author articles on art in various magazines. Lectures on painting, architecture and design; Art Consultant. Author-I. books for children. Des., traveling exhibitions on painting, architecture, advertising art, etc. (2 for AFA) Positions: A. Dir., Phillips Exeter Acad., Exeter, N.H., 1935-46; Prof. A., Chm. A. Dept., Northwestern Univ., Evanston, Ill., 1946-60; Dean, Dept. Education, Metropolitan Museum of Art, New York, N.Y., 1960- . Pres., School Art League, New York, N.Y., 1968- ; Member, (Chm., 1965-1968), International Committee for Education and Cultural Action, International Council of Museums, 1965- .

FONELLI, J. VINCENT—Sculptor, P., Arch. Des.
 5800 16th St., N.W., Washington, D.C. 20011; also, studio: Casella Postale Nr. 612, 50100 Florence, Italy
B. Salerno, Italy, Sept. 28, 1906. Studied: Univ. California, Los Angeles; Columbia Univ.; Hunter Col., N.Y.; Cooper Union; American Univ., Wash., D.C.; Corcoran Sch. Art, and with Oronzio Maldarelli, Ettore Salvatore, Richard Lahey and others; also privately with Renato Lucchetti. Member: N.Y. Chptr., AIA (assoc.); AFA; Nat. Soc. of Italian and American Sculptors-Artists (Founder); Fonelli Studios of FA (Founder & Pres.). Exhibited: Washington A. Cl.; permanent exh., Palazzo d' Arte Gallery, Wash., D.C.; one-man: Interstate Bank Bldg., Washington, D.C.; Air India Distr. Office, Wash., D.C., Publ. "Beauty in Sculpture, Painting . . ." and "Portraiture, Painting & Sculpture of Beauty." Positions: Founder, Pres., Palazzo d'Arte Gallery, Washington, D.C., 1960-1969, in 1969 moved studio & gallery to Florence, Italy.

FONTANINI, CLARE—Educator, S., Des., W., L.
 Catholic University of America; h. 1029 Perry St., Northeast, Washington, D.C. 20017
B. Rutland, Vt., Mar. 18, 1908. Studied: Col. of St. Catherine, St. Paul, Minn., A.B.; Columbia Univ., M.A., and with Oronzio Maldarelli, Joseph Albers. Member: AAUP; Am. Soc. for Aesthetics; Liturgical Arts Soc.; Soc. Washington A.; Washington A. Gld. Awards: prizes, Soc. Washington A., 1947, 1957; CGA, 1955; Univ. Wisconsin Christian Arts Festival, 1956, 1957; Archdiocese of Washington first annual Arts Festival, 1958; Bruce Fnd. award, 1958; medals, Soc. Washington A., 1942, 1952, 1955, 1957. Work: sculpture—St. Mary's Church, Winnsboro, La.; Gibbons Hall, Catholic Univ. of America; private Chapel of Archbishop of Washington; St. John's Church, McLean, Va.; St. Michael's Church, Annandale, Va.; Crucifixion group, All Saint's Episcopal Church, Chevy Chase, Md., 1968, and others. Exhibited: CGA; NCFA; Mint Mus. A.; VMFA; WAC; Univ. Illinois; Watkins Mem. Gal., Wash., D.C.; St. John's Univ., Collegeville, Minn.; Univ. Wisconsin; College of St. Catherine, St. Paul; Liturgical Week Exh., Pittsburgh, 1960; Assoc. A. Gal., Wash., D.C., 1961; Soc. Wash. A., 1961. Positions: Prof. A., Catholic University of America, Washington, D.C.

FORAKIS, PETER—Painter, S.
 222 West St., New York, N.Y. 10013
B. Hanna, Wyo., 1927. Studied: Cal. Sch. FA, B.F.A. Exhibited: San F. AA, 1955-1958; Oakland A. Mus., 1957; Martha Jackson Gal., N.Y., 1960; CM, 1964; Univ. Nebraska, 1964; Parke Bernet Gal.,

N.Y., 1963; Brookhaven Laboratories, 1963; one-man: Gal. 6, San Francisco, 1955-1958; Tibor de Nagy Gal., N.Y., 1962, 1963, 1964; 2-man: Gal. 6, San Francisco, 1957; Spatsa Gal., San Francisco, 1959; Martha Jackson Gal., N.Y., 1961.*

FORD, CHARLES HENRI—Painter, Photographer, Writer, Film-maker
 1 W. 72nd St., New York, N.Y. 10023
B. Mississippi, 1913. Exhibited: Inst. Contemp. A., London, "Images from Italy" (photographs), 1955; Galerie Morforen, Paris, 1956; Galerie du Dragon, Paris, 1957-1958; Salon du Mai, Paris, 1958; Feigen Gal., 1963; PVI Gal., N.Y., 1964; one-man: Cordier-Ekstrom Gal., N.Y., 1965; Souza Gal., Mexico City, 1966; Gotham Book Mart, 1968. Editor, Blues Magazine, 1929-30; View, 1940-47; Books edited: "The Mirror of Baudelaire," "A Night with Jupiter." Co-author (with Parker Tyler) "The Young and Evil," novel, 1933; Author: "Garden of Disorder" (poems), 1938; "The Overturned Lake" (poems), 1941; "Sleep in a Nest of Flames" (poems), 1949; "Spare Parts" (Litho Poems), 1966; "Silver Flower Coo," 1968. Films: "Poem Posters," 1966; "Johnny Minotaur," 1969.

FORD, JOHN GILMORE—Collector, Art Dealer
 John Ford Associates, Inc., 2601 N. Charles St. 21218; h. 3903 Greenway, Baltimore, Md. 21218
B. Baltimore, Md., Dec. 23, 1928. Studied: Maryland Institute of Art, B.F.A.; Johns Hopkins University. Member: The American Institute of Interior Designers. Collection: Oriental Art in all categories; Primitive Art. Positions: John Ford Associates, Inc., dealers in Oriental and Primitive Art; specialist in Interior Design.

FORMAN, ALICE—Painter, Des.
 8 Croft Rd., Poughkeepsie, N.Y. 12603
B. New York, N.Y., June 1, 1931. Studied: Cornell Univ., B.A., with Kenneth Evett, Norman Daly; ASL, with Morris Kantor. Awards: Nat. Students Assn. regional awards; Daniel Schnackenberg merit scholarship, ASL. Exhibited: WMAA, 1960; White Mus. A., Cornell Univ., 1961; Camino Gal., N.Y., (one-man) 1960, (2-man), 1959, 1961; Phoenix Gal., N.Y., 1966, 1968; Marist Col., 1968; Bennett Col., 1968, all one-man.

FORMAN, KENNETH W.—Painter, Gr., E.
 R. F. D. 1, Mansfield Center, Conn. 06250
B. Landour, India, June 5, 1925. Studied: Wittenberg Col., A.B., B.F.A.; Ohio State Univ., Columbus, M.A. Member: Conn. WC Soc.; Mystic AA; Springfield AA; Norwich AA; Victorian Soc. of England; Victorian Soc. of America. Awards: prizes, Ball State T. Col., 1958; Silvermine Gld. A., 1957, 1959; Mystic AA, 1956, 1958, 1963; Norwich AA, 1958, 1959, 1961, 1964; New Haven AA, 1956; University Research Grant to study Victorian Architecture in England. Work: Wittenberg Col.; Univ. of Rhode Island. Exhibited: BM, 1961; LC, 1961; SAM, 1960; Audubon A., 1959; Wash. Pr. M., 1960; Lyman Allyn Mus., 1960 (one-man); Spiral Gal., Boston, 1960 (one-man); Boston A. Festival, 1953-1955, 1957, 1959; New Haven A. Festival, 1959, 1960; Wadsworth Atheneum, 1960; Norwich Free A. Acad., 1956 (one-man); Ball State T. Col., 1964, 1965; AFA Nat. Print Exh., circulating; Conn. WC Soc., Hartford Atheneum, 1963, 1964. Positions: Prof., Art Dept., University of Connecticut, Storrs, Conn., 1951- .

FORSBERG, JAMES (JIM)—Painter, Gr.
 Provincetown, Mass. 02657
B. Sauk Centre, Minn., 1919. Studied: St. Paul Sch. A.; ASL; studied with Alexander Masley, Cameron Booth, Vaclav Vytlacil, Hans Hofmann. Exhibited: one-man and group shows. Positions: A. Instr., Provincetown, Mass., at present.

FORSLUND, CARL V., JR.—Painter
 122 E. Fulton St. 49502; h. 2141 Elmwood St., S.E., Grand Rapids, Mich. 49506
B. Grand Rapids, Mich., Nov. 12, 1927. Studied: Univ. Michigan, B.S. Member: Michigan Acad. FA; Natl. Soc. of Interior Des. Awards: prizes, Lois Hall Mem. Award, West Michigan Exh., Grand Rapids, 1960; Hackley A. Gal., Muskegon, Mich., 1965; Michigan Acad., 1968. Exhibited: one-man: Grand Rapids A. Gal., 1947, 1969; Hackley A. Gal., 1964, 1965; West Michigan Exh., 1954, 1958-1962; Michigan Acad. FA, 1963; invitational exhs. throughout Michigan; Butler Inst. Am. A., 1967. Positions: Pres., Friends of Art of Grand Rapids A. Museum and Bd. Trustees, 1961- ; Bd. Dirs., Grand Valley Artists, 1957-1962.

FORST, MILES—Painter, Gr. E.
 167 Crosby St., New York, N.Y. 10012
B. Brooklyn, N.Y., Aug. 18, 1923. Studied: Hans Hofmann Sch. A.; ASL; Esquela Obrera, Mexico, D.F. Awards: Larian grant, 1954; W. K. Gutman Fnd., 1960, 1962, 1965; Longview Fnd., 1961, 1962; Ford Fnd., AFA grant, 1965; McDowell Grant, 1965, 1967. Work: Newark

Mus.; Chrysler Mus., Provincetown, Mass.; Mint Mus., Charlotte, N.C.; Mass. Inst. of Tech.; Wadsworth Atheneum, Hartford, Conn.; Dillard Univ.; Tulane Univ. Art Mus.; Bowdoin Col. Mus.; Allentown Mus., Pa. Exhibited: Guggenheim Mus., 1954; Stable Gal., 1955-1957; Landau Gal., Los A.; Carnegie Inst., 1959; Green Gal., N.Y., 1960, 1961, 1962, 1964; Graham Gal., N.Y., 1961; Zabriskie Gal., 1961, 1962; AFA Core, 1964; New School, 1962; AFA Traveling Exh., 1962; MModA, 1963; Wadsworth Atheneum, 1964; Byron Gal., 1964; Gallery of Mod. Art, 1965; Aegis Gal., 1964; Area Gal., 1964; Bridge Gal., 1965; van Bovencamp, 1965; Sch. of Visual Arts Gal., 1965; one-man: Hansa Gal., 1953, 1955, 1958; Noah Goldowsky Gal., N.Y., 1964. Positions: Instr., Painting, Adult Education, Great Neck, N.Y., 1964, 1965; Sch. of Visual Arts, N.Y., 1964, 1965, 1969; Assistant to Hans Hofmann, 1952, 1953. Brooklyn Mus. Art Sch., 1966-1969; Univ. of California, Davis, 1965-1966.

FORSYTH, CONSTANCE—Etcher, Lith., P., E.
 Department of Art, University of Texas; h. 401 W. 42nd St., Austin, Texas 78712
B. Indianapolis, Ind., Aug. 18, 1903. Studied: Butler Univ., B.A.; John Herron A. Sch.; PAFA; Broadmoor A. Acad. Member: NAWA; Texas Pr. M. Awards: prizes, Dallas Pr. Soc., 1945; Indiana Soc. Pr. M., 1953; Texas FA Soc., 1954; NAWA, 1955, 1961. Work: John Herron AI; Ball State T. Col.; DMFA; Texas FA Assn; State of Indiana Coll.; Scottish Rite Cathedral, Indianapolis; DePauw Univ.; Witte Mem. Mus.; Joslyn A. Mus. Exhibited: John Herron AI, PAFA; SFMA; CM; Hoosier Salon; Phila, Pr. Cl.; NAD; Mus. FA of Houston; Dallas Mus. FA; Texas FA Assn.; Kansas City AI; Lib. Cong.; Denver A. Mus.; SAM; NAWA; SAGA; BM; NAWA Exh., Berne, Switzerland; Tokyo, Scotland, England, Japan, India, France; Mexico-Guadalajara, Morelia, Monterrey, etc.; Univ. Utah; Grand Rapids A. Gal. Color illus. for "The Friends," Positions: Instr., John Herron AI, 1931-33; Instr., Western Col., Oxford, Ohio, 1939; Prof. A., Univ. Texas, Austin, Tex., 1940- .

FORSYTH, WILLIAM H.—Museum Associate Curator, W.
 Metropolitan Museum of Art; h. 1105 Park Ave., New York, N.Y. 10028
B. Chicago, Ill., May 21, 1906. Studied: Hotchkiss Sch.; Princeton Univ., B.A., M.F.A.; & with C.R. Morey, A.M. Friend, F. Stohlman. Contributor to: Metropolitan Museum Studies and Journal; Art Bulletin; MMA Bulletin, with articles on mediaeval art. Author: "The Entombment of Christ in French Monumental Sculpture of the 15th and 16th Century," 1970. Positions: Asst., Mediaeval Dept., 1934-36; Asst. Cur., 1936-41; Assoc. Cur., 1941-1960, Cur., 1960- , MMA, New York, N.Y.; Assoc. Cor. Member, Société des Antiquaires de France; Société Archeologique du Limousin; The Century Assn.

FORTESS, KARL EUGENE—Painter, Lith., L.
 96 Bay State Rd., Boston, Mass. 02115; h. Plochman Lane, Woodstock, N.Y. 12498
B. Antwerp, Belgium, Oct. 13, 1907. Studied: AIC; ASL; Woodstock Sch. Painting. Member: Woodstock AA; AEA; SAGA; British Film Inst.; CAA; ASL (Life); AAUP. Awards: prize, Woodstock, N.Y.; Carnegie Inst.; Guggenheim F., 1946; Childe Hassam Fund, 1951. Work: Univ. Arizona; Rochester Mem. Gal.; BM; Montpelier Mus.; Butler Inst. Am. A.; MModA; Newark Mus. A.; Colby Col.; Univ. North Carolina. Munson-Williams-Proctor Inst.; Syracuse Univ.; Henry Gal., Univ. Washington; Roanoke (Va.) FA Center; Smith Col. Mus.; New Britain Mus., Conn.; Cornell Col., Iowa; Brandeis Univ.; Albrecht Gal., St. Joseph, Mo.; De Cordova and Dana Mus., Lincoln, Mass.; NCFA; USIA, and in private colls. Participated in making pictorial record of Alaska for U.S. Dept. Interior. Completed H.E.W. Grant for recording interviews with 80 contemporary artists. Exhibited: PAFA; AIC; CGA; WMAA; MModA; VMFA; Carnegie Inst.; Boston Univ.; Boston A. Festival; Boris Mirski Gal.; NAD; WFNY 1939; GGE, 1939; MMA; Univ. Iowa; Univ. Illinois; Nat. Inst. A. & Lets.; one-man: Bucknell Univ.; Ganso Gal.; Univ. Georgia; Louisiana State Univ.; Assn. Am. A.; Vose Gal., Boston; Boris Mirski Gal. Krasner Gal., N.Y.; Sawkill Gal., Woodstock, N.Y.; Louisiana A. Comm., Baton Rouge. Author of chapter on landscape painting in The Art of the Artist, 1951; "The Comics as Non-Art" in The Funnies: An American Idiom; 1963. Positions: Instr., Am. A. Sch., ASL, Brooklyn Mus. Sch., Louisiana State Univ.; Boston Univ., 1955- . Assoc. Prof., Boston Univ. Sch. of Fine & Applied Arts, at present.

FOSBURGH, JAMES WHITNEY—Painter, E., W., L.
 32 E. 64th St., New York, N.Y. 10021
B. New York, N.Y., Aug. 1, 1910. Studied: Yale Univ., B.A., M.A.; Univ. Rome, Italy. Awards: Hallmark Award, 1960. Exhibited: CGA; PAFA; one-man: Cal. PLH, 1955; Los A. Mus. A., 1955; Durlacher Brothers, 1950-1963. Work: MMA, Toledo Mus. A.; PAFA, and other museums. Contributor to: Art News; Harper's Bazaar; Art in America, 1955-1965. Lectures: Painting and Art History, Frick Collection, National Gallery of Art, Yale University,

Metropolitan Museum of Art, 1950-1960. Author: Catalogue "Winslow Homer in the Adirondacks," Adirondacks Museum, 1959. Positions: Chm., Committee for Paintings for The White House, 1961-63; Member, Landmarks Preservation Commission, New York, N.Y., 1962; Committee for the Preservation of The White House, appointed by Pres. Johnson, 1964; Trustee, Associates in Fine Arts, Yale University (currently); Committee for The Garvin Collection, Yale University (currently).*

FOSSUM, SYD(NEY) (GLENN)—
 Painter, Gr., E., L.
 2700 12th Ave. South, Minneapolis, Minn. 55407
B. Aberdeen, S.D., Nov. 13, 1909. Studied: Northern Normal & Indst. Sch.; Minneapolis Sch. A.; Universidad Michoacana, Mexico. Member: AEA; Minnesota AA (Pres.). Awards: prizes, Minneapolis Inst. A., 1939, 1941, 1947, 1950, 1954; SAM, 1942; Denver A. Mus., 1943, 1947; Nat. Ser. Soc., 1953; Sioux City A. Center, 1954; Walker A. Center, 1947; Kansas City AI, 1957. Work: MModA; Walker A. Center; Minneapolis Inst. A.; Newark Mus. A.; Univ. Minnesota; SAM; Univ. Montana; Wichita AA; Montgomery A. Mus.; San F. A. Comm.; Des Moines A. Center; Joslyn A. Mus.; Albright A. Gal.; New Britain A. Mus.; N.Y. Pub. Lib.; Springfield A. Mus.; Univ. Wisconsin; Univ. Michoacana; Sioux City A. Center. Exhibited: nationally. Positions: Instr., Minneapolis Sch. A., 1945-50; Univ. Colorado; Washington Univ., St. Louis, 1950-51; Des Moines Art Center, Des Moines, Iowa, 1953-1957; Univ. Nevada, Summers, 1957, 1958. Dir., Duluth A. Center, 1960-1962; Instr., Minnetonka A. Center; Art Instruction Schools, Minneapolis, Minn. at present.

FOSTER, HAL—Cartoonist, P.
 c/o King Features Syndicate, 235 E. 45th St., New York, N.Y. 10017
B. Halifax, Nova Scotia, Aug. 16, 1892. Awards: Banshees' "Silver Lady" and Nat. Soc. Cartoonists "Reuben." Elected to the Royal Society of Arts, London, England, 1965. Positions: Creator, artist, of "Prince Valiant," outstanding strip from which a motion picture has been made and seven books published.

FOSTER, JAMES W., JR.—Museum Director
 Honolulu Academy of Arts, 900 S. Beretania St. 96814; h. 69 Niuhi St., Honolulu, Hawaii 96821
B. Baltimore, Md., Jan. 4, 1920. Studied: Corcoran Sch. A.; Johns Hopkins Univ.; George Washington Univ.; American Univ., Wash., D.C., B.A., and with William H. Calfee. Member: AAMus.; Assn. A. Mus. Dirs.; Western AAMus. Positions: Asst. Dir., Baltimore Mus. A., 1947-57; Dir., Santa Barbara Mus. A., Santa Barbara, Cal., 1957-1963; Dir., Honolulu Academy of Arts, 1963- .

FOULKES, LLYN—Painter, E.
 7045 N. Figueroa St.; h. 6010 Eucalyptus Lane, Los Angeles, Cal. 90042
B. Yakima, Wash., Nov. 17, 1934. Studied: Central Washington Col.; Univ. Washington; Chouinard A. Inst., Los Angeles. Member: Hon. member, Pasadena A. Mus. Awards: prizes, Chouinard A. Inst., 1959; SFMA, 1963; Pacific A., Los Angeles, 1964; Mus. Mod. A., Paris, France, 1966; Los Angeles County Mus. Grant, 1964. Work: Los Angeles County Mus.; Pasadena A. Mus.; Oakland Mus.; Stanford Univ.; Univ. California; Vienna, Austria; Mus. Mod. A., Paris; La Jolla Mus. A. Exhibited: Sao Paulo Bienal, 1963, 1967; Paris, 1967; WMAA, 1967; MModA, 1966; Guggenheim Mus., 1966; SFMA, 1963, 1968; Los Angeles County Mus., 1960, 1964, 1966, 1969; Portland (Ore.) Mus. A., 1968; SAM, 1968; Univ. California at Los Angeles, 1966-1968; Univ. Illinois, 1964; Univ. Nevada, 1969; Fnd. Maeght, Paris, 1968; Art Council, London, 1969; one-man: Pasadena A. Mus., 1961; Oakland Mus., 1964; Rolf Nelson Gal., Los Angeles, 1963, 1964, 1966 and 4-man, 1967; other 4-man: Robert Frazier Gal., London, 1965; Frumkin Gal., Chicago, 1964. Positions: Prof., Grad. Painting and Drawing, Univ. California at Los Angeles, 1965- .

FOUSHEE, OLA MAIE (Mrs. John M., Sr.)
 Forty Oaks Farm, Box 866, Chapel Hill, N.C. 27514
B. Avalon, N.C., May 8, 1905. Studied: Univ. North Carolina, Greensboro and Chapel Hill; special study with Gregory D. Ivy, Earl Mueller, John Opper, Francis Speight, Eliot O'Hara, and others. Member: North Carolina State A. Soc.; Assoc. A., North Carolina; Durham A. Gld., and Allied A., Durham (Charter Member); AFA; MModA. Exhibited in group and one-man shows, North Carolina, South Carolina and Virginia. Awards: Several including Butler Inst. Am. A. Lectures on art education to various organizations. Organized a "Mile of Art," filmed by TV, Greensboro, 1962; Citation from State A. Soc., 1962. Columnist and feature writer; contributor to "Town and Gown," published annually by Chapel Hill Weekly.

FOWLER, MARY BLACKFORD (Mrs. Harold N.)—Sculptor, P., W.
 613 S. Main St., Findlay, Ohio 45840
B. Findlay, Ohio, Feb. 20, 1892. Studied: Oberlin College, A.B.;

Columbia Univ.; Corcoran Sch. A.; Famous Artists Sch., and with George Demetrios and Hans Hofmann. Member: Findlay A. Lg. Awards: prize, Findlay A. Lg., 1961. Work: Portrait bas-reliefs, Western Reserve Univ.; Springfield (Mass.) Pub. Lib.; Am. School Classical Studies, Athens, Greece; 5 murals, Fed. Bldg., Newport News, Va. Author: (with Harold N. Fowler) "The Picture Book of Sculpture."

FOX, MILTON S.—Painter, Lith., T., W., L.
 160 Riverside Drive, New York, N.Y. 10024
B. New York, N.Y., Mar. 29, 1904. Studied: Cleveland Sch. A.; Julian Acad., Ecole des Beaux-Arts, Paris; Western Reserve Univ., M.A. Member: CAA; Renaissance Soc; Writers Gld. of America; American Society for Aesthetics. Awards: prizes, CMA, 1927, 1928, 1933. Work: CMA; murals, Cleveland Pub. Auditorium. Exhibited: CMA, annually, 1927-1935. Contributor to: Art Magazines & educational publications; Art Appreciation. Vice President and Editor-in-Chief, Abrams Art Books, Publ. by Harry N. Abrams, New York, Amsterdam, and Tokyo.

FOX, ROY C.—Etcher, Eng., P.
 P.O. Box 356, Arnot Art Gallery, Elmira, N.Y. 14901
B. Oneonta, N.Y., April 14, 1908. Studied: with Ernfred Andersen, Arthur Abrams, James Swann, and others. Member: Elmira A. Cl.; Print Council of Am.; Print Cl., Rochester; Cooperstown AA. Work: Elmira Col.; Arnot A. Gal.; Fla. Southern Col. Exhibited: Audubon A., 1942-1944; Saranac Lake A. Lg., 1943, 1944; Northwest Pr.M., 1944-1946, 1947, 1948; Wawasee A. Gal., 1944, 1945; Laguna Beach AA, 1944, 1945; Oakland A. Gal., 1944, 1945; SAGA, 1944, 1946; Phila. Pr. Cl., 1956; Arnot A. Gal., 1936-1955, 1962, 1964, 1966-1968; Phila. Etchers, 1962; Finger Lakes Exh., Rochester, N.Y., 1938-1949; Elmira Col., 1943, 1957 (one-man); Albany Pr. Cl., 1947; Grand Central Gal., 1946; Cal. Soc. Et.; Cooperstown AA, 1957, 1958, 1966-1968; Soc. Min. P., S. & Gravers, 1956-1958; Horseheads, N.Y., 1958 (one-man); Burr Gal., N.Y., 1958; Min. Ptrs., S., & Gravers, Wash., D.C., 1962, 1963; Corning Glass Center, 1965; Delhi (N.Y.) Tech., 1962 (one-man); Print Cl., Rochester, N.Y.

FRACASSINI, SILVIO CARL—Painter, E., C.
 State University of Iowa, 911 Iowa Ave., Iowa City, Iowa 52240
B. Louisville, Colo., Nov. 4, 1907. Studied: Univ. Denver, B.F.A.; AIC; Santa Fe Sch. A.; Univ. Iowa, M.F.A.; Scripps Col., and with Walt Kuhn, John Edward Thompson, Cyril Kay-Scott. Member: CAA; Kappa Pi; N.A.E.A.; Midwest A. Conf.; Am. Craftsmen's Council. Awards: prizes, Univ. Denver, 1931; Denver A. Mus., 1931, 1943; Chappell Sch. A., 1931; Sioux City, Iowa, 1948; Iowa A. Show; Des Moines A. Center, 1955, 1958, 1960. Work: Denver A. Mus.; Sioux City A. Center; mural, Southern Hotel, Durango, Colo. Exhibited: Denver A. Mus., 1931-1934, 1936, 1937, 1939, 1940, 1941, 1943; Univ. Kansas; Joslyn Mus. A., 1940, 1949, 1950, 1957; Denver A. Gld., 1931, 1932, 1934, 1935, 1937-1947; AWS, 1949; William Rockhill Nelson Gal., 1950; Des Moines A. Center, 1952, 1961; Am. Color Pr. Soc., 1952; Colo. Springs FA Center; Springfield A. Lg., 1954; Alabama WC Soc., 1954; State Univ. Iowa, 1960, 1961; Sioux Falls, S.D., 1960; Nat. Dec. A. Ceramics, Wichita, 1960 and others; one-man: Denver A. Mus., 1941; Univ. Denver, 1942; Sioux City, 1949; Des Moines A. Center, 1955; Iowa Wesleyan Col., 1961; Dubuque A. Center, 1962; Coe Col., Cedar Rapids, 1965; Lubetkin Gal., Des Moines, 1964; Black Forest A. Gal., Colorado Springs, Colo., 1966; Elder Gal., Lincoln, Neb., 1967; Octagon Gal., Ames, Iowa, 1966. Positions: Assoc. Prof. A., State University of Iowa, Iowa City, Ia., at present.

FRAME, ROBERT (AARON)—Painter, T.
 112 W. Ortega St., Santa Barbara, Cal.; h. 629 State St., Santa Barbara, Cal. 93101
B. San Fernando, Cal., July 31, 1924. Studied: Pomona Col., B.A.; Claremont Col., M.F.A., and with McFee, Sheets, Lopez, Serisawa. Member: Los A. AA. Awards: Guggenheim Fellowship, 1957-1958; prizes, Arizona State Fair, 1948, 1949; Nat. Orange Show, 1949, 1950; Pasadena A. Mus., 1955, purchase, 1952; Cal. State Fair, 1955, 1958; Nat. Orange Show, 1959, 1962; James Phelan Awards, 1959; Cal. Invitational, Laguna Beach, 1961; purchase prizes, Sierra Madre, 1955; Mira Costa Invitational, 1956; Palos Verde Invitational, 1957; Municipal Exh., Los A. Mus. A., 1957, 1962, 1963 (prizes); Redondo Beach, 1965; Saint Albans-Home Savings & Loan prize (Los Angeles), 1968. Work: Lytton Savings Corp.; Home Savings & Loan Assn.; Pasadena A. Mus.; NAD; State California; Downey A. Mus. (Cal.), and in private colls. Exhibited: Butler Inst. Am. A.; SFMA; deYoung Mem. Mus., San F.; Univ. Illinois, 1957, 1963, 1965; Los A. Mus. A.; Carnegie Inst.; Pomona Col.; Otis AI, Los Angeles; Laguna A. Festival; Pasadena A. Mus.; Terry AI, Miami; Long Beach Mus. A.; Municipal Gals., Los Angeles; Santa Barbara Mus. A.; VMFA, 1966; Ankrum Gal., Los Angeles, 1965; Heritage Gal., Los Angeles, 1967; Austin Gal., Montecito, Cal., 1967; Desert Mus., Palm Springs, Cal., 1967; Bednarz Gal., Los Angeles, 1968, and many others; one-

man: Lang Gals., Scripps Col., 1951; Pasadena A. Mus., 1952; Dalzell Hatfield Gal., Los Angeles, 1954-1957; San Diego State Col., 1954; Ruthermore Gal., San F., 1955; Palos Verdes A. Assoc., 1958; Esther Robles Gal., Los Angeles, 1960; Rosequist Gal., Tucson; Laguna Beach, 1962; Ankrum Gal., Los Angeles, 1962, 1964; Phoenix A. Mus., 1964, and others. Positions: Instr., Westridge Sch., Pasadena, 1952-1962; Pasadena City Col. Adult Classes, 1953-1962; San Diego State Col., 1954; Otis AI, 1958-1965; Univ. Southern California, 1962-1963; Santa Barbara City Col., 1966- ; Laguna Beach Sch. of A. and Des., Summer sessions, 1966-1968.

FRANCIS, MURIEL B.—Collector
116 East 65th St., New York, N.Y. 10021*

FRANCIS, SAM—Painter
345 W. Channel Drive, Santa Monica Canyon, Los Angeles, Cal.
B. San Mateo, Cal., 1923. Studied: Univ. California, B.A., M.A. Awards: prize, Int. Exh., Tokyo, Japan, 1956; Hon. Doctorate, Univ. California, Berkeley, 1969; Tamarind Fellowship, 1963. Work: Guggenheim Mus., N.Y.; MModA; Albright A. Gal.; Kunsthalle, Berne, Switzerland; Sofu School of Flowers, Tokyo; Tate Gal., London; Kunsthaus, Zurich; Dayton AI. Exhibited: AIC, 1954; Carnegie Inst., 1955; MModA, 1956; Inst. Contemp. A., Houston, 1956; Albright A. Gal., 1957; Brussels World's Fair, 1958; Biennale, Sao Paulo, 1959; Nat. Mus. A. Tokyo, 1966; A. All of the Pasadena Mus. A., 1966, and in Paris, Rome, London, Stockholm, Berne and other European cities. One-man: Galerie Dausset, Paris, 1952; Galerie Rive-Droite, Paris, 1954; Martha Jackson Gal., N.Y., 1956, 1957, 1958, 1968; Gimpel Fils, London, 1957; Dusanne Gal., Seattle, 1957; Phillips Gal., Wash., D.C., 1958; SFMA, 1959, 1967; SAM, 1959; Dayton AI, 1959; Pasadena Mus. A., 1959 and in Berne, Switzerland; Tokyo, 1968, and Osaka, Japan; Dusseldorf, Germany; Kornfeld & Klipstein, Berne, Switzerland, 1966, 1968; Galerie Engelberts, Geneva, 1966; Dom Galerie, Cologne, Germany, 1967; Pierre Matisse, Gal., N.Y., 1967; Mus. FA of Houston, 1967; Univ. A. Mus., Univ. California, Berkeley, 1967; UCLA, 1967; Prague, 1967; Kunsthalle, Basel, 1968; Karlsruhe, 1968; Stedelijk Mus., Amsterdam, 1968; Ministry of Cultural Affairs, Paris, 1969.

FRANCK, FREDERICK S. (DR.)—Painter, I., Gr., W.
33 East 65th St., New York, N.Y. 10021
B. Maastricht, Holland, Apr. 12, 1909. Studied: Belgium, England, U.S. Member: AEA; Assoc. A. Pittsburgh; Fellow, Soc. for Art, Religion and Culture; PEN Cl. Awards: Prizes, Carnegie Inst., 1946, 1948, 1950; purchase, Am. Acad. A. & Lets., 1955; purchase, Univ. Illinois, 1950; Maastricht Mus., Holland; Living Arts Fnd., purchase, 1958; Hon. D.F.A., Univ. Pittsburgh, 1963; "Medal of the Pontificate," from Pope John, 1963. Work: Univ. Pittsburgh; Latrobe A. Fund; Hundred Friends of Art Coll.; Shell Oil Co.; Musée Nationaux de France; Univ. Illinois; Stedelijk Mus., Holland; Eindhoven Mus., Holland; Santa Barbara Mus. A.; WMAA; FAM; Saginaw Mus. A.; Carnegie Inst.; Georgia Mus. A.; SFMA; MModA; Carpenter A. Gal., Dartmouth Col.; N.Y. Pub. Lib.; Seattle Pub. Lib.; Honolulu Acad. A.; Cornell Univ. WAC; Achenbach Fnd.; Texas Wesleyan Col.; Int. Graphic 9. Soc.; Singer Mem. Mus., Holland; Utrecht Central Mus.; murals, Temple Beth-El, Elizabeth, N.J.; Albert Schweitzer Pub. Sch., Levittown, N.J.; Nat. Mus. Tokyo, Japan; stage des. for off-Broadway shows; drawings, The New Yorker, 1968; articles in Nat. Catholic Reporter; Commonweal. Exhibited: Carnegie Inst., 1942-1946; PAFA, 1944; Butler Inst. Am. A., 1944; Cal. PLH, 1946; Univ. Illinois, 1950-1952; CGA, 1951; Univ. Minnesota, 1952; Buffalo, N.Y., 1952; WMAA, 1950, 1951, 1958, 1968; MMA, 1950; John Herron AI, 1957; BMA, 1959; Wadsworth Atheneum, Hartford, 1959; Am. Acad. A. & Lets., 1959; Art:USA, 1959; AFA traveling exh., 1959, and others. One-man: Van Dieman-Lilienfeld Gal., 1949, 1952; Drouant-David, Paris, 1951; Benador, Geneva, Switzerland, 1951; Van Leir Gal., Amsterdam, 1951; Contemp. A. Gal., 1942; Passedoit Gal., 1954, 1958; Mus. FA of Houston, 1953; Santa Barbara Mus. A., 1953; SFMA, 1953; exh. drawings done at Albert Schweitzer Hospital, Lambarene, Fr. Africa (1958), Assoc. Am. A. Gal., N.Y., 1958; Landry Gal., N.Y., 1959, 1960; Saginaw Mus. A., 1960; Doll & Richards, Boston, 1961; deYoung Mus., San F., 1961; Centre Culturel, St. Severin, Paris, 1967; Waddell Gal., N.Y., 1967; FAR Gal., N.Y., 1968, and many exhs. in Holland, Belgium, France and England including Palazzo Doria, Rome, 1964; Singer Mem. Mus., Holland, 1964; Utrecht Central Mus., 1965; Haarlem Mus., 1965; Univ. Maine, 1965. Built a chapel, in Warwick, N.Y. with own sculpture, stained glass and mosaics, 1965-1968. Author: "Modern Dutch Art," 1943; "Au Pays du Soleil," 1958; "Days with Albert Schweitzer," 1959; "The Lambarene Landscape," 1959; "My Friend in Africa" (juvenile), 1960; "African Sketchbook," 1961; "My Eye is in Love," 1963 (Art in America "Special Book Citation"); "Au Fil de l'Eau," 1965; "Outsider in the Vatican," 1965; "I Love Life," (juvenile), 1967; "Exploding Church," 1968 (translations: England, Holland and Germany); "Croquis Parisiens," 1969; "Le Paris de Simenon," 1969. Contributor to Art in America, Fortune, Atlantic Monthly, Harpers.

FRANK, DAVID—Craftsman, P., T.
Mississippi State College for Women, Columbus, Miss. 39701; h. Box 243, Rte. #1, Steens, Miss. 39766
B. St. Paul, Minn., Sept. 13, 1940. Studied: Westmar Col., Iowa; Univ. Minnesota, Duluth, B.S. in A. Edu.; Tulane Univ., New Orleans, La., M.F.A. Member: Am. Craftsmen's Council; Nat. Council for Edu. in the Ceramic Arts. Work: Tweed Gal., Univ. Minnesota. Exhibited: Springfield (Mo.) Craftsmen's Exh., 1963; Miami Ceramic Nat., 1966; 3-man, Tweed Gal., 1963; Louisiana State Crafts, 1963, 1964; 2-man, Louisiana Ceramics, 1965; Craftsman, 1966, Piedmont Crafts, 1967, 1968; mid-South Crafts, 1969; 3-man, Mississippi State Col. for Women, 1965; Mississippi Craftsmen, 1968. Positions: Instr., Ceramics, Newcombe A. Sch.; Ceramics and Design, Mississippi State Col. for Women, Columbus, Miss., at present.

FRANK, HELEN—Painter, Des., I.
241 Lexington Ave., New York, N.Y. 10016
B. Berkeley, Cal. Studied: Cal. Col. A. & Crafts; ASL, and with Glenn Wessels, Hamilton A. Wolf, Joseph Paget-Fredericks, Sheldon Cheney. Awards: scholarships, Cal. Col. A. & Crafts; ASL. Member: Int. Platform Assn. Work: Crocker A. Gal., Sacramento, Cal.; Templeton Crocker Coll., and in private coll. New York, Cal., Texas and abroad. Several paintings reproduced in Christian Art, July, 1965; painting reproduced in Counsel of the Presbyterian Church, 1968. Costume-wardrobe, TV, 1968-1969. Exhibited: East-West Gal., 1932; Second Progressive Show, 1934; Gump's Gal., 1937 (all in San F.); SFMA, 1937, 1939, 1942; Oakland A. Gal., 1938, 1940, 1942; Newport AA, 1944; AIC, 1944; Los A. Mus. A., 1945; New-Age Gal., 1950, 1951; Fla. Southern Col., 1952; Milwaukee AI, 1954; de-Young Mem. Mus., San Francisco, 1957; one-man: Neighborhood Playhouse, San F., 1935; Crocker A. Gal., 1942; Pinacotheca, N.Y., 1943; Santa Barbara Mus. A., 1947; SFMA, 1947; Vancouver (B.C.) A. Gal., 1947; Curacao Mus., N.W.I., 1949; Parson's Gal., London, England 1954; Chase Gal., N.Y., 1958; Washington County Mus., Hagerstown, Md., 1961; St. Lawrence University, Canton, N.Y., 1963; Spencer Mem. Gallery, Brooklyn, N.Y., 1964; Int. Platform Assn., Washington, D.C., 1967; Christian Art (Chicago) exh., in Cincinnati, Ohio, 1969. Des., costumes for modern dance. I., series of text books, 1947-49; music books for children, 1944-45; "Mozart," 1946; Illus. for Sat. Review of Literature, New York Times, Harpers.

FRANK, MARY—Sculptor
203 W. 86th St., New York, N.Y. 10024
B. London, England, 1933. Awards: Ingram Merril Fnd. Grant, 1961; Longview Fnd. Grant, 1962-1964; Nat. Council on the Arts, 1968. Work: AIC; Kalamazoo Inst. A.; MModA; Southern Illinois Univ.; Massachusetts; WMA; Yale Univ. A. Gal. Exhibited: one-man: Poindexter Gal., N.Y., 1958; Stephen Radich Gal., N.Y., 1961, 1963, 1966; Boris Mirski Gal., Boston, 1965, 1967; Zabriskie Gal., N.Y., 1968, 1970; Donald Morris Gal., Detroit, 1968; Richard Gray Gal., Chicago, 1969.

FRANKEL, CHARLES—Sculptor
1956 S. Coast Highway, Laguna Beach, Cal. 92651*

FRANKEL, DEXTRA—Sculptor, C., Gr.
1956 South Coast Highway, Laguna Beach, Cal. 92651
B. Los Angeles, Cal., Nov. 28, 1924. Studied: Long Beach State. Member: Cal. Soc. Pr.M.: Am Color Pr. Soc.; Am. Craftsmen Council. Awards: Crocker A. Gal., Sacramento, Cal., 1959, 1961; Cal. State Fair, 1959-1961, 1961(purchase); St. Paul A. Center, St. Paul, Minn., 1962(purchase); La Jolla A. Mus., Cal., 1959(purchase); Am. Color Pr. Soc., 1961(purchase); Phila. Free Lib., 1961(purchase); Cal. Craftsmen, Oakland A. Mus., 1963. Work: Phila. Free Lib.; La Jolla A. Mus., Cal.; St. Paul A. Center, Minn.; Cal. State Fair; Pacific View Mem. Park, Corona Del Mar, Cal.; Los A. Athletic Cl.; Kennecott Copper Co., Salt Lake City, Utah; and in private collections. Organized, designed and directed exhs. for Cal. State Col. at Fullerton A. Gal.; Recorded Images/Dimensional Media 1967; Intersection of Line, 1967; Frazer/Lipofsky/Richardson, 1968; Transparency/Reflection, 1968, and others. Exhibited: San Diego Mus. FA, Cal.; Los A. AA; Wichita A. Mus., Kans.; Long Beach State Col., Cal.; Oakland A. Mus., Cal.; Newport AA, R.I.; Los A. County Mus. A., 1959, 1962, 1966; Pasadena A. Mus., Cal., 1959, 1961, 1962, 1965, 1968; La Jolla A. Mus., Cal., 1962(one-man); Long Beach Mus., Cal., 1962-1964(traveling); CAM, 1962; Ringling Mus. A., Sarasota, Fla., 1961; Butler Inst. Am. A., 1962; CAL.PLH, 1962; Denver A. Mus., 1962; SAM, 1962; SFMA, 1962; Scripps Col., Claremont, Cal., 1962; Everson Mus., Syracuse, N.Y., 1962-1964(traveling); Rochester Mem. A. Gal., N.Y., 1962; St. Paul A. Center, Minn., 1962; Pavilion Gal., Balboa, Cal., 1964; Tucson A. Center, Ariz., 1964, 1966; Crocker Gal., Sacramento, Cal., 1965; AFA, 1965-1967 (traveling); Mus. West, San Francisco, 1965, 1966-1968(traveling); Mus. Contemp. Crafts. N.Y., 1966, 1968; San Diego State Col., Cal., 1966; Cal. State Col. at Fullerton, 1964(one-man), 1968; Los A. State Col., 1969. Positions: Asst. Prof. A., Cal. State Col. at Fullerton, Cal., 1964- ; Dir., A. Gal., Cal. State Col. at Fullerton, Cal., 1967- .

FRANKENSTEIN, ALFRED VICTOR—Critic, W., L., T.
c/o San Francisco Chronicle, Fifth & Mission Sts., San Francisco, Cal.
B. Chicago, Ill., Oct. 5, 1906. Studied: Univ. Chicago, Ph.B. Member: Newspaper Gld.; CAA; Am. Studies Assn. Awards: Guggenheim F., 1947. Author: "After the Hunt," 1953, new ed. 1969; "Angels Over the Altar," 1961. Contributor to Art in America; Art Bulletin; N.Y. Times; Herald Tribune and other magazines and newspapers, with critical reviews. Lectures on Music and Art. Organized William Sidney Mount centennial exh., 1968-1969, and "The Reality of Appearance" (American still life exh.), 1970. Author: "The World of John Singleton Copley," in Time-Life series of artist biographies, 1970. Positions: Music and Art Cr., San Francisco Chronicle. 1934-1965, Art Critic only, 1965- ; Lecturer, American Art, Univ. California, 1950- . L., American Art, Mills Col., Oakland, Cal., 1955- . Instr., American Art, Salzburg Seminar in American Studies, 1962, 1964; conducted a course in American Art, Free University of Berlin 1964; Adjunct Prof., American Art, New York University, 1969.

FRANKENTHALER, HELEN (MOTHERWELL)—Painter
173 East 83rd St.; h. 173 East 94th St., New York, N.Y. 11212
B. New York, N.Y., Dec. 12, 1928. Studied: Bennington Col., B.A. Work: paintings in the colls. of MModA; WMAA; BM; Albright A. Gal.; Carnegie Inst.; BMA; Univ. Cal., Berkeley; CAM; Detroit Inst. A.; Honolulu Acad. A.; Milwaukee A. Inst.; Nat. Gal., Victoria and Melbourne, Australia; Univ. Nebraska; N.Y. Univ.; Newark Mus.; Smithsonian Inst.; Ulster Mus., Belfast; Wadsworth Athenum, Hartford; Washington Gal. Mod. A.; Yale Univ. Gal. A.; SFMA; Victoria & Albert Mus., London; AIC; Tokyo, Japan; CMA; Everson Mus. A., Syracuse, N.Y.; Bennington Col., and others, tapestries, Temple of Aaron, St. Paul, Minn. Awards: prize, Paris Int. Biennale, 1959. Fellow, Calhoun Col. Yale Univ., Temple Gold Medal, PAFA, 1968. Exhibited: Carnegie Inst., 1955, 1958, 1961, 1964; WMAA, 1955, 1957, 1958, 1961, 1963, 1967; Univ. Illinois, 1959; Minneapolis Inst. A., 1957; DMFA, 1958; AFA traveling exh., 1957, 1964; MModA. traveling exh., 1957 (Japan); Documenta, MModA, 1958; WAC, 1960; "54/64 Painting and Sculpture of a Decade," Tate Gal., London, 1964; Los A. Mus. A., 1964; PAFA, 1963, 1968; Washington Gal. Mod.A., 1963, 1966, 1967; Inst. Contemp. A., Boston, 1965, 1967-1968; Detroit Inst. A., 1965, 1967; Brandeis Univ., Rose A. Mus. traveling, 1964; SFMA, 1963, 1968 (2); AIC, 1961, 1963; CGA, 1967; NCFA, 1966; Art in Embassies, MModA traveling, 1966-1967; Washington Univ., St. Louis, 1969; Univ. Notre Dame, 1969; Univ. Oklahoma, Norman, 1968; Oklahoma A. Center, 1968; Philbrook A. Center, Tulsa, 1968; Guggenheim Mus., 1961; Columbus Gal. FA, 1960; Univ. Michigan, 1965; Norfolk Mus. A. & Sciences, 1966; Museum voor Stad en Lande, Groningen, The Netherlands, 1966; Venice Bienale, 1966; Expo '67; CM, 1968; Univ. Cal., San Diego, 1968; and many others. One-man: Emmerich Gal., N.Y., 1961-1965, 1966, 1968; Jewish Mus., 1959; Everitt Ellin Gal., Los A., 1961; Neufville Galerie, Paris, 1961; Kasmin Gal., London, England, 1964; Retrospective, WMAA, Feb. 20-Apr. 6, 1969; and then traveling under auspices of Int. Council of The Mus. Mod. A. to Whitechapel Gal., London and on the Continent.

FRANKLIN, ERNEST WASHINGTON, JR. (DR.)—Collector
1324 Scott Ave. 28204; h. 1141 Linganore Pl., Charlotte, N.C. 28203
B. Apex, N.C., Apr. 13, 1905. Studied: University of North Carolina, B.S.; Univ. Pennsylvania, M.D. Collection: Contemporary Art. Positions: Official of numerous medical societies.*

FRANKLIN, GILBERT A.—Sculptor, E., L.
c/o Kanegis Gallery, 123 Newbury St., Boston, Mass. 02116; h. 52 Angell St., Providence, R.I. 02906
B. Birmingham, England, June 6, 1919. Studied: Rhode Island Sch. Des.; National Museo, Mexico City; American Acad. in Rome, Italy. Member: Alumni Assn. of Am. Acad. in Rome; Providence A. Cl. Awards: Prix de Rome, American Academy in Rome; prize, Boston A. Festival. Work: BMFA; R.I. Mus. A.; Mus. of Miami Univ., Oxford, Ohio; Lincoln Monument, Providence, R.I.; Fountain, Providence, as well as numerous portrait commissions. Exhibited: PAFA, 1952, 1954, 1956; WMAA, 1950; View, 1960; Boston A. Festival, 1956, 1957, 1959; Selections: Inst. Contemp. A., Boston, 1959. Positions: Prof. Sculpture, Rhode Island School of Design; Visiting Lecturer, Yale and Harvard Universities, and Rinehart Sch. of Sculpture, Baltimore; Chm., Fulbright Selection Comm., for Sculpture, 1958, 1959, 1960; Sculptor-in-Residence, American Academy in Rome, 1965.*

FRANSIOLI, THOMAS (ADRIAN)—Painter, Gr.
Cornwall Hollow, Falls Village, Conn. 06031
B. Seattle, Wash., Sept. 15, 1906. Studied: Univ. Pennsylvania, B. Arch.; ASL. Awards: prizes, Boston A. Festival, 1952; Hon. Citizen of State of Maine, 1954. Work: BMFA; Currier Gal. A., Manchester, N.H.; WMAA; Farnsworth Mus. A., Rockland, Me.; SAM; Nelson Gal. A., Kansas City; DMFA; murals, Aetna Life Bldg., Hartford, Conn.; Princeton Club, N.Y.; Brevoort East Hotel, N.Y., 1966. Exhibited:

WMAA, 1948-1952, 1958; Carnegie Inst., 1949, 1952; MMA, 1950; Boston A. Festival, 1948, 1949; Sharon, Conn., 1960; one-man: Margaret Brown Gal., Boston; Kennedy & Co., N.Y.; Milch Gal., N.Y., 1961; Eleanor Rigelhaupt Gal., Boston, 1968-1969. Retrospectives: Farnsworth Mus., 1954; Cal. PLH, 1954; SAM, 1954.

FRASCONI, ANTONIO—Painter, Gr., Des., T., I.
26 Dock Rd., South Norwalk, Conn. 06854
B. Montevideo, Uruguay, Apr. 28, 1919. Studied: Circulo de Bellas Artes, Montevideo; ASL. Awards: scholarship, ASL; New School for Social Research; Guggenheim F., 1952-54; grant, Nat. Inst. A. & Let., 1954; film using more than 100 woodcuts & painting, "The Neighboring Shore," won Grand Prix, Venice Int. Film Festival, 1960; Le Prix du President de la Region de la Moravie, 2nd Biennale d'Art, Brno, Czechoslovakia, 1966; Gran Premio, Exposicion de la Habana, Cuba, 1968; First Prize, Salon Nacional de Bellas Artes, Montevideo, Uruguay, 1967. Member: ANA. Work: MMA; MModA; BM; N.Y. Pub. Lib.; PMA; FMA; R.I. Mus. A.; Munson-Williams-Proctor Inst.; Santa Barbara Mus. A.; San Diego Soc. FA; Princeton Univ.; Honolulu Acad. A.; Univ. Michigan; LC; CAM; BMA; Detroit Inst. A.; Wadsworth Atheneum; AIC; Museo Municipal, Montevideo; A. Council of Great Britain. Exhibited: 37 one-man shows in U.S., Mexico City and Montevideo; traveling exh. in U.S.A., circulated by Smithsonian Inst.; 34th Biennale, Venice, Italy, 1968. Retrospectives: Baltimore Mus. A., 1963; BM, 1964. Contributor: Fortune, Scientific American, Redbook, etc. Author, I., "12 Fables of Aesop," 1954; "See and Say," 1955; "Frasconi Woodcuts," 1958; "The House that Jack Built," 1958; "The Face of Edgar A. Poe," 1959; "A Whitman Portrait," 1960; "The Snow and the Sun," 1961; "A Sunday in Monterey," 1964; "See Again, Say Again," 1964; "Bestiary," 1965; "A Vision of Thoreau," 1965; "Overhead the Sun," 1969. Positions: A.-in-Res., Univ. Hawaii, Honolulu, Mar.-Apr. 1964.

FRASER, DOUGLAS (FERRAR)—Scholar
Columbia University; h. 445 Riverside Dr., New York, N.Y. 10027
B. Hornell, N.Y., Sept. 3, 1929. Studied: Columbia College, A.B.; Columbia University, A.M., Ph.D. Field of Research: Primitive and Pre-Columbian Art.

FRATER, HAL—Painter
215 Park Row, New York, N.Y. 10038
B. New York, N.Y., Mar. 3, 1909. Member: P. & S. Soc. of New Jersey; All. A. Am.; SI; AEA. Exhibited: NAD; Chrysler Mus., Provincetown, Mass.; BM; Seton Hall Univ.; All. A. Am.; Audubon A.; Gal. of Mod. A., N.Y., 1969; Grippi Gal., N.Y.; Harbor Gal., Long Island, N.Y., 1966, 1969 and others.

FRAUWIRTH, SIDNEY—Collector
82 Reed St., New Bedford, Mass. 02740
B. Poland, Nov. 2, 1908. Collection: American paintings, drawings, and sculpture.

FRAZER, JOHN THATCHER—Painter, E., Film-maker
Davison Art Center, Wesleyan University, Middletown, Conn. 06457
B. Akron, Ohio, Apr. 2, 1932. Studied: Univ. of Texas, B.F.A.; AIC; Yale Univ., M.F.A. (with Josef Albers). Member: CAA; AAUP. Awards: Fulbright Grant, to Paris, France, 1958-1959, and to Taiwan, 1963 (summer). Exhibited: Boston A. Festival, 1962; New Haven A. Festival, 1962. Positions: Assoc. Prof., Film History and Production, Drawing, Asian Art History, Davison A. Center, Middletown, Conn.

FRAZIER, CHARLES—Sculptor
c/o Dwan Gallery, 10846 Lindbrook Dr., Los Angeles, Cal. 90024
B. Morris, Okla., 1930. Studied: Chouinard AI, Los Angeles. Awards: prizes, A. Center of La Jolla, 1962; Long Beach Mus. A., 1963. Work: A. Center, La Jolla; Los A. Mus. A. Exhibited: Comara Gal., Los A., 1959; Los A. Mus. A., 1954, 1957, 1961; Cal. PLH, 1957, 1959, 1960; PAFA, 1960; Pasadena Mus. A., 1960-1962; FA Gal. of San Diego, 1961; A. Center of La Jolla, 1960; Dwan Gal., 1962; Long Beach Mus. A., 1963; AIC, 1964; one-man: A. Center of La Jolla, 1961; Everett Ellin Gal., Los A., 1962; Kornblee Gal., N.Y., 1963.*

FRAZIER, PAUL D.—Sculptor, T.
Knapp Rd., Hopewell Junction, N.Y. 12533
B. Paickaway County, Ohio, May 6, 1922. Studied: Ohio State Univ., B.F.A.; Cranbrook Acad. A., M.F.A. with William McVey; Skowhegan Sch. Painting & Sculpture with Jose de Creeft; Colarossi Academie, Paris, France. Awards: prizes, Ohio State Fair, 1947 (6); Ralph H. Beaton Mem. Prize, Columbus Gal. FA, 1949; Cranbrook Acad. A. medal for sculpture, 1949, purchase, 1952; Munson-Williams-Proctor purchase award, 1955, 1957, 1961; Cooperstown AA, 1958. Member: S. Gld. Work: Skowhegan Sch. Painting & Sculpture;

Cranbrook Acad. A.; Munson-Williams-Proctor Inst., Utica; Colgate Univ. Exhibited: Ohio State Fair, 1947; Columbus Gal. FA, 1947; Fairmount Park, Philadelphia, 1948; Cranbrook Acad. A., 1952; Munson-Williams-Proctor Inst., 1953; WMAA, 1954, 1956, 1957 1962, 1964, 1966; PAFA, 1954; Utica and Rochester, N.Y., 1956; Delgado Mus. A., New Orleans, 1956; Colgate Univ., 1957; Skowhegan Sch. Painting & Sculpture, 1957; Cooperstown AA, 1958; Riverside Mus. A., N.Y., 1963; Jewish Mus., N.Y., 1967; Finch Col., 1967; Parks Dept., N.Y., 1967; one-man: Rochester A. Center, 1950; Univ. Minnesota, 1950; WAC, 1953; Munson-Williams-Proctor Inst., 1953, 1957; Colgate Univ., 1955; Fischbach Gal., N.Y., 1966, 1968. Positions: Instr., Sculpture, Univ. Minnesota, 1950-1953; Munson-Williams-Proctor Inst., 1953-1958; Greenwich Pottery, New York City, 1962; Int. Artist's Seminar, Fairleigh-Dickinson Univ., Madison, N.J., 1963. Lecturer in art, Columbia University and Queens College, N.Y., 1964. Asst. Prof., Queens Col., N.Y. at present.

FREBORG, STAN(LEY)—Painter, S.
 6 Cook St., Provincetown, Mass. 02657
B. Chicago, Ill., Aug. 6, 1906. Studied: AIC, and with John Norton, Hans Hofmann. Member: Provincetown AA; Cape Cod AA; AFA. Work: Walter Chrysler Coll.; Univ. Mississippi; Univ. Arizona; N.Y. Univ.; Living Arts Fnd., and in private colls. Exhibited: Provincetown A. Festival, 1958; Provincetown AA, 1957-1961; Cape Cod AA, 1958-1960; James Gal., 1957-1959; Martha Jackson Gal., Provincetown, 1958; Munson-Williams-Proctor Inst., 1960; MModA Lending Lib., 1960-61; Chess Fnd., Parke-Bernet, N.Y., 1961; one-man: James Gal., 1959; Grand Central Moderns, N.Y., 1960-61.*

FREDERICKS, MARSHALL M.—Sculptor
 4113 & 4131 North Woodward Ave., Royal Oak, Mich. 48072; h. 440 Lake Park Dr., Birmingham, Mich. 48009
B. Rock Island, Ill., Jan. 31, 1908. Studied: John Huntington Polytechnic Inst.; Cleveland Sch. A.; Cranbrook Acad. A., and in Munich, Paris, London; Carl Milles Studio, Stockholm. Member: NA; F.I.A.L.; F., NSS; Hon. Memb., A.I.D.; Michigan Acad. Sc., A. & Let.; Arch. Lg.; N.Y.; Hon. Memb., Mich. Soc. Architects; AIA. Awards: Matzen Traveling European F; prizes, CMA, 1931, 1933; Detroit Inst. A., 1938, 1949; Barbour Mem. Nat. Comp.; gold medal, Michigan Acad. Sc. A. & Let., 1953; AIA; gold medal of Honor, Arch. Lg., N.Y.; medal, Michigan Soc. Arch. Work: WFNY 1939; Rackham Mem. Bldg., Detroit; Veteran's Mem. Bldg., Detroit; Univ. Michigan; Louisville-Courier Journal Bldg.; Fort Street Station, Detroit; Eaton Mfg. Co., war mem.; Cranbrook Acad. A.; City of Detroit Coll.; Detroit Inst. A.; Cleveland Sch. A.; Jefferson Sch., Wyandotte, Mich.; Holy Ghost Seminary, Ann Arbor, Mich.; Ohio State Univ.; Nat. Exchange Cl., Toledo; Ford Auditorium, Detroit; Dallas (Tex.) Pub. Lib.; Detroit Zoological Park; Indian River (Mich.) Catholic Shrine; Beaumont Hospital, Detroit; Michigan Horticultural Soc.; General Motors Corp.; Milwaukee Pub. Mus.; war mem. fountain, Cleveland; N.Y. World's Fair; Highway Dept. Bldg., Columbus, Ohio; Carson-Pirie-Scott Center, Urbana, Ill.; Federal Bldg., Cincinnati; Community Nat. Bank, Pontiac, Mich.; Chrysler Corp.; Dow Chemical Corp.; City of Grand Rapids Coll.; St. John's Church, Ft. Wayne; Emigrants Mem., Stavanger, Norway; Grand Haven, Michigan Cultural Center Fountain; Sir Winston Churchill mem., Freeport, Grand Bahama; Levi Barbour mem. fountain, Detroit; Ford Rotunda, Detroit; Fountain, McMorran Auditorium, Port Huron, Mich.; City-County Bldg., Detroit; Northland and Eastland Shopping Centers; Swan Fountain, Rochester, Mich.; London Embassy; State Dept. Bldg., Wash., D.C.; Our Lady of Sorrows Church, Farmington, Mich.; Good Shepherd Church, Pontiac, Mich. Exhibited: Carnegie Inst.; CMA; PAFA; AIC; WMAA; Detroit Inst. A.; John Herron AI; NSS; AIA; Cranbrook Mus. A.; Arch. Lg.; Michigan Acad. Sc. A. & Let., and in many other museums and galleries in U.S. and abroad. Positions: Instr., Cranbrook Acad. A., Bloomfield Hills, Mich., 1933-42. Faculty, Cleveland Sch. A., 1931-32.

FREED, ERNEST BRADFIELD—Etcher, Eng., P., E.
 Otis Art Institute, 2401 Wilshire Blvd., Los Angeles, Cal. 90057
B. Rockville, Ind., July 20, 1908. Studied: Univ. Illinois, B.F.A.; PAFA; Univ. Iowa, M.A., with Grant Wood, Philip Guston, Mauricio Lasansky. Member: SAGA; Am. Color Print Soc.; Cal. Soc. Etchers; Chicago Soc. Et. Awards: Tiffany F, 1936, 1939; prizes, Indiana State Fair, 1936-1938; BM, 1948; Northwest Territory Exh., 1947, 1950; Sao Paulo Mus., 1955; PAFA, 1953 (medal); Univ. So. Cal., 1954; MMA, 1954; SAGA, 1954, 1963; Intl. Color Print award, Japan, 1961; Phila. Color Print, 1962. Work: Cranbrook Acad. A.; BM; MMA; Sao Paulo Mus. A.; Univ. Iowa; Univ. Illinois; BMA. Exhibited: PAFA, 1937; Univ. Illinois, 1948, 1954, 1956; LC, 1946-1952; BM, 1948-1952; SAGA, 1947-1952; Audubon A., 1952; Phila. Pr. Cl., 1948, 1950, 1951; Northwest Pr. M., 1948-1951; Chicago Soc. Et., 1948-1951; Laguna Beach, 1948, 1949; Indiana A, 1949-1951; Univ. Kentucky, 1956; Wash. Univ., 1956; Royal Painters-Printers, 1953; MMA, 1953; Sao Paulo Mus., 1955; Denver A. Mus., 1946; Corpus Christi, Tex., 1949; Youngstown, Ohio; one-man: Ferargil Gal., 1936; Univ. So. Cal., 1948; Winnipeg Mus. A. 1948; Cranbrook Acad.

A., 1950; Bradley Univ., 1950; Pittsburgh A. & Crafts Soc., 1949; U.S.A. Prints, South America, 1960; Mus. Mod. Art, Athens, Greece; USIS, Europe, 1966; Accademia Firenze, 1967; Int. Graphics, Firenze, 1968, and others. Contributor article on prints, American Artist, 1960; Publ. in "Prizewinning Prints" No. 1 and No. 2, and in "Artists Proof," 1964. Positions: Hd. Graphic A., Otis Art Inst., Los Angeles, Cal.

FREEDBERG, SYDNEY JOSEPH—Scholar, Writer
 Harvard University, Fogg Art Museum 02138; h. 5 Channing Place, Cambridge, Mass. 02138
B. Boston, Mass., Nov. 11, 1914. Studied: Harvard University, A.B., A.M.; Ph.D. Awards: Guggenheim Fellow, 1949-1950, 1954-1955; Fellow, Am. Council Learned Societies, 1958-1959; Faculty Fellow, Wellesley College, 1949-1950; Faculty prize, Harvard Univ. Press, 1960-1961; Morey Award, College Art Assn., 1965; Fellow, American Academy Arts and Sciences, 1965; Grand Officer, Star of Solidarity of the Italian Republic, 1968. Author: "Parmigianino," 1950; "Painting of the High Renaissance in Rome and Florence," 1961; "Andrea del Sarto," 1963; "Painting in Italy in the 16th Century," 1970. Positions: Asst. and Tutor, 1938-1940, Assoc. Prof., 1953-1959, Prof., 1960- , Chm. Dept. of Fine Arts, 1959-1963, Harvard University; Asst. Prof., Assoc. Prof., Wellesley College, 1946-1954. Lecturer, Institute of Modern Art, Boston, 1947; Dir., College Art Assn., 1962- . Vice-Chairman, National Executive Committee to Rescue Italian Art, 1966- .

FREEDMAN, DORIS CHANIN (MRS.)—Collector, Administrator
 830 Fifth Ave. 10021; h. 25 Central Park West, New York, N.Y. 10023
B. Brooklyn, N.Y., Apr. 25, 1928. Studied: Albright Col., B.S.; Columbia Sch. Social Work, M.S.S. Awards: Nat. Women's Division, American Jewish Congress, for contributions to the cultural affairs of the City of New York. Positions: Cloisonne workshop, under direction of Robert Kulicke; Co-publisher, Tanglewood Press; Special Asst. to the Commissioner for Cultural Affairs, 1967-1968, Director, Department of Cultural Affairs, New York City, 1968- .

FREEDMAN, MAURICE—Painter
 121 Edgars Lane, Hastings-on-Hudson, N.Y. 10706
B. Boston, Mass., Nov. 14, 1904. Studied: Mass. Normal Sch. A.; BMFASch.; Andre Lhote, Paris, France. Member: Provincetown AA. Work: Carnegie Inst.; A. Center of La Jolla; Milwaukee AI; Los A. Mus. A.; Tel-Aviv Mus., Israel; PAFA; Lambert Coll.; CAM; Denver A. Mus.; Michener Coll., Univ. Texas, Austin; Allentown Mus.; Dartmouth Col.; BM; Minneapolis Inst. A. Exhibited: CGA; VMFA; Carnegie Inst.; MModA; WMAA; BM; CAM traveling exh.; PAFA; Dayton AI; AIC; Walker A. Center; Audubon A.; NAD; Illinois Wesleyan Univ.; Syracuse Mus. FA; Am. Acad. A. & Lets.; one-man: Midtown Gal. Lectures: Contemp. Painting, Vassar College.

FREEDMAN, ROBERT J.—Collector
 120 E. 71st St., New York, 10021*

FREELANDER, MRS. RONALD. See Richardson, Gretchen

FREEMAN, MARGARET B.—Museum Curator, W.
 The Cloisters, Fort Tryon Park ; h. 16 East 82nd St., New York, N.Y. 10028
B. West Orange, N.J. Studied: Wellesley Col., B.A.; Columbia Univ., M.A.; Summer Sch., Sorbonne, Paris. Member: Medieval Acad. A.; AAMus.; Medieval Club, N.Y.; Museum Council of New York; International Center of Romanesque Art. Awards: Phi Beta Kappa. Author: "Herbs for the Medieval Household"; "The Story of the Three Kings"; Co-author with James J. Rorimer: "The Belles Heures of Jean, Duke of Berry." Contributor of many articles in the Bulletin of the Metropolitan Museum of Art. Positions: Research Asst., Newark Museum, 1924-25; Instr., Dana Hall School, 1925-27; Sec. A. Mus., Wellesley College, 1927-28; Instr., 1928-40, Asst. Cur., 1940-43, Assoc. Cur., 1943-55, Curator of The Cloisters, 1955- , Metropolitan Museum of Art, New York, N.Y.*

FREEMAN, MARK—Lithographer, T., P.
 307 East 37th St.; h. 117 East 35th St., New York, N.Y. 10016
B. Austria, Sept. 27, 1908. Studied: Columbia Col., A.B.; Columbia Univ., B. Arch.; Sorbonne, Paris; NAD. Member: Boston Pr. M.; Wash. WC Cl.; Easthampton Gld. Hall; Lg. Present Day Artists, (Vice-pres.); Nat. Soc. Painters in Casein (Vice-pres.); All. A. Am.; Am. Soc. of Contemp. A.; P. & S. Soc. of New Jersey; Am. Color Pr. Cl. Awards: Knickerbocker A., medal; Easthampton Gld. Hall; Parrish A. Mus., 1963, 1964; Nat. Soc. Painters in Casein, medal, 1964; All. A. Am., 1968; Audubon A., medal, 1969; Work: LC; Parrish Mus., Southampton, L.I.; Butler Inst. Am. A.; Norfolk Mus. A. & Sciences; Holyoke A. Mus.; PMA; St. Vincent's Col. De Hengelose Kunstzaal, Holland, and in private collections. Exhibited: NAD, 1928-1934, 1960, 1967; WFNY 1939; CM, 1952, 1954; N.Y. City Center, 1954, 1959, 1960; Parrish Mus., 1954-1961; Portland Mus. A., 1954, 1956; Wichita AA, 1954; Boston Pr. M., 1954-1960; Wash.

WC Cl., 1953-1960; Knickerbocker A., 1954-1961; Audubon A., 1954, 1955, 1957, 1968, 1969; AWS, 1955, 1958; PAFA, 1957; Phila. Pr. Cl., 1959; Six Artists of the Region, Easthampton, 1966; Nat. Soc. Painters in Casein, 1964-1969; Lg. Present Day Artists, 1964-1969; Am. Color Pr. Cl., 1968; All. A. Am., 1967, 1968; Reese Mus., 1968; Nat. Inst. A. & Lets., 1968. Positions: Owner, Allied Arts Guild, 1934- . Dir., East Side Gal., New York, N.Y., 1961- .

FREEMAN, RICHARD B.—Educator
　　University of Kentucky, Lexington, Ky. 40506
B. Philadelphia, Pa., Oct. 7, 1908. Studied: Yale Univ., A.B.; Harvard Univ., A.M. Member: AFA; Southeastern Col. AA (Vice-Pres., 1951-52, Pres., 1952-53); Midwestern Col. A. Assn. (Pres., 1965-66); CAA. Author: "Ralston Crawford," 1953; "The Lithographs of Ralston Crawford," 1961. Positions: Registrar, FMA, 1936-38; Asst. Cur., CM, 1938-41; Dir., Flint Inst., Flint, Mich., 1941-47; Asst. Dir., SFMA, San Francisco, Cal., 1947-50; Hd. A. Dept., Cur., Univ. A. Mus., Univ. Alabama, 1950-56; Dir., Hartford A. Sch., Hartford, Conn., 1956-57; Visiting Prof., Hamilton Col., Clinton, N.Y., 1958; Hd., A. Dept., Cur., Univ. A. Gal., Univ. Kentucky, Lexington, Ky., 1958-1967; Prof. A., 1968- .

FREILICH, ANN (ANN F. SCHUTZ)—Painter, E.
　　c/o Roko Gallery, 645 Madison Ave., New York, N.Y. 10022
B. Czestochowa, Poland. Studied: Sch. Indst. A.; Edu. Alliance, N.Y.; Col. of City of N.Y. Awards: City Center Gal., 1959; N.J. Soc. Painters & Sculptors, 1960; Laura M. Gross Mem. Award, 1961; Silvermine Gld. Work: BM; Peabody Mus., Nashville, Tenn.; MModA; PMA; and in private collections in U.S. and Canada. Exhibited: Roko Gal., 1946-1965; BM, 1957, 1959, 1961, 1963; Am. Soc. Painters in Casein, 1960-1962; Kornblee Gal., 1962; Riverside Mus., N.Y., 1964; Bridge Gal., 1964; Bucknell Univ., 1965; PMA, 1966; Gal. Mod. A., 1967, 1968; Toledo Mus. A., Toledo, Ohio; Dartmouth Col.; Rockefeller Center, N.Y.; Contemp. A. Gal., N.Y.; Montclair Mus., Montclair, N.J.; Philbrook A. Center, Tulsa, Okla.; Silvermine Gld., New Canaan, Conn. One-man: Davids Gal., 1951; Roko Gal., 1954, 1959, 1962, 1965, 1967; City Center Gal., 1959, and others.

FREILICH, MICHAEL LEON—Art Dealer, Collector
　　867 Madison Ave. 10021; h. 407 E. 77th St., New York, N.Y. 10021
B. Czestchowa, Poland, May 1, 1912. Studied: College of the City of New York, B.A.; Columbia Univ. Grad. School. Collection: Contemporary Art; Primitive Art and Antiquity. Specialty of Gallery: Introduction and development of new talent in the fields of painting, sculpture and graphics, with the greatest concentration on American art. Positions: Director, Roko Gallery, New York, N.Y., 1938-39; Lecturer, Museum of Modern Art, N.Y., 1938-39; Lecturer, N.Y. Univ. Adult Education, 1958; Consultant, Center for Urban Education, New York City, 1969; Consultant, Community Church Art Gallery, New York City, 1969.

FREILICHER, JANE—Painter
　　51 Fifth Ave., New York, N.Y. 10003
B. New York, N.Y. Studied: Brooklyn Col., A.B.; Columbia Univ., A.M.; Hans Hofmann Sch. Art. Award: Hallmark Award, 1960. Work: BM; R.I. Sch. Des. Museum; Hampton Institute; N.Y. Univ.; MModA; Brandeis Univ. Exhibited: AIC; PAFA; Carnegie Inst.; WMAA; MModA; CGA; Univ. Nebraska, 12 one-man exhs., Tibor de Nagy Gal., N.Y., 1952- ; many group shows. Illus. "Turandot" and other poems, 1953. Visiting Artist, Univ. of Pa., Grad. Sch. FA; Skowhegan Sch. A.; Boston Univ.; Tanglewood Inst.; Swarthmore Col.

FREIMARK, ROBERT—Painter, Gr., T., W.
　　Rte. 2, Box 539-A, Morgan Hill, Cal. 95037
B. Doster, Mich., Jan. 27, 1922. Studied: Toledo Mus. A., B. Edu.; Cranbrook Acad. A., M.F.A.; Max Weber Workshop, and in Mexico. Awards: prizes, Toledo Area Annual, 13 awards, 1950-1959; New Talent, USA, 1957; Ohio Artists, 1958; Michiana Regional, 1958-1960 (3); State Fairs, Ohio, Illinois, Iowa; purchase awards: PAFA, 1953; Joslyn Mus. A., 1960; Fellowship, Art Interests Inc., 1953-1954; Grant, Ohio Univ., 1959; Membership Print, Des Moines A. Center, 1960; special commendation, Iowa Artists,1960; Ford Fnd. grant, 1965. Work: PAFA; AFA; Los A. County Mus. A.; U.S. Senate Office Bldg., Wash., D.C.; Seattle A. Mus.; Dayton (Ohio) A. Inst.; Univ. Mich., Minn., Kansas State, N. Dakota, Okla. City, Toledo; Canton AI; Albion Col.; Ford Motor Co.; South Bend A. Center; Butler Inst. Am. A.; Marietta Col.; Huntington Gals.; Ill. State Normal Univ.; West Virginia Wesleyan Col.; Georgia Mus. A.; SAM; Joslyn Mus. A.; LC; Smithsonian Inst.; Des Moines A. Center; Oregon State Univ.; Nat. By-Products Des Moines; Wesley Fnd. in Yale, Drew, Stanford, Chicago, Illinois Universities and Iowa State Col.; Equitable Life and American Republic Insurance Co., Iowa and many others. Exhibited: PAFA, 1952, 1953, 1957-1960; AIC, 1952; Ball State T. Col., 1955, 1957, 1961; Butler Inst. Am. A., 1955-56; NAD, 1956; Art:USA, 1958; Joslyn Mus. A., 1960; Nelson Gal. A., 1960; AFA traveling exh., 1960; Denver Mus. A., 1960; Kansas State Col., 1960; Grand Rapids AI, 1961; DePauw Univ., 1961; SFMA, 1961; Col-

orado Springs FA Center, 1961; Cultural Exchange Exp., Mexico City, 1963. Also, all major print annuals nationally. One-man: Toledo Mus. A., 1952; Morris Gallery, N.Y., 1956; Des Moines A. Center, 1959; Georgia Mus. A., 1959; South Bend AA, 1960; Minneapolis Inst. A., 1960; Salpeter Gal., N.Y., 1961; Paul Rivas Gal., Los A., 1963, 1964; Columbia Univ., 1963; Santa Barbara Mus., Cal., 1965; San Jose State Col., 1965-1969; Santa Clara Univ., Cal., 1969. Positions: Guest A., Parkersburg A. Lg., 1959; Joslyn Mus. A., 1961; A.-in-Res., Des Moines A. Center, 1958-1963; Assoc. Prof. A., San Jose State Col., Cal., 1964- .

FRELINGHUYSEN, MR. and MRS. H. B., JR.—Collectors
　　Morristown, N.J. 07960*

FRENCH, PALMER DONALDSON—Writer, Critic
　　Artforum, 667 Madison Ave., New York, N.Y. 10021; h. 579 Corbett Ave., San Francisco, Cal. 94114
B. Boston, Mass., Mar. 20, 1916. Contributing Editor, Artforum, 1967- . Articles: "Faberge," 1964; "Iranian Art, " 1965; Jugendstil," 1966; "Ancient Egyptian Art at the Lowie Museum," 1966; "The Age of Rembrandt," 1967; "Jules Pascin," 1967; "Medieval Manuscripts at Berkeley," 1967; "Plastics West Coast," 1968; Author of monthly review column, Artforum. Commentator, radio program "Critics'" Corner (Art/Music), San Francisco, 1964-1965.

FRENCH, JAMES C.—Museum Curator, W., L.
　　Rosicrucian Egyptian Museum; h. 1471 McDaniel Ave., San Jose, Cal. 95126
B. Hayward, Wis., Sept. 16, 1907. Studied: Minneapolis Col. of Music & Art, B.A., M.A.; MacPhail Col. of Music & Art. Member: AAMus.; AFA; Intl. Inst. Conservation of Museum Objects. Contributor to Rosicrucian Digest. Positions: Cur., Rosicrucian Egyptian, Oriental Museum and Art Gallery, San Jose, Cal., 1951- .

FRENCH, JARED—Painter, S.,
　　5 St. Luke's Pl., New York, N.Y. 10014; s. Hartland, Vt.
B. Ossining, N.Y., Feb. 4, 1905. Studied: Amherst Col., B.A.; ASL. Awards: grant, Am. Acad. A. & Lets., 1967. Work: WMAA; Dartmouth Col.; Baseball Mus., Cooperstown, N.Y.; BMA; murals, USPO, Richmond, Va.; Plymouth, Pa. Exhibited: Chicago AC; MModA; CGA; PAFA; WMAA; Carnegie Inst.; AIC; SFMA; NAD; Walker A. Center.

FREUND, HARRY LOUIS—Painter, E., I.
　　31 Steel St., Eureka Springs, Ark. 72632
B. Clinton, Mo., Sept. 16, 1905. Studied: Missouri Univ.; St. Louis Sch. FA; Princeton Univ.; Colorossi Acad., Paris; Colorado Springs FA Center. Member: Fla. A. Group; Fla. Fed. A.; Fla. Craftsmen; NSMP. Awards: St. Louis Sch. FA traveling scholarship, 1929; Carnegie F., 1940; Carnegie grant, 1950. Work: Springfield (Mo.) Mus. A.; Little Rock Mus. A.; Pub..Schs. in Missouri, Kansas & Arkansas: murals, USPO, Deland, Fla.; Herington, Kans.; Windsor, Mo.; Idabel, Okla.; Pocahontas & Heber Springs, Ark.; Camp Robinson, Camp Chaffee, Ark.; Hendrix Col.; Bishop Col. Library, 1968; Shaw Univ. Library, 1969; paintings: Govt. offices and hospitals, Wash., D.C.; Pentagon Bldg.; IBM; St. Louis Sch. FA; LC; Kansas City Pub. Schs.; Univ. Arkansas; Independence (Mo.) Court House; Hendrix Col. Exhibited: Denver A. Mus.; CMA; Kansas City AI; Arkansas A.; Ozark A.; WFNY 1939; IBM; NAD; PAFA; Carnegie Inst.; LC; CGA; CAM; CAM; Springfield A. Mus.; Little Rock Mus. A.; Philbrook A. Center; Brooks Mem. A. Gal.; DMFA; Joslyn A. Mus.; SAM; Wichita AA; Univ. Illinois, and others. Positions: Res. A., 1939-41, Hd. A. Dept., 1941-42, 1945-46, Hendrix Col., Conway, Ark.; A.-in-Res., Hendrix Col., 1949-1968; Bishop Col., 1968; Shaw Univ., 1969; Hd. A. Dept., 1951-60, Stetson Univ., Deland, Fla.; Illus., for Ford Motor Co. Publications, 1948- .

FREUND, TIBOR—Painter, Arch.
　　34-57 82nd St., Jackson Heights, N.Y. 11372
B. Budapest, Hungary, Dec. 29, 1910. Studied: Federal Tech. Col., Zurich, Diploma Arch., and Vilmos Aba-Novak A. Sch., Budapest. Awards: Prize, Silvermine Gld. A., 1968. Member: Fellow, Royal Soc. Arts, London, England; NSMP. Exhibited: Galerie Norval, N.Y., 1960 (one-man); AFA traveling exhibition, 1963-1965; and 1966-1967; Riverside Mus., N.Y., 1965; Bertha Shaefer Gal., N.Y. 1969 (one-man); The Contemporaries, N.Y.; 1965, 1967; (one-man). Work: Innovator of "motion paintings"; "moving mural" in N.Y. Public School No. 111, 1963. Contributor of article on his work to American Artist, 1964.

FREUND, WILLIAM F.—Painter, C., E.
　　301 Prospect St., Alton, Ill. 62002; s. Watersmeet, Mich. 49969
B. Jan. 20, 1916. Studied: Univ. Wisconsin, B.S., M.S.; Univ. Missouri. Awards: F. and prize, Tiffany Fnd., 1940, 1949; prizes, Mid-Am. A., 1950; Madison A. Salon; Milwaukee AI; AGAA, 1945, 1946; Denver A. Mus.; Mulvane Mus. A.; William Rockhill Nelson Gal.; CAM; Joslyn A. Mus., 1952, 1953; New Talent, U.S.A., 1956; Columbia, Mo.; Univ. Nebraska (purchase); Research grant, So. Ill. Univ., 1966-1969; North County AA., St. Louis, 1966, 1968 (2). Member:

F.I.A.L.; Int. Platform Assn. Work: Univ. Nebraska; Wm. Rockhill Nelson Gal. A., Kansas City, Mo.; Joslyn Mus. A., Omaha; Oklahoma A. Center; Mulvane Mus. A., Topeka; Stephens Col., Columbia, Mo. Exhibited: Madison Lib.; Wisconsin Union; Milwaukee AI; CAM; Nelson Gal. A.; Springfield A. Mus.; Joslyn Mus. A.; Mulvane Mun. A. Gal.; Denver A. Mus.; NAD; St. Louis Central Lib. Gal. (one-man); Butler AI; Univ. Indiana; Univ. Kansas City; AGAA; Detroit Inst. A.; J. L. Hudson Co., Detroit; Jackson, Miss; Sioux City, Iowa; Magnificent Mile, Chicago; Provincetown, Mass.; Gilcrease Inst. Am. Hist. & Art, Tulsa, Okla;; Morris Gal., N.Y.; Des Moines A. Center; Brooks Mem. Mus.; PAFA; Oklahoma City A. Center; Capper Fnd., Topeka; N.Y. World's Fair, 1964; Ill. State Mus., Springfield; North County AA, St. Louis, 1966, 1968; one-man: Paine A. Center, Oskosh, Wis.; Jewish Community Center, Kansas City, Mo.; Jewish Community Center Assn., St. Louis; Southern Ill. Univ.; Painters Gal., St. Louis, and others. Positions: Formerly, Instr., Stephens Col., Columbia, Mo. Assoc. Prof. FA, Southern Illinois Univ., Edwardsville, at present.

FREUNDLICH, AUGUST L.—Educator, Gallery Dir., L., W., P.
University of Miami; h. 3650 Stewart Ave., Coconut Grove, Fla. 33133
B. Frankfurt, Germany, May 9, 1924. Studied: Antioch Col., A.B.; T. Col., Columbia Univ., M.A.; Hill & Canyon Sch. A.; N.Y. Univ., Ph.D. Member: Western AA (Pres.); Nat. Comm. on A. Edu.; MModA; Michigan Acad. A. Sc.; Nashville A. Gld. (Pres.); Nashville Arts Council (Pres.); Int. Soc. A. Educs. (Exex. Council); Southeastern Mus. Conf., (V.P., 1968-); Southern Col. A.A., (Pres. 1968-1969). Exhibited: Ohio WC Soc.; Michigan Acad.; Arkansas Annual; Winston-Salem; Brooks Mem. A. Mus. Contributor to Art Digest (now Arts magazine); Junior Arts & Activities; School Arts; NAEA Journal; College Art Journal; Michigan Edu. Journal; Arkansas Edu. Journal; Peabody Journal, and others. Consulting Editor, NAEA Journal; Editor, Southeastern Mus. Conf. Notes, 1967- ; Juror, numerous art competitions; Consultant, Col. Art Programs. Monographs: "William Gropper," 1968; "Frank Kleinholz," 1969. Lectures: Art Education; Contemp. A.; Museum Practice. Positions: Bd. Member, Tennessee Fine Arts Center, Nashville; Chm., Art Dept., Univ. of Miami & Dir., Lowe Art Mus.

FRIBERG, ARNOLD—Illustrator, P., Des.
5867 Tolcate Lane, Salt Lake City, Utah 84121
B. Winnetka, Ill., Dec. 21, 1913. Studied: Art Instruction Schools; Chicago Acad. Fine Arts; American Acad. Art, Chicago. Member: Royal Soc. Arts, London, England (Life); Member, National Advisory Board, Art Instruction Schools, Minneapolis, Minn. Work: in private Collections. Other work: Series of 12 paintings, "The Book of Mormon," for The Church of Jesus Christ of Latter Day Saints, 1960; series of 15 monumental paintings, commissioned by Cecil B. De Mille for "The Ten Commandments," completed 1956; series of over 100 paintings for the Northwest Paper Company of "The Northwest Mounted Police," still in progress, 1969; series of paintings on 100 Years of Football, Chevrolet Sports A. Coll., 1968. Series of historical paintings of the American West, Sharp Rifle Co., 1969. Exhibited: Motion Picture Industry Exh. at N.Y. World's Fair, 1964-65; "Ten Commandments" series toured every continent, 1957-1958. Author, Illus., "Arnold Friberg's Little Christmas Book," 1958; "The Ten Commandments," 1957. Lectures: "Vitality in Religious Painting," "Art as Service," "Russell and Remington," etc. Positions: Chief Artist-Designer, Cecil B. De Mille, 1954-1957.

FRICK, MISS HELEN CLAY—Library Director
Frick Art Reference Library, 10 E. 71st St., New York, N.Y. 10021

FRIED, ALEXANDER—Critic
San Francisco Examiner, 110 5th St. 94119; h. 22 Crown Terrace, San Francisco, Cal. 94114
B. New York, N.Y., May 21, 1902. Studied: Columbia Col., A.B.; Columbia Univ., M.A. Positions: A. Ed., San Francisco Chronicle, 1930-34; A. Ed., San Francisco Examiner, 1934- .

FRIED, MICHAEL—Critic
c/o Artforum Magazine, 667 Madison Ave., New York, N.Y. 10021*

FRIED, ROSE—Gallery Director
Rose Fried Gallery, 40 E. 68th St., New York, N.Y. 10021
B. New York, N.Y. Studied: Columbia Univ.; ASL; New School for Social Research; Hans Hofmann and other teachers. Specialty of Gallery: Abstract Art; other forms of advanced ideas in the arts—Cubism, Futurism, Dadaists, etc. Pioneering many of the masters of modern art, and now exploring early Masters of South America. Positions: Dir., Rose Fried Gallery, New York, N.Y.*

FRIEDENSOHN, ELIAS—Painter, T.
43-44 149th St., Flushing, N.Y. 11355
B. New York, N.Y., Dec. 12, 1924. Studied: Tyler Sch. FA, Temple

Univ.; Queens Col., N.Y., A.B.; N.Y. Univ., and with Gabriel Zendel, Paris, France. Awards: prizes, Emily Lowe Fnd., 1951; NAC, 1958; Guggenheim F., 1961; purchase, Univ. Illinois, 1957; Fulbright grant, 1957-58. Work: Univ. Illinois.; Lowe Fnd.; Sarah Roby Fnd.; WMAA; AIC; WAC. Exhibited: WMAA, 1957, 1958, 1960, 1961, 1962, 1964; Univ. Illinois, 1957, 1959, 1961, 1963; VMFA, 1962; Michigan State Univ., 1962; Denver Mus. A., 1961; Louisiana State Univ., 1962; Los A. Mus. A., 1963; AIC, 1957, 1961; Audubon A., 1957; AFA traveling exh., 1961, 1968; Fulbright Annual, Galeria Schneider, Rome, 1958; Galeria Attico, Rome, 1958; Hirschl & Adler Gal., N.Y., 1959; Phila. A. All., 1961; Rochester Mem. Gal., 1961; DMFA, 1961; CM, 1961; Albright A. Gal., 1960; Spoleto, Italy, 1958; CGA, 1961-1962; Finch Col., 1967; Phila. WC Soc.; one-man: RoKo Gal., 1951; Edwin Hewitt Gal., N.Y., 1955, 1957; Vassar Col., 1957; Isaacson Gal., N.Y., 1959, 1961; Feingarten Gals., Chicago, 1961, Los Angeles, 1961, New York, 1962; The Contemporaries, 1965. Positions: Prof., Queens College, N.Y.

FRIEDMAN, B(ERNARD) H(ARPER)—Writer, Patron, Collector
237 E. 48th St., New York, N.Y. 10017
B. New York, N.Y., July 27, 1926. Studied: Cornell University, B.A. Author: "School of New York: Some Younger Artists," 1959; "Circles," 1962; "Robert Goodnough," 1962; "Yarborough," 1964; "Lee Krasner," 1965; "Museum," 1970. Contributor to numerous magazines. Lecturer in Writing, Cornell University, 1966-1967. Positions: Trustee, Whitney Museum of American Art, New York, N.Y., 1960—.

FRIEDMAN, MRS. BURR LEE. See Singer, Burr

FRIEDMAN, MARTIN L.—Museum Director
Walker Art Center, (temp. Admin. address): 807 Hennepin Ave., 55403; h. 1505 Mount Curve, Minneapolis, Minn. 55403
B. Pittsburgh, Pa., Sept. 23, 1925. Studied: Univ. Pennsylvania; Univ. Washington, B.A.; Univ. California at Los Angeles, M.A.; Columbia Univ.; Univ. Minnesota. Member: CAA; AA Mus. Dirs.; Bd. Member, Tyrone Guthrie Theatre Fnd. Awards: BM Fellowship, 1956-57; Belgian-American Edu. Fnd. Fellowship, 1957; Am. Art F., 1959; Ford Fnd. F., 1960. Contributor to Arts; Art in America; Art News; Art International; Quadrum. Arranged exhibitions at Walker Art Center: "Sculpture of Germaine Richier," 1958; "School of Paris: The Internationals," 1959; "The Precisionist View in American Art," 1960; "Adolph Gottlieb," paintings, 1963; "Ten American Sculptors," 1963; "London: The New Scene," 1965; Eight Sculptors: The Ambiguous Image," 1966; "Light/Motion/Space," 1967; "Art of the Congo," 1967; "6 Artists: 6 Exhibitions," 1968; "14 Sculptors: The Industrial Edge," 1969. Positions: Dir., Walker Art Center, Minneapolis, Minn. American Art Commissioner, São Paulo Bienal; Member, Nat. Com. for the Arts in Embassies Program; Smithsonian Art Com.; Advisory Board, Environmental Planning, Bureau of Reclamation.

FRINTA, MOJMIR SVATOPLUK—Scholar, Writer
State University of New York at Albany, N.Y. 12203; h. 150 Maple Ave., Altamont, N.Y. 12009
B. Prague, Czechoslovakia, July 28, 1922. Studied: School of Graphic Arts, Acad. of Applied Arts, Karlova Universita, B.A., all in Prague; Academie Andre Lhote, Ecole des Beaux-Arts, Ecole du Louvre, all Paris, France; University of Michigan, M.A., Ph.D. Member: CAA; Medieval Academy of America; International Institute for Conservation; Int. Center of Medieval Art. Awards: Exchange Scholarship of French Government, 1947-1948; Metropolitan Museum of Art Staff Travel Grant, 1960; Fellowship, Belgian-American Educational Foundation, 1963; Fellowship, American Philosophical Society, 1964-1965; Fellowship, Research Foundation of State University of New York, 1965, 1966; grant, Am. Council of Learned Soc., 1968. Author: "The Genius of Robert Campin," 1965. Contributor of articles and book reviews to The Art Quarterly, The Art Bulletin, Speculum, New Encyclopedia Catholica, Studies in Conservation, Gesta, IIC Abstracts, on medieval art and art technology. Positions: Senior Restorer, The Cloisters of the Metropolitan Museum of Art, 1955-1963; Asst. Prof., State University of New York at Albany, 1963- .

FROMER, MRS. LEON—Collector
1035 Fifth Avenue, New York, N.Y. 10028
Collection: French Impressionist paintings.

FRUDAKIS, EVANGELOS W(ILLIAM)—Sculptor, T., C.
1621 Sansom St., Philadelphia, Pa. 19103; h. (mail) Box 33, Westminster West, Vt. 05158
B. Rains, Utah, May 13, 1921. Studied: Greenwich Workshops, N.Y.; BAID; PAFA, with Walker Hancock, Paul Manship and others; Am. Acad. in Rome. Member: NA; F., PAFA; F. NSS; F., Am. Acad. in Rome; Phila. A. All.; All. A. Am.; Hon. Memb., Am. Inst. Commemorative Arts. Awards: prizes, PAFA; Scholarship, 1949, Gold Medals, 1949, 1954, 1956; NAD, 1948, 1956, Watrous Gold Medal, 1968; Tiffany Fnd., 1949; Woodmere A. Gal., 1955; Silver Medal, DaVinci

A. All., 1955; Tiffany Fnd. grant, 1949; Demarest Trust Fund, Pittsburgh, 1949; Prix de Rome, 1950-1952; All. A. Am., 1959; NSS (prizes) 1961, 1963; PAFA, 1964; Little Rock, Ark., 1965. Work: PAFA; Allentown Mus; Du Pont Co.; Phila. Electric Co.; J. F. Kennedy Mem. Shrine, Convention Hall, Atlantic City; Little Rock Library, and in private collections. Exhibited: PAFA, annually; NAD, annually; S. Gld., 1941; Am. Acad. in Rome, 1951-1953; Pyramid Cl. Phila., 1948, 1949; DaVinci A. All., 1955; Phila. A. All., 1955, 1958; PMA, 1954, 1959, 1962; Saxtons River, Vt., 1953 (one-man); PAFA, 1962 (one-man); Woodmere A. Gal., 1962 (one-man), and others.

FRUMKIN, ALLAN—Art Dealer
41 E. 57th St. 10022; h. 1185 Park Ave., New York, N.Y. 10028
B. Chicago, Ill., July 5, 1926. Studied: University of Chicago. Specialty of Gallery: Contemporary American Artists; 19th and 20th Century Drawings.

FUCHS, SISTER MARY THARSILLA—Educator, P.
Our Lady of the Lake College, 411 S.W. 24th St., San Antonio, Tex. 78207
B. Westphalia, Tex., Apr. 19, 1912. Studied: Our Lady of the Lake Col., B.A.; Columbia Univ., M.A.; AIC; Pratt Center for Contemp. Pr.M., N.Y.; N.Y. Univ.; Univ. Texas, and with Constantine Pougialis, Robert Lifendahl, Buckley MacGurrin. Member: CAA; Western AA; Texas A. Edu. Assn; Nat. A. Edu. Assn.; Texas WC Soc. Exhibited: Witte Mem. Mus., 1943, 1944, 1950; Texas General, 1945-1946; Texas WC Soc., 1950; San Antonio Press Cl., 1963; Positions: Prof. A., Chm., Dept. A., Our Lady of the Lake Col., San Antonio, Tex.; Sec., Liturgical Comm., Archdiocese of San Antonio, Art and Architecture Com., 1967-1969.

FUGAGLI, ALFONSO—Painter
564 Chestnut St., Meadville, Pa. 16335
B. Meadville, Pa., Jan. 23, 1912. Studied: Columbia T. Col.; Academy of Fine Arts and ASL, New York, N.Y.; Cleveland Sch. Art. Member: Erie A. Cl. Awards: Erickson Mem. Award, Erie, Pa.; prizes, 1953, 1960; Chautauqua A. Exh., N.Y., 1961; and others in regional exhs. Work: Theil Col., Greenville, Pa.; Holiday Inn, Erie, Pa. and in many private collections U.S. and South America. Exhibited: Contemporary Gal., N.Y.; Butler Inst. Am. A.; Santa Fe Gal. A.; Cleveland May Show; New Mexico State Fair; Chautauqua A. Exh.; one-man: Edinboro State College (Pa.); Thiel College, Greenville, Pa.; Art Forum, Warren, Ohio; Erie A. Gal.; The Arts Gallery, Youngstown, Ohio.

FULLER, RICHARD EUGENE—Museum Director
Seattle Art Museum, Volunteer Park; h. 3801 East Prospect St., Seattle, Wash. 98102
B. New York, N.Y., June 1, 1897. Studied: Yale Univ.; Univ. Washington, B.S., M.S., Ph.D. Member: Western Assn. A. Mus.; Chinese A. Soc. Am.; AAMus. (Council), Assn. A. Mus. Dir. (Vice-Pres., 1956-57, 1960-61, Pres., 1963-1966); U.S. Nat. Com. ICOM, 1958-64. Awards: Assoc. Off. Order St. John, of Jerusalem, London, 1964; Hon. Deg., LL.D., Washington State Univ., and Seattle Univ.; Univ. Washington, Summa Laude Dignitus, 1961; AID. Lectures: History of Oriental Art. Author: "Japanese Art in the Seattle Art Museum." Position: Co-Donor, with mother, the late Mrs. Eugene Fuller, of Seattle Art Museum, 1933, and the Eugene Fuller Memorial Collection; Research Prof. Geology, Univ. Washington, 1940- ; Pres., Western Assn. A. Mus. Dir., 1935-37; Pres., Dir., Seattle Art Museum, Seattle, Wash., 1933- .

FULLER, SUE—Painter, S., Gr., E., W., L.
44 East 63rd St., New York, N.Y. 10021
B. Pittsburgh, Pa., Aug. 11, 1914. Studied: Carnegie Inst., B.A.; T. Col., Columbia Univ., M.A. in FA Edu. Member: SAGA. Awards: Tiffany Fnd. F., 1948; Guggenheim F., 1949; Nat. Inst. A. & Let., 1950; Eliot D. Pratt Fnd. Fellowship, 1966-1968. Work: N.Y. Pub. Lib.; LC; Harvard Univ. Lib.; Carnegie Inst.; PMA; BMA; Amherst Col.; McNay AI, San Antonio; AGAA; WMAA; Ford Fnd.; AIC; SAM; MModA; MMA; BM; Chase Manhattan Bank; AGAA; Albion Col.; Des Moines A. Center; Herron AI; National Gal. A. (Rosenwald Coll.); Peabody Col.; Wadsworth Atheneum; Storm King A. Center; Oklahoma A. Center; NCFA; High Mus. A., Atlanta;·Univ. Rochester Mem. Mus.; Tate Gal., London, England; Joslyn Mus. A., Omaha; CGA; Honolulu Acad., and in private colls. Exhibited: USIS, 1961; BM, 1961; Contemp. A. of Houston, 1958; AIC, 1957; WMAA, 1951, 1954-1956, 1962; MMA, 1953; CGA, 1961, 1965; MModA., 1965; traveling exhs. of AFA, MMA, LC, USIS; foreign exhs. include Pairs Paris—Salon de Mai, Bibliotheque Nationale, Petit Palais; Barcelona—III Bianal Hispano Americano; Sao Paulo—1st Bianal; CGA; PAFA; Wadsworth Atheneum; MModA; Albright-Knox A. Gal.; Flint Inst. A.; NCFA; R.I.Sch.Des. Mus.; Carpenter A. Center, Harvard Univ.; BMA; Columbus A. Center; Southern Illinois Univ.; Univ. Colorado; Columbus Gal. FA; Herron A. Mus.; Newark Mus.; Larry Aldrich Mus. Contemp. A., Ridgefield, Conn.; Cornell Univ.; Univ. Indiana. One-man: Bertha Schaefer Gal., N.Y., 1949, 1950, 1953, 1956, 1961, 1965, 1967, 1969; Rigelhaupt Gal., Boston, Storm King A.

Center, Mountainville, N.Y.; McNay A. Inst., San Antonio, Norfolk Mus. A. & Sciences; Southern Vermont A. Center, Manchester. Positions: Instr., Pratt Inst., 'Brooklyn, N.Y., 1964-1965.

FULLER, MR. and MRS. WILLIAM MARSHALL—Collectors.
27 Valley Ridge Rd., Ft. Worth, Tex. 76107
Collection: American Impressionists.

FULTON, W. JOSEPH—Museum Director, E., W.
h. 529 Madison St., New Orleans, La. 70116
B. Longmont, Colo., Apr. 8, 1923. Studied: Univ. Colorado, B.F.A.; Harvard Univ. (Fogg A. Mus.), A.M. Member: CAA; AAMus.; Soc. Arch. Historians; AAUP. Awards: Joint-Honor Scholarship, Univ. Colorado, 1940-44; James Rogers Rich & Townsend Scholarships, Harvard Univ., 1945-46; Grad. F., Harvard Univ., 1946-47; F., Belgian American Edu. Fnd., 1951; Fulbright F., for France, 1953-54. Lectures: The Museum and the Community; 19th & 20th Century Art; American Decorative Arts, to clubs and civic groups; other lectures to colleges and universities. Arranged exhs.: "Pioneer American Moderns," Norfolk (Va.) Mus., 1953; "California Design," Pasadena A. Mus., 1957; "The Blue Four," Pasadena A. Mus., 1955; "Marsden Hartley," Univ. of Southern California and Univ. of Texas, 1968-1969. Positions: Instr., Humanities in the College, Univ. Chicago, 1948-51; Asst. Dir., Norfolk Mus., 1951-53; Dir., Pasadena A. Mus., Pasadena, Cal., 1953-1957; Writing & Research, 1958-59; Assoc., Maury A. Bromsen Assoc., 1958-1963, Vice-Pres., 1963- ; Asst. Prof. A. History, Mass. College of Art, Boston, Mass., 1960-1963; Asst. Dir., Oklahoma A. Center (summer) 1963; Cur., Collections, Delgado Museum of Art, New Orleans, La., 1964-1966; Cur., Collections, Louisiana State Museum, 1966-1968; Visiting Prof. and Acting Chief Cur., Univ. A. Mus., Univ. of Texas, 1968-1969; Museum Consultant, Lecturer, 1969- .

FULWIDER, EDWIN L.—Painter, E., Gr., Des.
101 East Central Ave., Oxford, Ohio 45056
B. Bloomington, Ind., Aug. 15, 1913. Studied: John Herron A. Sch., B.F.A. Awards: Traveling F., John Herron AI, 1936; prizes, Herron AI, 1940, 1943, 1945; Massillon A. Mus., 1956; Dayton AI, 1953. Work: Herron AI; Dayton AI; LC; SAM; Contributor to Ford Times (10 yrs.); Article to American Artist Magazine, 1961. Exhibited: CM, 1939, 1941, 1956-1960; AIC, 1940, 1941; John Herron AI, 1936-1946, 1957; LC, 1957; Butler Inst. Am. A.; Dayton AI, 1956, 1958; Massillon A. Mus., 1956. Positions: Instr., John Herron A. Sch., Indianapolis, Ind., 1945-47; Cornish Sch., Seattle, Wash., 1947-49; Prof., Dept. A., Miami Univ., Oxford, Ohio, 1963- .

FUSSINER, HOWARD ROBERT—Painter, Gr., T., W., L.
1 Everitt St., New Haven, Conn. 06511
B. New York, N.Y., May 25, 1923. Studied: American People's Sch., with C.G. Nelson; ASL, with Sternberg, Vytlacil, Blanch; CUASch., with Gwathmey, Ferren; Hans Hofmann Sch. FA; N.Y. Univ., B.S., M.A. Member: CAA; Inst. for Study of Art in Edu.; ASL. Awards: prizes, Rhode Island A. Festival; Berkshire AA, 1962; Boston A. Festival, 1963; New Haven Festival; Connecticut Acad. A.; Waterbury A. Festival, 1968, and others. Work: Staten Island Inst. Mus.; Everhart Mus. A., Scranton, N.Y.; mural, N.Y. Univ. Edu. Bldg. Exhibited: College Art Exh., 1949-50; Woodstock Conf. Exh.; Slater Mus., Norwich, 1968; one-man: Morehouse Col., Atlanta, 1954; Peter Cooper, N.Y., 1955; Nonagon Gal., 1961; Everhart Mus., 1957; Panoras Gal., 1958, 1959; Steindler Gal., N.Y., 1962; Greer Gal., N.Y., 1964; Athena Gal., New Haven, 1962-1965, 1967, 1968; Mattatuck Mus. Hist. & A., 1969; 3-man exh., Nonagon Gal., 1960; John Slade Ely House, New Haven, 1962; 4-man, Currier Gal. A. and Stony Creek, Conn. Contributor to College Art Journal; Phylon. Positions: Asst. Prof., Southern Connecticut State College, New Haven, Conn., at present.

GABIN, GEORGE J.—Painter, T.
121 Main St., Rockport, Mass. 01966
B. New York, N.Y., Apr. 16, 1931. Studied: Brooklyn Mus.; ASL. Member: Rockport AA; All. A. Am. Awards: Bernays Scholarship, ASL, 1953; prizes, Rockport AA, 1960, 1962, 1963 (2). Work: Republic Savings & Loan Co., Washington, D.C. Exhibited: NAD, 1960, 1965; All. A. Am., 1959, 1963; Conn. Acad. FA, 1960-1962; Academic A., 1960-1962; Boston A. Festival, 1962; Inst. Contemp. A., Boston, 1961, 1962; Providence A. Cl., 1962; AFA, 1964-1965; Rockport AA, 1959-1965; Inst. Contemp. A., Boston, traveling exh., 1961-1962; one-man: Carl Siembab Gal., Boston, 1963, 1967; Gallery 7 (2-man) 1965; Rockport AA, 1965. Position: Instr., Painting & Drawing, New England School of Art, Boston, Mass.

GABRIEL, ROBERT A.—Sculptor, E.
Carnegie-Mellon University; h. 6307 Hampton St., Pittsburgh, Pa. 15206
B. Cleveland, Ohio, July 21, 1931. Studied: Cleveland Inst. A.; Skowhegan Sch. P. & S. Member: Assoc. A. of Pittsburgh (Pres. 1966-1967); Pittsburgh Soc. S. (Pres., 1959-61). Awards: Mary Page traveling scholarship, Cleveland Inst. A., 1954; prize, Wichita,

Kans., 1953. Work: Des., Pittsburgh Hilton Hotel; S., Allegheny Ludlum Steel Co.; Des. for Peter Muller-Munk in Ankara, Turkey on Govt. project, 1957-58. Exhibited: PAFA, 1953; Wichita Dec. A. & Crafts Exh., 1953; Huntington AA, 1953; Texas State Fair, 1953; CMA, 1953-1955; Western Pa. Sculpture Exh., 1955, 1956; Faculty Exh., Allegheny Col., 1955; "Mainstreams' 69," Marietta, Ohio; one-man: Carnegie Inst., 1962; Carnegie-Mellon Univ., 1968. Positions: Assoc. Prof., Design, Carnegie Inst. Tech., Pittsburgh, Pa.; Instr. A., Allegheny Col., 1954.

GAGE, HARRY LAWRENCE—Typographic Designer, W., P., L., Gr.
16 River Rd., Annisquam, Gloucester, Mass. 01930
B. Battle Creek, Mich., Nov. 20, 1887. Studied: AIC; abroad, and with Gerry Pierce. Member: AAPL; AIGA; Boston Soc. Pr.M.; North Shore AA; Rockport AA. Awards: Friedman med., in Graphic A. Edu.; gold med., AIGA, 1951; New England Benjamin Franklin Award, 1959. Exhibited: North Shore AA; Copley Soc., Boston; Rockport AA. Author: "Applied Design for Printers"; "Composition Manual—Machines in the Composing Room." Contributor to graphic arts magazines. Lectures on Typographic Design and Graphic Arts Techniques. Positions: Prof. Graphic A., Carnegie Inst., 1913-1919; Sec., Bartlett-Orr Press, 1919-1931; Consultant on Typography, 1919-31, V.Pres., 1932-47, Consultant in Graphic A., 1947- , Mergenthaler Linotype Co., Plainview, N.Y.

GAHMAN, FLOYD—Painter, Et., L., C., Gr., E.
Summer: Jackson Hill, Morrisville, Vt.; h. 90 LaSalle St., New York, N.Y. 10027
B. Ohio, Oct. 14, 1899. Studied: Valparaiso (Ind.) Univ.; Columbia Univ., B.S., A.M., and with Hobart Nichols, Henry Varnum Poor. Member: NA; Audubon A.; SC; Woodmere A. Gal.; All. A. Am.; AAPL. Awards: F., Tiffany Fnd.; prizes, All. A. Am., 1942, 1961; SC, 1941, 1942, 1960, 1961, 1964, 1965. Exhibited: NAD annually; SC, annually; Montclair A. Mus., 1955; Pa. State Univ. and Indiana Univ., 1958. Lectures: Contemporary Painting.

GAINES, NATALIE EVELYN—Sculptor
410 E. 79th St., New York, N.Y. 10021; h. 18229 Lahser Rd., Detroit, Mich. 48219
B. Detroit, Mich. Studied: Detroit Soc. for A. & Crafts; Greason Sch., Detroit. Awards: Crespi Gal., 1958; Temple Emanu-El, N.Y., 1959, 1960, 1961, 1962. Exhibited: Detroit Inst. A., 1949, 1950; Wayne County A., 1950; Creative A., N.Y., 1951; Kirk-in-the-Hills A. Festival, Detroit, 1952; Crespi Gal., 1958, 1959, 1960; All. A. Am., 1958; Women's Int. Exh., N.Y., 1958; Temple Emanu-El Exh., 1959-1961; Int. A. Exh., Weintraub Cancer Fund, New York City, 1959; AEA, 1964; one-man: Crespi Gal., 1958; Glassboro Mus., 1961. Work: Glassboro (N.J.) Mus.

GAINES, WILLIAM R.—Museum Program Director, P.
Virginia Museum; h. 206 N. Meadow St., Richmond, Va. 23220
B. Madison, Va., Aug. 12, 1927. Studied: Virginia Commonwealth Univ., B.F.A.; Columbia Univ., M.F.A., and in Rome with Renato Guttuso. Awards: purchase prizes, Virginia Beach Exh., 1958; Thalhimers, 1963. Work: Univ. Virginia; Virginia Polytechnic Inst. and other permanent collections. Exhibited: VMFA, 1949, 1951, 1953, 1955, 1959, 1963; Abingdon Square Painters, New York, 1953. Lectures: "Form and Expression in the Arts"; "19th Century Art and Music in France"; "Interrelations of the Arts," etc. As Head of the Programs Division, VMFA, arranges special exhibition program for the Museum which includes 6 major shows, 15 smaller exhibitions and 20 traveling exhibitions each year. Exhibitions have included: "Painting in England, 1700-1850"; "The Collection of Mr. and Mrs. Paul Mellon"; "Master Prints From the Rosenwald Collection"; "19th Century American Art from the Karolick Collection"; "Homer and the Sea," "William Hogarth," "Treasures from the Guggenheim." Positions: Registrar, 1951-1953, Artmobile Cur., 1953-1954, Supv. Education, 1954-1956, 1957-1962, Hd., Programs Div., Virginia Museum, Richmond, Va., 1962- .

GAINS, JACOB—Painter, Gr.
400 Kings Point Dr., Miami Beach, Florida 33160
B. Vilno, Poland, Aug. 4, 1907. Studied: N.Y. Sch. of Fine and Applied Art; NAD; and with William Baziotes and Adja Yunkers. Member: P. & S. of New Jersey; Modern Artists Gld. Awards: Jersey City Mus., 1960, first prize & medal of honor, 1963; Jersey City Tercentenary, 1960; Grumbacher award, 1962. Work: Montclair A. Mus.; Washington and Jefferson Col. Exhibited: NAD; Newark Mus.; Riverside Mus.; Montclair A. Mus.; Jersey City Mus.

GALLAGHER, EDWARD J., JR.—Collector
3501 Ednor Road, Baltimore, Md. 21218*

GALLO, FRANK—Sculptor
804 W. Nevada St., Urbana, Ill. 61801
B. Toledo, Ohio, Jan. 13, 1933. Studied: Toledo Mus. Sch. A., B.F.A.; Univ. Iowa, M.F.A. Awards: prize, Interior Valley Comp., Cincinnati, 1961. Work: MModA; WMAA; AIC; Los. A. Mus. A. Commission: Commemorative Medal for Civil Engineering for Univ. of

Illinois. Exhibited: AIC, 1964; WMAA, 1964, 1965; Ravina Festival Art, 1964; Kennedy Memorial Exh.; Venice Biennale, 1968; Graham Gal., 1967; Gilman Gal., Chicago, 1968. Positions: Assoc. Prof., Sculpture, University of Illinois, Urbana, Ill.*

GAMBLE, KATHRYN ELIZABETH—Museum Director
The Montclair Art Museum, 3 South Mountain Ave. at Bloomfield Ave., Montclair, N.J. 07042
B. Van Wert, Ohio, Aug. 19, 1915. Studied: Oberlin Col., A.B.; N.Y. Univ. Grad. Sch. FA, M.A.; Newark Mus. Apprentice Course (Certif.), 1941. Member: AAMus.; Northeast Mus. Conference; Museums Council of New Jersey. Author: Thesis: "The Mother and Child in Egyptian Art"; "Methods and Materials of the Painter" (exh. catalogue for traveling show); numerous exhibition catalogues and bulletins compiled, introductions written, etc. Art Survey lectures. Exhibitions arranged: Pennsylvania German Arts and Crafts, 1952; Masks: Rites and Revelry, 1954; Methods and Materials of the Painter (assembled 1954 traveling through Canada for 18 month tour). Organized New Jersey art for Canadian request; American Illustration, 19th Century: Charles Parsons and his Domain, 1958. Positions: Asst. to the Dir., 1944-52, Dir., Montclair Art Museum, 1952- .

GARBATY, MARIE LOUISE (Mrs. Eugene L.)—Collector, Patron
Shorehaven, East Norwalk, Conn. 06855
B. Berlin, Germany, Mar. 9, 1910. Studied: University of Berlin. Collection: 15th to 17th Century Dutch and Flemish Paintings; Decorative Arts of the Renaissance; Antique Syrian Glass; 15th to 18th Century Blue White China; Antique Oriental Textiles; Old English Silver; Antique English Furniture. Patronage: Fellow in Perpetuity, Metropolitan Museum of Art; Life Fellow, Boston Museum of Fine Arts; International Centennial Patron of the Boston Museum of Fine Arts; Patron: Wadsworth Atheneum, Hartford, Conn.; Benefactor: Norfolk Museum of Arts & Sciences, Norfolk, Va.

GARBISCH, EDGAR WILLIAM and BERNICE CHRYSLER—
Collectors, Patrons
50 E. 77th St., New York, N.Y. 10021
Studied: Washington and Jefferson College, B.A.; United States Military Academy, B.S. (Col. Garbisch). Collection: American Naive Paintings, 18th and 19th centuries.

GARDINER, HENRY GILBERT—Museum Curator
Philadelphia Museum of Art, 26th St. & Parkway 19101; h. 2017 Waverly St., Philadelphia, Pa. 19146
B. Boston, Mass., Aug. 27, 1927. Studied: Harvard Univ., B.A. (Arch.), M.A. (Fine Arts). Member: Am. Assn. Museums. Author: Checklist of Sculpture, PMA Bulletin, 1961; "Philadelphia Collects 20th Century" (catalogue), 1963; "Louis E. Stern Collection" (catalogue), 1964; Checklist of Paintings in the Philadelphia Museum of Art, 1965; "Collection Mrs. John Wintersteen" (catalogue), 1966; "Samuel S. White, 3rd, and Vera White Collection" (catalogue), 1968. Positions: J. P. Morgan Company, New York, 1951-1957; Museum Asst., Wadsworth Atheneum, 1959; Museum Asst., Addison Gallery of American Art, Andover, Mass., 1959-1960; Asst. Curator of Paintings, Philadelphia Museum of Art, 1960- .

GARDINER, ROBERT D. L.—Collector
230 Park Ave. 10017; h. 990 5th Ave., New York, N.Y. 10021
B. New York, N.Y., Feb. 25, 1911. Studied: Columbia College, N.Y., A.B. Collection: Americana; 18th century French, English and American furniture, pictures, china, silver, gold boxes, watches and jewels; Furniture, portraits, silver from Gardiner's Island, N.Y., the first English settlement in N.Y., the only manorial grant from King Charles I of England (1639) intact today in the same name in North America.*

GARDNER, ROBERT EARL—Graphic Artist, E., P., C.
College of Fine Arts, Carnegie-Mellon University; h. 1522 S. Negley, Pittsburgh, Pa. 15217
B. Indianapolis, Ind., June 29, 1919. Studied: John Herron AI, B.F.A.; Cranbrook Acad. A., M.F.A., and with Stanley Hayter. Awards: purchase prizes, Wichita AA, 1948; Ohio Univ., 1948; L.S. Ayres Co., Indianapolis, 1949; prizes, Ohio Univ., 1948; Oklahoma AA, 1948 (2); Missouri Valley A., 1948; Indiana Soc. Pr.M., 1948; Ohio Valley Exh., 1949; Krannert Merit award, L.S. Ayres Co., 1949; Lake Michigan Pr. Exh., 1952; Tamarind Fellowship, June-Sept., 1962, 1963-1964. Exhibited: Wichita Graphic Arts Exh., 1948-1952, 1958, 1959, 1961; Phila. Pr. Cl., 1948-1952, 1960; PAFA, 1948-1950, 1952, 1957; LC, 1949, 1950; BM, 1949, 1954; Northwest Pr.M., 1948-1950; Laguna Beach Print Exh., 1948, 1949; Carnegie-Mellon Univ., 1949; Color Lith. Biennial, Cincinnati, 1950; Univ. So. California, 1954; Indiana A., 1948-1951, 1953, 1957-1959; Michigan A., 1951, 1954, 1960; Assoc. A. Pittsburgh, 1954-1957, 1960; Herron A. Mus., 1966, 1968; Mus. Contemp. A., Skopje, Yugoslavia, 1966; Pennational Exh., Ligonier, Pa., 1966, 1967; Gal. 40 West, Uniontown, Pa., 1967; Univ. Southern California, 1967; N.Y. State Univ. at Potsdam, 1967; Hunterdon County A. Center, Clinton, N.J., 1967; Silvermine Gld. A.,

1968; Temple Emanuel A. Festival, Tobian Auditorium, Dallas, Tex., 1968, 1969; Bradley Univ., 1968, and many others. Positions: Instr., Painting and Drawing, Univ. Oklahoma, 1948-51; Instr., Printmaking, Cranbrook Acad. A., 1951-1952; Assoc. Prof., Printmaking, Carnegie-Mellon University, at present.

GARNSEY, CLARKE HENDERSON—Educator, P., L.
University of Wichita 67208; h. 1562 Harvard Ave., Wichita, Kans. 67208
B. Joliet, Ill., Sept. 22, 1913. Studied: Cleveland Sch. A.; Western Reserve Univ.; Daytona Beach Sch. A., with Don Emery; Univ. Colorado; West Texas Univ. Member: CAA; Soc. Arch. Historians; Wichita AA; Kansas A. Educators Assn.; Wichita Art Mus. Members Fnd., Bd. Member. Work: murals in numerous high schools in Daytona Beach and Central Florida. Exhibited: Wichita A. Mus., 1964; Faculty Show, Duerksen A. Center, Wichita State Univ. Lectures: History of American Art; Latin American Architecture. Positions: Chm., Department of Art, College of Fine Arts, Wichita State University, at present.*

GARRETT, STUART GRAYSON, JR.—Painter, E.
517 E. 84th St., New York, N.Y. 10028
B. Oklahoma City, Okla., Feb. 15, 1922. Studied: Cooper Union; ASL. Member: AWS (Dir.); All. A. Am.; Southern Vermont Artists; SC; Artists Fellowship. Awards: prizes, AWS, 1961, 1965; SC, 1962 (2), 1963, 1965; AAPL, gold medal, 1959; So. Vermont A., 1961. Work: U.S. Naval Historical Collection. Exhibited: NAD, 1960, 1961, 1964, 1965; AWS, 1952, 1960-1965; All. A. AM.; AAPL, 1952-1963; Audubon A., 1964; Academic A. Soc. (Springfield, Mass.), 1954, 1959, 1960; Musée de la Marine, Paris, 1963; SC, 1954-1956; San Diego State Col., 1964; So. Vermont A., 1961, 1963. Positions: Prof. A., City College of New York.*

GARRISON, EVE—Painter
9201 So. Clyde Ave., Chicago, Ill. 60617
B. Boston, Mass. Studied: Wayne Univ.; Lawrence Inst. Tech., Detroit; AIC. Member: AEA; AIC Alumni Assn.; Renaissance Soc., Chicago. Awards: gold medal, CGA, 1933; purchase prize, Union Lg. Cl., Chicago, 1961. Work: Univ. Illinois, Urbana; U.S. Treasury Dept., Wash., D.C.; Miami Mus. Mod. A.; Sears' Vincent Price Gal.; Drian Gal., London; paintings reproduced in "Collage and Found Objects"; "Creating with Plaster"; "Creating with Anything;" and in private colls. Exhibited: Wichita AA; Los A. County Fair; Oakland A. Mus.; Portland (Ore.) A. Mus.; NAD; PAFA; Albany Inst. Hist. & A.; Kansas City AI; Contemp. A., N.Y.; AIC; VMFA; CGA; Conn. Acad. FA; Nat. Mus., Wash., D.C.; Albright A. Gal.; Detroit Inst. A.; Butler AI; Alabama WC Soc.; Portland Soc. A.; Springfield A. Mus.; Woodstock AA; Davenport, (Iowa) Mus., 1968; oneman: Arthur Newton Gal., 1950; Rafilson A. Gal., Chicago, 1953; Creative Gal., N.Y., 1953; Mandel Bros., 1954; Anna Werbe Gal., Detroit, 1954, 1959; Milwaukee AI, 1955; Well-of-the-Sea Gal., Chicago, 1955; Chicago Pub. Lib., 1957; Exhibit A. Gal., Chicago, 1958; Miami Mus. Mod. A., 1961, 1965; Duncan Gal., New York City and Paris, France, 1963; Drian Gal., London, England, 1964, 1968, 1970; Villanova (Pa.) Univ., 1966; New Masters Gal., N.Y., 1966; Sears' Vincent Price Gal., Chicago, 1968, 1969.

GARTH, JOHN—Painter, W., L., Cr., T., Gr., I., S.
Studios, 2155 26th Ave., San Francisco, Cal. 94116
B. Chicago, Ill., Dec. 21, 1894. Studied: AIC; Yale Col., B.A.; Yale Sch. FA, B.F.A.; & in London, Paris, Florence. Member: NSMP; Cal. Soc. Mural P.; AAPL; F., Royal Soc. A., London, England; Soc. Western A. Awards: Med., Palace Legion Honor; traveling scholarship, Yale Sch. FA; gold medal, AAPL, 1958. Work: murals, Univ. California; Cal. State Indst. Comm.; Wine & Grape Pavilion, Lodi, Cal.; General Electric Co.; San F. Arch. Cl.; Pacific Marine Contractors; "The Franklyn Murals," Franklyn Savings & Loan Assn., San F.; Masonic Temple (mural restoration); Woodlawn Mem. Park (triptych); Fairmont, Somerton, Sir Francis Drake Hotels, all in San F.; Miami Univ., Oxford, Ohio; Redding, Cal.; mosaic mural, Carmel (Cal.) Center, 1968. Exhibited: Local & national exh., annually. Positions: Dir., John Garth Sch. A.; A. Ed., The Argonaut, San Francisco, Cal., 1941-1956; A. Chm., San F. Press-Union Lg.; Artist-Painter memb. San Francisco Art. Comm., 1956-1959; Admissions Bd., Huntington Hartford Fnd., 1949- ; Fnd., Past Pres., Soc. Western A., 1939- ; A., San F. Rotary Cl.

GARVER, THOMAS H.—Museum Director, W., L.
Newport Harbor Art Museum, 400 Main St., Balboa, Cal. 92661; h. 2278 Columbia Drive, Costa Mesa, Cal. 92626
B. Duluth, Minn., Jan. 23, 1934. Studied: Barnes Fnd., Merion, Pa.; Haverford (Pa.) Col., B.A.; Univ. Minnesota, M.A. Member: CAA; Int. Inst. for the Conservation of Historic and Artistic Works (Associate). Author: Section titled "Administration and Operation of College and University Museums," for "Handbook of College and University Administration," 1969. Contributor to Artforum; Arts/ Canada. Exhibitions arranged: Rose Art Museum, Brandeis Univ.; Charles H. Currier: A. Boston Photographer; Bruce Connor: Assem-

blages, Drawings, Films; Twelve Photographers of the American Social Landscape; Recent American Drawings. Exhibitions at Newport Harbor Art Museum: Just Before the War: Urban America from 1935-1941 as seen by Photographers of the Farm Security Administration; Paul Brach and Miriam Schapiro, Paintings and Prints; New Art of Vancouver; Robert Rauschenberg in Black and White. Positions: Consultant, art gallery design for Univ. of Chicago and California Institute of the Arts; Asst. to the Dir., Krannert Art Museum, Univ. Illinois, 1960-1962; Asst. Dir., Fine Arts Dept., Seattle World's Fair, 1962; Asst. Dir., Rose Art Museum, Brandeis Univ., Waltham, Mass., 1962-1968; Dir., Newport Harbor Art Museum, Balboa, Cal., 1968- .

GARVEY, ELEANOR—Associate Curator
The Houghton Library, Harvard University, Cambridge, Mass. 02138
Positions: Associate Curator, Department of Printing and Graphic Arts, Harvard College Library.

GARY, DOROTHY HALES—Collector, Patron, Critic, Gallery Dir.
730 Park Ave., New York, N.Y. 10021
B. San Francisco, Cal., Nov. 21, 1917. Studied: Stanford College. Author: "Sun-Stones and Silence," 1963; Photography for Robert Payne's "Splendors of Asia." Specialty of Gallery: Abstract, contemporary art. Collection: Abstract art. Positions: Owner, private art gallery (123 E. 70th St., New York, N.Y.).*

GARY, JAN (Mrs. William D. Gorman)—Painter, Gr.
43 W. 33rd St., Bayonne, N.J. 07002
B. Fort Worth, Tex., Feb. 13, 1925. Studied: A. Center Sch., Los Angeles; San Antonio AI; ASL. Member: Nat. Soc. Painters in Casein; NAWA; Painters & Sculptors Soc.; New Jersey WC Soc.; Audubon A.; Assoc. A. of New Jersey. Awards: prizes, Painters & Sculptors Soc., 1955, 1963; Jersey City Museum annuals, 1954, 1956-1960, 1962, 1964; Hunterdon County A. Center, 1961-1963, 1968; Knickerbocker A., 1960; New Jersey WC Soc., 1963, 1964; Audubon A., 1966 (Grumbacher Purchase); Butler Inst. of Am. A., 1966 (purchase); NAWA 1967; Bamberger's Newark State Show, 1967; Plainfield (N.J.) A.A., 1965; Am. Acad. of A. and Lets., (Childe Hassam purchase) 1968. Work: Jersey City Mus.; Norfolk Mus. A. & Sciences; LaSalle College, Philadelphia; M. Grumbacher; Butler Inst. Am. Art; Pensacola Art Center; Brandeis Univ.; Wisc. State Univ., Eau Claire; Carver Mus., Tuskegee Inst. Ala. Exhibited: NAD, 1963, 1965; Butler Inst. Am. Art, 1963, 1966; Montclair Art Museum State Annuals, 1956-1962; Newark Museum Festival, 1960; New Jersey State Museum (invitational) 1956; Witte Mem. Mus., 1949; Silvermine Gld., 1966; N.J. Pavilion, N.Y. World's Fair, 1965; traveling exhibitions U.S., Canada, Scotland, England. One-man: Jersey City Museum, 1964; St. Scholastica Acad., Ft. Smith, Ark. 1965; Ark. State Teachers Col., Conway, 1965; Highgate Gal., 1966; Centenary Col. for Women (N.J.) 1967; Ringwood Manor State Mus. (N.J.) 1968. Contributor to American Artists Group. Work reproduced in Prizewinning Watercolors, 1967, Assoc. Dir., Old Bergen A. Gld.

GASPARO, ORONZO VITO—Painter
167½ East 115th St., New York, N.Y. 10029
B. Rutigliano-Prov., Bari, Italy, Oct. 16, 1903. Studied: Sch. Des. & Liberal Arts, N.Y.C., (scholarship); NAD, and with Preston Dickinson. Member: AEA; Village A. Center. Awards: prizes, Village A. Center, 1951, 1958; Huntington Hartford Fnd. Grant, 1956-1957. Work: MModA; MMA; WMAA; Four Arts, Palm Beach; Cover des., The Reporter magazine, 1967. Exhibited: MModA, 1936; AIC; CGA, 1939; WFNY 1939; GGE, 1939; WMAA, 1938-1941, 1944, 1946; CAM, 1945; Carnegie Inst., 1941, 1945; Riverside Mus., 1945, 1952; Staten Island Mus., 1961; Contemporaries, N.Y., 1964; Tacoma A. Mus., 1964; Retrospective No. 1, Tutti Gal., N.Y., 1962; one-man: Tilden & Thurber Gal., Providence, R.I., 1928; Ferargil Gal., 1942-1944, 1948; Mortimer Levitt Gal., 1945-1954; Village A. Center, 1949-1958; Rutigliano, Italy, 1955-56; Bari, Italy, 1956; Schneider Gal., Rome, 1956; Crespi Gal., N.Y., 1957; Morris Gal., N.Y., 1960; N.Y. Univ., 1963; N.Y. Univ. Catholic Center, 1964; Gallerie Fontainebleau, Miami Beach, Fla., 1967; AEA Gal., 1968; Dir., Oronzo's Studio Gallery, New York, N.Y.

GASPARRO, FRANK—Sculptor, T.
216 Westwood Park Drive, Havertown, Pa. 19083
B. Philadelphia, Pa., Aug. 26, 1909. Studied: PAFA, and with Charles Grafly. Member: Soc. Medalists; F., PAFA; French Soc. of the Medal; AEA. Awards: Cresson Traveling Scholarship, PAFA, 1930, 1931, Braverman sculpture prize, 1959, 1962-1965; DaVinci Silver Medal, Phila., 1959; Am. Numismatic Soc., gold medal as outstanding Numismatic Sculptor of year, 1968. Work: Designed and executed Stroud Jordan Medal, 1953; U.S. Coast Guard Commendation Medal, 1953; U.S. Central Intelligence Medal, 1955; Philadelphia Medal of Honor, 1955; U.S. Sec. of Treasury Robert B. Anderson Medal, 1958; U.S. Congressional Medal to Adm. Hyman Rickover, 1958; U.S. One Cent (reverse), 1959; Kennedy half-dollar (reverse), 1964; many medals designed and executed for U.S. Mint.

Medals of: Douglas MacArthur; Thomas A. Dooley III; Sam Rayburn; Winston Churchill; Secs. Treas., David Kennedy, Henry Fowler and Joseph Barr; Dir., of Mint, Eva Adams; Padre Serra (California Medal); Am. Numismatic Assn. medal, 1969; Pony Express medal, 1960; Statue of Liberty Series, Nat. Shrines medals, 1965; Pres. Richard M. Nixon medal (obverse & reverse), 1969. Exhibited: PMA sculpture exh., 1940; PAFA, 1946; medals at French Mint, Paris, France, 1950; Spanish Int. Medallic Art Exh., Madrid, 1952, 1968; Int. Medallic Exh., "Woman on the Medal." Recipient Diploma Citation as Engraver. Positions: Instr., Fleisher A. Sch., Phila., Pa., 1946- ; Engraver, United States Mint, Philadelphia, Pa., 1942- Chief Engraver, 1965- ; Bd. Dirs., PAFA Fellowship, 1958- .

GASSER, HENRY MARTIN—Painter, T., W., L.
654 Varsity Rd., South Orange, N.J. 07079
B. Newark, N.J., Oct. 31, 1909. Studied: Newark Sch. F. & Indst. A.; ASL, and with Brackman, Grabach. Member: Conn. Acad. FA; AWS; Phila. WC Cl.; New Jersey WC Cl.; Baltimore WC Cl.; SC; All. A. Am.; Audubon A; New Haven Paint & Clay Cl.; SSAL; AAPL; Springfield A. Lg.; NAD; NAC; ASL. Awards: prizes and medals, Smithsonian Inst., 1941; Montclair A. Mus., 1941, 1943, 1945, 1946; Balt. WC Cl., 1942, 1950; Alabama WC Cl., 1943, 1945, 1946, 1953; NAD, 1943, 1944; Oakland A. Gal., 1943, 1952; Springfield A. Lg., 1943, 1945; New Haven Paint & Clay Cl., 1944; Wash. WC Cl., 1945, 1946, 1948; New Orleans AA, 1945, 1946; Phila. WC Soc., 1945; State T. Col., Indiana, Pa., 1946; SSAL, 1946; AWS, 1943, 1944, 1947, 1948; SC, 1947, 1949, 1951; Corpus Christi Mus., 1947; Cal. WC Soc., 1948; Am. Veterans Soc. A., 1949, 1963; All. A. Am., 1950; Peale Mus. A., 1950; Conn. Acad. FA, 1951, 1952; Audubon A., 1952; AAPL, 1953; Rockport AA, 1953; Butler AI, 1954; NAC, 1954, 1955; New Jersey State Exh., 1954, 1965; AWS, 1955, 1967; SC, 1955; Balt. WC Cl., 1955; Palm Beach, Fla., 1955; Council of A. Soc., bronze medal, 1964. Work: PMA; New Haven Paint & Clay Cl.; Newark Mus. A.; Springfield (Mo.) Mus. A.; Washington State Col.; MMA; Dallas Mus. FA; IBM; Montclair A. Mus.; New Britain Inst.; BMFA; Canajoharie Mus. A.; NAC; Staten Island Inst. A. & Sc.; U.S. War Dept.; SAM; Farnsworth A. Mus.; Frye Mus.; Springfield (Mass.) Mus. and many others. Exhibited: Carnegie Inst.; NAD; AIC; AWS; Phila. WC Cl.; Wash. WC Cl.; All. A. Am.; SFMA; Audubon A.; Albany Inst. Hist. & A.; Texas Int. Exh.; Cal. PLH; Denver A. Mus.; Mississippi AA; Oakland A. Gal; Mint Mus. A.; Alabama WC Soc.; Smithsonian Inst.; Montclair A. Mus.; Balt. WC Cl.; New Haven Paint & Clay Cl.; New Orleans AA; High Mus. A.; Guatemala Nat. Fair; CGA; and in many other national museums. Positions: Dir., Newark Sch. F. & Indst. A., Newark, N.J., 1946-1954; Instr., ASL, N.Y.; Contributing editor, "American Artist Magazine." Author: "Casein Painting: Methods and Demonstrations"; "Oil Painting: Methods and Demonstrations"; "Watercolor—How to do it"; "Techniques of Painting"; "Techniques of Painting the Waterfront."

GASTON, MARIANNE BRODY—Painter, Comm., I., Des., Gr., S.
226 W. San Marino Dr., Miami Beach, Fla. 33139
B. New York, N.Y. Studied: Washington Irving A. Sch.; MMA; ASL, with Brackman, Vytlacil, R. Soyer; Parsons Sch. Des.; Great Neck AA, with M. Soyer and Irving Maranz; privately with Jack Levine. Member: ASL; Great Neck AA; NAWA; Knickerbocker A.; North Shore AA of N.Y.; AEA; Advertising Cl. of Greater Miami; A. Dir. Cl. Awards: Alexander medal, School A. Lg., 1934; Scholarships: MMA and Mus. Natural Hist., N.Y., 1934-1936; Parsons Inst. for Fashion Illus., 1936; A. Dir. Cl. award for Fashion Illustration, 1941; Atkins award, NAWA, 1955. Work: N.Y. Pub. Lib.; A. Dir. Cl., N.Y.; Freelance fashion commissions: Franklin Simon, Saks Fifth Ave., Bonwit Teller, Helena Rubinstein, B. Altman, De Pinna, Bloomingdales, Best & Co., all New York; Vogue; Harpers Bazaar; Cue (cover art); Glamour; McCalls; Parents; Simplicity (cover art); Good Housekeeping; N.Y. Times (color ads); Herald Tribune (color ads), and others; magazines and newspapers in Canada, Mexico and Sweden. Others include, Knox Hats; Pacific Mills; Pettingill Dorland Int.; and for many advertising agencies. Exhibited: NAWA, 1950-1960; Argent Gal., 1950; Riverside Mus., 1951; Knickerbocker A., 1950-1953; NAD, 1951-1953; Audubon A., 1952, 1953; Contemp. A., 1951-1953; one-man: Batten Barton Durstine & Osborn; Grey Adv., 1950; Best & Co., N.Y., 1958; Gilgolde Gal., Great Neck, N.Y., 1959, 1960; The Art Gal., Dallas, 1961; Hotel Fontainebleau, Miami Beach, 1961, Instr., A., New York, Great Neck and Miami Beach; Barcardi Gal., Miami. Creator of "Bead-L-Point," a new art craft sold as a "Do It Yourself Kit."

GATES, JOHN MONTEITH—Architectural Designer
715 Fifth Ave. 10022; h. 131 E. 66th St., New York, N.Y. 10021
B. Elyria, Ohio, June 25, 1905. Studied: Harvard College; Columbia Univ., Sch. of Architecture, B. Arch. Member: AIA; AFA; Benjamin Franklin Fellow, Royal Soc. A., London; IND Des. Soc. of America. Award: 1st prize, Intl. Comp. (Des.), Stockholm, Sweden, 1933. Work: Steuben Glass des. in several U.S. Museums (Toledo, Chicago, Kansas City, etc.). Exhibited: Fine Arts Soc., London; Paris Salon, and others. Positions: Dir. Des., Steuben Glass Co., 1934- ; and, Corning Glass Works, 1957- .

GATEWOOD, MAUD F.—Painter
2309 Pender Place, Charlotte, N.C. 28209
B. Yanceyville, N.C., Jan. 8, 1934. Studied: Univ. North Carolina, Greensboro, A.B.; Ohio State Univ., M.A.; also, Harvard Summer Sch.; Univ. Vienna; Acad. Applied Arts, Vienna; Oskar Kokoschka Summer Academy. Member: Assoc. A. North Carolina. Awards: Fulbright Grant, 1962-1963 (Vienna); prizes, North Carolina Artists Annual, 1959, 1968; Winston-Salem Gal FA, 1965; Fort Worth A. Center, Texas, 1962; Danville, Va., 1965; Piedmont Purchase Exh., Mint Mus., 1968. Exhibited: Alabama AA, 1957; Delgado Mus. A., New Orleans, 1957; Painting of the Year, Atlanta, 1958; N.C. Artists, 1958, 1961, 1966, 1968; Carolina Mus. A., Raleigh, 1960, 1966, 1968; LC, 1960; Sarasota, Fla., 1962; DMFA, 1962; Denver A. Mus., 1961; Univ. North Dakota, 1962; Southeastern Annual, Atlanta, 1966, 1967, 1968; Winston-Salem, 1964, 1965; one-man: Mint Mus. A., 1965, 1967; Winston-Salem Gal. FA, 1965, 1968. Positions: Asst. Prof., Univ. of No. Carolina at Charlotte.

GATRELL, MARION THOMPSON—Painter, Gr., E.
School of Fine and Applied Arts, Ohio State University; h. 1492 Perry St., Columbus, Ohio 43201
B. Columbus, Ohio, Nov. 13, 1909. Studied: Ohio State Univ., B.Sc. in Edu., M.A. Member: Columbus A. Lg.; NAWA; Ohio WC Soc. Awards: prizes, Columbus A. Lg., 1939, 1945, 1949, 1951, 1954, 1963, 1968; Massillon Mus., 1964, 1967; Ohio State Fair, 1938, 1939, 1941, 1950, 1951, 1953, 1955; Ohio Valley exh., Athens, 1943, 1948, 1949, 1959; Butler AI, 1950, 1957, 1958; Union A. Exh., 1957. Work: Univ. Sch., Columbus; Butler Inst. Am. A.; Otterbein Col.; Steubenville Col.; B'nai B'rith Hillel Fnd.; Massillon Mus.; Columbus Gal. FA. Exhibited: Audubon A., 1945; Ohio Valley exh., 1943-1946, 1948-1955, 1957; Butler AI, 1945, 1950-1952, 1957, 1958; Union A. Exh., 1957; Parkersburg, W. Va., 1942; Toledo Mus. A., 1939-1945; Columbus A. Lg., 1937-1960, 1964-1968; Ohio WC Soc., 1939-1956; Columbus Gal. FA, 1957; Ohio Wesleyan Univ., 1957; Ohio State Fair, 1938-1941, 1949-1960, 1964; Massillon Mus. A., 1950-1957, 1964-1967; Ohio Pr. M., 1951-1956, 1959; Union annual art exh., 1957-1960; Edgecliff Acad. FA, 1965; NAWA, 1965; Nat. Gal., Scotland, 1963; Royal Birmingham Soc. A., England, 1964; U.S. traveling exh., India and France, 1965; N.Y. World's Fair, 1965; USA traveling oils, 1967-1969; USA traveling graphics 1967-1969; traveling exh., France & Canada, 1969. 24 two-man shows, with R. Gatrell, including Huntington Gal., 1968; Canton A. Inst., 1968. Positions: Assoc. Prof., Sch. FA, Ohio State Univ., Columbus, Ohio, at present.

GATRELL, ROBERT M.—Painter, Gr., E.
School of Fine & Applied Arts, Ohio State University; h. 1492 Perry St., Columbus, Ohio 43201
B. Marietta, Ohio, May 18, 1906. Studied: Ohio State Univ., B.Sc. in Edu.; M.A. Member: Columbus A. Lg.; AWS; Hunterdon County AA, N.J. Awards: prizes, Ohio State Fair, 1938-1941, 1949-55, 1957, 1959; Governors Award, 1939, 1952; Ohio WC Soc., 1942-1944, 1954, 1956; Columbus A. Lg., 1938, 1941, 1943, 1947-1951, 1953-1961, 1965; Ohio Valley Exh., 1944, 1948, 1953; Veterans A. Exh., 1951; Canton, Ohio, 1952; Union Annual Exh., 1955, 1960; Massillon Mus., 1964, 1965; Northwestern Pr.M., 1956, Ohio Pr.M., 1956; College Print Exh., 1956; AWS, 1958, 1960; Nat. WC Exh., 1962; Ohio Drawing & Pr. Show, Cuyahoga A. Center, 1969. Work: Dunbar Mus., Dayton, Ohio; Dennison Univ.; Ohio Northern Univ.; Ohio State Univ.; Massillon Mus.; Canton Mus. A.; Otterbein College; Columbus Gallery of Fine Arts; University School, Columbus, Ohio; B'nai B'rith Hillel Foundation, Columbus, Ohio; Butler Inst. Am. A.; Crocker Gal. A.; Kent State Univ.; Grumbacher Coll. Exhibited: VMFA, 1938; AWS, 1942, 1943, 1950, 1955, 1958-1960; Audubon A., 1945, 1948, 1950, 1963; Oklahoma A. Center, 1941, 1965; Columbus A. Lg., 1929-1960; Ohio WCSoc., 1940-1956; Butler AI, 1938, 1942, 1948, 1950-1953, 1955, 1957, 1965; Ohio Valley, 1943, 1944, 1946, 1948-1959; Ohio Pr.M., 1939, 1947-1960, 1964; SAGA, 1947, 1948, 1950, 1951, 1954; BM, 1949, 1962; PAFA, 1949; Phila. Pr. Cl., 1949, 1951, 1952, 1954; Northwest Pr.M., 1948, 1956; Terry AI, 1952; Fla. Southern Col., 1952; Wichita A. Mus., 1952, 1953, 1956; Northwest Territory Sch., 1948; Nat. Ser. Soc., 1951, 1952, 1954; Massillon Mus., 1949-1961, 1963-1965; Canton Mus. A., 1951-1953, 1955, 1956; MMA, 1952; Inner Valley Exhib., 1955, 1961; Tri State Jury Show, Chautauqua, N.Y., 1955; LC, 1955; Magnificent Mile Art Festival, Chicago, 1955; Union Annual Exh., 1955, 1956-1960; Ball State T. Col., 1957, 1959, 1962; Springfield A. Mus., 1962, 1965; Norfolk Mus. A., 1963; Tweed Gal., 1963; Hunterdon A. Center, 1963-1969; Edgecliff Acad., 1965; CGA, 1959; Peoria, 1960; Cincinnati Biannual, 1968; Purdue Univ., 1966; Cuyahoga A. Center, 1967, 1969; Bexley A. Gld., 1967; Columbus Festival of A., 1967; Temple Israel Int. Show, 1967; Columbus Gal. FA, 1969; 24 one-man & two-man exhs. Positions: Prof., Sch. FA, Ohio State Univ., Columbus, Ohio, at present.

GAUCHER, YVES—Painter
c/o Martha Jackson Gallery, 32 E. 69th St., New York, N.Y. 10021*

GAYLORD, FRANK—Sculptor, P., T., L.
25 Delmont Ave., Barre, Vt. 05641
B. Clarksburg, W. Va., Mar. 9, 1925. Studied: Temple Univ., Tyler Sch. FA; Carnegie Inst. Tech. Member: NSS. Awards: prizes, Tyler Alumni Exh., 1950; Monument Builders of America, 1963. Work: Shrines (monuments), Detroit, Chicago, New Haven, Buffalo, Niagara Falls, Mamaroneck, N.Y., New Britain, Conn., Worcester, Mass. and others. Positions: Owner and Sculptor, F. C. Gaylord Sculpture Studios, Barre, Vermont.

GAYNE, CLIFTON ALEXANDER, JR.—Educator
Art Education Department, University of Minnesota, Minneapolis, Minn.; h. 1415 North Cleveland Ave., St. Paul, Minn. 55108
B. Watertown, Mass., July 13, 1912. Studied: Massachusetts Sch. A., B.S.; Univ. Minnesota, M.A., Ph.D., and widely in Europe. Member: NEA; Minnesota Edu. Assn.; Minnesota A. Edu. Assn.; Western AA; NAEA; Int. Soc. for Edu. Through Art; Comparative Edu. Soc.; AAUP. Contributor articles to professional journals. Positions: for Western AA: Council Memb., 1948-49, Chm., College T. of A. Edu. Section, 1952-56; Chm., Publications Com., 1952-54; Editor, Western Arts Bulletin, 1952-54; for NAEA: Chm., Nomination Com., 1949-51; Chm., Constitutional Revision Com., 1953-55; Chm., Accreditation Com., 1955-59; Rep. to NEA Comm. on T. Edu. and Prof. Standards, 1950, 1958; Chm., Com. on Standards for Preparation of A. Teachers of the NAEA College T. of A. Edu., 1953- ; for Minnesota State Dept. of Edu.: Consultant in A. Edu., 1945-48; Chm., Com. on Evaluation in Art, Dramatics and Music, 1955- ; Memb. Bd. Dir., Int. Inst. of St. Paul, 1953- ; Bd. Dir., St. Paul Council on Arts & Sciences, 1956- ; Comm. which est. the St. Anthony Park Community Interest Center, 1951-53; Chm., Dept. Art Edu., Univ. of Minnesota, Minneapolis, Minn. at present.*

GEBER, HANA—Sculptor, L., T.
168 W. 225th St., New York, N.Y. 10463
B. Prague, Czechoslovakia. Studied: T. Col., N.Y.; Charles Univ., Prague; ASL. Member: NAWA; N.Y. Women A.; Lg. of Present Day A.; Audubon A. Awards: Fellowship grant, Mem. Fnd. for Jewish Culture, 1968-1969. Work: Jewish Mus., N.Y.; Montclair (N.J.) Mus. A.; Univ. Massachusetts Mus.; Norfolk Mus. A. & Sciences; Riverside Mus., N.Y.; Fordham Univ.; N.Y. Univ.; Mills Col.; Lannan Fnd., Chicago; Int. Synagogue, Kennedy Airport, N.Y.; Lowe Mus., Miami; and in private colls. Memorial for Verona (N.J.) H.S., 1965. Exhibited: Buenos Aires, Argentina, 1962; traveling exhs.: USIA, South America, 1963-1965; AFA, 1960-1961; Jewish Mus., 1967; group exhs.: PAFA; Jewish Mus.; Riverside Mus., N.Y.; BMA; Montaclisr Mus. A.; BMFA; Mus. FA, Springfield, Mass.; Mus. FA, Montgomery, Ala.; Norfolk Mus. A. & Sciences; Mus. Contemp. Crafts, N.Y.; Art:USA. One-man: East Hampton Gal., N.Y., 1963, 1966; Fordham Univ., 1966; Chautauqua (N.Y.) AA, 1964; Phila. A. All., 1963; Montclair Mus. A., 1963.

GEBHARD, DAVID—Museum Director, E.
The Art Galleries, University of California, Santa Barbara, Cal. 93106
B. Canon Falls, Minn., July 21, 1927. Studied: Univ. Minnesota, B.A., M.A., Ph.D. Member: CAA; Soc. Arch. Historians; Soc. for Am. Archaeology; Archaeological Soc. New Mexico (Trustee); Southwest Des. Council (Sec.). Author: "Purcell & Elmslie, Architects," Walker A. Center, 1953; "Petroglyphs of Wyoming: A Preliminary Paper," El Palacio, Mar. 1951. Lectures: History of American Architecture from 1890-1920; North American Indian Art; "Cave Paintings of the Lower Pecos River"; "A Guide to Architecture in Southern California," 1965; "George Washington Smith," 1964; "The Art of Easter Island," 1963; "R. M. Schindler, Architect," 1967; "1868-1968 Architecture in California," 1968; "Kem Weber, The Moderne in Southern California," 1969. Positions: Instr. A. & Arch. Hist., Univ. New Mexico, 1953-55; Dir., Roswell Museum, Roswell, N.M., 1955-61; Assoc. Prof. A., Dir., A. Gal., University of California, Santa Barbara, Cal., 1961- , Prof. A., 1968- .

GEBHARDT, ANN STELLHORN (Mrs. Bruce)—Painter, E.
Queens College; h. 2500 Sherwood Ave., Charlotte, N.C. 28207
B. Leavenworth, Kans., Mar. 13, 1916. Studied: Lake Erie Col. for Women; Ohio State Univ., B.F.A., M.A., with Carolyn G. Bradley, James R. Hopkins, Alice Schille. Member: Charlotte A. Gld. Exhibited: Mint Mus. A., 1951 (two-man). Positions: Asst. Prof. A., and Dean of students, Queens College, Charlotte, N.C.

GEBHARDT, HAROLD—Sculptor, E.
13186 Glenoaks Blvd., Sylmar, Cal. 91342
B. Milwaukee, Wis., Aug. 21, 1907. Studied: Layton Sch. A. Awards: prizes and medals, Wisconsin U., 1936; Wisconsin P. & S., 1937; Milwaukee AI, 1937; Los A. Mus. A., 1946, 1950; City of Los Angeles, 1948. Member: Los A. Mus. A. Work: Milwaukee Pub. Lib.; State T. Col., Milwaukee, Los A. Mus. A., and in private colls. Exhibited: Fleischer Anhalt Gal., Los Angeles; Doane Col., Crete,

Nebr.; two-man: Occidental Col., Los Angeles; Trinity Univ. Gal., San Antonio, Tex.; one-man: Santa Barbara Mus.; Fleischer Anhalt Gal.; San Bernardino Col.; Father-Son show: University Gal., Univ. of Southern Cal., Los Angeles. Positions: Prof. S., Univ. Southern California, Los Angeles, Cal.

GECHTOFF, SONIA—Painter, E.
326 W. 15th St., New York, N.Y. 10011
B. Philadelphia, Pa., Sept. 25, 1926. Studied: PMSch. FA, B.F.A.; Cal. Sch. FA. Awards: prizes, San F. AA, 1952-1956; Santa Barbara Pacific Coast Exh., 1957; Ford Fnd. Fellowship, Tamarind Lithography Workshop, 1963 (summer). Work: Oakland A. Mus.; SFMA; Singer Co. Coll.; Lannan Fnd., Chicago; Woodward Fnd., Wash., D.C.; Univ. Mass.; Univ. Cal. (Davis). Exhibited: PAFA, 1952; Guggenheim Mus., 1953; Carnegie Inst., 1958; Brussels Worlds Fair, 1958; Univ. Illinois, 1959; WAC, 1960; Paris Biennale, 1959; WMAA, 1959, 1961; Sao Paulo, Brazil, 1961; Int. Council of MModA traveling exh. drawings, 1962-1963; SFMA, 1952-1958; Univ. Texas, 1966; Oklahoma A. Center, 1968; Los Angeles County Mus., 1969; one-man: de Young Mem. Mus., San Francisco, 1957; Ferus Gal., Los Angeles, 1955-1957; Poindexter Gal., N.Y., 1959-1960; East Hampton Gal., N.Y., 1963, 1966, 1969. Positions: Instr., Advanced Painting, Cal. Sch. FA, 1957-58; Adjunct Asst. Prof. A., New York Univ., N.Y., 1961- .

GECK, FRANCIS JOSEPH—Educator, Des., W., L., P.
University of Colorado; h. 407 16th St., Boulder, Colo. 80302
B. Detroit, Mich., Dec. 20, 1900. Studied: N.Y. Sch. F. & Appl. A., New York and Paris, France; Syracuse Univ. M.F.A. Member: Boulder A. Gld.; A. Assn. of Boulder; Mediaeval Acad. America; Bibliographical Soc. of America; Delta Phi Delta Nat. Pres. 1954-1958; Boulder Hist. Soc.; Michigan WC Soc.; Parsons Sch. Des. Alumni Council (V. Pres., 1952-1955); A.I.D.; Education Assn., 1954- , Chm., Comm. on Edu., Rocky Mountain Chptr., 1957-1958; Adult Education Council of Denver; Interior Des. Educators Council (Exec. Comm. 1963-1965). Awards: Florida International A. Exh., 1952; Gold Medal, AAPL, 1953; Citation of Merit, A.I.D., 1963. Exhibited: Univ. Washington, 1956; Bethany College, 1950, 1959, 1961; Colo. State Col., Greeley, 1958; Brigham Young Univ., 1959, 1961; Oklahoma A. Center, 1960; Mus. New Mexico, Santa Fe, 1960; Drake Univ., 1961; Denver A. Mus., 1962; Southeast Missouri State Col., Dakota Wesleyan Univ., Wichita Falls AA, all 1962; New Mexico State Univ., 1963; Kansas State Univ., 1963; Boulder Pub. Lib., 1964-1969; Pavilion of American Interiors, N.Y. World's Fair 1965, and many others in prior dates. Author: "Interior Design and Decoration," 1962; "Dial-A-Style: English Period Furniture," 1966. Contributor of many articles on art and education to The Palette, Bulletin of Colorado State A. Assn.; The School Executive, American Institute of Decorator's Magazine and others. Positions: Prof. FA, Cur. Exhibitions, Univ. Colorado, Boulder, Colo., 1930-1957; Dir., Exhibits, Pioneer Museum, Boulder, Colo., 1957- .

GEESEY, TITUS CORNELIUS—Collector, Patron
1100 Barton Circle, Westover Hills, Wilmington, Del. 19807
B. Winterstown, Pa., Feb. 3, 1893. Studied: Goldey Business College, Wilmington, Del. Awards: Citation from Pennsylvania German Folklore Society, 1964. Donor: Six galleries of Pennsylvania "Dutch" Folk Art to the Philadelphia Museum of Art; Collection of American Toys to York Historical Society, York, Pa.; Furnishings to Plough Tavern, York, Pa., etc. Collection: Early American Decorative Arts; American Paintings. Positions: Trustee, Philadelphia Museum of Art.

GEESLIN, LEE GADDIS—Painter, Gr., E.
Sam Houston State College; h. 1909 Avenue Q, Huntsville, Tex. 77340
B. Goldthwaite, Tex., June 28, 1920. Studied: Univ. Texas; New Orleans A. & Crafts; AIC, B.F.A., M.F.A. Member: Texas WC Soc.; Texas FA Soc.; Texas A. Edu. Assn.; AAUP; CAA. Exhibited: Annually with local and regional shows of the Southwest. One-man: Brownsville, San Angelo, Houston, Corpus Christi, Brady, Lufkin, Dallas, Texarkana, all Texas and Shreveport, La. (all since 1963). Positions: Prof. A., Hd. A. Dept., Dean, School of Art., Sam Houston State College, Huntsville, Texas.*

GEHNER, MARJORIE NIELSEN—Painter, C.
189 Park Ave., Leonia, N.J. 07605
B. Florence, Wis., May 26, 1909. Studied: Ripon (Wis.) Col.; Wisconsin State Col., B.E., with Robert Von Neumann; New School, N.Y., with Camilo Egas; BMSch.A.; T. Col., Columbia Univ., M.A.; and with Arthur Young. Member: NAWA; Am. Crafts Council; AFA; AWS; AAUW. Awards: prizes, NAWA, 1960; Des.-Craftsmens Exh., N.Y., 1960; State Fed. Women's Cl.; AAUW. Exhibited: NAWA, 1959-1969; AWS, 1961-1969; one-man: Leonia, N.J., 1959; Columbia Univ., 1960; Panoras Gal., N.Y., 1961; Ripon Col.; 5 one-man exhs. New York City since 1960; traveling exhs., U.S., Canada, France.

GEIGER, EDITH R. (Mrs. Arthur)—Painter
Amity Rd., Woodbridge, Conn. 06525
B. New Haven, Conn., July 13, 1912. Studied: Smith Col.; ASL; Yale Sch. FA, and in Denmark & Mexico. Member: NAWA; AWS; Conn. WC Soc. Awards: prizes, Conn. Acad. FA, 1951; Essex Gal., 1953, 1959; Cape Cod AA, 1954, 1955; New Haven Paint & Clay Cl., 1956; AWS, 1957; NAWA, 1957; New Haven A. Festival, 1958, "Best in Show," 1964. Work: Wadsworth Atheneum, Hartford; Smith Col. Mus.; Springfield Mus. A.; Ann Arbor, Mich. Exhibited: BM, 1961; Detroit Inst. A., 1961; AWS, N.Y. & traveling exhs.; The Contemporaries, N.Y., 1964; one-man: Bodley Gal., N.Y., 1956; Ruth White Gal., N.Y., 1959, 1962; Wellfleet A. Gal., Palm Beach, Fla., 1968; Naples (Fla.) A. Gal., 1969.

GEISEL, THEODOR SEUSS ("Dr. Seuss")—Illustrator, Des., Cart., W.
Random House, 457 Madison Ave., New York, N.Y. 10022
B. Springfield, Mass., Mar. 2, 1904. Studied: Dartmouth Col., A.B., and (Hon.) Doctor of Humane Letters, 1956; Lincoln Col., Oxford, England. Awards: Legion of Merit, World War II, for education and informational films; Academy Award, 1946: Your Job in Germany, for U.S. Army, Best Documentary Short; Academy Award, 1947: "Design for Death" (with Mrs. Geisel) a history of the Japanese people, Best Documentary Feature; Academy Award, 1951: "Gerald McBoing-Boing," animated cartoon. Work: All "Dr. Seuss" book illus. & Ms. in Library of Univ. of California, Los A. Exhibited: one-man: Fine Arts Gallery of San Diego, 1958. Lectures: Children's Books: Illustrating and Writing. Advertising campaigns for industrial firms including Standard Oil, New Jersey; Esso Marine Products; Atlas Products Tires; New Departure Bearings, and others. Magazine illus. and stories to Judge, Life, College Humor, Vanity Fair, Redbook, N.Y. Times Book Review, etc. Author, I., "And to Think I Saw It On Mulberry Street," 1937; "The 500 Hats of Bartholomew Cubbins," 1938; "The Cat in the Hat," 1957; "Yertle the Turtle," 1958; "The Cat in the Hat Comes Back," 1958; "The Cat in the Hat Songbook," 1967; "The Foot Book," 1968, and many others prior in date. Positions: Pres., Beginners Books (Division of Random House).*

GEIST, SIDNEY—Sculptor
11 Bleecker St., New York, N.Y. 10012
B. Paterson, N.J. Apr. 11, 1914. Studied: ASL; Academie de la Grande Chaumier, Paris, France. Awards: Olivetti Award, Silvermine Gld., 1960. Exhibited: Carnegie Inst., 1958; San Francisco AA, 1959, AIC, 1962; BMA, 1969, and others in New York, Paris and Mexico City; one-man: Galerie 8, Paris, 1950; Tanafer Gal., N.Y., 1957, 1960 (2); 2-man: Dilexi Gal., N.Y., 1959.

GEKIERE, MADELEINE—Painter, E., I.
427 West 21st St., New York, N.Y. 10011
B. Zurich, Switzerland, May 15, 1919. Studied: Gymnasium, Zurich; ASL, with Morris Kantor; BMSch. A., with Rufino Tamayo; N.Y. Univ. with Samuel Adler. Member: AEA; Audubon A. Awards: Citation by Art Jury, N.Y. Times, for children's book illustrations, 1953, 1955, 1957, 1959, 1963; prize, Audubon A., 1969. Work: WMA; Richmond (Ind.) AA; A. Gal., Toronto; BMA; BM; Butler Inst. Am. A.; City A. Mus., St. Louis; CMA; DMFA; Des Moines A. Center; FMA; SFMA; Norfolk Mus. A.; Phoenix FA Assn.; Univ. Nebraska; WMA; N.Y. Univ. Coll.; N.Y. Pub. Lib. Exhibited: One-man: Bonestell Gal., N.Y., 1948; Meltzer Gal., N.Y., 1954, 1956; Babcock Gal., N.Y., 1960, 1961, 1962, 1966, 1967; Univ. Georgia, 1967. Illus.: "The Fisherman and His Wife," 1959; "The Reason for the Pelican," 1959; "John J. Plenty and Fiddler Dan," 1963. Positions: Asst. Prof. A., New York University, New York, N.Y. Lecturer: Loeb Student Center, N.Y. Univ.; City Col., N.Y.; Visiting Prof., Univ. Georgia, 1967.

GELB, JAN—Painter, Et., T.
749 West End Ave., New York, N.Y. 10025
B. New York, N.Y., July 18, 1906. Studied: Yale Sch. FA; ASL; and with Sigurd Skou. Member: MacDowell Colonists; SAGA; Audubon Artists; Am. Color Print Soc.; Provincetown AA. Awards: prizes, Boston A. Festival, 1953; PMA purchase prize, Phila. Pr. Cl., 1958; Atwater Kent award, 4 Arts Soc., 1962; Vera List purchase award, SAGA, 1968; N.Y. State Univ., Potsdam, purchase, 1967; Dulin Gal., Knoxville, Tenn., purchase, 1968. Exhibited: BM, Phila. Pr. Cl., WMAA, PAFA, MMA, Kraushaar Gal., N.Y., Boston A. Festival, Am. Acad. A. & Lets.; NAD; Butler Inst. Am. A.; Provincetown A. Festival, de Cordova Mus., 1965; Ball State T. Col., 1965; one-man: Weyhe Gal., 1948, 1950; Ganso Gal., 1954; Esther Robles Gal., Los A., 1958; Ruth White Gal., N.Y., 1957, 1959, 1961, 1962, 1966; Smithsonian Inst., 1963; Galerie AG, Paris, 1960; Piccadilly Gal., London, 1961. Work: PMA; MModA; BMA; Abbot Acad.; Univ. Delaware; MMA; LC; BMA; Rosenwald Coll., Nat. Gal.; Howard Univ.; WMAA; St. Lawrence Univ.; Everson Mus., Syracuse; Phoenix Mus. of A.; Los Angeles County Mus.; Norfolk Mus. (Va.); Syracuse Univ.; U.S. Embassies Coll., and in private colls.

GELDZAHLER, HENRY—Museum Curator
Metropolitan Museum of Art, Fifth Ave. at 82nd St. 10028; h. 112 W. 81st St., New York, N.Y. 10024
B. Antwerp, Belgium. Studied: Yale University, B.A.; Year of study in Paris at the Sorbonne and Ecole du Louvre; Harvard Graduate School of Fine Arts; Teaching Fellow, Harvard University, Department of Fine Arts. Contributor articles to Herald Tribune Book Review, N.Y.; Art News; Arts; Gazette des Beaux-Arts; Art International; Art Forum; The Hudson Review. Author: "American Painting in the Twentieth Century." Positions: Curatorial Assistant, 1960-1962, Assistant Curator, 1962-1963, Associate Curator, 1963-1967, Curator of Contemporary Arts, 1967- , The Metropolitan Museum of Arts, Department of American Paintings and Sculpture, New York, N.Y. Commissioner, Venice Biennale Program, 1966; Director, Visual Arts, National Council on the Arts, (resigned, 1969).

GELINAS, ROBERT WILLIAM—Painter, E., S., Gr.
Art Department, University of South Florida; h. 14820 N. Rome Ave., Tampa, Fla. 33607
B. Springfield, Mass., Mar. 1, 1931. Studied: Univ. Connecticut; Univ. Alabama, B.F.A., M.A. Awards: prizes, Hunter Gal., Chattanooga, 1960; Mississippi AA, 1958; purchase: "Painting of the Year" exh., Atlanta, 1961; Mid-South Annual, Memphis, 1961; Little Rock, Ark., Graphics, 1960; Montgomery Mus. FA, 1957; Scholarship Grant & Assistantship Grant, Univ. Alabama, 1958. Work: Atlanta AA; Kelly Fitzpatrick Mem. Coll., Montgomery; Brooks Mem. Gal., Memphis; LC; Little Rock Mus. FA; sculpture: Wesley Fnd. Chapel, Memphis State Univ. Exhibited: Art: USA, 1958; CGA, 1959-1961; Butler Inst. Am. A., 1956; Wash. WC Cl., 1956; Birmingham AA, 1956-1958; Mississippi AA, 1956-1959; Delgado Mus. A., 1958, 1960; Montgomery, Ala., 1956, 1957; Little Rock, Ark., 1958-1960; Tennessee FA Center, Nashville, 1960; Hunter Gal., 1960; Mid-South, 1957-1961; Painting of the Year Exh., Atlanta, 1957, 1961; Fla. State Fair, Tampa, 1964; Fla. Showcase, Rockefeller Center, N.Y., 1964; one-man: Univ. Alabama, 1958; Univ. Mississippi, 1960; Memphis State Univ., 1958. Positions: A. Dir., Tuscaloosa News (Ala.), 1955-57; Instr. A., Univ. Alabama, 1958; Prof. A., Memphis State University, 1958-1962; Prof. A., Univ. South Florida, Tampa, Fla., 1962- .*

GELLER, ESTHER (SHAPERO)—Painter
9 Russell Circle, Natick, Mass. 01760
B. Boston, Mass., Oct. 26, 1921. Studied: BMFA Sch. A., with Karl Zerbe. Award: Cabot Award, Boston, 1949. Work: BMFA; Addison Gal. Am. Art; Brandeis Univ. Exhibited: 1945-1965: SFMA; AIC; Univ. Illinois; WMA; Smith College Mus.; Brandeis Univ.; de Cordova & Dana Mus.; Mount Holyoke; Miami Univ.; Boston A. Festivals; Inst. Contemp. A., Boston; Fitchburg A. Mus.; one-man: Boris Mirski Gal., Boston, 1945, 1947, 1949, 1952, 1961; AGAA; Decenter Gal., Copenhagen, Denmark, 1969. Work or articles in: Artists at Work; The Layman's Guide to Modern Art; Encaustic; American Painters.

GELLMAN, BEATRICE (McNULTY) (Mrs. William C.)—
Painter, S., T., W., L.
Rockport, Mass. 01966
B. Philadelphia, Pa., Nov. 20, 1904. Studied: Univ. Pennsylvania, B.S. in Edu.; ASL, with William C. McNulty, Morris Kantor, Robert Beverly Hale, Kenneth Hayes Miller. Member: Rockport A.A.; ASL (Life). Work: Sneed Gal., Rockford, Ill.; Berthold Gal., Rockport, Mass., and in private collections. Exhibited: Rockport AA (one-man and group shows to 1961); one-man: Granite Shore Hotel Gal., Rockport, 1965; Gallery Seven, Boston, 1968; three-man: Lobby Gal., Rockport, Mass., 1969. Lectures: "Styling and Design Principles in the Works of Masters of Painting."

GENAUER, EMILY—Critic, W., L.
243 East 49th St., New York, N.Y. 10017
B. New York, N.Y. Studied: Hunter Col.; Columbia Univ. Sch. Journalism, B.Litt. Member: N.Y. Newspaper Women's Cl.; Int. Assn. of A. Critics. Awards: N.Y. Newspaper Women's Cl., annual award for outstanding column in any specialized field, 1935, 1948, 1956, 1958, 1960; Columbia Univ. Sch. Journalism, 1960, for distinguished service to journalism. Author: "Best of Art," 1948; Metropolitan Museum monograph on "Toulouse-Lautrec," 1954, "Chagall," 1956. Regular contributor articles on art to major national magazines. Lectures: "American Art Today"; "Functions of Art Criticism," etc. Positions: A. Cr., A. Ed., New York World-Telegram, 1932-1948; A. Cr., Columnist, New York Herald-Tribune, 1948-1966; Cr.-at-large, Newsday Syndicate, Garden City, L.I., N.Y., at present.

GENDERS, RICHARD ATHERSTONE—Painter
Naval Facilities Engineering Command, Washington, D.C. 20390; h. 4423 Vacation Lane, Arlington, Va. 22207
B. London, England, Aug. 3, 1919. Studied: John Herron AI, and with John W. Taylor, Edwin L. Fulwider, Donald M. Mattison. Member: SC; Indiana A. Cl.; Tidewater AA; Vice-Pres., Northern Virginia A.

Lg., 1969. Exhibited: John Herron AI; Indiana A. Cl.; Ohio Valley Exh.; Am. A. Week Exh., New Castle, Ind.; Tidewater AA; Norfolk Mus. A. & Sciences; Navy YMCA Exh.; one-man; Seattle Seafair, Seattle, Wash., 1955; Nat. Bank of Commerce, Norfolk, Va., 1957; Musée de la Marine, Paris, 1961; Royal Scottish Mus., Edinburgh, 1960; Nat. Maritime Mus., London, 1960. Continually represented in "Operation Palette," traveling exh., U.S. Navy coll. of selected paintings from Combat Art Section. Awards: prizes, Indiana State Fair; John Herron AI; Ohio Valley Exh., Athens, Ohio. Work: Many paintings of U.S. Fleet for U.S. Naval Historical Records. Designed International Naval Review U.S. Postage Stamp, 1958. Positions: Director, Production Division, Naval Facilities Engineering Command, Washington, D.C. at present.

GENIUS, JEANNETTE M. (Mrs. Hugh F. McKean)—Painter
 Box 40, Winter Park, Fla. 32789
B. Chicago, Ill. Member: NAWA (Hon. Vice-Pres.); Pen & Brush Cl.; AEA; Fla. Fed. A.; Fla. A. Group; New Hampshire AA; NAC; A.I.D. Awards: prizes, Fla. Fed. A., 1948; Soc. Four A., 1949, 1950, 1954; Pen & Brush Cl., 1953, 1959, 1962; Cervantes medal of Hispanic Inst. in Fla., 1952; Dec. Honor, Rollins Col., 1943; Sullivan medallion, 1954; Hon. D.F.A., Rollins College, 1962. Work: Georgia Mus. A., Univ. Georgia; Columbus Mus. A. & Crafts; Univ. Cl., Orlando; First Nat. Bank, Winter Park; Winter Park City Hall; San Joachim Pioneer Mus., Stockton, Cal., and in private colls. Exhibited: All. A. Am.; Pen & Brush Cl.; NAC; Studio Gld., N.Y.; Norton Gal. A., Palm Beach; Soc. Four A.; Jacksonville A. Cl.; Currier Gal. A.; Delgado Mus. A.; NAWA; Contemporary A. Gal., N.Y.; Butler AI; Am. Embassy Gal., Athens, Greece, 1957; Kunst Mus., Berne, Switzerland, 1959; Ministry of Edu., Rio de Janeiro, 1960; Pioneer Gal., Stockton, Cal.; Royal Scottish Acad. Gals., Edinburgh; Royal Birmingham Soc. Artists, England; Museo des Bellas Artes, Buenos Aires; NAWA South American Tour and tour of Mexico; one-man: Research Studios, Maitland, Fla., 1951; Contemp. A. Gal., 1953, 1956, 1964; A. Lg. of Manatee County, Bradenton, Fla., 1955; Pen & Brush Cl., 1959. Positions: Trustee, Rollins Col.; Dir., Exhibitions, The Morse Gallery of Art, Rollins Col., Winter Park, Fla.

GEORGE, THOMAS—Painter, L.
 20 Greenhouse Dr., Princeton, N.J. 08540
B. New York, N.Y., July 1, 1918. Studied: Dartmouth College, B.A.; ASL; Academie de la Grande Chaumiere, Paris; Instituto Statale d'Arte, Florence, Italy. Member: International House, Tokyo, Japan; Allied Member, MacDowell Colony Assn. Awards: Purchase prize, BM, 1955; Rockefeller Fnd. Grant, Far East, 1957; Ford Fnd. Purchase, WMAA, 1961, 1962. Work: WMAA; BM; Albright-Knox Gal.; Washington Gal. Modern Art; Tate Gallery, London; LC; Riverside Mus., N.Y.; Dartmouth College; Bridgestone Mus., Tokyo; Oklahoma A. Center; NCFA; Chase Manhattan Bank; Mus. FA, Lausanne, Switzerland; Univ. California, Santa Cruz, and in private collections. Exhibited: WMAA, 1960, 1961, 1962, 1965; Carnegie Inst., 1958, 1961; PAFA, 1962; CGA, 1963; Japan Int. Biennal, 1963; MModA, 1956; Univ. Illinois, 1965; Drawing Soc., Gallery of Modern Art, N.Y., 1965; de Cordova & Dana Mus., 1963; NCFA, 1966, 1968; American Tapestries, Betty Parsons Coll., both national traveling; The White House, Washington, D.C., 1965, 1969; U.S. Mission to the United Nations, 1966-1968; Wadsworth Atheneum, Hartford, Conn., 1966; Lausanne, Switzerland, 1966; one-man: Ten Year Retrospective, Dartmouth College, 1965; Korman Gal., N.Y., 1954; Dartmouth Col., 1956; Contemporaries, N.Y., 1956; Bridgestone Gal., Tokyo, 1957; Betty Parsons Gal., N.Y., 1959, 1963, 1965, 1966, 1968; Reid Gal., London, England 1962, 1964; Bennington Col., 1967; Univ. California, Santa Cruz, 1967, 1969; Axiom Gal., London, England 1968 (4-man); Esther Bear Gal., Santa Barbara, 1969. Illus., "A Line of Poetry, A Row of Trees," 1965.

GEORGE, WALTER EUGENE, JR.—
 Architectural Designer, E., Cr., W., L.
 Department of Architecture, University of Kansas, 66045; h. 1606 W. 22nd St., Lawrence, Kans. 66044
B. Wichita Falls, Tex., Oct. 28, 1922. Studied: Univ. Texas, B. Arch; Harvard Univ., Grad. School of Design, M. Arch., under Walter Gropius. Member: AIA; Archaeological Inst. America; Soc. Architectural Historians. Awards: Mont San Michele and Chartres Award, 1949; Austin, Tex., 1949; prize, Furniture Design Comp., DMFA, 1958. Work: many architectural commissions, 1952-1965. Lectures: Design; History of Architecture of Southwestern U.S.A. Positions: Partner, Pendley, George and Bowman, Architects- Engineers, 1952-1957; Instr., University of Texas, 1956-1962; Chm. Dept. Architecture, University of Kansas, Lawrence, Kansas, 1962- .*

GEORGES, PAUL—Painter
 645 Broadway, New York, N.Y. 10012; also: Sagaponack, L.I., N.Y. 11962
B. Portland, Ore., 1923. Studied: Univ. of Oregon, and with Leger,

and Hans Hofmann. Awards: Longview Fellowship; Hallmark purchase award, 1961; Carol Beck Gold Medal, PAFA, 1964. Work: Longview Fnd.; Newark Mus. A.; M.I.T. Coll.; Reed College, Portland, Ore.; N.Y. Univ. Coll.; MModA; WMAA; Univ. Massachusetts. Exhibited: WMAA, 1962, 1963-64; PAFA, 1964; CGA, 1952; MModA, 1964; Boston Univ., 1964; School of Visual Arts, N.Y., 1965; New School for Social Research, 1965; one-man: Tibor de Nagy Gal., Zabriskie Gal., Allan Frumkin Gal., all New York City; Allan Frumkin Gal., Chicago; Louisiana State Univ. Contributor article to Art News, 1956. Positions: A.-in-Residence, Dartmouth Univ., 1964; Lead seminar on art, Yale Univ., 1964; Instr., Painting, Univ. Colorado, 1960; Staff, Yale School of Art, 1964- .

GERARD, ALLEE WHITTENBERGER (Mrs.)—Painter, T.
 1322 Country Club Drive, Warsaw, Ind. 46580; also 540 Northwest 49th St., Miami, Fla.
B. Rochester, Ind., Feb. 9, 1895. Studied: Ft. Wayne A. Sch.; Miami A. Sch., and with Homer Davisson, Clinton Sheperd, Curry Bohm, Robert Connavale. Member: Miami A. Lg.; Indiana A. Cl.; Nat. Lg. Am. Pen Women; AAPL; Blue Dome Fellowship. Awards: prizes, Hoosier Salon, 1944; Int. Exh., Miami, 1948-1951; Walter's award, 1950; Northern Indiana Salon, 1944; Ft. Wayne, 1954; Lg. Am. Pen Women, 1956; Miami Women's Cl., 1966; Mirell Gal., 1967; Flowers North Miami Gal., 1968. Work: Indiana Univ.; Hoosier Salon; YWCA, Logansport, Ind.; Warsaw (Ind.) H.S. Exhibited: Hoosier Salon, 1944-46, 1948-1951, 1958-1960, one-man: 1956, 1957; Coral Gables Country Club, 1956; DePauw Univ., 1958; Gary, Ind., 1948-1951; Smithsonian Inst., 1949; Miami Int. Exh., 1948-1952; Indiana A. Cl., 1956-1961, 1966-1969; Ft. Wayne Women's Cl., 1956-1958; Ft. Wayne A. Mus., 1957, 1958; Miami Beach A. Center, 1956-1958; AAPL, 1960, 1961; Blue Dome, 1959-1961; Miami A. Lg., 1960, 1961; Nat. Lg. Am. Pen Women, 1959-1961; Grandeville-Fisher Gal., Miami; Naples (Fla.) Gal.; Metropolitan Flower Show, Miami, 1952, 1969; North Miami A. Center, 1966-1968; Harbour House, Miami Beach, 1967-1969; Mirrell Gal., Coconut Grove, 1966-1968; Bacardi Bldg., Miami, 1967, 1968; Indiana A. Cl., traveling exh., 1967, 1968; one-man: Franklin, Ind., Col., 1948; Hoosier Salon, 1948; Sheldon Swope A. Gal., 1956; Frankfort, Ind., 1949; Anderson, Ind., 1950; Miami Beach A. Center, 1950; Peoples Nat. Bank, Miami Shores, 1959; Musician's Cl., Coral Gables, 1959; Summer Theatre, Warsaw, Ind., 1961; Chase Fed. Bank, Miami Shores, 1969; Tri-State Col., Angola, Ind., 1969.

GERARD, PAULA (Mrs. Herbert Renison)—Painter, Gr., E.
 2043 N. Mohawk St., Chicago, Ill. 60614
Studied: AIC, and abroad. Member: Renaissance Soc., Univ. Chicago; AEA; AIC Alumni Assn.; AAUP. Work: LC; Evansville Mus. A.; Earlham Col., Richmond, Ind.; Epstein Archives, Univ. Chicago; George F. Harding Mus., Chicago. Exhibited: Phila. Pr. Cl., 1937, 1941; Los A. Mus. A., 1937; AIC, 1937, 1946, 1948, 1949, 1955, 1961-62; San F. AA, 1938, 1945; Phila. A. All., 1938; NAD, 1945; Denver A. Mus., 1944, 1950; Milwaukee AI, 1946; Renaissance Soc., 1949-69; Mississippi Valley A.; Springfield, Ill., 1949, 1951, 1961; Wichita AA, 1958; Wash. WC Cl., Smithsonian Inst., 1963; Sarasota AA, 1960; Okla. Pr.M., 1960; one-man: Layton A. Gal., 1945, 1948; AIC, 1947; State T. Col., Terre Haute, 1947; Earlham Col., 1948; Woman's Cl., Milwaukee, 1956. Contributor to American Peoples Encyclopedia, Lecturer & Docent, AIC, 1940-46; lecture & demonstrations in drawing, Junior Mus. of AIC, 1965, 1967. Des., Illus. jacket for "The Great Speckled Bird," 1964; Illus. for "Is Your Contemporary Painting More Temporary than You Think?" 1962. Positions: Instr. A., Layton Sch. A., Milwaukee, Wis., 1945-1962; Visiting Instr., Graphics, Univ. Chicago, summers, 1956, 1958- , Instr., 1962-63, Asst. Prof. A., 1964-66; Assoc. Prof., 1966- .

GERARDIA, HELEN—Painter, Gr.
 2231 Broadway, Studio 12 B; h. 490 West End Ave., New York, N.Y. 10024
B. Ekaterinislav, Russia. Studied: BM; ASL,. and with Hans Hofmann, Charles Seide, Adams Garret, Nahum Tschacbasov. Member: Rudolph Gal., Woodstock, N.Y. and Coral Gables, Fla.; Am. Soc. Contemp. A.; ASL; NAWA; Lg. Present Day A.; AEA; Nat. Soc. Ptrs. in Casein; SAGA; Wash. Pr.M.; Silvermine Gld. A.; Woodstock AA; Am. Color Print Soc.; Soc. Am. A.; Pr. Cl. Awards: prizes, Village A. Center, 1952, 1954, 1955, 1961; F., Research Studios, Maitland, Fla., 1952-53, 1959, 1961; Ptrs. in Casein, 1960; Soc. P. & S. of N.J., 1960, 1961, 1968, 1969; F., Yaddo Fnd., 1955; Woodstock AA, 1956; Abraham Lincoln H.S. purchase; Silvermine Gld. A.; NAWA, 1958, medal, 1961, 1964 & prize, 1961, 1964, 1966; Am. Soc. Contemp. A., 1966, 1968. Work: Univ. Illinois; Smith Col.; Univ. Maine; Dartmouth Col.; Colby Col.; Yeshiva Col., and others. FMA; CM; Butler AI; Research Studios A. Center; Brandeis Univ.; MMA. Exhibited: Contemporary A., 1950-1952; BM, 1951; NAWA, 1950-65; ACA Gal., 1950; WMAA, 1951, 1952; AEA, 1951, 1953, 1955; Parish Mus., 1950; Rudolph Gal. N.Y., 1952, Fla., 1952; CM, 1953 (and on tour No. Africa and Europe); Berlin Acad., Germany, 1954; Amsterdam, Holland, 1956; Am. Jewish Tercentenary traveling exh.,

1954-55; Soc. Young Am. A.; SAGA, 1954; Sweat Mem. Mus., 1952-1955; Northwest Pr.M., 1954; Contemporaries, 1954; 1955; New Sch. Social Research, 1954-1956; CGA, 1960; Japanese-Am. traveling exh., Japan & U.S., 1960-61; Am. Color Pr. Soc. traveling, 1960-61; Albany Inst. Hist. & A., 1961; City Center Gal., 1953-1955; Southwest Pr.M., 1955; Albany Inst. Hist. & A., 1955; and others, 1956-1965; one-man: Research Studios, 1953, 1957, 1961; Univ. Maine, 1957; Bodley Gal., 1957, 1959, 1961, 1963, 1965, 1968; St. Lions Pub. Lib., 1957, 1961; Nashville Mus. A., 1957; Colby Col., 1958; Dartmouth Col., 1958; Mus. Nat. Hist. & Art, Holyoke, Mass., 1958; Zanesville AI, 1958; Rudolph Gal., Woodstock, N.Y., 1953, 1955; Albany Inst. Hist. & A., 1955; Georgia Mus. A., 1961, 1968; Evansville Mus., 1961; Decatur A. Center, 1961; Col. of William & Mary, 1961; Wilmington Soc. FA, 1961; Columbus Mus. A. & Crafts, 1967; George Washington Carver Mus., 1969; Asheville (N.C.) Mus., 1970, and others. Positions: Chm., Lg. Present Day A., 1954-55; Bd., Chm. travel exhs., Brooklyn Soc. A., 1955-56, Rec. Sec., 1961-62, Nom. Com., 1961-62; Alternate, Bd. Gov., Woodstock AA, 1956; Nat. Memb. Com., AEA, 1955-56; Rec. Sec., 1962, 1963, Cor. Sec., 1960-61, 1964-65. Exec. Bd., Soc. Ptrs. in Casein, 1960, & many other positions in art organizations, 1966-1970.

GERDINE, MRS. LEIGH—Collector
6244 Forsyth, St. Louis, Mo. 63105
B. Saint Louis, Mo., Sept. 30, 1905. Studied: Washington University, University of Geneva, Switzerland. Collection: Twentieth century paintings, sculpture and prints.*

GERDTS, WILLIAM H.—Museum Curator, T., Hist., W., L.
Coe Kerr Gallery, Inc., 49 E. 82nd St., New York, N.Y. 10028
B. Jersey City, N.J., Jan. 18, 1929. Studied: Amherst College, B.A.; Harvard Univ., M.A. Member: Phi Beta Kappa. Author: "Painting and Sculpture in New Jersey," 1965. Editor: "Drawings of Joseph Stella," 1962. Contributor to Antiques; Art Quarterly; New Jersey Historical Society Proceedings. Lectures: "American Art," "Collecting Art," "Conservation and Restoration" in colleges, universities, adult schools. Exhibitions Arranged: "Early New Jersey Artists," 1957; "Nature's Bounty and Man's Delight," 1959; "Old Master Drawings," 1960; "Nineteenth Century Master Drawings," 1961; "A Survey of American Sculpture," 1962; "Classical America 1815-1845," 1963; "The Golden Age of Spanish Still Life," 1964; "Women Artists of America" (1707-1964), 1965. Positions: Director, Myers House, Norfolk, Va., 1953-1954; Curator, Painting and Sculpture, The Newark Museum, Newark, N.J., 1954-1966; Assoc. Prof., Dir. Gal., Univ. of Maryland, 1966-1969; Associated with Coe Kerr Gallery, New York City, 1969- .

GERST, MRS. HILDE W.—Art Dealer
681 Madison Ave. 10021; h. 983 Park Ave., New York, N.Y. 10028
B. Austria. Studied: Ploner Institute, Italy. Specialty of Gallery: French Impressionist and Post-Impressionist Paintings. Positions: Owner, Hilde Gerst Gallery, New York, N.Y.

GESKE, NORMAN ALBERT—Museum Director, E., L.
Sheldon Memorial Art Gallery, University of Nebraska 68508; h. 2628 High St., Lincoln, Neb. 68502
B. Sioux City, Iowa, Oct. 31, 1915. Studied: Univ. Minnesota, B.A.; Inst. FA, New York Univ., M.A. Awards: Hon. Ph.D., Doane College. Member: CAA; AAMus.; Print Council of America (Dir. 1963-65); Assoc., Int. Inst. for Conservation of Historic & Artistic Works, Nebraska Arts Council (Dir.); U.S. Commissioner, 34th Biennale, Venice, Italy, 1968. Author: "The Figurative Tradition in Recent American Art," 1968. Positions: Asst. Dir., Univ. Nebraska Art Galleries, 1950-1953, Actg. Dir., 1953-1956, Director, 1956- .

GETTY, J. PAUL—Collector, W.
3810 Wilshire Blvd., Los Angeles, Cal. 90005; h. 17985 Pacific Coast Highway, Malibu, Cal. 90265
B. Minneapolis, Minn., Dec. 15, 1892. Studied: Univ. of Southern Cal., Los Angeles; Univ. of Cal., Berkeley; Oxford Univ., London. Author: "The Joys of Collecting," 1965 and (with Ethel Levane) "Collector's Choice."*

GETZ, DOROTHY—Educator, S.
Art Department, Ohio Wesleyan University; h. 40 West Winter St., Delaware, Ohio 43015
B. Grand Junction, Iowa, Sept. 7, 1901. Studied: Ohio State Univ., B.A., M.A.; Hans Hofmann Sch. FA. Awards: prizes, Ohio State Fair, 1953, 1958; Columbus A. Lg., 1956, 1957, 1960, purchase prizes, Butler Inst. Am. A., 1963; Columbus Gal. FA, 1965. Exhibited: Syracuse Mus. FA, 1952, 1954, 1956; Butler Inst. Am. A., 1954, 1955, 1957, 1959; A. of Dayton Area, 1959; Ball State T. Col., 1954, 1955, 1959; Ohio State Fair, 1953, 1955, 1958; Columbus A. Lg., 1953-1957, 1960; Akron AI, 1960; Canton AI, 1960; Retrospective Exh., Columbus Gal. FA, 1960. Positions: Instr., Fashion Illus.,

Columbus (Ohio) A. Sch., 1952- ; Prof. FA, Ohio Wesleyan Univ., Delaware, Ohio, at present.

GETZ, ILSE—Painter
Saw Mill Rd., Newtown, Conn. 06470
B. Nuremberg, Germany, Oct. 24, 1917. Studied: ASL, with Morris Kantor, George Grosz. Award: Yaddo Fellowship, 1959. Work: Carnegie Inst.; Coe College, Hinkhouse Coll., Cedar Rapids, Iowa; Phoenix A. Mus.; Tel Aviv Museum, Israel; N.Y. Univ. Gallery; Nelson Gallery, Kansas City, Mo. Exhibited: traveling exhibitions, USIA, to France, Italy, Holland, Scandinavia, 1954; Bertha Schaefer Gal., N.Y., 1955, 1956, 1957; Mus. Contemp. A., Houston, Tex., 1958; Wolfrom-Eschenbach, Germany, 1960-1961; Lincoln Gal., London, 1961; Iris Clert, Paris, 1962; American Embassy, London; Wales; PVI Gal., N.Y., 1964; Allan Stone Gal., N.Y., 1964; Museum St. Etienne, France, 1964; Larry Aldrich Mus., Hilles Coll., 1968; Finch Col., Kaplan Coll., 1969. One-man: Norlyst Gal., 1945; Gloucester A. Soc., Mass., 1946; Galleria Casa Sarodine, Ascona, Switzerland, 1947; Positano Workshop, Italy, 1956, 1960; Bertha Schaefer Gal., N.Y., 1957, 1958; Gump's Gal., San F., 1958, 1960; Stephen Radich Gal., N.Y., 1960; Iris Clert Gal., Paris, 1961; Galerie Prismes, Paris, 1961; Tibor de Nagy Gal., 1963; Phoenix A. Mus., 1964; Greenross Gal., N.Y., 1965; Rigelhaupt Gal., Boston, 1966; Dartmouth Col., 1967; Wesleyan Univ., 1967. Designed set for Ionesco's "The Killer," N.Y., 1960. Positions: Instr., summers, 1956, 1958, Positano, Italy.

GEWISS, MRS. HARRY. See Layton, Gloria

GHENT, HENRI—Assistant Museum Director, Writer, Collector
Brooklyn Museum, 200 Eastern Pkwy., Brooklyn, N.Y. 11238; h. 807 Madison Ave., New York, N.Y. 10021
B. Birmingham, Ala., June 23, 1926. Studied: Georges Longy School, Cambridge, Mass.; University of Paris, France. Special courses in Art History in France, Germany and England. Awards: Marian Anderson Scholarship Award, 1951, 1952; Boston Post and Lynn (Mass.) Daily Item prize, 1950; Martha Baird Rockefeller Study Grant, 1957; "Bourse Speciale" from French Government 1958-1960; Hon. L.H.D., Allen University, Columbus, S.C., 1966. Contributor to Elegant magazine and School Arts magazine as well as several newspapers. Collection: paintings, drawings, sculpture and etchings. Field of Research: Afro-American Art. Organized and directed: the first Afro-American Art and Contemporary Puerto Rican Artists exhibition at The Brooklyn Museum; "Afro-American Artists Since 1950" at Brooklyn College. Positions: Member Advisory Committee of a special exhibition honoring Dr. Martin Luther King, Jr., at the Museum of Modern Art, N.Y.; Chairman, Black Emergency Cultural Coalition; Member, Board of Trustees, School Art League, N.Y.; Guest Director, The Studio Museum in Harlem; Assistant Director, Brooklyn Institute of Arts and Sciences, 1968-; Director, Community Gallery, The Brooklyn Museum, 1968- .

GHEZ, OSCAR (DR.)—Collector
Petit Palais Geneve, 2 Terrasse Saint-Victor; h. 3 Rue de Beaumont, Geneva, Switzerland
B. Sousse, Tunisia, Jan. 22, 1905. Studied: University of Rome. Awards: Legion of Honour. Collection: Impressionists and post-impressionists from 1880 to 1940. Much of the collection is in The Petit Palais, Geneva, which was formally opened, November, 1968. The museum collection represents all of the great art movements and also includes 20th Century art. Dr. Ghez is President of Petit Palais.

GIAMBRUNI, TIO—Sculptor
1718 Jaynes St., Berkeley, Cal. 94703*

GIBBONS, HUGH JAMES—Painter, E.
3432 53rd St., Lubbock, Texas 79413
B. Scranton, Pa., Oct. 26, 1937. Studied: Pennsylvania State Univ., B.A., M.A. Member: CAA. Awards: Two Grad. Teaching Assistantships, 1959-60 and Grant-in-Aid for Painting, 1960 Pa. State Univ.; Patron's Award, Santa Fe Biennial, Mus. New Mexico, 1964, 1966; purchase prize, Bucknell Univ., 1965. Work: Bucknell Univ. Exhibited: Xavier Univ., New Orleans, 1959; Ohio Univ., 1964; Norfolk Mus. A. & Sciences, 1965, 1967, 1969; Newport Annual, 1964, 1966; PAFA, 1960, 1963, 1965; Bucknell Univ., 1965; 1967; Detroit Inst. A., 1960; Santa Fe Biennial, 1964, 1966; Soc. Four A., 1966; Purdue Univ., 1966; Drawings: USA, 1968; Otis AI, 1966; Hemisfair, San Antonio, 1968; Smithsonian Traveling Exh., 1969-1971; Witte Mem. Mus., 1969; 2-man, Kottler Gal., N.Y., 1967. One-man: Pa. State Mus., 1963; Lubbock A. Center, 1965. Positions: Instr., Drawing, Pa. State University; Asst. Prof., Drawing, Painting & Sculpture, Texas Technological College.

GIBRAN, KAHLIL—Sculptor
160 W. Canton St., Boston, Mass. 02118
B. Boston, Mass., Nov. 29, 1922. Studied: BMFA Sch. A., with Karl

Zerbe. Awards: Museum School scholarships; Boston A. Festival, 1956, 1964; George Widener Gold Medal, PAFA, 1958; Guggenheim Fellowship, 1959-1960, 1960-1961; Nat. Inst. A. & Let's., 1961; John Gregory award, NSS, 1965; Gold Medal, International Exh., Trieste, Italy, 1965. Work: Chrysler Museum, Provincetown; PAFA; Norfolk Mus. A. & Sciences; Tennessee FA Center, Nashville; Swope A. Gal., Terre Haute, Ind.; William Rockhill Nelson Gal., Kansas City, Mo.; Fuller Memorial, Brockton, Mass. Exhibited: PAFA, 1958, 1960; Mus. Contemp. A. Houston, 1957; Univ. Illinois, 1959, 1963; WMAA, 1960, 1962 and prior; AIC, 1961; NAD, 1961; Art:USA, 1958; Detroit Inst. A., 1958; Washington Cathedral, 1957; DMFA, 1958; Montreal Mus. A., 1965; Nat. Inst. A. & Lets, 1965; Boston A. Festival, annually from 1954-1965; Inst. Contemp. A., Boston; Provincetown Golden Anniversary, 1965, and many other museums and galleries in previous years.

GIBSON, GEORGE—Painter, Des., I., L.
MGM Studios, Culver City, Cal.; h. 12157 Leven Lane, Los Angeles, Cal. 90049
B. Edinburgh, Scotland, Oct. 16, 1904. Studied: Edinburgh Sch. A.; Glasgow Sch. A.; with William E. Glover, Scotland; Chouinard AI, and with F. Tolles Chamberlain. Member: ANA; AWS; Cal. WC Soc. (Vice-Pres., 1949-50, Pres., 1950-51). Awards: prizes, Santa Paula, Cal., 1946; City of Los Angeles, 1946, 1947, 1949; Santa Cruz annual, 1946-1948, 1950; Arizona State Fair, 1948, 1949; Montgomery, Ala., 1949; Westwood (Cal.) AA, 1951, 1952; Cal. WC Soc., 1953; Newport Beach, 1953; Oakland A. Mus., 1945; Birmingham, Ala., 1950; Phila. Pa., 1948; Orange County Fair, 1950. Work: San Diego FA Center; Los A. Mus. A.; AIC; Laguna Beach A. Gal. Exhibited: AWS, 1945-1958; Cal. WC Soc., annually and traveling exhs.; and in other galleries and museums in U.S.; one-man: Chabot Gal., Los A., 1950; Long Beach, Cal., 1950; Laguna Beach AA, 1951; Santa Barbara Mus. A., 1952; Santa Monica Lib., 1958; St. Mary's Col., 1958. Lectures on Scenic Art in Theatre and Motion Pictures. Positions: Scenic A. Dir., Hd. Scenic A. Dept., MGM Studios, 1934- .

GIBSON, ROLAND, Collector, Educator, Art Administrator
New Hampshire College, Manchester, N.H. 03101; h. R.F.D. 2, Concord, N.H. 03301
B. Potsdam, N.Y., Feb. 4, 1902. Studied: Columbia University, Ph.D.; Dartmouth College, A.B. Collection: 300 works of Contemporary Abstract Painting, Prints, and Sculpture, now being circulated throughout the U.S. by the Roland Gibson Art Foundation. Other works in the collection include Japanese and Italian Abstract Art. Positions: Taught Economics in universities and colleges since 1946; President and Treasurer, Roland Gibson Art Foundation, 1966- ; Director, Roland Gibson Museum of Contemporary Art, Dunbarton, N.H.

GIDDINGS, JANE GRANT. See Carmichael, Jae.

GIKOW, RUTH—Painter, I., Ser.
231 W. 11th St., New York, N.Y. 10014
B. Russia. Studied: CUASch. Awards: F., Yaddo Fnd., 1943; Nat. Inst. A. & Let. grant, 1959. Work: MMA; Butler Inst. Am. A.; Sheldon Swope A. Gal., Terre Haute, Ind.; Syracuse Univ.; MModA; PMA; WMAA; Brandeis Univ.; Springfield Mus. A.; Am. Acad. A. & Let.; murals, Bronx Hospital; Ulster County Community Col. Exhibited: Weyhe Gal., 1946 (one-man); Nat. Ser. Soc., 1947 (one-man); Grand Central Moderns, 1949, 1951; Phila. A. All., 1950; Ganso Gal. (one-man), 1952, 1954, 1956; Rehn Gal., 1958; Nordness Gal., N.Y., 1961, 1964 (one-man); Forum Gal., N.Y., 1967, and in national exhs. Illus., "Crime and Punishment," 1946. Included in publication, "Art: USA—Now."

GILBERT, ARTHUR HILL—Painter
5076 W. Muller Rd., Stockton, Cal. 95206
B. Chicago, Ill., June 10, 1894. Studied: Northwestern Univ.; Univ. California. Member: Carmel A. Cl.; Bohemian Cl., San F.; ANA. Awards: prizes, Hallgarten, Murphy and Ranger prizes, NAD; Santa Cruz A. Lg. Work: Springville, Utah Coll.; Mission Inn, Riverside, Cal.; Riverside Woman's Cl. Exhibited: NAD; PAFA; AIC, and widely in California.

GILBERT, CLYDE LINGLE—Painter, Comm. A., Des., C., Gr.
R.R. 1, Freetown, Ind. 47235; h. 139 Riverview Ave., Elkhart, Ind. 46514
B. Jackson County, Ind., Oct. 15, 1898. Studied: Sch. Appl. A., Battle Creek, Mich.; Natl. Acad. Commercial Art, Chicago; Studio of Fine Arts, Brazil, Ind. Member: Indiana Fed. Art Clubs; Elkhart A. Lg. Awards: Irwin D. Wolf Gold Medal for Highest Packaging Honors; 19 U.S. Letters Patents issued on mechanical tools, devices and paperboard novelty packages. Work: Designer of modified Caduceus Emblem for Miles Laboratories, Elkhart, Ind., enlarged version on front of Miles Medical Research Bldg., and inlaid in their Ames Library Bldg. terrazzo floor. Inventor-Des. of

Paperboard Crease-Scoring Machine. Exhibited: Wawasee A. Gal., Syracuse, Ind.; Howe Military School, Howe, Ind.; Weddleville, Ind., (one-man); Battle Creek Sanatorium, 1966 (one-man). Positions: Designer and Package Engineer, American Coating Mills, Inc., Elkhart, Ind., 1937-38, 1941-1952.

GILBERT, CREIGHTON—Art Historian, W., E.
Dept. of Art, Queens College, Flushing, N.Y. 11367
B. Durham, N.C., June 6, 1924. Studied: Duke Univ.; Johns Hopkins Univ.; N.Y. Univ., B.A., Ph.D.; Columbia Univ., with L. Venturi, W. Friedlander, Offner, Lehmann and others. Member: CAA; Ateneo di Brescia, Italy (Hon.); AAUP. Awards: Mather Award for best art criticism of the year 1963 (shared with Harold Rosenberg); F., Am. Acad. A. & Sciences, 1964; Fulbright award, 1951-52. Contributor to: Marsyas, Art Bulletin, Burlington Magazine, Gazette des Beaux-Arts, Arts, Master Drawings, Encyclopaedia Britannica, and other publications. Major exhs. organized: "Baroque Painters of Naples," 1961, Ringling Mus.; "17th Century Paintings from the Low Countries," 1966, Brandeis Univ., and others. Editor, translator, "Complete Poems & Selected Letters of Michelangelo," 1963. Author: "Michelangelo," 1967; "Change in Piero della Francesca," 1969. Positions: Instr. FA, Emory Univ., 1946-47; Univ. Louisville, 1947-55, Asst. Prof., 1955-56; Asst. Prof., 1956-1958, Indiana Univ. Visiting Prof., Univ. Rome, 1951-52; Cur., Ringling Mus., 1959-61; Assoc. Prof., Brandeis University, 1961-1965, Prof., 1965-1969, Chm., Dept., 1963-1966, 1968, 1969. Prof., Queens Col. of City Univ. of N.Y., 1969- .

GILBERTSON, CHARLOTTE—Painter, Gr.
Old School House Rd., Harwich Port, Mass. 02646; w. 164 E. 88th St., New York, N.Y. 10028
B. Boston, Mass., Nov. 11, 1934. Studied: Boston Univ.; ASL; Pratt Graphics; and with Fernand Leger, Paris. Exhibited: Galerie Mai, Paris, 1959; Pratt Graphics, N.Y., 1961-1963; PVI Gal., N.Y., 1965; Byron Gal., N.Y., 1965; Fischbach Gal., N.Y., 1966; Flint (Mich.) Col., 1967; Finch Col., New York, N.Y., 1968; BM, Nov. 1968-Jan. 1969; Inst. Contemp. A., Philadelphia, 1965.

GILCHRIST, AGNES ADDISON (Mrs. John M.)—
Architectural Historian, W., L.
286 E. Sidney Ave., Mount Vernon, N.Y. 10553
B. Philadelphia, Pa., Dec. 25, 1907. Studied: Wellesley Col., B.A.; Univ. Pennsylvania, M.A., Ph.D.; and in Europe. Member: CAA; Soc. Arch. Historians (Sec.-Treas., 1950-51, V. Pres., 1952). Awards: Carnegie scholarship, Paris, Harvard Univ., 1934, 1935, 1940; Am. Philosophical Soc., 1941. Exhibited: Phila. A. All.; Phila. Women's Univ. Cl. Author: "Romanticism and the Gothic Revival," 1938; "Early American Gothic," 1940; "Pennsylvania Portraits," 1940; "William Strickland," 1950. Contributor book reviews and articles to art magazines; Editor, Soc. Arch. Historians Newsletter, 1957-1961. Positions: Instr., Texas State Col. for Women, 1931-32; Univ. Pa., 1934-41; Prof., Randolph-Macon Col., 1941-42; Lecturer, N.Y. Univ., New York, N.Y., 1948-49; National Park Service, Phila., Pa., 1957-58; Arch. Hist., Sleepy Hollow Restorations, Tarrytown, N.Y., 1959-1960; New York City Landmarks Commission, Researcher 1962-1964. Fndr., Pres., Mt. Vernon Landmark Soc., 1964- .

GILES, CHARLES—Educator, P., L., W., Cr.
Art Department, Pensacola Junior College; h. 3535 Rothschild Dr., Pensacola, Fla. 32503
B. Arlington, Mass., Dec. 1, 1914. Studied: Vesper George Sch. A., with Lincoln Vesper George, Harold Lindergren, Fletcher Adams, Dwight Shepler, Nelson Chase, Dean Cornwell, and others; Massachusetts Sch. A., with Frank Rines; N.Y. Univ.; Univ. North Carolina; Rutgers Univ.; Boston Univ.; Florida Southern Col., B.S., M.A.; Univ. Florida, D. Edu. Member: AAPL; Creative A. Group, Tampa Bay; Fla. Fed. A.; Fla. Indst. A.; Fla. A. T. Assn.; Int. Hon. Soc. Indst. A.; Edu. Research & Scholastic Fraternity (Hon. Grad.); AAUP. Exhibited: Fla. Fed. A., 1960, 1962-1964; Pensacola Jr. Col., 1963. Positions: Instr., Comm. A., Essex County Voc. & Tech. H.S., Newark, N.J., 1940-42; Asst. Prof. A., Fla. Southern Col., 1946-51; Instr. A. & Voc. Edu., Univ. Florida, 1951-53; Asst. Prof. FA, Univ. Tampa, 1956-57; Assoc. Prof. FA & Indst. A., University of Tampa, Fla., 1957-1962. Pres., Fla. Federation of Art, 1962-1964; Chm., Pensacola Interstate Fair, 1964-1965; Regional Chm., Region XII, Fla. Federation of Art, 1965; Prof. Art, Humanities and Fine Art, Pensacola Junior College, 1962- .*

GILKEY, GORDON WAVERLY—Printmaker, E., W., L.
School of Humanities & Social Sciences, Oregon State University; h. 350 N.W. 35th St., Corvallis, Ore. 97330
B. Linn County, Ore., Mar. 10, 1912. Studied: Albany (Ore.) Col., B.S.; Univ. Oregon, M.F.A.; Lewis & Clark Col., Arts D. Member: AAMus.; Cal. Soc. Pr.M.; SAGA; Am. Soc. for Aesthetics. Awards:

Officier d'Academie, France, 1947; Gold Medal, IV Bordighera Biennale, Italy, 1957; Officer's Cross, 1st class, Order of Merit, Fed. Rep. of Germany, 1961; Order of the Star of Solidarity, Italy, 1963; Commander, Order of Merit, Italian Republic, 1967; Commander's Cross, Order of Merit, Fed. Rep. of Germany, 1968; Officer, Order of Academic Palms, France, 1969. Work: prints: MMA; N.Y. Pub. Lib.; LC; Pasadena A. Mus.; Oakland A. Mus.; Nat. Mus., Wash., D.C.; SFMA; Portland (Ore.) A. Mus.; SAM; Boston Pub. Lib.; PMA; British Mus.; Victoria & Albert Mus., London; Bibliotheque Nationale, Paris; Bibliotheque Royale, Brussels; Koninklyk Huis Archief, The Hague; Bordighera Mus., Italy. Exhibited: Northwest Pr. M., 1950-1963; LC, 1955-1957; Pr. M. of So. Cal., 1952, 1953; SFMA, 1957; Phila. Pr. Cl., 1954, 1955, 1957, 1958; SAGA, 1952, 1954-1969; Bay Pr. M. Soc., 1956, 1961; Butler Inst. Am. A., 1954; Silvermine Gld. A., 1958; Bordighera, Italy, 1957; USIA European traveling exh., Europe, 1956-1958; Turin, Italy, 1957; Centre Culturel Americaine, Paris, 1958; Bath Acad. A., 1958; South Africa, 1958; Portland A. Mus., 1949-1962; Northwest Pr. M., 1953-1965; Brooklyn Mus., 1962; Oklahoma Printmakers, 1962; Otis AI, Los A., 1963; 100 Prints of the Year, 1962; Athens, Greece, 1964-65; Yugoslavia, 1965, 1967-1969; Tokyo, 1967; Cracow, 1968, one-man: Kennedy Gal., N.Y., 1939; St. Louis A. Center, 1940; Portland A. Mus., 1953; Spokane A. Center, 1958. Author, I., "Etchings Showing Construction Progress, Univ. Oregon Library," 1936; "Etchings New York World's Fair," 1939. Contributor to "Impression," Magazine of Graphic Arts. Positions: Hd., War Dept. Special Staff A. Projects in Europe, 1946-47; Consulente Artistico in Stati Uniti, IV Bordighera Biennale, Italy, 1956-57; Dir., Int. Exchange Print Exhibits: from U.S.A., 1956, France, 1956, Italy, 1957, Great Britain, 1958, Norway, 1958; Yugoslavia & Holland, 1959; Germany, 1960; Japan & France II, 1961; Denmark, 1962; Greece, Germany II, Norway II; Contemp. Japanese Sumi Paintings, 1963; Yugoslavia II, 1964; Great Britain II and Japan II, 1965; France III, 1966; Czechoslovakia, 1968; Japan III and Yugoslavia III, 1969. Prof., Hd. A. Dept., 1947-1964, Dean, School of Humanities & Social Sciences, Oregon State University, Corvallis, Ore., 1963- .

GILL, FREDERICK JAMES—Painter, T., L.
 7461 Sunset Dr., Avalon, N.J. 08202; h. 164 West Hortter St., Philadelphia, Pa. 19119
B. Philadelphia, Pa., May 30, 1906. Studied: PMSchIA; Univ. Pennsylvania, B.F.A., and with Charles Woodbury, Cesare Ricciardi; Tyler Sch. FA, M.F.A. Member: AEA; Phila. A. All.; Phila. WC Cl.; AWS. Awards: prizes, AWS, 1948, 1960; Audubon A., 1950; PAFA, 1955, 1960; Woodmere A. Gal., 1955, 1958; Tyler Alumni exh., 1956, 1958, 1960, 1961; AWS, award, 1969. Work: PMA; Jefferson Hospital, Phila.; Millersville (Pa.) State T. Col.; Lehigh Univ.; Temple Univ.; Harcum Col.; Woodmere A. Gal.; West Chester State Col.; Phila. Civic Center; PMA, and others. Exhibited: nationally; oneman; group and traveling exhs. Lecturer, demonstrations. Positions: Lecturer and demonstrator, PMSchA., Philadelphia, Pa., 1954- .

GILL, JAMES (FRANCIS)—Painter, S., Gr.
 1820 Artiegue St., Topanga, Cal. 90290
B. Tahoka, Tex., Dec. 10, 1934. Studied: San Angelo Jr. Col.; Univ. Texas. Awards: Purchase prize, AIC, 1964; Painting Fellowship, Univ. Texas, 1960. Work: MModA; AIC; WMAA; Univ. California Mus. A., Berkeley; Mead Corp., Dayton; Container Corp. of America; Time, Inc. (cover painting). Exhibited: AIC, 1964; MModA, 1965; San Francisco A. Inst., 1965; WMAA, 1966-1968; Sao Paulo, Brazil, 1967; NCFA traveling exh., Europe, 1968-1969. Author: "Metamāge" (London), 1969.

GILL, SUE MAY (Mrs. Paul)—Portrait Painter, S., T.
 639 English Village, Wynnewood, Pa. 19096
B. Sabinal, Tex. Studied: PAFA; AIC. Member: PMA; Phila. A. All.; F., PAFA; Phila. Plastic Cl.; Portraits, Inc.; Woodmere A. Gal.; NAWA. Awards: prizes, F., PAFA; Cresson traveling scholarship, PAFA, 1922, prize, 1923, 1933; NAWA, 1932; Women's Achievement Exh., Phila., 1933; Phila. Sketch Cl., medal, 1942, prize, 1943; Phila. Plastic Cl., 1943, 1944, medal, 1942; Nat. Assn. Women P. & S., 1933; Wayne (Pa.) A. Center, 1966. Work: sc., West Point Military Acad.; numerous fountain sculptures in private gardens; ports. of many prominent persons in private collections nationally. Exhibited: one-man: Phila. A. Cl.; Women's City Cl., 1951; Phila. A. All., 1950; Feragil Gal.; Syracuse Mus. FA; Wash. A. Cl.; Davenport, Iowa; Denver AA; Denver Lib.; New Orleans AA; Instituto San Miguel Allende, Mexico, 1952; Miami Beach A. Center, 1955; Oklahoma City A. Center, 1955; Wichita Falls, Tex., 1955; Lancaster (Pa.), AA; Allentown A. Center; Woodmere A. Gal.; Phila. Country Cl., 1966, 1968; Phila. Sketch Cl., 1966; Reading (Pa.) A. Mus., 1966 (two-man); Auburn (N.Y.) Mus., 1967; Plastics Cl., 1969; Phila. A. Cl. and Warwick Gal., Phila. Also group shows, PAFA; NAD, and others. Positions: Instr., painting, Syracuse Univ. summer sessions. Lectures on painting, PAFA and to private clubs.

GILLIAM, SAM, JR.—Painter, T.
 1752 Lamont St., N.W., Washington, D.C. 20010
B. Tupelo, Miss., Nov. 30, 1933. Studied: Univ. Louisville, B.A., M.A. Awards: Allen R. Hite Scholarship, Louisville, Ky., 1955; Nat. Endowment on the Arts Grant, Washington, D.C., 1967; Fellow, Washington (D.C.) Gal. Mod. A., 1968-1970. Work: Mus. African A., Washington, D.C.; Art for Embassies; Woodward Fnd.; AFA; MModA; PC. Exhibited: Studio Mus. in Harlem, New York City, 1969; Martin Luther King Memorial Exh., MModA, 1969; Art for Embassies, Washington Gal. Mod. A., 1967; Byron Gal., N.Y., 1968; Jefferson Place Gal., Washington, D.C., 1965-1969; PC, 1967; CGA, 1969. Positions: Instr., Painting, Maryland Inst.; Corcoran School of Art, Washington, D.C.

GILMORE, ETHEL (Mrs. Charles J. Romans)—Painter, Gr., T.
 1033 New York Ave., Cape May, N.J. 08204
B. New York, N.Y. Studied: Hunter Col., B.A.; Columbia Univ., M.A. and with A. Dasburg, C.J. Martin, Oliver Chaffee, Aldro Hibbard, and others. Member: Prof. A. of So. New Jersey; NAWA; All. A. Am.; P. & S. Soc. New Jersey; Gotham Painters; Hudson Valley AA; Seven Mile Beach AA; Hudson A. of New Jersey. Awards: prizes, Kearney Mus., 1947; P. & S. Soc., New Jersey, 1947; A. Council of New Jersey, 1948, 1950; Gotham Painters, 1948; Jersey City Mus. Assn., 1949, 1951, 1953; All. A. Am., 1951; Hudson A., 1953; Atlantic City A. Center Annual, 1967; North Wildwood Boardwalk Show, 1967, 1968. Work: Junior Mus., Albany, Ga.; La Salle Col., Phila.; Jersey City Mus. Exhibited: NAWA, 1938-1969; All. A. Am., 1939-1969; Audubon A., 1945; P. & S. New Jersey, 1945-1960; Argent Gal., 1938-1946; Gotham Painters, 1944-1954; High Mus. A., 1943; Manchester (N.H.) Mus. A., 1940; Montclair A. Mus., 1947-1949; AFA traveling exh., 1939-40; Hudson Valley AA, 1952-1954; Hudson A. of New Jersey, 1953-1955; traveling exhs., Old Bergen Art Guild, 1963-1969; Atlantic City AA, 1962-1969. Positions: Rec. Sec., 1950-55, Cor. Sec., 1954-55, Jury of Selection-oils-1957, All. A. Am.; Trustee, Jersey City Mus. Assn., 1953-55; Jury of Selection-oils-NAWA, 1959-60; Chm. A. Dept., Womens Community Cl., Cape May, N.J., 1957-1969; Instr., Seven Mile Beach AA, 1960-65.

GILVARRY, JAMES—Collector
 210 E. 47 St., New York, N.Y. 10017*

GIMBEL, MRS. BERNARD F.—Collector, Patron
 Upper King St., Greenwich, Conn. 06830*

GINSBURG, MAX—Painter, T., I.
 11 Fort George Hill, New York, N.Y. 10040
B. Paris, France, Aug. 7, 1931. Studied: Syracuse Univ., B.F.A.; NAD; City College of New York, M.A. Member: All. A. Am.; Audubon A.; Am. Veterans Soc. A.; AEA. Awards: Gold Medal, Am. Veterans Soc. A., 1962, 1965, prize, 1961; All. A. Am., 1961, 1962; NAC, 1963. Exhibited: All. A. Am., 1956-1964; Audubon A., 1962-1964; Am. Veterans Soc. A., 1961-1965; Harbor Gal., Cold Spring Harbor, L.I., 1966, 1968, 1969. Positions: Instr., High School of Art & Design, New York, N.Y.

GINZEL, ROLAND—Painter, Lith., E.
 412 N. Clark St., Chicago, Ill. 60610
B. Lincoln, Ill., 1921. Studied: AIC, B.F.A.; State Univ. Iowa, M.F.A.; Slade Sch., London, England. Member: Momentum; P.A.C. Awards: Fulbright Fellowship to Rome, 1962; purchase prizes, 1956, Oppenheim prize, 1955, Campana prize, 1969, print and drawing prize, 1967, all AIC; purchase, Univ. Michigan, 1965. Work: Univ. So. Cal.; Univ. Michigan; Illinois Bell Telephone Co.; AIC; Am. Public Ins. Co.; U.S. Embassy, Warsaw, Poland. Exhibited: AIC, 1966, 1968, 1969; Soc. for Contemp. A., 1967; P.A.C. exhs., Chicago, 1966-1969; Mulvane A. Center, Topeka, 1967; "Chicago Artists," Des Moines, Iowa, 1968; Madison, Wis., 1969; Notre Dame Univ., 1969. One-man: Superior Street Gal., 1958, B.C. Holland Gal., 1962-1967, Bernard Horwich Center, 1966, Phyllis Kind Gal., 1969, all Chicago; Univ. Wisconsin, 1960. Positions: Prof. Printmaking, Univ. Chicago, 1957-1958; Prints and Painting, Univ. Illinois, Chicago Circle, 1958-1969; Painting, Univ. Wisconsin, 1960; Saugatuck Summer Sch., 1961-1962.

GIOBBI, EDWARD GIOACHINO—Painter, Gr.
 161 Croton Lake Rd., Katonah, N.Y. 10536
B. Waterbury, Conn., July 18, 1926. Studied: Whitney Sch. A.; Vesper George Sch. A.; ASL; Acad. Fine Arts, Florence, Italy. Member: ASL. Awards: Emily Lowe Award, 1951; Yaddo Fnd. Grant, 1952; Ford Fnd. Grant, A.-in-Res., 1966. Work: AIC; Brooks Mem. Mus., Memphis; McNey Mus. A., San Antonio; WMAA; Univ. Michigan; Tate Gal., London; Leeds Gal. of Art, Leeds, England; BMFA; BM; Magdalen Col., Cambridge, England; St. Edmund Hall, Oxford; BMA; Spelman Col., Atlanta; Allentown (Pa.) Mus.; Wesleyan Col., Macon; Syracuse Univ.; Academia di Belle Arti, Florence, Italy; Univ. Texas, Austin; Finch Col., N.Y. Exhibited: MModA, 1956, 1960, 1962; WMAA, 1957, 1960, 1961, 1962 1966; PAFA, 1960, 1964;

CGA, 1958; Univ. Illinois, 1956; DMFA; New Art Centre, London, England, 1964, 1967 (one-man); Italy and Switzerland, 1964; Artists Gal., 1956; John Heller Gal., N.Y., 1957, 1958; Contemporaries, N.Y., 1960-1963; one-man: Contemporaries Gal., N.Y., 1963; Bear Lane Gal., Oxford, 1964; Queen Square Gal., Leeds, 1964; Karlis Gal., Provincetown, Mass., 1964-1966; Michelson Gal., Washington, D.C., 1966; Alan Gal., N.Y., 1966; Arkansas A. Center, Little Rock, 1966; Waddell Gal., N.Y., 1967; Obelisk Gal., Boston, 1968; Kasle Gal., Detroit, 1968, and others. Positions: A.-in-Res., Memphis Academy of Art, 1959-1960.

GIUSTI, GEORGE—Designer, Consultant
Chalburn Rd., West Redding, Conn. 06896; also, 342 E. 53rd St., New York, N.Y. 10022; Prunarolo di Vergato, Italy.
B. Milan, Italy, Oct., 1908. Studied: Accademia di Brera, Milan, Italy, A.B. Member: A. Dir. Cl., N.Y. Nat. Soc. A. Dirs.; AIGA; Am. Graphic Inst.; Alliance Graphique Internationale; International Center for Typographic Arts. Awards: 60 major awards and 10 medals; A. Dir. of the Year, Nat. Soc. A. Dirs., 1958. Exhibited: MModA, 1941. Later in New York, Philadelphia, Boston, Chicago, Los Angeles and other U.S. cities. International exhibitions in Paris, London, Milan, Vienna, Latin America and the Orient. Work: Freelance work for major publications including Fortune, Holiday, Graphis, Saturday Eve. Post, etc., and industrial companies. Portfolios in Graphis, Idea, Pagina, American Artist, Communication Art, Gebrauchsgrafik. Author: "The Human Heart," 1961. Positions: Faculty Member, Famous Artists School, Westport, Conn.; Art Consultant for major companies.

GIVLER, WILLIAM HUBERT—Painter, Et., Lith., T.
2637 N.W. Northrup St., Portland, Ore. 97210
B. Omaha, Neb., Mar. 17, 1908. Studied: Portland (Ore.) Mus. A. Sch.; ASL. Member: Oregon Gld. P. & S. Awards: prizes, SAM, 1939; Portland A. Mus., 1938; Topeka, Kan., 1940; Northwest Pr.M., 1940, 1941. Work: Portland A. Mus.; PMA; SAM. Exhibited: WFNY 1939; PAFA, 1941; NAD, 1940; SFMA, 1940-1946; WMA, 1941, 1942. Positions: Instr. A., 1931-44; Dean, 1944- , Mus. A. Sch., Portland, Ore.

GLARNER, FRITZ—Painter
311 Round Swamp Rd., Melville, N.Y. 11746
B. Zurich, Switzerland, July 20, 1899. Studied: Royal Inst. FA, Naples, Italy. Awards: prizes, CGA, 1957. Work: Yale Univ.; PMA; MModA; WAC; Kunsthaus Zurich, Zurich, Switzerland; BMA; WMAA; Brandeis Univ.; mural, lobby of Time-Life Bldg., N.Y.; murals, lobby of Dag Hammarskjold Library of the United Nations; other work: N.Y. Univ.; Albright-Knox A. Gal., Buffalo; Mus. of Winterthur, Switzerland; NGA; Rockefeller Inst.; MMA; Woodward Fnd.; Art Council of Karachi; CMA; AIC, and others. Exhibited: Albright A. Gal., 1931, 1968; Am. Abstract A., 1938-1944; Gal. St. Etienne, 1940, 1957; N.Y. Univ., 1941; David Porter Gal., Wash., D.C., 1945; AIC, 1947, 1958, 1964; Toronto A. Gal., 1949; VMFA, 1950, 1958; Cal. PLH, 1950; WMAA, 1950, 1951, 1953-1955, 1962, 1964; MModA, 1951, 1952, 1954, 1955 (New York, Paris, Zurich, Barcelona), 1956, 1964, 1969; Sao Paulo, Brazil, 1951; BM, 1961; Univ. Illinois, 1952, 1965, 1968; Univ. Minnesota, 1951; Univ. Nebraska, 1955; Wildenstein Gal., 1952; Carnegie Inst., 1952, 1958, 1961; John D. Rockefeller Guest House, N.Y., 1954; Spoleto, Italy, 1961; CGA, 1955, 1957; Kassel, Germany, 1955; Solomon Guggenheim Mus. A., 1954; Tokyo, Japan, 1953; Kunsthaus, Zurich, Switzerland, 1956; Musee Neuchatel, 1957; Kunstverein Winterthur, 1958; Congresshalle, Berlin, 1958; AFA traveling, 1964, 1967; SFMA, PMA, 1965; Friends of Whitney Mus., 1965, 1966, 1968; Basel, Switzerland, 1968; N.Y. State Univ., Albany, 1967; Jewish Mus., 1969, and many others; one-man: Kootz Gal., 1945; Rose Fried Gal., 1949, 1951; Galerie Louis Carre, Paris, 1952, 1955, 1966; Venice, 1968.

GLASER, DAVID—Painter, Des., Comm., I., Ser.
33 Downhill Lane, Wantagh, L.I., N.Y. 11793
B. Brooklyn, N.Y., Sept. 29, 1919. Studied: ASL; NYSch. Indust. A.; NYSch. Contemp. A.; BMSchA, with M. Soyer, Xavier Gonzales. Member: All. A. Am.; Am. Veterans Soc. A. Awards: Scholarship, ASL, 1936; 1st prize, Levitt Home Improvement Design Award, 1967. Work: Experimental silk screen production for industry, 1954-56. Exhibited: All. A. Am., 1960-1968; Am. Veterans Soc. A., 1963-1968; Almus Gal., Great Neck, N.Y., 1963 (one-man); NAC, 1959; Hofstra Col., 1952-1958; Heckscher Mus., 1952-1956, 1963-1965; BM, 1949-1951; Art Directions, 1959; City Center, N.Y., 1960. Designer, Industrial Publications and Annual Reports. Positions: A. Dir., Des., 1946-48; Dir., 1954-60; Dir., Des., "Studio Concepts," 1960- .

GLASER, SAMUEL—Collector, Architect
585 Boylston St., Boston, Mass. 02116; h. 381 Dudley Rd., Newton Center, Mass. 02159
B. Riga, Latvia, Jan. 21, 1902. Studied: Mass. Inst. of Technology,

B.S., M.A. Collection: Late 19th and 20th century drawings, paintings, sculpture and rare illustrated books. Positions: Owner, Samuel Glaser Associates, architectural practice.*

GLASGALL, MRS. HENRY W.—Collector
930 Fifth Ave., New York, N.Y. 10021*

GLASS, HENRY P(ETER)—Designer, E.
666 Lake Shore Dr. 60611; h. 245 Dickens Rd., Northfield, Ill. 60093
B. Vienna, Austria, Sept. 24, 1911. Studied: Technical Univ., Vienna; Master Sch. for Arch., with Theiss. Member: F., Industrial Des. Soc. of Am. Awards: gold med., IDI, 1952; Fine Hardwoods Assn. award, 1955. Work: Furniture, Product, commercial interiors display & arch. des. Contributor: Interiors, Plastics & other trade magazines with articles on problems of design. Des. Ed., "Hitchcock's Woodworking Digest." Positions: Chief Des., Morris B. Sanders, N.Y., 1940-41; Hd., Arch. Des. Dept., W. L. Stensgaard, Chicago, 1942-45; Chm. Chicago Chapter, IDI, 1957-59; Prof. Indst. Des., AIC, Chicago, Ill., 1946-1967 (retired). Own business, Henry P. Glass Assoc., 1946 to present.

GLENN, AMELIA NEVILLE (Mrs. C. Leslie)—Patron
16 Kalorama Circle, Washington, D.C. 20008
B. Washington, D.C., June 8, 1903. Studied: Potomac School; Holton Arms School; National Cathedral School, all Washington, D.C. Positions: Bd. National Symphony (18 years); Junior League; Womens Committee, Washington Opera; Corcoran Gallery Art (Chm. Spring Ball, 1965); two committees, Washington Cathedral and many other board positions.*

GLICKMAN, MAURICE—Sculptor, P., T., W.
2231 Broadway 10024; h. 165 E. 66th St., New York, N.Y. 10021
B. Iasi, Romania, Jan. 6, 1906. Studied: ASL; Edu. All. Sch. and abroad. Member: Sculptors Gld.; NSS. Awards: Guggenheim Fellowship, 1934. Work: sculpture, Dept. Interior, Wash., D.C.; Howard Univ.; Roberson Mem. A. Center, Binghamton, N.Y.; Tel-Aviv Mus., Israel; Albany Inst. Hist. & Art; Phoenix A. Mus.; N.Y. Bd. Edu.; USPO, Northampton, Pa.; South River, N.J.; Joseph H. Hirshhorn Coll. Exhibited: WMAA, 1938-1961; PAFA, 1939-1960; Detroit Inst. A., 1960; PMA, 1940, 1950; MMA, 1935; S. Gld., 1938-1961; Art: USA, 1958; one-man: Morton Gal., 1931; North Carolina Woman's Col., 1941; Babcock Gal., N.Y., 1947; MModA; NAD; Arch. Lg., N.Y.; Phila. A. All.; Carnegie Inst.; NSS; CGA; BM; Assoc. Am. A.; Florence Lewison Gallery, N.Y. In 1961-62, 1963, 1966 and 40-year Drawing Retrospective, 1968; London, Paris & Rome; "A Selected Retrospective—1933-1963," Albany Inst. Hist. & Art. Contributor to Architectural Record, Coronet, American Artist and Design magazines. Positions: Instr., School for Art Studies, N.Y., 1945-55; Dir., 1945-55; Exec. Sec., Sculptor's Gld., 1954-55.

GLINCHER, ARNOLD B.—Art dealer
Pace Gallery, 32 E. 57th St., New York, N.Y. 10022*

GLINSKY, VINCENT—Sculptor, Et., T., Lith., P.
5 West 16th St. 10011; h. 9 Patchin Place, New York, N.Y. 10011
B. Russia, Dec. 18, 1895. Studied: Columbia Univ.; City Col., N.Y.; BAID. Member: NSS; S. Gld.; Audubon A.; Arch. Lg. Awards: Widener gold medal, PAFA, 1935; Guggenheim Fellowship, 1935-36; grant, Am. Acad. A. & Lets., and Nat. Inst. A. & Lets., 1945; Medal of Honor, NAC, 1958; prizes, PAFA, 1948; Arch. Lg., 1956; Adelphi Col., 1956; Audubon A., silver medal, 1967; NSS, gold medal, 1967, prize, 1968. Work: Brookgreen Gardens Outdoor Mus.; Norfolk Mus. A.; Wiltwyck Sch. for Boys, N.Y.; Dept., Memorial Tower, Wash. D.C.; Am. Cancer Fnd.; All Faiths Chapel, Paramus, N.J.; N.Y. Univ. Hall of Fame for Great Americans; S. dec., French Bldg., N.Y.; Public bldgs., Detroit; New Orleans; Bethesda, Md.; Health Center; Sun & Surf Cl., Atlantic Beach, N.Y.; USPO, Hudson, N.Y. and Weirton, W. Va.; Lady of Lourdes Shrine, St. Paul's Col., Wash., D.C.; medal for U. S. Navy; mem. plaque, Bd. Edu., New York City; Carol Lane Safety Award Trophy, and many private commissions. Exhibited: Paris, France, 1932; AIC; GGE 1939; WFNY 1939; PMA, 1940, 1949; Carnegie Inst., 1941; Contemp. Am. A., London, 1941; NAD, 1945, 1967; Westbury Gardens, N.Y., 1960; PAFA, 1958, 1960; Detroit Inst. A., 1958, 1960; Audubon A. 1962-1969; PAFA, 1964; Norfolk Mus. A., 1963; Arch. Lg., N.Y., 1962-1964, 1967-1968; N.Y. World's Fair, 1964; So. Vermont A. Center, 1964-1968; traveling exh., Bd. Edu., New York City, 1962-1969; S. Gld., 1962-1969; San Francisco, 1960; NSS, 1964-1969; Lamont Gal., Exeter, N.H., 1967; MMA; BM; WMAA; MModA, and others. Traveling group shows; one-man: New York City, 1956, 1957. Positions: S. Instr., BAID, 1938-40; Brooklyn Col., 1949-55; Columbia Univ., summer 1956-1961, 1957- ; Asst. Prof., N.Y. Univ., Div. Continuing Educ., 1950- .

GLOVER, DONALD MITCHELL—Curator of Education, L.
Dayton Art Institute, Forest & Riverview Aves. 45405; h. 316 E. Schantz Ave., Dayton, Ohio 45409
B. Cleveland, Ohio, May 23, 1930. Studied: Allegheny Col.; Cleveland Inst. A., B. Mus.; Western Reserve Univ., M.A. (Art history and Aesthetics). Positions: Cur., Education, Dayton Art Institute, Dayton, Ohio.

GLUCKMAN, MORRIS—Painter
945 Carrol St.; h. 1035 Union St., Brooklyn, N.Y. 11225
B. Kiev, Russia, Aug. 7, 1894. Studied: Odessa A. Sch.; NAD; Brooklyn Mus. Sch. A.; Davidson Sch. Modern Art. Member: AEA; AWS; Am. Soc. Contemp. A.; Lg. of Contemp. A. Awards: prizes, AWS, 1958; Winsor & Newton award, BM, 1955; Shannon, Judge Phillip, Max Granick and Heydenryk awards, Am. Soc. Contemp. A., 1956, 1969. Work: Norfolk Mus. A. & Sciences; Fordham Univ., and in private colls. Exhibited: Nordness Gal., City Center, Art:USA, Contemporary Arts, NAD, ACA Gal., Donell Lib., Hudson Park Lib., all New York; Brandeis Univ. (one-man); Fordham Univ. (one-man); Long Island Univ., 1967.

GLUECK, GRACE H.—Writer
New York Times, 229 W. 43rd St., New York, N.Y. 10036
B. New York, N.Y. Studied: Washington Square College, N.Y. Univ., B.A. Positions: Conducts Sunday art notes column and various articles, New York Times, New York, N.Y.

GODWIN, MRS. FRANK. See Harbeson, Georgiana Brown.

GODWIN, ROBERT LAWRENCE—Painter, S., T.
Brindidge, Ala. 36010
B. Enterprise, Ala., Oct. 20, 1934. Studied: Auburn Univ., Bach. Applied Art. Awards: prizes and purchase awards, Wiregrass A. Lg., 1965; Annual Comp., Dothan, Ala., 1965; Alabama A. Lg., 1964, 1968; Dixie Annual (Southeastern States Comp.), 1964; Southern Arts Festival, 1964 (2); Birmingham Festival of Arts, 1965 (accorded a one-man show). Exhibited: Florence, Ala.; Governor's Gal., Montgomery, Ala.; one-man: Huntsville, Ala.; Alabama Artists Gal., Birmingham; Panama City, Fla.; St. Louis, Mo.; Alabama College, Montevallo; Birmingham, Ala.; Montgomery Mus. FA, 1964. Work: Montgomery Mus. FA; murals, Holiday Inn and New Planetarium, Montgomery, Ala., and in private colls. Work published in "Prize Winning Watercolors," 1964.

GOFF, LLOYD LOZES—Painter, I., Gr., W., E.
136 W. 75th St., New York, N.Y. 10023
B. Dallas, Tex., Mar. 29, 1917. Studied: ASL; Univ. New Mexico, and with Nicolaides. Member: AEA; ASL. Work: LC; WMAA; MMA; Univ. Vermont; Wadsworth Atheneum; Herbert Mem. Mus., Augusta, Ga.; DMFA; Federal Bldg., Cooper, Tex.; West Point Military Acad.; Federal Bldg., Hollis, Okla.; Museo Nacionale de Bellas Artes, Mexico City; Instituto Anglo-Mexicano de Cultura, Mexico City; Instituto Mexicano-Norteamericano, Mexico City; Am. Acad. A. & Lets., 1968. Exhibited: WMAA, 1937, 1938, 1942, 1943; NAD, 1937, 1938; PAFA, 1936, 1938; AIC, 1936-1938; WFNY, 1939; San F. AA, 1941-1943; Mus. New Mexico, Santa Fé, 1940-1946, 1958 (one-man); Dallas Mus. FA, 1940, 1946; Galeria de Arte Mexicano, D.F., 1951 (one-man); AFA, 1951; Artzt Gal., N.Y., 1959 (one-man); Juster Gal., N.Y., 1960, 1961 (one-man); Am. Inst. A. & Lets., 1954-55; Botts Mem. Hall, Albuquerque, 1955, 1957 (one-man); recent one-man: Blondell Gal., 1966, Roko Gal., 1968, both New York City; La Plante Gal., Albuquerque, N.M., 1968. I., "New Mexico Village Arts," 1949. Author, I., "Run Sandpiper, Run," 1957 (Boy's Clubs of America award); "Fly Redwing Fly," 1959. Painting reproduced in "History of Water Color Painting in America," 1966. Positions: Asst. Prof. A., 1943-45, Actg. Hd. Dept. FA, Univ. of New Mexico, 1944-45.

GOLD, ALBERT—Painter, Gr., I., E., W., L.
6814 McCallum St., Philadelphia, Pa. 19119
B. Philadelphia, Pa., Oct. 31, 1916. Studied: PMSchIA, with Franklin Watkins, Earl Horter, Henry C. Pitz; Graphic Sketch Cl., Phila. Member: Phila WC Cl.; Phila. Pr. Cl.; Phila. A. All.; AEA. Awards: prizes, Phila. Pr. Cl., 1939; Prix de Rome, 1942; Order of the British Empire, 1947; Phila. A. All., 1953, 1955; AWS, 1953, 1955, 1961; Tiffany Fnd. grant, 1947, 1948; gold med., PAFA, 1950; Woodmere Endowment Fund, 1968. Work: PAFA; N.Y. Pub. Lib.; LC; PMA; Ford Motor Co.; Pentagon Bldg., Wash., D.C.; U.S. War Dept.; Abbott Laboratories Coll.; mural, Haverford, Pa. Exhibited: PAFA, 1938-1942, 1944, 1945, 1948, 1952; CGA, 1939; WFNY, 1939; AIC, 1939, 1941, 1942, 1943; Carnegie Inst., 1942, 1943; Nat. Gal., London, 1944; Musee Galliera, Paris, 1945; NAD; Penn Center Gal., Phila., 1961; Audubon A.; Gimbel Bros., traveling exh.; one-man: PAFA, 1948; Phila. A. All., 1951, 1965, 1967; Lehigh Univ., 1948; Woodmere A. Gal., Phila., Pa., 1948; Fischman-Weiner Gal., Phila., 1968. Illus., "The Commodore," 1954; "The Lamp," 1958 (Standard Oil Co.); "The Court Factor," 1964; "The Captive Rabbi," 1966; jacket, illus., "Our Philadelphia," 1948; "This Was Our War," 1961; "Sunday Bulletin" magazine, 1961-62; Alcoa Aluminum "Corregidor" The Surrender. Positions: Dir. Dept. of Illustration, Phila. Mus. College of Art, 1960- .

GOLD, FAY—Painter
503 W. 45th St., New York, N.Y. 10036
B. Brooklyn, N.Y. Studied: Parsons Inst. Des.; Master Inst. of United Arts, Riverside Mus.; ASL. Member: ASL; AEA; AWS. Awards: Prizes, Municipal A. Center, 1939; Yaddo Fnd. grant, 1949; Audubon A., 1964. Work: drawings, Library of Performing Arts, Lincoln Center, N.Y.; NAD. Exhibited: PAFA, 1961; Silvermine Gld. A., 1961, 1962; Jersey City Mus., 1961; Audubon A., 1962, 1964; AWS, 1963, 1964, 1966, 1967; Eastern States Comp., 1963; Soc. Four Arts, Fla., 1963; Village A. Center, N.Y., 1964 (and one-man); Springfield A. Lg., 1964; Oklahoma Printmakers Soc., 1964, 1969; Wash. WC Cl., Smithsonian Inst., 1964; Canton AI, 1964; Boise AA, 1964; Frye Mus. A., Seattle, 1964; Abilene Mus. A., 1964; Orlando AA, 1964; Columbus Mus. A., South Carolina, 1964; Davenport Municipal A. Gal., 1965; Moore College of Art, 1965; Arnot A. Gal., Elmira, N.Y., 1965; Baldwin-Wallace College, 1965; Brooks Mem. Mus., Memphis, 1965, 1968; NAD, 1966; Willamette Univ., 1968; Mansfield FA Gld., 1968; Sarasota AA, 1968; McMurry Col., 1969; Oklahoma A. Center, 1969; Norfolk Mus. A. & Sciences, 1969; one-man: Norlyst Gal., N.Y., 1946; Roko Gal., N.Y., 1949, 1951; Partita Gal., Southampton, L.I., 1956; John J. Myers Gal., N.Y., 1964.

GOLDBERG, MICHAEL—Painter
330 W. 11th St., New York, N.Y. 10014
B. New York, N.Y. 1924. Studied: City Col., N.Y.; ASL; Hans Hofmann Sch. A. Exhibited: one-man: Tibor de Nagy Gal., N.Y., 1953; Poindexter Gal., N.Y., 1956, 1958; Martha Jackson Gal., N.Y., 1960; Paul Kantor Gal., Beverly Hills, Cal., 1960; Holland Gal., Chicago, 1961; Anderson-Mayer Gal., Paris, 1963.*

GOLDBERG, NORMAN L. (Dr.)—Historian, W., L.
721 Brightwater Blvd., St. Petersburg, Fla. 33704
B. Nashville, Tenn., Feb. 10, 1906. Studied: Univ. Toledo, B.S.; Vanderbilt Univ., M.D. Member: CAA. Contributor to The Connoisseur, Antiques, London Times Literary Supplement. Arranged exh. & catalogue: Landscapes of the Norwich School, 1967. Lectures: 18th & 19th Century English Landscape; John Crome and The Norwich School; the lectures given at Victoria & Albert Museum, London, The Castle Museum, Norwich, England, Vanderbilt Univ., Tenn., FA Center, Isaac Delgado Mus. A., Cummer Gal. of A., and Metropolitan Mus., 1961-1969.

GOLDBERGER, MR. and MRS. EDWARD—Collectors, Patrons
1050 Park Ave., New York, N.Y. 10028; also 1367 Flagler Dr., Mamaroneck, N.Y. 10543
Collection: Modern sculpture; Abstract and modern art.*

GOLDIN, LEON—Painter, Lith., E.
438 W. 116th St., New York, N.Y. 10027
B. Chicago, Ill., Jan. 16, 1923. Studied: AIC, B.F.A.; State Univ. of Iowa, M.F.A. Awards: Tiffany Fnd. Grant, 1951; Fulbright F. for France, 1952; Prix de Rome, 1955, renewed, 1956-57; Guggenheim F., 1959; Ford Fnd. purchase prize, 1960; Jennie Sesnan gold medal, PAFA, 1965; Nat. Endowment for the Arts Grant (for sabbatical leave), 1967; Nat. Inst. A. & Lets. Grant, 1968. Work: BM; Worcester Mus. A.; Addison Gal. Am. A.; Santa Barbara Mus. A.; Los A. Mus. A.; Oakland Mus. A.; CMA; British Arts Council; CAM; Munson-Williams-Proctor Inst.; VMFA; Univ. Nebraska; Everson Mus. A., Syracuse; J.B. Speed Mus., Louisville; Portland (Me.) Mus. A.; PAFA; Univ. So. Cal., and others. Exhibited: MMA, 1950, 1952; MModA, 1953, 1956; CGA, 1963; Carnegie Inst., 1964; PAFA, 1951, 1959-1964; one-man: Oakland A. Mus., 1955; Felix Landau Gal., Los A., 1956, 1957, 1959; Galleria l'Attico, Rome, 1958; Kraushaar Gal., N.Y., 1960, 1964, 1968. Positions: Asst. Prof., Painting, Columbia University, New York, N.Y.

GOLDMAN, ALBERT MARTIN—Painter
245 Worth Ave., Palm Beach, Fla. 33480
B. New York, N.Y., June 12, 1924. Studied: NAD; Am. A. Sch.; Columbia Univ., B.F.A. Member: NSMP. Awards: Brevoort-Eickmeyer F., Columbia Univ., 1951-52; prize, Norton Gal. A., 1954; Alfred Morang Mem. Award, Santa Fé, 1958. Work: Columbia Univ.; MMA; murals, Palm Beach Towers; Gonzales Elem. Sch., Santa Fé, N.M.; Santa Fé Jewish Temple; L. J. Reynolds Co., Santa Fé. Exhibited: widely in New York, Florida, New Mexico; one-man: Prang Gal., N.Y., 1952; Norton Gal. A., 1954; Mus. New Mexico, 1954, 1958; Gallery Gemini, Palm Beach, Fla. Positions: Dir., Plaza Art School, Kansas City, Mo., 1962-1967.

GOLDOWSKY, NOAH—Art dealer
1078 Madison Ave., New York, N.Y. 10028*

GOLDSCHMIDT, LUCIEN—Art Dealer
1117 Madison Ave., New York, N.Y. 10028; h. 285 Riverside Dr., New York, N.Y. 10025
B. Brussels, Belgium, Mar. 3, 1912. Specialty of Gallery: Prints, Drawings, illustrated books, 1500-1950; continental art only. Exhibitions held include several on Jacques Villon, 20th Century Drawings, Callot, Chiaroscuro prints, Matisse, Picasso, etc. Positions: Advisory Committee for Dealers on the Print Council; Governor Antiquarian Booksellers Association; Ed., Unpublished Correspondence of Toulouse-Lautrec.

GOLDSMITH, MR. AND MRS. C. GERALD—Collectors, Patrons
655 Park Ave., New York, N.Y., 10021; also, Purchase, N.Y. 10573
(Mrs. Goldsmith)—B. New York, N.Y., May 18, 1931. Studied: Wellesley College, B.A. Member: Friends of The Whitney Museum of American Art Acquisitions, 1963-1965; Junior Council, The Museum of Modern Art, 1959-1969; A.F.A. Art Collectors Club. Collection: Contemporary American Art. Positions: Writer, art critic; Contributing Editor, New York Magazine, Harper's Bazaar, Town & Country.

(Mr. Goldsmith)—B. Orlando, Fla., Aug. 2, 1928. Studied: University of Michigan; Harvard Business School. Member: Art Collectors Club, Friends of The Whitney Museum of American Art; American Federation of Arts. Collection: Contemporary American Art.

GOLDSMITH, MORTON RALPH—Collector, Patron
Two Stonehouse Rd., Scarsdale, N.Y. 10583
B. Cleveland, Ohio, Apr. 26, 1882. Studied: Harvard University, B.A. Collection: Includes Matisse, Rousseau, Utrillo, Gris, Delacroix, Courbet, Rouault, Klee, Moro, Monticello, Derain, Maillol, Daumier, Cezanne, Orozco, Braque, Beckmann, Pascin, Redon, Vuillard, Renoir, Masson, Feininger, Marin, Weber, Kuniyoshi, Knaths, Hartley, Gatch, Bombois, Baziotes, Eilshemius, Kane, Dickinson, Spencer, Fiene, Avery, Bluemner, Grigoriev, Brook, Rivera, Hokusai, Mouillot, Blakelock, Hidalgo, Hogarth, Legrand, Maurer, Merida, Manigault, Hans Moller, Paalen, Turner, Bonhomme, and many others including American contermpraries.

GOLDSTEIN, MILTON—Etcher, P., T., L.
56-16 219th St., Bayside, N.Y. 11364
B. Holyoke, Mass., Nov. 14, 1914. Studied: ASL, and with Harry Sternberg, Homer Boss, Morris Kantor. Member: SAGA; ASL; AEA; Am. Color Pr. Soc. Awards: prizes, Springfield (Mass.) Mus. FA, 1946; PMA, 1949, 1952; Phila. Pr. Cl., 1952; Guggenheim F., 1950; N.Y. State Fair, 1950; LC, 1952; purchase awards: DMFA; Brooks Mem. Mus.; PMA; Univ. Delaware; Albion Col.; Suburban A. Lg., Syosset, L.I., 1964; Smithsonian Inst.; LC; Louisiana A. Comm.; award, Am. Color Pr. Soc., Phila., 1967. Work: Springfield Mus. FA; MModA; PMA; MMA; Univ. Pa.; Univ. Nebraska; Princeton Univ.; LC; SAGA; Univ. Maine; Des Moines A. Center; Adelphi Univ., N.Y.; Springfield Col., Mass.; Smithsonian Inst. Des. cover of "The Sketch Pad" magazine of Kappa Pi, 1962. Color etchings in 210 Prints Editions, Int. Graphic A. Soc., 1952. Credit for contribution to American Printmaking in "Printmaking Today," 1961. Exhibited: J.B. Speed A. Mus., 1949; Pr. Cl. of Albany, 1949; Wichita A. 1949; BM, 1947, 1949, 1952, 1966; PAFA, 1947, 1950; Carnegie Inst., 1947, 1950; LC, 1947, 1949, 1952; Phila. Pr. Cl., 1948-1952; SAGA. 1947-1952; Am. Color Pr. Soc., 1951, 1952, traveling exh., Japan and Hawaii, 1961; WMA, 1951; Phila. A. All., 1951, 1969; Univ. Maine; Univ. Utah; Cornell Univ.; Indiana Univ., 1951; Univ. Nebraska, 1952; Springfield Mus. FA, 1946-1949; MModA traveling exh. to Europe, 1951-52; traveling group show, Italy and Norway; World's Fair, N.Y., 1964; Modern Masters of Engraving exh., Queen's College, N.Y.; 1964; New Jersey State Mus., 1966, 1967. One-man: Weyhe Gal., 1954; Smithsonian Inst.; Louisiana A. Comm.; Retrospective Exh., Glassboro (N.J.) State T. Col., 1962; Springfield Col., Mass., 1968. Illus. educational film, "How to Make an Etching." Lectures on Color Etchings. Positions: Prof. A., Adelphi College, Garden City, N.Y.

GOLDSTONE, MR. and MRS. HERBERT—Collectors
1125 Park Ave., New York, N.Y. 10028*

GOLDWATER, ROBERT—Museum Administrator, W., Cr., L., E.
The Museum of Primitive Art, 15 West 54th St.; h. 347 W. 20th St., New York, N.Y. 10011
B. New York, N.Y., Nov. 23, 1907. Studied: Columbia Col., A.B.; Harvard Univ., M.A.; N.Y. Univ., Ph.D. Member: Am. Assn. Univ. Prof.; CAA (Dir. 1956-). Awards: Guggenheim F., 1944-1945; Fulbright F., 1950-51. Author: "Primitivism in Modern Painting," 1938; "Artists on Art," 1945; "Rufino Tamayo," 1947; "Modern Art in Your Life," 1949; "Jacques Lipchitz," 1954; "Paul Gauguin," 1957; "Senufo Sculpture," 1964. Contributor to: Art magazines with historical and critical articles on modern art. Lectures: 19th

& 20th century American and European Art. Positions: Instr., History of Art, New York Univ., 1934-39; Asst. Prof., History of Art; Assoc. Prof., 1948-55, Prof., 1955-1957, Queens Col., Flushing, L.I., N.Y.; Prof., New York University, 1957- ; Dir., Museum of Primitive Art, New York, N.Y., 1957-1963; Chairman, Administrative Committee, 1963- . Ed., Magazine of Art., 1947-53.*

GOLLIN, MR. and MRS. JOSHUA A.—Collectors
1290 Ave. of the Americas, 10019; h. 1025 Fifth Ave., New York, N.Y. 10028
B. New York, N.Y., Aug. 16, 1905 (Mr. Gollin). Studied: Washington University, St. Louis, Mo. (Mr. Gollin). Member: Sustaining Members, Metropolitan Museum of Art, Museum of Modern Art, The Solomon R. Guggenheim Museum, American Federation of Arts; Gave two prizes at 1964 Biennale in Venice for a painter and a sculptor under 40 years of age. Collection: Sculpture of the past fifty years and African Primitive Carvings.*

GOLUB, LEON (ALBERT)—Painter, Gr., E.
171 W. 71st St. 10023; h. 530 La Guardia Pl., New York, N.Y. 10012
B. Chicago, Ill., Jan. 23, 1922. Studied: Univ. Chicago, B.A.; AIC, B.F.A., M.F.A. Awards: Florsheim Mem. Prize, 1954, Watson F. Blair purchase prize, 1962, both AIC; prize, Bienal Interamericana, Mexico City, 1962; Ford Fnd. Grant, 1960; Tamarino Grant, 1965; Cassandra Fnd. Grant, 1967; Guggenheim Fnd. Grant, 1968. Work: AIC; MModA; La Jolla A. Center; Tel Aviv Mus.; Smithsonian Inst., NCAF; Univ. of Calif.,Berkeley; Southern Ill. Univ.; Indiana Univ.; Univ. Texas. Exhibited: Carnegie Inst., 1964, 1965, 1967; MModA, 1959; Guggenheim Mus., 1954; CGA, 1964; Univ. Illinois, 1957, 1961, 1963, 1964; AIC, 1954, 1960; SFMA, 1963; WMAA, 1955, 1956; Univ. Nebraska, 1957, 1960, 1961; Art:USA, 1963-64; Prix Marzotta, 1964, 1967, 1968; Mus. Mod. A., Paris, 1967; Inst. Contemp. A., London, 1968; II Bienal Int., Madrid, 1969, and in Italy and France. One-man: 30 exhibitions in U.S. including: Retrospective, Tyler Sch. FA, Temple Univ.; Pasadena A. Mus.; Univ. Chicago; Indiana Univ.; Purdue Univ.; Pomona Col.; Allan Frumkin Gal., N.Y. and Chicago. Other one-man: Inst. Contemp. A.; London; Centre Culturel Americain, Paris; Galerie Iris Clert, Paris; Galerie Europe, Paris; Hanover Gal., London. Positions: 1950-1956: Instr. A., Wright Jr. College, Chicago; Northwestern Univ.; Illinois Inst. Technology; Visiting Prof. A., Stella Elkins Tyler School of Fine Arts of Temple Univ., Philadelphia, Pa., 1965. Sch. of Visual A., N.Y., 1966-1969; Fairleigh Dickinson Univ., Teaneck, N.J., 1969- .

GONZALES, BOYER—Painter, E.
School of Art, University of Washington 98105; h. 6525 51st St., Northeast, Seattle, Wash. 98115
B. Galveston, Tex., Feb. 11, 1909. Studied: Univ. Virginia, B.S. in Arch.; and with Henry Lee McFee, Yasuo Kuniyoshi. Member: CAA; Scarab Cl. Awards: prizes, So. States A. Lg., 1939; Texas FA Assn., 1950, 1952; Texas A. & Crafts Fair, 1953; Dealy prize, Texas Exh. Painting & Sculpture, 1953; SAM, 1955, 1956. Work: Rochester Mem. A. Gal.; Elisabet Ney Mus. A., Austin, Tex.; Witte Mem. Mus., San Antonio; DMFA; SAM. Exhibited: CGA, 1935, 1939, 1951; PAFA, 1936, 1951; WFNY, 1939; GGE, 1939; Univ. Illinois, 1947; NAD, 1954; Colorado Springs FA Center, 1957, 1959, 1965; Santa Barbara Mus. A., 1957, 1962; Stanford Univ. A. Gal., 1958; deYoung Mem. Mus., San F., 1958; Vancouver (B.C.) A. Gal., 1958; Portland (Ore.) Mus. A., 1959, 1962; Los A. Mus. A., 1962; FA Gal., San Diego, 1962; SFMA, 1962; Denver A. Mus., 1960. Positions: Instr., A., Univ. Texas, 1939-54; Chm., A. Dept., Univ. Texas, 1946-48; Dir., Sch. A., Prof. A., University of Washington, Seattle, Wash., 1954-1966, Prof. A., 1966- .

GONZALES, CARLOTTA (Mrs. Richard Lahey)—Painter, S., T., I.
9530 Clark Crossing Rd., Vienna, Va. 22180; s. Box 412, Ogunquit, Me. 03907
B. Wilmington, N.C., Apr. 3, 1910. Studied: PAFA, with Laessle; NAD, with Aitken; ASL, with Laurent, Karfiol. Member: Soc. Indp. A.; Ogunquit AA. Exhibited: CGA; NAD; BMA; Goucher Col., Baltimore; George Washington Univ. 1939, 1950, 1951; Montclair A. Mus., 1952; NAD, 1931. Illus., "Stars in the Heavens"; "U.S.A. and State Seals." Commissioned by The American Battle Monuments Commission, to design, in collaboration with Richard Lahey, a mural for The Hawaii Memorial, Honolulu, 1960 (completed 1964). Co-author (with Richard Lahey) "Picasso, The Artist and His Work," 1968; "Rembrandt, The Artist and His Work," 1968. Positions: Instr. S. Goucher Col., 1940-42; CGA, 1940; A., Nat. Geographic Magazine, Washington, D.C., 1943- .

GONZALEZ, XAVIER—Painter, S., L.
222 Central Park South, New York, N.Y. 10019
B. Almeria, Spain, Feb. 15, 1898. Member: NA; Century Assn.; Audubon A. Awards: Grant, Am. Acad. A. & Lets.; Guggenheim Fellowship, 1947; Ford Fnd. Grant, 1965; winner, sculpture mural

for the City College of N.Y. Technology Bldg., 1963. Work: in many museums and private collections. Exhibited: nationally and internationally. Author: "Notes About Painting," 1955. Positions: Instr. A., Sophie Newcomb College, New Orleans, La.; Brooklyn Mus. School; Artist-in-Residence, Western Reserve Univ., 1953-54; Pres., NSMP, 1968, 1969; Lecturer, Metropolitan Museum of Art, New York, N.Y.

GONZALEZ, MRS. XAVIER. See Edwards, Ethel

GOO, BENJAMIN—Sculptor, Des., E.
 Art Department, Arizona State University, Tempe, Ariz. 85281; h. 5312 N. Wilkinson Rd., Scottsdale, Ariz. 85251
B. Honolulu, Hawaii, July 12, 1922. Studied: Honolulu Acad. A.; Univ. Hawaii; State Univ. Iowa, B.F.A.; Cranbrook Acad. A., M.F.A.; Brera Acad. FA, Sch. of Marino Marini, Milan, Italy. Member: NAEA; Pacific AA; AAEA; Arizona Des.-Craftsmen. Awards: "Institutions" magazine award of honor for furniture and interior des. of Memorial Union Bldg., Arizona State College, 1956; Jay Sternberg Mem. award, Arizona, 1957; St. Francis Xavier Religious Art purchase prize, 1957; Circle Art Exh. purchase prize, New Mexico, 1957; Arizona Crafts, 1961; Phoenix A. Mus., gold medal, 1959, prize, 1963, 1967; Arizona A., 1959; Tucson FA Assn., 1960; Arizona State Fair, 1957, 1959, 1962, 1963, 1966, 1968; Fulbright Fellowship to Italy, 1954-55; Roswell Mus. & A. Center, purchase, 1962; Yuma A. Center, purchase, 1969. Work: Cranbrook Acad. A.; Museum and A. Center, Roswell, N.M.; State Univ. of Iowa; St. Francis Xavier Parish Coll. of Religious Art; interior des. of main lounge, St. Augustine Episcopal Church, Arizona, 1958, and sculpture and garden sculpture in private homes and collections. Exhibited: Wichita A. Center, 1957, 1959, 1960; PAFA, 1958, 1960, 1964; Ball State T. Col., 1957; Des Moines A. Center, 1957; Sculpture Center, 1954-1958; Fulbright Designers Show, Mus. Contemp. Crafts, N.Y., 1958; Denver A. Mus., 1958; Santa Fe, N.M., 1957; Roswell, N.M., 1957, 1958; Tucson, Ariz., 1957; Phoenix, Ariz., 1957; Arizona State Fair, 1955-1957, 1962, 1963; Silvermine Gld. A., 1959; Detroit Inst. A., 1960; DMFA, 1960, 1964; SFMA, 1961-1964; WAC; St. Paul A. Center. Keynote address, "Dynamic Directions in Crafts," to South Central Regional Conference, Am. Craftsmen's Council, Univ. Oklahoma, Norman, 1967.

GOOCH, DONALD B.—Designer, I., E., P., Comm.
 Department of Art, College of Architecture & Design, University of Michigan; h. 1633 Leaird St., Ann Arbor, Mich. 48105
B. Bloomingdale, Mich., Oct. 17, 1907. Studied: Western Michigan Univ.; Univ. Michigan, B.S., M. Des.; Detroit A. Acad.; Am. Sch. Painting, Fontainebleau, France. Member: Detroit Mus. A. Fndrs. Soc.; F., Intl. Inst. A. & Lets.; Adcraft Cl. of Detroit; AAUP; Intl. Platform Assn. Awards: Alumni prize, MA. Acad. in Rome, 1935; Detroit Inst. A. Fndrs. award, 1947; Michigan WC Soc., 1948. Work: 1948-59; Advertising & Publication Design, Young & Rubicam; Kenyon & Eckhardt; Benton & Bowles; Univ. Michigan and others; painting & illus.; Ford Publications; Ford Motor Co.; Young America Films; McGraw-Hill Co.; Michigan Consolidated Gas Co.; Univ. Michigan Union. Exhibited: PAFA; Pepsi-Cola; SFMA; Detroit Inst. A., and others. Editor, "Advertising to the American Taste," 1956; Designer: "The Story of Willow Run," Editor, Des., "Theatre and Main Street," Univ. Michigan, 1964. Author: "Picture Talk in Kathmandu" (Papers of the Michigan Academy of Arts & Sciences, 1963); Artist: "A Literary Map of Michigan," Michigan Council of Teachers of English, 1965. Research: "Pictographic Communication for Non-Literate Communities," Kathmandu, Nepal, 1961, 1967. Positions: Conf. Chm., Univ. Michigan Advertising Conferences, 1956, 1959; Prof. Des., Art Dept., College of Arch. & Des., University of Michigan, Ann Arbor, Mich., 1951-; Co-Dir., Creative Advertising Workshop, A. Dept., Univ. of Mich., 1967- .

GOOD, LEONARD—Educator, P., Cr., L., W.
 Drake University; h. 750 34th St., Des Moines, Iowa 50312
B. Chickasha, Okla., June 25, 1907. Studied: Univ. Oklahoma, B.F.A. in A. Edu.; ASL, with Kimon Nicolaides; Univ. Iowa, with Jean Charlot. Member: Prairie WC Soc.; AEA; A. Dirs. Assn. of Iowa; Assn. Okla. A.; SSAL; Madison AA. Awards: med., Oklahoma Univ., 1927; prizes, Tulsa AA, 1939, 1941; Assn. Okla. A., 1942, 1949, 1953; Gimbel Bros., Milwaukee, 1951, 1952; Iowa State Fair, 1954; Kansas Fed. A., 1955; Lutheran Life of Christ Art Competition, 1968. Work: Oklahoma Hist. Mus.; Governor's Mansion, Des Moines, Iowa; Des Moines A. Center; Milwaukee A. Center; Iowa Historical Museum; Philbrook A. Center, Tulsa, Okla.; murals, Gardner Co., Madison, Wis.; Taft Jr. H.S., Oklahoma City. Illus., Instructional manuals for Army Air Corps, 1943, 1944. Author: Correspondence course for U.S. Armed Forces Inst. on Art, 1952. Positions: Cur. Paintings, Prof. A., Univ. Oklahoma, 1930-50; Univ. Wisconsin, 1950-52; Hd. A. Dept., Drake Univ., Des Moines, Iowa,

1952-68; Prof. A., Drake Univ., 1968- ; Visiting artist, Iowa State Univ., 1966; Nat. Pres., Delta Phi Delta, honor art fraternity, 1958-60.

GOODALL, DONALD B.—Educator, Mus. Dir., Cr., L.
 Department of Art, University of Texas, 23rd St. & San Jacinto 78712; h. 836 E. 37th St., Austin, Tex. 78705
B. Los Angeles, Cal. Studied: Univ. Oregon, A.B.; AIC; Univ. of Chicago, A.M.; Harvard Univ., Ph.D. Member: CAA; Archaeological Inst. Am.; So. California A. Hist.; Am. Studies Soc.; Bd. Dirs., Nat. Assn. Schs. of Art. Contributor to College Art Journal; Arts Digest magazine. Positions: Dir., Utah A. Center, 1938-42; Chm. Dept. A., Univ. Texas, 1945-46; Actg. Dean, Div. Edu., Toledo Mus. A., 1946-47; Chm., Dept. FA, University of Southern California, 1948-1959; Chm. Dept. Art, Dir., University Museum, 1959- ; Acting Dean, College of Fine Arts, University of Texas, Austin, Tex., 1965.

GOODELMAN, AARON—Sculptor
 c/o ACA Gallery, 63 E. 57th St., New York, N.Y. 10022*

GOODMAN, BENJAMIN—Patron
 1500 Commerce Title Bldg. 38103; h. 115 S. Rose Road, Memphis, Tenn. 38117
B. Memphis, Tenn., Jan. 18, 1904. Positions: Patron of regional art (Mid-South); Trustee (former President), The Memphis Academy of Arts; Chairman, Memphis Art Commission (Municipal), 1960- .

GOODMAN, ESTELLE—Sculptor
 115 Central Park West, New York, N.Y. 10023
B. New York, N.Y. Studied: Barnard College, B.A. Member: AEA; Artists-Craftsmen of N.Y.; Lg. Present Day A.; Knickerbocker A.; P. & S. of New Jersey; Yonkers AA. Awards: prizes, P. & Sc. of New Jersey, 1963, 1967; Yonkers AA; Mahopac AA; Vermont A. Center. Work: Norfolk Mus. A., and in private colls. Exhibited: All. A. Am., 1963-1965; Audubon A., 1965; Knickerbocker A., 1961, 1962, 1964; P. & Sc. of New Jersey, 1961-1964; Vermont A. Center, 1964; Yonkers AA; Rochester AA; Wolfe A. Cl.; Selected A. Gal., N.Y., 1962, 1964 (one-man); Nat. Des. Center, N.Y., 1966; W. & J. Sloane Co., 1967.

GOODMAN, JAMES—Art dealer
 James Goodman Gallery, The Park Lane, 33 Gates Circle, Buffalo, N.Y. 14209*

GOODMAN, SIDNEY—Painter, Gr.
 High School Rd. & Harrison Ave., Elkins Park, Pa. 19117
B. Philadelphia, Pa., Jan. 19, 1936. Studied: PMSch. A. Awards: Guggenheim Fellowship, 1963; Ford Fnd. purchase, 1963; PAFA, 1962; Phila. Print Cl., purchases, 1961, 1965. Work: MModA; WMAA; PMA; LC; BM. Exhibited: PAFA, 1959-1965; Phila. Print Cl., 1959-1965; WMAA, 1961-1963; MModA, 1962, 1964, 1965; CGA, 1963; BM, 1963; PMA, 1960, 1962, 1964, 1965; one-man: Terry Dintenfass Gal., N.Y., 1962-1964. Positions: Instr., Drawing and Composition, Philadelphia College of Art.*

GOODNOUGH, ROBERT—Painter
 189 W. 10th St., 10014; h. 122 Christopher St., New York, N.Y. 10014
B. Cortland, N.Y., Oct. 23, 1917. Studied: Syracuse Univ., B.F.A.; N.Y. Univ., M.A.; New School for Social Research; Ozenfant Sch. Art; Hans Hofmann Sch. Fine Arts. Awards: Ada Garrett Award, AIC, 1961; Hiram Gell Fellowship, Syracuse Univ., 1940; Ford Fnd. purchase, 1963 (CGA). Work: Albright-Knox A. Gal.; Guggenheim Mus; MMA; AIC; MModA; N.Y. Univ. Collection; WMAA; Wadsworth Atheneum. Exhibited: Art: USA; AIC, 1960-1961; Vanguard Art for Paris Exh., 1954; Kootz Gal., N.Y., 1950. Book: "Goodnough" by Barbara Guest & B.H. Friedman, 1962. Contributor reviews and articles for Art News, 1953-57. Positions: Instr., Painting, Cornell University and N.Y. University.

GOODNOW, FRANK A.—Painter, E.
 214 Dawley Rd., Fayetteville, N.Y. 13066
B. Evanston, Ill., Dec. 14, 1923. Studied: Northwestern Univ.; AIC; B.F.A., and in Europe. Member: AAUP. Awards: Foreign Traveling Fellowship, AIC; prizes, Rochester Mem. Mus., 1969; Everson Mus. A., 1966, 1967. Work: PMA; N.Y. State Univ.; Skidmore Col.; Everson Mus. A.; Univ. Rochester; Syracuse Univ.; Munson-Williams-Proctor Inst., Utica, N.Y. Exhibited: LC, 1961; Ohio Univ., 1962; Ball State Univ., Muncie, Ind., 1963, 1964; PAFA, 1965; Purdue Univ., 1964, 1969; Rochester Mem. Mus., 1966, 1969; Munson-Williams-Proctor Inst., 1967-1969; one-man: Westerly Gal., New York City, 1967; Everson Mus. A., 1967; Schuman Gal., Rochester, 1965, 1969. Positions: Assoc. Prof., Painting & Drawing, Syracuse Univ., Syracuse, N.Y. at present

GOODRICH, LLOYD—Museum Director, W., L.
Whitney Museum of American Art, 945 Madison Ave., New York, N.Y. 10021
B. Nutley, N.J., July 10, 1897. Studied: ASL, with Kenneth Hayes Miller; NAD. Author: Books on American Artists, "Thomas Eakins," 1933; "Winslow Homer," 1944; "Yasuo Kuniyoshi," 1948; "Max Weber," 1949; "Edward Hopper," 1950; "John Sloan," 1951; "Albert P. Ryder," 1959; "Pioneers of Modern Art in America," 1963; Co-author, "American Art of Our Century," 1961, and others. Ed., Research in American Art, 1945. Contributor to leading art magazines. Lectures on American Art. Positions: Assoc. Ed., The Arts, 1925-27, 1928-29, European Ed., 1927-28, Contributing Ed., 1929-31; Member N.Y. Regional Comm., Public Works of Art Project, 1933-34; Research Cur., WMAA, 1935-46, Assoc. Cur., 1946-48, Assoc. Dir., 1948-58, Dir., 1958-1968; Adv. Dir., 1968- ; Dir., American Art Research Council, 1942- ; Member Ed. Bds., Art in America; Vice-Chm., Com. on Govt. & Art; Member, Smithsonian Art Commission; Ed., "The Museum and the Artist," 1958; Contributor, "New Art in America," 1957; Trustee & Honorary Vice-Pres., AFA; Sec., Sara Roby Fnd.; Co-Chm., Joint Artists-Museums Com.; Memb. Adv. Bd., Carnegie Study of American Art; Memb., Conseil Scientifique International, Encyclopedia dell'Arte; Fellow, Am. Acad. A. & Sciences; Trustee, Whitney Museum of American Art.

GOODWIN, ALFRED—Collector
4325 SW 34th Ave., Portland, Ore. 97201
B. Germany, Aug. 4, 1914. Awards: Honorary Lifetime Trustee, Salt Lake Art Center, 1963. Collection: Prints. Positions: Chairman of Exhibitions, Salt Lake Art Barn, 1955-1961.

GOOSSEN, EUGENE C.—Critic
Hunter College, 695 Park Ave. 10021; h. R.F.D. No. 1, Buskirk, N.Y. 12028
B. Gloversville, N.Y., Aug. 6, 1920. Studied: Hamilton College; Corcoran Sch. FA; Sorbonne, Paris, France (Certif.); New School for Social Research, B.A. Member: International Art Critics Assn. (American Section); American Society for Aesthetics. Awards: Frank Jewett Mather Citation, Excellence in Art Criticism, 1958. Author: "Stuart Davis," 1959; "Three American Sculptors," 1959; "Ellsworth Kelly," 1958; articles in Arts Magazine, Art News, Art International. Positions: Freelance art criticism, 1948- ; Instr., Art History and Criticism and Director of Exhibitions, Bennington College, Bennington, Vt., 1958-1961; Prof. A., Chairman Art Dept., Hunter College, New York, N.Y., 1961- .*

GORCHOV, RON—Painter
74 Grand St., New York, N.Y. 10013
B. Chicago, Ill., Apr. 5, 1930. Studied: AIC; Univ. Illinois. Work: Wadsworth Atheneum, Hartford, Conn. Exhibited: WMAA, 1960; Carnegie Inst., 1961; BM, 1962; one-man: Tibor de Nagy Gal., N.Y., 1960, 1963, 1966. Positions: Instr., Painting, Hunter College, N.Y., 1962- .

GORDLEY, METZ T.—Painter, C., E.
Art Department, East Carolina University, Greenville, N.C. 27834
B. 1932. Studied: Washington Univ., St. Louis, B.F.A.; Univ. Oklahoma, M.F.A.; Ohio State Univ., Ph.D. Awards: Undergrad. scholarship, Washington Univ., St. Louis; Grad. study scholarships, Univ. Oklahoma; Ohio State Univ.; North Carolina Pr. & Drawing (purchase), 1966; East Carolina A. Soc., (purchase), 1968. Work: in private collections. Exhibited: Washington Univ., 1951, 1952, 1953, 1956; CAM, 1956; Theatre in the Round, Oklahoma City, 1956 (2-man); Oklahoma A. Mus., 1957; East Carolina College, 1959-1961; East Carolina A. Soc., 1959, 1960; North Carolina State Mus., Raleigh, 1960; Nat. WC Exh., Peoria, Ill., 1961; Univ. North Dakota, Grand Forks, 1961; Nashville, Tenn., 1961. Positions: Prof., Sch. of A. and Asst. Dean, East Carolina College, Greenville, N.C., 1959- .

GORDON, JOHN—Museum Director
Society of the Four Arts, Four Arts Plaza, Palm Beach, Fla. 33482
B. Brooklyn, N.Y., Jan. 20, 1912. Studied: Dartmouth Col., A.B. Member: The Drawing Society's National Committee; Corporate Member, The MacDowell Colony. Contributor to Art in America; Brooklyn Museum Bulletin. Arranged exhs., Brooklyn Mus.: International Watercolor Exhibition, 1953, 1955, 1957; 14 Painter-Printmakers, 1955; Face of America, BM, 1957. Exhibitions & Monographs on Karl Schrag, 1960 & José de Rivera, 1961 for AFA under grant from Ford Fnd.; Exhibition and Monograph on "Richard Pousette-Dart," 1963 for Whitney Mus. Am. Art; "Louise Nevelson," 1967; "Isamu Noguchi," 1968; "Franz Kline," 1968. Author: "Geometric Abstraction in America," 1962; "New York, New York," 1965. Positions: Asst. Dept. Circulating Exhibitions,

MModA, 1944-46; Sec., 1946-52, Cur., Paintings and Sculpture, 1952-1959. The Brooklyn Museum of Art, Brooklyn, N.Y.; Cur., Whitney Museum of American Art, New York, 1959-1969; Dir., Society of the Four Arts, Palm Beach, Fla., 1969- .

GORDON, MARTIN—Art Dealer
43 Greenwich Ave. 10014; h. 55 E. 9th St., New York, N.Y. 10003
B. New York, N.Y., Aug. 15, 1939. Studied: Rochester Institute of Technology, B.S. Specialty of Gallery: 20th Century Graphics and Contemporary American Paintings.*

GORDON, MAXWELL—Painter
Rio Hudson 28, Apt. No. 9, Mexico 5, D.F.
B. Chicago, Ill., Sept. 4, 1910. Studied: Cleveland Sch. A.; John Huntington Polytechnic Inst., Cleveland. Member: AEA; Audubon A. Awards: prizes, Butler AI, 1947; Springfield (Ill.) Mus. A., 1947, 1949; medal, Audubon A., 1954; CGA, 1947; CMA, 1931; Yaddo Fnd., 1957, 1960. Work: Brandeis Univ.; Ein Harod, Israel; Museo Nacional de Arte Moderno, Mexico City. Exhibited: PAFA; CMA; BM; MModA; Colorado Springs FA Center; BMA; SAM; Butler AI; Pepsi-Cola; CGA; WMAA; Univ. Illinois; Audubon A.; one-man: Pinacotheca Gal., 1943-1944; ACA Gal., 1948-1950, 1953, 1959, 1962; Las Galerias C.D.I., 1962, Galerias de Art Turok-Wasserman, 1964, Galeria Nios, 1964, Museo Nacional de Arte Moderno, 1965, Galeria Jose Maria Velasco, 1966, Galeria Sagitario, 1968, all Mexico City; Galeria San Miguel, San Miguel de Allende, Gto. Mexico, 1966.

GORDON, RUSSELL—Painter
Larcada Gallery, 23 E. 67th St., New York, N.Y. 10021
B. Altoona, Pa., 1932. Studied: PAFA; Barned Fnd., Merion, Pa., and with Hobson Pittman. Work: PAFA; AGAA; FMA; and in private colls. Exhibited: Yale Univ. A. Gal.; PAFA; Am. Acad. A. & Lets.; Gal. Mod. A., N.Y.; VMFA; Sarah Lawrence Col., N.Y.; AGAA; AFA; DeCordova and Dana Mus.; Deerfield Acad.; Newport AA; Contemp. Mus. A., Houston, Tex; one-man: Durlacher Bros., N.Y., 1957-1967; Fantasy Gal., Washington, D.C., 1958; Ft. Worth A. Center.

GORMAN, WILLIAM D.—Painter, Gr.
43 W. 33rd St., Bayonne, N.J. 07002
B. Jersey City, N.J., June 27, 1925. Studied: Newark Sch. Fine & Indst. A. Member: Audubon A.; All. A. Am.; Nat. Soc. Painters in Casein; Assoc. A. of New Jersey; Painters & Sculptors Soc.; New Jersey WC Soc. Awards: prizes, Butler Inst. Am. A., 1961; Audubon A., 1957, 1963; Nat. Soc. Painters in Casein, 1960, 1965, 1968; Painters & Sculptors Soc., 1955, 1957, 1961, 1963-1965, 1966, 1968, 1969; Knickerbocker A., 1957, 1959; New Jersey WC Soc., 1955, 1961, 1963, Silver Medal, 1964, 1966; Am. Veterans Soc. A., Gold Medal, 1963; Montclair A. Mus, 1962; Allied A. Am., 1961, 1963, 1968; Watercolor:USA, Springfield (Mo.) A. Mus., 1966 (purchase); Nat. Acad. (purchase), 1965; Am. Veterans Soc., 1962, silver medal, 1963, gold medal, 1963, 1967. Work: Butler Inst. Am. A.; Newark Mus.; Norfolk Mus. A. & Sciences; Syracuse Univ.; Jersey City Mus.; St. Vincent College (Pa.); LaSalle College (Pa.); U.S. State Dept.; Springfield (Mo.) Art Mus.; Colo. Springs FA Center; Geo. Washington Carver Mus., Ala.; Brandeis Univ. Exhibited: Butler Inst. Am. A., 1960, 1961, 1963, 1965-1968; PAFA, 1965, 1967, 1969; NAD, 1962, 1963, 1968; Newark Mus., 1955, 1958, 1964, 1968; Norfolk Mus., 1965; Ball State T. College, 1964, 1965; Montclair A. Mus., 1955-1963; Silvermine Gld. A., 1960, 1963, 1966; Jersey City Mus. (one-man), 1962; Revel Gal., N.Y., 1963 (one-man); Watercolor USA, 1966, 1967, 1968; Art in Embassies Program, U.S. State Dept. 1964-69 in Europe, Africa, Asia; Phila. Art Alliance (one-man) 1966; Wisc. State Univ., Eau Claire (one-man) 1967; East Side Gallery, N.Y. (one-man) 1968; Centenary Col., N.J. (two-man) 1969; traveling exhs. in U.S. and Canada. Covers, The Reporter Magazine. Reproductions of Works in Prizewinning Art Books, 2, 4, 5, 6. Dir., Old Bergen A. Gld.

GORMAN, MRS. WILLIAM D. See Gary, Jan

GORSLINE, DOUGLAS WARNER—Painter, I., W., T., Ser.
Box 710, Grand Central Station, New York, N.Y. 10017
B. Rochester, N.Y., May 24, 1913. Studied: Yale Sch. FA; ASL. Member: ANA; SAE. Awards: prizes, PAFA, 1942; Lib. Cong., 1942, 1946; NAD, 1942, 1944; Tiffany Fnd. grant, 1963-1964. Work: Lib. Cong.; Univ. Rochester; New Britain Mus.; Hamilton Col.; Sports Illustrated; Life; Horizon; Ladies Home Journal; Readers Digest. Designed 1964 5 cents Commemorative Stamp honoring William Shakespeare. Exhibited: Carnegie Inst.; PAFA; CGA; AIC; WMAA; NAD. Illus., "Look Homeward, Angel"; "Compleat Angler"; "Little Men"; "Citizen of New Salem." Author, I., "Farm Boy"; "What People Wore" (a history of costume).*

GOTH, MARIE—Portrait Painter
State Rd. 135, Nashville, Ind.; h. Indianapolis, Ind.
B. Indianapolis, Ind. Studied: ASL, with DuMond, Chase, Mora. Member: Brown County A. Gld.; Indiana AC; Hoosier Salon. Awards: prizes, NAD, 1931; Hoosier Salon, 1926-1929, 1932, 1934-1942, 1945, 1946, 1948, 1949, 1951, 1952, 1957, 1958, 1963 (2), 1965; 2 ports., Scottish Rite, Brown County A. Gal., 1933; Indiana AC, 1935, 1939, 1944, 1945, 1956, 1959, 1961; Evansville (Ind.) Mus. A. & Hist., 1939. Work: Hanover Col.; Franklin Col.; Purdue Univ.; Indiana Univ.; Butler Col.; port., James A. Allison Pub. Sch.; Davis Clinic all in Indiana; John Herron AI; Fla. State Univ., Tallahassee; John Howard Mitchell House, Kent, England; Honeywell Mem. Community Center, Wabash, Ind.; port. former Gov. Schricker, lobby of Service Area, No. Indiana Toll Road; Miami Univ., Oxford, Ohio portraits, 1959-1961: Indiana Univ.; Shortridge H.S.; Davis Clinic, Marion, Ind. Exhibited: Cincinnati A.Cl.; Hoosier Salon; Indiana A. Cl.; Brown County A. Gld.; Swope Mem. A. Mus.; one-man: Indiana Central Col., Indianapolis, 1968; A. Gld. Gal., 1969.

GOTO, JOSEPH—Sculptor
17 6th St., Providence, R.I. 02906*

GOTTLIEB, ABE—Collector, Patron
105 Madison Ave. 10021; h. 799 Park Ave., New York, N.Y. 10021
B. Poland, Apr. 17, 1908. Studied: New School for Social Research. Awards: Many from charitable institutions; Brandeis Univ., and others. Collection: From Renoir to Vlaminck; School of Paris; German Expressionism; Paintings, Sculpture from Daumier to Moore. Positions: Chm. Board, Federation of Jewish Philanthropies; United Jewish Appeal; Bd., Montefiore Hospital; Assn. for Help for Retarded Children; Brandeis University.*

GOTTLIEB, MRS. ABE—Collector, Patroness
799 Park Ave., New York, N.Y. 10021
See Gottlieb, Abe.*

GOTTLIEB, ADOLPH—Painter
190 Bowery 10012; h. 27 West 96th St., New York, N.Y. 10025
B. New York, N.Y., Mar. 14, 1903. Studied: ASL; and in Paris, France, Berlin, Germany. Awards: Dudensing Comp., 1929; U.S. Treasury Comp., 1939; prize, Brooklyn Soc. A., 1944; Carnegie Intl., 1961; Grande Premio, VII Bienal, Sao Paulo, 1963. Work: WMAA; MModA. Exhibited: nationally. Also, London, 1946; Paris, 1947, 1952; Tokyo, 1952, 1955; retrospective exhs., Bennington Col., 1954; Williams Col.; 15 year retrospective exh., Jewish Mus., N.Y., 1957; Simultaneous exhibitions at WMAA and Guggenheim Mus., 1968. Contributor articles to College Art Journal; Art in America. Des., stained glass facade, Milton Steinberg house, N.Y.

GOULET, LORRIE (Mrs. Lorrie deCreeft)—Sculptor, P.
22 E. 17th St.; h. 241 W. 20th St., New York, N.Y. 10011
B. Riverdale, N.Y., Aug. 17, 1925. Studied: Inwood Studios; Black Mountain Col., and with Jose deCreeft, Josef Albers. Member: AEA; Audubon A.; Nat. Com. on A. Edu.; S. Gld. AAUP; Rye A. Center (Bd. Dirs.). Awards: Norton Gal. A., 1950, 1951; Soc. Four A., 1950; Ball State T. Col., 1959; Westchester A. Soc., 1964; Audubon A., Solten Engel award, 1967. Work: ceramic relief for grand concourse, N.Y. Pub. Lib., 1958; Nurse's Res., Bronx (N.Y.) Municipal Hospital, 1961. Exhibited: PAFA; 1949-1958; WMAA, 1949-1951, 1953-1955; Fairmount Park, Phila., 1950; Audubon A., annually; Reverside Mus., 1950; Phila. A. All., 1950; Palm Beach A. Lg., 1949-1951; Soc. Four A., 1949-1951; S. Center, 1948-1952; Acad. A. & Lets., 1961; Jacksonville A. Center, 1950; Wilmington A. Center, 1949; Ball State T. Col., 1959; WMA, 1955; World Trade Fairs, Zagreb, Yugoslavia, Barcelona, Spain, 1958; New School for Social Research, N.Y., 1962; Philbrook A. Center, Tulsa, Okla., 1964; AFA, 1963; N.Y. World's Fair, 1964; Loeb A. Center, N.Y. Univ., 1966; CGA, 1966; New School, N.Y., 1968; Bryant Park, Sculptors Gld. exh., 1969; one-man: Clay Cl., 1948; Sculpture Center, N.Y., 1955; Contemporaries Gal., N.Y., 1959, 1962, 1966; Rye (N.Y.) Lib., 1966; New School, N.Y., 1968; Temple Emeth, Teaneck, N.J., 1969. Positions: Instr., New School, N.Y., 1961. Television-CBS-26 educational programs on sculpture for children, 1964-1968.

GOURLEY, HUGH J. III—Museum Curator
Museum of Art, Rhode Island School of Design, 224 Benefit St. 02903; h. 261 Benefit St., Providence, R.I. 02903
B. Fall River, Mass., Mar. 12, 1931. Studied: Brown Univ., A.B.; Yale Univ. Grad. School. Member: CAA; R.I. Historical Soc.; Providence Preservation Soc.; Providence A. Cl. Contributor to: Antiques; Museum Notes; Bulletin of Rhode Island School of Design. Lectures on Decorative Arts. Participated in the arrangement of exhibitions and collections: Italian Drawings from the Museum's Collection, 1961; China-Trade Porcelain, 1962; Paintings and Constructions of the 1960's selected from the Richard Brown Collec-

tions, 1964; Drawings from the Collection of Mr. and Mrs. Winslow Ames, 1965. Positions: Curatorial Asst., (summer) Wadsworth Atheneum, Hartford, Conn., 1957; Asst. in Research, Yale University Art Gallery, 1957-1959; Curator Decorative Arts, Museum of Art, Rhode Island School of Design, Providence, 1959- ; Actg. Dir., July, 1964-May, 1965.*

GOVAN, FRANCIS HAWKS (FRANK)—Educator, P., C., Des., L.
Marianna, Ark. 72360
B. Marianna, Ark., Dec. 19, 1916. Studied: Hendrix Col., B.A. in Humanities; Art Inst. of the South, Memphis; Univ. Wisconsin; Layton Sch. A.; Columbia Univ., M.A., and in Mexico. Member: Southeastern AA; Com. on A. Edu., MModA. Awards: Carnegie Research grant, 1950. Exhibited: Wisconsin Salon, 1940-1942; Wisconsin Des-Craftsmen, 1943, 1944; SSAL, 1945; Memphis Biennial, 1946; Arkansas annual, 1944-1953; Am. Watercolor Exh. circulated in France, 1953-1955; Art in Embassies, 1967-1968; Smithsonian Inst.; one-man: Mus. FA. Little Rock, 1944; Univ. Arkansas, 1944; Little Rock Pub. Lib., 1952; Serigraph Gal., N.Y., 1953; Feigl Gal., 1954-1955, 1956; Kunst uit Amerika, 1957-58; retrospective exh., Brooks Mem. A. Gal., 1957, one-man, 1967. Positions: Instr., Witte Voc. Sch., Wisconsin Rapids, Wis., 1941-43; Milwaukee Univ., Creative Writing, co-ord. Publ. Performances, 1943-45; Asst. Prof. A., Hendrix Col., 1945-52; Occupational Therapy Instr., Rockland State Hospital, Orangeburg, N.Y., 1952-54; Edu. Dir., Brooks Mem. A. Gal., Memphis, Tenn., 1955-56; Asst. Prof., Memphis State University, Memphis, Tenn., 1956-1961; Prof. A., 1961- ; Cur. Exhs., 1957-1967; Faculty Council, 1967-1970.

GOWANS, ALAN—Educator, W.
Art & Art History Department, University of Delaware; h. 104 Sypherd Dr., Newark, Del. 19711
B. Toronto, Ont., Canada, Nov. 30, 1923. Studied: Univ. Toronto, B.A., M.A.; Princeton Univ., M.F.A., Ph.D. Member: Soc. Arch. Hist. (Dir., 1957- , Sec. 1959-); CAA. Author: "Church Architecture in New France," 1955; "Looking at Architecture in Canada," 1958; "Images of American Living," 1964. Contributor articles to The Art Bulletin; College Art Journal; Journal of the Soc. of Arch. Historians; Journal of Architectural Education, etc. Positions: Dir., Fleming Mus. A., Univ. Vermont, 1954-56; Chm. Dept. Art & A. Hist., University of Delaware and Prof. A. History in the Winterthur Program, 1956- .*

GRABACH, JOHN R.—Painter, S.
915 Sanford Ave., Irvington, N.J. 07111
B. Greenfield, Mass. Studied: ASL. Member: ANA; Knickerbocker A.; SC; Audubon A.; Phila. WC Cl.; Irvington A. & Mus. Assn. Awards: prizes, AIC; Los A. Mus. A.; gold medal, PAFA; William Clark prize & medal, CGA; medal, IBM; prize & medal, Audubon A.; Herman Wick Mem. Prize and Louis Seley Purchase prize, SC; Medal, Knickerbocker A. Work: AIC; Vanderpoel Coll.; John Herron AI; IBM; Biro Bidjan Mus.; Phila. A. All.; Norton Gal. A.; CGA. Exhibited: CGA; AIC; Montclair A. Mus.; PAFA; Audubon A; Knickerbocker A.; Grand Central A. Gal. (one-man). Author: "How to Draw the Human Figure." Positions: Instr. A., Newark Sch. F. & Indust. A., Newark, N.J.

GRACE, CHARLES M.—Collector
50 E. 42nd St. 10017; h. 834 Fifth Ave., New York, N.Y. 10021
B. Manhasset, Long Island, N.Y., Sept. 13, 1926. Studied: Mount St. Mary's College, Emmitsburg, Maryland, A.B.; Columbia University School of Business, M.B.A. Positions: Board of Directors, The Museum of American Folk Arts; The Liturgical Arts Society; Member, Antique Collectors Club of America; The American Federation of Arts; Archives of American Art; Life Fellow, of the Metropolitan Museum of Art; Member, Whitney Museum of American Art; Guggenheim Museum, and others.

GRADO, ANGELO JOHN—Painter, Des.
641 46th St., Brooklyn, N.Y. 11220
B. New York, N.Y., Feb. 17, 1922. Studied: ASL with Robert Brackman; NAD with Robert Philipp; Famous Artists School. Member: AWS; AAPL; SC; ASL (life). Awards: prize, Bantam Book Award, N.Y., 1957. Exhibited: AAPL, 1963, 1965-1969; SC, 1969; AAPL, 1969; All. A. Am., 1961, 1963-1966; Audubon A., 1963; AWS, 1958, 1960, 1963, 1965, 1966, 1968; NAD, 1963; Heckscher Mus., 1962; Knickerbocker A., 1959, 1960, 1962; NAC, 1961, 1962; Boston Univ., 1959; Frye Mus., Seattle, 1958; Crocker A. Gal., Sacramento, Cal., 1958; Cleveland Inst., 1958; Joslyn A. Mus., 1959; Louisiana State Mus., 1959. Positions: Freelance Art Dir. & Illustrator, 1955- ; A. Dir., "The Art Times" magazine, 1964-1965.

GRAFLY, DOROTHY (Mrs. Charles Hawkins Drummond)—Writer, Cr., L.
131 North 20th St., Philadelphia, Pa. 19103
B. Paris, France, July 29, 1896. Studied: Wellesley Col., B.A.; grad.

work, Radcliffe Col. Member: Phila. A. All.; Phila. WC Cl. (hon.);
F., PAFA (hon.); Int. A. Cr. Assn.; Charter memb., Phila. Altrusa
Cl. Awards: Citation, DaVinci A. All., Phila., 1961; Elected Distinguished Daughter of Pennsylvania, 1960, for service to art and artists; Medal of Achievement, Phila. Art Alliance, 1969. Has contributed to Magazine of Art, Art News, American Artist, Design Magazine, Camera, and other leading publications. Lectures on contemporary American painting, prints, sculpture. Positions: W., Cr.,
Phila. North American, 1920-25; A. Cr., Public Ledger, 1925-34;
Phila. Record, 1934-42; Dir. A. & Research, Philip Ragan Assoc.,
1942-46; Corr., Art Digest, 1949-53; Corr., Christian Science Monitor, 1920-1962; Cur., Coll., Drexel Inst., 1934-45; Contributing Ed.,
American Artist, 1946-56; L., Temple Univ., 1938-39; Drexel Inst.,
1940-42; Ed. Publ., Art in Focus; Art Editor, The Evening and Sunday Bulletin, Phila., Pa., 1956- .

GRAHAM, BILL (WILLIAM KARR)—Cartoonist
 Arkansas Gazette; h. 5208 West 24th St., Little Rock, Ark.
72204
B. Coshocton, Ohio, Dec. 14, 1920. Studied: Centenary Col., B.S.
Member: Nat. Cartoonists Soc.; Assn. of Am. Editorial Cartoonists.
Work: murals, Camp Beauregard, La; Albert T. Reid perm. coll.,
Univ. Kansas; Gen. George C. Marshall Library, Va. Military Inst.,
1959; Political Cartoon Collection, Univ. Missouri, School of Journalism; Cartoon Collection, Syracuse Univ. Exhibited: Nat. Cartoonists Soc. traveling exh. in conjunction with U.S. Treasury Dept.,
1950; MMA, 1951; Liverpool, England, Press Cl. exh. 1951; Political cartoon Exh. & Coll., Wayne State Univ., 1960; Assn. Am.
Editorial Cartoonists traveling exh., 1960. Positions: Ed. Cart.,
Arkansas Gazette, 1948- .

GRAHAM, FRANK P.—Museum Administrator
 Philadelphia Museum of Art, Division of Education, Parkway
at 26th St. 19101; h. 210 Spruce St., Philadelphia, Pa. 19106
B. Grove City, Pa., Oct. 21, 1923. Studied: Graduate—Pennsylvania
State University, B.S. Arch.; Ecole d'Americaine des Beaux Arts,
Paris; School of Planning and Research for Regional Development,
London. Interests: Architecture, Architectural History (Lecturer),
Art History, City Planning. Positions: Chief, Division of Education,
Philadelphia Museum of Art.*

GRAHAM, JAMES—Gallery director
 Graham Gallery, 1014 Madison Ave., New York, N.Y. 10021*

GRAHAM, JOHN MEREDITH, II—Director of Collections
 Colonial Williamsburg, Inc.; h. Bracken House, Francis St.,
Williamsburg, Va. 23185
B. Floyd County, Ga., Dec. 23, 1905. Studied: Lehigh Univ.; and
abroad. Member: Soc. Architectural Historians; English Ceramic
Circle; Pewter Collectors Club, N.Y. (past Vice-Pres.); Honorary
Bd. Governors, Wedgwood International Seminar; Delta Tau Delta.
Contributor to: Antiques, American Collector magazines. Lectures:
American Decoration and Architecture: American glass, silver,
pewter. Author: "Popular Art in America"; "American Pewter";
Co-author: "Wedgwood, A Living Tradition"; Editor: "Old Pottery
and Porcelain Marks." Other work: Completed restoration and furnishings of interior of Van Cortlandt Manor House for Sleepy Hollow
Restoration. Positions: Advisor to the White House Fine Arts Committee; Cur., American Decorative Arts, Brooklyn Museum; Brooklyn, N.Y., 1938-1950; Vice-President & Director of Collections, Colonial Williamsburg, Williamsburg, Va., 1950- . Trustee and Consultant to Campbell Historical Mus.

GRAHAM, MRS. JOHN REGINALD. See Ray, Ruth

GRAHAM, ROBERT C.—Collector, Patron, Art Dealer
 Graham Gallery, 1014 Madison Ave., 10021; h. 215 E. 68th St.,
New York, N.Y. 10021
B. New York, N.Y., Apr. 28, 1913. Studied: Yale University, B.A.;
New York University; Studied Fine Arts in Europe. Specialty of
Gallery: Modern painting and sculpture (Graham Gallery); 18th,
19th and 20th century American and European paintings (James
Graham and Sons). Positions: Partner, firm of James Graham and
Sons; Director, Graham Gallery.

GRAMATKY, HARDIE—Illustrator, P., W., L.
 60 Roseville Rd., Westport, Conn. 06880
B. Dallas, Tex., April 12, 1907. Studied: Stanford Univ.; Chouinard
AI, and with Clarence Hinkle, Pruett Carter, F. Tolles Chamberlin,
Barse Miller. Member: NA; SI; AWS; Cal. WC Soc. Awards: prizes,
AIC, 1942; AWS, 1942, 1952; Cal. WC Soc., 1943; Los A. Mus. A.,
1931, 1934; Cal. State Fair, 1933; Audubon A., 1945, 1952; SC, 1952;
AWS, 1963. Work: AIC; Toledo Mus. A.; BM; Springfield (Mass.)
Mus. A.; Elmira (N.Y.) A. Mus.; U.S. Air Force Acad., Colorado
Springs; mss., illus., Kerlan Coll., Univ. of Minnesota Library;
Univ. of Oregon; Univ. of Southern Mississippi. Exhibited: AIC;

WMAA, 1939-1941; BM, 1938-1940; Audubon A.; AWS; Cal. WC Soc.;
Los A. Mus. A.; Sc. Author, I., "Hercules," 1940; "Loopy," 1941;
"Little Toot"; "Creeper's Jeep," 1946; "Sparky," 1952; "Homer
and the Circus Train," 1957; "Bolivar," 1961; "Nikos and the Sea
God," 1962; "Little Toot on the Thames," 1964. Illus. for True,
Today's Woman; Collier's; Woman's Day; American, and other
National Magazines. Contributor to American Artist magazine.
1962; The Horn Book, 1964. Lectures extensively.

GRANLUND, PAUL THEODORE—Sculptor, T.
 5320 Russell Ave., South, Minneapolis, Minn. 55410
B. Minneapolis, Minn., Oct. 6, 1925. Studied: Gustavus Adolphus
College, B.A.; Univ. Minnesota Grad. School.; Cranbrook Acad. A.,
M.F.A. Member: AAUP. Awards: Fulbright Fellow, 1954-1955;
Guggenheim Fellowship, 1957, renewed, 1958. Work: Cranbrook
Mus. A.; WAC; Minneapolis Inst. A.; Sheldon Mem. Mus. A. Gallery,
Lincoln, Neb.; sculpture: Gustavus Adolphus College; Lutheran
Church of the Good Shepherd, Minneapolis. Exhibited: Krannert A.
Mus., 1961; Carnegie Int., 1961; one-man: WAC, 1956; Minneapolis
Inst. A., 1959; Steinberg Hall, Washington Univ., St. Louis, 1965;
Sheldon Mem. A. Gal., 1964. Positions: Instr., Sculpture, Minneapolis School of Art, at present.*

GRASS, MRS. FRANK. See Patterson, Patty

GRASSO, DORIS ELSIE—Painter, S., T.
 88 W. 32nd St., Bayonne, N.J. 07002
B. Sullivan County, N.Y., May 3, 1914. Studied: Edu.-All. A. Sch.,
with Moses Soyer, Alexander Dobkin; Newark A. Center; North
Bergen A. Sch., with Fabian Zaccone. Member: Fellow, AAPL;
Hudson Artists; F.I.A.L.; Plainfield, Rutherford, Hunterdon AA; P.
& Sc. Soc. New Jersey. Awards: prizes, Knickerbocker A., 1958;
Jersey City Mus., 1957, 1959; Hudson Artists, 1956, 1961, 1965;
AAPL, 1959-1965; Gold Medallion, "Women of Achievement for
Art," Jersey Journal, 1963; Gold Medal, Bayonne Women's Club,
1964; Golden Lady Statuette, National Women of Achievement
Award for Art, Amita, Inc., 1966; prizes, Patron's Prize, P. & Sc.
of New Jersey, 1964; Bergen Mall Exh., 1964; Certif., AAPL, 1965.
Work: Paul Whitener Mem. Coll., Hickory (N.C.) Mus. A.; George
Burr Coll., Burr Gallery, N.Y.; Bamberger's Hall of Fame, and in
private colls. Exhibited: AAPL, 1954-1965; Burr Gal., 1956-1958;
Knickerbocker A., 1958; Hudson Artists, 1964; P. & Sc. of New
Jersey, 1964; Tercentennial Exh., 1964; Plainfield AA; Rutherford
AA; Hunterdon AA; Jersey City Mus. Galleries; Bayonne Mus. Galleries, 1964-65; Montclair A. Mus.; Hunterdon AA, and many others
1950-1965. One-man: Burr Gal., N.Y., 1959; Bennett College, 1960.
Positions: A. Chm., Bayonne (N.J.) Women's Club, 1950-1963; Pres.,
New Jersey Chptr. AAPL, 1965-1967; Bd. Dirs., AAPL; P. & Sc. of
New Jersey; Hudson Artists Assn.

GRAUBARD, MRS. ANN WOLFE. See Wolfe, Ann

GRAUEL, ANTON C.—Sculptor
 515 Loma Vista St., El Segundo, Cal. 90245
B. Bad Soden/Salmuenster, Germany, Jan. 25, 1897. Studied: in
Germany, Paris, Switzerland and Italy. Awards: prizes, Berlin
and Frankfurt, Germany. Work: National Gal., Berlin; Prussian
Acad. FA, Berlin; sculpture, panels, carvings, Beloit State Bank;
Notre Dame Univ.; Art Dept. Bldg., Stephen Austin State Col., Nacogdoches, Tex.; Father Judge Mission Seminary, Monroe, Va.;
YWCA, Beloit; Beloit College; St. Paul's Catholic Church, Congregational Church, both Beloit, Wis.; Marquette H.S., Alton, Ill.; Loyola
Univ., Los Angeles; and monuments in churches and schools, U.S.A.
and Germany. Exhibited: NSS, 1959, 1960 and prior; Univ. Illinois;
AIC; one-man: Milwaukee A. Center, 1951; Beloit Col., 1952, 1961;
Rockford AA, 1952; Univ. Wisconsin, 1953; Carl Schurz Mem. Fnd.,
Phila., Pa., 1954; Loyola Univ., Los Angeles, 1963, 1965; City Library, El Segundo, Cal., 1965, and in Germany. Contributor to National Sculpture Review, 1960.

GRAUSMAN, PHILIP—Sculptor, T.
 c/o Grace Borgenicht Gallery, 1018 Madison Ave., New York,
N.Y. 10021
B. 1935. Studied: ASL with De Creeft; Cranbrook Acad. A., Bloomfield Hills, Mich., M.F.A.; Syracuse Univ., B.A; Skowhegan Sch.
Painting & Sculpture. Awards: Huntington Hartford Fellowship,
1958; Tiffany Fnd. Grant, 1959; Nat. Inst. A. & Lets. Grant, 1961;
Rome Prize Fellowship in Sculpture, 1962-1965; prizes, Alfred G.
B. Steel Mem. Prize, PAFA, 1962; Gold Medal of Honor, Audubon
A., 1959; Special Honorable Mention, Arch. Lg., N.Y., 1958; Ida
Lewis Award, Rochester-Finger Lakes Exh., N.Y., 1957; purchase
prize, Skowhegan Sch. Painting & Sculpture, 1957. Exhibited: Detroit Inst. A., 1959; Jersey City Mus., 1958; Providence A. Cl.,
1958; NAD, 1958; L'Aguilla, Italy, 1965; WMAA, 1962-1963, 1964-
1965; Nat. Inst. A. & Lets., 1961; PAFA, 1960, 1962; Alpha Gal.,
Boston, 1968; Grace Borgenicht Gal., N.Y., 1966. Work: Bronze

"Cactus" for the Hebrew Union College Biblical & Archaeological School, Jerusalem, 1965. Positions: Instr., Ceramic Sculpture, Greenwich House Pottery, N.Y., 1960-1962; Sculpture, A. Center of Northern New Jersey, 1960-1962; Instr., Design, Cooper Union, N.Y., 1965-1966; Pratt Institute, Brooklyn, N.Y., 1965-1966.

GRAVES, MAITLAND—Painter, T., W.
 Edgartown, Mass. 02539
B. New York, N.Y., June 27, 1902. Studied: ASL; Grand Central A. Sch.; Brooklyn Polytechnic Inst. Awards: prizes, NAC, 1930, 1932, 1935, 1936; European traveling scholarship, 1936. Work: NAC. Exhibited: NAD, 1928; NAC, 1930, 1932, 1935; Newark Mus., 1934; All. A.Am., 1934, 1935; Arch. L., 1936. Author: "The Art of Color & Design," 1941, second ed., 1951; "Color Fundamentals," 1952; "Design Judgment," 1948. Contributor to: national magazines. Lectures: Color & Design. Positions: Assoc. Prof. of Art, Pratt Inst., Brooklyn, N.Y. and Univ. of Rhode Island; Adult Art Education Program, Trustee & Co-Founder, Island Craft Center, Vineyard Haven, Martha's Vineyard, Mass., at present.

GRAVES, MORRIS—Painter
 c/o Willard Gallery, 29 East 72nd St., New York, N.Y. 10021
B. Fox Valley, Ore., 1910. Member: Nat. Inst. A. & Lets. Awards: prizes, SAM, 1933; AIC, 1948; Univ. Illinois, 1955; medal, AIC, 1947; Guggenheim F., 1946; grant, Nat. Inst. A. & Lets., 1956; Windsor award, 1957. Work: SAM; MMoA; PC; Albright A. Gal.; WMAA; Pasadena AI; CMA; Milwaukee AI; Nat. Inst. A. & Let.; Detroit Inst. A.; A. Gal. Toronto; CAM; AIC; Ft. Wayne A. Sch.; MMA; Univ. Illinois; Wadsworth Atheneum; WMA; Wilmington AA; BMA. Exhibited: USIS "8 American Artists," Korea, Japan, Australia and Europe, 1957; Brussels World's Fair, 1958; one-man: SAM, 1936; MMoA, 1942; Willard Gal., 1942, 1944, 1945, 1948, 1953, 1954; Chicago A. Cl., 1943; Univ. Minnesota, 1943; Detroit Inst. A., 1943; PC, 1943, 1954; Phila. A. All., 1946; Cal. PLH, 1948; Santa Barbara Mus. A., 1948; Los A. Mus. A. 1948; AIC, 1948; Beaumont A. Mus., 1952; Oslo, Norway, 1955; retrospective, 1956, WMAA and various cities in U.S.; Bridgestone Gal., Tokyo and Kyoto, 1957. At the invitation of the National Gallery of Art, Washington, D.C., the artist is now under contract with the National Aeronautics & Space Agency to execute paintings on space exploration.*

GRAY, CHRISTOPHER—Educator
 Johns Hopkins University 21218; h. 17 Elmwood Rd., Baltimore, Md. 21210
B. Milton, Mass., June 22, 1915. Studied: Harvard Col., B.S.; Univ. California, Berkeley, M.A.; Harvard Univ., Ph.D. Member: CAA; Archaeological Inst. of Am.; Am. Soc. for Aesthetics. Author: "Cubist Aesthetic Theories," 1953. "Cubist Concepts of Reality"; "Marie Laurencin and Her Friends"; "Cezanne's Use of Perspective," College Art Journal, 1959; article, "The Idea of the Artist as a Creator," Topic 5, 1963. Author: "Sculpture and Ceramics of Paul Gauguin" (book), 1963. Positions: Instr., 1947-51, Asst. Prof., 1951-1964, Assoc. Prof., 1964- , Actg. Chm., 1965, Johns Hopkins University, Baltimore, Md.

GRAY, CLEVE—Painter, W., Gr., Cr.
 Cornwall Bridge, Conn. 06754
B. New York, N.Y., Sept. 22, 1918. Studied: Phillips Acad.; Princeton Univ., and with Jacques Villon, Andre Lhote. Work: MMA; Columbus Mus. FA; AGAA; Guggenheim Mus.; Univ. Illinois; Univ. Nebraska; Princeton Univ. Mus. FA; WMAA; Wadsworth Atheneum, NCFA, and others. Exhibited: nationally since 1947 incl. Jacques Seligmann Gal., N.Y., 1946-1959; Staempfli Gal., N.Y., 1960, 1961, 1964; Saidenberg Gal., 1965, 1967; Betty Parsons Gal., New York, 1969, Contributor articles to Perspectives (Ford Fnd.); College Art Journal; American Scholar; Art in America; Cosmopolitan. Positions: Book Ed., 1959-61, A. Cr., 1961-1963, Contributing Editor, 1963- , Art in America.

GRAY, DAVID—Sculptor
 1512 Portia St., Los Angeles, Cal. 90026
B. Waukesha, Wis., Nov. 9, 1927. Studied: Univ. Wisconsin, B.S., M.S. Awards: Ford Fnd. purchase award, WAC, 1963. Work: WAC; Milwaukee A. Center; Beloit College; sculpture. Sheraton Hotel, Minneapolis, Minn. Exhibited: WMAA, 1965; WAC, 1958, 1962; Denver A. Mus., 1962, 1963; Milwaukee A. Center, 1958-1964. Positions: Instr., Des., University of Wisconsin, 1960-1964.*

GRAY, FRANCINE du PLESSIX—Writer
 Warren, Conn. 06754
B. Warsaw, Poland, Sept. 25, 1930. Studied: Bryn Mawr College; Barnard College, B.A. in Philosophy. Contributor essays, fiction, profiles to: Art in America; The New Yorker; Vogue; Mademoiselle; House and Garden. Awards: Putnam Award for Creative Writing, Barnard College, 1952. Positions: Writer, United Press, 1953-1954; Editorial Assistant, Realities, 1954-1955; Member, Editorial Board, Art in America, 1965- .

GRAY, RICHARD—Art Dealer, Collector
 620 N. Michigan Ave. 60611; h. 5333 Hyde Park Blvd., Chicago, Ill. 60615
B. Chicago, Ill., Dec. 30, 1928. Studied: Univ. Illinois. Member: President, Chicago Art Dealers Association, 1969- . Collection: Late 19th century and contemporary American and European painting, drawing, sculpture. Positions: Director, Richard Gray Gallery, Chicago, Ill.

GRAY, ROBERT W.—Educator, C.
 Southern Highlands Handicraft Guild, 15 Reddick Rd., Asheville, N.C. 28805
B. Tallahassee, Fla. Studied: Univ. Florida; Tri-State Col. (Ind.); Sch. for Am. Craftsmen, Alfred, N.Y. Exhibited: WMA; Eastern States Fair; Mass. Assn. Handicraft Groups. Positions: Coordinator, Craft Program, Old Sturbridge Village, 1951; Memb., Old Sturbridge Village Bd. of Managers, 1951; Memb., Mass. Statewide Advisory Com. on Crafts, 1953-54; Sec., New England Craft Council, 1953-55, Chm., 1957-58; Memb. Adv. Bd., of "Cross-Country Craftsmen"; Co-Dir., New England Craft Exh., 1955; Dir., Worcester Craft Center, Worcester, Mass., 1951-1961; New England Rep. to "First National Craftsmen's Conference," Asilomar, Cal., 1957; Coordinator, Nat. Adv. Bd. Am. Craftsmen's Council, Lake Geneva, Wis., 1958; juror for many craft exhs., in Mass. and other states. Dir., Southern Highlands Handicraft Guild, Asheville, N.C., 1961- . Juror, Piedmont Craft Exh., Mint Museum Art, Charlotte, N.C., 1964; Chm., Finance Committee, Civic Arts Council and member of Exec. Committee, Asheville, N.C., 1964-65; Member, Statewide Committee on Crafts for North Carolina; Board Member, North Carolina Arts Council, 1966, Reappointed 1969; Member, Model Cities Committee, Asheville, N.C., 1968-1969.

GRAY, VERDELLE (Mrs. Robert W.)—Craftsman, Des.
 930 Tunnel Rd., Asheville, N.C. 28805
B. Pomona, Cal., Nov. 9, 1918. Studied: Univ. California at Santa Barbara; Sch. for Am. Craftsmen, Alfred, N.Y. Member: Southern Highland Handicraft Gld.; Am. Craftsmens Council. Exhibited: Syracuse Mus. FA, 1949; Miami, Fla. ceramic exh., 1954, 1955, 1956; St. Paul Gal. A., 1955; WMA, 1952, 1955; deCordova & Dana Mus., 1953; Fitchburg A. Mus., 1954; George W. V. Smith Mus. A., 1955; Va. Highlands Festival A. & Crafts, 1950; Eastern States Fair, Springfield, 1950; Worcester County Exh., 1950; Am. Craftsmen's Edu. Council, 1950; Inst. Contemp. A., Boston, 1954; Dey Gosse Gal., Providence, R.I., 1955; Boston Festival A., 1956, 1958, 1961; Craft Center Instructor's Exh., WMA, 1958; Ceramic exh. for Art Assn. of New England Prep. Schs., 1958; Int. Ceramic Expo., Ostend, Belgium, 1959; New Delhi, India, Fair; Craftsmen from the Southeastern States, Atlanta, Ga., 1963; Piedmont Craft Exh., Mint Mus. A., Charlotte, 1964. Positions: Instr., Pottery, Adult Edu., Alfred, N.Y., 1948; Worcester Craft Center, Worcester Craft Center, Worcester, Mass., 1951-1961 *

GRAY, WELLINGTON B.—Educator, P., C., Des.
 School of Art, East Carolina University; h. 2001 Brook Rd., Greenville, N.C. 27834
B. Albany, N.Y., April 25, 1919. Studied: Kutztown State Col., B.S. in A. Edu.; N.Y. Univ., M.A., Ed. D.; Univ. of the Philippines. Member: Western AA; Southeastern AA; Eastern AA; Pa. State A. Edu. Assn; Illinois Edu. Assn.; Nat. Soc. of Interior Des. (Southeast Chapter, Memb. of Bd., Vice Pres.); AIID; Int. Assn. of Deans of FA; Assoc. A. N.C.; East Carolina AA; N.C. Art Educ. Assn. Work: Kutztown (Pa.) State Col.; Edinboro (Pa.) State Col.; East Carolina Univ.; Santo Thomas Univ., Manila, P.I., and in private collections here and abroad. Exhibited: Faculty Show, East Carolina Col., 1956-1959; Faculty Show, Edinboro State T. Col., 1954, 1955; Glencoe, Ill., 1953; Highland Park, Ill., 1954; East Carolina A. Soc., 1956; Jewish Community Center, Richmond, Va., 1964; Studio Gal., Virginia Beach, 1964; two-man: Greenville (N.C.) A. Center, 1968; Mount Olive (N.C.) Col., 1968; one-man: Pa. State Col., Edinboro, 1954; East Carolina Univ., 1957, 1967; Glencoe, Ill., 1953; East Carolina A. Soc., 1956. Contributor to: Pa. School Journal; Related Arts Service Bulletin; Illinois Education; Journal of Educational Research; Student Teaching in Art, and others. Positions: Prof. & Dir. A. Educ., Pennsylvania State College, Edinboro; Alliance College, Cambridge Springs, Pa.; Prof. A. Dean, School of Art, East Carolina Univ., Greenville, N.C., at present. Member advisory com. on teacher educ., Dept. of Public Instruction, North Carolina.

GRAZIANI, SANTE—Painter, Des., T.
 Worcester Art Museum, Worcester, Mass.; h. 2 Eastwood Rd., Shrewsbury, Mass. 01545
B. Cleveland, Ohio, March 11, 1920. Studied: Cleveland Sch. A.; Yale Univ. Sch. FA, B.F.A., M.F.A. Member: NSMP. Awards: Pulitzer scholarship, 1942; Edwin Austin Abbey award, 1948; gold med., Arch. Lg., N.Y., 1950; gold medal, Boston A. Dir. Cl., 1954; special award, American Drawing Annual, Norfolk Mus. A., 1961. Work: murals, USPO, Bluffton, Ohio; Columbus Junction, Iowa;

Holyoke (Mass.) Pub.Lib.; Springfield Mus. FA; Burncoat Sch., Worcester, Mass.; 2 large murals, American Battle Monument in Henri-Chapelle, Belgium, 1955-58; Mayo Clinic, Rochester, Minn., 1969. Exhibited: MMA, 1942; Carnegie Inst., 1941; NAD, 1942; CMA, 1937-1941; one-man: WMA, 1957; Babcock Gal., N.Y., 1962, 1963, 1965, 1967, 1969; Kanegis Gal., Boston, 1964, 1965, 1966-1969; Bristol (R.I.) A. Mus., 1967. Positions: Officer in Charge, A. & Crafts, Pacific Theatre, 1945-46; Instr., Drawing & Painting, Yale Univ. Sch. FA, 1946-51; Dean, Whitney Sch. A., New Haven, Conn., 1950-51; Hd., Worcester A. Mus., Sch., Worcester, Mass., at present.

GREACEN, NAN (Mrs. Rene B. Faure)—Painter
184 San Juan Dr., Ponte Vedra Beach, Fla. 32082
B. Giverny, France. Studied: Grand Central Sch. A. Member: NA; All. A. Am.; Scarsdale AA; Audubon A.; Hudson Valley AA; Grand Central A. Gal.; AAPL; Yonkers AA. Awards: prizes, NAD; NAWA; All. A. Am., 1953; medal, NAC; Montclair A. Mus.; Hudson Valley AA; Albers Mem. medal, 1954; other prizes, Manhattan Savings Bank Exh. of Westchester Artists, 1963; Westchester Art Teachers Assn., 1963; NAC, 1964; Catherine L. Wolfe A. Cl., 1964. "Still Life is Exciting," 1969. Exhibited: NAD, 1933-1965; CGA; All. A. Am. Positions: Instr., port. & still life, privately.

GREAVER, HANNE—Graphics
314 S. Park St., Kalamazoo, Mich. 49006
B. Copenhagen, Denmark, Aug. 1, 1933. Studied: Kunsthaandvaer-skolen, Copenhagen. Work: Amherst College; Columbus Mus. A. & Crafts, Georgia; Univ. Georgia; Univ. Maine; Univ. of California, Davis; Beloit College, Beloit, Wis. Exhibited: Baker Univ., Baldwin, Kans., 1961; Boston Printmakers, 1961; Canadian Painters, Etchers & Engravers, 1960; Univ. Maine (one-man), 1960; Columbus Mus. A. & Crafts, 1963; Louisiana State Univ., 1963; Univ. Georgia, 1964; also in traveling exhibitions of Ferdinand Roten Galleries, Baltimore, and London Graphica, Detroit.

GREAVER, HARRY—Museum Director, P., Gr.
314 S. Park St., Kalamazoo, Mich. 49006
B. Los Angeles, Cal., Oct. 30, 1929. Studied: Univ. Kansas, B.F.A., M.F.A. Work: Colby College; Univ. Kansas; Amherst College; Univ. Georgia; N.Y. Pub.Lib.; Norfolk Mus. A. & Sc.; Univ. Maine; Baker Univ. Awards: purchase awards, Norfolk Mus., 1963, 1964. Exhibited: Knickerbocker A., 1958; Audubon A., 1960, 1962; Oklahoma Printmakers, 1960, 1963, 1965; Canadian Painters, Etchers & Engravers, 1960; Silvermine Gld. A., 1959; AWS, 1961; PAFA, 1961; Baker Univ., 1955 (one-man); Portland Mus. A., 1961; American Drawing Biennial, 1963-1965, 1967; Drawings/USA, 1962-1963; Butler Inst. Am. A., 1962; Colby College, 1964; Ball State T. College, 1964, 1968. Positions: Assoc. Prof. A., University of Maine, Orono, Me., 1955-1966; Dir., Kalamazoo Inst. Arts, Kalamazoo, Mich. at present.

GREBENAK, DOROTHY (Mrs. Louis)—Craftsman
16 Montgomery Pl., Brooklyn, N.Y. 11215
B. Oxford, Neb. Exhibited: Allan Stone Gal., N.Y., 1963, 1964; BM, 1962; Davison A. Center, 1963; Kansas City AI, 1964; Milwaukee A. Center, 1965; Larry Aldrich Mus., Ridgefield, Conn., 1967; AFA traveling exh., 1969; Chelsea Nat. Bank, New York City, "Money in Art," 1969. Work: in private collections.

GREEN, DAVID (OLIVER) (JR.)—Sculptor, Des., E., L.
176 West Jaxine Dr., Altadena, Cal. 91001
B. Enid, Okla., June 29, 1908. Studied: Am. Acad. A.; Nat. Acad. Chicago, and with Carl Hoeckner, Charles Wilimovsky. Member: Pasadena Soc. A.; F.I.A.L. Awards: Laguna Beach AA, 1966, 1967; Pasadena Soc. A., 1968. Work: Los A. Mus. A.; Pasadena A. Mus.; Shopping Center, San Mateo; Hillel Council Bldg., Univ. So. Cal.; Arcadia Civic Center; Lytton Savings & Loan Bldg., Hollywood; Industrial Des. Trophy for Los Angeles Chamber of Commerce; Glendale Federal Savings, Downey and Sherman Oaks, Cal.; Community Church, Seal Beach, Cal.; Bassett Shopping Center, El Paso; Bruggemeyer Mem. Library, Monterey Park, Cal.; Altadena Public Library. Exhibited: So. Cal. Expo., Del Mar, Cal.; Laguna Beach AA, 1966, 1967; Friends Service Com., Pasadena, 1967; Pasadena Soc. A., 1968; Citrus Col., Glendora, Cal., 1968; one-man: Snow Gal., San Marino, Cal., 1967; Retrospective Exh., Pacific Ocean Park, Santa Monica; Los A. Municipal A. Exh., 1957. Positions: Instr., Otis AI of Los Angeles County.

GREEN, EDWARD ANTHONY—Painter, Des., Gr., E., Mus. Cur.
Milwaukee Public Museum 53233; h. 3173 South 31st St., Milwaukee, Wis. 53215
B. Milwaukee, Wis., Apr. 20, 1922. Studied: Univ. Wisconsin, B.S., M.S., M.F.A.; Layton Sch. A. Member: Midwest Mus. Conference; Wisconsin P.&S. (Past Pres.); AAMus.; Mus. Artisans Gld. (Pres., 1969). Awards: prizes, Wis. Salon A., 1957 (2); Wis. Pr. M., 1959, 1969; Wis. P.&S., 1961; Wis. State Fair, 1964; City of Milwaukee

Grant, Museum Study in Europe, 1959; Ford Fnd. Grant, for Urban Redevelopment Studies & Planning, 1961. Exhibited: Wisconsin Pr. M.; Wisconsin State Fair; Wisconsin P.&S.; Wisconsin WC Soc; Beloit & Vicinity. One-man: Lawrence Col., 1957; Kenosha Pub. Mus. 1958; Cherokee, Sioux City & Le Mars, Iowa, 1959; Cardinal Stritch Col., Milwaukee; Oshkosh Pub. Mus.; Alverno College, 1965. Positions: Art Dir., Milwaukee Public Mus.; Instr., Univ. Wisconsin, Milwaukee, Wis., 1956- ; Milwaukee Landmarks Comm.; Instr., Whithall Park Arboretum.

GREEN, SAMUEL M.—Educator, P.
Box 256, Meriden Rd., Middletown, Conn. 06457
B. Oconomowoc, Wis., May 22, 1909. Studied: Harvard Col., B.A.; Harvard Univ., Ph.D.; PAFA. Work: FMA; LC; Smith Col. Mus. A.; Dartmouth Col. Author: "American Art: A Historical Survey," 1966. Positions: Prof. A. Dept., Wesleyan Univ., Middletown, Conn.

GREENBAUM, DOROTHEA S.—Sculptor, Gr.
104 Mercer St., Princeton, N.J. 08540
B. New York, N.Y., June 17, 1893. Member: S. Gld.; Audubon A.; Nat. Inst. A. & Lets. Awards: Med., PAFA, 1941; Soc. Wash. A., 1941; prizes, IBM, 1941; Audubon A., 1954; Grant, Am. Acad. A. & Let., 1947; med., NAWA, 1952, 1954; Ford Fnd. Grant, 1964; New Jersey State Mus. purchase prize, 1964, 1968. Work: WMAA; Lawrence Mus., Williamstown, Mass.; Oberlin Col.; Fitchburg (Mass) A. Center; Huntington Mus.; Brookgreen Gardens, S.C.; Newark Mus. A.; BMA; PAFA; Mus. Moscow, Russia; Puerto Rico; Ogunquit Mus. A., and in private colls. Exhibited: nationally and internationally; one-man: Weyhe Gal., 1934, 1938; SFMA, 1942; Lawrence Mus. Williams Col., 1943; Cal. PLH, 1950; Santa Barbara Mus. A., 1950; Pomona Col., 1950; San Diego FA Center, 1950; Sculpture Center, 1951, 1958, 1963; Hirschl & Adler Gal., New York, 1967. Sculpture Representative on U.S. delegation to Intl. Art. Conf., sponsored by UNESCO, Venice, 1952.

GREENBERG, CLEMENT—Writer, Cr., P., L.
275 Central Park West, New York, N.Y. 10024
B. New York, N.Y., Jan. 16, 1909. Studied: ASL; Syracuse Univ., A.B. Exhibited: Stable Gal., N.Y., annually. Contributor to: The Nation; Partisan Review; Horizon (England); Art News; Arts; N.Y. Times Book Review; Art International. Author: "Joan Miro," 1948; "Matisse," 1953; "Art and Culture," 1961; "Hofmann," 1961. Gave a Christian Gauss Seminar in Criticism, Princeton University, 1958; Seminar in Art, Bennington College, Vt., 1963; Advisor, French & Co., N.Y., 1959-1960.

GREENBERG, MRS. EDWARD W. See Heller, Goldie

GREENBOWE, F(REDERICK) DOUGLAS—Painter
8808 N. Tatum Blvd., Phoenix, Ariz. 85028
B. Bayonne, N.J., Sept. 19, 1921. Studied: ASL, with Frank DuMond. Member: AWS. Awards: medal, NAC, 1953; Arizona State Fair, 1963 (2). Work: Butler AI; Dayton AI; Am. Acad. A. & Let.; SAM; Phoenix Mus. A.; AIC; Bank of Douglas, Tucson; Arizona Bank of Tucson. Exhibited: AWS, 1948-1950, 1952, 1954, 1960; BM, 1949; PAFA, 1949; Am. Acad. A. & Let., 1950; AIC, 1949; Butler AI, 1948, 1953; Milch Gal., 1956-1960; New Jersey WC Soc., 1959; Phoenix Mus. A., 1961; Western Rouze Gal., Fresno, 1950-1959; Camblback Gal., Phoenix, 1961, 1963 (one-man).*

GREENE, BALCOMB—Painter, E.
345 E. 52nd St. 10022; h. 2 Sutton Place S., New York, N.Y. 10022; also, Montauk Point, L.I., N.Y. 11954
B. Niagara Falls, N.Y., May 22, 1904. Studied: Syracuse Univ., A.B.; N.Y. Univ., A.M.; Univ. Vienna, Grad. Study. Member: F., Int. Inst. A. & Lets; AFA; Guild Hall, East Hampton, N.Y.; Am. Abstract A. (First Chm., 1936-1937, 1938-1941). Awards: Carol H. Beck Medal; four times "Critic's Choice," Art News. Work: AIC; Ball State Mus., Muncie, Ind.; BMA; BM; Butler Inst. Am. A.; CGA; Guggenheim Mus., N.Y.; Guild Hall, East Hampton; James Michener Coll., Univ. Texas, Austin; Herron Mus. A.; Hirschhorn Coll.; Joslyn A. Mus.; Univ. Miami, Fla.; Pasadena A. Mus.; PAFA; Portland (Ore.) Mus. A.; Wadsworth Atheneum, Hartford, Conn.; WAC MMA; MModA; Univ. Nebraska; WMAA; Carnegie Inst., and many others. Exhibited: One-man: American Embassy, Paris, 1960; Retrospective, WMAA; Everhart Mus., Scranton, Pa.; Carnegie Inst.; Holyoke Col.; Bowdoin Col., Brunswick, Me.; Univ. Massachusetts, Amherst; Munson-Williams-Proctor Inst., Utica, N.Y.(all in 1961); Saidenberg Gal., N.Y., 1962-1965, 1967, 1968; Feingarten Gal., Los Angeles, 1963, 1964 and Chicago, 1963; La Jolla A. Mus., 1964; Univ. Florida, Gainesville, 1965; Tampa A. Inst., 1965; James David Gal., Coral Gables, Fla., 1965, 1966; A. & Crafts Center, Pittsburgh, 1966; Santa Barbara Mus. A., 1966; Phoenix A. Mus., 1966; Adele Bednarz Gal., Los Angeles, 1966-1969; Occidental Col., Los Angeles, 1967; Berenson Gal., Bay Harbor Islands, Fla., 1967-1969; Mackler Gal., Philadelphia, 1968, and others. Contributor articles to: Art Journal,

Art News, Carnegie Magazine, College Art Journal, South Atlantic Review, etc. Positions: Assoc. Prof., Carnegie Institute of Technology, 1942-1959.

GREENE, LUCILLE BROWN (Mrs. Roy)—Painter, T., W., L.
Santa Monica City College, 1815 Pearl St., Santa Monica, Cal.; h. 9766 Olympic Blvd., Beverly Hills, Cal. 90212
B. Los Angeles, Cal. Studied: UCLA, B. Edu., and with S. MacDonald Wright, Millard Sheets, Richard Haines. Member: Cal. WC Soc.; Women Painters of the West; Los A. AA; Long Beach AA; Westwood AA; NEA. Awards: medal, Cal. A. Cl., 1951, 1953; prizes, Westwood AA, 1954; Women Painters of the West; Long Beach AA purchase award, 1957, and many prizes in other regional shows. Work: Santa Monica H.S.; Utah State Agr. Col., Logan; Dixie Col., St. George, Utah; Long Beach A. Center. Exhibited: Laguna Beach, 1951; Cal. WC Soc., 1952, 1954, 1956, 1958-1961; and travel exh. to Mexico, 1959-1962; All. A. Am., 1955; Los A. Mus. A., 1952; Denver A. Mus., 1952, 1953; Nat. Orange Show, 1952, 1953, 1957; ACA Gal., N.Y.; Los A. Flower Show, 1955; Butler Inst. Am. A., 1958; Pittsburgh Plan for Art, 1958; Church Art Today, San F., 1960; Westside Jewish Community Center, Los A., 1960-1969; Santa Monica A. Gal., 1960, 1966; Los A. AA, 1961; one-man: Long Beach Mus. A., 1953, 1957; Santa Monica A. Gal., 1958; Galerie Internationale, N.Y., 1963, 1966; Galleria Schneider, Rome, Italy, 1965; Downey (Cal.) Mus. A. (4-man). Lecture: Valsolda (Italy) Inst., 1964. Contributor to Cal. Journal of Secondary Education, 1953. Positions: Chm. A. Dept., 1954-1959, Santa Monica H.S., Santa Monica, Cal. A. Instr., Santa Monica City College, 1959-1969. Sec., 1959-60, Historian, 1960-62, Cal. WC Soc.

GREENE, STEPHEN—Painter, E.
408A Storms Rd., Valley Cottage, N.Y. 10989
B. New York, N.Y., Sept. 19, 1918. Studied: NAD; ASL; State Univ. Iowa, B.F.A., M.A. Awards: prizes, VMFA, 1946; Prix de Rome, 1949-50; Cal. PLH, 1947; Milwaukee AI, 1946; Ohio Univ., 1946; John Herron AI, 1946; Joslyn Mus. A., 1941; Delgado Mus. A., 1958; William Clark Award and Corcoran Medal, 1965; Council of the Arts, 1966; Inst. A. & Lets., 1967. Work: VMFA; AIC; WMAA; Detroit Inst. A.; Nelson Gal. A.; CAM; Wadsworth Atheneum; MModA; N.Y. Univ.; FMA, AGAA. Santa Barbara Mus. A.; Univ. Illinois; SFMA; Pasadena A. Mus.; Indiana Univ.; Princeton Univ. Mus.; Brandeis Univ.; Guggenheim Mus.; Tate Gal., London; MMA; CGA; Isaac Delgado Mus. A. Exhibited: WMAA, 1945, 1946, 1955; MModA, 1956; VMFA, 1946; NAD, 1945; 1946; AIC, 1946; Univ. Iowa, 1946; Los A. Mus. A., 1945; Cal. PLH, 1946; Milwaukee AI, 1946; Carnegie Inst., 1953; John Herron AI; Butler AI, 1946; "Drawings in the U.S.," European exh., 1953-54; Sao Paulo, Brazil, Biennal, 1961; Guggenheim Mus., 1961; "American Drawings," South America, 1961, and in many nat. exhs. One-man: Durlacher Bros., N.Y., 1947, 1949, 1952; Borgenicht Gal., N.Y., 1956, 1958, 1959; Retrospective exhs., DeCordova & Dana Mus., 1953; Princeton Univ., 1957; Staempfli Gal., N.Y., 1961-1964, 1966, 1969; CGA, 1963. Positions: Artist-in-Res., Princeton University, 1956- . Guest Critic, Columbia Univ., New York, 1961-62, Asst. Prof.; Assoc. Prof., Tyler Sch. A., Temple Univ., Phila., Pa.

GREENE-MERCIER, MARIE ZOE—Sculptor
1232 East 57th St., Chicago, Ill. 60637
B. 1911. Studied: Radcliffe Col.; New Bauhaus, Chicago; and in France, Italy, Mexico. Member: AEA (Pres., Chicago Chptr., 1960-62, 1st Nat. Vice-Pres., 1962-64). Awards: Semaines Internationales de la Femme, Cannes, France, 1968(silver medal), 1969(gold medal). Work: Roosevelt Univ., Chicago; Southwest Missouri State Col.; First Baptist Church, Bloomington, Ind., Chicago, Illinois, and in private collections in U.S. and Italy. Inst. Contemp. A., Boston; Mus. Contemp. A., Chicago; Mus. of Modern A., Venice; BFMA: Internationals All'Aperto, Fondazione Pagani, Legnano, Arte Sacra, Trieste; U.S. Consulate, Trieste; Busch-Reisinger Mus. FA; Harvard Univ.; Royal Canadian Acad.; Montreal Mus. FA; AIC; NAC; ANTA Playhouse, N.Y. Numerous one-man shows including AIC, Chicago Chapter AIA, Paris, Florence, Rome, Venice, Trieste, Milan. Author: "Trieste, 101 Drawings," Edizioni Libreria Italo Svevo, Trieste, 1969. Exhibited: s., reliefs, drawings, etc., Salon des Beaux-Arts, Salon des Independants, Salon de la Jeune Sculpture Paris, France; Gallery 88, Rome; Royal Inst. Gal., London

GREENLEAF, ESTHER (Mrs. Robert)—Painter, Gr., C., T.
27 Woodcrest Ave., Short Hills, N.J. 07078
B. Ripon, Wis., Oct. 17, 1904. Studied: Univ. Minnesota, B.A. in Arch.; and with Andre Lhote, Paris, France; with Mary Bugbird, Tosun Bayrak, and Rudolf Rey. Member: Artist-Craftsmen of N.Y.; Pen & Brush Cl.; Am. Craftsmen's Council; NAWA; Summit A. Center; N.J. Des-Craftsmen; Millburn-Short Hills A. Center. Work: Millburn Township High Sch.; Taylor Park Recreation House, Millburn. Awards: prizes, Millburn-Short Hills A. Center, 1947, 1955, 1958, 1959, 1961, 1964; Summit A. Center, 1958, 1962, 1968, 1969; NAWA, 1956, 1962; Pen & Brush Cl., 1955, 1959, 1960, 1967, 1968

(Buell Mem. prize, also, best in show); A. Gal., So. Orange, 1959. Exhibited: NAWA, 1954-1969, traveling exhs. in Europe & U.S.; Lever House, N.Y., and N.Y. Bank for Savings, 1968; Artist-Craftsmen of N.Y., 1955, 1956, 1964; Millburn-Short Hills A. Center, 1942-1969; A. Center of the Oranges, 1955, 1956; Summit A. Center, 1954-1969, 1957 (one-man); P. & S. Soc. of New Jersey, 1957, 1969; Pen & Brush Cl., 1954-1969 (one-man) 1960; Montclair A. Mus., 1955-1957, 1963; Newark Mus., 1961, 1964; Carpenter Gal. (Dartmouth Col.), 1961 (one-man); Third Int. Min. Pr. Exh., Pratt Inst., 1968; Hunterdon A. Center, 1969. Positions: Formerly taught at Minneapolis Sch. A.; Univ. Minn.; Cooper Union; Millburn-Short Hills A. Center and private classes. Volunteer instr. in arts & crafts, Women's House of Detention, N.Y., 1967-1968.

GREENLY, COLIN—Sculptor
1153 Bellview Rd., McLean, Va. 22101
B. London, England, 1928. Studied: Harvard Univ., A.B.; Columbia Univ. Sch. Painting & Sculpture. Awards: purchase prizes, CGA, 1956, 1957, Nat. Playground Sc. Comp., 1967; Nat. Endowment for the Arts award, 1967. Work: Rosenwald Collection, National Gallery of Art; MMoAA; CGA; PMA; NCFA; Des Moines A. Center; Mfrs. & Traders Trust Co., Buffalo; Va. Nat. Bank, Norfolk, and in private collections. Other work: playground sc. in Dist. of Columbia, Baltimore and other cities. Exhibited: MMoAA, 1953; Franz Bader Gal., Wash., D.C., 1955 (3-man); U.S. Nat. Museum, Smithsonian Inst., 1956; BMFA, 1956; Isaac Delgado Mus., New Orleans, 1956; CGA, 1955, 1956, 1957; Delaware A. Center, 1955; Univ. Kentucky, 1958; Jefferson Place Gal., 1958-1965; Washington Gal. of Modern Art, 1964; Albright-Knox A. Gal., Buffalo, 1964; Marion Koogler McNay AI, San Antonio, 1964; Brookhaven Nat. Laboratories, N.Y.; Daniels Gal., N.Y., 1965; Inst. Contemp. A., Wash., D.C., 1965; George Washington Univ., Wash. D.C., 1965; Rigelhaupt Gal., Boston, 1965; Westmoreland (Pa.) Mus., 1966; Des Moines A. Center, 1967; Henri Gal., Wash., D.C., 1967-1969; Joslyn A. Mus., Omaha, 1967; NCFA, 1968, 1969; Witte Mem. Mus., San Antonio, 1969; Flint Inst. A., 1968; Krannert A. Mus., Univ. Ill.,1969; Grand Rapids A. Mus., 1969. One-man: Jefferson Place Gal., Wash., D.C., 1958, 1960, 1963, 1965; Bertha Schaefer Gal., N.Y., 1964, 1965, 1968; CGA, 1968; Royal Marks Gal., N.Y., 1968. Positions: Instr., Sculpture & Des., U.S. Dept. Agriculture Grad. Sch., 1955-1956; Dir. A., Madeira School, Greenway, Va., 1955-1967.

GREENSPAN, GEORGE—Collector
885 Park Ave., New York, N.Y. 10021*

GREENWALD, CHARLES D.—Collector, Patron
Coronet Floors, Inc., 360 S. Broadway, Yonkers, N.Y. 10705; h. 120 E. 81st St., New York, N.Y. 10028
B. New York, N.Y., Aug. 6, 1908. Studied: New York University. Collection: American paintings, drawings and etchings after 1900.

GREENWALD, DOROTHY KIRSTEIN—Collector
120 E. 81st St., New York, N.Y. 10028
B. New York, N.Y., Mar. 29, 1917. Studied: Hunter College, B.A. Collection: American paintings, drawings and etchings since 1900.

GREENWOOD, MARION—Painter, Lith., T.
71 Glasco Turnpike, Woodstock, N.Y. 12498
B. New York, N.Y., 1909. Studied: ASL; Grande Chaumiere, Paris, France. Member: NA; Audubon A. Awards: prizes, Carnegie Inst., 1944; John Herron AI, 1946; PAFA, 1951; NAD, 1952, Ranger Fund purchase, 1968; Butler Inst. Am. A. purchase prize, 1956; NAWA, 1959; Audubon A., 1964. Work: Boston Univ.; Free Lib., Phila.; Tel Aviv, Israel; Butler Inst. Am. A.; PAFA; Univ. Arizona; Encyclopaedia Britannica; MMA; Newark Mus. A.; Smith Col.; LC; Yale Univ., Univ. Georgia; Abbott Laboratories; N.Y. Pub. Lib.; Bibliotheque Nationale, Paris; Bloomington (Ill.) AA; Montclair A. Mus.; Norfolk Mus. A. & Sciences; murals, Univ. Tennessee; Univ. San Nicolas Hidalgo; Civic Center, Mexico City; Community Hall, Camden, N.J.; Red Hook Community Bldg., N.Y., Housing Authority; USPO, Crossville, Tenn.; Univ. Syracuse; ASL. Exhibited: MMA; WMAA; BM; Carnegie Inst.; CGA; AIC; PAFA; NAD; Am. Acad. FA; Audubon A., 1964; one-man: Assoc. Am. A.; Bloomington (Ill.) Univ.; Milch Gal., N.Y., 1959; Mint Mus. A., 1960; New Britain Mus. Am. A., 1960; Bard College, 1963; McClung Mus., Univ. Tenn., Knoxville, 1966, and various regional shows, 1966-1969; Retrospective graphic Exh., Univ. Maine, Orono, Me., 1965; Long Island Univ., Brooklyn, N.Y., 1967. Positions: Visiting Prof. FA, Univ. Tennessee, 1954-55. A.-in-Res., Univ. Syracuse, N.Y., 1965.

GREER, DAVID—Art dealer
Greer Gallery, 35 W. 53rd St., New York, N.Y. 10019*

GREGG, RICHARD NELSON—Museum Director, W., L., E.
Joslyn Art Museum, 2218 Dodge St., Omaha, Neb. 68102
B. Kalamazoo, Mich., Sept. 4, 1926. Studied: Western Michigan Univ.; Cranbrook Acad. A., B.F.A., M.F.A. Contributor to "Cura-

tor;'' Antiques, Hobbies, Museum News, Midwest Museums Quarterly, Wisconsin Architect, Connoisseur. Organized major exhibitions of work by Inness (1963), Daubigny (1964), Wedgwood (1965); Remington (1967); Dutch Art of the 1600's (1968); Costigan—for the Smithsonian Institution (1968); Antique Steins and Tankards (1969). Positions: Instr., Cranbrook Sch. for Boys; Instr., Des., WMA; Dir., Kalamazoo Inst. A.; Curatorial Asst., Toledo Museum of Art, Toledo, Ohio; Hd., Mus. Edu., AIC; Dir., Paine A. Center & Arboretum, Oshkosh, Wis., to 1969; Dir., Joslyn Art Museum, Omaha, Neb., 1969- .

GREGOROPOULOS, JOHN—Painter, T.
Art Department, University of Connecticut, Storrs, Conn.; Studio: R.R. 3, Box 107, Storrs, Conn. 06268
B. Athens, Greece, Dec. 16, 1921. Studied: Athens, Greece; Univ. Connecticut, B.A. Philosophy. Member: Mystic AA (Pres. 1960-61). Awards: prizes, Springfield A. Mus., 1956, 1958; Norwich AA, 1951-1956, 1958; Essex AA, 1954; Ball State T. Col., 1955; New Haven A. Festival, 1959, 1960. Work: Ball State T. Col.; Ball Brothers Fnd.; St. Paul A. Center; USIA Coll. Exhibited: WMAA, 1955; Boston A. Festival, 1954, 1955; Wadsworth Atheneum, 1951-1954; Springfield A. Mus., 1955, 1956; Delgado Mus. A., 1948, 1949, 1951; Albany Inst. Hist. & A., 1949; deCordova & Dana Mus., 1954-1956, 1963-1965; Lyman Allyn Mus. A., 1955, 1965; BMFA; 1954; Slater Mus. A., 1951-1956, 1965; Rosicrucian Egyptian Mus., 1955; Univ. Connecticut, 1950, 1954, 1955; Conn. Col., 1955; Howard Univ., 1955; Fla. State Univ., 1955; Ball State T. Col., 1955; ACA Gal., 1954; Duveen-Graham Gal., 1955; Alan Gal., 1955; Chase Gal., 1956; Pan Hellenic Salon of Greek Art, Athens, 1956, 1963; Norfolk Mus. A. & Sciences, 1962, 1969; New England Contemp. A., 1963, 1965; Smith College Mus.; Art:USA, 1958; Provincetown A. Festival, 1958; Nexus Gal., Boston, 1958, 1964 (one-man); work circulated by USIA abroad, and numerous regional exh. Positions: Prof., Univ. Connecticut, Storrs, Conn., 1953- .

GREGORY, WAYLANDE —Sculptor, Des., W., L., P.
Mountain Top Studio, RR1, Warren, N.J. 07060
B. Baxter Springs, Kan., June 13, 1905. Studied: Kansas State T. Col.; Univ. Chicago; Kansas City AI; & in Europe. Member: NSS; Soc. Designer-Craftsman; Hon. Life Mem., Academic Artists, Inc., Westfield, N.J.; Hon. Life Mem., Central J.J. AA; Int. Platform Assn. Awards: Med., Alfred Univ., 1939; Paris Exp., 1937; Syracuse Mus. FA, 1933, 1937, 1940; prize, Arch.L., 1936; CMA, 1929, 1931; gold medal, United Ceramic Glass Corp. Work: S., District Bldg., Wash., D.C.; fountain Roosevelt Park, N.J.; Syracuse Mus. FA; Cranbrook Mus.; CMA; General Motors Corp.; sc. groups, Theological Seminary Bldg., Chicago; sc. wall, Municipal Center, Wash., D.C.; group, Bound Brook, N.J.; sculpture, Ten Commandments, Tobey Coll., Plainfield, N.J.; Jacobson Col., Highland Park, N.J.; Moses sculpture, NSS exh. at Lever House, N.Y. Numerous ports. of prominent persons; Coll. ports., Hungarian Freedom Fighters, 1958. Exhibited: WMAA; MMA; AIC; Montclair A. Mus.; WMA; CAM; Richmond Acad., A. & Sc.; San Diego, Cal.; CMA; Toledo Mus. A.; Los A. County Fair; Cranbrook Fnd.; State Mus., Trenton, N.J.; Tiffany's, N.Y.; Morgan's Montreal; W.J. Sloane A. Gal., Beverly Hills; Shreve, Crump & Low, Boston; Brussels World's Fair, 1958; America House; Watts Gal., Milwaukee; special exh. "Sculpture in Wire," State Mus., Trenton, N.J., 1958, Princeton, 1964; Hunterdon A. Center 1964; Kennedy Memorial, Newark, 1964; Jewish Community Center, Plainfield, N.J., 1964; Municipal Gal., Warrentownship, N.J.; many one-man shows in leading museums, & in Europe. Contributor to: Art & national magazines. Lectures: Art; Sculpture; 20 TV shows "Creative Arts," NBC. Art Columnist, New Brunswick Sunday Home News, 1965; Dir., Berkshire A. Center, Middlefield, Mass., 1962-63.

GRESSEL, MICHAEL L.—Sculptor
North Greenwich Rd., Armonk, N.Y. 10504
B. Wurzburg, Germany, Sept. 20, 1902. Studied: Beaux Art Inst. Des., New York City and in art schools in Germany. Member: Hudson Valley AA; Westchester A. & Crafts Gld. Awards: prizes, Dr. Morris Woodrow prize, Hudson Valley AA, 1951, 1963, 1965 (prize and gold medal); White Plains Women's Cl., 1963; Valhalla (N.Y.) A. Exh., 1953, 1954. Work: MMA; Bruckner Mus., Albion, Mich.; carings, Nat. Theatre, Wash., D.C.; Nat. Theatre & Acad., New York City; figs. and reliefs: High Schools in Bronx, N.Y., Greenwich, Conn., and Valhalla, N.Y.; reliefs, County Trust Co., Mt. Kisco, N.Y.; Longines-Wittnauer Watch Co.; churches in Brooklyn and Ossining, N.Y.; models for: U.S. Bronze Co. and W. & E. Baum Bronze Co., New York; City Shield, Town Hall, Greenwich, Conn. Port., bas-relief in ivory for General Eisenhower; sc. Eagle, for International Hotel, Kennedy Airport, N.Y.; bust of General von Steuben; bas-relief, Good Shepherd Church, Brooklyn, N.Y. Exhibited: Hudson Valley AA, 1945-1969; Westchester A. & Crafts Gld., 1944-1960; one-man, Armonk Lib.

GREY, MRS. BENJAMIN EDWARDS—Patron, Collector
497 Otis Ave., St. Paul, Minn. 55104
B. St. Paul, Minn. Studied: Vassar College, B.A. Collection: Contemporary art from various countries, specializing, to date, on Middle East and South-Asian countries, Shown in Grey Foundation Gallery in St. Paul to interested groups and individuals by appointment. Sponsor: Project "Communication Through Art," including a package program (drawings, prints, library) circulating in India; an exhibit of American batiks, sent with artist, M. Cornelius, to Middle East and North Africa; an exhibition of young artists from Minnesota sent as entry to Bogota International Competition. Also three collections of contemporary art circulating in U.S.A., viz: Japanese prints, Turkish art (on paper), and oils and prints from India and Iran. Sponsorship of American section at 1st India International Trienalle, New Delhi. Positions: President, Ben and Abby Grey Foundation, Inc.

GRIER, HARRY DOBSON MILLER—Museum Director
The Frick Collection, 1 East 70th St.; h. 16 East 84th St., New York, N.Y. 10028
B. Philadelphia, Pa., Jan. 23, 1914. Studied: Pa. State Univ., B.S. in Arch.; Princeton Univ.; Univ. of Paris, Inst. d'Art et d'Archeologie, Inst. of FA, N.Y. Univ. Member: CAA; AAMus.; Int. Council of Museums; Assn. A. Mus. Dirs. (Pres. 1968-); Dir., Am. Friends of Attingham, Inc.; Trustee, Int. Exh. Fnd.; Trustee, Amon Carter Mus. of Western A.; Archives of Am. A.; A. Mus., Princeton; Culture Lg. of N.Y.; Am. Inst. Int. Des. (Edu. Assoc.); The Drawing Soc. (Memb. Nat. Com.); Museums Council of New York City, etc. Co-author: "Catalogue of the Frick Collection, Vols. I & II, Paintings," 1968. Contributor to Metropolitan Museum Bulletin; Minneapolis Inst. Arts Bulletin; Parnassus; College Art Journal; Museum (UNESCO). Lectures on Painting and Architecture, Mediaeval to Modern, museums and professional organizations. Television: CBS, NBC; Radio: WNYC. Positions: Asst. to Dean, MMA, 1938-41; U.S. Army, 1941-46; Chief, Monuments, Fine Arts & Archives, Office of Military Government, U.S. (Berlin), 1945-46; Asst. Dir., Minneapolis Inst. A., 1946-51; Asst. Dir., The Frick Collection, New York, N.Y., 1951-1964, Dir., 1964- .

GRIESSLER, FRANZ —Portrait Painter
2085 Makiki Place, Honolulu, Hawaii 96822
B. Vienna, Austria, June 2, 1897. Studied: Grafische Lehranstalt, Vienna, with Ludwig Michalek, Prof. Landa; Acad. A., Vienna, with Rudolf Bacher. Member: Vienna AA. Awards: prizes, Honolulu, 1959, 1960, and many others in Vienna. Work: Portraits, U.S., Vienna, Buenos Aires, London, City Mus. of Vienna, etc. Exhibited: Buenos Aires, 1949; extensively in Vienna; Honolulu Acad. A., 1956-1959; Norfolk (Va.) Mus. A. & Sciences, 1967, 1969. Drawing chosen for poster of Am. Drawing Biennial, Norfolk Mus. A. & Sciences, 1969. Positions: A. Dir., "Gewista" (city controlled, official advertising agency), Vienna, 1921-45; Instr., Univ. of Commerce, Vienna, 1933-38. Private art classes, Honolulu, Hawaii, at present.

GRIFFIN, RACHAEL—Museum Curator, Cr., E., W., L.
Portland Art Museum, Southwest Park at Madison St. 97205; h. 2327 S.W. Market St. Drive, Portland, Ore. 97201
B. Portland, Ore., Feb. 25, 1906. Studied: Univ. of Oregon; Portland Mus. A. Sch. (Grad.); Reed College. Member: AAMus.; Am. Assn. for Aesthetics; AEA; Oregon Gld. P. & S.; Pacific AA. Awards: Centennial Year Award, for Distinguished Service in the Arts, Portland Chaptr. AEA, 1959. Prepared policy plan on Museum television, 1955; organized television series on Karolik Coll. of American Paintings; organized Museum's Centennial Invitational Exh., "Paintings and Sculptures of the Pacific Northwest," 1958-59; organized invitational West Coast Now: Current Work From the Western Seaboard, 1967; Contributor to Design, Art Education Today, Craft Horizons, Art Digest, Bookman, News Critic magazines and others. Co-author: "A Course in Understanding Art," 1961; Editor, Portland AA Calendar; Editor, Eight Poetry Leaflets; Painting and Sculpture of the Pacific Northwest catalog and many other catalogs. Lectures: Art Education; Contemporary Painting and Sculpture. Publication: "Ernest Josephson," "Art Forum," 1964. Arranged numerous exhibitions. Positions: Instr., S. & Drawing, Reed College, 1936-37; Instr., Catlin Gabel Sch., 1939-44; Instr. A. Edu., Pacific Univ., 1952-56; Chm., Visual Arts Sub-Com., Oregon Centennial Comm., 1959; Hd., Children's Class program, Museum Art School, 1950- , Cur. 1957- , Portland Art Museum, Portland, Oregon. Bd. Trustees, Oregon Ceramic Studio, 1959-60; Citizens Com. for Art in Architecture, 1958-59; Art Com., Gifted Child Project, Ford Foundation, 1954; Member, Commission on the Humanities in the Schools, 1968, and many other positions in art and education.

GRIGGS, MAITLAND LEE—Collector
Ardsley-on-Hudson, N.Y. 10503
B. New York, N.Y., Sept. 13, 1902. Studied: Christ Church, Oxford.

Collection: Hudson River School of Painting (confining it to views of and on the Hudson River); Old Staffordshire china with Hudson River views; Modern paintings; Oriental, African and pre-Columbian artifacts.

GRILLEY, ROBERT L.—Painter, E.
University of Wisconsin, Madison, Wis.; h. 319 South Page St., Stoughton, Wis. 53589
B. Beloit, Wis., Nov. 14, 1920. Studied: Univ. Wisconsin, B.S., M.S. Awards: prizes, Univ. Illinois, 1953 (purchase); Milwaukee A. Center, 1967 (1st prize); Wisconsin Salon (6 times). Work: Univ. Illinois; Butler Inst. Am. A.; Univ. Wisconsin; Wisconsin Union. Exhibited: AIC, 1951; Univ. Illinois, 1953; Walker A. Center; Univ. Nebraska, 1955, 1956; Des Moines A. Center, 1955; Santa Barbara Mus. A., 1956; Denver A. Mus., 1956; Mus. FA of Houston, 1956; AFA traveling exh., 1957; Intl. A. Festival, Spoleto, Italy, 1958; Flint Mus. A., 1958; one-man: Chicago, Ill., 1952; Lawrence Col., 1953; Milwaukee AI, 1954; Univ. Wisconsin, 1956; Hewitt Gal., N.Y., 1957; Lane Gal., Los A., 1960-1963; Banfer Gal., N.Y., 1965; Gilman Gal., Chicago, 1969. Positions: Prof. A., Chm., Grad. Program, 1960-1964, Chm., Dept., 1962-1964, Univ. Wisconsin, Madison, Wis.

GRILLO, JOHN—Painter
111 Chestnut St., Amherst, Mass. 01002
B. Lawrence, Mass., July 4, 1917. Studied: Hartford A. Sch.; Cal. Sch. FA; Hans Hofmann Sch. FA. Member: Abstract A. Group; A. Cl. Awards: prizes, Albert M. Bender grant, San Francisco, 1947-48; Sacramento State Fair. Work: Olsen Fnd., Guilford, Conn.; Smith Col. Mus.; Hartford Atheneum; WMAA; WAC; Newark Mus.; BM; Guggenheim Mus.; Capitol Bldg., Baton Rouge; offices of Stearns & Co., New York; Chrysler Mus., Provincetown, Mass.; Wadsworth Atheneum, Hartford, Conn.; Los Angeles County Mus.; Butler Inst. Am. A.; Michener Coll., Univ. Texas, Austin; Bundy A. Gal., Waitsfield, Vt.; Bennington Col.; Portland (Me.) Mus.; Union Carbide Corp., N.Y.; Geigy Chemical Corp., Conn.; and private collections U.S. and abroad. Exhibited: Provincetown A. Festival, 1958; MMA, 1952; WMAA, 1952, 1959; Berkeley, Cal., 1947; HCE Gal., Provincetown, 1960; WAC, 1960; Guggenheim Mus., 1961, 1964-1966; Lever House, N.Y., 1961; Yale Univ.; Dallas Mus. Contemp. A., 1962; Seattle World's Fair, 1963; MModA traveling exh., 1963, also 1963-1966; SFMA, 1963; Albright-Knox, Buffalo, 1964; Rigelhaupt Gal., 1968; Simmons Col., Boston, 1969; St. Joseph Col., St. Joseph, Minn., 1969; one-man: Artists Gal., N.Y., 1948; Bertha Schaefer Gal., N.Y., 1953, 1958; HCE Gal., Provincetown, 1959; Tanager Gal., N.Y., 1960; Howard Wise Gal., N.Y., 1961-1963. Ankrum Gal., Los Angeles, 1962; Univ. Cal., Berkeley, 1962; Butler Inst. Am. A., 1964; retrospective, 1956-1960, circulated nationally; Bundy A. Gal., 1966; Univ. Iowa, 1967; New Sch. Social Research, 1967; Stanislaus State Col., Turlock, Calif., 1969. Positions: Visiting A., Southern Ill. Univ., 1960; Instr., Sch. Visual A., 1961; Visiting A., Univ. Calif., 1962-1963; Instr., New Sch. Social Research, 1964-1966; Pratt Inst., 1965-1966; A.-in-Res., Univ. Iowa, 1967; Univ. Mass., 1968-1969.

GRINER, NED—Educator, C.
Ball State University; h. 2908 Gishler Dr., Muncie, Ind. 47304
B. Tipton, Ind., Dec. 14, 1928. Studied: Ball State Univ., B.A.; State Univ. of Iowa, M.A.; Indiana Univ., M.F.A.; Pennsylvania State Univ., D. Edu. Member: Midwest College Art Assn.; Nat. Art Edu. Assn.; American Craftsmen's Council; Indiana Artist Craftsmen (Bd. Dir.). Awards: prizes, Ball State Drawing & Small Sculptures, 1959, 1964, 1965; Mid-States Craft, Evansville, 1965. Work: Ball State Univ. Gallery. Exhibited: Jewelry Makers Nat., Plattsburgh, N.Y., 1962, 1963; Mus. Contemp. Crafts, N.Y., 1962; Ball State Univ., 1959, 1961-1965; Wichita A. & Crafts, 1959; Mid-States Craft Exh., 1962-1965; Mississippi River Crafts, Memphis, 1959, and others. Lectures: Art Education and Community Responsibility. Positions: Prof., Jewelry, Des., Art Appreciation, Ball State University, Muncie, Ind., at present.

GRIPPE, FLORENCE—Craftsman, P., S., Des.
1190 Boylston St., Newton Upper Falls, Mass. 02164
B. New York, N.Y., Jan. 6, 1912. Studied: Edu. All.; Henry St. Settlement, with Hale and Soini. Member: Artist-Craftsmen of N.Y. Exhibited: NYC Council for A. Week, 1942; Syracuse Mus. FA; Orrefors Gal.; Georg Jensen; America House; Argent Gal.; NAC; Laurel Gal.; RoKo Gal.; Mus. Natural Hist., N.Y.; BM; Borgenicht Gal.; Betty Parsons Gal.; Morris Gal.; Zabriskie Gal.; Pyramid Gal.; 9th Street Avant Garde P. & S.; New Sch. Social Research, 1959; Lower East Side Indp. A., 1959, all NYC; Boston Univ., 1961. Contributor to Ceramic Age; Art News; Crafts Magazine (America House); Positions: Instr., United Art Workshop of Brooklyn Neighborhood Houses, 1947-54; Brooklyn Mus. A. Sch., 1951-57.

GRIPPE, PETER—Sculptor, Gr., P.
1190 Boylston St., Newton Upper Falls, Mass. 02164
B. Buffalo, N.Y., Aug. 8, 1912. Studied: Albright A. Sch.; Buffalo AI, and with E. Wilcox, Edwin Dickinson, William Ehrich. Member: AAUP. Awards: prizes, BM; MMA; Phila. Pr. Cl.; Boston A. Festival; United Nations Sculpture Competition; R.I. Arts Festival, 1961; Guggenheim Fellowship, 1964-65. Work: MModA; Albright A. Gal.; North Carolina Mus. A., Raleigh; Newark Mus. A.; AGAA; Toledo Mus. A.; Rosenwald Coll.; BM; N.Y. Pub. Lib.; Univ. Michigan; Tel-Aviv Mus. A.; Providence, R.I. Mus. A.; Georgia Mus. FA; Phila. Pr. Cl.; Univ. Washington, St. Louis, Mo.; Milwaukee-Downer Col.; PMA; Brandeis Univ.; LC; WMAA; Blanden Mem. Mus. Ft. Dodge, Iowa; MMA; USIS, Germany; WAC; Print Council of America; Creative Arts Award Medallion for Brandeis Univ.; two over-life size murals for Puerto Rican Information Center, New York City; free-standing sculpture for Theodore Shapiro Forum-Brandeis Univ. Exhibited: MMA, 1942, 1943, 1947, 1951, 1952; WMAA, 1944-1957; LC, 1946, 1947; Detroit Inst. A., 1945, 1947; PAFA, 1946, 1952; Albright A. Gal., 1935-1939; Willard Gal., 1942, 1944-1948; Wildenstein Gal., 1944, 1945; Am. Abstract A., 1946; Am-British A. Gal., 1946; Carnegie Inst., 1946; BM, 1947-1949, 1952, 1953, 1956, 1958; SAM, 1947; AIC, 1947, 1948; Univ. Minnesota, 1948, 1956; WMA, 1948; N.Y. Pub. Lib., 1948; Munson-Williams-Proctor Inst., 1949; Seligmann Gal., 1949; French Govt. sponsored exh., France and Germany, 1949; PMA, 1949; State Univ. Iowa, 1949; MModA, 1949, 1951, 1952; Univ. Chicago, 1950; AFA traveling exh., 1950-1953, 1956-1958; Smith Col., 1951; Phila. Pr. Cl., 1946, 1949, 1952, 1956, 1958; Washington Univ., St. Louis; United Nations Sculpture Comp.; Boston A. Festival, 1955-1961; Mich. State Univ., 1959; Pr. Council Am., 1959; Galerie Claude Bernard, Paris 1960; Inst. Contemp. A., Boston, 1960; Univ. Illinois, 1961; AIC, 1961; R.I. Festival, 1961; Univ. Kentucky, 1959; Boston Pub. Lib., 1952; AGAA, 1956; VMFA, 1956; Douglass Col., 1957; Peridot Gal., 1957; Pasadena A. Mus., 1958; Carnegie Inst., 1958, and many others. One-man: Orrefors Gal., 1942; Willard Gal., 1944, 1945, 1946, 1948; Brandeis Univ., 1958; Peridot Gal., N.Y., 1961; Nordness Gal., N.Y., 1960; Brandeis Univ., 1961, etc. Positions: Instr., S., Black Mountain Col. (N.C.), 1948; Instr., Drawing & Des., PIASch., 1949-50; Instr. S., Smith Col., 1951-52; Dir., Atelier 17, New York, N.Y., 1951-53; Prof., S. & Gr., Brandeis Univ., Waltham, Mass., 1953- .

GRIPPI, SALVATORE (WILLIAM)—Painter, E.
Art Department, Ithaca College, Ithaca, N.Y.; h. 916 Stewart Ave., Ithaca, N.Y. 14850
B. Buffalo, N.Y., Sept. 30, 1921. Studied: ASL; MModA Sch.; Istituto Statale d'Arte; Atelier 17, Florence, Italy. Member: ASL (Bd. Control, 1961-1964; Vice-Pres., 1961-1962); AAUP; CAA. Awards: Fulbright Fellowship, 1953-54; renewal, 1954-55. Work: N.Y. Pub. Lib.; MMA; WMAA. Milwaukee-Downer Col.; Hirshhorn Coll.; Ithaca Col. Exhibited: CGA, 1959; Carnegie Inst., 1958; WMAA & Smithsonian Inst., Fulbright Exh., 1958; LC, 1956; MMA, 1952; Univ. Nebraska, 1958; Texas Western Col., 1956; Phila. Pr. Cl., 1956; PAFA, 1952; Wash. WC Cl., 1952; Univ. So. Cal., 1952, 1953; Friends of the Whitney Mus., 1958; Fieldston Exh., 1958; Stable Gal., 1952, 1957; Zabriskie Gal., 1955; Camino Gal., 1956; Tanager Gal., 1953, 1958; Amherst Col., 1953; Milwaukee-Downer Col., 1953; Fourth St. Print Shop, N.Y., 1952; De Aenlle Gal., N.Y.; MModA, 1956, 1957, 1959, 1960; WMAA, 1960; WAC, 1960; La Jolla Mus. A., 1965; Cal.PLH, 1965; Scripps Col., 1966; Arts of Southern Calif., 1966-1968; Phoenix A. Mus., 1967; Wells Col., 1969; Ithaca Col., 1969; and in Rome, Florence, Milan, Italy; one-man: N.Y. Univ., 1958; Zabriskie Gal., 1956, 1959; Milwaukee-Downer Col., 1956; Krasner Gal., N.Y., 1962, 1964; Pomona Col., 1963; Rex Evans Gal., Los Angeles, 1965; Feingarten Gal., Los Angeles, 1967. Positions: Instr., Cooper Union, 1957-1960; Instr., Sch. Visual A., 1961-1962; Assoc. Prof. A., Claremont Grad. Sch., Pomona Col., 1962-1968; Prof. & Chm., A. Dept., Ithaca Col., 1968- .

GROFF, JUNE—Designer, P., Ser.
862 North 19th St., Philadelphia, Pa. 19130
B. North Lawrence, Ohio, June 26, 1903. Studied: PAFA; Barnes Fnd., and with Henry McCarter. Awards: Traveling scholarship, PAFA, 1935; F., PAFA, 1944; prizes, Women's Col., Greensboro, N.C. Int. Textile Exh., 1947, 1953, 1954, 1956; MModA, Textile Exh., 1947. Work: Barnes Fnd.; PAFA; Pa. State Univ.; PMA; MModA traveling coll., 1947-52; Friends Central coll., Phila., Pa., and in private collections; fabric des., Harper's Bazaar, Hattie Carnegie, Clare Potter, and others; des. & executed hanging, stained glass Cross for St. Barnabas Episcopal Church, Marshallton, Del., 1962; stained glass windows & bars for 3 Phila. restaurants and lounges. Exhibited: PAFA, 1936-1945, 1954, 1964; Harvard Univ., 1954; AWS, 1935, 1936, 1939, 1940; CGA, 1941 & traveling exh.; F., PAFA, annually; textiles in Int. Fabrics Exh., 1961-62, which travels throughout U.S., two years; Phila. A. All.; Carlen Gal., Phila.; Little

Art Gal., Canton, Ohio (one-man) of textiles which later circulated one year; Little Gal.,Phila., 1961 (one-man) to be circulated abroad later; Moore Col. of Art, 1962-1964; Drawing Soc., N.Y., 1965-1966; AFA traveling exh., 1965-1966; D'Ascenzo Studios, Phila.,(one-man) 1969. Positions: Des., Textiles, Jack L. Larsen, Inc., New York, N.Y., 1953-58. Conducts private des. & textile business, 1958- . Currently designing stained glass contemporary style, for D'Ascenzo Studios, Phila., Pa.

GROOMS, RED—Painter
234 W. 26th St., New York, N.Y. 10001
B. Nashville, Tenn., June 10, 1937. Studied: AIC; Peabody Col.; Hans Hofmann Sch. A. Work: Tenn. FA Center and in private collections. Exhibited: Tibor de Nagy Gal., N.Y., 1962; Martha Jackson Gal., 1960; Reuben Gal., N.Y., 1958; Wadsworth Atheneum, 1964; Brookhaven Labs., 1963; Univ. Nebraska, 1964; Fairleigh-Dickinson Univ., 1964; AIC, 1964.*

GROOMS, REGINALD L.—Educator, P.
3436 Lyleburn Pl., Cincinnati, Ohio 45220
B. Cincinnati, Ohio, Nov. 16, 1900. Studied: A. Acad. of Cincinnati; Julian Acad., Paris, and with Pages, Royer, Laurens. Member: Cincinnati A. Cl.; Scarab Cl.; Cincinnati Professional A.; Am. Soc. for Aesthetics; Cincinnati Chptr., Intl. Torch Cl.; Ohio WC Soc. Awards: prize, Ohio WC Soc., 1948. Work: Univ. & pub. sch. in Cincinnati; Ball State T. Col. Exhibited: CM, 1923-1944, 1948, 1949, 1953-1955; Butler AI, 1936-1945; PAFA, 1935, 1936; GGE, 1939; WFNY 1939; AIC, 1936, 1937; Kearney Gal., Milwaukee, 1946; Closson Gal., Cincinnati (one-man) 1953; Ball State T. Col., 1948 (one-man); Ohio WC Soc., 1948, 1953, 1954. Positions: Instr., 1925-45, Asst. Prof., 1945-46, Assoc. Prof., 1951, Alfred Streetman Prof. A., & Hd. Div. of Art, 1955-1965; Col. of Des., Arch & Art, Univ. Cincinnati; Instr., A. Acad. of Cincinnati, Ohio, to 1953.

GROPPER, WILLIAM—Painter, Lith., W.
Upland Lane, Croton-on-Hudson, N.Y. 10520
B. New York, N.Y., Dec. 3, 1897. Studied: NAD; Ferrer Sch.; N.Y. Sch. F. & App. A. Member: AEA; SAGA; National Institute of Arts & Letters, 1968. Awards: Collier prize, 1920; Harmon prize, 1930; Guggenheim F., 1937; Young Israel prize, 1931; AV, 1942; Los A. Mus. A., 1945; Lib. Cong., 1915; Carnegie Intl.; Ford Fnd.-AFA award, Artist-in-Residence in Museums; Tamarind Award. Work: MMA; MModA; WMAA; Mus. Western A., Moscow, Russia; Wadsworth Atheneum; PMG; Newark Mus.; CAM; Walker A. Center; Univ. Arizona; PAFA; FMA; AIC; Univ. Maine; Nat. Museums of Warsaw, Prague and Sofia; Encyclopaedia Britannica Coll.; Abbott Laboratories Coll.; Los A. Mus. A.; LC; Butler Inst. Am A.; Tel-Aviv Mus.; Kharkov Mus., USSR; Biro-Bidjan Mus.; BM; Mus. City of N.Y.; Syracuse Univ.; IBM; Brandeis Univ.; Cornell Univ.; Wellesley College; murals, USPO, Freeport, L.I., N.Y.; Northwestern Station, Detroit, Mich.; Interior Bldg., Wash., D.C.; Schenley Corp.; New Interior Dept. Bldg., Wash. D.C. Exhibited: CGA; PAFA; VMFA; AIC; Carnegie Inst.; WMAA; NAD; many one-man exhs., traveling exh., nat. & international; recent one-man: traveling, England, 1958; U.S.A., 1958; Retrospective Traveling Exhibition, 1968; Univ. of Miami, Fla., 1958; other one-man: ACA Gallery and other New York galleries; also in: Detroit, Los Angeles, Coral Gables, Chicago, Mexico City, London, Coventry, England. Paris, Prague, Warsaw, Moscow, Sofia, Rome, Milan, and others. Author: "The Golden Land," 1927; "American Folklore," 1953; "The Little Tailor," 1955; "Capricios," limited ed. lithographs, 1957; "Gropper" (coll. drawings); "56 drawings USSR"; "Caucasian Studies" (lithos); "Your Brothers Blood Cries Out" (Warsaw Ghetto), & other books; I., "Lidice," 1942; "The Crime of Imprisonment," 1945; & others. Illus., for national magazines.

GROSHANS, WERNER—Painter
941 Boulevard East, Weehawken, N.J. 07087
B. Eutingen, Germany, July 6, 1913. Studied: Newark Sch. Fine & Indst. Art, and with Bernard Gussow. Member: Assoc. A. of New Jersey (Dir. 1965-1967); Painters & Sculptors Soc. (Vice Pres. 1967-1968); NAD; Audubon A.; Conn. Acad. FA; All. A.Am.; Jersey City Mus. (Chm., FA Dept. 1966-1969). Awards: T.B. Clarke Award, 1960, Ranger Purchase Fund, 1961, both NAD; Montclair A. Mus., 1961; Pauline Wick Award, AAPL, 1961; Silver Medallion, N.J. Tercentenary, 1964; Painters & Sculptors award, 1964; Famous Artists School, Painters & Sculptors, 1965; All. A. Am., 1966; Jersey City Mus., 1966; Grumbacher award, Lever House, 1967. Work: Davenport Municipal A. Gal.; Distr. of Columbia Court of General Sessions, Wash. D.C.; Newark Pub. Lib.; Encyclopaedia Britannica; Newark Mus.; New Britain Mus. Am. A.; NAD. Exhibited: WMAA, 1948, 1949, 1952, 1953; Carnegie Int., 1950; MMA, 1950, 1952; Butler Inst. Am. A., 1959, 1965; NAD, 1959-1961, 1966, 1967, 1969; Montclair A. Mus. State Exh., 1961-1964, 1966, 1967, 1969; Newark Mus., 1963, 1964, 1966-1968; Hirschl-Adler Gal., N.Y., 1962; Silvermine Gld. A., 1963, 1968; Audubon A., 1962; 1964, 1965-1969; Parrish A.

Mus., Long Island, 1961; Springfield (Mass.) Mus. FA, 1963; Berkshire Mus., 1963; Fitzgerald Gal., 1964; Jersey City Mus., 1964, 1965-1968; AFA traveling exh., 1953; Tupperware Art Fund, 1954-1956; N.J. Pavilion, World's Fair, 1965; NAC, 1965; Wadsworth Atheneum, 1966, 1967; Michelson Gal., Wash., D.C., 1966; Everhart Mus., Pa., 1966; Capricorn Gal., Md., 1966; Kennedy Gals., 1966-1969; All. A., 1966-1969; N.J. State Mus., 1966, 1967; Univ. Md., 1966, 1967; Old Bergen A. Gld., 1966-1969; New Britain Mus. Am. A., 1967-1969; A. Lg. of Ligonier Valley, Pa., 1966, 1967; Mainstream '68, Ohio; Oklahoma Mus. A., 1969; Centenary Col., Hackettstown, N.J. (2-man), 1969. Painting on cover of "Prize-Winning Art" book 7 and "Prize-Winning Paintings," book 7.

GROSS, ALICE—Sculptor
8 Huguenot Drive, Larchmont, N.Y. 10538
B. New York, N.Y. Studied: Lausanne, Switzerland, and privately with Ruth Yates. Member: Audubon A.; All. A. Am.; Silvermine Gld. A.; Berkshire AA; New Rochelle AA; Westchester A. Soc.; Mamaroneck Gld. A.; Knickerbocker A. Awards: prizes, Sculpture House award, All. A. Am., 1957; Chesterwood Studio Award, 1956, 1957; Berkshire AA, 1953, 1956, 1957; New Rochelle AA, 1959, 1962, 1967; Creative Art Lg., 1960, 1961; Great Barrington A. Exh., 1953, 1958, 1959; Westchester A. & Crafts Gld., 1956, 1957; Nat. Lg. Am. Pen Women, 1963; Knickerbocker A., N.Y., 1968. Work: Berkshire Mus., Pittsfield, Mass. Exhibited: Audubon A., 1952, 1957-1965; All. A. Am., 1954, 1957-1964; NSS, 1961, 1962; NAD, 1956; Art:USA 1958; AAPL, 1956; Nat. Lg. Am. Pen Women, 1963; Knickerbocker A., 1955, 1957, 1959, 1960, 1962; Silvermine Gld. A., 1952, 1953, 1955-1957, 1959, 1960, 1963; Boston A. Festival, 1957; Eastern States Exh., 1959, 1964; Conn. Acad. FA, 1956, 1958; Providence A. Cl., 1958; Berkshire Mus., 1956-1959, 1960, 1962; P. & Sc. of New Jersey, 1954, 1956; Union Carbide Bldg., N.Y., 1968; Allied A., 1968; Col. of New Rochelle, 1968, 1969. 3-man exh., Wellons Gal., N.Y., 1954; Silvermine Gld. A., 1961; Berkshire Mus., 1956, 1962.

GROSS, CHAIM—Sculptor, T.
526 W. Broadway, New York, N.Y. 10012; s. 60 Franklin St., Provincetown, Mass.
B. Kolomea, Austria, Mar. 17, 1904. Studied: ASL; BAID; Edu. All. A. Sch. Member: AEA; Fed. Mod. P. & S.; Hall of Fame, Edu. All.; Audubon A.; Nat. Inst. A. & Lets.; Professors' Assn.; Provincetown AA; Provincetown Art Commission; Sculptors Gld.; Arch. Lg., N.Y. Awards: prizes, FAP, 1936; Cape Cod AA, 1951; Boston A. Festival, 1954, 1963; Audubon A., 1955; Nat. Inst. A. & Lets. grant, 1956; Am. Acad. A. & Lets., Medal of Merit, 1963. Work: USPO, Wash., D.C.; Irwin, Pa.; Queens Col., N.Y.; Fed. Trade Bldg., Wash. D.C.; MMA; WMAA; Newark Mus. A.; MModA; AGAA; Haifa Mus., Israel; AIC; BMA; Butler Inst. Am. A.; Canton AI; Dayton AI; Des Moines A. Center; Everhart Mus.; Jewish Mus., N.Y.; Kansas City AI; Massillon Mus.; Milwaukee A. Center; Norton Gal. A.; WMA; PAFA; PMA; Ogunquit Mus. A.; Phoenix A. Mus.; Los A. Mus. A.; Springfield Mus. FA; St. Paul A. Center; WAC; Westmoreland County Mus.; Tel-Aviv Mus., Israel; Bezalel, Nat. Mus. of Mod. Art; many university and college museums throughout the U.S.; bronze reliefs, Temple Shaaray Tefila, N.Y.; Menorah Old Age Home, Brooklyn, N.Y.; over-life size bronze sculpture "Seven Mystic Birds" for the campus of Hebrew Univ., Jerusalem (work in progress) and many other commissions. Exhibited: Sculpture Exhs. annually: WMAA; Sculptors Gld.; PAFA. Traveling exhibitions circulated by American Federation of Arts, Smithsonian Institution, Museum of Modern Art, U.S. State Department, WMAA, nationally and internationally. Many one-man exhs., 1932-1965 including Assoc. Am. A.; Butler Inst. Am. A.; Massillon Mus. A.; Jewish Mus., N.Y.; Duveen-Graham Gal.; WMAA (traveling); and many galleries throughout the nation. Contributor to art magazines. Art films: "Tree Trunk to Head" (with Louis Jacobs); "A Sculptor Speaks" (Jacobs), 1956; "Direction 61," Theodore Bikel interviews Gross whose sculpture and watercolors formed background of TV program, 1961; TV Program at Educational Alliance School of Art, 1964. Positions: Instr., Sculpture, New School for Social Research and Educational Alliance Art School, New York, N.Y.*

GROSS, MR. and MRS. MERRILL JAY—
Collectors, Patrons, Consultant
241 Springfield Pike, Wyoming, Ohio 45215
Studied: (Mrs. Gross)—Mills College, B.A.; Xavier University, M. Ed.; (Mr. Gross)—University of Pittsburgh, B.A., B.S.; Xavier University, M.B.A. Collection: American Art (19th and 20th centuries) Western, genre and impressionist. Paintings by Edward Potthast, N.A. (1857-1927) exhibited in: Cincinnati Art Museum, March, 1965; The Butler Institute of American Art, November, 1965; The Taft Museum, July, 1968.

GROSS, SIDNEY—Painter
54 West 74th St., New York, N.Y. 10023
B. New York, N.Y., Feb. 9, 1921. Studied: ASL. Member: Audubon

A.; Fed. Mod. P. & S.; AEA. Awards: Scholarships, ASL, 1939-40; Schnackenberg Scholarship, 1940-41; Tiffany Fnd. F., 1949; grand prize, Art:USA, 1958; Work: CGA; Riverside Mus., N.Y.; WMAA; Univ. Georgia; Univ. Omaha; Mt. Holyoke Col.; Butler Inst. Am. A.; BM; Chrysler Mus.; Columbia Univ.; Univ. of Rochester; Syracuse Univ.; Allentown Mus., Allentown, Pa.; Univ. Ill.; Univ. Tex.; Okla. A. Center; Lempert Inst., N.Y.; Am. Acad. A. & Let; Brandeis Univ.; Cornell Univ. Exhibited: WMAA, 1945-1949; Carnegie Inst., 1946-1949; PAFA, 1948-1952; NAD, 1947, 1949, 1950; Albright A. Gal., 1946; BM, 1945; Armory Show, 1945; Toledo Mus. A., 1947; VMFA, 1948; Univ. Illinois, 1949; Illinois Wesleyan Col., 1949; Walker A. Center, 1948; Univ. Nebraska, 1948; Audubon A. 1947-1952; MMA, 1950; Hallmark exh., 1949; Fla. State Univ., 1951; Fed. Mod. P. & S., 1947-1952; Pepsi-Cola, 1946-1948, and others. One-man: Contemporary Arts Gal., 1945, 1946; Rehn Gal., 1949, 1950, 1953, 1954, 1956, 1958, 1961, 1963, 1965, 1967, 1969; Minneapolis Inst. A., 1946. Positions: Instr., Parsons Sch. Des., New York, N.Y.; ASL, summer, 1958; Columbia Univ., New York, 1946- . Assoc. Prof. A., Univ. Maryland, 1967- .†

GROSSMAN, FRITZ — Educator
Univ. of Washington, Seattle, Wash. 98122*

GROSVENOR, ROBERT — Sculptor
c/o Fischbach Gallery, 29 W. 57th St., New York, N.Y. 10019*

GROTELL, MAIJA — Craftsman, T.
Cranbrook Academy of Art, Bloomfield Hills, Mich. 48013
B. Helsingfors, Finland, Aug. 19, 1899. Studied: in Finland. Member: Mich. Acad. Sc., A. & Let.; AAUP. Awards: Barcelona, Spain, 1929; med., Paris Salon, 1937; prizes, Syracuse Mus. FA, 1936, 1946, 1949; Wichita AA, 1947, 1951; Michigan A.-Craftsman, 1949-1951; Michigan Acad. Sc., A. & Let., 1949-1951, 1956; Detroit Inst. A., 1953, 1955 (purchase); Charles F. Binns Medal, Col. of Ceramics, Alfred Univ., 1961; Founders Medal, Cranbrook Fnd., 1964. Work: Ceramics, MMA; AIC; Ball State T. Col.; Central Mich. Col. Edu.; General Motors Tech. Center; Flint (Mich.) Journal Bldg.; Detroit Inst. A.; Springfield Mus.; Cranbrook Mus.; IBM; Mus. Contemp. Crafts, N.Y.C.; The Johnson Coll.; Syracuse Mus. FA; CMA; Toledo Mus. A.; Walker A. Center; Univ. Gal., Minneapolis; Univ. Michigan; Univ. Nebraska; Univ. Wisconsin; Children's Mus., Detroit; Wichita AA.; St. Paul A. Center; Illinois State Normal Univ.; Cranbrook Fnd. Exhibited: Syracuse Mus. FA, 1932-1955, 1956, 1958, 1959; MMA, 1940; Portland A. Mus., 1942; Nelson Gal. A., 1945; AIC, 1946; Wichita AA, 1947, 1952; Newark Mus. A., 1948; Scripps Col., 1949-1951; Wash. Kiln Cl., 1951, 1952, 1957; Detroit Inst. A., 1949, 1956, 1958; WMA, 1951; Univ. Gal., Minneapolis, 1951; Univ. Wisconsin, 1952; Des-Craftsman, U.S.A., 1953-1955; Univ. Illinois, 1953; Iowa State T. Col., 1953; Univ. Chicago, 1954; Cannes, France, 1955; State Univ. Iowa, 1955; Sioux City A. Center, 1955; Mus. Contemp. Crafts, 1956, 1958, 1959, 1968; Butler Inst. Am. A., 1956; Ball State T. Col., 1959; Louisville A. Center, 1959; U.S. Ceramic Traveling Exh. to Europe, 1959; 20th Century Design, USA; Royal Ontario Mus., 1959; Weatherspoon A. Gal., 1960; So. Ill. Univ., 1960; Kansas City AI, 1960; Copenhagen, Denmark, 1960; Exh. Am. Crafts, Europe, USIS, 1960; Smithsonian Inst., 1961; Mus. Contemp. Crafts, N.Y., 1963, 1968 (one-man); McPherson College, McPherson, Kans., 1963; Flint Inst. A., 1964; Birmingham A. Center, 1964; San Jose State College Gallery, 1964; Syracuse Univ. and Cranbrook Acad. A., both 1967 (one-man), and many others. Positions: Instr., Ceramics, Henry St. Crafts Sch., New York, N.Y., 1929-39; Instr., Res. Asst., Rutgers Univ., 1937-38; Dir., Dept. Ceramics, Cranbrook Acad. A., Bloomfield Hills, Mich., 1938-1967.

GROTENRATH, RUTH (Mrs. Ruth Grotenrath Lichtner)—
Painter, Ser., Eng., C., Des., T.
2626A North Maryland Ave., Milwaukee, Wis. 53211
B. Milwaukee, Wis., Mar. 17, 1912. Studied: State T. Col., Milwaukee, Wis., B.A. Awards: prizes, med., Milwaukee AI, 1934, 1940, 1944; Madison AA, 1935; AIC, 1936, 1944; William & Bertha Clusman award, 1963; Grand Rapids A. Gal.; Dayton Company, Minneapolis; Ser. Soc., N.Y. Work: Madison Un.; Milwaukee AI; PMA; IBM Coll.; Wisconsin State T. Col.; murals, USPO, Hart, Mich. and Wayzata, Minn.; Hudson, Wis.; Wisconsin State T. Col.; Timmerman Field (Airport) Bldg. Exhibited: CGA, 1939; AIC, 1942; GGE, 1939; MMA (AV), 1942; SFMA, 1946; Milwaukee AI, 1937 (one-man); Wustum Mus., Racine, Wis.; Layton A. Gal.; State Hist. Soc.; Wis. State Fair; Madison Un.; Renaissance Soc., Chicago; VMFA; Cal. PLH; Walker A. Center; Madison Salon, 1967, 1968; Bradley Gal., 1968; 2-man: Layton A. Gal., 1953; Lawrence Col.; Cardinal Stritch Col., 1954; (with Schomer Lichtner) Milwaukee, 1957; Frank Ryan Gal., Chicago, 1958; BM, 1958, 1959; Boston A. Festival, 1960; PMA, 1959; Milwaukee A. Center, 1960, 1961; Madison Salon, 1960; one-man: Chapman Gal., Milwaukee, 1965; Wisconsin State College, Stevens Point, Wis., 1964; Bradley Gal., 1966, 1969. Positions: Instr., Des., Univ. of Wisconsin, Milwaukee, 1961.

GROTH, BRUNO—Sculptor
P.O. Box 3, Trinidad, Cal. 95570
B. Germany, Dec. 14, 1905. Studied: U.S. and abroad. Work: Mem. sculpture, Humboldt College, 1953; City of Fresno fountain sculpture, 1965 and City of Crescent City, Cal.; sc. in Hirshhorn Coll.; Palm Springs (Cal.) Mus. Exhibited: Santa Barbara Mus. A.; Fine Art Gal., San Diego; Municipal A. Gal., Los Angeles; Portland A. Mus.; Mus. of Contemp. Crafts, N.Y.; one-man: de Young Mem. Mus., San Francisco; Assoc. Am. A., N.Y., 1954; Feingarten Galleries, Chicago, 1960, New York, 1961, San Francisco, 1963; Ankrum Gal., Los Angeles, 1964, 1968; Gump's Gal., San Francisco, 1965.

GROTH, JOHN—Painter, I., T., Gr.
61 East 57th St., New York, N.Y. 10022
B. Chicago, Ill., Feb. 26, 1908. Studied: AIC; ASL, and with Todros Geller, Arnold Blanch, George Grosz. Member: ANA; AWS; Audubon A.; Overseas Press Cl.; Am. Newspaper Gld.; SI.; All. A. Am.; Audubon A.; Lotos Cl. Work: MMoAC; LC, MMA; AIC; NGA; WMAA; Smithsonian Inst.; Mus. Western A., Moscow, Russia. Exhibited: nationally. One-man: Janet Nessler Gal., N.Y., 1960. Contributor to Vogue, Esquire, Collier's, and other magazines. Lectures: War Art. Illus., "Grapes of Wrath," 1947; "Men Without Men," 1946; "War and Peace," "Exodus" 1963; "Xmas Carol," 1964; "Black Beauty," 1962; "Short Stories of O. Henry," 1966; "Gone With the Wind," 1968; "The War Prayer" (Mark Twain), 1968; "All Quiet on the Western Front,"1969. Author, I., "Studio: Europe," 1945; "Studio: Asia," 1952; Contributor to Life; Sports Illustrated; Look; Esquire and other national magazines. Positions: A. Dir., Esquire magazine, 1933-37; Parade Publ., 1941-44; War Correspondent, Chicago Sun, 1944; American Legion magazine, 1945; Instr., ASL, New York, N.Y., currently; Pratt Inst., Brooklyn, N.Y.; Parsons Sch. Des., N.Y.; Nat. Acad. Des., 1963-64; Miami A. Center, 1968, 1969; War Correspondent, Korea and Indo-China, 1951; Asia, 1954, 1956; Europe, 1955, 1957; Arctic, 1958; Nigeria, The Congo, 1960, East Africa, 1963; Santo Domingo, 1966; Viet Nam, 1967.

GROTZ, DOROTHY (Mrs. Paul)—Painter
7 St. Lukes Place, New York, N.Y. 10014
B. Philadelphia, Pa., June 11, 1906. Studied: Univ. Berlin; Am. A. Sch.; ASL; Sculpture Center, N.Y.; Pratt Graphic A., and in Europe. Member: AEA; ASL. Work: Norfolk Mus. A. & Sciences; Rochester Mem. Mus.; Santa Barbara Mus. A.; Columbia Univ. Sch. Architecture; Kunstakademie, Stuttgart, Germany. Exhibited: Audubon A.; and in France, Germany and Italy. 10 one-man exhs. through traveling Art Guild in universities and museums for 1965-1966.

GROVE, EDWARD RYNEAL—Medallic Sculptor, Gr., P.
3215 S. Flagler Dr., West Palm Beach, Fla. 33405
B. Martinsburg, W. Va., Aug. 14, 1912. Studied: Nat. Sch. A., Washington, D.C.; Corcoran Sch. A. Member: AEA (Nat. Vice-Pres., 1965-1967); Phila. Sketch Cl.; Phila. A. All.; NSS; Soc. Washington A.; Washington WC Soc.; Landscape Cl., Palm Beach; Soc. Four A. Awards: Landscape Cl. bronze medals, 1948, 1953; Grumbacher award, 1965; prizes, Washington County Mus. FA; Hagerstown, Md.; Lindsey Morris Mem. prize, NSS, 1967. Work: Pangborn Corp., Hagerstown, Md.; Grad. Sch. Medicine, Univ. Pennsylvania; medallic sculpture: Dept. of the Navy, Office Chief of Naval Operations, Washington, D.C.; Pennsylvania Hist. Soc., Philadelphia. Commissions: Washington Cathedral, etchings, 1945, 1946, 1964; Church of the Holy Comforter, mural, "The Communion of Saints," Drexel Hill, Pa., with Jean Donner Grove, 1952-1958; Am. Air Mail Soc. design for U.S. Air Mail stamp, 1954, re-issue 1958; Statue of Liberty Centennial medal, 1964; Sov. Ord. St. John of Jerusalem, Knights of Malta, des. and sculptured 4 coins, 1965; William Penn Medal, Hall of Fame for Great Americans, 1966; Oakland Univ. Wilson Award Medal, 1965; Queen Isabella Medal, 1967; Presidential Art Medals, World War II Series, 30 medals, 1966-1970 and many other commissions. Exhibited: Norfolk Mus. A. & Sciences, 1958; NSS, 1964, 1967; Hagerstown, Md., 1962-1966; PAFA, 1964; Springfield (Mass.) Mus. FA, 1964; Phila. A. All., 1965; Phila. Pyramid Cl., 1956-1959; Phila. Sketch Cl., 1956, 1958, 1959; Da Vinci A. All., 1960; PMA, 1962; Norton Gal. A., 1969; "Grove Family" exh., Cayuga Mus. Hist. & A., Auburn, N.Y., 1964 and at Episcopal Acad. Gal., Philadelphia, 1966, and other exhs., in prior dates; one-man: Nat. Philatelic Mus., 1954; Phila. A. All., 1960. Article and illus. for "The Communion of Saints" brochure, 1958; Article on stamp design for Stamp Design Handbook, Nat. Philatelic Mus., Philadelphia; 18 portrait illus. for "Our Christian Heritage." Article and illus. to Coin World (newspaper), 1965. Lectures on Religion in Art; Medallic Sculpture to church groups, art organizations and numismatic clubs.

GROVE, JEAN DONNER (Mrs. Edward R.)—Sculptor
3215 S. Flagler Dr., West Palm Beach, Fla. 33405
B. Washington, D.C., May 15, 1912. Studied: Cornell Univ. Summer

Sch.; Wilson T. Col., B.S.; Catholic Univ. of America Summer Sch.; Corcoran Sch. A.; and with Clara Hill, Hans Schuler, Heinz Warneke. Member: AEA (Dir. Phila. Chptr., 1964-1966); Phila. A. All.; Washington (D.C.) soc. A.; Soc. Four A., Palm Beach; Norton Gal. A., Palm Beach. Awards: prizes, Goodman award, Herron Mus. A., Indianapolis, 1957; AEA Award, 1960 for design of layman's award, and other prizes in prior dates. Work: Numerous portrait heads, 1940-1969; "The Communion of Saints" mural (with E.R. Grove), 1952-1958; other work in private collections. Exhibited: PAFA, 1947, 1948, 1951, 1953; All. A. Am., 1949; NSS, 1957 (2); PMA, 1955, 1959, 1962; Pyramid Cl., 1955-1959; Herron Mus. A., 1957; Phila. A. All., 1957, 1960, 1966; CGA, 1943, 1945; Soc. Wash. A., 1943-1947; Friends Central Sch., 1954, 1965, 1966; Da Vinci All., 1959, 1960; Moore Col. A., Phila., 1962-1967 Civic Center Mus., Phila., 1968. Special exh.: "Grove Family," Cayuga Mus. Hist. & A., Auburn, N.Y., 1964; "Grove Family, 1966," Episcopal Acad. Gal., Philadelphia, Pa., 1966.

GROVE, RICHARD—Mus. Director, E., W.
The JDR 3rd Fund, 50 Rockefeller Plaza, New York, N.Y. 10020; h. 23 Hope Street, Ridgewood, N.J. 07450
B. Lakewood, N.J., Feb. 7, 1921. Studied: Mexico City Col., B.A., M.A. Member: AAMus; AFA; NAEA; Institute for the Study of Art in Education. Author: "Guide to Contemporary Mexican Architecture," 1952; "Mexican Popular Arts Today," 1954. Contributor articles to Art News; Craft Horizons; American Education; Museum News. Positions: Assoc. Cur., Taylor Mus. of the Colorado Springs FA Center, 1953-1958; Dir., Wichita A. Mus., Wichita, Kans., 1958-1964; Museum Education Specialist, U.S. Office of Education, Washington, D.C., 1964-1968. Assoc. Dir., Arts in Education Program, The JDR 3rd Fund, New York, N.Y., 1968- .

GRUBE, ERNST J(OSEPH)—E., W.
Columbia University, Department of Art and Archaeology, Islamic Art, New York, N.Y. 10027
B. Kufstein, Tirol, Austria, May 9, 1932. Studied: Freie Universität Berlin, Ph.D. Pupil of Ernst Kuhnel. Member; American Oriental Soc.; American Research Center in Egypt. Author: "Muslim Paintings from the XIII to XIX Century from Collections in the United States and Canada," Venice, 1962; "The World of Islam, Landmarks of the World's Art," 1967; "The Classical Style in Islamic Painting," 1968. Contributor to: Pantheon, Kunst des Orients, Oriental Art, Ars Orientalis, Journal of the American Research Center in Egypt. Lectures: Columbia Univ.; Univ. of Michigan; Metropolitan Museum of Art; International Congresses: Persian Art, N.Y., 1961; Turkish Art, Ankara, 1959, Venice, 1964. Arranged exhibition of Muslim Paintings from American Collections held in 1962 at the Cini Foundation, Venice, and Asia House, New York. Positions: Adjunct Prof., Columbia University, N.Y., subject-The Art of the Islamic World.

GRUBER, AARONEL DEROY—Sculptor, P.
1844 Ardmore Blvd.; h. 2409 Marbury Rd., Pittsburgh, Pa. 15221
B. Pittsburgh, Pa., July 10, 1928. Studied: Carnegie-Mellon Univ., B.S. Studied with Samuel Rosenberg, Robert Leper, Roy Hilton and Wilford Readio. Member: NAWA; Soc. of Sculptors; Assoc. A. of Pittsburgh; A. & Crafts Center, Pittsburgh. Awards: prizes, Pittsburgh Plan for Art, 1967; Newport R.I., 1960; Chautauqua, N.Y., 1964, 1966; Westinghouse Award, purchase, 1968; Western Pa. Sc. Soc., Heinz Award, 1965, Architects Award, 1969; Carnegie-Mellon Mus., Pittsburgh, prize, 1961, Award of Distinction, 1964, 1966. Work: Norfolk Mus. A. & Sciences; Syracuse Univ.; American Embassy, Argentina; Westmoreland County Mus., Greensburg, Pa.; Bundy A. Gal., Waitsfield, Vt.; Finch Col., Mus., N.Y.; Chase Manhattan Bank; Wayne State Univ.; Brandeis Univ. Library; deCordova and Dana Mus., Lincoln, Mass.; Butler Inst. Am. A.; Pittsburgh Public Schools; Also in private colls. U.S. and abroad. Represented in "Prize Winning Paintings," 1962, 1967-1969. Exhibited: Flint Inst. A., 1968; J.L. Hudson Gal., Detroit, 1968, 1969; NAWA traveling exh. to Europe and Canada, 1968-1969; Three Ricers Exh., Pittsburgh, 1968, 1969; Western Pa. Sc. Soc., 1965, 1969; Westmoreland County Mus., 1964-1968; Carnegie-Mellon Univ. Mus., 1958-1969; Chapman Sculpture Gal., N.Y., 1968, 1969; Horizon Gal., Rockport and Boston, 1966-1969; PMA Lending Library, 1969; Silvermine Gld. A., 1969; North Carolina Mus. A., 1969; Finch Col., N.Y., 1966; deCordova and Dana Mus., 1966; Chautauqua, N.Y., 1959-1968; Wash. (D.C.) WC Soc., 1967; Butler Inst. Am. A. (8 annuals); Purdue Univ., 1964; East Hampton Gal., N.Y., 1969 (2); also in Pineta si Arenzano, Spoleto and Rome, Italy. Many other exhs., 1958-1964. One-man: Bertha Schaefer Gal., N.Y., 1969; Galeria Juana Mordo, Madrid, Spain, 1969; USIS, Milan, 1965; Jason Gal., N.Y. 1965, 1967; Chautauqua, N.Y., Retrospective, 1967; Pittsburgh Plan for Art, 1967, 1968; Bundy A. Gal., 1968-1969; St. Paul's Sch., Concord, N.H., 1968 and others in previous years.

GRUBER, MRS. SHIRLEY EDITH MOSKOWITZ. See Moskowitz, Shirley

GRUBERT, CARL ALFRED—Cartoonist, Comm. A.
Woodlawn Ave., Des Plaines, Ill. 62216
B. Chicago, Ill., Sept. 10, 1911. Studied: Univ. Wisconsin, B.S.; Chicago Acad. FA. Member: Nat. Cartoonists Soc. Awards: U.S. Treasury award of merit, 1950; Freedom's Fnd. medal, 1950. Exhibited: Nat. Cartoonists Soc. exh., 1950, 1951; MMA, 1951; LC, 1949. Positions: Creator, Cart., "The Berrys," internationally syndicated cartoon, 1942- ; Staff A., Great Lakes Bulletin.

GRUPPE, KARL H.—Sculptor
138 Manhattan Ave., New York, N.Y. 10025
B. Rochester, N.Y., Mar. 18, 1893. Studied: Royal Acad., Antwerp, Belgium; ASL; & with Karl Bitter. Member: NA; Century Assn.; NAC (life); NSS. Awards: prizes, Arch. Lg., 1920; NAD, 1926; AAPL, 1955; gold med., 1952; The Elizabeth N. Watson Gold Medal, NAD, 1969. Work: Adelphi Col., Brooklyn, N.Y.; Curtis Inst. Music, Phila.; Brookgreen Gardens; Henry Hudson mem., Spuyten Duyvil Hill, N.Y.; Numismatic Soc.; N.Y.; garden figures, portrait busts privately commissioned. Exhibited: NSS, 1923; NAD, 1926, 1928, 1929, 1945; Arch. Lg.; WMAA, 1940; WFNY 1939; etc. Positions: S. Member, N.Y. Art Comm., 1943-47; A. Comm. Assoc., 1948; Pres., NSS, 1950-51; 2nd Vice-Pres., NAD, 1955, 1st Vice-Pres., NAD, 1957-58.

GRUSHKIN, PHILIP—Designer, T., Calligrapher, L.
86 East Linden Ave., Englewood, N.J. 07631
B. New York, N.Y., June 1, 1921. Studied: CUASch. Awards: Certif. of Excellence, Printing for Commerce Exh., 1950. Exhibited: Book Jacket Des. Gld., 1948-1952; Lettering & Calligraphy in Current Advertising and Publishing exh., 1945; Printing for Commerce, 1950; Victoria and Albert Mus., London, 1949; Cooper Union A. Sch. Instr. Exh., 1951; Gld. of Bookworkers, AIGA, 1954; Grolier Cl., 1956; Graphic Des., Peter Cooper Gal., 1954; Calligraphy, Grolier Cl., 1958; A. Dir. Cl., 1960; Int. Calligraphy & Lettering, Nat. Lib. of Scotland, 1960; Calligraphy & Handwriting in America, Peabody Inst. Lib., Balto., 1961; Calligraphy & Lettering, Brown Univ., 1961. Published: Calligrapher of "Aesop's Fables," 1946; "Christmas Carols," 1948; calligraphy represented in "Bouquet for Bruce Rogers," 1950 and "Calligraphics," 1955. Positions: Cartographer, U.S. Geological Survey, 1942-43; Office of Strategic Services, U.S. Army, 1943-45; Instr., Lettering, Calligraphy and Illustration, CUASch., New York, N.Y., 1946-1968; Instructor Book Design, New York Univ., 1968- ; Dir. Book Workshop, Radcliffe Publishing Procedures Course, Cambridge, Mass., 1966- ; Des., The World Publishing Co., New York, N.Y., 1955.-56; Freelance Des., 1946-1958; Des., 1957-59, A. Dir., 1959- , Vice-Pres., 1960-1969, Harry N. Abrams, Inc., New York, N.Y. Pres., Philip Grushkin Assoc., Englewood, N.J.. Lectures frequently on the book arts.

GRUSKIN, ALAN DANIEL—Dealer, Collector, W.
Midtown Galleries, 11 E. 57th St., New York, N.Y. 10022; h. R.D. 1, Stockton, N.J. 08559
B. Manorville, Pa., Dec. 28, 1904. Studied: Harvard University. Author: "Painting in the U.S.A.," 1946; "The Watercolors of Dong Kingman," 1958; "The Painter and his Techniques," 1964; "William Thon"; also various catalogue forewords, radio programs. Specialty of Gallery: Contemporary art. Collection: American paintings and drawings from "The Eight" to present. Circuit exhibitions to museums and universities; First showings of many artists who are today among our leading painters and sculptors. Member: Board of Directors, Art Dealers Assn. of America; Advisor, National Art Museum of Sport. Positions: Founder and owner, Midtown Galleries, New York, N.Y.

GUERIN, JOHN WILLIAM—Painter, E.
Department of Art, University of Texas; h. 3400 Stoneridge Rd., Austin, Tex. 78745
B. Houghton, Mich., Aug. 29, 1920. Studied: Am. Acad. A., Chicago; ASL; San Miguel de Allende, Mexico; Colorado Springs FA Center. Member: ANA; ASL; Texas FA Assn. Awards: Ranger purchase award, NAD, 1958; prize, Texas P. & S. Exh., 1955; Grants: Am. Acad. A. & Lets., 1959; Univ. Texas Research Inst., 1960, 1966. Work: DMFA; Mus. FA of Houston; Witte Mem. Mus.; Joslyn Mus. A.; Chrysler Mus. A.; Laguna Gloria Mus., Austin; and in many group colls. Exhibited: MMA, 1953; WMAA, 1956; AIC, 1957; Univ. Illinois, 1957; Colorado Springs FA Center, 1955, 1960; PAFA, 1958; Denver A. Mus., 1957; Time & Life Bldg. Exh., 1957; Nat. Inst. A. & Lets., 1957; DMFA, 1956; Survey of Texas Painting, 1957; Cushman Gal., Houston, 1957; Contemporary A. Gal., Dallas, 1957; CGA, 1961; PAFA, 1959; Detroit Inst. A., 1959; Gal. Realities, Taos, N.M., 1960; one-man: Kraushaar Gal., N.Y., 1959, 1963, 1968; Carlin Gal., Ft. Worth, 1961, 1964, 1968; Fort Worth A. Center Retrospective, 1964.

Positions: Instr. Painting, DMFA, 1950-52; Assoc. Prof. Art, University of Texas, Austin, Tex., 1953- .

GUERRERO, JOSE—Painter
406 West 20th St., New York, N.Y. 10011
B. Granada, Spain, Oct. 27, 1914. Studied: in Granada and Madrid, Spain; Ecole des Beaux-Arts, Paris, France. Awards: French Ministry of Edu.; Graham Fnd. for Advanced Study in the Fine Arts Fellowship, 1958-59; Ordre de Chevalier des Arts et des Lettres, French Govt., 1960. Work: paintings, French Ministry of Nat. Edu., Paris; Belgian Ministry of Nat. Edu., Brussels; AIC; WMAA; Albright A. Gal.; Chase Manhattan Bank, N.Y., Toronto A. Gal.; Museo Contemporaneo, Madrid; Solomon Guggenheim Mus. Exhibited: Solomon Guggenheim Mus., 1954; Salon des Realites Nouvelles, Musée de l'Art Moderne, 1957; WMA, 1958; Dallas Mus. Contemp. A., 1958; WMAA, 1958, 1959; Am. Abstract A., 1959, 1960; Biennale de Mexico, 1960; Carnegie Inst., 1958; Rome-New York Fnd., Rome; one-man: Galeria Secolo, Rome, 1948; Lou Cosyn Gal., Brussels, 1948; St. George's Gal., London, 1949; Buchholz Gal., Madrid, 1950; Betty Parsons Gal., 1954, 1957, 1958, 1960; A. Cl. of Chicago (2-man with Joan Miro), 1954; 10 Jeune Peintres de l'Ecole de Paris, Galerie de France, Paris, 1956.*

GUGGENHEIM, HARRY FRANK—Collector, Publisher, Writer
Newsday, 550 Stewart Ave., Garden City, L.I., N.Y. and 120 Broadway, New York, N.Y. 10005; h. Port Washington, L.I., N.Y.
B. West End, N.J., Aug. 23, 1890. Studied: Pembroke College, Cambridge University, England, B.A., M.A. Awards: Honorary Fellow, Pembroke College, 1962- ; Honorary Degrees: Georgia School of Technology, D.S.; Clark University, Worcester, Mass., LL.D.; New York University, Eng.D.; Columbia University, 1962, LL.D. Other awards include the General H. H. Arnold Award from the Veterans of Foreign Wars, 1956, for the American citizen contributing most outstandingly during the year to the field of aviation; the Laura Taber Barbour Award from the Society of Automotive Engineers for his contributions to air safety. Interests: in 1929, established the Harry Frank Guggenheim Foundation, which has made many grants to a number of charitable institutions. Pioneer in Aviation, Rockets, Jet Propulsion, he became President of the Daniel Guggenheim Fund for the Promotion of Aeronautics, 1926-1930. Author: "The Seven Skies," 1930; "The United States and Cuba," 1934. Career is wide and varied including the Diplomatic, Civic, Philanthropic and Cultural areas. Positions: Pres., Publisher, Newsday, Pulitzer Prize-Winning daily newspaper, Long Island, N.Y., 1940- ; Pres. & a Dir., The Daniel and Florence Guggenheim Foundation; Chm., Bd. of Trustees, of the Solomon R. Guggenheim Foundation, 1949-1957, Pres., 1957- ; The Board supervises the operation of the Solomon R. Guggenheim Museum, New York. At Mr. Guggenheim's suggestion, the Board established, in 1956, the Guggenheim International Award, a $10,000 grant for a painting selected by a jury of international experts made every two years until 1960 and every three years thereafter. Vice-Pres., Pembroke College Society.*

GUGGENHEIM, PEGGY (MRS.)—Collector, Patron
Palazzo Venier dei Leoni, 701 San Gregorio, Venice, Italy
B. New York, N.Y., Aug. 26, 1898. Author: "Out of This Century," 1946; "Una Collezionista Ricorda," 1956; "Confessions of an Art Addict," 1960. Exhibits: Directed and financed Gallery Guggenheim Jeune, London, 1938-1939; Art of This Century, N.Y., 1943-1947; Mus. Palazzo Venier dei Leoni, Venice, 1951- .*

GUGGENHEIMER, RICHARD H.—Painter, T., W., L.
784 Park Ave., New York, N.Y. 10021; also, Old Mill River Rd., Pound Ridge, N.Y. 10576
B. New York, N.Y., Apr. 2, 1906. Studied: Johns Hopkins Univ., A.B.; Sorbonne, Grande Chaumiere, Paris, France; & with Picart le Doux, Morrisset, Coubine. Member: Am. Soc. for Aesthetics. Exhibited: CGA; PAFA; NAD; WMAA; AFA; one-man exh.: Van Diemen-Lilienfeld, Macbeth, Georges Seligmann galleries; Maryville Col.; Norfolk Mus. A.; & in Paris. Author: "Sight and Insight, A Prediction of New Perceptions in Art," 1945; "Creative Vision, in Artist and Audience," 1950; "Creative Vision for Art and for Life," 1960; "Symposium Monogram"; "The Seen and Unseen in Art." Article, "Promising Expansions in the Fine Arts," for Art Education magazine; "Reciprocal Visions of Science and Art," for the Johns Hopkins magazine. Numerous lectures at colleges and universities. Positions: Dir., A. Dept., Briarcliff Col., Briarcliff Manor, N.Y.

GUION, MOLLY—Portrait Painter
c/o Portraits, Inc., 136 East 57th St., New York, N.Y. 10022
Studied: Grand Central A. Sch., with Arthur Woelfle; ASL, with George Bridgman; portraiture with Dimitri Romanovsky; and with Grigory Gluckmann. Member: NAWA; All. A. Am.; Pen & Brush

Cl.; Catherine L. Wolfe A. Cl.; New Rochelle AA; Hudson Valley AA; AAPL. Awards: prizes, Ellerhusen Mem. Prize, All. A. Am., 1954; Westchester Fed. Womens Cl.; Hudson Valley AA; Wolfe A. Cl.; Silver Medal, Hudson Valley AA; Gold Medals: NAC; AAPL, 1955, and New York Chptr. gold medal. Work: in many public and private colls. including British Royal Navy, Portsmouth; British Consulate, New York; Capitol, Albany, N.Y.; portraits of many prominent persons, U.S. and abroad. Exhibited: one-man: SAM; Vancouver (B.C.) A. Gal.; NAD; Grand Central A. Gals.; Kennedy Gal., N.Y.; Paris Salon; Royal Portrait Soc., London; private showing, Buckingham Palace. Many other exhibitions in galleries and museums, U.S., Canada and abroad.*

GUMBERTS, WILLIAM A.—Collector, Patron, Cr.
116 Main St. 47708; h. 618 S.E. Riverside Ave., Evansville, Ind. 47713
B. Evansville, Ind., May 21, 1912. Studied: Harvard University; Ohio State University. Member: Indiana Arts Commission. Collection: 19th century American oils; Etchings of classical periods, moderns. Positions: Board of Directors, Evansville Public Museum. Critic, Art, Music and Theatre, Evansville Press.

GUMPEL, HUGH—Painter, T.
335 Rushmore St., Mamaroneck, N.Y. 10543
B. New York, N.Y., Feb. 3, 1926. Studied: Columbia Univ.; ASL. Member: ANA; AWS. Awards: Tiffany Fnd. grants, 1956, 1957; AWS Grand Award with Gold Medal of Honor, 1968. Work: New York Hospital; Norfolk Mus. A. & Sciences; mural, Public Works Admin., Albany, N.Y.; New York State Pub. Works Admin. Bldg., Albany, N.Y. Positions: Instr., Painting, National Academy of Design, New York, N.Y.

GUND, GEORGE—Collector, Patron, W.
The Cleveland Trust Company, Cleveland, Ohio 44101; h. 2800 Selkirk Rd., Beachwood, Ohio 44124
B. LaCrosse, Wisconsin, Apr. 13, 1888. Studied: Harvard University, A.B., L.L.D.; Harvard Business School; Iowa State College. Awards: D.H.L., Kenyon College, 1950; Doctor of Laws, John Carroll University, 1958; Doctor of Laws, Fenn College, 1959. Author: "The Banker Looks at the College Library"; "The Banker's Attitude Toward Community Trusts." Collection: Remington original oils and bronzes; Charles M. Russell original oils and bronzes; The Old West. Positions: President, The Cleveland Institute of Art.*

GUNDERSHEIMER, HERMAN S(AMUEL)—Educator, W., L.
Tyler School of Art of Temple University, Philadelphia, Pa. 19126; h. 532 Laverock Rd., Glenside, Pa. 19038
B. Germany, Apr. 25, 1903. Studied: Universities of Munich, Wurzburg, Berlin, Leipzig, Ph.D. Member: CAA; Renaissance Soc. of Am.; Cambridge (Eng.) Univ. A. Soc. (Hon.); AAUP; Phila. Pr. Cl.; PMA. Author: "Matthaus Gunther"; "Fresco Painting in the Church Architecture of the 18th Century." Author & Contrib. Ed., Encyclopedia of the Arts; The Book of Knowledge; Dictionary of the Arts; Harper & Brothers New Encyclopedia; Encyclopaedia Judaica. Lectures: Art History of the Renaissance; Trends in Contemporary Art, in universities, to art organizations, clubs. Positions: Visiting Prof., Hist. of Art, American Univ., Wash., D.C., 1940-41; Dir., Rothschild Mus., Frankfurt, to 1939; Dir., European Art Study Tours of Temple Univ., 1952- ; Prof. A., Temple University, Phila., Pa., at present; Dir., Tyler School of Art, Rome, Italy, as of July, 1970.

GUNN, PAUL JAMES—Educator, P., Gr.
Art Dept., Oregon State University; h. 1440 Kings Road, Corvallis, Ore. 97330
B. Guys Mills, Pa., June 21, 1922. Studied: Edinboro (Pa.) State T. Col., B.S. in A. Edu.; Cal. Col. A. & Crafts, Oakland, Cal., M.F.A.; studied in Tokyo, 1961-1962 with wood block artist, Hideo Hagiwara. Member: AAUP; Portland AA. Awards: prizes, Oregon A. print exh., Portland A. Mus., 1950; SAM, 1954; Pacific Northwest A., Spokane, Wash., 1954, 1956. Work: Portland A. Mus.; City of Spokane Coll.; Victoria & Albert Mus., London; Bibliothique Nationale, Paris. Exhibited: Oakland A. Mus., 1951, 1956; Bordighera, Italy, 1956; Denver A. Mus., 1951; Portland A. Mus., 1950-1960; SAM, 1951, 1954, 1956, 1959; Spokane, Wash., 1954, 1956, 1958, 1960; one-man: Portland A. Mus., 1953. Positions: Prof. A., Chm. A. Dept., Oregon State University, Corvallis, Ore.

GURR, LENA—Painter, Ser., Lith., Woodcut
10 East 23rd St., New York, N.Y. 10010; h. 71 Remsen Ave., Brooklyn, N.Y. 11212
B. Brooklyn, N.Y., Oct. 27, 1897. Studied: Brooklyn Training Sch. for T.; Edu. All.; ASL, with John Sloan, Maurice Sterne. Member: NAWA; N.Y. Soc. Women A.; Brooklyn Soc. A.; Audubon A.; AEA; Soc. Painters in Casein; Am. Color Pr. Soc.; SAGA; P. & S. of New Jersey; Cape Cod AA; Provincetown AA; Hunterdon A. Center; Fal-

mouth A. Gld.; Albany Pr. Cl. Awards: prizes, NAWA, 1937, 1947, 1950, 1952, medal, 1954, 1956 (2), 1957, 1958, 1959, 1961 (2) and medal, 1962, 1963, Haldenstein prize, 1964, Abbott Treadwell prize, 1967; Comm. for Democratic Living, 1951; Brooklyn Soc. A., 1943, 1951, 1954, 1955, 1958, 1960, 1964; Nat. Ser. Soc., 1949; Albany Pr. Cl., 1955 (purchase); P. & S. of New Jersey, 1956; Silvermine Gld. A., 1957; Brower Park Young Women's Cl., 1959 (purchase); Painters in Casein, 1961; Audubon A., 1958; Childe Hassam Fund purchase award, 1958; Cape Cod AA, 1962, 1963; Grumbacher prize, 1966; Jersey City Mus., 1969 (medal); Benedictine award, 1966. Work: LC; Univ. Wisconsin; AAUW; Tel-Aviv Mus.; Ain-Harod Mus.; Israel; N.Y. Pub. Lib.; Cal. State Lib.; Kansas State Col.; Brandeis Univ.; VMFA; Howard Univ.; Butler Inst. Am. A.; Staten Island Mus. A. & Sc.; Am. Acad. A. & Lets., 1958; Phoenix Mus. A.; Atlanta Univ.; Phila. Free Lib.; P.S. 289, Brooklyn; Wingate H.S., Brooklyn; MMA; Oxford Univ., England; Univ. Syracuse; New Jersey State Col.; Safed Mus., Israel; Cornell Univ.; Norfolk Mus. A. & Sciences; Provincetown AA; Smithsonian Inst.; Boston Pub. Library; Slater Mem. Mus., Norwich, Conn.; Chrysler Mus., Provincetown; PMA; Kalamazoo A. Inst. Exhibited: PAFA, 1938, 1952-54; NAD, 1944-46, 1951; Carnegie Inst., 1945; VMFA, 1946; BM, 1936, 1954, 1956, 1958; Brooklyn Soc. A., 1941, 1943-1958; ACA Gal., 1935, 1939, 1945, 1947, 1950, 1953, 1959 (all one-man); MMA, 1942, 1952; WMAA, 1953; Oklahoma A. Center; Wichita AA; Syracuse Mus. FA; Riverside Mus.; Paris, France; Canada and Latin America; Am. Acad. A. & Lets., 1958, and others. Positions: Bd. Dirs., Brooklyn Soc. A., 1950-53, 1955-57; Audubon A., 1946; NAWA, 1950; AEA, 1949-50, 1950-51, 1952-53, 1962-1969, Vice-Pres., 1966-1969; Soc. Painters in Casein, 1957-1965, and others.

GUSSMAN, HERBERT—Collector, Patron
1714 First National Bldg. 74103; h. 4644 S. Zunis Ave., Tulsa, Okla. 74104
B. New York, N.Y., Aug. 25, 1911. Studied: Cornell University, A.B. Collection: French impressionists; American paintings and sculpture; African primitive art; Bronzes—Luristan, Africa.*

GUSSOW, ALAN—Painter, Gr., T.
121 New York Ave., Congers, N.Y. 10920; also, Monhegan Island, Me. 04852
B. New York, N.Y., May 8, 1931. Studied: Middlebury Col.(Vt.), B.A.; Cooper Union Sch. A., with Morris Kantor; Atelier 17. Member: Alumni Assn. of the American Acad. in Rome (Vice-Pres., 1953-54). Awards: Prix de Rome, 1953-1954 renewed, 1954-1955 to the Am. Acad. in Rome. Work: BMA, and in private colls. Exhibited: Art Dealers of America, 1964; Nebraska AA, 1964; Colby College (circulated by AFA), 1964; Illinois Wesleyan Univ. purchase Exh., 1964, 1968; Maine Coast Artists, Rockport, (4-man), 1964; Butler Inst. Am. A., 1963; Providence A. Cl., 1963; Rochester (N.Y.) Collectors Loan Exh., 1959; Bordighera, Italy, 1955; USIS Traveling Exh., 1954 (Bologna, Florence, Bari); PAFA, 1966; Indiana Univ., 1966; Am. Acad. A. & Lets., 1966; one-man: sixth show at Peridot Gal., N.Y., 1969. Organized and wrote catalog essay, "The American Landscape - a Living Tradition," 1966, circulated by Smithsonian Inst., 1968, 1969. Lectured: Vision '67, second world congress on communications sponsored by International Center for the Communication Arts and Sciences—subject "Ethics of Social Growth," N.Y., 1967. Positions: Instr., Painting and Life Drawing, Sarah Lawrence Collge, N.Y., 1958-1959; Parsons School of Design, N.Y., 1956-1968; A.-in-Res., Cape Cod Nat. Seashore, 1968; Consultant on the Arts, Nat. Park Service, 1968, 1969.

GUSSOW, ROY—Sculptor, E., Des.
4040 24th St., Long Island City, N.Y. 11101
B. Brooklyn, N.Y., Nov. 12, 1918. Studied: Chicago Inst. Des., B.A. Products Des.; and with Moholy Nagy, Archipenko. Awards: prizes, North Carolina State A. Mus., Raleigh, 1952, 1957; PAFA, 1958; Ford Fnd. (purchase), 1960, 1962. Work: s., North Carolina State A. Mus.; Atlanta AA; Phoenix Mutual Life Insurance, Hartford, Conn.; WMAA; MModA; Equitable Life Insurance, N.Y.; BM; Civic Center, Tulsa, Okla.; Xerox Corp., Rochester, N.Y.; numerous residential commissions. Exhibited: AIC, 1947-1949; SFMA, 1951; N.Y. Metropolitan Sculpture Exh., 1951; Denver A. Mus., 1949-1951; Omaha, Neb., 1949, 1950; Kansas City AI, 1950; N.C. State A., Mus., 1952-1961; PAFA, 1951-1959; Univ. Florida, 1953; AFA traveling exh., 1956; WMAA, 1956, 1962, 1964. One-man: Pa. State Univ., 1959; Borgenicht Gal., N.Y., 1964. Positions: Instr., S. Ceramics, Des., Bradley Univ.; Colorado Springs FA Center; Prof. Des., North Carolina State Col., Raleigh, N.C. Adjunct Prof. Sculpture, Pratt Institute, Brooklyn, N.Y., 1962-1968.

GUSTAFSON, DWIGHT LEONARD—Educator, Des.
Bob Jones University, Greenville, S.C. 29214
B. Seattle, Wash., Apr. 20, 1930. Studied: Bob Jones Univ., B.A., M.A.; Florida State Univ., D. Mus. Awards: Hon. LL.D., Tennessee Temple College, 1960. Positions: Dean, Sch. FA, Bob Jones Uni-

versity, Greenville, S.C., 1954- . Dir., Univ. Opera Assn. & Symphony Orchestra; Set des., university stage productions.

GUSTEN, THEODORE J. H.—Executive Director
International Graphic Arts Society, 410 E. 62nd St., New York, N.Y. 10021

GUSTON, PHILIP—Painter
Woodstock, N.Y. 12498
B. Montreal, Canada, June 27, 1913. Studied: Otis AI. Awards: prizes, Carnegie Inst., 1945; med., prize, VMFA, 1946; Guggenheim F., 1948, 1967-1968; Prix de Rome, 1948; grant, Am. Acad. A. & Let Let., 1948; Ford Fnd. Grant, 1958. Work: CAM; WMAA; PC; Albright A. Gal.; Wash. Univ., St. Louis; VMFA; Illinois Wesleyan Univ.; MMA; Univ. Illinois; MModA; Munson-Williams-Proctor Inst.; WMA; Iowa State Col.; Tate Gal., London; Seagram Coll., N.Y.; Guggenheim Mus.; Yale Univ. A. Gal.; AIC; CMA; BMA. Article on the artist, Art News Annual, 1966. Exhibited: Midtown Gal., 1945 (one-man); BMFA, 1946 (one-man); Carnegie Inst., 1941-1945, 1951, 1955; PAFA, 1944, 1945; CGA, 1943, 1944, 1955; VMFA, 1946; WMAA, 1941-1955; AIC, 1942-1945; AFA traveling exh., 1942; Peridot Gal., 1952 (one-man); MModA, 1951, 1956, 1969; Guggenheim Mus., 1954, traveling exh., 1955-56; Galerie de France, Paris, 1952; Musée Moderne, Paris, 1955; Rome, 1955; Museo de Arte Moderna, Barcellona, 1955; Tate Gal., London, 1956; Sao Paulo, Brazil, 1957; "New American Paintings," Rome, Milan, London, Paris, Basel, Madrid, 1958-59; Mexico City, 1958; Retrospective Exhs., Sao Paulo Biennale, 1959; Venice Biennale, 1960; one-man: Egan Gal., 1953; Janis Gal., N.Y., 1956, 1958, 1960, 1961; Jewish Mus., N.Y., 1966; Santa Barbara A. Mus., 1966; 25 years retrospectives: Guggenheim Mus., 1962; White Chapel Gal., London, 1963; Palace of Fine Arts, Brussels, 1963; Stedelijk Mus., Amsterdam, 1963; Los A. Mus. A., 1963; Rose A. Mus., Brandeis Univ., 1966. Contributor to art magazines with articles and illus. Monograph: "Philip Guston" by Dore Ashton, 1960.

GUTE, HERBERT JACOB—Painter, E.
Box 1605, Yale Station, New Haven, Conn. 06520
B. Jeffersonville, N.Y., Aug. 10, 1907. Studied: Yale Univ., B.F.A., & abroad. Member: ANA; Audubon A.; AWCS; SC; Phila. WC Cl.; Silvermine Gld. A. Awards: Fellow, Calhoun College; prizes, Alvord prize, 1932; AWCS, 1940, 1942; Wash. WC Cl., 1943; Silvermine Gld. A.; Conn. Contemporary Painting; Hallmark award; New England A. Exh.; Boston A. Festival, 1956; Watercolor:USA, 1961. Work: Yale Univ.; Dept. Interior, Wash., D.C.; IBM; Cambridge, England; Prudential Life Ins. Co. (10 paintings); Jewish Mus., N.Y.; New Britain Mus.; Louvre, Paris; Lyman Allyn Mus., New London, Conn.; Hartford Atheneum; New London Mus. A.; Wadsworth Atheneum; Submarine Base, New London, Conn. Exhibited: Audubon A.; AWCS; Phila. WC Cl.; NAD; Wash. WC Cl.; Silvermine Gld.; Boston A. Festival; one-man: Kennedy Gals., N.Y.; Grand Central Gals., N.Y.; Vose Gal., Boston. I., "Rise of American Democracy," 1942; & other books. Contributor to: American Artist magazine. Positions: Asst. Prof. A., Yale Univ., New Haven, Conn.; Univ. Virginia; Consultant, Art as Therapy, Conn. State Hospital; Staff A., Yale Univ. and French Acad. Expedition to Dura-Europos, Syria.

GUTHMAN, LEO S.—Collector
2629 S. Dearborn St. 60616; h. 1040 Lake Shore Dr., Apt. 32-D, Chicago, Ill. 60611
B. Chicago, Ill., Jan. 23, 1909. Studied: University of Chicago; University of Illinois. Member: Governing Life Member, Art Institute of Chicago; Fellow, Aspen Society of Fellows; Citizen's Board, University of Chicago. Collection: Paintings, a major portion of which are by contemporary American artists; Sculptures by international artists.

GUTMANN, JOHN—Educator, P., Gr.
San Francisco State College; h. 1543 Cole St., San Francisco, Cal. 94117
B. Breslau, Germany, May 28, 1905. Studied: State Acad. A. & Crafts, B.A., Breslau, Germany; State Acad., Berlin, M.A. Member: Am. Assn. Univ. Prof.; CAA. Work: San Diego FA Soc.; deYoung Mem. Mus.; MModA; Mills Col., Oakland, Cal. Exhibited: SFMA, 1935, 1939, 1942; deYoung Mem. Mus., 1938, 1941, 1948; New York, N.Y., 1938; Detroit, Mich., 1938; & abroad. Contributor to: Life, Time, Asia, Sat. Eve. Post, & other national magazines. Produced and photographed 2 documentary films on China, 1950. Positions: Prof. A., San F. State Col., San Francisco, Cal., 1938- .*

GUY, JAMES—Sculptor, P.
c/o Rose Fried Gallery, 40 E. 68th St., New York, N.Y. 10021*

GWATHMEY, ROBERT—Painter, Ser., T.
Amagansett, N.Y. 11930
B. Richmond, Va., Jan. 24, 1903. Studied: North Carolina State Col.;

Maryland Inst.; PAFA. Member: AEA. Awards: Cresson traveling scholarship, PAFA, 1929, 1930; prizes, 48 States Comp., 1939; ACA Gal., 1939; PM Artist as Reporter, 1940; Carnegie Inst., 1942; San Diego FA Soc., 1941; Pepsi-Cola, 1946; Rosenwald F., 1944; Grant, Am. Acad. A. & Lets., 1946; Birmingham Mus. A., 1956; CGA, 1957. Work: BMFA; BM; Birmingham Mus. A.; Butler AI; Mus. Mod. A., Sao Paulo, Brazil; Carnegie Inst.; IBM; Los A. Mus. A.; PAFA; Rochester Mem. Mus.; San Diego FA Gal.; Springfield (Mass.) Mus. A.; Telfair Acad.; Brandeis Univ.; Univ. Nebraska; Univ. Georgia; Univ. Illinois; Univ. Oklahoma; Univ. Texas; Randolph-Macon Woman's College; Smithsonian Institution; Alabama Inst. Tech.; VMFA; WMAA; Cal. PLH. Exhibited: nationally. Positions: Instr., CUASch, New York, N.Y., 1942-1968.

GYERMEK, STEPHEN A.—Museum Director, P., E., C.
 Pioneer Museum & Haggin Art Galleries; h. 1870 Douglas Rd., Stockton, Cal. 95207
B. Budapest, Hungary, Nov. 9, 1930. Studied: Rijks Akademie voor beeldende Kunsten, Amsterdam, Holland, and with Heinrich Campendonck; Oklahoma Univ. Awards: prizes, Van Alabbe award, Amsterdam, Holland, 1952, and other prizes. Member: AAMus.; ICOM. Work: murals in convent at Madrid, Spain, 1955; U.S. Embassy, Spain, 1955; stained glass windows, St. Gregory's Abbey, Shawnee. Exhibited: Amsterdam, 1952, 1953; Madrid, 1954; Okla. A. Center, 1960. Lectures: Painting Methods; Religious Art. Exhibitions arranged: Archaeology, Europe, Near and Far East, Egypt; American Indians & Central and South American Ethnology; Paintings from the Italian Renaissance; 19th Century American Paintings, and others. Positions: Dir., Gerrer Museum & Art Gallery, Shawnee, Okla., 1957-1962; Asst. Prof. A. Hist & Art, Univ. Oklahoma, Actg. Dir., Stovall Mus. Science & History, Univ. Oklahoma, 1962-1965; Dir., Pioneer Museum & Haggin Art Galleries, Stockton, Cal., 1965- ; Instr., Hist. A., San Joaquin Delta Col., 1967- .

GYRA, FRANCIS JOSEPH, JR.—Painter, I., T., L.
 6 Linden Hill, Woodstock, Vt. 05091
B. Newport, R.I., Feb. 23, 1914. Studied: R.I. Sch. Des.; Parsons Sch. Des.; Univ. Hawaii; McNeese State Col., Lake Charles, La.; Brighton Col. A. & Crafts, England; Keene (N.H.) State Col.; Frobel Inst., Roehampton, England, and in France, and Italy. Member: NAEA; Eastern AA; Vermont A. T. Assn. F.I.A.L. (Life). Awards: prize, Newport AA; Fulbright British-American T. Exchange, 1952-53 (Partner); State of Rhode Island scholarship, 1931-1935; Frank A. Parsons Mem. scholarship, 1935, 1937; Hon. Citizen, Nashville, Tenn., 1964; Norwich Univ.; Gebhard-Gourgaud Fnd. Grant, 1966-1969. Work: Providence Mus. A. Tenn. FA Center, Nashville. Exhibited: AIC; Phila. WC Cl.; AFA traveling exh., 1940; one-man: Wash. A. Cl.; Newport AA; L.D.M.Sweat Mus. A.; Robert Vose Gal., Boston. Chaffee A. Mus., Rutland, Vt.; Miller A. Center, Springfield, Vt.; Aquinas Jr. Col., Nashville, Tenn. (4 shows); Wood Gal. (2-man), Montpelier, Vt. I., "Letters of Father Page"; "A New Italian Reader for Beginners." Positions: Supv. A., Woodstock (Vt.) Pub. Schs.; Chm., Vermont Edu. A. Program, 1952; Sec-Treas., Vermont A. T. Assn., 1957-58; Dir. A. Workshops, 1954-56, 1958-1965, 1967, 1968; Advisory Memb. Faculty, Aquinas Junior Col., Nashville, 1964; Charter Memb., Vermont Council of the Arts, 1964; Art Consultant for the Cooperative Project for Curriculum Development, Bennington, Vt., 1965.

HAAS, ELISE S. (Mrs. Walter A.)—Collector, Patron
 2100 Pacific Ave., San Francisco, Cal. 94115
B. San Francisco, Cal., 1893. Studied: California School of Fine Arts; San Francisco Art Institute. Collection: 20th century art. Awards: First prize for sculpture, Church Art Today, Grace Cathedral, San Francisco. Positions: President, Women's Board, 1953-1955, Trustee, 1955- , Vice President, Board of Trustees, 1960, President, Board of Trustees, 1964-1966, San Francisco Museum of Art. Director, San Francisco Art Institute.

HAAS, LEZ (L.)—Painter, E.
 University of Arizona; h. 207 N. Camino del Norte, Tucson, Ariz. 85716
B. Berkeley, Cal., Mar. 10, 1911. Studied: San Francisco State T. Col.; Univ. California, Berkeley, A.B., M.A.; Hans Hofmann Sch. A. Member: AAUP; Soc. for Am. Archeology; Prof. Photog. of Am. Awards: prize, Mus. New Mexico, 1957. Work: Cedar City, Utah; paintings in private colls. Exhibited: SFMA, 1938-1940; New Mexico State Fair; Mus. New Mexico, Santa Fe, 1957; Roswell Mus. A.; Stanford Univ., 1958; one-man: Jonson Gal., Albuquerque, 1954; BMA, 1955; Roswell A. Mus., 1956, 1965; Santa Barbara Mus. A., 1956; Cal.PLH, 1959; New Mexico FA Mus., 1962; Univ. Arizona A. Gal., 1963. Lectures: History of American Indian Art; Design; Painting. Positions: Asst. Prof., 1946-47, Assoc. Prof., Chm. Dept. A., 1947-53, Prof., 1953- ; Acting Dean, College of FA, 1947-48, 1954-1955, Univ. New Mexico, Albuquerque, N.M.; Dir., Taos

Field Sch., Taos, N.M., 1947-48; Prof., Univ. New Mexico, Albuquerque, 1953-1963; Hd., A. Dept. & Prof. A., University of Arizona, Tucson, Ariz., 1963-1969.

HABER, LEONARD—Collector, Scholar, Designer
 8 E. 62nd St., New York, N.Y. 10021
B. New York, N.Y., Aug. 5, 1920. Studied: Parsons School of Design, and in Paris and Italy; University of Paris; Yale University, B.F.A. Awards: Medals (6), Beaux Art Institute of Design. Member: American Association of University Professors, 1937-1940. Collection: Contemporary drawings and paintings; Japanese lacquer. Positions: Assistant Professor of Fine Arts, College of William and Mary, 1936-1940.*

HABERGRITZ, GEORGE—Painter, S., T., C.
 150 Waverly Place, New York, N.Y. 10014
B. New York, N.Y., June 1, 1909. Studied: NAD; Cooper Union A. Sch.; Grande Chaumiere, Paris, France. Member: Nat. Soc. Painters in Casein,(Pres. 1963-1964); Am. Soc. Contemp. A. Awards: Painters in Casein, 1966, 1967, 1968. Work: Norfolk Mus. A. & Sciences; Safad Museum; Ein Hod Mus.; Jewish Mus., London; Butler Inst. Am. A.; Wilberforce Col.; Purdue Univ.; Evansville Mus.; Nat. Soc. Painters in Casein, 1952-1969; NAD, 1938-1949; AWS, 1948-1952; Audubon A., 1947-1952; WMAA, 1951; Am. Soc. Contemp. A., 1964, 1965; Detroit Inst. A.; Albright A. Gal., 1940; Galerie Klotz, Stuttgart, 1964-1966, 1968, 1969; traveling exh., U.S., 1964-1966; one-man: (African paintings) Wellons Gal., N.Y., 1956-1957; John Heller Gal., N.Y., 1955; Hutton Gal., 1958 (group). Lectures: The Artist in Africa, with color slides. Positions: Instr., ASL, New York, N.Y. and privately. Instr., David Friend Sch. of A., 1967-1969. Workshop in New Media, Soc. of Continuing A. Training, N.Y.

HACK, HOWARD E.—Painter, Gr.
 9 Mission St., San Francisco, Cal. 94105
B. Cheyenne, Wyo., July 6, 1932. Studied: Cal. Col. A. & Crafts; Mills Col., Oakland; Univ. of San Francisco, B.S. Awards: Oakland A. Mus., purchase prize, 1960; SFMA, 1965; WMAA (purchase), 1965; Nat. Inst. A. & Lets., 1966; Am. Acad. A. & Lets., Childe Hassam purchase award, 1968. Exhibited: San F. Drawing & Print Annual, 1961; Oakland A. Mus., 1953, 1955, 1957, 1960; Jack London Square Festival, 1956, 1961; Carnegie Inst., Pittsburgh, 1964; CGA, 1965; Lee Nordness Gal., N.Y., 1967, 1968; Gump's Gal., San Francisco, 1967, 1968.

HACK, MRS. JOHN T. See Ferriter, Clare

HACK, PATRICIA Y. (Mrs. Phillip S.)—Art Dealer
 Pat Hack Gallery, Inc.; h. 6526 N. 66th Pl., Scottsdale, Ariz. 85251
B. Los Angeles, Cal., Dec. 21, 1926. Studied: Univ. Arizona; Stanford Univ.; Oxford Univ. Specialty of Gallery: Contemporary Prints, Drawings, Painting and Sculpture. Positions: Pres., Pat Hack Gallery, Inc., Scottsdale, Ariz.

HACK, PHILLIP S.—Collector
 45 E. Monterey Way, Phoenix, Ariz. 85012; h. 6526 N. 66th Pl., Scottsdale, Ariz. 85251
B. Peoria, Ill., Dec. 8, 1916. Studied: Wabash College, A. B. Member: President, Friends of Art, Phoenix Art Museum. Collection: Contemporary.

HACKENBROCH, YVONNE ALIX—Scholar, Writer
 The Metropolitan Museum of Art, Fifth Avenue at 82nd St. 10028; h. 7 E. 85th St., New York, N.Y. 10028
B. Frankfurt, Germany, Apr. 27, 1912. Studied: Universities of Frankfurt, Rome and Munich. (Ph.D., Munich). Awards: Ford Fnd. Grant, 1963; Kress Fnd. Grants, 1964, 1965 for the preparation of book on "Renaissance Jewellery." Field of Research: The Decorative Arts. Publication of six Catalogues of the Irwin Untermyer Collection (Porcelain, Furniture, Textiles, Bronzes and Silver); Contributor to The Connoisseur and other magazines. Positions: Asst., British Museum; Curator, Lee Collection, University of Toronto, Canada; Assoc. Research Curator, The Metropolitan Museum of Art, New York, N.Y., at present.

HACKLIN, ALLAN—Painter
 462 Broome St., New York, N.Y. 10013
B. New York, N.Y., Feb. 11, 1943. Studied: City Col., N.Y.; Pratt Inst., Brooklyn, N.Y., B.F.A. Awards: Yaddo Fnd. Grant, 1969. Work: Union Carbide, N.Y.; Am. Broadcasting Corp. Exhibited: Allan Stone Gal., N.Y., 1967; Galerie Muller, Stuttgart, Germany, 1969; Betty Parsons Gal., N.Y., 1969; Carmen La Manna Gal., Toronto, Canada, 1969; Mus. Contemp. A., Toronto, 1969; Vassar Col., N.Y., 1969; New School, N.Y., 1969, (all one-man).

HADEN, E(UNICE) (BARNARD)—Painter, I., L., W.
5112 Connecticut Ave., Washington, D.C. 20008
B. Washington, D.C., Oct. 21, 1901. Studied: Oberlin Col., B.A.;
Abbott Sch. A., with Hugo Inden; and with Eliot O'Hara. Member:
Min. P. S. & Gravers Soc. (Treas. 1954-59, Pres., 1960-1964; Cor.
Sec., 1964-66); A. Cl. of Wash.; St. Augustine (Fla.) AA. Awards:
prize, A. Cl. of Wash., 1956, 1959, 1964. Work: in private collec-
tions. Exhibited: St. Augustine A., 1952, 1960; Min. P. S. & Gravers
Soc., 1939, 1940, 1946-1968; CGA, 1955; NCFA, 1953-1956; Garden
Gate Restaurant, Wash., D.C., 1957; Colony Restaurant, 1958; Burr
Gal., N.Y., 1959, 1960; one-man: A. Cl. of Wash., 1956; Silver Spring
(Md.) A. Gal., 1953, 1956; Napoli Restaurant, Wash., D.C., 1958;
Payne Gal., Wash. D.C., 1964. Positions: A. Cl. of Wash. Exh.
Comm. Chm., 1956-57, Vice-Chm., 1957-58, Vice-Chm. Program
Comm., 1956-59, Chm. Program, 1961-62; Com. on Admissions,
1961-63, Cor. Sec., 1964-1969; Chm., Metropolitan State A..Contest
(sponsored by AAPL), 1957, Co-Chm., Program Comm., 1964-65;
Bd. Governors, 1965-66; Editing and writing, 1966-1969: DAR Pa-
triot Index 1st ed., 1967, Suppl., 1969; American Clan Gregor Soc.,
Yearbooks for 1968, 1969.

HADER, ELMER (STANLEY)—Illustrator, W., P.
55 River Rd., Grand View-on-Hudson, N.Y.
B. Pajaro, Cal., Sept. 7, 1889. Studied: Cal. Sch. Des.; Academie
Julian, Paris, France. Awards: Caldecott medal (with Berta Hader),
1949. Work: San F. AA. Exhibited: NAD, 1920; Salon des Artistes
Francaise, Paris. Author, I., more than thirty story and picture
books for children, 1927-1958. Illus. for McCall's, Pictorial Re-
view, Good Housekeeping, Century magazines and for Christian Sci-
ence Monitor.*

HADLOCK, WENDELL STANWOOD—
Museum Director, L., E.
Rockland, Me. 04841
B. Islesford, Me., May 12, 1911. Studied: Univ. Maine, A.B.; Univ.
Pennsylvania, M.A.; Am. Mus. Nat. Hist., N.Y. (training). Member:
Maine Hist. Soc.; Am. Folklore Soc.; Am. Archaeological Soc.; F.,
Am. Anthropological Soc.; Colonial Soc. of Mass.; F., Am. Acad. A.
& Sciences. Contributor to: American Folklore; American Anthro-
pologist; American Antiquity. Lectures: Folklore; History; Ethnol-
ogy. Positions: Cur., Robert Abbe Mus., Bar Harbor; Admin. Asst.,
Peabody Mus., Salem, Mass.; Dir., William A. Farnsworth Lib. &
A. Mus., Rockland, Me., at present.

HADZI, DIMITRI—Sculptor
c/o Stanley Radich Gallery, 818 Madison Ave., New York,
N Y. 10021*

HAGEN, ETHEL HALL—Painter, C., T.
4407 Highland Drive, Carlsbad, Cal. 92008
B. Cleveland, Ohio, Jan. 2, 1898. Studied: NAD; PIA Sch.; CGA; and
with Eliot O'Hara, Richard Lahey, Weiss and others. Member: La-
guna Beach AA; La Jolla AA;Carlsbad-Oceanside A. Lg.; San Diego
County Fed. Art Cl.; Showcase of Arts, Escondido. Awards: prizes,
Fed. Women's Cl., 1950, 1952, 1961; San Diego AI, 1955, 1960;
Carlsbad-Oceanside A. Lg., 1956, 1958, 1960, 1967, 1969; Vista No.
County, 1961. Work: port. Gen. Merritt Edson, U.S. Destroyer
"Edson," 1958. Exhibited: San Diego AI; Vista Gld.; Carlsbad-
Oceanside A. Lg.; Am. Mus. Nat. Hist.; Smithsonian Inst. One-man:
Laguna Beach AA, 1960; Carlsbad Gal., 2-man. Positions: Sec.-
Treas., 1955-56, Pres., 1958-1960, Carlsbad-Oceanside A. Lg.
Instr. A., private classes.

HAGEN, GRANT O.—Painter
Box 25, Jackson, Wyo. 28739
B. Jackson Hole, Wyo. Member: Soc. Animal Artists. Work: De-
signing and painting museum visitor center exhibits of wildlife for
the National Park Service and National Forest Service, located in
many National Parks, Monuments, and National Forests in the West-
ern U.S. Positions: Instructor, Teton Artists Assoc., Jackson Hole.*

HAGGART, WINIFRED (WATKINS)—Educator, P.
53 Academy Ave., Pittsburgh, Pa. 15228, and 147 Lorraine Ct.,
Berea, Ky. 40403
B. Albany, N.Y., Nov. 19, 1911. Studied: Syracuse Univ., B.F.A.;
PAFA; Univ. Pennsylvania, M.F.A.; Univ. Pittsburgh. Member:
CAA; AAUW; Assoc. A. Pittsburgh; The Nature Conservancy; Ken-
tucky Gld. A. & Craftsmen. Awards: PAFA, Thouron prize. Work:
One Hundred Friends of Pittsburgh Art; Univ. North Carolina Wilson
Lib. Bldg.; Southern Seminary & Jr. Col. Exhibited: Carnegie Mu-
seum; Assoc. A. Pittsburgh. Positions: Asst. Prof. A., Sch. A.,
Richmond Professional Inst., of the Col. of William & Mary, 1947-
50; Hd. A. Dept., Southern Seminary & Jr. Col., Buena Vista, Va.,
1942-46, 1956-58; Assoc. Prof. A., Hd. A. Dept., Georgetown Col.,
Georgetown, Ky., 1950-52.

HAGGLUND, IRV(IN) (ARVID)—Cartoonist
RFD #2, Hendersonville, N.C. 28739
B. Holt, Minn., Mar. 11, 1915. Exhibited: Cartoon exh., N.Y., 1941;
Huckleberry Mt. Workshop, 1951-1954; No. Cal. Cartoon & Humor
Assn. Exh., San Mateo, Cal., 1951. Cartoons included in: "You've
Got Me in Stitches," 1954; "You've Got Me on the Hook," 1954;
"You've Got Me and How," 1955; "Happy Holiday," 1956; "You've
Got Me on the Rocks," 1956; "You've Got Me in the Suburbs," 1957;
You've Got Me in the Nursery," 1958; "For Stags Only," 1954;
"Words Fail Me," 1954; "Auto Antics," 1955; "Klever Kid Kar-
toons," 1955; Best Cartoons of the Year, 1956-1965; A Treasury of
Sports Cartoons, 1957, and many others. Contributor cartoons to:
New Yorker; Look; True; Collier's; Toronto Star; American; King
Features Syndicate; Better Homes & Gardens; Nation's Business;
Parade; Chatelaine; Gourmet; Elks; Sat. Eve. Post; Cosmopolitan;
Holiday; London's Tit Bits; Am. Legion; Argosy; Boston Post;
McNaught Syndicate; Etude; Canadian Home Journal; Sports Afield,
and others. Panel, "Little Inky," in collaboration with Hal Borden,
syndicated by Smith Service and syndicated in newspapers. Work:
permanent colls. of Syracuse Univ., Reader's Digest, Best Cartoons
of the Year (to 1967), and others.

HAHN, STEPHEN—Art dealer
960 Madison Ave., New York, N.Y. 10021*

HAINES, RICHARD—Painter, E., Lith., Des.
247 South Amalfi Drive, Santa Monica, Cal. 90402
B. Marion, Iowa, Dec. 29, 1906. Studied: Minneapolis Sch. A.; Ecole
des Beaux-Arts, Fontainebleau, France. Member: Cal. WC Soc.;
Audubon A. Awards: prizes, Los A. Mus. A., 1944, 1945, 1951; Cal.
State Fair, 1948, 1951; CGA, 1951; Cal. WC Soc., 1948, 1949, 1952;
Los Angeles County Fair; SFMA, 1948; Soc. Et. & Lith., N.Y., 1948;
Frye Mus., Seattle, 1964. Work: MMA; Los A. Mus. A.; Cal. State
Fair Coll.; Los Angeles County Fair Coll.; Cal. WC Soc.; DMFA;
CGA; Wm. Rockhill Nelson Gal. A.; Univ. Arizona; Santa Barbara
Mus. A.; Rosenwald Coll., and in private collections; murals, Ft.
Snelling, Roun Tower, Minn.; Sebeka (Minn.) H.S.; Willmar (Minn.)
Auditorium; New Diagnostic Clinic, Mayo Clinic, Rochester, Minn.
(one of 9 artists); panels facade of Music Bldg., Univ. Cal. at Los A.;
des., granite mural, facade of new Medical Center, Univ. Kentucky,
1961; mosaic murals, facade, Physics Bldg., Univ. California, Los
Angeles, 1963; 3 on Custom House & Federal Office Bldg., Los
Angeles, 1965; des. and supv., silk screen printing of "World Map"
mural for airlines of Lockheed Super Constellation planes. Exhib-
ited: Los A. Mus. A., 1944-1955; Cal. State and County Fairs; Cal.
WC Soc., 1948-1955; MMA, 1951; CGA, 1951; PAFA, 1951-1953; Den-
ver A. Mus., 1952, 1953; Santa Barbara Mus. A., 1955; Encyclopedia
Britannica, 1947; SFMA, 1948, 1949, 1951; Sao Paulo, Brazil, 1955;
Oakland A. Mus., 1947; Walnut Creek, Cal., 1950. Positions: Instr.,
Painting, Minneapolis Sch. A., 1941-42; Hd. Painting Dept., Chou-
inard AI, 1945-54; Otis AI, Los Angeles, Cal., 1954- .

HALBERS, FRED—Etcher, Painter
23-21 35th St., Astoria, N.Y. 11105
B. Berlin, Germany, July 6, 1894. Studied: in Berlin, Germany.
Member: AAPL; AFA; Print Council of America; Int. Platform Assn.
Awards: prizes, Greenwich Village Outdoor Exh., 1958-1960; Gold
Medal, AAPL, 1959, hon. men., 1960. Work: N.Y. Pub. Lib.; Frick
Art Ref. Lib., N.Y.; Museo National de Arte Moderno, Madrid; Nat.
Mus. Mod. A., Tokyo. Exhibited: La Paz, Sucre, Cochabamba, Po-
tosi, Bolivia, 1948-1954; AAPL, 1959, 1960; Greenwich Village Out-
door Exh., 1958-1960; Abraham Lincoln Gal., Brooklyn, 1960; West
Berlin, Germany, 1968; Int. Platform Assn., 1968. Lectures, In-
fluence of Religions on the Arts.

HALBERSTADT, ERNST—Painter, S., Photog.
261 Upland Rd., Newtonville, Mass. 02160
B. Budingen, Germany, Aug. 26, 1910. Awards: prizes, OEM Comp.,
1941; Pepsi-Cola, 1946. Awards: A. Dir. Cl., medal, 1956, 1958.
Work: New Britain Mus. FA; Univ. Georgia; AGAA; FMA; AA,
Springville, Utah; Harvard Univ.; Rose Mus., Brandeis Univ.; Chase-
Manhattan Bank Coll. murals; Jesuit Seminary Gld., Boston; For-
tress Monroe, Va.; USPO, Chicopee Falls, Mass.; Club House Rock-
ingham Park, Salem, N.H. Photography in colls. of MMA; MModA;
Addison Gal. of Am. Art, Andover, Mass.; CMA; murals & sc. in
Irving Trust Co. branches in N.Y., London & Hong Kong. Exhibited:
Kraushaar Gal., 1946 (one-man); Inst. Contemp. A., Boston, 1950
(one-man); Art:USA, 1958; Springfield (Mass.) Fair, 1958; drawings,
paintings& photos exh. in over 50 mus. shows, 1962-1968. Illus.,
"I Heard Them Sing"; "Three White Horses"; "On the Road to
Oqunquit," 1969. Folio, 12 lithographs, 1969. Lecture: "Contem-
porary Art," Harvard Bus. Sch.

HALE, NATHAN CABOT—Sculptor, T., W., L.
Midtown Galleries, 11 E. 57th St., 10022; h. 321 E. 10th St.,
New York, N.Y. 10009
B. Los Angeles, Cal., July 5, 1925. Studied: Chouinard AI, Los An-

geles; ASL; Santa Monica City College; Los Angeles Trade & Tech. College; N.Y. Univ. Member: ASL; Arch. Lg., New York; Am. Soc. for Aesthetics. Work: bronze Madonna, St. Anthony of Padua, East Northport, L.I., N.Y.; bronze reliefs, Rose Assoc. Bldg., Bronx, N.Y., and in museums and many private collections. Exhibited: Carlebach Gal., N.Y., 1946; Roko Gal., N.Y., 1948-1950, 1957, 1958; Jacques Seligmann Gal., 1947-1949; ACA Gal., N.Y., 1950; Felix Landau Gal., 1952-1957; Washington Irving Gal., N.Y., 1958-1960; Terrain Gal., N.Y., 1959; Feingarten Gals., (Chicago & New York), 1960, 1961; East Hampton Gal., 1961; Juster Gal., 1962; Hirschl & Adler Gal., 1962; Parke-Bernet Gals., 1962; Midtown Galleries, 1962, 1963, 1964; Los A. Mus. A., 1953-1955; Colorado Springs FA Center, 1961; Norfolk Mus. A. & Sciences, 1959; Lehigh Univ., 1963; Philbrook A. Center, Tulsa, 1962; Ball State T. Col., Muncie, 1963; Albright-Knox A. Gal., Buffalo, 1963, 1966, 1968; Indianapolis AA, 1963; CGA, 1963, 1964; Wayne State Univ., 1964; Pace Col., N.Y., 1964; Philbrook A. Center, Tulsa, 1966; CGA, 1966; Columbus Gal. FA, 1965; Heron Mus. A., 1966; Art in Embassies program, 1966-1969; Joslyn Mus., 1966; Tennessee FA Center, 1969; Kent State Univ., 1969; Heckscher Mus., 1968; Nat. Mus. Sport, 1969, and others; one-man: Landau Gal., Los A., 1957; Washington Irving Gal., 1960; Feingarten Gal., New York & Chicago, 1961; Midtown Gal., N.Y., 1962-1964, 1968; Fort Wayne Mus., 1966; Queens Col., N.Y., 1966; N.Y. Univ., 1967; Quinata Gal., Nantucket, 1968. Contributor articles to Journal of the American Institute of Architects, 1962; Environment, 1962; Indiana Architect, 1963; American Management Assn. Bulletin, 1963; American Artist Magazine, 1965. Author: "Welded Sculpture," 1968; "The Embrace of Life, The Sculpture of Gustav Vigeland," 1969. Positions: Instr., Los Angeles City Art Education and Recreation Program, 1956-57; Pratt Institute, Brooklyn, N.Y., 1963-64; ASL, 1966-1969.

HALE, ROBERT BEVERLY—Museum Curator, E., P., W., L.
Metropolitan Museum of Art, Fifth Ave. at 82nd St. 10028; h. 1200 Fifth Ave., New York, N.Y. 10029
B. Boston, Mass., Jan. 29, 1901. Studied: Columbia Univ., A.B.; Columbia Sch. Arch.; Fontainebleau, France; ASL, with George Bridgman, William C. McNulty. Member: P. & S. Soc. of New Jersey; Municipal A. Soc., N.Y.; Century Assn.; ASL (life); AAMus.; Fontainebleau Assn.; Benjamin Franklin Fellow of The Royal Society of Art, London. Work: WMAA; Univ. Arizona; Norfolk Mus. A. & Sciences, and many private colls. Exhibited: one-man: Stamford (Conn.) Mus., 1959; Staempfli Gal., N.Y., 1960. Author: "One Hundred American Painters of the 20th Century," 1950; "Drawing Lessons From the Great Masters." Article on Drawing, Encyclopaedia Britannica, 1957; Article on American Painting, Grolier Encyclopedia, 1961. Contributor to Art News; American Artist; New Yorker; MMA Bulletin; Craft Horizons. Lectures: American Painting. Exhibitions arranged: "American Artists Under 36," 1950; "American Painting Today," 1950; "20th Century Painters," 1950; "American Sculpture," 1951; "Edward Root Collection," 1953; "Whistler, Sargent, Cassatt," 1954; Art Students League 75th Anniversary Exh., 1951; "14 American Masters," 1959; "Winslow Homer," 1958; "Three Centuries of American Art," 1965, and many others. Positions: Instr., Drawing, ASL, 1942- ; Lecturer, 1943- ; Prof. Drawing, Columbia Univ., 1946- ; Assoc. Ed., Art News, 1941-49; Ed. Bd., Craft Horizons; Trustee, Am. Fine Arts Soc.; Pres., Tiffany Fnd.; Bd. Adv., Edward W. Root A. Center; Int. Com., AFA; Nat. Com., The Drawing Soc.; Vice-Pres., New York City A. Festival; A. Com., Inst. Int. Edu.; A. Com., Chase Manhattan Bank. Cur., American Painting and Sculpture, Metropolitan Mus. A., New York, N.Y., 1949-1968 (Emeritus).

HALEY, JOHN (CHARLES)—Painter, S., E.
University of California, Berkeley, Cal. 94720; h. 771 Ocean Ave., Richmond, Cal. 94801
B. Minneapolis, Minn., 1950. Studied: Munich, Paris, Ravenna. Awards: prizes, San F. AA, 1936, 1939, 1944, 1951, 1956; Cal. WC Soc., 1949; Cal. State Fair, 1950, 1951; Richmond (Cal.) A. Center, 1956. Work: PMG; SFMA; IBM; Mills Col. A. Gal; First Nat. Bank, Reno, Nev.; Chico (Cal.) State College; Oakland A. Mus. Exhibited: MMA; PMG; Univ. Illinois; Cal. PLH; AIC; CAM; Watkins Gal.; American Univ.; SFMA; Colorado Springs FA Center; Los A. County Fair; PAFA; Sao Paulo, Brazil, 1955, 1961; Dallas Mus. FA; MModA traveling exh., 1963-64; 1964-65; International House, Denver; Michigan State Univ.; Akron AI; Indiana Univ., Bloomington; Auburn Univ.; Hunter Gal. A., Chattanooga; Richmond (Va.) AA; Univ. North Carolina; Ohio Univ., Athens; Univ. South Florida, Tampa; Univ. A. Gal., Univ. of Cal., Berkeley, 1964; Los Angeles State Col. A. Festival, 1965; Denver A. Mus.; Des Moines A. Center; Cal. WC Soc.; San F. AA; One-man: Mortimer Levitt Gal., 1949, 1952; Richmond A. Center, 1954; Worth Ryder Gal., Univ. Cal., Berkeley, 1962; deYoung Mem. Mus., San F., 1962; Chico State Col., 1963. Positions: Prof. A., Univ. California, Berkeley, Cal. Memb. Bd. Dirs., San Francisco AI, 1959-62.

HALFF, ROBERT H.—Collector
Compton Advertising, Inc., 5670 Wilshire Blvd., Los Angeles, Cal. 90036; h. 1659 Waynecrest Dr., Beverly Hills, Cal. 90210
B. San Antonio, Tex., Dec. 1, 1908. Studied: Wharton School, University of Pennsylvania (Grad.); New School for Social Research, N.Y.; New York University post-graduate work; University of California at Los Angeles Extension. Collection: American Contemporary and European Art: Miro, Klee, Dubuffet, Marin, Dove, De Kooning, Kline, Lichtenstein, Oldenburg, Stella, Kelly, Hepworth, Tony Smith, Jasper Johns, etc.

HALL, CARL A.—Painter, Gr., Cr., T.
Route 3, Box 895, Salem, Ore. 97208
B. Washington, D.C., Sept. 17, 1921. Studied: Meinzinger A. Sch., Detroit, Mich., with Carlos Lopez. Awards: prizes, Detroit Inst. A., 1940, 1941; Sarah Sheridan prize, 1947; Newberry prize, 1949; Portland (Ore.) A. Mus. purchase prize, 1949; grant, Nat. Inst. A. & Lets., 1949. Work: Swope A. Gal.; BMFA; Springfield Mus. A.; Detroit Inst. A.; Portland A. Mus.; WMAA. Exhibited: AIC, 1941, 1946, 1947; CGA, 1941; Univ. Illinois, 1948, 1950, 1951; Cal. PLH, 1948-1951; Carnegie Inst., 1947-1949; Denver Mus. A., 1949, 1953, 1960; WMAA, 1946-1952, 1955, 1956; MMA, 1950; Des Moines A. Center, 1951; Phila. WC CL., 1950; Butler Inst. Am. A., 1958; Detroit Inst. A., 1939-1941, 1945, 1947, 1949; Portland A. Mus., annually; SAM, 1956, 1960; Univ. Oregon, 1961; Reed Col., Portland, 1961; Colorado Springs FA Center, 1961; Univ. Arizona, 1966; Am. Drawing Biennial, 1966. Positions: Artist-in-Res., Willamette Univ., Salem, Ore.

HALL, GEORGE W.—Sculptor
406 Iris St., Corona del Mar, Cal. 92625*

HALL, JOYCE C. (MR.)—Collector
Hallmark Cards, Inc., 25th and McGee Sts., Kansas City, Mo. 64108*

HALL, LOUISE—Educator
6636 College Station, Durham, N.C. 27708
B. Cambridge, Mass., July 23, 1905. Studied: Wellesley Col., B.A.; MIT, S.B. in Arch.; Univ. Paris; Harvard Univ. Grad. Sch. Des. (Radcliffe Col. degree, Ph.D., 1954). Member: AIA; CAA; AAUP; AAUW; Soc. Arch. Hist. (Sec.-Treas., 1949, Vice-Pres., 1951). Awards: grants, scholarships, Carnegie to Univ. Paris (twice); Carnegie & AIA for Harvard Univ. (twice); LC for studies in Hist. of Am. Civ.; F., AIA, 1950; F., AAUW, 1957. Positions: Instr. FA, 1931-36, Asst. Prof. FA, 1936-48, Assoc. Prof. Arch., 1948-1963, Prof. Arch., 1963- , Duke Univ., Durham, N.C.

HALL, REX EARL—Painter, E.
28 Union St., Emporia, Kans. 66801
B. Asbury, Mo., Feb. 3, 1924. Studied: Washburn Univ., A.B.; Kansas City AI; Univ. Wichita, M.F.A. Member: Kansas Fed. A. (Vice-Pres. 1962); Kansas A. Edu. Assn.; CAA; Fndr., Index A. Group, Wichita; Wichita A. Gld. (V-Pres.) 1958- . Awards: prizes, Wichita Air Capital award, 1957, 1958; "Living With Art," Wichita, 1960; Des-Craftsmens Show, Lawrence, Kans., 1962. Work: Wichita A. Mus.; Noskin Gal., Albuquerque, N.M.; Studio Gal., Topeka; Gal. 6, Manhattan, Kans.; Wichita State Univ. Ceramics awards reproduced in Ceramics Monthly, 1962. Exhibited: Wichita AA, 1962; Mus. New Mexico, 1959; Southwest Biennial traveling exh., 1960; Index Group, Arger Gal., Miami, Fla., 1961; Kansas Biennial, 1959-1964; Kansas Annual, 1956-1963; Kansas Centennial, traveling, 1960; Mid-America Exh., Kansas City, Mo., 1959; one-man: Wichita A. Mus., 1964; Birger Sandzen Gal., 1963; Univ. Kansas, 1960; Kansas State Col., 1962; A. Gal., Kansas State T. Col., 1962; Fort Hayes State Col., 1962; Kansas City, (Mo.) Pub. Lib., 1963; Unitarian Gal., Kansas City, 1964; Studio Gal., Topeka. Author: "A Profile," for the Kansas A. Edu. Assn. Journal, 1961 and three booklets for the Assn., 1964-65. Positions: Prof. A., Kansas State T. Col., 1960-1968; Emporia State T. Col.; Chm. A. Dept., Kansas State T. Col., 1968- .

HALLAM, BEVERLY (LINNEY)—Painter, E., L.
Neachmere Pl., Ogunquit, Me. 03907
B. Lynn, Mass., Nov. 22, 1923. Studied: Cranbrook Acad. A.; Massachusetts Col. A., B.S. in Edu.; Syracuse Univ., M.F.A. Member: Ogunquit AA (Pres., 1964); AFA; DeCordova and Dana Mus.; Barn Gal. Assoc. Awards: Pearl Safir Award, Silvermine Gld. A., 1955; Mina Pinter Memorial Award, Cambridge AA, 1956, prize, 1960; Hatfield Award, Boston Soc. WC Painters, at BMFA, 1960, 1964 and the Edwin Webster Award, 1962; A. H. Benoit Award, in graphics, Barn Gal., Ogunquit, 1967; Blanche E. Colman Fnd. Award, 1960; prizes, Boston A. Festival, 1957; Cohasset A., 1958; Jordan Marsh Co., Boston, 1959. Work: AGAA; CGA; WMA; Brandeis Univ.; DeCordova and Dana Mus., Lincoln, Mass.; Witte Mem. Mus., San Antonio; Univ. Massachusetts; Univ. Maine. Exhibited: Ogunquit Mus., 1964; Art for Embassies Program, 1966; Smithsonian Inst.,

1966; AWS, 1967 and traveling exh.; Watercolors: USA, Springfield (Mo.), 1968; Ogunquit AA, 1954-1969; Boston A. Festival, 1955-1957, 1960, 1962, 1964; Silvermine Gld. A., 1955; Cambridge AA, 1956, 1959, 1960; Boston Univ., 1957; Boston Soc. WC Painters, 1960-1965, 1967-1969; Pace Gal., Boston, 1962; Radcliffe Graduate Center, 1963; De Cordova and Dana Mus., 1963-1964; Fitchburg A. Mus., 1963; Northeastern Univ., 1963, 1965; Ward-Nasse Gal., Boston, 1964; R.I. Art Festival, 1966; Carpenter Center, Harvard Univ., 1967; Farnsworth Mus., 1967; Frye A. Mus., Seattle; Montgomery Mus. FA; Laguna Beach AA; Canton A. Inst.; Berwick (Me.) Acad., 1967; Gal III, Sudbury, Mass., 1968-1969, and others. One-man: Lowe A. Center, Syracuse Univ., 1953; De Cordova and Dana Mus., 1954; Springfield (Ill.) AA, 1956; Inst. Contemp. A., Boston (2-man) 1956; Shore Gals., Boston, 1959, 1962, 1968; Nasson Col., 1967; Witte Mem. Mus., San Antonio, 1968; Univ. Maine, 1969; Kittery Point, Me., 1969. Contributor to: Art Education Bulletin; Arts & Activities; Positions: Chm., A. Dept., Lasell Jr. Col., Auburndale, Mass., 1945-1949; Assoc. Prof., Painting and Teacher Edu., Massachusetts Col. of Art, Boston, Mass., 1949-1962.

HALLMAN, H. THEODORE, JR. (TED)—Craftsman, T., P.
 Harleysville, Pike, Souderton, Pa. 18964.
B. Bucks County, Pa., Dec. 23, 1933. Studied: Cranbrook Acad. A., M.F.A. in painting and M.F.A. in textiles; Fontainebleau Sch. FA, with Jacques Villon; Tyler Sch. FA, B.S. in Edu., B.F.A. Bundestexilschule, Dorbirn, Austria, 1962. Member: F., Int. Soc. A. & Lets. Awards: prizes, textiles, and prize for distinction in show, Young Americans, 1958; Pew prize for study in Fontainbleau, France, 1955; Joy Griffin West scholarship to Cranbrook Acad. A., 1956; bronze medal, Des.-Craftsmen USA, 1960; Tiffany Fnd. grant, 1962. Work: screens: Sara Lee Baking Co., Chicago; American Chemical Soc., Wash., D.C.; Victoria & Albert Mus., London; Cooper Union Mus.; AGAA; Mus. Contemp. Crafts, N.Y.; Ashbourne Co., Elkins Park, Phila., Pa.; church in Allentown, Pa.; Nieman Marcus, Dallas; Smithsonian Inst., screens, fountains and textiles commissioned. Exhibited: AFA Wall Hanging Exh., 1958; Young Americans, 1958; Midwest Des.-Craftsmen, 1957; Michigan Craftsmen, 1957; Woodmere A. Gal., 1955-1961; Bertha Schaefer Gal., N.Y., 1958; Design Center, 1958; Left Bank Gal., Flint, 1958; USIS Exh. So. America, India, etc., 1965; Mus. Contemp. Crafts, N.Y., 1964; N.Y. World's Fair, 1964-65; Milan, Italy; Stuttgart, Germany, 1960; traveling exh., organized by Victoria & Albert Mus., London, 1961-62; AIC (2-man) 1969; Mus. of Contemp. Crafts, N.Y., 1968; USIA traveling exh. in Brazil and Peru, 1966-1967; one-man: Phila. A. All., 1960; Ball State T. Col., 1960. Contributor to Craft Horizons (cover, July, Aug., 1960); Color Photographic; Japan's "Interior Design," 1967. Positions: Instr., Painting, Drawing, Weaving, Textile Des., Cranbrook Acad. A.; Tyler Sch. FA; Haystack Mt. Sch., Deer Isle, Me.; Ball State T. Col., Muncie, Ind.; Phila. Col. of Textiles & Science; Moore College of Art, Phila. Pa. at present. Freelance textile des., Larsen Des. Corp., and Thaibok Fabrics, N.Y.

HALM, ROBERT J.—Painter, Gr., E.
 h. 1517 Third Ave., North, Fort Dodge, Iowa 50501
B. Saginaw, Mich., June 9, 1922. Studied: Michigan State Univ., B.A.; State Univ. of Iowa, M.F.A., and with Lasansky, Edie, Ludins. Member: A. Educators of Iowa; AEA; NEA. Awards: prize, Iowa State Fair, 1950. Work: State Univ. of Iowa; Iowa State Capitol, 1969. Exhibited: SAGA, 1951; Terry AI, 1952; Iowa A., 1951, 1954, 1955; AEA Group show, 1968; Iowa Fed. Women's Cl. traveling exh., 1961-1968; Iowa Municipal Gal., 1965; Iowa State Fair, 1963, 1964; Fisher Center, Marshalltown, Iowa, 1964 (one-man); CAA; Iowa Arts Council, traveling exh., 1968-69. Positions: Hd. A. Dept., Iowa Central Community Col.; Dir., Blanden Mem. A. Gal., 1954-1967; Chm., Arts Exhs., Blanden Mem. A. Gal., 1967- .

HALPERN, NATHAN L.—Collector
 TNT Communications Inc., 575 Madison Ave. 10022; h. 993 Fifth Ave., New York, N.Y. 10028
B. Sioux City, Iowa, Oct. 22, 1914. Studied: Otis Art Institute, Los Angeles; University of Southern California, B.A.; Harvard Law School, L.L.B. Collection: Predominantly French impressionist and post-impressionist art.

HALSEY, MRS. WILLIAM. See McCallum, Corrie

HALSEY, WILLIAM MELTON—Painter, T., L., I., S.
 38 State St., Charleston, S.C. 29401
B. Charleston, S.C., Mar. 13, 1915. Studied: Univ. South Carolina; BMFA Sch., with A. Jacovleff, Karl Zerbe. Awards: traveling F., BMFA Sch., 1939-1941; Hughes F., 1950-1951, 1951-1952; prizes, South Carolina Annual, 1952, 1956-1964; Soc. Four Arts, 1958, 1962; Hunter Gal., 1962; Mint Mus. A., 1964; Portland (Me.) A. Festival, 1959; Gld. South Carolina A., 1956-1964; Central South Exh., Nashville, Tenn., 1967. Work: Gibbes A. Gal.; BMA; Container Corp. Am.; Ball State T. Col.; Mint Mus. A.; Univ. Georgia; frescoes,

Berkshire Mus., Pittsfield, Mass.; murals, Beth Elohim Synagogue, Charleston; Baltimore Hebrew Congregation Temple; Sears Roebuck & Co. Bldg., Charleston; Parthenon, Nashville, Tenn.; S.C. State A. Col. Exhibited: PAFA, 1943, 1950; BMA, 1949; VMFA, 1949-1951; BMFA, 1951; Jewish Mus., N.Y., 1952; BM, 1953, 1955, 1957, 1959; Watercolor: USA, 1962; Mint Mus. A., 1963, 1964; Soc. Four Arts, 1963; Birmingham Mus., 1959; Sarasota Nat., 1960; Hunter Gal., 1960, 1962, 1964; Columbia Mus. A., 1954, 1957, 1959, 1966-1969; Bertha Schaefer Gal., 1951, 1953, 1955, 1958; Greenville Mus. A., 1966-1969; Univ. North Carolina, 1967; Callaway Gardens, Ga., 1969. Work reproduced in: "American Painting Today," "Prize Winning Oil Paintings"; "Prize Winning Watercolors"; "Synagogue Art Today." Positions: Asst. Instr., A., BMFA Sch., 1938-39; Dir. A. Telfair Acad. A., 1942-43; Instr. A., Gibbes A. Gal., Charleston, S.C., 1945-53; Instr., Charleston A. Sch., 1953-1965; Dir., Castle Hill Art Center, Mass., 1956. Instr. A., Col. of Charleston, 1965- ; Instr. A., Newberry Col., S.C., 1968- .

HALVORSEN, RUTH ELISE—Painter, C., Des., W.
 422 North East Going St., Portland, Ore. 97211
B. Camas, Wash. Studied: Portland Mus. A. Sch.; PIASch; Univ. Oregon; Columbia Univ., B.S., M.A.; & with Walter Beck, Charles Martin, Jean Charlot. Awards: "Woman of the Year," Theta Sigma Phi. Member: AAPL; Int. Platform Assn.; Council Idmen, Int. Soc. for Edu. Through Art; CAA; Pacific AA; Nat. A. Edu. Assn.; Professional Women's Lg.; Oregon A. & S. Gld. Work: Univ. Oregon; Ft. Sumner Marine Hospital, New Mexico, and many private colls. Exhibited: SFMA, 1939; Wash., D.C., 1938; Oakland A. Gal.; traveling exh. on year's tour of Army bases; one-man: Portland A. Mus.; Reed Col., Portland; Henry Gal., Univ. Washington; Univ. Oregon; Monmouth State College; Lincoln County, Ore.; Vancouver (Wash.) A. Gal., 1967. Contributor of articles to Education, Arts & Activities; Art Education (Journal of the NAEA); NEA Journal. Author: (with Arne Randall) "Painting in the Classroom." Positions: A. Supv., Portland Pub. Sch., Portland, Ore., 1943-1962; Pres. Pacific AA 1955-1956; Bd. Dir., Vice-Pres., NAEA, 1959-61, Pres., 1961-63. Activities Com., Contemp. Crafts Assn. of Oregon; Instr., Portland State Col. (now Univ.), and Ashland (Ore.) State Col.; Consultant in Art Edu., Portland A. Mus., at present.

HAMBLETT, THEORA—Painter
 619 Van Buren Ave., Oxford, Miss. 38655
B. Paris, Miss., Jan. 15, 1895. Studied: Univ. Mississippi with Charles Mussett; Famous Artists Course; Mississippi Southern Univ. Member: Mississippi AA; Am. Craftsmens Council; Christian AA; Mississippi Folklore Soc.; Mississippi Hist. Soc. Work: MModA; Betty Parsons Gal; Morris Gal.; Maryland Plantation Coll., Shelby, Miss.; Bertha Schaefer Gal., N.Y.; Brook's Mem. A. Gal.; Bryant's Gal.; First Nat. Bank and Guaranty & Trust Bank, Jackson, Miss. Exhibited: Brooks Mem. Mus., 1956, 1957; Birmingham Mus. A., 1956; Atlanta, 1958; Mississippi AA, 1955; Miss. State Col. for Women, 1957; Jackson Municipal Gal., 1958; Maryland Plantation, Shelby, Miss., 1964; Pavilion Gal., Balboa, Cal., 1965; MModA, 1956, traveling exh. 1966; Fifty Artists, Fifty States tour, 1966; Religious Art Exh., AFA, 1969; one-man: Univ. Mississippi A. Center, 1955; Brooks Mem. Mus., 1956; Miss. State Col. for Women, 1957, 1967; Betty Parsons Gal., N.Y., 1958; Lauren Rogers Mem. A. Gal., 1957; Allison's Wells A. Colony, 1958; Bookshelf, Memphis, 1960-61; Mary Buie Mus., Oxford, 1960, 1967-1968; Morris Gal., 1963; McCarty's Gal., Monteagle, Tenn., 1967; Mississippi AA, 1968; Bryant Gal., Jackson, Miss., 1967-1968; Cavalry Episcopal Church, Cleveland, Miss., 1969; Western Assn. A. Mus., 12 month tour, 1969.

HAMILL, MILDRED—Painter, C.
 Bayview Manor, 11 W. Aloha, Seattle, Wash. 98119
B. Denver, Colo. Studied: Portland (Ore.) A. Mus.; AIC, and privately with Mark Tobey. Member: Alaskan A. Gld.; Nat. Lg. Am. Pen Women. Exhibited: Alaska Exhibit, Henry Gal., Univ. of Washington, 1952; Alaska Fur Rendezvous, 1955, 1956; Alaskan A. Gld.; Univ. Oregon, 1964; one-man: Bayview Manor, Seattle, 1964; permanent exh., Northwest Gals., Seattle; annual one-man exhs., Anchorage, 1942-1961. Work: Alaska Lib. & Mus., Juneau; Cuddy Memorial Coll., in Z.J. Loussac Library, and in private colls. U.S. and abroad.

HAMILTON, GEORGE HEARD—Museum Curator, E.
 Whitman St., Williamstown, Mass. 01267
B. Pittsburgh, Pa., June 23, 1910. Studied: Yale Univ., B.A., M.A., Ph.D. Member: CAA (Pres., 1966-1968); Association Internationale des critiques d'art; Soc. Art Historians. Contributor to: Art magazines, museum bulletins & reviews. Lectures: Modern & French art. Author: "Manet and His Critics," 1954; "Art and Architecture of Russia," 1954; "From the Green Box" (tr.), 1957; "European Painting and Sculpture, 1880-1940," 1967. Positions: Research Assoc., Walters A. Gal., 1934-36; Instr., 1936-43, Asst. Prof., Hist. A., 1943-1947, Assoc. Prof., 1947-56, Prof., 1956-1966, Yale Univ.

Cur., Mod. A., 1941- , Yale Univ. A. Gal., New Haven, Conn.; Robert Sterling Clark Professor Art, Williams College, Williamstown, Mass., 1963-64; Prof. Art, Williams Col., 1966- ; Dir., Sterling and Francine Clark Arts Inst., Williamstown, Mass., 1966- .

HAMMER, VICTOR J.—Art Gallery Director
Hammer Galleries, 51 E. 57th St. 10022; h. 781 Fifth Ave., New York, N.Y. 10022
B. New York, N.Y., Nov. 1, 1901. Studied: Colgate Univ.; Princeton Univ. Specialty of Gallery: 19th and 20th Century French Art; Western American Art, especially by Charles M. Russell and Frederic Remington; Impressionist and Post-Impressionists Paintings; Elegant Epoch Paintings. Positions: President, Appraisers Association of America, 1964; Dir., Hammer Galleries, New York, N.Y.

HAMMERSLEY, FREDERICK—Painter
c/o Heritage Gallery, 724 N. La Cienega Blvd., Los Angeles, Cal. 90069*

HAMMON, BILL J.—Sculptor, P., C., Des., Gr., I.
Studio 9, Aquila Court, Omaha, Neb. 68102; w. Box 952, Islamorada, Florida Keys 33036
B. Oklahoma City, Okla., Oct. 3, 1922. Studied: Oklahoma Art Center; Colorado Springs FA Center; Kansas City AI; Academia de San Carlos, Mexico City, and with Boardman Robinson, Arnold Blanch, Edward Laning, Thomas H. Benton. Member: AEA; Assoc. A. Omaha (Chm. Bd., 1951-56, 1958). Awards: prizes, Omaha, Neb., 1954; McDowell gold medal, 1947; Assoc. A. Omaha, 1948-1955; purchase prize, Joslyn Mem. A. Mus., 1955. Work: dioramas, murals, sc., mosaics, etc., State Hist. Soc., Omaha; Athletic Cl., Omaha; Clarkson Mem. Hospital, Lincoln Auditorium, both Omaha; Doane Col.; Okla. Chamber of Commerce; Okla. A. Center; Joslyn A. Mus.; Lincoln Airport; James Head Co., Birmingham; SAC Headquarters, Omaha; Nichols Business Equipment Co., Syracuse, N.Y.; Creighton Univ.; Brawner Bldg., Wash., D.C.; History of Notre Dame and St. Mary's, Notre Dame, Ind.; City Nat. Bank & Trust Co., Kansas City, Mo.; large outdoor mosaic (with Leonard) Theissen) Lincoln, Neb.; Asc., Cinderella City, Denver, Colo.; 200 figures cast concrete around Storz Pavillion, Clarkson Hospital, Omaha; 2 stained glass walls, menorah and eternal light, Temple Israel, Omaha; many fountains; work in numerous churches; 5 large bear grottoes and 5 small animal grottoes, Henry Doorley Zoo, Omaha; sc. and glass fountain, Methodist Hospital, Omaha; metal sc. screen of World War II, Command Bldg., SAC, Bellevue, Neb. Exhibited: Joslyn A. Mus., 1948, 1950, 1952, 1954; Walker A. Center, 1952, 1954; William Rockhill Nelson A. Gla., 1946, 1947, 1952, 1953; Mulvane A. Center, 1950-1952, 1954; Denver A. Mus., 1951-1953; Okla. A. Center; Philbrook A. Center; CAM; DMFA; Sioux City A. Center; Des Moines A. Center, and others. Contributor articles to Ford Motor publications. Positions: A. Dir., Omaha A. Sch., 1949-52; Freelance artist for business firms; Instr., Joslyn Mem. A. Mus.

HAMMOND, JOHN HAYS, JR.—Museum Director
Hammond Museum, Hesperus Ave., Gloucester, Mass. 01930*

HAMMOND, NATALIE HAYS—Painter, W., Mus. Dir.
"Argaty," Deveau Rd., North Salem, Westchester, N.Y. 10560
B. Lakewood, N.J., Jan. 6, 1905. Member: AFA; NAWA; Am. Medieval Acad.; Am. Union Dec. A. & Crafts; Assoc., Royal Min. Soc. of London; AA Mus. Work: French Govt.; Pittsfield Mus. A., and in private coll. Exhibited: Grieves Gal., London; PAFA; BM; one-man: Dunthorne Gal., Wash., D.C., 1927; Rochester Mem. A. Gal., 1928; Palette Francaise, Paris, 1929; Provincetown A. Gal., 1930; Roerich Gal., 1930; CGA, 1931; Marie Sterner Gal., 1932, 1934, 1936; Phila. A. All., 1933; Grace Horne Gal., Boston, 1938; Park Ave. Gal., 1939; Gal. on the Moors, Gloucester, Mass., 1939; Vose Gal., 1944; Arch. Lg., 1945; French & Co., New York, 1946; Seligmann-Helft Gal., New York, 1948; Hewitt Gal., N.Y., 1952; Hammond Museum, 1969. Author, I., "Elizabeth of England," 1936; "Anthology of Patterns," 1949. Positions: Fndr., Dir., Hammond Museum, North Salem, N.Y.

HAMMOND, RUTH EVELYN (Mrs. Edward S.)—Painter, T., W.
9 Thompson St., Brunswick, Me. 04011
B. West Haven, Conn., Mar. 19, 1894. Studied: Mt. Holyoke Col., B.A.; Yale Grad. Sch., and with Dante Ricci in Rome, Italy. Member: Ogunquit AA; Brick Store Mus., Kennebunk, Me. Awards: prizes, St. Petersburg A. Cl.; Soc. Four A.; St. Augustine A. Cl.; Brick Store Mus., Kennebunk, Me.; Rockport AA. Work: Bowdoin Col.; Walker A. Gal., Brunswick, Me.; William Farnsworth Mus., Rockland, Me.; Ford Motor Coll. Exhibited: PAFA, 1943; All. A. Am., 1944; NAWA, 1943-1945; Sweat Mem. Mus., 1942-1945; North Shore AA; Rockport AA, annually; St. Augustine A. Cl.; Soc. Four A.; New Haven Paint & Clay Cl., 1943; Walker A. Gal., Deerfield Acad., 1946, 1958; Mt. Holyoke Col. Mus.; Boston Soc. Indp. A., 1952; Boston A. Festival, 1952, 1958, 1963; Cape Ann Soc. Mod. A.; Boston,

Mass., 1958 (one-man); Ogunquit AA; Brick Store Mus., 1959-61; Maine State Festival, State House, Augusta; Bowdoin Col.

HAMPTON, PHILLIP JEWEL—Painter, E., Lith.
Southern Illinois University, Edwardsville, Ill. 62025.
B. Kansas City, Mo., Apr. 23, 1922. Studied: Kansas State Col., with John F. Helm; Drake Univ.; Kansas City AI, B.F.A., M.F.A.; Kansas City Univ. Awards: prizes, Contemp. Southern Exh., 1964; Coastal Empire Festival, 1964; Beaux Arts, Tuskegee, 1967; Atlanta Univ., 1960, 1962. Member: CAA; NAEA; AFA; Nat. Conf. of Artists; AAUP. Work: mural, Home Economics Bldg., Savannah State Col.; mural, J. W. Hubert Elem. Sch., Savannah, 1960. Exhibited: Atlanta Univ., 1957, 1970, 1962; Howard Univ., 1961; Telfair Acad., 1960; Contemp. Southern, 1964; Dulin Gal.; Coastal Empire Festival, 1964, 1969; Southeastern Regional Prints; Davis Gal., Columbia, Mo., 1968; Wellfleet, Mass.; Palm Beach, 1967; one-man: Savannah AA, 1969; Fla. A. & M. Univ., 1968; Lincoln Univ., 1966. Positions: Prof. FA, So. Illinois Univ., Edwardsville, Ill., at present.

HANAN, HARRY—Cartoonist
638 Coleman Place, Westfield, N.J. 07090
B. Liverpool, England, Dec. 14, 1916. Studied: Liverpool Sch. A. Member: Nat. Cartoonists Soc. Exhibited: MModA, 1951; Walker A. Gal., Liverpool, England, 1936, 1937. Work: Cart. daily comic strip, "Louie," in newspapers in U.S. and abroad, 1947- . Positions: Ed. Cart., Liverpool Evening Express, 1936-40; Ed. Cart., "The People," 1946-48.

HANCOCK, WALKER (KIRTLAND)—Sculptor, T.
Lanesville, Gloucester, Mass. 01930
B. St. Louis, Mo., June 28, 1901. Studied: St. Louis Sch. FA, Washington Univ. D.F.A.; Univ. Wisconsin; PAFA; Am. Acad. in Rome. Member: NA; NSS; Arch.L.; Smithsonian A. Comm.; Nat. Inst. A. & Let. Awards: prize, PAFA, 1921, Widener gold med., 1925, gold medal, 1932, F., PAFA, 1932; Cresson traveling scholarship, 1922, 1923; Prix de Rome, 1925; NAD, 1935, 1949, 1950, medal, 1953, Proctor prize, 1959; Saltus award, NSS, 1941, 1942, medal of achievement, 1968; Adams Mem. Award, 1954; Phila. A. All., 1953; Arch. Lg., 1955. Work: S., PAFA; John Herron AI; CGA; CAM; Brookgreen Gardens, S.C.; Parrish A. Mus., Southampton, N.Y.; Girard Col.; City Hall, Kansas City, Mo.; NGA; Am. Acad. A. & Let.; LC; Eisenhower Inaugural Medal; Kansas City War Mem.; St. Louis Soldier's Mem. Bldg.; Hall of Fame, N.Y. Univ.; Mun. Court Bldg., Phila., Pa.; Pa.R.R. Mem., 30th St. Station, Phila., Pa.; U.S. Air Mail Flyers Med. Honor; Army & Navy Air Med.; Medalist Soc.; John Paul Jones, Fairmount Park, Phila., Pa.; Founders' Mem., Bell Telephone Co. of Canada, Montreal; Alben Barkley, Ky. State Capitol; Douglas MacArthur, USMA, West Point, N.Y.; and many other medals, monuments, and portrait busts throughout U.S. and abroad. Exhibited: nationally and internationally. Contributor to: College Art Journal. Lectures: Sculpture. Sculptor in charge of Stone Mountain (Ga.) Memorial. Positions: Instr.; S., PAFA, Philadelphia, Pa., 1929-1968.

HANDLER, PROFESSOR and MRS. MILTON—Collectors, Patrons
425 Park Ave.; h. 625 Park Ave., New York, N.Y. 10021*

HANDVILLE, ROBERT TOMPKINS—Painter, I., L.
99 Woodland Drive, Pleasantville, N.Y. 10570
B. Paterson, N.J., Mar. 23, 1924. Studied: PIASch.; BMSch.A., with Reuben Tam. Member: SI; AWS. Awards: prizes, AWS, 1960-1964; Audubon A., 1960. Work: U.S. Air Force. Exhibited: AWS, 1948-1950, 1952, 1954, 1956-1958; Audubon A., 1954, 1957; Butler AI, 1961; Northern Westchester A., 1954, 1955-1958; Silvermine Gld. A., 1961; MMA. Contributor illus. to Reader's Digest; Dodd Mead Publishers. Positions: Treas., Soc. Illustrators, 1960-1961; Dir., Am. Watercolor Soc., 1962-1964. Artist, Reporter for Sports Illustrated.

HANFMANN, GEORGE M. A.—Museum Curator, Historian, E.
Fogg Art Museum, Harvard University, Cambridge, Mass. 02138; h. 20 Holden St., Cambridge, Mass. 02138
Positions: Curator, Classical Art, Fogg Art Museum, Cambridge, Mass.; Prof. FA, Harvard Univ., Cambridge, Mass.

HANNA, BOYD—Illustrator, Eng.
Swindell-Dressler Co., 441 Smithfield St. 15222; h. 1420 Centre Ave., Pittsburgh, Pa. 15219
B. Irwin, Pa., Jan. 15, 1907. Studied: Univ. Pittsburgh; Carnegie Inst. Work: MMA; LC; Boston Pub. Library; Pennsylvania State Univ.; Carnegie Inst.; N.Y. Pub. Lib.; Dist. Print, Min. Pr. Soc., 1951. Exhibited: SAGA, 1948-1956; Northwest Pr.M.; MMA; Am. Color Pr. Soc.; Washington WC Cl.; Denver A. Mus.; California Soc. Etchers; BM; NAD; Academic A., Springfield, 1956; Hunt Botanical Library, 1969. I., "Longfellow's Poems," 1944; "The Compleat Angler," 1947; "Dreamthorp," 1947; "The Greatest Thing in the World," 1949; "The Story of the Nativity," 1949; "Leaves of

Grass," 1952; "Sayings of Buddha," 1957; "Sayings of Mohammed," 1958. Commercial A., Swindell-Dressler Co., Pittsburgh, Pa., at present.

HANNA, KATHERINE—Museum Director
 The Taft Museum, 316 Pike St. 45215; h. 2214 Upland Pl., Cincinnati, Ohio 45206
B. Cleveland, Ohio, Jan. 25, 1913. Studied: Sweet Briar Col.; Oberlin Col.; Bryant & Straton, Boston. Member: Int. Council of Museums; Assn. Mus. Dirs.; AAMus.; AFA Mid-west Museum Conf. Hon. member: AID; Cincinnati Print & Drawing Circle; Cincinnati Altrusa Club Three Arts Scholarship Fund; Cincinnati Contemp. A. Soc. Editor, Taft Museum Catalog, 1957; contributor to Museum Bulletins, Art Magazines and newspapers. Lectures: Art, Architecture and Decorative Arts, 19th Century; French Renaissance; Chinese Porcelains; History of Art; Appreciation of the Arts. Positions: Fine Arts Commission, City of Cincinnati; Chm., Visual Arts Sect., UNESCO, 1955; Art Panel, Biennial Symposium, Oberlin College; Cincinnati American Red Cross, Arts and Skills Corps; Cur., 1941-52, Dir., 1952- , The Taft Museum, Cincinnati, Ohio. Chm., Adv. Com. on Art Edu. for Greater Cincinnati; Adv. Bd. on Policy, Cincinnati Council on World Affairs; Adv. Com., Office of Edu. Relations, and Bd. Member, American Red Cross, Cincinnati Area. Tech. Advisor for "Let's Go to an Art Museum," Putnam & Sons; Adv. Bd., Cincinnati Contemp. A. Center.

HANSEN, FRANCES FRAKES—Educator, P., Des.
 700 Pontiac St., Denver, Colo. 80220
B. Harrisburg, Mo. Studied: Univ. Denver, B.F.A., with John Edward Thompson; AIC; Colorado State Col. Edu., M.A.; grad. study, Univ. So. California; Univ. Denver; Fontainebleau Sch. FA, France. Awards: prizes, Colo. State Fair, 1958, 1960. Member: CAA; Delta Phi Delta; AEA; AAUP; Colorado A. Educ. Assn. Exhibited: Denver A. Mus.; Central City (Colo.) Festival; Mus. of New Mexico; Colo. State Fair; Colo. Springs FA Center; Colo. Southern State Col.; one-man: Temple Buell Col.; YMCA Conference, Estes Park. Article in Native Art of America was translated & published in 5 Near-East languages in FA bulletins of the 5 countries' Cultural Bulletin, from the Am. Embassy in Vienna. Positions: Instr. A., Univ. Denver, 1942-47 (part-time); Prof. A., Dir. A. Dept., 1944-58; Colorado Women's Col., Denver, Colo. Lectures, American Indian Art for Colo. Archaeological Soc., Denver A. Mus., International House, Am. Bell Assn., Denver Elem. Teachers Assn. Prof. of A., Temple Buell Col., at present.

HANSEN, JAMES LEE—Sculptor
 4115 Q St., Vancouver, Wash. 98663
B. Tacoma, Wash., June 13, 1925. Studied: Portland A. Mus. Sch. Member: Northwest Inst. of Sculptors; F.I.A.L. Awards: prizes, San F. AA, 1952, 1956; Am. Trust Co. award; Emanuel Walter purchase prize, SFMA, 1960; SAM, 1963. Work: Portland A. Mus.; SAM; SFMA; bronze figure, Vancouver Federal Savings & Loan Bldg.; stone relief, Vancouver Land Title Bldg.; bronze fig., Fresno (Cal.) Civic Mall; copper relief, Alderway Bldg., Portland Ore.; fountain, 1st Fed. Savings & Loan, Corvallis, Ore.; sc., St. Louise Parish, Bellvue, Wash.; Providence Heights College, Pine Lake, Wash.; Univ. Oregon permanent coll.; other work, 1966-1968: reredos, bronze doors, bronze figures (life-size), St. Ann's Church, Butte, Mont.; panels, Education Center, Baker, Ore.; reredos, Holy Trinity Parish, Bremerton, Wash.; bronze relief, St. Thomas Parish, Camas, Wash.; bronze fountain, Graphic Arts Center, Portland, Ore. Exhibited: WMAA, 1953; SFMA, 1952, 1956, 1960, 1963; Kraushaar Gal., N.Y., 1952-53; SAM, 1952-1957, 1959-1960; Denver A. Mus., 1952, 1961; Portland A. Mus., 1951-1960; Henry Gal., Univ. Wash. 1961 and prior; Santa Barbara Mus. A., 1959; Morris Gal., N.Y., 1961; Seattle World's Fair, 1962; Univ. Oregon, 1963, one-man, 1969; Washington Governor's traveling exhibition, 1964-1969; Fountain Gal., Portland, Ore., 1966, 1969 (both one-man); Collectors Gal., Bellevue, Wash., 1967; Civic Auditorium, Portland, Ore., (one year loan), 1968; traveling exh. of six major bronzes, through the Western Association of Museums, 1968-1969. Amon Carter Mus., Fort Worth. Positions: Instr., Sculpture, Oregon State Univ., 1957-58; summer session, Univ. California, Berkeley, 1958; Asst. Prof., Sc., Portland (Ore.) State Univ., 1964-1969.

HANSEN, ROBERT (WILLIAM)—Painter, S., E.
 1600 Campus Rd.; h. 1974 Addison Way, Los Angeles, Cal. 90041
B. Osceola, Neb., Jan. 1, 1924. Studied: Univ. Nebraska, A.B., B.F.A.; Escuela Universitaria de Bellas Artes, San Miguel de Allende, Mexico, M.F.A.; Universidad de Michoacan, Mexico, with Alfredo Zalce. Member: AAUP; CAA. Awards: Guggenheim Fellow, 1961, Southeast Asia; Fulbright Research Fellowship, 1961, India; Tamarind Fellow, 1965. Work: MModA; Long Beach (Cal.) Mus. A.; WMAA; Univ. Nebraska A. Gal.; Los Angeles County Mus.; Princeton Univ. Library (lithographic book). Exhibited: MModA, 1961; WMAA,

1963; Carnegie Int., 1962, 1964; Smithsonian traveling exh., U.S. State Dept. auspices, Europe and South America, 1968-1970. Publication: "Satan's Saint," 1965- , livre de luxe, hand-written by artist, with 17 images drawn on stone, hand printed by lithography from the text by Guy Endore (Tamarind Lithography Workshop). Positions: Prof. A., Drawing and Painting, Bradley Univ., 1949-1955; Univ. Hawaii, 1955-1956; Occidental Col., 1956- .

HARBART, GERTRUDE F. (Mrs. Frank)—Painter, T.
 2201 Maryben Ave., Long Beach, Michigan City, Ind. 46360
B. Michigan City, Ind. Studied: Univ. Illinois; Univ. California; ASL; AIC; Ohio Univ., and with Charles Burchfield, Hans Hofmann, and others. Member: South Bend AA; Northern Indiana A.; Indiana A. Cl.; Gary A. Lg.; Northern Indiana A. Patron's Assn.; Sarasota AA. Awards: prizes, John Herron AI, 1958; South Bend AA, 1954, 1956, 1957, 1959, 1960; Old Northwest Territory Exh., Springfield, Ill., 1954, 1956; Ohio Valley, 1955; Hoosier Salon, 1958; Indiana State Fair, 1948, 1950, 1953, 1955-1959; Northern Ind. A. Salon, 1953, 1956, 1957, 1959, 1960; Gary A. Lg., 1957-1960; Gary Music & Arts, 1960. Work: South Bend AA; St. Mary's of Notre Dame, South Bend; Michigan City H.S.; Ind. Univ.; Purdue Univ.; Ind. State T. Col.; Valparaiso Univ.; AIC. Exhibited: CGA, 1957; Butler Inst. Am. A., 1953-1969; Nat. Soc. Painters in Casein, 1956; Provincetown A. Festival, 1958; Art:USA, 1958; Terry AI, 1952; Springfield, Ill., 1953, 1958; Michiana Regional, 1951-1969; Southern Shores, 1956, 1958; Ohio Valley, 1953, 1955; Northern Indiana A., 1948-1969; Hoosier Salon, 1951-1958; Pittsburgh Plan for Art, 1956-1969; AIC, 1961; NAD, 1961; one-man: Evansville, Ind.; St. Mary's College, Notre Dame, Ind., and others. Contributor to Art News; School Arts. Positions: Instr., Niles, Mich., Adult Edu. classes; Long Beach, Michigan City, Ind.; Dunes A. Fnd., 1959-1969. Faculty, South Bend A. Center, at present.

HARBESON, GEORGIANA BROWN (Mrs. Frank Godwin) —
 Painter, Des., C., T., L.
 Box 6, New Hope, Pa. 18938
B. New Haven, Conn., May 13, 1894. Studied: PAFA; Moore Inst. A. Sc. & Indst.; N.Y. Sch. Des.; N.Y. Univ.; PMSchIA. Member: NAWA; N.Y. Soc. Craftsmen; Phila. WC Cl.; Pen & Brush Cl.; Women's Press Cl.; Needle & Bobbin Cl. Awards: prizes, PAFA; NAWA; Embroiderers Gld., Phila., 1962; Hist. Soc., New Hope, Pa., 1963 (2); N.Y.A. All. Work: Honolulu Acad. A.; altar rail, cushions, stalls and kneelers needlepoint for St. Joseph's Chapel, Wash, D.C., and for Trinity Cathedral, Trenton, N.J.; Nat. Cathedral, needlepoint for 40 kneelers, Bishop's Chapel, St. Paul's Cincinnati, Ohio, 1958; other work, St. Paul's, Rochester; St. Paul's, Dayton, Ohio; Trinity Church, Covington, Ky.; St. Phillips Chapel, New Hope, Pa. Exhibited: One-man: Milch Gal., N.Y.; Arden Gal.; Argent Gal.; Pen & Brush Cl.; AIC; Arch. Lg., Woodmere A. Gal., Phila., 1964, and others. Contributor articles on Furniture Decoration and Designs; Author: "American Needlework 17th Century to Contemporary"; "History of American Needlework," 1938, reprint, 1961, 1967. Articles published in "Studio," London and American Artists magazine. Positions: Memb. Bd., Embroiderers Gld., American Branch, N.Y.; Phila. Branch of Embroiderers Gld., London, England.

HARDIN, ADLAI S.—Sculptor
 Lyme, Conn. 06371
B. Minneapolis, Minn., Sept. 23, 1901. Studied: AIC; Princeton Univ., A.B. Member: NA; F., NSS (Pres., 1957-59). Awards: prizes, Arch. Lg., 1941; NSS, 1950, Lindsey Morris prize, 1956; Anna Hyatt Huntington prize, Daniel Chester French Medal, NAD; Hudson Valley AA, 1957; medal, NAD, 1945. Work: PAFA; New Britain Mus. Am. A.; IBM; Moravian Church, Bethlehem, Pa.; Stamford (Conn.) Hospital; stone figures, Princeton Univ. store, 1958; Congregational Church, Darien, Conn., 1958; Inter-church Center, N.Y., 1960, 1964; St. Paul's Church, Norwalk, Conn., 1961; murals, Seamen's Bank for Savings; St. Gabriel's Episcopal Church, Jamaica, N.Y.; McMaster Divinity College, McMaster Univ., Hamilton, Ont., Canada; Westminster Presbyterian Church, Buffalo, N.Y.; St. Ann's Episcopal Church, Old Lyme, Conn.; George Bancroft Medal, Hall of Fame for Great Americans, New York University. Exhibited: NAD; PAFA, annually.

HARDIN, MRS. SHIRLEY G.—Art dealer
 Fairweather-Hardin Gallery, 101 E. Ontario, Chicago, Ill. 60611*

HARDY, THOMAS AUSTIN (TOM)—Sculptor, T., Lith.
 1422 S.W. Harrison St., Portland, Ore. 97201
B. Redmond, Ore., Nov. 30, 1921. Studied: Oregon State Col.; Univ. Oregon, B.S., M.F.A. Member: Oregon Ceramic Studio; Portland A. Mus. Awards: prizes, Oregon Ceramic Studio, 1951, 1952; Portland A. Mus., 1951, 1952; SAM, 1951; SAGA, 1952; Fla. Southern Univ., 1952; Louisiana State A. Comm., 1958. Work: Portland A. Mus.; SAM; Springfield (Mo.) A. Mus.; Univ. Oregon; Oregon Cer-

amic Studio; WMAA; Portland State Col.; Lloyd Center, Portland, and in private collections. Exhibited: Sao Paulo Brazil, 1955; WMAA, 1954, 1955; MMA, 1953; CM, 1952; SAGA, 1952; Bradley Univ., 1952; SFMA, 1953, 1955; Denver A. Mus., 1953; SAM, 1947, 1951, 1952, 1954, 1955; Wichita AA, 1947; Syracuse Mus. FA, 1952; Portland A. Mus., 1936, 1941, 1952-1955; Oregon Ceramic Studio, 1951-1953; AFA, 1955; Univ. Oregon; Wichita AA; Mus. FA, Houston; VMFA; Des Moines A. Center; Univ. of Colorado and Nebraska; one-man: Kraushaar Gal., 1953; Stanford Univ., 1954; SAM, 1954; Oregon State Col., 1953; Univ. British Columbia, 1955; Univ. So. California, 1954; Kasper Gal., San F., 1954; de Young Mem. Mus., 1958; Columbia (S.C.) Mus., 1959; Ogunquit Mus. A.; 1958; Wash. State Univ.; Portland A. Mus., Retrospective, 1961; Tacoma A. Lg., 1961. Positions: Instr., Univ. Oregon, 1952; Oregon State System of Higher Edu., Adult Edu., 1953- ; Sculpture, Univ. British Columbia (summer), 1955; Coos A. Lg. (Ore.) Summer Art Workshop, 1954-55; Univ. California, Berkeley, 1956-1958; Visiting Assoc. Prof., 1958-1959, A.-in-Res., 1959-1961, Tulane Univ., New Orleans, La.

HARE, CHANNING—Painter
 220 Worth Ave., Palm Beach, Fla. 33482; also, "Son Juliá," Lluchmayor, Mallorca, Spain
B. New York, N.Y. Studied: ASL, and with Robert Henri, George Bellows, William Zorach. Member: Bd. of Dirs., Soc. Four A., Palm Beach, Fla. Awards: prizes, Soc. Four A., 1942, 1943, 1944. Work: Virginia Hist. Soc.; BMFA; PAFA; Colorado Springs FA Center; Davenport Mun. A. Gal.; IBM. Exhibited: WMA, 1935; BMA, 1936; John Herron AI, 1943; one-man: New York, N.Y.; Boston, Mass.; Findlay Gals., 1962; Palm Beach Gals.; 1964-1966, 1968; Lowe Gal. A., 1955; Grand Central Moderns, 1956; also exhibited at Carnegie Inst., 1950; MMA, 1952; Univ. Illinois, 1952.

HARE, DAVID—Sculptor
 34 Leroy St., New York, N.Y. 10014
B. 1917. Awards: Hon. D.F.A., Maryland Inst. A., Baltimore, 1969. Work: Brandeis Univ.; MMA; MMoDA.; SFMA; WMAA; Albright-Knox A. Gal., Buffalo, N.Y.; Wadsworth Atheneum, Hartford, Conn.; Yale Univ., and others. Exhibited: One-man: Saidenberg Gal., N.Y., 1960-1963, and others prior; group exhs.: MMoDA; Sao Paulo Biennials; WMAA; Brussels World's Fair, 1958; AIC, 1961; Seattle World's Fair, 1962.

HARKAVY, MINNA—Sculptor
 Hotel Ansonia, 2109 Broadway, New York, N.Y. 10023
Studied: ASL; and in Paris with Antoine Bourdelle; Hunter Col., B.A. Member: AEA; Fed. Mod. P. & S.; S. Gld.; Assoc. Memb., Int. Inst. A. & Let. Awards: prizes, NAWA, 1940, 1941, 1964, 1965, Medal of Honor, 1962; Nat. Exh. Am. Sc., MMA, 1951; Project award, U.S. Treasury; Nat. Acad. A. & Lets. grant, 1959; prize, Audubon A., 1965. Work: WMAA; MMoDA; Musee Municipal, St. Denis, France; Mus. Western A., U.S.S.R.; Tel-Aviv, Ain Harod Mus., Israel; USPO, Winchendon, Mass.; Norfolk Mus. A. & Sciences, and in many private collections U.S. and abroad. Exhibited: SFMA; AIC; PAFA; Albright A. Gal.; Munson-Williams-Proctor Inst.; WMAA; MMoDA; MMA; Univ. of Nebraska, Iowa, Virginia, etc.; Salon d'Automne, Salon des Tuileries, Jeu de Paume, Paris, France; Petit Palais; Toronto, Can.; Sao Paulo, Brazil; One-man: Paris, France; R.I. Sch. Des. Mus. A., 1956; Mus. Western Art, Moscow. Contributor articles to magazines. Represented in Encyclopaedia Britannica; Collier's Encyclopedia, and in books on art.*

HARLAN, ROMA CHRISTINE—Portrait Painter
 The River House, C-411, 1600 S. Joyce St., Arlington, Va. 22202
B. Warsaw, Ind., June 23, 1912. Studied: Purdue Univ.; AIC, with Constantine Pougialis, Francis Chapin; and with Ralph Clarkson, Marie Goth. Member: Wash. A. Cl.; Indiana Fed. A. Clubs; Lafayette (Ind.) AA. Work: St. Joseph's Col., Rensselaer, Ind.; Purdue Univ.; PEO Home, Mt. Pleasant, Iowa; Lake Shore Cl. of Chicago; Francis Hammond H.S., Alexandria, Va.; Nat. Guard Assn. of the U.S., Wash., D.C.; Nat. Bus. & Prof. Women's Fnd. Bldg., Wash., D.C.; Walter Reed Army Hospital, Wash., D.C.; U.S. Capitol, Wash., D.C., and many others. Author essay "Rembrandt" published in Congressional Record, 1957. Exhibited: Hoosier Salon, 1940; All-Illinois Soc. FA, 1940-1942; Kaufmann's Gal., Chicago, 1942; Lafayette AA; Wash. A. Cl., 1958-1966; one-man: Lake Shore Cl., Chicago; Little Gal., Chicago; Purdue Univ.; NBC-TV, 1966.

HARMAN, FRED—Illustrator, Cart., P.
 1215 Fruit Ave., N.W., Albuquerque, N.M. 87102
B. 1902. Member: SI. Creator of the cartoon strip "Red Ryder and Little Beaver." Technical consultant, movie and TV Westerns. Specializes in Western paintings.*

HARMON, LILY—Painter
 151 Central Park West, New York, N.Y. 10023
B. New Haven, Conn., Nov. 19, 1913. Studied: Yale Univ. Sch. FA; ASL, and in Paris, France. Member: ANA; Provincetown AA; Work: Encyclopaedia Britannica; Butler AI; Tel-Aviv, Ain Harod Mus.; Israel; Kalamazoo A. Center; Newark Mus. A.; WMAA; mural, Port Chester (N.Y.) Jewish Community Center. Exhibited: nationally and internationally; 12 one-man exhs., New York; Kyoto, Japan, and others. Illus., "Pride and Prejudice," 1945. Illus., 1967; Andre Gide-Sartre; Kafka- "The Castle"; Mann- "Buddenbrooks."

HARNETT, MR. and MRS. JOEL WILLIAM—Collectors
 The Look Bldg., 488 Madison Ave.; h. 2 Sutton Pl. S., New York, N.Y. 10022
B. New York, N.Y., Dec. 3, 1925. Studied: Univ. of Richmond, Virginia, B.A.; The New School for Social Research. Awards: Phi Beta Kappa, Univ. of Richmond, 1945. Positions: President, Phi Beta Kappa Alumni, N.Y., 1964-1965 (Mr. Harnett). Members: Friends of the Whitney Museum of American Art. Collection: (Mr. and Mrs. Harnett) Includes works by Hopper, Burchfield, Marsh, Greene, Anuszkiewcz, Raphael Soyer, Rosenberg, Seley, Tooker, Jenkins, Pearlstein, Rickey, Francis, Lamis, Fletcher Benton.

HARRIS, JOSEPHINE MARIE—Educator
 Wilson College; h. 756 Philadelphia Ave., Chambersburg, Pa. 17201
B. Webster Groves, Mo., Jan. 20, 1911. Studied: Washington Univ., St. Louis, B.A., M.A., Ph.D.; Am. Sch. of Classical Studies, Athens, Greece; Dumbarton Oaks Research Lib. & Coll. Member: Archaeological Inst. Am.; Am. Philological Assn.; Am. Research Center in Egypt; CAA; AAUP. Contributor to American Journal of Archaeology. Positions: Prof., Hist. of Art, Medieval, Renaissance, Baroque and American, Smith College, 1945-46; Wilson College, Chambersburg, Pa., 1946- .

HARRIS, JULIAN HOKE—Sculptor, E., W., L.
 177 Fifth St., Northwest, Atlanta, Ga. 30313
B. Carrollton, Ga., Aug. 22, 1906. Studied: Georgia Inst. Tech., B.S. in Arch.; PAFA. Member: F., NSS; AIA; Atlanta AA (Vice-Pres. 1953-55); Assoc. Georgia A. Awards: prizes, Tri-County Exh., Atlanta, 1940; IBM, 1942; Assoc. A. Georgia, 1951; Fine Arts Medal, AIA, 1954; Ivan Allen award for Civic Service, AIA, Georgia Chptr. Work: Des. & executed sc. on 50 public bldgs., and 49 mem. and portrait comm. including: Atlanta Constitution Bldg.; Uncle Remus Lib., 5 bldgs., Grant Park Zoo; 4 bldgs. at Georgia Tech.; Fulton County Health Center, State Agricultural Bldg., F. W. Olin Indst. Ed. Bldg., Grady Hospital, Mobile Airport; Commerce Bldg., Immaculate Heart Church, all in Atlanta; 1st Fed. Savings & Loan Bldg., Augusta, Ga., and others. Medals for Rich's, Atlanta; Ga. Civil War Cent.; Univ. Virginia Sesquicentennial Medallion; Nat. Inst. Park Directors; Georgia Gold Medal; AIA Arch. Award; Ralph Walker Medal, AIA; Vincent Bendix Award; Mandeville Mills, Carrollton, Ga. Contributor to architectural magazines including Journal of the AIA. Exhibited: nationally. Lectures: "Sculpture and Architecture" at principal colleges in the Southeast. Positions: Prof. Dept., Arch., Georgia Inst. Tech., and Freelance Sculptor, Atlanta, Ga.

HARRIS, LEON A., JR.—Collector, Patron, W., Lecturer
 4512 Fairfax, Dallas, Tex. 45205
B. New York, N.Y., June 20, 1926. Studied: Harvard College. Author: "The Great Picture Robbery"; "Young France"; "The Fine Art of Political Wit"; "Only to God: The Life of Godfrey Lowell Cabot"; "Young Peru"; and articles in Esquire, Good Housekeeping, McCalls, and the Encyclopedia Americana. Collection: General—paintings, drawings and prints. Positions: Trustee, Dallas Museum of Fine Arts; Donor to museums.

HARRIS, LUCILLE—Painter, Et., Des.
 5 Oak St. Path, Berkeley, Cal. 94608
B. Stockton, Cal. Studied: Univ. California, Berkeley; San Francisco State Col.; San Francisco AI. Member: San F. AI Artists Assn.; AEA; San F. Women A.; East Bay AA. Award: San F. AI Gold Seal Award & Traveling Exch., 1961. Work: St. Mary's Col., Moraga, Cal.; Haggin A. Gals., Stockton, Cal.; Playhouse Repertory, San Francisco. Mural, Gamut Theatre, Berkeley, Cal. Exhibited: Cal. PLH, 1961-1965; Smithsonian Inst., Painters & Gravers Exh., 1961; SFMA, 1958, 1959, 1964, 1965; Oakland A. Mus., 1959, 1964; Richmond A. Center, 1960, 1962; Crocker A. Gal., Sacramento, 1960, 1963, 1964; San F. AI, 1964, traveling exh., 1964-65; Western Museums traveling exh., 1964-1965; East Bay Artists traveling exh., 1964 and Exchange Exh., Japan, 1964; Unitarian Church, Kensington, 1963; Santa Clara Univ., 1963, 1965; Cal. State Fair, 1960; Jack London Square, Oakland, 1958, 1960; Grace Cathedral, San Francisco, 1962; other group shows in galleries of Oakland, San Francisco and Berkeley. One-man: Haggin A. Gal., Stockton, 1960; St. Mary's College, 1961; Berkeley Pub. Lib., 1963; Playhouse Theatre, San Francisco, 1959-60; Artists Cooperative, San Francisco, 1959; Brunn Gal., 1960; Contemp. A., Berkeley, 1962.

HARRIS, MARGO LIEBES—Sculptor
211 E. 60th St. 10022; h. 300 E. 74th St., New York, N.Y. 10021
B. Frankfurt, Germany, Oct. 17, 1925. Studied: in Germany and Italy; ASL, with William Zorach. Awards: prizes, PAFA; Detroit Inst. A.; Portland (Me.) Mus. A., 1962; Audubon A., 1962; NAWA, 1963; Maine State A. Festival, 1960, 1961. Member: AEA; NAWA; Am. Soc. Contemp. A.; Brunswick and Bath (Me.) AA. Work: in private colls.; Sheraton-Southland Hotel, Dallas, Tex., 1959; Portland (Me.) Mus. A. Exhibited: Audubon A., 1951, 1953, 1954, 1957; PAFA, 1953; Boston A. Festival, 1957; WMAA, 1951; NAWA, 1958; Brick Store Mus., Kennebunk, Me.; Portland (Me.) Mus. A.; Lever House, N.Y.; Sculpture Center, N.Y.; Union Carbide Gal., N.Y.

HARRIS, MRS. MASON DIX—Museum Director
Fitchburg Art Museum, 25 Merriam Parkway, Fitchburg, Mass.

HARRIS, PAUL—Sculptor
Box 214, Bolinas, Cal. 94924
B. Orlando, Fla., Nov. 5, 1925. Studied: Univ. New Mexico; New School for Social Research, with Johannes Molzahn; Hans Hofmann Sch. Fine Arts. Awards: Longview Fnd. Grant, 1960. Exhibited: MModA, 1958 and "Hans Hofmann and His Students" Exh., 1963; American Express Exh. of Modern Art, N.Y. World's Fair, 1965; A. Council Phila., 1966; Maryland Inst. A., 1966; Mus. Contemp. Crafts, 1966-1967; SFMA, 1966; PMA, 1967; Los Angeles County Mus., 1967; São Paulo Bieñal, 1967; Dusseldorf, 1968; U.S. traveling exh., 1968-1970; N.J. State Mus., 1969; one-man: Poindexter Gal., N.Y., 1957, 1960, 1963, 1966-1967; Berkeley Gal., 1965; Lanyon Gal., Palo Alto, 1965. Contributor to Art News and Art in America. Positions: Fulbright Prof. Sculpture, Universidad Catolica de Chile, 1961, 1962; California College of Arts & Crafts, Oakland, Cal.

HARRIS, PAUL STEWART—Museum Director, W., L.
Henry Ford Museum, Dearborn, Mich. 48124; h. 17880 Dunblaine Ave., Birmingham, Mich. 48009
B. Orange, Mass., 1906. Studied: Antioch Col., B.S.; Harvard Col., S.B.; N.Y. Univ. Grad. Sch. Member: AA Mus.; CAA; AFA. Contributor to museum publications. Author: "Fourteen Seasons of Art Accessions, 1947 to 1960." (1960). Positions: Asst. Cur., Dept. Mediaeval A., & The Cloisters, MMA, 1933-38; Dir., Sec., Des Moines Assn. FA, Des Moines, Iowa, 1938-40; Senior Cur., Minneapolis, Minn., 1941-42, 1946; Lecturer, Univ. Minnesota, 1946; Dir., J. B. Speed Art Mus., Louisville, Ky., 1946-1962. Deputy-Director, H. F. duPont Winterthur Museum, Winterthur, Del., 1962-1967; Dir. of Collections, Henry Ford Mus., Dearborn, Mich. 1967- .

HARRIS, ROBERT GEORGE—
Illustrator, Comm. A., P., L.
5720 North Saguaro Road, Scottsdale, Ariz. 85251
B. Kansas City, Mo., Sept. 9, 1911. Studied: Kansas City AI, with Monte Crews; Grand Central Sch. A., with Harvey Dunn; ASL, with George Bridgman. Member: SI; Phoenix FA Assn. Exhibited: SI; A. Dir. Cl., 1943-1946; Westport A. Group; one-man: Phoenix A. Mus., 1963. I., Ladies Home Journal; McCall's; Sat. Eve. Post, and other national magazines. Lectures: Modern Magazine Illustration; Story and Advertising.

HARRISON, CLEOBELLE—Educator
Northern Michigan University; h. 115 West Magnetic St., Marquette, Mich. 49855
B. Athens, Mich., Aug. 10, 1907. Studied: Western Michigan Col., A.B.; Am. Acad. A., Chicago; Wayne Univ., M.A.; Univ. Michigan, Ed. D.; Chicago Acad. A.; Northwestern Univ.; Ray Sch. Adv. A.; AIC. Member: Michigan Edu. Assn.; Michigan Art Edu. Assn.; NEA; Altrusa Dist. Bd. Work: student exh., Detroit Inst. A. Contributor to School Arts magazine. Positions: Instr. A., Lansing, Marshall, Mich.; Charleston, Oak Park, Ill.; City Supervisor Art, Saginaw, Mich., Elgin, Ill.; A. in Audio-Visual Aids, IBM, Endicott, N.Y., 1944-45; Hd., A. Dept., Northern Michigan University, Marquette, Mich., at present.*

HARRISON, ROBERT RICE—Educator, W., L.
6889 Hudson Ave., San Bernardino, Cal. 92404
B. Detroit, Mich., May 5, 1908. Studied: AIC; Wayne State Univ., B.F.A.; N.Y. Univ.; Iowa Univ., M.A., Ph.D. Member: CAA; Am. Soc. for Aesthetics; Art Historians of the California State Colleges; AAUP. Exhibited: VMFA, 1947, 1949; Contemp. Va. & North Carolina Exh.; Minneapolis Inst. A. Positions: Prof. A., Hd. Dept. A., Hamline Univ., St. Paul, Minn., 1954-1965; Prof., A. Hist., Art Dept., California State College, San Bernardino, Cal., 1965- .

HARRITON, ABRAHAM—Painter, T.
66 West 9th St., New York, N.Y. 10011
B. Bucharest, Roumania, Feb. 16, 1893. Studied: NAD, with George DeForest Brush, Emil Carlsen, Kenyon Cox, George Maynard.

Member: AEA; Audubon A. Awards: Recipient of the Marjorie Peabody Waite Award given by the American Academy of Arts and Letters and The National Institute of Arts and Letters "to an older artist for continuing achievement and integrity in his art," 1968; Hallgarten, Saltus, Baldwin and Suydam prizes, NAD Sch. A.; Patrons prize, Nat. Soc. Painters in Casein, 1956; Silvermine Gld. A., 1963. Work: Newark Mus. A.; AGAA; Norfolk Mus. A. & Sciences; Abraham Harriton Manuscript Coll., Syracuse Univ., 1964; Oakland A. Mus.; Tel-Aviv and Ain Harod Mus., Israel; State T. Col., Indiana, Pa.; Queens Col., N.Y.; Fordham Univ.; Oklahoma A. Center; Samuel Tilden H.S., N.Y.; mural, USPO and Agricultural Bldg., Louisville, Ga.; Living Arts Fnd. Exhibited: Carnegie Inst.; MMA; BM; Newark Mus. A.; CGA; PAFA; CAM; AIC; MModA; VMFA; WMAA; Provincetown A. Festival, 1958; Goodwill Exh. in England & Scotland; ACA Gal., N.Y. (14 one-man exhs. to date); Nat. Inst. A. & Lets., 1963; Childe Hassam Fund Exh., NAD, 1964. Contributor of article and reproductions to Esquire and American Artist magazines. Author: "Theory and Practice of Underpainting and Glazing."

HART, AGNES—Painter, T.
30 East 14th St., New York, N.Y. 10003; h. Maverick Rd., Woodstock, N.Y. 12498
B. Connecticut, Jan. 4, 1912. Studied: Ringling Sch. A., and with Josef Presser, Lucille Blanch, Paul Burlin. Member: Woodstock AA, (Bd. Dir., 1955-1956); Kaaterskill Group (Fnd. memb., Chm., 1958-1959), Awards: Fellowship, Yaddo Fnd., 1947, 1948; Presentation, Woodstock AA, 1953. Work: MMA. Exhibited: MMA, 1950, 1952; NAD, 1951; PAFA, 1952; Toledo Mus. A., 1945; AIC; VMFA; New Haven Paint and Clay Cl.; Phila. A. All.; Springfield Mus. FA, 1957; Berkshire AA; Riverside Mus.; Long Island Univ.; Art:USA, 1958; Butler Inst. Am. A. Woodstock AA, 1947-1969; one-man: New York City, 1948, 1954, 1956, 1960, 1961; Woodstock, N.Y., 1951, 1953, 1956-1961, 1963; Mercer Univ., Macon, Ga., 1962. Positions: Formerly Instr. at Dalton Schs., Birch-Wathen Sch., Anna Maria Sch.; Florida Childrens Workshop; Woodstock Gld. of Craftsmen. Instr., painting & drawing, ASL, N.Y., 1965- .

HART, ALLEN M.—Painter, T.
34 Jackson Rd., Valley Stream, N.Y. 11581
B. New York, N.Y., June 12, 1925. Studied: ASL; BMSch. A.; Universidad Michoacana, Mexico. Member: ASL. Work: Univ. Massachusetts, Amherst; Butler Inst. Am.A.; Slater Mem. Mus., Norwich, Conn. Exhibited: AFA traveling exh., 1967-1968; ASL Diamond Jubilee, 1950; AEA (WMAA), 1951; Conn. Acad. FA, 1952; G.W.V. Smith Mus., Springfield, Mass., 1952; City Center Gal., N.Y., 1953; Riverside Mus., N.Y., 1953; NAD, 1954; Art:USA, 1958; Roko Gal., N.Y., 1955-1959; N.Y. Public Library, 1961; Cober Gal., N.Y., 1964-1969. Positions: Dir., Visual A. Center of the Children's Aid Soc., New York, N.Y.

HART, MARVELL ALLISON—Museum Curator
Honolulu Academy of Arts, 900 South Beretania St., Honolulu, Hawaii 96814
Positions: Keeper of Collections, Honolulu Academy of Arts.

HARTER, TOM J.—Educator, P., Des., I.
Arizona State University; h. 320 Roosevelt St., Tempe, Ariz. 85281
B. Naperville, Ill., Oct. 8, 1905. Studied: Ariz. State Univ., B.A.; Univ. Oregon, M.F.A.; ASL; Member: Cal. Nat. WC Soc.; AAUP. Awards: Ariz. State Fair, 1955, 1959-62, 1964. Work: Ten portraits of administrators, Ariz. State Univ.; mural, Univ. Oregon. Collections: Arizona State Univ.; Glendale Community College, Glendale, Ariz.; Scottsdale Municipal Collection, Scottsdale, Ariz., and private collections. Exhibited: BM 1935; AWS, 1937-1938; Southwest A., 1941-1946; Cal. Nat. WC Soc., 1945, 1950, 1955, 1956, 1962; Ariz. State Fair, 1937-1966; Cal. State Fair, 1951; Univ. Ariz., 1954-1957; Tucson Festival A., 1958, 1960, 1962; Yuma FA Assn., Yuma, Ariz., 1966-1969. One-man: Phoenix Art Mus., 1964; Glendale Community Col., Glendale, Ariz., 1968. I. "Hunting in the Southwest," 1946; "Arizona: The History of a Frontier State," 1950. Positions: Art Dept., Ariz. State Univ., 1937- . Prof., A,, 1952- .

HARTFORD, HUNTINGTON—Collector, Patron, W.
420 Lexington Ave. 10017; h. One Beekman Pl., New York, N.Y. 10022
B. New York, N.Y., Apr. 18, 1911. Studied: Harvard University, A.B. Awards: Received awards for article written on art, "The Public be Damned?," 1955; National Arts Club, Salmagundi Club, American Artists Professional League; Honorary Fellow, National Sculpture Society; Art award, National Art Materials Trade Association, 1962; Citation from Salmagundi Club—member of its Honorary Roster of great contemporary Americans, 1964; award from American Artists Professional League, 1964. Author: "Art or

Anarchy?," 1964. Collections American and European painting and sculpture of the 19th and 20th centuries—housed in the Gallery of Modern Art including the Huntington Hartford Collection, N.Y. Positions: Founder, Huntington Hartford Foundation—Pacific Palisades, Cal., 1949-1965; Founder, Show Magazine, 1961- ; Founder, Gallery of Modern Art Including the Huntington Hartford Collection, N.Y., 1964.*

HARTGEN, VINCENT ANDREW—Educator, P., Mus. D.
Art Department, University of Maine, Orono, Me. 04473
B. Reading, Pa., Jan. 10, 1914. Studied: Univ. Pennsylvania, B.F.A., M.F.A. Member: CAA; Am. Assn. Univ. Prof.; Audubon A.; Maine WC Soc.; AWS. Awards: prizes, BAID, 1935; Soldier Art, 1945; Audubon A., 1950, Medal, 1965, Creative Aquarelle award, 1966; Kennebec Journal, 1960; F., Univ. Pa. Sch. FA, 1941; Distinguished Prof. award, 1966; Governor's State Art award, 1967. Work: Howard Univ.; Brooks Mem. A. Gal.; Kutztown State T. Col.; Univ. Maine; Everhart Mus. A.; BMFA; Smith Col.; Colby Col.; Hartford Atheneum; Nylander Mus.; Phoenix A. Mus.; Reading (Pa.) Mus.; Int. Tel. & Tel. Coll. Elvehjem A. Center; Rose Mus., Brandeis Univ. Exhibited: Audubon A., 1946-1961; AWS; Boston Soc. Indp. A.; Alabama WC Soc.; one-man: Maryland Inst.; George Binet Gal.; Howard Univ.; Everhart Mus. A.; Rochester Mem. A. Gal.; Benedict Col.; Claflin Univ., Orangeburg, S.C.; Col. of the Pacific; Pa. State Col.; Hallmark Gal., Kansas City; Greenwich (Conn.) Lib.; Doll & Richards, Boston; Collector's Gal., Wash., D.C.; Wiley Gal., Hartford; Chase Gal., N.Y.; Argus Gal., Madison, N.J., and others. Positions: Traveling Cur., Anna Hyatt Huntington Exh. Sculptures, 1937-39; Dir., Univ. Maine A. Gal., 1946- ; Prof. A., Hd. Dept. A., Univ. Maine; Orono, Me., 1946- . Apptd. J.J. Huddilston Chair, Univ. Maine, 1962; Governor's Comm. on the Arts & Humanities, 1965-1968.

HARTIGAN, GRACE—Painter
1701 1/2 Eastern Ave., Baltimore, Md. 21231
B. Newark, N.J., Mar. 28, 1922. Studied: with Isaac Lane Muse. Award: Mademoiselle Magazine Merit Award for Art, 1957. Work: MModA; WMAA; MMA; BM; AIC; Carnegie Inst.; Albright-Knox A. Gal.; WAC; Nelson Gal. A., Kansas City; Minneapolis Inst. A.; Washington Univ. A. Gal., St. Louis; Vassar College A. Gal.; Washington (D.C.) Gal. Mod. A.; Museum of North Carolina, Raleigh; New Paltz Mus., N.Y.; Mus. A., Rhode Island Sch. Des., Providence; Rose A. Gal., Brandeis Univ.; BMA; Israel Mus., Jerusalem; NCAF; PMA. Exhibited: Univ. Minnesota, 1955; MModA traveling exh., New York and eight European cities, 1955-56; MModA, 1956; Jewish Mus., 1957; Contemp. A. Exh., India, Japan, 1957; Sao Paulo Bienal, 1957; "New American Painting, New York and eight European cities, 1958-59; Brussels World's Fair, 1958; Art:USA, 1959; Documenta II, Kassel, Germany, 1959; Columbus Gal. FA, 1960; WAC, 1960; Univ. Michigan, 1961; Carnegie Int., 1961; Guggenheim Mus., N.Y., 1961; American Vanguard-Austria, England, Germany, Yugoslavia, organized by Guggenheim Museum for USIA, 1961-62; Ghent, Belgium, 1964; AFA Exh., "A Decade of New Talent," 1964-65. One-man: Tibor de Nagy Gal., N.Y., 1951-1955, 1957, 1959; Vassar College, Poughkeepsie, N.Y., 1954; Gres Gal., Wash. D.C., 1960; Chatham College, Pittsburgh, 1960; Martha Jackson Gal., N.Y., 1962, 1964, 1967; Univ. Minnesota, 1963; Franklin Siden Gal., Detroit, 1964; Univ. Chicago, 1967; Gertrude Kasle Gal., Detroit, 1968. Produced Silk Screen Prints for Four Volume Poetry Edition, 1961; illus., "Salute," by James Schuyler; Portfolio of Lithographs, 1965. Included in many books on art, 1959-1962. Included in articles in many magazines, newspapers, including Art in America, Saturday Review, Arts, New Yorker, Vogue, Fortune, Time, Mademoiselle, Art Internationale, Apollo, Horizon and many more. Positions: A.-in-Res., Maryland Inst. Graduate Sch. of Painting, 1965-1969.

HARTL, LEON—Painter
56 Seventh Ave., New York, N.Y. 10011
B. Paris, France, Jan. 31, 1889. Awards: Marjorie Peabody Waite Award, Nat. Inst. A. & Lets., 1959; purchase prize, Hallmark Exh., Wildenstein Gals., N.Y., 1960; Yaddo Fellowship, 1960-1962; McDowell Colony Fellowship, 1957-1961, 1963; Ingram Merrill Foundation, 1968. Work: Hallmark Coll.; PC; Soc. of New York Hospital; Univ. Nebraska; Wadsworth Atheneum; WMAA, and many others. Exhibited: Butler Inst. Am. A.; Carnegie Inst.; AIC, CGA; Nat. Inst. A. & Lets.; Bordighera, Italy; PAFA; Univ. Nebraska; one-man: Whitney Studios, 1925, 1926; Brummer Gal., N.Y., 1934, 1938; Valentine Gal., 1936, 1937, 1940; Peridot Gal., N.Y., 1954, 1955, 1958, 1960, 1962, 1964; Zabriskie Gal., New York City, 1966-1969.

HARTLEY, HARRISON SMITH—Painter, I., L.
402½ Felix St. 64501; h. Route 2, Huntoon Rd., St. Joseph, Mo. 64505
B. Savannah, Mo., Nov. 9, 1888. Studied: Kansas City AI; Chicago Acad. FA; AIC; Cumming Sch. FA., Des Moines, Iowa. Member: Greater Kansas City AA (Life); AAPL (Life); Int. Inst. A. & Lets. Awards: Platte purchase award, St. Joseph, Mo.; Fellowship, Hun-

tington Hartford Fnd. Work: Watercolors in many private colls. coast to coast, also at Hax A. Center, St. Joseph, Mol; Huntington Hartford Fnd., Pacific Palisades, Cal. Exhibited: WFNY 1939; Nelson Gal. A., 1943, 1948-1950; Joslyn Mus. A., 1945-1950, 1958; NAC, 1955, 1962; Plaza A. Fair, Kansas City, 1950-1962; Holly St. Studio, Kansas City, 1955; Kansas City AI, 1957, 1958, 1960; Arizona State Fair, 1952; Greater Kansas City Exh., 1958; Burr Gal., N.Y., 1960; Lever House, N.Y., 1964; K. C. Outdoor Exh.; one-man: Springfield AA; St. Louis Barn Gal., 1949; Hax A. Center, St. Joseph, (3). Contributor watercolors to Ford Times; Adv., Illus., Sat. Eve. Post. Positions: Former Cart. with J. N. Darling, Des Moines, Iowa; A. Dir., with adv. agencies, in Chicago, Kansas City, St. Joseph and Des Moines; freelance at present.*

HARTMAN, ROBERT—Painter, E.
University of California, Berkeley, Cal. 94720; h. 1265 Mountain Blvd., Oakland, Cal. 94611
B. Sharon, Pa., Dec. 17, 1926. Studied: Univ. Arizona, B.F.A., M.A.; Colorado Springs FA Center with Woelffer, Vytlacil and Sander; BMSch. A., with William King. Member: San Francisco A. Inst. Awards: Emanuel Walter purchase prize, San Francisco A. Inst., 1966; prize, La Jolla Mus. A., 1962. Work: NCFA; Oakland Mus.; Colorado Springs FA Center; San Francisco A. Inst.; Henry Gal., Univ. Washington; Achenbach Fnd. for the Graphic Arts; Mead Corp.; Butler Inst. Am. A.; Roswell Mus.; Strom King A. Center, Mountainville, N.Y. Exhibited: "Small Paintings for Museum Collections," AFA, 1968-1970; 4th Int. "Young Artists Exhibit, America-Japan," 1967; Henry Gal., Univ. Washington, 1966; VMFA, 1966; "Art Across America," 1965-1967; Krannert Mus., 1965, and others. One-man: Bertha Schaefer Gal., New York City, 1966, 1969; Berkeley Gal., San Francisco, 1965, 1967, 1968; Comara Gal., Los Angeles, 1963, 1965; Colorado Springs FA Center, 1967; San Francisco A. Inst., 1965, 1966. Positions: Instr., A., Texas Tech. Col., Lubbock, 1955-1958; Univ. Nevada, Reno, 1958-1961; Assoc. Prof. A., Univ. California, Berkeley, 1961- .

HARTMANN, MRS. GEORG T. See Bianco, Pamela (Ruby)

HARTT, FREDERICK—Scholar
302 Furness Bldg., University of Pennsylvania, Philadelphia, Pa., 19104; h. Route 2, Box 191 Chester Springs, Pa. 19425
B. Boston, Mass., May 22, 1914. Studied: National Academy of Design; Columbia College, A.B.; Princeton University; New York University, M.A., Ph.D. Member: College Art Assn. (Bd. Dirs.) 1959-62. Awards: Knight's Cross of the Crown of Italy, Quirinal Palace, Rome, 1946; Honorary Citizenship of Florence, Palazzo Vecchio, Italy, 1946. Field of Research: Italian Renaissance Art. Author: "Florentine Art Under Fire," 1949; "Botticelli," 1952; "Giulio Romano," 1958 (2 vols); "Love in Baroque Art," 1964; "The Chapel of the Cardinal of Portugal," 1964 (with Kennedy and Corti); "Michelangelo's Paintings," 1965; many articles and reviews in art periodicals. Positions: Prof. History of Art, University of Pennsylvania, Philadelphia, Pa.*

HARTWIG, CLEO—Sculptor, T.
5 West 16th St.; h. 9 Patchin Place, New York, N.Y. 10011
B. Webberville, Mich., Oct. 20, 1911. Studied: Western Mich. Univ., A.B., M.A. (hon.); AIC; Int. Sch. A., Europe. Member: Audubon A.; S. Gld. (Exec. Bd.); NSS (Council); Arch. Lg.; NAWA (Sculpture Jury). Awards: prizes, Detroit Inst. A., 1943; NAWA, 1945, 1951, medal of honor, 1967, I. Feist prize, 1968; N.Y. Soc. Ceramic A., 1945; Audubon A., 1952; Munson-Williams-Proctor Inst., 1958; NSS, silver medal, 1969. Work: Newark Mus.; Detroit Inst. A.; Oswego (N.Y.) State Univ.; Lenox Hill Hospital, N.Y.; PAFA; Montclair A. Mus.; Mt. Holyoke Col.; Norfolk Mus. A. & Sciences; All Faiths Memorial Tower, Paramus, N.J.; Western Mich. Univ.; Continental Companies Bldg., N.Y.; S.S. United States. Exhibited: NAD, 1967, 1969; PAFA, 1958, 1960; MMA; PMA; WMAA; AIC; Phila. A. All.; Detroit Inst. A., 1958-1960; Audubon A., 1958-1969; Sculptor's Gld., 1959-1969; Nebraska AA; Denver A. Mus.; Newark A. Mus.; Montclair A. Mus.; Am. Acad. A. & Lets.; Nat. Inst. A. & Lets.; Arch. Lg., N.Y., 1962-1968; N.Y. Worlds Fair, 1964; So. Vermont A. Center, 1964-1968; NAWA, 1964-1969; NSS, 1964-1969; N.Y.C. Bd. of Educ., 1964-1969; NAC, 1968; Lamont Gal., Exeter, N.H., 1967; one-man: Sculpture Center, 1943, 1947; one-man traveling show, Canada, 1949-1950; one-man traveling show, U.S., 1965-1966. Positions: Instr. S., Montclair A. Mus., Montclair, N.J., 1945- .

HARVEY, JACQUELINE—Painter
279 Park Ave., Manhasset, L.I., N.Y. 11030
B. Lille, France, Feb. 2, 1927. Studied: with Morris Davidson; Fernand Leger and Leopold Survage, Paris; William Hayter. Work: Birla Acad. Mus., Calcutta, India, 1969, and in private colls. Exhibited: Great Neck, L.I.; Panoras Gal., 1955, 1963 (one-man); Eola Gal., Orlando, Fla., 1957 (one-man); North Shore A. Festival, 1957; Art: USA, 1958; First annual, Metropolitan Young Artists Show, N.Y.

HARVEY, ROBERT MARTIN—Painter
 3340 Folsom St., San Francisco, Cal. 94110
B. Lexington, N.C., Sept. 16, 1924. Studied: Ringling A. Sch., Sarasota, Fla.; San Francisco A. Inst. Awards: purchase prize, CGA; "Painting of the Year," Art Across America, Mead Corp. Work: Wichita A. Mus.; CGA; Hirshhorn Coll., Washington, D.C.; Western Washington State Col.; Storm King A. Center, Mountainville, N.Y.; City of San Francisco; Crown-Zellerbach Fnd., San Francisco; Mead Corp.; Lytton Savings Co., Los Angeles. Exhibited: CGA, 1963, 1967; Univ. Illinois, 1967, 1969; Butler Inst. Am. A., 1966; VMFA, 1966; SFMA, 1965; Art Across America, 1965; Atkyns Mus. FA, Kansas City, 1962; Denver Mus. A., 1962; Mus. New Mexico, Santa Fe, 1962; La Jolla Mus., 1965.

HASELTINE, JAMES—Arts Administrator, L., W., E., Gr., P.
 Washington State Arts Commission, Suite 302, 1318 Capitol Way; h. Rt. 14, Olympia, Wash. 98501
B. Portland, Ore., Nov. 7, 1924. Studied: Reed Col., Portland; Portland A. Mus. Sch. A.; AIC; BMSch. A. Awards: prizes, Portland A. Mus., 1953 (purchase); SAM, 1957, 1959; Henry Gal., 1951; AEA "Art in Architecture," Oregon, 1960; Mormon History Assn. for Best Monograph, "100 Years of Utah Painting," 1965. Work: Portland A. Mus.; Oakland Mus. A. Catalog des., Utah Advertising AA, 1963. Exhibited: BM, 1951, 1952; LC, 1950; SFMA, 1953, 1954; Northwest A., SAM, 1952, 1953, 1957, 1959; A. of Oregon, Portland A. Mus., 1951-1958. Positions: Pres., Ore. Chptr. AEA, 1953-54, Dir., 1958; Trustee, Portland AA, 1953-55, Memb. A. Com., 1953-58, Chm. Sch. Com., 1954-55; Vice-Pres., Ore. A. All., 1954-56; Nat. Dir., AEA, 1955-56; Hd. Painting Dept., Oregon Centennial Expo., 1959; Hd., Petroglyph Project, Oregon Mus. Science & Indst., 1957-59; Ed., "The Oregon Scene," 1959; Member, Portland A. Comm., 1959-61; Dir., Salt Lake A. Center, 1961-1967. Visiting Lecturer, Univ. Utah, 1964-65; 2nd Vice-Pres., 1962-63, Treas., 1963-64, Pres., 1964-1966, Western Assn. Art Museums; Member, Exec. Com., North American Assembly of State 6 Provincial Arts Agencies, 1968- ; Member, State Advisory Council for Title III, 1968- ; Exec. Dir., Washington State Arts Commission, 1967- .

HASELTINE, MAURY—Painter, E., Gr., C.
 Rt. 14, Box 750, Olympia, Wash. 98501
B. Portland, Ore., May 7, 1925. Studied: Reed Col.; Portland Mus. A. Sch.; Eastern New Mexico Univ., and with Frederick Littman. Member: AEA; Portland AA. Awards: Intermountain Print Exh., 1962; All-Utah Exh., 1964; 2nd Intermountain, 1965; Salt Lake A. Center, 1966; SW Fiesta Biennial, Santa Fe, N. Mex., 1966. Work: Salt Lake A. Center; Univ. Ore. Mus.; Snow Col., Ephriam, Utah; and in private collections. Exhibited: Portland A. Mus., 1948, 1953-1960, 1965, 1967; SAM, 1953, 1959, 1961; Wash. AA, 1958; Coos Bay A. Festival, 1957; Oregon Centennial, 1959; Northwest Pr.M., 1961; Reed College, Portland, 1961; Salt Lake A. Center, 1962-1967; Colorado Springs FA Center, 1964; Cal. PLH, 1965; Mulvane A. Center, Topeka, Kan., 1965; New York, 1966; Salem AA; Concordia Col.; Cultural Exchange Show with Bolivia, 1966, 1967; Attic Gal., 1968, 1969. One-man: Salt Lake A. Center, 1964; Utah State Univ., 1964; Plumtree Gal., Salt Lake City, 1964, 1965; Attic Gal., Seattle, Wash., 1968.

HASEN, BURT(ON)—Painter
 169 Clinton St., Brooklyn, N.Y. 11201
B. New York, N.Y., Dec. 19, 1921. Studied: ASL; Hans Hofmann Sch. FA; Academie de la Grande Chaumiere, Paris, with Zadkine. Awards: Emily Lowe Fnd. purchase award, 1952; Fulbright Grant, 1959-1960. Work: Univ. Indiana; WMA; Allentown A. Mus. Exhibited: Speed Mus. A., Louisville, Ky., 1948; Smithsonian Institution, 1948; MMA, 1952; BM, 1952; Riverside Mus., N.Y., 1954; CGA, 1959; PAFA, 1959; Kresge A. Center, 1959; Nebraska AA, 1959; Mary Washington Col. of the Univ. Va., 1961, 1962; Univ. Colorado, 1959; Sarah Lawrence Univ., 1961; Krannert Mus., Univ. Illinois, 1962; Univ. Bridgeport, 1962; Allentown Mus. A., 1963; WMAA, 1963; WAC; also, Salon de Mai, Musée d'Arte Moderne, Musee de Nancy, France; one man: Five one-man exhs. in New York and one in Paris, France. Illus: De la terre á la lune-par Jules Verne, 1959; Contes de l'inattendu, 1959; Molière, 1961; Voltaire, 1962. Positions: Co-Chairman, Instr., Fine Arts Dept., School of Visual Arts, New York, N.Y. at present.

HASKELL, DOUGLAS—Critic, W.
 1 Lexington Ave., New York, N.Y. 10010
B. Monastir, Turkey, June 27, 1899. Studied: Oberlin College, Oberlin, Ohio, A.B. Awards: Hon. D.F.A., Oberlin College, 1961; several journalistic awards; F., AIA, 1962. Work: First student magazine article on modern architecture in The New Student, 1925; Editor of "Rehousing Urban America" by Henry Wright, 1933; first regular modern architecture criticism, monthly, in Nation, 1930, and of architecture as art of working on whole environment, 1941 (in review of TVA); first book on building industry in its effect on archi-

tecture: "Building, USA," 1957 (Editor); panel member "Urban Society," Eisenhower's National Goals Commission, 1960; Member President's Council on Pennsylvania Avenue appointed by Pres. Kennedy, 1962-1964, and report editor. Positions: Managing Editor, Creative Art, 1928; Asst. Editor, contributor, senior Assoc. Editor, Architectural Record, 1929-1949; Architectural Editor, Architectural Forum, 1949-1951; Editorial Chairman, 1952-1954, Editor, 1955-1964; Adjunct Prof. Architecture, Columbia University, 1960-1963; Lecturer, Pratt Institute, Brooklyn, N.Y., 1950-1951; Critic at various schools. Board of Governors, National Arts Club, New York City, 1967- .

HASKELL, HARRY G., JR.—Collector
 1300 Market St. 19801; h. 1600 Brinckle Ave., Wilmington, Del. 19806
B. Wilmington, Del., May 27, 1921. Studied: Princeton University. Collection: Andrew Wyeth.*

HASTIE, REID—Educator, P., W., L.
 University of Minnesota, Minneapolis, Minn. 55455; h. 2115 Dudley Ave., St. Paul, Minn. 55108
B. Donora, Pa., Feb. 14, 1916. Studied: Edinboro (Pa.) State Col., B.S.; Univ. West Virginia, Morgantown, M.A.; Univ. Pittsburgh, Ph.D.; Carnegie-Mellon Univ., Pittsburgh; Harvard Univ.; Univ. Minnesota. Member: NAEA (Past Pres.); Western AA; AEA; St. Paul P. & S. Assn.; Assoc. A. Pittsburgh; NEA. Awards: purchase prize, Minneapolis Inst. A.; Distinguished Art Educator Award, NAEA (Minnesota-combined art association); Award of Merit, NAEA, 1969. Work: Minneapolis Inst. A.; Northern States Power Co.; St. Paul Nat. Bank; Minnesota Mining & Mfg. Co.; and in private colls. Co-author (with Christian Schmidt) "Encounter With Art," 1969; Ed., 64th Yearbook, "Art Education," 1965. Contributor to: Art Education Journal; Review of Experimental Research; Research Yearbook, NAEA, 1955, 1957, 1959. Lectures: to national, regional, and state art and art education associations, 1950- . Positions: Prof., Univ. Pittsburgh; Univ. Southern California; Texas Tech. Univ., Lubbock; Univ. Minnesota, at present.

HASWELL, MR. and MRS. ANTHONY—Collectors
 4406 Southern Blvd., Dayton, Ohio 45429*

HASWELL, ERNEST BRUCE—Sculptor, W., L., T.
 1404 East McMillan St., Cincinnati, Ohio 45206
B. Hardinsburg, Ky., July 25, 1889. Studied: Cincinnati A. Acad.; Academie Royale des Beaux Arts, Brussels, Belgium. Member: Cincinnati AC. Awards: prize, Academie Royale des Beaux Arts, 1912; med., Cincinnati MacDowell Soc., 1939. Work: Brookgreen Gardens, S.C.; LaCrosse, Wis.; Salina Cathedral, Kansas City; CM; mem., Springfield, Ill.; St. Paul's Cathedral, Cincinnati, Ohio; Univ. Cincinnati; Miami Univ., Oxford, Ohio; Middletown, Ohio; portrait, Princeton Univ.; etc. Exhibited: NSS. Author: "Carving as an Aid to Rehabilitation," 1946. Lectures and articles on art. Positions: Assoc. Prof., Col. App. A., Univ. Cincinnati, Ohio.*

HATCH, JOHN DAVIS—
 Museum Administrator, A. Historian
 Lenox, Mass. 01240
B. Oakland, Cal., June 14, 1907. Studied: Univ. California; Harvard Univ.; Yale Univ.; Princeton Univ. Author: "Reproductions of Paintings in the Isabella Stewart Gardner Museum"; "Painting in Canada"; "Historic Church Silver in Virginia"; "The Negro Artist Comes of Age." Positions: Dir., SAM, 1928-30; Dir. U.S. Art Projects, New England States, 1933-34; Ed., "Parnassus," 1937-39; Founder, Am. Art Depository, 1938; Asst. Dir., Isabella Stewart Gardner Mus., 1932-35; Founder, Am. Drawing Annual, 1940; Dir., Albany Inst. Hist. & Art, 1940-48; Visiting Prof., Univ. Oregon, 1948-49; Univ. California, 1949 (summer); Dir., Norfolk Mus. A. & Sc., Norfolk, Va., 1950-60. Founder, Master Drawings Association, 1962; Coordinating Advisor, Spelman College, Atlanta, Ga., 1964- .

HATCH, JOHN W(OODSUM)—Painter, E.
 Paul Creative Arts Center, University of New Hampshire; h. 28 Mill Road, Durham, N.H. 03824
B. Saugus, Mass., Nov. 1, 1919. Studied: Massachusetts College of Art; Yale Univ. Sch. FA, B.F.A., M.F.A. Member: New Hampshire AA (Pres. 1958-60); AAUP; Boston WC Soc. Awards: prizes, Currier Mus. Art award, 1949, 1953, 1958; City of Manchester (N.H.) award, 1955, 1956, 1964; New Hampshire AA, 1964; Alexander Bower award, 1958 and C.S. Payson award, 1959, Portland Mus. A. Festivals. Work: De Cordova Mus., Lincoln, Mass.; Phillips Exeter Acad.; Portland Mus. A.; Univ. New Hampshire; murals, Army Map Service Bldg., Wash. D.C.; American Red Cross, Melbourne, Australia; Kingsbury Hall, Univ. New Hampshire; St. George's Church, Durham; Memorial window, Student Union, Univ. New Hampshire; Historic Mural, The Ledges, Durham, N.H.; Tufts Univ. Exhibited: USIA exhibition, Russia, 1961; Knoxville A. Center, 1962; Centennial

Exh. of Land Grant Colleges, Kansas City, Mo., 1962; Boston A. Festival, (and juror), 1961, also, 1954, 1956, 1958, 1960; De Cordova Mus., 1962, 1964; New Hampshire AA, Currier Gal. A., 1949-1965; Siembab Gal., 1960, 1962; Shore Gal., 1966; BMFA, 1967-1969. Positions: Prof. A., University of New Hampshire, Durham, N.H. at present. Visual Arts Com., New Hampshire Comm. on the Arts.

HATCHETT, DUANE —Sculptor, E.
347 Starin Ave., Buffalo, N.Y. 14216
B. Shawnee, Okla., May 12, 1925. Studied: Oklahoma Univ., B.F.A., M.F.A. Awards: Purchase prizes, Carnegie Int., 1969; Hemisfair, San Antonio, 1968. Work: sculptural commissions, 1960-64: Boston Avenue Methodist Church and First National Bank, Tulsa, Okla.; Traders Nat. Bank, Kansas City, Mo.; AGAA; Oklahoma A. Center; Oklahoma Univ., Norman; DMFA; McNay AI, San Antonio; Aldrich Mus. Contemp. A., Ridgefield, Conn.; Ohio State Univ.; Columbus Mus. FA; Univ. Gal., Minneapolis; WMAA; Carnegie Inst.; Atlanta Corp.; Des Moines A. Center, and in private homes. Exhibited: Delgado Mus. A., 1957; AGAA, 1958; Philbrook A. Center, Tulsa, 1954-1960; Dallas Mus. Contemp. A., 1961; DMFA, 1960; Southwest Annual, Oklahoma City, 1962; Mid-America Exh., Kansas City, 1963; Arkansas A. Center, Little Rock, 1964; N.Y. World's Fair, 1965; WMAA, 1966, 1968, 1969; Univ. Illinois, 1967; Southern Illinois, 1967; Los Angeles County Mus. A., 1967 and circulated to PMA, 1967; Carnegie Int., 1967; Aldrich Mus. Contemp. A., 1968; Hemisfair, San Antonio, 1968; Univ. Minnesota, 1969; one-man: Royal Marks Gal., N.Y., 1966, 1968, 1969. Positions: Instr., Sculpture, Tulsa University, Okla., 1954-1965; Assoc. Prof., Ohio State University, Columbus, Ohio, 1964-1968; Assoc. Prof., Sculpture, Univ. N.Y. at Buffalo, 1968- .

HATFIELD, MRS. RUTH —Art dealer
Dalzell Hatfield Galleries, Ambassador Hotel, Ambassador Station, Box K, Los Angeles, Cal. 90005*

HATGIL, PAUL PETER—Educator, Des., C., S.
Art Department, University of Texas; h. 1401 Red Bud Trail, Austin, Tex. 78746
B. Manchester, N.H., Feb. 18, 1921. Studied: Mass Sch. A., Boston, B.S.; Columbia Univ., M.F.A. Member: Am. Ceramic Soc.; AAMus.; AAUP; Am. Craftsmen Council; NAEA; Texas FA Soc., Southwest Ceramic Soc.; Texas Des.-Craftsmen. Work: ceramics, sculpture, Laguna Gloria Mus., Austin, Tex.; Witte Mem. Mus.; McNay AI; mosaic sc., Rio Bldg., Austin, 1960; murals, Huston-Tillotson Col., Austin, Tex., 1961; mosaic murals, KTBC-TV, Austin, 1960; St. Paul's Lutheran Church, Austin, 1959; Texas Lutheran Col., Seguin, Tex., 1961; Design Assoc. Bldg., Dallas, 1964; Freemont Complex, Dallas, 1965; Fed. Aviation Agency, Panama Canal, 1963; Univ. Texas Business Bldg., 1962; 40 Acres Bldg., Austin, 1962; Austin Club, Texas, 1962. Exhibited: Int. Exh., Wash., D.C., 1954, 1956, 1958; Wichita, Kans., 1953-1961; Mus. FA of Houston, 1956-1958; DMFA, 1952-1961; Texas FA Assn., 1951-1961; Syracuse Mus. FA, 1956; Delgado Mus. A., 1953; Miami, Fla., 1956; Int. Exh., Mus. FA of Houston, 1956; Community Lutheran Church, Victoria, Tex., 1957; Southwest Ceramic Exh., 1960; Smithsonian Inst., 1962; Munson-Williams-Proctor Inst., 1962; America House, N.Y., 1962, 1965; Carnegie Inst., 1963; Little Rock A. Center, 1963; Senate Office Bldg., Wash. D.C., 1964; Philbrook A. Center, 1964; So. Methodist Univ. A. Gal., 1964; Hardin-Simmons Univ., 1964; Univ. Chattanooga, 1965; N.Y. World's Fair, 1965; Hemisfair Pavilion, 1968; Southwest T. Col., 1969; Int. Minerals Corp., Skokie, Ill., 1968; Southwest Regional, Ceramics, 1969; Texas Des.-Craftsmen, Houston, 1969; Sol Del Rio Gal., 1969; one-man: Southwest Craft Center, 1969; Baker Gal., Lubbock, Tex., 1960. Contributor to Ceramic Monthly; Craft Horizons; Ceramic Age; School Arts, College Arts; La Revue Moderne, Paris, magazines. Positions: Prof. A., Univ. Texas, 1951- ; Des., Cur., Univ. Museum, 1964-1967, Univ. Texas, Austin.

HATHAWAY, CALVIN S.—Museum Curator
Philadelphia Museum of Art, P.O. Box 7646, Philadelphia, Pa. 19101; h. 2601 Parkway, No. 125, Philadelphia, Pa. 19130
Studied: Princeton Univ., A.B.; Harvard Univ.; N.Y. Univ. Awards: Traveling F., Am-Scandinavian Fnd., 1935. Member: Vice-Pres., Cor. Memb. Centre International d'Etude des Textiles Anciens; AAMus.; Inter-Society Color Council; Intl. Inst. for Conservation of Artistic and Historic Works (Assoc.); Fine Arts Committee for the White House; Research Assoc., Henry Francis du Pont Winterthur Museum; F., Royal Soc. Arts, London; Museums Council of New York City (Honorary); Artists-Craftsmen of New York (Honorary). Positions: Asst., Dept. Dec. Arts, 1930, Sec. to Dir., Ed., 1931-32, in charge Dept. Dec. Art, Ed., 1932-33, PMA; Asst. Cur., 1933-34, Assoc. Cur., 1934-42, Cur., 1946-51, Dir., Cooper Union Museum, New York, N.Y., 1951-1963; R. Wistar Harvey Cur. Decorative Arts, Philadelphia Museum of Art, 1964- .

HAUBERG, MR. AND MRS. JOHN —Collectors
1101 McGilvra Blvd., E., Seattle, Wash. 98102*

HAUPT, MRS. ENID—Collector
730 Park Ave., New York, N.Y. 10021*

HAUPT, ERIK GUIDE—Portrait Painter
1 Gramercy Park, New York, N.Y. 10003; h. South Egremont, Mass. 01258
B. Cassei, Germany, Aug. 7, 1891. Studied: Maryland Inst.; & in Europe. Work: All. A. Gal.; Princeton; N.Y. Chamber of Commerce; Braniff Airlines; N.Y. Athletic Club; Yale Medical Col.; Atlanta Univ., Ga.; N.Y. Univ.; Pace Col., N.Y.; U.S. Supreme Court, Washington, D.C.; Hamilton Col.; Colgate Univ.; Middleburg Col.; Rutgers Univ.; portraits: Col. of Medicine, Pa. State Univ. Portraits in business & private colls. Exhibited: Peabody Inst., Balt., Md.; BMA; CGA; PAFA; NAD; one-man: Great Barrington, Mass.

HAUPT, THEODORE G.—Painter
161 Kaluamoo St., Kailua, Hawaii 96734
B. St. Paul, Minn., Oct. 11, 1902. Studied: Minneapolis Sch. A.; Academie Julian, Paris, France and with Andre Lhote, Paris. Member: AEA. Work: Univ. Massachusetts Mus. A.; Finch Col., N.Y.; Memorial A. Gal. of the Univ. of Buffalo. Exhibited: WMAA; PAFA; AIC; AFA traveling exh., 1966-1967; eight one-man exhs. in New York City.

HAUSMAN, FRED S.—Painter, Des., Collector
424 Old Long Ridge Road, Stamford, Conn. 06903
B. Bingen, Germany, Apr. 27, 1921. Studied: Pratt Inst., with Herschel Levitt; Ernst, Burtin; New Sch. for Social Research, with Stuart Davis; Silvermine Gld. Exhibited: Roxbury Conn., 1957; Stamford Museum, 1963, 1964, 1967; Provincetown, 1965; Norfolk Mus., 1966; Silvermine, 1966; Baltimore Mus., 1966; Univ. of Toledo, 1967; City College of New York, 1968; New York University, 1968; Columbia University, 1968. One-man: Bodley Gal., New York, 1965, 1966, 1969. Work: Emily Lowe, Miami; Evansville Mus.; Fordham University; Rutgers University; Georgia Mus., Athens; Tampa Bay Center, Fla.; Cornell University, New York. Awards: AIGA, 1958, 1959; Art Director's Cl., New York, 1961; Illustrators Cl. of New York, 1959, 1961; Type Directors Cl. of New York, 1954, 1955, 1957; AIGA 50 Best Books of the Year; Detroit Art Directors Club, 1961; Graphis Annual, 1962. Collection: 15th to 20th Century Drawings and Lithography.

HAUSMAN, DR. JEROME —Educator
New York Univ., Washington Square, New York, N.Y. 10003*

HAVARD, JAMES PINKNEY—Painter
1811 Chestnut St. 19103; h. 2030 Spruce St., Philadelphia, Pa. 19103
B. Galveston, Tex., June 29, 1937. Studied: Sam Houston State Col., B.S.; PAFA. Member: F., PAFA. Awards: Cresson Scholarship to Europe, 1964, I. J. Henry Schiedt Scholarship, 1965, Mabel Wilson Woodrow award, 1962, all Pa. Acad. Fine Arts; purchase prize, Eastern Central Drawing Exh., PMA, 1965; Wechsler prize, Cheltenham A. Center. Work: PMA and in private colls. Exhibited: Nat. Drawing Exh., American Federation of Arts, 1965; Nat. Inst. A. & Lets., 1965; PAFA, 1965; Janet Nessler Gal., N.Y., 1964; Pioneer Gal., Cooperstown, N.Y., 1964; Germantown 1st Annual Exh., PMA, 1965; Eastern Central Exh., PMA, 1965.*

HAVELOCK, CHRISTINE MITCHELL—Educator
Art Department, Vassar College, Poughkeepsie, N.Y. 12601
B. Cochrane, Ont., Canada, June 2, 1924. Studied: Univ. Toronto, B.A.; Harvard Univ. (Radcliffe), Ph.D. Member: CAA; Archaeological Inst. of America. Contributor to American Journal of Archaeology, 1964, 1965. Lectures: Ancient Art; "Archaic Renascence"; "The So-called Statue of Mausollos," Ashmolean Museum, Oxford, History of Art Dept., Yale Univ., New England Classical Assn., College Art meetings, AIA meetings. Positions: Prof., Egyptian, Greek and Roman Art, Chm., Art Dept., Vassar College, Poughkeepsie, N.Y.

HAWTHORNE, JACK GARDNER—Educator, L.
2102 North Hancock St., Philadelphia, Pa. 19122
B. Philadelphia, Pa., May 8, 1921. Studied: Phila. Mus. Col. of Art, B.A.A. in Edu.; Univ. Pennsylvania, M.S. in Edu., M.F.A. Member: NEA (Life); Easter AA; NAEA; AAUP; Pa. State Edu. Assn. Awards: PAFA, 1939; City of Philadelphia Scholarship, 1939. Contributor to Course of Study for Art Education, Commonwealth of Pennsylvania, 1951. Lectures: Art in the Public Schools; Visual and Verbal Imagery; Teaching Art, given at Villanova Univ., Phila. Mus. Col. of Art, University of the Air, WFIL-TV. Positions: T. & Supv. A., Public Schools in Pennsylvania and New Jersey, 1943-57; Registrar, Phila. Mus. Col. of Art, 1957-59; Lecturer, summer sessions, Phila. Mus. Col. of Art, 1959; Villanova Univ., 1959; Asst. Prof. of Education, Beaver College, Jenkintown, Pa. 1960-1963; Assoc. Prof. A., West Chester State Col., West Chester, Pa., at present.

HAY, DOROTHY B.(Mrs. John L.)—Painter, Et.
205 S. Woodland Dr., Tucson, Ariz. 85711
B. Red Oak, Iowa, Nov. 22, 1901. Studied: Cal. Sch. FA, B.A.; Stanford Univ.; ASL; in Paris, France, Florence, Italy; also with Eliot O'Hara, Jon Corbino, Frederic Taubes. Awards: "Woman of the Year," Arizona Daily Star, 1964. Member: Nat. Pr. Council; New Mexico P. & S. Lg.; Texas FA Assn.; El Paso A. Awards: prizes, New Mexico State Fair, 1940; Colorado State Fair, 1932; Louisiana Etching & Engraving Exh., 1942; purchase prize, Texas FA Assn., 1960; Sweepstakes prizes, El Paso Mus. Regional, 1961; Tucson A. Center, 1967; prize and artist of month, Chochise County AA, 1967; Nat. Lg. Am. Pen Women, 1968. Work: murals, La Fonda, Santa Fe, 1946; Children's murals, Bishop's Lodge, Santa Fe & Alvarado Hotel, Albuquerque, 1947; Thomason General Hospital, El Paso, 1960. Exhibited: Assoc. Am. A., and Phila. Pr. C., 1937-1939; Denver A. Mus.; Academic A., Springfield, Mass., 1957-1959; Sun Carnival, El Paso, 1958; Mus. New Mexico, Santa Fe, traveling exh., 1947-1952; Beaumont A. Mus., 1958; Texas FA Assn. circuit, 1959; Mus. FA of Houston, 1961; San Antonio A. Lg., 1961; Arizona State Fair, 1964; Albany (N.Y.) Annual Pr. Show, 1967, 1968; Southwest A. Festival, 1969. Article for Kings Feature, 1967. Founded Art Dept, Marlboro Sch. for Girls, Los Angeles, 1925.

HAY, VELMA (Messick)—Painter
133 St. Joseph Ave., Long Beach, Cal. 90803
B. Bloomington, Ill., July 14, 1912. Studied: Otis AI, Los Angeles; Chouinard AI, Los Angeles, and with Ben Messick, Emil Bisttram, Dong Kingman. Member: Long Beach AA; Cultural A. Center Assn., Long Beach; Nat. Lg. Am. Pen Women. Awards: Seton Hall Univ., 1958. Work: Seton Hall Univ. Coll. Exhibited: San Diego FA Center, 1944; Santa Monica AA, 1945; Long Beach AA, 1946, 1953-1958, 1962; Grand Central A. Gal., 1957; Nat. Lg. Am. Pen Women, 1967-1969; Nat. Artists & A. Patrons Soc., Los Angeles, 1967; Messick-Hay Gal., Long Beach, Cal., continuous showing; 2-man: Bellflower (Cal.) AA, 1955; Crocker Gal., Sacramento, 1957; Pacific Coast Cl., Long Beach, 1956, one-man 1959; North Long Beach Woman's Cl., 1959 (one-man); San Pedro AA, 1959 (one-man); Long Beach AA, 1960 (one-man); 3-man: Palos Verdes AA, 1954; Pacific Coast Cl., 1961; Lakewood Presbyterian A. Series, 1961 (2-man); Long Beach AA, 1959 (2-man); one-man: Pacific Coast Cl. Gal., Long Beach, 1968; Y.W.C.A., Long Beach, 1968; other exhs.: Duncan Vail Gal., Los A., 1956, 1961; Grumbacher traveling exh., 1958-1964; Long Beach AA, 1959-60; Riviera Gal., Fresno A. Center, 1957; Int. Festival, Long Beach, 1962; Inglewood A. Lg., 1962.

HAYDON, HAROLD—
Painter-Educator, I., Gr., L., W., Cr.
5009 Greenwood Ave., Chicago, Ill. 60615
B. Fort William, Canada, Apr. 22, 1909. Studied: Univ. Chicago, Ph.B., M.A.; AIC. Member: Chicago Soc. A.; NSMP; Gld. for Religious Architecture; AEA; AAUP. Awards: prize, Univ. Chicago, 1945. Work: Mus. Science & Indst., Chicago; mural, Pickering Col., Newmarket, Ontario, Canada; Ark cover, 1958, mosaic mural, 1968, Temple Beth Am., Chicago; Shankman Orthogenic School, Chicago, ceramic tile mural and Brick Mosaic murals (18 walls), 1965; glass mosaic mural, Temple Beth El, Gary, Ind., 1959, 1960; glass mosaic mural, St. Francis of Assisi Chapel, St. Cletus Catholic Church, LaGrange, Ill., 1963. Exhibited: United States and Canada since 1933. Author: "Great Art Treasures in America's Smaller Museums," 1967. Positions: A. in Res., Pickering Col., Canada, 1932-33; Asst. Prof. A., George Williams Col., Chicago, 1933-44; Instr., Asst. Prof. A., Univ. Chicago, Ill., 1944-48; Assoc. Prof. 1948- ; Dean of Students, 1957-59, Marshal of the Univ., 1962-1967; Dir., Midway Studios (part of Univ. Chicago Art Dept.), 1963- ; Nat. Dir., Pres., Chicago Chptr. AEA, 1951-52, 1955-58. Pres., Chicago Soc. A., 1958-1960; Pres., Renaissance Soc., Univ. Chicago, 1956-1966; A. Cr., Chicago Sun-Times, 1963- ; memb., Cultural Advisory Comm. of the Committee on Cultural Development of Chicago.

HAYES, BARTLETT HARDING, JR.—Museum Dir., E., L., W.
Addison Gallery of American Art, Phillips Academy; h. off Phillips St., Andover, Mass. 01810
B. Andover, Mass., Aug. 5, 1904. Studied: Phillips Acad.; Harvard Univ., A.B. Member: F., Am. Acad. A. & Sc.; Col. Soc. Mass.; AFA; CAA; AAMus.; Assn. A. Mus. Dir.; Mus. Assn., England; Am. Soc. Arch. Hist.; Early Am. Indst. Assn.; Eastern AA; New England Sculptors Assn.; Adult Edu. Assn.; AID. Author: "Naked Truth and Personal Vision"; "American Drawings"; TV series (NET): "Intent of Art"; AGAA monographs; "The American Line"; Co-Author: "Layman's Guide to Modern Art." Positions: Ed. Bd., John Harvard Lib., 1958-1961; Ed. Bd., Art in America, 1944- ; Co-Editor, "Artist and Advocate." Art Acq. Comm., Brandeis Univ., 1957- ; Art Comm., Smithsonian Inst., 1954- ; Art Comm., MIT, 1960- ; Dir., Print Council Am., 1956-1963; CAA, 1957, Sec., 1958-1964; Mem. Corp. Ogunquit A. Mus., 1957- ; Trustee: Soc. for Preservation of New England Antiquities, 1956-1960; AFA, 1940- ; Boston A. Festi-

val, 1952- ; BMFA, 1949- ; Old Sturbridge Village, 1950- ; member various regional and national juries; Instr. A., Phillips Acad., 1933- ; Asst. Cur., Addison Gal. of American Art, 1933-40, Dir., 1940-1969; Faculty, Am. Seminar, Salzburg, Austria, Spring, 1960; Faculty, Summer Sch., Brandeis Univ., 1960; Research Associate, Graduate School of Education, Harvard University, 1965-1968; Visiting Critic, American Academy in Rome, 1965. Consultant, U.S. Office of Ed., 1965-1969; Adviser, Dept. Edu., Massachusetts, 1968-; Trustee, St. Gaudens Memorial, 1967- ; Trustee, Amon Carter Mus., 1968- ; Member, Exec. Com., Art in Embassies Program, Dept. of State, 1966- ;

HAYES, DAVID VINCENT —Sculptor
Willard Gallery, 29 E. 72nd St., New York, N.Y. 10021
B. Hartford, Conn., Mar. 15, 1931. Studied: Ogunquit Sch. P. & S., with Robert Laurent; Univ. Notre Dame, with Rev. Antony Lauck, A.B.; Indiana Univ., with Robert Laurent, David Smith, M.F.A. Awards: prizes, New Haven Festival A., 1958-1960; Providence, R.I., 1960; Logan Medal, AIC, 1961; Fulbright Award, 1961 (post-Doctoral) Guggenheim F., 1961; Am. Acad. A. & Lets., 1965. Work: Sc., Guggenheim Mus.; MModA; Addison Gal. Am. A.; Currier Gal. A.; drawings, Wadsworth Atheneum; Carnegie Inst.; Dallas Mus. Contemp. A.; Guggenheim Mus.; screen of Parables, Catholic Transcript, 1959; Holy Spirit, Univ. Notre Dame, 1961; Indiana Univ. Exhibited: AIC, 1961; Boston A. Festival, 1960; MModA, 1959; Claude Bernard, Paris, 1960; Silvermine Gld. A., 1959; Wadsworth Atheneum, 1959, 1960, 1963; Sharon A. Festival, 1959, 1960; New Haven A. Festival, 1959, 1960; Providence A. Festival, 1960; Galerie Tedesco, 1962, Salon de la Jeune Sculpture, 1963, 1964, American Cultural Center, 1964, Musée Rodin, 1964, all Paris, France; De Cordova & Dana Mus., 1964; Carnegie Inst. 1964; one-man: Indiana Univ., 1955; Wesleyan Univ., 1958; Lyman Allyn Mus., 1959; MModA, 1959; Willard Gal., N.Y., 1961, 1964; Univ. Notre Dame, 1962; Indiana Univ., 1962; Edward W. Root A. Center, Clinton, N.Y., 1963.

HAYES, MARIAN—Educator, L.
9 Bridgman Lane, South Hadley, Mass. 01075
B. Grand Rapids, Mich., May 23, 1905. Studied: Mount Holyoke Col., B.A.; Univ. Wisconsin; N.Y. Univ., M.A.; Rockford Col.; Radcliffe Col., M.A., Ph.D.; Western Michigan State T. Col., Kalamazoo. Member: Soc. Arch. Historians; Archaeological Inst. Am.; Am. Assn. Univ. Prof.; CAA; Mediaeval Acad. Am.; Conn. Antiquarian & Landmarks Soc.; Phi Beta Kappa. Awards: F., Mt. Holyoke Col., 1928-1929; Univ. F., N.Y. Univ., 1928-1929; Carnegie Grant to Radcliffe Col., 1929-1930; & study in Europe, 1930-1931. Ford Fnd. grants, 1964, 1965; Mt. Holyoke Faculty grants, 1968, 1969. Positions: Asst., Dept. A., 1925-28; Instr., 1937-45; Asst. Prof., 1937-45; Assoc. Prof., 1945-54, Prof., 1954- , Chm. A. Dept., 1948-60, Mt. Holyoke Col., South Hadley, Mass.; Prof. on the Alumni Fnd., 1969- .

HAYES, ROBERT T.—Painter, Des.
2859 Gilna Court, Cincinnati, Ohio 45211
B. Bloomfield, Ind., Jan. 18, 1915. Studied: Miami Univ. Member: AWS; Wash. WC Soc.; Knickerbocker A.; Cincinnati A. Cl.; Cincinnati Professional A. Cl.; A. Dirs. Cl., Cincinnati; North Shore AA, Gloucester and others. Awards: Nat. Watercolor Comp., 1964; Knickerbocker A., 1964. Work: in many private and public colls. Exhibited: in more than 90 national and regional juried exhibitions including Nat. Mus., Wash., D.C.; CM; John Herron AI; Butler Inst. Am. A.; Delgado Mus. A.; J. B. Speed Mus. A.; Springfield (Mass.) Mus. A.; Dayton AI; Springfield Mus. A. (Mo.); PMA; NAD; Hoosier Salon; NAC; Birmingham Mus. A.; Dayton AI; Massillon Mus., Ohio Univ., Athens; Jersey City Mus.; Exposition Intercontinentale Monaco, 1965, 1966, and many others. Numerous one-man exhs. Positions: A. Dir., Vice-Pres., Ralph H. Jones Co., Cincinnati, Ohio.

HAYTER, STANLEY WILLIAM—Painter, Gr., T., W., L.
Studio 36 Rue Boissonait, Paris 14, France; h. 737 Washington St., New York, N.Y. 10014
B. London, England, Dec. 27, 1901. Studied: King's Col., Univ. London. Member: London Group. Awards: Chevalier de la Legion d'Honneur, France; Order of the British Empire; prize, Tokyo Print Biennale, 1960. Work: NGA; MModA; BM; CAM; AIC; SFMA; VMFA; FMA; British Mus.; Victoria & Albert Mus.; Bibliotheque Nationale; Tate Gal., London; Grenoble Mus.; Bibliotheque Royale, Brussels; Albertina Mus., Vienna. Exhibited: Carnegie Inst., 1945, 1955, 1964; WMAA, 1945; LC, 1942-1946; SAGA, 1942-1945; NAD, 1943-1946; CMA, 1946; CAM, 1944; PAFA, 1943-1946; Oslo, Norway, 1955; Salon de Mai, Paris, 1951-1965; Salon Realities Nouvelles Paris, 1957-1965; Venice Biennale, 1958; Sao Paulo, 1959; Tokyo, 1960, 1964; Univ. Kentucky; Univ. California, and in other exhs., in U.S., England, France, Germany, Switzerland, Belgium, Japan, Italy and Mexico; one-man: Howard Wise Gal., N.Y.; Esther Robles Gal., Los A.; Whitechapel Gal., London, 1957. Con-

tributor to Art News, Transformation, Graphis, Documents and other publications. Author: "New Ways of Gravure," London, 1949, London & N.Y., 1965; "About Prints," London, 1962; "Nature and Art of Motion," 1965 (N.Y.). Lectures: Slade School and Royal College of Art, London, and in many universities, colleges and art schools in U.S. Positions: Dir., Atelier 17, Paris.*

HAYWARD, PETER—Painter, S.
53033 Kam Highway, Hauula, Hawaii 96717; also, 299 W. 12th St., New York, N.Y. 10014
B. Keene, N.H., Nov. 8, 1905. Studied: Middlebury, Vt. Member: Providence A. Cl.; SC; All. A. Am.; Assn. of Honolulu Artists; Windward A. Gld., Kailua, Hawaii. Awards: Proctor Prize, NAD, 1948, 1949; Washington Square Outdoor Show, N.Y., Grand Prize, 1956-1958; European travel grant, 1959; Key West, Fla., Exh., 1954; Narcissus Festival A. Exh., Honolulu, 1962; SC; Honolulu A., 1969. Work: Rochester Mem. Mus.; Montreal Mus. A.; Denver Mus. A.; Irving Trust Co., N.Y.; Trader Vic Restaurants. U.S. Navy Combat Art, 1960, 1967; to paint aboard "Yorktown," 1968-1969 on Apollo 8 recovery. Exhibited: Audubon A., 1951; NAD, 1941, 1942, 1944, 1945-1948, 1957; Providence A. Cl.; Silvermine Gld. A., 1964; All. A. Am., 1963, 1964; AAPL, 1958-1960; Easter A. Festival, Honolulu, 1963-1968.

HAZEN, MR. and MRS. JOSEPH H.—Collectors
888 Park Ave., New York, N.Y. 10021*

HEALY, ARTHUR K(ELLY) D(AVID)—Painter, Arch., W., L.
RD #2 Middlebury, Vt. 05753
B. New York, N.Y., Oct. 15, 1902. Studied: Princeton Univ., A.B., M.F.A.; Univ. Pennsylvania; Fontainebleau Sch. FA, France, and with Eliot O'Hara. Member: Boston Soc. WC Painters; Boston Soc. Indp. A.; Baltimore WC Cl.; Wash. WC Cl.; AEA; AWS; Audubon A.; Phila. WC Cl.; Mid-Vermont AA; SC; Springfield AA; Pittsfield A. Lg.; Audubon A.; Springfield AA; No. Vermont AA; Southern Vt. A.; Yaddo Fnd. Work: Harvard Univ.; Fleming Mus. A., Burlington, Vt.; FMA; Canajoharie A. Gal.; Kansas City AI; Sweat Mem. Mus.; BMFA; AGAA; Bennington Col. Mus.; St. Petersburg, Fla., Mus. A.; New Britain Mus. A. Awards: prizes, AWS, 1936; Stockbridge AA, 1936-1938; Springfield AA, 1951; Boston Soc. Indp. A., 1952. Exhibited: AWS; Phila. WC Cl.; Boston Soc. Indp. A.; Audubon A.; Boston WC Cl.; WMAA; BM; one-man: Ferargil Gal.; Vose Gal., Boston; Margaret Brown Gal.; Grace Horne Gal.; Macbeth Gal.;. Galleria di Pincio, Rome, Italy; England and Ireland; Middlebury Col. I., "Two Journeymen Painters." Positions: Prof., Hd. A. Dept., Middlebury Col., Middlebury, Vt., 1946- .*

HEALY, MARION MAXON (Mrs. Rufus Alan)—Painter, Et., Lith.
203 Hill Top Lane, Cincinnati, Ohio 45215
B. Mobile County, Ala. Studied: Cincinnati A. Acad.; ASL; PAFA. Member: Woman's A. Cl.; Prof. A., Cincinnati; NAWA; Ohio Pr. M.; Cincinnati A. Mus. Assn.; MacDowell Soc.; Santa Cruz Valley AA. Awards: Baker prize, Wyoming Cl., 1961. Exhibited: SSAL; Loring-Andrews Gal., Cincinnati (one-man shows annually); Butler Inst. Am. A., 1957; Hoosier Salon, 1958, 1960, 1961; Dayton AI, 1958, 1959, 1960; CM, 1958, 1959, 1960; Interior Valley Comp., 1958; NAWA, 1959-1968; 3-man: Argent Gal., N.Y., 1959; Mainstreams, 1968. Lectures on Etching.

HEATON, MAURICE—Craftsman
Old Mill Rd., Valley Cottage, N.Y. 10989
B. Neuchatel, Switzerland, Apr. 2, 1900. Studied: N.Y. Ethical Culture Sch.; Stevens Inst. Tech. Member: Artist-Craftsmen of N.Y.; York State Craftsmen; Rockland Fnd.; Am. Craftsmens Council; Boston Soc. A. & Crafts. Awards: medal, Boston Soc. A. & Crafts, 1956. Work: MMA; Newark Mus. A.; Corning Glass Mus.; Cooper Union Mus. A. Exhibited: Syracuse Mus. FA, 1948, 1951, 1956, 1958; MMA, 1950-1952; Wichita AA, 1950, 1951, 1953, 1954, 1956-1961; Royal Ontario Mus., 1952; State Dept. Traveling exh., 1952; Smithsonian Inst., traveling exh., 1955; MModA traveling exh., 1952; Guggenheim Mus. A., 1952; Phila. A. All., 1951; N.Y. Soc. Ceramic A., 1949-1954; Ceramic Lg., Miami, 1954; York State Craftsmen, 1954; Hampton Gal., 1954; Assoc. Am. A., 1953, 1954; Mayo Hill Gal., 1954; NGA, 1956; Brussels World's Fair, 1958; New Delhi, India, 1959; Int. Glass exh., Corning (N.Y.) Mus., 1958-59; Int. Ceramic, Syracuse, 1958; Nordness Gal., N.Y., 1960; Art: USA, 1959; St. Paul Gal., 1959; Munson-Williams-Proctor Inst., Utica, N.Y., 1961; Albright-Knox A. Gal.; Hopkins Center A. Gal.; North Truro A. Center; Univ. Maine; Mus. Contemp. Crafts, N.Y.; Columbia Univ.; one-man: Chautauqua AA; Boston Soc. A. & Crafts; Poughkeepsie Three Arts Gal. Lectures: Glass, to art and craft organizations. Instr., Brookfield Craft Center, N.Y., 1961; glass workshop, School for American Craftsmen, Rochester; Craft Students League; Willimantic (Conn.) State College; Craft Center, Worcester, Mass.*

HEBALD, MILTON ELTING—Sculptor, C., T.
Studio: Via. orti d'Aubert 7A, Rome, Italy; h. Viale Trastevere 60, Rome, Italy
B. New York, N.Y., May 24, 1917. Studied: ASL; NAD; BAID. Member: S. Gld.; An Am. Group. Awards: prizes, Am. A. Cong., 1937; Shilling award, 1947; Brooklyn Soc. A., 1948; PAFA, 1949; Audubon A., 1949; Bronx, N.Y., Tuberculosis Hospital Comp. for Sculpture, 1952; Prix de Rome, 1955-58. Work: WMAA; PMA; Tel-Aviv Mus.; murals, USPO, Tom's River, N.J.; des., Thunderbolt Trophy, 1st Fighter Air Force; port. Comm., Am. Acad. A. & Lets., 1957; Albert Gallatin Soc. medal; sc., Airport, Puerto Rico; bronze frieze, Pan-American Terminal, Idlewild Airport, N.Y., 1959; 2 reliefs, Queens Borough Pub. Lib., Jamaica, N.Y.; Ackland Mem., Univ. North Carolina; fountain, Arkansas A. Center, Little Rock; 2 bronzes, Notre Dame Univ., bronze (purchase) PAFA; fountain group, Univ. Arizona; outdoor bronze, Johnson Fnd., Racine, Wis. Exhibited: WMAA, 1937-1945; S. Gld., 1937-1944; WFNY 1939; PMA; one-man: Schneider Gal., Rome, Italy, 1957; Nordness Gal., N.Y., 1959, 1961, 1963; Penthouse Gal., San Francisco, 1964; Mickelson's, Wash. D.C., 1964. Positions: Hd. S. Dept., Skowhegan Sch. A., Skowhegan, Me., 1951-53; Long Beach (Cal.) State Col., (summer) 1968.

HECHT, H(ENRY) HARTMAN, (JR)—
Collector, Asst. Mus. Dir., Patron, L.
Museum of African Art, 316 A St., N.E. 20002; h. Montrose Walk, 3016 R. St., N.W., Washington, D.C. 20007
B. Baltimore, Md., Mar. 12, 1937. Studied: Washington & Lee Univ., B.A.; George Washington Univ., Wash. D.C. (post-grad. work in museum administration); Corcoran Gallery of Art (special training in museum technique, with Gudmund Vigetl). Awards: John Graham Award for contribution to the Arts, Washington & Lee University, 1959. Collection: Contemporary oils, graphics and sculpture, most recent emphasis on Contemporary Sculpture. The Collection has been exhibited at: Washington & Lee Univ., 1959 (entire collection), also oils and paintings, 1963-1965; Univ. Virginia, 1963 (graphics, drawings, sculpture). Established the nucleus collection of graphics for Washington & Lee Univ., 1958 and continuing to enlarge same. Positions: Grad. Asst., April, 1962-April, 1963 and Administrative Asst., April 1963-Sept., 1963, Corcoran Gallery of Art; Asst. Dir., Museum of African Art, Washington, D.C., 1964-1966; Art Consultant for corporations; Chm., Museum Committee to select and purchase works of Contemporary Negro Artists, Mar. 1965; Chm., Art Exhibition for Capitol Hill Restoration Soc., May, 1965; Asst. for Museum Programs, National Endowment for the Arts, 1966-1968; Executive Director, Artmongers & Manufactory, Inc., 1968. (Artmongers & Manufactory is a corporation which commissions unique designs from contemporary sculptors to be produced in unlimited editions for the American art market). Lectures: Tour of Australia, New Zealand, Malaysia, The Philippines, Hong Kong, Taiwan, Japan, Thailand, Ceylon and India, lecturing on American contemporary art, sculpture and American Museum Techniques. This tour resulted in several articles on art activities in Australia and New Zealand, published in Washington International Arts Letter, May, 1964.

HEERAMANECK, NASLI M.— Collector, Patron, Art Dealer
23 E. 83rd St., New York, N.Y. 10028
B. Bombay, India, June 18, 1902. Studied: With Curators at the British Museum, Victoria and Albert Museum, London; Bibliotheque Nationale and Louvre, Paris, France, and with Ananya K. Coomaraswamy. Collection: African Art, given to the Seattle Museum of Art, Seattle, Washington; Pre-Columbian Art for South and Central Americas, given to the National Museum of Art, New Delhi, India. Specialty of Gallery: Ancient Indian and Persian Art.

HEIDEL, FREDERICK (H.)—Painter, E.
Portland State College 97207; h. 932 Northwest Summit Ave., Portland, Ore. 97210
B. Corvallis, Ore., Dec. 29, 1915. Studied: Univ. Oregon, B.S., with Andrew Vincent, David McCosh; AIC, B.F.A., with Boris Anisfeld. Member: Portland AA; Oregon A. All. Awards: Anna Louise Raymond Foreign Traveling Fellowship, AIC, 1942; prizes, Cal. WC Soc., 1947; SFMA, 1948; Oakland A. Mus., 1950; Portland A. Mus., 1952, 1954; Oregon State Fair, 1957. Work: Portland A. Mus.; murals, Lane County Court House, Eugene, Ore.; Bess Kaiser Hospital, Portland. Exhibited: Int. Print Show, 1947; MMA, 1951; DMFA, 1954; United Nations, San Francisco, 1955; Sao Paulo Biennial, 1956; Denver A. Mus., 1958; Oakland A. Mus., 1950-1955; Oregon Annuals, Portland A. Mus., 1950-1958; Cal. WC Soc., 1946-1949; SFMA, 1947, 1948, 1952; SAM, 1951, 1955-1957; Seattle World's Fair, 1962; Portland A. Mus. (one-man). Positions: Instr. A., Biarritz Am. Univ. (Army), 1945; Long Beach City Col., 1946-1949; Univ. Oregon, 1949-1953; Prof. A., Hd. A. Dept., Portland State College, Portland, Ore., 1953- . Bd. Dirs., Albina Art Center, Portland, Ore., 1965- .*

HEIL, JOSEPH H.—Painter, Gr.
46 E. 82nd St., New York, N.Y. 10028
B. Chicago, Ill., Aug. 6, 1916. Studied: ASL; Yale Univ. Sch. FA.
Award: Pennell purchase award, LC. Work: LC; and in private
colls. Exhibited: Gal. of Modern Art; NAD; MModA traveling exhi-
bition.

HEILEMANN, CHARLES OTTO—
Commercial Artist, I., Des., P., E.
95 Lexington Ave., New York, N.Y. 10016
B. Brooklyn, N.Y., May 16, 1918. Studied: Parsons Sch. Des., N.Y.,
Paris, Italy; Croydon Sch. A., England. Exhibited: Yale Univ., 1955.
Contributor illus. to: Vogue, House & Gardens, McCalls, Woman's
Day; Good Housekeeping and other national magazines. Positions:
Indst. Des., Joseph B. Platt Assoc., New York, N.Y., 1938-41;
Assoc. Prof., Chm. Dept. Interior Des., Fashion Inst. of Technology,
N.Y.

HEILOMS, MAY—Painter, L.
340 W. 28th St., New York, N.Y. 10001
B. Russia. Studied: ASL. Member: NAWA; AEA; New Jersey P. &
S.; ASL; Knickerbocker A.; Audubon A.; Nat. Soc. Painters in
Casein; N.Y. Soc. Women A.; Brooklyn Soc. A.; Silvermine Gld. A.;
Young Am. A.; Am. Painters & Sculptors; Am. Soc. Contemp. A.;
F., Royal Soc. A., London; Alabama WC Soc.; Manhattan Gal. Group;
Creative A. Assoc.; All. A. Am. Awards: prizes, med., New Jersey
P. & S., 1952-1955, 1956, 1960, 1962; AEA, 1952; Jersey City
Mus. Assn., 1950, 1951, 1958, 1959, 1963; Am. Soc. Contemp.
A., 1957, 1958, 1960, 1966, 1967, 1968; NAWA, 1954, 1958, 1960,
1961, 1963; Nat. Soc. Ptrs. in Casein, 1966, 1967; NAWA, 1966.
Work: PMA; Samuel S. Fleisher Mem. A. Fnd.; Collectors of Am.
A.; Nat. Mus., Israel; Safad State Mus.; Norfolk Mus. A. & Sciences;
Bat Yam Mus. A., Israel, and in many private colls. Exhibited:
PAFA, 1953, 1954; Jersey City Mus., 1950-1952, 1956-1965; BM,
1954,1956; Birmingham Mus. A., 1955, 1956, 1957; Tyringham Gal.
(Mass.), 1954, 1955; Silvermine Gld. A., 1954, 1955, 1956-1958,
1960; Audubon A., 1952-1965; Kaufman Gal., 1952, 1955; Long Island
A., 1949, 1950; Assoc. Gal. A., Detroit, 1955; Argent Gal., 1952,
1953; John Myers Fnd., 1953; Riverside Mus., 1953-1961; Oklahoma
City A. Center, 1969; traveling exhs. to CGA; traveling exh., Portu-
gal, Italy, Greece, Belgium, Mexico, Argentina; traveling exh. to
Canada, 1967-1969; Albright Gal. A.; CMA; DMFA; Rochester Mem.
A. Gal.; Phila. A. All.; Butler Inst. Am. A.; Denver A. Mus., and in
other museums and universities; one-man: Silvermine Gld. A., 1955;
Petite Gal., 1957; Monmouth Gld. A., 1960; Bennett Col., 1961; Hud-
son Gal., N.Y., 1968; Muhlenberg Lib., N.Y., 1969; East Central
State Mus. Ada, Okla; Cortland (N.Y.) A. Center; Paducah A. Gld.,
Kentucky; Univ. Maine; Univ. Wyoming; Fine Arts Lib., Jersey City;
Freemont (Mich.) Fnd.; Univ. Detroit, and many colleges, semi-
naries and academies. Positions: Pres., Jersey P. & S. (Hon. Life);
Treas., Manhattan Gal. Group; Dir., Nat. Soc. Painters in Casein;
Vice-Pres. Audubon A.; Dir., Am. P. & S.; Advisor to Ford Fnd.
Program in Humanities, 1958-59; Instr., Fashion Inst. Technology,
New York, N.Y.

HEINEMAN, BERNARD, JR.—Collector
1430 Broadway 10018; h. 15 Bank St., New York, N.Y. 10014
B. New York, N.Y., Nov. 29, 1923. Studied: Williams College, Wil-
liamstown, Mass., B.A. Collection: Twentieth Century American
Art, including Prendergast, Demuth, Dove, Marin, Sheeler, Tam,
Jacob Lawrence, Heliker, and Sculpture by Lachaise, Cook, Donn
Russell.

HEINZ, MR. and MRS. HENRY J., II—Collectors
450 East 52 St., New York, N.Y. 10022*

HEITLAND, W. EMERTON—Painter, I., T., L.
625 29th Ave., N., St. Petersburg, Fla. 33704
B. Superior, Wis., July 5, 1893. Studied: PAFA; ASL, and in Paris.
Member: AWS; NA; Phila. A. All.; AEA; AAPL; Phila. WC Cl.;
Audubon A.; SI; A. Gld.; St. Petersburg A. Cl.; A. Center Assn., St.
Petersburg; Fla. Gulf Coast A. Center. Awards: Cresson traveling
scholarship, PAFA, 1913, and PAFA prize, 1913; medal, A. Dirs.
Cl., N.Y., 1921; Dana Gold Medal, 1922, Dawson Medal, 1963,
PAFA; AIC, 1923, Logan Medal, 1924; Phila. WC Cl., 1925, Medal,
1954; Balto. WC Cl., 1925; Gold Medal, Phila. A. Week, 1925; Sil-
ver Medal, AWS, 1935, and Grumbacher purchase award, 1951;
AWS Gold Medal, 1955, prize, 1962, 1965; Audubon A., 1951; Gold
Medal, 1956; prize, 1958, 1963, All. A. Am.; Gold Medal, NAC,
1957; prize, Academic A., Springfield, Mass., 1961; Knickerbocker
A., 1962; St. Petersburg A. Cl., 1964. Work: BM; AIC; PMA; Lowe
Gal. A.; NAD; Columbus Gal. FA; Amherst Col.; Wash. County Mus.
FA, Hagerstown, Md.; Brooks Mem. A. Gal.; Des Moines A. Cen-
ter; AGAA; Manchester (Vt.) A. Center; Vanderpoel Coll., Chicago;
Davenport Mun. A. Gal. Represented in "Watercolor Demonstra-
ted"; "Watercolor Methods"; "Pen, Brush and Ink" Exhibited:
Rehn Gal.; Arden Gal.; Macbeth Gal.; Marie Sterner Gal.; Hudson

Walker Gal.; O'Brien Gal., Chicago; Findlay Gal., Chicago; Miami
Beach A. Center; O'Brien Gal., Arizona; Woodmere A. Gal., Phila.,
Pa.; Grand Central A. Gal.; also A. Dirs. Cl.; PAFA; Phila. WC
Cl.; Balto. WC Cl.; AWS; Audubon A.; NAC, and others. Contribu-
tor to national magazines. I., "Ambling Through Acadia." Posi-
tions: Instr. A., ASL, PAFA, PMSchIA.; Dir., Eagle's Mere A. Cen-
ter. Instr. Ptg., Wilmington Studio Group. Instr., St. Petersburg
A. Club; Belleair A. Center.*

HELCK, C. PETER—Illustrator, P., G., T.
27 West 67th St., New York, N.Y. 10023; h. Boston Corners,
R.D. 2, Millerton, N.Y. 12546
B. New York, N.Y., June 17, 1893. Studied: with George Bridgman,
Sidney Dickinson, Frank Brangwyn, Harry Wickey, Lewis Daniel.
Member: NA; AWS; Phila. WC Cl.; All. A. Am.; Audubon A.; Colum-
bia County A. Gld.; SI; A. Dir. Cl. Awards: Pennell medal, PAFA,
1936; All. A. Am. medal, 1938; Rochester Medal for Lithography,
1941; Phila. Pr. Cl., 1938, 1939; A. Dir. Cl., Detroit, 1950, 1951; A.
Dir. Cl., New York, 1931, 1936, 1941, 1944, 1951; awards in Illustra-
tion and Advertising: Harvard award, 1929; Phila. Adv. Art. Annual,
1939, 1940; Chicago A. Dir. Cl. medal, 1947; Detroit A. Dir. awards,
1950, 1952, 1953 and medals, 1946, 1954; Cleveland A. Dir., 1951;
Elected To Society of Illustrators Hall of Fame, 1968. Illus. & Adv.
A. for: Saturday Evening Post; True; Esquire; The Lamp; General
Electric; General Motors; National Steel and other industrials. Au-
thor & Illus. of historic motoring articles published in Speed Age,
Sports Car Illustrated, Antique Automobile, Bulb Horn, 1942-1958.
Author-Illus., "The Checkered Flag," limited ed. history of Auto-
mobile Racing, 1961, awarded the Society of Illustrators medal and
Byron Hull Trophy, 1962. Work: Montagu Motor Mus., Beaulieu,
England; Cunningham Automotive Mus., Costa Mesa, Cal.; Long Is-
land Auto Mus., Southampton, N.Y.; Speed Mus., Austin, Tex.; Auto-
Aviation Mus., Cleveland, Ohio; Indianapolis Speedway Mus., Speed-
way, Ind. Positions: Fndg. Faculty member, Famous Artists
Schools, Westport, Conn.; Editorial Staff, of Antique Automobile,
Bulb Horn, Automobile Quarterly.

HELD, AL—Painter
940 Broadway, New York, N.Y. 10010*

HELD, ALMA M.—Painter, T.
623 West 8th St., Waterloo, Iowa 50702
Studied: State Univ. Iowa, B.A., M.A.; NAD; Cape Cod Sch. A. Mem-
ber: Waterloo AA; AEA. Awards: prizes, Iowa State Fair (several);
North East Iowa Exhs., Cedar Falls; Iowa Television A. Show, pur-
chase, 1968. Work: Fort Dodge Pub. Schools; Y.W.C.A., Waterloo;
Logan H.S.; First Congregational Church, Waterloo. Exhibited:
Widely in the Midwest, including: Joslyn Mus. A., Omaha; Kansas
City A. Center; Memorial Union, Iowa City; Cedar Rapids Pub. Lib.;
Iowa Artists, Des Moines A. Center, 1963, 1964; Annual Waterloo
Municipal Gal., 1964, 1969; First North East Iowa Invitational Exh.,
1965; Charles MacNider Mus., Mason City, Iowa, 1968; Iowa Artists
traveling show of AEA, 1968-1969; one-man: Waterloo Recreation
Center, 1962; Allen Mem. Hospital Gallery, 1963; Black's Gal.,
Waterloo, Iowa, 1968.

HELD, JULIUS S.—Scholar, Collector
Barnard College; h. 21 Claremont Avenue, New York, N.Y.
10027
B. Mosbach, Germany, Apr. 15, 1905. Studied: Universities of
Heidelberg, Berlin, Vienna, Freiburg; Ph.D., Freiburg. Member:
Inst. for Advanced Study, Princeton; Am. Friends of the Plantin-
Moretus Mus. (Pres., 1969-). Awards: Fellow, Carnegie Corpora-
tion, 1935; Special advanced fellow, Belgian American Educational
Foundation, 1947; Fellow, Guggenheim Foundation, 1952-1953, 1966,
1967; Fulbright Fellow, 1952-1953. Author: Publications chiefly on
Flemish and Dutch art, including "Rubens in America" (with Jan-
Albert Goris), 1947; "Flemish Painting," 1956; "Rubens, Selected
Drawings," 1959; "Rembrandt and the Book of Tobit," 1965; "Rem-
brandt's Aristotle and other Rembrandt Studies," 1969, and numer-
ous articles. Collection: Old master paintings and drawings. Posi-
tions: Director, College Art Association, 1959-1964; Member, Edi-
torial Board. The Art Bulletin; The Art Quarterly; Art Consultant,
Museo de Arte, Ponce, Puerto Rico. Clark Prof. A., Williams Col.,
Williamstown, Mass., 1969- .

HELD, PHILIP—Painter, Ser., T.
Woodstock (Lake Hill), N.Y.; also, 210 W. 101st St., New York,
N.Y. 10025
B. New York, N.Y., June 2, 1920. Studied: ASL; Columbia Univ. T.
Col. Member: Woodstock AA. Awards: Kleinert Fnd. Grant, 1966.
Work: MModA circulation coll.; Univ. Massachusetts; Berkshire
Mus., Pittsfield, Mass.; PMA lending coll. and in private colls. U.S.
and abroad. Exhibited: Phila. Pr. Cl., 1957; Audubon A., 1957; Nat.
Soc. Painters in Casein, 1959; Art: USA, 1958; Riverside Mus., 1959,
1960; Albany Inst. Hist. & A., 1960-1963; PAFA 1962; Winthrop Col.,

S.C., 1963; Brown Univ., 1963; St. Paul A. Center, 1963; Fairleigh Dickinson Univ., 1964; Woodstock AA, 1964; Bridge Gal., N.Y., 1964; Kaaterskill Group and Gladstone Gal., Woodstock, N.Y.; Fontana Gal., Phila., 1962-1964; Drew Univ., Madison, N.J., 1966; Univ. Mass., 1966; Capricorn Gal., N.Y., 1967; A.G. Gal., N.Y., 1967; one-man: Berkshire Mus., Pittsfield, Mass., 1949-1967; Camino Gal., N.Y., 1960, 1962; Kaaterskill Group, Woodstock, N.Y., 1957-1960; Eggleston Gal., N.Y., 1948; Phoenix Gal., N.Y., 1964-1967; Fontana Gal., Phila., 1965-1968. Contributor to 8th ed. International Directory of Arts; Art Voices winter, 1964-65. Positions: Instr. FA, ta Scarborough Sch., N.Y.; Chm. A. Dept., Fieldston School, N.Y. at present; Exec. Bd., Woodstock AA, 1957-58, 1960-61; Chm., Woodstock AA, 1960.

HELIKER, JOHN EDWARD—Painter, E.
 865 West End Ave., New York, N.Y. 10025
B. Yonkers, N.Y., Jan. 17, 1909. Studied: ASL; & with Kimon Nicolaides, Kenneth Hayes Miller, Boardman Robinson. Member: Nat. Inst. A. & Lets. Awards: prizes, CGA, 1941; Pepsi-Cola, 1946; F., Am. Acad. in Rome, 1948; Guggenheim F., 1951; Nat. Inst. A. & Lets., 1957; Ford Fnd. purchase awards, 1959-1961; Hon. D.F.A., Colby Col., 1966; Childe Hassam Fund Purchase, Award of Merit and Prize, Am. Acad. A. & Lets., 1967. Work: CGA; WMAA; New Britain Mus.; Telfair Acad.; Walker A. Center; Univ. Nebraska; FMA; SFMA; MMA; PMA; BM; Currier Gal. A.; AIC; Colo. Springs FA Center; Encyclopaedia Britannica Coll.; Ill. Wesleyan Univ.; Univ. Illinois; Murdock Coll., Wichita A. Mus.; Univ. Miami; PAFA; Sara Roby Fnd.; Wadsworth Atheneum; Wash. Univ., St. Louis; Nelson Gal. A.; Woodward Fnd., Wash. D.C.; Speed Mus. A., Louisville; Rochester Mus. A. Munson-Williams-Proctor Inst., Utica, N.Y., and many others. Exhibited: CGA, 1941, 1943, 1945-1956, 1958, 1959; WMAA, 1941-1965; MModA.; Carnegie Inst., 1943-1945, 1963, 1964; Toledo Mus. A., 1942, 1943, 1945; VMFA, 1942; AIC, 1942, 1943, 1945; MMA, 1942; WMA, 1945, 1948, 1952; PAFA, 1945-1961; CAM, 1946; Pepsi-Cola, 1946; Maynard Walker Gal., 1938, 1941 (one-man); Kraushaar Gal., 1945, 1951, 1954, 1959, 1964, 1967, (one-man); Brussels World's Fair, 1958; Univ. Illinois, 1961, 1967; CMA , 1965, 1966; Ft. Worth A. Center, 1960, 1961, 1965; Art for Embassies, 1967; Amherst Col., 1963; Norfolk Mus., A., 1966; many others. Positions: Prof. A., Columbia Univ., 1947- .

HELIOFF, ANNE—Painter
 c/o Capricorn Gallery, 11 W. 56th St., New York, N.Y. 10019*

HELLER, BEN—Collector
 1071 Ave. of the Americas 10018; h. 151 Central Park West, New York, N.Y. 10023
B. New York, N.Y., Oct. 16, 1925. Studied: Bard College, B.A. Collection: Contemporary American Painting and Ancient, Eastern and Primitive Sculpture. Positions: Adviser, Washington Gallery of Modern Art; Past Trustee or Board Member, The International Council of the Museum of Modern Art, Friends of the Whitney Museum of American Art and the Jewish Museum, all in New York City.

HELLER, DOROTHY—Painter
 8 West 13th St., New York, N.Y. 10011
B. New York, N.Y. Studied: With Hans Hofmann. Work: Univ. California at Berkeley Mus.; Allen Mem. Mus., Oberlin Col.; Mus. Mod. A., Haifa. Exhibited: 1953-1968: Denver A. Mus.; Stable Gal., N.Y.; Galerie Prismes, Paris, France; WAC; WMAA; Allen Mem. Mus., Oberlin; Carnegie Int. Exh.; MModA traveling exh.; Wadsworth Atheneum, Hartford, Conn.; Piccadilly Gal., London; Tibor de Nagy Gal., N.Y. (and one-man, 1953); New Sch. for Social Research, N.Y.; Univ. Nebraska; East Hampton Gal., N.Y.; Pace Col.; Int. House, Denver, Colo.; Michigan State Univ.; Hunter Gal., Chattanooga, Tenn.; Akron A. Inst.; AIC; Univ. North Carolina; Ohio Univ.; Sarah Lawrence Col., N.Y.; Phoenix Gal., N.Y.; Wagner Col., and others. One-man: Galerie Facchetti, Paris; Poindexter Gal., N.Y.(2); East Hampton Gal., N.Y.

HELLER, GOLDIE (Mrs. Edward W. Greenberg)—
 Collector, Advertising
 666 Third Ave., 10017; h. 440 E. 56th St., New York, N.Y. 10022
B. Salem, Mass. Studied: Massachusetts Sch. A. Collection: Hans Hartung, Henry Botkin, Ralph Rosenborg, Byron Browne, Noel Rockmore, Andy Warhol, Fransisco Larez, José de Creeft, Jean Marie Souverbie (School of Paris), John Ross, Clare Romano, and others. Positions: Vice-President Clinton E. Frank, Inc.

HELLER, JULES—Educator, W., Gr.
 York University, Downsview, Toronto; h. 64 Admiral Rd., Toronto 5, Ont., Canada
 See Canadian Section.

HELLER, LAWRENCE J.—Collector
 1729 21st St. N.W., Washington D.C. 20009*

HELM, JOHN F., JR.—Educator, P., Gr., L., Cr.
 College of Architecture & Design, Kansas State University; h. 1841 Fairchild St., Manhattan, Kansas 66502
B. Syracuse, N.Y., Sept. 16, 1900. Studied: Syracuse Univ., B.D.; and with Charman, Sandzen. Member: Cal. Soc. Et.; Prairie WC Painters; Prairie Pr.M.; CAA. Awards: prizes, Kansas City AI, 1937; D.F.A., Bethany Col., 1951; Kansas State Fed. A., 1953; Faculty Lectureship, Kansas State Univ., 1955. Work: Kansas State Univ.; Bethany Col.; McPherson (Kan.) Sch.; Cal. State Lib.; Tulsa AA; Kansas State Fed. Women's Cl.; Derby Mus., Derby, England. Lectures: Graphic Arts; The Changing Symbol in Painting. Positions: Prof., Design, College of Arch. & Des., Kansas State Univ. Manhattan, Kans., 1924- ; Dir., Kansas State Fed. A., 1935-53; A. Ed., Kansas Magazine, 1933- ; Dir., Friends of Art, Kansas State Univ., 1934- ; Chm., Fine Arts Festivals biennially, 1949-1967; Regional Exh., biennially, 1950-1968; Sec., Delta Phi Delta, 1956-59; Chm., Rural A. Program, 1952- . Chm., Kansas State Centennial A. Comm., 1959-61; Nat. Sec.-Treas., Tau Sigma Delta, 1964- ; Exec. Sec., Kansas State Art Center Foundation, 1966- .

HENDLER, RAYMOND—Painter, S., E.
 University of Minnesota 55455; h. 1776 Humboldt Ave., S., Minneapolis, Minn. 55403
B. Philadelphia, Pa., Feb. 22, 1923. Studied: Academie Grande Chaumiere, Paris, France; Contemporary Sch. A., Brooklyn, N.Y.; Tyler Sch., Temple Univ.; PAFA; PMA Sch. A.; Graphic Sketch Club, Phila., Pa. Member: Artists Cl., N.Y. Awards: Longview Fnd. purchase prize, 1963. Work: N.Y. Univ. Coll.; WAC; Birla Acad. Mus., Calcutta, India; Univ. Notre Dame; Geigy Chemical Corp., and others. Exhibited: Since 1949- : Newark Gal. A.; Stable, Camino, Davida, March Galleries, all New York City; Universities of South Carolina, Pennsylvania, New Mexico, Manitoba; N.Y. Univ.; Stanford Univ.; Mills College, Oakland, Cal.; Cheltenham A. Center, Phila.; PAFA; Gallery of Modern Art, Montreal, Canada; Washington County Mus., Hagerstown, Md.; Calgary Allied A. Center, Alberta, Can.; A. Center of Victoria, B.C.; Massillon Mus.; Mus. Contemp. A., Houston; Minneapolis Inst. A.; Widdifield Gal., N.Y.; MModA; WAC; Musee d'Art Moderne, Galerie Huit, both Paris, France. One-man: Galerie Huit, Paris, 1951; Dubin Gal., Phila., 1952; Hendler Gal., Phila., 1953; Minneapolis Inst. A., 1959; Studio Arts Dept. Gal., Univ. Minnesota, 1969; Rose Fried Gal., New York, 1962, 1964, 1967. Positions: Dir., Hendler Galleries, Philadelphia, Pa., 1952-1954; Artist-Design-Consultant, W.S. Roberts Inc., Phila., Pa, until 1954; Instr., A., Fleischer Mem., Phila.; Minneapolis Inst. A. (A.-in-Res.); Moore Inst., A., Phila.; Minneapolis School of Art (Hd. Painting Dept.); Painting & Drawing, Parsons School of Design, N.Y.; Pratt Institute, Brooklyn, N.Y.; Instr., Dir. of First Year Program, Sch. Visual Art, N.Y.; Prof. A., Long Island Univ., Brooklyn, N.Y.; Prof. A., Univ. Minnesota, at present.

HENDRICKS, GEOFFREY—Educator, P., Gr.
 Douglass College, Rutgers University, New Brunswick, N.J. 08903; h. 331 W. 20th St., New York, N.Y. 10011
B. Littleton, N.H., July 30, 1931. Studied: Amherst Col., B.A.; Yale-Norfolk A. Sch.; CUASch.; Columbia Univ., M.A. Member: CAA; AAUP. Awards: Yale-Norfolk A. Sch. Fellowship, 1953; MacDowell Colony Fellowship, 1955; Work: Springfield A. Mus.; mural, Amherst College; MModA; MMA; N.J. State Mus., Trenton; Weatherspoon Gal., Univ. N. Carolina. Exhibited: Newark Mus., 1958, 1961, 1962, 1964, 1965, 1968; BM, 1962, 1964; Riverside Mus., N.Y., 1964, 1966; Bianchini Gal., 1965; Nelson Gal. A., Kansas City, Mo., 1965; Jacksonville A. Mus., Fla., 1966; Norfolk Mus. A. & Sciences, 1966; Inst. Contemp. A., Boston, 1966; Univ. Colorado, 1966; NCFA traveling exh., Latin America, 1966; MModA traveling exh., 1966-1968; Southern Illinois Univ., 1967; Phila. A. Council, 1967; N.J. State Mus., Trenton, 1968, 1969. One-man: Bianchini Gal., 1966; Yokyo Gal., 1968. One-man: Dartmouth Col., 1951; Amherst Col., 1953; The Putney Sch., Vermont, 1956; Douglass Col. A. Gal., 1957, 1958, 1962. "Happenings" in New York City; New Jersey; Tokyo, Japan, 1965-1969; 4th-6th Avant Garde Festivals, New York City. Positions: Assoc. Prof. A., Dept. A., Douglass College. Rutgers Univ., New Brunswick, N.J., 1967- .

HENDRICKS, JAMES (POWELL)—Painter, E.
 University of Massachusetts, Department of Art; h. 27 Van Meter Dr., Amherst, Mass. 01002
B. Little Rock, Ark., Aug. 7, 1938. Studied: Univ. Arkansas, B.A.; Univ. Iowa, M.F.A. Awards: prizes, Arkansas Festival A., 1962; Container Corp., Rock Island, Ill., 1964; Soc. Four A., Palm Beach, Fla., 1968; Purdue Univ., Lafayette, Ind., 1969. Work: Smithsonian Inst. (Nat. Air & Space Mus.); Finch Col. Mus., N.Y.; Mount Holyoke Col., South Hadley, Mass.; Univ. Massachusetts, Amherst. Exhibited: N.Y. State Univ. at Oswego, 1968; Soc. Four A., Palm Beach, 1968; Ball State Univ., Muncie, Ind., 1969; Purdue Univ., 1969; Mississippi AA, 1969; Western Washington Univ., Bellingham, 1969; Northern Illinois Univ., 1969; Krannert Mus., Univ. Illinois, Champaign, 1969; Univ. Saskatchewan, Canada, 1964; Sophia A. Center,

Tokyo, 1964; Univ. Guelph, Ontario, Canada, 1967; Arkansas A. Festival, Little Rock, 1962; Des Moines A. Center, 1963; Humboldt State Col., Arcata, Cal., 1964; Container Corp., Rock Island, Ill., 1964, and Chicago, 1969 (one-man); Hope Col., Holland, Mich., 1965; Augustana Col., Rock Island, 1966; one-man: Univ. Massachusetts, 1966; Hinckley & Brohel Gal., N.Y., 1968; Ruth White Gal., N.Y., 1968; Smithsonian Inst., Nat. Air & Space Mus., 1969. Positions: Instr., drawing, State Univ. Iowa, 1963-1964; drawing and design, Mount Holyoke Col., 1964-1965; Asst. Prof. A., 1965- , Dir., Undergraduate Programs in Art, 1967- , Univ. Massachusetts, Amherst, Mass.

HENKLE, JAMES LEE—Sculptor, Indst. Des., P., T.
 School of Art, University of Oklahoma; h. 2719 Hollywood St., Norman, Okla. 73069
B. Cedar Rapids, Iowa, Mar. 13, 1927. Studied: Univ. Nebraska, B.A.; PIASch., Certif. Indst. Des. Awards: prizes, Assn. Oklahoma A., 1954, 1955, 1956; Mrs. Allen Brooks purchase prize, Oklahoma A., 1956; purchase prize, 26th Annual, Springfield, Mo.; Purchase Award, Oklahoma A. Center, 1965. Work: Springfield (Mo.) A. Mus.; Univ. Oklahoma A. Mus.; Sc. murals, Phillips Coll. Lib., Univ. Oklahoma, 1958; Numerical Analysis Lab. Bldg., Norman, Okla., 1960; fountain & sc., First Federal Bldg., Ft. Smith, Ark., 1961; Sculptural screen, Tulsa Central Lib., 1965; sculpture, Norman Public Library entrance, 1967. Exhibited: Nat. A. Students Exh., Andover, Mass., 1949; Denver A. Mus., 1949; Southwestern Annual, Oklahoma City, 1959, 1960, and Santa Fe, 1957; Missouri Valley Exh., 1958, 1959; 5th Biennial, Omaha, Neb., 1958. Positions: Indst. Des., Dave Chapman Industrial Design Co., Chicago, Ill., 1952-53; Instr., Indst. Des., Sculpture, School of Art, Acting Dir., Museum of Art, 1962-63, University of Oklahoma, Norman, Okla.

HENNING, EDWARD B.—Museum Curator, Scholar, Writer
 The Cleveland Museum of Art, 11150 East Boulevard, Cleveland, Ohio 44106; h. 3325 Fairmount Blvd., Cleveland Heights, Ohio 44118
B. Cleveland, Ohio, Oct. 23, 1922. Studied: Western Reserve Univ., B.S., M.A.; Cleveland Inst. A.; Academie Julian, Paris, France. Member: CAA; AAMus.; Am. Soc. of Aesthetics. Author: "Paths of Abstract Art," 1960; "Fifty Years of Modern Art," 1966. Articles published in Art International, Apollo, Journal of Aesthetics and Art Criticism and others. Positions: Chm., Cleveland Soc. for Aesthetics, 1960; Guest Lecturer, Western Reserve Univ. and The Cleveland Mus. A., 1951- ; Asst. to the Director, Assoc. Cur. of Education, 1955-1959, Cur. of Contemporary Art, 1960- , The Cleveland Museum of Art, Cleveland, Ohio. Adjunct Prof. of A. Hist. & Aesthetics, Western Reserve Univ., 1968- .

HENRICKSEN, RALF CHRISTIAN—Painter, E.
 Michigan State University; h. 619 Division St., East Lansing, Mich. 48823
B. Chicago, Ill., June 22, 1907. Studied: AIC, B.F.A.; Instituto de Allende, Mexico, M.F.A. Member: F.I.A.L.; East Lansing FA Com.; Mich. Acad. Sc. A. & Lets.; AAUP. Awards: prizes, AIC, 1933; Detroit Inst. A., 1952; South Bend AA, 1957. Work: murals, U.S. Treasury Dept., 1938-41; USPO, Monroe, Mich.; Staunton, Ill. Exhibited: Pomona, Cal., 1956; AIC, 1942; Butler Inst. Am. A.; Phila. WC Soc., 1954; AIC, 1947-1957; Detroit A. Market, 1957-1969; South Bend AA, 1956, 1957; Kresge A. Center, 1960-1967; Detroit Inst. A., 1960; Grand Rapids A. Gal., 1960, 1961. Positions: Prof. Drawing & Painting, Dept. A., Michigan State University, East Lansing, Mich., 1946- .

HENRICKSON, PAUL ROBERT—Educator, P., Gr., W.
 University of Northern Iowa, Cedar Falls, Iowa 50613
B. Boston, Mass., Dec. 25, 1928. Studied: R.I.Sch.Des., B.F.A.; State T. Col., Boston, M.Ed.; and in Norway. Work: LaJolla (Cal.) A. Center. Exhibited: Providence A. Cl., 1948-1950; R.I. Lg. for A. & Crafts, 1949, 1951, 1953; Mus. New Mexico, Santa Fe, 1951, 1952; Univ. Puerto Rico, 1952; Sioux City A. Center, 1957; USIS traveling exh., Norway; North Dakota FA Festival; Retrospective exh., Gray's Gal., Escondida, Cal., 1968. Contributor to North Dakota Teacher; Teachers Guide—North Dakota, 1959; (with Paul Torrance) Studies in Art Education, NAEA, 1961; Art Education Bulletin, 1961; contributor, "Two Forms of Primitive Art in Micronesia," to "Micronesia," 1968. Positions: Instr. A., Hill & Canyon Sch. A., Santa Fe, 1951-52; Instr. & Supv. A., Tantasqua H.S., Sturbridge, Mass., 1954-56; Prof. A., Hd. A. Dept., State T. Col., Valley City, N.D., 1956-1959; Asst. Instr., A. Edu., Univ. Minnesota, 1959-60; Research Asst., Bur. Edu. Research, Univ. Minn., 1960-61; Prof. A., Radford (Va.) Col., 1961-1964; Chm., Prof. A., College of Guam, 1964-1968; Exec. Dir., Insular Arts Councils, Guam, 1966-1968; Assoc. Prof. A. Edu. and Research, Univ. Northern Iowa, Cedar Falls, at present.

HENRY, STUART (COMPTON)—Museum Director, P., Des.
 Berkshire Museum; h. 127 Appleton Ave., Pittsfield, Mass. 01201
B. Tufts College, Mass., 1906. Studied: Phillips Acad., Andover, Mass.; Harvard Col., B.S. Member: AAMus. Work: FMA, and in private colls. Exhibited: Pittsfield A. Lg.; one-man: FMA; Berkshire Mus.; Symphony Hall, Boston. Author of catalogues of exhibitions, collections, guides to collections, etc., Berkshire Mus. Positions: Dir., Berkshire Mus., Pittsfield, Mass. Trustee, Chesterwood Studio of Daniel Chester French; Trustee, Shaker Community, Inc., Hancock, Mass.; Trustee, Berkshire Museum, Pittsfield, Mass.

HENSCHE, HENRY—Painter, L., E.
 Provincetown, Mass. 02657
B. Chicago, Ill., Feb. 20, 1901. Studied: AIC; NAD; ASL; BAID; & with Hawthorne, Bellows. Member: SC. Awards: Prize, NAD, 1930. Work: Harvard Cl., N.Y.; Boston Univ.; Conn. Agricultural Col.; Mint Mus. A.; H.S., Warrenton, N.C.; Provincetown, Mass.; Kenyon Col.; Walter Chrysler, Jr., Coll.; Scottish Rite Cathedral, Ft. Wayne, Ind. Exhibited: NAD; PAFA; CGA; Carnegie Inst.; AIC; Oklahoma AA; Provincetown AA; Mint Mus. A.; Jordan-Marsh, Boston, Mass. Lectures: History of Painting, St. John A. Club, Canada, 1965; Westchester A. Cl., N.Y. Positions: Dir., Instr., Cape Cod Sch. A., Cape Cod, Mass.

HENSEL, HOPKINS—Painter
 220 Worth Ave., Palm Beach, Fla.
B. New York, N.Y., Dec. 1, 1921. Studied: Yale Univ. Work: BMFA; BMA; Toledo Mus. A.; Mus. FA of Houston; IBM Collection; Norton Gal. A., West Palm Beach, Fla. Exhibited: MMA; WMAA; CGA; PAFA; AIC; Cal.PLH; WMA; Carnegie Inst.; Univ. Illinois; one-man: Margaret Brown Gal., Boston; Grand Central Moderns; Worth Avenue Gal., Palm Beach; Palm Beach Galleries.

HENSELMAN, CASPER—Collector
 414 E. 75th St., New York, N.Y. 10021*

HERARD, MARVIN T.—Sculptor, C., E.
 1131 23rd Ave. E., Seattle, Wash. 98102
B. Puyallup, Wash., July 4, 1929. Studied: Burnley Sch. A., Seattle; Seattle Univ.; Univ. Washington, B.A.; Cranbrook Acad. A., Bloomfield Hills, Michigan, M.F.A.; Acad. FA, Florence, Italy; Fonderia Artistica Fiorentina, Florence, Italy. Member: NAEA; AAUP. Awards: prizes, Western Washington Fair, 1952, 1961 (2); Am. Craftsmen's award, Henry Gal., Univ. Washington, 1961, 1965; Renton (Wash.) Creative Arts Festival, 1963; Spokane Pacific Northwest Exh., 1963, 1964, 1966; Pacific Northwest A. & Crafts Exh., 1963, 1964; SAM, 1965. Work: sculpture, Renton Pub. Library; Seattle Univ. Lemieux Library. Exhibited: SAM, 1949, 1952, 1959, 1960, 1962, 1963, 1965-1967; State Capitol Mus., Governor's Invitational, 1967-1969; Henry Gal., Univ. Washington, 1958, 1961, 1963-1965; 1967; Frye A. Mus., Seattle, 1958, 1961, 1964, 1969; Cheney Cowles Mus., Spokane, 1963-1965, 1969; Detroit Inst. A., 1960; Mus. Contemp. Crafts, New York City, 1961; Palazzo Venezia, Rome, Italy, 1962; Cranbrook Acad. A., 1959, 1960 Positions: Instr., Seattle Publ Schs., 1956-1958; Teaching Fellowship, Sculpture, Cranbrooks Acad. A., 1959-1960; Pius XII Inst. Art, Florence, Italy, Painting, 1962; Assoc. Prof., Seattle Univ., 1960- .

HERDLE, ISABEL C.—Assistant Museum Director
 Rochester Memorial Art Gallery, 490 University Ave., Rochester, N.Y. 14607
Positions: Asst. Dir., Rochester Mem. A. Gal.

HERMAN, VIC—Painter, Cart., I., Des., W.
 R.R.1 M-25 South Lane, Montecillo-Del Mar, Cal. 92014
B. Fall River, Mass., 1919. Studied: ASL with George Bridgman; N.Y. Comm. Illus. Sch. with Lu Kimmel, N.Y.; Columbia Univ., with Edward Johnson, and Mount Sinai Hospital with Dr. Samuel J. Penchansky, N.Y. Member: SI; San Diego AI; A. Gld. Fine Arts Soc., San Diego; New Rochelle A. Soc.; Nat. Cartoonists Soc.; Chicago Press Club; Graphic A. Assn. Awards: Army Medal for creation of "Winnie the WAC," 1945 (3-page picture spread in Life magazine and 1-page in Look magazine); N.Y. City Mayor Fiorello LaGuardia citation for city posters, 1945; Direct Mail award, 1952; Citation from United Defense Fund for programs created, 1954; Nat. Cartoonists Soc. Award of Honor, 1965; New Rochelle Proclamation Art Award, 1965; San Diego 200th Anniversary Medallion, 1969. Exhibited: Am. Soc. Magazine Cartoonists Exh., 1948; Audubon Soc., 1950, 1961; Mayor's Artist of the Month, New Rochelle, 1965; Westchester Women's Club, N.Y., 1967 and many other exhibitions. One-man: New Rochelle Pub. Lib., 1958; Mexico City Foreign Correspondents Club, 1966; Syracuse Univ. (N.Y.) permanent one-man exh., 1966-; U.S. Embassy, Mexico City, 1966; Gimbels A. Gal., N.Y., 1967, 1968;

Lincoln Center, N.Y., 1967; Consejo Nacional de Turismo, Mexico City, 1967; Mexican-U.S. Inst., Guadalajara, 1967, 1968; Municipal Gal., Veracruz, Mexico, 1968; Art Collectors Gal., Beverly Hills, Cal., 1968; U.S. Consul General, Tijuana, Mexico, 1969; San Diego AI, 1969; Consul General of Mexico, Los Angeles, 1969; San Fernando Valley, 1969. Represented in "Best Cartoons of the Year" 1943-51; Sat. Eve. Post's "Laugh It Off" 1944; Sat. Eve. Post's "Funny Business" 1945; Author, Illustrator "Winnie the Wac" 1945; "Fat Boy" 1952; "Pardon My Sex Doctor" 1959; Paintings, illustrations for magazines and book publishers, and cartoons appeared from 1939-present for N.Y. Times, Saturday Evening Post, Gourmet, Colliers, Liberty, Good Housekeeping, Cosmopolitan, Life, Look. Positions: A-War Correspondent, "Army Motors Magazine"; A. Dir. "Wac News Letter"; V.-Pres., Graphic Artists Assoc. Freelance I., Cart., for advertising agencies and magazines 1939-50. President and Art Production chief, Vic Herman Productions, visual communications consultants to corporations, nationally, 1950-1960, N.Y. Paintings under joint sponsorship of U.S. and Mexican governments to further better cultural relations (1960-).

HERMANOS, MAXIME L.—Collector
30 E. 60th St. 10022; h. 970 Park Ave., New York, N.Y. 10028
B. Paris, France, June 12, 1899. Studied: Sorbonne, Paris, History of Art with Henri Focillon. Collection: Paintings from Manet to Ossorio. Positions: President, Levy Hermanos, Inc., Manila; Columbia Eastern Corp., New York.*

HEROLD, DON G.—Museum Director, L., T.
Polk Public Museum, 115 E. Walnut St. 33802; h. 307 Pueblo Trail, Lakeland, Fla. 33801
B. Brooklyn, N.Y., June 8, 1927. Studied: N.Y. State Univ., at Albany, B.A. Member: Assoc., Am. Assn. of Museums. Positions: Director, Davenport Museum, Davenport, Iowa; Director, Polk Public Museum, Lakeland, Fla., at present.

HERPST, MARTHA (JANE)—Portrait Painter, T.
118 W. Main St., Titusville, Pa.
B. Titusville, Pa. Studied: PAFA and with Wayman Adams, Edmund Greacen, Harvey Dunn at Grand Central A. Sch. Privately with Guy Pène du Bois. Member: AAPL; NAC. Work: Titusville Recreation Center; St. Benedicts' Convent, Erie, Pa.; Masonic Lodge, Woman's Cl., U.S. Marine Corps Lg., YWCA, Pitt Campus (Univ. Pittsburgh), all in Titusville, Pa.; NAC; Gannon Col., Erie, Pa. Exhibited: NAC, 1933-1965; Ogunquit AA, 1951-1953; Catherine L. Wolfe A. Cl., 1954-1963; AAPL, 1953-1965; one-man: Titusville Woman's Cl., 1963, 1969; Benson Mem. Library, 1968. Positions: Instr. A., St. Joseph's Acad. H.S., Titusville, Pa.

HERRING, MR. and MRS. H. LAWRENCE—Collectors
190 E. 72nd St., New York, N.Y. 10021*

HERRING, JAN(ET) (M.)—Painter, L., T., C.
Box 143, Clint, Texas 79836
B. Haver, Mont., May 17, 1923. Studied: Northern State T. Col., Aberdeen, S.D.; Texas Western Col., El Paso; and with Frederic Taubes, Wiltz Harrison. Awards: prizes, New York City Center, 1956; All. A. Am., 1957, 1961; Ford Fnd. Program for Artists, 1958. Work: Grumbacher Coll.; New Mexico State Univ., Las Cruces; Idaho State Univ.; Roswell Mus.; 1st Nat. Bank, Lamesa, Tex.; and others. Exhibited: New York City Center, 1956, 1957, 1960, 1961; Knickerbocker A., 1956, 1959, 1960; All. A. Am., 1957, 1961; Sun Carnival, El Paso, 1953, 1954, 1957-1960; one-man: Petite Gal., N.Y., 1957; Philbrook A. Center, 1959; Mus. New Mexico, Santa Fe, 1959; Odessa (Tex.) Col., 1959; Olivet Nazarene Col., Kankakee, Ill., 1961; Lieber Gal., Indianapolis, 1961; Burr Gal., N.Y., 1962; other one-man (1962-64)-Patio Gal., Fort Worth; Black Tulip Gal., Dallas; L'Allegro Gal., Odessa; 222 Gal., El Paso (1966-1969)-El Paso Mus. A., 1966; New Mexico State Univ., 1967; Dallas North Gals., 1967-1969; Erdon Gal., Houston, 1968; Roswell Mus. and A. Center, 1969. Lectures: Technique of Oil Painting; Portrait Painting. Positions: Instr., Oil Painting & Drawing, El Paso Mus. A.; Riadosa Summer Art Colony, 1955-59; Idaho Falls A. Colony, Idaho; Instr., Jan Herring Cloudcroft A. Colony, New Mexico.

HERRINGTON, ARTHUR W. and NELL RAY—Collectors, Patrons
4500 N. Kessler Blvd., Indianapolis, Ind. 46208
Mr. Herrington: B. England, Mar. 30, 1891; Mrs. Herrington: B. U.S.A., Sept. 4, 1891. Positions: Mr. Herrington: Endowing Trustee, Member Development Committee of the John Herron Museum; Endowing Trustee, Board Member, and Head of Fine Arts Committee of the John Herron Museum.*

HERROLD, CLIFFORD H.—Educator, C.
Art Department, University of Northern Iowa; h. 2810 Walnut St., Cedar Falls, Iowa 50613
B. Luther, Okla., Dec. 6, 1913. Studied: Oklahoma Central State College, B.A. in A. Edu.; Colorado State College, M.A. in A. Edu.; Inst. Des., Chicago; Stanford Univ., Ed. D. in A. Edu.; School for American Craftsmen, 1963. Member: AAUP; NAEA; Western AA; Iowa Des.-Craftsmen (Pres. 1969-); Art Educators of Iowa. Exhibited: Contemp. Crafts of the United States, 1962; Craftsmen of the Central States, 1962; Fiber-Clay-Metal Exh., 1962; Jewelry Invitational, Tweed Gal., 1963; Gold and Silver Show, L'Atelier Gallerie, 1964; Jewelry 1964; Des.-Craftsmen, Madison, Wis., 1964; Iowa Des.-Craftsmen, 1964, 1968, 1969; Iowa Artists, 1962-1964; Craftsmen U.S.A., 1966; one-man: L'Atelier Galerie, 1967; Univ. Iowa, 1969, and other exhibitions in prior dates.

HERRON, JASON (Miss)—Sculptor, W., L.
1525 McCollum St., Los Angeles, Cal. 90026; h. 1425 Nathan Lane, Ventura, Cal. 93003
B. Denver, Colo., Sept. 11, 1900. Studied: Stanford Univ., B.A.; Otis AI; Univ. So. California, with Merrell Gage, and with F. Tolles Chamberlin. Member: Los A. AA.; Ventura County Potters Gld.; Santa Barbara Mus. Assn. Awards: prizes, Los A. County Fair, 1934; Los A. AA.; med., Soc. for Sanity in A., 1945; Cal. AC, 1946. Work: Los A. Mus. A.; Browning Mus., London, England; South Pasadena H.S.; Belmont Sch., Los A.; Santa Monica (Cal.) H.S. Exhibited: Palace Legion Honor, 1929; NAD, 1944, 1945; CGA, 1944; Medalic A. Soc., 1938; AIC; Los A. Mus. A., 1925, 1928-1932, 1937, 1940, 1943; Cal. AC, 1926-1935, 1938, 1943, 1944; Greek Theatre, Los A., Cal., 1946-1949; San Diego FA Soc.; Santa Barbara Mus. A., 1949; Madonna Festival, Los A., 1949-1954; NAD, 1947; Pomona Fair, 1949. Positions: Sec., Civic Com. for Los A. County A. Projects, 1945-50; Bd. Gov., Los A. County AI, 1952; Acting Dir., 1952, Los A. County AI; re-appt. Bd. Gov., 1954-60, Hon. Life Memb., 1960- ; Memb. Bd. Governors, Otis A. Inst., 1960.

HERSTAND, ARNOLD—Painter, Gr., E.
The Minneapolis School of Art, 200 E. 25th St. 55404; h. 105 Westwood Drive, South, Minneapolis, Minn. 55416
B. New York, N.Y., Sept. 10, 1925. Studied: Yale Univ., B.F.A.; Columbia Univ., M.A.; ASL; Pratt Inst., Brooklyn, N.Y., and with Leger, Paris, France, and with T. Munro, Western Reserve Univ. Member: AAUP; Am. Studies Assn.; Assn. for Asian Studies; CAA; Bd. Dir., Ben and Abby Grey Fnd., St. Paul; College Art Assoc.; Nat. Assoc. Schs. of Art; Dir., Union of Independent Cols. of Art. Awards: Helen Everson Award, Everson Mus. A., Syracuse, 1963; Ford Fnd. Grant, 1957-58; Littauer Fnd. Grants, 1957-1959; Danforth Grant, 1960. Work: The Dayton Company; Northwestern Nat. Life Ins. Co. and General Mills, Inc., Minneapolis, and in numerous private collections. Exhibited: CMA, 1947; Salpeter Gal., N.Y., 1947; WMAA, 1948; Galerie Mai, Paris, 1948 and St. Placide, 1948; The Contemporaries, N.Y., 1954; Roko Gal., N.Y., 1956; Bradley Univ., 1956; SFMA, 1956; Smithsonian Inst., 1956; Silvermine Gld. A., 1958; Munson-Williams-Proctor Inst., Utica, N.Y., 1955-1962; Everson Mus. A., 1955-1962; WAC, 1964; Time-Life Center, N.Y., 1965; one-man: Colgate Univ., 1954, 1958, 1962; Carl Siembab Gal., Boston, 1959; Gallery II Camino, Rome, Italy, 1962; Cornell Univ., 1963; Minneapolis Inst. A., 1964. Contributor to Art Journal; Eastern Arts Quarterly; Journal of General Education; Art News and other publications. Lectures on Asian Art; Modern Art at numerous universities and colleges. Positions: Lecturer, City College, N.Y., 1952-54; Ford Fellow, Harvard Univ., 1957-1958; Dir., Core Program of Music and Art, Colgate Univ., 1960-1963; Assoc. Prof. A., Colgate Univ., 1954-1963; Visiting Artist, Cornell Univ., 1963.

HESKETH—Sculptor
Bluehills Studio, Kempton, Pa. 19529
B. Maine. Studied: Wellesley Col., B.A., and with John Flannagan, Ahron Ben-Schmuel. Member: AEA. Work: Ferargil Gal.; Egan Gal.; SFMA; AGAA; Atlanta Mus. A. Exhibited: Detroit Inst. A., 1946; CAM, 1946; PMA, 1940; Carnegie Inst., 1941; AIC, 1942; PAFA, 1943; MMA, 1943; DeMotte Gal.; Egan Gal.; J.B. Neumann Gal.; one-man: SFMA, 1943; SAM, 1943; Ferargil Gal. 1942, 1943, 1945; Cosmopolitan Cl., Phila., Pa., 1946; WMAA; AGAA.

HESS, EMIL JOHN—Painter, S.
130 West 10th St., New York, N.Y. 10014
B. Willock, Pa., Sept. 25, 1913. Studied: Duquesne Univ.; A. Inst., Pittsburgh; ASL; BMSch; New York Univ. Work: Root Coll.; Pa. State Mus.; MModA. Exhibited: NAD, 1950; Pa. State Mus., 1950; ASL, 1947-1950; BM, 1951; Betty Parsons Gal., N.Y., 1949-1961; Root Coll., MMA, 1953; Stable Gal., N.Y., 1954-1956; Art:USA, 1958; MModA, 1959; one-man: Betty Parsons Gal., 1951, 1952, 1968; Univ. Bridgeport, 1963. Work appeared in Life magazine, 1952, 1954.

HESS, THOMAS B.—Executive Editor, Writer, Critic
Art News 4 E. 53rd St. 10022; h. 19 Beekman Place, New York, N.Y. 10022
B. Rye, N.Y., July 14, 1920. Studied: Yale University, B.A. Author: "Abstract Painting, Background and American Phase," 1951; "Wil-

lem de Kooning," 1959, 1967, 1968; "Barnett Newman," 1969. Contributor to New York Times, Saturday Review, Encounter, Museum Journal, and other publications. Positions: Pres., Longview Foundation, Inc.; Executive Editor, Art News, New York, N.Y.

HESSE, DON—Cartoonist
St. Louis Globe-Democrat, 12th & Delmar Sts. 63101; h. 30 Hemlock Dr., Belleville, Ill. 62221
B. Belleville, Ill., Feb. 20, 1918. Studied: St. Louis School of Fine Arts, Washington Univ. Member: Nat. Cartoonists Soc.; Assn. Am. Editorial Cartoonists. Awards: Freedoms Foundation award, 1954, 1964; Christopher Award, 1955; Nat. Headliners Award, 1960; honored in Washington, D.C. by Prince Bernhard of the Netherlands for depicting the plight of Dutch flood victims, 1953. Work: LC, and in private collections of public figures. Positions: Nationally syndicated cartoonist, McNaught Syndicate, N.Y.; regular feature in Hearst Newspapers.*

HESSE, EVA—Sculptor
134 Bowery, New York, N.Y. 10013
B. Hamburg, Germany, Jan. 11, 1936. Studied: Cooper Union, N.Y.; Yale-Norfolk Summer Sch. (Fellowship); Yale Univ., B.F.A. Work: Allen Mem. Mus. A., Oberlin, Ohio; Weatherspoon Gal., Univ. North Carolina, and in private colls. Exhibited: BM, 1961; Wadsworth Atheneum, 1961; Allan Stone Gal., N.Y., 1963; Park Place Gal., N.Y., 1964; Dusseldorf Kunsthalle, 1965; Graham Gal., N.Y., 1966; Fischbach Gal., N.Y., 1966; Ithaca Col. Mus., 1967; N.Y. State Fair, Syracuse, 1967, Weatherspoon Gal., Univ. North Carolina, 1967, Lannis Mus., N.Y., 1967; Moore Col. A., Philadelphia, 1968; Milwaukee A. Center, 1968; Castelli "Warehouse" Exh., 1968; AFA traveling exh., 1968; John Gibson Gal., N.Y., 1968; Flint Inst. A., 1968; WMAA, 1968, 1969; N.J. State Mus., 1969; Inst. Contemp. A., Philadelphia, 1969; MModA, traveling exh., 1969; Kunsthalle, Berne, Switzerland, 1969; Swarthmore Col., 1969; Westmoreland County Mus., Greensburg, Pa., 1969; Finch Col. Mus., N.Y., 1967, 1969; Univ. Mal., Minneapolis, 1969; Aldrich Mus. Contemp. A., Ridgefield, Conn., 1969; Jewish Mus., N.Y., 1969. One-man: Fischbach Gal., N.Y., 1968; Galerie Ricke, Cologne, West Germany, 1969. Positions: Instr., Sch. of Visual Art, New York, N.Y., at present.

HEUSSER, ELEANORE ELIZABETH—Painter, T.
1540 York Ave., New York, N.Y. 10028
B. North Haledon, N.J. Studied: CUASch.; Columbia Univ.; and in Mexico. Awards: Fulbright F., 1952-54. Work: Newark Mus. A.; MModA. Exhibited: Cooper Union, N.Y., 1944, 1948; Columbia Univ., 1948; Kunsthistorisches Institut, Innsbruck, 1954; Konzerthaus Gal., Vienna, 1954; Prix de Rome & Fulbright Fellows Exh., Cooper Union, 1956; Duveen-Graham Gal., N.Y., 1956-57, and traveling; Kaufman Gal., N.Y., 1959, 1960; PAFA, 1959. Positions: Instr., Painting & Sculpture, Columbia Univ., N.Y., 1945-52; Instr., Y.M.-Y.W.H.A., N.Y., 1958-61; City Col., N.Y., 1960.

HEWETT, EDWARD WILSON—Painter, E.
108 North Oval Dr., Columbus, Ohio 43220
B. Los Angeles, Cal., July 12, 1926. Studied: Cincinnati A. Acad.; Univ. Louisville, B.S., M.A. Awards: Wilder Scholarship to Europe, 1949; Hite Scholarship, Univ. Louisville, 1952, 1953; Fulbright award to Italy, 1954; prizes, Interior Valley Exh., CM, 1955, and several prizes in local and regional shows. Work: Walter Chrysler, Jr. Coll.; Dayton AI; J. B. Speed Mem. Mus., and in private colls. Exhibited: CGA, 1958; Mus. A., Rhode Island Sch. Des., 1958, regional and local exhs., 1950-1961; one-man: Dayton AI; Univ. Kentucky; Ohio State Univ. A. Gal.; Il Camino Gal., Rome, and elsewhere. Positions: Asst. Prof., Painting & Drawing, Ohio State University, 1955- ; Visiting Prof. Painting, Univ. Louisville, summer 1958, 1961; Part-time Instr., Murray State College, 1952.*

HEYMAN, MR. and MRS. DAVID M.—Collectors
King St., Armonk, New York 10504*

HIBBARD, A(LDRO) T(HOMPSON)—Painter, T.
Ledgendsea Gallery, Rockport, Mass. 01966
B. Falmouth, Mass., Aug. 25, 1886. Studied: Mass. Normal A. Sch.; BMFA Sch., and with E.L. Major, De Camp, Tarbell. Member: NA; Gld. Boston A.; North Shore AA; Rockport AA; SC; All. A. Am.; 50 Am. Artists; Audubon A.; Conn. Acad. FA; New Haven Paint & Clay Cl.; AAPL; Copley Soc., Boston; Academic A., Springfield. Awards: prizes, NAD, 1921, 1927, 1931; med., PAFA, 1922, prize, 1927, 1931; Springfield A. Lg., 1931; New Haven Paint & Clay Cl., 1933, 1941; Conn. Acad. FA, 1937; GGE, 1939; Springfield Acad. A., 1958; IBM, 1940; All. A. Am., 1943, 1946; SC, 1932, 1944; Academic A., 1953, 1961, 1962, 1964; Jordan Marsh, Boston, 1938; Palm Beach A. Center, 1936; North Shore AA 1956, 1960, 1963, 1964, 1965, and prior; Shelburne Falls, Mass., 1960; Ogunquit A. Center, 1960; Am. Abrasive Co., 1961; Rockport AA, 1942, 1948, 1954, 1957, 1960, gold medal, 1964, 1966; Gold Medal of Honor, Hudson Valley AA,

1964. Academic A.A., Springfield, Mass., 1964, 1965, 1966; Am. A. Professional Lg., Boston, 1966. Work: MMA; BMFA; Portland Mus. A.; AGAA; Currier Gal. A.; Rochester Atheneum; San Diego FA Soc.; IBM; Chandler Sch. for Women; Roosevelt H.S. Phila., Pa.; Newton (Mass.) H.S.; Milton Acad.; Northampton Sch. for Girls; Vermont Acad. Biography written by John L. Cooley, "Artist in Two Worlds," 1968. Exhibited: CGA; PAFA; AIC; NAD; and many other national exhibitions throughout the U.S. Former Pres., North Shore AA, Rockport AA.

HIBEL, EDNA—Painter
180 Clark Rd., Brookline, Mass. 02146
B. Boston, Mass., Jan. 13, 1917. Studied: BMFA Sch.; and with Jacovleff, Carl Zerbe. Member: AEA. Work: BMFA; Harvard Univ.; Boston Univ.; Norton Gal. A.; Lowe Gal., Miami, Fla.; Phoenix A. Mus.; Milwaukee A. Center. Awards: prize, Boston A. Festival, 1956. Exhibited: PAFA, 1936-1938, 1941, 1943; AIC, 1942, 1943; AWS, 1946; Vose Gal., 1940-1944; Smith Gal., 1944-1946; Inst. Mod. A., Boston, 1943; Shaw Gal., 1945; John Levy Gal., N.Y., 1948-49 (one-man); DeCordova & Dana Mus., 1951, 1952, 1954; Symphony Hall, Boston; Terry AI, 1952; Vose Gal., Boston, 1954; Neptune Gal., 1955, 1957, 1958; AFA traveling exh., 1956-1958; Lee Gal., 1955; NAD, 1961; Marble Arch Gal., Miami, 1959-1964; Hall of Art, N.Y., 1958-1969; Oehlschlaeger Gal., Sarasota, Fla., 1964-65; Chicago, 1966-1969; Kenmore Gal., Phila. Pa., 1964; Harmon Gal., Naples, Fla., 1965-1969; Bednarz Gal., Los Angeles, 1967-1969; Galerie de Tours, San Francisco and Carmel, Cal., 1968, 1969; Courtney Gal., Houston, 1966-1969; Rehoboth A. Lg., 1967; The Little Gal., Philadelphia, 1966-1969; one-man: Marin Gal., Mass., 1959-1965; Galerie di Ballado, Provincetown, 1961; Main St. Gal., Rockport, 1961-1969; Brookline Pub. Lib., 1959, 1961.

HICKEN, PHILIP BURNHAM—Painter, Ser., T., L.
108 Morse St., Newton, Mass.
B. Lynn, Mass., June 27, 1910. Studied: Mass. Sch. A. Member: F., Royal Soc. A., England; Am. Color Print Soc.; Boston Soc. WC Painters; Boston Pr.M. Awards: prizes, Black Mountain (N.C.) A. Cl., 1943; Springfield, Mass., Soldier Art, 1944; New England Soldier Art, 1944; San F., Cal., 1945; Mint Mus. A., 1946; Boston Pr.M., 1949, Cambridge AA, 1953; New England Art, Boston, 1954; BM, 1958, purchase, 1959; Directors prize, Nat. Soc. Painters in Casein, 1963; Nantucket AA, 1958, 1964. Work: MMA; PMA; U.S. State Dept.; Springfield Mus. A.; Berkshire Mus.; Univ. Iowa; Am. Assn. Univ. Women; Princeton Pr. Cl.; Northfield (Mass.) Seminary; BM; BMA; Ohio Univ.; Marshall Col.; VMFA; Howard Univ.; Univ. Mississippi; Kansas State Col.; Univ. Wisconsin; Bezalel Mus., Israel; Albright A. Gal.; LC; mural, Ft. Warren, Boston; Boston Five Savings Bank, 1961. Exhibited: LC, 1944, 1946; Wichita, Kans., 1946; Pittsfield A. Lg., 1942; Mint Mus. A., 1946; BM, 1958; Nantucket AA, 1958; USIS traveling exh., France, 1956-1958; Kansas City USO, 1944; 9th Service Command exh., Cal., 1945. Positions: Instr., Harvard Grad. Sch. Des., 1950-1953; Chm. Dept. Des., 1957- ; Sch. Practical A., Boston; Chm., Dept. FA, A. Inst. of Boston, 1969- .

HICKEN, RUSSELL BRADFORD—Museum Director, E., L.
Jacksonville Art Museum; h. 1351 Nicholson Rd., Jacksonville, Fla. 32207
B. Jacksonville, Fla., Dec. 24, 1926. Studied: Florida State Univ., B.S.; grad. study, Univ. Florida. Member: AAMus.; Southeastern Mus. Conf. (Pres.); Southern A. Mus. Dirs. Assn. Positions: Taught, Duval County Adult Education (Painting, History), 1953-1957; Duncan Fletcher H.S., 1951-1957; Art History, Jacksonville University, 1957; Dir., Jacksonville Art Museum, Jacksonville, Fla., 1957-1964; Dir., Tampa Art Institute, Tampa, Fla., 1964-1967; Dir., Mint Mus. A., Charlotte, N.C., 1967-1968; Dir., Jacksonville A. Mus., Fla., 1968- .

HIGGINS, (GEORGE) EDWARD—Sculptor
R.F.D. 4, Easton, Pa. 18042
B. Gaffney, S.C., Nov. 13, 1930. Studied: Univ. North Carolina, B.A. Work: MModA; Albright A. Gal.; Chase Manhattan Bank, N.Y. Exhibited: Art: USA, 1959; PAFA; Detroit Inst. A., 1959-60; Carnegie Inst., 1961; BMFA, 1961; WMAA, 1960; MModA, 1960; Martha Jackson Gal., N.Y., 1960; Andrew Dickson White Gal., 1960; Bernard Gal., Paris, France, 1960; one-man: Leo Castelli Gal., N.Y., 1960. Positions: Instr., Sculpture, Parsons School of Design, N.Y., 1961-62.*

HIGGINS, THOMAS J., Jr. (Tom)—Cartoonist
P.O. Box 388, Gracie Station, New York, N.Y. 10028
B. Far Rockaway, N.Y., Nov. 21, 1922. Studied: Cartoonists & Illustrators Sch., N.Y., with Jack Markow, Burne Hogarth, Dan Koerner. Work: IBM. Contributor cartoons to Sat. Eve. Post; Argosy; Theatre Arts; Extension; Parade, etc. Edited: "Cartoon Markets," trade publ. for cartoonists, 1959. Publishing "The Cartoon Collector" for collectors of original cartoon art and comic strips.

HIGHTOWER, JOHN B.—Administrative Executive
New York State Council on the Arts, 250 W. 57th St., New York, N.Y. 10019; h. 333 Central Park West, New York, N.Y. 10025
B. Atlanta, Ga., May 23, 1933. Studied: Mt. Hermon School, Mass.; Yale University, B.A. Member: Buffalo FA Acad. (hon. mem.). Positions: Exec. Asst., 1963-1964, Exec. Dir., 1964- , New York State Council on the Arts, New York, N.Y. (Testimony before the Senate Special Subcommittee on Arts & Humanities, Mar., 1965, Washington, D.C.). Dir., The MacDowell Colony; U.S. Representative to the UNESCO Seminar on the Performing Arts, Canberra, Australia, May 1969. Published in Curator.

HILDEBRAND, JUNE MARY ANN—Printmaker, T., P.
229 E. 12th St., Apt. 2, New York, N.Y. 10003
B. Eureka, Cal., Nov. 2, 1930. Studied: California College of Arts and Crafts; ASL; Queens College, B.F.A.; Hochschule für Bildende Kunste, Berlin; Hunter College, N.Y., M.A.; Pratt Graphic Center, N.Y. Member: American Color Print Soc. Awards: ASL Scholarship; German Government Grant Fellowship; Walter K. Gutman Fnd. Grant; travel and exh. grant, Stuttgart and Mannheim, Germany, 1966. Work: PMA; Univ. Wisconsin; Safed Mus., Israel; Everson Mus. A.; Univ. Minnesota; N.Y. Pub. Library. Exhibited: Print Exhs.; Hunterdon, N.J., 1962; BM, 1964; Am. Color Pr. Soc., 1964, 1965; Jewish Museum N.Y, 1964; PMA, 1964; SAGA, 1965; NAD, 1963; Am. Color Pr. Soc., 1964-1969; N.Y. State Pr.M., Everson Mus., 1965; Pratt Int. Min. Pr., 1966, 1968; N.Y. State Council on the Arts, 1966; one-man: Aspects Gal., N.Y., 1962, 1963; Univ. Wisconsin, 1964; Aegis Gal, N.Y., 1964, 1965, 1966; Luz Gal., Manila, P.I., 1965; Stuttgart, 1966; Mannheim, 1966; Oneonta State Univ., 1967; Montclair (N.J.) State Col., 1968; Gotham Book Mart, N.Y., 1969. Contributor to Artists Proof magazine (graphics).

HILDEBRANDT, WILLIAM ALBERT, JR.—Painter, S., Gr., E., I.
417 Turner Rd. & Baltimore Pike, Media, Pa. 19063
B. Philadelphia, Pa., Oct. 1, 1917. Studied: Tyler Sch. FA, Temple Univ., B.F.A., B.S. in Edu., M.F.A.; Phila. Col. A. Member: Phila. A.T.Assn.; Temple Univ. Alumni Assn.; Tyler A. Sch. Alumni Assn.; Assn. Prof. Supv. of Phila. Pub. Schs.; Phila. Sch. Admin. All. Awards: prizes, Temple Univ., 1948; Tyler A. Sch. Alumni, 1950, 1965; Phila. A.T.Assn., 1949, 1950, 1959; Phila. Book Show, 1953 (for illus.); Woodmere Gal., 1966; Wallingford A. Center, 1965. Work: mural, Glencroft Baptist Church, Glenolden, Pa. Exhibited: PAFA, 1941; Temple Univ., 1946 (one-man): Woodmere A. Gal., 1943-1969; Phila. A.T.Assn., 1946-1969; Ragan Gal., 1946; DaVinci A. All., 1948-1969; PMA, 1965; Norfolk Mus., 1967; Bucknell Univ., 1967; 5-man exh., Phila. A. All., 1968; Phila. A. All., 1956; Moore Inst., 1960; Mack Gal., 1961; one-man: Symphony Assn., Radnor, Pa., 1960; Womens Univ. Cl., 1961; Friends Sch., 1950-1952; Phila. Book Show, 1953; Phila. A. All., 1962; Springfield Twp. Library, 1969. Illus., "The Keystone State," 1953; "Minnesota's Government"; "Pixie Dictionary," 1953. Positions: A. Supv., Sharon Hill, Pa., 1939-44; T., A. Supv., Upper Darby Pub. Sch., 1944-52; A. Supv., Adv. to student teachers, Tyler Sch. A., 1944-47; A. Consultant, Franklin Inst. Lab. for Research & Development, 1947-52; A. Winston Publ. Co., 1952-54; A. Supv., Phila. Pub. Schs., 1954- .

HILL, DOROTHY KENT—Museum Curator
Walters Art Gallery; h. 259 West 31st St., Baltimore, Md. 21211
B. New York, N.Y., Feb. 3, 1907. Studied: Vassar Col., A.B.; Johns Hopkins Univ., Ph.D.; Am. Sch. Classical Studies, Athens. Member: Archaeological Inst. Am.; CAA; Am. Oriental Soc.; Corresponding Member: Deutsches Archäologisches Institut; Istituto di Studi Etruschi ed Italici. Contributor to: American Journal of Archaeology; Journal of the Walters Art Gallery (Classical Archaeology.) Author: Catalogue of Classical Bronze Sculpture in the Walters Art Gallery, 1949. Lectures: Greek, Etruscan & Roman Art. Positions: Research Assoc., 1934-37; Assoc. Cur., Ancient Art, 1937-40; Cur., Ancient A., 1941- , Ed., Bulletin, 1948- , Editor of Book Reviews, American Journal of Archaeology, 1957- , Walters A. Gal., Baltimore, Md.

HILL, (JAMES) JEROME—Painter, Lith.
Cassis, Bouches du Rhone, France; also, Hotel Algonquin, 59 W. 44th St., New York, N.Y. 10036
B. St. Paul, Minn., Mar. 2, 1905. Studied: British Academy, Rome, Italy; Academie Scandinave, Paris, France. Work: murals, St. Paul Academy, 1965; windows and paintings, Church of St. Mary, Boca Grande, Fla.; work also in collections of MModA; Minneapolis Inst. A.; St. Paul A. Center. Exhibited: Salon des Tuileries, Paris, 1933, 1934; Galerie Paquereau, Paris, 1939; Santa Barbara Mus. A., 1957; Carstairs Gal., N.Y., 1961; Babcock Gal., N.Y., 1964, 1969; St. Paul A. Center, 1965.

HILL, PETER—Painter, Educator
11734 Shirley St., Omaha, Neb. 68144
B. Detroit, Mich., Nov. 29, 1933. Studied: Albion Col., A.B.; Cran-

brook Acad. A., M.F.A. Awards: Ford Fnd. grant, 1962; prizes, Nelson Gal. Art, Kansas City, Mo., 1963; Springfield, Mo., purchase award, 1964, 1968; Waterloo, Iowa, Annual; Michigan A., Detroit; John F. Kennedy Memorial Prize, Detroit, Mich.; Sears Fnd., purchase, 1967; Spiva A. Center, Joplin, Mo., purchase, 1967; Sioux City A. Center, Iowa, purchase, 1967; Work: Joslyn Mus., Omaha; Sheldon Mem. Mus., Lincoln, Neb.; Springfield (Mo.) Mus. A.; Waterloo Municipal A. Gal.; Albion Col.; Wayne State Univ., Detroit. Painting for Shaw-Walker Co., Muskegon, Mich., 1961. Exhibited: Mid-America Annual, 1959-1962, 1964; Mid-West Bi-Annual, 1959, 1961, 1963; WAC, 1962; Missouri Valley Exh., 1959, 1961-1964; Springfield Annual, 1960, 1962-1964; Nat. Invitational Exh., Burpee A. Mus., Rockford, Ill., 1965 (represented the State of Nebraska); Nebraska Centennial Exh., 1967; Watercolor:U.S.A., Springfield A. Mus., 1967; Spiva A. Center, Joplin, Mo., 1967; Sioux City A. Center, 1967; "Max 24-66" and "Max 24-69," Nat. Painting Exh., Purdue Univ., 1966-1969; Nelson A. Gal., Kansas City, Mo., 1968; CAM, 1968; Springfield (Mo.) A. Mus., 1968. Positions: Prof. A., University of Nebraska, at Omaha.

HILL, POLLY KNIPP (Mrs. George S.)—Etcher, Eng., P., I.
2233 Green Way South, St. Petersburg, Fla. 33712; s. Hill Studio, Box 82, Highlands, N.C. 28741
B. Ithaca, N.Y., Apr. 2, 1900. Studied: Univ. Illinois; Syracuse Univ., B.P. and with Carl Hawley, George Hess, Jeannette Scott. Member: Chicago Soc. Et.; Fla. Fed. A.; Cal. Pr. M.; St. Petersburg A. Cl.; SAGA; Prairie Pr. M. Awards: prizes, SAGA 1929, 1948; Brooklyn Soc. Et., 1930-1933; Fla. Fed. A., 1933, 1944, 1950; SSAL, 1943; Gulf Coast Group, 1946; Phila. Pr. Cl., 1941; Phila. Sketch Cl., 1957; Fla. A. Group, 1951; LC, 1950. Work: LC; Tel-Aviv Mus., Israel; Syracuse Mus. FA; MMA; J. B. Speed Mem. Mus. and many ports. & etchings in private colls. Commissioned to make Gift Print for Printmaker's Soc. of California, 1962. Exhibited: NAD, 1927, 1929, 1935, 1940, 1944, 1946; SAGA, 1929-1944, 1948-1961; Chicago Soc Et., 1930, 1932, 1938-1946, 1948-1956; Phila. Pr. Cl., 1930-1942; LC, 1944, 1945, 1949-50; SSAL, 1940-1946; Fla. Fed. A., 1932-1934; 1942-1945, 1948-1951; Phila. Sketch Cl., 1955-1960; Prairie Pr. M., 1953-1961; Pr. M. Soc. Calif., 1958-1961; Wash. Pr. M., 1960; one-man: Smithsonian Inst.; Ferargil Gal., 1927, 1930 Albuquerque, N.M., 1964; Boston A. Festival, 1957; 1930; Newhouse; Syracuse Mus. FA; Speed Mem. Mus.; Brooks Mem. Mus.; Clearwater Mus. A.; Dayton AI; Miami Beach A. Center; exh. of 46 etchings, R & R Robinson Gal., Naples, Fla., 1963, and others; also extensively abroad. Annually, St. Petersburg, Fla. Positions: Member, George S. Hill Studios, St. Petersburg, Fla. and in summer at Hill Studio, Box 82, Highlands, N.C.

HILLES, SUSAN MORSE (Mrs. Frederick W.)—Collector, Patron
P.O. Box 553, Old Lyme, Conn. 06371
B. Simsbury, Conn., July 4, 1905. Studied: Museum of Fine Arts School, Boston, Mass.; Amy Sacker School of Design, Boston, Mass. Awards: Doctor of Civil Laws, King's College, Halifax, Nova Scotia, 1958; Litt.D., Wheaton College, Norton, Mass., 1967. Collection: Contemporary Sculpture and Painting. Positions: Trustee, Museum of Fine Arts of Boston, 1968; Trustee, Larry Aldrich Museum, Ridgefield, Conn., 1969.

HILLSMITH, FANNIE—Painter, Et., Eng., C.
915 Second Ave., New York, N.Y. 10017
B. Boston, Mass., Mar. 13, 1911. Studied: BMFA Sch.; ASL, with Alexander Brook, Kuniyoshi, Zorach and Sloan; Atelier 17 with Stanley Hayter. Member: Berkshire AA; New Hampshire AA; AEA. Awards: prizes, Currier Gal. A., 1952; Berkshire Mus., 1956, 1957, 1958, 1964; Tour Gal. Albuquerque, N.M., 1964; Boston A. Festival, 1957; Portland Mus. A., 1958; BMFA Sch. Alumni Traveling Scholarship, 1958. Work: MModA; BMFA; Currier Gal. A.; Gallatin Coll.; N.Y. Pub. Lib.; FMA; AGAA; Fitchburg A. Mus., 1969; Newark Mus. A. Exhibited: Am. Abstract A., 1946-1958; Fed. Mod. P. & S., 1956-1958; AIC, 1947, 1948, 1954; VMFA, 1948; WMAA, 1949-1951, 1955; WAC, 1953, 1954; Solomon Guggenheim Mus., 1954; Carnegie Inst., 1955; CGA, 1955, 1957; Phila. Pr. Cl.; BM; PC, 1955; Inst. Contemp. A., Boston, 1954, 1958; Springfield Mus. A., 1954; Boston A. Festival, 1950-1954, 1956-1961; New Hampshire AA, 1952-1958; Berkshire AA, 1956, 1957, 1958, 1964; Musee Galerie, Paris, 1957; Am. Acad. A. & Lets., 1962; Univ. Nebraska, 1957; Univ. Illinois, 1955, 1957, 1959; USIS traveling exh., Europe, 1957; one-man: Norlyst Gal., 1943; Egan Gal., 1949, 1954; Peridot Gal., 1957, 1958; Colby Col., 1950; Milton Acad., 1952; Deerfield Acad., 1953; Currier Gal. A., 1954; Swetzoff Gal., Boston, 1949, 1950, 1957; de Cordova & Dana Mus., 1953; Santa Barbara Mus. A., 1956; Cornell Univ., 1964; Dayton AI, 1954. Visiting Critic, Cornell Univ., 1963-64.

HILTON, JOHN W.—Painter, W., L.
P.O. Box 14, Twentynine Palms, Cal. 92277; (summer) P.O. Box 337, Lahaina, Maui, Hawaii 96761
B. Carrington, N.D., Sept. 9, 1904. Studied: privately with Maynard

Dixon, Nicolai Fechin, Swinnerton Forsythe and others. Member: Life memb. and founding President, Twentynine Palms A. Gld.; Life memb., Laguna Beach A. Soc.; Life memb. and Fellow, Am. Inst. Fine Arts; also, Int. Inst. A. & Lets.; Memb., Salmagundi Cl., N.Y.; Grand Central A. Gals.; Cal. A. Cl.; Lahaina A. Soc.; Western Soc. of Illustrators; San Diego AI, and many others. Awards: prizes, Death Valley Forty-Niners (4); Riverside (Cal.) County Fair (5), 1953-1957; others from Greek Theatre, Los Angeles, Laguna Beach, Los A. Mus. A.; Medal of Culture, given by the Governor of Tokyo. Work: paintings in the U.S. Air Force permanent collection; (3) in U.S. National Parks; others in Arizona Botanical Gardens, Phoenix; San Diego Museum of Natural History; Tokyo City Hall; City Hall of Phoenix; large mural, Desert Magazine Bldg., Palm Desert, Cal.; and in Saddleback Inn, Santa Ana, Cal. Exhibited: Greek Theatre Exhs., Los Angeles; Los Angeles and Riverside Counties Fairs; Laguna Beach; Salmagundi Club; over 100 one-man shows nationally. Author, Illus., "Sonora Sketch Book," 1947; "This Is My Desert," reprinted from Arizona Highways and Desert Magazine in color, 1962; "Hilton Paints the Desert" folio with text and 12 full color prints, 1964; Covers in color for Cactus and Succulent Journal; National Geographic magazine. Contributor articles and illustrations to Los Angeles Times, London Times, Westways, Saturday Eve. Post, Christian Science Monitor, Desert Magazine and many others. Painting demonstrations for art clubs and on T.V.

HINKHOUSE, FOREST MELICK—Art Consultant
 The Penthouse, 899 Pine St., San Francisco, Cal. 94108
B. West Liberty, Iowa, July 7, 1925. Studied: Coe Col., A.B.; Univ. Mexico; Harvard Univ. (Fogg Mus. Research); N.Y. Univ., Inst. FA, M.A.; Univ. Madrid, Ph.D. Member: del Claustro Extraordinario, Madrid; CAA; AAMus. Author, A. Cr., Buffalo Evening News; Arizona Republic; Phoenix Gazette. Lectures: Spanish Painting; Mediaeval Art; Art of the Far East; Contemporary Art. Assembled exhs.: "Industrial Gouaches of John Hultberg," 1957; "Paintings & Portraits by Frank Mason," 1958; "Contemporary Arizona Painting," 1958; "Festival of Arts," 1958; "One Hundred Years of French Painting 1860-1960," 1961; "English Landscape Painting," 1961; Editor, "Catalogue of the Phoenix Art Museum"; "French Masterworks from the Collection of the Phoenix Art Museum." Author: "American Art Since 1850," 1968. Positions: Pub. Rel., International House Assn., New York; Asst. Prof. Albright A. Sch., Univ. Buffalo, 1956-57; Dir., Phoenix A. Mus. & Phoenix FA Assn., 1957-1967. Consultant & Advisor, Phoenix A. Mus., 1967- ; Consultant, California A. Comm., 1968- . Co-Founder of the Hinkhouse Gal., Coe Col., Cedar Rapids, Iowa, 1965; Co-Founder, Hinkhouse Coll., Melick Library, Eureka Col., Eureka, Ill., 1969.

HINMAN, CHARLES—Painter
 2 Spring St., New York, N.Y. 10012
B. Syracuse, N.Y., Dec. 29, 1932. Studied: Syracuse Univ., B.F.A.; ASL. Awards: Nagaoka (Japan) Mus. Contemp. A. Work: MModA; WMAA; Aspen (Colo.) Institute for Humanistic Studies; Chase Manhattan Bank; Allen Mem. Mus., Oberlin, Ohio; Aldrich Mus. Contemp. A., Ridgefield, Conn.; Los Angeles County Mus.; Detroit Inst. A.; American Republic Ins. Co., Des Moines, Iowa; Mus. Mod. A., Nagaoka, Japan; The 180 Beacon Coll. Contemp. A., Boston; McCrory Corp.; Pennsylvania State Univ.; Lehigh Univ.; Krannert A. Mus., Univ. Illinois; Flint Inst. A.; Boise-Cascade, Boise, Idaho; Albright-Knox A. Gal., Buffalo. Exhibited: Long Island Univ., 1966; BM, 1966; Upsala Col., East Orange, N.J., 1966; AIC, 1966; Pasadena A. Mus., 1966; Santa Barbara A. Mus., 1966; Aldrich Mus. Contemp. A., 1966; Finch Col. Mus., 1966; WMAA, 1967; Ithaca Col. Mus., 1967; Krannert A. Mus., Univ. Illinois, 1967; Galerie Stadler, Paris, 1967; Biennale de San Marino, Italy, 1967; Carnegie Int., 1967; Mus. Contemp. A., Chicago, 1968; Honolulu Acad. A., 1968; Albright-Knox A. Gal., 1968; Smithsonian traveling exh., 1968; Richard Feigen Gal., Chicago, 1968; Jewish Mus., N.Y., 1969; Richard Feigen Gal., N.Y., 1969; Herron Mus., Indianapolis, 1969; AFA, 1969; AIC, 1969; N.Y. State Univ., 1969; N.Y. State Council on the Arts, 1969. One-man: Richard Feigen Gal., N.Y., 1966, 1967; Richard Feigen Gal., Chicago, 1966; Tokyo Gal., Japan, 1966; Lincoln Center, N.Y., Retrospective, 1969.

HIOS, THEO(DORE)—Painter, Gr.
 136 W. 95th St., New York, N.Y. 10025
B. Sparta, Greece, Feb. 2, 1910. Studied: Am. A. Sch.; ASL. Member: Fed. Mod. P. & S. Awards: prize, Silvermine Gld. A., 1952; Riverside Mus., N.Y., 1961. Work: Parrish Mus. A.; Tel-Aviv Mus., Israel; North Carolina State A. Gal.; Riverside Mus.; and in private colls. Exhibited: Critics' Show, 1946; BM, 1947, 1958; Traveling exh. U.S. Marines at War, U.S. and England; Traveling exh., AFA, 1954-1956; Fed. Mod. P. & S., 1950-1965; Gld. Hall, Easthampton, N.Y., 1949-1969; Parrish Mus., 1949-1969; Audubon A., 1947; Toledo Mus. A., 1946; Rose Fried Gal., 1961; Carnegie Inst., 1961; Retrospective Exh., Harpur Col., 1961; Grand Central A. Gal., 1946; Poindexter Gal., N.Y., 1960; PAFA, 1962; Grippi-Waddell

Gal., N.Y., 1964; Long Island Univ., 1964; C. W. Post Col., 1964; MModA Lending Lib., 1964, 1966; Stendhal Gal., Los Angeles, 1964; Smithsonian Inst.; Am. Acad. A. & Lets., 1963; Riverside Mus., N.Y., 1964; Southampton Col., since 1965; one-man: Silvermine Gld. A., 1949, 1952; North Carolina State A. Gal., 1947; Weatherspoon Gal., 1947; Contemporary A. Gal., N.Y., 1946, 1947, 1950; Chase Gal., N.Y., 1957; Hudson Gld., 1949; Smolin Gal., N.Y., 1963; Parrish A. Mus., 1964; New Sch. for Social Research, N.Y., 1967, and others. Positions: A. T., Horace Mann Sch., N.Y., 1959-1964; Dalton Schs., 1964-1969; New School for Social Research, N.Y., 1964-1969.

HIRSCH, DAVID W. (DAVE)—Cartoonist
 627 2nd Ave., New York, N.Y. 10016
B. New York, N.Y., Dec. 26, 1919. Studied: Brooklyn Col.; ASL; Grand Central A. Sch.; Cartoonist & Illus. Sch. Member: Nat. Cartoonists Soc. Contributor cartoons to Sat. Eve. Post; Look; Christian Science Monitor; Argosy; American Legion Magazine; U.S. Inf. Agency Russian publication "America"; True; Ladies Home Journal; American Weekly; Sports Illustrated; Wall St. Journal; King Features Syndicate; MacNaught Syndicate.

HIRSCH, HORTENSE M. (Mrs. Walter A.)—Patron
 Hotel Pierre, 2 E. 61st St., New York, N.Y. 10021
B. Chicago, Ill., Aug. 25, 1887. Studied: Smith College, B.A.; Museum of Modern Art Classes; and privately.*

HIRSCH, JOSEPH—Painter, Lith.
 2231 Broadway 10024; h. 90 Riverside Drive, New York, N.Y. 10024
B. Philadelphia, Pa., Apr. 25, 1910. Studied: PMSchIA, and with George Luks. Member: NA; Nat. Inst. A. & Lets., 1967; Phila. WC Cl.; AEA. Awards: prizes, PAFA, 1934; F., Inst. Int. Edu., 1935, 1936; WFNY 1939; Guggenheim F., 1942-43, 1943-44; LC, 1944, 1945; Grant, Am. Acad. A. & Let., 1947; Fulbright F., 1949; MMA, 1950; AIC, 1951; gold medal, Alumni Assn. of PMSch.A., 1958; Carnegie Inst., 1947; Altman award, 1959, 1967; Ranger Fund award, 1964; Carnegie prize, 1968; NAD; purchase prize, Butler Inst. Am. A., 1964. Work: WMAA; MModA; PMA; BMFA; CGA; AGAA; LC; Univ. Arizona; Encyclopaedia Britannica; IBM; Walker A. Center; DMFA; Nelson Gal. A.; Dartmouth Univ.; Springfield Mus. A.; Am. Acad. A. & Lets.; Chrysler Corp.; Brown Univ.; Utah State Agricultural Col.; Univ. Oklahoma; Univ. Georgia; Mus. Military History, Wash., D.C.; MMA; Univ. Southern Illinois; Johnson Collection, Racine, Wis.; murals, Benjamin Franklin H.S., Phila., Pa.; Amalgamated Clothing Workers Bldg., Phila., Pa.; Phila. Mun. Court Bldg.; Documentary Paintings, U.S. Govt. Exhibited: nationally since 1934. Positions: Instr., Art Students League, New York, N.Y.; Instr., Painting, Seminar, Univ. Utah, 1959 (June, July). Visiting Artist, Dartmouth Col., 1966.

HIRSCH, RICHARD TELLER—Museum Curator, W., L.
 The Michener Collection, University of Texas 78712; h. 301 Westhaven Dr., Austin, Tex. 78746
B. Denver, Colo., Sept. 12, 1914. Studied: Ecole du Louvre, Atelier de la Grande Chaumier, Institut d'Art Contemporain, Paris, France. Member: AAMus.; AFA; CAA; Am. Soc. for Aesthetics. Awards: Museology Study Grant, Samuel H. Kress Foundation, 1967. Contributor to Art News; Arts magazine; Art International; conducted nationally syndicated weekly newspaper column on art, 1960-1962. Lectures on Art History. Museum exhibitions arranged: Four Centuries of Still Life, 1959; Great Periods of Tapestry, 1960; The World of Benjamin West, 1962; James A. Michener Foundation Collection, 1963, 1965; Charles Sheeler Retrospective, 1963; Arms and Armor, 1964; 17th Century Painters of Haarlem, 1965; The History of Glass, 1966; Charles Dent Collection of Bronzes, 1967; Eugène Carrière, Seer of the Real, 1968. Positions: Publisher of Graphics, Paris, 1937-1939, 1945-1946; Art Critic, Palm Beach Times, 1954-1956; Director, Pensacola Art Center, 1956-1959; Director, Allentown Art Museum, Allentown, Pa., 1959-1968; Special Curator, The Michener Collection, University of Texas at Austin, 1968- .

HIRSCH, WILLARD—Sculptor, T.
 2 Queen St.; h. 207 Broad St., Charleston, S.C. 29401
B. Charleston, S.C., Nov. 19, 1905. Studied: Col. of Charleston; BAID; NAD. Member: AEA; South Carolina A. Gld. Awards: prizes, South Carolina A. Gld., 1951, 1955. Work: Lincoln Hospital, New York; IBM; Columbia (S.C.) Mus. A.; relief, Nat. Guard Armories throughout South Carolina; Clemson Col.; Richland County Pub. Lib., Col. S.C.; Home Fed. Savings & Loan Co. and American Mutual Fire Ins. Co.; Charleston County Lib.; Charleston City Hall; First Coml. Bank, Charleston County, S.C. (murals); "Justice," Toombs County Courthouse, Lyons, Ga.; Gibbes A. Gal.; Columbia (S.C.) Mus. A.; Woodsdale Temple, Wheeling, W.Va.; Florence (S.C.) Mus.; South Carolina Arts Commission Coll., 1969, and work in private homes. Exhibited: Syracuse Mus. FA, 1948; NAD, 1935, 1942; PAFA, 1942,

1952; Fairmount Park, Phila., 1949; WMAA, 1950; Wichita AA, 1949; South Carolina A., Gibbes A. Gal., 1947-1952; one-man: Columbia Mus. A., 1952; Gibbes A. Gal., 1943, 1945, 1946, 1951; Telfair Acad., 1953; Florence (S.C.) Mus. A., 1954; Mint Mus. A., Charlotte, N.C., 1957; Clemson College, 1960; Erskine College, 1960. Positions: Instr., S., Charleston A. Sch., Charleston, S.C.

HIRSCHFELD, ALBERT—Caricaturist, I., W., Gr.
 122 East 95th St., New York, N.Y. 10028
B. St. Louis, Mo., June 21, 1903. Studied: NAD; London County Council; ASL. Work: MMA; FMA; N.Y. Pub. Lib.; Mus. City of New York; CAM; BM; Musee d'Art Populaire Juif, Paris; Habima Mus., Israel; MMod.A.; Davenport Municipal A. Mus.; Roosevelt Mem., Hyde Park, N.Y.; Baseball Mus., Cooperstown, N.Y.; WMAA; CAM; murals, Fifth Avenue Playhouse, N.Y.; Eden Roc Hotel, Miami, Fla.; Manhattan Playbill Room; American Pavilion, World's Fair, Brussels, 1958. Exhibited: nationally and internationally. Author, I., "The American Theater As Seen by Hirschfeld," 1961; "Manhattan Oases," 1932; "Harlem," 1941; "Show Business is No Business," 1951; Author, Cart., I., to N.Y. Times; Holiday; Life magazines. Positions: Theatre Caricaturist, New York Times, 1926- . U.S. State Dept. Specialist for Graphic Art in South America, 1960.

HIRSCHL, NORMAN—Art Dealer
 Hirschl & Adler Galleries, 21 E. 67th St., New York, N.Y. 10021*

HIRSHHORN, JOSEPH H.—Collector
 277 Park Ave., New York, N.Y. 10017; h. "Round Hill," John St., Greenwich, Conn. 06833
B. Latvia, Aug. 11, 1899. Collection: American and European 20th century painting; Sculpture from antiquity to the present. Positions: Trustee, Friends of the Whitney Museum; Trustee, Archives of American Art, 1957-1965; Trustee, Washington University, Washington, D.C.; Trustee, Palm Springs Museum, Palm Springs, Cal.

HITCHCOCK, HENRY-RUSSELL—Historian, Cr.
 152 E. 62nd St., New York, N.Y. 10021
B. Boston, Mass., June 3, 1903. Studied: Harvard Col., A.B.; Harvard Grad. Sch., M.A. Member: Am. Soc. Arch. Hist. Awards: F., Harvard Univ., 1924-1925; Carnegie traveling F., 1928-1929; Guggenheim F., 1945-1946; Soc. Arch. Hist. Book Award, 1955; CAA Book Award, 1958; Am. Council of Learned Societies prize, 1961. Author: "In the Nature of Materials, the Buildings of Frank Lloyd Wright," 1942, 2nd ed. 1969; "Early Victorian Architecture in Britain," 1954; "Architecture: 19th and 20th Centuries," 1958, 3rd ed. 1969; "Rococo Architecture in Southern Germany," 1969, & many other books on architecture. Contributor to: Journals, bulletins, newspapers & magazines, with articles & reviews of art & architecture. Lectures at univ., col., & museums. Positions: Asst. Prof. A., Vassar Col., 1927-28; Asst. Prof. A., 1929-40, Assoc. Prof. A., 1940- , Wesleyan Univ., Middletown, Conn.; L., MIT, 1946-1949; Yale Univ., 1951-52; Prof. A., Smith Col., 1948-1968, Sophia Smith Prof., 1961-1968; Dir., Smith Col. Mus. A., 1949-55; Pres. Soc. Arch. Hist., 1952-54; Hon. Corresponding Member, Royal Inst. British Arch., 1950- ; Pres. Victorian Soc., 1969- ; Franklin Fellow Royal Soc. Arts, London, England; Prof., N.Y. Univ. Inst. of Fine Arts, 1969- .

HIXON, WILLIAM—Educator, P.
 Univ. of Washington, Seattle, Wash. 98122*

HNIZDOVSKY, JACQUES—Painter, Eng.
 5270 Post Rd., Riverdale, N.Y. 10471
B. Ukraine, Jan. 27, 1915. Studied: Acad. FA, Warsaw, and in Zagreb, Yugoslavia. Member: Audubon A.; Boston Printmakers; SAGA. Awards: prizes, Minneapolis Inst. A., 1950; purchase award, Butler Inst. Am. A., 1960; purchase award, Assoc. Am. A., 1959; BMFA, 1961; Tiffany Fnd. Grant, 1961; McDowell Colony Fellowship, 1963. Work: PMA; BMFA; CMA; Norfolk Mus. A. & Sciences; universities of Minnesota, North Dakota, Southern Illinois Univ.; Minneapolis Inst. A.; LC; Butler Inst. Am. A.; NCFA; The White House; AGAA; Wesleyan Univ., Middletown, Conn.; Nelson Rockefeller Coll., and others. Exhibited: Univ. Illinois, 1959, 1961; NAD, 1960; AIC, 1961; Butler Inst. Am. A., 1959-1961; Audubon A., 1959-1961; All. A. Am., 1958, 1959; New England Exh., 1960; Overseas Exh. Contemp. Graphic A., 1960-1962; Le Salon des Artistes Français, Paris, 1957; PAFA, 1963, 1965; Contemp. American Graphic Arts, USSR, 1964; Contemp. Am. Gr. Arts, Tokyo, 1967; traveling one-man show, Fine Prints Soc., 1966-1968; one-man: Lumley-Cuzalet, London, 1969. Illus., catalog for Fine Prints Soc.; "Poems of John Keats," 1964; "Poems of Samuel Taylor Coleridge," 1967.

HOBBIE, LUCILLE—Painter, Lith., T.
 Talmadge Road, Mendham, N.J. 07945
B. Boonton, N.J., June 14, 1915. Member: AWS; New Jersey WC

Soc.; Assoc. A. of New Jersey; Nat. Soc. A. & Lets.; Hunterdon A. Center. Awards: prizes, Montclair A. Mus., 1951, 1952, 1953; Seton Hall Univ., 1954; NAC, 1958; Newark A. Cl., 1954; Irvington Mus., 1951, 1952; New Jersey WC Soc., 1956, 1960; silver medal, New Jersey WC Soc., 1958, silver medal, 1963; South Orange-Maplewood Gal., 1960. Work: Montclair A. Mus.; Prudential Life Ins. Co.; Williamsburg Fnd., Va.; Newark Pub. Lib. Illus., "A Calendar for Dinah," 1966; "Ecliptics," 1969. Exhibited: NAD, 1956; Audubon A., 1953, 1955, 1957, Trenton State Mus., 1956; Montclair A. Mus., 1947, 1950-1953, 1956, 1958; NAC, 1958; Seton Hall Univ., 1954, 1956, 1958; Nat. Soc. Painters in Casein, 1956, 1958; Jersey City Mus., 1948, 1949; Irvington Mus. A., 1947-1949; Riverside Mus., 1951; Newark A. Cl.; New Jersey WC Soc.; Knickerbocker A.; AAPL; Catherine L. Wolfe A. Cl.; Brickstore Mus., Kennebunk, Me., 1968; Butler Inst. Am. A., Youngstown, Ohio, 1968, and others. Positions: Admin. Asst., Newark School Fine & Indst. Arts, Newark, N.J., 1962- .

HOBSON, KATHERINE THAYER—Sculptor
 27 West 67th St., New York, N.Y. 10023
B. Denver, Colo., April 11, 1889. Studied: ASL, and in Europe; sculpture with Walter Sintenis, Dresden. Member: NSS; All. A. Am.; Arch. Lg.; Hudson Valley AA; Pen & Brush Cl.; AAPL. Awards: prizes, All. A. Am., 1968; AAPL, 1967; Wolfe A. Cl., 1968; Hudson Valley AA, 1968. Work: statues, Bahnhofsplatz, Gottingen; Univ. Konigsberg and Gottingen; Sch. Tech., Dresden; Univ. Lib., Gottingen; St. James Church, New York, N.Y. Exhibited: Salon des Artistes Francaises, Paris, 1914; NAD, 1942-1944, 1949-1961, 1966-1969; All. A. Am., 1946, 1949-1961, 1966-1969; Audubon A., 1945, 1952; NAWA, 1944-1950; Pen & Brush Cl., 1947-1961; Princeton, N.J., 1933; Cooperstown, N.Y., 1948-1951, 1968; NSS, 1950-1952, 1954, 1958, 1960, 1961; AAPL, 1966-1969; Hudson Valley AA, 1966-1969; Wolfe A. Cl., 1954-1960, 1966-1969; Knickerbocker A., 1959, 1960; Belmont, N.Y.; Racing Mus., Saratoga, N.Y.; Thoroughbred Racing Assn., 1968. Lectures on Roman, Greek, Renaissance and Gothic Sculpture. Positions: Sec. FA Federation, New York, N.Y., 1952-1969.

HOCKNEY, DAVID—Lithographer
 c/o Tamarind Lithography Workshop, Tamarind Ave., Hollywood, Cal. 90028*

HODGE, G. STUART—Museum Director, Cur., P., Et.
 Flint Institute of Arts, 1120 East Kearsley St.,48503; h. 1619 Woodlawn Park Dr., Flint Mich. 48504
B. Worcester, Mass. Studied: Yale Sch. FA, B.F.A.; Cranbrook Acad. A., M.F.A.; State Univ. Iowa, Ph.D. Member: CAA; AAMus; AFA. Positions: Dir., Flint Institute of Arts; Cur., Flint Bd. of Edu. Art Collections, De Water's Art Center, Flint, Mich.

HODGELL, ROBERT OVERMAN—
 Printmaker, E., P., I., C., Des.
 Florida Presbyterian College, St. Petersburg, Fla. 33733
B. Mankato, Kans., July 14, 1922. Studied: Univ. Wisconsin, B.S., M.S.; Dartmouth Col.; State Univ. of Iowa; Univ. Illinois; Universidad Michoacana, Mexico; and with John Steuart Curry. Member: SAGA; Soc. Typographic A.; AIGA; Fla. A. Group; Fla. Craftsmen. Work: Joslyn A. Mus.; Dartmouth Col.; Wisconsin Union; Topeka A. Gld.; Kansas State T. Col.; Kansas State Univ.; LC; Des Moines A. Center; Rochester Mem. A. Gal.; MMA. Positions: A.-in-Res. & Instr., Des Moines A. Center, Des Moines, Iowa, 1949-53; Asst. A. Dir., in charge of Illus., "Our Wonderful World," Champaign, Ill., 1953-56; A. Dir., Editorial & Communication Services, Ext. Div., Univ. Wisconsin, Madison, Wis., 1957-59; Freelance Artist, 1959-1962; Book Illus. for UNESCO in Pakistan, 1961. Asst. Prof. A., Florida Presbyterian College, St. Petersburg, Fla., 1962-1967, A.-in-Res., 1967- .

HOFF, MARGO—Painter
 218 E. 12th St., New York, N.Y. 10003
B. Tulsa, Okla., June 14, 1912. Awards: Logan Medal, and Campana, Armstrong and Brower awards, all AIC; PMA purchase prize; WMAA purchase prize. Exhibited: AFA; Birmingham Mus. A.; BM, 1968 and prior; Cal.PLH; DMFA; Denver Mus. A.; Mus. FA of Houston; MMA; PAFA, WMAA and others. one-man: AIC; Saidenberg Gal., N.Y., 1955; Wildenstein, Paris, 1955; Barone Gal., N.Y., 1957; Obelisk Gal., Wash. D.C., 1960; Banfer Gal., N.Y., 1962-1964, 1966-1968; Fairweather Hardin Gal., Chicago; Akron AI, 1950; Beirut, Lebanon, 1953; SFMA; and others. Positions: A.-in-Res., Southern Illinois Univ., Carbondale, 1967-1968.

HOFF, SYD—Cartoonist
 4335 Post Ave., Miami Beach, Fla. 33140
B. New York, N.Y., Sept. 4, 1912. Studied: Nat. Acad. Sch. Des. Illus., "Feeling No Pain," 1944; Author, I., "Oops! Wrong Party," 1950; "Oops! Wrong Stateroom," 1953; "Okay, You Can Look

Now!," 1955; "It's Fun Learning Cartooning With Hoff," 1942; "Mom, I'm Home," 1946; "Eight Little Artists," 1954; "Patty's Pet," 1955; "Danny and the Dinosaur," 1958; "Albert the Albatross," 1961; "The Better Hoff Letters from Camp," 1961; "Oliver," "Chester," 1960; "Stanley," 1962; Illus., "Hello, Mudder, Hello Fadder," (Allan Sherman), 1964; "I Should Have Stayed in Bed," (Lexau), 1965, and others. Creator of daily newspaper panel "Laugh It Off," King Features Syndicate. Contributor to New Yorker, Look, Esquire and other national magazines.*

HOFFA, HARLAN—Scholar
 Art Education Program, University of Indiana 47401; h. 1903 E. 3rd St., Bloomington, Ind. 47401
B. Kalamazoo, Mich., June 23, 1925. Studied: Wayne University, B. Sc., M. Ed.; Pennsylvania State University, Ed. D. Field of Research: Art Education, especially Social Foundations of Art and Related Concerns. Positions: President, National Art Education Association, 1969-1971.

HOFFMAN, EDWARD FENNO, III—Sculptor
 501 Conestoga Rd.; h. 353 Oak Terrace, Wayne, Pa. 19087
B. Philadelphia, Pa., Oct. 20, 1916. Studied: PAFA; Henry Clews Mem. A. Fnd., La Napoule, France. Member: F., PAFA; NSS; AAPL; Council Am. Artists Societies (Rec. Sec.); Grand Central A. Gal.; All. A. Am. Awards: F., PAFA, 1961; 1st prize, Sc. Exh., sponsored by NSS & NAC, 1961; Silver Medal, AAPL, Smithsonian Exh., 1963; Medal of Honor, All. A. Am., 1965; Samuel F.B. Morse Medal, 1966 and Artists Fund prize, 1969, both NAD. Work: Villanova Univ.; Brookgreen Gardens, S.C.; Col. of Physicians, Phila., Pa.; Trinity Episcopal Church, Swarthmore, Pa.; St. Mary's Church, Wayne, Pa.; Am. Episcopal Cathedral, Rome; La Napoule, France; Huntington Mus., W. Va.; PMA; PAFA; Trinity Episcopal Church, Geneva, N.Y.; St. John's Church, Southampton, N.Y.; Portland (Me.) Mus. A.; Grand Central A. Gal.; Huntington Hartford; St. Martin's Church, Radnor, Pa.; St. Mathews, Phila.; Weightlifters Hall of Fame, York, Pa.; Woodmere A. Gal., Pa.; Col. of Life Underwriters, Bryn Mawr, Pa. Exhibited: NSS, 1962-1964; All. A. Am., 1962-1964; NAD, 1962-1964; AALP, 1962-1964; 5-man exh., Phila. A. All., 1965; one-man: Episcopal Acad., 1965; Rosemont Col., 1965; Pa. Military Col., 1965; Providence Nat. Bank, 1965; Newport AA, 1965; Woodmere A. Gal., 1966. Positions: Instr. Sc., Wayne (Pa.) A. Center; Council, NSS, 1965-1971.

HOFFMAN, HARRY ZEE—Painter, T.
 3910 Clarks Lane, Baltimore, Md. 21215
B. Baltimore, Md., Dec. 5, 1908. Studied: Univ. Maryland, Ph.G.; Maryland Inst.; PIASch., and with Robert Brackman, Aldro Hibbard, Bernard Meyers. Member: AEA; Wash. WC Cl.; Balt. WC Soc. F., Int. Inst. A. & Lets. Awards: prizes, Balt. Evening Sun, 1934, 1935, 1940, 1942, 1945; Outdoor A. Festival, 1957; purchase, Shavitz Gal., 1966; WCBM Gal., 1967. Work: Community Col., Baltimore; BMFA Film Coll. Exhibited: PAFA, 1941, 1953; Balt. WC Soc., 1939, 1940, 1942, 1949, 1957, 1958-1961; Albany Inst. Hist. & A., 1945; Audubon A., 1945; Laguna Beach AA, 1945, 1949; Irvington A. & Mus. Assn., 1946; Maryland Inst., 1934, 1936; Mun. Mus. Balt., 1941-1945, 1948-1952; A. Un., 1946; BMA, 1936, 1937, 1939, 1940-1946, 1949-1951, 1954, 1955, 1959-1961; Timonium Fair, 1950; Balt. A. Dir. Cl., 1952; Terry AI, 1952; Ogunquit A. Center, 1953; Peale Mus. A., 1954, 1955, 1959, 1960; Creative Gal., 1954; Wash. WC Cl., 1954, 1959, 1960; Maryland Regional, 1960; AEA, 1960 & traveling; Mississippi WC Exh., Jackson, 1961; Old Market Gal., Wash., D.C., 1961; Martick Gal., Balt., 1955 (one-man); "Racing at Laurel" exh., 1956, 1957; Outdoor A. Festival, 1957, 1959, 1961; Loyola Col. A. Festival, 1966-1968; WCBM Gal., Baltimore, 1968 (and one-man, 1968); Gal. One, Washington, D.C., 1966-1968; Jewish Community Center, Baltimore, 1968; Galerie Internationale, 1966-1968 (and one-man, 1966); other one-man exhs., Vertical Gal., 1968; Jefferson Gals., 1969; Park Tower Gal., 1969, all Baltimore.

HOFFMAN, RICHARD PETER —Painter
 1035 N. 30th St., Allentown, Pa. 18104
B. Allentown, Pa., 1911. Studied: Parsons Sch. Design. Member: Philadelphia Water Color Cl.; Woodmere Art Gal.; Lansdale Art Lg.; Lehigh Art Alliance; Allentown Art Mus.; Hazleton A. Lg.; Life memb., Friends of the Reading Mus., Pa.; Int. Platform Assn. Awards: Gertrude Rowan Capolino Prize, Woodmere Gal., 1952; Grumbacher Prize for Casein, Knickerbocker Artists, N.Y., 1955; Rotary Cl. Award for Landscape, Lansdale, Pa., 1956; Lions Award for an Abstraction, Lansdale, Pa., 1957; Second Prize, Moravian Col. Ann., Bethlehem, Pa., 1957; Silver Award, Lehigh Art Alliance, 1960; Best in the Exhibition, Hazleton Art Lg., Hazleton, Pa.; Buxmont Regional, Pa., 1964; Commercial Mus., Phila., 1963, 1965; Moravian Col., Bethleham, Pa., 1968. Work: Butler Inst. Am. A., Youngstown, Ohio; Pennsylvania Power and Light Co., Allentown, Pa.; Call-Chronicle Newspaper, Allentown, Pa.; Lehigh Valley Cooperative Farmers' Dairy, Allentown, Pa.; Liberty High School,

Bethlehem, Pa. Exhibited: Philadelphia Water Color Club, and other exhibitions in Philadelphia, 1948-62; Various colleges in Bethlehem and Allentown; Exhibitions in New York, Florida, Montclair, N.J., Harrisburg, Reading, Lancaster, and New Hope, Pa.; one-man; Salpeter Gal., N.Y., 1948; Gimbel's N.Y., 1955; Meierhans Gal., Hagerstown, Pa., 1959; Mercersburg Academy, Mercersburg, Pa., 1959; Universalist Church, Philadelphia, 1960; Ruth Hager Art Gal., Lancaster, Pa., 1961; Allentown Art Mus., 1962; Woodmere A. Gal., Phila., 1963; Hazleton A. Lg., Pa., 1966; Reading (Pa.) Public Mus. & A. Gal., 1968.

HOFFMANN, ARNOLD, JR.—
 Painter, Des., I., Comm. A.
 179 E. 70th St., New York, N.Y. 10021
B. New York, N.Y., Jan. 16, 1915. Studied: NAD, with Ivan Olinsky, Leon Kroll. Member: All. A. Am. Exhibited: AWCS, 1940, 1941, 1942, 1944, 1945; All. A. Am. 1940-1942, 1944, 1945; Audubon A., 1945; one-man: Stuttman Gal., N.Y., 1958; Angeleski Gal., N.Y., 1961; Osgood Gal., 1963. Positions: A. Dir., New York Times Sunday Magazine and Book Review sections.

HOFFMANN, LILLY E.—Craftsman, Des., T.
 Rte. #2, Concord, N.H. 03301
B. Alsace, France, Nov. 8, 1898. Studied: Columbia Univ., with Florence House; and in Germany. Member: Lg. New Hampshire A. & Crafts. Awards: Designer-Craftsman U.S.A., 1953; Work: MModA.; Currier Gal. A. Exhibited: Mus. Contemp. Crafts, N.Y., 1958; AFA traveling exh., 1958-59, and many exhibitions prior to these dates; Fabrics International, 1961. Lectures: Weaving as a Craft; Weaving for the Home, Television Series of 8 lectures for Educational Television, 1967. Positions: Instr., Weaving, Lg. New Hampshire A. & Crafts, 1948- ; Manchester Inst. A. & Sc., 1958- .

HOGUE, ALEXANDRE—Painter, Lith., W., E.
 4052 East 23rd St., Tulsa, Okla. 74114
B. Memphis, Mo., Feb. 22, 1898. Member: Southwestern AA. Awards: prizes, All. A., Dallas, Tex., 1930-1933; Dallas Pr. Soc., 1937; DMFA; Oklahoma A. (grand award). Work: Philbrook A. Center, Tulsa; Gilcrease Fnd.; Musee National d'Art Moderne, Paris, France; Dallas Mus. FA; IBM; Encyclopaedia Britannica Coll.; Lib. Cong.; Houston Mus. FA; Corpus Christi A. Fnd.; Springfield (Mo.) Mus.; Governor's Mansion (Oklahoma). Exhibited: Paris Salon, 1938; Carnegie Inst., 1938, 1939 (Int. exh.), 1946; WFNY, 1939; GGE, 1939; Tate Gal., London, England, 1946; MModA; Int. Color Lithography exh., frequently; SAGA; AIC; WMAA; CGA. Positions: Tech. I., North American Aviation Corp., 1942-45; Hd. A. Dept., Univ. Tulsa, Okla., 1945-1963; Prof. A. 1963-1968, (retired).

HOIE, CLAUS—Painter
 140 E. 40th St. 10016; h. 20 W. 12th St., New York, N.Y. 10011
B. Stavanger, Norway, Nov. 3, 1911. Studied: Pratt Institute, Brooklyn, N.Y.; Ecole des Beaux-Arts, Paris, France. Member: AWS (Vice-Pres., 1960-62); SI. Awards: American Artist magazine medal, 1956; Ted Kautsky Memorial Award, 1958, Gold Medal of Honor, 1962, prize, 1965 all AWS. Work: BM; Butler Inst. Am. A.; Norfolk Mus. A. & Sciences. Exhibited: AIC, 1939; AWS, 1956-1965, 1967-1969; NAD, 1956, 1967, 1968; Butler Inst. Am. A., 1963; Watercolor:USA, 1964, 1967-1969; BM, 1963; Audubon A., 1964; Denver A. Mus.; Norfolk Mus. A. & Sciences; Royal Acad. A., London, England, 1962; Mus. Watercolor, Mexico City, 1968; Oklahoma A. Center, 1969; PAFA, 1969; Guild Hall, East Hampton, N.Y., 1969, one-man 1970. One-man: Salpeter Gal., N.Y., 1962, 1963.

HOKIN, EDWIN E.—Collector
 Unarco Industries, 332 S. Michigan Ave., Chicago, Ill. 60604; h. 254 Hazel Ave., Highland Park, Ill. 60035
B. Chicago, Ill., Dec. 21, 1915. Studied: University of Illinois, B.S. Collection: African art; Contemporary painting and sculpture; Oceanic art; Pre-Columbian gold; Twentieth century school of Paris.*

HOLADAY, WILLIAM H., Jr.—Educator, P., C., Gr.
 Art Department, Northern State College; h. 1725 South Lincoln St., Aberdeen, S.D. 57401
B. Wheeling, W.Va., June 03, 1907. Studied: Ohio State Univ., B.A.; Franklin Univ.; Omaha Univ., M.A.; Univ. Chicago; Dakota Wesleyan Univ.; Univ. Iowa. Member: Kappa Pi; Assoc. Omaha A.; NAEA; Delta Phi Delta; Phi Kappa Phi. Awards: South Dakota State Fair, 1951-62. Exhibited: Little Gal., Spearfish, S.D., 1956 (one-man); Joslyn Mem. Mus., 1948; Assoc. A., Omaha, 1947; Ohio State Univ., 1945; Dakota Wesleyan Univ., 1953; Northern State Col., 1958; Dakota State Univ., Brookings, 1964; Univ. South Dakota, 1960-1964. Author: "Art History of the Middle Border" "Mobiles, a Family Art." Lectures: Contemporary Art: Art Education Today; Modern Painting, etc. Positions: Dean of Men, Dakota Wesleyan Univ., 1948,

Dir. Eve. Sch., 1952-58, Assoc. Prof. A., Hd. A. Dept., Dakota Wesleyan Univ., 1948-58; Prof. A., Hd. A. Dept., Northern State Col., Aberdeen, S.D., 1958- .

HOLBROOK, HOLLIS HOWARD—Educator, P., Des., I., L.
College of Architecture & Fine Arts, University of Florida; mail: 1710 S.W. 35th Pl., Gainesville, Fla. 32601
B. Natick, Mass., Feb. 7, 1909. Studied: Vesper George Sch. A.; Mass. Sch. A.; Boston Univ.; Yale Univ., B.F.A.; Universidad Michoacana. Member: SSAL; Fla. Edu. Assn.; AAUP; Fla. Fed. A.; Fla. A. Group (Pres. 1949-51); Southeastern College AA. Awards: mural comp., USPO, St. Louis, Mo.; Social Security Nat. Comp., 1941; Somerville (Mass.) USPO, 1937. Work: murals, Lib., Univ. Florida; St. Augustine, Fla.; USPO, Natick, Mass., Haleyville, Ala.; Biblioteca Michoacana, Mex.; Jeanerette, La.; Admin. Bldg., Col. of Rhode Island, Providence, 1959; 18 murals, USPO, Ocala, Fla., 1963; art work in colls. of Univ. Florida; Col. William & Mary; Univ. Georgia; Richmond (Va.) Lib.; Norfolk Mus. A. & Sciences, and in private colls. Exhibited: Soc. Four Arts, 1964; Delgado Mus. A., 1963; PAFA, 1964; Butler Inst. A., 1964; CGA, 1965. Contributor to Design Magazine; American Artist Magazine, 1960. Positions: I., Associated Press, 1943; Indst. Des., Warren Telechron Co., 1943-44; Instr. A., 1938-41, Asst. Prof. A., 1941-43, Assoc. Prof., 1946-48, Prof. A., Univ. Florida, 1948- .*

HOLBROOK, VIVIAN NICHOLAS—Painter
Bivens Arm, Gainesville, Fla.; mail, 1710 Southwest 35th Place, Gainesville, Fla. 32601
B. Mt. Vernon, N.Y., Mar. 31, 1913. Studied: Yale Sch. FA, B.F.A. Member: SSAL; Soc. Four A. Awards: prizes, Fla. Fed. A., 1942, 1943, 1951; Fla. State Fair, 1947; Harry Rich Comp., Miami, 1957; Soc. Four A., W. Palm Beach, 1958, 1966. Exhibited: Soc. Four A., 1963-64; Sarasota AA; Havana, Cuba, 1955; Atlanta AA, 1958; Norton Gal. A., 1958; Purdue Univ., 1964; one-man: Fla. Southern Col., 1948; Miami Beach A. Gal., 1950; Univ. Fla. Medical Center, 1962; Center of Mod.A., Micanopy, Fla.; Univ. Florida, 1957 (2-man). Lectures: Women in Art. Positions: A. Instr., Colby Jr. Col., 1936-38; Univ. Florida, Gainesville, Fla., 1943-44.

HOLCOMBE, BLANCHE KEATON (Mrs. Cressle Earl)—Painter, T.
Anderson College; h. 2602 Bellview Rd., Anderson, S.C., 29621
B. Anderson, S.C., July 12, 1912. Studied: Anderson College, A.A.; Univ. South Carolina; Furman Univ., A.B.; grad. study, Architecture, Clemson Univ. Member: Gld. South Carolina A.; AFA; Anderson AA; A.A.U.W.; Int. Platform Assn. Awards: Watson Village A. Exh., Anderson, S.C., 1964, 1965; Christian A. Festival, Seneca, S.C., 1965. Exhibited: Gibbes A. Gal., Charleston; Greenville Civic Gal.; Columbia Mus. A.; Florence A. Gal., Winston-Salem; Historical Exh. and tour, Pendleton Greens, 1969; Lancaster, S.C., 1968. Positions: Chm., A. Dept. Anderson College, South Carolina, 1956- .

HOLCOMBE, R. GORDON, JR. (DR.)—Collector, Patron
1607 Foster St. 70601; h. 3624 Lake St., Lake Charles, La. 70602
B. Lake Charles, La., Oct. 28, 1913. Studied: Vanderbilt University; Tulane University, B.S.; Tulane University School of Medicine, M.D. Collection: Paintings, including works by Bernard, Derain, Buffet, Levier, Courbet, and early 19th century American paintings. Positions: Past President Art Associates of Lake Charles, La;; Past President, Calcasieu Parish Medical Society; Past President, Louisiana Chapter, American College of Surgeons. Board of Governors, American College of Surgeons.

HOLDEN, R(AYMOND) J.—Illustrator, P., Comm. A.
R.F.D. Box 130, North Sterling, Conn. 06377
B. Wrentham, Mass., May 2, 1901. Studied: R.I.Sch.Des. Member: Providence WC Cl. Exhibited: AIGA, 1935, 1942; Providence A. Cl., 1953-1955, 1956, 1960, 1969; Ford Motor Co., 1955, 1956, 1958; U.S.I.A., 1962; one-man exh.: Jones Lib., Amherst, Mass., 1939, 1941, 1969; Boston Pub. Lib., 1941; Providence Pub. Lib., 1941; State Lib., Hartford, Conn., 1942; Children's Mus., Hartford, Conn., paintings of Connecticut Indians, 1969. I., "Flowering of New England," 1941; "Poems of Whittier," 1945; "The Autocrat of the Breakfast Table," 1955; "Thoreau's Cape Cod," Limited Editions Club, 1968, and others. Contributor to Ford Times.

HOLDER, CHARLES ALBERT—Painter, T.
110 Manatee Rd., Clearwater, Fla. 33516
B. Miami, Fla., June 15, 1925. Studied: Univ. Florida, B.F.A.; AIC; Jerry Farnsworth Sch. A. Member: SC; Artist's & Craftsman Assoc., Dallas, Tex.; Grand Central A. Gal., N.Y.; All. A. Am. Awards: prizes, Tiffany award, 1950; Fla. Fed. A., 1947, 1949; All-Florida College A. Forum, 1949; Greenwich Village Exh., 1953; Coral Gables AA, 1954; Harry Rich Comp., Miami, 1955; Sarasota AA, 1954, and others; Henry White Taylor Scholarship, 1949. Work: many portraits, 1948-58. Exhibited: Tiffany Fnd., 1950; Am.-Brit-

ish A. Gal., N.Y., 1950; Fla. Fed. A., 1946, 1947, 1949; Sarasota AA, 1954; Coral Gables AA, 1955; SC, 1954; Rich Comp., Miami, 1955; one-man: Univ. Florida, 1950; Los Angeles, Cal., 1956; Trenton, N.J., 1958; Gainesville, Fla., 1959; El Centro Cl., Miami, 1959; Fla. Fed. A.; Winter Haven AA; Lakeland A. Gld.; Ft. Pierce AA; New Smyrna Beach, Fla. all in 1963; Grand Central A. Gals., 1964. Positions: Dir., Holder Gal., Miami, 1960. Instr., Fla. Gulf Coast A. Center, Clearwater; Auburndale AA, Fla.; Lakeland A. Gld., 1964; Summer Sch. Dir., Fla. Fed. A., DeBary, Fla., 1964; Instr., Florida Gulf Coast Art Center, Belleair, Fla., 1967 to present.

HOLLAND, B. C.—Art dealer
Holland Gallery, 155 E. Ontario St., Chicago, Ill. 60611*

HOLLAND, DANIEL E.—Cartoonist
Chicago Tribune, 435 North Michigan Ave., Chicago, Ill.; h. 412 Laurel Ave., Libertyville, Ill. 60048
B. Guthrie, Ky., Feb. 2, 1918. Studied: Chicago Acad. A. Awards: Freedom Fnd., 1949-1952, 1969. Positions: Cartoonist, Chicago Tribune and Tribune Syndicate.

HOLLANDER, MRS. CLIFFORD. See Wingate, Arline

HOLLERBACH, SERGE—Painter, I.
894 Riverside Dr., New York, N.Y. 10032
B. Pushkin, Russia, Nov. 1, 1923. Studied: Acad. FA, Munich, Germany; ASL, with Ernst Fiene. Member: AWS; Knickerbocker A.; Painters in Casein; New Jersey Soc. of Painters and Sculptors; Audubon A. Awards: NAD, 1965; NAC gold medal, 1963; New Jersey Soc. of Painters, medal of honor, 1969, and others. Work: St. Paul Gal., Minnesota; Students Center A. Gal., So. Orange, N.J., and in private collections. Exhibited: MMA, 1966; Amer. Acad. A. Lets., 1967-1968; NAD; Watercolors:USA; Drawings:USA; one-man: Ground Floor Art Gal., N.Y., 1966-1968.

HOLLISTER, PAUL, JR.—Painter, W.
New York, N.Y.
B. New York, N.Y. Studied: Harvard Col., B.S. Member: Silvermine Gld. A.; Old Sturbridge Village; Nat. Early American Glass Cl.; Soc. for the Preservation of New England Antiquities. Exhibited: Critic's Show, Grand Central A. Gal., 1947; ACA Gal., 1949; Riverside Mus., 1951, 1953, 1954; WMAA, 1954; N.Y. City Center, 1954, 1955, 1956; New Sch. Social Research, 1954; RoKo Gal., 1954, 1955; One-man: Gal. Appollinaire, London, England, 1951; Panoras Gal., N.Y., 1957, 1968; Silvermine Gld. A., 1959 (6-man); 2-man, Graham Gal., N.Y., 1962; Gal. 100, Princeton, 1963 (one-man). Author, I., "Fine Tooth Comb," 1947. Articles: "Outstanding French and American Paperweights in The Wells Collection," 1966, "New Light on Gilliland, Cambridge and Gillinder Paperweights," 1968, both for Antiques magazine. Book: "The Encyclopedia of Glass Paperweights," 1969.

HOLMES, MR. and MRS. PAUL J. (Mary E.)—Collectors
836 Du Shane Court, South Bend, Ind. 46616
Mrs. Holmes: B. Chicago, Ill., Sept. 12, 1900. Studied: Privately with Sadie M. Hess of Gary, Ind. and Chicago, Ill.; Art Institute of Chicago. Mr. Holmes: B. North Henderson, Ill., Jan. 28, 1896. Studied: Univ. Michigan, B.S.; University of Toulouse, France. Collection: 18th Century Porcelains and Figurines; Miniatures; Patch and Snuff Boxes; Russian Enamels and Porcelain and Faberge; Russian Icons; Rare items in porcelain, art glass and graphics; Medieval and 18th Century Enamels of England and the Continent.

HOLTON, LEONARD T.—Cartoonist, I., W., Comm.
129 East 82nd St., New York, N.Y. 10028
B. Phila. Pa., Sept. 6, 1906. Member: SI; Writers Gld. of America. Illustrator for leading magazines and newspaper syndicates. Coauthor and/or illustrator of books published by Scribners, Simon & Schuster, etc. Script writer for stars of TV, stage, screen. Des., writer of award winning TV commercials starring Bert Lahr in national Cleo Festival and New York Advertising Club (Andy).

HOMER, WILLIAM INNES—Educator, W., L.
Art History Dept., University of Delaware, Newark, Del. 19711
B. Merion, Pa., Nov. 8, 1929. Studied: PMSchA.; Princeton Univ., B.A.; Temple Univ. (Tyler Sch.); N.Y. Univ.; Harvard Univ., M.A., Ph.D., and with Lester Cooke, Harmon Neill. Member: CAA; Soc. Arch. Hist.; American Studies Association; Wilmington Society of the Fine Arts. Author: "Seurat and the Science of Painting"; "Seurat's Port-en-Bessin"; "The Sculpture of Carl Walters"; "Robert Henri and His Circle." Contributor to Art in America; The Connoisseur; Burlington Magazine; Art Quarterly, Art News; Journal of American Art, and other periodicals and museum publications. Awards: Saltonstall F., Harvard Univ., 1954-55; F., Council of the Humanities, 1962-63; Sachs Traveling Research Fellowship, 1957-58; Fellow, Am. Council of Learned Societies, 1964-65.

Work: N.Y. Pub. Lib.; Princeton Univ. Lib. Theatre Coll. & Graphic Arts Dept. Lectures in A. History, Rutgers Univ., 1952-53. Positions: Asst. Ed. & Des., Prentice-Hall Publishers, 1952-53; Teaching F., FA, Harvard Univ., 1954-55; Instr. A. & Archaeology, Princeton Univ., 1955-59; Asst. Dir. (Actg.), The Art Museum, 1956-57; Lecturer, 1959-61., Asst. Prof., 1961-1964; Assoc. Prof., History of Art, Cornell Univ., Ithaca, N.Y., 1964-1966; Prof. & Chm., A. Hist. Dept., Univ. Delaware, Newark, Del., 1966- ; associated with Winterthur Program in Early American Culture, 1966- ; Lecturer, American Studies Institute, Lincoln University, Oxford, Pa., 1968- .

HONEYMAN, ROBERT B., JR.—Collector
Rancho Los Serritos, San Juan Capistrano, Cal. 92675*

HOOD, (THOMAS) RICHARD—Graphic Artist, Des., E.
1452 E. Cheltenham Ave., Philadelphia, Pa. 19124
B. Philadelphia, Pa., July 13, 1910. Studied: Univ. Pennsylvania; Phila. Col. A. Member: Phila. Pr. Cl., F.I.A.L.; Phila. A. All.; Am. Color Pr. Soc. (Pres. 1956-). Awards: Soldiers Art, NGA, 1945; Times-Herald Exh., Wash., D.C., 1945; Phila. Pr. Cl., 1937, 1949, 1951; Franklin medal, Printing Indst. of Phila., 1959, 1969, special recognition award, 1969; Nat. Printing Industry Award of Excellence, 1969. Work: Phila. Free Lib.; Pa. State Hospital; PMA; LC; Carnegie Inst.; Pa. State Col.; Carnegie Lib.; N.Y. Pub. Lib., and in private coll. Exhibited: in traveling and national print exhibitions since 1938; The Fabulous Decade, Smithsonian Institution, 1964. I., "Decoys" (a portfolio of Serigraphs), 1954. Positions: Des. Coordinator, Assoc. Prof., Philadelphia College of Art, Philadelphia, Pa.

HOOK, WALTER—Educator, P., S., C.
Art Department, University of Montana; h. 400 Pattee Canyon Drive, Missoula, Mont. 59801
B. Missoula, Mont., Apr. 25, 1919. Studied: Montana State Univ., B.A.; Univ. New Mexico, Albuquerque, M.A. Member: Cal. Nat. WC Soc.: Alabama WC Soc.; Phila. WC Soc.; Pacific AA. Awards: prizes, Butler Inst. Am. A., 1958, 1964, 1967, 1968; Las Vegas, 1964, 1968; Alabama WC Soc., 1963, 1964, 1968; Cal. WC Soc., 1962, 1963, 1968; Bellevue (Wash.) A. & Crafts Fair, 1958; Pacific Northwest Exh., Spokane, Wash., 1958; 1st Nat. Bank, Minneapolis, Minn., 1960; Okla. Pr. M., 1960; Watercolors: USA, Springfield, Mo., 1968; all purchase prizes; Sun Carnival, El Paso; Cal. Nat. WC Soc., Northwest WC Soc., Alabama WC Soc., Las Vegas Nat. A. Lg., PAFA, Phil. WC Cl., 1969; and others. Work: Butler Inst. Am. A.; Bellevue Pub. Sch. System; A. & I. Col., Art Dept., Kingsville, Tex.; Missoula County H.S.: Univ. Oregon; Univ. New Mexico; VMFA; Univ. Idaho; Las Vegas A. Lg.; Baptismal font, reliefs, Christ The King Church, Missoula; Statues, Stations of the Cross, Font, St. Anthony's Parish, Missoula; statues, St. Vincent dePaul Parish, Federal Way, Wash. Exhibited: Butler Inst. Am. A., 1958-1968; Pacific Northwest Exh., 1957-1968; Northwest WC Soc., 1956-1968; Las Vegas Nat. A. Roundup, 1957, 1958, 1961, 1964-1968; SAM 1956-1958; Alabama WC Soc., 1957-1968; Springfield Mus. A., 1958; Denver A. Mus., 1958; Drawings: USA, 1961; Watercolors: USA, 1963-1968; and others. One-man: Univ. Ore., Wash., Mont., Wyo., Wash. State; Idaho; Kalamazoo A. Inst.; Tacoma A. Mus.; Hallmark Gal.; State of Montana Hist. Mus. Positions: Visiting Memb. Faculty, Central Washington State; Univ. Oregon; Univ. New Mexico; Univ. Wash.; Univ. Alberta. Prof., A. Dept., Univ. Montana, Missoula, Mont., 1957- .

HOOKER, MRS. R. WOLCOTT—Collector, Patron
563 Park Ave., New York, N.Y. 10021
B. Missoula, Mont., Sept. 28, 1908. Studied: College of William and Mary; Art Students League—drawing, with Robert Beverly Hale; Albright Art School, Buffalo. Awards: First prize, painting award, Garrett Club, Buffalo, members' show. Collection: Contemporary painting and sculpture. Positions: Trustee, American Federation of Art; Director, International Council of the Museum of Modern Art; Trustee, Art Museum, Princeton University. Board of Governors; Goldovsky Opera Institute.

HOOPES, DONELSON F.—Museum Curator, W., L.
The Brooklyn Museum, Eastern Pkwy. and Washington Ave., Brooklyn, N.Y. 11238; h. 230 E. 15th St., New York, N.Y. 10003
B. Philadelphia, Pa., Dec. 3, 1932. Studied: PAFA; Univ. Pennsylvania, B.A. (American Civilization Studies); Univ. of Florence. Member: American Studies Assn.; AAMus. Author: "Maine and Its Role in American Art," 1963; "Winslow Homer Watercolors," 1969. Contributor to: Antiques; Art in America; Journal of the Long Island Historical Society; Brooklyn Museum Annual. Lectures: American 18th and 19th Century Painting; Limner Portraiture in the Hudson River Valley; Sargent's Impressionist Period; The American Landscape Painting in the 19th Century. Exhibitions arranged: "Winslow Homer: A Memorial Exhibition," 1960; "The Private World of John

Singer Sargent," 1964; "The Art of George L. K. Morris," 1965; "William Zorach: Paintings, Watercolors and Drawings: 1911-1922," 1968. Positions: Participated in The Shelburne Museum Seminar on American Folk Painting; Dir., Portland (Me.) Mus. A., 1960-1962; Cur., The Corcoran Gallery of Art, 1962-1964; Cur., Paintings and Sculpture, The Brooklyn Museum of Art, 1965- .

HOOVER, F. LOUIS—Educator, Editor, Writer
305 N. University Ave., Normal, Ill. 61761
B. Sherman, Tex., Mar. 12, 1913. Studied: North Texas State Univ., B.S.; Columbia Univ., M.A.; N.Y. Univ., Ed. D. Member: NAEA; Western AA; Illinois Edu. Assn.; Int. Soc. for Edu. Through Art; Int. Platform Assn. Contributor to Art Education. Author: "Arts and Activities in the Classroom," 1955; "Guide for Teaching Art Activities in the Classroom," 1956; "Art Activities for the Very Young," 1961; "Young Printmakers," 1964; "Young Sculptors," 1967. Editor: Arts and Activities Magazine, 1951-1966; Editor, Art Resource Publications, Davis Publications, Worcester, Mass., 1967- . Positions: Asst. Prof., North Texas State Univ., 1936-1940; Asst. Prof., Eastern Illinois Univ., 1941-1944; Dir., Fairway Gallery of Art, Bloomington, Ill., 1962-1968; Bd. Dirs., Art Edu. Fnd. (Hon.); Pres., Illinois A. Edu. Assn., 1951; Pres., Western AA, 1949; Exec. Council, NAEA, 1959-1961; Prof. A., Head Dept. of Art, Illinois State University, Normal, Ill., 1944- . Collector: Primitive and Pre-Columbian Art.

HOOVER, HERBERT —Gallery director
Hoover Gallery, 710 Sansome St., San Francisco, Cal. 94111*

HOOWIJ, JAN—Painter
16614 Chaplin Ave., Encino, Cal. 91316
B. Hengelo, Netherlands, Sept. 13, 1907. Studied: Acad. FA, The Hague; Grande Chaumiere, Paris. Member: AEA; Los Angeles AA. Awards: Royal subsidy for Artists, Holland, 1931-34; Van Duyl prize, 1935; Ebell Salon, Los A., Cal., 1952; gold medal, Los Angeles City A. Festival, 1951; Witte Mem. Mus. purchase, 1959; Tipps Award, Laguna Gloria, Austin, 1960; Corpus Christi Mus., 1960. Work: BM; Joslyn A. Mus.; Philbrook A. Center; Honolulu Acad. A.; Witte Mem. Mus., San Antonio. Exhibited: in 65 museum exhs. including, Holland, 1936, 1939, 1940; Palais de Chaillot, Paris, 1945; Carnegie Inst., 1948, 1949; Indianapolis, Ind., 1949; Los Angeles A. Festival, 1951; Los A. Mus., A., 1954; Butler AI, 1954; de Young Mus., 1955; DMFA, 1945, 1960; Elisabet Ney Mus., 1958; Laguna Gloria Mus., 1958-1960; Witte Mem. Mus., 1959, 1960. 47 one-man exhs.

HOPE, HENRY RADFORD—Educator, Art Historian
1 Las Olas Circle, Ft. Lauderdale, Fla. 33310
B. Chelsea, Mass., Dec. 15, 1905. Studied: Sorbonne, Paris, France; Harvard Univ., A.M., Ph.D. Member: CAA; AFA; Midwestern Col. A. Conference. Lectures: "Art of the 19th and 20th Centuries." Positions: Chm., FA Dept., Indiana Univ., Bloomington, Ind., 1941-1967; Dir., Indiana Univ. Art Mus., 1962- . Former Member, U.S. Nat. Comm. for UNESCO; Ed., Art Journal; Author: Cat. of Exh. of Georges Braque, MMoModA, 1949; Jacques Lipchitz, MModA., 1954.

HOPKINS, BUDD—Painter
246 W. 16th St., New York, N.Y. 10011
B. Wheeling, W.Va., June 15, 1931. Studied: Oberlin Col., Ohio, B.A. Work: WMAA; Washington (D.C.) Gal. Modern Art; Norfolk Mus. A. & Sciences; Chrysler Mus. A., Provincetown, Mass.; Montana Hist. Soc.; Guggenheim Mus.; Lytton Industries; United Aircraft Corp. Exhibited: Allen Mem. Mus., Oberlin, 1957; WMAA, 1958, 1963, 1965, 1967; Traveling exh., "Young America," 1960; PAFA, 1964; Inst. Contemp. A., Boston, 1964; Poindexter Gal., N.Y., 1964 (2-man); Selected by Art News as one of "Twelve Americans, Thirty and Under" for exh. in Spoleto, Italy, 1958; Selected by C.B.S. as one of the entrants for national TV Broadcast, "Exhibition," 1963; Yale Univ. A. Gal., 1969; CM, 1968; Ringling Mus. A., 1969; one-man: Poindexter Gal., 1956, 1962, 1963, 1966, 1967, 1969; Zabriskie Gal., N.Y., 1959; Karlis Gal., Provincetown, 1958, 1960-1969; Heman Gal., Chicago, 1962, 1963; A. Gal., Georgetown, Wash., D.C., 1963; Athena Gal., New Haven, Conn., 1964; Obelisk Gal., Boston, 1964, 1966; Reed Col., Portland, Ore., 1967; Phillips Exeter Acad., 1968. Lectures: History of Modern Art, Docent, MModA, 1955, 1956 (summers); WMAA, 1957-1960; Instr., Wagner College, Staten Island, N.Y. 1955.

HOPKINS, JOHN FORNACHON—Painter, E.
Hofstra University, 1000 Fulton Ave., Hempstead, N.Y.; h. 30 Vineyard Rd., Huntington, L.I., N.Y. 11743
B. Peking, China, June 30, 1920. Studied: Cornell Univ., B.F.A., M.F.A., with John Hartell, Norman Daly, Joseph Hanson. Member: N.Y. A. T. Assn.; Long Island A. T. Assn.; AAUP. Awards: Emily Lowe award, 1956. Work: Cornell Univ.; Hofstra Col.; Sewanahaka H.S. Illus. Art History Books. Exhibited: Denver A.

Mus., 1956; Munson-Williams-Proctor Inst., Utica, N.Y.; Addison Gal. Am. A., Andover, Mass.; Cornell Univ.; Morgans Island Gal., Glen Cove, N.Y.; ACA Gal., N.Y.; Miami Univ.; Hansa Gal., N.Y.; Roosevelt Field A. Center, N.Y.; Sunken Meadow Gal. Contemp. A., Long Island; Eva Lee Gal., Great Neck, N.Y.; one-man; Hofstra Col., 1950, 1958; Ward Eggleston Gal., N.Y., 1956. Positions: Asst. Dir., "Arts Around Us" & "American Art Today," WOR-TV, 1956 (2-26 wk. series); Prof. A. & A. Hist., Chm. Dept. FA, Hofstra University, Hempstead, N.Y.*

HOPKINS, KENDAL COLES—Painter, T.
R.D. 1, Phoenixville, Pa. 19460
B. Haddonfield, N.J., Jan. 6, 1908. Studied: PMSch. A.; PAFA, and in Europe. Member: Fellowship of PAFA. Work: in private colls. Exhibited: PAFA; Rockland Mus. A.; Phila. Sketch Cl.; MModA; 14 one-man exhs.; also exhibited Bryn Mawr A. Center; Westchester AA; Woodmere A. Gal.; Phillips Gal., Phila., Pa.; PMA; NAD, and others. Positions: Instr. Painting, Bryn Mawr Col.; Woodmere A. Gal.; Instr., Bryn Mawr, Pa., 1951-55.

HOPKINS, LIN (Mr.)—Painter, Et.
78 South C St., Fremont, Neb. 68025
B. Omaha, Neb., Mar. 5, 1886. Member: Casper A. Gld.; Wyoming AA; Assoc. A. Omaha. Work: State Capitol, Cheyenne, Wyo.; Ft. Casper (Wyo.) Mus.; Holdrege (Neb.) Mus. A.; Waddell Medical Clinic, Beatrice, Neb. Exhibited: Univ. Wyoming, 1940; Casper FA Center, 1945 (one-man); Rock Springs, Wyo., 1935 (one-man); Fremont (Neb.) Women's Cl., 1947; Morrill Hall, Lincoln, Neb., 1949; Midland Col., Fremont, 1963-1965 (one-man); 2-man exhs. (with Mrs. Ruth Joy Hopkins), St. Marks Church, Fremont, Neb., 1959; Casper (Wyo.) Col., 1961, (2-man), 1966; Midland Col., Fremont, Neb., 1961; Retrospective exh. (with Ruth Joy Hopkins), Casper, Wyo., 1966 and Fremont AA, Fremont, Neb., 1967. Officers Club, Fort Riley, Kans.; Casper, Wyo., 1963-1965; Beta Sigma Phi Sorority, Fremont, Neb.

HOPKINS, PETER — Painter, Des., Et., I., W., T., L.
New York-Phoenix School of Design, 160 Lexington Ave. 10016; h. 36 Horatio St., New York, N.Y. 10014
B. New York, N.Y., Dec. 18, 1911. Studied: ASL with Bridgman, Marsh, Miller, Zorach, McNulty, and others; also studied abroad. Member: ASL. Awards: Am. Acad. A. & Lets., Nat. Inst. A. & Lets., 1950. Work: Mus. City of New York. Exhibited: WMAA, 1952, 1953; Am. Acad. A. & Lets., 1950; Lyman Allyn Mus., New London, Conn.; ASL; Braverman Gal., N.Y., 1967; Grand Central A. Gals., 1969; Brandt Gal., N.Y., 1961; one-man: N.Y. Public Library; Junior League, Buffalo, 1960; St. James Gal., London, 1956; Eggleston Gal., N.Y., 1958, 1963, 1965; Women's Cl., Westport, Conn., 1961. Contributor to: Town & Country (author, Cart., Ill.) Author, mss., "The Essentials of Perspective," 1964. Positions: Instr., Painting, Moore Inst. A., Philadelphia, 1949; Dean of Men, 1962-1967, Chm., Fine A. Dept., 1968-1969, New York-Phoenix Sch. Des., New York, N.Y.

HOPKINS, ROBERT E.—Sculptor
2868 Fairview East, Seattle, Wash. 98102
B. Chicago, Ill., Aug. 6, 1934. Studied: Univ. Washington, B.A.; M.F.A. Member: Northwest Inst. Sculpture. Awards: Jurors' Choice, Puyallap Fair (Wash.), 1959; purchase prize, SAM, 1963. Work: SAM; small fountains, Mercer Island, Wash., Tacoma, Wash.; Seattle World's Fair, 1962; Bronze, Seattle, 1962. Exhibited: Western Wash. Fair, 1959, 1962; Bellevue, Wash., A. & Crafts Exh., 1961; SAM, 1963; Northwest Inst. Sculpture, Frye Mus., Seattle, 1964.*

HOPKINS, RUTH JOY (Mrs.)—Painter
s. 1607 South Elm St., Casper, Wyo.; h. 78 South "C" St., Fremont, Neb. 68025
B. Fremont, Neb., Aug. 17, 1891. Studied: Colorado Springs FA Center; Col. FA, Morelia, Mex. Member: Casper A. Gld.; Wyoming AA. Awards: prizes, Natrona County Fair, 1953; Wyoming State Fair, 1955. Work: Holdrege (Neb.) Mus.; Wyoming State Capitol, Cheyenne; Wyoming Nat. Bank, Casper; Fort Casper Mus.; St. Francis Boys' Home, Salina, Kans.; Kansas State Col.; Swedish Crucible Steel Co., Detroit. Exhibited: Denver A. Mus., 1935 (one-man); N.Y. Mun. Exh., 1937; NAWA, 1936, 1937; Univ. Wyoming (one-man); Rock Springs, Wyo., 1935, 1936; Joslyn A. Mus., 1947; Lincoln, Neb., 1949-1951; Natrona County Fair, 1953; Wyoming State Fair, 1955; Governor's Exh., Omaha, 1964; 2-man exhs. (with Mr. Lin Hopkins) St. Marks Church, Fremont, Neb., 1959; Casper (Wyo.) College, 1961 and Casper A. Gld., 1966 also Retrospective; Midland College, Fremont, Neb., 1961-1964; Pathfinder Hotel, Fremont, 1964; Beta Sigma Phi Sorority; Casper, Wyo., 1964, 1965; Fort Riley, Kans., 1963.

HOPPES, LOWELL E.—Cartoonist
642 Calle del Otono, Sarasota, Fla. 33581
B. Alliance, Ohio, July 1, 1913. Created over 12,000 cartoons in 30

years appearing in many publications including Colliers, Post, American, Esquire, New Yorker, Farm Journal, Parade, Family Weekly, Daily Mirror, N.Y., King Features Syndicate.

HORAN, CLAUDE F.—Ceramist
2895 Kalakaua Ave., Honolulu, Hawaii 96815*

HORCH, NETTIE S. (Mrs.)—Museum Director
Riverside Museum; h. 310 Riverside Drive, New York, N.Y. 10025
B. New York, N.Y., Nov. 15, 1896. Studied: Hunter Col.; Columbia Univ. Awards: Citation and Certif., from Mayor Wagner, New York City, for 20 years as Dir. of Riverside Mus.; Medal of Honor, NAWA, 1959; Citation, Brooklyn Soc. A., 1957. Exhibitions arranged: international women's Exh., 1940; First Canadian Women's Exhibit, 1946; First Comprehensive Exh. of Contemporary Puerto Rican Artists, 1957; Ein Harod-Israel Artists, 1957; numerous contemporary artist's organizations and group shows. Positions: Pres., Co-Founder, Master Institute of United Arts, Inc., 1922- ; Dir., Co-Founder Riverside Museum, New York, N.Y., 1937- . Fine Arts Chmn., Nat. Assn. Women of U.S.; Hon. Vice-Pres., NAWA.

HORIUCHI, PAUL—Painter
9773 Arrowsmith Ave., S., Seattle, Wash. 98118
B. Yamanashiken, Japan, 1906. Awards: Washington State Fair, 1947, 1950, 1951, 1953, 1955, 1956, 1957; Seattle Art Mus., 1948, 1952, 1955, 1958, 1959, 1961; Northwest Watercolor Annual, 1951, 1954, 1957; Henry Art Gal., Univ. Wash., 1953, 1955, 1956; AEA, 1954, 1955, 1957, 1958; Tupperware Nat. Competition, Orlando, 1955; Spokane Art Board Coliseum, 1955, 1957; Pacific Northwest Arts and Crafts Assn., Bellevue, 1956, 1959; Ford Fnd., 1960; Seattle World's Fair, 1962; Hon. L.H.D., Univ. of Puget Sound, Tacoma, Wash., 1968. Work: Harvard Univ.; Denver Art Mus.; Univ. Oregon, Eugene; Wadsworth Atheneum, Hartford; Santa Barbara Mus. Art; Seattle Art Mus.; The Civic Center, Univ. Wash., Seattle; Seattle Public Library; Spokane Art Board Coliseum; Imperial Household, Tokyo; Univ. Ariz., Tucson; SFMA; Victoria (B.C.) Mus.; Cambridge Univ., England. Exhibited: Rome-New York Art Fnd., Rome, 1958; New York Coliseum, 1959; Mus. of Art, Carnegie Inst., Pittsburgh, 1961, 1964; Seattle World's Fair, 1962; Ryukikai, Tokyo, 1963; Seattle Art Mus., 1963; Colorado Springs Fine Arts Center; Felix Landau Gal., Los Angeles; Terry Art Inst., Miami; Nordness Gal., N.Y.; Oakland Art Mus., Stanford Univ., Palo Alto; Pa. Academy of the Fine Arts, Philadelphia; Portland Art Mus.; SFMA; M.H. De Young Mem. Museum, San Francisco; Gordon Woodside Gal., Zoe Dusanne Gal., Seattle; Yoseido Gal., Tokyo; Vancouver City Mus., Br. Columbia; Retrospective Exh., Univ. Oregon Mus. A., 1969; SAM, 1969.

HORNUNG, CLARENCE PEARSON—Designer, I., W.
333 East 46th St., New York, N.Y.; h. 12 Glen Rd., West Hempstead, L.I., N.Y. 11552
B. June 12, 1899. Studied: Col. City of N.Y., B.S.; N.Y. Univ.; CUASch. Member: AIGA; IDI; Typophiles. Exhibited: drawings and prints of antique automobiles circulated to 60 museums and libraries in the U.S., 1951. Author: "Trade-marks," 1930; "Handbook of Design and Devices," 1932, 1946, 1952; "Lettering from A to Z," 1946, 1954; "Handbook of Early American Advertising Art," 1947, 1954, 1956; "Wheels Across America," 1959; "Pictorial Archives of American Business and Industry," 1959; "Treasury of Horse and Buggy Days," 1960. Ed., Des., Publ.: "Portraits of Antique Automobiles"; "Early American Automobiles"; "Early American Locomotives"; "Early American Carriages"; "Early American Trolley Cars"; "Early American Fire Engines" (all publ. by Autoprints); Publ., A. Dir., Assoc. Ed. of Automobile Quarterly; Des., I., Publ., "Gallery of the American Automobile," a history of the American automobile in 100 prints and portfolio, limited edition. This collection of prints has been exhibited in 40 museums and libraries of the United States, as well as in embassies, universities, libraries and information centers of the U.S.I.A. in over 140 cities throughout the world. Contributor to New York Times; Modern Packaging; American Printer; Printing News; Production Yearbook and other trade publications. Positions: Indst. Des. specializing in trade-marks, packaging and product identification. Publ. of prints and pictures under name Autoprints, and Collectors' Prints.*

HORNUNG, DR. GERTRUDE SEYMOUR (Mrs. Robert M.)—
Educator, Historian, Patron, Collector, W.
2240 Elandon Drive, Cleveland, Ohio 44106
B. Boston, Mass. Studied: Wellesley College, A.B.; Western Reserve University, M.A., Ph.D. Member: AAMus.; MModA; Fellow (Life) Cleveland Mus. A.; ICOM; Committee of Wellesley College Friends of Art; AFA; Am. Soc. for Aesthetics. Awards: Grant (Research, Italian Art History), Ministry of Foreign Affairs, Italy, 1962- . Author: "Cultural Directory of Greater Cleveland," 1947. Field of Research: History of Italian Art; Methodology in Museum

Art Education. Positions: Lecturer, Art Education for Adults, Cleveland Mus. A., 1937-1945; Supv., Special Activities, 1945-1958, Cleveland Mus.; Freelance lecturer and writer, 1960; Lectured on Palladio, His Influence in Europe and America, to the Irish Georgian Society, Dublin, Ireland, 1968; Delegate to White House Conference on Education, 1955; Pres. Adult Edu. Council of Cleveland, 1956-1958; Member, Natl. A. Edu. Comm., MModA, 1945- ; First Chm., Junior Council, Cleveland Mus. A., 1941-1942. Collection: Small collection Contemporary Italian and American Paintings and Prints.

HOROWITZ, MR. and MRS. RAYMOND J.—Collectors
1025 Fifth Ave., New York, N.Y. 10028*

HOROWITZ, SAUL—Collector
515 Madison Ave. 10022; h. 35 E. 76th St., New York, N.Y. 10021
B. New York, N.Y., May 27, 1897. Studied: City College of New York, A.B.; New York University Graduate School. Collection: French impressionist and post-impressionist paintings; 19th and 20th century sculpture. Benefactor, Whitney Museum of American Art. Chairman of the Board, HRH Construction Company, which built the Whitney Museum.

HORTER, ELIZABETH LENTZ—Painter, Etcher
310 W. Hortter St., Philadelphia, Pa. 19119
B. Philadelphia, Pa., Jan. 4, 1900. Studied: Westchester State T. Col.; Temple Univ., B.S. in Edu.; Tyler Sch. FA of Temple Univ., M.F.A. Also study at Cornell Univ., Univ. Pennsylvania, Moore Inst. A., Philadelphia Mus. Sch. A., with Earle Horter. Member: Print Cl., A. All., A. Teachers Assn., Museum of Art, all Philadelphia; Woodmere A. Gal.; Alumni Assn. of Tyler Sch. FA. Awards: Pennell purchase prize, Library of Congress. Work: Woodmere A. Gal. Exhibited: LC; PAFA; Soc. Am. Etchers; Carnegie Inst.; PMA; BM; Print Club, A. All., Sketch Cl., all Philadelphia; Tyler Alumni; Woodmere A. Gal.; Engineer's Cl., Phila.; Women's University Club. Positions: Supv. Art, Intern Program, Temple Univ., 1964.*

HORTON, JAN (Mrs.)—Painter
4305 Regency Ct., Jackson, Miss. 39211
Studied: Univ. Nebraska, B.F.A. Awards: prizes, Edgewater Plaza, Biloxi, Miss.; Mississippi AA; Tri-State Exh., Cheyenne, Wyo. and Biloxi, Miss.; 10-State Exh., Shreveport; Chebron A. Exh., 1967, 1968; Award of Merit and traveling exh., Holiday Inn Annual. Exhibited: Municipal A. Gal., Jackson; Mississippi A. Colony traveling; Edgewater Plaza, Biloxi; Mississippi AA traveling exhs., 1959-1969; Tri-State, Cheyenne and Biloxi; Univ. Hospital Galleries; 10 State Exh., Shreveport, La.; one-man: Municipal A. Gal., Jackson; Allison's Wells, Miss.; Junior League Gal.; Biloxi A. Gal.; Auburn, Ala.; 2-man: La Font Gals., Pascagoula, Miss.; Forest, Miss.; annually in jury exhs., Shreveport, Biloxi, Mobile, Jackson.

HORWITT, WILL—Sculptor
131 E. 15th St., New York, N.Y. 10003
B. New York, N.Y., Jan. 8, 1934. Studied: AIC. Awards: Guggenheim Fellowship, 1965-1966; Tiffany Fnd. purchase grant, 1968. Work: Wadsworth Atheneum; Chase Manhattan Bank, New York and Tokyo; Yale Univ. A. Gal. Exhibited: Radich Gal., N.Y., 1967; WMAA, 1966, 1968.

HOUGHTON, ARTHUR A., JR.—Museum President
Metropolitan Museum of Art, Fifth Ave. at 82nd St., New York, N.Y. 10028; h. 3 Sutton Place, New York, N.Y. 10022
B. Corning, N.Y., Dec. 12, 1906. Studied: Harvard University. Awards: Honorary Degrees from thirteen colleges and universities including Doctorates of Law, Humane Letters, Literature, Letters and Science; Officer of the French Legion of Honor; Senior Fellow and Ex-officio member of the Court, Royal College of Art, London; Life Fellow, Royal Society of Arts, London; Friedsam Medal in Industrial Arts. Positions: President, Steuben Glass, 1933- ; Director, Corning Glass Works, United States Steel Corporation and New York Life Insurance Company; Trustee, United States Trust Company, Rockefeller Foundation, New York Public Library and Cooper Union, New York; Honorary Trustee, Parsons School of Design and Institute of Contemporary Art, Boston; Curator, Rare Books, Library of Congress, 1940-1942 and currently Honorary Consultant in English Bibliography and Member of the Trust Fund Board; Honorary Curator, Keats Collection, Harvard University; President, The Metropolitan Museum of Art, New York, N.Y., 1964- .

HOUSE, JAMES (CHARLES), JR.—Sculptor, E.
810 Crum Creek Rd., Media, Pa. 19063
B. Benton Harbor, Mich., Jan. 19, 1902. Studied: Univ. Michigan; PAFA; Univ. Pennsylvania, B.Sc. in Edu. Work: S., WMAA; Grad. Library, Univ. Pennsylvania; St. Clements Episcopal Church, Phila., Pa.; Norfolk Medical Tower; Government Employees Ins. Co., Chevy

Chase, Md.; Swarthmore (Pa.) Presbyterian Church; Provident Tradesmen's Bank & Trust Co., Phila., Pa.; Bustleton Branch Lib., Phila.; Woodmere A. Gal., Phila.; Medical School, Univ. Pennsylvania. Exhibited: PAFA, 1939, 1940, 1942, 1945, 1946, 1948, 1952, 1957, 1968; Dallas Mus. FA, 1936; BM, 1932; WMAA, 1934, 1946; PMA, 1933, 1940, 1950, 1955; Carnegie Inst., 1941; Phila. A. All., 1954, 1955, 1957; N.Y. Mun. Exh., 1936; MMA (AV), 1942; MModA, 1942; Detroit Inst. A., 1932, 1935, 1938-1940, 1958; Kansas City AI, 1935. Author: "Fifty Drawings," 1930. Positions: Assoc. Prof., Sculpture & Drawing, Univ. Pennsylvania, Philadelphia, Pa. 1927- . San Diego State Col., summer, 1956.

HOUSER, JAMES COWING, JR. (JIM)—Painter, E.
Palm Beach Junior College, Palm Beach, Fla.; h. 138 North 13th Pl., Lantana, Fla. 33460
B. Dade City, Fla., Nov. 12, 1928. Studied: Ringling Sch. A. B.S.; Fla. Southern Col., AIC; Univ. Florida, M.F.A.; Johns Hopkins Univ. Member: CAA; Palm Beach County A. T. Assn.; Fla. A. Edu. Assn. Awards: prizes, Maryland A. Exh., 1954; Louisville A. Center, 1957; Norton Gal. A., West Palm Beach, purchase, 1960; Soc. Four Arts, Palm Beach, 1964-1968; purchase, Fort Lauderdale, Fla., 1965, 1969. Work: J.B. Speed Mem. Mus.; International Harvester Co.; Evansville (Ind.) Mus. A.; mural, Wesleyan Heights Methodist Church, Owensboro; Norton Gal.; Fort Lauderdale Mus.; Lowe Gal., Univ. Miami; Notre Dame Univ.; Cornell Univ.; N.Y. Univ.; Bethlehem (Pa.) City Center. Exhibited: ACA Gal., N.Y., 1954; Nebraska Wesleyan Univ., 1958; Jacksonville Mus. A., 1952, 1953; Maryland Artists, 1954; Ft. Lauderdale, 1960, 1961, 1966; 3-Arts Center, W. Palm Beach, 1960, 1961; 2-man: 3-Arts Center, 1960; Tri-State Annual, Evansville, 1955-57; Louisville A. Center, 1956-58; one-man: Jacksonville, Fla., Mus., 1953; Abbey Lane Theatre, Balt., Md., 1954; Carriage House Gal., Louisville, 1955; Murray State Col., 1957; Grand Central Moderns, 1967; Boca Raton, Fla., 1967; Lehigh Univ., 1968; 2-man: Evansville Mus., 1957. Positions: Instr., Palm Beach Jr. College, 1960- ; Chm. A. Dept., 1964- .

HOUSER, VIC(TOR) CARL—Sculptor, W., L., P., Des., T.
3200 Durand Dr., Hollywood, Cal. 90028
B. Los Angeles, Cal., Mar. 6, 1895. Studied: AIC; Carl Werntz Sch. FA, Chicago, and with Lorado Taft. Member: Cal. A. Cl. (Pres.); Laguna Beach AA; Vinculum of Fine Arts (Fndr. & Pres.); Professional Artists Roost (Fndr.). Awards: prizes, Soc. Western A., 1954; P. & S. of Los Angeles; Cal. A. Cl., 1954-58; Laguna Beach AA, 1956, 1957; Blakeman-Florence, Cal., Citation and Award, 1956; Southland AA, 1956. Work: 1st Award Medals (6) for Cal. A. Cl., 1958; monument to Joe Frisco, Delmar (Cal.) Race Track; Anita Metz trophy for Cal. Yacht Cl.; portraits, heraldic arms, figureheads for yachts in private colls.; ports. U.S. Treasury; Marion Davies Clinic, Univ. Cal. at Los Angeles; Mem. to combat flyers of all U.S. wars to be presented to U.S. Air Force Acad.; wood sculpture, Cathedrals in Los Angeles, Sacramento and Fresno, Cal. Lectures, demonstrations, TV and radio talks. Exhibited: WMA; CAM; Madonna Festival, Santa Ana and Los Angeles; Bakersfield A. Gld.; Palos Verdes AA; All-City Show, Los Angeles; Inglewood AA; Santa Barbara, and many others; one-man: Catholic Women's Cl., Los A.; Southland AA; Whittier AA; San Marino Women's Cl.; Pacific Palisades AA; Ebell Cl., Los A.; John Decker Gal.; Santa Monica AA; Gravers Soc., Univ. So. Cal.; Bowman Mann Gal., Los Angeles, and others. Positions: Memb. Adv. Bd., Cal. State Fair Art Show, nominating jury; Preparing "All Sculpture Show," Laguna Beach AA, 1962; Memb., Mayor's Com. to prepare new building code for building in California hills; Co-Chm., Arch. Bd. for approval of plans for hillside homes in Hollywood. Ed., Cal. A. Cl. Bulletin; Dir. & Ed., Monthly Bulletin, Am. Inst. FA. Advisor to Exec. Dir., California State Art Commission; Juror of Cal. State Fair Art Show, 1964; Judge, Madonna A. Festival, Los Angeles, 1965, and many other art positions.*

HOUSMAN, RUSSELL F.—Educator, Mus. D., P.
Art Department, Nassau Community College, Garden City, N.Y.; h. 38 Hampshire Rd., Great Neck, N.Y. 11023
B. Buffalo, N.Y., Jan. 13, 1928. Studied: Albright A. Sch., Dipl. FA; Teacher's Col., Buffalo, B.S. in A. Edu.; N.Y. Univ., M.A. in A. Edu., Ed. D.; and with Revington Arthur, Hale Woodruff. Member: Silvermine Gld. A.; CAA; AFA; MMA; NAEA. Awards: Chautauqua AA Scholarship, 1953; prizes, Silvermine Gld. A., 1960, 1961. Work: Forum Gallery, N.Y.; Human Resources Fnd., N.Y., State Univ. of N.Y. Col., and in private colls. Exhibited: over 300 group and one-man exhibitions.

HOVELL, JOSEPH—Sculptor, T.
130 West 57th St., New York, N.Y. 10019
B. Kiev, Russia. Studied: CUASch., with Brewster; NAD, with Robert Aitken. Awards: Agnon Gold Medal, Am. Friends of Hebrew Univ., Jerusalem, 1967. Work: portrait busts and bas-reliefs of many prominent persons, in private collections; plaques, busts,

Carnegie Hall, N.Y.; Nordacs Club; A.F. of L. Bldg., Wash., D.C.; CIO Bldg., Wash., D.C.; New Sch. for Social Research; Nathan Sachs bronze mem. plaque; Fairleigh Dickinson Univ.; mem. plaque, Hebrew Union Col. & Jewish Inst. Religion, Cincinnati. Exhibited: NAD; Soc. Indp. A.; BM; All. A. Am.; WMAA; Carnegie Hall Gal.; Mus. Sc. & Indst; Lotos Club, N.Y., Jewish Mus., N.Y., and others.

HOVEY, WALTER READ—Educator, Scholar, Collector
5732 Kentucky Ave., Pittsburgh, Pa. 15232
B. Springfield, Mass., July 21, 1895. Studied: Yale Univ., A.B.; Harvard Univ., A.M. Member: CAA; Assoc. A. Pittsburgh; Archaeological Society of America (Pres. Pittsburgh Chapter); Religious Art Center of America (Pres. 1965). Contributor to: Encyclopaedia of the Arts; Art in America; Art News; Parnassus, and other publications. Lectures: Chinese Mediaeval & Modern Art; Creative Impulse (Frick Coll., N.Y.); Early Art in France (Nat. Gal. A.) Author: "Catalogue of the Frick Collection, N.Y. vol. 8, Potteries and Porcelains," 1955. Awards: "Man of the Year in Art," Junior Chamber of Commerce, Pittsburgh, 1964; Hon. Ph.D., Wooster College. Collection: Oriental Ceramics. Field of Research: Iconography. Lectures: "Art as a Language" (Point Park College); "Spanish Art: a reflection of The History and Temperament of the Spanish People" (Smithsonian Institute, Washington, D.C.). Positions: Specialist, U.S. Int. Information Administration, Near East, Pakistan, Ceylon, 1954-55; Memb. Bd. Dirs., Westmoreland County Museum of Art; Pittsburgh Playhouse; Hd., Dept. Fine Arts, University of Pittsburgh, 1936-1962; Henry Clay Frick Professor, Univ. Pittsburgh, Dir., Henry Clay Frick Fine Arts Library & Building, 1965-1968, Pittsburgh, Pa.

HOVING, THOMAS—Museum director
Metropolitan Museum of Art, Fifth Ave. at 82nd St., New York, N.Y. 10028*

HOVSEPIAN, LEON—Painter, Gr., L., T.
96 Squantum St., Worcester, Mass. 01606
B. Bloomsburg, Pa., Nov. 20, 1915. Studied: WMA; Yale Univ., B.F.A. Awards: traveling F., Yale Univ., 1941; prize, Fitchburg A. Center, 1948; WMA, 1968 (purchase). Work: Fitchburg A. Center; PBA; murals, Ft. Warren, Mass.; Sheraton Hotel, Worcester, Mass.; Coronado, Aurora hotels, Worcester, Mass.; Clinton, Mass.; Hickory House, Worcester, Mass.; Hotel Lenox, Dartmouth House, Boston; Norton Abrasives Co., Worcester, Mass. Altarpiece, Holy Trinity Church, Worcester, Mass.; medical drawings, Hahnemann Hospital; Painting, Ofc. for Emergency Management, Wash., D.C.; Chief of Design, Immaculata Retreat House, Willimantic, Conn. Des. of Chapel incl. execution of: bronze sc., stained glass, mosaic Stations of the Cross, Fresco altar painting, altar & altar furnishings; designed executed stained glass windows, Church of Our Saviour, Worcester, Mass., 1964, and chapel at Holy Cross College, Worcester, Mass., 1966; Leicester Jr. Col.; Architect of new additions (sculpture, mosaics, murals), Oblates of Mary Immaculate Retreat House, Hudson, N.Y., 1966-1967; Exhibited: AIC, 1941; WMA, 1945; NGA; CGA; MMA; PAFA; Albright A. Gal.; Milwaukee AI; Fitchburg A. Center; R.I.Sch.Des.; CMA; Albany Inst. Hist. & A.; Margaret Brown Gal., Boston; School Instrs. Exh., WMA.; one-man: Trumbull Gallery, Worcester, Mass.; AGBU Gal., N.Y., 1966; Fitchburg A. Mus., Fitchburg, 1967. Positions: Instr., A., WMA Sch., Worcester, Mass.; Dir., Boylston Summer A. Sch., 1948- ; Instr., Int. Des., YWCA, 1955; Dir., Triart Designers; Consultant in Des. for mural painting for Seminary of The Oblates of Mary Immaculate, Bucksport, Me.

HOWARD, CHARLES—Painter
The End Cottage, Helions Bumpstead, Essex, England
B. Montclair, N.J., Jan. 2, 1899. Studied: Univ. California, B.A. Member: San F. AA. Awards: prizes, SFMA, 1940, 1942; MMA (AV), 1942; Palace Legion Honor, 1946; Pasadena AI, 1946. Work: SFMA; AIC; MMA; Pasadena AI; Mus. Non-Objective Painting: Art of This Century; Dallas Mus. for Contemp. A.; Melbourne (Australia) A. Gal.; Contemp. A. Soc., London, England. Exhibited: San F. AA, annually; AIC, 1943, 1945; Critic's Choice, Cincinnati, Ohio, 1945; MMA (AV), 1942; MModA, 1942; retrospective esh., Whitechapel A. Gal., London, 1956; St. George's Gal., London, 1958; McRoberts & Tunnard, London, 1964. Positions: Teaching Staff, Painting School, Camberwell School of A. & Crafts, London, England, 1959-1965.*

HOWARD, HUMBERT L.—Painter
1601 Walnut St. 19102; h. 3411 Hamilton St., Philadelphia, Pa. 19104
B. Philadelphia, Pa., July 12, 1915. Studied: Univ. Pennsylvania; Howard Univ. Sch. FA. Member: AEA; Phila. A. All. Work: Howard Univ.; PAFA; Phila. Civic Center Mus., and in private colls. Awards: Van Sciver Mem. prize, Woodmere A. Gal. (Pa.), 1968. Exhibited: PAFA, 1950, 1952, 1953, 1968; Temple Univ. PMA, 1954 and

prior; Phila. A. All., 1952; LC; Univ. So. California; Phila. Sketch Cl.; Howard Univ., 1961; City Col. of N.Y., 1967; one-man: PAFA; Phila. A. All.; Newman Gal.; Temple Univ.; Pyramid Cl.; Dubin Gal.; Grabar Gal., 1968; Howard Univ. Positions: Faculty, Allens Lane A. Center, Philadelphia; Am. Fnd. for Negro Affairs Comm. on Cultural and Performing Arts.

HOWARD, JOHN L(ANGLEY)—Painter, I., T.
Studio House, Ellen St., Upper Nyack, N.Y. 10960
B. Upper Montclair, N.J., Feb. 5, 1902. Studied: Univ. California; Cal. Sch. A. & Crafts; ASL, with Kenneth Hayes Miller. Member: San F. AA; Marin SA. Awards: prizes, San F. AA, 1934, 1937, 1945. Work: mural, Coit Mem. Tower, San F., Cal. Exhibited: CGA, 1943; Carnegie Inst., 1941; GGE, 1939; AIC, 1945; Palace Legion Honor, 1945, 1956. Positions: Illustrator for Scientific American Magazine, and others; covers of scientific subjects; Illus., "Origins of Angling." Instr., PIASch., Brooklyn, N.Y., 1958- .*

HOWARD, LEN R.—Craftsman, Des.
Kent, Conn. 06757
B. London, England, Aug. 2, 1891. Studied: PIASch; ASL; St. Martin's and Camberwell A. & Crafts, London, England. Member: Kent AA; SC; Meriden A. & Crafts. Award: prize, Meriden A. & Crafts. Work: stained glass windows for churches & schools in Torrington, New Milford, Brookfield Center, Canaan, Conn.; Memphis, Tenn.; Augusta, Ga.; Santa Maria, Cal.; Ann Arbor, Mich.; New Orleans, La.; Salina, Kans.; Nutley, N.J.; Summit, N.J.; Winsted and Bridgeport, Conn.; Stockbridge and Longmeadow, Mass.; LaGuardia Mem., Christ Church, Riverdale, N.Y., etc. Lectures on Stained Glass Techniques. V.-Pres., Kent AA.

HOWARD, RICHARD FOSTER—Museum Director
Birmingham Museum of Art, 2000 Eighth Ave., North, Birmingham, Ala. 35203
B. Plainfield, N.J., July 26, 1902. Studied: Harvard Col., B.S.; Harvard Grad. Sch.; Yale Univ.; Cornell Univ. Member: AAMus.; AFA; Southern A. Mus. Dir. Assn.; Southeastern Conf. AAMus.; Alabama A. Comm., 1961- . Awards: Order of the White Lion of Bohemia, 1947; Stella della Solidarieta d'Italia, 1950. Lectures on Art History & Appreciation. Positions: Dir., Dallas Mus. FA, 1935-42; Chief, Monuments FA Archives, 1946-49; Dir., Des Moines A.Center, 1949-50; Dir., Birmingham Mus. A., 1951- .

HOWARD, ROBERT A.—Sculptor, E.
Ackland Art Center, University of North Carolina; h. 1201 Hillview Rd., Chapel Hill, N.C. 27514
B. Sapulpa, Okla., Apr. 5, 1922. Studied: Phillips Univ.; Univ. Tulsa, B.A., M.A.; and with Zadkine, Paris, France. Awards: grant, The Cooperative Program in the Humanities, Duke Univ. and the Univ. North Carolina, for creative work, 1965. Work: North Carolina Mus. A., Raleigh; Ackland A. Center, Chapel Hill; sc. relief, Lenoir Hall, Univ. N.C. Exhibited: WMAA, 1964, 1966, 1968; N.Y. World's Fair, 1965; De Pauw Univ., 1965. 1966 exhs.: Portland (Me.) Mus. A.; Montclair (N.J.) A. Mus.; Madison (Wis.) A. Center; Fresno State Col.; Long Beach (Cal.) Mus. A.; Univ. Iowa; Witte Mem. Mus., San Antonio, Tex.; De Cordova and Dana Mus.; Univ. Missouri; MModA; Ogunquit (Me.) Mus. 1967 Exhs: Albright-Knox Gal.; Royal Marks Gal., N.Y.; Los Angeles County Mus.; Southern Ill. Univ., Alton; Minneapolis A. Center; PAFA; Root A. Center, Clinton, N Y.; Gal. of Contemp. A., Winston-Salem, N.C.; Coe Col., Cedar Rapids, Iowa; Contemp. AA, Houston; Univ. Fla., Gainsville; Ithaca Col., N.Y.; N.Y. State Univ., Potsdam; 1969 Exhs.: Univ. Ill., Champaign; one-man: Royal Marks Gal., N.Y., 1967, 1968. Lecture: "Michelangelo and Rodin," NGA, Wash., D.C. Positions: Assoc. Prof. A., University of North Carolina, Chapel Hill, N.C.

HOWARD, ROBERT BOARDMAN—Sculptor, P., C., T.
521 Francisco St., San Francisco, Cal. 94133
B. New York, N.Y., Sept. 20, 1896. Studied: Cal. Sch. A. & Crafts; ASL; & with Arthur Upham Pope, Kenneth Hayes Miller. Member: San F. AA. Comm.; San F. AA. Awards: Med., San F. AA, 1923; prize, 1924, 1941, 1943, 1944, 1947, 1950, 1951, 1955; Hon. mem., F. D. Roosevelt Mem. Comp., 1960. Work: SFMA; Mills Col., Oakland, Cal.; murals, Yosemite Nat. Park; San F. Stock Exchange Bldg.; relief maps, U.S. Navy; sc., P.G. & E. Bldg., San F.; Berkeley (Cal.) Auditorium; Univ. Cal.; sculpture, IBM, San Jose, Cal.; Fountain of Whales, California Academy of Sciences, Golden Gate Park, San Francisco, Cal., and many other arch. sc. commissions. Exhibited: San F. AA, 1924-1955, one-man, 1956; CGA, 1937; Carnegie Inst., 1941; AIC, 1944; Palace Legion Honor, 1946; WFNY, 1939; GGE, 1939; WMAA, 1948, 1950-1955; MMA, 1951; Sao Paulo, Brazil, 1951-1952, 1955; Salon de Mai, Paris, France, 1963, 1964; SFMA, 1963 (one-man); Univ. Cal., Santa Cruz, 1968 (one-man). Positions: Instr., Sculpture & Painting, Cal. Sch. FA, San Francisco, Cal., 1944-52; Mills Col., Oakland, Cal., 1945; Instr. Sc., San F. AI, summer, 1959-61.

HOWAT, JOHN K. —Museum Curator
Metropolitan Museum of Art; h. 55 East End Ave., New York, N.Y. 10028
B. Denver, Colo., Apr. 12, 1937. Studied: Harvard College, B.A.; Harvard Graduate School of Arts and Sciences, M.A. Member: AFA; The Victorian Society of America; National Trust for Historic Preservation. Contributor to Antiques magazine; Metropolitan Museum of Art Bulletin. Lectures: American Painting of the 18th and 19th Centuries; General Art History. Exhibitions arranged: "David Smith, Sculpture and Drawings," 1964; "John F. Kensett," 1968; "19th Century America," 1969-1970. Positions: Curator, The Hyde Collection, Glens Falls, N.Y., 1962-1964; Ford Fellow, Metropolitan Museum of Art, 1965; Chester Dale Fellow, Metropolitan Museum of Art, New York, N.Y., 1966-1967.

HOWE, NELSON SCOTT—Painter, Des., T.
25 Essex St., New York, N.Y. 10002
B. Lansing, Mich., Nov. 5, 1935. Studied: Univ. Michigan, B.A., M.A. Work: Chase Manhattan Bank, N.Y.; Finch Col. Mus.; N.Y. Univ. Coll.; Univ. California, Berkeley; Mus. of the Univ. Massachusetts. Exhibited: MModA traveling exh., 1962; Finch Col., N.Y., 1965; Univ. Massachusetts, 1966; Newark Mus., 1968. Illus., "Drawings from a Civil War," 1965; "To the Sincere Reader," 1969. Positions: Instr., Basic Design, Parsons Sch. Des., New York City; Art, Newark Col. of Engineering, Newark, N.J.

HOWE, OSCAR—Painter, E.
Art Department, University of South Dakota, Vermillion, S.D. 57069
B. Joe Creek, S.D., May 13, 1915. Studied: Dakota Wesleyan Univ.; Univ. Oklahoma, M.F.A. Member: F., F.I.I.A.L. Awards: prizes, Philbrook A. Center, Tulsa, 1947, 1949-1965; Honorary Doctor of Humanities, South Dakota State University, Brookings, S. Dak. 1968; Waite Phillips trophy, 1966; Denver A. Mus., 1952, 1953, 1954; Mus. New Mexico, 1956, 1958; South Dakota Artist Laureate, 1960. Work: murals, Mitchell (S.D.) Lib.; Mobridge Auditorium; Nebraska City, Neb.; exterior ceramic tile mural, Hinsdale, Ill.; paintings: Joslyn A. Mus.; Gallup (N.M.) A. Gal.; Mus. New Mexico; Philbrook A. Center; Denver A. Mus.; Montclair (N.J.) A. Mus. Illus., "Legends of the Mighty Sioux"; "The Little Lost Sioux"; "Bringer of the Mystery Dog"; "North American Indian Costumes." Contributor to School Arts; Indians at Work; Art Education Today; Time; Oklahoma Today; "Indian Art of the United States" (d'Harnoncourt); "A Pictorial History of the American Indian" (La Farge). Work published in foreign magazines "Riding"; "Animal and Zoo Magazine" (both London); "L'Illustration" (Paris). Exhibitions: Philbrook A. Center; AIC; Smithsonian Inst.; Denver A. Mus.; SFMA; Stanford Univ.; Mus. of the Southwest, Los Angeles; Mus. New Mexico; MModA; one-man: Philbrook A. Center; Fort Dodge, Iowa; Mus. New Mexico, 1957; Denver A. Mus., 1958; Joslyn A. Mus., 1959. Positions: Prof. of A. and A.-in-Res., University of South Dakota, Vermillion, S.D., 1957- .

HOWE, THOMAS CARR—Museum Director
2709 Larkin St., San Francisco, Cal. 94109
B. Kokomo, Ind., Aug. 12, 1904. Studied: Harvard Univ., A.B., A.M. Member: Assn. A. Mus. Dir.; Western Assn. A. Mus. Dir.; Century Assn.; Bohemian Cl., San F.; Harvard Cl., N.Y. Contributor to various art periodicals. Lectures, Art History; Art Appreciation. Author: "Salt Mines and Castles," 1946. Decorated by French (Chevalier, Legion of Honor) and Dutch (Officer, Order of Orange-Nassau) Governments for assisting in recovery of works of art looted by the Germans prior to and during the last war. Positions: Asst. Dir., 1931-39, Dir., 1939- , California Palace of the Legion of Honor, San F., Cal.; Deputy Chief, M.F.A. & A. Section, U.S.F.E.T. Hq., 1945-46; Cultural Affairs Adv., U.S. State Dept. to High Commissioner of Germany, 1950-51; Trustee, American Federation of Arts; Bd. Dirs., America-Italy Society and Iran-America Society.*

HOWELL, CLAUDE, FLYNN—Painter, E., L.
Wilmington College; h. Carolina Apts., Wilmington, N.C. 28401
B. Wilmington, N.C., Mar. 17, 1915. Studied: with Jon Corbino, Bernard Karfiol, Charles Rosen. Member: Assoc. A. North Carolina; N.C. State A. Soc. Work: IBM; North Carolina Mus. A.; Mint Mus. A., Charlotte; Queens Col, Charlotte; N.C. State Col.; mural, Hist. Mus., Brunswick; N.C. State Ports Authority, Wilmington; Atlanta AA Gal.; Wake Forest Col, Winston-Salem; Greenville A. Center; Univ. N.C. Gal., Durham. Awards: prizes, North Carolina State A. Soc., 1954, 1956; Mint Mus. A., 1959, 1963; Rosenwald F., 1948; Norfolk Mus. A. & Sc., 1954; N.C.-Va. Exh., 1957, 1959, 1960; Winston-Salem Gal. FA, 1963, 1964; Lancaster, S.C., 1960, 1963; North Carolina AA; Asheville A. Mus., 1966, "Art on Paper" Purchase, 1967; Univ. North Carolina, Raleigh, 1968. Exhibited: N.C. State A. Soc., 1940-1963; Atlanta, Ga., 1947-1959; Univ. Tennessee, 1951; MMA, 1952; BMA, 1954; Gibbes A. Gal., 1955; one-man: All. A., Durham; Mint Mus. A.; Asheville A. Mus.;

Wilmington Col.; 1964: Virginia Beach Va.; Rocky Mount A. Center; Haslem Gal., Chapel Hill; 1965: 20th Century Gal., Williamsburg.; Assoc. A. of N.C., (1962-1969); Spring Traveling Shows, 1962-1964. Univ. Georgia, 1958; Norfolk Mus., 1958, 1960; Hunter Gal., Chattanooga, 1960; 1966-1969: Mint Mus., Charlotte; Wake Forest Col.; Sears traveling exh.; Gal. Contemp. A., Winston-Salem; Univ. North Carolina, Greensboro; Carroll Reece Mus., Johnson City, Tenn. One-man: Lenoir Rhyne Col., Hickory, N.C., 1967; Meredith Col., Raleigh, 1968; Gal. Contemp. A., Winston-Salem, 1969. "The Hatterasman," 1958; "Exploring the Seacoast of North Carolina," 1969. Positions: Chm., A. Dept., Wilmington Col., Wilmington, N.C.

HOWELL, DOUGLASS (MORSE)—
Painter, Et., Eng., Hist., W., L.
107 E. Main St., Oyster Bay, L.I., N.Y. 11771
B. New York, N.Y., Nov. 30, 1906. Studied: in France and Italy (18 yrs.). Member: Am. Craftsmen's Council; Assoc. F., Intl. Inst. for Conservation of Historic & Artistic Works (Hdqtrs., London); Am. Ord. Assn. Award: Ford Fnd. F., for research in papers for the Fine Arts, 1961. Work: handmade papers; BMFA; BM; handpress printing books, N.Y. Pub. Lib.; Huntington Mus., San Marino, Cal., and in private collections. Exhibited: America House, 1953; Country A. Gal., Westbury, 1954, 1962; Phillips Exeter Acad.; Huntington Mus., Long Island, N.Y.; Univ. Texas, Austin, 1961; N.Y. State A. T. Assn. Convention, Corning, N.Y., 1961; one-man: Brooklyn Pub. Lib., 1947; Newport AA, 1948; Franklin Inst., Phila., Pa., 1948; Univ. Maine, 1951; Betty Parsons Gal., 1955. Lectures: Papers and the Artist: Past, Present and Future; Paper requirements of the various art mediums. Produces fascimiles of rare prints, duplicating paper, ink, and graphic process; Maintains Experimental Workshop for research in handmade papers for the Fine Arts, "A Papermill on Wheels"; Laboratory for Research. Author: "A Tentative Program for a Test of Handmade Papers for Watercolor Painting," 1954; "The Art of Hand Binding Books." Est. school, 1962. Special seminars: Handmade Papermaking for the Fine Arts; The Aesthetics of Skill; Albrecht Durer and His Handmade Papers; Rembrandt and the Handmade Papers He Used; Jackson Pollock Working Upon Handmade Papers; The Chinese Mi Fou and His Handmade Papers.

HOWELL, HANNAH JOHNSON (Mrs. Henry W., Jr.)
—Art Librarian
10 East 71st St. 10021; h. 151 East 83rd St., New York, N.Y. 10028
B. Oskaloosa, Iowa, June 22, 1905. Studied: Penn Col., Oskaloosa, Iowa; Univ. Chicago, Ph.B.; Columbia Univ. Sch. of Library Service, B.L.S. Member: Am. Lib. Assn.; Art Reference Round Table; Special Library Assn.; Museum Group. Positions: Hd. Librarian, Frick Art Reference Library, New York, N.Y., 1947- .

HOWELL, MARIE (W.)—Designer, C., T.
298 Elizabeth St., New York, N.Y. 10012
B. Milwaukee, Wis., July 30, 1931. Studied: Conn. Col. for Women; R.I. Sch. Des., B.F.A. (textile des.). Member: Nat. Soc. for Dec. Des.; Des.-Craftsmen of R.I.; Am. Craftsmen's Council; Nat. Home Fashions Lg. Awards: prizes, Women's Int. Expo., N.Y., 1959; R.I. Arts Festival, 1960, 1961. Work: Univ. California; Haystack Mountain Sch. of Crafts. Exhibited: Good Design, Chicago & N.Y., 1954; Community A. Center, Wallingford, Pa., 1953, 1954; New England Crafts, Worcester, Mass., 1955 and Old Sturbridge Village, Mass., 1959; Boston A. Festival, 1956, 1959; Pa. Gld. Craftsmen, 1958; Smithsonian Inst. traveling exh., 1955; Upholstery Leather Group Des. Comp. (with James Howell), 1957, 1958; Wichita AA, 1958; AID Des. Comp., 1957; R.I. Crafts, 1959; Colby Col., 1959; Univ. Nebraska A. Gal., 1959; Mus. A., R.I.Sch. Des., 1959, 1963; Brecks' Mill, Wilmington; Delaware A. Center, 1959; Riverdale, N.Y., 1959; Univ. Delaware, 1960; De Cordova & Dana Mus., 1960, 1962; Old Slater Mill Mus., Pawtucket, 1960; Eastern States Expo., Springfield, Mass., 1960; Silvermine Gld. A., 1960; Soc. Conn. Craftsmen, 1960; Univ. New Hampshire, 1960; Women's Int. Expo., 1960; Wilmington Soc. FA, 1960; PMCol. A., 1961; Denver A. Mus., 1961; Univ. Southwestern Louisiana, Lafayette, 1961. Recent exhs.: Mus. Contemp. Crafts, N.Y., 1961, 1962, 1964; R.I. Arts Festival, 1961-1963; Craft Center, Worcester, Mass., 1961; Brookfield (Conn.) Craft Center, 1962; Univ. Missouri, 1962; Beverly (Mass.) Farms Regional, 1963; Living Arts Center, Denver, 1963; Fiberglas Center, N.Y., 1964; USIA Textile Exh. touring Latin America, 1965; "Threads of History," AFA traveling exh., 1965. Positions: Asst. Prof., Textile Des., R.I. Sch.Des., Providence, R.I., 1955-1965; Governing Bd., Des.-Craftsmen of R.I.; Instr., Haystack Mountain Sch. of Crafts, 1958-1959. Visiting Scholar to A. Dept., Univ. of Delaware, 1960. Special Consultant, Alliance for Progress in Colombia, So. Am., 1965. Des. Assoc., Larson Des. Corp., 1965-1968. Designer, Carson, Lundin and Shaw Architects 1968- . Visiting lecturer, Sch. of Arch., Columbia Univ., 1965- . Instr., Parsons Sch. of Des., 1965- .

Contributor to Design (India); Upholstering; Handweaver and Craftsmen; Cross Country Craftsman; Decorative Art (England); American Fabrics; Casa y Jardines (Argentina).

HOWETT, JOHN—Museum Curator, T., Hist., Lith., W., L.
Art Gallery, University of Notre Dame, Notre Dame, Ind.;
h. 3004 Corby Blvd., South Bend, Ind. 46615
B. Kokomo, Ind., Aug. 7, 1926. Studied: John Herron AI, B.F.A.; Univ. Chicago, M.A. Member: CAA; AAUP. Exhibited: Southern Cal. Biennial, 1952; Bradley Univ. Print Exh., 1952; Indiana Print Makers, 1952. Contributor to Art Journal. Lectures: Medieval, Renaissance and Modern Art at John Herron AI, Univ. Notre Dame. Positions: Curator, Art Gallery and Asst. Prof. Art History, University of Notre Dame, Notre Dame, Ind.*

HOWLAND, RICHARD HUBBARD—
Historian, Mus. D., L., E.
Smithsonian Institution 20560; h. 1516 33rd St., Northwest, Washington, D.C. 20007
B. Providence, R.I., Aug. 23, 1910. Studied: Brown Univ., A.B.; Harvard Univ., A.M.; Johns Hopkins Univ., Ph.D. Author: "Greek Lamps from the Athenian Agora," 1958; Co-Author: "The Architecture of Baltimore," 1952. Positions: Chm., Managing Comm., Am. Sch. of Classical Studies; Athens, Greece; Trustee, Evergreen Fnd.; Pres., Nat. Trust for Hist. Preservation, 1956-60; Chm., Dept. Civil History, Smithsonian Institution, Wash., D.C., 1960-1967; Special Assistant to Secretary of the Smithsonian Institution, 1968- ; Memb. Bldg. Comm., Washington National Cathedral; (Chm., Consulting Committee); Dir., Society of Architectural Historians; Exec. Committee, Archaeological Inst. of America; Consulting Comm., Nat. Survey of Historic Sites & Buildings of Nat. Park Service; Trustee, Sottenley Foundation (Md.).

HOWLETT, MRS. ARTHUR E. See Daingerfield, Marjorie

HOWLETT, CAROLYN SVRLUGA—Educator, P., Gr., C., Des., L.
336 Coonley Rd., Riverside, Ill.; School of the Art Institute, Chicago, Ill. 60603
B. Berwyn, Ill., Jan. 13, 1914. Studied: AIC, B.A. in Edu., M.A.E.; Univ. Chicago; Northwestern Univ., M.A. Member: Chicago A. Cl.; Nat. A. Edu. Assn.; Chicago Soc. A.; Western AA; AFA; MModA (Pres. 1962-63); Illinois A. Edu. Assn.; Around-Chicago A. Edu. Assn. Awards: AIC, 1932. Exhibited: Pan-American Salon; Chicago Hist. Soc., 1942; AIC, 1945, 1946, 1952, 1953; Chicago Mus. Sc. & Indst., 1948, 1949; Chicago Soc. A., 1946-1969; Findlay Gal., 1949, 1950; Riverside Mus., 1947; Renaissance Soc., Chicago, 1948, 1959, 1960; AFA, 1948; Assoc. Am. A., Chicago, 1950; "Magnificent Mile A. Exh.," 1951; Chicago A., Cl., 1952-1969; Chicago Sun-Times Gal., 1960; Marshall Field Co., 1953; Western A. Regional, Houston, 1966; one-man: Chicago Press Cl., 1966, 1968. Contributor to Design, School Arts, NAEA yearbook, 1954, 1959; Junior Arts and Activities magazines; Author, chapter on drawing & painting, "Childcraft" encyclopedia; "Orientation to the Visual Arts," 1966 and "The Poster Revisited," 1968 in Arts and Activities magazine. Author, I., World Book Encyclopedia. Positions: Tech. Consultant, Arts & Skills Program, Am. Red Cross, 1942-45; Nat. A. Edu. Assn. Council member, 1947-50; Chm., Policy & Research Comm., 1947-53; Prof. (1953-); Hd. Dept. A. Edu., 1944-1964, Instr., 1937- , Assoc. Dean, 1963-1965, AIC, Chicago, Ill.; Chm., Curriculum Committee, NAEA, 1957-59, member, professional development com. of NAEA, 1969-1973. Contributor NEA project, Art for Academically Talented Students, 1959; Ed., Art Education Bibliography, 1959 and 1961.

HOWZE, JAMES DEAN—Educator, P., Gr. Des.
Texas Technological College 79409; h. 2503 45th St., Lubbock, Tex. 79413
B. Lubbock, Tex., Apr. 8, 1930. Studied: Austin Col., Sherman, Tex., B. A.; A. Center Sch., Los Angeles; Univ. Michigan, M.S. (Des.); Yale Univ., B.A., B.F.A., M.F.A. Member: CAA; Dallas-Ft. Worth A. Dirs. Cl. (Hon.). Awards: Award of Merit, Southwestern Exh. Adv. Art, Dallas, 1964; nat. award (2) for teachers from St. Regis package design competition; other prizes, Lubbock AA, 1967; Llano Estacado exh., Hobbs, N.M., 1967; Midland AA, 1968. Exhibited: Texas FA Assn., 1966; Llano Estacado, 1967; DMFA, 1967; Cranbrook Acad. A., 1967; Hemisfair, San Antonio, 1968; Angelo State Col., 1968; Cushing Gal., Dallas, 1969; Faculty Exh., West Texas Mus., Lubbock, 1969. Illus., "Athens of the Panhandle," 1958; Cart., illus., Sports Car Graphic and other trade publications. Positions: Prof. A., and studio program coordinator, Texas Technological College, Lubbock, Tex., at present.

HOYT, DOROTHY (DILLINGHAM)—Painter, Int. Des.
2 Fountain Place, Ithaca, N.Y. 14850; s. Trumansburg, N.Y. 14886
B. East Orange, N.J., Aug. 11, 1909. Studied: Cornell Univ., B.S.,

M.A.; ASL; New School for Social Research. Awards: Grumbacher award, NAWA, 1956; Jane Peterson Award, N.J. Soc. P. & Sc., 1957; Medal of Honor, NAWA, 1958; Mary Kelner Award for Graphics, Am. Soc. Contemp. A., 1959; Central Adirondack A.A., 1966. Exhibited: WMAA; PAFA; AIC; Toledo Mus. A.; Albright-Knox A. Gal., Buffalo; Butler Inst. Am. A., Youngstown, Ohio; Four Arts Club, Palm Beach; LC, and others. Also in museums and galleries in Europe and Japan. One-man: Macbeth Gal., N.Y., 1947; John Heller Gal., N.Y., 1951; Tyringham (Mass.) Gal., 1955; White Mus. A., Cornell Univ., 1958; Juster Gal., N.Y., 1960; Muggleton Gal. FA, Auburn, N.Y., 1962, 1963, 1966; Cornell Univ., Franklin Hall, 1963; The Upstairs Gal., Ithaca, N.Y., 1964, 1967; David Gal., Houston, Tex., 1965; Adirondack Lg. Cl., Little Moose, N.Y., 1967. Positions: In charge of executing interior designs of the new $40 million campus at Ithaca Col., N.Y., 1965-1968.

HOYT, WHITNEY F.—Painter
Greenbush Rd., Blauvelt, N.Y. 10913
B. Rochester, N.Y. 1910. Studied: N.Y. Sch. Fine & Appl. A.; Ecole des Beaux Arts, Fontainebleau, and with Camille Liausu, Paris, Fritz Trautman, Rochester, N.Y. Member: AEA; Artists' Fellowship, Inc.; All. A. Am.; Conn. Acad. FA. Work: Springfield (Mass.) Mus. A.; Munson-Williams-Proctor Inst., Utica, N.Y.; Rochester Mem. A. Gal. Awards: prizes, Rochester Finger Lakes Exh.; All. A. Am., 1951; Goerge L. Herdle Mem. Prize, Rochester Mem. A. Gal., 1953. Exhibited: Great Lakes Exh.; Inst. Contemp. Al, Boston; Rochester Mem. A. Gal., 1940, 1946; Dayton A. Inst., 1949; Ft. Worth A. Center, 1958; Buck Hill AA; Rochester Finger Lakes Exhs.; Lazuk Gal., Cold Spring Harbor, N.Y.; Rockland Fnd.; Des Moines A. Center; William Rockhill Nelson Gal. A., Kansas City, Mo.; Columbus Gal. A.; Springfield Mus. FA; Albright-Knox A. Gal.; DMFA; Birmingham Mus. A.; Univ. Nebraska; Lehigh Univ.; NAD; Audubon A.; AEA; Conn. Acad. FA; All. A. Am.; and others. One-man: Kraushaar Gals., N.Y., 1949, 1954, 1957; Market Fair Gal., Nyack, N.Y., 1961, 1964, 1965, 1967; Lazuk Gal., 1957, 1959, 1964; Jewett, Inc., Rochester, N.Y., 1956, 1957, 1961, 1966, 1969.

HSIAO, MRS. SIDNEY C. See Karawina, Erica

HUBBARD, EARL WADE—Painter, W., L.
Wells Hill Rd., Lakeville, Conn. 06039
B. Bradford, Pa., Feb. 3, 1924. Studied: Amherst Col., B.A. Exhibited: Sharon (Conn.) A. Gal., 1958-1960; Mystic AA, 1958; Rehn Gal., N.Y., 1958, 1961; Art: USA, 1958; PAFA, 1962; one-man: Panoras Gal., N.Y., 1956; Rehn Gal., 1960, 1962 (a full showing of the 1962 exh. on C.B.S.-TV with Aline Saarinen); Gal. Mod. A., N.Y., 1965. Author: "One Step Two Step," 1951.

HUBBARD, ROBERT—Sculptor
West Rd., Little Compton, R.I. 02837
B. New York, N.Y., Mar. 27, 1928. Studied: Lafayette Col., B.A.; Rhode Island Sch. of Des., B.F.A. Awards: Rhode Island A. Festival, 1960; Providence A. Cl., 1969; Howard Fellowship, 1969. Work: Lafayette Col.; Sara Roby Fnd. Exhibited: WMAA, 1966; Bristol (R.I.) A. Mus., 1967; Newport A.A. 1967; Providence A. Cl., 1969; Boston A. Festival, 1959; Rhode Island A. Festival, 1960, 1961; Silvermine Gld., 1960; Ravinia Festival (Chicago), 1963, 1969.

HUBENTHAL, KARL S.—Cartoonist
Los Angeles Herald-Examiner, Los Angeles, Cal.; h. 16863 Marmaduke Place, Encino, Cal. 91316
B. Beemer, Neb., May 1, 1917. Studied: Chouinard AI, Los Angeles. Member: SI (Pres. 1958-59); Nat. Cartoonists Soc.; Assn. American Editorial Cartoonists (Pres. 1963-64); Los Angeles A. Dir. Cl.; Los Angeles Press Cl.; Marine Corps Newsmen's Assn. Awards: Nation's Best Sports Cart., World's Fair, N.Y., 1940; National Headliner's Award for Outstanding Achievement in Journalism, 1959; Nation's Best Editorial Cartoonist, Nat. Cart. Soc., 1962, 1967; Freedoms Foundation awards, 1951, 1953, 1955-1967; Grand Award, Valley Forge, 1962; Helms Athletic Fnd. Medal, for contribution to sport in art, Los Angeles, 1964. Work: Detroit Archives of American Art; State Historical Soc. of Missouri (Univ. Missouri); LC; President Truman Mem. Library; President Eisenhower Mem. Lib.; Dept. of Journalism, Univ. So. California; Huntington Mem. Lib.; State Historical Soc. of Wisconsin; Syracuse Univ.; Univ. of Southern Mississippi. Positions: Cartoonist, all Hearst Newspapers; Editor & Publisher; Time; Newsweek; U.S. Business & World Report.

HUDSON, MRS. CECIL B.—Collector
35 N. Wynden Dr., Houston, Texas 77027*

HUDSON, KENNETH EUGENE—Educator, P.
St. Louis School of Fine Arts, Washington University; h. 7900 Stanford St., St. Louis, Mo. 63130
B. Xenia, Ohio, Dec. 28, 1903. Studied: Ohio Wesleyan Univ.; Acad-

emie Royale, Brussels, Belgium; Yale Univ, B.F.A.; Fontainebleau, France. Awards: F., Belgian-Am. Edu. Fnd., 1935. Work: murals, Univ. Oregon; Mun. Bldg., Columbia, Mo. Positions: Hd., Drawing & Painting Dept., Univ. Oregon, 1927-29; Chm. Dept. A., Univ. Missouri, 1928-38; Dean, St. Louis Sch. FA, Washington Univ., St. Louis, Mo., 1938- . Pres., Nat. Assn. Schs. Design, 1953-55.

HUDSON, RALPH M.—Educator, Des., P., W., L., Comm. A.
Dept. of Art, University of Alabama in Huntsville 35807; h. 7102 Criner Rd., S.E., Huntsville, Ala. 35802
B. Fields, Ohio, Dec. 18, 1907. Studied: Ohio State Univ., B.A., B.Sc.E., M.A.; Univ. Alabama, Ed.D.; Grad. study, Ohio State Univ. Mem.: Col. A. Assn. of Am.; Kappa Pi; Mississippi Edu. Assn.; Southeastern AA; Nat. A. Edu. Assn.; Mississippi AA; Southeastern Col. AA. Work: Mus. FA, Little Rock, Ark.; Univ. Arkansas. Exhibited: Morehead, Ky., 1931-1932, 1933-1936 (one-man); Hendrix Col., 1940-1941 (one-man); Univ. Arkansas; Little Rock Mus. FA; Kentucky A.T. traveling exh., 1931-1936; Arkansas WC Soc., 1937-1940; Grumbacher's Exh., 1938; Mississippi State Col. for Women; Meridian, Miss., AA, 1946-1968. Contributor to Design Magazine; Arkansas Historical Quarterly; Kappa Pi Sketch Book. Member of many exhibition juries. Positions: Guest Cr., Allison Art Colony, 1950-1960; Instr. A., Acting Hd., Dept. A., Morehead (Ky.) State T. Col., 1931-32, 1933-36; Hd. Dept. A., & Dir. A. Gal., Univ. Arkansas, Fayetteville, Ark., 1936-46; Prof. A., Hd. Dept. A., Mississippi State Col. for Women, Columbus, Miss., 1946-1969; Visiting Prof. A., Blue Mountain Col., summers, 1958-1960; Prof. A., Hd. Dept. A., Univ. Alabama, in Huntsville, 1969- ; Bd. Trustees, Miss. AA; Bd. Dir., Allison Art Colony; Pres., Art Section, Miss. Edu. Assn., 1958; Sec.-Treas., S.E. Col. A. Conf., 1961-64, Pres., 1966-1967; Pres., Northeast Miss. Graduate Assn., Phi Beta Kappa, 1961-62, 1967-1968; Council, Southeastern AA, 1964-1966.

HUDSON, ROBERT H.—Sculptor
Stinson Beach, Cal. 94970
B. Salt Lake City, Utah, 1938. Studied: San Francisco A. Inst., M.F.A. Awards: Nealie Sullivan award, San F., 1965. Work: Los Angeles County Mus.; San Francisco Mus. A.; Oakland Mus. A. Exhibited: WMAA, 1964, 1965, 1967, 1968; Los Angeles County Mus., 1967; PMA, 1967; AIC, 1967; WAC, 1969. Positions: Instr., San Francisco A. Inst., 1964-1965, Chm., Sculpture & Ceramic Dept., 1965-1966. Asst. Prof. A., Univ. of California, Berkeley, 1966- .

HUETER, JAMES W.— Sculptor, P., T.
190 E. Radcliffe Dr., Claremont, Cal. 91711
B. San Francisco, Cal., May 15, 1925. Studied: Pomona Col., B.A., M.F.A.; Claremont Grad. Sch., with Henry Lee McFee, Sueo Serisawa, Millard Sheets, Albert Stewart. Awards: prizes, Pasadena A. Mus., 1953; Nat. Orange Show, 1955; Los A. County Fair, 1951; Los A. Mus. A., 1955; Frye Mus. A., Seattle, 1957; Cal. State Fair, 1957 (purchase) Long Beach State Col., 1960, 1961, 1963; Laguna Beach A. Mus., 1964; Los Feliz Comm. Center, 1962; Riverside AA, 1963. Work: Pasadena A. Mus.; Nat. Orange Show; Scripps Col.; Long Beach State Col.; Los A. County Fair Assn.; Cal. State Fair Coll.; Lytton Coll., Los Angeles, and in private colls. Exhibited: Butler AI, 1955, 1958, 1959; Los A. County Fair, 1949, 1951, 1952; Cal. WC Soc., 1953, 1957, 1959, 1960; Chaffey Col., 1951, 1955, 1959, 1960; Denver A. Mus., 1954; Los A. Mus. A., 1952, 1954, 1955, 1957, 1958, 1961; Pasadena A. Mus., 1950-1954; Nat. Orange Show, 1949-1955; Cal. State Fair, 1950-1955, 1958; Newport Harbor, 1950, 1954, 1955; Palos Verdes, 1953, 1955; Frye Mus. A., 1957; Long Beach Mus., 1960; Mt. San Antonio Col., 1961; Pomona Col., 1961; Richmond Mus., 1960; Long Beach State Col., 1960, 1961, 1963; Los A. State Col., 1963; Laguna Beach A. Mus., 1964; Westside Jewish Community Center, 1962-1964; Scripps Col., 1962, 1963; Mt. San Antonio Col., 1963, 1964; Riverside AA, 1963; Cal. PLH, 1960; one-man: Mt. San Antonio Col., 1952; First Nat. Bank, Ontario, Cal., 1954; Pasadena A. Mus., 1955; Long Beach Col., 1957; Whittier AA, 1959; Monrovia Pub. Lib., 1961; Claremont A. Gal., 1966; Heritage Gal., Los A., 1962, 1964, 1967. Positions: Instr., Mt. San Antonio Col.; Instr. Sc., Pomona College, 1959-60.

HULBECK, BEATE—Painter
CH-6648 Minusio/Locarno, Via Borenco, Casa Orwal, Switzerland.
B. Berlin, Germany, Feb. 14, 1903. Studied: Berlin, Paris, and Switzerland with George Grosz, Hans Arp. Member: Am. Abstract A. Exhibited: Nat. Mus., Tokyo, 1955; Rose Fried Gal., N.Y., 1956; Galerie Creuze and Realites Nouvelles, Paris, 1957; New School for Social Research, N.Y., 1957; Workshop Gal., N.Y., 1959; Betty Parsons Gal., N.Y., 1962; Alexander Gal., N.Y., 1962; Ruth White Gal., N.Y., 1964; Riverside Mus., N.Y., 1967, 1969; Mus. North Carolina, 1969; St. Etienne, France, 1964; Pavillon de Marsan, Paris, 1964; Galerie Handschin, Basel, Switzerland, 1964; one-man: Galerie de Deux Iles, Paris, 1950; Kunstkabinet Wasmuth, Berlin, 1956; Work-

shop Gal., N.Y., 1958; Baden-Baden, Germany, 1961; Galerie Parnass, Wuppertal, Germany, 1962; Ruth White Gal., N.Y., 1962; Goethe House, N.Y., 1963; Galerie Handschin, Basel, 1965.

HULETT, CHARLES WILLARD—Painter, T., I.
5222½ Laurel Canyon Blvd., North Hollywood, Cal. 91607
B. Fairmount, Ind., July 25, 1903. Studied: Otis AI; A. Center Sch., with F. Tolles Chamberlin, and with Theodore Lukits, Christian von Schneidau, Ralph Holmes, Will Foster. Member: P. & S. Cl. of Los A.; Cal. A. Cl.; (Hon. V.P.) Campo de Cahuenga Mem. Assn.; San Fernando Valley A. Cl. Awards: prizes, San Fernando A. Cl., 1946, 1947, 1948, 1949, 1951, medal, 1952. Work: Campo de Cahuenga Mem., Los Angeles; Delta Tau Delta Fraternity, UCLA; Santa Teresita Hospital, Duarte, Cal.; Leonis Adobe Memorial, Calabasas, Cal.; Andres Pico Memorial, San Fernando, Cal.; Los A. Mus. A.; and in private colls. Exhibited: Palos Verdes Gal.; Clearwater A. Mus.; Raymond & Raymond Gal.; Santa Paula, Cal.; Los A. Mus. A.; Ebell Salon; Stendahl Gal., Los A.; Greek Theatre, North Hollywood; Van Nuys (Cal.) Pub. Lib.; Los A. City Hall Gal.; Hollywood Pub. Lib.; Santa Monica Pub. Lib.; Clearwater Annual; Friday Morning Cl.; Hollywood Athletic Cl.

HULL, JOHN R.—Educator
Art Dept., Marymount College, Tarrytown, N.Y. 10591*

HULL, MARIE ATKINSON (Mrs. Emmett J.)—Painter, T.
825 Belhaven St., Jackson, Miss. 39202
B. Summit, Miss. Studied: PAFA; ASL; Broadmoor A. Acad., and in France and Spain. Member: SSAL; New Orleans AA; Mississippi AA; Wash. WC Cl.; AWCS; NAWA. Awards: med., prize, 1951, Miss. AA; prizes, SSAL, 1926; New Orleans AA; San Antonio, Tex., 1929; Springville, Utah; Birmingham Mus. A., 1960, 1961, 1964; Shreveport Regional, 1960, 1961, 1964; Montgomery Mus. FA purchase award & Hill award, 1959-1960; Monroe (La.) Mus., 1964; Beaumont (Tex.) Mus., 1961 (purchase); Miss. AA purchase, 1962. Work: Witte Mem. Mus.; Springville (Utah) Mus.; Miss. AA; Mun. A. Gal., Jackson, Miss.; Miss. State Capitol; Governor's Mansion, Jackson, Miss.; Hinds County Court House; Memphis Court House; Delta State T. Col.; Miss. State Office Bldg.; Miss. Hall of Fame; Tulane Univ., New Orleans; Miss. Southern Col.; Montgomery Mus. FA; Beaumont (Tex.) A. Mus.; Port Gibson (Miss.) Pub. Lib.; Miss. State Col., Univ. Miss.; Texas State T. Col.; Meredith Col., N.C.; Blue Mountain Col.; Belhaven Col., Miss.; Brigham Young Univ.; Abilene, Tex.; Miss. State Col. for Women; Laurel (Miss.) Mus. A.; Pascagoula Lib.; Univ. Mississippi Medical Sch.; Hinds County Jr. Col. Miss.; McComb Pub. Lib. Exhibited: AFA traveling exh., 1939-1940; AIC, 1928, 1938; WFNY 1939; GGE, 1939; Miss. AA, annually; PAFA; AWCS; SSAL, annually. CM; Davenport Mus.; NAWA; BMA; Wichita Mus. A., BM; Atlanta, Ga., annually; Delgado Mus., annually; Brooks Mem. Mus.; Butler Inst. Am. A., 1957; Provincetown, Mass., 1958; one-man (1962-64) Univ. Miss.; Miss. State Univ.; Univ. Southern Miss.; Masur Mus., Monroe, La.; Louisiana State Univ.; Louisiana State Mus.*

HULSEY, WILLIAM HANSELL—Collector
600 Bank for Savings Building 35203; h. 2980 Cherokee Rd., Birmingham, Ala. 35223
B. Carbon Hill, Ala., May 2, 1901. Collection: Paintings, Including works by Laurencin, Modigliani, Rouault, Degas, Vlaminck, Buffet, Bezombes, Corbellini. Positions: Vice-President and Member of the Board of Directors, Birmingham Art Association.*

HULTBERG, JOHN PHILLIP—Painter
27 East 67th St., New York, N.Y. 10021
B. Berkeley, Cal., Feb. 8, 1922. Studied: Fresno State Col., B.A.; Cal. Sch. FA; ASL. Awards: Bender Grant, San Francisco, 1948; Guggenheim Fellowship, 1956; prizes, CGA, 1955; Congress for Cultural Freedom, 1955; Fellow, Tamarind Workshop, Los Angeles, 1963. Work: MMA; WMAA; Albright Gal. A.; Univ. Illinois, Fortune Magazine, 1957. Exhibited: CGA, 1955-1957; Carnegie Inst., 1955, 1957; WMAA, 1955-1958; one-man: New York, 1953, 1955, 1956, 1958, 1964; London, England, 1956; 1964; Paris, France, 1957, 1964; Boston, Mass., 1957; Provincetown, Mass., 1958; Wash., D.C., 1958; Roswell, N.M., 1964; Los Angeles, 1964; Portland, Ore., 1964; Detroit, Mich., 1964; Santa Barbara, Cal., 1964. Positions: Instr. A., ASL, New York, summer, 1960; BMSch. A., 1958; Instr., San Francisco Art Institute, 1964.

HUMPHREY, DONALD G.—Museum Director
Philbrook Art Center, 2727 S. Rockford Road 74114; h. 4621 S. Quaker Ave., Tulsa, Okla. 74105
B. Hutchinson, Kans., May 3, 1920. Studied: Univ. Kansas, B.F.A.; State Univ. Iowa, M.F.A., Ph.D. Member: AAMus.; Oklahoma Mus. Assn. Contributor to Museum News and other periodicals. Positions: Instr., State Univ. Iowa, 1950-51, 1957-58; Asst. Prof. Univ.

Oklahoma, 1952-59; Lecturer, Art History, Univ. Tulsa, 1967-1968; Visual Arts Chairman, Oklahoma Arts and Humanities Council; Dir., Philbrook Art Center, Tulsa, Okla., 1959- .

HUMPHREY, RALPH—Painter
c/o Bykert Gallery, 24 E. 81st St., New York, N.Y. 10028; h. 345 W. 88th St., New York, N.Y.*

HUNT, (JULIAN) COURTENAY—Painter, T.
Lake Side Drive, P.O. Box 247, Orange Park, Fla. 32073
B. Jacksonville, Fla., Sept. 17, 1917. Studied: Ringling A. Sch.; Farnsworth Sch. A., Sarasota. Member: Portraits, Inc. Awards: prizes, Fla. Southern Col. Intl., 1952; St. Augustine AA, 1958; Fla. A. Group, 1957 (for tour). Work: Portraits: Dean R. E. Page, Univ. of Fla.; Circuit Court Judges, Duval County Court House; Andrew Jackson, in Jacksonville City. Exhibited: All. A. Am., 1951, 1953, 1955, 1956; Audubon A., 1952, 1955, 1956; Sarasota AA, 1952, 1956; Fla. Southern Col., 1952; St. Augustine AA, 1951, 1958; High Mus. A., 1951, 1952, 1955; Jacksonville A. Mus., 1949-1958; Cummer Gal., Jacksonville, Fla., 1963 (one-man); Soc. Four Arts, Palm Beach, 1963; Palm Beach A. Gal., 1965.

HUNT, KARI (Mrs. Douglas M.)—Sculptor, L., W.
R.D. Box 358, Glen Gardner, N.J. 08826
B. Orange, N.J., Jan. 29, 1920. Studied: Cornell Univ.; Univ. Buffalo, and with Doane Powell. Member: Princeton A. Mus.; Archaeological Inst. Am. Exhibited: Montclair A. Mus., 1950; Jersey City Mus. Assn., 1950; N.J. Col. for Women, 1950, 1952; ANTA, 1952, and in numerous libraries. Work: specializes in sculptured Masks of the World; owns and exhibits the late Doane Powell coll. of portrait masks, books, masks of Java, Bali, Tibet, Siam, Japan, etc. Lectures and demonstrates the art of mask making at clubs, organizations, libraries and on television. Produced mask advertisements for Remington Rand, 1954; Geritol Corp.; Worthington Corp., 1955; Author: "Masks and Mask Makers," 1961; "Pantomine—The Silent Theater," 1964; Co-Author, with Douglas Hunt, "The Art of Magic," 1967.

HUNT, RICHARD HOWARD—Sculptor
1503 N. Cleveland Ave., Chicago, Ill. 60610
B. Chicago, Ill., Sept. 12, 1935. Studied: School of the Art Inst. of Chicago, B.A.E. Awards: James N. Raymond Traveling Fellowship, 1957; Guggenheim Fellowship, 1962; Logan prize, AIC; Campana prize; Palmer prize. Work: MMoDA, WMAA; Albright-Knox A. Gal., Buffalo; Milwaukee A. Center; AIC; Nat. Mus., Israel; CMA. Exhibited: AIC, 1957, 1959, 1960-1962; Univ. Illinois, 1963; Seattle World's Fair, 1962; WMAA, 1959, 1962, 1964, 1966, 1969; MModA, 1957; Sculpture:USA, 1960; Albright-Knox A. Gal., 1959; 1962; Carnegie Inst., 1958, 1961; Artists of Chicago & Vicinity, 1955-1957, 1960, 1961; Hemisfair, San Antonio, Tex., 1968; World Festival of Negro Art, Dakar, Senegal, 1967; one-man: CMA, 1967; Milwaukee A. Center, 1968; Holland Gal., Chicago, 1968; Dorsky Gal., N.Y., 1968, 1969. Positions: Instr., School of the Art Institute of Chicago, 1960-61; Univ. Illinois, 1960-62; Visiting Artist, Yale University, 1964; Northwestern Univ., 1968-1969; Northern Illinois Univ., 1968; Southern Illinois Univ., 1969; Visiting Prof., Chouinard Art Inst., Los Angeles, 1964-65. Member, Nat. Council on the Arts.

HUNT, ROBERT JAMES—Painter, Gr., T.
Washburn University; h. 4803 West 18th Terr., Topeka, Kans. 66604
B. Fargo, N.D., Apr. 5, 1921. Studied: State Univ. of Iowa, B.A., M.F.A. Member: Mid-West Col. AA; CAA. Work: State Univ. Iowa; Mid-Am. A.; Mulvane A. Mus.; Des Moines A. Center; Kansas State Coll.; Wichita A. Mus. Awards: purchase prize, Wichita A. Mus., 1954; Kansas State. Exhibited: Wichita A. Mus.; Kansas State Col.; Mid-Am. A.; Kansas Free Fair; AFA; Mulvane A. Center; Joslyn Mus. A.; Des Moines A. Center; Nelson Gal. A.; Kansas State Col.; St. Benedict's Gal.; Springfield (Mo.) Mus. A.; Colorado Springs FA Center. Positions: Prof. A., Chm. A. Dept., Dir. Mulvane A. Center, Washburn Univ., Topeka, Kans., 1950- .*

HUNTER, EDMUND ROBERT—Museum Director, L.
Norton Gallery & School of Art, Pioneer Park 33401; h. 201 Potter Road, West Palm Beach, Fla. 33405
B. Toronto, Canada, June 4, 1909. Studied: Ontario Col. A., Toronto; Royal Ontario Mus. Archaeology, Toronto, with Dr. C.T. Currelly; Courtauld Inst., Univ. London. Member: A. & Let. Cl., Toronto; AAMus.; Southern A. Mus. Dirs. Assn. (Chm., 1956-57); Florida A. Group (1st Pres.); Southeastern Mus. Conf. Author: "J.E.H. MacDonald, A Biography and Catalogue of His Work," 1940; "Thoreau MacDonald," 1942. Positions: Tech. Advisor, Montreal AA, 1938-40; Dir., Norton Gal. & Sch. A., West Palm Beach, Fla., 1943-49; Dir., Atlanta AA, High Mus. A., Atlanta, Ga., 1949-54; Consulting Dir., Pensacola AA, Pensacola, Fla., 1954-56; Dir., Jacksonville

Art Museum, 1955-57; Dir., Vizcaya Dade County Art Museum, 1957-60; Dir., Art Gallery, McCormick Pl., Chicago, Ill., 1960-1962; Dir., Norton Gallery & School of Art, (Palm Beach Art Institute) West Palm Beach, Fla., 1962- .

HUNTER, GRAHAM—Cartoonist, Comm. I., W.
"Lindenshade," 42 Clonavor Rd., Silver Spring Park, West Orange, N.J. 07052
B. La Grange, Ill. Studied: Landon Sch. of Cartooning, Cleveland, Ohio; AIC; Art Instruction, Inc., Minneapolis. Awards: Distinguished Service Citation for promotion war savings program, U.S. Treasury, 1943; George Washington Honor Medal, Freedoms Fnd. at Valley Forge, 1959, 1962; Honor Ctf. Award, Cartoon, Freedoms Fnd., 1960, 1961. Work: Nation's Agriculture, NAM News, Motor; Banking; various Canadian and English magazines; and through McNaught Syndicate, King Features Syndicate; Tiny Features, Inc.; Editorial cartoons in permanent J. Edgar Hoover FBI Collection; Peter Mayo Editorial Cartoon Collection at State Historical Society, Columbia, Mo. Author: Lesson on "Creating The Busy Scene Cartoon" for Art Instruction, Inc., cartoon course. Creator: "Jolly Jingles" strip for Chicago Sunday Tribune and McClure Syndicate; "Sycamore Center" cartoon page for Farm & Ranch; "Biceps Brothers," "Getting the Business" and "Motor Laffs" page for Motor magazine; "Rhubarb Ridge" feature for Curtis Pub. Co.; full page business cartoon feature in Banking magazine; "In Hometown America," and "The Office Cat," for Industrial Press syndicated Features, 1954- ; syndicated editorial cartoons for Nat. Assn. Manufacturers, 1952- ; "Barnyard Banter" comic strip, and "Uncle Dudley's Episodes," for Nation's Agriculture, 1964- ; watercolor spreads in Together magazine; specialist in "busy scene" drawings; sales, political, automotive, farm cartoons, magazine covers, advertising copy, etc. Exhibited: Wayne State Univ. editorial cartoon exhibit, Detroit, 1964.

HUNTER, JOHN—Painter, Pr. M.
2440 Fair Oaks Court, San Jose, Cal. 95125
B. Pennsylvania, 1934. Studied: Pomona Col., Claremont, Cal., B.A.; Claremont Grad. Sch., M.F.A. Awards: Fulbright Fellowships, 1963, 1964 to Florence, Italy; Tamarind Fellowship, 1969. Exhibited: Cal. PLH, 1967; Studio Internationale d'Arte Grafica, Macerata, Italy, 1969; Los Angeles County Mus., 1955; one-man: Ryder Gal., Los Angeles; Florence, Italy; Dayton A. Inst., and others.

HUNTER, ROBERT DOUGLAS—Painter, I., L.
30 Ipswich St., Boston, Mass. 02215
B. Boston, Mass., Mar. 17, 1928. Studied: Vesper George Sch. A.; Cape Sch. A., Provincetown, Mass.; R.H. Ives Gammel Studios, Boston. Member: Provincetown AA; North Shore AA; Copley Soc. Boston; AAPL; Boston Gld. A. Awards: prizes, Ogunquit A. Center, 1955, 1960, 1961, 1963; Jordan Marsh Co., 1954-1958, 1960-1964, 1967; North Shore AA, 1957, 1959-1961; Academic A., Springfield, 1961; Lennon prize, SC, 1965; gold medal, AAPL, 1962, prize, 1967; Boston A. Festival, 1962; Grumbacher prize, AAPL, 1964. Work: Boston Advertising Cl.; Maryhill (Wash.) Mus. A.; Tufts Col.; mural, St. Mary of the Harbor, Provincetown; Chrysler Mus. A. Exhibited: All. A. Am., 1954, 1955; Ogunquit A. Center, 1954, 1955, 1959, 1961; Provincetown AA, 1953-1955, 1959-1961; Academic A., 1954, 1961; Boston A. Festival, 1952-1955; Jordan Marsh Co., 1953-1955, 1959-1961; series of one-man exhs., West Coast, 1958; Shore Gal., Provincetown, 1960. Illus. "Walk Quietly," 1954; "True Places," 1955. Positions: Bd. Governors, Gld. of Boston A.

HUNTER, SAM—Museum Director, W., L.
The Jewish Museum, 1109 Fifth Ave., New York, N.Y. 10028
B. Springfield, Mass., Jan. 5, 1923. Studied: Williams Col., A.B.; Univ. Florence, Italy; Independent research Bernard Berenson Library, Villa I Tatti, Florence, Italy. Member: CAA. Awards: Karl Weston Grad. prize, Williams Col., 1943; Hubbard Hutchinson Fellowship, Williams Col. for 3 years research and travel. Author: "Toulouse-Lautrec," 1954; "Raoul Dufy," 1955; "Henri Matisse," 1956; "Modern French Painting," 1956; "Jackson Pollock," 1956; "Picasso: Cubism to the Present," 1957; "David Smith," 1957; "Piet Mondrian," 1958; "Modern Art: A Pictorial Anthology," 1958 (contributor); "The Graphic Art of Joan Miro," 1958; "Modern American Painting and Sculpture," 1959. "Art Since 1945," 1959; "Hans Hofmann," 1964; "New Art Around the World," 1965; "Larry Rivers," 1965. Contributor to: Sat. Review; New World Writing; Partisan Review; N.Y. Times Book Review; Art in America; College Art Journal. Lectures: Modern and Italian Renaissance Art. Arranged many exhs. for MMoDA. Positions: Assoc. A. Cr. & Ed., N.Y. Times, 1947-49; Assoc. Ed., Harry N. Abrams Inc., 1952-53; Assoc. Cur., Dept. Painting and Sculpture, MMoDA, 1956-58; Chief Cur., Minneapolis Inst. of Arts, Minneapolis, Minn., 1958-59; Actg. Dir., 1959-60; Dir., Rose Art Museum & Poses Institute of Fine Arts, Brandeis University, Waltham, Mass., 1960-1965, Prof. A. Hist., Brandeis University, 1960-1965; Dir., "American

Art Since 1950'' exhibition, Seattle World's Fair, 1962; Memb. Int. Jury, Venice Biennale, 1964; Dir., The Jewish Museum, New York, N.Y., 1965- .*

HUNTINGTON, ANNA HYATT (Mrs. Archer M.)—Sculptor
Bethel, Conn. 06801
B. Cambridge, Mass., Mar. 10, 1876. Studied: ASL, and with Hermon MacNeil, Gutzon Borglum. Member: NA; NSS; Am. Acad. A. & Let.; Hispanic Soc. Am. (trustee); Bd. member, Brookgreen Gardens, S.C. Awards: Accademia Cultural Adriaica; Internationalia Studia Scientiarum Literarumque; Accademia di Belle Artes di Santa Isabel de Hungaria di Seville; Accademia di Belles Arti, Perugia; Officer, Legion of Honor, France; Grand Cross Alfonsoo XII; hon. degree, Dr. FA, Syracuse Univ.; Pres., Brookgreen Gardens, 1956; Hon. F., Int. Inst. A. & Lets., 1957; Citizen of Cuba, 1958; Woman of the Americas, 1958; F., Pierpont Morgan Lib., 1958; Gold Medal, NAD, 1958. Work: in over 200 museums and galleries in U.S. Statues in New York City, San Francisco, San Diego, Cal., Gloucester, Mass., Newport News, Va., Brookgreen Gardens, Carmel, N.Y., S.C.; San Marcos, Tex., etc.; Blois, France; Seville, Spain; Buenos Aires, Argentina; Havana, Cuba; Madrid, Spain; Quebec, Canada; Salzburg, Austria.*

HUNTINGTON, JOHN W.—Collector, Patron, Architect
41 Lewis St. 06103; h. 159 Bloomfield Ave., Hartford, Conn. 06105
B. Hartford, Conn., Oct. 19, 1910. Studied: Yale College, B.A.; Columbia University School of Architecture, B. Arch. Awards: A.I.A. Bronze Medal, 1957. Member: A.I.A. Collection: Contemporary paintings and drawings. Positions: Program Chairman, Conn. Chapter, A.I.A., 1961-1963; Trustee and Vice-President, Wadsworth Atheneum, Hartford, Conn.; Board Chairman, Hartford Stage Company, 1967- ; Mayor, Town of West Hartford.

HUNTLEY, DAVID C.—Painter, S., E., C., Des.
Fine Arts Division, Southern Illinois University 62004; h. 1602 Liberty St., Alton, Ill. 62003
B. Lenoir, N.C., Oct. 17, 1930. Studied: Univ. North Carolina, A.B., M.A. Member: CAA; Com. on A. Edu., MModA; NAEA; Southeastern AA; Midwestern Col. A. Conf.; Illinois A. Edu. Assn.; AEA; Illinois A.A.; Alabama WC Soc.; South Carolina AA; North Carolina AA; Birmingham AA; Kappa Pi; AAUP. Awards: A. Scholarship, Raleigh, N. C., 1951; prizes, North Carolina A., Wilmington, 1953; Tri-State Exh., Spartanburg, 1954; North Carolina Mus., 1951; Birmingham Mus. A., 1958; 15 Young Southeastern Painters, Gainesville, Fla., 1954; Johnson award, Birmingham Mus. A., 1958; Award Winners, North Carolina Mus., Raleigh, 1960; Director's Choice, Birmingham, 1956; Soc. Indp. A. of St. Louis, 1966. Exhibited: PAFA, 1954; Provincetown, 1958; Southeastern Annual, 1956; Univ. Florida, 1954; Forum Gal., N.Y., 1956; Creative Gal., N.Y., 1955; Delfin Gal., 1960; Birmingham Mus. A., 1960; Oscar Wells Mem. Mus., 1961; Clark Memorial, 1962; North Carolina Mus., 1962; CAM, 1966; Raymond Duncan Gal., Paris, 1966; Ligoa Duncan Gal., N.Y., 1967; Peoria A. Center, 1968; Wesleyan Col., Macon, Ga., 1969; one-man, regional and national exhs. Lectures: Contemporary Art; Art History; Religious Art and Art Education. Positions: Instr., Children's Art, Univ. North Carolina; History of Art, Des., etc., Limestone College, Gaffney, S.C.; Prof. A., Alabama College, Montevallo; Assoc. Prof., Div. Fine Arts, Southern Illinois University, at present.

HUNTLEY, VICTORIA HUTSON—Lithographer, P., L.
314 River Rd., Chatham Township, N.J. 07928
B. Hasbrouck Heights, N.J., Oct. 9, 1900. Studied: ASL, and with John Sloan, Max Weber, William C. Palmer, Kenneth Hayes Miller. Member: ANA; NSMP; An Am. Group; Audubon A; Albany Pr. Cl.; SAGA; ASL; Pen and Brush Cl. Awards: prizes, AIC, 1930; Phila. Pr. Cl., 1933; LC, 1945, 1949; Assoc. Am. A., 1946; Grant, Am. Acad. A. & Let., 1947; Guggenheim F., 1948; SAGA, 1950, 1951; ASL, 1950, 1951; Municipal A. Lg. prize, AIC, 1961; NAD, 1962. Work: MMA; AIC; BMFA; PMA; CMA; WMAA; LC; BM; IBM, Univ. Fla.; Univ. Michigan; Albany Pr. Cl.; Rochester Mem. Mus.; ASL; CM; Paris, France, 1954, also touring Italy, 1955-56, 1956-57; Mus. FA of Houston; PAFA; Oklahoma A. Center, Oklahoma City; N.Y. Pub. Lib.; Newark Pub. Lib.; Phila. Pr. Cl.; Univ. Glasgow; Italian Govt.; and in private colls.; mural, USPO, Springville, N.Y.; Greenwich, Conn. Exhibited: nationally and internationally. One-man: Weyhe Gal., 1930-32; Phila. Pr. Cl., 1932; deYoung Mus. A., 1935; Kennedy Gal., N.Y., 1942, 1949; San Diego A. Center, 1950; Am. Acad. and Nat. Inst. A. & Let., 1947; Research Studio, Maitland, Fla., 1951; Albany Pr. Cl., 1952; Miami Beach A. Center, 1952; Circulating Pr. Gal., Wash., D.C., 1954; Bodley Gal., 1961; N.Y. Pen and Brush Cl., 1969. Lectures: "Fine Prints & Graphic Art Media"; "Five Famous Painters: Dégas, Cézanne, Van Gogh, Lautrec, Gauguin," 1956-57. Demonstrations: "How to Make a Lithograph," 1957-58; "Painting Techniques," 1958; article "On Making a Lithograph," American Artist Magazine, 1960.

HURD, JUSTIN G. (JUD)—Cartoonist
281 Bayberry Lane, Westport, Conn. 06880
B. Cleveland, Ohio, Nov. 12, 1912. Studied: Cleveland Inst. A.; Western Reserve Univ., A.B.; Chicago Acad. FA; Spencerian Col. Member: National Cartoonists Soc. (Ohio Regional Chm.); Deadline Club (N.Y. chapter of Sigma Delta Chi); The Advertising Club of New York; Newspaper Comics Council. Work: Daily cartoon "Health Capsules," syndicated by United Features Syndicate, Inc. In addition to U.S. newspapers, it appears in Turkey, East Pakistan, Argentina, The Philippines, Chile, Brazil and other countries. Writes and draws daily investment cartoon "Ticker Toons" syndicated by United Features Syndicate. Wrote and drew the cartoons for "Just Hurd in Hollywood," syndicated by Central Press Assn., 1937-38; Editorial Cartoons for Weekly Service of Newspaper Enterprise Assn., 1938-39; Contributed cartoons to Ladies Home Journal, 1958-59 Positions: With Charles Mintz Animated Cartoon Studio, Hollywood, 1936-37; Comic Book cartoons for Dell Publ. and others, 1940-42; U.S. Army weekly cartoon bulletin "Crypto Chris" dealing with cryptographic matters, 1942-46, distributed U.S. and Europe; Dir., "Jud Hurd Cartoons," cartoon studio supplying cartoons for advertising agencies and industrial firms, 1946-58; Established own syndicate to distribute "Ticker Toons," 1959- . Feature now distributed by United Features Syndicate. Editor, "The Cartoonist," magazine of Nat. Cartoonists Soc., 1965-1969. Publisher, "Cartoonist Profiles," professional magazine, 1969- .

HURD, PETER—Painter, W.
Sentinel Ranch, San Patricio, N.M.
B. Roswell, N.M., Feb. 22, 1904. Studied: PAFA; & with N.C. Wyeth. Member: NA; Century Assn.; Wash., D.C.; AWS; Wilmington Soc. Awards: prizes, AIC, 1937; Wilmington Soc. FA, 1941, 1945; med., PAFA, 1945; Isaac Maynard prize, NAD, 1954. Work: frescoes, USPO, Big Spring, Tex.; Dallas, Tex.; Texas Tech. Col., Lubbock; Alamogordo, N.M.; La Quinta Mun.A.Gal., Albuquerque, N.M.; AIC; mural, Prudential Insurance Co. bldg., Houston, Tex.; William Rockhill Nelson Gal.; MMA; BM; Nat. Gal., Edinburgh, Scotland; Newark Mus. A.; Denver A. Mus.; Colo. Springs FA Center; Minneapolis; Rochester Mem. Mus.; Wilmington FA Center, and others. Exhibited: nationally. Coll. paintings, drawings and lithographs permanently housed in new wing of Roswell (N.M.) Mus.; Retrospective exh., Amon Carter Mus. A., Ft. Worth, Tex., 1964; Shown at Cal. PLH, 1965. A. I., "The Last of the Mohicans," 1926; "Great Stories of the Sea and Ships," 1933; "Habit of Empire," 1938; & others. Author: "Count-Down at Canaveral," publ. Oct. 1963 in Art in America. Positions: War Correspondent for Life Magazine & USAAF, 1942-45; A., Life Magazine, 1946- . Appointed to Commission of Fine Arts by Pres. Eisenhower, 1958.

HURD, MRS. PETER. See Wyeth, Henriette

HURTIG, MARTIN—Painter, Et., Lith., E., S.
University of Illinois, Chicago Circle Campus; h. 1727 Wesley St., Evanston, Ill. 60201
B. Chicago, Ill., Aug. 11, 1929. Studied: Inst. Design, Chicago, B.S., M.A.; Atelier 17, Paris, with William Hayter. Awards: prize, Cape Cod AA, 1955. Work: Free Lib. of Phila.; Carroll Reece Mus., Johnson City, Tenn.; Bibliotheque Nationale, Paris; stained glass windows and mural, Union Church of Lake Bluff, Ill.; outdoor court sculpture, Waukegan Pub. Lib., Ill. Exhibited: AIC, 1952 (and traveling); Cape Cod AA, 1955-1957; Portland Mus. A., 1957; Wichita AA, 1957; PAFA, 1958, 1960; Soc. Wash. Pr.M., 1958; BM, 1958, 1968; Momentum, 1954-1956; Detroit Inst. A., 1957, 1959, 1960; Grand Rapids A. Gal., 1961; one-man: Flint Inst. A., 1961; AIA, 1967; Adele Rosenberg Gal., Chicago, 1968; Rosenstone Gal., Chicago, 1966; Alonzo Gal., N.Y., 1966-1968; Ecole Speciale d'Architecture, Paris, 1969. Positions: Prof. A., Michigan State University, East Lansing, Mich.; Prof. A., Univ. of Illinois, Chicago Circle Campus, at present.

HUSTED-ANDERSEN, ADDA—
Metal Craftsman, Des., T.
887 First Ave. 10022; h. 349 E. 49th St., New York, N.Y. 10017
B. Denmark. Studied: Thyra Vieth's Sch., Copenhagen; Technical State Sch., Copenhagen; Badishe Kunstgewerbe Schule, Pforzheim, Germany, and with Jean Dunand, in Paris. Member: Artist-Craftsmen of N.Y.; Am. Craftsmen's Council; World Crafts Council. Awards: medal, Gold & Silversmith Gld., Copenhagen. Work: Newark Mus. A. Exhibited: nationally; Brussels World's Fair, 1958. Positions: Hd., Jewelry and Enameling, Craft Student's League, New York, N.Y. Editorial Staff, Craft Horizons.

HUTCHINSON, JAMES FREDERICK, II—
Painter, S., Mus. Cur., Cart., L.
Box 83, Port Salerno, Fla. 33492
B. Buffalo, N.Y., May 6, 1932. Studied: Palm Beach Jr. Col.; Fla. State Univ., with Levindowski. Member: Fla. AA; Indian River A. Lg. Work: murals and portrait in private colls., 1956- . Commissioned by private collector to travel throughout Morocco exe-

cuting a series of paintings. Project of 25 paintings now completed. Exhibited: Traveling exh. of 30 paintings and drawings depicting the life of the present day Seminole Indians of Florida, on circuit to State and private museums and art galleries in Fla., Ala., Ga., Okla., N.M., etc. also at N.Y. World's Fair, Florida Pavillon, 1965. Numerous one-man exhs. concerned with the Seminoles. Contributor to Florida Historical Quarterly. Lectures: The Seminoles, The Artist's Concern of a Disappearing Culture. Positions: Cur. A. and Special Exhibits, Elliott Museum, Stuart, Fla.*

HUTCHINSON, MARY E(LISABETH)—Painter, T., L.
120 LaFayette Dr., Northeast, Atlanta, Ga.
B. Melrose, Mass., July 11, 1906. Studied: Agnes Scott Col.; NAD, and in Europe. Member: NAWA; N.Y. Soc. Women A.; Lg. Present-Day A.; Soc. Indp. A. Awards: prizes, NAWA, 1935, 1938. Work: High Mus. A.; Saratoga (Cal.) Mus.; Syracuse Univ.; Georgia Mus. A. Exhibited: WFNY 1939; AIC; N.Y. Mun. Exh.; AFA traveling exh.; High Mus. A., 1933, 1940 (one-man); Midtown Gal., 1934, 1938 (one-man); Phila. A. All.; Riverside Mus.; BM; Am-British A. Center; Contemporary A. Gal.; ACA Gal.; Castle Gal., Atlanta, 1950 (one-man), 1960, 1961; Chappelier Gal.; Ferargil Gal.; O'Karma's Picture House, Atlanta, 1961. Positions: Instr.,A., High Mus. A. Sch., 1946-49; A. Dir., Write-Away Adv. Co., 1950-51; Hd. A. Dept., Washington Seminary, 1951-53; Instr. A., Christ the King H.S., 1953-58; Instr. A., St. Pius X Catholic H.S., 1958- , all Atlanta, Ga.; D'Youville Academy, Chamblee, Ga., 1950- .*

HUTH, HANS—Former Museum Curator, W. L.
P.O. Box 4414, Carmel, Cal. 93921
B. Halle, Germany, Nov. 11, 1892. Studied: Univs. Vienna, Berlin, Ph.D. Member: CAA; ICOM; Nat. Trust for Historical Preservation. Author: "Künstler und Werkstatt der Spätgotik," 1923, 1967; "Abraham und David Röntgen," 1928; "Der Park von Sans Souci," 1929; "Talleyrand in America," 1942; "Europäische Lackarbeiten," 1955; "Nature and the American," 1957; "Friderizianische Möbel," 1958; "Lacquer of the West," 1970. Contributor to Encyclopaedia Britannica ("Museums"); Thieme-Becker; Encyclopedia of World Art; World Furniture; Encyclopedia delle Arte Decorative, and many art magazines. Positions: Cur., Royal Palaces and Parks, Berlin, 1926-37; Collaborator, U.S. Nat. Park Service, 1939-44, Consultant, 1944-1966; Cur., AIC, 1944-1964; Editor, Encyclopedia Britannica, 1944-1963. Lecturer, U.C.L.A., 1967- .

HUTH, MARTA—Painter
P.O. Box 4414, Carmel, Cal. 93921
B. Munich, Germany, Dec. 25, 1898. Studied: State Sch. of Photography, Acad., Munich. Exhibited: AWS, 1949; Cal. PLH, 1954 (one-man); Gld. Hall, Easthampton, N.Y., 1954; AIC, 1948-1953; Chicago Pub. Lib., 1955; Religious Art Show, U.S. Naval Postgrad. School, Monterey, Cal., 1964. Completed a systematic series of colored photographs of Baroque art & architecture in all important churches in South Germany, Austria & Switzerland which are used for lectures in universities & museums. (Co-Editor, Baroness von Riedesel, 1965).

HUTTON, DOROTHY WACKERMAN—Etcher, Lith., P.
42 Rosedale Rd., Overbrook Hills, Philadelphia, Pa. 19131
B. Cleveland, Ohio, Feb. 9, 1898. Studied: Minneapolis Sch. A.; Univ. Minnesota,and in Paris, France. Member: All. A., Pr. Cl., Plastic Cl., WC Cl., all of Phila., Pa. Awards: prizes, Phila. Plastic Cl., 1943-1945; Nat. Comp. for needlepoint des., Nat. Cathedral, Wash., D.C. Work: Smithsonian Inst.; Mint Mus. A.; Atwater Kent Mus., Phila; Harvard Univ. A. Gal. Exhibited: CGA, 1936; PAFA, 1937, 1958; Phila. A. All., annually; SAGA, 1946; Carnegie Inst., 1945, 1946; Phila. Pr. Cl., annually; Phila. Plastic Cl., annually; Phila. WC Cl., 1958; Carl Schurz Mem. Fnd., 1957; Phila. Sketch Cl., 1957-58; Am. Color Pr. Soc., 1946; LC, 1944-1947, 1952; one-man: Smithsonian Inst., 1950; Phila. Women's Cl., 1951; Phila. Plastic Cl., 1951; Mint Mus. A., 1951; Miami Beach A. Center, 1952. Positions: Bd. Dirs., Phila. WC Cl., 1961; Cor. Sec., Am. Color Pr. Soc.; Print Committee, Phila. A. All.

HUTTON, HUGH M.—Cartoonist
42 Rosedale Rd., Overbrook Hills, Philadelphia, Pa. 19151
B. Lincoln, Neb., Dec. 11, 1897. Studied: Univ. Minnesota. Member: Phila. Sketch Cl.; Nat. Press Cl.; Nat. Cartoonist Soc.; Phila. A. All.; Am. Assn. Ed. Cartoonists. Awards: prizes, Nat. Safety Council, 1954-1967; Freedoms Fnd., 1952-1969; Temple Univ. citation, 1969. Exhibited: Lib. Cong., 1946. Positions: Ed. Cart., Philadelphia Inquirer, 1934- .

HUTTON, LEONARD—Art Dealer
787 Madison Ave., New York, N.Y. 10021*

HUTTON, WILLIAM—Museum Director
Currier Gallery of Art, 192 Orange St., Manchester, N.H. 03104*

HUXTABLE, MRS. ADA LOUISE—Critic
New York Times, 229 W. 43rd St., New York, N.Y. 10036
Positions: Architecture Critic, New York Times, New York.

HYDE, ANDREW C.—Museum Director
Institute of Contemporary Art, 1175 Soldiers Field Rd., Boston, Mass. 02134; h. 3 Channing Circle, Cambridge, Mass. 02138
B. Detroit, Mich., Apr. 25, 1941. Studied: Washington & Lee University. Positions: Member, Advisory Committee of American Arts Expositions, Inc.; Member, Board of the Metropolitan Cultural Alliance, Boston; Owner, Director, Bell, Book and Candle Bookstore and Art Gallery, Northeast Harbor, Me.; Owner, Director, V-8 Gallery, San Francisco, Cal.; Visual Director, "Summerthing," 1968, Boston; Art Advisory Committee, Office of the Mayor, Boston, Mass.; Director, Institute of Contemporary Art, Boston, Mass., 1969- .

HYSLOP, ALFRED JOHN—Educator, S.
6912 Big Bear Dr., Tucson, Ariz. 85715
B. Castle-Douglas, Scotland, Apr. 10, 1898. Studied: Edinburgh Col. A., D.A., Royal Col. A., London, A.R.C.A. Work: murals, Buckham Mem. Lib.; Faribault, Minn.; other work in private colls. Positions: Chm. A. Dept., Carleton Col., Northfield, Minn., 1923-1963, Emeritus, 1963- .

HYSLOP, FRANCIS EDWIN, JR.—Educator
Arts II Bldg., University Park, Pa. 16802; h. 326 Hillcrest Ave., State College, Pa. 16801
B. Philadelphia, Pa., Jan. 7, 1909. Studied: Princeton Univ., B.A., M.A., M.F.A., and abroad. Member: AFA; CAA; Am. Assn. Univ. Prof.; Soc. Arch. Historians. Translator: Le Corbusier, "When the Cathedrals Were White," 1947; "New World of Space," 1948; "Baudelaire on Poe," 1952; "Baudelaire: A Self-Portrait," 1957 (with introduction and notes, in collaboration with Lois Boe Hyslop); "Baudelaire as a Literary Critic," 1964 (with Lois Boe Hyslop). Contributor to College Art Journal; Art Bulletin; Gazette des Beaux-Arts. Positions: Univ. Illinois, 1942-1945; Asst. Prof. FA, Pennsylvania State Univ., 1934-42, Assoc. Prof., 1946- ; Prof., 1957- .

IERVOLINO, JOSEPH A.—Art Dealer, Collector
271 Waukegan Rd.; h. 273 Waukegan Rd., Northfield, Ill. 60093
B. Brooklyn, N.Y., Aug. 4, 1920. Studied: City College of New York; University of Miami Law School, LL.B.; Americana A. Center. Member: Assoc. Member, International Institute for Conservation of Historic and Artistic Works; National Gallery, London, England. Gallery Specialty: Contemporary Paintings – North and South American and European.

IERVOLINO, PAULA—Gallery Director, Collector
Americana Galleries, 271 Waukegan Rd., Northfield, Ill. 60093
B. North Dakota. Studied: Art Institute of Chicago; Northwestern University. Collection: Contemporary works, drawings, paintings, etc. Positions: Commercial Artist, Advertisers Art Service, 1940, Furniture Manufacturing, 1941-1961, both Chicago; Owner, Director, Americana Galleries, Northfield, Ill., at present.

IGLEHART, ROBERT L.—Educator
117 Dixboro Rd., Ann Arbor, Mich. 48105
B. Baltimore, Md., Feb. 2, 1912. Studied: Maryland Inst. A.; Johns Hopkins Univ.; Columbia Univ., B.S. in Edu.; New Sch. for Social Research. Awards: Scholarship for European study, Md. Inst. A.; Nat. Gal. of Art Medal for Distinquished Service to Art Education, 1966. Member: MModA; John Dewey Soc.; CAA; NAEA. Author numerous articles for professional magazines. Positions: Instr., Sch. A., Univ. Washington, 1938-41; Chm., Dept. A. Edu., N.Y. Univ., 1946-55; Prof., Chm. Dept. A., Univ. Michigan, Ann Arbor, Mich., 1955- .

IHLENFELD, KLAUS—Sculptor
R.D. 3, Pottstown, Pa. 19464*

INDIANA, ROBERT—Painter, S., Ser., L.
2 Spring St., New York, N.Y. 10012
B. New Castle, Ind., Sept. 13, 1928. Studied: AIC, B.F.A.; Herron Sch. A., Indianapolis; Univ. Edinburgh and Edinburgh Col. A. Awards: Traveling Fellowship, AIC, 1953. Work: MModA; Albright-Knox A. Gal., Buffalo; Rose A. Mus., Brandeis Univ.; WAC; WMAA; Detroit Inst. A.; A. Gal. of Toronto; N.Y. State Pavilion, World's Fair, 1964-65; BMA; Carnegie Inst.; Finch Col.; Herron Mus.; Inst. Contemp. A., Philadelphia; Kaiser Wilhelm Mus., Krefeld, West Germany; Krannert Mus., Univ. Ill.; Larry Aldrich Mus. Contemp. A., Ridgefield, Conn.; Los Angeles County Mus.; Michigan Univ., Ann Arbor; Sheldon Mem. Mus.; Stedelijk Mus., Amsterdam and Eindhoven, Netherlands. Many commissions including posters for inaugural of the N.Y. State Theater, Lincoln Center, 1964; official poster for Hemisfair, San Antonio, Texas, 1968; 25th anniversary of

City Center, New York, by List Posters and included in portfolio of seven prints celebrating same occasion, 1968; Century City, Los Angeles, 1968; costumes, sets and poster for Walker Art Center's Opera Company's production of Virgil Thomson/Gertrude Stein opera "The Mother of Us All," 1967. Collaborated with poet Robert Creeley on the book "Numbers," issued also in portfolio in limited, signed edition. Exhibited: MModA, 1961, 1963, 1968; DMFA, 1962; SFMA, 1962; AIC, 1963; Contemp. A. Center, Cincinnati, 1963; Des Moines A. Center, 1963; Beaverbrook A. Mus., Fredericton, N.B., Canada, 1963; Tate Gal., London, 1963, 1964; Washington Gal. Mod. A., (D.C.), 1963; WMAA, 1964-1967, 1969; Guggenheim Mus., 1965; Herron Mus., 1966; Kassel, Germany, 1968; Nat. Inst. A. & Lets., 1968; N.Y. Council on the Arts, 1968-1969; Jewish Mus., N.Y., 1969, and many others nationally and internationally. Univ. Illinois, 1965, 1967; one-man: Stable Gal., N.Y., 1962, 1964, 1966; WAC, 1963; Inst. Contemp. A., Boston, 1963; Rolf Nelson Gal., Los Angeles, 1965; Dayron's Gal., Minneapolis, 1966; Univ. Pennsylvania, 1968; McNay A. Inst., San Antonio, 1968; Herron Mus., 1968; Toledo Mus. A., 1968; Hunter Gal., Aspen, Colo., 1968; Creighton Univ., Omaha, 1969; St. Mary's Col., Notre Dame, 1969 and in galleries and museums in Dusseldorf, W. Germany, 1966; Eindhoven, Holland, 1966; Krefeld, W. Germany, 1966; Stuttgart, W. Germany, 1966.

INDIVIGLIA, SALVATORE—Painter, T., Comm., I., L
 Vogue Wright Studios, 225 Park Ave. South 10003; h. 974 Lorraine Drive, Franklin Square, L.I., N.Y. 11010
B. New York, N.Y., Nov. 16, 1919. Studied: Leonardo da Vinci A. Sch.; Sch. Indst. Art; Pratt Institute, Brooklyn. Apprentice to Alfred Crimi; Illus. & Comm. A. with Earl Winslow and George Harrington, Jr. Member: AWS; All. A. Am.; Artists' Fellowship; Knickerbocker A.; SC; P. & Sc. of New Jersey; Am. Veterans Soc. A.; A. Lg. of Long Island; Grand Central Gal., N.Y. Awards: Gold Medal, Knickerbocker A., 1953, 1960 and Grumbacher award, 1964; Emily Lowe Award, 1959; SC, 1961, 1962; All. A. Am., 1960; A. Lg. Long Island, 1964; U.S.Navy Award of Achievement, 1960; U.S. Navy Seabee award, 1961; Am. Veterans' Soc. A., 1958, 1959, 1963; Nat. A. Lg., gold medals, 1966, 1967, 1968 (2); Four Navy Unit Commendations, Meritorious Unit Commendation for Viet Nam duty, 1967; Combat Action Medal, 1967. Work: U.S. Navy Combat A. Coll.; Tamiment Coll.; Mutual Benefit Life Ins. Co.; Ketterlinus Co.; Anin Flag Co. Exhibited: NAD, 1963, 1965; AWS, 1953-1969; Art:USA 1958; Audubon A., 1950, 1951, 1956, 1959, 1963, 1965; All. A. Am., 1949-1968; Knickerbocker A., 1949-1968; P. & Sc. of New Jersey, 1958-1968; Eastern States, Exh., 1960, 1963; AAPL, 1957-1964; A. Lg. Long Island, 1952-1969; Ala Moana Center, Hawaii, 1962; Royal WC Soc., London; Museo de la Marine, Paris, France, 1963; Operations Palette, Smithsonian Inst., 1965; Wash. WC Assn., 1953, 1954, 1958; NAC, 1951-1965; Grand Central Gal.; Ward Eggleston Gal., N.Y.; SC, 1960-1965. Work reproduced in "All Hands," "The Naval Reservist," "Direction," and "Naval Aviation News." Positions: U.S. Navy paintings, 1960-1964 (commissioned); U.S. Navy Combat Artist, Viet Nam, 1964, 1967 (selected by Sec. of the Navy). Actively participated in ground & surface combat as Official U.S. Navy Combat Artist with SEAL Team II. Pres., Artists Fellowship, Inc., 1960-1963, and other offices in many art organizations. Art Dir., Vogue Wright Studios, New York, N.Y. 1964- .

INGLE, TOM—Painter, T., L., Cr.
 R.R. No. 1, Box 369, Old Lyme, Conn. 06371
B. Evansville, Ind., Mar. 31, 1920. Studied: Princeton Univ., B.A., and with Robert Lahr, Fran Soldini. Member: Essex AA (Pres. 1949-57); Mystic AA (Pres. 1964-65). Awards: prize, Norwich AA., 1952, 1954, 1960, 1966; Silvermine Gld., 1956; Mystic AA, 1964, 1967. Work: Evansville Pub. Mus., Wadsworth Atheneum, Hartford, Conn.; New England Regional, 1957; Lyman Allyn Mus., New London, Conn. Exhibited: WMAA, 1956; New Talent, 1956; Conn. Contemp. A., 1951; "Eight from Connecticut," Wadsworth Atheneum, 1960; New England Contemp. A., Boston, 1963-1965; Eastern States Exh., Springfield, Mass., 1967; one-man: Carlebach Gal., N.Y., 1950; Lyman Allyn Mus., 1952, 1964; Wesleyan Univ., 1953; Silvermine Gld. A., 1957; Gal. of Realities, Taos, N.M., 1961; Contemporaries, Santa Fe, 1963; Connecticut, 1964; Univ. Hartford, 1965; Cinema I and II, New York, 1965; N.Y. World's Fair, 1965; Leone Kahl Assoc., Dallas, Tex., 1966, and others. Lectures: Philosophy of Art & Art History. Positions: Memb. Adv. Council, Lyman Allyn Mus. A., 1955- ; Lecturer in Art, Connecticut College, New London, Conn., 1961- .

INGRAHAM, ESTHER PRICE—Painter, C., T.
 907 Pohai Nani, Kaneohe, Hawaii 96744
B. Needham, Mass. Studied: Mt. Holyoke Col., B.A., with Jewett & Foss; Cleveland Sch. A.; Famous Artists Course, Ctf.; privately with Frederic Taubes, Tadashi Sato and Hon Chew Hee. Member: Windward A. Gld.; Hawaii WC & Serigraph Assn. Awards: Positano Art Workshop, Positano, Italy, 1961, Maui A. Show, 1967. Exhibited: San Diego AI, 1962-1964; Del Mar (Cal.) Art Shop, 1964; Riverside

Country Club, Bozeman, Mont., 1963; Maui County A. Show, 1964, 1967; Bank of Hawaii, 1965; Windward A. Show, 1969; Lahaina Mus., 1969. Positions: A.-in-Res., Seabury Hall, Makawao, Maui, 1964-65; Bd. of Dir., Lahaina Craft & Cultural Center, Hawaii, 1965-1967; Art Workshop, Maui, 1966-1968 and Kaneohe, 1969. Honolulu representative for Lahaina Mus., 1969- .

INMAN, PAULINE WINCHESTER (Mrs. Robert G.)—
 Graphic Artist, I.
 419 East 57th St., New York, N.Y. 10022
B. Chicago, Ill., Mar. 3, 1904. Studied: Smith Col., A.B.; and with Allen Lewis. Member: SAGA (Council, 1954-56, Cor. Sec. 1959-61, 1965-1966); Boston Pr. M.; Conn. Acad. FA; Academic A. Assn. Work: Carnegie Inst.; LC; MMA; Pennsylvania State; Montclair A. Mus.; Boston Public Library. Exhibited: Nationally and internationally including RPE Gal., London; Exchange Italian Exh.; Contemporary Print Exh., Tokyo, Japan. Illus., "How to Know American Antiques," 1951; "New World Writing No. 2," 1952; "Down East Reader," 1962. Contributor articles to Antiques, 1960, 1969; Artist's Proof, 1964.

INOKUMA, GENICHIRO—Painter
 33 E. 22nd St., New York, N.Y. 10010
B. Tatamatsu City, Japan, Dec. 14, 1902. Studied: Tokyo Acad. FA. Awards: Mainichi Cultural Prize (mural); prize, Mus. of Modern Art, Tokyo. Work: Nat. Mus., Tokyo; BMA; Mitsui Bank. Exhibited: Salon de Independents, 1952, Salon de Mai, 1953, both Paris, France; Carnegie Inst., 1952, 1954, 1955, 1958, 1961, 1964, 1967; Sao Paulo, 1954, 1955, 1959; BM. One-man: Tokyo Mus.; Willard Gal., N.Y., 1956, 1957, 1958, 1960, 1962, 1964, 1967, 1968; MModA; Mitsui Bank.

INSLEE, MARGUERITE T. (Mrs. Charles)—Collector, P.
 909 Floral Dr., Grand Rapids, Mich. 49506
B. Grand Rapids, Mich., June 17, 1891. Studied: Smith College, B.A.; Grand Rapids A. Mus.; Colorado Springs FA Center; in Mexico and in Salzburg with Kokoschka. Awards: prize (painting) Grand Rapids A. Mus., 1960. Collection: Redon; Picasso; Kokoschka; Ynez Johnston; Ben Nicholson; Kathe Kollwitz; Maillol (bronze); George le Deliou (wood sculpture, lithographs and graphic art).

INSLEY, WILL—Sculptor, P., W., T.
 2 Spring St., New York, N.Y. 10012
B. Indianapolis, Ind., Oct. 15, 1929. Studied: Amherst Col., B.A.; Harvard Grad. Sch. of Design, B. Arch. Awards: Nat. Fnd. on the Arts and Humanities, Oberlin Col., 1966; Guggenheim Fellowship, 1969-1970. Work: Allen Mem. Mus., Oberlin Col.; Rose A. Mus., Brandeis Univ.; NCFA; Weatherspoon Gal., Univ. North Carolina at Greensboro; Finch Col., New York City. Sculpture, Great Southwest Industrial Park, Atlanta, Ga., 1968. Exhibited: Daniels Gal., N.Y., 1965; Tibor deNagy Gal., N.Y., 1965; Inst. Contemp. A., Chicago, 1965; Lyman Allyn Mus., New London, Conn., 1965; Kornblee Gal., N.Y., 1965; WMAA, 1965, 1967; Grippi & Waddell Gal., N.Y., 1966, 1967; Finch Col., 1966, 1967; Park Place Gal., N.Y., 1966; Riverside Mus., N.Y., 1966; Guggenheim Mus., 1966; Kent Col., Ohio, 1967; Univ. Illinois, 1967; Mus. Merchandise, Philadelphia, 1967; Stadler Gal., Paris, France, 1967; Feigen Gal., N.Y., 1967; San Marino, Italy, 1967; Aldrich Mus. Contemp. A., Ridgefield, Conn., 1968; Des Moines A. Center, 1968; First Triennial of Contemporary World Art, New Delhi, India, 1968; Friedrich Gal., Munich Germany, 1968; University House, New York City, 1968; J. L. Hudson Gal., Detroit, 1968; Univ. Puerto Rico, 1968; AFA traveling exhibitions, 1968 (2); Paula Cooper Gal., N.Y., 1969; Sch. Visual A., N.Y., 1969; John Gibson, N.Y., 1969; Art Fnd., Long Beach, N.J., 1969; Andrew Dickson White Mus., Cornell Univ., (3-man) 1969. One-man: Amherst Col., 1951; Stable Gal., N.Y., 1965-1968; Oberlin Col., 1967; Univ. North Carolina, Greensboro, 1967; WAC, 1968; Albright-Knox A. Gal., Buffalo, 1968; John Gibson, N.Y., 1969. Contributor to Arts magazine and Arts International. Positions: A.-in-Res., Oberlin College, Ohio, Fall 1966; Visiting Artist, Univ. North Carolina, Greensboro, Fall, 1967 and 1968; Visiting Critic, Sculpture, Cornell Univ., Ithaca, N.Y., Spring, 1969; School of Visual Arts, New York, N.Y., Fall and Spring, 1969, 1970.

INTERLANDI, FRANK—Cartoonist, P.
 1199 Temple Hills Dr., Laguna Beach, Cal. 92651
B. Chicago, Ill., Mar. 10, 1924. Studied: Chicago Acad. FA; Univ. Iowa, B.A. Work: William Allen White Sch. Journalism, Univ. Kansas; Albert T. Reid Cartoon Coll. Exhibited: Los A. Mus. A., 1957; Laguna Beach Festival A., 1955, 1957, 1958. Positions: Syndicated Cartoonist for The Register & Tribune Syndicate, 1953- and Los Angeles Times.*

INVERARITY, ROBERT BRUCE—Designer, Mus. D.
 Philadelphia Maritime Museum, 427 Chestnut St. (19106); h.
 210 Locust St., Philadelphia, Pa. 19106
B. Seattle, Wash., July 5, 1909. Studied: Univ. Washington, B.A.;

Fremont Univ., M.F.A., Ph.D., and with Kazue Yamagishi, Mark Tobey, Blanding Sloan. Member: Am. Assn. for Advancement of Science; Int. Inst. for Conservation of Historic & Artistic Works, England. Awards: Wenner-Gren Fnd. grant, 1951. Work: U.S. Naval Coll.; mural, U.S.Naval Air Station, Seattle, Wash.; mosaics, Univ. Washington; panels, Wash. State Mus., Seattle. Exhibited: Brooklyn Soc. Et., Chicago Soc. Et.; Nat. Gal., Canada; Cal. WC Soc.; Northwest A.; SAM; Oakland A. Mus.; Western Painters, San F.; Los A. AA; Tokyo, Japan; John Herron AI; Columbus Gal. FA; CM; Dayton AI; Temple Univ.; Detroit Inst. A.; one-man: Edward Weston Gal., Carmel, Cal.; Workshop Gal., San F.; Santa Barbara A. Gal.; Palm Springs, Cal.; Hudson Bay Co., Vancouver, B.C.; Vancouver A. Gal., and many others. Author, I., "Blockprinting and Stenciling," 1930; "The Rainbow Book," 1931; "Manual of Puppetry," 1933; "Masks and Marionettes of the Northwest Coast Indians," 1940; "Art of the Northwest Coast Indians," 1950; "Anthropology in Primitive Art" in Yearbook of Anthropology, 1955; "Visual Files Coding Index," 1960; Ed. "Winslow Homer in the Adirondacks," 1959, and others. Contributor to "Curator," "National Micro-News," etc. Positions: Bd. Trustees, Mus. of Navajo Ceremonial A., Santa Fe, 1950-1954; Bd. Dir., Int. Folk A. Fnd., 1952-1954; Research Asst., Yale Univ., 1951-1953; Trustee, Eskimo Art, Inc., 1953- ; Dir., Mus. Int. Folk Art, Santa Fe, New Mexico, 1949-1954; Dir., Adirondack Mus., Blue Mountain Lake, N.Y., 1954-1965; Dir., Adirondack Hist. Assn., 1956-1965. Council Memb., New York State Assn. of Museums, 1963-1964, Vice-pres. 1964-1965; Designer, art books and classical series, Univ. Cal., Berkeley, 1967-1968. Dir., Phila. Maritime Mus., 1969- .

IOLAS, ALEXANDRE—Art Dealer
15 E. 55th St., New York, N.Y. 10022
Positions: Dir., Alexandre Iolas Gallery, New York, N.Y.*

IPPOLITO, ANGELO—Painter
P.O. Box 173, Okemos, Mich. 48864
B. S. Arsenio, Italy, Nov. 9, 1922. Studied: Ozenfant Sch., FA; BMSch. A.; Instituto Meschini, Rome, Italy. Awards: Fulbright Fellow, Italy, 1959-60; Ford Fnd. grant, 1965. Work: WMAA; PC; Munson-Williams-Proctor Inst.; Sarah Lawrence Col.; Massillon Mus. A.; Chrysler Mus. A., Provincetown; Michigan State Univ.; Univ. of Michigan; N.Y. Univ.; Montreal Trust Co., Canada; C.I.T. Bldg., N.Y.; N.Y. Hilton Hotel; Milwaukee A. Center; New American Library; Univ. Kentucky; Norfolk (Va.) Mus.; Western Mich. Univ. Exhibited: Museo d'Arte Moderna, Rome, 1949; Carnegie Inst., 1956-1958; WMAA, 1956-1958; Munson-Williams-Proctor Inst., 1955-1957; Inst. Contemp. A., Wash., D.C.; Columbus Gal. FA; WAC; PC; Detroit Inst. A.; BM; Chicago A. Cl.; Universities of Fla., Neb., Colo., and Wesleyan Univ.; VMFA; Stable Gal., 1953-1957; Provincetown AA; Provincetown A. Festival; Boston A. Festival; Birmingham Univ., England; Columbia Univ.; Wagner Col.; Bryn Mawr Col.; Sarah Lawrence Col.; AIC; MModA; Delaware A. Center; Am. Collage European tour; one-man: Galleria della Rotonda, Bergamo, Italy, 1950; Tanager Gal., N.Y., 1954, 1962; Bertha Schaefer Gal., N.Y., 1956, 1958; H.C.E. Gal., Provincetown, Mass., 1957, 1961; Cleveland Inst. A., 1960; Massillon Mus. A., 1960; Canton Mus. A., 1960; Univ. Cal., Berkeley, 1961; Mich. State Univ., 1962; Bolles Gal., San Francisco, 1962 (2-man); Grace Borgenicht Gal., N.Y., 1963, 1964, 1967; Springfield (Ohio) A. Center, 1967; Besser Mus., Alpina, Mich., 1968; Albion Col., Mich., 1968; Western Mich. Univ., 1969, and others. Positions: Instr. Painting, Sarah Lawrence Col.; Newark Sch. Fine & Indst. Art; Asst. Dir., Tanager Gal., New York, N.Y., 1952-1962. Instr., Univ. California, Berkeley, 1961-1962; Cooper Union, 1956-1959, 1962-1965; Queens College, N.Y., 1963-1964; Silvermine Sch. A., 1963-1964. A.-in-Res., Arnot A. Gal., Elmira, N.Y., 1965 and Besser Mus., Alpina, Mich., 1968. Visiting Artists, Mich. State Univ., East Lansing, 1966-1970.

IRELAND, RICHARD WILSON (DICK)—
Painter, T., I., Gr.
1300 Mt. Royal Ave.; h. 203 W. Lanvale St., Baltimore, Md. 21217
B. Marion, Ind., Mar. 31, 1925. Studied: Indiana Univ., B.A., M.A.; ASL. Work: MModA. Exhibited: MModA, 1956; Indiana Pr.M., 1952; John Herron AI, 1948, 1951, 1953; ACA Gal., N.Y., 1949, 1950; RoKo Gal., 1955; Stable Gal., 1956; Collectors Gal., 1956, 1957; Eastside A., 1956, 1957; March Gal., 1957, 1958; Pyramid Gal., 1957; Workshop Gal., 1958, all New York City; one-man: Indiana Univ., 1952; BMA; March Gal., N.Y., 1960. Positions: Instr. A., Dean, Extension Division, Maryland Inst. A., Baltimore.

IRVIN, SISTER MARY FRANCIS—Painter, E., Gr.
Seton Hill College, Greensburg, Pa. 15601
B. Canton, Ohio, Oct. 4, 1914. Studied: Seton Hill Col.; Carnegie Inst., B.F.A.; AIC; Cranbrook Acad. A., M.F.A. Member: Assoc. A. Pittsburgh; Greensburg A. Cl.; CAA; Catholic AA; Pa. A. Edu. Assn.; Eastern AA; NAEA. Awards: Assoc. A., Pittsburgh; Greensburg AA, 1944, 1945, 1955, 1957. Work: Carnegie Inst.; St. Charles

Borromeo Church, Twin Rocks, Pa.; Peabody, Central Catholic and Elizabeth Seton H.S., Pittsburgh. Exhibited: LC, 1944; Assoc. A. Pittsburgh, 1943-1946, 1954, 1957; Carnegie Inst., 1944, 1956; Greensburg A. Cl., 1944-1952, 1954, 1957; Pittsburgh Playhouse, 1950, 1953; Allegheny A. Lg., 1951; Westmoreland Hospital, 1956; Catholic AA, 1953; Religious A. Center of America, 1960; Westmoreland County Mus. A., 1964; Pittsburgh Nat. Bank, 1964. Positions: Prof. A., Dir. of Development, Seton Hill Col., Greensburg, Pa., 1965- . Bd. Memb., Religious A. Center of America.

IRVIN, REA—Painter, I., Cart.
Frederiksted, Virgin Islands
B. San Francisco, Cal., Aug. 26, 1881. Studied: Mark Hopkins AI. I., New Yorker magazine. Positions: A. Ed., New Yorker magazine, 30 years.*

IRWIN, JOHN—Publisher, Editor
1041 Folsom St., San Francisco, Cal. 94103; h. 90 Corte Placida, Greenbrae, Cal. 94104
B. Cleveland, Ohio, Jan. 18, 1931. Positions: Editor, Publisher, Founder of Artforum magazine, a monthly, critical art magazine published in San Francisco, Cal., 1962- .*

IRWIN, MR. and MRS. JOHN N., II—Collectors
888 Park Ave., New York, N.Y. 10021*

IRWIN, ROBERT—Painter
c/o Pace Gallery, 9 W. 57th St., New York, N.Y.*

ISAACS, BETTY LEWIS—Sculptor
21 East 10th St., New York, N.Y. 10003
B. Hobart, Tasmania, Sept. 2, 1894. Studied: CUASch; ASL; Alfred Univ.; Kunstgewerbe Schule, Vienna; private study Vienna and Warsaw. Member: NAWA; Am. Soc. Contemp. A. Awards: prizes, NAWA, 1955, 1957, 1960; Am. Soc. Contemp. A., 1958, 1960, 1961. Work: Cooper Union Mus. Coll.; Am. Soc. Contemp. A. Exhibited: Audubon A., A. All. of N.Y.; Phila. A. All.; Cooper Union; Argent Gal.; Ferargil Gal.; Nat. All. of Art in Industry, N.Y.; Pasadena, Cal.; Riverside Mus.; Contemporaries Gal.; Am. Soc. Contemp. A.; Bertha Schaefer Gal.; Stamford (Conn.) Mus.; one-man: Pasadena, Cal.; Hacker Gal., N.Y.; Univ. Louisville. Positions: Former Instr. A., CUASch., and Greenwich House, N.Y.

ISAACSON, ROBERT L.—Art Dealer
Durlacher Brothers, 538 Madison Ave., New York, N.Y. 10022*

ISENBURGER, ERIC—Painter
c/o M. Knoedler & Co., 14 East 57th St.; h. 140 E. 56th St., New York, N.Y. 10022
B. Frankfurt-on-Main, Germany, May 17, 1902. Member: Council, NAD. Awards: prizes, NAD, 1945, 1957, Proctor award, 1963; CGA, 1949 (prize and med.); med., Pepsi-Cola, 1948; prize Carnegie Inst., 1947; Audubon A., 1969. Work: Am. Acad. A. & Let.; MModA; PAFA; John Herron AI; IBM; NAD; deYoung Mem. Mus.; Mary Washington Col. of the Univ. Virginia; Encyclopaedia Britannica; CGA; Wadsworth Atheneum; Swarthmore Col.; Bezalel Mus., Jerusalem; Ein Harod, Israel. Exhibited: Carnegie Inst., 1943-1950; PAFA, 1943-1945, 1948, 1949, 1951, 1952; CGA, 1943, 1945, 1947, 1949, 1951, 1961; AIC, 1942, 1945; WMAA, 1944; CAM, 1945, 1951; NAD, 1942, 1945, 1948-1951, 1957-1961; Indianapolis, Ind., 1946; CMA, 1946; MMA, 1950; Univ. Illinois, 1948, 1951; WMA, 1948-1952; Toledo Mus. A., 1948, 1951, 1952; Los A. Mus. A., 1951; Detroit Inst. A., 1947; Denver A. Mus., 1951; Minneapolis Inst. A., 1948; Columbus Gal. FA, 1948; Lincoln, Neb., 1949; Tulsa, Okla., 1951; N.Y. World's Fair, 1964; one-man: Knoedler Gal. 1941, 1943, 1945, 1947, 1948, 1950, 1953, 1955; deYoung Mem. Mus., 1945; BMA, 1943; Springfield Mus. A., 1945; Colorado Springs FA Center, 1945; John Herron AI, 1946; Frances Taylor Gal., Los A., 1945; Assoc. Am. A. Hollywood, 1949; Gal. 100, Princeton 1960; Gallery Gurlitt, Munich, Germany, 1962. Positions: Instr., Nat. Acad. Sch. FA, New York,

ISHAM, SHEILA EATON (Mrs. Heyward)—Painter, Lith.
5126 Albemarle St., N.W., Washington, D.C. 20016; (studio) 1237 22nd St., N.W. Washington, D.C. 20007
B. New York, N.Y., 1927. Studied: Univ. Geneva; Bryn Mawr Col., B.A.; Berlin Acad. Fine Arts and with Profs. Hans Uhlman and Alexander Camaro; Pratt Graphic Art Center, N.Y. Work: MModA; LC; BMA; PMA; Nat. Gal. Art (Rosenwald Collection); Yale Univ. A. Gal.; WAC; N.Y. Pub. Lib.; Albright-Knox A. Gal., Buffalo; U.S. Embassies abroad; Oklahoma A. Center. Exhibited: Print Council of America, 1959 (traveling to 16 museums); LC, 1959, 1960, 1962, 1963; Soc. Washington Printmakers, 1959-1963; SAGA, 1959, 1962, 1963; Philadelphia Free Lib., 1959, 1960; Silvermine Gld. A., 1959, 1960; Univ. Maine, 1959; BM, 1960; Phila. Pr. Cl., 1959; CGA, 1959, 1962; Boston Print Show, 1960; one-man: Gallerie Springer, Berlin, Germany,

1954; Bader Gal., 1960, 1962, 1966; Nantucket Little Gal., 1961; Smithsonian Inst., 1961; Alliance Francaise, Hong Kong, 1964; Chatham Gal., Hong Kong, 1964; Nihonbashi Gal., Tokyo, 1964; Byron Gal., N.Y., 1966; Jefferson Place Gal., Washington, D.C., 1968-1969. Awards: prizes, Soc. Washington Printmakers, 1961; CGA, 1962. Positions: Instr., Contemp. Art, Asia College, 1962-64.

ISHIKAWA, JOSEPH—Museum Director, L., W.
Wright Art Center, Beloit College, Beloit, Wis. 53510
B. Los Angeles, Cal., July 29, 1919. Studied: Univ. Cal. at Los Angeles, A.B.; Grad. work, Univ. Nebraska. Member: AAMus.; Midwest Mus. Assn. Contributor to Art Digest, Art Journal, Cresset; Arts in Society. Participant in Am. Assn. Mus. Scandinavian Seminar. Positions: Cur., Univ. Nebraska A. Galleries; Cur. & Asst. Dir., Des Moines Art Center, 1951-58; Dir., Sioux City A. Center, 1958-61; Dir., Theodore Lyman Wright Art Center, Beloit, Wis., 1961- .*

ISRAEL, ROBERT—Painter, Des., T.
2439 3rd Ave. S.-Apt. C-9, Minneapolis, Minn. 55404
Studied: Pratt Inst., B.F.A.; Univ. Michigan, M.F.A. Work: Illus. and Design of record album covers for The Urania Record Corp.; Illus. for Opera News; Book Design, "The Craft of William Golden"; Member of design group working on U.S. Medical Pavillion in Russia; Kodak and IBM exhibitions, N.Y. World's Fair 1964. Designer, Detroit Inst. A., 1962. Exhibited: WAC, 1964. Positions: Instr., Graphic Des. & Drawing, Minneapolis School of Art, Minnesota.*

ITTLESON, HENRY, JR.—Collector
660 Madison Ave.; h. 2 E. 61st St., New York, N.Y. 10021
B. St. Louis, Mo., Oct. 25, 1900. Studied: Colgate University, B.A.; University of Michigan. Collection: French Impressionists. Positions: Honorary Trustee, Metropolitan Museum of Art, New York City, 1969- ; Member, Advisory Council, Department of Art and Archaeology, Columbia University, New York, 1959- .

IVEY, JAMES BURNETT—Cartoonist
San Francisco Examiner, 3rd & Market Sts.; h. 308 Presidio Ave., San Francisco, Cal. 94115
B. Chattanooga, Tenn., Apr. 15, 1925. Studied: Univ. Louisville; George Washington Univ., A.A.; National A. Sch., Wash., D.C. Member: Nat. Cartoonists Soc.; Assn. Am. Editorial Cartoonists. Awards: Nat. Bar Award, 1958; Florida Bar Award, 1958, 1959; Reid Fellowship, Europe, 1959. Exhibited: Nat. Cartoonists Soc. Exh., 1961. Contributor to Editor & Publisher; Freedom & Union. Lectures: European Political Cartooning. Positions: Cart., Wash., D.C. Star, 1950-53; Political Cart., St. Petersburg (Fla.) Times, 1953-59; Political Cart., San Francisco Examiner, 1959- .*

IVEY, GREGORY DOWLER—Educator, Des. Coordinator, P.
Department of Art, California State College, 800 N. State College Blvd., Fullerton, Cal. 92634
B. Clarksburg, Mo., May 7, 1904. Studied: Central Missouri State Col., B.S.; St. Louis Sch. FA, Washington Univ.; Columbia Univ., M.A.; N.Y. Univ. Exhibited: AIC, 1939-1942; BM, 1938-1942; MMA, 1943; Kansas City AI; High Mus. A.; Mint Mus. A., 1952; State A. Gal., Raleigh, 1952; Elliott Hall, Greensboro, 1958 (one-man); Blowing Rock, 1959; Community Gal., Winston-Salem, 1959; Merin Gal., Greensboro, 1959; Mint Mus. A., 1959; Chattanooga, Tenn., 1960; Nashville, 1960; Savannah, Ga., 1960; Jacksonville, Fla., 1960; Palm Beach, 1960; Davidson Col., 1961. Member: numerous art juries. Author, I., "An Approach to Design" (monograph). Positions: Instr., Dept. A., State T. Col, Indiana, Pa., 1932-35; Prof. A., Hd. Dept. A., Woman's Col., Univ. North Carolina, Greensboro, N.C., 1935-1961; Dir., Burnsville Sch. FA. of the Woman's Col., Univ. North Carolina, 1952-53; Dir. FA, Summer Session, Beaufort, N.C., 1954; Vice-Pres., Southeastern College A. Conf., 1957-58; Bd. Dir., Exec. Com., North Carolina Mus. A., 1956-58; Memb. Policy Com., CAA, 1956-58; Memb. Policy Com., NAEA, 1957-59; Bd. Memb., North Carolina State A. Soc., 1960-62; Memb., Ex. Com., Assoc. A. of North Carolina, 1959-60; Bd. Memb., North Carolina Council of Teachers of A., 1960. Prof. A., Chm. Dept. Art, California State College, Fullerton, Cal., 1965-1967, Prof., 1969- .

JACHMANN, KURT M.—Collector
215 E. 68th St., New York, N.Y. 10021
B. Germany. Collection: Pre-Columbian and Oceanic Art; French Abstract-Expressionist; Calligraphic Painting.

JACKSON, BEATRICE (HUMPHREYS)—Painter
450 East 63rd St., New York, N.Y. 10021; also Dorset, Vt. 05251
B. London, England, Dec. 25, 1905. Studied: Smith Col.; Grand Central A. Sch.; ASL; Colorossi Acad., Paris, and with Wayman Adams, George Elmer Browne, Andre Lhote, Paris. Member: All. A. Am.; NAWA; Nat. Lg. Am. Pen Women; Cosmopolitan Cl.; So. Vermont A.; Pen & Brush Cl.; Conn. Acad. FA; Catherine L. Wolfe A. Cl.;

Grand Central A. Gal.; Assoc. Societe des Beaux-Arts; AAPL; Royal Soc. A., London; Academic A.; Hudson Valley AA; NAC; North Shore AA; Audubon A.; Knickerbocker A. Awards: prizes, Morristown AA, 1941, 1943; NAWA, 1953, 1959; Nat. Lg. Am. Pen Women, 1955, 1957, 1959, 1961, 1964; Conn. Acad. FA, 1955; All. A. Am., medal, 1955, prize, 1958, 1960; Pen & Brush Cl., 1959; Academic A. Assn., 1956, 1959; Wolfe A. Cl., 1956, 1961, medal, 1967; Bronxville Pub. Lib., 1956; AAPL, 1967; NAC, 1966. Exhibited: NAD, 1941, 1955, 1964; Conn. Acad. FA, 1954-1959; NAWA, 1952-1969; All. A. Am., 1941, 1948, 1950-1968; Paris Salon, 1928 and later; Salon d'Automne, 1931; Salon des Tuileries; Knickerbocker A.; So. Vermont A., 1942-1969; Morristown AA, 1941-1943; Van Dieman-Lilienfeld Gal., 1955; Bronxville Pub. Lib., 1955, 1956; Studio Gld., 1953; Art:USA, 1958; Grand Central A. Gal., 1958 (one-man); Nat. Lg. Am. Pen Women, 1956-1961, 1964; Berkshire AA, 1959. Positions: Vice-Pres., NAWA; Chm. A. Com., So. Vermont A. Rec. Sec., Audubon A., 1969, and Knickerbocker A., 1964.

JACKSON, BILLY MORROW—Painter, Gr., E., I.
1009 W. Nevada St., Urbana, Ill. 61801; h. 608 S. Prospect, Champaign, Ill. 61822
B. Kansas City, Mo., Feb. 23, 1926. Studied: Washington Univ., St. Louis, B.F.A.; Univ. Illinois, Urbana, M.F.A. Member: SAGA; Boston Printmakers; Phila. WC Soc. Awards: Eyre Medal, Phila. WC Soc., 1957; prizes: Paul J. Sachs Award, Boston Printmakers, 1956; Erickson Award, SAGA, 1956, 1957; Cannon Award, NAD, 1956; Brockton AA, 1960; Conn. Acad. FA, 1960; Univ. North Dakota, 1961; Wash. WC Cl., 1961; Paul Magriel Award, Norfolk, Va., 1961; Mrs. John S. Lehman Award, CAM, 1963; Springfield State Fair (Ill.), 1963, 1964, 1966; Decatur A. Center, 1965; Purchase Prizes: Evansville Mus. A. & Sciences, 1960, 1966; Joslyn A. Mus., 1962, 1964; Boston Pub. Lib., 1962; Butler Inst. Am. A., 1963, 1965, 1966; Carver Community Center, Evansville, 1964; Ohio State Univ., Athens, 1964; Chautauqua, N.Y. 1966; Joslyn A. Mus., 1964; Union League Club, Chicago, 1965, 1967; Dulin Gallery, Knoxville, 1965. Work: Boston Pub. Lib.; MMA; Cal. PLH; LC; SAGA; State Capitol, Olympia, Wash.; Wichita AA; Springfield Mus. A. (Mo.); Sioux City A. Center; Conn. Acad. FA; USIA Collection; Univ. New Hampshire; Joslyn A. Mus.; Norfolk Mus. A.; Northern Illinois Univ., DeKalb; Butler Inst. Am. A.; AFA; Ben and Abbey Frey Fnd.; Univ. North Dakota; Ohio Univ.; Illinois State Mus.; Univ. Tennessee; Bradley Univ.; Evansville Mus., and others. Exhibited: McClung Mus., Univ. Tennessee, 1965, 1966, and 2-man, 1967; Pasadena, Cal. 1966; FA Gal. of San Diego, 1966; one-man: Millikin Univ., Decatur, Ill., 1956; Art Mart-Clayton, St. Louis, Mo., 1956, 1958, 1960, 1962; Arnold Finkel Gal., Phila. Pa., 1962; Antique Gal., Champaign, 1963; Banfer Gal., N.Y., 1963, 1964; Univ. Ill., 1964; Kenmore Gal., Phila., Pa., 1964. Work represented in Prize Winning Graphics, 1963, 1964; Lehigh Univ., Bethlehem, Pa., 1966; St. Louis (Mo.) Gal., 1966; State Col., Springfield, Mo.; Decatur A. Center, 1966; 4 Arts Gal., Evanston, Ill., 1967, and others. Illus. to Panorama Magazine; Chicago Daily News. Positions: Prof. A., Univ. Illinois, Urbana, Ill. at present.

JACKSON, EVERETT GEE—Educator, P., I.
1234 Franciscan Way, San Diego, Cal. 92116
B. Mexia, Tex., Oct. 8, 1900. Studied: Texas A. & M. Col.; AIC; San Diego State Col., A.B.; Univ. Southern California, M.A. Member: Am. Assn. Univ. Prof.; San Diego FA Soc. Awards: prizes, San F., Cal., 1928; Laguna Beach, Cal. AA, 1934; Los A. Mus. A., 1934. Work: Houston Mus.; FA; San Diego FA Soc.; Los A. Mus. A. Published: "Estudio de Evaluation de la Academia de Bellas Artes de la Universidad de Costa Rica," 1963. Exhibited: Houston Mus. FA; San Diego FA Soc.; Laguna Beach AA; Palace Legion Honor, 1946. I., "Paul Bunyan," 1945; "The Ugly Duckling," 1949; "Popol Vuh," 1955; "The Conquest of Peru," 1957; "Ramona," 1959; "American Chimney Sweeps," 1958; "North American Indian Legends," 1969. Positions: Prof. A., Chm. A. Dept., Emeritus, San Diego State Col., San Diego, Cal., 1930- .

JACKSON, HARRY—Painter, S.
Wyoming Foundry Studios, Camaiore, Italy; h. "Il Casone," Camaiore (Lucca) Italy 55041
B. Chicago, Ill., Apr. 18, 1924. Studied: AIC; BM Sch. A.; Hans Hofmann Sch. A.; Accademia de Belli Arti, Florence, Italy. Member: NSS; Fellow, AAPL; Cowboy Artists of America; U.S. Marine Corps Combat, Correspondents Assn. Awards: U.S. Interstate Gold Medal, Pennational Annual, 1967; S.F.B. Morse Medal, NAD, 1968. Work: Am. Mus. in Great Britain, Bath, England; Amon Carter Mus. Western A., Ft. Worth, Tex.; Buffalo Bill Mus., Cody, Wyo.; Coe Fnd., N.Y.; Dickinson Col., Carlisle, Pa.; Dietrich Inst.; Dobie Mem. Coll., Univ. Texas, Austin; Fort Ligonier (Pa.) Mus.; Fort Pitt Mus., Pittsburgh; Glenbow Fnd., Calgary, Canada; Harvie Fnd., Calgary; Montana Hist. Soc., Helena; Riveredge Fnd., Calgary; Norton Fnd., Shreveport, La.; Shelburne (Vt.) Mus.; Whitney Gal. Western Art, Cody, Wyo.; Woolaroc Mus., Bartleville, Okla.; Wyoming State Gal-

lery Mus., Cheyenne. Commissions: W.R. Coe Fnd., 2 murals and accompanying bronze statues for Whitney Gallery of Western Art; Amon Carter Mus., 2 bronze groups; bronze monument of Poet-Singer "Sor Capanna" for Piazza dei Mercanti, Rome, Italy; R. K. Mellon Fnd., mural, for Fort Pitt Mus., Pittsburgh; monumental sculpture of Lord Cochrane, Maritime liberator of Chile, for Valdivia, Chile. The preceding work completed 1958-1969. Exhibited: CGA; MMoA; Tate Gal., London; PAFA, 1961; BM, 1961; NCFA (one-man) Feb.-Mar., 1964; NAD, 1964, 1965, 1967, 1968; Pennational A., 1967; XVII Mostra Internazionale d'Arte, Florence, Italy, 1966; Nat. Cowboy Hall of Fame, 1966; AAPL, 1968; Stedahl Gal., Los Angeles; Los Angeles AA; Norlyst Gal., N.Y.; Jaques Seligmann Gal., N.Y.; Kootz Gal., N.Y.; New Gal., N.Y.; Bennington Col.; Stable Gal., N.Y.; Hirschl & Adler Gal., N.Y., 1962; Tibor de Nagy Gal., N.Y.; Martha Jackson Gal., N.Y., 1956; James Graham Gal., N.Y., 1959; Knoedler Gal., N.Y., 1961; Amon Carter Mus., 1961, 1962, 1968; Kennedy Gals., N.Y., 1964, 1968, 1969; Mile High Center, Colo., 1965; Cody A. Lg., 1968; Hammond Mus., North Salem, N.Y., 1968; Camaiore, Italy, 1968, and others.

JACKSON, HAZEL BRILL—Sculptor, Eng.
"Twin Oaks," Balmville Rd., Newburgh, N.Y. 12550
B. Philadelphia, Pa. Studied: BMFASch.; in Italy; & with Bela Pratt, Charles Grafly. Member: Gld. Boston A.; F.; NSS; NA. Awards: med., Nat. Acad., Rome, 1930; prize, NAD, 1945, 1948, 1965; Ellen Speyer Mem. prize, 1960; AAPL, 1963. Work: Concord A. Mus.; bronzes, Wellesley Col.; Vassar Col.; Dartmouth Col.; Calgary Mus., Canada. Exhibited: NAD, 1944-1948, 1950, 1953, 1955-1957; Nat. Acad., Rome, 1927-1930; Nat. Acad., Firenze, Italy, 1927-1930; Grand Central A. Gal.; Gld. Boston A. 1962 (one-man); CGA (one-man); NAD, 1967, 1968. Specializes in animal sculpture, especially horses and dogs.

JACKSON, LEE—Painter
Strongs Lane, Water Mill, N.Y. 11976
B. New York, N.Y., Feb. 2, 1909. Studied: ASL, and with William McNulty, George Luks, John Sloan. Member: ASL; Nat. Soc. Painters in Casein; Audubon A.; AEA; AWS. Awards: prizes, Nebraska AA, 1946; SC, 1950; Nat. Soc. Painters in Casein, 1955; Grumbacher, 1956; NAD, 1951, 1961; Guggenheim F., 1941; Audubon A., Grumbacher purchase, 1964. Work: MMA; CGA; Nebraska AA; Los A. Mus. A.; Athens Mus. A.; St. Bonaventure Col., N.Y.; Walker A. Center; Norfolk Mus. A. & Sciences; Syracuse Univ.; Butler Inst. Am. A. Exhibited: PAFA, 1937, 1948-1952; NAD, 1938, 1942, 1944, 1945, 1948-1955, 1957, 1958; GGE, 1939; Carnegie Inst., 1941, 1943, 1948; WMAA, 1941, 1943-1946, 1948-1952; CGA, 1941, 1943, 1945, 1949; AIC, 1942, 1946; VMFA, 1942; Nebraska AA, 1944, 1946, 1948-1951; CAM, 1945; Los A. Mus. A., 1945; Soc. Four A., 1942; Butler AI, 1946, 1961; Univ. Illinois, 1949; Newark Mus., 1952; Toledo Mus. A., 1949; Des Moines A. Center, 1951; Dayton AI, 1951; Altoona A. All., 1950; Dallas Mus. FA, 1949; Santa Barbara Mus. A., 1949; Mus. FA of Houston, 1949; Walker A. Center, 1948; Joslyn A. Mus., 1949; Audubon A., 1948-1955; BMFA, 1955; Mus. City of New York, 1958; Art:USA, 1958; Davenport Mun. A. Gal., 1951, and others. One-man: Babcock Gal., 1941, 1943, 1948-1952, 1958; Nat. Gal., Canada, 1940; A. Gal., Toronto, 1940; Montreal AA, 1940; Inst., Mod. A., Boston, 1945; Nat. A. Mus. of Sport, Madison Square Garden, N.Y., 1968.

JACKSON, MARTHA KELLOGG—Collector, Art Dealer
32 E. 69th St. 10021; h. 241 Central Park, W., New York, N.Y. 10024; also 1736 Mandeville Lane, Los Angeles, Cal. 90049
B. Buffalo, N.Y. Studied: Smith College; Johns Hopkins University; The Baltimore Museum; Hans Hofmann Sch. in New York and Provincetown. Member: Honorary member, Buffalo Academy of Fine Arts; other memberships: Art Dealers Association; American Association of Museums; American Federation of Arts; Archives of American Art; Friends of the Whitney Museum of American Art; Guggenheim Museum; Metropolitan Museum; Museum of Modern Art; National Council on Arts and Government; Long Beach Museum of Arts, California. Awards: Harper's Bazaar Magazine "100 Women of Accomplishment" 1967. Specialty of Gallery: Contemporary Art. Positions: President, Martha Jackson Gallery, New York, N.Y.†

JACKSON, VAUGHN LYLE—Painter, Comm., Des., I.
Research Analysis Corp., McLean, Va.; h. 5700 Kingswood Rd., Bethesda, Md. 20014
B. Raymond, Ohio, Jan. 7, 1920. Studied: Columbus A. Sch.; Ohio State Univ.; Corcoran Sch. A., with Richard Lahey, Edmund Archer; also with Eliot O'Hara, Hans Hofmann; American Univ., A.A. Member: Nat. Soc. A. Dir.; A. Dir. Cl. of Metropolitan Washington; Wash. WC Cl. (Bd. Managers, V.Pres., 1959-60); Landscape Cl. of Wash. (Pres. 1955); Am. A. Lg. Awards: prizes, Hilltop House Exh., Harpers Ferry, W.Va., 1956, 1962; silver medal, Landscape Cl. of Wash., 1955. Exhibited: Wash. WC Cl., 1954-1959; AAPL, 1950-1952, 1957; Landscape Cl. of Wash., 1954-1964; Wilson T.

Col., 1955; CGA, 1955, 1956; Am. A. Lg., 1958-1960; one-man: Washington, D.C., 1956, 1958, 1960. Adv. Illus.: Washington Post-Times Herald; Agricultural Chemicals magazine; Washington Evening & Sunday Star; Editor & Publisher magazine; Printers Ink; Aviation Age; Electronics magazine. Positions: Columbus Citizen, 1938-42; S. Kann Sons, Wash., D.C., 1946-47; Kal, Ehrlich & Merrick Adv., Inc., Wash., D.C., 1947-52; Asst. A. Dir. with Operations Research Office, The Johns Hopkins Univ., Bethesda, Md., 1952-1961; Asst. A. Dir., Research Analysis Corporation, 1961-1963, Publications A. Dir., 1963-1967, Visual & Graphics Manager, 1967- .

JACKSON, VIRGIL V.—Cartoonist, I., P., Des., Comm.
611 F St., Northwest, Washington, D.C. 20004; h. 3127 Beechwood Lane, Falls Church, Va. 22042
B. Peoria, Ohio, Sept. 17, 1909. Studied: Columbus A. Sch. Member: A. Dir. Cl., Wash. D.C.; Advertising Cl., Wash., D.C. Awards: Scholarships, Columbus A. Sch. Work: murals, U.S. Government at Marysville, Ohio, H.S.; portrait commissions in Ohio. Exhibited: Columbus A. Gal. Contributor cartoons and illustrations to: National Edu. Assn.; Signs of the Times; Ohio State Journal; Washington Post; Columbus Dispatch; Columbus Citizen. Positions: Instr., Drawing & Cartooning, Columbus Sch. A.; Comm. A. & Dir., Columbus Citizen, Washington Post; Vice-Pres., Treas., Commercial Art Studios, Inc., and Graphic Craftsmen, Inc., both Washington, D.C.

JACKSON, WARD—Painter, S., W., L.
65 Rivington St., New York, N.Y. 10002
B. Petersburg, Va., Sept. 10, 1928. Studied: Richmond Prof. Inst. of College of William and Mary, B.F.A., M.F.A.; Hans Hofmann Sch. FA. Awards: Fellowships, VMFA, 1948, 1949; N.Y. City Center, 1956; Certificate of Distinction, VMFA, 1963, 1969. Work: VMFA; Elvehjem A. Center, Univ. Wis.; Riverside Mus.; NCFA; Smithsonian Inst.; N.Y. Univ. Exhibited: Am. Abstract A., 1949; New A. Circle, J.B. Neumann Gal., 1950-1952; Linden Gal. of Contemp. A., 1949-1951; Provincetown A.A., 1952; Contemp. A. Gal., 1953-1956; Eola Gal., 1954; Contemp. A. Gal., 1955; Research Studio, Maitland, Fla., 1955; Morse Gal. A., Rollins Col., 1955; Chase Gal., N.Y., 1956; Fleischman Gal., 1956, 1957; Art: USA, 1958; N.Y. City Center, 1958-1960; Metropolitan Young Artists Show, 1960; Outer Banks Gal., 1958; VMFA, 1949-1969; 10-4 Gal., 1963; Kaymar Gal., 1964; John Daniels Gal., 1964, 1965; The Contemporaries, N.Y., 1965; Phoenix, 1966; Col. of William and Mary, 1967; Richmond, 1967; Riverside Mus., 1966; Graham Gal., 1969; one-man: Fleischman Gal., 1958-1960; Outer Banks Gal., 1959-1969; Atrium Gal., Seattle, 1965 (3-man); Univ. Wisconsin, 1967, and others. Positions: Co-editor, Folio, 1949, 1950; Instr., and Dir. of Morse Gal. A., Rollins College, 1954-1955. Editor, "Art Now," N.Y. 1969.

JACOBS, DAVID—Sculptor
36 East Fourth St., New York, N.Y. 10003
B. Niagara Falls, N.Y., 1932. Studied: Orange Coast Col., A.A.; Los Angeles State Col., A.B., M.A. Work: Guggenheim Mus., N.Y.; VMFA; Ohio State Univ. Exhibited: MMoA; Guggenheim Mus.; SFMA; Nelson Gal. of Art, Kansas City, 1966; AIC, 1966; Milwaukee A. Center, 1968; Chicago Mus. of Contemp. A., 1968; one-man: Barone Gal., N.Y., 1966; Kornblee Gal., N.Y., 1963-1965; Darcangelo Studio, N.Y., 1967; Hofstra Univ., 1967. Positions: Instr., Sculpture, Ohio State Univ., 1957-1962; Hofstra University, N.Y., 1962- ; Asst. Prof., Sculpture, Hofstra Univ., 1966- .

JACOBS, HAROLD—Painter, S.
R.D. No. 1, Glenmoore, Pa. 19343
B. New York, N.Y., Oct. 29, 1932. Studied: BMSch. A.; N.Y. Univ.; Cooper Union. Awards: Fulbright Scholarship to Paris, 1961. Work: WMAA. Exhibited: Butler Inst. Am. A., 1959, 1961; PAFA, 1960, 1963, 1968; BM; Terrain Gal., N.Y., 1960; Heller Gal., N.Y., 1961; SFMA, 1965; Colorado Springs FA Center, 1966; one-man: Amel Gal., N.Y., 1962, 1964; Portland (Ore.) Mus. A., 1964; Temple Univ., 1967; Vanderlip Gal., 1968. Positions: Assoc. Prof., Chm. Dept. of Painting, Moore Col. A., Philadelphia, Pa., at present.

JACOBS, JAY WESLEY—Portrait Painter
Jupiter Island, Hobe Sound, Fla.; also 4040 Altamont Rd., Birmingham, Ala. 35213
B. Carthage, Mo., Jan. 3, 1898. Studied: Harvard Col., A.B. Member: The Island Cl., Hobe Sound, Fla. Exhibited: Salon des Beaux-Arts, Paris, France (3 years). Work: portraits: Pres. Truman, in The Capitol, Wash., D.C.; Chm. Bd., du Pont Co., Wilmington, Del.; Admirals Halsey, Land, Vickery, and many others of prominent persons.*

JACOBS, TED SETH—Painter
523 E. 83rd St., New York, N.Y. 10028
B. Newark, N.J., June 11, 1927. Studied: ASL. Awards: prizes, Kansas City AI; ASL, 1953; John F. & Anna Lee Stacy award, 1954.

Work: ASL; Finch Col. Mus.; MModA, Print Coll.; other work in private colls. Exhibited: Springfield (Mass.) Mus. A., 1952; Randolph-Macon Col., 1954; Walker A. Center; Riverside Mus.; Fairleigh Dickinson Col., 1961; The Drawing Shop, N.Y., 1965. One-man: Wickersham Gal., N.Y., 1962; St. Vincents College, Latrobe, Pa., and, Rolling Rock Estates, Ligonier, Pa., 1963; Fisher Gal., Wash. D.C.; 1964; The Drawing Shop, N.Y., 1964, 1965; Noah Goldowsky Gal., N.Y., 1965; Adelson Gal., Boston, 1968, 1969.

JACOBS, WILLIAM KETCHUM, JR.—Collector
654 Madison Ave. 10021; h. 895 Park Ave., New York, N.Y. 10021
B. New York, N.Y., Mar. 17, 1908. Collection: Late 19th and 20th Century Paintings.*

JACOBSON, ARTHUR R.—Painter, Gr., E.
5618 E. Montecito, Phoenix, Ariz. 85018
B. Chicago, Ill., Jan. 10, 1924. Studied: AIC; Chicago Acad. FA; Univ. Wisconsin, B.S., M.S. Awards: prizes, New Mexico State Fair, 1954, 1955; Phoenix Annual, 1956; New Mexico Annual, 1956; Tucson, Ariz., 1958; Phoenix Jewish Community Center, 1969. Work: murals, Jewish Community Center, Phoenix; other work, Hastings Col., Hastings, Neb.; PAFA; DMFA; Ariz. State Univ. Exhibited: Denver A. Mus., 1952, 1958, 1961; Wisconsin Salon, 1950; Los A. Mus. A., 1948; Missouri Annual, 1951; Colorado Springs FA Center, 1953, 1959; Mus. New Mexico, Santa Fe, 1953-1956; Oklahoma A. Center, 1953; Arizona State Fair, 1954; Phoenix A. Center, 1954, 1966; Boston Pr. M., 1956; CGA, 1957; Phila. Pr. Cl., 1958; Butler Inst. Am. A., 1958; Terry AI, 1952; Tulsa, Okla., 1954; DMFA, 1957, 1960, 1962, 1963; Tucson, Ariz., 1958, 1967; Univ. Arizona, 1954, 1955, 1958; Stockton, Cal., 1955; PAFA, 1959, 1961; Okla. Pr. M., 1959; Cal. Soc. Et., 1959; Assoc. Am. A., 1959; LC, 1960; SAGA, 1960; USIS, 1960; Silvermine Gld. A., 1960; San F. AI, 1961; SAM, 1961, 1962, 1963; PAFA, 1963; Weatherspoon Ann., Univ. North Carolina, Greensboro, 1968; Yuma A. Center, Arizona, 1969; Phoenix Jewish Community Center, 1969; two-man: Bolles Gal., San Francisco, 1966; N.W. Printmakers, SAM, and Portland (Ore.) Mus. A., both 1966; one-man: Kendall Gal., San Angelo, Tex., 1952; Okla. A. & M. Col.; 1954; Ruins Gal., Taos, 1954; American Gal., Los A., 1955; Yares Gal., Scottsdale, Ariz., 1966. Positions: A.T., Philbrook A. Center; Phoenix A. Center; Desert Sch. A.; Prof. A., Arizona State University, Tempe, Ariz., 1956- .

JACOBSON, LEON—Painter, E., Gr.
Art Department, East Carolina College, Greenville, N.C. 27834
B. 1914. Studied: City Col., N.Y., A.B.; Univ. Southern California, M.A., Ph.D. Exhibited: MMA; Piedmont Festival A. & Music; Mus. Mod. Art, Beverly Hills, Cal. Author article "Art as Experience and American Visual Art Today," in Journal of Aesthetics and Criticism, 1960. Illus.: "The Short Stories of Katherine Mansfield"; "Poems of Emily Dickinson." Positions: Assoc. Prof., A. Dept., East Carolina College, Greenville, N.C.*

JACOBSON, YOLANDE (Mrs. J. Craig Sheppard)—
Sculptor, L., Cr.
1000 Primrose, Reno, Nev. 89502
B. Norman, Okla., May 28, 1921. Studied: University of Oklahoma, B.F.A.; and in Norway and France. Awards: prizes, Mid-West Annual, Kansas City, Mo., 1941; Denver Mus. A., 1941; Silver Centennial, Virginia City, Nev., 1961. Work: Gilcrease Mus. A., Tulsa; Jacobson Mus., Norman, Okla.; State Hist. Soc., Reno; Historical Mus., Carson City, Nev. Busts: Statuary Hall, Wash., D.C.; Univ. Nevada, Reno; bronze sculpture, Governor's Mansion, Carson City, Nev. Exhibited: Mid-West Annual, Kansas City, 1951; Oklahoma Annual, Tulsa, 1942, 1943, 1945; Denver Mus. A., 1941; Oakland Mus. A., 1956; Silver Centennial, Virginia City, 1961; Nevada Artists, Reno, 1951, 1953, 1957; Nevada A. Festival, Carson City, 1966; Governor's Mansion, 1968. Positions: Asst. Ed., University of Nevada Press, Reno, 1963-1965.

JAFFE, IRMA B. (Mrs.)—Research Curator, Scholar, Educator
Fordham University, Bronx, N.Y. 10458; h. 880 Fifth Ave., New York, N.Y., 10021
B. New Orleans, La. Studied: Columbia Univ., General Studies, B.S., Graduate Faculty, Art History, M.A., Ph.D. Awards: Phi Beta Kappa, Columbia Univ. General Studies, 1958, special Achievement Award, 1958, Distinguished Alumni Award, 1965. Contributor of articles and essays to Art:USA:Now; Burlington Magazine, Art Bulletin, Gazette des Beaux Arts, Author: "Joseph Stella." Field of Research: American Art, Modern Art. Positions: Editorial Staff Writer, Pictures on Exhibit, 1960-1964; Docent, Whitney Museum of American Art, 1964; Research Curator, Whitney Museum of American Art, N.Y. 1964-1966; Director of Special Events, American Studies Assn., 1968; Associate Professor of Art History and Chairman, Department of Fine Arts, Fordham University, 1966- ; Lecturer, Introduction to Art History, WABC-TV.

JAFFE, MR. and MRS. WILLIAM B.—Collectors
640 Park Ave., New York, N.Y. 10021*

JAGGER, GILLIAN—Painter, L., T., Des.
C. W. Post College, Brookville, N.Y.; h. 418 Central Park West, New York, N.Y. 10025
B. London, England, Oct. 27, 1930. Studied: Carnegie Inst., B.F.A.; Colorado Springs FA Center, with Vytlacil; Univ. Buffalo; Columbia Univ.; N.Y. Univ., M.A. Awards: Scholarship, Colorado Springs FA Center, 1952. Work: Finch Col. Mus., N.Y.; Brompton's, Montreal, Canada; Carnegie Inst.; portrait commissions, 1947-51. Exhibited: Assoc. A. Pittsburgh, 1952, 1953; Abstract A. Pittsburgh, 1953; 2-man & group shows, Loft Gal., 1955-1957; Finch Col. Mus., N.Y., 1964; one-man: Ruth White Gal., N.Y., 1961, 1963, 1964. Lectures on art: Radio Free Europe; Colleges; Professional Schools of Art, etc. Positions: Display Artist, 1953-55; Textile Des., Wamsutta Mills. Fruit of the Loom, 1955-57; Instr. Painting, N.Y. Univ., Post College, New Rochelle Academy; Asst. Prof., Hist. & Philosophy of A., Post College, Brookville, N.Y., at present.*

JAMEIKIS, BRONĖ ALEKSANDRA—Designer, E., L.
4841 N. Kenmore Ave., Chicago, Ill. 60640; h. 816 N. State St., Chicago, Ill. 60610
B. Vilnius, Lithuania, Feb. 16, 1919. Studied: Univ. of Kaunas; and in Vilnius, Lithuania; Ecole des Arts et Metiers, Freiburg, Germany; AIC, B.F.A., M.F.A.; Univ. Hawaii, M.A. Member: Lithuanian Inst. of Fine Arts; Am. Craftsmens Council. Awards: prizes, Exh. of Religious Art, Chicago, 1956; Int. Trade Fair, Chicago, 1960; Madonna in Art Exh., Honolulu, 1961. Work: Stained Glass, and Slab Glass, for various churches and buildings in U.S., and in private collections in Illinois, Michigan, Indiana and Hawaii. Exhibited: Chess House, Chicago, 1957; Windsor Mus., Canada, 1957; Denver Mus., 1957; Xavier Col., Chicago, 1958; Grand Rapids, Mich., 1960; Art in Hawaii, 1960; Madonna in Art Exh., Honolulu, 1961; State Fair and Expo., Honolulu, 1961; Crafts of the Western U.S., Del Mar, Cal., 1961; Nat. Biennial Religious Art Exh., 1960, 1962, 1964, 1966, 1969; St. Mary's Col., Notre Dame, 1964; Ecumenical Art Exh., St. Benet, Chicago, 1966; Ciurlionis A. Gal., Chicago, 1967, 1968, 1969; one-man: 414 Workshop, Chicago, 1956; Art Center, Evanston, 1957; Chicago Public Library, 1968; Stone-Brandel Art Center, Chicago, 1968; Lourdes H.S., Chicago, 1969. Works published: "Design Quarterly 50"; "Designs for Craftsmen" by Walter Miles; and in numerous magazines and periodicals. Lectures: Stained Glass. Positions: Instr., Univ. Hawaii; Des. of Stained Glass windows and mosaics; Art Dir., Valeska Art Studios, Chicago.

JAMES, FREDERIC—Painter
3626 Warwick Blvd.; h. 644 Westover Rd., Kansas City, Mo. 64113; s. Chilmark, Mass. 02535
B. Kansas City, Mo., Sept. 28, 1915. Studied: Univ. Michigan, Col. of Arch., B. Des.; Cranbrook Acad. A. Member: AWS. Awards: prizes, Denver A. Mus., 1950; Nelson Gal. A., Kansas City, 1951. Work: Nelson Gal. A.; Denver A. Mus.; Univ. Missouri; Cranbrook Acad. A.; murals, Trinity Lutheran Church, Mission, Kans.; Overland Park State Bank, Overland Park, Kans.; Consumer's Cooperative Assn., Kansas City. Exhibited: AIC, 1940, 1941; BM, 1941; NAD, 1949; AWS, 1950, 1952; Boston Soc. Indp. A., 1951; MMA, 1952; Midwestern A., 1935, 1940; Mid-America Annuals, 1950-1955, 1958; Denver A. Mus., 1950; Springfield (Mass.) Mus. A., 1954; one-man: Assoc. Am. A., N.Y., 1952; Univ. Kansas, 1952; Univ. Kansas City, 1953; Nelson Gal. A., 1954; Maynard Walker Gal., N.Y., 1955; Milch Gal., N.Y. 1960.*

JAMESON, DEMETRIOS GEORGE—Painter, Gr., E.
K-211, Art Department, Oregon State University; h. 735 North 28th St., Corvallis, Ore. 97330
B. St. Louis, Mo., Nov. 22, 1919. Studied: Corcoran Sch. A.; Washington Univ., Sch. FA, B.F.A.; Univ. Illinois, M.F.A. Member: AEA; AAUP; Portland A. Mus. Assn. Awards: John T. Milliken Foreign Traveling Scholarship, Washington Univ., 1949; prizes, and purchase prizes, CAM, 1947; Denver A. Mus., 1951; Portland A. Mus., 1951, 1952, 1954; SAM, 1954; Oregon State Fair, 1957 (2), 1960; Northwest A. & Crafts, Bellevue, Wash., 1957, and others. Work: Denver A. Mus.; Portland (Ore.) A. Mus.; SAM; Univ. Illinois. Exhibited: AEA exhs., Chicago, 1948-50; Butler Inst. Am. A., 1951, 1952, 1954, 1956; CAM, 1947-49; CGA, 1953; Denver A. Mus., 1951, 1953-1956; Frye Mus. A., Seattle, 1957; Joslyn A. Mus., 1949; LC, 1952-1958; Mulvane A. Mus., 1948; Oakland A. Mus., 1950, 1951, 1952; Oregon State Fair, 1956, 1957; Spokane, Wash., 1954-1957; Portland A. Mus., 1950-1960; St. Louis A. Gld., 1948, 1949; SFMA, 1951, 1952; SAM, 1951-57, 1958-1961; Parnassos Gal., Athens, Greece, 1960; Springfield (Mo.) A. Mus., 1948; Athens, Greece, 1955; Univ. Illinois, 1949; Univ. Oregon, 1950; Oregon State Univ., 1950-1954, 1956, 1958; DMFA, 1954; Guggenheim Mus., N.Y., 1954; others 1957-58 include: Oregon State Univ. Int. Exchange Exhibit in Italy, France and England; Provincetown A. Festival; Bellevue, Wash.; Pasadena Print Festival, and many others. One-man: Wil-

lamette Univ., Salem, Ore., 1952, 1955; Portland A. Mus., 1952, 1961; Kraushaar Gal., N.Y., 1953; Oregon State Univ., 1957, etc. Positions: Assoc. Prof. A., Oregon State University, Corvallis, Ore., at present.*

JAMIESON, MITCHELL—Painter, T.
1108 Prince St., Alexandria, Va. 22314
B. Kensington, Md., Oct. 27, 1915. Studied: Washington, D.C. and Mexico City. Awards: prizes, Soc. Wash. A., 1941; MModA, 1940; Marian Anderson mural comp., 1941; Guggenheim F., 1946; Bronze Star for work as Navy Combat Artist, 1946; Grant, Am. Acad. A. & Lets., 1947; CGA, 1953. Work: White House, Wash., D.C.; WMAA; MMA; BM; Cornell Univ.; CGA. PC; Wichita A. Mus.; SAM; Ft. Worth A. Center; Portland A. Mus.; Henry Gal., Univ. Washington, Seattle; Norton Gal. A.; WAC; murals, Interior Bldg., Wash., D.C.; Comptroller Gen. Suite, Wash., D.C.; USPO, Upper Marlboro, Laurel, Md.; Willard, Ohio. Exhibited: Nationally. One-man: Santa Barbara Mus. A.; SAM; Des Moines A. Center; Cal. PLH; Norton Gal. A.; Ft. Worth A. Center; CGA. Positions: Paintings for Life Magazine, 1957; Hd. Painting Dept., Cornish Sch., Seattle, Wash., 1949-51; Instr., Painting Madeira Sch., Greenway, Va., 1952-55; Visiting Instr. Norton Gal. & Sch. A., 1952-53, 1956-57.*

JAMISON, PHILIP—Painter
104 Price St.; h. 705 W. Union St., West Chester, Pa. 19380
B. Philadelphia, Pa., July 3, 1925. Studied: PMSch. A. Member: ANA; AWS; Phila. WC Soc.; All. A. Am.; Wilmington Soc. A.; Chester County AA. Awards: prizes, Wilmington Soc. A., 1957, 1959, 1961; NAC, 1960; All. A. Am., 1958, 1960; Phila. WC Soc., 1963; AWS, 1961, 1965; Dawson Medal, 1959, Dana Medal, 1961, PAFA; Medal of Honor, Knickerbocker A., 1961; Gold Medal of Honor, All. A. Am., 1964; Childe Hassam Fund purchase, Am. Acad. A. & Lets., 1965; NAD, prize 1967, Samuel Morse medal, 1969. Exhibited: AWS, 1956-1966, 1968; NAD, 1956, 1962, 1963, 1965, 1967, 1969; PAFA, 1949, 1953, 1957, 1959, 1961, 1963, 1965, 1967, 1969; All. A. Am., 1957-1964, 1966; Wilmington Soc. A.; Phila. WC Soc., 1963; Audubon A., 1959, 1961, 1962; MMA, 1967; Cleveland Inst. A., 1968; Mexican A. Inst., 1968; Butler Inst. Am. A., 1967, 1968; San Diego Invitational, 1961, 1968; Phila. WC Cl., 1967; PAFA, 1967; and prior; one-man: Chester County AA, 1956; Phila. A. All.; Hirschl Adler Gal., N.Y., 1959, 1962, 1965, 1967, 1969; Sessler Gal., Phila., 1963; Duke Univ., 1969.

JANIS, SIDNEY—Art Dealer, Collector, Writer
Sidney Janis Gallery, 15 E. 57th St., New York, N.Y. 10022
Studied: Great Lakes Aeronautical College, Great Lakes, Ill. Member: Advisory Committee, Museum of Modern Art, N.Y., 1934-1948. Sidney and Harriet Janis Collection: Modern Art, a gift to the Museum of Modern Art, New York City, 1967. Author: "They Taught Themselves: American Primitive Painters of the Twentieth Century," 1942; "Abstract and Surrealist Art in America," 1944; "Picasso, the Recent Years" (co-author with Harriet Janis), 1946. Specialty of the Gallery: 20th Century Art: From Brancusi to Giacometti to Oldenburg; From Picasso to Dubuffet to Wesselmann; From Mondrian to Albers to Kelly.

JANKOWSKI, JOSEPH P.—Painter, E., C., I.
The Cleveland Institute of Art, 11141 East Blvd., Cleveland, Ohio 44106
B. Cleveland, Ohio, Jan. 12, 1916. Studied: St. Mary's Col., Orchard Lake, Mich.; John Huntington Polytechnic Inst.; ASL; Cleveland Inst. A., B.F.A. Member: ASL; CAA; Polonaise A. Cl. Awards: Page scholarships, 1949, 1950; Ranney scholarship, 1940; prizes, Albright A. Gal., 1949; CMA, 1950, 1951; Alliance Col., 1951; Fla. Southern Col., 1952; Akron AI; Mississippi AA; Alabama AA; Wichita AA; Ohio State Fair, 1956, 1958; Butler Inst. Am. A., 1961. Work: CMA; Akron AI; Univ. Alabama; Cleveland Pr. Cl.; Cleveland AA; St. Mary's Col.; U.S. Air Force Coll.; Stations of the Cross, St. Mary's Church, McKeesport, Pa.; Westminster Col., New Wilmington, Pa.; Gilmour Acad., Gates Mills, Ohio; Jewish Community Center, Cleveland (mural). Exhibited: CMA; Akron AI; AIC; Albright A. Gal., Audubon A.; Delgado Mus. A.; High Mus. A.; Birmingham Mus. A.; Univ. of Alabama, Georgia, Florida, Mississippi; one-man: Women's Forum, Wichita Falls, Tex.; Univ. Alabama; Meridian, Miss.; Women's Cl., Cleveland; Notre Dame Col., Cleveland. Positions: Assoc. Prof. A., Univ. Alabama, 1949-53; Instr. A., Notre Dame Col., 1954; Cleveland Inst. A., Cleveland, Ohio, 1953- ; Supv. Evening School, Cleveland Inst. A., 1955- .

JANOWSKY, BELA—Sculptor, E.
52 West 57th St., New York, N.Y. 10019
B. Budapest, Hungary, 1900. Studied: Ontario Col. A.; PAFA; Cleveland Sch. A.; BAID. Member: All. A. Am. Awards: Lindsey Morris Mem. prize, All. A. Am., 1951, 1964. Work: bust, Queens Univ., Kingston, Ont.; gold medal, Royal Soc. Canada; bronze reliefs, U.S. Dept. Commerce Bldg., Wash., D.C.; bronze mem., USPO, Cooperstown, N.Y.; bronze 150th Anniversary plaque, Naval Shipyard,

Brooklyn, N.Y. Exhibited: All. A. Am. annually since 1939; AAPL, 1945, 1947; NAD, 1935, 1940, 1942; WFNY 1939; NSS; CMA; PAFA. Positions: Instr., Sculpture, Craft Students League of the Y.W.C.A., New York, N.Y., 1952- .

JANOWSKY, MRS. BELA. See Bell, Clara Louise

JANSON, HORST WOLDEMAR—Scholar
Department of Fine Arts, Washington Square College 10003; h. 29 Washington Square West, New York, N.Y. 10011
B. St. Petersburg, Russia, Oct. 4, 1913. Studied: Univ. Hamburg, Germany; Univ. Munich; Harvard Univ., M.A., Ph.D. Awards: Charles Rufus Morey Award, College Art Assn. Am., 1952, 1957; Guggenheim Fellowship, 1948, 1955. Fields of Research: Renaissance Art; Iconography. Author: "Apes and Ape Lore in the Middle Ages and the Renaissance," London, 1952; "The Story of Painting for Young People" (with Dora Jane Janson), New York, 1952; "The Sculpture of Donatello," Princeton, 1957; "Key Monuments of the History of Art," New York, 1959; "History of Art," New York, 1962. Positions: Editor-in-Chief, The Art Bulletin, College Art Assn. of Am., 1962-1965; Art Historian, Prof. Fine Arts, Chm., Dept. Fine Arts, Washington Square College, New York, N.Y., 1949- .

JANSS, ED—Collector
Chateau Marmont, 8221 Sunset Blvd., Hollywood, Cal. 90046*

JANSSEN, HANS—Educator, Mus. Cur., L., C.
104 East 15th St., Yankton, S.D. 57078
B. Wuppertal-Barmen, Germany, Dec. 11, 1896. Studied: Univ. Cologne; Univ. Pennsylvania; Pa. State Univ., M.A., Ph.D. Positions: Prof., Hd. Dept. A. Hist., Cur., Yankton Col. Durand Coll., Yankton, S.C., 1942- ; Visiting Prof., Freie Univ., Berlin, Germany, 1953.*

JARETZKI, MR. and MRS. ALFRED, JR.—Collectors
128 East 74th St., New York, N.Y. 10021*

JARMAN, WALTON MAXEY—Collector
Genesco, Inc., 111 7th Ave. North 37203; h. 3610 Woodlawn Drive, Nashville, Tenn. 37215
B. Nashville, Tenn., May 10, 1904. Collection: Abstract Paintings.

JARVAISE, JAMES J.—Painter
c/o Landau Gallery, 702 N. La Cienega, Los Angeles, Cal., 90069
B. Indianapolis, Ind., 1927. Studied: Carnegie Inst. Tech.; Ecole D'art, Biarritz, France, with Leger; Univ. Southern California, B.F.A., M.F.A. Work: Larry Aldrich Mus., Ridgefield, Conn.; MModA; Albright-Knox A. Gal., Buffalo, N.Y.; Los A. Mus. A.; Coca Cola Company, Los Angeles; Butler Inst. Am. Art, Youngstown, Ohio; Addison Gal., Andover, Mass.; Carnegie Inst., Pittsburgh. Exhibitions: Larry Aldrich Mus., 1965; VMFA, 1961, 1967; Denver Mus. A., 1953, 1954, 1958; Long Beach Mus. A., 1955, 1956; SFMA, 1953, 1964; SAM, 1955; Los A. Mus. A., 1952, 1956, 1958, 1961; Santa Barbara Mus. A., 1951, 1957; MModA, 1959; Carnegie Intl., 1959, 1965; MMA, 1953; Fine Arts Gallery, San Diego, 1954; Albright-Knox A. Gal., 1960; Addison Gal., Andover, Mass., 1952, 1957; Butler Inst. American Art, 1955; Colorado Springs FA Center, 1955; Univ. Nebraska, 1958; Univ. So. California, 1955, 1957, 1962; Univ. California at Los Angeles, 1960; Cal. Inst. of the Arts, Los Angeles, 1966, 1967; Univ. Illinois, 1953, 1957, 1966; Univ. Madrid, 1963; Fountain Gal., Portland, Ore., 1967; Univ. Oregon A. Mus., 1967; Univ. New Mexico, 1967; Palm Springs Desert Mus., 1966; J.B. Speed Mus., Louisville, 1965; Visual Art Project, Los Angeles, 1967; American Embassy, London, England, 1962; VMFA, 1966; Maeght Gal., Paris, France, 1955; Madrid, Barcelona, Spain, 1963; Gallery San Jorge, Madrid, 1963; Gimple Fils, London, 1959, 1962; Martha Jackson Gal., New York, 1964; John Heller Gal., New York, 1958; Poindexter Gal., New York, 1957; Downtown Gallery, New York, 1956; Thibault Gallery, New York, 1961; Lytton Center of Visual Arts/California Art Festival, 1967; Allan Gallery, New York, 1967; Director's Choice, N.Y. World's Fair, 1964; Bolles Gallery, San Francisco, Cal., 1959. One-man: Felix Landau Gallery, Los Angeles, 1952, 1955, 1958, 1960, 1961; Allan Gallery, New York, 1967; Thibault Gallery, New York, 1961; 2-man exh., Gump's Gallery, San F., 1961. Positions: Instr., Univ. Southern California, 1955-1962; Pennsylvania State Univ., summer session, 1963; Univ. Madrid, (in connection with International Art Exposition), 1963; Occidental Col., 1965, 1966, 1967; Cal. Institute of the Arts, 1965-1968; Univ. So. California, 1966, 1967 summer sessions.

JAUSS, ANNE MARIE—Painter, I., Des.
R.D. 1, Stockholm, N.J. 07460
B. Munich, Germany, Feb. 3, 1907. Studied: Sch.A., Munich. Member: AIGA. Work: N.Y. Pub. Lib., and work in private colls. Has illustrated 60 books. Exhibited: Salon of Mod. A., Portugal, 1942-1946; Neue Sezession, Munich; Flechtheim Gal., Berlin; Portraits,

Inc., 1947 (one-man); Suffolk Mus., 1949; Carl Schurz Fnd., 1951 (one-man); Lisbon, Portugal, 1940, 1943, 1945 (one-man). Illus., "The Stars in Our Heaven," 1948; (by Peter Lum); "The Golden Carnation," by Frances Toor, 1961; "Selections from Spanish Poetry" by S. Resnick, 1962; "The Golden Stag" by Isabel Wyatt, 1962; "King Bettle-Tamer" by Isabel Wyatt, 1963; "Our Fellow Immigrants" by R. Froman, 1965; Brothers Grimm "The Valiant Little Tailor," 1967; Alfred Duggan's "The Falcon and the Dove," 1966; J. Longland "Selections from Contemporary Portuguese Poetry," 1966; and others. Author I., "Wise and Otherwise," 1953; "Legends of Saints and Beasts," 1954; "Discovering Nature The Year Found," 1955; "The River's Journey," 1957; "Under a Green Roof," 1960; "The Pasture," 1968 (received the author's award of the New Jersey Assn. of Teachers of English). Contributor to American and European magazines.

JECT-KEY, ELSIE—Painter
333 East 41st St., New York, N.Y. 10017
B. Koege, Denmark. Studied: ASL, with Homer Boss, Frank Du-Mond, George Bridgman; NAD, with Murphy, Neilson, Olinsky; BAID. Member: NAWA; Knickerbocker A.; Creative A. Assoc.; All. A. Am; AWS (Treas.). Awards: prize, Knickerbocker A., 1960, 1965; All. A. Am., 1964, 1967; Butler Inst. Am. A., purchase, 1967; NAWA, 1968. Work: Norfolk Mus. A. & Sciences; Butler Inst. Am. A. Exhibited: NAWA, 1947-1969; Argent Gal., 1947, 1948, 1949, 1952-1954; State T. Col., Indiana, Pa., 1950, 1951, 1953; Knickerbocker A., 1951, 1952, 1955-1969; Newport AA, 1950; N.Y. City Center, 1955; Creative AA, 1948, 1950, 1951, 1953; Pen & Brush Cl., 1955; SC, 1955; All. A. Am., 1957, 1959, 1960; IBM Gal., 1960; NAD, 1960, 1964, 1969; Riverside Mus., 1960; Art:USA, 1958; All. A. Am., 1961-1964; Butler Inst. Am. A., 1963-64, 1967; AWS, 1965-1969; Athens and Salonika, Greece; Brussels, Belgium; Central Louisiana AA; Louisiana A. Lg.; group shows: State T. Col., Kutztown, Pa.; Canton AI; Massillon Mus. A.; Eastern Ky. State Col.; Decatur A. Center; Univ. Neb.; State Univ. Iowa; Stephens Col.; Cottey Col., Nevada, Mo.; State T. Col., Pittsburg, Kans.; Stephen Austin State Col., Nacogdoches, Tex.; Mary Hardin-Baylor Col., Belton, Tex., 1959-1961; Portland Mus. A.; Farnsworth Mus. A.; Arnot A. Gal., Elmira, N.Y.; Roberson Mem. Center; Lauren Rogers Mus., Laurel, Miss.; Telfair Acad., Savannah; Miss. State Col. for Women; Meridian (Miss.) AA; Everhart Mus., Scranton, N.Y.; Reading Pub. Mus.; Massillon Mus. A.; Zanesville AI; Evansville (Ind.) Mus. A.; Fairleigh Dickinson Univ.; Charles & Emma Fry Mus., Seattle; Sarasota A. Mus., Fla.; Municipal Mus., Tokyo, Japan; South America, Scotland, England, and in many colleges, universities and other museums. Traveling Exhs.: Akron AI; Univ. Notre Dame; Birmingham Mus. A.; Montgomery Mus. FA; Columbia Mus. A.; Brooks Mem. Mus.; Pensacola A. Center; Bass Mus. A., Miami, and others.

JEFFERY, CHARLES BARTLEY—Craftsman, T.
1865 Nela Ave., East Cleveland, Ohio 44112
B. Paducah, Ky., July 6, 1910. Studied: Cleveland Sch. A.; Western Reserve Univ., B.S., M.A. Member: Western AA; NAEA; NEA; Ohio A. Edu. Assn.; Ohio Edu. Assn.; F.I.A.L. Awards: prizes, Cleveland A. & Craftsmen, 1942-1961, 1964; Huntington Gal., W.Va. (purchase); Syracuse Mus. FA; Pomona, Cal. A. & Crafts Exh., 1953, 1956; Miami Nat. Ceramic, 1956, 1957; Butler Inst. Am. A., 1956, 1959 (purchase), 1960; Horace Potter Mem. award, CMA, 1954; Bronze medal, Intl. Expo., Paris, 1937; Wichita AA, 1958, 1960 (purchase). Work: CMA; Syracuse Mus. FA; Huntington Gal.; Univ. Michigan; Wichita AA. Exhibited: Syracuse Mus. FA, 1937-55, 1956, 1961; Des.-Craftsmen, 1953; Smithsonian Inst., 1953-55; Univ. Indiana, 1953; Wichita A. & Crafts, 1959, 1960; Boston Soc. A. & Crafts; Cooper Union, 1954; El Paso, Tex., 1954; Sioux City A. Center, 1954; Mus. Contemp. Crafts, N.Y., 1956, 1957, 1959; Albright A. Gal., 1960; Rochester Mem. A. Gal., 1956; AFA traveling Exh., 1958-59; Brussels World's Fair, 1958; Nelson Gal. A., Kansas City, 1963; DMFA, 1964; Nat. Religious A. Exh., Chicago, 1964; Decorative Arts-Ceramics Exh., Wichita AA, 1967, 1968; Des.-Craftsmen of Ohio, Columbus Gal. FA, 1966, 1968. Positions: Dir. A., Shaker Heights Bd. of Edu., Shaker Heights, Ohio, 1946- .

JELINEK, HANS—Graphic A., Wood Eng., E.
c/o City College, Eisner Hall, 133rd St. & Convent Ave., New York, N.Y. 10031; h. 675 West End Ave., New York, N.Y. 10025
B. Vienna, Austria, Aug. 21, 1910. Studied: Wiener Kunstgewerbe Schule; Univ. Vienna. Member: NA; Audubon A.; SAGA; Boston Pr.M.; Xylon. Awards: prizes, Tiffany award, 1947; AV, 1943; LC, 1945; Boston Pr.M., 1953, 1957; Paul J. Sachs prize, 1962; Audubon A., Medal and Award, 1962; Newport AA, 1963. Work: N.Y. Pub. Lib.; VMFA; Munson-Williams-Proctor Inst.; LC; Alabama Inst. Tech.; MMA; Cooper Union Mus.; NAD; Dartmouth Col.; Albion Col.; PMA; Smithsonian Institution; BMFA; Victoria & Albert Mus., London, and others. Exhibited: NAD, 1942-1946; Smithsonian Inst., 1951; PAFA, 1941, 1942; SFMA, 1943-1946; SAM, 1943-1945; Albany

Inst. Hist. & A.; Laguna Beach AA; Denver AA; MMA; Royal Soc. Etc, Gravers, London; Zurich, Switzerland; Rome, Naples, Florence, Italy; Denver A. Mus.; Santa Barbara Mus. A.; Carnegie Inst., 1945; LC, 1945, 1946; Oakland A. Gal., 1943, 1944; Cal. Soc. Et., 1943; VMFA; Mint Mus. A. Positions: Instr., Wood engraving & Illus., New School for Social Research; Prof. A., City Col., New York, N.Y.

JENKINS, PAUL—Painter, W.
15 rue Decres, Paris 14, France; also 831 Broadway, New York, N.Y. 10003
B. Kansas City, Mo., July 12, 1923. Studied: Kansas City AI; ASL. Awards: Silver medal, CGA, 1967. Work: MModA; WMAA; Guggenheim Mus.; Stedelijk Mus., Amsterdam; WAC; BM; Tate Gal., London, and in Japan and Paris, France. Exhibited: WMAA; Guggenheim Mus.; AIC, 1963; Carnegie Inst.; Univ. Illinois; CGA, and others in U.S.; also in France, England, Japan, Germany, Switzerland, India, Holland, Norway. One-man: Martha Jackson Gal., N.Y., 1958, 1960, 1964, 1969; Arthur Tooth Gal., London, 1960, 1963; Daniel Gervis Gal., Paris, 1968, and others. Contributor articles to Art News and Art International.

JENNEWEIN, C. PAUL —Sculptor
538 Van Nest Ave., Bronx, N.Y. 10460
B. Stuttgart, Germany, Dec. 2, 1890. Studied: ASL; Am. Acad. in Rome; & with Clinton Peters. Member: NA; Nat. Inst. A. & Let.; AIA; NSS; Century Cl.; FA Comm., New York, N.Y. Awards: Prix de Rome, 1916; F., Am. Acad. at Rome; prizes, Arch. L., 1912; Fairmount Park AA, 1926; Saltus award, 1949; med., Concord AA, 1926; Arch. L., 1927; PAFA, 1932, 1939; NAD, 1952; Elizabeth Watrous Gold Medal, NAD, 1960; prize, NSS, 1961; Am. Acad. of Achievement, Dallas; Academic A.A., Springfield, Mass.; medal of honor, and gold medal, NSS; gold medal, Am. A. Prof. Lg. Work: S., MMA; BMA; BM; CGA; CM; Detroit Inst. A.; Finance Bldg., Harrisburg, Pa.; Dept. Justice Bldg., Wash., D.C.; Mus. FA of Houston; Hartford Atheneum; Newark Mus.; PAFA; Brookgreen Gardens, S.C.; PMA; mem., Wash., D.C.; Providence, R.I.; Worcester, Mass.; Boston, Mass.; Dauphin County Court House, Harrisburg, Pa.; House of Representatives, Wash., D.C.; W.Va. State Office Bldg.; British Bldg., Rockefeller Center, N.Y.; George Washington Mem. Park; Admin. Bldg., Atlanta; statue of Geo. Washington, Valley Forge Tower for DAR; Am. Military Cemetery, Belgium; 2 panels, Exec. Mansion; Inaugural Medal, Harry S. Truman; Portrait Medal and Plaque of Judge Learned Hand, 1957; sc., Woodrow Wilson Mem. Bridge, Wash. D.C.; House Office Bldg. (Sam Rayburn Bldg.), Wash, D.C.; Nat. Lib. of Medicine, Wash. D.C.; Hall of Fame Medals: Mark Twain and Samuel Finley Breese Morse; Hall of Fame of Great Americans, N.Y. Univ., bronze bust and Medal of Edward Alexander MacDowell, Daniel Boone, Woodrow Wilson, James Monroe, and others; medals for Am. Legion, United Jewish Appeal; Catholic Comm. Soc. coin medal of Pope John XXIII, and coin medal for "Tomb of the Unknowns"; Port. plaque of David Sarnoff; Albert P. Loening trophy for Outstanding Reserve Aerospace Rescue and Recovery Unit award. Positions: Pres., Brookgreen Gardens, South Carolina.

JENNINGS, FRANCIS— Sculptor, P.
135 Grand St. 10013; h. 62 Perry St., New York, N.Y. 10014
B. Wilmington, Del. Feb. 27, 1910. Studied: Wilmington Acad. A.; Fleischer Mem. Sch. A. Work: Mural, Delaware Indst. Sch. for Boys. Exhibited: Pyramid Cl., Phila., 1950-1953; PAFA, 1939, 1941-1943, 1954, 1955; Cheltenham A. Center (Pa.), 1954; PMA, 1955; Carlin Gal., Phila., 1956; Moore Col. of A., 1957; Fleischer Mem. Sch. A., 1957; Makler Gal., Phila., 1960, 1961, 1964; Brandt Gal., N.Y., 1962; WMAA, 1962; BMA, 1963; one-man: Aegis Gal., N.Y., 1961; Phoenix Gal., N.Y., 1962; Makler Gal., Phila., 1963. Radio Series: "The Artist in New York," 1967; Television Series: "You and the Artist," 1969. Lecture: National Art Teachers Association Convention, April 1969.

JENNISON, MRS. M. W. See Kerfoot, Margaret

JENSEN, ALFRED—Painter
284 E. 10th St. 10009; h. 52 Division St., New York, N.Y. 10002
B. Guatemala City, 1903. Studied: Hans Hofmann Sch. FA, Munich, Germany; Mus. FA of San Diego. Work: Guggenheim Mus.; MModA; Rose A. Mus., Brandeis Univ.; Dayton AI; Chase Manhattan Bank; Time, Inc.; Galerie Beyeler, Basel, Switzerland; WMAA. Exhibited: Stable Gal., N.Y., 1954-1957; Martha Jackson Gal., N.Y., 1959; Mexico City Biennal, 1960; Inst. Contemp. A., Boston, 1960; CAM, 1960; Dilexi Gal., San Francisco, 1960; AIC, 1961; Guggenheim Mus., 1961; CGA, 1962; WMAA, 1962, 1963; SFMA, 1963; MModA at National Gal. A., 1963; Los A. Mus. A., 1964; Venice Biennale, 1964; Kane Mem. Exh., Brown Univ., 1965; Cordier & Ekstrom, Inc., 1967; Documenta, Kassel, Germany, 1968; one-man: Tanager Gal., N.Y., 1955; Bertha Schaefer Gal., N.Y., 1957; Martha Jackson Gal., N.Y., 1959, 1961; Guggenheim Mus., 1961; Graham Gal., N.Y., 1962, 1964,

1965; Fairleigh Dickinson Univ., 1963; Kornfeld und Klipstein, Berne, 1963; Kunsthalle, Basel, 1964 (with Franz Kline); Rolf Nelson Gal., Los Angeles, 1964; Stedelijk Mus., Amsterdam, 1964.

JENSEN, EVE—Painter
4170 Vanetta Drive, Studio City, Cal. 91604
B. Chicago, Ill., Aug. 22, 1919. Studied: AIC, and with Sergei Bongart, Leon Franks. Member: Cal. AC; Am. Inst. FA; Valley A. Gld.; Laguna Beach AA; San Fernando Valley AC; Am. Artists of the West. Awards: Prizes, Ebell Cl., Los A., 1959; All City A. Festival, 1957; San Fernando Valley AC, 1954, 1955, 1956 (3), 1957 (2), 1959 (2), 1961, gold trophy, 1962, 1964; gold trophy, City Hall Tower, 1959; Valley A. Gld., 1959; Burbank AA, 1957; Burbank On Parade, 1956; Glendale Federal, 1964; special jury award, San Fernando A.C., 1964; Greek Theatre, Los A., 1964; Bulloch's A. Festival, 1961-1963; Old Town Galleries, San Diego, 1964. Work: San Fernando Valley State College; Red Door A. Gal., Morro Bay, Cal. Paintings featured in five TV shows. Exhibited: Orange Show, San Bernardino; Carlsbad Oceanside Gal.; Old Town Galleries; Laguna Beach AA; Greek Theatre, Los A.; Ebell Salon of Art; San Fernando Valley Festival of Arts; Friday Morning Cl., Los A.; All City Festival, Los A., and others.

JENSEN, LAWRENCE N.—Painter, E., W., L.
Southern Connecticut State College, New Haven, Conn. 06015
B. Orange, N.J., Feb. 5, 1924. Studied: ASL; Columbia Univ., B.S., M.A., Ed.D. Member: AWS; NAEA; Eastern AA. Awards: prizes, Silvermine Gld. A., 1964; Watercolors: USA (purchase), 1963, 1964; Soc. Four Arts, 1962; AWS, 1964, and others. Work: Springfield Mus. A.; Frye Mus., Seattle. Exhibited: AWS, 1960-1965; Watercolors: USA, 1963, 1964; Soc. Four Arts, 1961-1963; Silvermine Gld. A., 1962-1964. Author: "Synthetic Painting Media," 1964. Work included in "Prize Winning Watercolors," Book III, 1965. Positions: Instr., Painting, Design, Swain School of Design; N.Y. Univ., Farmingdale, N.Y.; Chm., Art Dept., Southern Connecticut State College, 1965- ; Chm. A. Dept., Castleton State College, Vermont, 1962-1965.

JENSEN, LEO—Sculptor, P.
P.O. Box 264, Ivoryton, Conn. 06442
B. Montevideo, Minn., July 10, 1926. Studied: Walker Art Center Sch. Work: WAC; MModA lending coll.; New Britain Mus. Am. A.; Brown Univ. Gal.; Gertrude Herbert Mem. A. Inst., Augusta, Ga.; Philip Morris Inc., N.Y.; Sheraton Hotels, Minneapolis; Rose A. Mus., Brandeis Univ. Exhibited: Creative Gal., N.Y., 1952 (2); Norwich AA, 1953; State Teachers Col., Indiana, Pa., 1953; Butler Inst. Am. A.; Silvermine Gld. A., 1955, 1958; New Haven A. Festival, 1955-1965; Angeleski, Bodley, Burrell, Carus, Knapik, Steindler Galleries, N.Y., 1959-1961; J.S. Ely House, New Haven, 1962, 1963; Mystic (Conn.) A. Festival, 1962; Madison Gal., N.Y., 1962; Gordon's Fifth Ave. Gal., 1962; Allan Stone Gal., N.Y., 1963; H.C.E. Gal., Provincetown, 1963; Feigen Gal., Chicago, 1964; Morris Int. Gal., Toronto, 1963; David Mirvish Gal., Toronto, 1963; Cleveland A. Fair, 1963, 1964; Sakowitz Gal., Houston, 1964; Boston A. Festival, 1964; J.L. Hudson Gal., Detroit, 1964; Amel Gal., N.Y., 1964; Cosmopolitan Gal., N.Y., 1964; Milwaukee A. Center, 1965; Graham Gal., N.Y., 1965; Weatherspoon Gal., Univ. N.C., 1965; Loeb Student Center, N.Y. Univ., 1965; Inst. of Contemp. A., Boston, 1965; Norfolk Mus. A. & Sciences, 1966; Rigelhaupt Gal., Boston, 1966; Philip Morris Int., circulated by AFA, 1966-1967; R.M. Benjamin Coll., Yale A. Gal., 1967; Am. Greetings Gal., N.Y., 1967; Beth El Temple, West Hartford, Conn., 1968; Nat. A. Mus. of Sports, N.Y., 1968; one-man: Creative Gal., 1953; Studio 4, New Haven, 1954; Purdy-Vidito Gal., New Haven, 1956; Studio Gal., Rye, N.Y., 1957; Amel Gal., 1964, 1965; Sales Communications, Inc., N.Y., 1966; Young and Rubican, N.Y., 1966; New Britain Mus. Am. A., Conn., 1967. Awards: prizes, Norwich AA, 1953; Silvermine Gld. A., 1958; Mystic A. Festival, 1962 (2); J.S. Ely House, New Haven, 1963.

JENSEN, MARIT—Painter, Ser.
7 Anthony St., Provincetown, Mass. 02657
B. Buffalo, N.Y. Studied: Carnegie Inst.; Univ. Pittsburgh; Hans Hofmann Sch. FA. Member: NAWA; Print Cl.; Provincetown Group; Provincetown Art Assn. Awards: prizes, Carnegie Inst., 1945; VMFA, 1947 (purchase); NAWA, 1960. Work: VMFA; Pittsburgh Pub. Schs.; Unity Center of Pittsburgh; Cultural Div., USIA; Univ. of the South. Exhibited: CM, 1945; Portrait of America, 1946; VMFA, 1946; CGA, 1947; PAFA, 1952; NAD, 1954; BM, 1954; N.Y. City Center, 1954; Butler AI, 1946-1949, 1960; Ohio Univ., 1946, 1948; Provincetown AA, 1954-1968; AFA traveling exh., 1954-1955; Soc. Wash. Pr. M., 1957; Nat. Ser. Soc., 1951-1959 (Board of Trustees); Serigraph Int., 1959; One-Thirty Gal., Pittsburgh, 1956 (one-man); Gal. 256, Provincetown, 1956, 1957; James Gal., N.Y., 1958, 1960; New Gal., Provincetown, 1961; Cape Cod AA, 1962, 1963, 1968; Zabriskie Gal, Provincetown, 1963; Panoras Gal., N.Y., 1963 (one-man); Provincetown Group, 1964, 1965 (2-man), 1966 (one-man), 1967 (one-man), 1968; NAWA traveling Graphics, 1968-1969; Printclub, 1969; NAWA traveling exh. to India, 1965.

JENSEN, PAT—Painter, S.
P.O. Box 264 Ivoryton, Conn., 06442
B. Montevideo, Minn., Mar. 17, 1928. Exhibited: John Slade Ely House, New Haven, Conn., 1962 (3); Andrews Memorial, Clinton, Conn., 1962; Mystic Outdoor A. Festival, Mystic, Conn., 1962 (3 awards); Sakowitz Gal., Houston, Tex., 1963, 1964; Atkins Mus., Kansas City, Mo., 1963; O.K. Harris Gal., Provincetown, Mass., (one-man), 1963; Jerrold Morris Int. Gal., Toronto, Canada, 1963; Mandrake Root Gal., Toronto, 1963; Albright-Knox A. Gal., Buffalo, N.Y., 1963; Cleveland A. Fair, 1963, 1964; Amherst Col., 1963; Dilexi Gal., San Francisco, 1964; Amel Gal., N.Y., 1964 (one-man), 1965; Boston A. Festival, 1964; Ohio State Univ. traveling exh., 1965-1966; N.Y. Univ., 1965; Rigelhaupt Gal., Boston, 1966; Ceejee Gal., N.Y., 1967; American Greetings Gal., N.Y., 1967; Beth El Temple, Hartford, Conn., 1968; Nazareth Col., Rochester, N.Y., 1968; Ward Nasse Gal., Boston, 1968.

JERGENS, ROBERT JOSEPH—Painter, E.
Yale University School of Art & Architecture; h. 7590 Tamiami Dr., Parma, Ohio 44134
B. Cleveland, Ohio, Mar. 18, 1938. Studied: Cleveland Inst. A.; Skowhegan Sch. Painting & Sculpture; Yale Univ., B.F.A., M.F.A.; Am. Acad. in Rome. Awards: Rome prize for painting, 1961, renewed in 1962; prize, Mostra Univ., Rome, Italy; Ranney Fnd. Grants, 1956-1957, 1958-1959; Mary C. Page Grant, 1961; Johnson Award for Printmaking, 1961; prize, Cleveland Mus. A., 1961. Work: CMA; North American College, Rome; Seminary Archivescovile, Bari, Italy; Skowhegan Sch. A.; Newman Religious Art Gal. Mural, Cleveland Mus. A.-Early American Gallery. Exhibited: CGA, 1961; MModA; BM, 1964; Denison Univ., 1963; Exhs. by Cleveland Mus. & USIA: Mostra Univ., Rome; Cleveland Mus. A., 1957-1964; Il Bilico Gal., Rome, 1962; Bracksville Gal., Cleveland, 1963-1965; Yale Univ. A. Gal.; Trinity Col. A. Gal., New Haven, Conn.; Rose Fried Gal., N.Y. Positions: Instr., Design, Cooper Union, N.Y.; Drawing, Yale University School of Art & Architecture, New Haven, Conn., and Cleveland Institute of Art (Design).

JERRY, SYLVESTER—Museum Director, P.
2519 Northwestern Ave., Racine, Wis. 53404
B. Woodville, Wis., Sept. 20, 1904. Studied: Layton Sch. A.; ASL. Positions: Dir., Wustum Mus. FA, Racine, Wis. 1941- .

JESWALD, JOSEPH—Painter
Revere St., Gloucester, Mass. 01930
B. Leetonia, Ohio, May 17, 1927. Studied: Academie Julian, Paris, France; Fernand Leger, Paris, France; Columbia Univ. Member: Rockport AA. Award: prize, Beverly Farms Regional, 1961. Work: Hirschhorn Coll.; AGAA; Colby Col.; Simmons Col.; Rockefeller Univ. Exhibited: Ogunquit Mus. A., 1958; Univ. Iowa, 1958; "Americans in Paris" exh., Paris, 1949; Portland (Me.) Mus. A., 1960; Gal. North, Long Island, 1961; Constitution Gal., Hartford, Conn., 1961; Collectors Gal., Chicago, 1961; Gal. Seven, Magnolia, Mass., 1960, 1961; Palm Beach, 1961; Int. Gal., N.Y., 1961; A.F.I. Gal., N.Y.; G. Gal., N.Y.; VMFA; Simmons Col.; one-man: A.F.I. Gal., 1951, 1952; G. Gal.; Anna Herb Mus., Augusta, Ga., 1954; Grippi Gal., N.Y., 1959, 1960; Cober Gal., N.Y., 1963; Art Galleries, Ltd., Wash., D.C., 1963; Gal. 7, Boston, 1964-65. Positions: Bd. Dirs., Land's End Cultural Center, Rockport, Mass.; Chm. Dept. FA, New England Sch. A., Boston, Mass.

JEWELL, KESTER D.—Museum Administrator
Worcester Art Museum, 55 Salisbury St., Worcester, Mass. 01608; h. 15 Pleasant St., Northboro, Mass. 01532
B. Terre Haute, Ind., June 1, 1909. Studied: John Herron AI; NAD, with Arthur Covey; ASL, with Dumond and Bridgman; Newark Mus. A. (Museum Training). Awards: Carnegie Fnd. Grant for European Study, 1938. Field of Interest: General art museum administration and special fields of study in Pre-Columbian Art and Contemporary Sculpture. Positions: Hd., Adult Education, Newark Museum, 1935-1938; Dir., Fitchburg A. Museum, Fitchburg, Mass., 1938-1941; Administrator, Worcester (Mass.) Art Museum, 1941- ; Trustee, Fitchburg A. Mus., 1942- .

JOACHIM, HAROLD—Museum Curator
Art Institute of Chicago, Michigan Ave. at Adams St., Chicago, Ill. 60603
Positions: Cur., Prints & Drawings, Art Institute of Chicago.

JOFFE, BERTHA—Textile Designer
77 Parker Ave., Maplewood, N.J. 07040
B. Leningrad, Russia, Oct. 11, 1912. Studied: N.Y. Phoenix Sch. Des.; Col. City of N.Y., B.S. in Edu.; T. Col., Columbia Univ., M.A.; N.Y. Univ.; ASL; & with Zorach, Winold Reiss, Malderelli. Work: textile des. used in leading hotels. Exhibited: Provincetown AA, 1940; AV, 1942; Int. Textile Exh., 1944; Des., Art in Business Exh., 1942. Positions: Free lance textile des., Mead & Montague, Inc.; Schumacher & Co.; Thortel Fireproof Fabrics, Inc.; Seneca Textile, Inc.; Beacon Looms, etc., 1941- .

JOHANSEN, ANDERS D.—Painter
50 Hudson St., Chatham, N.Y. 12037
B. Denmark. Studied: Pratt Inst., Brooklyn, N.Y.; Tiffany Fnd.; and with Otto Beck, Charles Hawthorne, Daniel Garber, and others. Member: NAC; Columbia County A. & Crafts Gld.; All. A. Am.; Berkshire AA, Pittsfield, Mass. Awards: European Fellowship, Pratt Inst.; prizes, Pittsfield Mus., 1963; NAC, 1962-1964; Hillsdale award for painting, 1964. Work: Vanderpoel Mus. Collection, Chicago; Yale Univ.; Tiffany Fnd.; Reading Pub. Mus. (Pa.). Exhibited: NAD, 1927-1935, 1960-1965; All. A. Am.; NAC; Berkshire Mus.; Albany Inst. Hist. & Art; AWS, and others.

JOHANSON, GEORGE E.—Painter, Gr., T.
2237 S. W. Market St., Portland, Ore. 97501
B. Seattle, Wash., Nov. 1, 1928. Studied: Portland (Ore.) Mus. Sch.; Atelier 17, N.Y. Awards: purchase prizes, Northwest Printmakers, Henry Gal., Seattle, 1955, 1963; Int. Printmakers Exh., SAM, 1963. Positions: Instr., Painting & Printmaking, Portland (Ore.) Museum A. School, 1955- .*

JOHN, GRACE SPAULDING—Painter, I., W.
2424 Charleston St., Houston, Tex. 77021
B. Battle Creek, Mich. Studied: St. Louis Sch. FA; AIC; NAD, and with Charles Hawthorne, Emil Bistram. Awards: Matrix Award, Theta Sigma Phi, Houston, 1959. Work: Houston Pub. Lib.; Hist. Bldg., Austin, Tex.; Mus. of FA of Houston; Huntsville (Tex.) Lib.; Princeton Univ.; Port., Hist. Bldg., Oklahoma City; murals, City Hall and Sidney Lanier Sch., Houston, Tex.; Balinese Cl., Lakewood Yacht Cl., Houston; Galveston; Roanoke Steel Corp., Pub. Lib., Roanoke, Va.; Nat. Banks, Commerce, San Antonio and Houston; Nat. Bank of Lufkin, Tex. Exhibited: PAFA, 1923; Highland Park Mus., Dallas, 1928; Cal. PLH, 1933; World's Fair, Chicago, 1933; European Exh., (port. from life, Thomas Mann), Rice Univ., 1964; Meredith Long Gal., 1964; Mus. Contemp. A., Houston, 1964; A. Lg. of Houston, 1964-65; Rice Univ. Sculpture Exh., 1965; Pantechnichon Gal., San Francisco, 1964; one-man: Mus. of FA of Houston, 1936, 1953; Oakland A. Gal., 1935; Los A. Mus. A., 1935; Town Hall, N.Y., 1944; Galveston Pub. Lib., 1951; Stables Gal., Taos, 1955-1958; FA Soc. San Diego; The Bookman Gal., 1965; Wickersham Gal., N.Y., 1967. Author, I. "Memo"; "Azalea"; "The Living Line," 1962; "The Knotless Thread," 1969.

JOHNS, JASPER — Painter
c/o Leo Castelli Gallery, 4 East 77th St., New York, N.Y. 10021
B. Augusta, Ga., May, 1930. Studied: Univ. South Carolina. Work: Tate Gal., London; MModA; WMAA; Albright-Knox A. Gal., Buffalo; Wadsworth Atheneum; Moderna Museet, Stockholm. Exhibited: Castelli Gal., N.Y., 1964; Wadsworth Atheneum, 1964; WMAA, 1964; Lincoln Center, N.Y., 1964; Jewish Mus., N.Y., 1964, 1966; Albright-Knox A. Gal., 1963; Tate Gal., London, 1963; Brandeis Univ., 1963; Yugoslavia, 1963; Madrid, 1963; MModA; CGA; Expo '67, IX San Paulo Biennial; Carnegie-Mellon; The Netherlands; Maeght Fnd., St. Paul, France; NCFA; and many others in U.S. and abroad. One-man: Castelli Gal., N.Y., 1958, 1960, 1961, 1963, 1964, 1966, 1968; Milan, 1959; Paria, 1959; Columbia (S.C.) Mus. A., 1960; Tweed Gal., Minneapolis, 1960; Galerie Sonnabend, Paris, 1962; Ellin Gal., Los Angeles, 1962; Smithsonian, 1966; MModA, 1966; Galerie Buren, Stockholm, 1968.

JOHNSON, AVERY F. —Painter, I., T.
R.F.D. No. 1, Dover, N.J. 07801
B. Wheaton, Ill., Apr. 3, 1906. Studied: Wheaton Col., B.A.; AIC. Member: ANA; N.J. WC Soc.; AWS; Audubon A. Awards: prizes, Montclair A. Mus.; New Jersey WC Soc.; AWS; Springfield Mus. FA. Work: Newark Mus.; Montclair A. Mus.; Holyoke (Mass.) A. Mus.; murals, USPO, Marseilles, Ill.; Liberty, Ind.; Lake Village, Ark.; Bordentown, N.J.; North Bergen, N.J.; Catonsville, Md.; portfolio of paintings for Standard Oil Co., and Humble Oil & Refining Co.; paintings of Top Ten Plants of Year, McGraw-Hill's "Modern Manufacturing" magazine, 1967, 1968, 1969; Christmas card designs, Am. A. Group. Exhibited: PAFA; AIC; AWS; NAD; MMA, 1967; Aquarelle, Mexico City, 1968. Kansas City AI. I., books for leading publishers. Position: Instr. Painting, Montclair (N.J.) A. Mus.

JOHNSON, MRS. B. F. See Terry, Alice

JOHNSON, BUFFIE—Painter, Gr., E., W., L.
East Hampton, N.Y. 11937
B. New York, N.Y., Feb. 20, 1912. Studied: ASL; Univ. California at Los Angeles, M.A. Member: Group Espace, Paris. Work: BMFA; BMA; Newark Mus. A.; WAC; MMA; CM; Layton Gal. A.; Univ. Mich.; Munson-Williams-Proctor Inst.; WMAA; N.Y. Univ.; CM; Univ. Illinois; murals, Astor Theatre, N.Y., 1959. Exhibited: Carnegie Inst., 1941; Realties Nouvelles, 1949, 1950, 1957; BM, 1953; WMAA, 1954; Univ. Illinois, 1955; Minneapolis Inst. A., 1951;

Art of this Century, 1943; Howard Putzel Gal., 1945; Betty Parsons Gal., 1950; Stable Gal., 1954; Galerie Bing, Paris, 1956, 1960; Hanover Gal., London, 1949; Cavallino Gal., Venice, 1948; Ringling Mus. A., 1948; Bodley Gal., N.Y., 1960; Galerie Thibaut, N.Y., 1961, and in Bonn, Switzerland, Weimar, Germany, and others. Positions: Instr., Parsons Sch. Des., N.Y., 1946-50; Lecturer, for U.S. Dept. of State, Rome, Italy; Nürnberg, Germany; Universities of Bologna, Münster, Zagreb, Athens, and others.*

JOHNSON, CECILE RYDER — Painter
63 Church Lane, Scarsdale, N.Y. 10583
B. Jamestown, N.Y. Studied: Augustana Col., Rock Island, Ill., A.B.; PAFA; AIC; Am. Acad. FA. Member: AWS; Nat. Lg. Am. Pen Women; AAUW; Westchester A. Soc.; Scarsdale AA. Awards: Augustana Col. Alumni Outstanding Achievement Award; Catherine L. Wolfe A. Cl. Gold Medal; prizes, AWS; Knickerbocker A.; All-Illinois WC Exh., and others. Exhibited: AWS; Washington WC Soc.; AIC; A. Dirs. Annual, Chicago; Chicago A. Gld.; Ford Motor Co. traveling exh., Europe, Asia, Africa, South America, under sponsorship of State Dept. and USIA; one-man: Chicago Gals.; Davenport Mun. Mus.; Hudson River Mus.; Univ. Indiana; Bethany Col.; Augustana Col.; Univ. Texas; Grand Central Gals., N.Y., 1968. Work: Chicago Mus. Science & Industry; Davenport Mun. Mus.; Augustana Col.; Manufacturers Hanover Bank; Bank of Bermuda; Ford Motor Co. Coll.

JOHNSON, CHARLOTTE BUEL—Art Historian, E., Writer
Albright-Knox Art Gallery, 1285 Elmwood Ave. 14222; h. 153 Allen St., Buffalo, N.Y. 14201
B. Syracuse, N.Y., July 21, 1918. Studied: Barnard College, B.A.; Institute of Fine Arts, New York Univ., M.A. Awards: Kinnicut Travel Award, Worcester A. Mus., 1954 (summer); Scholarship for summer course in art history at the Rijksbureau, The Hague, 1962 (summer). Other study travels to Europe, 1949, 1950, 1954, 1962; also Mexico, 1961 (2 weeks). Participant in UNESCO Museums" Seminar, Athens, Greece, 1954. Author: "Alvan Fisher and the European Tradition," in Art in America, 1953; "Willem de Kooning, Innovator," in Art Education (Journal of the NAEA), 1961; articles in School Arts magazine, 1960. Contributing Editor, School Arts Magazine; cover stories for The Instructor. Albright-Knox Gallery "Gallery Notes"- "The Man from Eden, by Walt Kuhn," 1958; "Two Contemporary French Abstract Expressionists," 1958; "The Optical Illusion"; "Antonio Tapies," 1964. Positions: Lecturer, Hist. of Art, Hollins College, 1947-48; Instr. A., Maryville, College, Tenn., 1948-52 (appt. Asst. Prof., 1951); Lecturer, Instr., children's classes, Worcester A. Mus., 1952-1957; Lecturer, Clark Univ., Worcester, Mass. (summer), 1957; Lecturer, Research Asst., Albright-Knox A. Gal., Buffalo, 1957- (apptd. Cur. Education, 1958-); Lecturer, Teacher in a seminar on American Arts, State Univ. of New York, Buffalo, 1957-1968; Teaching, Millard Fillmore College Continuing Education program, State Univ. N.Y. at Buffalo, 1969.

JOHNSON, CLIFFORD LEO — Cartoonist
585 Fifth Ave., New York, N.Y.; h. 134-38 Blossom Ave., Flushing, N.Y. 11355
B. Minneapolis, Minn., Sept. 30, 1931. Studied: Art Instruction, Inc., Minneapolis; Am. Acad. A., Chicago. Awards: prize, Cartooning Award, Nat. Comp., Art Instruction, 1951. Contributor cartoons to True, Sports Afield, Golf Digest, Boy's Life, King Features.*

JOHNSON, CROCKETT—Painter, W., I.
Rowayton, Conn. 06853
B. New York, N.Y., Oct. 6, 1906. Studied: N.Y. Univ.; Cooper Union, N.Y. Member: Authors Gld.; Silvermine Gld. A. Exhibited: New York City, 1967; New England Exh., and other group shows. Author, I., Barnaby, 1943; Barnaby and Mr. O'Malley, 1944; Barkis, 1956; Who's Upside Down, 1952; Harold and the Purple Crayon, 1955; Harold's Fairy Tale, 1956; Harold at the North Pole, 1957; Harold's Circus, 1959; A Picture for Harold's Room, 1960; Time for Spring, 1955; Ellen's Lion, 1960; "The Lion's Own Story," 1963; "We Wonder What Walter Will Be?", 1964; "Castles in the Sand," 1965; "The Emperor's Gifts," 1965; and others. Contributor as author, illustrator to national magazines.

JOHNSON, DORIS MILLER (Mrs. Gardiner)—Painter, T.
329 Hampton Rd., Piedmont, Cal. 94611
B. Oakland, Cal., Dec. 8, 1909. Studied: Univ. California, B.A.; Cal. Col. A. & Crafts. Member: San F. Women A.; San F. AA. Awards: prizes, Colorado Springs FA Center; San F. Women A., 1938; San F. AA, 1940. Exhibited: AIC, 1934, 1935 (also traveling exh.); Oakland A. Gal.; San F. Women A.; San F. AA; Santa Cruz A. Lg., 1938; Sacramento State Fair, 1939; GGE, 1939; SFMA traveling exh., 1938-1942; Univ. Texas, 1941; Fnd. Western A., 1940; Portland (Ore) A. Mus., 1936; St. Paul A. Mus., 1936; one-man exh.; Berkeley Women's City Cl., 1936; SFMA, 1938; Crocker A. Gal., 1939; Hotel

Senator, Sacramento, Cal., 1937. Positions: Bd. Dir., San F. AA, 1940-44; Dir., Children's A. Classes, Oakland A. Mus., and A. Lg. of the East Bay, 1940-52; Pres., San F. Women A., 1946-48, Bd. Dir., 1958- ; Bd., Piedmont A. & Crafts Gld., 1952-56; Bd., Junior Center of A., Oakland, 1953-55; Memb. Bd., Oakland Mus. Assn., 1955- ; Chm., Rental Gal., Oakland Mus., 1955-57; Activities Bd., SFMA, 1958-1964; Chm., Acquisitions Committee, San Francisco Mus. Art, 1959; Contributing Memb. of The Art Bank, San F. AI, 1958-1965; Acquisition Committee, Art League of the East Bay, 1967- ; East Bay Alliance Francaise, charter member, board member, secretary; Chairman, Women's Board, 1968- , membership committee, 1969- , The California Historical Society.

JOHNSON, EDVARD ARTHUR—Painter, T., Des.
 Famous Artists Schools; h. 33 Otter Trail, Westport, Conn. 06880
B. Chicago, Ill., Dec. 18, 1911. Studied: Chicago Acad. FA; AIC; Univ. Georgia, B.F.A.; Inst. Des., Ill. Inst. of Technology, M.S. Member: AFA; Chicago AC; Conn. WC Soc.; Silvermine Gld. A. Awards: purchase award, Nat. Swedish-American Exh., Chicago, 1941; prizes, NGA, 1945; Mississippi AA, 1950; New Canaan (Conn.) Exh., 1964; Rockefeller Fellowship, 1951-52. Work: Nat. Mus., Vaxio, Sweden; Georgia Mus. A., Athens; Univ. Rochester, N.Y. Exhibited: Watercolor:USA, 1966; NAD, 1966; Bridgeport (Conn.) Mus. A., Science & Industry, 1966, 1967, 1969; Silvermine Gld., 1967; New Haven Festival, 1966, 1967; Stamford Mus. A., 1966-1968; Chicago A. Cl., 1966-1969; Jefferson A. Festival, Louisiana, 1969. Positions: Asst. Prof., Adv. Des., Illus., Drawing, etc., Univ. Georgia, Athens, Ga., 1947-51; Instr., Visual Fundamentals, Inst. Des., Ill. Inst. Tech., 1952; A. Dir., New Homes Guide, Home Modernizing Magazines, 1953-58; Instr., Famous Artists Schools, Westport, Conn., 1960- .

JOHNSON, EVERT A.—Gallery Curator, E., P.
 Southern Illinois University, Carbondale, Ill., 62901; h. Rte. 3, Cobden, Ill., 62920
B. Sioux City, Iowa, Mar. 2, 1929. Studied: Sioux City A. Center; Morningside Col., B.A.; State Univ. Iowa, M.A. Member: Sioux City A. Center Assn.; A. Ed. Iowa; AEA; Sioux City A. Group (Pres.). Awards: 2 purchase prizes, Sioux City A. Center. Exhibited: Iowa May Show, 1951, 1958, 1959, 1960; Iowa WC Exh.; A. Group, 1955-1958; Area Artists, 1956, 1958; Siouxland WC Exh., 1956; Laas-George Gal., San Francisco; Hastings, Neb., 1961; Springfield, Mo., 1961; Mulvane A. Center, 1961; one-man: Community Theatre, Sioux City, 1956; Sioux City Lib., 1957, 1958; Morningside Col., 1958; Unitarian Church, 1957; Univ. South Dakota, 1963; Neb. State T. Col., Wayne, Neb., 1963; Westmar Col., 1962; Sanford Mus., 1962; 3-man: Sioux City A. Center, 1957. Positions: Hd. Dept. A., Westmar Col., Le Mars, Iowa, 1957-61; Dir., Sioux City Art Center, Sioux City, Iowa, 1961-1965; Dir. Hampton Inst. Mus., Hampton, Va., 1965-1966; Cur., Univ. Galleries, Southern Illinois Univ. at Carbondale, at present.

JOHNSON, FRANCES G.—Painter
 291 Ave. de la Vereda, Ojai, Cal. 93023
B. Oakland, Cal., Dec. 7, 1924. Studied: Yuba Col., Cal.; Chico State Univ., Cal. Member: California Nat. WC Soc. Awards: Cal. Nat. WC Soc., 1968. Work: Home Savings and Loan Assn., Los Angeles. Exhibited: La Jolla Mus. A., 1961; Crocker Mus. A., 1961; Long Beach Mus. A., 1962, 1963; Richmond Mus. A., 1963, 1965; Oakland Mus. A., 1967, 1968; Cal. Fair, 1966, 1968; First Annual Invitational Exh. of Contemp. A., 1963; Cal. Nat. WC Soc., 1963, 1965-1968; "25 Cal. Women of Art" invitational, 1968; one-man: Santa Barbara Mus. A., 1967. Positions: Instr., pastel drawing, Ventura County Forum of the Arts.

JOHNSON, MRS. FRIDOLF L. See Lenssen, Heidi (Ruth)

JOHNSON, IVAN EARL—Educator, Cr., W., L.
 Arts Education Department, Florida State University; h. 920 West College St., Tallahassee, Fla. 32304
B. Denton, Tex., Sept. 23, 1911. Studied: North Texas State Univ., B.A., B.S.; Columbia Univ., M.A.; N.Y. Univ. FA; N.Y. Univ., Ed.D.; Inst. Middle Am. Research, Mexico, and with Henry McFee, William Zorach. Member: Southeastern AA; NAEA; Nat. Com. on A. Edu. Contributor to Journal of Art Education. Lectures on Art Education to universities and colleges and state art groups. Positions: Book Ed., Arts & Activities Magazine, 1950- ; Editorial Board, Journal of Art Education; Co-director, Arts & Humanities Institute on Evaluation in Art, 1968; Instructor, U.S.O.E.-NAEA Pre-Conference Training Institute, 1969; Inst. A. Edu. and Crafts, Southwest Texas State Col., North Texas State Univ., Woman's Col. of Univ. North Carolina, N.Y. Univ., Columbia Univ., Univ. Tulsa; Dir., Dallas Pub. Schs., 1946-52; Pres., Western AA; Past Pres., Vice-Pres., NAEA, etc.; Hd., Dept. Arts Edu., Florida State Univ., Tallahassee, Fla., at present.

JOHNSON, MRS. J. LEE, III—Collector, Patron
 Amon Carter Museum of Western Art, P.O. Box 2365, 76101; h. 1200 Broad Avenue, Fort Worth, Tex. 76107
B. Fort Worth, Tex., Oct. 19, 1923. Studied: Sarah Lawrence College, Bronxville, N.Y., B.A. Awards: Layman's award, Fort Worth Chapter, A.I.A., 1964; Special award, Texas Society of Architects, Dallas, 1964. Collection: French 19th and 20th centuries, American and French 20th century, contemporary American and Italian Sculpture. Positions: Vice-President, Fort Worth Art Association, 1949-1965; Co-Chairman, American Federation of Arts Convention, Fort Worth-Dallas, 1963; Chairman, Board of Trustees, Amon Carter Museum of Western Art; Member NCFA; National Council on The Arts, 1969-1971; Bd. Member, Nat. Trust for Historic Preservation, 1968.

JOHNSON, J. STEWART—Museum Curator
 The Brooklyn Museum, Eastern Pkwy. 11238; h. 64 Hicks St., Brooklyn, N.Y. 11201
B. Baltimore, Md., Aug. 31, 1925. Studied: Swarthmore Col., B.A.; Univ. Delaware, M.A. (in Early American Culture - Winterthur Program in Early American Culture). Member: The Victorian Soc. in America (Pres., 1966-1969); American Friends of Attingham Park (Dir.); The Lockwood-Mathews Mansion, Norwalk, Conn. (Advisor). Positions: Cur., Dec. Arts, Newark Mus., 1964-1968; Cur., Dec. Arts, Brooklyn Mus., 1968- .

JOHNSON, KATHERINE KING (Mrs. Norman F.)—Painter
 40 Piedmont Parkway, Rutland, Vt. 05701; w. 13 Sky Ridge Park, Cathedral City, Cal. 92234
B. Lincoln, Neb. Studied: Univ. Nebraska Col. FA. Member: Vermont Council on the Arts; Nat. Lg. Am. Pen Women; Shadow Mountain Palette Cl., Palm Desert, Cal.; Desert A. Center, Palm Springs, Cal. Work: L.B. Johnson Mem. Library, Austin, Tex.; Mus. A. & Hist., Bennington, Vt.; Rutland Hospital; Fleming Mus., Burlington; Southern Vermont A. Center; Kimball Union Acad., Meriden, N.H. Exhibited: 1962-64; Norwich Univ., Northfield, Vt.; Cracker Barrel Bazaar, Newbery, Vt.; Nat. Lg. Am. Pen Women; So. Vermont A. Exh., Manchester, Vt.; Indio (Cal.) Festival; Desert A. Center; Shadow Mountain Palette Cl.; Corner Gal., Grafton, Vt.; Chaffee A. Gal., Rutland, Vt., 1967 and Weston, Vt., 1969 (both one-man); New York World's Fair. Positions: Pres., Rutland AA; Hale Gal., Palm Springs; West Corner Gal., Grafton, Vt.; Former State A. Chm., Nat. Lg., Am. Pen Women; Executive Dir., Chaffee Art Gallery, Rutland, Vt.

JOHNSON, LESTER F.—Painter
 294 Gulf St., Milford, Conn. 06460
B. Minneapolis, Minn., Jan. 27, 1919. Studied: Minneapolis Sch. A., with Alexander Masley, Glen Mitchell; St. Paul A. Sch.; AIC. Awards: Pillsbury Scholarship, 1940; Harriet Johnson Scholarship, 1941; St. Paul Gallery Scholarship, 1942; F., Trumbull Col., Yale Univ.; prize, Minnesota State Fair, 1941. Work: Longview, Fnd.; BMA; MModA.; Mint Mus. A., Charlotte, N.C. Exhibited: Jewish Mus., N.Y., 1956; Minneapolis Inst. A., 1957; Stable Gal., N.Y., 1957; BMA, 1958; WMAA, 1958; Univ. Colorado, Boulder, 1959; Inst. Contemp. A., Boston, 1959, 1960; Salzburg Festival, 1959; Sarah Lawrence Col., N.Y., 1959; Nebraska AA, 1959; AFA traveling Exh., 1960; City & Town School, N.Y., 1960; Univ. North Carolina, 1960; Univ. Nebraska, 1960; Carnegie Inst., 1961; Hansa Gal., N.Y., 1955 (3-man); Zabriskie Gal., N.Y., 1954 (3-man); Ellison Gal., Ft. Worth. 1959 (2-man); Felix Landau Gal., Los A., 1960 (6-man); MModA., 1961; Lausanne Mus., 1963; Guggenheim Mus., 1964; Mus. of Ghent, Belgium, 1964; Anderson-Mayer Gal., Paris, 1964; Galerie Paul Facchetti, Paris, 1966; Dublin, Ireland, 1967; Smithsonian Inst., Latin America and Europe; 2nd Bienal, Madrid, Spain; one-man: Artists Gal., N.Y., 1951; Korman Gal., N.Y., 1954; Zabriskie Gal., N.Y., 1955, 1957, 1958-1961; Ellison Gal., Ft. Worth, 1961; Minneapolis Inst. A., 1961; Sun Gal., 1956-1959 and HCE Gal., 1960, both in Provincetown, Mass.; Holland Gal., Chicago, 1962; Martha Jackson Gal., N.Y., 1962, 1963, 1965, 1966, 1969; Dayton AI, 1962; Donal Morris Gal., Detroit, 1965; Yale Univ. A. Gal., 1965; Cal. Col. A. & Crafts, Oakland, 1968; Benson Gal., 1968. Positions: A.-in-Res., Ohio State University, Columbus, 1961-62; Assoc. Prof., Grad. Painting, Yale Univ. Sch. A. & Arch., New Haven, Conn., at present.

JOHNSON, MARIAN WILLARD—Art Dealer, Collector
 Willard Gallery, 29 E. 72nd St. 10021; h. 31 E. 72nd St., New York, N.Y. 10021
B. New York, N.Y., Apr. 20, 1904. Specialty of Gallery: Contemporary American art. Collection: From ancient to modern art. Positions: Owner and Director, Willard Gallery, New York, N.Y. Chairman, Advisory Committee, Museum of Modern Art, and Member, Board of Trustees and Acquisitions Committee, 1944-1946; Chairman, Asia House Gallery Advisory Council, 1959- , Trustee, 1961- , Executive Committee, 1965-1967; Vice-President, Museum

of American Folk Art, 1962- ; Board of Overseers, Art Department, Brandeis University, Waltham, Mass., 1965- .

JOHNSON, PAULINE B.—Writer, E.
 University of Washington 98105; h. 2910 N.E. 130th St., Seattle, Wash. 98125
Studied: Univ. Washington, B.A.; Columbia Univ., M.A., and with Peter Camferman (painter), Dorothy Macdonald (bookbinder). Awards: Hon. D.F.A., Moore College of Art, Philadelphia, Pa., 1968. Author: "Creating With Paper"; "Creative Bookbinding." Co-author: "Crafts Design." Positions: Pres., Washington AA, 1955-1956; Vice-Pres., Pacific A. Assn., 1958-1960; Instr., University of Washington, Seattle, at present.

JOHNSON, PHILIP—Collector, Architect
 375 Park Ave., New York, N.Y. 10022; h. Ponus St., New Canaan, Conn. 06840
B. Cleveland, Ohio, July 8, 1906. Studied: Harvard University, A.B.; Harvard University, Graduate School of Design, B. Arch. Awards: AIA-Award of Merit, 1956, First Honor Award, 1956, 1961 (2); Collaborative Achievement in Architecture, 1964; 1st prize, Sao Paulo Bienal, 1954; Grand Festival Award, Boston A. Festival, 1955; Architectural Record-Award of Excellence for house design, 1957 (Oneto House), and same award, 1962 (Leonhardt House); Architectural League, N.Y.-Silver Medal of Honor, 1950 (Glass House), Gold Medal (with Mies van der Rohe), 1960 (Seagram Bldg., N.Y.); Fifth Avenue Assn.-1962 (Best Institutional Bldg., Asia House); Progressive Architecture Design Award, 1964 (Kline Science Center, Yale Univ.); Scroll, for "Great Contribution to the Architectural Environment of Our City," Municipal Art Society, N.Y., 1964 (N.Y. State Theatre and Museum of Modern Art); Certificate of Commendation, Park Association, N.Y., 1964 (the design of open space in the Garden of the Museum of Modern Art and the plaza of the Seagram Bldg.); Elsie DeWolfe Award, N.Y. Chapter, Am. Inst. of Interior Designers, 1965. Author: (with Henry-Russell Hitchcock) "The International Style," 1932; "Machine Art," 1934; "Mies van der Rohe," 1947, rev. 1953. Collection: Young Americans. Positions: Design Critic, Cornell and Yale Universities; Inst., Pratt Institute, Brooklyn, N.Y.; Visiting Committee, Harvard School of Design, 1950-51; Council Committee, School of Art & Architecture, Yale University, New Haven, Conn., 1959- .*

JOHNSON, RAY—Painter
 c/o Feigen Gallery, 24 E. 81st St., New York, N.Y. 10028*

JOHNSON, SELINA (TETZLAFF)—
 Museum Director, E., I., S., Historian
 Bergen Community Museum; h. 24 Hawthorne Terrace, Leonia, N.J. 07605
B. New York, N.Y., Sept. 7, 1906. Studied: Hunter Col., A.B.; City Col. N.Y., M.S. in Ed.; N.Y. Univ., Ph.D. Member: AAMus.; Mus. Council of New Jersey; Nantucket Maria Mitchell Assn.; SAGA; Bergen County A. Gld.; N.Y. Acad. Sciences (Life); Caduceus (Hon.); Leonia (N.J.) Cultural Arts Committee; North Jersey Cultural Councils; Pres., North Jersey Opera Theatre, 1968- . Awards: Silver Orchid, N.J. State Fed. Women's Cl. Work: (photography) Bergen Community Mus.; Nantucket Mus. of Natural Science; port. sculpture, Bergen Mall, Paramus, N.J., I., "Classification of Insects," 1932; "Adventures with Living Things," 1938; Author: monographs: Creating a Community Museum, 1954; Developing a Community Museum, 1956; Museums for Youth in the United States (Ph.D. thesis, 1962); "Mastodon Dig Spurs Museology," 1962 in Museologist. Arranged exhs., "Prints and Printmakers of Bergen County," 1956; "The Art of Charles Chapman, N.A.—Three Score and Ten Years," 1957; "Paintings by People of Palisades Park," 1958; "350th Year—Henry Hudson Here 1609-1959"; "County Craftsmen Create Stained Glass"; "Driftwood Designs, Flower Paintings and Fresh Arrangements," 1960; "The Fine Art of Color Photography," 1961; "Excavating Our Hackensack Mastodon," color film and slides, 1962-64; "New Jersey Junior Historian's Fair," 1964- . Exhibited: Freedom House, N.Y., 1959; Bergen County A. Gld., 1960; Nantucket AA, 1961. Positions: Organizaing Dir., Youth Museum of Leonia, N.J., 1950-56; Founder, Pres., 1956-58, Dir., 1956- , Bergen Community Museum; Museum Coordinator, Fairleigh Dickinson Univ., 1962- ; Architectural Consultant for History Hall, Bergen County, N.J., 1968- .

JOHNSON, WESLEY E.—Painter, T.
 291 Avenida de la Vereda, Ojai, Cal. 93023
B. Ojai, Cal., June 15, 1934. Studied: Ventura Col.; Univ. of California at Santa Barbara and in Paris with Andre Lhote. Member: California Nat. WC Soc.; San Francisco A. Inst. Awards: prizes, James D. Phelan award, 1963; Forum of the Arts, 1964 (purchase); California State Fair, 1966, 1968; California Nat. WC Soc., 1966. Work: U.S. Dept. of State; Forum of the Arts. Exhibited: SFMA, 1960, 1965, 1966; Nat. Orange Show, 1964; Cal. Nat. WC Soc., 1963, 1965-1968; Water Color:USA, 1964; Los Angeles County Mus., 1959;

La Jolla Museum A., 1960; Newport Harbor annuals, 1961-1963; Ojai A. Center, 1960-1964, 1966-1968; Pasadena Mus. A., 1963; Long Beach Mus. A., 1963, 1964; FA Gal. of San Diego, 1963; Las Vegas A. Lg., 1964; Chicago State Col., 1963; Richmond Mus. A., 1963; Mun. A. Gal., Los Angeles, 1963; Otis A. Inst., Los Angeles, 1964; Univ. Colorado, 1964; Victoria, B.C., A. Center; Larson Gal., Yakima, Wash., 1964; Univ. Oregon, 1964; Santa Barbara Mus. A., 1963; California State Fair, 1965-1968; DeYoung Mem. Mus., San Francisco, 1966; Cal.PLH, 1964; Univ. Nevada, 1966; Col. of Idaho, 1966; Louisiana State Univ., 1966; Wustum Mus., Racine, Wis., 1967, and others. One-man: Santa Barbara Mus. A., 1963. Positions: Instr., Painting, Ventura College, Ventura, Cal., at present.

JOHNSTON, YNEZ—Painter, Et., S.
 2009 3rd St., Santa Monica, Cal. 90405.
B. Berkeley, Cal., May 12, 1920. Studied: Univ. California, Berkeley, B.M., M.A. Awards: Guggenheim F., 1952-53; Tiffany Fnd. grant, 1955; prize, MMA, 1952; Phelan award, 1958; IGAS print co comm., 1958, 1960; Tamarind Fellowship, 1966. Work: Santa Barbara Mus. A.; MMoDA; WMAA; MMA; CAM; Los A. Mus. A.; Philbrook A. Center; Univ. Michigan; Univ. Illinois; Wadsworth Atheneum; PMA. Exhibited: Carnegie Inst., 1955; WMAA, 1951-1955; Univ. Illinois, 1951-1954; SFMA, 1943 (one-man); Los A. Mus. A.; O'Hara Gal., London, 1958 (one-man); Kantor Gal., Los A., 1958, 1961 (one-man); Santa Barbara Mus. A.; Pasadena Mus. A., 1955, 1962 (one-man); 3-man MMoDA, 1951, and others. Positions: Instr., Univ. California, Berkeley, 1950, 1951; L., Colorado Springs FA Center, summers, 1954, 1955.

JONES, AMY (Mrs. Owen Phelps Frisble)—
 Painter, I., T., L., Gr., S.
 Byram Lake Rd., Mount Kisco, N.Y. 10549
B. Buffalo, N.Y., Apr. 4, 1899. Studied: PIASch.; & with Peppino Mangravite, Anthony di Bona, Xavier Gonzales, Gabor Peterdi, Carlus Dyer. Member: AEA; AWS; Phila. WC Cl.; Silvermine Gld. A.; Portraits, Inc.; Audubon A. Awards: F., Buffalo SA, 1931; prizes, Balt. WC Cl., 1941, 1954, 1958; Village A. Center, 1951 (2), 1954, 1957, 1959, 1960; Women's Cl., Ossining, N.Y.; Jr. Lg. of Westchester, 1955; Saranac A. Lg., 1939-1942; NAD, 1956; Pleasantville, N.Y., 1957; Washington County Mus. A., Hagerstown, Md., 1959; Artists of No. Westchester, 1962, 1967. Work: Wharton Sch. Finance, Univ. Pennsylvania, Phila., Pa.; N.Y. Hospital; Marine Hospital, Carville, La.; New Britain Mus. Am. A.; series watercolors for Standard Oil of N.J. "The Lamp," 1958 and for Woman's Day, 1962; murals, USPO, Winsted, Conn.; Painted Post, N.Y.; Schenectady, N.Y.; Norfolk Mus. A. & Sciences. Exhibited: AIC; NAD; PAFA; AWS, annually; Northwest Pr. M., Laguna Beach AA; Carnegie Inst.; Butler Inst. Am. A., 1963; New Haven Paint & Clay Cl.; AFA traveling exh.; Portraits, Inc., traveling exh.; Mississippi AA; Balt. WC Cl.; Albright A. Gal.; Mid-Vermont A.; Soc. Wash. A.; Phila. WC Cl.; Village A. Center; North Westchester A.; Butler AI; Leicester Gal., London, 1954-1956, 1964; Norfolk Mus. A., 1963, 1965, retrospective, 1967, and traveling; Brighton, England, 1954; NAC; Katonah (N.Y.) Gal., 1961-1964; many one-man exhs., including Venice, Italy, 1958; New York City, 1959; retrospective, New Britain (Conn.) Mus. Am. A., 1963; Ruth White Gal., N.Y., 1963, 1969; Phila. A. All., 1962; 2-man, Inst. for Rehabilitation Medicine, 1969. I., "Child's Garden of Verses," 1946; "Prance" 1950. Represented in "21 Water Color Painters"; Jacket des., "The Spider's Web," 1955. Contributor articles and paintings to Ford Publications. Positions: Instr. A., Bedford Rippowam Sch., 1950-54; Adult Edu., Valhalla Jr. H.S., N.Y., 1955 and Chappaqua, N.Y., 1963-64. L., N.Y. Pub. Lib., 1953-55. Bd. Dir., Katonah (N.Y.) Gal.; Chm., Surrealist Exh., Katonah Gal., 1960. 1968-1969, taught at Bedford A. Center, Greenwich A. Center and Silvermine Gld.

JONES, DAVID TAYLOR SWATLING—
 Museum Director, P., C., Gr., S.
 Gertrude Herbert Art Institute, 506 Telfair St., Augusta, Ga. 30901
B. Camden, N.J., May 13, 1926. Studied: Williams Col., B.A.; Yale Univ. Sch. FA. Work: Gertrude Herbert AI.; Olsen Fnd., Guilford, Conn. Westbrook Gal., Westbrook, Conn. Exhibited: Westbrook Gal., 1956-58; New Arts Gal., Atlanta; Atlanta AA; Knapik Gal., New York City. Co-author: "The Philistine Traveler," 1954. "Oedipus Rex," original audio-visual opera performed in Houston, Tex. and Ashtabula, Ohio; premiere performance by Augusta Symphony Orchestra of original music "Minotaur Waltz" and "Ariadne's Dance" (excerpts from work-in-progress ballet: "Tour of the Labyrinth," 1964). Positions: Instr. Painting, Dir., Gertrude Herbert Art Institute, Augusta, Ga.*

JONES, (CHARLES) DEXTER (WEATHERBEE), III—Sculptor
 1611 Sansom St. 19103; h. 1924 Waverly St., Philadelphia, Pa. 19146
B. Ardmore, Pa., Dec. 17, 1926. Studied: PAFA and Chester Springs

A. Sch., with Charles Rudy and Walker Hancock; Accademia Di Belli Arti, Florence, Italy. Member: F., NSS; A.I.A.; All. A. Am.; F., PAFA (Bd. Mngrs., 1953-55); NAC; ANA. Awards: PAFA, 1952; NSS, 1959; Gregory award, 1961; All. A. Am., 1959, 1962; NAD, 1960; Silver Medal, DaVinci All., 1960; Art Dir. Club of Phila., 1966. Work: PAFA; Woodmere A. Gal.; AMA Clinical Meeting Gold Medal, 1960; Moravian College Bronze Seal & Music Room decor, 1961; new Omaha Airport (A.C. Storz Tribute Tablet), 1961; New Bradford Nat. Bank Bldg. (2 historical relief panels), 1961; Newcomb Cleveland Medal, Am. Assn. for Advancement of Science, 1964; Great Seal of Philadelphia, Municipal Services Bldg., Phila., Pa., 1965; St. Paul's Lutheran Church, Warren, Ohio; Wittenberg Univ., Springfield, Ohio; Ex-Residents Assoc., Pennsylvania Hospital, Phila.; John H. Webster Public Sch., Phila.; Fire Station, Independence Mall, Phila.; National Presbyterian Church, Washington, D.C.; Phila. Psychiatric Hospital; numerous portraits, plaques and medals Exhibited: PAFA, 1949-1952; NAD, 1950, 1951, 1958-1960; NSS, 1959-1962; All. A. Am., 1959-1963; NAC, 1961; PMA, 1959, 1962; Carnegie Hall, 1961; DaVinci A. All., 1960; AIA, Phila., 1962-1964; Pa. Soc. Arch., 1962, 1963; Phila. A. All., 1964, 1965. Positions: Asst. to Jo Davidson, 1948-49; Paul Manship, 1952-53.

JONES, E(DWARD) P(OWIS)—Painter, Gr., S.
 1556 Third Ave.; h. 925 Park Ave., New York, N.Y. 10028
B. New York, N.Y., Jan. 8, 1919. Studied: Harvard Univ.; ASL; Academie Ranson, Paris. Member: Phila. Pr. Cl.; Century Assn.; Mun. A. Soc.; AEA. Work: MModA; Riverside Mus.; LC; PMA; BM; Parrish A. Mus.; Rochester Pr. Cl.; First Army Mus. Exhibited: PAFA, 1946; WMAA, 1946, 1947; Audubon A., 1948; Kraushaar Gal., 1946 (one-man); 1949, 1953; Bard Col., 1948 (one-man); Phila. Pr. Cl., 1954, 1955; MModA, 1953; John Herron AI, 1958; New Gal., 1955, 1957, 1958; IGAS, 1959; Pomfret (Conn.) Sch. (one-man); LC; BM; Sc. Workshop, 1968; MModA., "Modern Religious Prints" circulating exh., 1963; Tokyo Print Bienale, 1963. Contributor to Art in America. Illus. for Liturgical Arts. Lectures: The Modern Illustrated Book.

JONES, ELIZABETH ORTON—Illustrator, W., P., Gr.
 Mason, N.H.
B. Highland Park, Ill., June 25, 1910. Studied: Univ. Chicago; Ecole des Beaux-Arts; DeCordova & Dana Mus., Lincoln, Mass. Awards: Hon. deg. M.A., Wheaton Col.; Caldecott medal, 1945; Lewis Carroll Shelf award, Univ. Wisconsin, for "Prayer for a Child," 1958. Work: murals, Crotched Mt. Rehabilitation Center, Greenfield, N.H.; panel, Univ. New Hampshire Lib. Author, I., "Ragman of Paris"; "Minnie the Mermaid"; "Maminka's Children"; "Twig"; "Big Susan"; "How Far Is It to Bethlehem?"; Illus., "The Peddlar's Clock"; "Small Rain"; "Prayer for Little Things"; "Secrets"; "This is the Way"; "Song of the Sun"; "Lullaby for Eggs"; "Deep River," and many more books. Contributor to The Horn Book; Nat. Parent-Teacher.*

JONES, FRANCES FOLLIN—Museum Curator
 The Art Museum, Princeton University; h. 1041 Kingston Rd., Princeton, N.J. 08540
B. New York, N.Y., Sept. 8, 1913. Studied: Bryn Mawr Col., A.B., M.A., Ph.D.; Am. Sch. Classical Studies, Athens. Member: Archaeological Inst. Am. Contributor to American Journal of Archaeology; Hesperia; The Record of the Art Museum; "Excavations at Gözlü Kule, Tarsus," Vol. I. Positions: Asst., Inst. for Advanced Study, 1939-46; Sec., Asst. Cur., 1943-46, Asst. to Dir., Cur., 1946-65, Chief Cur., Cur. Classical Art, 1965- ; A.Mus., Princeton Univ., Princeton, N.J.

JONES, HOWARD (WILLIAM)—Sculptor, P.
 12 N. Newstead Ave., St. Louis, Mo. 63108
B. Ilion, N.Y., June 20, 1922. Studied: Syracuse Univ., B.F.A.; Columbia Univ.; Cranbrook Acad. A. Awards: Graham Fnd. grant for Advanced Studies in the Fine Arts, 1966-1967; prize, Art in America magazine, 1966. Work: Milwaukee A. Center; Albright-Knox A. Gal., Buffalo, N.Y.; WAC; Aldrich Mus. Contemp. A.; William Rockhill Nelson Mus. A., Kansas City, Mo.; CAM; Albrecht Mus., St. Joseph, Mo.; Washington Univ., St. Louis. Commissions: WMAA "Time Columns and the Sound of Light," 1968; William Rockhill Nelson Mus. A., "Sonic Room," for traveling exh., 1968. Exhibited: Royal Marks Gal., N.Y., 1965 (2), 1966; CAM, 1966; Albright-Knox A. Gal., 1966; Ohio Univ., Columbus, 1966; Inst. Contemp. A., Boston, 1966; Aldrich Mus. Contemp. A., Ridgefield, Conn., 1966; Nelson-Atkins Mus., Kansas City, 1966; Kent State Univ., 1967; Herron Mus., 1967; Yale Univ. A. Gal., 1967; Howard Wise Gal., N.Y., 1967 (2); Aldrich Mus. Contemp. A., 1967; WMA, 1967; So. Illinois Univ., 1967; Univ. Georgia, 1967; WAC, 1967; Milwaukee A. Center, 1967; Inst. Contemp. A., London, 1967; audience participation show, Milwaukee A. Center and Mus. of Contemp. A., Chicago, 1968; "The Sound of Light," a wall commissioned by WMAA, 1968; "Sonic Room," Nelson-Atkins Mus., Kansas City,

1968, CAM, 1968 and Toledo Mus. A., 1969; La Jolla Mus., 1969; Jewish Mus., N.Y., 1969; Aldrich Mus. Contemp. A., 1969. One-man: Carp Gal., St. Louis, 1965; Nelson-Atkins Mus., 1965; Royal Marks Gal., N.Y., 1966; Howard Wise Gal., N.Y., 1968. Positions: Taught: Instr., Art, Tulane Univ., New Orleans, La.; Asst. Prof. Art, Florida State Univ.; Assoc. Prof Art, Washington Univ., St. Louis, Mo., 1957- .

JONES, JOHN PAUL—Painter, Etcher
 22370 3rd Ave., South Laguna, Cal. 92677
B. Indianola, Iowa, Nov. 18, 1924. Studied: Iowa State Univ., B.F.A., M.F.A. Awards: Tiffany Fnd., 1951; Guggenheim Fellowship, 1960. Work: BM; SAM; Des Moines A. Center; Dallas Mus. FA; Joslyn A. Mus.; Kansas State Col.; Bibliotheque Nationale, Paris; Univ. California, Los Angeles; Hirshhorn Coll.; Univs. of Illinois; Iowa; Michigan; Nebraska; Tulane; LC; Los Angeles County Mus.; Oakland Mus.; SFMA; Santa Barbara A. Mus.; Victoria & Albert Mus., London; WAC; USIS; MModA; NGA, and others. Exhibited: BM, 1949-1952; Northwest Pr. M., 1950-1952; SFMA, 1949, 1950; PAFA, 1950; Univ. Minnesota, 1951; Bradley Univ., 1951, 1952; Des Moines A. Center, 1949-1951; Denver A. Mus., 1949, 1950; Springfield (Mo.) A. Mus., 1949-1952. One-man: Felix Landau Gal., Los Angeles, 1962, 1964, 1967, and prior; Milan, 1961; BM, 1963; Dintenfass Gal., N.Y., 1963, 1965; Los Angeles County Mus., 1965; Univ. Nebraska, 1963; Landau-Alan Gal., 1967, 1969, and many others in galleries and universities.

JONES, LOIS MAILOU (Mrs. Vergniaud Pierre-Noel)—
 Painter, Des., E., Comm. A.
 2401 Sixth St., Washington, D.C. 20001
B. Boston, Mass. Studied: Boston Normal A. Sch.; BMFA Sch.; T. Col., Columbia Univ., A.B.; Howard Univ.; Academie Julian, Paris, & in Rome. Also with Philip Hale, Jules Adler, Joseph Berges. Member: AWS; Wash. A. Gld.; Wash. WC Cl.; A. Dir. Cl.; Soc. Wash. A.; F., Royal Soc. Arts, London; AEA; Nat. Council of Artists. Awards: F., General Edu. Bd., 1937, 1938; prizes, BMFA Sch., 1926; Nat. Mus., Wash., D.C., 1940, 1947, 1954, 1960, 1964; CGA, 1941, 1949, 1951; Atlanta Univ., 1942, 1949, 1952, 1955, 1960; Haitian Gov. Dec. & Order, 1954; Lubin award, 1958; A.A.L., 1960.; Wash. Soc. A., 1962; award for Nat. and Int. contributions as an Artist and Teacher, from Assn. for Presentation and Preservation of the Arts, 1968. Work: PC; IBM; BM; Intl. Fair Gal., Izmir, Turkey; Univ. Punjab, Pakistan; Palais National, Haiti; Atlanta Univ.; Howard Univ.; W. Va., State Col.; Rosenwald Fnd.; Retreat for Foreign Missionaries, Wash., D.C. (mural); Col. FA, Howard Univ.; CGA; Barnett Aden Gal.; mural, Cook Hall, Howard Univ.; Galerie International, N.Y.; WAC; Bowdoin Col.; American Embassy, Luxembourg. Exhibited: Paris Salon, 1938, 1939; Galerie de Paris, 1938; Galerie Charpentier, 1938; PAFA, 1934-36, 1938, 1939; CAA traveling exh., 1934; Harmon Fnd., 1930, 1931; Texas Centennial, 1936; BMA, 1939, 1940, 1944; Inst. Mod. A., Boston, 1943; Am-British A. Center, 1944; NAD, 1942, 1944, 1969; AWCS, 1942, 1944, 1946, 1964; Albany Inst. Hist. & A., 1945; Vose Gal., 1939 (one-man); Howard Univ., 1937 (one-man); Barnett Aden Gal., 1946; PC, 1941, 1942, 1944, 1945; Wash. A. Gld., 1929-1958; Whyte Gal., 1941-1944; Soc. Wash. A., 1938-1943, 1945, 1946, 1959, 1960-1965; Wash. WC Cl., 1931-1936, 1939-1958, 1959, 1960-1965; Whyte Gal., 1948 (one-man); Dupont Theatre, 1951 (one-man); Haiti, 1954 (one-man); Pan-Am. Union, 1955 (one-man); ACA Gal.; Gr. Central A. Gal.; BMA; American Univ.; CGA, 1939, 1951, 1968; Salisbury (Rhodesia) Mus., 1960; Galerie Intl., New York City, 1961, 1968 (both one-man); Howard Univ., 1961, 1963 (one-man), 1967, 1968; Grumbacher Traveling, 1966-1969; I., books & periodicals. "Lois Mailou Jones Peintures 1937-1951" publ. France, 1952. Positions: Prof., Des. & WC Painting, Howard Univ., Washington, D.C., 1930- .

JONES, LOUIS C. —Museum Director
 New York State Historical Association, Fenimore House, Cooperstown, N.Y. 13326
Position: Director, Fenimore House, Cooperstown, N.Y.*

JONES, NELL CHOATE—Painter
 296 Clermont Ave., Brooklyn, N.Y. 11205
B. Hawkinsville, Ga. Studied: Adelphi Acad. Member: NAWA (Hon. Life Member); Pen & Brush Cl.; SSAL; Boston A. Cl.; Brooklyn Soc. A.; Int. Council of Women. Work: High Mus. A.; Ft. Worth Mus. A. Awards: prizes, Pen & Brush Cl., 1951, 1953; Lorillard Wolfe A. Cl., 1950, 1954; NAWA med., 1955, prize, 1958; citation, Milledgeville (Ga.) State Col. for Women, 1951. Exhibited: Clearwater Mus., 1946; FA Mus., Little Rock, Ark., 1946; Massillon Mus. A., 1947, 1950; Univ. Colorado, 1947; Wichita A. Mus., 1947; Illinois State Mus., 1947; Wustum Mus. A., 1947, 1949; Berkshire Mus. A., 1947; Dartmouth Col., 1947; Greenwich (N.Y.) Lib., 1947; Buck Hill Falls (Pa.) AA, 1947; Harrisburg AA, 1947; Pa. State Mus., 1947; Elisabet Ney Mus., 1948, 1951; Texas Tech. Col., 1948, 1951; Univ. Oklahoma, 1958; Nelson Gal. A., 1949, 1950; Butler AI, 1949; Springfield AA,

1949; Grinnell Col., 1949; Neville Pub. Mus., 1949; Kenosha A. Mus., 1949; Toronto, Canada, 1950; Paris, France, 1951, 1953; Amsterdam, Holland, Brussels and Antwerp, Ostend, Berne and Lugano, 1954-1957; Tokyo, Osaka, Japan, 1956; Athens and Salonica, Greece, 1958; Neville Pub. Mus., 1949; Kenosha A. Mus., 1949; Allegheny Col., 1949; Arnot A. Gal., 1950; Albany Inst. Hist. & A., 1950; CM, 1950; Canton IA, 1950; Richmond (Ind.) AA, 1951; Mulvane A. Mus., 1951; Brooks Mem. A. Gal., 1951; NAD; NAWA; Brooklyn Soc. A., etc. Positions: Pres. Brooklyn Soc. A., 1949-52; NAWA, 1951-55; Memb. U.S. Com. Int. Assn. of Plastic Arts, 1952-56; Bd., Nat. Council of Women of the U.S., 1956-62; Int. Council of Women, 1957-62.

JONES, THOMAS HUDSON—Sculptor
1415 36th St., Northwest, Washington, D.C. 20007
B. Buffalo, N.Y., July 24, 1892. Studied: Albright A. Gal.; Carnegie Inst.; BMFA Sch.; Am. Acad. in Rome. Member: ANA; F., Am. Acad. in Rome. Awards: Prix de Rome, 1919-1922. Work: Hall of Fame, N.Y.; Columbia Univ.; mem., reliefs, monuments, doors, busts, Holyoke, Mass.; St. Matthew's Church, Wash., D.C.; Mechanics Inst., N.Y.; Am. Acad. in Rome; Houston (Tex.) Pub. Lib.; Brooklyn Pub. Lib.; Rochester, N.Y.; House of Representatives, Wash., D.C.; House Chambers, U.S. Capitol, Wash. D.C.; Pennsylvania Station, Newark, N.J.; Trinity Col., Hartford, Conn.; Amherst Col.; war mem., Port Chester, N.Y.; U.S. Treasury Dept.; Tomb of the Unknown Soldier, Arlington, Va.; des. and executed many medals including: World War II; The Freedom Medal; Women's Army Corps; Armed Forces Reserves; Nat. Defense; Selective Service; For Humane Service (German Airlift); Army of Occupation; Univ. Missouri Journalism med.; N.Y. Univ. Meritorious Service, and others. Positions: Former instr. S., Albright A. Gal. Columbia Univ.; Am. Acad. in Rome.*

JONES, TOM DOUGLAS—Educator, L.
Long Island University, 385 Flatbush Ave. Ext., Brooklyn, N.Y. 11201; h. 2440 Sedgwick Ave., New York, N.Y.
B. Kansas City, Mo. Studied: Kansas City AI; T. Col., Columbia Univ.; N.Y. Univ.; Univ. Kansas; Univ. Iowa; Ecole des Beaux-Arts, and with Paul Bornet, in Paris. Member: Am. Soc. for Aesthetics; SC; SI. Awards: grant, Nat. Acad. Sc., 1943; Hon. D.F.A., Bethany Col., 1960. Positions: Asst. Prof., Univ. Kansas, 1937-45; L., Syracuse Univ., 1948-49; Dir., IBM Gal. of Arts & Science, New York, N.Y., 1952-1962; Research Prof., Long Island University, Brooklyn, N.Y., in charge of Laboratory of Color and Light. Inventor of Chromaton (color organ) and other devices in the field of color and light.*

JONNIAUX, ALFRED—Portrait Painter
712 Bay St., San Francisco, Cal.; and 7 East 63rd St., New York, N.Y. 10021; h. 1155 Jones St., San Francisco, Cal. 94109
B. Brussels, Belgium. Studied: Academie des Beaux-Arts, Brussels, Belgium. Awards: Hon. D.F.A., Calvin Coolidge College of Liberal Arts, Boston, 1958. Work: Univ. California; Northeastern Univ.; Mass. Inst. Tech.; Pentagon, Supreme Court, Capitol, Wash., D.C.; Rockefeller Inst.; Mills College; Boston Children's Hospital; Univ. California Univ. Hospital; Stanford Univ. Hospital; Mass. General Hospital; State House, Boston; State House, Columbus, Ohio; City Hall, Baltimore, and many portraits of prominent persons in U.S., South America, and Europe. Exhibited: Royal Acad., Royal Soc. Portrait Painters, London; de Young Mem. Mus.; Kennedy Gal., N.Y.; Portraits, Inc., N.Y.; Vose Gal., Boston; Municipal Mus., Baltimore; Gump's Gal., San Francisco; Smithsonian Inst.; United Nations Cl., Wash., D.C., and widely in Europe.

JONSON, RAYMOND—Painter, Gal. Dir.
1909 Las Lomas Rd., Northeast, Albuquerque, N.M. 87106
B. Chariton, Iowa, July 18, 1891. Studied: Portland (Ore.) A. Sch.; Chicago Acad. FA; AIC. Awards: prizes, AIC, 1920, 1923; Swedish Cl., Chicago, 1921; Mus. New Mexico, 1925; New Mexico State Fair, 1940, 1941, 1945; Hon. F., FA, Sch. Am. Research & Mus. New Mexico, 1956. Work: Amon Carter Mus., Ft. Worth; Encyclopaedia Britannica; Grunwald Graphic A. Coll.; La Jolla A. Mus.; Los Angeles County Mus.; McNay A. Inst., San Antonio; MModA; Oklahoma A. Center; Pasadena A. Mus.; Portland (Ore.) A. Mus.; Univ. British Columbia; Univ. Cincinnati; Nelson Gal. A., Kansas City, Mo.; Chicago Mun. Coll.; Univ. Oklahoma; Milwaukee AI; Mus. New Mexico; Vanderpoel Coll.; Mus. FA of Houston; Univ. Texas; CM; Texas Tech. Col.; Oklahoma State Univ.; Univ. Arkansas; Univ. Tulsa; Louisiana State Univ.; Sheldon Mem. A. Gal., Lincoln, Neb.; DMFA; Arizona State Univ.; Santa Barbara Mus. A.; retrospective group of 530 works owned by Univ. New Mexico; Riverside Mus., N.Y.; A. & M. Univ. of Texas; Univ. Kansas; Roswell (N.M.) Mus.; murals, Eastern New Mexico Univ. Exhibited: AIC, 1913-1915, 1917-1923, 1943-1947; Minneapolis Inst. A.; CAM; Milwaukee AI; CM; Roerich Mus.; Norfolk Mus.; GGE, 1939; Vancouver A. Gal.; Los A. Mus. A., Phila. A. All.; Colorado Springs FA Center; Dallas Mus. FA; Mus. New Mexico; Kansas City AI; Katharine Kuh Gal., Chicago; Cal.

PLH; SFMA; BM; San Diego Int. Expo.; in Europe: Stockholm, Goteborg, Malmo, Sweden; Salzburg, Austria; Secession Gal., Vienna; many one-man exh. Positions: Dir., Jonson Gal., Univ. New Mexico, Albuquerque, N.M., at present; Prof., Univ. N.M., 1934-54, Emeritus, 1954- .

JONYNAS, VYTAUTAS K.—Painter, Des., Gr., T.
182-39 Jamaica Ave., Jamaica-Hollis, N.Y. 11423; h. 85-52 168th St., Jamaica, N.Y. 11432
B. Alytus, Lithuania, Mar. 16, 1907. Studied: Nat. A. Col., Kaunas, Lithuania; Conservatoire Nat. des Arts et Metiers, and Ecole Boulle. Paris, France. Member: Audubon A.; SAGA; AWS. Awards: prizes, Phila. Pr. Cl., 1956; Conn. Acad. FA, 1959; Springfield A. Lg., 1959; Cal. Soc. Et., 1961 (purchase); winner Int. Stained Glass window Comp., Wilton, Conn.; gold medal, Paris World's Fair, 1937; medals, Audubon A., 1957, 1958. Work: National Museums in Lithuania, Latvia, Estonia; Weimar and Hamburg, Germany; Antwerp, Belgium, Amsterdam City Mus.; MMA; N.Y. Pub. Lib.; PMA; LC, and others. Stained glass windows for numerous churches in U.S. Designed and executed front entrance sculpture, Cross and Alter in the Vatican Pavilion, N.Y. World's Fair, 1964-65. Mosaics in chapel of Nat. Shrine of the Immaculate Conception, Wash., D.C.; redecoration: St. Patrick's Church, Newburg, N.Y.; St. Casimir's Church, Worcester, Mass.; St. Brenden's Church, N.Y.; St. Aloysius, New Canaan, Conn.; Franciscan Father's Chapel, Kennebunkport, Maine. Design of Chapel of Our Lady of Vilnius in St. Peter's Basilica, Rome. Exhibited: Weyhe Gal., N.Y., 1954; Univ. Maine, 1954; Alverno Col., Milwaukee, and in Europe, all one-man; also, Audubon A., 1957, 1958; MMA, 1954; BM, 1958; AWS traveling exh., 1956-58; AFA traveling exh., 1958-60; SAGA, 1953-1958; CM, 1956; Conn. Acad. FA, 1961; Fordham Univ., 1963; Int. A. Gal., Cleveland, 1964, and others. Contributor illus. to Das Kunstwerk, 1947, 1950, 1957; American Artist Magazine, 1952. Positions: Instr., Drawing, Painting, Graphic A., in colleges and institutes, Europe, 1935-51; Catan-Rose Inst. FA, 1952-57; Fordham, Univ., 1956- .

JORDAN, BARBARA SCHWINN (Mrs. F. Bertram)—
Painter, I., T., W., L.
1 West 67th St., New York, N.Y. 10023; also, Marbella, Spain, and, Paul's Lane, Bridgehampton, Long Island, N.Y. 11932
B. Glen Ridge, N.J., Oct. 20, 1907. Studied: Parsons Sch. Des.; Grand Central A. Sch.; ASL, with Frank DuMond, Luigi Lucioni, and others; Grand Chaumiere, Julian Acad., Paris, France. Member: SI. Awards: prizes, Gld. Hall, East Hampton, N.Y.; A. Dir. Cl. Work: Contributor to Ladies Homes Journal; Good Housekeeping; Colliers; Cosmopolitan; McCalls; Sat. Eve. Post, and French, British, Belgian, Danish, Swedish magazines and other publications; Palace, Thailand. Exhibited: SI (2 one-man exhs.); Barry Stephens Gal. (one-man); NAD, 1955; Royal Acad., England, 1956; Guild Hall, 1969. Lectures: Illustration; Portrait Painting. "The Technique of Barbara Schwinn" and "Fashion Illustration, Past and Present," 1968, publ. by Art Instruction Schools. Positions: Instr., Illus., Parsons Sch. Des., New York, N.Y., 1952-54; Advisory Council Art Instruction, Schools, 1956-1970. Founder, Chm. A. Com., UNICEF, 1950-61.

JOSTEN, PETER—Collector
161 East 61 St., New York, N.Y. 10021*

JOSTEN, MRS. WERNER E.—Collector
944 Fifth Ave., New York, N.Y. 10021*

JOYNER, HOWARD WARREN—Educator, P., L., Des.
Art Department, University of Texas at Arlington; h. 1611 West Second St., Arlington, Tex. 76010
B. Chicago, Ill., July 12, 1900. Studied: Kansas City AI; Univ. Missouri, B.F.A., A.M.; Univ. California; Univ. Iowa, M.F.A.; Ecole des Beaux-Arts, Fontainebleau, France. Member: Assoc. A. Instr. of Texas; Ft. Worth AA (Bd. Dir.). Awards: Carnegie scholarship, Harvard Univ., 1933; prize, Lansing, Mich., 1930. Exhibited: Rockefeller Center, N.Y., 1936; Detroit Inst. A., 1931; Kansas City AI, 1934; Joslyn Mem., 1936; Texas General Exh., 1941, 1942; Ft. Worth, Tex., 1941-1943. Positions: Prof., Chm., A. Dept., University of Texas at Arlington, Arlington, Tex.

JUDD, DON(ALD) CLARENCE—Sculptor, Gr.
101 Spring St., New York, N.Y. 10012
B. Excelsior Springs, Mo., June 3, 1928. Studied: ASL; Col. of William and Mary; Columbia Univ., B.S. Awards: Swedish Institute grant for travel in Sweden, 1965; Guggenheim Fellowship, 1968. Work: sculpture—MModA; WMAA; Pasadena Mus. A.; Kasmin Gal., London, England. Exhibited: AIC, 1965; SFMA, 1965; Vancouver (B.C.) A. Gal., and traveling, 1969; WAC, 1969; Expo '70, Osaka, Japan; WMAA, 1967; Jewish Mus., N.Y., 1966; one-man: Green Gal., N.Y., 1963, 1965; Leo Castelli Gal., N.Y., 1965; WMAA, 1968. Contributor to: Arts; Arts News; Artforum; Art International; Art in

America; Das Kunstwerk. Lectures: Contemporary Art and Art Criticism at Wadsworth Atheneum, Brooklyn Museum, N.Y. University. Teaching: Sculpture Seminar, Yale University, 1967. Positions: Art Reviewer, Art News, 1959- ; Contributing Editor, Magazine, 1959-65.

JUDSON, JEANNETTE A. (MRS.)—Painter
140 W. 57th St. 10019; h. 1130 Park Ave., New York, N.Y. 10028
B. New York, N.Y., Feb. 23, 1912. Studied: NAD with Robert Phillip, Leon Kroll; ASL with Vaclav Vytlacil, Charles Alston, Carl Holty and Sidney Gross. Member: NAWA; Lg. of Present Day A.; AEA. Awards: Grumbacher award, NAWA, 1967. Work: Joseph Hirshhorn Coll.; N.Y. Univ.; Peabody A. Mus.; Brandeis Univ.; Mus. Mod. A., Miami; Colby Col.; Butler Inst. Am. A.; Evansville Mus. A. & Sciences; Rutgers Univ.; Syracuse Univ.; Lowe Mus., Univ. Miami; Fairleigh Dickinson Univ.; Georgia Mus. A., Univ. of Georgia; Mus. New Mexico; Washington County Mus. FA, Hagerstown, Md.; Sheldon Swope A. Gal., Terre Haute, Ind.; Norfolk Mus. A. & Sciences; and in private colls. Exhibited: NAWA, 1965-1969; All. A. Am., 1966, 1967; AEA, 1966-1969; Nat. Soc. Painters in Casein, 1969; Audubon A., 1962, 1964, 1965, 1967; Lg. of Present Day A., 1965-1969; Knickerbocker A., 1965; P. & S. Soc. of New Jersey, 1965, 1966, 1968; oneman: Fairleigh Dickerson Univ., 1965; Bodley Gal., N.Y., 1967, 1969; N.Y. Univ., 1969; Pennsylvania State Univ. 1969; Laura Musser Mus., Iowa, 1969.

JUDSON, SYLVIA SHAW—Sculptor, C.
1230 Green Bay Rd., Lake Forest, Ill. 60045
B. Chicago, Ill., June 30, 1897. Studied: AIC; Grande Chaumiere, Paris, France, with Bourdelle. Member: NSS; Chicago A. Cl. Awards: prizes, AIC, 1929; Carr prize, 1947; Int. Sculpture Show, Phila., 1949; Mun. A. Lg., 1957; Hon. Degree, D.S., Lake Forest Col., 1952; Chicago Chptr. AIA, 1956; medal, Garden Cl. of Am., 1956. Work: PMA; Dayton AI; Springfield Mus. A.; Davenport, Iowa; Monument to Mary Dyer, in front of Mass. State House, Boston & duplicate on Benjamin Franklin Parkway, Phila.; 14 Stations of the Cross, Sacred Heart Church, Winnetka, Ill., 1962; Brookgreen Gardens, Georgia; Presbyterian St. Lukes Hosp., Chicago; Brookfield Zoo, Ill., Ravinia Park, Ill.; White House Rose Garden; Morton Arboretum, Lisle, Ill.; AIC. Exhibited: PMA; WMAA; MMoDA; MMA; Century of Progress, Chicago; WFNY 1939; GGE, 1939; one-man: AIC, and other midwestern mus.; Arden Gal., N.Y.; Illinois State Mus., 1948; Chicago Pub. Lib., 1955; Sculpture Center, N.Y., 1957. Author: "The Quiet Eye," 1954; "For Gardens and Other Places," 1968. Lectures, "Sculpture in Gardens." Instr. and Lecturer, American Univ., Cairo, Egypt.

JULES, MERVIN—Painter, Gr., I., L., E.
50 Dryads Green, Northampton, Mass. 01060; s. 613 Commercial St., Provincetown, Mass. 02657
B. Baltimore, Md., Mar. 21, 1912. Studied: Baltimore City Col.; Maryland Inst.; ASL, with Benton. Member: An Am. Group; A. Lg. Am; Boston Pr. M.; AEA; SAGA; AAUP; Provincetown A.; Springfield A.Lg.; Audubon A. Awards: med. and prizes, BMA, 1939-1941; prizes, MModA, 1941; LC, 1945; BM, 1946; Springfield A. Lg., 1955; Cape Cod AA, 1957; Carlisle award (purchase) Eastern States A. Exh., 1957. Work: MModA; MMA; BMA; BM; AIC; Smith Col.; Mt. Holyoke Col.; Tel-Aviv Mus., Israel; PMA; BMFA; LC; Portland (Ore.) A. Mus.; PC; Walker A. Center; Illinois State Mus.; Encyclopaedia Britannica; Brandeis Univ.; N.Y. Pub. Lib.; Princeton Univ.; Dartmouth Col.; Louisiana A. Comm.; Univ. Minnesota; Univ. North Carolina Woman's Col.; Abilene Christian Col.; Albion Col.; FMA; Carnegie Inst.; Springfield Mus. A. Exhibited: Nationally; 47 oneman exhibitions to 1968. Lectures: Understanding Modern Art. Positions: Instr., MModA, 1943-46; Visiting A., 1945-46, Assoc. Prof. A., 1946-1962, Prof. A., 1962- , Chm. A. Dept., 1962-1965, Smith Col., Northampton, Mass.; L., Univ. Wisconsin (summer), 1951; Staff, George Walter Vincent Smith Mus., 1952-53; L., Univ. Ext., Mass. Dept. Edu., 1955-56; Trustee, Cummington Sch. Music & Art; Bd. Memb., Instr., for the Study of Art in Education; Trustee, Provincetown AA; Chm., A. Dept., City Col., N.Y., 1969- .

JULIO, PAT T.—Educator, C., Gr.
Art Department, Western State College, h. Gunnison, Colo. 81230
B. Youngstown, Ohio, Mar. 1, 1923. Studied: Wittenberg Col., B.F.A., with Ralston Thompson; Univ. New Mexico, M.A., with Raymond Jonson, Lez Haas; Univ. Colorado, with Robert Lister; Ohio State Univ., with Edgar Littlefield; Texas Western Col., with Wiltz Harrison. Member: AAUP; CAA; Western AA; Colo.-Wyo. Acad. Science; Am. Ceramic Soc.; Am. Craftsmen's Council; Inst. of Indian Studies; Colorado AA. Work: in private colls.; stained glass windows, Episcopal Good Samaritan Church. Exhibited: Colorado Springs FA Center, 1951; Bradley Univ., 1951; DMFA, 1950; Community A. Gal., 1958; Colorado A. Faculty Show, 1958, 1963; Spring-

field AA, 1948; Columbus AA, 1955; Mus. New Mexico, 1949-1951; Denver A. Mus., 1950, 1963; Yuma FA Assn., 1964; small sculpture exh., Bellingham, Wash., 1965; Paul Shuster A. Gal., 1950-1952; Plaza A. Gal., 1949-1952; Pueblo Col., 1960, 1969; Canon City A. Exh., 1959, 1960; Pueblo A. Mus., 1960 (one-man), 1964 (3-man); Witte Mem. Mus., 1961; Roswell (N.M.) A. Mus., 1961; Western State Col. A. Gal., 1969 (one-man). Editor, Colorado Art Edu. Assn. Bulletin. Lectures: Indian Art; American Art; The Kachina Doll. Positions: Assoc. Prof. A. Western State College, Gunnison, Colo., 1956- .

JUNGWIRTH, IRENE GAYAS (Mrs. Leonard D.)—Painter, E., L., C.
Route 1, Box 603A, East Lansing, Mich. 48823
B. Pennsylvania, Dec. 23, 1913. Studied: Marygrove Col., Detroit, A.B.; Wayne Univ. Awards: prizes in national and local exhs.; Intl. Religious Art Exhs. Work: Detroit Inst. A. Exhibited: national, regional and local exhs.; one-man in Illinois and Michigan. Ecclesiastical commissions for stained glass windows, paintings and gold ornaments for churches; portraits. Lectures and writings on art and aesthetics.

JUNKIN, MARION MONTAGUE (Mr.)—Painter, E.
Stonewall St., Lexington, Va. 24450
B. Chunju, Korea, Aug. 23, 1905. Studied: Washington & Lee Univ., B.A.; ASL, and with Randolph Johnston, George Luks, George Bridgman, Edward McCarten. Awards: prizes, VMFA, 1946; Butler AI, 1946. Work: VMFA; IBM; murals, Hdq. Virginia State Police Dept., Richmond; McCormick Lib., Lexington, Va.; Stonewall Jackson Hospital, Lexington, Va.; Fed. Savings & Loan Assn., Memphis, Tenn.; frescoes, Richmond, Va.; Episcopal Chapel, Lexington, Va. Exhibited: AIC; PAFA; CGA; VMFA; Carnegie Inst.; WMAA; WFNY 1939; IBM, and others. Positions: Hd. Dept. FA, Vanderbilt Univ., Nashville, Tenn., 1941-46; Assoc. Dir., Richmond Sch. A., Richmond, Va.; Prof., Hd. Dept. FA, Washington & Lee Univ., Lexington, Va., at present.*

JUSTUS, ROY BRAXTON—Cartoonist
425 Portland Ave., South.; h. 19 S. First St., Minneapolis, Minn. 55401
B. Avon, S.D., May 16, 1901. Studied: Morningside Col., Sioux City, Iowa. Member: Nat. Cartoonists Soc.; Assn. Am. Editorial Cartoonists; Nat. Press Cl., Wash., D.C. Awards: Nat. Headliner's Award, 1944; Freedoms Fnd., annually, 1949-56; Christopher award, 1955; Hon. Degree, Litt.D., Morningside College, 1965; Sigma Delta Chi Award, 1965. Work: Permanent Coll., Syracuse University. Positions: Ed. Cart., Sioux City (Iowa) Journal & Tribune, 1927-43; Ed. Cart., Minneapolis Star, Minneapolis, Minn., 1944- ; Pres. Assn. Am. Ed. Cart., 1958.

KABAK, ROBERT—Painter, T.
Art Department, Northern Illinois University; h. 639 Lincoln Highway, De Kalb, Ill., 60115
B. Bronx, N.Y., Feb. 15, 1930. Studied: Brooklyn Col., B.A ; Yale Sch. FA, M.F.A. Awards: Huntington Hartford Fellowships, 1960, 1961, 1963; Res.-in-Painting, MacDowell Colony, 1956, 1957, 1959, 1961, 1966, 1967-1968; Appt. to Inst. for Creative Art of Univ. Cal., 1965-66; Yaddo, 1961; Wurlitzer Fnd. Fellowship, 1969. Work: MModA. Exhibited: WMAA, 1956, 1958; World House Gal., N.Y., 1957 (3-man); Univ. Illinois, 1959; MModA, 1956; Cal. PLH, 1964; SFMA, 1965; Carnegie Int., 1967; one-man: Salpeter Gal., 1958; Nonagon Gal., 1960; Angeleski Gal., 1960, 1961, all New York City; Gump's Gal., San F., 1963; SFMA, 1964; Santa Barbara Mus. A., 1965; Univ. California, Berkeley, 1965; Osgood Gal., N.Y., 1962; Univ. California, San Francisco, 1966, and San Diego, 1966; Oakland Mus., 1966; Betty Parsons Gal., N.Y., 1967; Rogue Gal., Medford, Ore., 1968; Lower Columbia Col., Longview, Wash., 1968; Wash. State Col., Bellingham, 1968; Cheney Cowles Mem. Mus., Spokane, Wash., 1969; Oregon State Univ., Corvallis, 1969. Positions: Instr., H.S. of Music & Art, N.Y., 1956-1960; Brooklyn College, 1960-1962; Asst. Prof. Des., Univ. of California, Berkeley, Cal., 1962-1968; Assoc. Prof. A., Northern Illinois Univ., De Kalb, 1968- .

KACERE, JOHN—Painter
100 W. 14th St., New York, N.Y. 10011
B. Walker, Iowa, 1920. Studied: State Univ. Iowa, B.F.A., M.F.A. Work: Wadsworth Atheneum, Hartford; Mt. Holyoke Col., Mass.; Yale Univ.; Brandeis Univ. Exhibited: Yale Univ., 1960-62; MModA, 1961, 1963; CGA, 1962-63; Univ. Colo., 1964; Byron Gal., N.Y., 1964; Geigy Chemical Corporation, Ardsley, N.Y.; one-man: Zabriskie Gal., N.Y., 1954, 1956; Allan Stone Gal., N.Y., 1962. Positions: Taught at Univ. Manitoba, Winnipeg, 1949-53; Univ. Fla.; Teaches at CUASch, Parsons Sch. Des.*

KACHADOORIAN, ZUBEL—Painter
via Nicola Fabrizi 8, Rome, Italy
B. Detroit, Mich., 1924. Studied: Meinzinger A. Schl., Detroit;

Saugatuck (Mich.) A. Schl.; Skowhegan Schl. A., Maine and Colorado Springs FA Center, all on scholarships. Member: Michigan Acad. A. & Lets. Awards: Prix-de-Rome Fellowship (3 yrs.) to Am. Acad. in Rome, 1956; Michigan Acad. A. & Lets. purchase award, 1956; Kirk-in-the-Hills, 1954, 1955; Scarab Cl. Gold Medal, 1947; Michigan WC Soc., 1946; Pepsi-Cola Midwest Fellowship, 1946-47; Rosenthal Award, Nat. Inst. A. & Lets., and other awards in prior dates. Work: AIC; Detroit Inst. A.; Muskegon A. Mus.; Tate Gal., London; WMA; Norton Gal., Palm Beach; Nelson Gal. A., Kansas City. Exhibited: Univ. Illinois, 1959-1961; Milwaukee A. Center, 1945; American Annual, Chicago, 1961; Pepsi-Cola Fellowship Exh., 1947; VMFA, 1947, 1949; PAFA, 1948, 1949; Cal.PLH, 1946, 1947; Pasadena Mus. A., 1945; 15 one-man exhs., 1943-1962, including Nordness Gal., N.Y., 1960, 1962. Other group exhibitions in France, England, Italy, 1957-1959.*

KACHERGIS, GEORGE—Painter, E.
25 Ridgecrest Drive, Chapel Hill, N.C. 27514
B. Waterbury, Conn., Apr. 11, 1917. Studied: AIC, B.F.A., M.F.A. Member: Southeastern College Art Teachers Assn. Awards: Tiffany Fellowship, 1951; prizes, Southeastern States Exh., Atlanta, 1950, 1953; Butler Inst. Am. Art, 1951; Central Illinois Annual, Decatur, 1949. Work: High Mus. A., Atlanta; Ackland A. Center and Schl. of Public Health, Univ. North Carolina. Mural, Lenoir Hall, Univ. North Carolina. Exhibited: AIC, 1940; 1941, 1946, 1947, 1948, PAFA, 1941, 1950, 1952, 1953; Butler Inst. Am. A., 1950, 1951; MMA, 1950, 1952; Intl. Exh. Watercolors, AIC, 1942; WMAA, 1952. Positions: Instr., Bradley Univ., 1947-1949; Assoc. Prof., University of North Carolina, Chapel Hill, N.C., 1949-1968; Prof., 1968- .

KAEP, LOUIS J.—Painter
225 Fourth Ave., New York, N.Y. 10003; h. 14 Anderson Rd., Greenwich, Conn. 06830
B. Dubuque, Iowa, Mar. 19, 1903. Studied: Loras Col., Dubuque; AIC; Julian Acad., Paris, France. Member: ANA; Baltimore WC Cl.; All. A. Am.; AWS (Dir. 1967-); Knickerbocker A., SI; Hudson Valley AA; Conn. WC Soc.; Iowa AA; Greenwich Soc. A.; AAPL; A. & Writers Assn.; Springfield A. Lg.; SC; Soc. Royal A., London; Fairfield WC Group. Awards: gold medal, Hudson Valley AA, 1955, 1966; Katharine M. Howe Mem. Award; Knickerbocker A., 1961, 1968; Jane Peterson Award, 1961; prizes, All. A. Am., 1955, 1968; Greenwich Soc. A., 1950-1957; AAPL, 1956; SC, 1958, 1969; AIA, 1958; A. Lg. of Long Island, 1958; Olsen award, 1962; Cropsey award, 1963; Winsor Newton award, 1964; U.S. Navy Meritorious Award, Public Service Citation, 1963. Work: Loras Col.; Dubuque Pub. Lib.; Dubuque Sr. H.S.; City of Chicago Coll.; Janesville (Wis.) A. Lg.; Chicago Galleries Assn.; Amherst Col.; Soc. of N.Y. Hospital; Series of paintings for U.S. Navy, Office of Information, Mediterranean Area, 1960, Pacific Area, 1961. Exhibited: AIC, 1927, 1928, 1930, 1932, 1940, 1943; PAFA, 1928-1934; New Westminster, Canada, 1928; Illinois Soc. FA, 1927-1931, 1934, 1936, 1937, 1939-1941; AWS, 1946-1958, 1963, 1966-1968; Wash. WC Cl., 1948, 1950; Conn. WC Soc., 1950-1954; Audubon A., 1946, 1951, 1954; NAC, 1950-1952, 1954, 1955, 1957, 1958; SC, 1950-1958; Greenwich Soc. A., 1950-1955; All. A. Am., 1955, 1957, 1958, 1964, 1967, 1969; Butler AI, 1955; Hudson Valley AA, 1955-1958, 1967; MMA, 1952, 1966; NAD, 1956-1958, 1963, 1966; AAPL, 1956-1958; Knickerbocker A., 1957, 1958; Mississippi AA, 1958; A. Lg. of Long Island, 1958; Balt. WC Cl., 1958; Smithsonian Inst., 1964; Musée de la Marine, Paris, 1963; Witte Mem., San Antonio, 1962; Royal WC Soc., London, 1962; Salem, N.Y., 1968; AWS exh. in Mexico City, 1968. Positions: Instr., AIC, 1923-25; Chicago Acad. FA, 1932-41; V-Pres., Chicago Gld. Freelance A., 1942-43; Bd. Dir., Chicago P. & S., 1943-45; Treas., AWS, N.Y., 1953- ; Treas., Greenwich Soc. A., 1953-54; Vice-Pres., Vogue-Wright Studio, New York, N.Y.; Pres., Electrographic Corp., New York, N.Y.

KAHANE, MELANIE (GRAUER)—Interior and Industrial Designer
32 E. 57th St. 10022; h. 29 E. 63rd St., New York, N.Y. 10021
B. New York, N.Y., Nov. 26, 1910. Studied: Parsons school of Design, New York and Paris, France. Awards: Decorator of the Year Award, 1953; Citation from U.S. Commissioner to the Brussels World Fair for work in U.S. Pavillion, 1958; Career Key Award from the Girls' Clubs of America, 1961; Elected Fellow, American Institute of Interior Designers; one of "100 American Women of Accomplishment", Harper's Bazaar, 1967, Work: invited by Governments of Denmark and Sweden to tour both countries and produce film on contemporary Scandinavian design. in 1958, appointed by U.S. Dept. of State as member of Committee of Selection of Industrial Design & Handicrafts for the U.S. Pavillion at Brussels World Fair. Received Citation from U.S. Commissioner General for work on this project. In 1959 was guest of the Government of Portugal. In 1960 sent to Russia by NBC to appraise the USSR housing developments and record the "woman's point of view". In 1961 appointed Member of Advisory Board, RCA Advance Design & Styling Center. In 1961 member of Official

Mission, U.S. World's Fair-to Southeast Asia (Indonesia, Singapore, Malaya, Saigon, Thailand and Cambodia). Author: "There's a Decorator in Your Doll House," 1968. Positions: Advertising and Fashion Illustrating, Fashion Designing, Theatrical Set Designing, 1931-1935; President, Melanie Kahane Associates, Interior and Industrial Design, New York, N.Y., 1935- . Lecturer, Parsons School of Design, New York City; Director of Design, Sprague & Carleton, Inc.

KAHN, BARRY—Painter, S., T.
110 First Ave. S., Seattle, Wash. 98104
B. New York, N.Y., Feb. 26, 1938. Studied: Slade Sch. FA, Univ. Col., London, England; Tulane Univ., M.F.A.; ASL; Rensselaer Polytechnic Inst., Troy, N.Y., B.Arch. Awards: purchase prize, Doane Col., Crete, Neb., 1968; Fulbright grant, London, 1962-1963; prize, Delgado Mus. A., New Orleans, 1961. Work: Sheldon Mem. Mus., Univ. Nebraska; Doane Col. Exhibited: Portland (Ore.) Mus. A., 1968; SAM, 1968; SFMA, 1968; Los A. County Mus., 1968; Sheldon Mem. Mus., 1968; Linfield Col., McMinnville, Ore., 1968; Henry Gal. Univ. Washington, 1967; Univ. Nebraska, 1966. Positions: Visiting A., Univ. Washington, Univ. Nebraska, Mt. Angel Col. (Ore.), Doane Col., Crete, Nebraska. Des. Consultant, Creative Education Systems, Edmonds, Wash., at present.

KAHN, MRS. LAWRENCE R. See Beling, Helen

KAHN, (H.) PETER—Educator, P., Gr., Des.
Art Department, Cornell University, Ithaca, N.Y. 14850; h. R.D. No. 2, Freeville, N.Y. 13068
B. Leipzig, Germany, July 5, 1921. Studied: ASL; Hans Hofmann Sch. FA; New York Univ., B.S., M.A. Awards: prizes, Munson-Williams-Proctor Inst., Utica, 1959, 1960; Governor's Award, VMFA, 1954, 1956; Roberson Mem. Mus., Binghamton, N.Y.; Artists of Central N.Y., 1958, 1959, 1961; Norfolk Mus. A. & Sciences, 1954, and others. Work: Louisiana Art Commission; VMFA; Munson-Williams-Proctor Inst.; White Mus. A., Cornell Univ.; American Export Lines, etc. Exhibited: Seligmann Gal., N.Y., 1954; VMFA; MModA traveling exh.; March Gal., N.Y.; PAFA; one-man: State Capitol, Baton Rouge, La.; Univ. Virginia; Norfolk Mus. A. & Sciences; Roberson Mem. Mus.; Greer Gal., N.Y., 1961, 1962; Illinois Inst. Technology; Morehouse College; Louisiana State Univ., and others. Positions: Typographer and book designer; Consultant for Louisiana State Univ.; State of Louisiana; Typographic Des., for Children's books; Instr., Graphics and graphic design, Louisiana State Univ., 1951-1953; Chm., A. Dept., Hampton Institute, 1953-1957; Ford Professor Virgin Islands Program, summer, 1956; Prof. FA, Cornell University, Ithaca, N.Y., 1957-1968.

KAHN, SUSAN (Mrs. Joseph)—Painter
870 United Nations Plaza, New York, N.Y. 10017
B. New York, N.Y., Aug. 26, 1924. Studied: Parsons Sch. Des., and privately. Member: NAWA; Knickerbocker A., AEA. Awards: Knickerbocker A., 1956, 1961, Medal of Honor, 1964; NAWA, prizes, 1958, 1961; NAC, 1967; Famous Artists Sch., 1967 (one-man). Work: Johns Hopkins Univ.; Syracuse Univ. A. Gal.; Sheldon Swope Mus., Terre Haute, Ind.; Montclair Mus. A.; Butler Inst. Am. A., Reading (Pa.) Mus. A. Exhibited: Knickerbocker A.; NAWA; one-man: Sagittarius Gal., N.Y., 1960; A.C.A. Gal., N.Y., 1964, 1968. Included in "Prize Winning Paintings" Book V; "Top Award Winning Graphics, Sculpture, Watercolor and Sculpture"; "How to Paint a Prize Winner."

KAHN, WOLF—Painter, T.
813 Broadway, New York, N.Y. 10003
B. Stuttgart, Germany, Oct. 4, 1927. Studied: Hans Hofmann. Sch. FA; Univ. Chicago, B.A. Awards: Fulbright Fellowship to Italy, 1964-1965; Guggenheim Fellowship, 1966. Work: MMA; CAM; FA Center of Houston: VMFA; Brandeis Univ.; Univ. Illinois; Univ. Nebraska. Exhibited: WMAA, 1957, 1960; CGA, 1958; Univ. Illinois, 1956; Stable Gal., N.Y., annually; 5 one-man exhs., N.Y., and others in Ft. Worth, Tex., Schenectady, N.Y.; San Antonio, Tex.; DMFA. Positions: Visiting Prof. Painting, Univ. Cal., Berkeley, 1960; Cooper Union, N.Y., 1961 (drawing), Painting, 1966- . Lectures: A. Ryder, in Brescia and Rome, Italy; "Landscape," Brooklyn Mus. A. Sch., 1969. Article, "Some Uses of Painting Today," Daedalus, 1969.

KAIDEN, NINA—Public Relations, Art Consultant
Ruder & Finn Fine Arts, 110 E. 59th St. 10022; h. 15 W. 81st St., New York, N.Y. 10024
B. New York, N.Y., May 18, 1931. Studied: Emerson College, Boston, B.A. Positions: Member, Nat. Advisory Council, the Museum of Graphic Art, N.Y.; Art Advisory Council, N.Y. Board of Trade; Editor, "Mother and Child in Modern Art,"; "Artist and Advocate." Consultant to Corporations, including Philip Morris' "Pop and Op," "When Attitudes Become Form;" Mead Corporation's "European

Painters Today;'' American Motors; Gulf and Western; Bristol-Myers; Coca-Cola; J.C. Penney; Capital Research, and others. President, Ruder & Finn Fine Arts, New York, N.Y.

KAINEN, JACOB—Museum Curator, Et., Lith., P., W.
4501 Connecticut Ave., N.W., Washington, D.C. 20008
B. Waterbury, Conn., Dec. 7, 1909. Studied: ASL; PIASch.; N.Y. Univ.; George Washington Univ.; N.Y. Sch. Indst. A., and with Kimon Nicolaides, Frank Leonard Allen. Member: Soc. Wash. Pr. M.; Print Council of Am. (Bd. Dirs.). Awards: prizes, CGA, 1950, 1951, 1953, 1955; Wash. WC Assn., 1961; Grant, Am. Phil. Soc., study in Europe, 1956. Work: MMA; BM; Brooklyn Pub. Lib.; Queens Col.; PMG, BMA; Carnegie Inst.; LC; CGA; Howard Univ.; East Texas State T. Col.; H. Biggs Mem. Hospital; Municipal Court, Wash., D.C.; Bezalel Mus., Jerusalem; NCFA. Exhibited: AIC; Albright A. Gal.; Phila. Pr. Cl.; PMG; Oakland A. Gal.; Springfield Mus. A.; LC; BMA; Nat. Mus., Wash., D.C.; VMFA; Grand Central Moderns; Italian-American Exchange Print Show; CGA; Graham Gal., N.Y.; Roko Gal.; USIA traveling exh., Latin America, 1961-62. Author: "George Clymer and the Columbian Press." 1950; "The Development of the Halftone Screen," 1951; "Why Bewick Succeeded," 1959; "John Baptist Jackson: 18th Century Color Print Master," 1961; "The Etchings of Canaletto," 1967. Article: "Gene Davis and the Art of Color Interval," Art International, 1966. Positions: Cur., Dept. Prints and Drawings, National Collection of Fine Arts, Washington, D.C.

KAISH, LUISE—Sculptor
610 West End Ave., New York, N.Y. 10024
B. Atlanta, Ga., Sept. 8, 1925. Studied: Syracuse Univ., Col. FA, B.F.A., M.F.A.; in Mexico and Italy; and with Ivan Mestrovic. Awards: prizes, Syracuse Mus. A., 1947; Rochester Mem. A. Gal., 1951; NAWA, 1954; Emily Lowe award, 1956; grant, Louis Comfort Tiffany Fnd., 1951; Guggenheim F., 1959; Ball State T. Col., 1963; Audubon A., 1961, 1963. Work: Rochester Mem. A. Gal.; Syracuse Univ. AMOCO offices, N.Y.; bronze Ark, Temple B'rith Kodesh, Rochester; WMAA; Jewish Mus., N.Y.; St. Paul (Minn.) A. Center; High Mus. A., Atlanta; Lowe Mus., Coral Gables, Fla.; "Christ in Glory" bronze, Holy Trinity Mission Seminary, Silver Springs, Md., 1966; bronze, Temple Israel, Westport, Conn., 1965; bronze doors, menorahs, Temple Beth Shalom, Wilmington, Del., 1968; commissioned for other work by Container Corp. of America, 1964. Exhibited: MMA, 1951; PAFA, 1952; NAD, 1952; Birmingham Mus. A., 1954; WMAA, 1955, 1962, 1964, 1966; Staten Island Mus. A. & Sc., 1956; Int. Biennial of Religious A., 1958-59; Rochester Mem. A. Gal., 1958; Univ. Iowa, 1958; Univ. Illinois, 1961, 1963, 1969; Mt. Holyoke Col., 1962; Univ. Ohio, 1963, 1966; Albright-Knox A. Gal., 1964; Ball State T. Col., 1963; Phila. A. All., 1964; Mint Mus. A., 1964; Newark Mus., 1965; New Sch., 1965, 1967; one-man: Sculpture Center, 1955, 1958; Rochester Mem. A. Gal., 1955; Manhattanville Col., 1955; Staempfli Gal., N.Y., 1968; St. Paul A. Center, 1969.

KALBFLEISCH, ROBERT S., JR.—Scholar, Collector, P.
3101 W. Lancaster St. 76107; h. 3847 Camp Bowie, Ft. Worth, Tex. 76107
B. Buffalo, N.Y., Feb. 16, 1939. Studied: Albright Art School of the University of Buffalo, B.F.A. Awards: Moeller Fnd. Scholarship; Sons of the American Revolution Medal, 1953; Vietnamese-American Assn. Photography Exhibition award, 1964 (Saigon); joint Commendation Medal, Vietnam service, 1963-64; 1st place all divisions of Photography and same for Painting, Ft. Bliss Summer Show, 1963. Collection: Prints and Drawings. Positions: Scenic Artist in Residence, Casa Manana Musicals, Inc., Ft. Worth; Tech. Theatre Instr., Casa Manana, 1967-1969; Set Des., Casa Playhouse Children's Theatre.

KALINOWSKI, EUGENE M.—Painter, T., S.
5409 Walnut St. 15232; h. 5356 Rosetta St., Pittsburgh, Pa. 15224
B. Pittsburgh, Pa., Jan. 19, 1929. Studied: Carnegie Inst. Tech., M.F.A. Member: Assoc. A. Pittsburgh; Pittsburgh WC Soc.; Pittsburgh Soc. Sculptors. Awards: prizes, Assoc. A., Pittsburgh, 1958, 1960; Assoc. A. & A. and B. Smith Co. award, 1961; Playhouse Annual, 1960. Work: private colls. Exhibited: Assoc. A., Pittsburgh, 1951-1965; Pittsburgh Three Rivers A. Festival, 1960, 1961; Penn Nat. A. Annual, 1959-1964. Positions: Inst., Pittsburgh Pub. Sch. System; Painting & Drawing, Carnegie Inst. of Technology, Pittsburgh, Pa.*

KALLEM, HERBERT—Sculptor, T.
45 W. 28th St. 10001; h. 365 W. 28th St., New York, N.Y. 10001
B. Philadelphia, Pa., Nov. 14, 1909. Studied: NAD; Pratt Inst., Brooklyn, N.Y.; Hans Hofmann Sch. FA. Member: Sculptors Gld.; Am. Abstract A. Work: WMAA; Wadsworth Atheneum, Hartford; N.Y. Univ. Loeb Colls.; Newark Mus. A.; Chrysler Mus., Provincetown, Mass.; and in private colls. Exhibited: WMAA; Carnegie Inst.; Univ. Illinois, and others. Positions: Instr., Sculpture, School of Visual Arts, N.Y., and N.Y. University.

KALLER, ROBERT JAMESON—Art Dealer, W., Critic
559 Sutter St., San Francisco, Cal. 94102; (Mail) P.O. Box 413, Pebble Beach, Cal. 93953
Studied: Columbia Univ.; Harvard Univ.; New York Univ. Specialty of Galleries: 19th and 20th Century American Art; German Expressionists. Positions: President, Director, Galerie de Tours, San Francisco and Carmel, Cal.; Pres., Arts and Humanities Society, Monterey Peninsula, 1961-62.

KALLIR, OTTO—Collector, Scholar, Art Dealer, Publisher
Galerie St. Etienne, 24 W. 57th St. 10019; h. 285 Riverside Dr., New York, N.Y. 10025
B. Vienna, Austria, Apr. 1, 1894. Studied: University of Vienna, Ph.D. Awards: "Grosses Ehrenzeichen" (Great Decoration), awarded by the President of the Austrian Republic for Merit in the field of art, 1960; "Silbernes Ehrenzeichen" (Silver Decoration) awarded by City of Vienna for fostering relations in art between Austria and the United States, 1968. Author: "Egon Schiele. Persoenlichkeit und Werk," 1930; new, rev. and enl. ed., 1966; "Grandma Moses: American Primitive," 1946; Editor, "My Life's History," by Grandma Moses, 1952. Published: Books on and by contemporary artists, many with original graphic works: "Das graphische Werk von Egon Schiele," 1922; Books and-or portfolios of works by Klimt, Kokoschka, Beckmann, Kubin, and others; Books by contemporary writers and poets, including Thomas Mann, Richard Beer-Hofmann, Rainer Maria Rilke, Hugo von Hofmannsthal; Extensive exhibition catalogues. Field of Research: Peter Vischer and medieval sculpture; Egon Schiele; History of aviation. Specialty of Gallery: Austrian and German Expressionists; American primitive art; Gave first exhibition in the U.S. to: Oskar Kokoschka, Grandma Moses, Egon Schiele, Alfred Kubin, Paula Modersohn-Becker, Gustav Klimt; Organized many traveling exhibitions for museums and colleges in the U.S. and abroad (several circulated by the Smithsonian Institution). Collection: Austrian 19th and 20th century art; American primitive art; History of aviation. Positions: Director, art department, Rikola Verlag, Vienna, 1920-1922. Founder, owner, Neue Galerie, Vienna; Founder, owner, Johannes Presse, Vienna, Johannes Press, New York; Founder, owner, Galerie St. Etienne, Paris, 1938-1939; Founder, owner, Galerie St. Etienne, New York; President, Grandma Moses Properties, Inc.

KALLOP, EDWARD—Museum Curator
Cooper Union Museum 10003; h. 432 Lafayette St., New York, N.Y. 10003
B. Newark, N.J., Jan. 10, 1926. Studied: Bowdoin College, B.A.; Princeton University, M.F.A. Positions: Organized numerous exhibitions for Cooper Union Museum; Author of catalogues and of articles for various art journals; Associate Curator, Cooper Union museum, New York, N.Y., 1957- .*

KALLWEIT, HELMUT G.—Painter, S., Des., Gr., W., L., Cr.
296 Delancey St., New York, N.Y. 10002; s. Shinnecock Hills, L.I., N.Y.
B. Germany, Sept 18, 1906. Exhibited: Riverside Mus.; Argent Gal.; Burliuk Gal.; RoKo Gal.; Contemporary A. Gal.; ACA Gal.; Wellons Gal.; Bodley Gal.; Crespi Gal.; James Gal.; Art:USA, 1958; Parrish Mus. A.; Guild Hall, Easthampton, L.I.; Arkep Gal.; Shinnecock Gal.; Long Island, N.Y.; New York Times Gal.; Hilda Carmel Gal.; Southampton College, N.Y.*

KAMIHIRA, BEN—Painter
Cheyney Road, Cheyney, Pa. 19319
B. Yakima, Wash., Mar. 16, 1925. Studied: Art Inst., Pittsburgh; PAFA. Member: F., PAFA; ANA. Awards: prizes, Hallgarten award, NAD, 1952, Altman prize, 1958, 1962; CGA, 1961; Silvermine Gld. A., 1961; Cresson F., PAFA, 1951; Sheidt Scholarship, PAFA, 1952; Tiffany Fnd. Fellowship, 1952, 1958; Guggenheim Fellowship, 1955-56; also Lippincott award, PAFA, 1958; Summer Fnd. purchase prize, WMAA, 1960; AIC, 1964; Hassam Fund purchase, Natl. Inst. A. & Lets., 1965, and Grant, 1969. Work: WMAA; PAFA; Ringling Mus., Sarasota, Fla. Exhibited: NAD, 1952, 1954, 1956, 1958-1961; PAFA, 1954, 1958, 1960; CGA, 1961, 1965; Butler Inst. Am. A., 1953, 1958-1961; WMAA, 1958; F. PAFA, 1952-1961; PAFA, 1956, (one-man); Carnegie Inst., 1964; AIC, 1964; MModA, 1962. Positions: Instr., Drawing & Painting, PAFA; Pa. State University.

KAMMERER, HERBERT LEWIS—Sculptor
Route 1, 64 Plains Rd., New Paltz, N.Y. 12561
B. New York, N.Y., July 11, 1915. Studied: Yale Univ., B.F.A.; Am. Acad. in Rome; NAD; ASL. Member: F., NSS (Pres. 1965); Am. Acad. in Rome; Century Assn. (Pres. 1965-1968). Awards: Widener gold medal, 1948; Fulbright award, 1949-51; Nat. Inst. A. & Lets., grant, 1952; NAD, 1953. Work: medals for Nat. Assn. for Prevention of Blindness; Elkins Nat. Bank; Beloit Machinery Co., and others; memorial, Gate of Heaven Cemetery, Chicago, Ill.; Skinner Mem., Oswego, N.Y.; Pardee Mem. (fountain), St. Paul's Sch., Concord, N.Y.; sc. map, Barnhart Power Dam, St. Lawrence Seaway.

Concord, N.H. Commemorative Medal, St. Lawrence Seaway. Many portraits of prominent persons, and work in private colls. Exhibited: Nationally and internationally since 1941. Positions: Prof. Sculpture, State Univ. of N.Y. at New Paltz, N.Y.

KAMROWSKI, GEROME—Painter, E.
Department of Art, University of Michigan; h. 1501 Beechwood Drive, Ann Arbor, Mich. 48103
B. Warren, Minn., Jan. 29, 1914. Studied: St. Paul Sch. A.; ASL. Awards: F., Solomon Guggenheim Fnd.; Research grant, Horace H. Rackham, 1957; prizes, Wayne Univ., 1948; Detroit Inst. A., 1949, 1954, 1955, 1961; Grand Rapids, 1958. Work: PC. Exhibited: WMAA; 1947, 1948, 1951, 1953; Univ. Illinois, 1950, 1952; AIC, 1945, 1946; Albright A. Gal., 1946; Hugo Gal., 1947; traveling exh., SFMA, CM, Denver A. Mus., SAM, Santa Barbara Mus. A.; Detroit Inst. A., 1948, 1950, 1952, 1954, 1958; GGE, 1939; Springfield, Ill.; Univ. Iowa, 1946; Ann Arbor AA, 1947-1954; Faculty Exh., Univ. Mich., 1946-1956; South Bend, 1955; Provincetown, 1958; Univ. Oklahoma, 1958; Artists Market, 1952, 1958; one-man: Hugo Gal., 1951; Betty Parsons Gal., 1948; Brandt Gal., 1946; Galerie Creuze, Paris, 1950, 1958; Saginaw Mus. A., 1954; Univ. Mich., 1952; Cranbrook Acad. A., 1947; Gal. Mayer, N.Y., 1961; Iolas Gal., N.Y.; Mus. A., Univ. Michigan, 1959, 1961; Scarab Cl., Detroit, 1967; Ohio Univ. Gal., Athens, 1967; Flint Inst. A., 1968, and others. Positions: Prof. Art, Dept. A., Univ. Michigan, Ann Arbor, Mich., 1946- .

KAMYS, WALTER—Painter, E.
Cave Hill Farm, Montague, Mass. 01351
B. Chicago, Ill., June 8, 1917. Studied: AIC, and with Gordon Onslow-Ford in Mexico. Member: New England Contemp. A. (Committee Memb.); Berkshire AA. Awards: Prix de Rome, 1942; F., AIC, 1942-43; Trebilcock award, AIC, 1943; Raymond traveling F., 1943-44; prizes, Springfield A. Lg., 1953 (2); Pittsfield, Mass., 1954; Boston A. Festival, 1955; Amherst, Mass., 1957, 1958; Westfield (Mass.) State Col., 1968 purchase. Work: Yale Univ.; Wesson Mem. Hospital, Springfield, Mass.; Smith Col.; Mount Holyoke Col.; Regional Contemp. A. Coll., Fargo, N.D.; N.Y. Univ.; Albion Col.; Univ. Mass. Fogg A. Mus., Harvard Univ. Exhibited: Salon des Realites Nouvelles, Paris, 1951; PAFA, 1952, 1953, 1954; Silvermine Gld. A., 1954, 1955, 1967; BM, 1955; Inst. Contemp. A., Wash., D.C., 1955, MModA, 1956; USIA, European Tour, 1956-57; AIC, 1957; Univ. Utah, 1957; Mt. Holyoke, 1957; Ball State T. Col., 1957; Crocker Gal. A., 1956; Adelphi Col., 1957; Canton AI, 1957; Bryn Mawr Col., 1957; No. Carolina State Col., 1957; Des Moines A. Center, 1958; Randolph-Macon Col., 1955; Nebraska AA, 1955; Carnegie Inst., 1955; Butler AI, 1955; A. of U.S., Latin America, 1955, 1956; Univ. Nebraska, 1959; Inst. Contemp. A., Boston, 1960; Univ. Colorado, 1960; Boston A. Festival, 1961; Ball State T. Col., 1961; de Cordova & Dana Mus., Lincoln, Mass., 1963; Univ. North Dakota, 1963; BM, 1963; Northeastern Univ., Boston, 1963-1965; Stanhope Gal. Boston, 1963; Art for U.S. Embassies, Inst. Contemp. A., Boston, 1966; Chelsea A. Festival, N.Y., 1966; R.I. Festival of Arts, 1968; Smithsonian Inst., 1968; Amherst Col., 1968; one-man: G.W.V. Smith Mus. A., 1948; Margaret Brown Gal., 1949; Mortimer Levitt Gal., 1953; Bertha Schaefer Gal., 1955, 1957, 1961; Inst. Contemp. A., Boston, 1954; Deerfield Acad., 1956; Concordia Col, Moorhead, Minn., 1957; New Vision Gal., London, England, 1960; Univision Gal., Newcastle, England, 1960; Univ. of Massachusetts, 1961; Ward-Nasse Gal., Boston, 1968. Positions: Prof., Painting & Drawing, and Dir., Art Acquisition Program, 1962- , Univ. Massachusetts, Amherst, Mass.

KANE, MARGARET BRASSLER—Sculptor
30 Strickland Rd., Cos Cob, Conn. 06807
B. East Orange, N.J., May 25, 1909. Studied: Syracuse Univ.; ASL; and with John Hovannes. Member: Sculptors Gld.; NAWA; Pen & Brush Cl.; Greenwich A. Soc.; Silvermine Gld. A.; F.I.A.L. Awards: prizes, NAWA, 1942, med., 1951; New Jersey State Exh., 1943; N.Y. Arch. Lg., 1944; BM, 1946, 1951; Greenwich Soc. A., 1952, 1954, 1958, 1960; Silvermine Gld. A., 1954-1956, 1963. Work: U.S. Maritime Commission; plaque, for "Burro" mon., Fairplay, Colo.; Limited Editions Lamp Co. Exhibited: Sculptors Gld., 1938-1958; NAWA, 1942-1958; Brooklyn Soc. A., 1946-1958; Pen & Brush Cl., 1950-1958; Greenwich Soc. A., 1952-1958; Silvermine Gld. A., 1954-1958; MMA, 1943; PMA, 1940, 1949; WMAA, 1938, 1939, 1940, 1945; PAFA, 1945, 1946, 1948; Audubon A., 1945; NSS, 1938, 1940, 1944; AIC, 1940; NAD, 1940; Am. Mus. Natural Hist., 1951-1954; Guggenheim Mus. Gardens, 1955; Grand Central A. Gal., 1956; Roosevelt A. Center, 1957; Argent Gal. nat. tour, 1958; Lever House, N.Y., 1959-1969; N.Y. Bank for Savings, 1968; Mattatuck (Conn.) Mus., 1967; Lamont Gal., Exeter, N.H., 1967- ; represented in "Contemporary Art with Stone," 1969; reproductions in nat. publications. Lectures: The Creative Approach to Sculpture, with color slides. Positions: Council & Jury Memb., Greenwich Soc. A., 1958; memb. jury of selection and award, Am. Machine & Foundry Co., 1957.

KANEGIS, SIDNEY—Art Dealer
123 Newbury St., Boston, Mass. 02116
B. Winthrop, Mass., Sept. 6, 1922. Studied: Boston Museum of Fine Arts School of Art. Specialty of the Gallery: Important Graphic Work by Modern Masters; one-man shows by contemporary artists. Positions: Dir., Kanegis Gallery, Boston, Mass., 1952- .

KANEMITSU, MATSUMI—Painter, Gr., S.
158 W. 22nd St., New York, N.Y. 10011
B. Ogden City, Utah, May 28, 1922. Studied: ASL, and with Karl Metzler and Leger. Member: AFA. Awards: Ford Fnd. Grant (lithography), 1961 and AFA-Ford Fnd. award, A.-in-Res., Akron AI; Longview Fnd., 1962, 1963. Work: Akron AI; BMA; Chrysler Mus. A.; Dillard Univ.; Grunewald Graphic Arts Fnd., U.C.L.A.; Galleria Moderna, Turin, Italy; Gutai Pinacotheca, Osaka, Japan, Los A. Mus. A.; Natl. Mus. of Wales, Cardiff; MModA; Natl. Mus. Mod. A., Tokyo; Santa Barbara Mus. A.; Univ. Arizona, Tucson; Nelson Gal. A., Kansas City. Exhibited: AIC, 1952; MModA, 1956; WMAA, 1956; CGA, 1950; Wadsworth Atheneum, Hartford, 1953; Western Maryland Col., 1954; BMA, 1954; Dusanne Gal., Seattle, 1955; New School, N.Y., 1955; Wagner Col., 1959; Albright-Knox A. Gal., Buffalo, 1959; Dwan Gal., Los A., 1960; Radich Gal., N.Y., 1960; Univ. Kentucky; Galerie d'Arte Moderne, Italy, 1962; Colorado Springs FA Center, 1962; New School for Social Research, N.Y., 1963; Heckscher Mus., 1963; Anderson-Mayer Gal., Paris, 1963; MModA, 1964; one-man: Berlin Acad., Germany, 1954; New Gal., N.Y., 1957; Dwan Gal., Los A., 1960-1962; Radich Gal., N.Y., 1961-1962; Akron AI, 1964 Retrospective.*

KANOVITZ, HOWARD—Painter
122 2nd Ave.; h. 237 E. 18th St., New York, N.Y. 10003
B. Fall River, Mass., Feb. 9, 1929. Studied: Providence Col., B.S.; R.I. Sch. Des. Work: Suermondt-Museum, Aachen, Germany; WMAA; 180 Beacon Corp., Boston, Mass. Exhibited: AIC, 1961; WMAA, 1965, 1967, 1969; Jewish Mus., N.Y., 1966 (one-man); State Univ. of N.Y. and N.Y. State Council on the Arts "Critics Choice," 1968-1969; Aldrich Mus. Contemp. A., 1968; Univ. Illinois, 1962; Wadsworth Atheneum, Hartford, Conn., 1964; Waddell Gal., N.Y., 1969. Positions: Instr., Painting, Brooklyn Col.; Pratt Institute, Brooklyn, N.Y.

KANTOR, MORRIS—Painter, T.
45 S. Mountain Rd., New City, N.Y. 10956
B. Minsk, Russia, Apr. 15, 1896. Studied: Indp. Sch. A., with Homer Boss. Member: Fed. Mod. P. & S. Awards: med., prize, AIC, 1931; prize, CGA, 1939; med., PAFA, 1940. Work: WMAA; Univ. Illinois; Carnegie Inst.; WMA; MMA; MModA; AIC; PAFA; Detroit Inst. A.; PMG; Denver A. Mus.; Univ. Nebraska; Univ. Arizona; Newark Mus.; Wilmington Soc. FA; Nat. Endowment for the Arts, 1968. Exhibited: Carnegie Inst., 1931, 1932, 1934, 1936, 1938, 1940-1945, 1950; PAFA, 1929-1946, 1947-1951; AIC, 1929-1945, 1948, 1951; CGA, 1945; Smithsonian Inst., 1966; The White House, 1966; NCFA, 1968; traveling exh. arranged by Univ. of New Mexico, 1967. Positions: Instr. FA, CUASch, ASL, New York, N.Y., at present. Visiting Prof.: Universities of Michigan, 1958, 1959; Michigan State, 1960; Colorado, 1962; Illinois, 1963; Minnesota, 1963-1964; New Mexico, 1964.

KANTOR, PAUL—Art Dealer
704 N. Palm Drive, Beverly Hills, Cal. 90210
Positions: Dir., Paul Kantor Gallery, Beverly Hills, Cal.

KAPLAN, ALICE MANHEIM (Mrs. Jacob M.)—Patron, Collector
53 E. 80th St., New York, N.Y. 10021
B. Hungary, Nov. 27, 1903. Studied: Columbia University-Teachers College, B.S.; Columbia School of General Studies; New York University Institute of Fine Arts; Columbia University, M.A. in Art History, 1966; Art Students League. Collection: Diversified with emphasis on Drawings; 19th and 20th century American Paintings, Sculpture; Oriental, Pre-Columbian and African. Awards: Hon. D.F.A., Cedar Crest College, Allentown, Pa., 1969. Positions: Trustee, 1959- , President, 1967- , American Federation of Arts; Trustee, Museum of the City of New York, 1966- ; Chairman, Board of Cooper-Hewitt Museum; Trustee, Carnegie Hall Corporation; Board Member, Henry Street Settlement. Member of Advisory Councils: Columbia University Department of Art History, New York University Institute of Fine Arts, Museum of American Folk Art. Member: Council of Fellows Morgan Library, Brandeis University Creative Arts Award Commission. Co-Chairman, 50th Anniversary Exhibition—"Armory Show-1963."

KAPLAN, JACQUES—Collector
730 Fifth Ave. 10019; h. 4 E. 70th St., New York, N.Y. 10021
B. Paris, France, Oct. 24, 1922. Studied: Sorbonne, Paris, Licence de Philosophie; St. Cyr. Collection: American contemporary art.

KAPLAN, JEROME—Printmaker, E.
The Philadelphia College of Art, 320 S. Broad St. 19102; h. 7029 Clearview St., Philadelphia, Pa. 19119
B. Philadelphia, Pa., July 12, 1920. Studied: Phila. Col. A. Member: SAGA; CAA; Print Council of America; Phila. Pr. Cl. Awards: Guggenheim Fellowship, Creative Printmaking, 1961; Tamarind Lithography Fellowship, 1962. Work: Bibliotheque Nationale, Paris; CM; LC; MModA; NGA; PMA; Rosenwald Coll.; New Jersey State Mus., Victoria & Albert Mus., London; Silkeborg Mus., Denmark, and others. Exhibited: PAFA, 1961, 1963, 1965, 1967, 1969; 2nd, 3rd, 4th International Exp. of Gravure, Ljubljana, Yugoslavia; American Prints Today, 1959, 1962; BM, Nat. Print Exh.; Florida State Univ., 1967, 1968; Tyler Sch. A., 1967; SAGA, 1968, 1969; Manchester Inst., 1968; Northwest Pr. M., 1969; Pr. Cl., 1967-1969; 3rd Int. Miniature Pr. Exh., 1968 and many others. Woodcuts for "The Ballad of the Spanish Civil Guard," 1964. Lecture: "Sculptors as Printmakers," Alfred Univ., 1968. Positions: Prof. and Dir., Printmaking Dept., Philadelphia College of Art, at present.

KAPLAN, JOSEPH—Painter
161 West 22nd St., New York, N.Y. 10011; also, 638 Commercial St., Provincetown, Mass. 02657
B. Minsk, Russia, Oct. 3, 1900. Studied: NAD; Edu. All. Member: AEA; Audubon A.; Nat. Soc. of Painters in Casein. Awards: prizes, Audubon A., 1950, 1952, 1954, 1956; gold medal, 1958; Cape Cod AA, 1952 (2), 1954-1956, 1958, 1960; Nat. Soc. Painters in Casein, medal of honor, 1955, 1959; Obrig prize, NAD, 1967. Work: Mus. Western A., Moscow; Newark Mus. A.; Living Arts Fnd.; Biro Bidjan Mus.; Tel-Aviv Mus.; Ain Harod Mus., Israel; Butler AI; Univ. Kentucky, and in many private colls. Exhibited: Carnegie Inst.; PAFA; NAD; CGA; Univ. Illinois; Hallmark Exh; AFA; Audubon A., Walker A. Center; Boston A. Festival, 1954-1957, 1959; one-man: Provincetown, Mass.; New York; Butler AI; Johnson-Humrickhouse Mem. Mus., Coshocton, Ohio; Massillon Mus. A.; Dayton AI; Univ. Nebraska; Cape Cod AA. and others.

KAPROW, ALLAN—Scholar, Artist
Department of Art, State University of New York at Stony Brook, Stony Brook, N.Y. 11790
Positions: Faculty, Department of Art. State University at Stony Brook, N.Y.*

KARABERI, MARIANTHE—Sculptor, P., L.
2990 Newcastle Ave., Silver Spring, Md. 20910
B. Boston, Mass. Studied: PAFA; Univ. Pennsylvania, B.F.A.; Barnes Fnd.; ASL, with John Hovannes; Corcoran Sch. A., with Heinz Warnecke. Awards: prizes, CGA, 1957; Pen & Brush Cl., 1960. Work: Many portrait busts of prominent persons including U.S. Sec. of Commerce, Luther H. Hodges; Prefect of Dodecanese, Rhodes, Andreas Ioannou; Dir. FA of Greece, George P. Kournoutos. Member: NAC; Pen & Brush Cl.; Phila. A. All. Exhibited: CGA, annually since 1955; NAD, 1958; Mint Mus. A., 1958 (one-man); Pen & Brush Cl., 1960; Panhellenion, Athens, 1960; French Inst., Athens, 1961 (one-man); and many group shows in New York, Philadelphia, Washington and Athens.*

KARAWINA, ERICA (Mrs. Sidney C. Hsiao)—
Craftsman, P., Des., L.
3529 Akaka Place, Honolulu, Hawaii 96814
B. Germany, Jan. 25, 1904. Studied: in Europe; and in Boston with Frederick W. Allen and Charles Connick. Member: Hawaii P. & S. Lg.; F., I.I.AL.; Honolulu Pr. M. Awards: John Poole Mem. award, 1952; Narcissus Festival A., Honolulu, 1961. Work: LC; MMA; BMFA; WMA; Colorado Springs FA Center; Los A. Mus. A.; AGAA; MModA; Honolulu Acad. A.; Stained glass windows (in collab. with the late Charles Connick): Cathedral of St. John the Divine, N.Y.C.; First Presbyterian Church, Chicago; Christ Church, Cincinnati; St. John's Cathedral, Denver, Colo.; Grace Cathedral, San Francisco; American Church, Paris, France and others. Six stained glass windows for Waioli Chapel, Honolulu and St. Anthony's in Kailua, 1968; stained glass Cross, Palolo Valley Methodist Church, Honolulu; Pieta Window, Our Lady of Sorrows, Wahiawa; Rose Window, Queen Liliuokalani Church, Haleiwa; St. Andrew's Priory Chapel, Honolulu, 1966; baptistry windows, Holy Family Church, Pearl Harbor, 1966; 20 lancets of faceted glass, Punahou Chapel, Honolulu, 1967; mural, Comm. Officers' Cl., Pearl Harbor; 2 stained glass windows, All Saints Episcopal Church, Kauai, Hawaii; Collage (purchase) Watumull Fnd., 1962; leaded glass "Chinese Madonna," Tennent Fnd., Honolulu, 1964; 7 faceted glass windows for churches in Hawaii, 1962-1964. Exhibited: PAFA; Honolulu Acad. A., 1950-1954, 1964; Honolulu Pr. M., 1950-1952; Pasadena A. Mus., 1954; San Diego FA Center, 1955; one-man: Grace Horne Gal., Boston, 1933; Univ. New Hampshire, 1936; Wadsworth Atheneum, 1938; Colby Col., 1938; Texas State Col., 1938; Univ. Dayton, 1938; Oklahoma A. Center, 1939; Grand Rapids A. Gal., 1940; Ferargil Gal., 1947; Charles

Smith Gal., Boston, 1948; Fitchburg A. Mus., 1949; Currier Gal. A., 1949; U.S. in Honolulu: Gima Gal., 1953; Beaux-Arts Gal., 1952; The Gallery, Honolulu, 1956; Hawaiian Village, 1957 (both one-man); N.Y. World's Fair, 1964-65, and others. Contributor to Stained Glass. Lectures on stained glass, 1962-65.

KARESH, ANN (BAMBERGER)—Painter, S., Des.
751 Woodward Rd., Charleston, S.C. 29407
B. Bamberg, Germany. Studied: Willesden Tech. Col., London, England; Hornsey Sch. A., London, England; and with William Halsey and Willard Hirsch. Member: Carolina AA; Gld. South Carolina A. Awards: prizes, South Carolina Annual, 1948, 1949 (purchase), 1954, 1959, 1963; CCF, 1959, 1960, 1963; Gld. South Carolina A., 1966, 1967. Work: Gibbes A. Gal., and in private colls. Exhibited: Florence Mus. A., 1955; Greenville Mus. A., 1956; High Mus. A., 1948, 1952; Gld. South Carolina A., 1953-1956, 1958, 1960, 1961, 1963; South Carolina Annual, Gibbes Gal. A., 1947-1954, 1957-1964; Columbia Mus. A., 1953, 1960; George Hunter Gal. A., Chattanooga, 1960, 1961; FA Festival, Lake Chickamauga, Tenn., 1961; "Directors Choice" Exh., 1960-61 at: Hunter Gal., Chattanooga; Tennessee FA Center, Nashville; Montgomery (Ala.) Mus. FA; Pensacola A. Center; Jacksonville (Fla.) A. Mus.; Telfair Acad. A.; Gibbes A. Gal.; Ann. exh. Contemp. American Paintings, 1961; Soc. Four Arts, Palm Beach; Watercolors USA, 1962; Springfield (Mo.) A. Mus.; one-man: Pink House Gal., Parnassus Book Shop A. Gal., both Charleston; The Gallery, Columbia, S.C. Positions: Exh. Com., Carolina AA, 1955-59; Instr., Painting & Sculpture, Jewish Community Center, Charleston, S.C.; Vice-Pres., Gld. South Carolina A., 1965-1966, Pres., 1966-1967.

KARN, GLORIA STOLL—Painter, Et.
151 Louise Rd., Pittsburgh, Pa. 15237
B. New York, N.Y., Nov. 13, 1923. Studied: ASL, with Eliot O'Hara, and with Samuel Rosenberg. Member: Assoc. A. Pittsburgh; Abstract Group of Pittsburgh, (Pres. 1966-1969); Pittsburgh WC Soc.; Pittsburgh Plan for Art; Three Rivers A. Festival (Advisory Com., 1968-1969); Pittsburgh A. Council (A. Advisory Com., 1968-1969). Awards: prizes, BM, 1949 (purchase); Carnegie Inst., 1960 (purchase); Pittsburgh WC Soc., 1955, 1956, 1957, 1958, 1964; Westinghouse (purchase), 1966. Work: Yale Univ.; BM; Carnegie Inst. Mus.; Pittsburgh Pub. Schs. Exhibited: Butler Inst. Am. A., 1960, 1961; BM, 1949; Grand Rapids A. Gal., 1961; Carnegie Inst., 1956, 1960; CM, 1959; Pittsburgh Playhouse, 1958 (one-man): Pittsburgh WC Soc., 1953-1964; Assoc. A. Pittsburgh, 1949-1962; Abstract Group, 1954-1964; Albright A. Gal., Buffalo, 1961; Inst. Contemp. A., Boston, 1961; one-man: Pittsburgh Plan for Art, 1965; Univ. Pittsburgh, 1963; Carnegie Inst. Mus. A., 1966. Positions: Instr., Artists' and Craftsmens' Gld.

KARNIOL, HILDA—Painter, T.
506 North 8th St., Sunbury, Pa. 17801
B. Vienna, Austria, Apr. 28, 1910. Studied: Acad. for Women, Vienna, and with Mrs. Olga Konetzny-Maly and A. F. Seligman, both Vienna, Austria. Member: Central Pa. Art Organization; Mid-State A. of Pennsylvania; Nat. Forum Prof. A., Philadelphia, Pa. Work: St. Vincent Abbey, Latrobe, Pa.; Susquehanna Univ., Selinsgrove, Pa.; Lincoln Sch., Honesdale, Pa., Delaware A. Center, Wilmington. Awards: prizes, Berwick, Pa., 1965; A.-in-Res., Fed. Government Cultural Enrichment Program, Lycoming County, Pa., 1967. Exhibited: 80 one-man exhs. including: Susquehanna Univ., annually, 1952-1968; Indiana (Pa.) State Col., 1958; Pa. State Mus., 1954; Galesburg (Ill.) Civic A. Lg., 1959; Hartwick Col., Oneonta, N.Y., 1960; Cornell Lib. Gal., 1960; Farnsworth Mus., Rockland, Me., 1960; Conn. State Col., 1960; Drexel Inst. Tech., Phila., 1960; Lauren Rogers Mus., Laurel, Miss., 1962; Columbus (Ga.) Mus. A., 1962; Fremont (Mich.) Fnd., 1963; Neville Mus. A., Green Bay, Wis., 1958; Mary Buie Mus., Oxford, Miss., 1960; Pub. Lib., Guntersville, Ala., 1961; Vernon Parish Lib., Leesville, La., 1961; Ft. Leonard Wood, Mo., 1961; Jefferson City Univ., Jefferson City, Mo., 1959; Ahda Artzt Gal., N.Y., 1960; Fremont (Mich.) Fnd., 1959; Mercy Col., St. Louis, 1959; LaSalle Col., Philadelphia, 1965; Rutgers Univ., 1965; FA Library, Jersey City, 1965; Hallmark A. Gal., Kansas City, 1967; Univ. Illinois, 1968; Univ. Michigan, Ann Arbor, 1969, and in many public libraries and colleges, 1954-1965. Positions: Instr. FA, Susquehanna University, Selinsgrove, Pa.

KAROLY, ANDREW B.—Painter, Et., I., L.
54 West 74th St., New York, N.Y. 10023
B. Varanno, Hungary, May 5, 1893. Studied: Univ. A. & Arch., Budapest, Hungary, B.A.; M.A.A. Member: Budapest AC; Royal Acad. A., Budapest. Work: Nat. Mus., Budapest; A. Mus., Helsinki, Finland; murals, Bellevue Hospital, St. Clement Church, Pennsylvania Hotel, N.Y.; Thompson Aircraft Products Co., Hotel Cleveland, Cleveland, Ohio; Manhattan Savings Bank; Soc. for Savings Bank, Cleveland; Farm Bureau Insurance Co., Columbus, Ohio; Cities Ser-

vice Oil Co., N.Y., Ohio Oil Co., Findlay, Ohio; City of Pittsburgh; City of Cleveland; City of Atlanta, Ga.; Poughkeepsie New Yorker; Newspaper Publ. Co.; Westchester County, Mount Kisco, N.Y. Other work: 1966-1968—murals, "The Romantic Past of the New York University in 1860"; "Mr. Abraham Lincoln Addressing in Cooper Union University in 1860"; "George Washington's Inauguration in the Vanderbilt Era" (in the Vanderbilt Bank); 1968-1969: "Light in the Wilderness," (City Community Center); easel painting: Rouen Cathedral; interior of St. Peter's, etc.

KAROLY, FREDRIC—Painter, S.
3 Crosby St., New York, N.Y. 10013
B. Budapest, Hungary, May 24, 1898. Awards: Nat. Council on the Arts, Washington, D.C., 1968. Work: WMAA. Exhibited: WMAA, 1952, 1953, 1963, 1964; Salon des Realites Nouvelles, Paris, 1949-1955; Tokyo, Japan, 1952; Sao Paulo, Brazil, 1951; Martha Jackson Gal., N.Y., 1959; Butler Inst. Am. A., 1960; AIC, 1960; BM, 1961; one-man; Hugo Gal.; New Gal., N.Y.; Galerie Mai, Paris; Univ. Brazil, Sao Paulo, 1951; Museu de Arte, Sao Paulo, Brazil; Miami Mus. Mod. A., 1960; Allan Stone Gal., N.Y., 1961; Castellane Gal., N.Y., 1965.

KARP, IVAN C.—Art Dealer, Writer, Collector, Critic
465-9 W. Broadway; h. 505 La Guardia Pl., New York, N.Y. 10012
B. New York, N.Y., June 4, 1926. Contributor numerous articles and catalogue prefaces for art exhibitions, etc. Collection: Antiquities; 19th and 20th century painting and sculpture. Specialty of Gallery: Avant Guarde painting and sculpture-all media. Positions: President and Director, O.K. Harris Gallery, New York, N.Y. (opening Fall 1969); President and Founder, Anonymous Arts Recovery Society, 1958- .

KARSHAN, DONALD H.—
Writer, Collector, Critic, Patron, Museum Director, Scholar
245 W. 19th St., New York, N.Y. 10011
B. New York, N.Y., Jan. 17, 1929. Studied: Art Students League with Bridgman, Kuniyoshi, Liberte; Columbia University with Seong Moy; New York University. Collection: Extensive Graphic Art Collection, five centuries, shown in its entirety in several U.S. museums. Author: "Language of the Print, A Selection from the Donald H. Karshan Collection," 1968; "Picasso Linocuts, 1958-1963"; "Archipenko: International Visionary"; "Archipenko: Content and Continuity"; "Three Centuries of American Printmaking." Many articles on graphic arts, catalogue introductions, etc., for art periodicals and museum exhibitions. Scholarship: American Graphic Art History - Archipenko Oeuvre and Biography. Positions: Trustee, American Federation of Arts; Trustee, New York Studio School; Advisory Board, Pratt Center for Contemporary Printmaking, New York; Member of Council, Whitney Museum of American Art; Editor, Prints, Art in America; Founder & President, The Museum of Graphic Art, New York City.

KASBA, ALEXANDRA—Sculptor, Mosaicist
43 W. 90th St., New York, N.Y. 10024*

KASSOY, BERNARD—Painter, T., Cart.
130 Gale Place, Bronx, N.Y. 10463
B. New York, N.Y., Oct. 23, 1914. Studied: CUASch.; BMSch. A., with John Ferren, Arthur Osver, Isaac Soyer; City Col. of New York, B.S.S., M.S. in Ed.; Grad. Sch., T. Col. Member: AEA (Bd. Dirs. 1964-66, 1968-1970; Editor, AEA Newsletter); A. T. Assn.; CAA; Lg. Present Day Artists. Work: in private colls. Exhibited: Riverside Mus., 1946, 1951, 1962; ACA Gal., 1950-1954; Photo Lg. of N.Y., 1950; AEA, 1951, 1960, 1964, 1967, 1969; Peter Cooper Gal., 1954-1956; Little Red Sch. House, 1952, 1954, 1956, 1960; Downtown Community Sch., 1954-1957; Vladeck Auditorium, 1961; Walden Sch., 1959; Jewish T. Assn., 1961; Art:USA, 1958; Steindler Gal., 1962, 1963; Bergen (N.J.) A. Gal., 1963, 1964; Galerie Couturier, Stamford, Conn., 1963, 1964; NAD, 1968; Loeb Gal., N.Y. Univ., 1966, 1968; Lever House, N.Y., 1966, 1967, 1969; Nat. Des. Center, 1968; United Fed. Teachers, N.Y., 1968; Gal. 72 West, N.Y., 1966; Book Gal., White Plains, N.Y., 1966, 1967; N.Y. Bank for Savings, 1967, 1968; Westchester A. Soc., 1967; Bronx Council of A. Showcase, 1968, 1969; LPDA traveling show. Colleges & Univ. Gal, U.S.A., 1968-1969, and others; one-man: SEAC Hq., Kandy, Ceylon, 1945; Bronx H.S. Science, 1951; Teachers Center Gal., N.Y., 1952; Philip Enfield Designs, N.Y., 1953, 1958, 1961; Panoras Gal., 1959; Mosholu-Montefiore Center, Bronx; 2-man: ACA Gal., 1954; Steindler Gal., N.Y., 1962; Am. Fed. Teachers, 1965. Contributor editorial cartoons to New York Teacher News (weekly), 1947- . Color film, "Birdiness," (photog. & film editing) produced at H.S. of Music & Art, N.Y.C., for Bd. of Edu., on teaching of a model lesson in watercolor painting. Exh. at NAEA Conf., 1960, at MModA and circulating; also being circulated by Bureau of Audio-Visual Instruction of Bd. of

Edu., New York City; included in State Dept. traveling exh., Europe, 1961; Lecture: Color woodcut printing, Brush & Palette Soc., N.Y., 1966. Positions: Art Faculty, H.S. of Music & Art, New York, N.Y.

KASTEN, KARL—Painter, E., Et.
Art Department, University of California, Berkeley, Cal. 94705; h. 1884 San Lorenzo Ave., Berkeley, Cal. 94707
B. San Francisco, Cal., Mar. 5, 1916. Studied: Univ. California, M.A.; Univ. Iowa; Hans Hofmann Sch. FA. Member: San F. AA; Cal. Pr.M. Soc. Awards: prizes, Artist Council, San F., 1939; San F. AA, 1953; Western Painters, 1954 (purchase); Nat. Print Exh., Oakland, 1955: Graphic award, Richmond A. Center, 1951, 1958; Fellowships, Tamarind Lith. Workshop, 1968 and Creative A. Inst., 1964 and others. Work: Oakland A. Mus.; Auckland City Mus.; Mills Col.; San F. AA; Univ. California; Oakland Pub. Lib.; deYoung Mem. Mus.; State of California,Coll; Victoria and Albert Mus., London; MModA. Exhibited: AIC, 1946; Detroit Inst. A., 1947; San F. AA, 1938, 1939, 1948-1950, 1952, 1956, 1957; WMAA, 1952; Sao Paulo, Brazil, 1955; Univ. Illinois, 1956, 1969; LC, 1956; Colorado Springs FA Center, 1955; Northwest Pr. M., 1955, 1957, etc. Positions: Instr. A., Univ. Michigan, 1946-47; Prof. A., San Francisco State Col., 1947-50; Prof. A., Univ. California, Berkeley, Cal., 1950- .

KATO, KAY—Cartoonist, I., L., P.
60 Chapman Place, Glen Ridge, N.J. 07028
B. Budapest, Hungary, Dec. 11, 1916. Studied: A. Acad., Budapest; PAFA; and with Janos Vaszary. Member: Overseas Press Cl. of America. Exhibited: cart., Wartime Conservation, Am. FA Soc. Gal., 1943; Anti-Axis War Bond Exh., Treas. Dept., 1942; OWI Exh., on Absenteeism, 1943; "Cartoonist Looks at War," Boston Pub. Lib., 1945 (one-man); Vose Gal., 1945 (one-man); PAFA, 1941; Montclair A. Mus., 1953, 1956, 1957; Bloomfield A. Lg., 1955; Glen Ridge Women's Cl., 1955 (one-man); Verona (N.J.) Pub. Lib., 1955 (one-man); Newark Pub. Lib., 1957; White Mountains A. Festival, 1963. Contributor to This Week; Nation's Business; N.Y. Times Magazine; Weekly cartoon column, Star Ledger, Newark, N.J.; included (3 cartoons) in cartoon anthology "Pretty Witty," 1968; Christian Science Monitor; Baby Talk, and others; "Best Cartoons of the Year," 1943; American Weekly. Book jacket for "The Television-Radio Audience and Religion," 1955; cover, Am. Tel. & Tel. Magazine, 1954; N.Y. Herald-Tribune "Today's Living," 1957. Lectures: The Art of Cartooning; etc., to women's clubs, professional groups, cruises. Guest Cartoonist on NBC-TV network; Jack Paar Show, 1958; Denver, Colo., 1957; ABC-TV, 1956-58; "Jimmy Dean Show," CBS-TV, 1959, and others in Phila., Las Vegas, Hollywood, Dayton, Wash., D.C., Boston, etc. Cartoonist, Am. Cyanamid Co.; Nat. Assn. Home Economists Convention, 1963; Special featured appearance, N.Y. World's Fair, 1964. Cartoon sketches of many prominent persons of government, theatre, cinema, and international note.

KATZ, A. RAYMOND—Painter, Des., L.
523 Sixth Ave. 10011; h. 260 Riverside Dr., New York, N.Y. 10025; s. Rt. #1, Poughquag, N.Y.
B. Kassa, Hungary. Studied: AIC; Chicago Acad. A. Member: NSMP; AEA; Dutchess Co. A.A.; Artists-Craftsmen, N.Y. Awards: prizes, Century of Progress, Chicago, 1934; Mississippi AA, 1944; Evanston AA, 1944. Work: Murals, frescoes, stained glass, mosaics, sculpture: Elizabeth (N.J.) YMHA; USPO, Madison, Ill.; Oak Park Temple, Ill.; Temple Beth El, Knoxville; Temple Emanuel, Chicago; Temple Emanuel, Roanoke; Beth El, Poughkeepsie, N.Y.; Anshe Emet Temple, Vaughan Army Hospital, Chicago; Stephen Wise Free Synagogue, N.Y.; Nassau Community Temple, Long Island, N.Y.; Temple Beth Miriam, Elberon; B'nai Israel, Little Rock, Ark.; Cong. Beth El, Balto.; Temple Emanuel, Camden, N.J.; Shaare Tikvah, Chicago; The Temple, Nashville; 36 murals, Starlight, Pa., 1966; Albany Temple, 1968, and others. Exhibited: AIC, 1930, 1934-1937, 1939, 1940, 1944; PAFA, 1934; BM, 1934; CGA, 1939; Mississippi AA; Ferargil Gal., 1940; CM, 1940; Carnegie Inst., 1941; Los A. Mus. A., 1945; SFMA, 1945; NAD, 1944, 1945; Albany Inst. Hist. & A., 1945; Milwaukee AI, 1941, 1942, 1944; WMAA; Riverside Mus.; Tercentenary travel. Exh., 1955; Newark Mus. A., 1957; Mus. Contemp. Crafts, 1957; Art: USA, 1958; Marino Gal., 1958; Arch Lg., N.Y., 1961; Ptrs. in Casein, 1961; one-man: Chicago Room, 1946; Evansville Mus. FA, 1937; Univ. Arkansas, 1941; Springfield Mus. A.; Binet Gal., 1949-1951; Jewish Mus., 1953; St. Vincent's Abbey, 1953, 1955; Rochester Inst. Tech., 1957; Univ. Kansas, 1958; Ghent, Belgium, 1956; Butler Inst. Am. A., 1959; Madison Gal., 1961; B'nai B'rith Mus., Wash. D.C., 1963; Columbia Univ., 1964; Carlson Fnd., Bridgeport, Conn., 1964; Comm. Gal., N.Y., 1967; Lathrop Gal., Pawling, 1967; Cooper Union Gal., 1969; national traveling exh. and lecture at numerous universities, 1963-1969, and others. Author: "Black on White," portfolio brush drawings, 1933; "The Ten Commandments," portfolio in color, 1946; "A New Art for an Old Reli-

gion,'' 3rd ed., 1952; ''Adventures in Casein,'' 1951; ''The Festivals,'' 1960; ''Song of Songs,'' 1968. Article, ''Raymond Katz, Master of Mixed Techniques,'' in American Artist, 1969. Art albums: ''The Seven Names,'' 1964; ''The Mishna,'' 1964.

KATZ, ALEX—Painter
435 W. Broadway, New York, N.Y. 10010
B. New York, N.Y., July 24, 1927. Studied: CUASch.; Skowhegan Sch. P. & S. Work: WMAA; MMod. A.; Detroit Inst. A.; Rose A. Mus., Brandeis Univ.; N.Y. Univ.; Bowdoin Col.; Allegheny (Pa.) Mus.; Univ. Utah. Exhibited: AIC, 1960; WMAA; CAM; BMA; CMA; CM; PAFA, 1959; New Haven A. Festival, 1959; VMFA, 1959; Colby Col., 1961; Stable Gal., N.Y., 1956, 1957; one-man: Stable Gal., 1950, 1961; Tanager Gal., N.Y., 1959, 1962, 3-man 1960, 2-man 1955, 1958; RoKo Gal., N.Y., 1955, 1957; Sun Gal., Provincetown, Mass., 1958, 1959; Woodstock, N.Y., 1961; Martha Jackson Gal., N.Y., 1962; Fischbach Gal., N.Y., 1963-1965. Positions: Visiting Cr., Painting, Yale Univ., 1960- ; BM, 1959; Skowhegan Sch. P. & S., 1959; A.-in-Res., Ogden, Utah, summer, 1968; Univ. West Virginia, Aug., 1969; Instr., N.Y. Studio Sch., 1968-1969.

KATZ, ETHEL—Painter, T., Lith.
45 Grove St., New York, N.Y. 10014
B. Boston, Mass., July 12, 1900. Studied: BMFA Sch.; Mass. Normal A. Sch.; ASL, and with Randall Davey, Howard Giles, Samuel Halpert. Member: NAWA; N.Y. Soc. Women A. Awards: prize, NAWA, 1939, 1947, 1963, med., 1950, 1954; Brooklyn Soc. A. Work: Riverside Mus.; Norfolk Mus. A. & Sciences; ASL. Exhibited: BM, 1935, 1950, 1952; CAA traveling exh., 1935-1937; AFA traveling exh.; WFNY 1939; Brooklyn Soc. A., 1949-1952; NAWA traveling exh., 1942, 1943, 1949-1952, 1963-1965; High Mus. A., 1944; NAWA, 1939-1958; N.Y. Soc. Women A., 1937-1965; Riverside Mus., 1954, 1956; Gal. Mod. A., New York City; traveling exhs., U.S. and Europe. Positions: Instr., ASL, New York, N.Y., 1943- .

KATZ, HILDA—Painter, Gr.
915 West End Ave., Apt. 5D, New York, N.Y. 10025
B. June 2, 1909. Studied: NAD; New Sch. for Social Research. Member: Audubon A.; SAGA; Conn. Acad. FA; Phila. WC Cl.; Print Council of Am.; Am. Color Pr. Soc.; Boston Pr. M.; NAWA; Int. Platform Assn.; Wash. Pr. M.; Albany Pr. Cl. Awards: prizes, NAWA, 1945, 1947; Mississippi AA, 1947; SAGA, 1950; Min. P. S. & Gravers Soc., Wash., D.C., 1959; Peoria A. Center, 1960; LC (purchase), 1966; MMA (Life F.), 1966; Life memb., Exec. and Professional Hall of Fame, 1966; plaque of honor, Hall of Fame, 1966; honorarium diploma, Two Thousand Women of Achievement, 1969; plaque, Community Leader of America, 1969. Work: LC; BMA; FMA; Santa Barbara Mus. A.; Colorado Springs FA Center; SAGA; Pennell Coll.; AGAA; Syracuse Univ.; California State Lib.; N.Y. Pub. Lib.; Newark Pub. Lib.; Pa. State T. Col.; Springfield (Mo.) A. Mus.; Pennsylvania State Univ.; St. Margaret and Mary College, Seton, Conn.; MMA; Bezalel Mus., Israel; Univ. Minn.; Pa. State Lib.; Bath Yam Mus., Israel; Univ. Maine; Richmond (Ind.) AA; Peoria A. Center; and in private colls. Works comprising the Lina and Max Katz Memorial Collection are in the permanent collections of the U.S. National Museum (18), Washington, D.C., the Library of Congress (37), University of Maine (16); MMA (29); NGA (3); NCFA (10). Exhibited: SAGA; CGA; LC; Phila. WC Cl.; Audubon A.; Albany Pr. Cl.; NAD; Conn. Acad. FA; BM; Delgado Mus. A.; N.Y. Pub. Lib.; Boston Pub. Lib.; MMA; Cal. State Lib.; Bowdoin Univ.; Jewish Mus.; Boston Pr. M.; Int. Women's Cl., England; Italian Fed. Women in Art, Italy; Paris, France; Venice Biennale; Ecuador; Israel; Graphic A. Exchange Exh., England; Am.-Italian Exchange Exh.; USIA; Massillon Mus.; Springfield Mus. A.; Miami Beach A. Center; Wash. Pr. M.; Peoria A. Center; Louisiana A. Comm.; Univ. Maine; Ball State T. Col., and many others; one-man: Bowdoin Univ., 1951; Cal. State Lib., 1953; Albany Pr. Cl., 1955; Univ. Maine, 1955, 1958; Massillon Mus., 1955; Jewish Mus., N.Y., 1956; Pa. State T. Col., 1956; Springfield A. Mus., 1957; Ball State T. Col., 1957; Miami Beach A. Center, 1958; Richmond (Ind.) AA, 1959; Old State Capitol, La.; St. Martin Parish Lib., La.; and in many Elem. & H.S. in Louisiana.

KATZ, JOSEPH M.—Collector, Patron
Papercraft Corporation, Papercraft Park, Pittsburgh, Pa. 15238; h. Gateway Towers, Pittsburgh, Pa. 15222
B. Iampol, Russia, July 8, 1913. Studied: University of Pittsburgh. Collection: 19th and 20th century paintings and sculpture; gold and enamel snuff boxes of 17th, 18th, and 19th centuries; ancient glass of Roman era; French and English porcelain; 18th century French furniture. Positions: Chairman of the Board, Papercraft Corporation.

KATZ, KARL—Museum Director
The Jewish Museum, 1109 Fifth Ave., New York, N.Y. 10028*

KATZ, LEO—Painter, Gr., E., W., L.
54 West 74th St., New York, N.Y. 10023
B. Roznau, Austria, Dec. 30, 1887. Studied: Acad. FA, Vienna and Munich. Member: Atelier 17; CAA; SAGA; AEA. Awards: prizes, Long Beach, Cal., 1938; LC, 1946; MacDowell Colony F., 1960-62. Work: Bibliotheque Nationale, Paris; MMA; BM; N.Y. Pub. Lib.; LC; BMA; Howard Univ.; BMFA; Boston Pub. Lib.; Jewish Community Center, Atlanta; MModA; Norfolk Mus. A.; NGA; Atlanta AA; Tel-Aviv Mus., Bezalel Mus., Israel; murals, Johns-Manville Bldg., Century of Progress, Chicago; Wiggins Trade Sch., Los A.; Albertina Mus., Vienna, and other work abroad; also private colls. U.S.A. Exhibited: Ehrich, Seligmann, Montross, Puma Gals., New York; CMA; Atlanta AA; U.S. Embassy, Paris; MMA, 1950; Los A. Mus. A.; San Diego FA Soc.; BM; Smithsonian Inst.; Govt. Exh. prints to India, Egypt, Israel, 1958; Emory Univ., 1958; A. Festival, Atlanta, Ga. Author, I., ''Understanding Modern Art,'' 1936 (3 vols.); Chapters to Encyclopaedia of Social Sciences, Encyclopaedia of Photography; Miniature Camera Work. Lectures on Pre-Columbian and Far Eastern Art; Living American Art. Positions: Instr., Brooklyn Col., 1943-46; CUASch., 1938-46; Chm. A. Dept., Hampton Inst., Hampton, Va., 1946-1953; Dir., Atelier 17, N.Y., 1954-55; Prof., A.-in-Res., Spelman Col., Atlanta, Ga., 1955-57.*

KATZEN, LILA—Sculptor, P., T., L.
1680 3rd Ave., New York, N.Y. 10028; h. 3305 Pinkney Rd., Baltimore, Md. 21215
B. Brooklyn, N.Y., Dec. 30, 1932. Studied: ASL; Cooper Union; Hans Hofmann Sch. A. Member: Architectural Lg., N.Y. Awards: Tiffany Fnd., 1964; Gutman Fnd., 1965; Lannan Fnd., 1966; Arch. Lg., N.Y., 1968. Work: BMA; Norfolk Mus. A. & Sciences; Goucher Col., Towson, Md.; Univ. Arizona, Tucson; Chrysler Mus., Provincetown; Wadsworth Atheneum, Hartford, Conn.; Col. William & Mary; Kalamazoo Inst. A.; Birmingham Mus. A.; Santa Barbara A. Mus. Exhibited: CGA, 1957, 1967; Western Maryland Col., 1957; Morgan State Col., 1957; Hyannis (Mass.) AA, 1958; Provincetown AA, 1958; BMA, 1957-1959; Tirca Karlis Gal., 1960; AFA traveling exhs., 1962, 1963, 1966; Univ. Arizona, Tucson, 1963; H.C.E. Gal., Provincetown, 1963, 1967; Zabriskie Gal., N.Y., 1963; Maryland Inst., 1963; Chrysler Mus., 1964-1966; Norfolk Mus. A. & Sciences, 1964; A.M. Sachs Gal., N.Y., 1965-1967; Gertrude Kasle Gal., Detroit, 1965; Lannan Mus., Palm Beach, 1966; Iris Clert Gal., 1967; Waddell Gal., N.Y., 1967; Delaware A. Center, Wilmington, 1967; Milwaukee A. Center, 1968; Jewish Mus., N.Y., 1969; Mus. Contemp. Crafts, N.Y., 1969. One-man: BMA, 1955; Univ. Maryland, 1957; Karlis Gal., 1958, 1959; Johns Hopkins Univ., 1959; Gallery Mayer, N.Y., 1960, 1962; Goucher Col., 1963; Kalamazoo A. Center, 1964; Birmingham Mus. A., 1964; Maryland Inst., 1965; Arch. Lg., N.Y., 1968; Georgia Mus., Athens, 1968; NCFA, 1968; Flint Inst. A., 1968; Santa Barbara Mus. A., 1969; N.Y. Univ., 1969.

KATZENBACH, WILLIAM E.—Designer, Writer, Scholar
c/o American Federation of Arts, 41 E. 65th St., New York, N.Y. 10021
B. Summit, N.J., Aug. 30, 1904. Studied: Princeton University; Oxford University; apprentice to Norman BelGeddes. Awards: Justin Allman Award, 1951; Trail Blazer Award (Home Fashion League), 1954. Co-author (with Mrs. Katzenbach) ''Practical Book of American Wallpaper,'' 1951. Work: As President and Design Director of Katzenbach & Warren, organized Mural Scroll Program and published three editions of Mural Scrolls by Calder, Matisse, Matta and Miro; Supervised production of the approved Williamsburg Wallpaper Reproductions. Participated in Wallpaper and Wall Decoration exhibitions at many museums and institutions including: Metropolitan Mus. A.; Corcoran Gal. A.; Baltimore Mus. A.; Cleveland Mus. A.; Philadelphia A. Alliance. Lectures at various institutions and before numerous professional groups including Am. Inst. Interior Designers, Inter Society Color Council, Drexel Inst., Moore Inst., Pratt Inst., N.Y. School of Design, Carnegie Inst., and others. Organized and designed the following exhibitions: ''Modern Wallpaper.'' circulated by the American Federation of Arts, 1948-49; ''Today's American Wallcoverings,'' circulated by the Smithsonian Institution, 1963-1965. Positions: Design Assoc. Member, Am. Inst. of Interior Designers; Critic and Lecturer, Parsons School of Design, 1946-1964; Dir., Rockland Foundation, 1953-54; Member, Advisory Board, Cooper-Hewitt Museum of Design, N.Y.; Member, Board of Managers, Moore Institute, Philadelphia, Pa.; Trustee, Rockland Country Day School, 1963-1965; Dir. & Vice Pres., Resources Council, 1963-1965; Coordinator, Decorative Arts Exhibition Program, and Trustee, The American Federation of Arts, N.Y., 1964- ; Founder, President, Katzenbach & Warren, Inc., 1928-1964.

KATZMAN, LAWRENCE—Designer, Cart.
614 West 49th St. 10019; h. 101 Central Park West, New York, N.Y. 10023
B. Ogdensburg, N.Y., June 14, 1922. Studied: Univ. Pennsylvania,

B.S.; ASL, with Reginald Marsh. Member: ASL; Nat. Cartoonists Soc. Author, I., "Nellie Nifty, R.N.," cartoon album, 1953; "Taking A Turn for the Nurse," 1956; "Nellie the Nurse," 1958; "For Doctors Only," (England), 1960; "Prima y Dopo I Pasti," (Italy), 1960; "Calling Nurse Nellie," 1961; "Nellie's Laff-In," 1968, and others. Awards: Silver Cup of the City of Bordighera, Italy, 1959, and Palma d'Oro, 1966. Contributor cartoons to: Esquire and other leading national magazines and newspapers; magazines and newspapers in France, England, Belgium, Holland, Italy, Mexico, etc. Positions: Pres., Chm. Bd., Kaz Mfg. Co., Inc., 1947- . Memb. Com., Overseas Tours; Bus. Mngr., "The Cartoonist."

KAUFFMAN, ROBERT CRAIG—Painter, T.
 20 E. 17th St., New York, N.Y. 10003; h. 160 La Brea, Laguna Beach, Cal. 92651
B. Los Angeles, Cal., Mar. 31, 1932. Studied: Univ. Southern California; Univ. California at Los Angeles, B.A., M.A. Work: MModA; WMAA; Tate Gal., London, England; WAC; Larry Aldrich Mus., Ridgefield, Conn.; Los Angeles County Mus.; Albright-Knox Gal. A., Buffalo; Pasadena A. Mus.; Univ. Arizona. Exhibited: SFMA, 1952, 1954, 1959, 1960, 1961; MModA, 1953, 1967, traveling, 1969; Univ. California, Los Angeles, 1959, 1960; Univ. Illinois, Urbana, 1961, 1967; Pace Gal., N.Y., 1965; Robert Fraser Gal., London, 1966; Detroit Inst. A., 1967; SAM, 1966; Hansen Gal., San Francisco, 1967; WMAA, 1967, 1968; Washington (D.C.) Gal. Mod. A., 1967; V Paris Biennale, 1967; Pasadena A. Mus., 1967, 1969; Krannert Mus., Univ. Illinois, 1967; California State Col., Los Angeles, 1968; Jane C. Lee Gal., Ft. Worth, Dallas, 1968; Univ. California, San Diego, 1968; Des Moines A. Center, 1968; Vancouver A. Gal., 1968; Univ. California, Irvine, 1968; Los Angeles County Mus., 1969; WAC, 1969; Univ. Pennsylvania, 1969; Larry Aldrich Mus., Ridgefield, Conn., 1969; one-man: Felix Landau Gal., Los Angeles, 1953; Dilexi Gal., San Francisco, 1958, 1960; Ferus Gal., Los Angeles, 1958, 1962, 1963, 1965; Ferus/Pace Gal., Los Angeles, 1967; Pace Gal., N.Y., 1967, 1969; Irving Blum Gal., Los Angeles, 1969.

KAUFMAN, EDGAR, JR.—Designer, Cr., W., L., Editor
 450 East 52nd St., New York, N.Y. 10022
B. Pittsburgh, Pa., Apr. 9, 1910. Studied: painting, in New York, Vienna, Florence, London; Apprentice with Frank Lloyd Wright. Member: F., Royal Soc. A., London; IDI; AID; Chicago A. Cl. Contributor to: Arts & Architecture; etc.; abroad in: Architects' Yearbook. Author, books for MModA: "Prize Designs for Modern Furniture"; "What is Modern Design?"; "What is Modern Interior Design?"; "Taliesin Drawings" (on Frank Lloyd Wright's work); Ed., "An American Architecture" by Frank Lloyd Wright; "Drawings for A Living Architecture," 1959; "Frank Lloyd Wright, Writings and Buildings," 1960. L., N.Y. Univ. Inst. FA, 1961; Bemis L., MIT, 1956; Adv., Dept. Des. in Indst., Parson's Sch. Des., N.Y., 1955-1961; Columbia Univ., 1961; MModA, 1938-55; Dir., "Good Design," thrice-yearly exhs. sponsored by Merchandise Mart, Chicago, and MModA; Dir., Dept. Indst. Des., MModA, 1946-50; Dir., Intl. Competition for Low-Cost Furniture Design and exh. "Textiles and Jewelry from India," 1954-55; Dir., two exhs. of "U.S. Consumer Wares," circulated by U.S.Govt. in Europe, 1950-1955, and many others. Member, AIC Comm. on 20th Century Painting & Sculpture; Departmental Ed., Applied Arts, Encyclopaedia Britannica, 1958- ; Chm., Des. Com., Inst. Intl. Education, administering the Kaufmann Intl. Design Award, 1959- ; U.S. Co-ordinator, The Arts of Denmark Exh., opened 1960 at Metropolitan Mus. A. Consultant duties with IBM and Union Carbide Corp. Traveling exhs. organized for Smithsonian Institution on work of Fulbright designers, and for USIA on American designers.*

KAUFMAN, IRVING—Painter, E., W., L.
 Art Department, City College, New York, N.Y. 10031; h. 34 Corell Rd., Scarsdale, N.Y. 10583
B. New York, N.Y., Oct. 4, 1920. Studied: ASL; N.Y. Univ., B.A., M.A. Member: CAA; NAEA; Nat. Committee on Art Education; Inst. for study of A. in Educ. (Vice-Pres. 1968-1970). Awards: Horace H. Rackham Award (painting in France), 1959 and (in Greece), 1962. Work: Univ. Michigan Mus. A.; Saginaw Mus. A.; Ohio State Univ.; Parke-Davis Coll.; Columbia Univ., Law Lib. Exhibited: AIC, 1960; Detroit Inst. A., 1957, 1958, 1960, 1961; PAFA, 1949, 1953, 1960; Butler Inst. Am. A., 1960; NAD, 1962; Watercolor USA, 1962, Art in Our Time, 1958; Silvermine Gld. A., 1954; Int. Drawing Exhibition, Potsdam, 1959; Boston A. Festival, 1958, 1959; Western Michigan Exh., 1959-1962; Michiana, 1958, 1960, 1961. Author: "Art and Education in Contemporary Culture," 1966; Editor, "Education and The Imagination in Science and Art," 1958. Contributor article Studies in Art Education, to the Art Education Journal; Art in Society, Journal of Aesthetic Education. Lectures at Ohio State Univ. and NGA. Positions: Assoc. Prof., Painting, Univ. Michigan, Ann Arbor; Prof. Painting and A. Educ., City College, New York, N.Y., at present. Visiting Prof., Ohio State Univ., summer, 1968 and Univ. of Wisconsin, summer, 1969.

KAUFMAN, JOE—Illustrator
 18 W. 70th St., New York, N.Y. 10023
B. Bridgeport, Conn., May 21, 1911. Studied: Laboratory Sch. Indst. Des., and with Herbert Bayer. Member: SI. Work: MModA. Exhibited: A. Dir. Cl., 1943-1960; SI, 1945; Fleisher A. Mem., Phila., 1950 (one-man). Illus. appeared in Fortune, Graphis, House & Garden, Seventeen, Sports Illustrated, Mademoiselle, McCalls, Look, Esquire, and other leading national magazines. Author, I., children's books: "Big and Little," "Zeke Zookeeper," "Things in My House," "Fred Fireman," "Perry Postman," "Carlo Clown."

KAUFMAN, STUART—Painter, I.
 36-05 High St., Fair Lawn, N.J. 07410
B. Brooklyn, N.Y., Dec. 1, 1926. Studied: Pratt Institute, Brooklyn, N.Y.; ASL with Dumond, Reilly. Awards: prizes, Montclair Mus. A., 1958, 1962, 1964; Art Center of the Oranges, 1963. Work: Newark Museum A. Exhibited: NAD, 1965; Butler Inst. Am. A., 1962; AIC, 1961; FA Center of San Diego, 1964; Newark Mus., 1958, 1959, 1964; Montclair A. Mus., 1957-1964; Art Center of the Oranges, 1963; Hirschl & Adler Gal., N.Y., 1962; NAC, 1961; Kenmore Gal., 1965; New Jersey Pavilion, N.Y. World's Fair, 1965; one-man: Rabin & Krieger Gal., Newark, 1958; Davis Gal., N.Y., 1960, 1961; Gallery 52, South Orange, N.J., 1964. Illus. for Esquire, McCalls, Sat. Eve. Post and other national magazines. Positions: Instr., Painting & Drawing, Sloan School of Art, South Orange, N.J.*

KAUPELIS, ROBERT JOHN—Painter, E.
 New York University, 10003; h. 988 Barberry Rd., Yorktown Heights, N.Y. 10595
B. Amsterdam, N.Y., Feb. 23, 1928. Studied: Albright A. Sch.; State T. Col., Buffalo, B.S.; T. Col., Columbia Univ., M.A., Ed. D. Member: N.Y. State A. T. Assn.; NAEA; Eastern AA. Award: First prize, Intl. Drawing Comp., Potsdam, N.Y., 1960; Silvermine Gld. A., 1969; Artists of Northern Westchester, 1967-1969. Work: Montclair State T. Col. (N.J.); Univ. A. Coll.; MModA Lending Service. Exhibited: Art:USA, 1958; Provincetown A. Festival, 1958; Butler Inst. Am. A., 1960; Soc. Four Arts, Palm Beach, 1960; Albright A. Gal., 1950; Silvermine New England Exh., 1957-1959; Shepherd Gal., 1967; Moore Col. A., 1968; Detroit Inst. A.; one-man: James Gal., N.Y.; Angeleski Gal., N.Y.; Lake Erie Col.; Bennett Col.; N.Y. Univ.; Bertha Schaefer Gal., 1969; Blue Moon Gal., Katonah, N.Y., 1969, and others. Contributor articles on art education to School Arts; Junior Arts and Activities; Eastern Arts Bulletin; The Grade Teacher; American Childhood; Art Education. Author: "Learning to Draw," 1966. Positions: Prof., Art, New York University, at present.

KAWA, FLORENCE KATHRYN—Painter, T.
 1545 29th St., Des Moines, Iowa 50311
B. Weyerhauser, Wis., Feb. 24, 1912. Studied: Wisconsin State T. Col., B.S.; Louisiana State Univ., M.A.; Columbia Univ.; Cranbrook Acad. A.; Minneapolis Sch. A. Member: F.I.A.L. Awards: prizes, Milwaukee AI, 1938; Wisconsin Salon, 1939, 1947; Wisconsin State Fair, 1939; Nat. Polish-Am. Exh., 1940; Jackson, Miss., 1943; Louisiana Art Comm., 1949; Fla. Fed. A., 1950; 1951; Fla. A. Group, 1951; Fla. Southern Col., 1952; Grant, Fla. State Univ. Research Council, 1961. Exhibited: in addition to the above, PAFA, 1946; Contemporary A. Gal., annually; BM, 1951, 1955, 1957, 1959, 1961; Terry AI, 1953; Nebraska AA, 1952; Fla. A. Group traveling exh., 1950-1952; MMA, 1952, 1953; Univ. Florida, 1953; WMAA, 1953; Contemp. A. Gal. traveling exh., annually incl. Rio de Janeiro & Sao Paulo, 1960. U.S. Embassy, Paris, 1954-1956; Sarasota AA, 1955; Ringling Mus. A., 1955; Minneapolis Sch. A., 1955; Forum Gal., N.Y., 1955; High Mus. A.; Soc. Four A., 1955; Fla. State Fair, 1956; San Joaquin Mus., Stockton, Cal., 1953 (one-man); USIA, European traveling exh., 1957-58; USIA permanent installation in U.S. Embassies abroad, 1957; Contemp. A. Gal., N.Y., 1951, 1953, 1962, 1966 (one-man); San Joaquin Mus., Stockton, Cal., 1953 (one-man); La. State Univ. Centennial, 1960; Washington Fed. Bank, Miami, 1959 (one-man); Jacksonville Mus. A.; Des Moines A. Center, 1969; Pacem in Terris Gal., N.Y. City, 1969 (one-man); Florida State Univ. A. Gal., 1962 (one-man); St. Paul A. Center; Le Moyne A. Fnd., Tallahassee, Fla., and in numerous Faculty Exhs. Positions: Asst. Prof., Florida State Univ., Tallahassee, Fla., 1946-1962; Asst. Prof., Drake University, Des Moines, Iowa, 1964- .

KAYE, GEORGE—Educator
 Bureau of Art, Board of Education, 131 Livingston St., Brooklyn, N.Y. 11201*

KAYSER, STEPHEN S.—Educator, W., L.
 401 Washington Ave., Santa Monica, Cal. 90403
B. Karlsruhe, Germany, Dec. 23, 1900. Studied: Classical State Sch., Karlsruhe, Germany; Univ. Heidelberg, Ph.D. Member: CAA; AFA. Contributor to: Parnassus, Review of Religion, Pacific Art Review; Art Quarterly; Art News. Author: "Jewish Ceremonial

Art," 1955; "The Book of Books in Art," 1956. Lectures: History of Painting; Synagogue Art & Architecture. Positions: L., Univ. California, Berkeley, Cal., 1941-44; Prof., Hist. A., San Jose Col., San Jose, Cal., 1945-1962; Cur., and Dir. of Exhibits, The Jewish Mus., New York, N.Y. Prof. A., University of Judaism, Los Angeles, Cal., at present (1962-). Visiting Prof. Art, Univ. California, Los Angeles, 1966- .

KAZ, NATHANIEL—Sculptor, T.
 253 W. 26th St. 10001; h. 160 W. 73rd St., New York, N.Y. 10023
B. New York, N.Y., Mar. 9, 1917. Studied: ASL, with George Bridgman. Member: S. Gld.; Woodstock Soc. A.; Brooklyn Soc. A.; Audubon A.; Arch. Lg. Awards: prizes, Detroit Inst. A., 1929; AV, 1943; Audubon A., 1947, Medal of Honor, 1960; Brooklyn Soc. A., 1948, 1952; Natl. Inst. A. & Lets. Grant, 1957. Work: BM; Abraham Lincoln H.S.; Jr. H.S. 164, Queens, N.Y.; WMAA; MMA; USPO, Hamburg, Pa.; Vine St. Temple, Nashville; Temple Beth Emeth, Albany, N.Y.; P.S. 59, Brooklyn, N.Y. Exhibited: AIC, 1937-1939; PMA, 1940; Univ. Gal., Lincoln, Neb., 1945; Riverside Mus., 1943; WMAA, 1938, 1942-1945; MMA; BM; MModA.; one-man: Downtown Gal., 1939; Assoc. Am. A., 1946; Grand Central Moderns, 1954; Joan Avnet Gal., Great Neck, N.Y., 1965. Positions: Instr. S., ASL, New York, N.Y.*

KEANE, BILL—Cartoonist
 5815 East Joshua Tree Lane, Scottsdale, Ariz. 85251
B. Philadelphia, Pa., Oct. 5, 1922. Member: Nat. Cartoonists Soc. Awards: "Best Syndicated Panel Cartoonist," Nat. Cartoonist Soc., 1967. Work: Syndicated nationally by The Register and Tribune syndicate feature: "Channel Chuckles"; "The Family Circus"; adv. cartoons and others for national magazines. Books: "Family Circus," Vol. 1 & 2; "Channel Chuckles"; "Jest in Pun"; "Pun-Abridged Dictionary"; "Sunday with the Family Circus"; "Through the Year with the Family Circus"; "I Need a Hug." Positions: Staff A., Philadelphia Bulletin, 1946-58.

KEANE, LUCINA MABEL—Educator, P., S., I., L.
 Art Department, Morris Harvey College; h. 2908 Noyes Ave., Charleston 4, W.Va. 25304
B. Gros, Neb. Studied: Ashland (Ohio) Col.; Ohio State Univ , B.S. in Ed.; T. Col., Columbia Univ., M.A.; Pa. State Univ.; Temple Univ.; N.Y. Univ. Member: CAA; NAEA; Eastern A. Edu. Assn.; All. A. of West Virginia; NEA; West Virginia Edu. Assn.; Int. Platform Assn. Awards: prizes, All. A. of West Virginia, 1936, 1939, 1955, 1957, 1959. Exhibited: All. A. West Virginia; Clarksburg A. Center; W. Va. Centennial Exh.; Huntington A. Gal. Lectures: Sculpture; Art Appreciation. Positions: Instr., A. Univ. North Dakota, 1926-29; Illinois State Normal Univ., 1930-31; Pres. Bd., and member ob Steering Com., Charleston A. Gal., 1963-1966; Bd. Memb., W. Va. Creative Arts Festival,; Prof. A., Morris Harvey College, Charleston, W. Va., 1936- .

KEARL, STANLEY BRANDON—Sculptor
 344 Sprain Rd., Scarsdale, N.Y. 10583*

KEARNEY, JOHN W(ALTER)—Sculptor, P., C., T.
 Contemporary Art Workshop, 542 West Grant Pl. 60614; h. 747 West Montrose Ave., Chicago, Ill. 60613
B. Omaha, Neb., Aug. 31, 1924. Studied: Cranbrook Acad. A., Bloomfield Hills, Mich. Member: AEA; Am. Craftsmen's Council; Provincetown AA, (Vice-Pres., 1967-1969). Awards: prizes, Magnificent Mile Exh., Chicago, 1952; Truman prize, NAD, 1953; Old Orchard A. Festival, Chicago, 1959; Sarasota AA, 1960; Fulbright Grant and Italian Government Grant, 1963-1964; "Man of the Year" in the Arts for contribution to the arts of Chicago, 1962; New Horizons sculpture prize, Chicago, 1965; Nat. Fnd. for Arts & Humanities 2-year grant from U.S. Govt., 1968. Work: Michael Reese Hospital, Chicago; Chrysler Mus., Provincetown; Norfolk Mus. A. & Sciences; St. Paul Gal. A.; Francis W. Parker Sch., Mundelein Col.; Roosevelt Univ. and Forkosh Hospital, all in Chicago, and work in private colls. Exhibited: CGA, 1953; NAD, 1953; Delgado Mus. A., 1954; Sarasota AA, 1960; Smithsonian Inst. traveling exhs. in Crafts, Mus. for Contemp. Crafts, 1958; Provincetown AA, 1959-1967; AIC, 1952-1954, 1956, 1958, 1960; Chicago Pub. Lib., 1955; Det. Inst. A.; Univ. Chicago, 1959; Joslyn A. Mus.; Syracuse Mus. FA; AGAA; Mus. FA of Houston; Venetian Palace, Rome, 1964; ACA Gal., Rome, 1963; Il Canale Gal., Venice, 1964; AFA traveling exh.; Brooks Mem. Gal.; Kalamazoo Inst. A.; Univ. Minnesota; Herron Mus. A., Indianapolis; Roosevelt Univ., 1967; Sherman Gal., Chicago, 1966; Fulbright A. Exh., Chicago, 1966; one-man: Univ. Minnesota, 1956; East End Gal., Provincetown, 1961-1963; Garelick's Gal., Detroit, 1961; ACA Gal., Rome, 1964 and New York, 1964; Fairweather Hardin Gal., Chicago, 1965 Ontario East Gal., Chicago, 1966; Ft. Wayne A. Mus., Indiana, 1966; Mundelein Col., Chicago, 1968; Galleria Schneider, Rome, 1969; ACA Gal., N.Y., 1969. Positions: Co-Fndr., Dir., Instr., Contemporary Art Workshop, Chicago, Ill., 1950- .

KEARNS, JAMES—Sculptor, P., Gr.
 452 Rockaway Rd., Dover, N.J. 07801
B. Scranton, Pa., Aug. 7, 1924. Studied: AIC, B.F.A. Awards: Nat. Inst. A. & Lets. Grant, 1959; WMAA, purchase, 1966. Work: MModA; WMAA; Newark Mus. A.; Sumner Fnd. of the Arts, Hackettstown, N.J.; Colby Col.; Topeka Pub. Lib.; Johnson Wax Coll.; Everhart Mus., Scranton; Sara Roby Fnd.; Montclair (N.J.) Mus.; N.J. State Mus., Trenton; NCFA; Alfred List Fnd., N.Y. Exhibited: WMAA, 1959-1961; Nat. Inst. A. & Lets., 1959, 1961; PAFA, 1964, 1965; Butler Inst. Am. A., 1964; Newark Mus. A., 1962, 1968; N.J. State Mus., Trenton, 1965-1968; Otis A. Inst., Los Angeles, 1966; one-man: Everhart Mus., Scranton, 1963; Fairleigh Dickinson Univ., 1962; Bloomfield, N.J., 1967; David Gal., Houston, Tex., 1969. Six one-man exhs., New York City, 1956, 1957, 1960, 1962, 1964, 1968. Illus., "Can These Bones Live?"; Heart of Beethoven." Positions: Instr., Painting, Drawing & Sculpture, Skowhegan School Painting & Sculpture, Skowhegan, Me., (summer) 1961-1964; Instr., School of Visual Arts, New York, N.Y., 1959- . Member Bd. Governors, Skowhegan School of Painting & Sculpture.

KECK, SHELDON—Conservator
 Byberry Cottage, Cooperstown, N.Y. 13326
B. Utica, N.Y., May 30, 1910. Studied: Harvard Univ., A.B. Awards: Guggenheim F., 1959; Fulbright F., 1959. Member: F., Int. Inst. for Conservation of Historic & Artistic Works; Century Assn.; Rembrandt Cl.; ICOM Com. for Conservation. Contributor: Technical Studies in the Fine Arts, for BM publications; Studies in Conservation. Positions: Dir., Conservation Center, Inst. FA, New York Univ., 1961-1965; Prof. FA, N.Y. Univ., 1964-1966, Adjunct Prof., 1966-; Memb., Governing Committee and Consultant Conservator, 1961- , Brooklyn Museum; Bd. Dirs., Cooperstown Art Association.

KEENE, PAUL F.—Painter, E.
 2843 Bristol St., Warrington, Pa. 18976
B. Philadelphia, Pa., Aug. 24, 1920. Studied: Univ. Pennsylvania; Academie Julien, Paris; Phila. Mus. Sch.; Tyler Sch. FA of Temple Univ., B.F.A., B. Sc. in Edu.; M.F.A. Member: AEA; Am. Soc. of African Culture. Work: Temple Univ.; DMFA; Tucson A. Center; Wilmington Soc. of the Fine Arts. PAFA; PMA; Bowdoin Col.; Howard Univ.; Morgan State Col.; Johnson C. Smith Univ., Charlotte, N.C. Exhibited: Salon de Mai and Salon des Jeunes, Paris, France, 1951; PAFA, 1952, 1953, 1963, 1965; Lagos Mus., Nigeria, 1961; Art in America New Talent, 1954; PMA, 1965; Gal. 1015, Wyncote, Pa., 1960, 1963, 1964; Johnson C. Smith Univ., Charlotte, N.C., 1968; San Jose State Col., 1968; La Salle Col., 1969; Woodmere Gal., Phila., 1969; one-man: Morgan State Col., Baltimore, 1966; Lighthouse Gal., Nyack, N.Y., 1967. Positions: Instr., Drawing, Painting, Sculpture, Color and Design: Philadelphia College of Art, Centre d'Art, Port-au-Prince, Haiti, and Tyler School of Fine Arts, Temple Univ.; Dir. of Courses, Centre d'Art, 1952-53; Asst. Prof. A., 1953-64, Assoc. Prof. A. & Chm. FA, Philadelphia College of Art, 1963-1968. Assoc. Prof. FA and Area Coordinator, Bucks County Community Col., 1968- .

KEENER, ANNA ELIZABETH (ANNA KEENER WILTON)—
 Painter, Gr., E.
 312 Cadiz Rd., Santa Fe, N.M. 87501
B. Flagler, Colo., Oct. 16, 1895. Studied: Bethany Col., B.F.A., A.B.; AIC; Kansas City AI; Colorado State T. Col.; Univ. New Mexico, M.A.; and in Mexico City. Member: AAUP; AAUW; Western AA; NAEA; New Mexico A. Edu., Assn.; AEA; Art of America Soc. (Charter memb.); F.I.A.L. Awards: Medal, Kansas City AI; prize, Mus. New Mexico, Santa Fe, 1953 (purchase); Roswell Mus. A., 1956; Alumni award of merit for distinguished service in Art and Edu., Bethany Col., Kansas, 1968. Work: San F. Pub. Lib.; Vanderpoel Coll.; Sul Ross State T. Col.; Mus. New Mexico; Oklahoma Univ., and in private colls.; mural, Court House, Gallup, N.M. Exhibited: Dallas Print Exh.; Avant Guard, Mus. New Mexico; Tucson A. Festival, 1959; traveling exhs. Mus. New Mexico; Witte Mem. Gal., San Antonio, 1964; Ann. Nat., Springville, Utah, 1957-1969; Southwest A. Festival, Tucson, 1959; AEA, Los Alamos, N.M., 1968; New Mexico A. Comm. Religious Print Show, 1969; New Mexico Biennial, Mus. of N.M., 1963, 1968; Ricks Col., Rexburg, Idaho, 1966, 1967; one-man: Mus. New Mexico, 1956; Springville, Utah, 1957, 1958; Tucson A. Festival, 1958; Rodeo de Santa Fe, 1958; Alcove Show, Mus. New Mexico, 1958; Sandzen Mem. Gal., Lindsborg, Kans., 1959; High Plains Gal., Amarillo, Tex., 1960. Botts Mem. Hall, Albuquerque, 1963; Univ. New Mexico, Albuquerque, 1964; Mesa Pub. Lib., Los Alamos, N.M., 1966; A. Comm, Santa Fe, N.M., 1967; Los Alamos Credit Union Bldg., 1963; Los Alamos Bldg. & Loan Assn., 1962, 1965. Positions: State Rec. Sec., Delta Kappa Gamma; Com. memb., Western AA; Judge, 1955 Graphic A., Mus. New Mexico; Council, New Mexico A. Edu. Assn.; A. Consultant, Rocky Mountains Rural Life & Edu.; State FA Chm., New Mexico Fed. Women's Cl., 1956-60.

KEITH, DAVID GRAEME—Museum Curator
M. H. de Young Memorial Museum 94118; h. 857 Ashbury St., San Francisco, Cal. 94117
B. Toronto, Canada, Sept. 21, 1912. Studied: Western Reserve Univ., B.A.; M.A.; Grad. Schools: Harvard Univ.; N.Y. Univ. Positions: Cur., Decorative Arts, M. H. de Young Memorial Museum, San Francisco, Cal., at present.

KELEMEN, PAL—Writer, Historian, E.
Box 447, Norfolk, Conn. 06058
B. Budapest, Hungary, Apr. 24, 1894. Studied: Univ. Budapest, Munich, Paris. Member: Corr. Memb. Acads. of Colombia, Guatemala; F., Royal Anthropological Inst.; Societe des Americanistes, Paris. Awards: Commander, Order of Merit, Ecuador, 1952. Author: "Battlefield of the Gods, Aspects of History, Exploration, and Travel of Mexico," 1937; "Medieval American Art, A Survey of pre-Columbian Art," 2 vols.; "Baroque and Rococo in Latin America," 1951; "El Greco Revisited—Canida, Venice, Toledo," 1961; "Art of the Americas," 1969. Contributor to: Encyclopaedia Britannica; World Art History (Stauffacher, Zurich), Art magazines. Lectures: pre-Columbian and Colonial Latin American Art; Art History for Americans; L., for State Dept., Inf. Service, 1956, in Portugal, Spain, Italy, Greece and Turkey; Visiting Prof., Univ. Texas, 1953; Trustee, Textile Mus., Wash., D.C.

KELLEHER, PATRICK J.—Museum Director, E., W.
Art Museum, Princeton University; h. 176 Parkside Dr., Princeton, N.J. 08540
B. Colorado Springs, Colo., July 26, 1917. Studied: Colorado Col., A.B.; Princeton Univ., M.F.A., Ph.D. Awards: Prix de Rome, 1947-49, Am. Acad. in Rome. Author: "The Holy Crown of Hungary," 1951; Handbook; Collections, Nelson Gallery-Atkins Museum (in collab.), 1958. Lectures: Ancient to Contemporary Art. Arranged exhs: "The Theatre Collects," 1950; "Expressionism in American Painting," 1952; "What Is Painting?," 1953 (Albright A. Gal.); "Century of Mozart," 1956 (Nelson Gal.); "The Stanley J. Seeger, Jr., Collection," 1961 (Princeton). Positions: Chief Cur. A., Los A. Mus. A., 1949; Cur. Collections, Albright A. Gal., Buffalo, 1950-54; Cur. European A., Nelson Gallery, Atkins Museum, Kansas City, Mo., 1954-59; Dir., The Art Museum & Prof., Dept. A. & Archaeology, Princeton University, N.J., 1960- .

KELLER, DEANE—Educator, P.
Yale University Art Gallery, New Haven, Conn.; h. 18 Brookhaven Rd., Hamden, Conn. 06514
B. New Haven, Conn., Dec. 14, 1901. Studied: Yale Univ., B.A., B.F.A., M.A.; F., Am. Acad. in Rome, and with George Bridgman, E. C. Taylor, Eugene Savage. Member: Portraits, Inc.; Council Am. Acad. in Rome; Grand Central A. Gal.; Conn. Acad. FA. Awards: prizes, Conn. Acad. FA; Prix de Rome; numerous military awards, 1944-46. Work: many portraits, Yale Univ.; many portraits in public and private coll. in U.S. and abroad; state port. Gov. Lodge, Hartford; Sen. Robt. Taft, Taft Sch., Watertown, Conn.; mural (with B. LaFarge), New Haven Pub. Lib.; 2 mural paintings, Shriver Hall, Johns Hopkins Univ.; port. of Sen. Robert Taft, Senate Reception Chamber, The Capitol, Wash., D.C. Positions: FA Officer, Fifth Army, in charge of returning art treasures to European museums; Prof., A., Yale Univ., New Haven, Conn., 1930- .

KELLEY, CHAPMAN—Painter
c/o Janet Nessler Gallery, 718 Madison Ave., New York, N.Y. 10021
B. San Antonio, Tex., 1923. Studied: Pohl Art Sch.; Trinity Univ.; PAFA. Exhibited: One-man: Junior League, San Antonio, 1956; Nessler Gal., N.Y., 1963, 1964; 12 one-man exhs. in Texas.*

KELLY, ELLSWORTH—Painter, S., Gr.
c/o Sidney Janis Gallery, 15 E. 57th St., New York, N.Y. 10022
B. Newburgh, N.Y., May 31, 1923. Studied: BMFA Sch.; Ecole des Beaux-Arts, Paris, France. Awards: prizes, Carnegie Inst., 1961, 1964; Tokyo Intl., 1963; Brandeis Univ., 1962; AIC, 1962. Work: MMA; MModA; WMAA; Tate Gal., London; AIC; Carnegie Inst.; CMA; A. Gal. of Toronto; Pasadena Mus. A.; Albright-Knox A. Gal., Buffalo; Foundation Maeght; aluminum sc., Transportation Bldg., Phila., Pa.; Worcester Mus. (Mass.); Stedelijk Mus., Amsterdam; Stedelijk van Abbe Mus., Eindhoven; Solomon Guggenheim Mus., N.Y.; CAM; Detroit Inst. of A.; Fort Worth A. Center; Oklahoma A. Center; SFMA; Los Angeles County Mus.; Yale Univ. A. Mus.; Rose A. Mus., Brandeis Univ.; Dartmouth Col.; Harvard Univ. Exhibited: Carnegie Inst., 1958, 1961, 1964, 1967; MModA, 1956, 1969, 1965, 1968; Sao Paulo, Brazil, 1961; WMAA, 1957, 1959, 1960, 1961, 1963, 1964, 1966, 1967, 1968; Venice Biennale, 1966; Documenta, Cassel, 1964, 1968; one-man: Sidney Janis Gal., N.Y., 1965, 1967, 1968; Ferus Gal., Los A., 1965; Washington Gal. of Modern Art, 1964; Inst. Contemp. A., Boston, 1964; Betty Parsons Gal., N.Y., 1956,

1957, 1959, 1961, 1963; Galerie Maeght, Paris, 1951; 1952, 1958, 1964; Galerie Arnaud, Paris, 1951; Tooth Gal., London, 1962; Irving Blum Gal., Los Angeles, 1967, 1968.

KELLY, JAMES—Painter, Lith.
326 W. 15th St., New York, N.Y. 10011
B. Philadelphia, Pa., Dec. 19, 1913. Studied: PMA Sch. A.; PAFA; Barnes Fnd.; Cal. Sch. FA. Awards: Ford Fnd. grant for Tamarind Lithography Workshop, 1963. Work: SFMA; San Francisco AA; Univ. Cal., Los Angeles; Los Angeles County Mus.; MModA; Amon Carter Mus. Western A., Ft. Worth; Pasadena Mus. A.; La Jolla Mus. A. Exhibited: SFMA, 1955-1958; Minneapolis Inst. A., 1957; Florida State Univ., 1967; AFA traveling exh., 1959-1960; Univ. Minnesota, 1956; PAFA, 1951; one-man: Stryke Gal., N.Y., 1963; Long Island Univ., 1968; East Hampton, N.Y., 1968, and others.

KELPE, PAUL—Painter, E.
705 Texas Ave., Austin, Tex. 78705
B. Minden, Germany, 1902. Studied: Hanover, Germany; Univ. Chicago, M.A., Ph.D. Member: Texas FA Assn.; Am. Abstract A. Work: Detroit Inst. A.; Dept. Labor, Wash., D.C.; Howard Univ., Wash., D.C.; Indiana State T. Col.; Maryland State T. Col.; Univ. Illinois; Univ. Nebraska. Exhibited: nationally and in Mexico. Positions: Prof. A., Univ. Texas, 1948-54; Howard Univ., Wash., D.C., 1957-60; East Texas State Univ., 1960-69.

KELSEY, MURIEL CHAMBERLIN—Sculptor
167 East 69th St., New York, N.Y. 10021; h. 1252 Fourth St., Sarasota, Fla. 33577
B. Milford, N.H. Studied: Univ. New Hampshire, B.S.; Columbia Univ.; New Sch. for Social Research, and with Dorothea Denslow. Member: S. Center; A. Lg. of Manatee County, Fla.; Sarasota AA. Awards: prize, Sarasota Festival of Arts, 1953; A. Lg. of Manatee County, Fla., 1959. Work: Brookgreen Gardens, S.C.; garden pieces and many small sculptures in private collections. Exhibited: Conn. Acad. FA; PAFA; Newark Mus. A.; Syracuse Mus. FA; Wilmington Mus. A.; Fairmount Park, Phila.; Ringling Mus. A.; Sarasota AA; Sculpture Center, N.Y., 1935-to date; Junior A. Gal., Louisville; A. Lg. Manatee County; Assoc. Fla. Sculptors; Audubon A.; Searles Gal., Bradenton A. Center, 1957 (one-man); NAD; Phila. A. All.; Jacksonville Mus.; Oehlschlaeger Gal., Sarasota, 1964, 1967 (one-man); Harmon Gal., Naples, Fla., 1964, 1968 (one-man).

KEMPER, JOHN GARNER—Educator, Des., L., W., P.
605 West Lovell St., Kalamazoo, Mich. 49007
B. Muncie, Ind., June 3, 1909. Studied: Ohio State Univ., B.F.A.; Chicago Acad. FA; T. Col., Columbia Univ., M.A. Awards: prizes, Prof. Exh. advertising art, Minneapolis, Minn., 1941, 1951-1958, 1960, 1961; Kalamazoo Inst. A., 1943; Grand Rapids A. Gal., 1946; Ohio Valley, 1954; Religious Christmas Card Comp., Detroit Inst. A., 1955; Award of Merit by American College Public Relations Association for design of booklet "Report of the President, Western Michigan University 1967-1968," 1969. Exhibited: Minneapolis, Minn., 1941, 1951-1958, 1961-1964; Kalamazoo Inst. A., 1943-1945 (one-man, 1946), 1946, 1947, 1951, 1955, 1956; Grand Rapids A. Gal., 1946, 1947, 1956, 1957; Butler AI, 1946; Detroit Inst. A., 1944, 1946, 1955; Ohio Valley Exh., 1947-1949, 1954; Ogunquit A. Center, 1948-1953, 1958, 1959, 1961, 1963; Mich. Acad. Sc. A. & Let., 1951, 1953, 1954, 1955, 1956; Hackley A. Gal., Muskegon, Mich, 1965. Illustrated lectures: "So You Don't Like Modern Art?"; "Scandinavia." Des. book jackets, mural, etc., Western Michigan Univ.; NAEA 1954 Yearbook "Research in Art Education"; des. seal for Western Mich. Univ., 1957. Positions: Assoc. Prof. A., 1942-1965, Prof. A., 1965- , Western Michigan Univ.

KEMPTON, ELMIRA—Painter, E.
Earlham College; h. 75 South 17th St., Richmond, Ind. 47374
B. Richmond, Ind. Studied: Cincinnati A. Acad.; Cincinnati Univ.; Earlham Col., and with Wayman Adams, Eliot O'Hara, Albert Krehbiel. Member: NAWA; Cincinnati Woman's A. Cl.; Indiana A. Cl.; FI.A.L.; Cincinnati Mus. Assn.; Indiana Assn. of A. Edu.; The Twenty; Am. Assn. of Studies. Exhibited: Nationally; one-man: Argent Gal.; Dayton AI; Loring Andrews Gal.; Lieber Gal.; NAWA traveling exh., nationally & in Europe; Indiana State Univ.; Richmond AA. Position: Asst. Prof. Emeritus, Earlham College. Asst. Prof., Eastern Indiana Education Center, Earlham College-Indiana University. Instr., Art History and Studio Classes.

KEMPTON, GRETA—Painter
14 E. 75th St., New York, N.Y. 10021
B. Vienna, Austria, Mar. 22, 1903. Studied: NAD; ASL. Member: Royal Soc. Art (Fellow). Work: The White House, Wash., D.C.; Truman Museum, Independence, Mo.; U.S. Treasury, The Pentagon, U.S. Supreme Court, Apostolic Delegation, Georgetown Univ., all Wash., D.C.; NAD; National Portrait Gallery, Wash., D.C.; State Capitol, Little Rock, Ark.; CGA; Oklahoma Art Center, Oklahoma City; The

Canton Art Inst., Canton, Ohio; Harrisburg Art Center, Harrisburg, Pa.; NAC; also many museums and private collections here and abroad.

KENDA, JUANITA ECHEVERRIA (Mrs.)—
Educator, P., S., Gr., W., L.
3708 Lurline Dr., Honolulu, Hawaii 96816; also, Box 507, Fojardo, Puerto Rico
B. Tarentum, Pa., Nov. 12, 1923. Studied: Stephens Col.; ASL; Temple Univ., B.F.A.; Univ. Hawaii, and with Jon Corbino, Sam Hershey, Boris Blai, Raphael Sabatini, Jean Charlot, George Bridgman and others. Member: NAEA; Eastern AA; Pacific AA; Int. Soc. of Edu.; Com. on A. Edu., N.Y.; AAMus.; Hawaii P. & S. Lg.; Honolulu Pr.M.; A. T. Assn.; AAUW. Awards: Honolulu Acad. A., 1963. Work: murals, Straub Clinic & Children's Hospital, Honolulu. Exhibited: Delgado Mus. A., 1946; Honolulu Acad. A., 1949, 1954-1956, 1958, 1959; Univ. Hawaii, 1958, 1959, 1965; Long Beach Fnd. A. & Sciences, 1954; Temple Univ., 1945; Honolulu P. & S., 1960, 1961; Boston, Mass., 1959; Moorestown Friends Sch., 1961; one-man: Ligoa Duncan Gal., N.Y., 1959; Da Vinci Gal., Phila., 1959; Echeverria Gal., Moorestown, N.J., 1960; The Gallery, Honolulu, 1960; Galleria Santiago, San Juan, P.R., 1967. Author, I., "Art Education in Hawaii," "Hawaii's Children Exhibit Their Art," "Art & Art Education in Hawaii," "Art Guide for Hawaii," all in School Arts Magazine; "Curriculum Outline-Elementary Art" and "Curriculum Outline-Secondary Art" for Dept. of Education, State of Hawaii; contributor to Paradise of the Pacific. Lectures, Art Education. Organized exhibition "Art of Hawaii Children" circulated by Smithsonian Institution, 1960-64. Positions: Instr. in Workshop, Univ. Hawaii Summer School, 1951; Organizer & Chm., Art Teaching Conference, 1951-52, 1953, 1955, 1956, 1958; Adv., A. T. Assn., 1950- ; Chm., School A. Exh., Honolulu Acad. A., 1950- ; Hd. Creative Art Section, Honolulu Acad. A., 1949-1963; State Program Specialist, State Dept. Edu., Honolulu, Hawaii, 1963-64; Instr., Univ. Hawaii, School of Education, 1965-66; Community Relations Officer, East-West Center, 1968- .

KENDALL, VIONA ANN (Mrs. Giles A.)—Painter, Gr., T.
3749 Cahuenga Blvd., North Hollywood, Cal.; h. 4808 Brewster Dr., Tarzana, Cal. 91356
B. Berkeley, Cal., Aug. 28, 1925. Studied: Occidental Col.; Otis AI; Lukits Acad. FA, and with T. N. Lukits, Samuel Hyde Harris, Leon Franks, Sergei Bongart. Member: Cal. A. Cl.; F.I.A.L.; AAPL; Los A. AA; Laguna Beach AA; Ebell Cl.; Nat. Soc. A. & Lets. Awards: prizes, Burbank AA, 1952-1954; Cal. A. Cl., 1954, 1955; Valley A. Gld., 1956-58; Friday Morning Cl., 1958; Cal. State Fair, 1958, 1962; Laguna Beach AA, 1960; Los A. Mus. A., 1960; All-City A. Festival, 1962; All-California Exh., 1963; Frye Mus., 1963. Work: in many private collections. Exhibited: Duncan Vail Gal., 1953-1955; Cal. A. Cl., 1953-1958; Laguna Beach A. Gal., 1954-1965; Burbank AA. 1953-1955; Friday Morning Cl., 1954-1958; Van Nuys and Burbank Woman's Cl., 1953; Burbank Pub. Lib., 1955; North Hollywood Woman's Cl., 1954; Greek Theatre, 1954-1958; Ebell Cl., 1954-1960; Cal. State Fair, 1957-1963; Orange Show, 1954-1960; AAPL, 1958-1961 and traveling exh.; Hawaii Pr. Exh., 1959; Barnsdale Park, 1957-1963; Frye Mus., Seattle, 1959-1963; Los A. Mus. A., 1960; Int. Gal., Las Vegas, Nev., 1964-1966; Long Beach Mus. A., 1966; Larsen Gal., Provo, Utah, 1967; Montana State Univ., 1967; Nevada A. Gal., 1967; Butler Inst. Am. A.; Long Beach City Col.; Alexander Gal., Beverly Hills, 1967 and others; one-man: Las Vegas, 1965; Orlando Gal., Encino, Cal., 1967, 1968. Demonstrations, lectures to women's clubs, art galleries and on TV; work reproduced in Revue Moderne, 1961, and in "Prize Winning Oil Paintings." Positions: Pres. 1954, Dir., 1955, Burbank AA; Cor. Sec., Bd. Dir., Valley A. Gld., 1954, 1955; Bd. Gov., Hollywood AA, 1954.

KENNEDY, DORIS WAINWRIGHT—Painter
19 Pine Ridge Lane, Birmingham, Ala. 35213
B. Bernice, La. Jan. 26, 1916. Studied: Louisiana Polytechnic Inst. (Deg. in Art). Member: Phila. WC Cl.; Audubon A.; Alabama WC Soc.; Birmingham AA. Awards: prizes, Birmingham Mus. A., 1953, 1956, 1960-1965, 1966, 1968, 1969; Wash. WC Soc., 1959; Alabama WC Soc., 1958, 1960, 1963, 1964; Butler Inst. Am. A., 1961, 1963, NAD, 1962; Audubon A. Medal of Honor, 1962; Southeastern Ann., 1966. Work: Springfield, (Mass.) Mus. A.; Butler Inst. Am. A.; Howard Col. Gal. A.; Springfield (Mo.) Mus. A.; Holyoke (Mass.) Mus.; Univ. of Tenn.; Birmingham Mus. A. Exhibited: Butler Inst. Am. A., 1957, 1958, 1960, 1961; AWS, 1960, 1961; Boston A. Festival, 1960, 1961; PAFA 1959; All. A. Am., 1959, 1960; New England Annual, 1960, 1961; South Coast A. Exh., 1960, 1961; Ft. Worth Mus. A., 1967; Univ. Tenn., 1967; Univ. S.C., 1968. One-man: Janet Nessler Gal., N.Y., 1959, 1961, 1963; Birmingham Mus. A., 1957, 1968; Alabama Col., 1958; Howard Col., 1958; Jacksonville State Col., 1960; Murray (Ky.) State Col., 1961; Art Collectors Gal., Mexico City, 1961, 1965. Positions: Instr. A., Birmingham Pub. Schools, 1936-41.

KENNEDY, JOHN WILLIAM—Painter, E.
1003 West Union St., Champaign, Ill. 61820
B. Cincinnati, Ohio, Aug. 17, 1903. Studied: Cincinnati A. Acad.; Carnegie Tech., A.B.; Univ. Illinois, M.F.A. Work: in many public and private collections. Seven portraits commissioned by Indiana Univ., and three by Univ. of Illinois. Exhibited: nationally. Positions: Prof. A., Dept. A., Univ. Illinois, Urbana, Ill., 1926- . Conducts summer school of painting, Wellfleet, Mass.

KENNEDY, LETA M.—Craftsman, Des., Gr., L., E.
2545 S.W. Terwilliger Blvd., Portland, Ore. 97201
B. Pendleton, Ore., July 4, 1895. Studied: Portland (Ore.) Mus. A. Sch.; T. Col., Columbia Univ., B.S.; & with Hermann Rosse, Hans Hofmann, Moholy-Nagy, Dorothy Wright Liebes, and others. Member: Portland AA; Contemp. Crafts Assn. Awards: prize, Northwest Pr.M., 1938; first prize, ceramics, Oregon State Fair, 1957. Works: Portland A. Mus.; Northwest Printmakers. Exhibited: Phila. A. All., 1939; Portland Mus. A. 1962, 1966, 1967; Northwest Pr.M., 1938, 1939; Contemp. Crafts Assn. 1946, 1956, 1958, 1962; Univ. of Oregon, 1965. Lectures: Ceramics. Positions: Instr. & Faculty Council, Design, Color, Mus. A. Sch., Portland, Ore.

KENNY, THOMAS HENRY—Painter, Lith.
Oak Ridge Lane, North Hills, Roslyn, N.Y. 11576
B. Bridgeport, Conn., Jan. 12, 1918. Studied: Knox Col. Member: Royal Soc. of Arts, London, England; AFA; CAA; Inst. Contemp. A., London. Work: Prints—Mus. FA of Houston; LC; CMA; Univ. Cal., Los Angeles; Princeton Univ.; Maryland Inst.; Des Moines A. Center; MMA; Howard Univ.; Boston Athenaeum; Davenport Mun. Gal.; Univ. Illinois; Ohio State Univ.; City Col., N.Y.; San Francisco A. Inst.; Knox Col.; Oklahoma A. Center; Louisiana A. Center; Queens Col., N.Y.; Rutgers Univ.; Univ. Idaho; Univ. Wisconsin; Columbia Univ.; Dartmouth Col.; Salt Lake A. Center; Mobile A. Gal.; Univ. Notre Dame; Univ. North Carolina; Albertina, Vienna; Mus. Mod. A., Haifa; Stedelijk Mus.; Lausanne, Switzerland; Neue Gal., Linz, Germany, and others. Paintings—Larry Aldrich Mus., Ridgefield, Conn.; Mus. Mod. A., Miami; Mus. Mod. A., Mexico City; Mus. FA, Sao Paulo, Brazil; Dublin, Ireland; Mus. FA, Liege, Belgium; Stadtmuseum, Helsinki; Mus. A., Tel Aviv; Mus. A., Grenoble, France, and others. (235 museums in 22 countries).

KENT, SISTER CORITA—Serigrapher, E.
Immaculate Heart College, 2021 N. Western Ave., Los Angeles Cal. 90027
B. Fort Dodge, Iowa, Nov. 20, 1918. Studied: Immaculate Heart Col., B.A.; Univ. of Southern California, M.A. Work: Victoria & Albert Mus., London; AIC; CM: LC; MMA; NGA: BMFA; N.Y. Public Library; PMA; VMFA; Bibliotheque Nationale, Paris; Los Angeles County Mus. Exhibited: Vatican Pavilion, World's Fair, 1964-1965; IBM Bldg., 1966; Morris Gal., 1967; Sala Gaspar Gal., Spain. Author & I., "Footnotes and Headlines: a Play-Pray Book," 1967; "Sister Corita," 1968. Positions: Instr., Immaculate Heart Col., Los Angeles, Cal.

KENT, FRANK WARD—Painter, Mus. Dir., W., L.
45 Sandburg Drive, Sacramento, Cal. 95819
B. Salt Lake City, Utah, Feb. 16, 1912. Studied: Univ. Utah; ASL; Syracuse Univ., B.F.A., M.F.A., and in Europe and Mexico. Member: Am. Soc. of Appraisers. Awards: prizes, Heyburn, Idaho, 1934; Univ. Utah, 1935; Syracuse Mus. FA, 1951; Rochester Mem. A. Gal., 1949. Exhibited: SFMA, 1934; Springville, Utah, 1934-1940; Univ. Utah, 1935-1939; All-Illinois, 1940-1942; Peoria A. Lg., 1940-1943; AIC, 1940-1942; Kansas City AI, 1940; Decatur, Ill., 1942; Syracuse Mus. FA, 1944-1955; Rochester Mem. A. Gal.; Utica, N.Y.; Pan-American Union, 1955; one-man: New Georgetown Gal., Wash., D.C., 1953; Mexican Embassy, Wash., D.C. 1954. Writer and Designer, Crocker Art Gallery "Catalogue of Collections," 1964; "Drawings at Crocker Art Gallery," 1962. Position: Instr., Bradley Univ., Peoria, Ill.; Prof. FA, Syracuse Univ.; Dir., Mexican Art Workshop, Taxco, Mexico, 1949-55; L., Positano A. Sch., Positano, Italy, 1956; Dir., E. B. Crocker Art Gallery, Sacramento, Cal., 1958- .

KENT, NORMAN—Engraver, P., W., L., Book Des.
165 W. 46th St., New York, N.Y. 10036; h. 437 Carroll Ave., Mamaroneck, N.Y. 10543
B. Pittsburgh, Pa., Oct. 24, 1903. Studied: Rochester Inst. Tech.; ASL; and in Italy. Member: NA; Rochester Pr. Cl.; ASL; Typophiles; All. A. Am.; Century Assn.; Phila. WC Cl.; AWS. Awards: prizes, Univ. Rochester, 1929; Rochester Pr. Cl., 1935; Phila. Pr. Cl., 1941; LC, 1951 (purchase); AWS, O'Hara prize, 1954; William C. Osborn Mem. Award, 1959; gold medal, NAC, 1967. Work: in more than 65 public collections, including: MMA; CMA; Syracuse Mus. FA; PMA; BMA; Rochester Mem. A. Gal.; Elmira Mus. A.; Milwaukee AI; Carnegie Inst.; Nat. Gal., Canada; LC; Rochester, Arlington, Haverhill

and New York public libraries. Exhibited: nationally; one-man: Milwaukee AI; Albright A. Gal.; Rochester Mem. A. Gal.; Syracuse Mus. FA; New Britain Mus. Am. A.; Woodmere A. Gal.; Racine, Wis.; Albany, N.Y.; and many others, in universities, colleges and libraries throughout U.S., 1927-1968; and in Rome, 1934, and Spain 1953-54, Co-Editor (with Ernest Watson) "Watercolor Demonstrated," 1945; "The Relief Print," 1945; Author: "Drawings by American Artists," 1968; "The Book of Edward A. Wilson," 1948; Watercolor Methods," 1955; "Seascapes and Landscapes in Watercolor," 1956; "100 Watercolor Techniques." 1968. Many reproductions with articles in major publications of woodcuts. Des. and illus., "The Genesee Country," and others. Positions: Mng. Ed., American Artist, 1943-48: A. Dir., International Editions, Reader's Digest, 1948-51; A. Ed., True, 1952-55; Ed., American Artist, New York, N.Y., 1956-1969.

KENT, ROCKWELL—Painter, Gr., W., I., L.
 Au Sable Forks, N.Y. 12912
B. Tarrytown Heights, N.Y., June 21, 1882. Studied: Columbia Univ.; & with William Chase, Robert Henri, Abbott Thayer. Member: Nat. Inst. A. & Lets.; Hon. member, Acad. FA of the U.S.S.R. Work: MMA; AIC; BM; CGA; PMG, etc.; murals, USPO, Fed. Bldg., Wash., D.C.; room of House Committee on Interstate & Foreign Commerce, Wash., D.C. Author, I., "Wilderness," 1920; "Voyaging," 1924; "N By E," 1930; "Salamina," 1935; "This Is My Own," 1940; "It's Me, O Lord," 1955; "Of Men and Mountains," 1959; "Greenland Journal," 1962. I., "Candide," "Leaves of Grass," & other books. Lectures: "Art and Democracy."*

KEPES, GYORGY — Painter, Des., E., W.
 90 Larchwood Dr., Cambridge, Mass. 02138
B. Selyp, Hungary, Oct. 4, 1906. Studied: Royal Acad. FA, Budapest, M.F.A. Member: F., Am. Acad. A. & Sc. Awards: Guggenheim F., 1960-61; prizes, AIGA, 1944, 1949; A. Dir. Cl., Chicago, 1943; Univ. Illinois, 1954 (purchase); hon. deg., Phila. Col. Art; prizes, Soc. Typographical A.; Boston A. Festival; Architectural Lg. Silver Medal. Work: Univ. Illinois; DMFA; de Cordova & Dana Mus.; San Diego FA Gal.; Mus. FA of Houston; SFMA; WMAA; Albright-Knox A. Gal.; Chase Manhattan Bank, N.Y.; MModA; AGAA; Cranbrook Mus. A.; murals, Grad. Center, Harvard Univ.; K.L.M. New York; Travelers Ins. Co., Los A.; Sheraton Hotel, Dallas, & Chicago; Children's Lib., Fitchburg, Mass.; des., Arts of the United Nations, AIC, 1944; Am. Housing Exh., Paris, France, 1946; Church of the Redeemer, Baltimore; Manufacturers' Trust, Time-Life Bldg., N.Y.; Trinity Church, Concord, Mass.; other work: BMFA; BM; CMA; Des Moines A. Center; Fogg Mus. A., Harvard Univ.; Herron Mus. A., Indianapolis; Kansas City AI; Phoenix A. Mus.; Rose A. Mus., Brandeis Univ.; VMFA; Wellesley, Col., and others. Exhibited: one-man: AIC, 1944; SFMA, 1952; San Diego FA Center, 1952; Royal Acad., Copenhagen, 1950; Stedelijk Mus., Amsterdam, Holland; Margaret Brown Gal., 1955; CM, 1954; Inst. Contemp. A., Boston 1954; Mun. A. Center, Long Beach, Cal., 1954; SFMA, 1954; Syracuse Mus. FA, 1957; Mus. of Houston, 1958; DMFA, 1958, and in Rome, Milan, Ivrea, Firenze, Italy, 1958; Saidenberg Gal., N.Y., 1958, 1960, 1963; WMA, 1962; Swetzoff Gal., Boston, 1959-1964; BMA, 1959; DeCordova & Dana Mus., 1953; Currier Gal. A., Manchester, N.H., 1953; group shows: MModA, 1947, 1951, 1960; Carnegie Inst. 1955, 1959, 1964; WMAA, 1956; CMA, 1965, and others. Contributor to Graphis; Arts & Architecture; Cimaise; Art in America; Craft Horizon; Transformation; College Art Journal and other publications. Author: "Language of Vision," 1944; "The New Landscape," 1956. Ed., Visual Arts Today, 1960; 3 volumes, 1965: "The Education of Vision"; "Structure in Art and Science"; "The Nature and Art of Motion," all of the Vision & Value series, of which Prof. Kepes is editor. Positions: Prof. Visual Des. Mass. Inst. Tech. 1946- .*

KERCHEVILLE, CHRISTINA (Mrs.) — Painter
 407 University Blvd., Kingsville, Tex. 78363
B. Altus, Ark., Aug. 14, 1906. Studied: Univ. South Dakota, B.A.; Univ. Wisconsin; Univ. New Mexico, and with Lynn Mitchell, Kenneth Adams, Lloyd Goff, Randall Davey, Frederic Taubes, Galvez Suares, Guatemala, and others. Member: AEA; South Tex. A. Lg.; Tex. FA Assn.; Tex. WC Soc. at Witte Mus., San Antonio. Awards: prizes, New Mexico A. Lg., 1959, 1962; New Mexico State Mus., 1959 (purchase), 1960; New Mexico State Fair, 1960; A. & Indst. Univ., 1967. Numerous hon. men. Work: New Mexico Mus. FA. Exhibited: Nat. Lg. Am. Pen Women, 1952; Las Artistas, 1956-1958; Mus. New Mexico, Santa Fe traveling exh., 1962-1964; Roswell Mus. A.; Clovis A. Lg.; State Col., Las Cruces; State Fairs; galleries in Taos, Albuquerque; Mus. New Mexico traveling exh., 1954, and in 1955 annual; A. Lg. of Albuquerque, Guadalajara, Mexico, 1955, 1958 (one-man); Clovis A. Lg. 1954 (one-man); Sheldon Swope A. Gal., 1956, 1957; San Juan A. Lg., Farmington, N.M. 1957; New Mexico A. Lg., 1956-1958; Sandia Base Exh., Albuquerque, 1958, Unitarian Church, Albuquerque 1960 (one-man); Guadalajara, Mexico, 1961 (one-man); Contemporaries Gal., Santa Fe; 1962-1964; Corpus Christi; Witte

Mem. Mus.; traveling exh., Laguna Gloria, Austin, 1965-1968; Sun Carnival, El Paso, 1966; group shows in South Texas; Revue Moderne des Arts et de la Vie, Paris, 1967, 1969; Texas FA Assn., Austin, 1967, 1968; other one-man: Texas Col. A. & Indst., Kingsville, 1964, 1967; Alice and Devine, Tex., both 1964; Goliad, Tex., 1965; Univ. New Mexico Student Union, Albuquerque, 1966.

KERFOOT, MARGARET (Mrs. M. W. Jennison)—Painter
 307 Standish Dr., Syracuse, N.Y. 13224
B. Winona, Minn., July 4, 1901. Studied: Hamline Univ., A.B.; AIC; N.Y. Sch. FA, in Paris; Univ. Iowa, M.A., with Grant Wood. Awards: Carnegie scholarship, Harvard Univ., 1941. Work: Denver Pub. Sch. I., "Guide to Central City, Colorado," 1946. Exhibited: Everson Mus., Syracuse, 1966- ; Syracuse Assoc. Artists, 1966-1969; Cooperstown A. Assoc., 1968; one-man shows: Syracuse, 1966-1968; Dewitt, N.Y., 1968. Positions: Instr. A., 1937-39, Asst. Prof. A., 1939-45, Carlton Col.; Asst. Prof., Acting Chm., 1945-46. Allegheny Col., Meadville, Pa.; Asst. Prof., 1946-48, Hood Col., Frederick, Md.; Prof. A., Hd. Dept. A., Hamline Univ., St. Paul, Minn., 1948-52; L., Syracuse Univ., 1952-1967.

KERKOVIUS, RUTH—Painter, Gr.
 "Le Paladium" Quartier Villevieille, Pont de Crau 13, Arles, France
B. Berlin, Germany, Sept. 6, 1921. Studied: ASL; Sch. Visual Arts, N.Y.; Pratt Graphic A. Center, N.Y. Member: SAGA (Council Memb.); Phila. Pr. Cl. Work: CM; Wesleyan Univ., Middletown, Conn.; Univ. California; Univ. Chicago; Amon Carter Mus. Western Art, Ft. Worth; LC; Albiob Col., Michigan; De Pauw Univ.; Univ. Delaware; N.Y. Pub. Library; BMFA; Columbia Univ.; Univ. Wisconsin; IBM; Ford Fnd.; and others. Exhibited: SAGA; Jersey City Mus.; Silvermine Gld.; Washington PrM.; PAFA; Olivet Col., BMFA; Wesleyan Col., Macon, Ga.; LC. One-man: 20th Century Gal., Williamsburg, Va.; Ross Gal., White Plains, N.Y.; Staten Island (N.Y.) Mus.; IFA Gal., Washington, D.C.; International Gal., Cincinnati; Bowling Green State Univ.; East Carolina Col.; Greenville, N.C.; Ft. Wayne A. Mus.; Art Originals Gal., New Canaan, Conn.; Argus Gal., Madison, N.Y.; Phila. Pr. Cl.; Chapel Hill, N.C.; Assoc. Am. A., N.Y.; Tennessee FA Center, Nashville.

KERMES, CONSTANTINE JOHN—Painter, Pr.M., Des.
 981 Landis Valley Road, Lancaster, Pa. 17601
B. Pittsburgh, Pa., Dec. 6, 1923. Studied: Carnegie-Mellon Univ., B.F.A. Awards: Design awards, Am. Iron & Steel Inst., 1965, 1969; Industrial Design magazine, 1960, 1961, 1962, 1964, 1968; Lancaster Regional exh., 1960. Work: Everhart Mus. Scranton, Pa.; Indiana (Pa.) State Col.; Shaker Heights Hist. Soc., Cleveland, Ohio; Shaker Mus., Old Chatham, N.Y.; 60 Paintings—Holy Cross Greek Orthodox Church, Pittsburgh, Pa.; Kutztown (Pa.) State Col.; Notre Dame A. Mus.; Storm King A. Center, Mountainville, N.Y.; Elizabethtown (Pa.) Col.; Pennsylvania State Mus. Exhibited: Jacques Seligmann Gal., N.Y., 1950, 1951, 1953, 1956, 1961, 1962, 1967; N.Y. State Mus. 1951; Notre Dame Univ., 1953; Des Moines A. Center, 1953; Roswell Mus., 1953; DMFA, 1953; Philbrook A. Center, Tulsa 1953; Art:USA, 1958; A. & Crafts Center, Pittsburgh, 1954; Indiana (Pa.) State Col., 1960; Lancaster Hist. Soc., 1961; Reading Pub. Mus., 1959, 1960; Butler Inst. Am. A., 1964; Wilmington Soc. FA, 1964; Boston Printmakers, 1964; Kutztown State Col., 1964; Bucknell Univ., 1965; Kutztown Folk Festival, 1961-1968; Smithsonian Inst., 1969; William Penn Mus., Harrisburg, 1967, 1968. Illus., "Shaker Cookbook," 1958; "There Is a Season," 1968.

KERN, ARTHUR (EDWARD) — Painter
 453 E. Orange St., Lancaster, Pa. 17602
B. New Orleans, La., Oct. 27, 1931. Studied: Tulane Univ., B.F.A., M.F.A. Exhibited: AFA, 1955; USIA exhibition to Near East, 1955-1956; MMA, 1962; New School A. Center, N.Y., 1962; Norfolk Mus. A. & Sciences, 1963; Randolph Macon Col., 1963; Univ. Miami, 1963; Ball State T. Col., 1963; Oklahoma A. Center, 1963; BM, 1963.*

KERR, E. COE, JR.—Art Dealer
 Coe Kerr Gallery, Inc., 49 E. 82nd St., New York, N.Y. 10028;
 h. Glen Head, N.Y. 11545
B. New York, N.Y., Sept. 3, 1914. Studied: Yale Univ., B.A. Positions: Pres., M. Knoedler & Co., Inc., 1956-1969; Pres., Coe Kerr Gallery, Inc., 1969- .

KERR, JAMES WILFRID—Painter, L.
 7017 Bellrose Ave., Northeast, Albuquerque, N.M. 87110
B. New York, N.Y., Aug. 7, 1897. Studied: N.Y. Sch. F. & App. A., with Howard Giles. Member: All. A. Am.; AEA (Nat. Treas., 1959-61); Am. Veterans Soc. A. (Pres. 1958-60); New Orleans AA; SC. Awards: prizes, N.J. State Exh., Montclair 1943; NAD, 1945; Plainfield AA, 1946; Irvington A. & Mus. Assn., 1948, 1949; Ridgewood AA, 1948, 1952; Am. Veteran's Soc. A., 1951, 1954, 1957, silver medal, 1963; New Mexico Artists, Mus. New Mexico, 1963; New

Mexico State Purchase Prize, N.M. State Fair, also, best painting, and best oil, 1963; Colorado AA, 1964; Grand Award, N.M. State Fair, 1965. Work: Community Church, New York City; Fla. Southern Col.; Grand Central A. Gal.; Am. Legion Hall, Waldwick, N.J.; Midland Park (N.J.) Mun. Bldg.; Traphagen Sch., Waldwick, N.J.; Valley Hospital, Ridgewood, N.J.; Masonic Home, Burlington, N.J. Exhibited: NAD, 1944, 1945; All. A. Am. 1944-1958; Am. Veteran's Soc. A., 1940-1958; VMFA, 1948; Ridgewood AA, 1940-1952; New Jersey P. & S., 1948-1955; Davenport Mus. A., 1948; Mus. FA of Houston, 1949; Norfolk Mus. A., 1948; Audubon A., 1948, 1950; Delgado Mus. A., 1948, 1952; Irvington A. & Mus. Assn., 1948-1952; Carnegie Inst., 1949; SC, 1950-1952; Conn. Acad. FA, 1950; Newark Mus. A., 1951, 1952, 1958; Trenton, N.J., 1953; Art:USA 1958; AEA Exh., Botts Mem. Hall, Albuquerque, 1961; Fiesta Show, New Mexico Mus. FA, Santa Fe, 1961; Springville (Utah) annually, 1962- ; State House, Denver, 1967, 1968; 3-man: FA Gal., Albuquerque, 1969. Positions: Treas., 1952-55, Bd. Dir., 1955-58, Jury of Selection, 1953, Jury Awards, 1955, 1958 of All. A. Am.; Exec. Com., Int. Assn. Plastic Arts, 1953-58; Jury Selection, New Jersey P. & S., 1955; Bd. Dir., Assoc. A. of N.J., 1954; Nat. Mus. Com., AEA, 1954-58; Chm. Nat. Mus. Com., AEA, 1958 and Co-Chm. Joint Artists-Museums Com., 1958. Pres., Albuquerque Museum Assn., 1967- ; Bd. Trustees, Museum of Albuquerque, 1967- .

KERR, JOHN HOARE —Scholar, Critic, Writer, Collector, Art Administrator
National Foundation for Arts and Humanities, 1800 G St., N.W. 20006; h. 3701 Massachusetts Ave., N.W., Washington, D.C. 20016; s. "Derrydown" Newport, R.I. 02840
B. Newport, R.I., Apr. 19, 1931. Studied: University Rhode Island; Art Students League, N.Y.; Yale School of Fine Arts; Boston Museum School, and abroad. Member: National Trust for Historic Preservation; American Association of Museums; American Foreign Service Association; Society of Architectural Historians; American Federation of Arts. Field of Research: American Art and Art History; Indian (South Indian Palava, Hoysala, Chola, and Vijayanaga) architecture and bronzes. Collection: 18th and 19th Century Painting and Decorative Arts; 18th, 19th and 20th Century Painting and Decorative Arts in American and Indian fields (early bronzes and scradotal Indian objects. Positions: United Nations Committee for UNICEF, 1959-1961; Head, Interpretation Program in the Arts and Humanities, Sleepy Hollow Restorations, 1961-1963; Consultant, Collection and Museum and Foundation Planning, Smithsonian Institution, National Collection of Fine Arts, 1963-1964; Director, Huntington (W.Va.) Galleries, 1964-1967; Cultural Consul (USIS), Madras, India, 1967-1969; Director of Grants in Education in the Arts, National Foundation for the Arts and Humanities, Washington, D.C., 1969- .

KERR, LESLIE—Painter, E.
298 E. Third St., New York, N.Y. 10009
B. Detroit, Mich., Mar. 26, 1934. Studied: Univ. California at Los Angeles, B.A., M.A. Awards: Schwabacher-Frey award, SFMA, 1961. Work: SFMA. Exhibited: AIC, 1961; SFMA, 1961; Pop Art: USA, Oakland A. Mus.; WMAA, 1962, 1967; Cal. PLH, 1962, 1963; Stanford Univ., 1962, 1965; one-man: Dilexi Gal., San F., 1962-1964, 1967; Odyssia Gal., N.Y., 1968. Positions: Instr., A., Univ. California at Los Angeles, 1957-58; Instr., N.Y. Univ., 1966-1967.

KERSLAKE, KENNETH ALVIN—Printmaker, E.
Department of Art, University of Florida; h. 2511 N.E. 11th Terr., Gainesville, Fla. 32601
B. Mount Vernon, N.Y., Mar. 8, 1930. Studied: Pratt Inst., Brooklyn, N.Y.; Univ. Illinois, B.F.A., M.F.A. Member: AAUP; Am. Pr. Council; Boston Pr.M. Awards: Tamarind Lithography Workshop Grant, 1964; Faculty Development Grant, Univ. Florida, 1970; prizes, Florida State Fair, 1964; Southwestern Print & Drawing, Jacksonville, 1968; Boston Pr. M., 1969; purchase awards: Florida State Univ., 1965; Ohio Univ., Athens, 1964, 1968; SAM, 1963; Univ. of the Pacific, San Diego, 1969. Work: LC; SAM; Florida State Univ.; Ohio Univ.; Oklahoma Pr.M.; Bay Pr. M., Oakland, Cal.; Tamarind Lithography Workshop, Los Angeles, BMFA; Univ. Utah. Exhibited: BM, 1960, 1964; traveling print exh., AFA, 1960, 1962; SAM, 1963, 1968, 1969; Ohio Univ., 1964, 1968, 1969; Boston Pr. M., 1968, 1969; Manchester (N.H.) Inst. A. & Sciences, 1968; Mercyhurst Col., Erie, Pa., 1969; Otis A. Inst., Los Angeles; N.Y. State Univ. Col., Oneonta, 1968; Lenoir County Community Col., Kinston, N.C.; St. Cloud (Minn.) State Col.; Group Gal., Jacksonville; St. Armand's Gal., Sarasota; Chapman Kelley Gal., Dallas; Berman-Medalie Gal., Newtonville, Mass. Positions: Instr., Drawing and Watercolor for Architects; Des., Univ. Illinois, Urbana, 1957-1958; Prof., Printmaking and Drawing, Univ. of Florida, Gainesville, at present.

KERTESS, KLAUS—Art Dealer
Bykert Gallery, 24 E. 81st St., 10028; h. 54 Bond St., New York, N.Y. 10012
B. New York, N.Y., July 16, 1940. Studied: Yale University, B.A.,
M.A. Specialty of Gallery: Contemporary Painting and Sculpture. Positions: Director, Bykert Gallery, 1966- .

KESKULLA, CAROLYN WINDELER—Painter, Gr., T.
R.F.D. 1, Millington, N.J. 07946
B. Farmingdale, N.J., Jan. 20, 1912. Studied: ASL; PIA Sch.; N.Y. Univ., B.S. in Edu. Member: Hunterdon County A. Center; Assoc. A. New Jersey; AEA; New Jersey WC Soc. Work: Newark Pub. Lib., and in private colls. Exhibited: SFMA, 1942, 1943; Phila. Pr. Cl., 1943; Lib. Cong. 1943; Newark Mus., 1940, 1941, 1949, 1951, 1955, 1964; Montclair A. Mus., 1939, 1940, 1946, 1950, 1954, 1955, 1956, 1957, 1960, 1962, 1964, 1967, 1969; CMA, 1942, 1943, 1945; Butler AI, 1943; Newark A. Lib., 1951, 1954, 1957, 1964, 1966, 1968; Ohio Pr. M., 1954, 1955; Hunterdon County A. Center, 1959-1969; Trenton State Mus., 1965, 1969. Position: Pres., Assoc. A. of New Jersey, 1957-58; Sec., 1952-65, Vice-Pres, 1965-1969. Teacher, public schools, Bernards Township, Basking Ridge, 1967-1969.

KESSLER, EDNA L.—Painter, Int. Des.
85-89 Chevy Chase St., Jamaica Estates, N.Y. 11432
B. Kingston, N.Y., Mar. 13, 1910. Studied: Parsons Sch. Des.; grad. work, N.Y. Univ., Columbia Univ., Queens Col., N.Y., and special training with prominent art teachers. Member: AAPL; Nat. A. Lg. (Dir. 1958-1966); Catherine L. Wolfe A. Cl.; Hudson Valley AA; A. Lg. Nassau County; Miami A. Center Island Gld. Work: In private colls. Awards: gold medal, Nat. A. Lg., 1961; prizes, Queensborough A. Soc., 1962-1964; Nassau A. Lg., 1962; Island A. Gld., 1964; Arbogast Mem. Award, 1965, and Fine Arts Festival prize, 1967, both Parrish A. Mus.; AAPL, 1962; Hudson Valley AA, 1965; Wolfe A. Cl., 1965; Int. Biennale, Vichy, France, Grande Prix, 1966; other prizes: A. Lg. Nassau County, 1967; Herrick, N.Y., 1967. Exhibited: Parrish Mus., 1962-1968; IBM Gal., 1965; NAC, 1965; All. A. Am., 1967; Int. Biennale, France, 1966, 1968; Int. Salon, Clermont-Ferrand, France, 1968; A. Lg. Nassau, 1961-1968; DMFA and Witte Mus., San Antonio, Tex., 1962 and other national and regional exhs. Positions: Pres., Edna L. Kessler Interior Designs, 1946- .

KESSLER, SHIRLEY —Painter
22 E. 17th St. 10003; h. 185 E. 85th St., New York, N.Y. 10028
B. New York, N.Y. Studied: ASL. Member: AEA; N.Y. Soc. Women Artists; P.&S. Soc., New Jersey; NAWA. Work: Iowa State Mus.; Nashville Mus. A.; Norfolk Mus. A. & Sciences. Exhibited: WMAA; Riverside Mus., N.Y.; SFMA; Butler Inst. Am. A.; AWS; NAD; Audubon A.; P. & S. Soc., New Jersey; Nat. Soc. Painters in Casein. Other group exhibitions in England, Scotland, France, South America, Mexico and Canada. One-man: Iowa State Mus.; Blanden Mem. Mus., Neville, Wis.; Brown Univ., Providence; Fairleigh Dickinson Univ., New Jersey; Jasper Rand Mus., Westfield, Mass.; Erie (Pa.) Pub. Library; Loyola Univ.; Purdue Univ.; Brandeis Univ., and in Canada. Positions: Bd. Dirs., 1959- , Chm., US traveling exhibitions, 1961-1965, Vice-Pres., 1965-1967, Pres., at present, NAWA.

KESTER, LENARD—Painter, Des., Gr., I., T., L.
8003 Jovenita Canyon Dr., 90046; (Studio) 1117 N. Genesee Ave., Los Angeles, Cal. 90046
B. New York, N.Y., May 10, 1917. Member: ANA; AWS; Soc. Western A. Awards: prizes, Los A. Mus. A., 1943, 1955; Oakland A. Gal., 1943, 1944, 1951; Soc. Western A., 1950, 1956, 1960, 1961; NAD, 1951, 1956, gold medal, 1958, Obrig award, 1959; Cal. State Fair, 1951, 1957, 1958, 1961; Denver A. Mus., 1952; Tiffany Fnd. grant, 1949; Laguna Beach AA 1957, 1958, 1960; AWS, 1959. Work: BM; Univ. Miami; Toledo Mus. A.; BMFA; Cal. State Fair Coll.; Denver A. Mus.; Mayo Clinic (mural). Des.stained glass windows, Billy Rose Mausoleum, 1967. Exhibited: nationally, including CGA; AIC; NAD; Carnegie Inst.; Encyclopaedia Britannica, and others. One-man: de Young Mem. Mus., 1946; Vigeveno Gal., Los A., 1946, 1948, 1952; Midtown Gal., 1947, 1948; Phila. A. All., 1948; Santa Barbara Mus. A., 1952; Gump's, San F., 1952; San Diego FA Gal., 1953; Nelson Gal., A., Kansas City, 1953; Assoc. Am. A., 1953; Pasadena A. Mus. 1958; Frye Mus. A., Seattle, 1958; Cowie Gal., Los A., 1961-1963.

KESTNBAUM, GERTRUDE DANA (Mrs. Meyer)—
Collector
209 E. Lake Shore Drive, Chicago, Ill. 60611
B. Boston, Mass., May 16, 1895. Studied: Wellesley College, B.A.; Simmons College, B.S. Collection: Contemporary paintings and sculpture.

KETCHAM, HENRY KING (HANK)—Cartoonist
Publishes-Hall Syndicate, Inc., 30 E. 42nd St., New York, N.Y. 10017; h. Geneva, Switzerland; also, Carmel Valley, Cal. 93924
B. Seattle, Wash., Mar. 14, 1920. Studied: Univ. Washington. Member: Nat. Cartoonists' Soc. Awards: Billy De Beck award: Cartoonist of the Year, 1952; Boys' Clubs of Am. Certif. for best comic magazine, 1956. Work: Albert T. Reid Coll.; William Allen White Fnd., Univ. Kansas; Achenbach Fnd. for Graphic Arts. Cal.PLH;

Boston Univ. Library. Author, Illus. of 16 "Dennis the Menace" book collections. (Dennis the Menace appears in over 700 daily and Sunday newspapers in U.S. and in 42 foreign countries in 14 languages.) Contributor cartoons to: San Francisco Chronicle; Wash. Post & Times-Herald; Chicago Tribune; Atlanta Journal & Constitution; Baltimore Sun; Phila. Bulletin; Spokane Spokesman-Review; Omaha World Herald, and many others.

KEVESS, MRS. ARTHUR. See Weingarten, Hilde

KEY, DONALD—Critic
The Milwaukee Journal, Journal Square, 53201; h. 7519 N. Crossway Rd., Milwaukee, Wis., 53217
B. Iowa City, Jan. 30, 1923. Studied: Univ. Iowa, B.A. Member: Wisconsin P. & S. (Hon.); Milwaukee Press Cl. Positions: Fine Arts and Editorial Writer, Cedar Rapids Gazette, Cedar Rapids, Iowa, 1950-1959; Art Editor, Milwaukee Journal, Milwaukee, Wis., 1959- . Reviews published in "Craft Horizons" and other art magazines. Lectures on contemporary painting at Univ. Wisc. and Carroll Col; on Wisconsin Art at Milwaukee A. Center, Wisc., State Hist. Soc. and Lakeside Col.

KEY, TED—Cartoonist, W.
1694 Glenhardie Rd., Wayne, Pa. 19087
B. Fresno, Cal., Aug. 25, 1912. Studied: Univ. California at Berkeley, A.B. Member: Nat. Cartoonists Soc.; The Players. Work: Drama, "The Clinic," selected for anthology "Best Broadcasts of 1939-40," written for NBC. Author, I., "Hazel," 1946; "Here's Hazel," 1949; "Many Happy Returns," 1951; "If You Like Hazel," 1952; "Hazel Rides Again," 1955; Author: "So'm I," 1954; "Fasten Your Seat Belts," 1956; "Phyllis," 1957; "All Hazel," 1958; "The Hazel Jubilee," 1959; "The Biggest Dog in the World," 1960; "Hazel Time," 1962; "Life With Hazel," 1965; "Squirrels in the Feeding Station," 1967. Work appears in many anthologies. Contributor to: Sat. Eve. Post; This Week; Look; Ladies Home Journal; Sports Illustrated, and other leading national magazines. "Hazel" syndicated by King Features Syndicate. Creator of "Diz and Liz" for Jack and Jill magazine, and three "Diz and Liz" books published. Weekly half-hour "Hazel" TV Show starring Shirley Booth, NBC-TV (started Sept., 1961).

KEYES, BERNARD M. — Portrait Painter
30 Oakley Lane, Waltham, Mass. 02154
B. Boston, Mass., Aug. 27, 1898. Studied: BMFA Sch.; FMA. Member: ANA; Gld. Boston A.; Provincetown AA. Awards: Paige traveling scholarship, 1921-22; prizes, CGA, 1937; NAD, 1938. Work: Harvard Univ.; Brown Univ.; Tufts Col.; Mt. Holyoke Col.; Holyoke (Mass.) Pub. Lib.; Newton-Andover Theological Col.; Gordon Col.; Leslie Col., Cambridge, Mass.; Boston City Hospital; Mass. General Hospital; Nat. Shawmut Bank; Newton Nat. Bank; Quincy Savings Bank; Masonic Bldg., Boston; John Hancock Ins. Co., Boston; Cuningham Mem., Quincy, Mass.; Boston Sch. of Business Education; City Hall, Waltham, Mass.; Thayer Acad., Braintree, Mass.; Tabor Acad., Marion, Mass.; State Capitol, Augusta, Me.; Newton Pub. Lib. Positions: Instr., Boston Mus. Sch. FA; Boston Univ.; Scott Carbee School; Boston YMCA.*

KEY-OBERG, ELLEN BURKE—Sculptor, T.
1700 York Ave., New York, N.Y. 10028
B. Marion, Ala., Apr. 11, 1905. Studied: CUASch. Member: Audubon A.; S. Gld.; NAWA; Artist-Craftsmen of New York; Sculpture Center. Awards: prizes, Audubon A., 1944, 1960; NAWA, 1949, 1959. Work: Univ. Wisconsin; Norfolk Mus. A. & Sciences. Exhibited: MMA, 1942; PAFA, 1942; All. A. Am., 1941; NAD, 1943; Audubon A., 1943; S. Gld., 1951, 1952; Phila. A. All., 1951; Syracuse Mus. FA, annually: AFA traveling exh. 1951-52; WMAA; Smithsonian Inst. Positions: Hd. A. Dept., S., Chapin Sch., N.Y.

KEYSER, ROBERT—Painter, T.
Box 258 Applebachsville, Quakertown Rt. 4, Pa. 18951
B. Philadelphia, Pa., July 27, 1924. Studied: Univ. Pennsylvania, and with Fernand Leger in Paris, France. Work: Lyman Allyn Mus.; PC; Munson-Williams-Proctor Inst.; Olsen Fnd., Guildford, Conn. Exhibited: PAFA, 1951, 1959-1964; WMAA, 1956, 1959-1961; Yale Univ., 1958; Univ. Illinois, 1959-1961. 14 one-man: Paris, Philadelphia, New York City, Washington, Chicago, and London. Positions: Assoc. Prof., Painting & Drawing, Philadelphia College of Art.

KHOURI, MRS. ALFRED. See Matson, Greta

KIDDER, ALFRED, II—Associate Museum Director
University of Pennsylvania Museum, 33rd & Spruce St., Philadelphia, Pa. 19104
Positions: Associate Director, Univ. Pennsylvania Museum.*

KIENBUSCH, WILLIAM AUSTIN—Painter, S.
c/o Kraushaar Gallery, 1055 Madison Ave.; h. 120 E. 80th St., New York, N.Y. 10021
B. New York, N.Y., Apr. 13, 1914. Studied: Princeton Univ., B.A. Member: AEA. Awards: prizes, MMA, 1952; Boston A. Festival, 1961; BM, 1952; Columbia (S.C.) Mus. A., 1957; Provincetown A. Festival, 1958; Portland (Me.) A. Festival, 1960; Guggenheim F., 1958; Ford Fnd. purchase prize, WMAA, 1963. Work: MModA; WMAA; Toledo Mus. A.; Wichita A. Mus.; New Britain Inst.; Ft. Worth AA; Univ. Nebraska; Univ. Michigan; MMA; Munson-Williams-Proctor Inst.; Univ. Delaware; VMFA; Newark Mus. A.; Univ. Minnesota; Mus. FA of Houston; Nelson Gal. A.; PMA; PAFA; A. Gal. of Toronto; BMFA; BM; Colo. Springs FA Center; Sara Roby Fnd.; Rochester Mem. Mus.; Detroit Inst. A.; Wadsworth Atheneum; Walter Chrysler Mus.; Carnegie Inst. Exhibited: Carnegie Inst., 1955 (retrospective 1954); Brussels World Fair; MMA; MModA; Carnegie Inst. (2-man); one-man: Univ. Maine, 1956; White Mus., Cornell Univ., 1958; Princeton Univ., 1962; Ft. Worth A. Center, 1964 (2-man), and others. Positions: Instr., Brooklyn Mus. Sch. A., 1948- . A.-in-Res., Univ. Maine, Orono, Me., 1968.

KIENBUSCH von, CARL OTTO—Collector, Patron
165 Front St. 10038; h. 12 E. 74th St., New York, N.Y. 10021
B. New York, N.Y., Nov. 21, 1884. Studied: Princeton University, A.B. Awards: Honorary Master of Arts, Princeton University, 1952; Honorary Doctor of Humane Letters, Wagner College, 1964. Collection: Ancient European armour and arms. Positions: Chairman, Visiting Council on Art and Archeology, Princeton University; Donor, Carl Otto von Kienbusch, Jr. Memorial Art Collection, Princeton University Art Museum; Board of Trustees, New York Historical Society.*

KIENHOLZ, EDWARD — Sculptor
Los Angeles, Cal.
B. Spokane, Wash., 1927. Work: WMAA; MModA; Boise A. Mus.; Los Angeles County Mus.; Univ. California (Berkeley) A. Mus.; Pasadena A. Mus., and in private colls. Exhibited: AIC, 1966; Los Angeles County Mus., 1967, 1968; Vancouver (B.C.) A. Gal., 1968; MModA, 1968 (2); Documenta, Kassel, Germany, 1968; SFMA, 1968; A. Mus. of Ateneum, Helsinki, Finland, 1969. One-man: Los Angeles County Mus., 1966; Inst. Contemp. A., Boston, 1966; Univ. Saskatchewan, Regina, Canada, 1966; Dwan Gal., N.Y., 1967; Washington Gal. Mod. A., 1967; Boise A. Mus., 1968; Eugenia Butler Gal., Los Angeles, 1969.

KILEY, ROBERT L.—Painter, Gr., E.
Art Dept., University of Connecticut, Storrs, Conn. 06268
B. Fall River, Mass., Dec. 7, 1924. Studied: Cleveland Sch. A.; Univ. New Mexico; Univ. Michigan, B.S., M.S. Member: National Ser. Soc. (Treas. 1959-61). Work: William Rockhill Nelson Gal. A.; VMFA; Wisconsin Union; Mus. of New Mexico, Santa Fe; MMA, and others. Exhibited: nationally. Also, Serigraphes Americaine, France, 1955; Bordighera, Italy, 1956; 20th Century Am. Graphic Arts traveling exh., 1956-1958; USIA, America House, Stuttgart, Germany, and others. One-man: Serigraph Gal., N.Y., 1948, 1950; Meltzer Gal., N.Y., 1955, 1958, 1960. Positions: Prof. A., Dept. Art. Univ. Connecticut, Storrs, Conn. at present.*

KILGORE, RUPERT—Educator, Gr., P., L., W.
School of Art, Illinois Wesleyan University; h. 18 White Pl., Bloomington, Ill.
B. Swayzee, Ind., Nov. 25, 1910. Studied: DePauw Univ.; Ball State T. Col.; State Univ. Iowa. Member: Midwest Col. A. Conf.; Illinois A. Edu. Assn. Awards: purchase award, Luther Col., Decorah, Iowa, 1961; Carver Community Organizations, Evansville, Ind., 1961. Work: Luther Col. Exhibited: Central Illinois Exh. Decatur, 1960; Nat. WC Exh., Peoria, 1961; Nat. Drawing Exh., Wichita, 1960, 1965; Oklahoma Printmakers, 1962; Northwest Printmakers, Seattle, 1962; Auburn Univ. Print Annual, 1962, 1963; Am. Color Print Soc., Phila., 1963; Religious Arts Festival, Rochester, N.Y., 1963, 1964; Miniature Print Show, Wash., D.C., 1963; Mid-States Exh., Evansville, 1962-1964; Wash. Soc. Printmakers, 1964; Fifty Indiana Prints, Indianapolis, 1964; One-man: Municipal Mus., LaFayette, Ind., 1966; Luther Col., Student Center, Decorah, Iowa, 1967. Contributor "Understanding Contemporary Painting," Think magazine, 1957. Author: "Aesthetics for the Layman," 1961. Many lectures on Fine Arts. Positions: Instr., Music & Art, Fairmount, Ind., schools, 1934-45; Prof. Art History, Aesthetics, Illinois Wesleyan University, Bloomington, Ill., 1946- , Dir., School of Art, 1961- .

KILIAN, AUSTIN—Educator, P., Des., L.
3720 Wawona Dr., Point Loma, San Diego, Cal. 92107
B. Lyons, S. Dak., Sept. 19, 1920. Studied: Augustana Col., B.A., with Palmer Eide; The University of Iowa, M.F.A., with James Lechay, Stuart Edie, Mauricio Lasansky, Humbert Albrizio; Mexico

City Col., with Jose Gutierrez; Acad. Montmartre, Paris, with Fernand Leger; Ohio State Univ., with James Grimes. Member: AAUP; CAA; Am. Studies Assn.; FA Soc. of San Diego; San Diego A. Gld., (Pres.), 1962; European Assn. for Am. Studies; La Jolla Museum of Art; Int. Inst. A. and Let. Awards: prizes, Texas F.A. Assn., 1954; D. D. Feldman Coll. Contemp. Texas A., 1955; Waco A. Forum, 1957; Mus. for Contemp. A., Waco, 1959; citation, Texas FA Assn., 1958. Exhibited: Terry AI, 1952; New Orleans AA, 1952-56; Cedar City, Utah, 1957; Texas FA Assn., 1953-60; Texas Fed. Women's Cl., 1954 (2-man); Contemp. Texas A., 1955, 1958; Univ. of Iowa, 1949; Ohio State Univ., 1954; Baylor Univ., (one-man) 1955; Stephen F. Austin Col., (one-man) 1957; Mus. Contemp. A., Dallas, 1959; A. Center, La Jolla, Cal., 1960; FA Gal., San Diego, 1961; La Jolla Athenaeum, 1961 (one-man); San Diego A. Gld., 1961-64; Woodbury Col., Los Angeles, 1965; JCC Gallery, San Diego, 1963-1968. Lectures: Design, Aesthetics, Art History, on TV and to groups. Positions: Instr., Photography, Univ. of Idaho, 1949-50; Instr., Painting, A. Hist., Dillard Univ., New Orleans, 1950-53; Asst. Prof., Design, A. Hist., Baylor Univ., Waco, Tex., 1953-59; Chm. A. Dept., 1962-64; Asst. Prof., 1959-64, California Western Univ., San Diego; Director, Art in All Media exhibition, Southern California Exposition, Del Mar, Cal., 1963- . Instr., A., San Diego Community Colleges, 1968- .

KILLAM, WALT—Painter, Gr., T., C.
 71 Middlesex Pike, Chester, Conn. 06412
B. Providence, R.I., June 18, 1907. Studied: R.I. Sch. Des. Member: Mystic AA; Essex AA; Norwich AA. Awards: prizes, Norwich AA, 1951-1953; Silvermine Gld. A., 1954; Hartford, Conn., 1934; Essex AA, 1956. Work: Millbrook Sch.; Lyman Allyn Mus. A.; South County AA, and in private colls. Exhibited: Nationally and internationally; one-man: Contemp. A., 1951, 1952; Conn. Col., New London, 1955; Lyman Allyn Mus. A., 1943, 1953; Providence, R.I., 1948, 1951, 1957; Detroit Inst. A.; Kingston AA, 1957; Wesleyan Univ., 1958.

KIMAK, GEORGE—Painter, Gr., T., L.
 Area 13 Educational Media Center, Route 1, Council Bluffs, Iowa 51501; h. 89 Van Anden St., Auburn, N.Y. 13021
B. Auburn, N.Y., May 14, 1921. Studied: AIC; Syracuse Univ., B.F.A. Member: N.Y. State T. Assn.; AAMus.; Volunteer Center, Council Bluffs, Iowa (Bd. of Dir.); Audio Visual Educ. Assn. of Iowa (Bd. of Dir. 1968-1969). Awards: 4 year Scholarship, Syracuse Univ., 1942. Exhibited: Cayuga Mus. Hist. & A., 1939-41; Everson Mus. A., Syracuse, 1953, 1955, 1958-1961-1964; Munson-Williams-Proctor Inst., 1956, 1959, 1960; Rochester Mem. A. Gal., 1956; Emily Lowe A. Gal., Syracuse Univ., 1956, 1961, 1962; Art:USA, 1958; Roberson Mem. Gal., 1959-1962; Cazenovia Jr. Col., N.Y., 1959-1961; New York State Fair, 1959-1960. Contributed articles on "Museum-on-Wheels" services for schools and communities to many newspapers and educational bulletins, 1952-1958. Arranged exhs.: Mestrovic Drawings for Univ. New Mexico, 1951; Print Show for State Teachers Col., New Paltz, N.Y., 1951; Exchange Exhibition with Cornell Univ., 1951; Contemporary Student Paintings for Addison Gal. Am. Art, 1951; Contemporary Student Exhibition for Wells College, Aurora, N.Y., 1952; Print Exhibition for Binghamton H.S., 1952. Museum-on-Wheels documentary papers given to Mayfield Library, Syracuse Univ., 1967. Positions: Instr. A., in many New York State grade and high schools; Gal. Asst., Cayuga Mus. Hist. & A., 1936-40; Gal. Asst., Emily Lowe A. Center, Syracuse Univ., 1949-52; Exh. Des., N.Y. State Fair, 1952-55; Chm. N.Y. State Fair A. Exh., 1959, Supt. A. & Crafts, 1960, Dir., 1947-54, Exec. Vice-Pres., 1954-58, Artmobile, Inc.; Dir. FA, N.Y. State Exposition, 1961-1963; Pres., Visual Arts Center, 1964-1965; Exh. Chm., Minoa Free Library, 1963, 1964-1965; Audio Visual Coordinator, East Syracuse-Minoa Central Schools, Minoa, N.Y., 1962- . Dir., Area 13 Educational Media Center, Council Bluffs, Iowa, 1968-69. Asst. Prof., Audio-Visual Education, Univ. of Northern Iowa.

KIMBALL, RICHARD A.—Scholar, Director
 American Academy in Rome, 101 Park Ave., New York, N.Y. 10017
Positions: Director, American Academy in Rome, New York Office.*

KIMBALL, YEFFE—Painter, Des., I., W.
 11 Bank St., New York, N.Y. 10014
B. Oklahoma, Mar. 30, 1914. Studied: ASL, with William McNulty, George Bridgman, Jon Corbino; East Central Col.; Univ. Oklahoma. Member: ASL; Nat. Congress Am. Indians; AEA; Arrow, Inc.; Oklahoma AA; Archaeological Soc. New Mexico. Awards: prize, Philbrook A. Center, 1959. Work: Portland (Ore.) A. Mus.; Encyclopaedia Britannica; Chrysler A. Mus.; BMA; Dayton AI; BMFA; Philbrook A. Center; Washington & Lee Univ., and in many private colls. Exhibited: 1942-1958: NAD; WMAA; Carnegie Inst.; Telfair Acad. A. & Sc., Savannah; Mint Mus. A.; Encyclopaedia Britannica;

San Diego FA Center; VMFA; Randolph-Macon Col.; Savannah A. Mus.; Norton Gal. A.; Clearwater A. Center; Delgado Mus. A.; Am. Indian Exh., Philbrook A. Center, Tulsa; Univ. Georgia; Rollins Col.; Wesleyan Sch. FA, Macon; High Mus. A.; William Rockhill Nelson Gal. A.; Mattatuck Hist. Soc., Conn.; La Jolla AA; Birmingham A. Mus.; Toledo Mus. A.; Montclair A. Mus.; PAFA; deYoung Mem. Mus.; James Graham Gal., N.Y.; Rehn Gal.; Art: USA, 1958; Provincetown A. Festival; Martha Jackson Gal., N.Y., 1960; Chrysler A. Mus. one-man: Rehn Gal., 1946, 1949, 1952, 1953; Denver A. Mus., 1947; Pasadena AI, 1947; Crocker Gal. A., Sacramento, 1947; Davenport Mun. Gal., 1947; Joslyn Mem. Mus., 1947; Wichita AA, 1947; Delgado Mus. A., 1947; Philbrook A. Center, 1948; Mus. New Mexico, Santa Fe, 1948, 1957, 1965; Univ. New Mexico, 1948, 1957; Galerie Gireaux, Brussels, 1948; Portland (Ore.) A. Mus., 1949; State Col. of Washington, 1950; FA Gal., San Diego, 1950; Santa Barbara Mus. A., 1950; Rochester A. Center, Minn., 1951; Golden Jubilee Exh., Okla. City, 1957; Gallery 313, Wash., D.C., 1957; Dayton AI, 1958; Karlis Gal., Provincetown, 1959-1965; Nova Gal., Boston, 1961; Silvermine Gld. A., 1961; Norfolk Mus., 1963; Univ. Virginia, 1963; Kennedy Airport, N.Y., 1964; World's Fair, N.Y., 1965; Hellenic American Union, Athens, Greece, 1965; Retrospective, Philbrook A. Center, Tulsa, 1966, which will tour to Univ. Oklahoma, Mus. of New Mexico, Heard Mus., Phoenix and then to other Western museums, with closing exhibition in Washington, D.C., under Government sponsorship and many others. Positions: Member, Nat. Cong. Am. Indians; Bd. Control, ASL, New York, N.Y.; Consultant on native arts, Portland (Ore.) A. Mus., and Chrysler Mus. A., Provincetown, Mass.; trustee, Arrow, Inc.; Advisor, Indian Art, U.S. State Dept. Revised & illus. American Indian section of Book of Knowledge, 1957; complete revision Indian section, World Book of Knowledge, 1958.*

KIMBROUGH, SARA DODGE—Painter, T.
 806 N. Beach Blvd., Bay St. Louis, Miss. 39520
B. New York, N.Y. Studied: CUASch.; Grand Central A. Sch. (Scholarship); special training with William de Leftwich Dodge, Frederick MacMonnies, Henry Lee McFee and Jerry Farnsworth. Member: Phoenix Mus. A.; NGA; Arizona A. Gld.; regional member, Portraits, Inc., N.Y. Awards: prizes, Grand Nat. Finalist, AAPL, Phoenix, 1953; Lg. Am. Pen Women, 1936; Illinois Valley A. Exh., 1960. Work: port., Senate Office Bldg., Wash., D.C.; Civic A. Col., Phoenix; many portraits of prominent persons. Exhibited: NGA, 1936; Arizona State Fair, 1951-1957; Phoenix A. Center, 1954-1956; Arizona A. Gld.; Mississippi AA traveling exh.; Mississippi A. Festival Exh., 1968.

KIMBROUGH, VERMAN—Educator
 Ringling School of Art; h. 1874 Wisteria St., Sarasota, Fla. 33579
B. Rockford, Ala., Apr. 6, 1902. Studied: Birmingham-Southern Col., A.B. and grad. work; Univ. Florida, and in France, Italy. Member: Sarasota AA; Ringling Museum's Guild; Friends of the Ringling Museum of Art (Vice-Pres.). Position: Pres. Ringling Sch. A., Sarasota, Fla., 1931- .

KIMMIG, ARTHUR—Painter
 233 First Ave., New York, N.Y. 10003*

KIMURA, SUEKO M. (Mrs.)—Painter, E., Des., I., Gr.
 2567-B Henry St., Honolulu, Hawaii
B. Hawaii. Studied: Univ. Hawaii, B.A., M.F.A.; Chouinard AI, Los A., with Rico Lebrun; Columbia Univ., with Dong Kingman; BMSch. A., with Arthur Osver, John Ferren; ASL, with Kuniyoshi. Member: Hawaii P. & S. Lg. (Sec.); Honolulu Pr. M. Awards: prizes, Honolulu Acad. A., 1953-1958; Artists of Hawaii, 1960; Wichita, Kans., 1958; Leeward A. Exh., 1962; Easter Art Show, 1962, 1965, 1968; purchase prize, State Fnd. of Culture and Arts, 1968, 1969; Honolulu Printmakers, 1962. Work: Honolulu Acad. A.; Fresco mural, Univ. Hawaii Bilger Hall; State Capitol Bldg. Book cover design and drawings for "Philosophy and Culture, East and West," 1962. Exhibited: Long Island, N.Y., 1956; Argent Gal., N.Y.; Honolulu Acad. A., 1952-1957; Wichita, Kans. 1958; Artists of Hawaii, 1960-1964; Madonna Exh., 1961; IBM, N.Y., 1964; State A. Show, 1961-1964; Gima A. Gal., 1963 (one-man); Kyoto Mus. Mod. A., 1967. Lectures: Communication in Magazine Layout; Princess Kaiulani. Positions: Assoc. Prof. A., Univ. Hawaii.

KING, EDWARD S.—Research Associate, E.
 4544 (B) N. Charles St., Baltimore, Md. 21210
B. Baltimore, Md., Jan. 27, 1900. Studied: Johns Hopkins Univ.; Princeton Univ., A.B., M.F.A.; Harvard Univ. Member: AAMus. Contributor to: Art Bulletin; Journal of the Walters Art Gallery. Lectures: Art History. Positions: Assoc. Cur., Paintings & Far Eastern A., 1934-41, Cur., 1941- , Acting Administrator, 1945-46, Administrator, 1946-51, Dir., Walters A. Gal., Baltimore, Md. (retired). Research Assoc., at present.

KING, ETHEL MAY—Collector, Patron, W.
 50 E. 79th St., New York, N.Y. 10021
B. New York, N.Y. Studied: Columbia University. Author: "Darley, the Most Popular Illustrator of his Time." Member: Museum of Primitive Art, New York; Fellow (Life), Metropolitan Museum of Art, New York. Collection: Religious art and Americana.*

KING, JOSEPH WALLACE (VINCIATA)—Painter
 Reynolda Estate; h. 1201 Arbor Road, Winston-Salem, N.C. 27104
B. Spencer, Va., May 11, 1912. Studied: Corcoran Sch. A., and in Italy and France. Member: Lotos Cl., N.Y.; Am. Int. Acad., N.Y.; Int. FA Council, Paris, France. Work: Wake Forest Col.; Lincoln Mus., Wash., D.C.; Va. Military Inst.; Governor's Mansion, Raleigh, N.C.; Lotos Cl., N.Y., and in private collections. Mural, Community Center Bldg., Winston-Salem, N.C. Exhibited: CGA, 1938; Paris, France, 1957; Fra Angelico Salon, Rome, 1957; Royal Soc. British A. Exh., London, 1959; Hammer Gal., 1960, 1962, 1965; one-man: Bernheim-Jeune, Dauberville, Paris, 1958; Hammer Gal., N.Y., 1968.

KING, ROY E(LWOOD)—Sculptor, T.
 81 Front St., Exeter, N.H. 03833
B. Richmond, Va., Nov. 22, 1903. Studied: BAID; ASL; Univ. Richmond; Univ. Hawaii. Member: F., NSS. Awards: purchase prize, Beaumont Mus. A., Texas, 1961; Grand Prize, Honolulu Acad. A., 1940. Work: War Memorials: Honolulu, Hilo, Hawaii; medical group, Honolulu Welfare Bldg.; College of the City of New York; Washington Hall, West Point; N.Y. World's Fair, 1964-65; Bloomsburg (Pa.) PO.; Schofield Barracks PO; Pub. School, Winter Harbor, Me. Exhibited: NSS traveling exh., 1960-61; Corning Glass Co., 1962; Doll & Richards Gal., Boston, 1964-1965.*

KING, WARREN—Cartoonist
 220 E. 42nd St. 10017; h. 12 W. 69th St., New York, N.Y. 10023
B. New York, N.Y., Jan. 3, 1916. Studied: Fordham Univ., B.S.; Grand Central Sch. FA with Ivan Olinsky, Grelian, Maura, Biggs; Phoenix AI with Franklin Booth and others. Member: SI; Nat. Cartoonists Soc.; Am. Assn. Editorial Cartoonists; Soc. of Silurians. Awards: Freedoms Fnd. at Valley Forge Medals of Honor, 1953, 1959, 1962 and Certif. of Merit, 1960; Newspaper Gld. Award, 1959, 1961; Soc. Silurians, 1960, 1961, 1964; Brotherhood Award, Nat. Conference of Christians and Jews, 1963. Work: Editorial Cartoons—MMA; AIC; paintings: The Pentagon, Wash., D.C.; Air Force Academy; tour of national museums, world-wide reproduction and national magazines. Contributor to New York Daily News; Chicago Tribune News Syndicate; national advertising, newspapers and magazines. Reprints: Time, Newsweek, Life, U.S. News and World Report, True, and other periodicals. Lectures: Fundamentals of Art; Editorial Cartooning at schools, art organizations and clubs. Exhibited: nationally; reproduced internationally.*

KING, WILLIAM DICKEY—Sculptor
 17 E. 17th St., New York, N.Y. 10003
B. Jacksonville, Fla., Feb. 25, 1925. Studied: Univ. Florida; CUASch.; and in Rome, Italy. Awards: Fulbright F., 1949; prizes, CUASch., 1948; BM, 1949; St. Gaudens Medal, Cooper Union, New York, 1964. Work: AGAA; SS "United States"; Bankers Trust Co., N.Y. Exhibited: PMA, 1949; WMAA, 1950, 1951, 1953-57, 1960, 1968; MModA, 1951, 1959; AGAA, 1951, 1958; Carnegie Inst., 1958; Downtown Gal., N.Y., 1952; Alan Gal., N.Y., 1952, 1958, 1960 (one-man); Univ. Illinois, 1954, 1956; BM, 1949, 1950, 1954, 1955, 1957, 1958; Cooper Union Mus., 1949; one-man Stenfass Gal., N.Y., 1962, 1963, 1964, and others. Positions: Instr., BMSch. A., 1953-1959; Lecturer, Sculpture, Univ. California, Berkeley, 1965-66; ASL, N.Y., 1968-1969.

KINGHAN, CHARLES R.—Painter, Comm., I., T.
 2 Division St.; h. 7 Lomond Place, New Rochelle, N.Y. 10801
B. Anthony, Kans., Jan. 18, 1895. Studied: Chicago Acad. FA; Am. Acad. A., Chicago; AIC, and with Carl Scheffler, J. Wellington Reynolds, H. A. Oberteuffer, and others. Member: ANA; AWS, (Vice-Pres. 1969); SC; Phila. WC Cl.; Hudson Valley AA; New Rochelle AA; All. A. Am. Awards: prizes, Hudson Valley AA, 1951, Gold Medal, 1964; New Rochelle AA, 1945, 1946, 1948, 1969; Larchmont Women's Cl., 1948; New Rochelle Woman's Cl., 1951, 1953; SC, 1953, 1957; Westchester Woman's Cl., 1954; AWS, 1954, 1957; gold medal, All-Illinois Soc. A., 1933; gold medal, 1959, prize, 1959, All. A. Am. Work: mural, New Rochelle YMCA. Exhibited: AWS, 1949-1956; All. A. Am., 1949-1956, 1959; AIC, traveling exh., 1933; Frye Mus. A., Seattle, Wash., 1955; Ft. Lauderdale (Fla.) Marina, 1969; one-man: Fort Worth, 1963; Dallas, 1964; Wichita A.A., 1967. Author, I., "Rendering Techniques," 1956; "Ted Kautzky—Master of Pencil and Water Color," 1959. Contributor to American Artist magazine.

Positions: Chm. Membership Comm., Aquareallists. Instr., summer seminars, Springfield (Mo.) Mus., 1968 and Col. of New Rochelle, 1969.

KINGMAN, DONG—Painter, T.
 21 West 58th St., New York, N.Y. 10019
B. Oakland, Cal., 1911. Studied: Hong Kong. Awards: many awards including gold medal, Audubon A.; Guggenheim F. (2); prizes, AWS; AIC. Work: MMA; WMAA; Am. Acad. A. & Let.; MModA; BM; BMFA; AIC; SFMA; Toledo Mus. A.; Atlanta AA; Dartmouth Col.; Wilmington Soc. FA; U.S. State Dept.; AGAA; Wadsworth Atheneum; Evansville Pub. Mus. Exhibited: Internationally. I., "China's Story"; "The Bamboo Gate"; covers for Fortune, Time, Life, Holiday, Reporter magazines. Paintings for film production, "Flower Drum Song." Painted his impressions, in Madrid, of the film "55 Days at Peking" also "King Rat," "Sand Pebbles," "Desperados," "Virgin Soldiers," "Circus World," etc. Cultural exchange lecture tour for U.S. Dept of State, 1954. Positions: Instr., Famous Artist Sch., Westport, Conn.

KINGMAN, EUGENE—Museum Director, P., Lith.
 Joslyn Art Museum, 2218 Dodge St. 68102; h. 312 South 56th St., Omaha, Neb. 68132
B. Providence, R.I., Nov. 10, 1909. Studied: Yale Univ., B.A.; Yale Sch. FA, B.F.A. Member: AAMus.; Assn. A. Mus. Dir.; Audubon A; Providence A. Cl.; Assoc. A. of Omaha. Awards: prizes, Providence A. Cl., 1929, 1957; Delgado Mus. A., 1940; Oklahoma A., 1940; Mulvane A. Center, 1952, Hon. D.F.A., Creighton Univ., 1968. Work: LC; Philbrook A. Center; Mulvane A. Center; murals, Crompton Richmond Co., N.Y.; USPO; Hyattsville, Md.; Kemmerer, Wyo.; East Providence, R.I.; Mus. Glacier Nat. Park, Montana; Crater Lake Mus., Oregon; New York Times Bldg., N.Y. Exhibited: NAD, 1937-1942; San F. AA, 1937-1939; Kansas City AI, 1940; Colorado Springs FA Center, 1940, 1942; Okla.A., 1940; Dallas Pr. Soc., 1943; Providence A. Cl., 1927-1952. I., "The Rocky Mountains," 1945. Positions: Instr., R.I. Sch. Des., 1936-39; Dir., Philbrook A. Center, 1939-42; Cartographer, OSS, 1942-45; Asst. Dir., 1946-47, Dir., 1947- , Trustee, 1961- , Joslyn A. Mus., Omaha, Neb.; Consultant on Exhibitions, Smithsonian Inst., 1957-58, 1959-61; Consultant, Missouri River Powerhouse Exhibits, U.S. Corps of Engineers, 1958- . Contributor article "Painters of the Plains," American Heritage Magazine, 1954; Midwest Heritage Conf., Coe College, Cedar Rapids, Iowa, 1956; Bd. Memb., Metropolitan Omaha Educational Broadcasting Assn., 1964- . Member, State Department National Accessions Committee, Art in Embassies Program, 1965; Sec - Treas., Am. Assn. of A. Mus. Directors, 1965, 1966; Vice-Pres. 1967. Neb. A. Council, Vice-pres., 1966- . Metropolitan A. Council, board member, 1966. Governor's Hall of Fame Comm. for Neb. State Capitol, 1968- .

KINGREY, KENNETH—Designer, E.
 University of Hawaii; h. 5959 Kalanianaole Highway, Honolulu, Hawaii 96816
B. Santa Ana, Cal., Dec. 23, 1913. Studied: Univ. Cal. at Los Angeles, B.E., M.A. Member: Los A. A. Dirs. Cl.; Hawaii P. & S. Lg.; Nat. A. Dirs. Cl.; NAEA. Awards: 50 Best Books award, AIGA, 1958; Western Books award, 1958, 1959. Exhibited: 50 Best Books, AIGA, 1958; Traveling exh., U.S., Europe, Central America, Russia; Univ. Hawaii annually; State Fair, etc. Editor: "Design Quarterly," WAC, 1960; contributor to "Idea," 1961. Positions: Prof., Adv. Art, Univ. California at Los Angeles, 1940-53; Visual Des. & Adv. Art, University of Hawaii, Honolulu, Hawaii, 1950-51, 1953- . Freelance Des., Home and Industrial Interiors.*

KINGSBURY, ROBERT DAVID—Sculptor, C.
 760 Wisconsin St., San Francisco, Cal. 94107
B. Detroit, Mich., Oct. 19, 1924. Studied: Univ. Michigan, B. Des.; Konstfackskolan, Stockholm, Sweden. Member: AEA. Work: Frieze, Domus Hotel, Stockholm; Font, Hope Lutheran Church, Colma, Cal.; Grace Cathedral, San Francisco. Exhibited: Detroit Inst. A., 1951; SFMA, 1963; Galerie de Tours, San Francisco, 1963; Fresno A. Center, 1963; Richmond A. Center, 1962; Cal. State Col., Hayward, Cal., 1964; Pasadena A. Mus., 1965, 1968; Mus. Contemp. A., New York City, 1968. Positions: Pres., AEA Northern California, Inc.

KINIGSTEIN, JONAH—Painter, Des., Comm. A.
 123 Second Ave., New York, N.Y. 10003
B. New York, N.Y., June 26, 1923. Studied: CUASch.; Grande Chaumiere, Paris, France. Awards: Fulbright F., 1953-54; Nat. Inst. A. & Lets. grant, 1958; prize, Butler AI, 1956; purchase prize, Univ. Illinois, 1959; Silvermine Gld., 1959; Tiffany Fnd. award, 1961. Work: MModA; WMAA; Albright A. Gal.; Brandeis Univ.; Wichita Mus. A.; William Rockhill Nelson Gal. A.; Butler AI; BM; Tel-Aviv; Univ. Illinois; Univ. Arizona. Exhibited: Univ. Illinois, 1956, 1958; WMAA, 1955, 1957; MModA.; BM; PAFA; AIC; Down-

town Gal., N.Y., 1952, 1953; Alan Gal., N.Y., 1954, 1958; Nat. Inst. A. & Lets., 1957; Butler Inst. Am. A., 1956; one-man: Siembab Gal., Boston, 1959; Werbin Gal., Detroit, 1957; ACA Gal., N.Y., 1959, and in Paris, France.*

KINSTLER, EVERETT RAYMOND—Portrait Painter, I.
15 Gramercy Park, New York, N.Y. 10003
B. New York, N.Y., Aug. 5, 1926. Studied: ASL, with DuMond and portraiture with Wayman Adams, J.C. Johansen, J.M. Flagg. Member: Portraits, Inc.; Grand Central A. Gal.; ASL (Life); SC; Hudson Valley AA; Century Assn.; All. A. Am.; NAC (Vice-Pres.); Audubon A. (Exec. Vice- Pres.); AWS; Artists Fellowship (Pres.). Awards: prizes, All. A. Am.; 1968; SC; Bronze medal, NAC, 1967. Work: Princeton, Columbia and New York Universities; Univ. Chicago; Mus. of the City of New York; Amherst Col.; Rutgers Univ.; U.S. Navy Art Coll.; Mystic Seaport Mus.; Univ. Wisconsin; Northwestern Univ.; Smithsonian Institution; MMA; Carnegie-Mellon Univ.; N.Y. Stock Exchange; West Point Military Acad. Portraits of many prominent persons in government, banking, industry, military forces, education, etc. Exhibited: NAC; Hudson Valley AA; SI; All. A. Am.; Grand Central A. Gal. (one-man), 1960; Portraits, Inc.; NAD, 1969, and others, Illus.: "Our Federal Government," 1958; "The Opera Companion," 1961; "Verdi," 1963; "Black Beauty," 1964; "Fury," 1964 and several hundred book jackets since 1945. Positions: Chm. Exhibition Committee, NAC, 1957-61; Dir., All. A. Am., 1958-60.

KIPNISS, ROBERT—Painter, Et., Lith.
829 Ave. of the Americas 10001; h. 376 Pacific St., Brooklyn, N.Y. 11217
B. Brooklyn, N.Y., Feb. 1, 1931. Studied: ASL; Wittenberg Col.; State Univ. Iowa, B.A., M.F.A. Exhibited: AFA 1963, 1964, 1965; Herron Mus., Indianapolis, 1964; Tweed Gal., Univ. Minnesota, 1961; Columbus (Ohio) Mus. FA, 1958; Butler Inst. Am. A., Youngstown, Ohio, 1953; Allen Hite Inst., Univ. Louisville (one-man). Illus., "Emily Dickinson Poems," 1964; "Poems of Robert Graves," 1966.

KIPP, LYMAN—Sculptor
North Salem, N.Y. 10560
B. Dobbs Ferry, N.Y., Dec. 24, 1929. Studied: PIASch.; Cranbrook Acad. A. Award: Guggenheim Fellowship, 1965. Work: Cranbrook Mus. A.; Albright-Knox A. Gal., Buffalo; Univs. of Kentucky and Michigan; Dartmoth Col. WMAA; M.I.T. Exhibited: nationally including Carnegie Inst., 1961; WMAA, 1955, 1960, 1962, 1964, 1966; Sao Paulo, 1963; BMA, 1955, 1959, 1967; Detroit Inst., 1955; BM, 1960; AIC, 1961, 1962; Banfer Gal., N.Y., 1964; F.A.R. Gal., N.Y., 1964; Inst. Contemp. A., Philadelphia, 1966; Jewish Mus., N.Y., 1966; Los Angeles County Mus., 1967; Aldrich Mus. Contemp. A., 1968 (2); Gray Gal., Chicago, 1967; Buffalo Festival A., 1968; MModA, 1968; N.Y. State Expo., Syracuse, 1968, and many others. One-man: Cranbrook Acad. A., 1954; Betty Parsons Gal., 1954, 1956, 1958, 1960, 1962, 1964, 1965, 1968; Myrtle Todes Gal., Glencoe, Ill., 1957, 1960; Arizona State Col., Tempe, 1957; Pensacola A. Center, 1958; Providence A. Cl., 1958; Bennington College, 1960; Albright-Knox Gal., 1967; Katonah, N.Y., 1968; Obelisk Gal., Boston, 1969; Dartmouth Col., 1965. Positions: Instr. Sculpture, Bennington College, 1960-63; Pratt Inst., Brooklyn, N.Y., 1962-63; Asst. prof., Hunter Col., N.Y. 1963- ; A.-in-Res., Dartmouth Col,, 1965; Hunter Col., 1963-1968; Assoc. Prof., Dept. Chm., Lehman Col., July, 1968.

KIPP, ORVAL—Painter, E., Gr., I., L.
Kiski School, Saltsburg, Pa.; h. 964 Oakland Ave., Indiana, Pa. 15701
B. Hyndman, Pa., May 21, 1904. Studied: J.B. Stetson Univ.; Carnegie Inst., A.B.; T. Col., Columbia Univ., A.M.; Univ. Pittsburgh, Ph.D. Member: NEA; Eastern AA; AAUP; Assoc. A., Pittsburgh; AEA; Indiana AA; All. A. Johnstown; Pa. A. Edu. Assn. (Council); Am. Artists in Particular. Awards: scholarships, Carnegie Inst.; prizes, Indiana AA, 1946, 1949, 1950, 1952-1957; special jury award, Pittsburgh Soc. A., 1968. Work: in the colls. of the following schs.: Latrobe H.S., Aspinwall H.S., Greensburg Pub. Schs., Indiana Pub. Schs., Uniontown H.S., all in Pennsylvania. Exhibited: Provincetown AA, 1936, 1937; All. A. Am., 1938; All. A. Johnstown, 1931-1957; Assoc. A. Pittsburgh, 1932-1957; Cooperative A. Exh., Indiana, Pa., 1944-1952; AFA traveling exh., 1940; Indiana AA, 1943-1952; Studio Gld., West Redding, Conn., traveling exh., 1957-1959; Kottler Gal., N.Y., 1958; Fla. Southern Col., 1952. I., Des., "Indiana Through the Camera's Eye"; "An Experimental Study of Color Perception." Lectures: "Trick or Treat in Art Education," Indianapolis, Ind., State Art Teachers, 1955; Lectures & demonstrations: "The Mystery of The Masters." Positions: Bd. Dir., Vice-Pres., Assoc. A. of Pittsburgh, 1955, Pres., 1957-58; Instr. A., 1936-41, Dir. A. Dept., 1941-60, Prof. & Chm., 1960-1964, Indiana State Col., Indiana, Pa., Prof. Emeritus, 1969.

KIRKLAND, VANCE HALL—Educator, P.
1311 Pearl St.; h. 817 Pearl St., Denver, Colo. 80203
B. Convoy, Ohio, Nov. 3, 1904. Studied: Cleveland Sch. A., B.E.A.; Western Reserve Univ. Work: AIC; William Rockhill Nelson Gal. A.; Norton Gal. A.; Colorado Springs FA Center; Denver A. Mus.; Santa Barbara Mus. A.; Oakland A. Mus.; San Diego FA Soc.; Columbus Gal. FA. Positions: Dir., Univ. of Denver Sch. A., 1946-1969.

KIRSCH, DWIGHT—Art Consultant, P., E., W., L.
1701 Casady Drive, Des Moines, Iowa 50315
B. Pawnee County, Neb., Jan. 28, 1899. Studied: Univ. Nebraska, A.B.; ASL, with Henri, Boardman Robinson, Frank DuMond, A.S. Calder, and others. Member: Assn. A. Mus. Dir.; AEA; Assoc. A. Omaha; AIA (Hon.); Des Moines Weavers Gld. (Hon.). Awards: Hon. Degree, D.F.A., Grinnell Col., 1953. Work: in collections including, Murdock Coll.; Wichita A. Mus.; PMA; Sioux City A. Center; Nebraska AA and several private colls.; mural commissions in Iowa, 1959, 1964, 1965. Exhibited: at many regional and national shows since 1916, including AIC; Colorado Springs FA Center; MMA; Phila. A. All.; PAFA; SFMA; Walker A. Center; WMAA. Juror of Regional Exhs. and lecturer in many states. Contributor of articles to Art in America; American Magazine of Art; New York Times, etc. Positions: Instr. A., Univ. Nebraska, 1924-1931; Chm. Dept. A., 1931-47; Dir., A. Gal., Univ. Nebraska, 1936-50; Guest Instr., Joslyn A. Mus., Omaha, 1949; Dir., Des Moines A. Center, 1950-1958, A.-in-Res., Iowa State Univ., Ames, 1959-1965. Freelance artist, art consultant and lecturer, at present.

KIRSCHENBAUM, JULES—Painter, Gr., E.
3908 Grand Ave., Des Moines, Iowa 50312
B. New York, N.Y., Mar. 25, 1930. Studied: BMSch.A. Member: AWS; Phila. A. All.; NA. Awards: Fulbright Fellowship, 1956; prizes, Emily Lowe Comp., 1950; NAD, 1953-1955, 1960; Butler Inst. Am. A., 1957; medal, PAFA, 1952; Am. Acad. A. & Lets., Childe Hassam purchase award, 1969. Work: WMAA; Butler Inst. Am. A.; Univ. Nebraska; Des Moines A. Center; Weatherspoon Gal. of Univ. North Carolina; Everhart Mus., Scranton, Pa. and in private colls. Exhibited: MMA, 1952; PAFA, 1952, 1953, 1954, 1957; CGA, 1952; WMAA, 1953-1957; MModA; BM; Santa Barbara Mus. A.; Pasadena A. Mus.; FA Center of Houston; DMFA; AFA traveling exh., 1955; AIC, 1957; Butler Inst. Am. A., 1957; Spoleto, Italy, 1958; Paris, France, 1958; Univ. Illinois, 1957. Positions: Assoc. Prof. A., Drake Univ., Des Moines, Iowa.

KIRSTEIN, MR. and MRS. LINCOLN—Collectors
128 East 19th St., New York, N.Y. 10003*

KIRSTEN, RICHARD CHARLES—Painter, Gr.
900 North 102nd St., Seattle, Wash. 98133
B. Chicago, Ill., April 16, 1920. Studied: AIC; Univ. Washington. Study in Japan, 1958-1969. Member: AFA; Northwest WC Soc.; (Pres., 1968, 1969); Northwest Pr. M. Awards: prizes SAM, 1949, 1950; Music & Art Fnd., 1951; Northwest WC Soc., 1952; Seattle Boat Show exh., 1955-1957; Bellevue (Wash.) A. & Crafts exh., 1956, 1957; purchase prizes, Univ. Oregon, 1968; Seattle First Nat. Bank, 1969. Work: SAM; LC; MMA; Tokyo Mus. Mod. A., and in private colls. Exhibited: SAM, 1945, 1947-1958, 1960-1965, 1966 (2), 1967-1969; Western Wash. Fair, 1947-1957; Music & Art Fnd., 1949-1958; Pacific Northwest exh., Spokane, Wash., 1949-1951; Northwest Pr. M., 1950-1958; Buffalo Pr. Cl., 1951; Riverside Mus., N.Y., 1953, 1956; Morris Gal., N.Y., 1955; MModA, 1954; Oakland A. Mus., 1955; SFMA, 1954; AEA (Seattle Chptr.), 1952; LC, 1957; NGA, 1957; Rochester Mem. A. Gal., 1958; Mobile AA, 1958; Univ. Wisconsin, 1958; Portland (Ore.) A. Mus., 1958; deYoung Mem. Mus., 1958; Bucknell Univ., 1958; Butler County Hist. Soc., El Dorado, Kans., 1958; Riverside Mus., N.Y., 1958; Frye Mus., Seattle, 1960-1965, 1969; Governor's Invitational, 1967; one-man: SAM, 1943, 1962; Studio Gal., 1949, Millard Pollard Assoc., 1952, Hathaway House, 1952, 1955, Campus Gal., 1955, 1956, 1958, all in Seattle; Yoseido Gal., Tokyo, Japan, 1958, 1961; Daimaru Gal., Hokkaido, Japan; Flint Inst. A., (Mich.), 1962; Port Townsend (Wash.) Gal., 1963-1965; Fran-Nell Gal., Tokyo, 1966; Collector's Gal., Bellevue, Wash., 1967; Richard White Gal., Seattle, 1968. Positions: Ed. A., Seattle Post-Intelligencer, 1948- .

KISELEWSKI, JOSEPH—Sculptor
433 East 82nd St., New York, N.Y. 10028
B. Browerville, Minn., Feb. 16, 1901. Studied: Minneapolis Sch. A.; NAD; BAID; AM. Acad. in Rome; Acad. Julian, Paris. Member: NA; NSS; Arch. Lg. Awards: Prix de Rome, 1926-1929; Watrous gold medal; prize, Beaux-Arts, Paris. Work: statues: Milwaukee, Wis.; Harold Vanderbilt, Nashville, Tenn. 1965; Moses, Law College, Syracuse University; Sylvanus Thayer, for Hall of Fame for Great Americans; groups, Bronx County Court House, N.Y.; fountain, Huntington Mus., S.C.; pediment, Commerce Bldg., Wash., D.C.;

George Rogers Clark mem., Vincennes, Ind.; plaques, Capitol Bldg., Wash., D.C., Covington, Ky., John Peter Zanger Sch., N.Y.; reliefs, General Accounting Bldg., Wash., D.C.; panels, Loyola Seminary, Shrub Oak, N.Y.; City & Municipal Courts Bldg., New York, N.Y., 1961; statue, Veterans' Cemetery, Margraten, Holland.

KISH, MAURICE—Painter
 70 South 3rd St., Brooklyn, N.Y. 11211
B. Dvinsk, Latvia, Feb. 19, 1898. Member: All. A. Am.; Am. Soc. Contemp. A.; Conn. Acad. FA; AAPL; P. & S. Soc., New Jersey; Am. Veterans' Soc. A.; Audubon A.; AEA. Work: Ein Harod Mus., Israel; Biro-Bidjan Mus., USSR; Seton Hall Univ., N.J.; BM; Norfolk Mus. A. & Sciences; Springville, Utah; Butler Inst. Am. A.; Awards: prizes, All. A. Am., 1945, Conn. Acad. FA, 1945; Grand Central A. Gal., 1949; Veteran's Soc. A., 1949 (prize and medal), 1954, 1955, 1957-1959, medal 1960, 1962, 1963 prize, 1968; P. & S. Soc., New Jersey, 1952, medal, 1963; A. Festival, 1951, 1952, 1958, 1962; Ogunquit A. Center, 1952; Inst. A., Temple Israel, 1963; Audubon A., 1964; Irvington A. & Mus. Assn., 1952; Fla. State Col., 1952; Dist. No. 65, 1952, 1958, 1962. Exhibited: NAD; CGA; PAFA; VMFA; AFA traveling exh.; All. A. Am.; Conn. Acad. FA; BM; Brooklyn Soc. A.; North Shore AA; Riverside Mus.; Audubon A.; Edu. All.; Findlay Gal.; ACA Gal.; Macbeth Gal.; P. & S. Soc., Fla. Southern Col.; Terry AI; Newport AA; Delgado Mus. A.; Carnegie Inst.; Ein Harod Mus., Israel; Grand Central A. Gal.; Butler Inst. Am. A.; Detroit Inst. FA; Springville Mus., Utah; Adam Miciewitz Mus., Warsaw, Poland; Audubon A.; Norfolk Mus. A. & Sciences; Biro-Bidjan Mus., USSR, and other national and international exhs.

KISKADDEN, ROBERT M(ORGAN)—Painter, E.
 301 N. Old Manor, Wichita, Kans. 67208
B. Tulsa, Okla., Dec. 6, 1918. Studied: Univ. Kansas, B.F.A.; Ohio Wesleyan Univ., M.A., and with Albert Bloch, Karl Mattern, Eugene McFarland and others. Member: Kansas Fed. A.; Mid-West College Art Assn.; Wichita A. Mus. Members Fnd.; Wichita A. Gld. Awards: Teaching F., Ohio Wesleyan Univ., 1947-1949; prizes, Ohio Valley Oil & Wc Soc., 1948; purchase award and 2 special merit awards, Wichita A. Mus., 1954, special merit award, 1955, 1961; purchase award, Pittsburg, Kans., 1963. Work: Wichita A. Mus.; Birger Sandzen Mem. Gal., Lindsborg, Kans.; Wichita State Univ.; Ohio Wesleyan Univ.; Kansas State College of Pittsburg; Univ. Texas, El Paso; Ft. Hays (Kans.) State Col.; Kansas State Col., Manhattan; Eastern Illinois State Univ; Wichita State Univ. Campus Activities Coll.; mural, Mid-Kansas Fed. Savings & Loan Assn., Wichita. Exhibited: Missouri Valley A., 1951-1955, 1958, 1961; Mid-America Exh., Kansas City, 1953-1955, 1957, 1959, 1963; Air Capitol Annual, Wichita, 1954-1960; 50 Years of Kansas Art, 1958; A. of the Southwest, 1959; Oklahoma City, 1959; Kansas Centennial, 1961 and traveling; Kansas Artists, 1964, 1965; Graphics and Drawings, Wichita, 1953, 1954, 1960, 1961; Art:USA, 1958; Stephens Col., 1964; Art Faculty Exh., Wichita State Univ., 1950-1954, 1957, 1958, 1960-1965; Wichita A. Gld., 1950-1956, 1958-1963; Art for Living, Wichita, 1960, 1961; Wichita A. Mus. Members Ex., 1961; Wichita AA, 1953, 1954, 1960, 1961; Knoxville, Tenn., 1964; one-man: Estes Park, Colo., 1951, 1952; Univ. Wichita, 1958; Hutchinson AA, 1960, 1961; Studio Gal., Topeka, 1963; Wichita A. Mus., 1965, and others. Positions: Bd., Kansas Fed. A.; Bd. Wichita A. Mus. Foundation, Inc.; Ex-offico Memb., Wichita A. Mus. Bd.; Accessions Comm. of Wichita A. Mus. Prof. A., Actg. Chm., Dept. A., Wichita State University.

KISSNER, FRANKLIN H.—Collector
 24 Gramercy Park S., New York, N.Y. 10003*

KITAJ, RONALD—Painter, printmaker
 c/o Marlborough-Gerson Gallery, 41 E. 57th St., New York, N.Y. 10022*

KITNER, HAROLD—Painter, E., Critic
 101 Bowman Hall, Kent State University, Kent, Ohio 44240; h. 531 Stonewood Drive, Akron, Ohio 44313
B. Cleveland, Ohio, May 18, 1921. Studied: Cleveland Inst. A., B.S.; Western Reserve Univ., M.A. Awards: 10 awards, Akron May Shows, 1950-1962; prize, Cleveland May Show, 1960, and others. Work: CMA; Akron AI; Kent State Univ.; mosaic triptych, Kent State Univ. Exhibited: Butler Inst. Am. A., 1955-1962; Akron, Cleveland, Canton, Massillon, Youngstown, museum competitions and one-man shows. Positions: Prof. A., Kent State University. Kent, Ohio; Coordinator, Div. Painting & Sculpture, 1958-1963 and 1964-1968. Acting Chm., 1963-1964, Gallery Director, 1956-1958. Dir., Blossom-Kent Art Program, 1967- ; Dean for Faculty Counsel, 1968- .

KITZINGER, ERNST—Scholar
 Room 2, Busch-Reisinger Museum, Cambridge, Mass. 02138
B. Munich, Germany, Dec. 27, 1912. Studied: Univ. Munich, Ph.D.; Univ. Rome. Field of Research: Early Christian, Byzantine and

Medieval Art. Positions: A. Kingsley Porter University Professor, Harvard University, 1967- .

KIZER, CHARLOTTE E.—Craftsman, P., T.
 Eton Lodge, Scarsdale, N.Y. 10583
B. Lincoln, Neb., Jan. 8, 1901. Studied: Univ. Nebraska, B.F.A.; T. Col., Columbia Univ., M.A.; & with Charles Martin, Adda Husted-Andersen; Rudolph Schumacher. Member: Artist-Craftsmen of New York; N.Y. Soc. Craftsmen (Vice-Pres., 1949-52, Pres., 1952-55); Westchester A. Soc.; Nat. A. Edu. Assn.; Eastern AA. Work: Joslyn Mem. Exhibited: Nat. Exh. Am. A., N.Y., 1936; Syracuse Mus. FA, 1936; Contemporary Crafts Exh., Phila., Pa., 1937; Artist Craftsmen of N.Y., 1958-1969; Craftsmen of Northeastern U.S., Worcester, Mass.; Mus. Contemp. Crafts, New York City; Circulating exhibits of The American Federation of Arts and Smithsonian Institution; N.Y. Soc. Craftsmen; Designer-Craftsmen U.S.A., 1953-1955; Westchester A. & Crafts Gld.; Kansas City AI; Joslyn Mem.; Nebraska AA.; Lincoln A. Gld.; Palm Beach, Miami, Fla. Positions: Former Dir., A. & Crafts, Westchester County Dept. of Parks, Recreation & Conservation, White Plains, N.Y.

KLEBE, CHARLES EUGENE (GENE)—Painter, I.
 Route 130, Bristol, Me. 04539
B. Philadelphia, Pa., Sept. 18, 1907. Studied: Phila. Col. A.; Univ. Pennsylvania. Member: ANA; AWS; All. A. Am; SC; Philadelphia, Baltimore and Maine WC Soc.; Maine A. Gal., Wiscasset; Pemaquid A. Group; Explorers Cl. Awards: Gold Medal, AAPL, 1961; prizes, SC, 1955, 1957, 1960, 1961, 1966, 1968, 1969; Baltimore WC Soc., 1953, 1955, 1957, 1961, 1964; All. A. Am. Mem. Prize, 1963, 1967; AWS, 1969. Work: paintings, U.S. Navy Art Coll.; Univ. Maine; First Nat. Bank, Portland, Me.; Expo' 67, State of Maine Bldg., mural. Assignments and commissions: U.S. Navy Assignments, 1960-1961, and 1961-1962, Gemini XI, 1966; U.S. Navy Middle East, 1964; Exhibited: AWS, 1961-1969; PAFA, 1945-1960; AAPL, 1961, 1962; U.S. Naval Art, Paris, London, Amsterdam and West Germany, 1963; Baltimore WC Soc., 1955-1969; SC, 1948-1965; Farnsworth Mus., 1958-1969; Ft. Lauderdale, Fla., 1969; Maine A. Gal., 1960-1964; Maine A. Festival, 1960-1965; one-man: Univ. Maine, 1963; Westbrook Col., 1968; Bowdoin Col., 1968. Co-author "An Antarctic Summer," 1965 (and illustrator). Positions: Dir., Pemaquid A. Gal., 1958-1969; Dir., Maine A-Gal., 1960-1969; Chm., Maine A. Commission, 1961, 1968, 1969; Governor's Council on Art & Culture, 1965.

KLEIN, DORIS—Painter, S. Pr.M.
 235 W. 76th St., New York, N.Y. 10023
B. New York, N.Y., Nov. 10, 1918. Studied: ASL, and privately. Member: NAWA. Awards: prizes, Jersey City Mus., 1964, 1966; Marion K. Haldenstein Mem. Prize, NAD, 1968. Work: Univ. Maine; Benedictine Art Awards, 1968, 1969. Exhibited: Maxwell Gal., San Francisco; Alley Gal., Houston, Tex.; Springfield (Mass.) Mus. FA; Jersey City Mus.; Purdue Univ.; Assoc. Am. A., N.Y.; Cober Gal., N.Y.; NAD; NAWA, 1960-1967; Boston Pr.M.; All. A. Am.; Audubon A.; Museo de Bellas Artes, Argentina, 1963; Corcoran Gal., Lending Library, 1968; MModA, Lending Library, N.Y., 1969; PMA, 1969. One-man: Roko Gal., N.Y., 1968; N.Y. Hilton Hotel, 1967; Jason Gal., N.Y., 1967; Granite Gal., 1966; Revel Gal., 1965. Painting reproduced in House Beautiful, 1969.

KLEIN, ESTHER M. (Mrs. Phillip)—Writer, Patron, Collector
 1530 Spruce St.; h. The Touraine, 1520 Spruce St., Philadelphia, Pa. 19102
B. Philadelphia, Pa., Nov. 3, 1907. Studied: School of Journalism, Temple University, B.S.; University of London, England. Awards: Honored as one of 80 most distinguished graduates, Temple University, 1964; Award for services in radio, Artists' Equity, 1950. Member: Academy of Fine Arts (Life), Print Club, Art Museum, Art Alliance, all Philadelphia, Pa.; Peale Club; Art Institute of Chicago; MModA, N.Y. Author: Articles in Philadelphia Art Alliance, Philadelphia Jewish Times; "Guidebook to Jewish Philadelphia," 1965; "International House Cookbook," 1966. Collection: Contemporary Philadelphia Artists, 1930-1965. Positions: Editor, Bulletin of Philadelphia Art Alliance, 1945-1959; Vice-President, American Color Print Society, 1958- ; Art Critic, WPEN, 1949-1953, Philadelphia Jewish Times; Founder, Long Beach Island Foundation for Arts and Sciences at Harvey Cedars, N.J., 1948; Chm., (Hon.) "The Communications Media" Conference at Temple University, 1969; Chm., "Israeli Art from Philadelphia Collections" exhibit at International House, 1969; Chm., "A Century of Fashions of Rittenhouse Square 1869-1969" at the Philadelphia Art Alliance, 1969. Donor of many prizes to various art groups and organizations.

KLEIN, MEDARD—Painter, Gr.
 1159 N. Dearborn St., Chicago, Ill. 60610
B. Appleton, Wis., Jan. 6, 1905. Studied: Chicago A. Schs. Exhibited: AIC; Salon des Realites Nouvelles, Paris, France; Palais des

Beaux-Arts, Paris; Mus. Non-Objective Painting (Solomon Guggenheim Mus.), N.Y.; Joslyn A. Mus.; SFMA; Everhart Mus. A.; Illinois State Mus.; Assoc. Am. A., Chicago; Benjamin, Finley, New Studio, Gambit galleries, Chicago; 1020 Art Center, Chicago; Oakland A. Mus.; Albany Inst. Hist. & A.; NAD; LC; Wichita AA; Phila. Pr. Cl.; PAFA; Northwest Pr.M.; Laguna Beach AA; BM; Rochester Mem. A. Gal.; Carnegie Inst.; CM; George Binet Gal.; Bookbuilders Workshop, Boston; AGAA; Olivet Col.; Univ. Washington; Lawrence Col.; Cal.PLH; Pasadena AI; Univ. Mich.; Cranbrook Acad; AFA traveling exh.; one-man; Paul Theobold Gal., Chicago; St. Louis A. Center; Univ. Minn.; Springfield A. Mus.; Lawrence Univ.; Chicago Pub. Lib.; Copley Soc. of Boston; Northeastern Univ.; Univ. Chicago; New Trier H.S.; Evanston H.S.; Wustum Mus. FA; Cliff Dwellers, Chicago; Iowa State T. Col.; Richardson Bros., Winnipeg, Canada, and others.

KLEIN, SANDOR—Sculptor, P.
 33 W. 67th St., New York, N.Y. 10023
B. New York, N.Y., Oct. 27, 1912. Studied: NAD; BAID; Academie Julien, Paris; Ecole des Beaux-Arts, Paris; Royal Acad. A., Budapest, Hungary. Member: F., Royal Soc. of Art, London. Awards: Pulitzer Prize, Painting, 1931; F., Am. Acad. in Rome; Silver Medal, Paris Salon; the Hallgarten and Tiffany awards and the Watrous Medal, N.Y. Work: NGA; State Museum at Albany, N.Y.; Luxembourg Museum (purchase); murals, Coast Guard Acad., New London, Conn. Congressional portraits for the Pentagon, Chm. of Joint Chiefs of Staff, Gen. Nathan Twining and Gen. Curtis E. LeMay. Exhibited: U.S. and abroad.

KLEINHOLZ, FRANK—Painter, T., Des., Gr., L.
 18 Prospect Ave., Port Washington, N.Y. 11050
B. Brooklyn, N.Y., Feb. 17, 1901. Studied: Fordham Univ., LL.B.; Am. A. Sch.; & with Alexander Dobkin, Yasuo Kuniyoshi, Sol Wilson. Member: An Am. Group; A. Lg. Am. Awards: AV, 1942. Work: MMA; PMG; BM; Newark Mus. A.; Univ. Alabama; Univ. Arizona Tel-Aviv Mus.; Encyclopaedia Britannica Coll.; Brandeis Univ.; triptych, Teatro Maria, Marquette Univ., Milwaukee, 1960. Exhibited: Carnegie Inst., 1941, 1943-1946; PAFA, 1942, 1944, 1945; VMFA, 1942, 1944; WMAA, 1943, 1945; AIC, 1943; Pepsi-Cola, 1944; Univ. Nebraska, 1944; State Univ. Iowa, 1944-1946; CGA, 1945; Albright A. Gal., 1946; CAM, 1945; Springfield Mus. A., 1945; MMA (AV), 1942; PMG, 1943 (one-man); Whyte Gal., 1944 (one-man); Assoc. Am. A., 1942, 1944, 1945 (one-man); An Am. Group, 1944, 1945; Art: USA, 1958; Audubon A., 1955-1958; NAD, 1957, 1958; BM, 1944; A. Lg. Am., 1944, 1945; one-man: New York City, 1948, 1950; Detroit, Mich., 1955, 1958, 1960 (one-man); Los Angeles, 1961 (one-man); Palmer House Gal., Chicago, 1956; Roosevelt Field A. Gal., Long Island, 1961 (one-man); Lectures: Contemporary Art. Positions: Instr., BM Sch. A., Brooklyn, N.Y., 1946. Visiting A., Hofstra Col., Hempstead, N.Y., 1952.*

KLEP, ROLF—Illustrator, Comm. A., Des.
 Surf Pines, Gearhart, Ore. 97138
B. Portland, Ore., Feb. 6, 1904. Studied: Univ. Oregon, B.A.; AIC; Grand Central Sch. A. Member: SI; Eugene Field Soc.; A. Gld.; Pacific A. Gld. Work: Paintings on exhibit: Baseball Hall of Fame; Univ. of Oregon Mus. A.; Haseltine Collection of Northwest Art; Mariner's Mus.; Maritime Mus., City Hall and Public Library, Astoria, Ore.; Sanctuary of the Sorrowful Mother, Portland, Ore. Author, I., "Album of the Great," 1937; "The Children's Shakespeare," 1938; I., "Beowulf," 1941; Contributing I., "Across the Space Frontier," 1952; "Conquest of the Moon," 1953. Lectures with slide illus. throughout Oregon, including Univ. Oregon Mus. Art, 1960. Positions: Technical, Marine and Aeronautical illus. for national magazines and advertising agencies. Bd. Dirs., Friends of the Museum, Univ. Oregon (Emeritus); Bd. Dirs., Univ. Oregon Development Fund, 1959-65. Founder, Pres., Columbia River Maritime Museum, Astoria, Ore., 1962-65, and present Director.

KLINE, ALMA—Sculptor
 225 E. 74th St., New York, N.Y. 10021
B. Nyack, N.Y. Studied: Radcliffe Col., A.B. and with Jose de Creeft. Member: Audubon A. (Exec. Bd.); Knickerbocker A.; NAWA (Exec. Bd.); Silvermine Gld. A.; Soc. Animal A.; Sculpture Center (Assoc. Memb.). Awards: Grumbacher purchase award, Audubon A., 1960; Medal of Honor, Knickerbocker A., 1964; P. & S. of New Jersey, 1969. Work: Radcliffe Col. Graduate Center; Norfolk Mus. A. & Sciences. Exhibited: BMFA, 1951, 1954; Riverside Mus., N.Y., 1962; Jersey City Mus., 1964, 1965, 1967, 1968; NAD, 1953, 1961, 1962; also in England, Argentina and Mexico; one-man: New York City, 1952, 1963, 1969; Silvermine Gld. A., 1958; Southern Vermont A. Center, 1967; NAC, 1968; NSS, 1969; 10 one-man in museums in U.S., 1964, 1965. Included in "Prize Winning Sculpture," 1964.

KLITGAARD, GEORGINA—Painter, Gr.
 Bearsville, N.Y. 12409
B. New York, N.Y., July 3, 1893. Studied: Barnard Col., A.B.; NAD.

Member: AEA; Audubon A.; Woodstock AA. Awards: med., PAFA, 1930; prize, Pan-Am. Exp., 1931; Guggenheim F., 1933; Carnegie Inst.; AIC; Fellowship, Huntington Hartford Fnd., 1965; grant, MacDowell Colony, 1966; grant, Ossibaw Island Project, 1966; Fellowships, Helen Wurlitzer Fnd. of New Mexico, 1967-1969; included in Carnegie Mss. of Memorabilia, Syracuse Univ., N.Y. 1968. Work: MMA; WMAA; Newark Mus.; Dayton AI; New Britain AI; BM; Wood Gal. A., Montpelier, Vt.; murals, USPO, Poughkeepsie, N.Y.; Goshen, N.Y.; Pelham, Ga.; painting reproduced in "Through the American Landscape." Exhibited: Carnegie Inst., 1929-1946; CGA, 1928-1946; AFA traveling exh.; one-man: Parnassus Gal., Woodstock, N.Y., 1955; Rehn Gal., N.Y., 1959; CGA; St. Gauden's Mem. Gal.; Cincinnati, Ohio; Miami, Fla.; PAFA, annually; VMFA, annually; & in many other U.S. museums. Positions: Instr., Durham Sch. of Painting.

KLITZKE, THEODORE E.—Educator, L.
 Maryland Institute, College of Art, Baltimore, Md. 21217; h. 7918 Sherwood Ave., Baltimore, Md. 21204
B. Chicago, Ill., Nov. 4, 1915. Studied: AIC; Ecole du Louvre, The Sorbonne, Paris; Univ. of Chicago. Member: CAA; Soc. Architectural Hist.; AAUP; Deutscher Verein fur Kunstwissenschaft. Contributor to College Art Journal and other periodicals. Lectures: "Art in America," "19th Century Landscape Painting," Amerika Haus, Erlangen, Germany; North American Cultural Inst., Anglo-Mexican Inst., Mexico City. Teaching: "Greek and Roman Art," "Art and Society in America," "Contemporary Problems in the Arts," Alfred Univ., N.Y., Univ. of Alabama and Maryland Institute. Positions: Dean and Vice-President for Academic Affairs, Maryland Institute, College of Art, Baltimore, Md.

KLONIS, STEWART—Painter, T., L.
 215 West 57th Street, New York, N.Y. 10019
B. Naugatuck, Conn., Dec. 24, 1901. Studied: ASL. Member: Century Assn.; The Edward MacDowell Association, Inc.; Benjamin Franklin Fellow of the Royal Society of Arts; Municipal A. Soc. of New York. Work: IBM Coll. Lectures: History of Art. Positions: member, A. Aid Comm., 1932-36; Bd. Control, 1934, Treas., 1935-36, Pres., 1937-45, Exec. Dir., 1946- , ASL, New York; V. Pres., 1939-41, Pres., 1941- , Am. FA Soc.; Trustee, McDowell Traveling Scholarship Fund, 1934-45; Instr., Queens Col., 1940-45; Bd. Governors, 1951-52, Pres., NAC, New York; Dir.-at-large, AEA, 1952; Member Arts Comm., Fulbright Awards, 1949-52; Chm., Arts Comm., Fulbright Awards, 1953-55 and 1957; Chm., Inst. of Intl. Education's Advisory Committee for the Arts, 1961- .

KLOSS, GENE—Etcher, P.
 Cory, Colo. 81414
B. Oakland, Cal., July 27, 1903. Studied: Univ. California, A.B.; Cal. Sch. FA. Member: NAD; SAGA; Pr. Cl., Albany; Phila. WC Cl.; Cal. Soc. Pr. M.; Hunterdon A. Center, N.J. Awards: med., PAFA, 1936; prizes, Cal. SE, 1934, 1940, 1941, 1944, 1949; Oakland A. Gal., 1939; Chicago SE, 1940, 1949, 1951, 1952, 1954, 1956; Tucson FA Assn., 1941; Phila. Pr. Cl., 1944; Lib. Cong., 1946; Meriden AA, 1947, 1951; SAGA, 1951, 1953; Phila. Sketch Cl., 1957; Pr. Cl. of Albany, 1959, purchase 1961; NAD, 1961; Philbrook A. Center, Tulsa, 1968; Mus. New Mexico, 1965. Work: Carnegie Inst.; Smithsonian Inst.; Lib. Cong.; N.Y. Pub. Lib.; PAFA; AIC; SFMA; Honolulu Acad. A.; Dallas Mus. FA; Mus. New Mexico, Santa Fé; Oklahoma Univ.; Univ. New Mexico A. Gal.; Birger Sandzen Mem. Gal., Lindsborg, Kans.; Achenbach Fnd. for Graphic Arts, San Francisco; Mus. of Tokyo; NGA; The Hague; Texas Tech. Inst.; MMA; Peabody Mus. A.; Univ. Pa.; & in many other col. & univ. Exhibited: annually; Phila. WC Cl.; Albany Pr. Cl.; Hunterdon A. Center; NAD; SAGA; also, Carnegie Inst., 1943-1945; DMFA, 1954; SAGA European traveling exh., 1954-55; Audubon A., 1955; WFNY 1939; GGE, 1939; U.S. exh. in Paris, France, 1938; Sweden, 1937; Italy, 1938; Mus. New Mexico, Santa Fé; SFMA; Oakland A. Gal.; San Diego FA Soc.; Denver A. Mus.; Baylor Univ.; Witte Mem. Mus. Executed Presentation Print, Albany Pr. Cl., 1953, SAGA, 1954; Pr. M. Soc. of California, 1956; Oklahoma A. Center, 1969; Cal. 200th Anniversary Exh., San Diego, 1969; one-man: Oakland A. Gal., 1932; Honolulu Acad. A., 1935; Smithsonian Inst., 1945; San F. A. Center, 1945; Gump's, San F., 1935, 1939, 1942, 1946; Botts Mem. Hall, Albuquerque, N.M., 1956, 1958; Findlay Gal., Chicago, 1957; Taos AA, 1958; Mus. New Mexico, Santa Fe, 1960; Birger Sandzen Mem. Gal., 1966; Mus. A. & Sciences, Grand Junction, Colo., 1968; L'Atelier Gal., Cedar Falls, Iowa, 1969, and in many galleries & universities throughout the West.

KNAPP, SADIE MAGNET—C., Painter, S., Gr., Enamelist
 106 82nd Dr., Kew Gardens, N.Y. 11415
B. New York, N.Y., July 18, 1909. Studied: N.Y. Training Sch. for Teachers; N.Y. City College; Atelier 17 with William Hayter; BMSch. A. Member: Am. Soc. Contemp. A.; NAWA; Nat. Soc. Painters in Casein; F.I.A.L.; AEA; Baltimore WC Soc.; Artists-Craftsmen, N.Y. Awards: prizes, Baltimore WC Soc.; Argent Gal.,

N.Y.; Silvermine Gld.; Grumbacher; NAWA; Artists-Craftsmen of N.Y. Work: Georgia Mus. A.; Riverside Mus., N.Y.; Norfolk Mus. Exhibited: Audubon A.; PAFA; NAD; Butler Inst. Am. A.; Art:USA, 1958; LC; Am. Jewish Tercentenary; BM; AFA traveling exh., 1953; N.Y. World's Fair, 1964; Japan, Argentina, France, India, Scotland, England, Mexico, Switzerland, etc. Positions: Chm. Foreign Exhs., 1960-61, delegate to Int. Assn. of Plastic Arts, 1961-1969, NAWA; treas., Nat. Soc. Painters in Casein, 1961-1964; 1st V. Pres., 1961-65, Pres., 1965-67, NAWA, Advisor to Bd., 1968- ; Instr., Worcester Craft Center, Mass.

KNATHS, (OTTO) KARL—Painter
8 Commercial St., Provincetown, Mass. 02657
B. Eau Claire, Wis., Oct. 21, 1891. Studied: AIC., M.F.A. Member: Nat. Inst. A. & Lets. Awards: silver medal, AIC; prizes, Carnegie Inst.; MMA, 1950; Hon. deg., AIC; Brandeis Univ., 1961; Benjamin Altman prize, NAD, 1963, 1965; Audubon A. award, 1964. Work: MMA; AIC; Detroit Inst. A.; PAFA; CAM; SFMA; WMAA; PMA; PMG; Albright A. Gal.; Walker A. Center; MModA. Exhibited: extensively in leading U.S. museums and abroad.

KNECHT, KARL KAE—Cartoonist, W.
Evansville Courier, 216 Vine St.; h. 1100 Erie Ave., Evansville, Ind. 47715
B. Iroquois, S.D., Dec. 4, 1883. Studied: AIC. Member: Am. Assn. Editorial Cartoonists. Work: Hoosier Salon; Evansville Univ. (permanent); Evansville Mus. A. Author, I., "Surprise Puzzle Drawing Book"; & others. Contributor to: Billboard, White Tops; Variety, Saw Dust Ring, & other publications. Positions: Director, Evansville Courier, Evansville, Ind.; Editorial Cart., Evansville Courier, 1906- ; Dean, U.S. Ed. Cart.

KNEE, GINA (Mrs. Alexander Brook)—Painter, Gr.
c/o Willard Gallery, 23 West 56th St., New York, N.Y.; h. Box 109, Sag Harbor, L.I., N.Y.
B. Marietta, Ohio, Oct. 31, 1898. Member: AEA. Awards: prizes, Cal. WC Soc., 1938; N.M. State Fair, 1939; New Orleans, La., 1947; Guild Hall, East Hampton, N.Y., 1963. Work: Denver A. Mus.; PMG; Santa Barbara Mus. A.; Buffalo FA Acad. Exhibited: AIC, 1940-1946, 1947; BM, 1946,1948; Cal. PLH, 1943; Los A. Mus. A., 1941-1944; PAFA, 1948; MMA, 1953; Bucknell Univ., 1955; Pyramid Gal., Wash., D.C., 1955; BM, 1955; Gld. Hall, East Hampton, 1954; Hampton Gal., 1954; Columbus A. Gal., 1951; VMFA, 1947; Guild Hall, East Hampton, L.I., 1949, 1950, 1963; "Taos and Santa Fe, 1882-1942," Amon Carter Mus., Ft. Worth, La Jolla A. Center and Univ. A. Gal., Albuquerque, N.M., 1963; "Women Artists of America, 1707-1964," Newark Mus. A., 1965. One-man: Hatfield Gal., Los A., 1942; Santa Barbara Mus. A., 1943; Cal. PLH, 1943; Willard Gal., 1941, 1943, 1949, 1955.*

KNIGHT, FREDERIC C.—Painter, E.
Spencertown, N.Y. 12165
B. Philadelphia, Pa., Oct. 29, 1898. Studied: PMSchIA. Member: AAUP. Awards: Woodstock AA for painting. Work: Dartmouth Col.; Univ. Arizona; IBM; Everhart Mus.; Berkshire Mus.; many private collections; murals, USPO Johnson City, N.Y. Exhibited: Carnegie Inst.; CGA; PAFA; PMA; WMAA; AIC; NAD; MMA; CM; CMA; WFNY, 1939; GGE, 1939; and other museums and national institutions; one-man: An American Group, Inc.; Babcock Gal.; Brill Gal., Cleveland, Ohio; Everhart Mus., Scranton, Pa.; Newcomb Sch. A.; Columbia Univ.; Berkshire Mus., Pittsfield, Mass., 1967; Albany Institute of History and Art, 1968. Positions: Instr., Newcomb Sch. A., 1943-46; Lehigh Univ., 1949; Columbia Univ., 1946-1964.

KNIGHT, HILARY—Illustrator, Des.
300 East 51st St., New York, N.Y. 10022
Studied: ASL. Illus.: "Eloise," "Eloise in Paris," "Eloise at Christmastime," "Eloise in Moscow," all by Kay Thompson; "Hilary Knight's ABC," "Hilary Knight's Mother Goose," for Golden Press; "Christmas Nutshell Library" (Story and drawings); "Where's Wallace" (story and drawings); "The Animal Garden" by Ogden Nash; drawings: "Beauty and The Beast" for Macmillan; "Captain Boldheart and The Magic Fishbone" for Macmillan; "Sunday Morning," by Judith Viorst; "SYLVIA The Sloth," written and illustrated by Hilary Knight; "A Childs Book of Natural History," written by Oliver Herford; "The Jeremy Morse Book," by Patricia M. Scarry.

KNIPSCHILD, ROBERT—Painter, T.
College of Design, Architecture & Art, University of Cincinnati 45221; h. 3346 Jefferson Ave., Cincinnati, Ohio 45220
B. Freeport, Ill., Aug. 17, 1927. Studied: Univ. Wisconsin, B.A.; Cranbrook Acad. A., M.F.A. Awards: prizes, Walker A. Center, 1949; Old Northwest Territory exh., 1951; Milwaukee AI, 1949; Springfield A. Mus., 1955. Work: PAFA; Cranbrook Acad. Mus.; LC; BMA; PC; Illinois State Mus.; Brandeis Univ.; Univ. Wisconsin;

Univ. Minnesota; Univ. Michigan; Wisconsin State Univ.; Stephens Col.; Hope Col.; Grinnell Col. Exhibited: Milwaukee AI, 1949; Denver A. Mus., 1949, 1950; Walker A. Center, 1949; BM, 1950; SAM, 1950; MMA, 1950; PAFA, 1950, 1952; Downtown Gal., 1951-1954; Cranbrook Mus., 1951, 1953; PC, 1952, 1953; CGA, 1953, 1955; Carnegie Inst., 1953; MModA, 1953-1955; WMAA, 1953, 1954; BMA, 1952-1955; Alan Gal., 1953-1961 (one-man); American Univ., 1951 (one-man); BMA, 1952-1954 (one-man); Butler AI, 1954-1955; Springfield A. Mus., 1955, 1956; Joslyn A. Mus., 1955; BMFA, 1955; Colorado Springs FA Center, 1955; Wadsworth Atheneum, 1955; Des Moines A. Center, 1955; CM, 1955; Stonebridge Gal., Tokyo, 1955; Grinnell Col.; Stephens Col.; Am. Federation of Arts "50 States Exhibition," 1966-1968; Davenport Municipal Gal.; other one-man: Coe College, 1960; Cornell College, 1961; Mankato State College, 1963; Univ. Cincinnati, 1967; Wisconsin State Univ., 1968; Moorhead State Col., 1969; Sneed's Gal., Rockford, Ill., 1964; Hope College, 1965. Positions: Instr., BMA, 1951, 1952; American Univ., 1952; University of Connecticut, 1954-1956. Visiting Lecturer, Univ. of Wisconsin, Madison, Wis., 1956-1960; Assoc. Prof., Univ. Iowa, 1960-1966; Prof., Chm. Div. of Art, Dir., Grad. Studies, College of Design, Architecture and Art, Univ. Cincinnati, 1966- .

KNOBLER, LOIS JEAN—Painter
R.F.D. 1, Mansfield Center, Conn. 06250
B. New York, N.Y., Feb. 2, 1929. Studied: Syracuse Univ., B.F.A.; Florida State Univ., M.A. Awards: Lyman Allyn Mus., 1960; Carling prize, Conn. WC Soc., 1963. Work: Florida State Univ.; WMA. Exhibited: AFA traveling exh., 1956-1958; Berkshire Mus. A., 1954-1957; Springfield Mus. A., 1955-1957; deCordova & Dana Mus., 1964; Slater Mem. Mus., 1968; Boston A. Festival, 1955-1958; New Haven A. Festival, 1958, 1959; Mystic AA, Wadsworth Atheneum, 1960, 1963; Lyman Allyn Mus., 1960; Inst. Contemp. A., Boston, 1963-1966; Northeastern Univ., 1963, 1965; Smith College, Northampton, Mass., 1963, 1965; Art for U.S. Embassies Exh., 1966; Smithsonian Inst., 1966; American Embassy, Montevideo, Uruguay; FMA, Cambridge, Mass., 1967; Converse A. Gal., Norwich, Conn., 1967; one-man: Gal. A., Univ. Conn., Storrs, 1967.

KNOBLER, NATHAN—Painter, E., S.
R.F.D. 1, Mansfield Center, Conn. 06250
B. Brooklyn, N.Y., Mar. 13, 1926. Studied: Syracuse Univ., B.F.A.; Florida State Univ., M.A. Member: CAA. Awards: prizes, Berkshire Mus. A., 1955; Conn. WC Soc., 1956, 1957; Norwich AA, 1957, 1968. Work: Florida State Univ.; Munson-Williams-Proctor Inst.; Smith College; U.S. Information Service. Exhibited: Ball State T. Col., 1955, 1958; BM, 1958; AFA traveling exh., 1958, 1965; Boston A. Festival, 1956, 1958, 1960; Conn. WC Soc., 1952-1957; Berkshire AA, 1954-1957; Springfield A. Mus., 1955-1957; deCordova & Dana Mus., 1956, 1957, 1963, 1968; New Haven A. Festival, 1958; Inst. Contemp. A., Boston, 1958, 1964; Norwich AA 1956-1958; PAFA, 1960; Lyman Allyn Mus., 1960; Wadsworth Atheneum, 1960, 1962; Northeastern Univ., 1963, 1965; Smith College Mus., 1963, 1965, 1966; Drawing Soc., traveling exh., 1966-1967; Slater Mus., 1966-1968; Carpenter A. Center, Harvard, 1967; Austin A. Center, Trinity Col., 1969; Univ. Conn. Mus. A., 1966-1968. Author: "The Visual Dialogue," 1967. Lecture: "The Creative Sequence," 1967-1969. Positions: Prof. A., University of Connecticut, Storrs, Conn.

KNORR, LESTER—Sculptor, P., C., E.
2012 E. Reservoir Blvd., Peoria, Ill. 61614
B. Wilder, Idaho, May 1, 1916. Studied: San Jose State Col., A.B.; Ohio State Univ., M.A., Ph.D. Awards: prize, Am. Veterans Soc. A., 1952. Work: Decorator Center, Dallas, Tex.; Ohio State Univ.; Bradley Univ., and in private colls. Exhibited: Am. Veterans Soc. A., N.Y., 1952; Ohio State Fair, 1955; League Guild A. (Laguna Gloria) Austin, Tex., 1956, 1957 (2-man), 1958; Witte Mem. Mus., San Antonio, 1957, 2-man, 1958; Southwest Texas State Col., 1957; Peoria A. Center, 1960-1962; Eureka Col., Eureka, Ill., 1965; one-man: Ohio State Univ., 1953, 1955; Southwest Texas State Col., 1958, 1959; Regional A. Gal., N.Y., 1956, 1958; Contemp. A. Gal., Peoria, 1961; Bradley Univ., 1962, 1964; Kohl Gal., Dallas, Tex., 1965; Sherman Gal., Chicago, Ill., 1965; Knox Col., Galesburg, Ill., 1968; Sherbeyn Gal., Chicago, Ill., 1967. Contributor to magazines, newspapers with articles on art publicity, criticism, reviews. Positions: Asst. Prof. (Philosophy & Humanities), art publicity for gallery, Southwest Texas State College, San Marcos, Tex., 1956-1959; Dir., School of Art, and Gallery 202, Bradley University, Peoria, Ill., 1959-1968.

KNORR, MRS. LESTER. See Boardman, Jeanne

KNOWLES, RICHARD H.—Painter, E.
Memphis State University; h. 765 Watson St., Memphis, Tenn. 38111
B. Evanston, Ill., June 29, 1934. Studied: Grinnell Col.; Northwestern Univ.; Indiana Univ., Bloomington. Member: CAA; AAUP.

Awards: prizes, Delta, Little Rock, 1961 (2), 1962. Work: State and University colls; and in private colls. Exhibited: Artists West of the Mississippi, Colorado Springs FA Center, 1963; 1st Annual Exh., Tyler, Tex., 1962; Arkansas A. Center, 1964; Natl. Land Grant College & Univ. Exh., 1962; Mid-America Exh., Kansas City, 1962, 1964, 1965; Delta at Little Rock Exh., 1961-1964; Stephens Col., 1964 and other group exhs.; one-man: Arkansas A. Center, 1962; Hightower Gal., Oklahoma City, 1962; Sneed Gal., Rockford, Ill., 1964, 1968; Memphis State Univ., 1966; Arkansas State Univ., 1968. Positions: Prof., Art History, and Painting, Memphis State Univ., Memphis, Tenn., at present.

KNOWLTON, DANIEL GIBSON—Craftsman, Des., T.
 1200 Hope St., Bristol, R.I. 02809
B. Washington, D.C., Nov. 14, 1922. Member: Boston Soc. A. & Crafts; Min. P. & S. Soc., Wash., D.C.; Providence Handicraft Cl. Exhibited: Smithsonian Inst., 1947, 1948, 1950, 1951; CGA, 1943-1945; R.I.Sch. Des., 1950, 1952, 1954, 1955, 1956, 1959; Bristol Hist. Soc., 1952; Providence Handicraft Cl., 1949-1952, 1954, 1956-1958, 1959-1964, 1966-1969; Providence Athenaeum, 1959; Brown Univ., 1955; Min. P. & S. Soc., 1954, 1956; Annmary Brown Mem, 1962-1964, 1966-1969; John D. Rockefeller, Jr., Library, 1964; Rogers Free Library, Bristol. Contributor to "Yankee Magazine," 1962. Positions: Instr., Bookbinding, Providence Handicraft Soc.; Owner, Knowlton Hand Bindery, Bristol, R.I.; Instr., Bookbinding, Brown Univ., Ext. Div., at present.

KNOX, KATHARINE McCOOK (Mrs.)—Art Historian, Collector
 3259 N St., N.W., Washington, D.C. 20007
B. Washington, D.C. Career: Consultant on many art exhibition committees, including the Washington Loan Exhibition of Early American Paintings, Miniatures and Silver at the National Museum, 1925; the Loan Exhibition assembled by the D.C. Committe of the Robert E. Lee Memorial Foundation at The Textile Museum, 1931; The George Washington Bicentennial Commission Exhibition of portraits, at the Corcoran Gallery of Art, 1932; the Exhibition "Privately Owned," a selection of privately owned works of art from the Washington area, Corcoran Gallery, 1952; the Exhibition, "Primarily American" (17th, 18th and 19th century heirlooms) at The Textile Museum, 1959. During the Hoover Administration, Mrs. Knox, a special Staff member of the Frick Reference Library, N.Y., supervised the photographing, examined the canvases, researched the history of each painting then in the White House. These notes and photographs were given to the White House collection by the founder of the Frick Library. Many other historical, cultural and scholarly projects have been undertaken and completed. Personal Collection: An extensive collection of Washingtoniana and Lincoln-iana, as well as some modern paintings and sculpture. Author: "The Sharples—Their Portraits of George Washington and His Contemporaries"; "The Portraits of the Adams-Clement Collection and Their Painters"; "Healy's Lincoln, No. 1," and other published works. Assisted the Lincoln Group in collecting data for a volume "Lincoln Day by Day, 1861-1865," published 1960. Positions: Many cultural positions in Historical Societies, Art Libraries and organizations.

KNOX, SEYMOUR H.—Patron
 1608 Marine Trust Bldg. 14203; h. 57 Oakland Pl., Buffalo, N.Y. 14222
B. Buffalo, N.Y., Sept. 1, 1898. Studied: Yale University, B.A. Awards: Honorary Doctor of Fine Arts, University of Buffalo, 1962; "Distinguished Citizens Achievement Award," Canisius College, 1962. Buffalo and Erie County Historical Society "Red Jacket Medal," 1962; Buffalo Club Medal, 1962; Michael Friedsam Architectural Award, 1966; Doctor of Humane Letters, Syracuse University, 1966; Doctor of Fine Arts, St. Lawrence University, 1967; Chancellor's Medal SUNY at Buffalo, 1967; Fellow, Rochester Museum and Science Center, 1968. Positions: Chairman, N.Y. State Council on the Arts, 1960- ; President, Buffalo Fine Arts Academy, 1938- ; Chairman of Board, Marine Trust Co. of Western New York, 1943- .

KOBLICK, FREDA—Sculptor, T.
 401 Francisco St., San Francisco, Cal. 94133
B. San Francisco, Cal. Studied: San Francisco State Col.; Plastics Industries Tech. Inst. Member: AEA. Work: mural, Rohm & Haas Bldg., Philadelphia, Pa.; fountain, City of Vallejo, Cal.; lighting forms for Manufacturer Traders Trust Co., Buffalo, N.Y., 1967 and many other commissions. Exhibited: Mus. of Contemp. Crafts, 1962, 1963, 1965 and one-man 1968; U.S. State Dept. traveling exhs., 1955, 1961; Henry Gal., Univ. Washington, 1963; San Jose State Col., 1964. Lectures: Plastics as an Art Medium. Positions: Instr., Royal Col. of A., London, 1965-1967 (arranged experimental plastics workshop); two week master class, Stockholm, 1966 and numerous intensive workshops in the U.S. and in England, Holland, Czechoslovakia.

KOCH, BERTHE COUCH—Painter, E., S., Gr., W., L.
 1224 S. Peninsula Drive, Apt. 502, Daytona Beach, Fla. 32018
B. Columbus, Ohio, Oct. 1, 1899. Studied: Columia Univ.; Ohio State Univ., B.A., M.A., Ph.D. in Fine Arts; & with Gifford Beal, Leon Kroll, Alexander Archipenko, James Hopkins. Member: CAA; Midwestern Col. A. Conference; AFA. Awards: F., Ohio State Univ., 1928, 1929. Work: IBM Coll.; Passedoit Gal.; Ohio State Univ.; Syracuse Mus. FA. Exhibited: Extensively in U.S. Author: monograph, "Apparent Weight of Colors"; "Chemistry of Art Materials"; "Physics of Light as Applied to Art"; "Lithography"; "Psychological Principles of Vision as Applied to Art Techniques." Contributor to: Parnassus, College Art Journal.

KOCH, GERD—Painter, S., Gr., T., Des.
 444 Aliso, Ventura, Cal. 93001
B. Detroit, Mich., Jan. 30, 1929. Studied: Wayne State Univ., B.F.A.; Univ. Cal. at Santa Barbara, M.F.A.; UCLA Film Workshop and Graduate School. Member: Cal. WC Soc.; Los A. AA; San F. AA. Awards: Cal. WC Soc., 1956, 1960, 1961, 1967; Palos Verde AA. 1960 (purchase); Los A. Mus. A., 1959 (purchase); La Jolla Mus. A., 1961; FA Center of San Diego, 1962; Cal. State Fair, 1963 (purchase); Long Beach State Col., 1965 (purchase); medal, Oakland A. Mus., 1960. Work: Santa Barbara Mus. A.; Long Beach Mus. A.; Pasadena Mus. A.; Los A. Mus. A.; Grumbacher, Inc. Exhibited: Cal. WC Soc., 1955-1960, 1962, 1963-1968; Nat. Orange Show, 1954, 1957-1959, 1961-1963; SFMA, 1957, 1963; 2-man (with Irene Koch), Ojai Music Festival, 1956; Santa Monica A. Gal., 1958; Pasadena A. Mus., 1958, 1959; Los A. Mus. A., 1957, 1959-1961; Tucson Annual, 1961-1963; La Jolla, 1960, 1961, 1962; Cal. State Fair, 1961-1964; Wayne State Univ., 1965-1968; one-man: Esther Robles Gal., Los A., 1959, 1961, 1963, 1965; Santa Barbara Mus. A., 1960; Long Beach Mus. A., 1961; La Jolla Mus. A., 1962; Esther Bear Gal., Santa Barbara, 1964, 1967; Laguna Beach A. Gal., 1966; Ojai A. Center, 1965 (two-man, 1969); Taft Col., Cal, 1968; Comara Gal., Los Angeles, 1968; Moor Park Col., Cal., 1968; Cal. Lutheran Col., 1969. 3-man national traveling exh., 1962-1965. Designed interior and exterior of "The Ash Grove" Gallery, Los Angeles, 1958; organized first exhibition of Southern Cal. Painters; Ojai Music Festival, 1959, 1960. Positions: Instr. A., Ventura Col., Cal., 1967- .

KOCH, IRENE SKIFFINGTON—Painter, S., T.
 Rt. 1, Box 60 K, Ojai, Cal. 93023; h. 444 Aliso, Ventura, Cal. 93001
B. Detroit, Mich., Nov. 5, 1929. Studied: Wayne Univ. Member: Cal. WC Soc.; Los A. AA; San F. AI. Award: Cal. WC Soc., 1960; Newport Harbor, 1959 (purchase); Nat. Orange Show, 1961; Cal. WC Soc., 1957; Long Beach A. Mus., 1963; Jewish Community Center, Los Angeles, 1967, 1969; Oxnard A. Festival, 1969. Work: Long Beach Mus. A.; Pasadena A. Mus. Exhibited: Cal. WC Soc., 1955-1957, 1959-1962, 1964-1967, traveling exh., 1967-1969; Michigan A., 1949; Pacific Coast Biennial, 1955, 1957; SFMA, 1957, 1959, 1967; Los A. Mus. A., 1957, 1961; Arts of So. California, 1958, 1960- 2-man (with Gerd Koch): Ojai Music Festival, 1956, 1966-1968; Santa Monica A. Gal, 1958; NOW Gal., Los A.; Pasadena A. Mus., 1958; Cal. State Fair, 1960, 1964; Wayne Univ., 1965; "Pacific Profile" traveling exh., 1962-1963; San F. Art Bank traveling exh., 1959-1966; "Arts of California" traveling exh., 1957-1958 and 1961-1963; La Jolla, 1960; Pacific Coast traveling, 1961; Nat. Orange Show, 1961; San Diego, 1961; Tucson, 1962, 1964; Adele Bednarz Gal., Los Angeles, 1967; one-man: Long Beach A. Mus., 1960; Robles Gal., 1961. Positions: Instr., privately, Ojai and Los Angeles, Cal., painting & drawing, Ventura AA, 1968-1969.

KOCH, JOHN—Painter
 c/o Kraushaar Gallery, 1055 Madison Ave., New York, N.Y. 10021; h. Setauket, L.I., N.Y. 11785
B. Toledo, Ohio, Aug. 18, 1909. Member: NA (Asst. Treas., 1959- Vice-Pres.); All. A. Am. (Dir.). Awards: NAD, 1952, Altman prize, 1959 and 1963, Saltus Gold Medal for Merit, 1962; Cal.PLH, 1952; Audubon A., 1958; Lotos Club Award of Merit, N.Y., 1964; Artists Fellowship Medal, 1964; prize, Butler Inst. Am. A., 1962 and the Dr. John J. McDonough Award, 1962. Work: BM; Boston Inst. Mod. A.; Nelson Gal. A.; Springfield Mus. A.; Canajoharie A. Gal.; Newark Mus.; Cal.PLH; NAD; MMA; Toledo Mus. A.; Joslyn A. Mus.; Des Moines A. Center; Lehigh Univ.; BMFA; Butler Inst. Am. A.; AIC; Ga. Mus. FA; Parrish Mus., Southampton; So. Vermont A. Center; Storm King A. Center, Mountainville, N.Y.; Univ. Georgia; VMFA; Bowdoin Col., and others. In many private colls. Exhibited: Carnegie Inst., 1939-1946, 1955; WMAA; CGA; PAFA; AIC; Valentine Gal., N.Y., 1939, 1941, 1943, 1946; BM; New Britain Mus. A.; Bennington Mus.; Univ. Georgia; Syracuse Mus. FA; Munson-Williams-Proctor Inst.; Santa Barbara Mus. A., and many others. one-man: Kraushaar Gal.; 1949-1951, 1954, 1958, 1961; Portraits, Inc., 1951; Syracuse Mus. FA, 1952; Suffolk County Mus., Stony Brook, L.I.,

1951 (retrospective); Cowie Gal., Los A., 1951; Provo, Utah, 1951. Retrospective Exh., Mus. of the City of New York, 1963; VMFA, 1962; Berkshire Mus., 1963.

KOCH, M. ROBERT—Craftsman, E., Gr., L.
1224 S. Peninsula Drive, Apt. 502, Daytona Beach, Fla. 32018
B. Columbus, Ohio, Jan. 23, 1888. Studied: Ohio State Univ.; N.Y. School of Ceramics; and with Alexandre Archipenko, Bernard Karfiol, Robert Laurent. Member: Am. Ceramic Soc.; Museo di Ceramiche, Faenze, Italy. Work: IBM. Exhibited: Syracuse Mus. FA, Ceramic Exh.; Columbus Gal. FA; Passedoit Gal., N.Y.; Univ. Omaha. Contributor articles on ceramics to Ceramic Age; Ceramic Industry. Lectures: Ceramic Materials; Influence of the Arabic Ceramics on the Faiences of France, Spain and Italy. Position: Ceramics Research.

KOCH, ROBERT—Educator, W., L.
9 Outer Road, South Norwalk, Conn. 06854
B. New York, N.Y., Apr. 7, 1918. Studied: Harvard Col., A.B.; N.Y. Univ. Inst. FA, M.A.; Yale Univ., Ph.D. Member: Soc. Arch. Hist.; Silvermine Gld. A.; C.A.A. Awards: Tiffany Fnd. Award, 1961. Author: Louis Comfort Tiffany (catalogue) 1957, publ. by Am. Craftsmen's Council; "New York Armories," Journal of the Soc. Arch. Hist., 1955; "Posters and the Art Nouveau," Gazette des Beaux-Arts, 1957; "Art Nouveau Bing," Gazette des Beaux-Arts, 1959; "Rookwood Pottery," Antiques, 1960; "A Tiffany-Byzantine Inkwell," Brooklyn Mus. Bulletin, 1960; "Will Bradley," 1962, "Artus Van Briggle," 1964, "Gibson Girl Revisited," 1965, all Art in America; "Artistic Books," Art Quarterly, 1962; Louis C. Tiffany, "Rebel in Glass," publ. 1964; "American Art Glass Circa 1900," The Glass Club Bulletin, 1965; "Tiffany Glass," Art at Auction, 1967; "Elbert Hubbard's Roycrofters," Winterthur Portfolio III, 1967. Lectures: Renaissance and Modern Art; American Decorative Art; The History of Glass, and Art Nouveau. Positions: Instr., History of Art, Queens Col., 1951-53; Yale Univ., 1953-56; Asst. Prof. A., 1956-1959; Chm. A. Dept., 1958-1959; So. Connecticut State College, New Haven Conn., Assoc. Prof., 1959-1966; Prof. of A. 1966- .

KOCHER, ROBERT LEE—Painter, E., Gallery Dir.
Coe College; h. 1955 Park Ave., S.E., Cedar Rapids, Iowa 52403
B. Jefferson City, Mo., Dec. 19, 1929. Studied: Univ. Missouri, A.B., M.A.; Summer Fellowship, Univ. Iowa, 1963, studying with Jean De Marco and Robert Knipschild. Member: Cedar Rapids AA (Bd. Dirs., Vice-Pres., 1964); MCAC. Exhibited: Trans-Mississippi Annual, Columbia, Mo., 1964; Stephens College; Des Moines A. Center, 1965-1967, 1968 (prize); one-man: Cornell College, 1965, 1967; Coe College, 1964, 1966, 1967; Laura Musser A. Gal., Burlington, Iowa, 1967; Waterloo A. Center, 1966. Positions: Chm., FA Festival, Culver-Stockton College, 1958-59 and Coe College, 1960-65; Director, Coe College Art Galleries, 1960- .

KOCHERTHALER, MINA—Painter
124 West 79th St., New York, N.Y. 10024
B. Munich, Germany. Studied: Columbia Univ.; NAD; City Col. of N.Y., ASL with Ralph Fabri. Member: Nat. Soc. Painters in Casein; AWS; P. & S. of New Jersey; F., Royal Soc. A., London; Audubon A. Awards: prize, Nat. Soc. Painters in Casein, 1958, 1963, 1964; Catherine Wolfe A. Cl., 1961; Audubon A., 1962; AWS, 1962. Work: Norfolk Mus. A. & Sciences. Exhibited: All. A. Am., 1958, 1960; Audubon A., 1959; Nat. Soc. Painters in Casein, 1957-1959; Knickerbocker A., 1958; NAC, 1958; Nat. traveling exh., Casein Soc., 1958-59; NAD, 1963-1965; traveling exh., AWS; MMA, 1966-67; Museo de la Aquarela, Mexico City, 1968. Positions: Cor. Sec., Audubon A., 1959-61; Dir., 1959-61, Vice-Pres., 1961- . Nat. Soc. Ptrs. in Casein; Rec. Sec., AWS, 1963- ; Delegate to U.S. Com. of Intl. Assn. of Plastic Arts, 1960-1964.

KOCSIS, ANN—Painter
327 West 76th St., New York, N.Y. 10023
B. New York, N.Y. Studied: Art Inst. Pittsburgh; NAD. Member: NAWA; Creative A. Assoc.; Knickerbocker A.; F., Royal Soc. A., London; F.I.A.L.; Pen & Brush Cl.; AAPL; Assoc. A. Pittsburgh; NAC; Tucson FA Assn. Awards: scholarship, Art Inst. Pittsburgh; citation, Fla. Southern Col., 1952; Gold Key and Grumbacher award, Seton Hall Univ., 1958. Work: San Manuel Lib., Ariz.; Arizona-Sonora Desert Mus., Tucson; Seton Hall Univ., New Jersey; Fla. Southern Col.; Square & Compass Crippled Children's Clinic, Tucson; American-Hungarian Mus., Elmhurst, Ill. Exhibited: Argent Gal.; Audubon A.; Westchester Fair; Newton Gal.; State Col., Fredonia, N.Y.; State Col., Indiana, Pa.; Swope Gal. A.; Brazil (Ind.) Pub. Lib.; Coker Col.; Mars Hill (N.C.) Col.; Guilford Col.; Mercersburg (Pa.) Acad. A. Gal.; St. Vincent's Archabbey, Latrobe, Pa.; Creative A. Gal., N.Y.; Peter Kolean Gal.; Carnegie Lib., Tucson, Ariz.; Arizona State Mus.; Burr Gal., 1955-56; Assoc. A. of Pittsburgh, 1948, 1951-1953; NAWA, 1947-1952; AAPL, 1951, 1952; Seton Hall

Univ.; Galerie Internationale, N.Y.; IBM; Sweat Mem. Mus.; Farnsworth Mus. A.; Attleboro (Mass.) Mus.; Fairleigh Dickinson Univ., 1964; Arnot A. Gal., Elmira, N.Y.; Everhart Mus., Scranton, Pa.; State T. Col., Kutztown, Pa.; Massillon Mus.; College of Wooster (Ohio); Reading Pub. Mus.; Zanesville AI; Evansville (Ind.) Mus. A. & Sciences; and others. Knickerbocker A. traveling exh., U.S.A. European traveling exhs., and exchange exhs., including Greece, Belgium, Tokyo and others. One-man: Montross Gal.; Morton, Vendome, Contemporary A. Gal., N.Y.; All. A. Am.; AAPL. Positions: Chm. A. Com., NAC; Cor. Sec., and Pub. Rel., 1961-62, Knickerbocker Artists, N.Y.

KOENIG, JOHN FRANKLIN—Painter, Pr.M
8 rue Madame, Paris 6, France
B. Seattle, Wash., Oct. 24, 1924. Studied: Univ. California, Berkeley; Washington State Col.; Univ. Washington, B.A. Work: Musée de Grenoble; Mus. Mod. A., Venice; Salzburg Mus.; Mus. Western Art, Tokyo; Mus. Mod. A., Tokyo; SAM; Mus. FA of Houston; McNay A. Inst., San Antonio; Nat. Gal., Ottawa; Mus. Contemp. A., Montreal; Tacoma A. Mus.; Nat. Gal., Oslo; Bibliotheque Nationale, Paris, and others. Exhibited: Many local, national and international group shows. One-man: Galerie Arnaud, Paris, 1952, 1953, 1955, 1957, 1959, 1960-1964, 1966, 1968, 1969; Dusanne Gal., Seattle, 1958, 1960; SAM, 1960; Tokyo Gal., 1960, 1962; Woodside Gal., Seattle, 1963, 1965, 1967; Willard Gal., N.Y., 1963, 1965; Mus. de Verviers, Belgium, 1963; McNay A. Inst., 1963; Galerie Hebert, Montreal, 1963; Musée du Quebec, 1966, and others. Contributor (on ballet) to: Cimaise, 1967- ; Art Vivant, 1969- .

KOEPNICK, ROBERT CHARLES—Sculptor, T.
R.R.2, Box 231, Lebanon, Ohio 45036
B. Dayton, Ohio, July 8, 1907. Studied: Dayton AI; Cranbrook Acad. A.; & with Carl Milles. Member: Dayton Soc. P. & S.; Dayton AI; Cincinnati Liturgical A. Group. Awards: prizes, CAA, 1931; NAD, 1940, 1941; Nat. Catholic Welfare Comp., 1942; NGA, 1945, Certif. of Distinction, Dayton Chptr., AIA, 1963. Work: S. County Court House, St. Paul's Church, Parker Cooperative Sch., Roosevelt H.S., Fairview H.S., Colonel White H.S., Hickorydale Elem. Sch., Dayton & Montgomery County Pub. Lib., Trinity Lutheran Church, Marian Lib., Dayton Univ., all in Dayton, Ohio, St. Mary's Church, Oxford, Ohio; St. Anthony's Church, Dayton; Sacred Heart Church, Salina, Kans.; Penrose Mem. Hospital Chapel, Colorado Springs, Colo., 1961; Saints Faith Hope & Charity Church, Winnetka, Ill., 1961; panels in schools in Dayton, Ohio; Our Lady of La Crosse (Wis.); 2 panels, Entry to Montgomery County Fairgrounds, 1959; bronze sc., St. Peter in Chains Cathedral, Cincinnati, 1956; relief panel, Convent of Carmelite Sisters, East Chicago, Ind., 1957; stone carvings, Society of Mary, St. Joseph's Chapel, Marcy, N.Y., 1957; marble sc., Franciscan House, Centerville, Ohio, 1958; bronze port. of Frank M. Tait, Tait Mfg. Co., Dayton, 1958; panel, wall, Lima (Ohio) Pub. Lib.; bronze fig. & screen, Mt. St. John Chapel, Univ. Dayton campus, 1967; sc., St. James of the Valley Church, Wyoming, Ohio, 1967; aluminum panel, Valentine Match Plate Co., Dayton, 1968; Johnny Appleseed Mem., Springgrove Cemetery, Cincinnati, 1968. Exhibited: PAFA, 1936-1938, 1940; NAD, 1938-1940, 1941; Dance Int., 1937; AIC, 1937; Syracuse Mus. FA, 1938; CM, 1935-1937, 1939, 1940, 1955; Dayton Soc. P. & S., 1937-1945. Positions: Sch. of Dayton AI, Dayton, Ohio, 1936-41, 1946- . Visiting Sculptor, Antioch Col., 1953-54; Mt. St. Joseph Col., 1951-1955. Tech. Advisor, Ohio A. Council, 1968- .

KOERNER, DANIEL—Painter, Cart.
408 East 10th St., New York, N.Y. 10009
B. New York, N.Y., Nov. 16, 1909. Studied: ASL; Edu. All. A. Sch. Work: MMA; Queens Col.; CAM. Contributor cartoons to: Colliers; N.Y. Times; Sat. Review; Nation's Business; Ladies Home Journal; This Week; Cosmopolitan; King Features; Better Homes & Gardens; True; Argosy, and other national magazines. Lectures: Cartooning. Textbook illustrations; Biology, Anatomy, Geology & Chemistry illus. for various companies and for Encyclopedia American. Positions: Private instr., 1938-41; Cartoon Instr., Cartoonist & Illustrators Sch., 1948-52.*

KOERNER, HENRY—Painter, W., L.
1046 Murray Hill Ave., Pittsburgh, Pa. 15217
B. Vienna, Austria, Aug. 28, 1915. Studied: Acad. App. A., Vienna, and with Victor Theodor Siama. Awards: medal, PAFA, 1949; Artist of the Year of Pittsburgh, 1965. Work: WMAA, MMoA; Springfield Mus. A.; Univ. Nebraska; Des Moines A. Center; AIC; MMA; Walker A. Center; Wichita Mus. A.; Delgado Mus. A. Exhibited: nationally, including Carnegie Inst.; CGA; PAFA; Cal. PLH; WMAA; MModA; Nat. Acad. A. & Let.; Des Moines A. Center; Midtown Gal., 1948-1963; Hammer Galleries, N.Y., 1964 (one-man); Cal. PLH, 1955 (one-man); Berlin, Germany, 1947; numerous one-man exhibitions. I., Saroyan's "Tracy's Tiger." Contributor to College Art Journal; 30 covers for Time magazine. "University of Pittsburgh

in Drawings," publ. 1962. Positions: A.-in-Res., Pa. Col. for Women, Pittsburgh, Pa., 1953-54; Instr., Cal. Col. A. & Crafts (summer) 1955.*

KOGAN, BELLE—Industrial Designer, W., L.
161 E. 91st St., New York, N.Y. 10028
B. Russia, June 26, 1902. Studied: N.Y. Univ.; R.I. Sch. Des.; ASL; Winold Reiss Studios, and in Germany. Member: F., IDI (Pres. N.Y. Chptr., Dir., and Nat. Trustee, 1940-65); Inter. Soc. Color Council; Nat. Home Fashions Lg.; Indst. Designers Soc. of America (Vice-Chm., N.Y. Chptr., 1965). Awards: medal, IDI, 1942. Exhibited: Phila. A. All., 1946 (one-man); Akron AI, 1955-56. Contributor to trade, shelter, and fashion magazines, newspapers. Designer for: Red Wing Potteries; Boonton Molding Co.; Reed & Barton; Towle Mfg. Co.; Libbey Glass Co.; Maryland Plastics Co.; Muench Kreuzer Candle Co.; Snyder Mfg. Co.; Prolon Plastics Co.; Dow Chemical Co.; Quaker Silver; United States Glass Co.; Morris Heller & Sons; Viking Stainless Steel Co.; Federal Glass Co. and many others. Lectured on "Color in the Home," N.Y. Univ.*

KOHLER, MEL(VIN) (OTTO)—Educator, Int. Des.
2523 Brooke Dr., Anchorage, Alaska 99503
B. Wilcox, Sask., Canada, Dec. 7, 1911. Studied: Univ. Washington, B.A.; Cal. Sch. FA, with Maurice Sterne, Otis Oldfield and Spencer Mackey; Columbia Univ. & T. Col., M.A., with Ray Faulkner, Arthur Young, Paul Wingert, Charles Martin, and others. Member: Kappa Pi; Kappa Delta Pi; SAM; former memb.: AAMus.; NAEA; Pacific AA; Tacoma AA; Tacoma A. Lg.; Washington AA; Western Assn. Mus. Dirs.; AFA. Work: Interior des.: Elmendorf Officers Club, Elmendorf Air Force Base, Medical Surgical Clinic, Academic Bldg. & Residence Hall of Alaska Methodist Univ., Exec. Office, Communications Equipment & Service Co., All Anchorage, Alaska. Designs exhibition catalogs and programs for Alaskan art and musical events. Positions: Instr. A., 1934-37, Asst. Prof. A., 1937-42 & 1947-48, Dir. A. Dept., 1936-41 & 1946-47, Chm. FA Div., 1940-41, Univ. Puget Sound, Tacoma, Wash.; Asst. in FA Dept., T. Col., Columbia Univ., 1941-42; Admin. Officer, Office of Circulating Exhs., 1948-52, Cur., Henry Gal., 1948-51, Univ. Washington; Lecturer in Art, Anchorage Community College, 1956; Assoc. Prof. A., 1960-1964, Chm., Univ. Forum, 1961- , Alaska Methodist University, Anchorage, Alaska. Des. & Color Consultant, with own showroom and Gallery, Anchorage, 1952- .*

KOHLHEPP, DOROTHY IRENE—Painter
2116 Lauderdale Rd., Louisville, Ky. 40205
B. Boston, Mass. Studied: Mass. Sch. A.; New Orleans A. & Crafts; Grande Chaumiere, Julian Acad., Andre L'Hote, Paris, France. Member: Salon des Tuileries; Mod. Eng. & Am. Painters, France; Louisville A. Center Assn. Awards: prizes, Louisville A., 1944, 1945; Jeffersontown, Ky., Fair, 1954; Kentucky & Southern Indiana A., 1945, 1946, 1949; Louisville A. Cl., 1946; CM, 1961. Work: Seagram Coll.; Univ. Louisville; J. B. Speed A. Mus.; Devoe & Raynolds Coll. Exhibited: Ky.-Indiana A.; J. B. Speed Mus. A., 1950; Interior Valley Exh., 1955; Chicago, Ill., 1955; Salon des Tuileries, Paris; VMFA; New Orleans, Louisville, 1932-1946; one-man: Louisville A. Cl., 1937, 1940, 1945, 1948, 1949; J.B. Speed A. Mus., 1938, 1948; Univ. Louisville, 1944; Anchorage, Ky., 1945; Nichols General Hospital, U.S. Army, 1947, 1949; Louisville Woman's Cl., 1947, 1950; CM, 1961. Retrospective exh. (with Norman Kohlhepp), 1961, Louisville. Positions: Pres. Bd., 1940-41, V. Pres. Bd., 1942-47, A. Center Sch. & Assn., Louisville, Ky.*

KOHLHEPP, NORMAN—Painter, Lith., S.
2116 Lauderdale Rd., Louisville, Ky. 40205
B. Louisville, Ky. Studied: Univ. Cincinnati; Grande Chaumiere, Paris; Academie Colorossi, and with Andre L'Hote. Awards: prizes, Ky. & Indiana A., 1940, 1941, 1947; Louisville A. Cl., 1945, 1948; Kentucky State Fair, 1952, 1953, 1955, 1967, 1968; Va.-Intermont Exh., 1958; first prize, Women's Cl., 1961, 1964; Work: J. B. Speed A. Mus.; Univ. Louisville; Seagram Coll.; Devoe & Raynolds Coll. Exhibited: J. B. Speed A. Mus., 1938, 1948, 1950, 1955, 1968; Louisville A. Cl., 1940, 1949, 1960 (one-man); Univ. Louisville; Chicago, Ill., 1955; Interior Valley Biennial, 1958; Retrospective Exh. (with Dorothy Kohlhepp) 1961, Louisville; PAFA, 1961; Mid-States Exh., 1965-1967; CM, 1967; Ky. Capitol Exh., 1967; Norfolk, Va., 1966; Junior Lg. A. Gal., 1969; Latin-Am. Festival, 1969 (one-man). Positions: Treas., A. Center Assn., 1958-59, Sec., 1960-61, Bd. Memb., 1962-1969; Co-Chm., "Downtown Salutes the Arts," Louisville, 1964, 1965.*

KOHLMEYER, IDA (Mrs. Hugh)—Painter, E.
11 Pelham Ave., Metairie, New Orleans, La. 70005
B. New Orleans, La., Nov. 3, 1912. Studied: Newcomb Col., M.F.A.; Hans Hofmann Sch. A. Awards: prizes, Delgado Mus. A., 1957, 1960, 1965; purchases, Louisiana State Exh., Baton Rouge, 1960, 1961; Knoxville A. Center, 1961 (purchase); Oklahoma A. Center,

1960 (purchase); Atlanta AA, 1962; Tyler A. Center, 1962, 1963; Chautauqua Nat., 1962, 1965; Monroe A. Center, 1963; Barranquilla, Colombia, 1963; Southeastern Annual, 1963; Ford Fnd. purchase award, CGA, 1963; "Collection of American Paintings," sponsored by Sears, Roebuck Co., purchase, 1964; Arkansas A. Center, Little Rock, 1966; Atwater Kent Award, Soc. Four Arts, Fla., 1965. Work: Delgado Mus. A.; Oklahoma A. Center; Metairie Park Country Day Sch., New Orleans; Rochester Mem. A. Gal.; Mead Packaging Co.; Columbus Mus. A.; Tyler A. Center; Monroe A. Center; Centro Artistico, Barranquilla, Columbia; Montgomery Mus. A.; Atlanta AA; Fort Lauderdale Mus. A. & Crafts; Mobile A. Gal.; AGAA, Andover, Mass.; Greenville(S.C.) County Mus. A.; Mus. FA, Houston, Texas; Sheldon Mem. A. Gal., Univ. Neb.; High Mus. A., Atlanta; Art in Embassies, USA; NCFA; Lauren Rogers Mem. A. Gal., Laurel, Miss.; Marion Koogler McNay A. Inst., San Antonio, Tex.; murals, Lykes Bros. Steamship Co., 1959. Exhibited: Columbus Gal. FA, 1961; Pittsburgh Plan for Art, 1961; Provincetown A. Festival, 1958; Chautauqua, N.Y., 1958; Soc. Four Arts, Fla., 1959; Knoxville A. Center, 1961; Oklahoma A. Center, 1959; Butler Inst. Am. A., 1961, 1965; So. Louisiana Inst., 1958-1960; Tulane Faculty Exh., 1956-1961; High Mus., Atlanta, 1959; Ringling Mus. A., 1961; Delgado Mus. A., 1955-1961; Birmingham A. Mus., 1959; Riverside Mus., N.Y., 1957; Pensacola A. Center, 1958; Vienna, Austria, 1959; Univ. Florida, 1960; Tokyo, Japan, 1961; Contemp. A. Gal., Manila, 1961; Hong Kong, China, 1961; Jacksonville A. Mus., 1960; VMFA, 1962; Denver A. Mus.; CGA, 1963; Knoedler Gal., N.Y., 1965; one-man: Delgado Mus. A., 1957; Orleans Gal., 1958, 1960, 1961; Ruth White Gal., N.Y., 1959, 1961, 1965; Tulane Univ., 1959, 1964; Henri Gal., Alexandria, Va., 1961, 1964, 1966, 1968; Columbus Mus., 1962; Haydon-Calhoun Gal., Dallas, 1963; Montgomery Mus. A., 1964; Houston, Tex., 1960; Bresler Gal., Milwaukee, 1960; Mun. A., Mississippi AA, 1965; The Glade Gal., New Orleans, 1965-1967; Masur A. Gal., Monroe, La., 1967; Greenville County Mus. A., 1967; Univ. Southwestern La., 1967; Lauren Rogers Mem. A. Gal., Laurel, Miss., 1967; Mississippi State Col. for Women, Columbus, 1967; Louisiana State Univ., Baton Rouge, 1967, 1969; Memphis Acad. A., 1967; Sheldon Mem. A. Gal., Lincoln, Neb., 1967; Wofford Col., Spartanburg, S.C., 1968; DuBose Gal., Houston, 1968; Marion Koogler McNay A. Inst., San Antonio, 1968; Fort Wayne(Ind.) Mus. A., 1968; Pensacola A. Center, 1969; Heath Gal., Atlanta, 1969. Positions: Instr., Drawing & Painting, Newcomb College, New Orleans, La., 1956-1964.

KOHN, GABRIEL—Sculptor
School of Art, University of Washington, Seattle, Wash. 98105
B. 1910. Awards: Guggenheim F., 1967. Exhibited: WMAA, 1964. Positions: Instr. and lecturer, Brooklyn Mus. A. Sch, 1959; La Jolla A. Center, 1962; San Francisco A. Inst., 1963; Univ. of Washington, 1963; Univ. of California, Long Beach, 1965; Univ. of California, Santa Barbara, 1967; California Inst. of FA, 1968.

KOHN, MISCH—Etcher, Eng., Lith., P., E.
Institute of Design, Illinois Institute of Technology; h. 1200 East Madison Park, Chicago, Ill. 60615
B. Kokomo, Ind., Mar. 26, 1916. Studied: John Herron AI, B.F.A. Member: SAGA. Awards: prizes, Phila. Pr. Cl., 1950, 1951, 1955, 1956, 1958, 1969; AIC, 1951, 1952, 1958; John Herron AI, 1952, 1956, 1963; SAM, 1950 (purchase); BM, 1950, 1951, 1968; (purchase); NAD, 1955; Guggenheim Fellowship, 1952, renewed 1954; Pennell medal, PAFA, 1952, Eyre medal, 1949; prize, Int. Print Exh., Ljubljana, Yugoslavia, 1961; Tamarind F., 1967; Ford Fnd. Grant for traveling retrospective exh., Salon de Mai, Paris, 1960; Hon. Memb., Accademia Firenze, 1964. Work: Bezalel Nat. Mus., Jerusalem; Bibliotheque Nationale, Paris; Mus. des Beaux Arts, Lyons, France; Mus. Nat. d'Art, Rio de Janeiro and Sao Paulo Slade Sch., Univ. of London; Victoria Mus., Melbourne, Australia; Moderna Galerija, Ljubljana, Yugoslavia; 14 U.S. Embassies abroad; Minestere des Arts et des Lettres, Paris; Nat. Mus., Stockholm, Sweden. Exhibited: Salon de Mai, Paris, France, 1952, 1953; PAFA, 1949, 1952, 1956; BM, 1949-1957; Phila. Pr. Cl., 1949-1958; Boston Pr. M.; Seattle Pr. Cl.; AIC; also AIC, 1949-1958; one-man: Weyhe Gal., N.Y.; Phila. A. All.; AIC, 1961; Los A. Mus., 1955; William Rockhill Nelson Mus. A.; one-man: Moderna Galerija, Ljubljana, Yugoslavia, 1964; Klagenfort, Austria, 1963, Kendall Col., 1967; Univ. Chicago, 1967; Rosary Col., 1968. Award Prints 1959 Exhibition Misch Kohn (an exh. catalog by AFA, auspices of Ford Fnd.). Positions: Prof. A., Inst. of Design, Illinois Institute of Technology, Chicago, Ill.

KOKINES, GEORGE—Painter
1816 W. Wilson Ave., Chicago, Ill., 60640
B. Chicago, Ill., Nov. 17, 1930. Studied: AIC; Univ. Chicago. Member: Chicago A. Cl. Awards: Frank C. Logan award, AIC, 1961. Work: in private colls. Exhibited: Superior Street Gal., Chicago, 1960, 1961; Richard Feigen Gal., Chicago, 1963-1965; John Gibson Gal., Chicago, 1961, 1962; Adele Rosenberg Gal., Chicago, 1962;

"12 Chicago Artists," McCormick Place Art Gal., 1962; AIC, 1960-1965; Univ. Chicago, 1963; Krannert Mus., Univ. Illinois, 1963; Henry Gal., Seattle, 1963; Denver Mus. A., 1963; WMAA, 1963; Purdue Univ., 1965; WAC, 1965; one-man: Feigen Gal., Chicago, 1962; Univ. Chicago, 1963; 2-man: John Gibson Gal., Chicago, 1962. Positions: Instr., Advanced Painting, Northwestern Univ., (summer) 1965.*

KOLLIKER, WILLIAM A.—Painter, Des., Comm., I., T., L.
 4120 Rio Bravo St., Suite 307; h. 3812 Hillcrest Dr., El Paso, Tex. 79902
B. Berne, Switzerland, Oct. 12, 1905. Studied: NAD; ASL; Maryland Inst.; Grand Central A. Sch.; Boston Sch. FA. Member: A. Dir. Cl., N.Y.; El Paso AA (Pres. 3 times); Royal Soc. for Encouragement of Art, London. Awards: prize, Sun Carnival, 1958, 1962; City of El Paso Conquistador, 1963; El Paso Adv. Cl., 1962-1963; El Paso Chamber Commerce, 1967. Work: painting, Mayor's Office, City Hall, El Paso; mosaic mural in lobby of El Paso Federal Savings & Loan Assn., 1961; El Paso Mus. A., designed El Paso Botanical Gardens; Amistad Dam Int. Monument; Chamizal Plaque & Gold medal for presentation by Pres. Johnson; portraits in private colls. Exhibited: Sun Carnival, El Paso, 1957-1961; Grumbacher traveling show, 1964; DMFA, 1964, 1965; El Paso Mus. A., 1964, 1966, 1968; Witte Mem., San Antonio, 1964, 1965; Univ. Tex., Austin, 1964, 1965; Sarasota Mus. A., 1964; Texas Western Col., 1965; Hemisfair, 1968; etchings in U.S. Embassies in Europe and Asia, and others. One-man: El Paso Women's Cl.; Mus. of New Mexico; Midland (Tex.) Pub. Lib. Illus. "Aesop's Fables"; "Adventures in Puddle Muddle" and several other books for children. Contributor of illustrations to American Weekly; Coronet. Positions: A. Dir. & A. Ed., American Weekly, Associated Press feature art dept. (17 years); A. Dir., Cunningham & Walsh; Staff Artist, N.Y. American; Baltimore American; Boston American; N.Y. Graphic; N.Y. Journal. Trustee, El Paso Museum of Art; Instr. A., Univ. Tex., El Paso, 1962-1965. Lectures to Art Assns. & clubs.

KOMOR, MATHIAS—Art Dealer
 19 E. 71st St. 10021; h. 439 E. 51st St., New York, N.Y. 10022
B. Szolnok, Hungary, Jan. 24, 1909. Studied: Univ. Grenoble, France. Specialty of Gallery: Antiquities (Greek, Egyptian, Far Eastern, etc.); Old Master Drawings and Primitive Arts.

KONI, NICOLAUS—Sculptor, P., C., T., L.
 41 East 60th St., New York, N.Y. 10022; also, 146 Australian Ave., Palm Beach, Fla. 33480
B. Transylvania, May 6, 1911. Studied: Acad. FA, Vienna; also in Paris, France and Florence, Italy. Member: NSS; Arch. L.; Navy Lg.; Quill A. Soc., Palm Beach (Co-Chm.). Awards: Pilsudski award; prize, Parrish A. Mus., N.Y., 1959. Work: BM; Rockford (Ill.) Mus.; Annapolis Naval Acad. Mus.; Washington County Mus. FA; Birmingham Mus. A.; High Mus. A.; Bezalel Mus., Israel; "Fountain of the Night," Oklahoma A. Center, Oklahoma City, 1964; portrait bust of Marian Anderson acquired by the Metropolitan Opera Assn. for Lincoln Center, N.Y., 1964; bronze sc. of Am. Indian, Palm Beach Seminole Golf Cl.; sculpture on exh. in Athens, Greece, under sponsorship of U.S. State Dept. of Cultural Affairs; sc. of Charles Nichols, N.Y. Univ. and Nichols medallion exh. at Int. Expo., Paris, 1967-1968; other work in many private colls., U.S. and abroad. monuments, mem., in Europe. Exhibited: U.S. and abroad. One-man: 1960-1964; Oklahoma A. Center; West Texas Mus., Lubbock, Springfield (Mass.) Mus. A.; Prentice Hall, N.Y.; Milch Gal., N.Y.; Ferargil Gal., N.Y.; Selected Artists Gal., N.Y.; BM; WMAA; Birmingham Mus. A.; Washington County Mus. A., Hagerstown, Md.; Atlanta AA; Hunter A. Gal., Chattanooga, Tenn.; Columbia Mus. A.; Parrish A. Mus.; Rockford Mus. A.; Bridgeport Mus. A. (Conn.); Ft. Lauderdale A. Center; Boca Raton Cultural Inst.; Palm Beach Galleries; Soc. Four Arts, Palm Beach; Fairhouse Galleries, Cincinnati; Carlson Cultural Fnd., Bridgeport (Conn.) Univ.

KONRAD, ADOLF FERDINAND—Painter, T., L.
 Bartley, R.D. Flanders, N.J. 07836
B. Bremen, Germany, Feb. 21, 1915. Studied: Newark Sch. F. & Indst. A.; Cummington Sch. A., with Herman Maril. Member. Assoc. A. of New Jersey (Pres., 1958-62); AEA (Pres. N.J. Chptr., 1953-56); ANA. Awards: Prizes, N.J. State Exh., Morris Plains, N.J.; 1954; N.J. State Exh., Tinton Falls, N.J., 1955; Montclair A. Mus., 1955, 1960, 1962, 1964; "Artist of the Year," Jersey City Mus. and Hudson County Artists, 1956; NAD, 1956; Springfield Mus. A., 1957, 1967; P. & S. of New Jersey, 1957; Red Bank (N.J.) A. Festival, 1959, 1963; Everhart Mus., Scranton, Pa., 1960, 1964; Tiffany Fnd. Fellowship, 1961; Silvermine Gld. A. Prize, 1962; Monmouth College, 1963; Wyoming Valley AA, Wilkes-Barre, 1960; Atlantic City A. Festival, 1961 (Grand Prize) 1963 (European traveling). Judson Dunaway award, 1967; New Jersey Symphony, 1969. Exhibited: Montclair A. Mus., 1953, 1955, 1957, 1962-1964; PAFA, 1964, 1965; NAD, 1953; Newark Mus. A., 1955, 1958, 1964, 1968; Springfield,

Mass., 1957; Butler Inst. Am. A., 1957; Marietta Col. (Ohio), 1969; one-man: Newark Mus., 1966; Glassboro State Col., 1967. Work: Newark Mus. A.; Newark Pub. Lib.; Ciba Pharmaceutical Co., Basle, Switzerland; Montclair A. Mus.; Springfield Mus. A.; NAD. Everhart Mus., Scranton, Pa.; State Mus., Trenton; Court of General Sessions Coll., Wash., D.C.; CGA. Article "Adolf Konrad, painter of the American Scene," in American Artist Magazine, 1968.

KONZAL, JOSEPH—Sculptor
 254 Warren St., Brooklyn, N.Y. 11201
B. Milwaukee, Wis., Nov. 5, 1905. Studied: BAID; ASL. Member: S. Gld.; ASL; Fed. Mod. P. & S.; Awards: prizes, BM, 1950, 1956; Riverside Mus., 1950, 1954; Silvermine Gld. A., 1955-1961; Audubon A., 1958; Yaddo Fnd. Fellowship, 1964, 1966; Guggenheim Fellowship for work in Creative Sculpture, 1965-1966; prize, closed competition, Nassau County Supreme Court Bldg., 1968. Work: WMAA; New Sch. Soc. Research, N.Y.; Tate Gal., London, England; Storm King A. Center, Mountainville, N.Y., and in private colls. Exhibited: AIC, 1938; WMAA, 1948, 1960, 1962, 1964, 1966, 1968; S. Gld., 1942-1965; PAFA, 1953, 1954, 1958; MModA, 1959; Newark Mus., 1960, 1963; New Jersey Tercentenary Commission Pavilion, N.Y. World's Fair, 1964-1965; Montclair A. Mus., 1964; N.J. State Mus., 1965; Carnegie Inst., 1961; one-man: Bertha Schaefer Gal., N.Y., 1959, 1963, 1965, 1967. Positions: Instr. Sculpture, Brooklyn Museum A. Sch.; Assoc. Prof. A., Adelphi Univ., Summer School, Garden City, N.Y., 1954-1965.

KOONS, DARELL JOHN—Painter, E.
 Box 34557, Bob Jones University, Greenville, S.C. 29614; s. R.R. No. 1, Concord, Mich. 49237
B. Albion, Mich., Dec. 18, 1924. Studied: Bob Jones Univ., B.S.; Univ. Michigan; Western Michigan Univ., M.A.; Eastern Michigan Univ. Member: Gld. S.C. Artists; Southeastern College A. Conf.; NAEA; Greenville AA; Int. Platform Assn. Awards: purchase awards, Mint Mus. A., 1963; Wake Forest Col., 1965; Gibbes Gal., A., Charleston, 1964, 1965; Calloway Gardens Exh., Pine Mountain, Ga., 1965; Gal. Contemp. A., Winston-Salem, purchase, 1966; Soc. of Four Arts, Palm Beach, Fla., 1967; Hunter Gal. A., Chattanooga, 1966, 1967; Butler Inst. Am. A., purchase, 1967. Work: Bob Jones Univ.; Univ. South Carolina; Liberty Life Ins. Co., and Woodside Mills, both Greenville; Home Fed. Savings & Loan Assn., Charleston; Kendall Co.; Owen-Corning Fiberglas Corp., Anderson, S.C.; Spartanburg Day Sch.; Florence (S.C.) Mus. A; Gibbes Gal. A.; Mint Mus. A.; Greenville County Mus. A., S.C. and others. Exhibited: Soc. Four Arts, Palm Beach; Academic A., Springfield, Mass.; Winston-Salem Gal. FA; Mint Mus. A.; Mead Paper Exh., Atlanta; Southeastern AA, Atlanta; Sheldon Swope Gal., Terre Haute, Ind.; Greenville Mus. A.; Carolina AA; Converse Col.; Hickory Mus. A.; Statesville, Mus. A.; Hilton Inn, Hilton Head, S.C.; one-man: Univ, South Carolina, 1963; People's Nat. Bank, Greenville, 1962, 1964; Mint Mus. A., Charlotte, 1963; Erskine Col., 1964; Bob Jones Univ.; Acquavella Gals., N.Y. Paintings represented in "Prize winning Paintings," 1965, 1966, 1967. Article, "Greenville's Barn Painter" in "The Sandlapper Magazine," 1968. Positions: Instr., A., Bob Jones University, Greenville, S.C.

KOOTZ, SAMUEL M.—Art Dealer, Writer
 655 Madison Ave. 10021; h. 75 East End Ave., New York, N.Y. 10028
B. Portsmouth Va., Aug. 23, 1898. Studied: Univ. of Virginia, LL.B. Author: "Modern American Painters," 1928; "New Frontiers in Painting," 1943; "Puzzle in Paint," 1943. Specialty of Gallery: Modern American and European Painting and Sculpture.*

KOPPE, RICHARD—Painter, S., E., Gr., W.
 College of Architecture & Art, Box 4348, University of Illinois 60680; h. 5256 N. Rockwell Ave., Chicago, Ill. 60625
B. St. Paul, Minn., Mar. 4, 1916. Studied: St. Paul Sch. A., with Cameron Booth, LeRoy Turner, Nicoli Cikovsky; New Bauhaus, Chicago, with Lazlo Moholy-Nagy, Gyorgy Kepes, Alexander Archipenko, and others. Awards: prizes, AIC, 1947, 1948, 1950, 1960; San F. AA, 1948; Springfield State Fair, 1950; Chicago A., Navy Pier, Chicago, 1958; Univ. Minnesota (purchase), 1950; BM (purchase), 1951, 1966; Ill. State Mus., Springfield, Ill., 1968. Work: Smith Col. Mus.; Illinois State Mus.; Univ. Minnesota; BM; WMAA; AIC; Indiana Univ.; St. Paul A. Center; Kalamazoo AI.; Southern Ill. Univ.; Syracuse Univ., "Richard Koppe Painting and Manuscript Collection at Syracuse" and in many private collections; murals, Hotel Sherman, Chicago, Ill.; Medical Bldg., Chicago; sc. panel, Club Lido, South Bend, Ind. Exhibited: Artists Gal., N.Y.; John Heller Gal., N.Y.; many Chicago galleries; Michigan State Univ., 1958; Oklahoma State Univ., 1958; Art:USA, 1958; AIC, 1941-1957, 1957 (on tour Europe, 1957-1959), 1958-1961, 1964, 1966 (2); Carnegie Inst., 1952; MMA, 1950, 1952; WMAA, 1951, 1953, 1954, 1956; BM, 1950, 1951, 1957, 1966; Univ. Illinois, 1948-1951: PAFA 1951, 1967; San F. AA, 1948,

1949; Nebraska AA, 1951; Illinois State Fair, 1947, 1948, 1950; Univ. Minnesota, 1951; Denver A. Mus., 1951, 1960; CGA, 1961; AFA traveling exh., 1949-1952, 1957-1960; Wildenstein Gal., 1949; Exhibition Momentum, Chicago, 1950, 1952, 1953; Illinois State Mus., 1949, 1963, 1966, 1968; NAD, 1947; A. & Crafts Cl., New Orleans, 1948; Ravinia (Ill.) Festival A., 1957; Providence A. Cl., 1963; St. Paul A. Center; Drawings: USA, St. Paul A. Center, 1966-1968; Bauhaus Archives, Darmstadt, Germany, 1968-1969 (traveling in Europe), and many others; one-man: 35 one-man exhs. since 1936. Illustrations in Art Digest, Arts & Architecture, Le Revue Moderne, Art International, and for numerous book covers. Positions: Assoc. Prof., Hd. Visual Des., Institute of Design, Illinois Institute of Technology, Chicago, Ill., 1946-1963; Prof. A., University of Illinois, Chicago, Ill., 1963- .

KOPPELMAN, CHAIM—Etcher, T.
 498 Broome St., New York, N.Y. 10012
B. New York, N.Y., Nov. 17, 1920. Studied: Am. Artists Sch.; A. Col. of Western England, Bristol; Ozenfant Sch. FA. Member: Soc. for Aesthetic Realism; SAGA (former Pres.); Awards: Tiffany Fnd. Grant, 1956, 1959; prize, SAGA, 1966; BM, 1968; 3rd Int. Min. Pr. Exh., 1968. Work: Victoria & Albert Mus., London, England; MModA; LC; MMA; Peabody Mus.; Mus. FA, Caracas; Yale Univ. A. Gal.; WMAA; BM; Los Angeles County Mus. Exhibited: WMAA, 1948, 1950, 1962; PAFA, 1963; BMFA, 1962-1964; BM, 1964, 1968; Oakland A. Mus., 1957, 1958; Yale Univ. A. Gal.; DMFA; Santa Barbara Mus. A.; MModA; Documenta II, West Germany, 1959; 2nd Biennial, Mexico City, 1960; Brooks Mem. Mus., 1962; Drawings: USA, St. Paul A. Center, 1966; Int. Pr. Invitational, Vancouver, Canada, 1967; two-man: Terrain Gal., N.Y., 1969; one-man: Phila. A. All., 1958; RoKo Gal., N.Y., 1966. Contributor: Liberation magazine, 1969. Co-Author: "Aesthetic Realism: We Have Been There," 1969. Author: "This is the Way I See Aesthetic Realism," 1969. Positions: New Paltz State T. Col., 1952-58; N.Y. Univ., Dept. A. Edu., 1947-55; Brooklyn College, Brooklyn, N.Y., 1950-1960, Hd., Printmaking Dept., School of Visual Arts, New York, N.Y., 1959- .

KOPPELMAN, DOROTHY (Mrs. Chaim)—
 Gallery Director, P., Cr., W.
 Terrain Gallery, 39 Grove St. 10014; h. 498 Broome St., New York, N.Y. 10012
B. New York, N.Y., June 13, 1920. Studied: Brooklyn Col.; Am. A. Sch.; ASL; and with Eli Siegel. Member: Soc. for Aesthetic Realism. Awards: prizes, City Center Gal., N.Y., 1957; Brooklyn Soc. A., 1960; Tiffany Fnd. grant 1965 (for painting, 1966). Work: Yale Univ. Exhibited: MModA, 1962; BM, 1961; Art:USA, 1958; Jersey City Mus.; Riverside Mus., NAC, Kornbluth Gal., Visual Arts Gal., Terrain Gal., including 2-man (with Chaim Koppelman), 1969, all New York, N.Y.; Columbus Gal. FA; Colo. Springs FA Center; BMA; CAM; SFMA; WAC; Pratt Graphics traveling exh., 1962-63, A. Cr., Washington Independent, 1966-1967; Co-author: "Aesthetic Realism: We Have Been There," 1969. Positions: Dir., Visual Arts Gallery, School of Visual Arts, N.Y., 1963-64; Dir., Terrain Gallery, New York, N.Y., at present; Instr. A., Adult Education, Brooklyn College, 1952.

KORN, ELIZABETH P.—Painter, E., I., L.
 531 Washington St., Hoboken, N.J. 07030
B. Germany. Studied: Breslau Univ.; Acad. F. & App. A., Berlin; ASL with Morris Kantor; Rome, Italy; Columbia Univ., and with Emil Orlik, Berlin. Member: AAPL; N.J. Art Council; CAA; NAWA; AAUP; Kappa Pi (Hon.); Sigma Psi (Hon.). Awards: prizes, Posnan Mus., Poland; Newark Mus.; N.J. State Mus., 1949; Orange, N.J. State Exh., 1952; Grumbacher prize, Rahway, N.J., 1951. Work: Columbia Univ.; Newark Mus. A. Exhibited: NAD, 1942, 1943; AWS, 1942, 1943; Newark Mus.; Montclair A. Mus.; N.J. State Mus.; Univ. Illinois, 1961; Drew Univ. (one-man); Rahway, N.J.; Theodore Kohn Gal., N.Y. (one-man); Morristown Woman's C.; N.J. Art Council; Rome, Italy (one-man); N.Y. City Center, 1956-1958; NAWA, 1958; Cornell Univ., 1960 (one-man); Roko Gal., N.Y., 1968 (one-man); other exhibitions in colleges and universities, 1959-1965. I., "At Home with Children," 1943; "Skippy's Family," 1945; "Portraits of Famous Physicists," 1944; "Aladdin"; "Apple Pie for Louis." Co-author, I., "Trail Blazer to Television," 1950; "Read Up On Life," 1952 (textbook); "Nando of the Beach," 1958. Contributor to leading magazines and newspapers. Positions: Guest Lecturer, various institutions. A.-in-Res., Emory and Henry Col., Virginia, 1969.

KORTHEUER, DAYRELL—
 Portrait Painter, T., Conservator; Landscape P.
 1924 Sharon Lane, Charlotte, N.C. 28211
B. New York, N.Y., July 25, 1906. Studied: McBurney Sch.; Rutgers Prep. Sch.; ASL, with Frank DuMond, George Bridgman, John Carroll; NAD, with Charles Hawthorne, and in Sweden. Member: Portraits, Inc.; Intl. Inst. for Conservation of Historic & Artistic Works (Assoc.); North Carolina State A. Soc.; Mint Mus. A. Awards:

F., Tiffany Fnd., 1928; prizes, NAC, 1928; Mint Mus. A., 1941, 1942; Blowing Rock AA, 1955, gold medal, 1954. Work: portraits, Merchant's Assn., N.Y.; Mint Mus. A.; Emory Univ.; Queens Col., Charlotte; Univ. North Carolina; Davidson Col.; Winthrop Col., Rock Hill, S.C.; Erskine Col.; Governor's Mansion, Raleigh, N.C.; Fulton Nat. Bank, Atlanta; Presbyterian Hospital, Charlotte; Supreme Court, Richmond Va., and in private collections. Exhibited: one-man: Mint Mus. A., 1945, 1951, 1963; Vose Gal., Boston, 1949; A. Cl., Wash., D.C., 1950; Hartford, Conn., 1950; Asheville Mus. A., 1953; Blowing Rock AA, 1955; Statesville, N.C., 1957, 1964; Hickory (N.C.), 1958; Carson-McKenna Gal., Charlotte, N.C., 1969. Positions: Instr., Painting, Mint Mus. A.

KORTLANDER, WILLIAM CLARK—Painter, Historian
 31 Forest St., Athens, Ohio 45701
B. Grand Rapids, Mich., Feb. 9, 1925. Studied: Michigan State Univ., B.A.; Univ. Iowa, M.A., Ph.D. Awards: Baker Research Award, Ohio Univ. (for painting in Europe), 1967; Painting of the Year award, Mead Paper Corp., 1965; prizes, Columbus Gal. FA, 1963, 1964, 1965 (2); Huntington Gals., W.Va., 1962, 1963, 1964 (2); Ohio State Fair, 1963; Capitol Univ., Columbus, Ohio, 1963 (2), 1965; Dayton A. Inst., 1963, 1964; Otterbein Col., 1964; Ball State Univ., 1965; Capitol Univ., 1969; Texas FA Assn., Austin, 1958, 1960. Work: Columbus Gal. FA; Mead Corp.; Huntington Gals.; Otterbein Col.; W. Va. State Col.; Zanesville A. Inst.; 20th St. Nat. Bank, Huntington. Exhibited: PAFA, 1965; Hanover Col., 1963; Ball State Univ., 1964, 1965; Ohio Univ., 1964; Knoedler Gal., N.Y., 1965; Texas FA Assn., 1958-1960; Witte Mem. Mus., San Antonio, 1961; DMFA, 1959, 1961; Dayton A. Inst., 1961, 1963 (2), 1964 (2); Capitol Univ., 1963, 1964, 1969; Columbus Gal. FA, 1962-1966; Illinois State Fair, 1962; Ohio State Fair, 1963, 1964; Huntington Gals., 1962-1964, 1965 (2); Southwestern Louisiana Exh., 1958; Feldman Exh. (traveling through Southwest and Mexico), Waco Mus., 1960; Southern Methodist Univ., 1957; one-man: A.M.Sachs Gal., N.Y., 1967, 1968; Otterbein Col., 1965; Jewish Center, Columbus, 1964; Zanesville A. Inst., 1966; W. Va. State Col., 1966; Denison Univ., 1965; Bryson Gal., Columbus, 1965; Batelle Mem. Inst., Columbus, 1966; Bennett Gal., Toledo, 1966; Merida Gal., Lousiville, 1967; Montana State Univ., 1969. Positions: Teaching Asst., Univ. Iowa, art history; Instr., Lawrence Univ., design, art history; Asst. Prof., art history, Univ. Texas; Visiting Prof., Michigan State Univ.; Prof. A., Ohio Univ., Athens, Ohio, at present.

KOTIN, ALBERT—Painter, E., L.
 90 East 10th St. 10003; h. 210 East 34th St., New York, N.Y. 10016
B. New York, N.Y., Aug. 7, 1907. Studied: ASL; NAD; BAID; in Paris; & with Charles Hawthorne and Hans Hofmann. Awards: Purchase award, Longview Fnd., 1962. Work: Syracuse Mus. FA; Brooklyn Pub. Lib.; Newark Bd. Edu.; Kalamazoo AI; murals, USPO, Arlington, N.J.; Ada, Ohio; N.Y. Univ., and in private colls. Exhibited: An Am. Group, 1938; LC; PAFA; Assoc. Am. A.; Wichita A. Mus.; Hacker Gal., 1951 (one-man); March Gal., 1957; Tanager Gal., 1957-58; Stable Gal., 1957; Grand Central Moderns, 1958 (one-man); Allyn Gal., Univ. So. Illinois, 1961; Milli-Jay Gal., Woodstock, N.Y., 1960-61; Tanager Gal., N.Y., 1959 (one-man); Pollock Gal., Toronto, 1960; Galerie Iris Clert, Paris, 1960; Aegis Gal., N.Y., 1962-63; Long Island Univ., Graham Gal., N.Y., 1962; MModA traveling, 1963-64; Byron Gal., N.Y., 1964 (one-man); Retrospective exh., Brooklyn Center, Long Island Univ., 1968. Positions: Instr., City Col. New York, 1947-51; Brooklyn Polytechnic Inst., Brooklyn, N.Y., 1952-1961. Visiting Prof. A., So. Illinois Univ., Apr., 1961; Artist-in-Res., Stout State University, Menomonie, Wis., 1964-1966; A.-in-Res., Brooklyn Center, Long Island Univ., 1966- ; Consultant to Cultural Comm., Mexican Olympic Organization, 1968.

KOTTLER, LYNN—Art Dealer
 Three E. 65th St., New York, N.Y. 10021; h. 1620 E. Second St., Brooklyn, N.Y. 11230
B. New York, N.Y., Oct. 25, 1908. Studied: Columbia Univ.; New York University; College of the City of New York; New School for Social Research. Member: Kappa Pi (Hon.); AAMus. Specialty of Gallery: Specializes in exhibitions of paintings and sculpture by Contemporary Artists. Positions: Founder, Academy Galleries; Portrait Painters Gld.; Dir., Lynn Kottler Galleries, New York, N.Y., at present.

KOWALSKI, RAYMOND A.—Painter, Des., T., A. Dir.
 12000 Fairhill Rd., Cleveland, Ohio 44120
B. Erie, Pa., June 21, 1933. Studied: Pa. State Teachers Col.; Cleveland Inst. A.; John Carroll Univ. Awards: prizes, Cleveland Inst. A. Exhibited: Watercolor:USA, 1968; Chautauqua N.Y. national exh., 1967; Cleveland Mus., 1969; Louisville AA, 1969; Ohio State Fair, 1968; Canton A. Inst., 1968; Bay Crafters, 1967; many local Cleveland exhs. Cover Designer and subject of article "The Wonderful World of Ohio," Cleveland Plain Dealer. Positions: Designer,

1959-1965, Art Director, 1965-1969, American Greetings Corp.; Instr., Design Courses, Cooper School of Art, Cleveland, Ohio, 1969- .

KOZLOFF, MAX —Critic
 225 W. 106th St., New York, N.Y. 10025
B. Chicago, Ill., June 21, 1933. Studied: Univ. Chicago, B.A., M.A.; New York University Institute of Fine Arts. Awards: Fulbright Scholarship, France, 1962-1963; Pulitzer Fellowship in Critical Writing, 1962-1963; Frank Jewett Mather Award in Art Criticism, 1966; Guggenheim Fellowship, 1968-1969. Contributor of Art and Film Criticism to major journals. Author: "Renderings: Critical Essays on a Century of Modern Art," 1969; "Jasper Johns," 1969. Positions: Art Critic, The Nation, 1961- ; New York Correspondent, Art International, 1961-1964, New York; Contributing Editor, Artforum, 1964- .

KOZLOW, SIGMUND—Painter
 Finesville, N.J. 08865
B. New York, N.Y., Dec. 7, 1913. Studied: NAD; Ecole des Beaux-Arts, Paris, France. Member: AEA; Audubon A.; Delaware Valley AA (Pres.); Tiffany Fnd.; Assoc. A. of New Jersey; MacDowell A. Colony; Grand Central A. Gals.; N.J. Watercolor Soc.; All. A. Am.; North Shore AA; Rockport AA; Springfield Acad. AA; Hunterdon A. Center; Fontainebleau Alumni. Awards: Pulitzer traveling scholarship, 1936-37; Tiffany F., 1936; prizes, MAD, 1945; Munson-Williams-Proctor Inst., Utica, N.Y.; Kosciuszko F., 1947, 1948, 1950; State T. Col., Pa., 1948-49; Cambridge Springs, Pa., 1951; Terry AI, 1952; Clinton, N.J., 1956, 1959, 1960, 1961, 1966; Orange, N.J., 1958, 1959, 1960, 1962, 1964, 1965; Wilkes-Barre, Pa., 1961; Montclair (N.J.) Mus., 1960; Silvermine Gld. A., 1960; Brick Store Mus., Kennebunk, Me., 1965, 1967, 1968; Hazleton A. Lg., Pa., 1961; Berwick, Pa., 1961, 1962, 1965; Atlantic City, N.J., 1963, 1967; Springfield Mus. FA, 1964, 1966; Morristown, N.J., 1964, 1967; Cooperstown (N.Y.) Mus., 1964; Clifton, N.J., 1967. Work: State T. Col., Indiana, Pa.; Univ. Georgia; AIC; Simmons Col.; Munson-Williams-Proctor Inst. Exhibited: AIC, 1936; CGA, 1943; Carnegie Inst., 1943-1945; PAFA, 1936, 1937, 1948, 1952, 1963; VMFA, 1938; NAD, 1934, 1945, 1950, 1963; Detroit Inst.: A., 1945; Albright A. Gal., 1946; BM, 1943; GGE, 1939; State T. Col., Indiana, Pa., 1945, 1946, 1948, 1949; Audubon A., 1948-1964, 1968; AWS, 1948; Alliance Col., Pa., 1951; Butler AI, 1948-1953, 1963; Newark Mus., 1952; Trenton Mus. A., 1954, 1956, 1958; Montclair A. Mus., 1956, 1958, 1960-1962, 1966, 1969; Phila. A. All., 1956, 1958; Everhart Mus. A., 1958, 1960, 1962, 1964, 1968; New Hope, Pa., 1948-1968; Monmouth Col., N.J., 1961, 1962-1964, 1966; Atlantic City, 1962-1964, 1966; Ogunquit, Me., 1967. Positions: Trustee, Hunterdon County Art Center; Instr., Adult Edu., Somerville, N.J., 1967-1969; Summit A. Center, 1965-1969.

KRAMARSKY, MRS. SIEGFRIED—Collector
 101 Central Park West, New York, N.Y. 10023*

KRAMER, HELEN KROLL—Craftsman
 1172 Park Ave., New York, N.Y. 10028
B. Buffalo, N.Y., July 9, 1907. Studied: Traphagen A. Sch., and in Munich, Germany. Member: Am. Craftsmen's Council. Work: Cooper Union Mus.; Jewish Mus., N.Y.; Hesslein Lib. of the Phila. Textile Sch.; Mem. Lib., Lowell Technological Inst., and in museums in Israel. Tapestry, Brandeis Univ. Jewish Chapel. Exhibited: WFNY 1939; GGE, 1939; Univ. Minnesota A. Gal., 1951; Wisconsin Union, 1952; Rochester Mem. A. Gal., 1951; Fla. Gulf Coast A. Center, Clearwater, 1955; Des Moines A. Center, 1954; Coe College, Cedar Rapids, 1954; Dwight Mus., Mount Holyoke, 1955; The Logic and Magic of Color, Cooper Union, N.Y., 1960; one-man traveling exh. to museums and colleges in the U.S.; Artist-Craftsmen Exh., Cooper Union, 1961; Retrospective Exh., Jewish Mus., N.Y., 1960. Contributor to Journal of the Am. Assn. Univ. Women. Lectures: Texture, Color and Material; Textiles; History of Textures.*

KRAMER, HILTON—Critic, W., T., L.
 162 West 88th St., New York, N.Y. 10024
B. Gloucester, Mass., Mar. 25, 1928. Studied: Syracuse Univ., B.A.; Columbia Univ.; New Sch. for Social Research; Harvard Univ.; Indiana Univ. Contributor to Arts Magazine; Partisan Review; Commentary; New Republic; The Progressive; Western Review; Industrial Design and other publications. Lectures: "Art Today." Positions: Assoc. Ed., Feature Ed., Arts Digest, 1954-55; Managing Ed., Arts Magazine, 1955-1964.*

KRAMER, JACK N.—Painter, E.
 67 Thatcher St., Brookline, Mass. 02146
B. Lynn, Mass., Feb. 24, 1923. Studied: BMFA Sch. FA; Univ. of Reading (England); Rhode Island Sch. Des., B.F.A.; and privately with Oskar Kokoschka in London. Awards: Albert Whitin Traveling

Scholarship from Boston Mus. Sch. of FA, 1949-1952. Work: Gurlitt Mus., Linz, Austria; AGAA. Exhibited: Morris Gal., N.Y., 1955; Univ. Illinois, 1957; NAD, 1956; Univ. Colorado, 1961; Fitchburg Mus. A., 1962; Smith College Mus., 1962; Thieme Gal., Palm Beach, 1962; Boston Univ., 1958, 1963, 1966; Siembab Gal., Boston, 1958, 1960, 1961; Inst. Contemp. A., Boston, 1960, 1961; Cambridge AA, 1964; BMFA Sch. FA, 1963, 1964; Boris Mirski Gal., Boston, 1964, 1966. Contributor illus., to Audience magazine, 1961; Drawing magazine; Liberal Context, 1965. Positions: "School of Vision," Intl. Summer Academy of Fine Arts, Salzburg, Austria, Asst. to Kokoschka, summers, 1955-1958; Assoc. Prof. of Art, Drawing & Painting, Sch. of Fine & Applied Arts, Boston University, Boston, Mass.

KRAMER, REUBEN ROBERT—Sculptor, T.
 1201 Eutaw Pl., Baltimore, Md. 21217
B. Baltimore, Md., Oct. 9, 1909. Studied: Rinehart Sch. S.; Am. Acad. in Rome, and in London and Paris. Member: F., Am. Acad. in Rome; AEA; Am. Acad. in Rome Alumni Assn. Awards: Rinehart traveling scholarship, 1931, 1933; Prix de Rome, 1934; medal, prizes, Frederick Douglas Homes Comp., Balt., 1940; Nat. A. Week, Md., 1941; BMA, 1940, 1946, 1948, 1949, 1951, 1952, 1954; Peale Mus. A., 1949; S. Gld., 1947; Wash. S. Group, Smithsonian Inst., 1952, 1954; BMA, IBM, CGA (all purchase awards), award for sc., 1957; Elected to Baltimore City College "Hall of Fame," 1962; Nat. Inst. A. & Lets. Grant for Sculpture, 1964. Work: Martinet Col., Balt.; USPO, St. Albans, W.Va.; relief, St. Mary's Seminary, Alexandria, Va.; BMA; IBM; CGA; Lord Coll., Johns Hopkins Univ., and in private colls. Monograph, "The Art of Reuben Kramer," by Dr. Theodore Low, Publ. by Walters A. Gallery, 1963. Exhibited: BMA, 1940, 1941, 1943-1958; PMA, 1940, 1949; PAFA, 1949-1953, 1957, 1958, 1960; Am. Jewish Tercentenary Exh. traveling, 1954-55; Am. Acad. in Rome; Grand Central A. Gal.; CGA, 1951-1957; one-man: BMA, 1939, 1951, 1959, 1966; Am. Univ., Wash., D.C., 1953; Hagerstown, Md., 1955; CGA, 1960.

KRAMRISCH, STELLA (Dr.)—Museum Curator, E., Cr., L.
 Philadelphia Museum of Art; mail: Box 17, Bennett Hall, University of Pennsylvania, Philadelphia 19104; h. R.D. 1, Malvern, Pa. 19355
B. Mikulov, Austria. Studies: Univ. Vienna, Ph.D., with J. Strzygowski, A. Dvorak. Member: CAA; Am. Oriental Soc.; Assn. of Asian Studies; Asia Soc.; Oriental Cl. (Phila.); Royal Soc. of India and Pakistan (London); Indian Soc. of Oriental Art (Calcutta); The Asiatic Soc. (Calcutta). Author, "The Hindu Temple," 1946; "The Art of India," 1954; "Kerala and Dravida," 1952; "Indian Sculpture," 1932; "Principles of Indian Art," 1922; "Indian Art in the Philadelphia Museum of Art," 1961; "The Art of Nepal," 1964; "Unknown India, Ritual Art in Tribe and Village," 1968, and many others; numerous articles, particularly in the Journal of the Indian Society of Oriental Art, Calcutta (Ed. of the Journal, 1932-50). Ed., Indian Section, Artibus Asiae; American Oriental Soc.; Bulletin of the Philadelphia Mus. ILectures: Indian Art to universities in India, US and Europe. Positions: Prof. Indian Art, University of Calcutta, 1923-50; Consultant to the government of India on the teaching of art and of art in industry; Consultant to the Exhibition of Indian Art (Royal Acad. A., London, 1947); Prof. South Asian Art, University of Pennsylvania; Prof. Indian Art, Inst. of FA, New York Univ.; Cur., Indian Art, Philadelphia Museum of Art, Philadelphia, Pa., at present.

KRANER, FLORIAN—Painter, Des., T., I., L., Comm.
 182 Bennett Ave., New York, N.Y. 10040
B. Vienna, Austria, June 7, 1908. Studied: Kunstgewerbeschule, Vienna. Member: Nat. Soc. Painters in Casein (Pres. 1963-1966); AWS; New Jersey Soc. P. & S.; Allied A.; Ringwood Manor AA; (Pres. 1965-); Nat. Soc. Painters in Casein. Awards: Direct Mail Adv. Assn., 1947; Nat. Soc. Painters in Casein award, 1961, Newman medal, 1966, 1969; Allied A., 1966, 1967, 1968. Work: Illus., books, in Univ. Minnesota Lib. permanent collection; Norfolk Mus. A. & Sciences. Murals, Pictorial Maps, VMFA, (for Jamestown Festival), 1957. Exhibited: Annually-Audubon A.; AWS; Nat. Soc. Painters in Casein; New Jersey Soc. P. & S.; Knickerbocker A. Others: 1958-1965: Oklahoma A. Center; South Bend AA; Wustum Mus. A., Racine, Wis.; Columbus Mus. A. (Ga.); State Exhibit Mus., Shreveport, La.; Univ. Illinois; Blanden Mem. A. Gal., Ft. Dodge, Iowa; Butler Inst. Am. Art; Huntington Galleries; W. Va.; Florida State Museum, Gainesville; also in many colleges, universities and public libraries. Int. Traveling Exhibitions, 1959-1962; Book Illustrations for the U.S. thru the United Nations to Europe and to Asia; One-man traveling exhs. U.S., 1964-65; Ringwood Manor AA, Lib., 1961; Pompton Valley AA, 1964; 3-man, East-Side Gal., N.Y., 1964. Contributor portrait covers to Time Magazine, and She Magazine; illus., Life Magazine. Illus. "Famous Myths of a Golden Age"; "King Arthur and Knights of the Round Table"; "Wondertales of Giants and Dwarfs"

and others, (1945-1965); text books for Silver Burdett Co. Positions: Asst. Prof., Dept. of Art, City College of New York, 1952- .

KRASNER, LEE—Painter
The Springs, East Hampton, L.I., N.Y. 11937
B. Brooklyn, N.Y. Studied: Cooper Union; NAD; City Col., N.Y. and with Hans Hofmann. Work: PMA; WMAA, and in private colls. Exhibited: Palazzo Graneri, Turin, Italy, 1959; Galerie Beyeler, Basle, Switzerland, 1961; Laing A. Gal., Newcastle-upon-Tyne, England, 1961; Marlborough Fine Art, London, 1961; Yale Univ. A. Gal., 1961-1962; Mt. Holyoke Col., 1962; Wadsworth Atheneum, Hartford, Conn., 1962; Guild Hall, East Hampton, N.Y., 1962-1964; Mary Washington Col., Univ. of Virginia, Fredericksburg, 1962; Queens Col., N.Y., 1962; "Hans Hofmann and His Students," circulating exh. organized by MModA, 1963-1964; "Abstract Watercolors by 14 Americans," MModA, for the Embassy of the USA, 1963-1965; Marlborough-Gerson Gal., N.Y., 1964; Guggenheim Mus., N.Y., 1964; Gal. of Mod. A., N.Y., 1965; Southampton Col. of Long Island Univ., 1965; White House traveling exh. organized by Smithsonian Institution, 1967; The Jewish Mus., N.Y., 1967. One-man: Betty Parsons Gal., N.Y., 1955; Stable Gal., N.Y., 1955; Martha Jackson Gal., N.Y., 1958; Signa Gal., East Hampton, 1959; Howard Wise Gal., 1960, 1962; Whitechapel Gal., London, 1965; Arts Council of Great Britain, London, 1966; touring exh. seen at museums in York, Hull, Nottingham, Newcastle, Manchester and Cardiff, 1966; Univ. Alabama A. Gal., 1967; Marlborough-Gerson Gal., N.Y., 1968.

KRASNER, OSCAR—Art Dealer
Krasner Gallery, 1061 Madison Ave., New York, N.Y. 10028
Specialty of the Gallery: Contemporary American Painting and Sculpture. Positions: Dir., Krasner Gallery, New York, N.Y., 1954- .

KRATINA, K. GEORGE—Sculptor
R.D. No. 1, Old Chatham, N.Y. 12136
B. New York, N.Y., Feb. 12, 1910. Studied: Syracuse Univ., B.S., M.S.; Yale Univ., B.F.A. Member: F., NSS. Awards: Prix de Rome, 1938; Nat. prize for sculpture competition for The Catholic National Welfare Conference Bldg., Wash. D.C., 1940; AIA awards for collaborative excellence, 1958, 1960. Work: USPO, Wollaston, Mass.; monuments: York, Pa.; campus, St. Paul College, Wash. D.C.; Centerville (Ohio) Seminary; Pope Pius XI Seminary, Garrison, N.Y.; heroic Pioneer monument, Chattanooga, Tenn.; relief, Bonaventure Univ., N.Y.; statues, St. Paul Cathedral, Los Angeles; Sanctuary sculptures for Faculty Chapel, Fr. Judge Seminary, Va.; steel sculpture, Adath Israel Temple, Merion, Pa.; Trinity Seminary, Silver Springs, Md.; N.Y. State Univ., Albany, and many other works from 1939 to date. Lectures: Art and Architecture; Collaboration in the Arts; New Horizons for Sculpture, etc., to sculpture seminars and forums, museums, universities, institutes and others. Positions: Educational Council, 1945-51, Visiting Sculptor & Critic, 1949-51; Council Member, Art & Architecture, 1950-54, Yale Univ.; Des. Consultant, Am. Car & Foundry Co., 1948-50; Committee, Art in New York State Housing, 1958; Council Member, NSS, 1960-62; Prof. Des., Sch. Arch., Rensselaer Poly-technic Inst., 1963-1964; Prof., Div. A. & Arch., Cooper Union, New York City, at present.

KRAUSHAAR, ANTOINETTE M.—Art Dealer
1055 Madison Ave. 10028; h. 440 E. 79th St., New York, N.Y. 10028
B. New York, N.Y., Dec. 25, 1902. Specialty of Gallery: Works by 20th Century American Artists. Positions: Member, Board of Directors, Art Dealers Association of America, Inc., 1963-64; Director, Kraushaar Galleries, New York, N.Y.*

KRAUTHEIMER, RICHARD—Scholar
Institute of Fine Arts, 1 E. 78th St., New York, N.Y. 10021*

KREDEL, FRITZ—Illustrator, Cart.
180 Pinehurst Ave., New York, N.Y. 10033
B. Michelstadt, Germany, Feb. 8, 1900. Studied: in Europe, with Rudolph Koch, and Victor Hammer. Awards: gold medal, Paris Salon, 1938; Citations, Limited Editions Cl., 1949, 1954; Goethe plaque, 1960; Johann Heinrich Merck-Ehrung, City of Darmstadt, 1960. Exhibited: Washington County Mus., Hagerstown, Md., 1957; Darmstadt, West Germany, 1960; Offenbach, West Germany, 1961; Mannheim, W. Germany, 1961. I., The True Meaning of Christmas, 1955; All About Birds, 1955; The Complete Andersen, 1954 (Limited Ed.); Oscar Wilde: Epigrams, 1955; Prose and Poetry of England, 1955; Prose and Poetry of America, 1955; Map of "Michelstadt," 1955; Book of Books, 1956; Book of Life, 1956; Rebel's Roost, 1956; The Warden, 1956 (Limited Ed.); Tom Paine, 1957; Poems of Heinrich Heine, 1957 (Limited Ed.); All About Moths and Butterflies 1957; Aucassin and Nicolette, 1957; The Journal and Letters of Philip Vickers Fithian, 1957; The Life of the Book, 1957; Sim-

plicissimus, 1958; Barchester Towers, 1958 (Limited Ed.); All About the Desert, 1958; Dolls and Puppets of the XVIII Century, 1958 (Limited Ed.); "Die Wasserkufe" (privately printed in Germany); "Am Wegesrand," 1961; "The Innocents Abroad" (Limited Ed.) 1961; "Hawaii," 1959; The Complete Works of the Gawain Poet, 1965; The Golden Journey, 1965; The Conspirator's Cookbook, 1967; Fables of a Jewish Aesop, 1967; The Book of Ballads, 1967; The World's Best Fairy Tales, 1967; Proverbs to Live By, 1968. Des. & created new Presidential Seal (woodcut) for Inaugural Address program, 1960. Illus. for Woman's Day magazine: "Wild Flowers," 1960; "Annuals and Perennials," 1961; "The Food of Italy" (Edwin Knopf), 1964; "A Williamsburg Songbook," 1964; "Emma" (Limited Ed. Club), 1964; "A Treasury of Great Recipes" (Mary & Vincent Price), 1965, and many other books prior to 1950.

KREEGER, DAVID LLOYD—Collector, Patron
2401 Foxhall Road, N.W. 20007; h. 3201 Fessenden St., N.W., Washington, D.C. 20008
B. New York, N.Y., Jan. 4, 1909. Studied: Rutgers University, A.B.; Harvard Law School, LL.B. Awards: "Bronze Medal of Appreciation," Corcoran Art Gallery, Washington, D.C., 1965. Collection: From Barbizon school (Corot, Diaz) through pre-impressionists (Boudin, Monticelli, Courbet), impressionists (Monet, Renoir, Sisley), post-impressionists (Degas, Cezanne, Van Gogh, Gauguin) to 20th centruy painters (Bonnard, Picasso, Miro, Kandinsky, Tanguy, Beckmann, Matisse, Chagall, Dubuffet, Klee), and works by American artists. Exhibited: CGA, 1965; BMA, 1965; works on loan to many museums in U.S. and abroad. Positions: Trustee, Baltimore Mus. Art and Corcoran Gallery of Art; Member, International Council, Museum of Modern Art; Donor of "Kreeger Annual Purchase Awards" at Corcoran Gallery Biennial and Area Shows; Donor, "Kreeger Annual Art Prize" to best art students at American University, Washington, D.C.

KREINDLER, DORIS BARSKY—Painter, Et., Lith., Eng., L., T.
75 Central Park, West, New York, N.Y. 10023; s. South Salem, N.Y. 10590
B. Passaic, N.J., Aug. 12, 1901. Studied: Contemporaries Graphic A. Center; N.Y. Sch. App. Des. for Women; NAD; ASL, and with Ethel Katz, Hans Hofmann, Ivan Olinsky, Charles Hinton. Member: Am. Soc. Contemp. A. (Bd. Governors); NAWA; Nat. Soc. Painters in Casein (Bd. Governors). Work: Birmingham Mus. A.; Brandeis Univ.; Norfolk Mus. A. & Sciences; MMA; MModA.; FMA; Butler Inst. Am. A.; Boston Mus. A. & Sciences; Chase Manhattan Bank; Notre Dame Univ.; BM; N.Y. Public Library; PMA; Smithsonian Inst., Graphic A. Div.; AIC; NCFA; Stephen Wise Synagogue, N.Y., and in many private colls. Awards: F., Research Studios, Maitland, Fla.; Am. Soc. Contemp. A., 1955, Margaret Lowengrund Mem. prize, 1960, graphic prize, 1962; AEA, 1953; Collectors Print. Contemporaries Gal., 1958; Sarasota A. Center, 1960; Nat. Soc. Painters in Casein, 1963. Exhibited: BM, annually; PAFA, 1932-1944; Columbus Mus. FA; Brooklyn Soc. A. traveling exh.; traveling exh. to Switzerland, Greece, Canada; Montross Gal.; NAWA; Butler Inst. Am. A., 1958; one-man: Seligmann Gal., 1952, 1954, 1964, 1967, 1970; Research Studios; Esther Robles Gal., Los A., 1957; Santa Monica A. Gal., 1957; Fresno A. Center; Rosequist Gal., Tucson, Ariz., 1958. Lectures on Painting & Graphics. Reproduction of "March Ballet" in Peters edition Music Calendar, 1964, and "Prize Winning Prints," 1963.

KRENECK, LYNWOOD A.—Printmaker, P., E.
4507 48th St., Lubbock, Tex. 79414
B. Kenedy, Tex., June 11, 1936. Studied: Univ. Texas, B.F.A., M.F.A. (printmaking). Member: Texas WC Soc. Awards: purchase prizes, Wichita Nat. Gr. & Drawing, 1969; Bucknell Univ., 1967; Deborah Weisel Mem. Prize, Watercolor: USA, 1967; Texas WC Soc., 1967, 1968. Work: Wichita AA; Bucknell Univ.; Univ. Texas; West Texas Mus. of Texas Tech. Univ., Lubbock; Springfield (Mo.) A. Mus. Exhibited: Boston Pr.M., 1967, 1969; Northwest Pr.M., 1965, 1969; Wichita Gr. A. & Drawing, 1969; Bucknell Univ., 1967; "Imprint" print Exh., 1967; Watercolor:USA, 1966, 1967, 1969; Butler Inst. Am. A., 1967; Texas WC Soc., 1962, 1966-1968; Southwestern Prints, 1965; Texas Annual, 1962; Oklahoma Southwestern, 1962; Texas FA Assn., 1964, 1965, 1967. Positions: Prof., Printmaking and Drawing, Texas Tech. Univ., 1965- ; Drawing, Univ. Texas, 1964.

KRENTZIN, EARL—Sculptor, C.
412 Hillcrest Ave., Grosse Pointe Farms, Mich. 48236
B. Detroit, Mich., Dec. 28, 1929. Studied: Wayne Univ., B.F.A.; Cranbrook Acad. A., M.F.A.; Royal Col. A. (London). Awards: Fulbright Fellowship, 1957-58; prizes, Mich. Artist-Craftsmen, 1954, 1958, 1962-64; Young Americans exh., 1956; Wisconsin Salon A., 1956; Wis. P.&S., 1957; Michigan Artists, 1960; Fiber-Clay-Metal Exh., 1964; Louis Comfort Tiffany Grant in metalwork, 1966; Wichita Dec. A. Exh., silversmithing award, 1966. Work: Detroit Inst.

A.; Cranbrook Mus. A.; Jewish Mus., N.Y.; St. Paul A. Center. Also work in private colls. Exhibited: Mus. Contemp. Crafts, 1955, 1957, 1958, 1963, 1964; AFA traveling exhs.; Mich. Artists, 1950-1960; Mich. Craftsmen, 1952-1967; Fiber, Clay, Metal Exh., 1962, 1964; Nat. Religious Art, 1962, 1964; Detroit Inst. A.; Wisconsin Salon A., 1956-1958; Wisconsin P. & S., 1957, 1958; Wisconsin Craftsmen, 1956-1958; Midwest Des.-Craftsmen, 1956-1958, 1962; Grippi Gal., N.Y., 1961 (one-man); Morris Gal., Detroit, 1962; Ft. Wayne Mus. A., 1963; Lafayette (Ind.) Mus. A., 1964; James Graham & Sons, N.Y., 1965; Neville Mus., Green Bay, Wis., 1966; Wichita Dec. A. Exh., 1966; Mich. Sculptors Exh., 1967; Univ. Texas Mus., Austin, 1967; Fla. State Univ., Tallahassee, 1967; Illinois State Univ., Normal, 1968; Detroit A. Inst., 1968; Mich. Artist-Craftsman, 1966; Craftsmen U.S.A., DMFA, 1966; one-man: Kennedy Gal., N.Y., 1968; Fla. State Univ., 1969. Contributor to Craft Horizons. Positions: Instr., A. & A. Edu., University of Wisconsin, Madison, Wis., 1956-60. Visiting Lecturer, Design Dept., Univ. of Kansas, Lawrence, Kans., 1965-1966. Visiting Prof., A. Educ. & Constructive Des. Dept., Fla. State Univ., 1969.

KRESS, MRS. RUSH H.—Collector
1020 Fifth Ave., New York, N.Y. 10028*

KREVOLIN, LEWIS—Craftsman, Des., T.
Krevolin & Constantine, 61 W. 74th St., New York, N.Y. 10023; h. 18 New Paltz Rd., Highland, N.Y. 12528
B. New Haven, Conn., June 21, 1933. Studied: Alfred University, B.F.A.; in Finland with Kja Franck. Member: Am. Craftsmen's Council; York State Craftsmen; Artist-Craftsmen of New York. Awards: Fulbright Grant in glass and ceramics to Finalnd, 1961. Work: Bethlehem Steel; Travelers Insurance Co., and work for private clients—architects and designers. Terra cotta mural, Bethes-da-Bradley Bldg., Maryland (1964). Exhibited: "Young America" exh., 1958, 1962; "The Craftsmen Designs," 1964 and "Craftsmen of the Northeast," 1963; (both exhibitions circulated by AFA and Smithsonian Institution); Cooper Union, N.Y., 1961; Silvermine Gld. A., 1963; Arch. Lg. of New York, 1965. Author, Illus., "Ceramics" publ. 1965 in collaboration with Elizabeth Constantine; author, illus., "Poland" major feature in 1962 (Oct.) issue of Craft Horizons (research in Poland as guest of Polish Handicrafts Union). Positions: Instr., Ceramics, Brooklyn Mus. Sch. Art; Dutchess Community College (ceramics & design); Chief Des., Russell Wright Assoc., 1959-1961; Design Consultant to numerous manufacturers, 1955- .*

KREZNAR, RICHARD J.—Painter, S., T.
104 Franklin St., New York, N.Y. 10013
B. Milwaukee, Wis., May 1, 1940. Studied: Univ. Wisconsin, B.F.A.; Brooklyn Col., N.Y., M.F.A.; Instituto de Allende, Mexico. Awards: prizes, Milwaukee A. Center, 1962-1964; WAC, 1962, 1964; Wisconsin Salon of Art, 1963; Ford Fnd. purchase award, 1964. Work: WAC; Milwaukee A. Center; Univ. Wisconsin, Madison; Wisconsin Nat. Bank, Milwaukee. Exhibited: Butler Inst. Am. A., 1965; PAFA, 1963; Milwaukee A. Center (3-man), 1966. Positions: Instr., Beginning A. Courses, Brooklyn College, N.Y., 1964- .

KRIENSKY, MORRIS E.—Painter
241 W. 20th St., New York, N.Y. 10011
B. Glasgow, Scotland, July 27, 1917. Studied: ASL; Sch. P. & S., Mexico; Professional Des. Sch.; BMFA Sch.; & with Alma O. Le Brect. Member: AWCS; ASL; AEA. Work: M. Knoedler & Co.; Norfolk Mus. A. & Sciences. Exhibited: AWCS, 1946; Inst. Inter-American Relations, Mexico, 1951; one-man exh.: Dept. Interior, Wash., D.C.; White House, Wash., D.C.; Malden (Mass.) Pub. Lib.; George Walter Vincent Smith A. Gal.; Indiana Univ.; Currier A. Gal.; AIC; Hackley A. Gal.; Willmington Soc. FA; Dartmouth Col.; M. Knoedler & Co.; Carus Gal., N.Y., 1961; Revel Gal., N.Y., 1964; Castagno Gal., N.Y., 1965; Retrospective Exh.; Univ. of Connecticut, Student Union, Storrs, Conn., 1960. Frick Library, N.Y.; Shreve, Crump & Low Co., Boston, 1968-1969.

KRIGSTEIN, BERNARD—Painter, I., T., Gr.
140-21 Burden Crescent, Jamaica, N.Y. 11435
B. New York, N.Y., Mar. 22, 1919. Work: Many album cover paintings for Epic-Columbia Records; cover painting for "Manchurian Candidate" by Richard Condon. Member: P. & S. Soc. of New Jersey. Exhibited: AWS, 1965, 1968; Nat. Soc. Painters in Casein, 1965; SI, 1963, 1964; Salpeter Gal., N.Y., 1964, 1967; Harbor Gal., N.Y., 1966 (one-man); New England Exh., Silvermine Gld. A., 1965; Riverside Mus., N.Y.; BM; All. A. Am., 1968; NAC, 1967, 1968; P. & S. Soc. of New Jersey, 1969. Illustrated: "Various Fables from Various Places," 1960; "Buccaneers and Pirates of Our Coasts," 1961. Contributor of illustrations to American Heritage Magazine; Harper's; New York Times Sunday Magazine; Saturday Eve. Post; Herald-Tribune Sunday Magazine, "This Week"; Boys Life Magazine and others. Positions: Instr., Painting, Drawing, Graphics, High School of Art & Design, New York, N.Y.

KROLL, LEON—Painter, Lith.
15 West 67th St., New York, N.Y. 10023
B. New York, N.Y., Dec. 6, 1884. Studied: ASL; NAD; Julian Acad., Paris; & with John Twachtman, Jean Paul Laurens. Member: NA; Am. Acad. A. & Let.; Nat. Inst. A. & Let. Awards: many national prizes; First Int. prize, Carnegie Inst., 1936; Chevalier Legion of Honor, France. Work: MMA; WMAA; AIC; MMoDA; CGA; SFMA; Carnegie Inst.; Dayton AI; Columbus Gal. FA; CMA; Detroit Inst. A.; Minneapolis Inst. A.; Denver A. Mus.; San Diego FA Soc.; Clearwater (Fla.) Mus.; Norton Gal.; Los A. Mus.; PAFA; Univ. Nebraska; Wilmington Soc. FA, and many others; murals, Justice Bldg., Wash., D.C.; war mem., Worcester, Mass.; Senate Chamber, Indianapolis, Ind.; Johns Hopkins Univ. auditorium; mosaic dome, U.S. Military Cemetery Omaha Beach, France. Exhibited: nationally and internationally. Positions: (Hon.) Pres., U.S. Com., Intl. Assn. Plastic Arts. Bd. Dirs., American Academy of Arts & Letters.

KRUEGER, JACK—Sculptor
310 Spring St., New York, N.Y. 10013
B. Appleton, Wis., Aug. 3, 1941. Exhibited: Bank of Minneapolis, 1960; WAC, 1961; Wisconsin Salon of Art, Univ. Wisconsin, Madison, 1962; Univ. Wisconsin, 1962; Castellane Gal., Provincetown, Mass., 1964; Alan Stone Gal., N.Y., 1964; N Y. Univ., 1966: Park Place Gal., N.Y., 1967; Hemisfair, San Antonio, Tex., 1968; Moore Col. A., Philadelphia, Pa., 1968; Washington Univ., St. Louis, Mo., 1969; Krannert A. Mus., Univ. Illinois, 1969; one-man: Leo Castelli Gal., N.Y., 1968 and Leo Castelli Warehouse Exh., 1969.

KRUGER, LOUISE—Sculptor, Des., Gr.
Schoelkopf Gallery, 825 Madison Ave. 10021; h. 30 E. 2nd St., New York, N.Y. 10003
B. Los Angeles, Cal. Work: MMoDA; N.Y. Pub. Lib.; Mus. Mod. A., Sao Paulo, Brazil. Exhibited: MMoDA; Carnegie Inst.; WMAA; BMA; BM; Bradley Univ.; PAFA; MMA; LC; Kunsthaus, Geneva, Switzerland, and other exhibitions in U.S., Europe and South America.

KRUGIER, JAN—Art Dealer
Loeb & Krugier Gallery, 12 E. 57 St., New York, N.Y. 10022*

KRUKOWSKI, LUCIAN—Painter, E.
299 Garfield Place, Brooklyn, N.Y. 11215
B. New York, N.Y., Nov. 22, 1929. Studied: Brooklyn College, B.A.; Yale Univ., B.F.A.; Pratt Institute, Brooklyn, N.Y., M.S. Member: CAA; Am. Soc. for Aesthetics. Exhibited: BM, 1956-1958; Univ. Nebraska, 1958; MMoDA, 1962; Tanager Gal., N.Y., 1957-1959; one-man: Staempfli Gal., N.Y., 1959-1963. Positions: Prof. A., Chm., Dept. of Fine Arts, Pratt Institute Art School, Brooklyn, N.Y.

KRUSE, ALEXANDER ZERDIN—Painter, Et., Lith., W., Cr., L., T.
54 Riverside Dr., New York, N.Y. 10024
B. New York, N.Y., Feb. 9, 1890. Studied: Edu. All.; NAD; ASL, with McBride, Carlsen, Sloan, Luks, Henri. Work: MMA; MMoDA; Philbrook A. Center; BM; N.Y. Pub. Lib.; Lib. Cong.; British Mus.; Royal Albert Mus.; Nat. Gal., Canada; PMA; AGAA; State Mus., Biro-Bidjan, Mus. Mod. A., Russia; Bibliotheque Nationale, Paris; Univ. Arizona; Berry Col., Ga.; Mus. City of N.Y. Exhibited: AIC; 50 Prints of the Year; Phila. SE; Fine Prints of the Year; Los A. Mus. A.; Int. Exh., Sweden; SAE; WMAA; NAD; Grand Central A. Gal.; BM; Dudensing Gal.; Findlay Gal.; Weyhe Gal. I., "Two New Yorkers." Author: "How to Draw and Paint"; "A-B-C's of Pencil Drawing"; contributor to New York Post, Art Digest. Positions: A. Cr., Brooklyn Eagle, Brooklyn, N.Y., 1938-46; Instr., Portrait & Figure Painting, Brooklyn Mus. A. Sch. & Brooklyn Col., 1946- ; Fndr., Heywood Broun Mem. Coll.; Newspaper Gld.; Lena Kruse Mem. Coll., BM, Brooklyn, N.Y.*

KRUSE, DONALD—Etcher, T.
331 W. Pontiac St., Fort Wayne, Ind. 46807
B. Fort Wayne, Ind., Mar. 10, 1934. Studied: Fort Wayne A. Schl.; Mexico City College; Indiana Univ., B.S. in Edu.; Ball State Teachers College. Awards: Thieme Award for study in Mexico, 1955; Fort Wayne Art School Scholarship, 1954-1955; Grad. Assistantships, Ball State and Indiana Univ. Edu. Dept.; prizes, Fort Wayne A. Exh., 1963-1965; South Bend Exh., 1964. Exhibited: Print Shows: LC, 1963, 1966; Western Michigan, 1964; North Dakota Prints, 1965; Wichita, 1965; Fort Wayne, 1963-1965; Herron A. Mus., 1964, 1966, 1968; South Bend, 1964; one-man; Fort Wayne A. Mus., 1964; Corner Gallery, Louisville, 1965; Van Wert (Ohio) AA, 1967. Positions: Instr., A. Edu., Indiana Univ.; Printmaking, Fort Wayne A. Schl., 1962- .

KRUSHENICK, JOHN—Painter
126 W. 11th St., New York, N.Y. 10011
B. New York, N.Y., Mar. 18, 1927. Studied: City Col. of N.Y.; ASL; Hans Hofmann Sch. FA. Member: Assoc. Teachers Indp. Schs. Exhibited: group shows in U.S., 1966-1969, and in Japan; one-man:

Brata Gal., N.Y., 1957; Dorsky Gal., N.Y., 1964, 1966, and others in U.S. and abroad. Positions: Adjunct Prof., Cooper Union, N.U.; In charge of program and classes, Art Dept., Lower School, Staten Island Academy, 1967-1969.

KRUSHENICK, NICHOLAS—Painter
131 W. 21st St., New York, N.Y. 10011
B. New York, N.Y., 1929. Studied: ASL; Hans Hofmann Sch. FA. Awards: Tamarind Fellowship, 1965. Work: Kalamazoo AI; Chrysler Mus. A., Provincetown, Mass.; MModA; WAC; Los Angeles County Mus., and in private collections. Exhibited: Allan Stone Gal., N.Y., 1961; Toronto, Canada, 1960; Wagner College, Staten Island, 1958; Howard Wise Gal., Cleveland, 1960; Anderson Gal., N.Y., 1961, 1962; de Cordova & Dana Mus., 1963; Tokyo, Japan, 1959; Paris, France, 1958; MModA, 1963, 1965; Los Angeles County Mus., 1964 and others; one-man: Camino Gal., 1956; Brata Gal., N.Y., 1958, 1959, 1960; Gratham Gal., N.Y., 1961, 1964; Fishbach Gal., N.Y., 1965.*

KUBLER, GEORGE—Educator, W., L.
406 Humphrey St., New Haven, Conn. 06511
B. Los Angeles, Cal., July 26, 1912. Studied: Univ. Berlin & Munich; Yale Univ.; N.Y. Univ. Member: CAA. Awards: Guggenheim F., 1943-1944, 1952-1953, 1956-1957; F., Am. Council Learned Soc., 1941; Fulbright Research Fellow, Spain and Portugal, 1963-1964. Author: "Religious Architecture of New Mexico," 1940; "Mexican Architecture of the Sixteenth Century," 1948; "The Tovar Calendar," 1951; "Cuzco" (UNESCO), 1952; "Arquitectura Española, 1600-1800" (Ars Hispaniae XIV, Madrid, 1957); "Art and Architecture of Ancient America," 1962; "The Shape of Time," 1962. Contributor to: Art & Archaelogical publications. Lectures: American Archaeology; Mediaeval Architecture, etc. Positions: L., Wesleyan Univ., 1942-43; L., Univ. Chicago, 1946; Univ. San Marcos, Lima, Peru; L., Univ. Mexico, 1958; Harvard Univ., 1966-1967; Prof., Hist. A., Yale Univ., New Haven, Conn., 1947- .

KUEKES, EDWARD D.—Cartoonist
1280 Medfield Dr., Rocky River, Ohio 44116
B. Pittsburgh, Pa., Feb. 2, 1901. Studied: Baldwin-Wallace Col.; Cleveland Inst. A.; Chicago Acad. FA. Awards: C.I.T. Fnd. award, 1937; Newspaper Gld., 1947, 1958; Freedoms Fnd. at Valley Forge, 1949, and medal; 1950, 1951, 1952, 1953, 1954, 1956, 1957, 1958 and Distinguished Service award for winning the awards in 1949-1952, 1962, 1963, 1964; three prize Awards from Freedoms Foundation, 1969; Nat. Safety Council, 1949; Pulitzer Prize, 1953; Resolution, 100th General Assembly State of Ohio, House of Representatives, 1953; Baldwin-Wallace Col. Alumni Merit Award, 1953; Governor's Award, State of Ohio, 1953; Silver "T" Square award, Nat. Cartoonists Soc., 1954; Ohio State Dental Assn. Award, 1954; U.S. Treasury Presidential Prayer Award, 1954; Christopher Award, 1955; Certif. of Recognition, Nat. Conf. of Christians and Jews, 1955, 1958; Eisenhower appointment "People to People" Committee, 1956; George M. Humphrey Medal, 1957; Hon. Degree, D.L.H., Baldwin-Wallace Col., 1957; Capitol Flag Award, U.S. Treasury Dept., 1963; Salvation Army Centennial Medal, 1964. Author, I., "Funny Fables," 1938; Cart., "Alice in Wonderland" for United Features Syndicate (1940). Lectures: "So You Can't Draw a Straight Line, Either," to art groups. Cartoonist Emeritus, Cleveland Plain Dealer, 1966- ; Cartoonist, Metro Newspapers, Cleveland.

KUGHLER, (WILLIAM) FRANCIS VANDEVEER—Painter, W.
Hotel des Artistes, 1 West 67th St., New York, N.Y. 10023
B. New York, N.Y., Sept. 20, 1901. Studied: NAD. Member: SC; NAC. Awards: prizes, SC, 1944, gold medal, 1969; Hon. President, Naval Historical Fnd., Naval Dept., Washington, D.C., 1968-1971. Work: portrait, Hudson River Mus.; War Correspondents Mem., Associated Press, 1946; Univ. North Carolina; Mus. A., Oslo, Norway; Doctors Mem. Sch. Medicine, Chapel Hill, N.C.; murals, Univ. North Carolina. Exhibited: NAD; PAFA; SC; NAC; Chappelier Gal., N.Y., 1954 (one-man). Gave testimony on the Arts & Humanities, before Congressional Committee on the Arts, 1967. Editorial in "National Sculpture Review," 1967-1968. Positions: Pres. A. Fellowship, New York, N.Y., 1950-53; Pres., SC, 1963-1965; NACAL Artists, 1963-1965.

KUGHLER, MRS. FRANCIS VANDEVEER. See Livingston, Charlotte

KUH, KATHARINE (Mrs.)—Critic, W., L.
140 E. 83rd St., New York, N.Y. 10028
B. St. Louis, Mo., July 15, 1904. Studied: Vassar Col., B.A.; Univ. Chicago, M.A.; N.Y. Univ. Author: "Art Has Many Faces," 1951; "Leger," 1953; "The Artist's Voice," 1963; "Break-Up: The Core of Modern Art," 1965. Worked on grant from Fund for Adult Education of the Ford Fnd., developing a series of discussion groups in modern art. Wrote special book "Looking At Modern Art," for the

groups. Positions: Cur. Painting and Sculpture, AIC, Chicago, Ill., to 1959. Art Ed., Saturday Review; Art Consultant, Southern Illinois University, 1963-1968.

KUHN, BRENDA—Patron
Cape Neddick Park, Cape Neddick, Me. 03902
B. New York, N.Y., June 13, 1911. Member: American Federation of Arts (Life); Metropolitan Museum of Art (Fellow in Perpetuity); Munson-Williams-Proctor Institute (Life); Portland, Me. Museum of Art (Life); Friends of Currier Gallery of Art (Life); Archives of American Art; Museum of Fine Arts, Boston; Brooklyn Museum; The Friends of Art at Colby; Cincinnati Art Museum; The Association of the Corcoran Gallery of Art; The Museum of Modern Art; Friends of Museum of Art of Ogunquit; Philadelphia Museum of Art; San Antonio Museum Association; Wichita Art Museum Members Foundation; The Woodmere Art Gallery; Tucson Art Center; UCLA Art Council (Life); Smithsonian Society of Associates (Life); New Britain Museum of American Art; Wadsworth Atheneum; Art Institute of Chicago (Life); Copley Society of Boston; Contemporary Arts Association of Houston; Museum of Fine Arts, Houston, Tex.; Phoenix Art Museum. President, Kuhn Memorial Corporation.

KUHN, CHARLES L.—Museum Curator
Busch-Reisinger Museum of Germanic Culture, Harvard University, Cambridge, Mass. 02138
Positions: Cur., Busch-Reisinger Museum.*

KUHN, MARYLOU—Educator, P.
Department of Art Education, Florida State University; h. 1403 Betton Rd., Tallahassee, Fla. 32303
B. South Bend, Ind., Oct. 18, 1923. Studied: Layton School of Art; Ohio State University, B. Sc., Ph.D. in Fine Arts; Teachers College, Columbia University, M.A.; also studied at University of Wisconsin and the Art Institute of Chicago. Member: NAEA; International Society for Education Through Art; Adult Education Association of the U.S.A.; Florida Art Education Association; Florida Arts Council. Awards: Gold Medal, Notre Dame University, 1941; Scholastic Art Scholarship, 1941; University Fellow, Ohio State University, 1953; Exhibited: LeMoyne Art Foundation, 1965 (2-man) and continuous showing at the Foundation; Gulf Coast Junior College, 1966 (one-man). Author, Editor, Florida Art News, 1960-1962; Southeastern Arts Association Bulletin, 1962-1964; Regional Editor, Art Education Jr. of the NAEA, 1964-1966; Research Jr. of NAEA "Studies in Art Education," Editorial Board, 1962-1966. Contributor to "Studies in Art Education"; Author of book "Report of Papers given at Congress, Prague, Czechoslovakia, International Society for Education Through Art," 1966. Teaching: Philosophy and Theory of Art Education, Florida State University; Teacher Education, Research in Art Education, University of London, England. Positions: Prof., Florida State University, Tallahassee, 1951- ; Guest lecturer, Institute of Education, University of London, 1966-1967.

KULICKE, ROBERT M.—Painter, C.
258 Riverside Drive, New York, N.Y. 10025
B. Philadelphia, Pa., Mar. 9, 1924. Studied: PMS Sch. A.; Tyler Sch. FA, Philadelphia; Atelier Leger, Paris, France.

KUP, KARL—Art Historian, T., L., Cr.
136 E. 36th St., New York, N.Y. 10016
B. Haarlem, Holland, May 7, 1903. Studied: Univ. Munich with Wolfflin; Univ. Berlin with Goldschmidt; in Paris with Diehl; Lakeside Press, Sch. of Printing, Chicago. Member: Bibliographical Society of Am.; Grolier Club; China Institute; Asia Society. Trustee Corning Mus. of Glass, Print Council of Am., Pratt Inst. Print Center, Fellow of Pierpont Morgan Library. Author: "The Council of Constance, 1414-1418"; "The Girdle Book"; "Books and Printing" (with Carolyn F. Ulrich); "The Christmas Story in Medieval Manuscripts." Contributor: to N.Y. Pub. Lib. Bulletin, American Artist, Artist's Proof, Library Journal, Publishers Weekly, and other publications. Lectures and teaching: Book Illustration; Illuminated Manuscripts; Book of the Orient. Positions: Contributing Ed. Publishers Weekly, 1941-52; American Artist, 1941-49; Juvenile Dept., Oxford Univ. Press, 1928-34; New York Public Library: 1934-68, Cur. of Spencer Coll., 1934-68, Cur. of Prints, 1941-68, Dir. of Exhibitions, 1947-55, Chief A. & Architecture Div., 1956-65. Instructor, Dept. of Graphic Arts, Princeton Univ. Lib., 1969- .

KUPFERMAN, LAWRENCE—Painter, E.
Massachusetts College of Art, 370 Brookline Ave., Boston, Mass. 02115; h. 38 Devon Rd., Newton Centre, Mass. 02159
B. Boston, Mass., Mar. 25, 1909. Studied: BMFA Sch.; Mass. Sch. A., B.S. in Edu. Member: ANA; SAGA; Phila. WC Cl.; F., Royal Soc. A., London; CAA; AAUP; Boston Soc. WC Painters. Awards: prizes, AV, 1942; San F. AA, 1938; SAGA, 1939; first prize, R.I. Art Festival, 1961. Work: Mills Col., Oakland, Cal.; LC; MMA; Carnegie Inst.; BMFA; IBM; BMA; SFMA; FMA; Harvard Univ.; WMA;

Boston Pub. Lib.; AGAA; MModA; WMAA; Wadsworth Atheneum; Univ. Michigan; BM; N.Y. Univ. Art Collection; Univ. Massachusetts, Amherst; 390 drawings and 27 etchings, Syracuse Univ. (1964); murals; Am. Export Lines "Independence" and "Constitution." Exhibited: Carnegie Inst., 1941; PAFA, 1938, 1940-1945, 1950; WMAA, 1938, 1940-1942, 1945, 1946, 1948-1952, 1953, 1956, 1957; AIC, 1938, 1948, 1957; BM, 1943, 1945, 1951, 1953, 1955; SFMA, 1938, 1939, 1941-1944, 1946; SAGA, 1937, 1939-1941, 1943, 1944; WFNY, 1939; MModA, 1943; Walker A. Center, 1954; Butler AI; Tokyo, Japan, 1955; MMA, 1955; Nat. Acad. FA, Rome, Italy, 1955; Inst. Mod. A., Boston, 1943; Univ. Nebraska, 1948, 1956; Univ. Illinois, 1949, 1953, 1961; BMA, 1948, 1949; CAM, 1951; Brandeis Univ., 1956; BMFA, 1956, 1957; de Cordova & Dana Mus., 1956; Boston A. Festival, 1956-1958, 1959-1961; NAD, 1958; AFA traveling exh., 1959; Strasbourg, France, 1956; one-man: Mortimer Levitt Gal., 1948, 1949, 1951, 1953; Mortimer Brandt Gal., 1946; Phila. A. All., 1946; Boris Mirski Gal., Boston, 1944-1946; Shore Studio, Boston, 1953; Martha Jackson Gal., N.Y., 1955; Swetzoff Gal., 1956; Verna Wear Gal., 1956; Ruth White Gal., 1958; Gropper Gal., Cambridge, 1958; Pace Gal., Boston, 1960, 1961, 1963; de-Cordova & Dana Mus., 1961; Galerie Irla Kert, Montreal, 1962; Art Unlimited Gal., Providence, 1963. Positions: Prof. Painting, Hd., Dept. of Painting, Mass. College A., Boston, Mass., 1941- .

KUPFERMAN, MRS. LAWRENCE. See Cobb, Ruth

KUPFERMAN, MURRAY —Painter, C., T., S., Des.
1270 East 19th St., Brooklyn, N.Y. 11230
B. Brooklyn, N.Y., Mar. 10, 1897. Studied: PIASch.; NAD; BAID. Member: Provincetown AA; Cape Cod AA; All. A. Am.; AWS; Lg. Present Day A.; Maine AA. Work: murals, churches and theatres, and in private collections; murals, Plymouth Plan, Newark, N.J. Exhibited: America House; Georg Jensen Co.; Arch. Lg.; NAD; G-R-D Gal.; Marie Harriman Gal.; Ferargil Gal.; BM; Am. Mus. Natural Hist.; Midtown Gal.; N.Y. WC Cl.; Dudensing Gal.; Brooklyn Soc. A.; Riverside Mus.; Morton Gal.; Provincetown AA; Brooklyn Pub. Lib.; Lord & Taylor; John Wanamaker; W.J.Sloane Co.; Cape Cod AA; McElvey Gal., Clearwater, Fla; All. A. Am.; Lowe Gal., Miami Univ.; Audubon A.; Eve Tucker Gal., Miami Beach; Boca Raton, Fla.; Gulf AA; Mystic AA; Woodstock AA; Normandie & Paris Theatres, N.Y.; Little Gal., N.Y. and Phila.; Salpeter Gal., N.Y.; Shaw Gal., Provincetown, Mass.; Babcock Gal., N.Y.; Herring Gal., Provincetown, Mass.; McKnight Gal., Camden, Me.; Long Island Univ.; Carousel Gal., Wellfleet; Lg. Present Day A.; Eva de Nagy Gal., Provincetown, Mass.; AWS; ACA Gal., N.Y.; Rudolf Gal., Woodstock, N.Y.; Wiscasset (Me.) Mus.; Portland A. Mus.; Arkep Gal., N.Y.; Bodley Gal., N.Y.; Village A. Center, N.Y.; Rena Rosenthal, N.Y.; Churchill's, N.Y.; Cahlo Bros., N.Y.; Ruth White Gal., N.Y.; All A. Am.; CGA; Cayuga (N.Y.) Mus. A.; Long Island Univ; Univ. Missouri; Albany Mus., Albany, Ga.; Brandeis Univ., Waltham, Mass.; Holyoke Mus., Mass.; Mercer Mus., Marion, Ga.; Univ. Tenn., Knoxville; LaSalle Col., Phila.; Univ. Houston, Tex.; Univ. Oregon, and other colleges, universities and public libraries. Inventor of Kuli Printing Press for schools and studios. Also of Kupferman Pre-Flight Ground Training Machine. Positions: Instr. FA, N.Y. Bd. of Edu., 1927- ; Brooklyn Tech. H.S., 1948-1965.

KURDIAN, H(AROUTIUN)—
Collector, Patron, W., Scholar, Art Dealer
2724 E. Douglas, Wichita, Kans. 67211
B. Constantinople (Istanbul), Aug. 9, 1902. Member: Royal Asiatic Society of Great Britain and Ireland; American Oriental Society; Bibliophiles. Collection: Armenian manuscripts; Armenian minor arts; Pre-Columbian Art; Irish and other Georgian silver; Armenian history.

KURWACZ, WILLIAM—Craftsman
Craft Center, 25 Sagamore Road; h. 10 Dean St., Worcester, Mass. 01609
B. Shutesbury, Mass., July 29, 1919. Studied: Sch. for Am. Craftsmen, Alfred Univ.; Ringling Sch. A. Member: Mass. Assn. Handicraft Groups. Awards: Baron Fleming award, Wichita, Kans., 1950; Va. Highlands Exh., Abingdon, Va. Exhibited: Va. Highlands Exh., 1950; Mass. Crafts Exh., 1955; New England Crafts Exh., 1955; Smithsonian Inst. traveling exh., 1956-57; Sterling Silversmiths Gld. of Am., 1957; U.S. Nat. Pavilion, Brussels World's Fair, 1958; Mass. Crafts of Today, 1959-1961; AGAA, 1959; Am. Craftsmen's Council, Lake George, N.Y., 1959; Boston A. Festival, 1959-1961. Positions: Metalsmith, Old Sturbridge Village (Mass.), 1950-51; Instr., silversmithing and jewelry, Craft Center, Worcester, Mass., 1953- . Resident Craftsman, Craft Center, Worcester, Mass.*

KUSHNER, DOROTHY BROWDY—Painter, C., T.
1210 South Fourth Ave., Arcadia, Cal. 91006
B. Kansas City, Mo., Mar. 20, 1909. Studied: Kansas City T. Col.;

B.S.; AIC; Columbia Univ., M.A.; Kansas City AI, with Thomas Hart Benton; ASL, with Reginald Marsh. Member: Kansas City Soc. A.; A.T. Gld.; Cal. WC Soc.; Pasadena Soc. A.; Laguna Beach AA; Am. Color Print Soc.; Los Angeles AA. Awards: medal, Univ. Missouri, 1926; prize, Highland Park, Cal., 1951; Santa Paula, Cal., 1952, 1955; San Gabriel Mission, 1954, 1955; Pasadena A. Mus., 1955; Pasadena Soc. A., 1962-1964; Laguna Beach AA, 1964, 1965; AAUW, 1963; Litton's Saving Award, 1968; Cal. WC Soc. Award, 1969. Work: Pasadena A. Mus.; Camino Grove Sch., Arcadia, Cal.; Univ. Illinois; Los Angeles Unitarian Church. Exhibited: Kansas City AI, 1934, 1935; Women's City Cl., Kansas City, 1938; Kansas City Soc. A., 1935-1938; Los A. Mus. A., 1952, 1954, 1955, 1961; Los A. City Exh., 1951; Cal. WC Soc., 1951-1965; San Gabriel Valley Exh., 1951-1958; Los Angeles AA, 1952-1958; Cal. State Fair, 1952-1955; Oakland A. Gal., 1952; Boston Pr. M., 1954; LC, 1955; AM. Color Pr. Soc., 1956-1965; Wash. Pr. M., 1956-1958; Pasadena A. Mus., 1961; Raymond Lopez Gal., 1961; Creative A. Gal., 1965; Dodgson Gal., 1965; Laguna Beach AA, 1968, 1969; Tower Gallery, 1968; Los Angeles AA, 1969.

KUSSOY, BERNICE (HELEN)—Sculptor
3169 Washington St., San Francisco, Cal. 94115
B. Brooklyn, N.Y., 1934. Studied: ASL; Cooper Union, N.Y.; Western Reserve Univ., B.S.; Cleveland Inst. A., M.F.A. Awards: prizes, Butler Inst. Am. A., 1958; CMA, 1958. Work: Brancusi Marble Co., Los Angeles; United Research Services, Burlingame, Cal.; Butler Inst. Am. A.; Kalamazoo AI; Temple Beth Israel, Pomona, Cal.; Univ. California at Santa Barbara; Mexican-American Inst. Cultural Relations, Mexico City; Bundy A. Gal., Waitsfield, Vt.; San Francisco A. Commission, and in private collections. Exhibited: Butler Inst. Am. A., 1958; CMA, 1958; Providence A. Cl., 1958; Oakland A. Mus., 1958; SFMA, 1959, 1961; Denver A. Mus., 1961; Ankrum Gal., Los A., 1963, 1964; Riverside, Cal., 1963; Bundy A. Gal., Waitsfield, Vt., 1963; Laguna Beach AA, 1964; Otis AI, Los A., 1964; one-man: Stanford Research Inst., Palo Alto, Cal., 1960; deYoung Mem. Mus., San F., 1961; Ankrum Gal., 1962, 1963, 1965, 1968; Fresno A. Center, 1962; College of Notre Dame, Belmont, Cal., 1963; Pioneer Mus. & Haggin Gals., Stockton, 1964; Mexico City, 1965; Judah L. Magnes Jewish Mus. of the West, Berkeley, Cal., 1968.

KUTKA, ANNE (Mrs. David McCosh)—Painter
1870 Fairmount Blvd., Eugene, Ore. 97403
B. Danbury, Conn. Studied: ASL, with Nicolaides, Miller, Fitsch. Awards: Tiffany F.; Gladys Roosevelt Dick traveling scholarship. Work: Portland (Ore.) A. Mus., and in private collections. Exhibited: AIC; Denver A. Mus.; SAM; Portland A. Mus.; Northwest Printmakers; Contemporary A.; Univ. Oregon; MMA; Willamette Univ., Salem, Ore.; Northwest Craftsmen, 1964; Artists of Oregon, 1964, 1967; Pr.M. of Oregon, 1967, 1968; Coos Bay A. Lg., 1966, 1968, and others. Positions: Instr., Kerns Art Center, Eugene, Ore.

KUWAYAMA, TADAAKI—Painter
725 Avenue of the Americas, New York, N.Y. 10010
B. Nagoya, Japan, 1932. Studied: Tokyo Univ. of Art. Awards: "New Talent, 1964," Art in America; Nat. Council on the Arts, 1969. Work: Albright-Knox A. Gal., Buffalo, N.Y.; Contemporary A. Center, Cincinnati; Chrysler Mus., Provincetown; Aldrich Mus. Contemp. A., Ridgefield, Conn.; Wadsworth Atheneum, Hartford, Conn. Exhibited: Mimatsu Gal., Tokyo, 1956-1958; Morris Gal., Toronto, 1962; Carnegie Inst., 1961, 1967; AGAA, 1966; Guggenheim Mus., 1966; Stedelijk Mus., Amsterdam, 1966; Stuttgart, Germany, 1967; Kunsthalle, Bern, Switzerland, 1967; Aldrich Mus. Contemp. A., 1968; Albright-Knox A. Gal., 1968; First Indian Triennial of contemp. world art, New Delhi, India, 1968; Cologne (Germany) A. Festival, 1968; Goldowsky Gal., N.Y., 1969. Washington Gallery of Modern Art, 1963; Contemporary A. Center, Cincinnati, 1964; AFA traveling exhibition, 1964-1966; one-man: Green Gal., N.Y., 1961, 1962; Swetzoff Gal., Boston, 1962; Kornblee Gal., N.Y., 1964; Tokyo Gal., 1967; Richard Gray Gal., Chicago, 1967; Franklin Siden Gal., Detroit, 1967; Henri Gal., Washington, D.C., 1969; also in Zurich, 1967, 1968; Dortmund, Germany, 1967; Venice, Italy, 1968; Brussels, Belgium, 1968.

LACHMAN, MR. and MRS. CHARLES R.—Collectors
124 E. 64th St., New York, N.Y. 10021*

LADERMAN, GABRIEL—Painter, Gr., E., W., L.
Queens College, 65-30 Kissena Blvd., Flushing, N.Y. 11367; h. 760 West End Ave., New York, N.Y. 10025
B. Brooklyn, N.Y., Dec. 26, 1929. Studied: Brooklyn Mus. Sch.; Brooklyn College, B.A.; Hans Hofmann Sch. FA; Cornell Univ., M.F.A.; Atelier 17. Awards: Atelier 17 Fellowship, 1952; Cornell Assistantship, 1955; Tiffany Fnd. Award, 1959; Fulbright Fellowship to Italy, 1962-1963; Yaddo Fellowship, 1960, 1961, 1965. Exhibited: BM, 1952, 1955, 1957, 1959, 1961; LC, 1955, 1957; BMFA, 1957; Munson-Williams-Proctor Inst., Utica, N.Y., 1957; Silvermine Gld.

A., 1963; Nebraska Univ., 1965; SAGA, 1961; Hunterdon County A. Center, 1959, 1961; Tanager Gal., N.Y., 1957, 1959, 1961, 1962; Kornblee Gal., N.Y., 1961, 1962; Schoelkopf Gal., N.Y., 1963, 1964 (one-man), 1965; Pratt Inst., 1962; Schoelkopf Gal., N.Y., 1967 (one-man); Milwaukee A. Center, 1969; State Univ. of N.Y. at New Paltz and traveling, 1969, Vassar Col.; 1968; Bennington Col., 1967; Indiana Univ., 1969; Peridot Gal., N.Y. and Smithsonian Inst. traveling, 1967; Dintenfass Gal., N.Y., 1967; CGA, 1969; White Mus., Cornell Univ., 1963. Lectured at universities, art schools, colleges in N.Y., Mass., Iowa, Ind., Ohio, etc. Positions: Asst., Cornell Univ., 1955-1957; Asst. Prof., State Univ. at New Paltz, 1957-1959; Asst. Prof., Pratt Institute, Brooklyn, 1959-1969; Asst. Prof., Queens Col. N.Y., 1969- . Grad. Lecturer, Yale Univ.

LAGING, DUARD WALTER—Art Historian, E.
 204 Nelle Cochrane Woods Bldg., University of Nebraska; h. 1140 S. 20th St., Lincoln, Neb. 68502
B. Spring Valley, Minn., Nov. 7, 1906. Studied: Univ. Minnesota, B.A., M.A.; Minneapolis AI; Univ. Iowa with Philip Guston. Author: "The Methods Used in Making the Bronze Doors of Augsburg Cathedral" printed in The Art Bulletin, 1967. Member: Nebraska AA; CAA; Midwest College AA; AAUP. Positions: Asst. prof., Michigan State University, 1945-1947; Prof., Art History & Chm. Art Dept., Univ. Nebraska, 1948-1955; Director, Univ. Art Galleries, 1952-1956; Chm., Dept. Art, University of Nebraska, 1962- .

LAGORIO, IRENE R.—Painter, Gr., Des., C., L.
 First & Mission Sts., Carmel, Cal. 93921
B. Oakland, Cal., May 2, 1921. Studied: Univ. California, A.B., M.A.; Columbia Univ. Member: Ars Associated Fnd. (Bd. Dirs.); AFA; F.I.A.L. Awards: prizes, San F. Women A., 1955; SFMA, 1953 (purchase): Cal. WC Soc., 1953; Grant from Chapelbrook Fnd. of Boston for illustrations to "This Open Zoo—A Bestiary," 1968. Work: SFMA, San F. Women A. Coll.; VMFA; Cal. State Lib.; Univ. Hawaii; Louisiana State Art Commission Coll.; San F. Pub. Schools; murals, S.S. Pres. Roosevelt; sculpture, murals, Mark Thomas Inn, Monterey, Cal.; Sculpture U.S. Nat. Bank at Portland and Salem, Ore.; mosaic mural, Society Nat. Bank, Cleveland, Ohio, 1968. Exhibited: Boston Pr.M., 1954, 1955; Newport, 1954, 1955; Sao Paulo, Brazil, 1955; WMAA, 1953; MMA, 1952; SFMA, 1943-1956; BM, 1958; Meltzer Gal., N.Y., 1958; Am. Color Pr. Soc. exh., Tokyo, 1961; SAM, 1961; Oklahoma A. Center, 1961; one-man: Gump's, San F., 1958; Kramer Gal., Los A., 1958; Richmond A. Center, 1958; Valley A. Center, 1958; Louisiana A. Comm., 1958-59; Laky Gal., Carmel, 1961; Ross-Talalay Gal., New Haven, 1962; Univ. California, Berkeley, 1963; Kramer Gal., Los A., 1964; Galleria Pro-Padova, Padua, Italy; Trieste, Italy; Universite Teknik, Trabazon, Turkey, all in 1967; Garden-Cafe Gal., Burlingame, Cal., 1965-1967; 3-man exh., SFMA, 1960. Contributor to Cal.PLH catalogues and bulletins. Lectures: "Prints & Printing"; "From Durer to Dali"; "Squares and Circles"; "Trends in Contemporary Art," etc. Exhibitions arranged: "The Garden—Romantic and Classic"; "New Directions in Contemporary Printmaking"; Approaches to Leisure"; "Jose Posada: Artist of the People" and others for Cal.PLH; des. catalog for Pier Luigi Nervi exh., SFMA, 1961.

LAHEY, RICHARD (FRANCIS)—Painter, Gr., E., L.
 9530 Clark Crossing Rd., Vienna, Va. 22180; s. Box 412, Ogunquit, Me. 03907
B. Jersey City, N.J., June 23, 1893. Studied: ASL; & with Henri, Bridgman. Member: Soc. Wash. A.; Wash. A. Gld.; Ogunquit AA. Awards: prizes, AIC, 1925; PAFA, 1929; med., Soc. Wash. A., 1940 1944, 1946, prize, 1951; Ogunquit AA; Ford Fnd. grant, A.-in-Res., Parrish A. Mus., Southampton, 1965. Work: PAFA; Goucher Col.; BM; Detroit Inst. A.; WMAA; AGAA; Toledo Mus. A.; CGA; BMA; MModA; Lib. Cong.; Parrish A. Mus.; Univ. Georgia; N.Y. Pub. Lib.; ASL; U.S. Supreme Court; Newark Pub. Lib.; Elk's Cl., Wash., D.C.; mural, USPO, Brownsville, Pa. Commissioned by Am. Battle Monuments Commission to design, in collaboration with wife, Carlotta Gonzales, a mural for The Hawaii Memorial in Honolulu, 1960 (completed 1966); Author: "Rembrandt, The Artist and His Work," 1968; "Picasso, The Artist and His Work," 1968. Exhibited: VMFA, 1943 (one-man); CGA, 1935-1945, 1949-1951, 1953, 1955, 1957; Carnegie Inst., 1943, 1944; AIC, 1945; PAFA, 1940-1946, 1950, 1951; VMFA, 1942-1946; WFNY 1939; GGE, 1939; CMA; George Washington Univ., 1951 (one-man); Groucher Col. (one-man) 1951; Parrish A. Mus., Hamilton Easter Field Mus., 1965; Visual Arts Bldg., Univ. Georgia, 1968. Lectures: "American Artists I Have Known"; "How Modern Painting Evolved"; "The Artist's Point of View" (demonstration). Positions: Instr., ASL, New York, N.Y., 1923-35; Principal, Emeritus, Corcoran Sch. A., 1935- ; Prof., Goucher Col., 1935-60; George Washington Univ., Washington, D.C., 1940-1963 (ret.). A.-in-Res., Univ. Georgia, 1968.

LAHEY, MRS. RICHARD. See Gonzales, Carlotta

LA HOTAN, ROBERT L.—Painter
 865 West End Ave., New York, N.Y. 10025
B. Cleveland, Ohio, Apr. 8, 1927. Studied: Columbia College, B.A.; Columbia Univ., B.F.A.(grad. Dept. FA and Archaeology). Awards: Brevoort-Eickemeyer Fellowship, Columbia, Univ., 1952; Fulbright Fellowship, 1953, 1954; Emily Lowe award, 1952, 1957. Exhibited: CGA, 1956; DMFA, 1958; Kornblee Gal., N.Y., 1962; Riverside Mus., N.Y., 1964, 1966; Colby Col., Waterville, Me., 1964; "Maine-50 Artists of the 20th Century," AFA traveling exh., 1964-1965; Rochester Mem. Gal.; Springfield Mus. A.; Inst. for Int. Edu., 1966; Art for Embassies, Portland Mus. A., 1967; one-man: James Gal., N.Y., 1960, 1961; Kraushaar Gal., N.Y., 1968; Lehigh Univ., 1969.

LAINE, LENORE—Painter
 116 Central Park South, New York, N.Y. 10019
B. Philadelphia, Pa. Work: Finch Col. Mus., N.Y.; Mus. Mod. A., Miami; Univ. Miami; Phoenix A. Mus.; Ohio State Univ. Mus.; Ft. Worth A. Center; Riverside Mus., N.Y.; Univ. New Hampshire; Fairleigh Dickinson Col.; Univ. Massachusetts; Nat. Mus. Mod. A., Tokyo. Exhibited: Westmoreland County Mus., Greensburg, Pa., 1969; Lyons Mus., France, 1968, and other museums in France; "USA Group 67" traveling exh. to French museums, 1967; AFA traveling exh., 1966-1967; Fordham Univ., 1967; Brookhaven Nat. Laboratories, N.Y., 1967; Heckscher Mus., Huntington, L.I., N.Y., 1966; Ohio State Univ., Univ. Iowa, Univ. Southern Illinois, all 1966.

LAING, MR. and MRS. CHESTER W.—Collectors
 5 Hanover Square, 10004; h. 870 United Nations Plaza (Apt. 31F), New York, N.Y. 10017
(Mrs. Laing): B. Evanston, Ill., June 24, 1924. Studied: Smith College, A.B.; Yale Univ.; Northwestern Univ.; Univ. of Chicago. (Mr. Laing): B. Glace Bay, Nova Scotia, Apr. 6, 1910. Studied: Univ. of Chicago, Ph.B. Collection: American antique furniture (Queen Anne, Chippendale, Hepplewhite, Sheraton; also pewter, brass and silver); Early American and Contemporary Canadian art; Contemporary Spanish paintings.*

LALIBERTE, NORMAN—Painter
 c/o Osborne Gallery, 965A Madison Ave., New York, N.Y. 10021
B. Worcester, Mass., 1925. Studied: Mus. FA, Montreal, Canada; Inst. Design, Chicago; Cranbrook Acad. A., Bloomfield Hills, Mich. Exhibited: Mus. FA, Montreal, 1948; Lawson Gal., Chicago, 1950; Detroit Inst. A., 1952; AIC. 1953 (4-man); Illinois Inst. Design, 1954, 1955; Nelson Gal. A., Kansas City, 1956, 1959; Purdue Univ., 1960; Butler Inst. Am. A.; one-man: Pacer Gal., Atlanta, 1951; Botolph Cl., Boston, 1956; Studio Gal., Chicago, 1956; Kansas City AI, 1956 and others. One-man: Osborne Gal., N.Y., 1963.*

LAM, JENNETT—Painter, E.
 University of Bridgeport, Bridgeport, Conn.; studio; 510 E. 85th St., New York, N.Y. 10028
B. Conn., May 2, 1911. Studied: Yale Sch. FA; Yale Sch. Art & Architecture, B.F.A., M.F.A. (painting with Josef Albers). Member: MacDowell Colonist. Awards: prizes, Silvermine Gld. A. (Famous Artists award), 1964. Work: Krannert Mus., Univ. Illinois; Mount Holyoke College; New York Univ.; Univ. of Bridgeport; Bradford Jr. College; New Haven Nat. Bank; WMAA; PMA; Chase Manhattan Bank; Andrew Dickson White Mu. A., Cornell Univ.; Univ. of Notre Dame; BM; Univ. Nebraska and in private collections. Exhibited: PAFA; 1964; Univ. Illinois, 1961, 1963; Univ. Nebraska, 1961-1964; USIS traveling exhibition, 1961-1962; Salon de Mai, Paris, 1963; Carnegie Inst., 1964; Mary Washington College, Fredericksburg, Va.; Am. Acad. A. & Lets.; WMAA, 1966; Cordier Ekstrom Gal., 1966 and yearly group exhs., 1967-1969; U.S.I.S. circulating exhs. to museums in France, circulated by U.S. Embassy, Paris; Grand Central Moderns, N.Y., 1960-1966. Positions: Assoc. Prof. A., University of Bridgeport, Bridgeport, Conn., 1954- .

LA MALFA, JAMES THOMAS—Sculptor
 University of Wisconsin-Marinette Campus, Green Bay, Wis.
B. Milwaukee, Wis., Nov. 30, 1937. Studied: Univ. Wisconsin, Madison, B.S., M.S., M.F.A. Member: Wisconsin P. & S. Awards: prizes, Wisconsin Salon, 1960; Racine A. Festival, 1963; Whitewater State Univ., 1965. Research grants,(bronze casting), Wisconsin State Univ., Eau Claire, 1966; Wittenberg Univ., Springfield, Ohio, 1968. Work: Wiscon State Univ., La Crosse; Phillips Hall, Univ. Wisconsin, Eau Claire; Weaver Chapel, Wittenberg Univ., Springfield; Memphis Acad. A. Exhibited: Gallery Arkep, N.Y., 1966; Koening Gal., Concordia Col., Seward, Neb. Traveling Exh., 1967; Springfield A. Center, 1968; Rikes Salon, Dayton, Ohio, 1969, and numerous exhs., in prior dates. Positions: Instr., Sculpture, Wittenberg Univ., Springfield, Ohio, to 1969; Asst. Prof., Sculpture, Drawing, Design, University of Wisconsin, Green Bay, Wis., 1969- .

LAMANTIA, JAMES ROGERS, JR.—Collector, Architect
7 E. 78th St., New York, N.Y. 10021; h. 539 Bienville St., New Orleans, La. 70130
B. New Orleans, La., Sept. 22, 1923. Studied: Tulane University, B.S.; Harvard Graduate School of Design, B. Arch.; Skowhegan School. Awards: American Academy in Rome, Prix de Rome, 1948 in Arch.; Fulbright Fellow in Architecture and Painting, Italy 1949-1950. Collection: 19th century Drawings and Architectural Drawings especially in English and American. Recent acquisitions to collection—drawings by George Bellows.

LAMB, ADRIAN—Portrait Painter
1 West 67th St., New York, N.Y. 10023; h. 41 Cherry St., New Canaan, Conn.
B. New York, N.Y., Mar. 22, 1901. Studied: ASL; Julien Acad., Paris, France. Member: All. A. Am.; ASL; SC. Work: portraits: Columbia Univ.; Union Col.; American Embassy, Paris; Anderson House, Wash., D.C.; Univ. North Carolina; N.Y. Univ.; Univ. Wyoming; N.Y. Law Sch.; Harvard Business Sch.; Supreme Court, Florida; War Dept., Wash., D.C.; Knickerbocker Cl. N.Y.; Brownsville (Tex.) Mem. Center; Roosevelt Mem. Mus.; Greenwich Hosptial, Conn.; St. Luke's Hospital, N.Y.; Glasgow Memb. Lib., Richmond, Va.; Catholic Univ., Wash., D.C.; U.S. Capitol Bldg.; Cambridge Univ., England; St. John The Divine Church, N.Y.; Varner Plantation Mus., Houston, Tex.; Clarence House, Antigua, W.I.; Naval Acad., Annapolis, Md.; Alpha Phi Exec. Office, Evanston, Ill.; American Embassy, Moscow, Russia; N.Y. Chamber of Commerce. Exhibited: All. A. Am., 1950, 1953-1965; New Canaan Lib., 1956; Greenwich, Conn., 1967.*

LAMB, KATHARINE (Mrs. Trevor S. Tait)—Designer, P., C.
Lambs' Lane, Cresskill, N.J. 07626
B. Alpine, N.J., June 3, 1895. Studied: T. Col., Columbia Univ.; NAD; ASL; CUASch. Member: NSMP; NAC; Stained Glass Assn. of America; Bergen County A. Gld.. Work: stained glass windows, for J. & R. Lamb Studios, Tenafly, N.J.; First Presbyterian Church, Mt. Vernon, N.Y.; all windows in both Protestant and Roman Catholic Chapels, Camp Le Jeune, N.C.; U.S. Naval Hospital Chapel, Chelsea, Mass.; First Baptist Church, St. Peter's Church, Richmond, Va.; All Souls Chapel, Morris, N.Y.; Old Mariners Church, Detroit, Mich.; All Saints Episcopal Church, Detroit, Mich.; St. James Church, Birmingham, Mich.; Ogden Mem. Church, Chatham, N.J.; All Saints Church, Birmingham, Ala.; mosaic murals, churches in Wash., D.C.; Brooklyn, N.Y.; First Presbyterian Church, Vancouver, Wash.; Holy Trinity Lutheran Church, New York City, and others.

LAMIS, LEROY—Sculptor
3101 Oak St., Terre Haute, Ind. 47803
B. Eddyville, Iowa, 1925. Studied: New Mexico Highlands Univ.; Columbia Univ. Work: Albright-Knox A. Gal.; J. B. Speed A. Mus.; Larry Aldrich Mus.; Sheldon Swope A. Gal.; WAC; WMAA; Lytton Center Visual A.; Des Moines A. Center; Hirshhorn Coll., Wash., D.C. Exhibited: WMAA, 1964, 1966, 1968; MModA. (in collaboration with CAM, SAM, Pasadena Mus. A., BMA), 1965; Flint Inst. A., 1966; Larry Aldrich Mus., 1965, 1966; Univ. Illinois, 1965, 1969; R.I. Sch. Des., and Smithsonian Inst., 1968; Milwaukee A. Center, 1968, 1969; Riverside Mus., N.Y., 1965, 1967; Albright-Knox A. Gal., 1963, 1965; Jewish Mus., N.Y., 1969. One-man: Staempfli Gal., N.Y., 1966, 1969; Gilman Gal., Chicago, 1967; Ft. Wayne A. Mus., 1968; J. B. Speed A. Mus., Louisville, 1969; Herron Mus. A., 1969; Des Moines A. Center, 1969; La Jolla Mus. A., 1969. Positions: Taught at Cornell Col., Mount Vernon, Iowa, 1956-1961; Indiana State Univ., Terre Haute, Ind., 1961- .

LAMONT, FRANCES (Mrs.)—Sculptor
21 West 10th St., New York, N.Y. 10011
Studied: with Solon Borglum, Mahonri Young, Charles Despian. Member: NSS. Awards: prizes, AV, 1942; All. A. Am., 1958; NSS, 1969. Work: CMA; Mem., New Canaan, Conn.; New Rochelle, N.Y.; MMA; Cranbrook Mus. A.; Denver A. Mus.; Colorado Springs FA Center; Ogunquit A. Mus.; Albright A. Gal.; Musée Nationale d'Art Moderne, Paris; Blérancourt Musée de l'Amitie Franco-Americaine, Paris, France. Exhibited: Salon des Tuileries, Paris, 1937-1939; AV, 1942; WMAA, 1941-1951; PMA, 1940-1949; PAFA, 1940, 1948, 1949; Ogunquit A. Mus., 1953-1955, 1960; All. A. Am., 1958, 1959, 1960; NAC, 1961; one-man: G.W.V. Smith Mus., 1950; Denver A. Mus., 1952; traveling exh., 1952-53; Nelson Gal. A., Kansas City, Mo., 1953; Albright A. Gal., 1953; Bermuda Soc. A., 1956; Far Gal., N.Y., 1967.

LA MORE, CHET HARMON—Sculptor, P., Gr., E.
503 South First St., Ann Arbor, Mich. 48103
B. Dane County, Wis., July 30, 1908. Studied: Colt Sch. A., Madison, Wis.; Univ. Wisconsin, B.A., M.A.; Columbia Univ. Awards: prizes, MModA, 1941. Work: MMA; Lib. Cong.; San Diego FA Soc.; Dallas Mus. FA; Syracuse Mus. FA; Albright A. Gal.; FMA; Birmingham Mus. A.; Mich. State Col.; Mills Col., Oakland; Lowe Gal., Coral

Gables; Saginaw Mus. A.; Eastern Michigan Univ.; Albion Col.; Hirshhorn Fnd.; Olsen Fnd. Exhibited: NAD, 1938; WMAA, 1942-1943, 1945-1946, 1948, 1950; PAFA, 1939, 1940, 1945; WFNY, 1939; AIC, 1938; MModA, 1943-1945; Palace Legion Honor, 1945; Paris, France, 1946; Carnegie Inst., 1949; Albright A. Gal., 1943-1945; one-man exh.: ACA Gal., 1941, 1942; Perls Gal., 1944; Albright A. Gal., 1943; AFA traveling exh., 1941, 1943-1944; Carlebach Gal., 1948, 1950; Krasner Gal., 1960, 1962, 1964; Forsythe Gal., 1963, 1965-1968; Michigan State Univ. Gal., 1963. Positions: Prof. Painting, Dept. A., Univ. Michigan, 1947- .

LANDAU, FELIX—Art Dealer
Felix Landau Gallery, 702 N. La Cienega 90069; h. 711 Orlando Ave., Los Angeles, Cal. 90069
B. Vienna, Austria, Oct. 24, 1924. Studied: City College of New York; Univ. of California at Los Angeles. Member: Art Dealers Association of America, Inc.; Board of Directors, Otis Art Institute, Los Angeles, Cal. Specialty of Gallery: 20th Century American and European Art. Positions: Director, Felix Landau Galleries, Los Angeles, Cal. President, Landau-Alan Gallery, New York, N.Y.

LANDAU, JACOB—Painter, Gr.
2 Pine Drive, Roosevelt, N.Y. 08555
B. Philadelphia, Pa., Dec. 17, 1917. Studied: Phila. College of Art; New School for Social Research, N.Y.; Academie de la Grande Chaumiere, Paris, France. Member: SI; Assoc. A. of New Jersey; Phila. WC Soc. Work: Designs for Steuben Glass, N.Y.; designs and illustrations for: Container Corp. of America; IBM; Lederle Pharmaceuticals; NBC; Columbia Records; Business Week and Life magazines. Prints: Intl. Graphic Arts Soc., 1955; NBC, 1960; McGraw-Hill Co., 1960; Limbach Co., 1960; Assoc. Am. Artists, 1960, 1962, 1967-1969; Work in the collections of LC; BMFA; MModA; MMA; PMA; Norfolk Mus. A. & Sciences; Montclair A. Mus.; McNay AI, San Antonio; BM; Princeton, Rutgers, Yale Universities and the universities of Maine, Minnesota, Kentucky. Awards: Lessing Rosenwald purchase awards, Phila. Print Cl., 1955, 1959; prizes, Print Fair, Free Library of Philadelphia, 1960; F. Paul Norton and Assoc. Am. A. awards, SAGA, 1962; Tiffany Fnd. Scholarship, 1962; PAFA, 1963; New Jersey Tercentenary A. Festival, New Brunswick, 1964; Tamarind Workshop Fellowship, Los Angeles, 1965; Guggenheim Fellowship, 1968-1969; purchase awards: Bradley Univ., 1968; St. Paul A. Center, 1968; Munson-Williams-Proctor Inst., 1968. Exhibited: NAD, 1953; BMFA, 1955; Little Gallery, Princeton, N.J., 1956; SAM, 1957; Gallery 10, New Hope, Pa., 1959, 1961; Phila. Pr. Cl., 1959; Xylon Intl. Exh. of Woodcuts European traveling exh., 1960; Cober Gal., N.Y., 1960; BM, 1960, 1962; NAD, 1960, 1962; Nordness Gal., N.Y., 1961; St. Paul Sch. A., 1961; PAFA, 1961, 1963; Phila. A. All., 1962; Nat. Inst. A. & Lets., 1962; Container Corp. of Am., 1963; Univ. Mexico, Mexico City, 1963; Banfer Gal., N.Y., 1963; Lafayette Col., Easton, Pa., 1963; Otis AI, Los Angeles, 1963, 1964; BM, 1963; USIA traveling exh., USSR, 1963; LC, 1963; USIA, IBM Gal., and European tour, 1964; School of Visual Arts, N.Y., 1964; CGA, 1964; DePauw Univ., 1966; Newark Mus., 1966; N.Y. State A. Council, prize-winning prints, 1966; Detroit Inst. A.,m 1966; WMAA, 1966; Univ. Southern California, 1967; Florida State Univ., 1967; Tyler Sch. A., Philadelphia 1967; USIA Art in Embassies program, 1967- ; Kalamazoo A. Inst., 1967; Univ. Kentucky, 1968; Amsterdam, Holland, 1968, and Mexico City, 1967; New Jersey State Mus., 1968; The White House, Washington, D.C., 1966, and others. One-man: Galerie Lebar, Paris, 1952; Phila. A. All., 1954; New Brunswick (N.J.) A. Center, 1957; Fleisher Mem. Gal., Phila., Pa., 1959; Assoc. Am. A., 1960; Univ. Maine, Orono, 1961; Cober Gal., N.Y., 1961, 1963; Zora Gal., Los Angeles, 1964; Earlham Col., Richmond, Va., 1967; St. Andrew's Col., Laurinburg, N.C., 1967; Calapai Workshop, Glencoe, Ill., 1967; The Other Gallery, Philadelphia, 1968; Bertha Eccles A. Center, Ogden, Utah, 1969. Positions: Instr., Philadelphia Museum School of Art, 1953-1958; Instr., 1958-1964, Chm., Dept. Graphic Arts, Pratt Institute, Brooklyn, N.Y., 1964- .

LANDAU, ROM—Sculptor, E., W., L.
Marrakech, Morocco
B. England, Oct. 17, 1899. Studied: with George Kolbe; and in Germany, Italy. Exhibited: in England and the Continent. Author: "Minos the Incorruptible," 1925; "The Arabesque, The Abstract Art of Islam," 1955; Chapters on art in "Love for a Country," 1939; "Outline of Moroccan Culture," 1957; "Arab Contribution to Civilization," 1958; "Islam and the Arabs," 1958; "Morocco," 1967; "The Kasbas of Southern Morocco," 1969. Lectures: The Arts of Islam, at various universities and clubs. Positions: Prof. Islamic & North African Studies, University of the Pacific, Stockton, Cal., 1954-1967.

LANDECK, ARMIN—Etcher, Eng., Lith.
3 East 14th St., New York, N.Y. 10003; h. R.D. 1, Litchfield, Conn. 06759
B. Crandon, Wis., June 4, 1905. Studied: Columbia Univ. Member:

NA; SAGA; Am. Inst. A. & Lets.; F.I.A.L. Awards: prizes, Lib. Cong., 1943, 1944, 1945; SAGA, 1932, 1955, 1969; AIC, 1942; med., PAFA, 1938; Int. Graphic Exh., Yugoslavia, 1955; Guggenheim F., 1954-55; S.F.B. Morse Medal, NAD, 1968, prize, 1969; Phila. Print Cl., purchase award, 1968; Wiggin award, Boston, 1969. Work: MMA; AIC; N.Y. Pub. Lib.; Toledo Mus. A.; Newark Mus.; Nebraska State Mus.; Lib. Cong.; Swedish Nat. Mus., Stockholm; Kaiser Friedrich Mus., Berlin; MModA; Boston Library.

LANDON, EDWARD—Serigrapher, S., W.
 Lawrence Hill Rd., Weston, Vt. 05161
B. Hartford, Conn., Mar. 13, 1911. Studied: Hartford A. Sch.; ASL; & in Mexico. Member: Boston Pr. M.; Phila. Pr. Cl.; Am. Color Pr. Soc.; Nat. Serigraph Soc. Awards: prizes, Springfield A. Lg., 1934, 1945; Northwest Pr. M., 1944, 1946; Fulbright award, 1950-51; Bradley Univ., 1952; Pr. M. of So. Cal., 1952; Boston Pr. M., 1954; Nat. Ser. Soc., 1958. Work: Springfield Mus. FA; Smith Col.; PMA; Cornell Univ.; Wesleyan Univ.; AGAA; SFMA; Carnegie Inst.; Lib. Cong.; U.S. State Dept.; Albright A. Gal.; PAFA; Honolulu Acad. A.; Berkshire Mus.; SAM; Mt. Holyoke Col.; Florida State Col.; MMA; Phila. Pr. Cl.; Am. Assn. Univ. Women; Berkeley Bd. Edu.; Bibliotheque Nationale, Paris; in National Gallery, Stockholm; Tel-Aviv and Jerusalem Art Museums; Turku Museum, Finland; Victoria and Albert Museum, London; Cooper Union, N.Y.; murals, Trade Sch., Springfield, Mass. Exhibited: nationally in print exh. since 1941. Author, I., "Picture Framing," 1946; "Scandinavian Design," 1951. Lectures: Serigraphy.

LANDRY, ALBERT—Art Dealer, Gallery Director
 The J. L. Hudson Company Art Gallery, 1206 Woodward Ave., 48226; h. 1300 E. Lafayette, Detroit, Mich., 48207
B. New York, N.Y., Oct. 9, 1919. Studied: Columbia Univ., M.A.; NAD; Atelier Leger, Paris, France. Specialty of Gallery: Contemporary American and European Painting & Sculpture. Positions: Dir., Galerie Villard-Galanis, Paris, 1950-54; Assoc. American Artists, 1954-58; Albert Landry Galleries, N.Y., 1958-1964; J. L. Hudson Company Art Gallery, Detroit, Mich., 1964- .*

LANDSMAN, STANLEY—Sculptor
 c/o Castelli Gallery, 4 E. 77th St., New York, N.Y. 10021*

LANDY, JACOB—Educator, L.
 11 Gardenia Lane, Hicksville, N.Y. 11801
B. New York, N.Y., Apr. 18, 1917. Studied: City Col. of N.Y., B.S.S., M.S. in Edu.; N.Y. University, M.A., Ph. D. Member: Soc. Architectural Historians; CAA; Victorian Soc. in Am. Awards: grants, Am. Council of Learned Soc.; Edgar J. Kaufmann Fnd. Contributor to Archaeology; Enciclopedia Dello Spettacolo; Journal of the Soc. of Architectural Historians; Problems of Communism. Lectures: Modern Art, American Art at Five Towns Music & Arts Fnd, Cedarhurst, N.Y.; N.Y. Pub. Lib.; Temple Beth-EI, Great Neck, N.Y., etc. Author: "History of Art" (College Quiz Series); "The Architecture of Minard Lafever," and introduction for a new ed. of Minard Lafever's "The Modern Builder's Guide." Positions: Assoc. Prof. A., Supv. A., Dept. Summer Session, 1959- , City College of New York.

LANE, ALVIN S.—Collector
 60 E. 42nd St., New York, N.Y. 10017; h. 5204 Delafield Ave., Riverdale, N.Y. 10471
B. Englewood, N.J., June 17, 1918. Studied: University of Wisconsin, Ph.B.; Harvard Law School, LL.B.; Studied sculpture with Seymour Lipton at The New School of Social Research, N.Y. Field of Research: Problems on authentication of sculpture and the documentation regarding authenticity. Lectures and writes on the problems of authentication and the documentation of art. Collection: Contemporary sculpture and sculptor's drawings. Positions: Chairman, Committee on Art, Association of the Bar of the City of New York, 1963-1965; Board of Overseers of the Fine Arts Department of Brandeis University, 1966- ; Secretary, 1968- , Board of Directors, 1969- , The Larry Aldrich Museum of Contemporary Art; Advisory Board to N.Y. Attorney General on Art Legislation, 1966- .

LANE, BENT (Mrs. Clayton Lane)—Painter, C., W., L., E.
 421 Cleveland Dr., Sarasota, Fla. 33577
B. Chicago, Ill. Studied: Univ. California. Berkeley, A.B.; ASL; Cal. Sch. FA; American Univ., Washington, D.C. Member: Nat. Lg. Am. Pen Women (1st V.P., 1967; 2nd V.P., 1968; Prog. Chm. 1964-1969); Sarasota AA (Rec. Sec. 1969). Awards: prizes, BMA, 1954; Ursell Award, Soc. Wash. A., 1961; Aileen Vanderbilt Webb Award, NAWA, 1961; Nat. Lg. Am. Pen Women, prize, 1966. Work: Univ. Vermont; Simpson College, Indianola, Iowa, (aa) and in private collections. Exhibited: Soc. Wash. A., 1953, 1961; Min. P., Sculptors & Gravers, 1953; CGA, 1953; Univ. Maryland, 1953; BMA, 1954; Provincetown Gal., 1955; Joslyn Mem. Mus., 1956, 1957; AEA traveling exh., 1956, 1959; Luther Col., Decorah, Iowa, 1957, 1959; Cedar Falls, 1957;

NAWA, 1958 (2), 1960, 1964; Des Moines A. Center, 1959; Sioux City A. Center, 1959; Japan-New York Exch. Exh., Riverside Mus., 1960; Church Arch. Gld. of Am., Pittsburgh, 1961; Fla. State Fair, 1962; Sarasota AA, 1962; Mead Exh., Atlanta, 1962; Ringling Mus. A., 1963; Fla. A. Group, 1963; A. Festival, Jacksonville, 1963; Southeastern Annual and traveling exh., Atlanta, 1964; Florida A. Group traveling exh., 1966, and many others. One-man: Beirut, Lebanon, 1947; Ferargil Gal., N.Y., 1947; St. John's Col., Annapolis, 1955; Simpson Col., Indianola, Iowa, 1955-1959; Central Iowa AA, 1957; Brick Store Mus., Kennebunk, Me., 1959; Fleming Mus. A., Univ. Vermont, 1961; Manatee A. Lg., 1966; Sarasota AA, 1966; Stetson Univ., Deland, Fla., 1967; Longboat Key A. Center, 1969; Friends Gal., 1967. Positions: Hd., Office War Inf., Calcutta, India, 1942-43; Artist-in-Res., St. John's College, Annapolis, Md., 1954-55; Artist-in-Res., Asst. Prof., Simpson College, Indianola, Iowa, 1955-60.

LANE, CHRISTOPHER—Painter
 229 E. 4th St., New York, N.Y. 10009
B. New York, N.Y., June 7, 1937. Studied: Goddard College; School of Painting and Sculpture, Mexico City. Exhibited: Paris Biennale, 1961; Salon de la Jeune Peinture, Paris, 1965; City Center Gal., N.Y., 1958; Castro Gal., Paris, 1961; Beaux Arts Gal., London, 1962; Osborne Gal., N.Y., 1963; Yale School of Art and Architecture, 1964; MModA, 1964-65; Martha Jackson Gal., N.Y., 1965; Paula Johnson Gal., N.Y., 1964; Univ. Illinois, 1965; West Village, N.Y., 1965; St. Marks Pl. Gal., N.Y., 1967 (4-man); MModA Traveling exh., Mus. Mod. A., Mexico City, 1967; Spring St. Gal, N.Y., 1967; Kiko Gal., Houston, Tex., 1968 (3-man); Esther Bear Gal., Santa Barbara, 1968; Quay Gal., San Francisco, 1968; Ryder Gal., Los Angeles, 1968; one-man: Beaux Arts Gal., London, 1962; Osborne Gal., N.Y., 1964; New Art Centre, London, 1965; Karmanduca Gal., San Francisco, 1968.

LANE, WILLIAM H.—Collector
 Holmes St., Box 150, Lunenberg, Mass.*

LANES, JERROLD—Critic
 26 E. 91st St., New York, N.Y. 10028*

LANG, MARGO TERZIAN (Mrs. J.M.)—Painter
 6127 Calle del Paisano, Scottsdale, Ariz. 85251
B. Fresno, Cal., July 29, 1920. Studied: Fresno State Col.; Stanford Univ.; Prado Mus., Madris, Spain; Arizona State Univ.; and with William Schimmel, F. Douglas Greenbowe, Warren Brandon and Paul Coze. Member: Nat. Soc. A. & Lets.; Arizona WC Assn. Awards: United States and Canada Competition at Grand Central Gals., New York, 1968, 1969; Selected, 1968 and 1969 for N.Y. Life Ins. Co.'s Fine Arts Calendar; Special Governor's Award, Arizona, 1968. Work: The late Mrs. Nancy Kefauver selected 15 paintings for the State Dept., Art in Embassies program and are now in U.S. Embassies in Sofia, Bulgaria, Teheran, Iran, Valetta, Malta, Tripoli, Libya, Dahomey, Leopoldville, and others. Exhibited: Arizona WC Assn. traveling exh., 1968-1969; Mexican-North American Cultural Inst., Guadalajara, Mexico, 1968; group exhs., San Francisco, Carmel, Santa Barbara, Cal.; Chicago, Ill.; Sedona, Prescott, Flagstaff, Yuma and Tucson, Arizona; 14 one-man exhs., 1967-1969, Scottsdale, Phoenix, Prescott, Arizona and Fresno, California.

LANGE, MRS. FREDERIC G. M. See Condit, (Eleanor) Louise

LANGLAIS, BERNARD—Sculptor
 Star Route, Cushing, Me. 04861
B. Old Town, Me., July 23, 1921. Studied: Corcoran Sch. A.; BMSch. A.; Grande Chaumiere, Paris, France; Nat. Acad., Oslo, Norway, Skowhegan Sch. of Painting & Sculpture, and with Richard Lahey, Henry Varnum Poor. Awards: Scholarship, CGA, Grant, BM, 1952; Fulbright Grant to Norway, 1954-55, 1956; Am. Acad. A. & Lets. award, 1968. Work: AIC; WMAA; Chrysler Mus., Provincetown, Mass.; Univ. Indiana; Univ. Maine; Olson Fnd.; world's largest wood Indian statue, Skowhegan, Maine; and in other public and private collections. Exhibited: Seton Hall Univ., 1965; Grippi & Waddell Gal., N.Y., 1964; N.Y. World's Fair, 1964; AIC, 1964; J. L. Hudson Gal., Detroit, 1964; WMAA, 1963, 1966; Carnegie Inst., 1961; MModA, traveling exh., 1963; Yale Univ., 1963; XX Siecle Galerie, Paris, 1962; Allan Stone Gal., N.Y., 1962; DMFA, 1962; SFMA, 1962; Leo Castelli Gal., N.Y., 1961; Syracuse Univ., 1967; Makler Gal., Phila., 1966; Art in the Embassies, 1967-1968; Univ. Maine, 1967; Inst. Contemp. A., Boston, 1966, and others.

LANGSTON, MR. and MRS. LOYD H. (MILDRED J.)—
 Art Dealers, Collectors
 Langston & Company, 2 Third St.; h. Riverlands, Rumson, N.J. 07760
(Mrs. Langston): Studied: Columbia University, M.A. (Mr. Langston): Columbia University, Ph.D. Specialty of Gallery: Oriental

rugs; Chinese jades and porcelain; Contemporary French Paintings. Positions: Mr. Langston: Trustee, Monmouth (N.J.) Museum; Trustee, The Association for the Arts, New Jersey State Museum.

LANIER, DR. VINCENT—Educator
School of Architecture & Allied Arts, Univ. of Oregon, Eugene, Ore. 97403*

LANING, EDWARD—Painter, T.
30 East 14th St., New York, N.Y. 10003
B. Petersburg, Ill., Apr. 26, 1906. Studied: Univ. Chicago; AIC; ASL. Member: NA. Awards: prizes, AIC, 1945; VMFA, 1945, grant, Am. Acad. A. & Let., 1945; Guggenheim F., 1945; Fulbright F., 1950-52. Work: WMMA; MMA; William Rockhill Nelson Gal. A.; Pentagon, Wash., D.C., murals, N.Y. Pub. Lib.; Richmond Professional Inst.; Admin. Bldg., Ellis Island, N.Y.; Hudson Gld., N.Y.; Mayflower Hotel, Wash., D.C.; Sheraton Hotels, Los Angeles, Cal., Dallas, Tex., Park Sheraton and Sheraton East, N.Y., Niagara Falls, Montreal & Louisville; USPO, Rockingham, N.C.; Bowling Green, Ky. Exhibited: nationally & internationally. Author: "Perspective for Artists," 1967; "East Side, West Side," essay for catalogue of Reginald Marsh Retrospective Exh., Univ. of Arizona Museum, April, 1969. Positions: Hd., Painting Dept., Kansas City AI, 1945-50; Instr., ASL, New York, N.Y., 1952- .

LANING, Mrs. Edward. See Fife, Mary E.

LANSNER, FAY GROSS—Painter, Des., Cr.
317 W. 80th St., New York, N.Y. 10024
B. Philadelphia, Pa., June 21, 1921. Studied: Wanamaker Inst.; Tyler Sch. FA, Temple Univ.; ASL; with Hans Hofmann, and in Paris, with Leger, L'Hote; Holland; England. Member: A. Cl., New York. Exhibited: Contemporaries, 1952; N.Y. City Center Gal., 1953; Hansa Gal., N.Y., 1955, one-man: 1956, 1958; David Herbert Gal., 1960; Kornblee Gal., N.Y., 1962, 1963, and abroad. Reviewer, Art News magazine. Illus. children's books; Textile Des.*

LANTZ, MICHAEL—Sculptor
979 Webster Ave., New Rochelle, N.Y. 10804
B. New Rochelle, N.Y., Apr. 6, 1908. Studied: NAD; BAID, and with Lee Lawrie. Member: NA; F.; NSS; BAID. Awards: prizes, bronze & silver medals, BAID, 1926, 1927, 1929, 1930, 1931; Nat. Comp. Fed. Trade Comm. Bldg., Wash., D.C., 1938; City of N.Y. Comp. for Golden Anniversary Medal, 1948; Morris award, 1950; Bennett award, 1947; Silver medal, Int. Exh. of medals, Madrid, Spain, 1952; Saltus medal award, 1968. Work: equestrian groups, Fed. Trade Bldg., Wash., D.C.; U.S. Battle Monument, St. Avold, France; s. panels, Columbus Sch., New Rochelle, N.Y.; Celanese Corp. Bldg., Charlotte, N.C.; Spring Hill Temple, Mobile, Ala.; Court House, Lynchburg, Va.; Dupont Plaza Hotel, Wash., D.C.; Burlington Mills Corp.; Lone Star Cement Corp.; Sinclair Oil Tourist Bureau, N.Y.; Howard Trust Co., Burlington, Vt.; SS "United States"; med., Soc. Medalists; Golden Anniversary med., N.Y.C.; Edgar Allan Poe Medal, Hall of Fame, N.Y. Univ.; Medal, World Press Achievement Award; Christmas Font, Steuben Glass Corp.; med., Forbes Magazine; eagle, Nat. Assn. Home Builders, Wash., D.C.; sc. outlines: Milwaukee Mun. Bldg.; sc., Architects' Bldg., Albany, N.Y.; sc. medals, Oliver Wendell Holmes, Sr.; John Paul Jones; Nat. Guard Mem. Bldg., Wash., D.C.; Two Chapels, Cathedral of Mary Our Queen, Balto., Md. Exhibited: PAFA, 1941, 1945; Phila. A. All., 1946; Arch. Lg., 1946; NAD.

LANYON, ELLEN—Painter
412 Clark St., Chicago, Ill. 60610
B. Chicago, Ill., Dec. 21, 1926. Studied: AIC, B.F.A.; State Univ. Iowa, M.F.A.; Courtauld Inst., Univ. London. Awards: prizes, AIC, 1946, 1955, 1958, 1962, 1964, 1967; Denver A. Mus., 1950; LC, 1950; DMFA, 1965. Work: AIC; Denver A. Mus.; LC; Inst. Int. Education; Univ. Illinois Krannert Mus.; Finch Col.; Illinois Wesleyan Univ.; Illinois Bell Telephone Co. Exhibited: AAA Gal., Chicago, 1948; Seligmann Gal., N.Y., 1948; Carlebach Gal., N.Y., 1948, 1949; Iowa Print Group traveling exh., 1951; Benjamin Gal., Chicago, 1947-1954; Downtown Gal., N.Y., 1954; Chicago Graphic Workshop, 1955; Stuart Brent Gal., Chicago, 1957-1958; Fairweather-Hardin Gal., 1962; AFA traveling exhs., 1946-1948, 1950, 1953, 1957, 1963, 1965-1968; AIC, 1946, 1947, 1951, 1953, 1955, 1957, 1960-1962, 1964, 1966-1969; CGA, 1961; Denver A. Mus., 1950, 1952; Joslyn A. Mus., 1949, 1958; LC, 1950, 1952; MMA, 1952; MMoDA, 1953, 1962; Nat. Drawing Soc., 1965; SAM, 1954; PMA, 1946, 1947, 1950, 1954; SFMA, 1946, 1950; Univ. Illinois, 1953, 1954, 1957; Univ. Iowa, 1957; Univ. Wisconsin, 1955; Univ. New Mexico, 1964-65 (traveling); Finch Col., N.Y., 1965; Illinois Arts Council, traveling, 1967-1969; Soc. Contemp. A., 1964, 1967. One-man: Superior St. Gal., Chicago, 1960; Stewart Rickard Gal., San Antonio, 1962, 1965; Fairweather-Hardin, Chicago, 1962; Zabriskie Gal., N.Y., 1962, 1964, 1969; B. C. Holland Gal., Chicago, 1965, 1968; Richard Gray Gal., Chicago, 1969; Ft.

Wayne A. Mus., 1967; Northern Illinois Univ., 1968; Illinois Arts Council, 1967. Positions: Instr., AIC, 1966; Univ. Illinois, Chicago, 1967.

LARCADA, JOSEPH—Art Dealer
Larcada Gallery, 23 E. 67th St., New York, N.Y. 10021*

LARIAR, LAWRENCE—Cartoonist, I., W., Editor, S.
57 West Lena Ave., Freeport, N.Y. 11520
B. Brooklyn, N.Y., Dec. 25, 1908. Studied: N.Y. Sch. F. & App. A.; Colorossi, Paris; ASL. Exhibited: MMA. Author: "Easy Way to Cartooning," 1951; "Careers in Cartooning," 1951; I., "Ordeal of Sergeant Smoot." Author: "The Man with the Lumpy Nose"; "He Died Laughing"; "The Day I Died"; "The Salesman's Treasury"; "Best Cartoons from Abroad," 1955; "Fish and Be Damned," 1953; "You've Got Me in Stitches," 1954; "You've Got Me and How!," 1955; "Happy Holidays," 1956; "You've Got Me from 9 to 5," 1956; "How Green Was My Sex Life," 1955; "You've Got Me Behind the Wheel," 1956; "You've Got Me in the Suburbs," 1957; "Treasury of Sport Cartoons," 1957; "Bed and Bored," 1958, etc., and many other books. Positions: Pres., Am. Soc. Magazine Cartoonists; OWI Cartoon Exhibits Staff; Dir., Professional Sch. Cartooning; Writer, Walt Disney Studios, 1938- ; Ed., Cartoons for Parade Magazine, 1957- ; Ed., "The Best of Best Cartoons" (20 year anthology), 1961. Contributor to leading national magazines. Pres., Long Island Craftsmen's Gld., 1958.

LARKIN, EUGENE—Printmaker, E.
200 E. 25th St. 55404; h. 64 Grove Terr., Minneapolis, Minn. 55403
B. Minneapolis, Minn., June 27, 1921. Studied: Univ. Minnesota, B.A., M.A. Member: AEA. Awards: Over 30 awards to date; recent awards include Washington WC and Print Exh., 1963; WAC, 1960. Work: MMoDA; NGA; LC; AIC; AGAA; Brandeis Univ.; Minneapolis Inst. A., Nelson Gal. A., Kansas City; St. Lawrence Univ., Canton, N.Y.; United States Information Agency, and others. Commissions: Int. Graphic A. Soc.; General Mills; Business Week; Minneapolis Soc. FA. Exhibited: Print Council Exh. (with simultaneous showings in 8 museums), 1959; BM, 1960; Silvermine Gld. A., 1960; LC, 1958, 1960; Nat. Litho. Competition, Florida, 1965; New Forms Gallery, Athens, Greece, 1964; USIA traveling exh. to Iran, Italy, France, Spain and Germany; N.Y. Univ., Albany, 1969; Univ. Cal., Long Beach, 1969; State Univ. N.Y., Albany, 1968; Otis A. Inst., Los Angeles, 1967; Carleton Col., Northfield, Minn., 1966; one-man: New Forms Gal., Athens, Greece, 1967; WAC, 1967; Univ. Cal., Sacramento, 1968; Minneapolis Inst. of A., 1968; Hamline Univ., 1968. Positions: Kansas State College, Pittsburg, Kansas, 1948-1954; Hd., Printmaking Dept. & Chm. Div. Fine Arts, Minneapolis School of Art, 1954-1969; Prof., Dept. of Related A., Univ. of Minnesota, 1969- .

LARKIN, OLIVER—Educator, W., Cr., L.
37 Henshaw Ave., Northampton, Mass. 01060
B. Medford, Mass., Aug. 17, 1896. Studied: Harvard Col., A.B., A.M. Member: Am. Assn. Univ. Prof.; Soc. American Historians. Awards: Pulitzer prize in History, 1950. Contributor to Magazine of Art, Art in America, College Art Journal, and others. Author: "Art and Life in America," 1949; "Samuel F. B. Morse," 1954; "Daumier, Man of His Time," 1966. Positions: Prof. A., Smith Col., Northampton, Mass., 1924-1964, Emeritus, 1964- . Instr., Salzburg (Austria) Seminar in American Studies, 1950-1952.

LARKIN, WILLIAM—Painter, Gr.
405 E. 54th St., New York, N.Y. 10022
B. Washington, D.C., Dec. 8, 1902. Studied: Univ. Virginia, Charlottesville; George Washington Univ., Wash., D.C.; ASL. Member: Am. Color Print Soc.; AEA; Boston Printmakers. Awards: hon. mentions: Am. Color Pr. Soc., 1955; Springfield A. Lg., 1955; Northwest Pr.M., 1956; Audubon A., 1957. Work: MMA; Brandeis Univ.; de Young Mem. Mus., San Francisco; SAM; Denver A. Mus.; Berkshire Mus., Pittsfield, Mass.; Smithsonian Inst.; Nat. Coll. FA; Slater Mem. Mus., Norwich, Conn. Exhibited: Boston Printmakers, 1954-1968; Am. Color Pr. Soc., 1955, 1965; SAGA, 1955, 1956; LC, 1956, 1957; BM, 1955; SAM, 1956; Audubon A., 1955-1958; NAD, 1956; San F. AA, 1956; PAFA, 1957; Virginia Mus. FA, Loan-Own Art Service, 1963-1969.

La ROCCO, ANTHONY—Craftsman
Craft Center, 25 Sagamore Rd., Worcester, Mass. 01605; h. 10 Carrol Dr., Boylston, Mass. 01505
B. Torrington, Conn., Dec. 13, 1920. Studied: Sch. for Am. Craftsmen, Alfred Univ.; Acad. FA, Milan, Italy. Member: De Cordova Craftsmen. Awards: Fulbright F., 1949-50; prize, St. Paul (Minn.) A. Gal., 1952. Work: St. Paul A. Gal. Exhibited: BM, 1953; St. Paul A. Gal., 1952; WMA, 1955; Smithsonian Inst. traveling exh., 1953; Eastern States Fair, Springfield, 1953; deCordova & Dana

Mus., 1953; Fitchburg A. Mus., 1954; Geo. Walter Vincent Smith Mus., Springfield, 1955; Mus. Contemp. Crafts, N.Y., 1956, 1957; Mass. Crafts, Boston, 1956; Boston A. Festival, 1956, 1957; Univ. Illinois, 1957; Craft Center Instructors' Exh., WMA, 1958; Article on Woodworking for Sloan Report, 1961; Article on "Workshop for the Aged," New England "Adage," 1961. Positions: Dir., Cabinet Shop, Old Sturbridge Village, 1950-51; Instr., woodworking, cabinet making, Craft Center, Worcester, Mass., 1951- .*

LARSEN, ERIK—Educator, Cr., W., L.
Department History of Art, Spooner Hall, University of Kansas; h. 3103 Trail Rd., Lawrence, Kans. 66044
B. Vienna, Austria, Oct. 10, 1911. Studied: Institut Sup. d'Histoire de l'Art et d'Archéologie, Brussels, Belgium; Louvain Univ., M.F.A., Ph.D. (magna c. laude); Sequoia Univ., Litt. D. (Hon.). Member: CAA; AAUP; Cor. Memb., Académie d'Aix-en-Provence, France; Cor. Academician, Real Academia de Bellas Artes, Malaga, Spain; Hon. Memb. Comité Cultural, Argentina; Hon. Academician, Accademia di Belle Arti, Perugia, Italy; F.I.A.L.; Schweizerisches Institut f. Kunstwissenschaft, Switzerland; Correspondent-Academician, Real Academia de Bellas Artes de San Jorge, Barcelona, Spain; Academia Tiberina, Rome, Italy; Fellow, Royal Soc. Arts, London, England. Awards: Knight's Cross of the Order of the Belgian Crown; Laureate, Institute of France. Author: Peter Paul Rubens (with a complete catalog of his works in America), 1952; Les Primitifs flamands au Musée Métropolitan de New York, 1960; Frans Post, Interprète du Brésil, 1962; Catalogue of the Georgetown University Art Collection 1963; Entries on Flemish Painting, 17th Century, for McGraw-Hill "Dictionary of Art"; Flemish Painting 17th Century, 1967; Rembrandt and the Dutch School, 1967; El Greco and the Spanish Golden Age, 1969. Contributor to many art magazines in Europe including "Apollo." "Gazette des Beaux-Arts," "L'Arte," "Artis," "Oud Holland." Positions: Dir. & Ed.-in-Chief, "Pictura," 1945-46; Research Prof. in Art, Manhattanville College of the Sacred Heart, 1947-55; Instr., City Col. of N.Y., 1948-55; L., Visiting Prof., Assoc. Prof., Prof. FA, Chm. Dept. FA, Georgetown University, Wash., D.C., 1955-1967; Prof. Hist. Art, Univ. Kansas, 1967- . American Ed., "Artis," 1961- . American Editor, "Raggi," 1968- .

LARSEN, JACK LENOR—Textile Designer, C., W., L., T.
41 E. 11th St.; h. 126 E. 19th St., New York, N.Y. 10003
B. Seattle, Wash., Aug. 5, 1927. Studied: Univ. Southern California; Univ. Washington, B.F.A.; Cranbrook Acad. A., M.F.A. Member: Am. Inst. Des.; Arch. Lg., N.Y. (Vice-Pres. 1966-1967); Nat. Soc. Int. Des.; Am. Craftsmen's Council. Awards: numerous awards including Int. Textile Exh., Am. Inst. Des.; Design Derby, Miami, Fla.; Cal. State Fair, and others. Work: MMA; BM; Cooper Union, N.Y.; Victoria & Albert Mus., London; Designer for many firms, hotels, libraries, etc. Exhibited: Good Design Exh., MModA; Brussels, Moscow, Pozen, Casablanca Fairs; Milan Triennale; N.Y. World's Fair; USIA. One-man: City of Paris, San Francisco, Cal.; Phila. A. All.; Henry Gal., Univ. Washington; N.Y. Arch. Lg.; SAM; deYoung Mem. Mus., San Francisco; Akron A. Inst.; A. Cl. of Chicago, 1961; Cranbrook Acad. A., 1963; Otis A. Inst., Los Angeles, 1964; Nat. Design Center, New York City, 1965, and others. Author (with Azalea Thorpe) "Elements of Weaving," 1967. Positions: Des. Dir., U.S. Comm. to 13th Triennale, Milan, 1964; Guest Dir., MModA, 1967-1968; Special Cons., State Dept., Taiwan and Vietnam, 1956-1959; Trustee, Haystack Mountain Sch. Crafts; Contemp. Crafts Gal., Portland, Ore.; Pres., Jack Lenor Larsen, Inc., N.Y., 1952- ; Vice-Pres., Karl Mann Assoc., N.Y., 1958- ; Larsen Design Corp., N.Y. 1958- ; Dir., Fabrics International, 1962- ; Dir., Des. Dept., Philadelphia Museum College of Art, 1960-1962; U.S. Commissioner, Triennale, Milan, 1964.

LARSEN, OLE—Painter, Comm., I.
441 S. Adams St., Hinsdale, Ill. 60521
B. Manistee, Mich. Studied: Chicago Acad. FA; AIC, and with Edward Timmons. Member: Hinsdale (Ill.) Community Artists; Soc. Animal Artists. Awards: prizes, Kentucky State Fair; Illinois State Fair, 1955. Work: Pub. Lib., Michigan City, Ind.; Riveredge Fnd., Calgary, Alberta, Canada; Saddle Horse Hall of Fame (American Saddle Horse Mus.), Lexington, Ky. Many portraits of throughbred animals; illustrations for a horse judging manual, 1964; illustrations for veterinarian pharmaceutical publications, circulars; pictorials on purebred horses and dogs; livestock; 1947-1969. Exhibited: Illinois State Fair, Springfield, 1955, 1956, 1958; Soc. Animal Artists, 1961-1969, other exhibitions in New York, Pittsburgh, St. Louis, Chicago, Lansing and Detroit.

LARSON, SIDNEY—Painter, Mus. C., E., I., W.
2025 Crest Ridge Dr., Columbia, Mo. 65201
B. Sterling, Colo., June 16, 1923. Studied: Univ. Missouri, A.B., M.A. Studied with Fred Shane; Univ. Oklahoma and private study

with Thomas Hart Benton. Member: NSMP; Missouri College AA. Awards: Fellow, Huntington Hartford Fnd., 1962; Ittner Fine Arts prize, Univ. Missouri, 1950; Oklahoma Annual, Philbrook A. Mus., Tulsa, 1951; Columbia, (Mo.) A. Lg., 1960, 1961. Work: Christian College, Columbia; murals: churches, Oklahoma City, and Morrilton, Ark.; Insurance Co. Hdqtrs., Columbia; 15 murals and 3 sculptures, Riback Industries, Columbia; restoration of murals in Missouri State Capital Bldg. Exhibited: Missouri Pavillion, N.Y. World's Fair, 1965; St. Louis People's A. Center, 1964; one-man or invitational exhs., Oklahoma City, Univ. Missouri, Christian College, Columbia A. Lg., 1949- . Co-contributor with Thomas Hart Benton for book "Fred Shane," 1964, contributing biographical and critical essay on the drawings. Illus., for numerous articles in the Historical Review (State Hist. Soc.), 1961-65; Medical illus. for "Missouri Medicine," 1961, 1962. Positions: Responsible for museum program of the Art Gallery of State Hist. Soc., 1961- ; Christian College, 1961- ; Asst. to Thomas Hart Benton on Truman Library murals, 1960; Chm. A. Dept., Christian College, Columbia, Mo., 1951- ; Cur., State Art Gallery, 1961- ; Coordinator, Cultural Exhibit, State of Missouri, N.Y. World's Fair, 1964-65.

LASANSKY, MAURICIO—Painter, Gr.
Art Department, State University of Iowa; h. 404 South Summit St., Iowa City, Iowa 52240
B. Buenos Aires, Argentina, Oct. 12, 1914. Studied: Superior Sch. FA, Buenos Aires. Awards: Guggenheim F., 1943, 1945, 1953; Guggenheim Fellowship to Spain and South America, 1965; Accademico Onorario of the Classe de Incisione from Accademia Delle Arti Del Designo, Florence, Italy, 1965; Hon. D.F.A., Iowa Wesleyan Col.; Mt. Pleasant, 1959; prizes, SAM, 1944; PMA, 1945, 1946; LC, 1945, 1948, 1950; Denver A. Mus., 1946; BM, 1948; Northwest Pr. M., 1948, 1951, 1955; PAFA, 1948; Springfield Mus. A., 1948, 1951; Des Moines A. Center, 1949, 1951, 1955; Walker A. Center, 1949; Iowa State A. Salon, 1950, 1955; Phila. Pr. Cl., 1951; Bradley Univ., 1951; Instituto Nacional de Bellas Artes, First Mexican Biennial, 1958; Special mention with Gold Medal & one-man exh., 2nd Biennial, Mexico City, 1960; other prizes: Des Moines A. Center, 1959; Cal. Soc. Et., 1959; Des Moines A. Center, 1960, 1961; Hon. men. & one-man Exh., PAFA, 1961; purchase awards: Junior Gal. A., Louisville, Ky., 1959; SAM, 1959; Bradley Univ., 1960; Yale Univ., 1960; Nelson Gal. A., 1960; Luther Col. FA Festival, Decorah, Iowa, 1961; purchase awards: Ford Fnd., Nelson Gal. A., Kansas City, 1962; Otis AI, Los Angeles, 1963; LC, 1963; Luther Col., 1964. Work: NGA; MMoA; AIC; BM; PMA; SAM; N.Y. Pub. Lib.; Rosenwald Coll.; CAM; Univ. Washington; PAFA; Springfield Mus. A.; Colorado Springs FA Center; IBM; Univ. Indiana; Univ., Minnesota, Illinois, Nebraska, Georgia, and Bradley Univ.; New Britain Mus. A.; Univ. Delaware; Des Moines A. Center; Iowa Wesleyan Univ.; Nelson Gal. A.; Oakland A. Mus. Exhibited: PMA, 1945, 1946; Fairfield, Conn., 1953; Brooks Mem. Gal., 1953; Mus. Mod. A., Paris, 1955; Yugoslavia, 1955, 1963, 1965; Washington Univ., St. Louis, 1955; Barcelona, Spain, 1955; SAM, 1944; LC, 1945, 1948, 1950; Denver A. Mus., 1946; Albertina Mus., Vienna, 1963; Sao Paulo, 1963; "Graphic Arts-USA" cultural exchange, program to Russia, 1963; Phila. Pr. Cl., 1964, 1965; one-man: Walker A. Center, 1949; Louisiana State Univ., 1952; Univ. Georgia, 1952; Tulane Univ., 1952; Univ. Kentucky, 1952; Memphis Acad. A., 1953; Univ. Arkansas, 1953; Museo de Arte Moderna, Madrid, Spain, 1954; Barcelona, 1954; Cedar Rapids AA, 1954. Positions: Prof. Printmaking, Dept. Art, State Univ. Iowa, Iowa City, Iowa, 1945- . Univ. Research Professorship, State Univ. of Iowa, 1965; Lucas Lecturer, Carleton College, Northfield, Minn., 1965.*

LASKER, MRS. ALBERT D.—Collector
29 Beekman Pl., New York, N.Y. 10022*

LASKER, JOSEPH LEON (JOE)—Painter
20 Dock Rd., South Norwalk, Conn. 06854
B. Brooklyn, N.Y., June 26, 1919. Studied: CUASch.; and in Mexico. Member: NAD. Awards: prizes, Abbey Mem. Scholarship, 1946-47; Prix de Rome, 1950-51; Guggenheim F., 1954; NAD Altman prize, 1958; Nat. Inst. A. & Lets. Grant, 1968. Work: WMAA; PMA; Springfield (Mass.) Mus. A., BMA; Cal. PLH; Munson-Williams-Proctor Inst.; Joseph H. Hirshhorn Coll.; murals, Henry Street Settlement, N.Y.; USPO, Calumet, Mich., Millbury, Mass. Exhibited: one-man: Kraushaar Gal., N.Y., 1951, 1955, 1959, 1964, 1969. Other exhibitions nationally. Positions: Assoc. Prof. Painting, Univ. Illinois, 1953-54; Instr., Famous Artists School, Westport, Conn., 1954- .

LASKEY, DR. and MRS. NORMAN F.—Collectors
1150 Park Ave., New York, N.Y. 10028; h. Croton Lake Rd., Mt. Kisco, N.Y. 10549
Collection: 20th Century Primitives, Fauve-Non Objective, Op, Sculpture; American Primitive.

LASSAW, IBRAM—Sculptor, L.
487 Sixth Ave., New York, N.Y. 10011; also 678 Fireplace Rd., East Hampton, L.I., N.Y. 11937
B. Alexandria, Egypt, May 4, 1913. Studied: BAID; Col. City of N.Y., and with Dorothea Denslow, Ozenfant. Member: Am. Abstract A.; A. Cl., N.Y. Work: Washington Univ., St. Louis; WMA; Cornell Univ.; BM; FMA; Newark Mus.; Wadsworth Atheneum; BMA; Albright A. Gal.; WMAA; MModA; Carnegie Inst.; Museu de l'Arte Moderna, Rio de Janeiro; Temple Beth El, Springfield, Mass.; Temple Beth El, Providence, R.I.; and for temples in Cleveland, Ohio and St. Paul, Minn.; St. Leonard Priory, Centerville, Ohio; Temple in Portchester, N.Y.; Arts Bldg., Washington Univ., St. Louis. Numerous Architectural commissions. Exhibited: WMAA, 1936-1952, 1954, 1955, 1957, 1964, 1966 (2), 1968; Brown Univ., 1965; Am. Abstract A., 1936-1955, 1962; MModA, 1951, 1953, 1956, 1967 traveling, 1969 (2); Mus. Modern A., Paris, 1950; AFA traveling Exh., 1951; Phila. A. All.; AIC, 1951, 1954, 1955; Univ. Indiana; Univ. Nebraska; PMA; Venice Biennale, 1954; Stable Gal., 1953, 1954; PAFA, 1954, 1966; Japan, 1955; Am. Exh., Paris, France, 1955; BM, 1955; Cornell Univ., Sao Paulo, Brazil, 1958; Yale Univ., 1954; Am. A. Exh., Moscow, 1959; Documenta II, Kassel, Germany; Westbury, N.Y., 1960; Carnegie Inst., 1961, 1964; CMA, 1960, 1963; Washington Gal. Mod. A., 1963; Kalamazoo A. Center, 1961; Univ. Illinois, 1961; Ringling Mus., Sarasota, 1962; Bundy Gal., 1963; Albright-Knox A. Gal., Buffalo, 1964; Cornell Univ., 1964; F.A.R. Gal., N.Y., 1964; Critics Choice, Providence, R.I., 1965; Rodin Mus., Paris, France, 1965; Israel, 1965; DMFA, 1965; Flint Inst. A., 1965; Mus. Contemp. Crafts, N.Y., 1965; White House, Washington, 1965; Herron Mus. A., 1965; St. Paul A. Center, 1966; Am. Embassy, Damascus, 1966; Drexel Inst., Philadelphia, 1966; Sc. Center, N.Y., 1968; Sachs Gal., N.Y., 1967; one-man: Mass. Inst. Tech., 1957 (retrospective): Kootz Gal., N.Y., 1951, 1952, 1954, 1955, 1958, 1960, 1963, 1964; Duke Univ., 1963; Benson Gal., East Hampton, N.Y., 1966, 1967; Gertrude Kassel Gal., Detroit, 1968, and many others in U.S. and abroad. Positions: A.-in-Res., Duke University, Durham, N.C., 1962-1963; Univ. California, Berkeley, 1965-66.

LASSITER, BARBARA BABCOCK—Collector
660 Park Ave., New York, N.Y. 10021
B. New York, N.Y., July 2, 1934. Studied: Smith College, B.A.; Parsons School of Design. Awards: Canon Cup Award, Winston-Salem, N.C., 1966. Collection: American Painting. Positions: President, Reynolda House, 1965; National Committee, Whitney Museum of American Art, 1965; Advisory Committee, Mary Duke Biddle Gallery for the Blind, North Carolina Museum, 1967; Visiting Committee, Department of American Paintings and Sculpture, The Metropolitan Museum of Art, New York City, 1968.

LASSWELL, FRED—Cartoonist
c/o King Features Syndicate, 235 East 45th St., New York, N.Y. 10017
Creator of "Snuffy Smith" syndicated cartoon.*

LATHAM, BARBARA — Painter, Gr. I.
Ranchos de Taos, N.M. 87557
B. Walpole, Mass., June 6, 1896. Studied: Norwich (Conn.) A. Sch.; ASL. Work: MMA; Mus. New Mexico; Dallas Mus. FA. Exhibited: AIC; PAFA; Denver A. Mus.; Colorado Springs FA Center; WMAA; BM; NAD; Phila. Pr. Cl.; Phila. A. All.; Lib. Cong.; one-man exh., Roswell Mus.; Weyhe Gal.; Slater Mem. Mus.; Witte Mem. Mus.; Dallas Mus. FA. I., "The Silver Dollar"; "Hurdy-Gurdy Holiday"; "Maggie"; "The Green Thumb Story"; "Honey Bee"; "Downy Woodpecker," 1953; "Monarch Butterfly," 1954; "Tree Frog," 1954; "Flying Horse Ranch," 1955; "Tales of Old-Time Texas," 1955; "I Like Caterpillars," 1958; "I Like Butterflies," 1960; "The Frightened Hero," 1966, and other juvenile books.

LATHROP, CHURCHILL PIERCE—Educator, Gal. Dir., L.
Seven Sargent St., Hanover, N.H. 03755
B. New York, N.Y., Aug. 26, 1900. Studied: Rutgers Univ., Litt. B.; Princeton Univ., A.M. Member: Am. Assn. Univ. Prof.; CAA; Soc. Arch. Historians; AAMus. Awards: Hon. degree, A.M., Dartmouth Col. Author: sections on Sculpture and the Pictorial Arts in "The Individual and the World," 1942; "Orozco at Dartmouth," 1969. Positions: Instr. A., 1928-31, Asst. Prof., 1931-36, Prof. A., 1936-1969, Chm. A. Dept., 1964-1968, Dir. Acquisitions, 1966-1969, Dir., Carpenter Gal. A., 1940-1966, Dartmouth Col., Hanover, N.H.; Bldg. Com., Hopkins A. Center, 1958-1962; Dir., Hopkins Center A. Galleries, 1962-1966.

LATHROP, DOROTHY P(ULIS)—Illustrator, W., Eng., P.
Undermountain Rd., Falls Village, Conn. 06031
B. Albany, N.Y., Apr. 16, 1891. Studied: T. Col., Columbia Univ.; PAFA; ASL, and with Henry McCarter, F. Luis Mora. Member: ANA; SAGA; Albany Pr. Cl.; Phila. WC Cl.; Academic A.; Kent AA. Awards: Caldecott Award, 1938; Eyre medal; PAFA, 1941; prize,

LC, 1946; AAPL, 1954, gold medal, 1960, prize, 1961; SAGA, 1956; A. & Crafts Assn., Meriden, Conn., 1967. Work: LC; Albany Pr. Cl. Exhibited: NAD; PAFA; LC; SAGA; NAWA. Author, I., "The Little White Goat"; "The Snail Who Ran"; "The Colt from Moon Mountain"; "An Angel in the Woods"; "Let Them Live"; "Puppies for Keeps," 1943; "The Littlest Mouse," 1955; "Follow the Brook," 1960; "The Dog in the Tapestry Garden," 1962, and many other children's books. Illus. "Animals of the Bible"; "Crossings"; "Silverhorn"; "Made-to-Order Stories"; "The Little Mermaid"; "The Snow Image"; "Mr. Bumps and His Monkey"; "The Happy Flute"; "Bells and Grass," and numerous other books.

LATHROP, GERTRUDE K.—Sculptor
Undermountain Rd., Falls Village, Conn. 06031
B. Albany, N.Y., Dec. 24, 1896. Studied: ASL; Sch. Am. Sculpture, N.Y., and with Solon Borglum, Charles Grafly. Member: NA; Nat. Inst. A. & Let.; Hispanic Soc. Am.; Am. Numismatic Soc.; All.A.-Am.; Albany Pr. Cl.; NSS; Soc. Medalists. Awards: prizes, NAD, 1928, 1931, 1936; Stockbridge AA, 1937; NAWA, 1933, 1943; Am. Acad. A. & Let. grant, 1943; NSS, 1944; All.A.Am., 1950, 1964; AAPL, 1960, 1961; Pen & Brush Cl., 1967; medals, Hispanic Soc. Am., 1950; Am. Numismatic Soc., 1950. Work: Houston (Tex.) Pub. Lib.; Albany Pub. Lib.; N.Y. State T. Col.; Smithsonian Inst.; war mem., Memorial Grove, Albany, N.Y.; commemorative Half-Dollar Albany and New Rochelle, N.Y.; medals, Garden Cl. of Am., 1942, 1950; Brookgreen Garden, S.C., 1946; Hispanic Soc. Am., 1950; Mariners' Mus., Newport News, Va., 1954; N.Y. State Univ. Hall of Fame, 1962, 1966; Nat. Steeplechase & Hunt Assn., 1964.

LAUCK, ANTHONY (REV.)—Sculptor, E., W., P., Cr., L.
University of Notre Dame; h. Moreau Seminary, Notre Dame, Ind. 46556
B. Indianapolis, Ind., Dec. 30, 1908. Studied: John Herron AI, D.F.A.; Corcoran Sch. A.; ASL; Columbia Univ., and with Richard Lahey, Louis Bouche, Julian Levi, Carl Milles, Ivan Mestrovic, Hugo Robus, Oronzio Maldarelli, Heinz Warneke. Member: Indianapolis AA; Newport AA; Audubon A.; Awards: prizes, Fairmount Park AA, 1949 (purchase); Indiana State Fair, 1954, 1955; Indiana AA, 1954; Ecclesiastical A. Gld., Detroit, 1955; gold medal; PAFA, 1953; Indiana Arts, 1962-1964. Work: PAFA; CGA; John Herron AI; Norfolk Mus. A.; Notre Dame A. Gal.; Univ. Notre Dame; South Bend AA; sculpture, Notre Dame Univ. Campus; Chicago H.S.: 16 stained glass windows, Ursiline Chapel, Chatham, Ontario, Canada. Exhibited: NAD; PAFA, 1948, 1949, 1953, 1954; Audubon A., 1948-1965; Conn. Acad. FA; Provincetown AA; New Jersey P. & S., 1948-1950, 1954; Indiana AA; Indiana State Fair; South Bend AA; Hoosier Salon; Wash. A. Exh., and others. Contributor to Catholic Art Quarterly; Ave Maria; The Priest; Catholic Digest; Liturgical Arts Quarterly; Catholic Mind. Assembled exh. of Greek Art for the A. Festival, Notre Dame, 1954; Early Christian Arts Festival, 1957, and other art exhibitions. Positions: Prof. A., Notre Dame Univ., Notre Dame, Ind., 1950- ; Hd. A. Dept. & Art Gallery, 1960-1968; Dir., Art Gallery, 1962- ; Chm. Jury for Nat. Comp. Drawings of the Sacred Heart, 1956. Indiana Commission on the Fine Arts, 1964.

LAUFMAN, SIDNEY—Painter, T.
Forum Gallery, 1018 Madison Ave., N.Y. 10021; h. 62 Glasco Turnpike, Woodstock, N.Y. 12498
B. Cleveland, Ohio, Oct. 29, 1891. Studied: AIC; ASL. Member: NA; Woodstock AA. Awards: prizes, AIC, 1932, gold medal, 1941; ASL, 1950; Carnegie Intl., 1934; gold medal, PAFA, 1951; NAD, 1st Altman Prize, 1937, 1949, gold medal, 1953, Andrew Carnegie prize, 1959; Altman prize, 1963; Ranger Fund purchase, 1954; Hassam Fund purchase, 1954, prize, Butler AI, 1st Prize Purchase Award, 1954; PAFA, Jennie Sesnan Gold Medal, 1951, Sally Jacobs Memorial Award, Woodstock A.A., 1968. Work: MMA; WMAA; MModA; Chrysler Mus.; Brandeis Univ.; Univ. Miami (Lowe Gallery); Ft. Lauderdale Mus.; Peabody Mus., Nashville, Tenn.; AIC; CMA; Toledo Mus. A.; Nelson Gal. A.; John Herron AI; Minneapolis Inst. A.; Univ. Oregon; Am. Acad. A. & Let.; Zanesville AI; Washington County Mus. FA, Hagerstown, Md.; Dudley Peter Allen Mem. Mus., Oberlin, Ohio; CAM; Butler Inst. Am. A.; Parrish Mus., Southampton, L.I.; Colorado Springs FA Center; Georgia Mus. A., Athens, Ga.; Museums of Tel Aviv and Jerusalem, Israel. Exhibited: Nationally. Retrospective exhs.: Forum Gal., N.Y., 1962; Peabody Mus., 1963; Lowe Art Gal., Univ. Miami, 1964; Ft. Lauderdale Mus., 1964. Positions: Instr., ASL, New York, N.Y., 1938-1950; Memb. Council, NAD, 1947-50; Nat. Sec., AEA, 1948-49; Pres., N.Y. Chapter, AEA, 1949-50; Chm., Woodstock A. Conf., 1950; Visiting Lecturer, Brandeis Univ., 1959-60.

LAUGHLIN, MORTIMER—Painter
245 Milbank Ave., Greenwich, Conn. 06830
B. San Francisco, Cal., July 24, 1918. Studied: Hollywood A. Center Sch., Cal.; Abbott A. Sch., Wash., D.C.; ASL. Exhibited: Art: USA, 1958; Provincetown A. Festival, 1958; SFMA; MModA; Albany

Inst. Hist. & Art; Newport AA, 1949, 1950; Stephen Austin Col., Nacodoches, Tex., 1959; Louisiana Polytechnic Inst., 1960; Northwestern State Col., 1960; Pioneer Mus. & Haggin Gals., Stockton, Cal., 1959; Silvermine Gld. A., 1964; one-man: Ruth White Gal., N.Y., 1957, 1960, 1962; The Owl Gallery, 1963.*

LAURENT, JOHN LOUIS—Painter, T., Gr.
c/o Kraushaar Galleries, 1055 Madison Ave., New York, N.Y. 10028
B. Brooklyn, N.Y., Nov. 27, 1921. Studied: Syracuse Univ., B.F.A.; Academie de la Grande Chaumiere, Paris; Indiana Univ., M.F.A., and with Walt Kuhn. Member: Boston Pr. M.; New Hampshire AA; Ogunquit AA. Awards: Hazard Traveling F., Syracuse Univ., 1948; Tiffany Fnd. award, 1960; prizes, John Herron AI, 1954; Currier Gal. A., Manchester, N.H., 1954-1960; Sweat Mus. A., Portland, Me., 1955; purchase prize, South Bend AA, 1956; Silvermine Gld. A., 1963; Nat. Council on the Arts Grant, 1966. Exhibited: PAFA, 1951, 1954; CGA, 1955; John Herron AI, 1950-1954; Sweat Mus. A., 1955; J. B. Speed Mus. A., 1954; WMAA, 1956, 1964; Currier Gal. A., 1956, 1957; Boston A. Festival, 1958; Art:USA, 1958; Wiscasset, Me., 1960-61; Butler Inst. Am. A., 1961; Provincetown A. Festival, 1958; Colby Col., 1964; Silvermine Gld. A.; Northeastern Univ., 1965; others include: DMFA; Grand Rapids A. Gal.; Univ. Illinois; Indiana Univ.; Smithsonian Inst.; Springfield Mus. FA; VMFA; one-man: Kraushaar Gal., N.Y., 1955, 1958, 1962, 1968; de Cordova & Dana Mus., 1959; Lamont Gal., Exeter Acad., N.H., 1964; Ogunquit Mus., 1968; 2-man: Bowdoin Col., Brunswick, Me., 1959. Positions: Instr., Des., Painting, Graphics, Va. Polytechnic Inst., 1949-53; Asst. Prof. Univ. New Hampshire, 1954- .

LAURENT, ROBERT—Sculptor, E., Collector
Indiana University, Bloomington, Ind. 47401; h. Cape Neddick, Me. 03902
B. Concarneau, France, June 29, 1890. Studied: British Acad., Rome, Italy; & in Paris, with H.E. Field, Frank Burty. Member: Audubon A.; F., NSS; New England Sculptors Assn.; Ogunquit AA; Salons of Am.; S.Gld., AEA. Awards: Hon. degree, D.F.A., Nasson Col., Springvale, Me., 1968; med., prize, AIC, 1924, 1938; prizes, BM, 1942; John Herron AI, 1943, 1944, 1945, 1947, 1949, 1952, 1953; J.B. Speed Mus. A., 1954; Hoosier Salon, 1945, 1946, 1947-1949, 1952, 1953; Audubon A., 1945; medal of honor and prize, 1967; Indiana A., 1957, 1959. Work: WMAA; BM; PAFA; AIC; MMA; Newark Mus.; Vassar Col.; Ariz. State Col.; PAFA; Univ. Nebraska; Barnes Fnd.; Brookgreen Gardens, S.C.; Hamilton Easter Field Fnd.; Fairmount Park, Phila., Pa.; Radio City Music Hall, N.Y.; Fed Trade Bldg., Wash., D.C.; MMA; IBM Coll.; Norton Gal. A.; MModA; Indiana Univ.; USPO, Garfield, N.J.; fountain, St. Andrews Cathedral, Honolulu; Wadsworth Atheneum, Hartford; large fountain, "Birth of Venus," Indiana Univ., 1961. Exhibited: WMAA; BM; PAFA; AIC; MMA; WFNY 1939; GGE, 1939; one-man exh.: Daniel Gal.; Bourgeois Gal.; Kraushaar Gal.; Valentine Gal.; A. & Crafts Cl., New Orleans, La.; Vassar Col.; CGA; John Herron AI; Rome, Italy, 1955; Indiana Univ. Retrospective Exh.; "Laurent—50 Years of Sculpture," 1961; one-man, Richmond Mus. A., 1957; Nasson Col., 1968. Contributor to Encyclopaedia Britannica, 1946, 1957. Collection: 19th & 20th Century American Paintings & Sculpture; French Paintings & Sculpture; Japanese Prints & Paintings; Early Italian Drawings. Positions: Prof., Indiana Univ., Bloomington, Ind., 1942- , Emeritus, 1960- ; Dir., Ogunquit Sch. P. & S., Ogunquit, Me.; Pres. Hamilton Easter Field Fnd.; A.-in-Res., Am. Acad. in Rome, 1954-55.

LAURER, ROBERT A.—Educator
Fine Arts Department, Fairleigh Dickinson University, Rutherford, N.J. 07070
B. Rochester, N.Y., Mar. 10, 1921. Studied: Univ. Rochester, B.A.; Harvard Univ., M.A. Positions: Asst. Prof., University Colorado, 1949-53; Univ. Arkansas, 1954-55; Skidmore Col., 1955-56; Asst. Dir., 1956-60, Assoc. Dir., 1960-1962, Museum of Contemporary Crafts, New York, N.Y. Acting Chm., Asst. Prof., Art Dept., Fairleigh Dickinson University, Rutherford, N.J., 1962-1968; Assoc. Prof., 1968- .

LAURITZ, PAUL—Painter, T., L.
3955 Clayton Ave., Los Angeles, Cal. 90027
B. Larvik, Norway, Apr. 18, 1889. Member: Soc. Western A.; Cal. A. Cl.; Royal Soc. A., London. Awards: prizes, Cal. State Exp., 1920, 1922-1926, 1930, 1932, 1934, 1939, 1940, 1958 (silver trophy); State Exp., Santa Ana, Cal., 1923; San Diego FA Soc., 1928; Long Beach, 1928; Pasadena AI, 1928; Pomona (Cal.) 1930; Santa Cruz, 1929, 1943, 1949, 1950; State Exp., Phoenix, Ariz., 1931, 1948; Acad. Western Painters, 1936; Cal. A. Cl., 1940, 1946, 1947, 1949, 1950, 1952, 1953 (2 gold med.), 1954 (gold medal) and 1956; Cal. PLH, 1942 (medal and prize); Los A. Mus. A., 1943, 1954; Oakland A. Gal., 1944, 1949, 1950; Friday Morning Cl., 1946, 1952, 1955; Patrons of Art, San Pedro, 1955; deYoung Mem. Mus., 1950, 1955; Long Beach, Western A., 1951; Ebell Cl., Los A., 1943, 1949, 1950, 1951, 1952,

1956, 1960; Lodi, Cal., 1956, 1957; Laguna AA, 1957, 1958; medals, SFMA, 1939; Scandinavian-Am. Painters, 1939; Soc. Western A., 1940, 1943; Cal. PLH, 1942; Oakland A. Gal., 1943, 1944, 1950; Cal. A. Cl., 1950; San Fernando AA, 1950; de Young Mem. Mus., 1949; Frye Mus. A., Seattle, 1959; Santa Paula, 1959 (2), 1962, 1964; Nat. Exh., Maine, 1959; purchase award, Cedar City, Utah, 1960; Sacramento Expo., 1962, 1964; Springville, Utah (2), and many others. Work: Vanderpoel Coll.; Univ. Chicago; San Diego FA Gal.; Univ. California; Santa Paula Chamber of Commerce; Ebell Cl., Los A.; Hollywood Athletic Cl.; Cal. State Coll.; Joslyn Mus. A., Omaha; Los Angeles City College, and in many H.S. and private coll. Exhibited: nationally.

LAWRENCE, JACK—Collector
229 E. 52 St., New York, N.Y. 10022*

LAWRENCE, JACOB—Painter, I.
211 W. 106th St., New York, N.Y. 10025
B. Atlantic City, N.J., Sept. 7, 1917. Studied: Am. A. Sch.; Harlem A. Workshop. Member: AEA; Nat. Inst. A. & Lets. Awards: prize, MMA, 1942; medal, AIC, 1948; grant, Am. Acad. A. & Let., 1953; Chapelbrook F., 1955; Guggenheim F., 1946; Rosenwald F., 1940-1942; Retrospective Exh. sponsored by Ford Fnd., 1960. Work: MMA; MModA; WMAA; PC; BM; BMA; VMFA; WMA; Mus. Modern A., Sao Paulo, Brazil; Alabama Polytechnic Inst.; Portland (Ore.) Mus. A.; Wichita A. Mus.; Albright-Knox A. Gal., Buffalo; Am. Acad. A. & Lets.; R.I. Sch. Des.; Container Corp. Am. Illus., Fortune magazine; "One Way Ticket," 1948; Time magazine cover, Aug. 1968. Book: "Harriet and the Promised Land," 1968. Exhibited: nationally. One-man: Downtown Gal., N.Y.; M'Bari A. & Writers Club, Nigeria, 1962; Terry Dintenfass Gal., N.Y., 1963; Johnson Wax Co. world tour exh., 1963; State Dept. exh., Pakistan, 1963; State Dept. exchange exh. with Soviet Union, 1959. Positions: A.-in-Res., Brandeis University, Waltham, Mass., 1965. Served on Fulbright Art. Com., 1966-1967; Instr., Pratt Inst., 1958-1967; New Sch., N.Y., 1966- ; ASL, 1967- .

LAWRENCE, MARION—Educator, Historian, W.
88 Morningside Dr., New York, N.Y. 10027
B. Longport, N.J., Aug. 25, 1901. Studied: Bryn Mawr Col., A.B.; Radcliffe Col., A.M., Ph.D.; Am. Acad. in Rome; Inst. for Advanced Study, Princeton, N.J. Member: CAA; Archaeological Inst. Am.; Mediaeval Acad. Am. Awards: Carnegie F., 1926-1927; F., Inst. for Advanced Study, 1941-1942; Fulbright award, 1949-50. Author: "The Sarcophagi of Ravenna," 1945. Contributor to: art magazines & journals. Lectures: Early Christian Art, Roman Art, Iconography, etc. Positions: Instr., Asst. Prof., Assoc. Prof., Prof., Chm. FA Dept., Barnard Col., Columbia Univ., New York, N.Y., 1929-1968, Emeritus, 1968- ; Pres., Mediaeval Cl. of N.Y., 1953-55; Pres. Women's Faculty Cl., Columbia Univ., 1958-60.

LAWSON, EDWARD PITT—Assistant Exhibitions Administrator
International Exhibitions Foundations, Inc., 1616 H St., N.W., Washington, D.C. 20006
B. Newton, Mass., Sept. 12, 1927. Studied: Bowdoin Col., B.A.; N.Y. Univ., Inst. FA, A.M. Member: Medieval Acad. of America; AAMus.; Canadian Mus. Assn. (Council Memb. 1963-); Province of Quebec Mus. Assn. (V-Pres., 1963-65, Pres., 1965-); Archaeological Inst. of Am. Awards: Belgian-American Summer Fellowship, 1956; Metropolitan Museum of Art Travel Grant, 1961. Positions: Instr., Toledo Mus. A. Sch. of Design, 1954-56; Curatorial Asst., 1956-57, Supv. A. Edu., 1957-59, Toledo Mus. A.; Asst. Cur., The Cloisters, New York, N.Y., 1959-1962; Asst. Director, Montreal Museum of Fine Arts, 1962- ; Visiting Lecturer, Sir George Williams University, Montreal, 1963-1967; Dir., Tucson Art Center, Arizona, 1967-1969; Lecturer, Univ. of Arizona, 1968-1969; Vice-Pres., Western Mus. League, 1969- ; Administrative Asst., International Exhibitions Fnd., Inc., Washington, D.C. 1969- .

LAX, DAVID—Painter, E., Lith.
Box 94, Red Hook, N.Y. 12571
B. New York, N.Y., May 16, 1910. Studied: Ethical Culture Sch.; & with Victor Frisch, Alexander Archipenko. Member: F.I.A.L. Awards: prizes, Ethical Culture Sch., 1929; Mills grant, 1932-1940. Work: War Dept., Wash., D.C.; Clearwater A. Mus.; Grand Central Gal.; Gal. Mod. A., New York City; in Paris, France; Veteran's Admin. Bldg., N.Y. (mural); s. frieze, Brill Bldg., N.Y. Book of paintings, "Denunciation, A Series of Paintings Concerning Man's Fate." Exhibited: War Dept., Wash., D.C., 1945; Galerie Borghese, Paris, 1945; Convocation of Arts, State Univ. of New York, 1969; one-man exh.: Grand Central Gal., 1940, 1944, 1949; Mus. Sc. & Indust., Radio City, N.Y., 1945; Union Col., 1945; Filene's, Boston, 1945; Westfield Atheneum, 1945; Providence Sch. Des., 1945; High Mus. A., 1945; Clearwater A. Mus., 1945; Zanesville AI, 1945; Springfield A. Mus., 1946; Mus. New Mexico, Santa Fé, 1946; de Young Mem. Mus., 1946; Crocker A. Gal., 1946; Portland A. Mus.,

1946; Assoc. Am. A., Los A. & N.Y., 1950; British Mus., London; N.Y. Pub. Lib.; Columbia, Harvard Univ.; FMA; SAM, 1946; also, Carnegie Inst., 1940; Grand Central Gal., 1939-1946; Arden Gal., 1941; CGA, 1943; Phila. A. All., 1939; Joslyn Mem., 1941. I., "A Series of Paintings of the Transportation Corps., U.S. Army, in the Battle of Europe," 1945; Contributor to: Yank magazine, newspapers & art periodicals. Positions: Chm., Art Department, Dutchess Community College, Poughkeepsie, N.Y., at present.

LAYCOX, (WILLIAM) JACK—Painter, I., Des.
 1533 San Luis Rd., Walnut Creek, Cal. 94596; (Mail): P.O. Box 5054, Carmel, Cal. 93921
B. Auburn, Cal., Mar. 11, 1921. Studied: Univ. Cal., Berkeley; San Francisco State Col., B.A. Member: Soc. Western A.; Diablo AA, Walnut Creek, Cal. Awards: prizes, Diablo Pageant of the Arts, 1959, 1961; Soc. Western A., 1963; Jack London Festival, Oakland, Cal., 1962; Livermore (Cal.) A. Festival, 1963; Diablo annuals, Walnut Creek, 1962, 1963, 1965; Cal. State Fair, 1965. Work: St. Mary's Col., Cal.; Chamber of Commerce, Spokane; Stockton Port Commission; Naval Hospital, Oakland; Crown Zellerbach Coll., San Francisco; Latter Day Saints, Salt Lake City, Utah; Phillips Petroleum Corp., San Francisco; Shell Chemical Co.; Peninsula Nat. Bank, Burlingame, Cal.; Yosemite Park; Hanover Trust Co., N.Y.; Port Authority, Portland, Ore., and others. Work also in private colls. Exhibited: AWS, 1965, 1966 and traveling, 1965; Contemp. Am. A. Exh., Tokyo and Kyoto, Japan, 1965; Soc. Western A., San Francisco, 1963, 1964, 1966, 1967; Cal. State Fair, 1963, 1964, 1966-1968; De-Saisset Gal., Santa Clara, Cal., 1962, 1964; Diablo AA, Walnut Creek, Cal., 1960-1965; Diablo Pageant of Arts, 1959-1962; Zellerbach Plaza, San Francisco, 1964; Brooks Mem. Mus., Memphis, 1965; Yellowstone A. Center, Billings, Mont., 1965; one-man: Sandpiper Gal., Monterey, Cal., 1962; Lincoln Square Gal., Oakland, 1964, 1965; Royce Gals., Los Angeles, 1966-1968; Winblad Gals., San Francisco, 1964-1966; Parks Gal., San Jose, 1966-1968. Illustrations to Christian Science Monitor. Numerous lectures, many with slides and demonstrations. Positions: Technical Illustrator, Atomic Energy Comm., 1943-1956; A. Dir., Bacon American Corp., 1949-1956; Illus., Donald Art Co., 1965- ; Des., Mission Card Co., 1966- .

LAYTON, GLORIA (Mrs. Harry Gewiss)—Painter
 1842 Watson Ave., New York, N.Y. 10072
B. New York, N.Y., Jan. 5, 1914. Member: AAPL; Conn. Acad. FA; All. A. Am.; AEA; A. Lg. of Ling Island; NAWA. Awards: prize, Conn. Acad. FA, 1956; Silvermine Gld. A., 1959; All. A. Am., 1959, 1963. Exhibited: NAD, 1954, 1958; All. A. Am., 1939-1964; NAC, 1939-1961, 1964; AAPL, 1958-1961, 1964; Butler Inst. Am.A., 1953, 1954, 1957, 1958; Academic A., Springfield, 1958-1961, 1964; Eastern States Exh., 1957, 1960; Conn. Acad. FA, 1956, 1958, 1963, 1964; Silvermine Gld. A., 1957, 1958, 1959; Hudson Valley AA, 1953, 1955, 1958, 1959, 1962; New Sch. Assoc., 1957; So. Vermont A. Center, 1957; Ogunquit A. Center, 1954, 1955; A. Lg. of Long Island, 1956, 1963; Audubon A., 1957; Catherine L. Wolfe A. Cl., 1958, 1959, 1961, 1963, 1964; P. & S. Soc. of New Jersey, 1954, 1955; Knickerbocker A., 1953, 1955, 1961; Seton Hall Univ., 1958; N.Y. Coliseum, 1957; ACA Gal., 1959; Galerie Internationale, N.Y., 1960; Berkshire AA, 1961; NAWA, 1960-1964; Cooperstown AA, 1961. Work: Norfolk Mus. A. & Sciences; ports. in private colls. Positions: Rec. Sec., 1957-60, Asst. Treas., 1961-1963, Awards Fund Chm., 1961-1963, Catalog Chm., 1957-63, Jury of Selection, 1959, 1961, All. A. Am.; Publ.Chm., NAWA, 1962; U.S. Delegate, Int. Assn. Plastic Arts, 1962-63; Delegate, FA Fed. of N.Y. 1962-63.*

LAZARD, ALICE A.—Painter
 1610 Linden Ave., Highland Park, Ill. 60035
B. New Orleans, La., 1893. Studied: Newcomb Col., Tulane Univ.; AIC. Member: North Shore A. Lg.; AEA; Evanston A. Center, AIC. Awards: prizes, North Shore A. Lg., 1948-1952; Mile of A. Exh., Highland Park, 1954. Work: Vanderpoel Coll.; Sinai Temple, Chicago; Vance Publ. Co., Chicago. Exhibited: MModA; AIC; PAFA; Am. Lib. Color Slides; Springfield A. Mus.; Evanston, Ill.; Winnetka, Ill.; Roosevelt Univ., 1959; Ravinia (Ill.) A. Festival, 1959; Old Orchard A. Fair, 1959, 1960, 1964; AEA Exh., Univ. of Chicago & Navy Pier, 1960, 1961, and Monroe Gal., and City Hall, Chicago; Park Ridge, Ill., 1960, 1961; Methodist Church, Chicago, 1960, 1961; Bethel Festival, Glencoe, Ill., 1960; Sun Times Exh., Chicago, 1961; Springfield State House; Presbyterian Church, Springfield, 1964; one-man: Avant Garde Gal., N.Y., 1959; Strassel Co. galleries, Louisville, Ky.; Miami Mus. Mod. A., 1960; Ravinia A. Gal.; Congregational Church, Mason City.

LAZAREVICH, EMIL—Sculptor
 1958 Ivy Lane, Palo Alto, Cal. 94303
B. San Francisco, Cal., Apr. 11, 1910. Awards: Bronze Medal, Cal. State Fair; purchase awards, San Francisco Art Commission and San Francisco AA. Exhibited: Santa Barbara Mus. A.; MMA;

San F. AA; Jepson AI, Los Angeles; de Young Mem. Mus., San Francisco; Cal. State Fair; Long Beach Mus. A.; A. Center of La Jolla; Fullerton (Cal.) Col.*

LAZZARI, PIETRO—Painter, S.
 3609 Abermarle St., Northwest, Washington, D.C. 20008
B. Rome, Italy, May 15, 1898. Studied: Ornamental Sch. of Rome, M.A. Member: NSMP; A. Gld. of Wash.; Soc. Wash. A.; AAUP. Awards: Fulbright F., 1950; prize, Ornamental Sch. Rome; BMA; Soc. Wash. A.; CGA; Wash. WC Cl. Work: BMA; AIC; PC; Collectors of Am. A.; Howard Univ.; American Univ.; Honolulu Acad. FA; SFMA; Truman Lib.; Roosevelt Lib., Hyde Park, N.Y.; WMAA; CGA; Smithsonian Inst.; BMA; murals, Jasper, Fla.; Brevard, N.C. Sanford, N.C. Bronze bust of Eleanor Roosevelt, Roosevelt Lib.; bronze bust, Adlai Stevenson at U.S. Mission to the United Nations; bronze bust, Norman Thomas at Debs Mus., Terre Haute, Ind.; sc. frieze, Watergate West, Wash., D.C.; bronze monument of founder, Gallandet College, Wash., D.C. Exhibited: MMA, 1942; WMAA, 1934, 1956, 1957, 1964; AIC, 1943, 1952; NAD, 1944, 1945; Contemporary A. Gal., 1939; Whyte Gal., 1943; Crosby Gal., 1945; Musée Nationale d'Art Moderne, Paris, France, 1954; Smithsonian Inst.; CGA; PAFA, 1965; BMA; Arch. Lg.; MModA, 1957; Venice, 1948; Betty Parsons Gal., N.Y., 1955, 1959; Gal. International, N.Y., 1965; Stuttman Gal., Wash., D.C., 1968; Wang Wing Gal., Wash., D.C., 1969. Illus., "Washington is Wonderful."

LEA, TOM—Painter, I., W.
 2401 Savannah St., El Paso, Tex. 79930
B. El Paso, Tex., July 11, 1907. Studied: AIC. Work: Dallas Mus. FA; El Paso Mus. A.; State Capitol, Austin, Tex.; Pentagon War Art Coll.; murals, Court House, El Paso, Tex.; El Paso Pub. Lib.; USPO, Pleasant Hill, Mo.; Odessa, Tex. Author: I., "Peleliu Landing," 1945; "A Grizzly from the Coral Sea," 1944; "The Brave Bulls," 1949; "The Wonderful Country," 1952; "The King Ranch" (2 vols.), 1957; "The Primal Yoke," 1960; "The Hands of Cantu," 1964. Contributor to Life Magazine, eye-witness paintings of war, accompanying text; Atlantic Monthly. Exhibited: One-man: Ft. Worth (Tex.) A. Center, 1961; El Paso Mus. A., 1963. Positions: A., War Correspondent, Life Magazine, 1941-45.*

LEACH, FREDERICK DARWIN—Educator, P., Lith., Eng., L., Cr.
 Hamline Univ., 55101; h. 1650 Hewitt Ave., St. Paul, Minn. 55104
B. Arkansas City, Kans., Sept. 19, 1924. Studied: James Millikin Univ., B.A., Univ. Wisconsin; State Univ. Iowa, M.A., M.F.A., Ph.D. Member: AAUP; Midwest Col. A. Conf.; CAA. Awards: prizes, Central Illinois A.; Ohio State Fair; Exhibition 80; Ball State T. Col. Lectures: Contemporary Art; Renaissance, Baroque, Classical Art; Italian Renaissance; Theory of Art. Positions: Asst. Prof., A., State Univ. Iowa; James Millikin Univ.; Prof. A. & Dir. School of Painting & Allied Arts, Ohio University, Athens, Ohio, 1956-1968; Prof., A., Hamline Univ., St. Paul, Minn., 1968-1969.

LEAKE, EUGENE WALTER, JR.—Painter, E., L.
 Maryland Institute, 1300 Mt. Royal Ave., Baltimore, Md.; h. Garrison Forest Rd., Garrison, Md. 21055
B. Jersey City, N.J., Aug. 31, 1911. Studied: Yale Sch. A. & Arch., B.F.A., M.F.A.; ASL. Work: BMA; J. B. Speed A. Mus., Louisville, Ky. Exhibited: Butler AI, 1952, 1953; BM, 1943; AIC, 1942; MMA, 1942; Ohio Valley Watercolor Exh., 1948, 1950, 1952; Virginia Intermont Col., 1950, 1952; PAFA, 1957; Columbia Biennial, 1957; Art: USA, 1958; Interior Valley Exh., 1955, 1958; Betty Parsons Gal., 1959-60; M. Knoedler, 1960; MModA, 1960. Positions: Dir., Art Center Assn., Louisville, Ky., 1949-1959; Pres., Maryland Institute, Baltimore, 1961- .

LEAKE, GERALD—Painter
 1000 15th St., Marathon, Fla. 33050
B. London, England, Nov. 26, 1884. Member: ANA; SI; NAC; Royal Soc. A., London; Lakeland FA Soc.; Key West A. & Hist. Soc. Awards: prizes, SC, 1923, 1926, 1927; NAD, 1934, 1937; Key West A. & Hist. Soc., 1952, 1953; Grumbacher award, 1953; medals, All. A. Am., 1929; NAD; Fla. Southern Col., 1952. Work: NAC. Exhibited: Norton Gal. A., Palm Beach; Naples, Fla.; and in Dallas, Fort Worth, Tex.; Atlanta, Ga.; Royal Acad., England; Royal Soc. British A.; Walker Gal., Liverpool, England; NAD; All. A. Am.; NAC; SC; Conn. Acad. FA; Grand Central A. Gal.; BMFA; AIC; PAFA; CGA; Albright A. Gal.; Santa Barbara Mus. A.; Detroit Inst. A.; Knoedler Gal.; Ogunquit A. Cl., Maine; one-man: Ferargil Gal.; Grand Central A. Gal.

LEAVITT, THOMAS WHITTLESEY—Museum Director
 Andrew Dickson White Museum of Art, Cornell University, 27 East Ave.; h. 220 Triphammer Rd., Ithaca, N.Y. 14850
B. Boston, Mass., Jan. 8, 1930. Studied: Middlebury Col., A.B.;

Boston Univ., M.A.; Harvard Univ., Ph.D. Member: CAA; Western Assn. A. Mus. Pres., 1966-1967; Assn. A. Mus. Dirs. Awards: Bacon Traveling Fellowship, Harvard Univ., 1956. Contributor articles to art periodicals. Lectures: Frequent lectures on art and museums. Arranged numerous exhibitions. Positions: Exec. Dir., The Fine Arts Comm. of the People-to-People Program, Wash., D.C.; Asst. to Dir., Fogg Museum of Art, 1954-56; Dir., Pasadena Art Museum, Pasadena, Cal., 1957-1963; Director, Santa Barbara Museum of Art, Santa Barbara, Cal., 1963-1968; Lecturer, Univ. California at Santa Barbara, 1965-1968; Dir., Andrew Dickson White Museum of Art, Cornell Univ., 1968- , Prof., Dept. of History of Art, 1968- .

LEBEDEV, VLADIMIR—Painter
144 E. 36th St., New York, N.Y. 10016
B. Moscow, Russia, June 17, 1911. Studied: Acad. A., Leningrad. Member: AFA; AEA. Work: Acad. A., Leningrad; in museums of Moscow and Khazan, Russia; in private colls., Cleveland, Los Angeles and New York. Awards: Block Island (R.I.) Exh., 1961. Exhibited: in France, Holland, Belgium and Germany, 1945-1950; M. Antoville Gal., N.Y., 1956, 1958; Barzansky Gal., N.Y., 1957 (oneman); Block Island, R.I., 1961; Maryhill Mus. A., Maryhill, Wash., 1961; NAD, 1965, 1966; Butler Inst. Am. A., 1965; Brooklyn Col., 1968; Pacem in Terris Gal., New York City, 1969.

LEBER, ROBERTA (McVEIGH)—Craftsman, T.
Wingarth Studios; h. 117 Leber Rd., Blauvelt, N.Y. 10913
B. Hoboken, N.J. Studied: N.Y. State Col. Ceramics, Alfred Univ., B.S.; Columbia Univ. Member: Artists-Craftsmen of N.Y. (Vice-Pres. 1958); Keramic Soc. N.Y. (hon. memb.); AAUS; Religious Soc. of Friends. Exhibited: WMA; MMA; WFNY 1939; Seligmann Gal.; Argent Gal., N.Y.; Univ. Minnesota; Staten Island Mus. A. & Sc., 1955; Syracuse Mus. FA, 1958, 1964, and prior. Positions: Instr., Ceramics, Hd. Ceramic Dept., Craft Students Lg., New York, 1939- ; Rockland Fnd., 1953- . (Bd. Dirs., 1963-65, 1968, 1969); Art Coordinator-Community Resources Pool, So. Orangetown Central School Dist. No. 1, Orangeburg, N.Y., 1962, 1963; Bd. Dirs., Artist-Craftsmen of New York, 1968.

LECHAY, JAMES—Painter, E.
State University of Iowa; h. 1191 Hotz Ave., Iowa City, Iowa 52240; s. Wellfleet, Mass.
B. New York, N.Y., July, 1907. Studied: Univ. Illinois, B.A. Awards: prizes, PAFA, 1942; med., AIC, 1941, 1943; Iowa State Fair, 1946, 1951, 1955; Denver A. Mus.,1946; Walker A. Center, 1947; Minnesota Centennial, 1949; Des Moines A. Center, 1950, 1952, 1953, 1960 (purchase); Davenport A. Center, 1950; Hon. degree, D.F.A., Coe College, 1961. Work: AIC; PAFA; Univ. Arizona; State Univ. Iowa; BM; New Britain Mus. A.; Davenport A. Center; Syracuse Univ.; Rensselaer Polytechnic Inst.; Davenport A. Center; Mulvane A. Center, Topeka; Univ. Nebraska; Illinois Wesleyan Univ.; Wichita A. Center; Philbrook A. Center; Brooks Mem. Mus.; Des Moines A. Center; Coe College; Iowa State T. Col.; Joslyn Mem. A. Mus.; AGAA. Exhibited: nationally. One-man: Akron, Ohio; Rochester, Minn.; New York City; Toledo, Ohio; Chicago, Ill.; Springfield, Ill.; Louisville, Ky.; Wesleyan Univ., Conn.; Hollins Col.; Mary Baldwin Col.; Grinnell Col., 1966; Randolph-Macon Col.; Joslyn A. Mus.; in Iowa: Cedar Rapids, Des Moines, Iowa City, Ft. Dodge, Cedar Falls, Davenport, Mt. Pleasant, Sioux City and Univ. Iowa, 1967; Kraushaar Gal., N.Y., 1955, 1960, 1965, 1968, and others. Positions: Prof. A., State Univ. of Iowa, Iowa City, Iowa; Instr. Painting Stanford Univ., 1949; N.Y. Univ., 1953; Skowhegan Sch. Painting & Sculpture, 1961.

LE CLAIR, CHARLES (GEORGE)—Painter, E., L.
Tyler School of Art, Beech & Penrose Aves.; h. 7614 Lafayette Ave., Philadelphia, Pa. 19126
B. Columbia, Mo., May 23, 1914. Studied: Univ. Wisconsin, B.S. in Edu.; Columbia Univ., and with Cameron Booth. Awards: prizes, Albright A. Gal., 1944; Assoc. A. Pittsburgh, 1947, 1948, 1951, 1952, 1954, 1955, 1956, 1957, 1960; Butler Inst. Am. A., 1956; "Pittsburgh Artist of the Year," 1957; Pittsburgh Playhouse Comp., 1950; Ford F., 1952-53; Pennell Medal, PAFA, 1965. Work: Milwaukee Journal Coll; Albright A. Gal.; Wisconsin Union; Madison Pub. Schs.; Tuscaloosa Pub. Sch.; Ala. Col. for Women; Hundred Friends of Pittsburgh coll.; Butler Inst. Am. A. Exhibited: Carnegie Inst., 1941, 1943-1945, 1947-1949; AIC, 1944, 1945; VMFA, 1944; Albright A. Gal., 1944-1946, 1955; MMA, 1950; WMAA, 1951, 1956; Butler AI, 1951, 1956; CGA, 1953; one-man: Carnegie Inst., 1954; Rochester Inst. Tech., 1958; Salpeter Gal., 1956, 1959, 1965. Author: "Integration of the Arts" in Accent on Teaching, 1954. Positions: Hd. Dept., A., Asst. Prof., Univ. Alabama, 1935-42; Ha. A. Dept., Asst. Prof., Albion Col., 1942-43; Instr. A., Albright A. Sch., 1943-46; Hd. A. Dept., Assoc. Prof., 1946-52, Prof. 1952-60, Chatham College, Pittsburgh, Pa.; Dean, Tyler School Fine Arts, Temple University, Philadelphia, Pa., 1960- .

LEDERER, WOLFGANG—Designer, I., E.
251 Kearny St., San Francisco, Cal. 94108; h. 325 Molino Ave., Mill Valley, Cal. 94941
B. Mannheim, Germany, Jan. 16, 1912. Studied: Akademie fuer Graphische Kuenste und Buchgewerbe, Leipzig, Germany; Academie Scandinave, with Othon Friesz, Paris, France; Officina Pragensis, with H. Steiner-Prag, Prague, Czechoslovakia. Work: SFMA. Exhibited: San F. AA, 1943; one-man: Vienna, Austria, 1937; Elder Gal., San Francisco, 1941; SFMA, 1942. I., A. Dir., Western Farm Publications; Lectures: Design; Illustrations; The Work of H. Steiner-Prag, museums and art societies. Book design, Univ. of California Press and others. Positions: Prof., Graphic Des. & Illustration, Chm., Dept. Design, California College of Arts & Crafts, Oakland, Cal., 1945- .

LEDERMAN, MARTIN—Collector
50 Central Park West, New York, N.Y. 10023
B. Dresden, Germany, Apr. 13, 1904. Collection: Modern paintings; Chinese art; Rare books; Incunabula; Calligraphy; Typography; Illustrated books—15th to 20th centuries; Judaica.*

LEDYARD, WALTER WILLIAM (DR.)—Collector, Sculptor
2009 Hampton St. 29204; h. 3900 McGregor Drive, Columbia, S.C. 29206
B. Rockford, Ill., Mar. 6, 1915. Studied: Rockford College; University of Illinois, A.B.; University of Illinois College of Medicine, M.D. Work: sculpture, South Carolina State Art Collection, and in private collections in U.S., Japan, Taiwan, etc. Exhibited: Columbia Museum of Arts, 1965; So. Sculptors exhibition, Clemsen, 1966. Collection: Graphics and Sculpture. Positions: Board of Trustees 1963- , Vice-President, 1967, 1968, President, 1969, Columbia Mus. of Arts; Bd., South Carolina Artists Guild, 1965.

LEE, AMY FREEMAN—Painter, Cr., L., W., T.
127 Canterbury Hill, San Antonio, Tex. 78209; s. Box 446, Ogunquit, Me. 03907
B. San Antonio, Tex., Oct. 3, 1914. Studied: Univ. Texas; special work, aesthetics and criticism, Incarnate Word Col. Member: Nat. Soc. A. & Let.; AFA; Boston Soc. Indp. A.; New Orleans AA; San Antonio A. Lg.; NAEA (Western AA Div.); Silvermine Gld. A.; Hon. memb., Kappa Pi; Texas FA Assn.; Am. Soc. for Aesthetics; Nat. Soc. Ptrs. in Casein; Texas A. Edu. Assn.; CAA; AEA; Assn. Internationale des Critiques d'Art, Paris, France; Cal. Nat. WC Soc. Awards: prizes, San Antonio A., 1949, 1956; Smith Col., 1950; Soc. Indp. A.; Charles Rosen award, 1950; Texas FA Assn., 1950, 1958, citation, 1959; Texas WC Sco., 1955, 1964 (purchase); Nieman-Marcus award, 1953; Grumbacher award, 1953; Hall Mem. (purchase), 1954; Rosengren award, 1953; Silvermine Gld. A., 1957; Beaumont Mus., 1957; "Artist of the Year," San Antonio, 1958; Theta Sigma Phi Headliner award, 1958; Witte Mem. Mus., 1959-1960, 1969; and Elizabeth Arden Purchase award, 1961; El Paso Mus. A., 1964; S.W. WC Soc., 1966, 1969; Otis A. Inst.; 1967; Beaumont Mus., 1967; many honorary awards, 1962-1964; Hon. Deg., LL.D., Incarnate Word College, San Antonio, 1965, and others. Work: Witte Mem. Mus.; Smith Col.; Baylor Univ.; BMA lending coll.; Community Guidance Center, San Antonio; Feldman Coll., Dallas (Republic Nat. Bank); Housing project for the Aged, San Antonio, Ft. Worth A. Center; Norfolk Mus. A.; Univ. Texas; Beaumont Mus. Exhibited: Miami Beach A. Center, 1947; New Orleans AA, 1948, 1953, 1954; Boston Soc. Indp. A., 1949-58; State T. Col., Indiana, Pa., 1949, 1951, 1952, 1954; Colorado Springs FA Center, 1950; Newport AA, 1951, 1954; Alabama WC Soc., 1952; Fla. Southern Col., 1952; Experimental Painters, New Zealand, 1948; Dayton AI, 1950, 1951; Witte Mem. Mus., 1945-1955, 1957, 1958-1961, 1965; Texas WC Soc., 1950-1955, 1959-1961, 1965; Texas FA Assn., 1946-1955, 1959, 1960, 1963, 1966-1969; Beaumont Mus., 1952, 1959, 1960; Knoedler Gal., 1952; Houston Contemp. A., 1952; Texas P. & S., 1949, 1953-1955; Maine WC Soc., 1953-1955; Butler AI, 1954, 1958; McNay AI, 1955; Silvermine Gld. A., 1955, 1959, 1960; Foreign Service of U.S.A., Paris, 1956; DMFA, 1956, 1957, 1958, 1959; Feldman Exh., 1956-1958, 1959; Austin, Tex., 1956-1958; Audubon A., 1957, 1965; PAFA, 1957, 1961; Exchange Exh., Paris, France, 1956-58; Waco Mus., 1959; AWS, 1959; Delgado Mus., 1959-1961; Miami Beach A. Center, 1959; Dalzell Hatfield Gal., 1960; Norfolk Mus., 1961; Miss. AA, 1961; San Antonio Adult Edu. Center, 1962, and many others (1962-1969.) One-man: Beaumont Mus., Randolph Gal., Houston, Arizona State Univ., all 1966. Author: "Hobby Horses"; "A Critic's Note Book"; "Remember Pearl Harbor." Positions: A. Cr., San Antonio Express, 1939-41; Staff Cr., Radio Station KONO, San Antonio, 1947-51; L., Trinity Univ., 1954-56; San Antonio AI, 1955-56, and many other colleges, libraries, organizations, and museums, 1956-1969.

LEE, CUTHBERT—Portrait Painter
327 Charlotte St., Asheville, N.C. 28801
B. Boston, Mass., June 26, 1891. Studied: Harvard Univ., A.B.;

Académie Julian, Paris, France. Member: AAPL; Harvard Cl.; Pen & Plate Cl.; Biltmore Forest Country Cl. Work: Busch-Reisinger Mus., Harvard; Columbia Univ.; Columbia Cl.; Univ. North Carolina; Georgia Inst. Technology; Capitol, North Dakota; Governor's Mansion, N.C.; De le Brook Manor, Md.; Studebaker-Worthington Corp., N.Y.; Episcopal Cathedrals, Boston and Atlanta; Federal Court of Appeals; Am. Hospital Assn., Chicago. Author: "Contemporary American Portrait Painters," 1929; "Early American Portrait Painters," 1930; "Portrait Register," 1969.

LEE, DORIS—Painter, Gr., I.
 R.D. 496, Woodstock, N.Y. 12498
B. Aledo, Ill., Feb. 1, 1905. Studied: Rockford Col.; Kansas City AI, with Ernest Lawson; Cal. Sch. FA, with Arnold Blanch and in Paris, France with Andre Lhote. Member: An Am. Group; Woodstock AA. Awards: prize and medal, 1935, prize, 1936, AIC; med., PAFA, 1944; Hon. deg., LL.D., Rockford Col.; D.L.T., Russell Sage Col.; prizes, Carnegie Inst., 1943; LC, 1947; A. Dir. Cl., N.Y., 1946, 1950, gold medal, 1957; WMA, 1938; Berkshire Annual, 1964. Work: mural, USPO, Wash. D.C.; AIC; MMA; LC; PMG; Albright-Knox A. Gal.; Univ. Nebraska; Cranbrook Mus.; Encyclopaedia Britannica Coll.; PAFA Lowe Gal., Miami; Honolulu Acad. FA; R.I. Sch. Des.; Univ. Arizona; Rockford Col.; Mt. Holyoke Mus.; Fla. Gulf Coast A. Center. Exhibited: nationally. One-man, World House, N Y.C., 1965. Contributor to Life Magazine. I., "The Great Quillon"; "Hired Man's Elephant"; "St. John's River," "Painting for Enjoyment," "Mr. Benedict's Lion"; "Rodgers & Hart Songbook"; "Touch Blue," 1958. Des. curtain for "Oklahoma!" Guest Artist, Univ. Hawaii, 1957.*

LEE, GEORGE JOSEPH—Museum Curator
 Yale University Art Gallery, 1111 Chapel St. 06520; h. 10 Edgewood Ave., New Haven, Conn. 06511
B. Boston, Mass., July 14, 1919. Studied: Harvard Univ., A.B., A.M. Member: Chinese A. Soc. of Am.; Oriental Ceramic Group (London); Oriental Club of New York City. Awards: Chinese Government Cultural Fellowship, Harvard Univ., 1945-48. Contributor of articles to scholarly magazines, museum bulletins and catalogues. Exhibited: one-man: CGA, Color photographs, 1969. Some exhs. arranged: "The Floating World of Japan" (BM, 1950); "The Art of T'ang China" (New York, 1953); "Thank God for Tea!" (Brooklyn, 1955); "Many an Urn and Pot" (Brooklyn, 1959) "Chinese Paintings at Yale," Yale Univ., 1963; "Islamic Art at Yale," Yale Univ., 1969. Positions: Staff Memb., Harvard Army Specialized Training Program (Far Eastern Language and Area Studies) and (simultaneously) Fogg Mus. A., 1942-45; Asst. Cur., Oriental A., Fogg Mus. A., 1948-49; Cur. Oriental Art, Brooklyn Museum, 1949-59; Cur. Oriental Art, Yale University A. Gal., New Haven, Conn., 1959- .

LEE, MANNING DE VILLENEUVE—Painter, I.
 Boxwood Farm, Ambler, Pa. 19002
B. Summerville, S.C., Mar. 15, 1894. Studied: PAFA, with Hugh Breckenridge, Daniel Garber, Philip Hale. Member: Phila. A. All.; F., Royal Soc. A., London. Awards: 2nd Toppan prize, PAFA, 1922; Cresson traveling scholarship, 1921. Work: U.S. Mint. Phila., Pa.; series commemorative postage stamps for Republics of Liberia and Indonesia (the original portraits of the Presidents of Liberia, made for the stamp series, hang in the Executive Mansion in Monrovia); 1947, 1948; Republic of Guinea, 1960. U.S. Naval Acad., Annapolis, Md.; William S. Hart County Mus., Los Angeles, Cal. I., numerous books & contributor to national magazines. Illus., Vol. I of "The Children's King James Bible," with 400 illus. in color & black & white, 1960; Vol. II, 1961.

LEE, RENSSELAER WRIGHT—Educator, L.
 120 Mercer St., Princeton, N.J.
B. Philadelphia, Pa., June 15, 1898. Studied: Princeton Univ., A.B., Ph.D. Member: Archaeological Inst. Am.; Am. Acad. A. & Sciences; Mediaeval Acad. Am.; CAA; Am. Soc. for Aesthetics; Renaissance Soc. of Am. (Bd. Dirs., 1961-). Positions: Assoc. Prof. A., 1931-33, Prof. Chm. A. Dept., 1933-40, Northwestern Univ.; Prof. A., Smith Col., 1941-48; Columbia Univ., 1948-54; N.Y. Univ., 1954-55; Chm. Dept., Princeton Univ., 1955- ; Ed., The Art Bulletin, 1943, 1944; Chm. Com. Research & Publ. in FA, Am. Council of Learned Soc., 1942-44, Bd. of Dir., 1953-61; Exec. Sec., Am. Council Learned Soc. on Protection of Cultural Treasures in War Areas, 1944-45; Memb., Inst. for Advanced Study, Princeton, N.J., 1939, 1942-44, 1946-47; Adv. Council to Inst. FA, N.Y. Univ.; Trustee, Am. Acad. in Rome, 1958- (Pres. 1969-). Pres., Union Academique Internationale, 1962-65; Vice Pres., Fed. of Renaissance Societies & Institutes. Vice Pres., International Council for Philosophy and Humanistic Studies. Author: "Ut Pictura Poesis: the Humanistic Theory of Painting," reprinted 1967; articles and reviews in learned journals. Harris Lecturer, North Western University, 1966.

LEE, ROBERT J.—Painter, I., Cart.
 Seminary Hill, Carmel, N.Y. 10512
B. Oakland, Cal., Dec. 26, 1921. Studied: San Francisco Acad. A.

Member: SI; All. A. Am. Awards: prizes, Assn. A. Studios, Chicago, 1947 (5); gold medal, All. A. Am., 1958; Mt. Kisco Annual, prize, 1960. Work: Springfield (Mass.) Mus. FA; Columbia (S.C.) Mus.; Mt. Holyoke Mus. A. Exhibited: Cal. PLH; NAD; All. A. Am.; Provincetown A. Festival; Oakland A. Mus.; AIC; Springfield Mus. A.; Boston A. Festival; SI; Butler Inst. AM. A.; N.Y. City Center, and others. One-man: San F. Acad. A.; Feingarten Gals., San F. and Chicago; Petite Gal., N.Y.; Ferargil Gal., N.Y.; Janet Nessler Gal., N.Y.; Queens Col., Charlotte, N.C.; Lord & Taylor, N.Y.; The Gallery, Palm Springs; Long Island Univ.; SI. I., "Heroes of the Bible"; "The Science of Man." Illus. many books for Random House, Follett, Bobbs-Merrill, Doubleday, Simon & Schuster. Illus. & Cartoons for N.Y. Times, Esquire, N.Y. Herald Tribune, Phila. Bulletin, N.Y. Journal-American and many others. Positions: Instr., Painting & Illustration, San Francisco Acad. A.; Pratt Inst., Brooklyn, N.Y. Asst. Prof., Advanced Painting, Marymount College, Tarrytown, N.Y., 1962- .

LEE, SHERMAN EMERY—Museum Director, Cur.
 Cleveland Museum of Art, 11150 East Blvd., (6); h. 2536 Norfolk Rd., Cleveland, Ohio 44106
B. Seattle, Wash., Apr. 19, 1918. Studied: Washington Univ., B.A., M.A.; Western Reserve Univ., Ph.D. Member: Am. Oriental Soc.; CAA; AAMus.; AFA; Assn. A. Mus. Dirs. Author: "Chinese Landscape Painting," 1954; "Japanese Decorative Style," 1961; Co-author: (with Wen Fong) "Streams and Mountains Without End," 1955; "History of Far Eastern Art," 1964; Co-author (with W.K. Ho), "Chinese Art Under the Mongols," 1968. Positions: Cur., Far Eastern Art, Detroit Inst. A., 1941-47; Asst. Dir., Assoc. Dir., Seattle A. Mus., 1948-52; Cur., Oriental Art, 1952- , Asst. Dir., 1956—thru May, 1957, Assoc. Dir., 1957—thru March, 1958, Dir., 1958- , Cleveland Mus. A., Cleveland, Ohio.

LEECH, HILTON—Painter, T.
 2362 Pine Terrace, Sarasota, Fla. 33581
B. Bridgeport, Conn. Studied: Grand Central A. Sch.; ASL. Member: AWS; Phila. WC Cl.; SC; Florida A. Group; Sarasota AA; New Orleans AA; Wash. WC Cl. Awards: prizes, Atlanta, Ga.; Fla. A. Group; SC; N.Y. WC Cl.; Western N.Y. Exh.; Four Arts Cl., Fla. Fed. A.; West Palm Beach A. Lg.; Audubon A.; Knickerbocker A.; All. A. Am.; NAC; Morse Award, NAD, 1965. Work: High Mus. A.; DMFA; Hickory (N.C.) Mus. A.; Univ. Florida; John Herron AI; Guild Hall, Easthampton, L.I., N.Y.; Hamilton A. Gal., Canada; Stetson Univ.; Norton Gal. A., West Palm Beach, and in private collections: murals, Court House, Chattanooga; USPO, Bay Minette, Ala. Contributor to American Artist magazine. Included in "Prize Winning Paintings II," 1963. Established Amagansett A. 1964; Guest Instr., John Herron AI, Indianapolis, Ind., 1953; Southern Artists, Hot Springs, Ark.; Dir., T., Madison A. Sch., Virginia City, Montana (Summer). Guest Instr., Springfield (Mo.) A. Mus., 1965.

LEEPA, ALLEN—Painter, E., W.
 1023 North Capitol Ave., Lansing, Mich. 48906
B. New York, N.Y., Jan. 9, 1919. Studied: Am. A. Sch., N.Y.; ASL; New Bauhaus, Chicago; Columbia Univ., B.S., M.A., Ed. D.; Sorbonne, Paris, France; Grande Chaumiere, Paris. Member: AAUP; Michigan Acad. A., Sc. & Let. Awards: Fulbright award, 1950-51; Dean's Fellowship, Columbia Univ., 1947; Ford Fnd. grant, Brazil, 1967; Am. Acad. A. & Lets., Childe Hassam award, 1969; scholarships to Am. A. Sch., New Bauhaus, Chicago; Hans Hofmann Sch. A., Columbia Univ.; prize, Michiana Annual, South Bend Mus., 1954; Western Mich. A., 1949, 1958; Grand Rapids Mus., 1958, 1965; Mich. Acad. Science, A. & Lets., 1961; AFA Printmakers, 1967. Work: South Bend Mus. A.; Royal Acad., Scotland. Exhibited: MModA traveling exh.; PAFA, 1950, 1951; Birmingham Mus. A., 1954, 1960; Detroit Inst. A., 1945, 1946, 1948-1950, 1953-1955, 1958-1961; Northwest Territory Exh., 1948; Madison, Wis., 1953; Grand Rapids, Mich., 1948; Sao Paulo Biennale, 1963. One-man: Artists Gal., N.Y., 1954; Charles Fourth, N.Y., 1948; Cliff Dwellers, Chicago, 1954; AAA Gal., Detroit, 1958; Vence, France, 1951; Galerie la Cour D'Ingres, Paris, 1963; Musée d'Art Moderne, Paris, 1964-65; Centre d'Art Visuel, Paris, 1963; Edinburgh Festival, Scotland, 1964; Detroit Artists Market, 1964; Hofstra Univ., N.Y., 1965, Retrospective; Musée Moderne, Paris, 1966; Renee Gal., Detroit, 1967; Keep Gal., Denver, 1968. Author: "The Challenge of Modern Art," 1949, pocketbook, 1961. "Abraham Rattner," 1969. Contributor (articles and book reviews) College Art Journal; New Art, 1966; Minimal Art, 1968. Teaching, Grad. Painting. Positions: Instr., Hull Sch., Chicago, 1947-48; Brooklyn A. Center, 1939-41; Brooklyn Mus., 1940-41; MMA, 1940-41; Prof. A., Michigan State Univ., Lansing, Mich., 1945- .

LEEPER, DORIS—Painter, S.
 River Rd., El Dora, Fla.
B. Charlotte, N.C., Apr. 4, 1929. Studied: Duke Univ., B.A. Awards: prizes, Gal. Arkep, N.Y., 1965; Jacksonville, Fla., 1965, 1967; Tampa, Fla., 1966; special award, Hunter Gals., Chattanooga,

1966; purchase award, Raleigh, N.C., 1966; Award of Merit, Nat. Exh. Oil Painting, Jackson, Miss., 1966; purchase, Mint Mus. A., Charlotte, N.C. Work: Mint Mus. A.; IBM, N.Y.; Illinois Wesleyan Univ., Bloomington; Salem Col., Winston-Salem; Duke Univ. A. Mus.; North Carolina Nat. Bank, Winston-Salem; Chase Manhattan Bank; 180 Beacon Coll., Boston, and others. Exhibited: Contemp. Am. Paintings, Palm Beach, Fla., 1965-1967; Gal. Arkep, N.Y., 1965; Nat. Biennial, Lafayette, Ind., 1966; Butler Inst. Am. A., 1966, 1967; Jersey City Mus., 1967; North Carolina Mus., Raleigh, 1965, 1966; Southeastern Ann., Atlanta, 1965, 1966; Hunter Gals., 1966, 1967; A. Festival, Savannah, Ga., 1966, 1967; Jacksonville, Fla., 1966, 1967; Gulf Coast Annual, Mobile, Ala., 1967; Mint Mus. A., 1965-1968; Ft. Lauderdale, Fla., 1968; Ringling Mus., Sarasota, 1968; Des Moines A. Center, 1968; "Florida 17", Washington, D.C., 1968; Ft. Wayne Inst. A., 1968-1969; Illinois Wesleyan Univ., Bloomington, 1968; Stamford (Conn.) Mus. A., 1968; MModA Lending Service, 1967-1969; Fla. Mus. Dirs. Exh., 1969; Duke Univ., 1969; Westmoreland County Mus., Greensburg, Pa., 1969, and many others. One-man: Webb Gal., Winter Park, Fla., 1966; Hunter Gals., 1968; Mint Mus. A., 1968; Bertha Schaefer Gal., N.Y., 1969 (3-man), 1967; Jacksonville A. Mus., 1968; Civic Auditorium, Jacksonville, 1969; Group Gal., Jacksonville, 1969; Loch Haven Mus., Orlando, Fla., 1970. 2-man: Columbia (S.C.), 1965; Gal. Arkep, N.Y., 1965; Greenville (S.C.) Mus. A., 1965.

LEEPER, JOHN P.—Painter
 624 W. 46th Ave., Los Angeles, Cal. 90065
B. Dandridge, Tenn., Apr. 23, 1909. Studied: Los A. County AI. Member: Cal. WC Soc. Awards: prizes, Cal. WC Soc., 1952, 1957 (purchase), 1964 (purchase); Cal. State Fair; 1954 (purchase); Newport Harbor, 1955, 1958, 1963; Los A. Mus. A., 1956, 1958; Los A. Festival Art, 1956, 1957, 1964 (purchase); San Jose State Col., 1957; Laguna Beach Festival Art, 1958, 1960; Nat. Orange Show, San Bernardino, 1964. Work: IBM; Long Beach Mus. Coll.; Cal. State Fair Coll., mural, Arizona State Univ. Exhibited: Cal. WC Soc.; Los A. Mus. A.; Cal. and Canadian traveling exh., 1955, Los A. County Fair, 1953; one-man: Cowie Gal., Los A., 1949, 1952; Santa Barbara Mus. A., 1950; Landau Gal., 1954; Simone Gal., 1959, 1961; Long Beach Mus., A., 1959; Arizona State Univ., 1959; Adele Bednarz Gal., Los Angeles, 1966, 1969.

LEEPER, JOHN PALMER —Museum Director
 McNay Art Institute, 6000 N. New Braunfels, San Antonio, Tex. 78209
B. Denison, Tex., Feb. 4, 1921. Studied: Southern Methodist Univ., B.S.; Harvard Univ., M.A. Member: AAMus.; Assn. A. Mus. Dirs. Contributor to Arts; National Geographic; Texas Quarterly; New Mexico Quarterly, and museum bulletins. (Editor): "Autobiography of Jose Clemente Orozco"; Author: "Pascin's Caribbean Sketchbook"; "Otis Dozier"; "Everett Spruce." Positions: Instr., Univ. So. California, 1952; Ford Fnd. Fund for Adult Edu., 1953; Trinity Univ., San Antonio, 1956-58; Asst. Dir., CGA; Dir., Pasadena A. Mus.; Dir., McNay AI, San Antonio, Tex., 1953- .

LEE-SMITH, HUGHIE—Painter, T., L.
 780 Riverside Dr., Apt. 4CC, New York, N.Y. 10032; s. 41 Union Square, Rm. 819, New York, N.Y. 10003.
B. Eustis, Fla., Sept. 20, 1915. Studied: Cleveland Inst. A.; Wayne State Univ., B.S. Member: AEA; ANA. Awards: prizes, CMA, 1938-1940; Atlanta Univ., 1943; Detroit Inst. A., 1951-1953, 1955; Michigan State Fair, 1952-1954; Kirk-in-the-Hills, Mich., 1954; Mich. Acad. A. & Sciences, 1956; Emily Lowe Award, 1957; All. A. Am., 1958; NAD, 1959, 1963; City Center, N.Y., 1959; Am. Soc. of African Culture, 1960. Lectures: Afro-American Artists of the 19th Century, at colleges and universities. Exhibited: CMA; Detroit Inst. A.; BM; USIA traveling exh.; Butler Inst. Am. A.; Grand Rapids A. Mus.; Buck Hill (Pa.) AA; Provincetown A. Festival; All. A. Am.; MMA; Art: USA 1959; NAD; Audubon A.; City Col., N.Y.; Swarthmore Col., and others; traveling exhibition to numerous universities and colleges; other group shows: Assoc. Am. Artists, 1953; Detroit Artists Market, 1950; Kraushaar Gal., N.Y., 1953; Barnet Aden Galleries, Wash., D.C., 1957; Eggleston Gal., N.Y., 1957; City Center, N.Y.C., 1958; one-man: Janet Nessler Gal., N.Y., 1958, 1960, 1962, 1964; Grand Central A. Gal., 1969; Forsythe Gal., Ann Arbor, Mich., 1966; Detroit A. Market, 1966; Univ. Chicago, 1969. Work: Detroit Inst. A.; Univ. Michigan; Wayne State Univ.; Howard Univ.; Atlanta Univ.; Detroit Soc. A. & Crafts; E.R. Squibb & Sons; Univ. Mich.; Wayne State Univ.; Flint Pub. Schs. Positions: Instr., Princeton Country Day School, Princeton, N.J., at present.

LEETE, WILLIAM WHITE—Painter, E.
 University of Rhode Island, Kingston, R.I. 02881; h. 50 Silver Lake Ave., Wakefield, R.I. 02879
B. Portsmouth, Ohio, June 12, 1929. Studied: Yale Univ., B.A., B.F.A., M.F.A. Member: CAA. Awards: prize, Silvermine Gld.,

1966. Work: deCordova and Dana Mus., Lincoln, Mass.; CMA; Univ. Massachusetts; extended loan Art in Embassies Program (U.S. Embassy, Bern, Switzerland). Exhibited: Silvermine Gld., 1966; Univ. Connecticut, 1965; Inst. Contemp. A., Boston, 1966; Dean Jr. Col., Franklin, Mass. 1967 (one-man); de Cordova and Dana Mus., 1967, 1969; Univ. Massachusetts, 1969; Ringling Mus., Sarasota, Fla., 1969; Portland Mus. A., 1969; Currier Gal. A., 1969; R.I. A. Festival, 1966, 1968. Positions: Assoc. Prof. A., Univ. Rhode Island, at present.

LEFEBRE, H. JOHN—Art Dealer, Collector, Writer
 Lefebre Gallery, 47 E. 77th St. 10021; h. 411 West End Ave., New York, N.Y. 10024
B. Germany. Studied: University of Berlin. Author of essays on European artists, published in European and American magazines and catalogues. Collection: Contemporary Art since 1945, gallery specialty same. Positions: European Manager of Twentieth Century-Fox to 1960; Dir., Lefebre Gallery, New York City.

LEFF, JAY C.—Collector
 Fayette Bank and Trust Company; h. 10 Linden Pl., Uniontown, Pa. 15401
B. Brownsville, Pa., Jan. 7, 1925. Collection: Ancient and tribal art; jewelry. The following exhibits were totally from the Leff Collection: Exotic Art from Ancient and Primitive Civilizations, Collection of Jay C. Leff, Carnegie Institute, 1959; Exotic Art, The American Federation of Arts Traveling Exhibition Program, March 1960-March 1961; African Sculpture from the Collection of Jay C. Leff, Mus. of Primitive Art, N.Y., Nov. 25, 1964 through Feb. 7, 1965; Faces and Figures, Pacific Island Art from the Collection of Jay C. Leff, American Mus. of Natural History, Jan. 27, 1965-May 1965.*

LEFF, RITA —Painter, Pr. M.
 125 Amherst St., Brooklyn, N.Y. 11235
B. New York, N.Y. Studied: ASL; BMSch. A., and with George Picken, Louis Schanker, Abraham Rattner, Adja Yunkers. Member: Audubon A.; SAGA; Boston Pr. M.; Am. Color Pr. Soc.; NAWA; Brooklyn Soc. A.; N.Y. Soc. Women A.; Nat. Soc. Painters in Casein; AEA; Silvermine Gld. A. Awards: prizes, Audubon A., 1955-58, 1964, 1966; NAWA, 1951, 1954, 1955, 1958, 1965; Medal of Honor 1964-1966; Brooklyn Soc. A., 1950, 1953, 1957, 1959, 1960, 1964; Brooklyn Mus. Alumni Assn., 1955-57, 1958; Boston Pr. M., 1954; SAGA, 1954; Village A. Center, 1953-1955; Nat. Soc. Painters in Casein, 1961, 1962, 1966, 1969; Creative Graphic Exh., 1958; Am. Soc. Contemp. A., medal of honor, 1968; Int. Exh. of Women Artists, Cannes, France, medal of honor, 1969, and many exhs. prior to these dates. Work: MMA; Norfolk Mus. A. & Sciences; Japan A. Center, Tokyo; LC; Univ. Maine. Pa. State Univ.; DMFA; Abraham Lincoln H.S.; ed. of 100 prints, Collectors of Am. Art, 1951, 1952, 1954, 1956, 1960; limited ed 30 prints, Contemporary Art, 1956; MModA; PAFA; Riverside Mus.; Honolulu Acad. A.; PMA; BMFA; Lafayette A. Center, Indiana; LC; Boston Pub. Lib.; Phila. Pub. Lib. Exhibited: MMA; MModA; LC; WMAA; BM; Conn. Acad. FA; DMFA; Silvermine Gld. A.; BMFA; PAFA; Smithsonian Inst.; Galerie Bosc, Paris, France; Maison de Arts, Brussels, and other galleries and museums in U.S., Canada, Japan & Hawaii. One-man: Abraham Lincoln H.S., 1951; Bodley Gal., 1958, 1965; Village A. Center, 1954, 1955, 1956; Univ. Maine, 1958; traveling print exhs.; Bay Pr. M.; BM; AFA; Am. Color Pr. Soc.; Boston Pr. M.; NAWA; Brooklyn Soc. A.; Silvermine Gld. A., 1964; Loring A. Gal., N.Y., 1967, illus., "Little Boy and Girl Land" "Audacious Ann"; "A Double Story." and other children's books and book jackets. Included in "Prize Winning Watercolors," 1964; "How to Paint a Prize Winner"; "Prize Winning Art." 1964-1966.

LEHMAN, IRVING G.—Sculptor, P., C., Gr.
 70 LaSalle St., New York, N.Y. 10027; also, Red Rock Studio, R.D. 1, East Chatham, N.Y. 12060
B. Russia, Jan. 1, 1900. Studied: CUASch.; NAD. Member: Am. Abstract A.; Audubon A.; AEA; Am. Soc. Contemp. A.; Sarasota AA. Awards: prizes, SAGA, 1947; Alabama WC Soc., 1948; Wash. WC Cl., 1949; Terry AI, 1952; Am. Soc. Contemp. A., 1958, 1959, 1961; Lafayette Nat. Bank award, 1964. Work: Oxford Univ., England; Ain-Harod, Bezalel Museums, Israel; Archives et Musee d'Art Populaire Juif, Paris; Syracuse Univ. Lib. of Manuscripts, Abbey A. Gal., Univ. Pittsburgh; and in private collections. Exhibited: Albany Inst. Hist. & A.; Alabama WC Soc.; BM; AIC; CAM; Davenport Mun. Mus.; Mobile AA; Nat. Mus., Wash., D.C.; Nebraska AA; Norfolk Mus. A.; PAFA; Riverside Mus.; SAM; South Bend AA; J. B. Speed Mus. A.; WMAA; Lever House, N.Y.; Hudson River Mus.; Long Island Univ. New Sch. Social Res.; N.Y. Univ.; Sarasota AA; IBM, N.Y.; and in Europe; one-man: ACA Gal.; Uptown Gal., 1938-1940; Salpeter Gal., 1947, 1948, 1950, 1954, 1955; Phila. A. All., Oxford Univ., 1950; Columbia (S.C.) Mus. A., 1958; Gallery Ten, Mt. Vernon, N.Y., 1960;

Gladstone Gal., Woodstock, N.Y., 1961-1966; Knapik Gal., 1961; Berkshire Playhouse, Stockbirdge, Mass., 1963; Gal. One, Hillsdale, N.Y., 1966, 1967.

LEHMAN, LOUISE BRASELL (Mrs. John)—Painter
 476 North Willett St., Memphis, Tenn. 38112
B. Orwood, Miss., Oct. 15, 1901. Studied: Mississippi State Col. for Women; George Washington Univ.; Corcoran Sch. A.; T. Col., Columbia Univ., B.S. Member: Bd. Dirs., Artist's Registry; New Orleans AA; Awards: prizes, Brooks Mem. A. Gal., 1954, 1968; Tenn. All-State A. Exh., Nashville, 1955, 1968; Tenn. A. Com. purchase prize, 1968; Tenn. WC Comp., 1967; Southern A. Festival, 1967 (2). Memphis Acad. A., 1959 (2), 1960. Work: Montgomery Mus. FA; Miss. State Col. for Women. Exhibited: Audubon A., 1945; VMFA, 1946; Whistler Mus.; New Orleans AA; Palette & Brush Cl.; Brooks Mem. A. Gal., 1953-1955, 1960-1961, 1968; Hunter A. Gal., 1960-1961; Tennessee All-State, NGA, 1960; F., Memphis Acad. A., 1959, 1960; Mississippi National 1960; Sarasota AA, 1955; Nat. Mus., Wash., D.C., 1954; Atlanta-Mead Paper Co. Exh., 1958; Provincetown A. Festival, 1958; Delta A. Exh., Little Rock, 1958; Mississippi AA, 1958; Soc. Four Arts, Palm Beach, 1958; Memphis Acad. A., 1958; Mississippi AA, 1968; Southern A. Festival, 1967; one-man: Mary Buie Mus., 1953; Allison's Wells A. Colony, 1953; Miss. State Col. for Women, 1953; Municipal Gal., Jackson, Miss., 1961. Included in traveling exhs.: Tenn. A. Com., 1968; Smithsonian Inst., to Europe, 1968; Mississippi AA, 1968; Southern A. Festival, 1967.

LEHMAN, ROBERT—Collector
 1 William St. 10004; h. 625 Park Ave., New York, N.Y. 10021
B. New York, N.Y., Sept. 29, 1896. Studied: Yale University, A.B. Awards: Hon. degree, L.H.D., Yale University, 1968. Collection: Impressionist and Post-Impressionist periods. Positions: Chairman of the Board, Metropolitan Museum of Art; Member, Advisory Council, New York University Institute of Fine Arts.

LEIBER, GERSON A.—Painter, Pr.M.
 749 West End Ave., New York, N.Y. 10025; also, 464 Old Stone Rd., The Springs, East Hampton, L.I., N.Y. 11937
B. Brooklyn, N.Y., Nov. 12, 1921. Studied: Hungarian Royal Acad.; ASL; Brooklyn Mus. Sch. A. Member: SAGA; Cal. Soc. Etchers; ASL; Boston Printmakers Soc. Awards: Tiffany Fellowships, 1957, 1960; Medals, Audubon A., 1963, 1965; purchase awards: BM, 1953, 1966; Abraham Lincoln H.S., 1959, 1962; Hunterdon A. Center, Clinton, N.J.; Graphic Chemical & Ink purchase award, 1963; prizes, Am. Color Print Soc., 1968 and prior; Assoc. Am. A. purchase, 1968; Boston Pr.M., 1962; Soc. Wash. Pr.M., 1962; BMFA purchase, 1966; Charles Lea prize, 1966, and Soc. Wash. Pr.M. prize, Phila. Pr. Cl., 1964; New Jersey State Mus., 1964, 1966; and others. Work: BM; SAM; Univ. Delaware; N.Y. Pub. Lib.; CMA; NGA; MMA; Wilmington Soc. FA; WAC; Wesleyan Univ.; Guild Hall, East Hampton; Free Lib. of Philadelphia; So. Illinois Univ.; Yale Gal. FA; U.S. Embassies Overseas Coll.; Rutgers Univ.; USIA; Hamilton Col.; Univ. Maine; LC; Cooper Union, N.Y.; de Cordova & Dana Mus.; Montclair A. Mus.; Art Council, Pakistan; Brooks Mem. Mus.; Norfolk Mus. A. & Sciences; Art Collection of New York Hilton Hotels; ASL; PMA; BMFA; Dennison Univ.; Brockton (Mass.) Mus.; New Jersey State Mus.; Victoria & Albert Mus., London; Malmo Mus., Sweden; Minneapolis Inst. A.; WMAA; Ohio State Univ.; Univ. Nebraska, and others. Exhibited: Over 150 national and international exhibitions; one-man: 1960-1964. Positions: Inst., Graphics, Newark School of Fine & Industrial Arts, Newark, N.J.

LEIDER, PHILIP—Editor, W., Critic
 Artforum, 667 Madison Ave. 10021; h. 61 E. 86th St., New York, N.Y. 10028
B. New York, N.Y., Oct. 20, 1929. Studied: Univ. Nebraska, M.A.; Brooklyn College, B.A. Contributor various critical articles in Artforum, and New York Times. Positions: Editor, Artforum; Instr., History of Art, New York School of Visual Arts, New York City.

LEIFERMAN, SILVIA W.—Painter, S.
 5255 Collins Ave., Miami Beach, Fla. 33140
B. Chicago, Ill., Dec. 26, 1913. Studied: Design and painting in U.S. and abroad. Member: Brandeis Univ. (Life and Board member); Charter member, Women's Div., Hebrew Univ., Chicago; other Life Memberships: Art Inst. Chicago; Miami Mus. Modern A.; membership in organizations: Int. Platform Assn.; Int. Council of Museums; American Federation of Arts; AEA; Miami A. Center; Greater Miami Cultural A. Center; Sculptors of Florida; Lowe A. Mus., Univ. Miami. Donor: The Leiferman Award under auspices of City of Hope. Awards: Citations and awards from U.S. Government and the Treasury Dept.; Citation, Community Leaders of America, and others from civic, fraternal, and cultural organizations. Work: Roosevelt Univ., Chicago; Lowe A. Museum, Univ. of Miami; Miami Museum of Modern A.; and in private collections. Exhibited: Barry Col., Mi-

ami, 1968; Westview Country Cl., 1968; Gal. 99, Miami, 1968; Hollywood (Fla.) Mus. A., 1968; Miami Mus. Modern A., 1967 (2); Int. Platform Assn., 1967; AEA, Miami Beach, 1968; D'Arcy Gal., N.Y., 1965; Lowe A. Mus.; Hialeah, Fla., 1969; one-man: Schram Gal., Ft. Lauderdale, 1966; Miami Mus. Modern A., 1966, 1970; Contemp. Gal., Palm Beach, 1966; D'Arcy Gal., N.Y., 1964. Positions: Co-founder, Vice-Pres., Silvia and Irwin Leiferman Foundation; Pres., Active Accessories by Silvia, Chicago, Ill., 1964- .

LEIGH, DAVID I.—Collector
 c/o Sandgren & Murtha, Inc., 866 Third Ave., 10017; h. 1245 Park Ave., New York, N.Y. 10028
B. New York, N.Y., June 27, 1933. Studied: Pratt Institute, B.A.; Member: American Institute of Graphic Arts; Package Designers Council. Collection: Sculpture, Graphics, Icons, African Art, and Paintings—14th century to the present.

LEIGHTON, CLARE—Engraver
 Woodbury, Conn. 06798
B. London, England, Apr. 12, 1901. Studied: Slade School of Fine Art and the Univ. of London, England. Member: NA; Nat. Inst. A. & Lets.; SAGA; Royal Soc. of Painters, Etchers & Engravers, London, England. Awards: Logan Medal, AIC, Int. Engraving Exh. Work: Prints in leading museums in U.S. and England. Represented Great Britain at Venice Biennale. Designed 33 stained glass windows for St. Paul's Cathedral, Worcester, Mass.*

LEIGHTON, THOMAS C.—Portrait Painter, T., L.
 471 Buena Vista Avenue, East, San Francisco, Calif. 94117
B. Toronto, Canada, Sept. 3, 1913. Studied: Ontario Col. A.; Evanston Acad. FA, Chicago, with Karl Scheffler; Russell Acad., Toronto, with John Russell, and in England. Member: Bohemian Cl.; Soc. Western A.; Keith AA; Santa Cruz AA; AAPL (Nat. Dir., 1956-); F.I.A.L. Awards: prizes, Brittany Scholarship, Toronto, 1934; Soc. Western A., 1954, 1956, 1963, 1965; Santa Cruz Statewide Exh., 1953, 1957; Lodi (Cal.) Statewide Exh., 1952, 1953, 1954; Lodi A. Festival, 1964; de Young Mem. Mus., San F., 1963, 1968; Council of Am. Artists, 1964; Work: Wakefield A. Gal., Yorkshire, England; Cal. Hist. Soc.; portraits in many private colls. in Canada, Britain, U.S., and Denmark. Exhibited: Royal Canadian Acad., 1938-1942, 1948, Nat. Gal., Ottawa, 1941; Montreal A. Gal., 1940; A. Gal. of Toronto, 1938, 1939, 1942, 1948; Canadian Nat. Exh., 1939, 1940; Los A. Mus. A., 1955; Soc. Western A., de Young Mus., 1950-1957, 1967; Cal. State Fair, 1952, 1954, 1957; Oakland A. Mus., 1955, 1956, 1966-1969; Santa Cruz, 1952-1957; SC, 1960; Springfield A. Mus., 1961; others, 1963-65; SC; Lever House, N.Y.; Smithsonian Inst., Wash., D.C.; AWS, 1966; Bohemian Cl., San F., 1966-1969; 38 one-man exhs., U.S. and Canada; Seven 2-man exhs. in California. Positions: Instr. A., Russell Acad., 1934, 1936; Dir. Fine Arts, Ridley Col., 1936-42; Dir. Vocational A., Niagara Falls Voc. Inst., 1938-42; Instr. A., Arts & Lets. Cl., Toronto, 1948; Instr. of port. painting, figure & still-life, Art. Lg. of California, San Francisco, Cal., 1948-55. Freelance Artist, Teacher & Lecturer, 1955- .

LEIN, MALCOLM E. —Museum Director
 St. Paul Art Center, 30 E. 10th St. 55101; h. 857 Fairmont Ave., St. Paul, Minn. 55105
B. Havre, Mont., July 19, 1913. Studied: Univ. Minnesota, B. Arch. Position: Dir., St. Paul Art Center, St. Paul, Minn.

LEITH-ROSS, HARRY—Painter, Comm. A., W.
 R.D. 2, Box 103, New Hope, Pa. 18938
B. Mauritius (British Colony), Jan. 27, 1886. Studied: NAD with C. Y. Turner; ASL, with Birge Harrison, J. F. Carlson; Julian Acad., Paris, with Jean Paul Laurens; in England with Stanhope Forbes. Member: NA; SC; Conn. Acad. FA; AWS; Phila. WC Cl.; Balt. WC Cl. Awards: NAD, 1927, 1955 (purchases); Morse gold medal, 1955; Obrig prize, 1956; NAC, bronze medal, 1953, gold medal, 1955; prizes, SC, 1915, 1938, 1944, 1946, 1949, 1953, 1958, 1960, 1961; Conn. Acad. FA, 1921, 1943; AWS, 1937, 1941, 1953, 1956; PAFA, 1946; Balt. WC Cl., 1948, 1955, 1956, 1959, 1960, 1962. Work: PAFA; NAD; Phila. WC Cl.; mural, USPO, Masontown, Pa. Exhibited: NAD, 1915-1958, 1966-1968; PAFA, 1916, 1922-1929, 1933, 1935, 1937, 1939, 1941, 1943, 1945-1947, 1952; CGA, 1919, 1921, 1933, 1935, 1937, 1939, 1941, 1943, 1945, 1956; Carnegie Inst., 1943-45; AIC, 1914, 1916, 1920-1927; AWS, 1936, 1938-1955; MMA, 1942; NAC, 1953, 1955. Positions: Visiting Instr., Univ. Buffalo, 1941, Univ. Utah, 1955, Col. of So. Utah, 1955. Author: "The Landscape Painter's Manual," 1956, second edition, 1961.

LEKAKIS, MICHAEL—Sculptor
 57 W. 28th St., New York, N.Y. 10001
B. New York, N.Y., 1907. Work: Guggenheim Mus. A.; Portland (Ore.) Mus. A.; MModA; WMAA; Dayton A. Inst.; Wadsworth Atheneum, Hartford, Conn.; Mus. of Israel; Pinakothiki Mus., Athens,

and in private collections. Exhibited: Guggenheim Mus. A., 1958; WMAA, 1960; one-man: Artists Gal., N.Y., 1941; Witte Mem. Mus., San Antonio, 1946; Bertha Schaefer Gal., N.Y., 1946, 1948; American Univ., Wash. D.C., 1949; Signa Gal., Easthampton, N.Y., 1959; Howard Wise Gal., 1963; MModA., 1963; Dayton A. Inst., 1968, and others.

LEKBERG, BARBARA (HULT)—Sculptor
 Sculpture Center, 167 East 69th St.; h. 911 Stuart Ave., Mamaroneck, N.Y. 10543
B. Portland, Ore., Mar. 19, 1925. Studied: Univ. Iowa, B.F.A., M.A., with Humbert Albrizio. Member: Sculpture Center; Audubon A.; Am. Soc. for Aesthetics. Awards: Nat. Inst. A. & Lets., Grant, 1956; Guggenheim F., 1957, 1959; Hon. D.F.A., Simpson Col. Iowa, 1963; Audubon A., 1968. Work: Knoxville, Tenn., A. Center; Socony Bldg., N.Y.; Riedl & Freede Bldg., Clifton, N.J., 1963; Des Moines A. Center; Beldon-Stratford Hotel, Chicago; Montclair (N.J.) A. Mus.; Birmingham Mus. A., 1966, and in private colls. Exhibited: PAFA, 1950, 1952, 1958, 1960, 1962, 1964; Nebraska AA, 1952; SFMA, 1952; Phila. A. All., 1951, Sculpture Center, 1949-1969; Denver A. Mus., 1959; Walker A. Center; Des Moines A. Center; WMAA; 1953, 1957; Rochester Mem. A. Gal.; Cranbrook Acad. A., 1954; Inst. A. & Lets., 1956; Sculpture Center, 1959, 1965 (one-man): Montclair A. Mus. 1956 (one-man); Sculpture Center, N.Y., 1956 (2-man); AFA traveling exh., 1959-1960; Los A. Mus. A., 1960; CAM, 1960; BMFA, 1960; Univ. Indiana, 1960; Univ. Illinois, 1961; MModA, 1959; Rutgers Univ., 1965 (one-man); Phila. A. All., 1966; Stamford (Conn.) Mus. A., 1968.

LELAND, LYNN—Painter, T., Gr.
 309 E. 93rd St., New York, N.Y. 10028
B. Buffalo, N.Y., 1937. Studied: Pratt Inst., Brooklyn, N.Y., B.F.A.; N.Y. Univ.; Hunter Col. Awards: Fulbright Grant, 1961-1962 for study in Germany. Exhibited: Albright-Knox A. Gal., 1960; BM, 1960; Staten Island Mus. A., 1963; MModA, 1965, traveling, 1966-1967; Ohio Univ., 1965-1966; Inst. Contemp. A., Boston, 1966; Jewish Mus., N.Y., 1966; Dutchess Community Col., N.Y., 1967; one-man: Preston Gal., N.Y., 1962; A. M. Sachs Gal., N.Y., 1965, 1966. Positions: Teaching Asst., Pratt Inst., Graphic Dept., 1960-1961; Asst. to the Dean, Parsons Sch. Des., New York, N.Y., at present.

LENNEY, ANNIE (Mrs. William Shannon)—Painter, T., L.
 Mohican Rd., Blairstown, N.J. 07825
B. Potsdam, N.Y. Studied: Col. St. Elizabeth, N.J., B.A.; Grand Central A. Sch.; ASL; N.Y. Univ.; St. Lawrence Univ.; Syracuse Univ., and with Hayley Lever. Member: All. A. Am.; Audubon A.; NAWA; N.J. WC Cl. Awards: prizes, Newark A. Cl., 1940, 1949, 1951; Irvington A. & Mus. Assn., 1940, 1948; Kresge Exh., 1940; Spring Lake, 1948, 1950; NAWA, 1948, 1954; A. Cl. of the Oranges, 1952; Montclair A. Mus., 1952, 1953; Seton Hall Univ., 1958. Work: Seton Hall Univ.; College of St. Elizabeth, Convent, N.J.; Kappa Pi.; Pub. Sch., Newark; Oklahoma A. Center; Buie Mus.; Massillon Mus.; St. Vincent's Col., Latrobe, Pa.; Notre Dame Univ.; Paterson (N.J.) Mus. A.; Norfolk Mus. A. & Sciences; Newark Mus. A.; Montclair A. Mus.; Farnsworth Mus.; Fairleigh Dickinson Univ.; Butler Inst. Am. A.; Munson-Williams-Proctor Inst., Utica, N.Y.; Brooks Mem. Mus., Memphis; Everhart Mus., Scranton; Staten Island Inst. A. & Sciences, N.Y.; and in private colls. Exhibited: Newark Mus. A.; Montclair A. Mus.; State Mus., Trenton; Oakland A. Mus.; Lehigh A. Gal.; Princeton Univ.; Massillon Mus. A.; Richmond (Ind.) AA; Decatur A. Center; Joslyn Mus. A.; Mus. New Mexico, Santa Fe; Art:USA, 1958; NAD; Argent Gal.; Creative Gal.; N.Y. City Center; Riverside Mus.; Mills Col., Oakland, Cal.; Univ. Wyoming; Boise AA; Wash. State Hist. Soc.; State T. Col., Valley City, N.D.; Kansas City AI; Kenosha Pub. Mus.; one-man: Argent Gal., 1949; Creative Gal., N.Y., 1954; Ward Eggleston Gal., N.Y., 1956, 1957, 1958, 1960, 1961, 1964; Cortland Pub. Lib., 1958; Col. of St. Elizabeth, 1956; Attleboro Mus. A., 1958; Utica Pub. Lib., 1958; Charlotte (N.C.) Pub. Lib., 1958; Neville Mus., 1959; Fremont, Mich., 1960; Farnsworth Mus., 1960; State Col., Savannah, 1960; St. Vincent's Col., Latrobe, Pa., 1961; Alabama State Col., 1961; East Central State Mus., Ada, Okla., 1961; Seton Hall Univ. A. Gal., 1966; Barzansky Gal., N.Y., 1968; Centenary Col., Hackettstown, N.J., 1969; also exhibited in Athens, Salonika, Greece; Brussels, Belgium; Lisbon, Portugal; Naples, Italy; Tokyo, 1965; N.Y. World's Fair, 1965. Paris, France. Contributor to art magazines.

LENSKI, LOIS (Mrs. Arthur Covey)—Illustrator, W., P.
 Tarpon Springs, Fla. 33589
B. Springfield, Ohio, Oct. 14, 1893. Studied: Ohio State Univ., B.Sc. in Edu.; ASL; Westminster Sch. A., London. Awards: Ohioana med., 1944; Newbery med., 1946; Child Study Assn. award, 1947; Special Children's Collection Medallion, Univ. of Southern Mississippi, 1969; Catholic Library Assn., Regina Medal, 1969; Hon. Degrees, Litt.D., Wartburg College, Iowa, 1959; D.H.L., Univ. North Carolina, Greensboro, 1962; Litt.D., Southwestern College, Winfield, Kans.

Author, I., "Blueberry Corners," 1940; "The Little Farm," 1942; "Strawberry Girl," 1945; "Blue Ridge Billy," 1946; "Prairie School," 1951; "We Are Thy Children" (Hymnal), 1952; "On a Summer Day," 1953; "Mama Hattie's Girl," 1953; "Corn-Farm Boy," 1954; "Songs of Mr. Small," 1954; "San Francisco Boy," 1955; "A Dog Came to School," 1955; "Flood Friday," 1956; "Houseboat Girl," 1957; "Davy and His Dog," 1957; "Little Sioux Girl," 1958; "Coal Camp Girl," 1959; "At Our House," 1959; "We Live in the Country," 1960; "When I Grow Up," 1960; "Davy Goes Places," 1961; "Shoo-Fly Girl," 1963; "The Life I Live: Collected Poems," 1965; "To Be a Logger," 1967; "Deer Valley Girl," 1968; Christmas Stories," 1968, & many other juvenile books. I., numerous books.

LENSON, MICHAEL—Painter, E., L., W., Cr.
 16 Enclosure, Nutley, N.J. 07110
B. Russia, Feb. 21, 1903. Studied: NAD; Univ. London; Ecole des Beaux-Arts, Paris. Member: Assoc. A., New Jersey. Awards: Chaloner Paris prize, 1928; prizes, Montclair A. Mus., 1957; Bamberger award, 1957; New Jersey "Artist of the Year," 1958. Work: Newark Mus. A.; New Jersey State Mus.; Butler Inst. Am. A.; Smithsonian Inst.; Newark City Hall; Mt. Hope, W. Va. Exhibited: CGA, 1938, 1950; PAFA, 1939; Carnegie Inst., 1943; Newark Mus. A. 1944-1946; Riverside Mus., 1944-1946; Albright A. Gal., 1955; DMFA, 1955; N.Y. City Center, 1955; Art:USA, 1958; Butler Inst. Am. A., 1958; N.Y. World's Fair, 1965. Author: "Realm of Art," art column in Newark Sunday News. Lecturer: Art Techniques and Aesthetics. Positions: Instr., Montclair A. Mus.; Formerly Dir., Newark Sch. F. & Indst. A., Newark, N.J., 1944-45, 1945-46; Instr., Rutgers Univ. Ext., Newark, N.J.

LENSSEN, HEIDI (RUTH) (Mrs. Fridolf L. Johnson)—
 Painter, I., W., T.
 336 Central Park West, New York, N.Y. 10025
B. Frankfurt, Germany. Studied: in Europe. Member: Audubon A. Awards: prizes, Baden Germany, 1929, 1931. Work: European museums & galleries. Exhibited: WFNY 1939; Audubon A., 1944, 1945; Mod. A. Studio, N.Y., 1945; one-man exh.; Jordan Gal., 1937; Schoneman Gal., 1940; Am. Sch. Des., 1940; Lynn Kottler Gal., 1954, 1956, 3-man show, 1969. Author, I., "Art and Anatomy," 1944, second edition, 1946; 3rd ed., 1964; "Hands in Nature and Art," 1955. Positions: Instr., Adult Edu., N.Y. City Col., 1945- ; Hunter Col., 1949-51; Jamesine Franklin Sch. Prof. A., New York, N.Y., 1952- .

LENT, BLAIR—Illustrator, Gr., P., W., Des.
 10 Dana St., Cambridge, Mass. 02138
B. Boston, Mass., Jan. 22, 1930. Studied: BMFA Sch. A.; and in Switzerland and Italy. Member: Boston Soc. Printmakers. Awards: Cummings Traveling Scholarship, BMFA, 1953; Caldecott Medal Runner-up, 1964, 1968; Bartlett traveling scholarship to Soviet Union, BMFA, 1968; Honor Book, N.Y. Herald-Tribune (Book Week), 1966; Book World, 1968; Boston Globe-Horn Book Award for Children's Literature, 1968; prize, Bienal Internacional do Livro e Arte Grafica, Sao Paulo, Brazil, 1965. Work: Wiggins Print Collection, Boston Public Library. Exhibited: Boston A. Festival, 1953, 1955, 1956, 1957 (prints); Illustrators '63, New York City; AIGA 50 Books of 1964 (Illus.); Best Children's Books of 1963 to 1968; Graphics, 1967; one-man exhs. paintings: Boston, Provincetown and New York City. Included in New York Times 10 Best Illustrated Books, 1964. Author, Illus., "Pistachio"; "John Tabor's Ride"; "Baba Yaga." Compiler, Illus., "From King Boggen's Hall to Nothing-at-all"; Illus., "The Wave" (Margaret Hodges). Contributor cover designs for Atlantic Monthly; Boston magazine. Contributor to Publisher's Weekly, 1969; Horn Book, 1965. Positions: Assoc. A. Dir., Container Corp. of America, 1954-56; Designer, Bresnick Adv. Co., Boston, Mass., 1956-61.

LEON, DENNIS—Sculptor, T., Cr.
 Stump Rd., New Britain Township, Bucks County, Pa. 18901
B. London, England, July 27, 1933. Studied: Tyler Sch. A., M.F.A., B.F.A.; Teachers College, Temple Univ., B.S. in Edu. Member: AEA; AAUP; Sculptors' Guild, N.Y. Awards: Guggenheim Fellow, 1967-1968; Nat. Inst. of A. and Let., 1967; Temple Univ. Fountain Comp., 1963; Tyler Sch. A. Alumni Exh., 1963; Cheltenham Township A. Center, 1960; Phila. A. All., 1957. Exhibited: Kraushaar Gal., N.Y., 1965, 1967; PAFA, 1956, 1964; Ball State T. Col., Muncie, Ind., 1965; Am. Color Print Soc., 1957; PMA, 1958, 1963, 1964; Delaware A. Center, 1964; Cheltenham Township (Pa.) A. Center; Temple Univ.; Phila. A. All.; Makler Gal., Phila., 1962; Tyler Sch. A., 1963; Gallery 1015, Wyncote, Pa., 1963, 1964; one-man: Dubin Gal., Phila., 1957; Phila. A. All., 1961; Gal. 1015, 1963; Cober Gal., N.Y., 1964; Henri Gal., Alexandria, Va., 1965. Positions: Art Critic, Philadelphia Inquirer, 1959-1962 and contributor of feature articles on contemporary art and art history; Chm., Sculpture Dept., Philadelphia College of Art, 1965; Prof., Sculpture, Philadelphia College of Art, 1959- .

LEONARDI, HECTOR—Painter, T.
254 E. 53rd St., New York, N.Y. 10022
B. Waterbury, Conn., Jan. 18, 1930. Studied: Rhode Island Sch. Des., B.F.A.; Yale Univ., M.F.A. Work: Univ. Notre Dame; Univ. Bridgeport, Conn. Exhibited: N.Y. World's Fair, 1964; Feingarten Gal., N.Y., 1962; Rose Fried Gal., N.Y., 1963-64; Byron Gal., N.Y., 1965; The Contemporaries, N.Y., 1966, 1967; Albright-Knox Gal., Buffalo, N.Y., 1966; Invitational exh., Tokyo, Japan (critics choice), 1967; Obelisk Gal., Boston, 1968, 1969; Sneed Gal., Rockford, Ill., 1968, 1969. Positions: Instr., Color, Design, Drawing, Painting, Univ. of Bridgeport, Bridgeport, Conn.; Color, Parsons School of Design, New York, N.Y.

LEONG, JAMES CHAN—Painter
Piazza del Biscione, 95, Int. 4, Rome, Italy
B. San Francisco, Cal., Nov. 27, 1929. Studied: California College of A. & Crafts, B.F.A., M.F.A.; San Francisco State College, M.A. Awards: John Hay Whitney Fnd. Opportunity F., 1952-53; Fulbright grant (Norway), 1956-57; Guggenheim Fellowship, 1958-59; San Francisco AI, 1962. Work: murals, Chung Mei Home for Boys, El Cerrito, Cal.; Ping Yuen Housing Project, San Francisco; San Francisco State Col. Exhibited: Barone Gal., N.Y., 1956, 1957, 1960; WMAA, 1955; Holst Halvorsen Gal., Oslo, Norway, 1956; Western Assn. Mus. Dirs. traveling exh., 1958; Mi Chou Gal., N.Y., 1958; Contemp. A. Soc., Tate Gal., London, 1959; 10 American Artists, Palazzo Venezia, 1959; Am. Acad. in Rome, 1959; Spoleto, 1959; Galleria San Marco, Rome, 1959; Gimpel Fils, London, 1959; MModA, 1960; Obelisco Gal., Rome; Palazzo Pretorio, Prato, 1960; BM, 1961; Carnegie Intl., 1961; Feingarten Gal., New York, 1962 and Chicago, 1962; San F. AI, 1962; Rochester Mem. Mus., 1962; Princeton A. Gal., 1962; Galleria 88, Rome, 1963; A.C.A. Gal., Rome, 1963; USIA traveling exh., 1963; 5th exhibition of figurative art of Rome and vicinity, 1965; Munich, Frankfurt, Stuttgart, Hamburg, Cologne, Berlin (USIS), 1966; Gallery Dache', New York, 1966; Bednarz Gallery, Los A., 1966; London, England, Ascher Award Exh., 1967; VI Biennial, Rome, 1968; one-man: Barone Gal., 1954, 1956; American Gal., Los A., 1955; Paletten Gal., Oslo, Norway, 1957; Haghfelt Gal., Copenhagen, 1957; Obelisco Gal., Rome, 1959, 1960, 1961, 1967; Feingarten Gal., N.Y., 1962, and Chicago, 1962; Galleria Ariete, Milan, 1962; Royal Athena II, N.Y., 1963, 1967; Temple Univ., Tyler Sch. A., 1967.

LEPPER, ROBERT LEWIS—Sculptor, E., P.
5732 Kentucky Ave., Pittsburgh, Pa. 15232
B. Aspinwall, Pa., Sept. 10, 1906. Studied: Carnegie Inst., B.A., Harvard Univ. Grad. Sch. Member: Abstract Group of Pittsburgh; Soc. Sculptors; Assoc. A. Pittsburgh. Awards: prizes, Soc. Sculptors, 1961; For Craftsmanship, Pa. Soc. Arch., 1961; "Artist-of-the-Year," Arts & Crafts Center, Pittsburgh, 1962; Carnegie Inst. purchase prize, 1963. Work: KLM Royal Dutch Airlines, Wash., D.C.; Children's Hospital, Pittsburgh; Thos. Cook & Son, Pittsburgh; murals: USPO, Caldwell, Ohio; Grayling, Mich.; West Virginia Univ.; Airport, Charleston, W. Va.; Sch. Indst. A., Carnegie Inst. Tech.; Pittsburgh Hilton Hotel; N.Y. World's Fair, 1964-65; windows: St. Lucy Church, Campbell, Ohio; Convent of Immaculate Conception, Washington, Pa. Work in collections: Butler Inst. Am. A.; Carnegie-Mellon Mus. A.; Copperweld Steel Co.; Indiana Univ.; MModA; Stedelijk Mus., Amsterdam; College of Steubenville, Ohio; United Steelworkers of America. Exhibited: AIC, 1936; Carnegie Inst., 1941, and one-man 1961; Pittsburgh Intl., 1961; Arch. Lg., N.Y., 1952; Aspen, Colo., 1959; Mus. for Contemp. A., Houston, 1960; Pa. Soc. Arch., 1961 (one-man); A. & Crafts Center, Pittsburgh, 1962 (one-man); Pittsburg Plan for Art, 1964 (one-man); Seton Hall Univ., South Orange, N.J., 1969 (one-man). Contributor to College Art Journal; Architectural Record; Journal of Eastern AA; Industrial Design Magazine. Positions: Prof. Des., Carnegie Inst. Tech., Pittsburgh, Pa., 1930- .

LERMAN, LEO—Writer, E., L., Des.
1453 Lexington Ave., New York, N.Y. 10028
B. New York, N.Y. Author: "Leonardo da Vinci: Artist and Scientist"; "Michaelangelo, A Renaissance Profile." Contributor to Vogue First Reader; High Lights of Modern Literature; Dance Annual. Contributing editor, Mademoiselle; Consulting Ed.; Playbill, Dance Magazine, and contributor to national magazines and literary journals. Lectures frequently on TV and radio. For seven seasons wrote program notes for New York Philharmonic Symphony Saturday morning concerts. Lectured, N.Y. Univ. on the art of biography and the writing of children's books.*

LERNER, ABE—Book Designer, A. Dir., Prod. Mgr.
The Macmillan Company, 866 Third Ave., New York, N.Y. 10022; h. 69 W. 9th St., New York, N.Y. 10011
B. New York, N.Y., Sept. 14, 1908. Member: AIGA. Awards: Books included in "Fifty Books of the Year," 1938, 1939, 1941, 1943, 1945, 1948, 1951, 1954; Trade Book Clinic Monthly Selections, since 1938.

Exhibited: Cooper Union, 1948. Contributor of articles on typography and book production to Publisher's Weekly and Book Production (formerly Bookbinding and Book Production); also articles to The Writer. Lectures: Series of lectures on design problems and their solution, for young book designers, AIGA. Arranged exh. of art books "Every Home a Museum," 1951, Assoc. Am. A. Gallery, under auspices of AIGA. Member Exec. Com., Trade Book Clinic, AIGA, 1941-42; Chm., Trade Book Clinic, 1953-54; Chm., Fifty Books of the Year Com., 1955. Positions: Instr., Book Des., and Production, AIGA, 1941-42, Bd. Dirs., 1959-60, 1960-61; Instr., Book Des. and Production, Columbia Univ., New York, N.Y., 1953- ; Dir., Design & Production, Adult Trade Books, The Macmillan Co., New York, N.Y.

LERNER, ABRAM—Museum Director
135 E. 65th St., New York, N.Y. 10021; h. 33-64 21st St., Long Island City, N.Y. 11106
B. New York, N.Y., Apr. 11, 1913. Studied: New York University, B.A.; and painting and drawing in various art schools. Positions: Assistant Director, A.C.A. Gallery and Artists' Gallery, New York City, 1945-1955; Curator, Hirshhorn Collection, 1956-1967; Member, New York Advisory Board, Archives of American Art, 1961- ; Director, Hirshhorn Museum & Sculpture Garden, Smithsonian Institution, Washington, D. C., 1967- .

LERNER, ALEXANDER—Collector
Phoenix Clothes, 1290 Ave. of the Americas, New York, N.Y. 10019; h. 30 Whig Road, Scarsdale, N.Y. 10583
B. Philadelphia, Pa., Dec. 18, 1906. Studied: University of Pennsylvania. Collection: Modern art, including works by Durant, Cassat, Pissaro, Signac, Dufy, Vlaminck, Chagall, Villon, Bernard, Valtat, Manessier, De Kooning, Appel, Kline, Gottlieb, Baziotes, Lebenstein, Capigrossi, Dine, Segal, Basarelly, Moore, Arp, Casear, Armitage, Buffet.

LE ROY, HAROLD M.—Painter, W., L.
191C Ave. K., Brooklyn, N.Y. 11230
B. New York, N.Y., Dec. 12, 1905. Studied: Columbia Univ., B.A.; BMFA Sch. A.; ASL; Hans Hofmann A. Sch. Member: AEA; Independents of the Old Bergen A. Gld.; The Artists Circle; Group Three, AEA. Work: Paintings—Butler Inst. Am. A.; Mus. Mod. A., London, Ontario; Safad Mus., Israel. Costume designs for the theatre. Exhibited: Traveling exh., Old Bergen A. Gld.; Huntsville (Ala.) A. Mus., 1968; Crestview (Fla.) A. Center, 1968; Virginia State Col., 1968; Univ. Michigan, 1968; Bowling Green (Ohio) State Col., 1969; La Salle Univ., Philadelphia, 1969; one-man: Ella Lerner Gal., 1968; Donnell A. Library, New York City, 1968; previous exhs.: Am. Art for Safad, N.Y., 1963; Am. Art Gal., Brooklyn, 1965; B'nai Brith, Brooklyn, 1962; BM, 1960; Hilda Carmel Gal., N.Y., 1959, 1960; Intercontinental A. Gal., E. Hanover, N.J., 1965, 1966; Orange A. Colony, 1965; Sally Robbins A. Gal., 1965; Staeb Gal., Brooklyn, 1959-1961; Gertrude Stein Gal., 1965; Westburgy, N.Y., exh., 1964, and others. Contributor articles, illus., to Hollywood Screen World, Hollywood Filmograph. Lectures: Art Appreciation; Twentieth Century Art and Artists; Art in Advertising.

LESH, RICHARD D.—Educator, P.
Art Department, Wayne State College; h. 505 East 10th St., Wayne, Neb. 68787
B. Grand Island, Neb., May 3, 1927. Studied: Univ. Denver, B.A., M.A.; Grad. study, Mexico City Col. Member: CAA; Nebraska A. Edu. Assn. (Vice-Pres., 1959-62); NAEA; Omaha Assoc. A.; Midwest College AA. Awards: prizes, Nat. Scholastic awards, 1943, 1944, 1945; Joslyn Mem. Mus., 1943-1945, 1947, 1948; Omaha Assoc. A., 1947, 1948; Area Artists, 1961. Exhibited: Nat. Scholastic Comp., 1942-1945; Midwest A., 1952, 1954, 1958; Joslyn Mem. Mus., 1943-1945, 1947, 1948, 1953, 1954, 1957, 1958; Denver A. Mus., 1950; Area Artists, 1956, 1957, 1961; Sioux City A. Center, 1955-1957; Governor's Show, 1963-1965; "Art Today" invitational Nebr. Centennial Show, Joslyn Art Museum & Sheldon Galleries, 1967-68. Positions: Assoc. Prof. A., Nebraska State College, Wayne, Neb., 1951- , Hd. Dept. A., 1967- . Pres., Nebraska Arts Council, 1968-69.

LESLIE, ALFRED—Painter
940 Broadway 10010; h. 1150 Fifth Ave., New York, N.Y. 10028
B. New York, N.Y., Oct. 29, 1927. Studied: N.Y. Univ. Work: MModA; WMAA; Mus. Mod. A., Sao Paulo; Mus. de Moderna, Sweden; Kunsthalle, Basel, Switzerland; Univ. Alabama; White Mus., Cornell Univ.; Albright A. Gal.; WAC; Union Sanatorium, Intl. Ladies Garment Workers Union. Exhibited: MModA, 1959; WAC, 1960; White Mus., Cornell Univ., 1959; AFA traveling exh., 1958; Vanderbilt Purchase Fund Traveling Exh., 1954; Univ. Nebraska, 1958; Jewish Mus., 1957; Pittsburgh, Pa., 1958, 1959, 1960, 1962; WMAA, 1955, 1957, 1959-1961; one-man: Tibor DeNagy Gal., N.Y., 1951-

955, 1958; Martha Jackson Gal., N.Y., 1959, and in many other local gallery exhibitions. Ed., The Hasty Papers, 1960; ed., publ., co-dir., co-producer film: Pull My Daisy.*

LE SUEUR, MAC—Painter, L., T.
638 Summit Ave., St. Paul, Minn. 55105
B. San Antonio, Tex., Dec. 13, 1908. Studied: Minneapolis Sch. A. Member: Minnesota AA. Awards: prizes, Minneapolis Inst. A.; Minn. State Fair. Work: Minneapolis Inst. A.; Walker A. Center; Pub. Lib., Community A. Center and Academy, Bureau of Health, Charles Miller Hospital, all St. Paul; Univ. Minnesota; Univ. of Agriculture, St. Paul. Exhibited: Palace Legion Honor; AIC; WMAA; Critics Show, 1944; WFNY 1939; Minn. State Fair; Minneapolis Inst. A.; Walker A. Center (one-man); St. Paul Gal. & Sch. A., 1959 (one-man); Pensacola A. Center, 1960 (one-man). Other one-man exhs.: St. Paul: College of St. Thomas, 1966; Univ. Minn., St. Paul Campus, 1967; St. Paul A. Center, 1967; Kramer Gal., 1967; Sky Gal., 1968; West Lake Gal. of Minneapolis, 1969. Lectures: Abstract Art in Teaching; Modern Art. Positions: Dir., Walker A. Sch., 1940-50; Dean, St. Paul's Sch. A., St. Paul, Minn.; Instr. Advanced Painting, Minneapolis Sch. A.; Instr. Painting, Univ. Minnesota Ext. Instr., Dakota County Fine Arts Center, St. Paul.

LETENDRE, RITA (RITA LETENDRE-ELOUL)—Painter, Gr.
2237 N. New Hampshire Ave., Los Angeles, Cal. 90027
B. Drummondville, Quebec, Canada, Nov. 1, 1929. Studied: Ecole des Beaux Arts, Montreal. Awards: Prix de la Province de Quebec, 1961; Canada Arts Council grants, 1962 (traveling), 1963; Quebec Art Council grant, 1967. Work: Mus. FA, Montreal; Musée d'Art Contemporain, Montreal; Musée du Quebec; A. Gal. Toronto; A. Gal. Vancouver; Long Beach Mus. FA, Long Beach, Cal.; Brandeis Univ., Waltham, Mass.; and in many private collections in U.S. and Europe. Exhibited: Mus. FA, Montreal, 1955, 1960-1961 (traveling), 1960-1962, 1967; Gal. Parma, N.Y., 1957; Mus. FA, Hamiliton, Canada, 1957; Canada House, N.Y., 1959; Nat. Gal. Canada, 1960-1961 (traveling), 1961 (traveling: U.S. and Canada), 1962 (traveling: British Commonwealth), 1968 (traveling); Spoleto, Italy, 1967; Galerie Arnaud, Paris, 1964; Lytton Center of Visual A., Hollywood, 1968. One-man: Galerie Denise Delrue, Montreal, 1959, 1961; Mus. FA, Montreal, 1961; Gal. Dorothy Cameron, Toronto, 1961, 1963; Univ. Ottawa, 1963; Galerie Camille Herbert, Montreal, 1963, 1965; Pascal Gal., Toronto, 1967; Gordon Gal., Tel Aviv, 1969.

LEVAL, MRS. FERNAND—Collector
660 Park Ave., New York, N.Y. 10021
B. New York, N.Y., Apr. 5, 1911. Collection: Impressionist, post-impressionist, contemporary painting, drawing and sculpture. Positions: Partner, Jacques Schiffrin and Co., publishers; Director, Pantheon Books, 1945-1960.*

LEVEE, JOHN HARRISON—Painter, Lith., Eng.
119 rue Notre Dame des Champs, Paris 6, France
B. Los Angeles, Cal., Apr. 10, 1924. Studied: Univ. Cal. at Los Angeles, B.A.; New School, N.Y.; Acad. Julien, Paris. Awards: prizes, Acad. Julien, 1951; Prix de Deauville, 1951; Cal. WC Soc., 1953, 1954; Int. prize, Bienniele, Paris, 1959; purchase prize, MModA.; purchase prize, Commonwealth of Virginia Biennial, 1966. Work: Kunst, Basel, Switzerland; Smith Col.; MModA; N.Y. Pub. Lib.; Stedelijk Mus., Amsterdam; Carnegie Inst.; CMA; Musee du Havre, France; WMAA; FMA; Harvard Univ.; Haifa, Israel; Yale Univ.; Santa Barbara, Cal., and others. Exhibited: Carnegie Inst., 1955, 1958, 1961; MModA, N.Y., 1956, 1961; CMA, 1956, 1958; CGA, 1956, 1958, 1960; WMAA, 1957-1959, 1966; WAC, 1960; AIC, 1960; Salon de Mai, 1954-1961; Réalites Nouvelles, Paris, 1956-1969; Biennale de Paris, 1959; L'Ecole de Paris, 1958-1961; Am. Painters in France Exh., 1960-61 (touring museums in U.S. and France); Guggenheim Mus., N.Y., 1966; USA: New Painting, touring French museums, 1966-1967; one-man: Mus. Art, Haifa, Israel, 1963; Phoenix A. Mus., 1964; Univ. Illinois, Krannert Mus., 1965; WAC, 1965; Mus. A., Tel Aviv, 1969; Gimpel Gal., London, 1966; Emmerrich Gal., N.Y., 1967. Positions: Visiting Prof. Art, Univ. Illinois, 1965; Carnegie Institute, (Andrew Mellon Chair), 1966.

LEVENSON, MINNIE G. (Mrs.)—Educator
8 Hawthorne Rd., Holden, Mass. 01520
B. Russia, Feb. 5, 1905. Studied: Boston Univ., B.A.; Harvard Univ.; Columbia Univ., M.A. Positions: Sec. for School Service and Head, Div. of Public Instruction, 1933- , Cur., of Education, 1955-1967; engaged in experimental projects for adolescents in New England area; Consultant in Films and Music, 1967- , all at Worcester Art Museum, Worcester, Mass.

LEVENTHAL, ETHEL S.—Painter, Et.
47 Plaza St., Brooklyn, N.Y. 11217
B. Brooklyn, N.Y., Dec. 20, 1911. Studied: N.Y. Univ.; Brooklyn Mus. Sch. A.; ASL; New Sch. for Social Research. Member: NAWA;

AEA; Woodstock AA; Kaaterskill Group. Awards: prizes, Argent Gal., 1961; Village A. Center, 1960. Exhibited: NAWA, 1947-1949, 1951, 1952, 1954, 1959, traveling exh., 1963-1964; All. A. Am., 1953; AEA, 1950, 1952, 1964; Hyde Park Playhouse; Woodstock AA; NAWA traveling exh., U.S. and in Europe; Argent Gal.; RoKo Gal.; Parnassus Square Galleries, Woodstock, 1968; Burr Gal., BM, 1958, 1968; Riverside Mus., N.Y., 1960; Audubon A., 1960; Village A. Center, 1960; NAD, 1969; 2-man, Brooklyn, 1961; Long Island Univ., 1960; Appleton Gal., Syracuse; 326 Gal., Albany, N.Y.; BM, 1961; Norfolk Mus. A. & Sciences, 1964; Royal Scottish Acad. of England and Royal Birmingham Soc., 1964; Pepsi Cola Bldg., N.Y., 1964.

LEVERING ROBERT K.—Painter, I.
330 East 79th St., New York, N.Y. 10021
B. Ypsilanti, Mich., May 22, 1919. Studied: Univ. Arizona, A.B.; AIC, BMSch. A.; ASL; PAFA; New School, N.Y. Awards: Citations from Soc. Illustrators, 1962-1964, 1969 (gold medal); citation, New Jersey A. Dirs. Cl., 1969; Soc. of Publications Designers, 1969. Work: paintings, U.S. Air Force coll., Pentagon, Wash., D.C., and in private colls. Contributor illus. to McCalls; Good Housekeeping; Cosmopolitan; Sat. Eve. Post; Red Book; Woman's Day, Look, Reader's Digest, Playboy, Seventeen, and other leading national magazines. Exhibited: New York City Center Gal. (7 exhs.); SI Gal., N.Y.; A. Dirs. Exh., 1969; Mikelson Gal., Wash., D.C., 1968. Positions: Guest Lecturer and Critic, Parsons School of Design, New York, 1965, 1966, 1968.

LEVI, JOSEF—Sculptor, P.
171 W. 71st St., New York, N.Y. 10023
B. New York, N.Y., Feb. 17, 1938. Studied: Univ. Connecticut, B.A.; Columbia Univ. Work: MModA; Albright-Knox A. Gal., Buffalo, N.Y.; Aldrich Mus. Contemp. A., Ridgefield, Conn.; Krannert Mus., Univ. Illinois; Des Moines A. Center; J.B. Speed A. Mus., Louisville, Ky.; Albion (Mich.) Col.; Univ. Notre Dame; Spelman Col., Atlanta, Ga. Exhibited: Mus. Contemp. A., Houston, Tex., 1966; Des Moines A. Center, 1966; MModA, 1966, traveling 1966-1967; Aldrich Mus. Contemp. A., 1966; Mus. Contemp. A., Philadelphia, Pa., 1966; Nelson-Atkins Mus., Kansas City, Mo., 1966; Flint (Mich.) Inst. A., 1966; Krannert Mus., Univ. Illinois, Urbana; Inst. Contemp. A., Washington, D.C., 1967; Kent State Univ., Ohio, 1967; WAC, 1967; Milwaukee A. Center, 1967; Newark (N.J.) Mus, 1967; MModA, 1967; Herron A. Mus., Indianapolis, Ind., 1968; Mus. Contemp. A., Chicago, Ill., 1968; Aldrich Mus. Contemp. A., 1968; WMAA, 1968, 1969; Jewish Mus., N.Y., 1969. One-man: Stable Gal., N.Y., 1966, 1967, 1969; A. Cl. of Chicago, 1967; J.B. Speed A. Mus., Louisville, Ky., 1968. Positions: A.-in-Res., Appalachian State Univ., Boone, N.C. (Spring) 1969.

LEVI, JULIAN (E)—Painter, T., Lith.
Fireplace Rd., East Hampton, L.I., N.Y. 11937
B. New York, N.Y., June 20, 1900. Studied: PAFA; & in France. Member: Nat. Inst. A. & Lets. Awards: Cresson traveling scholarship, PAFA, 1919; F., PAFA, 1944, 1956; Temple Gold Medal, PAFA, 1962; prizes, AIC, 1942, 1943; NAD, 1945; Pepsi-Cola, 1945; VMFA, 1946; Univ. Illinois, 1948; East Hampton, 1952; Am. Inst. A. & Lets. grant, 1955; N.Y. State Fair, 1958. Work: MMA; MModA; WMMA; Springfield (Mass.) Mus.; Albright A. Gal.; AIC; Toledo Mus. A.; New Britain AI; PAFA; Newark Mus.; Univ. Nebraska; Univ. Arizona; Cranbrook Acad. A.; Encyclopaedia Britannica Coll.; Walker A. Center; U.S. State Dept.; Butler Inst. Am. A.; NAD; Detroit Inst. A.; Michigan State Univ.; Munson-Williams-Proctor Inst., Utica, N.Y. Exhibited: nationally and internationally; one-man: Downtown Gal., Alan Gal., Nordness Gal., all New York City. Author: "Modern Art: A Survey," 1961. Positions: Instr., ASL, New York, N.Y.; Dir., Art Workshops. New School for Social Research, N.Y.; Visiting Critic, Pa. Acad. FA, Phila., Pa.

LEVICK, MR. and MRS. IRVING (MILDRED)—Collectors
701 Seneca St.; h. 227 Nottingham Terrace, Buffalo, N.Y. 14216
Collection: Contemporary American and European artists, including Gatch, Weber, Dove, Hartley, Rivers, Levine, Marin, Weinberg, King, Knaths, Shahn, Roth, Tam, Greene, Guerero, Avery, Soutine, Matisse, Dubuffet, Matta, Marchand, Levee, Nikos, Nicolson, Sutherland, Marini, Fraser, Francis, Wiley, Buggiani, Kinley, Lawrence, Appel, Corneille, Severini, Kinigstein, Katzman, Rouault, Graves, Brice, Heerup, Wols, Bauermeister, Jimmy Ernst, James Wines, Lynn Chadwick, Georgia O'Keeffe, Saul Steinberg, Davies, and others.

LEVIN, MRS. ISADORE (JEANNE L.)—Collector, Patron, Artist
316 Garden Road, Palm Beach, Fla. 33480
B. Cleveland, Ohio, Dec. 13, 1901. Studied: Cleveland School of Art; Wells College, B.A.; Cranbrook Academy of Art; Society of Arts and Crafts, Detroit, Mich.; Norton Gallery and School of Art, W. Palm Beach, Fla.; Private painting instruction with Gerald Brockhurst, Ernest Fiene, Bruce Mitchell, Zubel Katchadoorian. Awards:

Honorable Mention, Michigan Artists Exhibition, Detroit Institute of Arts, 1946; Paley Award, Norton Gallery of Art, W. Palm Beach, Fla., 1962, 1966. Four Arts Soc., Palm Beach, 1968. Collection: Post-impressionists (paintings and sculpture); Contemporary paintings and sculpture; Primitive sculpture (Greek, African, Pre-Columbian). The complete collection was exhibited at Cranbrook Academy of Art, Birmingham, Mich., 1954, Detroit Institute of Arts, 1959, and Norton Gallery of Art, W. Palm Beach, Fla., 1959. Exhibited: Benson Gal., Bridgehampton, N.Y., 1967; Compass Gal., Nantucket, Mass., 1967; Gemini Gal., Palm Beach, 1969. One-man: Norton Gal., Palm Beach, 1967; Contemporary Gal., Palm Beach, 1963, 1965, 1968. Positions: Associate Trustee, 1958-1963, Chairman, Friends of Modern Art, 1958-1963, Chairman, Futurists Exhibition, 1961, Chairman, Acquisition Committee for Modern Art, Detroit Institute of Arts; Founding member of Gallery of Contemporary Art, Palm Beach, Fla.; New York Studio Sch., Trustee 1965- .

LEVIN, KIM—Painter, Cr., W.
134 Sullivan St., New York, N.Y. 10012
B. New York, N.Y. Studied: Yale-Norfolk Summer School of Art; Vassar College, A.B.; Columbia Univ., M.A. Exhibited: one-man: Suffolk Mus., Stony Brook, N.Y., 1963; Vassar Col., 1964; Poindexter Gal., N.Y., 1964, 1967. Contributor articles to Art: USA: Now, 1962; American Journal of Archaeology, 1964; Art News, 1964, 1965, 1967-1969 (and monthly reviews); Art News Annual, 1969. Positions: Editorial Assoc., Art News, 1962- , Instr., Drawing, Phila. Col. A., 1967- .

LEVINE, DAVID—Painter, Cart.
c/o Forum Gallery, 1018 Madison Ave., New York, N.Y. 10021*

LEVINE, JACK—Painter
95 Bedford St.; h. 231 W. 11th St., New York, N.Y., 10014
B. Boston, Mass., Jan. 3, 1915. Studied: with Denman W. Ross; Harold Zimmerman. Member: Am. Acad. A. & Sciences; Nat. Inst. A. & Let. Awards: prize, AV, 1943; Guggenheim F., 1945, 1946; grant, Acad. A. & Sciences, 1946; Hon. degree, D.F.A., Colby Col., Waterville, Me., 1957. Work: MMA; MModA; AGAA; Univ. Nebraska; Portland (Ore.) Mus. A.; Walker A. Center; Univ. Arizona; WMAA; AIC. Exhibited: annually; Carnegie Inst.; AIC; WMMA, etc.; Retrospective exh., Inst. Contemp. A., Boston, 1953; Retrospective, WMAA, 1955; Palacio de Bellas Artes, Mexico City, 1960. Lectures: AIC And Skowhegan Sch. Painting and Sculpture.

LEVINE, LES —Sculptor
119 Bowery, New York, N.Y. 10002
B. Dublin, Ireland, Oct. 6, 1936. Studied: Central Sch. A. & Crafts, London. Member: Architectural Lg., New York. Awards: Canada Council of Arts, 1967, 1968; Canadian A., 1968. Work: Nat. Gal., Canada; A. Gal. of Toronto; Vancouver (B.C.) A. Gal.; Hart House, Univ. Toronto; Montreal Mus. FA; MModA; WMAA; PMA. Exhibited: Fischbach Gal., N.Y., 1966; Westmoreland County Mus., Greensburg, Pa., 1966; MModA, 1966 (2), 1967 (2); So. Illinois Univ., 1967; Canadian Government Exh., Union Carbide Bldg., N.Y., 1967; Expo '67; Nat. Gal., Canada, Toronto, 1967; Inst. Contemp. A., Boston, 1967 (2); Sch. Visual Arts, N.Y., 1967; Hemisfair, San Antonio, 1968; Arch. Lg., N.Y., 1968; Univ. Mus., Mexico City, 1968; Fnd. Maeght, St. Paul, France, 1968; Mus. Mod. A., Paris, 1968; Finch Col., N.Y., 1967, 1968; Mus. Contemp. Crafts, N.Y., 1968; Douglas Gal., Vancouver, 1968; Edinburgh Festival, Scotland, 1968; WMAA, 1968, 1969; Flint Inst. A., 1968; Univ. California at Los Angeles, 1969; Albright-Knox A. Gal., 1969; Arts Council of Philadelphia traveling, 1969; Inst. Contemp. A., Philadelphia, 1969; Jewish Mus., N.Y., 1969; Univ. Mus., Mexico City, 1968; Paris Biennial, 1969; Sao Paulo Bienal, 1969; one-man: Arch. Lg., N.Y., 1967; MModA, 1967; WAC, 1967; Isaacs Gal., Toronto 1967; N.Y. State Council on the Arts, 1968; Gibson Gal., N.Y., 1968; York Univ., Toronto, 1969; Rowan Gal., London, 1969; Univ. Michigan, Ann Arbor, 1969; Inst. Contemp. A., Chicago, 1969; Fischbach Gal., N.Y., 1966-1969. Also in Toronto, Ottawa and London, Canada, 1964-1966. Contributor to: Aspen Times, 1967; Arts Canada, 1968; Other Scenes, 1969; Arts & Artists, 1969. Positions: Vice-Pres., Architectural League of New York, 1968-1969; A.-in-Res., Aspen, Colo., 1967, 1969; Viterbo College, La Crosse, Wis., 1968.

LEVINE, REEVA (ANNA) MILLER (Mrs.)—
Portrait Painter, Des., C., T., L., I.
2830 Cascadia Ave., South, Seattle, Wash. 98144
B. Hollywood, Cal., Nov. 23, 1912. Studied: Santa Monica City. Col.; Univ. Cal. at Los Angeles. Member: Santa Monica AA. Westwood AA; SAM; Cal. AA. Awards: prizes, Santa Monica AA, 1945, 1956. Work: stained glass windows: Temple Beth Sholom, Santa Monica; Temple Sinai, Oakland, Cal.; Maarev Temple, Encino, Cal. Dome, Al Jolson Memorial, Los Angeles; portraits: Temple Israel, Long Beach; Temple Beth Sholom, Santa Monica; Temple De Hirsch, Seat-

tle, 1961; des. and dec. religious Arks in Temples in Santa Monica, Inglewood, Long Beach and Burbank, Cal., Camp Schrader, Colorado. Des. and dec. Temple bldg. and Ark in Temple Beth Israel, Aberdeen, Wash., 1960. Paintings in private colls. Illus., "Holy Mountain" and "Youth Hagadah." Exhibited: Santa Monica AA (one-man); Westwood AA; Los A. AA; Cal. AA; West Los A. Synagogue (one-man); Greek Theatre, Los A.; Santa Monica Jewish Comm. Center; Univ. Seattle, 1960, 1965, 1967; Seattle Jewish Comm. Center, 1961; Liturgical Conf., Seattle World's Fair, 1962; Seattle A. Mus., 1967; Doces Aurora Gal., Seattle, 1968, 1969 (both one-man). Lectures, demonstrations, TV program "NOW," Las Vegas, 1959 and in many Temples in Cal.; TV program "Community Work Shop," Seattle, 1966, 1967, 1969. Positions: A. & Crafts Dir., Camp Saratoga, Cal., 1953-58; Instr., Dula. Mem. Center, Las Vegas, 1959; Jewish Comm. Center, Seattle, 1960-61.

LEVINE, SEYMOUR R.—Collector
1019 Park St.; h. Carhart Ave., Peekskill, N.Y. 10566
B. Russia, May 28, 1906. Studied: Washington Square College, New York University; New York University School of Law, J.D. Collection: Includes works by de Creeft, Elkan, Rubin, Blum, Neujean, and others. Positions: City Judge, City Court of Peekskill.*

LEVINE, SHEPARD—Painter, E., Lith., L., W.
Oregon State University; h. 3750 Hayes St., Corvallis, Ore. 97330
B. New York, N.Y., June 21, 1922. Studied: Univ. New Mexico, B.A., M.A.; Univ. Toulouse, France. Member: AAUP. Work: prints in Parnassus Hall, Athens, Greece, sponsored by USIS Coll. of U.S. Embassy, 1960; Frye Mus. A., Seattle, Wash., 1961 (painting). Exhibited: AGAA, 1951; BM, 1953; Henry Gal., Univ. Washington, 1954; SFMA, 1957; Portland (Ore.) A. Mus., 1954-1958; SAM, 1954-1958; Spokane A. Mus., 1954-1958; one-man: France-Etats Unis., Toulouse, 1953; Mus. New Mexico, 1952; Portland A. Mus., 1956. Lectures: "Roots of Contemporary Expression"; "The Artist's Vision," to museum and private groups. Positions: Prof. A., Oregon State University, Corvallis, Ore.*

LEVINSON, FRED (FLOYD)—Industrial, Adv. Designer, Cart.
1160 Midland Ave., Bronxville, N.Y. 10708
B. New York, N.Y., May 23, 1928. Studied: Syracuse Univ., B.F.A. Member: SI. Exhibited: English (1953), Italian (1954) and French (1954) exhibitions of cartoons. All New York State Exhs.; Cannes Film Festival, 1960; N.Y. Film Festival; Edinburgh Film Festival, 1960. Awards: Hollywood Film Festival, 1960 (for NBC network); Edinburgh Film Festival, 1960 (for Bristol Myers); N.Y. Film Festival, 1961 (for Standard Brands & award for program openings). Contributor of cartoons to: "Best Cartoons from True," 1954-55; "Cartoon Cavalcade," 1954; "Best Cartoons of the Year," 1954-55. Cartoons for Sat. Eve. Post; Colliers; Look; True; This Week; American Weekly; American magazine; Redbook; Better Homes & Gardens; New York Post; Liberty; MacLean's, and others. Positions: Pres., Wylde Productions (industrial shows, films, live & animated TV commercials).*

LEVINSON, MON—Sculptor
147 W. 88th St., New York, N.Y. 10024
B. New York, N.Y., Jan. 6, 1926. Studied: American Univ., Biarritz; Univ. Pennsylvania, B.S. Work: WMAA; Rose A. Mus., Brandeis Univ.; Spelman Col., Atlanta; Museo de Bellas Artes, Caracas. Exhibited: Martha Jackson Gal., N.Y., 1960, 1965; Marion Koogler McNay Mus., San Antonio, 1961; Mus. Contemp. A., Dallas, 1961; Contemp. A. Assn., Houston, 1961, 1964; MModA Penthouse, 1962, 1963, 1966; AFA traveling exh., 1964, 1966 (2), 1968; Daniels Gal., N.Y., 1964; Albright-Knox Gal., Buffalo, 1964, 1965, 1968; AIC, 1964, 1965; Sidney Janis Gal., N.Y., 1964; Jewish Mus., N.Y., 1965, 1967; Ft. Worth A. Center, 1965; Univ. Kansas and Univ. Texas, 1965; Byron Gal., N.Y., 1965; MModA, 1965, 1967; Spelman Col., 1966; Pratt Inst., 1966; BMFA, 1966; Flint Inst. A., 1966, 1968; Des Moines A. Center, 1966; Rose A. Mus., Brandeis Univ., 1966, 1967; Wadsworth Atheneum, Hartford, 1966; Mus. Contemp. Crafts, N.Y., 1967, 1968; Aldrich Mus. Contemp. A., 1967, 1968; Yale A. Gal., 1967; WMAA, 1968; Inst. Contemp. A., Chicago, 1968; Caracas, Venezuela, 1968; Grand Rapids Mus. A., 1969, and many others. One-man: Barone Gal., N.Y., 1961; Kornblee Gal., N.Y., 1961, 1963-1966, 1968; Siden Gal., Detroit, 1965-1967, 1969; Cinema I-II, N.Y., 1965; Obelisk Gal., Boston, 1968. Positions: Visiting Artist, BMFA Sch. FA, 1969.

LEVIT, HERSCHEL—Painter, I., E.
220 West 93rd St., New York, N.Y. 10025
B. Shenandoah, Pa., May 29, 1912. Studied: PAFA; Barnes Fnd. Awards: Cresson traveling scholarship, PAFA, 1933. Work: murals, Rowan Sch., Phila.; Recorder of Deeds Bldg., Wash., D.C.; USPO, Lewisville, Ohio; Jenkintown, Pa.; 33 portrait drawings of Red Seal Artists, RCA Victor, 1958; photographs, MModA. Exhibited: PAFA,

1966-1969; AIC; Phila. A. All.; Springfield A. Mus.; All. A. Am;. Phila. Pr. Cl.; BM; MMA; WMAA; Carnegie Inst.; Am. Soc. Pr. M.; Grand Central A. Gal.; and others, 1962-64; one-man: John Myers Gal., N.Y., 1954; one-man photog. exh., Village Camera Cl., 1961. RoKo Gal., N.Y., 1958, 1962. Author: Avant Garde section in "Graphic Forms," 1950. Illus., "Red Badge of Courage," 1963; "Pegasus, the Winged Horse," 1963; "King Arthur," 1964; "Louis Pasteur," 1966; "Horizon Book of Ancient Rome," 1966; Horizon Book of The Elizabethan World," 1967; Horizon Book of Great Cathedrals," 1968; "Master Builders of the Middle Ages," 1969. Positions: Prof. Advanced Des., PIA Sch., Brooklyn, N.Y.

LEVITAN, ISRAEL—Sculptor, T., L.
299 East 10th St., New York, N.Y. 10009
B. Lawrence, Mass., June 13, 1912. Studied: A. & Crafts Sch., Detroit; AIC; with Zadkine in Paris, France and with Ozenfant, Hofmann. Awards: McDowell Fellowship, 1956; prize, East Hampton Gld. Hall, 1959. Work: Abstract ceiling, Interchurch Center, N.Y., and in many private collections. Work reproduced and discussed in "Sculpture of the Century"; Life; Look; Das Kunstwerk; Portfolio No. 1. Exhibited: Musee d'Art Moderne, Paris, France, 1951; WMAA, 1952, 1953; Am. Abstract A., 1953, 1954, 1955 (and traveling show to Tokyo, Yokohama, Honolulu, San Francisco), 1956, 1957; PAFA, 1953; Stable Gal., 1954-1957; Tanager Gal., 1955, 1956, 1962; Artists Gal., 1955; Barone Gal., 1957 (2-man) and group shows; Assoc. Am. A. Gal., 1957 (5-man); Contemporaries, 1957; Hansa Gal., 1957; (these galleries are in New York City); East Hampton Gld. Hall, 1959, 1961; Ohio State Univ., 1954; Detroit Inst. A., 1955; BM, 1960; Claude Bernard Gal., Paris, 1960; MModA, 1960; USIA, Dacca, Pakistan, 1961; Tirca Karlis Gal., Provincetown, 1961; Phila. Mus. Col. A., 1963; Long Island Univ., 1967, 1969; one-man: Artists Gal., 1952; Weyhe Gal., 1953; Retrospective, Barone Gal., 1959, one-man, 1960; Worth Ryder Gal., Univ. Cal., Berkeley, 1962; Grand Central Moderns, 1964; Retrospective, The Gallery, Memphis, Tenn., 1964; Jane Wade Gal., 1966-1969; Bet Torah, Mt. Kisco, N.Y., 1968, 1969. Positions: Instr., L., Sculpture, BM; Cooper Union Drawing Group; N.Y. Univ., Edu. Dept.; Univ. California, Berkeley; Phila. Mus. Col. A.; Queens Col., N.Y. Conducted workshop, N.Y. Univ., 1967.

LEVITINE, DR. GEORGE—Scholar
Art Department, University of Maryland, College Park, Md.; h. 420 Pershing Drive, Silver Spring, Md. 20910
B. Karkov, Russia, Mar. 17, 1916. Studied: Univ. Paris; Boston Univ., M.A.; Harvard University, Ph.D. Awards: Edward N. Bacon Scholarship for Travel and Research Abroad, Harvard Univ., 1949; Grant-in-Aid for Scholarly Research, American Council of Learned Societies, 1962. Field of Research: Romanticism in Art. Contributor to articles and monographs in The Art Bulletin, Burlington Magazine, Journal of the Warburg and Courtauld Institutes, Gazette des Beaux Arts, Journal of Aesthetics and Criticism, and others. Positions: Instr., Harvard University Extension Program; Professor, Boston University; Professor, Hd., Art Dept., University of Maryland, College Park, Md., at present.

LEVITT, ALFRED—Painter, T., W., L.
505 W. Broadway, New York, N.Y. 10012
B. 1894. Studied: Columbia Univ.; ASL; Hans Hofmann Sch., and Grande Chaumiere, Paris, France. Member: Archaeological Inst. of America; La Societe Prehistorique de L'Ariege, France; Life Member: Archaeology Soc. of Staten Island, N.Y.; Am. Program Bureau, Boston, as lecturer on art. Awards: MacDowell Colony Fellowship, Peterboro, N.H., 1956. Work: Yad Labanim Mus., Israel, and in private collections, United States and Europe. Exhibited: Butler Inst. Am. A.; PAFA; BM; WMAA; Manchester (N.H.) Community Center; Modern Artists of Cape Ann, Rockport, Mass.; Ferrargil Gal., Wildenstein Gal., A.C.A. Gal., and Tanzer Gal., all New York City; one-man: Babcock Gal., N.Y.; Philadelphia A. All. Lectures: "Cave Art-The Birth of Painting," at N.Y. Univ.; Cooper Union Forum; N.Y. Public Library; Archaeological Institute of America at Wagner College, Staten Island and the North Shore Society, both New York; Philadelphia Art Alliance as well as in France. Positions: Founder, Director and Teacher of Painting at Ecole Moderne de Provence, St. Remy de Provence, France, 1949-1950, 1959-1962.

LEVY, BEATRICE S.—Painter, Gr., T.
1451 Torrey Pines Road, La Jolla, Cal. 92037
B. Chicago, Ill., Apr. 3, 1892. Studied: AIC; & with Charles Hawthorne, Vojtech Preissig. Member: Chicago SA; Renaissance Soc., Univ. Chicago; San Diego FA Gld.; La Jolla Mus. A. Awards: prizes, AIC, 1923, 1930; Springfield (Ill.) Acad., 1928; Coronado AA, 1952, 1956, 1957; Del Mar, Cal., 1953; San Diego FA Gld., 1955, 1957; med., Chicago SA, 1928. Work: Chicago Mun. Coll.; Bibliotheque Nationale, Paris; AIC; Lib. Cong.; FA Gal. of San Diego; La Jolla Mus. A.; Davenport Mun. A. Gal.; Smithsonian Inst.; Univ. New Mex-

ico; Long Beach Mus. A.; Vanderpoel Coll. Exhibited: AIC, 1917, 1919, 1922, 1923, 1928, 1929-1940, 1942-1946; Carnegie Inst., 1929; PAFA, 1923, 1924, 1929, 1931; NAD, 1945, 1946; SAE, 1938, 1940, 1944, 1945; Chicago SE, 1914-1919, 1922-1931, 1935-1945; Lib. Cong., 1945, 1946; Fifty Prints of the Year, 1932, 1933; Chicago, 1953; Davenport Mun. A. Gal., 1953; Des Moines, Iowa, 1953; Grinnell, Iowa, 1953; San Diego FA Gld., 1953-1963; Univ. New Mexico, 1957 (one-man); Long Beach Mus. A. traveling print exh., 1959-60, traveling drawing exh., 1960-61; SFMA, 1960; La Jolla A. Center, 1959-1961; traveling ceramic exh., Yokohama, Japan, 1963-64.

LEVY, HILDA—Painter, Ser.
2411 Brigden Road, Pasadena, Cal. 91104
B. Pinsk, Russia. Studied: Univ. California, Berkeley, A.B.; Pasadena City Col.; Jepson AI; Univ. California, Los Angeles and with Adolph Gottlieb. Member: Cal. WC Soc.; Bay Printmakers; San Francisco AI. Awards: 27 local and National awards. Exhibited: Downey Mus., 1961; Los A. Municipal Gal., 1961; Santa Barbara Mus. A., 1957; Knoxville, Tenn., 1962; deCordova & Dana Gal., 1960; Long Beach Mus., 1962; Nat. Gal. of Canada, Ottawa, 1956-1958; Los A. AA, 1956; Palos Verdes AA, 1964; LC; Butler Inst. Am. Art; Nat. Mus., Wash., D.C.; PMA; AWS; All. A. Am.; Audubon A.; Los A. Mus. A.; SFMA; La Jolla Mus. A.; Pasadena Mus.; Oakland A. Mus.; de Young Mem. Mus.; Delgado Mus., New Orleans, and others. Traveling exhs.: LC; Cal. WC Soc.; San F. AI; Bay Printmakers, and others. One-man: Cal. PLH; Pasadena A. Mus.; Long Beach Mus. A.; Downey (Cal.) Mus.; Santa Monica A. Gal.; Occidental and Chapman colleges.*

LEVY, TIBBIE—Painter
2 Sutton Place South, New York, N.Y. 10022
B. New York, N.Y., Oct. 29, 1908. Studied: Cornell Univ., with Arshile Gorky; ASL; Andre L'Hote and Grande Chaumiere, Paris. Work: Witte Mus. A., San Antonio; Phoenix A. Mus.; Jewish Mus., N.Y.; Hebrew Union Col., Cincinnati; Evansville Mus. A. & Sciences; Arkansas A. Center, Little Rock; Boston Univ. Mus.; Rose A. Mus., Brandeis Univ.; Cornell Univ. A. Mus.; Hinckhouse Coll., Cedar Rapids; Peabody Mus. A; Swope Gal. A.; Mus. Mod A., Miami, Fla.; Washington County Mus. A., Hagerstown, Md.; Queens Col., N.Y.; Norfolk Mus. A. & Sciences; Georgia Mus. A., Athens; other univ. museums: Colgate, Princeton, Rutgers, and Syracuse; Fairleigh Dickinson Univ.; Mus. Contemp. A., Madrid, Spain; Mus. Mod. A., Barcelona; Mus. Mod. A., Bilbao, Spain; Contemp. A. Soc., London, England. Exhibited: New York, 1960, 1962, 1964, 1965, 1968; Paris, France, 1961; Pennsylvania, 1961; Madrid, Spain, 1962, 1963; London, England, 1963, 1965.

LEWANDOWSKI, EDMUND D.—Painter, E.
1360 North Prospect Ave., Milwaukee, Wis. 53202
B. Milwaukee, Wis., July 3, 1914. Studied: Layton Sch. A. Member: Wisconsin P. & S.; Polish-Am. A.; Chicago FA Cl. Awards: prizes, Wisconsin P. & S., 1938; Wisconsin State Fair, 1939, 1946; Univ. Wisconsin, 1939; Grand Rapids A. Gal., 1940; Milwaukee Journal, 1940; Gimbel Centennial, 1948, 1952; Polish-Am. A., 1949; Hallmark Award, 1952, 1953, 1957; Southeastern WC award, 1953; Wisconsin State Centennial, 1948; medal, Milwaukee AI, 1940. Work: AGAA; BM; BMFA; Grand Rapids A. Gal.; Layton A. Gal.; Milwaukee AI; Univ. Wisconsin; Beloit Col.; Marquette Univ.; St. Patrick's, Menasha, Wis.; Am. Acad. A. & Let.; Acad. FA, Warsaw, Poland; Mus. FA, Krakow, Poland; Univ. Oklahoma; Gimbel Bros. Coll.; Florida State Univ.; Hallmark Coll.; Dartmouth Col.; Layton School of Art; MModA; Shell Oil Co.; U.S. Maritime Comm.; Allen-Bradley Co.; Flint A. Center; AIC; U.S. Treasury Dept.; Milwaukee A. Center; Univ. Wisconsin; Ford Motor Co.; Container Corp. of Am.; General Motors; General Electric Co.; Am. Export Lines; N.Y. Stock Exchange, and many more leading industrial firms nationally. Exhibited: AIC; Carnegie Inst.; CGA; PAFA; BM; Wisconsin P. & S.; Wisconsin Salon; one-man: MModA, 1943; Layton A. Gal.; Minnesota State Fair; Fla. State Univ., 1950. Contributor covers and reproductions to Fortune magazine. Positions: Prof., Painting, 1949-1952, Hd. Dept. A., 1952-1954, Florida State Univ.; Dir., Layton School of Art, Milwaukee, Wis., at present.*

LEWICKI, JAMES—Illustrator, E., P., Des.
5 Hawthorne Court, Centerport, N.Y. 11721
B. Buffalo, N.Y., Dec. 13, 1917. Studied: Detroit Soc. A. & Crafts Sch.; PIASch. Member: Audubon A.; AWS; SI; CAA; AAUP. Awards: prize, Am. A. Group, 1943. Exhibited: Hopkins Center, Hanover, N.H., 1963; Swirbul Lib., Adelphi Univ., N.Y., 1964; AWS, 1940-1965; Audubon A., 1945-1965. I., "New York from Village to Metropolis," 1939; "The United States in Literature," 1952; "Christmas Tales"; Life's "World We Live In"; paintings for Life's series on American Folklore. Illus. in Life, Collier's, N.Y. Times, Holiday, Sat. Eve. Post and other national magazines. Positions: Chm. Art Dept., Dir. Summer Art Workshops, C. W. Post College, 1964-1969; Chm. FA, Long Island A. Center, 1964-1965.

LEWIN, ALBERT—Collector
880 Fifth Ave., New York, N.Y. 10021
B. New York, N.Y., Sept. 23, 1894. Studied: New York University, B.A.; Harvard University, M.A. Collection: Contemporary painting; Archaic and archeological ceramics and sculpture.*

LEWIS, HAROLD—Painter, E.
1337A Spencer Ave., Lancaster, Pa. 17603
B. New York, N.Y., Mar. 6, 1918. Studied: ASL; Ozenfant Sch. A.; N.Y. Univ., M.A., Ph.D. Member: Wash. WC Cl.; Am. Soc. for Aesthetics; CAA; Art Educators of the City of New York; Cal. WC Soc.; AEA. Awards: prizes, Jersey City Mus. (2); Yaddo Fellowship, 1957-59; MacDowell Colony F., 1958; Huntington Hartford Fnd., 1961. Work: N.Y. Univ.; Newark State Col. Exhibited: Butler Inst. Am. A., 1956; CGA, 1957; Art:USA, 1958; PAFA, 1959; U.S. Nat. Mus., 1959; Boston A. Festival, 1961; Audubon A., 1965; Marietta Col., 1968; one-man: Delacorte Gal., N.Y., 1956, 1958; Angeleski Gal., N.Y., 1960; Newark State Col., 1960; Ryder Gal., Los A., 1961; Millersville (Pa.) State Col., 1969. Positions: Instr., A. & A. Hist., New School, N.Y. and Millersville State Col., Pa.

LEWIS, JEANNETTE MAXFIELD (Mrs. H. C.)—Etcher, Eng., P.
P.O. Box 352, Pebble Beach, Cal. 93953
B. Oakland, Cal., Apr. 19, 1896. Studied: Cal. Sch. FA, with Armin Hansen; and with Winold Reiss, Hans Hofmann. Member: SAGA; NAWA; AFA; Soc. Western A.; Albany Pr. Cl.; Hunterdon County A. Center, N.J.; AAPL; Wash. WC Cl.; Cal. Soc. Et.; Fresno A. Lg.; Carmel AA.; Conn. Acad. FA. Awards: prizes, Cal. State Fair, 1954, 1959, 1962, 1964; SAGA, 1954; Soc. Western A., 1955; Academic AA, Springfield, Mass., 1962; Knickerbocker A., N.Y., 1962; Saugatuck (Mich.) A. Festival, 1963; AAPL, 1959, Silver Medal, 1963; Lodi Grape Festival, 1959; Phila. Sketch Cl., 1960. Work: N.Y. Pub. Lib.; Brooks Mem. Mus., Memphis; Cal. State Coll.; Oakland A. Mus. Exhibited: SAGA, 1953-1955; NAWA, 1953-1955; Pr. M. of So. Cal., 1953-1955; Portland Soc. A. (Me.), 1953; Chicago Soc. Et., 1953, 1954; Academic A. Springfield Mass., 1954, 1955; LC, 1955; Soc. Western A., 1954, 1955; Cal. Soc. Et., 1954; Boston Pr. M., 1954; Conn. Acad. FA, 1955; Wash. WC Cl., 1954, 1955; and Sketch Cl., 1955; Santa Cruz A. Lg., 1954, 1955; and many others prior to these dates; exh. extensively in U.S. print shows, 1950-61; one-man: A. Gld., Carmel, 1954; Humbolt State Col., 1955; Western Rouze Gal., Fresno, 1955; Cal. PLH, 1955; Pebble Beach (Cal.) Gal., 1955; deYoung Mem. Mus., 1955; Argent Gal., N.Y., 1956; Brooks Mem. A. Gal., 1957; San Joaquin Mus. A., Stockton, Cal., 1957; Hidden Village A. Gal., Monterey, 1960; Rosicrucian A. Gal., San José, Cal., 1964; Old Bergen A. Gld., traveling exh., 1963-1964. Positions: Adv. Bd. Cal. Soc. Et.

LEWIS, MRS. MADISON H.—Collector
12 E. 73rd St., New York, N.Y. 10017
B. Warwick, N.Y., Jan. 29, 1905. Studied: Smith College; Mary Turlay Robinson's art group. Collection: Includes works by Delacroix, Matisse, Boudin, Dufy, Burchfield, Wyeth, Prendergast, Davies, Bishop, Homer, Segonzac, Marin, Cropsey, Utrillo, Beal, and others.

LEWIS, NORMAN—Painter
c/o Nordness Gallery, 134 E. 70th St., New York, N.Y. 10021*

LEWIS, PHILLIP HAROLD—Museum Curator
Field Museum of Natural History, Roosevelt Rd. & Lake Shore Dr. 60605; h. 1361 E. 57th St., Chicago, Ill. 60637
B. Chicago, Ill., July 31, 1922. Studied: AIC, B.F.A.; Univ. Chicago, M.A. (Anthropology), Ph.D. Member: Am. Anthropological Assn.; F., Am. Authors Assn. Awards: Chicago Nat. Hist. Mus. Fellowship, 1950-51, 1954-55; Fulbright Grant to Australian Nat. Univ., Canberra, Australia, 1953-54. Author: "A Definition of Primitive Art" in Fieldiana, Anthropology Series, Vol. 36, No. 10, 1961; "The Social Context of Art in Northern New Ireland," Fieldiana: Anthropological Series, Vol. 58, 1969, Field Mus. Nat. Hist. Lectures: Definition of Primitive Art; Primitive Art of New Ireland. Exhibitions arranged: What is Primitive Art?, 1958; Established new Hall of Primitive Art, 1961, including exhibitions: Primitive Artists Look at Civilization and The Human Image in Primitive Art, all at Field Mus. of Nat. Hist. Positions: Asst. Cur., 1957-59, Assoc. Cur., 1960, Cur., Primitive Art, 1961- , Cur., Primitive Art & Melanesian Ethnology, 1967- , Field Museum of Natural History, Chicago, Ill. Lecturer, Dept. of Anthropology, Univ. Chicago, 1967- .

LEWITT, SOL—Sculptor
c/o Dwan Gallery, 29 W. 57th St., New York, N.Y. 10019*

LIBERI, DANTE—Painter, S., I.
15 Ardis Lane, Plainview, L.I., N.Y. 11803
B. New York, N.Y., Oct. 15, 1919. Member: Huntington Township A. Lg.; East Hampton Guild Hall. Award: First prize, sculpture. Lo-

cust Valley, N.Y. Exhibited: BM; Audubon A.; Norlyst Gal. (one-man); Heckscher Mus., Huntington, N.Y.; Lazuk Gal., Cold Spring Harbor, N.Y., 1967, 1968, (one-man); Sioux Falls, S.D.; Galleria Vanucci, Pistoia, Italy, 1968; Galerie St. George, Marseille, France, 1969. Contributor illus. to New Yorker magazine.

LIBERMAN, ALEXANDER—Painter
173 E. 70th St., New York, N.Y. 10021
B. Kiev, Russia, 1912. Studied: With Andre L'Hote and at the Ecole des Beaux Arts, Paris, France. Work: AGAA; Albright-Knox A. Gal., Buffalo; AIC; Tate Gal., London; MModA; WMAA; Washington (D.C.) Gal. Mod. A.; Chase Manhattan Bank; Yale Univ.; Smith College; Rose A. Mus., Brandeis Univ.; NCFA; R.I. Sch. Des.; CGA; VMFA; Wadsworth Atheneum, Hartford, Conn., and others; also in many private collections. Exhibited: Guggenheim Mus., N.Y., 1954, 1964; AIC, 1961, 1962; Milwaukee A. Center, 1956; Albright-Knox A. Gal., 1962, 1964; MModA, 1962, 1964, 1965, traveling 1966, 1968; WMAA, 1962, 1963, 1965-1969; De Cordova & Dana Mus., 1963; CGA, 1963, 1964-1965, traveling; Washington Gal. Mod. A., 1963; David Herbert Gal., N.Y., 1961; Roswell Mus., New Mexico; Wadsworth Atheneum, Hartford, 1964; Los A. Mus. A., 1964; N.Y. World's Fair, 1964; Zurich, Switzerland, 1959, 1960; Arthur Tooth & Sons, London, 1961; Helsinki World's Fair, 1962; Tokyo Biennale, 1962; Galerie Claude Bernard, Paris, 1963; Galerie Denise Rene, Paris, 1964; Univ. Michigan Mus., 1964; U.S. Embassy, The Hague, 1965; Munson-Williams-Proctor Inst., Utica, N.Y., 1965-1969; Stedlijk Mus., Amsterdam, 1965; VMFA, 1966; Musee Cantonal des Beaux Arts, 1966; Los Angeles County Mus., 1967; PMA, 1967, 1969; Stuttgart, Germany, 1967; Aldrich Mus. Contemp. A., Ridgefield, Conn., 1967, 1968. One-man: MModA, 1959; Bennington College, 1964; Robert Fraser Gal., London, 1964; Betty Parsons Gal., N.Y., 1960, 1962-1964, 1966, 1967, 1969; Galleria dell 'Ariete, Milan, 1965; Galleria d'Arte, Naples, 1965; Jewish Mus. N.Y., 1966; Andre Emmerich Gal., N.Y., 1967 (2). Author: "The Artist in his Studio," 1960; "Greece, Gods and Art," 1968. Positions: Editorial Director, Conde Nast Publications, N.Y., 1962.

LICHT, FREDERICK—Art historian
Brown Univ., Providence, R.I. 02912*

LICHTENBERG, MANES—Painter, T.
26 Adele Rd., Cedarhurst, L.I., N.Y. 11516
B. New York, N.Y., July 22, 1920. Studied: Academie Grande Chaumiere, Paris, France; ASL, and with Leger, Paris, France. Member: AWS; All. A. Am. Awards: prizes, Emily Lowe award, 1954; All. A. Am., 1955, Gold Medal, 1964 prize, 1966; NAD, 1957; Costa Brava, Spain, 1957; Prix Othon Friesz, Paris, 1961, 1962; Wash. Square Exh., 1951, 1952, 1954-1956, 1960 (5 Grand Prizes, 2 Firsts); Thomas Stevens prize, 1957; Ullric Bell prize, 1960; AWS, 1958; Int. Prix Maurice Utrillo, Paris, 1964; Prix S. Roy, Cannes, France, 1964; Henry Joseph Award, N.Y. 1964. Exhibited: PAFA, 1952; Los A. Mus. A., 1955; NAD, 1958. 1962-1964, 1966, 1967, 1968; Salon d'Automne, Paris, 1958, 1960; AWS, 1951, 1952, 1954-1956, 1958, 1964; All. A. Am., 1954, 1955, 1957, 1958, 1959-1964, 1965, 1968; Audubon A., 1952, 1955; Berkshire Mus. A., 1955; Galerie Bernheim, Paris, 1958; Galerie Montmorency, Paris, 1960; Maxwell Gal., San F., 1960, 1961, 1964, 1966, 1969; Little Gal., Kansas City, 1960, 1961, 1963; Swarthe-Burr Gal., Los A., 1960, 1961; Washington Square A. Exh., N.Y., 1951-1960; Galerie du Carlton, Cannes, France, 1964; Lawrence Gal., Kansas City, Mo., 1964; Cowie Gal., Los Angeles, 1964; Dallas North Gal., Texas, 1966, 1968; Loring A. Gal., Cedarhurst, L.I., 1967-1969; Galerie de Ville, Los Angeles, 1966-1968.

LICHTENSTEIN, ROY—Painter, S.
c/o Leo Castelli Gallery, 4 E. 77th St., New York, N.Y. 10021
B. New York, N.Y., 1923. Studied: Ohio State Univ., B.F.A., M.A. Work: Guggenheim Mus., WMAA; MModA; Pasadena Mus. A.; Albright-Knox A. Gal., Buffalo, N.Y.; Tate Gal., London, England; Stedelijk Mus., Amsterdam, Holland; and others. Exhibited: one-man: Carlebach Gal., N.Y., 1951; Heller Gal., N.Y., 1952-1954, 1957; Castelli Gal., N.Y., 1962-1967; Galerie Sonnabend, Paris, 1963, 1965, 1967; Ferus Gal., Los Angeles, 1963, 1964; Pasadena A. Mus., 1967; WAC, 1967; Stedelijk Mus., Amsterdam, 1967; Tate Gal., London, 1968; U.S. Pavilion, Venice Bienale, 1966; Kunsthalle, Bern, Switzerland, 1968.

LICHTNER, MRS. RUTH GROTENRATH. See Grotenrath, Ruth

LICHTNER, SCHOMER—Painter, C., Des., Ser., T.
2626 A North Maryland Ave., Milwaukee, Wis. 53211
B. Peoria, Ill., Mar. 18, 1905. Studied: State T. Col. Milwaukee, Wis.; AIC; ASL; Univ. Wisconsin, and with Gustave Moeller. Awards: prizes, Milwaukee A. Center, 1965; Wis. Salon, 1967, AIC, 1964. Exhibited: three-man: AIC, 1969; 2-man (with Ruth Grotenrath Lichtner) Milwaukee A. Center, 1962, Univ. Wisconsin, 1963,

and others; one-man: Bradley Gal., 1968; Rahr Civic Center, 1968; Mount Mary Col., 1969. Book: "Schomer Lichtner Drawings," 1964. Work reproduced in "Art Scene," 1968.

LIEB, LEONARD—Painter, T. Gr.
 409 Cato St., Pittsburgh, Pa. 15213
B. Poland, Dec. 27, 1912. Studied: Irene Kaufmann A. Sch., with Samuel Rosenberg, Armondo del Cimmuto. Member: Assoc. A. of Pittsburgh; Abstract Group, Pittsburgh; Pittsburgh WC Soc. Awards: prizes, Nat. WC award sponsored by U.S. Govt., 1940; Henry Posner prize, 1945; Charles Rosbloom prize, 1947; 1st Federal Award, Pittsburgh, 1963; Carnegie Inst., 1951, 1954, purchase, 1958. Work: Carville Marine Hospital, Louisiana; Carnegie Inst.; Pittsburgh Pub. School; Indiana State T. Col., Indiana, Pa. Exhibited: NGA, 1940; AIC, 1947; Pan-American Exh., 1945; PAFA, 1951; Butler Inst. Am. A., 1949-1953; Assoc. A. of Pittsburgh, 1936-1961; Abstract Group of Pittsburgh, 1948-1961; Albright A. Gal., 1961; Inst. Contemp. A., Boston, 1962; St. Paul A. Center, 1963; Drawing Soc., PMA, 1965; Pittsburgh Plan for Art exhs., 1955-1965; one-man, Gulf Gal., 1935; A. & Crafts Center, 1957; Pittsburgh Playhouse, 1958; Shadyside Acad., 1957; Gal. Upstairs, 1960; Regent House, Inc., 1963, 1967; Ivy School of Prof. Art, 1965, all in Pittsburgh; Creative Gal., N.Y.C.; Pennsylvania State Col., New Kensington, Pa., 1967. Lectures: From Impressionism to the Art of Today; Lecture on work over WQED radio. Positions: Instr., Drawing & Painting, A. & Crafts Center, Pittsburgh; Irene Kaufmann Center; Vice-Pres., Assoc. A. of Pittsburgh, 1954; Bd. Dirs., 1948-50, 1954-56.

LIEBERMAN, MEYER F.—Painter, Gr., T.
 24 E. 21st St., New York, N.Y. 10010; h. 21 Lewis Place, Brooklyn, N.Y. 11218
B. New York, N.Y., Aug. 28, 1923. Studied: ASL, with Reginald Marsh; Pratt Graphic Workshop. Member: AEA. Work: Jewish Mus., N.Y.; Nat. Shrine Jewish War Dead, Wash., D.C. Exhibited: MMoDA, 1956; Raymond Duncan Gal., Paris, 1959; one-man: Jewish Mus., N.Y., 1954; Gallery G, New York, 1955; Collectors Gal., Chicago, 1961; Brooklyn Col., 1967; Herzl Inst., N.Y., 1969. Positions: Instr., drawing and painting, Adult Edu. Institutes, Brooklyn and Yonkers, N.Y.

LIEBERMAN, WILLIAM S.—Museum Curator
 Museum of Modern Art, 11 West 53rd St., New York, N.Y. 10019
B. Paris, France, Feb. 14, 1924. Studied: Swarthmore Col., B.A.; Harvard Univ. Member: Int. Graphic Arts Soc. (juror); Adv. Bd., Pratt Contemp. Graphic A. Centre; Print Council of Am. (Dir.); American Federation of Arts (Trustee); List Foundation Poster Committee. Author of numerous monographs on modern artists; contributor to art magazines. Arranged 26 exhs. devoted to prints and 6 exhs. including graphic work, 1949- . Organized exhibitions for the International Program. Positions: Cur., Drawings & Prints, The Museum of Modern Art, New York, N.Y., 1960- . Advisor, William and Norma Copley Fnd.*

LIEBES, DOROTHY (Mrs. Relman Morin)—
 Textile Designer, C., L., W., T.
 767 Lexington Ave. 10021; h. 131 East 66th St., New York, N.Y. 10021
B. Santa Rosa, Cal., Oct. 14, 1899. Studied: Cal. Sch. FA; Univ. California, A.B.; Columbia Univ. Member: Cosmopolitan Cl.; Am. Des. Inst.; Fashion Group (Bd. Gov.); F., Royal Soc. A. Awards: prizes, textiles, Lord & Taylor, N.Y.; Neiman-Marcus, Dallas, Tex.; Paris, Exp.; AID; AIA; ADI; Plastic Assn.; Am. Women's Assn., 1950; Nat. Business & Prof. Women; Arch. Lg., 1950; deg., LL.D., Mills Col., 1948; Elsie de Wolfe Award, AID, 1963 and Highest Award Design Influence, AID, 1969; Trailblazer Award, N.H.F.L., 1969. Exhibited: one-man textile exh., SFMA; BM; CAM; Dayton AI; CM; MIT; Portland A. Mus.; AIC; Walker A. Center; MMoDA; MMA; Cranbrook Museum; Taft Museum A.; deYoung Mem. Mus.; Detroit Inst. A.; Albright A. Gal.; MMoDA, traveling exh., Europe, 1950; Univ. Minnesota, 1951; BMFA, 1951; Univ. Illinois, 1952; Univ. Missouri, 1955; Cornell Univ., 1955; MMoDA, 1955; deYoung Mus., 1955, 1956; Mus. Contemp. Crafts, 1956; Fabrics Int., 1961. Contributor to leading design and art magazines. Positions: A. Dir., Arts & Skills Corps, Wash., D.C., 1943-46; Des., Goodall Textiles, Rosemary Sales, New York, N.Y.; United Wall Paper, Chicago, Ill.; Kenwood Mills, Rensselaer, N.Y.; Columbia Mills, Syracuse, N.Y.; Galashiels Mills, Scotland; Doebeckmun Co.; DuPont de Nemours Co.; Dow Chemical Co.; Jantzen, Inc.; Quaker Lace Co.; Stead & Miller Co.; Bates Mfg. Co.; Forstmann Woolen Co.; Eagle-Ottawa Leathers; Bigelow-Sanford Carpets; Beacon Mfg. Co.; Bridgeport Brass Co. (blinds); Stroheim & Romann, Inc. (fabrics); Forster Textile Mills (orlon casements); Jasco Fabrics (apparel tweeds); Chas. Bloom, Inc. (home furnishings fabrics); Fairtex Sales, Inc. (metallic yarns); CONSO (trims), and others; Bd., America House, New York, N.Y.;

Bd., California Arts & Architecture; Adv. Com., Indst. Des., BM; Adv. Com., Norfolk Mus. A.; Adv. Bd., Parsons Sch. Des., New York, N.Y.; Bd., Am. Craftsmen's Council; Dir., Nat. Des. Center; Memb., Am. Arbitration Assn.; Nat. Council on the Arts & Govt.; Chm., Jury on Indst. & Appl. A., Inst. of Int. Edu.; Bd. Dirs., N.Y. World's Fair 1964 Corp.

LIGHT, ROBERT MacKENZIE—Art Dealer
 190 Marlborough St., Boston, Mass. 02116
B. New York, N.Y., May 25, 1929. Studied: Oberlin College, B.A.; Fogg Museum of Art, Harvard University. Specialty: Old Master Prints and Drawings. Positions: President, R.M. Light & Co., Inc.; Member, Advisory Committee of Dealers, Print Council of America; Member, Board of Directors, Art Dealers Association of America, Inc.

LILES, RAEFORD—Painter
 446 W. 38th St., New York, N.Y. 10018
B. Birmingham, Ala., July 20, 1923. Studied: With Fernand Leger, Paris, France. Work: Andrew Dickson White Gal., Cornell Univ.; Univ. Miami; The Governor's Gal., Montgomery, Ala.; N.Y. Univ.; Norfolk Mus. A. & Sciences; Univ. Alabama; Finch Col., Mus., N.Y.; Ferkauf Grad. Sch., Yeshiva Univ., N.Y.; Univ. Massachusetts; CGA. Exhibited: Galerie Iris Clert, Paris, 1955; Finnish-American Soc., Helsinki, 1956; Salon de Realites Nouvelles, Paris, 1957; Alabama WC Soc., 1956; Univ. Pennsylvania, 1967; East Hampton Gal., N.Y., 1967, 1968.

LILIENTHAL, MR. and MRS. PHILIP N., JR.—Collectors
 2275 Summit Dr., Burlingame, Cal. 94010*

LILJEGREN, FRANK—Painter, T.
 64 Lispenard Ave., New Rochelle, N.Y., 10801
B. New York, N.Y., Feb. 23, 1930. Studied: ASL, with John Groth, Dean Cornwell, Frank J. Reilly. Member: Artists Fellowship; Hudson Valley AA (Exh. Chm. 1965-1968, Dir., 1967-1968); All. A. Am. (Cor. Sec., 1967, Exh. Chm., 1968-1970); SC; Acad. A. Assn.; ASL (life). Awards: prizes, Women's Clubs of Mamaroneck, New Rochelle, Larchmont and Westchester, 1960-1964; New Rochelle AA, 1961, 1964, 1969; Manhattan Savings Bank Exh., Mt. Kisco, N.Y., 1962 (purchase); Hudson Valley AA, 1962, 1965, gold medal, 1967; Council of Am. Artists Soc., 1964; Mamaroneck A. Gld., 1964; Acad. A. Assn., 1966, 1968, 1969; SC, 1965, 1967, 1968. Work: Am. Edu. Pub. Inst.; Manhattan Savings Bank. Exhibited: All. A. Am., 1960-1968; Acad. A. Assn., 1966-1969; Hudson Valley AA, 1960-1968; Council. A. Artists Soc., 1964; SC, 1965-1969; New Rochelle AA, 1960, 1961, 1964, 1969; Westchester Fed. Women's Clubs, 1960-1965; Mamaroneck A. Gld., 1960-1965; Stevens Center, N.J., 1968; Philbrook Mus. A., Tulsa, 1967, 1968; Suffolk (L.I.) Mus. A., 1965; McNay A. Inst., San Antonio, 1969; Springfield Mus. FA, 1966-1969. Positions: Instr. A., Westchester Center Workshop, White Plains, N.Y.

LILLIE, ELLA FILLMORE (Mrs. Charles D.)—
 Lithographer, P., Ser.
 1055 Charles St., Clearwater, Fla. 33515
B. Minneapolis, Minn. Studied: Minneapolis Sch. FA; AIC; N.Y.Sch. FA; Cincinnati A. Sch. Member: Hoosier Salon; Albany Pr. Cl.; So. Vermont AA; SAGA. Awards: prizes, Southern Pr. M., 1938; Hoosier Salon, 1945, 1946, 1950, 1958; John Herron AI, 1956; Northwest Pr. M., 1947; Springfield, Mo., 1941, 1942; LC, 1945; Indiana Pr. M., 1947; Boston Pr. M., 1948; Montgomery Mus. FA (purchase); SAGA, 1951; Albany Pr. Cl., 1967. Work: Fleming Mus.; BMFA; LC; Dayton AI; Cal. State Lib.; SAM; Wesleyan Col., Macon, Ga.; MMA; Pa. State Univ.; Colt, Avery, Morgan Mem.; Carnegie Inst.; AIC; Toledo Mus. A.; Telfair Acad.; High Mus. A.; Brooks Mem. A. Gal.; Honolulu Inst. A.; Minneapolis AI; NGA; Herron Mus., Indianapolis; Boston Pub. Library; Montgomery (Ala.) Mus. FA. Exhibited: AIC; CGA; PAFA; Minneapolis Inst. A.; SFMA; John Herron AI; Albright A. Gal.; SAM; Conn. Acad. FA; Oklahoma A. Center; Oakland A. Gal.; Carnegie Inst.; LC; NAD; Mid-Vermont A.; Hoosier Salon So. Vermont AA; SAGA Exchange Exh., England, 1954, and other shows, 1956-64; Montgomery (Ala.) Annual, 1969; Mobile Annual, 1969; Highland (N.C.) Annual, 1968; Southern Vermont, 1966-1969; Stratton Mt. A. Festival, Vermont, 1967, 1968; Cal. Pr. M.; SAGA; Ohio Pr. M.; Albany Pr. M., 1966-1969; one-man: Currier Gal. A.; Bryn Mawr Col.; Western Reserve Mus.; Berkshire Mus. A.; Stockbridge (Mass.) Theatre Gal.; Tryon (N.C.) Lib.; Brooks Mem. Mus.; Wood A. Gal., Montpelier, Vt.; Albany Inst. Hist. & Art; Guanajuato, Mexico; Bronxville (N.Y.) Pub. Lib.; So. Vermont A. Center; Springfield (Vt.) A. Center; Wenham (Mass.) 1959; Island Gal.; St. Simons, Ga., 1960; Bradenton (Fla.) A. Center, 1960; Clearwater (Fla.) AA., 1968; Dunedin Pub. Lib., Fla., 1968, 1969.

LILLIE, LLOYD—Sculptor
 248 Kelton St., Allston, Mass. 02134*

LIMBACH, RUSSELL T. —Lithographer, Et., P., E., W.
Davison Art Center, Wesleyan Univ., Middletown, Conn.; h.
179 Wesleyan Station, Middletown, Conn. 06457
B. Massillon, Ohio, Nov. 9, 1904. Studied: Cleveland Sch. A. Member: ANA; SAGA; AAUP. Awards: prizes, CMA, 1926-1929, 1931, 1934, 1935; med., Phila. Pr.M., 1928; prize, Lib. Cong., 1946.
Work: CMA; AIC; BM; MMA; N.Y.Pub.Lib.; WMAA; Lib. Cong.;
Yale Univ.; Wesleyan Univ.; SFMA; Herron AI; U.S. Nat. Mus.;
Carnegie Inst.; Glassgow Univ.; Lyman Allyn Mus.; Massillon Mus.;
Hunter Col.; Univ. Wisconsin. Author, I., "American Trees," 1942;
"But Once a Year," Am. A. Group, 1941. Lectures: The Art of
Lithography. Position: Prof. Painting, Gr. A., Wesleyan Univ.,
Middletown, Conn., at present.

LINDNER, RICHARD—Painter, Lith., E.
333 E. 69th St., New York, N.Y. 10021
B. Hamburg, Germany, Nov. 11, 1901. Studied: Academy Nuremburg; Academy Munich, and in Paris. Awards: Copley Fnd. Work:
Container Corp., Chicago; MModA; WMAA; Tate Gal., London;
CMA; AIC; BMA; DMFA, and in private collections. Exhibited: AIC,
1954; Walker A. Center; MModA; one-man: Betty Parsons Gallery
(4); MModA; Cordier & Ekstrom Gal., N.Y.; Berkeley (Cal.) Mus.,
1968; WAC, 1969; Staatliche Kunsthalle, Baden, Baden; Mus. Schloss
Morsbroich; London, England; Paris, France, Italy, and Berlin,
Germany. Illus., "Tales of Hoffman," 1946; "Madame Bovary,"
1944; "Continental Tales of Longfellow," 1948. Contributor illus. to
Vogue, Harpers Bazaar, Fortune, Esquire, McCall, Seventeen, and
other national magazines. Positions: Prof., Pratt Institute, Brooklyn, N.Y.; Lecturer, Yale Univ.

LINDSAY, KENNETH C.—Art Historian, W., L.
State University of New York at Binghamton, Harpur College;
h. R.D. 2, Bunn Hill Rd., Binghamton, N.Y. 13903
B. Milwaukee, Wis., Dec. 23, 1919. Studied: Univ. Wisconsin, Ph.B.,
Ph.D., M.A. Member: CAA; Int. Soc. of Romanesque Art. Awards:
Fulbright Fellowship, 1949; N.Y. State Research Fnd. grant, 1956,
1957. Author: "The Harpur Index of Masters' Thesis in Art," 1956.
Contributor to Art Bulletin; College Art Journal; Journal of Aesthetics and Art; Criticism (Denmark), and others. Lectures: 19th and
20th Century Painting. Positions: Prof. A. Hist., Harpur College,
Binghamton, N.Y.

LINDSTROM, CHARLES WESLEY—
Museum Curator, T., L., P., Des.
M. H. deYoung Memorial Museum, Golden Gate Park; h. 838
Arguello Blvd., San Francisco, Cal. 94118
B. Tacoma, Wash., Jan. 23, 1910. Studied: Stanford Univ., B.A.;
grad. study, Univ. California. Author, I., "What Makes Art Work?,"
1941; contributor to Pacific Art Review; San Francisco Chronicle
"This World." Exhibited: Gelber-Lilienthal Gal., San F. Designed
book, "Children's Art" by Miriam Lindstrom, 1957; wrote and
narrated motion picture "Art in Woodcut," 1961. Positions: Cur.,
San Francisco Museum Art, 1935-41; Cur. & Dir. Edu., deYoung
Memorial Museum, San Francisco, 1941- ; Lecturer, Univ. of California, 1963- .*

LINDSTROM, GAELL—Painter, C., E.
Utah State University; h. 1350 East 1700 North, Logan, Utah
84321
B. Salt Lake City, Utah, July 4, 1919. Studied: Univ. Utah, B.S.;
California Col. of A. & Crafts, M.F.A., and with Roy Wilhelm, Gloucester, Mass. Member: AWS; Cal. WC Soc. Awards: prizes, Utah
State Fair, 1952, 1953, 1954; purchase awards, Utah State Fair,
1954, Utah State AI, 1954; AWS, 1957. Work: Utah State Univ.; College So. Utah; State of Utah Coll. Murals, College So. Utah; Cedar
City Pub. Lib.; mosaic mural, Utah State Univ. Forestry Bldg.,
1961. Exhibited: AWS, 1953, 1957; Cal. WC Soc., 1957. Arranged
exhs.: Nat. Painting Exh., 1958, Nat. Ceramic Exh., 1957, 1958, both
at Utah State Univ.; Maynard Dixon Exh., 1955 at College of So. Utah.
Positions: Prof. A., Col. So. Utah, 1953-56; Utah State Univ., 1957,
1969; Utah State Inst. FA, 1957-61.

LINDSTROM, MIRIAM B. (Mrs. Charles W.)—
Museum Curator, E., W., L.
deYoung Memorial Museum, Golden Gate Park; h. 838
Arguello Blvd., San Francisco, Cal. 94118
B. Chicago, Ill., May 19, 1914. Studied: N.Y. Univ.; ASL; Univ. Chicago; AIC; Univ. of Paris and School of the Louvre. Member: AFA;
deYoung Mus. Soc.; AAMus.; Soc. for Asian Art (Dir.); NCAE;
SFMA. Exhibited: CAA; Univ. Chicago; Cite Universitaire, Paris.
Author: "Children's Art," 1957. Contributor to Pacific Art Review; Everyday Art. Lectures: Tradition and Transition; Children's
Art; Works of Art in the Museum. Arranged series of exhs. "Tradition and Transition"; series of children's art exhs., local and
foreign; "Art of the Pacific Basin," all for the deYoung Mem. Mus.
Positions: Asst., San Francisco Museum of Art, 1937-39; Cur.,

Assoc. Dir. of Edu., deYoung Mem. Museum, San Francisco, Cal.,
1942- . Consultant, International Child Art Center.*

LINSKY, MR. and MRS. JACK—Collectors
927 Fifth Ave., New York, N.Y. 10028*

LIONNI, LEO—Painter, Des., E., Cr.
San Bernardo Lavagna, Genoa, Italy.
B. Amsterdam, Holland, May 5, 1910. Studied: Univ. Zurich; Univ.
Genoa, Ph.D. Member: AEA; AIGA (Pres.). Awards: "A. Dir. of
the Year," 1955, Nat. Soc. A. Dir.; numerous awards and medals
from A. Dir. Cl., and AIGA; German Government Illustrated Book
award, 1965; "Golden Apple" award, First International Biennial,
Bratisslava, 1967. Work: PMA; MModA. Exhibited: MModA, 1954;
one-man: Norlyst Gal., 1947; Phila. Pr. Cl., 1948; WMA, 1958;
SFMA, 1959; Phila. A. All., 1959; Naviglio Gal., Milan, Italy, 1963;
Obelisco Gal., Rome, 1964. Contributor illus. to Ladies Home
Journal; Charm; Fortune; Holiday and other national magazines.
Author, I., "Little Blue and Little Yellow," 1959; "Inch by Inch,"
1960; "On My Beach There Are Many Pebbles," 1961; "Swimmy,"
1963; "Tico," 1964; "Frederick," 1967; "The Alphabet Tree,"
1968; "The Biggest House in the World," 1968; "Alexander and the
Wind-up Mouse," 1969. Positions: Ed., Print Magazine, 1965; A.
Dir., N.W. Ayer Co., 1939-49; A. Dir., Fortune Magazine, 1949- ;
Des. Dir., Olivetti Corp., 1950- . Editor, "Panorama," 1964-1966.

LIPCHITZ, JACQUES —Sculptor
Fine Arts Associates, 44 Walker St., New York, N.Y. 10013;
h. Hastings-on-Hudson, N.Y. 10706
Studied: Ecole des Beaux-Arts and Academie Julian, Paris, France.
Member: Am. Acad. A. & Lets.; Nat. Inst. A. & Lets.(Member of the
Council). Awards: Gold Medal, Am. Acad. and Nat. Inst. A. & Lets.,
1966. Work: Musee de L'Arte Moderne, Paris; Musée de Grenoble;
MModA; MMA; Albright-Knox A. Gal., Buffalo, N.Y.; PMA; WMA.
Exhibited: Nationally and Internationally. Recently: Marlborough
Gal., 1968; Dunkelman Gal., 1968.

LIPINSKY DE ORLOV, LINO SIGISMONDO—
Museum Director, P., Et.
John Jay Homestead, Jay St., Katonah, N.Y. 10536
B. Rome, Italy, Jan. 14, 1908. Studied: British Acad. A.; Royal
Acad. A., Rome, and with Siegmund Lipinsky. Member: SAGA;
Audubon A.; Chicago Soc. Et.; United Scenic A. Union; AA Mus.
Awards: silver medal, Rome, Italy, 1928, 1931; Officer of the Order
of Merit of the Republic of Italy, 1958; Grand Prix, gold medal,
Paris Expo. Intl., 1937; silver medal, Budapest, Hungary, 1936;
prizes, Chicago Soc. Et., 1941, 1950; SAGA, 1942; LC, 1942; Detroit
Inst. A., 1943; Kosciusko Fnd., 1948; Gold medal, Ctf. Merit, Nat.
Hist. Soc., OSIA, 1961. Work: Severance Music Hall, Cleveland,
Ohio; St. Patrick's Cathedral, N.Y.; Mus. City of New York; Boston
Symphony Hall; N.Y. Pub. Lib.; LC; Detroit Inst. A.; Cranbrook
Acad. A.; MMA; Vassar Col.; Fla. State Univ.; Yale Univ.; Radcliffe
Music Bldg.; Nat. Gal. Mod. A., Rome, Italy; many churches in U.S.
and abroad. Exhibited: Los A. Mus. A., 1927, 1928, 1932; AIC,
1934; Chicago Soc. Et.; SAGA; Grand Central A. Gal.; LC; NAD;
CMA; Detroit Inst. A.; Albany Inst. Hist. & A.; Audubon A.; Carnegie Inst.; Mills Col., Oakland, Cal.; Albright A. Gal., and abroad;
one-man: Avery Hall, Columbia Univ.; Cosmos Cl., Wash., D.C.;
Smithsonian Inst.; Nat. Mus., Wash., D.C.; Galleria Costa, Palma
di Mallorca, Spain; Vose Gal.; Symphony Hall, Boston; Jr. Lg.,
Boston; St. Paul'a Gld.; Knoedler Gal. Co-author: "Anatomy for
Artists," 1931; Author: "Pocket Anatomy in Color for Artists,"
1947; "Giovanni da Verrazzano, The Discoverer of New York Bay,
1524," 1958, 1964. Positions: Curator of History, John Jay Homestead, New York State Historic Site, Katonah, N.Y., 1967- ; Hd.
Exhibits Des. Dept., Mus. City of New York, 1959-1967; Dir.,
Garibaldi & Meucci Mem. Mus., Staten Island, N.Y.; Art Consultant,
Italian Embassy, Wash., D.C., and to Consulate General of Italy in
New York.

LIPMAN, HOWARD W.—Collector
120 Broadway, New York, N.Y. 10005; h. 226 Cannon Rd.,
Wilton, Conn. 06897
B. Albany, N.Y., July 11, 1905. Collection: Contemporary American
Sculpture. Positions: Vice-President, The Archives of American
Art; Trustee, The Whitney Museum of American Art; Trustee, The
Aldrich Museum of Contemporary Art, Ridgefield, Conn., all at present.

LIPMAN, JEAN—Writer, Editor, L.
Art in America, 635 Madison Ave., New York, N.Y. 10022; h.
Cannondale, Conn.
B. New York, N.Y., Aug. 31, 1909. Studied: Wellesley Col., B.A.;
N.Y. Univ., M.A. Author: "American Primitive Painting," 1942;
"American Folk Art," 1948; "Primitive Painters in America" (with
Alice Winchester), 1950; "Rufus Porter, Yankee Wall Painter,"

1950; "American Folk Decoration" (with Eve Meulendyke), 1951; "American Folk Painting," (with Mary Black), 1966; "Rufus Porter, Yankee Pioneer," 1968. Contributor to art and national magazines. Positions: Assoc. Ed., Art in America, 1938-40, Ed., 1941-65.

LIPMAN-WULF, PETER—Sculptor, Pr.M., T.
361 Bleecker St., New York, N.Y. 10014
B. Berlin, Germany, Apr. 27, 1905. Studied: State Acad. FA, Berlin, M.A., with Ludwig Gies. Member: AEA; Brooklyn Soc. A. Awards: gold medal, Exposition Mondiale, Paris, 1937; Guggenheim Fellowship, 1949; Olivetti award, Silvermine, Conn., 1961. Work: sc., WMAA; Isaac Delgado Mus. A.; Metropolitan Opera Assn.; Yale Univ. Lib.; Puerto Rico State Conservatory; First Presbyterian Church, Stamford, Conn.; St. Andrew Protestant Church, Chicago, Ill.; State Opera, Munich; State Conservatory, Berlin; Mill Lane J.H.S., Farmingdale, N.Y.; Jerico H.S., Jerico, N.Y.; Adelphi Univ.; Broch Mus., Teesdorf, Austria; drawings; Smith Col.; Southern Methodist Univ.; Detroit Inst. A.; Staten Island Mus. A. & Sc.; Evansville (Ind.) Mus. A. & Sc.; Richmond AA; Birmingham Mus. A.; Lowe Gal., Coral Gables; prints; PMA; MMA; BMA; Phila. Pr. Cl.; Cooper Union; N.Y. Pub. Lib.; BM; CMA, and in museums in Karlsruhe, Munchen, Stuttgart, Koln, Hanover, Germany; Basel, Switzerland; Paris, France; Victoria and Albert Mus., London; British Mus., London; Jewish Mus., N.Y.; fountains: city of Berlin; many ports. of prominent persons. Exhibited: One-man: New School, 1950; Delius Gal., 1950, 1952; Hudson Gld., 1957; Carl Schurz Fnd., 1958; Phila. A. All., 1960; Düsseldorf Mus., 1960; Karlsruhe Kunsthalle, 1960; Silvermine Gld. A., 1961; Jewish Mus., N.Y., 1961; Bibliotheque Nationale, Paris, 1961; Frankfurter Kunstkabinett, 1961; Joan Avnet Gal.; Tannenbaum Gal., N.Y., 1965; Harbor Gal., Coldsprings Harbor, N.Y., 1966-1968; München-Regensburg, Am. House, Germany, 1968; Kunstamt Neukoeln, Berlin, 1968; So. Conn. State Col., New Haven, 1968. Positions: Instr., N.Y. City Col., Sch. of Gen. Studies, 1948-58; Queens Col., N.Y., L., 1951-56 (intermittently), Instr., Sch. Gen. Studies, 1952-58; Prof. of A., Adelphi Univ., N.Y., 1960- .

LIPPARD, LUCY ROWLAND—Critic
138 Prince St., New York, N.Y. 10012
B. New York, N.Y., Apr. 14, 1937. Studied: Smith College, B.A.; N.Y. University Institute of Fine Arts, M.A. Awards: Guggenheim Fellowship, 1968-1969. Author: "Pop Art," 1966; "The Graphic Work of Philip Evergood," 1966; others in preparation. Author of museum catalogues for Museum of Modern Art, New York; Los Angeles County Museum of Art; The Jewish Museum, New York, etc. Contributor to: Art International; Art forum; Hudson Review; New York Times; Arts; Art News; Art in America; Arts Canada. Lectures: Contemporary Art at art museums, schools and universities. Gallery exhibitions organized: "Eccentric Abstraction," Fischbach Gallery, New York, 1966; "Number 7," Paula Cooper, New York. Guest Director: Museum of Modern Art, New York—"Max Ernst, Works on Paper, 1967-1968; Richard Pousette-Dart, 1969; New Jersey State Museum, "Focus on Light," 1967; also Seattle Museum and Vancouver (B.C.) Art Gallery, and others.

LIPPOLD, RICHARD—Sculptor, E., Des.
Locust Valley, N.Y. 11560
B. Milwaukee, Wis., May 3, 1915. Studied: AIC, B.F.A.; Univ. Chicago; Ripon (Wis.) Col., Hon. D.F.A. Member: Nat. Inst. A. & Lets., 1963. Awards: prize, Intl. Sculpture Comp., Inst. Contemp. A., London, 1954; Brandeis Univ., 1958; silver medal, Arch. Lg., N.Y., 1960. Work: MModA; AGAA; Wadsworth Atheneum; Munson-Williams-Proctor Inst.; MMA; Detroit Inst. A.; Inland Steel Co., Chicago; Carnegie Fnd.; Seagram Bldg., N.Y.; Portsmouth Priory Church, R.I.; J. Walter Thompson Co., N.Y.; Baron de Rothschild Musée de Vin, Bordeaux, France; monument, Harvard Univ.; Pan-American Bldg., N.Y.; Philharmonic Hall, Lincoln Center, N.Y.; Jesse Jones Hall, Houston. Exhibited: Mus. Mod. A., Sao Paulo, Brazil, 1951; PMA, 1949; WMAA, 1947, 1951, 1954; Detroit Inst. A., 1948, 1949; CAM, 1948; Cal. PLH, 1948; Tate Gal., London, 1954; Musée d'Arte Moderne, Paris, 1955; A. Cl., Chicago, 1953; AIC, 1953; Willard Gal., 1947, 1948, 1950, 1952 (one-man), 1962, 1968; MModA, 1952, 1965; Contemp. A. Mus., Houston, Tex., 1957; Brandeis Univ., 1958. Contributor articles to art magazines. Positions: Instr., Layton Sch. A., Milwaukee, 1940-41; Univ. Michigan, 1941-44; Goddard Col., 1945-47; Hd. A. Dept., Trenton Jr. Col., Trenton, N.J., 1947-52; Prof., Hunter Col., 1952-1967.

LIPTON, SEYMOUR—Sculptor
302 West 98th St., New York, N.Y. 10025
B. New York, N.Y., Nov. 6, 1903. Awards: prizes, AIC, first prize, 1957; Sao Paulo, Brazil, 1957 (Purchase); Inst. A. & Lets. grant, 1958; Guggenheim F., 1960; Ford Fnd. Grant, 1962; awards, Arch. Lg., 1961, 1963; Widener gold medal, PAFA, 1968. Work: MModA; MMA; BM; Des Moines A. Center; Albright A. Gal.; Franklin Inst., Phila., Pa.; Toronto A. Gal.; Sao Paulo, Brazil, Mus.; WMAA; Yale Univ. Mus.; Wadsworth Atheneum; Manufacturers Trust Co.; Temple

Israel, Tulsa, Okla.; Temple Beth-El, Gary, Ind.; Santa Barbara Mus. A.; Tel-Aviv Mus., Israel, Detroit Inst. A.; IBM Research Center, Kichawan, N.Y., Reynolds Metal Co.; Munson-Williams-Proctor Inst.; PC; Gallery of Mod. Art, Wash., D.C.; New School (N.Y.) Mus.; Dulles Airport, Wash., D.C.; Philharmonic Hall, Lincoln Center, N.Y.; Golden Gate Project, San Francisco; Wasserman Development Corp., Boston; N.Y. Univ. Coll.; Univ. Massachusetts, Amherst, Mass.; Cornell Univ. A. Mus.; Commission: Center for the Performing Arts, Milwaukee, Wis., 1969; Carstairs Mus., Bahamas, West Indies. Exhibited: In leading museums nationally and internationally. One-man: Betty Parsons Gal., 1948, 1950, 1952, 1954, 1958, 1961; Marlborough Gals., 1965; PC, 1963. New Paltz Col., 1955; Watkins Gal., Wash., D.C., 1950; MModA, 1956; Venice, Italy, 1958; Milwaukee A. Center; Wisconsin-Milwaukee Univ. A. Center. Contributor articles to art magazines.

LISSIM, SIMON—Painter, Des., E., I., L.
55 Magnolia Dr., Dobbs Ferry, N.Y. 10522
B. Kiev, Russia, Oct. 24, 1900. Studied: Sorbonne, Louvre Sch., Paris, France, and in Russia. Member: Salon d'Automne; Artistes Decorateurs, Paris; Audubon A.; CAA; Theatre Lib. Assn.; AAMus.; AIGA; Sr., Hon. Corr. member in U.S.A. & a Vice-Pres. of Council, Royal Soc. A., Royal Soc. Min. P., S. & Gravers, England; corr. member, Royal Acad. FA of St. George, Spain; Hon., F., Am.-Scandinavian Fnd. Awards: medals, Int. Exh., Paris, 1925; Barcelona, 1928; two Grande Diplomes d'Honneur, Paris, 1937. Work: Musee du Jeu de Paume; Musee des Arts Decoratifs, Paris; The City of Paris; Sevres Mus.; Victoria and Albert Mus.; Stratford-on-Avon Mus., England; Albertina Mus., Nat. Lib., Vienna; Nat. Mus., Mun. Mus., Theatre Mus., Riga, Latvia; BM; N.Y. Pub. Lib.; MMA; CMA; BMFA; PMA; VMFA; Nat. Gal. of Canada; Hyde Park Lib., and others. Exhibited: nationally and internationally. I, books and contributor of articles on art and art education to newspapers and art magazines. Lectures on art and design. Six monographs pub. in France, 1928, 1933; U.S., 1949, 1958; England, 1955, 1962. Positions: Hd., A. Edu. Project, N.Y. Pub. Lib., 1942-1966; Assoc. Prof., 1947- , Prof. A., 1960- , City College of New York; Asst. Dir., Sch. General Studies, Ext. Div., City College of N.Y., 1948-1964; Chm. Nat. Selection Com. on Fulbright Awards in painting, sculpture & graphic arts, 1956.

LIST, VERA G. (Mrs. Albert A.)—Patron, Collector, Publisher
1740 Broadway, New York, N.Y. 10019; h. Byram Shore Rd., Byram, Conn. 10573
B. Boston, Mass., Jan. 6, 1908. Studied: Simmons College. Awards: Solomon Schechter Medal, The Jewish Theological Seminary of America, 1959; The Louise Waterman Wise Award, 1964; New York State Council on the Arts, New York State Award—Albert A. List Foundation for the List Art Poster Program, 1969. Collection: Contemporary sculpture and painting. Art Interests: Financed the establishment of New School Art Center (1960) and Purchase Fund (1962); Fund established by grant of the A.A. List Foundation for purchase of art at the Lincoln Center, New York; Established the List Art Posters program. Many gifts of art to New York museums and others. Positions: Chm., Art Center Committee and Trustee of The New School for Social Research, N.Y.; Hon. Chm., Board of Governors of The Jewish Museum, N.Y.; Director, List Art Posters, New York, N.Y.

LISZT, MARIA—Painter
12 Wonson St., East Gloucester, Mass. 01930
B. Boston, Mass. Studied: Boston Mus. Sch. FA; ASL; Cincinnati A. Acad.; Harvard Univ. Summer Sch.; and with Emile Gruppe, Aldro Hibbard, Lester Stevens. Member: North Shore AA; NAWA; New Jersey P. & S. Soc.; Boston Soc. Indp. A.; Grand Central A. Gal.; Academic A. of Springfield (Mass.). Awards: prizes, New England Fed. Womens Cl. (3 purchase); Grand Central A. Gal., 1957; Elizabeth Greenshield Mem. Grant, 1960. Work: murals, hotels and restaurants, New York, Boston and Florida. Exhibited: NAD; NAWA; North Shore AA; New Jersey P. & S. Soc.; Ogunquit A. Center; Cincinnati Acad. A.; ASL. Specializes in portrait and landscape painting.

LITAKER, THOMAS FRANKLIN—Painter, T.
3913 Gail St., Honolulu, Hawaii 96815
B. Concord, N.C., Apr. 26, 1906. Studied: Georgia Tech., B.S. Arch.; Mass. Inst. Tech., M.S.; and with John Whorf, John Frazer, Ralston Crawford, Max Ernst, Arnold Blanch, Hans Hofmann. Member: Hawaii P. & S. Lg.; Honolulu Pr. M.; AIA. Awards: prizes, Honolulu A. Soc., 1942 (purchase); Honolulu A. Acad., 1950, 1953, 1964 (purchase); Easter A. Festival, 1962; Artists of Hawaii, 1962, 1963; 50th State Fair, 1963. Work: Honolulu A. Acad. Exhibited: Artists of Hawaii, 1942-1963; Honolulu Pr. M., 1942-1958; FAR Gal., N.Y., 1961; Country A. Gal., Westbury, N.Y., 1961; one-man: Mint Mus. A., Charlotte, N.C.; Federal A. Gal., Miami; High Mus. A., Atlanta; Honolulu Acad. A.; Gima's, Honolulu; The Gallery,

Honolulu; Grinnel's Gal., Detroit; Gump's, Honolulu; Royal Hawaiian A. Gal., 1964. Positions: Former Instr., Univ. of Hawaii, College of General Studies, 1948-1961; Honolulu Acad. A. Sch., 1961.*

LITTLE, JOHN—Painter
367 Three Mile Harbor Rd., East Hampton, N.Y. 11937
B. Andalusia, Ala., Mar. 18, 1907. Studied: Buffalo Acad. A.; ASL; Hans Hofmann Sch. FA. Awards: prize, SFMA, 1948; Longview Fnd. purchase prize, 1962. Work: in many private collections U.S. and abroad; permanent Coll., Univ. Cal., Berkeley, Mus. A., 1968. Exhibited: Guild Hall, East Hampton, 1953, 1967; Stable Gal., N.Y., 1955; Executive House, N.Y., 1956-57; Signa Gal., East Hampton, 1957-1960; Castelli Gal., N.Y., 1958; traveling exh. to France (MModA), 1958; Osaka (Japan) A. Festival, 1958; Mus. Contemp. A., Dallas, 1958; traveling exh., American Federation of Arts, 1959-60; Galerie Beyeler, Basle, Switzerland, 1959; Martha Jackson Gal., N.Y., 1960; James Gal., N.Y., 1960; G. David Thompson Collection exh., Dusseldorf, The Hague, Guggenheim Mus., N.Y., 1960-61; Carnegie Inst., 1961; Comara Gal., Los Angeles, (2-man), 1963; Festival of the Arts, Long Island Univ., Post College, Southampton College, 1964; Festival of the Arts, Guild Hall, East Hampton, 1964; Festival of the Arts, Long Island Univ., Parrish A. Mus., 1966; Parrish A. Mus. Exh., 1966; one-man: Cal. PLH, 1946; Betty Parsons Gal., N.Y., 1948; Bertha Schaefer Gal., N.Y., 1957, 1958; Executive House, N.Y., 1958; Mills College, N.Y., 1958; Latow Gal., N.Y., 1961; Worth Ryder Gal., Univ. Cal., Berkeley, 1963; East Hampton Gal., 1963. Positions: Guest Lecturer, Painting, Univ. California, Berkeley, Cal., 1963; Southampton (N.Y.) Col., 1967.

LITTLE, NINA FLETCHER (Mrs. Bertram K.)—
Collector, Scholar, W.
305 Warren St., Brookline, Mass. 02146
B. Brookline, Mass., Jan. 25, 1903. Awards: Historical Society of Early American Decoration (for art research), 1953; Award of Merit, American Assoc. for State and Local History (for research in regional art and architecture), 1953; Rotary Club of Brookline (for distinguished public service in appreciation of life and arts of America's past), 1956; Crowninshield Award (for superlative achievement in the preservation of American history and culture), National Trust for Historic Preservation, 1964. Author: "American Decorative Wall Painting," 1952; Catalogue, Abby Aldrich Rockefeller Folk Art Collection, 1957; "Maine's Role in American Art" (one section, 1700-1865), 1963; "Country Art in New England," 1965; various magazine articles. Field of Research: New England painting, architecture, and decorative arts. Collection: American decorative arts, especially folk paintings and furniture. Positions: Trustee, Member of Art Committee, New York State Hist. Assoc.; Trustee, Consultant, Chairman of Curatorial Comm., Old Sturbridge Village; Cataloguer, 1954-1957, Research consultant, Abby Aldrich Rockefeller Folk Art Collection.

LITTLEFIELD, WILLIAM HORACE—Painter
537 E. 13th St., New York, N.Y. 10009
B. Roxbury, Mass., Oct. 28, 1902. Studied: Harvard Col., A.B. Work: BMFA; FMA; WMA; Smith Col.; Vassar Col.; Albright A. Gal.; Lockwood Mem. Lib., Univ. Buffalo; William Rockhill Nelson Gal.; MModA; Univ. Michigan; AGAA; Univ. Nebraska; Univ. Massachusetts; Kunstmuseum, Berne, Switzerland. mural, Falmouth (Mass.) Sch. Exhibited: nationally, group and one-man exhibitions; annually with Provincetown and Cape Cod AA.*

LITTLEMAN, HARVEY KLINE—Glass Sculptor, C., E.
Department of Art, University of Wisconsin, Madison, Wis. 53706; h. Rte. 1, Littleton Rd., Verona, Wis. 53593
B. Corning, N.Y., June 14, 1922. Studied: Univ. Michigan, B. Des.; Cranbrook Acad. A., M.F.A. Member: Am. Crafts Council (Trustee 1957-1958, 1961-1964); Wisconsin Des.-Craftsmen. Awards: prizes, Toledo Mus. A., purchase, 1966; Syracuse Mus. FA, 1954; Detroit Inst. A., 1951, 1954; Milwaukee A. Center, 1951, 1954, 1957-1963, and others. Work: MModA; Mus. Contemp. Crafts, N.Y.; Kunstgewerbe Mus., Cologne, Germany; Victoria & Albert Mus., London; Smithsonian Inst., Washington, D.C.; Corning Mus. of Glass, N.Y.; Toledo Mus. A.; Milwaukee A. Center; Republic of San Marino; Detroit Inst. A.; Arno A. Gal., Elmira, N.Y.; St. Paul Gal. & Sch. A.; Univ. Michigan; Univ. Illinois; Ohio State Univ.; Univ. Nebraska; Univ. Utah; Illinois State Univ., and others. Exhibited: Int. Expo, Cannes, 1955; Brussels, 1958; Stuttgart, 1965; Munich 1968 and 1969; Milan, 1964; Am. Craft Exh., 1954, 1960, 1966. One-man and small groups: Toledo Mus. A., 1954; AIC, 1963; Corning Mus. Glass, 1964; Mus. Contemp. Crafts, N.Y., 1964; Milwaukee A. Center, 1966; Cologne and Munich, 1969; Lee Nordness Gal., N.Y., 1969. Positions: Instr., Toledo Mus. A., 1949-1951; Instr., 1951-1954, Asst. Prof., 1954-1961, Assoc. Prof., 1961-1965, Prof., 1965-; Chm., 1964-1967, 1969-, Univ. Wisconsin, Madison.

LITTMAN, FREDERIC—Sculptor
445 N. W. Skyline Blvd., Portland, Ore. 97210
B. Hidegszamos, Hungary, Feb. 17, 1907. Studied: Nat. Sch. FA, Budapest; Academies Julien, Ranson and Ecole des Beaux Arts, Paris, France. Member: Northwest Inst. of Sculptors. Work: Portland A. Mus.; Mus. of the Univ. of Oregon; Reed College, Portland; Antioch College; monument to F. D. Roosevelt, Grand Coulee Dam; architectural sculptures: Zion Lutheran Church, Temple Beth Israel, Federal Reserve Bank, Portland, Ore; other work in Washington and California and the Pacific Northwest. Exhibited: Chicago, Philadelphia, San Francisco, Santa Barbara and Eugene and Portland, Ore. One-man: Corvallis, 1968, Salem, 1969; Portland State Univ., 1969, Portland A. Mus., all in Ore., New York and Paris, France. Retrospective Exh., Portland A. Mus., 1966. Positions: A.-in-Res., Antioch College, 1941; Reed College, 1941-1945; Instr., Sculpture, Portland Mus. A. Sch.; 1945-1961; Assoc. Prof. Sculpture, 1961-1966, Prof., 1966-, Portland State University.

LIVINGSTON, CHARLOTTE (Mrs. Francis Vandeveer Kughler)—
Painter
2870 Heath Ave., New York, N.Y. 10063
B. New York, N.Y. Studied: NAD Sch. FA; ASL; Columbia Univ.; City Col. of New York. Member: Gotham Painters (Pres.); Bronx A. Gld. (Pres.); AAPL; NAC. Work: Ford Mus., Dearborn, Mich.; Hickory (N.C.) Mus. A.; Greenville (S.C.) Mus.; Jumel Mansion, N.Y., and in private colls. Exhibited: Gotham Painters; Bronx A. Gld.; NAC; one-man annually including Burr Gal., N.Y., 1961; Artzt Gal., N.Y., 1965. Positions: Dir., Kingsbridge Hist. Soc., 1959-.

LIVINGSTON, SIDNEE—Painter, Pr.M.
14 Minetta St., New York, N.Y. 10012
B. New York, N.Y. Studied: N.Y. Univ.; NAD. Member: AEA; NAWA. Awards: F., MacDowell Colony, 1960, 1963; prize, Painters & Sculptors of New Jersey, 1965. Work: Altoona (Pa.) A. Center; Collectors Am. A., N.Y.; Lincoln A. Gld.; Univ. Mississippi; Princeton Univ.; Everhart Mus.; and in private collections in U.S. and Europe. Exhibited: Kansas City AI; Denver A. Mus.; Butler AI, 1949, 1951; PAFA, 1949, 1951, 1953-1955; Univ. Nebraska, 1948, 1950, 1953, 1954; AIC, 1948-1950; Minn. State Fair, 1947; VMFA, 1948; Ill. State Mus., 1949; Wells Col., 1948; Stephens Col., 1949; Springfield (Mo.) Mus. A., 1948; Ohio State Univ., 1949; South Bend A. Center, 1949-1951; Davenport Mun. Gal., 1950; Cowie Gal., Los A., 1950; WMAA, 1951; CAM, 1951; Terry AI, 1952; NAD, 1952; Joslyn Mus. A., 1953-1955; Audubon A., 1953, 1966; Silvermine Gld. A., 1953; NAWA, 1953-1955, 1966-1969; NAC, 1953-1955; Little Gal., Phila., Pa., 1953-1955; Midwest Landscape Exh., 1953; Contemp. A. Gal., 1953-1955; Springfield A. Lg., 1955; SFMA, 1954; Dayton AI, 1956; LC, 1956; New School, N.Y., 1957; AWS, 1958; Jersey City Mus. A., 1958; Tasca Gal., N.Y., 1966; Carr Gal., N.Y., 1967-1968; Lucinda Gal., N.J., 1968-1969; New Jersey P. & S., 1968; Galerie Philadelphie, Paris, France, 1957; Am. Gal., Greece, 1958; Edinburgh, Scotland, 1963; Birmingham, England, 1964; 3 traveling exhs. U.S.A., 1965; traveling exh., France, 1965, and others; one-man: Salpeter Gal., 1947; Assoc. Am. A., Chicago, 1949; Wellons Gal., 1951-1954; Univ. Miss., 1953; Elizabeth Nelson Gal., Chicago, 1953; Everhart Mus., 1957; Univ. Miami, Coral Gables, Fla., 1958; Martello Mus., Key West Fla., 1959; Condon Riley Gal., N.Y., 1959-1960; Rose Gal., Nantucket, 1967. Positions: Instr. Figure Painting, Oxbow Summer School of Painting, 1964.

LIVINGSTONE, BIGANESS (Mrs. Melvin)—Painter, E., L.
Winn Hill, Sunapee, N.H.
B. Cambridge, Mass., 1926. Studied: Massachusetts Col. A., B.F.A.; Boston Univ. Sch. of Fine & Applied A. Awards: prize, Silvermine Gld. A., 1960; Radcliffe Inst. for Independent Study, Grant, 1963-1965. Work: Chase Manhattan Bank, N.Y.; Radcliffe Col.; Sheraton, Boston. Exhibited: Boston A. Festival, 1958, 1959; Carl Seimbab Gal., Boston, 1960-1962; Silvermine Gld. A., 1960, 1964; Univ. Colorado, 1961; De Cordova Mus., 1963; Radcliffe College, 1964; Boston Pr.M., 1949; WMA, 1962; Weeden Gal., Boston, 1967; one-man: De Cordova Mus., 1954, 1958; Seimbab Gal., 1962; Harvard Univ., 1966. Positions: Instr., drawing & painting, Newton Col. of the Sacred Heart, 1967-.

LLOYD, MRS. H. GATES—Collector, Patron
Darby Road, Haverford, Pa. 19401
B. Devon, Pa., July 19, 1910. Collection: Contemporary painting and sculpture. Positions: Chairman, Advisory Council, ICA at the University of Pennsylvania; Trustee: Philadelphia Museum of Art, The American Federation of Arts, Washington Gallery of Modern Art.*

LLOYD, TOM—Sculptor
154-02 107th Ave., Jamaica, N.Y. 11433
B. New York, N.Y., Jan. 13, 1929. Studied: Pratt Inst., Brooklyn,

N.Y., with Gottlieb, McNeil, Guston, Nakian; Brooklyn Museum Scholarship, 1961; private study with Peter Agostini. Work: in private colls. Exhibited: Amel Gal., N.Y., 1964, 1965; Ohio Univ. traveling exh., Oct. 1965-Apr. 1966; Inst. Contemp. A., Boston, 1965; Carpenter Gal., Harvard Univ., 1965; WAC, 1966; Contemp. A. Mus., Houston, Tex., 1966; Galerie Sonnabend, Paris, France, 1966; Wadsworth Atheneum, Hartford, Conn., 1966; MModA, Dr. Martin Luther King Benefit Exh., 1968; American Greetings Gal., N.Y., 1968; Minneapolis Inst. A., 1968; Nassau Community Gal., Garden City, N.Y., 1968; C.W. Post Col., Greenvale, N.Y., 1969; Waddell Gal., N.Y., Scholarship, Education and Defense Fund for Racial Equality, 1966, 1967; Univ. California at Los Angeles, 1969; Phoenix A. Mus., 1969; one-man: Amel Gal., N.Y., 1965; Wadsworth Atheneum, Hartford, Conn., 1966; Studio Museum in Harlem, 1968; Howard Wise Gal., N.Y., 1968. Positions: A. Consultant, Group Service Agencies, and Education Div., Lincoln Hospital, N.Y., 1966; Dir., Painting and Sculpture, Adult Creative Arts Workshop, Dept. of Parks, Office of Cultural Affairs, New York City, 1967- ; Instr., Light Media, Sarah Lawrence Col., Bronxville, N.Y., 1969- ; Three Dimensional Design, Cooper Union, N.Y., 1969- .

LOBDELL, FRANK—Painter, E.
340 Palo Alto Ave., Palo Alto, Cal. 94301
B. Kansas City, Mo., Aug. 3, 1921. Studied: St. Paul Sch. FA; Cal. Sch. FA; Academie de la Grande Chaumiére, Paris, France. Awards: Neale Sullivan award, 1960. Work: Pasadena Mus. A.; Los Angeles County Mus.; SFMA; Oakland Mus. Exhibited: 3rd Biennial, Sao Paulo, Brazil, 1955; WMAA, 1962; paintings and graphics organized by Pasadena Mus. A. and Stamford Mus., 1948-1965; SFMA, 1969; one-man: Martha Jackson Gal., 1958, 1960, 1963; Galerie D. Benador, Geneva, 1964; Galerie Anderson-Mayer, Paris, 1965. Illus., "Poems by Kenneth Sawyer." Positions: Assoc. Prof. A., Stanford (Cal.) University.

LOBELLO, PETER—Painter
c/o Ruth Sherman Gallery, 306 E. 72nd St., New York, N.Y. 10021
B. New Orleans, La., Nov. 18, 1935. Exhibited: Delgado Mus. A., New Orleans, 1956-1961; 331 Gallery, New Orleans, 1958-1962; Spring Fiesta, New Orleans, 1960; Louisiana State Annual, Baton Rouge, 1961; Nat. Painting Exh., Municipal A. Gal., Jackson, Miss., 1961; Birmingham Mus. A., 1961; Ringling Mus., Sarasota, Fla., 1962; Ruth Sherman Gal., N.Y., 1961; Castellane Gal., Provincetown, Mass., 1962; Art Invitational, New Orleans, 1963; one-man: 331 Gal., New Orleans, 1962, 1963; Ruth Sherman Gal., 1962; Henri Gal., Boston, 1963; Pierson Gal., New Orleans, 1963.*

LOBERG, ROBERT WARREN—Painter, T.
2787 Folsom St., San Francisco, Cal. 94110
B. Chicago, Ill., Dec. 1, 1927. Studied: City Col. of San Francisco, A.A.; Univ. California, Berkeley, B.A., M.A.; State Col. of San Francisco; Hans Hofmann Sch. A., Provincetown, Mass. Awards: prizes, Richmond (Cal.) A. Center, 1958, 1959; Jack London Square A. Exh., Oakland, 1959; La Jolla A. Mus., 1962; Anne Bremer Memorial prize, SFMA, 1961; Scholarship, Yaddo Fnd., Saratoga Springs, N.Y., 1957; Scholarship, MacDowell Colony, Peterborough, N.H., 1959, 1960. Work: AIC; San Francisco Art Commission; Portland (Ore.) A. Mus.; Henry Gallery, Univ. Washington; Oakland A. Mus.; Gal. Mod. A., Wash., D.C.; Synanon House, Oakland; Cal. Col. A. & Crafts, Oakland. Exhibited: Richmond A. Center, Oakland A. Mus., and SFMA, annually since 1955; Forum Gal., N.Y., 1955; Univ. California at Los Angeles, 1955; Cal. State Fair, 1955, 1959; Artists Gal., New York City, 1957; Art:USA, 1959; Berkeley Gal., Berkeley, Cal., 1958-1960, 1962, 1963; Jack London Square, Oakland, 1957-1959, 1961; San Francisco AA members exh., Cal.PLH and DeYoung Mem. Mus., 1959-1961; Cal. Sch. FA, San Francisco, 1960, 1961; Univ. California Ext., 1960, 1962; Staempfli Gal., N.Y., 1960, 1962; national traveling exhs. sponsored by Art Bank of San Francisco; SFMA, 1962; La Jolla A. Mus., 1962; Dilexi Gal., San Francisco, 1960, 1961; Faculty Annual, Cal. Col. A. & Crafts, Oakland, 1962; "Fifty California Artists" organized by SFMA and Los Angeles County Museum for: WMAA, 1962, WAC, 1963, Albright-Knox A. Gal., Buffalo, 1963, Des Moines A. Center, 1963; AIC, 1963; Pasadena A. Mus., 1963; USIA Exh., Paris, France, 1964; Berkeley Gal., Berkeley, Cal., 1963 (3-man), 1964; Mead Corp., SFMA, 1965; Naples (Fla.) A. Gal., 1965; White Gal., Seattle, 1968; Ithaca (N.Y.) Col. A. Mus., 1968, and others. One-man: Artists Gal., N.Y., 1959; Oakland Jewish Community Center, 1960; Staempfli Gal., N.Y., 1962; Primus-Stuart Gal., Los Angeles, 1962; David Stuart Gal., Los Angeles, 1964; Henry Gal., Univ. Washington, 1968; Cal. Col. A. & Crafts, Oakland, 1969; Berkeley Gal., San Francisco, 1969. Positions: Lecturer in Art, 1955, 1956, 1959, 1965, Instr. A., 1965, Univ. California, Berkeley; Instr., Painting and Drawing, Cal. Col. A. & Crafts, Oakland, 1961-1963; Instr., San Francisco A. Inst., 1963-1966; Visiting Faculty, Dept. Art, Univ. Washington, Seattle, 1967-1968.

LOCHRIE, ELIZABETH—Painter, S., E., L.
1102 West Granite St., Butte, Mont. 59701
B. Deer Lodge, Mont., July 1, 1890. Studied: PIASch., B.A.; Stanford Univ., and with Winold Reiss, Dorothy Puccinelli, Victor Arnautoff, Nicholas Brewer. Member: AAPL; Northwest AA; AFA; Montana Hist. Soc.; Delta Kappa Gamma (Life) for service in Education; F.I.A.L. Awards: Nat. Pencil Comp., 1937; Nat. WC Comp., 1939. Work: murals, USPO, Burley, Idaho; St. Anthony, Idaho; Dillon, Mont.; Montana State Tuberculosis Hospital, Galen, Mont.; panel and fountain, Finlen Hotel, Butte, and many port. busts. Exhibited: Arthur Newton Gal., 1952 (one-man); Young Gal., Chicago; Finlay Gal., Chicago; Donaldsons, Minneapolis; Lounsbery's, Seattle; Lynch Gal., Los A. (one-man); River Oaks Garden Cl., Houston; Town Hall, N.Y.; 7 nat. exhs. 1957-58, and others including London, England. Lectures: "Art in Montana"; "Indians of the Plains"; "Indian History"; "Northwest Art," etc. State Chm. Nat. Art, 1958. Founding Memb., Montana Hist. Soc.; Judge of Plains Indian Cultures (13 yrs.).

LOCK, CHARLES K.—Art dealer
Lock Gallery, 20 E. 67th St., New York, N.Y. 10021*

LOCKE, CHARLES WHEELER—Painter, Gr., Cart., I.
Old Post Rd., Garrison, N.Y. 10524
B. Cincinnati, Ohio, Aug. 31, 1899. Studied: Ohio Mechanics Inst.; Cincinnati A. Acad.; ASL, with Joseph Pennell. Member: NA; Century Cl. Awards: Logan award, 1936; Tiffany F., 1920; grant, Am. Acad. A. & Let. Work: MMA; WMAA; Nat. Gal., London; CM; CGA; PC; N.Y. Pub. Lib. Exhibited: nationally. Illus. "Tale of a Tub"; "Walden"; "Capt. Stormfield's Visit to Heaven." Contributor illus. to Freeman magazine. Lectures: Lithography. Positions: Instr., Lithography, ASL, New York, 1922-37.

LOCKHART, JAMES LELAND—Illustrator, P., W.
980 East Walden Lane, Lake Forest, Ill. 60045
B. Sedalia, Mo., Sept. 26, 1912. Studied: Univ. Arkansas; Am. Acad. A.; AIC, with Edmund Giesbert. Member: A. Gld. Chicago; F.I.A.L.; A. Cl. of Chicago. Awards: medal, A. Dirs. of Chicago, 1947; prizes, A. Gld. of Chicago, 1948, 1957. Work: Container Corp. of America; Baseball Hall of Fame Mus., Cooperstown, N.Y.; Ferry Hall Sch.; Lincoln Room, Gettysburg Mus.; Prints of Waterfowl and Game Birds publ. 1964. Exhibited: one-man: A. Gld. of Chicago, 1958; Ferry Hall Sch., 1958; Great Lakes Naval Base, 1958; Lake Forest Pub. Lib., 1958, 1961; Lake Forest Acad., 1968. Illus. for Saturday Evening Post; Colliers; Coronet; Sports Afield; American Artist's True Magazine. Lectures: Wild Life Paint; Magazine Illustration. Portfolio of Upland Game Bird Prints, publ. 1960; Portfolio of Cats, publ. 1961. Artist, Author: Book, "Portraits of Nature," which won Nat. Graphic Arts award; Chicago Graphic Arts award; Mead Paper Co. award, as well as the Printing Industries of America award, 1968 (all first place).

LOEB, ALBERT—Art Dealer
Albert Loeb and Krugier Gallery, 119 E. 57th St., New York, N.Y. 10022; h. 11 rue des Beaux Arts, Paris 6, France.

LOEB, MR. and MRS. JOHN L.—Collectors
730 Park Ave., New York, N.Y. 10021*

LOEHR, MAX—Scholar, Museum Curator
Harvard University, Cambridge, Mass. 02138; h. 14 Loring Road, Lexington, Mass. 02173
B. Chemnitz, Germany, Dec. 4, 1903. Studied: Munich University, Ph.D.; Berlin University. Awards: Hon. M.A., Harvard University, 1960; Guggenheim Fnd. Grant, 1957-1958. Field of Research: Chinese Art & Archaeology. Contributor of articles to: Artibus Asiae; Ars Orientalis; Archives of the Chinese Art Society of America; Oriental Art; Journal of Asian Studies; Ostasiat. Zeitschrift; Monumenta Serica. Author: "Chinese Bronze Age Weapons," 1956; "Relics of Ancient China" (Dr. Paul Singer Coll.), 1965; Co-Author: "Chinese Calligraphy and Painting" (John M. Crawford Coll.), 1962. Positions: Assistant, Museum fur Völkerkunde, Munich, 1936-1940; Sino-German Institute, Peking, China, 1941-1948; Univ. of Michigan, Ann Arbor, 1951-1960; Curator Oriental Art, Harvard University, Fogg Museum of Art, Cambridge, Mass., 1960- .*

LOEW, MICHAEL—Painter, T., W.
287 7th Ave. 10001; h. 280 9th Ave., New York, N.Y. 10001; s. Monhegan, Me.
B. New York, N.Y., May 8, 1907. Studied: ASL, with Boardman Robinson, Richard Lahey, Thomas Benton; Academie Scandinave, Paris, with Othon Friesze and DuFresne; Hans Hofmann Sch. FA; Atelier Leger, Paris. Member: Am. Abstract A.; CAA; Fed. P. & S. Awards: Sadie A. May Fellowship, Baltimore, 1929; hon. mentions, Nat. mural Comp. for Social Security Bldg., and War Dept. Bldg., Wash., D.C., 1940, 1941; Ford Fnd. purchase award, 1964. Work: Gal. Contemp. A., Univ. of Atlanta; Union Carbide Co., N.Y.; PMA;

BMA; murals, Hall of Pharmacy and Hall of Man, WFNY, 1939; USPO, Amherst, Ohio; Belle Vernon, Pa.; WMAA; Hirshhorn Fnd.; Sheldon Mem. Mus., Lincoln, Neb.; Geigy Chemical Corp., N.Y.; Univ. California Mus., Berkeley; Hampton Inst., Va.; Birla Acad. of Art & Culture, Calcutta, India. Exhibited: WMAA, 1949, 1961, 1962; MMA, 1952; WAC, 1953; traveling exh. to Europe, U.S. Com. for IAPA, 1956-57; AFA traveling exh., 1957-58, 1964-65; Stable Gal., 1953-1956; Farnsworth Mus. A., 1950; Springfield (Mass.) Mus. A., 1952; Riverside Mus., 1950-1965; New School, N.Y., 1948, 1950, 1951, 1953; Portland (Ore.) A. Mus., 1957; Art: USA, 1959; Douglass Col., N.J., 1959 (2-man); Esther Stuttman Gal., N.Y., 1960; Maine A. Gal., Wiscasset, 1960-1964; Morgan Col., Balto., 1959; AIC, 1964; MModA. traveling exh., 1963; Colby Col., 1964; Yale Univ., 1961; SFMA, 1955; Maine Coast Artists, 1964, and in France, Italy, Denmark, Germany and Japan; one-man: Artists Gal., N.Y., 1949; Rose Fried Gal., N.Y., 1953, 1955, 1957, 1959; Portland (Ore.) A. Mus., 1956; Holland-Goldowsky Gal., Chicago, 1960; Univ. Cal., Berkeley, 1960, 1967; Stable Gal., N.Y., 1961, 1962, 1965; T.K. Gal., Provincetown, Mass., 1958. Positions: Visiting Artist, Museum A. Sch., Portland (Ore.) A. Mus., 1956-57; Univ. Cal., Berkeley, 1960-61; Instr., School of Visual Arts, N.Y., 1958- , Co-chm, FA Dept., 1962- ; Visiting Prof., Univ. California, Berkeley, 1967. Contributor to Art News and "It Is" magazines.

LOFTUS, JOHN—Painter
R.F.D. #2, Old Lyme, Conn. 06371
B. Cumberland, Md., July 1, 1921. Studied: ASL; Hans Hofmann Sch. FA; Columbia Univ., M.A. Work: Mulvane Mus. A., Topeka, Kans. Exhibited: Laurel Gal., N.Y., 1949; Norwich (Conn.) AA, 1958-1961; Mystic AA, 1959-1961; PAFA, 1959; Silvermine Gld. A., 1959-1961; Lyman Allyn Mus., 1960; Conn. Acad. FA, 1959; New Haven A. Festival, 1958, 1959; one-man: Mulvane Mus. A., 1948; Artists Gal., 1954, 1958, 1959, 1960; Record Gal., Denver, Colo., 1957; Central City, Colo., 1957. Positions: Staff Memb., Sch. Appl. & Fine Arts, Ohio State Univ.*

LOGAN, FREDERICK M.—Educator, L., W., P.
2913 Waunona Way, Madison, Wis. 53713
B. Racine, Wis., July 18, 1909. Studied: Milwaukee State T. Col., B.E.; AIC; T. Col., Columbia Univ., M.A., with Gustave Moeller, Arthur Young, E.H. Swift, Victor D'Amico. Member: NAEA; Wisconsin Edu. Assn.; Wisconsin A. Edu. Assn.; AAUP; Inst. on Art Edu.; Western AA (Council Memb.) Wisconsin Acad. A., Lets. & Sc. Exhibited: In Wisconsin and the Midwest. Contributor articles to: College Art Journal; Journal of Aesthetics; Review of Educational Research; Studies in Art Education. Author: "Growth of Art in American Schools," 1955. Positions: Prof., A. & A. Edu., University of Wisconsin, Madison, Wis., at present. Visiting Lecturer: Pa. State Univ., Toledo Mus. A., Birmingham Col. for Teachers of Art, England. Research project on Urban Aesthetics, Milwaukee. Northern Nigerian Teacher Education Project 1968-1969 (Chief of Party).

LOGAN, MAURICE—Painter
7117 Chabot Rd., Oakland, Cal. 94618
B. San Francisco, Cal., Feb. 21, 1886. Studied: Mark Hopkins Inst., San Fr., Partington's A. Sch., San F.; AIC. Member: NA; AWS; Soc. Western A.; Oakland Club, San F. (Art Committee); SI; West Coast WC Soc. Awards: D.F.A., Cal. Col. of Arts & Crafts, Oakland, 1956; prizes, AWS, 1954, 1958, 1960, 1962, 1965; NAD, 1958, 1961; State of California, 1958; Oakland A. Mus., 1946, 1950; gold medal, AWS, 1958; Lodi Grape Festival, 1959, 1960, 1962, 1968; Cal. State Fair, 1958, 1962-1965; Soc. Western A., 1960, 1962, 1966; Laguna Beach AA, 1962; Los A. County Fair, 1961; and others. Work: Cal. Acad. Sciences; Oakland A. Mus.; Haggin A. Gal., Stockton, Cal.; NAD; FA Gal. of San Diego; Staten Island (N.Y.) Inst. Arts & Sciences; Cal. Col. A. & Crafts; Cal. State Fair Coll.; Bohemian Club, San F.; Los A. Mus. A.; Reading (Pa.) Mus. A.; Frye Mus. A., Seattle, Wash., and in many private collections. Exhibited: NAD, 1954-1967; MMA, 1966; Otis A. Inst., Los A., 1966; De Young Mus. A., San F., 1966; Lodi Grape Festival, 1967, 1968; AWS, 1968; Oakland AA, 1968; San Diego 200th Anniversary, 1969; St. Mary's College, Cal., 1969. Positions: Trustee, Emeritus, California College of Arts & Crafts.

LOGGIE, HELEN A.—Etcher, Draughtsman
2203 Utter St., Bellingham, Wash. 98225; s. Orcas Island Wash.
B. Bellingham, Wash. Studied: Smith Col.; ASL, and with John Taylor Arms, Mahonri Young. Member: ANA; SAGA; Cal. Pr. M.; Meriden A. & Crafts; Academic A.; Conn. Acad. FA; Cal. Soc. Et.; Northwest Pr. M.; Audubon A.; Phila. WC Cl.; Albany Pr. Cl.; Wash WC Cl.; Hunterdon County A. Center. Awards: prizes, Albany Pr. Cl., 1953; Fla. Southern Col., 1952; NAD, 1955, 1960, 1964, Samuel Morse Medal, 1969; Children's Mus., Hartford, Conn.; Northwest Pr. M., 1939; LC, 1943; Pacific Northwest A. & Crafts Assn., 1950;

Irene Leach Mem. prize; Phila. Sketch Cl., 1960; Academic Artists, 1960; SAGA; AAPL gold medal, 1960, and numerous hon. mentions. Work: Univ. Nebraska; LC; Mus. FA of Houston; SAM; Western Wash. Col. of Edu.; Springfield Mus. A.; LC; MMA; Pa. State Univ.; Nat. Mus., Stockholm; Glasgow Univ., Scotland; British Mus., England; Lyman Allyn Mus.; PMA; IBM; Albany Inst. Hist. & A.; Seattle Pub. Library; Norfolk Mus. A.; 1968; Beaverbrook A. Gal., Fredericton, N.B., Canada. Exhibited: NAD, 1969, 1965 and prior; SAGA; PAFA; Phila. Pr. Cl.; Denver A.Mus.; SAM; Cal. Soc. Et.; Southern Pr. M.; Albany Inst. Hist. & A. Albany Pr. Cl.; San F. AA; SFMA; Carnegie Inst.; WMAA; LC; Audubon A.; Phila. WC Cl.; Laguna Beach AA; Chicago Soc. Et.; Wichita AA; Northwest Pr. M.; NAD; Fla. Southern Col.; L. D. M. Sweat Mem. Mus.; AFA travel. exh.; Am. Acad. A. & Let; Smithsonian Inst. Travel. exh.; London, England; Rochester Pr. Cl.; Colby Col.; Fairfield (Conn.) Pub. Lib.; New Britain Mus., 1969 and prior; Academic A.; Boston Soc. Indp. A.; Conn. Acad. FA; Boston Pr. M.; Meriden A. & Crafts; Conn. Acad. FA, Hartford; Oklahoma A. Center, 1969 (selected for Nat. Drawing Exh.); Wash. WC Cl.; Henry Gal., Univ. Washington; Cal. Soc. Pr. M.; Overseas exh. Graphic Art, SAGA, sponsored by U.S. Comm. of Intl. Assn. of Plastic Arts, 1960-62; Norfolk Mus. A., 1965 (one-man); Phila. Sketch Cl.; Hunterdon County A. Center; State Capital, Olympia, Wash.; Los A. Mus. A.; AIC; CGA; Buffalo Pr. Cl., and many others. Article on the artist and portfolio of drawings in American Artist Magazine, 1969.

LOMBARDO, JOSEF VINCENT—Educator, P., W., L.
100-11 70th Ave., Forest Hills, N.Y. 11375
B. New York, N.Y., Nov. 11, 1908. Studied: Assoc. A.; CUASch.; Royal Acad. FA, Florence, Italy; N.Y. Univ., B.F.A., B.A.; Columbia Univ., M.A., Ph.D.; Univ. Florence, Litt. D.; Villanova Univ., LL.D. Member: Renaissance Soc. Am.; Soc. Arch. Historians; MMA; MModA; Exec. Bd., United Fed. of College Teachers; Eastern AA; Nat. A. Edu. Assn.; Inst. Int. Edu. Awards: Carnegie scholarship; gold medal, Univ. medal, Univ. Florence; F., Royal Acad. FA, Florence, Italy; scholarships, Columbia Univ.; Columbia Univ. research grant for a special study of Michelangelo, 1968. Author: "Santa Maria del Fiore: Arnolfo di Cambio," 1934; "Attilio Piccirilli, Life of an American Sculptor," 1944; "Chaim Gross, Sculptor," 1949; Co-author: "Engineering Drawing," 1953, rev. ed. 1956 (Chinese ed. 1959); "Michelangelo: The Pieta and Other Masterpieces," 1965. Lectures: Modern Art in Italy. Positions: Chm. A. Dept., Queens Col., 1938-42; Columbia Univ., 1946-49; N.Y. Univ,, 1944; Queens Col., 1938- . Chm., Adv. Com. FA, Carlton Publ. Corp.; A. Consultant, Prang Company Publ.; Memb. Adv. Com. on Schools, Borough Pres. of Queens, N.Y.

LO MEDICO, THOMAS G.—Sculptor
61 Main St., Tappan, N.Y. 10983
B. New York, N.Y., July 11, 1904. Studied: BAID. Member: F., NSS; S. Gld.; All A. Am.; Arch. Lg.; F., Am. Numismatic Soc.; ANA. Awards: Citation, 1948, awards, 1949, 1952; Saltus medal, Am. Numismatic Soc., 1956. Work: panels, groups, medals, trophies: USPO, Wilmington, N.C.; Crooksville, Ohio; WFNY 1939; Herbert Adams Mem. Award Medal, NSS; Soc. Medalists; Walter W. Moyer Mem.; "Hall of Fame Tablet" for Popular Mechanics; Public Service Award of Inst. of Life Insurance; 6 statues for the National Shrine of the Immaculate Conception, Wash., D.C.; Univ. Puerto Rico medal; panels, Court House, Wilmington, N.C.; 3 heraldic medallions, Deerfield Acad., 1961; sc., N.Y. Pub. Schs., 1960; Seal for the City of Rye, N.Y., 1964; Alice Freeman Palmer Medal for Hall of Fame, N.Y. Univ., 1964; sculpture, Jr. H.S., Staten Island, N.Y., 1964. Positions: Instr., NAD Sch. FA, New York, N.Y.

LONDON, ALEXANDER—Collector, Patron
229 W. 28th St. 10001; h. 350 Central Park West, New York, N.Y. 10025
B. Paris, France, June 15, 1930. Studied: University of Pennsylvania, M.S. in Chemical Engineering. Awards: Typographical Award of Merit, 1968; Hon. Phi Lambda Upsilon, Chemical Society. Member: American Institute of Aeronautics and Astronautics (Associate Fellow); Sustaining Member, New York Academy of Science, and many others. Collection: French Impressionists; American Contemporary.

LONEY, DORIS HOWARD (Mrs. Boudinot S.)—Painter, L., Gr.
2200 North Alvernon Way, Tucson, Ariz. 85716
B. Everett, Wash., Jan. 24, 1902. Studied: Univ. Washington B.A.; ASL, with Robert Brackman, Yasuo Kuniyoshi; Farnsworth Sch. A.; Scripps Col. Grad. A. Dept., and with Millard Sheets, Henry Lee McFee. Member: Tucson Palette & Brush Cl.; Portraits, Inc.; Nat. Lg. Am. Pen Women (Tucson Br.); ASL; Pen & Brush Cl., and other local A. Assns. Awards: prizes, SAM, 1950; Arrow Head Show, Duluth, Minn.; 1948-1950, 1958; Tri-State Fair, Superior, Wis., 1948-1950; other prizes in Tucson, Ariz. Work: Ports.: Wisconsin State College, Superior, Wis.; First Nat. Bank, Superior, Wis.; Univ. Ari-

zona, and many portraits of prominent persons, 1945-1958. Exhibited: SAM, 1950; Sarasota AA, 1947-1959; Minn. State Fair, 1948; Tri-State Fair, Superior, Wis., 1948-1950; Arizona State Fair, 1952, 1953, 1958, 1959, 1963, 1964, 1968; Nat. Lg. Am. Pen Women, 1962, 1964, traveling exh., 1965; Arrow Head Show, Duluth, 1959, 1960; Tucson FA Assn., etc.; one-man: 7 one-man exhs. in Superior, Wis.; Duluth, Minn.; Everett, Wash.; Tucson, Ariz.; 2-man, Univ. Arizona FA Gal., 1961; 3-man, Tucson A. Center, 1962; Tucson A. Festival, and others.

LONG, STANLEY M.—Painter
140 Arundel Rd., San Carlos, Cal. 94070
B. Oakland, Cal., May 4, 1892. Studied: Cal. Col. A. & Crafts; Mark Hopkins Inst. A., B.A.; Julian Acad., Paris, France. Member: Soc. Western A.; Napa Valley AA; Peninsula AA. Awards: prizes, Stonestown A. Annual, 1959; Lithographers Nat. Assn., San F. Work: watercolors, Prudential Life Ins. Co., New Jersey; Shasta City Mus. & Gal.; Grand Central A. Gal., N.Y. Exhibited: deYoung Mem. Mus., San F., 1960; Oakland A. Mus., 1950; Cal. PLH, 1950; Maxwell Gal., San F., 1960; Laguna Beach, Cal., 1959; St. Mary's Col., 1959; Stonestown Gal., San F., 1960; Witte Mem. Mus., San Antonio, Texas, 1968; Hamel Gal., Sacramento, Cal., 1968; one-man: Kaastra Gal., Palm Beach, Fla., 1956, 1958-1960; Sartor Gal., Dallas, Tex., 1956, 1958-1960; Maxwell Gal., San Francisco, 1968. Illus., "Susan and the Little Black Boy," 1952. Contributor illus. to Sunset Magazine; Los Angeles Times; book "Cowboy in Art." Positions: Instr. A., San Francisco Unified School Dist., Polytechnic High School and Mission Adult High School, San Francisco, Cal.

LONG, WALTER KINSCELLA—
Museum Director, P., S., Des., T., L.
Cayuga Museum of Art; h. 10 Nelson St., Auburn, N.Y. 13021
B. Auburn, N.Y., Feb. 2, 1904. Studied: Syracuse Univ., B.F.A., M.F.A. Member: F., Royal Soc. A., London; IDI; F.I.A.L.; Nat. Acad. Television Arts & Sciences; Int. Platform Assn. Awards: F., Mus. Assn., Rochester Mus. A. & Sciences; Auburn (N.Y.) "Citizen of the Year," 1963; Honor Teacher of the Year, (Kappa Pi), 1964. Work: paintings, Syracuse Mus. FA; sc., Univ. Florida Bldgs.; WFNY 1939; church murals; portraits privately owned; City of Auburn Civic Award medal; Syracuse Univ. School of Journalism. Exhibited: Syracuse Mus. FA; Rochester Mem. A. Gal. Editor, Archaeological Soc. of Central N.Y. Bulletin. Lectures: Art Appreciation; World Art; History of Art, etc., to civic groups, museums, schools, study groups. Arranged exhibitions: "Homespun Art"; "Shoes Thru the Ages"; "Cayuga County Inventions," and others. Positions: Dir., Cayuga Museum of Hist. & A., Auburn, N.Y.; Cayuga County Historian; Instr., Basic Art & Art Appreciation, Auburn Community College; Sec.-Treas., Northeast Mus. Conf.; Dir., Finger Lakes AA; Dir., Instrument Research Inst. Memb., ICOM of UNESCO; Soc. Cinema Collectors & Historians; Treas., County Historians Assn. of N.Y. State.

LONGACRE, MARGARET GRUEN (Mrs. J. J., IV)—
Etcher, Lith., L., P., C.
3460 Oxford Terrace, Cincinnati, Ohio 45220
B. Cincinnati, Ohio, Nov. 21, 1910. Studied: Univ. Cincinnati, B.A.; Cincinnati A. Acad.; & with E. T. Hurley; and in Paris, France and Lausanne, Switzerland. Member: New Orleans AA; Springfield A. Lg.; Ohio Pr. M.; New England Pr. Assn.; Am. Color Pr. Soc.; Wash. WC Cl.; Soc. Min. P., Gravers & S.; Woman's AC, Mus. Assn., A. Circle, Pr. Soc., MacDowell Soc., all of Cincinnati. Awards: prizes, Lib. Cong., 1943; Cincinnati Crafters, 1950, 1952; Cincinnati Woman's Cl., 1951, 1953, 1955, 1956, purchase, 1960, 1963; Wash. Min. P. & Gr. Soc., 1952, 1954, 1958; Pan-Am. Exh., 1949; Print of the Year, Mass., 1943; CM, 1944; CMA, 1941; Graphic Arts prize, San Francisco, 1964. Exhibited: NAD, 1941, 1943-1958; Ohio Pr.M., 1938-1958; Northwest Pr.M., 1941, 1942; Phila. Pr. Cl., 1941, 1942, 1944-1946; Boston Soc. Indp. A., 1941; Conn. Acad. FA, 1941-1943, 1945; Springfield A. Lg., 1941-1946; Oakland A. Gal., 1941, 1945; PAFA, 1941; SAGA, 1942-1945; New England Pr. Assn., 1941; San F. AA, 1942, 1943; CGA, 1942-1946; New Haven Paint & Clay Cl., 1942, 1944; Am. Color Pr. Soc., 1942-1944; Denver A. Mus., 1942-1944; MMA, 1942, 1943; Texas FA Assn., 1943, 1944; Lib. Cong., 1943-1958; Laguna Beach AA, 1942-1944; Mint Mus. A., 1943-1946; New Orleans AA, 1944-1958; CM, 1940-1958; Audubon A., 1945; SFMA, 1941; Balt. WC Cl., 1942; one-man exh.: Loring Andrews Gal., 1942, 1946; Town Cl. Gals., 1959, and others; private exhs., Oxford, England, 1945, 1955; Geneva and Zurich, Switzerland, 1955; Sao Paulo, Brazil, 1956. Has participated in 276 exhs. in U.S., Europe & South America to 1961. Lectures: "The Making of Etchings and Drypoints"; "The Graphic Arts and Artists Through the Ages"; "The Symphony of Art and Music." Lecture & Graphic Arts demonstration given at Showcase of the Arts, Cincinnati, 1960, 1961. Chm. A. Dept., Cincinnati Woman's Cl., 1964-1966.*

LONGLEY, BERNIQUE—Painter
427 Camino Del Monte Sol, Santa Fe, N.M. 87501
B. Moline, Ill., Sept. 27, 1923. Studied: AIC, and with Francis Chapin, Edouard Chassaing. Member: AEA. Award: Lathrop traveling Fellowship, AIC, 1945. Work: Mus. New Mexico, Santa Fe; murals, "La Fonda del Sol" restaurant, New York City, and in private homes and collections. Contributor to House Beautiful, Sports Illustrated, Holiday, New Mexico Magazine; five covers in color to Empire Magazine of the Denver Sunday Post. Exhibited: AIC, 1948; Denver A. Mus., 1948, 1952; Mus. New Mexico, 1949-1962, 1965, 1966, 1968; Scottsdale, Ariz.; Dallas, Tex.; Sante Fe, N.M.; Tulsa, Okla.; Taos, N.M., 1968; and others. One-man: Van Dieman-Lilienfeld Gal., N.Y., 1953; Denver A. Mus., 1952-1955; SFMA, 1955; Sante Fe, 1950-1969; San Francisco, 1955, 1956, 1963; Palm Springs, Cal., 1961-1969; Taos, N.M., 1967; Dallas, 1968.

LONGMAN, LESTER D.—Educator, L., W.
University of California, Los Angeles, Cal. 90024; h. 718 Enchanted Way, Pacific Palisades, Cal. 90272
B. Harrison, Ohio, Aug. 27, 1905. Studied: Oberlin Col., A.B., M.A.; Princeton Univ., M.F.A., Ph.D.; Harvard Univ. Member: Am. Soc. for Aesthetics (Pres. 1953-55, Trustee, 1953-58); CAA. Awards: Phi Beta Kappa, Oberlin Col.; Carnegie F., Princeton Univ., 1928-29, 1929-30; F., Am. Council of Learned Soc. for research in Europe, 1930-31; Fulbright Research F., Italy, 1952-53; Hon. L.H.D., Iowa Wesleyan Col., 1955; Hon. D.F.A., Simpson College, 1961. Author: "History and Appreciation of Art"; "Toward General Education." Contributor to: Art Bulletin; College Art Journal; Journal of Aesthetics and Art Criticism; Art News, etc. Former Ed., Parnassus. Lectures in various universities and museums on Modern Art, Aesthetics and Art Criticisms, etc. Positions: Hd. A. Dept., Prof. A. Hist., Univ. of Iowa, Iowa City, Iowa, 1936-1958; Chm. A. Dept., University of California, Los Angeles, Cal. 1958-1962, Prof. A., 1962- .

LONGO, VINCENT—Painter, Gr.
Art Department, Bennington College, Bennington, Vt. 05201
Studied: Cooper Union Sch. A.; BM Sch. A. Awards: Fulbright Fellowship, Italy, 1951; purchase prizes, Washington Univ., St. Louis, 1955; BM, 1956; Bordighera, Italy, 1952; N.Y. State Univ. at Potsdam, N.Y., 1962; other prizes, Oakland A. Mus., 1956; Phila. Pr. Club, 1953, 1958; PAFA, 1953; Lyman Allyn Mus., 1958. Member: Am. Abstract Artists; Xylon: Societe Internationale des Graveurs sur bois; SAGA; Silvermine Gld. A. Work: PMA; Galleria d'arte Moderna, Bordighera, Italy; Washington Univ.; Oakland A. Mus.; Milwaukee-Downer Inst.; BM; MModA; Lyman Allyn Mus.; Victoria and Albert Mus., London; Bibliotheque Nationale, Paris; LC; Fleming Mus., Univ. Vermont; Erskine Col.; Nat. Mus., Stockholm; NGA; Karachi A. Council, Pakistan; Smithsonian Inst.; USIA, and others. Exhibited: WMAA, 1951, 1956; MModA, 1954; BM, 1954, 1955, 1960; Phila. Pr. Cl., 1953, 1954, 3-man, 1955; Munson-Williams-Proctor Inst., 1954; Italy, 1957; Lyman Allyn Mus., 1958; Terrain Gal., N.Y., 1958 (3-man); Am. Abstract A., 1958, 1959; PAFA, 1959; New Jersey State Mus., 1959; Univ. Nebraska and Kentucky, 1960; New School, N.Y., 1960; Brown Mem. Gal., Tenn., 1961; De Pauw Univ., 1961; Visual Arts Gal., N.Y., 1962; Am. Print Council, 1962; Dintenfass Gal., N.Y., 1962; N.Y. State Univ., Potsdam, 1962. Traveling Exhs.: WMAA, 1956; USIS-AFA, Italy, 1956; Smithsonian Inst., 1958; BM to Italy, 1959; Inst. Contemp. A., Boston, 1959; USIA, 1962-63. One-man: Regional Arts, N.Y., 1949; Korman Gal., N.Y., 1954; Zabriskie Gal., N.Y., 1956; Yamada Gal., Kyoto, Japan, 1959; Area Gal., N.Y., 1960; Wheaton Col., 1960; Thibaut Gal., N.Y., 1962; Middlebury Col. (Vt.), 1965. Positions: Contributing Ed., Arts magazine, 1955-56; Yaddo-in-Res., 1954 (summer); Instr., Brooklyn Mus. A. Sch., 1955-56; Instr., Bennington College, Bennington, Vt., 1957- .*

LOOMER, GIFFORD C.—Educator, P., S.
Art Department, Western Illinois University; h. 227 Western Ave., Macomb, Ill. 61455
B. Millard, Wis., Nov. 29, 1916. Studied: Northern Iowa Univ., B.A. Columbia Univ., M.A.; Univ. Wisconsin, Ph.D.; post-doctoral work in Mexico. Member: NAEA; Western AA; Illinois A. Edu. Assn.; Life memb., F.I.A.L.; NEA. Exhibited: Eighteen one-man shows since 1963. Researched two books and six articles on "Evalution in Art" and "Award Winning Art." Dir. or instr. on six foreign art tours. Jurist of state, regional and national art shows. Lectures: "Art of Mexico." Positions: Prof. A., Western Ill. Univ., Macomb.

LOOMIS, LILLIAN (ANDERSON) (Mrs.)—Painter
International Business Machines Corp., Kingston, N.Y.; h. Old Witchtree Rd., Woodstock, N.Y. 12498
B. Peitaiho, N. China, July 29, 1908. Studied: Mass. Sch. A., Boston, and with Marion Huse; summer schools of Eliot O'Hara, Guy Wiggins, Lester Stevens. Member: Dutchess County AA (Pres.

1946); Woodstock Gld. Craftsmen. Work: Adv. Illus. for D. H. Brigham Co., Springfield, Mass., 1931-33; Luckey Platt & Co., Poughkeepsie, N.Y., 1933-42; murals in private homes. Exhibited: Vendome, Fifteen and Morton Gals., N.Y.; traveling exhs., NAWA, AWS; Three Arts, Poughkeepsie; Vassar Col.; Marist Col., Poughkeepsie, 1965 (2-man); one-man: Jones Library, Amherst, Mass., 1939; Am. Int. Col., Springfield, Mass., 1939; Oakwood School, Poughkeepsie, 1954; IBM Eng. Lab., Kingston, N.Y., 1961; IBM A. Cl., 1954; 2-man, Webster Gal., Woodstock, N.Y., 1961. Positions: Jury of Awards, IBM A. Cl.; T., N.Y. State Adult Edu. evening courses in painting, Poughkeepsie, New Paltz and Hudson, N.Y.; Artist, IBM Corp., Kingston, N.Y., 1942- .*

LOPEZ, RHODA LeBLANC—Craftsman, T., S., Des., L.
1020 Pacific Beach Dr., San Diego, Cal. 92109
B. Detroit, Mich., Mar. 16, 1912. Studied: Wayne Univ.; Univ. Michigan; Cranbrook Acad. A.; Claremont Col., Claremont, Cal., and special work with Maija Grotell, Cranbrook. Member: All. Craftsmen, San Diego (Pres.); Am. Craftsmen's Council. Work: Univ. Wisconsin; Claremont Col.; Detroit Inst. A., and in private colls. Exhibited: Cranbrook Acad. A., 1951; Scripps Col., 1955, 1964; Syracuse Mus. FA, 1949-1952; Michigan A.-Craftsmen, 1949-1958; Ceramic Exh. (with the late Carlos Lopez) 2-man; Detroit, Chicago, Claremont Col., Univ. Wisconsin, 1949-1952; Ann Arbor Potters Gld., 1955; Alumni Exh., Cranbrook Acad. A., 1954; Los A. County Fair, 1952, 1954, 1955, 1962-1964; All. Craftsmen, 1961-1969; Pasadena, Design 8, 1963, Design 9, 1965, Design 10, 1967; La Jolla A. Center, 1961 (one-man); San Diego Fair, 1960, 1961; Oakland, Cal., 1961; Nexus Gal., 1961; Medical Art one-man exhs.: Wesleyan Univ.; Univ. Michigan. Contributor illus. to Medical Journals. Positions: Instr., Potters Gld., 1950-1959; A., Univ. Michigan Medical School, Ann Arbor, Mich., 1953-59; Instr., Ceramics, Mosaics, La Jolla A. Center, 1960-1964; Univ. California Extension School, 1964- .; Instr., Mira Costa Jr. Col., Oceanside, Cal.; Des., Joma, Los Angeles, 1969; Dir., Advisor, Design Associates, 1969.

LOPEZ-REY, JOSE—Educator, W., L.
Institute of Fine Arts, 1 East 78th St., New York, N.Y. 10021; h. 1 Dogwood Lane, Westport, Conn. 06880
B. Madrid, Spain, May 14, 1905. Studied: Univ. Madrid, B.A., M.A., Ph.D.; Univ. Florence; Univ. Vienna. Member: Corr. member, Hispanic Soc. Am.; Bd. Int. Fnd. for Art Research. Author: "Antonio del Pollaiuolo y el fin del 'Quatrocento'," 1935; "Realismo e impresionismo en las artes figurativas espanolas del siglo XIX," 1937; "Goya y el mundo a su alrededor," 1947; "Francisco de Goya," 1950; "Goya's Caprichos: Beauty, Reason and Caricature," 1952; "A Cycle of Goya's Drawings: The Expression of Truth and Liberty," 1956; "Velazquez: A Catalogue Raisonné of His Oeuvre," 1963; "Velazquez' Work and World," 1968. Contributor to leading art magazines in U.S. and abroad, with articles on aesthetic criticism of old and 20th-century masters. Positions: Prof., Univ. Madrid, 1932-39; Advisor FA to Spanish Ministry of Edu., 1933-39; L., Smith Col., 1940-47; L., Inst. FA, N.Y. Univ., 1944-51; Adjunct Prof., Inst. FA, New York, N.Y., 1951-53; Assoc. Prof. 1953-1964; Prof., 1964- .

LORAN, ERLE—Painter, E., W.
10 Kenilworth Court, Berkeley, Cal. 94707
B. Minneapolis, Minn., Oct. 3, 1905. Studied: Univ. Minnesota; Minneapolis Sch. A., with Cameron Booth. Awards: Paris prize, Chaloner F., 1926; Minn. A. Soc., 1924; Minneapolis Inst. A., 1925, 1931; Minn. State Fair, 1924, 1945, 1946; SFMA, 1942, 1944, 1945, 1950, 1952, 1954; Cal. WC Soc., 1947; Pepsi-Cola, 1948; Cal. State Fair, 1940, 1947-1950. Work: SFMA; Denver A. Mus.; Univ. Minnesota; U.S. Treasury Dept., Wash., D.C.; San Diego AI; Univ. Utah; Santa Barbara Mus. A.; IBM; Krannert Mus., Univ. Illinois, 1965 (purchase). Exhibited: MMoA traveling exh., 1933; Rockefeller Center, 1935; Colorado Springs FA Center, 1938, 1959; WMAA, 1937, 1941, 1944, 1948, 1951, 1952; AIC, 1933, 1938, 1939, 1941, 1943, 1944, 1946; Toledo Mus. A., 1943; Cal. PLH, 1945, 1946, 1948, 1951, 1952; PAFA, 1940, 1945; Chicago A. Cl., 1943; SFMA, 1936-1946, 1948-1952, 1954, 1955; Oakland A. Gal., 1936-1946; Cal. WC Soc., 1941-1946; Carnegie Inst., 1941; Univ. Illinois, 1949, 1951, 1953; MMA, 1951, 1953; Pepsi-Cola, 1948, 1949; Cranbrook Acad. A.; Stanford A. Gal., 1956; Faculty Artists, AFA traveling exh., 1961-62; one-man: Kraushaar Gal., 1931; Viviano Gal., 1952, 1954; Dalzell Hatfield Gal., 1949; SFMA, 1952; Bertha Schaefer Gal., N.Y., 1965, and others. Author: "Cezanne's Composition," 6th printing, 1950. Contributor to The Arts; Am. Magazine of Art; Art News and others. Positions: Prof. A., Dept. A., Univ. California, Berkeley, Cal.

LORING, CLARE—Painter, Gr.
352 Royal Hawaiian Ave., Honolulu, Hawaii 96815
B. Vancouver, B.C., Canada. Studied: Vancouver (B.C.) A. Sch.; Univ. Washington; ASL, with George Bridgman, Morris Kantor, Will Barnet, Harry Sternberg; Univ. of San Nicolas, Morelia, Mexico;

Cal. Sch. FA, San F.; Univ. California, Santa Barbara, B.A.; Univ. California, Berkeley, M.A. Member: Hawaii P. & S. Lg.; Honolulu Pr. M. (Bd. Memb.). Work: outdoor ceramic tile and aluminum mural for Aloha Airlines; mural, Waikiki Savings & Loan Co. Exhibited: numerous juried shows in San Francisco Bay area, Canada and Hawaii; one-man exhs., Contemp. A. Center, Honolulu, 1965, and in California, Canada and Hawaii. Positions: Instr., Univ. Hawaii, College of General Studies, Honolulu.*

LORING, PAULE STETSON—Watercolorist, Des., Cart., I.
Pleasant St. at Mill Cove, Wickford, North Kingstown, R.I. 02852
B. Portland, Me., Mar. 24, 1899. Member: South County AA; Lymington Yacht Cl., England; 50 American Artists; Am. Assn. Editorial Cartoonists; F., Royal Soc. A., London, England. Work: Fla. Southern Col.; many cartoons in public and private coll. Contributor to Yachting Magazine, Yankee Magazine, Saltwater Sportsman Magazine, Skipper magazine; American Heritage. Illus., "Never Argue with the Tape," 1054; "Three Sides to the Sea," 1956; "Dud Sinker, Lobsterman," "Lancelot the Swordfish," "Loring's Marine Sketchbook," all 3 publ., 1964. Cartoon reproduced in the American Peoples Encyclopedia Year Book, 1958. Positions: Ed. Cart., Providence Sunday Journal, Providence Evening Bulletin.*

LOTTERMAN, HAL—Painter, T.
125 S. Randall Ave., Madison, Wis. 53715
B. Chicago, Ill., Sept. 29, 1920. Studied: Univ. Illinois, B.F.A.; State Univ. Iowa, M.F.A. Awards: Tiffany Fnd. Grant, 1951; purchase prizes: Akron AI, 1953; Ohio Univ., 1957; State Univ. of Iowa, 1957; Ball State Col., Indiana, 1958, 1959, and others. Work: Butler Inst. Am. A.; Ohio Univ.; State Univ. Iowa; Akron AI; Ft. Worth AA; Dayton Co., Minn.; Toledo Fed. A. Soc.; Zanesville AI; Ball State Col.; Wright A. Center, Beloit Col.; Mulvane A. Center, Topeka, Kans.; St. Cloud Col., Minn. Exhibited: CGA, 1955, 1957; Carnegie Inst., 1952; PAFA, 1949, 1953, 1957, 1959; Butler Inst. Am. A., 1957, 1958; NAD, 1954; MMA, 1950; SFMA, 1949, 1950; VMFA, 1948; Denver Mus. A., 1946, 1949; Des Moines A. Center, 1950; Joslyn Mem. Mus., 1949, 1950, and others; one-man: State Univ. Iowa, 1960; Harry Salpeter Gal., N.Y., 1960; Butler Inst. Am. A., 1958; Albion Col., Mich., 1953 (3-man); Toledo Mus. A., 1951. Positions: Instr. A., State Univ. Iowa, 1947-50; Toledo Mus. Sch., 1950-56; Visiting Prof. A., State Univ., Iowa 1959-60; Visiting Lecturer, Univ. Wisconsin, (spring and summer), 1963; Assoc. Prof., Univ. Wisconsin, 1965- .

LOUDEN, ORREN R.—Painter, W., L.
2441 Oxford Ave., Cardiff-by-the-Sea, Cal. 92007
B. Trenton, Ill., Apr. 24, 1903. Studied: George Washington Univ.; Corcoran Sch. A.; ASL; Provincetown Sch. A.; Santa Clara Univ.; & with DuMond, Bridgman, Tucker, Benton. Member: Springfield AA; A. Council, San Diego; F.I.A.L. Exhibited: Progressive A., N.Y.; Am. Salon, N.Y.; Springfield AA; Georgetown Gal., Wash., D.C.; Ferguson Gal., La Jolla, Cal.; Village Sch. A. Gal., San Diego, Cal. Contributor to: Nat. Geographic magazine; American Motorist magazine. Positions: Dir., Village Sch. A., San Diego, Cal., 1945-46; Former Dir., San Diego Sch. A., La Jolla, Cal.; Dir., Village Sch. A., Cardiff-by-the-Sea, Cal., at present; Art Corr., San Diego Citizen; Mng. Ed., Cardiff Star News.

LOUGHEED, R(OBERT) E(LMER)—Painter, Comm., I.
Eden Hill Road, Newtown, Conn. 06470
B. Massie, Ont., Canada, May 27, 1910. Studied: Ontario College of Art, Toronto; Ecole des Beaux Arts, Montreal; and with DuMond. Member: SC; Soc. Animal Artists. Awards: Grumbacher award, 1962 and Jasper Cropsey award, 1964, Hudson Valley AA. Work: Montreal AA Gallery. Exhibited: "Sports in Art," Grand Central Galleries, N.Y., 1965; Animal Artists Annual, 1960-1965; Hudson Valley AA, 1960-1965; Springfield (Mass.) Mus. FA, 1964; SC Annuals. Illustrated: "Bell Ranch Sketches," 1964; illus. for Red River Co., 1965. Illustrations for Toronto Star Weekly; National Geographic Magazine; Reader's Digest; True Magazine; Sports Afield, etc.*

LOURIE, HERBERT S.—Painter, E.
83 Ridgewood Ave., Keene, N.H. 03431
B. Boston, Mass., Dec. 26, 1923. Studied: Indiana Univ.; Yale Univ., B.F.A., M.F.A. Member: CAA; New Hampshire AA. Awards: prize, Currier Gal. A., 1955; Arnot A. Gal., Elmira, N.Y., 1961 (purchase). Work: Munson-Williams-Proctor Inst., Utica, N.Y. Exhibited: Dartmouth Col.; Colby Junior Col.; Fitchburg A. Mus.; Keene State T. Col.; Phillips Exeter Acad.; N.H. Hist. Soc.; Currier Gal. A.; Inst. Contemp. A., Boston; R.I. Sch. Des Mus.; deCordova & Dana Mus.; Univ. New Hampshire; Univ. Rhode Island; Springfield Mus. A.; Berkshire Mus.; Wadsworth Atheneum; Farnsworth Mus.; Rockport Soc. A.; Brookline A. Soc.; Boston A. Festival; Saratoga (N.Y.) Gal. (one-man), and others. Positions: Asst. Prof. A., Nasson Col.,

Springvale, Me., 1952-55; Visiting L., Univ. New Hampshire, 1953-54; Instr., Univ. Rhode Island, 1956-58; Asst. Prof. A., Elmira College, Elmira, N.Y., 1958-61; Assoc. Prof. Chm., Art Dept., Keene State College, Keene, N.H., 1966- .

LOVE, C. RUXTON—Collector
120 Broadway 10005; h. 651 Park Ave., New York, N.Y. 10021
B. New York, N.Y., Nov. 11, 1903. Studied: Yale University, B.A. Member: Benefactor, MMA. Collection: Paintings by George Bellows; Napoleonic silver; Chinese and Greco-Buddhist art; Renaissance jewels.*

LOVE, IRIS CORNELIA—Scholar, Writer, Collector, Patron
25 E. 83rd St., New York, N.Y. 10028
B. New York, N.Y., Aug. 1, 1933. Studied: Smith College, B.A.; Universita di Firenze, Italy; New York University Institute of Fine Arts. Member: Archaeological Institute of America; American Association of University Professors; Turkish-American Society. Collection: Egyptian, Chinese, Iranian, Greek, Roman and Etruscan; 18th and 19th century objets d'Arts; Peruvian, Tibetan; Pre-Columbian, Indian and Nepalese. Field of Research: Archaeology; Greek and Roman Art; Art History. Contributor to: Bollingen Series; Marsyas; American Journal of Archaeology; Anatolian Studies, and others. Author: "Greece, Gods and Art," 1968. Positions: Instr., Greek and Roman Art, Cooper Union, N.Y., 1963 and Smith College, 1964-1965; Assistant Professor, Art History and Archaeology, Long Island University, 1966-1967, Research Assistant Professor, 1967-1968; Instructor and Coordinator, three lecture series, N.Y. University School of Continuing Studies, 1968-1969, and at Institute for Community Education, Hofstra University, N.Y., 1969. Archaeological Field and Excavation: Staff Member, Archaeological Expedition to the Island of Samothrace (New York Institute of Fine Arts), 1955-1965; Collaborated with the Director of the British School in Rome on the excavation Quattro Fontanile at Isola Farnese, Italy; Director, Archaeological Expedition to Knidos in Turkey, sponsored by Long Island University, 1967.

LOVE, JIM—Sculptor
906 Truxillo St., Houston, Tex. 77002
B. Amarillo, Tex., 1927. Exhibited: Dallas Mus. for Contemp. A., 1957, 1960, 1961; Fine Arts Gal., Univ. of St. Thomas, Houston, 1958, 1962, 1963; MModA, 1961; Haydon Calhoun Gal., Dallas, 1962, 1963; Mus. FA of Houston, 1961, 1963; one-man: New Arts Gallery, Houston, 1958, 1959, 1961-1963.*

LOVE, PAUL—Museum Curator, E.
Kresge Art Center, Michigan State University, East Lansing, Mich.; h. 3891 Okemos Rd., Okemos, Mich. 48864
B. Long Branch, N.J., Aug. 1, 1908. Studied: Princeton Univ., B.A.; Columbia Univ., M.A., Ph.D. Member: CAA; Midwestern Museums. Awards: AIA scholarship to Univ. Pennsylvania, 1945; Scholarship for study at N.Y. Univ., 1948; Fellowship to Columbia Univ., 1948. Exhibited: Cal. WC Soc., 1953; Alabama WC Soc., 1953; BMA, 1953; Michigan WC Soc., 1952, 1953. Arranged exhibitions: "The Turn of the Century," 1964; "Nigerian Bronzes" (collection), 1964. Contributing author: An Introduction to Literature and Fine Arts, 1950 (6 chapters); Modern Dance Terminology, 1953. Contributor reviews and articles on theatre, modern dance to Theatre Guild Magazine, The Stage, Modern Music Quarterly, Dance Observer, New Republic, N.Y. World-Telegram and others. Positions: Asst. Prof., 1946-1948, Assoc. Prof., 1949-1956, Prof., 1956- , Gallery Dir., 1963- , Ed., Kresge A. Center Bulletin, 1967- , Michigan State University, East Lansing, Mich.

LOVE, ROSALIE BOWEN—Painter, T.
14265 Oxnard St., Van Nuys, Cal. 93030; h. 15635 Vandorf Place, Encino, Cal. 91316
B. Jamestown, N.Y., Aug. 4, 1927. Studied: Jepson A. Sch., with Will Foster; and other study with Paul Puzinas, Bennett Bradbury, J. Thompson Pritchard. Member: Am. Inst. FA (life); Laguna Beach AA; Cal. A. Cl. (Bd. Dirs.); Valley Artists Gld. Awards: prizes, San Fernando Valley A. Cl., 1953; Valley A. Gld., 1953; Friday Morning Cl., Los A., 1954, 1960 (2), 1961, 1962, 1964 (2); Cal. A. Cl., 1957; Hollywood Woman's Cl., 1957; Beverly Hills Woman's Cl., 1958; Greek Theatre, Los A., 1958 (2), 1962, 1965; Santa Monica Lib., 1960; City Hall Gal., Los A., 1960; Wilshire Federal Gal., Beverly Hills, 1961; Laguna Beach, 1961; Ebell Cl., Los A., 1962; De Grimm Gal., Detroit, 1962; Nat. Orange Show, San Bernardino, 1963. Exhibited: In addition to the above: Frye Mus. A., Seattle, 1960; Chautauqua, N.Y., 1962; Laguna Festival of Arts, 1963; Tucson, Ariz., 1969. Ports. in many collections throughout U.S.A. and abroad. Positions: Freelance artist & teacher, 1955- .

LOVELL, TOM—Illustrator
3 Skytop Rd., Norwalk, Conn. 06855
B. New York, N.Y., Feb. 5, 1909. Studied: Syracuse Univ., B.A.

Member: SI; SC. Awards: Gold Medal, SI, 1964. Work: U.S. Marine Corps. Hdqtrs., Wash., D.C.; Merchant Marine Acad., Kings Point, N.Y.; Explorers Cl., N.Y.C.; Armed Forces Room, U.S. Capitol, Wash., D.C. Illus.: Nat. Geographic Society; Reader's Digest condensed books— "7 Days in May," "Tunsa," "Life of Admiral Byrd." Exhibited: SI. illus. for Cosmopolitan; McCalls; Ladies Home Journal; True. Good Housekeeping, and other national magazines.*

LOVET-LORSKI, BORIS—Sculptor
131 East 69th St., New York, N.Y. 10021; also Rome, Italy
B. Lithuania, Dec. 25, 1894. Studied: Acad. A., St. Petersburg, Russia. Member: NA; F., NSS; Lotos Cl.; Am. Soc. French Legion of Honor. Awards: Knight of the Legion of Honor, 1948. Work: Luxembourg Mus., Petit Palais, Bibliotheque Nationale, Paris, France; British Mus., London; MMA; Dumbarton Oaks; San Diego FA Assn.; Los A. Mus. A.; SAM; SFMA; City Hall, Decatur, Ill.; City of Paris, France; sculpture and mosaics for Chapel of American War Mem., Manila, Philippines. Bronze head of Gen. DeGaulle, for City Hall, Paris, France, 1959-60; Heroic size bronze head of John Foster Dulles, for Washington Int. Airport; Heroic bronze portrait for Brandeis Univ., 1964. Exhibited: one-man exh. Caracas, Venezuela, London, Philadelphia, New York, Manila, Philippines, and nationally.*

LOW, JOSEPH—Graphic Artist, Des.
7 Dock Road, South Norwalk, Conn. 06854
B. Coraopolis, Pa., Aug. 11, 1911. Studied: Univ. Illinois; ASL with George Grosz. Work: Princeton Univ.; Harvard Univ.; Dartmouth Col.; Newberry Lib., Chicago; Pratt Inst. Lib.; Univ. Okla., Ill., Ky., Pittsburgh; San Antonio Lib.; Wilmington Soc. FA; Ohio State Univ.; Newark Pub. Lib.; LC; Williams Col.; Wesleyan Univ.; VMFA; U.S. State Dept.; MMA; BMFA; Univ. Illinois; Boston Atheneum, and in many private colls. Exhibited: BMFA; VMFA; N.Y. Pub. Lib.; MMA; one-man: Princeton Univ.; Dartmourth Col.; Univ. Illinois; Rhode Island Sch. Des.; Pratt Inst.; Wilmington Soc. FA; BMA; John Herron AI; PMA; Newark Public Library; Ohio State Univ.; Univ. Oklahoma; San Francisco Public Library; Washington Univ.; Wesleyan Univ.; Williams Col.

LOWE, HARRY—Museum Curator, L., E., Des., P.
National Collection of Fine Arts, 8th & G Sts., N.W., Washington, D.C. 20560
B. Opelika, Ala., Apr. 9, 1922. Studied: Auburn Univ., B.A., M.A.; Cranbrook Acad. A. Member: AAMus.; AFA; CAA; Int. Soc. for Edu. through Art; Nat. Trust for Historic Preservation; Soc. Arch. Historians; Thornton Soc. of Washington; Midwest Mus. Conf.; NAEA; Southeast Mus. Conf. Positions: Prof. A., Chm. Exhibitions & Permanent Collections, Auburn Univ., 1947-1949; Dir., Tennessee Fine Arts Center, Cheekwood, 1949-1964; Dir., of the Stuart Davis Memorial Exhibition, NCFA, Washington, D.C., Art Institute of Chicago, Whitney Mus. Am. Art, Art Gallery-Univ. California at Los Angeles, 1965; Dir., Charles Sheeler Exhibition, NCFA, Washington, D.C., Philadelphia Mus. A., Whitney Mus. Am. A., 1968-1969; Cur., Exhibitions, National Collection of Fine Arts, Washington, D.C., at present.

LOWE, JOE—Collector
785 Park Ave., New York, N.Y. 10021*

LOWENTHAL, MILTON—Collector
1150 Park Ave., New York, N.Y. 10029*

LOWRY, BATES—Scholar, Writer, Critic
941 Park Ave.; New York, N.Y. 10028
B. Cincinnati, Ohio, June 21, 1923. Studied: Univ. Chicago, Ph.B., M.A., Ph.D. Member: CAA (Bd. Dirs.); Soc. Architectural Historians (Bd. Dirs.); Bd., Center for Inter American Relations; Trustee, American Federation of Arts, 1969- ; Bd., N.Y. Cultural Foundation, 1968- ; Nat. Exec. Chm., Committee to Rescue Italian Art, 1966- ; Advisory Bd., Studio Museum in Harlem, 1968- ; Grand Officer, Star of Solidarity, Republic of Italy, 1968. Field of Research: History of the Renaissance; Baroque Art and Architecture; Modern Art. Author: "The Visual Experience: an Introduction to Art," (N.Y. 1961); "Renaissance Architecture" (N.Y. 1962). Positions: Editor, The Art Bulletin and College Art Association Monograph Series, 1965-1968; Instr., Univ. Chicago, 1952-1953; Asst. Prof., Univ. California at Riverside, 1954-1957; Asst. Prof., N.Y. Univ. Inst. Fine Arts, 1957-1959; Assoc. Prof., Chm., Pomona College, 1959-1962, Prof., Pomona College, 1962-1963; Prof., Art Department, Brown University, Providence, R.I., 1963-1967; Dir., Museum of Modern Art, New York, 1968-1969.

LOWRY, W. McNEIL—Foundation Officer
320 E. 43rd St., New York, N.Y. 10017; h. 1161 York Ave., New York, N.Y., 10021
B. Columbus, Kansas, Feb. 17, 1913. Studied: University of Illinois,

A.B., Ph.D. Positions: Director, Humanities and the Arts, The Ford Foundation, 1957-1964; Vice-President, The Ford Foundation, 1964- .

LOXLEY, MRS. BENJAMIN RHEES. See Younglove, Ruth Ann

LOY, JOHN SHERIDAN—Educator, P.
Munson-Williams-Proctor Institute; h. 602 Tracy St., Utica, N.Y. 13502
B. St. Louis, Mo., Nov. 4, 1930. Studied: Colorado College and Colorado Springs FA Center; Washington Univ. Sch. FA, B.F.A.; Cranbrook Acad. A., Bloomfield Hills, Mich., M.F.A. Awards: Fellowship, Yale-Norfolk A. Sch., 1954; Painting award, CAM, 1959. Work: Munson-Williams-Proctor Inst., Utica, N.Y.; Utica College of Syracuse Univ. Exhibited: CAM; St. Louis A. Gld.; Washington Univ.; Colgate Univ.; Utica College; Munson-Williams-Proctor Inst.; MModA; N.Y. State Capital, Albany; Hamilton College; People's A. Center, St. Louis, 1960 (one-man); Utica College, 1961, 1964 (one-man); Munson-Williams-Proctor Inst., 1960, 1964 (one-man). Positions: Instr., People's A. Center, St. Louis, 1959-1960; Instr., Painting & Drawing, Munson-Williams-Proctor Inst., & Utica College, N.Y., 1960- .

LOZOWICK, LOUIS—Printmaker, P., W., L.
62 Massel Terrace, South Orange, N.J. 07079
B. Russia, Dec. 10, 1892. Studied: Ohio State Univ., B.A.; NAD; & abroad. Member: AEA; Assoc. A. New Jersey; Printmakers of Albany; Nat. Soc. Ptrs. in Casein; Phila. WC Cl.; Audubon A.; Boston Pr. M.; Academic AA; Am. Color Pr. Soc. Awards: prizes, AIC, 1929; Phila. A. All., 1930; CMA print prize, 1930; Oakland A. Gal., 1946; Rochester Pr. Cl., 1948; BM, 1950; SAGA, 1951, 1957, 1962; Audubon A., 1954; DMFA, 1953; Creative Graphics, N.Y., 1958; A. Festival, Newark Mus., 1959; Montclair A. Mus., 1959; Hunterdon A. Center, N.J., 1959; Jersey City Mus., 1960; Boston Pr. M.; Academic A., 1962, 1967; So. Orange, N.J., Gal., 1964; P. & S. of New Jersey, 1965; New Jersey State Mus., 1966 (purchase); Soc. Washington Printmakers, 1964. Work: WMAA; MModA; MMA; N.Y. Pub. Lib.; CMA; Lib. Cong.; PMA; CM; BMFA; Honolulu Acad. A.; Mus. FA of Houston; Los A. AA; Carnegie Inst.; Syracuse Mus. FA; Montclair A. Mus.; Rochester Mem. A. Gal.; Newark Mus.; Victoria & Albert Mus., London; Mus. Western A., Moscow; Yale Univ.; Memphis (Tenn.) Mus.; WAC; murals, USPO, New York, N.Y. Exhibited: BM, 1926; Steinway Hall, 1926; MModA, 1943; WMAA, 1933, 1941; AIC, 1929; Carnegie Inst., 1930; CGA, 1932; WFNY 1939; MMA (AV), 1942; Pepsi-Cola, 1946; New Art Circle, 1926; Weyhe Gal., 1929, 1931, 1933, 1935; Grand Central A. Gal., 1930; Stendahl Gal., Los A., 1932; Courvoisier Gal., San F., 1932; Downtown Gal., 1929, 1930, 1931; An Am. Group, 1938-1941; PAFA, 1929; NAD, 1935; Audubon A.; SAGA, 1965 and prior; Conn. Acad. FA; Smithsonian Inst.; Am. Acad. A. & Let.; Birmingham Mus.; Montclair Mus. A.; Newark Mus. A.; Springfield (Mass.) A. Mus.; Tel-Aviv Mus., Israel, and in Paris; AEA; "Precisionist View in Art" Exh., 1960-61, New York, Detroit, Minneapolis, Los Angeles, San Francisco; Fairleigh Dickinson, 1964; N.J. State Mus., Trenton, 1963, 1966; USIA exh. to Europe, Asia and Latin America, 1963-64; Ptrs. & Sculptors of New Jersey, 1965; Zabriskie Gal., N.Y., 1961 (one-man); Bloomfield Col., 1968 (one-man); Retrospective Exh., Newark Public Library, 1969. Co-Author: "Voices of October," 1930; Co-Editor, "America Today," 1936. Author: "Treasury of Drawings"; "Modern Russian Art"; "100 American Jewish Artists." Contributor to: Nation, Theatre Arts, New Masses, Hound and Horn, Encyclopaedia Americana, "Russian Art," etc., with articles on art & the theatre. Lectures: Evolution of Modern Art; Russian Art.

LUBBERS, LELAND EUGENE, S. J.—Sculptor, P., Scholar, W.
1415 Davenport St. 68102; h. 1902 Wirt St., Omaha, Neb. 68110
B. Stoughton, Wis., June 6, 1928. Studied: Layton Gal. A., Milwaukee; Washington Univ., St. Louis, A.B., M.A., Ph. L.; Marquette Univ.; Grande Chaumiere, Paris, France; Univ. Paris, Docteur de l'Universite de Paris (Sorbonne). Contributor article, "Phenomene du XX Siecle, L'Affiche a Change la Rue," Galerie des Arts, 1964. Work: Duchesne Col., Omaha; Sheldon Swope Gal., Univ. Nebraska; Seattle Opera Assn.; Jacksonville (Fla.) A. Mus.; fountain for market area, Omaha. Sculptured sets for "Fidelio," Seattle Opera Assn. Field of Research: The Modern Poster; Art Nouveau. Exhibited: Joslyn Mus., Omaha, 1967; Nebraska Centennial A. Gal., 1967; Pro Arts Graphica, Chicago, 1968; Gal. in the Market, Omaha, 1968; Sheldon Swope Gal., Lincoln, Neb., 1965; one-man: Sheldon Swope Gal., 1965; Col. of St. Mary, Omaha, 1966; Mus. A., Jacksonville, 1967; Frye A. Mus., Seattle, 1968; Concordia Col., Seward, Neb., 1968; Stuhr Mus., Grand Isle, Neb., 1968. Positions: Fnd. & Chm., Fine Arts Dept., Creighton Univ., Omaha, Neb.

LUBIN, EDWARD R.—Art Dealer
Edward R. Lubin, Inc., 17 E. 64th St., New York, N.Y. 10021*

LUCAS, CHARLES C., JR.—Collector
The Juilliard School, Lincoln Center Plaza, New York, N.Y. 10023; h. 1009 Park Ave., New York, N.Y. 10028
B. Charlotte, N.C., March 4, 1939. Studied: Duke University, B.A. 1961. Member: Metropolitan Museum of Art, N.Y.; Museum of Modern Art, N.Y.; Friends of The Whitney Museum of American Art, N.Y.; The Mint Museum of Art. Charlotte, N.C.; N.C. State Art Society and N.C. Museum of Art, Raleigh, N.C. Collection: Primarily twentieth century American art with special interests in the "Ashcan School" and in both abstract and realist contemporary painting and sculpture. Collection also includes Pre-Columbian art of Central and South America. Positions: Controller, The Juilliard School, New York, N.Y.

LUCCHESI, BRUNO—Sculptor, T.
5 St. Marks Place, New York, N.Y., 10003; h. 537 First St., Brooklyn, N.Y. 11215
B. Lucca, Italy, July 31, 1926. Studied: Art Institute, Lucca, Italy. Member: Sculptors Gld.; AEA; AAUP. Awards: Guggenheim Fellowship, 1962-1963; Gold Medal, NAC, 1963; H. Foster Barnett prize, 1959, Watrous Gold Medal, 1961, Morse Medal, 1965, all NAD. Work: PAFA; DMFA; Ringling Mus., Sarasota; Cornell Univ.; Trade Bank & Trust Co., N.Y. Exhibited: WMAA, 1959, 1965; BM, 1958; PAFA, 1961; CGA; Nat. Inst. A. & Lets. Positions: Instr., Univ. Florence, Italy, Sch. of Architecture, 1954-1957; New School for Social Research, N.Y.; Univ. of Utah, 1965.*

LUCIONI, LUIGI — Painter, Et.
33 West 10th St., New York, N.Y. 10011; h. Manchester Depot, Vt. 05256
B. Malnate, Italy, Nov. 4, 1900. Studied: CUASch; NAD. Member: NA; SAE. Awards: Tiffany med., 1929; All. med. of honor, 1929; prizes, Carnegie Inst., 1939; CGA, 1939, 1941, 1949; Lib. Cong., 1946; Nat. Print Exh., 1947; NAD purchase award, 1959. Work: MMA; WMAA; Carnegie Inst.; PAFA; Lib. Cong.; Toledo Mus. A.; Denver A. Mus.; SAM; BM; NAD; Victoria & Albert Mus., London. Exhibited: NAD; CGA; Carnegie Inst.; PAFA; AIC; Toledo Mus. A.; Herron AI; PAFA; MMA; WMAA; Audubon A., etc.

LUCK, ROBERT HENRY—Art Administrator, Asst. Dir.
The American Federation of Arts, 41 E. 65th St., New York, N.Y. 10021; h. 152 E. 94th St., New York, N.Y. 10028
B. Tonawanda, N.Y., Oct. 31, 1921. Studied: Albright A. Sch.; Univ. Buffalo, B.F.A.; Harvard Univ., M.A.; Instituti Meschini, Rome, Certif. Member: CAA; AAMus. Contributor to The Art Quarterly; Arts Digest. Lectures: "The Child and His Art"; "Collectors and Collecting," etc., in museum galleries to clubs, art students, universities and colleges. Exhibitions arranged with catalogues: "David Smith, Sculpture, Drawings, Graphics," 1954, CM; "The Interior Valley Painting Competition," 1955, CM; "The Edwin C. Shaw Collection of Paintings," 1955, Akron. Director of Exhibition for 19 retrospective exhibitions for living American artists, sponsored by The Ford Foundation, circulated by The American Federation of Arts, 1959-1963. Positions: Instr., Toledo Mus. A., 1952-54; Cur., Contemporary A. Center, CM, 1954-55; Dir., Akron AI, Akron, Ohio, 1955-56; Dir., Telfair Academy Arts & Sciences, Savannah, Ga., 1956-1957; Asst. Director, The American Federation of Arts, New York, N.Y., at present.

LUDEKENS, FRED — Illustrator, Des.
Belvedere, Cal. 94920
B. Hueneme, Cal. Member: SI; A. Dir. Cl., N.Y. & San F. Exhibited: Int. Gal., N.Y. (Contemporary Am. Illustration). I., "Ghost Town"; "The Ranch Book"; Contributor to: Saturday Evening Post, This Week, Fawcett Publ. Positions: Co-founder, Chm. of the Bd., Faculty, Famous Artists Schools, Westport, Conn.

LUDGIN, EARLE—Collector
410 N. Michigan Ave., Chicago, Ill. 60611; h. 1127 Sheridan Road, Hubbard Woods, Ill. 60095
B. Chicago, Ill., July 22, 1898. Member: Governing Life Member, AIC. Collection: Contemporary American Art. Positions: Committee on Painting and Sculpture, Trustee, Chairman of Development Committee, Member of Executive Committee, The Art Institute of Chicago; President, Society for Contemporary Art, 1948-1949; Committee on Membership, Development and Promotion, Chairman of Convention in Chicago, April 1961, Trustee, The American Federation of Arts; Member, Committee for United Nations Art.

LUDINGTON, WRIGHT S.—Collector, P.
Buckthorn Road, Santa Barbara, Cal. 93103
B. New York, N.Y., June 10, 1900. Studied: Yale University; Pennsylvania Academy of Fine Arts; Art Students League of New York. Collections: Paintings and sculptures, early 20th century; Classical

Greek and Roman sculpture and vases; Gothic, Romanesque, Egyptian sculpture. Positions: President, Santa Barbara Museum of Art, 1950-1951.*

LUDINS, EUGENE—Painter
Woodstock, N.Y. 12498
B. Mariupol, Russia, Mar. 23, 1904. Studied: ASL. Member: Woodstock AA. Awards: Temple medal, PAFA, 1948; Am. Acad. A. & Lets. Grant, 1960. Work: WMAA; Des Moines A. Center; Univ. Iowa. Exhibited: Carnegie Intl., 1956; PAFA; AIC; VMFA; WMAA; MModA; MMA; Cal. PLH; one-man: Des Moines A. Center; Assoc. Am. A.; Passedoit Gal. (7 exhs.); Krasner Gal., N.Y. (2 exhs.). Positions: Chm., Woodstock AA, 1955-56; Prof. Painting, State Univ. Iowa, 1948-1969.

LUKE, ALEXANDRA (Margaret Alexandra Luke McLaughlin)—
Painter
705 Simcoe St., North, Oshawa, Ont.
B. Montreal, P.Q., May 14, 1901. Studied: Banff Sch. FA; Hans Hoffmann Sch. FA. Member: Heliconian; CGP; CSPWC; Painters Eleven, Toronto; Women's Lyceum AA, Oshawa; F.I.A.L.; OSA. Work: Univ. Alberta; Trinity Col.; Univ. Toronto; King St. H.S., Oshawa; Public Library and A. Mus., London, Ont. Exhibited: RCA, 1954, 1955, 1964; OSA, 1950-1952, 1957, 1959, 1961, 1962-1965; CGP, 1950-1956, 1958, 1960, 1962-1965; Canadian Nat. Exh., 1954-1961; Canadian Biennial, 1955; Mtl. Mus. FA, 1952; Provincetown AA, 1950; Painters Eleven, 1954, 1955, traveling exh., 1958; Riverside Mus., N.Y., 1956; Toronto, 1957; DMFA, 1958; Winnipeg Show, 1957; CSPWC, 1953-1958, 1962-1964; Four Canadians, A. Gal., Toronto, 1959; Traveling exh., A. Inst. Ont., 1964, 1965; one-man: Picture Loan Soc., Toronto, 1952; Eglinton Gal., Toronto, 1955; Park Gal., Toronto, 1958; Baker Gal., Toronto, 1960; 2-man: Kitchener-Waterloo A. Gal., 1959.*

LUKIN, PHILIP—Collector
380 Madison Ave. 10017; h. 322 E. 57th St., New York, N.Y. 10022
B. New York, N.Y., June 26, 1903. Studied: Brown University, Ph.B. Collection: catholic in scope and representative. Positions: Consultant, Lennen and Newell. Inc.. advertising agency.

LUKIN, SVEN—Painter
168 Delancey St., New York, N.Y. 10002
Exhibited: Martha Jackson Gal., N.Y.; Pace Gal., N.Y., 1964-1969.

LUKOSIUS, RICHARD—Painter, E.
Connecticut College, New London, Conn. 06320
B. Waterbury, Conn., Oct. 26, 1918. Studied: Yale Univ. Sch. FA, B.F.A., M.F.A. Exhibited: Boston A. Festival, 1956, 1958; Lyman Allyn Mus. A., 1958, 1968 (one-man); WMA, 1958; Lymna Allyn Mus. A., 1958 (one-man); AFA, 1956-57; Mystic A. Gal., 1961; 2-man: Holiday A. Center, Watch Hill, R.I., 1959; Mystic A. Gal., 1960; Univ. Connecticut, Storrs, 1962 (one-man); John Herron Mus. A., Indianapolis, 1962; Northeastern Univ., Boston, 1962; Staff exh., Converse A. Gal., Norwich, Conn., 1965. Positions: Assoc. Prof. A., Connecticut College, New London, Conn.

LUND, DAVID—Painter
470 West End Ave., New York, N.Y. 10024
B. New York, N.Y., Oct. 16, 1925. Studied: Queens Col., N.Y., B.A. Awards: Fulbright Grant to Italy, 1957-58, 1958-59; Ford Fnd. purchase prize, WMAA, 1961. Work: Toronto A. Gal.; WMAA; Chase Manhattan Bank, N.Y.; Finch Col. Mus.; Univ. of Mass.; N.Y. Times; Manufactures-Hanover Trust; Harcourt-Brace. Exhibited: Assoc. Am. A., 1957; Nebraska Annual, 1958, 1964, 1966; Galeria Schneider, 1958, 1959, Galeria l'Attico, 1958, Palazzo Venezia, 1959, Galeria San Marco, 1959, all Rome, Italy; WMAA, 1958, 1960 (traveling), 1961, 1962 (2) one group and one traveling; Michigan State Univ., 1962; Washington Gal. of Modern Art, 1963; R.I. Sch. Design, 1964-65; PAFA, 1965, 1966, 1969; Toledo Mus., 1966; Grace Borgenicht Gal., N.Y., 1960, 1963, 1968, 1969 (one-man shows); and others. Positions: Instr., Painting, Art School of The Cooper Union, N.Y., 1955-57, 1959- ; Haystack Sch., Deer Isle, Me., 1963 (summer); Parsons Sch. Design, N.Y., 1963-1969; Columbia Univ., 1969- .

LUNDE, KARL—Teacher, P.
Department of Art History and Archaeology, Columbia University, New York, N.Y. 10027
B. New York, N.Y., Nov. 1, 1931. Studied: Columbia Univ., B.A., M.A. Exhibited: MModA art lending service; Alice Nash Gal., N.Y., 1964, 1965. Fields of specialization: Italian Renaissance bronzes; 19th century Romantic art in Scandinavia. Positions: Asst. Dir., The Picture Loan Soc., Toronto, Canada, 1954; Dir., Forum Gal., N.Y., 1955-56; Asst. Dir., The Contemporaries (Art Gallery), N.Y., 1956-57, Dir., 1957-1965; Instr., History of Fine Arts, Columbia Univ. School of General Studies, 1958- . Contributor to various scholarly magazines.

LUNDGREN, ERIC (B. E. K.)—Painter, Gr., T., L., I.
17 Country Club Rd., West Palm Beach, Fla. 33406
B. Linkoping, Sweden, May 5, 1906. Studied: N.Y. Sch. Des.; ASL; AIC. Member: A. Gld.; Palm Beach A. Lg. Work: BMFA. Exhibited: PAFA, 1937; Phila. A. All., 1939; AIC, 1938; Marshall Field Gal., 1937, 1938 (one-man); Palm Beach A. Lg.; Hays Gal. (one-man); Palm Beach A. Gal., 1961 (one-man). Contributor to: Esquire, Coronet, Professional Art Quarterly. Lectures: "Primitives & Children's Art." Positions: Instr. A., Norton Gal. A., West Palm Beach, Fla., at present. A.-in-Res., St. Leo College, St. Leo, Fla.*

LUNTZ, IRVING—Art Dealer, Writer, Collector
Irving Galleries, Inc., 400 E. Wisconsin Ave.; h. 2533 N. Wahl Ave., Milwaukee, Wis. 53202
B. Milwaukee, Wis., Jan. 9, 1929. Studied: Marquette University; Northwestern University. Collection: Contemporary paintings and sculpture with emphasis on constructions. Specialty of Gallery: Important American and European paintings, sculpture and prints. Contributor to various magazines, articles and catalogues. Member: Art Dealers Association of America; Appraisers Association of America. Positions: Owner, Director, Irving Galleries, Inc., Milwaukee, Wisconsin.

LUTZ, DAN—Painter, T.
369 Hot Springs Rd., Santa Barbara, Cal. 93103
B. Decatur, Ill., July 7, 1906. Studied: AIC; Univ. Southern California, B.F.A.; & with Boris Anisfeld. Member: Cal. WC Soc.; AWCS; Phila. WC Cl. Awards: Raymond traveling scholarship, AIC, 1931; prizes, NAD, 1941; Cal. WC Soc., 1942, 1952; Los A. Mus. A., 1942, 1954, 1956; PAFA, 1945; VMFA, 1940, 1946; AWS Certif. of Merit, 1962; Millikin Univ. Alumni Merit Award, 1962. Work: PMG; Los A. Mus. A.; Encyclopaedia Britannica Coll.; San Diego FA Soc.; Colo. Springs FA Center; Arizona State Univ.; Santa Barbara A. Mus.; Pasadena AI; Beverly Hills Pub. Library; Witte Mem. Mus.; La Jolla A. Center; Wood A. Gal., Montpelier, Vt.; and in private colls. Exhibited: CGA, 1941, 1943; VMFA, 1940, 1942, 1944, 1946; NAD, 1941, 1942; PAFA, 1940-1946; Los A. Mus. A.; AIC, 1940-1946; WMAA, 1944; Cal. WC Soc., 1966; Long Beach Mus. A.; Santa Barbara Mus. A., and many other leading museums and galleries; one-man: Dalzell-Hatfield Gal., Los Angeles; Milch Gal., N.Y.. The Gallery, Palm Springs; Esther Esther Bear Gal., Santa Barbara. Positions: Instr., Chouinard AI, Los Angeles, Cal., 1945-53; Summer Sch. Painting, Saugatuck, Mich., 1950-52; Visiting A., San Antonio, AI, 1953; Univ. Georgia, 1955.

LUX, GLADYS MARIE—Illustrator, P., C., Gr.
Nebraska Wesleyan University, 50th & St. Paul Sts.; h. 5203 Garland St., Lincoln, Neb. 68504
B. Chapman, Neb. Studied: Univ. Nebraska, B.F.A., A.B., M.A.; AIC. Member: Lincoln A. Gld.; Nebraska A. T. Assn.; Western AA; Nat. A. T. Assn. Work: Doane Col.; Miller & Paine Coll., Lincoln, Neb.; Peru State Col.; Nebraska Wesleyan; Lincoln A. Gld.; Pub. Sch., Kearney, Neb. Awards: Int. Stores exh., Lincoln, 1965; "Service Award," Neb. Art. Teachers Assoc., 1968. Exhibited: Rockefeller Center, N.Y., 1936-1938; WFNY 1939; AIC, 1936; Women's Nat. Exh., Wichita, 1936-1938; LC, 1944; Kansas City AI, 1934-1938; Denver A. Mus.; Joslyn A. Mus.; Lincoln A. Gld.; Walker A. Center, 1947; Topeka, Kans., 1947, 1948; Sioux City A. Center, 1955; Cheyenne, Wyo., 1955; Capper Fnd. Exh., 1949-50; State T. Col., Peru, Neb.; Univ. Nebraska, 1952; Midwest A. Exh., sponsored by Brownville (Neb.) Hist. Soc., 1959, 1960; Governor's Show, Omaha, 1963, 1964. Contributor to Western AA bulletin; Illus., "In a Tall Land," 1963. Author, Ed., "Through the Years with Art, 1867-1967," for Nebraska Art Teachers Association, 1967. Positions: Assoc. Prof. A., Nebraska Wesleyan Univ., Lincoln, Neb., to 1967.

LUX, GWEN (Mrs. Thomas H. Creighton)—Sculptor
5112 Maunalani Circle, Honolulu, Hawaii 96816
B. Chicago, Ill. Studied: Maryland Inst. A.; BMFA Sch.; in Paris, and with Ivan Mestrovic. Member: Arch. Lg.; S. Gld.; Audubon A.; Nat. Women P. & S. Soc. Awards: Guggenheim F., 1933; prizes, Detroit Inst. A., 1945, 1946; Nat. Lith. prize 1947; NAWA, 1947; Audubon A, 1954; Arch. Lg., 1958; Municipal A. Soc., 1959; Nat. Indst. A. Council, Canada, 1961; San Francisco Women A., 1965. Work: S., Assoc. Am. A.; Radio City, N.Y.; McGraw-Hill Bldg., Chicago; Trustees System Service, Chicago; Univ. Arkansas; Victoria Theatre, N.Y.; Bristol (Tenn.) Hospital; SS. "United States." Texas Petroleum Cl., Dallas; Northland Shopping Center, Detroit; General Wingate Sch., Brooklyn; General Motors Research Center, Detroit; Socony Bldg., N.Y.C.; R.H. Macy-Roosevelt Field, N.Y.; Laguna Towers and KRON-TV Bldg., both San Francisco; P.S. 19, New York City; Aviation Trades H.S., Long Island, N.Y.; Country Day Sch., Lake Placid, N.Y.; nuclear ship "Savannah." Exhibited: PMA, 1933; NAD, 1933; Salon d'Automne, Salon des Tuileries, Paris; Weyhe Gal., 1932; Detroit A. Market, 1942; WMAA, 1947; Audubon A., 1956;

Sculptors Gld., 1957; World House Gal., N.Y., 1962; San Francisco A. Inst., 1964; SFMA, 1965; Hoover Gal., San Francisco, 1969; one-man: Delphic Studio, 1932; Detroit A. Market, 1942; Assoc. Am. A., 1946. Positions: Instr. S., A. & Crafts Soc., Detroit, Mich. 1945-48; Pomeroy Gal., San Francisco, 1966; Contemp. A. Center, Honolulu, 1969.

LYE, BIX—Sculptor
 801 Greenwich St., New York, N.Y. 10014
B. 1937. Exhibited: WMAA, 1964, 1968.

LYE, LEN—Sculptor, Film Maker, P., E., L., W.
 41 Bethune St., New York 14, N.Y. 10014
B. Christchurch, New Zealand, July 5, 1901. Studied: Wellington (N.Z.) Tech. Col. Awards: Intl. Film Festival, film "Colour Box," Brussels, Belgium; Experimental film comp., Worlds Fair Intl., Brussels, 1958. Work: 8 films in library and shown by MModA., N.Y. Films made for British Government; Invented "Direct Technique" of painting or etching image on film itself—no camera used. Exhibited: one-man show of "Motion Sculpture," MModA, 1961; Leo Castelli Gal., and Howard Wise Gal., N.Y., 1961. Author: "No Trouble," Paris, 1930. Contributor to Life & Letters, London; Tiger's Eye, 1949.

LYFORD, CABOT —Sculptor, T.
 Phillips Exeter Academy, 9 Center St., Exeter, N.H. 03833
B. Sayre, Pa., May 22, 1925. Studied: Cornell Univ., B.F.A.; Skowhegan Sch. A. Work: Wichita A. Mus., private colls.; Lamont A. Gal.; Sculpture, Mount Sunapee Summit for State Park; mobile, N.Y. World's Fair, 1965. Exhibited: in numerous exhibitions. Positions: Assoc. Producer-Director, Kraft Theatre, 1952-55; Producer-Director, TV programs of Museum of Fine Arts, Boston (Brian O'Doherty and Bartlett Hayes series); 1955-58; Program Mngr., ETV station WENH, 1958-62; Chm., A. Dept. and Instr., Sculpture, Painting. The Phillips Exeter Academy, Exeter, N.H., 1963- .

LYNCH, JAMES O'CONNOR—Collector
 240 West 98th St., New York, N.Y. 10025*

LYNES, RUSSELL (Jr.)— Writer, Critic
 Harper's Magazine, 49 E. 33rd St., New York, N.Y. 10016
B. Great Barrington, Mass., Dec. 2, 1910. Studied: Yale Univ., B.A., Awards: Hon.D.F.A., Union College, Schenectady, N.Y. Author: "The Tastemakers," 1954; "The Domesticated Americans," 1963; "Confessions of a Dilettante," 1966 (and four other books not having to do with the arts or architecture). Many articles for Harper's Magazine, Life, Look, Yale Review, Vogue, Harper's Bazaar, Horizon, Art in America and other periodicals on subjects dealing with the arts from 1945 to present. Positions: Pres., MacDowell Colony, Peterborough, N.H.; Pres., The Archives of American Art; Fellow, Society of American Historians; Fellow, Berkeley College, Yale University; Trustee, New York Historical Soc.; Contributing Editor, Harper's Magazine, and for Art in America, producing a column "The State of Taste," for the latter.

LYTLE, WILLIAM RICHARD—Painter, E., Et., L.
 Sperry Rd., Woodbridge, Conn.
B. Albany, N.Y., Feb. 14, 1935. Studied: CUASch.; Yale Univ., B.F.A., M.F.A., with Albers. Awards: Fulbright F., for study in Italy, 1958-59; prize, New Haven A. Festival, 1958. Work: MModA; Int. House, Columbia Univ.; De Cordova & Dana Mus.; Yale Gal., FA; CM; NCFA; Fairfield Univ., and in private colls. Exhibited: MModA, 1959; AIC, 1959, 1960; Mus. Contemp. A., Houston, Tex., 1961; De Cordova & Dana Mus., Lincoln, Mass., 1960, 1968; WMAA, 1963; PAFA, 1963-1969; Krannert Mus., Univ. Ill., 1968; Ringling Mus., Sarasota, 1969; CM, 1968; one-man: Grace Borgenicht Gal., N.Y., 1961, 1963, 1964, 1966, 1968; Silvermine Gld., 1964; Yale Gal. FA, 1967; Cortland Col., 1968; Univ. of Connecticut, 1964. Lectures: Bosch & Gorky, at Yale-Norfolk Summer School, 1961. Positions: Instr., Color, Drawing and Painting, Yale University, 1960-1963; Printmaking and Drawing, Yale Summer School, 1960, 1962, 1963; Dean, Silvermine College of Art, New Canaan, Conn., 1963-1965; Assoc. Prof. A., Yale Univ., New Haven, Conn., 1966- .

MacAGY, DOUGLAS—Art Administrar., W., E., Mus. Dir., L.
 1800 G St., N.W. 20506; h. 3309 35th St., N.W., Washington, D.C. 20506
B. Winnipeg, Canada, July 8, 1913. Studied: Univ. Toronto, Canada; Courtauld Inst., London, England; Univ. Pennsylvania; Barnes Fnd.; Western Reserve Univ. Member: CAA; AAMus.; Com. on Church and Culture, Nat. Council of Churches, N.Y.; Advisory Council, Tamarind Lithography Workshop Inc., Los Angeles; Dir., World A. Fnd.; Bd., Four Winds Theatre, N.Y. Contributor to professional journals, general periodicals. Ed. Staff, Gazette des Beaux-Arts. Author: "The Museum Looks in on TV," 1955; "Going for a Walk

with a Line," 1959; "The Art that Broke the Looking-Glass," 1961. Positions: Cur., San Francisco Museum of Art, 1941-43; Dir., Cal. Sch. Fine Arts, San F., 1945-50; Exec. Sec., N.Y. Museum Comm. for UNESCO, 1951; Special Consultant, to Dir. MModA, N.Y. & Dir. Television, 1952-55; Dir., Research & Consultant to Museums, Wildenstein & Co., N.Y., 1955-59; Dir., Dallas Museum for Contemporary Arts, Dallas, Tex., 1959-1964; Consultant 1964-1968; Howard Wise Gal., N.Y.; Univ. of Pa., Phila.; N.Y. A. Int.; 2nd Buffalo Festival of the Arts Today, Buffalo, N.Y.; Northwood Inst., Texas. Deputy Chairman, Nat. Endowment for the Arts, Nat. Council on the Arts, Washington, D.C. 1968-69; Acting Chairman 1969- .

MacALISTER, PAUL (R.)—Designer, C., L., W., Mus. Dir.
 h. Arden Shore Lane, Lake Bluff, Ill. 60044
B. Camden, N.J., Oct. 15, 1901. Studied: PAFA; PMSchIA; Yale Univ.; PIASch; Ecole des Beaux-Arts, Fontainebleau, France. Member: F., IDSA; F., Royal Soc. A., London; Early American Industries Assn. Work: Interiors for leading manufacturers and industrial companies. Creator, miniature room settings for TV use, AIC, and Chicago Pub. Lib. Des. & Manufacturer, 3 dimensional planning device, "Plan-a-Room"; "Display for Better Business," Producer, Dir., numerous TV programs having decorating and design themes. Exhibited: Lake Forest Library. Awards: prize, Better Rooms contest, Chicago Tribune, 1948. Dorothy Dawes award for contribution to TV field; silver medal, IDI. Contributor to Industrial Design, Interior Design, American Home; House & Garden; History of Industrial Design; IDSA Tape Library; World Topics Year Book, 1967. Positions: Pres., Paul MacAlister, Inc., 1926-46; Dir., Bureau Indst. Des. & Int. Dec., Montgomery Ward & Co., Chicago, 1946-48; Paul MacAlister Assoc., 1948- ; Nat. Pres., IDI, 1950-51; Chm. & Fndr., IDI Des. Award Comm., 1950-1960; Indst. Des. & Color Consultant, NBC Home Show, 1954-56; Des., Producer of Decorama Slide Film. Founder, Dir., "Americana Hayloft," private museum devoted to American Eagle in art forms & early hand tools.

McALPIN, DAVID H.—Collector
 P.O. Box 670, Princeton, N.J. 08540*

McANDREW, JOHN—Scholar, W., E., Collector, L.
 Wellesley College; h. 107 Dover Rd., Wellesley, Mass. 02181
B. New York, N.Y., May 4, 1904. Studied: Harvard Col., B.S.; Harvard Univ. Grad. Sch. Arch., M. Arch. Member: CAA; Soc. Arch. Historians. Author: "Open-air Churches of Sixteenth-century Mexico," 1965. Ed., Several catalogues of exhs., MModA and Wellesley Col. Contributor to Art Bulletin; Art News; Art in America; Arts; San Carlos (Mexico); Goya (Spain); Das Werk (Switzerland). Lectures: Architecture; Modern Art; Mexican Art, in museums, universities and colleges, U.S., Yugoslavia, Latin America and India. Arranged about 20 exhs. of modern architecture and industrial art, MModA; 40 exhs. of various kinds, Farnsworth Museum, Wellesley College. Field of Research: Venetian Architecture; Modern Painting. Collection: Modern and Primitive Art. Positions: Prof., Hist. Art & Arch., Vassar, Wellesley, MIT, Univ. So. California, Universidad Nacional de Mexico, Instituto Nacional de Antropologia e Historia de Mexico. Cur., Arch., MModA, N.Y., 1936-40; Dir., Farnsworth Mus., 1950-1960; L., (Cultural Exchange Program) U.S. Dept. State, Latin America 1953, India, 1956, 1959; Visiting Com., Fogg Art Mus., Harvard Univ.; Trustee, Bear Run Fnd.; Hancock Shaker Community; Prof., Wellesley College, 1944-1968.

McBRIDE, WALTER H.—Museum Director, C.
 2738 Elmwood Dr., Southeast, Grand Rapids, Mich. 49506
B. Waterloo, Ind., Apr. 20, 1905. Studied: Harvard Univ.; Herron A. Sch., B.A.E.; Indiana Univ. Member: Midwest Mus. Dir.; Am. Assn. Mus. Dir. Positions: Instr. Des., John Herron A. Sch., Indianapolis, Ind., 1929; Dir., Ft. Wayne A. Sch. & Mus., Ft. Wayne, Ind., 1933-54; Dir., Grand Rapids A. Mus., 1954- . Pres., Midwest Mus. Assn., 1958-59.

McCALL, ROBERT THEADOR— Painter, Des., Comm. A., I.
 252 East 48th St., New York, N.Y.; also, 102 Seven Bridges
 Rd., Chappaqua, N.Y. 10017
B. Columbus, Ohio, Dec. 23, 1919. Studied: Columbus Sch. FA. Member: SI; Aviation Writers Assn. Awards: scholarship, Columbus Sch. FA. Work: U.S. Air Force Hist. Coll., Pentagon, Wash., D.C. (made during tour of Arctic bases). Exhibited: Westchester AA, 1954, 1955; NGA; AWS, 1965 and traveling. Illus., covers, Popular Science magazine; adv. illus., for leading publications including Life, Time, Sat. Eve. Post, (also story illus.); series of paintings for Life Magazine on Space Vehicles of the Future, 1961; series of full color paintings for General Electric Co., 1961, of Record Breaking Aircraft. Series of paintings illus. "The Day of Infamy," for Life magazine, also for Life, cover and paintings for special issue on Space, Sept., 1964; commissioned by NASA, to document in paintings, major space events; U.S. Air Force painting assignment 1957 and 1964 (Greece and Turkey), to document the world-wide

activities of the Air Force. Campaigns for Ford, Buick, Goodyear, Sperry, Douglas Aircraft, United Aircraft and others.*

McCALLUM, CORRIE (Mrs. William Halsey) —
Painter, T., L., I., Gr.
38 State St., Charleston, S.C. 29401
B. Sumter, S.C., Mar. 14, 1914. Studied: Univ. South Carolina; BMFA Sch., with Karl Zerbe. Member: Gld. South Carolina A. (Pres. 1961). Awards: prizes, South Carolina Annual, 1955; Gld. South Carolina A., 1953, 1954, 1961; mural comp., Home Fed. Bank, 1962; Piedmont Graphics exh., 1964 (purchase); grant, Chas. Scientific & Cultural Educ. Fund, for travel & study in Middle and Far East. Work: Gibbes A. Gal.; Univ. South Carolina; Louisiana State Univ., Baton Rouge; Columbia Col., S.C.; Mint Mus. A., Charlotte, N.C. and in private collections. Exhibited: Telfair Acad. A., 1960; VMFA, 1947; BMFA, 1951; High Mus. A., 1955, 1957; Norfolk Mus. A., 1954, 1958; Jacksonville A. Mus., 1960; Hunter Gal., Chattanooga, 1961; Kunstsalon Wolfsberg, Zurich, 1968; Piedmont Graphics, Mint Mus., 1968; Dixie annual, Montgomery Mus., 1969; Columbia Mus. A., 1969; one-man: Gibbes Gal. A., 1959, 1967; Columbia Mus. A., 1954, 1960; Exeter Gal., Marblehead, Mass., 1963; Florence (S.C.) Mus., 1954; Winston-Salem Mus. A., 1954; Mint Mus. A., 1955, 1967; Clemson Col., 1955; Davidson Col., 1954; Augusta Mus. A., 1967; Florence (S.C.) Mus., 1967; Kunstsalon Wolfsberg, Zurich, 1969. Illus., "Dutch Fork Farm Boy," 1952; Ford Times, 1956, 1960, 1961. Positions: Instr. A., Gibbes Gal. A., Charleston, S.C., 1946-53; Instr. A., Charleston A. Sch., 1953- . Artist-in-Residence, Castle Hill Art Center, Ipswich, Mass., 1956; Cur., Education, Gibbes Art Gallery, 1960-1968. Instr. A., Newberry Col., S.C., 1969- .

McCANNEL, MRS. MALCOLM A. (LOUISE W.)—Collector
58 Groveland Terrace, Minneapolis, Minn. 55403
B. Minneapolis, Minn., Nov. 20, 1915. Studied: Smith College, B.A.; Minneapolis School of Art. Collection: Contemporary American Sculpture and Painting. Positions: Board Member, Walker Art Center.

McCHESNEY, ROBERT PEARSON—Painter
2955 Mountain Rd., Petaluma, Cal. 94952
B. Marshall, Mo., Jan. 16, 1913. Studied: Washington Univ. A. Sch., St. Louis; Otis AI, Los Angeles. Member: San F. AI (Bd. Trustees). Awards: prizes, San F. Art Commission, 1950 (purchase); WMAA, 1955 (purchase); SFMA, 1960. Work: San F. Art Commission; WMAA; Oakland A. Mus.; SFMA. Exhibited: U.N. Merchant Marine Exh., Seattle, Wash., 1946; PC, 1947; AIC, 1947, 1954, 1960, 1961; Los A. Mus. A., 1949; Sao Paulo, Brazil, 1955; La Galeria Escondida, Taos, N.M., 1952; WMAA, 1955; CGA, 1957; SFMA, 1945-1950, 1953, 1960; San F. Art Commission, 1946, 1950; Landau Gal., Los A., 1948, 1949; Artists Gal., San F., 1947; deYoung Mem. Mus., San F., 1947, 1951, 1953; Parsons Gal., Los A., 1960, 1961; Bolles Gal., San F., 1960, 1961; 20th Century West, N.Y., 1963, 1964; Nordness Gal., N.Y., 1964; Arleigh Gal., San F., 1965; one-man: Raymond & Raymond Gal., 1944, Lebaudt Gal., 1947, 1951; SFMA, 1949, 1953; Gump's Gal., 1952, 1953, 1955, San F. AI, 1957; Bolles Gal., 1960, 1961, all in San Francisco; Pat Wall Gal., Monterey, Cal., 1946; Marquis Gal., Los A., 1949; Daliel's Gal., Berkeley, 1950; Galerie Suse Brecher-Parsons, Los A., 1960; Parsons Gal., Los A., 1961; Myrtle Todes Gal., Glencoe, Ill., 1958; Bolles Gal., N.Y., 1962; San F. A. Center, 1964; XX Century West Gal., N.Y., 1965; Triangle Gal., San Francisco, 1966; San Francisco Theological Seminary, San Anselmo, Cal., 1966.

MACHETANZ, FRED—Painter, Pr.M., I., L., W.
High Ridge, Palmer, Alaska 99645
B. Kenton, Ohio, 1908. Studied: AIC; American Acad.; Ohio State Univ., B.A., M.A.; AIC; Am. Acad.; ASL. Member: AEA; Traditional Artists of Alaska; Explorers' Cl. of N.Y.; Polar Soc.; Artic Inst. N.A. Work: Explorers Cl., N.Y.; Glenbow Fnd. of Alberta Mus., Canada; N.W. Indian Center of Gonzaga Univ.; Univ. of Alaska Mus.; Anchorage A. & Hist. Mus. Awards: illustrations for "Barney Hits The Trail," Jr. Literary Gld. award; Alaska Hall of Fame, 1966. Exhibited: Detroit Inst. A.; Columbus Gal. FA; traveling exh., Ford Motor Co.; permanent exh., Univ. Alaska Museum; "Ketchikan to Barrow" Exh. & traveling exh., 1961; Univ. Alaska, 1964 (one-man); Anchorage Fur Rendezvous Exh., 1964, 1965; East Anchorage A. Show, 1964, purchase award. Illus. many books by Sara Machetanz. Author & illus. of many books on Alaska. Positions: Guest artist and lecturer, Alaska Arts and Crafts Show, Juneau, 1965; Guest Panelist, Univ. Alaska "Cultures in Conflict," 1965; Instr., Portrait Painting, Univ. Alaska, 1964, 1965. Appointed "Distinguished Assoc. of Art," Univ. Alaska, guest instr. there each summer.

MACHETANZ, SARA (Mrs. Fred)—Writer
High Ridge, Rte A, B56, Palmer, Alaska 99645
B. Johnson City, Tenn., June 25, 1918. Studied: East Tennessee State Univ., B.S.; grad. work, Peabody College, Nashville. Member: Author's Lg. of America. Awards: Jr. Literary Gld. award for "Barney Hits the Trail." Author: "Barney Hits the Trail"; "Rick of High Ridge"; "Where Else But Alaska"; "The Howl of the Malemute"; "Robbie and the Sled Dog Race" (1964), and others. Co-photographer, "Alaska, Modern Frontier" (Encyclopaedia Britannica Films); "Alaska Sled Dog" (Disney); Co-producer, co-photographer, "Alaska: U.S.A."; co-photographer, "Eskimos" (Encyclopaedia Britannica Films).

McCHRISTY, QUENTIN L. —Painter, Des., Gr., I.
815 N.W. 22nd, Apt.2, Oklahoma City, Okla. 73106
B. Cushing, Okla., Jan. 24, 1921. Studied: Oklahoma State Univ., B.A., with Doel Reed; Cincinnati A. Acad., with Helwhig, Crawford. Member: Int. Platform Assn., 1966-1969. Awards: prizes, Philbrook A. Center, 1947, 1948, 1962 (purchase); Oklahoma A., 1948; Mulvane Mus. A., 1948; Joslyn Mus. A., 1950 (purchase); Western Art, 1951; St. Louis A. Gld., 1954; Citizen's Gas & Coke Co., Indianapolis, 1957; Butler Inst. Am. A., 1960 (purchase); Wind River Valley Nat., 1961. Work: Pa. State Univ.; Dean, College of FA, Univ. Illinois, Urbana; Art Dept., Oklahoma State Univ., murals; Ft. Worth Children's Mus.; Wesley Fnd., Methodist Church, Stillwater, Okla. Designed decorations of glassware for Bartlett Collins, manufacturers of domestic and export glassware. Work also in many private colls. Exhibited: Graphic exh., Wichita, Kans., 1947; New Orleans A. & Crafts exh., 1948; DMFA, 1947, 1948, 1950; All. A. Am., 1958; Alabama WC Soc., 1958; Boston Soc. Ind. A., 1958; CGA, 1959; Contemp. Am. A., Oklahoma City, 1960; All City A. Festival, Los Angeles, 1960; Audubon A., 1962; PAFA, 1963; Wind River Valley AA, Nat. A. show judge, 1965; Las Vegas revolving show, judge, 1969; private showings, El Paso, 1965-1969 and New Orleans, La., 1966-1967. One-man: Morrill Hall Gal., 1948; Collins Gal., Ft. Worth, 1950; Phillips Univ., Enid, Okla., 1951. Publication: Article and reproductions of work, titled "Four Pen Drawings," American Artist magazine, June, July, Aug., 1964. Taught drawing, Oklahoma State Univ.

McCLELLAN, ROBERT JOHN—Painter, C., Gr., W., I., L.
218 Towpath, New Hope, Bucks County, Pa. 18938
B. Hopewell, N.J., May 19, 1906. Studied: Newark Sch. Indst. Art; ASL; Pratt Inst., Brooklyn, N.Y., and privately with prominent instructors. Member: SC; ASL (Life); Photo-Engravers A. Soc.; New Hope Hist. Soc.; Plainfield (N.J.) AA. Awards: prizes, Irvington A. Assn., 1946 (2); P. & S. Soc. Medal of Honor, 1950 and Rubenstein Award, 1951; Florida Int., 1952; Plainfield AA, 1953, 1958, 1959; Trailside Mus., 1960 (2); Philip Swain Mem. Award, 1962. Work: Documentary series of Bucks County Covered Bridges, Thompson Neely House, Washington Crossing, Pa. State Park. Many works in numerous private collections. Exhibited: All major exhibitions in Eastern area. Specialized in 3 and 4-color Roto-Gravure field. Author: "The Delaware Canal," 1967. Position: Owner, Dir., New Hope School of Art (5 years); Instr., N.Y. Trade Schools.

McCLOSKEY, EUNICE LonCOSKE —Painter, W., L.
403 Oak St., Ridgway, Pa.
B. Ridgway, Pa., May 25, 1906. Studied: Columbia Univ. Member: Nat. Lg. Am. Pen Women; Pittsburgh Plan for Art; Assoc. A. of Pittsburgh; Pa. Fed. Women's Cl.; Phila. A. All.; F.I.A.L. Awards: prizes, Carnegie Inst. (Assoc. A.), 1950, Posner award, 1953; Nat. Lg. Am. Pen Women, Kansas City, 1947, Wash., D.C., 1954; Aimee Jackson Short prize. Edwin Forrest Gal., Phila., 1953; "Woman of the Year" award, 1958; elected to Professional Hall of Fame, 1966 and Prominent Americans, 1967; (Bd. Trustees); elected, 1000 Creative Women, London, 1969. Work: in private colls. Exhibited: Nat. Lg. Am. Pen Women, 1947-1954; Carnegie Inst.; 1948-1958; Everyman's Gal., Phila., Lioga Duncan Gal., N.Y.; Galerie Paula Insel, N.Y.; one-man: Chautauqua, N.Y., 1957; Forrest Gal., Phila., 1951, 1953; Creative A. Gal., N.Y., 1953; Pittsburgh Plan for Art, 1958; McElhaney Gal., Indiana, Pa., 1961; Langheim Gal., Greenville, Pa., 1961; Assoc. A. Pittsburgh, 1961. Author, I., "Coal Dust and Crystals," 1939; "Strange Alchemy," 1940; "The Heart Knows This," 1944; "This is the Hour," 1948; "The Golden Hill," 1952; "These Rugged Hills," 1954; "This is My Art," 4 vols., 1956, 1957, 1959, 1961; "So Dear to My Heart," autobiography, 1964; "Potpourri," 1967; "This Is My Art," 1969. Contributor to Ladies' Home Journal; McCalls; Good Housekeeping; Farm Journal; Household; Canadian Home Journal; Chatelaine; Woman (England); and reprints in magazines in South Africa, Australia, New Zealand. Positions: Nat. Poetry Ed., 1950-54, Asst. State Chm. Art, 1956-60, County Chm. Poetry, 1950-60, Nat. Lg. Am. Pen Women; Dir., Pittsburgh Assoc. A.; County Chm. Art, Pa. Fed. Womens Cl., 1954-56.

McCLOSKEY, ROBERT—Illustrator, W.
Viking Press, 625 Madison Ave., New York, N.Y. 10022; h. Scott Islands, Harborside, Me.
B. Hamilton, Ohio, Sept. 15, 1914. Studied: Vesper George Sch. A.;

NAD, and with Jerry Farnsworth..Member: Am. Acad. in Rome; P.E.N.; Author's Gld. of America. Awards: Scholastic Magazine award, 1932; Tiffany Fnd., 1935, 1936; Prix de Rome, 1939; Caldecott award, 1942, 1958 (for "Time of Wonder"); LL.D., Miami Univ., Oxford, Ohio, 1964. Work: bas reliefs, City Bldg., Hamilton, Ohio. Author, I., "One Morning in Maine," 1953; "Lentil," 1939; "Make Way for Ducklings," 1941; "Homer Price," 1943; "Blueberries for Sal," 1948; "Centerburg Tales," 1951; "Time of Wonder," 1957.*

McCLOY, WILLIAM ASHBY—Educator, P., Et.
 Connecticut College; h. 3 Winchester Rd., New London, Conn. 06320
B. Baltimore, Md., Jan. 2, 1913. Studied: Iowa Univ., B.A., M.A., M.F.A., Ph.D.; Yale Sch. FA. Work: Winnipeg A. Gal.; LC; Walker A. Center, Carnegie Inst.; Joslyn Mus. A. Exhibited: PAFA, 1936, 1938, 1948; AIC, 1936, 1938, 1940; WMAA, 1938, 1940; Carnegie Inst., 1941; NAD, 1942; Audubon A., 1947; Canadian National, 1951, 1953; Toronto A. Gal., 1954; Boston A. Festival, 1955, and others. Positions: Chm. Dept. A., Connecticut Col., 1954- .

McCLURE, THOMAS F.—Sculptor, E.
 3361 North Maple Road, Ann Arbor, Mich. 48103
B. Pawnee City, Neb., Apr. 17, 1920. Studied: Univ. Nebraska, B.F.A.; Wash. State Col., Pullman, Wash.; Cranbrook Acad. A., M.F.A. Awards: prizes; SAM, 1942, 1953; Syracuse Mus. FA, 1948, 1949, 1950; Tulsa Mus. A., 1949; Detroit Inst. A., 1950, 1951, 1953, 1954, 1955; Kirk of the Hills, Bloomfield Hills, Mich., 1954, 1955; Rackham grant, to Italy, 1961; prizes, Detroit Inst. A., 1960, 1961. Exhibited: Oakland Mus. A.; Albright A. Gal.; Wichita AA; MMA; AIC; Los Angeles; Univ. North Carolina; Kansas City AI, 1960; CM, 1961; Feingarten Gal., Chicago, 1961; PMA; PAFA, 1958, 1959; Syracuse Mus. FA, 1958. Work: SAM; Univ. Nebraska; Cranbrook Acad. A.; Syracuse Mus. FA; Ford Motor Co.; Eastland Shopping Center, Detroit, 1957; DeWaters A. Mus., Flint, Mich., 1958; Univ. Michigan, Dearborn Center, 1961; Eastern Mich. Univ., 1960; Iowa State T. Col., 1959; Beloit Col., 1963. Positions: Prof., Dept. A., Univ. Michigan, Ann Arbor, Mich.*

McCLUSKY, JOHN—Painter
 Ash Dr., Northford, Conn. 06472
B. East Haven, Conn., 1914. Studied: Ohlm's Sch. FA, New Haven; Colgate Univ. Awards: Beaux-Arts First Medal Award in mural painting, 1934-1935; Thomas E. Saxe, Jr., award, Silvermine Gld. A., 1968. Work: Mint Mus. A., Charlotte, N.C.; CGA; Joslyn A. Mus., Omaha, Neb.; Mattatuck Mus., Waterbury Conn.; Cummer Gal. A., Jacksonville, Fla., and others. Exhibited: In numerous group exhs. in museums. One-man: Isaacson Gal., 1960; Durlacher Bros., 1965; Banfer Gal., 1968, all in New York City. Positions: Instr., Paier School of Art, New Haven, Conn., at present.

McCORMICK, JO MARY—Art Critic, W., P., I., L.
 Pictures on Exhibit Magazine, 30 E. 60th St., New York, N.Y. 10022; h. 312 E. 25th St., New York, N.Y. 10010
B. New York, N.Y., Mar. 6, 1918. Studied: Columbia Univ.; ASL; NAD. Member: ASL (Life); Author's Gld.; Women's Press Club. Work: Photographs for Departments of Architecture of the following institutions: MModA; Yale Univ. Dept. FA; Columbia Univ.; New York Transit Authority; American Artist magazine. Portrait commission from Monsignor Le Roy McWilliams. Exhibited: NAC, 1964; Barzansky Gal., 1962-1964; Burr Gal., N.Y., 1963, 1964. Author, Illus.: "An Ant is Born," 1964; "Etti-Cat, the Courtesy Cat," 1965; "Pearls in Pictures," 1966. Photos in Art, USA Now, Vol. I (for Isabel Bishop). Contributor to N.Y. Times Book Reviews, 1965; Pictures on Exhibit, monthly. Positions: Art Critic, Pictures on Exhibit, New York, N.Y., 1959- .

McCOSH, DAVID (JOHN)—Painter, E.
 1870 Fairmount Blvd., Eugene, Ore. 97403
B. Cedar Rapids, Iowa, July 11, 1903. Studied: Coe Col.; AIC. Member: AWS; AAUP. Awards: traveling scholarship, AIC, 1928; Tiffany Fnd. F., 1930. Work: Cedar Rapids AA; Portland A. Mus.; SAM; WMAA; IBM; U.S. Nat. Bank, Eugene, Ore.; Reading (Pa.) Mus.; Eastern Oregon Col.; murals, USPO, Kelso, Wash.; Beresford, S.D.; Dept. Interior, Wash., D.C.; Kaiser Fnd.; Univ. Oregon Mus., Portland State Univ. Illus., "Lightless Ferry," by E. G. Moll, 1962. Exhibited: National juried and invitational shows since 1929 including Seattle World's Fair, 1962; Portland A. Mus., 1962; Artists of Oregon, 1964. One-man: in Northwest museums and universities since 1953, Portland A. Mus., 1963, 1964; Univ. Oregon, 1965, 1967; Longview, Wash., 1968. Positions: Prof. A., Univ. Oregon, Eugene, Ore.; Guest Artist (summers): Art Inst. of Chicago, Montana State College, San Jose State College.

McCOSH, MRS. DAVID. See Kutka, Anne

McCOY, JOHN W. (II)—Painter, T.
 R.F.D., Chadds Ford, Pa. 19317
B. Pinole, Cal., May 11, 1910. Studied: Cornell Univ., B.F.A.; Am. Sch., Fontainebleau, France. Member: NA; Audubon A.; AWCS; Phila. WC Cl.; Wilmington Soc. FA. Awards: prizes; AWS, 1946, 1947, 1955; Audubon A., 1948; NAD, 1951; Phila. WC Cl., 1949, 1955; Balt. WC Cl., 1948; Delaware A. Center, 1940, 1941. Work: Delaware A. Center; Farnsworth Mus.; PAFA; Montclair (N.J.) Mus. A.; Newark Mus. A.; Univ. Delaware Coll.; Tel-Aviv Mus., Israel; murals, Metropolitan Life Insurance Bldg., N.Y.; Nemours Bldg., Wilmington, Del. Exhibited: Carnegie Inst., 1941, 1946; PAFA, 1940, 1946; BM, 1945; AIC, 1944; and many others nationally; one-man exh.; New York, N.Y., 1941, 1945, 1946; Boston, Mass., 1940; Utica, N.Y., 1942; Retrospective exh., Farnsworth Mus., 1955; Manchester, N.H., 1945; Wilmington, Del., 1940. Positions: Dir., Wilmington, Del., Soc. FA; Instr. Painting, PAFA, Philadelphia, Pa.*

McCOY, WIRTH VAUGHAN—Painter, E., L.
 Department of Art, Pennsylvania State University, University Park, Pa. 16802; h. 706 University Drive, State College, Pa. 16801
B. Duluth, Minn., Dec. 16, 1913. Studied: Univ. Minnesota, B.A.; State Univ. Iowa, M.F.A.; California Sch. FA; Grande Chaumiere, Paris, France. Member: CAA; Peale Cl. of PAFA; Allied Arts, Central, Pa. Work: Univ. Iowa; Spokane A. Center; Univ. Minnesota; City of Spokane; City of Duluth; Washington State Univ.; Pa. State Univ. Exhibited: SFMA, 1956, 1959; Oregon Artists, 1949, 1950, 1953; A. of the Pacific Northwest, 1954-1957; Northwest A. traveling exh., 1954-55, 1958-1960; SAM, 1949, 1954-1957, 1958-1960; Portland (Ore.) A. Mus., 1949-1953; Western Wash. A., 1955, 1956; Henry Gal., Univ. Washington, 1954; Univ. Colorado; Univ. Iowa; Washington State Univ.; Oregon State Univ.; Yakima and Tacoma, Wash.; Frye Mus. A., Seattle, 1960; Wenatchee (Wash.) A. Exh., 1959; Univ. Montana, 1963; Univ. Idaho, 1964; Eastern Washington Col., 1964; SAM; Kansas City AI, Central Pa. Festival of Art Annual, 1967-1968, numerous invitational exhs.; 15 one-man shows, and others. Positions: Asst. Prof. A., Oregon State Col., Corvallis, Ore., 1948-53; Assoc. Prof. A., Washington State Col., 1953-58; Res. Artists & Dir., Spokane Art Center, 1953-1964; Pres., City A. Bd., 1956-57, Juror, 3rd Am. Exh., San Miguel de Allende, Mexico, 1961. Chm. A. Com., Central Pa. Festival of Arts, 1967-1969; Hd., Dept. Art, Pennsylvania State University, University Park, Pa., 1964 to present.

McCRACKEN, JOHN (HARVEY)—Sculptor, T.
 1116 W. Washington Blvd., Venice, Cal. 90291
B. Berkeley, Cal., Dec. 9, 1934. Studied: Cal. Col. A. & Crafts, B.F.A., and Graduate Studies. Awards: Nat. Endowment for the Arts, 1968. Work: MModA; WMAA; Milwaukee A. Center; Pasadena Mus. A.; Los Angeles County Mus. Exhibited: WMAA, 1966, 1968; Fifth Paris Biennale, 1967; Guggenheim Int., 1967; one-man: Wilder Gal., Los Angeles, 1965, 1967, 1968; Elkon Gal., N.Y., 1966, 1967, 1968; Sonnabend Gal., Paris, 1969; A. Gal. of Ontario, Toronto, 1969. Positions: Instr., Painting and Sculpture, Univ. California, at Irvine and Los Angeles, 1965-1968; Sch. Visual Arts, New York, N.Y., 1968-1969.

McCRACKEN, PHILIP—Sculptor
 Guemes Island, Anacortes, Wash. 98221
B. Bellingham, Wash., Nov. 14, 1928. Studied: Univ. Washington, B.A. Awards: Norman Davis Award, 1957; Artist of the Year, 1964; Irene Wright Mem. Award, SAM, 1965. Work: SAM; Henssler Mem., Mt. Erie, Wash., 1966; Weyerhaeuser Corp., Tacoma, 1967; Detroit Inst. A.; Univ. Oregon Mus.; and in private collections. Exhibited: Seattle World's Fair, 1962; Univ. Illinois, 1961; Galerie Claude Bernard, Paris, 1960; Santa Barbara Mus. A., 1960; Pacific Coast Invitational, 1963; Mus. FA of Houston, 1960; Willard Gal., N.Y., 1964; Ogunquit, Me., 1957; SAM, 1955-1968; PAFA; Detroit Inst. A.; Henry Gal., Univ. Wash., 1958-1960; de Young Mem. Mus., San Francisco, 1960; Portland (Ore.) Mus., 1960; Univ. Oregon, 1961, 1963; Los Angeles County Mus., 1960; SFMA, 1962; PC, 1966; Washington Governor's Invitational traveling to Japan, 1966; CGA, 1966; Rutgers Univ., 1968; White Gal., Seattle, (2-man), 1968; Grand Rapids A. Mus., 1969, and others; one-man: Willard Gal., N.Y., 1960, 1965, 1968; Wash. State Capitol, 1964; Victoria (B.C.) Mus., 1964; SAM, 1961.

McCRAY, DOROTHY (Mrs. Francis)—
 Printmaker, P., E.
 Western New Mexico University; h. 802 Cheyenne St., Silver City, N.M. 88061
Studied: State Univ. Iowa, B.A., M.A.; Cal. Col. of A. & Crafts, M.F.A. Member: Pr. Council of Am.; Am. Color Print Soc.; CAA; NAEA. Awards: prizes, Am. Color Pr. Soc., 1956; Mus. New Mexico, 1956, 1958 (purchase); others, 1950, 1957; Midwestern A., 1941.

Exhibited: AIC, 1940, 1941, 1956; CM, 1957; Northwest Pr.M., 1957; Kansas City AI, 1941; Am. Color Pr. Soc., 1956; Mus. New Mexico, 1950, 1956, 1957, 1958; Oakland A. Mus., 1955; Bradley Univ., 1956; Soc. Washington Pr.M., 1958; Wichita AA, 1956-1958; DMFA, 1951, 1956-1959; SAGA, 1957; NAD, 1957; Texas Western Col., 1956; Joslyn Mem. Mus., 1947; WAC, 1947; PAFA, 1941; NGA, 1941; Phila. Pr. Cl., 1958; Am. Color Pr. Soc., 1960; Original Graphics, 1960; BM, 1960; traveling exhs.: AFA; DMFA; Am. Color Pr. Soc.; SAGA; Original Graphics; Mus. New Mexico; one-man: Mus. New Mexico; Massanine Gal., Oakland, Cal.; Silver City, N.M.; Rapid City, S.D.; New York City, 1963; College and University Art Galleries, 1964-1969. Positions: Assoc. Prof. A. & Crafts, New Mexico Western College, Silver City, N.M., 12 yrs. Dir., New Mexico Western Univ., A. Study Program, Italy, 1969 (Summer).

McCRAY, PORTER—Administrator
 Positions: Director, John D. Rockefeller 3rd Fund, 30 Rockefeller Plaza, New York, N.Y. 10020*

MACDONALD, HERBERT—Painter, T., L.
 173 Stonehouse Rd., Glen Ridge, N.J. 07028
B. Brooklyn, N.Y., Nov. 14, 1898. Studied: ASL, with DuMond, Grosz, Vytlacil, Kantor and others. Member: New Jersey WC Soc.; ASL (life); AEA; Assoc. A. New Jersey. Awards: prizes, New Jersey WC Soc., 1958, 1959, 1968; Am. Acad. A. & Lets. purchase prize, 1958. Exhibited: Montclair A. Mus., Trenton, N.J.; Newark A. Mus.; Art: USA, 1958; 4 one-man exhs., N.Y. including Grand Central Moderns, 1964. Work: New Jersey State Mus.; Montclair A. Mus.; A. Gal. of Greater Victoria, Canada; Newark Mus. A. Positions: A.-in-Res., Bloomfield College, Bloomfield, N.J.

MacDONALD, WILLIAM ALLAN—Educator
 6 Pine Hill Drive, Westminster, Md. 21157
B. Lorain, Ohio, July 28, 1911. Studied: Oberlin Col., A.B.; Johns Hopkins Univ., A.M., Ph.D. Member: Archaeological Inst. Am. Contributor article, "Hellenistic Art," to the New Catholic Encyclopedia. Positions: Prof. Hist. A., Western Maryland Col., Westminster, Md.; Asst. Dir., Baltimore Museum of Art, Baltimore, Md. to 1959; Prof. A. & Archaeology, George Washington University, Washington, D.C., 1959- .

MACDONALD-WRIGHT, STANTON — Painter, W., L.
 336 Bellino Drive, Pacific Palisades, Cal. 90272
B. Charlottesville, Va., July 8, 1890. Studied: Sorbonne, Grande Chaumiere, Julian Acad., Ecole des Beaux-Arts, Paris, France. Work: MMA, MModA; Detroit Inst. A.; BMFA; PMA; Columbus Gal. FA; Newark Mus. A.; BM; Grand Rapids A. Gal; Denver A. Mus; Pasadena AI; San Diego FA Soc.; Los A. Mus. A.; Univ. Chicago; Univ. Minnesota; murals, Santa Monica City Hall, H.S. and Pub. Lib. Exhibited: Nationally and internationally including MMA; MModA; Janis Gal.; BM; Honolulu Acad. FA; Mus. Sc., Hist. & A., Los Angeles, 1956 (retrospective); An American Place, N.Y.; Bernheim Jeune, Galerie Arnaud, Galerie Creuze, Galerie Denise Rene, all in Paris, France; Saint-Etienne Musee d'Art et d'Industrie, Saint-Etienne, France; Galerie Kasper, Lausanne, and in Milan, London, and Warsaw. Author: "Treatise on Color"; "History of Mosaics"; "Beyond Aesthetics" (in Japanese), Tokyo. Contributor to Encyclopaedia of the Arts, and to art magazines. Positions: Prof. Oriental A. Hist., Aesthetics and Iconography, Univ. California at Los Angeles (to 1954). Also, Univ. Hawaii; Tokyo, Japan; Univ. So. California; Scripps Col., Claremont, Cal.*

McDONOUGH, DR. JOHN JOSEPH—Collector, Patron
 1005 Belmont Ave. 44504; h. 46 Newport Dr., Youngstown, Ohio 44512
B. Carnondale, Pa. Studied: St. John's College, Toledo, Ohio, B.S.; Loyola University Medical School, Chicago, Ill., M.D. Member: Many leading medical associations; Art Collectors Club of America; American Federation of Arts. Activities: Served aboard "SS Hope" (People to People Health Foundation, Inc.) in Peru, 1963, Ecuador, 1964; General Chairman of Youngstown Fine Arts Festival for Project Hope, 1963, 1966. Donor, "The John J. McDonough, M.D., Award for Best Realistic Work in Oil," given annually at the Midyear Show at the Butler Institute of American Art. Collection: 18th, 19th and 20th century American Art. Positions: Board of Trustees, Friends of American Art, 1963-1966; Trustee, Butler Institute of American Art, Youngstown, Ohio, 1968- .

McDOWELL, BARRIE—Sculptor
 Star Route, Bolinas, Cal. 94924
B. Easton, Pa., Mar. 10, 1923. Studied: Yale Univ. Sch. FA. Exhibited: Pace Gal., N.Y.; WMAA, 1964; Byron Gal., N.Y. Positions: Prof., A. Dept., San Francisco State Col., at present.

McFADDEN, ELIZABETH—Painter, W.
 92 Bank St., New York, N.Y. 10014
B. Belmar, N.J. Awards: Soc. Four Arts, Palm Beach, 1958.

Work: MModA. Exhibited: WMAA, 1958; MModA, 1961; Provincetown A. Festival, 1958; Betty Parsons Gal., N.Y., 1956-1958, 1960; Soc. Four Arts, 1958; Katonah Gal., 1958*

McFEE, JUNE KING—Scholar, Writer
 Institute for Community Studies, School of Architecture & Allied Arts, University of Oregon, Eugene, Ore. 97403; h. Rte. 3, Box 598, Eugene, Ore. 97405
Studied: Stanford University, Ed. D.; Central Washington College, M.Ed.; University of Washington, B.A. Art Training: Amede Ozenfant; Archipenko School of Art; Cornish School of Art. Exhibited: Seattle Art Museum; Seattle Artists Summer Shows; Washington State Invitational; Stanford Art Gallery Faculty Exhibitions. Author: "Preparation for Art," 1961 (Japanese edition, 1967; Chapters in: A Seminar in Art Education for Research and Curriculum Development;" "Readings in Art Education"; "Visual Communication in Educational Media: Theory into Practice," 1969. Articles in: Research in Art Education; Western Arts Bulletin; University of Kansas Bulletin of Education; Creative Crafts; Everyday Art; California Teachers Association Bulletin; The Instructor; Southwestern Arts Association Bulletin, and others. Research: A Study of the Creative Potential of Academically Superior Adolescents, supported by a Ford Foundation Grant to a Secondary Education Project at Stanford University; A Study of the City for Children supported by the American Institute of Architects. Positions: President, Pacific Regional of the National Art Education Association; Editor, Studies in Art Education

McGARRELL, JAMES—Painter, Gr., T.
 Department of Fine Arts, Indiana University; h. RR. 2, Bloomington, Ind. 47401
B. Indianapolis, Ind., Feb. 22, 1930. Studied: Indiana Univ., A.B.; Univ. California at Los Angeles, M.A.; Skowhegan Sch. Painting & Sculpture. Member: CAA (Bd. Dirs.). Awards: Natl. Inst. A. & Lets. Grant, 1963; Fulbright Fellowship, 1955; Guggenheim Fellowship, 1964-1965. Work: MModA; Santa Barbara Mus. A.; WMAA; Portland (Ore.) Mus. A.; San Francisco AI; PAFA; AIC; NGA; BM; Univ. Nebraska. Exhibited: WMAA, 1957, 1959, 1960, 1964, 1968; Univ. Illinois, 1959, 1961, 1963; Carnegie Intl., 1958, 1964; MModA, 1959; Documenta III, 1964; AIC, 1963, and others. Positions: Artist-in-Res., Reed College, Portland, Ore., 1956-1959; Dir., Graduate Studies, in Painting, Indiana University, Bloomington, Ind., 1959- .

McGARVEY, ELSIE SIRATZ (Mrs. James P.)—Museum Curator, E.
 Philadelphia Museum of Art, Parkway at 26th St., Philadelphia, Pa. 19101; h. 2030 Old Welsh Rd., Abington, Pa. 19001
B. Bethlehem, Pa., May 25, 1912. Studied: Graphic Sketch Cl., Phila.; Phila. College of Art (grad.). Member: AAMus.; Fashion Group of Phila.; Phila. A. All.; PAFA. Activities: Displays, lectures and period costume fashion shows at schools, Phila. A. All., Phila. Acad. of Music, women's clubs, etc. Arranged Exhibition: "The Bride in Fashion: Three Centuries of Wedding Gowns," Philadelphia Museum of Art, June - July, 1966. Positions: Curator of Costumes and Textiles, Philadelphia Museum of Art (Fashion Wing containing 18th, 19th and 20th century costume display galleries; textile and costume study collection), 1956- ; Instr., Beaver College, Glenside, Pa. (Lectures on historic costume, instructor in Fashion Illustration), 1939- ; Instr., Fashion Design, Phila. College of Art, 1941-1954; Artist, Condé Nast Vogue Pattern Service, Greenwich, Conn., 1934-39.

McGEE, WINSTON EUGENE—Educator, P.
 Art Department, Lake Erie College; h. 348 Mentor Ave., Painesville, Ohio 44077
B. Salem, Ill., Sept. 4, 1924. Studied: Univ. Missouri, B.J., M.A.; Univ. Wisconsin; Ecole Superieux des Beaux-Arts, France, under M. Souverbie. Member: AAUP; AFA; F.I.A.L. Awards: Fulbright award, 1949-50; prizes, Baldwin Mus., 1954; Cleveland Journalism Show, 1956; CMA, 1961. Work: mural, Lincoln Commons Bldg., Lake Erie College. Exhibited: "American Artists in Europe" traveling exh., 1950; Fulbright Exh., 1951; Artists of the Western Reserve traveling exh., 1966; CMA, 50th Year Anniversary Exh., 1967; Butler Inst. Am. A., 1955; Duveen-Graham Fulbright Exh., 1956; Barone Gal., N.Y., 1959 (one-man); Springfield Mus. A., 1948; Erie May Show, 1955; Howard Wise Gal., Cleveland, 1960; Galleria Minima, Milan, Italy, 1960; Trabia Gal., N.Y., 1961 (one-man), and others. Positions: Hd. A. Dept., Lake Erie College, Painesville, Ohio, 1951- . Buckminster Fuller Symposium Lecture, Painesville, Ohio, 1968.

McGINNIS, MRS. PATRICK B. —Collector, Patron
 215 E. 68th St., Apt. 25E, New York, N.Y. 10021
B. Gouverneur, N.Y., Jan 1, 1906. Studied: St. Lawrence University, Canton, N.Y., B.A.; Parsons School of Design, New York. Collection: Primarily contemporary American art; includes works by Rothko, Francis, Albers, Hartigan, Botero, Soulages, Marca-Relli, Corbett, Matisse, Leger, and others; Presented works to St. Lawrence University, Whitney Museum.*

McGOUGH, CHARLES E. — Educator, Gr., P., Des., Comm.
East Texas State University, Commerce, Tex.; h. 1603 Walnut St., Commerce, Tex. 75428
B. Elmhurst, Ill., Aug. 2, 1927. Studied: Southwestern Univ.; Hardin-Simmons Univ.; Ray Vogue A. Sch.; AIC; North Texas State Univ.; Univ. Tulsa, B.A., M.A. Member: Nat. Ser. Soc.; Texas Pr. M.; Dallas Pr. & Drawing Soc.; NEA; Texas A. Edu. Assn. Work: Philbrook A. Center; DMFA; Mus. FA of Little Rock; murals, Goodfellow Air Base; Southern Hills Country Cl., Tulsa; First Natl. Bank and Southwestern Ins. Agcy., both Dallas; Univ. Tulsa; East Texas State Univ. Exhibited: Drawings USA, 1963-64; Texas Annual, 1962-1964; Southwest Print Annual, 1962-1964; Boston Pr. M., 1965; Wichita Print Annual, 1962-1965; Ball State Drawing, 1962-1964; Silvermine Gld. A., 1964; Natl. Serigraph Annual, 1964; Phila. Print Club, 1964; Troup Gal., Dallas, and others in prior dates. Positions: Hd. A. Dept., East Texas State University, Commerce, Tex., 1956- . Editor, Texas Trends in Art Education. Lectures on Contemporary Graphics.*

McGOWIN, ED(WARD) (WILLIAM) (JR.) — Sculptor
1884 Columbia Rd., Washington, D.C. 20009; h. 1215 Ft. Myer Dr., Arlington, Va. 22209
B. Hattiesburg, Miss., June 2, 1938. Studied: Univ. of Southern Miss., B.S.; Univ. Ala., M.F.A. Awards: Nat. Endowment for the Arts grant, 1968; Birmingham AA, 1961. Work: WMAA; AGAA. Exhibited: Latin America(traveling exh.), 1964; WMAA, 1967 (2), 1968, 1969; AGAA, 1967; Martha Jackson Gal., N.Y., 1967; Mus. Contemp. Crafts, N.Y., 1968; BM, 1968; Witte Mus., San Antonio, 1968; Riverside Mus., N.Y., 1968; Mus. Mod. A., Wash. D.C., 1968; San Juan, Puerto Rico, 1968; Inst. Contemp. A., Phila., 1968. One-man: Univ. Ala., 1963; CGA, 1963; Henri Gal., Wash., D.C., 1964, 1967; Martha Jackson Gal., N.Y., 1968. Positions: Grad. Asst., A., Univ. Ala., 1963-1964; Dir., McGowin-Bright Sch., Alexandria, Va., 1965-1966; Instr., Corcoran A. Sch., Wash., D.C., 1967-1968; Head, Sculpture Dept., Corcoran A. Sch., 1969- .

McGRATH, KYRAN M. — Association Director
2306 Massachusetts Ave., N.W., 20008; h. 1929 Upshur St., N.W., Washington, D.C. 20008
B. Chicago, Ill., Aug. 24, 1934. Studied: Georgetown University, B.S.S. Positions: Director, American Association of Museums, 1968- .

McGREGOR, JACK R. — Museum Director
M. H. de Young Memorial Museum, Golden Gate Park; h. 2603 California St., San Francisco, Cal. 94115
B. Coffeyville, Kans., Mar 17, 1930. Studied: Univ. Kansas, B.A.; Brown Univ. Graduate School as special student in Fine Arts Dept.; Universita Italiano per Stranieri, Perugia, Italy (1955 summer); Student Fellow, Metropolitan Museum of Art; N.Y. Univ. Inst. FA. Member: AAMus. Contributor articles to Mar. 1960 "Bulletin" of the Metropolitan Mus. Art; April 1963 "Connaissance des Arts." Positions: Director, M.H. de Young Memorial Museum, San Francisco, Cal., 1963- .*

MACHLIN, SHELDON (MERRITT) — Sculptor, Photog-Journalist, Gr.
39 Columbia Place, Brooklyn, N.Y. 11201
B. New York, N.Y., Sept. 6, 1918. Member: Overseas Press Club of America. Work: sculpture: VMFA; MModA; WMAA; Milwaukee A. Center, Wis.; Aldrich Mus. Contemp. A., Ridgefield, Conn.; and in private collections; relief prints: MModA; Colgate Univ.; Svenska Handelsbanken, Stockholm, Sweden; photographs: MModA; MMA; Gal. of Mod. A., N.Y. and others. Exhibited: Sculpture: NAD, 1962; BMFA, 1962; MModA, 1963, 1965, 1966; VMFA, 1963; AFA, 1963 (traveling); Flint Inst. A., Mich., 1964; J.B. Speed A. Mus., Louisville, Ky., 1964; PMA, 1964; WMAA, 1964, 1966, 1968; R.I.Sch.Des., 1965, 1966; Inst. Contemp. A., Boston, 1966; Des Moines A. Center, Iowa, 1966; Riverside Mus., N.Y., 1966, 1967; N.J. State Mus., Trenton, 1967; State Univ. N.Y. at Albany, 1967; Milwaukee A. Center, Wis., 1968; Mus. Contemp. A., Chicago, 1968; David Stuart Gal., Los A., 1969; La Jolla Mus., Cal., 1969; BM, 1969. One-man: Bolles Gal., N.Y., 1962, San Francisco, 1963; Galerie Galaxie, Detroit, 1963; Waddell Gal., N.Y., 1965, 1967. Photographs widely exhibited in major museums, art galleries, and universities prior to 1962, including MMA; BMA; BMFA; CAM; DMFA; R.I.Sch.Des.; Minneapolis Inst. A.; Munson-Williams-Proctor Inst., Utica, N.Y.; Wadsworth Atheneum, Hartford, Conn.; Mus. FA, Springfield, Mass.

MacIVER, LOREN — Painter
2 rue Furstenberg, Paris 6, France
Exhibited: nationally and internationally.*

McILHENNY, HENRY P. — Collector
1914 Rittenhouse Square, Philadelphia, Pa., 19103*

MACK, RODGER A. — Sculptor
Lowe Art Center, School of Art, Syracuse University; h. 1033 Ackerman St., Syracuse, N.Y. 13210
B. Barberton, Ohio, Nov. 8, 1939. Studied: Cleveland Inst. A., B.F.A.; Cranbrook Acad. A., M.F.A., and further study in Perugia and Florence, Italy. Awards: Fulbright Grant for study in Italy, 1963; Nat. Council on the Arts Award, 1967; prizes, Canton Mus., 1959; Univ. Kansas, 1962; Detroit Inst. A., 1963; Arkansas A. Center, 1964-1966. Work: Bronze sculpture, Market Plaza, North Little Rock, Ark.; bronze casting, Syracuse Univ. Campus. Exhibited: Butler Inst. Am. A., 1959-1960; Akron A. Inst., 1960; USIA traveling exh., Europe, 1960-1962; Canton Mus., 1959; Cleveland Inst. A., 1959, 1961; Univ. Kansas Metal Casting Comp., 1962; Ball State Univ., 1963; Cranbrook Acad. A., 1962, 1963; Detroit Inst. A., 1963; Fulbright Artists, Village A. Center, N.Y., 1963; Palzzo Venezia, Rome, Italy, 1964; Florence, Italy, 1964; Arkansas A. Center, 1964-1966, 1967 (2); Springfield A. Mus. (Mo.), 1964-1967; Brooks Mem. Mus., Memphis, 1963; Nelson-Atkins Mus., Kansas City, 1965, 1966; Sculpture traveling exh., Pembroke, North Carolina, 1965; USIA traveling exh., Yugoslavia, Eastern Europe and India, 1965-1967; Southern Sculpture traveling exh., 1966; Ellis A. Center, Southwest Missouri State Col., 1966 (2-man); Art in Embassies Program, 1966, traveling Japan, Europe; Memphis A. Acad., 1967; Arkansas A. Festival, 1967; Univ. Mississippi, 1968 (2-man); Faculty Exh., Syracuse Univ., 1968; Nat. Council on the Arts and Nat. Endowment for the Arts Exh., Witte Mem. Mus., San Antonio, Tex., 1968; Munson-Williams-Proctor Inst., Utica, N.Y., 1969; Humboldt State Col., Arcata, Cal., 1969; Rochester-Finger Lakes Exh., Rochester, N.Y., 1969; one-man: bronzes, Galleria d'Arte Internazionale, Florence, Italy, 1964; Col. of the ozarks, Clarksville, Ark., 1967; Lakewood House Gal., North Little Rock, 1967. Positions: Instr., Sculpture, Arkansas A. Center, 1964-1968; Chm., Sculpture Dept., Syracuse University, N.Y., at present.

McKEAN, MRS. HUGH F. See Genius, Jeannette M.

McKEAN, HUGH FERGUSON — Painter, L., E.
Rollins College; h. 930 Genius Dr., Winter Park, Fla. 32789
B. Beaver Falls, Pa., July 28, 1908. Studied: PAFA; ASL; Ecole des Beaux-Arts, Fontainebleau, France; Rollins Col., B.A.; Williams Col., M.A.; Harvard Univ.; Stetson Univ., L.H.D.; Doctor of Space Education degree from Brevard Engineering College. Member: Fla. Fed. A.; SSAL; AEA; New Hampshire AA; Orlando AA; AFA; CAA; Palm Beach A. Lg.; Fla. A. Group; Tiffany Fnd.; McDowell Colony. Awards: prizes, Fla. Fed. A., 1931, 1949; Cervantes medal, Spanish Inst.; Decoration of Honor, Rollins Col. Work: Toledo Mus. A.; Univ. Virginia. Exhibited: Soc. Four A., 1948; All. A. Am., 1949; Atlanta, Ga., 1949. Positions: Dir., Morse Gal. A., Rollins Col.; Pres., Fla. Fed. A., 1951-52; Acting Pres., 1951-52, Pres., Prof., A., 1952- , Rollins Col., Winter Park, Fla. Trustee, Louis Comfort Tiffany Fnd.

MacKENDRICK, LILIAN — Painter
230 Central Park, South, New York, N.Y. 10019
B. Brooklyn, N.Y. Studied: N.Y. Univ., B.S.; Col. City of N.Y.; ASL. Member: AEA. Awards: gold medal, Bordighera, Italy; Northside Center award for Public Service, 1961. Work: WAC; Georgia Mus. A.; Wadsworth Atheneum; Mus. FA of Houston, MMA; Brandeis Univ., Bezalel Mus., Jerusalem; Galeria di Arti Contemporanea, Bordighera, Italy; Museo de Arte, Ponce, P.R.; Morgan State Col., Baltimore, Md.; Illus., "The Cat in My Mind," Putnam's, London, 1958. Exhibited: "Eleven Americans," touring France, 1956-57; USIS, Mexico City, 1966; Lillian Phipps Gal., Palm Beach, Fla., 1966; one-man: Mortimer Levitt Gal., N.Y., 1949, 1951; Feigl Gal., N.Y., 1953, 1955; Georgia Mus. A., 1955; Northside Center, 1949-59; Hirschl & Adler Gal., N.Y., 1958, 1960, 1962, 1964, 1967; Benezit Galerie, Paris, France, 1956, 1957, 1959, 1965; Ohana Gal. London, 1959; Main St. Gal., Chicago, 1959; Closson's, Cincinnati, 1961; Callard's, Chicago, 1962; Galaxy Gal., Phoenix, 1963; Volta Place Gal., Wash., D.C., 1964. Articles on the artist in Am. Artist, 1959; Vogue, 1959; Jardin des Arts, Paris, 1956. USIS, Ostend, 1957, and in Italy.

McKIM, WILLIAM WIND — Lithographer, P., T.
Kansas City Art Institute, 4415 Warwick Blvd., Kansas City, Mo. 64102; h. 8704 East 32nd St., Kansas City, Mo. 64129
B. Independence, Mo., May 13, 1916. Studied: Kansas City AI, with Benton, de Martelly. Member: Mid-Am. A. Awards: prizes, N.Y. State Fair, 1938; Kansas City AI, 1938-1941; Missouri annual, 1946, 1947; William Rockhill Nelson Gal. A., 1948; Kansas City AI, 1946-1952; AIC; Denver A. Mus.; Assoc. Am. A., 1940, 1941; mid-Am. A., 1950, 1952; Tupperware Fnd. Exh., 1956; Missouri Pavilion, N.Y. World's Fair, 1964. One-man: Kansas City AI, 1967; Albrecht Gal., St. Joseph, Mo., 1968; "10 Missouri Painters" traveling exh., 1968-1969. Positions: Instr., Lith., Drawing, Kansas City AI, Kansas City, Mo., 1948- ; Asst. Prof., Dept. Painting and Drawing, Kansas City AI.

McKININ, LAWRENCE—Educator, P., C.
Department of Art, University of Missouri; h. 703 Ingleside Dr., Columbia, Mo. 65201
B. Yukon, Pa., Aug. 24, 1917. Studied: Wayne Univ., B.S.; Soc. A. & Crafts, Detroit; Cranbrook Acad. A., M.F.A.; Handy & Harman Silversmithing Workshop. Member: Midwestern College AA; Friends of the Art Gal., Kansas City, Mo.; Missouri College AA. Awards: prizes, Stephens Col. All-Missouri Salon, 1949; Mid-America Annual, 1950 (purchase); Springfield (Mo.) Mus. A., 1950 (purchase). Work: Mid-America AA; Springfield Mus., A. Book des. and layout for Missouri Press Publ., "Fred Shane Drawings," 1964. Exhibited: Am. Craftsmen's Exh., Univ. Illinois, 1951; Decorative A. Exh., Wichita, 1950, 1952; Am. Jewelry & Related Objects exh., 1955 (circulated by Smithsonian Inst.); Michigan A., 1937, 1938, 1946, 1947; Michigan A.-Craftsmen, 1948; CAM, 1949, 1951, 1954, 1961; Springfield Mus. A., 1950, 1961, 1966; Mid-America annual, 1950; 1951; Midwest Des. Exh., 1951; Missouri Pavilion, N.Y. World's Fair, 1964; one-man: Univ. Missouri, Christian Col.; "Mid-Missouri Artists," and "10 Missouri Painters II," Missouri Arts Council traveling exhs., 1968-1969. Positions: Instr. A., Detroit Pub. Schs., 1941-42, 1946; A. Dir., Archaeology Magazine, 1954-55; Instr., 1948-50, Asst. Prof., 1950-54, Assoc. Prof., & Chm., Dept. A., 1955-59, Prof., 1959, University of Missouri, Columbia, Mo.

McKNIGHT, ELINE—Printmaker
100 Riverside Dr., New York, N.Y. 10024
B. Yokohama, Japan, 1910. Studied: Barnard Col., and, Teachers Col., Columbia Univ.; ASL; Yale School FA. Work: LC; New York Hilton, Rockefeller Center (100 prints); Univ. Tennessee, 1962; USIA purchase, prints for U.S. Embassies abroad. Conducted discussion groups on "Looking at Modern Art" for the Ford Fund for Adult Education. Exhibited: in national and international exhibitions including USIA exh. touring Europe, 1960-1962; Gunther Franke Gal., Munich, 1959; Assoc. Am. A. Gal., N.Y., 1963; LC, 1959, 1960; BM, 1960, 1964, 1966; SAGA traveling, 1960-1962; Soc. Washington Pr. M., 1961; Phila. Pr. M., 1961; Amerika Haus, Stuttgart, 1965; CGA, 1967. Positions: Editorial Staff, New York Arts Calendar, 1964; Assoc. Ed., The Collectors Almanac, 1965.

McLANATHAN, RICHARD BARTON KENNEDY—
Writer, L., Consultant
439 E. 51st St., New York, N.Y. 10022
B. Methuen, Mass., Mar. 12, 1916. Studied: The Choate Sch.; Harvard Univ., A.B., Ph.D.; Harvard Grad. Sch. Member: Am. Studies Assn.; Societe Poussin; AAMus.; Soc. Arch. Historians, and others. Awards: Soc. of Fellows, Harvard; Prix de Rome, 1948; Senior F., Am. Acad. in Rome, 1948-49; Special Service Award, USIA, 1959; Award of Merit, Am. Assn. for State & Local History, 1961. Author: "Great Americans," 1956; "Martin J. Heade, 1819-1904," 1955-56; "Ship Models," 1957; "Queen Tomyris and the Head of Cyrus," 1956; "American Marine Painting," 1955-56; "Images of the Universe: Leonardo da Vinci, The Artist as Scientist," 1966; "The Pageant of Medieval Art and Life," 1966; The American Tradition in the Arts," 1968; Co-author: "The M. and M. Karolik Collection of American Painting, 1815-1865," 1949; Editor: "Catalogue of Greek Coins" by Agnes Baldwin Brett, 1955, and others. Contributor to Encyclopaedia Britannica; Encyclopedia of World Art; Art News. Journal of the Society of Architectural Historians; BMFA Arts Bulletins; Arte Veneta; Atlantic Monthly; Antiques; U.S. Philanthropic Foundations ("Visual Arts"), 1967; Museum News. Decorative Arts Editor for new edition of Webster's unabridged International Dictionary; Restoration of "Fountain Elms" an 1850 house, Utica, N.Y. Installed various collections at Museum of Fine Arts, Boston Educational & TV and Radio programs including Harvard Extension Course, "The Arts in America"; Host on "Open House at the Museum" (BMFA). Positions: Asst. Cur., Dept. Paintings, 1946-48; Asst. Cur., Decorative Arts, 1949-54, Cur., Decorative Arts, 1955-57, Boston Museum of Fine Arts; Trustee, Boston A. Festival, 1952-57; Sec., BMFA, 1952-56; Ed. Publications, 1952-57; Dir., Museum of Art, Munson-Williams-Proctor Inst., Utica, N.Y., 1957-61; Cur., Americna Nat. Exh. A., Moscow, 1959; Am. Specialist for State Dept. in Poland, Germany, Denmark (1959) and Yugoslavia (1961); Pres., The Association of Fellows of the American Academy in Rome, 1964. Member, N.Y. State Council on The Arts, Commissioner's Comm. on Art and Museum Resources, N.Y. State, 1961-1966.

McLARTY, WILLIAM JAMES (JACK)—Painter, E., Gr., L.
2483 N. W. Overton St., Portland, Ore. 97210
B. Seattle, Wash., Apr. 24, 1919. Studied: Mus. A. Sch., Portland, Ore.; Am. A. Sch., N.Y., and with Anton Refregier, Joseph Solman. Member: Portland AA. Awards: Special mention, Artists of Oregon, 1962; Oregon Centennial Exh., 1959; Cheney Cowles Mus., Spokane, 1965; Lewis & Clark Col. invitational, Portland, Ore., purchase, 1965; Northwest Pr.M., Seattle, 1966. Work: murals, Collins-View

Sch., Laurelhurst Sch., Riverdale Sch., Ridgewood Sch., Portland, Ore.; Portland Civic Auditorium. Exhibited: Santa Barbara Mus. A., 1958; Paintings & Sculptures of the Northwest, 1959; Northwest Art Today (World's Fair Invitational, Seattle, 1962); Pacific Coast Invitational organized by Santa Barbara Mus. A., 1963; Colo. Springs FA Center, 1963; Recent Paintings: USA, MModA, 1962-63; 1st and 2nd Int. Miniature Print Exh., Pratt Graphic A. Center, N.Y., 1964; Multiform, Oregon State Univ., invitational, 1968; one-man: Reed College, Portland, 1960; College of Puget Sound, Tacoma, 1960; Bush House Mus., Salem, Ore., 1961; Ruthermore Gal., San Francisco, 1961; The Image Gal., Portland, 1962, 1965, 1967; Salt Lake A. Center, 1962 (drawings); Woodside Gal., Seattle, 1964; 20 Year Retrospective Exh., Portland A. Mus., 1963. Publications: "17 Love Poems," 1967; "Prize-Winning Graphics," 1967; Northwest Review, Univ. of Oregon, 1967. Positions: Instr., Painting, Drawing & Composition, Portland Museum Art School, Portland, Oregon.

McLAUGHLIN, JOHN—Painter
c/o Landau Gallery, 702 N. La Cienega, Los Angeles, Cal. 90069
B. Sharon, Mass., May 21, 1898. Awards: Nat. Fnd. on the Arts and Humanities Grant, 1967; bronze medal, CGA, 1967. Exhibited: Pavillion Gal., Balboa, Cal., 1966; MModA, 1966, 1969; Univ. California Mus., Berkeley, 1967; CGA, 1967; Krannert Mus. A., Univ. Illinois, 1967; AGAA, 1969; one-man: Felix Landau Gal., Los Angeles, 1966; Landau-Alan Gal., N.Y., 1968; Henri Gal., Washington, D.C., 1969.

McLAUGHLIN, MARGARET ALEXANDRA LUKE. See Luke, Alexandra

MacLEAN, ARTHUR—Painter, Comm.
267 Brookside Rd., Darien, Conn. 06822
B. New York, N.Y., Apr. 1, 1906. Studied: ASL; NAD; Grand Central Sch. A. Member: All. A. Am.; Knickerbocker A. (Bd. Member); Academic A.; Conn. FA Soc.; AAPL; SC. Awards: Medal of Honor, Knickerbocker A., 1963; Silver Medal, AAPL, 1963; Margaret Cooper prize, Hartford, Conn., 1963; Conn. Classic A., New Haven, 1962; Essex A., 1967; SC, 1966, 1967; Darien, Conn., 1964. Exhibited: NAD, 1960, 1962-1965, 1969; All. A. Am., 1963-1968; Knickerbocker A., 1962-1965, 1968, 1969; AAPL, 1963-1965; Audubon A., 1963; Conn. FA Soc., 1963-1965; Hudson Valley AA, 1962-1969.

McLEAN, MRS. DONALD J. See Porter, Doris

McMILLAN, CONSTANCE—Painter, I., T.
2760 Heather Way, Ann Arbor, Mich. 48104
B. Millinocket, Me., Mar. 10, 1924. Studied: Bennington Col., B.A.; Colorado Springs FA Center; Mills College, Oakland, Cal., M.A. Member: NAWA; Detroit Soc. Women P. & S.; Ann Arbor AA. Awards: Two year Fellowship, Mills College; Morris Galler Annual prize, 1958; Michigan WC Soc., 1967, 1968. Exhibited: Univ. of Mich., 1968; Lawrence Stevens Gal., Detroit, 1968, 1969; Artists Market, Detroit, 1968, 1969; Flint Mus., Michigan, 1967. One-man: Panoras Gal., N.Y., 1966, 1969. Illus. "Chikka" (Hira Nirodi), 1962; "Memory of a Large Christmas" (Lillian Smith), 1962; "Ponies for a King" (Helen Walters), 1963.

McMILLAN, ROBERT W.—Educator, P., L.
Department of Art, University of Arizona, Tucson, Ariz. 85721
B. Belleville, Ill., Jan. 22, 1915. Studied: Southern Illinois Univ., B. Ed.; Columbia Univ., M.A.; Washington Univ., St. Louis; Univ. Iowa, Ph.D. Positions: Instr. A., Univ. Kansas City, 1946-1948; Prof. A., Southern Illinois Univ., Carbondale, 1950-1960; Prof. A., Grinnell Col., Grinnell, Iowa, 1960-1969, Chm. Dept. A., 1961-1968; Hd. Dept. A., Univ. of Arizona, Tucson, 1969- .

McNAB, ALLAN—Museum Director, Eng., W.
40 E. Oak St., Chicago, Ill. 60611
B. England, May 27, 1901. Studied: Royal Col. A., London; Ecole des Beaux-Arts, Paris. Member: Royal Geographical Soc., Chelsea A. Cl., London; Arch. Lg., N.Y. Awards: Chicago Lighting Inst. award for museum lighting, 1963. Exhibited: Royal Acad., London; Royal Scottish Acad.; Royal Soc. P. & Et.; New English A. Cl.; AIC, and in Liverpool, Leeds, Manchester, England; Glasgow, Scotland. Work: British Mus.; and in galleries of Australia, Italy, France, Holland. Positions: A. Dir., UFA, 1928-30; Des. Dir., Norman Bel Geddes, 1938-45; A. Dir., Life Magazine, 1945-50; Dir., Lowe Gallery, 1950-55; Dir., Soc. Four A., Palm Beach, Fla., 1955-56; Adv. to Nat. Mus., Havana, Cuba, 1955- ; Chm., Southern A. Mus. Dir. Assn., 1953-54; Asst. Dir., 1956-57, Assoc. Dir., 1957-59, Dir., Administration, 1959-1966, The Art Institute of Chicago, Chicago, Ill. (Ret. 1966). Consultant to the City of Oakland, Cal., on building of new city museum, 1962- .*

McNAMARA, RAYMOND—Graphic Printmaker, E., P.
 1712 Quarrier St., Charleston, W.Va. 25311
B. Chicago, Ill., Sept. 25, 1923. Studied: AIC, B.A.E.; Univ. Mich-
igan, M.A.; Wayne State Univ. Studied with Anisfeld, Kahn, Gilleran,
Woodward and Hayter. Member: AAUP. Awards: Prizes, Charles-
ton A. Gal., 1964, 1966; Gal. Arkep, N.Y.C., Comp. in Graphics,
1964; Scarab Cl., Detroit, 1964; Mountain St. A. & Craft Fair 1966;
W.Va. A. & Humanities Council Award for Painting and Graphics,
1967; Huntington Galleries Exh. 180, 1966, 1967; Allied Artists of
W.Va., 1968; Amer. Drawing Bienniel, 1969. Work: Huntington
Galleries; Gallery Arkep; Concord Col.; DeCinque National Graphic,
State of W.Va.; Positions: Assoc. Prof. of Art, Gal. Dir., W.Va.
State Col. Exhibited: All local and regional exhibits in area, 1964-
1969; Ball State Univ. Nat. Drawing Biennial, 1967; Piedmont Draw-
ing and Print Exh., 1969; Smithsonian Traveling Exh., 1969-71;
Appalachian Corridors, 1968. One-man: St. Mary's Col., Notre
Dame, 1966; W.Va. State Col., 1964, 1966, 1967, 1969; Huntington
Galleries, 1966, 1968.

McNEAR, EVERETT C.—Painter, Des.
 1448 Lake Shore Dr., Chicago, Ill. 60610
B. Minneapolis, Minn., Sept. 30, 1904. Studied: Minneapolis Sch. A.,
with Cameron Booth; also with Edmund Kinzinger, Louis Marcoussis.
Member: Chicago A. Cl.; 27 Designers. Awards: prizes, AIC, 1948;
Minnesota Centennial, 1950; A. Gld., 1951, 1955, 1957, 1958; Illinois
State Mus., 1960; Soc. Typographic A., 1949-1952; medal, A. Dir.
Cl., Chicago, 1950, 1955; New York, 1951. Work: mosaic panels,
Skiles Sch., Evanston, 1959. Mural, Perkins and Will Partnership.
Contributor articles to Bulletin of Atomic Scientists; American Art-
ist magazine. Exhibited: AIC; PAFA; one-man: SFMA, 1946;
Crocker A. Gal., Sacramento, 1946; Rouillier Gal., 1944; St. Paul
Gal. A., 1943; Walker A. Center, 1948; Univ. Gal., Notre Dame, 1961;
Seligmann Gal., N.Y., 1963, 1969; Goldwach Gal., 1964, 1965. I.,
"Many a Green Isle," 1941; "Young Eye Seeing," 1956. Des. Con-
sultant, AIC, 1958- ; Chm. Exh. Com., Chicago A. Cl., 1953- .
Member Advisory Council, Art Gallery, Univ. of Notre Dame.

McNEIL, GEORGE—Painter, E.
 42 Washington Ave.; h. 226A Willoughby Ave., Brooklyn, N.Y.
 11205
B. New York, N.Y., Feb. 22, 1908. Studied: Pratt Inst., Brooklyn;
ASL; Hans Hofmann Sch. FA; Columbia Univ., Ed. D. Awards: Nat.
Council on the Arts award, 1966; Guggenheim Fellowship, 1969.
Work: Bundy Gal., Waitsfield, Vt.; MModA; Nat. Mus., Havana, Cuba;
Newark Mus. A.; WAC; WMAA; Oklahoma A. Center; WAC; Mitch-
ner Fnd., Univ. of Texas, and in private colls. Exhibited: Am. Ab-
stract A., 1936, in Japan, 1955; MModA, 1936, 1951; AIC, 1948;
WMAA, 1953, 1957, 1961; Carnegie Inst., 1953, 1955, 1958; WAC,
1960; CMA, 1961; Guggenheim Mus., N.Y., 1961; Pan-American Exh.
circulated by USIA to Latin America, 1961-62; Yale Univ. A. Gal.,
1961-62; PAFA, 1962; Wadsworth Atheneum, Hartford, 1962; one-
man: Univ. Texas, 1966; Des Moines A. Center, 1969; co-exhibitor
with Stephen Pace: Brandeis Univ., WAC, Columbus (Ohio) Gal. FA,
A.Cl. of Chicago and Kalamazoo A. Center. Positions: Prof. A.,
Pratt Institute, Brooklyn, N.Y.

McNETT, ELIZABETH VARDELL (Mrs. W. B.)—
 Painter, Medical I., T., Gr.
 120 Pennsylvania Ave., Southern Pines, S.C. 28387
B. Newbern, N.C., Nov. 17, 1896. Studied: Flora Macdonald Col.,
A.B.; ASL; NAD; PAFA; Univ. Pennsylvania, B.F.A., M.F.A.; Johns
Hopkins Univ. Medical Sch., Dept. Medical Art. Awards: Schol-
arship to PAFA from Univ. Pa. Work: murals, College of Phar-
macy, Phila., Pa.; Lankenau Hospital, Phila., Pa.; Inst. of Cancer
Research, Phila., Pa. Exhibited: Phila. A. All.; Montgomery County
AA; one-man; Allied A., Durham, 1956; Fleischer Mus. Sch., Phila.,
Pa., 1953. Illus. many medical books. Contributor illus. to medical
journals. Lectures: Medical Illustration. Positions: Instr. A.,
Andrew Col.; Cuthbert, Ga.; Fleischer Mus. Sch., Phila., Pa.; Med-
ical Artist, Lankenau Hospital, Phila., Pa., 18 years.

MacNICOL, ROY VINCENT—Painter, Des., T., W., L.
 Casa MacNicol, Zaragosa 307, Chapala-on-the-Lake, Jalisco,
 Mexico; h. 100 Sullivan St., New York, N.Y. 10012
B. New York, N.Y., Nov. 27, 1889. Member: Baltimore WC Soc.; Lotos
Cl., N.Y.; Pan-American Union. Work: Randolph-Macon Woman's
Col.; Univ. Havana, Cuba; Univ. Illinois; Reporter's Cl., Havana; Find-
lay Gal., Chicago, and in private colls. Murals, Geneve Hotel, Mexico
City; Moore-McCormack SS Lines; Harmon Fnd. Exhibited: Arch.
Lg.; NAD; Anderson Gal.; Seligmann Gal.; AIC; Dudensing Gal., N.Y.;
Seville, Spain; Everglades Cl., Palm Beach; Los A. Mus. A.; Ham-
ilton House, Shanghai, China; Marshall Field Co.; Lyceum, Havana,
Cuba; Newhouse Gal.; Royal Victoria Inst., Trinidad, B.W.I.; Bridge-
town, B.W.I.; Milch Gal.; Pan-American Union; Hudson Co., Detroit;
Findlay Gal., Chicago; Barker Bros., Los A.; Bellas Artes, Mexico
City; Aeta Gal., Stockholm, Sweden (first American one-man exh. to

be presented there); Paris, France and Copenhagen, Denmark, 1956;
Weil Gal., Paris; Gallery Vivienne, N.Y., 1949 (exh. televised by
NBC), and many others nationally and internationally. Creator of
first Good Neighbor Exhs., Mexican theme, in interest of interna-
tional good will 50 one-man exhs., opened in Wash., D.C., 1943 at
Pan-American Union, sponsored by Mrs. Eleanor Roosevelt and
Pres. Miguel Aleman, the Mexican Cabinet and Pan-American Un-
ion. Author: "Paint Brush Ambassador," 1957; "A Man and His
Glory: El Greco," 1970. Positions: Assoc. Ed., American Histori-
cal Company, New York, N.Y. Contributor to Christian Science Mon-
itor; Atlanta Journal; Times-Herald; Mexico City News; Havana
Post, etc. Lectures: Art and Spain.

McNULTY, MRS. WILLIAM C. See Gellman, Beatrice

MACPHERSON, MRS. J. HAVARD. See Edgerly, Beatrice

MacRAE, EMMA FORDYCE (Mrs. Homer Swift)—Painter
 888 Park Ave., New York, N.Y. 10021
B. Vienna, Austria. Studied: ASL; N.Y. Sch. A., with Kenneth Hayes
Miller. Member: NA; NAWA; All. A. Am.; NSMP; North Shore AA;
Cosmpolitan Cl. Awards: prizes, Pen & Brush Cl., 1946, 1950, 1955;
NAWA, 1941, 1945; All. A. Am., 1942; medal, NAC, 1930; Medal of
Merit, Royal Acad. A., England, 1963 (given to all members of NAD).
Work: Wesleyan Col.; Cosmopolitan Cl.; NAD, and in private colls.
Exhibited: Carnegie Inst.; AIC; CGA; PAFA; Joslyn Mus. A.; Mus.
FA of Houston; de Young Mus. A.; SAM; Knickerbocker A.; Colorado
Springs FA Center; Newport AA; NAD; All. A. Am.; NAWA; one-man:
Lyman Allyn Mus. A.; Berkshire Mus., Pittsfield, Mass.; Joslyn
Mus. A.; Rutgers Univ.; Oxford (Miss.) Mus. A.; Nashville Mus. A.;
Currier Mus. A.

McVEY, LEZA S. (Mrs.)—Ceramic Sculptor
 Pepper Ridge Rd., Cleveland, Ohio 44124
B. Cleveland, Ohio, May 1, 1907. Studied: Cleveland Sch. A.; Cran-
brook Acad. A. Awards: prizes, Syracuse Mus. FA, 1950, 1951;
Michigan A. & Crafts, 1951; CMA, 1953-1958, 1959 (purchase), 1961;
Butler Inst. Am. A., 1958; Grand Prix des Nations, Int. Congress of
Contemp. Ceramics, Ostend, Belgium. Work: Syracuse Mus. FA;
CMA; General Motors, Detroit, Mich.; Smithsonian Inst.; Mus. Con-
temp. Crafts, New York City; Syracuse Univ. Coll.; Butler Inst. Am.
A.; Cleveland Inst. Music. Exhibited: Detroit Inst. A., 1947-1952;
Syracuse Mus. FA, and Nat. Circuit, 1945-1948, 1958, 1961; Wichita,
Kans., 1947-1954; Smithsonian Inst., 1951-1961; Scripps Col., 1969
and prior; University galleries: Minneapolis, Wisconsin, Nebraska,
Illinois, Syracuse; Pomona, Cal., 1954; PAFA, 1954; Int. Craftsman
Exh., 1953; AFA traveling exh., 1954; BM, 1953, 1954; Butler Inst.
Am. A., 1953-1958, 1969; Des.-Craftsman, 1954, 1955; CMA, 1948-
1969; Akron AI; Art Colony, Cleveland, 1955; De Waters A. Center,
Flint, Mich.; Everson Mus. A., 1960-1962; Mus. of Contemp. Craft,
1962; Nat. Craft Exh., Northridge, Cal.; Int. Cultural Exchange, Ge-
neva, Switzerland; Ball State Univ., 1967. One-man: Albright-Knox
A. Gal., Buffalo, 1963; Cleveland Inst. A., 1965. Contributor to
House Beautiful; Ceramic Monthly; Everyday Art Quarterly; Work
reproduced in museum catalogues on awards; and in Domus; Craft
Horizons. Positions: Instr., Cranbrook Acad. A.

McVEY, WILLIAM M.—Sculptor, E., L.
 Pepper Ridge Rd., Cleveland, Ohio 44124
B. Boston, Mass., July 12, 1905. Studied: WMA; Cleveland Inst. A.;
Academie Colorossi, Academie de la Grande Chaumiere, Paris,
France; Academie Scandinave, with Despiau, Marcel Gimond. Mem-
ber: F.I.A.L.; Am. Soc. for Aesthetics; CAA; NSS. Awards: prizes,
Los Angeles County Fair, 1941; Syracuse Mus. FA, 1951, 1952, 1956;
Wichita Des. National, 1951; Mich. Acad. Sc., A & Let., 1961; Detroit
Inst. A., 1952; Frank Bernard Award, Ball State T. Col., 1961; nu-
merous prizes Cleveland May Shows, Houston A. Exhs., Texas and
Oklahoma Generals. Cleveland Creative Fine Arts award, 1964.
Work: CMA; Univ. Mus., Pomona, Cal.; Syracuse Mus. FA; Harvard
Univ. Lib.; Wichita AA; Mus. FA of Houston; Rice Univ.; Texas
Southern Univ.; Cranbrook Mus. A.; Ariana Mus., Geneva, Switzer-
land (Acad. Int. de la Ceramique); panels, Christ Lutheran Church,
Minneapolis (with Eeliel and Eero Saarinen); reliefs, and doors, San
Jacinto Monument, Texas; Fed. Trade Comm., Wash., D.C.; Texas
Mem. Mus., Austin; Lakeview Terrace Housing Project, Cleveland;
gateposts, Cleveland Zoo; capitals, Christ Church, Cranbrook; fig-
ures, Fairmount Presbyterian Chapel, Cleveland Heights, Ohio;
Abercrombie Laboratory, Rice Univ., Houston; statue, Wade Park,
Cleveland; Medusa Cement Nat. Hq., Cleveland; Masonic Temple,
Houston; Eastland Shopping Center, Detroit (with Victor Gruen);
Berry Monument, Cleveland Mun. Airport; relief, Jewish Community
Center, Cleveland; John Carroll Univ., Cleveland; monuments, Tex-
arkana, Tex., Ozona, Tex.; Founders Mem., Brookside Sch., Bloom-
field Hills, Mich.; 34 ceramic tiles, Hanzen Col., Rice Univ.; 5-ton
terrazzo whale, Lincoln Center, Urbana, Ill., and many others. Win-
ning model for 9' statue of Sir Winston Churchill for British Em-

bassy, by the English Speaking Union, Washington, D.C., 1965 (installed 1966); St. Margaret of Scotland, Nat. Cathedral, Wash. D.C. Other work in over 50 private collections. Positions: Hd., Sculpture Dept., Cranbrook Acad., 1947-54; Hd., Sculpture Dept., Cleveland Inst. A., Cleveland, Ohio, 1954-1968; Nat. Fulbright Selection Com., 1959, Chm., 1960, 1961, 1962. Fine Arts Advisory Committee to the City Plan Commission, 1965-1968; Bd. of Governors, Int. Platform Assn.

McVICKER, J. JAY—Painter, S., Gr., E.
Oklahoma State University 74075; h. Route 2, Stillwater, Okla. 74074
B. Vici, Okla., Oct. 18, 1911. Studied: Oklahoma State University, B.A., M.A. Member: Audubon A.; SAGA; Phila. Pr. Cl. Work: Joslyn Mem. Mus.; DMFA; MMA; Philbrook A. Center; LC. Exhibited: Denver A. Mus.; DMFA; Nelson Gal. A., and others. Positions: Prof., Hd. Dept. A., Oklahoma State University, Stillwater, Okla.

McWHINNIE, HAROLD JAMES—Printmaker, T., W.
School of Fine Arts, Ohio State University, Columbus, Ohio 43210
B. Chicago, Ill., July 15, 1929. Studied: AIC, B.A.E.; Univ. Oregon; Univ. Chicago, M.F.A.; Stanford Univ., Ed. D. Member: CAA; NAEA; Western AA. Awards: Huntington Hartford F., 1956; Fulbright Grant, 1960-61; Faculty Research Project, San Fernando Valley State Col., 1964-65; Faculty Fellowship, Ohio State Univ., 1966-1967. Work: Lowe Gal. A., Coral Gables, Fla.; Los A. Mus. A.; Pasadena A. Mus. Exhibited: LC, 1955, 1956; Phila. Pr. Cl., 1954-1958, 1959; Boston Pr. M., 1954, 1958; PAFA, 1954; Portland (Ore.) A. Mus., 1955; Portland, Me., 1957; Denver A. Mus., 1953; Renaissance Soc., Chicago, 1953-1958; AIC, 1952, 1958, 1960; De Pauw Univ., 1959, 1960; Los Angeles Print Soc., 1964; Ball State Col., 1964; Pasadena A. Mus., 1964; Dayton A. Inst., 1967, 1968; Pratt Graphic Center, N.Y., 1968; Toledo Mus. A., 1968; Antioch Col., 1967; Univ. California, Berkeley, 1967, 1969; one-man: Stanford Univ., 1962; San Fernando Valley State Col., 1964; Ohio State Univ., 1965-1967. Contributor to Art & Activities; School Arts; Ceramic Monthly; Studies in Art Education; Acta Psychologica; Journal of Aesthetic Education; British Journal of Aesthetics; College Art Journal; Art Education. Positions: Prof. A., Ohio State University, Columbus, Ohio, 1965- .

McWHORTER, ARTHUR A., JR. — Painter, T.
134 Filbert Ave., Sausalito, Cal. 94965
B. Aberdeen, S.D. Studied: Univ. Montana; Univ. Washington; Northern Col., Aberdeen, S.D. Member: AAPL; Soc. Western A.; Santa Cruz A. Lg.; AWS; F.I.A.L. Awards: prizes, Montana State Fair, 1950, 1951. Exhibited: Soc. Western A., 1960, 1961; Univ. Santa Clara, 1960; FA Assoc., 1960; Canon City, Colo., 1960 (one-man); Santa Cruz A. Lg., 1959-1961; Pueblo Jr. Col., Colo., 1960 (one-man); Ferrell Gal., El Paso, 1959-1961; Gallery FA, San F., 1959-1961; Art Fair Gallery, Sausalito, 1961 and one-man, 1961. Instr., watercolor marines, landscape, private classes.*

MADSEN, VIGGO HOLM—Painter, T., Gr., W.
5 Meldon Ave., Albertson, L.I., N.Y. 11507
B. Kaas, Denmark, Apr. 21, 1925. Studied: Syracuse Univ., B.F.A., M.F.A.; N.Y. State T. Col., Cortland, N.Y.; N.Y. Univ.; Columbia Univ.; Instituto de Allende, Mexico, with Jack Pinto. Member: N.Y. State A. T. Assn. (Pres., 1964-65); NAEA; Prof. A. Gld.; Eastern AA; Long Island A. T. Assn. (Pres., 1959-60); Phila. P. Cl.; Am. Craftsmen's Council. Awards: prizes, Syracuse Univ., 1951; N.Y. State A. T. Exh., 1957, 1965; Hofstra Univ., 1958, 1968; Locust Valley, L.I., 1963, 1965; Massapequa (L.I.) Symphony A. Exh., 1962; Lincoln House, 1964; Long Beach AA, 1964-1966, 1968; Huntington A. Lg., 1966, 1967; L.I. Craftsman Gld., 1966, 1967; Int. Platform Assn., 1967; NAC, 1958; and others. Work: Peck Mem. Lib., Marathon, N.Y.; Doniphan Pub. Lib., Doniphan, Mo.; Nassau Community Col.; C. W. Post Col.; and in private colls. Mural, Phila. Y.M.C.A. Camps, Downingtown, Pa. Exhibited: Silvermine Gld. A., 1956; A. Lg. of Long Island, 1956; Syracuse Mus. FA, 1950-1954; Rochester Mem. A. Gal., 1953, 1954; Heckscher Mus., Huntington, N.Y., 1956-1958; Bryant Lib., Roslyn, N.Y.; Suffolk Mus., Stony Brook, L.I.; Wantagh Pub. Schs.; colored graphics exh., Grenchen, Switzerland, 1964; Drawings:USA, St. Paul A. Center, St. Paul, Minn.; Albany Pr. Cl., Albany, N.Y.; U.S. Senate Chambers, Wash., D.C.; one-man: Syracuse Univ., 1951; Marathon (N.Y.) Pub. Lib., 1953-1956; Doniphan, Mo., 1956; Rockville Centre Pub. Lib., 1956-1958; Panoras Gal., N.Y., 1958, 1961, 1963-1965; Retrospective, Oceanside Pub. Lib. A. Gal., 1965; Setauket A. Gal., 1958. Contributor to N.Y. State Art Teachers Newsletter; Art Education Journal; Art in Action; Eastern Arts Bulletin. Positions: Instr. A., Marathon and Rockville Centre, N.Y. Pub. Schs. and Adult Evening Classes; Roslyn (N.Y.) H.S.; Adult Edu. Div., City Col. of N.Y.; Instr., Nassau Community Col.; Dir. of Exh., Baiter Gal., Huntington, L.I., N.Y.

MAEHARA, HIROMU—Painter, Des., T.
2885 Kalili Valley Rd., Honolulu, Hawaii 96814
B. Nawiliwili, Kauai, Hawaii, Nov. 1, 1914. Studied: N.Y. Sch. Des. Member: Assn. of Honolulu Artists. Awards: prizes, Honolulu Artists, 1955, 1957, 1959-1961 (3 Grand Prizes), 1966, 1967, 1968, 1969; 50th State Exh., 1960; Int. Assn. Printing House Craftsmen, Cincinnati, 1954; Hawaii Home Bldrs., 1966. Exhibited: Honolulu Artists, 1941-1961. Positions: Teaching Drawing & Painting, Honolulu; A. Dir. (Adv. Art), 14 years.

MAGAFAN, ETHEL—Painter
R.F.D. Box 284, Woodstock, N.Y. 12498
B. Chicago, Ill., Oct. 10, 1916. Studied: Colorado Springs FA Center, with Frank Mechau, Boardman Robinson, Peppino Mangravite. Member: NA. Awards: Fulbright F., 1951; Tiffany scholarship, 1949; Stacey scholarship, 1947; prizes, NAD, 1951, 1956, 1964, 1967; Hallmark award, 1952; AWS, 1955, 1962; SFMA, 1950; Nat. Exh., Pomona, Cal., 1956 (purchase); Norfolk Mus. A., 1957; Ball State T. Col., 1958 (purchase), 1964; Albany Inst. Hist. & A., 1962; N.Y. State Fair, 1962; purchase prizes: Portland (Me.) Mus. A., 1959; Columbia Mus. A., 1959; Childe Hassam Fund, 1958, 1961; Ranger award, 1964; purchase award, Springfield (Mo.) Mus. A., 1966; Berkshire AA, 1966-1968; Conn. Acad. FA, 1966. Work: Butler Inst. Am. A.; Portland (Me.) Mus. A.; Columbia Mus. A.; Newark Mus.; Howard Univ.; MMA; Denver A. Mus.; Wilmington Soc. FA; Norfolk Mus. A.; Des Moines A. Center; murals, Senate Chamber, Recorder of Deeds Bldg., Social Security Bldg., all in Wash., D.C.; USPO, Auburn, Neb.; Wynne, Ark.; Madill, Okla.; South Denver Branch, Colo; Colo. Springs FA Center; Ball State T. Col.; Univ. So. Illinois; Univ. of Notre Dame; Munson-Williams-Proctor Inst. Mus. A.; N.Y. State Univ. at Albany; Springfield (Mo.) Mus.; Weatherspoon Gal., Univ. North Carolina; Rotron Europa, Breda, Holland. Exhibited: one-man: Denver A. Mus., 1938; Utah State A. Center, Salt Lake City; Contemp. A., N.Y., 1940; Raymond & Raymond Gal., Beverly Hills, 1944; Santa Barbara Mus. A., 1944; Scripps Col., 1945; Ganso Gal., 1950, 1953, 1954; Athens, Greece, 1952; Schenectady Mus. A., 1953; Albany Inst. Hist. & A., 1955; Univ. Maine, 1958; Phila. A. All., 1959; Ulster Co. Community Col., 1963; Colorado Springs FA Center, 1968; Univ. Hartford, 1968; Gal. Mod. A., Scottsdale, Ariz., 1968; Midtown Gal., N.Y. 1969; Seligmann Gal., N.Y., 1961-1963; Provincetown, Mass., 1961-1963. Other exhibitions: Carnegie Inst., 1938, 1941, 1943-1945, 1947, 1952; AIC, 1937-1941; Colorado Springs FA Center, 1938-1940, 1945; NAD, 1940, 1942, 1943, 1948, 1953, 1955-1958, 1966-1969; Watercolor:USA, 1966-1968; Audubon A., 1966-1968; AWS, 1966-1969; Berkshire AA, 1966-1969; State Univ. at Albany, 1968; Kent State Univ., 1968; Flint Inst. A., 1966; Conn. Acad. FA, 1967; Phila. WC Soc., 1966-1968; MMA, 1942, 1950; PAFA, 1939, 1941, 1942, 1947-1949, 1952, 1954, 1967-1969; CGA, 1939, 1948, 1949, 1951, 1953; SFMA, 1941, 1945, 1946, 1948; Watkins Gal., Am. Univ., 1951; Birmingham Mus. A., 1952, 1953; Wildenstein Gal., 1949, 1952, 1955; Univ. Texas, 1951; Springfield Mus. A., 1951; Butler AI, 1953, 1954, 1957, 1958, 1966-1968; WMAA, 1952, 1957, 1958; Detroit Inst. A., 1958; Provincetown A. Festival, 1958; BM, 1958; Albany Inst. Hist. & A., 1950, 1952-1955; Munson-Williams-Proctor Inst., 1955, 1966-1969; Brandeis Univ., 1954; Univ. Illinois; BMFA; Dayton AI; Am. Embassy, Mexico City.

MAGRIEL, PAUL—Collector, W.
85 East End Ave., New York, N.Y. 10028
B. Mar. 12, 1906. Studied: Columbia University. Collection: Sport in art; American still life paintings, numismatics, drawings, watercolors; Collection has been exhibited in 84 American museums. Positions: Curator, Dance Archives, MModA, N.Y., 1939-1942.*

MAHONEY, JAMES OWEN — Painter, E.
Twin Glens Rd., Ithaca, N.Y. 14850
B. Dallas, Tex., Oct. 16, 1907. Studied: Southern Methodist Univ., B.A.; Yale Sch. FA, B.F.A.; Am. Acad in Rome, F.A.A.R. Member: NSMP. Awards: Prix de Rome, 1932. Work: murals, Hall of State, Dallas, Tex.; Johns Hopkins Univ.; All Saints Episcopal Church, Chevy Chase, Md.; Fed. Bldg., Communications Bldg., WFNY 1939; Adolphus Hotel, Dallas; Clinton Hotel, Ithaca, N.Y. Exhibited: PAFA, 1942; Grand Central A. Gal., 1935; Mace Gal., Dallas, 1946; Arch. Lg., 1936, 1938. Positions: Prof. FA, and Chm., Dept. A., Cornell Univ., Ithaca, N.Y., 1962- .*

MAITIN, SAMUEL (CALMAN) — Painter, Gr., T.
704 Pine St., Philadelphia, Pa. 19106
B. Philadelphia, Pa., Oct. 26, 1928. Studied: Univ. Pennsylvania, B.A.; Phila. Col. of A. Member: AEA; Nat. Soc. of the Study of Communication. Awards: purchase prize, Oakland A. Mus.; various print prizes, Phila. Print Cl.; gold medal, P. & S. of New Jersey; Guggenheim Fellowship, 1968-1969, and others. Work: Oakland A. Mus.; PMA; MModA; Victoria & Albert Mus., London; U.S. Office of Information; LC, Wash. D.C.; Camden A. Center, London; Pr. Cl.

Coll.; Smithsonian Inst.; Free Lib of Phila. Exhibited: PAFA; Phila. Pr. Cl.; Oakland A. Mus.; Yoseido Gal., Tokyo; Franz Bader Gal., Wash., D.C.; Carol Lane Gal., Houston; Comsky Gal., Los Angeles; Prints for People Gal., Phila.; PMA; A. All., Phila.; Curwen Gal., London, local and national exhs. and traveling shows. Contributor covers to Holiday Magazine. Positions: Taught Philadelphia Museum College of Art—10 years; Acad. FA and Moore Inst. A.; Philadelphia Museum of Art. Head of Graphic Communications Lab., Annenberg Sch. of Communications, Univ. of Pennsylvania, at present.

MAJORS, WILLIAM—Painter, printmaker
c/o Weyh Gallery, 794 Lexington Ave., New York, N.Y. 10021*

MAKI, ROBERT RICHARD—Sculptor, T.
14341 Interlake Ave. N., Seattle, Wash. 98133
B. Walla Walla, Wash., Sept. 15, 1938. Studied: Western Washington State Col., B.A. in Edu. and Indst. A.; Univ. Washington, M.F.A.; (summer) San Francisco A. Inst., 1967. Awards: Nat. Endowment for the Arts and Humanities, 1968. Work: Henry Gal., Univ. Washington; Washington Univ., St. Louis, Mo. Exhibited: Cal. State Col., Hayward, 1969; Governor's Invitational, State Capitol, Olympia, Wash., 1969; Donae Col., Crete, Neb., 1969; Portland (Ore.) Mus. A., 1968; Los Angeles County Mus., 1968; de Young Mus. A., San Francisco, 1968; SAM, 1968; Univ. Oregon Mus. A., 1968; Judd Gal., Portland, 1968; Palmer Gal., Los Angeles, 1967; Michael Walls Gal., San Francisco, 1967; Henry Gal., Univ. Washington, 1967; Central Washington State Col., 1967; Univ. North Carolina, 1966; Woodside Gal., Seattle, 1969. One-man: Walls Gal., 1969; Richard White Gal., Seattle, 1969; Richmond (Cal.) A. Center, 1967; Attica Gal., Seattle 1967. Positions: Instr., drawing and design, Univ. Washington, 1966-1968.

MAKLER, HOPE—Art dealer
Makler Gallery, 1716 Locust St., Philadelphia, Pa. 19103*

MALBIN, LYDIA WINSTON (Mrs. Barnett)—Collector, Patron
483 Aspen Rd., Birmingham, Mich. 48009
B. Detroit, Mich. Studied: Vassar College, B.A.; Cranbrook Academy of Art, M.F.A.; Wayne State Univ. Awards: Doctor of Humanities, Wayne State University, 1961; Cranbrook Award in Ceramics, 1944. Collection: 20th century art collection (formed with the late Mr. Harry Lewis Winston) of European and American painting, sculpture, graphics, drawings, from cubism, futurism, Dada, constructivism, and surrealism to works by Pollock, Tobey, Stella, Noland, and Morris Louis; Numerous articles have been published about the collection, including an article in "Great Private Collections," and articles in Arts, Art News, European journals, and other magazines and books; Collection was exhibited as a whole in 1957-1958 in Detroit and other cities. Positions: Member Detroit Commissioners of Art; Trustee, Founders Society, Detroit Institute of Arts; Chairman, Art Policy Committee of the Trustees for the Detroit Institute of Arts; Chairman, Arts Policy Committee, of Bennington College; AIC; Member, Advisory Committee, Skowhegan School of Art, Skowhegan, Me.; Member, International Council, MModA.

MALICOAT, PHILIP C.—Painter
320 Bradford St., Provincetown, Mass. 02657
B. Indianapolis, Ind., Dec. 9, 1908. Studied: John Herron A. Sch.; & with Hawthorne, Hensche, Dickinson. Member: Provincetown AA. (Hon. Vice-Pres. & Trustee). Awards: prize, Cape Cod AA, 1959; Chapelbrook Fnd. grant, 1968. Work: Chrysler Mus. A., Provincetown; Rochester Mem. A. Gal.; Smith College Mus., Northampton, Mass. and in many private collections. Exhibited: PAFA, 1933; CGA, 1935, 1937, 1939; NAD, 1936, 1938-1940, 1954; AIC, 1947; Phila. WC Cl., 1931, 1935; Inst. Mod. A., Boston, 1939; Provincetown AA, 1931-1964, 1966-1968; Seligmann Gal., 1947 (one-man); Boston A. Festival, 1955-1957; Chrysler Mus. A., Provincetown, 1958; Falmouth A. Gld., 1966-1968; Wellons Gal., 1955 (one-man); Art:USA, 1959; Shore Gal., Boston, 1959 (one-man); Miami Univ., Oxford, Ohio, 1960 (one-man); Graham Gal., N.Y., 1965 (one-man); traveling exh., Provincetown AA, 1964.

MALLARY, ROBERT—Sculptor, P., Gr., E.
463 Broome St., New York, N.Y. 10013; h. 239 Davenport Ave., New Rochelle, N.Y. 10805
B. Toledo, Ohio, Dec. 2, 1917. Studied: Laboratory Workshop, Boston, Mass., and in Mexico City. Awards: F., Tamarind Workshop (summer), 1962; Guggenheim Grant, 1964-1965, for Creative Sculpture; Artist-in-Residence, (AFA) to Crocker Gal., Sacramento, Cal., Jan.-Feb., 1965. Work: MModA; WMAA; Maremont Fnd.; Smith Col.; Brandeis Univ.; Women's Col., Univ. of No. Carolina; Univ. Texas; Kalamazoo A. Center; Univ. California, Berkeley; Roswell (N.M.) Mus.; Los A. Mus. A.; Univ. New Mexico, Santa Fe. Collaborator (with Dale Owen) mural, Beverly Hilton Hotel, Beverly Hills, Cal. Exhibited: Stanford Univ., 1958 and traveling; Los A. Mus. A., 1951,

1953, 1954; Colo. Springs FA Center, 1953; Denver A. Mus., 1955; Sao Paulo, Brazil, 1955; MModA, 1959, 1961 and traveling; Great Jones Gal., N.Y., 1959; Guggenheim Mus., 1960; WMAA, 1960, 1962, 1964, 1966, 1968; Pace Gal., Boston, 1960; Stable Gal., N.Y., 1960; Martha Jackson Gal., N.Y., 1961; Inst. Contemp. A., Houston, 1961, 1962; Traveling exhibitions, AFA (2); Riverside Mus., N.Y., 1961; Paris, France, 1962; Seattle World's Fair, 1962; Carnegie Inst., 1962; DMFA, 1962; AIC, 1962; Allan Stone, Gal., N.Y., 1961, 1962 and prior. One-man: SFMA, 1944; Crocker A. Gal., Sacramento, 1944; Cal. Exhibitors Gal., Los A., 1951; Santa Barbara Mus. A., 1952; Gump's, San F., 1953; FA Gal. of San Diego, 1953; Urban Gal., N.Y., 1954; Col. FA, Univ. New Mexico, 1956; Jonson Gal., Albuquerque, N.M., 1957-1959; Santa Fe, 1958; Allan Stone Gal., N.Y., 1961, 1962, 1966; 20 year survey exhibition, State Univ. College at Potsdam, N.Y., 1969.

MALLORY, MARGARET—Collector
305 Ortega Ridge Rd., Santa Barbara, Cal. 93103
B. Brooklyn, N.Y., Oct. 30, 1911. Collection: 19th and 20th century European and American paintings, drawings, sculpture; Baroque sculpture. Positions: President, Falcon Films, Inc. (Art documentary film company), producers of "Henry Moore," "French Tapestries Visit America," "Grandma Moses"; Trustee, Santa Barbara Museum of Art; Trustee, Marine Historical Association, Mystic, Conn.; Chariman, Affiliates of Art, University of California at Santa Barbara.

MALLORY, RONALD—Sculptor
509 E. 72nd St.; h. 333 E. 69th St., New York, N.Y. 10021
B. Los Angeles, Cal., June 17, 1935. Studied: Univ. Florida, B. Arch.; Univ. Colorado, B.A. Work: MModA; WMAA; Univ. Mus., Berkeley, Cal.; Inst. Contemp. A., Boston; Inst. Contemp. A., Philadelphia; MModA, Munich, Germany; Chase Manhattan Bank, N.Y. Exhibited: WMA, 1967; Paris, France, 1967; Di Tella Int., 1969; MModA, 1968; Univ. Cal. at Los Angeles; SFMA, 1966; Mus. Contemp. A., Houston, 1966; MModA, 1966; Kent Col., 1967; Krannert A. Mus., Univ. Illinois, 1967, 1968; Carnegie Int., 1967; Flint Inst., 1967; Larry Aldrich Mus., Ridgefield, Conn., 1967, 1968.

MALONE, LEE H. B.—Mus. Dir., T., L.
Museum of Fine Arts, 255 Beach Drive, N.E. 33701; h. 1222 Brightwaters, N.E., St. Petersburg, Fla. 33704
B. Las Cruces, N.M., May 28, 1913. Studied: Univ. Sch., Cleveland, Ohio; Yale Sch. FA, B.A., and in Switzerland. Member: AAMus.; Assn. A. Mus. Dir.; AFA; Century Assn., N.Y. Awards: W.L.Ehrich Mem. prize for research, Yale Univ., 1939. Author: "Spiritual Values in Art," 1953. Lectures: "Venetian Villas," MMA, 1959; "Still Life," BMFA, 1961. Exhibitions arranged: "Art in Colonial Mexico," 1952; "The Three Brothers," 1957; "The Human Image," 1958. Positions: Aide to Dir., Yale Univ. Gal., 1937-39; Instr., Hist. A., Notre Dame Col., Staten Island, N.Y., 1940; Dir., Columbus Gal. FA, Columbus, Ohio, 1946-53; Dir., Mus. FA of Houston, Houston, Tex., 1953-59; Exec. Dir., Nat. Development Com., Pierpont Morgan Library, New York City, 1960-1961; Art Consultant, New York, N.Y., 1961-67; Dir., Mus. FA, St. Petersburg, Fla., 1968- .

MANCA, ALBINO—Sculptor
131 West 11th St., New York, N.Y. 10011
B. Tertenia, Sardinia, Italy, Jan. 1, 1898. Studied: Royal Acad. FA, Rome, with Ferrari, Zanelli. Member: NAD; F., NSS; AAPL; All. A. Am. Awards: prizes, Royal Acad. FA, Rome, 1926, 1927; Animal in Art Exh., Rome, 1938; Montclair A. Mus., 1941; AAPL, 1941, 1950; All. A. Am., 1943; NAD, 1964. Work: Monument, Cagliari, Italy; USPO, Lyons, Ga.; many portraits, busts, medals; Nat. Mus., Sassari, Italy; Gal. Modern A., Littoria, Italy; Brookgreen Gardens, S.C.; Henry Hering Memorial Medal, 1959; Emblem of the Louise DuPont Crowninshield Award of the Nat. Trust for Historic Preservation, 1960; New York City East Coast Mem., Battery Park, 1961; sculpture, Fairmount Park Assn., Phila. Pa.; "Verrazano" portrait, Verrazano-Narrows Bridge, N.Y. (1965); Sculptural entrance—gate to the Children's Zoo, Flushing-Meadows, N.Y., 1968; Commemorative medals in numismatics collections of: Smithsonian Inst.; American Numismatic Soc.; MMA, and work in private colls. Exhibited: Nationally and internationally. Positions: Former Professor, Academy of Fine Arts, Rome, Italy.

MANDEL, HOWARD—Painter, S., I.
285 Central Park West, New York, N.Y. 10024
B. Bayside, N.Y., Feb. 24, 1917. Studied: PIASch.; N.Y. Sculpture Center; ASL; and with Fernand Leger, Andre Lhote, Paris, France. Member: AWS. Awards: Tiffany F., 1939, 1949; Hallmark Award, 1949, 1952, 1955; Fulbright F., 1951-52; grant, Nat. Inst. A. & Let., 1955; A. Dir. Cl., prize, 1955; Du Prix Arts, M.G.M., Paris, France, 1952. Work: Ft. Stanton Marine Hospital, N.M.; Lexington (Ky.) H.S. Exhibited: Salon des Jeunes Peintres, Paris, 1952; MMA, 1950, 1952; WMAA, 1948-1955; AWS, 1937-1955; PAFA; AIC; CGA; Del-

gado Mus. A.; Munson-Williams-Proctor Inst.; Columbia (S.C.) Mus. A.; Norton Gal. A.; High Mus. A.; NAD; one-man: Assoc. Am. A., 1949; Ganso Gal., 1951, 1953; Phila. A. All., 1955; Fairleigh Dickinson Col., Rutherford, N.J., 1955; Luria Gal., Miami, Fla., 1968.

MANDELBAUM, DR. and MRS. ROBERT A. — Collectors
 571 Ocean Ave., Brooklyn, N.Y. 11226
(Mrs. Mandelbaum) — B. New York, N.Y., Dec. 20, 1920. Studied: Mt. Holyoke College. (Dr. Mandelbaum) — B. New York, N.Y., Feb. 11, 1922. Studied: Wesleyan University; New York University College of Medicine. Collection: African Sculpture; Modern Sculpture, including works by Moore, Marini, Lipchitz, Chadwick, Calder, Lipton, Stanckiewicz, Penalba, Arp; Modern Painting, including works by Knaths, Weber, O'Keeffe, Shahn, Avery, Davis, Sutherland, Nicolson, Davie, Greene, Gatch, Burchfield, Ernst, Pearlstein, Rattner, Wonner; Modern Graphics.*

MANGIONE, PATRICIA ANTHONY — Painter
 2048 Cherry St., Philadelphia, Pa. 19103
B. Seattle, Wash. Studied: Fleisher A. Mem., Phila.; Barnes Fnd., Merion, Pa.; and with Leon Karp. Member: Phila. A. All.; AEA (Vice-pres. 1961-63, Dir., 1963 of Phila. Chapter); Phila. A. T. Assn. Awards: MacDowell Assn. Fellowships, 1957-1967; Yaddo Fellowships, 1962, 1963, 1966, 1968; Fleisher A. Mem. Medal, 1948; Gold Medal, Plastic Cl., Phila., 1953, Silver Medal, 1954; Phila. A. T. Assn. prize, 1957, 1964; Da Vinci Assn. prize, 1960. Exhibited: MMoDA, 1963-1969; BMA, 1957; Dayton AI; Phila A. All., 1953, 1955, 1958, 1960, 1962, 1964, 1966, 1968; PMA, 1958, 1963; Moore Col. A., 1962-1968; PAFA, 1961, 1964; Smithsonian Inst., 1958, Butler Inst. Am. A. 1958; Am. Acad. A. & Lets., 1963; Albright-Knox A. Gal., 1968; One-man: Rehn Gal., N.Y., 1960, 1963, 1965, 1968; Gallery 252, Phila., 1968; Yaddo, Saratoga Springs, 1963, 1968; Fontana Gal., Narberth, Pa., 1961; Carlen Gal., Phila., 1958, Wellons Gal., N.Y. 1954; Phila. A. All., 1953, 1954, 1957, 1960; U.S. Information Service Gal., Palermo, Italy, 1965. Work: Inst. Contemp. A., Dallas; Moore Col. A.; Fleisher A. Mem., private collections. Positions: Instr., Fleisher A. Mem., 1948-1961.

MANGOLD, ROBERT — Painter, T.
 90 Eldridge St., New York, N.Y. 10002
B. North Tonawanda, N.Y. Studied: Cleveland Inst. A.; Yale Univ., B.F.A., M.F.A. Awards: Nat. Council on the Arts, 1966; Guggenheim Fnd. Fellowship, 1969. Work: WMAA; MMoDA; Los Angeles County Mus. Exhibited: Thibaut Gal., N.Y., 1962 (3-man); Fischbach Gal., N.Y., 1964, 1965, 1967, 1969 (one-man); Müller Galerie, Stuttgart, W. Germany (one-man), 1968. Positions: Instr., Hunter College, N.Y., 1964- ; School of Visual Arts, N.Y., 1964-1969.

MANGRAVITE, PEPPINO — Painter, E., Lith., W.
 West Cornwall, Conn. 06796
B. Lipari, Italy, June 28, 1896. Studied: Scuole Techniche, Belle Arti, Italy, and with Robert Henri; ASL; CUASch., N.Y. Member: Century Assn.; NSMP. Awards: Medal and Citation, and named a Cavaliere Ufficiale of the Order "Al Merito della Repubblica Italiana" by the Italian Government, 1960, for "his contributions to the American art community and for the Distinction he has brought to Italy." Guggenheim F., 1932, 1935; prizes, GGE, 1939; Woodmere Gal., Phila., Pa., 1944; Grant, Am. Inst. A. & Let., 1950; gold medal, Sesquicentennial Expo., Phila., 1926; Silver medal & Prize, AIC, 1942; Eyre Medal, PAFA, 1950; Silver medal, Arch. Lb., 1955; Citation, Cooper Union, N.Y., 1956. Work: MMA; WMAA; CGA; CAM; PC; AIC; Denver A. Mus.; Cal.PLH; CM; Colorado Springs FA Center; PAFA; Carnegie Inst.; Santa Barbara Mus. A.; LC; Encyclopaedia Britannica; murals, USPO, Hempstead, L.I., N.Y.; Atlantic City, N.J.; Jackson Heights, L.I., N.Y.; mosaic murals, St. Anthony's Shrine, Boston, Mass. Exhibited: nationally and internationally. Contributor to art magazines with articles on art and art education. Positions: Trustee, AFA, 1940-42; Am. Acad. in Rome, 1948-49; Prof. Emeritus, Painting, Dept. Painting & Sculpture, Columbia University, New York, N.Y.

MANKOWSKI, BRUNO — Sculptor, P., C.
 2231 Broadway, New York, N.Y. 10024
B. Germany, Oct. 30, 1902. Studied: BAID, and in Berlin, Germany. Member: NA; NSS; All. A. Am.; Audubon A.; AAPL; Arch. Lg.; F., Am. Numismatic Soc. Awards: Certif. Craftsmanship, N.Y. Building Congress, 1937; prizes, New Jersey State Exh., 1945; NSS, 1953; AAPL, 1955, 1956; Syracuse Mus. FA, 1949; Medallic Art Comp., 1949; Nat. Inst. A. & Let. grant, 1950; Mus. A. & Crafts, Meriden, Conn.; Lindsey-Morris Mem. prize, All. A. Am., 1960 and the Daniel Chester French award, 1965; Saltus Medal, Am. Numismatic Soc., 1960. Work: Steuben Glass Co.; USPO, Chesterfield, S.C.; monument, Brooklyn, N.Y.; Loyola Seminary, Shrub Oak, N.Y.; Va. Polytechnic Inst.; plaque, Macombs Jr. H.S., N.Y.; figureheads, SS. Independence and Constitution; plaque, Medallic Art Co. Bldg.; Motion Picture Pioneers Award plaques; MMA; Michigan State Col.;

U.S. Capitol, Wash., D.C.; Franklin D. Roosevelt Commemorative medal; Soc. of Medalists medal. Exhibited: Am. Acad. A. & Lets., 1949, 1950; PMA, 1949; PAFA, 1948-1954; NAD, 1948-1950, 1956, 1958, 1969; Arch. Lg., 1949, 1957; Syracuse Mus. FA, 1949, 1950, 1958; NSS, 1948-1952, 1956-1958, 1968; NAWA, 1950, 1951; Parke-Bernet Garden Exh., 1951, 1952; AAPL, 1955, 1956; All. A. Am., 1956, 1957, 1968; Meriden A. & Crafts, 1956-1958; NAC, 1957; Audubon A., 1969, and others. Positions: Chm. Exh. Com., NSS, 1956-1958.

MANN, DAVID — Art dealer
 Bodley Gallery, 787 Madison Ave., New York, N.Y. 10021*

MANN, MRS. FERDINAND. See Dehner, Dorothy

MANN, MR. and MRS. T. B. — Collectors
 441 Drexel Dr., Shreveport, La. 71106*

MANNEN, PAUL WILLIAM — Painter, E., L., W.
 1700 S. Luna St., Las Cruces, N.M. 88001
B. Topeka, Kans., June 22, 1906. Studied: Univ. Kansas, B.F.A.; Ohio State Univ., M.A. and with Profs. Albert Bloch, Karl Mattern and Raymond J. Eastwood. Member: Kansas Fed. A.; AAUP; Prairie WC Painters; MacDowell FA Soc. Awards: prize, Dayton AI, 1943. Work: Thayer A. Mus., Student Mem. Union, Pub. Sch., Pub. Lib., all in Lawrence, Kans. Exhibited: Kansas City AI, 1931-1934, 1936, 1941, 1942; Joslyn Mus. A., 1934, 1491; Columbus Gal. FA, 1938; Kansas Artists, 1936-1941; Prairie WC Traveling Exh., 1937-1942, 1959-1964; Kansas Traveling Exh., 1938, 1951, 1955, 1958-1964; Mus. New Mexico Traveling Exh., 1954-55; Dayton AI, 1942; Prairie WC Painters, 1959-1961; Mus. N.M., Santa Fe, 1959; N.M. State Univ. Faculty exh., 1959; Las Cruces, N.M. Chihuahua, Mex., 1965; Univ. Juarez, Mex. 45 one-man exhs. including Canton AI, 1960; Okla. Col. for Women, 1960; El Paso Lib., 1960, 1964; N.M. State Univ., 1960, 1962; Philbrook A. Center, Tulsa, 1962; Alamogordo Lib., 1964; Univ. Kansas, 1961; McNeece State Univ., Lake Charles, La.; Calhoon Jr. College, Decatur, Ala. (2). Lectures: Mexican Arts & Crafts; European Art, with personal collection of over 10,000 color slides of painting, sculpture and architecture, photographed from original objects in U.S., Mexico and Europe. Positions: Prof. A., H. A. Dept., Oklahoma Col. for Women, Chickasha, Okla., 1945-48; Prof. A. & Hist. A., Hd. & Fndr. A. Dept., New Mexico State Univ., 1948-1959, Prof. A. Painting, & A. History, 1959- .

MANNING, REG(INALD) (WEST) —
 Cartoonist, W., Des., L.
 Republic-Gazette Bldg.; h. 5724 East Cambridge St., Scottsdale, Ariz. 85257
B. Kansas City, Mo., April 8, 1905. Member: Arizona Press Cl.; Nat. Cartoonists; Phoenix Press Cl.; Am. Assn. Editorial Cartoonists; Phoenix FA Assn. Awards: Pulitzer prize, 1951; Nat. Airborne Assn., Ernie Pyle award, 1955; Freedom Fnd. award, 1950, 1951, 1952, 1955, 1959, 1960, 1961, 1963, 1967, 1968; Nat. Safety Council award, 1957. Work: Cartoons in Reg Manning Collection, Syracuse Univ.; also in LC, Huntington Lib., Missouri State Hist. Soc. Author:, I., "Cartoon Guide of Arizona," 1938; "What Kind of Cactus Izzat?," 1941; "From Tee to Cup," 1954; "What is Arizona Really Like?" 1968. Positions: Cart., Arizona Republic, 1926-48; Ed. Cart. McNaught Syndicate, 1948- .

MANNO, JOHN — Sculptor, T., L.
 155 Chambers St., New York, N.Y. 10007
B. New York, N.Y., Apr. 27, 1922. Studied: Sculpture Center, N.Y.; ASL. Awards: Ford Fnd.-American Federation of Arts Artist-in-Residence Grant, N.Y., 1965. Work: AFA. Exhibited: WMAA, 1964-65; Southwestern Col., 1964; La Jolla Mus. A., 1964; Jersey City Mus. A., 1959; one-man: N.Y. Univ., 1965; Greenross Gal., 1965; Bridge Gal., 1962, 1964; Osgood Gal., 1962; Sculpture Center, 1959; Henri Gal., 1965. Positions: Instr., metal sculpture, Aesthetics of Structure, Bd. of Education, Adult Edu., N.Y.; Pres., Co-Fndr., Bridge Gal., N.Y., 1962-1964.*

MANSFIELD, RICHARD HARVEY (DICK) — Cartoonist, L., T.
 Washington Evening Star, Washington, D.C.; h. 2800 Cheverly Ave., Cheverly, Md. 20785
B. Washington, D.C., Feb. 5, 1888. Studied: Corcoran A. Sch.; Evans Sch. Cartooning, Cleveland, Ohio. Member: Columbia Hist. Soc., Wash. D.C. Awards: prizes and other awards, Washington Times Nat. Comp. for Cartoonists; American Legion for school talks on Safety; Nat. Safety Council; D.A.R. award; Kiwanis award, and other commendations and citations for safety talks in schools; Cosmopolitan Award for cartoon, "Safety Circus," in the Wash., D.C., Md. & Va. Schools in promotion of Child Safety, 1960. Conducts cartoons show "Safety Circus" on TV. Work: Dist. of Columbia Hist. Soc. Positions: Cart., Washington, D.C. Evening Star; Creator of Sunday feature "Those Were the Happy Days," Sunday

Star, Wash., D.C., since 1926; Drawing Safety Cartoons publ. in 35 papers in State of Maryland, sponsored by Md. Traffic Safety Commission, at present.*

MANSO, LEO—Painter, T.
 206 W. 23rd St. 10011; h. 460 Riverside Drive, New York, N.Y. 10027
B. New York, N.Y., Apr. 15, 1914. Studied: NAD; New Sch. for Social Research. Member: AEA. Awards: prizes, Urbana, Ill., 1951 (purchase); Audubon A., 1952; Wesleyan Univ. A. Festival, Ill., 1954 (purchase); Emily Lowe Award; BM; Ford Fnd. purchase, 1962; Am. Acad. A. & Lets., purchase, 1963. Work: WMAA; Urbana, Ill.; Wesleyan Univ.; Loeb Mem. Center, N.Y. Univ.; Brandeis Univ.; Lichtenstein Mus., Israel; BMFA; MModA; Norfolk Mus. A.; Riverside Mus., N.Y.; BM; mural, Pub. Lib., Lincoln, Neb. Exhibited: WMAA, 1948-1950, 1952, 1955, 1961, 1963; PAFA, 1947-1950, 1952, 1953; Audubon A., 1946-1952, 1954; Walker A. Center, 1952; BM, 1949; WMA, 1951; AFA traveling exh.; Am. Abstract A.; CAM; Boston A. Festival; DMFA; Art:USA; Phila. A. All.; Smith Col.; Mt. Holyoke Col.; CGA; Grand Central Gal., 1963, 1964; Karlis Gal., Provincetown, 1963; one-man: Norlyst Gal., 1947; Mortimer Levitt Gal., 1950; Babcock Gal., 1953, 1956; Grand Central Moderns, 1957, 1960; Guadalajara, Mex., 1948; H.C.E. Gal., 1958; Columbia Univ., 1955; N.Y. Univ., 1958. Positions: Instr., Adj. Prof. A., Painting & Drawing, New York Univ.; Design & Drawing, Columbia Univ., 1950-56; Painting, Cooper Union Sch. A., New York, N.Y.; Guest Lecturer, MModA, Smith Col., Univ. Michigan, BM, etc. Co-Fndr., Provincetown Workshop Sch. of Painting & Drawing.*

MANVILLE, ELSIE—Painter
 175 Lexington Ave., New York, N.Y. 10016*

MARANS, MOISSAYE (Mr.)—Sculptor, L. T.
 127 Livingston St. 11201; h. 200 Clinton St., Brooklyn, N.Y. 11201
B. Kisinau, Roumania, 1902. Studied: Tech. Inst., Bucharest; Univ. Jassy, Roumania; CUASch.; NAD; PAFA; Cincinnati Acad. FA; BAID; N.Y. Univ. Member: F., NSS; Arch. Lg. (Vice-Pres., 1954-56); Audubon A., (Treas., 1955-56). Awards: prizes, PAFA; Football Coach of the year plaque comp., 1946; USPO Comp., York, Pa.; Avery award, Arch. Lg., 1957; AFA traveling exh.; silver medal, Arch Lg., 1953; Knickerbocker A., 1959; Henry Hering Medal, 1963 and Herbert Adams Medal, 1965, both NSS; Therese Richard Mem. Prize, 1967, and Sc. award, All. A. Am., 1968; Daniel Chester French Medal, NAD, 1967; Sculpture Award, Knickerbocker A., 1968. Work: Brooklyn Botanical Gardens; USPO, Boyertown, Pa.; Chagrin Falls, Ohio; West Baden Col., West Baden Springs, Ind.; WFNY, 1939; Temple Emanuel, Houston, Tex.; Norfolk Mus. A. & Sciences; First Presbyterian Church, Beloit, Wis.; First Universalist Church, Chicago; Har Zion Temple, Phila.; Community Church, N.Y.; Sunnyside Pub. Lib., Linden, N.J.; Church Center for The United Nations; Smithsonian Inst. Exhibited: NAD; All. A. Am.; Los A. Mus. A.; AFA; BM; Jewish Mus.; CGA; WFNY, 1939; WMAA; PMA; PAFA; NSS; Arch. Lg. Am.-Jewish Tercentenary; Univ. St. Louis, 1949; Univ. Minnesota, 1950; Mint Mus. A., 1950; Univ. St. Thomas, Houston, 1950; CMA, 1954; Sc. Center, N.Y., 1952, 1956; Detroit Inst. A., 1958; Audubon A., 1955-1958, and many others. Lectures: Sculpture, Brooklyn Col., Brooklyn, N.Y., 1955- .

MARANTZ, IRVING—Painter, T., S., Gr.
 198 Sixth Ave., New York, N.Y. 10013
B. Elizabeth, N.J., Mar. 22, 1912. Studied: Newark Sch. F. & Indst. A.; ASL, and in China. Member: AEA; Provincetown AA (Trustee). Awards: prizes, Pepsi-Cola (one-man at Opportunity Gal.); Cape Cod AA, 1953. Work: Norfolk Mus. A. & Sciences; Holbrook Mus., Univ. Georgia; Wisconsin State Univ., Stout State Univ., Menomonie, Wis.; Mansfield State Col.; N.Y. Univ., Loeb A. Center; Univ. Iowa; Ein Harod Mus., Israel; Tel-Aviv Mus., Israel; Fla. Southern Col.; Butler Inst. Am. A.; Living Arts Fnd.; Bayonne Jewish Community Center; Dartmouth Col. Portfolio publ. 1961, "A Series on Man"; outdoor sculpture, Bayonne (N.J.) Jewish Community Center, 1968. Exhibited: Butler Inst. Am. A., 1958; Newark Mus. A., 1958; N.Y. Univ., 1957; Congress for Jewish Culture, 1956-1958; Far East Exh., USIS; Audubon A., 1945, 1946, 1951; PAFA, 1947-1952; CGA, 1947, 1951; Univ. Illinois, 1948, 1950; WMAA, 1948; Carnegie Inst., 1949; VMFA, 1946; NAD, 1953; AFA traveling exh., 1955; Newark Mus. A., 1960; Nat. Inst. A. & Lets, 1968, 1969; one-man: Shore Studios, Provincetown, Mass., 1950, 1954, 1955; Babcock Gal., 1952, 1954, 1957, 1958, 1960, 1962, 1963; DeNagy Gal., Provincetown, 1960; Carpenter Gal., Dartmouth Col., 1961; Galleria Schneider, Rome, Italy, 1964; Univ. Iowa, 1964. Positions: Instr., Painting, Newark Sch. F. & Indst. A., 1949-52; Col. City of N.Y., 1951-52; Marantz Studio, 1951-61 (formerly Provincetown Sch. Ptg.). Artist-in-Res., Univ. Iowa, 1964; Visiting Professor, Univ. Georgia, 1965-1966; N.Y. Univ., 1966-1969.

MARCA-RELLI, CONRAD—Painter
 c/o Marlborough-Gerson Gallery, 41 E. 57th St., New York, N.Y. 10022
B. Boston, Mass., 1913. Awards: Logan Medal and purchase prize, 1954, and, Kohnstamm prize, 1963, both AIC; Ford Fnd. award, 1959; Detroit Inst. A., 1960 (purchase). Work: MModA; WMAA; Wadsworth Atheneum; MMA; Michener Fnd.; Guggenheim Mus., N.Y.; FMA; Detroit Inst. A.; CMA; and many more major museums. Exhibited: Univ. Nebraska; Carnegie Inst.; WMAA, retrospective, 1967; AIC; CGA; PAFA; Yale Univ. Gal. FA; Sao Paulo Biennale; Brussels World's Fair, and others, U.S. and abroad. One-man: Stable Gal., N.Y., 1953-1958; Perls Gal., Hollywood, Cal., 1956; Kootz Gal., N.Y., 1959-1963; retrospective, Sharon, Conn., 1960; Bolles Gal., San Francisco, 1961; Joan Peterson Gal., Boston, 1961; other exhs. in prior dates; also, Rome, Italy, 1957; Galeria Neviglio, Milan, 1957-1962; Galerie Schmela (with Motherwell), Dusseldorf, Germany, 1961; Lima, Peru, 1961; Zurich, 1963; Tokyo, Japan, 1963, etc. Positions: Visiting Critic, Yale Univ., Univ. Cal., Berkeley and New College, Sarasota, Fla.

MARCEAU, HENRI—Museum Curator
 Philadelphia Museum of Art; h. 8028 Roanoke Court, Philadelphia, Pa. 19118
B. Richmond, Va., June 21, 1896. Studied: Columbia Univ., B.Arch.; F., Am. Acad. in Rome. Member: Am. Philosophical Soc. (1949-). Author: numerous exhibition catalogs, etc. Contributor to: art magazines in U.S. & abroad. Positions: Cur., John G. Johnson Coll., PMA, Philadelphia, Pa., 1926- ; Asst. Dir., PMA, to 1945; Assoc. Dir., PMA, to 1955, Dir., 1955-1964, Cur., John G. Johnson Collection, 1964- ; member Phila. A. Comm., 1943- , Vice-Pres., 1947- ; member Advisory Com., Walters A. Gal., Baltimore, Md., 1935-59; Hon. Assoc. AIA; Hon. D.F.A., Temple Univ., Franklin & Marshall College, Beaver College; Vice-Pres., Fairmount Park Assn.; Hon. Member, Nat. Soc. A. Dirs.; Fellow, Int. Inst. for the Preservation of Museum Objects; Chevalier, Belgian Order of the Crown; Chevalier, French National Order of the Legion of Honor, and other awards and citations.†

MARCUS, EDWARD S.—Collector
 Nieman-Marcus Company, 1624 Main St. 75201; h. 4007 Stonebridge, Dallas, Tex. 75204
B. Dallas, Tex., Oct. 13, 1909. Collection: Contemporary Art (American and European painting and sculpture); Pre-Columbian Art (Peruvian, Mexican). Positions: Founding President, Dallas Museum for Contemporary Art (now merged with Dallas Museum of Fine Arts).

MARCUS, IRVING E.—Painter, Gr., E.
 601 Shanri Lane, Sacramento, Cal. 95825
B. Minneapolis, Minn., May 17, 1929. Studied: Univ. Minnesota, B.A.; Univ. Iowa, M.F.A. Member: San F. AA. Awards: Minneapolis Inst. A., 1952 (purchase); Denver Mus. A., 1952, 1958; Temple Israel, St. Louis; Jacksonville (Ill.) A. Center, 1958; Crocker A. Mus., 1963. Work: Minneapolis Inst. A., Allen A. Mus., Oberlin Col.; Temple Israel, St. Louis; State Univ. of Iowa; and in many private collections. Exhibited: MMA, 1952; BM, 1952; Joslyn A. Mus., 1952; Denver Mus. A., 1952, 1959; Minneapolis Inst. A., 1952; LC, 1955; Northrup Gal., Univ. Minnesota, 1955; Wash. Printmakers (D.C.), 1956; Phila. Pr. Cl., 1956; WAC, 1956; Temple Israel, St. Louis, 1958; St. Louis A. Gld., 1958, 1959; CAM, 1958; Decatur A. Center, 1958; Jacksonville (Ill.) A. Center, 1959; San F. Inst. A., 1960, 1963, 1964; Crocker A. Gal., Sacramento, 1960-1964; Feingarten Gal., San Francisco, 1960, 1962; Belmonte Gal., Sacramento, 1962-1964; Feingarten Gal., Los Angeles, 1962, 1964; Cal.PLH, 1963; Orange State College, 1963; Redding (Cal.) Mus., 1963; Los A. Mus. A., 1963; La Jolla Mus. A., 1963; "Printmaking '64" touring, 1964; Luz Mus., Manila, Philippines, 1964; Univ. Wisconsin, 1964; one-man: Westgate Gal., Minneapolis, 1955; George Hall Gal., Univ. Hawaii, 1957; Martin Schweig Gal., St. Louis, 1959; Feingarten Gal., San Francisco and Carmel, both 1961; Barrios Gal., Sacramento, 1961 (2-man). Positions: Instr., Oberlin College, Ohio, 1955-56; Univ. Hawaii, 1956-57; Blackburn College, Carlinville, Ill., 1957-59; Prof., Painting & Printmaking, Sacramento State College, Sacramento, Cal., 1959- . Chm., Dept. A., 1966- .

MARCUS, MARCIA (BARRELL)—Painter
 703 E. 6th St., New York, N.Y. 10009
B. New York, N.Y., Jan. 11, 1928. Studied: N.Y. Univ.; ASL, with Edwin Dickinson. Awards: Fulbright Fellowship, 1962-63 to France; Ingrim Merrill award, 1965; Rosenthal Fnd. Award, Am. Acad. A. & Lets., 1965. Work: WMAA; Newark Mus. A.; Univ. Colorado; Woodward Fnd. Exhibited: WMAA, 1960, 1964; Carnegie Inst., 1964-65; CGA, 1965; Am. Acad. A. & Lets., 1965; many group exhibitions in various galleries since 1951.

MARCUS, STANLEY — Collector, Patron
Neiman-Marcus Co., Main and Ervay Sts., 75201; h. 1 Nonesuch Rd., Dallas, Tex. 75214
B. Dallas, Tex., Apr. 20, 1905. Studied: Harvard University, B.A.; Harvard Business School. Member: Advisory Committee, Dallas Association for the U.N.; Philosophic Society of Texas; Board of Directors, and Chairman of Resources Committee, Graduate Research Center of the Southwest; Board of Directors, Texas Law Enforcement Foundation; Research Fellow, Southwestern Legal Foundation; Committee for the Acquisition of American Art for the White House; Fellow, Pierpont-Morgan Library; Blair House Fine Arts Committee; Performing Arts Panel, Rockefeller Brothers Fund; Committee for the National Arts Trust Fund. Awards: Honorary Member, Dallas Chapter, American Institute of Architects; Chevalier of French Legion of Honor, 1949; "Star of Italian Solidarity," (Italian Government), 1956; Commandeur of Economic Merit (French Government), 1957; "Headliner," Dallas Press Club, 1958; Grand Officer, Confrerie des Chevaliers du Tastevin, 1958; Officier of French Legion of Honor, 1958; New York Fashion Designers Annual Award, 1958; Honorary Order of the British Empire, 1959; Chevalier of the Order of Leopold II (Bestowed by His Majesty King Baudouin of Belgium), 1959; Gold Medal, National Retail Merchants Association, 1961; Commendetore al Merito della Republica Italiana (Italian Government), 1961; Ambassador Award for Achievement, London, 1963; Royal order of Dannebrog (Danish), 1965. Positions: Trustee, Graduate Research Center, Inc., Southern Methodist University; Chairman, Texas Committee of Selection for Rhodes Scholarships; Board of Publications, Southern Methodist University; Board of Directors, New York World's Fair, 1964-1965; Trustee, American Federation of Arts; President, Neiman-Marcus, Dallas, Tex., 1950- .*

MARDEN, BRICE — Designer
74 Grand St., New York, N.Y. 10013
Exhibited: Bykert Gal., 1966, 1969.*

MAREMONT, ADELE H. (Mrs. Arnold H.) — Collector
614 Pine Lane, Winnetka, Ill. 60093
B. St. Louis, Mo., Jan. 30, 1902. Studied: Washington University, St. Louis, Mo. Collection: 20th century art; Arranged showings of private collection at Illinois Institute of Technology, March-April 1961, Washington, D.C. Gallery of Modern Art, March-April 1964; Works from private collection have been exhibited internationally. Positions: Women's Board, Community Music Schools of North Shore, 1950- ; Board, Winnetka Associate of AIC, 1953-1958; Women's Board, Lyric Opera of Chicago, 1955-1965; Acquisition Committee for 20th Century Art, AIC, 1962- ; International Council, MModA, New York, 1961- ; National Advisory Board, Washington, D.C. Gallery of Modern Art, 1962; Trustee, American Federation of Arts, 1964- .*

MAREMONT, ARNOLD H. — Collector
168 N. Michigan Ave., Chicago, Ill. 60601; h. 614 Pine Lane, Winnetka, Ill. 60093
B. Chicago, Ill., Aug. 24, 1904. Studied: University of Michigan, Ann Arbor, Mich.; University of Chicago, Ph.B., J. D. Member: AIC (Governing Life Member), 1956-1965. Collection: 20th century art. Positions: Trustee, Lyric Opera of Chicago, 1959-1965; Trustee, City Center of Music and Drama, New York, 1959-1965; Trustee, American Federation of Arts, 1958-1964.*

MARGO, BORIS — Painter, Gr., E., S.
8 East 18th St. 10003; h. 749 West End Ave., New York, N.Y. 10025
B. Wolotschisk, Russia, Nov. 7, 1902. Studied: Leningrad, Moscow, Odessa, Russia. Awards: prizes, Phila. Pr. Cl., 1946; AIC, 1947; purchase awards, BM, 1947, 1953, 1955, 1960, 1964; 1968 purchase award, Portland (Me.) A. Mus., 1960; Diploma of Merit, Saigon, Viet Nam 1st Int. Arts Exhibit. Work: MMA; WMAA; BM; PMA; BMA; CM; SFMA; Munson-Williams-Proctor Inst.; Phoenix Mus. A.; Evansville (Ind.) Mus.; CGA; Delgado Mus. A., AIC, Joslyn Mus. A., Sao Paulo, Brazil; U.S. Nat. Mus., Wash., D.C.; Univ. of Maine, Mich., North Carolina, Arizona, Louisville, Minnesota; Yale Univ.; Cornell Univ.; Brown Univ.; Syracuse Univ.; Ohio State Univ.; colleges: Albion, Dartmouth, Texas Wesleyan, San Jose State; public libraries; LC; New York City, Kansas City, Mo.; Currier Gal. A.; Research Studio, Fla.; R.I.Sch.Des.; Albright A. Gal.; Mass. Inst. Technology; IBM Coll.; U.S. Embassies; Chase Nat. Banks, and in many European print collections and in private collections in the U.S. Work included in Prize-winning Paintings, 1962 and in numerous art books on painting and printmaking. Exhibited: WMAA, 1946, 1950, 1952-1956; Walker A. Center, 1950; MMA, 1942, 1950, 1952; Univ. Michigan, 1950; Univ. Illinois, 1950-1952, 1954; AIC, 1950, 1951, 1954, 1956; Mus. A., Sao Paulo, Brazil, 1951, 1952, 1954; Museums in Tokyo and Osaka, Japan, 1951, 1957, 1962; AFA traveling exh., 1951; Carnegie Inst., 1952; Nat. Inst. A. & Let., 1953, 1958;

Betty Parsons Gal., 1946-1964 (one-man); MModA, 1954; LC, 1944, 1946, 1954; Nat. Acad., Rome, 1954; Fed. Modern P. & S., 1955; Barcelona, Spain, 1955; Biennale, Venice, Italy, 1956; Tate Gal., London; Retrospective traveling exhibition, 1963-1964 at Univ. Minnesota, Duluth, Norton Gal. A., West Palm Beach, and several Southeastern Museums. Positions: Instr., American Univ., Washington, D.C.; Univ. Louisville, Visiting Artist, AIC; Michigan State Univ.; Visiting Prof. A., Univ. Illinois, Syracuse Univ., Ohio State Univ. at Columbus, Univ. of Minn. (Duluth); Univ. of N. Carolina (Greensboro). Artist-in-Res. (Ford Fnd. Grant) Bowers Mus., Santa Ana, Cal. Inventor of cellocut process for making fine arts prints (1931).

MARGOLIES, ETHEL POLACHECK — Painter, Gallery Dir.
103 Jelliff Mill Rd., New Canaan, Conn. 06840
B. Milwaukee, Wis., Aug. 1, 1907. Studied: Smith Col., A.B.; Silvermine Gld. Sch. A., with Revington Arthur, Gail Symon; and with Umberto Romano, Robert Roche. Member: Silvermine Gld. A.; New Haven Paint & Clay Cl.; Conn. WC Soc. Awards: prizes, Burndy Engineering Award, Silvermine Gld. A., 1957, 1960, 1964; Electric Regulator Corp., 1954; New Haven Paint & Clay Cl., 1955 (purchase); Springfield A. Lg., 1957 (purchase); Int. Petroleum Corp. A. Festival award and purchase, 1966. Chautauqua AA, 1958. Work: Burndy Lib., Norwalk, Conn.; Springfield Mus. A.; New Haven Paint & Clay Cl. Exhibited: Audubon A., 1954, 1962-1969; ACA Gal., 1955-1958; Conn. Acad. FA, 1952-1969; Springfield A. Lg., 1955-1968; New Haven Paint & Clay Cl., 1952, 1954-1969; Conn. WC Soc., 1952-1965, 1968, 1969; Nat. Soc. Painters in Casein, 1958-1965; Silvermine Gld. A., 1953-1969; Chautauqua AA, 1958; New School, 1957; Art:USA, 1958 traveling exh.; Nat. Soc. Painters in Casein, 1958-1965. Positions: Gallery Dir., "Old Hundred," The Larry Aldrich Museum, Ridgefield, Conn., 1965, 1966; Gallery Dir., Silvermine Gallery, 1958-1965, 1967-1969.

MARGOLIES, JOHN SAMUEL — Writer, Critic.
299 W. 12th St., New York, N.Y. 10014
B. New York, N.Y., May 16, 1940. Studied: University Pennsylvania, A.B.; Annenberg School of Communications, University of Pennsylvania, M.A. Contributor of articles to Art Voices, Arts Yearbook, Arts Magazine and Art in America, 1966-1969; Exhibit and Program Coordinator in charge of overall events, lectures, exhibitions, social activities with emphasis on organization of environmental, multimedia events, Architectural League of New York, 1966-1968; Art Reviews and Criticism, Arts Magazine, 1967-1968. Member, Executive Committee, 1968-1971, Architectural League of New York.

MARGULIES, JOSEPH — Painter, Gr., L.
27 West 67th St., New York, N.Y. 10023
B. Vienna, Austria, July 7, 1896. Studied: NAD; ASL, and with Joseph Pennell. Member: AWS; SAGA; Chicago Soc. Et.; North Shore AA; SC; Audubon A. (Council); AAPL (Bd. memb.); All. A. Am.; Soc. Western A.; Provincetown Soc. A. Awards: F., Tiffany Fnd., 1920; prizes, NAD; A. Lg. Long Island, 1950, 1951, 1953; AAPL and Gold Medal; North Shore AA, 1954; Rockport AA, 1954, 1961; SC, Seeley purchase prize. Work: MMA; BM; SFMA; BMA; N.Y. State Capitol; N.Y. Theological Seminary; Queens Col.; Brooklyn Jewish Hospital; Yale Univ. Lib.; LC; N.Y. Pub. Lib.; Fed. Court, Brooklyn, N.Y.; Carnegie Inst.; Smithsonian Inst.; N.Y. County Bar Assn.; Midwood H.S., Brooklyn; MModA; State Capitol, Albany; Univ. State of New York; Bellevue Med. Col.; Albert Einstein Med. Col.; Willkie Mem. Bldg., N.Y.; Iowa State Col.; Brooklyn Col.; Col. City of N.Y.; Tel-Aviv Mus. Israel; Brandeis Univ; CMA; portraits: Chm. of The Judiciary, Judiciary House of Representatives, Wash., D.C.; Superior Court, Hartford, Conn., and Cambridge, Mass. and others. Exhibited: one-man: Smithsonian Inst.; Pan-Am. Bldg., Wash., D.C.; Stendahl Gal., Los A., Cal.; Midtown, Milch, Grand Central, Ferargil, Ainsley, Assoc. Am. A. galleries, N.Y.; Miami Beach A. Center, 1961. I., "Art of Aquatint," "Understanding Prints." Lectures: Making of an Etching; Contributor to Arts magazine with 3 articles (series) on Portrait Watercolor, 1957; ports. of Eisenhower & Nixon in Newsweek; work in other magazines.

MARIL, HERMAN — Painter, T.
5602 Roxbury Pl., Baltimore, Md. 21209
B. Baltimore, Md., Oct. 13, 1908. Studied: Baltimore Polytechnic Inst.; Maryland Inst. Member: CAA; AEA. Awards: prizes, BMA, 1935, 1939, 1940, 1946, 1951, 1952, 1960, 1961, 1963; Peale Mus., 1947, 1948, 1950, 1951; Riverside Mus., 1959; CGA, 1952, 1953, 1955; Silvermine Gld. A., 1963; Mead "Painting of the Year" award, 1963. Work: MMA; Encyclopaedia Britannica; BMA; Bezalel Nat. Mus., Jerusalem; CGA; VMFA; Newark Mus.; Univ. Arizona; Bernstein Mem. Coll.; Amherst Col.; PMG; Howard Univ.; American Univ., Cone Coll.; WMAA; Morgan Col.; Western Maryland Col., and others, murals, USPO, Alta Vista, Va.; West Scranton, Pa., Randolph-Macon Women's Col., (Va.); Baltimore Community Col. Exhibited: CGA, 1939, 1941, 1943, 1945; PAFA, 1935, 1938, 1939, 1943; VMFA, 1940, 1942, 1944, 1946; Macbeth Gal.; Provincetown A. Fes-

tival, 1958; Boston A. Festival, 1958; Carnegie Inst., 1943-1945; AIC; WMAA; Pasadena AI; Cal. PLH; WFNY, 1939; GGE, 1939; BMA annually; Retrospective exh., Univ. Maryland, 1957; Retrospective, BMA, 1967; one-man: Babcock Gal., 1953, 1956, 1959; Phila. A. All., 1955; Castellane Gal., N.Y., 1961; CGA, 1961; Wellfleet Gal., 1964, 1968; Forum Gal., N.Y., 1965, 1968; Bader Gal., Wash. D.C., 1963, 1968, & others. Monograph "Herman Maril," by Frank Getlen, published by Baltimore Mus. A., 1967. Positions: Prof., Dept. A., Univ. Maryland, College Park, Md., 1946- .

MARIS, VALDI S. (Mr.)—Painter, T., Cr., S.
Maris House, Gates Ave., East Brunswick, N.J. 08816
B. Riga, Latvia, Sept. 4, 1919. Studied: Acad. FA, Riga, Latvia; Univ. Heidelberg, Germany. Member: AEA (Bd. Directors, N.J. Chap., 1967-1968); Gld. Creative Art, Shrewsbury, N.J. Awards: prizes, New Jersey State Exh., Clinton, N.J., 1960, 1961, 1964; AAPL, 1959-1961. Work: in private colls., U.S., Canada, Australia and Europe, R.S. Pierrepont Coll., Princeton, N.J.; East Brunswick Pub. Lib., N.J. Exhibited: Jersey City Mus., 1956, 1967; nat. one-man traveling exh., 1963-1965; Reading Mus. A. (Pa.); Indianapolis; Smithsonian Inst.; Montclair A. Mus., 1954, 1955, 1960, 1961, 1963; Newark Mus. A., 1959; Festival of Arts, Princeton, N.J., 1962; Holyoke Mus., Mass.; Int. Platform Assn., Wash., D.C., 1967, 1968; A. Festival, Short Hills, N.J., 1969; and other New Jersey Exhs. Positions: Instr., Gld. of Creative Arts, Shrewsbury, N.J., and privately. Art Critic for Sunday Home News, New Brunswick, N.J., 1957-1965.

MARKELL, ISABELLA BANKS—Painter, Gr., S., C.
10 Gracie Square, New York, N.Y. 10028
B. Superior, Wis. Studied: Maryland Inst.; PAFA; Ecole des Beaux-Arts, Paris, and with Farnsworth, Brackman, O'Hara. Member: SAGA; Pen & Brush Cl.; Phila. Pr. Cl.; Wash. Pr.M.; Miami AA; All. A. Am.; AAPL; New Jersey Soc. P. & S.; Boston Soc. Pr.M.; Wolfe A. Cl.; NAWA; Royal Soc. P. & Et., London, New Haven Paint & Clay Cl., and others. Awards: prizes, Boston Pr.M., 1955; Pen & Brush Cl., 1953, 1955, 1964; Providence, R.I., 1953, 1955; NAWA, 1956, 1958-1960, 1964; Wilmington Soc. FA, 1958, 1964; N.J. Painters & Sculptors, 1956; AAPL, gold medals (3), 1960, prize, 1964; Smithsonian Inst., 1964, and others. Work: N.Y. Pub. Lib.; N.Y. Hist. Soc.; Mus. City of N.Y.; Northwest Pr.M.; MMA; Phila. Pr. Cl.; N.Y. Hospital; Providence Mus. A.; Pa. State Col.; Phila. Free Lib.; Grinnell Pub. Lib.; Wilmington Soc. FA; First Nat. Bank, Superior, Wis.; Rockefeller Fnd.; PMA; Norfolk Mus. A. & Sciences; many ports. of prominent persons. Exhibited: Newark Mus. A.; Northwest Pr.M.; MMA; BMA; Birmingham Mus. A.; High Mus. A.; All. A. Am.; N.Y. Hist. Soc.; AWS; SAGA; Mus. City of N.Y.; Argent Gal.; Pen & Brush Cl.; PAFA: Southampton, N.Y.; BMFA; NAWA; AAPL; Roanoke Mus. A.; Arch. Lg.; Engineering Cl., Audubon A.; LC; CAL.PLH; Laguna Beach AA; Irvington (N.J.) A. Mus.; Toronto A. Gal.; Miami Beach, Fla.; New Jersey Soc. P. & S.; New Haven Paint & Clay Cl.; Ringling Mus. A.; NAD; PMA; Wilmington Soc. FA; Royal Soc. P. & Et.; Milwaukee AI; SFMA; SAM; Smithsonian Inst.; Riverside Mus.; Soc. Wash. Pr.M.; Springfield Mus. A.; in Amsterdam, Brussels, Antwerp, Ostend, and many others. Traveling Exhs.: SAGA; LC; NAWA; Studio Cl.; Pratt Contemporaries. One-man: Univ. Tulsa; Univ. South Carolina; Mint Mus. A.; Hudson River Mus.; Bodley Gal.; Arch. Lg.; Cornell Col.; Douglas County Mus., Superior; N.Y. Pub. Lib.; Wustum A. Mus.; NAWA; Mus. City of New York; Albany Inst. Hist. & A.; Wilmington Soc. FA; N.Y. Pub. Lib.; Sanford Mus.; Neville Pub. Mus.; Pa. State Col.; Pen & Brush Cl., and many more.

MARKHAM, RONALD—Painter
c/o Dintenfass Gallery, 18 E. 67th St., New York, N.Y. 10021; h. 411 E. University St., Bloomington, Ind. 47401
B. Bronx, N.Y., May 29, 1931. Studied: Yale Univ., B.F.A., M.F.A. Work: MMA; MModA; AIC; BM; CM; WMA; Indiana Univ. Mus.; LC; Univ. Alberta Mus., Canada. Exhibited: MModA, 1960, 1966; WMAA, 1960, 1961; one-man: Kanegis Gal., Boston, 1959; Terry Dintenfass Gal., N.Y., 1965, 1966, 1968; Reed Col., Portland, Ore., 1966. Positions: Instr., Painting and Drawing, Indiana Univ., Bloomington, at present.

MARKOW, JACK—Painter, Lith., Cart. W.
2428 Cedar St., Manasquan Park, N.J.; h. 465 West 23rd St., New York, N.Y. 10011
B. London, England, Jan. 23, 1905. Studied: ASL, with Boardman Robinson, Richard Lahey and Walter Jack Duncan. Member: Nat. Soc. Cartoonists; ASL (Life); Magazine Cartoonists Guild. Work: MMA; Hunter Col.; Col. of City of N.Y.; BM; Univ. Georgia; Brooklyn and Queensboro Pub. Libs. Exhibited: one-man: ACA Gal., 1938; School of Visual A., N.Y., 1957; Hudson Gld. A., 1958. Cartoons in New Yorker, Saturday Evening Post, This Week, Times Book Review, Sunday Times Magazine, Holiday, Argosy, True, Sports Illustrated, Red Book, McCalls, Cosmopolitan, Saturday Review and other

national publications. Monthly column "Cartoonist Q's," Writer's Digest, 1963- . Author: "Drawing and Selling Cartoons" and "Cartoonist's and Gag Writer's Handbook." Positions: Instr., School of Visual Arts, New York, N.Y., 1947-1955; Cartoon Editor, Argosy Magazine, 1950-1952.

MARKS, MR. and MRS. CEDRIC H.—Collectors, Patrons
880 Fifth Avenue, New York, N.Y. 10021
Collection: Far Eastern, Near Eastern, Pre-Columbian Medieval and Classical antiquities. Have donated works to various museums and colleges in the U.S. and Israel.

MARKS, MRS. LAURENCE M.—Trustee
Frost Mill Rd., Mill Neck, N.Y. 11765
Positions: Board of Trustees, School Art League, N.Y.*

MARKS, ROYAL S.—Art Dealer, Collector
Royal Marks Gallery, 19 E. 71st St. 10023; h. 29 E. 64th St., New York, N.Y. 10021
B. Detroit, Mich., Sept. 11, 1929. Studied: Wayne University, Detroit. Specialty of Gallery: Works by Kupka, Tobey, Torres Garcia; also Delaunay, Robert, Villon, Jacques, Braque. Contemporary sculptors: Roger Bolomey, Robert Howard, Duayne Hatchett. Positions: Owner and Director, Royal Marks Gallery. New York. N.Y.

MARKS, STANLEY A.—Collector
910 Fifth Ave., New York, N.Y. 10021*

MARKUS, MR. and MRS. HENRY (Jeanette)—Collectors
1300 Lake Shore Drive, Chicago, Ill., 60610
Collection: Contemporary Art.

MAROZZI, ELI RAPHAEL—Sculptor, P., Gr., E., L., W.
1081 Young St., Honolulu, Hawaii 96814
B. Rome, Italy, Aug. 13, 1913. Studied: Menzinger A. Sch., Detroit; Univ. Washington, B.A.; Univ. Hawaii, M.A., and with Mark Tobey, Jaimini Roy (India). Member: Hawaii P. & S. Lg.; Honolulu Pr.M. Awards: prize, Hawaii, 1953. Work: Sun-dial fig., Hanahaoli Pub. Sch.; stone bas-relief, Tennent A. Fnd.; marble garden figures, Ramakrishna Vedanta Center, Seattle, Wash.; Watumull Fnd.; carved main capitals of the nave of St. Andrew's Cathedral. Exhibited: SAM, 1947-1949; Artists of Hawaii, annually since 1950; Honolulu Pr.M., annually since 1950; Hawaii P. & S. Lg., since 1953; Contemp. A. Center, 1962 (2-man), group show, 1965. Contributor to: Times of India; Vedanta for East and West; Essays in Philosophy (pub. in Madras). Honolulu Star-Bulletin. Lectures: Art of Sculpture; Art of Drawing; Printmaking, Mosaics, at Honolulu Acad. A.; Honolulu Assoc. A.; local TV programs. Positions: Instr., A., Univ. Hawaii, Honolulu Acad. A., Y.W.C.A. Adult Education.

MARSH, ANNE STEELE (Mrs. James R.)—Painter, Gr., T., C.
Fiddler's Forge, Pittstown, N.J. 08867
B. Nutley, N.J., Sept. 7, 1901. Studied: CUASch. Member: N.Y. Soc. Women A.; Assoc. A. New Jersey; NAWA; Delaware Valley AA; SAGA; Boston Soc. Pr.M.; Audubon A.; Pr. Cl. of Albany; Soc. Washington Pr.M.; Pen & Brush Cl.; P. & S. Soc. of New Jersey; Hunterdon A. Center (Dir. Exhibits). Awards: prize, Phila. Pr. Cl., 1952; NAWA, 1964; New Jersey State Mus., 1966; Hunterdon A. Center, 1965, 1966; Pen & Brush Cl., 1967; NAC, 1968. Work: Newark Pub. Lib.; MMA; N.J. State Mus., Trenton; Collectors of Am. A.; PMA; MModA; LC; Montclair A. Mus. Exhibited: MMA; NAD; AIC; WFNY 1939; AWS; BM; Newark Mus. A.; PAFA; Venice, Italy; SAGA; BMFA; CGA; Phila. A. All.; Portland A. Mus.; Wichita AA; Montclair Mus. A.; Albany Inst. Hist. & A.; SAM; Conn. Acad. FA; DMFA; Smithsonian Inst.; Silvermine Gld. A.; Everhart Mus. A., Scranton, Pa.

MARSHALL, JOHN CARL—Craftsman
Art Department, Syracuse University; h. 504 Fellows Ave., Syracuse, N.Y. 13210
B. Pittsburgh, Pa., Feb. 25, 1936. Studied: Cleveland Inst. A. (Silversmithing), B.F.A.; Syracuse Univ. (Craft-Metalworking), M.F.A. Member: Am. Craftsmens Council; AAUP. Awards: prizes, Sterling Silversmiths Gld. of America, 1964, 1965; Am. Craftsmens Council, 1966; Craftsmen:USA, Wilmington, Del., 1966 and Am. Craftsmens Council, 1966; Finger Lakes Regional, Rochester, N.Y., 1969; Thomson Prize, Ceramic National (Enamel), to become part of the Everson Museum's permanent collection and included in traveling exh., Syracuse, 1969. Work: Syracuse Univ.; Everson Museum; Johnson Wax Coll.; Memorial Trophy, Rolling Rock Hunt Racing, 1966; Altar Pieces, Cathedral of the Immaculate Conception, Syracuse, 1967. Exhibited: Sterling Silversmiths Gld. America, 1964, 1965; Annual Exh. of works by Artists & Craftsmen of Western Reserve, Cleveland, 1963; Mus. Contemp. Crafts, N.Y., 1967; Craftsmen:USA, 1966; Ceramic Nat., Everson Mus., 1966; Finger Lakes, Exh., Rochester Mem. Gal., 1966, 1969; Maryland Inst. A. Gal., 1965; Lowe A. Cen-

ter, Syracuse, one-man, 1966; State Univ. Col. at Cortland, N.Y., 1967; LeMoyne Col., Syracuse, 1968; work selected for International Film Strip, "Sterling Art Treasure for Today, 1967. Positions: Instr., Jewelry, Metalworking and Design, Syracuse Univ., N.Y., at present.

MARSICANO, NICHOLAS—Painter, E.
12 West Little 12th St., h. 23 W. 16th St., New York, N.Y. 10011
B. Shenandoah, Pa., Oct. 1, 1914. Studied: PAFA; Barnes Fnd. Awards: European traveling Scholarship, PAFA; (2) European traveling Scholarships. Barnes Fnd. Work: MModA; Hallmark Coll.; Michener Fnd., Pipersville, Pa.; Larry Aldrich Mus.; DMFA; Des Moines A. Center; BMA; Inst. Contemp. A., Boston; Huntington Gals., W.Va.; Weatherspoon Gal., Greensboro, N.C.; Univ. Texas, Austin; Mass. Inst. Tech.; N.Y. Univ.; Geigy Chemical Corp., and in private colls. Exhibited: PAFA, 1942; Stable Gal., N.Y., 1950-1955; Joslyn Mus. A., 1954; WAC, 1958; Vanguard, 1955; BM, 1950; Wagner Col., 1955; Douglass Col., Rutgers Univ.; Nebraska AA, 1954, 1958, 1960; WAC, 1955; Inst. Contemp. A., Boston, 1958; Provincetown A. Festival, 1958; New Haven A. Festival, 1959; Palacio de Bellas Artes, Mexico, 1960; Hallmark, 1960 (award); AFA, 1960-61; AIC, 1961, 1964; traveling exh., South America, MModA, 1962, 1966; PAFA, 1962; MModA, 1961, 1962; Mus. Contemp. A., Dallas, 1962; WMAA, 1960-1962; Univ. Kentucky, 1963; Larry Aldrich Mus., Ridgefield, Conn., 1964; "Art in Embassies" (auspices of MModA), 1965-1967; Univ. Texas, Austin, 1964, 1966, 1968; Gallery of Modern Art, N.Y., 1965; Weatherspoon A. Gal., Greensboro, N.C., 1966; Palais Galliera, Paris, France, 1966. One-man: Salpeter Gal., N.Y., 1948; Bertha Schaefer Gal., N.Y., 1957-1961; Pioneer Mus., Stockton, Cal., 1959; Richard Gal., San Antonio, 1959; Howard Wise Gal., N.Y., 1963; Des Moines A. Center, 1963, 1964; Great Jones Gal., N.Y., 1966; Huntington (W.Va.) Gals. Contributor to "It Is" magazine and Art News. Print of Painting on cover Art News, 1960; Color print reproduced in Oeri's book, "Man and His Image," 1968. Positions: Assoc. Prof. A., Cooper Union, New York City, 1948- . Other teaching, Pratt Inst., Brooklyn, N.Y., 1957-60 and summers, 1950-1964 including Yale Univ., BM Sch. A., Univ. Michigan, and others.

MARSTELLER, WILLIAM A.—Collector
866 Third Ave. 10022; h. 1060 Fifth Ave., New York, N.Y. 10028
B. Champaign, Ill., Feb. 23, 1914. Studied: University of Illinois, B.S. Collection: Modern American, Latin American and South American Painting and Sculpture.

MARTIN, AGNES—Painter
28 South St., New York, N.Y. 10004
B. Macklin, Canada, 1911. Studied: Columbia Univ., B.A. Work: Union Carbide Co.; Wadsworth Atheneum; WMAA. Exhibited: Dayton AI, 1964; Guggenheim Mus., 1964; Brandeis Univ., 1964; WMAA; Wash. Gal. Mod. A., 1963; SFMA, 1963; Wadsworth Atheneum, 1963; Dilexi Gal., San Francisco, 1963; Carnegie Inst., 1961; one-man: Betty Parsons Gal., N.Y., 1958, 1959, 1961; Elkon Gal., N.Y., 1961, 1963.*

MARTIN, CHARLES E.—Cartoonist, P., Des., L.
45 E. 85th St., New York, N.Y. 10028
B. Chelsea, Mass., Jan. 12, 1911. Member: Gld. of Magazine Cartoonists of America; Overseas Press Cl. Work: Mus. City of N.Y.; LC; MMA; Archives of Syracuse (N.Y.) Univ. Exhibited: BMSch. A.; Rockland Fnd.; Ruth White Gal. Contributor cartoons and illus. to PM; New Yorker; Life; Time; Fortune; This Week; Harpers; Punch; Look; Sports Illustrated; Saturday Review; Esquire; Playboy, and other national magazines. Published in New Yorker Album and most cartoon anthologies. Lectures on cartoons. Taught at BMSch. A.

MARTIN, FLETCHER—Painter, Gr., I., E., L.
224 Mead Mountain Rd., Woodstock, N.Y. 12498
B. Palisade, Colo., Apr. 29, 1904. Member: CAA; Woodstock AA. Awards: prizes, Los A. Mus. A., 1935, 1939; FAP, 1937; 48 States Comp., 1939; PAFA, 1947; NAD, 1949, 1954; AFA-Ford Fnd. grant, Artist-in-Res., Roswell Mus. (N.M.), 1964. Work: MModA; MMA; WMAA; Butler Inst. Am. A.; Cranbrook Acad. A.; William Rockhill Nelson Gal.; Los A. Mus. A.; LC; Denver A. Mus.; SFMA; PAFA; Brandeis Univ.; State Univ. Iowa; AGAA; frescoes, North Hollywood (Cal.) H.S.; murals, Fed. Bldg., San Pedro, Cal.; USPO, La Mesa, Tex.; Kellogg, Idaho. Exhibited: Phila. A. All., 1955; one-man: Los A. Mus. A., 1935; MModA, 1942; Tweed Gal., Univ. Minn., Duluth, 1954-1956; Cheney-Cowles Mem. Mus., Spokane, Wash., 1961; Milch Gal., N.Y., 1963; Rochester (Minn.) A. Center, 1964; Parsons Col. (Iowa), 1964; Roswell (N.M.) Mus., 1964. I., "Tales of the Gold Rush," 1944; "Mutiny on the Bounty," 1946; "Sea Wolf," 1961;

"The Jungle," 1965; "Of Mice and Men," 1969, all Limited Editions. War A., Correspondent, Life Magazine, 1943, 1944. Positions: Instr., Univ. Iowa, 1940; Kansas City AI, 1941-42; ASL, 1947-49, 1965; Univ. Florida, 1950-53; Mills Col., 1951; Univ. Minnesota, 1954; San Antonio AI, 1957; No. Mich. Col., 1958; Hd. Dept. Drawing, Los A. County AI, 1958-59; N.Y. State Univ., Col. of Edu., 1959; Washington State Univ., 1960-61; Rochester A. Center, 1963; Member Guiding Faculty, Famous Artists Schs.; A.-in-Res., Roberson Center for the Arts & Sciences, Binghamton, N.Y., 1967-1968.

MARTIN, FRED—Painter
232 Monte Vista, Oakland, Cal. 94611
B. San Francisco, Cal., June 13, 1927. Studied: Univ. California, Berkeley, B.A., M.A.; Cal. Sch. FA, with David Park, Mark Rothko and Clyfford Still. Awards: prizes, Oakland A. Mus., 1951, 1958; SFMA, 1957, 1958; Richmond A. Mus., 1962. Work: SFMA. Exhibited: One-man: de Young Mem. Mus., San Francisco, 1954, 1964; Oakland A. Mus., 1958; SFMA, 1958; Royal Marks Gal., N.Y., 1964, 1966, 1968, and others. Contributor to College Art Journal; Artforum, Art International magazines. Positions: Instr., Oakland A. Mus. (painting); San F. AI; Dir., San Francisco Art Institute.

MARTIN, G(AIL) W(YCOFF)—Painter, E., Gr.
618 Willard Ave., Newington, Conn. 06111
B. Tacoma, Wash., Apr. 19, 1913. Studied: Herron A. Sch., B.F.A.; State Univ. Iowa, M.F.A., with Philip Guston, Fletcher Martin, Emil Ganso; Boston Mus. A. Sch., with Karl Zerbe. Member: Conn. WC Soc.; Conn. Acad. FA; CAA. Awards: prizes, A. Gld., St. Louis, 1943; New England Drawing Exh., 1958; Millikan European traveling scholarship, Herron A. Sch., 1938; won mural competition, Gengras Campus Center, Univ. Hartford, 1968. Work: LC; Wadsworth Atheneum, Hartford, Conn. Mural, USPO, Danville, Ind. Exhibited: AIC, 1936, 1937; Northwest Pr. M., 1941, 1952; MMA, 1942; Color Pr. Soc., Phila., 1942; PAFA, 1942; Carnegie Inst., 1942, 1943; Conn. Acad. FA, 1947-1957, 1962; Audubon A., 1953; Butler Inst. Am. A., 1958; Boston A. Festival, 1955, 1956; Eastern States Exh., 1954, 1958; Silvermine Gld. A., 1954-1956; Springfield Mus. A., 1953, 1955. Positions: Hd. A. Dept. & Prof. A., Lindenwood Col., Missouri, 1941-43; Assoc. Prof., Hartford A. Sch., Univ. Hartford, Conn., 1957- .

MARTIN, KEITH—Museum Director, P., E.
Roberson Center for the Arts and Sciences, 30 Front St.; h. 99½ Oak St., Binghamton, N.Y. 13905
B. Perth Amboy, N.J., Jan. 22, 1910. Studied: Harvard Univ., B.A., and with Wayman Adams. Member: AAMus.; N.Y. State Assn. of Mus.; Northeast Assn. Mus.; Assoc. Councils of the Arts; Trustee, Eastern Regional Inst. for Education. Exhibitions arranged: Models of Inventions of Leonardo da Vinci, 1952; Exhibition of Art of the Americas, Int. Exposition, Port-au-Prince, Haiti, 1950. Positions: Dir., Kansas City A. Inst. and Sch. of Des., 1939-1943; Dir., Fine Arts Dept., IBM, 1946-1953; Hd. A. Dept., Syracuse Univ., 1946-1948; Dir., Roberson Center for the Arts and Sciences, Binghamton, N.Y., 1954- .

MARTIN, KEITH MORROW—Painter, E.
3208 St. Paul St., Baltimore, Md. 21218
B. Lincoln, Neb., Jan. 27, 1911. Studied: Univ. Nebraska; AIC. Awards: prizes, AIC, 1948 (purchase); Denver A. Mus., 1948 (3 purchase awards); BMA, 1952, 1955 (purchase), 1958, 1960-1962, 1964, 1969; Delgado Mus. A.; Soc. Four Arts, 1959, 1962; Sarasota AA, 1960; Norfolk Mus., 1961 (purchase); Md. Regional, 1961, 1965; CGA, 1953, 1964; Butler Inst. Am. A., 1958; Ford Fnd. purchase, 1969; Michigan WC Soc., 1960; Tour Gal., Albuquerque, 1962-63; Okla. Gr. Soc., 1963; Ball State Univ., 1964, 1965. Chautauqua AA, 1961; Acad. A., Easton, Md., 1966; Benedictine A. Purchase, 1967. Work: Univ. Nebraska; AIC; Denver A. Mus.; BMA; Munson-Williams-Proctor Inst.; Butler Inst. Am. A.; WMAA; CGA; Norfolk Mus. A. & Sciences; Santa Barbara Mus. A.; Morgan Col., Md.; Okla. Gr. Soc. Exhibited: AIC, 1936, 1948; VMFA, 1946; Nebraska AA, 1953; Julien Levy Gal., 1936 (2-man), 1937; Kuh Gal., Chicago, 1937; Vendome Gal., Paris, 1945; Batsford Gal., London, 1945; SFMA, 1947; Joslyn Mus. A., 1947; Hugo Gal., 1949, 1951; BMA, 1953 (one-man), 1955, 1967 (one-man); Norfolk Mus. A., 1954 (one-man), 1961, 1962; CGA, 1955; Obelisk Gal., Wash., D.C., 1955 (one-man); WMAA, 1955, 1959; Soc. Four Arts, 1959; Delgado Mus. A.; Duveen-Graham Gal., N.Y., 1956, 1958 (one-man); PAFA, 1957; BM, 1957; Columbia, S.C., 1957; Delgado Mus. A., 1957; Butler Inst. Am. A., 1957; D'Amacourt Gal., Wash., D.C., 1957 (2-man); Provincetown A. Festival, 1958; Sarasota AA, 1960; Mich. WC Soc., 1960; Juster Gal., N.Y., 1961 (one-man); Maryland Regional, 1961; Chautauqua AA, 1961; Santa Barbara Mus., 1963; Int. Gal., Baltimore, 1965; St. Paul A. Center, 1968 (one-man); group shows nationally 1936-1969. Positions: Instr., Painting, Baltimore Mus. A., 1958-1968.

MARTIN, KNOX—Painter, S., Gr.
458 W. 168th St. 10032; h. 145 Audubon Ave., New York, N.Y. 10032
B. Colombia, S.A., Jan. 12, 1923. Studied: ASL. Work: WMAA; MModA; N.Y. Univ. Coll.; Univ. Cal. A. Mus., Berkeley; in private collections internationally. Exhibited: Univ. Illinois; CGA; WMAA; MModA; Austin Tex.; N.Y. Univ.; one-man: Charles Egan Gal., N.Y. 1954, 1961; Avant Garde Gal., N.Y., 1956; Rose Fried Gal., N.Y., 1963; Fischback Gal., N.Y., 1964, 1965.*

MARTIN, ROGER (H.)—Painter, Gr., I., Des.
Mt. Locust Ave., Rockport, Mass. 01966
B. Gloucester, Mass., Sept. 3, 1925. Studied: BMFA Sch. Member: Rockport AA. Exhibited: Boston A. Festival, 1956, 1961, and traveling (AFA); Rockport AA, 1957; Nexus Gal., Boston, 1955; Intl. Gal., N.Y.; Cape Ann A. Festival; Portland (Me.) A. Festival; Gal. Seven; Trinity Col., Hartford, Conn. (one-man); Collector's Gal., Wash. D.C., 1962 and Gal. 7, Boston, 1962, both one-man; DeCordova Mus., 1966, 1967, 1969; Eugenics Gal., Magnolia, Mass., 1968; Phoenix Gal., Rockport, 1968; Carl Siembab Gal., Boston, 1968, 1969. Graphic art for D.C. Heath & Co., Allyn & Bacon, Beacon Press (1965-1968) and United Teaching Pictures; church curriculum and textbooks; brochure for Cambridge Electron Accelerator, Harvard Univ. and Mass. Inst. Tech., 1964; Illus. for New Yorker Magazine, Atlantic Monthly, N.Y. Times; articles and illus. for Child Life Magazine, and textbooks. Des. cases & executed carvings for C. B. Fisk pipe organs at Harvard Univ. and Pohick Church, Lorton, Va., 1965-1969. Positions: Head, Freshman Dept. & Instr., Des. & Drawing, New England Sch. A., Boston, 1967-1969.

MARTINELLI, EZIO—Sculptor, P., Gr.
121 West 85th St., New York, N.Y. 10024
B. West Hoboken, N.J., Nov. 27, 1913. Studied: NAD; Barnes Fnd.; Tiffany Fnd., and in Italy. Awards: Guggenheim Fellowship, 1958, 1962; Tiffany Fnd. Grant, 1964. Inst. A. & Lets. Grant, 1966. Work: sc., United Nations General Assembly Bldg., 1960; SAM; WMAA; Guggenheim Mus.; Newark Mus. Exhibited: Art of This Century, 1942, 1943; AIC, 1952, 1962; USIS, Europe and Asia, 1956, 1957; Carnegie Inst., 1958; WMAA, 1961, 1962; Newark Mus., 1962; PAFA, 1964; one-man: Willard Gal., N.Y., 1946, 1947, 1952, 1955-1958, 1959, 1964; SAM, 1956; Univ. Minnesota, 1956. Positions: Assoc. Prof., Sarah Lawrence Col., 1947- ; Instr., Parsons Sch. Des., New York, N.Y., 1953- . AFA-Ford Fnd. grant, Artist-in-Residence, Ringling Mus., Sarasota, Fla., 1964; Sculptor-in Residence, American Academy in Rome, 1964.

MARTINET, MARJORIE D.—Painter, E.
4102 Ridgewood Ave., Baltimore, Md. 21215
B. Baltimore, Md., Nov. 3, 1886. Studied: Maryland Inst.; Rhinehart Sch. S.; PAFA; & with Cecelia Beaux, William Chase, and in Europe. Member: Phila. A. All.; NAWA, AFA. Awards: F., PAFA; Cresson traveling scholarship, PAFA, 1909; Thoron prize, PAFA. Work: Assn. Jewish Charities Bldg., Balto. Exhibited: Peabody Inst.; PAFA; Phila. Plastic Cl.; Phila. AC; BMA, 1930 (one-man); Newman Gal., Phila., 1936; Toronto, Canada, 1937; McClees Gal., Phila., 1946; NAWA, 1960, 1961, 1962. Positions: Chm. Art Com. for Lizette Woodworth Reese Mem. Tablet for Pratt Library, Baltimore Art Consultant, Oldfields School, Glencoe, Md., 1962; Dir. Martinet Sch. A., Baltimore, Md., at present.

MARTINO, ANTONIO P.—Painter
Gradyville Rd., Newtown Square, Pa. 19073
B. Philadelphia, Pa., Apr. 13, 1902. Studied: PMSchIA; Spring Garden AI; Phila. Sketch Cl.; La France Inst. Member: NA; AWS; Phila. WC Cl. Awards: prizes, NAD, 1926, 1927, 1937, 1943; Saltus Gold Medal, 1964; VMFA, 1938; PMSchIA, 1939; IBM, 1940; Woodmere A. Gal., 1942, 1957; SC, 1943-1945, 1956-1958; New Haven Paint & Clay Cl., 1943; Indiana State T. Col., 1944; DaVinci All., 1944, 1947, 1964; AWS, 1945, 1946, 1953, 1961 (purchase); Audubon A., 1946; SC, 1953; Springville, Utah, AA, 1953, 1963; Hickory Mus., 1954; Wayne A. Center, 1957; Warren (Pa.) A. Gal., 1957; Delaware A. Center, 1957; Chester (Pa.) AA, 1958 (2), 1962-1964; Chautauqua AA, 1958, 1960; Wilmington Soc. FA, 1961, 1962; Phila. A. All., 1955; medals, Phila. Sketch Cl., 1926; Phila. Sesqui-centennial, 1926; PAFA, 1938; DaVinci All., 1942, 1952, 1957; NAC, 1958, prize, 1960; Cape May, N.J., 1950; Chester County AA, 1960; AWS, 1963; West Chester AA, 1960, and others. Work: Wanamaker Coll.; PMA; Reading Mus. A.; PAFA; IBM; Woodmere A. Gal.; Univ. Delaware; York College (Pa.); West Chester State Teachers College (Pa.); Phila. WC Cl.; Allentown Mus.; NAD; Springville (Utah) H.S.; Parrish Mus., L.I., N.Y.; Warren (Pa.) A. Gal.; Kutztown State T. Col.; Everhart Mus.; Randolph-Macon Women's Col.; Butler Inst. Am. Art; New Mexico State Univ. Exhibited: Carnegie Inst.; PAFA; NAD; CGA; AIC; WMAA; Detroit Inst. A.; VMFA; Macbeth Gal.; Colorado Springs FA Center; MMA; Butler Inst. Am. A., 1962; Springville, Utah, 1693; Royal Acad. Design, London, 1963.

MARTINO, GIOVANNI—Painter
1428 S. Penn Square, Philadelphia, Pa. 19102; h. 1435 Manor Lane, Blue Bell, Pa. 19422
B. Philadelphia, Pa., May 1, 1908. Studied: Spring Garden Inst.; La France AI; Phila. Sketch Cl. Member: NA; AWS. Awards: prizes, Phila. A. All., 1934; VMFA, 1940; Da-Vinci All., 1940, 1944, med., 1939, gold medal, 1964; NAD, 1941, 1942; Woodmere A. Gal., 1941, 1963; PAFA, 1942; Sweat Mem. Mus., 1946; State T. Col., Pa., 1946, 1959; Pepsi-Cola, 1946; SC, 1956; AWS, 1958; Medal, Phila. Sketch Cl., 1957; Gold Medal, All. A. Am., 1957; Portland A. Festival, 1959 (purchase); Lawrence Park Festival, 1960; Wyoming Valley A. Lg., 1962; Perkiomen Valley A. Center, 1963; Moreland Township Sch. Dist. (purchase), 1964. Exhibited: PAFA; CGA; WMAA; AIC; Carnegie Inst.; NAD; VMFA; & other galleries & museums.*

MARTINSEN, IVAR RICHARD—Educator, P.
Art Department, Sheridan College; h. 1422 Big Horn Ave., Sheridan, Wyo. 82801
B. Butte, Montana, Dec. 9, 1922. Studied: Montana State Col.; Univ. Wyoming. Member: Western Edu. Assn.; Sheridan A. Gld. Awards: prize, Wyoming-Nebraska Exh., 1958, 1959; Wyo. State Fair, 1960. Exhibited: Sheridan and Laramie, Wyo., traveling exh. Wyoming A.; Scottsbluff, Neb. Positions: Prof., A. Dept., Sheridan, Wyo.

MARTINSON, JOSEPH B.—Collector
200 E. 57th St., New York, N.Y. 10022
B. New York, N.Y., June 24, 1911. Studied: N.Y. School of Fine and Applied Arts, Paris; Art Students League (with Guy DuBois); Studied with Paul Colin in Paris. Awards: Handel Award, City of N.Y., 1964. Collection: General. Positions: President and Co-Founder, Museum of American Folk Art, New York.

MARTYL (MARTYL SCHWEIG LANGSDORF)—
Painter, Muralist, T.
R.R. 1, Meacham Rd., Roselle, Ill. 60172
B. St. Louis, Mo., Mar. 16, 1918. Studied: Washington Univ., A.B.; Colorado Springs FA Center, with Arnold Blanch, Boardman Robinson. Member: AEA; Chicago A. Cl.; Renaissance Soc., Univ. Chicago. Awards: prizes, Kansas City AI, 1940; CAM, 1941, 1943; AIC, 1945, 1950, 1957; Los A. Mus. A., 1945; AIA, Chicago, 1962. Work: Recorder of Deeds Bldg., Wash., D.C.; PAFA; Univ. Arizona; CAM; AIC; Wash. Univ.; Phoenix Mus. A.; Santa Barbara Mus. A.; Ill. State Mus.; WMAA; Davenport Mun. Mus.; Arnot Gal., Elmira, N.Y.; Ill. Athletic Assn.; New Trier H.S.; Oliver Morton Sch., Indiana; murals, USPO, Russell, Kan.; Unitarian Church, Evanston, Ill.; Sainte Genevieve, Mo. Exhibited: Carnegie Inst., 1940-1945; PAFA, 1944, 1952; CAM, 1941-1944, 1946; VMFA, 1946; AIC, 1944-1946, 1948-1952, 1953-1956; CGA, 1941; WMAA, 1945, 1946, 1960; Milwaukee AI, 1946; Univ. Illinois, 1951, 1953, 1955, 1957, 1961; Univ. Wisconsin, 1952, 1953; Denver Mus. A., 1960 (30 one-man to 1965). I., "How to Paint a Gouache," 1946. Positions: A. Ed. The Bulletin of the Atomic Scientists.; Instr., University of Chicago.

MARX, ROBERT ERNEST—Painter, Gr., E.
Impressions Workshop Inc., 27 Stanhope St., Boston, Mass., 02116; h. 104 Elm St., Newbury, Mass. 01950
B. Northeim, Germany, Dec. 10, 1925. Studied: Univ. Illinois, B.F.A., M.F.A., and with Abraham Rattner, Lee Chesney. Awards: prizes, Munson-Williams-Proctor Inst., 1959, 1964; Syracuse Mus. A., 1959; Rochester Memorial A. Gal., 1959, 1962, 1963; Louis D'Amanda Mem. Award, Rochester, 1960; Chautauqua AA, 1964; purchase prizes: Dallas Print Soc., 1954; Bradley Univ., 1954; Washington Univ., 1956; Northwest Printmakers, 1957; Otis AI; Los Angeles, 1962; LC, 1963; State Univ. Col., Potsdam, N.Y., 1963; Everson Mus. A., Syracuse, 1964 and Hancock award, 1964; Syracuse Assoc. A., 1964; Western Michigan Nat. Print Show, 1964. Work: MModA; PMA; N.Y. Pub. Lib.; MMA; Munson-Williams-Proctor Inst.; Syracuse Univ.; LC; WMAA; Rochester Mem. Gal.; DMFA; Bradley Univ.; Detroit Inst. A.; Int. Graphic A. Soc.; Milwaukee AI; Washington Univ.; SAM; Los A. Mus. A.; Everson Mus.; De Pauw Univ.; USIA; Phila. Pub. Lib.; Joseph Hirshhorn Coll.; State Univ. of N.Y., Binghamton, Cortland and Brockport; Monmouth Col., N.J. and others. Exhibited: BM, 1951, 1953-1955; MMA, 1952; Northwest Printmakers, 1953-1955; DMFA, 1953; MModA, 1953; Bradley Univ., 1952, 1954, 1955; Phila. Pr. Cl., 1951, 1953-1955; Univ. Illinois, 1954; Victoria & Albert Mus., London, 1954; PAFA, 1959, 1962; Rochester Mem. A. Gal., 1959-1961; Silvermine Gld. A., 1960-1962; Butler Inst. Am. A., 1960, 1961; CGA, 1962, 1963; One-man: Syracuse Univ., 1959; Juror's Show, Rochester, 1960; Krasner Gal., N.Y., 1961-1963; N.Y. State T. Col., Oneonta, 1960, 1966; Beloit Col., 1956-1960; N.Y. State Col., Albany, 1961; Univ. Ill., 1963; Bard Col., 1963; Schuman Gal., Rochester, 1964, 1966, 1969; Syracuse Juror's Show, 1965; Colgate Univ., 1964; Muggleton Gal., Auburn, N.Y., 1966-1968; State Univ. N.Y., Binghamton (1967), Cortland (1967); Gilmore A. Center, Kalamazoo, Mich., 1967; Fronta Gal., Prague, 1967; USIA Gal., Paris, 1967; House of Artists Gal., Brno, Czecho-

slovakia, 1968; Ohio State Univ., 1968; and others. Traveling Exhs.: USIA to USSR and traveling to Rumania, Poland, Yugoslavia, 1963-1965; USA Graphics to India, 1965; Am. Graphics to Czechoslovakia, 1965 and exh. in Prague and Bratislava, 1965; Eastern Asia, 1966; AFA traveling exh.—Brooklyn Mus. Nat. Biennial Print Exh., 1964-1966. Positions: Assoc. Prof., School of Art, Syracuse University, Syracuse, N.Y. 1958-1965; Assoc. Prof., State Univ. of New York, 1966-1968; Director, Impressions Workshop, Inc., Boston, Mass., 1969- .

MARYAN, HAZEL SINAIKO — Painter, S., Collector
625 Mendota Court; h. 1521 Vilas Ave., Madison, Wis. 53711
B. Madison, Wis., May 15, 1905. Studied: Univ. Wisconsin, B.S.; Post Grad., AIC, and with E. Chassaing, A. Polasek, E. Simone, Archipenko. Member: Chicago A. Cl.; Nat. Lg. Am. Pen Women; AEA. Work: in private colls. Exhibited: AIC, 1930-1932, 1937-1941; Wis. Salon, 1932-1965 (award, 1964); Chicago No-Jury Exh., 1933, 1934; AEA, 1952, 1965; Union League; Madison AA, 1965; Wisconsin P. & S., 1965; Waterloo, Iowa Annual, 1965; Beloit Annual, 1964-1965; B'nai B'rith Annual, 1964 (award). Personal Collection: Alberto Burri paintings; work by Chagall, Miro, Braque and others; a large collection of affiches. Positions: Former Instr., Western Mich. Col.; Hull House, Chicago; Chicago Bd. Edu. Owner, Little Studio Gallery, Madison, Wis.*

MARZANO, ALBERT—Painter, Des., Ser.
1949 Locust St.; h. 1809 Delancey Pl., Philadelphia, Pa. 19103
B. Philadelphia, Pa., Aug. 22, 1919. Studied: Phila. Graphic Sketch Cl.(now Fleisher A. Mem.); Phila. Plastic Cl. Member: A. Dir. Cl., Philadelphia; AEA; Phila. WC Cl.; Phila. A. All. Awards: prizes, Phila. A. Dir. Cl., 1954, 1955, 1956; Certif. of Excellence, 1957, 1958; Delaware Valley Graphic Arts Exh., Phila,, 1961; Gold Medals: Haddonfield (N.J.) A. Lg., 1959; Nat. Soc. Painters in Casein, 1961; Delaware Valley Exh., 1958, 1961 (2), 1964, 1966, 1967; Peninsular Paper Co., Ypsilanti, Mich., 1958; Best of the Year award, 3 M Company, 1967; Certif. for Outstanding Achievement in the Graphic Arts Field, The Brown Co., 1968. Work: many portraits in private colls. Exhibited: Chautauqua AA, 1959; All. A. Am., 1959; Knickerbocker A., 1960; Butler Inst. Am. A., 1960; Art Directions Gal., 1960; Nat. Soc. Painters in Casein, 1961; USO, Phila., 1955 (one-man); Haddonfield (N.J.) A. Lg., 1958, 1959; PMA, 1959; DaVinci A. All., Phila., 1959-1961; Woodmere A. Gal., 1960; Phila. Sketch Cl., 1960; Italian A. Festival, Commercial Mus., Phila., 1961; Penn A. Center, (one-man) 1961; Phila. A. All., 1965, 1967; PAFA, 1965; AEA, 1967, 1968. Originator and Des. of new painting method "Abstractos" now on the market. Lectures: Functional Design Adapted to Everyday Living. Positions: Des.-Consultant for Phila. Assn. for the Blind, 1953-56; Art Consultant & Graphic Des., Public Health Dept., City of Philadelphia, 1958-60; Rudd-Melikian, Inc., 1958- . A. Dir.-Consultant, for J. Cunningham Cox Agency, Bala-Cynwyd, Pa.; Benn Associates, Philadelphia, Pa.

MASAAKI, SHIRAISHI—Painter
c/o East Hampton Gallery, 22 W. 56th St., New York, N.Y. 10019*

MASER, EDWARD ANDREW—Educator
Department of Art, University of Chicago 60637; h. 5318 Hyde Park Blvd., Chicago, Ill. 60615
B. Detroit, Mich., Dec. 23, 1923. Studied: Univ. Michigan; Univ. Chicago, M.A., Ph.D.; also, Univ. Frankfurt, Germany and Univ. Florence, Italy. Member: CAA; AAUP; Renaissance Soc. Am. Awards: Fulbright Scholar, 1950-1952; Fulbright Senior Research Fellow, 1965-1966; Guggenheim Fellow, 1969-1970. Author (with Lando Bartoli) "The Museum of the Manufactory of Florentine Mosaic," 1954. Ed:, The Register of the Museum of Art of the University of Kansas, 1953-1961; Contributor articles to Connoisseur; Gazette des Beaux Arts. Exhibitions arranged: "18th Century German and Austrian Art in American Collections" (series of 3); "Austrian Rococo Drawings from the Vienna Academy," 1956; "Disguises of Harlequin by G. D. Ferretti," 1957; "Fontinalia—the Art of the Fountain," 1957; Author: "Gian Domenico Ferretti," 1968. Contributor: "Drawings of Giuseppe Zocchi," to Master Drawings, 1967; "Five Early Paintings by Johann Michael Rottmayr," to Museum Studies, AIC, 1967. Lectures: National Gallery of Art; Nelson Gallery, Kansas City, Mo.; Toledo Museum of Art; University of Minnesota; Art Institute of Chicago. Positions: Asst. to Dir., Univ. Chicago Exchange Project at Frankfurt, Germany, 1949-50; Dir., Museum of Art, University of Kansas, Lawrence, Kans., 1953-61; Chm., Dept. Art, The University of Chicago, 1961-1964, Prof. A., University of Chicago, 1962- .

MASON, ALDEN C.—Painter, E.
University of Washington 98105; Studio: 1916 N.E. 73rd St., Seattle, Wash. 98115
B. Everett, Wash., July 14, 1919. Studied: Univ. Washington, B.A.,

M.F.A. Awards: prizes, SAM, 1960, 1964, 1965, 1968. Work: SAM; Henry Gal., Univ. Washington; Central Washington State Col. Exhibited: SFMA, 1965; Kobe (Japan) Mun. A. Mus., 1966; Seattle World's Fair, 1962; Portland (Ore.) A. Mus., 1966; one and two man: Bau-Xi Gal., Vancouver, B.C., 1965, 1969; Esther Robles Gal., Los Angeles, 1965; Gordon Woodside Gal., Seattle, 1965, 1967, 1969 and Woodside Gal., San Francisco, 1969. Positions: Prof. Painting, Univ. Washington, Seattle, Wash., 1947- .

MASON, ALICE F. (Mrs. Michael L.)—Lithographer, P., L., T.
443 Grove Ave., Wood Dale, Ill. 60191
B. Chicago, Ill., Jan. 16, 1895. Studied: Northwestern Univ., B.S.; AIC, B.F.A., M.F.A. Member: Chicago Soc. A. (1st V. Pres., 1964-65); Chicago A. Cl.; AEA; Renaissance Soc.; Hunterdon County A. Center; AFA; Conn. Acad. FA. Awards: prizes, New Britain Mus., 1953; Phila. Pr. Cl., 1957; PAFA, 1956; Ill. State Mus., 1956; Ill. State Fair, 1957; Mun. A. Lg., 1957. Work: MMA; LC; CM; New Britain Mus. Exhibited: CGA, 1941; AIC, 1943, 1946, 1948, 1949, 1951, 1952, 1955; CM, 1950, 1952, 1954, 1956; Chicago Soc. A., 1949-1965; Phila. Pr. Cl., 1951, 1954, 1957; Buffalo Pr. Cl., 1951; SAGA, 1952-1955; New Britain Mus., 1952; LC, 1952, 1956, 1957; Conn. Acad. FA, 1954-1969; Soc. Wash. Pr. M., 1958; Hunterdon County A. Center, 1958, 1962-1965; Illinois State Mus., 1957, 1958; Chicago Pub. Lib., 1961 (one-man); Union League, 1963-1965; AIC art rental, 1962-1968; Am. College of Surgeons, 1964 (one-man); Quincy (Ill.) A. Center, 1950, 1966 (one-man). Positions: Pres., Chicago Soc. A., 1954-55, 1955-56, 1957-58, 1958-59, Bd. Dirs., 1960- . Instr. Summer Sch. Painting, Saugatuck, Mich., 1954- .

MASON, ALICE TRUMBULL — Painter, Gr.
334 West 85th St., New York, N.Y. 10024
B. Litchfield, Conn., Nov. 16, 1904. Member: Am. Abstract A. (Pres., 1959-), Fed. Mod. P. & S.; SAGA; Am. Color Print Soc. Awards: prizes, Phila. Pr. Cl., 1946; SAGA, 1947; Silvermine Gld. A., 1952; Longview award, 1963 (painting presented to Walker Art Center). Work: PMA; MModA; N.Y. Pub. Lib.; Berkshire Mus. A.; LC; BM; Solomon Guggenheim Mus. A. Exhibited: Pinacotheca Gal., 1948; Mus. Living A., 1942; Solomon Guggenheim Mus. A., 1954, 1955; Mid-Western A. Conf., Indiana, 1954; CGA, 1955; WMAA, 1951, 1953, 1955; Riverside Mus., N.Y.; New School for Social Research, N.Y.; Phila. Pr. Cl.; Assoc. Am. A.; Lever House, N.Y.; IBM Gal.; SAGA traveling exh., auspices of USIA to Europe, 1961-62, extended to Asia Minor and Pakistan, 1963. Entire show exhibited at Pepsi-Cola Bldg., N.Y., 1963; one-man traveling exh., 1951-52; 20th Century Gal., N.Y., 1967; Retrospective Exh., Nassau Community Col., Garden City, N.Y., 1967, and others. Positions: Instr,, PAL Center, Bronx, N.Y., 1954-55.

MASON, JOHN—Sculptor
2101 Glendale Blvd. 90039; h. 2277 Baxter St., Los Angeles, Cal. 90039
B. Madrid, Neb., Mar. 31, 1927. Studied: Otis AI; Chouinard AI, Los Angeles. Awards: prizes, Contemp. A. in America, Pomona, Cal., 1956; Miami Ceramic National, Lowe A. Mus., 1957, 1958; Wichita, Kans., 1959; Mus. Contemp. Crafts, N.Y., 1959 (2-ceramics and sculpture); La Jolla Mus., 1960, 1961 (purchase); FA Gal. of San Diego, 1961; Architectural Comp. sponsored by Tishman Co., 1961 (purchase); Ford Fnd. Purchase, AIC, 1964; Skokie, Ill., 1966. Work: sc., Palm Springs Spa, 1959; Tishman-Wilshire Bldg., Los Angeles, 1961; La Jolla Mus. A.; Scripps Col., Claremont, Cal.; Wichita AA; Pasadena A. Mus.; AIC; Los Angeles County Mus.; Mus. Contemp. Crafts, N.Y. and in numerous private residences. Exhibited: Everson Mus., Syracuse Nat., 1956; Scripps Col., Claremont, Cal., 1956-1960; Wichita, 1956-1958; Nat. Sculpture Exh., Oregon Ceramic National, Portland, Ore., 1958; Pasadena A. Mus., 1959; Int. Ceramics, Ostend, Belgium, 1959; Los A. Mus. A., 1959; Univ. Michigan, 1960; Architectural show sponsored by Am. Craftsmens Council Research Service, Sun Valley, Idaho, 1960; Santa Barbara Mus., 1960, 1962; Phila. Mus. Col. of Art, 1961; Univ. So. California, 1961; Pomona Col., 1962; Mus. Contemp. Craft, N.Y., 1962, 1967; Int. Contemp. Ceramics, Prague, 1962; Seattle World's Fair, 1962; "Artist and His Environment" organized by Amon Carter Mus., 1962; WMAA, 1962, 1964 and traveling; Long Beach Mus., 1962; Nat. Mus. Art, Buenos Aires, 1962; State Univ. Iowa, 1963; Univ. Minnesota, 1963; Kaiser Center Exh., sponsored by Oakland A. Mus., 1963; Long Beach State College, 1963; La Jolla Mus. A., 1963; N.Y. World's Fair, 1964; Int. Exh. Ceramics, Tokyo, Japan, 1964; Univ. California, Irvine, 1966; Los Angeles County Mus., 1967, 1968; Mus. Contemp. Crafts, N.Y., 1967; Hansen Gal., San Francisco, 1967; one-man: Gump's, San F., 1956; Oregon Ceramic Studios, 1957; Ferus Gal., Los Angeles, 1958, 1959, 1961, 1963; Pasadena A. Mus., 1960; Los Angeles County Mus., 1966. Positions: Visiting Asst. Prof., Univ. Cal. at Berkeley, 1964-1965; Univ. Cal. at Irvine, 1967- .

MASON, ROY MARTELL—Painter
 12 East Roseland Dr., La Jolla, Cal. 92037
B. Gilbert Mills, N.Y., Mar. 15, 1886. Member: NA; AWS; SC; All.
A. Am.; Audubon A.; Phila. WC Cl.; Grand Central Gal.; Buffalo
Soc. A.; Rochester A. Cl.; Cornell Univ. Lab. of Ornithology; F.,
Rochester Mus. A. & Sc.; Baltimore WC Soc. Awards: prizes, SC,
1930, 1931; NAD, 1930; Rochester Mem. A. Gal., 1931; AWS, 1931,
1940, 1956, gold medal, 1961; Watson Blair prize, Chicago, 1941;
AIC, 1941; Pennell medal, Phila. WC Cl., 1941; Albright A. Gal.,
1941, gold medal, 1943; gold medal, All. A. Am., 1952; gold medal,
Audubon A., 1945; North Shore AA, 1956; N.Y., New Haven & Hart-
ford Railroad Contest, 1956; Chautauqua AA, 1958; Laguna Beach
AA, 1960, 1961; Ford-Lido Show, Corona del Mar, Cal., 1961; Los
A. Fair, 1961. Work: Reading Mus. A.; AIC; Currier Gal. A.; Illi-
nois State Mus.; Abilene Mus. A.; Parrish A. Mus., L.I., N.Y.; Univ.
Iowa; Hickory Mus. A., N.C.; Haggin A. Gal.; Dartmouth Col.; Colo-
nial Williamsburgh; MMA; Toledo Mus A. Art contributor to Read-
ers Digest, True magazines.*

MASSEY, ROBERT JOSEPH—Painter, Et., S., E., L.
 708 McKelligon St., El Paso, Tex. 79902
B. Ft. Worth, Tex., May 14, 1921. Studied: Oklahoma A. & M. Col.,
with Doel Reed, B.A.; Syracuse Univ., M.F.A., and with Xavier Gon-
zalez; Univ. Texas, Ph.D. Member: All. A. Am.; Texas FA Assn.
Awards: prizes, Philbrook Mus., Tulsa, 1941; Springfield, Mass.,
1950; Palm Beach A. Lg., 1950; Syracuse Mus. FA, 1951 (purchase);
El Paso Mus. FA, 1961; Southwestern Prints & Drawings, DMFA;
Kleburg award, Texas Fine Arts Assn., 1963. Work: DMFA; Syra-
cuse Mus. FA.; mosaic, Admin. Bldg., Texas Western Col., 1956;
State Nat. Bank, El Paso, 1955. Exhibited: Philbrook Mus., 1940;
NAD, 1941; LC, 1941, 1950; DMFA, 1944, 1946; Wichita AA, 1946,
1951, 1958; Boston. Soc. Indp. A., 1949, 1951; Springfield, Mass.,
1950; BM, 1950; Conn. Acad. FA, 1950; Audubon A., 1950, 1951;
Palm Beach, 1950; Phila. Pr. Cl., 1950; Laguna Beach, 1950; Carne-
gie Inst., 1950; AFA traveling exh., 1950-51; Assoc. Okla. A., 1950;
SAGA, 1951, 1952; Buffalo Pr. Cl., 1952; Syracuse Mus. FA, 1953;
Denver A. Mus., 1954; Texas FA Assn., 1954, 1955, 1958-1960,
1963; Cal. Soc. Et., 1960; 21st Am. Biennial, 1965. Author:
"Formulas for Painters," 1967; "Formulas for Artists," 1968;
Lectures: Painting Structure; Materials & Techniques; Mosaic His-
tory to community and art organizations. Positions: Instr. A., Okla-
homa A. & M.; Syracuse Univ.; Visiting Prof., Florida State Univ.;
Prof. A., Univ. of Texas, El Paso, 1953- .

MASSIN, EUGENE MAX—Painter, E.
 3891 Little Ave., Coconut Grove, Fla.; h. 12201 Southwest 62nd
 Ave., Miami, Fla. 33156
B. Galveston, Tex., Apr. 10, 1920. Studied: AIC, B.F.A.; Univ. Chi-
cago; Escuela Univ. de Bellas Artes, Mexico, M.F.A. Member:
AEA; CAA. Awards: James Nelson F., AIC, 1948; prizes, Wisconsin
Salon, 1950; Beloit Col., 1950; AIC; South Carolina A. Group, 1951,
1952; Baltimore Nat., 1955; Gibbes A. Gal., Charleston, 1955-1961;
purchase prizes, Rose Mus., Brandeis Univ., 1963; Ringling Mus.,
1964; Lowe Gal. A., Coral Gables, 1965. Work: Univ. Wisconsin;
Beloit Col.; Jacksonville Mus.; Gibbes A. Gal.; murals, Mexican
Colonial Bldg. (in collaboration with David Siqueiros); Cafritz Bldg.,
Wash., D.C.; City Nat. Bank Bldg., Miami. Exhibited: Chicago Vet-
eran's Exh., 1947; Univ. Wisconsin, 1950; Beloit Col., 1950; South-
eastern annual, 1951; Gibbes A. Gal., 1951-1952; Ringling Mus. A.;
MMA; WMAA, 1955; One-man: RoKo Gal., N.Y., 1961; Nordness
Gal., N.Y., 1961; James David Gal., Miami, Fla., 1963-1965. Posi-
tions: Instr., Univ. South Carolina, 1953; Asst. Prof., Univ. Miami,
Coral Gables, Fla., 1953-1964, Assoc. Prof., 1964-1967; Prof. A.,
Univ. of Miami Graduate School, 1967- . Pres., Fla. Chptr, AEA,
1957-58.

MAST, GERALD—Painter, E., Gr., Des.
 University of Michigan Extension Center; h. 361 Lakeside Dr.,
 Southeast, Grand Rapids, Mich. 49561
B. Topeka, Ind., July 28, 1908. Studied: John Herron AI; Detroit
Sch. A. & Crafts; Rhode Island Sch. Des., B.F.A. Member: Grand
Rapids AA; Acad. A., Sci. & Lets. Awards: prize, Western Michi-
gan A., 1957; Nat. Ecclesiastical Exh., Birmingham, Mich., 1960.
Work: Detroit Inst. A.; Grand Rapids A. Gal.; Kalamazoo AI; Hackley
A. Mus., Muskegon, Mich.; murals, Harrick Pub. Lib., Holland,
Mich.; East Grand Rapids High Sch.; tapestry, Broadmoor, Colorado
Springs. Exhibited: Rhode Island Sch. Des., and Providence A. Cl.,
1940-1950; Detroit Inst. A., 1940-1967; Herron AI, Indianapolis,
1930-1964. Positions: Prof., of Art, Col. Arch. & Des., Univ. Mich-
igan; A.-in-Res., Grand Rapids Center, 1948.

MASTERSON, JAMES W.—Painter, S.
 1615 Pearl St., Miles City, Mont. 59301
B. Hoard, Wis., June 27, 1894. Studied: Chicago Acad. FA; AIC;
San Jose, Cal., A. Sch. Awards: Huntington Hartford Fnd. Fellow-
ship, 1962. Work: Paintings: Custer County H.S.; State Indst. Sch.;

Carnegie Lib., Miles City Club, Miles City Bank, Medical Arts
Bldg., all Miles City, Mont.; Commerce Trust & Savings Bank,
Helena, Mont. Exhibited: Northwest Artists, Spokane, Wash.; Mon-
tana Hist. Soc., Helena; Russell Mem. Studio, Great Falls; sculpture
exh., Trailside Gal., Jackson, Wyo., 1964. Author, Illus., "It Hap-
pened in Montana" (four vols.). Positions: Instr., Custer County
Jr. College.*

MATHESON, DONALD ROY—Printmaker, P., E., (former) Mus.
 Dir.
 Art Department, University of Massachusetts; h. 62 Mt.
 Pleasant St., Amherst, Mass. 01002
B. Honolulu, Hawaii, Jan. 30, 1914. Studied: U.S. Military Acad.,
West Point, B.S.; Univ. Michigan, A.M.; Ecole du Louvre, Paris,
France. Member: CAA; Michigan Acad. Sc., A. & Let., Print Coun-
cil of Am. Awards: prizes, Lias award, South Bend, Ind., 1955;
Graphic Arts award, Jackson, Mich., 1955; Michigan WC Soc., De-
troit Inst. A., 1955; Scarab Cl. award, 1957; Yankee Magazine award
in Natl. Print Show, Boston Printmakers, 1963. Work: Detroit Inst.
A.; CM; LC; South Bend A. Center; Univ. Oklahoma. Exhibited: LC,
1955-1957; CM, 1956, 1958; SAGA, 1956; Boston Pr. M., 1955, 1957,
1958; Am. Color Pr. Soc., 1958; Northwest Pr. M., 1956; Detroit
Inst. A., 1954, 1955, 1957; Western New York A., 1954, and others.
Positions: Dir., West Point Mus., 1952-53; Instr. A. & Dir. Mus.,
Univ. Oklahoma, 1956-57; Prof A., Univ. Massachusetts, Amherst,
Mass., 1958- .*

MATISSE, PIERRE—Art Dealer
 Pierre Matisse Gallery, 41 E. 57th St., New York, N.Y.
 10022*

MATSON, ELINA (Mrs. Mathew Augustus)—Craftsman
 8750 Old Ocean View Rd., Norfolk, Va. 23503
B. Finland, Dec. 12, 1892. Studied: Norfolk Mus. (weaving); Pen-
land Sch. of Handicrafts, Penland, N.C. Member: Tidewater A.
Council; Tidewater Weavers Gld. (Pres., 1959-61, Treas., 1952-56,
Libn., 1956-59); Pen & Brush Cl. Awards: Norfolk Mus. A., 1954;
Certif. of Distinction, VMFA, 1955; Chesapeake Craftsmen Exh.,
purchase award, 1956; Pen & Brush Cl., 1956, 1958. Work: hand-
woven stoles, Norfolk Mus. A., and VMFA. Exhibited: Delgado Mus.
A., 1953; Pen & Brush Cl.; Women's Int. Exh., N.Y., 1956, 1957;
VMFA, 1955, 1957, 1959; Chesapeake Craftsmen, Norfolk Mus. A.,
1954, 1956.

MATSON, GRETA (Mrs. Alfred Khouri)—Painter, Lith., T.
 4121 7th Ave., Brooklyn, N.Y. 11232; h. 8750 Old Ocean View
 Rd., Norfolk, Va. 23503
B. Claremont, Va., June 7, 1915. Studied: Grand Central Pen &
Brush Cl.; Brooklyn Soc. A.; Tidewater A.; New Jersey P. & S. Soc.;
AWS; All. A. Am; Audubon A. Awards: prizes, NAD, 1943, 1945;
SSAL, 1945, 1946; Virginia A., 1943, 1945, 1955; NAWA, 1943, 1952,
1953, 1955-1958, 1960, 1963; State T. Col., Indiana, Pa., 1945, 1949,
1950; Norfolk Mus. A., 1943, 1948, 1954; AWS, 1949, 1955; Alabama
WC Soc., 1950, 1951; Mississippi AA, 1951; Pen & Brush Cl., 1948,
1951, 1952, 1954, 1956, 1958; Conn. Acad. FA, 1952, 1953; New Or-
leans AA, 1949, 1952; Butler AI; 1948; New Jersey A., 1948, 1951;
VMFA, 1957; New Jersey Soc. P. & S., 1957; All. A. Am. Medal of
Honor, 1963. Work: VMFA; Norfolk Mus. A.; State T. Col., Indiana,
Pa.; New Britain AI; Texas Tech. Col.; William and Mary Col.;
Texas Col. A. & Indst.; Mary Calcott Sch., Norfolk, Va.; Fla. South-
ern Col.; Longwood Col., Farmville, Va.; Little Rock Mus. FA;
Seton Hall Univ. Exhibited: AIC, 1942, 1943, 1946; Carnegie Inst.,
1941, 1944, 1945; NAD, 1941, 1943-1945, 1956, 1957, 1962, 1963; Al-
bany Inst. Hist. & A., 1940, 1945; Butler AI, 1943-1945, 1957, 1959;
VMFA, 1939, 1941-1946, 1957; SAGA, 1954; Am. Color Pr. Soc.,
1954; Audubon A., 1955, 1956, 1956-61; AWS, 1954, 1957, 1959-1961;
All.A.Am., 1953-1955, 1956-1961; NAWA, 1966-1969; one-man: Nor-
folk Mus. A., 1952, 1955; Pen & Brush Cl., 1955; VMFA, 1953, 1957.
Organizational positions: First Vice-Pres., NAWA, 1959, 1960;
Pres., NAWA, 1961-1965, Bd. Dirs., 1968-1972; Audubon A. Cor.
Sec., 1961, Pub. Rel. Chm., 1963-1965; First Vice Pres., Brooklyn
Soc., A., 1961, Bd. Dirs., 1963-1964. Instr., Painting, Norfolk Mus.
A. & Sciences, (summer) 1966, 1967.

MATSON, VICTOR (STANLEY)—Painter
 2038 Stratford Ave., South Pasadena, Cal. 91030
B. Salt Lake City, Utah, Mar. 18, 1895. Studied: Univ. Utah, B.S;
special art training with McDermitt, Jack W. Smith, Frans Geritz,
Trude Hanscom. Member: Cal. A. Cl.; P. & S. Cl., Los A. (Pres.
1964); Am. Inst. FA (Chm. Advisory Bd., 1964-65); Laguna Beach
AA (Life); A. of the Southwest (treas., 1965); AAPL; Valley A. Gld.;
Cal. State Fair Art Advisory Bd. Awards: prizes, P. & S. Cl., 1953,
1955, 1961, 1963; A. of the Southwest, 1957, 1966, 1968; Cal. A. Cl.,
1961-1963, 1966; Friday Morning Cl., 1965, 66, 69; San Gabriel FA
Assn., 1968; Scandinavian-American A. Soc., gold medal, 1967,
prize, 1968; Ebell Cl., Los A., 1964, 1965, 1967; Work: City of Los

Angeles Coll.; City of Eilat Israeli Coll. Exhibited: Valley A. Gld., 1955-1964; P. & S. Cl., 1953, 1955, 1956, 1963, 1964; Ebell Salon, 1957, 1964-1969; City of Los Angeles A. Festival, 1953-1968; Laguna Beach AA, 1943-1951; de Saisset A. Gal., Univ. of Santa Clara, 1963; Cal. A. Cl. Annual, 1961-1969; A. of the Southwest, 1957-1965. One-man: Glendale AA, 1968; Alhambra (Cal.) City Hall, 1967; Los Angeles City Hall, 1965. Other group shows: Oakland Mus.; Santa Cruz A. Lg.; Los Angeles County Mus., and others.

MATSUOKA, JIRO ISAAC—Painter, W.
1111 14th Ave., Honolulu, Hawaii 96816
B. Honolulu, Hawaii, Mar. 17, 1930. Studied: Honolulu Sch. A.; Honolulu Acad. A., with Joseph Feher; ASL, with Bouche, Grosz, Bernard Klonis; Baker Univ.; Univ. Hawaii, B.F.A., with Ben Norris, Jean Charlot, Dorothea Tanning. Member: ASL; Hawaii WC Soc.; Honolulu Pr. M.; Honolulu AA; AFA; Hawaii A. T. Assn.; Int. Platform Assn.; Centro Studi e Scambi Internationali; Rome; Int. A. Gld., Monaco; Collector's Gld. Awards: prizes, Honolulu AA, 1952; Hawaii State Fair, 1953; Annual Art in Hawaii Exh., 1960; Narcissus Festival Art, Honolulu, 1963; Ala Moana Easter Festival, 1963; St. Paul A. Center, 1963 (purchase). Work: Honolulu Acad. A., Dept. Edu.; Baker Univ. Exhibited: Kansas State Regional, 1950, 1951; Hawaii local exhs., 1949, 1952, 1953, 1960-1969; ASL, 1955; Honolulu City Hall and Hawaii State Fair Exhs., 1963; Ala Moana Easter Festival, 1963; Washington State College, 1963; St. Paul A. Center, 1963; Mississippi AA, 1965; Ball State Univ., Muncie, Ind., 1965; Ohio Univ., 1965; Univ. Hawaii, 1968 (2-man); Pacific Gal. of Honolulu, 1968 (2-man); one-man: Gima's A. Gal., Honolulu, 1963; Birger Sandzen Mem. Gal., Lindsborg, Kans., 1963; Baker Univ., 1964; Galerie Internationale, N.Y., 1964-1967; 1969. Lectures: Motivation in Art, Community Program for Arts & Sciences, 1959.

MATTAHEI, MRS. FREDERICK—Collector
1025 Fifth Ave., New York, N.Y. 10028*

MATTHEWS, EUGENE EDWARD—Painter, E.
Fine Arts Bldg., University of Colorado; h. 2865 Jay Rd., Boulder, Colo. 80302
B. Davenport, Iowa, Mar. 22, 1931. Studied: Bradley Univ. A. Sch.; Univ. Iowa, B.F.A., M.F.A. Member: Am. Acad. in Rome Alumni Assn. Awards: Prix de Rome Fellowship in Painting, Am. Acad. in Rome, 1957-1959; Gold Medal of Honor, Milwaukee Inst. A., 1960; purchase awards, Watercolor:USA, Springfield, Mo., 1969; Butler Inst. Am. A., 1964. Work: NCFA; Butler Inst. Am. A.; Springfield A. Mus.; Denver A. Mus.; Joslyn Mus., Omaha, Neb.; Colorado Springs FA Center; Milwaukee A. Center; Des Moines A. Center; Sheldon Gals., Univ. Nebraska. Exhibited: Intl. Exh., Palais du Louvre, Paris, 1960; Spoleto, Italy, 1958; Rome, Italy, 1959; MMA, 1952; PAFA, 1962, 1963, 1965, 1967; Watercolor:USA, 1962-1969; Butler Inst. Am. A., 1961, 1962, 1964; Drawing:USA, 1963, 1968; CMA, 1968; Denver A. Mus., 1963, 1964, 1966; Colorado Springs FA Center, 1965; Joslyn Mus., 1962, 1968; Salt Lake A. Center, 1965, 1967; Oklahoma A. Center, 1963, 1966. Positions: Prof. A., University of Colorado, Boulder, Colo., at present.

MATTIL, EDWARD L.—Writer, Scholar, Teacher
269 Chambers Bldg., University Park, Pa. 16802; h. 1020 Glenn Circle N., State College, Pa. 16801
B. Williamsport, Pa., Oct. 25, 1918. Studied: Pennsylvania State Univ., B.S., M.Ed., D.Ed.; and with Viktor Lowenfeld and Hobson Pittman. Member: NAEA (Pres. 1963-1965). Awards: NGA, distinguished service award, 1965. Author: "Meaning in Crafts," 1965; Editor: "Everyday Art," and "A Seminar in Art Education for Research and Curriculum Development." Positions: Head, Dept. of A. Educ., Pennsylvania State Univ.

MATTISON, DONALD MAGNUS—Painter, E.
110 East 16th St.; h. 3845 Woodstock Dr., Indianapolis. Ind. 46208
B. Beloit, Wis., Apr. 24, 1905. Studied: Yale Sch. FA, B.F.A.; Am. Acad. in Rome, F.A.A.R. Member: Am. Acad. in Rome Alum.; CAA; Mid-West Col. A. Conference; Indiana A. Cl.; Grand Central A. Gal. Awards: Prix Hoosier Salon; Indiana A. Cl.; Tri-State Print Exh.; L. S. de Rome; prizes, Delgado Mus. A.; John Herron AI; Ayers Anniversary Exh.; Piedmont Festival. Work: John Herron AI; AIC; Riley Mem. Hospital; ports., N.Y. Stock Exchange; Episcopal Diocese of Western New York; American Fletcher Bank, Indianapolis; mural, Standard Life Bldg., Indianapolis. Monograph on artists' work in "Twenty Painters." Exhibited: GGE, 1939; MMA, 1950; PAFA; McDowell Cl.; AIC; CGA; VMFA; Delgado Mus. A.; NAD; John Herron AI; Hoosier Salon; Indiana A. Cl.; CM, and others. Positions: Dir., John Herron A. Sch., Indianapolis, Ind., 1933- .*

MATTSON, HENRY (ELIS)—Painter
c/o Frank K.M. Rehn Gallery, 683 Fifth Ave., New York, N.Y. 10022; h. Woodstock, N.Y. 12498
B. Gothenburg, Sweden, Aug. 7, 1887. Member: NA. Awards:

prizes, AIC, 1931; WMA, 1933; CGA, 1935, 1943; Carnegie Inst., 1935; Ft. Dodge award, 1940; med., PAFA, 1945, 1950; SC, 1946; Guggenheim F., 1935; Palmer Award, NAD. Work: MMA; WMAA; Carnegie Inst.; PAFA; Newark Mus.; Cranbrook Acad.; CAM; CGA; Wichita A. Mus.; WMA; BM; CMA; Toledo Mus. A.; CM; Santa Barbara Mus. A.; Kansas City AI; Detroit Inst. A.; Ft. Dodge Mus. A.; Syracuse Univ., & others; murals, USPO, Portland, Me. Exhibited: nationally & internationally.

MAULDIN, BILL—Cartoonist, W.
Chicago Sun-Times, Chicago, Ill. 60611
B. Mountain Park, N. Mex., Oct. 29, 1921. Studied: Chicago Acad. FA. Member: Nat. Cartoonists Soc. Awards: Pulitzer Prize, 1944, 1958; Sigma Delta Chi Award, 1964. Books: Sicily Sketchbook; This Damn Tree Leaks; Mud, Men and Mountains; Up Front; Back Home; A Sort of a Saga; Bill Mauldin's Army; Bill Mauldin in Korea; What's Got Your Back Up? Contributor articles for Life; Saturday Evening Post; Sports Illustrated; Atlantic Monthly; New Republic. Positions: Cartoonist, Chicago Sun-Times, Chicago, Ill., at present.*

MAURICE, ALFRED PAUL—Museum Director, Des., Gr., E.
University of Illinois at Chicago Circle, Box 4348, Chicago, Ill., 60680; h. 2725A S. Michigan Ave., Chicago, Ill. 60616
B. Nashua, N.H., Mar. 11, 1921. Studied: Univ. New Hampshire; Michigan State Univ., B.A., M.A. Member: Graphic Arts Sect., Michigan Governor's Council on the Arts; CAA; NAEA. Work: murals, Hudson (N.H.) Jr. H.S.; Community Chest Bldg., New Hampshire; Kalamazoo College; The Upjohn Co. Exhibited: BM; Phila. Pr. Cl.; Washington WC Cl.; Laguna Beach AA; Detroit Inst. A.; South Bend A. Center; Central Michigan Univ. Positions: Instr., Gr. A., Macalester Col., St. Paul, Minn.; Lettering & Layout, Michigan State Univ.; Gr. A., Des., State Univ. T. Col., New Paltz, N.Y., and Actg. Chm. A. Dept., 1955; Exec. Dir., The Maryland Institute, Baltimore, Md., 1957-59; Dir., Kalamazoo Art Center, Kalamazoo, Mich., 1959-1965; Prof. A., Chm. A. Dept., 1965-1967, Assoc. Dean of Faculties, 1969- , Univ. Illinois at Chicago Circle.

MAUZEY, MERRITT—Lithographer, W., P., I.
3424 Stanford St., Dallas, Tex. 75205
B. Clifton, Tex., Nov. 16, 1898. Member: Dallas Pr. Soc.; Texas FA Assn.; Dallas AA; AAPL; Texas A. T. Assn.; SAGA; Audubon A.; Cal. Soc. Et. Awards: Guggenheim F., 1946; prizes, Dallas Mus. FA; Beaumont, Tex., 1952; Dallas All. A.; Texas FA Assn.; Arizona State Fair, 1946, 1947; SSAL, 1947; LC, 1947; SAGA, 1948, 1956. Work: lithographs, AIC; CGA; LC; PMA; PAFA; MMA; Witte Mem. Mus.; Elisabet Ney Mus.; Mus. FA of Houston; Fondren Lib., Dallas; MMA; Dallas Mus. FA; N.Y. Pub. Lib.; New Britain Mus. A.; Brooks Mem. Mus.; Cal. State Lib.; Pa. State Univ.; Univ. Okla., Me., Wisc.; Dallas; Southern Methodist Univ.; Heintzleman Mem. Coll., Boston Pub. Lib.; Kerlan Coll., Univ. Minn.; Colorado Springs FA Center; and in private colls. Exhibited: WFNY 1939; WMAA; MMA; NAD, 1939-1956; PAFA, 1939-1956; Conn. Acad. FA, 1939-1956; AIC, 1939; LC; Assoc. Am. A.; BM; Audubon A.; Albany Inst. Hist. & A.; Denver A. Mus.; SFMA; Oakland A. Gal.; Carnegie Inst.; Rochester Mem. A. Gal., and many others. One-man: Delphic Studios, Lectures: Lithography. Prints included in "The Artist in America"; "Prize Prints of the 20th Century"; Southwest Review of Literature: "The Land of Beginning Again"; Author, I., "Cotton Farm Boy," 1954; "Texas Ranch Boy," 1955; "Oilfield Boy," 1956; "Rice Boy," 1958; "Rubber Boy," 1962; "Salt Boy," 1963.

MAWICKE, TRAN—Illustrator, P.
60 Summit Ave., Bronxville, N.Y. 10708
B. Chicago, Ill., Sept. 20, 1911. Studied: AIC; Am. Acad. A. Member: SI; AWS; Fairfield W.C. Group. Work: Schenectady Mus. A.; General Electric Laboratories; U.S. Air Force Historical Fnd.; Williamsburg Restoration. Exhibited: AWS, 1953-1955; Balt. WC Cl., 1953, 1954; West Chester AA, 1954, 1955; SC, 1953-1955; Frye Mus. A., Seattle, 1954; SI, 1953-1955; Santa Monica, Cal., 1954; Los Angeles, 1960; New Britain, Conn., 1961; U.S. Air Force, 1963-1966; Fairfield Univ., 1968; one-man: New York City, 1958. Illustrator: "South America," "Answers and More Answers," "R. E. Lee," "John Paul Jones," "Major Andre." Positions: Chm., Joint Ethics, SI, 1954-1959; Instr., Bronxville Adult Sch., 1956-58. Pres., Society of Illustrators, 1960-61. Dir., AWS, 1969-1971. Official artist, U.S. Air Force.

MAXON, JOHN—Associate Museum Director
Art Institute of Chicago, Chicago, Ill. 60603
Studied: Univ. Michigan, B. Des.; Harvard Univ., Ph.D. Member: AAMus. Dirs.; AAMus.; CAA. Positions: Dir., Mus. A., Rhode Island School of Design, Providence, R.I. to 1959; Dir. of Fine Arts, Art Institute of Chicago, 1959-1966; Assoc. Dir., 1966- .

MAXWELL, JOHN—Painter
415 Holly Lane, Wynnewood, Pa. 19096
B. Rochester, N.Y., 1909. Studied: Rochester Atheneum (now Roch-

ester Polytechnic Inst.); Provincetown Workshop with Victor Candell and Leo Manso; privately with nationally known instructors. Awards: PAFA; Audubon A. (2); AWS (3); Butler Inst. Am. A.; Phila. Sketch Cl. (3); Phila. WC Cl. (3); State Teachers Col., Indiana, Pa. (2); Washington WC Cl. (3); Woodmere A. Gal. (9); DaVinci A. All. (2). Work: Lehigh Univ.; Butler Inst. Am. A.; PMA, Phila. WC Cl.; and in many private colls. Exhibited: Smithsonian Inst. Traveling Exh.; Indiana State Teachers Col. Annuals; AWS annuals and traveling exhs.; Woodmere A. Gal.; "Watercolors: USA"; Tyler Sch. A.; Silvermine Gld. A. annuals; Pittsburgh Plan for Art; Phila. WC Cl; Phila. A. Festivals; PAFA; Nordness Gal., N.Y.; NAD oil annuals; Lehigh Univ.; Detroit Inst. A.; CGA; Butler Inst. Am. A.; PMA. One-man: Lehigh Univ.; Woodmere A. Gal., Phila.; Panoras Gal., N.Y.; Phila. A. All.; Bryn Mawr A.Center; Beaver Col.; Ahda Artzt Gal., N.Y.; Gallery Vendome, Pittsburgh; Argus Gal., Madison, N.J.; Everhart Mus., Scranton, Fontana Gal., Phila., and others.

MAY, A. WILFRED—Writer, Collector
Commercial and Financial Chronicle, 25 Park Place 10007; h. The Plaza, 5th Ave. at 59th St., New York, N.Y. 10019
B. Philadelphia, Pa., Apr. 5, 1900. Studied: Columbia College, A.B.; Columbia University, A.M. Author: Numerous books, articles in the U.S. and Europe; Contributor, article "Art as an Investment," to Saturday Review, 1958. Positions: Foreign Correspondent: New York Herald Tribune, North American Newspaper Alliance, London Financial Times, etc.; Executive editor, Commercial and Financial Chronicle, N.Y.C.; Accredited press member, U.N.; Faculty, New School, N.Y.C.; Trustee, Educational Alliance; Overseas Press Correspondents Fund; Financial Writers Association.*

MAY, MORTON DAVID—Collector, Patron
12 Brentmoor Park, St. Louis, Mo. 63105
B. St. Louis, Mar. 25, 1914. Studied: Dartmouth College, B.A. Awards: Great Cross of German government, for fostering interest in German painting in the U.S.A., 1963. Collection: German expressionism; Oceanic and Pre-Columbian collections; Other primitive sculpture; 20th century painting and sculpture.*

MAY, WILLIAM L.—Collector
Spencer Business College, 745 Laurel St. 70821; h. 10022 E. Coronado Drive, Baton Rouge, La. 70815
B. La Grange, Ga., Apr. 4, 1913. Studied: Columbia University, B.S.; Art History with Dr. Robert E. Day, Spencer College. Awards: Nomination for Pulitzer Prize in Journalism, 1955; International Patron of Art, Boston Museum of Fine Arts, 1969. Collection: Graphic prints (Old masters); Works by contemporary artists: oils, watercolors, gouache, polymer, including works by Moore, Rockmore. Article: "A Businessman Looks at Art," The Register, 1968; Author of brochures for artists and galleries in New Orleans, 1968. Positions: Secretary, U.S. Navy Press Club, San Francisco, Cal., 1945; Asst. Field Director, American Red Cross, 1953; Professional photographic participation, N.Y.C., 1945-1948; Photographed students' art work via contract, Columbia University art department; Bd. Directors, Louisiana Interior Design Institute, 1969.

MAYEN, PAUL—Designer
341 E. 62nd St., New York, N.Y. 10021; h. 61 Cedar Road, Cresskill, N.J. 07626
B. La Linea, Spain, May 31, 1918. Studied: CUASch.; ASL, Columbia Univ.; New Sch. for Social Research. Awards: A. Dir. Cl., N.Y. Work: MModA. Exhibited: BM; MModA; Nelson Gal. A.; Annual of Adv. Art. Contributor to Industrial Design; Interiors; Progressive Architecture; Art News Annual; Arts & Architecture; Architectural Forum magazines. Lectures: "Use of Symbols in Advertising Design"; "Is Decoration Good Design?"; "Structure & Form." Positions: Asst. A. Dir., F.W. Dodge-Sweet's Catalog; Des. Consultant to various industrial organizations; Book des. for leading publishers, ads, booklets, etc.; Instr., Adv. Des., CUASch.; Adv. Des., Parsons Sch., New York, N.Y.; A. Dir. for Agfa, Inc., Orradio and North American Philips Co.; Design Coordinator, Cadre Industries & Habitat, Inc. Designing foreign exhibits for USIA; Staff Des., Intrex, Inc.

MAYER, GRACE M.—Museum Curator, W., Collector
Museum of Modern Art, 11 West 53rd St. 10019; h. 35 E. 76th St., New York, N.Y. 10021
B. New York, N.Y. Member: Cosmopolitan Club, New York. Contributor to: Bulletin of the Mus. City of N.Y. Arranged many exh. including "Currier & Ives and the New York Scene," 1939; "Philip Hone's New York," 1940; "New York Between Two Wars," 1944; "Stranger in Manhattan," 1950; "Charles Dana Gibson's New York," 1950; "Currier & Ives Printmakers to the American People," the Harry Peters Coll., 1957-58; "Once Upon a City" Photographs by Byron, 1958; Served as Asst. to Edward Steichen—"70 Photographers Look at New York," MModA, 1957-58. Author: "Once Upon a City," New York from 1890 to 1910 as photographed by Byron and described by Grace Mayer with foreword by Steichen, 1958. Con-

tributor of articles to Popular Photography, Infinity, and other publications. Assisted in preparation of various photography exhibitions, initial installation in The Edward Steichen Photography Center, Museum of Modern Art, N.Y. Collection: Toulouse-Lautrec; Photography. Positions: Cur., N.Y. Iconography, Mus. City of New York, 1931-1959; Special Asst. to Dir. Dept. of Photography, Mus. Modern Art, New York, N.Y., 1959-60; Assoc. Cur., Dept. of Photography, Museum of Modern Art, New York, N.Y., 1961-1962, Cur., 1962-1968; Cur., The Edward Steichen Archive, The Museum of Modern Art, 1968- . Bd. Dirs., Print Council of America.

MAYER, RALPH—Painter, W., T., L.
207 West 106th St., New York, N.Y. 10025
B. New York, N.Y., Aug. 11, 1895. Studied: Rensselaer Polytechnic Inst.; ASL. Member: AEA; F., Am. Inst. Chemists; F., Int. Inst. for Conservation; Am. Soc. Contemp. A. (Bd. Governors, 1963, 1965, Vice-Pres., 1968-1969). Awards: Guggenheim F., 1952-53; "Man of the Year in Art" award, Nat. Art Materials Trade Assn., 1969; Grumbacher award, Am. Soc. Contemp. A., 1967. Author: "The Artist's Handbook of Materials and Techniques," 1941; rev., enl., 1957, 3rd ed. rev., enl., 1969; "The Painter's Craft," 1948, rev., enlarged, 1965; "A Dictionary of Art Terms and Techniques," 1969. Contributor to Technical Studies in the field of Fine Arts; Creative Art; College Art Journal; Encyclopaedia Britannica, and other publications. Exhibited: Annual exhibitions, 1962-1969. Retrospective Exh., Nassau Community College, 1967. Positions: Instr., Columbia Univ. Dept. of Painting & Sculpture; Lecturer, ASL; New School for Social Research, N.Y., and at numerous art schools and colleges in U.S. Author monthly page in Arts magazine, 1949-1958; American Artist, 1961- . Dir. Artists Technical Research Institute.

MAYER, ROBERT BLOOM—Collector
920 N. Michigan Ave., Chicago, Ill. 60605; h. 915 Sheridan Road, Winnetka, Ill. 60093
B. Chicago, Ill., Sept. 10, 1910. Studied: University of Chicago, Ph.D. Collection: Contemporary art; Oriental art; Antiques. Positions: Treasurer, Gallery of Contemporary Art, Chicago, Ill., 1964-1965; Committee on 20th century painting and sculpture, AIC 1964- .*

MAYERS, JOHN J. (DR.)—Collector
64 Metropolitan Oval, New York, N.Y. 10462; h. 1200 Midland Ave., Bronxville, N.Y. 10708
B. New York, N.Y., Aug. 16, 1906. Studied: University of Florida; School of Dental and Oral Surgery, Columbia University, D.D.S.; Certificate of Proficiency, Orthodontics, Columbia University. Awards: University Alumni Medal for Conspicuous Service, Columbia University, 1949. Collection: Oils, watercolors, drawings and sculpture, including works by Braque, Picasso, Matisse, Chagall, Laurens, Maillol, Renoir, Utrillo, Prendergast, Marin, Kuniyoshi. Positions: President, Association of Dental Alumni, Columbia University, 1940-1942.

MAYHALL, DOROTHY A.—Museum Director, S.
The Aldrich Museum of Contemporary Art, Ridgefield, Conn. 06877; h. 1070 Ridgefield Rd., Wilton, Conn. 06897
B. Portland, Ore., May 31, 1925. Studied: Univ. Iowa, M.F.A. Awards: Fulbright Scholar, Ecole des Beaux-Arts, Paris, France, 1950. Exhibited: A.M.Sachs Gal., N.Y., 1969; Silvermine Gld. A., 1968, 1969; Westchester A. Soc., 1967. Exhibitions assembled or arranged at the Aldrich Museum: Brandeis Univ. Creative Arts Awards 1957-1966, 1966; Highlights of the 1965-1966 Art Season, 1966; The Powers Collection, 1966; Art of 1964-1966 from the Aldrich Collection, 1967; Highlights of the 1966-1967 Art Season, 1967; Collection of Susan Morse Hilles, 1967; Cool Art 1967, 1968; Art of the Fifties, 1968; Highlights of the 1967-1968 Art Season, 1968; The Hanford Yang Collection, 1968; A Review of the Contemporary Art Scene 1964-1968, 1969; Highlights of the 1968-1969 Art Season, 1969. Positions: Instr., Design, Painting and Sculpture, Univ. Omaha, 1951, 1952; Exec. Sec., Junior Council, MModA, 1961-1964; Dir., The Aldrich Museum of Contemporary Art, Ridgefield, Conn., at present.

MAYHEW, EDGAR DE NOAILLES—Educator, Mus. Dir., L., W.
613 Williams St., New London, Conn. 06320
B. Newark, N.J., Oct. 1, 1913. Studied: Amherst Col., B.A.; Yale Univ., M.A.; Johns Hopkins Univ., Ph.D. Member: CAA; Conn. Antiquarian & Landmark Soc.; Soc. for Preservation of New England Antiquities; Bd. Memb., New London County Hist. Soc., Conn.; Antiquarian and Landmarks Soc. Member, Connecticut Commission on the Arts, 1967- ; Board Member, Thames Science Center; Lawrence Hospital, New London, Conn. Author: "Drawings of Sir James Thornhill," 1968 (London). Awards: Carnegie F. to Johns Hopkins Univ., 1939-1941. Author: "English Baroque," 1943. Lectures: Renaissance, Gothic & Modern Art. Positions: Inst. FA, Johns Hopkins Univ., 1941-42; Instr. FA, Wellesley Col., 1944-45; Prof. FA, Connecticut Col., New London, Conn., 1945- ; Cur., Lyman Allyn Mus., New London, Conn., 1950-1960, Dir., 1960- .

MAYHEW, RICHARD—Painter, I.
 3223 Glenwood Rd., Brooklyn, N.Y. 11210
B. Amityville, L.I., N.Y., Apr. 3, 1924. Studied: Brooklyn Mus. A.
Sch. Awards: John Hay Whitney Fellowship, 1958; Ingram Merrill
Fnd. Award, 1960; Tiffany Fnd. Fellowship, 1963; Am. Acad. A. &
Lets. Grant, 1965. Work: WMAA; Olsen Fnd.; BM; and in other pub-
lic and private collections, U.S. and abroad. Exhibited: Am. Acad.
A. & Lets.; BM; Butler Inst. Am. A.; AIC; Gallery of Modern Art,
N.Y.; NAD; Nat. Inst. A. & Lets.; New Sch. for Social Research;
Carnegie Inst.; Univ. Illinois; WMAA. One-man: Six in New York.
Positions: Instr. A., Brooklyn Museum Art School and the Art Stu-
dents League.*

MAYS, MAXWELL—Illustrator, W., P., Des.
 Woodlot Farm, Coventry Center, R.I. 02816
B. Providence, R.I., Aug. 13, 1918. Studied: R.I.Sch. Des.; Parsons
Sch. Des.; ASL. Member: SI; Providence A. Cl.; Am. A. Group;
Providence WC Cl. Author, I., Colliers; Cosmopolitan; Ford Times;
Lincoln Mercury Times; Yankee Magazine; This Week; The Rhode
Islander Magazine. Exhibited: Providence A. Cl.; Attleboro Mus A.*

MAYTHAM, THOMAS NORTHRUP—Associate Museum Director
 Seattle Art Museum, Volunteer Park; h. 201 36th Ave., Seattle,
 Wash. 98102
B. Buffalo, N.Y., July 30, 1931. Studied: Williams College, B.A.;
Yale University, M.A. Member: American Association of Museums;
ICOM; Western Association of Art Museums. Editor, "Catalogue of
American Painting in the Boston Museum," 1969. Contributor of
articles to: Antiques; Canadian Art; Boston Museum Bulletins. Lec-
tures: All periods of Western Art, especially European and Ameri-
can painting. Exhibitions arranged: "Ernest Ludwig Kirchner,"
retrospective exhibition, 1968-1969, Seattle Art Museum. Positions:
Assistantship, Wadsworth Atheneum, Hartford, Conn., 1955; Assis-
tant Curator and Head Department of Paintings, Museum of Fine
Arts, Boston, Massachusetts, 1956-1967; Associate Director, Seat-
tle Art Museum, 1967- .

MAZUR, MICHAEL—Printmaker, S.
 69 Harvey St.; h. 5 Fuller Place, Cambridge, Mass. 02140
B. New York, N.Y., Nov. 2, 1935. Studied: Amherst College, A.B.;
Yale Sch. Art & Architecture, B.F.A., M.F.A. Awards: Tiffany
Scholarship, 1962, 1964; Guggenheim Grant, (Fellowship), 1964-
1965; Nat. Inst. A. & Lets. Award, 1964; Tamarind Fellowship, 1968;
awards and purchase prizes from Phila. Print Cl., SAGA, LC, and
others. Work: LC; Smith College; Mus. FA of Boston; MMA; Yale
Gallery of FA; AGAA; AIC; FMA; Portland Mus. A.; BM; USIA Col-
lection; WMAA; Rose A. Mus., Brandeis Univ.; CM. Exhibited:
PAFA, 1965, 1969; 50th Anniversary Exh., Phila. Pr. Cl., 1963;
MModA, 1963, 1964, 1969; Friends of the Whitney Museum, 1965;
BM, 1960, 1962, 1964, 1966, 1967, 1968; LC, 1959, 1961, 1963, 1965, 1967,
1969; SAGA, 1963-1969; Kane Memorial, Providence, 1962; Boston
Pr. M., 1960, 1962-1964; Boston A. Festival, 1960, 1963; Smith Col.,
1965; deCordova & Dana Mus., 1965; Rose A. Mus., Brandeis Univ.,
1969; WMAA, 1969; Ringling Mus., Sarasota, Fla., 1969; Alpha Gal.,
Boston, 1969; AAA Gal., N.Y., 1968; Univ. Ind., 1967; Univ. Wash.,
1967; Carlton Col., 1968; BMFA, 1968; Wellesley Col., 1969; Paris
Biennale, 1969; Rijksacademie, Amsterdam, 1968; Smithsonian
traveling exh., 1968; Santiago Biennale, 1967; Positions: Instr.,
Drawing and Prints, Rhode Island School of Design, 1961-1964; Yale
Summer Session, 1963. Asst. Prof., Brandeis Univ., 1964- .

MEADMORE, CLEMENT—Sculptor
 317 W. 99th St., New York, N.Y. 10025
B. Melbourne, Australia, Feb. 9, 1929. Studied: Royal Melbourne
Inst. Technology. Work: Columbia Univ., N.Y.; Australian Govern-
ment; City-Olympic Games Commission (1968); Chase Manhattan
Bank; State of New York-South Mall, Albany, N.Y.; Australian Mutual
Provident Soc., Melbourne. Exhibited: WMAA, 1969; Rockefeller
Coll., MModA, 1969; Int. Sculpture Bienale, Paris, 1961; Guggen-
heim Int., 1967; Nat. A. Gal. of Victoria, Melbourne, 1968; Sydney A.
Gal., 1968; Aldrich Mus. Contemp. A., Ridgefield, Conn., 1968, 1969.
Author: "Megaliths," 1970. Contributor to Arts magazine, 1969.

MEADOWS, ALGUR H.—Patron
 6601 Turtle Creek, Dallas, Texas 75205*

MEEHAN, WILLIAM D.—Designer, P., T.
 De Pauw Art Center; h. 411 E. Seminary, Greencastle, Ind.
 46135
B. Decatur, Ill., Oct. 23, 1930. Studied: AIC, B.F.A.; Bradley Univ.,
M.A. Awards: prizes, Ohio Valley Exh., Ohio Univ., 1959 (pur-
chase); Eunice Bannister Award, Peoria A. Center, 1959; Peoria &
Vicinity Exh., 1960; Lincoln Nat. Bank award, Syracuse, 1962; Mid-
States Exh., Evansville, 1964; Indiana Artists, Indianapolis, 1964,
1967; Central Illinois Exhibit, Decatur, Ill., 1966. Work: Bradley
Univ.; Ohio Univ.; Evansville Mus. A. & Sciences. Exhibited: Nat.

Small Paintings exh., Purdue Univ., 1964; Contemp. Religious Art
Exh., Peoria, Ill., 1960; Ohio Univ., 1959; Central Ill. A., Decatur,
1960; Peoria A. Center, 1955-1960; Artists of Illinois, 1959-60; Ill.
State Fair, 1960-61; Syracuse, 1961-1963; Munson-Williams-Proc-
tor Inst., 1962-63; Finger Lakes Exh., 1962-63; N.Y. State Fair,
1962; Indiana Artists, 1964-65; Mid-States, 1964. Positions: Artist
for Caterpillar Tractor Co., 1956-1960; Thompson Adv. Agcy.,
1960; A. Dir., Southwestern Press, 1955-56; Instr., Painting, Peoria
A. Center; A. Consultant, De Pauw Univ., 1964- ; Instr., design &
drawing, Syracuse Univ., 1960-1964; Prof., design painting & draw-
ing, De Pauw Univ., 1964-present.

MEEKER, DEAN JACKSON—Printmaker, Muralist
 309 Parkway, Glen Oak Hills, Madison, Wis. 53716
B. Orchard, Colo., May 18, 1920. Studied: AIC, B.F.A., M.F.A.;
Northwestern Univ.; Univ. Wisconsin. Awards: Medal Honor, Mil-
waukee AI, 1952, 1956; Guggenheim Fellowship, 1958. Work: BMFA;
SAM; SFMA; DMFA; Denver A. Mus.; Milwaukee AI; Beloit Col.;
Wis. State T. Col.; Phila. Pr. Cl.; Univ. Oklahoma; Wisconsin Union;
Gimbel Coll.; Bibliotheque Nationale, Paris; Victoria & Albert Mus.,
London; LC; deCordova & Dana Mus.; MModA; USIA, Bonn, Ger-
many. Exhibited: BMFA, 1954-1956; PAFA, 1946-1953; BM, 1951-
1955; LC, 1952, 1954, 1955; SAM, 1953-1955; SFMA, 1952-1954;
Walker A. Center, 1952-1954; Exh. Momentum, Chicago, 1952-1954;
MMA, 1953; MModA, 1955; AIC, 1952; Mun. Mus., The Hague, 1954;
one-man AIC; Milwaukee AI; Connecticut Col.; Univ. Missouri; La
Gravure, 1959; Los A. Mus. A., 1959. Lawrence Col. Positions:
Assoc. Prof., A. Edu. Dept., Univ. Wisconsin, Madison, Wis.,
1946- .

MEGARGEE, LAWRENCE A.—Animal Illustrator
 16 Garden Pl., Brooklyn, N.Y. 11201
B. Philadelphia, Pa., July 10, 1900. Studied: PAFA; NAD; ASL;
PIASch; CUASch; Grand Central A. Sch. Work: Grand Central A.
Gal.; Cross Roads of Sport; Ackerman Gal.; Harlow Gal., all in New
York, N.Y. I., The Spur; Town & Country; Country Life; The Sports-
man magazines.

MEGREW, ALDEN FRICK—Educator, Hist.
 Department of Fine Arts, Theatre 201, University of Colorado;
 h. 505 Baseline Road, Boulder, Colo. 80302
B. Plainfield, N.J., Aug. 30, 1908. Studied: Harvard Univ., B.S.,
M.A. Member: CAA; Colo. Edu. Assn. (Council, 1947-); Midwest-
ern Col. A. Conf. (Sec., VP, Pres.); Southwestern Col. A. Conf.
(pres. twice). Author: "Outline of Northern Renaissance Art,"
1947; "Outline of Medieval Art," 1947. Contributor to College Art
Journal. Lectures on Art History to conferences and public audi-
ences. Positions: Instr., Lawrence College, Appleton, Wis., 1934-
40; Univ. Iowa, 1940-47; Prof. A., Hd. Dept. Fine Arts, University
of Colorado, Boulder, Colo., 1947-1964. Now on University Faculty
Fellowship from Univ. of Colorado, 1965, for research on Roman-
esque architecture and sculpture. Visiting Professor, American
College, Paris, 1968.

MEHRING, HOWARD WILLIAM—Painter, T.
 735 10th St., S.E., Washington, D.C. 20003
B. Washington, D.C., Feb. 19, 1931. Studied: Wilson T. Col., Wash-
ington, D.C., B.S.; Catholic Univ. of America, Washington, D.C.,
M.F.A. Work: Woodward Fnd., CGA, NCFA, Washington Gal. Mod.
A., all Washington, D.C.; MModA; Guggenheim Mus.; WMAA; River-
side Mus.; Los Angeles County Mus.; Rose A. Mus., Brandeis Univ.;
Wadsworth Atheneum, Hartford, Conn.; Chase Manhattan Bank;
Joseph Seagram & Sons, N.Y.; Michener Coll., Univ. Texas; PC;
Exhibited: WMAA, 1967 (2); Wash. Gal. Mod. A., 1967; MModA, 1967;
Guggenheim Mus., 1966, 1967; Jewish Mus., N.Y., 1966; NCFA, 1966;
CGA, 1966; "Washington Color Painters," organized by Washington
Gal. Mod. A. and traveling to Univ. Texas; Univ. California, Bran-
deis Univ. and Walker A. Center, 1965-1966; Los A. County Mus.,
traveling, 1964; Carnegie Int., 1961. One-man: Origo Gal., 1959,
Jefferson Place Gal., 1961, 1962, Adams Morgan Gal., 1963, all
Washington, D.C.; A. M. Sachs Gal., N.Y., 1965, 1966, 1968.

MEIGS, JOHN (LIGGETT)—Painter, W., L., Des.
 San Patricio, N.M. 88348
B. Chicago, Ill., May 10, 1916. Studied: Redlands Univ.; Paris,
France. Awards: prizes, Texas WC Soc., 1955; Roswell Mus., 1955;
Cattlemen's Assn., 1953, 1954; El Paso, Tex., 1952, 1953; Southwest
Biennial, 1964. Work: Texas Tech. Col.; Roswell Mus.; Feldman
Col.; Ball State Mus., Muncie, Ind.; Snyder (Tex.) H.S.; Anderson Oil
Co., Roswell, N.M.; Reese Elementary Sch., Lubbock; murals, North
Jr. H.S., Abilene, Tex.; Univ. Texas, Austin; (with Peter Hurd)
pioneer murals, Texas Tech. Univ., Lubbock. Exhibited: Walker A.
Center, 1954; Mus. New Mexico, Santa Fe, 1953-1955 and traveling
exhs.; AWS, 1953; Texas WC Soc., 1955; Roswell Mus., 1953-1955;
Texas Western Col., 1952, 1953; Cattleman's Assn., 1953, 1954;
Hackley A. Gal., 1954; one-man: Mus. New Mexico, 1953; Texas

Tech. Col., 1953; Southwest Oil Men's Assn., 1953; Snyder AA, 1954; Grand Central A. Gal., 1954; Plainview AA, 1954; Hackley A. Gal. (3-man), 1954; Ball State Mus., 1954; Little Gal., Santa Fe, 1954; Abilene AA, 1955; Dayton AI, 1955; Honolulu Acad. A., 1958; Currier Gal. A., 1958; North Park, Dallas, 1968; Gold Key Gal., Scottsdale, Ariz., 1968, and others. Contributor to Ford Times, Humble Way. Positions: Dir., Baker Collector Gallery, Lubbock, Tex. Editor: "Peter Hurd: The Lithographs," 1969. Lectures: "The World of Andrew Wyeth."

MEIGS, WALTER—Painter, E.
c/o Lee Nordness Galleries, 236/238 E. 75th St., New York, N.Y. 10021
B. New York, N.Y., Sept. 21, 1918. Studied: Syracuse Univ., B.F.A.; Fontainebleau, France; State Univ. Iowa, M.F.A. Awards: 37 prizes in National and Regional Exhibitions. Work: Munson-Williams-Proctor Inst.; Pa. State Univ.; Birmingham Mus. A.; Denver. A. Mus.; Amherst College; Springfield (Mo.) Mus. A.; Lyman Allyn Mus. A; Cultural Div., U.S.I.S;; Wadsworth Atheneum; Butler Inst. Am. A.; Fort Worth A. Center; Wichita AA; de Cordova & Dana Mus.; VMFA; Johnson Coll.; Morristown Jewish Center; LC. Exhibited: nationally. One-man: Alan Gal., N.Y., 1954; Wesleyan Univ., Middletown, Conn., 1956; Lyman Allyn Mus. A., 1956; Mirski Gal., Boston, 1957, 1961, 1963; Nordness Gal., N.Y., 1958, 1962, 1964, 1967; Harmon Gal., Naples, Fla., 1966, 1969.

MEISS, MILLARD—Educator, W.
Institute for Advanced Study, Princeton, N.J. 08540
B. Cincinnati, Ohio, Mar. 25, 1904. Studied: Princeton Univ., A.B.; Harvard Univ.; N.Y. Univ., M.A., Ph.D. Awards: Honorary trustee Metropolitan Museum of Arts; Corresponding member: Accademia Senese degli Intronati. Member: CAA; Mediaeval Acad. Am. Author: "Painting in Florence and Siena after the Black Death," 1951; "Andrea Mantegna as Illuminator," 1957; "Giotto and Assisi," 1960; (with Leonetto Tintori) "The Painting of the Life of St. Francis in Assisi," 1962; "Giovanni Bellini's St. Frances in the Frick Collection," 1964; "French Painting in the Time of Jean de Berry: The Late XIV Century and the Patronage of the Duke," 1967, 2nd ed. 1969; "French Painting in the Time of Jean de Berry: The Boucicaut Master," 1968. Contributor articles on Mediaeval & Renaissance Painting to Art Bulletin, Art in America, Burlington Magazine, & other art publications. Positions: Prof. History of Art, Institute for Advanced Study, Princeton, N.J. Ed. Bd., Art Bulletin.

MEISSNER, BERNIECE (Bunny) (Mrs. Leo)—
Shore Acres, Cape Elizabeth, Me.; s. Monhegan Island, Me. 04852
B. Scarborough, Me., Nov. 30, 1903. Studied: Portland Sch. F. & App. A., with Alexander Bower and with Eliot O'Hara, Bradford Brown, John Muench. Member: Portland Soc. A.; Portland Sch. F. & App. A. Alumni; Maine A. Gal. Positions: Art Columnist, writer, for Gannett Pub. Co., Portland, Me. (Ret.).

MEISSNER, LEO—Engraver, P.
Avon Rd., Cape Elizabeth, Me. 04107; s. Monhegan, Me. 04852
B. Detroit, Mich., June 28, 1895. Studied: Detroit Sch. FA, with John P. Wicker; ASL. Member: NA; Albany Pr. Cl.; SAGA; Audubon A.; Boston Pr.M.; AAPL; Mich. Acad. Sc., A. & Let. Awards: prizes, Southern Pr.M., 1937, 1938; Wichita, Kan., 1937; Detroit Inst.A., 1943, 1945; LC, 1931-1936; NAD, 1953, 1964; Ogunquit A. Center (2); Academic A., Springfield, Mass. (2); Boston Pr.M. (2). Work: Lib. Cong.; Currier Gal. A.; PMG; PMA; Arnot A. Gal., Elmira, N.Y.; Detroit Inst. A.; Joslyn Mem.; City Lib. Assn., Springfield, Mass.; MMA; Brooklyn Inst. A.; Pa. State Univ.; Syracuse Univ.; N.Y. Pub. Lib.; IBM; Univ. Maine; Farnsworth Mus., Rockland, Me.; Smith Col.; Newark Pub. Lib.; Colby Col.; Bates Col. Exhibited: 50 Prints of the Year, 1927-1929, 1933; AIC; CMA; Lib. Cong.; AV, 1943; AFA traveling exh.; Carnegie Inst., 1941, 1944, 1945; Int. Pr. Exh., Warsaw, Poland; Smithsonian Inst.; Los A. Mus. A.; NAD; Southern Pr.M.; Prairie Pr.M.; Northwest Pr.M.; Detroit Inst. A.; PAFA; SAGA traveling exh., England, 1954-55; Swope A. Gal.; Farnsworth A. Mus.; Portland (Me.) Mus. A.; deYoung Mem. Mus.; Wash. Pr.M.; Five Centuries of Fine Prints, N.Y.; USIA & SAGA traveling US & Europe, and many others.

MEIZNER, PAULA—Sculptor, T.
126 Seacord Rd., New Rochelle, N.Y. 10804
B. Poland. Member: Audubon A.; NAWA; Silvermine Gld. A.; Knickerbocker A.; Westchester A. Soc.; Yonkers AA. Awards: prizes, Silvermine Gld. A., 1959, 1961; Knickerbocker A., Medal of Honor, P. & S. Soc. of New Jersey; The Sculpture House Award, 1962; Westchester A. & Crafts Gld., 1959; Westchester A. Soc., 1962; Yokers AA, 1960. Exhibited: PAFA, 1960; Detroit Inst. A., 1959; Connecticut Acad. FA, 1963, 1967, 1968; Tyler, Texas, 1962; Syracuse, N.Y., 1967; New England Artists exhs., 1958-1967; P. & S. Soc. of New Jersey annually; Audubon A.; All. A. Am.; Knickerbocker A.; West-

chester A. Soc., 1962, 1967; Gal. 10, Mt. Vernon, 1960; Stamford (Conn.) Mus., 1966; Marymount Col., 1967. Katonah, N.Y., 1967; one-man: Silvermine Gld. A., 1967.

MELAMED, ABRAHAM (DR.)—Collector, Patron
2500 N. Mayfair Rd. 53226; h. 1107 E. Lilac Lane, Milwaukee, Wis. 53217
B. Chicago, Ill., Nov. 19, 1914. Member: Wisconsin Arts Foundation and Council; Milwaukee Chapter, American Friends of Hebrew University; Milwaukee Roentgen Ray Society. Collection: 20th Century American and European graphics, sculpture, paintings. Positions: Chairman, member, Awards Committee, Governor's Council on the Arts, Wis., 1963, 1964; Trustee, Archives of American Art, Detroit, Mich.; Member, National Board, American Friends of Hebrew University; Past President, Wisconsin Radiological Society; Board Directors, Wisconsin Arts Foundation and Council, appointed by the Governor, 1965- .

MELCARTH, EDWARD—Painter, T., S., C., L.
203 W. 14th St., New York, N.Y. 10011
B. Louisville, Ky., Jan. 31, 1914. Studied: Harvard Col.; with Karl Zerbe, Cambridge, Mass.; Academie Ranson, Atelier 17, Paris, France. Member: NSMP; Arch. Lg. Awards: Am. Inst. A. & Let. grant; prizes, AIC; Bordighera, Italy; Kentucky-Indiana annual, 1957; Altman prize, NAD, 1964 and Ranger prize, 1964; "Painting by an American Artist," 1969. Work: Wadsworth Atheneum; BMFA; Detroit Inst. A.; Seagram Co.; IBM; Univ. Louisville; Bradford, England; Bordighera, Italy. Other work: ceiling, Lunt Fontanne Theatre, 1958; Time Life, 1958; lobby & auditorium, Rooftop Theatre, N.Y., 1957; painting and sculpture, walls and ceiling, Oval Room, Hotel Pierre, N.Y.C.; IBM, 1958; two folios, Fortune Magazine; Folio "The Lamp," Esso, 1951; two commissioned works, Frankfurt, Germany, etc. Exhibited: WMAA; CGA; PAFA; AIC; AFA traveling exh.; Contemp. A., Boston; Univ. Wisconsin; J. B. Speed Mus. A.; Los A. Mus. A.; Univ. Illinois; Sarasota, Fla.; Palm Beach, Fla. (one-man), and others. Illus. for Fortune, Harper's, Life, The Lamp, Town & Country, etc. Instr., Painting & Drawing, Univ. Louisville, Parsons Sch. Des., Columbia Univ., Univ. Washington.

MELIKIAN, MARY—Painter, T., Des., L., W., I.
338 E. 55th St., New York, N.Y. 10022
B. Worcester, Mass., Nov. 19, 1927. Studied: R.I. Sch. Des., B.F.A.; Columbia Univ. T. Col. Member: Alumni Bd. Governors, R.I. Sch. Des., 1967-1970; Burr Gal. Artists; Nutley (N.J.) Teachers Assn. Awards: Kit Kat Cl., 1961; Armenian Students Assn., 1961, 1962. Work: WMA; Near East Fnd. N.Y.; Armenian Union Center, N.Y.; Catholicate of the Armenian Church, Etcmiadzin, Armenia. Exhibited: Providence A. Cl., 1954; Art for Embassies Program, U.S. State Dept., 1967-1969; Burr Gal., 1967, 1968; Grand Central A. Gal., N.Y., 1961-1969; one-man Exhs., Burr Gal., 1962; Myers Gal., 1964; Armenian Benevolent Union Center, 1968, all New York City; Casdin Gal., Worcester, Mass., 1969. Positions: Asst. Des., "Modern Masters Series," Fuller Fabrics, N.Y., 1956; Asst. Dir., Grand Central Moderns, 1960; Dir., Public Relations, Grand Central Galleries, 1961-1967.

MELLON, MRS. GERTRUDE A.—Collector
Riversville Road, Greenwich, Conn. 06833*

MELLON, JAMES—Printmaker, P., T.
498 Broome St. 10012; h. 37 Grove St., New York, N.Y. 10014
B. New York, N.Y., Feb. 14, 1941. Studied: Creative Graphic Workshop with Chaim Koppleman; ASL. Member: SAGA (council). Awards: prizes, Pennell purchase prize, LC, 1958, 1961; Warren Mack Memorial Award, 1965; purchase prize, Everson Mus. A., Syracuse, N.Y. Work: Pennell Coll., LC; Smithsonian Inst.; Univ. Pennsylvania. Exhibited: LC, 1959; BMFA Print Exh., 1959; Univ. Kentucky, 1958; Art:USA, 1959; Oakland A. Mus., 1958; School of Visual A. Gal., N.Y., 1962; SAGA traveling exh. to South America, 1962; Terrain Gal., N.Y., regularly; Everson Mus. A., 1968; Pratt Inst., Int. Miniature Print exh., 1967, 1968; Cranbrook Acad. A., Bloomfield Hills, Mich.; colleges throughout U.S. Positions: Instr., Graphics, School of Visual Arts, N.Y.; Instr., Media, Brooklyn College Adult Education Department.

MELLON, PAUL—Collector
1729 H St., N.W., Washington, D.C. 20006; h. Oak Spring, Upperville, Virginia 22176
B. Pittsburgh, Pa., June 11, 1907. Studied: Yale University, B.A.; Clare College, Cambridge University, England, B.A., M.A. Awards: Award for Distinguished Service to the Arts, National Institute of Arts and Letters, 1962; Benjamin Franklin Medal, Royal Society of Arts, London, England, 1965; Honorary D. Litt., Oxford University, England, 1961; Honorary LL.D., Carnegie Institute of Technology, 1967; Honorary L.H.D., Yale University, New Haven, Conn.; Benjamin Franklin Fellow, Royal Society of Arts, London, England, 1969.

Collection: (Mr. and Mrs. Paul Mellon) English paintings, 1700-1850; Impressionist and post-impressionist paintings. Positions: President, Trustee, NGA; Chairman, Old Dominion Foundation, New York; Chairman, Bollingen Foundation, New York; Trustee VMFA, Richmond, Va; Trustee, Yale University Art Gallery Associates, New Haven, Conn.

MELLOW, JAMES R.—Critic
298 8th Ave., Sea Cliff, N.Y. 11579
B. Gloucester, Mass., Feb. 28, 1926. Studied: Northwestern Univ., B.S. Editor: "The Best in Arts," 1962; "New York: The Art World," 1964. Contributor to New York Times, The New Leader, Art International, Commonweal.

MELTZER, ANNA E(LKAN)—Painter, T.
315 West End Ave., New York, N.Y. 10023
B. New York, N.Y., Aug. 6, 1896. Studied: CUASch.; ASL, and with Alexander Brook. Member: F., Royal Soc. A., London, England; AAPL; Golden Legion. Awards: medal, Audubon A., 1942; citation, Fla. Southern Col. Work: BM; Pittsfield (Mass.) Mus. A.; Joslyn Mem. Mus.; Cal. PLH; Fla. Southern Col.; Georgia Mus. A.; Lawrence R. Schumann A. Fnd., Boston; Washington County Mus. FA, Hagerstown, Md.; Phoenix,Mus. A.; Philathea Mus. of Modern A. London, Ontario, Canada. Exhibited: Audubon A., 1942, 1944, 1945; NAWA, 1944-1946; All. A. Am., 1944; Pasadena AI; Erie (Pa.) Pub. Mus.; Cortland, N.Y., Gal. & Lib.; French & Co.; Fla. Southern Col.; Marie Sterner Gal.; Collectors Gal., N.Y., 1959; PACEM in Terris Gal., N.Y., 1968; one-man: Rockford AA; Massillon Mus. A.; Bloomington AA; Evansville Mus.; Plainfield AA; Rundle Gal., Rochester; Cayuga Mus. Hist. & A.; Univ. Florida; Vendome Gal.; Newhouse Gal.; Francis Taylor Gal., Los A.; Chase Gal., N.Y., 1958. Peter Cooper Gal., N.Y.; Rutgers Univ.; Castleton (Vt.) State Col.; Jasper Rand Mus., Westfield, Mass.; Arlington (Tex.) State Col.; Erb Mem. Union, Univ. Oregon, Eugene; Loyola Univ., Chicago, and many other colleges. Positions: Dir., Anna Meltzer Sch. A., New York, N.Y. (Anna E. Meltzer Art Society, founded 1959, by students of the Anna Meltzer Sch. of A.).

MELTZER, ARTHUR—Painter, C., L.
1521 Welsh Rd., Huntingdon Valley, Pa. 19006
B. Minneapolis, Minn., July 31, 1893. Studied: Minneapolis Sch. FA; PAFA; & with Robert Koehler, Joseph Pearson, Daniel Garber. Member: Woodmere AA (Bd. member); Phila. A. All.; PMA; F., PAFA, AEA. Awards: F., PAFA, 1925; Cresson traveling scholarship, PAFA; prizes, Woodmere Gal. A., 1949, 1951, 1967; prize, Conn. Acad. FA, 1931; gold medal, A. Lg. of Ligonier Valley, 1961; Rosenau prize, Old York Rd. A. Gld., 1967. Work: PAFA; Storrs Col., Conn.; Illinois Athletic Cl., Chicago; Columbus Gal. FA; Phila. A. All.; Moore Inst. A. Sc. & Indst.; Carlisle A. Mus., Pa.; Woodmere A. Gal. Exhibited: PAFA, 1921-1946; AIC; CGA; Woodmere A. Gal.; F., PAFA. Lectures: Artistic Anatomy. Positions: Instr., Drawing & Painting, L., Anatomy 1925- , Hd. Dept. FA, 1925-49, Moore Inst., Philadelphia, Pa.

MELTZER, DORIS—Printmaker, P., A. Dir.
Doris Meltzer Gallery, 38 West 57th St., New York, N.Y. 10019
B. Ellenville, N.Y., Jan. 1, 1908. Studied: N.Y. Univ., B.S.; ASL, and in Europe. Member: AAMus; Print Council Am.; Nat. Ser. Soc. (Vice-Pres., Dir., 1943-63). As printmaker has exhibited in Nat. Print shows 1940-50. Founded Nat. Ser. Soc., 1940, traveling exhibition service, school and gallery. Introduced Scandinavian graphic art to U.S. in series of exhibitions from 1951. Arranged exhibitions of prints and paintings for travel under auspices of U.S. Embassy, Cultural Div., Paris, 1952- . Prepared 4 educational exhibitions on American serigraphy for foreign travel, 1950. Founded the Meltzer Gallery, 1954. Prepared exhibitions for travel under sponsorship of USIA for the Overseas Program, including "American Serigraphs and How They Are Made," 1955, 1956; "Fifty Years of American Graphic Art," 1957-58 and supervised the publishing of 300 exhibitions of reproductions of 40 American paintings for "20th Century Highlights of American Painting" for the USIA, 1958. Positions: Dir., Doris Meltzer Gallery, New York, N.Y. (founded 1963).*

MENCONI, RALPH JOSEPH—Sculptor
154 West 55th St., New York, N.Y. 10019; h. Old School Lane, Pleasantville, N.Y. 10570
B. Union City, N.J., June 17, 1915. Studied: Yale Univ., B.F.A.; Hamilton Col.; NAD; Tiffany Fnd. Member: F., NSS; Century Assn.; Mun. A. Soc. Awards: Speyer award, NAD, 1941; Tiffany Fnd. grant, 1947; Nat. Jefferson Expansion Mem. (in collaboration with Caleb Hornbostel), 1947; Jefferson Comp., 1948. Work: Brookgreen Gardens, S.C.; Bambergers, N.J.; St. Rose of Lima, Short Hills, N.J.; St. Joseph's Catholic Church, Camden, N.J.; Speer Mem. Lib., Princeton, N.J.; Herkimer County Office Bldg.; AFL-CIO Bldg., Wash., D.C.; South Bend Pub. Lib.; Nassau Cathedral, Bahamas; medals,

plaques, Nat. Book Award: N.Y. Univ. Law Center; Kenyon Col.; Lebanon Steel Co.; Ford Centennial; Univ. Cincinnati; MacArthur Memorial, Norfolk; Massey-Ferguson United Fund; Reader's Digest; Diamonds USA, Puerto Rico; Pittsburgh Bicentennial Medal; Michigan State; General Electric; Buckley Sch.; Grenfell Assoc.; other medals: Project Mercury—7 Astronauts; John F. Kennedy Mem. Medal; Robert F. Kennedy Memorial Medal, 1968; Official Inaugural Medal, Richard M. Nixon, 1969; State Visit Medal, Levi Eshkol (Israel), 1968; Sir Winston Churchill Mem. Medal; L.B.J. Medal; U.S. Pavillion, N.Y. World's Fair; Alaska Statehood; Borden Co.; Centro d'Italia (Ford), Aureomycin (Am. Cyanamid). Three Historic Commemorative Series of Collector Medals: (1) All Presidents of the U.S. (Portrait obv., Seal rev.), 32 of 36 completed. (2) States of the Union (Portraits with State Seals), 30 of 50 completed. (3) All Signers of the Declaration of Independence (Portraits), 29 of 57 completed. Port. busts and bas-reliefs include Samuel Gompers, Philip Murray, William Green, Gen. Somervell, Rev. Thomas D. Acheson, Wilbur Cross, Thomas Jefferson, and many other prominent persons. Reredos-Lutheran Church, Pleasantville, N.Y.; Pace College, New York City, N.Y. Exhibited: NAD; NSS; Medallic Art Co.; Int. Comp., Imperial Palace, Addis Ababa; Int. Comp. Herzl Mem., Israel; Govt. of Portugal, Int. Comp.

MENDELOWITZ, DANIEL MARCUS—Painter, E., W.
Stanford University; h. 800 Lathrop Drive, Stanford, Cal. 94305
B. Linton, N.D., Jan. 28, 1905. Studied: Stanford Univ., A.B., M.A., ASL; Cal. Sch. FA. Member: Pacific AA. Awards: prize, Santa Cruz A. Lg., 1945; Santa Clara County Fair, 1955. Work: mural, USPO, Oxnard, Cal. Exhibited: CGA, 1941; AWS, 1944-1946; San F. AA, 1946, 1954; Santa Cruz A. Lg., 1935-1946; Mississippi AA, 1945: Santa Clara County Fair, 1955; deYoung Mem. Mus., 1955; one-man: Gump's, San F., 1944; Courvoisier Gal., San F., 1940; Thos. Welton Stanford Gal., 1953-1966; Kendall Mem. Gal., San Angelo, Tex., 1954; Maxwell Gal., San F., 1955, 1959, 1960, 1962. Author: "Challenge of Education," 1937; "Education in War Time and After," 1943; "Children Are Artists," 1953, rev. ed. 1963; "History of American Art," 1960; "Drawing," 1967. Contributor to Design magazine, with articles on Art Education. Positions: Asst. Prof. A., San Jose State Col., San Jose, Cal., 1927-34; Instr., Asst. Prof., Assoc. Prof., Stanford Univ., Stanford, Cal., 1934-46; Prof., 1949- .

MENIHAN, JOHN C.—Painter, Lith., Ser., L., Des.
208 Alpine Dr., Rochester, N.Y. 14618
B. Rochester, N.Y., Feb. 14, 1908. Studied: Univ. Pennsylvania, B.S. Member: ANA; Rochester A. Cl.; Rochester Pr. Cl.; AWS; SAGA. Awards: Lillian Fairchild award, Rochester, 1940; Marion S. Gould award, Rochester, 1946. Work: LC; Carnegie Inst.; Nazareth Col., Pittsford, N.Y.; ports., St. John Fisher Col., Rochester; St. Louis Catholic Church, Pittsford; St. Thomas Catholic Church, Rochester; Rochester Mem. A. Gal.; Rochester Pr. Cl.; Univ. Rochester; Nazareth College; des. interiors for B. Formon's "Young World," Rochester; des. & printed 1954 Presentation Print, Rochester Pr. Cl.; des. chapel, St. John the Evangelist Convent, Rochester, N.Y.; Illus., Des., "The New St. Basil Hymnal." Des. and executed mural for: Xerox Corp.; Rochester Telephone Co.; Security Trust Co. of Rochester; R.T. French Co., Rochester, N.Y. and Fresno, Cal.; Lowenthal Tennessee, Columbia, Tenn. Exhibited: LC, 1952; Finger Lakes Exh., 1952. Illus., "Faculty for Cooking," 1950; "How Scientists Find Out." Positions: Board of Managers, Rochester Mem. Art Gal.

MENKEN, MARIE—Painter, C.
252 Fulton St.; h. 62 Montague St., Brooklyn, N.Y. 10001
B. Brooklyn, N.Y., May 25, 1917. Studied: N.Y. Sch. F. & Indst. A., ASL, and with Joseph Hafner, Carl Link, Kenneth Hayes Miller, K. M. Ballantyne. Awards: Yaddo Fnd. scholarship, 1949, 1950; film "Dwightiana" won Creative Film Fnd. award, 1959. Work: in numerous private coll.; made 3 abstract films 16 mm. (1952-55), "Visual Variations on Noguchi"; "Hurry! Hurry!"; "Glimpse of a Garden," for Gryphon Productions (all shown at Intl. Experimental Film Festival, Brussels World's Fair, 1958); created sets for Willard Maas' film poems "Image in the Snow" and "Narcissus." Completed art films: "Arabesque for Kenneth Anger" (based on Alhambra, Granada, Spain), 1958; "Dwightiana" (based on work of artist Dwight Ripley), 1958; "Grave Diggers of Guadix," poetic documentary made in Spain; "Bagatelle for Willard Maas," made in Versailles; "Gee Whiz," animated film, all 1961, for Gryphon Productions. Exhibited: BM, 1951; BMA, 1951; DeMotte Gal., 1940; Mus. Non-Objective Painting, 1939-1941; BMFA, 1939; Inst. Mod. A., 1940; one-man: Tibor de Nagy Gal., N.Y., 1951; Betty Parsons Gal., 1949, 1951.*

MENKES, SIGMUND—Painter
5075 Fieldstone Road, Riverdale, N.Y. 10471
B. Lwow, Poland, May 7, 1896. Studied: in Europe. Member: ANA;

Fed. Mod. P. & S.; FIAL. Awards: prize and medal, 1947, prize, CGA, 1941; med., PAFA, 1945; award, Nat. Inst. A. & Let., 1955; Art:USA, 1958; Audubon A., medal of honor, 1965, silver medal, 1967; prize, Polish Inst. A. & Science, 1968. Work: MMA; Wichita AA; Cranbrook Acad. A.; Encyclopaedia Britannica Coll.; PAFA; WMAA; BM; St. Claire (N.J.) Mus.; Walker A. Center; Emily Lowe Mus. A., Miami; Davenport Mun. Gal.; Nat. Inst. A. & Let.; Abbott Laboratories Coll.; Musée du Jeu de Paume, Paris, France; Nat. Mus. Warsaw, Poland; Nat. Mus., Belgrade, Yugoslavia; Nat. Mus., Athens, Greece; Tel-Aviv, Palestine. Exhibited: Carnegie Inst.; AIC; CGA; PAFA; Univ. Nebraska; CMA; Am. Univ., Wash., D.C.; State Univ. Iowa; Cranbrook Acad. A.; MMA; WMAA; one-man exh.: Cornelius Sullivan Gal., N.Y.; Durand-Ruel Gal.; Assoc. Am. A., 1936-1954.

MEREDITH, DOROTHY L(AVERNE)—Painter, C., E
2932 North 69th St., Milwaukee, Wis. 53210
B. Milwaukee, Wis., Nov. 17, 1906. Studied: Layton Sch. A.; Wisconsin State T. Col., B.A. (now Univ. Wisconsin-Milwaukee); Cranbrook Acad. A., M.F.A.; & with Zoltan Sepeshy, Robert von Neumann, Myron Nutting. Awards: many in national and international exhs. Member: Wis. P. & S.; Wis. WC Soc. (Treas.); Midwest Des.-Craftsmen; Wis. Designer-Craftsmen; Am. Craftsmen's Council, Trustee, 1958-1961, State Rep., 1962-1963. Awards: prizes, Milwaukee AI; Wisconsin State Fair, 1960, 1961 & prior; Wisconsin Designer-Craftsmen; Crafts State Fair; Milwaukee AI, 1958. Work: Cranbrook Acad. A.; Milwaukee AI; Nat. Soldiers Home, Wood, Wis.; Bay View H.S., South Division H.S., Milwaukee, Wis. Exhibited: AIC; Milwaukee AI, 1927-1955; Madison Salon; Midwest Des.-Craftsmen, and traveling exh., 1956-1958; Layton Sch. A.; Charles Allis Lib.; Wisconsin Des.-Craftsmen; Cornell Univ.; Craft groups in Ky., Mich., Ind., Ill., Iowa, Wis., and many others; also in Japan and Lebanon. Contributor to "Handweaver." Positions: Prof. A., Univ. Wisconsin, Milwaukee, Wis.; Chm., Midwest Des.-Craftsmen, 1957-58; One of 6 Nat. Craftsmen Trustees, Am. Craftsmen's Council, 1958-61. On travel grant from Univ. Wisconsin, for research in textiles in the Orient. (1965)

MERKIN, RICHARD MARSHALL—Painter, Ser.
500 West End Ave., New York, N.Y. 10024
B. Brooklyn, N.Y., Oct. 1938. Studied: Syracuse Univ. Sch. A., B.F.A.; Teaching Fellowship, R.I.Sch.Des., M.F.A. Awards: Tiffany Fnd. Fellowship in Painting. Work: Mus. A., R.I.Sch.Des.; MModA; Finch Col., N.Y.; Rose A. Mus., Brandeis Univ.; M.I.T.; WMAA. Exhibited: WMAA; Chicago Inst. Contemp. A.; Finch Col. Mus.; one-man: Obelisk Gal., Boston; Byron Gal., N.Y.; M.I.T., Cambridge, Mass. Teaching: R.I.Sch.Des.

MERRIAM, JOHN F.—Trustee
Liberal Arts Society, Joslyn Art Museum, 2218 Dodge St., Omaha, Neb. 68102
Positions: Chairman of the Board of Trustees, Joslyn Art Museum, Omaha, Neb.*

MERRIAM, RUTH (Mrs. John W.)—Conservator, Collector, W.
Philadelphia Museum of Art, Philadelphia, Pa. 19103; h. "Maybrook," Wynnewood, Pa. 19096
B. Denver, Colo., May 15, 1909. Studied: Bryn Mawr College, B.A., M.A. Author: "History of the Deanery," Bryn Mawr College. Specialty: Record photography in conservation department, PMA; Also, assisting in cleaning, relining and in-painting. Collection: From old masters to contemporary art. Positions: Assistant to Conservator, PMA, 1954- ; Assistant Curator, Classical Section, University Museum, 1932-1940.*

MERRICK, JAMES KIRK—
Painter, T., I., W., L., Mus. Dir.
341 South Hicks St., Philadelphia, Pa. 19102; s. Provincetown, Mass. 02657
B. Philadelphia, Pa., Oct. 8, 1905. Studied: PMSchIA; & with Thornton Oakley, Henry Hensche. Member: Phila. A. All.; Phila. WC Cl.; Woodmere AA; SC. Awards: prizes, Phila. A. All., 1936; Cape May AA, 1945; SC, 1950; European traveling scholarship, PMSchA., 1931; gold medal, PM Sch. A. Alumni, 1953; medal, Phila. WC Cl., 1955; Dawson Medal, 1964. Work: Phila. A. All.; Phila. WC Cl. (Life Hon. Pres.); PMA; Cape May Col.; Phila. Pub. Sch. Exhibited: PAFA, 1935-1969; Phila. WC Cl., 1935-1969; AIC, 1940; State Mus., Trenton, N.J.; SC; Herron AI; NAD; Audubon A.; Woodmere AA; Lawrence Col.; Harcum Col.; State Mus., Harrisburg, Pa.; Phila. A. All. Author, I., "Brian"; I., "These Were Actors." Positions: Sec.-Treas., Phila. WC Cl., 1938-1953; Sec., Bd Dir., Phila. A. All., 1938-1960, Exec. Dir., 1960- ; Pres., Alumni Assn., PMSch. IA, 1941-1953.

MERRITT, FRANCIS SUMNER—Painter, T., Lith., Des., L., W.
Haystack Mountain School of Crafts, Deer Isle, Me. 04627
B. Danvers, Mass., Apr. 8, 1913. Studied: Vesper George Sch. A.;

Mass. Sch. A.; BMFA Sch. A.; Yale Univ. Member: AEA. Awards: prize, Flint Inst. A., 1947. Work: murals, Waldo County Gen. Hosp., Belfast, Me.; Knox County Gen. Hosp., Rockland, Me. Exhibited: CGA, 1941; Carnegie Inst., 1941; AFA traveling exh., 1942; Detroit Inst. A., 1947-1951; Butler AI, 1949, 1950; Stuart Gal., Boston, 1946; Vose Gal., 1935, 1937 (one-man); Portland Mus. A., 1953; Saginaw (Mich.) Mus. A., 1956 (one-man); Maine A. Gal., 1959, 1960; MModA., 1966. Positions: Dir., Flint Inst. A., Flint, Mich., 1947-51; Dir., Dept. A., Bradford Jr. Col., Bradford, Mass., 1953-57; Des. 1957 Crafts Exh., Arch. Lg., N.Y.; Des., Portland A. Festival, 1957, 1958; Trustee, Am. Craftsmen's Council; Member, Crafts Adv. Bd., Hopkins Center, Dartmouth Col.; Co-Chm., Maine State Comm. on the Arts and Humanities, 1969; Friends Art Committee, Colby College; Dir., Haystack Mountain School of Crafts, 1951- .

MESCHES, ARNOLD—Painter, T., L.
9507 Santa Monica Blvd., Beverly Hills, Cal. 90210; h. 5424 Gentry Ave., N. Hollywood, Cal. 91607
B. New York, N.Y., Aug. 11, 1923. Studied: Art Center Sch., Jepson's Inst. A., Chouinard AI, all Los Angeles. Awards: numerous awards, purchase prizes prior to 1960; others: Long Beach State Col., 1960, 1962; purchase, PMA, 1968; Univ. of Judaism, 1969. Work: Los A. Mus. A.; Hirshhorn Fnd.; Wichita A. Mus.; First Unitarian Church, Los Angeles; Brown Pharmaceutical Co.; Ford Motor Co.; Gorham State Col. (Me.), and in private collections. Mural, Newhouse Hotel, Salt Lake City. Exhibited: Los A. Mus. A.; Denver A. Mus.; PAFA; Long Beach State College; Westwood (Cal.) AA; MMA; LC; Butler Inst. Am. A.; ACA Gal., N.Y.; Pasadena A. Mus.; Dulin A. Center, Knoxville; Los Angeles Pr.M. Soc.; Gorham State Col. (3-man) 1967; Denver, Colo, (3-man), 1967; Seal Beach, Cal. (2-man), 1968; Sylvia Mesches Gal., Sherman Oaks, Cal. (5-man), 1968. One-man: 18 one-man including Pasadena A. Mus., 1953; Landau Gal., Los A., 1953; Ohio State Univ., 1958; Univ. Buffalo, 1958; Paul Rivas Gal., Los A., 1960; Ankrum Gal., Los A., 1964; Santa Barbara Mus. A., 1966; Fleischer-Anhalt Gal., Los Angeles, 1968; Ojai A. Center, 1968; Carol Reece Mus., Johnson City, Tex., 1969. Court Artist at: Sirhan pre-trial hearing, Navy Court inquiry into "Pueblo" incident and Sealab III inquiry. A selection of the drawings exhibited at Long Beach Mus. (Cal.), 1969. Positions: Art Editor, Frontier Magazine (6 yrs.); contributor illus. to "What's New" (Abbott Labs.); The Nation, Instr., Art, Otis Art Institute, Los Angeles, at present.

MESIBOV, HUGH—Painter, E., Gr., L., C.
377 Saddle River Rd., Monsey, N.Y. 10952
B. Philadelphia, Pa., Dec. 29, 1916. Studied: Phila. Graphic Sketch Cl.; PAFA; Barnes Fnd. Member: F., PAFA; Phila. WC Cl. Awards: prizes, PAFA, 1952; Hallmark Award, 1952; F., PAFA, 1958; Rockland County A., 1964; State Univ. N.Y., 1967; Phila. WC Cl., 1968. Work: PMA. Free Lib., Phila.; Carnegie Inst.; Univ. Wyoming; N.Y. Univ.; MMA; Barnes Fnd.; PAFA; USPO, Hubbard, Ohio. Exhibited: PAFA, 1943, 1952-1955, 1957; State Mus., Harrisburg, Pa.; BM; 1951, 1953-1955; LC, 1951; AFA traveling exh., 1951, 1954; Soc. Wash. Pr. M., 1951, 1952; WMAA, 1956, 1957, 1958, 1959; CGA, 1959; MModA, 1961; Mint Mus. A., 1956; Butler Inst. Am. A.; Hallmark Traveling Exh., 1952-1954; Farnsworth Mus., Rockland, Me., 1955; PMA, 1958; Ringling Mus., 1958; Fort Worth, Tex., 1960; Rockland Fnd., N.Y., 1961, 1963, 1964; Kornblee Gal., N.Y., 1962; East Hampton Gal., N.Y., 1963; Babcock Gal., N.Y., 1964; Phila. WC Cl., 1968; State Univ. N.Y., 1969. One-man: Elizabeth Nelson Gal., Chicago, 1952; Chinese Gal., N.Y., 1947; Artists Gal., N.Y., 1956, 1958; Carlen Gal., Phila., 1940; Phila. A. All., 1945; Gal. Mayer, 1959; Babcock Gal., N.Y., 1965; Mansfield State Col., Pa., 1968; Rockland Community Col., N.Y., 1968, 1969. Positions: Asst. Prof., Rockland Community Col., Suffern, N.Y..

MESS, EVELYNNE B. (Mrs. George Jo)—Painter, Et., T., C.
6237 Central Ave., Indianapolis, Ind. 46220
B. Indianapolis, Ind., Jan. 8, 1903. Studied: John Herron AI; Butler Univ.; AIC; Ecole des Beaux-Arts, Fontainebleau, France, and with Andre Strauss, Despujols. Member: F., Indianapolis A. Lg.; The "20" Indiana Artists; Am. Color Pr. Soc.; Nat. Soc. A. & Let.; Cal. Soc. Et.; Indiana A. Cl.; Indiana Soc. Pr. M.; Brown County AA; Indiana Fed. A. Cl. Awards: prizes, Ind. State Fair, 1930, 1950, 1951; Indiana A. Cl., 1949, 1951, 1955, 1957; Ind. Fed. A. Cl., 1942; Hoosier Salon, 1947, 1948, 1950, 1953, 1958; Nat. Soc. A. & Let., 1948; Indiana A., 1949, 1955; Cal. Soc. Et.; Holcomb prize, John Herron AI, 1958; Clowes prize, L. S. Ayres Co., Indianapolis, 1958; AIC, 1959; Tribute to the Arts in Indianapolis Award, 1966. Work: John Herron AI; LC; De Pauw Univ.; Indiana State Lib.; Ft. Wayne A. Mus. Exhibited: SAGA, 1931, 1933-1935; Los A. Mus. A., 1934, 1936; PAFA, 1934; Phila. Soc. Et., 1935; Phila. A. All., 1936; Am. Color Pr. Soc., 1945, 1946; Phila. Pr. Cl., 1946; Hoosier Salon, 1934, 1942, 1943, 1945-1948, 1950; Indiana Soc. Pr. M., 1934-1938, 1940, 1944-1946; Herron AI, 1928, 1929, 1932-1934, 1945, 1947, 1948, 1950, 1957, 1958; Brown County AA, 1943-1946; SAM; Ball State Univ., one-man: John Herron AI; Lieber Gal.; Hoosier Salon, all Indianapo-

lis. I., "Old Fauntleroy Home," 1939. Positions: Instr. A., Indianapolis A. Lg. Pres., Indiana State Federation of Art Clubs, 1968-1970; Dir., Oxbow Acres Summer Art School, Nashville, Ind.

MESSER, THOMAS M.—Museum Director, T., W., L., Hist.
 The Solomon R. Guggenheim Museum, 1071 Fifth Ave. 10028;
 h. 1105 Park Ave., New York, N.Y., 10028
B. Bratislava, Czechoslovakia, Feb. 9, 1920. Studied: Thiel Col., Greenville, Pa.; Boston Univ., B.A.; Sorbonne, Paris, France; Harvard Univ., M.A.; Exchange student, Inst. Int. Edu. Member: AAMus. Dirs.; F., Belgian-American Edu. Soc., 1953. Awards: A.F.D. (honoris causa), Univ. Massachusetts, 1962. Contributor to museum bulletins, catalogs, professional journals; Art in America. Completed survey and published report on Puerto Rican cultural projects upon invitation of Economic Development Administration in San Juan, P.R., 1954. Positions: Dir., Roswell Mus., Roswell, N.M., 1949-52; Asst. Dir., in charge of National Exhibitions Program, 1952-53; Dir., 1955-56, American Federation of Arts, New York, N.Y.; Dir., Inst. Contemp. A., Boston, Mass., 1956-61; Dir., FA, Boston A. Festival, 1957-58; Dir., Special Exhibition Project, Time, Inc., N.Y., 1959-60; Summer Sch. Faculty, Harvard Univ., 1960; Dir., The Solomon R. Guggenheim Museum, New York, N.Y., 1961- .

MESSERSMITH, FRED LAWRENCE—Painter, E.
 Art Department, Stetson University; h. 726 North Boston Ave., DeLane, Fla. 32720
B. Sharon, Pa., Apr. 3, 1924. Studied: Ohio Wesleyan Univ., M.A., B.F.A.; Ohio State Univ. Member: AWS; Nat. Soc. Ptrs. in Casein; Fla. Artists Group; CAA; AFA. Awards: prizes, All. A. W. Va., 1958; Clarksburg A. Center, 1954, 1958; Oglebay Inst., 1956, 1957; Ohio WC Soc., 1955; Butler Inst. Am. A., 1956, 1957; AWS, 1958; Painting of the Year award, Atlanta, 1961, 1964; Fla. A. Group, 1961; Soc. Ptrs. in Casein, 1960, 1965; Soc. of Four Arts Palm Beach, 1963; Governor's Award, Fla. Fed. A., 1962; Alabama WC Soc., 1966; Florida State Fair, 1967; Winter Park, 1967, 1968, 1969. Work: Daywood A. Gal., Lewisburg, W. Va.; Ohio Univ. Mus.; Baker Univ.; Stetson Univ.; Springfield (Mo.) Mus. A.; W. Va. Wesleyan Col.; Butler Inst. Am. A.; ACAA; Randolph-Macon Women's Col.; World Book Encyclopedia. Exhibited: AWS, 1955, 1958 (traveling), 1959, 1960, 1962, 1965, 1966; Columbus A. Lg.; All. A. Am., 1957; Butler Inst. Am. A., 1951, 1952, 1960, 1964, 1965, 1966, 1968; "Religion and Man" exh., Washington (D.C.) Cathedral, 1957; Ohio WC Soc., 1954, 1955, 1956; State Regional, Bristol, Va., 1950-1954; Ohio Drawing exh., 1951-1953; Ohio Valley, 1951, 1954; All. A., Charleston, 1952-1958; Audubon A., 1960; Dulin Gal., Knoxville; Soc. Four A., 1962, 1963; Nat. Soc. Painters in Casein, 1968; Watercolor USA, traveling, 1968; Alabama WC Soc., 1966; Florida State Fair, 1967; Florida A. Group Circuit, 1967; Winter Park, 1967; Ft. Lauderdale Mus. A., 1968; Telfair Acad., Savannah, 1968; one-man: Baker Univ., Baldwin, Kans., 1957; Chancellor Hotel, Parkersburg, 1957; Clarksburg A. Center, 1957; Laskin Gal., Charleston, 1957; Chatham Col., Pittsburgh, 1958; Barzansky Gal., N.Y., 1957, 1961; Springfield A. Mus., 1962; Winter Park, Fla.; 1962; Loch Haven A. Center, Orlando, 1964; Spiva A. Center, Joplin, Mo., 1964; Ringling Mus. A., 1967; Jacksonville (Fla.) Univ., 1966, and others. Contributor illus. to La Revue Moderne, Paris; Motive; American Artist Magazine, Span Magazine. Work represented in "100 Watercolor Techniques," 1968 and "Artist and Advocate," 1967. Lectures: Landmarks in American Painting. Positions: Assoc. Prof. A., West Virginia Wesleyan College, Buckhannon, W. Va., 1949-1959; Chm. A. Dept., Stetson University, DeLand, Fla., 1959- .

MESSICK, BENJAMIN NEWTON (BEN)—Painter, Lith., Et., T., L.
 133 St. Joseph Ave., Long Beach, Cal. 90803
B. Strafford, Mo., Jan. 9, 1901. Studied: Chouinard AI, and with F. Tolles Chamberlin, Clarence Hinkle, Pruett Carter. Member: Long Beach AA (Hon.); Laguna Beach AA; Cal. A. Cl.; F., Royal Soc. A., London, England; AFA. Awards: prizes, Los A. County Fair, 1925; PAFA, 1927; Fla. Southern Col., 1952; Seton Hall Univ., 1958. Work: Los A. Mus. A.; SFMA; U.S. Nat. Mus.; Smithsonian Inst.; Strafford (Mo.) Consolidated Schools; Springfield Mus. A.; Fla. Southern Col.; KWTO radio station, Springfield, Mo.; murals, Wiggins Trade Sch., Cal. State Bldg., Hall of Records, all in Los A. Exhibited: Albany Inst. Hist. & A., 1943; LC, 1945; MMA, 1942; Carnegie Inst., 1941; NAD, 1945; Stendahl Gal., 1938-1940; Los A. Mus. A., 1943; Phila. Pr. Cl., 1943; Long Beach, 1955, 1959-1961; SAGA, 1947; City of Los A., 1947; Grumbacher traveling exh., 1952, 1954, 1955, 1958-1961; Fla. Southern Col., 1952; Cal. A. Cl., 1952; San Diego, Cal., 1952; Grand Central A. Gal., 1958; Duncan Vail Gal., Los A., 1961; Bowers Mem. Mus., Santa Ana, 1959; Nat. A. & A. Patrons Soc., 1967; Messick-Hay Gal., Long Beach, Cal. (continuous exhs.); one-man: Los A. Mus. A., 1935; Chouinard AI, 1941; SFMA, 1942; Springfield Mus. A., 1943, 1948, 1967; Santa Barbara Mus. A., 1945, 1948; U.S. Nat. Mus., 1944; Nelson Gal. A., 1945; Pasadena AI, 1946; deYoung Mem. Mus., 1947; La Jolla A. Center, 1947; Palos Verde Gal., 1947; Long

Beach AA, 1948, 1950, 1960; Drury Col., 1948; San Diego Sch. FA, La Jolla, 1948, 1951; San Diego FA Gal., 1950; South Pasadena A. Gal., 1950; Crocker A. Gal., 1950, 1957; Illinois State Mus., 1951; Decatur A. Center, 1951; Davenport Mun. A. Gal., 1951; Peoria A. Center, 1952; New Mexico A. Lg., 1952; Laguna Beach, 1952; Fresno A. Center, 1957; Long Beach Mus. A., 1957; San Pedro AA, 1958, 1959; Illinois State Mus., 1961; Norton Gal. A., 1953; Glendale AA, 1953; Orange County AA, 1954; Palos Verde A. Gal., 1954, 1958 (3-man); Pacific Coast Cl., Long Beach, 1959, 1960, 1964, 1966-1969; Long Beach, 1963; Palm Springs, 1963; Apple Valley, Cal., 1969; Pacific Coast Cl., 1961 (3-man); Community Playhouse Gal., Long Beach, 1966. Positions: Instr., FA, Messick Studios, Long Beach, Cal. Lectures widely in California; 5 State lecture tour and demonstrations, 1956, others, 1961. A. Instr., Y.W.C.A., Long Beach. Instr., Messick-Hay Studio, 1966- .

METCALF, JAMES—Sculptor
 c/o Albert Loeb Gallery, 12 E. 57th St., New York, N.Y.
 10022
Exhibited: WMAA, 1964; one-man: Albert Loeb Gal., 1964.*

METCALF, ROBERT MARION—Stained Glass Designer, P., E., L.
 Springfield Pike, Yellow Springs, Ohio 45387
B. Springfield Ohio, Dec. 23, 1902. Studied: Columbus (Ohio) A. Sch.; Wittenberg Col.; PAFA. Awards: Cresson traveling scholarship, PAFA, 1924; Great Lakes College Assn. Fellowship, to study and photograph art works of Mesoamerica, 1965-1966. Work: Dayton AI (Coll. 10,000 color slides of European stained glass); stained glass windows; St. James Chapel, Cathedral of St. John the Divine, N.Y., St. Paul's Sch., Concord, N.H.; History of Medicine window, Mayo Clinic, Rochester, Minn., and others; stained glass wall, Church of the Ascension, Cincinnati. Lectures: Stained Glass. Positions: Prof., Chm., Creative A. Dept., Antioch Col., Yellow Springs, Ohio, 1945- .

METZ, FRANK R.—Painter
 800 West End Ave., New York, N.Y. 10025; Roxbury, Conn.
 06783
B. Philadelphia, Pa., July 3, 1925. Studied: PMSch. A., with Martinelli; ASL, with Will Barnet, Nahum Tschacbasov; New School, with Camilo Egas. Work: Olsen Fnd.; Rosenwald Coll.; Simon & Schuster, Inc.; Ball State T. Col., and private colls. Exhibited: PAFA, 1947, 1948, 1953, 1954; MMA, 1952; Washington Univ., St. Louis, 1958; Little International traveling exh., 1957; Parma Gal., N.Y., 1955-1958, Phila. Pr. Cl., 1947, 1948, 1952; Lyman Allyn Mus., 1959, 1960; Obelisk Gal., Wash., D.C., 1960 (2-man); Ball State T. Col., Muncie, Ind., 1962-1964; Silvermine Gld. A., 1962, 1963; one-man: Parma Gal., 1955, 1958; Roko Gal., N.Y., 1961, 1963, 1964, 1966; Am. Acad. of Arts & Lets., Childe Hassam Fund, 1966; Peridot Gal., 1968; Weyhe Gal., 1969. Positions: Art Dir., Simon and Schuster, Publ., New York, N.Y.

METZL, ERVINE—Illustrator, Cart., Des., W., E.
 20 Park Ave.; h. 135 East 39th St., New York, N.Y. 10016
B. Chicago, Ill., May 28, 1899. Studied: AIC. Member: SI; First P.O. Stamp Advisory Com. (1957-61). Work: Morgan Lib., N.Y.; Kensington Mus., London, England. Contributor to art magazines; Contrib. Ed., American Artist Magazine. I., books for Limited Editions Club and other publishers. Author: "The Poster." Positions: Instr., Pratt Institute; Columbia Univ.*

MEYER, MR. and MRS. ANDRE—Collectors
 35 E. 76th St., New York, N.Y. 10021*

MEYER, FRED(ERICK) ROBERT—
 Painter, S., Des., E., Film-Maker
 Rochester Institute of Technology, 1 Lomb Memorial Dr.,
 Rochester, N.Y. 14623; h. 17 Church St., Scottsville, N.Y.
 14546
B. Oshkosh, Wis., Dec. 20, 1922. Studied: Wis. State T. Col.; Univ. Wisconsin; Harvard Grad. Sch.; Cranbrook Acad. A., B.F.A., M.F.A. Member: Nat. Soc. Interior Designers. Awards: F., Ford Fnd., 1955; Rochester-Finger Lakes Exh., 1954, 1958, 1961 (3), 1963; Syracuse Regional, 1963 (2); Albright-Knox Mus., 1963; San F. Intl. Film Festival, 1963. Work: Cranbrook Acad. A.; Munson-Williams-Proctor Inst.; AFA Coll.; Everson Mus., Syracuse; Little Rock A. Gal., Arkansas; cover paintings, N.Y. Times Magazine, 1955; Cosmopolitan magazine color reproductions, 1964; mural, Schrafft's Motel, Binghamton, N.Y.; sculpture, Lincoln Center, N.Y.; bronzes, Eastland Mall, Lazarus Dept. Store, Columbus, Ohio, and in private colls. Exhibited: BM, 1952; AIC, 1949, 1951; WMAA, 1953; PAFA, 1952, 1962; Detroit Inst. A., 1952; Phila. A. All.; WAC; Univ. Nebraska; Syracuse Mus. FA., 1957; Rochester-Finger Lakes Exh., 1957, 1958; N.Y. State Fair, 1958; Scripps Col., 1964; AFA traveling exh., Middle East, 1963; Herron Mus. A., 1965; East Tennessee State Col.; Midtown Gal., N.Y., 11th, 31st Anniversary Exhs.;

Rochester Mem. Gal., 1964; Ann Arbor Film Festival Tour, 1968; John Herron Mus., 1965; N.Y. World's Fair, 1965; Everson Mus., Syracuse, 1965; one-man: Midtown Gal., N.Y., 1947, 1948, 1968; Phila. A. All., 1962; Everson Mus., 1963; 3-man, Phila. A. All., 1953; Morehead State Col., (Ky.), 1969. Positions: Instr., School for American Craftsmen, Rochester Inst., 1949-1958; Prof., Grad. Painting and 3-D, Furniture and Silver Design, Rochester Institute of Technology, 1958- .

MEYER, MRS. GUNTHER. See Neustadt, Barbara

MEYER, URSALA—Sculptor
241 W. 97th St.; h. 20 Riverside Dr., New York, N.Y. 10025
Studied: New Sch. for Social Research, N.Y., B.A.; Columbia Univ. Teachers Col., M.A. Work: City Univ. of New York; Finch Col. Mus., N.Y.; Hunter Col., N.Y.; BM. Awards: Estelle Goodman Award, Nat. Design Center, N.Y., 1966. Exhibited: Amel Gal., 1964, Cooper Union Mus., 1966, Nat. Design Center, 1964, 1965; Riverside Mus., 1967, Hunter Col., 1967, Finch Col., 1967, all New York City; Guild Hall, East Hampton, 1964; Aldrich Mus. Contemp. A., Ridgefield, Conn., 1968; one-man: A. M. Sachs Gal., N.Y., 1968. Positions: Asst. Prof., Art Dept., Hunter College, New York, N.Y. at present.

MEYEROWITZ, WILLIAM—Etcher, P.
54 West 74th St., New York, N.Y. 10023
B. Russia. Studied: NAD; & with F.C. Jones, Douglas Volk. Member: NA; Audubon A.; SAE; Am. Color Pr. Soc.; Soc. Indp. A.; Gloucester SA; North Shore AA; Rockport AA; City Arts Council, Gloucester, Mass.; Cape Ann Soc. Mod. A.; All.A.Am. Awards: prizes, Audubon A., 1958; Seton Hall Univ., 1958, gold medal, 1959; North Shore AA, 1932, 1939, 1957, 1968; Am. Contemporary A. of New England, 1944; Currier Gal. A., 1942; Lib. Cong., 1943, 1944; Audubon A., 1955; Rockport AA, 1960, 1964, 1967; Speyer award, NAD, 1965; All.A.Am., 1961. Work: PMG; BM; U.S. Nat. Mus.; BMFA; Concord Mus. A.; Bibliotheque Nationale, Paris; Harvard Univ. Law Sch.; N.Y. Pub. Lib.; MModA; Brandeis Univ.; Jewish Mus., N.Y.; Tel-Aviv Mus., Israel; Cooper Union; State House, Albany; Fitchburg Mus. A.; Bezalel Mus., Jerusalem; Yale Univ.; Col. City of N.Y.; Univ. Pennsylvania; J.B. Speed Mem. Mus.; Boston Univ.; Univ. Maine; Herron AI; Univ. Kentucky; Harvard Cl.; MMA; Albany Inst. Hist. & A.; Lib. Cong.; Currier Gal. A.; Columbus (Ga.) Mus. A. & Crafts; Univ. Georgia, Athens; George Washington Univ.; mural, USPO, Clinton, Conn.; etc. Exhibited: CGA, 1935, 1941, 1945; PAFA, 1935, 1936, 1940; WMA, 1935, 1937, 1939, 1945; AIC, 1935, 1936, 1940; WMAA, 1936; Toledo Mus. A.; NAD; MMA; Carnegie Inst.; Dayton AI; Amer. Acad. A. & Let., 1964 and prior; BMFA; BMA; one-man: Chase Gal., N.Y., 1959, 1965, 1968; Park Gal., Detroit, 1959, 1961, 1963; Univ. Maine, 1960; Columbus Mus. A. & Crafts, 1966, 1967; Univ. Georgia, 1966; Bar Harbor Gal., 1966, 1968; Carus Gal., 1966; Gainesville (Fla.) AA, 1967; Montgomery Mus. FA, 1968. Contributor to: The Menorah Journal.

MEYEROWITZ, MRS. WILLIAM. See Bernstein, Theresa F.

MEYERS, DALE (Mrs. Mario Cooper)—Painter, Gr., T.
54 W. 74th St., New York, N.Y. 10023
B. Chicago, Ill., Jan. 24, 1922. Studied: CGA Sch. A.; ASL; water color with Mario Cooper; graphics with Seong Moy. Member: AWS; All. A. Am.; Fellow, Royal Soc. Arts, London; ASL; Knickerbocker A.; Am. A. Lg. (Washington, D.C.). Awards: Bronze medal, AWS, 1958; purchase prize, Ranger Fund, 1968; other prizes, Catherine L. Wolfe A. Cl., 1968; Newmark Award, Art Advisory Council, 1961; Manhasset (N.Y.), 1961-1963; Metropolitan Washington Exh., Smithsonian Inst., 1963. Work: NAD; Museo de la Acuarela, Mexico City, D.F. Exhibited: MMA, 1966, 1967; NAD, 1967, 1969; AWS, 1962-1969; All. A. Am., 1966-1968; Audubon A., 1968; NAC; Museo de la Acuarela, Mexico; Smithsonian Inst., 1962, 1963; George Washington Univ. (D.C.); CGA, 1963; Frye Mus., Seattle; Butler Inst. Am. A.; Abilene Inst. FA; Utah Mus. FA, Salt Lake City; Kalamazoo Inst. A.; Oklahoma A. Center; Purdue Univ.; Canton A. Inst.; Saginaw A. Mus.; Univ. Wyoming, Laramie; Laguna Beach (Cal.) AA; Montgomery Mus. FA; Hamline Univ.; Laguna Gloria Mus., Austin, Tex., and others. Contributor to American Artist Magazine, 1969. Positions: Contributor and Editor, American Watercolor Society Newsletter, 1961- . Chairman Awards, American Watercolor Society; Asst. Instr., to Mario Cooper, ASL.

MEYERS, ROBERT WILLIAM—Illustrator
Circle M Ranch, South Fork Rte., Cody, Wyo. 82414
B. New York, N.Y., June 17, 1919. Studied: NAD, with Ivan Olinsky; Grand Central A. Sch.; Traphagen Sch. Fashion. Member: Grand Central A. Gal. Awards: prize, A. Dir. Cl., Chicago, for one of "100 Best Posters for 1955." Exhibited: one-man: SI, 1955-56; Western Watercolor Exh., Grand Central Gal., 1960; Whitney Mus.

Western Art, Cody, Wyo., 1967; Desert Southwest Gal., Palm Desert, Cal., 1969; Gal. 85, Billings, Mont., 1969; Golden Eagle Gal. of Western Art, Cody, Wyo., 1969. Illus., "Prince of the Range," 1949; "The Winning Dive," 1950; "The Base Stealer," 1951; "The Mysterious Caboose," 1950; "The Haunted Hut," 1950; "Jockie," 1951, and other children's books, Illus., Bellows Whiskey Campaign, 1960-61, and Poster, 1961; General Reinsurance Corp. magazine campaign, 1960, 1961-62. Contributor illus. to: True; Argosy; Reader's Digest. Specializes in Western Paintings.

MICHAELS, GLEN—Sculptor, P.
763 Lakeview St., Birmingham, Mich. 48009
B. Spokane, Wash., July 21, 1927. Studied: Eastern Washington Sch. of Edu., B.A.; Cranbrook Acad. A., M.F.A. Awards: prizes, Ditson award, Yale Univ., 1950. Finalist, F.D. Roosevelt Memorial Comp., with Galler & Assoc., 1960; Century 21 fountain Comp., 1960; Stuttgart Int. Handcraft Exh. Work: illuminated wall panels, Continental Can Co., 1961; mural, Bulova Watch Co., 1961; 2 murals, Chase-Park Plaza Hotel, St. Louis, 1962; recent work: Ford Exh., World's Fair, N.Y., 1964; Walter Thompson, N.Y., 1964; El Al Airlines, N.Y., 1964; Detroit Inst. A.; Duns Scotus Col., Southfield, Mich., 1965; Nat. Aeronautics & Space Admin., Goddard Space Center, Greenbelt, Md., 1966; St. Bede's Church, Southfield, Mich., 1968; Mt. Clemens Pub. Library, 1968; Henry Ford Library, Dearborn, Mich., 1968 and work in private homes; Int. Monetary Fund, 1964. Exhibited: Michigan Artists Exh., 1958; Bertha Schaefer Gal., 1960, 2-man, 1961; Martha Jackson Gal., N.Y., 1960; Mus. Contemp. Crafts, 1963-64; Milan, 1964; Mich. A. Exh., 1969; Mus. Contemp. Crafts, N.Y., 1968. Author; I., "Oh, You're a Musician," 1951. Contributor illus. to Harpers Magazine; Domus, 1961; Craft Horizon, 1961; Progressive Architecture, 1961; Design Quarterly, Advertising Age, Interiors, Industrial Design, all 1964.

MICHELSON, ANNETTE—Critic
101 W. 80th St., New York, N.Y. 10024*

MIDENER, WALTER—Sculptor, C., T.
245 East Kirby St., Detroit, Mich. 48202; h. 80 Moss Ave., Highland Park, Mich. 48203
B. Germany, Oct. 11, 1912. Studied: Berlin Acad. F. & Appl. A.; Wayne State Univ., M.A. Awards: Tiffany Grant, 1940; prizes, Honolulu, Hawaii, 1943; Detroit Inst. A., 1950, 1952, 1954, 1955. Work: Detroit Inst. A.; Flint Inst. A.; House of Living Judaism, N.Y.; Suburban Temple, Cleveland; Temple Beth El, Detroit; Supreme Court, Lansing; Detroit Pub. Lib. Exhibited: Detroit Inst. A., 1946-1962; PAFA, 1941, 1948, 1951, 1953, 1958, 1960; PMA, 1949; WMAA, 1950, 1951, 1953, 1955, 1956, 1964; MMA, 1951; MModA, 1950; Herron AI, 1951, 1961; Cincinnati AI, 1951; Cranbrook Acad. A., 1950, 1953, 1962. Positions: Hd. Sculpture Dept., Art School of the Soc. A. & Crafts, Detroit, Mich., 1946- , Assoc. Dir., 1962-1968, Dir., 1968- ; Visiting Instr., Cleveland Inst. Art, 1955 (summer).

MIECZKOWSKI, EDWIN—Painter
132-35 Sanford Ave., Flushing, New York 11355
B. Pittsburgh, Pa., 1929. Studied: Cleveland Inst. of Art, B.F.A.; Carnegie Inst., M.F.A. Work: CMA. Exhibited: Albright-Knox A. Gal., 1968; Anonima Gal., 1966, 1967, 1968, 1969. Founding member, Anonima Group.

MIELZINER, JO—Stage Designer, Arch. Theatre Consultant
1 West 72nd St., New York, N.Y. 10023
B. Paris, France, 1901. Studied: ASL; NAD; PAFA. Member: Scenic A. Un. Awards: 2 Cresson traveling scholarships, PAFA; hon. deg., D.F.A., Fordham Univ.; hon. L.H.D., Otterbein College; Benjamin Franklin Fellow, Royal Soc. Arts; awards for set designs, 5 Donaldson awards; 3 Antoinette Perry awards; Ford Fnd. award in Program for Theatre Design, 1960; Acad. Motion Pictures "Oscar" for color art direction on "Picnic," 1955; New England Theatre Conf. First Award for Creative Achievement in the American Theatre, 1957; Cushman Award for Achievement in American Theatre, 1958; Brandeis Univ. Award for same, 1963. Work: Stage settings: 2 operas, Metropolitan Opera Assn.; Tudor's Ballet "Pillar of Fire," Ballet Theatre; over 280 musical and dramatic productions, New York, N.Y., 1924-1968. Commissioned by the U.S. State Dept. to design setting for United Nations Conference, San Francisco, Cal., 1945. Collaborating Designer of the Repertory Theatre of Lincoln Center for the Performing Arts, N.Y., 1958; Theatre and lighting consultant for Forum Theatre unit of new Music Center, Los Angeles, 1961; Consultant on Krannert Center for the Performing Arts at Univ. of Illinois and Collaborating Designer of Univ. Michigan Theatre. Author: "Designing for the Theatre," 1965. Exhibited: MModA; Mus. City of N.Y.; Sao Paulo, Brazil; CGA; VMFA; Library and Museum of the Performing Arts, Lincoln Center, N.Y. Contributor to Theatre Arts magazine, New York Times. Lectures: Theatre Design.

MIKUS, ELEANORE—Painter, T.
429 Broome St., New York, N.Y. 10013
B. Detroit, Mich., July 25, 1927. Studied: Detroit Sch. A. & Crafts; ASL; Univ. Denver, B.F.A., M.A. Awards: Guggenheim Fellowship, 1966; Tamarind Fellowship, 1968; MacDowell Fellow, 1969. Work: MModA; WMAA; Los Angeles County Mus.; CM; Birmingham Mus. A.; Pasadena A. Mus.; Aldrich Mus. Contemp. A., Ridgefield, Conn. De Cordova and Dana Mus., Lincoln, Mass.; Cornell Univ.; Amon Carter Mus. Western Art, Ft. Worth; Univ. Denver; Grunwald Coll. of Graphic Art, Univ. California at Los Angeles. Exhibited: PAFA, 1969; WMAA, 1969; Bradford City A. Gal., Bradford, England, Int. Print Exh., 1968-1969; Dayton A. Inst., 1968; Martha Jackson Gal., N.Y., 1969. Positions: Asst. Prof. A., Monmouth College, Long Branch, N.J., 1966- .

MILCH, HAROLD CARLTON—Art Dealer
1014 Madison Ave., 10021; 140 E. 72nd St., New York, N.Y. 10021
B. New York, N.Y., Jan. 2, 1908. Studied: City College of New York, B.A.; Columbia Univ. Sch. of Art. Specialty of Gallery: American Painting. The Milch Galleries have been concerned with American Art since 1916 and have been responsible for some of the most prominent names in the American art field. Have assisted in formulating some of the great American collections, both with museums and privately. Positions: Pres., Milch & Vogel, Inc., 1929-1934; Associated with Milch Galleries, 1935- ; Pres., E. & A. Milch, Inc. (Milch Galleries), 1951- . Pres., Art Dealers Association of America, 1968-1970.

MILDER, JAY—Painter, S., Gr., T.
315 Walnut St., Yellow Springs, Ohio 45387
B. Omaha, Neb., May 12, 1934. Studied: Univ. Nebraska; AIC, and with Andre L'Hote and Ossip Zadkine, Paris, France. Awards: Walter Gutman Award, N.Y., 1961; Dayton AI purchase award, 1963. Work: Yale Univ. Gal. FA; Dayton AI; Univ. Puerto Rico; BMA; Chrysler Mus., Provincetown, Mass. Exhibited: Dayton AI, 1961; Natl. Graphic Exh., 1963; Yale Univ., 1964; Univ. Nebraska, 1965; Burpee Mus., Rockford, Ill., 1965; Univ. Puerto Rico, 1960; All Ohio Exh., 1965; Antioch Col., 1964; Joslyn Mem. Mus., Omaha, 1964; Martha Jackson Gal., N.Y. Positions: Instr., Painting, Dayton Art Institute, Dayton, Ohio, 1963- .*

MILES, JEANNE PATTERSON—Painter, T.
1335 Madison Ave., New York, N.Y. 10028
B. Baltimore, Md. Studied: George Washington Univ., B.A.; Phillips Mem. Gal., Wash., D.C.; Grande Chaumiere, Paris; Atelier Marcel Gromaire, Paris; N.Y. Univ. Member: Abstract A. of Am.; NSMP. Awards: Traveling scholarship, 1937-1939; Nat. Inst. A. & Lets., 1968. Work: mural (100 portraits) Ramon's, Wash., D.C.; Kentile Co., N.Y., St. Louis, Los Angeles, Kansas City, Atlanta, Ga.; N.Y. Univ.; Munson-Williams-Proctor Inst.; Rutgers Univ.; Mus. Santa Barbara Mus. A.; Guggenheim Mus.; Chrysler Mus.; CMA; Newark Mus.; Univ. Arizona; Univ. Massachusetts; Univ. Michigan; and others. Exhibited: Salon des Independents, Paris, 1938; Walker A. Gal., 1952; Los Angeles State Fair, 1953; CGA, 1955; Int. Drawing Exh., Greece, 1954; Rome, 1958; Religious Art Exh., Columbia Univ. Seminary, 1954-1955; Betty Parsons Gal., N.Y., 1956 and 3 one-man exhs.; Yale Univ., 1957; Am. Abstract A., 1958, 1966-1968; MMod. exhibition to Embassies, 1967-1968; Grand Central Moderns, N.Y., 1968 (one-man); N.Y. Coliseum, 1958; AFA traveling exh., 1961, 1968-1969; Lever Bldg., N.Y., 1961; Stuttman Gal., N.Y., 1960; Knapik Gal., N.Y., 1961; WMAA, 1963; Mus. FA of Houston; Daniels Gal.; Riverside Mus., N.Y.; Phila. A. Forum; Cornell Univ. Lectures: Contemporary Art; Early Moderns, etc. Illus. in Art in America; Arts; Art International and other magazines. Positions: Instr., Moravian Col., Pa.; Asst. Prof. A., Oberlin Col., Oberlin, Ohio; Private Sch., New York, N.Y. Lecturer, N.Y. Univ. Extension Courses. Instr. Painting, N.Y. Inst. Technology, 1967, 1968.

MILLER, BARSE—Painter, E.
190 Bayview Rd., Plandome Manor, L.I., N.Y. 11030; s. "Rangemark," Birch Harbor, Me. 04613
B. New York, N.Y., Jan. 24, 1904. Studied: NAD; PAFA, and with Henry Snell, Hugh Breckenridge. Member: NA; Audubon A.; Cal. WC Soc.; AWS; F., PAFA; Hon. Member, San Diego WC Soc., 1966; Southwestern WC Soc., 1968. Awards: F., PAFA; Cresson traveling scholarships, PAFA, 1922, 1923, medal, 1936; medal, prize, Cal. A. Cl., 1929; prizes, Los A. Mus. A., 1932; Cal. WC Soc., 1933, 1935; Phila. WC Cl., 1938; Guggenheim F., 1946; AWS, 1950, 1954, 1956, 1967; NAD, 1955; Santa Barbara Mus. A.; Medal of Honor, Audubon A., 1958, 1967; Joseph Mayer award, 1961; Portland Mus. Festival of Art purchase prize, 1961. Work: San Diego FA Soc.; PAFA; Wood A. Gal., Montpelier, Vt.; Hackley A. Gal.; Los A. Mus. A.; AIC; Portland Mus. A.; Denver A. Mus.; AIC; Butler AI; PMA; BM; MMA; Glasgow Mus., Scotland; Nat. Gal., Melbourne, Australia; Hyde Park Mem. Lib. Exhibited: nationally. Series of feature

articles, Life and Fortune magazines. Positions: Prof., Dept. A., Queens Col., Flushing, L.I., N.Y. Council, NAD, 1959-61, Asst. Corr. Sec., 1968-1969; School Committee, 1960; Committee for Abbey Murals, 1961. Memb. Art Advisory Council, Port Washington, (N.Y.) Pub. Lib. Guest Instr., Rex Brandt Sch. A., Coronado Del Mar, Cal., 1966; Lecturer, Guest Critic, for members of Southwestern WC Soc., Dallas and Oklahoma City, 1966; Member, Jury of Selection, AWS section in "200 Years of Watercolor Painting in America," MMA.

MILLER, DOROTHY CANNING—Museum Curator
Museum of Modern Art, 11 West 53rd St., New York, N.Y. 10019
B. Hopedale, Mass. Studied: Smith Col., B.A., Doctor of Humane Letters, 1959, Specialist in American Art. Ed., "Charles Sheeler," 1939; "Romantic Painting in America," 1943; "Americans, 1942"; "The Sculpture of John B. Flannagin," 1942; "Lyonel Feininger," 1944; "14 Americans," 1946; "15 Americans" 1952; "12 Americans," 1956; "The New American Painting," 1958; "16 Americans," 1959; "Americans 1963," "20th Century Art from the Nelson Aldrich Rockefeller Collection," 1969, & others. Arranged many exhibitions, MModA, 1936-69. Positions: Asst. to Dir., 1934, Assoc. Cur., Painting & Sculpture, 1935-43, Cur., Painting & Sculpture, 1943-47; Cur. of the Mus. Collections, 1947-67; Senior Cur. of Painting & Sculpture 1967-69, MModA, New York, N.Y.

MILLER, LEON GORDON—Designer, P., Gr., S.
1220 Huron Rd.; h. 16250 Aldersyde, Cleveland, Ohio 44120
B. New York, N.Y., Aug. 3, 1917. Studied: N.J. State T. Col., B.S.; ASL; Newark Sch. F. & Indst. A., C.F.A.; Fawcett A. Sch., and with Bernard Gussow. Member: Fellow, Indst. Des. Soc. of America; member: AEA; Am. Craftsmens' Council; Stained Glass Assn. of America; Cleveland Pr. Cl.; U.S. Delegate, Int. Council Soc. Indst. Des., 1959, 1961; AIA Gld. for Religious Architecture; Past Pres., Bd. Chm., Indst. Des. Inst. Awards: Silver Medal, Indst. Des. Inst.; prizes, Institutions Annual Des. award, 1959, 1962, 1968; Nat. Office Furniture award, 1961; Am. Inst. Decorators, 1961; Fine Hardwoods Assn., 1960; Florida Des. Derby, 1960; CMA, 1947, 1948, 1950, 1952-1954, 1956. Work: LC; Yale Univ. Library and in private and institutional collections. Exhibited: In many U.S. museums and galleries; Represented by sculpture, stained glass in religious and business institutions in Florida, Georgia, Indiana, Iowa, Kentucky, Massachusetts, Nebraska, New York, Ohio and Tennessee. Nine one-man exhibitions. Co-author: "Lost Heritage of Alaska," 1967. Positions: Design Consultant to the State of Israel, 1968-1969; Pres., Leon Gordon Miller & Associates, Inc., 1947- .

MILLER, MRS. McCULLOUGH—Collector
c/o Whitney Museum, 945 Madison Ave., New York, N.Y. 10021*

MILLER, MITCHELL—Collector
146 Central Park West, New York, N.Y. 10023*

MILLER, RALPH R(ILLMAN)—
Museum Director, P., Des., L., W.
Museum of the City of New York, 103rd St. & Fifth Ave., New York, N.Y.; h. 11 E. 92nd St., New York, N.Y. 10028
B. Wayne, Pa., Dec. 12, 1915. Studied: Univ. Washington; Columbia Univ., B.S., and with A. Archipenko. Member: AAMus; Northeast Conf. AAMus.; Museums Council of New York City. Exhibited: Audubon A., 1965. Positions: Adv. Bd., Stamford Mus. A. & Nature Center; Treas., N.Y. State Mus. Assn.; Memb. Council, AAMus.; Chm., Museums Council, N.Y.C., 1964-65; Advisory Panel, N.Y. State Council on the Arts; Dir., Museum of the City of New York. Instr., Painting, Unitarian Church, New York City.

MILLER, RICHARD—Painter
104 E. 96th St., New York, N.Y. 10028*

MILLER, RICHARD A.— Sculptor
64 Grand St. 10013; h. 61 Grove St., New York, N.Y. 10014
B. New Philadelphia, Ohio, Apr. 30, 1922. Studied: Cleveland Inst. Art. Awards: Mary Page Scholarship, Cleveland, 1951; Butler Inst. Am. A., purchase award, 1954. Exhibited: WMAA, 1964; Am. Acad. A. & Lets., 1965; one-man: Peridot Gal., N.Y., 1964, 1966, 1967, 1969; Holland Gal., Chicago, 1965; Feingarten Gal., Los Angeles, 1966; Duke Univ., 1967; Cleveland Inst. A., 1968; Alwin Gal., London, 1968; Columbia (S.C.), 1969. Positions: Instr., Sculpture, Queens Col., N.Y.

MILLER, MRS. ROBERT WATT—Patron
1021 California St., San Francisco, Cal. 94108
B. Oakland, Cal., July 20, 1898. Awards: Italian Cross of Solidarity, San Francisco, 1959. Art Activities: Specialty-presentation of shows in museums; Sponsor, Harry Lehman show, Maxwell Gallery, San Francisco, Chairman, Van Gogh show; Chairman, Faberge show;

Chairman, de Young Memorial Museum Society, 1961-1963; Chairman, San Francisco Opera Guild, 1950-1952; Chairman, Italian Festival, San Francisco, 1959; Board of Trustees, Childrens Hospital, San Francisco.

MILLER, SAMUEL CLIFFORD—Museum Director
43-49 Washington St., Newark, N.J. 07102
B. Roseburg, Ore., May 6, 1930. Studied: Stanford Univ., B.A.; New York Univ. Inst. of Fine Arts (grad. study). Further study in Japan, Europe and Mexico to study foreign collections. Member: AAMus.; Northwest Mus. Conf.; Mus. Council of New Jersey; AFA. Positions: Asst. to Dir., Nat. Serigraph Soc. and Meltzer Gallery, N.Y., 1956-61; Asst. to the Director, Albright-Knox Art Gallery, Buffalo, N.Y., 1964-1967; Asst. Dir., Newark Museum, 1967, Museum Dir., Newark Museum, 1968- .

MILLIKEN, GIBBS—Painter, E.
Department of Art, University of Texas, Austin, Tex. 78712
B. Houston, Tex., Dec. 15, 1935. Studied: Scheiner Inst.; Univ. Colorado; Trinity Univ., B.Sc.; Cranbrook Acad. A., M.F.A. Member: AFA; AAUP; Men of Art Gld.; Contemp. A. Group. Awards: purchase awards: San Antonio Artists, Witte Mem. Mus., 1961, 1962 (2), 1963; Western Exh., High Plains Gal., Amarillo, 1961; Texas FA Assn. (graphics); Grumbacher award, Texas WC Soc., Witte Mem. Mus., 1964, Naylor award, 1966, Freeman purchase prize, 1967; Hertzberg Gal., San Antonio, 1963. Other prizes: Motorola Regional, San Antonio, 1962; Elliot Paint Co., 1963; Darrah Mem. prize, Chautauqua, N.Y., 1963; Mus. of FA of Houston; Longview (Texas) Service League, 1964, 1965; Tex. FA Assn., 1966. Work: Cranbrook Acad. A.; Montgomery (Ala.) Mus. FA; Service League, Longview, Tex.; Butler Inst. Am. A. Exhibited: Trinity Univ., 1960, 1961, 1968; San Antonio A., Witte Mus., 1960-1968; Men of Art Gld. Gal., 1961; Texas WC Soc., 1962-1966; Motorola Exh., San Antonio, 1962, Chicago, 1962; Contemp. A. Exh., 1962, traveling State of Louisiana, 1962-63, traveling Texas, 1962-63, 1963-64; Texas Annual P. & S., Witte, Mus., Corpus Christi, Beaumont Mus., and DMFA, 1962-1966; Southern States, Roswell (N.M.) Mus., 1962; Delgado Mus. A., New Orleans, 1963; Watercolor: USA, 1963; Chautauqua AA, 1963, 1965; Texas FA Assn., 1963; Audubon A., N.Y., 1964; DMFA, 1964 and traveling; Longview, Tex., 1964; Texas FA Assn., Spring Jury Exh., 1964, traveling 1964-65; AFA, 1965; Ball State Univ., Ind., 1965; Bucknell Univ., 1967; Tex. FA. Comm., Hemisfair, San Antonio, 1968; and many others. One-man: Witte Mem. Mus., 1961; San Antonio Pub. Lib., 1962; Junior League, San Antonio (Artist of the Month), 1962; traveling one-man sponsored by U.S. Fourth Army, 1963-64; Forsythe Gal., Ann Arbor, Mich., 1965; North Star Gal., San Antonio, Tex., 1967, 1968; Winn Gal., Austin, Tex., 1969. Positions: (1956-63) Asst., Univ. of Colorado Mus.; Witte Mem. Mus., San Antonio, Tex., Artist, Photog., Asst. Cur., Cur. & Hd. Dept. of Exhibitions: Instr., Painting & Drawing, Cranbrook Acad. A., Bloomfield Hills, Mich., 1964, 1965. Univ. Tex., Austin, Instr., 1965-1969, Asst. Prof. A., 1969- .

MILLONZI, VICTOR—Sculptor
412 Cathedral Parkway, New York, N.Y. 10025; studio: Box 232 Stone Ridge, N.Y. 12484
B. Buffalo, N.Y., Dec. 17, 1915. Studied: Univ. Buffalo, B.A.; Albright A. Sch., Buffalo, B.F.A.; Columbia Univ., M.A. Work: Finch Col., N.Y.; MMoDA; CGA; BM; NCFA; New Jersey State Mus., Trenton; N.J.; commission: NBC, Rockefeller Center, N.Y., 1969. Exhibited: Carnegie Int., 1967; Holland, 1966; BM, 1969; other exhibitions: "Art in Process," 1966; "Sculpture-The New York Scene," 1967; "Focus on Light," 1967.

MILLS, GEORGE THOMPSON—Educator
Lake Forest College; h. 705 S. Green Bay St., Lake Forest, Ill. 60045
B. East Cleveland, Ohio, May 8, 1919. Studied: Dartmouth Col., B.A.; Harvard Univ., M.A., Ph.D. Member: AA Mus.; Am. Soc. for Aesthetics; Am. Anthropological Assn. (Fellow); Am. Assn. for Advancement of Science; Soc. for App. Anthropology. Author: "Navaho Art and Culture." Contributor of articles to College Art Journal; American Anthropologist; Brand Book; dealing with the educational role of the art museums and with the relations of art and culture. Exhibitions arranged: Saints and Kachinas, 1956; Penitentes of New Mexico and Colorado (in collaboration with Richard Grove), 1955. Positions: Cur., Taylor Museum, Asst. Dir., Colorado Springs Fine Arts Center, Colorado Springs, Colo.; Prof., Anthropology, Lake Forest College, at present.

MILLS, PAUL CHADBOURNE—Museum Curator
The Oakland Museum, Art Division, 1000 Fallon St.; h. 15 Bonita Ave., Piedmont, Cal. 94611
B. Seattle, Wash., Sept. 24, 1924. Studied: Reed Col., Portland, Ore.; Univ. Washington, A.B.; Univ. California, Berkeley, M.A. Member: AAMus.; Western Mus. Conf.; Western Assn. A. Mus.

Awards: Ford Fnd. F., Program for Studies in the Creative Arts. Author: "Early Paintings of California"; "Contemporary Bay Area Figurative Painting." Positions: Former Vice-Pres., Western Assn. A. Mus. and of Western Mus. Conf.; Cur., of Art, Oakland Mus., Oakland, Cal. Former Memb., U.S. State Dept. National Accessions Committee.

MILLSAPS, DANIEL WEBSTER, III—Writer, P., Des., Gr.
115 5th St., S.E., Washington, D.C. 20003
B. Darlington, S.C., June 30, 1919. Studied: Univ. South Carolina, A.B.; ASL, and with Heyward, Rembert, Marshall, and others. Member: ASL; F.I.A.L. Awards: Anthony B. Hampton award, Univ. South Carolina, 1940; VMFA, 1947; 50 Books of the Year, AIGA, 1948. Work: N.Y. Pub. Lib.; LC; VMFA; Univ. South Carolina; Berkshire Mus., Pittsfield, Mass.; Abbot Hall, Kendall, England; Columbia Mus., S.C.; "Arts in Embassies Collection," U.S. State Dept.; Mississippi State Col. for Women; CGA. Exhibited: AIGA, 1948; Terry AI, 1952; WMAA, 1950, 1951; CGA, 1952; Delgado Mus. A., 1947, 1948; VMFA, 1947; Gibbes A. Gal., 1941; Mus. Non-Objective Painting, 1948; Ferargil Gal., 1952; Circulating, 1955; Dupont, 1955; Am-Korean Fnd., 1955-56; Columbia Mus. A., (10 yr. retrospective); Univ. Colorado, 1958; Trans-Lux & Plaza Gals.; Litchfield (Conn.) Gal., 1961; Old Market Gal., 1961. Author, I., "Sounds Pretty," 1948; "Millsap's First Portfolio," 1960; "Community Art Show Organization Guide," 1961. Positions: Founder, Editor and Publisher, "Washington International Arts Letters" 1962; Founder, The Millsaps Collection, 1969.

MINER, DOROTHY—Museum Curator, L., W.
Walters Art Gallery, 600 North Charles St. 21201; h. 207 West Lanvale St., Baltimore, Md. 21217
B. New York, N.Y., Nov. 4, 1904. Studied: Barnard Col., A.B.; Columbia Univ.; N.Y. Univ.; Univ. London. Member: CAA (Bd. Dir., 1958-62); Mediaeval Acad. Am. (Council, 1958-61); Renaissance Soc. Am. (Council); Bibliographical Soc. Am. (Chm. Southern Regional Council); Balt. Bibliophiles (Pres. 1955); Evergreen House Fnd. (Trustee); Adv. Council, Dept. A. Hist. & Archaeology, Columbia Univ.; Hon. Memb. Société de la Reliure Originale; Iconographical Comm. of Comitié Internationale des Sciences Historiques; Memb., Inst. for Advanced Studies, Princeton Univ., 1960-61; Hon. Fellow, Pierpont Morgan Lib., N.Y., (Memb. Council, 1964-67). Awards; Int. F., Barnard Col., 1926-27; Carnegie FA F., 1928-29, Carnegie European F., 1929-30, President's F., 1930-31 Columbia Univ., Rosenbach F., Univ. Pa.; Goucher Col., LL.D., 1957. Ed., Journal, monographs, and periodicals, of the Walters A. Gal.; Co-author: "Proverbes en Rimes," 1937; Author: "Illuminated Books of the Middle Ages and Renaissance," 1949; Ed., "Studies in Art and Literature for Belle da Costa Green," 1952; "History of Bookbinding, 525-1950 A.D.," 1958; Co-author, "The International Style," 1962; "2000 Years of Calligraphy," 1965. Contributor of articles and reviews to leading art and museum publications. Lectures: Mediaeval Art. Positions: Instr., Barnard Col., 1931-32; Johns Hopkins Univ., 1947, 1951, 1960, 1963, 1964; Adj. Prof. New York Univ., Fine Arts Seminar, Brussels, Belgium, Summer, 1962; Librarian & Keeper of Manuscripts, Walters Art Gal., Baltimore, Md., 1934- .

MINTZ, HARRY—Painter, T., L.
452 Belden Ave., Chicago, Ill. 60614
B. Ostrowiec, Poland, Sept. 27, 1909. Studied: Warsaw Acad. FA, Poland; AIC. Member: North Shore A. Lg.; Renaissance Soc., Chicago; AEA. Awards: prizes, AIC, 1937, 1939, 1945, 1946, 1948, 1952, 1954, 1962, 1964; Springfield, Ill., 1948; Evanston Woman's Cl., 1948, 1949, 1953; Am.-Jewish A. Cl., Chicago, 1948; Magnificent Mile Exh., Chicago, 1956; medal, Cal. PLH, 1946; Univ. Chicago, 1953; Sarasota Nat. Exh., 1959; Union Lg. Cl., Chicago, 1959 (purchase); Old Orchard Exh., Ill., 1959, hon-mem., 1958, 1960, 1962, 1963. Work: AIC; Hackley A. Gal.; Warsaw Acad. FA; Tel-Aviv Mus., Israel; WMAA; Evansville (Ind.) Mus.; Notre Dame Univ.; Rio de Janeiro Mus. of A.; Downtown Gal., N.Y.; Stephens Col., Missouri and many private collections. Exhibited: AIC, 1932-1964; WMAA; PAFA; CGA; Carnegie Inst.; Cal. PLH; CM; Milwaukee AI; VMFA; Univ. Illinois; Springfield Ill.; State Univ. Iowa; Soc. Liberal A., Omaha; Denver A. Mus.; SAM; Kalamazoo AI; Kansas City AI; Lehigh Univ.; Minnesota State Fair; Currier Gal. A.; Arnot A. Gal.; Davenport Mun. A. Gal.; Sarasota AA; Minneapolis Inst. A.; CAM; Krannert Mus., 1961, 1963; Columbus Gal. FA; Rochester Mem. A. Gal.; Los A. Mus A., and many others; one-man: John Heller Gal., N.Y.; AIC; Los A., Cal.; Palmer House Gal., Chicago, 1952, 1953; Cliff Dwellers, Chicago, 1954; Stevens Gross Gal., Chicago, 1951; Feingarten Gal., Chicago, 1961; Feingarten Gal., Beverly Hills, Cal., 1961, and others. Positions: Instr., Evanston (Ill.) A. Center; Prof., AIC, Chicago, Ill., at present; Visiting Prof., Washington Univ., St. Louis, Mo., 1954-55.

MIRSKI, BORIS—Art dealer
166 Newbury St., Boston, Mass. 02116*

MITCHELL, DANA COVINGTON, JR. (DR.) — Collector
1404 Gregg St. 29201; h. 600 Spring Lake Rd., Columbia,
S.C. 29206
B. Bluefield, West Va., Feb. 22, 1918. Studied: University of West
Virginia, B.A., M.D. Collection: Contemporary American art. Po-
sitions: President, Board of Trustees, Columbia Museum of Art,
1960-1961.*

MITCHELL, ELEANOR — Fine Arts Specialist & Librarian
USAID/Quito, c/o American Embassy, Quito, Ecuador, S.A.
B. Orange, N.J., Apr. 4, 1907. Studied: Douglass Col., New Bruns-
wick, N.J., B.A.; Columbia Univ. Sch. Lib. Service, B.S.; Smith Col.,
M.A.; Institut d'Art et d'Archeologie, Universite de Paris (Carnegie
Summer Schol.); Harvard Univ., and additional studies in art, lan-
guages and music at Harvard Univ., Univ. Florence, Italy, Carnegie
Inst., Univ. Pittsburgh, George Washington Univ. Member: Am. Li-
brary Assn.; Special Libraries Assn.; AAMus.; AFA; CAA. Contrib-
utor to: Gazette des Beaux-Arts; College Research Libraries; Bul-
letin of the N.Y. Public Library; Art Education Bulletin; Douglass
Alumnae Bulletin, 1937-61. Positions: Asst. Cur., Books & Photo-
graphs, A. Dept., Smith College, 1929-36; Asst., The Graduate
House, Florence, Italy, 1936-37; Librarian, Dept. FA, Univ. Pitts-
burgh, 1937-42; Asst. to Dir., Biblioteca Publica del Estado de
Jalisco, Guadalajara, Mexico, 1942-43; Chief, A. Div., N.Y. Pub.
Lib., 1943-52. Program Specialist, Cultural Activities Dept.,
UNESCO, Paris, 1948-49; Dir., Library Service, United States In-
formation Service, Italy, 1951-54; Consultant on Fine Arts, Library
of Congress, Dec., 1954-Mar., 1955; Consultant, Montclair (N.J.)
Free Public Library, Apr.-Sept., 1955; U.S. Specialist, Dept. of
State, Intl. Educational Exchange Service, Univ. of Antioquia, Medel-
lin, Columbia, Nov., 1956-June, 1957; Biblioteca Publica Depart-
mental, Cali, Nov., 1955-Oct., 1956; Executive Dir., Fine Arts
Com., People-to-People Program, Corcoran Gal., Nov., 1957-June,
1961. Specialist, Books for the People Fund, Inc., c/o Pan Ameri-
can Union, Washington, D.C., 1961-62; Bibliographic Asst., Rocke-
feller Fnd., Project for Intl. Rice Research Inst.-Philippines, Wash.
D.C. Sept. 1962-Mar. 1963; Consultant, Hispanic Fnd., Library of
Congress, Apr.-Aug. 1963; Library Consultant, Universidad Cato-
lica, Quito, Ecuador under St. Louis Univ. AID Contract, Aug.
1963- .*

MITCHELL, (MADISON) FRED — Painter
92 Hester St., New York, N.Y. 10002
B. Meridian, Miss., Nov. 24, 1923. Studied: Carnegie Inst. Tech.;
Accademia di Belle Arti, Rome, Italy; Cranbrook Acad. A., M.F.A.,
B.F.A. Awards: Pepsi-Cola Painting Fellowship, 1948. Work:
Cranbrook Acad. Mus., Bloomfield Hills, Mich.; architectural
screen, Miss. State Col. for Women. Exhibited: Pittsburgh Assoc.
A., 1943; Soldier A. Exh., NGA, 1944; Detroit Inst. A., 1946-1948,
1955; Pepsi-Cola Exh., and traveling, 1947-1948; Museo del Arte
Moderna, Rome, 1949; Stable Gal., N.Y., 1953-1955; Guggenheim
Mus., N.Y., 1954 and traveling, 1955; DMFA, 1955; WAC and Stable
Gal., 1955; Founders Exh., Tanager Gal., N.Y., 1956, 1960; Cran-
brook Acad. A., 1957; Int. Exh., Galerie Greuze, Paris, 1957; Rome-
New York Fnd., in Rome, 1958; Carnegie Int., 1961; one-man: Mun.
Gal., Jackson, Miss., 1942; Tanager Gal., 1953; Howard Wise Gal.,
Cleveland, 1958, 1961 and Howard Wise Gal., N.Y., 1960, 1963; Co-
lumbia (S.C.) Mus. A., 1965; Wooster A. Center, Danbury, Conn.
1966; White Art Museum, Cornell Univ., 1969. Positions: Cr., Pic-
tures on Exhibit, N.Y., 1952-53; Instr., Adult Classes, Riverdale
Neighborhood House, N.Y., 1953; Instr., Design, Finch College, N.Y.,
1954; Instr., Painting, Positano Art Workshop, Italy, (summer),
1956; Instr., Drawing & Painting, Cranbrook Acad. A., Bloomfield
Hills, Mich., 1955-1959; Instr., Drawing & Painting, New York
University, New York, N.Y., 1961. Artist-in-Res., Columbia (S.C.)
Mus. A.; Visiting Critic in Art, Cornell Univ., 1969.

MITCHELL, GLEN — Painter, T., I.
550 West 157th St., New York, N.Y. 10032
B. New Richmond, Ind., June 9, 1894. Studied: Chicago Acad. FA;
AIC; Univ. Illinois; Grande Chaumiéré, Paris, France. Awards:
Guggenheim F., 1926-1927, 1928; CGA, 1936; Minneapolis Salon,
1937; Hoosier Salon, 1939. Work: murals, theatres in Minneapolis
and Red Wing, Minn.; Macy's, N.Y.; Freeman's, Toronto; Hecht's,
Wash., D.C. Exhibited: MModA; WMAA; PAFA; NAD; AIC; William
Rockhill Nelson Gal.; SFMA; Oakland A. Gal. Lectures: Painting;
Composition. Contributor to American Artist magazine. Positions:
Hd., Painting Dept., Minneapolis Sch. A., Minneapolis, Minn., 1929-
1941; Instr., Parsons Sch. Des., New York, N.Y., 1949-54; Asst.
Prof. Painting, Display, Fashion Inst. of Technology, New York,
N.Y. at present.

MITCHELL, HENRY (WEBER) — Sculptor
Valley House, Arcola, Pa. 19420
B. Canton, Ohio, Aug. 27, 1915. Studied: Princeton Univ., A.B.;
Tyler Sch. FA, Temple Univ., M.F.A.; Academia di Brera, Milan,

Italy, with Marion Marini. Member: AEA; Phila. A. All.; Franklin
Inn Cl., Phila. Awards: Fulbright F., 1950-51; Gold medal of N.Y.
show at Phila. Flower Show, 1964. Work: fountain, PMA; sculpture
in three Phila. park playgrounds; Impala fountain, Phila. Zoo; 2 sc.,
Phila. Free Library; reliefs, Phila. Zoo & Cobbs Creek Park; Owl,
Hoosac Sch.; Tiger, Newtown Marple High Sch.; lg. works in gardens
in Phila., Milano, Maine, "Logos" Mem. to Adlai Stevenson, Ill.
State Univ., Normal, Ill. In colls. of PMA; PAFA; Wilmington Soc.
FA.; Provident Nat. Bank, Phila.; John Wanamaker, King of Prussia,
Pa.; Univ. of Pa. Law Sch. Exhibited: PMA, 1955; Munson-Williams-
Proctor Inst., 1956; Rochester Mem. A. Gal., 1956; one-man: Flor-
ence, Italy, 1952; Canton AI, 1952; Kraushaar Gal., N.Y., 1953, 1959;
Baltimore, 1953; Phila. A. All., 1954; Bryn Mawr A. Center, 1955;
Ft. Lauderdale, Fla., 1959; PAFA, 1956; MModA Penthouse; Wil-
mington Soc. FA.; one-man: Drexel Inst., 1964; Provident Nat. Bank,
1968. Positions: Instr., Des., S., PMA, Philadelphia, Pa.; Wilming-
ton Soc. FA.

MITCHELL, JOAN — Painter
60 St. Marks Place, New York, N.Y. 10003*

MITCHELL, PETER TODD — Painter, Des.
116 E. 57th St., New York, N.Y. 10022; also, C. Parelladas 64,
Sitges, Spain
B. New York, N.Y., Nov. 16, 1928. Studied: Yale Sch. FA. Awards:
Tiffany Fnd., 1952. Work: MMA; Univ. Texas. Exhibited: Galerie
Morihien, Paris, 1948; Am-British Gal., N.Y., 1948; Galerie de
L'Elysee, Paris, 1951; Hanover Gal., London, 1953, 1956; Carstairs
Gal., N.Y., 1956, 1957; Jeffress Gal., London, 1964; Griffin Gal.,
N.Y., 1964, 1965; Emile Walter Gal., New York City, 1969.

MITCHELL, WALLACE (MacMAHON) — Museum Dir., P.
Cranbrook Academy of Art, Bloomfield Hills, Mich. 48013
B. Detroit, Mich., Oct. 9, 1911. Studied: Northwestern Univ., B.A.;
Cranbrook Acad. A., with Zoltan Sepeshy; Columbia Univ., M.A.
Work: Cranbrook Acad. A. Mus.; Detroit Inst. A.; Guggenheim Mus.;
Kalamazoo A. Center; murals, General Motors Tech. Center; Univ.
Kentucky Medical Center. Exhibited: AIC, 1938-1941; Detroit Inst.
A., annually; Albright A. Gal., 1939; Univ. Nebraska; Bertha Schae-
fer Gal., 1950, 1958 (one-man); Old Northwest Territory Exh. Posi-
tions: Instr., 1936-1955, Registrar, 1944-1964, Dir., Galleries,
1955- , Cranbrook Acad. Art, Bloomfield Hills, Mich.*

MITTLEMAN, ANN — Painter
710 Park Ave., New York, N.Y. 10021
B. New York, N.Y. Studied: N.Y. Univ., and with Philip Evergood,
Robert Laurent, Tschacbasov. Member: AEA; F., Royal Soc. Arts,
London, England; NAWA; Brooklyn Soc. A. Work: Everhart Mus. A.,
SAM; Zanesville, Ohio; Smith Col.; Jewish Mus.; Hickory, N.C.;
N.Y. Univ. Mus.; Richmond (Ind.) AA; Evansville (Ind.); Florence
(S.C.) Mus. A.; Delgado Mus. A.; Lowe Gal. A., Coral Gables; Bir-
mingham Mus. A.; Archives of American Art. Exhibited: ACA Gal.;
N.Y. City Center; Berlin Acad. FA, Germany; Tokyo, Japan; WMAA;
Riverside Mus.; Creative Gal.; Panoras Gal.; Wickersham Gal., N.Y.
(one-man) 1968; Rockland A. Fnd.; NAWA; Bodley Gal., 1958; Sagit-
tarius Gal., N.Y., 1959; 25 year retrospective, Univ. Minnesota,
1969; one-man traveling exhibition to: Wittenberg Univ., Springfield,
Ohio; Peoria Art Center; Wesleyan Col. Mus., Macon, Ga.; Richmond
(Ind.) AA; Georgia Mus. A., Athens; Hickory Mus. A., N.C.; A. Inst.
of Zanesville, Ohio; South Bend AA; Everhart Mus., Scranton, Pa.;
Auburn Univ. Mus., Ala.; Columbus Mus. A., Ga.; Sheldon Swope
Mus., Terre Haute, Ind.; Panama (Fla.) AA; Pensacola A. Center;
Mobile A. Center; Birmingham Mus. A.; Lafayette (Ind.) A. Center;
Univ. Minnesota, Duluth.

MIYASAKI, GEORGE JOJI — Painter, Gr., E.
1215 Carlotta Ave., Berkeley, Cal. 94707
B. Kalopa, Hawaii, Mar. 24, 1935. Studied: Cal. Col. A. & Crafts,
Oakland, B.F.A., B.A. in Edu., M.F.A. Member: SAGA. Awards:
Madison (Wis.) A. Center, purchase, 1966; SAGA, award, 1968; BM,
purchase, 1968. Work: MModA; Madison (Wis.) A. Center; Univ.
Tex. A. Mus., Austin; Univ. New Mexico, Albuquerque; Andrew
Dickson White Mus., Cornell Univ. Positions: Prof., Painting,
Printmaking, Univ. California, Berkeley, 1964- .

MIYASHITA, TAD — Painter
121 E. 23rd St., New York, N.Y. 10010
B. Maui, Hawaii, May 10, 1922. Studied: Corcoran Sch. A., with
Richard Lahey; ASL, with Vaclav Vytlacil and Morris Kantor. Work:
WMAA; N.Y. Univ. Collection; Lowe Gal., Univ. of Miami; Guggen-
heim Mus., New York. Exhibited: WMAA, 1965-1968; Fordham
Univ., 1968; Rochester A. Gal. of the Univ. of Rochester, 1965; Mary
Washington Col., 1965; "One Hundred Works on Paper" exh., se-
lected by Thomas Messer, Salzburg, Austria, 1959; Inst. Contemp.
A., Boston, 1959; Nebraska AA, 1952, 1954; PAFA, 1951, 1954;
CGA, 1948. One-man: Hacker A. Gal. N.Y., 1952, 1953; Whyte Gal.,

Wash., D.C., 1954; Graham Gal., N.Y., 1958; Grand Central Moderns, 1965, 1966; A.M. Sachs Gal., N.Y., 1967, 1969.

MOCHI, UGO—Animal Artist, I., L.
26 Orchard Place, New Rochelle, N.Y. 10801
B. Firenze, Italy, Mar. 11, 1889. Studied: Accademia di Belle Arti, Firenze; Berliner Akademie der Kunste and with August Gaul, animal sculptor. Member: Hon. Mem., Past Pres., New Rochelle AA; Animal Artists Soc., N.Y. Work: MMA; Queen Mary Windsor Castle Coll., London; Cranbrook Mus. A., and in many private colls. Exhibited: London, England; Villa Reale-Monza, Italy; Boston Arch. Club; N.Y. Mus. Science & Industry; Univ. Michigan; Columbia Univ.; College of New Rochelle; McGill Univ., Montreal, Canada; Phila. A. All., and others. Illus.: "African Shadows" (N.Y. 1934); "Hoofed Mammals of the World" (Mochi-Carter, N.Y., 1953); "Theodore Roosevelt's America" (Ed. by F. A. Wiley); "American Water and Gamebirds" (Rand), 1956. 14 illuminated windows in Am. Mus. of Nat. History, New York City, N.Y. Lectures: "History of the Art of Outline from Prehistoric Time."

MOCHON, DONALD—Educator, P., Mus. D.
State University of New York at Albany, 1400 Washington Ave., Albany, N.Y. 12203; h. 226 Brunswick Road, Troy, N.Y. 12180
B. Troy, N.Y., Mar. 20, 1916. Studied: Rensselaer Polytechnic Inst., M. Arch. Awards: Student Medal, AIA, 1936. Exhibited: SFMA; PAFA; Berkshire Mus.; Everson Mus. A.; Munson-Williams-Proctor Inst., Utica, N.Y.; Albany Inst. History & Art; de Cordova & Dana Mus.; Boston A. Festival. Positions: Director, Art Gallery, State University of N.Y. at Albany; Professor of Art, SUNY; Adjunct Prof. Architecture, Rensselaer Polytechnic Inst.; Visiting Critic in Architecture at Williams College.

MOCK, GLADYS—Painter, Eng.
24 Washington Sq., New York, N.Y. 10011
B. New York, N.Y. Studied: ASL, and with Kenneth Hayes Miller. Member: SAGA; NAWA; Audubon A.; Pen & Brush Cl. Awards: prizes, NAWA, 1946, medal, 1954; Pen & Brush Cl., 1946, 1955, 1960, 1968; Audubon A., hon. men., 1960; Champlain Valley Exh., 1951; medal, NAWA, 1951; John Taylor Arms Mem. medal and purchase prize, 1968; Hunterdon County A. Center, purchase, 1968. Work: Todd Mus., Kalamazoo, Mich.; LC; Kansas State Col., Hays, Kans.; MMA; Smithsonian Inst.; Georgia Mus.; Elliott Mus., Stuart, Fla. Exhibited: CGA; LC; PAFA; AIC; Carnegie Inst.; NAD; SAGA; NAWA; WFNY 1939; Venice, Italy; Overseas Exh., USIA, 1960-62. Positions: Bd. Dir., (1955-57) Delegate to U.S. Com. of Int. Assn. Plastic A., 1956, Audubon A., Vice-Pres., 1964-1966; Council Memb., Pres. 1959-1961; SAGA.

MOCSANYI, PAUL—Art Center Director
New School for Social Research, 66 West 12th St., New York, N.Y. 10011
Positions: Director, Art Center, New School for Social Research, New York, N.Y.

MOE, HENRY ALLEN—Trustee
New York State Council on the Arts, Museum of Modern Art, 11 W. 53rd St., New York, N.Y. 10019*

MOFFETT, ROSS E.—Painter
Provincetown, Mass. 02657
B. Clearfield, Iowa, Feb. 18, 1888. Studied: AIC; & with Charles Hawthorne. Member: NA; Audubon A.; Mass. Archaeological Soc.; Soc. Am. Archaeology. Awards: med., AIC, 1918, 1927; prize, NAD, 1921, 1951; Minnie B. Stern Medal, Audubon A., 1965. Work: PAFA; J.B. Speed Mem. Mus.; CGA; WMAA; Univ. Nebraska; Miami Univ.; murals, USPO, Holyoke, Mass.; Eisenhower Mus., Abilene, Kans.; Somerville, Mass.; Revere, Mass. Exhibited: CGA; PAFA; AIC; NAD; Carnegie Inst.; Detroit Inst. A.; Albright A. Gal.; WMA; Springfield Mus. A.; Minneapolis Inst. A.; CAM; VMFA; Dayton AI; Louisville, Ky.; CMA; etc. Author: "Art in Narrow Streets," publ. 1964.

MOIR, ALFRED KUMMER—Scholar, E.
Art Department, University of California, Santa Barbara, Cal. 93106; h. 103 Mesa Lane, Santa Barbara, Cal. 93105
B. Minneapolis, Minn., Apr. 14, 1924. Studied: Harvard College, A.B.; Harvard Univ., A.M., Ph.D.; Univ. Rome. Author of articles in various art journals, Art Bulletin and others, particularly on Caravaggio and his Italian followers; various reviews in Art Journal. Field of Research: Italian Baroque art; drawings; 20th century painting. Author: "The Italian Followers of Caravaggio," 2 vols., 1967. Positions: Instr. to Assoc. Prof. of Art History, 1952-1963, Assoc. Chm., Art Dept., 1957-1959, Newcomb College of Tulane Univ., New Orleans; Visiting Prof., Prof. Art, Chm. Dept. of Art, Univ. California, Santa Barbara, Cal., 1964- ; Pres., Art Historians

of Southern California, 1964- ; Exec. Comm., New Orleans AA, 1954-58. Art Historian in Residence, American Academy in Rome, 1969-1970.

MOIR, ROBERT—Sculptor, P., T.
400 East 93rd St., New York, N.Y. 10028
B. Chicago, Ill., Jan. 7, 1917. Studied: AIC; Columbia Univ.; N.Y. Univ.; ASL. Member: New Sculpture Group; S. Gld. Work: Honolulu Acad. A.; WMAA; Rittenhouse Savoy, Phila., Pa., and in private colls., Nassau, Bahamas; New York State and City; New Jersey, etc. Exhibited: AIC, 1940, 1941, 1948; WMAA, 1951-1955, 1956; MMA, 1951, 1952; Sculpture Center, N.Y., 1951 (one-man), 1952; John Heller Gal., 1954, 1955; Parma Gal., 1956 (one-man); S. Gld., Lever House, N.Y., 1959, 1960. Positions: Exec. Sec., Sculptors Gld., N.Y., 1960-61; Juror, NAD, 1961; Pittsburgh Sculptors' Group, 1960.

MOLDROSKI, AL R.—Painter, E.
33 Meadowview, Charleston, Ill. 61920
B. Terre Haute, Ind., Aug. 27, 1928. Studied: Indiana State Univ, B. Sc.; Michigan State Univ., M.A. Awards: Tiffany Fnd. Grant.; Research Grant in Painting, Southern Illinois Univ.; purchase award, PAFA; Mary Richart Mem. Award in Painting and the Art Directors Award, both Detroit Mus. A.; prizes, Decatur A. Center; Swope A. Gal.; DeWaters A. Center, Flint, Mich. Indiana Artists Exh., Indianapolis, Ind. Exhibited: PAFA; Detroit Mus. A.; CAM; DeWaters A. Center; Boston Festival Arts; deCordova & Dana Mus.; Michiana Exh., South Bend; Nat. Drawing and Small Sculpture Comp., Muncie; Decatur A. Center; Swope A. Gal.; Evansville Mus. A.; AIC; Kresge A. Center, East Lansing; So. Illinois Univ., Carbondale; Traveling Printmakers Exh.; Paul Sargent Gal., Charleston; Mississippi Valley, Springfield, Ill.; one-man: Pietrantonio Gal., N.Y.; Huntington (W. Va.) Galleries. Positions: Lecturer in Art, Southern Illinois Univ.; Asst. Prof. A., Glenville (W. Va.) State College; Instr., Art, Eastern Illinois Univ., Charleston.*

MOLLA (MRS. MOLLA MOSS)—Painter
c/o East Hampton Gallery, 22 W. 56th St., New York, N.Y. 10019*

MOLLER, HANS—Painter
2207 Allen St., Allentown, Pa. 18104; s. Monhegan, Me.
B. Wuppertal-Barmen, Germany, Mar. 20, 1905. Studied: in Germany. Member: ANA. Awards: Purchase prize, Nat. Religious A. Exh., Sacred Heart Seminary, Detroit, 1964; Palmer Mem. prize, NAD, 1968; Samuel Morse medal, NAD, 1969. Work: PAFA; PC; Walker A. Center; Univ. Georgia; Soc. Four Arts, Palm Beach; WMAA; MMoDA; BM; Detroit Inst. A.; Staedtisches Mus., Wuppertal, Germany; N.Y. Pub. Lib.; James Michener Fnd. Coll., Allentown Mus., Pa.; Tapestry des. for Temple Israel, Tulsa, Okla; Temple Beth-El, Gary, Ind., Spelman Col., Atlanta, Ga.; N.Y. Univ.; Yellowstone A. Center, Billings, Mont.; Norfolk Mus. A. & Sciences, Va.; Melbourne Mus., Australia; U.S.I.A. Commissions: 7 stained-glass windows for Christ Church, Georgetown, Wash., D.C. & others. Exhibited: PAFA, 1944, 1946-1952; AIC, 1943-1946; VMFA, 1946, 1948; CGA, 1949, 1951, 1961; BM, 1947, 1951; CM, 1952; MMA, 1950; Univ. Illinois, 1949, 1950, 1952, 1953, 1955, 1957, 1959; Art: USA, 1959; Nordness Gal., N.Y., 1961; Portland Mus. A., 1960; Albright A. Gal. 1952; WMAA, 1946-1952, 1953, 1960; and in France, Germany, Japan; Provincetown A. Festival, 1958; one-man: Borgenicht Gal., N.Y., 1951, 1953, 1954, 1956; Bonestell Gal., 1942, 1943; Chicago A. Cl., 1945; Univ. Michigan, 1945; Kleeman Gal., 1945, 1947-1950; Pen & Palette Cl., St. Louis, 1949; Macon, Ga., 1949; Atlanta, Ga., 1950; Fine Arts Assoc., 1957, 1960; Landry Gal., N.Y., 1962; Midtown Gal., N.Y., 1964, 1967; Phila. A. All., 1968; retrospective exh., Leetes Island, Conn., 1955; retrospective exh. to universities, colleges and museums, U.S. and Canada (booked to 1962). Work in "Arts of the United States," publ., 1960; "Nature in Abstraction," publ. by WMAA. Positions: Instr., Graphic Des., Painting, CUASch., New York, N.Y., 1944-1956.

MONAGHAN, EILEEN (Mrs. Frederic Whitaker)—Painter
6453 El Camino del Teatro, La Jolla, Cal. 92037
B. Holyoke, Mass. Studied: Mass. Col. A. Member: ANA; AWS; All. A. Am.; Providence WC Cl.; Cal. WC Soc.; West Coast WC Soc.; Soc. of Western A. Awards: Over 55 awards including NAD Ranger Fund purchase, and Obrig prize; AWS (3) and silver medal; All. A. Am. (several); Providence WC Cl.; Cal. WC Soc.; Springville (Utah) Mus.; Soc. of Western A., and others. Huntington Hartford Fnd. Grant, 1964. Work: Hispanic Soc. Mus.; Univ. Massachusetts; Atlanta A. Mus.; Norfolk Mus. A.; Springfield (Mass.) Mus. A.; Reading (Pa.) Pub. Mus., and in private colls. Exhibited: Regularly in national and regional watercolor exhs. and several one-man shows in Cal., N.M. and N.Y. Featured in American Artist, 1964 and series of three articles in The Artist of London, 1959.

MONAGHAN, KEITH—Educator, P.
Art Department, Washington State Univ.; h. 1501 Lower Drive, Pullman, Wash. 99163
B. San Rafael, Cal., May 15, 1921. Studied: Univ. California, Berkeley, B.A., M.A. Member: San F. AA; Washington AA. Awards: prizes, San F. AA, 1948; SAM, 1950; Spokane Coliseum, 1954; Seattle Music & A. Fnd., 1954, 1957; Puget Sound Group, 1956; Frye Mus. A., 1956; Bellevue (Wash.) A. & Crafts, 1956, 1958; Spokane A. Center, 1957; Woessner Gal., 1958. Exhibited: San F. AA., 1946-1948, 1950, 1953; deYoung Mem. Mus.; Cal.PLH; Cal. State Fair; SAM; Henry Gal., Seattle; Woessner Gal., Seattle; Bellevue A. & Crafts Fair; Spokane A. Center; Spokane Coliseum; Vancouver A. Gal., Oakland A. Mus.; "Northwest Art Today," Seattle World's Fair; Butler Inst. Am. A.; Kinorn Gal., Seattle; Frye Mus., Seattle; Fountain Gallery, Portland, Ore.; and in many universities and colleges. Positions: Chm. A. Dept., Washington State Univ., Pullman, Wash., 1951- .

MONGAN, AGNES—Museum Director, W., Cr., L.
Fogg Museum of Art, Harvard University; h. 1558 Massachusetts Ave., Boston, Mass. 02125
B. Somerville, Mass., Jan. 21, 1905. Studied: Bryn Mawr Col., A.B.; Smith Col., A.M. Awards: hon. degree, L.H.D., Smith Col., 1941; Officier d'Academie (France), 1949; deg., Litt. D., Wheaton Col., 1954; Benjamin Franklin F., Royal Acad. A., London. Member: American Acad. A. & Sciences; Assoc., AA Mus. Dirs.; A. Founder & Vice-Pres., Pan American Soc. New England. Co-author (with Paul Sachs): "Drawings in the Fogg Museum of Art," 3 vols., 1940; Ed., Georgiana Goddard King's "Heart of Spain," 1941; "One Hundred Master Drawings" (in collaboration), 1949; Catalogue of the Frick Collection, French Paintings, 1950. Author: "Works of Art from the Collection of Paul Sachs," 1965; "Ingres Centennial Exhibition," 1967; (with Mary Lee Bennett) "Selections from the Drawing Collection of David Daniels," 1968. Contributor of articles to American, English and French art periodicals; U.S. Nat. Comm. for UNESCO, 1954-57. Positions: Cur., Drawings and Director, FMA, Harvard Univ., Cambridge, Mass. Adv. Council, Colby College Museum of Art, Waterville, Me. Martin A. Ryerson Lecturer on the Fine Arts; Memb. Visiting Committee of Smith College Museum of Art.

MONSEN, DR. & MRS. JOSEPH—Collectors
c/o Dept. of Business Administration, Univ. of Washington, 2000 E. Galer St., Seattle, Wash. 98102*

MONT, FREDERICK—Art dealer
465 Park Ave., New York, N.Y. 10022*

MONTAGUE, RUTH DuBARRY—Painter, L., T., W., I.
P.O. Box 9304, Washington, D.C. 20005; also Montmarte Studio, Paris, France
B. Paris, France. Studied: Ecole des Beaux-Arts, Paris; Univ. Nevada, M.F.A.; Lumis A. Acad., with Harriet Randall Lumis; PAFA; MMA Seminars; Prickett School of Color. Member: Nat. Audubon Soc.; Int. Oceanographic Fnd.; Int. Com. Centro Studi e Scambi Internazionali, Rome; Acad. Leonardo da Vinci, Italy; Int. Arts Gld., Monaco; Life Fellow, Int. Inst. A. & Lets., and others. Exhibited: Nationally and internationally. Work: in many private colls. Positions: Former Studio-Gallery Dir., & Instr., Prickett-Montague Studio of Painting; Ed., "The Happy Painter," national art bulletin; contributor syndicated articles on art to weekly newspapers; contributor to New Yorker Magazine; Health Culture; Nature magazine and others; Author, I., travel chronicle, "Bahamian Ah-h-h," 1969; Author pub. monographs on various phases of oil painting; co-author, 5 Home Study Courses in oil painting; lectures; Interpretive Oil Painting to public and private organizations. Resident teaching all phases oil painting with semi-annual exhs. pupils' work. Positions: Dir.-Teacher, Montague y Loret Studio of Painting, Wash. D.C., at present.

MONTANA, BOB—Cartoonist
Meredith, N.H. 03253
B. Stockton, Cal., Oct. 23, 1920. Studied: Boston Mus. A.; Phoenix Art Inst., N.Y.; ASL. Member: National Cartoonist Soc. Creator of syndicated comic strip, "Archie."

MONTE, JAMES—Associate curator
Whitney Museum, 945 Madison Ave., New York, N.Y. 10021*

MONTEBELLO de, GUY-PHILIPPE LANNES—Museum Director
The Museum of Fine Arts of Houston 77005; h. 3440 Wickersham St., Houston, Tex. 77027
B. Paris, France, May 16, 1936. Studied: Harvard College, B.A.; New York University Institute of Fine Arts. Author: "Peter Paul Rubens," 1968. Contributor to Metropolitan Museum of Art Bulletin.

Lectures: French Art; Romanticism; 18th Century Women Painters. Exhibitions arranged: The Spingold Collection exhibition at Brandeis University, 1965, 1967, 1968; Summer Loan Exhibition at the Metropolitan Museum of Art. Positions: Associate Curator, European Paintings, The Metropolitan Museum of Art; Director, The Museum of Fine Arts of Houston, Texas, 1969- .

MONTENEGRO, ENRIQUE—Painter, E.
Pennsylvania State University, Department of Art; h. 411 Waupelani C235, State College, Pa. 16801
B. Valparaiso, Chile, Dec. 7, 1917. Studied: Univ. Florida, B.F.A.; Colorado Springs FA Center; ASL (Scholarship). Awards: Catherwood Award for study in Europe, 1956; purchase prize, Denver A. Mus., 1955. Work: Denver Mus. A.; North Carolina Mus. A.; Colo. Springs FA Center; Delgado Mus. A., New Orleans; Mt. Holyoke College Mus.; Univ. Florida; Mus. Mod. A., Miami. Exhibited: Krannert A. Center, Univ. Illinois, 1963; New Accessions, USA, Colo. Springs FA Center, 1964; Rose Mus. A., Brandeis Univ.; Indiana Univ.; Univ. Iowa A. Gal.; Delgado Mus. A.; Univ. New Mexico; Santa Barbara Mus. A.; one-man: Three one-man, Univ. New Mexico; Denver A. Mus., 1954; North Carolina Mus. A., Raleigh, 1957; Parma Gal., N.Y., 1959; Mt. Holyoke College (Retrospective), 1960; Witte Mem. Mus., San Antonio, 1961; Univ. Texas, 1961; Landau Gal., Los A., 1960 (group); Univ. Florida. Positions: Instr., Painting & Drawing, Denver A. Mus., 1954-56; Asst. Prof., Drawing & Des., State College, Raleigh, 1956-57; same, Univ. Texas, 1957-62; Visiting Prof., Painting, Mt. Holyoke College, 1960-61; Visiting Prof., Brown Univ., 1961, 1962 (summer); and Univ. Florida 1962 (Spring). Prof. A., Art Dept., Pennsylvania State University, at present; A.-in-Res., Univ. New Mexico, Albuquerque, 1965-1966; Guest Artist, Tamarind Lithography.

MONTGOMERY, CHARLES FRANKLIN—
Museum Educator, Author, Lecturer
Henry Francis du Pont Winterthur Museum, Winterthur, Del. 19735; h. 2316 W. 17th St., Wilmington, Del. 19806
B. Austin Township, Ill., Apr. 14, 1910. Studied: Harvard University, A.B. Awards: Honorary M.A., University of Delaware. Member: American Association of Museums (Council); Committee for Furnishing Independence Hall; Fellow: American Studies Conference; British Studies; American Antiquarian Society; American Historical Association; College Art Association; Early American Industries Association; International Council of Museums; Society Architectural Historians; Museums Association of Great Britain; National Trust for Historic Preservation; Pewter Collectors Club of America; Walpole Society; Wilmington Club. Author: "American Furniture: The Federal Period," and numerous articles on American arts in magazines and journals. Editor, "Prints Pertaining to America." Contributor to "Arts of the United States." Positions: Honorary Vice President, Furniture History Society of Great Britian; Advisory Board, American Studies Institute of Lincoln University; Lecturer, 1952-1967, Adjunct Professor, 1967- , University of Delaware; Visiting Lecturer, University Pennsylvania, 1965 and Harvard University, 1969; Executive Secretary, Associate Curator, 1951-1954, Director, 1954-1961, Senior Research Fellow, 1962- . Henry Francis du Pont Winterthur Museum.

MONTLACK, EDITH—Painter, T.
90 Taymil Rd., New Rochelle, N.Y. 10804
B. New York, N.Y., Dec. 30, 1916. Studied: NAD, and with Louis Bouche. Member: Royal Soc. A., London; NAWA; Fifty American Artists; Creative Club. Awards: prizes, NAWA; Creative Club; scholarship, Metropolitan A. Sch.; St. Gaudens Medal; Emil Kahn Medal; Grumbacher award, 1960. Work: in private colls. Exhibited: NAWA, annually; Norval Gallery, N.Y.; Galerie Internationale, N.Y.; Hall of Art, N.Y.; Leger Gal., White Plains, N.Y.; Parrish Mus. A., Southampton, N.Y.; World's Fair, N.Y., 1965; Pietrantonio Gal., N.Y., 1965 (one-man); Cord Gal., Southampton, N.Y., 1966; Crespi Gal., N.Y., 1967. Instr., Painting, private classes.

MONTOYA, GERONIMA CRUZ (PO-TSU-NU)—Painter, T.
1008 Calle de Suenos, Santa Fe, N.M. 87501
B. San Juan Pueblo, N.M., Sept. 22, 1915. Studied: Santa Fe Indian Sch.; Claremont Col.; Col. St. Joseph, Albuquerque, B.S. in Edu.; & with Dorothy Dunn, Kenneth Chapman, Alfredo Martinez. Member: New Mexico Edu. Assn. Awards: purchase prize, deYoung Mus. A., 1954; New Mexico Mus., 1961 (purchase); Ceremonial for Modern Indian Painting, Gallup, N.M., 1961; Special Award for Indian Art, New Mexico State Fair, 1960. Work: deYoung Mus. A.; Hall of Ethnology; Mus. New Mexico; Indian A. & Crafts Market, Wash., D.C. Exhibited: Mus. New Mexico, Santa Fe; Indian A. Exh., 1954, 1955; Mus. New Mexico traveling exh. of Indian paintings; Hall of Ethnology, Santa Fe, 1959, (one-man); Germany (one-man); Philbrook A. Center, 1965 (one-man). Lectures: Indian Design; Indian Painting. Positions: Instr., Adult Education, San Juan Day School, San Juan Pueblo, New Mexico.*

MOORE, E. BRUCE—Sculptor
One St. Matthews Court, Washington, D.C. 20036
B. Bern, Kan., Aug. 5, 1905. Studied: PAFA, with Albert Laessle, Charles Grafly. Member: NA; Nat. Inst. A. & Lets.; NSS; F. Am. Numismatic Soc. Awards: Cresson traveling scholarship, PAFA, 1925, 1926; med., PAFA, 1929; Guggenheim F., 1929-1930, 1930-1931; prizes, NAD, 1935, 1937; Meriden A. & Crafts Assn., 1940; M. R. Cromwell F., 1937-1940; Grant, Nat. Inst. A. & Let., 1943; medal, Am. Numismatic Soc., 1952; Henry Hering mem. medal, NSS, 1968. Work: WMAA; Wichita A. Mus.; PAFA; Brookgreen Gardens, S.C.; Wichita AA; Steuben Glass Co.; Smithsonian Inst.; Am. Acad. in Rome; Wichita (Kan.) H.S.; ports. and animal sc. in private colls.; Monumental sculpture, Nat. Mem. Cemetery of the Pacific, Honolulu, Hawaii, 1960-61; Osgood Hooker Doors, Grace Cathedral, San Francisco; Walter H. Beech memorial doors, Wichita AA ; 2 bronze tigers, Princeton Univ. Exhibited: Am. Acad. in Rome, 1938, 1939; NSS; PAFA, 1929, 1930, 1940; NAD, 1935, 1937; WMAA, 1942; Meriden A. & Crafts, 1940, 1942; Nat. Inst. A. & Let., 1943; VMFA, 1958; Mostra d'art Moderna, Camlore, Italy, 1968.

MOORE, ETHEL—Art Editor
Albright-Knox Art Gallery 14222; h. 151 Park St., Buffalo, N.Y. 14201
Studied: Vanderbilt Univ., Nashville, Tenn., B.A.; College of William and Mary; ASL; State College of Iowa. Positions: Editor of Publications, Albright-Knox Art Gallery, Buffalo, N.Y.

MOORE, FANNY HANNA (MRS. PAUL)—Collector, Patron
Canfield, Convent, N.J. 07961
B. Cleveland, Ohio, June 29, 1885. Awards: The King's Medal, English-Speaking Union, 1946; Award, National Audubon Society, 1954; Yale Medal; Associate Dame, Venerable Order of the Hospital of St. John of Jerusalem, 1963; George McAneny medal for Historic Preservation, American Scenic and Historic Preservation Society. Member: Cleveland Museum of Art; Friends of the Whitney Museum; Metropolitan Museum of Art; American Federation of Arts; Associates in Fine Arts, Yale University, (Trustee and Benefactor); Museum of Modern Art; The Pierpont Morgan Library. Collection: English paintings (horse) 18th and 19th Century. Positions: Chairman, Associates in Fine Arts, Yale University, 1955-1965.

MOORE, MARTHA E. (Mrs. Louis A. Burnett)—Painter, T.
4 Hoffman Rd., High Bridge, N.J. 08829; s. 17 Dock Square, Rockport, Mass. 01966
B. Bayonne, N.J. Studied: ASL. Member: ASL (life); NAWA; Catherine L. Wolfe A. Cl.; All. A. Am.; Audubon A.; Rockport AA; Cape Ann Mod. A. Awards: prizes, ASL, 1943, scholarships, 1943-45; A. Lg. of Long Island, 1950; Wolfe A. Cl., 1951, Gold Medal, 1963; Barbizon Plaza Gal., 1951, 1952; 8th St. Gal., 1951, AAPL, 1948; All. A. Am., 1951; Knickerbocker A., 1955; NAD, 1960; NAWA, 1960, Gold Medal, 1963; Rockport AA, 1960-1964; Parrish A. Mus., 1959; City Center, N.Y., 1959; East Hampton Gld., 1959; New Jersey Soc. P. & S., 1959; Atlantic City A. Festival, 1962-1969; Niantic, Conn., 1964; Moorestown, N.J., 1965; Audubon A., Grumbacher purchase award, 1967; AAUW, 1969; N.J. State Annual, 1966, 1967. Work: Paintings, ports., St. Vincent's Hospital, N.Y.; Merchant Marine Military Acad.; King's Point, N.Y., Passionist Monastery, West Springfield, Mass.; Harvard Univ.; Norfolk Mus.; Tyler (Tex.) A. Mus.; Glassboro State Col., N.J. and in private colls. in U.S., Canada and South America. Exhibited: Audubon A., 1946-1969; All. A. Am., 1946, 1951; AWS, 1949, 1950; NAWA, 1950-1969; New Jersey P. & S. Soc., 1950; New Jersey WC Soc., 1950; A. Lg. of Long Island, 1950; Newton A. Gal., N.Y., 1948; Butler A. Gal., N.Y., 1953-1955; Portraits, Inc., 1948-1969; Grand Central A. Gal., 1949-1955; USA, 1958; BM, 1958, 1962; Montclair A. Mus.; Riverside Mus.; Hickory (N.C.) Mus. A.; Parrish Mus. A.; Springfield A. Mus.; Rockport AA; NAC; Knickerbocker A.; Janet Nessler Gal., N.Y.; NAD; IBM Gal., N.Y.; Lever House, N.Y.; Woodmere A. Gal., Phila., 1969; Phila. Sketch Cl., 1969; Westfield (N.J.), AA, 1968-1969; many universities and colleges, 1964, and abroad, to 1965, one-man: Pen & Brush Cl., 1961; Geminaire Gal., N.Y., 1962; di Ballardo Gal., N.Y., 1962 and Provincetown, 1963; Schooner Gal., Provincetown, 1965, and in museums and galleries throughout U.S. Lectures and painting demonstrations, on portraits and the figure, at universities, art schs. and art organizations.

MOORE, ROBERT JAMES—Painter, E., Gr.
246 E. 51st., New York, N.Y. 10022
B. San Jose, Cal., July 24, 1922. Studied: (Grad.) USAAF Photography Sch., Lowry Field, Colo.; San Jose State Col., B.A.; ASL, with Brackman, Miller, Barnet and others; graduate studies, N.Y. Univ. Inst. of Fine Arts with Salmony, Schoenberger, Panofsky and Offner; Teachers Col., Columbia Univ., M.F.A. Member: Eastern Arts Assn. of NAEA; AEA; ASL. Awards: prizes, Village A. Center; Blue Ribbon, Ruth Sherman Gal., N.Y., 1964; AA of Berkshire Mus., 1966. Work: N.Y. Public Lib. Print Coll.; ASL, and in private colls. Exhibited: SAM, 1950; Soc. Graphic A., Brooklyn, 1950; PAFA,

1952; SAGA, Kennedy Gals., N.Y., 1951; SFMA, 1951; Buffalo Pr. Cl., 1951; Riverside Mus., N.Y., 1953; Village A. Center Graphics, 1953, and 2-man, 1953; ACA Gal., N.Y., 1954; WMAA, 1954; Am. Color Pr. Soc., Phila., 1955; Englewood, N.J., 1958; N.Y. City Center Gal., 1959 (3); Audubon A., at NAD, 1962; 4-man exh., Graphics, Studio of Lesley Frost-Ballantine, N.Y. 1962 and group exhs; Ruth Sherman Gal., N.Y., 1964; YMYWHA exh., Elizabeth, N.J., 1964; Berkshire Mus., 1966; Westchester A. Soc. AEA show, 1967; one-man: Ruth Sherman Gal., 1964; Adele Bednarz Gal., Los Angeles, 1965. Positions: Assoc. Prof. A., Goddard College, Plainfield, Vt., 1954-57; A. T., Weehawken H.S., New Jersey, 1958-59; Art & Photography Advisor & Production Mngr., Yearbook, 1960-64; A. Instr., Julia Richman H.S., N.Y., 1964- .

MOOSE, PHILIP ANTHONY—Painter, E., L.
Linville Rd., Blowing Rock, N. C. 28605
B. Newton, N.C., Jan. 16, 1921. Studied: NAD; Columbia Univ.; Skowhegan Sch. A.; Acad. FA, Munich, Germany. Member: AWS; Gld. Charlotte A. Awards: Pulitzer prize, 1948; Tiffany award, 1949; Fulbright award, 1953, and to Taiwan, China, 1963; East Tenn. State Col. (purchase); Springs Award, 1963, 1964. Work: Colchester Mus., England; Atlanta Mus. A.; Norfolk Mus. A.; Mint Mus. A.; North Carolina State Mus., Raleigh; Taos Coll., N.M. Exhibited: MMA, 1952; CGA, 1953; Southeastern annuals, 1950-1955; East-West Gal., San F., 1955; Ferargil Gal., 1950; one-man: Duke Univ., 1955; Univ. North Carolina, 1951; North Carolina State Gal., 1950; Gallery 14, Palm Beach, 1960; Mint Mus. A., Charlotte, N.C., 1961; Carson-McKenna Gal., Charlotte, N.C., 1968; St. Johns Gal., Wilmington, N.C., 1969; Guilford Col., Greensboro, N.C., 1969. Illus., "History of Catawba County," 1954. Positions: Assoc. Prof. FA, Davidson (N.C.) Col., 1951-53; Prof. FA, Queens College, Charlotte, N.C., 1955-1967.

MORDVINOFF, NICOLAS—Painter, I., W.
Route 1, Hampton, N.J. 08827
B. St. Petersburg, Russia, Sept. 27, 1911. Studied: Univ. Paris, and with Fernand Leger, Amedee Ozenfant. Awards: Caldecott award, 1952; Herald Tribune award, 1954; AIGA Certif. Excellence, 1955-57. Work: N.Y. Publ. Lib.; MMA. Exhibited: Paris, France; New Zealand; Hawaii; San Francisco, Los Angeles, Washington and many other U.S. cities; one-man: Tahiti, 1936, 1940, 1950; Phila. A. All., 1952; Luyber Gal., N.Y., 1949; N.Y. Pub. Lib., 1952. Contributor illus. to Harper's Magazine; Atlantic Monthly. Author, I., Des.: "Bear's Land," 1955; "Coral Island," 1957; Illus., Des.: "Just So Stories," 1952; "Alphonse, That Bearded One," 1954; "Evangeline," 1959, and many others. Books by Will and Nicolas: "The Two Reds," 1950; "Finders Keepers," 1951 (Caldecott award); "The Magic Feather Duster," 1958; "Four Leaf Clover," 1959; "Russet and The Two Reds," 1962; "The Boy and The Forest," 1964, and many more.

MORGAN, ARTHUR C.—Sculptor, E., W., L.
657 Jordan St., Shreveport, La. 71101
B. Riverton Plantation, Ascension Parish, La., Aug. 3, 1904. Studied: BAID; & with Gutzon Borglum, Mario Korbel, Edward McCarten, & others. Member: NAC; F.I.A.L. Work: S., Centenary Col., St. Mark's Church, Shreveport, La.; U.S. Capitol (bronze figure of Chief Justice Edward D. White); USPO & Court House, Alexandria, La.; Terrebonne Parish Court House, Houma, La.; Earl K. Long monument, Winnfield, La.; monolith, Civic Theatre, Shreveport, La.; Mem. Hospital, Lufkin, Tex.; First Fed. Savings & Loan Assn. Bldg.; Shreveport, La.; Paul Geisler memorial, Berwick, La.; Henry Miller Shreve monument, River Parkway, Shreveport, La.; Southwestern Inst. A.; ports. in bronze, terra cotta and marble, dec. bronzes and garden sculpture in many private colls. Exhibited: Louisiana State Univ., 1927; Southwestern Inst. A., 1938; La. State Exh., 1940, 1950; Philbrook A. Center, 1952; Centennial Mus., Corpus Christi, Tex., 1957 (one-man exh.); NAC, 1960. Contributor of: art reviews to newspapers. Lectures: Garden Sculpture; Sculptural Processes, to art associations, women & garden clubs, civic organizations. Positions: Dir., A. Dept., Centenary Col., Shreveport, La., 1928-33; Dir., Southwestern Inst. A., Shreveport, La., 1933- .

MORGAN, BARBARA BROOKS (Mrs.) —
Painter, Photog., P., Gr., W., L.
120 High Point Rd., Scarsdale, N.Y. 10584
B. July 8, 1900. Studied: Univ. California at Los Angeles. Work: George Eastman House Coll., Rochester, N.Y. Author, Des., Photographer: "Martha Graham: Sixteen Dances in Photographs," 1941, 2nd ed., 1942; "Summer's Children: A Photographic Cycle of Life at Camp," 1951 (Carnegie Fnd. selection, 350 books portraying American life. In USA Book Fair, Moscow). Book Collaborator: jackets, photographs, design, picture editing, etc., for—"Conquest of Civilization," 1938; "Prestini's Art in Wood," 1950; "The World of Albert Schweitzer," 1955. Work (photographs) reproduced in Leica Annual, Photography Annual, Popular Photography, Soleils,

(Paris), U.S. Camera Annual and many others. Large number of articles contributed to newspapers, Photography Annuals and other photographic publications, books and bulletins, nationally. Work reproduced in many books, U.S. and Europe, 1944-1963. Lectures: (slides)-"Dynamics of Composition," Art Dept., Univ. California, Los Angeles, Mills College, Oakland, Cal. With seminar, Everett Jr. College, Washington, all 1965. Exhibited: Los. A. Mus. A.; FA Gal. of San Diego; Los. A. Pub. Lib.; Oakland A. Mus.; Henry Gal., Univ. of Washington, Seattle; Nat. Gal. of Canada, Ottawa, circulated by Weyhe Gal., N.Y.; Phila. Pr. Cl.; Int. Olympic FA Exh., Graphic Arts Sect., Berlin; and Art: USA, 1958. Photography Exhs.: George Eastman House, Rochester, 1960; MMA, 1960, 1967; circulated nationally; "Modern Dance," Newark Pub. Lib., 1960; Gal. VII, Provincetown, Mass., 1962-63; MModA, 1940, 1942 traveling exh. for Army & Navy, 1943, 1944, 1946-47, circulating, 1948-49, 1951; "Family of Man," 1955 circulated nationally; USIA internationally, 1957 (2); Festival of Arts, The White House, Wash. D.C., 1965 and subsequently at Smithsonian Institution, 1965; Kodak Pavilion Exh., N.Y. World's Fair, 1965; Chicago Exchange Nat. Bank, 1968; Massachusetts Inst. Tech., 1968; Hudson River Mus., N.Y., 1969 (paintings); NAC, 1969; Witkin Gal., N.Y., 1969, and many more in U.S. and abroad. One-man: Mellon Gal., Philadelphia, 1934; Sherman Gal., N.Y. 1961; Retrospective Photographic Exh., Arizona State Univ., Tempe, 1962; New Canaan Lib., 1960; Hoff-Barthelson Music Sch. 1962; Photographs: George Eastman House, Rochester, 1955, 1965; Paintings, Drawings, Photographs: Ceeje Gal., Los Angeles, 1965; Societie Francaise de Photographie, Paris, 1964; Braircliff (N.Y.) Pub. Lib., 1965; Smithsonian Inst., 1969-1970, and others.

MORGAN, CHARLES HILL—Educator, Mus. Dir.
317 South Pleasant St., Amherst, Mass. 01002
B. Worcester, Mass., Sept. 19, 1902. Studied: Harvard Univ., A.B., A.M., Ph.D. Author: Corinth, Vol. XI, The Byzantine Pottery, 1942; The Life of Michelangelo, 1960; "George Bellows, Painter of America." Contributor to: American Journal of Archaeology; Art in America; Hesperia. Positions: Dir., Am. Sch. Classical Studies, Athens, Greece, 1936-38; Prof. FA, Dir., A. Mus., Amherst Col., Amherst, Mass., 1938-1969; Actg. Hd., Dept. of the Arts, Trinity Col., 1964-65.

MORGAN, FRANCES MALLORY—Sculptor
Sunset Lane, Rye, N.Y. 10580
B. Memphis, Tenn. Studied: Grand Central A. Sch.; PAFA; NAD, and with Archipenko, Hovannes. Member: NAWA; Audubon A.; S. Gld.; F.I.A.L. Awards: prizes, NAC, 1933, 1934; NAWA, 1941, 1944, 1946; Audubon A., 1961. Work: IBM; Brooks Mem. Mus., and in private colls. Exhibited: Albright A. Gal.; WMAA; CGA; Am.-British A. Center; Arch. Lg.; Riverside Mus.; PMA; PAFA; MMA; Montclair A. Mus.; NAWA, 1934-1964; Audubon A., 1945-1964; S. Gld., 1939-1964; Studio Gld. Traveling Exh., 1951-1955; Providence A. Cl., 1958; Brooks Mem. Mus.; All. A. Am.; Philadelphia A. All.; Clay Cl.

MORGAN, GLADYS B. (Mrs. Arthur C.)—Painter, L., T.
657 Jordan St., Shreveport, La. 71101
B. Houma, La., Mar. 24, 1899. Studied: Randolph-Macon Col. for Women, A.B.; Columbia Univ.; & with Arthur C. Morgan, Will H. Stevens. Member: Shreveport WC Soc.; Louisiana Artists, Inc.; Louisiana A.; Shreveport A. Cl.; Univ. Woman's Cl. Work: Excelsior Hotel, Jefferson, Tex.; Gilmer Hospital, Shreveport, La.; Centenary Col. A. coll., and in private colls. Series of watercolors of Louisiana scenes for Louisiana Magazine, 1961, to run several years. Exhibited: Mus. FA, Montgomery, Ala.; Old Capitol Mus., Baton Rouge, La.; La. State Mus., Shreveport, 1959-1961; Columbia (La.) A. Festival, 1961; Delgado Mus. A.; La. Artists, Inc.; Natchitoches A. Festival, 1969; Exh. of Randolph-Macon alumnae, 1969; one-man: Lake Charles, La.; Houma, La.; Shreveport Mus. A.; Woman's Dept. Cl., Shreveport; Barksdale Air Force Base, Bossier City, La.; Shreveport AI, 1964; Columbia, La., 1963; Southern Galleries, Shreveport, 1964; Centenary Col., Shreveport, La., 1968, and others. Positions: Instr. A. & Hist. A., Centenary Col., 1928-33; Southwestern Inst. A., Shreveport, La., 1934- . Lectures: "The Arts of Mexico." Organized Art Colony, New Iberia, La., 1964 (June), and Art Colony in Mexico, 1967-1968.

MORGAN, HELEN BOSART (Mrs. J. W.)—Sculptor, T.
845 East High St., Springfield, Ohio 45505
B. Springfield, Ohio, Oct. 17, 1902. Studied: AIC; Wittenberg Col., A.B.; Dayton AI. Member: NAWA; Dayton AI; Springfield AA; Dayton AI. Awards: prizes, Springfield County Fair, 1951; Dayton AI, 1945, 1946, 1948; Springfield A. Exh., 1946-1948, 1952, 1954, 1960, 1968; Clark County Fair, 1951; Ohio State Fair, 1952; Columbus A. Lg., 1960; Columbus Gal. A., 1963. Work: Warder Pub. Lib., Spfld.; Springfield A. Center, Snyder Park, Springfield. Exhibited: NAD, 1945; All. A. Am., 1944, 1945; NAWA, 1944, 1946, 1948, 1955, 1960, 1963, 1969; Miami Valley A., 1943, 1946, 1960; Butler AI.,

1946, 1948, 1955, 1967; Springfield AA, 1946, 1948-1958, 1967; Wichita AA, 1948; Syracuse Mus. FA, 1948; CM, 1948, 1951, 1956, 1957, 1962-1967; Ohio State Fair, 1957, 1968; Dayton AI, 1948, 1952-1958, 1960, 1962, 1963; Columbus Gal. A., 1962, 1963; Capital Univ., 1963; one-man: Newman Brown Gal., Chicago, 1953; 5-man exh., Springfield A. Center, 1969.

MORGAN, LUCY CALISTA—Craftsman, T., W.
Webster, N.C. 28788
B. Franklin, N.C., Sept. 20, 1889. Studied: Central T. Col., Mt. Pleasant, Mich.; Univ. Chicago; & with Edward F. Worst. Member: Southern Highland Handicraft Gld.; Bus. & Prof. Women's Cl., Spruce Pine, N.C. Contributor to: The Weaver: Practical Weaving Suggestions magazines. Awards: hon. deg., Dr. Humanities, Central Mich. Col. of Edu., 1952; D.H.L., Women's Col., Univ. North Carolina, 1955; Co-author (with Le Gette Blythe) "Gift From The Hills," 1958. Appointed, 1965, by Governor Sanford of North Carolina, to organize and work with a State project of finding, collecting and selecting photographs of the past, particularly in the mountain section of the State, to preserve a visual record of the life and development of the people of North Carolina, to be known as a Photographic History of Western North Carolina. Positions: Dir., Penland Weavers & Potters, 1936-46; Founder & Bd. member, Penland Sch. Handicrafts, Penland, N.C., 1929- .

MORGAN, NORMA (GLORIA)—Printmaker, P.
239 W. 63rd St., New York, N.Y. 10023
B. New Haven, Conn., Jan. 16, 1928. Studied: Whitney Sch. A., New Haven; Hans Hofmann Sch. A.; ASL; Atelier 17 with Stanley Hayter. Awards: Prize and Purchase, PMA, 1955; gold medals, AAPL, 1962, 1963 and P. & S. Soc., New Jersey, 1967; prizes, Audubon A., 1963; Composers, Authors and Artists of America, 1969; Academic A., Springfield Mus. FA, 1960; Washington WC Cl. (20; Ball State Univ.; Fellowships: Tiffany Fnd.; John Hay Whitney Fnd.; John and Anna Lee Stacey Fnd. Member: IGAS; SAGA; Composers, Authors and Artists of America; New Haven Paint and Clay Cl.; Knickerbocker A. Work: LC; NGA; Smithsonian Inst. Graphic Coll.; MModA; PMA; Victoria & Albert Mus., London; Mus. African Art, Wash., D.C.; Yorkshire, England; BMFA; WAC; CAM. Rosenwald Coll.; CAM; N.Y. Pub. Library, Spencer Coll.; Howard Univ.; Yale Univ. Gal. FA; PMA; Brooks Mem. Mus., Memphis; Assoc. Am.A., N.Y.; DeSales Co., Cincinnati, and many others. Exhibited: U.S. State Dept., Graphics, to Soviet Union, 1964; PAFA, 1957, 1965; Audubon A., 1963; Springfield Mus. FA, 1960; Paris Biennale, 1964; Yugoslavia, 1965; Int. Contemp. A. Exh., Italy, 1969; AAPL, 1962, 1963; Boston A. Festival; Phila. Pr. Cl., 1969; SAGA, 1965, 1969; All. A. Am., 1951; WMAA, 1959, 1962; Am. Embassy, London, The Hague, New Delhi, Bonn, Athens; Silvermine Gld. A., 1967, 1968; Butler Inst. Am. A. (Old Bergen traveling exh.), 1967; Norfolk Mus. A. & Sciences, 1963; Cliffe Castle, Keighley, Yorkshire, England, 1965 (one-man); other exhibitions include: Achenbach Fnd. for Graphic A.; AIC; BMA; BMFA; Carnegie Inst.; CAM; Detroit Inst. A.; Wadsworth Atheneum, Hartford, Conn.; CM, and others nationally.

MORGAN, RANDALL—Painter
c/o Roko Gallery, 407 E. 77th St., New York, N.Y. 10021
B. Knightstown, Ind., Feb. 24, 1920. Studied: Indiana Univ.; Cincinnati Univ.; Teachers Col., Columbia Univ. Awards: Fellowship, Indiana Univ., painting in Italy, 1949-1951; A.-in-Res., Festival of Two Worlds, Spoleto, Italy, 1964; Ingram Merrill Fnd. Fellowship, 1965-1966. Work: WMAA; Barnes Fnd.; Detroit Inst. A.; Toledo Mus. A.; CAM; Amherst Col.; Dartmouth Col.; Univ. Nebraska; Munson-Williams-Proctor Inst., Utica, N.Y.; PMA. Exhibited: in group shows at MModA; WMAA; CGA; PAFA, and others. One-man: Borgenicht Gal., N.Y., 1955, 1958; Albert Landry Gal., N.Y., 1962, 1963; Galleria 88, Rome, Italy, 1966, 1968; Roko Gal., N.Y., 1967. Positions: Instr., Ceramics, Teachers Col., Columbia Univ., 1948; A. Dir., Positano Art Workshop, Italy, 1953-1960; Instr., Painting, Washington Univ., Sch. FA, St. Louis, Mo., 1962-1963; Dir., Randall Morgan Sch. A., Sant' Agata, Due Golfi (Naples) Italy, 1967-

MORIN, MRS. RELMAN. See Liebes, Dorothy

MORIN, THOMAS EDWARD—Sculptor
62 Waterman St., Providence, R.I. 02906
B. Malone, N.Y., Sept. 22, 1934. Studied: Mass. Sch. A., B.S. in Edu.; Cranbrook Acad. A., M.F.A; Accademia de Belle Arti, Florence, Italy; Brown Univ. Member: Boston Soc. Indp. A.; AFA; Silvermine Gld. A. Awards: prizes, Silvermine Gld. A., 1959 (2), 1960; New Haven A. Festival, 1960; Fulbright scholarship, 1960-1961; Tiffany grant, 1967; R.I. A. Festival, 1963, 1964, 1968; New Canaan (Conn.) A. Festival, 1962; Work: VMFA; Brown Univ.; Barn Gal. Assn., Oqunquit, Me. Exhibited: PAFA, 1959; WMAA, 1961; Boston A. Festival, 1958-1962; BMFA, 1955; Detroit Inst. A. 1957, 1958, 1964; R.I. Sch. Des., 1957, 1965; Fitchburg Mus. FA, 1957; De Cordova and Dana Mus., 1958, 1964, 1966; Cranbrook Acad. A., 1958; Silvermine Gld. A., 1959, 1960, 1962-1965, 1967, 1968; Providence

A. Cl., 1960, 1964; Inst. Contemp. A., Boston, 1960, 1963; Mus. FA of Houston, 1962; Audubon A., 1962; R.I. A. Festival, 1962-1964, 1968; Northeastern Univ., Boston, 1963, 1965; R.I. Sch. Des., 1965. One-man: Margaret Brown Gal., Boston, 1954; Gal. 4, Detroit, 1957; Kanegis Gal., Boston, 1958, 1960; Kornblee Gal., N.Y., 1962, 1964; Silvermine Gld. A., 1960; Providence A. Cl., 1963; De Cordova and Dana Mus., 1963; South County AA, Kingston, R.I., 1966; State Univ. of New York at Oneonta, 1968; Univ. New Hampshire, 1969. Positions: Instr., Sculpture, Cranbrook Acad. A., 1957-58; Silvermine Gld. A., 1958-60; Assoc. Prof., Chm., Sculpture Dept., R.I. Sch. Des., Providence, R.I., 1961- .

MORLEY, GRACE L. McCANN—Museum Director, L., W., Cr., E.
 National Museum, New Delhi, India
B. Berkeley, Cal., Nov. 3, 1900. Studied: Univ. California, A.B., M.A.; Univ. Paris, Docteur de l'Universite; & in Grenoble, France. Member: CAA; AFA; AAMus.; Am. Assn. A. Mus. Dir.; Nat. Comm. for UNESCO, 1950-1956. Awards: hon. degree, LL.D., Mills Col., Oakland, Cal., 1937; D.H.L., Smith College, 1957; Chevalier Legion d'Honneur, 1949; D.F.A., Cal. Col. A. & Crafts, 1957; LL.D., Univ. California at Los Angeles, 1958; Wattamul Award, 1963. Author: "Le sentiment de la Nature en France dans la premiére moitié du 17e siecle," Paris, 1926. "Carl Morris," Exhibition and Monograph, AFA, 1959; "Art in Museums," 1963; "Museums Today," University of Baroda, 1967; "Pre-Columbian Art" (introduction to the Heeramoneck Collection), National Museum, New Delhi, 1967; Contributor to: professional periodicals, encyclopaedias, museum publications. Lectures: Latin American Art; Contemporary Art; etc. Positions: Instr., French & A., Goucher Col., Baltimore, Md., 1927-30; Cur., CM, 1930-33; Dir., SFMA, San Francisco, Cal., 1935-1958; Dir., Pacific House, GGE, 1939; Consultant, A. Com., Office Inter-Am. Affairs, 1941-43; Advisor, Museums, UNESCO, 1946; Hd., Museums, UNESCO, 1947-49; Ed. Bd., "Museum." Asst. Dir., Solomon R Guggenheim Museum, New York, N.Y., 1959; Dir., National Museum, New Delhi, India, 1960-1966; Adviser on Museums, Government of India, 1966-1968; Head, Regional Agency in Asia of the International Council of Museums, 1947- .

MORLEY, MALCOLM—Painter
 Kornblee Gallery, 58 E. 79th St., New York, N.Y. 10021*

MORRELL, WAYNE BEAM, JR.—Painter, W., L.
 153 Main St., Rockport, Mass. 01966
B. Clementon, N.J., Dec. 24, 1923. Studied: Phila. Sch. Indst. A.; Drexel Inst. Member: Hudson Valley AA; Rockport AA; Gld. Boston A.; North Shore AA; Springfield (Mass.) Academic A.; SC; Grand Central Gal., N.Y. Awards: Richard Mitton Mem. Gold Medal, Boston; G. B. Mitchel Award and the Del Padre Award, Springfield; Barth Mem. Award, North Shore AA; Rose Strisik Mem. Award, Rockport AA; prizes, SC, and others. Work: Mural, Harford Nat. Bank & Trust Co., Hartford, Conn. Other work in private colls. Exhibited: Hudson Valley AA, 1961, 1962, 1964; NAD, 1964; Knickerbocker A., 1964; All. A. Am., 1964, 1965; AAPL, Smithsonian Inst., 1963, 1964; SC, 1963-1965; Springfield Academic A., since 1957; Conn. Acad. FA, 1955; Rockport AA; North Shore AA; AGAA; Columbus (Ga.) Mus. A., and others. Author, Illus., "The Essentials of Landscape Painting," 1964; "Sketching" 1965.*

MORRIS, CARL—Painter
 919 N.W. Skyline Blvd., Portland, Ore. 97229
B. California, 1911. Studied: AIC; Kunstgewerbeschule and the Akademie der Bildenden Kunste, Vienna; Inst. Intl. Education, Paris (Fellowship). Awards: Fellowship, Inst. Intl. Education; Ford Fnd. Retrospective Exh. and Purchase Prize; Fellowship, Tamarind Lithograph Workshop; Nat. Inst. A. & Lets. Purchase Award; other prizes: SAM; SFMA, Anne Bremer Mem. Award and the Phelan Award; Stanford Univ. A. Gal. Purchase Award; Univ. Illinois Purchase; Vancouver (B.C.) A. Gal. Work: SFMA (Walters purchase prize); SAM; Portland (Ore.) A. Mus.; Denver A. Mus.; WAC; Guggenheim Mus.; MMA; WMAA; Munson-Williams-Proctor Inst.; Cal. PLH; Santa Barbara Mus. A.; Rochester Mem. A. Gal.; Allentown Mus. A.; Mus. FA of Houston; Toronto A. Gal.; Mus. FA, Sao Paulo, Brazil; AIC; Colorado Springs FA Center; Dayton AI; Stanford Univ.; Univ. of Oregon; Portland State Col.; Univ. Illinois; Reed Col. Portland; Nat. Inst. A. & Lets.; NGA (Hirshhorn Coll.); Univ. Illinois; Wadsworth Atheneum; Albright-Knox Gal., Buffalo; Kresge A. Center, Univ. Michigan; Mus. FA of Houston; and others nationally. Mills Col.; and in many private collections. Exhibited: Most major exhibitions nationally and internationally. Included are: exhibitions in Sao Paulo, 1955; Rio de Janeiro, 1955; Rome, 1957-58, by the Rome-New York Foundation, "Capolavori del Museo Guggenheim di New York"; Art USA circulated internationally; American Federation of Arts-Japan; Ford Fnd. Retrospective circulated nationally; Pacific Heritage Exh., U.S. and Berlin Festival of Arts, 1965; Carnegie Inst.; others: WMAA; AIC; PAFA; CGA;

VMFA; SFMA; Detroit Inst. A.; Amon Carter Mus.; Oakland Mus.; "Museum Directors' Choice," Baltimore; Univ. Southern Cal., and more. One-man: Kraushaar Gal., N.Y., 1956- ; others in Portland, Seattle, San Francisco, etc.

MORRIS, DONALD F.—Art Dealer, Collector
 20082 Livernois St., Detroit, Mich. 48221; h. 25915 Salem Rd., Huntington Woods, Mich. 48070
B. Detroit, Mich., Apr. 12, 1925. Studied: Wayne State Univ., B.A. Member: Art Dealers Association of America; Print Council of America; Michigan State Council for the Arts (Visual Arts Committee), 1966- . Collection: Avery, Calder, Dubuffet, Giacometti, Grosz, Lindner, Miro, Richier; African Art. Specialty of the Gallery: Twentieth Century American and European Painting and Sculpture (Avery, Calder, deKooning, Dubuffet, Gorky, Grosz, Hinman, Lester Johnson, Miro, Tony Smith). Positions: Director, Donald Morris Gallery, Detroit, Michigan.

MORRIS, EDWARD A.—Painter, Comm., I.
 822 Plymouth Bldg. 55402; h. 6824 38th Ave., North, Minneapolis, Minn. 55427
B. Philadelphia, Pa., July 28, 1917. Studied: Philadelphia Col. A., with Henry C. Pitz and W. Emerton Heitland. Member: Assn. of Professional Artists; Ducks Unlimited. Awards: Winner of the Federal Migratory Duck Stamp Design, 1961-62, 1962-63 (only wildlife artist to win two consecutive years). Work: in many private collections. Wide coverage of his work in Gopher Historian, Naturalist, Linn's Weekly Stamp News and other publications. Contributor to The Northwestern Banks Hunting Guide, 1962. Exhibited: Annual exhs., AWS; in numerous Eastern galleries and museums.*

MORRIS, GEORGE L. K.—Painter, S., W., L., T., Cr.
 1 Sutton Place, South, New York, N.Y. 10022
B. New York, N.Y., Nov. 14, 1906. Studied: Yale Univ., B.A.; ASL; Academie Moderne, Paris, France. Member: Am. Abstract A.; Fed. Mod. P. & S. Awards: Berkshire Mus., 1964; Temple Gold Medal, PAFA, 1967. Work: Univ. Illinois; Munson-Williams-Proctor Inst. Utica, N.Y.; Univ. Michigan; N.C. Mus. A., Raleigh; Univ. Georgia; Darmstadt, Germany; PMA; WMAA; Berkshire Mus.; Yale Sch. FA; PC; MMA; PAFA; Wichita Mus. A.; Mosaic mural, Elementary School, Lenox, Mass., 1962. Exhibited: WMAA, 1938-1946; PAFA, 1945, 1946; Carnegie Inst., 1944-1958; Am. Abstract A., 1936-1958; Fed. Mod. P. & S., 1941-1958; VMFA, 1946; Berkshire Mus., 1935, 1938, 1945; Alan Gal., N.Y., 1956, 1957, 1961; Downtown Gal., N.Y., 1964, 1967; Century Assn., N.Y., 1965; CGA, 1965; Berkshire Mus.; Contributor to Partisan Review, with articles on abstract art. Lectured on American Art in London, Vienna, Rome, Milan, Athens, Istanbul, 1952. Editor, "The World of Abstract Art," 1957. Positions: U.S. Painting Delegate to 1952, UNESCO Conference, Venice, Italy; A.-in-Res., St. John's College, Annapolis, Md. 1960-61.

MORRIS, HILDA (Mrs. Carl)—Sculptor
 919 N.W. Skyline Blvd., Portland, Ore. 97229
B. New York, N.Y., 1911. Studied: ASL; CUASch. Award: Ford Fnd. Fellowship, 1960. Work: SAM; Munson-Williams-Proctor Inst.; Cal. PLG; Reed Col., Portland, Ore.; Portland A. Mus.; SFMA; Chrysler Coll.; Univ. Oregon; Chase Manhattan Bank, N.Y.; Tacoma A. Lg.; Seattle Opera House; Dayton AI; and in private collections nationally. Exhibited: Annuals of SAM; SFMA; Portland A. Mus.; Denver A. Mus. Others: MMA, 1951; BM, 1953; Sao Paulo, Bienale, 1955; New Talent USA, Art in America, 1957-58; "West Coast Artists," AFA, 1958, 1959 and "Private Worlds," 1960, 1961 and Nat. Print Exh.; Boston A. Festival, 1959; Portland A. Mus., 1959; Santa Barbara Mus., 1959; Dayton AI, 1961; Seattle World's Fair, 1962 (2); "Artists Environment": West Coast—Amon Carter Mus; UCLA A. Galleries; Oakland A. Mus., 1962-1963; Univ. Illinois, 1963; BM, 1964; Museo de Arte Moderno, Rio de Janeiro; Reed Col., Portland, Ore.; deYoung Mem. Mus., San Francisco; Univ. Oregon Mus. A.; deCordova & Dana Mus., Lincoln, Mass.; Woodside Gal., Seattle; San Francisco A. Inst.; Henry Gal., Univ. Washington; FA Soc. of San Diego; Municipal A. Gal., Los Angeles, and others.

MORRIS, KYLE RANDOLPH—Painter
 243 East 17th St., New York, N.Y. 10003
B. Des Moines, Iowa, Jan. 17, 1918. Studied: Northwestern Univ., B.A., M.A.; AIC; Cranbrook Acad. A., M.F.A. Awards: prizes, WAC, 1948 (purchase); SFMA, 1953 (purchase). Exhibited: WAC, 1948, 1960; WMAA, annually; Guggenheim Mus., 1954, 1959; AIC, 1954, 1961; Univ. Illinois, 1954, 1956; Univ. Nebraska, 1954, 1956; CGA, 1956, 1958, 1961; Minneapolis Inst. A., 1957; Worcester Mus. A., 1958; Brussels World's Fair, 1958; N.Y.-Rome Fnd., Rome, Italy, 1958; VMFA, 1958; PAFA, 1964; Brandeis Univ., Dec. '63-Jan. '64; BMFA, 1966; one-man: WAC, 1952; Des Moines A. Center, 1955; The Berenson Gal., Fla., 1966; 3-man, Tanager Gal., N.Y.,

1952; Kootz Gal., N.Y., 1959, 1960, 1962-1964; Galerie Naviglio, Milan, Italy, 1960. Positions: Instr., A. Hist. & P., Stephens Col., Columbia, Mo., 1940-41; Asst. Prof. A., Univ. Texas, Austin, 1941-46; Assoc. Prof. Painting, Univ. Minnesota, 1947-51; Assoc. Prof., Painting, Univ. California, Berkeley, 1952-54; L., A. Hist., CUASch. New York, N.Y., 1958. Ed., "Contemporary Slides," 1954-58; Delegate to UNESCO meetings, United Nations, 1952.

MORRIS, LAWRENCE—Patron
67 Wall St. 10005; h. 140 E. 72nd St., New York, N.Y. 10021
B. New York, N.Y., Apr 29, 1904. Studied: Harvard University, Columbia University. Member: MMA (Life); MModA; Mus. Contemp. Crafts. Collection: Contemporary furniture by Wharton Esherick of Paoli, Pa.; Other decorative arts ranging from school of Donatello to contemporary works including Karash, Milliken, Jegart, Peterdi, and others.*

MORRIS, ROBERT—Sculptor
c/o Castelli Gallery, 4 E. 77th St., New York, N.Y. 10021*

MORRISON, ROBERT CLIFTON—Printmaker, T.
2815 Woody Drive, Billings, Mont. 59102
B. Billings, Mont., Aug. 13, 1924. Studied: Carleton Coll., B.A.; Univ. New Mexico, M.A. Awards: Selected "Artist-Teacher for Montana 1964," by AAPL. Work: six mural panels, Lockwood School, Billings, 1958; mosaic mural, Unemployment Compensation Comm. Bldg., Helena, 1961; exterior mural, Lucerne School, Lucerne, Wyo., 1961. Prints and paintings in public collections: Harvard University Library; University of New Mexico; Ministry of Art & Culture, Ghana. Work in numerous private collections. Graphic designer for "Rocky Mountain Review" publ. by Rocky Mountain College; translator & illustrator of "Maxims of LaRochefoucauld" print portfolio published privately. Positions: Assoc. Prof. of Art, Rocky Mountain College, Billings, Montana.

MORSE, A. REYNOLDS—Collector
24050 Commerce Park Rd.; h. 21709 Chagrin Blvd., Cleveland, Ohio 44122
B. Denver, Colo., Oct. 20, 1914. Studied: University of Colorado, B.A.; Harvard Business School, M.B.A. Awards: Phi Beta Kappa, 1939; Outstanding Alumni Award, University of Colorado, 1961. Author: "The Works of M. P. Shiel"; "Salvador Dali, A Study of His Life and Works," 1958; "A New Introduction to Salvador Dali," 1960. Collection: World's largest collection of art by Salvador Dali; Plans for a Salvador Dali museum being formed; Entire collection was shown Jan.-Mar. 1966 at Hartford Gallery of Modern Art, N.Y., as part of largest Dali retrospective; Intarsias of Mary Bowling; Obelisk Collection (Plaisir de France) 1968. Positions: Curator, George Elbert Burr Memorial Collection of Western Art, Denver Public Library, 1950- . President, The Reynolds Morse Foundation, a non-profit institution for the display and display of works by Salvador Dali, in all media: book illustrations, lithographs, oils, watercolors, drawings, etc.

MORSE, JENNIE GREENE (Mrs. Henry W.)—
Educator, Des., P., C.
Fashion Institute of Technology, 227 West 27th St., New York, N.Y. 10001; h. 1327 Shore Parkway, Brooklyn, N.Y. 11214
B. New York, N.Y., Mar. 19, 1908. Studied: N.Y. Sch. App. Des. for Women. Member: Am. Un. Dec. Artists & Craftsmen; Am. Assn. Jr. Col.; School A. Lg.; AAUP. Awards: Sch. A. Lg. scholarship, 1925-26, 1926-27; Design awards: Loren O. Thompson; Witcombe McGeachin Col. Susquehanna Silk Mills; Schwarzenbach, Huber Co. Exhibited: MMA, 1931; Am. Mus. Natural Hist.; Grand Central A. Gal. Positions: Instr., Textile Des., N.Y. Evening Sch. Indst. A., 1929-43; Instr., H.S., New York, N.Y., 1938-45; Fashion Inst. Tech., New York, N.Y., 1945-54; Prof. & Chm., Textile Des. Dept., Fashion Inst. Technology, Div. of Advanced Studies, 1954- ; Co-ordinator of Exec. Training Seminar in Fabric Styling, Converting & Merchandising for the Textile Industry, 1955-58. Judge for national art awards.

MORSE, JOHN D.—Writer, Editor, E.
Winterthur Museum, Winterthur, Del. 19735
B. Gifford, Ill., Sept. 26, 1906. Studied: Univ. Illinois, A.B., M.A.; Wayne Univ.; N.Y. Univ. Member: Am. Soc. for Aesthetics. Author: "Wartime Guide to American Collections of the Metropolitan Museum of Art," 1942; "The Artist and the Museum," 1947; "Old Masters in America," 1955. Producer of films "Flanders in the Fifteenth Century," 1960; "The Gardens of Winterthur," 1964; filmstrip "Winterthur in Bloom," 1969. Contributor to: Adventures in Reading, 3rd series, 1947; Magazine of Art; museum bulletins; fiction & nonfiction in Esquire, London Evening Standard, & other magazines. Lectures: General Art History and Interpretation. Positions: Asst. Ed., Am. Boy Magazine, 1928-29, 1930-31; Instr., Univ. Illinois, 1934-35; Mus. Instr., Detroit Inst. A., 1935-41; Managing Ed., The Art Quarterly, 1938-41; Assoc. in Radio, MMA, New York,

N.Y., 1941-42; Ed., Magazine of Art, 1942-47; A. Ed., '47, the Magazine of the Year, 1947-48; Dir. Publ., ASL, New York, N.Y., 1948-50; Assoc. Ed., American Artist magazine, 1951-53; Conductor, American Artist magazine European Tours, 1950-52; Exec. Dir., Amateur Artists Assn. Am., 1951-53; Exec. Sec., Kent Sch., Instr., A. Hist., 1954-1956. Chief of Communications, Detroit Institute of Arts, 1959-1962; Head, National Extension Program, Henri Francis du Pont Winterthur Museum, Winterthur, Delaware, 1962- .

MORSE, MRS. McLENNAN—Collector, Photographer
San Ysidro Ranch, Santa Barbara, Cal. 93103
B. Lake Forest, Ill., Apr. 30, 1911. Member: Collectors Club of America; Several art museums. Collection: Chiefly 20th century art. Positions: Trustee, Santa Barbara Museum of Art.*

MORTELLITO, MRS. JANE WASEY. See Wasey, Jane

MORTON, RICHARD H.—Educator.
Division of Fine Arts, Northeast Missouri State College, Kirksville, Mo. 63501
B. Dallas, Tex., Aug. 8, 1921. Studied: PIASch.; Oklahoma City Univ., B.A.; Univ. Tulsa, M.A.; Instituto Allende, Mexico; M.F.A. Member: NEA; NAEA; CAA; Appointed to Visual Arts Advisory Panel, Governor's Council for Cultural Development, Oklahoma, 1964- ; Steering Com., Missouri Col. A. A. Awards: Purchase Award, Exh. Southwest American Art, 1962 at Okla. Art Center. Work: Univ. Tulsa; Okla. Art Center. Exhibited: Philbrook A. Center, 1964, 1965; Okla. A. Center, 1962, 1967; Watercolor, U. S. A., Springfield A. Mus. Mo., 1966; Quincy A. Center Ill., 1966; Instituto Allende, Mexico, 1969. Contributor illus. to "G.I. Sketch Book," 1944; Prize-Winning Water Colors, 1963. Positions: Southern Illinois Univ., Carbondale, Ill., 1955-1959; Asst. Dean, Columbus A. School, Columbus, Ohio, 1959-1960; Asst. Prof. A., Central State College, Edmond, Okla., 1960-1965; Asst. Prof. Watercolor Painting, Northeast Missouri State Col. 1965- .

MOSCATT, PAUL N.J.—Painter, T., Etcher
1029 St. Gregory St., Cincinnati, Ohio 45202
B. Brooklyn, N.Y., July 9, 1931. Studied: CUASch.; Yale Univ. Sch. FA, B.F.A., M.F.A. Work: Univ. Bridgeport (Conn.); Yale Univ. A. Dept. Exhibited: Northwest Printmakers, 1962; Silvermine Gld. A., Print Show, 1962; Louisiana State Univ., 1962; CM, 1964, 1965; Wadsworth Atheneum, Hartford, 1962; Univ. Bridgeport, 1963; Ross-Talalay Gal., New Haven, 1961; one-man: Aspect Gal., N.Y., 1962, 1963 and 2-man, 1961, 1964. Positions: Instr., Creative Arts Workshop, New Haven, Conn., 1962-64; Univ. Bridgeport, 1963, 1964; Painting and Design, Art Academy of Cincinnati, 1964- .*

MOSELEY, SPENCER—Educator
Art Dept., Univ. of Washington, Seattle, Wash. 98105*

MOSHIER, ELIZABETH ALICE—
Educator, P., C., Des., L., W.
8 Watson Pl., Utica, N.Y. 13502
B. Utica, N.Y., Dec. 24, 1901. Studied: Skidmore Col., B.S.; Columbia Univ., M.A.; Andre L'Hote Studio, Paris; Kunstgewerbe Schule, Vienna; & with Moholy-Nagy, Josef Albers, and with Mirko, in Rome, Italy. Member: CAA; Am. Asn. Univ. Prof.; Am. Assn. Univ. Women. Exhibited: Albany Inst. Hist. & A.; Syracuse Mus. FA; Indiana Univ. A. Gal.; Rochester Mem. A. Gal.; Skidmore Col. Lectures: Modern Painting; India; Contemporary Design. Positions: Instr. A., 1925- , Prof. A., 1941-59, Chm. Dept. A., 1959-1968; Skidmore Col., Saratoga Springs, N.Y.

MOSKOWITZ, IRA—Etcher, Lith., P.
39 Ave. de Charlebourg, La Garenne-Colombes, Seine, France
B. Poland, Mar. 15, 1912. Studied: ASL. Member: SAGA. Awards: prizes, "America in the War" exh., 1943; Lib. Cong., 1945; Guggenheim F., 1943. Work: MMA; Mus. New Mexico; Natural Hist. Mus., New York and Cincinnati; Philbrook A. Center; WMAA; BM; N.Y.Pub. Lib.; Albany Inst. Hist. & A.; Mus. FA of Houston; Carnegie Inst.; Lib. Cong.; Mus. Navajo Ceremonial A., Santa Fé, N.M. Exhibited: MMA, 1941; AIC; NAD, 1946; Carnegie Inst., 1946; Lib.Cong., 1943, 1945, 1946; Los A. Mus A., 1945; Albany Inst. Hist. & A.; Phila. Pr. Cl.; Laguna Beach AA; Springfield (Mo.) Mus. A.; Mus. FA of Houston (one-man); San Antonio Mus. A. (one-man); Natural Hist. Mus., N.Y. (one-man). Author: "Pattern and Ceremonials of the Indians of the Southwest," 1949. Selected & edited 4 vols., "Great Drawings of All Time," 1962. Positions: Editor, Shorewood Publishers, Inc., 1957- .*

MOSKOWITZ, ROBERT—Painter
70 Irving Place, New York, N.Y. 10003
B. Brooklyn, N.Y., 1935. Studied: Pratt Institute, with Adolph Gottlieb. Work: In private collections. Exhibited: MMod A, 1961; Leo Castelli Gal., N.Y., 1962, 1963; Albright-Knox Gal, Buffalo, 1963;

Brandeis Univ., 1963; Wadsworth Atheneum, Hartford, 1964; Univ. Ill., 1965; one-man; Leo Castelli Gal., N.Y., 1962.*

MOSKOWITZ, SHIRLEY (Mrs. Shirley Edith Moskowitz Gruber)—
Painter, S., Gr., T., L.
2211 Delancey Pl., Philadelphia, Pa. 19103
B. Houston, Tex., Aug. 4, 1920. Studied: Mus. Sch. A., Houston; Rice Univ. B.A.; Oberlin Col., M.A.; Morris Davidson Sch. A. Member: Phila. WC Cl. (Sec., 1968-); AEA; PAFA; Phila. A. T. Assn.; Woodmere A. Gal. Awards: prizes, Mus. FA of Houston, 1945; Norristown A. Lg., 1958, 1960, 1961-1967; Cheltenham A. Center, 1962. Work: Allen Mem. Mus., Oberlin Col.; Har Zion Temple, Phila. Exhibited: Texas General; Mus. FA of Houston; Texas FA Assn.; Akron AI; Temple Univ., 1948, 1956 (one-man); PAFA, 1957-1969; Phila. A. All., 1953, 1956, 1958-1969; Cheltenham A. Center, 1955, 1957, 1959, 1961; Allens Lane A. Center, 1960, 1961; Temple Har Zion, Phila., 1960, 1962, 1966; Woodmere A. Gal., 1957-1961; Detroit Inst. A., 1958; Wolpert A. Gal., Springhouse, Pa., 1957 (one-man); James M. Propper, Inc., Plymouth Meeting, Pa., 1960 (one-man); Beaver Col., 1962 (3-man); Cheltenham A. Center, 1962 (one-man); Woodmere (Pa.) A. Gal. 1968 (one-man). Lectures on art to colleges and women's clubs. Positions: Instr., Hist. A., Univ. Texas, 1943; A. T., Texas Southern Univ., 1944-45; L., Pub. Sch., Houston; A. Dir., Oberlin (Ohio) Pub. Schs., 1947-48; A. T., Norristown A. Lg., 1959-65, Program Chm., 1960-62; A. T., Norristown YWCA, 1960-61.

MOSLEY, ZACK T.—Illustrator, Cart.
Edgewood Drive, Stuart, Fla. 33494
B. Hickory, Okla., Dec. 12, 1906. Studied: Chicago Acad. FA; AIC. Member: Nat. Cartoonists Soc.; Creator of "Smilin' Jack," comic strip syndicated by Chicago Tribune-New York News syndicate.

MOSS, JOE FRANCIS—Painter, S., Des., E.
Creative Arts Center, West Virginia University, Morgantown, W. Va.; h. Rte. 7, Box 735, Morgantown, W. Va. 26502
B. Kincheloe, W. Va., Jan. 26, 1933. Studied: West Virginia Univ., B.A., M.A. Awards: Prizes, W. Va. Centennial A. Exh., Huntington, 1963; Jurors Award, Huntington Exh.; W.Va. Univ. Research Grants, 1963, 1967; purchase prize, Huntington Gals., 1967; Appalachian Exh., 1968, and numerous other prizes. Work: Huntington and Charleston Museums of Art; W. Va. Univ.; steel and glass Cross, Presbyterian Church, Morgantown, 1965; steel and glass sculpture, W. Va. University, 1965. Exhibited: Watercolor: USA, 1964; Bucknell Drawing Exh., 1965; Indiana Univ., 1964; Land Grant Colleges, Kansas City, Mo., 1961; Western Pennsylvania Sculpture Exh., 1954, 1955, 1957; Huntington, Gal., 1958-1963, 1965, 1967, 1968; Allied A. of W. Va., 1954, 1957, 1958, 1961; Nat. Invitational Exh. of Painting, Burpee Museum, Rockford, Ill., 1965; Univ. Maryland, 1964; Drexel Inst., Philadelphia, 1964; Pa. State Univ., 1964; Univ. Pittsburgh, 1964; W. Va. Univ., 1964, 1967; Canton (Ohio) A. Inst., 1966; Illinois State Mus., 1966, 1967; Decatur A. Center, 1966; El Paso Mus. A., 1966; Univ. Alabama, 1966; N.Y. Univ., 1966; Fischback Gal., N.Y., 1966; MModA, 1966; Tyler Sch. FA, Philadelphia, 1967; Univ. Utah, 1968; Fla. Gulf Coast A. Center, 1968, and many others; one-man: W. Va. Univ., 1963; Pa. State Univ., 1965; Huntington Gals., 1966; Waynesburg, Pa., 1967; Univ. Maryland, 1967; Washington (D.C.) Gal. Mod. A., 1967, etc. Positions: Assoc. Prof. A., Instr., drawing, design, painting, West Virginia University, 1960- .

MOSS, JOEL (Dr.)—Painter, E., S., C.
Kansas State College; h. 408 West Fourth St., Hays, Kan. 67601
B. Murray, Ky., June 2, 1912. Studied: Kansas State Col., B.S.; George Peabody Col., M.A.; Univ. Southern California; Columbia Univ., Ed.D., and with Glen Lukens, Saul Baizerman, Charles Martin. Awards: prize, Des.-Craftsmen, 1955, 1958; Air Capital, 1958, 1960. Work: Wichita A. Mus.; Kansas State Univ. Mus. Exhibited: Nat. Dec. A. Exh., Wichita, 1948-1963; Kansas Painters, 1949-1965; Ward Eggleston Gal., N.Y., 1951 (one-man); Nelson Gal., 1952-1955; Wash. WC Soc., 1954-1969; Des.-Craftsmen, 1955, 1965; Delgado Mus. A., 1958; SFMA, 1957, 1958; Watercolor:USA, 1964-1969; Nebraska-land East, 1969; Friends of Art, Kansas State Univ.; one-man: Western Ill. Univ.; Colorado Women's Col.; Colorado State Univ.; Northern Ill. Univ., 1964, 1965. Positions: Prof. A., Hd. Dept. A., Kansas State Col., Hays, Kans., 1946- .

MOSS, MORRIE ALFRED—Collector, Patron
5050 Poplar Ave.; h. 41 N. Perkins Rd., Memphis, Tenn. 38117
B. Chicago, Ill., June 2, 1907. Studied: University of Ill., 1928, B.S. Collection: Includes Paul Storr silver; paintings, ivory and jade, books, porcelains, Faberge, Dorothy Doughty birds.

MOTHERWELL, ROBERT—Painter, Gr., L., W.
c/o Marlborough-Gerson Galleries, 41 E. 57th St., 10022; h. 173 East 94th St., New York, N.Y. 10028
B. Aberdeen, Wash., Jan. 24, 1915. Studied: Stanford Univ., A.B.;

Harvard Univ.; Columbia Univ.; Grenoble Univ., France. Awards: Guest Artist, West German Fed. Rep., 1955; Guggenheim Mus. Int. award, 1964; Belgian Art Critics, 1966; Fellow in Perpetuity, MMA. Work: Albright-Knox A. Gal., Buffalo, N.Y.; AGAA; AIC; BMA; Blanden Mem. Mus., Fort Dodge, Iowa; BM; CMA; DMFA; Chrysler Mus., Provincetown, Mass.; Dayton A. Inst.; FMA; Peggy Guggenheim Fnd., Venice, Italy; Mus. FA of Houston; Kultusministerium Baden-Wuerttenberg, Stuttgart; Los Angeles County Mus.; MMA; MModA; Mus. Mod. A., Rio de Janeiro; Norton Gal. A., Palm Beach; Pasadena A. Mus.; PC; SFMA; Smithsonian Inst.; Stedelijk Mus., Amsterdam, Holland; Tel-Aviv Mus., Israel; A. Gal., Toronto, Canada; WAC; Brown Univ., Providence, R.I.; N.Y. Univ.; Washington Univ., St. Louis, Mo.; Yale Univ.; Bennington Col., Vt.; North Carolina Mus., Raleigh; Smith Col.; Univs. of Minn., Neb., and in private colls. Exhibited: Sao Paulo, Brazil, 1951, 1953; Documenta II, Kassel, Germany, 1959, 1964; Carnegie Int., 1961, 1964, 1968; Dunn Int., London, 1964; WMAA, 1965; SFMA, 1966; Flint Inst. A., 1966; Krannert Mus., Univ. Illinois, 1967; White House Rotating Exh., Smithsonian Inst., 1967; Winnipeg A. Gal., Canada, 1967; Dayton A. Inst., 1967; MModA, 1966-1967 (traveling); Art in Embassies (circulated by MModA); Inst. Contemp. A., Boston, 1963. One-man: Retrospective, PC, 1965; Duke Univ., 1965; Witte Mem. Mus., San Antonio, Tex., 1966; Contemp. Arts Assn., Houston, 1966; BM, 1966; Stedelijk Mus., Amsterdam, Holland, 1966; Whitechapel Gal., London, 1966; WMAA, 1968; Marlborough-Gerson Gal., N.Y., 1969; VMFA, Richmond, 1969; Marlborough Galleria, Rome, Italy, 1969; Toledo Mus. A., 1969. Two-man: Tella Inst., Buenos Aires 1967; FA Mus., Caracas, 1968; A. Mus., Bogata, 1968; Univ. A. Mus., Mexico City, 1968; Reese Gal., San Francisco, 1968. Positions: Editor, "Documents of Modern Art," 1944-1952; Assoc. Prof., Hunter Col., N.Y., 1951-1958; Visiting Critic, Univ. Pennsylvania, 1962; Columbia Univ., 1964-1965; A. Advisor, Partisan Review, 1963-1965; Dir., CAA, 1965-1968; Educational Advisor, Guggenheim Fnd., 1965- ; Counselor, Smithsonian Inst., Washington, D.C., 1966-1968; Advisor, Bliss Int. Study Center, MModA, 1968- ; Gen. Editor, "Documents of Twentieth Century Art," 1968- ; Advisory Editor, The American Scholar, 1969-1971.

MOUNT, (PAULINE) WARD—Painter, S., E.
74 Sherman Place, Jersey City, N.J.
B. Batavia, N.Y. Studied: ASL; N.Y. Univ., and with Kenneth Hayes Miller, Albert P. Lucas, Joseph P. Pollia, Fiske Kimball, and others. Member: P. & S. Soc., New Jersey; AEA; F.I.A.L.; Royal Soc. A., London, England; Int. Platform Assn. Awards: F., Royal Soc. A., London; prizes, Jersey City Mus., 1941; P. & S. Soc., New Jersey, 1943, 1951; Montclair A. Mus., 1945; New Jersey A., 1945; Asbury Park Soc. FA, 1946; Kearney Mus., 1947; Art Fair, N.Y., 1950; AAPL, certif. of award. Work: LC; F. D. Roosevelt Mus.; Jersey City Mus.; Carlebach Gal.; NAC; designed silver bell of Am. for Am. Bell Assn., 1950; bronze Medal of Honor for P. & S. Soc., New Jersey; work also in Italy, Ireland, Holland, Germany, Switzerland, Sweden and France. Exhibited: NAD, 1944; PAFA, 1949; NSS, 1945-1948; Audubon A., 1942-1944; Trenton State Mus., 1950; Smithsonian Inst., 1951; All. A. Am., 1939-1947; Jersey City Mus., 1941-1951; Hudson River Mus., 1946; AAPL, 1941-1945, 1947, 1949; New Jersey A., 1945; N.Y. Soc. Painters, 1940-1943; Montclair A. Mus., 1944, 1945; Acad. All. A., 1938-1940; VMFA, 1940; New Orleans AA, 1947; Plainfield AA, 1947; Los A. Mus., 1945; New Jersey, 1941-1951; New Jersey State Mus., 1940; P. & S. of New Jersey, 1941-1951; N.Y. Hist. Mus., 1942-1947; N.Y. Pub. Lib., 1939; Am.-British A. Center, 1942; Carlebach Gal.; Art Center of the Oranges, 1941, 1942; Hebrew Assn., Phila., 1950; NAC, 1954; Riverside Mus., 1953; N.Y. Worlds Fair, 1965; Westchester AA, 1967, and others. Positions: Founder, Former Pres., P. & S. Soc., New Jersey (12 years); Founder, Former Dir. A., Jersey City Medical Center; Former Hd. Dept., Painting & Sculpture, New Jersey State T. Col., Jersey City, N.J.; Dir., Ward Mount A. Classes, Jersey City, N.J.

MOY, SEONG—Painter, Gr., T., L.
2231 Broadway 10024; h. 100 La Salle St., New York, N.Y. 10027
B. Canton, China, Oct. 20, 1921. Studied: St. Paul Sch. A.; Hans Hofmann Sch. A.; ASL; Atelier 17, N.Y. Member: ASL; AFA; AEA; CAA; Fed. Mod. P. & S. Awards: John Hay Whitney Fnd. Grant, 1950-51; Guggenheim F., 1955-56. Work: MModA; BM; MMA; PAFA; N.Y. Pub. Lib.; Smithsonian Inst.; BM; WMA; Univ. Minnesota; Univ. Indiana; Smith Col., and others; "Print of the Month," The Contemporaries, N.Y., 1955. Exhibited: BM, 1947-55; MMA, 1942; Phila. Pr. Cl., 1947-54; MMA, 1950; WMAA, 1950; Univ. Illinois, 1951, 1953, 1954; Carnegie Inst., 1952, 1955; 17 one-man exhs. since 1943. Lectures: Modern Art; Oriental Art; Graphic Art. Positions: Instr., Univ. Minnesota, 1951; Indiana Univ., 1952-53; Smith Col., 1954-55; Univ. Arkansas, 1955; Vassar Col., 1955; Columbia Univ., Art Students League; CUASch., at present; Dir., Seong Moy Sch. Painting & Gr. A., Provincetown, Mass. (summers), 1954- .

MOYER, ROY—Painter, Dir. Art Federation, T.
American Federation of Arts, 41 East 65th St., New York,
N.Y. 10021
B. Allentown, Pa., Aug. 20, 1921. Studied: Columbia Col., B.A.;
Columbia Univ., M.A. Member: Arch. Lg. of New York; Exec.
Committee of National Council on the Arts and Government. Work:
Wichita A. Mus.; Sara Roby Fnd., N.Y.; Rochester Mem. A. Gal.;
Riverside Mus., N.Y., and in private colls., U.S. and Europe. Ex-
hibited: Univ. Illinois, 1959; WMAA, 1960; Washington Univ., St.
Louis, 1967; Colorado Springs FA Center, 1967; J.B. Speed Mus.,
Louisville, 1967; Akron A. Inst., 1968; Georgia Mus. A., Athens,
1968; Greenville County Mus., 1969; one-man: Contemporaries,
N.Y., 1958, 1959, 1961, 1963, 1965; Midtown Gal., N.Y., 1967; Sneed
Gal., Rockford, Ill., 1969. Assisted Yugoslavian Government in se-
lection of AFA traveling exhibition, "New Painting from Yugosla-
via," 1958; selected traveling exhs.: "Art and the Objet Trouve,"
1959; "Impressionism in Sculpture," 1960; "Explorers of Space,"
1961; "Moods of Light," 1964. Positions: Instr., English and Art,
Salonica, Greece, 1948-51; L., A. Hist., Univ. Toronto, Canada,
1953-55; Lectures frequently on art education, museums, business
and art, new trends in art. Dir., American Federation of Arts, New
York, N.Y., at present.

MUDGE, EDMUND WEBSTER, JR. —Collector
2931 Republic National Bank Bldg. 75201; h. 5926 Averill Way,
Dallas, Tex. 75225
B. Pittsburgh, Pa., Nov. 29, 1904. Studied: Harvard University,
A.B. Collection: Impressionist and post-impressionist paintings;
English, French and German antique porcelain and pottery; Antique
Chinese snuff bottles and Chinese export porcelains; Porcelain birds
of Dorothy Doughty (Royal Worcester) and Edward Marshall Boehm
(Trenton, N.J.).*

MUELLER, EARL GEORGE—Scholar, Critic
Duke University, College Station 6605; h. 1001 Gloria Ave.,
Durham, N.C. 27701
B. Harvard, Ill., Feb. 12, 1914. Studied: University of Rochester, B.
Music; State Univ. Iowa, M.F.A., Ph.D. Field of Research: Northern
Renaissance Art; Graphics. Positions: Chairman, Department of
Art, Duke University, Durham, N.C., 1964- .

MUELLER, FREDERIC—Art dealer
Pace Gallery, 32 E. 57th St., New York, N.Y. 10022*

MUELLER, GEORGE LUDWIG—Painter
9 Summit St., East Orange, N.J. 07017
B. Newark, N.J., Mar. 13, 1929. Studied: CUASch. Awards: prize,
DMFA, 1955; Guggenheim Fellowship, 1956; Brandeis Creative
Award, 1961; Newark Mus. A., 1961 (purchase); AIC, 1960 (purchase).
Work: Guggenheim Mus. A.; WMAA; AIC; Newark Mus. A. Exhibited:
DMFA, 1954, 1955; WMAA, 1954, 1955, 1957, 1961, 1963, 1965; Guggen-
heim Mus. A., 1955; Carnegie Inst., 1955; Univ. Illinois, 1965, 1967;
Venice Biennale, 1956; Rome, Italy, 1958; Brussels World's Fair,
1958; WMA, 1958; PAFA, 1960; Art: USA, 1959; Newark Mus. A., 1961;
Detroit Inst. A., 1960; AIC, 1960, 1964; N.J. State Mus., 1967; West-
moreland County Mus. A., 1969; one-man: Artists Gal., N.Y., 1951;
Visiting Artist, Oklahoma Univ., 1960 (summer).

MUELLER, HENRIETTE W. (Mrs.)—
Painter, Des., Gr., E., S.
1309 Steele St., Laramie, Wyo. 82070
B. Pittsburgh, Pa., April 13, 1915. Studied: Northwestern Univ.;
AIC, B.F.A.; ASL; Univ. Wyoming, M.A., M. Ed., and with Will Bar-
net, Ilya Bolotowsky, John Opper, George McNeil, and others.
Member: Am. Color Pr. Soc.; AEA; Nebraska AA; Mid-Am. A.; Nat.
Ser. Soc. Awards: Mary Griffiths Marshall Mem. F., Alpha Chi
Omega, 1952; Tri-State Exh., 1958; Cummington F., 1954. Work:
N.Y. Pub. Lib.; Joslyn A. Mus.; Henry Gal., Univ. Washington; Nel-
son Gal. A.; Woman's Col., Univ. North Carolina. Exhibited: An-
chorage, Alaska, 1952; SAGA, 1950; MMA, 1950; BM, 1950-1952;
LC, 1950; Northwest Pr.M., 1950-1952; Bradley Univ., 1951, 1952;
Univ. So. California, 1952; Am. Color Pr. Soc., 1951, 1952, 1955;
John Herron AI, 1952; Denver A. Mus., 1950-1952, 1958, 1960, 1961,
1964, 1965; Colorado Springs FA Center, 1951; Joslyn A. Mus., 1951,
1952; Nelson Gal. A., 1950, 1951; Nebraska All-State, 1957; Meltzer
Gal., 1953-1955; Western A., 1953-1955; Phila. A. All., 1955; Crea-
tive Gal., N.Y., 1954; The Contemporaries, 1953-1955; AFA travel-
ing exh., 1952, 1954; Mills Gal., N.Y., 1960 (one-man); Salt Lake
City, 1965; Univ. Wyoming, Coe Gallery, 1968. Positions: Instr., J.
Sterling Morton H. S., Chicago, 1937-38; Colby Jr. Col., New Lon-
don, N.H., 1938-40; Univ. Wyoming, Laramie, Wyo., 1948-58; sum-
mer school, 1961, 1964, 1965, Art Dept., 1963-64, 1964-65, 1965-
67; Fairview High Sch., Boulder, Colo., 1968-69; Univ. Nebraska,
1957-58.

MUENCH, JOHN—Painter, Gr., E.
97 Spring St., Portland, Me. 04111
B. Medford, Mass., Oct. 15, 1914. Studied: ASL, and in France.
Member: Phila. WC Cl.; SAGA; Audubon A. Awards: prizes, LC,
1951, 1954; BM, 1947; SAGA, 1953, 1955; Boston Pr. M., 1953;
DMFA, 1954; Univ. So. Cal. 1954; Audubon A., 1956, 1959, 1960,
John Taylor Arms Award & Medal, 1965; Portland Soc. A., 1957,
1961; Silvermine Gld. A., 1959; Tiffany F., 1948, 1954; med., Phila.
WC Cl., 1954; Visiting Fellowship, Tamarind Lithography Workshop,
Los Angeles, 1962; Pennell Mem. Award & Medal, PAFA, 1963;
purchase award, de Cordova & Dana Mus., 1962. Work: Princeton
Univ.; BM; N.Y. Pub. Lib.; Univ. Maine; Bowdoin Col.; LC; DMFA;
Univ. So. Cal.; FMA; MModA; MMA; Bibliotheque Nationale, Paris;
Smith Col.; Jerusalem; Victoria & Albert Mus., London; Portland
Mus. A.; PAFA; Pa. State Col. Exhibited: LC, 1945, 1948, 1949,
1951-1954, 1955, 1956; Carnegie Inst., 1945, 1948; NAD, 1946, 1949;
Northwest Pr. M., 1946; BM, 1947, 1950; SAGA, 1947, 1950-1952;
Boston Pr. M., 1948-1952; Audubon A., 1947, 1948, 1956; PAFA,
1949, 1950; Contemp. Am. Gr. A., France, 1950-1951, 1952; Phila.
Pr. Cl., 1947; Albany Pr. Cl., 1949-1951; Buffalo Pr. Cl., 1951;
Springfield A. Lg., 1951-1952; Conn. Acad. F., 1950, 1952; Soc.
Canadian P., Et. & Eng., 1951, 1952; MMA, 1952; PAFA, 1953-1955;
Univ. So. Cal.; DMFA; Bradley Univ.; CM, 1954, 1956; BM; Hartford
Atheneum, and others. Positions: Dir., Portland (Me.) Sch. F. &
App. A.*

MUENSTERBERGER, HELENE COLER (Mrs.)—Art Dealer
Seiferheld & Company, 183 E. 64th St.; h. 160 E. 65th St., New
York, N.Y. 10021
B. Montreal, Canada. Studied: Smith College, Columbia University,
New York University Institute of Fine Arts. Collection: Old Master
Drawings. Positions: Assistant Director, Van Diemen-Lilienfeld
Galleries, 1956-1958; President, Seiferheld & Company, New York,
N.Y., 1958- .

MUIR, EMILY—Painter, Des., C., S., W., L.
Stonington, Me. 04681
B. Chicago, Ill., 1904. Studied: Vassar Col.; ASL, with Richard
Lahey, John Carroll, George Bridgman, Leo Lentelli. Awards: Hon.
D.L.H., Univ. Maine, 1969. Work: BM; Univ. Maine; U.S. Govt., and
in private colls. Art Work for: Moore-McCormack Lines; American
Caribbean Lines; American Scantic Lines; French Line; Pan-Ameri-
can Airways; Finnish Travel Bureau; Swedish Travel Bureau; Trin-
idad Chamber of Commerce; Aluminum Corp. Am.; Aluminum
Corp., Canada. Mosaics, interiors, in churches and homes. Exhib-
ited: NGA; CGA; BM; Phila. WC Cl.; PAFA; NAD; N.Y. WC Cl.; Soc.
Indp. A., Boston, traveling exh.; Springfield A. Mus.; Portland A.
Festival; Maine Artists; Maine A. Gal.; many joint exhibitions with
William Muir in colleges and universities in North and South Caro-
lina, New York, West Virginia, Ohio, Pennsylvania, New Jersey, etc.
One-man: Farnsworth Mus. A.; Univ. Maine; Bowdoin Col.; Scranton
Univ.; Montross Gal., N.Y.; Norlyst Gal., N.Y. and others. Lecture
tours for Assn. Am. Colleges; Memb. Nat. Comm. FA, 1955-59.
Author: "Small Potatoes."

MULCAHY, FREDA—Painter, Mus. Cur.
Staten Island Institute of Arts & Sciences; h. 3 Gordon Place,
Staten Island, N.Y. 10301
B. Staten Island, N.Y., April 22, 1918. Studied: New School for So-
cial Research, N.Y.; N.Y. Univ. and with Sol Wilson, Jack Tworkov.
Member: NAWA. Awards: ACA Gallery, N.Y., 1955; Staten Island
Mus., 1956, 1962, 1963. Exhibited: CGA, 1959; Smithsonian Inst.,
1960; Art:USA; one-man: Jefferson Place, Wash., D.C., 1964. Posi-
tions: Cur., Education, Staten Island Institute of Arts & Sciences,
N.Y.*

MULLEN, BUELL (Mrs. J. Bernard)—Painter, Muralist, L.
222 Central Park South, New York, N.Y. 10019; also Lake
Forest, Ill.
B. Chicago, Ill., Sept. 10, 1901. Studied: Tyler Sch. A.; British
Acad. A., London; Rome, Italy, with Petrucci, Lipinsky; Cicquier,
Belgium. Member: NSMP; Arch. Lg.; F., Royal Soc. A., London.
Work: murals on stainless steel: Hispanic Room in Library of Con-
gress (first mural to be made on stainless steel); U.S. Naval Re-
search Lab.; Ministry of Pub. Works, Rio de Janeiro; Ministry of
War, Buenos Aires; Great Lakes Naval Station; Dun & Bradstreet;
Metals Research Lab., Niagara; Electronic Tower, I.T. & T. Co.;
Int. Expo., Milan; General Motors Styling Admin., Detroit; U.S.
Steel panels for private car; Nat. Carbon Lab.; Searle Lab.; Inland
Steel, Indiana Harbor; first ceiling mural on stainless steel, North
Adams (Mass.) Hospital; Sorg Paper Co., Middletown, Ohio; Gard-
ner Board & Carton Co., Middletown; Bd. Room, International
Nickel Co.; 2 murals, Simon Fraser Univ., Vancouver, B.C.; John
Woodman Higgins Armory Worcester, Mass.; room of stainless
steel mural treatment, Republic Steel Co.; wall Physics Auditorium,

Case Inst. Tech.; Am. Chemical Soc., Wash., D.C.; large mural on stainless steel in foyer of Western Electric Co., on "Communications." Mural, Houston (Tex.) FA Center; 4 panels for Wolfe Memorial, Inter.-Am. Univ., Puerto Rico. Many ports. on metal of prominent army, musical, theatrical and national figures. Exhibited: Paris Salon; Rome, Italy; Ill. Soc. FA; Smithsonian Inst.; Dayton AI; Knoedler Gal.; Ferargil Gal.; Findlay Gal.(one-man); AIC. Positions: Sec., NSMP. Awards Comm., Architectural League, N.Y. Representative, Int. Assn. of Arts for the Nat. Com. of UNESCO. Bd. Memb. of N.Y. Fed. F.A. and NSMP.

MULLER-MUNK, PETER—Designer
 Four Gateway Center 15222; h. 8 Darlington Court, Pittsburgh, Pa. 15217
B. Berlin, Germany, June 25, 1904. Studied: Univ. Berlin, B.A.; Acad. F. & App. A., Berlin, and with W. Raemisch. Member: F., Am. Soc. Indst. Des.; Intl. Council of Soc. of Indst. Des. (Pres.). Work: Detroit Inst. A.; Newark Mus. Exhibited: MModA; Paris Salon; GGE, 1939; Assoc. A., Pittsburgh; Phila. A. All.; Detroit Inst. A.; Newark Mus.; CMA; Triennale de Milano, 1951, 1954, 1957. Contributor to numerous magazines. Positions: Assoc. Prof., Indst. Des., Carnegie Inst., 1935-45; Managing Partner, Peter Muller-Munk Assoc., Pittsburgh, Pa., 1945- .*

MULLICAN, LEE—Painter, S., E.
 370 Mesa Road, Santa Monica, Cal. 90402.
B. Chickasha, Okla., Dec. 2, 1919. Studied: Abilene Christian Col.; Univ. Oklahoma; Kansas City AI; Cal. Sch. FA. Awards: Inst. of Creative Arts, Univ. Cal., 1963-64; Tamarind Lithograph Workshop, Los Angeles, 1964; Guggenheim F., 1960-61. Work: Santa Barbara Mus. A.; SFMA; San F. Mun. Coll.; Denver A. Mus.; Colorado Springs FA Center; PC; Detroit Inst. A.; MModA; Oklahoma A. Center; Univ. Oklahoma; Delgado Mus. A., New Orleans; Syracuse Univ.; Los A. Mus. A.; Pasadena A. Mus. Exhibited: CGA, 1948, 1957; MMA, 1951; AIC, 1951, 1954; Los A. Mus. A., 1951; Carnegie Inst., 1952, 1964, 1966; Univ. Illinois, 1953, 1955, 1957; WMAA, 1952, 1956, 1963; Denver A. Mus., 1950, 1955-1957; Sao Paulo, Brazil, 1955; MModA, 1957; Santa Barbara Mus. A., 1957; Rome-N.Y. Foundation, Rome, Italy, 1960; Pasadena A. Mus., 1961; Paul Kantor Gal., 1959; SFMA, 1965; Mt. St. Mary's College, Los A., 1964; PAFA, 1967; one-man: SFMA, 1949; Willard Gal., N.Y., 1950, 1952, 1953, 1961, 1966; Philbrook A. Center, 1951; Oklahoma City A. Center, 1951, 1967; Oklahoma Col. for Women, 1952; Univ. Oklahoma, 1952; Paul Kantor Gal., Los A., 1952, 1954, 1956; Rabow Gal., San F., 1955; Santa Barbara Mus. A., 1958; Mus. A., Santiago, Chile, 1967. Positions: Assoc. Prof., Univ. California at Los Angeles; A.-in-Res., Univ. Chile.

MUNDT, ERNEST KARL—Sculptor, W., L., E.
 574 Congo St., San Francisco, Cal. 94112
B. Germany, Oct. 30, 1905. Studied: in Berlin, Grad. in Arch.; Univ. California, Ph.D. Member: CAA. Work: SFMA; steel sculpture, Westmoor H.S., Daly City, Cal. Exhibited: WMAA, 1951; MMA, 1950; Detroit Inst. A., 1944; Nierendorf Gal., 1945, 1946; SFMA, 1946; Cal. PLH, 1949. Author, I., "A Primer of Visual Art," 1950; "Art, Form, and Society," 1952; "Birth of a Cook," 1956. Contributor to Arts & Architecture, College Art Journal, Art Quarterly, Journal of Aesthetics magazines. Positions: Asst. Prof., Univ. Michigan, 1941-44; Instr., Brooklyn Col., 1945-46; Cal. Sch. FA, 1947-50; Dir., Cal. Sch. FA, San Francisco, Cal., 1950-55; Asst. Prof. A., San F. State Col., 1955-59; Chm. A. Dept., 1958-1961; Assoc. Prof., 1959-1964, Prof., 1964- .

MUNSTERBERG, HUGO—Scholar, W., Collector
 State University College; h. 48 Elting Ave., New Paltz, N.Y. 12561
B. Berlin, Germany, Sept. 13, 1916. Studied: Harvard College, A.B.; Harvard University, Ph.D. Author: "A Short History of Chinese Art," 1949; "Twentieth Century Painting," 1951; "Landscape Painting of China and Japan," 1955; "The Arts of Japan," 1957; "The Folk Arts of Japan," 1958; "The Art of the Chinese Sculptor," 1960; "The Ceramic Art of Japan," 1964; "Minjei, the Traditional Folk Art of Japan," 1965; "Zen and Oriental Art," 1965; "Chinese Buddhist Bronzes," 1967; "Art of the Far East," 1968 (also in German, Dutch, French, Italian and Yugoslav editions). Field of Research: Oriental art (China and Japan). Collection: Oriental art, especially ceramics. Positions: Professor of Art History, Michigan State University, International Christian University, Tokyo, Hunter College, New York State University College, New Paltz.

MUNZER, ARIBERT—Painter, T.
 Minneapolis School of Art, 200 E. 25th St., Minneapolis, Minn., 55404
B. Mannheim, Germany, Jan. 9, 1930. Studied: Syracuse Univ., B.F.A.; Cranbrook Acad. A., Bloomfield Hills, Mich., M.F.A. Ex-

hibited: National and regional shows, 1953-63. Positions: Instr., Painting & Design, Minneapolis School of Art, 1955- .*

MURCHISON, JOHN D. — Collector
 2300 First National Bank Bldg., Dallas, Tex. 75202; h. P.O. Box 55, Addison, Tex. 75001
B. Tyler, Tex., Sept. 5, 1921. Studied: Yale University. Collection: Contemporary American art.*

MURPHY, GLADYS WILKINS (Mrs. Herbert A.)—
 Painter, C., Des., Pr.M.
 The Old Mill, 19 King St., Rockport, Mass. 01966
B. Providence, R.I., Apr. 15, 1907. Studied: R.I. Sch. Des. Member: Providence AC; Providence WC Cl.; Rockport AA. Exhibited: AWS; NAD; LC; Phila. Pr. Cl.; Phila. A. All.; Cal. Pr.M.; Northwest Pr.M.; Southern Pr.M.; Rockport AA, one-man, 1964; North Shore AA; Providence WC CL.; Providence A. Cl. Positions: Dir., A. Gal. Rockport, Mass., 1946- .

MURPHY, HERBERT A.—Architect, P., C.
 19 King St., Rockport, Mass. 01966
B. Fall River, Mass., June 13, 1911. Studied: R.I. Sch. Des. Member: Rockport AA (Pres., 1963-65); Providence A. Cl.; Boston Arch. Cl.; Providence WC Cl. Exhibited: Rockport AA; North Shore AA; Providence A. Cl.; Providence WC Cl.; R.I. Sch. Des.; Gloucester A. Festival annually. Positions: Co-Dir., A. Gal. & Craft Studio, Rockport, Mass.; Reg. Architect, private practice, 1941- . Vice-Pres., 1960-61, 1961-62, Graphics Jury; 1961-62, Rockport AA.

MURRAY, ALBERT K.—Portrait Painter
 33 West 67th St., New York, N.Y. 10023
B. Emporia, Kan., Dec. 29, 1906. Studied: Cornell Univ.; Syracuse Univ.; abroad; & with Wayman Adams. Member: Newport AA; Soc. Four A., Palm Beach, Fla. Work: Syracuse Univ.; Univ. Illinois; Princeton Univ.; Univ. Cl., N.Y.; Mem. Hospital, N.Y.; IBM; U.S. Govt., Defense Dept.; NGA; La Fayette Col.; U.S. Naval Acad., Annapolis, Md.; Union Cl., N.Y.; Univ. North Carolina; Columbia Univ.; Smithsonian Inst.; U.S. State Dept.; Union College; Stanford Univ.; U.S. Military Acad., West. Point; U.S. Justice Dept.; U.S. Navy Dept.; Dept. of the Air Force; State House, Raleigh, N.C.; State House, Annapolis, Md.; Clark Univ.; Chicago Cl.; U.S. Embassy, Paris; Am. Philosophical Soc.; Univ. of the South; Spelman Col., Atlanta; U.S. Space Agency. Exhibited: war paintings, Nat. Gal., London, England; Salon de la Marine, Paris, France; in Melbourne, Sydney, Australia; Carnegie Inst.; WMA; VMFA; CGA; PMA; U.S. Naval Acad.; NAD, 1941; NGA; MMA; deYoung Mem. Mus., San F.; Honolulu Acad. A.; DMFA; BMA.

MURRAY, FLORETTA—Educator, P., S.
 Art Department, Winona State College; h. 501 Harriet St., Winona, Minn.
B. Minnesota. Studied: Winona State Col., B.Ed.; Univ. Minnesota, M.A., plus work toward Ph.D.; Minneapolis Sch. A.; Univ. Chicago, and in France, Belgium and Italy. Member: AAUP; NAEA (Life); Nat. Lg. Am. Pen Women; Minnesota Sculpture Assn.; CAA; Minnesota Edu. Assn. Int. Platform Assn.; Int. Soc. of A. Awards: prizes, Minn. State Fair, 1938; Women's Week Expo., 1942; Indp. A., N.Y., 1947; WAC, 1941, 1945; St. Paul A. Gal., 1956. Work: Winona County Hist. Soc. (mural). Exhibited: Indp. A. Assn., N.Y., 1947, 1948; Nat. Lg. Am. Pen Women, 1956; Indiana (Pa.) Univ.; Minnesota State Fair; WAC; Minneapolis Sch. A.; Univ. Chicago; Univ. Minnesota, Smithsonian Inst.; Grand Central Gals.; Northrop Gal., Univ. Minnesota; one-man: Winona Pub. Lib., 1954, 1958, 1962; Rochester A. Center, 1957, 1958; Univ. Minn. A. Gal., 1958, 1960-1962; St. Paul A. Gal., and others. Lectures: Modern Painting; Medieval Painting; American Colonial Painters, etc. Positions: Prof. A., Hd. A. Dept., Winona State College, Winona, Minn., 1942- . Sec., Fine Arts Adv. Com. to State of Minnesota Bd. of Edu.; Sec., Minnesota Centennial Com. for Minnesota Centennial Conf. on Higher Education.

MURRAY, ROBERT (GRAY)—Sculptor
 66 Grand St., 10013; h. 138 E. 22nd St., New York, N.Y. 10010
B. Vancouver, B.C., Mar. 2, 1936. Studied: Regina Col. Sch. Art; Univ. Saskatchewan. Also in Mexico. Awards: Canada Council Grant, 1960, 1969; Nat. Endowment for the Arts Award, 1968. Work: Montreal Mus. FA; Nat. Gal. Canada; Joseph Hirshhorn Coll.; A. Gal. Ontario; Aldrich Mus. Contemp. A., Ridgefield, Conn.; New Brunswick Mus., St. John, Canada; WMAA; Everson Mus., Syracuse; Seagrams Coll., Montreal; Saskatoon City Hall, Saskatchewan, Canada; Canadian Corporation, 1967 World Exh. (Expo 67); Vancouver International Airport, British Columbia, Canada. Exhibited: Nat. Gal. of Canada, 1962, 1967; Montreal Mus. FA, 1963; Jerrold Morris Gal., Toronto, 1963; Dorothy Cameron Gal., Toronto, 1965; Fischbach Gal., N.Y., 1964; Washington Square Gal., 1964; Finch Col. A. Mus., N.Y., 1964; WMAA, 1964, 1966-1968; Tibor de Nagy

Gal., N.Y., 1965; World House Gal., N.Y., 1966; Betty Parsons Gal., 1966; Musée Cantonal des Beaux-Arts, Lausanne, Switzerland, 1966; Sch. Visual A., 1967; Inst. Contemp. A., Boston, 1967; Los A. County A. Mus., 1967; PMA, 1967; New York, N.Y., 1967; Guggenheim Mus., 1967; Instituto Torcuato Di Tella, Buenos Aires, 1967; Museé d'Art Moderne, Paris, 1968; Grand Rapids A. Mus., Mich., 1969; Sao Paulo, Brazil, 1969. One-man: Betty Parsons Gal., N.Y., 1965, 1966, 1968; David Mirvish Gal., Toronto, 1967-1969; Jewish Mus., N.Y., 1967; New York, N.Y., 1968.

MURRAY, WILLIAM COLMAN—Collector, Patron
 310 Genesee St. 13502; h. 1603 Sherman Drive, Utica, N.Y. 13501
B. Dunkirk, N.Y., Mar. 15, 1899. Studied: Cornell University, A.B. Awards: Honorary L.H.D., Hamilton College, Clinton, N.Y., 1963; Civic Award, Colgate University, Hamilton, N.Y., 1958. Member: Collectors Club, 1960- . Collection: Primarily contemporary American art. Positions: Trustee, 1949- , President and Secretary, 1955- , Munson-Williams-Proctor Institute, Utica, N.Y.; Trustee, AFA, 1955-1963; Trustee, Root Art Center, Clinton, N.Y., 1959- ; Substantial donations to the collection of the Munson-Williams-Proctor Institute.

MUSSELMAN, DARWIN B.—Painter, E., L.
 5161 N. Sequoia Dr., Fresno, Cal. 93705
B. Selma, Cal., Feb. 16, 1916. Studied: Fresno State Col., A.B.; Cal. Col. A. & Crafts, M.F.A.; Univ. California, M.A.; Mills Col., and with Lyonel Feininger, Yasuo Kuniyoshi. Member: Cal. WC Soc.; AWS; San F. AI. Awards: prizes, San Joaquin Valley A. Comp., 1947; Fresno A. Lg., 1947; Oakland A. Mus., 1948; Cal. State Fair, 1949-1952, 1955; No. Cal. A., 1954, 1955, 1956; Western A., 1954; Fresno Fair, 1955, 1956. Exhibited: San F. AA, 1943, 1947, 1948, 1950, 1956, 1958; Oakland A. Gal., 1944, 1948, 1950, 1954; Cal., PLH, 1948; Los A. Mus. A., 1949; Cal. WC Soc., 1947-1949, 1951, 1954; Denver A. Mus., 1950-1954; SAM, 1951; Butler Inst. Am. A., 1956; Fresno A. Center, 1955, 1958; San F. Art Bank, 1958-1961; Cal. PLH, 1960; Esther Robles Gal. traveling exh., 1959-60; Cal. WC Soc., 1959; one-man: Fresno A. Center, 1955, 1958, 1962, 1967; Haggin A. Gal., Sacramento, 1957; Bakersfield A. Gal., 1959; Univ. of the Pacific, 1959; Crocker A. Gal., 1960, 1968; Contemp. A. Gal., El Cerrito, Cal., 1960; Vacaville, 1960; Boise A. Mus., 1961; touring exhibitions, San Francisco Art Bank throughout U.S. Positions: Prof. A., Fresno State Col., 1953- .

MYER, PETER LIVINGSTON—Painter, C., Gr., S. T.
 4505 Maryland Pkwy.; h. 3185 Greenbrier Dr., Las Vegas, Nev. 89109
B. Ozone Park, Long Island, N.Y., Sept. 19, 1934. Studied: Brigham Young Univ., B.A.; Univ. Utah, M.F.A. Awards: Brockbank Award, Brigham Young Univ., 1956; prizes, Univ. Utah, 1959; Nat. A. Roundup, 1963, 1965, Spring A. Roundup, 1965, Las Vegas, Nev. Work: Brigham Young Univ.; Univ. Utah; Col. of Eastern Utah; Denver A. Mus. Exhibited: Nat. A. Roundup, Las Vegas, 1962-1967; Howard Wise Gal., N.Y., 1967; WAC, 1967; Flint Inst. A., 1967; WMA, 1967; Esther Robles Gal., Los Angeles, 1968; Long Beach Mus. (Cal.), 1969; BM, 1968-1969; regionals: Intermountain Biennial, Salt Lake City A. Center, 1967, 1969; one-man exhs.: Brigham Young Univ., 1958; Univ. Utah, 1959; Provo A. Gal., 1962; The Gallery, Denver, 1968; Robels Gal., Los Angeles, 1968. Positions: Art Editor, Sage Magazine, 1967-1969; Chm., A. Dept. 1963-1969, and Dir., A. Gals., 1967-1969, Univ. Las Vegas, Nev.

MYERS, DENYS PETER—Museum Director, E., L., W.
 Northern Virginia Fine Arts Association, 201 Prince St., Alexandria, Va. 22314
B. Boston, Mass., Apr. 23, 1916. Studied: Harvard Col., B.S., Harvard Univ. (candidate for Ph.D); Columbia Univ., M.A. Member: CAA; Soc. Arch. Hist. (Bd. Dirs. 1962-65); AAmus.; Steamship Hist. Soc. Am. Contributor to Soc. Architectural Historians Journal. Lectures: Historical & Critical Lectures on Medieval, Baroque, Romantic and Contemporary subjects. Exhibitions arranged: Zanesville Sesquicentennial Exh., 1947; Adorations of the Magi, 1948; The Grand Manner (Baroque Exh.) 1949; Romanticism (architectural section selected, arranged and catalogued for the Columbus Gal. FA). Positions: Dir., Art Inst. of Zanesville, Ohio, 1947-55; Dir., Philbrook A. Center, Tulsa, Okla, 1955-1958; Dir., Des Moines A. Center, Des Moines, Iowa, 1958-59; Asst. Dir., Baltimore Museum of Art, 1959-1964; Lecturer, Johns Hopkins Univ., 1960-64; Dir., Northern Virginia Fine Arts Assn., 1964- .*

MYERS, FORREST WARDEN —Sculptor, Light Auras
 235 Park Ave., South, New York, N.Y 10011; h. 238 Park Ave., South, New York, N.Y 10003
B. Long Beach, Cal., Feb. 14, 1941. Studied: San Francisco A. Inst. Member: Experiments in Art and Technology; Art Research, Inc. (Dir. of A. Research, 1964-1969); Dynamite Lite Aura Co.,

(Pres. 1968-1969). Awards: Am. Steel Inst., 1968; Aero Space Industries Des. award, 1968. Work: MModA; Patric Lannon Mus., Palm Beach; Great South West Corp., Atlanta Ga.; American Embassy, Mexico City. Exhibited: Jewish Mus., 1967; Park Place Gal., 1964-1967; WMAA, 1968; PMA, 1968; Los Angeles County Mus., 1968; Cal. Sch. of FA, San Francisco, 1959; Paula Cooper Gal., 1968-1969. Lectures: Art and Industry, I.B.M., 1968. Positions: Instr. Sculpture, San Francisco A. Inst., 1967; Sch. of Visual Art, N.Y., 1968.

MYERS, JOHN—Art Dealer, Collector, Patron, W.
 30 Rockefeller Plaza 10020; h. 45 Sutton Place South, New York, N.Y. 10022
B. London, England, Sept. 1, 1900. Studied: School of Dentistry, Paris, France. Awards: Key to City, Perth Amboy, N.J.; Special Feature Award, Great Neck Tribune, Great Neck, N.Y. Member: MModA; MMA. Author: "Old Masters Come to Life," 1964. Collection: Far Eastern art. Positions: Vice-President, Secretary and General Manager, American Flange and Manufacturing Co., Inc.; Scientific Reporter, Great Neck Tribune; Owner, President, John Myers Gallery, N.Y.; President, John Myers Foundation; Donor of art scholarships to New School for Social Research annually; Various television appearances concerning art.*

MYERS, JOHN B.—Art Dealer
 149 E. 72nd St., New York, N.Y. 10021
Position: Dir., Tibor de Nagy Gallery, New York, N.Y.*

MYERS, MALCOLM HAYNIE—Painter, Et., Eng.
 1715 James Ave. S., Minneapolis, Minn. 55403
B. Lucerne, Mo., June 19, 1917. Studied: Wichita State Univ., B.F.A.; Univ. Iowa, M.A., M.F.A. Awards: Guggenheim F., 1950, 1951, 1953-54; prizes, SAM, 1958; WAC, 1958; Ford Fnd. (purchase), 1958. Work: LC; Walker A. Center; CAM; SAM; Bibliotheque Nationale, Paris; Minneapolis Inst. A.; MModA.; American Embassy, Bonn, Germany; N.Y. Pub. Library; CM; BM and many college, university and private collections. Exhibited: Salon de Mai, Paris, 1951; Am. Embassy Paris, 1951; all nat. print shows since 1946; Contemp. Am. Gravure, Paris, 1951; MMA, 1952; Northwest Pr.M., 1946; Phila. Pr. Cl., 1949; LC, 1945; PAFA, 1949; Bordighera, Italy, 1956; Minneapolis Inst. A., 1958; SAM, 1958; Kansas City AI, 1958; Univ. Illinois, 1958; Int. Colour Print Exh., Grenchen, Switzerland; Am. Prints Today at N.Y. World's Fair; one-man: Walker A. Center, 1949, 1953, 1958; Univ. Minnesota, 1953; Harriet Hanley Gal., 1952 (Minneapolis); High Acre Gal., Minneapolis, 1952; Minneapolis Inst. A., 1958. Positions: Instr., Pr.M., Univ. Iowa, 1946-48; Assoc. Prof., Hd. Print Dept., Univ. Minnesota, Minneapolis, Minn., 1948-1960, Prof., A., 1960- ; Chm. A. Dept. of Studio Arts, 1966- . Instr., Painting, Walker Art Center, 1958.

MYERS, (CHARLES) STOWE—Industrial Designer, E., L.
 2114 Central St.; h. 2229 Simpson St., Evanston, Ill. 60201
B. Altoona, Pa., Dec. 7, 1906. Studied: Univ. Pennsylvania, B.A. in Arch. Member: Indst. Des. Soc. of America; AWCS. Awards: Naval Ordnance Award, 1945. Work: Assoc. Des., Eastman Kodak Bldg., WFNY 1939. Exhibited: AWCS; product designs, 1957 Triennial, Milan; U.S. Pavilion, Brussels World's Fair, 1958; Int. Des. Exh., The Louvre, Paris, 1963; Designer of USA Exhs. at Casablanca & Tunis Int. Fairs, 1959; Tripoli, Libya, 1962, and other Int. Trade Fairs since 1956. Positions: Indst. Des., Walter Dorwin Teague, New York & Los Angeles, Cal., 1934- , Partner, 1945-48; Design Projects Dir., Raymond Loewy Assoc., 1950-54; Independent Consultant Des., 1954- ; L., Inst. Des., Ill. Inst. Tech., 1955-1969; Consultant Des. to various national manufacturers; Contributor to Industrial Design Magazine, represented in each "Annual Review" issue.

MYHR, DEAN ANDREW—Arts Administrator
 366 Jackson St. 55101; h. 825 St. Clair St., St. Paul, Minn. 55105
B. Swea City, Iowa, Mar. 16, 1930. Studied: Lake Forest (Ill.) College; Univ. Northern Iowa, Cedar Falls, (Graduate work) majoring in Art Education and Administration. Positions: Director, Waterloo Municipal Galleries, 1958-1961; Director of Education, The Minneapolis Institute of Arts, 1961-1964; Director, Rochester (Minn.) Art Center, 1964-1966; Executive Director, Minnesota State Arts Council, 1966- .

NADALINI, LOUIS E.—Painter
 793 Cole St. 94117; h. 1230 Grant Ave, #295, San Francisco, Cal. 94133
B. San Francisco, Cal., Jan. 21, 1927. Studied: ASL, and privately. Member: AEA; East Bay AA; AFA; San Francisco Inst. Artist Assn. Awards: prizes, James D. Phelan Award, 1965, 1967. Exhibited: Village A. Center, N.Y., 1953; American Students & Artists Center, Paris, 1954; San Francisco A. Festivals, 1956-1964; San F. AA, at San Francisco Mus. A., 1957, 1966; Richmond (Cal.) A. Center,

1958, 1959, 1965; Univ. California Ext., 1959; de Young Mem. Mus., 1959, 1962; James Gal., N.Y., 1960; Cadmium Gal., San F., 1962; Cal. PLH, 1963-1965; traveling exh., 1963-1965; Art Bank of San F. AI, 1964-1966; Cornell College, Mt. Vernon, Iowa, 1964; Univ. Notre Dame, 1964; Univ. Nebraska, 1965; Art Across America, traveling exh., 1965; San Francisco A. Comm. traveling, 1968; San Francisco Pub. Library, 1969; Univ. Oregon, 1967; Univ. Utah, 1968; Pensacolo A. Center, 1967; Oakland Mus , 1966-1969; AEA, 1966, traveling, 1966-1968; Western Mus., traveling, 1966-1969; Painting of the Year Comp., SFMA, 1965; and many others; one-man: Lenvoi Gal., 1956, Coffee Gal., 1957, Labaudt Gal., 1960, Cadmium Gal., 1963, Flux Gal., 1964; Arleigh Gal., 1966, all San Francisco; Atlantic City A. Center, 1960; Univ. California, Berkeley, 1967.

NÁGARE, MASAYUKI—Sculptor
 c/o Staempfli Gallery, 44 E. 77th St., New York, N.Y. 10021*

NAGLER, EDITH (KROGER)—Painter, I., T., W.
 Alderbrook Rd., Riverdale, New York, N.Y. 10471; h. Stone House, Huntington, Mass. 01050
B. New York, N.Y., June 18, 1890. Studied: NAD; ASL; & With Douglas Volk, Robert Henri, Frank DuMond. Member: AWCS; AAPL; Springfield A. Lg.; Audubon A. Awards: prizes, Springfield, Mass., 1934; Stockbridge, Mass., 1932; Bronx A. Gld. Work: Wadsworth Atheneum, Hartford, Conn.; Springfield Mus. A.; Highland Park Mus., Dallas, Tex.; Federal Court House, Boston; and in private colls. Exhibited: CGA; AIC; NAD; AWCS, 1932-1946; PAFA; Springfield Mus. A.; BMA; New Haven Paint & Clay Cl.; Bronx A. Gld.; Midtown Gal.; Eastern States Exh., 1957, 1958, 1959, 1960; Grand Central A. Gal., 1957, 1958; Burr Gal., N.Y., 1959 (one-man); Audubon A., 1960-1969; G.W.V. Smith A. Mus., Springfield, Mass. (group & one-man); Springfield Mus. FA, 1969 (one-man).

NAGLER, FRED—Painter, S., Gr., L.
 Alderbrook Rd., New York, N.Y. 10471
B. Springfield, Mass., Feb. 27, 1891. Studied: ASL; & with William Stock, Robert Henri, Frank DuMond. Awards: med., prize, VMFA; CGA, 1941; Springfield Mus. FA; Carnegie award; Altman award, NAD; Hallmark award; Grant, Am. Acad. A. & Lets.; Lamont award, Audubon A. Work: deYoung Mem. Mus.; Lutheran Church, Reading, Pa.; Capehart Coll.; Springfield Mus. A.; AGAA; Temple Univ.; Dwight Chapel, Yale Univ.; Hallmark Coll.; James Michener Coll.; Ranger Fund, NAD; Carl Milles Col. Exhibited: CGA; AIC; Albright A. Gal.; Detroit Inst. A.; PAFA; deYoung Mem. Mus.; Dallas Mus. FA; NAD; WMAA; Carnegie Inst.; CMA; Butler Inst. Am. A.; LC; John Herron AI; Los A. Mus. A.; Univ. Nebraska; Univ. Iowa, and others. One-man: (5) Midtown Gal., N.Y.; Phila. A. All.; G. W. V. Smith A. Mus.; Wesleyan College, Macon, Ga.

NAKIAN, REUBEN—Sculptor
 c/o Egan Gallery, 41 E. 57th St., New York, N.Y. 10022
B. College Point, N.Y., Aug. 10, 1897. Studied: Robert Henri Sch.; ASL. Awards: Guggenheim Fnd. Fellowship, 1930; Ford Fnd. Grant, 1959; prize, Sao Paulo, 1960. Work: MModA; New Sch. A. Center; N.Y. Univ. Exhibited: WMAA; AIC; PAFA; one-man: Felix Landau Gal., Los Angeles, 1967; Downtown Gal., N.Y.; Egan Gallery, N.Y., 1949, 1950, 1952, 1963, 1964; Washington Gal. Mod. A., 1963; Los Angeles County Mus., 1962; Sao Paulo, 1961.*

NAMUTH, HANS—Photographer, Film Maker
 157 W. 54th St. 10019; h. 125 E. 78th St., New York, N.Y. 10021
B. Essen, Germany, Mar. 17, 1915. Awards: Award of Merit, Film Festival of Film Council of Greater Boston, 1953, for Jackson Pollock Film; Special Citation, Gran Premio Bergamo (Italy), Concorso Internazionale del Film d'Arte, 1958; Recognition of Public Service, U.S. State Dept., 1958 (Photos of American Painters). Work: Film: The Image from the Sea (The Painter John Little).*

NAROTZKY, NORMAN (DAVID)—Painter, Gr., Cr.
 Córcega 198-6, Barcelona 11, Spain
B. Brooklyn, N.Y., Mar. 14, 1928. Studied: Brooklyn Col., B.A.; ASL; CUASch.; Atelier 17, Paris; N.Y. Univ., Inst. FA; Univ. Barcelona. Member: ASL; Real Circulo Artistico, Barcelona. Awards: ASL Scholarships, 1945-48; Fellowships: Wooley Fnd., 1954; French Government, 1955; Fulbright, 1956; prizes, CUASch., 1952; Pearl Brewery Award, Texas WC Soc., 1954; PMA purchase, 1956; Hebrew Edu. Soc., 1958. Work: PMA; Museo de Arte Contemporaneo, Madrid and Barcelona. Mural, Banco Guipuzcoano, San Sebastian, Spain; Fayette Bank, Uniontown, Pa.; Allentown A. Mus., Pa. Exhibited: BM, 1952; Nat. Gal., Oslo; 1955-56; Salon de Mai, and Salon des Rèalités Nouvelles, Musée d'art Moderne, Paris; Palais des Beaux Arts, Brussels and museums of Helsinki, Hamburg, Bonn, Berlin and Munich, 1961-62; USIA traveling exh., 1961-62; Sao Paulo Bienale, 1961; Bertha Schaefer Gal., N.Y., 1962; MModA, Columbus Gal. FA, Colorado Springs FA Center, BMA, CAM, SFMA, WAC, 1962-63

("Recent Painting U.S.A."); WMAA, 1962; Fulbright Artists, Germany, 1962-63; Ball State Univ., 1963; Brook St. Gal., London, 1963; Barcelona, 1963-1966; Downey Mus. A., Cal., 1967; Palazzo Strozzi, Florence, Italy, 1968; O'Hana Gal., London, 1968; Grosvenor Gal., London, 1968, and others. One-man: 1957-65—Paris, Munich, Valencia, Barcelona, Lisbon, Madrid, Mallorca; also, Grand Central Moderns, N.Y., 1963, 1965; Lehigh Univ., Pa., 1965; Mills Col. A. Gal., Oakland, Cal., 1966. Articles in Arts Magazine, Art Voices and Leonardo.

NASH, KATHERINE (Mrs. Robert C.)—
 Sculptor, E., L.
 Christmas Lake, Route 3, Excelsior, Minn. 55331
B. Minneapolis, Minn., May 20, 1910. Studied: Univ. Minnesota, B.S.; Minneapolis Sch. A.; Walker A. Center. Member: AEA; S. Gld.; Soc. Minn. Sculptors (Hon. Memb.). Awards: prizes, Minneapolis Inst. A.; Swedish-Am., Exh.; Lincoln A. Gld., 1950; Joslyn A. Mus., 1954; Hon. D.F.A., Doane Col., 1964; Nebraska AA, 1955; Walker A. Center, 1951; Sioux City, 1952; Minnesota State Art Grant, 1969. Work: Univ. Medical Bldg., Omaha; Buffalo (Minn.) Court House; Walker A. Center; Lincoln A. Gld.; Nebraska AA; Kansas State Col.; Concordia Col.; Minneapolis Pub. Lib.; Joslyn A. Museum; Omaha Assoc. A.; Houston, Tex.; Council Bluffs, Iowa; Doane Col.; Edina (Minn.) Library Sc., 1968. Exhibited: Minneapolis Inst. A.; Minn. State Fair; Walker A. Center; St. Paul Gal.; Lincoln A. Gld.; Joslyn A. Mus.; Nebraska AA; Springfield A. Mus.; Denver A. Mus.; SFMA; Kansas City AI; St. Louis; Univ. Manitoba, Canada; Des Moines A. Center; S. Center, N.Y.; WMAA; Cranbrook Acad.; Indianapolis, Ind.; CM; World House Gal., N.Y.; Brussels World's Fair; London, England, and others; Minn. Council of the Arts traveling exh., 1969-70; U.S. Embassy traveling exh., 1967-69; one-man: Univ. Manitoba; Sioux City A. Center; WAC; Gump's Gal., San F.; Minneapolis Inst. A.; Lewinson Gal., Los A.; Tweed Gal., Duluth; Columbus Mus., Doane Col.; Rochester A. Mus. Positions: Prof. Sculpture, Univ. Minnesota, Minneapolis. Minn.

NASH, RAY—Writer, E., L., Cr.
 Dartmouth College, Hanover, N.H. 03755; h. Royalton, Vt. 05063
B. Milwaukee, Ore., Feb. 27, 1905. Studied: Univ. Oregon, B.A.; Harvard Univ., M.A. Member: CAA; Am. Antiquarian Soc.; Bibliographical Soc., London; AIGA (Hon. life memb.); F., Am. Acad. A. & Sciences; Int. P.E.N.; Cor. Memb., Mass. Hist. Soc. Awards: F., Belgian-Am. Edu. Fnd.; Hon. Degree, A.M., Dartmouth Col.; gold med., AIGA, 1956; Art D., New England Col.; C.R.B. Educational Foundation Fellowship for study of Flemish art; Ford Foundation grant for bibliography study in England; decorated Officier Order of Leopold (Belgium); Fellow, Society of Antiquaries of London; Member, commission on paleography, Federation Internationale des Institute et Societes pour l'Etude de la Renaissance. Author: "Calligraphy and Printing in the Sixteenth Century," 1940 (enl. & Illus. 1964); "Durer's 1511 Drawing of a Press and Printer," 1947; "Printing as an Art," 1955; "American Writing Masters and Copybooks," 1959; "American Penmanship, 1800-1850," 1969. Ed., "Renaissance News"; Ed., "Printing and Graphic Arts." Positions: Prof., Hist. Gr. A., Printing Advisor, Dartmouth Col., Hanover, N.H., 1937- ; Advisor, Musee Plantin-Moretus, Antwerp, 1953; Visiting L, Univ. Oregon; Amherst Col.; Antwerp Int. Congress on Printing and Humanism.; Harvard Phi Beta Kappa Orator, 1960. Bd. Educational Advisors, Marlboro College, Montegna Convegno, Florence, Venice, Mantua.

NASON, THOMAS W.—Engraver, Et., I., P.
 R.F.D. 2, Old Lyme, Conn. 06371
B. Dracut, Mass., Jan. 7, 1889. Studied: Tufts Col., M.A. (hon. degree). Member: NA; Nat. Inst. A. & Let.; F., Am. Acad. A. & Sciences; Lyme AA. Awards: prizes, Phila. Pr. Cl., 1929, 1930; AIC, 1930; City of Warsaw, Poland, 1933; Lib. Cong. 1943, 1945; SAE, 1935, 1938, 1945, 1950, 1951; Woodcut Soc., Kansas City, Mo., 1937; Albany Pr. Cl., 1946. Work: N.Y. Pub. Lib.; BM; WMAA; AIC; CMA; AGAA; Smithsonian Inst.; BMFA; Boston Pub. Lib.; Victoria & Albert Mus., London, England; Bibliotheque Nationale, Paris, France.

NATKIN, ROBERT—Painter
 924 West End Ave., New York, N.Y. 10025
B. Chicago, Ill., Nov. 7, 1930. Studied: Art Inst. Chicago, B.A. Work: Guggenheim Mus., N.Y.; WMAA; Los A. Mus. A.; Carnegie Inst.; Hartford Atheneum; Inst. Contemp. A., Boston; Univ. Illinois; N.Y. Univ.; Riverside Mus.; WMA, SFMA. Exhibited: AIC, 1963; Carnegie Inst., 1963; Int. Biennale, Japan, 1963; Mus. FA of Houston, 1963; PAFA, 1962; WMAA, 1960; Retrospective, SFMA, 1969; Galerie Facchetti, Paris, 1968.

NATZLER, GERTRUD—Ceramic Craftsman
 7837 Woodrow Wilson Dr., Los Angeles, Cal. 90046
B. Vienna, Austria, July 7, 1908. Awards: med., Paris Salon, 1937; prizes, Everson Mus. FA, 1939-1941, 1946, 1956, 1958, 1960; Cal.

State Fair, 1948, 1949, 1952, 1954, 1955, 1956 (2), 1957; Los Angeles County Fair, 1948, 1949, 1951; "Good Design" award, MMoDA, 1952, 1953; Silver Medal, Int. Ceramic Exh., Prague, 1962. Work: MMoDA; Everson Mus. FA; San Diego FA Soc.; BMA; CM; PMA; Santa Barbara Mus. A.; SAM; Los A. Mus. A.; AIC; Walker A. Center; Detroit Inst. A.; Univ. Minnesota; Univ. Oregon; Cranbrook Acad. A.; Newark Mus.; Slater Mem. Mus.; Dallas Mus. FA; Portland A. Mus.; Univ. Wisconsin; MMA; SFMA; Joslyn A. Mus.; Ft. Worth A. Center Mus.; Palm Springs Desert Mus.; Oakland A. Mus.; Mills Col., Oakland; Univ. Nebraska; Springfield A. Mus.; UCLA; Cal. State Fair Coll.; Arizona State Col.; Mus. FA of Houston; Faenza, Italy; Kunstgewerbe Mus., Zurich; Kantonal Mus., Berne, Switzerland; Phoenix A. Mus.; Krannert A. Mus., Univ. Illinois; La Crosse (Ind.) State Col.; St. Paul A. Center; Crocker A. Gal., Sacramento; Smithsonian Inst.; Northwestern Univ., Evanston, Ill. Exhibited: one-man: SFMA; Los A. Mus. A.; San Diego FA Soc.; Santa Barbara Mus. A.; AIC; Mus. FA of Houston; Bezalel Mus., Israel; Mus. Mod. A., Haifa, Israel; Zurich, Switzerland; Stedelijk Mus., Amsterdam; CM; Tulane Univ.; St. Paul A. Center; Joslyn A. Mus., Omaha; Jewish Mus., N.Y., SFMA; Los Angeles County Mus., (retrospective exh.) 1966; Palm Springs Desert Mus., 1968; Mus. Contemp. Crafts, N.Y.; Birger Sandzen Mem. Gal., Lindsborg, Kans. Documentary Film, "The Ceramic Art of the Natzlers," produced by Los Angeles County Museum, 1968.

NATZLER, OTTO—Ceramic Craftsman
7837 Woodrow Wilson Dr., Los Angeles, Cal. 90046
B. Vienna, Austria, Jan. 31, 1908. Awards: med., Paris Salon, 1937; prizes, Everson Mus. FA, 1939-1941, 1946, 1956, 1958, 1960; Cal. State Fair, 1948, 1949, 1952, 1954, 1955, 1956 (2), 1957; Los Angeles County Fair, 1948, 1949, 1951; "Good Design" award, MMoDA, 1952, 1953; Silver Medal, Int. Ceramic Exh., Prague, 1962. Work: MMoDA; Everson Mus. FA; San Diego FA Soc.; BMA; CM; PMA; Santa Barbara Mus. A.; SAM; Los A. Mus. A.; AIC; Walker A. Center; Detroit Inst. A.; Univ. Minnesota; Univ. Oregon; Cranbrook Acad. A.; Newark Mus.; Slater Mem. Mus.; Dallas Mus. FA; Portland A. Mus.; Univ. Wisconsin; MMA; SFMA; Joslyn A. Mus.; Ft. Worth A. Center Mus.; Palm Springs Desert Mus.; Oakland A. Mus.; Mills Col., Oakland; Univ. Nebraska; Springfield A. Mus.; UCLA; Cal. State Fair Coll.; Arizona State Col.; Mus. FA of Houston; Faenza, Italy; Kunstegewerbe Mus., Zurich, Switzerland; Kantonal Mus. Mus., Berne; Phoenix A. Mus.; Krannert A. Mus., Univ. Illinois; La Crosse (Ind.) State Col.; St. Paul A. Center; Crocker A. Gal., Sacramento; Smithsonian Inst.; Northwestern Univ., Evanston, Ill. Exhibited: one-man: SFMA; Los A. Mus. A.; San Diego FA Soc.; Santa Barbara Mus. A.; AIC; Mus. FA of Houston; Bezalel Mus., Israel; Mus. Mod. A., Haifa, Israel; Zurich, Switzerland; Stedelijk Mus., Amsterdam; CM; Tulane Univ.; Joslyn A. Mus., Omaha; Jewish Mus., N.Y.; SFMA; Los Angeles County Mus., (retrospective exh.) 1966; Palm Springs Mus., 1968; St. Paul A. Center; Mus. Contemp. Crafts, N.Y. Author: "Natzler Ceramics in the L.M. Sperry Collection," monograph, 1968; Documentary Film, "The Ceramic Art of the Natzlers," produced by Los Angeles County Museum, 1968.

NAUMER, HELMUTH—Painter
Rancho de San Sebastian; h. Rte. 3, Box 39A, Santa Fe, N.M. 87501
B. Reutlingen, Germany, Sept. 1, 1907. Studied: in Germany; Frank Wiggins Sch. A., and with Franz Weegman, Josef Reichelt. Member: Am. Inst. FA. Work: Mus. New Mexico, Santa Fé; Governor's Mansion, Santa Fé; Univ. New Mexico; Univ. Wyoming; Bandelier & White Sands nat. monuments, New Mexico; New Mexico Sch. of Mines, Socorro; Wichita A. Mus.; Oakland (Cal.) Mus.; El Paso Mus. A.; Frank Lloyd Wright's "Wing Spread," Milwaukee, Wis., and in many private colls. U.S., Canada, Mexico and Europe. Exhibited: Springfield, Utah, 1941, 1946; Mus. New Mexico, Santa Fé, annually, with one-man exh., 1935-1965; other one-man exhs., New York, Philadelphia and Los Angeles. Also exhibited: Johannesburg, South Africa, 1966; AAMus. and Canadian Mus. Assn. joint meetings, Toronto, Canada, 1967.

NAVAS, ELIZABETH S. (Mrs. Rafael)—Collector, Critic
250 E. 63rd St., New York, N.Y. 10021
B. Coffeyville, Kans., June 29, 1895. Studied: Teachers College, Columbia University, and private art study. Collection: American Art of the 18th, 19th, 20th centuries. Member: College Art Assn.; Municipal A. Soc.; Metropolitan Museum of Art; American Federation of Arts. Interior Designer in New York, Washington, D.C. and in Kansas. Positions: Trustee of the Louise C. Murdock Collection, 1915- ; purchaser and Administrator of the Roland P. Murdock Collection, Wichita Art Museum, Kansas, 1939- . Honorary Trustee, 1966- , The American Federation of Arts. Served on all committees of the AFA.

NAVIN, RICHARD—Sculptor
160 W. 88th St., New York, N.Y. 10024
B. 1934. Exhibited: WMAA, 1964.*

NAY, MARY SPENCER (Mrs. Lou Block)—Painter, Gr., E.
207 S. Galt Ave., Louisville, Ky. 40206
B. Crestwood, Ky., May 13, 1913. Studied: Louisville A. Center Assn. Sch.; Univ. Louisville, A.B.; Cincinnati A. Acad., with Maebelle Stamper; ASL, with Kuniyoshi, Barnet, Grosz; Int. Sch. A., Mexico, with Merida, Zalce. Member: Louisville A. Center Assn.; Louisville A. Cl.; Western AA; Kentucky Edu. Assn. Awards: prizes, Aetna Oil purchase award, 1945, 1950; Evansville Tri-State Exh.; Ohio Valley Exh., Athens, 1954 (purchase), 1955; Kentucky State Fair, 1954; Woman's Cl., 1955; medal, IBM, 1940. Work: Univ. Louisville; Evansville Pub. Mus.; J.B. Speed A. Mus.; Univ. Athens (Ohio), and in private colls. Mural, Children's Room, Louisville Pub. Lib. Exhibited: Int. Color Litho. Exh., Cincinnati, 1950, 1952, 1954; AIC, 1950, 1954; MMA, 1942; WFNY, 1939; Minneapolis Print Exh., 1951; Ohio Valley Exhs., 1942-1955; Evansville, 1951-1955; W. Va. Regional, 1947-1954; Va. Intermont, 1946-1952; Ky.-So. Indiana Exhs., 1928-1955; Ky. State Fair, 1948-1955; Contemp. A. Soc., Cincinnati, 1955; Louisville Woman's Cl., annually; Louisville A. Cl., annually; one-man, Ruth White Gal., N.Y., 1963. Positions: Instr., Louisville A. Center Sch., 1935-56; Dir., 1944-49; Assoc. Prof. A., Univ. Louisville, 1964.*

NAYLOR, ALICE (Mrs. James K.)—Painter, Lith., T.
Incarnate Word College; h. 125 Magnolia Dr., San Antonio, Tex. 78202
B. Columbus, Tex. Studied: Witte Mem. Mus. Sch. A.; San Antonio AI, and with Charles Rosen, Etienne Ret, Andrew Dasburg, Xavier Gonzalez, Dan Lutz. Member: San Antonio A. Lg.; Palette & Chisel Cl.; San Antonio Pr.M.; Texas FA Assn. (Trustee); Nat. Soc. A. & Let.; River A. Group; Texas WC Soc.; Beaumont A. Lg.; Contemp. A. Group (Pres.); San Antonio Craft Gld.; Texas A. Educators Assn. Exhibited: CM, 1945; Mus. New Mexico, 1945; Texas FA Assn.; LC, 1943; Austin, Tex., 1942; Texas WC Exh., 1950-1955; Beaumont A. Mus.; Corpus Christi A. Mus.; Romano Gal., Mexico City (4-man), 1950; Escuela Nationale, Mexico City (4-man), 1950; Sul Ross Col.; A. & M. Col., Bryan, Tex.; Designs for Living Gal., San Antonio; Laguna Gloria Mus., Austin; Elisabet Ney Mus., Austin; Texas Fed. Women's Cl., Austin (one-man); Incarnate Word Col. (one-man); Southwest Texas State T. Col. (one-man); and others. Awards: numerous prizes and awards, 1943-1965. "Woman Artist of the Year," Express-News, San Antonio, 1953; "Headliner in Art," Theta Sigma Phi, 1961. Positions: A. Faculty, San Antonio A. Inst., 1949-1960; Incarnate Word College, 1960-1965.

NEAL, (MINOR) AVON—Printmaker, W., L.
Thistle Hill, North Brookfield, Mass. 01535
B. Indiana, July 16, 1922. Studied: Long Beach (Cal.) Col.; Escuela de Bellas Artes, Mexico, M.F.A. and with Siqueiros. Member: Advisory Bd., Mus. of American Folk Art, New York City. Awards: Ford Fnd. grant, 1962-1963, 1963-1964. Work: BM; FMA; MMA; Amon Carter Mus., Fort Worth; N.Y. Pub. Library; Smithsonian Inst.; Toledo Mus. A.; Winterthur Mus., Delaware; Univ. Cal. at Los Angeles; Univ. Florida; Univ. St. Thomas; Wadsworth Atheneum, Hartford; American Mus. in Britain; Albany Inst. Hist. & Art; International Folk Art Mus., Santa Fe; Rosenwald Coll.; Paul Mellon Coll.; Abby Aldrich Rockefeller Mus. Am. Folk Art; N.Y. State Historical Coll.; Milwaukee A. Center, and others. Exhibited: Over 30 one-man and two-man exhs. (with Ann Parker) including: BM, 1961, 1963; Carnegie Inst., 1963; Princeton Univ., 1963; Smith Col. Mus., 1963; Detroit Inst. A., 1964; Abby Aldrich Rockefeller Mus. Am. Folk A., 1964; American Embassy, London, 1965; Cooperstown, N.Y. (Fenimore House), 1966; Amon Carter Mus., 1968; Hallmark Gal., N.Y., 1968; Smithsonian Inst., 1968; N.Y. State Mus. Hist. & Art, 1969. (several of these exhs. have become traveling exhs.). Author: "Ephemeral Folk Figures," 1969. Co-author, I., "Rubbings from Early American Stone Sculpture," 1964. Contributor article and illus. to: Artists Proof, Art in America, Craft Horizons, Time, Look, N.Y. Times Magazine; New England Quarterly, Ciba Journal; Vermont Life and other publications. Lectures on Folk Art, universities, museums, television and radio.

NEAL, REGINALD H.—Educator, P., Gr.
Art Dept., Douglass College—Rutgers University, New Brunswick, N.J. h. Circle Drive, R.D. No. 1, Lebanon, N.J. 08833
B. Leicester, England, May 20, 1909. Studied: Bradley Univ., B.Sc.; Univ. Chicago, M.A.; Yale Univ. Sch. FA; Univ. Iowa. Member: CAA. Work: Davenport Mun. A. Gal.; LC; MMoDA; Queen's Col., Kingston, Canada; Brigham Young Univ.; Brooks Mem. Gal.; Decatur A. Center; So. Illinois Univ.; CM; Grenchen A. Soc., Switzerland; Wadsworth Atheneum; Chrysler A. Mus.; James A. Michener Coll.; Des Moines A. Center; Univ. Massachusetts Mus.; Atlanta AA; New Jersey State Mus. Exhibited: AIC, 1935, 1951; PAFA, 1936, 1938, 1940; MMA, 1952; CM, 1954; A. Soc., Grenchen, Switzerland; Lyublyana, Yugoslavia; Amel Gal., N.Y., 1964; MMoDA, 1965; World House Gal., 1965; Des Moines A. Center, 1966; New Jersey State Mus., 1967; Camden A. Center, London, 1967; East Hampton Gal., N.Y., 1968; Mus. Mod. A., Belgrade; one-man: Salpeter Gal.,

N.Y., 1953; Assoc. Am. A., 1950; Alan Stone Gal., N.Y., 1961; Contemporaries Gal., N.Y., 1956; Amel Gal., N.Y., 1965, 1966; A.M. Sachs Gal., 1968; Primus-Stuart Gal., Los Angeles, 1962. Lectures: tours for Assn. Am. Colleges, 1953, 1954; Lecture-Demonstrations on Lithography; Film: "Color Lithography—An Art Medium," produced 1954 (Golden Reel Award); Univ. Miss., with demonstration and narration. Positions: Chm., Dept. A., Douglass College—Rutgers Univ., New Brunswick, N.J., at present.

NEHER, FRED—Cartoonist
 1 Neher Lane, Boulder, Colo. 80302
B. Nappanee, Ind., Sept. 29, 1903. Studied: Chicago Acad. FA. Member: SI; A. & Writers Soc.; Nat. Cartoonists Soc.; Denver Press Cl. Awards: U. S. Treasury Dept.; Am. Red Cross. Work: Syracuse Univ. Manuscript Coll.; Albright-Knox Col.; Butler Inst. Am. A. Creator of cartoon "Life's Like That," for Bell-McClure Syndicate, 1934- . Instr., Cartooning, Univ. Colorado.

NEIKRUG, MARJORIE (CAMPE)—Writer, Art Dealer, Consultant
 224 E. 68th St., New York, N.Y. 10021
B. New Rochelle, N.Y., Aug. 24, 1920. Studied: Sarah Lawrence College. Specialty of Gallery: Fine Arts; Pre-Columbian. Positions: Art Critic, Chelsea News. Organizational Consultant for art exhibitions and art collectors. Senior Appraiser, American Society of Appraisers.

NEILSON, KATHARINE B(ISHOP)—Educator, L., W.
 460 Middlesex Road, Darien, Conn. 06820
B. New York, N.Y., Apr. 8, 1902. Studied: Bryn Mawr Col., A.B.; Radcliffe Col., A.M., Ph.D. Member: AFA; CAA; AAMus.; Archaeological Assn. Am. Author: "Filippino Lippi: A Critical Study," 1938. Contributor of articles and book reviews to art periodicals. Positions: Instr., Asst. Prof. A., Assoc. Prof. A., Wheaton Col., 1933-43; Cur. Edu., Albright A. Gal., Buffalo, N.Y., 1943-49; Acting Dir. Edu. & Public Relations, Mus. A., R.I. Sch. Des., Providence, R.I., 1949-52; Dir. Edu. & Ed. Museum Publications, Mus. A., R.I. Sch. Des., 1952-55; Edu. Dir., Wadsworth Atheneum, Hartford, Conn., 1955-68; Assoc. Prof. A., Hartford College, 1955-68. Editorial Associate, Yale Univ. Art Gal., 1968- .

NEIMAN, LEROY—Painter, T.
 1 W. 67th St., New York, N.Y. 10023
B. St. Paul, Minn., June 8, 1921. Studied: AIC; Univ. Chicago; Univ. Illinois. Member: AAUP. Awards: Gold Medal, Salon d'Art Moderne, Paris, 1961; prizes, Twin-City exh., Minneapolis, 1953; Minnesota State Exh., 1954; Clark Mem. Prize, AIC, 1957 and Municipal Prize, 1958; Ball State Univ., 1958; Mississippi Valley Exh., purchase, 1959. Work: Minneapolis Inst. A.; Illinois State Mus.; Joslyn A. Mus.; Wodham Col., Oxford, England; Harding Mus., Chicago; Nat. Mus. of Sport in Art, New York, N.Y. Murals, Continental Hotel, Chicago; Mercantile Nat. Bank, Hammond, Ind.; Swedish Lloyd ship "SS Patricia," Stockholm. Exhibited: Carnegie Inst., 1956; CGA, 1957; AIC, 1957, 1960; Herron A. Mus., 1965; Chicago & Vicinity Exhs., AIC, 1954-1960; St. Paul, 1952, 1954; WAC, 1957; Toledo Mus. A., 1957; Ringling Mus., 1959; Butler Inst. Am. A., 1960; Des Moines A. Center, 1960; one-man: Oehlschlager Gal., Chicago, 1961; O'Hana Gal., London, 1962; Galerie Bosc, Paris, 1962; Hammer Gal., N.Y., 1963, 1965, 1967; Heath Gal., Atlanta, 1969; Gal. Mod. A., N.Y., 1967; The Choate Sch., Wallingford, Conn., 1969; French Center, Chicago, 1965. Positions: Instr., Drawing, Art Institute of Chicago, 1950-1960; Painting, Winston-Salem A. Center, 1964. Instr., drawing and painting, Atlanta Art Council, 1968-1969.

NELSON, GEORGE LAURENCE—Painter, Lith., L.
 Kent, Conn. 06757
B. New Rochelle, N.Y., Sept. 26, 1887. Studied: NAD; ASL; Julian Acad., Paris, with J.P. Laurens. Member: NA; Kent AA (Pres.); Grand Central Gal.; AWS; NAC; AllA.Am.; SC; Conn. Acad. FA. Awards: med., NAD, 1921; NAC, 1939, 1960; prizes, Conn. Acad. FA, 1926, 1935; Meriden (Conn.) A. & Crafts Soc., 1945, 1964. Work: Portraits, NAD; NAC; Am. Acad. A. & Let.; N.Y. Hospital, Mt. Sinai Hospital, N.Y.; N.Y. Acad. Medicine; Univ. Buffalo; New Britain A. Mus.; Bennington (Vt.) Hist. Soc.; Peace Palace, Geneva, Switzerland; "Cochran House," Fairfield State Hospital, Newtown, Conn.; Canterbury Sch., New Milford, Conn.; Canajoharie A. Gal.; South Kent Sch., Conn.; Shipley Sch., Bryn Mawr, Pa.; lithographs, MMA; N.Y. Pub. Lib.; Carnegie Inst.; mural, Pub. Sch., Bronx, N.Y. Exhibited: Los A. Mus. A.; Toledo Mus. A.; Albright A. Gal.; Rochester Mem. A. Gal.; Montclair A. Mus.; AIC; John Herron AI; Texas State Fair; Detroit Inst. A.; Maryland Inst.; Retrospective Exh., "Fifty Years of Painting," New Britain A. Mus., 1958; Choate School, Wallingford, Conn. (1960) with demonstration (one-man). Lectures: Portrait Painting; Still Life and Flowers, with demonstrations, Conn. AA; Meriden A. & Crafts Assn.; Washington (Conn.) AA; Kent AA, and others. Positions: Instr., Drawing & Painting, CUASch, 1915-23; Instr., Drawing, NAD, New York, N.Y., 1915-1941.

NELSON, HANS PETER—Industrial Designer, E., I., C.
 Wayne State University, Detroit, Mich. 48202; h. 532 North York Blvd., Dearborn, Mich. 48128
B. Chicago, Ill. Studied: Illinois Inst. Technology, B.S. Northwestern Univ.; Wayne State Univ., M.A. Member: AAUP; Am. Ordnance Assn.; Am. Soc. for Engineering Edu.; Nat. Eng. Register; AIA. Exhibited: BM, 1945, 1961; Detroit Inst. A., 1953-1955; Dearborn Hist. Mus., 1956, 1958; Dearborn AI, 1956, 1957; Ecclesiastical A. Gld. of Detroit; J.L. Hudson Co. A. Gal., 1957; Detroit Pub. Lib., 1957; Mus. Science & Indst., Chicago, 1960; AIA, Detroit, 1961; Smithsonian Institution, 1966; Tekniska Museet Nat. Mus. Science & Technology, Sweden, 1966; Oregon Mus. Science & Industry, 1966; Kunstgewerbemuseum, Zurich, 1966. Awards: Army-Navy Prod. Award, for Excellence in Manufacturing, 1944; Ill. Inst. Tech. Alumni award, 1951; Fine Hardwoods Asn., 1960; Precision Instrument Components Des. Corp., Gold Key award for Recommendations to Industry, 1960; Des. publ.: "Modern Plastics," "Plastics," "Armour Research Bulletin." Contributor to Industrial Finishing magazine, "Design of the Little Chef," 1947; Author: articles, "Tomorrow's Toy Designers Go To School" and "Designs of the Future," Toys and Novelties magazine, 1949, 1950. Author: "A Guide to Technical Illustration," Machine Design magazine, 1958; "Graphical Communications for the Design Engineer," 1967, Design News magazine. Positions: Indst. Des., Bureau of Des., Montgomery Ward & Co., Chicago, and Westclox Co., Peru, Ill.; Hd., Indst. Des., Tacoma (Wash.) Metal Products Co., 1949-51; private practice, Indst. &.Arch. Des., 1946- ; Assoc. Prof. A. Wayne State Univ., Detroit, Mich., 1952- .

NELSON, LEONARD L.—Painter, T., Gr., S.
 825 N. 27th St., Philadelphia, Pa. 19130
B. Camden, N.J., Mar. 5, 1912. Studied: PAFA; Barnes Fnd.; PMSchIA. Member: Phila. Pr. Cl. Awards: Cresson traveling scholarship, PAFA, 1939, 1956; prize, Nat. Woodblock Exh., 1948. Work: PMA; Walker A. Center. Exhibited: PAFA, 1943, 1946, 1949-1958; Phila. Pr. Cl., 1946 (one-man); Brandt Gal., 1944, 1945; Phila. A. All., 1944, 1958 (one-man); PMA, 1946; BM, 1946, 1950-1952; MModA, 1950-1952; Binet Gal., 1950; one-man: Moore Inst. A., 1948; Dubin Gal.. Phila., 1949-1952; Peridot Gal., New York, 1949; Hugo Gal., 1954; Dubin Gal., Phila., 1955; Newman Gal., Phila., 1961. Positions: Prof. A., Moore College of Art, Philadelphia, Pa.*

NELSON, LUCRETIA—Educator, P.
 Department of Decorative Art, University of California, Berkeley, Cal.; h. 1641 Grand View Dr., Berkeley, Cal. 94705
B. Nashua, N.H., Feb. 19, 1912. Studied: Univ. California, A.B., M.A.; California Inst. Tech. Member: San F. AA; CAA; AAUP. Awards: Taliesin F., 1934-1935; European scholarship, Univ. California, 1936-1937; prize, San F. Soc. Women A., 1944. Exhibited: PAFA, 1938; SAM, 1947 (one-man); deYoung Mem. Mus.; San F. AA. I., "Textiles of the Guatemala Highlands," 1945. Positions: Instr. Design, 1938-42, Asst. Prof. Design, 1942-46, Assoc. Prof. Des., 1946-52; Chm., Dept. Dec. Art, 1954-1961; Prof. Des., 1956- , Univ. California, Berkeley, Cal.*

NELSON, RICHARD L.—Educator, P., L.
 Department of Art, University of California; h. 752 Campus Way, Davis, Cal. 95616
B. Georgetown, Tex., Feb. 27, 1901. Studied: AIC; Stevens Inst. Tech., Univ. California, Berkeley, B.A., M.A.; Ecole des Beaux-Arts, Paris. Member: Pacific AA; CAA; Am. Soc. for Aesthetics; Western A. Dirs. Assn. Awards: prizes, San F. AA, 1950; SFMA, 1953; Crocker Mus. A., Sacramento, 1953. Exhibited: nationally, including SFMA, 1950, 1951, 1953, 1954; Oakland A. Mus., 1954; deYoung Mem. Mus., 1956, 1958; California State Fair, 1953, 1955-1957, and in Canada. Lectures: Contemporary Art & Aesthetics. Positions: Prof. A., Washington State College, 1948-52; Prof. A., Chm., A. Dept., Univ. of California, Davis, Cal., at present. Director of Laboratory for Research in Fine Arts & Museology, Univ. of Cal., Davis, Dal., 1966-1969.

NELSON, ROBERT ALLEN—Painter, E., Pr. M.
 2509 9th Ave., Grand Forks, N.D. 58201
B. Milwaukee, Wis., Aug. 1, 1925. Studied: Art Inst. Chicago, B.A.E., M.A.E. Member: Boston Pr. M.; SAGA. Awards: prizes, Knoxville, Tenn., Nat. Drawing Exh., 1962; North Dakota Annual, Grand Forks, 1960; purchase prizes: WAC, 1964; Wisconsin Salon, 1964; Butler Mus. Am. A., 1961, 1963; North Dakota Annual, 1962; Ball State, Muncie, Ind., 1961, 1968; Norfolk Mus. A. & Sciences, 1969; Fla. State Univ., 1967; SAM, purchase, 1968; Bucknell Univ., 1967; Ohio State Univ., 1968; N.Y. State Univ., Potsdam, 1968 (2); No. Illinois Univ., 1968; Albion Col., 1968; Winnipeg, Canada, 1968; Danforth Teachers Grant, 1963-1964. Work:WAC; Univ. Tennessee, Knoxville; Univ. Omaha; Allentown (Pa.) Mus. A.; Madison (Wis.) Properties Coll.; Concordia Col., Moorhead, Minn.; Univ. North Dakota; Ball State Univ., and others. Murals, Univ. North Dakota

hester Fritz Library; Bridston Savings & Loan Co. (mosaic outdoor mural); The Viking School (tile mural), Grand Forks, N.D.; oslyn Mus. A.; Univ. Texas; N.Y. State Univ., Potsdam; No. Illinois niv.; Butler Mus. Am. A.; Univ. Florida; SAM; Bucknell Univ. Exhibited: Mead Co., traveling exh., 1963; MModA, 1961; CGA, 1961; Wisconsin Salon, 1961-1964; WAC, 1964; Butler Mus. Am. A., 1962-966; Ball State Univ., 1962, 1963, 1965, 1968; Watercolor:USA, 1963; Denver Mus. A., 1962-1965; Pratt Graphic . Center, N.Y., 1964, 1967; BM, 1964, 1968, 1969; Joslyn Mus., maha, 1962-1965, 1969. Boston Printmakers, 1962, 1963, 1965, 968, 1969; PAFA, 1965; Univ. North Dakota, 1962-1965; Okla. Printmakers, 1961, 1963, 1964, 1969; Red River Annual, 1961-1964, 1969; AM, 1968, 1969; Valley City, 1961-1963, 1968, 1969; Positions: Prof. A., University of North Dakota; also, taught at Univ. Manitoba, Winnipeg, Canada, AIC.

ELSON, ROLF G.—Gallery Director, P., S., Gr.
11355 Farlin St., Los Angeles, Cal. 90049
. New York, N.Y., Sept. 11, 1935. Specialty of Gallery: Modern Masters. Positions: Director, Rolf Nelson Gallery, Los Angeles, al.

EMEC, NANCY—Graphic Artist, P.
11 Kent Ave., Hastings-on-Hudson, N.Y. 10706
. Pinehurst, N.C., Nov. 30, 1923. Studied: Colby Jr. Col. New London, N.H.; Vesper George Sch. A., Boston. Member: Yonkers AA; ilvermine Gld. A.; Pr. Council of Am., NAWA; Knickerbocker A.; Wash. WC Assn.; New Hampshire AA; Hunterdon County A. Center; m. Color Pr., Soc.; Print Cl. of Albany; Miniature Painters & Gravers Soc.; Academic AA; AEA; Westchester A. Soc. (Past Pres.). Awards: prizes, Hudson River Mus., Yonkers AA, 1958-1960, 1964, 966; N.Y. State Year of History Exh. at Hudson River Mus., 1959 World Book Co. award), 1959; NAWA, 1959, 1962, 1963, 1965; Brick core Mus., 1959, 1960; Knickerbocker A., 1960, 1965; New Hampshire AA, 1968; Audubon A. medal, 1968; N. Jersey P. & S., 1967; Westchester A. & Crafts Gld., 1959, 1960, 1965, 1967, 1968; Westchester Fed. Women's Cl., 1960; Hecht Co. award, Wash. WC Assn., 964; other prizes, Texas-Okla. A. Festival, Lawton, Okla; Saugatuck-Douglas A. Festival, Mich.; purchase prize, W. Va. Wesleyan ol.; Jameson award, Miniature Painters & Gravers, prizes, 1963, 966, 1968; Work: LC; New Britain Mus. Am. A., Conn.; Stamford Mus.; Holyoke (Mass.) Mus.; Hudson River Mus., N.Y.; Phila. Free Lib.; New York Hospital; Greenville (S.C.) Mus. A.; Edition (1960, 962, 1965) for Collectors of Am. Art. Exhibited: Audubon A., 1960, 961, 1966-1969; P. & S. of New Jersey, 1958-1969; Conn. Acad. FA, 958-1961, 1966-1968; Wash. Pr. M., 1960; Wash. WC Assn., 959-961, 1966-1969; Am. Color Pr. Soc., 1960, 1966-1969; Knickerbocker ., 1958-1964, 1966-1968; Newport AA, 1958-1964; NAC, 1958, 1959; AWA, 1959-1961, 1966-1969; Northwest Pr. M., 1961; other group xhs; 1961-1969—Silvermine Gld. A.; Phila. Pr. Cl.; Springfield A. g.; Academic A.; Hunterdon County A. Center; Auburn Univ.; Ohio niv.; Pr. Cl. of Albany; Min. P. & S. Soc.; NAD; New Hampshire AA; r. Cl. of Albany; Pratt Inst., Brooklyn; Butler Inst. Am. A.; Newport A, and others. One-man: Hudson River Mus., 1959, 1962; Gulf Coast . Center, Clearwater, 1959; Albany Inst. Hist. & Art, 1962, ilvermine Gld. A., 1962; Westfield Atheneum, Jasper Rand Mus., 963; LaSalle Col., Phila., 1963; Modern Masters Gal., N.Y., 1964; St. dwards Univ., Austin, Tex., 1964; East Central State Mus., Ada, kla.; W. Va. Wesleyan Col., 1964; Jersey City FA Lib., 1965; Tuskegee Inst., 1967; Arizona State Univ., 1966; Univ. Oregon, 1966, and many others.

EPOTE, ALEXANDER—Painter, E., L.
410 Taylor Blvd., Millbrae, Cal. 94030
. Valley Home, Cal., Nov. 6, 1913. Studied: Cal. Col. A. & Crafts, .A. in A. Edu.; Mills Col.; Univ. California, M.A. Member: Cal. WC c.; San F. A. Inst; Peninsula AA. Awards: Phelan Award, San F., 41-42; Cal. WC Soc., 1955 (purchase); Oakland A. Mus., 1955 (purhase); prizes, Oakland A. Mus., 1947, 1948; San Mateo County Fair, 954-1957, 1969; San F. A. Festival, 1951-53, 1959, 1960 (purchase); FMA, 1953; Pasadena A. Mus., 1957 (purchase); Cal. State Fair, 957, 1958; Peninsula A. Festival, 1958; CAL.PLH, 1958; silver edal, Oakland A. Mus., 1957; Century Bank award, Cal. WC Soc., 963; No. California A, 1965; Jack London Square Exh., 1965; Rio ondo, Cal., 1968. Work: SFMA; Oakland A. Mus.; Los A. Mus. A.; asadena A. Mus.; CAL.PLH; Mills Col.; Univ. Michigan; San F. Mun. oll.; Denver A. Mus. Exhibited: United Nations Conf. Exh., 1945; rand Central A. Gal., N.Y., 1948; CAL.PLH, 1947, 1948, 1952, 959-1961; Univ. Illinois, 1951, 1952; WMA, 1951; AFA traveling xhs., 1958-1959; MMA, 1952; Sao Paulo, Brazil, 1955; SFMA, 1955; rovincetown, Mass., 1958; Art: USA, 1958; West Coast Museums, 957 and AFA traveling exh.; Americans, 1962, VMFA. Positions: rof. A., Dean of Faculty, Cal. Col. A. & Crafts, Oakland, 1945-950; Prof. A., San F. State Col., San Francisco, Cal., 1950- .

NESBITT, ALEXANDER JOHN—Designer, E., W., L.
Southeastern Massachusetts Technological Institute, North Dartmouth, Mass.; h. 29 Elm St., Newport, R.I. 02840
B. Paterson, N.J., Nov. 14, 1901. Studied: ASL; CUASch, with Harry Wickey, and abroad. Member: Type Dir. Cl. of New York; Providence A. Cl.; AAUP; Inter-Society Color Council; A.I.G.A. Work: St. John's Church, Stamford, Conn.; Providence Pub. Lib.; Houghton Lib., Harvard Univ.; Cooper Union Mus.; mem. tablets, book and catalog des., lettering, etc. Exhibited: NAD; Houghton Lib., Harvard Univ.; R.I. Sch. Des. Museum, 1959; Providence A. Cl., 1960; Nat. Lib. of Scotland, 1960; Annmary Brown Mem., 1961; Peabody Library, (Baltimore) 1965; Crapo Gal., (New Bedford) 1966 (one-man show). Author I., "The History and Technique of Lettering," 1950, 2nd ed., 1957; "Decorative Alphabets and Initials," 1959 "200 Decorative Title-Pages," 1964; I., "Color: Order and Harmony" by Paul Renner, 1965. Contributor to Direct Advertising; Graphis; Int. Assn. Printing House Craftsmen's "Printing Progress"; The Concise Encyclopedia of American Antiques; Polygraph Jahrbuch, 1967-1968. Filmstrip, "500 Years of Type Founding," 1964. Lectures on Lettering and Direct Advertising Design. Positions: Prod. Mngr., A. Dir., Technographic Pub., 1943-44; Instr., Lettering and Typography, Cooper Union; Instr., Dir., Adv. Des., N.Y. Univ., 1950-57; Assoc. Prof., Lettering & Typography, Actg. Hd., Graphic Des. Dept., 1962, Rhode Island Sch. Des., Providence, R.I., 1957-1965; Prof., Chm., Visual Design, Dir. of Vis. Des., Graduate Program, Southeastern Mass. Tech. Inst., North Dartmouth, Mass. Proprietor, with Ilse Buchert, of the Third & Elm Press.

NESBITT, LOWELL—Painter
212 E. 14th St., New York, N.Y. 10003
B. Baltimore, Md., 1933. Studied: Tyler Sch. FA, Philadelphia, Pa.; Royal Col. A., London, England. Work: BMA; CGA; Goucher Col., Baltimore; La Jolla Mus. A.; LC; MModA, Chicago; Northern Trust Co., Chicago; PC; Temple Univ.; Univ. Virginia, Charlottesville; AIC; NCFA; Embassies in Monrovia, Tanzania and Tel-Aviv. Exhibited: Pan American Union, Washington, D.C., 1964 (toured Latin America, 1964-1966); Larry Aldrich Mus., 1965-1966, 1967, 1968; Flint Inst. A., 1966; Herron A. Inst., Indianapolis, 1966; Kent Univ., 1967; Print Exh., Mus. Mod. A., Mexico City, 1966; Krannert A. Mus., Univ. Illinois, 1967; Akron A. Inst., 1967; Los Angeles County Mus., 1967; Tokyo Biennial, 1967; Sao Paulo Bienal, 1967; WMAA, 1967; Inst. Contemp. A., London, 1968; Vassar Col., 1968; New Sch., N.Y., 1968; Sch. Visual A., N.Y., 1968; Weatherspoon A. Gal., Univ. North Carolina, 1968; Feigen Gal., Chicago, and Cincinnati Contemp. A. Soc.; Univ. Puerto Rico, Mayaguez; "Nostalgia and the Contemporary American Artist," selected by the American Federation of Arts, touring, 1968 through 1969; Int. A. Program Smithsonian Inst., 1968-1969; MModA, traveling, 1969; one-man: BMA, 1958, 1969; Franz Bader Gal., Washington, D.C., 1963; CGA, 1964; Rolf Nelson Gal., Los Angeles, 1965, 1966; Henri Gal., Washington, D.C., 1965, 1966, 1967; Howard Wise Gal., N.Y., 1965, 1966; Kasle Gal., Detroit, 1966, 1967, 1969; Jefferson Gal., San Diego, 1967; Louisiana Gal., Houston, Tex., 1967; Stable Gal., N.Y., 1968, 1969.

NESS, (ALBERT) KENNETH—Painter, E., Des.
Ackland Art Center, University North Carolina; h. Farrington Mill Rd., Chapel Hill, N.C. 27514
B. St. Ignace, Mich., June 21, 1903. Studied: Univ. Detroit; Detroit Sch. App. A.; Wicker Sch. FA; AIC. Member: North Carolina Chptr. AIA (hon.); F.I.A.L. Awards: prizes, traveling scholarship, 1932, prize, 1934, AIC; prize, North Carolina AA, 1953. Exhibited: Johnson Gal., Chicago (one-man); WMAA, 1933; AIC. 1934-1940; GGE, 1939; Evanston A. Center, 1940; San Diego FA Soc., 1938; Cal. PLH, 1938; SAM, 1938; Dayton AI; Flint Inst. A., 1938; Grand Rapids A. Gal., 1938; Person Hall, Univ. N.C., 1941 (one-man); Butler AI; Va. Intermont; High Mus. A., 1951; North Carolina AA, 1952, 1953; Atlanta, Ga., 1952; PAFA; Univ. Florida; Birmingham Mus. A.; Lowe Gal. A., Miami; Soc. Four Arts, Palm Beach; Georgia Mus. A., Athens; Norton Gal. A.; Witherspoon A. Gal., Greensboro; Beloit, Wis., 1954; Duke Univ. (one-man); AGAA; AFA traveling exh., 1955; CMA; Florence (S.C.) Mus. Positions: Resident A., Prof. A., Univ. North Carolina, Chapel Hill, N.C., 1941- ; Des., photography, editing, brochure "Student Art at the University of North Carolina at Chapel Hill," 1964; "Word Assemblage" for the multi-media production "The Dome Project"; (shown in Chapel Hill, Raleigh and Asheville), 1968. Produced experimental film, "Mona Lisa Rides Again," 1968. Actg. Chm., Dept. A., 1957, 1958; Dir., Person Hall A. Gal., 1957, 1958.

NEUBERGER, ROY R.—Collector, Benefactor
120 Broadway 10005; h. 993 Fifth Ave., New York, N.Y. 10028
B. Bridgeport, Conn., July 21, 1903. Studied: New York University; University of Sorbonne. Awards: Art in America, 1959; North Shore Community Arts Center, 1961. Contributor to Art in America, and various art catalogues. Lectures on Art given at Wadsworth Athe-

neum, Vassar College, Brooklyn Museum, Detroit Institute of Art and others. Parts of private collection, which is primarily American Art, have been exhibited in museums, universities and galleries, U.S., and abroad. Positions: President, 1958-1967, Hon. President, 1968- , The American Federation of Arts; Trustee, 1961-1968, Trustee Emeritus, 1969- , The Whitney Museum of American Art; President, 1960-1962, Friends of the Whitney Museum of American Art; Board of Directors, 1957- , City Center of Music and Drama, Inc. (also Executive Committee); Hon. Trustee, 1968- , The Metropolitan Museum of Art; Trustee, 1967- , Art Center Committee, 1962-1968, New School for Social Research; Advisory Council of the Institute of Fine Arts, New York University, 1961- ; Advisory Committee for Art of Mount Holyoke College, 1963- ; Fine Arts Advisory Committee, Amherst College, 1963- ; Fine Arts Gifts Committee of the National Cultural Center, 1962- ; Advisory Committee of the Museum of American Folk Arts, 1965- ; Committee for the Beautification of New York, 1965- ; Chairman-Advisory Council on the Arts of the New York City Housing Authority, 1960- ; National Advisory Committee of the Washington Gallery of Modern Art, Washington, D.C., 1963-1965; A Benjamin Franklin Fellow of the Royal Society of Arts, London, England, 1969- .

NEUFELD, PAULA—Painter, T.
 4732 Summit St. Apt. 203, Kansas City, Mo. 64112
B. Berlin, Germany. Studied: Art Inst., Berlin; Berlin Acad. A., and with von Koenig, Eugene Spiro, Willy Jaekel and Annot; Colo. Springs FA Center. Awards: F., Huntington Hartford Fnd., 1957, 1959; prizes, Jewish Mus., Berlin, 1935; Lighton Studio, Kansas City, 1938; Kansas City AI, 1942; Nelson-Atkins Mus., Kansas City, 1958. Work: Bernheimer Mem., Kansas City, Mo.; Temple B'nai Jehudah, Kansas City; Mannheim Mus., Germany; Jewish Mus., Berlin; ports., Jackson County Circuit Court; William Fishman Lib., Kansas City; and in Germany; murals, ports. in many private colls. U.S. and abroad. Exhibited: AIC; Kansas City AI; William Rockhill Nelson Gal.; CAM; Women's City Cl., 1938; Breslau; London, England; Macy, Kansas City, 1963; one-man: Broadmoor Hotel, Colorado Springs; Denver A. Mus.; Kansas City Pub. Lib.; Woman's City Cl., Kansas City; Berlin, Stuttgart, Mannheim, Germany; AIC; Jewish Center, Kansas City; Kansas City AI; Denver A. Mus.; Retrospective Exh., Lawrence Gal., Kansas City, 1960; Kansas City Pub. Lib., 1961; Ben Uri Gal., London, 1964 and to Art Colony, Ein Harod, Israel, 1964.*

NEUGASS, LUDWIG—Collector
 80 Wall St. 10005; h. 211 Central Park West, New York, N.Y. 10024
B. Mannheim, Germany, Apr. 1, 1895. Collection: Includes French impressionist, Expressionist paintings; Collection is exhibited from time to time in various galleries and museums.*

NEUMAN, ROBERT S(TERLING)—Painter, E.
 104 Inman St., Cambridge, Mass. 02139
B. Kellogg, Idaho, Sept. 9, 1926. Studied: California Col. A. & Crafts; Cal. Sch. FA; Univ. Idaho; Mills Col.; and in Stuttgart, Germany. Awards: Fulbright Grant, 1953-54; Guggenheim Fellowship, 1956-57; prizes, SFMA; Inst. Contemp. A., Boston; Boston A. Festival. Work: Lane Fnd.; SFMA; BMFA; WMA; MModA; AGAA. Exhibited: MModA, 1964; Art Across America, Boston, 1965; Seattle World's Fair, 1962; Carnegie Inst., 1961; WMAA, 1958; MMA, 1952; de Cordova & Dana Mus., 1960-1965; New England Art Today, 1963, 1965; Denver Mus. A., 1952; SFMA, 1951-1953. Positions: Instr., Cal. Col. A. & Crafts, Oakland, 1951-53; Brown University, Providence, R.I., 1961-1963; Carpenter Center for the Visual Arts, Harvard University, Cambridge, Mass., 1964-65.

NEUMANN, HANS—Collector
 P.O. Box 5475, Caracas, Venezuela*

NEUMANN, MRS. J. B. See Schmid, Elsa

NEUMANN, MORTON G.—Collector
 5555 Everett Ave., Chicago, Ill. 60637
B. Chicago, Ill., Feb. 21, 1898. Studied: University of Illinois, B.S. Collection: Contemporary art.*

NEUMEYER, ALFRED—Educator, W.
 5575 Fernhoff Rd., Oakland, Cal. 94619
B. Munich, Germany, Jan. 7, 1901. Studied: Univ. Munich; Univ. Berlin, Ph.D. Member: CAA. Awards: Guggenheim F., 1958; Ford F., 1952, 1953-54; Fulbright Fellowship, 1968. Author: "Durer," 1929; "Josef Scharl," 1945; "Cezanne Drawings," 1958; "The Search for Meaning in Modern Art," 1965. Contributor to: Art Bulletin, College Art Journal, Journal of Aesthetics; Books Abroad; Art Quarterly, & other publications, with articles on contemporary & historical art. Positions: Prof. A. Hist., 1935-1966, Emeritus, Dir. A. Gal., 1937-1961, Mills Col., Oakland, Cal.; Hon. Prof., Free

Univ., Berlin; Guest L., Harvard Univ., 1938, 1948; Free Univ. of Berlin, 1952, 1953-54; Univ. Heidelberg, 1958; Univ. California, Berkeley, 1966-1967. Chm., Section on Art, 2nd Conference on Humanities, Stanford Univ., Palo Alto, Cal., 1943; Vice-Pres., Renaissance Conference Northern California, 1957-58; Free Univ. of Berlin, 1968; Bd. Memb., Drawing Soc.

NEUSTADT, BARBARA (Mrs. Gunther Meyer)—
 Graphic Artist, I., L.
 California Quarry Rd, Woodstock, N.Y. 12498
B. Davenport, Iowa, June 21, 1922. Studied: Smith Col., B.A.; Univ. Chicago; Ohio Univ. Sch. FA; ASL; and with Ben Shahn, Arnold Blanch. Member: SAGA; AFA; Phila. WC Cl.; Hunterdon County A. Center; Woodstock AA. Awards: Scholarship, ASL, 1952; prizes, SAGA, 1954; Boston Pr.M., 1956, 1957; Hunterdon County A. Center 1959. Work: MMA; LC; PMA; NGA; Des Moines A. Center; Tryon Mus., Smith Col.; Marquette Univ. Mem. Lib. (First Ed. Children's Books); Permanent Coll. of American Prints, Bonn, Germany; SAG. The Kerlan Coll., Univ. Minnesota; St. Joseph's Col. for Women, N.Y. 3 editions of Etchings for Collectors of Am. Art, 1956, 1958, 1961 and one edition for Intl. Graphic Arts Soc., 1960. Exhibited: PAFA, 1952, 1953, 1956; CM, 1954; Boston Pr.M., 1954, 1956-1959; SAGA, 1953, 1954, 1957, 1959, 1960; BM, 1954, 1958, 1960; Univ. So California, 1954; Phila. Color Pr. Soc., 1954, 1957, 1960; Phila. Pr. Cl., 1954, 1957; Soc. Wash. Pr.M., 1957, 1958; LC, 1957; NAD, 1956 Riverside Mus., 1959; MMA, 1958; New Jersey State Mus., 1959; Art:USA, 1959; AFA traveling exh., 1954, 1957, 1958, 1960; American Prints, 1959 (USA, France, Venezuela, 1959, 1960); Yale Univ. Gal., 1960; Intl. Exh., SAGA, 1960, 1968. Contemp. A. Gal., N.Y., 1961; N.Y. City Center, 1954; L'Antipoete Galerie Librairie, Paris, France, 1961. One-man: Ruth White Gal., N.Y., 1958; Phila. A. All 1959; Detroit, Mich., 1962; Portland (Me.) Mus. A., 1965; Polari Gal., Woodstock, N.Y., 1963. Illus.: "The First Christmas," 1960. Lectures: Printmaking, Etching, Engraving, etc., Hunterdon County A. Center, 1959, 1960; Primary, Secondary Schools, 1968, 1969. Positions: A. Dir., Shepherd Cards, Inc., New York, N.Y., 1956-1963.

NEUSTADTER, EDWARD L.—Collector, Patron
 333 7th Ave., New York, N.Y. 10001; h. Woodlands Rd., Harrison, N.Y. 10528
B. New York, N.Y., Mar. 29, 1928. Studied: Ohio State University, B.S.C. Collection: 20th century American sculpture and oils; French, German and Spanish sculpture and oils.*

NEVELL, THOMAS G.—Industrial Designer, W.
 101 Park Ave., New York, N.Y. 10017; h. Leeward Lane, Riverside, Conn. 06878
B. London, England, Sept. 16, 1910. Studied: N.Y. Univ., Col. of FA Columbia Univ. Member: Indst. Des. Soc. of America; Assoc., Am Soc. Mechanical Engineers; IDI. Awards: Modern Plastic award, 1939; Electrical Manufacturing award, 1940 (all in collaboration with George Cushing); N.Y. Employing Printers Assn. 1960, 1961, 1964. Contributor of articles on Industrial Design to leading trade magazines. Positions: Partner, Cushing & Nevell, Ne York, N.Y., 1933- . Sec.-Treas. of subsidiary companies in New York City, Los Angeles, Toronto, Canada and Cushing & Nevell Tech. Design Corp. of New York City.*

NEVELSON, LOUISE—Sculptor, Gr.
 29 Spring St., New York, N.Y. 10012
B. Kiev, Russia, 1900. Studied: U.S., Europe and Central America. Member: Fed. Mod. P. & S. (1st V-Pres.); AEA (Exec. Bd.); ASL; NAWA; Sculpture Center; S. Gld. (Exec. Bd.); All. A. Am. Work: Mus. FA of Houston; Farnsworth Mus., Rockland, Me.; Sara Roby Fnd.; Newark Mus. A.; Brandeis Univ.; Birmingham Mus. A.; WMAA; MModA; N.Y. Univ.; Queens Col.; Carnegie Inst.; Riverside Mus.; Univ. Nebraska; BM; DMFA; Lincoln Center for the Perform ing Arts, (Julliard), New York, N.Y.; Princeton Univ.; Tate Gal., London, and others. Exhibited: U.S.; England; Japan; France; Germany; Italy.

NEVELSON, MIKE—Sculptor, C.
 3 Milltown Rd., New Fairfield, Conn. 06815
B. New York, N.Y., Feb. 23, 1922. Work: Colby College; Wadswort Atheneum; WMAA. Exhibited: WMAA, 1963, 1965; Carnegie Inst., 1963; Krannert A. Mus. of Univ. Illinois; Contemp. A. Mus., Housto Tennessee FA Center, 1962; Herron A. Mus., Indianapolis, 1963; Roko Gal., N.Y., 1947; Staempfli Gal., N.Y., 1961-1964; Amel Gal., N.Y., 1964; Obelisk Gal., 1964; Silvermine Gld. A., 1964. Grand Central Moderns, 1967; Expo' 68, Montreal, Canada.

NEWBERRY, CLARE TURLAY—Illustrator, W., P.
 235 Washington Ave., Santa Fe, N.M. 85701
B. Enterprise, Ore., Apr. 10, 1903. Studied: Univ. Oregon; Portlan (Ore.) Mus. A. Sch.; San F. Sch. FA; Grande Chaumiere, Paris. Au

thor, I., "Herbert the Lion," 1931; "Mittens," 1936; "Babette," 1937; "Barkis," 1938; "April's Kittens," 1940; "Drawing a Cat," 1940 (new ed., 1959); "Lambert's Bargain," 1941; "Marshmallow," 1942; "Cats" (a portfolio of drawings), 1943; "Pandora," 1944; "The Kittens' A B C," 1946, new ed., 1965; "Smudge," 1948; "T-Bone the Baby Sitter," 1950; "Percy, Polly, and Pete," 1952; "Ice Cream for Two," 1953; "Cats & Kittens" (a portfolio of drawings), 1956; "Widget," 1958; "Frosty," 1961, & other animal stories for children.*

NEWBILL, AL(BERT) JAMES—Painter, T., Cr.
 108 W. 28th St., New York, N.Y. 10001
B. Springfield, Mo., Jan. 13, 1921. Studied: Detroit Soc. A. & Crafts; BMSch. A.; Hans Hofmann Sch. A. Work: Southern Illinois Univ.; Olson Fnd. Exhibited: Stable Gal., N.Y., 1955, 1956; Rose Fried Gal., N.Y., 1957; one-man: Leo Castelli Gal., N.Y., 1959; Parma Gal., N.Y., 1960. Contributor art criticisms, Arts Magazine; Pictures on Exhibit. Positions: Instr., Painting, Queens College, N.Y., 1958; Visiting Artist, Southern Illinois University, 1960-61; Univ. California, Berkeley.*

NEWHALL, BEAUMONT—Museum Director
 George Eastman House, 900 East Ave.; h. 7 Rundel Park, Rochester, N.Y. 14607
B. Lynn, Mass., June 22, 1908. Studied: Harvard Univ., A.B., A.M.; Institut d'Art et d'Archeologie, Univ. Paris; Courtauld Inst. A., Univ. London, England. Member: F., Royal Photographic Soc. of Great Britain; F., Photographic Soc. Am.; Professional Photographers Assn. (Hon. Master of Photography; Corr. Memb., Deutsche Gesellschaft fuer Photographie. Awards: Guggenheim F., 1947. Author: "The History of Photography," MModA, 1964; "On Photography: A Source-Book of Photo-History in Facsimile," 1956; (with Nancy Newhall) "Masters of Photography," 1958; "The Daguerreotype in America," 1961; "Frederick H. Evans," 1964; "Latent Image, the Discovery of Photography," 1967; "Airborne Camera," 1969. Contributor to national magazines and encyclopedias. Lectures frequently on the history of photography at museums and universities. Positions: Asst., PMA, 1931-32; Asst., MMA, 1932-33; Libn., 1935-42, Cur. Photography, 1940-42, 1945, 1946; MModA; Cur., George Eastman House, Rochester, N.Y., 1948-58, Dir., 1958-. Instr., Hist. of Photography, Univ. Rochester, 1954-56; Rochester Inst. Tech., 1957-68; Visiting Prof., State Univ. of New York at Buffalo, 1968-. History and practice of photography, Black Mountain College Summer Art Inst., 1946-48. History of Motion Pictures: Salzburg Seminar in American Studies, Salzburg, Austria, 1958, 1959.

NEWHOUSE, BERTRAM M.—
 Collector, Writer, Scholar, Art Importer
 15 E. 57th St.; h. 525 Park Ave., New York, N.Y. 10022
B. St. Louis, Mo., Oct. 15, 1884. Studied: Smith Academy. Awards: Commander of the Order of Alfonso X, Spain. Collection: Old Masters and American Art. Fields of Research: Old Masters of all schools from the 14th through the 18th Centuries. Author: "Paintings by William Merritt Chase," and Catalogue of the American School up to and including 1860. Positions: Formerly member of the Board, Kimbell Foundation, Fort Worth, Texas. Member: Art Dealers Association of America; Art Committee, Lotos Club, New York, N.Y.

NEWMAN, ARNOLD—Photographer, Collector
 39 W. 67th St., New York, N.Y. 10023
B. New York, N.Y., Mar. 3, 1918. Studied: University of Miami, Coral Gables, Fla. Work: MModA; MMA; AIC; and others. Exhibited: One man and group—MModA; Milwaukee Art Institute; BM; Detroit Art Institute; Santa Barbara Mus. of Art; Portland Museum of Art, Portland, Ore. Biennale Della Fotografia, Venice, Italy. Awards: First Annual Photojournalism Conference Award, Univ. of Miami, 1957; Newhouse Citation, Syracuse University, 1961; Citation, Phila. Mus. College of Art, Philadelphia, Pa., 1961; San Marco Gold Medal, Biennale Della Fotografia, Venice, Italy, 1963. Collection: Modern European and American art; African art. Positions: Alternate Secretary (1957-1959), Alternate Treasurer (1963-1965), Trustee (1965-1967), American Society of Magazine Photographers.*

NEWMAN, BARNETT—Painter, S., Gr.
 685 West End Ave., New York, N.Y. 10025
B. New York, N.Y., Jan. 29, 1905. Studied: Col. City of New York, B.A.; Cornell Univ.; ASL, with Duncan Smith, John Sloan, William von Schlegell. hors de concours: Dunn Intl., Tate Gallery, London, 1963; AIC, 1964; Guggenheim Mus., 1964; Sao Paulo Bienal, 1965. Work: MModA; Kunsthalle Mus., Basle, Switzerland; MMA; WMAA; Wadsworth Atheneum; Stedelijk Mus., Amsterdam; Moderna Museet, Stockholm; Tate Gal., London, and in many private colls., U.S., Paris, London. Exhibited: AIC, 1947, 1964; WAC, 1950; Minneapolis Inst. A., 1957; Carnegie Inst., 1958; Intl. Council, MModA European Tour, 1958-59 (hors de concours); Documenta II, Kassel, Germany, 1959; Rome-New York Fnd., Rome, Italy, 1959; Gallery Kimura, Tokyo, Japan, 1959; WMAA, 1959, 1963, 1964; Columbus Gal. FA,

1960; Galerie Neufville, Paris, 1960; Everett Ellin Gal., Los A., 1960; USIA Exh., Yugoslavia, Austria, Poland, 1961; Am. Tour Heller Coll., Intl. Council, MModA, 1961 and to Paris, Germany, Scandinavia, 1965; Guggenheim Mus., 1961, 1964; Betty Parsons Gal., N.Y., 1947, 1955; Galleria dell'Ariete, Milan, 1960; Ferus Gal., Los A., 1960; Seattle World's Fair, 1962; Jewish Mus., N.Y., 1963; Onskemuseet, Moderna Museet, Stockholm, 1963; Dunn Intl., Beaverbrook A. Gal., Frederickton, Can., Tate Gal., London, 1963; Sidney Janis Gal., N.Y., 1963, 1964; Poses Inst., Brandeis Univ., 1963; Dilexi Gal., San F., 1963; Gulbenkian Fnd., Tate Gal., London, 1964; Bilanz Intl., Malerei seit 1950, Kunsthalle, Basle, Switzerland, 1964; Inst. Contemp. A., Univ. Pa., 1965; Los A. Mus. A., 1965; Drawings from the Collection of Betty Parsons, Am. Fed. Arts, 1965; Sao Paulo Bienal, 1965. One-man: Betty Parsons Gal., 1947, 1950, 1951, 1955; Bennington Col., 1958; French & Co., 1959; Allan Stone Gal., N.Y. (with DeKooning), 1962; Guggenheim Mus., N.Y., 1966; Knoedler Gal., N.Y., 1969.

NEWMAN, BEATRICE D.—Collector, Researcher
 5915 Lindell Blvd., St. Louis, Mo. 63112
Field of Research: Authenticity research on silversmithing in the Mississippi Valley. Collection: 18th century English and French furniture, porcelain and silver; 18th and 19th century Mississippi Valley silver; 19th century Mississippi Valley paintings.*

NEWMAN, ELIAS—Painter, L., W.
 215 Park Row 10038; (studio) 32 Union Sq., New York, N.Y. 10003
B. Stashow, Poland, Feb. 12, 1903. Studied: NAD; Edu. All. A. Sch.; Grande Chaumiere, Paris. Member: AEA (Nat. Sec. 1953, Dir. 1955, Exec. Dir., 1957-58); Mun. A. Soc., N.Y; Cape Ann Soc. Mod A. (Pres. 1955, 1958); Audubon A.; Nat. Soc. Painters in Casein; Rockport AA. Awards: Minnie R. Stern Mem. Medal & prize, Audubon A., 1960; The Mayer Company award, 1966, Gramercy Award, Nat. Soc. Painters in Casein, 1968. Work: BMA; BM; Butler AI; AGAA; Joslyn Mus. A.; deCordova & Dana Mus.; Boston Univ.; Everson Mus. A., Syracuse; Haifa Mus., Israel; Brandeis Univ.; BMFA; Jewish Mus., N.Y.; SFMA; Denver A. Mus.; John Herron AI; Tel-Aviv Mus., Israel; Histadrut Bldg., Tel-Aviv; Norfolk Mus. A.; Univ. Nebraska; Jewish Theological Seminary, N.Y.; Phoenix A. Mus.; Prudential Life Ins. Co. Bldg., Newark, N.J. Exhibited: Los A. Mus. A., 1944; Rockport AA, 1953-1962; NAD, 1950, 1953, 1964; Audubon A., 1945, 1954, 1958-1965; Am.-British A. Center, 1944, 1945; Assoc. Am. A., 1944; Norfolk Mus. A. & Sc.; Dayton AI; Birmingham Mus. A.; Rochester Mem. A. Gal.; AWS; Butler Inst. Am. A., 1960; Art:USA, 1958; Cape Ann A. Festival; Nat. Soc. Painters in Casein; Am. Acad. A. & Lets., 1960; Bass Mus. A., Miami, Fla., 1965; Mansfield State Col. (Pa.), 1965; Israel Mus., Jerusalem, 1968; George Washington Univ. A. Gal., Washington, D.C., 1968; one-man: Montross Gal., 1932; A. Center, N.Y., 1935; BMA, 1934, 1940; Maryland Inst. A., 1932, 1935, 1938; Tel-Aviv Mus., 1939, 1949, 1960-61; Maxwell Gal., San F., 1945; Modernage Gal., 1945; Phila. A. All., 1946; Babcock Gal., 1947, 1949, 1951, 1953, 1960; Doll & Richards, Boston, 1948, 1950, 1960; Jewish Mus., 1949; Werbe Gal., Detroit, 1956; one-man traveling exh. (casein paintings): (Sept., 1967-Apr. 1969), Rural Suppl. Edu. Center, Stamford, N.Y.; Mt. Aloyisus Col., Cresson, Pa.; Belknap Col., N.H.; St. Joseph Col., Pa.; Cortland (N.Y.) Library; Rand A. Mus., Westfield, Mass.; Greenville (Miss.) AA; Crestview (Fla.) A. Center; Bossier Parrish Library, Bossier City, La.; Hallmark Gal., Kansas City; Union Co. Library, Monroe, N.C.; Warder Pub. Library, Springfield, Ohio; Asbury Col., Wilmore, Ky.; Henderson Co. A. Council, Lexington, Tenn.; LaSalle Col., Phila., Pa.; Hillsdale (Mich.) Col.; Univ. Illinois, Urbana. Positions: Inst., Edu. All. A. Sch., N.Y.; Dir., AEA, N.Y. Chapter, 1951-52, Cor. Sec., 1952-53, Nat. Sec., 1953, Dir., 1954, 1955, Pres., 1960-62, Vice-Pres., 1963-1969, Ed., AEA, "Improvisations," 1950-52, Bulletin, "News," 1957-58; "Directory of Open Exhibitions," 1957-58; Author: "Art in Palestine," 1938. Chm., Cape Ann Soc. Mod. A., 1961; Dir. Nat. Soc. Ptrs. in Casein, 1960-1965, Pres., 1966-1969; Instr., Y.M.H.A., many years.

NEWMAN, L. JAMES—Art Dealer
 1858 Union St. 94123; h. 2159 Union St., San Francisco, Cal., 94123
B. Omaha, Neb., May 25, 1933. Studied: Stanford Univ.; Oberlin Col., B.A. Member: Exec. Committee, the Society for the Encouragement of Contemporary Art, San Francisco Museum of Art. Specialty of Gallery: Contemporary painting and sculpture with special emphasis on the vanguard work of the San Francisco Bay Area. Positions: Associated with the organization of art, exhibitions and art dealership since 1955; Owner, Dir., Dilexi Gallery, San Francisco, Cal., 1958-.*

NEWMAN, RALPH ALBERT— Cartoonist, W.
 189 Old Kings Highway South, Darien, Conn. 06821
B. Newberry, Mich., June 27, 1914. Studied: Albion Col., A.B.

Awards: Fairfield County (Conn.) art exhibitions, 1956-58. Contributor cartoons to New Yorker, Colliers, This Week, True and many others. Gagman to many cartoonists; contributor greeting card ideas, verse, design to Norcross, Barker, Citation and other card companies. Positions: Cart., Stars and Stripes, 1944-46; Research, Terrytoons, 1948-54; Animated cartoon gagman and plotter, Terrytoons, 1955-56. Author of over 5200 short scripts for comic books, animated cartoons.

NEWTON, EARLE WILLIAMS—
Museum Director, Collector, Hist., E.
Pensacola Historic Restoration & Preservation Commission; h. 105 W. Gonzalez St., Pensacola, Fla. 32501
B. Cortland, N.Y., Apr. 10, 1917. Studied: Amherst Col., A.B.; Columbia Univ., A.M. Member: AAMus.; Northeast Mus. Assn. (Vice-Pres.); New England Mus. Conf.; Soc.Am. Historians; (Sec. 1947-1949); Am. Assn. for State & Local History (Sec. 1946-53); Inter-American Inst. F.A. (Pres. 1966-1967). Awards: 3 awards of merit, AIGA, 1950-1952; Nat. award, Am. Assn. for State & Local History, 1949; Decorations from Spanish government: Commander, Order of Isabella la Catolica, 1965, Order of Merit, 1968. Author: "Vermont: History of the Green Mountain State," 1949; Ed., "American Wall Painting" (Nina F. Little), 1953. Contributor to American Heritage; Vermont Life; Vermont Quarterly. Lectures: Historic Restorations and Museums. Arranged exhs.; English and American 18th Century Portraits, Pa. State Mus., 1958; Jacob Eicholtz, Pennsylvania Painter, 1959; Hogarth and His Contemporaries, Carpenter A. Gal., Dartmouth College, 1960. Personal collection: Hogarth and 16th - 18th century Anglo-American painting; Pre-Columbian art; American maps. Positions: Ed. Bd., Art in America, 1953-56; Ed., American Heritage, 1949-54; Ed., Vermont Life, 1946-50; Senior Research F., Univ. London, 1955-56; Dir., Old Sturbridge Village, 1950-54; Dir., Bureau of Museums, Commonwealth of Pennsylvania, 1956-59; Dir., Mus. Art, Science & Industry, Bridgeport, Conn., 1959-1962; Exec. Dir., St. Augustine (Fla.) Hist. Restoration & Preservation Commission, 1959-1968; Exec. Dir., Pensacola Hist. Restoration & Preservation Comm., 1968- .

NEWTON, FRANCIS JOHN—Museum Director
Portland Art Museum, Southwest Park at Madison St.; h. 6805 S. E. 31st Ave., Portland, Ore. 97202
B. Butte, Montana, Dec. 27, 1912. Studied: Univ. Idaho, B.A., M.A.; Univ. Iowa, Ph.D. Member: CAA; AAMus.; Western Assn. A. Mus. (Pres. 1960-61); Assn. A. Mus. Dirs.; Hon. Assoc. Memb., Oregon Chptr., AIA. Awards: Decorated, Order of North Star, Sweden, 1965. Positions: Cur. Asst., WMA, Worcester, Mass., 1951-53; Cur. of the Museum, Portland Art Museum, Portland, Ore., 1953-60; Dir., 1960- ; Chief Consultant on Art, Portland Curriculum Study, 1959; Visiting Prof. Art History, Univ. Oregon Summer Session, 1959; Portland State College Summer Session, 1961. Member, Governor's Planning Council for Arts and Humanities.

NICHOLAS, THOMAS ANDREW—Painter
8 B Main St.; h. 7 Wildon Heights, Rockport, Mass. 01966
B. Middletown, Conn., Sept. 26, 1934. Studied: School of Visual Arts, N.Y. (Scholarship). Member: ANA; AWS; All. A. Am.; SC; Knickerbocker A.; Gld. Boston A.; Boston WC Soc.; Academic A.; Rockport AA; Conn. WC Soc.; Meriden A. & Crafts Assn. Awards: Rockport AA, 1957, 1959, 1962 (2), 1968, gold medal, 1966; Meriden A. & Crafts Assn., 1958, 1968; Silvermine Gld. A., 1958; North Shore AA, 1962; SC, 1958, 1960, 1962 (2), 1963 (3), 1964, 1967; Seley purchase, 1965; AWS, 1961, 1963, 1964, gold medal of honor, 1969; Knickerbocker A., Medal, 1962; Sidney Taylor Mem. prize, 1964; Hudson Valley AA, prize, 1962, gold medal, 1964; Butler Inst. Am. A., 1962; Ranger Fund Purchase, NAD, 1962, Obrig prize, 1964 and 1966; All. A. Am., 1962, Jane Peterson prize, 1963 and Chandler Award, 1964, 1965, 1966, Emily Lowe award, 1968; Academic A., 1963, 1964, 1969; AAPL, 1963, gold medal, 1964; Edwin S. Webster Award, Boston Soc. Watercolorists, 1964; Audubon A., 1967; purchase prize, Watercolor: USA, 1965; gold medal, NAC, 1965; gold medal of honor, Concord AA, 1968, and others. Elizabeth T. Greenshields Mem. Fnd. Grants, 1961, 1962. Exhibited: Major exhibitions in New York City and New England, since 1959, including Butler Inst. Am. Art, 1962-1964; Springfield Mus. A., 1962, 1963; Rockport AA since 1957, and others Over 20 one-man exhs. Positions: Instr., Famous Artists Schools, Westport, Conn., 1958-1961.

NICHOLS, ALICE WELTY—Educator, P., Gal. Dir., Des., L.
Art Dept., Ball State University; h. 402 N. Calvert St., Muncie, Ind. 47303
B. St. Joseph, Mo., June 15, 1906. Studied: Texas State Col. for Women; Univ. Texas, B.A., M.A.; PIASch.; Columbia Univ., Ed.D. Member: NAEA; Western AA; AIID; Indiana A. Edu. Assn.; CAA. Exhibited: Texas, Colorado, Indiana. Author: "Let's Make Something." Contributor to School Arts; State Art Publications; The Palette; Western Arts Journal; Hoosier Schoolmaster. Ed., The Pa-

lette. Positions: Prof., A. Edu., West Texas State T. Col.; Univ. Texas; Des. & Crafts, Univ. Denver; Prof. A., Hd. Art Dept., Dir., Ball State Gallery, Ball State Univ., Muncie, Ind., at present. Pres., Nichols Assoc., Inc., Interior Design.

NICHOLS, EDWARD EDSON—Painter, E.
Mississippi State College for Women, Box 1138, Columbus, Miss.
B. Chicago, Ill., Nov. 6, 1929. Studied: Univ. Kansas, B.F.A., M.F.A.; and with Karl Mattern, Robert Sudlow, Herbert Fink, R. J. Eastwood; Louisiana State Univ., with Tom Cavanaugh, Armin Scheler. Member: CAA; Southeastern Col. A. Conf.; Mississippi AA. Awards: prize, Annual Navy Dept. A. Exh., 1956; F., Huntington Hartford Fnd., 1960, 1964; Miss. AA, 1962 (purchase), 1963; Southeastern A., 1963; Grad. Teaching F., Louisiana State Univ., 1958. Work: Univ. Kansas; Louisiana State Univ.; Mississippi State Col. for Women. Exhibited: Atlanta AA, 1963; Brooks Mem. Gal., 1964; Hunter Gal. A., 1964; Pan-American Col., 1964; Henri Gal., 1964. Asst. Prof., Drawing, Painting & Printmaking, Mississippi State College for Women, Columbus, Miss.*

NICKERSON, RUTH (Jennie Ruth Greacen)—Sculptor, L.
106 Woodcrest Ave., White Plains, N.Y. 10604
B. Appleton, Wis., Nov. 23, 1905. Studied: NAD; BAID. Member: NA; F., NSS; Scarsdale AA; Westchester A. Soc.; Audubon A.; White Plains Civic A. Comm. (to 1960); Hudson Valley A.A. Awards: medal, NAD, 1933; NAC, 1933; Hudson Valley AA, 1953, 1963; Westchester A. & Crafts Gld., 1955; Westchester A. Soc., 1964; AAPL, 1937; Montclair A. Mus., 1939; prize, NAWA, 1946; Guggenheim F., 1946; Pen & Brush Cl., gold medal, 1967. Work: Newark Mus.; Cedar Rapids AA; S., USPO, New Brunswick, N.J.; mural, USPO, Leaksville, N.C.; s. group, Children's Lib., Brooklyn, N.Y.; Mem. relief, New Rochelle (N.Y.) City Hall; fountain, Grasslands Hospital, Valhalla, N.Y.; bust of Alan Kurtz, JHS 101, Bronx, N.Y.; Stone carving, Montclair A. Mus., N.J.; stone carving (temporary loan), Church Center for U.N., Nat. Council of Churches. Exhibited: NAD, 1932-1933, 1937, 1945, 1949, 1951, 1952, 1959-1965, 1967; PAFA, 1934, 1949; Soc. Indp. A., 1935; All. A. Am., 1934, 1967; WMAA, 1936; Montclair A. Mus.; Roerich Mus.; BM; MMA; Audubon A., 1948, 1949, 1951, 1952, 1959-1964, 1967; Westchester A. Soc., 1948-1952, 1963, 1964; Hudson Valley AA, 1948, 1951, 1964; PAFA; Har-Zion Tabernacle, 1960, 1962, 1964, Phila., and locally; one-man: White Plains Pub. Lib.; NAWA, 1949; Manhattanville Col. of Sacred Heart, 1963; Pelham Manor, 1967; Westchester AA.; 1966; Hudson Valley AA., 1966. Positions: Nat. Sc. Soc. Council, 1961-64. Instr., Westchester Art Workshop, 1966-1967; modeling, private classes & stone carving at own studio, 1968.

NICKFORD, JUAN—Sculptor
161 Old Tappan Rd., Tappan, N.Y. 10983
B. Havana, Cuba, Aug. 8, 1925. Studied: San Alejandro A. Sch., Havana; Univ. Havana Sch. Arch. Member: Sculptors Gld. (Exec. Bd.); Sc. Center, New York City. Awards: prizes, Audubon A., 1955; Arch. Lg., 1955; N.Y. State Expo., 1964. Work: Outdoor, mural, wall, group sculpture: Malibu Beach, Cal.; Trade Show Bldg., N.Y.; Socony Mobil Bldg., N.Y.; Merchandise Mart, Chicago; S.S. Santa Rosa; Ambassador Town House, Phila., Pa.; 1959-61; Sculpture installed in 5 new buildings, New York City; and in private colls. Exhibited: WMAA, 1950, 1951, 1953, 1955-1958; PAFA, 1949-1951, 1953, 1958, 1964; Audubon A., 1955, 1956, 1965; NAD, 1949; de Cordova & Dana Mus., 1951, 1958; VMFA, 1950, 1956; Nebraska AA, 1950, 1953, 1955; Iowa State Univ., 1949; MMA, 1951; Fairmont Park, Phila., 1949; Sculpture Center, 1947-1958; WMA; Rochester Mem. A. Gal.; Wash. A. Cl.; SFMA; Univ. Arkansas; Los A. County Fair; Phila. A. All.; N.Y. Bd. Edu. traveling exh.; WAC; Conn. Acad. FA, 1965; N.Y. World's Fair, 1964; Silvermine Gld. A., 1964; Smith College Mus., 1964; Sculptors Gld., 1963, 1964, 1966-1968; Bundy A. Gal., 1963; one-man: Sculpture Center, N.Y., 1963; Vassar Col., 1963; Smith Col., 1967. Positions: Instr., S., Sculpture Center, New York, N.Y., 1953-1962; Vassar College, 1962-1963. Visiting Artist, Smith College, 1967-1969; Sculpture Instructor, Brooklyn Museum.

NICKLE, ROBERT W.—Painter, E.
624 W. Willow St., Chicago, Ill. 60614
B. Saginaw, Mich., May 22, 1919. Studied: Univ. Michigan, B.D.; Inst. Des., Chicago. Awards: Purchase prize, AIC. Work: AIC. Exhibited: MModA, 1961; Carnegie Inst., 1959; Urbana-Champaign, 1969; Purdue Univ., 1969; AIC (16 exhs.); one-man: B.C. Holland Gal., Chicago, 1963; Feigan-Palmer Gal., Los Angeles, Cal., 1964; Gray Gal., Chicago, 1968. Positions: Prof., Drawing & Design, University of Illinois at Chicago Circle, 1955- .

NIEL, ALICE—Painter
c/o Graham Gallery, 1041 Madison Ave., New York, N.Y. 10021*

NIEMANN, EDMUND E.—Painter
 38-15 208th St., Bayside, N.Y. 11361
B. New York, N.Y., Oct. 27, 1910. Studied: NAD; ASL, and with
Harry Wickey. Member: Audubon A.; ASL (Life); Silvermine Gld.
A.; Nat. Soc. Painters in Casein; AWS; Knickerbocker A. Awards:
prizes, Emily Lowe award, 1955; Chautauqua AA, 1958; Nat. Soc.
Painters in Casein, 1960, 1963, 1968, medal of merit, 1969; Conn.
Acad., 1964; Ball State Univ., 1964; NAD, 1966; purchase prizes:
Norfolk Mus. A., 1958; Ball State T. Col., Muncie, Ind., 1960; Ran-
ger Fund, AWS, 1964; Springfield (Mass.) Mus. A., 1959. Work:
Norfolk Mus. A.; Ball State T. Col.; Springfield Mus. A.; Storm King
A. Center, Mountainville, N.Y.; Syracuse Univ.; Swarthmore Col.;
murals & dec., for churches and homes. Exhibited: Carnegie Inst.
1941; PAFA, 1935, 1948, 1959, 1965; NAD, 1942, 1943, 1947, 1962,
1966, 1968; Audubon A., 1945, 1947, 1959-1965, 1966, 1969; Art:
USA, 1958; Provincetown A. Festival, 1958; Chautauqua, 1958; Co-
lumbia (S.C.) Mus., 1959; Portland Mus. A., 1959, 1961; Conn. Acad.
FA, 1957, 1959, 1963, 1964, 1966, 1969; Springfield A. Lg., 1958,
1959, 1961, 1962; Norfolk Mus., 1956, 1957, 1959, 1961, 1965; AWS,
1962, 1964, 1965, 1966, 1969; Butler Inst. Am. A., 1960, 1962, 1963,
1968; Drawings: USA, 1963; Watercolors, USA, 1964, 1968; one-man:
Ward Eggleston Gal., N.Y., 1957, 1959, 1961; Silvermine Gld. A.,
1961; Storm King A. Center, N.Y., 1961; Steinhardt Gal., Westbury,
N.Y., 1965, 1967.

NIEMEYER, ARNOLD M.—Collector, Patron
 1018 Pioneer Bldg., 55101; h. 1364 Summit Ave., St. Paul,
 Minn. 55105
B. Saint Paul, Minn., Mar. 7, 1913. Collection: Graphics. Positions:
Trustee, St. Paul Art Center.

NIEMEYER, TRENTON A.—Art Dealer, Collector, Patron
 1611 Pioneer Bldg. 55101; h. 1364 Summit Ave., St. Paul,
 Minn. 55105
B. St. Paul, Minn., Mar. 18, 1945. Studied: College of St. Thomas,
B.A. Specialty of Gallery: Fine Arts Graphics.

NIESE, HENRY ERNST—Painter, T.
 108 W. 28th St., New York, N.Y. 10001; h. 180 Walnut St.,
 Montclair, N.J. 07042
B. Jersey City, N.J., Oct. 11, 1924. Studied: Cooper Union; Colum-
bia Univ. Sch. P. & S., B.F.A.; Academie Grande Chaumiere, Paris.
Member: CAA. Awards: Pulitzer traveling scholarship, 1954; Emily
Lowe award, 1954; CGA, 1955; Int. Cinema Prize, Museo De Arte
Moderno, Brazil, 1969. Work: CGA; Columbia Univ.; WMAA; New-
ark Mus. A.; Everhart Mus.; Chrysler Mus.; Sumner Fnd.; New Jer-
sey State Mus., and in private colls. Exhibited: Passedoit Gal.,
1953-1955; Canada A. Circuit, 1955-56; CGA, 1955, 1957, 1959; But-
ler AI, 1955-1956; Montclair A. Mus., 1947-1949, 1951, 1953, 1955;
Newark Mus. A., 1952-1958; WMAA, 1958, 1960, 1962; Ogunquit
Mus., 1958; Univ. Nebraska, 1958; MModA, 1956; Toledo Mus. A.,
1957; Stanford Univ., 1958; Delgado Mus. A., 1958; Am. Acad. A. &
Lets., 1958; BMA, 1960; Contemp. A. Center, Cincinnati, 1961; CAM,
1961; Columbus Gal. FA, 1961; Munson-Williams-Proctor Inst.; one-
man: 'G' Gal., 1957, 1959, 1960; Everhart Mus. A., 1959; Nonagon
Gal., 1960; Fairleigh Dickinson Univ., 1959, 1960; Lehigh Univ.,
1960; Castellane Gal., Provincetown, 1962; Grippi-Waddell, N.Y.,
1964; Atelier Chapman Kelley, Dallas, 1964; Athena Gal., New Ha-
ven, 1964; Janet Nessler Gal., N.Y., 1964; N.Y. World's Fair, 1965.
Positions: Instr., BMSch A., Brooklyn, N.Y., 1951-54; Children's
Art, Newark Mus. A.; painting, Summit (N.J.) AA; Morris County
AA. Hd. Art Dept., Saint Bernards School, Gladstone, N.J., 1960-66;
Instr., Fairleigh Dickinson Univ., Madison, N.J., 1959-65; Asst.
Prof., Ohio State Univ., 1966-1969; Asst. Prof., Univ. of Maryland,
1969- .

NIIZUMA, MINORU—Sculptor
 458 W. 168th St. 10032; h. 87 Christopher St., New York, N.Y.
 10014
B. Tokyo, Japan, Sept. 29, 1930. Studied: Nat. Tokyo Univ. A., B.A.
Work: MModA; Mus. Mod. A., Tokyo; Albright-Knox A. Gal., Buffalo,
N.Y.; Chase Manhattan Bank, N.Y.; Des Moines A. Center; Tokyo
Metropolitan; Asia Center, Tokyo. Exhibited: Carnegie Int., 1967;
MModA, 1965, 1966; WMAA, 1966, 1968; Herron Mus. A., Indianap-
olis, Ind.; one-man: Tokyo, 1955-1958; Howard Wise Gal., N.Y.,
1966, 1968. Positions: Instr., Sculpture, BMSch. A., 1964- .

NIKOLENKO, NIKOLAY—Painter, I., Restorer
 151 E. 80th St., New York, N.Y. 10021
B. Russia, Sept. 10, 1912. Studied: In Kiev with Prof. Kruger-
Prahova; Kiev Inst. FA with Prof. Boytchuk; School of Icon Painting,
Hamburg, with George Kiverov. Work: Icons for churches in
Hamburg, Brussels, London, Syracuse and New York City, N.Y.,
and work in private colls., USA. Illus. publ., n Y. Times, 1965;
100 illustrations in "Myths of the Hero," 1962. Exhibited: in
Germany, 1946-1950; Fordham Univ., N.Y., 1951; Inst. for Study of

USSR, 1956; Byzantine Art Exch., Wash., D.C., 1956; Art:USA,
1958; Bob Jones Univ., 1961; Janet Nessler Gal., 1964; Audubon A.,
1968; Nat. Soc. Painters in Casein, 1968; P. & S. Soc. of New
Jersey, 1968; Avanti Gal., 1969; Harmon Gal., 1969; Yelitza Gal.,
1969; one-man: Petite Gal., N.Y., 1958; Atlanta AA Gal., 1961.
Freelance restorer antique paintings for museums and galleries.

NITSCHE, ERIK—Designer, I.
 R.F.D. 1, Ridgefield, Conn. 06877
B. Lausanne, Switzerland, July 8, 1908. Studied: Switzerland; Mu-
nich, Germany with Prof. Ehmke; Paris, France, with Maximilien
Vox. Member: A. Dirs. Cl., N.Y.; Alliance Graphique Int., Paris;
AIGA; F.I.A.L. Exhibited: A. Dir. Cl., 1949, 1961; AIGA, 1951-1955,
1958, 1960; Nat. Ex. Adv. & Editorial Art, 1937-1961; Int. Poster
Exh., Paris, 1949; MModA, 1947-1951; Assoc. Am. A., 1950; Akron
AI, 1950; Int. Exh. Typography, London, England, 1952; Tokyo, 1957;
Stockholm, 1957; Crawford Hall, London, 1958; Cologne, 1958; SI,
1959; School Visual Arts, N.Y., 1960; Zurich, 1960; Rockefeller Cen-
ter, N.Y., 1960, 1961, and others. Awards: Direct Mail Adv. Assn.,
1948; gold medal, A. Dir. Cl., 1949, prizes, 1957, 1958, 1959-1961;
AIGA, 1951-1961. Covers, illus., photographs, art dir. for Vanity
Fair; Today; Arts & Decorations; Harper's Bazaar; Vogue; House &
Garden; House Beautiful; Town & Country; Life; Fortune; Woman's
Home Companion; U.S. Camera; McCalls; Look Holiday; Mademoi-
selle, and other national magazines from 1935-48; Magazine A. Dir.
for: Air Tech.; Air News; Home & Food; Mademoiselle; RCA Victor
"Record Review"; Advertising campaigns, Direct Mail, Promotion,
Industrial Design, etc., for many leading retail stores, film com-
panies, RCA Victor, Decca Records, airlines and many others, 1946-
1961. Articles published, work shows or reviewed in A. Dir. An-
nuals; Graphis; Publimondial; American Printer; American Artist;
Industrial Design; Print; Fortune and other magazines. Other posi-
tions: Consultant, Des. of books & brochures, Standard Oil, N.J.,
1953-60; General Dynamics Corp: 1953-1961; Consultant, A. Dir.;
Des. & Supv. Production of General Dynamics Corporate History,
1957-59; "Dynamic America" (420 pp., 1500 illustrations), 1960;
Des. exhibit "Dynamic America," Rockefeller Center, 1960-61.
Founder, ENI, S.A., Geneva, Switzerland, 1960, Int. Des. Organiza-
tion.*

NIVOLA, CONSTANTINO—Sculptor
 123 Waverly Place, New York, N.Y. 10011
Exhibited: Parrish A. Mus.; WMAA, 1964.*

NOBLE, JOSEPH VEACH—
 Museum Administrator, Collector, Scholar
 The Metropolitan Museum of Art, 5th Ave. and 82nd St., New
 York, N.Y. 10028; h. 107 Durand Rd., Maplewood, N.J. 07040
B. Philadelphia, Pa., Apr. 3, 1920. Studied: University of Pennsyl-
vania. Awards: Venice Film Festival Medal, for motion picture
"Photography in Science," 1948. Member: Museums Council of
New York City; Cultural League of New York City; Vice-President,
New York State Association of Museums; Life Member and Trea-
surer, Archaeological Institute of America; Chairman, Committee
on Films and Television and Vice-President Exec. Committee, N.Y.
Society of the AIA; Life Member, Society for Promotion of Hellenic
Studies, England; Fellow in Perpetuity, Metropolitan Museum of Art;
American Association of Museums; Century Association, and others.
Contributor to American Journal of Archaeology; American Philo-
sophical Society Proceedings. Author: "The Techniques of Painted
Attic Pottery," 1965; "An Inquiry Into the Forgery of the Etruscan
Terracotta Warriors in the Metropolitan Museum of Art." 1961
(with Dietrich von Bothmer). Collection: Ancient Greek and Roman
pottery. Positions: Operating Administrator, 1956-1966, Chairman
of Administrative Committee, 1966-1967; Vice-Director for Admin-
istration, 1967- , The Metropolitan Museum of Art.

NOBLE, VERRILL RUTH—Designer, W.
 18 Brattle St.; h. 5 Craigie Circle, Cambridge, Mass. 02138
B. Portland, Me. Studied: Wellesley Col., B.A.; Columbia Univ.
Sch. Lib. Service, B.S. Member: Nat. Trust for Historic Preserva-
tion; BMFA. Ed., "Bibliography of W.A. Dwiggins" in selective
check list of Press Books, 1947; Co-author, Preliminary Memo-
randa for Conference on International Cultural, Educational and Sci-
entific Exchanges, Chicago Am. Lib. Assn., 1947; Author: "Dwig-
gins, Master of Arts," Publishers' Weekly, 1947; "Maine Profile,"
1954; "A Guide to Distinctive Dining," 1957; "A Guide to New Eng-
land Dining," 1960; the following engagement calendars published
annually: Cat; Dog; Horse; Massachusetts; Cape Cod; Berkshire;
etc. Positions: A. Libn., FMA, Harvard Univ., 1940-42:Libn., R.I.
Sch. Des., Providence, 1942-46; Pres., Ed.-in-Chief, Berkshire
Publ. Co., 1950- .

NOCHLIN, LINDA (POMMER)—Scholar, Critic, Writer
 Vassar College, Poughkeepsie, N.Y. 12601
B. New York, N.Y., Jan. 30, 1931. Studied: Vassar College, B.A.;

New York University, Institute of Fine Arts, Ph.D. Awards: Kingsley Porter prize for best article in Art Bulletin, 1967. Field of interest: Painting and Sculpture of 19th and 20th Century. Contributor to Art Bulletin; Art News; Art News Annual; Artforum. Author: "Realism and Tradition in Art"; "Impressionism and Post-Impressionism."

NODEL, SOL—Painter, Illuminator
 55 W. 42nd St. 10036; h. 639 West End Ave., New York, N.Y. 10025
B. Washington, D.C., Sept. 29, 1912. Studied: Washington Univ. Sch. FA; Grand Central Sch. A. Studied with Edmund Wuerpel; miniatures with Leo Dubson; illustration with Harvey Dunn. Member: F., Royal Soc. Arts (Life); Elected to U.S. Hall of Fame Society, 1968; Member Fine Arts Comm., Bethune Memorial, Wash., D.C.; Chm., Art Comm. International Synagogue, J.F.K. International Airport, N.Y.; Honorary Founding Memb. Law Science Fnd.; Univ. Texas. Awards: Monsanto Chemical Award; Procter & Gamble Award; Gold Medal, U.S. Army Art; St. Louis A. Gld., and others. Work: (all illuminations)—National Archives, Wash., D.C.; Herbert Hoover Mus.; Harry Truman Library; LC; F.D. Roosevelt Library; Temple Shaare Emeth, St. Louis; in Royal Collections in Great Britain, Denmark, Thailand, The Netherlands, and in many private colls. in U.S.; Illumination for House of the President of the State of Israel, 1964; Legacy, Mary McLeod Bethune, 1962; J. F. Kennedy Family Bible; Designed, Stained Glass Windows, New Mt. Sinai Chapel, St. Louis, Mo.; Designed Ark, Cong. Shaare Zedek, N.Y.; many other commissions. Exhibited: One-man: N.Y. Univ., 1962; Queens College, N.Y., 1962; Shenango Valley (Pa.), 1963; Pope Pius XII Library of St. Louis Univ., 1964; High Mus. A., Atlanta; CAM; St. Louis A. Gld.; Bnai Brith Mus., Washington, D.C. 1968.

NOGUCHI, ISAMU—Sculptor
 33-38 10th St., Long Island City, N.Y. 11106
B. Los Angeles, Cal., Nov. 17, 1904. Studied: Apprentice to Onorio Ruotolo and to Brancusi. Member: Arch. Lg.; Nat. Inst. A. & Lets., N.Y. Awards: Guggenheim Fellowship; Bollingen Fellowship, 1950-51; Logan Medal, AIC. Work: MMA; MModA; WMAA; Guggenheim Mus.; BM; Toledo Mus. A.; Albright-Knox A. Gal., Buffalo; Los A. Mus. A.; AIC; Tate Gal., London; Honolulu Acad. FA; Art Gallery of Toronto; UNESCO gardens, Paris; Connecticut Life Ins. Co. gardens, Hartford; Plaza; First Nat. Bank, Ft. Worth, Tex., 1960; fountain and sculpture, John Hancock Bldg.; Chase Manhattan Bank, N.Y.; garden, Yale Library of Rare Books, 1964; IBM, Armonk, N.Y., 1964; Billy Rose Sculpture Garden for the National Museum, Jerusalem, 1965; sculptures, Kröller-Muller Mus., Otterlo, Holland; fountains, entrance sculpture, for new Mus. Mod. A., Tokyo, 1969. Designer of many stage sets. Exhibited: Nationally and internationally. Recent exhibitions include Cordier & Ekstrom, N.Y., 1963, 1968; Paris, 1964; Claude Bernard Gal., Paris, 1964; Documenta, 1962; Kassel, Germany, 1964; Gulbenkian Exh., Tate Gal., London, 1964; Carnegie Inst., 1959-1961; WMAA, retrospective, 1966; Gimpel Fils, London and Gimpel Hanover, Zurich, 1968.

NOLAND, KENNETH—Painter
 South Shaftsbury, Vt. 05262
B. Asheville, N.C., 1924. Studied: Black Mountain Col., N.C., and in Paris with Ossip Zadkine. Awards: Brandeis Univ., 1965; Int. Di Tella prize, Buenos Aires, 1964. Work: Albright-Knox A. Gal., Buffalo; Harvard Univ.; Detroit Inst. A.; WMAA; Brandeis Univ. Exhibited: Kootz Gal., N.Y., 1954; WMAA, 1957, 1963; CGA, 1958, 1963; Guggenheim Mus., N.Y., 1961; The Jewish Mus., N.Y., 1962; Seattle World's Fair, 1962; AIC, 1963; Instituto Torcuato Di Tella, Buenos Aires, 1964; one-man: Tibor di Nagy Gal., N.Y., 1956-1958; French & Co., N.Y., 1959; Galleria dell 'Ariete, Milan, 1960; Bennington Col., 1961; Rubin Gal., N.Y., 1961; Emmerich Gal., N.Y., 1961-1964, 1967; Galerie Lawrence, Paris, 1961, 1963; Galerie Neufville, Paris, 1961; Galerie Schmela, Dusseldorf, 1962, 1964; Galerie Charles Lienhard, Zurich, 1962; Kasmin, Ltd., London, 1963, 1968; Venice Biennale, U.S. Pavilion, 1964.

NONAY, PAUL—Painter, T., L.
 39 Riverside Ave., Westport, Conn. 06880; h. 188 Highland Ave., Rowayton, Conn. 06853
B. Simeria, Rumania, May 1, 1922. Studied: Royal Acad. FA, Budapest; Acad. FA, Munich; Univ. of Munich. Member: Silvermine Gld. A.; Berkshire AA; Springfield A. Lg.; New Haven Paint & Clay Cl.; Int. A. Gld. (Monte Carlo); Rowayton A. Center. Awards: prizes, Conn. Acad. FA, 1962; Carl Blenner prize, New Haven, 1963; Penrose prize, Hartford, 1963; Munson prize, New Haven, 1965; Ford Fnd. purchase, 1965. Work: So. New England T. Col., New Haven; Univ. Bridgeport; New Haven Paint & Clay Cl. Exhibited: Audubon A., 1961, 1962, 1965; Art:USA, 1958; AWS, 1958-1964; Boston A. Festival, 1964; Festivals of New Haven, 1960-1962; Rhode Island, 1960, 1961; Berkshire, 1964; Conn. Acad. FA, 1958-1964; Conn. WC Annual, 1958-1964; Springfield A. Lg., 1960-1965; Eastern States

Exh., 1960-1964, etc. Positions: Instr. A., Bridgeport Univ., Bridgeport, Conn., 1960- ; Lecturer, Silvermine College of Art, 1960-61.*

NORDLAND, GERALD JOHN—Museum Director, Cr., W., L.
 San Francisco Museum of Art, McAllister at Van Ness Avenue, San Francisco 94102. h. 3965 Sacramento, San Francisco 94118.
B. Los Angeles, Cal., July 10, 1927. Studied: Univ. of Southern California, A.B., J.D. Exhibitions Arranged: Gaston Lachaise, Los Angeles County Museum of Art, Oct-Nov, 1963 and Whitney Museum of American Art, Jan-Feb 1964; Raoul Hague, Sep-Oct 1964, Washington Gallery of Modern Art. Other WGMA exhibtions include: Richard Diebenkorn, 1964; Anthony Caro Sculpture, 1965; Piet Mondrian Retrospective, 1965; Josef Albers: The American Years, 1965; The Washington Color Painters, 1965; Raymond Parker, 1966; Phillip Pavia, 1966; SFMA: John Altoon, 1967; Gene Davis, 1968; Julius Bissier (with Guggenheim Museum), 1968; Edward Corbett, 1969. Author: Catalogs for all of the above exhibitions. Also: Connor Everts, Pasadena Art Museum, 1959; Frederick Sommer, Philadelphia College of Art, 1968; Sam Tchakalian, Newport Museum of Art, 1967; Emerson Woelffer, Pasadena Art Museum, 1962, others. Contributor to the Catholic Encyclopedia on 20th century art subjects; also to Art News, Arts, Art International and Das Kunstwerk. Positions: Art Critic, Frontier Magazine, 1955-1964; Art Critic, Editor, Los Angeles Mirror, 1960-1962; Assoc. Editor, Artforum Magazine, San Francisco, 1963-1964; Dean, Chouinard Art School, California Institute of the Arts, Los Angeles, 1960-1964; Dir., Washington Gallery of Modern Art, Washington, D.C., 1964-1966; Dir., San Francisco Museum of Art, 1966- .

NORDNESS, LEE—Art Dealer
 Lee Nordness Galleries, 236-238 E. 75th St., New York, N.Y. 10021
B. Olympia, Wash. Studied: University of Washington; Stanford University; Uppsala University, Sweden. Conceived and directed: Art: USA: 58, Madison Square Garden; Art:USA: 59, New York Coliseum; Art:USA, The Johnson Collection of Contemporary American Paintings; Objects:USA, The Johnson Collection of Contemporary Crafts. Author: "Art:USA Now," 1963; "Objects:USA," 1969. Positions: Director, Lee Nordness Galleries, New York, N.Y.

NORMAN, DOROTHY (S.)—Writer, Editor, Photog.
 124 E. 70th St., New York, N.Y. 10021
B. Philadelphia, Pa., Mar. 28, 1905. Studied: Smith College; University Pennsylvania; Barnes Foundation. Co-edited and contributed to "America and Alfred Stieglitz"; Editor and Publisher of "Twice a Year," a Book of Literature, the Arts and Civil Liberties (1937-1948). Prof. Wasserstrom, Syracuse University, published an important anthology of "Twice a Year," entitled "Civil Liberties and the Arts," 1964. The entire run of "Twice a Year" was reissued in 1967. Contributor of numerous poems, reviews, articles, photographs to various publications, U.S. and abroad. Conceived and prepared "The Heroic Encounter" exhibit of Symbolic Art, introduced at the Willard Gallery, N.Y., 1958, subsequently circulated by the American Federation of Arts, 1958-1959. Chose the captions for the Museum of Modern Art's "Family of Man" photographic exhibition. Assembled captions for "Forms of Israel Exhibit," circulated by The American Federation of Arts, 1958-1960. Her photographs have been shown at the Museum of Modern Art, N.Y. in the "60 Photographs" exhibition; Limelight Gallery, N.Y.; George Eastman House, Rochester; Los Angeles County Mus.; Guild Hall, Easthampton; San Francisco Museum of Art; Philadelphia Museum of Art; Massachusetts Institute of Technology, and others. Edited, with introduction, "Selected Writings of John Marin"; Wrote a special issue of "Aperture," on Alfred Stieglitz, distinguished photographer and pioneer in introducing modern art to America, with whom she was closely associated. The special issue was also published in hard covers, 1960. Author of "Alfred Stieglitz: Introduction to an American Seer; two volumes on Jawaharlal Nehru-"The First Sixty Years," published in the U.S., Britain and India, 1965; "The Hero: Myth/Image/Symbol," 1969. An Exhibition of "Selections from Dorothy Norman Collection" was held at the Philadelphia Museum of Art, 1968.

NORONHA DE, MARIA (Mrs. Harold M. Shafron)—Painter, T.
 Mail: P.O. Box 6094, Atlanta, Ga. 30308
B. Cascais, Portugal, Sept. 17, 1927. Studied: Sagrado Coracao—Junior Col., Cascais and Lisbon, Portugal; Hunter Col., N.Y., B.A.; Montclair (N.J.) State Col. (grad. work); ASL, and with Dong Kingman, John Groth, Frank Reilly and others. Member: F. Royal Soc. A., London; Nat. Soc. A. & Lets.; Atlanta AA; Life F., Kappa Pi; Bergen County A. Educator's Assn., New Jersey; Carolina AA; Catherine Lorillard Wolfe A. Cl.; Gld. South Carolina A. Work: Fla. Southern Col., Lakeland, Fla.; Seton Hall Univ., South Orange, N.J.; Grumbacher Palette Coll., N.Y.; Hackensack (N.J.) Hospital Painting Coll.; College of Charleston; Oglethorpe Univ., Atlanta; Greensboro

(N.C.) Col.; and in private colls. U.S. and Europe. Exhibited: Bergen County A. Educators Exh., Paramus, N.J., 1959; Gibbes A. Gal., Charleston, 1961; Fairleigh Dickinson Univ., 1960 (one-man); Gld. So. Carolina A., Columbia, S.C., 1961; NAC; Kappa Pi Nat. Exh.; College Art Faculties Exh., Gainesville, Ga.; Grand Central Gals., N.Y.; Atlanta A. Festival; House of Portugal, N.Y.; Alice Lloyd Col. A. Festival, 1965; Lynn Kottler Gal., N.Y.; Schoneman Gal., N.Y.; Fifty American Artists annual; one-man: Little Theatre, Macon; American Gal., Atlanta; Unitarian Art Center, Wichita, Kans.; College of Charleston; Greensboro Col.; Oglethorpe Univ. Positions: A. T., Chm. FA Dept., Lyndhurst (N.J.) Sr. H.S., 1958-59, 1959-60. Instr., Painting & Drawing, Oglethorpe University, Atlanta, Ga., 1964-65.*

NORRIS, BEN—Painter, E., Des.
Art Department, University of Hawaii, Honolulu, Hawaii 96822
B. Redlands, Cal., Sept. 6, 1910. Studied: Pomona Col., B.A.; Harvard Univ. (FMA); Sorbonne, Paris, and with S. MacDonald-Wright, Jean Charlot, Max Ernst, Josef Albers. Member: Cal. WC Soc.; Phila. WC Cl.; Hawaii P. & S.; Honolulu Pr. M. Awards: prizes, Honolulu Acad. A., 1938, 1941, 1944, 1948, 1950, 1952, 1958, 1959, 1961, 1962; Honor Citation, AIA, Hawaii Chptr., 1961; Honolulu Pr. M., 1943, and others. Work: LC; N.Y. Pub. Lib.; Honolulu Acad. A.; NCFA; AFA Mus. Coll.; Oregon State Univ.; murals, First Nat. Bank, Kapiolani Branch, Honolulu; Royal Hawaiian Hotel; Royal Lahaina Hotel, Kaanapali, Maui, 1964; Colorplate in Henry Seldis' article "Pacific Heritage," Art in America Magazine, 1965. Exhibited: Cal. WC Soc., 1935-41, 1947-1949; AIC, 1938-1941; Phila. WC Cl., 1938-1940, 1941, 1949; WFNY, 1939; AWS, 1936, 1938, 1939; "7 Artists from Hawaii," Downtown Gal., N.Y., 1960; WMAA, 1960; Wayne State Univ., Detroit, 1960; IBM Gal., N.Y., 1965; "A Pacific Heritage," Los Angeles Municipal Gal. and Cal. Museum Circuit, 1965; Weatherspoon Invitational, Greensboro, N.C., 1967; Oswego, N.Y., 1968; Long Beach (Cal.) Mus., 1968; Crocker A. Gal., Sacramento, Cal., 1968; one-man: Honolulu Acad. A., 1936, 1938, 1940, 1942, 1944, 1959, 1965; Honolulu Advertizer Art Center for the Contemporary Arts, 1963; Cal. PLH, 1945; Crocker A. Gal.; 1946; Santa Barbara Mus. A., 1946; SAM, 1946; Pomona Col., 1935, 1946; Passedoit Gal., 1952; Gima and Beaux Arts Galleries, Honolulu, 1952, 1968; The Gallery, Honolulu, 1956; Comara Gal., Los Angeles, 1967. Positions: Instr., A., 1937-52, Prof. A., 1952- , Chm. A. Dept., 1946-1955, Prof. A., 1955- , Univ. Hawaii, Honolulu. Fulbright Lecturer (Prof. Western Art), Tokyo Univ. of Edu., Tokyo, Japan, 1955-56. A.-in-Res., Yaddo, Saratoga Springs, N.Y., 1968. Arch. Des. Collaboration and Art Supv., on major Honolulu buildings.

NORTON, PAUL F.—Educator, Hist.
Department of Art, University of Massachusetts, Amherst, Mass.; h. 57 Woodside Ave., Amherst, Mass. 01002
B. Newton, Mass., Jan. 23, 1917. Studied: Oberlin Col., A.B.; Princeton Univ., M.F.A., Ph.D. Member: Soc. Arch. Historians, Great Britain; CAA; Nat. Trust for Hist. Preservation (USA); Archaeological Inst. of America; Nat. Trust (England). Soc. Arch. Bibliographers; Societe francaise d'archeologie; Royal Soc. Arts; Soc. for the Preservation of New England Antiquities. Awards: Am. Council of Learned Societies Fellowship, 1951-52; Fulbright Fellowship, 1953-54; Ford Foundation Grant, Asian, African Studies, 1965; National Historical Publications Commission Grant for the study of Latrobe Papers. Author two chapters, "Nassau Hall," Princeton, 1956. Contributor to Journal of Soc. of Arch. Historians; Art Bulletin; Encyclopaedia Britannica; Encyclopedia of World Art; American Heritage; Catholic Encyclopedia. Chapter in monograph on "Decatur House," National Trust, 1967; Pamphlet (with M. Hill), "New St. Chad's and its Architect," Shrewsbury, England, 1967. Co-author: "Arts in America, the Nineteenth Century," 1969. Lectures extensively on Art History. Positions: Ed. Bd. Dirs., Journal of the Society of Architectural Historians; Prof. A. History, Pennsylvania State Univ., 1947-58; Visiting Assoc. Prof. of Art, Amherst College, 1959-60; Member, Massachusetts Board of Higher Education, Committee on Art in Higher Education; Prof. A. Hist., Chm., Dept. Art, University of Massachusetts, Amherst, Mass., 1958- .

NORWOOD, MALCOLM MARK—Educator, P., C.
Box 1807 Delta State College; h. 600 Canal Ave., Cleveland, Miss. 38732
B. Drew, Miss., Jan. 21, 1928. Studied: Mississippi Col., B.A., M. Edu.; Univ. North Carolina; Univ. Colorado; Univ. Alabama, M.A. Member: NAEA; Southeastern A. Edu. Assn.; Southeastern Col. A. Conf.; Mississippi AA. Awards: prizes, Jackson, Miss., 1963; Miss. AA, 1960. Work: Mun. A. Mus., First Nat. Bank, Belhaven Col., all Jackson, Miss.; First Nat. Bank, Cleveland, Miss. Exhibited: Smithsonian Inst., 1963; Mid-South Exh., Memphis, 1965, 1967, 1969; Weatherspoon A. Mus., Greensboro, N.C., 1966; Masur Mus. A., 1966; Montgomery, Ala., 1962. Positions: Chm., A. Section, Mississippi Edu. Assn., 1954, 1965; Southeastern A. Council,

1965-1966; Mississippi A. Colony Bd. Dirs., 1963, 1966; Dept. Head, Painting, Art History, Delta State College, Cleveland, Miss., at present.

NOTARO, ANTHONY—Sculptor
19 Pinecrest Terrace, Wayne, N.J. 07470
B. Italy, Jan. 10, 1915. Studied: Rinehart Sch. Sculpture, Maryland Inst., Balto.; and with Harry Lewis Raul, Hans Schuler, Herbert Adams, William Simpson. Member: NSS; Arch. Lg.; All. A. Am. Awards: Rinehart Sch. S., scholarship, 1935, prize, 1939; prizes, NAD, 1956; Tiffany Fnd., 1957; Mrs. Louis Bennett prize, NSS, 1960, and regional awards. Work: Sarah Josepha Hale Award Medal, 1957; Anniversary Medallion, Geiger Engineering & Mfg. Co., 1957; Hemerocallis Soc. Medal, 1960; New Jersey Tercentenary Medallion, 1962; University of Iowa Medal, 1963; port. reliefs, medals and architectural sculpture. Exhibited: NAD; NSS; Providence A. Cl.; All. A. Am.; Audubon A.; New Haven Paint & Clay Cl.; Conn. Acad. FA; Newark Mus. A.; Montclair A. Mus.; Greenwich Soc. A.; NAC; AAPL.*

NOVOTNY, ELMER LADISLAW—Painter, E.
Twin Lakes, Kent, Ohio 44240
B. Cleveland, Ohio, July 27, 1909. Studied: Cleveland Sch. A.; Univ. London; Yale Univ.; Western Reserve Univ., A.B.; Kent Univ., M.A. Member: Cleveland SA; Akron SA. Awards: prizes, CMA, 1930, 1937, 1938; Canton AI, 1944, 1945, 1946, 1968; Butler Inst. Am. A., 1958 (purchase); Akron AI, 1958 (purchase), 1967; awarded, Distinguished Professor of Kent State University, 1965; Life Fellow, Int. Inst. A. & Lets. Work: CMA; Cleveland Mun. Coll.; Coshocton Mus.; Butler Inst. Am. A.; Akron AI; Canton AI. Exhibited: Carnegie Inst., 1941; Milwaukee AI, 1945; Butler AI, 1940-1950, 1956-1961; Akron AI, 1946, 1952-1961; CMA, 1929-1945, 1961. Positions: Instr., Portrait Painting, Cleveland Sch. A., 1944-1952; Asst. Prof., 1938-40, Assoc. Prof., 1941-43, Prof. A., 1944- , Chm., Sch. A., Kent State Univ., Kent, Ohio. "By-Ways of Southern Europe" a portfolio of Drawing, 1969.

NOVROS, DAVID—Painter
c/o Bykert Gallery, 24 E. 81st St., New York, N.Y. 10019*

NOWACK, WAYNE K.—Painter
c/o Allan Stone Gallery, 48 E. 86th St., New York, N.Y. 10028*

NOYES, ELIOT—Architectural designer
96 Main St., New Canaan, Conn. 06840; 17 W. 54th St., New York, N.Y. 10019*

NUGENT, A(RTHUR) W(ILLIAM)—Cartoonist, I., W.
12 Tuxedo Parkway, Newark, N.J. 07106
B. Wallingford, Conn., Feb. 20, 1891. Studied: Fawcett A. Sch., Newark, N.J.; SI A. Sch., N.Y. Member: SI. Author, I., numerous children's puzzle & game books; Author, Cart., Publ., comic books and contest puzzles. Creator, "Funland," a puzzle-page feature syndicated by the Bell-McClure Syndicate in U.S. and abroad. Positions: Puzzle Cart., The Bell-McClure Syndicate, 1932- .

NULF, FRANK A.—Painter, E.
University of Saskatchewan, Division of Fine Arts, Regina, Sask., Canada
B. Lima, Ohio, Sept. 23, 1931. Studied: Arizona State Univ., B.S.; Michigan State Univ., M.A.; Ohio Univ., Ph.D. Awards: prize, Michigan-Indiana Biennial, 1960; Fulbright Grant to Madrid, Spain, 1962-1963. Work: Michigan State Univ.; N.Y. State Univ., St. Lawrence Univ., Canton, N.Y.; Arizona Electronics Corp. Exhibited: Soc. Wash. Pr. M., 1962; Boston Pr. M., 1965; Purdue Univ., 1964; Oklahoma City A. Center, 1962; Southwestern Annual, 1958, 1959; Everson Mus. A., 1966; Detroit Inst. A., 1960; Munson-Williams-Proctor Inst., Utica, N.Y., 1963, 1964; Contributor to Film Comment magazine. Positions: Assoc. Prof. A., State Univ. of N.Y., Potsdam, N.Y., 1960-1969; Dean, Division of Fine Arts, Univ. Saskatchewan, Regina, Sask., Canada, 1969- .

OCHIKUBO, TETSUO—Painter, Gr., E., Des.
1010 Westcott St., Syracuse, N.Y. 13210
B. Waipahu, Hawaii, July 29, 1923. Studied: Univ. Hawaii; AIC; Ray Vogue Sch. Art; ASL; Pratt Inst., and privately. Member: ASL. Awards: Tamarind Lithography Workshop Fellowship, 1960; Guggenheim Fellowship, 1958-59; Bernays Scholarship, ASL, 1956-57; John Hay Whitney Fnd. Fellowship, 1957-58; prizes, Boston Printmakers, 1959; Honolulu Acad. A., 1952; Soc. Four Arts, Palm Beach, 1960; Sarasota AA, 1960; Maganini Award, Silvermine Gld. A., 1960 and Lucille Lortel Award, 1957; ASL, 1957; Leeward A. Exh., Honolulu, 1962. Work: Albright-Knox A. Gal.; Mary Washington Col.; Chrysler Mus., Provincetown; Syracuse Univ.; Oswego (N.Y.) Col.; St. Lawrence Univ.; De Cordova & Dana Mus.; William & Mary Col.; USIA,

Wash. D.C.; CM; Honolulu Acad. A.; Phila. Print Cl.; ASL; LC. Exhibited: Sarasota AA, 1960; Oklahoma A. Center, 1960, 1965; BM, 1960; Butler Inst. Am. A.; Detroit Inst. A.; PAFA, 1960; Mus. Mod. A., Tokyo, 1960; Am. Acad. A. & Lets., 1959, 1960; Mary Washington Col., 1958, 1961, 1962, 1963; CGA, 1961; American Printmakers, Syracuse Univ., 1964; Boston Printmakers, 1959, 1960; Phila. Pr. Cl., 1959; Leeward Exh., Hawaii, 1962; American Prints Around the World, USIA, 1963; Soc. Four Arts, 1960; Skidmore Univ., 1965; Everson Mus. A., Syracuse, N.Y., 1965; Contemporary A. Center of Hawaii, 1968; Munson-Williams-Proctor Inst., Utica, 1967; State Univ. of N.Y. at Albany, 1967; Pratt Center for Contemp. Pr. M., 1968; Roberson Center, Binghamton, N.Y., 1968; Soc. of Four Arts, Palm Beach, Fla.; one-man: Rollins Col., Winter Park, Fla., 1969. Positions: Univ. Mississippi (Instr. Lith.); Mary Washington Col., Fredericksburg, Va.; Printmaking, ASL; Prof., Art Dept., Syracuse University, N.Y.

OCHTMAN, DOROTHY (Mrs. W. A. Del Mar)—
Painter
Stanwich Lane, Greenwich, Conn. 06830
B. Riverside, Conn., May 8, 1892. Studied: Smith Col., A.B.; Bryn Mawr Col.; NAD, and abroad. Member: ANA; Audubon A.; Hudson Valley AA; Grand Central A. Gal.; Greenwich A. Soc., Inc.; All. A. Am.; NAWA. Awards: prizes, NAD, 1921, 1924; Greenwich Soc. A., 1930, 1945, 1947, 1951, 1953-1957; Hooker prize & Best in Show, 1960; Fontainebleau Alum. Assn., 1937; NAWA, 1941, medal, 1952; Guggenheim F., 1927. Work: Smith College Mus. Exhibited: NAD; NAWA; Audubon A.; All. A. Am.; Greenwich Soc. A.; Hudson Valley AA; Silvermine Gld. A.; Conn. Acad. FA; NAC; Montclair A. Mus.; CGA; PAFA; Currier Gal. A.; Toledo Mus. A.; one-man: Grand Central Gal., 1931, 1946; Pasadena AI, 1931; Greenwich Lib., 1941, 1953.

O'CONNOR, THOM—Lithographer
81 Maple St., Voorheesville, N.Y. 12186
B. Detroit, Mich., June 26, 1937. Studied: Univ. Michigan; Florida State Univ., B.A., with Karl Zerbe; Cranbrook Acad. A., M.F.A. Member: Print Council of America. Awards: Purchase awards - Michigan Printmakers, 1962; Detroit Inst. Arts, 1962; State College, Potsdam, N.Y., 1962; Schenectady Mus., 1963; Univ. Massachusetts, 1963; Univ. North Dakota, 1965; Fellowship, Tamarind Lithography Workshop, 1964. Work: Cranbrook Acad. A.; Detroit AI; Univ. Massachusetts; State College, Potsdam, N.Y.; Univ. North Dakota; Schenectady Mus.; John Herron Mus. A.; Kalamazoo A. Center; Minneapolis Inst. A.; MModA; LC; Butler Inst. Am. A.; PMA. Exhibited: BM, 1964; Florida State Univ., 1964, 1965; Northwest PrM., 1965; Print Club, 1965; "Art Across America" exh., 1965; San F. AI, 1964; Albany Inst. Hist. & Art, 1963, 1964; Munson-Williams-Proctor Inst., 1963-1965; Berkshire Mus., 1963; Schenectady Mus., 1963-1965. Positions: Prof., Graphics, State University of New York, Albany, N.Y.

ODATE, TOSHIO—Sculptor
201 Eastern Pkwy., Brooklyn, N.Y. 11238
B. Tokyo, Japan, July 9, 1930. Studied: Chiba Univ., Japan; ASL. Work: Rochester Mem. A. Gal.; Bundy A. Gal., Waitsfield, Vt.; Great Southwest Atlanta Corp. Lectures: N.Y. Univ.; Denver A. Mus.; Univ. Wisconsin. Positions: Instr., Sculpture, Brooklyn Mus. A. Sch.; Pratt Inst., Brooklyn, N.Y.

O'DOHERTY, BRIAN—Sculptor, W.
15 W. 67th St., New York, N.Y. 10023
B. Ballaghaderrin, Ireland, May 4, 1920. Author: "Object and Idea," 1967; "The Voice and the Myth: 8 American Artists," 1970. Exhibited: one-man: Byron Gal., N.Y., 1966. Positions: Art News Staff, New York Times; Art Critic, Newsweek; Program Director for the Visual Arts, National Endowment for the Arts, 1969- .

ODORFER, ADOLF—Ceramic Craftsman, E.
Fresno State College; h. 4715 North Thorne St., Fresno, Cal. 93705
B. Vienna, Austria, Dec. 6, 1902. Studied: in Austria; Brazil; Mexico; Fresno State Col., A.B. Awards: prizes for ceramics, Syracuse Mus. FA (several). Work: Syracuse Mus. FA. Exhibited: SFMA (2). Work: Syracuse Mus. FA Ceramic exhs., 1937-1943, 1945, 1947-1958; Cranbrook Acad. A., 1948, 1950, 1953; Scripps Col., 1949; Los A. County Fair; Denver A. Mus., and others. Positions: Assoc. Prof. A., Ceramics, Fresno State College, Fresno, Cal., 1948- .

OEHLER, HELEN GAPEN (Mrs. Arnold J.)—Painter, L., T.
Hacienda Carmel, Studio No. 195, Carmel, Cal. 93921
B. Ottawa, Ill., May 30, 1893. Studied: AIC; & with George Elmer Browne. Member: All.A.Am.; AWCS; AAPL; NAWA; Audubon A.; Lg. Am. Pen Women; New Jersey WC Soc.; P. & S. Soc. New Jersey; Ridgewood AA.; Art Assoc. Mill Valley, Cal.; Soc. Western A. Work: Walter Chrysler Coll. Exhibited: NAD, 1941, 1943; Salon

d'Automne, 1938; Salon des Artistes Francaise, 1939; AFA traveling exh.; WFNY 1939; Pepsi-Cola, 1945; Dayton AI; Newark Mus.; Audubon A., 1953-1955, 1959-1961; All.A.Am., 1953-1955, 1959-61; State Fed. Women's Cl.; Mill Valley (Cal.) Outdoor Exh., 1954 (one-man); New Jersey State Mus.; Montclair A. Mus.; Crocker A. Gal., Sacramento; Santa Cruz, Cal.; Grape Festival, Lodi, Cal.; one-man exh. watercolors, traveling U.S. three years, and to Alaska 6 months, 1969; El Paso Mus. A.; de Young Mem. Mus.; Univ. San Francisco (one-man); Provincetown AA; Carmel Valley A. Gal.; Cal. Centennial Exh., San Diego, 1969; Soc. Western A., de Young Mem. Mus., San Francisco. Positions: Nat. Dir. Am. A. Week, 1949-50; Nat. Sec., AAPL, 1950-52; Trustee, A. Council of New Jersey, 1945-52; Hon. Sec., Art Council of New Jersey, 1952- ; Com. local A. Festival, Am. A. Week; Chm., Art Assoc., Mill Valley. Lectures: Univ. Cal., Century Club & other groups, 1959-1964.

OEHLSCHLAEGER, FRANK J.—Art Dealer
28 S. Blvd. of Presidents, Sarasota, Fla., and 107 E. Oak St., Chicago, Ill. 60611; h. 103 Filmore Dr., Sarasota, Fla. 33577
B. Paducah, Ky., Sept. 8, 1910. Studied: Cornell University, B.A. Also studied with William McNulty and Louis Bosa. Specialty of Gallery: Contemporary American and European Paintings. Positions: Member, Chicago Art Dealers Association, 1966-1969; Art Dealers Association of America, 1968, 1969. Director, Associated American Artists Chicago galleries, 1946-1947; Owner, Frank J. Oehlschlaeger Galleries, Chicago, Illinois and Sarasota, Florida.

OENSLAGER, DONALD (MITCHELL)—
Scenic Designer, Theatre Consultant, E., Collector
1501 Broadway, Suite 1915, 10036; h. 825 Fifth Ave., New York, N.Y. 10021
B. Harrisburg, Pa., Mar. 7, 1902. Studied: Harvard Univ. Member: Century Assn.; Harvard Cl.; United Scenic A.; Neighborhood Playhouse School for Theatre (Pres. 1928-1963); The Grolier Club; Benjamin Franklin F., Royal Soc. of A., London, 1969. Awards: Sachs FA traveling F.; hon. deg., D.F.A., Colorado Col., 1953; Hon. Phi Beta Kappa, Harvard Univ., 1954; Artist-in-Res., American Academy in Rome, 1955; Antoinette Perry Award for best stage design on Broadway in 1958-59 season, "A Majority of One," 1959. Des. over 250 productions for the New York Theatre. Exhibited: Nat. Lib., Vienna; MModA; Phillips Acad.; Ohio State Univ. Theatre; Conn. Exh. of Am. Scene Designers; Norton Gal. A., West Palm Beach; Mus. City of N.Y.; Marie Sterner Gal.; Am.-British A. Center; BM; Pratt Inst.; FMA; PMSchIA; Detroit Inst. A., 1956; AFA traveling exh., 1957-58. One-man: Wright-Hepburn-Webster Gal., N.Y., 1969. Author: "Scenery, Then and Now," 1938; "Theatre of Bali," 1941; Ed., "Handbook of Scene Painting," 1952. Contributor to newspapers and theatrical magazines. Lectures: The Theatre; "Stage Design." Collection: Drawings & Prints of theatrical designs of the 16th-20th Century. Positions: Prof. Stage Design, and theatre consultant, Yale Univ. Sch. FA, New Haven, Conn.; Bd. Dirs., Parsons Sch. Des.; MacDowell Assn., ANTA; Brooklyn Acad. A. & Sc.; Pratt Inst.; Mun. A. Soc.; President's Advisory Committee on The Arts, 1960 (appt). Bd. Trustees, American Academy of Dramatic Arts, 1964-65; Bd. Trustees, The Museum of the City of New York; Member, U.S. Nat. Commission for UNESCO, 1963-1968; Art. Comm. City of N.Y., 1965- ; Member, Nat. Committee, The Drawing Society; Bd. Dirs., Vice-Pres., Master Drawings Assn.; Consultant: Am. Pavillion Theatre, Brussels World's Fair, 1958; Broadmoor Int. Center, 1961; Montreal Cultural Center, 1961; N.Y. State Theatre, Brandeis Univ.; Wilkes College FA Center, Wilkes-Barre, Pa.; John F. Kennedy Center for the Performing Arts, Wash. D.C.; Meeting Center of Albany South Mall Project, N.Y.; Communication Arts Bldg., Univ. of Wisconsin, Madison; Performing Arts Area of Northwestern High School, Detroit; Design Consultant, Philharmonic Hall, Lincoln Center, 1962; Des. & Consultant, Fort Worth Performing Arts Center, Texas; Designer, Fountains & Lighting for the N.Y. World's Fair, 1964-65.

OFFIN, CHARLES Z.—Publisher, Critic, Collector
30 East 60th St. 10022; h. 907 Fifth Ave., New York, N.Y. 10021
B. New York, N.Y., Feb. 5, 1899. Studied: Col. City of N.Y.; NAD; ASL; Ecole des Beaux-Arts, Fontainebleau, France. Work: etchings, MMA; N.Y.Pub.Lib. Exhibited: one-man exh.: Paris, Barcelona, New York. Collection: 20th Century European Art. Positions: Instr., Col. City of New York, 1932-35; A. Cr., Brooklyn Eagle, 1933-36; Ed., Pub., "Pictures on Exhibit," 1937- ; President and Treasurer, Charles Z. Offin A. Fund.

OFFNER, ELLIOT—Sculptor, Typographer, E.
Smith College, Northampton, Mass.; h. 74 Washington Ave., Northampton, Mass. 01060
B. New York, N.Y., July 12, 1931. Studied: Cooper Union, N.Y.; Yale Univ., B.F.A., M.F.A., with Albers and Lebrun. Member: AAUP; William Morris Soc. Awards: Tiffany Fnd. Grant, 1963, 1964; Nat. Inst. A. & Lets. award, 1965; PAFA, 1967; Plaza 7,

1967. Work: Smith College, Facade sculpture, B'nai Israel, North-ampton, Mass., 1963; Kehilleth Israel, Brookline, Mass. (eight sculptures); DeCordova Mus.; BM; Low Mus., Syracuse Univ.; Joseph Hirshhorn Fnd.; Allen A. Mus. of Oberlin Col.; Slater Mem. Mus., prizes, Springfield Mus. FA, 1963, 1965; Berkshire Mus., 1961. Exhibited: Springfield Mus. FA; Univ. Massachusetts; Univ. Colorado; Univ. Connecticut; Smith College Mus.; Nat. Inst. A. & Lets.; Carnegie Inst., traveling exh.; and others. One-man: Forum Gal., 1964, 1967; Peabody Inst., Baltimore, 1965; Boston A. Festival, 1961, 1963, 1964; R.I. Art Festival, 1960, 1961; Berkshire Mus., 1959-1961, 1966; Wadsworth Atheneum, 1960, 1961, 1964; Northwestern Univ., 1963, 1965; De Cordova Mus., 1964; Schenectady Mus., 1962; "Plaza Seven" sculpture exh., Hartford, Conn., 1965; Tragos Gal., 1967;,IFA Gal., 1968; Wells Col., retrospective, 1968. Positions: Calligrapher, Des., Steuben Glass Co., 1953-55; Prof. Design & Sculpture, Univ. Massachusetts, 1959-60; Prof., Des., Sculpture, Calligraphy, Smith College, Northampton, Mass., 1960- . Dir., Rosemary Press, 1968- .

OGG, OSCAR—Designer, W., L., T., Cr.
345 Hudson St., New York, N.Y. 10014; h. Westover Rd., Stamford, Conn. 06902
B. Richmond, Va., Dec. 13, 1908. Studied: Univ. Illinois, B.S. in Arch.; Colorado Springs FA Center. Member: Grolier Cl.; Typophiles; AIGA; Soc. Typographic A., Chicago; Type Dir. Cl., N.Y. Author, I., "An Alphabet Source Book," 1940; "Lettering as a Book Art," 1946; "The 26 Letters," 1948. Contributor to Encyclopaedia Americana; Art of the Book; Books and Printers; American Artist; Three Italian Writing Masters, 1953; Sixty-three Drawings by Warren Chappell, 1955. Lectures on Calligraphy. Positions: V.-Pres. & A. Dir., Bd. Memb., Book-of-the-Month Club, New York, N.Y,, at present.*

O'HANLON, RICHARD EMMETT—Sculptor, L., E.
616 Throckmorton Ave., Mill Valley, Cal. 94941
B., Long Beach, Cal., Oct. 7, 1906. Studied: Cal. Col. A. & Crafts; Cal. Sch. FA. Member: San F. AI (Bd. Memb. 1956-1959, 1963-1966, Arch. Com., 1966-1967); Memb., Architectural Review Board, San Francisco Redevelopment Agcy.; Bd., San F. AI; Bd. Memb., Marin County Mus. Assn.; Art Adv. Bd., Cal. State Fair; Memb., Int. House of Japan. Awards: Bender Grant, San F., 1941; Creative Arts Fellowship, Univ. California, 1965-66; purchase award, Denver A. Mus., 1963; grant-in-aid, travel study Turkey, Iran, India, Nepal, Japan, 1968. Work: Sculpture, Univ. California, Berkeley and Davis; black granite group, Univ. California at Riverside, 1969; SFMA; Denver Mus. A.; USPO, Salinas, Cal.; WMAA, AGAA; WMA; WAC; BMA; Smith Col. Mus., and in private colls. Exhibited: WMAA, 1962; Willard Gal., N.Y., 1962-1965; Denver A. Mus., 1962, 1964, 1965; SFMA; WAC; and many others nationally. One-man: Willard Gal., 1963; Carnegie Inst., 1963; Univ. Kentucky, 1964; Rochester Mem. Gal.; SFMA; BMFA; Santa Barbara Mus. A., 1969, and others. Lectures on sculpture: Carnegie Inst., SFMA, Univ. California, Fresno A. Center, UCLA, Oakland A. Mus., etc. Positions: Sculpture Research, Mexico & Yucatan, 1956; Europe and Near East, 1953-54; Scandinavia, India & Japan, 1958-59, 1962; Prof. Sculpture, Art Dept., University of California, Berkeley, 1960-1967, Prof. A., 1967- .

O'HARA, DOROTHEA WARREN—Potter, P., W.
Apple Tree Lane, Darien, Conn. 06820
B. Malta Bend, Mo. Studied: Munich, Germany; Royal Col. A., London, England; Columbia Univ., and with Lewis Day, C. F. Binns. Member: NAC; Pen & Brush Cl.; Keramic Soc. & Des. Gld., N.Y. Awards: med., Pan-Pacific Expo., 1915. Work: MMA; Cranbrook Acad. A.; Syracuse Mus. FA; William Rockhill Nelson Gal. A.; Mary Atkins Mus., Kansas City; Stamford (Conn.) Mus. A.; Bennington Mus. A. Exhibited: Paris Salon; MMA; Harlow Gal.; Grand Central A. Gal.; NAC; Pen & Brush Cl.; and in London, Stockholm, Tokyo.*

O'HARA, ELIOT—Painter, Gr., W., L., T.
2000 N St. N.W., Washington, D.C. 20036
B. Waltham, Mass., June 14, 1890. Studied: In U.S. and Europe. Member: NA; AWS; Wash. WC Cl., Gld. and Landscape Cl.; Laguna Beach AA; Alameda AA; St. Augustine AA. Awards: Guggenheim F., 1928; prizes, AWS, 1931; Ogunquit AA; New Haven Paint & Clay Cl.; Phila. WC Cl., 1938; Wash. Landscape Cl., 1946, 1950; Soc. Four A., 1945, 1947; Laguna Beach AA, 1949, 1953-1955; Alabama WC Soc., 1950; Wash. WC Cl., 1952; Soc. Western A., 1953. Work: Fitzgerald Mus., Brookline, Mass.; Mappin Gal., Sheffield, England; Guggenheim Mem. Fnd.; Hispanic Soc., N.Y.; BM; A. Gal., La Paz, Bolivia: The White House, Wash., D.C.; LC; Telfair Acad. A.; Choate Sch., Wallingford; Carolina AA; San Diego FA Soc.; Phila. WC Cl.; John Herron AI; Montana State Col.; Indiana Univ.; U.S. State Dept.; Joslyn A. Mus.; CAM; Toledo Mus. A.; Brooks Mem. A. Gal.; Encyclopaedia Britannica; NAD; IBM; BMFA; Norton Gal. A., and many

other major colls. Exhibited: nationally. Over 500 one-man exhs. Author: "Making Watercolor Behave," 1932; "Making the Brush Behave," 1935; "Watercolor Fares Forth," 1938; "Art Teacher's Primer," 1939; "Watercolor at Large," 1946; "Portraits in the Making," 1948; "Watercolor Portraiture" (With Walker & Short), 1948, 1949; "Watercolor Painting in the United States" (With Shirley P. O'Hara) 1949 (in "Old Water-Colour Society's Club Volume," Pub. London); "Watercolor with O'Hara," 1966. Maker of 14 films on art. Positions: Dir., Eliot O'Hara Water Color Sch., Washington, D.C.

O'HARA, (JAMES) FREDERICK—Printmaker, P., E.
846 Forward St., La Jolla, Cal. 92037
B. Ottawa, Canada, Aug. 16, 1904. Studied: Massachusetts Sch. A., Boston; Grad. Sch. of BMFA Sch. A. Awards: Faculty medal, Massachusetts Sch. A., 1926; Paige Traveling Scholarship, 1929-1931, BMFA; purchase prizes, Mus. of New Mexico, 1952, 1953, 1957; print award, San Diego Open Exh., 1963, 1967; A. Fellowship, Tamarind Lithography Workshop, Los Angeles, Cal., 1962. Work: graphics—Mus. of New Mexico; Springfield (Mass.) Mus. FA; NGA; MMA; MModA; N.Y. Public Library; City Mus., Karlsruhe, West Germany; BMA; Denver A. Mus.; AIC; CM; Achenbach Fnd. of Graphic Art, San Francisco, Cal.; Brandeis Univ.; FA Gal. of San Diego; Santa Barbara A. Mus.; New Mexico Highlands Univ., Univ. California, Santa Barbara; Immaculate Heart Col., Los Angeles. Exhibited: CMA Int. Color Lithography, 1958, 1960, 1962; Prints of the World, London, England, 1962; BM, 1951; Phila. Pr. Cl., 1956; 50 Years of American Prints, USIS, 1957. One-man: Karlsruhe, West Germany, 1956; Tokyo, Japan, 1956; Santa Barbara A. Mus., 1953, 1955; La Jolla A. Mus., 1958; Mus. of New Mexico, 1958; DMFA, 1959; Coronado (Cal.) Sch. FA, 1960; Faulkner Gal., Santa Barbara, 1937; and others. Work reproduced in "Graphic Arts of the 20th Century," 1962; Life magazine, 1954. Articles in "Artist's Proof" Pratt Graphic Art Center, N.Y., 1961, 1962. Positions: Visiting Prof., New Mexico Highlands Univ., 1958; Instr., graphics and painting, Coronado Sch. FA, 1953, 1962.

OHASHI, YUTAKA—Painter
5 Great Jones St., New York, N.Y. 10012.
B. Hiroshima, Japan, 1923. Studied: Tokyo Acad. FA, B.F.A.; BMFA Sch. A.; Yale Summer Sch. Awards: Paige and Bartlett traveling scholarships, BMFA; Guggenheim Fellowship for painting in Japan; prizes, Portland (Me.) A. Festival, 1960; Boston A. Festival, 1964. Work: Guggenheim Mus., N.Y.; deCordova and Dana Mus., Lincoln, Mass.; AGAA; Cornell Univ.; Univ. Wyoming; Univ. Texas; Yale Gal. FA; BMFA; Albright-Knox A. Gal.; Philharmonic Hall, Lincoln Center, N.Y.; Nat. Mus. Mod. A., Tokyo. Exhibited: Inst. Contemp. A., Boston; BMFA; deCordova & Dana Mus.; Guggenheim Mus.; AIC; Carnegie Int.; Nat. Mus., Tokyo; VMFA; Munson-Williams-Proctor Inst., Utica, N.Y.; New York-Rome Fnd. (Rome); one-man: Alan Gal., N.Y., 1957, 1960, 1963, 1965; Swetzoff Gal., Boston, 1958, 1960, 1964, 1966, 1967; Cornell Univ., 1961; Lee Nordness Gal., N.Y., 1969.

OHLSON, DOUGLAS D.—Painter, T.
53 W. 28th St., New York, N.Y. 10001
B. Cherokee, Iowa, Nov. 18, 1936. Studied: Univ. Minnesota, B.A. Awards: Guggenheim Fellowship, 1968. Work: Museum Purchase Coll., AFA; Bethel Col., St. Paul. Exhibited: AFA, 1964; Minneapolis Inst. A., 1961; Vassar Col., 1964; Hudson River Mus., N.Y., 1964; Bennington Col., 1964; one-man: Fischbach Gal., N.Y., 1964, 1966, 1967-1969; Westmoreland County Mus., Greensburg, Pa., 1966; Detroit Inst. A., 1967; PMA, 1968; MModA, 1968, 1969; Grand Palais, Paris, 1968, 1969; Kunsthaus, Zurich, 1968, 1969; Tate Gal., London; BM, 1968. Positions: Instr., Drawing & Design, Hunter College, New York, N.Y.

OHRBACH, JEROME K.—Collector
1901 Ave. of the Stars 90067; h. 423 N. Faring Rd., Los Angeles, Cal. 90024
B. New York, N.Y., Dec. 17, 1907. Studied: Cornell University, A.B. Collection: Impressionist and Post-impressionist art and sculpture.

OKADA, KENZO—Painter
51 W. 11th St., New York, N.Y. 10011
B. Yokohama, Japan, Sept. 28, 1902. Studied: Tokyo Fine Arts Univ., and in Paris. Awards: Nikakai, 1936; Showa Shorei, 1938; AIC, 1954, 1957; Carnegie Inst., 1955; Columbia (S.C.) Biennial, 1957; Venice Biennal, 1958; Dunn Int., 1963; Ford Fnd. Grant, 1959. Work: MMA; MModA; AIC; Guggenheim Mus.; WMAA; Carnegie Inst.; Albright-Knox A. Gal.; PGA; BM; Reynolds Metals Co.; Univ. Colorado; BMA; SFMA; BMFA; Munson-Williams-Proctor Inst.; Santa Barbara Mus. A.; Yale Gal. FA; Rockefeller Inst.; Chase Manhattan Bank, and others. Exhibited: Sao Paulo Bienal, 1955; Venice Biennal, 1958; one-man: Hokuso Gal., 1948, 1950; U.S. Army Edu.

Center, Tokyo, 1949, 1950 and Yokohama, 1950; Betty Parsons Gal., N.Y., 1953, 1955, 1956, 1959, 1962, 1964; MIT, 1962; CGA, 1955; Fairweather-Hardin Gal., Chicago, 1956; Todes Gal., Glencoe, Ill., 1957; Ferus Gal., Los Angeles, 1959.*

OKAMURA, ARTHUR—Painter
Box 21 Ocean Parkway, Bolinas, Cal. 94924
B. Long Beach, Cal., Feb. 24, 1932. Studied: AIC. Awards: prizes, Univ. Chicago, Religious Arts, 1953, and Cahn award, 1957; Univ. Illinois (purchase), 1959; SFMA, 1960; WMAA (purchase), 1960; Nat. Soc. A. & Lets. (purchase); Ryerson Foreign Travel Fellowship, 1954. Work: Univ. Chicago; Santa Barbara Mus. A.; AIC; WMAA; SFMA; Univ. Illinois; Borg Warner Coll., Chicago; Phoenix A. Mus.; Illinois State Normal Sch.; Container Corp. of America; Nat. Soc. A. & Lets; Johnson Wax Coll.; U.S. Steel Service Inst.; CGA; Miles Laboratory; Kalamazoo AI; Achenbach Fnd., Cal. PLH. Exhibited: AIC, 1951-1954, 1957, 1959; MModA, 1954; Downtown Gal., N.Y., 1954; Univ. Illinois, 1955, 1959; Ravinia A. Festival, Highland Park, Ill., 1956, 1959; Los A. Mus. A., 1957, 1965; SFMA, 1957-1962; West Coast Painters, AFA, 1958, 1959 and New Talent, 1959; DMFA, 1959; de Young Mem. Mus., 1958; Knoedler Gal., N.Y., 1958; Cal. PLH, 1959, 1965; WMAA, 1960, 1962-1964; Time-Life Bldg., N.Y., 1961; PAFA, 1954; Univ. Washington, Seattle, 1955; Carnegie Inst., 1964; Univ. Nebraska, 1958; CGA, 1964; Denver Mus. A., 1958; USIA, Berlin, Cologne, Germany, 1958-59; one-man: Ryan Gal., Chicago, 1953; Feingarten Galleries, Chicago, New York, San Francisco, Los Angeles, 1956-1964; Santa Barbara Mus. A., 1958; Oakland A. Mus., 1959; Cal. PLH, 1961; Calhoun Gal., Dallas, 1962; La Jolla Mus. A., 1963; Univ. Utah, 1964; Knoedler Gal., N.Y., 1965; Hansen Gal., San F., 1965. Positions: Instr., Sch. of the Art Inst. of Chicago, 1957; California Sch. FA, San Francisco, 1958; California Col. of Arts & Crafts, Oakland, 1958, 1959; Saugatuck (Mich.) Summer Art Sch., 1959, 1962; guest lecturer, Univ. Utah, 1964, and others.*

O'KEEFE, GEORGIA—Painter
Abiquiu, N.M. 87510
B. Sun Prairie, Wis., Nov. 15, 1887. Studied: AIC; ASL; Univ. Virginia; Columbia Univ. Member: Am. Acad. A. & Let.; Am. Acad. A. & Sciences; Nat. Inst. A. & Let. Awards: Hon. degrees, D.F.A., William & Mary Col.; Litt.D., Mills Col.; D.F.A., Univ. New Mexico, 1964; Creative Arts award, Brandeis Univ., 1963; Litt.D., Univ. Wisconsin. Work: MMA; MModA; WMAA; BM; AIC; PMG; Detroit Inst. A.; Springfield Mus. A.; CMA; BMFA; PMA; Newark Mus.; John Herron AI, and many others. Exhibited: nationally. Paintings first exhibited by Alfred Stieglitz at "291" in 1916-17; yearly exh. 1926-1946, 1950, Intimate Gal., and An American Place. Retrospective one-man exh.: BM, 1927; AIC, 1943; MModA., 1946; WMA, 1960; Amon Carter Mus., Ft. Worth, Tex., 1966; Mus. FA of Houston, 1966. Portfolio, Georgia O'Keefe Drawings," published, 1968.

OLDENBURG, CLAES—Painter, S.
404 E. 14th St., New York, N.Y. 10009
B. Stockholm, Sweden, 1929. Studied: Yale Univ., B.A.; AIC. Exhibited: Martha Jackson Gal., N.Y., 1960; Sidney Janis Gal., N.Y., 1962-1967; MModA, 1963; Gallery of Modern Art, Wash. D.C., 1963; Stedelijk Mus., Amsterdam, 1963, 1964; Staatliche Kunsthalle, Baden-Baden, 1963; Oakland A. Mus., 1963; Inst. Contemp. Art, London, 1963; Moderna Museet, Stockholm, 1964; Museum Louisiana, Denmark, 1964; Haags Gemeente, The Hague, 1964; Ileana Sonnabend Gal., Paris, 1967; Pollock Gal., 1968; Indian Triennial of Cent. World A., New Delhi, 1968, and others. One-man: Judson Gal., N.Y., 1959; Reuben Gal., N.Y., 1960; "The Store" and "Ray Gun Manufacturing Company," at his N.Y. studio, 1961; Green Gal., N.Y., 1962; Dwan Gal., Los Angeles, 1964; Sidney Janis Gal., N.Y., 1964, 1966; Mus. Contemp. Arts, Dallas, 1962; Univ. Chicago, 1962; Film Makers' Cinematheque, N.Y., 1965. Author & I., "Store Days," 1967.*

OLDS, ELIZABETH—Painter, Gr., I., W.
Brown Hill Rd., Tamworth, N.H. 03886
B. Minneapolis, Minn., Dec. 10, 1896. Studied: Univ. Minnesota, Minneapolis Sch. A.; ASL, and with George Luks. Awards: Guggenheim F., 1926-27; prizes, Phila. Pr. Cl., 1937; Phila. A. All., 1938; MModA, 1941; BMA, 1953; medal, Kansas City AI, 1934. Work: MMA; MModA; BM; PMA; N.Y. Pub. Lib.; LC; BMA; SAM; Joseph Hirshhorn Coll.; SFMA; Glasgow Univ. Exhibited: WMAA; Univ. Pittsburgh; Berkshire Mus.; Munson-Williams-Proctor Inst.; one-man: ACA Gal., 1937-1941, 1950, 1952, 1955, 1960, 1962; Staten Island Inst. A. & Sciences, 1969. Author, I., "The Big Fire," 1945, Jr. Literary Gld. selection: "Riding the Rails," 1948; "Feather Mountain," 1951; "Deep Treasure," 1948, Junior Literary Guild selection; "Plop, Plop, Ploppie," 1962, Jr. Lit. Gld. Selection; "Little Una," 1963. Lectures: Origin and Growth of Silk Screen Process; History and Technique of Serigraphy, etc.

OLINSKY, TOSCA—Painter
27 West 67th St., New York, N.Y. 10023
Member: ANA.*

OLITSKI, JULES—Painter, E.
323 W. 21st St., New York, N.Y. 10011; h. R.D.1, Box 16A, Shaftsbury, Vt. 05262
B. Gomel, Russia, Mar. 27, 1922. Studied: NAD; Academie de la Grande Chaumiere, Paris; Ossip Zadkine Sch., Paris; N.Y. Univ., B.A., M.A. Awards: prize Carnegie Int., 1961; CGA, 1967. Work: MModA; Norman Mackenzie Mus., Regina, Saskatchewan; WMAA; Chrysler Mus., Provincetown, Mass.; AIC. Exhibited: Carnegie Inst., 1961, 1965; Norman Mackenzie A. Mus., 1963; Washington Gal. Modern Art, 1963; Brandeis Univ., 1964; WMAA, 1964; Guggenheim Mus., 1964; Los A. Mus. A., 1964; Univ. Pennsylvania, 1964; FMA, 1965; MModA, 1962, 1965; Los Angeles County Mus., 1964; Pasadena A. Mus., 1965; Basel, Switzerland, 1965, and other exhs. in New York, London, Paris, Italy, Toronto, Chicago. One-man: Poindexter Gal., N.Y., 1961-1968; Gray Gal., Chicago, 1964; Mirvish Gal., Toronto, 1964-1968; Kasmin Gal., London, 1964-1968; Galerie Lawrence, Paris, 1964; Toninelli Gal., Milan, 1963; Bennington Col., 1962; Lawrence Rubin Gal., 1969; Emmerich Gal., N.Y., 1966-1968, and others. Positions: Instr. Co-ordinator of FA, C. W. Post College, Brookville, N.Y., 1956-1963; Art Chairman, Art Dept., Bennington College, Bennington, Vt., 1963-1967.

OLIVER, HENRY, JR.—Collector
Blackburn Road, Sewickley, Pa. 15143*

OLKINETZKY, SAM—Museum Director, P., E.
Museum of Art, University of Oklahoma; h. 1015 McNamee St., Norman, Okla. 73069
B. New York, N.Y., Nov. 22, 1919. Studied: Brooklyn College, B.A.; N.Y. Univ., Inst. FA. Member: AAMus.; AFA; Mt. Plains Mus. Conf.; Oklahoma Mus. Assn. Awards: prizes, Philbrook A. Center, Tulsa, 1953 (purchase); Oklahoma A. Center, 1963 (purchase). Work: Philbrook A. Center; Okla. A. Center; Mus. of Art, Univ. Oklahoma. Exhibited: MModA, 1955, 1956; Mus. Non-Objective Painting, N.Y., 1951-1952; Oklahoma A. Center, 1963; DMFA. Lectures: Modern Art; Medieval Art. Exhibitions arranged: Young Talent in Oklahoma Annuals, 1960-1965; Joseph Glasco, Lee Mullican, Leon Polk Smith, 1965; East Coast-West Coast Paintings, 1968; Black Heritage, 1969. Positions: Asst. Prof. A., 1947-1957, Oklahoma State Univ.; Prof. A. and Director, Museum of Art, University of Oklahoma, 1957- . Visiting Prof., Univ. Arkansas, 1962-63; Consultant, Kerr-McGee Industries; Bd. of Trustees, Contemporary A. Fnd., Oklahoma City; Bd. of Dir., Oklahoma A. Exh. Bd.; Advisor, Oklahoma Arts & Humanities Council.

OLSEN, DON—Painter
77 West 7065 South, Midvale, Utah 84047
B. Provo, Utah., Dec. 3, 1910. Studied: Hans Hofmann Sch. FA.; Brigham Young Univ., B.S.; Univ. Utah. Awards: Utah State Inst. FA, 1958 (purchase); Ford Fnd. award, Salt Lake City A. Center, 1963; prize, Intermountain Exh., 1960, 1962, 1964. Work: Salt Lake City A. Center; Utah State Inst. FA. Exhibited: San F. AA, 1957; Nordness Gal., N.Y.; Art: USA, 1958; Intermountain Exh., 1960, 1962, 1964; Colorado Springs FA Center, 1964; Provincetown A.A. (Mass.); San Francisco A.A., 1957; Rockford A.A., Ill., 1966; AFA traveling exh., 1966-1968; Hack-Light Gal., Phoenix, Ariz., 1967; Gordon Woodside Gal., Seattle, 1966; Univ. Utah, 1965; Utah State Univ., 1957; one-man: Univ. Utah, 1966; Utah State Univ., 1957; Weber Col., Ogden, Utah, 1965; Salt Lake City A. Center, 1959; Salt Lake Pub. Lib., 1958-1960; Phillips Gal., Salt Lake, 1965-1967.

OLSEN, HERB(ERT) (VINCENT)—Painter
Bayberry Lane, Westport, Conn. 06880
B. Chicago, Ill., July 12, 1905. Studied: AIC; Am. Acad. A., Chicago. Member: ANA; AWS; Phila. WC Soc.; SC; Balt. WC Soc.; Conn. WC Soc.; All. A. Am.; SC; Authors Gld.; Artists and Writers. Awards: prizes, NAD, 1949, 1953 (2), Edwin Palmer Mem. prize, 1964; AWS, 1951, 1959 (purchase), Ranger Fund purchase, 1961; Hudson Valley AA, 1951, 1960, gold medal, 1953, gold medal, 1964; SC, 1951, 1957, 1959; silver medal, Swedish-Am. A., 1951, gold medal, 1953; NAC, 1951; New England Exh., 1953; All. A. Am., 1953; Conn. WC Soc., 1954; New Haven R.R. Exh., 1956; Audubon A., 1957; Balt. WC Cl., 1957; AIA, 1957; Springville, Utah, 1960, purchase, 1964; gold medal Art. Thompson for best Christmas card, 1964. Work: Notre Dame Univ.; Lafayette Mus. A.; Kennedy Gal.; Jacksonville (Fla.) Mus.; Cayuga Mus. Hist. & Art, Auburn, N.Y.; Lafayette (Ind.) Mus. A.; Union Lg. & Swedish Cl., Chicago. Exhibited: AIC; NAD; Conn. Contemporaries and others. Over 60 one-man exhs. Contributor of illus. to Collier's, American, Outdoor Life and other national magazines. Author: "Water Color Made Easy," 1955; "Painting the Figure in Water Color," 1958; "Painting Children in Water Color,"

60; "Herb Olsen's Guide to Water Color Painting," 1965; "Painting the Marine Scene in Water Color," 1967.

MEILIA, PHILIP JAY—Painter, T., I.
1108 Sunset Drive, Tulsa, Okla. 79114
Tulsa, Okla., July 17, 1927. Studied: ASL; Cape Sch. A., Provincetown, Mass.; Chicago Acad. FA; George Washington Univ.; Tulsa Univ. Member: AWS; Hon. Life Member, Assoc. A. of Tulsa. Awards: prizes, Assoc. A. of Tulsa, 1949; Tulsa Annual, 1950; Oklahoma Annual, 1950, 1051, 1956-1959, 1961; Tulsa A. Gld., 1953; 4th Nat. Bank Annual, 1955, 1956; Okla. Conservative A., 1959, 1962, 1963; Metropolitan State A. Contest, Nat. Museum, Wash. D.C.; Okla. City State Fair Exhibit, 1956 (purchase); Mus. New Mexico, Santa Fe, 1962; Watercolor:USA, Springfield, Mo., 1964 (purchase); Nat. Sports Exh., 1966; Int. A. Exh., 1966; Southwestern WC Exh., MFA. Work: Ford Motor Co.; Oklahoma A. Mus.; Gilcrease Mus., Tulsa; Tower Life Ins. Co., Springfield, Mo.; Philbrook Mus., Tulsa. Murals, United Founders Life Ins. Co., Okla. City; Assembly of God Church, Tulsa; mural, Corp. of Engineers. Exhibited: AWS, 1962-1964, 1965, 1967; Watercolor:USA, 1964; Mus. New Mexico, 1962; GA, 1952; Smithsonian Inst., 1951, 1952; Okla. A. Center, 1956-1965 (one-man 1965); Reynolds Gal., Taos, 1964, 1965; Philbrook A. Center, 1964-1967; Gilcrease Mus., 1958 (one-man 1960); Southwestern WC Soc., 1967; Watercolor:U.S.A., 1967; one-man: Newport, R.I., 1967; First Nat. Bank, Tulsa, 1968; Marith Gals., Dallas, 1968.

NEIL, JOHN—Painter, E.
Rice University, Houston, Tex. 77001; studio: 2224 Wroxton Rd., Houston, Tex. 77005
Kansas City, Mo., June 16, 1915. Studied: Univ. Oklahoma, B.FA., M.F.A.; Colorado Springs FA Center; Univ. Florence, Italy. Member: Cal. WC Soc. Work: SAM; Joslyn A. Mus.; Laguna Beach A; DMFA; Kansas State Col.; Philbrook A. Center, Tulsa, Okla.; Denver A. Mus.; Univ. Massachusetts; Springfield (Mo.) A. Center. Exhibited: Abstract & Surrealist A., Chicago, 1947; Carnegie Inst., 1941; Colorado Springs FA Center, 1946-1950; Denver A. Mus., 1946-1950, 1955; Kansas City A. Inst., 1953; AFA, 1954; Southwest A., Santa Fe, 1957; Houston, Tex., 1966; Southwest American Art, Kyoto, Japan, 1967; Int. Exh., Galleria Schneider, Rome, 1964. One-man: Copenhagen, Denmark, 1960; Philbrook A. Center, 1964; Longview, Tex., A. Center, 1966; Encounter Gal., Oklahoma City, 1965; Louisiana Gal., Houston, 1968 (3-man). Positions: Chm. Dept. FA, Rice University, Houston, Tex., at present.

OPPENHEIM, S. EDMUND—Painter
144 West 57th St. 10019; h. 355 8th Ave., New York, N.Y. 10001
Studied: NAD; ASL. Member: SC; All. A. Am.; Grand Central A. Gal.; AAPL; Hudson Valley AA; A. Fellowship. Awards: prizes, All. A. Am.; Hudson Valley AA; AAPL; SC. Exhibited: NAD; Grand Central A. Gal. (one-man); Audubon A.; All. A. Am.; Hudson Valley AA; AAPL; Mus. of the City of New York; Provincetown AA. Work: Chrysler Mus. A.; The White House, Wash., D.C.; West Point Military Acad.; NAD; Grand Central A. Gal.; Oxford Paper Co.; Rhode Island State Capitol; Sylvania Electric Co.; Otis Elevator Co.; Fed. Bank & Trust Co.; Univ. Rhode Island; Emory Univ.; Univ. Pennsylvania; De Beers Diamond Coll.; Mus. FA, St. Petersburg, Fla.; Heathcote Fnd.; The Pentagon, Washington, D.C., and others.

OPPENHEIMER, SELMA L.—Painter
3506 Bancroft Rd., Baltimore, Md. 21215
B. Baltimore, Md., Jan. 13, 1898. Studied: Goucher Col., A.B.; Maryland Inst. Member: AEA (Pres. Md. Chptr., 1953-1955); Balt. WC Soc.; AFA; NAWA. Awards: med., Maryland Inst., 1933; BMA, 1935, 1938; NAWA, 1952, 1960, 1965; Maryland Fed. Women's Cl., 1952; Loyola Col. (purchase) 1967. Work: Pub. Schs., Balt., Md.; Loyola Col., Baltimore. Exhibited: PAFA; BMFA; AIC; CGA; MModA; NAWA, and traveling exhs., U.S. and abroad; PC; NAD; BMA, 1968; Rockefeller Center, N.Y.; Friends of Art, Balt.; Peale Mus. A., Balt; Hagerstown, Md.; Western Maryland Col., Westminster; Goucher Col.; Southern States Art, 1947; Midtown Gal.; Phila. A. All., 1940; PC; Contemp. Gal., Atlantic City, 1955; Smithsonian Inst., 1957, 1958; Ringling Mus. A., 1960; retrospectives, Jewish Community Center, 1967 and Villa Julie Col., 1969; Baltimore Jr. Col., 1967, 1968; one-man: BMA, 1941; Hilltop Sch. A., 1954; Vagabond Theatre, Baltimore, 1960; Vertical Gal. Baltimore; Johns Hopkins Residence Hall; Catholic Information Center, Baltimore, 1966, 1967. Positions: Memb. A. Com., BMA, 1953-55, 1960-61; 1962-64; Bd. Trustees, BMA, 1959-60, 1960-1969.

OPPER, JOHN—Painter, E.
222 Bowery 10012; h. 32 King St., New York, N.Y. 10014
B. Chicago, Ill., Oct. 29, 1908. Studied: Cleveland Inst. A.; Hans Hofmann Sch. FA; Western Reserve Univ., B.S.; Columbia Univ., M.A., Ed. D. Member: Nat. Comm. on Art Edu.; CAA; AAUP;

NAEA; Eastern AA. Awards: Guggenheim Fellowship; prizes, Atlanta, Ga.; Birmingham, Ala. Work: MModA; Univ. North Carolina at Greensboro; N.Y. Univ.; Union Carbide, N.Y. Exhibited: MMA; WMAA; Carnegie Inst.; AIC; MModA; PAFA; SFMA; Santa Barbara Mus. A.; BM; CGA; CMA, and others. One-man: Artists Gal., Egan Gal., Stable Gal., Borgenicht Gal., all New York City. Positions: Prof. A., Univ. North Carolina; Univ. Wyoming; Univ. Alabama; Teachers Col., Columbia Univ.; N.Y. Univ.

ORDWAY, KATHARINE—Collector
40 Central Park South, New York, N.Y. 10019*

ORFUSS, ELSIE—Painter, E.
55 E. 10th St. 10003; h. 7 Cooper Rd., New York, N.Y. 10010
B. Harrisburg, Pa., Oct. 4, 1913. Studied: Grand Central A. Sch.; Hans Hofmann Sch. FA; ASL, and in Europe. Member: NAWA; ASL; AFA; Provincetown AA. Awards: Bronze Medal, NAWA, 1956, 1960; included in Prize Awards, 1960, 1962. Work: Chrysler Coll.; Jewish Mus., N.Y. Exhibited: NAWA, 1956-1964; Argent Gal., N.Y., 1957-1959; Art:USA, 1959; Audubon A.; Detroit Inst. A.; PAFA; PMA; East End Gal., Provincetown, Mass.; Staten Island Inst. Arts & Sciences; one-man: Jewish Mus., 1960. Positions: Asst. Prof., Painting-Workshop and lecturer, Fashion Institute of Technology, New York, N.Y.*

ORKIN, RUTH (ENGEL)—Photographer, Film Maker
65 Central Park West, New York, N.Y. 10023
B. Boston, Mass., Sept. 3, 1921. Studied: Los Angeles City Col. Member: Acad. Motion Picture Arts & Sciences; Soc. Magazine Photographers. Awards: "Silver Lion of San Marco," Venice Film Festival, 1953, for direction of "Little Fugitive"; Academy nomination for writing on "Little Fugitive," 1953; various awards for still photos in museums (MModA, MMA, etc). Exhibited: A. Dirs. Cl.; Kodak World's Fair Shows, N.Y., 1964, 1965.*

ORR, ELLIOT—Painter
733 Main St., Chatham, Mass. 02633
B. Flushing, N.Y., June 26, 1904. Studied: Grand Central A. Sch. with George Ennis, Charles Hawthorne, George Luks and others. Member: Provincetown AA. Awards: prizes, BMA, 1930; Cape Cod AA, 1948. Work: BM; PMG; Spokane A. Mus.; WMAA; BMFA; Detroit Inst. A.; Addison Gallery of Americana Art, Andover, Mass. Exhibited: MMA, 1950; Carnegie Inst.; PAFA; WMAA; Boston A. Festival; Chrysler Mus. A.; Univ. Illinois; VMFA; MModA; CGA; AIC, and other national exhs. Provincetown AA Golden Anniversary exh., 1964. One-man: Contemporary A., 1931; Balzac Gal., 1932; Macbeth Gal., 1936; Kleeman Gal., 1941, 1942; Babcock Gal., 1948; Mellon Gal., Phila., 1934; Rochester Mem. A. Gal., 1937; Cape Cod AA, 1955; Country A. Gal., Westbury, N.Y., 1956; Munson Gal., 1961; Naples (Fla.) A. Gal., 1967.

ORR, FORREST (WALKER)—Painter, I.
67 Boardman St., Norfolk, Mass. 02056
B. Harpswell, Me., May 5, 1892. Studied: Portland (Me.) Mus. Sch. A.; ASL, with George Bridgman, Frank DuMond, Harvey Dunn. Member: Gld. Boston A.; Boston Soc. WC Painters; AWS. Awards: prizes, NAD, 1956 (purchase), Ranger Fund purchase, 1963; Boston Soc. WC Painters, 1960, 1961, 1963; Univ. North Carolina, Chapel Hill. Work: BMFA; Farnsworth Mus. A. Rockland, Me.; Univ. Maine. Exhibited: Boston Soc. WC Painters, annually; AWS, annually; AWS, annually; NAD; Gld. Boston A.; Boston A. Festival, 1953-1955, 1961-1964; Portland, Me., 1955; Univ. Maine traveling exh. I., juvenile books, fiction. Contributor to national magazines.

ORTIZ, RALPH—Sculptor, P.
Box 44, Village P.O., New York, N.Y. 10014
B. New York, N.Y., Jan. 29, 1934. Studied: ASL; BMSch. A.; Pratt Inst., Brooklyn, B. Sc., M.F.A.; Columbia Univ. T. Col.; N.Y. Univ. Awards: John Hay Whitney Fellowship, 1965-1967. Work: MModA; WMAA; Chrysler Mus. A., Provincetown, Mass.; Oxford Mus. Mod. A., London, England. Exhibited: Artists Gal., N.Y., 1960; Bolles Gal., N.Y., 1962 (2); BMFA Sch. A., 1962; MModA, 1963-1964 and traveling 1965-1966, film, 1967; Riverside Mus., N.Y., 1963; BM, 1963; Park Place Gal., N.Y., 1964; WMAA, 1965 (2); Chrysler Mus. A., 1965, film, 1966; Grippi Waddell Gal., N.Y., 1966; BBC Television, 1966; ABC Television 1966; Expo '67; film, Forham Univ., N.Y., 1967; Judson Gal., N.Y., 1967; Judson Church, 1968 (2). Articles on work in: Life magazine, Arts magazine, Evergreen Review, The Villager, Village Voice, West Side News, all New York City.

ORTMAN, GEORGE—Painter, S., Gr., T., L.
Box 192, Castine, Me. 04421
B. Oakland, Cal., Oct. 17, 1926. Studied: Gal. Col. A. & Crafts; Atelier 17, with S. W. Hayter; Andre L'Hote, Paris, France; Hans Hofmann Sch. FA. Awards: Guggenheim Fellowship, 1965; Tamarind

Fellowship, 1966. Work: MModA; Joslyn Mem. Mus., Omaha; WMAA; WAC; Albright-Knox A. Gal.; N.Y. Univ.; N.Y. Pub. Lib. Exhibited: WMAA, 1960; MModA, 1960-61; Carnegie Inst., 1961; AIC, 1961; Staten Island Mus. Hist. & A., 1960; one-man: Swetzoff Gal., Boston, 1961, 1962; Howard Wise Gal., N.Y., 1962-1964; Stable Gal., N.Y., 1957, 1960; Wittenborn Gal., N.Y., 1955; Tanager Gal., N.Y., 1953. Lectures: Primitive Art; Conditioning of an Artist, Yale Grad. Sch. A. Positions: A.-in-Res., Princeton Univ., 1966-1967.*

OSBORN, ELODIE COURTER (Mrs. Robert C.)—
 Scholar, Collector, Writer
 R.F.D., Salisbury, Conn. 06068
B. New York, N.Y., Dec. 6, 1911. Studied: Wellesley College, B.A.; New York University; Sorbonne, Institut des Arts et Archaeologies (Certificate). Author: "Modern Sculpture," "Texture and Pattern," educational portfolios published by the Museum of Modern Art; "Traveling Exhibitions," published by UNESCO, 1953. Collection: Contemporary painting, sculpture, drawings, prints. Positions: Director of Traveling Exhibitions, for U.S. and abroad (under government sponsorship), the Museum of Modern Art, 1933-1948; Exhibitions Comm., American Federation of Arts, 1942-1958; Vice-President, American Fed. Film Societies, 1953-1954; Founder and Director, Salisbury Film Society, 1951- . Member, Advisory Committee, Robert Flaherty Foundation, 1960-1968; Trustee, International Film Seminars, 1968- (This is new title of what was originally the Robert Flaherty Foundation). Member, Wellesley College Friends of Arts Committee, 1967- ; Trustee, The MacDowell Colony, 1969.

OSBORN, ROBERT CHESLEY—Cartoonist, P., I., W., T., L.
 R.F.D., Salisbury, Conn. 06068
B. Oshkosh, Wis., Oct. 26, 1904. Studied: Univ. Wisconsin; Yale Univ.; British Acad.; Rome, Italy; Acad. Scandinav, Paris, France, and with Othon Friesz, and Despiau. Awards: Legion of Merit, U.S. Navy, World War II; Distinguished Public Service award, U.S. Navy, 1958; Citation, Phila. Museum College of Art, 1960; Flight Safety Fnd. award, New York, N.Y., 1960; D.F.A., Maryland Inst. A., 1964; Governor's Award from the State of Wisconsin, 1964. Work: MModA; AGAA; Detroit Inst. A.; Hartford (Conn.) Atheneum; mural of bullfighting, Azeitao, Portugal, 1939. Exhibited: AIC, 1944; BM, 1959, 1961; Hartford Atheneum, 1958; CGA, 1965; Downtown Gal., N.Y. Author: "Leisure," 1958; "Vulgarians," 1960; "Dying to Smoke," (drawings and text), 1964; "Mankind May Never Make It," 1968. Illus. many books. Contributor cartoons, illus. to New Republic; Look; Harpers; Esquire and other national magazines. Lectures: America & Americans at Aspen, Colo., New York, Providence, R.I., Yale Univ., New Haven, Conn.; Aspen Design Conference, 1969. Positions: Instr., History of Art, Greek Philosophy, Hotchkiss School; Chm., Yale Council Committee on Art & Architecture, 1954-60. President's Committee on Art in Public Schools, 1964-1965; Member, Exec. Com., Yale AA, 1968-1971; Member, Yale-New Haven Edu. Corp., 1969-1972.

OSBORNE, ROBERT LEE—Educator, P., Des., S., L.
 5001 Warren Dr., Evansville, Ind. 47710
B. Chandler, Ind., June 24, 1928. Studied: Indiana Univ., B.S., with Pickens, Marx, Engel, Ballinger and Hope; Univ. Iowa, M.A., with Lechay, Hecksher, Longman, Ludens, Tomasini, Member: AEA; Evansville State T. Assn.; NEA; Evansville Mus.; Tri-State A. Gld. (Pres. 1958-61). Awards: Gold Key award, Evansville, Ind., 1946; Indiana Univ., 1952. Exhibited: CM, 1955; John Herron AI, 1955-1960; Tri-State Exh., 1950-1960; Evansville Col., 1955, 1958 (one-man); Art:USA. I., "Organization of Aquatic Clubs," 1955. Positions: Hd. Dept. A., Asst. Prof., Evansville College; Staff Instr., Evansville Museum; Des., Olszewski Art Glass Co., St. Louis. Lectures, gallery talks, painting critique, Evansville Mus.*

OSBY, LARISSA GEISS—Painter, T.
 5627 Meridian Rd., Gibsonia, Pa. 15044
B. Artemowsk, Russia, June 7, 1928. Studied: The Lyceum and the Univ. of Goettingen, Germany; Univ. Munich; Acad. FA, Munich with Prof. Willy Geiger. Member: Assoc. A. Pittsburgh; Abstract Group of Pittsburgh; Pittsburgh WC Soc. Awards: prizes, Assoc. A. Pittsburgh, Carnegie Inst., 1958 (purchase); Pittsburgh Playhouse, 1958 (2); Arthur Brown award, 1959; first prize watercolor, 1960; Pittsburgh WC Soc., 1963; 100 Friends of Pittsburgh Art, 1961, 1965 (purchase). Work: Carnegie Inst.; Univ. Pittsburgh; Pittsburgh Bd. Edu.; Carnegie H.S. Exhibited: "Young Art in Germany," traveling in West Germany, 1951; Butler Inst. Am. A., 1958, 1959; Pittsburgh WC Soc. Awards: prizes, Assoc. A. Pittsburgh, 1956-1965; Pittsburgh WC Soc., 1960-1964; Contemp. A. Center, Cincinnati, 1959; Inst. Contemp. A., Boston, 1961; Albright-Knox A. Gal., Buffalo, 1961; traveling exh., Ohio & Miss. Valley, sponsored by Am. Wind Symphony, 1961; A. & Crafts Center, Pittsburgh, 1961; Chautauqua Annual, 1964; St. Paul Inst. A., 1963; Ligonier, Pa., 1961; one-man. A. & Crafts Center, Pittsburgh, 1960; Sherwood Forest Theatre,

Pittsburgh, 1961; Pittsburgh Plan for Art, 1963; Pittsburgh Playhouse Gal., 1965; 4-man: Detroit, Mich., 1961. Positions: Instr. A., YWCA, Pittsburgh and privately; Pres., Abstract Group of Pittsburgh; Instr., painting, Pittsburgh A. & Crafts Center, 1961-63.*

O'SICKEY, JOSEPH BENJAMIN—Painter, Des., E.
 Art Department, Kent State University; h. 7308 State Rte. 43,
 Kent, Ohio 44240
B. Detroit, Mich., Nov. 9, 1918. Studied: Cleveland Sch. A., and with Paul Travis, Henry Keller and Hoyt Sherman (Ohio State). Member: AAUP. Awards: prizes, CMA, 1948, 1962, 1964-1967; Akron A. Inst., 1969. Work: Posters, MModA; CMA; Adron Pub. Library; Edward Howard Co., Cleveland and N.Y. offices. Exhibited: CMA (15 exhs.); Akron AI (20 one-man: Akron AI; Goldwach Gal., Chicago; Jacques Seligmann Gal., N.Y., 1969 and prior; Malmquist & Wood Gal., Cleveland; Ohio State Univ. Positions: Prof. A., Ohio State Univ., Akron AI, Western Reserve Univ., Kent State Univ.; Private Graphic Design Company. Assoc. Prof., Coordinator of Painting and Sculpture, Kent State Univ., at present.

OSSORIO, ALFONSO A.—Painter, S., Collector
 Cordier & Ekstrom Gallery, 980 Madison Ave., New York,
 N.Y. 10021; h. The Creeks, East Hampton, N.Y. 11937
B. Manila, P.I., Aug. 2, 1916. Studied: Harvard Univ., A.B. Work: MMA; MModA; WMAA; Finch Col. Mus.; N.Y. Univ. Gal.; Yale Univ. A. Gal.; PMA; Wadsworth Atheneum, Hartford; Ateneo de Manila, P.I.; Int. Inst. Aesthetic Research, Turin, Italy; Museo de Arte Abstracto, Cuenca, Spain. Exhibited: WMAA annuals of painting and sculpture, 1953- ; WAC, 1954; Santa Barbara Mus. A., 1954; Denver Mus. A., 1954; Downtown Gal., N.Y., 1954; Stable Gal., N.Y., 1955, 1956; AFA, 1957; Rome-New York A. Fnd., 1957-1959; Signa Gal., East Hampton, 1958; Martha Jackson Gal., N.Y., 1960; Carnegie Int., 1961; MModA, 1961, 1967 (2), 1969; Documenta, 1964; Univ. Illinois, 1965; Southampton Col. Festival Arts, 1954, 1955, 1968; AIC, 1966; Finch Col., 1964, 1967; Osaka A. Festival, Japan, 1958, 1960; Galerie Beyeler, Basle, 1959; Stadische Gal., Munich, 1960; Marlborough Gal., London, 1961; Turin, Italy and Bochum, West Germany, 1962; USIS Gal., London, 1962; Musee Cantonal, Lausanne, 1963; Visual A. Center, Buenos Aires, 1964; St. Etienne, France, 1964; Venice, Italy, 1967; Munich, 1968. One-man: Wakefield Gal., 1941, 1943; Mortimer Brandt Gal., 1945; Betty Parsons Gal., 1951, 1953, 1956, 1958, 1959, 1961; Cordier & Warren Gal., 1961; Cordier & Ekstrom Gal., 1963, 1965, 1967, 1968, all New York City; Galerie Fachetti, Paris, 1952; Galerie Stadler, Paris, 1960, 1961; Galerie Cordier-Stadler, Frankfort, 1961. Positions: Dir., Exhibitions, Executive House, New York, 1956-1957; Co-Founder & Dir., Signa Gallery, East Hampton, N.Y., 1957-1960. Collector: Contemporary Painting and Sculpture; Art Brut, Primitive and Oriental.

OSTENDORF, (ARTHUR) LLOYD, JR.—
 Painter, W., I., Hist., Comm.
 225 Lookout Dr., Dayton (Oakwood), Ohio 45419
B. Dayton, Ohio, June 23, 1921. Studied: Dayton AI. Member: Manuscript Soc.; Dayton Soc. P. & S.; Dayton and Montgomery County Hist. Soc. (Vice-Pres., 1958-) F., Royal Soc. Arts, London, 1963. Awards: Winner's prize for design of the Chicago Lincoln statue, 1958; Hon. Doctorate, Litt.D., by Lincoln College, Lincoln, Ill., 1968. Work: IBM (purchase). Paintings: Hoyne Chapel, Dayton; Jesuit Retreat Chapel; portraits since 1953. Exhibited: watercolors and magazine illustrations, Dayton AI, 1938- . Illus. many books, mostly religious books, 1939- . Illus. have appeared in Marianist Magazine since 1949; Dayton Daily News Magazine since 1953. Contributor cover illus. for Lincoln Herald quarterly magazine; Young Catholic Messengers, nationally circulated schools weekly, since 1939; Illus., textbooks, histories and literature. Author, Illus., "Mr. Lincoln Came to Dayton," 1959; "A Picture Story of Abraham Lincoln," 1962; "Lincoln in Photographs: An Album of Every Known Pose," (with Charles Hamilton), Univ. Oklahoma Press, 1963; "The Photographs of Mary Todd Lincoln," 1969, Illinois State Historical Society, Springfield, Ill. Positions: Art Editor, Lincoln Herald, quarterly publ. at Lincoln Memorial Univ., Harrogate, Tenn., 1957- .

OSTER, GERALD —Painter C.
 241 W. 11th St., New York, N.Y. 10014
B. Providence, R.I., Mar. 24, 1918. Studied: Brown Univ., Sc.B.; Cornell Univ., PhD. Work: Milwaukee A. Center; SFMA. Exhibited: MModA, 1964; Albright-Knox A. Gal., Buffalo, 1965; Milwaukee A. Center, 1968; Inst. Contemp. A., Chicago, 1968; WAC, 1967, and others. Author: "The Science of Moire Patterns," 1964 2nd ed. 1969. Contributor to: Art International.

OSTUNI, PETER W.—Sculptor, P., E.
 Kirkland College, Clinton, N.Y. 13323; h. Four Corners Rd.,
 Warwick, N.Y. 10990
B. New York, N.Y., Oct. 9, 1908. Studied: Cooper Union, N.Y.

Member: AAUP. Work: 1951-1964; murals, S.S. United States; Prudential Lines; panels, Children's Mus., Ft. Worth, Tex.; S.S. Matsonia, Monterey, Santa Paula, Santa Rosa, Santa Mercedes; illuminated walls, Savoy Hilton, N.Y.; Sheraton Palace Hotel, San Francisco; Park Sheraton Hotel, N.Y.; free standing walls, U.S. Nat. Bank of Denver; transparent wall, Prudential Life Ins. Co., Newark, N.J.; sculptured symbol, Olivetti-Underwood, N.Y. Exhibited: Munson-Williams-Proctor Inst., Utica, N.Y., 1969; one-man: Bertha Schaefer Gal., N.Y., 1951; Panoras Gal., N.Y., 1953; Obelisk Gal., Washington, D.C., 1960; Raven Gal., Detroit, 1963; Sleepy Valley Gal., Warwick, N.Y., 1965; Galeria Steccini, Milan, Italy, 1964. Contributor to Craft Horizons. Positions: Prof. A., Kirkland College, Clinton, N.Y.

OSVER, ARTHUR—Painter
 465 Foote Ave., St. Louis, Mo. 63119
B. Chicago, Ill., July 26, 1912. Studied: Northwestern Univ.; AIC, and with Boris Anisfeld. Member: AEA; Audubon A. Awards: Raymond traveling F., 1936; medal, PAFA, 1946, J. Henry Schiedt mem. prize, 1966; VMFA, 1944; prizes, Pepsi-Cola, 1944; Audubon A.; Critic's Show, N.Y., 1946; Guggenheim F., 1949-51; Prix de Rome, 1952, 1953; Nat. Endowment for the Arts, Wash., D.C., Sabbatical grant, 1966. Work: MMoA; Pepsi-Cola Coll.; WMAA; Davenport Mun. A. Gal.; Peabody Mus., Salem, Mass.; PAFA; MMA; PMA; Toledo Mus. A.; Mus. FA of Houston; Walker A. Center; Colorado Springs FA Center; Montclair A. Mus.; CAM; Delgado Mus. A.; Sarah Lawrence Col.; Univ. Cincinnati; Geo. Washington Univ.; Univ. Georgia; Univ. Syracuse; Univ. Illinois; Univ. Nebraska; Univ. Michigan; IBM; Mus. Mod. A., Rio de Janeiro. Exhibited: AIC, 1938, 1939, 1942, 1943, 1945; PAFA, 1940, 1944, 1946; GGE, 1939; Carnegie Inst. 1944-1946; VMFA, 1944, 1946; WMAA, 1944, 1945, 1963; Grand Central A. Gal., 1947; Art:USA Now, 1964-65; one-man: Fairweather-Garnett Gal., Evanston, 1954; Univ. Chattanooga, 1948; Univ. Syracuse, 1949; Fairweather-Hardin Gal., Chicago, 1955, 1969; Grand Central Moderns, 1949, 1951, 1957; Univ. Hamline (Minn.). 1950; Univ. Florida, 1952; Martin Schweig Gal., St. Louis, 1966, 1969; Coe Col., Cedar Rapids, Iowa, 1966; Gal. of Loretto-Hilton, St. Louis, 1966; retrospective, Iowa State Col., Ames, 1968. Positions: Instr. Painting, BM A. Sch., 1949-51; Columbia Univ., 1952; Univ. Florida, 1954-55; Visiting Critic in Painting, Yale Univ., 1956-57; Painter-in-Res., Am. Acad. in Rome, 1957-58; Instr., Painting, CUASch., New York, N.Y.; Washington Univ., St. Louis, Mo., at present.

OSVER, MRS. ARTHUR. See Betsberg, Ernestine

OWENS, WINIFRED (WHITEBERGH)—Painter, W., L.
 3405 Cypress Drive, Falls Church, Va. 22042
B. Colorado Springs, Colo., July 21, 1911. Studied: Colorado College; Taos (N.M.) Sch. A. and privately. Member: AEA; Taos Art Colony. Awards: prizes, Colorado Springs FA Center; Canon City A. Festival. Work: murals, Bethany Baptist Church, Press Club, Stratton Estate, all Colorado Springs; Theatre murals, Taos, N.M. Exhibited: Smithsonian Inst.; Artists' Mart; and in galleries in the Washington (D.C.) area. One-man: Mus. of New Mexico, Santa Fe (2); Colorado Springs FA Center (2); Nelson Gal., Kansas City; Panoras Gal., N.Y., 1962; Lee Gal., Alexandria, Va., 1965; Arthur Newton Gal., N.Y., 1961. Contributor articles to Colorado Springs Gazette, Denver Post.

PACE, MARGARET BOSSHARDT (Mrs. David E.)—
 Designer, P., S., E., C.
 208 Morningside Dr., San Antonio 9, Tex 78209
B. San Antonio, Tex., Dec. 9, 1919. Studied: Newcomb Col., B.F.A., and with Will Stevens, Etienne Ret, Xavier Gonzalez. Member: San Antonio A. Lg. (Bd. Member, 1967-1968); Texas FA Assn; River A. Group; Texas WC Soc.; Contemporary A. Group; San Antonio Craft Gld. Awards: Charles Rosen award, 1947; Henry Steinbomer award. Texas WC Soc., 1949, 1966; Emma Freeman award, 1951; Texas Craft Exh., 1957, 1959; Texas FA, 1958, 1959; Grumbacher purchase award, 1960; Richard Kleberg purchase award, 1960; AIA Citation for mural, San Antonio, 1960; Orco A. Center, 1964. Work: murals, recreation room, Victoria Plaza, Golden Age Center, 1960; mosaic murals, St. Lukes Episcopal Church, San Antonio, 1959; Episcopal Diocesan Center, Diocese of West Texas, 1961; Episcopal Cathedral, 1965; commission, designed and executed chalice, pattern, and pix for ordination of Father Braun, Pinckneyville, Ill., 1969; other work in private collections. Exhibited: Winston-Salem, N.C., 1945; Texas FA Assn., 1947, traveling exh., 1954-1961; SFMA, 1948; Texas A. & M. Col., 1949; Texas WC Soc., 1950-1961; Miami Beach, 1950; Witte Mem. Mus., 1952 (one-man), group, 1967, 1968; Beaumont A. Mus., 1957-1961; Feldman annual, 1959, 1960; El Paso Sun Festival, 1960; Texas annual, 1958, 1959, 1969; San Francisco Cathedral Church Art Exh., 1959; Nat. Church Arch. & Art exh., San F., 1960; Seven State Craft Exh., 1960; Wichita Falls A. Mus., 1960, 1961; San Marcos State T. Col., 1960; Religious Art Exh., Purdue Univ.,

1964; Invitational Contemp. A. Group, Mexico City Consulate, 1965, 1968; Nat. Church Architecture Exhibit of Church Art, 1964; Religious Art, Hemisfair, 1968; Mall Gal., 1966-1968; Trinity Univ., San Antonio, 1969; Men of A. Gld. Gal., Dec-Jan. 1968-1969; A. Inst. Texan Cultures; 1969; Junior Lg., 1966; one-man: San Angelo Col., 1961; Bright Shawl Gal., 1961; San Antonio Little Theater, 1967; Temple Bethel, 1968; 2-man: Incarnate Word Col., 1961; 4-man: Laguna Gloria Mus., Austin, 1958; Univ. Arkansas. Positions: Bd. Memb., Vice-Pres., San Antonio AI; Asst. Prof. A., San Antonio College, 1965- . Bd. Member, Friends of McNay Mus., San Antonio, 1967- .

PACE, STEPHEN—Painter
 164 11th Ave. 10011; h. 345 W. 29th St., New York, N.Y. 10001
B. Charleston, Mo., Dec. 12, 1918. Studied: ASL; Hans Hofmann; Inst. FA, San Miguel, Mexico; Grande Chaumiere, Paris; Inst. d'Arte Statale, Florence, Italy. Awards: Dolia Lorian Award, 1954; Hallmark Award, 1961. Work: WMAA; Chrysler Mus.; Evansville (Ind.) Mus. Art; Univ. Southern Illinois; Michener Fnd.; WAC; Hallmark Coll.; Bundy A. Gal., Waitsville, Vt.; Univ. Cal., Berkeley; Michener Coll., Univ. Texas, Austin. Exhibited: WMAA, 1953, 1954, 1956-1958, 1961, 1963; BM, 1953, 1955; Carnegie Inst., 1955; PAFA, 1954; CGA, 1957, 1963; Art:USA, 1959; CMA; 1960; Hallmark Award Exh., Wildenstein Gal., N.Y., 1960; MModA traveling exh., Asia, 1964-1966 and Australia, 1964; AIC, 1966; Univ. Texas, Austin. One-man: Ridley Gal., Evansville, Ind., 1966; Univ. California, Berkeley, 1968; Graham Gal., N.Y., 1969. Other exhibitions in England, France, Italy, Japan, Switzerland, Holland, Germany.. Positions: Artist-in-Res., Washington University, St. Louis, Mo., 1959; Pratt Institute, Brooklyn, N.Y., 1961- . Instr., Univ. California, Berkeley, 1968- .

PACHNER, WILLIAM—Painter, T.
 Woodstock, N.Y. 12498; Clearwater, Fla. 33515
B. Brtnice, Czechoslovakia, Apr. 7, 1915. Studied: Acad. A. & Crafts, Vienna, Austria. Awards: Grant, Nat. Inst. A. & Let.; New Orleans AA, 1958; Fla. State Fair, 1958; first prize, Painting of the Year, Mead, Atlanta Paper Co., Atlanta, 1958; first prize, Butler Inst. Am. A., 1958; Ford Fnd. Retrospective Exhs., 1959, circulated by AFA; Guggenheim F., 1960-61. Sarasota AA, 1958 (purchase); Southeastern Annual, Atlanta, 1963; Ringling Mus., 1963; Fla. State Fair, 1964, 1965; Ford Fnd. Grant and appt. as Artist-in-Residence, Fort Worth A. Center, 1964. Work: Milwaukee AI; Ain-Harod Mus., Israel; Florida Gulf Coast A. Center; WMAA; Brandeis Univ.; Iowa State T. Col.; Butler Inst. Am. A.; Chrysler Mus.; Ft. Worth A. Center; Ringling Mus. A.; Hamline Univ. Exhibited: Carnegie Inst., 1948; WMAA, 1948-1951, 1958, 1960; CGA, 1949, 1951; Am. Acad. A. & Let., 1949; PAFA, 1950, 1959; Univ. Colorado, 1951; Springfield Mus. A., 1951; Witte Mem. Mus., 1951; Albany Inst. Hist. & A.; Assoc. Am. A., 1949; Weyhe Gal., 1948; Ganso Gal., 1951, 1955 (one-man); Sarasota AA, 1953 (one-man), 1958; AFA traveling exh.; Provincetown A. Festival, 1958; Art:USA, 1958; Ringling Mus. A., 1955, 1959, 1964 (one-man); Univ. Michigan, 1959; Univ. Nebraska, 1959; Detroit Inst. A., 1959; Art:USA, 1964; N.Y. World's Fair, 1964; recent one-man exhs.: Krasner Gal., N.Y., 1958-1963, 1967, 1968; Ft. Worth A. Center, 1964; Univ. South Florida, 1963. Contributed article to "The Art of the Artists," 1951. Positions: Dir., own art school, Clearwater, Fla.; Instr., ASL, 1969.

PACKER, CLAIR LANGE (MR.)—
 Painter, W., I., Comm., Cart., Des.
 3307 East Fifth Place, Tulsa, Okla. 74112
B. Geuda Springs, Kans., Aug. 27, 1901. Studied: Univ. New Mexico, and with Millard Sheets, Barse Miller, Kenneth Adams, Victor Higgins, O.E. Berninghaus, and others. Member: Tulsa A. Gld. Work: Gilcrease Mus., Fourth Nat. Bank, Tulsa. Contributor articles to Tulsa World; True West magazine. Exhibited: Witte Mem. Mus.; Philbrook A. Center; Dallas Mus. FA; Terry AI; Mus. FA of Houston; Elisabet Ney Mus. A. Contributor of articles to Tulsa World, Western Publications, Inc., and others.

PADDOCK, DENIS—Collector
 Grumman Aircraft Company, Bethpage, L.I., N.Y. 11714
B. Chicago, Ill., May 17, 1927. Studied: Northwestern University, B.S. in E.E.; Polytechnic Institute of Brooklyn, M.E.E. Collection: Surrealist and Geometric Paintings; Modern Sculpture; Modern Graphics with empasis on Geometric. The most recent painting from the collection to be exhibited was a 1929 Tanguy which appeared in the 1968 summer loan show of the Metropolitan Museum of Art.

PADOVANO, ANTHONY JOHN—Sculptor, E.
 729 Liberty Ave., North Bergen, N.J. 07047
B. Brooklyn, N.Y., July 19, 1933. Studied: Carnegie Inst. Tech.; Pratt Inst., Brooklyn; Columbia Univ., B.F.A. Member: Silvermine Gld A.; F., Am. Acad. In Rome. Awards: Prix de Rome, 1960-1962; prize, Terza Mostra Internazionale d'Arte Figurative, Rome, Italy,

1962; Fellowship, Guggenheim Fnd., 1964. Work: Larry Aldrich Mus.; Howard Lipman Fnd.; Storm King A. Center; Finch Col. Mus. A.; Am. Acad. in Rome. Exhibited: WMAA, 1962-1964; MMoedA, 1963-64; Gallery of Modern Art, Wash. D.C., 1964; Smith Col. Mus. A., 1963-64; Norfolk Mus., 1963; deCordova & Dana Mus., 1964; Silvermine Gld. A., 1963-65; Columbia Univ., 1964-65; N.Y. World's Fair, American Express Pavilion, 1965; Providence A. Cl., 1963; Bertha Schaefer Gal., New York, 1968 (one-man) and group, 1968-1969; "Hemisphere-San Antonio, Texas," 1968. Lectures: Contemporary Sculpture, TV, New Haven, Conn. Educational Program. Positions: Instr., A., Univ. Connecticut, Storrs, Conn; Prof., Drawing & Sculpture, Columbia Univ., New York, N.Y.; Vice-Pres, Sculptors Gld., 1968-1969; N.Y. State Council on the Arts Sculptor chosen for 1969.

PAEFF, BASHKA (Mrs. Bashka Paeff Waxman)—Sculptor, L.
 21 Foster St., Cambridge, Mass. 02138
B. Minsk, Russia, Aug. 12, 1893. Studied: Mass. Normal A. Sch.; BMFA Sch., with Bela Pratt, and in Paris. Member: Gld. Boston A.; NSS. Awards: medal, Tercentenary Exp., Boston, 1933; Daniel Chester French Medal, NAD, 1969. Work: mem., monuments, statues, portraits, State House, Boston, Kittery, Me., Westbrook, Me., Ravina, Ill., Waverly, Mass., Birmingham, Ala.; MIT; Grad. Center, Radcliffe Col., Cambridge; BMFA; Harvard Univ.; Rockefeller Inst., N.Y.; Univ. Buenos Aires; BMFA; bronze figure, Brookgreen Gardens; bas-reliefs: life size, Justice Oliver Wendell Holmes, Harvard Law Library; Jane Addams for Addams House, Philadelphia, Pa.; bronze relief, Dr. Southard, for Harvard Medical Library; bronze relief Dir. Augusta Bronner for Judge Baker Fnd., Boston; bronze relief, Dr. Martin Luther King, Jr., Boston Univ., 1969, and others. Exhibited: Boston Gld. A. (one-man), 1959; NAD; NSS; Hopkins A. Center. Positions: Memb. Bd., Cambridge AA.

PAGE, ADDISON FRANKLIN—Museum Director, T.
 J. B. Speed Art Museum, 2035 S. Third St.; h. 9 Rebel Rd.,
 Louisville, Ky. 40206
B. Princeton, Ky., Oct. 9, 1911. Studied: Wayne State Univ., B.F.A., M.A.; Belgian A. Seminar; Art Club and A. Center Assn., Louisville. Author: "Modern Sculpture," 1950 (museum handbook); "Diego Rivera's Detroit Frescoes," 1956 (museum handbook). Lectures: Understanding Modern Art; Collecting Modern Art; Impressionism to Cubism, etc. Exhs. arranged: "Treasures of Persian Art," 1966; "The Stitch in Time," 1966; "Indian Buddhist Sculpture," 1968; "The Sirak Collection," 1968. Positions: Cur. Contemp. A., 1957-1962, Detroit Institute of Arts, Detroit, Mich. Teaching: Hist. of 19th and 20th Century Art, Cranbrook Acad. A., 1959-1962; The Art Museum as a Source for Education, Wayne State Univ., 1961. Director, J. B. Speed Art Museum, Louisville, Ky., 1962- .

PAGE, JOHN HENRY, JR.—Etcher, P., E.
 University of Northern Iowa; h. 1615 Tremont St., Cedar Falls,
 Iowa 50613
B. Ann Arbor, Mich., Jan. 18, 1923. Studied: Minneapolis Sch. A., with Frances Greenman; ASL, with Kuniyoshi, Kantor, Brook; Univ. Michigan, B. Des., with Carlos Lopez, Emil Weddige; Univ. Iowa, M.F.A. with Mauricio Lasansky. Awards: Pillsbury Scholarship, 1941, 1942; Scholastic Magazine Scholarship, 1940; Tagge Scholar, 1948; Penneli purchase, LC, 1955, 1957, 1964; MacNider, Mus., Mason City, Iowa, 1968; purchase prizes, Waterloo Mun. Gal., 1967 and Luther Col., 1968. Member: AEA; CAA; NAEA. Work: prints, Carnegie Inst.; WAC; LC; SAM; Des Moines A. Center; Joslyn A. Mus.; St. Olaf Col.; Illinois Wesleyan Univ.; Omaha Univ.; Luther Col.; Augustana Col. U.S. Embassies. Exhibited: LC, 1950, 1953-1955, 1957, 1960, 1964; SAM, 1950, 1953, 1954; Carnegie Inst., 1950; MMA, 1952; PAFA, 1953, 1961; BM, 1956; Soc. Wash. Pr. M., 1957, 1964; Univ. Illinois, 1954; MMoedA, 1953; WAC, 1951, 1953, 1956; Michigan A., 1946, 1949, 1952, 1953; Iowa A., 1955-1960, 1962, 1963; Okla. Pr. M., 1964; Wichita Univ.; Missouri Valley Drawing Exh., 1967; Rochester A. Center (2-man), 1967; traveling exh., State A. Council, 1968-1969. Positions: Instr., Mankato State Col.; Dept. Hd., Omaha Univ.; Prof., State College of Iowa, at present; Jury memb., Nat. Scholastic Magazine, 1969.

PALANCHIAN, MRS. ENID BELL. See Bell, Enid

PALEY, MR. AND MRS. WILLIAM S.—Collectors
 Kiluna Farm, Manhasset, L.I., N.Y. 11030*

PALITZ, MRS. CLARENCE Y.—Collector
 895 Park Avenue, New York, N.Y. 10028*

PALL, DR. & MRS. DAVID B.—Collectors
 5 Hickory Hill, Roslyn Estates, N.Y. 11576*

PALMER, FRED LOREN—Collector, Patron
 10 Woodcroft Rd., Summit, N.J. 07901
B. Richmond Hill, N.Y., Sept. 12, 1901. Studied: Hamilton College,

A.B. Collection: Includes watercolors by Homer, Hopper, Robert Parker, Kingman, Cushing, Penney, Vytlacil, Fredenthal, Campanella, Demuth, Rattner; drawings by Kuniyoshi, Tam, Hirsch, Liberman, Thomas George, Shahn, Gibson, Francesconi, Millman, MacIver, Callahan, Baskin, Kearns, Lebrun; oils by William Palmer, Rattner, Kerkam, Venard, Meigs, Knipschild, Yoram, von Wicht; prints and etchings by Matisse, Picasso; sculpture by Maldarelli, Hardy. Positions: Trustee (1955-1963), Member, Executive Comm. (1957-1963), AFA; Chairman, Board of Advisers, Edward W. Root Art Center, Hamilton College, 1958- ; Member, Advisory Council, State Museum of N.J., 1960-1963.

PALMER, LUCIE MACKAY—Painter, L.
 459 Henkel Circle, Winter Park, Fla. 32789
B. St. Louis, Mo., May 23, 1913. Studied: BMFA Sch.; St. Louis Sch. FA, Washington Univ.; ASL, with Raphael Soyer, J. N. Newell, Robert Brackman. Member: NAWA; St. Louis A. Gld.; Orlando AA; A. Lg. of Orange County (Cor. Sec.). Awards: prize, NAWA, 1944; hon. men., A. Lg. Orange County, 1961. Exhibited: NAWA, 1944-1946; Am. Mus. Natural Hist., 1943, 1958-59, (both one-man): Chicago Nat. Hist. Mus., 1960 (one-man); Rochester Mus. A. & Sc., 1959 (one-man); Cal. Acad. of Sciences, San F., 1961 (one-man); Boston Mus. Natural Hist., 1942; St. Louis A. Gld., 1934-1946. Specializes in under water painting. Lectures: "Painting Above and Below the Sea"*

PALMER, WILLIAM C.—Painter, L., E.
 Munson-Williams-Proctor Institute School of Art, 310 Genesee
 St., Utica 4, N.Y.; h. Butternut Hill, Clinton, N.Y. 13323
B. Des Moines, Iowa, Jan. 20, 1906. Studied: ASL; Ecole des Beaux-Arts, Fontainebleau, France. Member: NA; Arch. Lg.; AEA; AA-Mus.; Audubon Soc. Awards: med., Paris Salon, 1937; Audubon A., 1947; prize, NAD, 1946; grant, Am. Acad. A. & Let., 1953. Work: WMAA; AGAA; Des Moines A. Center; Munson-Williams-Proctor Inst.; MMA; Cranbrook Acad. A.; Encyclopedia Britannica Coll.; Am. Acad. A & Let.; Rochester Mem. A. Gal.; DMFA; James Michener Coll.; murals, PO Dept. Bldg., Wash., D.C.; First Nat. City Bank, N.Y.; Queens General Hospital, Jamaica, L.I., N.Y., Homestead Savings & Loan Ass., Utica, N.Y., 1957. Exhibited: CGA; VMFA; Carnegie Inst.; BM; AIC; Toledo Mus. A.; WMAA; MMoedA; Kansas City AI; one-man: Midtown Gal., N.Y., 1963, 1965, 1967; Root A. Center, Hamilton Col., 1964.; Allentown A. Mus., 1965; Des Moines A. Center, 1962. Contributor to: American Artist magazine. Positions: Dir., Munson-Williams-Proctor Inst. Sch. A., Utica, N.Y., 1941- .

PANCOAST, JOHN—Museum Director
 Portland Museum of Art, 111 High St., Portland, Me. 04101;
 h. 10 Grayhurst Park, Portland, Me. 04102
B. Wellsville, N.Y., Mar. 10, 1924. Studied: Yale University, B.A., M.A. Awards: Fulbright Grant, 1952-1953. Positions: Cur. 1954-1956, and Registrar 1956-1961, National Gallery of Art, Washington, D.C.; Asst. Dir., Albright-Knox Art Gallery, Buffalo, N.Y., 1962-1969; Director, Portland Museum of Art, Portland, Me., 1963- .

PAONE, PETER—Printmaker, P.
 2223 Green St., Philadelphia, Pa. 19130
B. Philadelphia, Pa., Oct. 2, 1936. Studied: Philadelphia Col. A., B.F.A. in Edu.; Albert Barnes Fnd., Merion, Pa. Member: SAGA. Awards: Tiffany Fnd. Grant, 1962, 1964; Guggenheim Fellowship, 1965-1966. Work: LC; PMA; MMoedA; Fort Worth A. Center Mus.; Victoria & Albert Mus., London; British Mus., London; New Jersey State Mus., Trenton; Princeton Library; Syracuse Univ.; Rosenwald Coll. Exhibited: BM, 1962, 1964; Butler Inst. Am. A., 1965; Contemp. A. Overseas; N.Y. World's Fair, 1965; Otis A. Inst., Los Angeles, Cal., 1964, 1966. One-man: Dubin Gal., Philadelphia, 1957; Phila. Pr. Cl., 1958, 1961, 1962; Grippi Gal., N.Y., 1959, 1960-1962; Fort Worth, 1964. Author, I., "Paone's Zoo," 1961; "Five Insane Dolls," 1966; "My Father," 1968; others. Positions: Instr., A. History, Positano A. Sch., Italy; Philadelphia Col. A., 1959; Pratt Institute, Brooklyn, 1959-1966.

PAPASHVILY, GEORGE—Sculptor
 Ertoba Farm, Bucks County, Quakertown, Pa. 18951
B. Kobiankari, Georgia (now USSR), Aug. 23, 1898. Member: Phila. A. All.; Lehigh A. All.; AEA. Exhibited: PAFA, 1952-1965; All. A. Am., 1953, 1954; Audubon A., 1952-1964; Phila. A. All., 1952; Lehigh Univ., 1953, 1954, 1957; Detroit Inst. A., 1958, 1960; one-man: Phila. A. All., 1953; Allentown Mus. A., 1951, 1962; Lehigh Univ. 1957; Washington Irving Gal., N.Y., 1958; Merrill Gal., N.Y., 1961; Woodmere Gal., Phila., 1964; Colonial Williamsburg Conf. Center Gal., 1965; Scripps College (Cal) 1966; Pomona Pub. Library 1966; Fleisher Memorial, PMA, 1967; Rosemont College (Pa.) 1968. Awards: prizes, All. A. Am., 1953; Phila. A. All., 1952; Audubon A., 1956, 1958; Allentown A. Mus., 1961, 1964. Work: Smalley Sch., Bound Brook, N.J.; Free Library of Phila. (Oak Lane Branch); Free Library of Phila. (Fox Chase Branch); Baltimore County (Md) Public Library (Catonsville Branch); Colonial Williamsburg--(Cascades

Conference Center); Colonial Williamsburg (Walkway). Author (in collaboration with Helen Waite Papashvily): "Anything Can Happen," 1945; "Yes and No Stories," 1946; "Thanks to Noah, " 1950; "Dogs and People," 1954.

PARADISE, PHIL—Painter, Lith., Ser., T., L., S.
P.O. Box 416, Cambria, Cal. 93428
B. Ontario, Ore., Aug. 26, 1905. Studied: Chouinard AI. Member: AWS; ANA; Cal. WC Soc.; Phila. WC Cl. Awards: prizes, GGE, 1939; Phila. WC Cl., 1943; Cal. State Fair, 1949; Los A. County Fair Assn., 1952; merit award, AV, 1943; San Diego FA Soc., 1940; Pepsi-Cola, 1945; med., PAFA, 1941. Work: Cornell Univ.; San Diego FA Soc.; Univ. California; Marine Hospital, Carville, La.; PAFA; Kansas State Univ.; Los A. County Fair. Exhibited: Carnegie Inst., 1943-1945; CGA, 1942, 1944; AIC; PAFA; NAD; WMAA; SFMA; Los A. Mus. A.; San Diego FA Soc.; Denver A. Mus. I., Fortune, & other national magazines. Positions: Dir., FA Dept., Chouinard AI, Los A., Cal., 1936-40; Production Des., Motion Picture Studios, 1944-45; Dir. Painting, Gerry Peirce Sch., Tucson, Ariz., 1952-53; L., Scripps Col., 1955-56; Claremont Col., 1956; Dir., Phil Paradise Summer A. Sch., Cambria, Cal., 1957- ; Dir., Greystone Galleries, 1965- .

PARDON, EARL B.—Educator, C., S., P.
Art Department, Skidmore College; h. 11 Ten Springs Dr., Saratoga Springs, N.Y.
B. Memphis, Tenn., Sept. 6, 1926. Studied: Memphis Acad. A., B.F.A.; Syracuse Univ., M.F.A. Work: Mus. Contemp. Crafts of the Am. Crafts Council; St. Paul Mus. and Sch. A.; Lowe A. Center, Syracuse; Memphis Acad. A.; Skidmore Col.; Huntington Gals., W. Va. Commissions: Mus. Contemp. Crafts of the Am. Craftsmen's Council, N.Y.; Prudential Life Ins. Co., Newark, N.J. Exhibited: Mus. Contemp. Crafts of the A. Craftsmens Council; Wichita Craft Biennial; Syracuse Nat. Ceramics; Skidmore Col.; Schenectady Mus. A.; Albany Mus. Hist. & Art. Lectures: Painting, Jewelry, Design at art schools, craftsmens organizations, college alumni groups. Positions: Chm., Art Dept., Prof. A., teaching metal work and painting, Skidmore College, Saratoga Springs, N.Y., at present.

PARIS, DOROTHY—Painter
88 Seventh Ave., South, New York, N.Y. 10014
B. Boston, Mass. Studied: Grande Chaumiere, Paris; Univ. Hawaii; Honolulu Acad. A.; ASL. Columbia Univ. Ext. Member: Am. Soc. Contemp. A. (Exec. Bd., 1st Vice-Pres., 1965-1967, Pres., 1967-1969); NAWA (Exec. Bd.). Awards: prizes, Honolulu Acad. A., 1946; NAWA, 1953; Fla. Int. Exh., 1952; Jersey City Mus. A., 1956; Am. Soc. Contemp. A., 1958; Swope A. Mus., 1964; elected to Albert Gallatin Associates, N.Y. Univ. Work: Univ. Miami; Evansville Mus. A.; Richmond (Ind.) Mus. A.; Birmingham Mus. A.; Colby Col.; Brandeis Univ.; N.Y. Univ.; Peabody Mus., Nashville; Notre Dame Univ.; DMFA; White Mus. A., Cornell Univ.; Oakland Mus. A.; Norfolk Mus. A. & Sciences; Witte Mem. Mus.; Phoenix A. Mus.; Mus. FA, Little Rock; Mus. Mod A.; Miami; Akron AI; Jewish Mus., Hebrew Union Col., Cincinnati; Univ. Miami; Tweed Gal., Univ. Minnesota; Purdue Univ.; Butler Inst. Am. A.; Tufts Univ.; and in private colls. Exhibited: WMAA; Mus. Mod A., Tokyo; Everhart Mus.; Massillon Mus. A.; Zanesville AI; Evansville Mus.; Mint Mus. A.; Hickory Mus. A.; Georgia Mus. A.; Columbus Gal FA; Wesleyan Col.; Mus. des Bellas Artes, Argentina; Mus. FA, Mexico; Univ. Miami; Auburn Univ.; Swope Gal. A.; World's Fair, N.Y.; Riverside Mus., N.Y., 1966; Cannes, France, 1965, and others; one-man: Gallerie Zak, Paris, 1950; Van Dieman-Lilienfeld Gal., 1951; Barzansky Gal., N.Y., 1954; Bodley Gal., N.Y. 1959. Positions: Instr., Ceramic Workshop & Sch. FA, N.Y., 1938-40; Organized first ceramic Co-operative for Puerto Rican Govt., 1937; 1st Vice-Pres., Chm. Ways & Means Comm., Am. Soc. Contemp. A., 1963-1964. Delegate to the U.S. Com. of the Int. Assn. of Artists, Amsterdam, 1969.

PARIS, HAROLD PERSICO —Sculptor, Gr., E.
1401 Middle Harbor Rd., Oakland, Cal. 94607
B. Edgemere, N.Y., Aug. 16, 1925. Studied: Atelier 17, N.Y.; Akademie der Bildenden Kunste, Munich. Member: San F. AA; SAGA. Awards: Tiffany Fnd. Fellowship, 1948-1950; Guggenheim Fellowship, 1953-1955; prizes, San F. AA, 1963, 1964; Creative Arts Award, special grant, 1967-1968; Inst. of Creative Art, Univ. California, 1967-1968. Work: La Jolla Mus.; Univ. Mus., Berkeley: Goddard Col., Vt.; WMAA; SFMA; Phoenix A. Mus.; MMoA; PMA; NGA; Oakland A Mus.; AIC; LC; Univ. Wisconsin; Univ. Delaware; Univ. North Dakota; Cal. PLH; N.Y. Pub. Lib. Exhibited: 1966: Cornell Col., Mt. Vernon, Iowa; Norman Hunter Gal., San Anselmo, Cal.; Junior Center Arts, Oakland; Hansen Gal., San Francisco; Raymond Col., Univ. of the Pacific, Stockton, Cal.; Los Angeles County Mus.; Mus. Contemp. Crafts, N.Y.; 1967: Richmond (Cal.) A. Center; Crocker A. Gal., Sacramento; Univ. Cal., Los Angeles; Reed Col., Portland, Ore.; Hayward (Cal.) State Col.; Univ. A. Mus., Berkeley; Tyler Sch. A., Rome, Italy; PMA (2); Inst. Contemp. A., Boston,

1967; Univ. Mus., Berkeley; Mead Corp. traveling exh., 1966-1967; Queens Col., N.Y.; Univ. Nevada. 1968-1969: Bolles Gal., San Francisco; BM; WMAA; Ithaca Col.; Inst. Contemp. A., Philadelphia; Krannert Mus., Univ. Illinois; N.J. State Mus., Trenton; Bern, Switzerland, and others. One-man: Mills Col., Oakland, 1967; Reed Col., Portland, Ores, 1967; Hansen Gal., San Francisco, 1967; Judd Gal., Portland, Ore., 1968; Studio Marconi, Milan, Italy, 1969.

PARIS, JEANNE C.—Critic, Collector
Long Island Press, 92-24 168th St., Jamaica, N.Y. 11433; h. 21 Whitney Circle, Glen Cove, N.Y. 11542
B. Newark, N.J. Studied: Newark School of Fine Arts; Tyler School of Art at Temple University; Columbia University. Collection: American paintings and sculpture. Arranged: Music and art tours of European countries; arranged and sent exhibitions of American art through U.S.A., South and Central America and the Caribbean; organized and directed "The Artist of the Month" providing lecturers and demonstrators for organizations and schools, 1950-1963; lectured on art to women's clubs, museum associations, organizations and radio. Positions: Associate Director, Valente Gallery, 1963-1965; Author, articles on art for weekly newspaper chain, "Record Pilot," 1962, and for Newsday, 1962; Art Critic, Long Island Press, 1963- .

PARIS, LUCILLE MARIE. See Bichler, Lucille Marie

PARISH, BETTY WALDO (Mrs. Richard Comyn Eames)
—Painter, Pr., M.
41 Union Square; h. 69 Fifth Ave., New York, N.Y. 10003
B. Cologne, Germany, Dec. 6, 1910. Studied: Chicago Acad. FA; ASL; Julian Acad., Paris; New Sch. for Social Research. Member: SAGA; NAWA (Chm. oil jury, 1948-51, 1956-58, Exec. Bd. 12 yrs.); Pen & Brush Cl. (Chm. Art Sect., 1946-49, 1959-60, Dir., 1960-63); All. A. Am.; Audubon A.; Phila WC Cl.; ASL (life); Chicago Soc. Et.; AAPL; Hunterdon County (N.J.) A. Center; New Sch. Assoc.; Cal. Soc. Et. Awards: prizes, NAWA, 1939, 1946, 1957, 1961; U.S. Treasury Dept.; SAGA, 1943; Washington Square A. Show, 1949; LC, 1949, 1952; Pen & Brush Cl., 1944, 1954, 1956, 1959, 1961, 1963; Cal. Soc. Et., 1947; Knickerbocker A., 1961; Collectors of Am. Art, purchase, 1940, 1941, 1944, 1946, 1948, 1955, 1958; AAPL, 1963. Work: MMA; SAM; LC; AIC; Treasury Dept., Wash., D.C.; Collectors of Am. A.; N.Y. Pub. Lib.; Montgomery Mus. A.; Birmingham Pub. Lib.; Col. FA, Syracuse Univ.; Pa. State Univ.; N.Y. Historical Soc.; Mus. of the City of N.Y.; British Mus., London; Royal Mus. Brussels; Cal. State Lib.; PAFA; Phila. Pr. Cl.; Norfolk Mus. A. & Sciences; Am. Soc. Et. Exhibited: LC, NAD; PAFA; NAWA; WFNY 1939; SAGA; AIC; Argent Gal.; Albany Inst. Hist & A.; Carnegie Inst.; Cal. Soc. Et.; NAWA traveling exh., Japan, Greece, India, France, 1964; London Exchange Exh., SAGA; Audubon A.; Greece, Holland, Switzerland, 1956-58; Pulitzer Gal., N.Y., 1959 (one-man); CGA; Smithsonian Inst.; SAM; WMAA; MMA; BM; New Sch. for Social Research, N.Y., 1963 (one-man); AGAA; traveling exhs. of graphic art, and many others. One-man: Pen & Brush Cl., 1945, 1949; Montgomery Mus. FA, 1947; many Colleges and Libraries.

PARKER, ALFRED—Illustrator
P.O. Box 227, Carmel Valley, Cal. 93924
B. St. Louis, Mo., Oct. 16, 1906. Studied: St. Louis Sch. FA. Member: SI; Westport A. (Pres. 1950); A. Gld.; St. Louis Ad Cl. (hon.); San F. Ad Cl. Awards: N.Y. A. Dir. Cl.; Phila. A. Dir. Cl.; Citation Washington Univ., St. Louis. Lectures and exhibitions in major cities of U.S. and Canada. Contributor illus. to: Ladies Home Journal; Good Housekeeping; Town & Country; McCalls; Cosmopolitan, and other leading national magazines. Creator of Mother and Daughter covers for Ladies Home Journal. Fndr.-Memb., Famous Artists Schools, Westport, Conn.*

PARKER, ANN—Printmaker, W., L.
Thistle Hill, North Brookfield, Mass. 01535
B. London, England, Mar. 6, 1934. Studied: R.I. Sch. Des.; Yale Univ., B.F.A. Member: Advisory Bd., Mus. Am. Folk Art, New York, N.Y. Awards: 50 Books of the Year award, AIGA, 1957; Ford Fnd. Grant, 1962-1963 renewed 1963-1964. Work: BM; FMA; LC; MMA; MModA; Amon Carter Mus. Western A., Ft. Worth, Tex.; N.Y. Public Library; Smith Col. Mus.; Smithsonian Inst.; Toledo Mus. A.; Winterthur Mus., Delaware; universities of California, Florida and St. Thomas; Wadsworth Atheneum, Hartford; Milwaukee A. Center; Am. Mus. in Britain; Albany (N.Y.) Inst. Hist. & A.; Int. Folk Art Mus., Santa Fe, N.M.; Rosenwald Coll.; Mellon Coll.; Abby Aldrich Rockefeller Folk Art Coll.; N.Y. State Historical Assn., and others. Exhibited: Over 30 one-man exhs. and 2-man (with Avon Neal) including: BM, 1961, 1963; Carnegie Inst., 1963; Princeton Univ., 1963; Smith Col., Mus., 1963; Detroit Inst. A., 1964; Abby Aldrich Collection American Folk Art, 1964; American Embassy London, 1965; Amon Carter Mus., 1968; Hallmark Gal., N.Y., 1968; Smithsonian Inst., 1968; N.Y. State History Mus., 1969, and others. Illus.: "Ephemeral Folk Figures," 1969; Co-author, I., "Rubbings

from Early American Stone Sculpture," limited edition, 1964. Contributor, articles and illus. to: Artists Proof; Art in America; Craft Horizons; Time; Look; N.Y. Times Magazine; Ciba Journal; Vermont Life, and other publications. Lectures on Folk Art of various periods; Art of Early American Gravestone Carving, at universities, museums and on radio and television.

PARKER, HARRY S. III—Museum Educator
 The Metropolitan Museum of Art, 1000 Fifth Ave., New York, N.Y. 10028; h. Westchester Ave., Pound Ridge, N.Y. 10576
B. St. Petersburg, Fla., Dec. 23, 1939. Studied: Harvard University, B.A.; New York University Institute of Fine Arts, M.A. Member: American Association of Museums; American Federation of Arts; International Council of Museums. Contributor to The Metropolitan Museum of Art "Bulletin." Lectures: Museum Education. Positions: Assistant to the Director, The Metropolitan Museum of Art, 1963-1967.

PARKER, RAYMOND—Painter
 101 Prince St. 10012; h. 52 Carmine St., New York, N.Y. 10014
B. Beresford, S.D., Aug. 22, 1922. Studied: State Univ. Iowa, B.A., M.F.A. Awards: Minneapolis Inst. A., 1948, 1949; "Centennial Minnesota," award and purchase, 1949, 1951; Ford Fnd. purchase, CGA, 1963; Nat. Council on the Arts, 1967; Guggenheim Fellowship, 1967. Work: Larry Aldrich Mus., Conn.; Albright-Knox A. Gal.; Dayton AI; Des Moines A. Center; Ft. Worth A. Mus.; Guggenheim Mus.; Michener Coll.; Los A. Mus. A.; Minneapolis Inst. A.; Minnesota Historical Soc.; MModA; Rose A. Mus., Brandeis Univ.; State Univ. Iowa; Tate Gal., London; WAC; WMAA; AIC; Wadsworth Atheneum, Hartford; Mass. Inst. Tech.; SFMA; Univ. New Mexico; Delgado Mus. A., New Orleans; Project South Mall, Albany, N.Y. Exhibited: Minneapolis Inst. A., 1948, 1949; St. Paul Gal. A., 1949; WAC, 1951, 1956, 1960; MModA, 1950; WMAA, 1950, 1952, 1958; 1963; MMA, 1950; Oberlin Col., 1951; Stable Gal., N.Y., 1956; MModA Exh., Japan, 1957-58; Biennale de Bellas Artes, Mexico City, 1960; Univ. Illinois, 1962-63; Guggenheim Mus., 1961; Seattle World's Fair, 1962; CGA, 1963; Jewish Mus., N.Y., 1963; Kane Mem. Exh., Providence, R.I., 1965 (Critics' Choice); Univ. Vermont, Fleming Mus., 1964; Wadsworth Atheneum, 1964; AIC, 1964; Brandeis Univ., 1964; Los A. Mus. A., 1964; Reed Col., Portland, Ore., 1964; White Mus. A., Cornell Univ., 1965; Carnegie Inst., 1964-65; PMA, 1964; Fairleigh Dickinson Univ., 1964-65; Univ. Texas, Austin, 1964; Tate Gal., London, 1964; "Selections from the Guggenheim Museum," Venice Biennale, Italian Pavilion, 1964. One-man: WAC, 1950; Paul Kantor Gal., Los A., 1953, 1956; Memphis Acad. A., 1953; Louisville A. Center, 1954; Union Col., Schenectady, 1955; Widdifield Gal., N.Y., 1957, 1959; Univ. So. Cal., 1959; Dwan Gal., Los A., 1960, 1962; Galerie Lawrence, Paris, 1960; Kootz Gal., N.Y., 1960-1966; Galleria dell'Ariete, Milan, 1961; Guggenheim Mus., N.Y., 1961; Kasle Gal., Detroit, 1966; Gal. Mod. A., Wash., D.C., 1966; SFMA, 1967; Univ. New Mexico Mus., 1967; Molly Barnes Gal., Los Angeles, 1968; Lithographs, SFMA, 1968; Bennington Col., 1961; Des Moines A. Center (3-man), 1962-63; Retrospective, Dayton AI, 1965. Positions: Taught, State Univ. Iowa and Univ. Minnesota; Instr., A., Hunter College, Univ., 1955- .

PARKER, ROBERT ANDREW—Painter
 Kent Cliffs Rd., Carmel, N.Y. 10512
B. Norfolk, Va., May 14, 1927. Studied: AIC, B.A.E.; Skowhegan Sch. Painting & Sculpture; Atelier 17, N.Y. Awards: prize, NAC, 1959; Rosenthal Fnd. Grant, Nat. Inst. A. & Lets, 1962; Tamarind Lithography Workshop Fellowship, 1967; Guggenheim Fellowship, 1969-1970. Work: Los Angeles County Mus.; MMA; Morgan Library, New York City; MModA; WMAA; BM; Des. sets for a William Schuman Opera, MModA, N.Y., 1961; Illus., hand-colored Limited Edition of Poems by Marianne Moore, pub. by MModA, 1962. Exhibited: MMA, 1952; MModA, 1953; Circulating 1954-56; WMAA, 1955, 1956, 1958-1960, traveling exh., 1962; BM, 1955; Art in America circulating, 1956; MModA, 1957; La Napoule, France, 1957; Laon Museum, (Aisne), France, 1956; New Sch. N.Y., 1965; Sch. Visual Arts, N.Y., 1965; Gallery of Modern Art, N.Y., 1965; World House Gal., N.Y., 1961; Landau Gal., Los A., 1961; Obelisk Gal., Wash. D.C., 1963; J.L. Hudson Gal., Detroit, 1964, 1965, 1968; World House, N.Y., 1964; Dintenfass Gal., N.Y., 1967-1969 (one-man).

PARKER, ROY D.—Painter
 88 Highland Ave., Middletown, N.Y.
B. Raymond, Iowa, Feb. 23, 1882. Member: Middletown A. Group; Pocono Mountain AA; Sussex County AA. Awards: prizes, 32 prizes to date. Work: Coe College, Cedar Rapids, Iowa; Everhart Mus., Scranton, Pa., Bridgeport Mus. A., Science & Industry; Berkshire Mus., Pittsfield, Mass. Private coll. of D.D. Eisenhower, and others. Exhibited: one-man: Panoras Gal., N.Y.; Everhart Mus., Scranton, Pa.; Berkshire Mus. A., Pittsfield, Mass., 1958, and in local and regional exhs.; Grout Hist. Mus., Waterloo, Iowa, 1960; Centerville, Iowa, 1960.

PARKHURST, CHARLES PERCY—
 Museum Director, E., Hist.
 Baltimore Museum of Art, Wyman Park, Baltimore, Md., 21218
B. Columbus, Ohio, Jan. 23, 1913. Studied: Williams Col., B.A.; Oberlin Col., M.A.; Princeton Univ., M.F.A. Member: CAA (Pres., 1958-1960); Am. Assn. Mus. Dirs.; Int. Inst. for Conservation (Fellow). Awards: Jacobus F., Princeton Univ., 1940-41; Ford Fnd. F., 1952-53; Fulbright F., 1956-57; Chevalier, Legion of Honor, France, 1947. Work: NGA; Albright A. Gal.; Princeton Univ. Mus.; Allen A. Mus. Author: Articles on color theory and art history; "Gutman Collection of Ancient and Medieval Gold"; contributor to museum bulletins and catalogs. Positions: Asst. Cur., NGA; Asst. Cur., Albright A. Gal., Buffalo; Prof., A. & Arch. Hist., Princeton Univ.; Pres., AAMus., 1966-1968; Co-Founder and past Pres., Intermuseum Conservation Assn.; Prof., Art Hist., Dir., Allen Mem A. Mus., Oberlin College, Oberlin, Ohio, 1949-1962; Dir., Baltimore Museum of Art, 1962- .

PARKINSON, MRS. ELIZABETH BLISS—
 Patron, Collector
 215 E. 72nd St., New York, N.Y. 10021
B. New York, N.Y., Sept. 25, 1907. Positions: President, International Council, MModA, 1957-1965; President, Museum of Modern Art, 1965-1968, Trustee, 1939- .

PARSONS, BETTY (BIERNE) MRS.—Gallery Director, Collector
 25 W. 57th St., 10019; h. 7 W. 81st St., New York, N.Y. 10024
B. New York, N.Y., Jan. 31, 1900. Studied: in Paris with Bourdelle, Archipenko, Zadkine; in Brittany with Arthur Lindsey. Member: Art Dealers Association of America; American Abstract Artists; Artists Equity; National Council of Women; Guggenheim Museum; Museum of Modern Art; Whitney Museum; American Federation of Arts; Jewish Museum; Cosmopolitan Club. Exhibited: One-man: Galerie des Quatre Chemins; Stendall Gallery, 1934; Midtown Gallery, N.Y., (10 one-man exhibitions), 1936-1957; Pensacola A. Center, 1958; Georgia Museum of Art, 1958; Latow Gallery, 1960; Sydney Wolfson Gallery, 1962; Miami Museum of Modern Art, 1963; New Arts Gallery, 1963; Bennington College, 1966; Gallery Seven, 1967; Grand Central Moderns, 1967; Whitechapel Gallery, London, 1968. Specialty of Gallery: Exclusively Contemporary Art. Collection: Predominantly Contemporary Art. Publicity: Vogue, 1951, by Aline Loucheim; "Ten Years," by Clement Greenberg, 1956; Vogue, 1963, by Lawrence Alloway; Bennington College Exhibition Catalogue by Lawrence Alloway, 1966; "100 American Women of Accomplishment," Harpers Bazaar, 1967; House & Garden, 1967; Finch College Catalogue by Eugene Goossen, 1968; Art News, 1968 by Rosalind Constable. Positions: Director, Wakefield Gallery, N.Y., 1941; Director, Contemporary Gallery at Brandt Gallery, N.Y., 1944; Director, Art Dealers Association, 1964-1965; Director, Little Red School House, N.Y.; Owner and Director, The Betty Parsons Gallery, New York City, 1946- .

PARSONS, KITTY (Mrs. Richard H. Recchia)—Painter, W.
 Hardscrabble, Rockport, Mass. 01966
B. Stratford, Conn. Studied: PIASch; T. Col., Columbia Univ.; Boston Univ.; Univ. Chicago; & with Richard H. Recchia. Member: NAWA; Rockport AA; Lg. Am. Pen Women; Concord AA; North Shore AA; Boston Authors Cl.; Am. Poetry Lg.; Penn-Poetry Soc.; Awards: prize, Nat. Lg. Am. Pen Women, 1955, 1956. Work: Rockport H.S.; Syracuse Univ. Exhibited: NAWA, 1941, 1944; CGA, 1941; Portland SA, 1942, 1944; Soc. Indp. A.; Springfield A. Lg.; Mint Mus. A.; Alabama WC Soc.; Newport AA, 1944, 1945; Rockport AA; North Shore AA; Conn. Acad. FA; J. B. Speed Mem. Mus.; Palm Beach A. Lg.; one-man exh: Doll & Richards, Boston; Berkshire A. Mus.; Argent Gal.; Bennington Mus.; Whistler House, Lowell, Mass.; Winchester (Mass.) AA; Nashville Mus. A.; Milwaukee Pub. Lib.; Bowdoin Col.; Copley Soc., Boston, 1966. Author: "Ancestral Timber," 1957; "Down to Earth," 1964; juvenile book, "Up and Down and Roundabout," 1967; several books of poetry; contributor to magazines & newspapers. Positions: Bd. member, Rockport AA, 1940-55, Publ. Chm., 1959-61; Bd. Maine Writers' Conf., 1957-58, Chm., 1961-64, Poetry Chm., 1958-61.

PARTCH, VIRGIL FRANKLIN (VIP)—Cartoonist, I., Comm., L., W.
 Box 35 A, Capistrano Beach, Cal. 92624
B. St. Paul Island, Alaska, Oct. 17, 1916. Studied: Chouinard AI, Los Angeles. Awards: First prize, Brussels Cartoon Exh., 1964. Author: "It's Hot in Here"; "Water on the Brain"; Author, I., "Bottle Fatigue"; "Here We Go Again"; "Wild, Wild Women"; "Man the Beast"; "Deadgame Sportsman"; "Hanging Way Over"; "VIP Throws a Party"; "New Faces on the Bar Room Floor"; "Big George." Comic strip and daily panel, "Big George" (syndicated). Contributor cartoons to Look, True magazines.*

PARTIN, ROBERT (EDWARDS)—Painter, E.
Dept. of Art, California State College, Fullerton, Cal. 92631; h. 1130 Corrida Pl., Orange, Cal. 92667
B. Los Angeles, Cal., June 22, 1927. Studied: Univ. Cal. at Los Angeles, B.A.; Columbia Univ., Sch. Painting & Sculpture, M.F.A.; Yale-Norfolk A. Sch., Norfolk, Conn.; Tamarind Lithography Workshop; John Herron Sch. of Art. Member: CAA; Southeastern College A. Conf. Awards: North Carolina Mus. A., 1958, prize, 1960; Winston-Salem Gal. FA, purchase, 1960; Ringling Mus. A., purchase, 1961; Univ. So. Fla., Tampa, 1962; purchase; Ford Fnd. purchase prize, WMAA, 1963; FA Gal. of San Diego, 1969. Work: North Carolina Mus. A.; Mem. Lib., Winston-Salem; Ryder System, Miami; Univ. South Florida; Guggenheim Mus., N.Y.; Jonson Gal., Univ. New Mexico; Weatherspoon Gal., Univ. N.C. at Greensboro. Exhibited: Provincetown A. Festival, 1958; Boston A. Festival, 1960; Soc. Four A., Palm Beach, 1958-1960; Pietrantonio Gal., N.Y., 1961; Bertha Schaefer Gal., N.Y.; Smithsonian Inst., 1963; WMAA, 1963; N.C. Mus. A., 1958-1960, 1962, 1964; Winston Salem Gal. FA, 1958-1961; Montgomery Mus. FA, 1961, 1962; Ringling Mus. A., Sarasota, 1961, 1962; Dorian Hunter Gal., Fullerton, Cal., 1968; Laguna Beach AA, 1968; Cal. State College, Dominguez Hills, Cal., 1968; Orlando Gal., Encino, Cal, 1968, 1969. Positions: Teaching Asst., UCLA, 1952-54; Instr. A., Univ. Kentucky, 1957; Asst. Prof. A., 1957-62, Assoc. Prof. A., 1962-1966, Univ. North Carolina at Greensboro; Visiting Assoc. Prof. A., Univ. New Mexico, 1963-64; Prof. A., California State College, Fullerton, 1966- .

PARTON, NIKE—Painter, S., C.
840 Edgemere Lane, Sarasota, Fla. 33581
B. New York, N.Y., June 23, 1922. Studied: ASL, with George Grosz; Jay Connaway Sch. A.; Ringling Sch. A., with Leslie Posey. Member: A. Lg. Manatee County; Sarasota AA; Cor. memb., Int. Inst. A. & Lets. Awards: prizes, Sarasota AA, 1953, 1967; A. Lg. Manatee County, 1954, 1957, 1958, 1960; St. Boniface Church, 1961; Longboat Key A. Center; Fla. A. Group, 1956, 1957. Work: A. Lg. Manatee County; Univ. Fla., Gainesville; Stetson Univ. Exhibited: Sarasota AA, 1953-1969; PAFA, 1947; Fla. A. Group, 1955-1968; Southern Vt. A., 1947-1950; Boston A. Festival, 1953; A. Lg. Manatee County, 1952-1969; Assoc. Sculptors, 1957, 1958; Fla. Fed. A., 1957-1961; one-man: Sarasota AA, 1953, 1969; A. Lg. Manatee County, 1953, 1956-1958, 1960; Tampa AI, 1957, 1958; Clearwater AA, 1959; Southern Vt. AA., 1969; Westport A. Cl., 1966.

PASCAL, DAVID—Illustrator, Cart., P.
P.O. Box 31, Village Station, New York, N.Y. 10014
B. New York, N.Y, Aug. 16, 1918. Member: Nat. Cartoonists Soc. Awards: Nat. Cartoonists Soc., 1969; First prizes, United Seamen's Service, 1943, 1944; Bordighera, Italy, 1963. Exhibited: MMA, Cartoon Exh., 1951; Grand Central A. Gal.; CGA; Soc. of Illustrator's Show, 1967, 1968 and other galleries and museums. One-man: Librairie le Kiosque, Paris, 1966; Musee des Arts Decoratifs, Paris, 1967. Illus., "The Art of Inferior Decorating," 1963; "Fifteen Fables of Krylov," 1965; Best Cartoons of 1947-1959; many cartoon anthologies. Author, I., "The Silly Knight," 1967. Contributor of Cartoons to Punch; Sat. Eve. Post; Sports Illustrated; New Yorker; Paris-Match; Esquire, Evergreen Review and other national magazines. Contributor articles and illustrations to N.Y. Times, "Ski" and "Skiing." Positions: Former Instr., Sch. Visual Arts, New York, N.Y. Toured Far East Military Installations, Auspices of U.S. Army, Dept. of Defense, 1958, 1959, and Mediterranean Bases, 1961. American delegate to the first International Comics Congress, sponsored by Univ. of Rome, at Bordighera, Italy, 1963, and Lucca, Italy, 1967.

PASILIS, FELIX—Painter
95 E. 10th St., New York, N.Y. 10003*

PATRICK, JOSEPH—Painter
1190 E. Court St., Iowa City, Iowa 52240
B. Chester, S.C., Feb. 10, 1938. Studied: Univ. Georgia, B.F.A.; Univ. Colorado, M.F.A. Member: CAA. Awards: Hartford Fnd. Fellowship, 1964; Univ. Iowa Faculty Research Fellowship, 1969. Exhibited: Container Corp. Exh., Rock Island, Ill., 1967; Sioux City A. Center, 1967; Richard Gray Gal., Chicago, 1967; Wichita AA, 1967; Waterloo (Iowa) Mun. Gals., 1967; Univ. Omaha, 1966; Stephens Col., Columbia, Mo., 1966; Faculty Exh., Sch. A., Univ. Iowa, 1966, 1967; Des Moines A. Center, 1966; Joslyn A. Mus., Omaha, 1965; Old Salem Gal., Winston-Salem, 1964, 1965; Hunter Gal., Chattanooga, 1964. One-man: Va. Polytechnic Inst., Blacksburg, 1965; Radford Col., 1965; Southwestern Univ., Memphis, 1963; Lambuth Col., Jackson, Tenn., 1962; Cedar Rapids A. Center, 1968; Dubuque AA, 1968; Keokuk AA, 1969; Davenport Mun. A. Gal., 1969; Murray State Univ., Murray, Ky., 1969; 2-man: Simpson Col., Iowa, 1966; Mississippi State Col. for Women, Columbus, 1966; Amarillo, Tex., 1964. Positions: Instr. A., Northeast Mississippi Jr. Col., 1962-1964; Radford Col., 1964-1965; Drawing, Univ. Iowa, Iowa City, 1965- .

PATRICK, RANSOM R.—Educator, P., Hist., Des., Comm., L., Cr.
Dept. Aesthetics, Art & Music, Duke University, 6605 College Station; h. 116 Pinecrest Rd., Durham, N.C. 28305
B. Santa Barbara, Cal., July 28, 1906. Studied: Univ. Washington, B.A.; Princeton Univ., M.F.A., Ph.D. Member: CAA; Am. Soc. for Aesthetics (Sec., 1950-55, Trustee, 1955-58); AAUP; Int. Platform Assn. Work: mural, U.S. Naval Air Base, Sand Point, Wash. Exhibited: SAM, 1930-1942. Contributor to Art Bulletin. Bus. Mngr., Journal of Aesthetics & Art Criticism, 1950-55. Lectures: Aesthetic Criticism; Art History and The Humanities; Nineteenth Century American Portrait Painting; Interrelationship of the Arts; History of Aesthetics and the Arts in a University Curriculum, and others, to art associations, art museums, college art conferences, etc., 1958-60. Positions: Prof., A. Hist., Aesthetics & Criticism, Oberlin College, Univ. Minnesota, Western Reserve Univ., Duke University; Dir., Div. A. & Arch., Western Reserve Univ., 1949-54; Chmn, Dept. Aesthetics, Art & Music, Duke Univ., Durham, N.C, 1954-60; Chm. Dept. Art, 1960- .*

PATTERSON, GEORGE W. PATRICK—
Painter, Mus. Dir., Des., Hist., W.
Woolaroc Museum; h. 912 Osage St., Bartlesville, Okla. 74003
B. Centralia, Ill., Dec. 29, 1914. Studied: Univ. Oklahoma, B.F.A., and with Paul Laune, O. McDowell. Work: Ecclesiastical art; many portraits. Author, I., "Kemoha," 1948. Lectures: Art History; Western Art; Prehistoric Art. Assembled, arranged, catalogued museum collection, 55,000 items, Western Art, American Indian Artifacts. Positions: Dir., Woolaroc Museum, Bartlesville, Okla., 1939- .

PATTERSON, PATTY (Mrs. Frank Grass)—Painter, C., T., L., W.
2506 Northwest 66th St., Oklahoma City, Okla. 73116
B. Oklahoma City, Okla., Jan. 16, 1909. Studied: Univ. Oklahoma, B.F.A.; Ecole des Beaux-Arts, Fontainebleau, France; Taos Sch. A.; ASL; Okla. State Univ.; Okla. Univ., & with Emil Bisttram. Member: Okla. AA; Okla. A. Lg., Okla. Writers; Okla. Conservative Artists. Awards: med., McDowell Cl., 1940, 1944; Okla. A. Lg., 1942. Exhibited: Fontainebleau, France; Arch. L.; Okla. Hist. Soc.; YWCA, Okla. City (one-man); MIT; Okla. AA, 1932-1958; Tulsa AA; Okla. City A. Center, 1962-1964. Lectures: Art Trends; Art; Genealogy, to Clubs and Art Organizations. Positions: A. Instr., Oklahoma City Schs. and Oklahoma City Univ., Okla., 1934- ; Vice-Pres., Sec., Okla. AA.*

PATTISON, ABBOTT—Sculptor, P.
526 Aldine Ave., Chicago, Ill. 60013; h. 334 Woodland Ave., Winnetka, Ill. 60093
B. Chicago, Ill., May 15, 1916. Studied: Yale Col., B.A.; Yale Sch. FA, B.F.A. Member: Chicago A. Cl. Awards: Scholarships, Yale Univ. and Yale Col., 1937-38, traveling F., 1939; prizes, AIC, 1942, 1946, 1950, 1953, 1968; Bundy Art Gal., Waitsfield, Vt.; MMA; 1020 A. Center, Chicago, 1955. Work: sc., South Side Filtration Plant, Chicago; Nat. Bar. Assn. Hdqs., Chicago; Chicago Branch Lib.; Louis Solomon Bldg., Chicago; AIC; Outer Drive East, Chicago; Palm Springs (Cal.) Spa Hotel; Stanford Medical Center, Palo Alto, Cal.; Phoenix Mus. A.; WMAA; AGAA; Portland (Me.) Mus. A.; Chrysler Mus. A.; La Jolla A. Center; Davenport Mus. A.; Univs. of: Notre Dame; Brandeis; Syracuse; Minnesota; Northwestern; Mt. Holyoke; Georgia; Cal. PLH; Evansville Mus.; CGA; Holbrook Mus., Georgia. Sculpture of the following buildings: La Salle-Jackson; Garland; 4100 & 4250 Marine Drive; Stratford House, all in Chicago; Central Nat. Bank, Cleveland; Mayo Clinic, St. Thomas Acad., St. Paul, Minn.; New Trier West H.S., Joseph Block School, East Chicago Sc., U.S. State Dept.; Buckingham Palace, London, England. Exhibited: AIC, 1940-1969; WMAA, 1953, 1956, 1957, 1959; MMA, 1951, 1952, and others including Chicago Area exhs. since 1942; one-man: AIC, 1946; Contemp. Gal., Chicago, 1950; Feingarten Gal., 1952, 1957, 1968; Elgin Acad. A., Winnetka; Holbrook Mus., Univ. Georgia, 1954; Hill Gal., Wellfleet, Mass., 1954; Sculpture Center, N.Y., 1956. Positions: Instr., AIC, 1946-52; Sculptor-in-Res., Univ. Georgia, 1954; Instr., Skowhegan Sch. A., 1955-56.

PAUL, BERNARD H.—Craftsman
414 Hawthorne Rd., Linthicum Heights, Md. 21091
B. Baltimore, Md., Apr. 22, 1907. Studied: Maryland Inst. Awards: prizes, Maryland Inst., 1929, 1933, 1937. Positions: Instr., Puppetry, Maryland Inst., Baltimore, Md., 1929-47, 1958-61; Dir. television program, "Paul's Puppets," WBAL-TV, Baltimore, Md., 1948-1957; WMAR-TV, 1957-58. Puppets used by U.S. Dept. Health, Edu. & Welfare for series of motion pictures for Social Security TV spots. Miniature model sets for Hutzler's Dept. Store's 100th Anniversary, 1958; marionettes for opera with Peabody Conservatory of Music, 1957; Christmas Shows, Colonial Williamsburg, 1956-57, 1960-61.*

PAUL, BORIS DuPONT—Painter, E., Mus. Cur., Cr., W., L.
Lowe Art Museum, University of Miami, Miller Dr., Coral Gables, Fla. 33146; h. 205 E. Rivo Alto Dr., Miami Beach, Fla. 33139
B. Ulan Bator, China, Apr. 1, 1901. Studied: Baccalaureate, Diploma, Petrograd; Univ. California; Art Students League; National Academy of Design, and with Ilya Repin, Robert Henri, Robert Brackman, Theodoros Stamos, Stephen Greene. Member: Miami Art League; Friends of Art, University of Miami. Awards: William H. Fogg Memorial Award, 1952; Brandeis Merit Award, 1964; Flagler Museum; National Boat Show, Miami Beach, 1969; purchase prize, Satinover Galleries, Paris, France. Work: Lowe Art Museum, Coral Gables, Fla.; Miami Museum of Modern Art. Exhibited: Lowe Art Museum, 1966-1968; Bass Museum of Art, Miami Beach, 1965 (one-man); Barker Memorial Exhibition, 1965; Coconut Grove, Fla., 1968 (3-man); Hortt Memorial Exhibition, Ft. Lauderdale, 1964; Flagler Museum, 1964; National Academy of Design, N.Y., 1952; Key Gallery, 1962 (one-man). Contributor to Miami Beach Sun; Arts Magazine. Positions: Associate Professor of Art, University of Miami, 1964- ; Art Editor, Miami Beach Sun, 1966- ; Curator, Lowe Art Museum, Coral Gables, Fla., 1964- ; Director, Continental Gallery, 1959- .

PAUL, WILLIAM D., JR.—Museum Director, Painter, Educator
Georgia Museum of Art, University of Georgia; h. Rte. 3, Sun Valley Rd., Athens, Ga. 30601
B. Wadley, Ga., Sept. 26, 1934. Studied: Atlanta Art Institute; B.F.A.; University of Georgia, A.B., M.F.A.; Emory University; Georgia State College; University of Rome, Italy. Member: American Federation of Arts (Trustee); College Art Association; American Association of Museums. Awards: prizes, Georgia Artists Association, 1956; Delta Annual, Little Rock, 1960; Macy's Annual, Kansas City, Mo., 1959, 1961, 1963, 1964; Atlanta Paper Co. Annual, 1961; Mid-America Annual, Hallmark Award, 1962. Work: General Mills, Inc., Minneapolis; Hallmark Cards, Kansas City; Little Rock A. Center; Georgia Museum of Art; University of Georgia, Athens; Art in Embassies Program. Exhibited: Southeastern Annual, Atlanta, Ga.; Virginia Intermont College, Bristol, Va.; Birmingham Annual; Mead Packaging Co., Atlanta, Ga.; Corcoran Gallery of Art, Washington, D.C.; Delta Annual, Little Rock, Art,; Joslyn Museum, Omaha, Neb.; Macy's Annual, Kansas City, Mo.; Georgia Artists, Athens, Ga.; East Tennessee State College, Johnson City, Tenn.; Mid-America Annual, Kansas City, Mo.; American Federation of Arts traveling exhibitions (Tupperware), also "Art of Two Cities," national traveling exhibition; New Arts Gallery, Atlanta, Ga. One-man: Georgia Museum of Art; Atlanta Art Association; Unitarian Gallery, Kansas City, Mo.; Palmer Gallery, Kansas City; 2-man: Kansas City Art Institute; Park College, Parkville, Mo. Exhibitions organized: Sixty small original exhibitions from Sept. 1961-June, 1965, for the Charlotte Crosby Kemper Gallery of the Kansas City Art Institute; For the American Federation of Arts for national circulation: "Art of Two Cities," 1965; "American Painting: The 1940's," 1968; "American Painting: The 1950's," 1968; "American Painting: The 1960's," 1969. For the Georgia Museum of Art: "The Visual Assault," 1967; "Drawings by Richard Diebenkorn;" "Selections: The Downtown Gallery"; "Drawing and Watercolors by Raphael Soyer"; "Recent Collages by Samuel Adler," 1968; Twentieth Anniversary Exhibition, Georgia Museum of Art; "Art of Ancient Peru, The Paul Clifford Collection." Contributor to: Focus/Midwest; Atlanta Journal. Positions: Instructor, Art and Art History, Kansas City Art Institute, Park College and University of Georgia; Director Exhibitions and Curator of Study Collections, Kansas City Art Institute, 1969-1965; Curator, Georgia Museum of Art, 1967-1969; Director, Goergia Museum of Art, Athens, Ga., 1969- .

PAULIN, RICHARD CALKINS—Museum Director, T., Gr., C.
Harry & Della Burpee Art Gallery, 737 North Main St.; h. 913 North Main St., Rockford, Ill. 61103
B. Chicago, Ill., Oct. 25, 1928. Studied: DePauw Univ., B.A.; Univ. Denver, M.A.; Inst. FA, N.Y.; Guadalajara, Mexico. Member: Rockford Edu. Assn.; NEA; Nat. Council on Art Edu.; Mus. Dirs. Assn. of North America; Western AA; Mid-Western Mus. Dirs. Assn.; Kappa Pi; Illinois A. Edu. Assn. Exhibited: Univ. Illinois, 1960; Beloit Col., 1961-1963, 1965; Nat. Col. Edu., Evanston, 1964 (2-man); Rockford AA, 1961. Awards: Canfield award, Rockford AA, 1961. Assembled exhs., "Teachers Who Paint," 1959; "Chicago Painters," 1960; "Six Chicago Painters," 1961; "Picasso Preview," 1962; "Georges Rouault-His Aqua Tints and Wood Engravings," 1963; "Collectors Showcase 1964: 30 Contemporary Living American Painters," 1964; "First National Invitational Painting Exhibition: Fifty States of Art," 1965; "Swedish Handcraft," 1961. Positions: Instr. A. & Crafts, Roosevelt Jr. H.S., Rockford, Ill.; Basic & Intermediate A. Courses, Rockford AA; Dir., Harry and Della Burpee Art Gallery, Rockford, Ill., at present.*

PAULLIN, ETHEL PARSONS (Mrs. Telford)—
Painter, Eng., Textile Des.
54 West 74th St., New York, N.Y. 10023
B. Chardon, Ohio. Studied: BMFA Sch. Member: NSMP. Work: St.

Bartholomew's Church, Church of St. Vincent Ferrer, N.Y.; St. Stephen's Church, Stevens Point, Wis.; Fed. Bldg., Albany, N.Y.; Brooke General Hospital Chapel, U.S. Army, San Antonio, Tex.; stained glass windows: Dana Chapel, Madison Ave. Presbyterian Church, N.Y.; St. John's Episcopal Church, Bernardsville, N.J., 1961; port., Ex-Pres., John Henry Barrows, Oberlin College, 1958; 30 religious triptychs for U.S. Armed Forces, 1962-1964; Portraits & decorative paintings for homes, engravings, 1966-1969.

PAVAL, PHILIP—Painter, C.
15016 Ventura Blvd., Sherman Oaks, Cal.; h. 2244 Stanley Hills Dr., Hollywood, Cal. 90046
B. Nykobing Falster, Denmark, Apr. 20, 1899. Studied: Borger Sch.; Tech. Sch. Des., Denmark. Member: Cal. A. Cl. (Pres.); P. & S. Cl.; Los A. Mus. A.; F., Royal Numismatic Soc., London; F., AIFA; Scandinavian-Am. AA; Sociedade Brasileira de Belas Artes, Brazil; and honorary member of many art societies and organizations in South America and abroad. Awards: many honorary degrees and decorations from France, Sweden, Belgium, Italy, British India and the U.S.; Hon. Litt.D., Trinity Southern Bible Col. & Seminary, Mullins, S.C.; Jose Drudis Traveling F., 1959, 1960; gold medal, Univ. Cl., Los A.; gold medal, S.A.A.S., Los A.; prizes, Los A. Mus. A., 1935, 1936, med., 1942; Hollywood Riviera Gal., 1936; Wichita, Kans., 1946; Ebell Cl., Los A., 1950; Madonna Festival, Los A., 1960; gold medals, State Expo., 1941; Cal. A. Cl., 1953, and others. Work: MMA; Los A. Mus. A.; Philbrook A. Center; Wichita AA; Smithsonian Inst.; Newark Mus.; Pasadena AI; Presidential Palace, Quito, Ecuador; Royal Palace, Athens; Governor's Palace, Hawaii; Buckingham Palace, London; Mus. Am. Comedy, Fla.; Rosenborg Castle, Denmark; St. Martin of Tours, Brentwood, Cal.; Lutheran Church, Los A.; Mataro Mus., Spain; Nat. Mus., Iceland; Nat. Mus., Copenhagen, Denmark; Nat. Mus., Oslo, Norway; Masonic Lodge, Hollywood, Frederikborg Castle, Denmark; museums in Sweden, France, Vienna, Sidney, Australia National Museum, Art gallery, New Zealand, Austria, Portugal, Germany, England, and many others; work also in numerous private colls. Exhibited: leading galleries and museums, nationally and internationally.

PAVIA, PHILIP
c/o Martha Jackson Gallery, 32 E. 69th St., New York, N.Y. 10021*

PAYER, MRS. ERNST. See Shepherd, Dorothy G.

PAYSON, MR. AND MRS. CHARLES S.—Collectors
2 East 88th St., New York, N.Y. 10028*

PEABODY, AMELIA—Sculptor
Dedham St., Dover, Mass.; h. 120 Commonwealth Ave., Boston, Mass. 02116
B. Marblehead Neck, Mass., July 3, 1890. Studied: BMFA Sch., and with Charles Grafly; Archipenko Sch. A. Member: Copley Soc., Boston; North Shore AA; Gld. Boston A.; NSS; NAWA; AAPL; New England Sculptors' Assn. Award: Medalist, A. & Crafts Soc., Boston, 1950; The Mrs. Oakleigh Thorne Medal, Garden Club of America; Bronze Medal, Mass. Horticultural Soc. Work: BMFA; portraits, medals, garden and architectural sculpture, in bronze, stone, and pottery. Exhibited: PAFA; WFNY 1939; AIC; Boston S. Soc.; Gld. Boston A., 3 one-man exhs.; PMA; BMFA, 1950. 1951; NAD, 1952; Festival of Boston, 1952; New England Sculptors Assn., 1952-1965. Positions: Chm. A. & Skills Corps, Am. Red Cross, 1944-65; Trustee, Mus. Science; Vice-Pres., New England Sculptors Assn.

PEAKE, CHANNING—Painter
c/o Felix Landau Gallery, 702 N. La Cienega, Los Angeles, Cal. 90069*

PEARLMAN, HENRY—Collector
630 Third Ave. 10017; h. 993 Park Ave., New York, N.Y. 10028
B. New York, N.Y., May 25, 1895. Collection: Impressionist and post-impressionist paintings, including works by Cezanne, Van Gogh, Lautrec, Modigliani, Soutine, Lipchitz.*

PEARLSTEIN, PHILIP—Painter, E.
163 W. 88th St., New York, N.Y. 10024
B. Pittsburgh, Pa., May 24, 1924. Studied: Carnegie Inst., B.F.A.; N.Y. Univ., M.A. Awards: National Endowment for the Arts Grant, 1969; Fulbright F. to Italy, 1958-59. Work: WMAA; N.Y. Univ.; Syracuse Univ.; James Michener Fnd., Hirshhorn Collection, and in private colls. Exhibited: Carnegie Inst., 1955, 1964, 1967; WMAA, 1955, 1963, 1965, 1968; Univ. Nebraska, 1956; Walker A. Center, 1956; AIC, 1959; Univ. Illinois, 1965, 1968; Brown Univ., 1965; one-man exhs. in N.Y. & Chicago, Los Angeles and others, 1960-1965, 1969. Positions: Assoc. Prof. A., Brooklyn College, at present.

PEARSON, HENRY C.—Painter
1810 Second Ave., New York, N.Y. 10028
B. Kinston, N.C. Studied: Univ. North Carolina, B.A.; Yale Univ.,

.F.A.; ASL. Member: Am.Abstract Artists. Award: Tamarind
orkshop Fellowship, 1964; CGA, (purchase), 1965; PAFA, 1968.
ork: MModA; Nelson Gal A., Kansas City, Mo.; Univ. Massachu-
etts; CGA; N.Y. Univ.; List Art Poster Coll. (Admin. by AFA);
lbright-Knox A. Gal.; Trinity Col., Dublin; WMAA; MMA; Univ.
ebraska. Exhibited: WMAA, 1960, 1961, 1962, 1965, 1966, 1968;
MFA, 1962; Rose A. Mus., Brandeis Univ., 1964; MModA, 1964,
965, 1966-1969; CGA, 1965; Gallery of Modern Art, N.Y., 1965;
hilip Morris Coll., 1967-1968; Grolier Cl., 1966; BM, 1966;
*unson-Williams-Proctor Inst., 1968; Smithsonian Inst., 1969.
*etrospectives: Tweed Gal. A., Duluth, Minn., 1965; North Carolina
*lus. A., 1969. Illus.: "Rime of the Ancient Mariner," 1964.
*ositions: Inst., Painting, New School for Social Research, New
*ork, N.Y., at present.

PEARSON, JAMES E.—Sculptor, T., P., C.
 5117 Barnard Mill Rd., Ringwood, Ill. 60072
*. Woodstock, Ill., Dec. 12, 1939. Studied: Northern Illinois Univ.,
*.S. and M.S. in Edu., MFA. Member: AFA; CAA; Kappa Pi; Illinois
*du. Assn.; Illinois A. Edu. Assn.; Int. Platform Assn.; Illinois
*raftsmen's Council; Centro Studi e Scambi Int., Rome. Awards:
*old Keys, Carnegie Inst., 1951, 1954, 1956; Patron's Purchase,
*965, Norfolk Mus. A. & Sciences; William Boyd Andrews Award,
*cHenry Art Fair, 1961; prizes, Univ. of Illinois, 1961, 1964.
*ork: Edgebrook School; McHenry and Woodstock (Ill.) H.S.; sculp-
*ure: Northern Ill. Univ., DeKalb, Ill.; Graphic Des., university pub-
*ications, Northern Ill. Univ., 1963-67; Graphic Des. School Arts
*agazine, 1966-67; other work in private colls. Exhibited: Carnegie
*nst., 1951, 1954, 1956; Dept. Interior, Wash., D.C., Stamp Comp.,
*961, 1962, 1968; Norfolk Mus., 1965; Newport AA, 1965; Ricks Col.,
*exburg, Idaho, First Ann A. Exh., 1965, 1967; AIC, 1958; Univ. Illi-
*ois, 1961, 1964; Northern Ill. Univ. A. Gal., 1962, 1964 (one-man);
*cCormack Place, Chicago, 1963; Brooks Mem. Mus., Memphis,
*enn., 1965; Burpee A. Gal., Rockford, 1965; Illinois State Museum,
*pringfield, 1964; St. Mary's Col. of Maryland, 1966; Zème Salon
*nt. de Charleroi, Charleroi, Belgium, 1969; Int. Grand Prix, Paint-
*ng and Etching, Monte Carlo, Monaco, 1969; Laura Davidson Sears
*Gal., Elgin, Ill., 1966 (one-man). Positions: Chm. A. Dept., Wood-
*stock Community H.S., Woodstock, Ill., at present.

PEARSON, LOUIS—Sculptor
 224 12th St., San Francisco, Cal. 94103; h. 55 Poncetta Dr.,
 Daly City, Cal. 94015
*B. Wallace, Idaho, Apr. 28, 1925. Work: Storm King A. Center,
Mountainville, N.Y. Exhibited: Collectors' Choice, Joslyn A. Mus.,
Omaha, Neb., 1966; 3-man: Northern Arizona A. Gal., 1969; one-
man: Maxwell Gals., San Francisco, Cal., 1965. Specializes in
sculpture in stainless steel and space.

PEARSON, MARGUERITE S.—Painter, T.
 47 Marmion Way, Rockport, Mass. 01966
B. Philadelphia, Pa. Studied: BMFA Sch., with William James, F.
A. Bosley; also with A. T. Hibbard, Harry Leith-Ross. Member:
Gld. Boston A.; All. A. Am.; North Shore AA; Rockport AA; AAPL;
New England Artists Group; Springfield AA. Awards: prizes,
Springville (Utah) AA; New Haven Paint & Clay Cl.; All. A. Am.;
Ogunquit A. Center, Gold Medal, 1964; Academic A, Springfield
(Mass.) A. Mus.; Rockport AA, 1965; NAC, 1966; North Shore AA,
1965, 1967. Gold Medal, AAPL. Work: Springville A. Gal.; New
Haven Paint Lib.; Beach Mem. A. Gal., Storrs, Conn.; Monson (Mass.)
State Hospital; Gardiner (Mass.) H.S.; Boston Music Sch.; Brigham
Young Univ.; Mechanics Bldg., Boston; Episcopal Diocesan House,
Boston; Trade Sch. for Girls, and Wilson, Brooks, and Burke Sch.,
Boston; Grimmins and Chandler Sch., Somerville, Mass.; Somer-
ville, Medford and Gloucester City Halls; Case Inst. Tech., Cleve-
land, Ohio; Brooks Sch., Andover, Mass.; Draper Sch., Draper,
Utah; Salem (Mass.) Court House; Bruckner Mus., Albion, Mich.;
Christ Episcopal Church and Public Library, both Somerville, Mass.
Essex Tech. Inst., Danvers, Mass.; N. E. Hospital, Boston. Exhib-
ited: NAD; PAFA; CGA; All. A. Am.; Portraits, Inc.; Jordan Marsh
Gal., Boston; North Shore AA; Rockport AA.

PEASE, DAVID—Painter, T.
 611 65th Ave., Philadelphia, Pa. 19126
B. Bloomington, Ill., June 2, 1932. Studied: Univ. Wisconsin, B.S.,
M.S., M.F.A. Member: CAA. Awards: Guggenheim Fellowship,
1965-1966; William A. Clark Award and Ford Fnd. Purchase, CGA,
1963; prizes, Cheltenham A. Center (Pa.), 1962, 1963; Phila. A. All.,
1963; Jenkintown A. Festival, 1963; Madison (Wis.) AA, 1955, 1958;
Wisconsin State Col., 1958; Wisconsin Salon of Art, 1953. Work:
WMAA; CGA; PAFA; PMA; Wisconsin State Col.; Madison AA; uni-
versities of Virginia and Wisconsin. Exhibited: Approx. 100 group
exhs. since 1953 including: Carnegie Inst., 1961; CGA, 1961, 1963;
WMAA, 1964; PAFA, 1959-1965; AFA Exhibition of Drawings (trav-
eling), 1965; Detroit Inst. A., 1959; Butler Inst. Am. A., 1959-1961;
PMA, 1962, 1965; Wisconsin Ptrs. & Sculptors, 1958; Wisconsin
Salon Art, 1953; also numerous local and regional exhs., Wisconsin,

Michigan and Pennsylvania. One-man: Henri Gal., Wash., D.C.,
1964; Gallery 1015, Phila., 1963, 1966; Phila. A. All., 1962; Gallery
Espresso, East Lansing, 1960; Wisconsin State Col., Platteville,
Wis., 1958; Stout Inst., Menomonie, Wis., 1959; Univ. Virginia,
Charlottesville, 1955; Makler Gal., Phila., 1967, 1969; Tyler Sch. A.;
1968. Positions: Assoc. Prof. & Chm. Dept. of Painting & Drawing,
Tyler School of Art of Temple University, Philadelphia, Pa.

PEASE, ROLAND FOLSOM, JR.—Writer, Editor, Critic, Collector
 11 W. 42nd St. 10036; h. 11 E. 71st St., New York, N.Y. 10021
B. Boston, Mass., Dec. 11, 1921. Studied: Dartmouth College; Co-
lumbia University, B.S. Contributor of art criticism to: Art Inter-
national, Metro, Pictures on Exhibit, Authors Guild Bulletin. Col-
lection: Includes works by Grace Hartigan, Larry Rivers, Robert
Goodnough, Fairfield Porter, Jane Wilson, Sherman Drexler, Red
Grooms, Gorchov, Jane Freilicher, George L.K. Morris, Diego
Rivera. Positions: Reporter, U.P.I., 1952-1955; Exec. Ed., (1962),
Assoc. Ed. (1962-1963); Contributing Ed. (1963), Art Voices; Man-
aging Ed., Harry N. Abrams, Inc., March 1963-October 1964; Den-
hard & Stewart, Inc., New York, N.Y. (literary advertising agency),
at present.

PECK, AUGUSTUS—Educator
 Brooklyn Museum Art School, Eastern Parkway, Brooklyn,
 N.Y.
Positions: Supv., Brooklyn Museum Art School.*

PECK, EDWARD—Director University Galleries, E.
 University of Southern California, Los Angeles 90007; h. 4968
 Loleta Ave., Los Angeles, Cal. 90041
B. Colorado Springs, Colo. Studied: Oberlin Col., B.A., M.A.;
American Sch. of Classical Studies, Athens, Greece; Harvard Univ.,
Ph.D. Member: CAA; Archeological Inst. of America; Western
Assn. A. Mus.; Art Historians of Southern California. Positions:
Formerly, Chm., Dept. A., Hollins Col., Va.; Chm., FA Dept., Col.
of Wooster, Ohio; Prof. A. History, and Dir., Univ. Galleries, Univ.
of Southern California, 1950- .

PECK, JAMES EDWARD—Designer, P., C., T.
 1917 Broadway East, Seattle, Wash. 98102
B. Pittsburgh, Pa., Nov. 7, 1907. Studied: Cleveland AI; John Hunt-
ington Polytechnic Inst., and with Henry G. Keller, Rolf Stoll, Carl
Gaertner. Member: Puget Sound Group of Northwest Painters; Se-
attle A. Dir. Soc. Awards: prizes, 1937-1947; CMA; Guggenheim F.,
1942, 1945; Dayton AI; SAM; Bellevue (Wash.) Fair; Western Wash.
Fair; prizes in adv. des. Work: CMA; Dayton AI; Carville (La.)
Mem. Hospital; Cleveland AA; City of Cleveland Coll.; Am. Acad. A.
& Let.; SAM; enamels: Butler AI. Exhibited: PAFA; AWS; AIC;
CMA; Dayton AI; Cleveland Sch. A.; Cincinnati Mod. A. Soc.; Little
A. Center, Dayton; Butler AI, 1953-55; Anchorage, Alaska; SAM;
Henry Gal., Univ. Washington; Univ. Cal., Univ. Minnesota; Frye
Mus. A., Seattle; MMA; one-man: Dayton AI; Ten Thirty Gal., Cleve-
land; Henry Gal.; Frederick and Nelson, Seattle; Klamath Falls,
Ore.; Portland, Ore.; Manchester-Pierce Gal., Bellevue, Wash. Con-
tributor to Ford Times; Lincoln-Mercury Times; American Artist
magazine. Positions: Dir. A. Dept., Cornish Sch., Seattle, 1946-52;
Asst. A. Dir., Miller, Mackay, Hoeck & Hartung Adv. Agcy., Seattle,
Wash., 1954-1960; Vice-Pres., 1954, Pres., 1955, Puget Sound
Group Painters; Vice-Pres., Seattle A. Dir. Soc., 1955, Pres., 1957.
Memb. Seattle Mun. A. Commission, 1960-1966; Graphic Des.,
Boeing Co., 1965- .

PEELER, RICHARD E.—Craftsman, S., E.
 De Pauw University Art Center, Greencastle, Ind. 46135; h.
 Rte. 2, Reelsville, Ind. 46171
B. Indianapolis, Ind., Aug. 8, 1926. Studied: Butler Univ.; De Pauw
Univ., A.B.; Indiana Univ., M.A.T. Member: Am. Craftsmens Coun-
cil; Indiana Artists-Craftsmen; Awards: prizes, Mrs. C. V. Hickox
Award, Hoosier Salon, 1951, 1953, 1959, 1961; Indiana State Fair,
1959; Indiana Ceramic Exh., 1959; Michiana Show, South Bend, Ind.,
1963; Mid-States Craft Exh., Evansville, Ind., 1966. Work: Indiana
State College; South Bend A. Center; Armstrong Cork Co. Many
sculpture and ceramics commissions. Exhibited: 23rd Nat. Ceramic
Traveling Exhs.; Craftsmen of the Middle States; Mus. Contemp.
Crafts, N.Y.C.; Armstrong Cork Co.; Rockefeller Center, 1961;
Hoosier Salon; Indiana A.; Michiana Ceramic Show; Midwest Des.-
Craftsmen, Kalamazoo, Mich., 1962; Indiana State Fair, 1949-1958;
Indiana Craftsman, 1967; Cincinnati, Ohio, 1967; Fort Wayne, 1968;
Craftsmen Central States, etc. Contributor articles to Ceramics
Monthly; Ceramic Projects. Positions: Prof., Sculpture, Ceramics;
De Pauw University, 1958- . Visiting Lecturer, Kyoto City Col. FA,
Kyoto, Japan, 1966.

PEERS, GORDON FRANKLIN—Painter, E.
 Rhode Island School of Design, Providence, R.I.; h. 65 Halsey
 St., Providence, R.I. 02906
B. Easton, Pa., Mar. 17, 1909. Studied: R.I. Sch. Des.; ASL; BAID;

& with John R. Frazier. Awards: prize, Boston A. Festival, 1955; Newport AA, 1958. Work: R.I. Sch. Des. Exhibited: Carnegie Inst., 1942, 1943; VMFA, 1940; WFNY, 1939; GGE, 1939; Nat. Exh. Am. A., N.Y., 1936, 1938; Pepsi-Cola, 1946; Mus., R.I. Sch. Des.; Newport AA; WMA, 1958; Boston AC; Provincetown AA, 1958; Dept. Interior, Wash., D.C.; Univ. Illinois; Rockford (Ill.) AA; Boston A. Festival, 1958. Positions: Hd., Dept. Painting, R.I. Sch. Des., Providence, R.I., 1934-36, 1938-1969; Chief Critic, R.I. School Design European Honors Program, Rome, Italy, 1961-62; Chm., Div. Fine Arts, R.I. School of Design, Providence R.I., 1969- .

PEIRCE, WALDO—Painter, I., W.
Searsport, Me.
B. Bangor, Me., Dec. 17, 1884. Studied: Phillips Acad.; Harvard Univ., A.B., and in Paris, France. Awards: prizes, Pomona, Cal., 1939; Pepsi-Cola, 1944; Carnegie Inst., 1944. Work: MMA; WMAA; AGAA; PAFA; BM; Farnsworth Mus. A.; Encyclopaedia Britannica; Pepsi-Cola Co.; The Upjohn Co.; Univ. Arizona; State House, Augusta, Me.; Bangor (Me.) Pub. Lib.; murals, USPO, Westbrooke, Me.; Troy, N.Y.; Peabody, Mass.; American Field Service Bldg., New York, N.Y., 1961. Exhibited: nationally, Il., "The Magic Bed Knob," 1943; "The Children's Hour," 1944.*

PELLEW, JOHN C.—Painter
123 Murray St., Norwalk, Conn. 06851
B. Penzance, England, Apr. 9, 1903. Member: NA; AWS; All. A. Am.; SC. Awards: prizes, AWS, 1951, 1954, 1959, 1961, 1965; SC, 1950, 1951, 1964; medal, All. A. Am., 1951, 1958; NAD, 1960, 1961. Work: MMA; BM; Newark Mus.; Unio Cultural, Sao Paulo, Brazil; Univ. Illinois; Norfolk Mus. A. & Sciences; Butler Inst. Am. A.; New Britain (Conn.) Museum of Amer. Art; Adelphi Univ., Garden City, N.Y.; Columbia Univ., N.Y.; Georgia Mus. A., Athens; mural, Pub. Sch. No. 122, Queens, N.Y. Exhibited: CGA, 1935, 1936; Carnegie Inst., 1943-1946; PAFA, 1936-1938; BM, 1935, 1939, 1943; NAD, 1937, 1942, 1944, 1949-1961; AIC, 1938, 1939, 1943; MModA, 1943; All. A. Am., 1950-1961; one-man: New York, N.Y., 1934, 1938, 1944, 1948.

PELS, ALBERT—Painter, T., I., L.
2109 Broadway, New York, N.Y. 10023
B. Cincinnati, Ohio, May 7, 1910. Studied: Univ. Cincinnati; Cincinnati A. Acad.; ASL; BAID; & with Benton, Palmer, Brook & others. Member: NSMP; Soc. Indp. A.; SC; AEA; Audubon A. Awards: med., BAID, 1936; prize, Parkersburg, W.Va., 1942. Work: CM; Massillon Mus. A.; PMA; murals, Wilmington (Del.) Court House; Norfolk Naval Base; Anniston, Ala., Army Base; S.S. Monroe; USPO, Normal, Ill.; assisted with murals, USPO, Wash., D.C.; Queens General Hospital. Exhibited: WMAA, 1938, 1939, 1942, 1944; Carnegie Inst., 1941-1945; NAD, 1938, 1940-1942, 1945; PAFA, 1937, 1943, 1944; CM, 1932-1938, 1940, 1941, 1942 (one-man); Rochester Mem. A. Gal. Gal.; William Rockhill Nelson Gal.; N.Y. World's Fair, 1964; Dayton AI; Riverside Mus.; Butler AI; Conn. Acad. FA; Massillon Mus. A.; Parkersburg FA Center; one-man: Macbeth, Babcock, Laurel Gal., Chase Gal., Int. A. Gal., Cord Gal., all New York City. Illus. juvenile books. Positions: Dir., Albert Pels Sch. A., Inc. (N.Y. State licensed), New York, N.Y.

PEN, RUDOLPH T.—Painter, Lith., T.
55 West Schiller St., Chicago, Ill. 60610
B. Chicago, Ill., Jan. 1, 1918. Studied: AIC, B.F.A. Member: Chicago A. Cl.; AEA; AWS; Union Lg., Chicago (Hon.); Chicago Mun. A. Lg. (Board). Awards: Ryerson traveling scholarship, AIC, 1943, 1961; Huntington Hartford Fnd. Grant, 1958; prizes, NAD, 1945; PAFA (purchase), 1945; Illinois State Fair, 1954; Union Lg. Cl., Chicago, 1957, 1961, 1965. Exhibited: NAD; LC; Carnegie Inst., 1943-1955; AIC, annually, 1943-1961; PMA; Illinois State Fair; Butler Inst. Am. A.; CGA; Milwaukee AI; AWS; PAFA; one-man: Carroll Carstairs Gal., N.Y.; Mexico City; Marshall Field Gal.; Palmer House Gal.; Frank Oehlschlaeger Gal., Chicago. Positions: Faculty memb., AIC, Chicago, Ill., 1946-1961. Pres., Alumni Assn., Art Inst. Chicago, 1960. Dir., Summer School of Painting, Saugatuck, Mich., 1964.

PENKOFF, RONALD PETER—Educator, Pr.M., P.
University of Wisconsin, Waukesha Campus; h. R.R. 2, Box 245, Waukesha, Wis. 53186
B. Toledo, Ohio, May 18, 1932. Studied: Bowling Green State Univ., B.F.A.; Ohio State Univ., Columbus, M.A., and Atelier 17, Paris, with Hayter. Member: CAA. Awards: Art Directions Gal., purchase award and 2-man show, 1958; N.Y. State Fair, 1957; Michiana Show, South Bend, 1964; Eastern Indiana Exh., Ball State Gal., 1964; Mt. St. Paul Col, purchase, 1969; Grant, Univ. Wisconsin Center System for Woyzeck Portfolio, 1969, of 18 color woodcuts, featured at Notre Dame's A. Festival. Based on the play "Woyzeck" by Georg Buchner. Work: LC; Columbus Gal. FA; Munson-Williams-Proctor Inst.; Montclair (N.J.) Mus. A.; Ohio State Univ.; Rockford AA Coll.; Lafayette, (Ind.) AA Coll.; Ball State Univ. Gallery. Commissioned by State

Univ. College, Oneonta, N.Y. for paintings for residence hall, 1959; Muncie AA Print for Patrons. Exhibited: LC, 1955, 1956; Boston Printmakers, 1956; Phila. Pr. Cl., 1956, 1958, 1959; Hunterdon County (N.J.), 1956, 1961, 1962; Audubon A., 1957, 1962; The Etchers National, 1958; Albany Inst. Hist. & A., 1958; Wash. WC Soc., 1961, 1963; Conn. Acad. FA, 1961, 1962; Soc. Wash. Printmakers, 1962; Okla. Printmakers, 1962; Silvermine Gld. A., 1964; Munson-Williams Proctor Inst., 1956, 1958, 1959; Cooperstown, N.Y., 1957-1959; John Herron Mus. A., Indianapolis, 1960-1964; Indiana Prints, 1960, 1964. Author: "The Roots of Ukiyo-E," 1964. Contributor to Forum and Quartet Magazines. Lectures: Early Japanese Woodcuts. Exhibition arranged: Fifteen American Printmakers, 1964; 11th Annual Drawing and Small Sculpture Exhibition, 1965. Positions: Instr., N.Y. State Univ. College, Oneonta, N.Y.; Asst. Prof., Printmaking, Des., Drawing & Painting, Ball State University, Muncie, Ind., 1959-1967. Visiting Prof., Bath Academy, Corsham, England, summer, 1966; Assoc. Prof., Univ. Wisconsin, Waukesha Campus, at present.

PENNEY, BRUCE BARTON—Painter
South Pomfret, Vt. 05067
B. Laconia, N.H., Aug. 9, 1929. Studied: Worcester (Mass.) Mus. Sch.; New York-Phoenix Sch. Des.; and with Cleveland Woodward. Work: Worcester Polytechnic Inst.; Dartmouth Col.; Stockholm, Sweden. Exhibited: Berney Gal., Los Angeles; Hyannis AA; Los Angeles AA; Nexus Gal., Boston; Hanover Gal., N.H.; Gallery 2, Woodstock, N.Y.; Southern Vermont AA; Center St. Gal., Winter Park, Fla.; Wiener Gal., N.Y., 1968.

PENNEY, CHARLES RAND— Collector
Olcott, N.Y. 14126
B. Buffalo, N.Y., July 26, 1923. Studied: Yale University, B.A.; University of Virginia Law School, LL.B. Collection: Internal Contemporary Art—sculpture, oils, watercolors, drawings and prints; Charles E. Burchfield—watercolors, drawings, prints, oils; Emil Ganso—watercolors, drawings, prints and oils; Niagara Frontier—oils, drawings, watercolors, prints; Spanish-American Santos and Retablos; Victorian Staffordshire Portrait Figures; American Antique Historic Glass; American Antique Pressed Glass-covered Compotes and Trays; The Charles Rand Penney Foundation—Contemporary Art. Member: Albright-Knox Art Gallery, Buffalo (Life); Museum of Modern Art; American Federation of Arts; Cleveland Museum of Art; Art Gallery of Toronto, Canada. Positions: Director, Trustee, Charles Rand Penney Foundation, 1964- .

PENNEY, JAMES—Painter
101 Campus Road, Clinton, N.Y. 13323
B. St. Joseph, Mo., Sept. 6, 1910. Studied: Univ. Kansas, B.F.A., with Albert Bloch, Karl Mattern and Raymond Eastwood; ASL, with Charles Locke, John Sloan and George Grosz. Member: Audubon A.; NSMP; AAUP; ASL. Awards: prizes, Paintings of the Year, 1948; West N.Y. Pr. M., 1950; Yaddo Fellowship, 1956, 1961; Faculty Fellowship, Europe & N.Y., 1955-56; Audubon A. award, 1967; medal, Kansas City AI, 1931; Mural commission, Nebraska State Capitol Comp., 1962. Work: Springfield Mus. A.; Munson-Williams-Proctor Inst.; Univ. Nebraska; Lehigh Univ.; Columbus Gal. FA; Kansas State Col.; New Britain Inst.; Nelson Gal. A.; Clearwater Mus. A.; Phillips Acad.; Wichita A. Mus.; Nat. Soc. A. & Let.; Ft. Worth A. Center; Des Moines A. Center; Utica Col.; Cal. College of Arts & Crafts; Howard Univ.; Continental Grain Corp., N.Y.; Hamilton Col.; Omaha Nat. Bank, 1966; Univ. Minnesota; Joslyn A. Mus; Mt. Holyoke Col.; Hirshhorn Coll.; murals, Flushing (L.I.) H.S.; USPO, Union, Palmyra, Mo.; Dunham Hall, Hamilton College; foyer, Neb. State Capitol, Lincoln, 1962. Exhibited: CGA, 1937, 1941, 1947, 1949, 1951, 1953, 1967; Carnegie Inst. 1942, 1943, 1952; Toledo Mus. A., 1950; WMAA, 1941, 1942, 1951, 1955, 1958, 1960; PC; Los A. Mus. A.; SFMA; CAM, 1958; Provincetown A. Festival, 1958; Audubon A., 1957, 1958, 1959-1965; Am. Acad. A. & Lets., 1960; Munson-Williams-Proctor Inst., 1957, 1958, 1960, 1969; Univ. Nebraska, 1957, 1958; PAFA, 1950, 1952-1954, 1966; Walker A. Center, 1949, 1954; Des Moines A. Center, 1949-1951, 1953-1958; Am. Acad. A. & Lets., 1965; Colby Col., 1964-65, and many others; one-man: Kraushaar Gal., 1950, 1954, 1957, 1961, 1965, 1969; Utica Col., 1957; Colgate Univ., 1951, 1954; Union Col., 1955; Wells Col., 1953; Kansas State Col., 1955; Wichita A. Mus., 1955; Vassar Col., 1955; Cazenovia Col., 1962; Edward Root A. Center, Hamilton Col., 1967; Ithaca, N.Y., 1967, 1968; Cooperstown AA, 1969; Omaha, Neb., 1966. Positions: Instr. A., Hunter Col., 1941-42; Bennington Col., 1946-47; F., in Art, Hamilton Col., 1948-1955; Instr., Munson-Williams-Proctor Inst., 1948-55; Asst. Prof. A., Vassar Col., 1955-56; Assoc. Prof., Hamilton Col., 1962-68, Prof., 1969- .

PENNY, AUBREY J(OHN) R(OBERT)—Painter
1551 Cahuenga Blvd., Los Angeles, Cal. 90028; h. 12216 Montana Ave., West Los Angeles, Cal. 90049
B. London, England, July 30, 1917. Studied: London Univ.; Univ. California at Los A., A.B., M.A. Member: Contemp. A. Soc.; Cal. Nat. WC Soc.; Am. Soc. for Aesthetics. Awards: Cal. WC Soc.,

1955. Exhibited: Cal. Nat. WC Soc., 1953-1956, 1958, 1960, 1965, 1967 (2); Nat. Orange Show, 1953; Los A. Mus. A., 1954-1957, rental gallery, 1967; AWS, 1957, 1958; CGA, 1957; Santa Barbara Mus. A., 1955; Oakland A. Mus., 1959; PAFA, 1959; Madison Gal., N.Y., 1962, 1963; Galerie Galaxie, Detroit, 1963; Cahuenga Gal., Los A., 1963; No-Os Gal., Los A., 1964; Int. A. Festival, Century City, Los Angeles, 1965; Laguna Beach, Cal., 1966; Herbert Palmer Gal. Los Angeles, 1967; Occidental Col., Los Angeles, 1967.

PEPPER, BEVERLY—Sculptor, P., Gr.
Vicolo del Cinque 30, Rome, Italy 00153
B. New York, N.Y., Dec. 20, 1924. Studied: Pratt Inst., Brooklyn, N.Y.; ASL; and with Leger and Lhote, Paris, France. Awards: Silver Medal, Bordighera, Italy, 1954; Gold Medal, Florence, Italy, 1966; prize, Am. Steel Inst., 1969. Work: Albright-Knox A. Gal.; WAC; Museo Civica d'Arte Moderna, Turin. Commissions: U.S. Plywood Bldg., N.Y., 1963; Weizmann Inst., Israel, 1964; Southland Mall, Memphis, Tenn., 1966; "Flags Over Georgia," Atlanta, 1968; Sonesta Hotel, Milan, 1969. Exhibited: AIC, 1956; Staten Island Mus., 1965; MIT, 1967; Marlborough-Gerson Gal., N.Y., 1966; USIS, Rome, 1968; Albright-Knox A. Gal., 1968; MModA traveling exh., 1968; Jewish Mus., N.Y., 1968; many other group exhs. abroad, 1952-1968 including, Paris, France; Spoleto, Rome, Torino, Florence, San Marino, Italy; Yugoslavia, Germany and Denmark; one-man: Gallerias: Zodiaco, 1952, Schneider, 1956, Obelisco, 1959, Pogliani, 1961, all in Rome, Italy; Barone Gal., N.Y., 1954, 1956, 1958; Obelisk Gal., Wash., D.C., 1955; Thibault Gal., N.Y., 1962; Marlborough Gal., Rome, 1965, 1968; McCormick Place, Chicago, 1966; Galleria Barozzi, Venice, 1968; Marlborough-Gerson Gal., N.Y., 1969; Mus. Contemp. A., Chicago, 1969; MIT, 1969; Albright-Knox A., Gal., Buffalo, N.Y., 1969.

PEREIRA, I. RICE—Painter, W.
121 West 15th St., New York, N.Y. 10011
B. Boston, Mass. Studied: ASL, and with Richard Lahey, Jan Matulka. Member: AEA; Centro Studi e Scambi Internationali; Int. Platform Assn. Work: MModA; MMA; Newark Mus.; Univ. Arizona; Howard Univ.; WMAA; Wadsworth Atheneum; Toledo Mus. A.; SFMA; AIC; BMF; AGAA; DMFA; Detroit Inst. A.; Vassar Col.; Delgado Mus. A.; Walker A. Center; PMG; Smith Col.; Ball State T. Col.; Boston Univ.; Brandeis Univ.; Catholic Univ., Wash., D.C.; Goucher Col.; Atkins Mus., Kansas City; Univ. Iowa; Guggenheim Mus.; State T. Col., New Paltz, N.Y.; Syracuse Univ.; WMA; Univ. Minnesota; Butler Inst. Am. A.; CM; Mus. A., Phoenix, Ariz.; Houghton Lib., Harvard Univ. (org. mss. of "The Lapis"); Am. Assn. Univ. Women; Miller Coll., Meriden, Conn.; Dutch Ministry of Information, The Hague; Munson-Williams-Proctor Inst.; BMFA; BM; CGA; NCFA; Finch Col., N.Y.; Atlanta Univ., Atlanta, Ga.; Ariz. State Col.; N.Y. Univ., N.Y.; and in private colls. Exhibited: CGA; Carnegie Inst.; PAFA; AIC; and others; Musee d'Art Moderne, Paris; Tate Gal. A., Inst. Contemp. A., both in London; Brussels, Berlin, Antwerp, Vienna and other European cities; Sao Paulo, Brazil; Barcelona, Belgrade, Lille, Tours, Toulouse, and many others; one-man: Barnett Aden Gal., Wash., D.C.; ACA Gal., 1933-35, 1949; Phillips Acad., 1949; Santa Barbara Mus. A., 1950; deYoung Mem. Mus., 1950; Memphis Acad. A., 1951; Univ. Syracuse, 1951; BMA, 1951; Ball State T. Col., 1951; Burlacher Bros., 1951, 1953, 1954; PC, 1952; Dayton AI, 1952; WMAA, retrospective, 1953; Des Moines A. Center, 1953; SFMA, 1947, 1953; DMFA, 1953; Vassar Col., 1953; Adele Lawson Gal., 1954; Hofstra Col., 1954; Univ. Michigan, 1954; Phila. A. All., 1955; CGA, 1956; Wellons Gal., N.Y., 1956; Nordness Gal., N.Y., 1958, 1959, 1961; Agra Gal., Wash., D.C., 1965; Wilmington Col., Wilmington, N.C., 1968; Weatherspoon Gal., Univ. N.C., 1968; Mint Mus., Charlotte, N.C., 1968; Rome-New York Fnd., Rome, Italy, 1960. Contributor to the Palette; Mysindia; Western AA Bulletin. Author: "Light and New Reality"; "The Transformation of Nothing and the Parasox of Space"; "The Nature of Space"; "The Lapis"; "The Crystal of the Rose"; "The Poetics of the Form of Space, Light, and the Infinite."

PERHAM, ROY GATES—Painter, L.
269 Raymond St., Hasbrouck Heights, N.J. 07604
B. Paterson, N.J., Apr. 18, 1916. Studied: Grand Central A. Sch., and with Frank DuMond, Frank J. Reilly. Member: Bergen County A. Gld.; Rutherford AA; Hacksensack A. Cl., 1960; Portraits, Inc.; Fair Lawn (N.J.) AA, 1968. Awards: Ridgewood AA, 1940, 1950; Rutherford AA, 1951; Bergen County A. Gld., 1953; Rutherford Trust Co., 1952. Work: Univ. South Carolina; Bergen Mall Coll., Paramus, N.J.; murals, First Reformed Church, Hasbrouck Heights, N.J.; Lutheran Church, East Orange, N.J.; Rutherford (N.J.) Baptist Church; Madison Ave. Presbyterian Church, Paterson, N.J.; port., Diocesan Col. Magill Univ., Montreal, Canada; So. Jersey Col., Rutgers Univ.; Asbury Methodist Church, Salisbury, Md.; First Methodist Church, Hasbrouck Heights, N.J.; Wilmington Manor (Del.) Methodist Church; Peninsula Hospital, Salisbury, Md.; Central College, Pella, Iowa. Exhibited: All. A. Am., 1946, 1967; Newcomb-

Macklin Gal., 1948, 1950 (one-man); Montclair Mus. A., 1940, 1943; Ridgewood AA, 1940-1947; Bergen County A. Gld., 1946-1952; Art Center of the Oranges, 1952; Fairleigh Dickinson Univ., Rutherford, N.J., 1967 (one-man).

PERKINS, G. HOLMES—Educator
University of Pennsylvania, Philadelphia, Pa. 19104
B. Cambridge, Mass. Oct. 10, 1904. Studied: Harvard Univ., A.B., M.Arch. Member: AIA. Positions: Dean, Graduate School Fine Arts, Univ. Pennsylvania, Philadelphia, Pa.; Chancellor, College of Fellows, Am. Inst. Architects, 1964-66.

PERKINS, MABEL H.—Collector
327 Washington St. S.E., Grand Rapids, Mich. 49503
B. Grand Rapids, Mich., July 26, 1880. Studied: Vassar College, B.A. Collection: Fine prints of all categories, specializing in Durer and Rembrandt. Positions: Board Member, Secretary, Vice-President, President, Grand Rapids Art Museum; Established print gallery in Grand Rapids Art Museum.*

PERLIN, BERNARD—Painter, I.
Shadow Lake Road, Ridgefield, Conn.
B. Richmond, Va., Nov. 21, 1918. Studied: NAD; ASL, and in Poland. Awards: Kosciuszko Fnd. Scholarship, 1938; Chaloner Fnd. award, 1948; Fulbright F., 1950; Guggenheim F., 1954-55, 1959; Nat. Inst. A. & Lets. Award, 1964. Work: MModA; Tate Gal., London; Springfield (Mass.) Mus. A.; Cal. PLH; VMFA; USPO, South Orange, N.J.; U.S.S. "Pres. Hayes." Exhibited: Carnegie Inst., 1948-50 and later; WMAA, from 1947; ICA Gal., London, 1951; Brussels World's Fair, 1958; Univ. Illinois, 1950 and later, and others nationally. Contributor illus. to Life, Fortune magazines.*

PERLMUTTER, JACK—Painter, Lith., E.
2511 Cliffbourne Place, N.W., Washington, D.C. 20009
B. New York, N.Y., Jan. 23, 1920. Member: SAGA. Awards: prizes, Butler Inst., Am. A., 1956; LC, 1950, 1951, 1956, 1957; CGA, 1951, 1952, 1955, 1956, 1959, 1963; Phila. Pr. Cl., 1954; Bradley Univ., 1953; BM, 1958, 1963, 1965; Fulbright Grant, 1959-1960 (Prof. A., Tokyo Univ. of Arts); 1st Intl. Exh., Saigon, 1962; CM, 1958; Turkish Govt., 1958; BMFA, 1957. Work: PC; CGA; Smithsonian Inst.; MMA; Pa. State Univ.; PMA; LC; Carnegie Inst.; N.Y. Univ.; Watkins Gal.; CAM; BM; CM; Turkish Govt.; Mus. Mod. A., Tokyo. NCFA; Carleton Col.; Univ. Minnesota; Howard Univ.; American embassies in Dublin, London, Tokyo, Bucharest, Prague and Budapest. Exhibited: CGA, 1949, 1956; Butler AI, 1945, 1957, 1960; PAFA, 1952; BM, 1952, 1953, 1956, 1958; Phila. Pr. Cl., 1950, 1952, 1956, 1963-1965, 1966-1969; LC, 1950, 1951, 1954, 1956, 1957; CM, 1952, 1954, 1956, 1958; AFA European Traveling exh., 1952-1954, 1956-1958, 1963-1965; U.S., 1956-1958; U.S. Foreign Service Traveling exh. Europe, 1954-1956; International Triennial, Grenchen, Switzerland, 1958; Youngstown, Ohio, 1956; Amer. Color Print Soc., 1949, 1952, 1953, 1955, 1956; SAGA, 1950-1956, 1958, 1959, 1965-1969; Boston Pr. M., 1954, 1956, 1958; Audubon A., 1948, 1950, 1953; BMA, 1955, 1957, 1958; Oakland A. Mus., 1953; PC; Smithsonian Inst.; CGA, annually; many one-man Wash., D.C. since 1945; CGA, 1956; Tokyo, Japan, 1960 (one-man); New York City, 1961, 1962; (one-man); Graphic A. Exh., Yugoslavia, 1960; CGA, 1960. Positions: Chm., Printmaking Dept., Corcoran Gal. Sch. of Art.

PERLS, FRANK (RICHARD)—Art Dealer, Collector
9777 Wilshire Blvd., Beverly Hills, Cal. 90212
B. Zehlendorf, Germany, Oct. 23, 1910. Studied: Univ. Vienna, Munich and Berlin. Member: Art Dealers Association of America. Author of various articles on art. Field of Research: 15th Century Cologne School. Collection: Picasso, Braque, Matisse, Lautrec. Positions: Director, Frank Perls Gallery, Beverly Hills, California.

PERLS, KLAUS G.—Art Dealer, W.
Perls Galleries, 1016 Madison Ave., New York, N.Y. 10021; h. 1016 Madison Ave., New York, N.Y. 10021
B. Berlin, Germany, Jan. 15, 1912. Studied: Univ. Basle, Switzerland, Ph.D. Member: Art Dealers Assn. of Am. (Pres. 1966-1968). Awards: Lotos Club Award of Merit, 1967. Author: "The Complete Works of Jean Fouquet" (Hyperion); "Vlaminck" (monograph, Hyperion). Specialty of Gallery: Modern Masters of the generation of Picasso. Also agent for Alexander Calder. Positions: Owner-Director, Perls Galleries, New York, N.Y., since 1937.

PERRIN, C(HARLES) ROBERT—
Painter, Des., Cart., I., L.
39 Newbury St., Boston, Mass. 02116; h. 61 Warren St., West Medford, Mass.; s. 50 Washington St., Nantucket Island, Mass. 02554
B. Medford, Mass., July 13, 1915. Studied: Sch. Practical A. Member: AWS; Boston WC Soc.; Rockport AA; Copley Soc.; A. Assoc. of Nantucket; North Shore AA; Boston Soc. Indp. A.; A. Dir. Cl., Bos-

ton; Gld. Boston A. Awards: prizes, Boston Soc. Indp. A., 1952; Rockport AA, 1953, 1954; North Shore AA, 1954; Boston Soc. WC Painters, 1955; Grand Central A. Gal., 1956; Copley Soc., 1959, 1964; Richard Mitton Mem. award, 1961; Patrons Show, Nantucket AA, 1963. Work: Ford Motor Co.; Lyman Allyn Mus.; Russell Large Fnd. Illus., "Dixie Dishes," 1941; "Whopper, the Tale of a Nantucket Whale," 1963; "Further Adventures of Whopper and Winnie," 1964. Contributor to Ford Times, Christian Science Monitor, American Artist magazine.

PERROT, PAUL N.—Museum Director
 The Corning Museum of Glass; h. 10 West 2nd St., Corning, N.Y. 14830
B. Paris, France, July 28, 1926. Studied: Ecole du Louvre, Paris; N.Y. Univ. Inst. FA. Member: CAA; AAMus.; Special Lib. Assn.; Soc. Glass Technology; York State Craftsmen; Vice-Pres., Int. Assn. History of Glass; Chm., Com. B., Int. Commission on Glass; Pres., N.Y. State Assn. of Museums; Editor, "Journal of Glass Studies." Author: "Three Great Centuries of Venetian Glass," 1958 (catalogue and introd.). Contributor to Antiques, Arts in Virginia, Craft Horizons magazines. Lectures: History and Aesthetics of Glass; Liturgical Art; Medieval Art. Positions: Asst., The Cloisters, Metropolitan Mus. Art.; Dir., The Corning Museum of Glass, Corning, N.Y., at present.

PERRY, CHARLES OWEN—Sculptor, Arch. & Indst. Des.
 American Academy in Rome, Via Angelo, Rome, Italy; (studio) Via Ippolito Pindemonte 14, Rome 00152 Italy
B. Helena, Mont., Oct. 19, 1929. Studied: Columbia Univ.; Univ. California; Yale Univ., B. Arch. Awards: Prix de Rome in Architecture, 1964-1966; A.I. S.D., 1968. Work: AGAA; Mus. Contemp. A., London; MModA; AIC; Fountain, City of Fresno Mall; Alcoa Bldg.; Bank of California, Bank of America, Golden Gateway, all San Francisco; Torrington (Conn.) Mfg.; Stone Oil Co., Cincinnati, Ohio. Exhibited: WMAA, 1964; Hansen Gal., San Francisco, Cal., 1964, 1967; Philadelphia Park Assn., 1965; American Acad. in Rome, 1965; USIS, Rome, 1968; Milwaukee A. Center; Chicago Mus. Contemp. A.; Jewish Mus., N.Y., 1969. One-man: Axiom Gal., London, 1966; Santa Barbara Mus. A., 1969; Spoleto A. Festival, 1969; Gavina and Torino, Italy, 1968.

PETERDI, GABOR—Painter, Et., Eng., L., T.
 108 Highland Ave., Rowayton, Conn. 06853
B. Budapest, Hungary, Sept. 17, 1915. Studied: Hungarian Acad., Budapest; Julian Acad., Paris; Academie Scandinavian, Paris, and others. Awards: Prix de Rome, 1930; gold med., for mural with Lurcat, Paris, 1937; BM, 1950, 1952, 1960; Am. Color Pr. Soc., 1951, 1960; New England Annual, 1953-1957; Oakland Mus. A., 1957, 1960; gold medal, PAFA, 1957; prizes, Boston Pr.M., 1959; SAM, purchase, 1960; Pasadena Mus. A., purchase, 1960; Morrison Medal, Bay Pr.M., 1960; Pennell Medal, PAFA, 1961; Ford Fnd. Grant, 1960; Guggenheim Fellowship, 1964-65; prizes, Int. Graphics, Lugano, 1962; Mus. of Western Art, Tokyo; Albert Dorne Professor, Bridgeport, Conn. Work: MModA; MMA; N.Y. Pub. Lib.; BM; Smithsonian Inst.; AIC; Cranbrook Acad. A.; PMA; Sao Paulo, Brazil; Clearwater Mus. A.; Univ. Indiana; Vassar Col.; Brown Univ.; Univ. Michigan; Northwestern Univ.; Univ. Oklahoma; Illinois Wesleyan; Currier Gal. A.; Smith Col.; Achenbach Fnd., San F.; Abilene Christian Col.; Berea Col.; Dartmouth Col.; Michigan State Univ.; New Jersey State Univ.; Oregon State Col.; Smith Col.; Texas Wesleyan; Honolulu Acad. FA; Mus. of Budapest; Mus. of Prague; Mus. of Rome; Brooks Mem. Mus.; Univ. Nebraska; Brandeis Univ.; Univ. Georgia; Yale Univ.; Albion Col.; Princeton Univ.; Firestone Lib., Princeton WMAA; R.I.Sch.Des.; PAFA; Minneapolis Inst. A.; BMFA; Oakland A. Mus.; Beloit Col.; Columbia (S.C.) Mus. A.; Univ. Illinois. Author: "Printmaking," 1960; "Great Prints of the World," 1969. Exhibited: nationally. One-man: Ernst Mus., Budapest, 1930, 1934; Rome, 1930; Galerie Jean Bucher, Paris, 1936; Julian Levy Gal., N.Y., 1939; Norlyst Gal., 1943, 1944; Laurel Gal., 1948-1950; Phila. A. All., 1950, 1955, 1967; Galeria Colibri, San Juan, P.R., 1969; Phila. Pr. Cl., 1969; Grand Ave. Gal., Milwaukee, 1969; Honolulu Acad. A., 1968; Smithsonian Inst., 1951; Silvermine Gld. A., 1952, 1969; Fla. Gulf Coast A. Center, 1953; Borgenicht Gal., 1952, 1953, 1955, 1957, 1959, 1961, 1967; N.Y. Pub. Lib., 1956; Kanegis Gal., Boston, 1956-57, 1959-1961, 1969; Wise Gal., Cleveland, 1959; BM, 1959; Achenbach Fnd., 1960; St. George's Gal., London, 1958. Retrospectives: CMA, 1962; Univ. Southern Illinois, 1962; Salt Lake A. Center, 1962; CGA, 1964; De Cordova & Dana Mus., 1964; Kresge A. Center, Mich. State Univ.; Atlanta Art Assn., 1964; Yale Gal. FA, 1964; Jacksonville Mus. A., 1964; Tampa A. Center, 1964. Positions: Instr., BM Sch. A., 1949-53; Prof. A., Yale Univ., at present.

PETERS, CARL W.—Painter, T.
 Jefferson Ave., Fairport, N.Y. 14453
B. Rochester, N.Y., Nov. 14, 1897. Studied: with Charles Rosen, John F. Carlsen, Harry Leith-Ross. Awards: prizes, Univ. Roch-

ester, 1924; NAD, 1925, 1926, 1928, 1932; Rochester A. Cl., 1927, 1928; North Shore AA, 1931; Rockport AA, 1951, 1952, 1954, 1955, 1960, 1961, 1964, 1967; Rochester Mem. A. Gal., 1946; medal, Rochester A. Cl., 1925; Academic A., 1956, 1966, 1969. Work: murals, Genessee Valley Trust Co., Rochester; Acad. Medicine, Univ. Rochester; Fairport Pub. Lib.; Madison, West and Charlotte H.S.; Rochester. Exhibited: NAD; CGA; PAFA; Milwaukee AI; AIC; North Shore AA; Rockport AA; Springfield Mus. A.; Rochester Mem. A. Gal.; Albright A. Gal.; Syracuse Mus. FA; Fort Worth (Tex.) Mus. A.

PETERSEN, ROLAND—Painter
 c/o Staempfli Gallery, 47 E. 77th St., New York, N.Y. 10021*

PETERSHAM, MAUD FULLER—Illustrator, W.
 Woodstock, N.Y. 12498
B. Kingston, N.Y., Aug. 5, 1889. Studied: Vassar Col.; N.Y.Sch. F.&App.A. Awards: Caldecott med., 1946. Work: children's books in libraries. Several books now in foreign editions. Author, I., children's books, text books.

PETRO, JOSEPH (VICTOR) JR.—Painter, I.
 305 Henry Clay Blvd., Lexington, Ky. 40502
B. Lexington, Ky., Nov. 4, 1932. Studied: Transylvania Col., with Victor Hammer; Grad. Sch., Cincinnati Medical Sch., Art as Applied to Medicine. Member: AFA; C.S.E.S.I., Rome. Work: covers, Family Weekly Magazine, N.Y.; Brown & Bigelow calendars; Brown-Forman Distillers, Louisville; Holland Furnace Co., Mich.; Eli Lilly Pharmaceutical Co., Indianapolis; Westinghouse; other commissions: The Keeneland Collection (32 horse paintings which are on permanent display at the Keeneland Racing Assn., Lexington;) The President's Room of Transylvania College (27 portraits of all the Presidents of Transylvania College dating back to 1794). Paintings are in many private collections throughout the U.S. Exhibited: One-man: Univ. Kentucky, 1965; Transylvania College, 1963; Stewarts Gal., Vero Beach, Fla., 1967; Rich's Gal., Atlanta, 1968; Sanger-Harris, Dallas, 1968; Abercrombie-Fitch, N.Y., 1968; Bass Gals., Louisville, Ky., 1968; Cain-Sloan, Nashville, 1967; Clossons, Cinn., Ohio, 1969. Illus.: Cincinnati Pictorial Enquirer; The Thoroughbred Record; National Geographic, Holiday, Better Homes & Gardens, and others. Exhs. at state & nat. levels of Am. Medical Assn. Consultant, Spindletop Research, Inc., Lexington, Ky., 1965-1968. Published series of limited number collector prints on horses, 1954-1969.

PETROV, BASIL—Art Dealer
 M. Knoedler & Company, 14 E. 57th St., New York, N.Y. 10022*

PEZZATI, PIETRO—Portrait Painter
 Fenway Studios, 30 Ipswich St., Boston, Mass. 02215
B. Boston, Mass., Sept. 18, 1902. Studied: Child-Walker Sch. A.; in Europe and privately with Charles Hopkinson. Work: Harvard Univ., including Medical Sch. & Business Sch.; Univ. Pa., Sch. of Medicine & Sch. of Educ.; Univ. Manitoba Sch. Medicine; Yale Sch. of Medicine; Symphony Hall, Boston; Mass. Hist. Soc.; Harvard Cl., Boston; Mass. Gen. Hospital, Boston; Clowes Mem. Hall, Indianapolis; various private schs. & court houses in Mass.; Air Force Acad., Colo.; Pease Air Force Base, N.H.; U.S. Navy Coll.; FMA; Cambridge (Mass.) AA; Mississippi AA and in private colls. Exhibited in group and one-man shows. Taught in schools and privately, giving demonstrations on technique and slide lectures on Hist. of Portraiture, before private groups.

PFRIEM, BERNARD—Painter
 115 Spring St. 10012; h. 448 West Broadway, New York, N.Y. 10012
B. Cleveland, Ohio, Sept. 7, 1916. Studied: John Huntington Polytechnic, Cleveland; Cleveland Inst. A. Awards: Scholarships from Cleveland Inst. for study in Mexico (worked with Orozco and Castellanos); Agnes Gund traveling Scholarship, Cleveland Inst. A.; Mary Ranney traveling Scholarship, Western Reserve Univ.; Copley award for painting, 1959; prize, Norfolk Mus. A. & Sciences (drawing). Work: MModA; Chase Manhattan Bank, N.Y.; Dorado Beach Hotel, Puerto Rico; Columbia Banking, Savings & Loan Assn., Rochester, N.Y. Murals, Guerrero and Mexico City, Mexico. Exhibited: Carnegie Inst.; WMAA, 1952, 1965; Iolas Gal., N.Y., 1949-1951, 1960, 1962, 1963; Richard Feigen Gallery, Chicago, Ill., 1967; other exhibitions in Washington, D.C., Cleveland, and in France, Germany and Italy. Positions: Instr., Drawing and Painting, MModA Peoples Art Center; drawing, Cooper Union Sch. of Art & Architecture, N.Y.; Silvermine College of Art, New Canaan, Conn.

PHARR, MR. and MRS. WALTER NELSON—Collectors, Patrons
 154 E. 66th St., New York, N.Y. 10021
Mrs. Pharr—B. Detroit, Mich., Apr. 1, 1923. Studied: Garland Junior College, Boston, Mass. Collection: International Modern Art.

Mr. Pharr—B. Greenwood, Miss., Nov. 9, 1906. Studied: Washington and Lee University, Lexington, Va. Collection: Marine paintings including 18 by J. E. Butterworth, others by R. Salmon, T. Birch, etc.

PHELAN, LINN LOVEJOY—Craftsman, Des., T.
Linnwood Pottery, Almond, N.Y. 14804
B. Rochester, N.Y., Aug. 25, 1906. Studied: Rochester Inst. Tech.; Ohio State Univ., B.F.A.; Alfred Univ., M.S. in Edu. Member: N.Y. Art T. Assn.; York State Craftsmen; Am. Craftsmens Council; Olean A. Cl. Work: Cranbrook Acad. A.; Dartnouth Col. Exhibited: Everson Mus. FA, 1932-1960; Rochester Mem. A. Gal., 1929-1967; David Howe Lib., Wellsville, N.Y., 1962, 1964, 1968; Syracuse State Fair, 1962-1968; Olean (N.Y.) A. Cl., 1964; Roberson Mem. Gal., Binghamton, 1963; Houghton Col., N.Y., 1968; Alfred Col., N.Y., 1968. Positions: Owner, "Linwood Pottery," Almond, N.Y.; A. Supv., Alfred-Almond Central Sch., Almond, N.Y. 1950-1967. Lecturer, N.Y. State Col. of Ceramics, Alfred, N.Y., 1967-1968.

PHILBRICK, MARGARET ELDER (Mrs.)—Graphic, P., I.
323 Dover Rd., Westwood, Mass. 02090
B. Northampton, Mass., July 4, 1914. Studied: Mass. Col. A. Member: SAGA; Boston Pr.M.; Boston WC Soc.; Am. Color Print Soc.; Copley Soc. Awards: co-winner, Southern Pr.M. Presentation Print award, 1939; LC, 1948 (purchase); SAGA, 1953; New Britain A. Mus., 1953 (purchase); Presentation Print award, Boston Pr. M., 1954; Yankee Magazine Citation, Boston Pr.M., 1960; Springfield Mus. A., 1958; Hatfield award, Boston Soc. WC Painters, 1962; Brockton AA, 1964; Pratt Graphic A. Center, New York City, 1966; Concord AA, 1964, 1968; Cambridge A.A., 1966; Ipswich A. Festival, 1966; Hamilton A. Exh., 1967; Carl Zigrosser, Multum in Parvo Award. Work: LC; Bezalel Mus., Jerusalem; AGAA; FMA; Amherst Col.; MMA; New Britain A. Mus.; Univ. Maine. Illus., "On Gardening" (Jekyll). Exhibited: SAGA, annually; Chicago Soc. Et., annually; Northwest Pr.M.; Albany Pr. Cl.; Buffalo Pr. Cl.; LC; Carnegie Inst.; BM; BMFA; Boston A. Festival, 1952, 1953, 1955-1958, 1961; Weeden Gal., 1964 (one-man); Hudson (Mass.) Nat. Bank, 1964, and in American Exhs. in Italy, Israel, England; U.S. State Dept. traveling exh. Far East.

PHILBRICK, OTIS—Painter, Lith., E., Gr.
Massachusetts College of Art, Brookline Ave., Boston, Mass.; h. 323 Dover Rd., Westwood, Mass. 02090
B. Mattapan, Mass., Oct. 21, 1888. Studied: Mass. Sch. A. Member: Boston Soc. WC Painters; SAGA; Boston Pr. M.; Copley Soc.; Boston WC Soc. Awards: Boston Pr. M., 1949 (purchase); Presentation Print award, Boston Pr. M., 1951; Cambridge AA, 1954, 1959; Jordan Marsh Co., 1963; Mohawk Paper Co. purchase award, 1963. Work: Boston Pub. Lib.; LC; Bezalel Mus., Jerusalem; Amherst Col.; FMA; Dartmouth Col.; AGAA; Univ. Maine. Exhibited: Nat. Mus., Wash., D.C.; NAD; Albany Pr. Cl.; Buffalo Pr. Cl.; LC; Carnegie Inst.; Boston WC Soc., annually; Boston A. Festival, 1953-1955, 1958, 1961; American Exhs. in France, Israel, Italy, England; U.S. State Dept. traveling exh. Far East. Positions: Prof. Emeritus, Mass. College A., Boston, Mass.; Pres., Boston Pr. M.

PHILIPP, ROBERT—Painter
157 East 57th St., New York, N.Y. 10022
B. New York, N.Y., Feb. 2, 1895. Studied: ASL, with DuMond, Bridgman; NAD, with Volk, Maynard. Member: NA; Lotos Cl. Awards: prizes, NAD, 1922, 1947, 1951; Carnegie Inst., 1937; Laguna Beach AA; medal, prize, AIC, 1936; CGA, 1939; IBM, 1939; bronze medal, All. A. Am. 1958. Work: WMAA; BM; Mus. FA of Houston; CGA; Norton Gal. A.; High Mus. A.; IBM; Davenport Mun. A. Gal.; Encyclopaedia Britannica; Dallas Mus.; Univ. Arizona; Joslyn A. Mus. Exhibited: nationally. Positions: Instr., High Mus. A., 1946; Visiting Prof., Univ. Illinois, 1940; Instr., ASL, NAD, New York, N.Y., at present.*

PHILLIPS, BLANCHE (HOWARD)—Sculptor
Studio House, Ellen St., Upper Nyack, N.Y. 10960
B. Mt. Union, Pa., Feb. 26, 1908. Studied: CUASch.; ASL; Stienhofs Inst. Des.; Cal. Sch. FA, and with Zadkine, Hofmann. Member: S. Gld.; Chrysler Mus., Provincetown; Norfolk Mus. A. & Sciences; All Faith Temple, Val Moren, Canada, 1965. Awards: NAWA, 1963, 1964. Exhibited: SFMA, 1942, 1943, 1945-1947, 1949; Oakland A. Mus., 1946, 1948; Los A. Mus. A., 1949; WMAA, 1952, 1957; BMFA, 1958; Mus. FA of Houston, 1958; Riverside Mus., 1958, 1962; Art: USA, 1958; Stable Gal., N.Y., 1959, 1960; Claude Bernard Gal., Paris, France, 1960; Holland-Goldowsky Gal., Chicago, 1960; Silvermine Gld. A., 1963, 1964; Museo de Bellas Artes, Argentina, 1962; one-man: SFMA, 1943, 1949; Crocker A. Gal., Sacramento, Cal., 1949; RoKo Gal., N.Y., 1955, 1957; New Gal., Provincetown, Mass., 1961; East Hampton Gal., L.I., 1963, N.Y., 1964; Silvermine Gld. A., 1963; Mari Gal., Woodstock, 1964; Galerie Internationale, N.Y., 1962, and in Mexico, 1951.*

PHILLIPS, MRS. DOROTHY SKLAR. See Sklar, Dorothy

PHILLIPS, GIFFORD—Collector, W.
825 S. Barrington St., Los Angeles, Cal. 90049; h. 2501 La Mesa Drive, Santa Monica, Cal. 90402
B. Washington, D.C., June 30, 1918. Studied: Stanford University; Yale University, B.A. Collection: Contemporary American painting and sculpture. Positions: Publisher, Frontier Magazine, 1951- ; Chairman Contemporary Art Council, Los Angeles County Museum, 1962-1965; Member, Board of Directors, UCLA Art Council; Trustee, Phillips Gallery, Washington, D.C.; Trustee, Pasadena Art Museum, MModA. West Coast Publisher, Nation magazine.

PHILLIPS, IRVING W.—Cartoonist, I.
Meadow Lane, South Britain, Conn. 06487
B. Wilton, Wis., Nov. 29, 1905. Studied: Chicago Acad. FA. Member: Writers Gld. Am.; Dramatists Gld.; Nat. Cartoonists Soc.; Magazine Cartoonists Gld.; Newspaper Cartoon Council; Authors Lg. Author, Illus., "The Strange World of Mr. Mum," syndicated strip appearing internationally in 180 papers in 22 countries; also in book form, 1965. Author & Co-author of 260 produced TV scripts. Stage play adaptations include One Foot in Heaven; Gown of Glory; Mother Was a Bachelor; "Rumple" (original stage musical), Alvin Theater, New York City, 1955, and many others. Motion picture assignments with Warner Bros., RKO, Charles Rodgers Productions, United Artists. Contributor to: Sat. Eve. Post; Colliers; Esquire; American; New Yorker and others. Author: "The Twin Witches of Fingle Fu," 1969 (children's book). Positions: Cartoon Humor Editor, Esquire magazine, 1937-39; Cartoon staff, Chicago Sun-Times Syndicate, 1940-1952.

PHILLIPS, JOHN GOLDSMITH—Museum Curator
Metropolitan Museum of Art, Fifth Ave., at 82nd St.; h. 170 E. 77th St., New York, N.Y. 10021
B. Glens Falls, N.Y., Jan. 22, 1907. Studied: Harvard Univ., A.B. Awards: Guggenheim Fellowship, 1957. Author: "Early Florentine Designers and Engravers," 1955; "China-Trade Procelain," 1956. Lectures on various aspects of European Art, including New Installations at the Metropolitan Museum. Positions: Chm., Western European Arts, Metropolitan Museum of Art, New York, N.Y.

PHILLIPS, MARGARET McDONALD—Painter, T., W., L.
19 E. 37th St., New York, N.Y. 10016
B. New York, N.Y. Studied: Hunter Col., B.A.; Grand Central Sch. A.; Wayman Adams Sch. of Portraiture, and with Eric Pape, Frank Schwartz, Edmund Graecen. Member: F., Royal Soc. A., London; The Fifty American Artists, Inc. (Fndr., Pres.); Palm Beach A. Lg.; Rockport AA; A Gld.; AAPL; Nat. Lg. Am. Pen Women; Wolfe A. Cl. Awards: Citation, Fla. Southern Col.; PAFA scholarship; Grand Central Sch. A. scholarship; Nancy Ashton award, Hunter Col.; voted "Woman of the Year" by Greater N.Y. Citizens Soc., 1969. Work: Fla. Southern Col.; Muskingum Col., New Concord, Ohio; Fifth Avenue Presbyterian Church, N.Y.; Columbia Univ., Home for the Aged and Infirm, N.Y.; Eastern Star of N.Y. State, and in private colls. Exhibited: Fla. Southern Col., 1952; Fifty Am. A., 1954-1960; SC, 1958, 1963; Internationale, New York City, 1959-1960; Women's Cl., White Plains, N.Y.; Ogunquit A. Center, 1954, 1955; Grand Central A. Gal., 1954; Virgin Isles A. Center, 1950; traveling exh. to Mint Mus. A., Columbus Gal. FA, Hickory Mus. A., Asheville Mus. A., Oklahoma A. Center; Schoneman Gal., N.Y., 1965; Rembrandt Gal., N.Y., 1965, 1968; Whitehouse Gal., N.Y., 1968; N.Y. Advertising Cl., 1969, and others; one-man: Metropolitan Gal., 1945; Arthur Newton Gal., 1954; Pelham Manor Cl., 1955; Schneider-Gabriel Gal., 1944. Contributor to art magazines. Lectures: "Portrait Painting Today"; "Aesthetic Enjoyment"; "Judging an Art Exhibition," Portraiture; "You and Your Portrait"; "Aesthetic Criticism," given at universities, Women's Clubs, and on TV. Author: "The 50 American Artists," 1969. Talks on Contemporary and Modern Art, WABC, WNEW-TV & WOR-TV. Instr., Painting, private classes, New York City & White Plains, Pelham, N;Y. and N.Y. Phoenix Sch. of Des., N.Y.

PHILLIPS, MARJORIE—Museum Director, P.
Phillips Collection, 1600-1612 21st St., 20007; h. 2101 Foxhall Rd., Northwest, Washington, D.C.
B. Bourbon, Ind., Oct. 25, 1894. Studied: ASL, with Boardman Robinson, Kenneth Hayes Miller. Awards: prize, CGA, 1955. Work: BMFA; PC; Yale Univ. Mus.; WMAA; CGA. Exhibited: CGA, 1925-1945, 1955; Carnegie Inst., 1934-1946; AIC, 1931, 1940, 1941; WMA; MModA, 1933; PAFA, 1944, 1945, 1953; WFNY;1939; GGE 1939; Tate Gal., London, England, 1946; Denver A. Mus., 1941; PC, 1941; Butler AI, 1953; Franz Bader Gal., Wash., D.C.; one-man: Durlacher Bros., 1956, 1958; Kraushaar Gal., 1941; Durand-Ruel Gal., 1941; Santa Barbara Mus. A., 1945; CGA, 1955, 1956; PC, 1958, 1960; Cal. PLH, 1958; Retrospective Exh., Edward W. Root A. Center. Arranged many exhs. for PC, 1937- including: Collages by Robert Motherwell; Sculpture of Seymour Lipton, Alberto Giacometti, David Smith; Paintings by Manessier, Riopelle, Mark Tobey, Hamada, and others. Exhibits arranged, in new sculpture court of the museum's

new wing: Alicia Penalba, Henry Moore, Alexander Calder, Sam Gilliam, Jack Youngerman, Edward Munch, Charles Prendergast (retrospective), and many others. Lecture at BMA, "Highlights of the Phillips Collection," 1965. Positions: Director, PC, Washington, D.C., 1922- . Directed furnishing of new gallery wing, PC, 1960.

PHIPPS, CYNTHIA—Collector
 3 E. 77th St., New York, N.Y. 10021*

PHIPPS, MR. and MRS. OGDEN—Collectors
 635 Park Avenue, New York, N.Y. 10021*

PICARD, LIL—Painter, Cr.
 40 E. 9th St., New York, N.Y. 10003
B. Germany. Studied: Strasbourg, Alsace-Lorraine; and in Vienna and Berlin. Exhibited: 1959-1969: March, Tanager, Fleischmann, Martha Jackson, David Anderson, Reuben, Byron, West Hampton, Finch Col., Judson and Smolen galleries, New York, also, Hamburg, Wuppertel, Baden-Baden, Cologne and Berlin, Germany; Stedelijk Mus., Amsterdam, and others. One-man: Fleischmann Gal., 1959; Parma Gal., N.Y. Contributor to: East Village Other; Arts; and to publications in Germany; art critic for Die Welt, 1956- .

PICCIRILLI, BRUNO—Sculptor
 Vassar College, Poughkeepsie, N.Y.
B. New York, N.Y., Mar. 30, 1903. Studied: NAD; Beaux-Arts Inst., N.Y.; Am. Acad. in Rome. Member: NSS. Work: Exterior and interior sculpture, Riverside Church, N.Y.; mural, USPO, Marion, N.C.; sculpture, Mount Carmel Church, Poughkeepsie, N.Y.; statue, Brookgreen Gardens, S.C.; Priscilla G. L. Plimpton Memorial, Wheaton College; All Saints Episcopal Church, Baldwin, N.Y.; many portraits, fountains, etc., in private colls. Exhibited: NSS; NAD; Arch. Lg., N.Y.; MMA; San Francisco Nat. Exh.; Am. Acad. in Rome; Dutchess County AA, Poughkeepsie, N.Y.; IBM; F.D. Roosevelt Lib., Hyde Park, N.Y., and many others. Positions: Instr., Sc., Vassar College, at present.*

PICK, JOHN—University Art Administrator, W.
 Marquette University, 53233; h. 2419 N. Wahl Ave., Milwaukee, Wis. 53211
B. West Bend, Wis., Sept. 18, 1911. Studied: Univ. Notre Dame, B.A.; Grad. study, Harvard Univ. and Oxford Univ.; Univ. Wisconsin, Ph.D. Member: AFA; Milwaukee A. Center (Trustee, 1950-62); Friends of Art of the Milwaukee A. Center; F., Royal Soc. Arts, London. Positions: Chm., Marquette Univ. Committee on the Fine Arts, 1953- ; Cur., University Art Collection; Organized all exhibitions and art lecture series; author of the catalogs for the various exhibitions; Cultural Attaché, Embassy of Malta (Washington, D.C.). Author: "Marquette University Art Collection," 1964; brochure, "Wisconsin-Owned Icons."

PICKEN, GEORGE—Painter, Et., Lith., E.
 Tyringham, Mass. 01264
B. New York, N.Y., Oct. 26, 1898. Studied: ASL; & abroad. Member: Fed. Mod. P. & S.; SAGA; AAUP. Awards: prizes, CGA, 1943. Work: CGA; Lowe A. Center, Syracuse Univ.; Lowe A. Gal., Miami Univ.; Hudson River Mus.; WMAA; Newark Mus.; N.Y. Pub. Lib.; Dartmouth Col.; IBM Col.; Univ Arizona; Hofstra Univ. Coll.; Staten Island Mus. Hist. & Art; Inland Steel Corp., Chicago; murals, USPO, Edward, N.Y.; Hudson Falls, N.Y.; Chardon, Ohio. Exhibited: Herron AI, 1944, 1945; CGA, 1941, 1943, 1945, 1961; WMA, 1943; AIC, 1941-1945; MMA, 1943; PAFA, 1944-1946; WMAA, 1942-1946, 1960; BM, 1944-1946; Carnegie Inst., 1944-1946; Iowa State Univ., 1946; VMFA, 1942, 1944, 1946; Berkshire Mus.; one-man: Marie Harriman Gal., Frank Rehn Gal., 1960 & prior; Cowie Gal., Los A., 1949; USIA traveling exh. to Europe & South America. Contributor to: Magazine of Art; ASL Bulletin. Positions: Instr. A., CUASch, 1943-1964; Asst. Prof. Painting, Departmental Rep., Sch. Painting & Sc., Columbia Univ., New York, N.Y., 1943-1964. Special Asst. Prof. FA, Hofstra University, N.Y., 1965-1966; Visiting Prof., Painting, Kansas City Art Institute, 1965-1966; Visiting Prof., Painting, University of Hartford, Conn., 1967-1968; Instructor, Painting, Lenox School for Boys, Lenox, Mass., 1967-1968.

PICKENS, ALTON—Painter
 Art Department, Vassar College, Poughkeepsie, N.Y.
B. Seattle, Wash., Jan. 19, 1917. Studied: Reed College, Portland, Ore. Work: MModA. Positions: Instr., Painting, Vassar College, Poughkeepsie, N.Y., at present.*

PICKFORD, ROLLIN, JR.—Painter, Des., I., T.
 1839 Van Ness 93721; h. 930 East Sierra Madre, Fresno,Cal. 93704
B. Fresno, Cal., May 23, 1912. Studied: Fresno State Col.; Stanford Univ., A.B., and with Louis Rogers. Member: West Coast WC Soc.; AFA; Cal. WC Soc.; Carmel AA; Laguna Beach AA; Fresno Arts

Center, Fresno. Awards: prizes, A. Lg. Fresno, 1946-1950, 1952-1958; Santa Cruz, 1947, 1949, 1952, 1958, 1960; Festival of Art, Laguna Beach, 1947, 1957, 1960, 1961; San Joaquin Valley, 1947, 1959-1963; Laguna Beach AA, 1948, 1949, 1953, 1958; Soc. Western A., 1950; Mississippi AA, 1951; Monterey Fair, 1952, 1953; Stockton, Cal., 1952, 1953, 1954, 1956, 1957; No. Cal. A., 1954, 1956, 1960, 1964, 1965; Santa Paula, 1962; Watercolor: U.S.A.; Cal. State Fair, 1955, 1959, 1963 (purchase), 1964; Fresno Fair, 1959; Los A. Fair, 1960; Tucson Festival, 1961; San Juan Bautista, Cal., 1961; Mother Lode, 1961; Rotunda Gal., San F., 1955. Work: Ford Motor Co.; State of California; Springfield A. Mus. Exhibited: Cal. WC Soc., 1946-1950, 1952; San F. AA, 1946, 1952; Terry AI, 1952; Soc. Western A., 1949, 1950, 1952; Santa Cruz A. Lg., 1946, 1947, 1949, 1950, 1952, 1956-1958; Oakland A. Gal., 1946, 1948, 1950; Cal. State Fair, 1949, 1950, 1956, 1957; Monterey County Fair, 1952; Stockton, Cal., 1952, 1956, 1957; Fresno A. Lg., 1956-1958; San Luis Obispo AA, 1957; No. Cal. A., 1956, 1957; All-Cal. A., 1956, 1957; New Orleans AA, 1957; Rotunda Gal., San F., 1956. Contributor to Ford Times, Lincoln-Mercury Times, with illus. Illus. of stories by William Saroyan & Peter B. Kyne. Positions: A. Instr., Fresno State College, 1948-49, 1956, 1962; Fresno Arts Center.

PICKHARDT, CARL E., JR.—Painter, Et., Lith., T., L.
 66 Forest St., Sherborn, Mass. 01770
B. Westwood, Mass., May 28, 1908. Studied: Harvard Univ., B.A. Member: F.I.A.L. Awards: prizes, NAD, 1942; Boston Soc. Indp. A., 1950. Work: BMFA; BM; LC; N.Y. Pub. Lib.; AGAA; PMA; FMA; WMA; DeCordova Mus.; MMA; CM; Wadsworth Atheneum. Exhibited: Illinois Exh., 1951; BM; 1952; New Britain Inst., 1952; Phila. Pr. Cl., 1952; Int. Color Lith. Exh., 1952; Carnegie Inst., 1953; Int. Exh., Japan, 1952; France, 1957; Bucknell Univ., 1965; Norfolk Mus. A. & Sciences, 1965; 2nd Nat. Lithography Exh., Tallahassee, Fla., 1965; PAFA, 1968; one-man: Meltzer Gal., N.Y.; Jacques Seligman Gal., N.Y.; Artek Gal., Helsinki; Margaret Braun Gal., Boston; Lawrence Gal., Kansas City; Stuart Gal., Boston; Berkshire A. Mus.; Fitchburg A. Mus.; Laguna Gloria Mus., Austin, Tex., 1966. Positions: Instr. A., Worcester Mus. Sch., 1953-54; Fitchburg (Mass.) A. Mus., 1951-1963. Ford Fnd-American Federation of Arts A.-in-Res. grant, Laguna Gloria Mus., Austin, Tex., 1966.

PIENE, OTTO—Sculptor
 60 Wadsworth St., Apt. 19 G, Cambridge, Mass. 02142*

PIERCE, DANNY—Painter, Et., Eng., W.
 330 Summit Ave., Kent, Wash.
B. Woodlake, Cal., Sept. 10, 1920. Studied: Am. A. Sch.; BM Sch. A.; Chouinard AI. Member: Soc. Indp. A., Boston; Conn. Acad. FA; AEA; Am. Color Pr. Soc.; F.I.A.L. Awards: prizes, BM, 1952 (purchase); Bradley Univ., 1952; LC, 1952, 1953, 1958 (purchase); Univ. So. California, 1952; SAM, 1952; Henry Gal., 1955. Work: BM; N.Y. Pub. Lib.; LC; MModA; Clearwater Mus. A.; Bradley Univ.; Univ. So. California; Princeton Univ.; SAM; Sweat Mem. Mus.; Nat. Mus., Stockholm, Sweden. Exhibited: Los A. Mus. A.; Oakland A. Mus.; BMFA; Springfield A. Mus.; SAM; Portland (Ore.) A. Mus.; BM; Munson-Williams-Proctor Inst.; LC; CGA; Carnegie Inst.; Erie Pub. Mus.; Milwaukee AI; Butler AI; New Britain Mus. A.; Avery Mem.; Univ. Maine; Clearwater Mus. A.; Bradley Univ.; Univ. Mississippi; Creative Gal. (one-man); Contemporaries (one-man); Univ. So. Cal.; DMFA; Denver A. Mus.; MModA; Sanford-Tiel Mem. Mus.; Cherokee, Iowa; PAFA; Nat. Mus., Stockholm; Sao Paulo, Brazil; Barcelona, Spain; Modern Masters of Intaglio, Queens Col., N.Y., 1964; USIS Graphic Exhs. to Prague, Yugoslavia, India, 1965; Northwest Printmakers, Henry Gal., Seattle, 1964, SAM, 1965. One-man: (Prints)-Tacoma A. Mus., 1964; Hanga Gal., Seattle, 1964; Gonzaga Univ., Spokane, Wash., 1964; Central Washington Col. Edu., 1965. Positions: Hd., Art Dept., University of Alaska, 1960-1963 and Artist-in-Res., 1964-1965; Visiting Instr., Graphics, Univ. Wisconsin, Milwaukee, 1965.*

PIERCE, DELILAH W. (Mrs.)—Educator, P.
 Art Department, District of Columbia Teachers College, 1100 Harvard St. 20009; h. 1753 Verbena St., N.W., Washington, D.C. 20012
B. Washington, D.C. Studied: Dist. of Columbia Teachers Col., B.S. (previously Miner Col.); Teachers Col., Columbia Univ., M.A.; Univ. Pennsylvania; N.Y. Univ.; Univ. Chicago. Member: Soc. Washington A.; AEA; AFA; NAEA; AAUW (Arts Com.); Nat. Conf. Artists. Awards: Agnes Meyer Summer Fellowship for study in Africa, Europe and the Middle East, 1962; Phi Delta Kappa Award for Service and Achievement in Art and Art Education; AFA, Museum-Donor Program purchase award, 1964. Work: Howard Univ., and in private colls. Exhibited: Smithsonian Inst., 1952, 1953, 1955; Margaret Dickey Gal., (D.C.), 1957, 1958, 1962, 1963, 1965; CGA, 1957-1959; and traveling exh., 1960-1961; Barnett Aden Gal., 1958; BMA, 1959; Artists Mart, (D.C.), 1960-1968; Howard Univ., 1960, 1963, 1964, 1966; Martha's Vineyard (Mass.), 1960; Collectors Corner, 1960;

20th Century Gal., Williamsburg, Va., 1960; No. Virginia Hadassa Exhs., 1968, 1969; Anacostia Neighborhood Mus.(Smithsonian Inst.), 1968, 1969; Catholic Univ. of America, 1969; Smith-Mason Gal., 1969. One-man: Dickey Gal., 1957, 1969; Artists Mart, 1963, 1965, 1968. Positions: Asst. Prof. A., District of Columbia Teachers College, Washington, D.C., at present.

PIEROTTI, JOHN—Cartoonist
New York Post, 75 West St., New York, N.Y.; h. 72 Bay 25th St., Brooklyn, N.Y. 11214
B. New York, N.Y., July 26, 1911. Studied: ASL; Mechanics AI; CUASch. Member: Baseball Writers of Am.; Newspaper Reporters Assn. of New York; A. Writers Soc.; Nat. Cartoonists Soc. Awards: prize, Best Editroial Cartoon, Los A. Pub. Assn., 1955; Page One Award, 1955; Best Sports Cartoon, 1965; Best Editorial Cartoon, 1967; Silurian Awards: Best Editorial cartoons, 1965, 1967, 1968. Exhibited: MMA, 1947, 1951. Positions: Sport Cart., Washington Post, 1933-34; King Features, 1938; Sports Ed. & Cart., United Features, 1937-39; Cart., PM, 1940-50; Sports Ed., Cart., McClure Syndicate, 1950-51; Sports Cart., New York Post, 1951- ; Treas., Nat. Cart. Soc., 1948-57; Pres., 1957-59; Sec., New York Harness Writers, 1969.

PIERRE-NOEL, MRS. VERGNIAUD. See Jones, Lois Mailou

PIKE, JOHN—Illustrator, P., T.
Woodstock, N.Y. 12498
B. Boston, Mass., June 30, 1911. Studied: with Charles Hawthorne, Richard Miller. Member: NA; AWS; SI; SC; Woodstock AA; Phila. WC Cl. Awards: prizes, AWS; NAD; SC, and others. Work: paintings for U.S. Air Force Hist. Fnd.—France, Germany, Greenland, Ecuador, Columbia, Panama, etc. Exhibited: nationally, and 51 one-man exhs. Other exhs. 1960-61: Grand Central A. Gal.; St. Petersburg (Fla.) A. Cl.; Oklahoma City Mus. of Conservative Art; Great Plains Mus., Lawton, Okla.; San Diego Fine Arts Festival. Contributor illus. and covers to Colliers; Readers Digest; Life; Fortune; True magazine; advertisements for: Lederle Laboratories; Alcoa; Standard Oil; Falstaff; Goodyear; Hamilton Propeller, etc. Positions: Instr., John Pike Watercolor School, Woodstock, N.Y. (Summer).

PINARDI, ENRICO VITTORIO—Sculptor, P., E., L.
c/o Kanegis Gallery, 123 Newbury St., Boston, Mass. 02116
B. Cambridge, Mass., Feb. 11, 1934. Studied: Apprentice sculptor with Pellegrini and Cascieri; BMFA Sch. FA; Boston Architectural Center; Massachusetts College of Art, B.S.E. Exhibited: New England Painters & Sculptors, 1963; Boston A. Festival, 1964; De Cordova & Dana Mus., 1964; New England A., 1965. Positions: Instr., Sculpture, Worcester Museum School of Fine Arts, Worcester, Mass.*

PINCUS-WITTEN, ROBERT—Scholar, Critic
Queens College, 65-30 Kissena Blvd., Flushing, N.Y. 11367
B. New York, N.Y., Apr. 5, 1935. Studied: University of Chicago, M.A., Ph.D.; Cooper Union, New York City. Author: "Les Salons de la Rose + Croix, 1892-1897," 1968. Contributor articles and reviews on modern and American art. Field of Research: Symbolism. Positions: Asst. Prof. Art History, Queens College, New York; Contributing Editor, Artforum.

PINEDA, MARIANNA (PACKARD TOVISH)—Sculptor
164 Rawson Road, Brookline, Mass. 02146
B. Evanston, Ill., May 10, 1925. Studied: Cranbrook Acad. A.; Bennington Col.; Univ. Cal., Berkeley; Columbia Univ.; Zadkine Sch. S., Paris, France. Member: S. Gld.; AEA. Awards: prizes, Albright A. Gal., 1948; WAC, 1951 (purchase); San F. AA, 1955; AIC, 1957; Portland, Me., 1957; Providence A. Cl., 1958; Inst. Contemp. A., Boston, 1958; Boston A. Festival, 1957, 1960. Work: WAC; BMFA; Williams Col.; Dartmouth Col.; Bowdoin Col.; Wadsworth Atheneum; AGAA; Munson-Williams-Proctor Inst. Exhibited: BM, 1947; WMAA, 1953, 1954, 1957; AIC, 1957, 1960; Albright A. Gal., Buffalo, 1948; WAC, 1951-1953; Minneapolis Inst. A., 1955; Denver A. Mus., 1956; Boston A. Festival, 1957, 1958, 1960, 1962-1964; San F. AA, 1957; Univ. Illinois; Portland (Me.) Mus. A., 1957; Providence A. Cl., 1958; United Nations Exh., San F., 1955; Galerie 8, Paris, France, 1951; Currier Gal. A., 1954; de Cordova & Dana Mus., Lincoln, Mass., 1954, 1964, 1966; Colorado Springs FA Center, 1953; Inst. Contemp. A., Boston, 1959; Premiere Gal., Minneapolis, 1963; BMFA, 1960; Carnegie Inst., 1960; Boston Univ., 1960, 1961, 1963; Univ. Colorado, 1961; WMA, 1961; DMFA, 1961; Nat. Inst. A. & Lets., 1961; AIC, 1961; Mt. Holyoke Col., 1962; Bundy A. Gal., Waitsfield, Vt., 1963; N.Y. World's Fair, 1964; Swetzoff Gal., Boston, 1956-1964. 1st and 2nd Prudential Sculpture Exhs., Boston, 1968, 1969.

PINES, NED L.—Collector, Patron
355 Lexington Ave. 10017; h. 605 Park Ave., New York, N.Y. 10021
B. Malden, Mass., Dec. 10, 1905. Collection: Modern art.

PINI di SAN MINIATO, ARTURO—Collector
135 E. 65th St.; h. 535 Park Ave., New York, N.Y. 10021
B. Falconara, Italy, May 25, 1923. Studied: Instituto Tecnico-Commerciale, Ancona, Italy. Awards: Honorary president, Committee for Festivities, 1966-1967, of the City of San Miniato, Italy. Collection: 19th century furniture, porcelain, decorative arts. Positions: National President, National Society of Interior Designers, 1964-1965.*

PINKERTON, CLAYTON—Painter, T.
35 Washington St. 94801; h. P.O. Box 97, Point Station, Richmond, Cal. 94807
B. San Francisco, Cal., Mar. 6, 1931. Studied: Cal. Col. of A. & Crafts, B.A. in Edu., M.F.A.; Univ. New Mexico. Awards: Fulbright Grant, 1957-1958, France. Work: deYoung Mem. Mus., San Francisco; Cal.PLH. Exhibited: MModA, 1962; Carnegie Inst., 1961; Univ. Illinois, 1967, 1969; Mus. Contemp. A., Chicago, 1968; Phoenix A. Mus., 1967; WMAA, 1969; one-man: SFMA, 1967; Cal.PLH, 1960; deYoung Mem. Mus., 1963. Positions: Instr., Painting, Cal. Col. A. & Crafts, Oakland.

PINKNEY, HELEN LOUISE—Museum Curator, Librarian
Dayton Art Institute, Forest & Riverview Aves.; h. 37 Stoddard Ave., Dayton, Ohio 45405
B. Decatur, Ill. Studied: Dayton AI Sch. Exhibited: Dayton AI Alum. Assn., annually. Member: AAMus.; Special Libraries Assn. Positions: Librarian, Registrar of Collections, 1936-1945, Cur., Librarian, 1945- , Dayton AI, Dayton, Ohio.

PINTO, JAMES—Painter, T., S.
Beneficencia #6 Bis, San Miguel de Allende, Gto., Mexico
B. Yugoslavia, Apr. 23, 1907. Studied: Univ. Zagreb, Yugoslavia; Chouinard AI, Los Angeles. Member: Int. Platform Assn. Awards: prizes, Univ. Mexico, 1948; Fresno A. Lg., 1949; Fargo, N.D., 1957; Instituto Allende, Mexico, 1961, 1962. Work: Witte Mem. Mus.; Berg A. Center, Concordia Col., Moorhead, Minn.; Univ. Gal., Albuquerque, N.M.; Xerox Coll., Mexico, D.F.; Gal. Portraia, Tuzla, Yugoslavia, and in private collections U.S. and abroad. American Life Ins. Co. Exhibited: AIC, 1955; MMA, 1952; Denver A. Mus., 1956; Santa Monica, 1947; Los A. Mus. A., 1952, 1956; Santa Barbara Mus. A., 1952; de Young Mem. Mus. San F., 1952; Los A. AA, 1953; Pasadena AA, 1950; Mexico City, 1948, 1949, 1951, 1956; San Jose, 1957; Ft. Worth, Tex.; Witte Mem. Mus., San Antonio. One-man: Instituto Allende, Mexico, 1952, 1954, 1957, 1959, 1960, 1963, 1964; Landau Gal., Los Angeles, 1953, 1955; Witte Mem. Mus., 1957; Simone Gal., Los Angeles, 1958, 1960, 1963, 1965; Nye Gal., Dallas; 1961; Concordia Col., 1963; Newport AA, 1964; Univ. Southern Florida, Tampa, 1964; Pageant Gal., Miami, 1968; Gal. de Arte Misrachi, Mexico, 1968; Mus. Arte Moderno, Mexico, 1967, and others. Positions: Hd. Dept. Painting, Instr. Painting and Mural Painting, Instituto Allende, Mexico, 1951- .

PITTMAN, HOBSON—Painter, L., Cr., T.
560 New Gulph Rd., Bryn Mawr, Pa. 17010
B. Tarboro, N.C., Jan. 14, 1900. Studied: Rouse A. Sch., Tarboro, N.C.; Pa. State Col.; Carnegie Inst.; Columbia Univ., and abroad. Member: NA; Phila. WC Cl.; F.I.A.L.; Int. Platform of Lecturers; Phila. A. All.; AEA. Awards: prizes, PAFA, 1943; Cal. PLH, 1947; CGA, 1947; Carnegie Inst., 1949; Butler AI, 1950; medal, PAFA, 1944; gold med., NAD, 1953; Guggenheim F., 1955; prize & purchase, Butler AI, 1955; Brevoort prize, Columbia Univ., 1960; North Carolina Museum of Fine Arts, 1969; Percy M. Owens Memorial Prize, Fellowship of PAFA, 1968. Work: MMA; PAFA; WMAA; BM; PMG; VMFA; Nebraska AA; Butler AI; CMA; Carnegie Inst.; Brooks Mem. A. Gal.; AGAA; Florence (S.C.) Mus. A.; PMA; Nat. Inst. A. & Let.; Cranbrook Acad. A.; PMA; Herron AI; Santa Barbara Mus. A.; Wilmington Soc. FA; IBM; Pa. State Univ.; Encyclopaedia Britannica; Toledo Mus. A.; Montclair A. Mus.; Abbott Laboratories. Exhibited: nationally, with many one-man exh., also in Paris, London, Cairo, Venice and other European art centers. Exh. 1959-1969: CGA; PAFA; NAD; McNay AI, San Antonio (one-man); PAFA Faculty Exh., 1960 (one-man). Lectures: "American Painting Today," "Portrait and Figure Painting Today"; "International Contemporary Painting"; "The Artist's Vision"; "Influences in Art"; "Chardin and Picasso" and many others. Lectures given 1956-65: PAFA, Univ. Virginia, Mary Washington Col., Univ. Richmond, Randolph-Macon Col., PMA, and William & Mary Col. Positions: Instr., Painting & Criticism, PAFA; Instr., Painting & Lecturer, PMA and Pa. State Univ.

PITZ, HENRY C.—Painter, I., E., W.
320 South Broad St., Philadelphia, Pa.; h. 3 Cornelia Pl., Philadelphia, Pa. 19118
B. Philadelphia, Pa., June 16, 1895. Studied: PMSchIA; Spring Garden Inst., Phila. Member: ANA; AWCS; Phila. A. All. (V.Pres.); Phila. Sketch Cl.; Phila. Pr. Cl.; Audubon A.; A.Lg.Am.; SI (Hon.

Life); Phila. WC Cl. (Dir.); Franklin Inn Cl. (Dir.). Awards: med., Los A. Mus. A., 1932; PAFA, 1933, 1951, gold medal, 1956; PMSchIA, 1934; Phila. A. All., 1941; Paris Salon, 1934; prize, Phila. Pr. Cl., 1937; AWS, 1952, 1959, 1961, 1962; NAD, 1953, 1957 (3 Obrig prizes), 1959, Ranger Fund purchase, 1964; Morse Medal, 1964; Butler AI, 1953; SC, 1951; gold med., Phila. Sketch Cl., 1955; Woodmere A. Gal., 1952; Silver Star Cluster, Phila. Mus. Col. A., 1956; SI; Dorne award, Audubon A., 1962; Phila. WC Cl., 1957, 1963; Woodmere Gal., 1965; Huntington Hartford Fnd., 1965. Work: Los A. Mus. A.; Lib. Cong.; Nat. Acad. of Design; CMA; PAFA; Harcum Col.; Univ. Maine; N.Y. Pub. Lib.; PMA; Norfolk Mus.; Univ. Colorado; Reading (Pa.) Mus.; Denver A. Mus.; Allentown Mus.; New Britain (Conn.) Mus. Am. A.; Civic Center, Bethlehem, Pa.; Universities of Oregon, Southern Mississippi, and Minnesota; Central Free Library, Philadelphia, Pa.; Nat. Gal. Coll., Washington D.C.; mural, Franklin Inst., Phila. Exhibited: Dayton AI; Univ. Maine; Rochester Inst.; Cayuga Mus. A.; NAD; AIC; Los A. Mus. A.; Stockholm, Sweden; PAFA, 1930-1946; PMA; AWCS, 1933-1937, 1944; BM; BMA; Wilmington Soc. FA; Paris Salon, 1934; WFNY 1939; etc. Author. "Early American Costumes," 1930, rev. ed. 1964; "The Practice of Illustration," 1946; "Treasury of American Book Illustration," 1947; "Pen, Brush and Ink," 1948; "Drawing Trees," 1956; "Pen Drawing Techniques," 1957; "Sketching with the Felt-Nib Pen"; Illustrating Children's Books," 1963; "Drawing Outdoors," 1965; "The Figure in Painting and Illustration," 1965; "Early American Dress," 1965; "The Brandywine Tradition," 1969. I., 160 books; and illus. for Colliers, Readers Digest. Gourmet and other magazines. Contributor to: national magazines. Positions: Dir. Dept. Illus., PMSchIA, Philadelphia, Pa., 1934-60; Instr. A., PAFA summer session, 1938-45; visiting L., Univ. Pennsylvania, 1941, Carnegie Inst. Tech., 1964; Assoc. Ed., American Artist magazine, 1942-. Official Artist NASA, Apollo 10, 1969.

PITZ, MOLLY WOOD (Mrs. Henry C.)—Painter, T.
 3 Cornelia Pl., Philadelphia, Pa. 19118
B. Ambler, Pa., May 12, 1913. Studied: PMSchIA. Member: Phila. A. All.; Phila. WC Cl.; Bryn Mawr A. Center A.T. Workshop; Allen Lane A. Center; PMSch. A. Alumni Assn. Awards: Hartford Fnd. Fellowship, 1964. Work: Pa. State Univ., and in private colls. Exhibited: Phila. WC Cl., 1935-1945, 1963; Woodmere A. Gal., 1943-1946, 1948-1952; Plymouth Meeting Friends Sch., 1948-1952; William Jeanes Mem. Lib., 1948-1952, 1953-1955, 1959-1969; Phila. A. All., 1965; Phila. Mus. Col. A., 1959.

PLATE, WALTER—Painter, T.
 Box 292, Woodstock, N.Y. 12498
B. Woodhaven, L.I., N.Y., June 9, 1925. Studied: Ecole des Beaux-Arts, Grande Chaumiere, Leger, all Paris, France. Awards: prizes, Woodstock Fnd., 1953; CGA, 1959; Albany Inst. Hist. & Art, 1961; Woodstock Klienert award, 1961. Work: CGA; WMAA; and in private collections. Exhibited: AIC, 1959, 1961; CGA, 1959, 1961; Kresge A. Center, 1959; WMAA, 1956-1960; Albany Inst. Hist. & A., 1961; Denver A. Mus., 1957; Univ. Illinois, 1959; Detroit Inst. A., 1960; PAFA, 1960; Carnegie Inst., 1955; WAC, 1960; Tate Gal., London, England; 1959; Int. Exh., Tokyo, Japan, 1959; one-man: Ganso Gal., N.Y., 1954; Stable Gal., 1958, 1960. Positions: Instr., ASL, 1959-65 (summers); Assoc. Prof. A., Rensselaer Polytechnic Institute, Troy, N.Y., 1964-65.*

PLATH, IONA (Mrs. Jay Alan)—Textile Designer, W.
 17 Mountain View Ave., Woodstock, N.Y. 12498
B. Dodge Center, Minn., May 24, 1907. Studied: AIC; ASL; Westmoreland Col., San Antonio, Tex.; Grand Central A. Sch. Author: "The Decorative Arts of Sweden"; Author and I. "Handweaving," 1964. Contributor to Woman's Day, House and Garden and Handweaver and Craftsman magazines. Positions: Instr., Weaving, Mountain View House, Woodstock, N.Y.; Woodstock Guild of Craftsmen and Mid-Hudson Regional Supplementary Educational Center.

PLATT, ELEANOR—Portrait Sculptor
 50 West 77th St., New York, N. Y. 10024
B. Woodbridge, N.J., May 6, 1910. Studied: ASL. Member: NAD; NSS. Awards: Chaloner scholarship, 1939-1941; Grant, Am. Acad. A. & Let., 1944; Guggenheim F., 1945. Work: BMFA; MMA; Truman Library; portraits, N.Y. Bar Assn.; Hebrew Univ., Jerusalem; Carnegie Corp.; Harvard Univ. Law Sch. Lib.; Mus. of the City of New York; Supreme Court Bldg.; MMA. Executed medals to be awarded for merit: James Kent, N.Y. Univ. Hall of Fame for Great Americans; Manley O. Hudson, James Ewing, George Wharton Pepper, Reginald Heber Smith, Arthur Von Briesen; Harlan F. Stone, Charles Evans Hughes, John Jay. Bas-reliefs, Louis Brandeis Wehle; Samuel J. Tilden; Arthur T. Vanderbilt. Plaques: Orison Marden and Charles S. Whitman, N.Y. Sch. of Law. Busts: Arnold Grant, Syracuse Univ. Law Sch.; Jose Bosch, Bacardi Corp.; Emilio Bacardi y Moreau,

Facundo Bacardi y Moreau and Enrique Scheug y Chassin, museum all in Puerto Rico. Positions: Member New York City Art Commission, 1964-1967.

PLAUT, JAMES S.—Museum Consultant
 225 Brattle St., Cambridge, Mass. 02138
B. Cincinnati, Ohio, Feb. 1, 1912. Studied: Harvard Col., A.B.; Harvard Univ., A.M. Awards: Legion of Merit (U.S.); Legion d'Honneur, Paris (Chevalier); Royal Order of St. Olav, Norway; Royal Order of Leopold (Belgium) (Commander). Adv. to State of Israel in indust. des. matters, 1951; Author: "Steuben Glass," 1949; "Oskar Kokoschka," 1950; Ed., of approx. 20 books published by Inst. of Contemp. A., Boston. Frequent contributor to Atlantic Monthly; Saturday Review and art periodicals. Positions: Asst., Dept. FA, Harvard, 1934-35; Asst. to Cur. Paintings, BMFA, 1935-39; Dir., Inst. Mod. A., Boston, 1939; after World War II duty resumed Dir., Inst. of Contemp. A., Boston, 1946-56 (Dec.); Dir. Emeritus, Trustee, 1956-; Deputy United States Commissioner General, Brussels World's Fair, 1958; Dir. of Development, New England Aquarium; Member, MacDowell Colony Corp. Visiting Committee, Wheaton College. Secretary General, World Crafts Council and Chairman, Exhibition Services International Corp., at present.

PLEASANTS, FREDERICK R.—Collector, Patron, W., Scholar
 Arizona State Museum; h. 5 Sierra Vista Drive, Tucson, Ariz. 85719
B. Upper Montclair, N.J., Nov. 30, 1906. Studied: Princeton University, B.S.; Harvard University, M.A. Field of Research: Primitive art, problems of anthropology in relation to museums in America. Collection: Primitive art of Africa, Oceania and Pre-Columbian America. Positions: Curator, BM, 1950-1958; Curator, 1958-1964, Lecturer, 1960-1964, Arizona State Museum.*

PLEISSNER, OGDEN—Painter
 33 West 67th St.; h. 35 East 9th St., New York, N.Y. 10003
B. Brooklyn, N.Y., Apr. 29, 1905. Studied: ASL. Member: SC; NA; All. A. Am.; AWS; Balt. WC Soc.; Phila. WC Soc.; So. Vermont AA; Conn. Acad. FA; NAC; Royal Soc. Arts, London; Century Assn.; ASL. Awards: prizes, All. A. Am., 1951; NAC, 1952 (medal); NAD, 1952; Concord AA (medal), 1950; Conn. Acad. FA, 1950; Balt. WC Cl., 1949; Saportas prize, AWS, 1961, 1968, 1969; 2nd Altman prize, NAD, 1961; gold medal, NAC, 1961; SC, 1961, Herman Wicks prize, 1968; Audubon A., 1969; Medal of Honor, Century Assn., 1960. Work: BM; Davenport Mun. A. Gal.; PAFA; U.S. Army Air Force Coll.; U.S. Navy Coll.; Wilmington Soc. FA; Civic Center Commission, Detroit, Mich.; Lyman Allyn Mus. A.; Univ. Georgia; Philbrook A. Center; Univ. Maine; Colby Col.; IBM; U.S. War Dept.; MIT; New Hampshire State Lib.; Syracuse Mus. FA; Chrysler Coll. War Art; Univ. Vermont; WMA; Springville (Utah) H.S.; NAD; MMA; Shelburne Mus., Vermont; PMA; W.R. Conner Fnd.; Amherst Col.; CM; New Britain A. Mus.; West Point Mus.; Smith College Mus.; Ford Mus., Greenfield, Mich.; Miami Univ., Oxford, Ohio; Daywood A. Gal., Lewisburg, W. Va.; Parrish A. Mus., Southampton, N.Y.; Univ. Club, N.Y. Trust Co.; Bank of New York Coll.; Wash. County Mus. A.; Los A. Mus. A.; WMA; Minneapolis Inst. A.; Toledo Mus. A. Exhibited: AWS; All. A. Am.; NAD; Conn. Acad. FA; Balt. WC Cl.; Phila. WC Cl.; WMAA; MMA; PAFA; ASL; Concord AA; Maine WC Soc.; New Britain Inst.; Southern Vermont A.; and many others. Positions: Art Commission, Smithsonian Inst.; Trustee, Shelburne Museum, Vt.; Trustee, Southern Vermont AA.

PLIMPTON, RUSSELL —Museum Director
 Society of the Four Arts; h. 10 Four Arts Plaza, Palm Beach, Fla. 33480
B. Hillis, N.Y., Aug. 26, 1891. Studied: Princeton Univ. Member: Assn. A. Mus. Dirs.; AAMus.; AFA; and others. Contributor to Bulletin of the Minneapolis AI. Lectures: Painting; Decorative Arts, Radio and TV, Minneapolis. Increased collections and arranged many exhibitions at Minneapolis AI. Positions: Asst. Cur., Dept. Dec. A., Metropolitan Museum of Art, N.Y., 7 years; Dir., Minneapolis AI, 35 years; Dir., Society of the Four Arts, Palm Beach, Fla., 1956-1969.

PLUMMER, JOHN H.—Curator, E.
 The Pierpont Morgan Library, 29 E. 36th St., New York, N.Y. 10016; h. 453 N. Western Highway, Blauvelt, N.Y. 10913
B. Rochester, Minn., Dec. 15, 1919. Studied: Carleton College, A.B.; Columbia University, Ph.D. Field of Research: Mediaeval and Modern Art. Author: "The Hours of Catherine of Cleves" (New York, 1966); "The Glazier Collection of Illuminated Manuscripts," (New York, 1968); "Liturgical Manuscripts" (New York, 1964). Positions: Lecturer and Instructor, 1950-55, Visiting Prof., 1961, Adjunct Prof., 1964-, Columbia University; Instructor, 1952-56, Barnard College; Research Associate, 1955-56, Curator of Mediaeval and Renaissance Manuscripts, 1956-1966, Research Fellow for Art,

1966- , The Pierpont Morgan Library, New York, N.Y.; Visiting Lecturer, Harvard University, Cambridge, Mass., 1963.

PNEUMAN, MILDRED YOUNG (Mrs. Fred A.)—Painter, Gr.
1129 11th St., Boulder, Colo. 80302
B. Oskaloosa, Iowa, Sept. 15, 1899. Studied: Univ. Colorado, B.A., B. Ed., M.F.A. Member: Boulder A. Gld.; Multi Media; Boulder AA; F.I.A.L. Work: P.E.O. Mem. Lib., Mt. Pleasant, Iowa; Univ. Colorado; I.B.M. Coll.; and in private colls. Exhibited: Phila. Color Pr. Soc., 1945; Hoosier Salon, 1928-1935; Denver A. Mus., 1967, Univ. Colorado; Central City A. Gal.; Boulder A. Gld. traveling exh., 1954-1958, 1960-61; Brewster Gal., Boulder, 1954 (one-man); Colorado Chautauqua Assn., 1957 (one-man); Am. Color Pr. Soc.; Canon City Blossom Festival; Mus. New Mexico, Santa Fe; South Bend AA; Drake Univ., Univ. Wyoming. Positions: Member, Boulder Library Gallery Art Board, 1964-1969.

POHL, LOUIS G.—Painter, Pr.M., T., W., I.
3507 Nuuanu Pali Drive, Honolulu, Hawaii 96187
B. Cincinnati, Ohio, Sept. 14, 1915. Studied: Cincinnati A. Acad. Member: Hawaii P. & S. Lg.; Honolulu Pr. M. Awards: prizes, Honolulu Acad. A., 1947, 1949, 1956, 1957; Watamull Fnd. purchase awards, 1950, 1952; McInerny Fnd. Grant, 1954-1955; "Printmaker of the Year," 1965. Work: CM; Honolulu Acad. A. Exhibited: Annual exh. American Art, 1938, 1940, 1941; Butler Inst. Am. A., 1939, 1944; Riverside Mus., N.Y.; Art of Cincinnati, 1940-1942; one-man: CM; Contemp. A. Center, 1961; Honolulu Acad. A., and many galleries in Cincinnati and Honolulu; local exhs., 1960-1965. Cartoonist: "School Daze," daily cartoon, Honolulu Advertiser. Positions: Instr., Univ. Hawaii, 1953-56; Honolulu Sch. A.; Instr., Drawing, Painting, Illustration, Honolulu Acad. A., at present.*

POINDEXTER, ELINOR F. (Mrs. E.G.)—Art Dealer, Collector
24 E. 84th St., New York, N.Y. 10028
B. Montreal, Canada, Dec. 9, 1905. Studied: Finch College, New York, Diploma in Art History. Collection: Abstract Expressionist Artists, American Contemporary. Gave and continues to give works owned to the State of Montana, The George and Elinor Poindexter collection. Specialty of Gallery: Mostly Contemporary American Paintings and Sculpture since 1955. Also English. Positions: Director, Poindexter Gallery, New York, N.Y.

POLAN, LINCOLN M. (DR.)—Collector
2 Prospect Drive, Huntington, W.Va. 25701
B. Wheeling, W.Va., Feb. 12, 1909. Studied: New York University; University of Virginia; Ohio State University. Member: MMA (Contributing). Collection: Line and wash drawings by Rodin; Drawings by French impressionists; American paintings, predominantly of the Ash Can school; Renaissance portraits of men; Renaissance prints and engravings; Collections exhibited at Huntington Galleries Art Museum; University of W.Va. Art Museum; Museum of Fine Arts, Houston, Tex.; Phoenix Art Museum, Phoenix, Ariz. Positions: Member, Board of Directors, Huntington Galleries, Huntington, W.Va.

POLAN, NANCY M. (Mrs. Lincoln M.)—Painter
2 Prospect Drive, Huntington, W.Va. 25701
B. Newark, Ohio. Studied: Marshall Univ., A.B. Also with Fletcher Martin, Hilton Leech, Paul Puzinas, Robert Friemark. Member: NAC; All. A. Am. (Assoc.); AFA; Leonardo da Vinci Acad., Rome; All. A. of West Virginia. Awards: Ralph H. and Elizabeth C. Norton Memorial Award, Chautauqua AA, 1960; prizes, NAC, 1964, 1969; Huntington Galleries, 1960 (purchase), 1961; Huntington A. Festival, 1968; All. A. West Virginia, 1960, 1961; Charleston A. Gal., 1964; Merit Award, Religious A. Festival, Marshall Univ., 1965; State Fed. Women's Clubs, 1963, 1964, 1966-1968. Exhibited: Chautauqua (N.Y.) AA, 1960; All. A. Am., 1960; PAFA, 1961; AWS, 1961; 1966; Int. Platform Assn., 1967, 1968; Painters & Sculptors Soc. of New Jersey, 1962; NAC, 1961-1965, 1966-1969; Huntington Galleries, 1960, 1961, 1963-1965; All. A. of W. Virginia, 1960, 1961, 1963-1965; Appalachian Artists, 1964; Charleston Mus., 1963, 1964; traveling exhs.: W.Va. Artists, 1967-1968; All. A. of W.Va., 1966; Regional exhs., 1966-1969; one-man: Huntington Galleries, 1963, 1966; The Greenbrier, 1963; N.Y. World's Fair, 1965; W.Va. Univ., 1966; Charleston A. Gal., 1967; Reese Mem. Mus., 1967. Work reproduced on cover of La Revue Moderne, Paris, France, 1961, 1966.

POLESKIE, STEPHEN F., JR.—Printmaker, P.
306 Stone Quarry Rd., Ithaca, N.Y. 14850
Studied: Wilkes Col., Wilkes-Barre, Pa.; New Sch. for Social Research, N.Y. Awards: Purchase prize, AFA, 1966; Carnegie Fnd., 1968 (poster design award). Work: MMA; MModA; WAC; Brooks Mem. Mus., Memphis; Ft. Worth A. Center; Marion Koogler McNay A. Inst., San Antonio; Tennessee State Mus., Nashville; Everhart Mus. A., Scranton, Pa.; Andrew Dickson White Mus., Cornell Univ.,

and others. Exhibited: PAFA, 1961, 1963, 1969; Wadsworth Atheneum, Hartford, Conn., 1965; Serigraphs, N.Y. State Council on the Arts, 1966; South London Mus., England; Munson-Williams-Proctor Inst., Utica, N.Y., 1968; Assoc. Am. A. Gal., N.Y., 1969. Positions: Visiting Critic, Pratt Center for Contemp. Printmaking, N.Y.; Instr., Graphics, School of Visual Arts; Graphics, Cornell University, Ithaca, N.Y.

POLKES, ALAN H.—Collector, Patron
565 Fifth Ave. 10017; h. 70 E. 77th St., New York, N.Y. 10021
B. New York, N.Y., Feb. 26, 1931. Studied: Brooklyn College; College of the City of New York. Collection: Old Masters and Modern Art. Presented works of art for the first lobby devoted to original art (333 E. 79th St., N.Y.C.). These included: fountain by Milton Hebald; mural, Sason Soffer, Ivan Mosca; tapestry, Jan Yoors; and works by Xanti Schwanski, Sam Goodman and Sironi.*

POLLACK, LOUIS—Art Dealer
Peridot Gallery, 820 Madison Ave. 10021; h. 260 W. 72nd St., New York, N.Y. 10023
B. New York, N.Y., May 21, 1921. Member: Art Dealers Association of America. Specialty of Gallery: Contemporary American Paintings and Sculpture. Presented the first exhibition in America of sculptures by Medardo Rosso. Positions: Founder, Peridot Gallery, 1948; Pres., Collectors Graphics, 1961.

POLLACK, PETER—Art Gallery Director, Mus. Cur., W., L., Photog.
W. & J. Sloane, Inc., Fifth Ave. at 38th St.; h. 6 West 77th St., New York, N.Y. 10024
B. Wing, N.D., Mar. 21, 1911. Studied: Inst. Design, Chicago; Univ. Chicago; AIC. Author: "Picture History of Photography," publ., New York, 1959, Italy, 1960, France, 1961, Germany, 1962; "The New Picture History of Photography," 1969; "Understanding Primitive Art—Sula's Zoo," 1969. Contributor articles and photographs to Art News; Arts; Life; Look; American Artist magazines. Lectures: Van Gogh; Cezanne; Photography, etc. at universities, art clubs and museums. Visiting Lecturer, Pratt Inst., Brooklyn, N.Y. Positions: Cur., Photography, Art Inst., Chicago; Consultant, Editor, Archives of American Art, Detroit, Mich.; Consultant, Guggenheim Museum, N.Y.; Dir., American Federation of Arts, New York, N.Y., 1962-64; Dir., World of Ancient Gold Exhibition, N.Y. World's Fair, 1964; Dir., Art Galleries, W. & J. Sloane, New York, N.Y., 1965- .

POLLACK, REGINALD MURRAY—Painter, S., Gr.
331 W. 19th St., New York, N.Y. 10011
B. Middle Village, L.I., N.Y., July 29, 1924. Studied: Academie de la Grande Chaumiere, Paris. Awards: Prix Neuman, Jewish Mus., Paris, 1952; Prix Othon Friesz, Paris (medal), 1954, 1956, 1957; Prix du Dome, 1955-1957; Prix du Ville d'Auvers, 1956. Work: BM; MModA; Rockefeller Inst., N.Y.; Univ. Nebraska; WMAA; WMA; Hilton Hotel, N.Y.; State of France Coll.; Tel-Aviv Mus.; Haifa Mus.; Jerusalem Mus., Israel; Univ. Glasgow, Scotland; Commissions: Seagram Bldg., N.Y.; Int. Council of the Mus. Modern Art, N.Y.; Container Corporation of America. Exhibited: Salon de Mai, 1949, 1950, Salon d'Automne, 1949, 1950, 1954, Jewish Mus., 1952, Galerie des Arts en France et Dans le Monde, 1956, Salon Comparaisons 1957, 1958, Galerie Synthese, 1959, all in Paris, France; WMAA, 1953, 1955, 1959, 1961, 1963; Stable Gal., N.Y., 1954, 1955; VMFA, 1954; Universities of Colorado, 1956, 1960, Wisconsin, 1956, Nebraska, 1951, 1956, 1957, 1960, 1963, Illinois, 1957, 1963, Iowa, 1960; A. Festival, Avignon, France, 1957; "American Painters in Europe," Univ. Wisconsin, 1958; "10 American Artists in Rome," Palazzo Venezia, Rome, 1959; AIC, 1960; Carnegie Inst., 1961; Galerie Charpentier, Paris, 1961; Print Council of Am., 1962 (circulating); PAFA, 1962; MModA, 1962 (circulating); Friends of the Whitney Mus. Assn., 1962; Landau Gal., Los Angeles, 1962; Am. Acad. A. & Lets., 1962; CGA, 1963; Providence A. Cl., 1963; New School, N.Y., 1964. One-man: Peridot Gal., N.Y., 1949, 1952, 1955-1960, 1962-1965; Peter Deitsch Gal., N.Y., 1958; Dwan Gal., Los Angeles, 1960; Gump's Gal., San F., 1963; Jefferson Gal., La Jolla, Cal., 1963; Yale-Norfolk Summer Sch., 1963; Goldwach Gal., Chicago, 1964, 1965; Landau Gal., Los A., 1964.*

POLLARO, PAUL—Painter, E., L.
7005 Shore Road, Brooklyn, N.Y. 11209
B. New York, N.Y., Aug. 2, 1921. Studied: ASL. Member: Artists Fellowship. Awards: Fellowship, MacDowell Colony, 1964, 1968, 1969; prize, Jersey City Mus., 1962; Springfield (Mo.) Mus. A., 1966; Tiffany Fnd, grant, 1967. Exhibited: All.A.Am., 1959; Saratoga, N.Y., 1960; Audubon A., 1961; Jersey City Mus., 1962; Silvermine Gld. A., 1962, 1963; AWS, 1963 (traveling); Conn. Acad. FA, 1963; Mus. New Mexico, Santa Fe, 1963; Frye Mus., Seattle, 1963; Brooks Mem. Mus., Memphis, 1963; Davenport Mun. A. Gal., 1963; Abilene FA Mus., 1963; Columbia (S.C.) Mus. A., 1963; Washington County Mus., Hagerstown, Md., 1964; Mulvane A. Center, Topeka, 1964;

Baldwin-Wallace Col., 1964; Butler Inst. Am. A., 1964, 1965; PAFA, 1964; San F. AI, 1965; Springfield (Mo.) A. Mus., 1966; Am. Acad. A. & Lets., 1966; Brooklyn Col., 1966; Finch Col., 1967; AFA traveling exh., 1967-1968; PC, 1968; MModA (lending), 1968; CGA, 1968; Nat. Inst. A. & Lets., 1969; one-man: Manhattanville Col., N.Y., 1967; Babcock Gal., N.Y., 1967; New Sch. for Social Research, 1969. Positions: Instr., Painting, Univ. Notre Dame, 1965, 1967; New School for Social Research, N.Y., 1964-1969; Wagner Col., 1966-1969.

POLLOCK, MERLIN F.—Painter, E.
School of Art, Syracuse University, Syracuse, N.Y. 13210; h. 120 Wellwood Drive, Fayetteville, N.Y. 13006
B. Manitowoc, Wis., Jan. 3, 1905. Studied: Art Inst. Chicago, B.F.A., M.F.A.; Ecole des Beaux-Arts, Fontainebleau, France. Awards: American traveling scholarship, 1929 and James Nelson Raymond Fellowship, 1930, both AIC; prizes, Everson Mus., Syracus, 1956, 1960, 1964; Rochester Mem. Mus., 1956, 1958, 1960; N.Y. State Fair, Syracuse, 1957, 1958; Roberson Mem. Center, Binghamton, N.Y., 1961; Cooperstown AA, 1962. Work: Syracuse Univ.; Everson Mus.; Munson-Williams-Proctor Inst., Utica; N.Y. State Univ., College of Forestry, and in private colls. Exhibited: AIC; A. Mus. of New Britain, Conn.; Cazenovia Col.; Colgate Univ.; Cooperstown AA; Wesleyan Univ., Lincoln, Neb.; Everson Mus., Syracuse; Flint Mich. Inst. of A.; Hamilton Col.; Kresge A. Center, Mich. State Univ.; Lowe A. Center, Syracuse; Moore Inst., Phila.; Munson-Williams-Proctor Inst.; Mus. FA, Springfield, Mass.; Roberson Mem. A. Gal.; Rochester Mem. A. Gal.; Utah State Univ.; Skidmore Col., N.Y.; State Mem. Mus., Norwich, Conn.; State Univs. of N.Y. at Cortland and Albany; Syracuse Univ.; Univ. of Mass.; WAC. One-man: Cazenovia Col., N.Y.; Michigan State Univ.; Everson Mus., Syracuse. Positions: Prof. A., Chm. Grad. Program, School of Art, Syracuse University, Syracuse, N.Y., 1946- .

POLONSKY, ARTHUR—Painter, E., I.
364 Cabot St., Newtonville, Mass. 02160
B. Lynn, Mass., June 6, 1925. Studied: BMFA Sch. with Karl Zerbe.; Hebrew T. Col., Boston. Member: AEA. Awards: European traveling scholarship, BMFA Sch., 1948-50; Tiffany Fnd. award, 1951; prizes, Boston A. Festival, 1954; Silvermine Gld. A., 1954. Work: FMA; SFMA; AGAA; Brandeis Univ.; Stedelijk Mus., Amsterdam; Boston Pub. Library. Portraits in private colls. Exhibited: Univ. Illinois, 1951; MMA, 1950; Carnegie Inst., 1950; Inst. Contemp. A., Boston; and in Paris and Amsterdam as well as other museums in the U.S. One-man: Boris Mirski Gal., Boston, 1951, 1956, 1964, 1966, Brandeis Univ., 1959; Durlacher Bros., N.Y., 1965; Mickelson Gal., Wash., D.C., 1966; Clark Univ., Worcester, 1967; Boston Pub. Library, 1969. Illus.: "Lincoln, a Big Man" and "The Sling and the Swallow." Positions: Instr., Painting, Boston Mus. Sch. A., 1950-1960; Asst. Prof. FA, Brandeis Univ., Waltham, Mass., 1955-1965. Assoc. Prof. A., Boston Univ., at present.

POMERANCE, LEON—Collector, W., Patron
7 Amherst Rd., Great Neck, N.Y. 11021
B. New York, N.Y., Aug. 2, 1907. Studied: New York University, B.S.; New York University Law School, LL.B., LL.M. Collection: Ancient pre-Greek, Greek and Near Eastern art. Positions: Trustee, Archaeological Institute of America, 1965- ; Pres., N.Y. Soc., Archaeological Inst. of Am., 1968-1970; Co-sponsor of the excavations at Kato Zakro, Crete, Greece.

PONCE DE LEON, MICHAEL—Printmaker, T.
30 East 14th St., New York, N.Y. 10003
B. Miami, Fla., July 4, 1922. Studied: NAD; PAFA; Univ. Mexico City, B.A.; ASL. BM Sch. A. Member: AAUP. Awards: prizes, Bradley Univ., 1954 (purchase); DMFA, 1954 (purchase); gold medal, SAGA, 1954; Tiffany F., 1953, 1955; Phila. Pr. Cl., 1958; Univ. Nebraska; Oakland A. Mus.; Fulbright F., 1956-57; Medal of Honor, Audubon A., 1964; Eyre Medal, PAFA, 1965; NAD, 1963; Guggenheim Fellowship; purchase prizes: Potsdam Univ., 1958, 1965; Wash. Pr. M., 1964; SAGA, 1963; Cal. Soc. Etchers, 1964; Univ. Kansas and many others. Work: DMFA; BM; Bradley Univ.; MModA; CM; Sarasota AA; Palacio de Bellas Artes, Mexico; Stockholm Mus. A.; Nat. Mus., Oslo, PMA; LC; N.Y. Pub. Lib.; PAFA; NGA; WAC; Victoria & Albert Mus.; Univ. Nebraska; Indiana Univ.; Bonn, Germany; N.Y. Univ.; MMA; Auckland, N.Z. Mus.; Norfolk Mus. A.; United Nations Coll.; Columbus (S.C.) Mus.; Smithsonian Inst.; Univ. Eastern Mich.; Univ. Illinois; Univ. Kansas; in American Embassies in Prague, Belgrade, Berlin, Moscow, New Delhi. Exhibited: MMA; MModA; BM; LC; WMAA; NGA; Mus. Mod. A., Madrid; Tate Gal., London; PAFA; DMFA; BMFA; CM; SAM; Univ. So. California; Portland A. Mus.; Phila. Pr. Cl.; SAGA; New York City Center; Contemporary Gal.; Audubon A.; Mexico City, 1958; Grenchen, Switzerland, 1958; Bradley Univ.; Denver A. Mus.; AIC; Oslo, Norway; Stockholm; Yugoslavia Biennial; Japan; So. America; New Zealand; Middle East; Am. Pr. Council traveling exh., 1959; State Dept. Exh., Salzburg; NAD; BMFA; Univ. Illinois; Bodley Gal., 1958, and many others; one-man:

Mexico City; Oslo, Norway; Milwaukee, Wis.; New York City; Long Island, N.Y.; Oakland, Cal.; CGA; Univ. Nebraska; BM, and many others, U.S. and abroad. Commissioned by U.S. Postal Dept. to design U.S. stamp "Honoring the Fine Arts," 1964; Invited by USIA to go to Yugoslavia in a Cultural Exchange, 1965. Positions: Instr., Vassar College, 1953; Cooper Union and Pratt Graphic A. Center, N.Y.; Hunter College, N.Y., at present.

POOLE, EARL L(INCOLN)—
Former Museum Director, I., Gr., S., P., E.
509 Sunset Rd., West Reading, Pa.
B. Haddonfield, N.J., Oct. 30, 1891. Studied: PMSchIA; PAFA; Univ. Pennsylvania. Member: Reading T. Assn.; Berks A. All. (Vice-Pres., 1958-61); Pa. State Edu. Assn.; Nat. Edu. Assn.; AAMus. Awards: F., PAFA; Hon. degree, Sc. D., Franklin and Marshall Col., 1948. Work: Univ. Michigan; s. Reading Mus. Park, Reading, Pa.; State Capitol, Harrisburg, Pa.; Muhlenberg College. Exhibited: PAFA; Univ. Michigan; Lib. Cong.; Los A. Mus. A.; Harrisburg (Pa.) AA; CAM; Am. Mus. Natural Hist. I., "Birds of Virginia," 1913. "Mammals of Eastern North America," 1943; & 45 other books. Lectures: Symbolism in Art. Positions: Dir. A. Edu., Reading Sch. District, 1916-39; Asst. Dir., 1926-39, Dir., 1939-57, Reading (Pa.) Pub. Mus.

POONS, LAWRENCE (LARRY)—Painter
120 Pearl St., New York, N.Y. 10005
B. Tokyo, Japan, Oct. 1, 1937. Studied: BMFA Sch. Work: MModA; Albright-Knox A. Gal.; Stedelijk Mus., Holland; Woodward Fnd., Wash., D.C. Exhibited: Green Gal., N.Y., 1963; Pollock Gal., 1968; Leo Castelli Gal., 1968; Kasmin Gal., London, 1968; Allen A. Mus., Oberlin Col. Positions: Visiting Faculty, N.Y. Studio Sch., 1967.*

POOR, HENRY VARNUM—Painter, C., S., E., W.
c/o Frank K. M. Rehn Gallery, 36 East 61st St., New York, N.Y. 10022; h. South Mountain Rd., New City, N.Y. 10956
B. Chapman, Kan., Sept. 30, 1888. Studied: Stanford Univ., A.B.; Slade Sch., London; Julian Acad., Paris; & with Walter Sickert. Work: MMA; WMAA; PMG; Nat. Inst. A. & Let.; SFMA; CMA; AGAA; BM; Newark Mus.; PMA; Kansas City AI; Los A. Mus. A.; Dallas Mus. FA; WMA; frescoes, Dept. Justice, Interior Bldg., Wash., D.C.; Pa. State Univ.; ceramic mural, Mt. Sinai Hospital; ceramic mural, exterior H.S., Flushing, N.Y.; Traveler's Ins. Bldg., Boston; Deerfield Acad., Mass. Exhibited: nationally; one-man: Rehn Gal., N.Y., 1961, 1964, 1967, 1969. Author, I., "Artist Sees Alaska," 1945; "A Book of Pottery," 1958; I., Jack London's "Call of the Wild" (Limited Editions Cl.). Positions: Chm., Bd. of Governors, Skowhegan Sch. P. & S., Skowhegan, Me.

POPE, ANNEMARIE H. (Mrs. John A.)—
Consultant, Traveling Exhibitions
2425 California St., Northwest, Washington, D.C. 20008
B. Dortmund, Germany. Studied: Univ. Munich; Univ. Heidelberg, Ph.D.; Sorbonne, Paris, France; Radcliffe Col. Member: ICOM; AAMus.; CAA; Archaeological Inst. Am.; Nat. Trust for Hist. Preservation; Asia Soc.; Japan Soc.; Museum of Modern Art, N.Y.; Musée National d'Art Moderne, Paris; Master Drawings Association, N.Y. Arranged exhibition: "Master Drawings," GGE, 1939. Awards: Order of Merit, Fed. Republic of Germany, 1956; Royal Swedish Order of the Polar Star, 1957; St. Olaf Medal, Norway, 1959; Order of Dannebrog, Denmark, 1961; Order of Merit, Italy, 1963; Commander, Order of Merit, Germany, 1965. Positions: Asst. Dir., Portland (Ore.) A. Mus., 1942-43; Asst. Dir. in charge of Traveling Exhs., AFA, 1947-51; Chief, Traveling Exh. Service, Smithsonian Inst., Washington, D.C., 1951-1964; Pres., International Exhibitions Foundation, Wash., D.C., 1616 H Street, N.W., Washington, D.C. 20006, 1965- .

POPE, JOHN ALEXANDER—Museum Director
Freer Gallery of Art, Washington, D.C. 20560
B. Detroit, Mich., Aug. 4, 1906. Studied: Yale Col., A.B.; Harvard Univ., A.M., Ph.D.; Courtauld Inst., Univ. London. Member: Am. Oriental Soc.; Oriental Ceramic Soc., London; Assn. for Asian Studies; The Asia Soc.; The Japan Soc. Compiler: A Descriptive and Illustrative Catalogue of Chinese Bronzes, 1946. Author: Fourteenth Century Blue and White: A group of Chinese porcelains in the Topkapu Sarayi Müzesi, Istanbul, Freer Gal. A. Occasional Papers, vol. 2, no. 1, 1952; Chinese Porcelains from the Ardebil Shrine, xvi, 171 pp. 144 plates, Freer Gal. A., 1956. Senior Co-author of the "Freer Chinese Bronzes," Vol. 1, xx, 638 pp., 116 plates (Freer Gallery of Art Oriental Studies No. 7), 1967; Co-chairman of the Manila Trade Pottery Seminar, Manila, 1968, relating to the 40-50 thousand pieces of Chinese pottery excavated in the Philippines in the last half century or so. Lectures in the U.S., Europe, and the Far East, 1966-1969. Contributor to Harvard Journal of Asiatic Studies; Archives of the Chinese Art Society of America; Oriental Art (Oxford); Transactions of the Oriental Ceramic Society. Posi-

tions; L., Chinese A., Columbia Univ., 1941-43; Assoc. in Research, 1943-46, Asst. Dir., 1946-1962, Director, 1962- , Freer Gal. A., Washington, D.C.

PORTANOVA, JOSEPH DOMENICO—
Portrait Sculptor, Indst. Des.
Packard Bell Co., 12333 W. Olympic Blvd., Los Angeles, Cal., 90064; (studio) 13741 Romany Dr., Pacific Palisades, Cal. 90272
B. Boston, Mass., May 16, 1909. Studied: Boston Trade School and privately with Cyrus E. Dallin (sculpture). Member; F., Am. Inst. FA; Cal. A. Cl.; Pasadena Soc. A.; Laguna Beach AA; Indst. Des. Soc. of America; Cal. Furniture Des. Assn. Awards: Gold Medal, Cal. State Fair, Sacramento, 1963; prizes, Nat. Orange Show, San Bernardino, 1965; Cal. A. Cl., 1962, 1965; All-City A. Festival, Los Angeles, 1962; Laguna Beach A. Festival, 1954, 1955; Laguna Beach AA, 1960, 1962; Painters & Sculptors Cl., Los A., 1954, 1958, 1961; Artists of the Southwest, 1959 (2). Work: Portrait Sculpture: Twentieth Century Club, City Club, Trade School, Conservatory of Music, all in Boston, Mass.; Smithsonian Inst.; Cal. Inst. Technology; Orthopedic Hospital, Los A.; Harvey Aluminum Co., Torrence, Cal.; Los Angeles Memorial Coliseum; Dade County Auditorium, Miami, Fla., and in many private collections. Exhibited: NAD, 1964; NSS, 1961; Cal. State Fair, 1961, 1963; Pomona Fair, 1961; Tri Club Exhs., 1954-1965; Laguna Beach AA, 1960-1962; Los A. County Mus., 1958; Nat. Orange Show, 1964, 1965, and many others. Consultant: Indst. & Furniture Des., 1927- .

PORTER, (EDWIN) DAVID—Painter, Lith., W., L., S.
Wainscott, N.Y. 11975
B. Chicago, Ill., May 18, 1912. Awards: prizes, Provincetown A. Festival, 1958; Guild Hall, East Hampton, N.Y., 1964; Gold Medal of Pres. Gronchi of Italy, Sassoferrato, Italy, 1961; Beaux Arts award, painting, 1969. Work: WMAA; Miami Mus. Mod. A.; Chrysler A. Mus., Provincetown; Guild Hall, East Hampton, N.Y.; Parrish A. Mus., Dartmouth Col.; Norfolk Mus. A. & Sciences; one of five artists who designed mural for American Airlines Terminal, N.Y., 1959; decorated chapel of 16th century church, Sassoferrato, Italy, 1961; other work, Hempstead, N.Y., Bank; Brown Univ.; N.Y. Univ. Exhibited: one-man, Hugo Gal., N.Y., 1952; Deerfield (Mass.) Acad., 1953; Galerie Herve, N.Y., 1955; New Gal., N.Y., 1957; Obelisk Gal., Wash., D.C., 1958; Tirka Karlis Gal., Provincetown, 1959; Galleria L'Incontro, Rome, 1960; Mod. A. Gal., Palermo, 1960; Ann Ross Gal., White Plains, N.Y., 1961, 1962; Southampton A. Gal., 1962; Auslander Gal., N.Y., 1962; Ferrill Gal., Santa Fe, 1963; Royal Athena II, N.Y., 1964; Mickelson Gal., Wash., D.C., 1964, 1968; Dartmouth Col., 1965; Parrish A. Mus., Southampton, 1965; N.Y. Pub. Lib., 1966; AIA, N.Y., 1969. Group Exhs.: Contemporary A. Gal., N.Y., 1950; Parrish A. Mus., 1951, 1962, 1964; Guild Hall, East Hampton, 1951, 1953-1956, 1964 (3); WMAA, 1951; AIC, 1952; Univ. Illinois, 1952, 1953; MModA, 1953, 1959; Hampton Gal., Amagansett, N.Y., 1953, 1954, 1956, 1958; Voss Gal., Southampton, 1957; Provincetown A. Festival, 1958; Carnegie Inst., 1958; Dayton AI, 1959; Int. Exh., Sassoferrato, Italy, 1960, 1961; CGA, 1962; Milan, Italy, 1962; Keane Gal., Southampton, 1963; Mickelson Gal., Wash., D.C., 1963; Castellane Gal., Provincetown, 1963; Long Island Univ., 1964; Parrish A. Mus., 1964; De Cordova Mus., Lincoln, Mass., 1965; Rigelhaupt Gal., Boston, 1965. Lectures: Corcoran Gal. Art Sch., Wash., D.C., 1968, 1969. Positions: A.-in-Res., Dartmouth College, Hanover, N.H., (Fall) 1964-(Spring) 1965; Cooper Union, N.Y., 1967-1968.

PORTER, DORIS (Mrs. Donald J. McLean)—Painter, L., T., S.
7710 Shirland Ave., Norfolk, Va. 23505
B. Portsmouth, Va. Studied: PAFA; Wayne Univ., M.A.; Univ. Michigan, M.A. Member: Tidewater Artists; Detroit Soc. Women Painters (Life); Portrait Assn., Detroit; Grosse Pointe A.; Ann Arbor AA; Mich. WC Soc.; Ann Arbor Women Painters (Hon. Life) (Pres.); Palette and Brush Cl., Detroit. Awards: prizes, Grosse Pointe A., 1950; Detroit Soc. Women Painters, 1947, 1949. Work: Toledo Mus. A.; PAFA; Univ. Michigan; Cranbrook Acad. A.; St. Mary's Hall, Burlington, N.J.; Ford Sch., Highland Park, Mich.; Eastern Mich. Univ., Ypsilanti; Dearborn Hist. Soc. Exhibited: CGA, 1939; NAD, 1934; PAFA, 1934; 1943, 1946, 1948, 1953, 1955, 1956; Terry AI, 1952; VMFA, 1952; Flint Mus. A., 1950 (one-man); Mich. WC Soc., 1952; Scarab Cl., 1950; Univ. Michigan; Ann Arbor Women Painters, 1962-64; Ann Arbor A., 1962-64; Detroit Soc. Women P. & S., 1962-1964; Michigan Acad. A. & Sc.; Grosse Pointe A., annually; Palette & Brush Cl., 1951, 1952; Int. Platform Assn.; Southern Art Col. Conference. Positions: A. Instr., Michigan State Normal Col., 1939-41; Univ. Michigan, Ann Arbor, Mich., 1945; Art Inst., Wayne, Mich. Chm. A. Section, Mich. Acad. A., Sciences & Letters, 1962-63; Frederick College, 1966-1968; Head, A. Dept., Frederick Comm. Col., Portsmouth, Va., 1968 to present.

PORTER, ELMER JOHNSON—Educator, P.
Art Department, Indiana State University 47809; h. Clifton House, 3115 Margaret Ave., Terre Haute, Indiana 47802
B. Richmond, Ind., May 5, 1907. Studied: AIC, B.A.E.; Ohio State Univ., M.A.; Earlham Col.; Univ. Cincinnati; Univ. Colorado; Butler Univ., and in Guatemala. Member: Western AA; Am. Soc. Bookplate Collectors & Des.; Com. A. Edu.; Nat A. Edu. Assn.; CAA; Pen & Brush Cl.; Indiana A. Edu. Assn. (Sec-Treas., Pres., 1952-53); AAUP; Intl. Soc. for Edu. Through Art. Awards: prizes, Indianapolis AA, 1929; Hoosier Salon, 1939. Work: Richmond (Ind.) H.S. Coll.; Earlham Col.; Indiana State Univ. Exhibited: Hoosier Salon; Columbia A. Lg.; Richmond, Ind.; Cincinnati, Ohio; Chicago, Ill.; New York, N.Y. Position: Chm. A. Dept., Dir. College A. Gal., Indiana State University, Terre Haute, Ind.

PORTER, FAIRFIELD—Painter, E., Cr., W., L.
49 S. Main St., Southampton, N.Y. 11968
B. Winnetka, Ill., June 10, 1907. Studied: Harvard Col., B.S.; ASL. Member: Int. Assn. of Art Critics. Awards: Longview Fnd. Award for criticism in The Nation, June, 1959. Work: MModA; Wadsworth Atheneum; Univ. Nebraska; Purdue Univ.; Univ. New Mexico; Parrish A. Mus., Southampton, N.Y.; WMAA; CMA; Univ. No. Carolina. Numerous portrait commissions. Exhibited: WMAA, 1959, 1961, 1963, 1965, 1967, 1968; Parrish A. Mus., 1963; Univ. So. Illinois, 1964; Univ. of Alabama, 1964; CMA, 1967; Colby Col., 1969. Author: "Thomas Eakins," 1959. Contributor to Art News; The Nation; Art in America; Art & Literature; Evergreen Review. Lectures: Aesthetics; What Is Art; Can Art Be Taught—given at many universities and colleges. Positions: Adjunct Prof. A., Southampton College of Long Island University, N.Y.; Teaching Queens College, N.Y., 1969; Prof., A.-in-Res., Amherst Col., 1969-70.

PORTER, DR. JAMES A.—Educator
Head, Fine Arts Dept., Howard University, 2401 6th St., N.W., Washington, D.C. 20001*

PORTER, PRISCILLA MANNING—Craftsman, T., W., L.
Plumb Hill Rd., Washington, Conn. 06793
B. Baltimore, Md., Feb. 1, 1917. Studied: Bennington Col., B.A.; Greenwich House Pottery, N.Y.; Alfred Univ., (summer). Member: Artist-Craftsmen of N.Y.; Soc. Conn. Craftsmen (Bd. Dirs.). Awards: award of merit, Artists-Craftsmen of N.Y., 1968. Work: Intl. Pottery Mus., Faenza, Italy; mosaic triptychs, Emmanuel Church, Balt., Md.; First Unitarian Church, Balt., Md.; fused glass, Corning Mus., Corning, N.Y.; fused stained glass panel, New Britain (Conn.) Mus. Am. Art.; Cross, St. John's Episcopal Church Parish House, Washington, Conn. Exhibited: Syracuse Mus. FA, 1953; N.Y. Soc. Ceramic A., 1947-1955; N.Y. Soc. Craftsman, 1954, 1955; Corning Mus. Glass, 1959; 6th Bienniel Nat. Religious A. Show, Cranbrook, Michigan, 1969. Contributor articles on ceramics to Ceramics Monthly; American Girl (Girl Scout official magazine). Lectures: Ceramics and fused glass technique. Originated classes in fused glass technique, People's Art Center, Mus. Mod. A., New York City. Instr. fused glass technique, Worcester (Mass.) Craft Center, 1963-65; Brookfield (Conn.) Craft Center, 1965 (summer).

PORTMANN, FRIEDA (BERTHA) (ANNE)—
Educator, P., S., Gr., W., C.
1330 Boren Ave., Seattle, Wash. 98101
B. Tacoma, Wash. Studied: Univ. Washington; Oregon State Col., B.S.; AIC; Univ. Chicago; Cal. Sch. FA; Univ. So. California. Member: Northwest Pr. M.; Boston Pr. M.; Wash. (D.C.) Pr. M.; San F. AA; AEA; Awards: prizes, Women Painters of Wash., 1940, 1943, 1946; Puyallup (Wash.) Fair, 1946, 1952. Work: Cal. Col. A. & Crafts; St. Joseph's Sch., Seattle. Exhibited: Northwest Pr. M., 1936-1954; NAWA, 1936-1939; SAM, 1937-1954; Puyallup Fair, 1946-1954; BM; Wichita AA; Portland (Me.) Mus. A.; Albright A. Gal.; Albany Inst. Hist. & A.; BMFA; Phila. Pr. Cl.; Arch. Inst., Wash., D.C.; Oakland A. Gal.; Bradley Univ.; Henry A. Gal., Seattle; Syracuse Mus. FA; Denver A. Mus.; Arizona State Fair. Contributor to: Seattle Post-Intelligencer; Seattle Times. Positions: Hd. A. Dept., C.W. Sharples Jr. H.S, Seattle, Wash.

POSES, MR. and MRS. JACK I.—Collectors
400 Madison Ave., 10017; h. 1107 Fifth Ave., New York, N.Y. 10028
(Mr. Poses): B. Russia, 1899. Studied: The School of Commerce, B:A., Graduate School, M.A. Awards: Chevalier of the Legion of Honor, 1958; Citation from Mayor Lindsay, City of New York, for "Distinguished and Exceptional Service to the City of New York," 1967; Honorary Doctorate by Brandeis University, 1968; Honorary Member for 1969, by Beta Gamma Sigma. Collection: French and American. Activities and Positions: Vice-Chairman, New York City Board of Higher Education, 1963- ; Member, Board of Trustees, Brandeis University and a member of its Education and Bud-

get Committees. Founder of the Poses Institute of Fine Arts at Brandeis and Chairman of its Council of Fine Arts; Founder of the Einstein Medical School, and has established numerous scholarships at many leading universities, as well as devoting active support to major art museums.

POSEY, LESLIE THOMAS—Sculptor, T., C., L.
 401 North Tuttle Ave., Sarasota, Fla. 33580
B. Harshaw, Wis., Jan. 20, 1900. Studied: Wis. Sch. F. & App. A.; PAFA; AIC. Member: Indianapolis Arch. Assn.; Bradenton A. Center; Wisconsin P. & S.; Fla. Sculptors & Ceramists. Awards: med., prize, Milwaukee AI, 1923; prizes, Hoosier Salon, 1930; Fla. Fed. A., 1945; Creative Arts, 1957, 1960; Manatee A. Lg., 1960; Ringling Mus. A., 1961; Fla. Religious Exh., 1961; Sarasota AA, 1967, 1968; Longboat Key A. Center, 1968, 1969; med. Indiana Arch. Assn., 1928. Work: mem. arch. des., monuments, Walker A. Center; Brightwood Park, Indianapolis; Wildwood Park, Wis.; Oneco, Fla.; Univ. Georgia, Athens, Ga. Exhibited: Nationally and internationally. Lectures: Sculpture—Old and New; Sculpture & Architecture. Positions: Dir., Instr., Posey Sch. Sculpture, Sarasota, Fla., Hd. Sculpture Dept., Longboat Key A. Center; Pres., Fla. Sculptors & Ceramists.

POSNER, DONALD—Scholar
 Institute of Fine Arts, New York University, 1 E. 78th St., 10021; h. 37 Washington Square West, New York, N.Y. 10011
B. New York, N.Y., Aug. 30, 1931. Studied: Queens College, A.B.; Harvard University, A.M.; New York University, Ph.D. Awards: Fellowship, American Academy in Rome, 1959-1960; American Council of Learned Societies Grant, 1965; Art Historian in Residence, American Academy in Rome, 1968-1969. Specialties: European Art 16th, 17th, 18th centuries. Positions: Instructor, Columbia University, 1961-1962; Assistant, Associate, Full Professor, Institute of Fine Arts, New York University, 1962- ; Editor-in-Chief, The Art Bulletin, 1968-1971.

POST, GEORGE (BOOTH)—Painter, E.
 327 Cumberland St., San Francisco, Cal. 94114
B. Oakland, Cal., Sept. 29, 1906. Studied: Cal. Sch. FA. Member: AWS; San F. AA; Cal. WC Soc.; Int. Inst. A. & Lets.; West Coast WC Soc. Awards: prizes, Cal. WC Soc., 1953; San F. A. Comm., 1954; Mother Lode Exh., 1955, 1958, 1960; Lodi Festival, 1959; Oakland A. Gal., 1936, 1947; Cal. WC Soc., 1947; Los A. Mus. A., 1945; SFMA, 1936; Jack London Sq. A. Festival, 1957; Richmond A. Center, 1958. Work: SFMA; SAM; Cal. PLH; San Diego FA Soc.; MMA; VMFA; Wharton Sch., Univ. Pennsylvania; Mills Col.; Univ. Oklahoma; Santa Barbara Mus. A.; Univ. California; Grinnell (Iowa) Col.; Univ. So. Utah; Odessa Col., Texas; Bowdoin Col. A. Mus.; Texas Tech. Exhibited: MMA; SFMA; deYoung Mem. Mus.; SAM; San Diego FA Gal.; Oakland A. Gal.; Riverside Mus., N.Y.; PMG; Santa Barbara Mus. A.; Gump's Gal., San F.; WMA; CMA; AIC; Cal. PLH; Mills Col.; Henry Gal., Seattle; San Diego FA Center; Denver A. Mus.; Colorado Springs FA, and others. Contributor illus., to Fortune, California Arts & Architecture, Art Digest; American Artist, Ford Times, magazines. Positions: Instr., Stanford Univ., 1940; San Jose Col., 1951-52; Prof., Painting, Cal. Col. A. & Crafts, Oakland, Cal., 1947- .

POTAMKIN, MEYER P.—Collector
 2608 Cottman Ave. 19149; h. 1808 Delancey Place, Philadelphia, Pa. 19103
B. Philadelphia, Pa., Nov. 11, 1909. Studied: Dickinson College, Ph.B.; Temple University, M.E. Collection: American paintings, 1860- ; International sculpture from Rodin to Henry Moore. Positions: Board of Trustees, Philadelphia Museum of Art.

POTTER, G. KENNETH—Painter, T., L., Gr., S.
 105 Sonora Way, Corte Madera, Cal. 94925
B. California, Feb. 26, 1926. Studied: San Francisco Acad. A.; Academie Frochot, Paris, France, with Jean Metzinger; and in Florence, Italy. Member: A. Dirs. & Artists Cl., San F.; AEA; East Bay AA (Vice-pres., 1968-1969); West Coast WC Soc. (Pres., 1968-1970). Awards: prizes, Sonora National, 1957, 1958, 1960, 1962; Marin Soc. A., 1948, 1958, 1961; Marin Art & Garden Show, 1962, 1965, Art Commission, San F., 1958 (purchase); Richmond Mus. A., 1958; Jack London Exh., 1958; Macy's Discovery Show, 1958; Santa Cruz Annual, 1958; Cal. State Fair, 1958; Northern Calif. A., 1968. Work: Olympic Cl., San F.; murals, Macy's, Sacramento and San Mateo, 1963-64; Univ. San Francisco; Corte Madera Town Hall, Calif.; Federal Housing & Urban Development, Regional Office, San Francisco. Exhibited: AWS, 1961 and traveling; de Young Mem. Mus., 1956-1964; Mother Lode Annual, 1957, 1958, 1960-68; Cal. State Fair, 1957-1968; Jack London Exh., Oakland, 1957-1965, 1967, 1968; Richmond Mus., 1957-58; Phelan Awards, 1949, 1958; SFMA (rental), 1957-65; Springville, Utah, 1963; Academic A., Springfield, Mass., 1962; No. Cal. Arts, 1961, 1968; Diablo Pageant of Arts,

1958-1961; Kingsley Annual, Sacramento, 1948, 1962; Marin Soc. A., 1948, 1949, 1958, 1961, 1967, 1968; Marin A. & Garden Show, 1962, 1963, 1965, 1967; Macy's, 1958; Statewide WC Exh., 1958; Oakland Mus. A., 1958-62, 1965; West Coast WC Soc., 1963-1968; Univ. Santa Clara, 1964; Crocker A. Gal., Sacramento, 1965; East Bay AA, 1963-1969; Exchange Exh., Fukuoka, Japan, 1964; Kaiser Center, Oakland, 1965; Univ. Washington, 1964; Cerritos Col., Norwalk, Cal., 1965, and others; one-man: Maxwell Galleries, San F., 1959, 1962; Villa Montalvo, Saratoga, Cal., 1963, 1968; Berkeley Pub. Lib., 1965; Gal. III, Corte Modera, Calif., 1969. Contributor to: Christian Science Monitor; O'Cruzeiro, Manchette. Lectures: Watercolor Technique, Mural painting.

POUCHER, ELIZABETH MORRIS—Sculptor, Gr.
 8 Beech Tree Lane, Bronxville, N.Y. 10708
B. Yonkers, N.Y. Studied: Vassar Col., A.B.; FA Grd. Study, N.Y. Univ., Columbia Univ.; ASL, and with Alexander Archipenko. In Paris, France: La Grande Chaumiere, Ecole Animalier, and with Andre L'Hote. Member: All. A. Am.; Pen & Brush Cl.; Hudson Valley AA; NSS. Awards: Gold medal, Hudson Valley AA, 1958; Medal of Honor, Pen & Brush Cl., 1954; prizes, Bronxville A. Project, 1953, 1957, 1959; Westchester Fed. Women's Cl., 1955, 1956; Mamaroneck, N.Y., 1960; Anna H. Huntington award, Pen & Brush Cl., 1961. Work: Taylor A. Gal., Vassar Col.; NCFA, and in private colls. Illus. two genealogical books, with heraldic designs, 1967. Exhibited: All. A. Am., 1953, 1955, 1956, 1958, 1960, 1962, 1963, 1964, 1966, 1967; Bronxville A. Project, 1953-1959, 1962-1964, 1966, 1967; Hudson Valley AA, 1954-1958, 1960-1964, 1966-1969; NSS, 1968, 1969; NAD, 1956, 1960; Pen & Brush Cl., 1953-1964, 1966-1968, one-man, 1965; Bronxville Pub. Lib., 1959 (one-man); Larchmont, N.Y., 1956; Mamaroneck, N.Y., 1960; NSS, 1961; Westchester County Fed. Women's Cl., 1955, 1956, 1961. Positions: Chm., Sculpture section, Pen & Brush Cl., 1967-1969.

POUSETTE-DART, RICHARD—Painter, T.
 286 Haverstraw Road, Suffern, N.Y. 10901
B. St. Paul, Minn., June 8, 1916. Studied: Bard College. Awards: Guggenheim Fnd. Fellowship, 1951; Ford Fnd. Grant, 1959; Corcoran Gal. Silver Award, 1965; AIC, 1960, 1964; Hon., D.L.H., Bard College, 1965; Nat. Arts Comm. award, 1967. Work: MMoA; WMAA; AGAA; Albright-Knox A. Gal.; Equitable Life Assurance Corp.; Chase Manhattan Bank; Union Carbide, N.Y.; Upjohn Bldg., Michigan; Johnson Wax Coll.; Singer Corp., N.Y. Exhibited: MMoA, 1944, 1949, 1955, 1961, 1969 and traveling, 1969; VMFA, 1946, 1954, 1958; AIC, 1947, 1949, 1954, 1956, 1960, 1961; Detroit Inst. A., 1947, 1954, 1958; PAFA, 1947, 1948; Minneapolis Inst. A., 1947, 1957; WMAA, 1950, 1951, 1953, 1955-1959, 1961, 1964; CGA, 1950, 1954, 1958, 1965; Toledo Mus. A., 1950; 1954; Univ. Illinois, 1950-1953, 1958, 1960; Iowa State Univ., 1954, 1956, 1960; Carnegie Inst., 1956, 1958, 1961; First Inter-American Biennal, Mexico City, 1958; Documenta II, Kassel, Germany; Guggenheim Mus., 1961; Wadsworth Atheneum, 1962; Smithsonian Inst. (Mus. Mod. A. Show), 1964; Los A. County Mus. A., 1965. One-man: Artists Gal., N.Y., 1941; Willard Gal., N.Y., 1943, 1945, 1946; Art of This Century Gal., N.Y., 1947; Betty Parsons Gal., N.Y., 1948-1951, 1953, 1955, 1958, 1959, 1961, 1964, 1967; Retrospective Exh., WMAA, 1963. Positions: Instr., Painting New School for Social Research, N.Y.; Advanced Paintings, School for Visual Arts, New York, at present. Guest Critic, Columbia Univ., 1968; Lecturer, Minneapolis Inst. FA., 1965.

POWELL, LESLIE J.—Painter, Des., Et., Cr.
 39 1/2 Washington Square, S., New York, N.Y. 10012
B. Fort Sill, Okla., Mar. 16, 1906. Studied: Univ. Oklahoma; Chicago Acad. FA; ASL; N.Y. Univ.; Columbia Univ., B.F.A., M.A. Member: AEA; Audubon A.A. Work: Univ. Arizona; BM; Newark Mus. A.; Columbia Univ.; Lehigh Univ.; Univ. Oklahoma; BM; Matthews Mus. Theatre Arts; Cooper Union Mus. for Des. A. Exhibited: New Orleans A. & Crafts, 1926, 1931, 1945; Delgado Mus. A., 1927; Morgan Gal., N.Y., 1939, 1940; Lehigh Univ., 1943; Carlebach Gal., N.Y., 1948; Monmouth (Ill.) Col., 1949; Norlyst Gal., 1949; Third St. Gal., Los A., 1950; Avery Lib., Columbia Univ., 1950; Mercersburg (Pa.) A. Gal., 1951; NSMP, 1961; Gal. 331, New Orleans, 1963; Galerie Raymond Duncan, Paris, 1966; Springfield (Mass.) Mus., 1964, 1965; Audubon A., 1969; AEA, 1969; one-man: Esther Gentle Gal., 1955; Gal. "21," 1955; Barzansky Gal., 1956; Philbrook A. Center, 1957; Oklahoma A. Center, 1958; Bodley Gal., N.Y., 1958, 1960; Laguna Gloria A. Center, Austin, Tex., 1958; Galleria Mexico, Santa Fe, 1958; Mus. New Mexico, Santa Fe, 1959; Old Mill Gal., Tinton Falls, N.J., 1960; RFD Gal., Brookfield, Conn., 1961; Galerie International, N.Y., 1964; 5-man: Donnell Lib. Center, N.Y., 1958.

POZZATTI, RUDY O.—Painter, Gr., I., E.
 Art Department, Indiana University, Bloomington, Ind.; h. Silverton, Colo.
B. Telluride, Colo., Jan. 14, 1925. Studied: Univ. Colorado, B.F.A.,

M.F.A., and with Emilio Amero, Max Beckmann, Ben Shahn. Member: CAA. Awards: prizes, Urbana, Ill., 1949; Nebraska State Fair, 1950; Fulbright award, 1952-53, Travel Grant, Italy, 1963-64; Guggenheim Fellowship, 1963-64; F., Yale-Norfolk Summer Sch., 1955; U.S. State Dept. Cultural Exch. Grant to Russia, 1961, and to Yugoslavia, 1965; purchase awards: 1952-55, Bradley Univ.; CAM; Joslyn A. Mus.; Mulvane A. Center; Phila. Pr. Cl.; Univ. Illinois; Youngstown Col.; SAM; Sioux City A. Center; Texas Western Col.; Oakland A. Mus.; prizes, Boston Pr.M., 1958; Soc. Wash. Pr.M., 1958; LC, 1958; John Herron AI, 1958; SAGA, 1962. Work: in the above colls., and Munson-Williams-Proctor Inst.; Univ. Puerto Rico; LC; FMA; CMA; MMA; Achenbach Fnd., San F.; BMA; SFMA; N.Y. Pub. Lib.; BMFA; Univ. Nebraska; Univ. Maine; PAFA; BM; Herron AI; Indiana Univ. Exhibited: nationally, including the following one-man exhs.: Phila. A. All.; AIC, 1954; Martha Jackson Gal., N.Y., 1954; Concordia Col., 1955; CMA, 1955; Weyhe Gal., 1957, 1965; Phila. Pr. Cl., 1965; Carleton Col., 1957; Jacques Seligmann Gal., N.Y., 1961; Smithsonian Inst., 1956; traveling exh., Art Schools, U.S.A., 1955; WAC traveling exh., 1960-61; prints in Frankfurt and Karlsruhe, Germany, 1969; First Retrospective Exhibition, Sheldon Memorial Art Gallery, Lincoln, Nebraska, 1969. Positions: Prof. A., Indiana Univ., Bloomington, Ind., 1956- . Member Pennell Selection Committee, Library Congress, Wash., D.C., 1963-1970.

PRAEGER, FREDERICK A.—Collector, Publisher
 Frederick A. Praeger, Inc., 111 Fourth Ave. 10003; h. 79 W. 12th St., New York, N.Y. 10011
B. Vienna, Austria, Sept. 16, 1915. Studied: University of Vienna. Collection: Modern art; Gothic and Baroque sculpture; Colonial Latin American sculpture. Positions: formerly President and Chief Editor, Frederick A. Praeger, Inc., publisher of books in the fields of art, archaeology, architecture and design; publisher of the World of Art series; the Ancient Peoples and Places series; the books of the Whitney Museum.

PRAGER, DAVID A.—Collector
 509 Madison Ave. 10022; h. 14 E. 90th St., New York, N.Y. 10028
B. Long Branch, N.J., July 25, 1913. Studied: Columbia University, B.A., LL.D.; Studied with Jack Tworkov. Collection: American painting, 1946- . Positions: Director and Secretary, Friends of the Whitney Museum, 1958- .*

PRATT, DALLAS (DR.)—Patron
 228 E. 49th St., New York, N.Y. 10017
B. Islip, N.Y., Aug. 21, 1914. Studied: Yale University, A.B.; Columbia University, M.D. Positions: Trustee, of the American Museum in Britain, Claverton Manor, Bath, England, 1959- ; Co-founder, with the late John Judkyn, of the American Museum in Britain, where he helped to form the collections of American furniture, regional and folk art, domestic accessories and historical Americana. In 1964, organized the John Judkyn Memorial at Freshford Manor, Bath, England, which has small loan exhibits of historical Americana, crafts and folk art available for classroom use, and larger loan exhibits, including a collection of contemporary American prints, for museum display.

PRATT, DUDLEY—Sculptor
 Recreo 39, San Miguel de Allende, Gto., Mexico
B. Paris, France, June 14, 1897. Studied: Yale Univ., B.A.H.C.; BMFA Sch.; Grande Chaumiere, Paris, and with E. A. Bourdelle, Charles Grafly. Work: SAM; IBM Coll.; arch. s., Civic Auditorium, Henry A. Gal., Doctor's Hospital, Univ. Washington Medical Sch., World War II Mem., all in Seattle, Wash.; Womens' Gymnasium, Social Science Bldg., Univ. Washington; Hoquiam (Wash.) City Hall; Bellingham City Hall; Washington State College Lib., etc. Exhibited: SAM; Oakland A. Gal.; WFNY 1939; Sculpture Center, N.Y., 1957-69; PAFA; Detroit Inst. A., 1958; Park Avenue Gal., Mt. Kisco, 1960-69; San Miguel de Allende, Mexico, 1967-1969.

PRATT, FRANCES (Mrs. Bumpel Usui)—Painter
 33 West 12th St., New York, N.Y. 10011
B. Glen Ridge, N.J., May 25, 1913. Studied: N.Y. Sch. App. Des. for Women; ASL, with Richard Lahey, Hans Hofmann. Awards: prizes, NAWA, 1946, 1950, 1955; Audubon A., 1952. Work: VMFA; BM. Exhibited: Layton Gal. A., 1941; Denver A. Mus., 1942; Mun. A. Gal., Jackson, Miss., 1943, 1946; AGAA, 1945; Mint Mus. A., 1946; Marquie Gal., 1943 (one-man); Am.-British A. Center, 1945 (one-man); Laurel Gal., 1946 (one-man); BM, 1947, 1949; CGA, 1949; Retrospective watercolor exh., Meltzer Gal., N.Y., 1961 (one-man). Author: "Encaustic, Materials and Methods." Illus., "Mezcala Stone Sculpture," (Museum Primitive Art), 1967. Positions: Inst. Painting, YWCA, Central Branch, New York, N.Y., 1941-61; Parsons Sch. Des., 1948-51; Mexican Art Workshop, 1950-51; Dir., Frances Pratt Gal. A., New York, N.Y.; Dir., Teochita, Inc., Gallery.

PRESTINI, JAMES—Sculptor, E. Des., C.
 Dept. of Architecture, University of California; h. 2324 Blake St., Berkeley, Cal. 94704
B. Waterford, Conn., Jan. 13, 1908. Studied: Yale Univ.; BAID; and in Sweden and Italy. Awards: prizes, MModA, Int. Comp. Low-Cost Furniture Des.; Los Angeles County Fair, Contemp. Crafts; 10th Triennale, Italy, Diploma d'Onore; deYoung Mem. Mus., Des-Craftsmen of the West award; Research co-grantee, Graham Fnd. for Advanced Studies in the Fine Arts, Chicago, 1962; Architectural research grant, 1965, Sculpture research grant, 1968, 1969 and Appointed Fellow to the Institute for Creative Arts, 1967-1968, all Univ. of California at Berkeley. Work: MModA; CMA; SAM; WAC; Mus. Contemp. Crafts; Dept. of State Coll. of U.S.A. design for India; Albright A. Gal.; Northwestern Univ.; Wayne Univ.; Univ. Minnesota; Ball State T. Col.; Russell Sage Fnd.; Smithsonian Inst.; MMA; Crocker A. Gal., Sacramento, Cal. Exhibited: Brussels World's Fair; Milan Trade Fair; 10th Triennale, Italy; Guatemala Nat. Fair; Haiti Peace Festival; AIC; Smithsonian Inst.; WMA; Detroit Inst. A.; DMFA; SFMA; Denver A. Mus.; BMA; Inst. Contemp. A.; Portland (Ore.) A. Mus.; Akron AI; CAM; Newark Mus. A.; Toledo Mus. A.; Dayton AI; Ruth White Gal., N.Y. (one-man); SFMA, 1969 (one-man); Crocker A. Gal., 1968; Van der Voort Gal., San Francisco, 1968; Univ. Illinois, 1969. Author: "The Place of Scientific Research in Design"; "Research in Low-Cost Seating for Homes"; "Survey of Construction Materials Demonstration & Training Center." Invited by West German Republic to survey the leading design schools and important art collections in the principal German cities. Positions: Instr., Lake Forest Acad.; Mills College; Black Mountain College; Texas State T. College; Research Des., Armour Research Fnd.; Des. Research Consultant, Midwest Research Inst.; Survey of Italian furniture industry for Knoll International; Survey construction materials in Latin America for Dept. of State. Consultant to the Office of Science and Technology, Washington; Consultant to the Government of India and the Ford Foundation at the National Design Institute, Ahmedabad, India. Prof. Des., Dept. Architecture, Univ. California, Berkeley, 1956- ; Des. Consultant, Univs. of Washington, California, New Mexico, and Idaho, 1964-1967.

PRESTON, H. MALCOLM—Painter, E.
 Hofstra University, Hempstead, N.Y. 11560; h. 85 Abbey Rd., Manhasset, N.Y. 11030: s. North Pamet Rd., Truro, Mass.
B. West New York, N.J., May 25, 1918. Studied: Univ. Wisconsin, B.S.; Columbia Univ., M.A., Ph.D. Member: AAUP; CAA; Nat. A. Edu. Assn.; N.Y. State A. T. Assn.; AEA; Eastern AA; AFA. Awards: Emily Lowe award, 1950; Joe and Emily Lowe Fnd. Edu. Research awards, 1951; Ford Fnd. (Art Curriculum Study), 1958; prize, Utica, N.Y., 1957. Work: Dayton AI; Univ. Miami; Lowe Coll. Exhibited: one-man: Ward Eggleston Gal., 1951, 1952, 1954, 1956; Assoc. Am. A.; New-Age Gal.; Wisconsin Salon of Art, 1938-1940; San Diego WC Exh., 1939; 3-man, Roosevelt Field A. Center, 1957; Art:USA, 1958; Hansa Gal., 1958; Shore Studio Gal., Provincetown, 1957, 1958; ACA Gal., N.Y., 1959; East End Gal., 1960-61; Forum Gal., 1961; S.A.G. Gal., N.Y., 1963; Provincetown AA, 1964 (group); Palm Beach, Fla., 1968. Positions: Prof., Chm. Dept. FA, Coordinator of the Arts, Hofstra Univ., Hempstead, N.Y., 1949-1963; developed and conducted TV series "The Arts Around Us," and "American Art Today," 1955-56; Art Critic, NEWSDAY, Garden City, L.I., N.Y., 1968- .

PRESTOPINO, GREGORIO—Painter, T.
 Roosevelt, N.J. 08555
B. New York, N.Y., June 21, 1907. Studied: NAD. Awards: prize, Pepsi-Cola, 1946, 1947; Temple med., PAFA, 1946. Work: WMAA; MModA; Hawaii, T.H.; Univ. Oklahoma; Univ. Nebraska; Univ. Illinois; Walker A. Center; Rochester Mem. A. Gal.; U.S. State Dept.; Univ. Texas Mus.; N.J. State Mus., Trenton; Johnson Coll.; PC; IBM; Univ. Alabama; AIC; Martha Washington Univ.; AGAA; Butler Inst. Am. A. Awards: Nat. Inst. A. & Lets., Grant, 1961. Exhibited: WMAA; AIC; WFNY 1939; CAM; GGE, 1939; PAFA; Albright A. Gal.; Pepsi-Cola; MModA; Rochester Mem. A. Gal.; CGA; Smith Col.; Phillips Acad.; Univ. Iowa; Univ. Minnesota; Santa Barbara Mus. A.; Witte Mem. Mus.; CAM; Venice, Italy; U.S. State Dept. Exh., Paris, France, (all exhs., 1936-58). 14 one-man exhs., New York City, 1936-1964. Positions: Instr. Painting, New Sch. for Social Research, New York, N.Y., 1949- .

PRETSCH, JOHN EDWARD—Cartoonist, Comm. A., P.
 Philadelphia Bulletin Co., 30th and Market Sts.; h. 4337 H. St., Philadelphia, Pa. 19124
B. Philadelphia, Pa., Apr. 14, 1925. Illus., "Five Years, Five Countries, Five Campaigns with the 141st Infantry Regiment," 1945. Contributor cartoons to Colliers; Sat. Eve. Post; Phila. Evening Bulletin. Positions: Sunday Supplement A., 6 years, News A., 2 years, Promotional Layout A., 7 years, Phila. Evening Bulletin, Philadelphia, Pa.; Adv. Layout, Sears Roebuck & Co. At present Bulletin News Artist, 1966- .

PREUSS, ROGER—Painter, I., W., L.
2224 Grand Ave., Minneapolis, Minn. 55405
B. Waterville, Minn., Jan. 29, 1922. Studied: Minneapolis Sch. A.
Member: Minneapolis Soc. FA; Minnesota AA; Outdoor Writers of
America; F.I.A.L.; Minn. Mycological Soc.; Ornithologists Union;
Soc. Animal A.; Am. Mus. Nat. Hist.; Int. Platform Assn.; Nat. Au-
dubon Soc. Awards: prizes, Federal Duck Stamp Des. award, U.S.
Dept. of Interior, 1949; Minnesota Outdoor Art Award, 1955; gold
award, Minneapolis, 1957; Centennial Award, Minneapolis, 1958;
Audubon Soc. award, for service to Ornithology; Art Print of the
Year, Nat. Wildlife Fed.; Conservationist-of-the-year award for
contributions to wildlife art; citation of Merit, VFW. Work: Demar-
est Mus.; St. Paul FA Gal.; Montana Hist. Mus.; Minn. State Capitol,
and work in many private colls. in U.S. and Canada; Nat. Wildlife
Fed. Coll.; Inst. Contemp. A., London; Montana State Univ.; N.Y.
Journal of Commerce; Wildlife of America Coll.; Le Seuer Hist.
Mus.; Smithsonian Inst.; Harlem Savings Bank, N.Y. Exhibited:
Joslyn Mem. Mus., 1948; Nat. Wildlife A. Exh., Milwaukee, 1949,
1951-1954; North American Wildlife Exh., 1952; Minnesota Centen-
nial Exh., 1949; Fed. Author's Exh., Minneapolis, 1951; Minn. Hist.
Soc., 1952; Minnesota AA, 1955-1961; American-Swedish Inst.,
Minneapolis, 1958-1961; Gal. of Western Art, 1964; Lutheran Broth-
erhood FA Annual, 1965; one-man: Northwest Sportsman's Show,
Minneapolis, 1947; Kerr Gal., Beverly Hills, Cal., 1947; Beard Gal.,
Minneapolis, 1951; St. Paul FA Gal., 1958; St. Paul Library (one-
man); Minneapolis Pub. Lib. (one-man); Sc. Compiler, I., "Outdoor
Horizons," 1957; I., "Wing Shooting, Trap & Skeet," 1955; "Popular
Waterfowl" (Portfolio), 1960; "Hunting Adventures," 1958; repre-
sented: "Wonders of Animal Migration"; "National Wildlife";
"American Game Birds" and many other leading publications.
Author, I., Official "Wildlife of America Calendar."

PREUSSER, ROBERT ORMEROD—Painter, E., L., W.
2 Willard St. Court, Cambridge, Mass. 02138
B. Houston, Tex., Nov. 13, 1919. Studied: Chicago Inst. Des., with
Moholy-Nagy, Gyorgy Kepes, Robert J. Wolff; Los A. A. Center, and
with McNeill Davidson. Awards: prizes, Texas State Fair, 1946;
San Antonio A. Lg., 1948; Mus. FA of Houston, 1940, 1949, 1951;
Texas WC Exh., 1950; Contemp. AA, 1952. Work: Mus. FA of Hous-
ton; Contemp. A. Mus., Houston; Witte Mem. Mus.; Texas Christian
Univ.; AGAA; Exhibited: Carnegie Inst., 1941; AIC, 1942, 1947, 1951;
VMFA, 1946; Mus. FA of Houston, 1935-1955; Kansas City AI, 1936;
Southeast Texas Exh., 1937-1939; Texas General, 1940-1952, 1953,
1955; Denver Mus. A., 1954; Pepsi-Cola, 1946; WMAA, 1946, 1947;
Colorado Springs FA Center, 1948; Exchange Exh., New Zealand,
1948; Mus. FA of Houston, 1948 (one-man); Mus. New Mexico, 1951,
1952; San Antonio, 1951, 1952; Downtown Gal., N.Y., 1954; Mirski
Gal., Boston, 1955, 1960 (one-man); Houston Artists Gal., 1960 (one-
man); Boston A. Festival, 1960, 1962; Northeastern Univ., Boston,
1963; No. Texas State Univ., 1964; Pine Manor Jr. College, Welles-
ley, Mass., 1965; one-man: The Randolph Gal., Houston, 1965; North
Star Gal., San Antonio, 1966; Valley House Gal., Dallas, 1966; Cam-
bridge Art Assn., 1966; Joan Peterson Gal., Boston, 1966, 1969.
Lectures: Color in Art & Architecture, Producers Council, Boston,
1960; Art Education at M.I.T., AIC, 1961; contributor chapter
"Visual Education for Science & Engineering Students" in Educa-
tion of Vision, publ. 1965. Positions: Assoc. Prof., Visual Des.
Sch. Arch. Planning, Mass. Inst. Technology. Lectures extensively.

PRIBBLE, EASTON—Painter, T. L.
Munson-Williams-Proctor Institute, 310 Genesee St.; h. 1407
Sunset Ave., Utica, N.Y. 13502
B. Falmouth, Ky., July 31, 1917. Studied: Univ. Cincinnati. Awards:
Prizes, Everson Mus. A., Syracuse, N.Y. 1961; Munson-Williams-
Proctor Inst., 1963, 1964. Work: WMAA; Munson-Williams-Proctor
Inst.; Parrish A. Mus., Southampton, N.Y.; Hirschhorn Coll., Wash-
ington, D.C. Work: Mural, Oneida County (N.Y.) Office Bldg., 1969.
Exhibited: AIC; WMAA; WAC, 1953; Brandeis Univ., 1954; Univ.
Nebraska, 1954, 1955, 1957, 1958; BMA, 1955; CM; Munson-
Williams-Proctor Inst., 1957-1969; Everson Mus. A., 1961-1964;
1967; one-man: Alan Gal., N.Y., 1955; Munson-Williams-Proctor
Inst., 1957; Hamilton Col., 1965. Positions: Instr., Painting,
Munson-Williams-Proctor Inst., Utica, N.Y., 1960- .

PRICE, GARRETT—Illustrator
393 Kings Highway, Westport, Conn. 06880
Member: SI.*

PRICE, GEORGE—Cartoonist
81 Westervelt Ave., Tenafly, N.J. 07670
Contributor cartoons to New Yorker Magazine.*

PRICE, JOHN M.—Art Director, Des., Cart., Film Producer
2100 Walnut St., Philadelphia, Pa. 19103
B. Plymouth Meeting, Pa., Feb. 5, 1918. Studied: Pa. State Univ.,
B.A. Member: A. Dirs. Cl., Philadelphia. Awards: Int. Broadcast-
ing Award of the Hollywood Advertising Club for Best Use of Color
and for TV Animation, 1961; Silver Medal and 2 Gold Medals, Phila.
A. Dirs. Club for audio-visual shows, 1959, 1962, 1964. Exhibited:
Greenwich Soc. A., 1949-1952; Ferargil Gal., 1952. Author, I., Ed.,
"Don't Get Polite With Me!," 1952. (A collection of Price cartoons
reprinted from Sat. Eve. Post, New Yorker and other publications).
Contributor Cartoons to Sat. Eve. Post; Esquire; New Yorker;
American; Ladies Home Journal; King Features Syndicate; Marshall
Field Syndicate and others. Positions: Des., A. Dir., for television,
1954-1962; Producer of films for advertising and industry, 1962- ;
Designer, Photographer & Producer of three 80-minute film presen-
tations, consisting of color photography and art synchronized to
stereophonic sound: "Who Says the Danube Isn't Blue?" (1959) and
"There Grows the Alpenrose" (1961), "Alpine Fantasy" (1965).
Producer of "Why Philadelphia?" half-hour multiple-projection
show for Phila. 1976 Bicentennial Corp. & City of Phila., 1967.

PRICE, KENNETH—Lithographer, S.
2360 S. Robertson Blvd., Los Angeles, Cal. 90034
B. Los Angeles, Cal., 1935. Studied: Univ. Southern California,
B.F.A.; State Univ. of N.Y. at Albany, M.F.A. Awards: Tamarind
Fellowship, Nov. 1968-Jan. 1969. Exhibited: Los Angeles County
Mus.; WMAA; Pasadena A. Mus.; SAM; one-man: Ferus Gal., Los
Angeles, 1960, 1961, 1964; Kasmin Ltd., London, 1968.*

PRICE, VINCENT—Collector, W., Lecturer, Actor
580 N. Beverly Glen, Los Angeles, Cal. 90024
B. Saint Louis, Mo., May 27, 1911. Studied: Yale University, B.A.;
Courtauld Institute of Art, University of London. Awards: Hon.
D.F.A., California College of Arts and Crafts; Hon. LL.D., Ohio
Wesleyan University. Lectures: Primitive art; Modern art; Letters
of Van Gogh; Three American Voices (Walt Whitman, Whistler,
Tennessee Williams); Enjoyment of Great Art. Author: "I Like
What I Know," 1958; "Book of Joe," 1960; "Michelangelo Bible,"
1964; "A Treasury of Great Recipes," 1965. Member: Chairman,
Indian Arts and Crafts Board, Dept. of Interior; Board of Directors,
Center for Arts of Indian America; National Committee, Whitney
Museum of American Art; Royal Society of Arts, London; The Col-
lector's Circle, Virginia Museum of Fine Arts; Art Council, Univer-
sity of California at Los Angeles; Advisory Committee of the
Friends of Art, University of Southern California, Los Angeles; Art
Committee, Performing Arts Council of the Music Center, Los An-
geles. Past Member: Fine Arts Committee for the White House;
Board of Directors, Archives of American Art; Board of Trustees,
Scripps College, Pomona, California; Board of Trustees, Los Ange-
les County Museum of Art; Board of Directors, Ethnic Art Council
of Los Angeles. Positions: Art Consultant, Sears, Roebuck and Co.;
Numerous stage and motion picture appearances; Narration work
with many symphonic performances.

PRIDE, JOY—Painter, Des., T., L.
1 Norway St., Boston, Mass. 02115
B. Lexington, Ky. Studied: Univ. Kentucky, A.B., M.A.; Julian Acad.,
Paris; ASL; Barnes Fnd.; N.Y. Univ.; and with Stuart Davis. Mem-
ber: NAWA; Pen & Brush Cl.; Newburyport A. Assn. Work: Senate
Office Bldg., Wash., D.C. Exhibited: CAA; CGA; NAWA, 1943-1967;
Pen & Brush Cl., 1947-1967; J. B. Speed A. Mus., 1929-1933; Univ.
Kentucky, 1932 (one-man); Circle Gal., Hollywood, Cal., 1943. Po-
sitions: A.T., Barmore Sch., New York, N.Y., 1950-53; A. Ed., Am.
Book Co., 1953-56; Radio Scripts, Voice of America, CBS, WQXR
1948-52; Assoc. A. Ed., The Macmillan Co., New York, N.Y., 1956-
60; Senior A. Ed., 1960-61; A. Dir., McCormick Mathers Pub. Col.,
Wichita, Kans., 1961-1962; New York City, 1962-1966; Prod. Supv.,
The Christian Science Publishing Soc., Boston, 1966- .

PRIEST, HARTWELL WYSE—Printmaker, P.
41 Old Farm Rd., Bellair, Charlottesville, Va. 22901
B. Brantford, Ontario, Canada, Jan. 1, 1901. Studied: Smith Col.,
A.B.; with Maurice Sievan, Joe Jones, Hans Hofmann and with Andre
Lhote in Paris, France. Member: NAWA; Pen & Brush Cl.; Soc.
Wash. Pr. M.; SAGA; Wash. WC Assn.; Hunterdon County A. Center,
Clinton, N.J. Awards: Pen & Brush Cl., 1954; Palm Beach A. Lg.,
1953; Wash. WC Cl., 1955; medal, NAWA, 1953, prize, 1961, 1962;
Albany Inst. Hist. & A., 1955. Work: LC; Newark Pub. Lib.; Univ.
Maine; Albany Inst. Hist. & A.; murals, Children's Ward, University
Hospital, Charlottesville, Va. Exhibited: Chicago Soc. Et., 1930,
1931; Brooklyn Soc. Et., 1931; Int. Pr. M. Soc. of Cal., 1933; Phila.
WC Cl., 1931; Carnegie Inst., 1945; NAWA, 1940-1964; LC, 1944,
1947, 1952, 1953; SAGA, 1932, 1934, 1944, 1947, 1951, 1952, 1954,
1955-1964; New Orleans AA, 1954, 1955; Conn. Acad. FA, 1954,
1955; Albany Pr. Cl., 1953-1955; Audubon A., 1954; Knickerbocker
A., 1954, 1955; Phila. Pr. Cl., 1947, 1955; Pen & Brush Cl., 1942-
1955, 1960 (one-man); Springfield A. Lg., 1954, 1955; Creative Gal.,
1954; Summit (N.J.) AA, 1935-1952; New Jersey A., Newark, 1952;
Albermarle AA, 1953-1955; one-man: The Print Corner, Hingham,
Mass., 1931; Col. of Idaho, 1941; Univ. Maine, 1950; Summit AA,

1951; Morristown, N.J., 1951; Argent Gal., 1955; Longwood Col., Farmville, Va., 1964. Lectures: "Making an Etching," "Lithography," "Printmaking," to women's clubs and art groups. Positions: Inst., Graphics, Virginia A. Inst., Charlottesville.

PRINS, BENJAMIN KIMBERLY—Illustrator
Wilton, Conn. 06897
B. Leiden, Holland, Jan. 20, 1904. Studied: N.Y. Sch. F. & App. A.; PIASch.; ASL. Member: Wilton Hist. Soc. Awards: gold medal, A. Dir. Cl., N.Y. Work: Book illustrations; illustrations for Reader's Digest. Position: Reader's Digest.

PRINS, (J.) WARNER—Painter, C., I.
888 Park Ave., New York, N.Y. 10021
B. Amsterdam, Holland, July 24, 1901. Member: AEA. Work: MMA; Jewish Mus., N.Y.; Munson-Williams-Proctor Inst., Utica, N.Y. Ceramic Murals, public bldg., N.Y.; International Hotel, Airport, N.Y.C. Exhibited: One-man: Carlebach Gal., N.Y., 1950; Arch. Lg., N.Y., 1952; The Contemporaries, N.Y., 1953; Juster Gal., N.Y., 1959. Illus., "An Old Faith in the New World"; Racine's "Phedre," (Paris), 1968; "Haggadah," 1969.

PRIOR, HARRIS KING—Museum Director, E.
Memorial Art Gallery of the University of Rochester, 490 University Ave., Rochester, N.Y. 14607
B. Hazardville, Conn., Mar. 10, 1911. Studied: Trinity Col., Hartford, Conn., B.S., M.A.; Harvard Univ.; Yale Univ.; Univ. Paris; Univ. Brussels; N.Y. Univ., Inst. FA. Award: Hon. degree, D.F.A., Cal. Col. A. & Crafts, Oakland, Cal., 1959. Member: AAMus.; CAA; Assoc., AAMus. Dirs.; Am. Studies Assn.; Century Assn. (N.Y.). Contributor to Italian Encyclopaedia; Museum News; Oregon Hist. Quarterly; ASL Quarterly; Art in America. Lectures: Early Art of the American West; Contemporary Painters of the Pacific Northwest; The Artist in an Age of Science; Conservation of Works of Art in Transit; Arthur B. Davies and American Art. Positions: Asst. Instr., English & FA, Trinity Col., 1932-36; Hd. Sch. FA, Olivet Col., Mich., 1937-39; Dir., Community A. Program, Munson-Williams-Proctor Inst., Utica, N.Y., 1947-56; Dir., American Federation of Arts, New York, 1956 (Dec.)-1962 (May 1); Dir., Memorial Art Gallery of the University of Rochester (N.Y.) and Prof. FA, 1962 (June)- . Trustee, Trinity College, Columbia School.

PRITZLAFF, MR. and MRS. JOHN JR.—Collectors
4954 E. Rockridge Road, Phoenix, Arizona 85018*

PROBST, JOACHIM—Painter
144 Bleeker St., New York, N.Y.
B. New York, N.Y., Sept. 1, 1913. Studied: Williston Academy, Easthampton, Mass. Awards: N.Y. State Exp., 1963. Work: N.Y. Univ.; Fairleigh Dickinson Univ., Madison, N.J.; Duke Univ. Exhibited: AFA(traveling), 1958; Univ. Ill., 1959; Princeton Univ., 1960; Yale Univ., 1960; AIC, 1961; Nordness Gal., N.Y., 1961; Jewish Comm. Center, 1961; Cornell Col., Mt. Vernon, Iowa, 1961; Sullivan County A. Show, 1961, 1962; Scripps Col., Claremont, Calif., 1962; Roanoke FA Center, Va., 1962; Purdue Univ., 1964; Greer Gal., N.Y., 1964; Carnegie Inst. Center, N.Y., 1965; Intercontinental A. Gal., Union, N.J., 1965. One-man: Duke Univ., 1960; Univ. N.C., 1960; Gal. 14, Palm Beach, Fla., 1961; Agnes Scott Col., Atlanta, Ga., 1961; Southern Methodist Univ., Dallas, 1961; Westminister Fnd., 1961; Wesley Fnd., 1961, 1962, 1968; Iowa State Univ., 1961; Krannert A. Mus., Univ. Ill., 1961; Grace Cathedral, San Francisco, 1962, and many other churches; Mississippi Univ., 1962; Colby Col., Waterville, Me., 1966; Emory Univ., Atlanta, 1966; Georgia Inst. Tech., Atlanta, 1966; St. Louis Univ., St. Louis, 1966.

PROHASKA, RAY—Painter, E.
Bridgehampton, N.Y. 11932
B. Mulo Dalmata, Yugoslavia, Feb. 5, 1901. Studied: Cal. Sch. FA. Member: SI (Pres. 1958-59); Audubon A.; Nat. Soc. Painters in Casein. Awards: prizes, Hallmark Award, 1949; Audubon A., 1954, medal, 1956; Nat. Soc. Painters in Casein, 1956; Parrish Mus., 1949; Gld. Hall, East Hampton, N.Y., 1956; SI Gold Medal, 1963; John Marin Mem. Award, Watercolor:USA, 1962. Work: Butler Inst. Am. A.; Univ. Illinois; Georgia Mus. A.; Miami Mus. Mod. A.; Washington County Mus. A., Hagerstown, Md.; Univ. Maine; Phoenix Mus. A.; Int. Tel. & Tel. Co.; Integrated Design Corp.; U.S. Air Force Coll.; Gld. Hall, East Hampton, N.Y., and in private colls. Exhibited: Audubon A.; Terry AI; Butler Inst. Am. A.; WMAA; PAFA; Univ. Illinois; NAD; Hallmark Comp.; Nat. Soc. Painters in Casein: Gld. Hall, East Hampton, 1961 and prior; Parrish Mus.; A. Dir., Cl.; one-man: SI, 1948; Mortimer Levitt, 1952; Washington & Lee Univ., 1960; Parrish Mus., Southampton, 1966; Randolph-Macon Col., 1967; Hollins Col., 1967; Univ. Va., 1967; Benson Gal., Bridgehampton-Southampton Col., 1968, 1969; Gal. of Contemp. A., Winston-Salem, 1969; Hallmark Gal., Kansas City, 1969; Norfolk Mus., 1969. Positions:

Instr., ASL, New York, 1961. A.-in-Res., Washington & Lee University, 1964-1969; A.-in-Res., Wake Forest Univ., Winston Salem, N.C., 1969-1970.

PROOM, AL(BERT E.)—Painter, Des.
San Francisco, Cal.
B. Nevada City, Cal., June 11, 1933. Awards: Purchase prizes, for "City Beautification," San Francisco, 1967; Butler Inst. Am. A., 1969. Exhibited: Butler Inst. Am. A., 1964; Spokane (Wash.) Mus. A., 1964; Rochester Mem. A. Gal., 1964; McNay AI, San Antonio, 1965; Cal. PLH, 1962-1964; Oakland A. Mus., 1962, 1964; Crocker A. Gal., Sacramento, Cal., 1961, 1968; Sports annual, Ambercrombie & Fitch, N.Y., 1966 and Sports Mus. A., N.Y. 1966; Civic A. Gal., Walnut Creek, Cal., 1969; one-man: Banfer Gal., N.Y.; Gump's Gal., San Francisco, 1968.

PROSS, LESTER FRED—Educator, P.
Berea College, Art Department; h. Peach Bloom Hill, Berea, Ky. 40403
B. Bristol, Conn., Aug. 14, 1924. Studied: Oberlin Col., B.A., M.A.; Skowhegan Sch. Painting & Sculpture. Awards: Haskell Traveling F., Oberlin Col., 1957-58. Member: AAUP; Ky. A. Edu. Assn.; Asia Soc.; Ky. Gld. A. & Craftsmen (Pres., 1961-1963); CAA; Assn. for Asian Studies. Illus., "Mountain Life and Work." Positions: Co-Chm., Prof. A., A. Dept., Berea Col., 1950- . Fulbright Lecturer, Dept. FA, Univ. of the Panjab, Lahore, Pakistan, 1957-58. Visiting Prof. A., Union College, Ky., Summer 1961. Chm., Advisory Bd., The Mountain Mus.; Visiting lecturer in A, American Univ. in Cairo, United Arab Republic, 1967-1968.

PRYCE-JONES, ALAN—Writer
19 E. 55th St., New York, N.Y. 10022*

PUCCINELLI, RAYMOND—Sculptor, P., E., L., W.
Piazza Donatello 18, Florence, Italy 50132
B. San Francisco, Cal., May 5, 1904. Studied: Univ. California; Schaeffer Sch. Des., San F., and abroad. Awards: Oakland A. Gal., 1938, 1941, 1942; Los A. Mus. A., 1939; San F. AA, 1938; Sacramento, Cal., 1949; Premio Donatello, Florence, 1962; Premio Fiorino, Florence, 1966. Work: S., Mills Col.; Univ. Cal.; SFMA; IBM; Salinas (Cal.) Jr. Col.; House of Theology, Centerville, Ohio; San F. Stock Exchange; Corpus Christi Church, Piedmont, Cal.; Baptismal Fount, Annapolis, Md.; Cross, St. Andrew's Church, Mayo, Md.; sc., Fresno Mall, Fresno, Cal.; Stadtheater, Schleswig, Germany; Mod. Mus., Pitti Palace, Florence, Italy; Columbia Univ., N.Y. Exhibited: WMAA, 1940, 1948, 1949; PAFA, 1942, 1952, 1963; CM, 1941; NSS; Arch. Lg.; WFNY 1939; SFMA, 1936-1946; Los A. Mus. A., 1939; San Diego Exp., 1935; Portland A. Mus., 1939; CGA, 1942, 1962; Grand Central A. Gal., 1946, 1947; BM, 1954; Nat. Inst. A. & Let., 1953, 1955; Pomona, Cal., 1952; Fairmount Park, Phila., 1949; Detroit Inst. A., 1960, 1963; PMA, 1960; MModA, 1960; Festival of Italy, Phila., 1961; CMA, 1963; N.Y. World's Fair, 1964; La Palette Bleue, Paris, 1967; Padora, Italy, 1967; Galleria Spinetti, Florence, Italy, 1967; one-man: Cal. PLH, 1946; Mills Col., 1945; Univ. California, 1945; deYoung Mem. Mus., 1944; Santa Barbara Mus. A., 1946; Oakland A. Gal., 1938-1942; Scripps Col., 1941; Crocker A. Gal., 1941; SFMA; Bucknell Univ., 1954; Coeval Gal., N.Y., 1954; Phila. A. All.; Schneider Gal., Rome, Italy, 1957, 1960, 1966; Pater Gal., Milan, Italy, 1958; Midtown Gal., N.Y., 1959; Vanucci Gal., Pistoia, Italy, 1961; Gal. Nicole, N.Y., 1963; Cube Gal., Tokyo, 1966. Article: Architects Report, "Sculpture, A Visual Language," 1961. Positions: L., Univ. California, Berkeley, Cal., 1942-47; Instr. S., Mills Col., Oakland, Cal., 1938-47; A. in Residence, Univ. North Carolina, 1948-49; Instr., Queens Col., Flushing, N.Y., 1948-51; U.S. Dept. State Cultural Representative in Latin America, 1956; Dean Rinehart Sch. of Sculpture, Baltimore, Md., 1958-60.

PULITZER, MR. and MRS. JOSEPH JR.—Collectors
4903 Pershing Ave., St. Louis, Mo. 63108*

PURDY, DONALD ROY—Painter
163 Westport Rd., Wilton, Conn. 06897
B. Bridgeport, Conn., Apr. 10, 1924. Studied: Univ. Connecticut, B.A.; Boston Univ., M.A. Member: Silvermine Gld. A.; All. A. Am. Awards: prizes, Audubon A., 1961; Silvermine Gld. A., 1957-1961; gold medal, All. A. Am., 1961. Work: New Britain Mus. Am. A.; VMFA; Butler Inst. Am. A.; Chase Manhattan Bank Coll. and in private colls. Exhibited: Butler Inst. Am. A., 1961, 1965; USIA exh. abroad, Germany, Switzerland, France, 1959; Boston A. Festival; Springfield, Mass.; New Haven, Conn.; Silvermine Gld. A., annually; one-man: Bernheim Gals., Paris, 1964.

PURVES, AUSTIN—Mural Painter, S., C.
P.O. Box 935, Litchfield, Conn. 06795
B. Chestnut Hill, Pa., Dec. 31, 1900. Studied: PAFA; Julian Acad.,

Am. Conservatory, Fountainebleau, France. Member: Arch.L.; NSMP; Century Assn. Work: reredos, St. Paul's Church, Duluth, Minn.; Grace Church, Honesdale, Pa.; mem., Wash., D.C.; fresco, St. Michael's Church, Torresdale, Pa.; s., S.S. America; various Grace Lines Ships; U.S. Military Acad., West Point, N.Y.; Colgate Univ. Lib.; St. Stephen's Church, Armonk, N.Y.; All Souls Church, Waterbury, Conn.; Cadet Barracks, West Point, N.Y.; other work, Firestone Mem. Lib., Princeton Univ.; Am. Battle Monuments Comm.; S.S. United States; Fed. Reserve Bank of Boston; Providence Hospital, Wash., D.C.; Conn. Mutual Life Ins. Co.; mural, Children's Chapel, Trinity Church, Ft. Wayne, Ind.; Washington Hall Barracks Complex, U.S.M.A. West Point, N.Y.; mosaics, Nat. Shrine of the Immaculate Conception, Wash., D. C. Positions: Trustee, Hartford A. Sch., Univ. of Hartford, Conn. Taught, Yale Sch. FA; NAD; Dir., Cooper Union A. Sch., 1931-38; Bennington College, 1940-42.

PUTNAM, MRS. JOHN B.—Collector
12817 Lake Shore Blvd., Cleveland, Ohio 44108
B. Cleveland, Ohio, June 19, 1903.*

PUTNAM, MRS. MARION WALTON. See Walton, Marion

PUTTERMAN, FLORENCE—
Painter, Printmaker, Collector, Patron
101 Charles Ave., Selinsgrove, Pa. 17870
B. Brooklyn, N.Y., Apr. 14, 1927. Studied: New York University, B.S.; Bucknell University, worked under Neil Anderson. Awards: Berwick A. Center (Pa.) 1966, 1967; Everhart Mus., Scranton, Pa. 1968. Exhibited: Bucknell University; Susquehanna University; Lycoming College; Hazleton Art League; Harrisburg Art League; Butler Inst. Am. A.; Silvermine Gld.; New Jersey State Mus.; Newark; Everhart Mus., Scranton, Pa.; William Penn Mus., Harrisburg, Pa.; NAD; SAM; one-man: Bucknell Univ., 1968; Brown Lib., Williamsport, Pa., 1969. Member: AFA (Contributing). Collection: Contemporary American paintings and prints; Primitive sculpture. Positions: A.-in-Res., Federal Title 111 Program Arts Unlimited, Mid-State Artists; Founder & Pres., Arts Unlimited, Selingsgrove, Pa.

QUANCHI, LEO—Painter
2-01 28th St., Fair Lawn, N.J. 07410.
B. New York, N.Y., Sept. 23, 1892. Studied: Col. City of N.Y.; NAD; ASL; Parsons Sch. Des. Member: Audubon A.; Assoc. A., New Jersey; AEA. Awards: prizes, Montclair A. Mus., 1944; Newark Mus. A., 1952; PAFA, 1953; Audubon A., 1968. Work: WMAA; Newark Mus. A.; PAFA; Bloomfield (N.J.) Col. Exhibited: NAD, annually; Pepsi-Cola, 1944, 1946; Montclair A. Mus., annually; WMAA, 1954, 1959-60; Newark Mus. A., 1952, 1958; CGA, 1951, 1957; Univ. Illinois, 1951; Birmingham Mus. A., 1954; Butler Inst. Am. A., 1958; Columbia Univ., Columbia, S.C., 1958; Fairleigh Dickinson Univ., Madison, N.J.; PAFA; Carnegie Inst.; Los Angeles County Mus.; Syracuse (N.Y.) Mus. FA; WAC; Detroit Inst. A.; Audubon A.; Monmouth Col., N.J.; South Bend AA; MMA; Davenport Mun. A. Gal.; and others; one-man: New York, N.Y., 1923, 1940, 1947, 1949, 1950, 1952; St. Louis, Mo., 1949; Silvermine Gld. A., 1951; Univ. Florida, 1953; Salpeter Gal., 1952, 1958; Joan Avnet Gal., Great Neck, L.I., 1964.

QUANDT, RUSSELL JEROME—Museum Art Restorer
Corcoran Gallery of Art, 510 17th St., Northwest, Washington, D.C. 20006; h. 3433 34th St., Northwest, Washington, D.C. 20008
B. New London, Conn., Sept. 18, 1919. Studied: Yale Col. Member: F., Int. Inst. for the Conservation of Museum Objects. Restoration commissions for Phillips Gal., J.B. Speed A. Mus., Colonial Williamsburg, and others. Positions: Restorer, Corcoran Gal. A., 1950- ; Conservator, Abby Aldrich Rockefeller Folk Art Coll., Williamsburg, Va., 1954- .*

QUAYTMAN, HARVEY—Painter
74 Grand St., New York, N.Y. 10013
B. Far Rockaway, N.Y., Apr. 20, 1937. Studied: Syracuse Univ.; Tufts Univ.; BMFA Sch. A., B.F.A. Awards: J. W. Paige Traveling Fellowship, BMFA, 1960-1961. Work: Pasadena A. Mus.; WMAA; Dartmouth Col.; Hopkins A. Center, Univ. Massachusetts; Harvard Univ.; N.Y. Univ. Exhibited: Krannert Mus., Univ. Illinois, 1967; AFA traveling exhibition; Inst. Contemp. A., Boston, 1965; Ohio State Univ., 1967; Inst. Contemp. A., Houston, Tex., 1967; Redfern Gal., London, England, 1962; De Cordova & Dana Mus., Lincoln, Mass., 1964; Royal Marks Gal., N.Y., 1967; Paula Cooper Gal., N.Y., 1969. Positions: Taught, BMFA Sch. A.; Middlebury Col.; Commonwealth Sch., Boston; Essex Col. A., Colchester, England.

QUERIDO, ZITA—Painter, T., L.
3515 Henry Hudson Parkway, New York, N.Y. 10063
B. Vienna, Austria, Feb. 15, 1917. Studied: Hans Hofmann Sch. FA.

Member: AFA; Nat. Comm. on A. Edu. Work: Mus. Mod. A., Sao Paulo, Brazil; Mus. Mod. A., Rio de Janeiro; MModA, N.Y. (lending); Rose A. Mus., Brandeis Univ.; Arkansas A. Center; Smith Col. Mus.; Andrew Dickson White, Mus., Cornell Univ.; Peabody Col.; Ft. Lauderdale Mus. A.; Jewish Mus., N.Y. Work presented on ABC-TV and NBC-TV. Also, broadcast on work over Voice of America. Exhibited: Miami Mus. Mod. A., 1964; Provincetown Group, 1958; Sao Paulo, Brazil, 1965; one-man: Bodley Gal., N.Y., 1957, 1961, 1962. Lectures on art in many museums, as Director of Riverdale (N.Y.) FA Soc. Positions: Instr., Riverdale FA Soc., N.Y.*

QUEST, CHARLES F.—Painter, Gr., E., L.
Washington University School of Fine Arts 63130; h. 12331 Harflo Lane, Town and Country, St. Louis, Mo. 63131
B. Troy, N.Y., June 6, 1904. Studied: Washington Univ. Sch. FA; and in Europe. Member: SAGA; St. Louis A. Gld.; So. Vermont A. Center; Painters Gal., St. Louis; Am. Color Pr. Soc.; Phila. Pr. Cl. Awards: prizes, St. Louis A. Gld., 1923, 1925, 1927, 1929, 1930-1933, 1948-1952, 1962; CAM, 1932, 1942, 1944, 1947, 1948, 1950, 1951; Kansas City AI, 1932; Springfield Mus. A., 1945, 1947; Phila. Pr. Cl., 1946, 1947, 1950; Joslyn A. Mus., 1948; BMFA, 1949; Bradley Univ., 1951; LC, 1952; Rensselaer Hist. Soc., Troy, N.Y. 1963; Temple Israel Exh., St. Louis, 1964. A large room in the new Pierre Laclede Building in St. Louis (Clayton) Mo., was dedicated to Mr. Quest as the Charles Quest Gallery, which contains changing exhibitions of his many works. Work: MMA; MModA; LC; CAM; Springfield A. Mus.; Joslyn A. Mus.; PMA; U.S. War Dept.; AIC; Univ. Michigan; Univ. Wisconsin; Mills Col.; Munson-Williams-Proctor Inst.; Washington Univ.; Beloit Col.; BM; FMA; Toledo Mus. A.; Smithsonian Inst.; CMA; BMFA; N.Y. Pub. Lib.; Bibliotheque Nationale, Paris; Victoria & Albert Mus., London; British Mus., London; Nat. Mus., Stockholm; Nat. Mus., Jerusalem; murals, Carpenter Lib.; St. Michael, St. George Episcopal Church, Trinity Church, Herzog Sch., all St. Louis; St. Mary's Church, Helena, Ark.; mural, Old Cathedral, St. Louis. Exhibited: nationally and internationally; since 1953: Vienna, Austria; Sao Paulo, Brazil; Univ. Puerto Rico; St. Thomas, Virgin Islands; Middle East; Rome, Bologna, Carrara, Venice, Milan, Florence, Turin, Italy; other exhs., 1962-64: Washington Univ.; Temple Israel, St. Louis; St. Louis A. Gld.; SAGA; Univ. Nebraska; Stuttman Gal., Wash., D.C. (5-man). One-man exh. in Uruapan, Mexico, 1961. Positions: Prof. Drawing, Washington Univ. Sch. FA, St. Louis, Mo., 1945- . Lectures on the mural, with slides showing each step of procedure, at Washington Univ., Mary Inst., City A. Mus., St. Louis.

QUEST, DOROTHY (JOHNSON) (Mrs. Charles F.)—
Portrait Painter, T., L.
12331 Harflo Lane, Town and Country, St. Louis, Mo. 63131
B. St. Louis, Mo., Feb. 28, 1909. Studied: Washington Univ. Sch. FA; Columbia Univ., and in Europe. Member: St. Louis A. Gld.; St. Louis Assn. Women A.; So. Vermont A. Center; Washington Univ. Faculty Women's Cl. Work: Collaborated with Charles F. Quest in painting murals, Carpenter Lib., St. Michael, St. George Episcopal Church, Trinity Church, Herzog Sch.; Old Cathedral, all St. Louis; St. Mary's Church, Helena, Ark. Over 600 portrait commissions, 1931-61, including Mr. & Mrs. Karl Umrath, donors to Washington Univ., to be placed in Univ. Lib.; Joseph R. Long, Dean Law Sch., Washington & Lee Univ., Virginia; Dr. Frederick W. Schroeder, Pres., Eden Seminary, St. Louis. Des. and painted 16 murals for the Church of the Epiphany, St. Louis. Exhibited: CAM, 1932, 1934, 1938-1940; St. Louis A. Gld., 1935, 1938, 1940, 1962-1964; So. Vermont A. Center, 1962-1964; L'Atelier Gal., St. Louis (one-man); 7 one-man: 1933, 1939, 1940, 1943, 1945, 1951, 1955. Lectures: Portraiture. Positions: A. Instr., Community Sch., Clayton, Mo., 1936-1938; Sacred Heart Acad., St. Louis, 1939-1941; Maryville Col., St. Louis, 1944-1945.

QUICK, BIRNEY MacNABB—Painter, E.
2101 Pillsbury Ave. South 55404; h. 4537 Dupont Ave. South, Minneapolis, Minn. 55409
B. Proctor, Minn., Nov. 9, 1912. Studied: Vesper George Sch. A.; Minneapolis Sch. A., B.F.A. Awards: Tiffany Fnd. Fellowship; Chaloner Fellowship. Work: Minneapolis AI; AIC; murals, Medical Arts Bldg., Duluth, Minn.; Mutual Life Ins. Co.; Minn. Fed. Savings & Loan Co.; Grand Marais State Bank. Exhibited: AIC; Grand Central Gal., N.Y.; Tiffany Fnd. Exh.; Minneapolis AI; one-man: Minneapolis AI; WAC. Contributor illus. to Ford Times; Lincoln Mercury Times. Positions: Prof. Painting & Drawing, Minneapolis School of Art, Dir., Grand Marais Art Colony.

QUINN, HENRIETTA REIST (Mrs. Thomas Sydney Quinn, Jr.)
Collector, P.
"Rolling Meadows," Cornwall, Pa. 17016
B. Lancaster, Pa., Dec. 11, 1918. Studied: Edgewood Park Junior College, Briarcliff, N.Y. Collection: American primitive paintings; 18th century procelain; 18th century miniature furniture.

QUINN, NOEL—Painter, Des., E., I., Gr.
3946 San Rafael Ave., Los Angeles, Cal. 90065
B. Pawtucket, R.I., Dec. 25, 1915. Studied: R.I.Sch. Des.; Parsons Sch. Des., Italy; N.Y. Sch. F. & App. A.; Ecole des Beaux-Arts, Paris, France. Member: Cal. WC Soc.; Nat. Soc. A. Dir.; Int. Inst. A. & Lets.; AWS; SI; Soc. Motion Picture Illustrators (Pres.). Awards: prizes, Parsons F., R.I. Sch. Des., 1936; Cal. State Fair, 1949, 1954; deYoung Mem. Mus., 1949; Cal. WC Soc., 1951; Hallmark, 1952; AWS, 1954; Los A. Mus. A., 1954, 1957; Santa Cruz, 1955; Wash. WC Cl., 1956; Butler Inst. Am. A., 1958; Laguna Beach AA, 1958; Watercolor: U.S.A., 1964. Work: Cal. State Agricultural Soc.; Cole Coll.; Hollywood Turf Cl.; Air Force Acad., Colorado; Butler Inst. Am. A., and in numerous private colls. in U.S. and abroad. Toured Guam, Philippines, Formosa, Japan, 1959, on commission for series of paintings for U.S. Air Force that hang in the Pentagon & Air Force Acad. Completed, 12 educational films, (color & sound) now used in teaching throughout U.S., "Alphabet of Watercolor." Series of Watercolors "Santa Anita Portfolio," on Contemporary Thoroughbred Racing, publ. 1961. Since 1959 has worked on a project for the education of the blind which has resulted in the "Quinn Language for Education of the Blind," a new concept in education for the blind. Exhibited: nationally and internationally; one-man: Cal. Mus. Science & Indst., 1963. Positions: Instr., Watercolor Painting, Otis Art Inst. of Los Angeles County, Los Angeles, Cal.

QUIRK, FRANCIS J.—Painter, E., L., Dir. Exhibitions
Peterspen, Macada Rd., Bethlehem, Pa. 18017; s. Peterspen North, Box 305, Ocean Park, Me. 04063
B. Pawtucket, R.I., June 3, 1907. Studied: R.I.Sch.Des.; Univ. Pennsylvania, and in Provincetown, Mass.; Woodstock, N.Y., and in Europe. Member: Phila. A. All.; Phila. WC Cl.; Bethlehem Palette Cl.; Lehigh A. All. Awards: prizes, R.I.Sch.Des.; Providence A. Cl.; Kinney Shores (Pres.) Ocean Park; Phila. WC Cl.; Woodmere A. Gal.; Chassey Mem. Award; Benedict Award; Tiffany Fellowship; Lindbach Award (Distinguished Teaching). Work: Colby Col. Mus.; Lehigh Univ. Coll.; Rhode Island Sch. Des.; Ogontz Col.; City Hall, Bethlehem, Pa.; NCFA; Smithsonian Inst. Exhibited: PAFA; CGA; Buffalo, N.Y.; Portland, Me.; Providence, Newport, R.I.; Bethlehem Palette Cl.; Lehigh A. All.; Exchange Cl.; 1959-61; Woodmere A. Gal.; Kutztown State Col.; Lehigh AA; Old Orchard AA; Allentown Mus. A.; Hazleton A. Cl.; Pa. Playhouse. Positions: Hd. A. Dept., Montgomery Sch., 1930-35, 1938-45; Instr., A. Ogontz Jr. Col., Ogontz Sch., Pa., 1935-46, Hd. Dept. A., Ogontz, 1946-50; Assoc. Prof., Hd. Dept. FA, Lehigh Univ., Bethlehem, Pa., 1950- , Prof., 1953- ; Cur. & Dir., Lehigh Univ. Permanent A. Coll., and A. Gal., 1950- . Conducts biweekly radio program; Memb., Comm. on Architecture for public bldgs., Bethlehem, Pa. Chm., Art Comm. City Centre.

QUIRK, THOMAS CHARLES, JR.—Painter, T.
310 E. Main St., Kutztown, Pa. 19530
B. Pittsburgh, Pa., Dec. 31, 1922. Studied: Edinboro State Col., B.S. in A. Edu.; Univ. of Pittsburgh, M.Ed. Member: Phila. WC Club. Awards: Assoc. A. Pittsburgh, 1958-1962; Friends of Am. A., Butler Inst. Am. A., purchase, 1957, 1963; Ligonier, Pa., 1964. Work: Butler Inst. Am. A., Youngstown, Ohio. Exhibited: Carnegie Inst., 1956; PAFA, 1958-1960, 1967, 1969; NAD, 1958-1961; Butler Inst. Am. A., 1957-1962, 1966-1968; Harry Salpeter Gal., N.Y.; Assoc. A. Pittsburgh, 1958-1962; Pittsburgh Playhouse, 1958, 1960, 1961; Swope Gal.; Mus. of A., Houston, Texas, 1965; Pen Nat. Exh., 1966, 1967; Orr Gal., San Diego, 1969; Oklahoma A. Center, Oklahoma City, 1968 and others. One-man: Westmoreland County Mus. A., Greensburg, Pa., 1961; Chatham Col., 1960; Thiel Col., Greenville, Pa., 1961; Temple Univ., Phila., Pa., 1961; Salpeter Gal., 1962; Univ. of Pittsburgh, 1966; Banfer Gal., N.Y., 1968. Positions: Asst. Prof., drawing and painting, Kutztown State Col., Kutztown, Pa.

QUISGARD, LIZ WHITNEY—Painter, S., T., Cr.
321 Rossiter Ave., Baltimore, Md. 21212
B. Philadelphia, Pa., Oct. 23, 1929. Studied: Maryland Inst. A.; privately with Morris Louis; completing M.F.A. at Rinehart Sch. of Sculpture. Member: AEA. Awards: prize, BMA, 1958; Rinehart Fellowship in Sculpture, Maryland Inst., 1964-66; Loyola Col., 1966. Work: Gallagher Mem. Coll., Univ. Arizona, Tucson; Univ. Baltimore; port. commission, Univ. of Baltimore, 1963; many private commissions in portraiture. Exhibited: Provincetown AA, 1956; Butler Inst. Am. A., 1956; CGA, 1958, 1963, 1964; PAFA, 1964; AIC, 1965; BMA, 1951-1953, 1958; Peale Mus. A., 1947, 1957; Goucher Col.; Johns Hopkins Univ.; Towson State Col.; one-man: Jefferson Place Gal., Wash., D.C., 1961; Emmerich Gal., N.Y., 1962; Goucher Col., 1966; Gilden Gal., Baltimore, 1968. Lectures: "Young Artists in Maryland," Baltimore County Lib., 1969. Positions: Instr., Painting & Drawing, Baltimore Hebrew Congregation; Lecturer, Goucher Col., 1966-1968; Instr., Maryland Inst., 1965- ; Art Critic, Baltimore Sun; Theatrical Designer, Goucher Col., 1966-1968 and Theatre Hoplins, at present.

RABB, MR. and MRS. IRVING W.—Collectors
393 D St., Boston, Mass. 02210; h. 1010 Memorial Dr., Cambridge, Mass. 02138
Studied: Mrs. Rabb—Smith College, A.B.; Radcliffe College, A.M.; Mr. Rabb—Harvard College, A.B.; Harvard Business School. Collection: 20th century Sculpture; Drawings, Sculpture, Collages of Cubist works. Positions: Mr. Rabb—Member Visiting Committee on Fine Arts, Harvard University.

RABIN, BERNARD—Restorer, Conservator
Rabin & Krueger, 47 Halsey St., Newark, N.J. 07102; h. 43 Boyden Ave., Maplewood, N.J. 07040
B. New York, N.Y., Nov. 1, 1916. Studied: Newark Sch. Fine & Indst. Art; Brooklyn Museum-N.Y. University Restoration of Paintings, with Sheldon Keck; Uffizi Gallery, Restoration Laboratory, Florence, Italy. Awards: Fellowship, Uffizi, Florence, Italy, 1959. Positions: Restorer on Staff of Newark Museum, New Jersey Historical Society, Rutgers University; Restorer for Montclair (N.J.) Mus., Carnegie Institute Museum.*

RABKIN, LEO—Sculptor, P.
218 W. 20th St., New York, N.Y. 10011
B. Cincinnati, Ohio, July 21, 1919. Studied: N.Y. Univ. Member: Am. Abstract A. Awards: Larry Aldrich purchase award, MModA, 1960; Ford Fnd. award, WMAA, 1962; Silvermine Gld. A., 1961, 1964. Work: MModA; Guggenheim Mus.; N.Y. Univ.; Woodward Fnd., Wash., D.C.; Savings Bank Assn. of State of N.Y.; Singer Co.; Geigy Chemicals Co.; WMAA; Finch Col.; PMA; Univ. A. Mus., Berkeley, Calif.; Chase Manhattan Bank, N.Y.; Smithsonian Inst.; N.C. Mus. A., Raleigh. Exhibited: AGAA, 1950 and traveling; WMAA, 1959, 1961, 1964-1966, 1968; Hirschl & Adler Gal., N.Y., 1959; Martha Jackson Gal., N.Y., 1960; MModA, 1960, 1963-66 (traveling exh. USA, London, Yugoslavia, Athens, Greece, India, Ceylon, Nat. Gal., Melbourne, Australia), 1965 (2); Guggenheim Mus., 1962, 1965; Am. Fed. Arts "Affinities" traveling USA, 1962-63, Loan Exh., American Embassy, Copenhagen, 1964; Betty Parsons Gal., N.Y., 1963; Byron Gal., 1964; N.Y. Univ., 1964 (2); Am. Abstract A., 1964, 1965; Riverside Mus., 1965; Gertrude Kasle Gal., Detroit, 1965 (3-man); Mus. A., Rhode Island Sch. Des., 1965; Graham Gal., 1965; Finch Col., 1965, 1968; Univ. Michigan, 1965; Flint Mus. A., 1966; Cranbrook Acad. A., 1966; Drew Univ., 1966 (2-man); Gal. Ileana Sonnabond, Paris, 1966; Stedelijk Mus., Holland, 1966; Aldrich Mus. Contemp. A., Ridgefield, Conn., 1966; Howard Wise Gal., N.Y., 1967; WAC, 1967; N.J. State Mus., Trenton, N.J., 1967; Henri Gal., Wash., D.C., 1967; Smithsonian Inst. (traveling: Europe), 1967-1970; BM, 1968; Mus. Contemp. Crafts, N.Y., 1968; Univ. A. Mus., Berkeley, Calif., 1968; N.C. Mus. A., Raleigh, 1969; Smithsonian Inst., 1969. One-man: Stairway Gal., N.Y., 1954; Latow Gal., N.Y., 1961; Louis-Alexander Gal., 1962; Feigen Gal., N.Y., 1965-1967. Positions: Pres., Am. Abstract A. 1965-

RABUT, PAUL—Illustrator, Des., P.
27 West 67th St., New York, N.Y.; h. 104 Easton Rd., Westport, Conn.
B. New York, N.Y., Apr. 6, 1914. Studied: Col. City of N.Y.; NAD; ASL, and with Jules Gottlieb, Harvey Dunn, Lewis Daniel. Member: SI; Westport A. Awards: medal, NAD, 1932; A. Dir. Cl., 1942, 1943, 1946, 1951. Work: U.S. Army Medical Mus., Wash., D.C. Exhibited: AIC, 1943; MMA, 1942; PAFA, 1941; A. Dir. Cl., 1942-1953; SI, 1941-1961; NAD, 1950; State Dept. traveling exhibition to Europe and South America, of adv. art, 1952-1953. Lectures on Illustration; "An Artist Looks at Photography"; "Primitive Arts of Africa, Northwest Coast and South Seas." Illus. for leading national magazines. Author, I., "Paul Rabut Visits the Tall Timber," True magazine, 1949, "My Life as a Head Hunter," 1953, Argosy magazine. Consultant to Galleries & Collectors in the field of Primitive Art.*

RACZ, ANDRE—Painter, Gr., E., W., L.
P.O. Box 43; h. 83 Hardenburg Ave., Demarest, N.Y. 07627
B. Cluj, Rumania, Nov. 21, 1916. Studied: Univ. Bucharest. Awards: Guggenheim F., 1956; Fulbright Research F., Univ. Chile, 1957; Ford Fnd. Award, 1962. Member: SAGA; AAUP. Work: MModA; BM; N.Y. Pub. Lib.; LC; NGA; Rosenwald Coll.; State Dept., Wash., D.C.; Hartford Catholic Lib.; WMAA; Nat. Gal., Melbourne, Australia; Butler Inst. Am. A.; Kentucky; Univ. Minnesota; Univ. St. Louis; Univ. Tennessee; Mus. of Cordoba, Argentina; SFMA; Tulsa, Okla; Bibliotheque Nationale, Paris; Mus. Salzburg; Univ. Chile; Columbia Univ.; Smith Col.; Smithsonian Inst. Exhibited: MModA, 1944-1946, 1948, 1949, 1951; WMAA; BM; N.Y. Pub. Lib.; LC; Carnegie Inst.; SAM; SFMA; and in London, Paris, Rome, Zurich, Hawaii, Warsaw, Barcelona, Oslo, Capetown, and others; Univ. Tennessee, 1948; Univ. Iowa, 1948; Green Lake, Wis., 1951; AFA traveling exh. (one-man) 1948-1951; Rio de Janeiro, 1946; Buenos Aires, 1949; Santiago de Chile, 1947-1950; 1952; one-man: New York, N.Y., 1942-1944, 1946, 1948, 1949, 1951, 1953, 1956, 1957, 1959, 1961; retrospective, N.Y. Pub. Lib., 1955; Museo de Bellas Artes, Santiago, Vina del Mar, Chile, 1957; Valparaiso, 1957;

Bordighera, Italy, 1957; Mexico City, 1958; Religious Art, Salzburg, 1958; Retrospective, Univ. Kentucky, 1960 and Avery Lib., Columbia Univ., 1961. Author, I., books of engravings, "The Flowering Rock," 1943; "The Battle of the Starfish," 1944; "The Reign of Claws," 1945; "The XII Prophets," 1947; "Via Crucis," 1948; "Mother and Child," 1949; "Voz de Luna," 1952; "Sal de Dunas," 1953; "Canciones Negras," 1953; "Salmos y Piedras," 1955. I., "Poemas de las Madres," 1950. Positions: Instr., Sch. Painting & Sculpture, Columbia Univ., New York, N.Y., 1951-55, Asst. Prof., 1956-61, Assoc. Prof., 1961-67, Professor, 1967- , Chairman, Division of Painting & Sculpture, School of the Arts, Columbia University, 1964- , Hd. Dept. Painting & Sculpture, 1964- .

RADICH, STEPHEN—Art Dealer
 Stephen Radich Gallery, 818 Madison Ave., New York, N.Y. 10021*

RADIN, DAN—Painter, C., T.
 140 Orchard St., New Bedford, Mass. 02740; h. Rte. 1, Norwich, Conn. 06360
B. New York, N.Y., May 12, 1929. Studied: Queens Col., N.Y.; Univ. Conn.; Cranbrook Acad. A., Bloomfield Hills, Mich., B.F.A., M.F.A.; Am. Acad. in Rome (Visiting Painter, 1963-64). Member: AFA. Awards: Prizes, Detroit Inst. A., 1960 (purchase); Butler Inst. Am. A., 1961 (purchase); Connecticut Artists, Norwich; Northeast Regional, Mystic, Conn., 1962; Conn. Acad. FA, 1963; Miami Nat., Lowe Gal., Coral Gables, 1963; Tiffany Fnd., 1962, 1964; Springfield Mus. FA, Marietta Col., 1968. Work: Detroit Inst. A.; Butler Inst. Am. A.; Lowe Gal., Miami; Cranbrook Mus. A. Exhibited: Providence A.Cl., 1967, 1968; Providence A. Festival, 1966, 1967, 1969; Marietta Col., 1968; Bucknell Univ., 1967; J. B. Speed Mus., Louisville, Ky., 1966; Swain Sch. of Des., 1966-1968; Stevens Gal., Detroit, 1968; Wheelock Col., Boston, 1968. Positions: Instr., Des., Painting, Swain School of Design, New Bedford, Mass., 1964- .

RADOCZY, ALBERT—Painter, T.
 61 Cedar St., Cresskill, N.J. 07626
B. Stamford, Conn., Oct. 22, 1914. Studied: Parsons Sch. Des., N.Y.; Cooper Union, N.Y. Exhibited: WMAA, 1962; BM, 1962; St. Paul A. Center, 1963; MModA Lending Service, 1964; Dwan Gal., Los A., 1965. Positions: Instr., Drawing, Cooper Union A. Sch., 1950-55; City College of N.Y., at present.*

RADULOVIC, SAVO—Painter, C., Gr., L.
 25 West 88th St., New York, N.Y. 10024
B. Yugoslavia, Jan. 27, 1911. Studied: St. Louis Sch. FA, Washington Univ.; FMA, Harvard Univ.; Academie de Belle Arte, Rome, Italy. Awards: Carnegie F. to Fogg Mus. A., Harvard Univ., 1937; purchase prize, CAM, 1941; Fulbright F., Rome, Italy, 1949-50. Work: CAM; Univ. Arizona; Hist. Section, War Dept., Pentagon, Wash., D.C.; Col. of William and Mary, Williamsburg, Va.; Mus. Mod. A., Miami Beach, Fla.; in private colls. U.S.A. and abroad. Exhibited: NAD; PAFA; WMAA; CAM; Wildenstein Gal., N.Y.; PMA; Washington Irving Gal., N.Y.; Park Ave. Gal., Mt. Kisco, N.Y.; Exh. by Fulbright painters being exhibited in twenty colleges & museums in U.S.; Rome, Italy; Societe des Peintres de la Montenegro; Mus. Archaeology, Yugoslavia.

RAFFAEL, JOSEPH—Painter
 Art Department, University of California, Berkeley, Cal. 94720
B. New York, N.Y., Feb. 22, 1933. Studied: Cooper Union Art Sch., N.Y.; Yale Univ., B.F.A. Awards: Fulbright Award, 1958; Tiffany Fellowship, 1961. Work: Kliner Fnd. Exhibited: Univ. Pennsylvania, 1966; Larry Aldrich Mus., MModA, 1966; Guggenheim Mus., 1966; Yale Univ. A. Gal., 1966; AIC, 1967; CGA, 1967; Finch Col., 1967; Galleria d'Arte Moderna, Milan, Italy, 1967; Galleria Sperone, Turin, 1967 (2-man); Univ. Illinois, 1967; Los. A. County Mus., 1967; Sao Paulo Biennial, 1967; ICA, London, 1968; Herron Mus. A., Indianapolis, 1969; Newport (Cal.) Mus., 1970, and others. Contributor to Art News; Arts magazine. Positions: Instr., Painting, Univ. California, Davis; Sch. Visual Arts, New York City; Univ. California, Berkeley; Sacramento State Col.

RAFSKY, JESSICA C.—Collector
 356 W. 40th St. 10018; h. 200 E. 62nd St., New York, N.Y. 10021
B. New York, N.Y., Sept. 18, 1924. Studied: George Washington University; New York University. Member: Guggenheim Museum (Associate); Fellow, MModA; MMA (Associate). Collection: Contemporary art.

RAHJA, VIRGINIA HELGA—Educator, P., S., C., Gal., Dir.
 344 Summit Ave. 55102; h. 360 S. Lexington Pkwy., St. Paul, Minn. 55105
B. Aurora, Minn., Apr. 21, 1921. Studied: Hamline Univ., B.A., and

grad. work with Lowell Bobleter. Member: National Assoc. Interior Designers; AAUW; Minnesota Edu. Assn. Awards: various awards in local and national exhs. Work: paintings and ceramics in private colls. Exhibited: WAC; Univ. Minnesota; Minneapolis Inst. A.; St. Paul Gallery; Minnesota State Fair; Hamline Univ., all annually since 1941. One-man exhs. annually in musuems & galleries in U.S. Positions: Asst. Prof. A., 1941-48, Prof. A., 1948- , Hamline University, St. Paul, Minn.; Dir. Hamline Univ. Galleries, 1941-48; Asst. Supt., Minn. State Fair, 1942-48; Dir., Assoc. Arts Gal. and Dean & Dir. FA, Sch. of the Assoc. Arts, 1948- .

RAHR, FREDERIC H.—Collector, Patron
 1 East End Ave., New York, N.Y. 10021; also 46191 Joshua Tree, Palm Desert, Cal. 92262
B. Malden, Mass., Apr. 23, 1904. Studied: Harvard Col.; Famous Artists School; National Academy School of Fine Arts, and with Francis Scott Bradford. Awards: Honorary Member, Eta Mu Pi, Baruch School of Business and Administration, City College, N.Y. Collection: Paintings, Prints, Engravings. Positions: President, Consumer research of Preference Trendsall fashion items for apparel and home goods in design, style, size, color, types of material, price, 1936-1969.

RAIN, CHARLES (WHEDON)—Painter
 10 Mitchell Pl., New York, N.Y. 10017
B. Knoxville, Tenn., Dec. 27, 1911. Studied: AIC. Awards: purchase prizes, Springfield (Mass.) Mus. FA, 1947; Univ. Illinois, 1950. Work: Springfield Mus. FA; Univ. Illinois; Arizona State Col., Tempe; DeBeers Mus., Johannesburg, South Africa; VMFA. Exhibited: Univ. Nebraska, 1947-1949, 1951, 1954; Springfield Mus. FA, 1947, 1963; Univ. Illinois, 1949, 1950, 1951, 1953, 1957; Inst. Contemp. A., London, 1950; CAL.PLH, 1949, 1950; Los A. Mus. A., 1951, 1956; FA Gal. of San Diego, 1956; Toledo Mus. A., 1950, 1953, 1954; AIC, 1947; Carnegie Inst., 1943, 1944, 1946-1949; Inst. Mod. A., Boston, 1944; PMA, 1950; PAFA, 1947; CAM, 1951; WAC, 1953; Albright-Knox A. Gal., Buffalo, 1961; VMFA, 1954; Denver A. Mus., 1957; Mus. FA of Houston, 1956; CGA; MModA, 1943; WMAA, 1941, 1949; Knoedler Gal., N.Y., 1947, 1952; Banfer Gal., N.Y., 1963.

RAINEY, FROELICH—Museum Director, E., W., L.
 University of Pennsylvania Museum, 33rd & Spruce Sts., Philadelphia, Pa.; h. Valley Forge, Pa. 19481
B. Black River Falls, Wis., June 18, 1907. Contributor to American Antiquity; American Anthropologist; Applied Anthropology. Positions: Prof. Anthropology, 1935-42; Consultant, State Dept., 1948-52; Dir., Univ. Pennsylvania Museum, Philadelphia, Pa., 1948- .*

RALSTON, J(AMES) K(ENNETH)—Painter, I., S. W.
 2103 Alderson Ave., Billings, Mont. 59102
B. Choteau, Mont., Mar. 31, 1896. Studied: AIC. Member: Billings AA; Montana Inst. A. Work: Jefferson National Expansion Mem., St. Louis, 1964; Custer Battlefield Nat. Monument, 1964; bronze statues, "Buffalo Bull" and "Cow and Calf" for Montana Historical Soc., Helena; paintings & pen drawings in private colls. Exhibited: Yellowstone A. Gal., Billings, Mont., 1967; Sidney Nat. Bank, Mont., 1968; Desert Southwest Gal., Palm Desert, Cal., 1968-1969; Big Sky Gal., Billings, Mont., 1968. Illus. "New Anthology of Cowboy and Western Songs," 1969; Author & I., "Rhymes of a Cowboy." Cover, "Montana Arts" magazine, 1969. Positions: Exec. Bd., Custer Battlefield Hist. Mus. & Mus. Assn.; Yellowstone Hist. Soc.

RAMBO, JAMES I.—Museum Curator
 California Palace of the Legion of Honor; h. 155 Varennes St., San Francisco, Cal. 94133
B. San Jose, Cal., June 24, 1923. Studied: San Jose State Col., B.A.; Cal. Sch. FA; Texas A. & M. Contributor articles in professional publications and catalogues. Positions: Staff, Cooper Union Musuem, New York, 1949-52; Keeper Decorative Arts, 1950-52; Staff, California Palace of the Legion of Honor, San Francisco, Cal., 1953- , Cur. Collections, 1955-1966, Chief Cur., 1966- .

RAMBUSH, ROBERT—Designer
 281 W. 4th St., New York, N.Y. 10014*

RAND, PAUL—Designer, P., E., I., Cr., W., Typog.
 Goodhill Rd., Weston, Conn. 06880
B. Brooklyn, N.Y., Aug. 15, 1914. Studied: PIASch.; Parsons Sch. Des.; ASL. Member: Benjamin Franklin Fellow, Royal Soc. A., London; A. Dir. Cl.; Swedish Soc. Indst. Des.; AIGA; Alliance Graphique International, Paris; Visiting Com., Graphic Design Dept., Philadelphia Col. A. Awards: prizes, AIGA, 1938, gold medal, 1966; medal, A. Dir. Cl., 1945, 1952, 1953; included in selection "50 Books of the Year"; Sch. A. Lg., medals and scholarship; Direct Mail Advertising award; Soc. Typographic A., Chicago. One of the 10 Best Houses of 1953, MModA and Merchandise Mart; Best Fabric, "Good Design" Exh., 1954; 1 of 10 Best A. Dir., A. Dir. Cl. poll; Citation, Phila.

Mus. College of Art, 1962; medals for best design and typography (annual reports), Financial World, and many other awards. Work: N.Y. Pub. Lib.; MModA. Exhibited: AIGA, since 1938; A. Dir. Cl., 1936-1955; Musee de l'Art Moderna, Paris, 1955; Louvre Mus., Paris, 1955. Author, I., "Thoughts on Design"; "Typography in the United States"; "Black in the Visual Arts"; "The Trademark as an Illustrative Device"; "The Poster"; "The Trademarks of Paul Rand." Author, "Design and the Play Instinct," ("Education of Vision"), 1965; numerous papers on design, advertising, typography. Book about Paul Rand: "Paul Rand, His Work from 1946-58," edited by Y. Kamekura. Illus. children's books: "I Know a Lot of Things," 1956; "Sparkle and Spin"; "Little 1." Positions: A. Dir., Esquire magazine (N.Y. Office), 1937-41; Instr., Pratt Inst., Brooklyn, N.Y., 1946; CUASch., New York, N.Y., 1942; N.Y. Des Laboratory, 1941; Prof., Yale Univ., 1956- . Adv. Bd., Cambridge Sch. Des. Book des. for leading publishers. Consultant to IBM, Westinghouse, and other corporations. Hon. Prof., Tama Univ., Tokyo, 1958.

RANDALL, RUTH HUNIE (Mrs.)—Educator, C., W.
334 N.E. La Salle Rd., Port Charlotte, Fla. 33950
B. Dayton, Ohio, Sept. 30, 1896. Studied: Cleveland Sch. A.; Syracuse Univ., B.F.A., M.F.A.; in Vienna; & with Ruth Reeves; one year's research on Ceramics, in the Orient, 1957. Member: Syracuse Ceramic Gld.; York State Craftsmen. Awards: prizes, Nat. Ceramic Exh., Assoc. A. Syracuse, 1945; Syracuse Mus. FA, 1939. Work: IBM Coll.; Syracuse Mus. FA; San Antonio Mus. A.; Butler AI. Exhibited: Nat. Ceramic Exh., 1932-1964; Cranbrook Acad. A., 1946; Paris Salon, 1937; MMA; Phila. A. All., 1936, 1942-1945; Finger Lakes Exh., Rochester, Utica, N.Y., Youngstown, Ohio, Kansas City, Mo.; Western Texas; Everson Mus. A., 1960 (one-man); ceramic exh., Scandinavian countries. Retrospective Exh., Syracuse Univ., 1962. Contributor to: Craft Horizons & Design magazines. Author: "Ceramic Sculpture." Lectures: Ceramic Sculpture. Positions: Prof. Emeritus, Syracuse Univ., Syracuse, N.Y., crafts Instr., Adult Edu. Cultural Center, Charlotte County, Fla.

RANDALL, THEODORE A.—Educator, S.
State University of New York, College of Ceramics at Alfred University, Alfred, N.Y. 14802
B. Indianapolis, Ind., Oct. 18, 1914. Studied: Yale Univ., B.F.A.; State Univ. of N.Y. Col. of Ceramics, M.F.A. Member: F., Am. Ceramic Soc.; Acad. Int. Ceramics; CAA. Awards: prizes, Syracuse Mus. FA; Wichita; Finger Lakes, N.Y.; Albright A. Gal.; Pomona, Cal.; Smithsonian Inst.; York State Craftsmen. Work: pottery, Syracuse Mus. FA; Wichita; Pomona. S., St. Stephens Church, Albany, N.Y. Contributor to Journal and Bulletin of the Am. Ceramic Soc.; Ceramic Age; Ceramic Industry; Ceramics Monthly; article, "Notions about the Usefulness of Pottery" in Pottery Quarterly, 1961. Lectures: Motives and Meaning in Art; Ceramics Today, etc. Positions: Chm., Dept. Art, Prof., Des., Pottery, Sculpture, College of Ceramics, Alfred Univ., Alfred, N.Y.; Past Pres., National Council on Education for the Ceramic Arts; Council Member, National Council for the Arts in Education; President, National Association of Schools of Art.

RANDELL, RICHARD—Sculptor
c/o Royal Marks Gallery, 19 E. 71st St., New York, N.Y. 10021*

RANDOLPH, GLADYS CONRAD (Mrs. Paul H.)—Painter, W.
Sailboat Bay Apts., 2951 S. Bayshore Dr., Miami, Fla. 33133
B. Whitestone, L.I., N.Y. Studied: N.Y.Sch. F. & App. A.; Terry AI; Portland (Ore.) A. Mus.; Univ. Pennsylvania; N.Y. Univ., and with Hobson Pittman, Revington Arthur. Member: Fla. Fed. A.; Miami WC Soc.; AEA; Arts Council, Inc., Miami, Fla. (Art Chm.); Fla. A. Group; Miami AA; Miami A. Lg. (Exec. Chm.); Blue Dome Fellowship; Nat. Lg. Am. Pen Women (A. Chm.). Awards: prizes, Miami A. Lg.; Blue Dome; Fla. Fed. A.; AAPL; Terry AI; Nat. Lg. Am. Pen Women; Miami Art Center (A. Chm.). Work: Lowe Gal. A.; Columbus (Ga.) Mus. A. Mirell Gal., Miami, Pageant Gal., Miami. Exhibited: Terry AI, 1952; Fla. Southern Col., 1952; Ringling Mus. A.; Tampa State Fair; Lg. Am. Pen Women, 1950; Norton Gal. A., 1952; Soc. Four A., 1951; Miami A. Lg.; Blue Dome; AAPL; Poinciana Festival; Columbia (N.C.) Mus.; Miami Women's Cl., and other local and regional exhibitions; group traveling exhs. of Fla. Fed. A.; Fla. A. Group; Miami AA.; one-man: Research Center, Maitland, Fla.(2); Miami Beach A. Center; Columbus, Ga.; Mirell Gal., Miami (2). Also exh. in Havana, Cuba. Contributor of articles to The Mineralogist, Portland Oregonian, Oregon Journal, American Boy, and other publications and newspapers.

RANNIT, ALEKSIS—Educator, Hist., Cr., W.
Yale University; h. 198 Lawrence St., New Haven, Conn. 06511
B. Kallaste, Estonia, Oct. 14, 1914. Studied: Univ. Tartu, Estonia, Diploma in A. Hist.; Columbia Univ., M.S. Member: Int. Assn. A. Critics; Int. Congresses A. Hist.; Int. Pen Clubs, London (Exec.

Com.); Assn. German A. Hist.; Assn. German Writers; Lithuanian Writers' Assn.; Estonian Literary Soc. (Pres.); Academician, Academie Internationale des Sciences et des Lettres, Paris. Awards: Olsen Fnd. F., for research and writing on Coptic art and symbolism, 1955. Author: Monographs, "Eduard Wiiralt," 1943, 1946 (2); "V. K. Jonynas," 1947; "M. K. Ciurlionis," 1949 (UNESCO publ.). Contributor to Brockhaus Encyclopaedia; Schweizer Lexicon; Benezit; Das Kunstwerk (American Corr.); La Biennale di Venezia; Les Arts Plastique and others. Positions: Chief cur. Prints and Rare Books, Lithuanian Nat. Lib., Kaunas, Lithuania, 1941-44; Prof. A. Hist., Ecole Superieure des Arts et Metiers, Freiburg, Germany, 1946-50; Scientific Sec., Div. FA, French High Comm. in Germany, 1950-53; A. Reference Libn. & Cataloger of Prints, Art & Arch. Div., New York Public Library, 1953, 1961; Prof., Cur., Russian and East European Collections and Research Associate, Yale University, New Haven, Conn., at present.*

RANSON, NANCY SUSSMAN (Mrs.)—Painter, Ser., L.
1299 Ocean Ave., Brooklyn, N.Y. 11230
B. New York, N.Y., Sept. 13, 1905. Studied: PIASch.; ASL, and with Laurent, Charlot, Brackman, Brook. Member: NAWA; Am. Soc. Contemp. A., (Cor. Sec., 1948-53, Pres., 1954-56); Am. Color Pr. Soc.; N.Y. Soc. Women A.; Audubon A.; Nat. Soc. Painters in Casein; Hunterdon A. Center. Awards: prizes, Critic's Choice Exh., 1947; NAWA, 1952, 1953, 1956, 1958, medal, 1956; Nat. Ser. Soc., 1953; Grumbacher award in Casein, 1954; Print chosen for Am. Color Pr. Soc. presentation, 1955, prize, 1955; Brooklyn Soc. A., 1946, 1954, 1955, 1957, 1958, 1960, 1962, 1964; Audubon A., 1958, 1961; Nat. Soc. Ptrs. in Casein, 1963; MacDowell Fnd. Fellowship, 1964. Work: Brandeis Univ.; Mexican Govt. Tourist Comm.; Key West A. & Hist. Soc.; Reading Pub. Mus.; Free Lib., Phila.; Mus. of the City of N.Y.; A. Gal. of New South Wales; Bezalel Mus., Jerusalem; Nat. Gal. Mod. A., New Delhi, India; Nat. Mus. Modern A., Tokyo, Japan; Norfolk Mus. A.; Queensland A. Gal., Brisbane, Australia; FMA; Univ. Maine. Exhibited: AWS, 1940, 1942, 1943, 1951; NAWA, 1943-1969; Am. Soc. Contemp. A., 1941-1969; A. for Victory, 1944; Critic's Choice, 1947; Prize Winners Show, 1947; Butler AI, 1950; BM, 1950, 1954, 1956; Ferargil Gal., 1947; Paris, 1964; Switzerland, 1958; Audubon A., 1950-1969; Nat. Ser. Soc., traveling exh., 1952-55; NAWA traveling exh., 1948-1969; Am. Soc. Contemp. A., traveling, 1954-59; Am. Color Print Soc. traveling, 1952-64; WMAA, 1951; Mobile WC Soc., 1951; Nat. Ser. Soc., 1951-1955; Portland Soc. A., 1952, 1954; Bradley Univ., 1952, 1954; Northwest Pr. M., 1952; N.Y. Soc. Women A., 1952-1965 Am. Color Pr. Soc., 1954-1969; Nat. Soc. Painters in Casein, 1955, 1958, 1961-1965; Boston Pr. M., 1955; Nat. Exh. Contemp. A., 1956; PAFA, 1957; Hunterdon A. Center, 1957-1969; one-man: Binet Gal., 1948, 1950; Brooklyn Pub. Lib., 1951; Mexican Govt. Tourist Comm., Radio City, 1952; Univ. Maine, 1964. Lecture: "Art and Archaeology Around the World," 1961. Positions: Chm., Foreign Exhs., 1963-67, Delegate, U.S. Committee I.A.A., 1962-65, Chm. Admissions, 1969- , NAWA. Pres., Am. Soc. Contemp. A., 1969- .

RAPPAPORT, MAURICE I.—Collector, Critic, Art Dealer
13855 Superior Rd., Cleveland Heights, Ohio 44118
B. Russia, Aug. 5, 1899. Studied: Art Students League, under Henri, Bridgman, Neilson. Member: Cleveland Art Directors' Club, 1952- . Specialty of Gallery: Contemporary realist art. Collection: 19th and 20th century traditional art. Positions: President, Rappaport Exhibits, Inc., 1932- ; Director, Circle Gallery, 1961- .*

RAPPIN, ADRIAN—Painter
14 W. 68th St., New York, N.Y. 10023
B. New York, N.Y., Jan 20, 1934. Studied: Acad. FA, Rome, Italy; Brandeis Univ., B.A.; Art Acad., Cincinnati; ASL. Member: All. A. Am.; The 50 Am. Artists; Intercontinental Artists. Work: Staten Island Mus.; N.Y.; Gibbes Gal., Charleston, S.C.; Brandeis Univ.; Lincoln Univ., Oxford, Pa.; Randolph-Macon Col., Lynchburg, Va.; Stratford Col., Stratford, Va. Reproductions of painting, New York Times "Christmas Fund, 1967, 1968. Exhibited: All. A. Am., 1961-1969; 50 Am. Artists, 1965-1969; Unicef Intercontinental Exh., Monaco, 1965-1967; one-man: Pushkin Mus., Moscow, 1969; Barzansky Gal., N.Y., Kalamazoo, Mich., 1970.

RASCOE, STEPHEN THOMAS—Painter, E.
University of Texas at Arlington, Art Department 76010; h. 2002 Westview Terr., Arlington, Tex. 76010
B. Uvalde, Tex., May 8, 1924. Studied: Univ. Texas; AIC, B.F.A., M.F.A. Member: Texas FA Assn.; South Texas A. Lg.; Corpus Christi A. Fnd.; Dallas AA; Fort Worth AA. Awards: prizes, Jr. Service League of Longview, 1960, 1962, 1963; South Texas A. Lg., 1956, 1957, 1959, 1962, 1963; South Texas A. Lg., 1956, 1957, 1959, 1962, 1963; South Texas A. Lg., 1956, 1957, 1959, 1962, 1963; purchase prizes; Mus. FA of Houston, 1956; Texas State Fair, 1957; Friends of Texas Fine Arts, 1958; D. D. Feldman Exh., 1959. Work: DMFA; Mus. FA of Houston; Centennial A. Mus., Corpus Christi;

Texas FA Assn.; So. Methodist Univ., Dallas; Texas Univ., Austin; Ford Motor Co., Dearborn; mural, The Rancho Seco Land & Cattle Co., Corpus Christi; mural, LTV Research Center, Arlington; 1st Natl. Bank, Dallas. Exhibited: Knoedler Gal., N.Y., 1952; Denver Mus., 1958; Art: USA, 1958; Ringling Mus. A., 1959; Nelson Gal., Kansas City, 1952; Corpus Christi A. Fnd., 1951-1964; So. Texas A. Lg., 1952-1958; Jr. Service Lg. of Longview, 1959-1965; DMFA, 1960; Roswell Mus. A., 1962; Mus. New Mexico, Santa Fe, 1963; Texas FA Assn., 1953-1963; Texas Painting & Sculpture Annual, (1951-1965) primarily at Dallas Mus. FA. but also shown in other Texas museums throughout the state; Nessler Gal., N.Y., 1958; Dallas Mus. for Contemp. A., 1959; Oklahoma City, 1963; El Sol Gal., Corpus Christi, 1963; Rice Univ., 1963; Univ. Corpus Christi, 1964; Del Mar Col., 1961; numerous one-man exhs. in Texas, 1951-1969. Contributor illus. to Ford Times including cover, 1961. Positions: Prof. A., Del Mar College, Corpus Christi and Univ. of Texas at Arlington.

RATH, FREDERICK L., Jr.—Historian, Mus. Dir., L., W.
 New York State Historical Association; h. 103 Pioneer St., Cooperstown, N.Y. 13326
B. New York, N.Y., May 19, 1913. Studied: Dartmouth Col., B.A.; Harvard Univ., M.A. (Am. Hist.). Member: Am. Hist. Assn.; Am. Assn. for State & Local Hist.; AAMus. Awards: Ctf. of Merit, Am. Scenic & Historic Preservation Soc.; F., Rochester Mus. A. & Sciences. Ed., "FDR's Hyde Park" (with Lili Rethi); "New York State Historical Association Selective Reference Guide to Historic Preservation," and "The New York State Historical Association and its Museums: An Informed Guide." Lectures: New Trends in Historic Preservation, etc. Positions: Historian, Nat. Park Service, 1937-42, 1946-48; Exec. Sec., Nat. Council for Historic Sites & Bldgs., 1948-50; Dir., Nat. Trust for Historic Preservation, 1950-56; Vice-Dir., New York State Hist. Assn., Cooperstown, N.Y., 1956- ; Pres., Am. Assn. for State & Local History, 1960-1962; Council, 1954- . Adjunct Prof., State Univ. College at Oneonta; Comm. of Admin., Cooperstown Graduate Programs (History Museum Training and American Folk Culture.

RATH, HILDEGARD—Painter, T., Gr., W., L., Ser.
 3 Cypress Ave., Kings Point, N.Y. 11024
B. Freudenstadt, Germany, Mar. 22, 1909. Studied: in Stuttgart, Germany with Adolf Senglaub; Kunstgewerbe Schüle, Stuttgart with Vogt and Otto Heim; Berlin Acad. FA. Member: Knickerbocker A. AEA; Nat. Assn. Pub. Sch. Adult Edu.; Southern Vermont A.; North Shore Community A. Center, Roslyn, N.Y.; Int. Platform Assn., and art societies in Germany. Awards: Grumbacher award, Florida Int. Exh., 1952; Prix de Paris, 1963. Work: MMA; N.Y. Pub. Lib.; LC; BM; MModA; WMAA; and in museums and private colls. in Europe, and U.S. Exhibited: All.A.Am., 1951; Knickerbocker A., 1950-1965; Fla. Int. Exh., 1952; Terry AI, 1952; Albany, N.Y., 1957, 1963; Springfield A. Lg., 1957; LC, 1957; Bucknell Univ., 1957; Springfield (Ill.) AA, 1957; Rochester Mem. A. Gal., 1957; Mobile AA, 1958; Univ. Wisconsin, 1958; Southern Vermont A., 1948-1965; AEA, 1951-1953; Hall of Art, N.Y., 1951, 1952; Bertha Schaefer Gal., N.Y., 1951; I.F.A. Gal., Wash., D.C., 1957-1960; Koltnow Gal., N.Y., 1957-1959; New Art Center, N.Y., 1957-1960; Brentano's, N.Y., 1958-1960; Deitsch Gal., N.Y., 1957-1965; Weyhe Gal., N.Y., 1957-1965; North Shore Community A. Center, 1960, 1961; Manufacturers Hanover Trust Co., 1965, 1966; C.W. Post Col., 1961; The Contemporaries, N.Y., 1957-1963; Ligoa Duncan Gal., N.Y., 1962, 1963, 1965; FAR Gal., N.Y., 1957-1965; Print Cl., Albany, N.Y., 1957, 1963, 1964; Lever Bros., N.Y., 1965, and many others; one-man: Stuttgart, Germany, 1927, 1946, 1959; Freudenstadt, Germany, 1946; Concord, N.H., 1948, 1952; Raymond Duncan Gal., Paris, 1963; Ligoa Duncan Gal., N.Y., 1965, 1967; Dorset, Vt., 1949 (2-man); Wuerttemberg, Germany, 1959 (4-man); Almus Gal., N.Y., 1961 (one-man); Avant-garde Gal., New York City, 1961, and others. Lectures on art and artists, From Pre-Historic Times to the Present, at Adult Education organizations, art societies, museums and galleries. Positions: Instr., A., European Sch. FA, New York, N.Y.; Dir., European Sch., 1949-54; Summer Classes, Concord, N.H., 1952; Serigraphy, North Shore Community A. Center, 1960; History of Art, (Museum visits) Great Neck, N.Y. Pub. Schs., 1960-61.

RATHBONE, PERRY TOWNSEND—Museum Director
 Boston Museum of Fine Arts, Huntington Ave., Boston, Mass. 02115; h. 151 Coolidge Hill, Cambridge, Mass. 02138
B. Germantown, Pa., July 3, 1911. Studied: Harvard Col., A.B.; Harvard Univ. Member: AAMus. (Vice-Pres.); AAMus. Council; AAMus. Dirs. (Pres.); Royal Soc. A., London. Awards: Hon. Phi Beta Kappa, Harvard Chptr., 1958; Hon. D.F.A., Washington Univ., St. Louis, Mo., 1958; Hon. D.H.L, Northeastern Univ., Boston, 1960; Hon. D.F.A., Bates College, 1964; Hon. D.H.L., Suffolk Univ., Boston. Mass., 1969. Author: "Charles Wimar: Painter of the Indian Frontier," 1946; "Max Beckmann," 1948; "Mississippi Panorama," 1949; "Westward the Way," 1954; "Lee Gatch," 1960; "Handbook

for the Forsyth Wickes Collection," 1968. Contributor to art magazines and museum bulletins. Positions: Cur., Detroit Inst. A., 1936-40; Sec., Dir., Masterpieces of Art, WFNY, 1939; Dir., CAM, St. Louis, Mo., 1940-55; Chm. Bd., Metropolitan Boston A. Center; Trustee, New England Conservatory of Music; Inst. Contemp. A., Boston; Boston A. Festival; Committee to Visit the Fine Arts Dept., Harvard Univ. (Vice-Chairman); Trustee, R.I. Sch. Des.; Int. Exhibitions Foundation, Washington, D.C.; Fine Arts Visiting Committee R.I. Sch. Des.; Visiting Committee for Art and Archeology, Dept. Fine Arts, Washington Univ., St. Louis, Mo.; Member, Mayor of Boston's Art Advisory Committee, 1969- ; Art Advisory Committee of the Chase Manhattan Bank, New York; Dir., Boston Mus. FA, Boston, Mass., 1955- .

RATKAI, GEORGE—Painter, S., I., Lith.
 350 West 57th St., New York, N.Y. 10019
B. Budapest, Hungary, Dec. 24, 1907. Member: A. Lg. Am.; AEA; Provincetown AA; Audubon A.; F.I.A.L.; AFA; Nat. Soc. Painters in Casein. Awards: prize, Art of Democratic Living, 1951; gold medal, Audubon A., 1953, 1965, memorial medal, 1956; Childe Hassam award, 1959. Work: Tel-Aviv Mus., Israel; Abbott Lab. Coll.; Univ. Illinois; Butler Inst. Am. A.; Univ. Nebraska; WMA; Rochester Mem. A. Gal.; Maryhill (Wash.) Mus. A. Exhibited: Pepsi-Cola, 1945, 1946; Springfield Mus. A.; Hungarian A. in Am.; PAFA, 1961; Carnegie Inst.; Illinois Wesleyan Univ., 1955-1958; Univ. Illinois, 1950-1957; WMAA, 1949, 1950, 1952-1956, 1958, 1959; Nebraska AA; Toledo Mus. A.; NAD; CGA, 1959, 1960, 1961, 1963; Audubon A., 1955-1965 and prior; MMA; WMA, 1951, 1956; Des Moines A. Center, 1951, 1956; BM, 1951, 1956; MModA, 1956; Provincetown AA, 1956-1964; Davenport Mus. A., 1957; Altoona AA, 1957; Mint Mus. A., 1957; AWS, 1956; Rochester Mem. A. Gal., 1957; Columbus Ga. FA, 1956, 1957; Milwaukee Downer Col., 1960; AFA traveling exh., 1964-65; Spoleto, Italy, 1961; Butler Inst. Am. A., 1962; Bennett Col., 1962; Lehigh Univ., 1963; Univ. Nebraska, Religious Art exh., 1965; Mansfield State Col., Pa., 1965; Bass Mus. A., Miami, 1965; one-man: Assoc. Am. A., 1947; Babcock Gal., N.Y., 1950, 1954, 1956, 1959, 1960.

RATTNER, ABRAHAM—Painter
 7 rue Antoine Chantin, Paris 14, France; also, 8 W. 13th St., New York, N.Y. 10011
B. Poughkeepsie, N.Y., July 8, 1895. Studied: Corcoran Sch. A.; PAFA; Ecole des Beaux-Arts, Julian Acad., Grande Chaumiere, Paris, France. Member: French Societe des Arts Decoratif; Nat. Inst. A. & Lets. Awards: Cresson traveling scholarship, PAFA, 1919; gold medal, PAFA, 1945; Citation, gold medal and one-man exh., Temple Univ., Phila., Pa., 1955; gold medal, A. Dirs. Cl., Phila., 1956; prize, Univ. Illinois, 1948. Work: U.S. State Dept.; MModA; WMAA; PAFA; Albright-Knox A. Gal., Buffalo; AIC; BMA; Ft. Worth AA; Encyclopaedia Britannica; Pepsi-Cola Co.; Clearwater A. Mus.; PMG; MMA; PMA; CMA; Univ. Illinois; Des Moines A. Center; French Govt.; mosaic columns and tapestry murals, Fairmount Temple, Cleveland; stained glass facade, Loop Synagogue, Chicago; mosaic mural, St. Francis Monastery, Ohio; facade for St. Leonard's Friary and College. Exhibited: nationally and extensively abroad including, among others: CGA, 1958; WMAA, 1959; Chicago A. Cl.; Stendahl A. Gal., Los A.; Santa Barbara Mus. A.; Renaissance Soc., Chicago; and all museums and colleges mentioned under Work above; also, Vatican Exh. of Religious Art, N.Y. World's Fair, 1965; Salon de Mai, 1964, Salon des Comparaisons, 1964, 1965, Paris, France; one-man: Vassar College; Univ. Illinois, 1952; Paul Rosenberg & Co., N.Y., 1942-1965; Coard Gal., Paris, 1965; Fabre Mus., Montpelier, France, 1965 (auspices of U.S.A.); Edinburgh Festival, Scotland, 1964. Positions: A.-in-Res., Am. Acad. in Rome, 1951; Visiting Prof., Columbia Univ., 1955-56, PAFA, 1955; Skowhegan Sch. A., 1949-50 (summers); Instr., and Artist-in-Residence at many leading schools and universities.*

RAUCH, JOHN G.—Collector
 3050 N. Meridian St., Indianapolis, Ind. 46208
B. Indianapolis, Ind., July 16, 1890. Studied: Harvard College, A.B.; Harvard Law School. Positions: Trustee, 1940- , Pres., 1962- , Art Association of Indianapolis; Chm. Bd. Trustees, Indiana Historical Society. Awards: Hon. LL.D., Butler Univ., 1968.

RAUSCHENBERG, ROBERT—Painter
 c/o Leo Castelli Gallery, 4 E. 77th St., New York, N.Y. 10021
B. Port Arthur, Tex., 1925. Studied: Kansas City AI; Black Mountain Col., with Albers; ASL, with Vytlacil and Kantor. Awards: Winner, Venice Biennale, 1964; 1st prize, Gal. Mod. A., (Prints) Ljubljana, Yugoslavia, 1963; Chicago Art Inst., 1966; Corcoran Biennial Contemp. Am. Painters, 1965. Work: Albright-Knox A. Gal.; WMAA; White Mus.; Cornell Univ.; Tate Gal., London; Goucher Col.; and in many private collections. Exhibited: Nationally and internationally, 1951-1965. One-man: Betty Parsons Gal., N.Y., 1951; Florence and Rome, Italy, 1953; Egan Gal., N.Y., 1955; Stable Gal., N.Y., 1953;

Castelli Gal., N.Y., 1958-1961, 1965, 1967, 1968; Galerie Cordier, Paris, 1961; Dwan Gal., Los A., 1962; Whitechapel Gal., London, 1964; Richard Feigen Gal., 1967; Ileana Sonnabend, 1967; Pollock Gal., 1968; Stedelijk Mus., 1968, and others.*

RAVESON, SHERMAN HAROLD —
Painter, Des., Typographer, A. Dir., W., Ed.
Wayah Valley Rd., Franklin, N.C. 28734
B. New Haven, Conn., June 11, 1907. Studied: Cumberland Univ., A.B., L.L.B.; ASL, and with Vincent Mundo. Member: AWS; Phila. WC Cl.; Grand Central A. Gal. Awards: medal, A. Dir. Cl., 1934, 1939; Nat. Advertising award, 1941; Certif. of Award, Best Nat. Adv. of 1949-50; prize, AWS, 1950; NAC, medal of honor, 1951; Four A. Soc., Palm Beach, 1968. Work: Nat. Mus. of Racing, Saratoga Springs, N.Y.; Saratoga Raceway; Sporting Gal., New York City; Hialeah Club House; Hall of Fame of The Trotter, Goshen, N.Y. Exhibited: CGA, 1935-1939; PAFA, 1935-1939; NAD, 1935, 1937, 1939; Toledo Mus. A., 1938; Phila. WC Cl., All. A. Am.; AWS, 1934-1958; Carnegie Inst., 1936; Iowa State Fair, 1936; Wash. State Fair, 1936; AIC, 1935, 1936, 1938-1940; WFNY 1939; one-man: Assoc. Am. A., 1941; Grand Central A. Gal., 1955, 1956; Carriage House Studios, Phila., 1956; others, 1956-58 in the following club houses: Hialeah, Churchill Downs, Monmouth Park, Saratoga Raceway, Seagate; 1959-1969; Grand Central A. Gal., N.Y.; Sportsman's Gal., N.Y.; Crossroads of Sports, N.Y.; Palm Beach Gals.; N.Y. World's Fair, 1964-65; (11 ptgs. of N.Y. racetracks); Pompano Park Raceway; Harness Tracks of America, Chicago; Royal Poinciana Travel, Palm Beach; Hialeah Club House; Saratoga Raceway Club House. Positions: A. Ed., Vanity Fair magazine, 1929-34; A. Dir., Life magazine, 1935; Esquire magazine, 1936; Pettingell & Fenton, 1937-41; Consultant A. Dir., 1945-51; Editor: Classified Boating Directory of the Florida East-West Coast, 1967- ; Palm Beach Shopping Guide to Worth Avenue, 1967- . V. Pres. & A. Dir., Sterling Adv. Agcy., New York, N.Y., 1951-1955. Editor, 1967- .

RAWSKI, CONRAD HENRY—Educator, L., W.
School of Library Science, Western Reserve University, Cleveland, Ohio 44106
B. Vienna, Austria, May 25, 1914. Studied: Univ. Vienna, Ph.D.; Western Reserve Univ., Sch. Lib. Sc., M.S., in L.S.; Harvard Univ.; Cornell Univ. (Visiting Fellow). Member: Am. Soc. for Aesthetics; Mediaeval Acad. of Am.; Am. Lib. Assn.; Ohio Lib. Assn.; Am. Musicological Soc. Awards: Ford F., 1952-53. Contributor criticisms, articles and reviews to publications on art, music and medieval aesthetics. Lectures: The Gothic Cathedral; Education Through Art; History of the Book; Book Selection and Reference in Fine Arts. Author: "Petrarch: Four Dialogues for Scholars," 1967. Positions: Prof., Ithaca College, 1940-56; L., Schenectady Mus., 1946-48; Hd. FA Dept., Cleveland Public Lib., 1957-1962; L., History of the Book; Lit. of the Humanities; Fine Arts Librarianship; Assoc. Prof. of Library Science, 1962-65; Prof. of Library Science and Co-ordinator, Ph.D. Program, 1965- , Sch. of Lib.Sci., Western Reserve Univ., Cleveland.

RAY, ROBERT DONALD—Painter, Gr., S.
115 Los Cordovas Rte., Taos, N.M. 87571
B. Denver, Colo., Oct. 2, 1924. Studied: Drake Univ., Des Moines, Iowa; Univ. So. California, B.F.A.; Mexico City College, M.A. Member: Taos AA (Bd. Dirs., 1961, Chm. A. Com., 1961). Awards: prize, DMFA, 1955; purchase prizes, BM, 1956; Mus. of New Mexico, 1956; Columbia Mus. A. (S.C.), 1957; Ball State T. Col., 1959; Roswell Mus., 1959. Work: Joslyn Mem. Mus.; Mus. of New Mexico; Roswell Mus.; Columbia Mus. A.; Colorado Springs FA Center; BM; BMA; Ball State T. Col.; Aspen (Colo.) Inst.; Utah State Univ., Logan; First Nat. Bank, Dallas, Tex. Exhibited: Conn. Acad. FA, 1954; LC, 1955; BM, 1956; Phila. Pr. Cl., 1956; Univ. Illinois, 1957, 1959, 1960; Colorado Springs FA Center, 1955, 1957, 1958, 1959, 1960, 1963, 1965; Columbia Mus. A., 1957; AFA traveling exh., 1956; Denver A. Mus., 1954-1957, 1960, 1962, 1963, 1965, 1966; Univ. Nebraska, 1957; Provincetown AA, 1958; Joslyn Mem. Mus., 1954; DMFA, 1956, 1960; Mus. of New Mexico, 1956-1963, 1965-1969; Jonson Gal., Univ. N.M., 1956; Nelson Gal. A., Kansas City, 1957, 1958, 1959; Highlands Univ., Las Vegas, N.M., 1957, 1959; Tucson A. Festival, 1958, 1959; Dallas Mus. Contemp. A., 1959; Ball State T. Col., 1959; Roswell (N.M.) Mus., 1959, 1962; Okla. A. Center, 1959, 1960; San Diego FA Soc., 1960, 1964; Georgia Mus. FA, Athens, 1960; El Paso Mus. A., 1963; Ft. Worth AA, 1964; Cal. PLH, 1964; N.Y. World's Fair, 1964; Birmingham Mus. A., 1966; Springvale Mus. A., Utah, 1967-1969; Univ. Arizona, 1967; one-man: Roswell Mus., 1957, 1964; Kahl Gal., Dallas, 1965; Missions Gal., Taos, 1965, 1967; Mus. of New Mexico A. Gal., 1959; 1st Nat. Bank, Colo. Springs, 1960; Realities Gal., Taos, 1960; Stables Gal., Taos, 1961; Rosequist Gal., Tucson, 1966; Colorado Springs FA Center, 1968.

RAY, RUDOLF—Painter
221 E. 35th St., New York, N.Y. 10016*

RAY, RUTH (Mrs. John Reginald Graham)—Painter, Comm. A., L.
291 Mansfield Ave., Darien, Conn. 06820
B. New York, N.Y., Nov. 8, 1919. Studied: ASL; Swarthmore Col.; Barnard Col. Member: NA; ASL; All. A. Am.; Conn. Acad. FA; New Haven Paint & Clay Cl. Silvermine Gld. A. Awards: NAWA, 1945, 1952, 1953; La Tausca Comp., 1946; NAD, 1948; Springfield Mus. A., 1946; Conn. Contemp. Exh., 1951; Silvermine Gld. A., 1953, 1959; Conn. Acad. FA, 1953; Alice Collins Durham award, 1954, 1955; Medal of Honor, Am. Artist magazine, 1956; Bronze Medal of Honor, 1957, Lillian Cotton prize, 1960, Grumbacher purchase prize, 1963; Gloria Layton award, 1964, all from All. A. Am.; Prize, New Haven Paint & Clay Cl., 1960. Work: Springfield Mus. Mus. A.; NAD. Exhibited: Carnegie Inst., 1946-1949; NAD, 1948, 1950, 1952-1955, and later; Pepsi-Cola, 1945; Terry AI, 1952; NAWA, 1945-1955; All. A. Am., 1949-1955; Audubon A., 1949-1955; Contemp. A., Conn., 1951, 1952; Silvermine Gld. A., 1950, 1951, 1953-1955; WMAA, 1949; Slater Mus. A., 1955; Argent Gal., 1956; PAFA, 1959; one-man: Norlyst Gal., 1944; Ferargil Gal., 1947, 1949; Raymond & Raymond, 1947; Stamford Mus., 1950; Silvermine Gld. A., 1952; Darien (Conn.) Lib., 1958, 1963, Columbus Mus. A., 1964; Grand Central A. Gal., 1958, 1962; East River Savings Bank, N.Y., 1958; 19 one-man exhs. to date including Marymount Col., 1968. Contributor illus. to Abbott Laboratories "What's New?"; Lederle "Bulletin"; "Seventeen," book jackets for leading publishers; Xmas cards for Am. A. Group. Radio and TV programs for Am. A. Group, 1955. Positions: Conn. State Dir. Am. A. Week; 1st Vice-Pres., NAWA; Council, NAD, 1969.

RAYDON, ALEXANDER R.—Art Dealer
Raydon Gallery, 1091 Madison Ave., New York, N.Y. 10028
Specialty of Gallery: Paintings; Objets d'Art. American and European Schools.

READ, HELEN APPLETON (Mrs.)—Gallery Director, Writer, Scholar, Critic
Portraits, Inc., 41 E. 57th St., New York, N.Y. 10022; h. 146 Hicks St., Brooklyn, N.Y. 11201
ASL, with Dumond, Chase, Mora; Henri School, Giverny, France, with Frederick Friesek, Richard Miller. Awards: Salmagundi Medal for Distinguished Service to the Arts, 1967; Smith College Medal for Outstanding Service to American Art, 1968. Author: "Robert Henri," American Artists Series, sponsored by the Whitney Museum American Art (monograph), 1929; "Caspar David Friedrich, Apostle of Romanticism," 1939, the first biography of the artist and survey of the Romantic movement as expressed in German painting to have appeared in English. Forewords for many catalogues of art exhibitions, including biographical data. Contributor to Arts Magazine; American Magazine of Art; International Studio; College Art Magazine and the Bulletin of Carnegie Institute. Grant Awards: Grant from Carnegie Corporation to make a nationwide survey on Government activities in art, 1938-1939; Oberlander Grant and Fellowship for study of German Art, 1932. In 1934 a second Oberlander Fellowship was awarded to visit German museums for the purpose of assembling loan exhibitions of German art to be shown in American museums under sponsorship of The Oberlander Trust and Carl Schurz Memorial Foundation. Directed ten benefit exhibitions, held at Portraits, Inc., 1944-1968. Lecture courses conducted at leading museums, galleries, colleges, universities, art organizations and clubs. Positions: Assoc. Art Editor, Vogue magazine, 1923-1931; Director, Art Alliance of America, 1924-1930; Art Editor, American-German Review, 1932-1937; Director, Portraits, Inc., 1943-1957, President, 1957- . Specialty of Gallery: Contemporary Portraiture.

REALE, NICHOLAS ALBERT—Painter
1000 Salem Ave., Hillside, N.J. 07205
B. Irvington, N.J., Mar. 20, 1922. Studied: Newark Sch. FA; Pratt Inst.; ASL. Member: AWS; All. A. Am.; Phila. WC Cl.; New Jersey WC Soc.; P. & S. of New Jersey; Assoc. A. of New Jersey. Awards: prizes, Montclair Mus. A., 1957, 1961, 1962; Newark Mus., 1959; Jersey City Mus. purchase, 1960; N.J. WC Soc., 1957, 1962, 1967, 1968, and Medal of Honor, 1960; Audubon A., Grumbacher purchase, 1963; Westfield State Show, 1969; Art Center of the Oranges, 1967, 1969, and others. Work: Newark Mus.; Jersey City Mus.; NAD; Monmouth Col. Exhibited: AWS, 1959-1965; NAD, 1964, 1965; Audubon A., 1959-1965; Watercolor: USA, 1962, 1963, 1965; P. & S. of New Jersey, 1959-1965; Montclair Mus. A., 1957-1965; N.J. Watercolor Annual, 1957-1964; Westfield AA, 1963-1965; 1969; Art Center of the Oranges, 1967, 1969; Monmouth Col. Festival of Arts, 1960-1965, and many others. Positions: Instr., Newark School of Fine & Indst. Art, Newark, N.J.

REARDON, M(ARY) A.—Painter, Et., Lith., I.
30 Ipswich St., Boston, Mass. 02215; h. 12 Martin's Lane, Hingham, Mass. 02043
B. Quincy, Mass., July 19, 1912. Studied: Radcliffe Col., A.B.; Yale

Sch. FA, B.F.A., and in Mexico. Member: Cambridge AA; North Shore AA; Copley Soc.; Liturgical A. Soc.; AEA; NSMP. Work: St. Theresa's, Watertown, Mass.; Good Shepherd Convent, N.Y.; murals, Radcliffe Col.; Cardinal Spellman H.S., Brockton, Mass.; Boston Col.; St. Francis Xavier Chapel, Boston; St. Peter & St. Paul Church, Boston, Mass.; San Miguel Allende, Mexico; Chapel, Daughters of St. Paul, Brookline, Mass.; Baltimore Cathedral; Retreat, Padua, Italy; mosaic des. of Chapel of Our Lady of Guadalupe, Nat. Shrine of Immaculate Conception, Washington, D.C., 1965; Maryknoll & Brookline Chapel, Boston; altar fresco, St. John's Seminary, Boston; ports., Children's Medical Center, Boston; Boston State T. Col.; Ursuline Acad., Dedham, Mass.; triptych, U.S.S. Wasp. Exhibited: Northwest Pr.M., 1940; Inst. Mod. A., Boston; Univ. Illinois; Radcliffe Col.; Cambridge AA; BMFA; North Shore AA; Quincy, Mass. (one-man), 1968; St. Thomas Univ., Houston, Tex.; Eastern State Exh., Springfield; 1st Int. Exh. Sacred Art, Trieste, Italy, 1961, 2nd exh., 1966 (awarded President's Medal); Arch. Lg., N.Y., 1961; Richmond Mus. A.; Mint Mus. A.; Grand Central A. Gal.; Jordan Marsh, Boston; 7th Centenary Exh., Basilica, Padua, Italy, 1963; Copley Soc., Boston, 1966; Emmanuel Col., Boston, 1966 (one-man); Braintree, Mass.; Cambridge, 1967; Religious Art Exh., Cohasset, Mass., 1968; Hingham, Mass., 1968, and others. I., "Snow Treasure," 1942; "They Came from Scotland," 1944; "Bird in Hand," 1945; "Giant Mountain"; "Young Brave Algonquin," 1955; Co-author, "Pope Pius XII, Rock of Peace." Positions: Asst. Prof., Dept. Art, Emmanuel Col., Boston, Mass.

REARICK, MRS. JANET—Scholar
133 E. 79th St., New York, N.Y. 10021*

RECCHIA, RICHARD H(ENRY)—Sculptor
Hardscrabble, Rockport, Mass. 01966
B. Quincy, Mass. Studied: BMFA Sch.; & abroad. Member: NA; NSS. Awards: prizes, BMFA Sch.; NSS, 1939; med., Pan-Pacific Exp., 1915; Int. Exp., Bologna, Italy, 1931; NAD, 1944. Work: Harvard Univ.; Brown Univ.; Purdue Univ.; Boston State House; Somerville Pub. Lib.; Boston Commons; St. Mary's Church, Rockport, Mass.; Malden H.S.; Red Cross Mus., Wash., D.C.; Buffalo Mus. A. & Sc.; J. B. Speed Mem. Mus.; Boston Psychoanalytical Inst.; Brookgreen Gardens, S.C.; mem., Northeastern, Mass.; equestrian statue, Manchester, N.H.; heroic size port. bust of Gen. Stark, Bennington (Vt.) A. Mus., 1964; bas-reliefs on BMFA. Exhibited: AIC; NAD, annually; NSS, 1939-1946; CGA, 1928; BMFA; many one-man exh.

RECCHIA, MRS. RICHARD H. See Parsons, Kitty

REDDEN, ALVIE EDWARD—Educator, P.
Art Department, Mesa College; h. 2114 Yellowstone Rd., Grand Junction, Colo. 81501
B. Hamilton, Tex., July 22, 1915. Studied: West Texas State Col., B.S.; Univ. Colorado, M.F.A.; grad. study, Ohio State Univ. and Columbia Univ.; Mexico City Col., Latin-Am. Culture Workshop, and with Grant Reynard. Member: Mesa County FA Center (Trustee, 1953-63); NAEA; Colorado A. Edu. Assn.; Pacific AA. Positions: Prin., Samnorwood Elem. Schs., 1940-42, 1945; Instr. A., West Texas State University, 1946; Non-resident A. Instr., Univ. Colorado, 1949- ; A. Dir., 1947- , Chm., Div. FA, Mesa College, Grand Junction, Colo., 1964- .

REED, DOEL—Etcher, P., E., L.
Box 1244, Taos, N.M. 87571
B. Logansport, Ind., May 21, 1894. Studied: Cincinnati A. Acad., and in France and Mexico. Member: NA; SAGA; All. A. Am.; Phila. WC Cl.; Audubon A.; Indiana Pr. M.; SSAL; Albany Pr. Cl.; Nat. Soc. Ptrs. in Casein; Boston Pr. M. Awards: prizes, Phila. Pr. Cl., 1940; Chicago Soc. Et., 1938, 1949; Currier Gal. A., 1942; Northwest Pr. M., 1942, 1944; Tulsa AA, 1935; Philbrook A. Center, 1944, 1946, 1947, 1948, 1957; LC, 1944, 1949; Laguna Beach AA, 1944, 1947; SSAL, 1944; Oakland A. Gal., 1945, 1947; Wichita AA, 1946, 1952, 1958; Assoc. Am. A., 1947; Conn. Acad. FA, 1947, 1953; Dayton AI, 1947, 1949; Carnegie Inst., 1948; Joslyn A. Mus., 1948, 1952; Dallas Mus. FA, 1948, 1949; John Herron AI, 1949, 1952, 1958; Okla. A. Center, 1949, 1951; Delgado Mus. A., 1949, 1951; Indiana Soc. Pr. M., 1950; Mid-Am. A., 1950; SAGA, 1950, 1957; Audubon A., 1950; medal, 1951, 1954; Boston Pr. M., 1953; Ohio State Univ., 1954; Kansas State Col., 1952; Assoc. Okla. A., 1957 (2); Contemp. A., Pomona, Cal., 1956; Cannon award 1957, prize 1961, NAD: Mus. New Mexico, Santa Fe, 1962; Medal, Nat. Soc. Ptrs. in Casein, 1963; Morse Medal, NAD, 1965. Work: PMA; LC; Carnegie Inst.; Okla. A. Center; Mus. New Mexico, Santa Fe; SAM; Honolulu Acad. A.; N.Y. Pub. Lib.; Philbrook A. Center; Mus. FA of Houston; Univ. Montana; Joslyn A. Mus.; Kansas State Col.; Ohio State Univ.; MMA; Delgado Mus. A.; Zanesville AI; Nelson Gal. A., Kansas City; Butler AI; DMFA; Dayton AI; Cal. State Lib.; Bibliotheque Nationale, Paris;

Victoria & Albert Mus., London; De Pauw Univ., and many others; murals, Okla. State Office Bldg. Exhibited: nationally and internationally. Positions: Prof. A., Chm. A. Dept., Oklahoma State Univ., Stillwater, Okla., 1924-59, Emeritus, 1959- . Bd. of Regents, Mus. New Mexico; Chm., Harwood Fnd., Advisory Bd., Mus. New Mexico.

REED, HAROLD—Art Dealer
118 E. 78th St., New York, N.Y. 10021
B. Newark, N.J., Jan. 11, 1937. Studied: Stanford University, B.A.; ASL. Positions: Director, Harold Reed Gallery, New York, N.Y.

REED, PAUL—Painter
3541 N. Utah St., Arlington, Va. 22207*

REEP, EDWARD—Painter, T., Lith., L.
3235 Berry Dr., Studio City, Cal. 91604
B. Brooklyn, N.Y., May 10, 1918. Studied: A. Center Sch., Los A., & with Willard Nash, Emil Bisttram, Stanley Reckless. Member: Cal. WC Soc.; Awards: prizes, Life magazine Comp., 1942; Am. Contemp. Gal., 1946; San Diego, Cal., 1946, 1950; Los A. County Fair, 1948; Coronado Int. Exh., 1949; Los A. Mus. A., 1950, 1952; Cal. Int. Flower Show, 1951; Gardena, Cal., 1952; Guggenheim F., 1945-46; Cal. WC Soc., 1955; Los Angeles All City exh., 1963. Work: Life magazine war painting coll.; Grunewald Graphic Art Coll., U.C.L.A.; New Mexico Marine Hospital; A. Group Am.; U.S. War Dept.; World-wide painting Commission by Life magazine, 1956; Cole of California Coll.; State of California Coll.; Los A. Mus. A.; Gardena (Cal.) H.S. Exhibited: WMAA, 1946-1948; NAD; Los A. Mus. A.; NGA; Los A. AA; Mod. Inst., Los A.; CGA; PAFA; SFMA; CAM; Oakland A. Gal.; BMA; VMFA; Pa. State Mus.; Syracuse Mus. FA; Dayton AI; Newark Mus.; Slater Mem. Mus.; Decatur AI; Cedar Falls AA; Rockford AA; Zanesville AI; Brooks Mem. Mus.; Currier Gal. A.; LC; and others. One-man: Italy, 1944; Cowie Gal., Los A., 1949; Bisttram Sch. A., 1950; Coronado Sch. FA, 1950; Fresno State Col., 1951; San Diego Mus. A., 1951; Pasadena Mus. A., 1955; Simone Gal., 1959; Rivas Gal., 1960, 1962, 1964; Long Beach Mus. A., 1965. Author, "The Content of Watercolor," 1969. Positions: Instr., Drawing & Painting, A. Center Sch., Los Angeles, 1947-50; Bisttram Sch. A., 1950-51; Chouinard AI, Los Angeles, 1950- . Pres., Cal. WC Soc., 1956-57; Chm. Foundation Dept., Chouinard AI, at present.

REESE, ALBERT—Art dealer
82 Irving Place, New York, N.Y. 10003*

REEVES, MR. and MRS. BENJAMIN—Collectors
150 Central Park South, New York, N.Y. 10019*

REEVES, J. MASON, JR.—Painter, E., L.
749 N. Kenmore Ave., Los Angeles, Cal. 90029
B. Washington, D.C., Nov. 29, 1898. Studied: PAFA; Julian Acad., Paris, France; Rome, Italy, and with Edmund Tarbell and others. Member: Artists of the Southwest (Pres. 1960-61); P. & S. Cl.; Cal. A. Cl.; Laguna Beach AA; Am. Inst. FA; AAPL; Los A. AA. Awards: prizes, Sacramento, Cal.; P. & S. Cl.; Cal. A. Cl.; Ebell Cl., Los A.; Greek Theatre, Tri-Club, 1962; Award of Merit, Los A. AA; other awards at Coronado, Santa Cruz and Artists of the Southwest, and in Arizona. Work: U.S. Navy Dept.; Univ. California; State of California; Los Angeles County; St. Francis Hospital; Bohemian Cl.; Ebell Cl., Los Angeles; Seaboard Citizen's Nat. Bank, Norfolk, Va., and in private colls. Exhibited: Bohemian Cl.; Cal. A. Cl.; P. & S. Cl.; Artists of the Southwest; Santa Cruz; San Diego; Coronado; San Rafael; Ebell Cl.; Security Nat. Bank, all California; NAD; Societe des Artistes Francais, Paris, and in London, England.

REFREGIER, ANTON—Painter
Woodstock, N.Y.
B. Moscow, Russia, 1905. Studied: R.I. Sch. Des.; in France, & with Hans Hoffman, Munich. Member: AEA; NSMP. Awards: Hallmark Comp., 1953. Work: MModA; WMAA; MMA; Walker A. Center; Univ. Arizona; Encyclopaedia Britannica, and many others; murals, USPO, San F., Cal.; Plainfield, N.J.; SS "Independence"; SS "Constitution"; Phoenix Insurance Co., Hartford, Conn.; Mayo Clinic, Rochester, Minn.; Covington Fabrics, N.Y.; Hillcrest Jewish Center, L.I., N.Y.; ceramic and tile mural, Tokeneke Sch., Darien, Conn.; Tapestry, Bowery Savings Bank, N.Y.; mural, Watson Hall, Syracuse Univ.; Dec. in several public rooms, Sheraton Hotel, Phila.; ceramic tile mural, P.S. 146, for N.Y. Bd. Edu. Exhibited: ACA Gal. (one-man) 1955, 1958, 1965, & in leading national exhibitions. Contributor to Fortune, What's New, & other magazines. Author: "Natural Figure Drawing"; "An Artist's Journey," 1965; "We Make Our Tomorrow," 1965. Positions: Artist-Correspondent, Fortune magazine, at UNO Conference, San F., Cal. Visiting Instr., Univ. Arkansas; Cleveland Sch. FA (summer session); Assoc. Prof., Bard College, 1962-64.*

REGENSTEINER, ELSE F.—Educator, C., L., Des., W.
1416 E. 55th St., Chicago, Ill. 60615
B. Munich, Germany, Apr. 21, 1906. Studied: Univ. Munich; Inst. Des., Chicago, & with Moholy-Nagy, Marli Ehrman, Annie and Joseph Albers. Member: Am. Craftsmen's Council; Ill. Craftsmen's Council; AAUP. Awards: prize, Int. Textile Exh., Univ. North Carolina, 1949; Citation, AID, 1947, 1948, 1951. Work: AIC; Cooper Union Mus.; Ill. State Univ.; many commissions for textiles for architects and interior decorators, 1946-52. Exhibited: Int. Textile Exh., Greensboro, N.C., 1946-1948; Inst. Contemp. A., Boston; traveling exhibition AID, 1947, 1948, 1951; Walker A. Center, 1962 and prior; Des Moines A. Center, 1962; Western AA, 1950; Ohio State Univ., 1950; St. Paul Gal., 1950; AIC, 1948, 1961; Chicago Pub. Lib., 1951, 1961; Univ. Southwestern Louisiana, 1961; Indiana Univ., 1961; Brooks Mem. Mus., 1961; MModA; traveling exhs., Am. Designer-Craftsmen and Midwest Designer-Craftsmen; Merchandise Mart, Chicago; Renaissance Soc., Univ. Chicago, 1948, 1950-1952; Mus. Contemp. Crafts, N.Y., 1956, 1958; Ravina A. Festival, 1957, 1958; "Design Derby," 1957, 1960; Amherst Col., 1963; Univ. Wisconsin, 1963; St. Mary's Col., Notre Dame, 1964; Bloomington (Ill.) AA, 1964; State Mus., Springfield, 1964, 1966; Mundelein Univ., 1966; Ill. State Univ., 1966; Wichita AA, 1967; Univ. Texas A. Mus., 1967; Univ. Missouri, 1967; Ill. Craftsmens Council & traveling show, 1968; Wis. Designer-Craftsmen, Univ. Wis., 1968, and Workshops throughout U.S. Lectures on Textile Design; Hand Weaving. Contributor articles to Handweaver & Craftsman magazine; Chicago Market News; Craftsmen in Illionois. Positions: Instr., Inst. Des., Chicago, 1942-46; Hull House, Chicago, 1942-46; Asst. Prof., AIC, Chicago, Ill., 1945-1957, Prof. 1957- . Bd. Member, Ill. Craftsmen, 1964, 1965- .

REHBERGER, GUSTAV—Painter, I. Comm., Des., L., E., Lith.
1206 Carnegie Hall, New York, N.Y. 10019
B. Riedlingsdorf, Austria, Oct. 20, 1910. Studied: AIC., & Art Instruction Schools, Minneapolis. Member: Audubon A.; SI; MModA. Awards: prizes, Audubon A., 1948; A. Dir. Cl., 1954, 1955; Soc. Typographic A., Chicago, 1938. Work: mural, St. Paul's Lutheran Church, Chicago. Paintings of "The Marlboro Man" (1959 campaign) appeared in Life, Look, Time, New Yorker, Sports Illustrated, Sat. Eve. Post, TV Guide. Lectures: "The Spirit of Form and Movement." Exhibited: SI, 1957, 1965 (one-man); Audubon A., 1959-1969, NAD, 1961, 1966; Allied Artists, 1965, 1967.

REIBACK, EARL—Sculptor
c/o Wise Gallery, 50 W. 57th St., New York, N.Y. 10019*

REIBEL, BERTRAM—Wood Engraver, Gr., S.
1127 Hardscrabble Road, Chappaqua, N.Y. 10514
B. New York, N.Y., June 14, 1901. Studied: AIC, & with Alexander Archipenko. Member: AEA; Am-Jewish A. Cl.; National Committee of Plastic Arts. Exhibited: NAD; Int. Pr. M.; PAFA; MMA; CM; Oakland A. Gal.; Northwest Pr.M.; AIC; Kansas City AI; Detroit Inst. A.; Southern Pr. M.; Buffalo Pr. Cl.; Denver A. Mus.; Phila. Pr. Cl.; SFMA; LC; Conn. Acad. FA; Los A. Mus. A.; Rochester Pr. Cl., Wichita AA.

REICH, NATHANIEL E.—Painter
1620 Ave. I, Brooklyn, N.Y. 11230
B. New York, N.Y., May 19, 1907. Studied: ASL; Pratt Inst., Brooklyn; N.Y. Univ., B.S.; Brooklyn Acad. A. & Sciences; Univ. Chicago, M.D. Work: Gal. of Mod. A., N.Y.; Washington County Mus. A., Hagerstown, Md.; Evansville Mus. A. & Sciences, Lowe Mus., Univ. of Miami, Coral Gables; Long Island Univ.; N.Y. Univ. Exhibited: Prospect Park, N.Y., 1966; Little Studio, N.Y., 1950; "Biblical Themes," Philadelphia, Pa., 1966; one-man: Retrospectives, N.Y. Univ., 1963 and Long Island Univ., 1964; Greer Gal., N.Y., 1963; Bodley Gal., 1965, 1969; Brooklyn Assn. for Mental Health, 1965-1967, 1969; Karen Horney Clinic, Brooklyn, 1963; Capricorn Gal., N.Y., 1969; St. Charles Parish, La., 1967. Positions: Assoc. Clinical Prof. Medicine, State University of New York, Downtown Medical Center, 1938- .

REICHEK, JESSE—Printmaker, Des., P., E.
2801 Ashby Ave., Berkeley, Cal. 94705
B. Brooklyn, N.Y., 1916. Studied: Inst. Des., Chicago; Academie Julian, Paris, France. Awards: Graham Fnd. Grant, co-participant, for the purpose of "The Development of a System for Architectural Practice and Education," 1962; Research travel grant, Creative Arts Inst., Univ. California, summer, 1963; Work: Amon Carter Mus. of Western Art, Ft. Worth, Tex.; AIC; Bibliotheque Nationale, Paris, France; Grunwald Graphic A. Fnd., Univ. California, Los Angeles; La Jolla A. Mus.; Los Angeles County Mus.; MModA; Pasadena A. Mus.; Fine Arts Gal. of San Diego; Univ. New Mexico A. Mus.; Victoria & Albert Mus., London, England; Univ. California Mus., Berkeley. Exhibited: BM, 1959; MModA, 1962, 1965, 1969;

Albright-Knox A. Gal., Buffalo, 1965; Univ. Michigan, Ann Arbor, 1965; FAR Gal., N.Y., 1965; Byron Gal., N.Y., 1965; CM, 1966; BMA, 1966; A. Cl., Chicago, 1966; Cranbrook Acad. A., 1967; Finch Col., N.Y., 1967; Univ. Texas Mus., Austin, 1967; Univ. California, Berkeley, 1967; Yale Univ. A. Gal., 1968; Univ. Michigan A. Gal., 1968; SFMA, 1969; Museo de Bellas Artes, Caracas, Venezuela, 1969; Univ. Kansas Mus., Lawrence, 1969. One-man: Betty Parsons Gal., N.Y., 1958-1960, 1963, 1965, 1967-1969; Molton Gal., London, 1962; Bennington Col., 1963; American Culture Center, Florence, Italy, 1964; Univ. New Mexico Mus., 1966; Univ. So. California A. Mus., 1967; Axiom Gal., London, 1968; Yoseido Gal., Tokyo, 1968; Galeria Van Der Voort, San Francisco, Cal., 1969. Positions: A.-in-Res., Tamarind Lithography Workshop, Los Angeles, 1966 (2 months); Research Prof., Creative A. Inst., Univ. California, 1966-1967; Assoc. Prof. Des., Univ. California, Berkeley, 1958-1960; Prof. Des., Univ. California, Berkeley, 1960- . Other teaching positions in prior dates.

REICHMAN, FRED—Painter
1235 Stanyan St., San Francisco, Cal. 94117
B. Bellingham, Wash., Jan. 28, 1925. Studied: Univ. California, Berkeley, B.A., M.A. Member: San Francisco Art Inst. Awards: Taussig Traveling Fellowship, 1952-1953. Work: City and County of San Francisco; Oakland A. Mus.; SFMA; Bank of America World Hdq., Bldg., San Francisco, Cal.; Oklahoma A. Center; commissions: mural, Boche Pediatrics Clinic, Stanford Univ. Exhibited: WMAA, 1962; WAC; Albright-Knox A. Gal.; Des Moines A. Center; AIC; PAFA; Detroit Inst. A.; Santa Barbara Mus. A.; Univ. California at Los Angeles; Los Angeles County Mus.; Galerie 8, Paris, France; Mus. Mod. A., Paris, and others. One-man: Rose Rabow Gal., San Francisco, 1958, 1961, 1963, 1965; Benson Gal., Bridgehampton, N.Y., 1966; Dominican Col., San Rafael, Cal., 1961; Esther Robles Gal., Los Angeles, 1961; Cal.PLH, 1960; SFMA, 1960; Gump's, San Francisco, 1952. Positions: Instr., A., Univ. of California Ext., San Francisco; Dir., Children's Art Classes, Junior Center of Art and Science, Oakland, Cal., at present.

REICHMAN, GERSON—Collector
Lincoln Ave., Portchester, N.Y. 10573*

REID, (WILLIAM) RICHARD—Painter
268 River Rd., Richmond (Vancouver) B.C., Canada
B. Regina, Sask., Apr. 3, 1930. Studied: Univ. Manitoba Sch. A., B.F.A.; Instituto de Allende, Mexico; and with Oskar Kokoschka. Member: Young Commonwealth Artists. Awards: CAC, 1963-64, 1967. Exhibited: Univ. Manitoba traveling exh., 1953-1955; Washburn F.A. Center, 1955; CPE, Toronto, 1954; Vancouver, 1958; London, England, 1961, 1962; Winnipeg, 1954-1957; Mexico, 1957; London, 1960, 1962, 1963; Paris, 1963; one-man: Griffiths Gal., Vancouver, 1968; Albert White Gal., Toronto, 1968; Pandora's Box Gal., Victoria, 1968. Positions: Teacher of painting, Vancouver.

REID, ROBERT—Painter
233 Lafayette St. 10012; h. 112 W. 45th St., New York, N.Y. 10036
B. Atlanta, Ga., Nov. 9, 1924. Studied: Clark Col., Atlanta; AIC; Parsons Sch. Des., N.Y. Awards: purchase, Am. Acad. A. & Lets., Hassam Fund., 1968. Exhibited: N.Y. City Center Gal., 1959; Brandt Gal., N.Y., 1961; Barnard Col., Columbia Univ., 1965; Am. Acad. A. & Lets., 1965, 1966; Bucknell Univ., 1965, 1966; 1st World Festival of Negro Arts, Dakar, Senegal, 1965; Univ. California at Los Angeles, 1966-1967; PAFA, 1966; Art in Embassies, (Malta), 1967; Studio Mus. in Harlem, N.Y., 1968; 30 Contemporary Black Artists, Minneapolis Inst. A., traveling, 1968-1970; Fairweather-Hardin Gal., Chicago, 1969; Ruth White Gal., N.Y., 1969; Am. Embassy, Paris, 1969; one-man: Grand Central Moderns, N.Y., 1965-1967; Baruch Col., N.Y., 1968; Lehigh Univ., Bethlehem, Pa., 1969; two-man: James Gal., 1961; three-man: Osborne Gal., N.Y., 1963. Work: Pennsylvania State Univ., Altoona; Myers Col., Birmingham; N.Y. Univ.; Andrew Dickson White Mus., Cornell Univ.; Syracuse Univ.; Laura Musser Mus., Muscatine, Iowa; Lehigh Univ., Bethlehem, Pa.; Civic Center, Bethlehem, Pa.

REIDER, DAVID H.—Designer, E., Photog.
361 Hilldale Dr., Ann Arbor, Mich. 48105
B. Portsmouth, Ohio, Apr. 6, 1916. Studied: Univ. Buffalo; Cleveland Sch. A. Member: AAUP; Com. on A. Edu., MModA. Work: Milwaukee AI. Exhibited: (photography) Milwaukee AI; Albion Col.; Univ. Michigan; Saarbrucken, Germany; AFA exh., 1959-61. Photographs reproduced in numerous architectural and industrial publications. Positions: L., Des., Buffalo State T. Col., 1942; Instr. Des., Univ. Buffalo, 1942-46; Hd. Dept. Des., Albright A. Sch., 1942-47; Asst. Prof. Des., 1947-54, Assoc. Prof. Des., 1955-59, Prof., 1959- . Univ. Michigan, Ann Arbor, Mich.

REIF, RUBIN—Painter, Gr., Des., Comm. A., E., C.
Art Dept., University of Arkansas; h. 416 Gunter St., Fayetteville, Ark. 72701
B. Warsaw, Poland, Aug. 10, 1910. Studied: CUASch.; ASL; Hans Hofmann Sch. FA; Acad. FA, Florence, Italy. Awards: purchase prizes, ASL, 1947; Ohio Univ., 1948; prize, Ohio State Fair, 1952; Arkansas Festival of Arts, 1962, 1963; Oklahoma Annual, 1964, and others. Work: Ohio Univ.; ASL; Cooper Union Coll.; Arkansas Indst. Development Comm., and work in many private colls. Exhibited: BM, 1947; AFA traveling exh., 1948-49, 1967-69; Phila. Pr. Cl., 1947; PAFA, 1949; Akron AI, 1950, 1951; Butler Inst. Am. A., 1952, 1953; Bradley Univ., 1953, 1955, 1957; Kansas City AI, 1953; Seligmann Gal., N.Y.; J.B. Speed Mus. A.; Beloit Col.; Ohio State Univ.; Illinois Wesleyan Univ.; Columbus A. Gal.; The Jewish Center, Columbus, Ohio; CM; Arkansas A. Center, Little Rock, 1960, 1961, 1967-1969; Hallmark Gal., 1967-1969; Oklahoma A. Center, 1967-1969; Springfield (Mo.) A. Mus., 1967-1969; one-man: Cedar-Crest Col., Pa., 1967-1969. Positions: Assoc. Prof. A., Art Dept., University of Arkansas, Fayetteville, Ark.

REIFF, ROBERT FRANK—Painter, E.
Department of Fine Arts, Middlebury College; h. 20 Gorham Lane, Middlebury, Vt. 05753
B. Rochester, N.Y., Jan. 23, 1918. Studied: Columbia Univ., M.A., Ph.D.; Univ. Rochester, A.B.; Colorado Springs FA Center, and with Boardman Robinson, Adolf Dehn, Hans Hofmann. Awards: Belgian-Am. Edu. Fnd. traveling scholarship, 1952; prizes, Rochester Mem. A. Gal., 1941, 1945, 1958, 1962; Albright A. Gal., 1956. Work: Pasadena AI; Rochester Mem. A. Gal.; SFMA. Exhibited: Rochester Mem. A. Gal., 1936-1969; Albright A. Gal., 1952; WAC, 1957; Berkshire AA, 1958, 1961; Bundy A. Mus., 1967; one-man: deYoung Mem. Mus., 1944; Santa Barbara Mus. A., 1944; Pasadena AI, 1944; Rochester Mem. A. Gal., 1945; Univ. Virginia; Arena A. Gal., Rochester, 1955; Allen A. Mus., Oberlin Col., 1952; Yaddo Fnd., 1961; Univ. Vermont (3-man), 1962; Johnson Gal., Middlebury Col., 1969. Author: "Indian Miniatures: The Rajput Painters," 1959; "Renoir," 1968. Positions: Instr. A., Muhlenberg Col., Allentown, Pa., 1947-49; Oberlin Col., Oberlin, Ohio, 1950-55; Asst. Prof., Univ. Chicago, 1954-55; State Col., St. Cloud, Minn., 1955-1957; Prof., Middlebury (Vt.) College, 1958- .

REIMANN, WILLIAM P (AGE)—Sculptor, E., C.
17 Hubbard Ave., Cambridge, Mass. 02140; h. Iron Works Rd., Clinton, Conn. 06413
B. Minneapolis, Minn., Nov. 29, 1935. Studied: Yale Univ., B.F.A., M.F.A. Studied with Albers, Lebrun, Franklin, Rosati, Engman, and others. Member: AAUP. Awards: Yale Alumni Fellowship, 1957; Alice Kimball English Fellowship, 1959. Work: MModA; De Cordova & Dana Mus.; Yale Univ. Sch. of Art & Architecture; Endo Laboratories; WMAA; BMFA. Exhibited: MModA, 1959; USIA traveling exh. to USSR, 1960-61; Boston and New Haven A. Festivals, 1960; WMAA, 1961, 1962, 1964, 1965; Galerie Chalette, N.Y., 1961, 1968; Univ. Texas, Austin, 1965; Carnegie Int., 1967; DeCordova Mus., 1969; Harvard Univ., 1966. Lecture: "Current Work and Contemporary Art," De Cordova Mus. Positions: Instr., Yale Univ., 1960-61; Old Dominion College, Norfold, Va., 1961-63; Asst. Prof., Harvard University, Cambridge, Mass., 1964-1967; Lecturer, 1967- . Visiting Critic, Dept. Arch., Univ. of Washington, 1969.

REINDORF, SAMUEL—Painter, Eng.
92 Bayberry Lane, Westport, Conn. 06880
B. Warsaw, Poland, Sept. 1, 1914. Studied: Toronto A. Sch. Member: AEA. Awards: prizes, Connecticut Acad. FA, 1961; Newport AA, 1963; Soc. Four Arts, Palm Beach, 1964. Work: Toronto A. Gal.; Fairfield Univ. Exhibited: N.Y. World's Fair, 1965; Butler Inst. Am. A., Youngstown, Ohio, 1963, 1965; Contemp. Am. Painting, Palm Beach, Fla., 1964; Riverside Mus., N.Y., 1939, 1940; other exhs.: Connecticut Acad. FA; Newport AA; Springfield Mus. FA; Slater Mem. Mus.; All. A. Am.; New Britain Mus. Am. A.; Morris Gal., Southampton, N.Y.; and others. One-man: Geminaire Gal., N.Y., 1960, 1962; Tygesen Gal., Toronto, Canada, 1964, 1966; Hall of Art, N.Y., 1964; Bellas Artes, San Miguel de Allende, Mexico, 1966, 1967; Centro Deportivo Israelita, Mexico City, 1966; Galleria Artes Plasticas, Guadalajara, Mexico, 1967, all sponsored by Cultural Section, U.S. Embassy; Cushing Gal., Dallas, Tex., 1967; Galeria Felipe Zamora, Taxco, Mexico, 1967; Shaw-Rimmington Gal., Toronto, 1967; Fairfield (Conn.), Univ., 1968; Pace College, N.Y., 1968.

REINER, MR. and MRS. JULES—Collectors, Patrons
295 Madison Ave., New York, N.Y. 10017; h. 13 Pine Tree Dr., Great Neck, N.Y. 11024
Members: Friends of the Whitney Museum of American Art; Associates, Guggenheim Museum; Associates; Museum of Modern Art; Members, Metropolitan Museum of Art, all New York City. Collection: American art, including Primitives, Regional, "Ashcan," and Contemporaries. European art of the 19th and 20th centuries.

REINHARDT, SIEGFRIED GERHARD—Painter, Des., T., L.
635 Craig Woods Drive, Kirkwood, Mo. 63122
B. Eydkuhnen, Germany, July 31, 1925. Studied: Washington Univ., St. Louis, A.B. Member: St. Louis A. Gld. Awards: Scholarship, John Herron AI, 1943; prizes, 20th Century Book Cl. award, 1945; St. Louis A. Gld., 1951, 1953, 1954, 1955, 1957, 1958; CAM, 1951, 1953, 1955, 1956; Rand McNally Comp., 1952; Cincinnati Contemp. A. Center, 1958; Int. Exh. Sacred Art, Trieste, Italy, 1961. Work: Abbott Laboratories; Am. Acad. A. & Lets.; CAM; Concordia T. Col.; Southern Illinois Univ.; Beloit Col.; WMAA; Cincinnati Contemp. A. Center; R.I. Sch. Des.; Nelson Gal. A., Kansas City; Spaeth Fnd., N.Y. Murals, Rand McNally, Skokie, Ill.; Edison Bros. Shoe Co., St. Louis; Medical Bldg., Teamsters Local 88; Nooter Corp., St. Louis. Exhibited: Hugo Gal., N.Y., 1945; Washington Univ., 1950 (5-man); Inst. Contemp. A., Boston, 1958; USIA traveling exh. Europe, 1959; CAM, 1943-1945, 1947-1949, 1951, 1953-1958, 1961; AIC, 1947, 1954; MMA, 1950; Los A. Mus. A., 1951, 1955; WMAA, 1951-1955, 1960; WAC, 1954; DMFA, 1954; Beloit Col., 1954; AFA traveling exh., stained glass; Cincinnati A. Center, 1955, 1958, 1961; PAFA, 1958; Schweig Gal., St. Louis, 1955; Art:USA, 1958; N.Y. City Center, 1955; Hewitt Gal., N.Y., 1957, 1958; Kansas State Col., 1958; BMA, 1960-61; Columbus Gal. FA, 1961; Int. Exh. Sacred Art, Trieste, Italy, 1961. One-man: Eleanor Smith Gal., St. Louis, 1942, 1943, 1947; St. Louis A. Gld., 1951; Southern Illinois Univ., 1951, 1952; A. Mart, Clayton, Mo., 1953; Stevens-Gross Gal., Chicago, 1952; Texas Western Univ., 1954; T. Col., Bloomington, Ill., 1954; Schweig Gal., St. Louis, 1956; Hewitt Gal., 1957; St. Louis A. Gld., 1958, and others. Lectures to private groups and on TV and radio. Painted "Man of Sorrows" on 7 half-hour weekly TV shows, 1955, 1957, 1958. Work reproduced in leading art publications and national magazines. Positions: Des., executor of stained glass windows for Emil Frei, Inc., 1948- ; Instr., painting & drawing, Washington University, St. Louis, Mo., 1955- .*

REINSEL, WALTER—Painter, Des.
2219 Rittenhouse Sq., Philadelphia, Pa. 19103; (studio) 721 Walnut St., Philadelphia, Pa. 19106
B. Reading, Pa., Aug. 11, 1905. Studied: PAFA, & with Andre L'Hote, in Paris; also with Arthur B. Carles. Member: Phila. A. All.; Phila. WC Cl.; AEA; Peale Cl. Awards: F., PAFA (3); numerous medals for layout design and typography; medal and prize, Phila. WC Cl., 1967, 1968; medal, Phila. Sketch Cl., 1952, 1966. Work: IBM; Reading Mus. A.; PMA; Capehart Coll.; Container Corp. Coll.; Woodmere A. Gal., 1968. Exhibited: PAFA, 1939-1968; Reading Mus. A., 1945-1947, one-man, 1960; Phila. A. All. (9 one-man); Dubin Gal., Phila., 1951 (one-man); PAFA, 1948 (one-man); Audubon A., 1953-1965.

REIS, MRS. BERNARD J.—Collector, Patron
252 E. 68th St., New York, N.Y. 10021
B. New York, N.Y., Sept. 15, 1900. Studied: University of Michigan. Positions: Trustee, Jewish Museum, New York, N.Y.; Member, Arts Committee, Brandeis University, Waltham, Mass.

REISMAN, PHILIP—Painter, I., Gr., T.
4 West 18th St. 10011; h. Chatham Green, 185 Park Row, New York, N.Y. 10038
B. Warsaw, Poland, July 18, 1904. Studied: ASL, with George Bridgman, Wallace Morgan, and privately with Harry Wickey. Member: An Am. Group; A. Lg. Am.; AEA (Pres., N.Y. Chptr., 1959-1961, Treas., 1961-64, Sec., 1964-66.) Awards: prizes, Mickiewicz Centenary Comp., 1956; NAD, 1956 (gold medal); Yaddo Fellowship; Childe Hassam Fund Award, (purchase) 1968. Work: MMA; Wadsworth Atheneum; N.Y. Lib.; MModA; Bibliotheque Nationale, Paris; mural, Bellevue Hospital, N.Y.; Norfolk Mus.; Israeli Museums. Exhibited: PAFA; Pepsi-Cola; MModA; nat. print exhs.; WMAA; Montclair A. Mus.; NAD; Norwalk, Ohio; Cold Spring Harbor, N.Y.; Beaux-Arts Gal.; and others; one-man exhs., mainly at ACA Gal., N.Y. I., "Anna Karenina," 1940; "Crime and Punishment," 1945. Contributor to national magazines. Positions: Former Instr., Workshop Sch., New York, N.Y.; South Shore Arts Workshop, Rockville Center, N.Y., and privately.

REISS, LEE (Mrs. Manuel)—Painter
75-30 Vleigh Place, Flushing, N.Y. 11367
B. New York, N.Y. Studied: A. All. Sch.; ASL; Am. A. Sch.; Queens Col.; Cornell Univ. Member: All. A. Am.; Nat. A. Lg., Long Island; NAWA. Awards: prize, AAPL, 1956, 1959, 1960-1962, 1964. Work: Washington County Mus., Hagerstown, Md., and in private colls. Exhibited: AAPL, Long Island A. Lg., NAD; NAC; CGA; Grand Central Gal.; Barbizon Plaza Hotel, N.Y.; traveling shows; Knickerbocker A.; demonstrations: NAWA, Nat. A. Lg., L.I.; Chase Gal., N.Y. and one-man, 1959. One-man: Nat. A. Lg., L.I., 1965; Norfolk Mus. of A. & Sciences, 1969. Positions: Instr., Painting, National Art Lg., L.I.; Chm., traveling oil shows, NAWA.

REMBSKI, STANISLAV—Painter, W., T., L., Cr.
1404 Park Ave., Baltimore, Md. 21217; s. Deer Isle, Me.
B. Sochaczew, Poland, Oct. 8, 1896. Studied: Technological Inst.,
Ecole des Beaux-Arts, Warsaw, Poland; Royal Acad. A., Berlin,
Germany. Member: Charcoal Cl., Balt.; SC; All. A. Am.; NSMP;
AAPL. Work: Univ. Cl., Balt.; Cathedral Church of the Incarnation,
Balt.; Univ. Maryland Medical Sch.; NAD; Univ. North Carolina; mu-
rals, St. Bernard Sch., Gladstone, N.J.; port., Columbia Univ.; Kent
Sch. Conn.; Adelphi Col.; Brooklyn Polytechnic Inst.; NAD; St.
John's Hospital, Brooklyn, N.Y.; F.D. Roosevelt Library, Hyde Park,
N.Y.; St. Andrew's Soc., Baltimore, Md.; Mus. Osage Indian, Paw-
huska, Okla.; Johns Hopkins Univ.; Goucher Col.; Loyola Col.; Bd.
Edu., Balt.; Johns Hopkins Univ.; Goucher Col.; Loyola Col.; Bd. Edu.,
Balt.; State House, Annapolis, Md.; Woodrow Wilson Shrine, Wash.,
D.C.; Naval War Col., Newport, R.I.; Acad. Sciences, N.Y.; Wake
Forest (N.C.) Col.; Meredith Col., N.C. Exhibited: All. A. Am., 1959;
Old Market Gal., Wash., D.C., 1961; one-man: Dudensing Gal.;
Carnegie Hall Gal.; Newton Gal.; Chambers Gal., Balt.; BMA; Mary-
land Inst. A. Lectures: "Art for Life's Sake"; "Greatness in Art";
"Michelangelo"; "The Individual, Freedom, and Art"; "Mysticism
in Art," and others, to universities, clubs and groups.

REMENICK, SEYMOUR—Painter
1836 Pine St., Philadelphia, Pa. 19103
B. Detroit, Mich., 1923. Studied: Tyler Sch. FA.; Academie des
Beaux-Arts, Paris; PAFA; Hans Hofmann Sch. A. Awards: Tiffany
Grant, 1955; Altman Award, NAD, 1960; Hallmark purchase Award;
prizes, Cheltenham A. Center, Pa., 1962; Philadelphia Sketch Cl.,
1963, 1965; Woodmere A. Gal., 1965, 1966. Work: Allens Lane A.
Center, Philadelphia; Bowdoin Col., Brunswick, Me.; Dallas Mus. for
Contemp. A.; Delaware A. Center; Ft. Worth A. Center; PAFA;
PMA; Phoenix A. Mus.; R.I. Sch. Des. Exhibited: Dubin Gal., and
Lush Gal., both Philadelphia, 1952; Philadelphia A. All., 1955; Stable
Gal., N.Y., 1956; R.I. Sch. Des., 1956; Paris, France, 1956; PAFA,
1957, 1964, 1968; Nebraska AA, 1957; Moore Inst. A., Philadelphia,
1959; Minneapolis Inst. A., 1960; NAD, 1960, 1963, 1966; Butler
Inst. Am. A., 1960, 1963, 1964, 1965; NAC, 1961; AIC, 1961; St. Paul
Gal. & Sch. A., 1961; PMA, 1962, 1965; Tyler Sch. FA, Temple
Univ., 1963; Davis Gal., N.Y., 1963; Hinkhouse Coll., Phoenix, Ariz.,
1964; Oklahoma A. Center, 1964; Chautauqua, N.Y., 1964; Woodmere
A. Gal., Philadelphia, 1966; Peridot Gal., N.Y., 1960, 1966, 1968;
Bayonne (N.J.) Jewish Community Center, 1968; traveling exh.,
Smithsonian Inst., 1968. Traveling Exhs: Collection of Josephine &
Philip Bruno, 1961; Collection of Mr. & Mrs. Walter Fillin, 1963.
One-man: Dubin Gal., 1949, 1951, 1952; Lush Gal., 1954; Davis Gal.,
N.Y., 1954-1962; Philadelphia A. All., 1961; Peridot Gal., N.Y., 1967
1968; Bordentown, N.J. 2-man, 1962.

REMINGTON, DEBORAH W.—Painter
361 Canal St., New York, N.Y. 10013
B. Haddonfield, N.J., June 25, 1930. Studied: Cal. Sch. FA; San
Francisco AI, B.F.A. Awards: prizes, Texas Western College,
1955; SFMA, 1956, 1963; Cal. PLH. Work: SFMA; Cal. PLH;
Auckland Mus. A., N.Z.; WMAA; Musée du XXéme Siecle, Paris.
Exhibited: SFMA, 1956, 1960, 1961, 1963; 1964; CM, 1954; Auckland,
N.Z., 1962; Cal. PLH, 1962, 1965; SFMA, 1964 (2); Univ. Ill., Ur-
bana, 1967; WMAA, 1965, 1967; Smithsonian, 1965; Fondation
Maeght, St. Paul de Vence, France, 1968; Galleries Pilotes, Lau-
sanne Mus., Switzerland, 1966. One-man: Bykert Gal., N.Y., 1967;
Galerie Speyer, Paris, 1968. Positions: Taught Painting & Drawing,
San F. AI; Drawing: Univ. California at Davis; San F. State College.

REMSEN, HELEN Q.—Sculptor, T.
Sunset House, Apt. 306, 225 Hourglass Way, Sarasota, Fla.
33581
B. Algona, Iowa, Mar. 9, 1897. Studied: Univ. Iowa; Northwestern
Univ., B.A.; Grand Central Sch. A., and with Georg Lober, John
Hovannes. Awards: prizes, Soc. Four A., Palm Beach, Fla., 1942;
Norton Gal. A., 1944; DMFA, 1944; Fla. Fed. A., 1941, 1942, 1944;
Nat. Sculpture Exh., Sarasota, 1953; Smithsonian Inst., 1954; New
Orleans AA, 1955, 1957. Exhibited: NAD, 1936; PAFA, 1937; All. A.
Am.; Soc. Four A., 1942-1945; Norton Gal. A., 1944; Fla. Fed. A.,
1939, 1941-1945; Berkshire Sc. Group, 1954; New Orleans AA, 1954,
1955, 1956, 1957; Washington Sc., 1954; Silvermine Gld. A., 1955;
All. A. Am., 1955; Sarasota AA, 1957, 1958; Fla. Sculptors, 1958,
1960, 1961; Manatee A. Center, 1958 (one-man); NSS, 1961. Work:
fountains: Jungle Gardens, Sarasota; St. Boniface Church, Sarasota;
Three Marys (marble) dedicated 1964, Grace and Holy Trinity Ca-
thedral, Kansas City, Mo.; Memorial sculpture, Algona (Iowa) Public
Library, dedicated June, 1969, and other work in private homes.
Instr., Sculpture, Sarasota, Fla., 25 years.

RENISON, MRS. HERBERT. See Gerard, Paula

RENNIE, HELEN SEWELL—Painter, Des.
3073 Canal St., Northwest, Washington, D.C. 20007
B. Cambridge, Md. Studied: Corcoran Sch. A.; NAD. Member: AWS;

Soc. Wash. A. Awards: prizes, Soc. Wash. A., 1948, 1959, 1960,
1961; BMA, 1958, 1960. Work: PC; Barnett Aden Gal., Wash., D.C.,
Dept. of Commerce and Dept. of State, Wash., D.C. and in many pri-
vate collections. Exhibited: MModA, 1946, 1956; three-man: Capri-
corn Gal., N.Y., 1966, 1969; one-man: Franz Bader Gal., Wash.,
D.C., 1954, 1958, 1962, 1965; BMA, 1959; Univ. Puerto Rico Mus.,
1961; Bridge Gal., N.Y., 1963, 1965; Capricorn Gal., N.Y., 1968.

RENOUF, EDWARD—Sculptor, P.
Washington, Conn. 06793; also, 12 East 87th St., New York,
N.Y. 10028
B. Hsiku, China, Nov. 23, 1906. Studied: Harvard College; Columbia
Univ. grad. studies; and in Mexico with Merida. Member: Sculptors
Gld.; Fed. Mod. P. & S. Awards: prize, Sharon (Conn.) Creative
Arts Fnd., 1964. Work: Horace Mann Sch.; Horace Mann Lib. Ex-
hibited: WMAA, 1960, 1964; Sculptors Gld., 1963-1969; Wadsworth
Atheneum, Hartford, 1961; Sculpture Center, N.Y., 1965-1968; Conn.
Acad. FA, 1961; Ruth White Gal., N.Y., 1960-1964; Zabriskie Gal.,
N.Y., 1960; Hahn Gal., N.Y., 1960; Henri Gal., Wash., D.C., 1963;
Washington (Conn.) A. Gal., 1959; PAFA, 1966; New Haven Festival
of A., 1967; Mattatuck Mus., Waterbury, Conn., 1967; Stamford Mus.,
1967; Fed. of Mod. P. & S., 1966-1968; Spectrum Gal., 1969, and
others. Three sc., State Dept. Art in Embassies Program, 1966.

REOPEL, JOYCE—Sculptor, Gr.
161 South St., Portsmouth, N.H. 03801
B. Worcester, Mass., Jan. 21, 1933. Studied: Ruskin Sch. Drawing &
FA, Oxford, England; Yale-Norfolk A. Sch.; Sch. of the Worcester
Mus. A. (grad.). Awards: Fellowship, Yale-Norfolk Sch.; Radcliffe
Grant; Nat. Inst. A. & Lets.; Wheaton Col. for research; Ford Fnd.
Grant; prize, Boston A. Festival. Work: Drake Univ.; Ohio State
Univ.; Radcliffe Inst. for Independent Study; FMA; PAFA; Univ.
Massachusetts, Amherst; Peabody Col.; AGAA. Exhibited: Boston
Arts Festival (several, and Juror, 1969); Nat. Inst. A. & Lets.; St.
Paul Gal. & Sch.; AGAA; WMA; De Cordova & Dana Mus., Lincoln,
Mass. (5); Smith Col. Mus.; Providence Arts Festival; Victoria &
Albert Mus., London; Boston Univ.; Wheaton Col.; AFA traveling
exh.; Cober Gal., N.Y., 1965-1969; Tragos Gal., Boston, 1966, and
many others.

RESIKA, PAUL—Painter
3 Washington Square North, New York, N.Y. 10003
B. New York, N.Y., Aug. 15, 1928. Studied: with Sol Wilson, Hans
Hofmann and in Venice and Rome, Italy. Awards: Tiffany Fnd.,
1959-60; NAD Ranger purchase prize, 1962; Ingram Merrill Fnd.
award, 1969. Work: Mus. of Bordighera, Italy; Sheldon Mem. A.
Gal., Lincoln, Neb.; Joseph Hirshhorn Coll.; portrait commissions.
Exhibited: Rijksacademie, Amsterdam, Holland, 1968; Smithsonian
Inst., 1968; State Univs. of N.Y., 1969; numerous exhs. in galleries
and museums, U.S. and Italy; one-man: George Dix Gal., N.Y., 1948;
Peridot Gal., N.Y., 1964, 1965, 1967-1969. Positions: Instr., ASL,
1968-1969; Cooper Union, 1966- .

RESNICK, MILTON—Painter
80 Forsyth St., New York, N.Y. 10002
B. Bratslav, Russia, Jan. 8, 1917. Studied: New York and Paris.
Work: Bundy A. Gal., Waitsfield, Vt.; Cal. Mus. FA, Berkeley, Cal.;
MModA; WMAA; Wadsworth Atheneum. Hartford; Wake Forest Col.,
Winston-Salem, N.C.; Skidmore, Owings & Merrill, N.Y.; CMA;
Weatherspoon Gal., Univ. of North Carolina at Greensboro; Akron A.
Inst.; Milwaukee A. Center; Smithsonian Inst.; and in private colls.
Exhibited: WMAA, 1957, 1959, 1961, 1967; Traveling Exh., MModA
to Japan, 1957-58; Carnegie Inst., 1958; WAC, 1960; Arch. Contemp.
Am. Painting, Belgrade, Yugoslavia and Salzburg, Austria, 1961;
Guggenheim Mus., 1961; Yale Univ. A. Gal., 1961-62; AIC, 1962; Pan
American Exh., circulated by USIA in Latin America, 1961-1962;
PAFA, 1962; Seattle World's Fair, 1962; SFMA, 1963; Univ. Texas
A. Mus., 1964, 1968; Jewish Mus., N.Y., 1967. One-man: De Young
Mem. Mus., San F., 1955; Poindexter Gal., N.Y., 1955, 1957, 1959;
Ellison Gal., Ft. Worth, 1959; Holland-Goldowsky Gal., Chicago,
1959; Howard Wise Gal., Cleveland, 1960 and New York, 1960, 1961,
1964; Zabriskie Gal., Provincetown, 1963; Feiner Gal., N.Y., 1964;
Madison A. Center, Wis., 1967; Reed Col., Portland, Oregon, 1968.
Positions: Taught—Pratt Inst., Brooklyn; Univ. California, Berke-
ley; N.Y. University. Visiting Prof., Univ. Wis. at Madison, 1966-
1967; Visiting lecturer & critic at various schools, including Rhode
Island, Yale Summer Sch.; Wagner Col., Staten Island, N.Y.; Silver-
mine; and N.Y. Studio Sch., 1965 to present. Instr., N.Y. Univ.,
1964- .

RÉTHI, LILI—Industrial Artist, I., Lith.
102 West 85th St., New York, N.Y. 10024
B. Vienna, Austria. Studied: Vienna Acad., with Otto Friedrich.
Member: F., Royal Soc. Arts, London, England. Work: Sperry Gyro-
scope Co.; Turner Construction Co.; Spencer, White & Prentis;
Eastern Stainless Steel Corp., Balt., Md.; Cities Service Co.; Bd. of
Water Supply, New York City (painting); Gibbs & Hill's "50 Years of

Engineering Accomplishment," 1961 (painting); New York Times and Esquire Magazine (drawings); Surveyor, Nenninger & Chênevert, Montreal, Canada; Moran Towing & Transportation, N.Y.; Am. Soc. Mech. Engineers; New York World's Fair Corp., 1964. Exhibited: one-man: Arch. Lg.; Am. Soc. Civil Eng.; MMA; also in Austria, Germany, Denmark, Sweden, etc. Other recent exhs.: 46 pictures of the Verrazano-Narrows Bridge construction, N.Y., at Smithsonian Inst., 1965, and following at N.Y. World's Fair, 1965. "The Bridge" (40 construction pictures) publ. 1965; Assoc. Am. A., N.Y., 1967, 1968. I., "The White House Reconstruction," 1950; illus. for Encyclopaedia Americana, N.Y. and Chicago; Illus., "Big Bridge to Brooklyn," 1956; "The Kennebec River," "The Illinois River," "Second Greatest Invention," 1968; "U.S. Lines Container Ships," 1968; "Atomic Power Plant, Canada," (drawings), 1968; "Manicousgan Dam Construction, 1962-1968" (75 pictures) of greatest multiarched Dam, near Arctic Circle, Canada, 1970. Contributor of drawings to New York Times Magazine on construction of U.N. Buildings; Brooklyn Bridge; The White House, etc. Autobiography over Radio Salzburg in series "Culture & Science," 1955.

REVINGTON, GEORGE D., III—Collector
 1211 Ravinia Rd., W. Lafayette, Ind. 47906
Collection: Modern American painting and sculpture; Works from the collection have been exhibited at the AFA, MModA, and at various galleries and art shows.*

REVOR, SISTER MARY REMY—Educator, Des., C., W., L.
 Mount Mary College, Milwaukee, Wis. 53222
B. Chippewa Falls, Wis., Sept. 17, 1914. Studied: Mount Mary Col., B.A.; AIC, B.F.A., M.F.A.; John Herron AI. Member: CAA; Wis. Des-Craftsmen; Am. Craftsmen's Council; Mid-West Col. Art Conf.; Western AA; Alumni Assn., AIC. Awards; prizes, Fleischman Nat. Comp. (carpet des.), Detroit, 1951; Wisconsin Des.-Craftsmen (textile des.), 1953, 1956, 1960-1964; Wisconsin State Fair, 1955-1960; Tiffany Fnd. Grant, 1962; Wichita Nat. Crafts Comp., 1964; Wisconsin Governor's Award for achievement in the arts, 1968; Fulbright Research Scholar to Finland, for textile study, 1969. Exhibited: St. Paul A. Gal., 1957; Univ. Illinois, 1957, 1965; Milwaukee A. Center, 1963; Chicago Pub. Lib., 1964; Cornell Univ., 1962; Wustum Mus. A, Racine; Alverno Col., Milwaukee; Milwaukee-Downer Col.; AIC; Midwest Des.-Craftsmen. Lectures: "Contemporary European Religious Art" and "Ecclesiastical Vestments," both at Milwaukee A. Center; "Textiles as an Art Form," at Marquette Univ.; "Putting Knowledge to the Task," at Univ. Wisconsin-Design Conference. Positions: Prof. Des., Mount Mary College, Milwaukee, Wis.

REWALD, JOHN—Writer, Scholar, E.
 1075 Park Ave., New York, N.Y. 10028
B. Berlin, Germany, May 12, 1912. Studied: Univ. Hamburg; Univ. Frankfort-on-Main; Sorbonne, Paris, Ph.D. Awards: Prix Charles Blanc, Académie Francaise, 1941; Knight, Legion of Honor, 1954. Author: "Cézanne," 1948; "Gauguin," 1938; "Maillol," 1939; "Georges Seurat," 1943; "The History of Impressionism," 1946, 1961; "Bonnard," 1948; "Post-Impressionism—From Van Gogh to Gauguin," 1956, 1962. Ed., Cézanne's "Lettres," 1941; Gaugin's "Letters to Vollard and Fontainas," 1943; Pissarro's "Letters to His Son Lucien," 1943; Degas' "Works in Sculpture," 1944, 1948; "The Woodcuts of Maillol," 1943, 1951; "Renoir Drawings," 1946; "Cézanne, Carnets de Dessins," 1951; "Gauguin Drawings," 1958; "Camille Pissarro," 1963, etc. Various volumes trans. into French, German, Italian, Russian, Japanese. Contributor to art magazines. Lectures on The Revolution of Impressionism; Aristide Maillol, etc. Positions: Prof. Art History, Univ. of Chicago, 1964- .

REY, H(ANS) A(UGUSTO)—Illustrator, W., Lith., Cart., L.
 14 Hilliard St., Cambridge, Mass. 02138; also, Waterville Valley, N.H. 03223
B. Hamburg, Germany, Sept. 16, 1898. Studied: Univ. Munich; Univ. Hamburg. Member: Am. Craftsmen's Council. Awards: "Curious George" chosen by AIGA, 1941, as one of 24 best Picture Books published in U.S. between 1937 and 1941; "Look for the Letters" and "Park Book" chosen as one of 58 best Picture Books, 1943 to 1945, by "1946 Books by Offset Lithography Exhibit," New York, 1946. Special citation (with Margret Rey) for "Curious George Goes to the Hospital," Child Study Assn. of Am., 1967. Author; I., "Curious George," 1941; "Cecily G." 1942; "Pretzel" (with Margret Rey), 1944; "Look for the Letters," 1945; & numerous others, mainly for children. I., "Park Book," 1944; "Spotty," 1945; "Curious George Takes a Job," 1947; "Billy's Picture," 1948; "The Stars—A New Way to See Them," 1952 (publ. by Book-of-the-Month Club as dividend book, 1962); "Curious George Rides a Bike," 1952; "Find the Constellations, 1954; "See the Circus," 1956; "Curious George Gets a Medal," 1957; "Curious George Flies a Kite," (with Margret Rey), 1958; "Elizabite," 1962; "Curious George Learns the Alphabet," 1964; "Curious George Goes to the Hospital," (with Margret Rey), 1966 and others.

REYNAL, JEANNE—Mosaic Artist
 240 W. 11th St., New York, N.Y. 10014
B. White Plains, N.Y., Apr. 1, 1903. Awards: purchase prize, SFMA. Work: WMAA; MModA; SFMA; Denver Mus. A.; AGAA; mural, Fund for Adult Edu., White Plains; wall, Our Lady of Florida, 1963; State Capitol, Lincoln, Neb., 1965, 1966. Exhibited: MModA; WMAA; SFMA; BMA; Mills Col.; N.Y. Univ., 1961; PVI Gal., N.Y., 1964; Sheldon Mem. Mus., Lincoln, Neb., 1965; New School, N.Y., 1962. Monograph, "The Mosaics of Jeanne Reynal," 1964; "The Architect Chooses Art," 1965. Film: Mosaics: The Work of Jeanne Reynal.

REYNOLDS, DOUGLAS WOLCOTT—Painter, E., L.
 7 Mt. Vernon Terr., Newtonville, Mass. 02160
B. Columbus, Ga., June 14, 1913. Studied: Columbia Univ., M.A., F.A. in Edu.; North Carolina State Col., Sch. Des.; Yale Univ., B.F.A. Member: Am. Soc. for Aesthetics; Boston Regional Council A. Educators. Awards: F., Yale Univ., 1941-42; Beaux-Arts Comp., 1940; Southern F. Fund grant, 1955. Work: Southwestern Univ., and in private colls. Exhibited: North Carolina State Col. Union; Columbia A. Gal.; Rome, Italy, 1941; Fla. Fed. A., 1934-1936; New Haven, Conn., 1941, 1942 (one-man); North Carolina, 1947-1955; New York City, 1949 (one-man); Virginia, 1952; Akron, Ohio, 1959; Massillon, Ohio, 1959; Tufts Univ. 1964, World A. Gal., Newton, Mass., 1965 (one-man). Lectures: Oriental Art and Philosophy; "On Bringing Criticism of Southern Sung Painting Up to Date," (Col. A. Conf., Cleveland), 1958; "Sincerity & Decadence in Art," Am. Soc. Aesthetics Conf., Cincinnati, 1959; "Development of Modern Painting," Inst. Contemp. A., Boston, 1960; "Art and Society," Boston Mus. FA, 1965, and others. Positions: Hd. A. Dept., Southwestern Univ., Georgetown, Tex., 1943-46; Hd., A. Dept., Meredith Col., Raleigh, N.C., 1946-1957; Kent State Univ., School of Art, Kent, Ohio, 1957-59; Wheelock College, Boston, 1959-1964; Tufts Univ., Medford, Mass., 1960- ; Consultant, Oriental Art History, Lexington, Mass., Public Schools, 1964, 1965; Faculty, Boston Mus. FA School, 1960- .*

REYNOLDS, HARRY REUBEN—Painter, C., E.
 519 North 6th East, Logan, Utah 84321
B. Centerburg, Ohio, Jan. 29, 1898. Studied: AIC; Iowa State Univ., and with Birger Sandzen, B.J.O. Nordfeldt, Grant Wood and others. Awards: med., AIC, 1923. Work: Bethany Col., Lindsborg, Kans.; Utah State Fair Coll.; Ogden Pub. Schs.; Branch Agricultural Col., Cedar City, Utah; Logan H.S.; Utah State Agricultural Col. Exhibited: SFMA, 1931; Oakland A. Mus., 1929, 1932; Utah State Fair; Salt Lake City A. Center (one-man); photographs and paintings, Univ. Utah Lib., 1954-55 and Cache County Lib., Logan, Utah, 1954-55. Positions: Instr., Asst. Prof., Assoc. Prof. A., Utah State University, Logan, Utah, 1923- ; Chm. A. Com., Exec. Com. FA, Utah State Centennial Comm., 1946-47, Production of Cache County, Utah, 1955-56; Instr. A., Art Barn, Salt Lake City, Utah, 1952; Bd. Dirs., Utah State Fair Assn., 1963-65; Fine Arts Inventory and Evaluation of State owned works of art for Utah State Institute of Fine Arts for Utah, 1963-64 (summers).*

REYNOLDS, JOSEPH G., JR.—Designer, C., L., W.
 296 Payson Rd., Belmont, Mass. 02178
B. Wickford, R.I., Apr. 9, 1886. Studied: R.I. Sch. Des., and abroad. Member: Mediaeval Acad. Am.; Nat. Inst. Social Sc.; Boston Soc. A. & Crafts (Life). Awards: medals, Boston Soc. A. & Crafts, 1929; Boston Tercentenary Exh., 1930; Paris Int. Exp., 1937; AIA, 1950; First annual Alumni Medal, R.I. Sch. Des., 1963. Work: stained glass windows, Washington Cathedral; Cathedral of St. John the Divine, N.Y.; Riverside and St. Bartholomew churches, N.Y.; Princeton Univ. Chapel; American church in Paris; Am. Mem. Cemetery Chapel, Belleau, France; churches in Pittsburgh, Glens Falls, N.Y.; Providence, Newport, Pawtucket, Westerly and Narragansett, R.I.; Philadelphia, Lancaster, Mercersburg, Pa.; Litchfield, Conn.; Laconia, Franklin, Dover, N.H.; Wellesley Col. Chapel; Colorado Col. Chapel, and many others. Contributor to Cathedral Age, American Architect. Lectures on Stained Glass at art museums, clubs and societies, universities, colleges.

REYNOLDS, RALPH WILLIAM—Educator, P.
 363 South Third St., Indiana, Pa. 15701
B. Albany, Wis., Nov. 10, 1905. Studied: AIC; Beloit Col., B.A.; State Univ. Iowa, M.A., and with Grant Wood, Jean Charlot, Eliot O'Hara, Charles Burchfield, William Thon, Clarence Carter. Member: Assoc. A. Pittsburgh; Pittsburgh WC Soc.; All. A. Johnstown; NEA; Pa. State Edu. Assn.; Pa. Art Edu. Assn.; AAUP. Exhibited: Oklahoma A. Center, 1939; Phila. A. All., 1939; Am. Color Pr. Soc., 1942; Iowa State Fair, 1939, 1940; Kansas City AI, 1490; Butler AI, 1941, 1942; Assoc. A. Pittsburgh, 1942-1960; Athens, Ohio, 1945, 1946; Parkersburgh FA Center 1945, 1946; P. & S. Soc., New Jersey, 1947; Pittsburgh WC Soc., 1951-1964; All. A. Johnstown, 1953-1964; AWS, 1959. Awards: prizes, Cornell Col., 1940; Assoc. A. Pitts-

burgh, 1943; All A. Johnstown, 1953-1963; U.S. Bank purchase, Johnstown, 1960, 1964, 1965; Penelac purchase award, Johnstown, 1962. Pittsburgh WC Soc., 1951, 1952, 1955, 1959, 1963, 1964. Positions: Asst. Prof., Hd. A. Dept., Univ. South Dakota, 1940-41; Assoc. Prof., State Col., Indiana, Pa. 1941- .*

REYNOLDS, RICHARD (HENRY)—
 Educator, S., Des., P., Cr., W., L.
 Department of Art, University of the Pacific; h. 1656 W. Long-view Ave., Stockton, Cal. 95207
B. New York, N.Y., May 16, 1913. Studied: Santa Barbara Community A. Sch.; San Bernardino Valley Col., A.A.; Univ. California, A.B.; UCLA; Mills Col.; University of the Pacific, M.A.; Oregon State Univ., Shell Grant, 1961 (summer). Member: CAA; NAEA; Pacific AA; F.I.A.L.; San Francisco A. Inst.; Western Col. AA; Stockton A. Lg.; AAUP. Awards: Bank of Stockton Hist. Exh., 1960; Ballet Gld. A. Show, 1967; Haggin Gals., 1960, 1968. Work: wall sc., lounge, Women's Dormitory, Univ. of the Pacific; sc. of Amos A. Stagg, and "Delta King" monument (1964), Amos Alonzo Stagg H.S., Stockton; sc., Edison H.S., Stockton; life-size Bengal tiger, Univ. of the Pacific Campus; bronze relief head of Chancellor Tully, Univ. of the Pacific; life size Buffalo sculpture, Manteca (Cal.) H.S., 1964; Trojan Victory figure, Lincoln H.S., Stockton, 1964; bronze head, Bert Swenson, on plaque, Swenson Golf Course, City of Stockton, 1965; bronze relief, Stockton Daily Record Bldg., 1966; metal falcon sculpture, Atwater, Cal. H.S.; garden and other sc. in private colls. Exhibited: Eric Locke Gal., San F., 1960; Silvermine Gld. A., 1959; de Young Mus., 1959; Shasta Col., Redding, 1959 and many others since. Contributor to Arts & Architecture magazine; College Art Journal; American Artist. Lectures: Modern Art; Abstraction; Today's Sculpture, etc., to clubs, church groups, civic organizations, television. Positions: Instr. A., Asst. Chm., Div. A. & Lets., Stockton College, 1939-48; Prof. A., Chm. Dept. A., University of the Pacific, Stockton, Cal., 1948- , Chm., Academic Council (Faculty Senate) 1967-1968, member, executive bd., Academic Council, 1968-1969. Guest lecturer, Alaska Methodist Univ., 1962.

RHODEN, JOHN W.—Sculptor
 23 Cranberry St., Brooklyn, N.Y. 11201
B. Birmingham, Ala., Mar. 13, 1918. Studied: Columbia Univ., and with Maldarelli, Robus, Zorach. Member: Municipal A. Soc. Awards: Rosenwald award, 1947-48; Tiffany Fnd. award, 1950; Fulbright Fellowship, 1951-52; Prix de Rome, 1953-54; prizes, Columbia Univ., 1948-1950; New Jersey P. & S., 1950; Atlanta Univ., 1955; Rockefeller Grant, 1959; Howard Univ., Prize & medal, 1961; Guggenheim F., 1961. Work: Carl Milles Mus., Stockholm, Sweden; Wilmington Soc. FA; Columbia Univ.; s., Sheraton Hotel, Phila., Pa.; Metropolitan Hospital and Harlem Hospital, N.Y., and in private colls. Exhibited: MMA, 1950; Audubon A., annually; PAFA; NAD; Nat. Acad. A. & Lets.; Camino Gal., Rome, Italy; Fairweather-Hardin Gal., Chicago, 1955; AIC; Univ. Illinois; Howard Univ.; Saidenberg Gal., N.Y., 1955; Schneider Gal., Rome, 1954 (one-man); traveling exh. sponsored by U.S. Dept., (one-man) to Iceland, Ireland, Finland, Norway, Italy, Germany, etc., 1955-56; traveling exh., U.S. State Dept., to Russia, Poland, India, Siam, Cambodia, etc., 1958-59; Dept. of State traveling exh., India, Cambodia, Thailand, Viet Nam, Korea, etc., 1960; BM, 1969; Brooklyn Col., 1969; Community Church Gal.; Plymouth Church Gal. One-man: Fisk Univ., 1967 and Univ. Georgia, 1968.

RICCI, JERRI—Painter
 12 Hale St., Rockport, Mass. 01966
B. Perth Amboy, N.J. Studied: N.Y. Sch. App. Des. for Women; ASL, with Scott Williams, George Bridgman, Mahonri Young, and others. Member: AWS; All. A. Am.; ANA; Phila. WC Cl.; Audubon A.; Rockport AA; North Shore AA; Gld. Boston A. Awards: gold medal, All. A. Am., 1942; prizes, Rockport AA, 1943, 1946; All. A. Am., 1948; AWS, 1948; North Shore AA, 1949; Charles Stuart Mem. prize, 1953; NAD, 1954; Herbert Pratt purchase prize, 1950; Butler AI; gold med., Audubon A., 1955; bronze med., Concord AA, 1953; silver med., Catherine L. Wolfe A. Cl. Work: Fairleigh Dickinson Col.; Parrish Mus., Southampton, N.Y.; Am. Acad. A. & Let.; Clark Univ.; Butler AI; Ranger Fund. Exhibited: Toledo Mus. A.; PAFA; AIC; Dayton AI; AGAA; Am. Acad. A. & Let.; one-man: Milch Gal., 1947, 1951, 1953, 1955.*

RICE, DAN—Painter
 c/o Catherine Viviano Gallery, 42 E. 57th St., New York, N.Y. 10022*

RICE, HAROLD R.—Educator, Cr., W., Gr., L.
 College of Design, Architecture and Art, University of Cincinnati, 45221; h. 640 Evening Star Lane, Cincinnati, Ohio 45220
B. Salineville, Ohio, May 22, 1912. Studied: Univ. Cincinnati, B.S. in A.A., B.S. in Edu., M. Edu.; Columbia Univ., Ed.D.; Moore College

of Art, L.H.D. Member: MModA; Cincinnati A. Cl.; University Cl.; Contemporary Arts Center; Nat. Assn. of Schs. of Art; Eastern AA; Pacific AA; AFA; NAEA; AAUP. Awards: Arthur Wesley Dow Scholar, Columbia Univ., 1943-44. Exhibited: CM; Montgomery Mus. FA; Birmingham Pub. Lib.; Univ. Cincinnati; Univ. Alabama. Contributing Ed., Junior Arts & Activities, 1937-46; compiled and published Encyclopedia of Silk Magic, Vol. 1, 1948, Vol. 2, 1952, Vol. 3, 1962. Positions: A. Supv., Wyoming, Ohio, Pub. Schs., 1934-42; Instr., Univ. Cincinnati, 1940-42; Teaching Fellow, Columbia Univ., 1942-44; Hd. Dept. A., Univ. Alabama, 1944-46; Dean, Moore College of Art, 1946-51, Pres. & Dean, 1951-63; Dean, College of Design, Arch. & Art, Univ. Cincinnati, 1963- . Adv. A. Ed., The Book of Knowledge, The Children's Encyclopedia, Grolier Soc., 1951- ; General Chm., Arts & Skills Corps, Am. Red Cross, Alabama, 1944-46; Nat. Scholarship Juror, Scholastic Awards, 1949, 1960, 1963, 1967. Dir., Harcum Jr. Col., 1953-54, 1958- ; Sec., 1950-55, Pres., 1955-57, Nat. Assn. Schs. of Art; Vice-Pres., Eastern AA, 1956-58, Pres., 1958-60; Dir., Phila. A. All., 1947-63; Dir., Wynnewood Civic Assn., 1958-63; Eastern Arts Council, 1960-63; NAEA Council, 1960-63; Dir., Cincinnati Contemp. A. Center, 1964- ; Hon. Member, Cincinnati A. Cl., 1964- .

RICE, NORMAN LEWIS—Educator, Gr., P.
 Carnegie-Mellon University, Pittsburgh, Pa. 15213
B. Aurora, Ill., July 22, 1905. Studied: Univ. Illinois, B.A.; AIC. Member: Cliff Dwellers, Chicago; CAA. Positions: Assoc. Dean, Dean, AIC, 1930-42; Dir., Sch. A., Col. FA, Syracuse Univ., Syracuse, N.Y., 1946-54; Pres., Nat. Assn. Schs. of Des., 1957-60; Pres., Pittsburgh Plan for Art, 1958-1962; Pres., Nat. Council of the Arts in Education, 1965-1967. Dean, Col. FA, Carnegie-Mellon University, Pittsburgh, Pa., 1954- .

RICH, DANIEL CATTON—Museum Director, W., L.
 Worcester Art Museum; h. 3 Tuckerman St., Worcester, Mass. 01609
B. South Bend, Ind., Apr. 16, 1904. Studied: Univ. Chicago, Ph.B.; Harvard Univ. Member: Intl. Council of Museums; AID; Hon. Memb., Chicago Chptr., AIA; Assn. A. Mus. Dirs.; Am. Assn. Mus.; United States Commissioner, Venice Biennale, 1956. Awards: Chevalier, Officer Legion d'Honneur; Officer of the Order of Orange Nassau. Author: "Scurat and The Evolution of 'La Grande Jatte,' " 1935; Charles H. and Mary F. S. Worcester Collection Catalogue, 1938; "Degas," 1951. Contributor to Atlantic Monthly; College Art Journal, etc. Lectures: Degas; The Two Tiepolos; all phases of Painting and Sculpture especially in 17th, 18th and 19th century painting, Arranged exhs.: The Two Tiepolos; Henri Rousseau, 1946; Toulouse-Lautrec, 1931; Rembrandt and His Circle, 1935; Hogarth, Constable & Turner, 1946; The Art of Fr. Goya, 1941; Chauncey McCormick Memorial Exhibition, 1955; Georges Seurat, 1958, and others. Positions: Ed., "Bulletin," 1927-32, Asst. Cur. Painting & Sculpture, 1929-31, Assoc. Cur., 1931-38, Cur., 1938- , Dir. FA, 1938-43, Dir., 1943-58, Art Institute of Chicago; Trustee, 1955-58, Hon. Gov. Life Memb., Art Institute of Chicago; Dir., Worcester Art Museum, Worcester, Mass., 1958- . Visiting Lecturer, Harvard College, 1960; Trustee, Guggenheim Mus., N.Y., 1961- ; Vice-Chairman, Massachusetts Board of Higher Education, 1969- .

RICH, FRANCES—Sculptor, E., L.
 Shumway Ranch, Pinyon Crest, Cal.; h. P.O. Box 1147, Palm Desert, Cal. 92260
B. Spokane, Wash., Jan. 8, 1910. Studied: Smith Col., B.A.; Cranbrook Acad. A.; Claremont Col.; Columbia Univ., and with Malvina Hoffman, Carl Milles, Alexander Jacovleff. Member: Arch. Lg.; Cosmopolitan Cl.; Botolph Group, Boston; Liturgical A. Soc. Work: Army-Navy Nurse mem., Arlington Nat. Cemetery; Purdue Univ.; Wayside Chapel of St. Francis, Grace Cathedral, San F.; Mt. Angel Abbey, St. Benedict, Ore.; Hall of Fame, Ponca City, Okla.; Oklahoma A. & M. Col.; Smith Col.; St. Peters Church, Redwood City, Cal.; Univ. Cal., Berkeley; Madonna House, Combermere, Ont., Canada; Chapel, Marian Centre, Edmonton, Canada, 1965; Carl Milles Mus., Garden, Stockholm; St. Cecilia Church, Stanwood, Wash.; Univ. Oklahoma; sc. medals, Dr. Jonas Salk; Florence Corliss Lamont; crucifix, Grace Cathedral Sacristy, San Francisco; bronze Pelican, Pelican Magazine Bldg. entrance, Univ. Cal., Berkeley; Port. busts, Alice Stone Blackwell, Boston Pub. Lib., 1960; Katherine Hepburn as Cleopatra, Am. Shakespeare Festival Theatre, Stratford, Conn., 1961, Mem. bust of Lawrence Langner, 1964; terra cotta figure of Hepburn, Shakespeare Collection Museum; bas relief Madonna and Child, Holy Trinity Church, Bremerton, Wash.; bronze St. Francis of Assisi, Episcopal Church, Carmel, Cal.; many port. busts and small bronzes in private colls. Exhibited: Am. Acad. Des., N.Y., 1936; Cranbrook Acad. A., 1938, 1939; Santa Barbara Mus. A., 1941, 1942, 1952 (one-man); Nat. Mus. Mod. A., Rome, Italy, 1952; deYoung Mem. Mus., 1952; Madonna Festival, Bel Air and Santa Barbara, Cal., 1954, 1955; Margaret Brown Gal., Boston, 1954; Merrill Coll. Religious Art, Wash., D.C. and Alexandria, Va., 1954, 1955; Denver

A. Mus., 1955; Nat. Decorators' Show, San F., 1956; Grace Cathedral, San F., 1957; one-man: Cal. PLH, 1955; Desert Southwest A. Gal., Palm Desert, Cal., 1964; one-man retrospective, Palm Springs Desert Mus. (Cal.), 1969. Book: "The Sculpture of Frances Rich," 1969. Conducts weekly sculpture class at studio.

RICHARD, BETTI—Sculptor
15 Gramercy Park, New York, N.Y. 10003; h. Durham Road, Larchmont, N.Y. 10538
B. New York, N.Y., Mar. 16, 1916. Studied: ASL with Mahonri Young, Paul Manship. Member: All. A. Am.; F., NSS; Arch. Lg. (V. Pres., 1962-1964); Audubon A.; NAC. Awards: prizes, NAD, 1947; med., Pen & Brush Cl., 1951; gold medal, All. A. Am., 1956; John Gregory award, NSS, 1960. Work: doors, Church of the Immaculate Conception, N.Y.; Pieta, Skouras Mem., N.Y.; three bronze panels, Bellingrath Gardens, Mobile, Ala.; monument to race horse "Omaha" at Ak-Sar-Ben Track, Omaha; fig., Austrian Legation, Tokyo; fig., Sacred Heart Rectory, Roslindale, Mass.; statue, St. Francis of Assisi Church, N.Y.; House of Theology, Centerville, Ohio; St. Francis altar and St. Anthony of Padua Altar, in St. Francis of Assisi Church, N.Y.; marble Madonna, Rosary Hill College, Buffalo, N.Y.; St. John Baptiste de La Salle statue, St. John Vianney Seminary, East Aurora, N.Y.; St. Francis statue, St. Raymond's Cemetery, New York City; 3 bronzes, Phoenix A. Mus.; Cardinal Gibbons Memorial, Baltimore; bronze fig., Eureka Col. Lib., Ill.; bronze busts of Mozart and Wagner, Metropolitan Opera, N.Y. Exhibited: NAD, 1944-1969; PAFA, 1949; All A. Am.; Audubon A.; PMA, 1949; Arch. Lg.; Pen & Brush Cl.; Vienna, Austria, 1954, 1955; NAC; NSS, 1968.

RICHARDS, JEANNE HERRON—Etcher, Eng., Lith.
3506 Cameron Mills Rd., Alexandria, Va. 22305
B. Aurora, Ill., Apr. 8, 1923. Studied: Univ. Illinois; Colorado Springs FA Center; Univ. Iowa, B.F.A., M.F.A., and with William S. Hayter, Mauricio Lasansky. Member: CAA. Awards: Fulbright F., 1954-55; prizes, Des Moines A. Center, 1953 (purchase); purchase prize, CGA, 1957; Univ. So. Cal., 1954; Bradley Univ., 1954; Nelson Gal. A., 1954, 1961 (purchase); U.S. Nat. Mus., Wash., D.C., 1964 (purchase) by Sheldon Mem. Mus., Univ. Nebraska), 1964; purchase award from Soc. Wash. Pr. M. to LC. Work: SAGA; Des Moines A. Center; Rosenwald Coll.; LC. Exhibited: SAM, 1946, 1961; Denver A. Mus., 1946; SAGA, 1947, 1950, 1951, 1957; LC, 1948, 1957, 1958, 1961; J. B. Speed A. Mus., 1950; Flint Inst. A., 1950; Syracuse Mus. FA, 1950; BM, 1951, 1953, 1954; Bradley Univ., 1952, 1954; Joslyn A. Mus., 1952, and Neb. Centennial exh. at Joslyn; SFMA, 1952; Wash. A. Cl., 1948 (one-man); Des Moines A. Center, 1952, 1953; Phila. Pr. Cl., 1949; MMA, 1952; SAM, 1953, 1955; DMFA, 1953, 1954; Univ. So. Cal., 1953, 1954; LC, 1954; Youngstown Col., 1954; Springfield A. Mus., 1955; Oakland A. Mus., 1955; Paris, France, 1955; Oakland A. Mus., 1955; Paris, France, 1955; Soc. Boston Pr. M., 1956, 1957, 1959; Bay Pr. M., 1956, 1957, 1959; Wash. Pr. M., 1957, 1958, 1960, 1964; Univ. Kansas, 1958; CGA, 1957, 1963, 1966; 3-man: Studio Gal., Alexandria, Va., 1957, 1962; State Univ. Iowa, 1957; Nelson Gal. Art, 1958, 1963 (2); Oklahoma Pr. M., 1959; Univ. Nebraska, 1959 (one-man); U.S. Embassy, New Delhi, India, 1959; Brooks Mem. Mus., Memphis, 1960; Univ. Wichita, 1962; Otis AI, Los Angeles, 1962; Sioux City A. Center, 1962; Univ. Kansas Mus., 1964; Hastings Col., 1964; Soc. Wash. Artists, 1964, Univ. Illinois, 1969 (one-man); Soc. Wash. Pr. M., 1966, 1968, 1969; Mickelson Gal., Wash. D.C., 1966-1968; Sheldon Mem. Mus., Lincoln, Neb., 1967, 1969; Pr. Cl. of Albany, 1967; Kansas AA, 1967; Dulin Gal., Knoxville, 1968. Positions: Asst. Prof., Prints & Drawing, University of Nebraska, Lincoln, Neb., 1957-1963.

RICHARDS, KARL FREDERICK—Educator, P., E., W.
Art Department, Texas Christian University; h. 2440 Winton Terrace West, Fort Worth, Tex. 76109
B. Youngstown, Ohio, June 14, 1920. Studied: Cleveland Inst. A.; Western Reserve Univ., B.S. in Edu.; State Univ. Iowa, M.A.; Ohio State Univ., Ph.D. Member: NAEA; Western AA; Texas A. Edu. Assn; CAA; Texas Assn. Schs. of A. (memb. of Academic Standards Com.). Awards: prizes, Ohio Valley Exh., 1948; Toledo Area Exh., 1953; Butler Inst. Am. A., 1953, 1954; A. Festival, Pinellas Park, Fla., 1956; Ft. Worth A. Center, 1964. Exhibited: Indiana (Pa.) State T. Col., 1954; Creative Gal., N.Y., 1954; Contemp. A. Gal., N.Y., 1954; Palm Beach, Fla., 1955; Massillon A. Mus., 1953, 1955; Sarasota, Fla., 1955; Florida State Fair, 1956; Ohio Valley Exh., Athens, Ohio, 1948; Butler Inst. Am. A., 1944, 1949, 1953, 1954; Canton AI, 1950, 1952, 1953, 1955; North Texas State Univ., 1962; Lubbock A. Center, 1964; Louisville, Ky., 1950; DMFA, 1958, 1959; Ft. Worth A. Center, 1958-1960, 1964, 1967; Drawing exh., State Univ. Colleges of central N.Y., 1969, and numerous local exhs.; one-man: Pinellas Park, Fla.; Ohio State Univ., 1955; Arlington (Tex.) State Col., 1963; San Angelo Col., 1964. Positions: Asst. Prof., A., Bowling Green State University, Bowling Green, Ohio, 1947-56; Prof. A., Chm., A. Dept., Texas Christian University, Fort Worth, Tex., 1956- .

RICHARDSON, CONSTANCE (COLEMAN) (Mrs. E. P.)—Painter
285 Locust St., Philadelphia, Pa. 19106
B. Indianapolis, Ind., Jan. 18, 1905. Studied: Vassar Col.; PAFA. Work: John Herron AI; Detroit Inst. A.; Univ. Michigan; U.S. Embassy, Rio de Janeiro; PAFA; Saginaw Mus. A.; Grand Rapids A. Mus.; New Britain Inst.; Columbus (Ohio) Gal. FA; Santa Barbara Mus. A. Exhibited: PAFA, 1944, 1945, 1958, 1962-1964; deYoung Mem. Mus., 1943, 1947; Detroit Inst. A., 1933-1961; Cal. PLH, 1948; Montclair A. Mus., 1951; MMA, 1951; Utica, N.Y., 1951; Macbeth Gal., 1944, 1946, 1950; Wildenstein Gal., 1955; Butler Inst. Am. A., 1958; USIS traveling exh., Latin America, 1956-57; USIS traveling exh., Greece, Israel, Turkey, 1958-59; Kennedy Gal., 1960, 1963.

RICHARDSON, E(DGAR) P(RESTON)—Educator, W., L.
285 Locust St., Philadelphia, Pa. 19106
B. Glens Falls, N.Y., Dec. 2, 1902. Studied: Univ. Pennsylvania; Williams Col., A.B.; PAFA. Author: "The Way of Western Art," 1939; "American Romantic Painting," 1944; "Washington Allston," 1948; "Painting in America—The Story of 450 Years," 1956; "A Short History of Painting in America," 1963. Positions: Dir., Detroit Institute of Arts, Detroit, Mich., to 1962; Dir., Henry Francis Du Pont Winterthur Museum, Winterthur, Del., Apr., 1962-1966; Ed., The Art Quarterly; Dir., to 1964, President, Pennsylvania Academy of the Fine Art, 1968- ; Council, Historical Society of Pennsylvania, 1968- ; American Philosophical Society; Smithsonian Art Commission, 1962- ; National Portrait Gallery Commission, 1966- .

RICHARDSON, GERARD—Painter, Des., I.
1534 N. 22nd St., Arlington, Va. 22209
B. New York, N.Y., 1910. Studied: In Europe. Work: Specialist in portrayal of nautical, sportscar, and air activities, historical combat scenes and all-subject murals for homes and business buildings. Patrons include well-known names in sports, finance, industry and the professions in four countries. Created the official White House painting: "The (PT) 109," a large oil which was reproduced in the book, and in newspapers, with final destination the Kennedy Library. Other large oils in the French Naval Club, Paris; Nat. Naval Memorial Mus., Wash., D.C.; Adm. Jerauld Wright Bldg., Norfolk Naval Base; Lyndon B. Johnson Ranch; Capitol; and Sam Rayburn Library, Texas.

RICHARDSON, GRETCHEN (Mrs. Ronald Freelander)—Sculptor
631 Park Ave., New York, N.Y. 10021
B. Detroit, Mich., Nov. 14, 1910. Studied: Wellesley Col., B.A.; ASL with William Zorach, and Jose de Creeft. Acad. Julian, Paris, France. Member: NAWA; AEA; N.Y. Soc. Women Artists. Awards: prizes, NAWA, 1952, 1955, 1959-1963. Exhibited: PAFA, 1953, 1961; NAD, 1948, 1950; Audubon A., 1948-1962, 1968; NAWA, 1950-1969; Argent Gallery; Pen & Brush Cl., 1950, 1952; Women's Intl. A. Cl., London, 1955; Lever House annually; NAWA Sculpture Jury, 1969-1971.

RICHARDSON, JERI (PAMELA)—Sculptor, E.
414 30th Ave. E., Tuscaloosa, Ala. 35401
B. Columbus, Miss., Sept. 27, 1938. Studied: Miss. State Col. for Women, B.F.A.; Colorado Springs FA Center; Univ. Ala., M.A.; Ind. Univ., Ed.D. in A. Edu.; 1966. Member: Am. Craftsmen's Council; World Crafts Council; NAEA. Awards: Birmingham Mus. A., 1967. Work: Miss. State Col. for Women. Exhibited: Mus. Contemp. Crafts, N.Y., 1962; Birmingham, Ala., 1967; Atlanta, 1959(2); Delgado Mus. A., New Orleans, 1960; Chattanooga, Tenn., 1960. One-man: Jacksonville State Univ., 1963; Miss. State Col. for Women, 1968; Indiana Univ., 1968. Positions: Instr., Univ. Ala., 1962- .

RICHENBURG, ROBERT BARTLETT—Painter, S., E.
121 E. Remington Rd., (Cayuga Heights) Ithaca, N.Y. 14850; (Studio) 359 W. Broadway, New York, N.Y. 10013
B. Boston, Mass., July 17, 1917. Studied: George Washington Univ.; Boston Univ.; Corcoran Sch. Art; ASL; Ozenfant Sch. Art; Hans Hofmann Sch. FA. Member: AEA (Comm. on International Cultural Relations); AAUP; CAA; ASL (Life). Awards: American Federation of Arts award, 1964. Work: Chrysler Mus. A.; College of William & Mary; Norfolk Mus. A. & Sciences; Allentwon Mus. A.; WMAA; Larry Aldrich Mus.; MMoMA; Univ. California Mus., Berkeley; PMA; Pasadena A. Mus.; Living Arts Fnd. Exhibited: Guggenheim Mus., 1949-1952, 1961; Annuals in New York Gals., 1951-1957; Chrysler Mus. A., 1958- ; American Federation of Arts traveling exh. (U.S. and Canada), 1960-1961; Provincetown AA, 1946, 1950-1952; MMoMA, 1961; Larry Aldrich Mus., 1964; Yale Univ. Gal. FA, 1961; WMAA, 1961, 1964, 1969; BMA, 1961; Dayton AI, 1962; Nelson Gal. A., Kansas City, 1962; Krannert Mus., Univ. Illinois, 1963; CGA, 1963; MMoDA traveling exh., 1963; Parke Bernet Gal., N.Y.; 1962; Michener Fnd. Collection, 1962 (also shown at Allentown Mus. A., Penn State Univ., Arkansas A. Center, 1962-1963); BM, 1963; American Federation of Arts Gal., 1964 and traveling 1964-65;

Brookhaven Nat. Laboratroy, 1963-1964; Louisiana State Univ., 1964; Hamilton Col., 1965; Univ. California Mus., Berkeley, 1967; Smithsonian Inst. traveling exh. (Michener Coll.), 1967-1968; Univ. Texas, Auston, 1968; AFA traveling exh., 1968-1969; WMAA, 1968; Archives of American Art, 1965, 1968. One-man: Hendler Gal., Phila., Pa., 1953; Artists Gal., N.Y., 1957; Chrysler Mus. A., 1958; Hansa Gal., N.Y., 1958; Dwan Gal., Los A., 1960; Santa Barbara Mus. A., 1961; R.I. Sch. Des., 1960 (4-man); Dayton AI, 1962; Tibor de Nagy Gal., N.Y., 1959-1964; Andrew Dickson White Mus., Cornell Univ., 1964. Positions: Instr., College of the City of New York, 1947-52; Cooper Union, 1954-1955; N.Y. University, 1960-61; Pratt Institute, Brooklyn, 1951-1964 (to June); Assoc. Prof. A., Cornell University, Ithaca, N.Y., Sep. 1964-1967; Assoc. Prof. A., Grad. Advisor A. Dept., Faculty Council Member, Chm., Self Study Committee, Hunter College, New York, N.Y., 1967- .

RICHMAN, ROBERT M.—Museum Director, W., Cr., E.
Institute of Contemporary Arts, The Meridian House; h. 3102 R St., Northwest, Washington, D.C. 20007
B. Connersville, Ind., Dec. 22, 1914. Studied: Western Michigan Univ., A.B. (English), A.B. (Hist.); Univ. Michigan, A.M. Member: Cosmos Cl.; Am. Assn. Mus. Dirs.; AAMus.; F.I.A.L.; CAA; AEA. Awards: Commander of the British Empire, 1959; Hopwood awards, 1942-44. Ed., "The Arts at Mid-Century," 1954; publ., "The Potter's Portfolio," 1950; Author: "Nature in the Modern Arts." Contributor to New Republic; Kenyon Review; Casa Bella; Encounter; and other magazines. Lectures: The Philosophy of Art, at the Nat. Gal. A.; Phillips Gal.; Lib. Congress. Arranged over 90 exhs. of recent work by contemporary artists from Europe, Asia and the Americas. Positions: Literary & Art Ed., The New Republic Magazine, 1951-54; Dir., Washington Festival, 1958; Consultant on The Arts for the Dept. of State, U.S. Govt., 1961; Trustee, National Cultural Center, 1959- ; The Arena Stage (Wash. Drama Soc.), 1960- ; Trustee & Memb. Exec. Committee, Bd. of Trustees: Inst. Contemporary Arts, 1947- ; President's Fine Arts Committee, 1956- ; Washington Festival, 1957- ; ANTA, 1958- ; Opera Soc. of Washington, 1959- ; The Meridian House Fnd., 1960- . Fndr. & Pres., The Institute of Contemporary Arts, Washington, D.C., 1947- .*

RICHMOND, FREDERICK W.—Collector, Patron
743 Fifth Ave.; h. 175 Willoughby St., Brooklyn, N.Y. 11201
B. Boston, Mass., Nov. 15, 1923. Studied: Harvard University; Boston University, B.A. Positions: Chairman of the Board, Carnegie Hall Corp., 1961- ; Member, New York State Council on the Arts; Chairman, New York Committee of Young Audiences; Co-Chairman, Mayor's Committee on Scholastic Achievement; Board Member, New York Studio School.

RICHMOND, LAWRENCE—Collector
426 W. 55th St., New York, N.Y. 10019; h. 7 Woodcrest Rd., Great Neck, N.Y. 11024
B. Hollis, N.Y., Oct. 30, 1909. Studied: Dartmouth College, A.B. Collection: Primarily modern American Painting and Sculpture; African Sculpture. Positions: Trustee, Provincetown Art Association, 1962; President, Provincetown Symphony Society, 1968-1969.

RICHTER, GISELA MARIE AUGUSTA—Museum Curator, W., L., C.
American Academy, Rome, Italy; 81, Viale delle Mura Gianicolensi, Rome, Italy
B. London, England, Aug. 15, 1882. Studied: Girton Col., Cambridge; British Sch. Archaeology, Athens, Greece; Trinity Col. Dublin, Litt. D.; Cambridge Univ., England, Litt. D. Member: F., Am. Numismatic Soc.; Archaeological Inst. Am.; Accademia dei Lincei; Pont. Accademia Romana; Am. Acad. in Rome; Hellenic & Roman Soc., London; Hon. F., Somerville Col., Oxford; Hon. F., Girton Col., Cambridge; hon. degrees, L.H.D., Smith Col., 1935; D.F.A., Rochester Univ., 1940; Univ. of Oxford, 1952; Ph.D., Basle Univ.; award, Am. Assn. Univ. Women, 1944; gold medal for Distinguished Archaeological Achievement, Archaeological Inst. America, 1968. Author: "The Craft of Athenian Pottery," 1923; "Ancient Furniture," 1926; "Animals in Greek Sculpture," 1930; "Kouroi," 1942, 2nd ed. 1960; "Attic Red-figures Vases, A Survey," 1946, 2nd ed. 1958; "Archaic Greek Art," 1949; "Sculpture and Sculptors of the Greeks," 1950; "Three Critical Periods in Greek Sculpture," 1951; "Ancient Italy," 1955; Handbook of Greek Art," 1959, 6th ed. 1969; "The Archaic Gravestones of Attica," 1961; "The Portraits of the Greeks," 3 vols. 1965; "The Furniture of the Greeks, Etruscans, and Romans," 1966; "Korai, Archaic Greek Maidens," 1968; "The Engraved Gems of the Greeks, Etruscans, and Romans, Part I," 1968. Contributor to: Archaeological & museum journals and bulletins. Lectures: Greek, Roman and Etruscan Art & Archaeology, 1000 B.C.-300 A.D. Positions: Asst., Classical Dept., 1906-10, Asst. Cur., 1910-22, Assoc. Cur., 1922-25; Cur., 1925-48, Hon. Cur., 1948- , MMA, New York, N.Y.; Assoc. Ed., Am. Journal of Archaeology; Pres., N.Y. Soc. of the Archaeological Inst. Am., 1941-46; L., Yale Univ., 1938, Bryn Mawr Col., 1941, Oberlin Col., 1943; Dumbarton Oaks, 1949; Univ. Michi-

gan, 1952; Am. Acad. in Rome, 1952; Somerville Col., Oxford, 1954; Roman Soc., London, 1957; Visiting Lecturer, American School of Classical Studies, Athens, 1961.

RICHTER, HORACE—Collector
180 Madison Ave., New York, N.Y. 10016; h. Keewaydin, Sands Point, N.Y. 11050
B. Ossining, N.Y., Nov. 2, 1918. Studied: University of North Carolina, B.A. Collection: New York school, second generation; Primitive art-African, pre-Columbian. Positions: Board of Governors, Jewish Museum.*

RICKEY, GEORGE WARREN—Sculptor, E., W., L., Cr.
R.D. 2, East Chatham, N.Y. 12060
B. South Bend, Ind., June 6, 1907. Studied: Trinity Col., Glenamond, Scotland; Balliol Col., Oxford, B.A., M.A.; Ruskin Sch. Drawing; Academie Lhote, Paris; N.Y. Univ.; Univ. Iowa; Inst. Des., Chicago. Member: CAA; AAUP. Awards: Guggenheim Fellowship, 1961, renewed 1962; Stipendium as Res. A., Berlin, 1968; Osaka, Japan, (fall) 1969. Work: Allentown Mus. A.; BMA; DMFA; AGAA; Dartmouth Col.; North Carolina Mus. A.; Kunsthalle, Hamburg, Germany; WMAA; Montclair A. Mus.; MModA; Bethlehem Steel Co.; Union Carbide Co., Toronto; Siemens Research Co., Erlangen, Germany; Westland Center, Detroit; Hirshhorn Coll.; Lytton Savings & Loan Assn., Oakland, Cal.; Nordpark, Dusseldorf; Kunsthall, Germany; Nat. Gal., Berlin; Kroller-Müller, Holland, NCFA, and others. Exhibited: MMA, 1951; PAFA, 1952, 1954; WMAA, 1952, 1953, 1964, 1966, 1968, 1969; MModa, 1959; Stedelijk Mus., Amsterdam, 1961 (also to Stockholm and Copenhagen); Battersea Park, London, 1963; Howard Wise Gal., 1964; Kassel, Germany, 1964; New Sch. for Social Research, N.Y., 1961, 1964; Hanover Gal., London, 1964; Galerie Denise Rene, Paris, 1964; U.S. Embassy, Mexico City, 1964; Albright-Knox Gal., Buffalo, 1965, 1968; MModa Int. Council, opened Musee Rodin, Paris, June 1965; Stedelijk Mus., 1965; SFMA, 1966; Park Sonsbeek, Netherlands, 1966; Los Angeles County Mus., 1967; Guggenheim Mus., 1967; Carnegie Int., 1967; Kroller-Müller Mus., Holland, 1968; Venice Biennale, 1968; one-man Herron AI, 1953; Kraushaar Gal., N.Y., 1955, 1959, 1961; Delgado Mus. A., New Orleans, 1956; Amerika Haus, Hamburg, 1957; Santa Barbara Mus. A., 1960; Phoenix A. Mus., 1961; Primus-Stuart Gal., 1962; Galerie Springer, Berlin, 1962; Kunstverein, Dusseldorf and Hamburg, 1962; Inst. Contemp. A., 1964; David Stuart Gal., 1964; Staempfli Gal., N.Y., 1964, 1967; WAC, 1967; Berlin, 1969, and traveling to Nurnberg, Munich, London, Zurich. Author, chapter, "Kinetic Sculpture" in "Art and Artist," 1956; "The Morphology of Movement," in Gyorgy Kepes' "The Nature and Art of Motion," 1965; "Constructivism: Origin and Evolution," 1967. Contributor to College Art Journal; Les Temps Modernes; Arts magazine, 1961, 1962; Art International, 1965. Positions: Hd. A. Dept., Olivet Col., 1937-39; Kalamazoo Col., 1939-40; Kalamazoo Inst. A., 1939-40; Knox Col., 1940-41; Muhlenberg Col., 1941-48; Univ. Indiana, 1949-55; Chm. A. Dept., 1955-58, Prof. A., 1958-60, Tulane University, New Orleans, La.; Prof. A., Rensselaer Polytechnic Inst., Troy, N.Y., 1961-1965.

RIDABOCK, RAY(MOND) (BUDD)—Painter, T.
South Lane, Redding Ridge, Conn. 06876
B. Stamford, Conn., Feb. 16, 1904. Studied: Williams Col., and with Amy Jones, Anthony di Bona, Peppino Mangravite, Xavier Gonzalez. Member: AWS; AEA; Audubon A.; Conn. Acad. FA; Wash. WC Cl.; F., Silvermine Gld. A.; Alabama WC Soc.; Conn WC Soc.; Nat. Soc. Painters in Casein. Awards: New Jersey P. & S. Soc., 1949, 1950, 1954, 1955, 1956, 1958; Ross A. Gal., 1949; Knickerbocker A., 1952, 1954, 1958; Munson-Williams-Proctor Inst., 1954; Springfield A. Lg., 1954, 1955, 1964; State T. Col., Indiana, Pa., 1954; Wilmington Soc. FA, 1954, 1956; Caravan Gal., 1955; Albany Inst. Hist. & A., 1955, 1959; Village A. Center, 1955; New Haven Paint & Clay Cl., 1956, 1958, 1959; Silvermine Gld. A., 1956, 1957, 1961; Wash. WC Cl., 1956; New Orleans AA, 1957; Audubon A., 1961, medal, 1958; Williams Col., 1957 (purchase); Berkshire AA, 1959; Conn. WC Soc., 1963, 1967, 1968; Ptrs. in Casein medal of merit, 1965; Portland A. Festival, 1960; Greenwich A. Soc., 1967. Work: New Britain A. Mus.; N.Y. Hospital; Ross A. Gal.; Williams Col.; Munson-Williams-Proctor Inst.; State T. Col., Indiana, Pa.; Hoffman Fuel Co., Danbury; U.S. Embassy, Lima, Peru; Delaware A. Center; Dr. Lawrason Brown Mem. Coll., Saranac Lake, N.Y.; St. Vincent Col.; Norfolk Mus. A. & Sciences; Stamford (Conn.) Mus. A.; Mattatuck (Conn.) Mus. A.; New Haven Paint & Clay Cl.; Conover Mast Coll. Exhibited: Nationally & internationally; one-man: Lawrence A. Mus., Williams Col., 1947, 1959; Hoffman Fuel Co., Danbury, 1960; St. Lawrence Univ., 1951, 1953; Silvermine Gld. A., 1955; Danbury State T. Coll., 1957; Kipnis Gal., Westport, 1956, 1957; Taft School, 1961; Wooster School, 1964, and others. AWS traveling exhs., 1962-1964. One-man: Silvermine Gld., 1967; Rockland Col., 1968; Rye Library, 1969. Positions: Instr., Silvermine Gld. A., 1958- ; Greenwich Art Soc., 1962- .

RIDLON, JAMES A.—Educator, P., S., Et.
31 Smith Hall, Syracuse University, Syracuse, N.Y. 13210; h. 128 Lincklaen St., Cazenovia, N.Y. 13035
B. Nyack, N.Y., July 11, 1934. Studied: San Francisco State College; Syracuse University, B.F.A., M.F.A. Member: NAEA; N.Y. State Teachers Assn.; Assoc. Artists; Cooperstown AA. Awards: Purchase prize, Munson-Williams-Proctor Inst., 1969. Work: Munson-Williams-Proctor Inst.; State Col. of N.Y.; Morrisville (N.Y.) Junior Col.; mural, C & U Broadcasting Building, Syracuse; Bert Bell Memorial Trophy for outstanding football player Am. Football League and Nat. Football League, 1966. Exhibited: Everson Mus. A., Syracuse, N.Y., 1965-1967; Munson-Williams-Proctor Inst., 1967-1969; Rochester Memorial Gal., 1965, 1969; Cooperstown (N.Y.) annual competition, 1965-1969; Edward Root A. Center, Hamilton College, 1967; Geneva (N.Y.) Historical Soc., 1967. Positions: Instr., Sculpture, San Francisco State College, 1959; Assoc. Prof., Design, Sculpture and Art Education, Syracuse University, 1964- .

RIEGGER, HAL—Craftsman, E., S.
469 Panoramic Highway, Mill Valley, Cal. 94941
B. Ithaca, N.Y., July 21, 1913. Studied: N.Y. State Ceramic Col., Alfred Univ., B.S.; Ohio State Univ., M.A. Awards: prizes, Syracuse Mus. FA, 1939, 1949; West Coast Ceramic Annual, 1948; San F. Potters Assn., 1956; Cal. State Fair, 1956. Work: Syracuse Mus. FA; MMA; MModA. Exhibited: GGE, 1939; Syracuse Mus. FA; WFNY, 1939; WMAA; Phila. A. All.; European traveling exh. ceramics; AFA traveling exh. "California Crafts"; one-man: Tampa AI; Norton Gal. A., West Palm Beach; Phila. Pa.; Portland, Ore.; Long Beach, Cal.; and others. Contributor to Ceramic Industry; Ceramics Monthly. Architectural commissions: New Orleans, La., Tampa & Clearwater, Fla. TV series, 1959. Conducts Own Classes and Primitive Outdoor Pottery Workshops.

RIES, MARTIN—Assistant Museum Dir., P., S., Gr., T., W., L.
36 Livingston Rd., Scarsdale, N.Y. 10583
B. Washington, D.C., Dec. 26, 1926. Studied: Corcoran Sch. A.; American Univ., Wash., D.C., B.A.; Hunter Col., M.A.; Pratt Graphic A. Center, N.Y. Awards: CGA, 1952; G., Yaddo, 1955. Work: Riverside Mus., N.Y.; Pace Col. Exhibited: CGA, 1952, 1957; Toledo Mus. A., 1957; Art:USA, 1958; MModA, 1956; Smithsonian Inst., 1952; Instituto de Cultura Hispanica, Madrid, 1955; Albany Inst. Hist. & A., 1965; Loeb Center, N.Y. Univ., 1966; East Hampton Gal., N.Y., 1967; Paul Gal., Japan, 1968 (one-man); Riverside Mus., N.Y., 1957, 1964, 1965; Silvermine Gld. A., 1959; one-man: Hudson River Mus., N.Y., 1960. Contributor to New Republic; Art Voices; Hudson River Museum Bulletin. Arranged exhs.: Hudson River Art-Past and Present, 1959; Eight Young Artists (with E. C. Goossen), 1964, and many open shows for local artists at Hudson River Museum. Positions: Asst. Dir., Hudson River Museum, Yonkers, N.Y., 1957-1967; Asst. Prof., Long Island Univ., Brooklyn, N.Y., 1968- .

RIFKIN, DR. and MRS. HAROLD—Collectors
35 E. 75th St., New York, N.Y. 10021; h. 4682 Waldo Ave., Riverdale, N.Y. 10471
Collection: American art of the early 20th century.

RIGGS, ROBERT—Lithographer, I., P.
51 West Walnut Lane, Germantown, Philadelphia, Pa. 19144
B. Decatur, Ill., Feb. 5, 1896. Member: NA. Awards: med., Phila. WC Cl., 1932; PAFA, 1934; prizes, Phila. Pr. Cl., 1938; N.Y. A. Dir. Cl. medal, six times. Work: Phila. WC Cl.; AIC; BM; WMAA; N.Y. Pub. Lib.; Dallas Mus. FA; LC; MMA; Nat. Mus., Copenhagen, Denmark; MMA; WMAA; BM; PMA; Phila. Free Lib.; Atwater Kent Mus.; AIC; Phillips Acad., Andover, Mass., and others. All lithographic work (73 prints) in Lib. Congress, Pennell Fund.

RILEY, ART(HUR IRWIN)—Painter, Des., Cart., I.
Walt Disney Studios, Burbank, Cal.; h. 615 N. 1st St., Burbank, Cal. 91502
B. Boston, Mass., Sept. 14, 1911. Studied: A. Center Sch., Los Angeles. Member: AWS; Laguna Beach AA; SI; Motion Picture Acad. A. & Sciences. Awards: Purchase awards, Butler Inst. Am. A.; AWS purchased by NAD, 1964 and the Herb Olsen Award, 1965; Santa Paula Annual, 2 purchases for U.S. Air Force; silver Trophy, Monterey County Fair; prize, Springfield Mus. A., Springfield, Mo. Exhibited: AWS, 1960-1965; Springfield Mus. A., 1960-1965; Butler Inst. Am. A., 1960-1965; Cal. State Fair; Nat. Orange Show; Laguna Beach AA; Santa Paula Annual; one-man: Pacific Grove Mus. A.; Laguna Beach AA. Positions: MGM studios, 1933- ; Walt Disney Studios, 1938- .

RILEY, CHAPIN—Collector
9 Old Colony Road, Worcester, Mass. 01609*

RILEY, OLIVE—Educator
School Art League of New York City, 110 Livingston St., Brooklyn, N.Y. 11201
Positions: Treasurer, School Art League of New York City.*

RING, EDWARD A.—Collector, Art Dealer, Patron
720 Monmouth St., Trenton, N.J. 08609; h. R. R. #1, River Rd., Washington Crossing, N.J. 08560
B. New York, N.Y., Dec. 23, 1922. Studied: Stevens Institute of Technology, M.E.; Rider College; Training under Gregorio Prestopino. Specialty of Gallery: Contemporary sculpture, painting, lithography. Collection: French masters and contemporary art. Sponsor, "Focus on Light" Exhibition, New Jersey State Museum, May-September, 1967. Positions: Vice-Chairman, New Jersey Council on the Arts, 1967- .

RISING, DOROTHY MILNE—Painter, T., L.
5033 17th Ave., Northeast, Seattle, Wash. 98122
B. Tacoma, Wash., Sept. 13, 1895. Studied: PIASch.; Cleveland Sch. A.; Univ. Puget Sound; Univ. Washington, B.A., M.F.A. Member: Women Painters of Washington; Nat. Lg. Am. Pen Women; Northwest WC Soc.; AEA; Women's Univ. Cl. Awards: prizes, Nat. Lg. Am. Pen Women, 1946, 1948, 1950, 1951, 1955, 1956, 1957, 1959, 1961; (Seattle, Wash., D.C., Tulsa, Okla., and San Jose, Cal.); Women Painters of Wash., 1948, 1954, 1956, 1957, 1959; Woessner Gal., Seattle, 1955, 1959; Spokane, Wash., 1948; Henry Gal., 1951; Northwest WC Soc., 1957, 1961. Work: City of Spokane Coll.; Lakeside School, Seattle. Exhibited: Massillon Mus., 1953-1955; Ohio WC Soc., 1954-55 traveling exh.; Springfield Mus. FA, 1953-1955; Oakland A. Mus., 1953, 1954; SAM, 1940-1963; Lucien Labaudt Gal., 1948 (one-man); Univ. Washington, 1955; Port Angeles, Wash., 1955 (one-man); Wash., D.C., 1956. Grand Central A. Gal., 1957; Tacoma, Wash., 1957; Frye Mus., Seattle, 1957, 1958, 1959, 1961, 1963; Woessner Gal., Seattle, 1957, 1958, 1959-1961; Bellevue (Wash.) traveling exh., 1956, 1957; 8 one-man exhs., Seattle, 1957, 1958, 1959-1961; Everett, Wash., 1961; Chautauqua, N.Y., 1959; Grumbacher traveling exh., 1959-1965; Nat. Lg. Am. Pen Women traveling exh., 1965; Pacific Northwest Annual, Eugene, Ore., 1965.*

RISLEY, JOHN—Sculptor, Des., E.
Davison Art Center, Wesleyan University; h. Maple Shade Rd., Middletown, Conn.
B. Brookline, Mass., Sept. 20, 1919. Studied: Malvern Col., England, B.L.A.; Amherst Col., B.A.; R.I.Sch. Des., B.F.A., with Valdimar Raemisch; Cranbrook Acad. A., M.F.A., with William McVey. Member: Silvermine Gld. A.; New England Sculptors Assn. Awards: prizes; Syracuse Mus. FA, 1954; BM, 1953; Mystic AA, 1955; Manila, P.I., 1953; R.I. Artists, 1948; Norwich AA, 1958; Meriden AA, 1958; Silvermine Gld. A., 1958; Portland A. Festival, 1958. Work: sculpture in private collections; furniture and wood products in national production. Exhibited: Syracuse Mus. FA, 1950, 1951, 1954; Wichita AA, 1950, 1958; Delgado Mus. A., 1951; Boston A. Festival, 1953-1958; U.S. Des.-Craftsmen, BM, 1953; Manila, P.I., 1952; Sweat Mem. Mus., 1954; BMFA, 1951; Detroit Inst. A., 1951; Brooks Mem. Mus., 1952; Univ. Miss., 1952; Alabama Polytechnic Inst., 1952; Univ. Fla., 1952; Cornell Univ., 1953; Tacoma A. Lg., 1953; Haggin Gal., Sacramento, 1953; Montana State Col., 1953; Univ. Minnesota, 1953; North Dakota Agricultural Col., 1953; AIC, 1953; SFMA, 1953; Silvermine Gld. A., 1954, 1955, 1957, 1958; Mystic AA, 1955, 1957; Rochester Mem. A. Gal., 1955; Fleming Mus. A., 1955; CM, 1955; Ohio State Univ., 1955; Toledo Mus. A., 1955; Oregon Ceramic Studios, 1955; Cranbrook Acad. A., 1951; Univ. Conn., 1955; Slater Mem. Mus., 1955; Norwich AA, 1956, 1958; NAD; Univ. Rhode Island, 1956; J. B. Speed A Mus., 1956; Jacksonville A. Mus., 1957; Fla. Gulf Coast A. Center, 1957; Conn. Acad. FA, 1957; New Britain A. Mus., 1957; Mus. Contemp. Craft, 1957; Springfield A. Lg., 1957; Brookfield Craft Center, 1957; St. Paul Gal. A., 1958; Meriden, Conn., 1958; Portland A. Festival, 1958, and others. Positions: Instr. S., Cranbrook Acad. A.; Philippine Islands under ECA; Consultant, MSA, Formosa, 1960; Consultant, Camp Crosier, Puerto Rico, Peace Corps.; Prof. S., Des., Wesleyan Univ., Middletown, Conn., at present and Chairman, Art Dept.

RISSMAN, ARTHUR HENRY LOUIS—Painter, E., L., Des.
h. 1031 E. 50th St., Chicago, Ill. 60615
B. Chicago, Ill., Mar. 4, 1920. Studied: Univ. Southern California; Northwestern Univ., B.S. in Edu.; Chicago Acad. FA; AIC; ASL. Member: AEA; Chicago A. Cl.; Univ. Chicago Renaissance Soc. Exhibited: AIC; Layton Gal. A.; Springfield A. Mus.; Pensacola A. Center; Delgado Mus. A., New Orleans; Atlanta AA; Frye Mus. A., Seattle; Mint Mus. A.; Philbrook A. Center, Tulsa; Feingarten Gal., Chicago; Renaissance Soc., Chicago; Chicago A. Cl., annually; Old Orchard Exh., Winnetka, Ill.; Werbe Gal., Detroit; one-man: M. Singer & Son, Chicago, 1958; Exhibit A, Chicago, 1959; Blackhawk Restaurant, 1964-1969; Chicago Public Library, 1964; Vincent Price Gal., Chicago, 1968. Positions: Lecturer, Contemporary Art, Adult Education Council of Chicago, 1959- ; Assoc., Contemporary Art Workshop, Chicago, 1960- ; Fndg. & Directing Chm., The Arts Assembly of the Adult Edu. Council, Chicago, 1959- , Vice-Pres., 1960- ; Instr., Sch. of the Art Inst. of Chicago, 1963-1965; Nat. Project Dir., Arts & Crafts Program, President's Committee on Employment of

the Handicapped (1965-1966) and Nat. Soc. for Crippled Children and Adults. Res. Artist, Wheaton College, 1964.

RITCHIE, ANDREW C.—Museum Director, L., W.
Yale University Art Gallery, 1111 Chapel St., New Haven, Conn. 06520
B. Bellshill, Scotland, Sept. 18, 1907. Studied: Univ. Pittsburgh, B.A., M.A.; Univ. London, Ph.D. Member: CAA; Assn. A. Mus. Dir. Awards: Foreign Study F., Univ. Pittsburgh, 1933-35. Author: "English Painters, Hogarth to Constable," 1942; "Aristide Maillol" (Ed.), 1945; "British Contemporary Painters," 1946; Catalogs of Painting and Sculpture.(Ed.), Albright A. Gal., 1949; "Charles Demuth," 1950; "Franklin Watkins," 1950; "Abstract Painting and Sculpture in America," 1951; "Sculpture of the 20th Century," 1953; "Edouard Vuillard," 1954; "The New Decade: 22 European Painters and Sculptors" (Ed.), 1955. Contributor to art publications with articles and book reviews on English and French art. Lectures on British Art; French and Spanish Post-Renaissance Painting; Modern Art. Positions: L., Research Asst., Frick Coll., N.Y., 1935-42; Visiting L., N.Y. Univ., 1936-40; Dir., Albright A. Gal., Buffalo, N.Y., 1942-49; Dir., Dept. Painting & Sculpture, MModA, New York, N.Y., 1949-1957; Dir., Yale University Art Gallery, New Haven, Conn., 1957- .

RITTENBERG, HENRY R.—Painter, T.
222 Central Park South, New York, N.Y. 10019
B. Libau, Latvia, Oct. 2, 1879. Studied: PAFA; Bavarian Acad., Munich (scholarship); & with William Chase. Member: NA; BAID (hon.); P. & S. Assn.; AAPL; N.Y. Soc. Painters; Audubon A.; A. Fellowship; SC (hon.). Awards: F., PAFA; Cresson traveling scholarship, PAFA, 1904; prizes, NAD, 1920, 1926; AIC, 1925; NAC, 1938. Work: N.Y. Hist. Soc.; Columbia Univ.; Butler AI; Dept. Justice, Wash., D.C.; State Capitol, Harrisburg, Pa.; Univ. Pennsylvania; Fed. Court, Phila.; Phila. Bar Assn.; Univ. Panama; Panama Republic; Jefferson Medical Col.; Univ. Virginia; N.Y. Chamber of Commerce; N.Y. Acad. Medicine; Franklin Marshall Col.; Skidmore Col. Taught Life class, BAID; Port., Still Life, ASL; NAD; Rutgers Univ.; Phila. Free Lib.; Am. Acad. A. & Lets.; Hall of Am. Artists, N.Y. Univ. Exhibited: nationally and internationally.*

RITTER, CHRIS—Painter
Ogunquit, Me. 03907
B. Iola, Kans., Dec. 9, 1908. Studied: Univ. Kansas, B.A.; ASL; Columbia Univ.; BMSch. A. Awards: prizes, Denver A. Mus., 1938; Nat. Army A. Exh., 1945; Phila. Pr. Cl., 1948; Mississippi AA, 1947; BM, 1949. Work: BM; WMA; Ogunquit Mus. A.; Univ. Maine; N.Y. Pub. Lib.; LC; Everhart Mus. A. Exhibited: MMA; BM; PAFA; CGA; AIC; Kansas City AI; Oakland A. Mus.; Mississippi AA; CM; Boston A. Festival, 1961; AWS, 1960; one-man: Uptown Gal., 1939, 1942; Marquie Gal., 1943; Am.-British Gal., 1945, Laurel Gal., 1948, 1950, all in N.Y.; Phila. A. All., 1948; Univ. Maine, 1964, Pinetree Designs Gal., Ogunquit, Me., 1964. Positions: Dir., Laurel Gal., New York, N.Y., 1946-51; Instr. A., Hunter Col., 1939-41; Cornell Univ., 1947; Ballard Sch., 1947-53; Midland (Tex.) A. Center, 1954; Instr., York & Kittery (Me.) AA; York Adult Edu. program; Portsmouth (N.H.) AA; Pres., Ogunquit AA, 1957-61. Owner, Dir., Pinetree Designs Gall, Ogunquit, Me., at present.*

RIU, VICTOR—Sculptor
201 East State St., Coopersburg, Pa. 18036
B. Italy, July 18, 1887. Studied: in Italy. Member: Lehigh A. All.; Woodmere A. Gal.; Allentown A. Mus. Awards: prize, PAFA, 1958; Woodmere A. Gal., 1959, hon. mention, 1962; Charles K. Smith award, 1966; Woodmere Endowment Fund prize, 1969; Lehigh AA, 1960, hon. men., 1961, award 1965; Allentown A. Mus., 1961, 1964; Moravian Col., Bethlehem, Pa., 1962; New Hope, Pa., 1962. Work: PAFA; Lehigh Univ. Exhibited: Phila. A. Festival, 1955; PAFA, 1958, 1964; Detroit Inst. A., 1958; Cheltenham A. Cl.; New Hope Workshop; Phila. A. All., 1957, 1958; Lehigh Univ., 1955, 1962 (oneman); Phillips Mill, Parry Barn, New Hope, Pa.; Woodmere A. Gal., 1963 (one-man); Allentown A. Mus.; 1964 (one-man); A. Lg., Ligonier Valley.

RIVAS, PAUL GEORGE—Painter, Gallery Dir., T., Cr., L., W., Et.
725 N. La Cienega Blvd., Los Angeles, Cal. 90069; h. 18116 Pacific Coast Highway, Malibu, Cal. 90265
B. Mexico City, Mexico, Oct. 27, 1930. Studied: Univ. Cal. at Los Angeles, M.A.; Univ. Cal. at Berkeley; College of A. & Crafts, Oakland, Cal. Awards: purchase awards, Nat. Orange Show, 1957; Newport Harbor Exh., 1958; prizes, Nat. Orange Show, 1958 and Newport Harbor, 1958. Work: Phoenix A. Mus.; La Jolla Mus. A.; Mus. FA of Houston; Univ. Cal. at Los Angeles; Newport Harbor H.S.; Nat. Orange Show Coll. Commissioned by ABC-TV, Los Angeles, for a painting in conjunction with TV Special "The Young Man

from Boston" dealing with the life of John F. Kennedy, 1965. Painting will be placed in the Kennedy Library. Exhibited: SAM, 1955; Los A. AA, 1955; Butler Inst. Am. A., 1955; Cal. State Fair, 1955, 1956; LC, 1955; Newport Beach, 1955; Texas Western Col., 1955; Long Beach A. Mus., 1955; Oakland A. Mus., 1955; Wichita AA, 1956; Santa Barbara Mus. A., 1956; Cal. PLH, 1956; Smithsonian Inst., 1956; UCLA, 1956; Nat. Orange Show, 1956, 1957; BM, 1956; Chaffey Col., 1959; Denver A. Mus., 1957; Los Angeles Valley Col., 1964; Newport Beach, 1964; Chateau Lascombes, Margaux (Gironde), France, 1964, 1965; Comara Gal., Los A., 1965. Positions: Teaching Asst., UCLA, 1954-56 and Instr., Ext. Div., 1960-62; Asst. A. Coordinator, Los Angeles Municipal A. Dept., City of Los Angeles, 1957-59; Instr., Downey Mus. A., 1963; A. Ed., Beverly Hills Times; columnist for Artforum; Instr., Otis AI, 1963- ; Dir., Paul Rivas Gallery, Los Angeles, 1959- .*

RIVERS, LARRY—Painter
Marlborough-Gerson Gal., 41 E. 57th St., New York, N.Y. 10022; h. 92 Little Plains Rd., Southampton, L.I., N.Y.
B. New York, N.Y. Studied: Hans Hofmann Sch. FA; N.Y. Univ. Awards: CGA, 1954. Work: BM; CGA; Kansas City AI; MMA; Minneapolis Inst. A.; MModA; North Carolina Mus. A.; R.I. Sch. Des.; T. Col., New Paltz, N.Y.; Tate Gal., London; WMAA; and in private colls. Exhibited: WMAA, 1954-1958, 1960, 1961, 1963, 1964; MModA 1956; Sao Paulo Bienale, 1957; Mexican Biennial, 1960; Seattle World's Fair, 1962; PAFA, 1963; retrospective exh., Jewish Mus., N.Y., 1965; Marlborough Gal., 1968; Gotham Gal., 1968. One-man: Tibor de Nagy Gal., N.Y., 1951-1954, 1957-1960, 1962; Stable Gal., N.Y., 1954; Martha Jackson Gal. N.Y., 1960; Dwan Gal., Los A., 1960; Gimpel Fils, London, 1962; Rive Droite Gal., Paris, 1962. Illus., "When the Sun Tries to Go On." Positions: A.-in-Res., Slade Sch. FA, London, 1964.*

ROBB, DAVID M.—Educator
University of Pennsylvania, Philadelphia, Pa. 19104; h. 506 Narberth Ave., Merion Station, Pa. 19066
B. Tak Hing Chau, South China, Sept. 19, 1903. Studied: Oberlin Col., A.B., A.M.; Princeton Univ., M.F.A., Ph.D. Member: CAA; Archaeological Inst. Am.; Soc. Arch. Historians. Awards: Guggenheim F., 1956-1957; Fulbright Research F., 1956-1957, 1963-1964. Co-Author: "Art in the Western World," 1935, revised 1942, 1953, 1962; Author: "Harper History of Painting," 1951, rev., 1955. Contributor to: Art Bulletin, Encyclopedia Americana, Art Journal, Archaeological Journal. Lectures: Mediaeval, Modern, American Art. Positions: Assoc. Prof. FA, Univ. Minnesota, 1935-39; Prof. A. Hist., 1939- , Chm. Dept. FA, 1946-1955, Univ. Pennsylvania, Philadelphia, Pa. Pres., College Art Assn., 1960-62.

ROBB, MR. and MRS. SIDNEY R.—Collectors
393 D St. 02210; h. 65 Commonwealth Ave., Boston, Mass. 02116
Mr. Robb—B. Boston, Mass., Oct. 20, 1900. Studied: Harvard University. Awards: Honorary Degrees: LL.D., Tufts University, 1961; M.A., Harvard, 1962; L.H.D., Boston College, 1964; D.C.S., Suffolk University, 1966; Honorary Alumni, Hebrew University of Jerusalem, 1965. Collection: Impressionists, primarily Degas, Pissarro, Vuillard, Mary Cassatt, Bonnard, Moore; sculptures—Degas, Maillol, Lehmbruck, Moore. Positions: Trustee, Boston Museum of Fine Arts.

ROBBINS, DANIEL J.—Museum Director, E., Historian
Museum of Art, Rhode Island School of Design, 224 Benefit St. 02903; h. 297 Wayland Ave., Providence, R.I. 02906
B. New York, N.Y., Jan. 15, 1933. Studied: Univ. Chicago, B.A.; Yale Univ., M.A.; N.Y. Univ. Inst. FA; Univ. of Paris. Awards: French Government Fellow, Paris, 1958; Fulbright Grant, 1958-1959. Author: "Painting Between the Wars," 1965. Contributor to Art Journal; Art de France; Art International; Art News; Apollo; Studio International; Bulletin of the Baltimore Museum of Art. Exhibitions Assembled: Albert Gleizes Retrospective, Guggenheim Museum of Art, 1964-1965; Cezanne and Structure, Guggenheim Museum of Art, 1963; Contemporary Wall Sculpture, 1963-1964 and Decade of New Talent, 1964-1965, American Federation of Arts. Positions: Instr., Indiana University, 1955; Cur., National Gallery of Art, Washington, D.C., 1959-1960; Cur., Guggenheim Museum of Art, N.Y., 1961-1964; Director, Museum of Art, Rhode Island School of Design, Providence, R.I., 1964- .*

ROBBINS, FRANK—Cartoonist, P., I.
285 Central Park West, New York, N.Y. 10024
B. Boston, Mass., Sept. 9, 1917. Studied: BMFA Sch.; NAD. Member: Nat. Cartoonists Soc. Awards: prize, NAD, 1936. Work: port., Polyclinic Hospital, N.Y. Exhibited: NAD, 1936, 1937; Roerich Mus., 1945; WMAA, 1956; CGA, 1957, 1958; Toledo Mus. A., 1957, 1958; NAD, 1957, 1958; Audubon A., 1957, 1958; Little Studio, N.Y.,

1961 (one-man). Author, I., "Scorchy Smith" comic strip, 1939-44; "Johnny Hazard" comic strip, Kings Features Syndicate, at present. Contributor to: Life, Look, Cosmopolitan, & other national magazines.*

ROBBINS, HULDA D(ORNBLATT)—Painter, T., Ser.
16 South Buffalo Ave., Ventnor, N.J. 08406
B. Atlanta, Ga., Oct. 19, 1910. Studied: PMSchIA; Barnes Fnd.; Prussian Acad., Berlin. Member: Nat. Ser. Soc.; Am. Color Pr. Soc.; Phila. Pr. Cl. Awards: Scholarship, Barnes Fnd., 1939; prizes, MModA, 1941; Pepsi-Cola, 1945; Nat. Ser. Soc., 1947-1949, 1954. Work: Lehigh Univ.; Am. Assn. Univ. Women; Smithsonian Inst.; A. Mus., Ontario, Canada; Princeton Pr. Cl.; N.Y. Sch. Int. Dec.; Purchase Sch., N.Y.; Highview Sch., Oakville, Tenn.; U.S. Army; MMA; Victoria & Albert Mus., London; Bibliotheque Nationale, Paris. Exhibited: Oakland A. Gal., 1939, 1940; Northwest Pr.M., 1941; Indiana Pr., 1948; Carnegie Inst., 1948; Wichita A. Mus., 1949; Lehigh Univ., 1933; Little Gal., Phila., Pa., 1962-1965; MModA, 1940; Serigraph Gal., 1947 (one-man); Nat. Ser. Soc., 1940-1952; France, 1956-57; Italy, 1957; Atlantic City A. Center, 1961 (one-man).

ROBERDS, GENE ALLEN—Printmaker, S., E.
College of Fine Arts, Jacksonville University, Jacksonville, Fla. 32211; h. Box 395, Atlantic Beach, Fla. 32233
B. Cole Camp, Mo., May 4, 1935. Studied: Eastern Illinois State Col., B.S.; Univ. Illinois, M.F.A. Member: CAA; Minneapolis Soc. FA. Awards: prizes, Carver A. Center, Evansville, Ind., 1964; Sarasota AA, 1960; Jacksonville A. Mus., 1960; Central Illinois Artists, Decatur, 1957; Paris (Ill.) A. Lg., 1956; and others. Cover. illus., The Minnesota Review, 1967; cover and illus., The Metaphysical Giraffe, 1968. Exhibited: Ohio Univ., 1965; Wichita AA, 1965; Smithsonian Inst. traveling exh., 1964; Drawings: USA, St. Paul A. Center, 1963; LC, 1958; P. & S. Soc. of New Jersey, 1964; Sarasota AA, 1960; Auburn Univ.,1962, 1963; Silvermine Gld. A., 1958; Knoxville A. Center, 1962; Bradley Univ., 1959; Carver A. Center, Evansville, 1963, 1964; Butler Inst.Am. A., 1955, 1957; Brooks A. Gal., Memphis, 1964; Evansville Mus. A., 1962, 1963; Louisville A. Center, 1962; Jacksonville A. Mus., 1961; Jacksonville A. Lg., 1961; Youngstown Univ., 1959; Decatur A. Center, 1955-1958; Paris, Ill., 1956; Studio Gal. One, Jacksonville, 1959; Walker A. Center, Minneapolis, Minn., 1966; one-man: Markethouse Gal., Paducah, 1964; Jacksonville (Fla.) A. Mus., 1960; Rochester (Minn.) A. Center, 1966; Stevens Gal., Detroit, 1967 (2-man). Positions: Instr., Painting, Jacksonville A. Mus., 1959-61; Instr., Printmaking, painting, drawing, Murray State College, Kentucky, 1961-64; Printmaking and drawing, Minneapolis School of Art, 1964-1968; Asst. Prof., Col. FA, Jacksonville, Fla., 1968- .

ROBERTS, CLYDE H.—Painter, T.
219 N. Colonial Dr., Hagerstown, Md. 21741
B. Sandusky, Ohio, June 12, 1923. Studied: Cleveland Inst. A.; Western Reserve Univ., B.S.; Columbia Univ., M.A. Member: Baltimore WC Cl.; F., Royal Soc. A., London; Maryland AA; Am. Craftsmans Gld. Awards: prizes, Baltimore WC Exh., 1951-1969; Washington County Mus. A., Hagerstown, 1961, 1965. Work: Ford Motor Co.; Washington County Mus.; Pangborn Coll. of Art, and in private colls. Exhibited: Washington County Cumberland Valley Exh., 1949-1969; Baltimore, 1949-1969; Hilltop Art Festival, Harpers Ferry, 1949-1969; Alabama Open, 1959, 1960, and others. Contributor to Design Magazine; illus. to Ford Times. Positions: Graphic Arts Consultant for Northern Nigeria, Africa, 1965 (2 months); Council Member, Maryland Art Assn., 1965; Supv. Art, Washington County Schools, 1964; Director, Museum Art School, Hagerstown, Md., 1965 ; Ex. Council Member, Wash. County Arts Council, 1968-69; Instr., Fine Arts, Hagerstown Jr. College, 1959- .

ROBERTS, COLETTE (JACQUELINE)—
Art Critic, W., L., Gal. Dir., P.
510 E. 85th St., New York, N.Y., 10028
B. Paris, France, Sept. 16, 1910. Studied: Sorbonne. M.A.; Academie Ranson, with Roger Bissiere; Ecole du Louvre; Institut d'Art et Archeologie, with Henri Focillon. Awards: Palmes Academiques, 1960; McDowell Colony F., 1960. Exhibited: in France. Author: "Mark Tobey," 1960; "Louise Nevelson, Sculptor," 1964; "Pocket Museum," 1964. Contributor art editorials to France-Amerique, 1953- . Aujourd Hui, Art & Architecture, 1960-1967; article, "Cahiers du Musée de Poche," Paris, 1960. Summer lecture series on "The Road to Modern Art" for Council on Int. Edu. Exchang, 1951- . Directed and organized a "Meet the Artist" program for N.Y. Univ. Arranged Int. Exh., and various exchange exhs. with Paris, France, under the sponsorship of French Embassy, N.Y., and American Embassy, Paris, Specialty of Gallery: A non-profit organization for the promotion of modern American art. Positions: Dir., Grand Central Moderns Gallery, N.Y., 1952-1968; Assoc. Dir.,

Sachs Gal., 1968-1969; Adjunct. Asst. Prof. of A. History, N.Y. Univ., 1968- . Instr., N.Y. Univ., "Meet the Artist" course, 1960; Queens Col., N.Y., "Man and the Arts" course, 1960.

ROBERTS, GILROY—Engraver, S.
General Numismatics Corp., Yeadon, Pa. 19050; h. 7 Llangollen Lane, Newtown Square, Pa., 19073
B. Philadelphia, Pa., Mar. 11, 1905. Studied: Corcoran Sch. A., and with John R. Sinnock, Paul Remy, Eugene Weis, Heinz Warnecke. Member: NSS. Awards: gold medal, Madrid Exh. of Medals, 1951. Work: medals, Drexel Inst., 1936; Brandeis Lawyer's Soc., 1948; Einstein award medal, 1950; Schaefer Brewing Co. Achievement Award, 1951; Am. Medical Assn., Dr. Hektoen Medal, 1952; plaques; Dr. Albert Hardt Mem., 1950; Lewis N. Cassett Fnd., 1950; Theodore Roosevelt H.S., 1952; State Seals: Valley Forge Patriots Mem., 1952; Congressional medals; ports. of prominent persons. Work from 1955-1958: medals, des. and modeled ports. for Congressional and Presidential gold medals honoring Irving Berlin, Dr. Jonas Salk, Winston Churchill, Enrico Fermi, Veterans of the Civil War; coins: ports. of Pres. Marti, Cuba, Pres. Duvalier, Haiti; U.S. Kennedy half dollar (obv.); plaques and medals, Helen Keller; Gen. David Sarnoff; Pres. Riley and Haag, Todd Shipyards; and others. Exhibited: PAFA, 1930, 1934, 1945, 1946; Int. Exh. of coins and medals, Paris, France, 1949, Madrid, Spain, 1951. Positions: Banknote Engraver, Bureau of Engraving & Printing, Wash., D.C., 1938-44; Former Chief Sculptor, Engraver, U.S. Mint, Philadelphia, Pa., 1936-1964. Chm. Bd., General Numismatics Corp., Yeadon, Pa., at present.

ROBERTSON, BRYAN—Writer
c/o Arts Magazine, 60 Madison Ave., New York, N.Y. 10010*

ROBINSON, FREDERICK BRUCE—Museum Director, E., L.
49 Chestnut St., Springfield, Mass. 01103; h. 135 Forest Glen Rd., Longmeadow, Mass. 01106
B. Boston, Mass., Dec. 23, 1907. Studied: Harvard Univ., B.S. Contributor to: museum bulletins, art magazines & newspapers. Lectures: "Art & Architecture of 17th and 18th Century America"; "General Art History & Criticism." Positions: Asst. to Dir., FMA, Harvard Univ., 1931-37; Asst. to Dir., BMFA, 1937-40; Dir., Springfield Mus. FA, Springfield, Mass., (Hon. D.H.L.), 1940- .

ROBINSON, MARY TURLAY—Painter, L.
171 West 12th St., New York, N.Y. 10011
B. Massachusetts, Sept. 7, 1888. Studied: Vassar Col., A.B.; ASL; Am. Sch. FA, Fontainebleau, France; & with DuMond, Luks, Beaudoin, Despujols. Member: AFA; AEA. Awards: Officer of French Acad., France, 1933; prize, Am. Woman's Assn., 1937. Work: CAD; Vassar Col. A. Gal.; Cooper Union Mus., N.Y., and in private colls. Exhibited: NAWA, 1929-1936; Am. Woman's Assn., 1932-1938; Anderson Gal., 1930 (one-man); Nantucket AA, 1933-1969; Bignou Gal., 1941, 1942; Binet Gal., 1950 (one-man); Hartford Atheneum; Salon d'Automne, 1926; Les Independents, Paris, France, 1926. Positions: French-American Liaison Officer, Fontainebleau Am. Sch. FA, 1928-32; Com. On Int. Cultural Relations, AEA, 1951- . Lectures (on grant from Int. Edu. Services, Dept. of State) in Switzerland, Belgium, France, Algeria and Yugoslavia, 1954. Talks on current exhs. and discussion groups for laymen. Exec. Com., Nantucket AA, 1957-61.

ROBINSON, ROBERT DOKE—Educator, P., E.
27 Prospect St., Fair Haven, Vt. 05743
B. Kansas City, Kans., Nov. 11, 1922. Studied: Minneapolis Sch. A; Walker A. Center Sch.; Univ. Minnesota, B.A., B.S., M.A., with S. Chatwood Burton; Oklahoma State Univ., ASTP Certif., with Ivan Doseff, Schaefer-Simmern. Member: Delta Phi Delta; Omega Rho; NAEA; Eastern AA. Exhibited: So. Vermont A. Center, Manchester, 1961. Contributor illus., Modern Medicine publications, national and international; commercial illus. to many publications. Lectures: Art and the Community; Art Education, to art clubs, gallery groups, high schools and colleges. Positions: Owner, Pres., R. D. Robinson Adv. Co., 1951-58; A. Dir., Grubb-Clealand Adv. Agcy., both Minneapolis; Prof., Castleton State College, Castleton, Vermont, 1960- ; Pres. Mid-Vermont Artists, 1963-1965.

ROBLES, ESTHER WAGGONER—Art Dealer, Collector, Lecturer
Esther-Robles Gallery, 665 N. La Cienega, Los Angeles, Cal. 90069
B. Sacramento, Cal. Studied: Los Angeles School of Expression; University of California at Los Angeles, and in Europe. Member: International Platform Association; Mayor's Citizen's Advisory Board; Graphic Arts Council, Los Angeles County Museum of Art. Specialty of the Gallery: Contemporary art and sculpture in new materials. Collection: Paintings by: Appel, Assetto, Bell, Bissier, Benjamin, Capogrossi, Davie, Drexler, Ehrenhalt, Frost, Hartung,

Hofmann, Jenkins, Klix, Lebrocquy, Levee, Matta, Robles, Scott, Tharrats. Drawings by: Magritte, Seuphor, Thomas. Original Prints by: Falkenstein, Hayter, Hultberg, Tapies, Feininger, Giacometti, Johns. Sculpture by: Battenberg, Casanova, Cremean, Falkenstein, Guadagnucci, Hajdu, Macdonald, Schulthess, Thomas. Tapestries by: Seuphor. Lectures: "Art Fraud"; "Development of Los Angeles and La Cienega as a Major Art Center"; "Current Materials of Art: Light/Plastics"; "Brief Survey of Traditional Art as Opposed to Current Art"; "Giant Jump from Impressionism to Art Styles of Today"; "Contemporary Art History." Writer: Art Correspondent for Los Angeles newspapers at Venice Biennale, 1960 and 1968. Positions: Advisor, Federal Arts Project, San Bernardino, 1967; Cohsultant, California Arts Commission, Committee to Investigate Taxation in the Arts, 1966; Organizer, traveling art exhibitions for Western Association of Art Museums, 1964- ; Director Exhibitions, Esther Robles Gallery, Los Angeles, California.

ROBY, SARA (MARY BARNES)—Patron, Collector
 720 Park Avenue, New York, N.Y. 10021
B. Pittsburgh, Pa. Studied: Pennsylvania Academy of Fine Arts; Art Students League, N.Y. and with Kenneth Hayes Miller, Reginald Marsh. Collection: Contemporary American Art including paintings, sculpture, watercolors and drawings, with particular emphasis on the elements of form and craftsmanship in painting and sculpture. This collection is of the Sara Roby Foundation. The collection was shown at the Whitney Museum of American Art in 1959. It was then exhibited in leading museums in the United States Tour, 1960 to 1962. Between 1962 and 1963, the Collection, under the sponsorship of the U.S. Information Agency, was shown in eleven countries in Latin America. In April 1965, the Collection was shown at the Stephen Wise House, a public housing project in New York City under the sponsorship of the Goddard-Riverside Community Center. In March, 1966 the Collection was shown at the Hartford Art School of the University of Hartford in Connecticut. The American Federation of Arts will circulate the Sara Roby Foundation Collection throughout the United States from September 1966 through June 1968. Positions: Founder, Director & Treasurer, The Sara Roby Foundation, 1956- ; Director & Chairman of the Visual Arts Committee at Goddard-Riverside Community Center, New York, N.Y., 1965- .*

ROCHOW, ELIZABETH MOELLER (Mrs. A. M.)—
 Museum Director, P., E.
 Davenport Municipal Art Gallery, 120 West Fifth St.; h. 1117 West Locust St., Davenport, Iowa 52804
B. Davenport, Iowa, Apr. 18, 1906. Studied: State Univ. of Iowa, B.A., M.A.; PAFA. Laura Spellman Rockefeller Grad. F., State Univ. Iowa. Member: Delta Kappa Gamma. Positions: Instr. A., Univ. Iowa Experimental Sch., 1928-31; Chm. A. Dept., Shimer Col., Mt. Carroll, Ill., 1931-34, 1936-38; Instr. A., Montana State Normal Col., Dillon, 1934-36; Visiting Instr. A., Augustana Col., Rock Island, Ill., 1955-1962; Gal. Dir. & Lecturer in A. Hist., Davenport Mun. A. Gal., 1938- .

ROCKEFELLER, MR. and MRS. DAVID—Collectors
 146 E. 65th St., New York, N.Y. 10021*

ROCKEFELLER, JOHN DAVISON 3rd—Collector
 30 Rockefeller Plaza, 10020; h. One Beekman Pl., New York, N.Y. 10022
B. New York, N.Y., Mar. 21, 1906. Studied: Princeton Univ. Collection: Emphasis on Asian Art. Positions: Pres. & Trustee, 1956-1964, Chm., 1965- , The Asia Society; Bd. Memb., American Museum of Natural History, 1933-1955; Mem., Am. Assn. of Museums; Life Memb., Brooklyn Museum and Metropolitan Museum of Art; Corporate Memb., Museum of Modern Art; Memb., Museum of Primitive Art.*

ROCKEFELLER, MRS. LAURENCE II—Collector
 834 Fifth Ave., New York, N.Y. 10021*

ROCKEFELLER, GOVERNOR NELSON ALDRICH—
 Collector, Patron
 The Executive Mansion, Albany, N.Y., also Pocantico Hills, Tarrytown, N.Y. 10591
B. Bar Harbor, Me., July 8, 1908. Studied: Dartmouth College. Member: American Association of Museums; Asia Society; Associates of the Guggenheim Museum; College Art Association of America (Life); Council of National Museums of France. Collection: Emphasis on modern art. Positions: Trustee, 1932- , President, 1939-1941, 1946-1953, Chairman, 1957-1958, MModA; Founder, Trustee, President, 1954- , Museum of Primitive Art; Honorary Trustee, MMA.*

ROCKEFELLER, MR. and MRS. WINTHROP—Collectors
 Winrock Farms, Route 3, Morrilton, Arkansas 72110*

ROCKLIN, RAYMOND—Sculptor
 118 East 10th St., New York, N.Y. 10003
B. Moodus, Conn., Aug. 18, 1922. Studied: Edu. Alliance, N.Y., with Abbo Ostrowsky; CUASch., with Milton Hebald, John Hovannes. Member: Am. Abstract A; Fed. Mod. P. & S.; Sculptors Gld. Awards: Yaddo Grant, 1956; CUASch. scholarship to Skowhegan Sch. Painting & Sculpture; Fulbright Grant to Italy, 1952-53. Work: WMAA; Temple Israel, St. Louis, Mo.; Skowhegan Sch. Painting & Sculpture; Chrysler Mus. A. Exhibited: WMAA, 1957, 1960; Galleria Tiberina, Rome, 1959; Oakland A. Mus.; Univ. California, Berkeley; Pomona Col.; Claude Bernard Gal., Paris, 1960; Bertha Schaefer Gal., N.Y.; Stable Gal., N.Y.; Tanager Gal., N.Y., 1956 (one-man). Lectures: Modern Art at art schools and colleges. Works published in "Dictionary of Modern Sculpture"; "Sculpture of This Century." Positions: Instr. Sculpture, Brooklyn Mus. Edu. Dept., 1952-56; Guest Instr., Sculpture, American Univ., 1956-57; Univ. California, Berkeley, 1959-60; Visiting Artist, Sculpture & Drawing, Ball State College, Muncie, Ind., 1964 (summer).

ROCKMORE, NOEL—Painter
 638 Royal St., New Orleans, La. 70130; h. 33 W. 67th St., New York, N.Y. 10023
B. New York, N.Y., Dec. 1928. Awards: Tupperware F., 1955; Tiffany Fnd. F., 1956, 1963; Hallgarten prize, NAD, 1956, 1957 and Wallace Truman prize, 1959; Ford Fnd-AFA Grant, 1964. Exhibited: CMA, 1964; Delgado Mus. A., 1964; Butler Inst. Am. A., 1963; WMAA, 1956; MModA, 1956; PAFA, 1953; MMA, 1952; one-man: Butler Inst. Am. A., 1958; Salpeter Gal., N.Y.; Downtown Gal., New Orleans; Swope A. Gal., 1962; Greer Gal., N.Y., 1962, 1963, 1964; Univ. Minnesota, 1963; Borenstein Gal., 1962-1964. Author: "Preservation Hall Portraits," 1968.

ROCKWELL, FREDERICK (F.)—Sculptor, P.
 East Boothbay, Me.
B. Brooklyn, N.Y., Jan. 12, 1917. Studied: Columbia Univ.; NAD; Tiffany Fnd.; & with Oronzio Malderelli, Arnold Blanch, George Grosz, William Zorach, & others. Member: Audubon A.; Kennebec Valley AA.; Lincoln County Hist. Assn., Wiscasset, Me. Awards: F., Tiffany Fnd., 1948. Work: U.S. Marine Hospital, Carville, La.; Chrysler Mus., Provincetown, Mass. Exhibited: WFNY 1939; AWCS, 1938, 1942, 1943; AIC, 1940, 1943, 1944; PAFA, 1943, 1946; NGA, 1941; WMAA, 1941; Portland Mus. A., 1944, 1956; Ogunquit A. Center, 1945, 1957, 1958; Audubon A., 1945, 1949-1952; MMA, 1952; Farnsworth Mus., 1949; Morton Gal., 1941 (one-man), 1943; Univ. Maine, 1956 (one-man); NSS, 1956, 1957; Five Islands annual, 1957; Art: USA, 1958; Wiscasset, Me., 1958, 1959-1961; Bowdoin Col., 1960 (one-man); Maine State A. Festival, Augusta, 1960-61.*

ROCKWELL, NORMAN—Illustrator
 Stockbridge, Mass. 01262
B. New York, N.Y., Feb. 3, 1894. Studied: ASL. Member: SI. Contributor to Look and McCall's magazines.

RODMAN, SELDEN—Writer, Critic, Collector, Patron
 659 Valley Rd., Oakland, N.J. 07436
B. New York, N.Y., Feb. 19, 1909. Studied: Yale University, B.A. Awards: Commander, Legion of Honor, Haiti, 1943. Author: "Portrait of the Artist as an American"; "Horace Pippin: A Negro Painter in America"; "The Eye of Man"; "Conversations with Artists," 1961; "The Insiders," 1960; "The Complete Frescoes of Orozco." Initialed and directed Mural Painting of Cathedral St.-Trinité, Port-au-Prince, Haiti, 1950-51. Collection: Contemporary figurative painting and sculpture; Collection has been widely shown in the U.S. and Mexico, and has been catalogued by Vanderbilt University, 1960. Positions: New Jersey State Art Commission, 1963-1964; New Jersey Tercentenary Art Commission, 1963-1964.

ROEBLING, MRS. MARY G.—Collector, Patron
 P.O. Box 880 08605; h. 40 W. State St., Trenton, N.J. 08608
B. Collingswood, N.J., July 29, 1905. Member: AFA. Collection: Paintings; Sculpture; Fine ceramics and glass. Positions: Chairman, Citizens Advisory Council to the State of New Jersey Cultural Center; Provides scholarship to N.J. High School senior, awarded for best painting, to further art education; Hostess for past five years—Exhibit for Multiple Sclerosis Christmas Card Art, Central Jersey Chapter; Chairman, Board of Directors, Trenton Trust Company.

ROELOFS, MRS. RICHARD, JR.—Collector
 115 East 67th St., New York, N.Y. 10021*

ROESCH, KURT (FERDINAND)—Painter, Et., Eng., T., I.
 R.D. 3, Todd Rd., Katonah, N.Y. 10536
B. Berlin, Germany, Sept. 12, 1905. Studied: Acad. A., Berlin, with Karl Hofer. Member: New Hampshire AA. Work: MMA; MModA; Univ. Minnesota; Univ. Nebraska; Albright A. Gal; VMFA; Ft.

Worth Mus. A.; Currier Gal., Manchester, N.H. Exhibited: Carnegie Inst., 1941-1945, 1952, 1958; AIC; VMFA; traveling exh., German Fed. Republic, 1951; WMAA, 1964; one-man: Curt Valentin Gal., 1949, 1953; Currier Gal. A., 1955; Kassel, Germany, 1955; Rose Fried Gal., 1958, and in major national exhibitions, 1948-1958. Positions: Member Advisory Bd., Katonah Gallery and of Colby College, Me.

ROGALSKI, WALTER—Printmaker, T., L.
Pratt Institute, School of Art and Design, Brooklyn, N.Y. 11205; h. 15 Cross St., Locust Valley, L.I., N.Y. 11560
B. Glen Cove, N.Y., Apr. 10, 1925. Studied: BMSch. A., with Gonzales, Osver, Seide, Peterdi. Member: SAGA. Awards: prize, BM, 1954; purchase awards; BM, 1952; SAM, 1952; DMFA, 1953; William & Mary Col., 1959; N.Y. Pub. Lib., 1959, 1961; deCordova & Dana Mus., 1961; Yale Gal. FA, 1961; New York Univ., 1961; Associated Am. A., purchase, 1966. Work: MModA; BM; CMA; FMA; SAM; New Britain Inst.; Yale Univ.; N.Y. Pub. Lib.; DMFA; LC; New Britain (Conn.) A. Mus.; N.Y. Univ.; Phila. Free Lib.; Silvermine Gld.; Hudson River Mus., N.Y.; WMAA; Gilmore A. Center, Kalamazoo, Mich.; Georgian Court Col., N.J.; Associated Am. A. Gal., N.Y. Exhibited: Univ. Minnesota, 1950; BM, 1951, 1952, 1954, 1960, 1966, 1968; LC, 1951; MModA, 1952, 1953 (4-man); SAM, 1952; DMFA, 1953; Phila. Pr. Cl., 1958, 1960; Korman Gal., 1954, 1955 (one-man); Riverside Mus., 1959; CMA, 1954 (one-man); Fleischer A. Mem., 1961 (one-man); Terrain Gal., 1961; SAGA, 1966, 1969, traveling exh., 1961; AAA Gal., 1961; Merrick A. Gal., 1961; WMAA, 1966; Frank H. McClung Mus. Gal., Univ. Tenn., 1967; Univ. Kentucky A. Gal., 1968; CM, 1968; AFA traveling exh., 1969; Nat. Pr. Exh., Potsdam, N.Y., 1969. Lectures on Etching, Engraving, Lithography, Photo Silkscreening. Positions: Contributor to Artists Proof Magazine. Assoc. Prof. of Graphic Art, Grad. Sch. A. & Des., Pratt Inst.

ROGERS, JOHN—Painter, T., L.
2107 Renfrew Ave., Elmont, L.I., N.Y. 11003
B. Brooklyn, N.Y., Dec. 9, 1906. Studied: ASL. Member: ASL (life); AWS; SC; Am. A. Group; Balt. WC Cl.; Nassau A. Lg. (Pres.); A. Lg. of Long Island. Awards: medal, AWS, 1944; prizes, Brooklyn Soc. A., 1950; SC, 1956, 1969; Baltimore WC Cl., 1959; 1st prize, Operation Democracy, 1960; A. Lg. of Long Island, 1961; Locust, Va., 1964; Silver Medal, AAPL, 1967. Work: Landscape, industrial, marine and railroad colls. Exhibited: AWS, 1939-1965; Brooklyn Soc. A., 1939-1955; St. Botolph Cl., Boston, 1947; SC, 1950-1965; NAC, 1952, 1965; Grand Central A. Gal., 1954, 1955-1965; Bohne Gal., 1943-1965; Academic A., 1955, 1961, 1965; Royal WC Soc., London, 1963. Garden City Gal., N.Y., 1966-1969. Contributor to art magazines and newspapers. Lectures. Author: "Watercolor Simplified."

ROGERS, LEO M.—Collector
Rogers Engraving Company, Inc., 45-61 Court Square, Long Island City, N.Y. 11101; h. 465 Park Ave., New York, N.Y. 10022
B. Boston, Mass., Dec. 24, 1902. Studied: Columbia College, A.B.; Columbia University, School of Engineering, Ch.E. Collection: Sculpture: Lipchitz, Gauguin, Maillol, de la Fresnaye, Kolbe, Degas. German Expressionists: Nolde, Dix, Scharl. French Impressionists and Post Impressionists: Cezanne, Renoir, Degas, Manet, Picasso, Modigliani, Sisley, Signac, Vuillard, Rouault, Soutine, Braque, Morisot, Cassatt, Daumier, Matisse, Lautrec, Pisano, Delacroix. Americans: Homer, Marsden Hartley, Ryder, Maurer, Raphael Soyer.

ROGERS, MEYRIC REYNOLD—Museum Curator, E., W., L.
3482 Flamingo Dr., Sarasota, Fla. 33581
B. Kings Norton, England, Jan. 8, 1893. Studied: Harvard Univ., A.B., M.Arch. Member: AAMus.; CAA. Awards: Legion of Honor, 1948; Star of Italy, 1952. Author: "Carl Milles, Sculptor," 1940; "American Interior Design," 1947; "Italy at Work," 1950. Coauthor: "Handbook to the Pierpont Morgan Wing," MMA, 1923; "Handbook to the Lucy Maud Buckingham Medieval Collection," 1945. Contributor to Encyclopaedia Britannica and Encyclopaedia of World Art with articles on American Interior Decoration and American Furniture, 1956-1957; museum bulletins and art periodicals, 1924-1964. Positions: Asst., Asst. Cur., Decorative Arts Dept., MMA, 1917-1923; Prof. A., Smith Col., 1923-1926; Assoc. Prof. FA, Harvard Univ., 1927; Dir., BMA, 1928-1929; Dir., CAM, 1929-1939; Cur., Decorative A. & Indst. A., AIC, Chicago, Ill., 1939-1959 (leave 1958-1959); Organizing Sec., "Italy at Work" Exh., 1950; Lecturer, Am. Art, Yale Univ., 1956; Trustee, Am. Craftsmen's Edu. Council, N.Y.; Cur., Garvan and related Collections, Yale Univ. A. Gal., New Haven, Conn., 1958-1964; Emeritus, 1964- ; Technical Consultant, Historic Columbia Foundation, Columbia, South Carolina, 1966-1967.

ROGERS, MILLARD BUXTON—Art Historian
University of Washington, Seattle, Wash.; h. 801 N.W. Culbertson Dr., Seattle, Wash. 98177
B. Danville, Ill., Sept. 1, 1912. Studied: AIC, M.F.A.; Univ. Chicago,

M.A., Ph.D. Member: CAA, Oriental Ceramic Soc.; Far Eastern Assn. Awards: F., AIC, 1935; F., Univ. Chicago, 1938-1940; Rockefeller Grant, travel and study in the Orient, 1948-1949. Contributor of articles to Artibus Asiae; reviews to Jounal of Asiatic Studies; Far Eastern Ceramic Bulletin, and others. Lectures: Oriental Art. Positions: Instr., Humanities, Univ. Chicago, 1940-43; Hd. A. Dept., Univ. So. California, 1946-47 and Visiting L., 1947; Asst. Prof., Stanford Univ., 1947-50, Visiting L., 1952; L. in Art History, Univ. Washington, 9952- ; Asst. in Anthropology, Field Mus. Nat. Hist., Chicago, 1941-43; Assoc. Dir., Seattle Art Museum, Seattle, Wash., 1952-61; Director of the Center for Asian Arts and Assoc. Prof. in the School of Art, Univ. Washington, 1961- .

ROHLFING, CHRISTIAN—Museum Administrator
Cooper-Hewitt Museum of Design, Smithsonian Institution, Third Ave. 7th St., New York, N.Y. 10003; h. 343 E. 30th St., New York, N.Y. 10016
B. Philadelphia, Pa., Nov. 11, 1916. Studied: University of Chicago. Positions: Board of Directors, and Advisory Board, "The Four Winds Museum Theatre"; Administrator and Curator of Exhibitions, Cooper-Hewitt Museum of Design, New York City.

ROHM, ROBERT—Sculptor
406 Clinton Ave., Brooklyn, N.Y. 11238
B. 1934. Exhibited: WMAA, 1964.*

ROIR, IRVING—Cartoonist
2095 Cruger Ave., New York, N.Y. 10062
B. Austria, Dec. 26, 1907. Studied: CUASch.; NAD; ASL, with William McNulty, George Bridgman. Member: Nat. Cartoonists Soc. Contributor cartoons to King Features; Chicago Tribune; N.Y. News Syndicate; Esquire; Sat. Eve. Post; Colliers; American and other national magazines.

ROJANKOVSKY, FEODOR STEPANOVICH—Illustrator
17 McIntyre St., Bronxville, N.Y. 10708
B. Mitava, Russia, Dec. 24, 1891. Studied: Acad. FA, Moscow. Awards: Caldecott Award, 1956 for illus. in "Frog Went A-Courtin'." I., "Daniel Boone"; "Jacques Cartier"; "Tall Mother Goose"; "Treasure Trove of the Sun"; "Frog Went A-Courtin'," and many other children's books.

ROJTMAN, MR. and MRS. MARC B.—Collectors
955 Fifth Ave., New York, N.Y. 10021*

ROLLER, MARION—Sculptor
156-08 Riverside Drive, West, New York, N.Y. 10032
B. Boston, Mass., Sept. 4, 1925. Studied: Vesper George Sch. A.; ASL. Member: All. A. Am.; Pen & Brush Cl.; Wolfe A. Cl.; Columbia County A. & Crafts Gld. Awards: prizes, All. A. Am.; Knickerbocker A.; Great Barrington Exh.; AAPL; Archer Huntington award, Hudson Valley AA, John Newton award, 1967; Pen & Brush Cl., gold medal, 1967; AAPL, 1968. Exhibited: All. A. Am., 1959-1968; NAD, 1962, 1963, 1965, 1969; AWS; Albany Inst. Hist. & Art; Pittsfield Mus.; Great Barrington Exh.; Audubon A., 1967; one-man: Pen & Brush Cl., 1967; Sculpture Garden Gal., 1968. Positions: Asst. Corresponding Sec., All. A. Am., 1966-1969. Instr. A., Fashion Inst. of Technology.

ROMANO, CLARE (ROSS)—Painter, Pr.M., T.
110 Davison Place, Englewood, N.J.
B. Palisade, N.J., Aug. 24, 1922. Studied: CUASch.; Ecole des Beaux-Arts, Fontainebleau, France; Instituto Statale d'Arte, Florence, Italy. Member: SAGA. Awards: Fulbright F., 1958-59; Tiffany F., 1952; prizes, BM, 1951; Audubon A., 1962, 1966; medals and awards, 1963, 1965; LC, 1951, 1966; SAGA, 1962, 1967, 1968; Boston Pr.M., 1967; Citation, Cooper Union, N.Y., 1966; Eames prize, Phila. Pr. Cl., 1960. Work: BM; MMA; N.Y. Pub. Lib.; LC; Rochester Mem. A. Gal.; Pa. State Univ.; CM; Int. Graphic A. Soc. (woodcut ed.) 1963; Jewish Mus., 1962; New Jersey State Mus.; PMA; Hanover Bank; Newark Pub. Lib.; Norfolk Mus. A. & Sciences; U.S. State Dept.; Slater Mus., Norwich, Conn.; Ithaca Col.; Syracuse Univ., and in numerous other university colls. Commission: Tapestry, main lobby, Manufacturers Hanover Trust Co., N.Y., 1969. Exhibited: MModA, 1953; BM, 1951-1953, 1956-1958; MMA, 1953; LC, 1951, 1952, 1955; Phila. Pr. Cl., 1956, 1958, 1967 (one-man); Santa Monica City Col., 1957; Carnegie Inst.; PAFA; SAGA; CM; WMAA, 1963; Arts Council traveling exh. Europe; SAM; Bradley Univ.; Newark Mus. A.; Grenchen, Switzerland, 1961; USIA exh., South America. One-man: AAA Gal., N.Y., 1967; Phila. A. All., 1969; Troup Gal., Dallas, 1969; Univ. Missouri, 1967. Illus., (in collab.) "Spoon River Anthology" woodcuts, 1963; "Leaves of Grass" woodcuts, 1964. Positions: Instr., Relief Print and Etching, New School, New York City, 1960- ; Pratt Inst., Brooklyn, 1964- ; woodcut & etching, Manhattanville Col., 1964- ; Guest Instr., Pratt Graphic A. Center, 1963, 1964 (summer); A.-in-Res., with USIA Graphics Exhibit, Yugoslavia, 1965-1966.

ROMANO, EMANUEL GLICEN—Painter, I., T.
163 East 74th St., New York, N.Y. 10021
B. Rome, Italy, Sept. 23, 1897. Studied: in Switzerland; and with Enrico Glicenstein. Member: A. Lg. Am. Work: FMA; New London Mus.; Detroit Inst. A.; Musee de La Ville de Paris; Musee Nationaux de France; mural, Klondike Bldg., Welfare Island, N.Y.; portraits in many private colls., Drawings for T. S. Eliot's "The Waste Land" and "The Hollow Men"; McLeish's "Songs for Eye"; Rose Auslander's "Poems"; Conrad Aiken's "Poems"; Ivo Andric's "The Vizier's Elephant"; woodcuts, limited editions, "Waiting for Godot," "Becket." Exhibited: PAFA, 1945; AIC, 1940; WMAA; N.Y. Pub. Lib.; City Col. of N.Y.; Four Freedoms Gal., Wash., D.C.; Ft. Worth AA; Contemporaries, N.Y.; Kagan & Dreyfuss, N.Y.; Gotham Book Mart Gal., N.Y., 1968; one-man: Passedoit Gal.; Feigl Gal.; Macon (Ga.) AA; Kleeman Gal.; Katia Granoff Galerie, Paris; French American Gal., Long Beach, N.Y.; Haifa Mus. & Tel Aviv Mus., Israel; Greenville (S.C.) Mus. A., 1962. Portraits of T. S. Eliot, W. H. Auden, William Carlos Williams, Tennessee Williams, Carson McCullers, André Gide acquired by Univ. A. Mus., Univ. of Texas, Austin, 1969. Lectures: Mural Painting in Ancient and Modern Times.

ROMANO, UMBERTO—Painter, Lith., S., T., L.
162 East 83rd St., New York, N.Y. 10028; s. Gallery-on-the-Moors, East Gloucester, Mass. & 644 Commercial St., Provincetown, Mass. 02657
B. Salerno, Italy, Feb. 26, 1906. Studied: NAD, and in Italy. Member: NA. Awards: prizes, Conn. Acad. FA; North Shore AA, AIC; Pulitzer Prize; Springfield A. Lg.; Carnegie award, Saltus Gold Medal for Merit, Isidor Gold Medal, 1961, all NAD; medals, Tiffany Fnd.; Century Assn., New York, Gold Medal of Honor, 1967 and Gold Medal, popular vote, 1968; Suydam silver medal; Crowninshield award; Emily Lowe award, Lillian Cotton award, All. A. Am.; Rockport AA. Work: FMA; WMA; Springfield Mus. FA; AGAA; BMA; Mt. Holyoke Col.; Tel-Aviv Mus., Israel; Univ. Miami; Univ. Maine; Evansville (Ind.) Mus.; WMAA; CGA; Chrysler Mus., Provincetown; Univ. Georgia; PAFA; R.I. Sch. Des.; Smith Col. Mus.; Encyclopaedia Britannica; CM; NAD; Smithsonian Inst.; Brandeis Univ.; Norfolk Mus. A. & Sciences; Birmingham Mus. A.; Andrew Dickson White Mus., Cornell Univ.; Phoenix Mus. A.; Oklahoma A. Center; Univ. Southern Illinois; Ohio Univ.; NCFA., and in many private colls. in U.S. and abroad; murals, Springfield (Mass.) Post office; mosaic mural, Civic & Municipal Court House, N.Y., 1960. Exhibited: nationally, and in Europe, Orient & South America, 1959-61. One-man: Rehn Gal., 1928 and subsequently; Paris, France, 1948; Assoc. Am. A., 1942, 1944, 1946, 1950; WMA, 1933; Kleemann Gal., 1934; Springfield Mus. FA, 1943; Assoc. Am. A., Chicago, 1947; Chicago, Ill., 1955; Rochester, N.Y., 1955; Castle Hill Fnd. (Mass.) 1955; Heller Gal., N.Y., 1958; Krasner Gal., 1959, 1960; Karlis Gal., Provincetown, 1960-1963; Gallery 63, N.Y., 1963-1965; Franz Bader Gal., Wash., D.C., 1962; Oehlschlaeger Gal., Chicago, 1953 and Sarasota, Fla., 1964; Birmingham Mus. A., 1963; Wellfleet A. Gal., Cape Cod, 1966-1968 and Palm Beach, 1967; Harmon Gal., Naples, Fla., 1967; Galerie Moos, Montreal, Canada, 1967, and others. One-man traveling exhs. in many leading museums U.S. and abroad, 1946-1961. I., Dante's "Divine Comedy," 1946. Positions: Hd., WMA Sch. A., Worcester, Mass., 1934-40; Hd., Romano Sch. A., Gloucester, Mass., 1933- ; New York City, 1954- . Vice-Pres., Audubon A., 1963, U.S. Comm. of I.A.P.A., 1964, and Nat.Soc. Mural Painters, 1965; Council member, NAD, 1963; Bd. member of The Abbey Fnd., N.Y.C., 1963; Chm. of the School Committee of NAD, 1965.

ROMANS, MRS. CHARLES J. See Gilmore, Ethel

ROMANS, CHARLES JOHN—Painter, T., C.
1033 New York Ave., Cape May, N.J. 08204
B. New York, N.Y., Mar. 4, 1893. Studied: State T. Col., Buffalo, N.Y.; N.Y. Univ.; NAD, and with George Elmer Browne, X.J. Barile. Member: Provincetown AA; Gotham Painters; Hudson Valley AA; All. A. Am.; Prof. A. of South Jersey; P. & S. Soc. New Jersey; SC; Nat. Assn. Painters in Casein. Work: Junior Mus., Albany, Ga.; LaSalle Col., Philadelphia, Pa. Awards: New Jersey P. & S. Soc., 1944, 1950, 1960; Jersey City Mus. A., 1948, 1952; Asbury Park FA Assn., 1948; Newark A. Cl., 1949; A. Council of New Jersey, 1950, 1951; Hudson A. of New Jersey, 1953; Rahway A. Center, 1953; Hudson Valley AA, 1954; Atlantic City A. Center, 1966-1968. Exhibited: AWS, 1939; NAD, 1941; Montclair A. Mus., 1937-1950; All. A. Am., 1938-1961; Audubon A., 1944; Jersey City Mus., 1944-1957; Asbury Park FA Assn., 1946-1950; NAC, 1950-1952; Hudson Valley AA, 1952-1954; Riverside Mus., 1954, 1955; Polish-American A. Exh., 1948-1950; AFA traveling exh., 1939, 1940; Old Bergen A. Gld. traveling exh., 1962-1965; East Side Gal., N.Y., 1966-1968. Positions: Instr., FA Workshop; Seven Mile Beach A. Lg., Stone Harbor, N.J.

ROME, HAROLD—Collector, P. W., Composer
1035 Fifth Ave., New York, N.Y. 10028
B. Hartford, Conn., May 27, 1908. Studied: Yale University, B.A.;

Yale Law School; Yale School of Architecture, B.F.A. Exhibited: (One-man) Marble Arch Gallery, N.Y., Dec. 1964. Collection: African sculpture; Large collection of heddle-pulleys (West African). Positions: Composer; Writer.*

RONALD, WILLIAM—Painter
P.O. Box 231, Kingston, N.J. 08528
B. Stratford, Ont., Canada, Aug. 13, 1926. Studied: Ontario Col. of A. Awards: Hallmark award, N.Y., 1952; Scholarship, Canada Fnd., Ottawa, 1954; Guggenheim award, 1956. Work: Albright-Knox A. Gal.; BMA; BM; Carnegie Inst.; AIC; Guggenheim Mus., N.Y.; MModA; Nat. Gal. Canada, Ottawa; N.Y. Univ.; Montreal Mus. FA; Univ. North Carolina; Phoenix A. Mus.; R.I. Sch. of Des.; A. Gal. of Toronto; WAC; Williams Col.; Gal. Mod. A., Wash., D.C.; Princeton Univ. Mus.; Queens Univ., Kingston, Ontario; Univ. British Columbia; WMAA; Larry Aldrich Mus.; Int. Minerals & Chemicals Corp., Skokie, Ill.; Michener Fnd.; Wadsworth Atheneum, Hartford, Conn. Exhibited: Trinity Col., Toronto (3-man); Eglinton Gal., Toronto (2-man); Smithsonian Inst. traveling exh., 1956; A. Gal. of Toronto, 1956; Riverside Mus., N.Y., 1956; Carnegie Inst., 1958; Brussels Worlds Fair, 1958; WMAA, 1959; Sao Paulo Bienale, 1959; Guggenheim Mus., 1961; Univ. Illinois, 1961, 1963; CGA, 1962, 1963; Dunn Int. Exh., 1963, 1964; and widely abroad.*

RONAY, STEPHEN R.—Painter
12 Hillside Ave., Port Washington, L.I., N.Y. 11050
B. Hungary, Feb. 27, 1900. Studied: Royal Acad. Des., Budapest; Vienna, Austria; NAD. Exhibited: Assoc. Am. A.; Contemporary A. Gal.; Macbeth Gal.; MModA; CGA; Van Dieman-Lilienfeld Gal., 1951 (one-man); GGE 1939; CM; NAD; Audubon A.; Hutton Gal., N.Y.; Schoeneman Gal., N.Y.; PAFA; AIC; Lib. of Paintings, N.Y.; Norfolk Mus. A. & Sciences, 1965; Parrish A. Mus., Southampton, N.Y.; Geminaire Gal., N.Y., 1960 (one-man); Vera Lazak Gal., Cold Spring Harbor, N.Y., 1964, 1966 (one-man). Contributor drawings and cartoons to Hearst Publications; Vanity Fair; New Yorker; Sat. Eve. Post; Cosmopolitan; Colliers and other national magazines.

RONEY, HAROLD ARTHUR—Painter, T., L.
R.R. No. 8, Box 294B, San Antonio, Tex. 78228
B. Sullivan, Ill., Nov. 7, 1899. Studied: Chicago Acad. A.; AIC; & with Harry Leith-Ross, John Folinsbee, George A. Aldrich, & others. Member: SSAL; Texas FA Assn.; AAPL; Artists & Craftsmen Assoc., Dallas; San Antonio AA; Academic A., Springfield, Mass. Awards: prize, South Bend, Ind., 1923; Texas Women's Cl., 1930. Work: Sullivan (Ill.) Pub. Lib.; Witte Mem. Mus.; Austin (Tex.) Pub. Lib.; South Bend (Ind.) Pub. Sch.; Southwest Texas State T. Col.; Panhandle Plains Mus., Canyon, Tex. Exhibited: SSAL, 1929-1932, 1945; Conn. Acad. FA, 1937; Texas FA Assn., 1929-1933, 1944, 1952; San Antonio, Tex., 1944, 1945; New Orleans AA, 1928, 1929, 1931; New Hope, Pa., 1935, 1936; San Angelo, Tex., 1952; Beaumont, Tex., 1952; Academic A., 1959, 1960, 1965; AAPL, 1962-1966; A. & Craftsmen, Dallas, 1963, 1964; Coppini Acad. FA traveling exh., 1962-1964; Canyon, Victoria, Dallas, Tex.; Central Texas Mus., Salada, Tex; one-man exh.: Phila., Pa.; San Antonio, Austin, San Angelo, Dallas, Gonzales, Tex.; Oklahoma City; Cloudcroft, N.M. Instr. A., Antonio, Tex. (winter); Cloudcroft Sch. A., N.M. (summer), etc. Positions: Pres., Coppini Acad. FA, San Antonio, Tex., 1963-66. Instr. Painting, Cloudcroft, N.M., Gonzales, Brownwood and San Antonio, Tex.

ROOD, JOHN—Sculptor, P., W., L., E.
2441 California St., N.W., Washington, D.C. 20008
B. Athens, Ohio, Feb. 2, 1902. Studied: Ohio Univ. Member: Minnesota AA; Soc. Minn. Sculptors; AEA. (Nat. Pres., 1959-). Awards: Minneapolis Inst. A.; Minnesota State Fair; WAC; SFMA, and others. Work: Cranbrook Acad. A.; Ohio Univ.; St. Mark's Cathedral, Minneapolis; Our Lady of Grace Church, Edina, Minn.; Mt. Zion Lutheran Church, Minneapolis; Hamline Univ.; Wellesley Col.; Austin Jr. H.S. Austin, Minn.; Minneapolis Athletic Cl.; fountain & sc.; Minneapolis Pub. Lib.; Minneapolis Inst. A.; WAC; CGA; Nat. Hdqtrs., AAUW, Wash., D.C.; AGAA. Exhibited: nationally; 17 one-man exhs., New York; and in Milan and Rome, Italy, 1956; Mexico City, 1958. Author: "Wood Sculpture," 1940; "Sculpture in Wood," 1950; "Sculpture with a Torch," 1961. Chapter on Sculpture, Book of Knowledge, 1952.*

ROOT, MRS. EDWARD W.—Collector
College Hill, Clinton, N.Y. 13323*

ROPER, JO—Sculptor
P.O. Box 6, Montezuma, N.M. 87731*

ROSATI, JAMES—Sculptor, E.
56 Third Ave. 10003; h. 252 W. 14th St., New York, N.Y. 10011
B. Washington, Pa., June 9, 1912. Awards: Brandeis Univ. Creative Arts Award, 1960; Logan Medal and Prize, AIC, 1962; Providence A. Cl., 1962; Carborundum Major Abrasive Marketing Award, 1963;

Guggenheim Fellowship, 1964. Work: Yale Gall FA; N.Y. Univ.; WMAA; Geigy Chemical Corp., Ardsley, N.Y.; Hopkins A. Center, Dartmouth Col., and in many private colls. Exhibited: Stable Gal., N.Y., annually; WMAA, 1952-1954, 1960, 1962, 1964; Carnegie Inst. 1958, 1961, 1964; Rutgers Univ., 1958; Smith Col., 1960; Int. Outdoor Sculpture, Otterlo, Holland, 1961; Galerie Claude Bernard, Paris, 1960; Indiana Univ., 1960; AFA Contemporary Sculpture traveling exh., 1960-1961; Boston A. Festival, 1961; Dayton AI, 1961; New Sch. for Social Research, N.Y., 1961; AIC, 1961, 1962; Guggenheim Mus., 1962-1963; Seattle World's Fair, 1962; Smithsonian Inst.; Providence A. Cl., 1962; Acquisitions by Friends of the Whitney Museum; Spoleto, Italy, 1962; Wadsworth Atheneum, 1962; Herron A. Mus., Indianapolis, 1963; Phila. A. All., 1963; N.Y. Univ. A. Collection, 1963; Boston Univ., 1963; Washington Gal. Mod. A., 1963; London County Council, Battersea Park, London, 1963; Parke-Bernet Gal., N.Y., 1963; Brandeis Creative Arts Awards Exh., AFA, 1963; MModA traveling exh., 1964-1965; Int. Council of the Mus. Mod. A. Exh. to France, Germany and Scandinavia, 1965-1966; New Sch. A. Center, 1966; WMAA, 1965. Oneman: Peridot Gal., N.Y., 1954; Otto Gerson Gal., N.Y., 1959, 1962, 1968; Hopkins A. Center, Dartmouth Col., Hanover, N.H., 1963. Positions: Instr., Pratt Inst. and Cooper Union, N.Y.; Visiting Critic in Sculpture, Hopkins A. Center, Dartmouth College, 1963 (Spring); Assoc. Prof. in Sculpture, Yale University, 1964- .*

ROSE, BARBARA—Critic
Chateau Marmont, 8221 Sunset Blvd., Hollywood, Cal. 90046*

ROSE, DOROTHY—Painter
312 East 21st St., Brooklyn, N.Y. 11226
B. Brooklyn, N.Y. Studied: BAID; New Sch. for Social Research; ASL. Member: AEA; ASL. Awards: Village A. Center, N.Y., 1960. Work: Staten Island Mus. Hist. & A., and in private colls. Exhibited: N.Y. City Center, 1956-1958; Panoras Gal., N.Y., 1955, 1956, 1958, 1961, 1965, (all one-man); Village A. Center, 1957, 1958; Silvermine Gld. A., 1956; Arts:USA, 1958; Ringling Mus. A., 1960; Galerie Nicole, 1963 (one-man); BM, 1963; AEA, 1969; retrospective, Progressive Synagogue, Brooklyn, N.Y., 1968. Positions: Adv. Council, Village A. Center, N.Y., 1959; Juror, Norfolk (Va.) AA, 1969; Chm., Group 6, AEA, 1969.

ROSE, HANNA TOBY—Museum Curator of Education
The Brooklyn Museum, 188 Eastern Pkwy., Brooklyn, N.Y. 11238; h. 55 E. 9th St., New York, N.Y. 10003
B. New York, N.Y., Apr. 12, 1909. Studied: Wellesley College, courses with Alfred Barr; special student, New School for Social Research, N.Y., courses with Meyer Shapiro. Positions: President, International Education Commission of ICOM, 1953-1962; Member of Council of NCAE, 1954-1964; Vice-President, ISAE, 1965-1967; Associate Director, Unesco Seminar "The Role of Museums in Education," 1952; Editor, "Museums and Teachers" ICOM, Paris, 1956; Principal Investigator and Organizer of seminar supported by U.S. Office of Education "The Role of the Arts in Meeting Social and Education Needs of the Disadvantaged," 1966. Museum Curator of Education, The Brooklyn Museum, N.Y., at present.

ROSE, HERMAN—Painter, Et., T., L.
49 Greenwich Ave., New York, N.Y. 10014
B. Brooklyn, N.Y., Nov. 6, 1909. Studied: NAD. Awards: F., Yaddo Fnd., 1955. Work: MModA; WMAA. Exhibited: PAFA, 1952; MModA, 1948, 1952; WMAA, 1948, 1949, 1953, 1955, 1957, 1958; ACA Gal., 1955, 1956; Forum Gal., N.Y., 1962 (one-man). Positions: Instr., New Sch. for Social Research, N.Y., 1954-1955.*

ROSE, IVER—Painter
210 Maple St., Springfield, Mass. 01105; s. Rockport, Mass. 01966
B. Chicago, Ill., Apr. 17, 1899. Studied: Hull House, Chicago; AIC; Cincinnati Acad. A. Member: Audubon A.; All. A. Am.; Rockport AA. Awards: prizes, Audubon A., 1950, 1953; Rockport AA, 1944, 1955, 1961, 1963, gold medal, 1964; NAD purchase prize, 1959. Work: Chicago Pub. Libraries; Walker A. Center; Cranbrook Acad. A.; AGAA; Univ. Georgia; Des Moines A. Center; Phila. A. All.; San Diego FA Gal.; Witte Mem. Mus.; Am. Acad. A. & Let.; Birmingham Mus. A.; Hassam Fund; Mus. of the New Britain Inst.; Parrish Mus., Southampton, L.I.; San Angelo A. Lg.; Encyclopaedia Britannica; NAD; Springfield (Mass.) Mus. A. Exhibited: MMA; Carnegie Inst.; AIC; PAFA; CGA; Clearwater Mus. A.; BMA; Univ. Nebraska; Springfield A. Mus.; CMA; AFA traveling exh.; Montclair A. Mus.; VMFA; DePauw Univ.; Nelson Gal. A.; Kansas City AI; Dayton AI; Joslyn A. Mus.; Univ. Illinois; NAD; Audubon A.; All. A. Am; Milch Gal., 1949-1952; MModA traveling exh., 1954-55; one-man: Kleeman Gal.; Schneider-Gabriel Gal.; Kraushaar Gal., 1938, 1940, 1942, 1945, 1947, 1949.

ROSE, RUTH STARR—Painter, Lith., Ser., L., T., Des., I.
"High Design," 733 Latham St., Alexandria, Va. 22304
B. Eau Claire, Wis. Studied: Vassar Col., A.B.; ASL. Member: NAWA; N.Y. Soc. Women A.; Phila. Pr. Cl.; Wash. WC Cl.; Nat. Lg. Am. Pen Women; Washington Pr. M.; Nat. Ser. Soc. Awards: prizes, NAWA, 1937, 1944; State of New Jersey, 1944; Washington Pr.M., 1951; Norfolk Mus. A. & Sc., 1950; CGA, 1951; Va. Pr. M., 1957; Wash. Area Pr. M., 1957; A. Fair, Alexandria & Wash., 1957; Religious A. Fair, 1958. Work: LC; MMA; Vassar Col.; PMA; Wells Col.; Williams Col.; Milliken Col.; Norfolk Mus. A. & Sc., Univ. Virginia. Exhibited: NAD, 1945, 1946; Nat. Color Pr. Soc., 1945-1950; LC, 1945, 1946, 1950; Carnegie Inst., 1950; Phila. Pr. Cl.; 1944, 1945; Northwest Pr. M., 1949; NAWA, 1944, 1945, 1949, 1950; CM, 1954; one-man: Reheboth A. Lg.; Farnsworth Mus. A., Rockland, Me., 1954; Howard Univ., 1958 (one-man); Virginia Pr. M., 1960; City Hall, Alexandria, Va., 1964 (one-man). Lecturer to schools, and professional organizations. Instr., Serigraphy, YWCA, Wash., D.C., 1959-1965; Bolling Air Force Base, Wash., D.C., 1965.*

ROSEBERG, CARL ANDERSSON—Sculptor, Eng., E., I.
College of William and Mary, Williamsburg, Va. 23185; h. P.O. Box 1166, Williamsburg, Va. 23185
B. Vinton, Iowa, Sept. 26, 1916. Studied: State Univ. of Iowa, B.F.A., M.F.A., Cranbrook Acad. A.; Mysore University, Mysore, India; Tyler School of A. Member: Audubon A.; CAA; F.I.A.L.; Asian Soc.; Southeastern AA. Awards: prizes, Springfield, Mo.; WAC; Huckleberry Mountain A. Center; VMFA, 1955, 1957, 1961; Thalhimers Invitational, 1967; Va. Chap. AIA, Award of Honor for Contributions to Education, 1968; Heritage Fellow, William & Mary, 1968- ; Work: Monuments, Rockingham County, Harrisonburg, Va. Illus: Child's book for Colonial Williamsburg (hand set type and wood engravings), 1955; Roll titles for Colonial Williamsburg film, "The Colonial Naturalist," 1964. Designed: Marshall-Wythe Law School honor medallion, 1967; College of William and Mary 275th Anniversary Year Medallion. Exhibited: PAFA, 1948; Syracuse Mus. FA, 1948; Audubon A., 1948, 1950-1958, 1961-69; Ball State Univ., Muncie, Ind., 1955; WAC, 1946, 1947; Springfield Mus. A.; Denver A. Mus., 1947; Wash. Sculptors Group, 1952; VMFA, 1948, 1951, 1953, 1955, 1957, 1959, 1961; Univ. Iowa, 1957; Jamestown Festival, 1957; Norfolk Museum, 1960-63, 1964, 1965-69; 20th Century Gallery, 1959-60; Fredericksburg, 1964; Newport News, 1964; Thalhimers Invitational, Richmond, 1963, 1964, 1968; Richmond Artists Fall Exhib., 1968; one-man: Radford Col., 1962; Roanoke FA Center, 1963; Longwood College, 1966; Norfolk, 1963; Asheville, N.C., 1963. Represented numerous private collections. Lectures: "Sculpture Techniques," "Contemporary Sculpture," "Twentieth Century Look at Education." Positions: Instr., Asst. Prof., Assoc. Prof. FA, 1947-66; Professor 1966- ; Heritage Fellow 1968-69, 1969-70.

ROSEMAN, AARON—Painter
868 Broadway, New York, N.Y. 10003*

ROSEN, HY(MAN) (JOSEPH)—Editorial Cartoonist
Times-Union, Sheridan Ave.; h. 77 Marsdale St., Albany, N.Y. 12208
B. Albany, N.Y., Feb. 10, 1923. Studied: AIC; ASL; N.Y. State Univ. at Albany. Member: Nat. Cartoonists Soc.; Assn. of Am. Editorial Cartoonists (Vice-Pres.); Stanford Professional Journalism F. Awards: prizes, Nat. Physicians Comm., 1948; Disabled Am. Veterans, 1949; Freedom Fnd., 1950-1960, 1964. Work: LC; work used by Voice of America and USIA. Cartoons in colls. at L.B. Johnson Lib. and Syracuse, N.Y., State Lib. Exhibited: MMA, Cartoonists Exh., 1951; London cartoon exh., 1958. Positions: Ed. Cart., Times-Union, Albany, N.Y., 1945- . Syndicated in 8 other Hearst newspapers.

ROSEN, ISRAEL, (Dr.)—Collector
2413 E. Monument St. 21205; h. 1 E. University Pkwy., Baltimore, Md. 21218
B. Baltimore, Md., Dec. 28, 1911. Studied: Johns Hopkins University, B.A.; University of Maryland Medical School, M.D. Member: Committee for Contemporary Art, BMA, 1961-1968. Author: Articles—"Toward a Definition of Abstract Expressionism," Baltimore Museum News, 1959; Preface to the Edward Joseph Gallagher III Memorial Collection, BMA, 1964, MMA, 1965; "The Cone Sisters: Myths, Realities and Some Conjectures," BMA Annual III, 1969. Collection: Modern art, with special emphasis on abstract expressionism, including works by Pollock, de Kooning, Still, Kline, Rothko, Baziotes, Tobey, David Smith, Robert Rauschenberg, as well as works by 20th century European artists including Picasso, Mondrian, Kandinsky, Klee, Leger, Gris.

ROSENBERG, ALEXANDER—Art dealer
20 E. 79th St., New York, N.Y. 10021*

ROSENBERG, HAROLD—Writer
30 Neck Path Rd., The Springs, East Hampton, N.Y. 11937
B. New York, N.Y., Feb. 2, 1906. Studied: City Col., N.Y.; Brooklyn Law Sch., L.L.B. Awards: Frank Jewett Mather Award, College Art Assn., 1964. Author: "The Tradition of the New," 1959; "Arshile Gorky," 1962; "The Anxious Object"; "Artworks and Packages," 1969. Art critic, The New Yorker. Contributor to Art News and Art News Annual. Positions: Christian Gauss Seminar, Princeton; Baldwin Seminar, Oberlin; Regents Lecturer, University of California. Art editor, "American Guide Series," 1938-1940. Visiting Prof., Univ. of Southern Illinois, 1966; Prof., Univ. Chicago, 1967- .

ROSENBERG, JAKOB—Museum Curator, E., W.
19 Bellevue Rd., Arlington, Mass. 02174
B. Berlin, Germany, Sept. 5, 1893. Studied: Univ. Munich, Ph.D.; Bern, Zurich, Frankfort. Member: CAA; F., Am. Acad. A. & Sc.; Hon. F., Pierpont Morgan Lib. Awards: Hon. degree, D.A., Harvard Univ., 1961. Author: "Drawings of Martin Schongauer," 1922; "Jacob van Ruisdael," 1928; "Lucas Cranach," 1932 (with Max J. Friedländer); "Rembrandt," 1948, 1964; "German Expressionism" (with C. L. Kuhn), 1957; "Great Draughtsmen from Pisanello to Picasso," 1959; "Zeichnungen Cranachs," 1960; "On Quality in Art," 1967. Positions: Resident F., L., Harvard Univ., 1937-39; Cur. Prints, FA, FMA, Cambridge, Mass., 1939-1964, Prof. Emeritus, 1964- ; Robert Sterling Clark Professor, Williams College, 1964-65. Senior Fellow, National Gallery, Washington D.C., 1966-67.

ROSENBERG, LOUIS CONRAD—Etcher, I., Arch.
555 Country Club Rd., Lake Oswego, Ore. 97034
B. Portland, Ore., May 6, 1890. Studied: MIT; Royal Col. A., London, England. Member: NA; F., Royal Soc. Painters, Etchers & Engravers, London; AIA. Awards: med., Cal. Pr. M., 1924; AIA, Fine Arts Gold Medal, 1948; Chicago SE, 1925, 1927; prizes, AIC, 1932; Brooklyn SE, 1926; SAE, 1932, 1938; Albany Pr. Cl., 1946. Work: Smithsonian Inst.; Lib. Cong.; N.Y. Pub. Lib.; Boston Pub. Lib.; BMFA; Albany Inst. Hist. & A.; British Mus., Victoria & Albert Mus., London; Univ. Nebraska; Honolulu Acad. A.; CMA; Montana State Col.; Slater Mem. Mus., Norwich, Conn.; Cal. State Libl. AGAA; Howard Univ.; Acad. A., Stockholm; Peabody Mus., Cambridge; Royal Insurance Co., N.Y.; Cleveland Terminal Co.; Cincinnati Terminal Co. Exhibited: NAD, 1930-1958; SAE, 1932-1941; AIC, 1932; Albany Inst. Hist, & A., 1945; Albany Pr. Cl., 1945; Wichita AA, 1946; Am.-British Goodwill Exh., London, 1945; etc. Author: "Davanzati Palace," 1922; I., "Bridges of France," 1924; "Middle East War Projects of Johnson-Drake & Piper," 1943, & other books. Contributor to: print magazines.*

ROSENBERG, PIERCE—Collector
1101 W. Mitchell St. 53204; h. 8216 N. Gray Log Lane, Milwaukee, Wis. 53217
B. Milwaukee, Wis., July 19, 1908. Studied: University of Michigan, A.B. Collection: Prints, paintings and sculpture.*

ROSENBERG, SAEMY—Art dealer
32 E. 57th St., New York, N.Y. 10022*

ROSENBERG, SAMUEL—Painter, E.
Carnegie-Mellon University, Fine Arts College; h. 2721 Mt. Royal Rd., Pittsburgh, Pa. 15217
B. Philadelphia, Pa., June 28, 1896. Studied: Carnegie Inst., B.A. Member: Assoc. A. Pittsburgh (Hon.); Abstract Group; CAA; AAUP; A. Comm. City of Pittsburgh. Awards: prizes, Carnegie Inst., 1945, 1954; Assoc. A. Pittsburgh, 1917, 1920, 1921, 1930, 1936, 1946, 1948; Pittsburgh Soc. A., 1928, 1929; Butler AI, 1939, 1943, 1947; Indiana State T. Col., 1946; Pepsi-Cola, 1947, 1948; Grensfelder prize, 1953, 1955; "Man of the Year in Art," Pittsburgh Jr. Chamber Commerce and A. & Crafts Center, 1950; prize and silver medal, Ligonier Valley A. Lg.; Award of Merit, Alumni Fed., Carnegie-Mellon Univ., 1962. Work: Carnegie Inst.; Encyclopaedia Britannica; Butler AI; Somerset County Sch.; Pittsburgh Bd. Edu.; Slippery Rock (Pa.) State T. Col.; Pa. State Univ.; Univ. Indiana (Pa.); Wash. County Mus. FA; BMA; Westmoreland County Mus. A., Pa. Exhibited: Carnegie Inst. (15 Internationals, 1920- 1967, and 8 American, 1940-1949); WMAA; John Herron AI; Univ. Illinois; Butler AI; AIC; Walker A. Center; Milwaukee AI; AGAA; CGA; Dayton AI; MModA; Los A. County Mus.; NAD; PAFA; Univ. Nebraska; Nelson Gal. A., Kansas City; Riverside Mus., N.Y.; Rochester Mem. A. Gal.; Minneapolis Inst. A.; CAM; Toledo Mus. A.; Springfield Mus. FA; VMFA; Columbia (S.C.) Mus. A.; Bucknell Univ.; Univ. Tennessee; Butler AI: Cheltenham A. Center; BMFA Sch.; Pittsburgh Playhouse; Jewish Community Center, Cleveland; Indiana (Pa.) State T. Col.; Pittsburgh A. & Crafts Center; Carnegie Inst., 1922-1937, 1956; Greensburgh A. Cl., 1940; Assoc. Am. A., 1944, 1947; BMA, 1959; Westmoreland County Mus. A., 1960; Miami Univ., Oxford, Ohio,

1962; Pittsburgh Plan for Art, 1963; House Office Bldg., in office of Congressman Moorehead, 1963; Weirton Community Center, 1957; Hewlett Gal., Carnegie Inst., 1958, 1965; Assoc. A. of Pittsburgh, 1962. Positions: Prof., Drawing & Painting, Carnegie-Mellon Univ., Pittsburgh, Pa.

ROSENBLATT, ADOLPH—Painter, Lith., S.
31 W. 31st St. 10001; h. 130 W. 16th St., New York, N.Y. 10011
B. New Haven, Conn., Feb. 23, 1933. Studied: Yale Sch. Des., with Albers, Brooks and Marca-Relli. Work: LC. Exhibited: Contemporary Gal., N.Y., 1957; AFA traveling exh., 1958; Boston A. Festival, 1961; Artists Gal., N.Y., 1961-62; New Gal., Provincetown, Mass., 1962 (2-man); American Gal., 1962; Riverside Mus., N.Y., 1962; Castellane Gal., N.Y., 1963 and Provincetown, 1963; Griffin Gal., N.Y., 1964; Dorsky Gal., N.Y., 1964; Schoelkopf Gal., N.Y., 1964; one-man: Kanegis Gal., Boston, 1958; Dorsky Gal., 1964.*

ROSENBLOOM, CHARLES J.—Collector
1036 Beechwood Blvd., Pittsburgh, Pa. 15206*

ROSENBLUM, ROBERT—Scholar, W., Cr., E.
New York University, Institute of Fine Arts, 1 E. 78th St., New York, N.Y. 10021; h. 105 W. 72nd St., New York, N.Y. 10023
B. New York, N.Y., July 24, 1927. Studied: Queens College, B.A.; Yale University, M.A.; N.Y. University Institute of Fine Arts, Ph.D. Author: (books)-"Cubism and Twentieth-Century Art," 1960; "Transformations in Late Eighteenth Century Art," 1967; "Ingres," 1967; many articles in scholarly and critical magazines. Major fields of research: Romantic Art and contemporary Art. Positions: Instr., Univ. Michigan, 1955-56; Instr., Asst. Prof., Assoc. Prof., Princeton Univ., 1956-1966; Visiting Assoc. Prof., Columbia University; Prof., New York University, 1966- .

ROSENBLUM, SADIE—Painter, Et.
178-D Daytonia Rd., Miami Beach, Fla. 33139
Studied: New Sch. Social Research, N.Y.; ASL; N.Y. Univ., and in Europe, South America and Near East. Member: Miami AA; Woodstock AA; AEA; NAWA. Awards: prizes, Adirondack Annual, 1960; Harry Rich award, Miami, Fla., 1957; City of Miami, 1956 (hon. men.); purchase award, painting, Collectors of Am. A., 1954, 1956, 1958, 1959 and purchase full edition of etchings, 1959. Work: Lowe Gal., Miami; Ft. Lauderdale A. Center; Peabody Mus.; Nashville, Tenn.; Norton Gal. A., Atlanta AA; CGA; Peabody Mus. A.; CMA; SFMA; West Palm Beach. Exhibited: Columbia (S.C.) Mus. A.; Albright A. Gal.; Riverside Mus., N.Y.; RoKo Gal., N.Y.; Woodstock AA; Graham Gal., N.Y.; Contemp. A. Gal., N.Y.; Rudolph Gal., N.Y. and Fla.; Norton Gal. A.; Lowe Gal., Miami; Soc. Four A., Fla.; Art: USA, 1958; Ft. Lauderdale A. Center; one-man: RoKo Gal., N.Y., 1960, 1965; Ft. Lauderdale A. Center, 1962, 1965; 327 Gal., Albany, N.Y., 1962; Lowe A. Gal., 1964; Little Gal., Phila., Pa., 1965. Work reproduced: Miami News; Christian Science Monitor; Toledo Blade; Miami Herald; N.Y. World Telegram; Contemp. A., N.Y. (cover of catalogue); N.Y. Times. Positions: Assoc. Member Museum Advisory Bd., Peabody College for Teachers, 1961-1964.*

ROSENBORG, RALPH M.—Painter
165 Lexington Ave., New York, N.Y. 10016
B. Brooklyn, N.Y., June 9, 1913. Studied: School A. Lg., N.Y.; classes, Am. Mus. Nat. Hist. Member: Fed. Mod. P. & S. Awards: purchase award, Am. Acad. A. & Lets., 1960. Work: MModA; Guggenheim Mus.; PC; MMA; CAM; Newark Mus. A.; Montclair (N.J.) A. Mus.; Yale Univ. Gal.; Galerie Bucher, Paris, France; Cornell Univ.; Brandeis Univ.; Smith Col.; Univ. Georgia; Colby Col.; Univ. Oregon. Exhibited: more than 300 group exhs., since 1934, including CGA, WMAA, Univ. Illinois, etc.; 53 one-man exhs. in New York City and other principal cities of the U.S., since 1935, including New York Galleries: Neirendorf, Willard, Seligmann, Passedoit, Artists, etc. Instr., A., Brooklyn Mus., 1936-38; Ox-Bow Summer Sch., Saugatuck, Mich., 1949, and others.*

ROSENDALE, HARRIET—Painter
Bayberry Lane, Westport, Conn. 06880
B. Buffalo, N.Y. Studied: N.Y. Sch. F. & App. A.; ASL, with Frank DuMond, Jon Corbino. Member: NAWA; Conn. Acad. FA; New Haven Paint & Clay Cl.; Silvermine Gld. A.; Springfield A. Lg. Awards: prizes, NAWA, 1953, 1959; New England Regional, 1957; New Haven (Conn.) Annual, 1959; Conn. Classic Arts, 1960. Work: painting, "First Born," used as Christmas card by Book-of-the-Month Club. Exhibited: NAWA, 1950-1964; Conn. Acad. FA, 1954-1958; New Haven Paint & Clay Cl., 1954-1958; Hartford Atheneum; Massillon Mus. A.; Univ. Bridgeport, 1957, 1967 (one-Man); Springfield A. Lg., 1955; Grand Central A. Gal.; NAD. Seven one-man shows since 1958. Contributor to Am. A. Group, 1958-1969.

ROSENHOUSE, IRWIN JACOB—Lithographer, Des., I., P.
85 Christopher St., New York, N.Y. 10014
B. Chicago, Ill., Mar. 1, 1924. Studied: Los A. City Col.; CUASch,
ASL. Member: AEA; Print Council of Am. Awards: Huntington
Hartford F., 1954, 1960; Tiffany Fnd. F., 1966. Work: Cooper Union
Mus.; N.Y. Pub. Lib.; MMA; Everhart Mus., Scranton, Pa. Illus.:
"What Kind of Feet Does a Bear Have?", 1963; "Science Book of
Magnets;" "The Rabbi's Bible." Illus. and des. for many publish-
ers, record companies, magazines, advertising agencies. Exhibited:
BM, 1949, 1958; Phila. Pr. Cl., 1951, 1956, 1957; Sweat Mem. Mus.,
1952; PAFA, 1953, 1954, 1957, 1959, 1963; LC, 1954, 1955; Boston
Pr. M., 1955; DMFA, 1954; Newport AA, 1954; CM, 1954, 1956; Au-
dubon A., 1956; MMoDA, 1953, 1956; Howard Univ., 1956; SFMA,
1957; AFA; Brooks Mem. Mus.; Univ. Kentucky; NGA; Soc. Wash. Pr.
M., 1958; one-man: Everhart Mus., 1958; Hicks Street Gal., Brook-
lyn, 1961; Silvermine Gld. A., 1964; Stendler Gal., N.Y., 1962; West-
ern Reserve Univ.; Loyola Univ., Chicago; Rosenberg Library, Gal-
veston, Tex., and others. Positions: Instr., MMoDA Art Edu. Center,
N.Y., 1967-1969; Owner, Dir., Rosenhouse Gal., N.Y., 1963- .

ROSENQUIT, BERNARD—Painter, Etcher
1437 First Ave., New York, N.Y. 10021
B. Hotin, Roumania, Dec. 26, 1923. Studied: ASL; Atelier 17, N.Y.;
BM Sch. A.; Fontainebleau Sch. FA, France; Inst. Art & Archaeol-
ogy, Paris. Member: ASL; Phila. Pr. Cl; AEA. Awards; Fulbright
Grant (Painting) to Paris, France, 1958; Tiffany Fnd. Grant (Print-
making), 1959. Work: MMA; BM; Victoria & Albert Mus., London;
Smithsonian Inst.; Bryn Mawr Col.; Univ. Kansas; Dallas AA; Long
Beach Pub. Lib.; Peabody Col., Nashville, Tenn. Work also in pri-
vate colls., U.S., Europe and Canada. Exhibited: Honolulu Acad. A.;
BMFA; BM; Newark Mus. A.; A. Gal. of Toronto; Oakland A. Mus.;
U.S. Nat. Mus., Wash., D.C.; New School, N.Y.; Phila. Print Cl.;
SAM. One-man: Roko Gal., N.Y., 1951, 1953, 1958, 1961, 1962, 1966.

ROSENTHAL, MRS. ALAN H.—Collector
169 E. 69th St., New York, N.Y. 10021*

ROSENTHAL, BERNARD—Sculptor
358 East 57th St., New York, N.Y. 10022
B. Highland Park, Ill., 1914. Studied: Univ. Michigan, B.A.; Cran-
brook Acad. A. Awards: prizes, SFMA, 1950; Los A. Mus. A., 1950,
1957; So. Cal. Chapter, AIA; PAFA, 1954; Audubon A., 1953; dis-
tinguished honorary award, Univ. Michigan. Work: S., Los A. Mus.
A.; Illinois State Mus.; Univ. Arizona; Milwaukee A. Center; Ari-
zona State Col.; deCordova & Dana Mus.; Long Beach Mus. A.;
MMoDA; Albright A. Gal.; BMA; Milwaukee A. Center; Los A. Mus.
A.; Santa Barbara Mus. A.; Illinois State Mus. Architectural com-
missions: Robinson's, Beverly Hills; General Petroleum Bldg., Los
A.; 1000 Lake Shore Dr., Chicago; Police Bldg., Los A.; Century
City, Los Angeles; Southland Center, Dallas; Temple Emanuel, Bev-
erly Hills; Israel Mus., Jerusalem; New York Univ.; Univ. Indiana;
Univ. California at Los Angeles; Herron Mus., Indianapolis; Birla
Acad. of Arts & Culture, Calcutta, India; Krannert A. Mus., Univ.
Illinois; sculpture, Jefferson Plaza, Univ. Michigan; sculpture,
Astor Place, N.Y., and others. Exhibited: MMA; AIC; PAFA; Arch.
Lg.; PMA; SFMA; S. Gld.; AFA traveling exh.; Los A. Mus. A.;
WMAA; Univ. Nebraska; Yale Univ.; Univ. Illinois; Sao Paulo, Bra-
zil; WAC; Inst. Contemp. A., Boston; Brussels World's Fair, 1958;
one-man: SFMA, 1951; Western Mus. Assn. traveling exh., 1951;
Santa Barbara Mus. A., 1952; Catherine Viviano Gal., N.Y., 1953,
1958, 1960; Carnegie Inst., 1959; Kootz Gal., N.Y., 1961, 1963,
1965; M. Knoedler & Co., N.Y., 1968; and others. Positions: Instr.,
UCLA, Los Angeles, Cal., 1952-53.

ROSENTHAL, DORIS—Painter, Lith., Des., T.
c/o Midtown Galleries, 11 East 57th St., New York, N.Y.;
10022; h. Porfirio Diaz 1220, Oaxaca, Oax., Mexico
B. Riverside, Cal. Studied: T. Col., Los A., Cal.; Columbia Univ.;
ASL with George Bellows, John Sloan. Awards: Guggenheim F.,
1932, 1936; prize, Northwest Pr.M.; NAD, 1952; Am. Acad. A. &
Let., grant, 1952. Work: MMA; AGAA; MMoDA; Colorado Springs
FA Center; Rochester Mem. A. Gal.; Toledo Mus. A.; Univ. Arizona;
Lib. Cong.; San Diego FA Gal.; Davenport Mun. A. Gal.; Cranbrook
Acad. A.; Encyclopaedia Britannica Mus. of Natural & Cultural His-
tory, Oklahoma State Univ. at Stillwater; Bemidji State College. Ex-
hibited: Mus. Mod. A., Paris, 1938; PAFA; WMA; VMFA; R.I.Sch.
Des.; Dallas Mus. FA; GGE, 1939; AIC; Latin America traveling
exh., MMA; Dayton AI; Collectors Gal., Chicago, 1961; St. Augus-
tine AA, 1961; NAD, 1965. One-man: BMA; Slater Mem. Mus.; Mid-
town Gal., 1965.

ROSENTHAL, GERTRUDE—Museum Curator, E.
3925 Beech Ave., Baltimore, Md. 21211
B. Mayen, Germany, May 19, 1906. Studied: Sorbonne, Paris; Univ.
Cologne, Ph.D. Member: CAA. Awards: Traveling F., Inst. FA,
Univ. Cologne, 1930; hon. degree, L.H.D., Goucher Col., 1968 and

D.F.A., Maryland Inst., Col. of A. Author: "French Sculpture in the
Beginning of the 18th Century," 1933. Contributor to: Journal of the
Walters A. Gal., Vol. V-VIII; Journal of Aesthetics; BMA "News,"
with articles on paintings & sculptures and their attribution. Ed.,
"The Age of Elegance: The Rococo and its Effects," 1959; Ed. &
Contributor, "Bacchiacca and His Friends" (Florentine Mannerist
Paintings and Drawings), 1961; Organizer of exhibition, Editor,
"From El Greco to Pollock"; "Early and Late Works by European
and American Artists," 1968. Contributor to art magazines, 1960-
61. Research grant from Nat. Fnd. on A. & Humanities, for "A
Comparative Study of American and German Romantic Painting in
First Half of 19th Century," 1968. Positions: A. Librarian, Goucher
Col., 1940-45; Dir. Research, BMA, Baltimore, Md.; 1945-48; Gen-
eral Cur., BMA, 1948-1957; Chief Cur., 1957-1969; Dep. Commis-
sioner for U.S., Venice Biennale, 1960; German Museums Study
Tour participant (sponsored by Fed. Republic of Germany, 1961).
Organizer of Baltimore Museum of Art 50th Anniversary Exh.
"1914." Editor and contributor to the catalog of this exhibition.

ROSENTHAL, NAN (Mrs. Otto Piene)—Writer
60 Wadsworth St., Cambridge, Mass. 02142
B. New York, N.Y., Aug. 27, 1937. Studied: Sarah Lawrence Col.,
B.A.; Smith Col. Awards: Radcliffe Inst. Scholar, 1968-1969. Con-
tributor articles on current art and architecture to Art in America,
Arts Canada, House and Garden, etc. Positions: Assoc. Editor, Art
in America, 1964-1966, Contributing Editor, at present.

ROSENTHAL, SEYMOUR—Lithographer, P.
161-08 Jewel Ave., Flushing, N.Y. 11365
B. New York City, N.Y. Aug. 14, 1921. Awards: St. Gaudens Medal.
Work: MMA; Herron A., Indianapolis, Ind.; Suffolk Mus., Stony
Brook, N.Y.; Assoc. Am. A., N.Y. Exhibited: Gal. Mod. A., N.Y.,
Dec.-Jan., 1964-1965 and Dec.-Jan., 1967-1968; one-man: Suffolk
Mus., Stony Brook, N.Y.; ACA Gal., N.Y., 1969.

ROSENWALD, MRS. BARBARA K.—Collector
Box 496, Rushland, Bucks County, Pa. 18956
B. Norfolk, Va., July 30, 1924. Studied: Boston Museum School of
Fine Arts; Fogg Museum, Harvard; Stella Elkins Tyler, School of
Fine Arts; Studied in Paris and Florence. Collection: Modern Ital-
ian art, including works by Afro, Campigli, Moscha; French modern
art, including works by Pignon and others.

ROSENWALD, LESSING JULIUS—Collector, Patron, Writer
Alverthorpe Gallery, 511 Meetinghouse Road 19046; h. 1146
Fox Chase Road, Jenkintown, Pa. 19046
B. Chicago, Ill., Feb. 10, 1891. Studied: Cornell University.
Awards: Honorary Degrees—D.H.L., University of Pennsylvania;
D.H.L., Lincoln University; LL.D, Jefferson Medical College.
Award for Distinguished Achievement, Philadelphia Art Alliance,
1963; Philadelphia Award, Artist's Equity Association, 1961. Mem-
ber: Grolier Club, N.Y.; Benjamin Franklin Fellow, Royal Society
of Arts, England; Print Council of America. Collection: Prints,
Drawings, Miniatures, Rare Illustrated Books. "Fior di Virtu 1491."
"The Nineteenth Book." Positions: Hon. Member, Bd. of Governors,
Philadelphia Museum of Art; Trustee, Free Library of Philadelphia;
Pres., Rosenbach Foundation, Philadelphia; Associate, Blake Trust,
London; Trustee National Gallery of Art (and Benefactor); Benefac-
tor, Library of Congress, Washington, D.C.; Institute of Advanced
Study, Philadelphia Museum of Art (Honorary).

ROSIN, HARRY—Sculptor, T.
New Hope, Pa. 18938
B. Philadelphia, Pa., Dec. 21, 1897. Studied: PMSchIA; PAFA; & in
Paris, France. Awards: Cresson traveling scholarship, 1926, med.,
1939, 1940, prize 1941, PAFA; Grant, Am. Acad. A. & Let., 1946;
med., PMA, 1951; prize, Audubon A., 1956; "Distinguished Pennsyl-
vania Artist," Phila., 1964. Work: PAFA; PMA; Papeete, Tahiti;
Deerfield, Mass.; mem., Fairmount Park, Phila.; bronze statue,
Connie Mack, City of Phila.; heroic statue of "Jack Kelly, Olympic
champion," Fairmount Park, 1965; four stone reliefs for facade of
the Chester County Court House, West Chester, Pa.; 1966. Exhib-
ited: World's Fair, Chicago, 1934; Texas Centennial, 1936; GGE,
1939; WFNY, 1939; AIC, 1934, 1946; WMAA; PAFA, 1933-1946, 1958,
one-man 1960; Detroit Inst. A.; 1958; Carnegie Inst.; Mod. Am. A.,
Paris, 1932; Salon de L'Oeuvre Unique, Paris, 1932; MMA, 1951.
Positions: Instr., S. and Drawing, PAFA, Philadelphia, Pa., 1939- .

ROSKILL, MARK WENTWORTH—Scholar, W., Cr., E.
Dept. of Art, University of Massachusetts, Amherst, Mass.
01003; h. 576 Main St., Amherst, Mass. 01002
B. London, England, Nov. 10, 1933. Studied: Cambridge Univ., Eng-
land, B.A., M.A.; Harvard University, M.A.; Courtauld Inst., London
University; Princeton University, M.F.A., Ph.D. Awards: Henry
Fellow, Harvard Univ., 1956-1957; American Council of Learned So-
cieties Fellowship, 1965-1966. Contributor to Art News, Art Inter-

national. Author: "English Painting from 1500 to 1865" (1959); "The Letters of Vincent van Gogh" (1963); "Dolce's Aretino and Venetian Art/Theory of the Cinquecento," (1968). Field of Research: Modern Art (19th and 20th century) and 16th century Italian Art. Positions: Instr., Princeton University, Princeton, N.J., 1959-1961; Instr., 1961-1963, Asst. Prof., 1964-1968, Harvard University, Cambridge, Mass. Assoc. Prof., Univ. Massachusetts, Amherst, 1968- .

ROSOFSKY, SEYMOUR—Printmaker
859 W. Fullerton St., Chicago, Ill. 60614
B. Chicago, Ill., 1924. Studied: AIC; M.F.A. Awards: Fulbright Fellowship, Rome; Guggenheim Fellowship (2) to Paris; Tamarind Fellowship, 1968. Work: MModA; AIC; Joseph Hirshhorn Coll., and others. Exhibited: more than 21 one-man exhibitions. Also in group exhibitions including France, Belgium, Italy, Canada and U.S.*

ROSS, ALEX—Illustrator, P.
Hawthorn Rd., Ridgebury, Conn.
B. Dunfermline, Scotland, Oct. 28, 1909. Studied: Carnegie Inst., with Robert Lepper. Member: ANA; SI; AWS; Silvermine Gld. A.; Fairfield WC Group; Westport AA. Awards: prize, New England Regional Exh., 1957; Hon. deg. M.A., Boston Col., 1953. Other awards: medal, Los Angeles County Fair, 1960; Award of Merit, SI, 1963, 1964, 1965; Ranger Fund purchase, AWS, 1964; prizes, AWS, 1962; New Canaan WC Exh., 1964; Conn. WC Soc., 1964. Work: U.S. Air Force Acad., Colorado Springs, Colo.; murals, Mormon Pavillion, N.Y. World's Fair, 1964; and in private colls. Exhibited: Covers for Good Housekeeping magazine, 1942-1954. Contributor to Sat. Eve. Post; Ladies' Home Journal; Cosmopolitan; McCalls magazines. Illus: "Saints" (52); "This Is the Rosary" (17); "Father Gilbert's Prayer Book" (25). Lectures: colleges, art clubs and organizations on Art of Illustration. Positions: Bd. of Trustees, Fairfield (Conn.) University, 1965.

ROSS, ALVIN—Painter, E.
127 West 20th St., New York, N.Y. 10011
B. Vineland, N.J., Jan. 12, 1920. Studied: Tyler Sch. FA, Temple Univ., B.F.A., B.S. in Ed.; Barnes Fnd., and in Florence, Italy. Work: Minneapolis Inst. A.; R.I. Sch. Des. Mus.; La Jolla A. Center. Exhibited: NAD, 1969; Isaacson Gal., N.Y., 1959, 1961; MModA, 1960; AIC, 1961; Peridot Gal., N.Y., 1961; AIC, 1960; New Sch. for Social Research, 1964; Banfer Gal., N.Y., 1966-1968; Graham Gal., N.Y., 1962; Hirschl & Adler Gal., N.Y., 1963; Butler Inst. Am. A., 1968; Audubon A., 1968; Bertha Schaeffer Gal., 1968; Am. Acad. A. & Lets., N.Y., 1962. Lectures on Art & Architecture, Pratt Inst., New York School of Int. Des. and New School for Social Research, N.Y. Contributor to Journal of Aesthetic Education. Positions: Hd., History of Art Dept., Pratt Institute, Brooklyn, N.Y.

ROSS, CHARLES—Sculptor
c/o Dwan Gallery, 29 W. 57th St., New York, N.Y. 10019*

ROSS, JAMES MATTHEW—Painter, Et., E.
Box 123, Platteville, Wis.; s. Box 109, Rte. 1, Roscommon, Mich. 53818
B. Ann Arbor, Mich., Sept. 8, 1931. Studied: Univ. Michigan, A.B.; Cranbrook Acad. A., M.F.A.; Rackham Sch. Grad. Studies, Ann Arbor; Accademia di Belle Arti, Rome. Member: CAA; Wis. P. & S. Soc.; AAUP. Awards: Fulbright Grant (Painting) to Italy, 1960, 1961; prizes, Mich. Artists Exh., 1955, 1960; Midwest Landscape Exh., 1953; Butler Inst. Am. A., 1955; Mich. State Fair, 1960; Mich. WC Soc., 1957, 1959, 1960; Wis. P. & S., 1963; Mich. FA Exh., 1964. Work: Butler Inst. Am. A.; Cranbrook Mus. A.; Detroit Inst. A. Exhibited: Butler Inst. Am. A., 1953-1955, 1957, 1958; Birmingham Mus. A., 1954; Detroit Inst. A., and PAFA 1959-60; Mich. State Fair, 1955, 1957, 1959-60, 1965; Flint Inst. A., 1960; Wis. State Univ., Whitewater, 1965; Mich. A., 1951-1960, 1963; Mich. WC Soc., 1955-1960, traveling 1955-1958; Midwest Landscape Exh., 1953; WAC, 1959-60; Wis. P. & S., at Milwaukee A. Center, 1963-1965; Wis. Salon, 1963-1965. Positions: Asst. Prof. A., Wisconsin State Univ., Platteville, Wis., 1962- .*

ROSS, JOHN—Printmaker, E., Gr., Des.
110 Davison Place, Englewood, N.J. 07631
B. New York, N.Y., Sept. 25, 1921. Studied: CUASch.; Ecole des Beaux-Arts, Fontainebleau, France; Columbia Univ.; and in Florence, Italy. Member: SAGA (Pres. 1961-65); Phila. Pr. Cl.; Am. Color Print Soc.; Boston Pr.M. Awards: Tiffany F., 1954; purchase prizes, DMFA, 1954; New Britain Mus.; Bradley Univ., 1953; Albany Pr. Cl., 1952; Wichita Pr. Cl.; SAGA, 1956, 1965, 1967, 1969; Int. Color Print Exh., Grenchen, Switzerland, 1961; purchase prizes: Phila. Pr. Cl., 1966; N.J. State Mus., 1967; NAD, 1963; Boston Pr. M., 1962; New Sch., N.Y., 1960. Work: MMA; LC; DMFA; New Britain Mus. A.; Albany Pr. Cl.; N.Y. Univ.; N.J. State Mus.; N.J. State T. Col.; CM; Pa. State Coll.; Hamilton Col.; Phila. Free Lib.; Smithsonian Inst.; New

School, N.Y.; Malmo Mus., Sweden; Princeton Univ.; Nat. Mus., Bucharest; CMA; Bradley Univ.; Tokyo A. Center; Univ. So. Illinois; Jewish Mus., N.Y., and many others. Exhibited: MModA, 1953; BM, 1951, 1953, 1955; Albright-Knox A. Gal., 1952; Carnegie Inst.; AAA Gal., 1965; LC, 1951, 1955, 1958 and traveling exh. to Germany, 1959; Swedish A. Council, 1954; BMFA; MMA, 1955; So. Cal. Pr. Cl.; PMA; DMFA; Oakland A. Mus.; Phila. Pr. Cl.; Princeton Univ.; VMFA; Cornell Univ.; Norfolk Mus. A. & Sciences; PAFA; Ringling Mus. A.; Albany Inst. Hist. & A., 1968; Hunter Gal., Chattanooga, 1968; Cal. State Col., Long Beach, 1969; Pratt Center for Contemp. Pr.M., 1968; Hofstra Univ., N.Y., 1968; in Krakow, Poland, 1968 and in Amsterdam, Madrid and Mexico City. One-man: Fairleigh Dickinson Univ., 1964; Yugoslavia, 1965; Manhattanville Col., 1965; Assoc. Am. Artists, N.Y., 1965; Houghton Col., 1966; Rochester Inst. Tech., 1967; Brandeis Univ., 1967; Medalie Gal., Boston, 1967; Univ. Maryland, 1967; Princeton Univ., 1968; Phila. A. All., 1969; Gordon Craig Gal., Miami, 1968, and many others. Positions: Pres., Exec. Bd., U.S. Com. of the Int. Assn. of Art, 1966-1967, 1968-1969; Chm., Advisory Council, Cooper Union, 1967-1968; Advisory Panel, New Jersey Council on the Arts; Instr., New Sch. for Social Research, N.Y., 1957-1965; Chm., A. Dept., Manhattanville College, 1966- . Chief Graphic Artist with USIA "Graphic Arts, USA" exhibit in Romania, 1964. Illus. (with Clare Romano) "Manhattan Island," 1957; "Spoon River Anthology," 1963; "Leaves of Grass," 1964; "Poems of Longfellow," 1967. Positions: Instr., New Sch. for Social Research, New York, N.Y., 1957-65; Instr., Manhattanville College, 1964-65.

ROSS, KENNETH—Museum Director, Cr., L.
Municipal Art Commission, Art Department, City Hall, Los Angeles, Cal.; h. 3533 Carnation Ave., Los Angeles, Cal. 90026
B. El Paso, Tex., Aug. 1, 1910. Studied: A. Center, Los Angeles; NAD; Florence, Italy; Grande Chaumiere, Paris, and with Duncan Grant, London; Othon Frieze, Paris. Member: Municipal Art Patrons, Los A. (Sec.-Treas.); Charter Member of Los Angeles County Museum of Arts; AFA; AAMus.; hon. memb.: AID, AIID, Cal. State College of Los Angeles. Positions: (1940-1965)-Cr., Pasadena Star News; Los A. Daily News; L., Univ. So. California, Art Dept.; Dir., Pasadena AI; Modern AI, Beverly Hills; General Mngr., Municipal Art Department, Los Angeles, Cal., at present.

ROSS, MARVIN CHAUNCEY—Museum Curator; W., E., L.
2222 Que St., Northwest, Washington, D.C. 20008
B. Moriches, N.Y., Nov. 21, 1904. Studied: Harvard Univ., A.B., A.M.; N.Y. Univ.; Univ. Berlin; Centro de Etudios Historicos, Madrid. Member: CAA; AFA; Archaeological Inst. Am.; Hispanic Soc. Am. (Cor. Memb.); Soc. Archaeology du Limousin (Cor. Memb.). Contributor to many art periodicals including Art Bulletin; Art Quarterly; Berlington Magazine; Gazette des Beaux-Arts; Pantheon; Journal of the Walters Art Gallery, etc. Author: Catalogue of Exhibition of Early Christian and Byzantine Art, Baltimore, 1947; Life of Christ in Masterpieces of Art; Catalogue of Folkwandering Antiquities, Walters A. Gal., 1961; Catalogue of Byzantine Antiquities at Dumbarton Oaks, Vol. I, Vol. II; The Art of Karl Faberge and His Contemporaries, 1965; Russian Porcelains in the Collection of Mrs. Merriweather Post, 1968. Co-author (with E. S. King) A Catalogue of American Art in the Walters Gallery; (with Anna W. Rutlidge) The Sculpture of W. H. Rinehart; (with Joan F. Erdberg) A Catalogue of Italian Majolica in the Walters Art Gallery; Editor: The West of Alfred J. Miller and George Catlin's Last Rambles; The West of Alfred Jacob Miller rev. ed., 1967. Positions: Cur., BM, 1934; Cur., Medieval Art, Walters Art Gallery, Baltimore, Md., 1934-52; Special Adv., Dumbarton Oaks Collection, 1940- ; Chief Cur., Los Angeles County Museum, 1952-55. Curator, Hillwood, Washington, D.C., at present. (Hillwood is the private home and art collections of Mrs. Merriweather Post). Fulbright Lecturer on Byzantine Art, Kunsthistorisches Institut, Univ. Vienna, 1960-61; Adviser, Medieval Art, Virginia Mus. FA, Richmond.

ROSS, MRS. WALTER—Collector, Patron
169 E. 69th St., New York, N.Y. 10021
B. New York, N.Y. Studied: Columbia University Extension; New York University. Collection: Late 19th and early 20th century art.*

ROSSI, JOSEPH—Painter, Des., T., L.
45 Lockwood Dr., Clifton, N.J. 07013
B. Paterson, N.J. Studied: Newark Sch. F. & Indst. A.; post-grad., Columbia Univ., and with John Grabach, Harvey Dunn. Member: AWS; SC; All. A. Am.; New Jersey WC Soc.; Audubon A.; North Shore arts Assn. Awards: prizes, Montclair A. Mus., 1946, 1948; SC, 1950; All. A. Am., 1953, 1959; Winsor Newton award, 1954; New Jersey WC Soc., 1955; Arthur Hill Mem. prize, 1951; Ernest Townsend purchase prize, 1952; Ellerhusen award, 1952; Gold medal, Seton Hall Univ., 1956; Jersey City Mus.; AAPL, also, Artist of the Year; Springfield, Mass. award; Bergen Mall purchase awards; Tercentennial Award and Gold Medal; Point Pleasant, 1968; Jersey City WC,

1968; Ringwood Manor WC, 1968, and others. Work: SC, and in private colls. Exhibited: NAD; AWS; Audubon A.; All. A. Am.; SC; NAC; Newark Mus. A.; Montclair A. Mus.; Trenton Mus. A.; and other galleries and museums. Positions: Instr., Newark Sch. F. & Indst. A., Newark, N.J.

ROSTON, ARNOLD —Designer, P., E., W., Patron, Collector
 Station Road, Great Neck, L.I., N.Y. 11023
B. Racine, Wis. Studied: NAD; The New School. Member: A. Dir. Cl. Awards: gold medal, A. Dir. Cl., 1954; Suydam Silver Medal, NAD; over 50 nat. and int. prizes from Nat. Exh. Advertising A.; MModA; AIGA; and other Adv., Educational, & Printing Trade associations, etc. Work: LC; MMA; Windsor Castle, England; MModA; Aldrich Mus. Contemp. A., Ridgefield, Conn.; New York Pub. Lib. Print coll. Exhibited: PAFA; Contemp. A. Gal.; Mun. A. Exh., N.Y.; Montclair A. Mus.; A. Dir. Cl., 1940- ; Lever House, 1963- ; BM; Cooper Union Mus.; MMA; Contributor to American Printer, Graphis, Art Directors' Annual and other trade magazines. Collection: Old Master drawings; contemporary drawings, paintings & sculpture. Donated Master drawings to Nat. Port. Gal., WMAA; N.Y. Phoenix Sch. A. Positions: A. Dir., Assoc. Creative Dir., Mutual Broadcasting System-RKO Teleradio Pictures, 1942-56; N.Y. Times Promotion Dept., 1935-1941; Visual Information Specialist, U.S. Govt., 1942-43; Instr., Adv. Des., Cooper Union, N.Y., 1945- ; BMSchA., Brooklyn, N.Y., 1951; Pratt Inst., Brooklyn, 1951, 1954-55; N.Y. Univ., 1969- ; Chm., 36th Annual Nat. Exh. Adv. Art & Des.; Des., 29th Art Directors Annual; Group Hd., A. Dir., Grey Advertising Agency, N.Y., 1956-57; Pres. & Chm. of Bd., A. Dirs. Cl. Scholarship Fund, Inc., 1960- ; Exec. Bd. & Dir., Art Dirs. Club, N.Y., 1961- .

ROSZAK, THEODORE J. —Sculptor
 1 St. Lukes Pl., New York, N.Y. 10014
B. Poland, May 1, 1907. Studied: AIC; NAD; Columbia Univ. Awards: F., AIC, 1928, 1929, prize, 1934, Campagna award, 1961; WMAA, 1934; medals, World's Fair, Poznan, Poland, 1930; AIC, 1948; 1951; PAFA, 1956; prize, Sao Paulo, Brazil, 1951. Work: WMAA; AIC; MIT Chapel, Cambridge, Mass.; Smith Col.; MModA.; Norton Gal. A.; CMA; NCFA; PAFA; Elvejham Mus., Madison, Wis.; BMA; WAC; Mich. State Univ.; Tate Gal., London; Mus. Mod. A., Sao Paulo, Brazil; sc., Eagle, U.S. Embassy, London, England; sculpture, N.Y. World's Fair, 1964-65, Transportation Area, Court of New Horizons. Exhibited: AIC, 1929-1931, 1933, 1934, 1938, 1941, 1947, 1948, 1951, 1961; WMAA, 1932-1938, 1941-1945, 1946-1952, retrospective, 1956, 1959; Minneapolis Inst. A., 1932-1937; AGAA, 1932; Cal. PLH, 1932; Honolulu Acad. A., 1933; PAFA, 1936; Columbus Gal. FA, 1937; Roerich Mus., 1934, 1935; A. Gld., 1936; Julien Levy Gal., 1941; MMA, 1946, 1950, 1952, 1953; Antwerp, Belgium, 1950; PMA, 1949; WAC, 1957; Los A. Mus. A., 1957; SFMA, 1957; SAM, 1957; Brussels World's Fair, 1958; one-man: Matisse Gal., 1950, 1952; Venice Biennale, 1960; AIC, 1961. Positions: Intl. Architectural Sculpture Comm., 1957; L., "The New Sculpture," MModA; "In Pursuit of an Image," AIC (publ. by AIC, 1955); Faculty, Sarah Lawrence Col., N.Y., 1941-56; Nat. Adv. Com., Nat. Council on Arts & Govt.; Nat. Adv. Com., Drawing Soc.; Trustee, Tiffany Fnd.; U.S. Delegate to Int. Congress of Arts, Vienna, 1960; President's Fine Arts Commission, Wash., D.C.; Trustee, Am. Acad. in Rome.

ROTAN, WALTER —Sculptor
 45 Christopher St., New York, N.Y. 10014
B. Baltimore, Md., Mar. 29, 1912. Studied: Maryland Inst.; PAFA; & with Albert Laessie. Member: F., NSS; Audubon A. Awards: F., PAFA; Cresson traveling scholarship, 1933, prize, 1946, PAFA; Tiffany Fnd. F., 1938; prizes, NAD, 1936, 1942, 1944, 1945; All. A. Am., 1956. Work: PAFA; Brookgreen Gardens, S.C. Exhibited: NAD; PAFA; AIC; PMA; Carnegie Inst.; Chicago AC; MMA; CM; WMAA; Audubon A.; Phila. A. All.; Conn. Acad. FA; Arch. L.; Springfield A. Lg.; NAC; NSS; New Haven Paint & Clay Cl.; Milch Gal.; Andre Seligmann Gal.; Arden Gal.; Ferargil Gal.; All. A. Am. Positions: Hd. A. Dept., Taft Sch., Watertown, Conn., 1938-1953.

ROTH, FRANK —Painter
 20 E. 17th St., New York, N.Y. 10003
B. Boston, Mass., Feb. 22, 1936. Studied: CUASch.; Hans Hofmann Sch. FA. Awards: Chaloner prize, 1960; Ford Fnd. purchase award, 1962; Guggenheim Fellowship, 1964; Ford Fnd. A.-in-Res., Univ. Rhode Island, 1966; Minister of Foreign Affairs Award, Int. Exh. of Young Artists, Tokyo, Japan, 1967. Work: Albright-Knox A. Gal., Buffalo; WMAA; Santa Barbara Mus. A.; BMA; WAC; Tate Gal, London; Michigan State Univ., East Lansing; Chase Manhattan Bank; Manufacturers Hanover Trust Co., N.Y.; McDonnell & Co., N.Y.; Am. Republic Ins. Co., Des Moines; Des Moines A. Center; Stedelijk Mus., Netherlands; John & Mable Ringling Mus. A., Sarasota; R.I. Sch. of Des., Museum; Leceister Edu. Committee, London, England; Mus. of the Univ. Utah; Pasadena Mus. A.; Mead Paper Co., New York, and in many private colls. Exhibited: Carnegie Inst., 1959;

WMAA, 1960 and Annuals; AFA traveling Exh., 1960 (group) 1968; Newark Mus., 1961; BMA, 1961; Nat. Inst. A. & Lets., N.Y., 1961; Flint Inst. Arts, 1961, 1963; CGA, 1962; Univ. Colorado, 1963; Univ. Illinois, 1965; AIC, 1959; Univ. Colorado, 1963; Tate Gal., London, 1965; Midland Group, Nottingham, England, 1966; Ulster Mus., Belfast, Ireland; Kent (Ohio) State Univ., 1968; Art in Embassies, 1969; Phila. A. All., 1969; Toledo Mus. A., 1969; Madrid, Spain, 1969; one-man: The Artists Gal., N.Y., 1958; Grace Borgenicht Gal., N.Y., 1960, 1962, 1963, 1964, 1965; The American Gal., N.Y., 1962; Galerie Anderson-Mayer, Paris, 1964; Hamilton Galleries, London, 1965; Paris, France, 1968; and others. Positions: Instr., Painting, State Univ. of Iowa, 1964 (summer); Instr., Painting, The School of Visual Arts, N.Y., 1963- ; Univ. Cal., Berkeley, 1968.

ROTH, JAMES BUFORD —Painter, Conservator
 William Rockhill Nelson Gallery of Art, Kansas City, Mo.; h. 235 Ward Parkway, Kansas City, Mo. 64112
B. California, Mo., May 11, 1910. Studied: Kansas City AI; Harvard Univ. Member: F., Intl. Inst. for Conservation of Mus. Objects. Awards: medal, 1932, prize, 1937, Kansas City AI; prize, CAA, 1933. Work: Altarpiece, Grace and Holy Trinity Cathedral, Chapel, Rockhurst Col., both in Kansas City, Mo. Lectures on Method and Processes, Materials and Techniques of Painting. Author: "Discovery and Separation of Two Layers of Ancient Chinese Wall Painting," Artibus Asiae. Positions: Resident Conservator, William Rockhill Nelson Gallery of Art, Kansas City, Mo., 1935- .

ROTHKO, MARK —Painter
 118 E. 95th St., New York, N.Y. 10028*

ROTHSCHILD, HERBERT M. —Collector, Patron
 R.D. 1, Ossining, N.Y. 10562
B. New York, N.Y., Nov. 18, 1891. Collection: 20th century European art.*

ROTHSCHILD, LINCOLN —Sculptor, P., W., E., L.
 63 Livingston Ave., Dobbs Ferry, N.Y. 10522
B. New York, N.Y., Aug. 9, 1902. Studied: Columbia Univ., A.B., A.M.; ASL, with Kenneth Hayes Miller. Work: WMAA. Awards: prize, Village A. Center, 1948. Author: "Sculpture Through the Ages," 1942; "Style in Art," 1960. Monograph on Hugo Robus for AFA series of Retrospective Exhs. on Ford Fnd. grant, 1960. Contributor to Sat. Review of Lit., World Book Encyclopaedia, Collier's Encyclopaedia, Encyclopedia Americana; The American Scholar, Teachers College Record. Editor, The Pragmatist in Art. Positions: Instr., FA Dept., Columbia Univ., 1925-35; Dir., N.Y. Unit of American Design, 1938-40; Asst. Prof., Chm. A. Dept., Adelphi Col., Garden City, N.Y., 1946-50; L., ASL, 1948-51; Exec. Dir., AEA, New York, N.Y., 1951-1957. Lecturer: Art Dept., City Col. of N.Y., 1964-1968.

ROUSE, MARY JANE DICKARD —Scholar
 Indiana University; h. 2633 Dekist St., Bloomington, Ind. 47401
B. Monroe, La., Oct. 17, 1924. Studied: Louisiana Polytechnic Inst., B.A.; Institute of Design, Chicago; Louisiana State University, M.A.; Stanford (Cal.) University, Ph.D. Awards: Danforth College Teacher Fellowship, 1960-1961; Stanford Fellowship, 1961-1962. Author: articles on research, curriculum, and research monographs. Fields of research: Experimental aesthetics; evaluation; curriculum. Positions: Instr., Art Department, Louisiana Polytechnic Institute, 1956-1960; Assistant and Associate Professor of Art Education, Indiana University, 1963- ; Teaching Specialties: Research and Curriculum Development; 13 articles and monographs currently involved in development of curriculum, grades 1-6, being tested in Bloomington Schools and in University City, Missouri; will be published, 1970.

ROUSSEAU, THEODORE, JR. —Museum Curator
 Metropolitan Museum of Art, Fifth Ave. at 82nd St.; h. 4 East 78th St., New York, N.Y. 10021
B. Freeport, L.I., N.Y., Oct. 8, 1912. Studied: Harvard Univ., B.A., M.A.; Eton Col., Windsor. Member:Century Assn.; Grolier Cl. Awards: Harvard Traveling F., 1938-1939; Legion of Merit; Legion of Honor, France; Order of Orange-Nassau. Contributor to MMA and other museum Bulletins; Art News; Revue de Paris. Lectures on Painting, at universities and museums. Author: "Paul Cezanne," 1953; "Titian," 1955; "The Metropolitan Museum," 1957. Arranged Van Gogh Exhibition, MMA, AIC, 1949-50; Cezanne Exhibition, MMA, AIC, 1952; Vienna Art Treasures, 1950; Dutch Painting: The Golden Age, MMA, Toledo Mus. A., Art Gal. of Toronto, 1954-55. Positions: Asst. Cur., Paintings, Nat. Gal. A., Wash., D.C., 1940-41; U.S. Navy, 1941-46; Assoc. Cur., Paintings 1947, Cur., 1948- , MMA, New York, N.Y.*

ROVELSTAD, TRYGVE A. —Sculptor, Des., E.
 535 Ryerson Ave., Elgin, Ill. 60120
B. Elgin, Ill. Studied: AIC; Univ. Washington, and with Lorado Taft.

Work: Designed and Edited the American Roll of Honor, World War II which is placed in the American Chapel of St. Paul's Cathedral, London, England. Des. and executed U.S. Elgin Commemorative Half Dollar; U.S. Army of Occupation of Germany Medal; Legion of Merit; Bronze Star; sc. life size port. of Sen. William Barr, placed in the Capitol, Springfield, Ill.; dedication plaque of Gov. Stratton in Illinois State Office Bldg.; bronze portrait medallions of Gov. Stratton for new Elgin, Ill. bridge; "I WILL Medal" Associated I Will Sculptors of Chicago, 1964; Logan Hay "Lincoln" Medal, Abraham Lincoln Assoc., Springfield, Ill., 1967; Mark Twain Medal, Chase Commemorative Society, N.Y., 1967; Illinois Sesquicentennial Medal, Illinois Sesquicentennial Commission, 1968; Lincoln Heritage Trail Medal, Lincoln Heritage Trail Foundation, Champaign, Ill., 1969; "Screaming Eagle Medal," 101st Airborne Division Assoc. Medal, 1969; Captive Nations Proclamation Medal, Chicago Captive Nations Committee, 1969; Chicago Coin Club 50th Anniversary Medal, 1969, and other works. Exhibited: 1959-60, "A Thousand Years of Calligraphy and Illumination," Peabody Inst. of the City of Baltimore, Md. Positions: Sculptor, U.S. War Dept., Shrivenham, England, 1945-46; Des.-Sculptor for business firms and studios; Heraldic Artist, Medalist, O.Q.M., Wash., D.C.; A.-Lith., Coast & Geodetic Survey, Map Div., Wash., D.C.; Pres., Pioneer Memorial Fnd. of Illinois, Inc.; Gov., Assoc. S. of Chicago.

ROWAN, FRANCES—Painter, Gr., T.
210 Pine St., Freeport, L.I., N.Y. 11520
B. Ossining, N.Y., Dec. 17, 1908. Studied: Randolph-Macon Woman's Col.; CUASch. Member: Nassau A. Lg.; Malverne A.; Silvermine Gld.; Prof. A. Gld. Awards: prizes, Nassau A. Lg., 1951, 1952, 1958; Malverne A., 1954; gold medal, Hofstra Col., 1957; gold medal, Malverne A., 1952; prize, Knickerbocker A., 1961. Exhibited: Audubon A., 1958, 1961, 1962; BM, 1958; AFA traveling exh., 1958; Country A. Gal., 1955-1964; Hofstra Col., 1950, 1951, 1954-1957, 1959, 1960, 1962; Knickerbocker A., 1961, 1962; Panoras Gal., N.Y., 1958 (2-man); Heckscher Mus., 1963; Silvermine Gld., 1967; Country A. Gal., 1955-1968. Positions: Instr., Country A. Gal., Westbury, N.Y., 1955-1966.

ROWAN, HERMAN—Painter, E.
2020 Washington Ave.; h. 1778 Emerson Ave., South, Minneapolis, Minn. 55403
B. New York, N.Y., July 20, 1923. Studied: CUASch.; San Francisco State Col.; Kansas State T. Col., B.S.; Univ. Iowa, M.F.A.; New School for Social Research, N.Y. Member: AEA. Awards: Two research grants, 1963, 1964 for color study in painting, Univ. Minnesota; purchase prize, Fine A. Gal. of San Diego, 1963; Albright-Knox A. Gal., Buffalo, N.Y.; purchase, Gilpin County Annual, Central City Colo. Work: WAC; FA Gal. of San Diego; Gilpin County AA.; BM; Univ. Notre Dame; Southwestern Col.; California Western Univ. Exhibited: Southwestern Col., 1965; WAC, 1965 (4-man); WAC, group exh., 1964, 1965, 1967; Cal. Western Univ., 1963; FA Gal. of San Diego, 1963, 1968; Mus. FA of Houston, 1962; SFMA, 1962; Grand Central Moderns, N.Y., 1961; MModA lending service, 1960, 1962, 1963; Columbus Mus. A., 1960; Univ. Nebraska, 1960; Mary Washington Col., 1960; Albright-Knox Gal., 1959; Art: USA 1959; Gilpin County AA, Colo.; Hunter Gal., Chattanooga, 1955; Joslyn Mus., Omaha, 1949, 1955; Woodstock (N.Y.) A. Gal., 1953; AIC, 1952; Nelson Gal. A., Kansas City, 1951; Mulvane A. Center, Topeka, 1949; one-man: 3 one-man exhs., Grand Central Moderns, N.Y., to 1965. Positions: Instr., State University of New York at Fredonia, 1956-61; San Diego State College, 1961-63; Assoc. Prof., Dept. Art, Univ. of Minnesota, 1963-1968, Asst. Chm., 1969- .

ROWLAND, BENJAMIN, JR.—Educator, W., P., L.
154 Brattle St., Cambridge, Mass. 02138
B. Overbrook, Pa., Dec. 2, 1904. Studied: Harvard Col., B.S.; Harvard Univ., Ph.D. Member: Royal Soc. Arts, London; Am. Archaeological Assn.; Boston Soc. WC Painters; Chinese A. Soc. (Ed.). Exhibited: WMAA, 1949, 1950; New Hampshire AA, 1951; PAFA, 1953; Boston A. Festival, 1954, 1956, 1957, 1961; one-man: Doll & Richards, Boston, 1949, 1950, 1952, 1954, 1962; BMA, 1949; Detroit Inst. A., 1952; Cal. PLH, 1953; Cambridge AA, 1969. Work: BMFA; FMA; Detroit Inst. A.; CAM. Author: "Jaume Huguet," 1932; "Wall-Paintings of India, Central Asia and Ceylon," 1938; Ed., Translator: "The Wall-Paintings of Horyuji," 1944; Author: "Harvard Outline and Reading List for Oriental Art," 1959, 1967; "Art and Architecture of India," 1953, 1959, 1967; "Art in East and West," 1955, paperback ed., 1964, Russian ed., 1958, Japanese ed., 1964; "The Classical Tradition in Western Art," 1963; "Ancient Art from Afghanistan," 1966; "From Cave to Renaissance," 1966. Contributor to art publications. Positions: Instr., 1930-35, Asst. Prof., 1935-40, Assoc. Prof., 1940-50, Prof., 1950- , Fogg Art Museum, Harvard Univ., Cambridge, Mass. Teaching: Indian and Iranian Art; Central Asia Art; American Art; Medieval Italian Art, all at Harvard University.

ROWLAND, ELDEN—Painter, T.
5453 Avenida del Mare, Sarasota, Fla. 33581
B. Cincinnati, Ohio, May 31, 1915. Studied: Cincinnati A. Acad.; Central Acad. Comm. A., Cincinnati; Farnsworth Sch. A.; San Antonio AI, and with Robert Brackman. Member: Sarasota AA; Bradenton AA; Florida A. Group; Friends of the Arts & Sciences, Sarasota. Awards: Richard Milton award, Boston, 1951; Soc. Four A., 1960; South Coast A. Show, 1961; Lowe Gal., Coral Gables, 1962; Spring Hill Col., 1962; A. Festival, Mobile, Ala., 1962; Gulf Coast Ann., Clearwater, Fla., 1964; Bradenton, Fla., 1967; Sarasota AA, 1967. Work: Monsanto Chemical Co., Springfield, Mass.; McGuire Hall A. Mus., Richmond Ind.; Stetson Univ.; Ryder System, Inc., Jacksonville, Fla.; New College, Sarasota; Lowe Gal.; Spring Hill Col., Mobile. Exhibited: Fla. State Fair; Soc. Four Arts; Callaway Gardens; Sun Carnival, El Paso; Hunter Gal., Chattanooga; Fla. Gulf Coast A. Center; Springville, Utah; traveling exhs., Fla. Artist Group; Eight Florida Artists, Venice, Italy, and circulated by USIS. One-man: Columbus (Ga.) Mus. A. & Crafts; Greenville (S.C.) Mus.; Sarasota AA; Bradenton A. Center; Asheville (N.C.) Mus.; Oak Room Gal., Schenectady, N.Y. Positions: Dir., Rowland Traveling Exh. Service, 1956-1961; Instr., Venice (Fla.) A. Lg.; Guest Instr., Tenn. Valley AA, 1968, 1969; Eden Isle Workshop, Heber Springs, Ark., 1968, 1969.

ROWLAND, MRS. HERRON—Museum Director
Mary Buie Museum, 510 University Ave.; h. 618 University Ave., Oxford, Miss. 38655
B. Ft. Smith, Ark., Apr. 30, 1891. Studied: Ward Seminary, Nashville, Tenn.; Deshler Inst., Tuscumbia, Ala. Positions: Dir., Mary Buie Mus., Oxford, Miss., 1939-1964.

ROWLANDS, TOM—Painter
Westmoreland County Museum of Art, Greensburg, Pa.; h. 68 Chestnut St., Boston, Mass. 02108
B. Pleasant City, Ohio, Mar. 8, 1926. Studied: Parsons Sch. Des., N.Y.; ASL; New Sch. for Social Research; CUASch. Awards: Gold medal, Assoc. A. Pittsburgh, 1960, prizes, 1962 (2); PAFA purchase, 1962; purchase award, Carnegie Inst., 1961, Posner prize, 1953; Pittsburgh Playhouse, 1956, 1957. Work: Carnegie Inst.; PAFA; City Hall, Boston; Westmoreland County Museum of Art, Greensburg, Pa. Exhibited: Carnegie International, 1955; Butler Inst. Am. A., 1960; Pittsburgh Assoc. A., 1953, 1961, 1962; one-man: Nasse Gal., Boston, 1964; Westmoreland Mus. A.. Greensburg, Pa., 1969. Positions: Artist-in-Res., Westmoreland County Museum of Art, Greensburg, Pa., at present.

ROX, HENRY—Sculptor, E., I., Comm. A.
15 Ashfield Lane, South Hadley, Mass. 01075
B. Berlin, Germany, Mar. 18, 1899. Studied: Univ. Berlin; Julian Acad., Paris, France. Member: NA; NS3; Springfield A. Lg. Awards: prizes, Springfield A. Lg., 1941, 1943, 1945, 1947, 1949, 1953, 1955; Syracuse Mus. FA, 1948, 1950; Wichita AA, 1949; Arch. Lg., 1949, 1954, 1955; Silvermine Gld. A., 1950, 1952; A. Dir. Cl., N.Y., 1950; A. Dir. Cl., Chicago, 1957; Audubon A., 1951, 1954, 1956 (medal); Boston A. Festival, 1953; Guggenheim F., 1954; NAD, 1952 (medal). Work: Springfield Mus. FA; Mt. Holyoke Col.; Father Judge Mission Seminary, Monroe, Va.; Los A. Mus. A.; Smith Col.; Merchandise Mart, Chicago; AGAA; John Herron AI; Dartmouth Col.; Syracuse Mus. FA; Faenza, Italy; Wisteriahurst Mus., Holyoke, Mass. Exhibited: PAFA; WMAA; PMA; Nat. Inst. A. & Let.; Syracuse Mus. FA; Yale Univ.; A. Dir. Cl.; AGAA; Wadsworth Atheneum; MMA; Smith Col.; Inst. Contemp. A., Boston; WMA; Boston A. Festival; Univ. Wisconsin; Denver A. Mus.; Detroit Inst. A.; Oregon Ceramic Studio, Portland; Portland (Me.) A. Festival, and in Europe; one-man: Concord State Lib., 1945; A. Headquarters Gal., N.Y., 1945; Springfield Mus. FA, 1945; Kleeman Gal., 1946; deYoung Mem. Mus., 1947; WMA, 1948; Mt. Holyoke Col., 1940, 1947, 1959; Univ. New Hampshire, 1950; Dartmouth Col., 1950; Fitchburg A. Mus., 1953. I: Originator of "Photo-Sculpture," advertising, children's books, motion pictures. Positions: Prof. A., Mount Holyoke Col., 1939-9964; Mary Lyon Prof., 1963. Instr. S., Worcester A. Mus., Worcester, Mass., 1946-52.*

ROYSHER, HUDSON (BRISBINE)—Designer, C., E., L.
1784 South Santa Anita Ave., Arcadia, Cal. 91006.
B. Cleveland, Ohio, Nov. 21, 1911. Studied: Cleveland Inst. A.; Western Reserve Univ., B.S.; Univ. So. California, M.F.A. Member: Am. Soc. Indst. Des.; Am. Craftsmen's Council; CAA; Pacific AA; NAEA; So. California Des.-Craftsmen (Chm., 1958-59). Awards: prizes, CMA, 1933, 1934, 1936, 1940, 1946; Wichita AA, 1949, Work: All Saints' Episcopal Church, Beverly Hills, Cal.; Assumption Roman Catholic Church, Pasadena; Assumption Roman Catholic Church, Ventura; St. Peter's Episcopal Church, San Pedro; Holy Innocent's Catholic Church, Long Beach; St. Paul's Episcopal Church, Cleveland Heights, Ohio; St. Brigid's Church, Los A.; Univ.

So. California; Immaculate Heart Retreat Chapel, Montecito; Syracuse Univ.; Cal. State Col. at Los A.; Sketches and drawings to be preserved in Hudson Roysher Manuscript Collection at Syracuse University Library. Work also in churches in Oakland, Apple Valley, Long Beach, Arcadia, La Crescenta, Pasadena, Anaheim, Newport Beach, Palm Springs, Salinas, Encino, Ventura, Altadena, Los Angeles, Tustin, Hermosa Beach, Corona, No. Hollywood, Cal.; Claremont (Cal.) Community Church; Queen of Angels Hospital, Covina, Cal.; Univ. Buffalo (Charter Mace); Cal. State Col. (Pres. Seal). Exhibited: America House, N.Y., 1950; Eleven So. Californians, 1952; deYoung Mem. Mus., 1952; Cal. State Fair, 1950-1952; Des.-Craftsmen of the West, 1957; So. Cal. Des.-Craftsmen, 1958; Los A. County Fair, 1952; State Dept. traveling exh., 1950-1952; Univ. Illinois, 1953; Smithsonian Inst. traveling exh., 1953-1955; Denver A. Mus., 1955; BM, 1961 (9-man invitational); CAM, 1964. Contributor to Craft Horizons; American Artist; Design; College Art Journal; Progressive Architecture. Positions: Instr., Indst. Des., Univ. Illinois, 1937-39; Asst. Prof. Indst. Des., Univ. So. California, 1939-42; Des., Gump's, San F., 1944-45; Dir., Indst. Des., Chouinard AI, 1945-50; Prof., Cal. State College at Los Angeles, App. A. & Sc., 1950- .

RUBEN, RICHARDS—Painter, T., Ser.
 8893 Central Ave., Montclair, Cal. 91763
B. Los Angeles, Cal., Nov. 29, 1924. Studied: Chouinard AI. Member: Cal. WC Soc. Awards: prizes, Bradley Univ., 1952; SFMA, 1953-1955; Pasadena A. Mus., 1953-1955; BM, 1953, 1954; Los A. Mus. A., 1957; Cal. WC Soc., 1953-1957; Oakland A. Mus., 1956; Stanford Univ., 1958; Univ. So. Cal., 1954; Tiffany Grant, 1954. Work: Pasadena A. Mus.; Los A. Mus. A.; BM; Bradley Univ.; Stanford Univ.; North Carolina Mus. A.; Univ. So. Cal.; Oakland A. Mus. Exhibited: Carnegie Inst., 1955; Sao Paulo, 1955; BM, 1953-1955; Guggenheim Mus., 1954; Univ. Illinois, 1952, 1956; CGA, 1953; PAFA, 1954; SFMA, 1953-1955; Bradley Univ., 1952, 1953; DMFA, 1953; Northwest Pr. M., 1954, 1955; Santa Barbara Mus. A., 1955, 1958; Los A. Mus. A., 1948, 1953, 1955, 1957; Cal. WC Soc., 1953-1957; Pasadena A. Mus., 1951-1957; Downtown Gal., N.Y., 1955; Colorado Springs FA Center, 1958; Stanford Univ., 1958; one-man: Grand Central Moderns, N.Y., 1958. Positions: Instr., Chouinard AI, Los Angeles, 1954- ; Dept. A., Pomona Col., 1958-59.*

RUBENSTEIN, LEWIS W.—Painter, E., Gr.
 Art Department, Vassar College; h. 153 College Ave., Poughkeepsie, N.Y. 12603
B. Buffalo, N.Y., Dec. 5, 1908. Studied: Harvard Col., A.B., and in France, Italy, Mexico, Japan and Spain. Member: SAGA. Awards: Traveling F., Harvard Univ., 1931-33; Fulbright F., 1957-58; prizes, SAGA, 1952, 1954; Silvermine Gld. A., 1959; U.S. State Dept. Grant to South America, 1961. Work: FMA; MMA; Pa. State Univ.; American Univ.; Ford Fnd.; USIA; Butler Inst. Am. A.; Vassar Col.; AGAA; R.I. Sch. Des. Mus.; murals. Buffalo Jewish Center. Exhibited: WMAA, 1941; CGA, 1942, 1944; NAD, 1946, 1952, 1963; Albright A. Gal., 1941, 1946; FMA, 1936, 1937; AGAA, 1935; Vassar Col., 1940, 1945, 1952, 1959, 1965; LC, 1952-1955, 1961; Munson-Williams-Proctor Inst., 1951; Berkshire Mus., 1955; Busch-Reisinger Mus., 1955; AWS, 1955, 1964; Birmingham Mus. A., 1954; SAGA, 1952-1965; CMA, 1954; Audubon A., 1961; Boston A. Festival, 1961; International House, Tokyo, 1958; Intl. Graphic Art traveling exh., 1960-61; Provincetown AA, 1959, 1960, 1962, 1964; Janet Nessler Gal., N.Y., 1959; Shore Gal., Boston & Provincetown, 1960-61, 1965; Ruth White Gal., N.Y., 1966. Produced film "Time Painting," 1956 (distr. by Edu. Film Lib. Assn., N.Y.); "Psalm 104," Weston Woods Studios, 1969. Contributor to Foreign Service Journal (covers, illus. 1958-1963). Positions: Prof. A., Vassar Col., Poughkeepsie, N.Y.

RUBIN, MR. and MRS. HARRY—Collectors
 700 Park Ave., New York, N.Y. 10021*

RUBIN, IRWIN—Painter, Des., E.
 126 Lincoln Place, Brooklyn, N.Y. 11217
B. Brooklyn, N.Y., July 26, 1930. Studied: BMSch. A.; CUASch.; Yale Univ., B.F.A., M.F.A. Exhibited: Fla. State Univ., 1960; BMA, 1960; Bertha Schaefer Gal., N.Y., 1960-1963; Martha Jackson Gal., N.Y., 1960, 1961; Nordness Gal., N.Y., 1961; Stable Gal., N.Y., 1964; Byron Gal., 1965. Contributor article, "Permanency in Collage" to Arts magazine, 1957. Positions: Instr., Drawing, Color Des., Univ. Texas, 1955; Asst. Prof., Fla. State Univ., 1956-58; Art Dir., Mc-Graw-Hill Book Co., New York, N.Y., 1958-1963; Instr., Pratt Institute, Brooklyn, N.Y., 1964- . Instr., Cooper Union Art School, 1967- .

RUBIN, LAWRENCE—Art Dealer, Collector
 49 W. 57th St. 10019; h. 65 East 91st St., New York, N.Y. 10028
B. New York, N.Y., Feb. 22, 1933. Studied: Brown University; Co-

lumbia Univ., B.A.; University of Paris. Specialty of Gallery: Contemporary painting and sculpture.

RUBIN, WILLIAM—Museum Curator, Writer
 Museum of Modern Art, 11 W. 53rd St. 10019; h. 831 Broadway, New York, N.Y. 10011
B. New York, N.Y., Aug. 11, 1927. Studied: Columbia University, A.B., M.A., Ph.D.; University of Paris. Author: "Modern Sacred Art and the Church of Assy," 1961; "Matta," "Dada, Surrealism and Their Heritage," 1968; "Dada and Surrealist Art," 1969. Positions: Professor of Art History, Sarah Lawrence College, 1952-1967; Professor of Art History, City University of New York, Graduate Division, 1960-67; American Editor, Art International magazine, 1959-1964; Adjunct Professor of Art History, Institute of Fine Arts, New York University, 1969- ; Chief Curator of the Painting and Sculpture Collection, Museum of Modern Art, 1969- .

RUBINGTON, NORMAN—Painter, S.
 c/o Siemab Gallery, 172 Newbury St., Boston, Mass. 02116*

RUBINS, DAVID KRESZ—Sculptor, T.
 3923 La Salle Court, Indianapolis, Ind. 46205
B. Minneapolis, Minn., Sept. 5, 1902. Studied: Dartmouth Col.; BAID; Ecole des Beaux-Arts, Julian Acad., Paris; & with James E. Fraser. Awards: F., Am. Acad. in Rome, 1928; grant, Nat. Inst. A. & Let., 1954; prize Arch.L., 1932. Work: Minneapolis Inst. A.; John Herron AI; Indiana Univ.; Archives Bldg., Wash., D.C. (in collaboration); State House and State Office Bldg., Indianapolis. Exhibited: Arch.L., 1932; NAD, 1932; Indiana A., 1936, 1938, 1940, 1942, 1944, 1946. Author: "The Human Figure—An Anatomy for Artists," 1953. Positions: Professor, S., Anatomy, John Herron A. Sch. of Indiana University at Indianapolis, Ind.

RUDA, EDWIN—Painter
 44 Walker St., New York, N.Y. 10013
B. New York, N.Y., 1922. Studied: ASL; Cornell Univ., B.S.; Columbia Univ. Teachers Col., M.A.; Sch. Painting and Sculpture, Mexico City, Mexico. Work: DMFA; Peoria A. Center; Allentown (Pa.) A. Mus., and in private collections. Exhibited: Great Jones Gal., N.Y., 1961; Camino Gal., N.Y., 1962; Park Place Gal., N.Y., 1963, 1967; Goldowsky Gal., N.Y., 1964; John Daniels Gal., N.Y., 1964; World's Fair, N.Y., 1965; Smithsonian traveling exh., Latin America, 1966; Guggenheim Mus., 1966; N.Y. Univ., 1966-1967; Krannert A. Mus., Univ. Illinois, 1967; Heath's Gal., Atlanta, 1966, 1967; Inst. Contemp. A., Phila., 1967; Park Place Groups exhs., Denver Mus. A., 1967 and M.I.T., Cambridge, Mass., 1968; Des Moines A. Center, 1968; Newark Mus., 1969; Aldrich Mus. Contemp. A., Ridgefield, Conn., 1968; J. L. Hudson Gal., Detroit, 1968; Paula Cooper Gal., N.Y., 1968, 1969; Sch. Visual A., N.Y., 1969. One-man: Globe Gal., N.Y., 1961; Feiner Gal., N.Y., 1963; Park Place Gal., (2-man), 1966, 1967; Paula Cooper Gal., N.Y., 1969. Positions: Instr., painting, design, drawing, Pratt Inst., Evening Sch., 1961-1967; Sch. Visual Arts, N.Y. (painting), 1968, 1969.

RUDOLPH, PROF. and MRS. C. FREDERICK—Collectors
 Ide Road, Williamstown, Mass. 01267*

RUDQUIST, JERRY J.—Painter, E.
 Art Department, Macalester College, St. Paul, Minn. 55101; h. 3100 46th Ave., South, Minneapolis, Minn. 55406
B. Fargo, N.D., June 13, 1934. Studied: Minneapolis Sch. A., B.F.A.; Cranbrook Acad. A., M.F.A. Member: CAA. Awards: George Booth Mem. Fellowship, Cranbrook Acad. A., 1956; Dayton Award, 1962 and Ford Fnd. purchase award, 1962; WAC, 1965; Minn. State Fair, 1967; Joslyn Mus. A., 1968; Minneapolis Inst. A., 1963 (2), 1965. Work: WAC; Bethel Col.; St. Cloud State Col.; Minneapolis Inst. A. Mural, Hubbard Bldg., St. Paul. Exhibited: Minnesota Biennial, 1959, 1961, 1963; WAC, 1958, 1962, 1964, 1966; Denver A. Mus., 1963; Colo. Springs FA Center, 1963; Joslyn A. Mus., 1964; 16 Younger Minnesota Artists, WAC, 1960; Mead Corp., 1965; Birmingham Mus., 1966; Artin Embassies program; Austin (Minn.) State Jr. Col., 1969; one-man: WAC, 1963; Minneapolis Inst. A., 1964; 3-man exh., WAC, 1966; 2-man, St. Cloud State Col., 1968. Positions: Assoc. Prof. A., Macalester College, St. Paul, Minn., at present.

RUDY, CHARLES—Sculptor, E.
 R.D., Ottsville, Pa. 18942
B. York, Pa., Nov. 14, 1904. Studied: PAFA. Member: ANA; NSS; AFA; Pa. State A. Comm.; NAD. Awards: Cresson traveling scholarship, PAFA, 1927-28, prize, 1947; Guggenheim F., 1942; prizes, Am. Acad. A. & Let., 1944; Woodmere A. Gal.; Phillips Mill, New Hope, Pa., 1961. Work: Brookgreen Gardens (S.C.); Michigan State Col.; PAFA; Univ. Virginia; Sun Oil Co.; Univ. Pennsylvania; USPO, Bronx, N.Y.; war mem., Virginia Polytechnic Inst.; Audubon Shrine, Montgomery County, Pa.; fig., Republic Steel Co., Cleveland; Edgar

Allan Poe statue for Capitol Grounds, Richmond, Va.; medal of Soc. of Medalists, 1958; Bust of Sec. of Labor, Goldberg, Labor Bldg., Wash., D.C., 1961; other work (1962-64): 2 marble reliefs, Abbot Dairies, Phila.; granite sculpture, Lehigh County Court House, Allentown, Pa.; sculpture for the new William Penn Mem. Historical Bldg. on the grounds of the Capitol, Harrisburg; MMA; PMA. Exhibited: PAFA, 1930, 1946, 1948, 1954, 1956, 1957, 1959-1961; WMAA, 1935, 1941-1946; Carnegie Inst., 1938; AIC, 1932, 1943; NAD, 1942, 1952-1955, 1960, 1961; AFA traveling exh.; Trenton, N.J.; MMA, 1951; S. Gld., 1952; PMA, 1950; NAD, 1956-1958; NSS traveling exh., 1958. Positions: Instr., PAFA, Philadelphia, Pa., 1956-1962.

RUELLAN, ANDREE—Painter, Lith., Et.
 c/o Kraushaar Gallery, 1055 Madison Ave., New York, N.Y. 10028; h. Shady, N.Y. 12479
B. New York, N.Y., Apr. 6, 1905. Studied: ASL; in Europe, and with Maurice Sterne, Charles Dufresne, and others. Member: Woodstock AA; Phila. WC Cl.; SAGA; ASL. Awards: prizes, WMA, 1938; N.Y. State Fair, 1951; Ball State T. Col., 1958; Am. Acad. A. & Let. Grant, 1945; Guggenheim F., 1950; medal, PAFA, 1945, 1950; Pepsi-Cola, 1948. Work: MMA; FMA; Nelson Gal. A; PMG; Springfield Mus. FA; Zanesville AI; Encyclopaedia Britannica; IBM; PMA; Pa. State Univ.; Butler Inst. Am. A.; Staten Island Mus.; Univ. Nebraska; LC; WMAA; Norton Gal. A.; Univ. Georgia; New Britain Mus.; Lehigh Univ.; PAFA; Storm King Art Center, N.Y.; Columbia (S.C.) Mus. A.; murals, USPO, Emporia, Va.; Lawrenceville, Ga. Exhibited: AIC, 1937, 1938, 1940, 1941, 1943; Carnegie Inst., 1930, 1938-1940, 1943-1945, 1948-1950; CGA, 1939, 1941, 1943; CM, 1937, 1938, 1940; PAFA, 1934, 1935, 1939-1944, 1948-1953, 1957, 1958, 1965; VMFA, 1943; CAM, 1938, 1939, 1941, 1946; Detroit Inst. A., 1943, 1958; WMAA, 1934, 1937, 1938, 1940, 1942-1945, 1949, 1951-1954, 1956, 1958, 1959; MMA, 1938, 1939, 1941; Univ. Nebraska; LC; WMAA; Norton Gal. A.; Univ. Georgia; New Britain Mus.; Lehigh Univ.; PAFA; Storm King Art Center, N.Y.; Columbia (S.C.)
Mus. A.; Univ. Nebraska, 1938, 1939, 1941; Univ. Illinois; Los A. County Fair, 1953; Century Cl., 1953; Witte Mem. Mus., 1954; Southern Circuit, 1953-54; Am. Acad. A. & Let., 1953 and traveling exh.; Phila. AA, 1956; IBM, 1957; So. Vermont A., 1957-58; Springville, Utah, 1957, 1958; Des Moines A. Center, 1958; DMFA, 1960; Mus. City of N.Y., 1958; Riverside Mus., 1960; IBM, 1960; Boston A. Festival, 1960; John Herron AI, 1958, 1959; Lehigh Univ., 1959, 1964; "Five Painters," Woodstock AA, 1964; Springfield Mus. A., 1960, 1962, 1964; Am. Acad. A. & Lets., 1960; Rensselaer Poly. Inst., 1958, 1959; Butler Inst. Am. A., 1958; Norfolk Mus. A., 1957, 1965; Ball State T. Col., 1958, 1965, and others; one-man: Phila. A. All., 1954; Kraushaar Gal., 1945, 1952, 1956, 1963; Columbia (S.C.) Mus., 1965; Sarasota AA, 1965; Staten Island Mus., 1958; Tulane Univ., 1959; and others. Retrospective Exh., Storm King A. Center, Mountainville, N.Y., 1966.

RUEPPEL, MERRILL C.—Museum Director
 Dallas Museum of Fine Arts, Fair Park, Dallas, Tex. 75226
B. Haddonfield, N.J., May 7, 1925. Studied: Beloit College, B.A.; University of Wisconsin, M.A., Ph.D. Member: Association of Art Museum Directors; American Association of Museums; Archaeological Institute of America. Author: Exhibition Catalogues: "Japanese Paintings and Prints from the Collection of Mr. and Mrs. Richard P. Gale," Minneapolis Institute of Arts, 1961; "200 Years of American Painting," City Art Museum of St. Louis, 1964; "Sculpture Twentieth Century," 1965, "Dubuffet," 1966, "Mark Tobey," 1968, all Dallas Museum of Fine Arts. Teaching: Associate Professor, Department of Art and Archaeology, Washington University, St. Louis, Mo., 1963. Positions: Research Assistant, 1956-1957, Assistant to Director, 1957-1959, Assistant Director, 1959-1961, Minneapolis Institute of Arts; Assistant Director, 1961-1964, City Art Museum, St. Louis, Mo.; Director, Dallas Museum of Fine Arts, Dallas, Texas, 1967- . Sec-Treas., Association Art Museum Directors, 1967-1968; Consultant to Ford Foundation Museum Training Program, 1963-1968.

RUHTENBERG, CORNELIS—Painter
 3908 Grand Ave., Des Moines, Iowa 50312
B. Riga, Latvia, Nov. 18, 1923. Studied: Hochschule für Bildende Künste, Berlin. Awards: Childe Hassam purchase award, Am. Acad. A. & Lets., N.Y., 1956, 1965; prizes, Scranton, Pa., 1960, 1962; Des Moines A. Center, 1964. Work: Everhart Mus., Scranton; Denver A. Mus.; Colorado Springs FA Center; Des Moines A. Center; BMFA. Exhibited: Paintings: USA, 1950; MMA, 1956; MModA, 1962; CGA; PAFA; AIC; NAD; Am. Acad. A. & Lets.; Denver A. Mus.; Colorado Springs FA Center; Des Moines A. Center and others.*

RUSCHA, EDWARD JOSEPH—Painter, Des.
 1024 N. Western Ave., Hollywood, Cal. 90029
B. Omaha, Neb., Dec. 16, 1937. Studied: Chouinard A. Inst.; Los Angeles City Col. Work: Los Angeles County Mus.; Pasadena A. Mus.; MModA; Joseph Hirshhorn Coll. Exhibited: Pasadena A. Mus., 1962; Los Angeles County Mus., 1963; Oakland Mus., 1963; Guggen-

heim Mus., N.Y., 1964, 1965; Collectors Show, Fine Arts Patrons, Balboa, Cal., 1964; Art Across America, Mead Paper Corp., 1965; Pace Gallery, N.Y., 1965; SAM, 1966; Robert Fraser Gal., London, England, 1966; Sao Paulo Biennale, 1967; V Paris Biennale, 1967; WMAA, 1967; Gallery Reese Palley, San Francisco, Cal., 1969; Inst. Contemp. A., London, 1969; 4-man: Oklahoma A. Center, 1960. One-man: Ferus Gal., Los Angeles, 1963-1965; Iolas Gal., N.Y., 1967; Irving Blum Gal., Los Angeles, 1968, 1969; Gallerie Rudolf Zwirner, Cologne, 1968.

RUSKIN, LEWIS J.—Collector, Patron
 5800 N. Foothill Dr., Scottsdale, Ariz. 85251
B. London, England, July 30, 1905. Awards: Hon. L.L.D., Arizona State University, 1968; Hon. Fellow, Phoenix Art Museum. Collection: 16th, 17th and 18th Century Paintings. Donor: Renaissance and Baroque Paintings to the Phoenix Art Museum; Renaissance, Baroque and Barbizon Paintings and Sculpture to Arizona State University Gallery. Positions: Chairman, Arizona Commission Arts and Humanities, 1967- .

RUSKIN, MICKEY—Collector
 Max's Kansas City, 213 Park Ave. S., New York, N.Y. 10003*

RUSSELL, SHIRLEY (HOPPER)—Painter, Ser., C., T.
 4220 Puu Panini Ave., Honolulu, Hawaii 96816
B. Del Rey, Cal., May 16, 1886. Studied: Stanford Univ., A.B.; San Jose State Col.; Cal. Col. A. & Crafts; San Francisco Sch. FA; Univ. Hawaii; Honolulu Acad. A.; Jepson Sch. A., with Lebrun, MacCoy; Immaculate Heart Col.; and with Umberto Romano, Hans Hofmann. In Paris, France: Colarossi, Grande Chaumiere, Andre L'Hote. Member: Palo Alto A. Cl.; Hawaii P. & S.; Hawaii A. Council; Honolulu Acad. A.; and several teachers' organizations. Awards: prizes, Honolulu Acad. A., 1933, 1935, 1938, 1943 (purchase), 1946 and numerous hon. men.; Grand prize, Territorial Fair, 1952, 1953; Hawaiian Electric Co., 1961 plus purchase award at Narcissus Festival. Work: Honolulu Acad. A.; Supreme Court; Moana Hotel; Royal Hawaiian Hotel; Tripler Hospital; Imperial Household Mus., Tokyo; Halekulani Hotel; Matson Navigation Co.; Gates Rubber Co., Denver; Tennant Fnd.; Hawaii Savings and Loan Co., and others. Exhibited: Nationale des Beaux-Arts, Paris, 1928; Galerie des Saussaies, Paris, 1954; Cal. PLH, 1946; Oakland A. Mus., 1940, 1942; Honolulu Acad. A., 1930-1964, 1968-1969; Palo Alto A. Cl., 1947; Terr. & State Fair, Honolulu, 1952, 1953, 1959, 1960; Univ. Hawaii, 1956, 1957; Chinese Chamber of Commerce, Honolulu, 1960; Hawaiian P. & S.; Ala Moana Easter Show; and others; one-man: Honolulu Acad. A., 1936, 1950, 1964; Gumps, Honolulu; Nickerson's Gal.; Moody Gal.; Moana Hotel; Hawaiian Village, 1958; Given & Given; Gima's, all Honolulu; Maxwell Gal., San F.; Gump's San F.; Harlow & Keppel & Kennedy Gal., both N.Y.; Cloissons, Cincinnati; Madonna Gal., 1959; Contemp. A. Center of Hawaii, 1967, and others. Included in Design Quarterly, "Art in Hawaii," 1960. Lectures on Art and Design. Positions: A. T., High Schools on mainland and in Hawaii; Summer sessions, Univ. Hawaii and Honolulu Acad. A.; Sec., 1939-40 & Pres., 1941, Assn. of Honolulu Artists; Chm., A.T. of Honolulu, 1946.

RUSSIN, ROBERT I.—Sculptor, E., L., W.
 Art Department, University of Wyoming, Laramie, Wyo. 82070
B. New York, N.Y., Aug. 26, 1914. Studied: BAID; Col. of City of N.Y. Member: S. Gld.; AIA (Assoc.); AAUP; NSS; F.I.A.L. Awards: prizes, Ford Fnd. F., 1953-54; Research F., Univ. Wyoming, 1954. Work: S., USPO, Evanston, Ill., Conshohocken, Pa.; bronze monument, campus, and relief, Law School, Univ. Wyoming; s. mural, Wyo. Highway Bldg., Cheyenne; Bas-relief, Wyo. Northern Community Col., Sheridan; marble bust, Am. Studies Bldg., Univ. Wyo.; Hd. F. D. Roosevelt, Roosevelt Univ., Chicago, Ill.; mural, Park Hotel, Rock Springs, Wyo.; bronze head of Lincoln at Summit of Lincoln Hghwy., Wyo.; bronze relief, Federal Bldg., Denver, Colo., and Cheyenne, Wyo.; bronze head of Lincoln, Lincoln Mus., Wash., D.C.; mosaic relief, College of Commerce & Industry, Univ. Wyo.; bronze fountain, Provident Fed. Savings & Loan Bldg., Casper, Wyo. Exhibited: MMA; WMAA; Main St. Gal., Chicago; AIC; Denver A. Mus.; Heritage Gal., Los A.; Joslyn A. Mus.; Schneider Gal., Rome; Univ. Nebraska; PAFA; Colorado Springs FA Center; NAD; New Orleans A. & Crafts; Arch. Lg.; Fairmount Park, Phila.; Phila. A. All.; Oakland A. Gal.; Syracuse Mus. FA, and others. Contributor to American Artist, College Art Journal. Positions: Prof. A., Univ. Wyoming, Laramie, Wyo.*

RUST, EDWIN C.—Sculptor, E.
 3725 Waynoka Ave., Memphis, Tenn. 38111
B. Hammonton, Cal., Dec. 5, 1910. Studied: Cornell Univ.; Yale Univ., B.F.A., and with Archipenko, Milles. Member: Nat. Assn. Schools of Art (Treas., 1963-); NSS. Work: Col. William and Mary; St. Regis Hotel, N.Y.; U.S. Court House, Wash., D.C.; Memphis Pub.

Lib.; Baptist Mem. Hospital, Univ. Tenn, Medical Sch., Presbyterian Church, Memphis State Univ., Memphis; Univ. of Tennessee (Knoxville); Univ. of Mississippi. Exhibited: WMAA, 1940; Carnegie Inst., 1940; MMA, 1942; VMFA, 1938; PMA, 1940, 1949; Brooks Mem. Mus., 1950, 1952. Positions: Assoc. Prof. S., 1936-43, Hd. FA Dept., 1939-43, College of William and Mary, Williamsburg, Va.; Dir., Memphis Acad. A., 1949- .

RUTA, PETER—Editor
23 E. 26th St. 10011; h. 853 Lexington Ave., New York, N.Y. 10021
B. Germany, Feb. 7, 1918. Studied: ASL; Acad. FA, Venice (degree). Exhibited: paintings—Hugo Gal., 1951; Iolas Gal., 1954; Angeleski Gal., 1964; Hacker Gal., 1964, all New York City; Galerie Schneider, Rome, Italy, 1953; Stonington (Conn.) Gal., 1961. Positions: Managing Editor, Arts Magazine, New York, N.Y., 1967- .

RUTLAND, EMILY (Mrs.)—Painter
Route 2, Box 49, Robstown, Tex. 78380
B. Travis County, Tex., July 5, 1894. Studied: with Xavier Gonzales, Frederick Taubes, Jacob Getlar Smith. Member: South Texas A. Lg.; Texas FA Assn.; Texas WC Soc.; A. Fnd., Corpus Christi (Hon.). Awards: prizes, South Tex. A. Lg., 1953-1958, 1961, 1962, 1963, 1965; Texas WC Soc., 1953, 1955; A. Fnd., 1953, 1954, 1956, 1958; Kingsville, Tex., 1955. Work: Witte Mem. Mus., San Antonio; DMFA; Texas Tech. Col., Lubbock; Delmar Col., Corpus Christi; Corpus Christi Mus. A. Exhibited: Miami Beach, 1953; Texas WC Soc., 1959, 1964; Beaumont A. Lg., 1959; South Texas Art, 1959, 1960, 1961; Texas Annual, Dallas, 1959; A. Fnd., Corpus Christi, 1960, 1965; Laguna Gloria Mus., Austin, 1961, 1965; A. & I. Col., Kingsville, 1965; Yuca Gal., Alice, Tex., 1965; Texas FA, Austin, 1964; one-man: Corpus Christi Mus. A., 1953; A. & I. Col., Kingsville, Tex., 1954, 1957, 1964; Goliad, Tex., 1958; Alice, Tex., 1955, 1964.*

RUVOLO, FELIX—Painter, E. '
78 Strathmore Drive, Berkeley, Cal. 94705
B. New York, N.Y., Apr. 28, 1912. Studied: AIC, and in Sicily. Awards: prizes, AIC, 1942, 1946, 1947; Cal. PLH, medal, 1946; SFMA, 1942, 1945, 1946, 1949, 1950, 1953, 1955, 1958, 1964; VMFA, 1944; Milwaukee AI, 1946; Grand Central A. Gal., 1946; Pepsi-Cola, 1947, 1948; Univ. Illinois, 1949; Philbrook A. Center, 1951; San F. A. Festival, 1951; Richmond (Cal.) A. Center, 1956, 1957, 1959 (2); Jack London Square Exh., 1956; Univ. Cal. Inst. Creative Arts grant to Europe, 1964-65; purchase prize, Hall of Justice, 1967. Work: AIC; Univ. Illinois; Denver A. Mus.; Creative Press, San Francisco; Dennison Col.; Mills Col.; SFMA; Des Moines A. Center; Philbrook A. Center; Univ. Wisconsin; Univ. Michigan; WAC. Exhibited: Universities of Illinois, Wisconsin, Michigan, Minnesota, Ohio, Kansas, Nebraska, Iowa, Oklahoma, Colorado, Indiana, Southern Illinois, Utah; Cornell Univ.; colleges: Mills, Adelphi, Smith, Carleton, Skidmore, North Dakota Agricultural, MacMurray, Eastern Illinois State; WMAA; VMFA; Carnegie Inst; PAFA; CGA; AIC; SFMA; BM; MModA; MMA; NAD; PC; PMFA; Galerie Creuze, Paris, 1957; Sao Paulo, Brazil, 1955, 1961; Vancouver (B.C.) A. Gal., 1958; AFA traveling exh., 1958; Inst. Creative Arts traveling exh., 1969-1970; Ithaca Col., 1969; Moore Col. A., Philadelphia, 1968; Galeria Van Der Voort, San Francisco, 1968, 1969; in Spain and England; and many others. One-man: Viviano Gal., 1950, 1951, 1954; Grand Central Moderns, 1949; deYoung Mem. Mus., 1948, 1957; Poindexter Gal., N.Y., 1958, 1960; Mills Col., 1948; Durand Ruel Gal., 1947; Rockford (Ill.) Mus., 1942. Positions: Prof. A., Univ. California, Berkeley, Cal., 1950- . Visiting Prof., Univ. So. California, (summer), 1963.

RYERSON, MARGERY AUSTEN—Painter, Et., Lith., W., I.
15 Gramercy Park South, New York, N.Y. 10003
B. Morristown, N.J., Sept. 15, 1886. Studied: Vassar Col., A.B.; Columbia Univ.; ASL, with Bridgman, Henri, Hawthorne. Member: NA; All.A.Am. (Vice-Pres., 1952-53); Baltimore WC Soc.; Audubon A. (Cor. Sec., 1958-59); AWS; SAGA; New Jersey WC Soc. Awards: prize, SAGA; med., Montclair A. Mus.; Hudson Valley AA, 1952, 1956, 1957, 1958; gold medal, NAC, 1957, 1962 and prize, 1964, prize, 1968; gold medal, 1969; New Jersey WC Soc., 1963, 1968; medal, Knickerbocker A., 1963; Maynard prize, NAD; Silvermine Gld. A. Work: BM, Bibliotheque Nationale, Paris; CMA; William Rockhill Nelson Gal.; IBM; Smithsonian Inst.; Lib.Cong.; Honolulu Acad. A.; N.Y. Pub. Lib.; Montclair A. Mus.; MMA; Uffizi Gal., Florence, Italy; Vassar Col.; NAD; Philbrook A. Center, Tulsa, Okla; Frye Mus., Seattle; Virginia State Col., Petersberg; Peck Sch., Morristown, N.J.; Junior Col., Cranford, N.J.; Norfolk Mus. A. & Sciences. Exhibited: NAD; PAFA; CGA; AIC; CAM; Phila. WC Cl.; Wash. WC Cl.; BM; AWCS; Chicago WC Cl.; New Jersey WC Cl.; Audubon A.; SAGA; Chicago SE; Phila. SE; Southern Pr.M.; Cal. Pr.M.; Phila. Pr. Cl.; All.A.Am.; NAC; Baltimore WC Cl. Ed., Henri's "The Art Spirit," 1924; "Hawthorne on Painting"; I., "Winkie Boo."

RYMAN, ROBERT—Painter
163 Bowery 10002; h. 116 E. 14th St., New York, N.Y. 10003
B. Nashville, Tenn., May 30, 1930. Studied: Tennessee Polytechnic Inst.; George Peabody Col. for Teachers. Exhibited: Loeb Student Center, N.Y. Univ., 1965, 1966; Guggenheim Mus., 1966; A. M. Sachs Gal., N.Y., 1967; Inst. Contemp. A., Philadelphia, 1967; Ithaca (N.Y.) Col. Mus. A., 1967; Paula Cooper Gal., N.Y., 1968; John Gibson Gal., N.Y., 1968; Riverside Mus., N.Y., 1965, 1968; AFA, 1967, 1968; MModA circulating exhs., 1967-1968, 1968; Contemp. A. Center, Cincinnati (4-man), 1968; WMAA, 1969; North Carolina Mus. A., 1969; Washington Univ. Gal., St. Louis, 1969 and in Switzerland, Holland, Germany. One-man: Bianchini Gal., N.Y., 1967; Konrad Fischer Gal., Dusseldorf, Germany, 1968; Gal. Heiner Friedrich, Munich, Germany, 1968; Fischbach Gal., N.Y., 1969.

SABATINI, RAPHAEL—Painter, S., E., Gr., L.
7318 Oak Lane Rd., Melrose Park, Pa. 19126
B. Philadelphia, Pa., Nov. 26, 1898. Studied: PAFA with Charles Graffy; in Europe with Leger, Bourdelle. Member: AAUP; F., PAFA; Phila. Pr. Cl.; Am. Color Pr. Soc.; Phila. WC Cl.; Phila. A. All.; AEA. Awards: Two Cresson European scholarships, PAFA, 1918, 1919; silver medal, Da Vinci All., 1952; prizes, F. PAFA, 1951, 1954, 1958; Phila. A. All., 1957; Church Arch. Gld., Pittsburgh, 1960; Phila. A. Dirs., 1960; Limback Fnd. Award for Distinguished Teaching, 1962; Percy M. Owens Memorial Award for Distinguished Pennsylvania Artist, 1963; 400th Anniversary of Michelangelo awarded by the American Institute of Italian Culture, 1964. Work: PAFA; PMA; Allentown (Pa.) Mus. A.; arch. sc., FA Bldg., Sesquicentennial, Phila., Pa.; N.W. Ayer Bldg.; Mother Mary Drexel Chapel, Langhorne, Pa.; Central Heating Plant, Wash., D.C. Exhibited: PAFA, 1918-1920, 1924-1930, 1949-1954, 1956, 1958, 1959, 1960; GGE, 1939; Intl. Sc. Exh., Phila., 1932, 1940, 1949; Phila. Pr. Cl., 1949-1954, 1956, 1957; Phila. A. All., 1954, 1956, 1958, 1959; AIC, 1957; Columbia (S.C.) A. Mus., 1957 (one-man); Festival of Italy, Phila., 1960; Phila. A. Dirs., 1960; one-man: PAFA, 1952; Temple Univ., 1953; Atlantic City A. Center, 1956; Columbia (S.C.) A. Mus., 1957; Lancaster, Pa., 1958; W. Va. State Col., 1958; Retrospective Exh., Phila. Pa., 1962. Lectures on Fine Arts to groups, in galleries and on TV. Author: "Manual for Sculpture Processes." Positions: Prof. FA, Temple Univ., 1936-1966. Vice-Pres., Phila. A. All., 1957- .

SABINE, JULIA—Art Librarian
Newark Public Library, 5 Washington St.; h. 371 Lake St., Newark, N.J. 07104
B. Chicago, Ill., Feb. 4, 1905. Studied: Cornell Univ., B.A.; Yale Univ.; Institut d'Art et d'Archeologie, Paris; Univ. Chicago, Ph.D. Contributor to professional, art and historical publications. Positions: Supv. Art & Music Librarian, Newark Pub. Library, Newark, N.J. Visiting Instr., Univ. of Kentucky; Rutgers Univ.

SACHS, A. M.—Art dealer
29 W. 57th St., New York, N.Y.; h. 20 E. 68th St., New York; N.Y. 10021*

SACHS, JAMES H.—Collector, Patron
60 E. 55th St., New York, N.Y. 10022; h. Long Ridge Rd., Pound Ridge, N.Y. 10576
B. New York, N.Y., Nov. 17, 1907. Studied: Harvard College, A.B.; Trinity College, Cambridge, England; Harvard Business School; French painting, prints and drawings under Paul J. Sachs. Collection: Prints, drawings, paintings, association copies, first editions, manuscripts. Donor (1958), Paul J. Sachs National Scholarship (Harvard) "for a National Scholarship of Scholarships in the field of the Fine Arts." Book Publisher, Co-owner, David White, Inc., New York City.

SACHS, SAMUEL II—Museum Chief Curator, Scholar, W., L.
The Minneapolis Institute of Arts, 201 E. 24th St., Minneapolis, Minn. 55404; h. Route 3, Wayzata, Minn. 55391
B. New York, N.Y., Nov. 30, 1935. Studied: Harvard Univ., B.A.; N.Y. Univ. Inst. FA, M.A. Member: IIC; CAA; AAMus. Contributor to Art News. Lectures: "American 19th Century Landscape Painting"; "Fakes and Forgeries." Awards: Order of the North Star (Sweden), Knight First Class, 1967. Field of Research: American 19th and 20th Century Art. Exhibitions arranged: Modern Illustrated Books from the Louis E. Stern Collection; Drawings and Watercolors by Leon Dabo; The Past Rediscovered: French Painting 1800-1900. Positions: Taught Graphic Art, University of Michigan, Ann Arbor; Chief Researcher, Armory Show Reconstruction, 1963; Asst. Dir., University of Michigan Museum of Art, 1962-64; Chief Curator, Minneapolis Inst. of Arts, 1964- .

SACHSE, JANICE R.—Painter
370 S. Lakeshore Dr., Baton Rouge, La. 70808
B. New Orleans, La., May 6, 1908. Studied: Newcomb A. Sch.; Louisiana State Univ.; Corcoran Sch. A. Member: AFA. Awards:

Award of Merit, Vincent Price-Sears Gal., Chicago, 1968 and prize 1966; Beaumont (Tex.) A. Mus., 1965; purchase prizes, Brooks Mem. Mus., Memphis, 1967; Loch Haven A. Center, Orlando, Fla., 1968. Work: Louisiana Art Commission; Pine Bluff A. Center, Ark.; Loch Haven A. Center; Fidelity Nat. Bank, Baton Rouge, La. Exhibited: Temple Israel (Pope Pius 1st annual Religious A. Exh., St. Louis, Mo.), 1963; N.Y. World's Fair, 1965; Louisiana A. Comm., 1964-1966; Pope Pius Library, St. Louis Univ.; Delgado Mus. A., New Orleans; Arkansas A. Center, Little Rock; Dixie Annual, Montgomery, Ala.; Mobile A. Gal.; Masur Mus., Monroe, La., 1966-1969; Oklahoma A. Center; Univ. North Carolina; La Boetie Gal., N.Y., 1966-1968; Int. House, New Orleans, 1968; one-man: New Orleans, 1963-1966, 1968; Baton Rouge, 1962, 1965-1967; Memphis, 1968; Jackson, Miss., 1968; Baton Rouge Gal., 1967-1970; other New Orleans galleries: Downtown, 1962, 1963; Glad, 1964, 1965; 331 Gal., 1966-1970; New Orleans Pub. Library, 1965.

SAFFORD, RUTH PERKINS—Painter
 2821 Dumbarton Ave., Washington, D.C. 20007
B. Boston, Mass. Studied: Mass. Sch. A., B.S.; & with Henry B. Snell. Member: Gld. Boston A.; AWS; Grand Central A. Gal.; Wash. WC Cl.; Wash. AC. Work: portraits of interiors: Lee Mansion, Marblehead, Mass.; Arlington, Va.; U.S. Naval Acad., Annapolis, Md.; Roosevelt home, Hyde Park; Nat. Gal. A., Wash., D.C.; Nat. Headquarters, AIA, Octagon House. Exhibited: Critics Choice, Cincinnati; New England Contemporary A.; AWCS; CGA; etc. More than 100 one-man exhs. Traveling exh. portraits of Interiors of Famous Homes of Virginia, sponsored by VMFA.

SAHRBECK, EVERETT WILLIAM—Painter, Des.
 South Harwich, Mass. 02661
B. East Orange, N.J., Nov. 4, 1910. Studied: N.Y. Univ., B.S.C. Member: AWS; N.Y. Art Dirs. Cl.; New Jersey W Soc. Awards: prizes, A. Dirs. Cl., N.Y., 1949-1954, 1960, 1962, 1965; N.J. WC Soc., 1950, 1955, 1956, 1958; AWS, 1961; All. A. Am., 1954. Work: Newark Mus. A.; Montclair A. Mus. Exhibited: AWS, 1948-1965; Art at Mid-Century Exh., 1955-1965; Methods and Materials of the Painter (nat. traveling exh.), 1954-1956; New Jersey WC Soc., 1948-1965; Montclair A. Mus., 1948-1965; 8 one-man exhs., in New Jersey, Mass., Fla., New York City and in N.J. Highgate Gal., 1963, 1965. Positions: Art Dir., Reach, McClinton & Co., Inc., 1934-1968.

SAIDENBERG, DANIEL—Collector, Art Dealer
 Saidenberg Gallery, 1037 Madison Ave. 10021; h. 941 Park Ave., New York, N.Y. 10028
B. Winnipeg, Canada, Oct. 12, 1906. Studied: The Julliard School of Music. Specialty of Gallery: 20th century European and American masters. Collection: 20th century European and American masters. Positions: President, Saidenberg Gallery, Inc., New York, N.Y.*

ST.'AMAND, JOSEPH—Painter
 950 Rhode Island St., San Francisco, Cal. 94107
B. New York, N.Y., Nov. 10, 1925. Studied: Loyola Univ. at Los Angeles; Univ. California at Berkeley; Cal. Col. of A. & Crafts; Cal. Sch. FA. Exhibited: SFMA, 1956; Carnegie Int., 1964; Cal. PLH, 1960-1964.*

ST. CLAIR, MICHAEL—Art Dealer
 Babcock Galleries, 805 Madison Ave. 10021; h. 865 First Ave., New York, N.Y. 10017
B. Bradford, Pa., May 28, 1912. Studied: Kansas City Art Institute, with Thomas Hart Benton; Art Students League, N.Y., with George Grosz; Colorado Springs Fine Arts Center, with Boardman Robinson. Awards: Vanderslice Scholarship, Kansas City Art Institute; Scholarship, Colorado Springs Fine Arts Center; prize, graphic arts, Kansas City Society of Artists. Exhibited: One-man, Oklahoma Art Center. Specialty of Gallery: American Paintings, 19th and 20th Century. Positions: Instr., Drawing and Painting, Oklahoma Art Center School; Director, Babcock Galleries, New York City, 1959- .

ST. JOHN, BRUCE—Museum Director
 Delaware Art Center, 2301 Kentmere Pkwy. 19806; h. 2300 Riddle Ave., Wilmington, Del. 19806
B. Brooklyn, N.Y., Jan. 10, 1916. Studied: Middlebury Col., (Conn.), B.A. Lectures on American Art. Major exhibitions organizer 50th Anniversary of Exhibition of Independent Artists of 1910; Exhibition of The Calder Family; Life and Times of John Sloan; Editor of "John Sloan's New York Scene, 1906-1913" (1965). Positions: Instr., Burton Jr. Col., Charlotte, N.C., 1950-55; Dir., Mint Mus. A., Charlotte, N.C., 1951-55; Cur., Bancroft Collection, Delaware Art Center, 1955-57; Dir., Delaware Art Center, 1957- & Cur., John Sloan Collection, Wilmington, Del.

SAINT-PHALLE, NIKI DE—Sculptor, P.
 c/o Iolas Gallery, 15 E. 55th St., New York, N.Y. 10022*

SAINZ, FRANCISCO—Painter, C., Des., Gr., L.
 151 Avenue B, New York, N.Y. 10009
B. Santander, Spain, May 8, 1923. Studied: Acad. FA, Madrid, and with F. Sainz de la Maza, Barcelona. Exhibited: Knickerbocker A., 1956; Panoras Gal., 1956 (one-man); Huebsch Gal., Woodstock, 1957; Saranac Lake, 1957; FAR Gal., N.Y., 1958; Downtown Community School, 1959, 1960; Assoc. Am. A., 1961; East Hampton Gal., 1961; Dorsky Gal., N.Y., 1964. Des. I., "Antique French Paperweights," 1955. Lectures: Wrought Iron; Spanish Art.*

SALEMME, ANTONIO—Sculptor, P., T., L.
 R.D. No. 4, Easton, Pa. 18042
B. Gaeta, Italy, Nov. 2, 1892. Member: BAID (Hon.); Internal. Platform Assoc. Awards: Guggenheim F., 1932, 1936; Guild Hall, East Hampton, N.Y. Work: MMA; Newark Mus.; Syracuse Mus. FA; port, C.I.T. Bldg., N.Y.; N.Y. Hospital; bronze port. of Gen. Eisenhower, Columbia Univ., 1964; bronze port. of Vilhjamur Stefansson, Manitoba Centennial Centre, Winnipeg, Can.; ports. at Kleinhan's Music Hall, Buffalo, N.Y., Yale Univ., Univ. of Chicago. Exhibited: PAFA; AIC; WMAA; MMA; Salon d'Automne, Paris; Salon des Tuileries, Paris; Weatherspoon Gal., Greensboro, N.C., 1967; traveling exh. to leading museums; eight one-man exhs., New York City; Weintraub Gal., N.Y., 1964; Pietrantonio Gal.; Guild Hall, East Hampton, N.Y.; Art: USA, 1958; Sagittarius Gal., N.Y., 1961 (one-man); Schoelkopf Gal., 1964 (one-man); Vestart Gal., N.Y.(one-man), 1969.

SALEMME, AUTORINO LUCIA—Painter
 112 W. 21st St. 10011; h. 130 W. 16th St., New York, N.Y. 10011
B. New York, N.Y., Sept. 23, 1919. Studied: NAD. Member: AEA. Awards: Guggenheim Scholarship, 1942. Work: WMAA; N.Y. Pub. Lib. Print Coll.; NGA. Mosaic mural, Central Park South, N.Y. Exhibited: WMAA; AIC; LC; Carnegie Inst.; BMA; Denver A. Mus.; Cornell Univ.; BM; one-man shows in 1942, 1956, 1960, 1962, 1965. Positions: Instr., Drawing, Advanced Painting, MModA; same, N.Y. University.

SALEMME, MARTHA—Painter
 R.D. No 4, Easton, Pa. 18042
B. Geneva, Ill., Aug. 30, 1912. Studied: with Antonio Salemme. Work: N.Y. Hospital. Member: Int. Platform Assn. Exhibited: Van Diemen-Lillienfeld Gal., 1948 (one-man), 1949 (2-man); Burr Gal., 1957, 1958; Guild Hall, East Hampton, N.Y., 1958-1961; Pietrantonio Gal., N.Y., 1958; Sagittarius Gal., 1961, 1962; Hudson River Mus., 1959; Jersey City Mus., 1959, 1961; Rizzoli Gal., 1967; Int. Platform Assn. Exh., Washington, D.C., 1969.

SALERNO, CHARLES—Sculptor, E.
 269 Little Clove Road, Staten Island, N.Y. 10301
B. New York, N.Y., Aug. 21, 1916. Studied: ASL, with Nicolaides; Univ. of the State of New York, T. Col.; and in Mexico; Grande Chaumiere, Paris, with Zadkine. Member: S. Gld.; Audubon A. Arch. Lg. Awards: Tiffany F., and grant, 1948; Macdowell F., 1948, 1949; McKinney award, Silvermine Gld. A., 1960. Work: sculpture, Wadsworth Atheneum; R.I. Mus. A.; High Mus. A., Atlanta; Staten Island Mus. Hist. & A.; Arizona State Col., Tempe; Albion Col., Mich.; St. Simon's Episcopal Church, Staten Island, N.Y. Exhibited: Brussels World's Fair, 1958; Fairmount Park, Phila., 1949; WMAA, 1952; PAFA, 1950, 1953, 1954; N.Y. World's Fair, 1964; Audubon A., 1955, 1956; traveling exh., MModA, 1950-1952, 1955; AFA traveling exh., 1953; NSS, 1969; one-man: Weyhe Gal., 1946, 1947, 1949, 1951, 1958, 1961, 1965, 1969; Mexico City, 1950; Fort Worth AA, 1950; S. Gld., 1947, 1951, 1952, 1954, 1955, 1963, 1964, 1968. Monograph, "Salerno Sculpture," by Frances Christoph, 1965 (95 reproductions). Positions: Asst. Prof., S., City College of New York, 1964- . Guest Instr. Adelphi Col., Garden City, N.Y., 1957.

SALINAS, PORFIRIO—Painter
 c/o Dewey Bradford, 401 Guadelupe St., Austin, Tex. 78701*

SALTER, JOHN RANDALL—Sculptor, P., Des.
 811 N. Humphrey St., Flagstaff, Ariz. 86001
B. Boston, Mass., Apr. 16, 1898. Studied: AIC: B.F.A.; Univ. Iowa, M.A., M.F.A.; and with John Frazier, Jean Charlot. Awards: plaque for Distinguished Achievement in Liturgical Art, Scottsdale, Ariz. Member: Arizona WC Assn. Work: des. Chapel, des. and executed the stained glass, altarpiece, and devotional figures for the Episcopal Church, Flagstaff; triptych, St. Michael's and All Angeles Church, Tucson; Stations of the Cross, St. Philip Berinizi Catholic church, Black Canyon Village, Ariz.; Exhibited: Elgin (Ill.) Acad.; AIC; Oakland A. Mus.; Phoenix A. Mus., 1960; Joslyn Mus. A., Omaha; Liturgical Art Exh., Wichita, 1963; traveling exh., Arizona Artists, and others. One-man: (invitational)-Univ. Kansas; Rockford Col.; Beloit Col.; Kansas State Col.; Arizona State Univ., Topeka, Kans.; New Mexico State Col.; Wichita AA. Other recent exhibitions: Ahda Artz Gal., N.Y.; Burpee Gal., Rockford, Ill.; Sneed Gal., Rockford.

SALTER, STEFAN—Book Designer, T.
Cove Ridge Lane, Old Greenwich, Conn. 06870
B. Berlin, Germany, Sept. 28, 1907. Studied: in England & Germany. Awards: prizes, AIGA, "50 Books of the Year," Exhibited: AIGA, 1945. Contributor to: Book Binding & Book Production Magazine; Book Parade; Publisher's Weekly. Conducted workshops in book design. Positions: A. Dir., American Book-Stratford Press, 1937-43; H. Wolff Book Manufacturing Co., 1943-47; freelance, 1947- . Dir., AIGA.

SALTONSTALL, ELIZABETH—Lithographer, P., T.
231 Chestnut Hill Rd., Chestnut Hill, Mass. 02167
B. Chestnut Hill, Mass., July 26, 1900. Studied: BMFA Sch. A.; Andre L'hote Sch. A., Paris, France; lithography with Stow Wengenroth. Member: AEA; Audubon A.; Boston Pr.M.; NAWA; Pen & Brush Cl.; Springfield A. Lg.; Nantucket AA. Work: LC; BMFA; Yale Univ. A. Gal.; Bixler Mus., Colby Col.; Boston Public Library; Farnsworth A. Gal., Rockland, Me. Exhibited: LC (8 exhs.); Carnegie Inst.; BM; Audubon A.; NAWA; Hunterdon County A. Center; Pen & Brush Cl.; Print Cl. of Albany; Soc. Washington Pr.M.; Boston Pr.M., all numerous times.

SALTONSTALL, NATHANIEL—Collector
43 Commonwealth Ave., Boston, Mass. 02116
B. Milton, Mass., Apr. 24, 1903. Studied: Harvard University; Massachusetts Institute of Technology. Collection: American contemporary art. Positions: AiA Registered Architect (Partner), Massachusetts, New York and Virginia; Hon. President, Institute of Contemporary Art, Boston; Trustee and Advisory Committee, Decorative Arts Exhibition Program, AFA; Trustee and Chairman, Visiting Committee, Textiles Department, BMFA; Advisory Council, Friends of Art, Colby College, Waterville, Me.; Advisory Board, Skowhegan School of Painting and Sculpture, Skowhegan, Me.*

SALTZMAN, WILLIAM—Painter, E., S., Des.
5140 Lyndale Ave. South, Minneapolis, Minn. 55419
B. Minneapolis, Minn., July 9, 1916. Studied: Univ. Minnesota, B.S. Member: Minnesota AA; NSMP; CAA. Awards: prizes, Minneapolis Inst. A., 1936; Minn. State Fair, 1937, 1940; Walker A. Center, 1949, 1951. Work: Minneapolis Pub. Lib.; Walker A. Center; St. Olaf Col.; St. Paul Women's Cl.; Joslyn Mus. A.; Sioux City A. Center; Ft. Hayes (Kans.) Mus.; Dayton Co., Minneapolis; mural, Mayo Clinic; First Universalist Church, Rochester; Northwest Nat. Bank, mosaics, Northwest Nat.-Bank Bldg., Rochester, Minn; 10 stained glass windows, Temple of Aaron, St. Paul; stained glass: Univ. Minn. Chapel and Midwest Federal Bldg. Chapel, Minneapolis; sc., Lincoln General Hospital, Nebraska and First Congregational Church, Lincoln, Neb. Other work (1964-65): sc., B'nai Abraham Synagogue, Minneapolis; Univ. Minn. Hospitals; St. Edward's Parish, Austin, Minn. Exhibited: Cal. PLH, 1946; Minn. State Fair, 1936-41, 1946-1958; Minneapolis Inst. A., 1936-1941, 1959; St. Paul Gal. A., 1946, 1954, 1957; Minneapolis Women's Cl., 1953-1955, 1965; Walker A. Center, 1941 (one-man), 1949, 1951-1958, 1962; St. Olaf Col., 1952; Univ. Minnesota, 1939 (one-man); SFMA, 1948; Colorado Springs FA Center, 1948; Joslyn A. Mus., 1949, 1951, 1958, 1961, 1964; WMAA, 1951; CGA, 1950; Walker A. Center traveling exh., 1950-1952; Chicago, Ill., 1952; Carnegie Inst., 1952; AIC, 1947; other exhs. 1961-65: Faribault A. Center; Krannert Gal., Univ. Ill.; WAC; Mankato State Col.; Springfield A. Mus.; Water color: USA, 1963; St. Paul A. Center; Drawing:USA, 1963; Soc. Four Arts, Palm Beach; Denver A. Mus.; Mankato FA Center; Ball State T. Col., Muncie; PAFA; NAD; Olivet Col., and others. One-man (1961-65): Little Gal., Madison, Wis.; Waterloo A. Center; Women's City Cl., St. Paul; Luther Col., Decorah, Iowa; St. Paul A. Center St. Olaf Col., Northfield, Minn. Other one-man: Rochester A. Center, 1948-1958, 1963; Kilbride-Bradley A. Gal., Minneapolis; Univ. Nebraska, 1950; Stephens Col., 1950; Carlton Col., 1951; Dayton AI, 1952; Little Studio, N.Y., 1960-61; Swarthe-Burr Gal., Beverly Hills, Cal., 1960-61; WAC, 1960; Tweed Gal., Univ. Minn., Duluth, 1966; Macalester Col., St. Paul, 1966. Positions: Asst. Dir., Univ. Minnesota A. Gal., 1946-48; Res. A., Dir., Rochester A. Center, Rochester, Minn., 1948-1964. Visiting Prof. A., Univ. Neb., 1964. Macalester Col., St. Paul, Minn, Visiting Prof., 1966-1967, Assoc. Prof. A., 1968- .

SALZ, SAMUEL—Art Dealer
7 E. 76th St., New York, N.Y. 10021*

SAMARAS, LUCAS—Sculptor
233 E. 77th St., New York, N.Y. 10021
B. Kastoria, Macedonia, Greece, Sept. 14, 1936. Studied: Rutgers Univ., B.A., with Alan Kaprow; Columbia Univ., with Meyer Schapiro. Awards: Woodrow Wilson Fellowship, 1959; Copley Award, 1964. Work: MModA. Exhibited: Hansa Gal., 1959; Reuben Gal., 1960; Martha Jackson Gal., 1960; Green Gal., 1961-1963; MModA, 1961, 1962; DMFA, 1962; SFMA, 1962; CGA, 1963; Preston Gal., 1963; Washington Gal. Mod. A., 1963; Albright-Knox A. Gal.,

Buffalo, 1963; Bianchi Gal., N.Y., 1964; Dwan Gal., Los A., 1964; WMAA, 1964, 1965; one-man: Rutgers Univ., 1955, 1958; Reuben Gal., 1959; Green Gal., N.Y., 1961, 1964; Dwan Gal., Los A., 1964.*

SAMERJAN, GEORGE E.—Designer, P., T., L., S.
240 E. 46th St., New York, N.Y. 10017; h. Cantitoe St., Katonah, N.Y. 10536
B. Boston, Mass., May 12, 1915. Studied: Otis AI; Chouinard AI; A. Center Col.; & with Alexander Brook, Willard Nash. Member: SI; A. Dirs. Cl., N.Y.; AWS; Audubon A. Awards: prizes, AWS, 1952, 1962; Fla. Southern Col., 1952; A. Dir. Cl., 1950, 1952, 1956; A. Dir. Cl., Phila., 1951; Westchester A. & Crafts Gld., 1952; AIGA, 1941; Los A. Advertising Cl.,1940; A. Fiesta, San Diego, 1938; Cal. WC Soc., 1943; Santa Cruz A. Lg., 1942; med., Oakland A. Gal., 1940. Work: San Diego FA Soc.; Hospital, Lexington, Ky.; Am. Red Cross; N.Y. Hospital; Fla. Southern Col.; Cole of California; murals, USPO, Maywood, Calexico, Culver City, Cal. Illus., Harper's, Reader's Digest, Science Digest, and others. Designed 4¢ Arctic Commemorative Stamp, USPO, (Discovery of the North Pole), 1959; Adlai Stevenson 5¢ Memorial Stamp, 1965; Erie Canal 5¢ Sesqui-centennial Stamp, 1967. Exhibited: NAD, 1941; VMFA, 1940, 1942, 1943; PAFA, 1938-1940, 1943; AWCS, 1941, 1942; CAL. WC Soc., 1938-1942; Denver A. Mus., 1941, 1942; San F. AA, 1940-1942; San Diego FA Soc., 1938-1942; Los A. Mus. A., 1939, 1941, 1942; New Haven Paint & Clay Cl., 1941; Wash. WC Cl.; CGA; Riverside Mus.; CGA; Oakland A. Gal.; Los A. County Fair, 1938, 1939, 1941; Cal. State Fair, 1939-1941; Santa Paula, Cal., 1942-1945; Santa Barbara A. Mus.; Laguna Beach AA; Grand Central A. Gal.; SAM; Los A. AA; Santa Cruz A. Lg.; Cal. Inst. Tech.; Assoc. Am. A.; SFMA; A. Dir. Cl.; All.A.Am.; Portland Mus.; Audubon A.; Fla. Southern Col.; Silvermine Gld. A.; SI, 1963, and many others; Liege, Belgium; Paris, France. Positions: Documentary Artist, U.S. Air Force in Arctic, etc. Lecturer, "Introduction to the Graphic Arts," N.Y. University. Chm., Soc. Illus. Seminars, 1962-63.

SAMPLE, PAUL—Painter
Norwich, Vt. 05055
B. Louisville, Ky., Sept. 14, 1896. Studied: Dartmouth Col., B.S.; Otis AI; & with Jonas Lie, F. Tolles Chamberlin. Member: NA; AWCS; Cal. AC; New Hampshire AA (Hon.). Awards: prizes, Los A. Mus. A., 1930, 1936; NAD, 1931, med., 1932; NAD, 1947, and Altman prize, 1962; Honorary degrees: M.F.A., Dartmouth College, 1936; D.H.L., Dartmouth College, 1962; D.F.A., Nasson College, Springvale, Me., 1964; med., PAFA, 1936. Work: MMA; BMA; AIC; Springfield Mus. A.; Miami Univ.; New Jersey State Mus., Trenton; White House, Wash., D.C.; San Diego FA Soc.; AGAA; Butler AI; PAFA; Joslyn Mem.; Brooks Mem. A. Gal.; Univ. Nebraska; Swarthmore Col.; Williams Col.; Univ. Minnesota; High Mus. A.; Montclair A. Mus.; Encyclopaedia Britannica; Currier Gal.; New Britain Mus. A.; Dartmouth Col.; Univ. Iceland; Ft. Worth A. Center; Allegheny Col.; Hallmark Coll.; Utah State Col.; Sheldon Swope A. Gal.; Parrish Mus., Long Island, N.Y.; L.D.M. Sweat Mem. Mus., Portland, Me.; Colgate Univ.; murals, Bevoort Hotel, N.Y.; Nat. Life Ins. Co., Montpelier, Vt.; Massachusetts Mutual Life Ins. Co., Springfield. Positions: Assoc. Prof. Painting, Univ. Southern California, 1926-36; War A.-Correspondent, Life Magazine, 1942-45; A. in Residence, Dartmouth Col., Hanover, N.H., 1938-1962.

SAMPLINER, MR. and MRS. PAUL H.—Collectors
909 Third Ave., 10022; 150 Central Park South, New York, N.Y. 10019
Collection: French impressionist paintings.

SAMSTAG, GORDON—Painter, T.
South Australian School of Art, North Terrace Ave., Adelaide, Australia; h. 23 Sunnyside Rd., St. Georges, South Australia
B. New York, N.Y., June 21, 1906. Studied: NAD. Member: ANA; AWS; Audubon A.; Mamaroneck A. Gld.; Burnside Painting Group (Pres.) Royal South Australian Soc. A.; Contemp. A. Soc. of South Australia. Awards: prizes, NAD, 1936; PAFA, 1936; All.A.Am., 1936; Conn. Acad. FA; Pulitzer traveling scholarship, 1928. Work: Toledo Mus. A.; Santa Barbara A. Mus.; murals, USPO, Scarsdale, N.Y.; Reedsville, N.C. Exhibited: Carnegie Inst.; CGA; PAFA; NAD All.A.Am.; one-man: Montross Gal.; Milch Gal., N.Y., Gimbels, Phila., Pa.; Janet Nessler Gal., N.Y., 1961, etc.; 1962-1969 one-man exhs. in Sydney, Melbourne, and Adelaide, Australia, and many group exhibitions. Co-Author, Co-Illus. (with Anne Samstag) "Training Your Own Dog," 1961. Positions: Dir., American A. Sch New York, N.Y. Senior Lecturer Fine Arts, South Australian School of Art, Adelaide, Australia, at present.

SAMUELS, BETTY ESMAN. See Esman, Betty

SAMUELSON, FRED B.—Painter, E.
Apartado Postal 70, San Miguel de Allende, Mexico; h. Box 27 Estes Park, Colo. 80517
B. Harvey, Ill., Nov. 29, 1925. Studied: Knox Col.; AIC; B.F.A.,

M.F.A.; Univ. Chicago. Member: Texas WC Soc.; ASL. Awards: prizes, Denver A. Mus., purchase, 1954; Witte Mus. A., San Antonio, purchase, 1958, 1960, 1964; Colo. Centennial, Alamosa, 1959; Wesley and Westminster Fnd., Ohio Univ., purchase, 1964; Texas FA Assn. purchase, 1964. Work: Mural, "Hemisfair," 1968, San Antonio, Tex. Exhibited: Denver A. Mus., 1953-1958; Mulvane A. Center, Topeka, Kans., 1955, 1958, 1959, 1961; Cheyenne, 1955; Atkins Mus., Kansas City, 1956; Mus. New Mexico, 1957; Elisabet Ney Mus., 1957; Beaumont A. Mus., 1957; Joslyn A. Mus., 1958; DMFA, 1958; Mus. FA of Houston, 1959; Univ. Nebraska, 1959; Art:USA, 1959; Ft. Worth A. Center, 1961; Butler Inst. Am. A., 1964; Instituto Mexicano Norteamericano de Relaciones Culturales, 1964. Positions: Instr., Instituto Allende, San Miguel de Allende, Mexico, 1955-63; Chm. of Faculty, San Antonio AI, 1963-1964.

SANBORN, HERBERT J.—Lithographer, L.
 3541 Forest Drive, Alexandria, Va. 22302
B. Worcester, Mass., Oct. 28, 1907. Studied: NAD; T. Col., Columbia Univ.; Univ. Chicago. Awards: Pulitzer traveling F., 1929; prize, Hunterdon County A. Center, purchase, 1964. Member: AIGA; Soc. Wash. Pr.M.; Print Club, Phila., Pa. Work: LC. Exhibited: VMFA; CGA. I., Ed., "Hill Towns of Spain," ten lithographs, 1930. Lectures: American Art; The Art of the Book in the 20th Century. Contributor to American Artist; Publisher's Weekly; Library Journal. Author (brochure): "Modern Art Influences in Printing Design." Positions: Dir., Davenport Mun. A. Gal., 1933-35; Dir. Mus. Oglebay Inst., Wheeling, W.Va., 1936-42; Exhibits Officer, U.S. Library of Congress, Washington, D.C., 1946- .

SANDER, LUDWIG—Painter
 68 E. 12th St., New York, N.Y. 10003
B. New York, N.Y., 1906. Studied: N.Y. Univ., B.A., and with Hans Hofmann, in Munich. Awards: Longview Fnd., 1959; Nat. Council on the Arts Grant, 1967; Guggenheim Fellow, 1968. Work: Albright-Knox A. Gal.; Rose A. Mus., Brandeis Univ., WMAA; BMA; WAC; Guggenheim Mus.; Michener Fnd. Coll., Univ. Texas, Austin; Aldrich Mus. Contemp. A., Ridgefield, Conn.; AIC; Ft. Worth A. Center Mus.; CGA; M.I.T.; Chase Manhattan Bank; Union Carbide Corp., N.Y.; Geigy Chemical Corp.; Int. Minerals & Chemicals Corp., Skokie, Ill.; Columbia Broadcasting System, N.Y. Exhibited: AIC, 1961, 1962; Guggenheim Mus., 1961; WMAA, 1962; Brandeis Univ., 1962; Los Angeles County Mus., 1964; MMoA, 1965; CGA, 1967; Albright-Knox A. Gal., 1968; AFA, 1968; Dayton A. Inst., 1968; Mus. Mod. A., Munich, 1968; NGA, 1968; Art in Embassies, U.S. Embassy, Santiago de Chile, 1968. One-man: Kootz Gal., N.Y., 1962, 1964, 1965; Leo Castelli Gal., N.Y., 1959, 1961; Rubin Gal., 1969; A.M. Sachs Gal., N.Y., 1967, 1969.

SANDERS, JOOP—Painter, E.
 464 W. Broadway, New York, N.Y. 10012
B. Amsterdam, Holland, Oct. 6, 1922. Studied: ASL with Grosz, and privately with de Kooning. Member: Artists Club. Awards: Longview Fnd. purchase, 1960, 1962. Work: Stedelijke Mus., Amsterdam; The Municipal Mus., The Hague; Bezalel Mus., Jerusalem; Dillard Univ.; Univ. Indiana, Bloomington. Exhibited: Mus. of Contemporary A., 1968; Milwaukee A. Center, 1968; Univ. Nebraska, 1965; Flint AI, 1964; N.Y. Univ. Leob A. Center, 1964; Potsdam State Col., 1964; Memphis Acad. FA, 1963; Albright-Knox A. Gal., 1962; Carnegie Inst., 1961; The Stedelijke Mus., Amsterdam (one-man retrospective) and others in New York City, Amsterdam, Paris, London and West Germany; one-man: Bertha Schaefer Gal., N.Y., 1968. Positions: Assoc. Prof., Carnegie Inst. of Tech., 1965; Visiting Artist, Pennsylvania State Univ., 1964; Cooper Union, N.Y., 1962-1965; State Univ. of N.Y. at New Paltz, 1966- ; Guest Lecturer, Univ. of Calif. at Berkeley, 1968.

SANDGREN, ERNEST NELSON—Painter, Lith., E.
 Art Department, Oregon State University; h. 421 North 11th St., Corvallis, Ore. 97330
B. Dauphin, Man., Canada, Dec. 17, 1917. Studied: Univ. Oregon, B.A., M.F.A.; Univ. Michoacan, Mexico; Chicago Inst. Des. Member: Portland A. Mus.; Oregon A. All. Awards: prizes, SAM, 1955; Portland A. Mus., 1952, 1956 (purchase); Northwest Painting, Exh., Spokane, Wash., 1957; deYoung Mem. Mus., 1958; Yaddo F., 1961. Work: Portland A. Mus.; Am. Embassy Coll.; Victoria & Albert Mus., London. Murals in Eugene, Ore.; State Univ. Lib., Corvallis; Portland, Ore. Exhibited: Denver A. Mus., 1954, 1958; Santa Barbara Mus. A., 1955, 1957, and nat. tour; BM, 1958 and nat. tour; Am. Cultural Center, Paris; Victoria & Albert Mus., London; Turin and Bordighera, Italy; Johannesburg, Africa. "46 U.S.A. Printmakers," New Forms Gal., Athens, Greece, 1964. Creator (with William Lesher) 25 min., full color art film, "A Search for Visual Relationships," for educational use. Color art film (with Lesher) "Northwest Four and Two," showing six artists at work. Positions: Instr. A., Univ. Oregon, Eugene, Ore., 1947; Prof. A., Oregon State Univ., Corvallis, Ore., 1948- .*

SANDGROUND, MARK B., SR.—Collector, Patron
 700 Colorado Bldg., Washington, D.C. 20005; h. 3508 Sterling Ave., Alexandria, Va. 22304
B. Brookline, Mass., June 6, 1932. Studied: University of Michigan, B.A.; University of Virginia Law School, LL.B. Collection: Jose Luis Cuevas, Rico Lebrun, Leonard Baskin. Interests: The acquisition of contemporary paintings by public collections, galleries and private foundations. Positions: President, The Friends of the Corcoran Gallery of Art, 1968, 1969; Director, of The Friends of the Corcoran Gallery of Art, 1965- .

SANDLER, IRVING HARRY—Critic, Writer
 301 E. 10th St., New York, N.Y. 10009
B. New York, N.Y., July 22, 1925. Studied: Temple University, B.A.; Univ. Pennsylvania, M.A. Awards: Tona Shepherd Grant for travel in Germany and Austria, 1960; Guggenheim Fellowship, 1965-1966. Author: "Ibram Lassaw," chapter in "Three American Sculptors," 1959; "Joan Mitchell," chapter, "School of New York," 1959; "Paul Burlin," 1961. Contributor of articles to: Evergreen Review; Saturday Review; Arts; Art in America; Art Aujourd' Hui; Quadrum; It Is, and other publications. Positions: Art Critic: Art News, 1956-62; Art International, 1960-61; N.Y. Post, 1961-64. Director, Tanager Gallery, N.Y., 1956-59.*

SANDOL, MAYNARD—Painter
 Box 985, Rte. 2, Parker Rd., Chester, N.J. 07830
B. Newark, N.J., 1930. Studied: Newark State Col., and with Robert Motherwell. Work: Newark Mus. A.; Wadsworth Atheneum, Hartford, Conn.; Princeton Univ.; Finch Col. Mus.; Joseph Hirshhorn Coll., and in private colls. Exhibited: Newark Mus. A.; Wadsworth Atheneum; MModA; CGA; N.Y. World's Fair, New Jersey Pavillion; American Greetings Gal., N.Y.; New Jersey State Mus., Trenton; Visual Arts Gal., N.Y.; one-man: Stuttman-Riley Gallery, N.Y., 1958; Artists Gal., N.Y.; Castellane Gal., N.Y., 1960, 1962, 1963; Athena Gal., New Haven, Conn., 1963; Chapman Kelly Gal., Dallas, Tex., 1964; Fairleigh Dickinson Univ., Madison, N.J., 1965; Peridot Gal., N.Y., 1967, 1968.

SARFF, WALTER—Painter, Des., I., Comm. Photog.
 213 Sommerville Place, Apt. 3N, Yonkers, N.Y. 10703.
B. Pekin, Ill., Oct. 29, 1905. Studied: Chicago Acad. A.; Woodstock Sch. Painting; ASL; Grand Central Sch. A.; Sch. Mod. Photography, and with Hubert Ropp, Adolph Fassbender. Member: Woodstock AA; AEA; ASL; Am. Soc. Magazine Photographers; Photographic Soc. Am.; Village Camera Cl. Awards: prizes, Woodstock AA, 1931; WMA, 1937. Exhibited: San Diego Expo., 1935; U.S. Nat. Mus.; CGA; Grand Central A. Gal.; WMA; Natural Hist. Bldg., Wash., D.C.; Denver A. Mus.; Bard Col.; Pekin Pub. Lib.; Springfield Mus. A.; SFMA; SAM; Montclair A. Mus.; Portland (Ore.) Mus. A.; Albany Inst. Hist. & A.; Woodstock AA; Sawkill Gal., Woodstock; Assoc. Am. A.; Palmer House, Chicago; Grand Central A. Gal.; Rockefeller Center, and others. Contributor to American Annual of Photography; American Photography (Cover); Art Photography; Catholic Digest; Charm; Child Life; Dance; Esquire; Focus; IBM World Trade News; Illustrated Weekly; Look; McCalls; Photo Arts; This Week; U.S. Camera; Woman's Day; World News (Holland) and many other major publications. Adv. for leading agencies, Ringling Bros. & Barnum & Bailey Combined Shows; album covers for Decca Records and Mechano Music, etc.

SARKISIAN, SARKIS—Educator, P.
 The Society of Arts & Crafts, 245 East Kirby St.; h. 91 Atkinson Ave., Detroit, Mich. 48202
B. Smyrna, Turkey, May 15, 1909. Studied: John P. Wicker A. Sch.; Soc. A. & Crafts, Detroit. Member: Mich. Acad. A. & Science. Awards: prizes, Michigan A., 1931, 1935, 1937-1942, 1945, 1947-1960, 1952, 1954, 1957; GGE, 1939; Old Northwest Territory Exh., 1950; Butler AI, 1951, 1955. Work: Detroit Inst. A.; Univ. Michigan; Butler AI; Ford Admin. Bldg.; Church of the Incarnation, Detroit; St. Mary's Episcopal Church, Detroit; Flint (Mich.) Armory, and in private collections. Exhibited: Butler AI, 1953, 1955; Michigan A.; CGA, 1954; Grand Rapids AI, 1954; South Bend AA, 1955; Cal. PLH; AIC; Cincinnati AI; Toledo Mus. A.; PAFA; Carnegie Inst., and numerous exhs., New York. Positions: Hd. Dept. Painting, Dir., Soc. A. & Crafts, Detroit, Mich., 1947- .*

SARNOFF, MR. and MRS. ROBERT W.—Collectors
 885 Park Ave., New York, N.Y. 10021*

SASLOW, HERBERT—Painter
 568 Thurnau Dr., River Vale, Westwood, N.J. 07675
B. Waterbury, Conn., Apr. 1, 1920. Studied: NAD; ASL. Member: ASL. Awards: Suydam medal, NAD, 1940; purchase award, Am. Acad. A. & Let., 1955. Work: Massillon Mus. A.; Newark Mus. A., Crocker A. Gal., Sacramento, Cal.; Am. Acad. A. & Let.; De Beers Diamond Coll. Exhibited: MMA, 1942; Univ. Illinois, 1955, 1957;

WMAA, 1955; Univ. Nebraska, 1956; Mint Mus. A.; BM; PAFA, 1958; CGA, 1957; Babcock Gal., 1955, 1958 (both one-man). Contributor illus. to Cosmopolitan; Redbook; Field & Stream; Good Housekeeping magazines.*

SATURENSKY, RUTH—Painter, T., L.
 12425 Rochedale Lane, Los Angeles, Cal. 90049
B. Denver, Colo., Jan. 18, 1920. Studied: Colorado Woman's Col.; Otis AI, Jepson AI and Chouinard AI, all Los Angeles. Awards: prizes, Los A. Mus. A., 1960; Westside Jewish Community Center, Los A., 1963; First Methodist Church, Santa Monica, 1963. Exhibited: PAFA, 1961, FA Gal. of San Diego, 1962; Newport Harbor, 1962, 1963; Los A. Mus. A., 1960; SFMA, 1959; Long Beach A. Mus., 1965; Jewish Community Center, 1964; Santa Barbara Mus. A., 1965; Frank Perls Gal., Beverly Hills, 1961, 1962.*

SAUL, PETER—Painter
 c/o Allan Frumkin Gallery, 41 E. 57th St., New York, N.Y. 10022*

SAUNDERS, AULUS WARD — Educator, P.
 165 East Third St., Oswego, N.Y. 13126
B. Perry, Mo., Sept. 22, 1904. Studied: Westminster Col., Fulton, Mo., A.B.; Washington Univ., M.A.; Univ. Iowa, Ph.D.; St. Louis Sch. FA; N.Y. Univ, and with Charles Cagle, and others. Member: Eastern AA; AAUP. Awards: prizes, Finger Lakes Exh., 1946; Syracuse Mus. FA, 1947; Oneida Community Plate Co., 1947. Exhibited: Munson-Williams-Proctor Inst.; Kansas City AI; CAM; Syracuse Mus. FA; State Univ. N.Y. at Albany; State Univ. N.Y. at Oneonta; one-man: Denison Univ.; State Univ. N.Y. at Morrisville. Author: "The Stability of Artistic Aptitude." Lectures: "Structure and Emotion in Painting"; "The Psychology of Child Art." Position: Prof. A., State Univ. New York, College at Oswego, 1937- .

SAUNDERS, GUY HOWARD—Painter, Des., T.
 Ringling School of Art; h. 1191 27th St., Sarasota, Fla. 33580
B. Anita, Iowa, Dec. 18, 1901. Studied: Chicago Acad. FA. Member: Fla. A. Group; Sarasota AA; Manatee A. Lg.; Contemp. A. Group, Pinellas, Fla.; Tampa Realistic A. Awards: Contemp. A. Gal., Pinellas Park, 1957. Exhibited: one-man: Sarasota AA; Mint Mus. A.; Gertrude Herbert Mus., Augusta; St. Petersburg AA; Bradenton, Fla.; Contemp. Gal., Pinellas; Pasadena AI; Tampa Realistic Gal.; Tampa AI; Hartman A. Gal., Sarasota. Instr., Ringling School of Art, Sarasota, Fla.

SAUNDERS, JOHN ALLEN—Cartoonist, W., L.
 717 Security Bldg. 43604; h. 4108 River Rd., Toledo, Ohio 43614
B. Lebanon, Ind., Mar. 24, 1899. Studied: Wabash Col., A.B., M.A.; Univ. Chicago; Chicago Acad. FA. Member: The Players, N.Y.; Tile Cl., Nat. Cartoonist Soc.; Newspaper Comics Council (Past Chm.). Work: Author, I., "Steve Roper"; "Mary Worth"; "Kerry Drake," widely syndicated comic strips. Author: "A Career for Your Child in the Comics" (pamphlet). Contributor to Coronet, Colliers and many popular fiction magazines. Lectures: "Comics are Serious Business"; "The Philosophy of Humor." Positions: Continuity Writer, Publishers Syndicate, 1940- . Past Pres., Art Interests, Inc., an organization providing scholarships for talented young artists of the area.

SAUNDERS, RAYMOND (JENNINGS)—Painter
 c/o Terry Dintenfass Gallery, 18 E. 67th St., New York, N.Y. 10021
B. Homestead, Pa., 1934. Studied: Carnegie Inst. (now Carnegie-Mellon Univ.): B.F.A.; PAFA; Barnes Fnd., Merion, Pa.; Univ. Pennsylvania; Cal. Col. A. & Crafts, M.F.A. Awards: Scholarships, 1954-1957, PAFA; Cresson European traveling, 1956; prizes, SFMA, 1960; Nat. Inst. A. & Lets., 1963; Ford Fnd. purchase, 1964; Prix de Rome, 1965; Lee Cultural Center, 1968. Work: WMAA; PAFA; Michener Coll., Univ. Texas, Austin; Howard Univ.; Cal. Col. A. & Crafts; AGAA; Nat. Inst. A. & Lets.; other colls. U.S. and abroad. Exhibited: SFMA, 1961; Philadelphia, Wilmington and Pittsburgh, 1953-1960; Cal. Sch. FA, 1961; Cal. Col. A. & Crafts, 1961; PAFA, 1962-1969; Cheltenham, Pa., 1962; PMA, 1962, 1968; New School, New York City, 1963, 1964, 1966, 1967; Forum Gal., N.Y., 1967; Univ. Cal. at Los Angeles, 1966, 1967; AFA traveling exh., 1968; "15 New York Artists," 1968; R.I. Sch. Des. Faculty Exh., 1968; MModA traveling exh., 1968-1969; Drawings:USA, St. Paul A. Center, 1968-1970; WMAA, 1969. One-man: Dintenfass Gal., N.Y., 1962, 1964, 1966, 1967, 1969. Positions: A.-in-Res., California State Col., Hayward, 1968-1969; Consultant, Volt Information Sciences, Inc., N.Y.; Senior Painting Seminar, Cal. Col. A, & Crafts.

SAVAGE, W. LEE—Painter
 c/o Krasner Gallery, 1061 Madison Ave., New York, N.Y. 10028*

SAWYER, ALAN R.—Museum Director, L., W.
 The Textile Museum, 2320 S St., N.W., 20008; h. 5504 33rd St., N.W., Washington, D.C. 20015
B. Wakefield, Mass., June 18, 1919. Studied: Bates Col., Lewiston Me., B.S., D.F.A. (Hon.); B.M.F.A. Sch.; Boston Univ.; Harvard Univ., M.A. Author: "Handbook of the Nathan Cummings Collection of Ancient Peruvian Art," 1954; "Animal Sculpture in Pre-Columbian Art,"1957, both A.I.C. Co-author (with Dr. Leon Goldman) "Medicine in Ancient Peruvian Art," Journal of the History of Medicine and Allied Sciences, 1958. Author: "Paracas Necropolis Headdress and Face Ornaments," Textile Museum Workshop Notes No. 21, 1960; "A Group of Early Nasca Sculptures in the Whyte Collection," Archaeology Magazine, 1962; "Tiahuanaco Tapestry Design," Textile Museum Journal, Vol. 1, No. 2, 1963, and numerous other articles and catalogs on Peruvian art. "Ancient Peruvian Ceramics--The Nathan Cummings Collection," Metropolitan Museum of Art, 1966. Group discussion leader "Looking at Modern Art," Ford Fnd.—A.I.C., 1955-1957. Installed exhs., A.I.C., Designer-Craftsmen U.S.A., 1954; Design in Scandinavia, 1956; Co-ordinator of Midwest Designer-Craftsmen 1957 exh.; and installation of all primitive art exhibitions 1952-1959. Installations of rug and textile exhibitions at the Textile Museum, 1959-present. Positions: Instructor and Curator, Primitive Art, Texas State College for Women, 1949-1952; Asst. to the Cur., Dec. A., 1952- ; Asst. Cur., Dec. A., 1954- ; Assoc. Cur. in charge of Primitive Arts, 1956- ; Cur. Primitive Arts, 1958-1959, Art Institute of Chicago, Chicago, Ill. Director, The Textile Museum, Washington, D. C., 1959-present; Adjunct Professor of Art and Archaeology at Columbia University, 1968-69; Memb., Univ. Pennsylvania Archaeological Expedition to Bolivia, 1955; Leader of the Textile Museum Expedition to Peru, 1960; Leader of the Brooklyn Museum Study Tour to Peru, 1965; Curator of "Mastercraftsmen of Ancient Peru" Exhibition, Guggenheim Museum, 1965-1969.

SAWYER, CHARLES HENRY—Museum Director, E.
 University of Michigan 48104; h. 2 Highland Lane, Ann Arbor, Mich. 48104
B. Andover, Mass., Oct. 20, 1906. Studied: Yale Univ., A.B.; Harvard Univ. Graduate Sch. Member: AFA; AA Mus.; Assn. A. Mus. Dir.; CAA; Am. Antiquarian Soc.; Am. Acad. A. & Let.; Am. Acad. A. & Sciences; Century Assn. Author: "Art Education in English Public Schools," 1937. Contributor to: various art magazines. Positions: A. Com., AGAA, Andover, Mass., 1940- ; A. Com., Amherst Col., 1941- ; Mass. A. Comm., 1943-45; Asst. Sec., Am. Comm. for Protection & Salvage of Artistic & Historical Monuments in War Areas, 1945; Dir., Addison Gal. Am. Art, Andover, Mass., 1930-1940; Dir., WMA, Worcester, Mass., 1940-1947; Dean, Sch. Arch. & Des., Prof. Hist. A., Yale Univ. Sch. Arch. & Des., New Haven, Conn., 1947-1956; Dir. Mus. A., Prof. Hist. A., Univ. of Michigan, Ann Arbor, Mich., 1957- . Smithsonian A. Comm., 1954- , (Chm. 1968-). Trustee, Corning Mus. of Glass, 1950- .

SAWYER, HELEN (Mrs. Helen Sawyer Farnsworth)—
 Painter, Lith., T., W.
 s. North Truro, Mass.; w. 3482 Flamingo, Sarasota, Fla. 33581
B. Washington, D.C. Studied: NAD, and with Charles Hawthorne. Member: NA; NAC; Florida A. Group (Pres. 1953-55); Sarasota AA; Provincetown AA; Audubon A. Awards: prizes, Hudson Valley A. Inst., 1935, 1936; Fine Prints of the Year, 1937; Ringling Mus. A. Circus Exh., 1950, 1951; Fla. Fed. A., 1956, 1957. Work: LC; Toledo Mus. A.; WMAA; John Herron AI; PAFA; Vanderpoel Coll.; Miami Univ., Oxford, Ohio; IBM; Chesapeake & Ohio Coll.; Nat. City Bank, N.Y.; High Mus. A., Atlanta; Chrysler Mus. A.; Norfolk Mus. A. & Sciences; Amherst Col.; Williams Col.; Randolph Macon Women's Col.; Albany Inst. Hist. & Art; LC; and others. Exhibited: Carnegie Inst.; CGA; PAFA; GGE, 1939; MMA; NAD; Audubon A.; PMA; Univ. Illinois; Montclair A. Mus.; New Britain Inst.; one-man: Milch Gal.; Grand Central Gal.; Speed Mus. A., Louisville; Miami, Clearwater and Winter Park, Fla.; Univ. Illinois; Sarasota Mus., 1952, 1962. Positions: Instr., Farnsworth Sch. A., Sarasota, Fla.

SAXON, CHARLES D.—Cartoonist
 228 Weed St., New Canaan, Conn. 06840
B. New York, N.Y., Nov. 13, 1920. Studied: Columbia Univ., B.A. Awards: Gold Medal, Art Dirs. Exh., 1963; American Poster Award, 1964. Venice Film Festival for TV animation, 1966. Contributor cartoons to New Yorker magazine and other major publications. Author: "Don't Worry About Poopsie," 1958; "Oh, Happy, Happy, Happy," 1960; I., "Minty's Magic Garden," 1954; "Little Dog Who Wore Earmuffs," 1957; "What Makes You Tick?," 1958; "Gabriel Wrinkles," 1959; "Out On a Limerick," 1960; "Mediatrics," 1963; "Cold Comfort Farm," 1964; "Child's Garden of Misinformation," 1965. Work in humor anthologies, 1957-1964; "Great Cartoons of the World," 1969; originals from New Yorker magazine in Brooklyn

Mus. and Lib. Congress collection; mural, Am. Airlines Terminal, Dallas, Tex. Positions: Cartoon Ed., This Week, 1948-49; Ed., Dell Publ. Co., 1950-55.

SAYPOL, MR. and MRS. RONALD D.—Collectors
1160 Park Avenue, New York, N.Y. 10028*

SCARAVAGLIONE, CONCETTA— Sculptor, T.
441 West 21st St., New York, N.Y. 10011
B. New York, N.Y., July 9, 1900. Studied: NAD; ASL. Member: NSS; S. Gld.; An. Am. Group. Awards: Prix de Rome, 1947-50; Medal, PAFA; Am. Acad. A. & Let. grant. Work: WMAA; Roerich Mus.; PAFA; Vassar Col.; Arizona State Col.; U.S. Federal Trade Commerce Bldg., Wash., D.C.; WFNY, 1939. Exhibited: WMAA; MMoDA; BM; AIC; Fairmount Park, Phila., Pa.; CGA; Carnegie Inst.; PAFA; GGE, 1939; MMA.; World's Fair, 1964; Newark Mus. A. Positions: Instr., N.Y. Univ., Masters Inst., Sarah Lawrence Col.; Vassar Col., Lecturer, Emeritus, in Art (1952-67).

SCARPITTA, NADJA—Sculptor, L., W., T., P.
2684 North Beachwood St., Hollywood, Cal. 90028
B. Kovel, Poland, Mar. 5, 1900. Studied: ASL, and in Munich, Germany, Rome, Italy. Work: sculpture, portraits in private colls. Lectures for television and clubs.*

SCARPITTA, SALVATORE—Sculptor
c/o Castelli Gallery, 4 E. 77th St., New York, N.Y. 10021*

SCHAB, WILLIAM H.—Art Dealer
48 E. 57th St., New York, N.Y. 10022*

SCHACHTER, JUSTINE RANSON—Painter, Des., I.
14 Trumpet Lane, Levittown, N.Y. 11756
B. Brooklyn, N.Y., Dec. 18, 1927. Studied: BMSch. A., with John Bindrum, Milton Hebald, John Ferren; Tyler Sch. FA, Temple Univ. (Scholarship); ASL, with Will Barnet. Member: Am. Soc. Contemp. A.; NAWA; AEA. Awards: prizes, BM, 1949; Riverside Mus., 1955. Exhibited: Traveling graphic exh., NAWA, U.S. and Europe, 1956-58, 1959-61; BM; Riverside Mus.; Lever House, N.Y.; Brooklyn Pub. Lib.; Ruth White Gal., N.Y.; Argent Gal., N.Y.; one-man: Argent Gal., 1950; Ruth White Gal., 1960; Gal. Downstairs, 1963-1965, 1968, 1969; Roryan Gal., L.I., 1968; Mineola H.S. (N.Y.), 1964; 5-man exh., AEA, 1952. Positions: A. Consultant, Mineola Pub. Schs., Audio Visual-TV Dept., 1964-65. Admissions Chm., for American Society of Contemporary Artists, 1968-71.

SCHAEFER, BERTHA—Art Dealer
41 E. 57th St. 10022; h. 400 E. 58th St., New York, N.Y. 10022
Studied: Mississippi State College for Women; Parsons School of Design, New York and Paris. Member: AID; Arch. Lg. of New York; Decorators Club of New York; American Federation of Arts; Art Dealer's Association of America. Awards: Good Design Award, Museum of Modern Art, 1952; Gold Medal, Decorator's Club, 1959. Specialty of the Gallery: Contemporary American and European painting and sculpture. Positions: Pres., Decorator's Club of New York, 1947-1948, 1955-1957; Director, Bertha Schaefer Gallery, New York, N.Y., 1944- .

SCHAEFER, HENRI-BELLA (Mrs. H. Bella De Vitis)—Painter, T.
111 Bank St., New York, N.Y. 10014
B. New York, N.Y. Studied: Columbia Univ. Ext.; Fashion Inst. Tech., N.Y., Certif.; Grande Chaumiere, All. Francaise, and with William A. MacKay; Andre Lhote, Paris. Member: NAWA; AEA. Awards: Medal of Honor & Tucker prize, 1962; Ctf., Fashion Inst. Tech., 1961. Work: Fla. Southern Col.; Butler Inst. Am. A.; Norfolk Mus. A. & Sciences; Hollis Price Library, LeMoyne Col., Memphis, and in private colls. Exhibited: A. Gal., N.Y., 1941, 1942, 1948-1950, 1953-1958, 1960; NAC, 1946-1951; NAWA, 1948, 1950, 1951, 1961-1965, 1969; Bar Harbor, 1950, 1951; AEA, 1951; WMAA, 1951; Fla. Southern Col., 1952; North Side Center for Child Development, N.Y., 1944-1957; Art:USA, 1958; Butler Inst. Am. A., 1958; AFA, 1955, 1956; Soc. Am. P. & S., 1961; Hudson River Mus., 1961; Int. A. Gal., 1961; Salon d'Automne, 1938; Salon des Tuileries, Paris, 1939; Prize Winning Paintings traveling exh., 1963-65; Group traveling exh., Europe, 1965- ; Exhs. in France: La Napoule, Cognac, and Int. Women P. & S., Cannes. One-man: A. Gal., 1941, 1949, 1951, 1953; Hollis Price Library, Le Moyne Col., Memphis, Tenn., 1966. Positions: Equity Fund Com., 1954-55, Dir., N.Y. Chapter, 1954, Bd. Dir., 1954-55, Cor. Sec., 1957-58, 3rd Vice-Pres., 1958-59, 1960-1962, Nat. Sec., 1962-1964, 1964-1966, AEA.

SCHAEFER, JOSEPHINE M.—Painter, T.
1961 North Summit Ave., Milwaukee, Wis. 53202
B. Milwaukee, Wis., May 12, 1910. Studied: Layton Sch. A.; AIC; in Europe, South America, and with Louis Ritman. Member: Chicago AC; Wis. P. & S. Awards: prizes, Wis. P. & S., 1945. Exhibited:

AIC, 1935-1937, 1939-1941, 1943, 1944, 1946, 1949, 1950; Grand Rapids A. Gal., 1940; Wis. P. & S., 1936, 1939-1941, 1944-1946; Minneapolis Inst. A., 1942; Columbus A. Gal., 1942; Illinois State Mus., 1935-1937, 1940; Rochester Mem. A. Gal., 1940, 1941; Kansas City AI, 1940; WMA, 1945; AGAA, 1945; CMA, 1945; Gimbel Wisconsin Exh., 1949; Wis. P. & S., 1947, 1949, 1950, 1952; Springfield (Mo.) A. Mus., 1945; Walker A. Center, 1945; Portland (Ore.) A. Mus., 1945; Kalamazoo Inst. A.; Layton A. Gal. (one-man); Milwaukee AI (one-man), and group, 1953. Positions: Instr., Layton Sch. A., Milwaukee, Wis., at present.

SCHAEFFLER, LIZBETH—Sculptor, C., P., T., Comm.
78 Irving Pl., New Rochelle, N.Y. 10801; s. 6 Lily St., Nantucket, Mass. 02554
B. Somerville, Mass., Oct. 27, 1907. Studied: PIASch; NAD; ASL; Clay Cl., N.Y., and with Mahonri Young. Member: Nantucket AA (Treas. & Bd. Memb.); New Rochelle AA. Awards: prize, New Rochelle AA, 1960, 1961 and prior. Work: mem., Church of the Highlands, White Plains, N.Y.; Mem. Garden Figure, Kenneth Taylor Gal., Nantucket. Contributor article on glazes, Ceramic Monthly Magazine. Exhibited: NSS, 1936-1938, 1957, 1958, 1965; Clay Cl.; N.Y. Soc. Ceramic A.; New Rochelle AA; Nantucket AA (one-man); Kenneth Taylor Gal., 1962-1964. Positions: Dir., Kenneth Taylor Gal., Nantucket, Mass.; Instr., Ceramics & Sculpture in studio.

SCHAFER, ALICE PAULINE—Etcher, Eng.
33 Hawthorne Ave., Albany, N.Y. 12203
B. Albany, N.Y., Feb. 11, 1899. Studied: Albany Sch. FA. Member: Print Cl. of Albany (Pres.); SAGA; Pen & Brush Cl.; NAWA; Academic A. Assn.; Southern Vermont Artists. Work: MMA; SAGA; Nat. Commercial Bank & Trust Co., Albany; LC. Awards: prize, Pen & Brush Cl., 1957; AAPL, 1958, 1959, 1966; Academic Artists, 1961-1965; Print Cl. of Albany, 1968. Exhibited: Albany Pr. Cl., 1940-1969; SAGA, 1947-1969; NAD, 1949, 1956, 1962; LC, 1949; Cooperstown, 1949-1969; NAWA, 1951-1969; Pen & Brush Cl., 1957-1969; Southern Vermont Artists, 1960-1969; London, England, 1954; Holland, 1956; India, 1956; Switzerland, 1957; Japan, 1967.

SCHAFFER, ROSE (Mrs. Jacob)—Painter, Gr., T., L.
85 Gregory Ave., West Orange, N.J. 07050
B. Newark, N.J. Studied: ASL, and with many leading art instructors. Member: AEA; NAWA; AFA. Awards: prizes, Art Center of the Oranges, 1946; Ida Wells Stroud award, 1951; P. & Sc. of New Jersey, 1956; Seton Hall Univ., 1956; New Haven Paint & Print Cl., 1958; So. Orange-Maplewood A. Gal., 1958; Art for Overlook Hospital, 1961, 1962 (both purchase awards); Bamberger Annual, 1960; West Orange Civic Award. Work: Montclair Mus. A.; Springfield Mus. FA; Newark Pub. Lib.; West Orange Lib.; Jewish Community Council; Overlook Hospital; Tenn. FA Center; Burpee A. Mus., Ill.; Richmond (Ind.) AA; Norfolk Mus. A. & Sciences, Va.; Newark Beth Israel Hospital; Congregation Oheb Sholom; Rutgers Univ. Mus.; N.J. State Mus. Exhibited: 1948-1965; NAD; NAWA; Audubon A.; Knickerbocker A.; AAPL; Nat. Soc. Painters in Casein; LC; Smithsonian Inst.; Montclair, Newark, Trenton, Jersey City, Delgado, Boston, Wichita and Brooklyn Museums; Am. Color Pr. Soc.; Phila. Print Cl.; Conn. Acad. FA; Rochester Mem. A. Gal.; Cape Cod and Provincetown galleries; Albany Pr. Club. New York Galleries: ACA; Argent, Burr, Barznasky, Lever House and Art Directions. Traveling exh., circulated by American Federation of Arts and Library of Congress. NAWA exh. at Henry Clews Fnd., La Napoule, France. Several one-man exhs., including New York City. Reproduction and biography in "Le Revue des Moderne Arts," Paris. Positions: Conducts museum and gallery tours. Lectures & demonstrations to schools, groups and organizations.

SCHANG, FREDERICK, JR.—Collector
Columbia Artists Management, Inc., 165 W. 57th St., 10019; h. 45 Sutton Place South, New York, N.Y. 10022
B. New York, N.Y., Dec. 15, 1893. Studied: Columbia University School of Journalism, B.Lit. Collection: Mexican art; Works by Paul Klee.*

SCHANKER, LOUIS—Pr.M., E., P., S.
Box 359, Stamford, Conn. 06904
B. New York, N.Y., July 20, 1903. Studied: ASL; CUASch., and abroad. Member: Fed. Mod. P. & S.; S.Gld. Awards: F., Yaddo Fnd., Saratoga Springs, 1958; prizes, BM, 1947; Wash. Pr. Cl., 1949; Univ. Illinois, 1958. Work: BM; MMA; PMA; CM; WMAA; AIC; PMG; CMA; Toledo Mus. A.; MMoDA; Detroit Inst. A.; Univ. Michigan; Univ. Wisconsin; Wesleyan Col.; N.Y. Pub. Lib.; Walker A. Center; Rosenwald Coll.; NCFA. Exhibited: VMFA; WMAA, 1935, 1936, 1940, 1941, 1942, 1951, 1958; Passedoit Gal., 1937; Am. Abstract A., 1937-1941; Bennington Col., 1938; BM, 1938, 1951, 1955; Guggenheim Mus., 1954; SFMA, 1938, 1942; Phila. A. All., 1938, 1939; WFNY 1939; SAGA, 1937-1939; Berkshire Mus., 1939; Willard Gal., 1940; GGE, 1939; Valentine Mus. A., 1940; LC, 1944; Inst.

Mod. A., 1944; N.Y. Pub. Lib., 1944; MModA, 1944; Victoria & Albert Mus., London, 1954; Rome, Italy, 1958; Univ. Illinois, 1950, 1954; S.Gld., 1969, Univ. Illinois, 1967, and many others; one-man: Contemp. A., 1933; New Sch. for Social Research, 1934, 1938, 1942; A. Gal., 1939, 1941, 1942; BM, 1943; Munson-Williams-Proctor Inst., 1942; Univ. Michigan, 1943; Willard Gal., 1944-1948, 1950; Kleeman Gal., 1944; Bloomington A. Gal., 1944; Univ. Wisconsin, 1944; PMG, 1946; Grace Borgenicht Gal., 1952, 1953, 1955, 1957; N.Y. Pub. Lib., 1955; Sculpture Center, 1952; WAC, 1959; Stuttman Gal., 1959; Dewey Gal., N.Y., 1962; Granite Gal., N.Y., 1964; Dorsky Gal., N.Y., 1966, and others. Author: "Line-Form-Color," 1944. Positions: Assoc. Prof. A., Bard Col., Annandale-on-Hudson, N.Y., 1949-1964, Emeritus, 1964- .

SCHAPIRO, MEYER—Educator
 279 W. Fourth St., New York, N.Y. 10014
B. Shavly, Lithuania, Sept. 23, 1904. Studied: Columbia Univ., A.B., M.A., Ph.D. Awards: Guggenheim F., 1939, 1942; F., Am. Acad. A. & Sciences. Author of books and articles on mediaeval and modern art. Positions: L., Dept. FA & Archaeology, 1928-36, Asst. Prof., 1936-46, Assoc. Prof., 1946-52, Prof., 1952- , University Prof., 1965- , Columbia Univ.; L., New Sch. for Social Research, N.Y., 1938, 1940-1953; Warburg Inst., London Univ., 1947, 1957; New York Studio School, 1964- ; Bd. Ed., Journal of the History of Ideas, 1957; Dissent, 1954; Semiotica, 1969. Slade Professor, Oxford Univ. 1968; Charles Eliot Norton Professor, Harvard Univ., 1967.

SCHAPIRO, MIRIAM—Painter, Pr.M., Des.
 7860 Calle Juela, La Jolla, Cal. 92037
B. Toronto, Canada, Nov. 15, 1923. Studied: Hunter College; Univ. Iowa, B.A., M.A., M.F.A. Awards: Ford Fnd. Grant for Tamarind Lithography Workshop, Los Angeles, 1964. Work: CAM; N.Y. Univ. Coll.; Stephens Col., Columbia, Mo.; Albion Col., Mich.; Illinois Wesleyan Univ. Print commission for Hilton Hotel, N.Y.; Cloisonne enamel commissions for private collections. Exhibited: BM, 1947, 1949, 1951; Denver A. Mus., 1948, 1950, 1963; Stable Gal., 1952-1955; Abstract Impressionists, Nottingham Univ., England, 1958; Carnegie Inst., 1958; WMAA, 1959; Univ. Illinois, 1961, 1965; AIC; MModA traveling exh., 1962-1964; Jewsih Mus., N.Y., 1963; Rose A. Mus., Brandeis Univ. traveling exh., 1964-65. One-man: Univ. Missouri; Illinois Wesleyan Univ.; Skidmore Col.; Emmerich Gal., N.Y.*

SCHARFF, CONSTANCE (KRAMER)—Painter, Pr. M.
 115 Jaffrey St., Brooklyn, N.Y. 11235
B. New York, N.Y. Studied: With George Pickens, Louis Schanker, Adja Yunkers, A. Rattner. Member: Audubon A.; Brooklyn Soc. A.; NAWA; Nat. Soc. Painters in Casein; SAGA; Washington Pr. M.; N.Y. Soc. Women A. Awards: prizes, NAWA, 1965, 1967, 1968 (Medal of Honor); Brooklyn Soc. A., 1954, 1958, 1959, 1962; British Pr. M., 1962; gold medal, Audubon A., 1955, 1967; Nat. Soc. Painters in Casein, 1968. Work: BM; PMA; Boston Lib.; Israel Mus., Jerusalem; Norfolk Mus.; A.; Inst. of Jamaica, W.I.; Clairol; Region I Artmobile N.C. Pa.; Singer Co.; Xerox Corp.; Lummus Corp. Exhibited: BM, 1967; Audubon A., traveling print exh., Amsterdam, Holland, 1956; traveling exhs. U.S., Europe, Canada, Japan, Mexico, India; Contemp. A. of U.S., 1956; Conn. Acad. FA; Silvermine, Conn., 1966, 1967, 1968; LC, 1965; Potsdam, 1966. Positions: Am. Soc. Contemp. A., Exec. Bd., 1966-1970, Chm., nominating, 1969-1970, juror-watercolor, 1967-1970; NAWA, juror-graphics, 1968, 1969, juror-watercolor, 1966, 1967; Nat. Soc. Ptrs. in Casein, jury of selection, 1969, recording secy., 1967-1970.

SCHARFF, WILLIAM—Painter
 800 Riverside Drive, New York, N.Y. 10032*

SCHARY, MRS. DORE. See Svet, M(iriam)

SCHEIER, EDWIN—Ceramist, E., S., P.
 Sto, Tomas 112, Xoch. Oaxaca, Oax., Mexico
B. New York, N.Y., Nov. 11, 1910. Studied: ASL; Columbia Univ. Member: Am. Ceramic Soc.; Am. Assn. Univ. Prof. Awards: prize, Syracuse Mus. F.A.; BM, 1953; medal, Intl. Exh. ceramics, Cannes, France, 1955. Work: Walker A. Center: CM; AIC; MModA; Syracuse Mus. FA; Phila. A. All.; Mus. R.I. Sch. Des.; Detroit Inst. A.; MMA; Exeter Acad.; Fitchburg A. Mus.; Currier Gal. A.; Stuttgart, Germany; Tokyo Mus., Japan; Royal Ontario Mus.; Intl. Mus. of Ceramics, Florence, Italy; Rochester Mem. A. Gal.; Newark Mus.; VMFA; AGAA; Univ. Kansas; Univ. Nebraska; Univ. Minnesota; Univ. Illinois and Wisconsin. Exhibited: WMA; BMA; CM; Syracuse Mus. FA; Phila. A. All.; one-man: Detroit Inst. A.; Toledo Mus. A.; Milwaukee AI; Dartmouth Col.; Univ. Puerto Rico; Univ. Minnesota; Univ. New Hampshire; Currier Gal. A.; Mt. Holyoke Col., 1964; Chatham Col., 1963.

SCHEIER, MARY—Ceramist, Des., C., E., P.
 Sto, Tomas 112, Xoch. Oaxaca, Oax., Mexico
B. Salem, Va., May 9, 1910. Studied: ASL; Parsons Sch. Des. Awards: prizes, Syracuse Mus. FA, 1940 and subsequently. Work: AIC; Syracuse Mus. FA; CM; MModA; Univ. New Hampshire; Walker A. Center; Detroit Inst. A.; Rochester Mem. A. Gal.; Newark Mus.; VMFA; Currier Gal. A.; Fitchburg A. Mus.; Tokyo Mus., Japan; Royal Ontario Mus.; Univ. Illinois; AGAA; Univ. of Kansas, Nebraska, Minnesota, Wisconsin. Exhibited: Syracuse Mus. FA; WMA; BMA; CM; Phila. A. All.; Mus. R.I.Sch.Des.; Currier Gal. A., Univ. New Hampshire; VMFA; one-man: Detroit Inst. A.; Toledo Mus. A.; Milwaukee AI; Dartmouth Col.; Univ. Puerto Rico; Univ. Minnesota; Univ. New Hampshire; Currier Gal. A., Mt. Holyoke Col., 1964, Chatham Col., 1963 (one-man in collaboration with Edwin Scheier); Worcester (Mass.) Craft Center, 1964.

SCHEIN, EUGENIE—Painter, T.
 239 N.E. 79th St., Miami, Fla.; h. 1070 Stillwater Drive, Miami Beach, Fla. 33141
Studied: Hunter Col., B.A.; Columbia Univ., M.A.; Univ. New Mexico; Nat. Univ., Mexico. Member: AEA; AAUP; NAWA. Awards: 1st prize, Fla. A., 1968. Work: Carville Mus. A.; Lowe Gal. of A.; Norton Gal. A.; Georgia Mus. A., Athens, Ga. Exhibited: BM; NGA; CM; PAFA; 1950; Riverside Mus., 1951; Wash. WC Cl., 1957; one-man: Midtown Gal., N.Y., 1937, 1941; Argent Gal., 1940; Salpeter Gal., 1950; Huber Gal., Miami, 1959; Havana, Cuba, 1956; Mexico City, D.F., 1956; Kaufmann Gal., N.Y.; Uptown Gal., N.Y.; Barzansky Gal., N.Y., 1961; Granville Gal., Coral Gables, 1960; Mirrell Gal., Coconut Grove, 1962; Barry College, Miami, 1965; Miami Mus. Mod. A., 1967. Positions: Pres., Fla. Chptr., AEA, 1964, 1965.

SCHELLIN, ROBERT—Painter, C., E.
 3335 North Bartlett Ave., Milwaukee, Wis. 53211
B. Akron, Ohio, July 28, 1910. Studied: Milwaukee State T. Col.; B.E.; Columbia Univ.; Univ. Wisconsin, M.S., and with Hans Hofmann. Member: Wis. P. & S.; Wis. A. Edu. Assn.; Midwest Des.-Craftsmen; Wis. Des.-Craftsmen; Am. Craftsmen's Council. Awards: prizes, Wis. State Fair, 1943, 1944, 1954, 1956, 1957, 1959; Madison AA; 1945; Milwaukee AI, 1947, 1949, 1950 (2), 1952 (2), 1953, 1957, 1961, 1962; Wis. Des.-Craftsmen, 1952, 1957, 1962; medal, AIC, 1933; Research Grants, Univ. Wisconsin, 1961, 1964. Work: Milwaukee AI; Whitefish Bay (Wis.), Pub. Sch.; Milwaukee State T. Col.; Univ. Wisconsin. Exhibited: AIC, 1944; AGAA, 1945; CMA, 1945; WAC, 1946; Milwaukee AI, 1939, 1956-1960; Newark Mus., 1943; Portland A. Mus., 1946; Kalamazoo AI, 1946; Wis. P. & S., 1930-1965; Wis. State Fair, 1956-1960; Midwest Des.-Craftsmen, 1956, 1957 to date; St. Paul, Minn., 1959; USIA European traveling exh., 1959-1961; Huntington (W.Va.) Gal., 1963; Arkansas A. Center, 1963; Nat. Housing Center, Wash., D.C., 1964; Parsons Col., Iowa, 1964; N.D. State Univ., Fargo, 1964; Cardinal Stritch Col., 1959; Wustum Mus. A., Racine, 1961, 1963; Tweed Gal. A., Duluth, 1962; Madison AA, 1955, 1963; River Falls (Wis.) State Col., 1962; Kenosha Pub. Mus., 1964, and others. Positions: Chm., Dept. A. & A. Edu., 1957-59, Chm., Grad. Studies in Art & Art Edu., Prof. FA., Univ. Wisconsin, Milwaukee, Wis.

SCHEU, LEONARD—Painter, T., Lith., L.
 309 Agate St., Laguna Beach, Cal. 92651
B. San Francisco, Cal., Feb. 19, 1904. Studied: Cal. Sch. FA; ASL. Member: Cal. WC Soc.; Nat. Soc. Painters in Casein; Laguna Beach AA; New Jersey P. & S. Soc. Exhibited: Laguna Beach AA, 1935-1948-1955, 1958 1958 (one-man); GGE, 1939; BM, 1941; Oakland A. Gal., 1938, 1945, 1946, 1951; Cal. State Fair, 1938, 1940, 1941; Santa Paula, Cal., 1941, 1942; Cal. WC Soc., 1943; Riverside Mus., 1946; Walnut Creek (Cal.), 1950; Orange County Fair, 1951; Newport Harbor Exh., 1952; Los A. Mus. A., 1948, 1952; Nat. Orange Show, 1952-1963; Orange County AA, 1955; Nat. Soc. Painters in Casein, 1955-1965; Los A. AA, 1954, 1955; Oakland A. Mus., 1953; Ford Motor Co., 1955; Sonora, Cal., 1955; deYoung Mem. Mus., 1957; Crocker A. Gal., Sacramento (one-man); Mus. New Mexico (one-man). Other one-man exhs.: Stanford Univ.; Laguna Beach A. Gal.; Pioneer Mus., Stockton; Orange Coast Col.; Modesto Col.; Fla. Gulf Coast A. Center; Whittier Pub. Lib.; La Salle Col., Phila.; U.S. Naval Acad., Annapolis. 22 one-man exhibitions in U.S., 1966-69. Contributor to Ford Times; Lincoln Mercury Times. Positions: Instr. Painting, Whittier Sch. Dist.

SCHIMMEL, NORBERT—Collector
 154 W. 14th St., New York, N.Y. 10011; h. 15 Mitchell Dr., Kings Point, N.Y. 11024
B. Berlin, Germany, Sept. 2, 1904. Studied: School of Commerce, Berlin University. Collection: Ancient art (Greek, Etruscan, Anatolic, Egyptian and Near Eastern). Positions: Trustee, Archaeological Institute of America; Member, Visiting Committee, FMA; Member, Visiting Committee, Ancient Art Department, BMFA.*

SCHINNELLER, JAMES A.—Educator
 University of Wisconsin, 600 W. Kilbourn, Milwaukee, Wis.
 53203
Position: Director, Visual Arts/Extension Dept.*

SCHLAGETER, ROBERT—Museum Director
 William Hayes Ackland Memorial Art Center, Chapel Hill,
 N.C. 27514
B. Streator, Ill., May 10, 1925. Studied: Univ. Illinois; Univ. Mar-
burg; Univ. Heidelberg; Univ. Chicago; Harvard Univ. Positions:
Former Dir., Mint Museum of Art, Charlotte, N.C.; Assoc. Dir.,
William Hayes Ackland Memorial Art Center, Chapel Hill, N.C., at
present.

SCHLAIKJER, JES WILHELM—Portrait Painter, I., T.
 4526 Verplanck Pl., Washington, D.C. 20016
B. New York, N.Y., Sept. 22, 1897. Studied: Ecole des Beaux-Arts,
France; AIC; & with Forsberg, Cornwell, Dunn. Member: NA.
Awards: prizes, NAD, 1926, 1928. Work: NAD; U.S. War Dept.; U.S.
Naval Acad., Annapolis, Md.; Dept. of State; Am. Red Cross; Nelson
Gal. A., Kansas City; Univ. Indiana; Walter Reed Hospital, Wash.,
D.C.; Marine Corps Sch., Quantico, Va.; Federal Reserve Bank,
Kansas City; Georgetown Univ.; U.S. Public Health Service, Wash.,
D.C.; port. of Gov. Lowe in Legislative Hall, Agana, Guam. Exhib-
ited: nationally. Contributor to: national magazines. Positions:
Official A., 1942-44, A. Consultant, 1945- , U.S. War Dept., Wash-
ington, D.C.

SCHLEMM, BETTY LOU—Painter, L.
 Caleb's Lane, Rockport, Mass. 01966
B. Jersey City, N.J., Jan. 13, 1934. Studied: N.Y.-Phoenix Sch.
Des.; NAD. Member: AWS; All. A. Am.; Hudson Valley AA; NAC;
N.J. Watercolor Soc. Awards: Silver Medal, AAPL, 1963 and prize,
1964; Medal of Honor, Knickerbocker A., 1963; Silver Medal, AWS,
1964 and prize, 1963; Gold Medal, Wolfe A. Cl., 1964; Bronze Medal,
Newark Mus. A., 1964; New Jersey "Artist of the Year," 1965; Rob-
ert Lehman travel grant, Jersey City Mus., 1967; numerous water-
color prizes, 1959-1969. Work: U.S. Navy Coll.; Virginia State Col.;
Bergen Mall Coll. Exhibited: AWS, 1961-1969; All. A. Am., 1959-
1969; Audubon A., 1959, 1961; NAD, 1963, 1965; Knickerbocker A.,
1959-1963; AAPL, 1960, 1963, 1964; Hudson Valley AA, 1963, 1964;
1969; Springfield Mus. FA; Newark Museum, 1964. Watercolor page
in American Artist (Feb. 1964); included in "Prize Winning Water-
colors," 1964, "Prize Winning Paintings," 1964, 1965.

SCHLEMOWITZ, ABRAM—Sculptor
 128 W. 23rd St., New York, N.Y. 10011
B. New York, N.Y., 1911. Studied: ASL; NAD. Awards: Guggenheim
Fellowship, 1963. Work: Chrysler Mus., Provincetown, Mass.; Univ.
California, Berkeley. Exhibited: Parsons Gal., N.Y., 1959; Stable
Gal., N.Y., 1961; Mus. Contemp. Crafts, N.Y., 1962; New School,
N.Y., 1963; MModA Art in Embassies traveling exh., U.S. and
abroad, 1963-1964; one-man: Howard Wise Gal., N.Y., 1961-1967.

SCHLICHER, KARL THEODORE—Educator, P., W.
 Art Department, Stephen F. Austin State College; h. 315 East
 California St., Nacogdoches, Tex. 75961
B. Terre Haute, Ind., May 14, 1905. Studied: Univ. Wisconsin, B.S.,
M.S.; Colt Sch. A.; AIC; Univ. Chicago; Ohio State Univ.; Ph.D., and
with Reynolds, Giesbert, Coats, Hopkins, Grimes, and others. Mem-
ber: CAA; Texas FA Assn.; Texas A. Edu. Assn. (Pres. 1956-58);
Texas State T. Assn.; Royal Soc. A., London; Western A.; NAEA.
Work: portraits in private colls. Exhibited: Contemp. A. of the
Southwest, 1956; Lufkin A. Lg.; Nacogdoches Fair; Stephen F. Aus-
tin State Col. Faculty Exhs. Contributor to Texas Outlook; Western
Arts Assn. Research Bulletin; Texas Trends in Art Education (Ed. &
Publ., 1951-56). Positions: Prof. A., Stephen F. Austin State Col-
lege, Nacogdoches, Tex. Hd. Dept. Art, Stephen F. Austin State Col-
lege, 1948-1965.

SCHMECKEBIER, LAURENCE E.—
 Educator, L., Cr., W., S.
 Syracuse University, School of Art 13210; h. 227 Scottholm
 Terrace, Syracuse, N.Y. 13224
B. Chicago Heights, Ill., Mar. 1, 1906. Studied: Univ. Wisconsin,
B.A.; Univ. Marburg, Germany; Sorbonne, Paris, France; Univ.
Munich, Germany, Ph.D., and with Max Doerner, Hans Hofmann.
Member: CAA. Author: "A Handbook of Italian Renaissance Paint-
ing," 1938; "Modern Mexican Art," 1939; "Appreciation of Art"
(U.S. Armed Forces Institute), 1945; "John Steuart Curry's Pageant
of America," 1943; "Art in Red Wing," 1946; "Ivan Mestrovic,
Sculptor and Patriot," 1959. Contributor to Art magazines and jour-
nals. Exhibited: Cleveland Inst. A.; CMA; Syracuse Mus. FA; Mun-
son-Williams-Proctor Inst.; Rochester Mem. A. Gal.; Corning Glass
Center. Awards: Cleveland, 1949-1951; George L. Herdle award,
Rochester, 1955; N.Y. State Fair, 1958. Positions: Asst. Prof. A.

Hist., Univ. Wisconsin, 1931-38; Prof., Chm. Dept. FA, Univ. Min-
nesota, 1938-46; Dir., Cleveland Inst. A., 1946-54; Prof. A. Hist.,
Dean, Sch. A., Syracuse Univ., Syracuse, N.Y., 1954- ; Ed., College
Art Journal, 1949-53; Adv. A. Ed., Encyclopaedia Americana, 1952-
60; Bd. Trustees, Everson Mus. A., 1955-1965. Fulbright Research
Scholar, Univ. of Munich, Germany, 1960-61.

SCHMEIDLER, BLANCHE J.—Painter, Gr., Des., C., L.
 Studio #604, 10 West 23rd St., New York, N.Y. 10010; h.
 35-35 75th St., Jackson Heights, N.Y. 11372
B. New York, N.Y., Nov. 1, 1915. Studied: Hunter Col.; Columbia
Univ., B.A.; Samuel Brecher A. Sch.; ASL, with Vytlacil; Seong Moy
Gr. Workshop. Member: NAWA; Silvermine Gld. A.; AEA; N.Y.
Soc. Women A.; P. & S. Soc. of New Jersey; Nat. Soc. Painters in
Casein; Am. Soc. Contemp. A. Awards: prizes, NAWA, 1959; Jer-
sey City Mus. A., 1958; Grumbacher prize, NAWA, 1960; P. & S.
Soc. of New Jersey, 1961. Work: in private collections, also, St.
Vincent's Col., Latrobe, Pa.; Seton Hall Univ., Newark, N.J.; John
Herron A. Mus. Exhibited: Amsterdam, Holland; Greece, Japan;
ACA Gal.; Assoc. Am. A. Gal.; Argent Gal.; NAD; Audubon A ;
NAC; WMAA; Herron A. Mus.; Lever House, N.Y.; IBM; NAD;
Riverside Mus.; Queens Soc. FA, all of N.Y.; Silvermine Gld.; Al-
bany Inst. Hist. & A.; Ball State T. Col.; Stratford Col., Danville,
Va.; Univ. South Carolina; Herbert Inst. A., Augusta; Beaumont
(Tex.) AI; Stephen Austin State Col.; Oklahoma A. & M. Col., Still-
water; Jersey City Mus.; South Bend AA; Oklahoma A. Center; Co-
lumbus Mus. A.; Massillon Mus. A.; Swope Gal. A.; Univ. New
Mexico; Univ. Texas; Everhart Mus. A.; Georgia Mus. A.; Wesleyan
Col.; Univ. South Carolina, and others. One-man: Feigl Gal., N.Y.,
1957. Other one-man exhs., 1960-61; Willimantic (Conn.) State
Col.; Cortland (N.Y.) Lib.; St. Vincent's Col., Latrobe, Pa.; Rundell
Gal., Rochester; Utica Pub. Lib.; Pack Mem. Lib., Asheville, N.C.;
Fremont Fnd., Mich.; Thiel Col., Pa.; Wustum Mus. A.; Greenville
(S.C.) Mus.; Oconee (S.C.) Gal., and others. Lecture: History &
Application of Woodcut, NAD. Positions: Chm., Memb. Comm.,
N.Y. Soc. Women A., 1962-65; Chm., Traveling Exhs., Am. Soc.
Contemp. A., 1963-66; Memb. Bd.,Dirs., N.Y. Soc. Women A., 1963-
66.*

SCHMID, ELSA (Mrs. J. B. Neumann)—Mosaic Artist
 10 Newberry Pl., Rye, N.Y. 10580; s. Chilmark, Martha's
 Vineyard, Mass. 02535
B. Stuttgart, Germany, 1897. Studied: ASL. Work: PC; MModA;
BMA; FMA; Newark Mus., and private collections. Mosaics, St.
Brigid's Church, Peapack, N.J.; Jewish Community Center,
Harrison, N.Y.; Caramoor, Katonah, N.Y.; memorial floor, U.S.
Cemetary, Carthage, Africa; stained glass windows, Church of
St. John the Apostle, Lyford Bay, Nassau.

SCHMID, RICHARD—Painter
 River View Rd., Gaylordsville, Conn. 06755
B. Chicago, Ill., Oct. 5, 1934. Studied: Am. Acad. A., Chicago.
Awards: AIC, 1956; Municipal A. Lg., Chicago, 1958. Work: Am.
Acad. A., Chicago; Oklahoma A. Center. Exhibited: AIC; IFA Gal.,
Wash., D.C.; Reynolds Gal., Taos, N.M.; Navy Pier Show, Chicago;
Ill. State Fair; Int. Gal., Palette & Chisel Club, Welna Gal., all Chi-
cago; Kent (Conn.) AA; N.Y. World's Fair, 1964; 2-man: Reynolds
Gal., Taos, 1962, 1963; Welna Gal., 1964; Merrall (Conn.) Com-
munity Center, 1964; one-man: Milwaukee, 1958; IFA Gal., Wash.,
D.C., 1959-1964; Welna Gal., 1963, 1964; Oklahoma A. Center,
1964; New Milford (Conn.) Lib., 1962, 1964.*

SCHMIDT, JULIUS—Sculptor
 Cranbrook Academy of Art, Bloomfield Hills, Mich. 48013
B. Stamford, Conn., June 2, 1923. Studied: Oklahoma A. & M. Col.,
Stillwater; Cranbrook Acad. A. Awards: prize and purchase, Mid-
America Annual, Kansas City, 1957, 1958; Guggenheim Fellowship,
1964. Work: MModA; WMAA; AIC; Detroit Inst. A.; WAC; Washing-
ton Univ., St. Louis; Univ. Nebraska; Univ. Michigan; Krannert A.
Mus., Univ. Illinois; Nelson Gal. A., Kansas City; Albright-Knox A.
Gal.; Cranbrook Acad. A.; Princeton Mus. A.; Santa Barbara Mus.
A.; Univ. Mus. A., Berkeley, Cal.; State Univ. N.Y. at Oswego. Ex-
hibited: Sao Paulo Bienale, 1964; Carnegie Inst., 1962; Battersea
Park, London, 1963; AIC; WMAA, 1960, 1963, 1965 and also, 1959,
1961, 1963, 1965 (Contemp. Am. Painting & Sculpture); MModA;
White House A. Festival, 1965; Whitney Annuals, 1967, 1969; Con-
temp. Am. P. & S., 1967; Rome Sculptura Internazionale, Marl-
borough, 1968; 14 one-man shows. Lectures on Sculpture. Posi-
tions: Instr., S., R.I. School of Design; Univ. California, Berkeley;
Chm., Sculpture Dept., Kansas City AI; Hd., Sculpture Dept., Cran-
brook Academy of Art, Bloomfield Hills, Mich., at present.

SCHMIDT, STEPHEN—Museum Director
 Fort Concho Restoration and Museum, 716 Burges St. 76901;
 h. 717 W. Washington Dr., San Angelo, Tex. 76901
B. New York, N.Y., Dec. 11, 1925. Studied: Mohawk Col., N.Y.;

Univ. New Mexico, B.A. Member: AAMus.; Mountain-Plains Mus.
Conf.; Am. Assn. for State & Local History; Nat. Trust for Histori-
cal Preservation; Texas Historical Fnd.; Texas State Historical Sur-
vey Comm.; San Angelo FA Council. Positions: Dir., Fort Concho
Restoration and Museum, Texas.

SCHNAKENBERG, HENRY—Painter
 Taunton District, Newtown, Conn. 06470
B. New Brighton, N.Y., Sept. 14, 1892. Studied: Staten Island Acad;
ASL. Member: Nat. Inst. A. & Let. Awards: hon. degree, D.F.A.,
Univ. Vermont. Work: MMA; WMAA; BM; Montclair A. Mus.;
PAFA; Savannah (Ga.) Gal.; Hartford (Conn.) State Library; Scripps
Col., Claremont, Cal.; U.S. Military Acad., West Point; Yale Univ.;
Am. Acad. A. & Lets.; AGAA; Springfield, (Mass.) Mus.; Newark
Mus.; New Britain A. Mus.; Wichita A. Gal.; Princeton Univ. A.
Mus.; Wadsworth Atheneum; Fleming Mus.; Wood Mus., Montpelier,
Vt.; Dartmouth Col. Gal.; Canajoharie (N.Y.) A. Gal.; AIC; Univ.
Nebraska; Minneapolis Inst. A.; Palace Legion Honor; murals,
USPO, Amsterdam, N.Y.; Fort Lee, N.J. Exhibited: nationally.

SCHNEEBAUM, TOBIAS—Painter
 29 Stuyvesant St., New York, N.Y. 10003
B. New York, N.Y., Mar. 25, 1921. Studied: City Col. of New York;
Brooklyn Museum with Tamayo. Award: Buenos Aires Fellowship to
Peru, 1955. Exhibited: Ganso Gal., N.Y., 1953; Peridot Gal., N.Y.,
1957, 1960, 1963, 1965, 1966, and in various group exhibitions in mu-
seums, 1956- . Illus.: "The Girl in the Abstract Bed," 1954; "Jun-
gle Journey," 1959.

SCHNEIDER, JO ANNE—Painter
 35 E. 75th St., New York, N.Y. 10021
Studied: Syracuse Univ. Sch. FA, and with Sol Wilson, Jack Levine.
Member: Audubon A.; NAWA. Work: Butler Inst. Am. A.; Jewish
Mus., N.Y.; Colby Col., Syracuse Univ. Exhibited: WMAA; PAFA;
CGA; Butler Inst. Am. A.; Univ. Nebraska; Toledo Mus. A.; AFA
circulating exh. One-man: John Heller Gal., N.Y., 1955, 1957, 1958;
Karlis Gal., Provincetown, 1962; Frank Rehn Gal., N.Y., 1965, 1966.

SCHNEIDER, NOEL—Sculptor
 124 Oxford St., Manhattan Beach, Brooklyn, N.Y. 11235
B. New York, N.Y., July 31, 1920. Studied: ASL with William
Zorach; Brooklyn Col. Member: Am. Veterans Soc. A.; Sculpture
Center, N.Y.; Shorefront Prof. A. Awards: prizes, award and cita-
tion, Lever House, N.Y., 1968; purchase prizes, Collectors of Am.
A., 1962, 1963, 1964. Exhibited: Stamford (Conn.) Mus., 1968; P. &
S. Soc. of New Jersey, 1969; Am. Veterans Soc. A., at Lever House,
1968; Union Carbide Gal., 1967; Contemp. A. Gal., N.Y.; Sculpture
Center, N.Y.; Carnegie Int. House; N.Y. State Exposition, Syracuse,
1964; Shorefront Prof. A., 1964.

SCHNIER, JACQUES—Sculptor
 4081 Happy Valley Rd., Lafayette, Cal. 94549
B. Roumania, Dec. 25, 1898. Studied: Stanford Univ., A.B.; Univ.
California, M.A.; Cal. Sch. FA. Awards: prizes, San F. AA, 1928;
Seattle AI, 1928; Oakland A. Mus., 1936, medal, 1940, 1948; Los A.
Mus. A., 1934; Inst. for Creative Art, Univ. Cal., 1963-64. Work:
SFMA; Cal. PLH; Faculty Cl., Univ. Cal., Berkeley; Cal. Hist.
Soc.; SS "Lurline"; Congressional Cl., Wash., D.C.; Mills College;
Univ. California; Berkeley H.S.; Ann Bremer Mem. Lib., San F.;
Stanford Univ. Mus.; Santa Barbara Mus. A.; Hebrew Univ., Jeru-
salem; Oakland A. Mus.; Crocker A. Gal., Sacramento; Honolulu
Acad. A.; Smithsonian Inst.; designed U.S. half-dollar commem-
orating San F.-Oakland Bay Bridge. Contributor of articles on
Psychoanalysis and Art to Journal of Aesthetics & Art Criticism;
College Art Journal; Intl. Journal of Psychoanalysis; American
Imago; Psychoanalytical Review; Yearbook of Psychoanalysis,
Samiksa, India; Proceeding of Nat. Sculpture Conference, Univ. of
Kansas, 1962, 1964, 1966, 1968; Leonardo, 1969. Lecture: "Psy-
choanalytic Interpretation of Art," Menninger Fnd., 1969. Exhib-
ited: Seattle FA Inst., 1927; San F., AA, 1926-1928; AIC; SFMA,
1934, 1936, 1939, 1950; M.H. deYoung Mem. Mus., 1947, 1960; Los
A. Mus. A., 1934, 1937, 1960; Portland (Ore.) Mus. A., 1937, 1960;
Henry Gal., Univ. Wash., 1957, 1960; San Diego, FA Soc., 1960;
Cal.-Pacific Intl. Expo., San Diego, 1935; GGE, 1939; Cal. PLH,
1940; Intl. Exh. Sculpture, Phila., 1949; NAD, 1950; NSS, 1950;
Santa Barbara Mus. A., 1959; Crocker A. Gal., Sacramento, Cal.,
1939, 1948; Inst. of Creative A., traveling exh., 1969-1970; one-
man: Stanford Univ. Mus., 1962; Crocker A. Gal., 1963; Santa
Barbara Mus., 1963; CAM; Ryder Gal., Univ. Cal., 1965; Valley A.
Center, Walnut Creek, Cal. Positions: Prof. of A., Emeritus, Univ.
of Cal., Berkeley. Regional Advisor, Nat. Sculpture Conference,
Univ. Kansas, 1964, 1966, 1968.

SCHNITTMANN, SASCHA S.—Sculptor, W., L., E.
 915 Commercial St., San Jose, Cal. 95112
B. New York, N.Y., Sept. 1, 1913. Studied: CUASch; NAD; BAID;

Columbia Univ.; & with Attilio Piccirilli, Robert Aitken, Olympio
Brindesi, & others. Member: NSS; Medallic A. Soc.; Am. Inst.
Arch. Sculptors; Am. Acad. Sculptors; Ecole des Beaux-Arts, Paris
(Hon. Life); BAID, Soc. Indp. A.; Russian S. Soc. and others.
Awards: prizes, Soc. Indp. A., 1942; CAM, 1942; Jr. Lg. Missouri
Exh., 1942; Kansas City AI, 1942; Pan-Am. Arch. Soc., 1933; Fraser
med., 1937, AIC, 1943. Work: busts, mem., monuments; Martin
Luther King heroic, memorial portrait bust four times life size,
1968. Copies of this work to Sweden, Ethiopia, Detroit, Atlanta, Los
Angeles, New York City and others. Pan-Am. Soc.; Am. Mus. Nat-
ural Hist.; Dayton AI; Kansas City AI; Nelson Mus. A.; Delgado Mus.
A.; Moscow State Univ., Russia; Mem. Plaza, St. Louis, Mo.; Dorsa
Bldg., St. Louis, Mo.; New Orleans, La.; San Diego, Cal.; American
Legion Monument, St. Louis; Monsanto Chemical Co., St. Louis;
Triton Mus., San Jose, Cal.; aluminum figures, War Memorial Sta-
dium, Little Rock; fragment torso, Willoughby-Toschi Gal., San
Francisco; Morgan Horse, life-size bronze, State of Vermont, 1967,
as a public monument; others in Wash., D.C., New York, N.Y., Vir-
ginia, etc. Many busts and portraits of notable persons throughout
the world. Exhibited: All. A. Am., 1935, 1936; William Rockhill
Nelson Gal., 1942; Soc. Indp. A., 1942-1944; St. Louis A. Gld., 1942;
WMAA, 1943; Chicago AC, 1943; Kansas City AI, 1942; CAM, 1942;
Indp. A., St. Louis, 1941-1943; SAM, 1942, Author, I., "Anatomy and
Dissection for Artists," 1939; "Plastic Histology," 1940. Contrib-
utor to: Architectural magazines, with articles on arch. sculpture.

SCHOELKOPF, ROBERT J., JR.—Art Dealer
 Schoelkopf Gallery, 825 Madison Ave. 10021; h. 118 W. 79th
 St., New York, N.Y. 10024
B. New York, N.Y., Nov. 9, 1927. Studied: Yale Col., B.A. Member:
Art Dealers Association of America. Specialty of Gallery: 19th and
20th century American painting, sculpture and photography. Posi-
tions: Dir., owner, Schoelkopf Gallery, New York, N.Y.

SCHOEN, MR. and MRS. ARTHUR BOYER—Collectors, Patrons
 17 E. 89th St., New York, N.Y. 10028
(Mr. Schoen)—B. Pittsburgh, Pa., April 17, 1923. Studied: Prince-
ton University. (Mrs. Schoen)—B. New York, N.Y., Sept. 27, 1915.
Awards: (Mrs. Schoen)—"Dame of Malta" of the "Sovereign Order
of The Hospitallers of St. John of Jerusalem, Knights of Malta,"
1969. Studied: Columbia University, Grand Central Art School.
Collection: Paintings; 18th century Lowestoft (Chinese export porce-
lain); 18th century English and American furniture and porcelains.
Positions: (Mrs. Schoen)—Trustee, Parrish Art Museum, South-
ampton, N.Y.

SCHOENER, ALLON THEODORE—
 Writer, Critic, Exh. Consultant
 New York State Council on the Arts, 250 W. 57th St., 10019; h.
 114 E. 90th St., New York, N.Y. 10028
B. Cleveland, Ohio, Jan. 1, 1926. Studied: Yale Col., B.A.; Yale
Univ., M.A.; Courtauld Inst. A., Univ. London. Member: Int. Des.
Conf., Aspen, Colo. Contributor to Zodiac; New Yorker; Art in
America; Arts Magazine, and others. Arranged Swiss Graphic De-
signers exhibition; Amedeo Modigliani retrospective; Ladislav Sut-
nar circulating exhs.; Georges Braque Retrospective, 1962. Di-
rected the following exhibitions: Lower East Side, Portal to Ameri-
can Life, at The Jewish Museum, New York, 1966; Erie Canal, 1817-
1967, for the New York State Council on the Arts, 1967; Harlem On
My Mind, at the Metropolitan Museum of Art, 1969. Editor of two
books: Portal to America: The Lower East Side, and Harlem On My
Mind. Positions: Asst. Cur., San Francisco Mus. A., 1950-55; Cur.,
The Contemporary Arts Center, Cincinnati A. Mus., 1955-1964;
Asst. Dir., Jewish Museum, New York, N.Y., 1965- .

SCHOENER, JASON—Painter, C., S., E.
 74 Ross Circle, Oakland, Cal. 94618
B. Cleveland, Ohio, May 17, 1919. Studied: Cleveland Inst. A.;
Western Reserve Univ., B.S. in A. Edu.; ASL, with Morris Kantor;
T. Col.; Columbia Univ., M.A. Member: San F. AI; CAA; ASL;
AAUP. Awards: prizes, Syracuse Mus. FA, 1953; CMA, 1947; Ohio
WC Soc., 1951; Brick Store Mus., Kennebunk, Me., 1953, 1958; Rich-
mond (Cal.) A. Center, 1957, 1961; Maine A. Gal., 1961; San F. Fes-
tival of A., 1956; Cal. State Fair, 1958; CMA, 1956. Work: CMA;
Munson-Williams-Proctor Inst.; Bates Col.; Athens Tech. Inst.,
Athens, Greece; Cal. PLH; WAC; Bowdoin Col.; Atlanta Univ.;
Zellerbach Corp.; N.Y. Hospitals Coll.; WMAA; Columbus (Ohio)
Gal. FA; Colby Col.; Syracuse Univ.; Fresno A. Center. Exhibited:
PAFA, 1940-1942, 1959-1965; Butler AI, 1940, 1941, 1947, 1948,
1950-1953, 1958, 1959, 1961, 1963; Audubon A., 1947; Syracuse Mus.
FA, 1951-1953; Wichita AA, 1951, 1952; San F. AA, 1951, 1955-
1957; Munson-Williams-Proctor Inst., 1950-1953; CMA, 1938-1943,
1948-1964; Ohio WC Soc., 1949-1953; Oakland A. Mus., 1953; West-
ern Painters, 1954; Cal. PLH, 1958 (one-man); CGA, 1957; Univ.
Nebraska, 1958; Art: USA, 1958; Colo. Springs FA, 1957; Univ.
Maine, 1958 (one-man); Bowdoin Col., 1958; Humboldt State Col.,

1956 (one-man); BM, 1959, 1961; Gump's Gal., San F., 1954, 1956, 1958, 1962, 1966, 1969, (one-man); Midtown Gal., N.Y., 1959, 1960, 1962, 1963, 1966, 1969, (one-man); AWS, 1961; Phila. A. All., 1961 (one-man); Cal. PLH, 1960, 1961, 1964; Oakland A. Mus., 1960, 1961; San F. AI, 1959-1965; Sacramento State Col., 1959 (one-man); Fresno A. Center, 1963 (one-man); Lehigh Univ., 1964 (one-man); Gimas Gal., Honolulu, Hawaii, 1969 (one-man). Contributor article "Art Patronage in Greece," to Art Journal, 1966/1967 winter edition. Positions: Instr., Munson-Williams-Proctor Inst., Utica, N.Y., 1949-53; Assoc. Prof., 1953- , Prof., 1961- , Chm. Dept. FA, 1955- , Dir. Pub. Relations & Special Services, 1953-55, Dir., Evening Col., California Col. A. & Crafts, Oakland, Cal., 1955- . Visiting Lecturer, Mills College, 1962-1963; Visiting Prof., Athens Technological Inst., Athens, Greece, 1964-1965.

SCHOLDER, FRITZ—Painter
P.O. Box 4712, Santa Fe, N.M. 87502
B. Breckenridge, Minn., Oct. 6, 1937. Studied: Univ. Kansas; Wisconsin State Col.; Sacramento City Col.; Sacramento State Col., B.A.; Univ. Arizona, M.F.A. Awards: Scholarship, Univ. Kansas, 1955; Kingsley Scholarship, Sacramento State Col., 1959; Rockefeller Scholarship, Univ. Arizona, 1961; John Hay Whitney Opportunity Fellowship, 1962-1963; Ford Fnd. purchase prize, Mus. FA of Houston, 1962; other prizes, W. Va. Centennial Exh., 1963; North Dakota Annual, 1964; Wisconsin A., 1956; Northern Cal. Annual, 1958; Cal. State Lib., 1958; Philbrook A. Center, 1959; Auburn (Cal.) A. Festival, 1960; Southwest Painters, Tucson A. Center, 1960; Cal. Spring Festival, 1961; grand prize, Am. Indian Biennal, Center for Indian America, Wash., D.C.; Scottsdale Nat. Indian Exh., special award, 1968, grand award, 1969. Exhibited: Univ. South Dakota. 1953, 1954; Carnegie Inst., 1955; Univ. Kansas, 1955; Univ. Wisconsin, 1956; Luther Col., 1956; Wisconsin State Col., 1956, 1957; Sacramento City Col., 1957, 1958; Crocker A. Gal., 1958-1964; Cal. State Lib., 1959; Philbrook A. Center, 1959, 1961, 1962, 1964; Shasta Col., 1959, 1960; Tucson A. Center, 1960, 1962, 1964; Mother Lode Exh., 1960; Sacramento Garden & Arts Center, 1960; Int. Drawing Exh., Barcelona, Spain, 1960; Oakland A. Mus., 1961; Mus. New Mexico, 1961; Butler Inst. Am. A., 1961; Denver A. Mus., 1961, 1962; Cal. PLH, 1962; DMFA, 1963; Roswell A. Center, 1962, one-man 1968; Mus. FA of Houston, 1962; Ft. Worth A. Center, 1964; Gallery of the Am. Indian, Wash., D.C., 1964; "Three From Santa Fe," Wash., D.C., 1968; Lee Nordness Gal., N.Y., 1968; Edinburgh A. Festival, 1967; Univ. North Carolina, 1967; Alaska Centennial Exh., Anchorage, 1967; Colorado Spings FA Center, 1967; Nat. Mus., Santiago, Chile, 1968; Andre Schoeller Gallerie, Paris, 1969; Rijksmuseum voor Volkenkunde, Leiden, Holland, 1969.

SCHOLZ, JANOS—Collector, Scholar, W.
863 Park Ave., New York, N.Y. 10021
B. Sopron, Hungary, Dec. 20, 1903. Studied: Royal Hungarian College of Agriculture, Dipl. Ing.; Royal Hungarian Conservatory of Music, Dipl. Professor. Author: Articles and books on Italian drawings. Field of Research: Italian drawings. Collection: Italian drawings. Positions: Prof., music faculty, Westminster Choir College, Princeton, N.J., 1937-1944; Instructor, lecturer, music faculty, Stanford University, 1938-1939. Has been on music faculties of University of California, Berkeley, Brigham Young University, Provo, Utah, University of California, Los Angeles, University of Colorado; Associate in Art History, Columbia University, N.Y., 1965.*

SCHONWALTER, JEAN —Painter, Lith., S., L.
67 Fielding Court, South Orange, N.J. 07079
B. Philadelphia, Pa., Apr. 22, 1925. Studied: Moore Col. A., Philadelphia, B.F.A. Member: AEA; SAGA; NAWA; Boston Pr.M. Awards: Russell Mount award, Montclair, N.J., 1958; Stauffer award, lithography, IBM Gal., N.Y., 1961, 1966; New Jersey State Mus. purchase, 1967; Bienfang award, Jersey City Mus., 1967. Work: PMA; New Jersey State Mus., Trenton; Slater Mem. Mus., Norwich, Conn.; Boston Pub. Library; Newark Pub. Library; Auburn Univ.; Univ. South Carolina; Adams Col., Colorado; Mercyhurst Col., and others. Exhibited: "American Prints Around the World," USIA, 1961-1962; Cultural Exchange, India, 1964-1965; Int. Exchange, Tokyo, 1966-1967; PAFA, 1961; LC, 1958; Boston Pr.M., 1966-1969; Butler Inst. Am. A., 1964-1967; PMA, 1965; NAWA, 1964, 1966, 1967, 1969; New Jersey State Mus., 1967-1969; New Jersey AA, 1966-1969; Springfield Mus., 1967; Montclair A. Mus., 1966. Positions: Instr., Moore Col. A., Philadelphia; juror, for exhibitions of SAGA, 1967; NAWA, 1969; Summit (N.J.) A. Exh., 1969.

SCHOOLER, LEE—Collector, Patron
75 E. Wacker Dr. 60601; h. 43 E. Elm St., Chicago, Ill. 60611
B. Chicago, Ill., June 15, 1923. Studied: Roosevelt University, B.S. Collection: Contemporary art, including works by Klee, Golub, Katchadoorian, Hunt, Hebald, Pattison, Lasansky, Dubuffet, Samaris, and others; Greek Classical, Etruscan, Luristan and Pre-Columbian artifacts. Positions: Chairman, Board of Trustees, Mundelein College.

SCHOOLEY, MRS. ELMER. See Du Jardin, Gussie

SCHOOLEY, ELMER WAYNE—Painter, Pr.M., T.
Montezuma, N.M. 87731
B. Lawrence, Kans., Feb. 20, 1916. Studied: Univ. Colorado, B.F.A.; Univ. Iowa, M.A. Awards: prizes, BM; Wichita AA; DMFA; SAGA; Mus. New Mexico; Mus. FA of Houston, 1962. Exhibited: Denver A. Mus.; Nelson Gal. A., Kansas City; SAM; Los A. Mus. A.; New Britain Mus. A.; LC; Carnegie Inst.; Rochester Mem. A. Gal. Work: Mus. New Mexico; DMFA; Wichita AA; BM; LC; Roswell (N.M.) Mus.; MMoA; Hallmark Coll.; MMA. Positions: Hd. Dept. A. & Crafts, New Mexico Highlands Univ., Las Vegas, N.M.

SCHORR, JUSTIN—Painter, E.
788 Riverside Drive, New York, N.Y. 10032
B. New York, N.Y., June 10, 1928. Studied: City Col. of New York, B.S.S.; T. Col., Columbia Univ., Ed. D. Author: "Aspects of Art," 1967. Exhibited: Audubon A., 1958; NAD, 1961; PAFA, 1961; Butler Inst. Am. A., 1964, 1966, 1968; BM, 1960; Metropolitan Young Artists, 1958; one-man: Fleming Mus., Vt., 1958; Harpur Col., 1961; N.Y. Univ. Loeb A. Center, 1965; Carlson Gal., N.Y. 1967. Positions Prof. A., T. Col., Columbia University, New York, N.Y. at present.

SCHRAG, KARL—Painter, Pr.M., T., L., I.
127 East 95th St., New York, N.Y. 10028
B. Karlsruhe, Germany, Dec. 7, 1912. Studied: Ecole des Beaux-Arts, Grande Chaumiere, Paris, France; ASL, with Lucien Simon. Harry Sternberg, Stanley W. Hayter. Awards: prizes, SAGA, 1954, 1962, 1967; Phila. Pr. Cl., 1954; Am. Color Pr. Soc., 1957, 1960, 1963, 1964; Nelson Rockefeller purchase award, N.Y. State Exh., 1963; purchase award, Int. Exh., "Original Prints." San Francisco, 1964; Bay Pr. M., Oakland, 1959 (purchase); Sarasota AA, 1960; Otis A. Inst., 1961 (purchase); Certificate of Merit, Exh. Contemp. A., New Delhi, India, 1962; Ford Fnd. Fellowship, Tamarind Lithography Workshop, 1962; Am. Acad. A. & Lets. Grant, 1966; Albion Col., 1968 (purchase); Ball State Univ., 1969. Work: LC; NGA; U.S. Nat. Mus.; MMoA; BM; PMA; N.Y. Pub. Lib.; CMA; MMA; Wadsworth Atheneum; Joslyn Mem. Mus.; Los A. Mus. A.; Dartmouth Col.; Providence Mus. A.; WMAA; AIC; Oakland A. Mus.; BMFA; Bibliotheque Nationale, Paris, France; Staatliche Kunsthalle, Karlsruhe; Univs. of Ala., Ill., Me.; Detroit Inst. A.; Munson-Williams-Proctor Inst.; Smithsonian Inst.; State Univ. N.Y., Oswego; Achenbach Graphic Coll., Cal. PLH; Art in Embassies Program; Bradley, Brandeis, Lehigh, Syracuse, Rockefeller, and Yale Univs.; one of four artists in the film "Printmakers-U.S.A.," produced by USIA. Exhibited: BM; Carnegie Int.; CMA; Columbia Mus.A.; AIC; Cornell Univ.; Dartmouth Col.; DMFA; Des Moines A. Center; Hamilton Col.; Herron Mus.; BMFA; Howard Univ.; MMA; MMoA; Mus. FA, Mexico City; Mus. Mod. A., Paris; Nat. Gal. Mod. A., Rome; New Britain Mus.; PAFA; Petit Palais, Paris; Rochester Mem. Gal.; CAM; Tate Gal., London; WMAA, and others. Retrospective Exh., AFA, BM, and traveling, 1960-1962. One-man: Smithsonian Inst., 1945; Phila. A. All., 1953; Univ. Maine, 1953, 1958; State Univ. of N.Y., Oneonta, 1953, 1959; Baden-Baden, Germany, 1958, 1961; Staatliche Kunsthalle, Karlsruhe, Germany, 1968; Storm King A. Center, N.Y., 1967; Kraushaar Gal., N.Y., 1947, 1950, 1952, 1956, 1959, 1962, 1964, 1966, 1968. Contributor to: "Artists Proof!"; "The Cable," Yearbook of Cooper Union; "New University Thought," 1967. Positions: Dir., Atelier 17 (1950); Instr., Gr. A., CUASch., New York, N.Y., 1954-65; L., A. Dept., Columbia Univ., 1958.

SCHRAMM, JAMES S.—Collector, Patron
J. S. Schramm Company, 216-220 Jefferson St.; h. 2700 S. Main St., Burlington, Iowa 52601
B. Burlington, Iowa, Feb. 4, 1904. Studied: Amherst College; Coe College. Awards: LL.D., Coe College, 1954; L.H.D., Amherst College, 1961. Collection: Contemporary American, European, Japanese painting and sculpture; African sculpture. Positions: President, American Federation of Arts, 1956-1958; President, Des Moines Art Center, 1963; Executive Committee and Exhibition Committee, American Federation of Arts, 1957-1965; Chairman, Convention Committee, AFA, 1959, 1961, 1963, 1965; Chairman, Des Moines Art Center Acquisition Committee, 1962, 1964-1965; Chairman, Amherst College Advisory Committee on Contemporary Art, 1959-1961. Trustee, Chicago Museum of Contemporary Art, 1967- .

SCHRECK, MICHAEL—Painter, S., L., T.
62 Susquehanna Ave., Thomaston, L.I., N.Y. 11021
B. Tarnov, Austria, July 13, 1901. Studied: in Vienna; also with Fernand Leger and Colin Collahan, London, England; ASL. Member: Life Fellow, Royal Soc. A., London; AFA. Awards: prizes, Vienna,

Austria (3); Grand Prix, Deauville, France; Prix de Vichy; Prix Rencontre, Chateau Senou, France. Work: N.Y. Univ. Medical Center, (2) and N.Y. Univ. Coll. Exhibited: Montreal Mus. FA, 1953-1956; Mus. Mod. A., Paris, 1964; Jersey City Mus., 1959; Salon les Amis des Arts, Roanna, France, 1964, 1965; Dominion Gal., Montreal; Oesterr Kuenstlerbund, Vienna; Galerie des Arts, Lyon, France; Galerie Lacloche, Paris; Anglo-French A. Soc., London; Little Studio, N.Y.; Madison Ave. Gal., Carleton House, N.Y.; one-man: Selected Artists Gal., N.Y., 1961; Collectors Gal., Long Island, N.Y., 1966; Roslyn Gal., 1967; Rockville Center, N.Y., 1968.

SCHREIBER, GEORGES—Painter, Lith., Des.
 8 West 13th St., New York, N.Y. 10011
B. Brussels, Belgium, Apr. 25, 1904. Studied: Acad. FA, Berlin and Dusseldorf, Germany. Awards: prizes, AIC, 1932; MModA, 1939; medal, A. Dir. Cl., 1943; prize, Springville, Utah, Mus., 1963. Work: MIT; Philbrook A. Center; Maryland Inst.; Lehigh Univ.; Rutgers Univ., WMA; Univ. Maryland; Conn. State T. Col.; Syracuse Mus. FA; Smith Col.; Mint Mus. A.; Springfield (Mass.) Mus. A.; MMA; BM; WMAA; Swope A. Gal.; Davenport Mun. A. Gal.; Mus. City of N.Y.; White House Lib., Wash., D.C.; Toledo Mus. A.; LC; Univ. Minnesota; No. Michigan Univ.; Encyclopaedia Britannica; U.S. Navy Dept.; Bibliotheque Nationale, Paris, France; Newark Mus. A.; Montclair (N.J.) A. Mus. Exhibited: nationally in leading museums and galleries. Author, I., Ed., "Portraits and Self Portraits," 1936; Author, I., "Bombino the Clown," 1947; I., "Light of Tern Rock," 1952; "Professor Bull's Umbrella," 1954; "Ride on the Wind," 1956; "That Jud!," 1957; "Bombino Goes Home," (Author, I.), 1959. Positions: Instr., New School for Social Research, Art Dept., New York, N.Y., 1959- .

SCHROEDER, ERIC—Museum Curator, P.
 9 Follen St., Cambridge, Mass. 02138
B. Sale, Cheshire, England, Nov. 20, 1904. Studied: Corpus Christi Col., Oxford Univ., B.A.; Harvard Univ. Graduate Sch. Work: BMFA; FMA. Exhibited: Margaret Brown Gal., Boston, 1949; Today's A. Gal., Boston, 1945. Author: "Iranian Book Painting," 1940; "Persian Miniatures in the Fogg Museum," 1942; "Muhammad's People," 1955; "Visions of Element," 1963. Co-Author: "Iranian & Islamic Art," 1941. Contributor to: Collier's Encyclopaedia; Book of Knowledge; Survey of Persian Art, Encyclopaedia of the Arts, Ars Islamica, Parnassus, & other art publications. Positions: Keeper of Islamic Art, FMA, Harvard Univ., Cambridge, Mass., 1938- .

SCHROYER, ROBERT McCLELLAND—Designer, I., T.
 68 E. 86th St., New York, N.Y. 10028
B. Oakland, Cal., Aug. 13, 1907. Studied: Carnegie Inst.; Parsons Sch. Des., and in Europe. Member: SI; AID; Parsons Sch. Des. Alumni Assn. Awards: scholarship (3) Parsons Sch. Des.; scholarship, House & Garden; Upholstery Leather Group Des. Award; Nat. Award for Adv. A. for Burdine's, Miami, Fla. Contributor illus. to House & Garden, House Beautiful, Good Housekeeping, Woman's Home Companion, Interior Design, and other national magazines. Exhibited: Lowe Gal., Miami, Fla. Positions: Des., Delineator Magazine, 1931-35 and subsequently; Freelance Des.-Illus., for advertising and publications specializing in interior architecture, design. Asst. Instr., Stage Des., Parsons Sch. Des.; Instr., Interior Arch. & Dec., Parsons Schs., France & Italy.

SCHUCKER, CHARLES—Painter, E.
 33 Middagh St., Brooklyn, N.Y. 11201
B. Gap, Pa., Jan. 9, 1908. Studied: Maryland Inst. Member: Yaddo Fnd. Awards: Walters traveling scholarship, Maryland Inst., 1936; Guggenheim F., 1953; Bd. Dirs., Yaddo Fnd. (last 4 years). Work: New Britain Mus.; BM; WMAA; Am. Acad. A. & Let., and in private colls.; mural, Balt. City Col., Balt., Md. Exhibited: nationally including MMA; PAFA; AIC; WMAA; WAC; SFMA; Carnegie Inst., Lincoln Center, N.Y., 1968, and many others. One-man: Macbeth Gal., 1946, 1949, 1953; Passedoit Gal., 1955, 1958; Howard Wise Gal., 1963. Positions: Prof., PIASch., Brooklyn, N.Y., 1956- .

SCHUELER, JON R.—Painter, T., L.
 901 Broadway, New York, N.Y. 10003
B. Milwaukee, Wis., Sept. 12, 1916. Studied: Univ. Wisconsin, B.A., M.A.; California Sch. FA, San Francisco, with Clyfford Still. Work: WMAA. Exhibited: CGA; WMAA; Minneapolis AI; one-man: Stable Gal., N.Y., 1954, 1961, 1963; Castelli Gal., N.Y., 1957, 1959; Hirschl & Adler Gal., N.Y., 1960. Contributor, "Letter on the Sky" to It Is Magazine. Lectures: Painting, at Yale Summer School of Art; Maryland Inst.; CAA meetings, etc. Instr., Advanced Painting, Yale Univ. and Maryland Inst.*

SCHULHOF, MR. and MRS. RUDOLPH B.—Collectors
 Dock Lane, Kings Point, N.Y. 11024
Collection: Modern Art since 1945.

SCHULLER, GRETE—Sculptor
 116 East 83rd St., New York, N.Y. 10028
B. Vienna, Austria. Studied: ASL, and with William Zorach. Member: NAWA; NSS; All. A. Am.; Audubon A. Awards: prizes, NAWA; Medal of Honor, Knickerbocker A.; Hon. Mem., Arch. Lg.; Prize, Silvermine Gld. A.; NSS, 1963; NAD, 1964; P. & S. of New Jersey, 1964; Art Lg. of Long Island, 1964. Work: Norfolk Mus. A. & Sciences; Mus. Natural History, New York City. Exhibited: NAWA; NAD; NSS; Sculpture Center, 1952-1955, 1958 (one-man); AFI Gal., 1963 (one-man); Des Moines A. Center; Audubon A.; PAFA, 1952-1954; Am. Acad. A. & Let., 1955; "150 Years of Sculpture" exh., Old Westbury (N.Y.) Garden Exh., 1960; Roko Gal., N.Y., 1966; All. A. Am.; Knickerbocker A.; Detroit Inst. A.; Univ. Notre Dame; PMA, and many others.

SCHULMAN, JACOB—Collector
 97 N. Main St. 12078; h. 117 First Ave., Gloversville, N.Y. 12078
B. New York, N.Y., July 2, 1915. Studied: New York University School of Education, B.S. Collection: Contemporary Painters and Sculptors with emphasis on Jewish or Biblical themes, including works by Baskin, Bloom, Levine, Rattner, Shahn, Weber, Zorach.

SCHULTE, MR. and MRS. ARTHUR D.—Collectors
 1 William St. 10004; h. 480 Park Ave., New York, N.Y. 10022
B. New York, N.Y. Studied: Yale University (Mr. Schulte); Hunter College, Columbia University, New York University (Mrs. Schulte). Collection: French, American, Italian and Greek paintings and sculpture.*

SCHULTZ, HAROLD A.—Painter, L., E.
 116 Fine Arts Bldg., University of Illinois; h. 2017 Burlison Dr., Urbana, Ill. 01801
B. Grafton, Wis., Jan. 6, 1907. Studied: Layton Sch. A.; Northwestern Univ., B.S., M.A. Member: Illinois A. Edu. Assn.; Nat. A. Edu. Assn.; Western AA.; Intl. Soc. for Edu. Through Art (UNESCO). Exhibited: AIC, 1928-1942; Chicago SA, 1931-1942; BM, 1931; Ferargil Gal., 1940. Lectures: American Art Today. Author: (with J. Harlan Shores) "Art in the Elementary School," 1948. Positions: Hd. A. Dept., Francis W. Parker Sch., Chicago, 1932-40; Prof., A. Edu., Univ. Illinois, Urbana, Ill., 1940- .

SCHULZ, CHARLES MONROE—Cartoonist
 2162 Coffee Lane, Sebastopol, Cal. 95472
B. Minneapolis, Minn., Nov 26, 1922. Awards: Outstanding Cartoonist of the Year, Nat. Cartoonists Soc., 1955; Outstanding Humorist of the Year, Yale Univ., 1957. Author, I., "Peanuts," 1953; "More Peanuts," 1954; "Good Grief, More Peanuts," 1955; "Good Ol' Charlie Brown," 1957; "Snoopy," 1958; "The Weekend Peanuts," 1959. Illus., "Kids Say the Darndest Things" (Art Linkletter). Cartoons reproduced in 400 newspapers, U.S. and abroad.*

SCHULZE, FRANZ—Educator, Critic
 Department of Art, Lake Forest College; h. 2078 Linden Ave., Highland Park, Ill. 60035
B. Uniontown, Pa., Jan. 30, 1927. Studied: Northwestern Univ.; Univ. Chicago, Ph.B.; AIC, B.F.A., M.F.A.; Akademie der bildenden Kuenste, Munich, Germany, grad. research. Member: AAUP; CAA; Archives of Am. A. Awards: Adenauer Fellowship in Painting, 1956-1957; Ford Fnd. Grant in Program for Reporters, Editors, Critics, 1964-1965. Positions: Instr., Dept. A., Purdue Univ., 1950-52; Lecturer in Humanities, Univ. Chicago, 1952-53; Chm. Dept. A., 1952-65; A.-in-Res., 1958-1961, Prof. A., 1962- , Lake Forest College; Chicago Critic, Art News, 1958-1964; Chicago Art Editor, Christian Science Monitor, 1958-64; Chicago Daily News, 1961- . Chicago Correspondent, Art in America 1965- ; Art International, 1967-1968. Articles in Apollo; Art Journal; Perspective; N.Y. Times; Modern Age, Art in America. Author: "Art, Architecture and Civilization," 1969.

SCHUMAN, ROBERT CONRAD—Painter, T., W., L.
 Lahaina, Maui, Hawaii.
B. Baldwin, N.Y., July 12, 1923. Studied: PIASch.; Columbia Univ., with Robert Brackman; New York Univ.; Univ. Hawaii. Member: Oahu A. T. Assn.; NAEA; Hawaii Edu. Assn.; NEA; Hawaii Arts Council; Hui Noeau; Pacific AA. Awards: prizes, Hui Noeau, 1964; Maui County Fair, 1964. Exhibited: Easter A. Exh., Honolulu, 1963, 1965; Honolulu Acad. A., 1963; Lib. of Hawaii, Honolulu, 1965; Hui Noeau, 1965; one-man: Ft. Roger, Honolulu, 1962; Gima's Gal., 1963; 2-man: Hawaiian Savings & Loan, Kauai and Honolulu, 1963. Work: Honolulu Acad. A. (Thesis "The Educational Department of the Honolulu Academy of Art"—bound vol., 1959). Author: "Teaching Teachers How to Teach Art," School Art Magazine, 1960; "Towards Aesthetic Growth." National Catholic Education Association, 1959. Lectures: Creativity in Art, NAEA, Miami, Fla., 1961. Posi-

tions: Instr., Public Schools of Hawaii; Prof., Univ. Hawaii; Coordinator, Adult Edu., Kauai, Hawaii; State Dir., National Art Week, Hawaii, 1959-61. Instr., Baldwin H.S., Wailuku, Maui, Hawaii, at present.*

SCHUSTER, CARL—Writer, Scholar
R.F.D. Box 416, Woodstock, N.Y. 12498
B. Milwaukee, Wis., Nov. 9, 1904. Studied: Harvard Col., A.B.; Harvard Univ., A.M.; Univ. Vienna, Ph.D. Awards: Harvard-Yenching F., 1929-1932; Guggenheim F., 1937-1939; Fulbright F., 1950-1951; Bollingen F., 1952-1953. Contributor of articles on design-traditions among primitive peoples to Anthropos, Far Eastern Quarterly, Communications of the Royal Tropical Institute (Amsterdam), Mankind (Sydney, Australia), Sudan Notes and Records (Khartum), Papers of 29th International Congress of Americanists, Anales del Museo de Historia Natural de Montevideo, Revista do Museu Paulista, Paul Rivet Memorial Volume, Artibus Asiae, and other publications.

SCHUTZ, ANTON—Etcher, Editor
95 East Putnam Ave., Greenwich, Conn. 06830; h. 4 Heathcote Rd., Scarsdale, N.Y. 10583
B. Berndorf, Germany, Apr. 19, 1894. Studied: Univ. Munich, M.E.; Royal Acad. A., Munich; ASL. Member: SAGA; Chicago Soc. Et.; AFA. Exhibited: in the U.S. and abroad. Author: "New York in Etchings," 1939 (book of 24 etchings); "Fine Art Reproductions of Old and Modern Masters," 1951; "Reproductions of American Paintings," 1962. Publ., Co-Editor, UNESCO World Art Series: India, Egypt, Australia, 1954; Yugoslavia, Norway, 1955; Italy, Iran, Spain, Ceylon, Japan, 1956; U.S.S.R., Czechoslovakia, 1957; Turkey, Greece, Bulgaria, Israel, 1958; Ethiopia, 1959; Burma, Tunisia, Roumania, Poland, 1960. Positions: Founder (1925), Dir., New York Graphic Society, Book & Art Publishers.

SCHWAB, ELOISA (RODRIGUEZ)—Painter
15-26 B, Plaza Rd., Fair Lawn, N.J.
B. Havana, Cuba, July 4, 1894. Studied: Academie Julian, Paris, France; ASL, with Bridgman, Miller. Member: ASL (Life); Fair Lawn AA; Paterson A. Lg.; Gotham Painters; Composers, Authors, Artists of America. Awards: prizes, State Show, Paterson, N.J., 1953 (2); Fair Lawn AA. Work: Kate Duncan Smith D.A.R. School, Grant, Ala.; Hickory (N.C.) Mus. A.; Paterson (N.J.) Mus. Exhibited: PAFA, 1923, 1938; one-man: Delphic Studios, N.Y.; Crespi Gal., N.Y.; RoKo Gal., N.Y.; Ridgewood AA; Paterson Pub. Lib.; Ahda Artzt Gal., N.Y., 1965, one-man, 1969. Positions: Sec., Gotham Painters, New York; Sec., Burr Artists.

SCHWABACHER, ALFRED—Collector
91 Central Park West, New York, N.Y. 10023
B. Felheim, Germany, Dec. 1, 1879. Collection: French impressionists.*

SCHWABACHER, ETHEL K.—Painter, W., Cr., L.
1192 Park Ave., New York, N.Y. 10028
B. New York, N.Y., May 20, 1903. Studied: in Europe and with Max Weber, Arshile Gorky. Work: WMAA; Albright-Knox A. Gal.; Rockefeller Inst.; Syracuse Univ. A. Gal. Exhibited: PAFA, 1953; CGA, 1959; WMAA touring exh., 1958-59; PC; Los A. Mus. A.; SFMA; WAC; CAM; Riverside Mus.; Carnegie Inst., 1961; BM, 1959, 1961; Mexico City Biennale, 1961; Albright-Knox A. Gal., 1962; Collector's Choice, St. Louis, 1963; WMAA annuals, 1948-1964; one-man: Passedoit Gal., 1935, 1947; Betty Parsons Gal., 1953, 1956, 1957, 1960, 1962; Greenross Gal., 1964. Author: "Arshile Gorky," 1957; Foreword to catalogue Arshile Gorky Memorial Show, WMAA, 1951.

SCHWACHA, GEORGE—Painter, T., L.
4 Huguenot St., Hanover, N.J.; also, 273 Glenwood Ave., Bloomfield, N.J. 07936
B. Newark, N.J., Oct. 2, 1908. Studied: with Arthur W. Woelle, John Grabach. Member: AWCS; Audubon A. (V.Pres.); Phila. WC Cl.; Art Centre of the Oranges (Pres.). Awards: prizes, Mun. A. Exh., Irvington, N.J., 1936; New Jersey Gal., 1937, 1939, 1940, 1942; A. Center of the Oranges, 1937; AAPL, 1939; New Haven Paint & Clay Cl., 1939, 1944; Asbury Park Soc. FA, 1940, 1942; Newark AC, 1942; Mint Mus. A., 1943, 1946; Springfield A. Lg., 1943; AWCS, 1944; Denver A. Mus., 1944; Alabama WC Soc., 1944, 1951, medal, 1954, prize, 1955; New Jersey P. & S. Soc., 1945; All. A. Am., 1945; Meriden A. & Crafts, 1952; Fla. Southern Col., 1952; Wash. WC Cl., 1946, 1955; Audubon A., 1953, Medal of Honor, 1961; Conn. Acad. FA, 1946; med., State A. Exh., Montclair, N.J., 1937, prize, 1963; gold medal, Nat. Soc. Painters in Casein, 1956. Work: Albany Inst. Hist. & A.; Mint Mus. A.; AWCS; Elisabet Ney Mus.; Laguna Beach, Cal.; New Haven Paint & Clay Cl.; Montgomery Mus. FA; Montclair A. Mus.; Fla. Southern Col.; Newark Mus.; Women's Cl., Perth Amboy, Bloomfield, N.J.; Norfolk Mus. A. & Sciences; Washington County Mus. A., Hagerstown, Md.; Butler AI; Delgado Mus. A. Exhibited: CM; CGA; Currier Gal. A.; Denver A. Mus.; Elgin Acad. A.;

Delgado Mus. A.; Mint Mus. A.; NAD; NAC; Newark Mus.; New Jersey State Mus., Trenton; PAFA; VMFA; AIC; etc.

SCHWADERER, FRITZ—Painter
12624 Westminster Ave., Los Angeles, Cal. 90066
B. Darmstadt, West Germany, July 4, 1901. Studied: Art. Sch. of Prof. Bayer, Municipal A. Sch., Mainz, Acad. FA, Berlin, Germany. Instructors include Liebermann, Slevogt and Pechstein. Member: Rheinischer Kunstlerbund (Pres. 1946-49). Work: Museums of Mainz, Cologne and Munich; Univ. Judaism, Los Angeles; La Jolla A. Mus.; Colorado Springs FA Center; Palm Springs Mus. Murals: Mission Center, Marburg-Lahn. Exhibited: United Nations Art Exh., 1960; Mus. FA of Houston, 1963; Los A. Mus. A., 1963; Phoenix A. Mus., 1964; Palm Springs, 1964; Univ. of Judaism, Los A., 1965; Ankrum Gal., Los A.; 11 one-man Exhs. Others in Europe.*

SCHWARTZ, AUBREY—Printmaker, S.
Henry St., Sag Harbor, N.Y. 11963
B. New York, N.Y., Jan. 13, 1928. Studied: ASL; BM A. Sch.; New School for Social Research. Member: SAGA; Print Council of America. Awards: Guggenheim Fellowships in Creative Printmaking, 1958-1959, 1959-1960; Tamarind Fellowship, 1960; prizes, Graphic Arts Festival, Boston, 1958; Pratt Inst., Miniature Print Exh., 1965; Brooklyn Museum Awards Winners Exh., 1961. Work: BM; AIC; NGA; PMA; WAC; LC; N.Y. Public Library. Exhibited: WMAA, 1957; Print Council of America, 1957, 1959, 1962; N.Y. Coliseum, Art: USA, 1959; State Dept. Contemporary Graphic Art, 1959; Paris Biennale, 1964; Pratt Inst., Brooklyn; San Francisco Printmakers, and others. Books: Portfolios with poetry: "Predatory Birds," 1958; "A Bestiary," 1961. Others—"Mothers and Children"; "The Midget and The Dwarf." Positions: Instr., Graphics, Harpur Col. of the State Univ. of N.Y., 1969-1972; Asst. Dir., Brooklyn Mus. A. Sch., 1968-1969. A.-in-Res., Mint. Mus., Charlotte, N.C., and Ogden, Utah.

SCHWARTZ, CARL E.—Painter, T., Lith.
2137 N. Clark St., Chicago, Ill. 60614
B. Detroit, Mich., Sept. 20, 1935. Studied: AIC, B.F.A.; Univ. Chicago. Member: A. Cl. of Chicago; North Shore A. Lg.; Suburban FA Center. Awards: Logan Medal and prize, AIC, 1958; other prizes; Michiana Exh., 1958; Old Orchard Festival, 1958, 1962, 1964; New Horizons Exh., 1960, 1965; Magnificent Mile, Chicago, 1961; Evanston Annual, 1962; Chicago Arts Comp., 1962; Park Forest (Ill.) A. Center purchase, 1967; Ball State Univ., 1966; Union Lg. purchase, 1967, and others. Exhibited: Butler Inst. Am. A., 1963, 1964; Ringling Mus., 1959, 1960; LC, 1958, 1959 and traveling to Europe; Ravinia A. Festival, 1960; Purdue Univ., 1964; Univ. Minnesota, 1963; Michigan Annual, 1955-1965, 1969; Michiana Exh., South Bend, 1958, 1962; A. Cl. of Chicago, 1964-1968; "Eye on Chicago," 1964; Annual Chicago Comp., 1962; "Spectrum '63"; AIC, 1958-1964; Momentum, 1955, 1956, 1964; New Horizons, 1959, 1960, 1963-1965, 1969; Old Orchard Exh., 1958-1968; Union Lg., 1958-1967; "Art Across America," 1965-1967, and others. One-man: in many galleries in Chicago, 1956-1965, including Feingarten, 1961; Edens Gal., 1963; Adele Rosenberg Gal., 1965; Barat Col., 1964; also, Chicago Pub. Lib., 1960; South Bend A. Center, 1964; Meredith Long Gal., Houston, 1963; Suburban FA Center, 1960.

SCHWARTZ, EUGENE M.—Collector, Patron
200 Madison Ave. 10016; h. 1160 Park Ave., New York, N.Y. 10028
B. Butte, Mont., Mar. 18, 1927. Studied: New School for Social Research, N.Y.; New York University; Columbia University; University of Washington. Collection: Contemporary American Art since World War II, chiefly of the sixties. Parts of the collection (shown as a group); Jewish Museum, New York, 1968; Everson Museum of Art, Syracuse, N.Y., Albany Institute of History and Art, Rochester Memorial Museum, 1969-1970. Positions: Acquisitions Committee, Whitney Museum of American Art, New York City, 1967-1968, 1968-1969.

SCHWARTZ, HENRY—Painter, T.
8 Garrison St., Boston, Mass. 02115
B. Winthrop, Mass., Oct. 27, 1927. Studied: BMFA Sch. FA; and with Kokoschka, Salzburg. Awards: James Paige Traveling Fellowship to Europe, 1953-1955. Work: Brandeis Univ.; De Cordova & Dana Mus., Lincoln, Mass.; BMFA; Wheaton Col., Norton, Mass., and in private colls. Series of 54 panels for filmstrip for United Churches of Christ, 1962. Exhibited: AIC, 1952; Carnegie Inst., 1961; Boston A. Festival, 1953-1958, 1964; One-man: Boris Mirski Gal., Boston, 1956, 1958, 1962, 1965, 1968. Contributor illus. to Boston Magazine. Positions: Instr., A., Boston Museum School of Fine Arts, 1955- .

SCHWARTZ, MANFRED—Painter, T., L., W.
22 East 8th St., New York, N.Y. 10003
B. Lodz, Poland, Nov. 11, 1909. Studied: ASL; NAD. Member: Fed.

Mod. P. & S. Awards: Silvermine Gld., 1965, 1967; Sesnam gold medal, PAFA. Work: Guggenheim Mus.; MModA; N.Y. Pub. Lib.; MMA; BM; WMAA; Newark Mus.; Rochester Mem. A. Gal.; PMA. Exhibited: 1942-1955: Carnegie Inst.; WMAA; MMA; VMFA; PAFA; AIC; BM; Wildenstein Gal.; Durand-Ruel Gal.; Butler AI; BMA; Cal. PLH; Inst. Contemp. A., Boston; Nelson Gal. A.; Walker A. Center; Portland (Ore). Mus. A.; CAM; MModA; Denver A. Mus.; CM; High Mus. A.; Norton Gal. A.; Delgado Mus. A.; one-man: Durand-Ruel Gal., 1947, 1949, 1950; FA Assoc., 1953, 1955, 1956-1958; BM, 1959, 1960; Albert Landry Gal., N.Y., 1962, 1963; New Sch., N.Y., 1967. Author of text for: "Etretat: An Artist's Theme and Development," 1965 (Shorewood Publ.). Positions: Faculty, Brooklyn Museum Art School, New York and New School for Social Research, N.Y.

SCHWARTZ, MARVIN DAVID—Museum Curator
Brooklyn Museum, Eastern Parkway, Brooklyn, N.Y. 10038; h. 515 E. 89th St., New York, N.Y. 10028
B. New York, N.Y., Feb. 15, 1926. Studied: City Col., N.Y., B.S.; N.Y. Univ. Inst. FA; Univ. Delaware, M.A. Member: CAA; Soc. Arch. Hist.; Soc. for Preservation of New England Antiquities. Awards: Belgian-American Edu. Fnd., 1949; Winterthur Mus. Fellowship, 1952-54. Contributor articles on American furniture to Encyclopedia of American Antiques, 1958. Also articles to Apollo Magazine; New York News & Views. Lectures: American Decorative Arts and Architecture (1640-1900) to museums, historical societies, women's clubs, etc. Arranged exhibitions "Victorians"; "Masters of Contemporary Crafts." Publications: Articles "Calligraphy" and "Enamels," Grolier Encyclopedia, 1962; "Robert Adam," The Seventh Wedgwood Int. Seminar, 1962; "Classical America, 1815-1845," Art Quarterly, 1963; "The Jan Martense Schenck House," Brooklyn Museum, 1964; "The Jan Martense House in the Brooklyn Museum," Antiques, 1964; "Treasures in English Silver from the Morrison Collection," Antiques, 1964. Positions: Instr., Art Appreciation, City Col., N.Y. (evening sessions); Junior Cur., Detroit Inst. A., 1950-51; Cur., American Decorative Arts, Brooklyn Museum, Brooklyn, N.Y., at present. Advisor, Van Cortlandt Mansion; Advisor, Fine Arts Committee, The White House. Advisor, The Long Island Historical Society.*

SCHWARTZ, THERESE—Painter
369 W. 36th St.; h. 161 West 75th St., New York, N.Y. 10023
B. New York, N.Y. Studied: Corcoran Sch. A.; BMSch. A., American Univ. Awards: CGA, 1951. Work: Olsen Fnd.; Howard Univ. Watercolor exh. for Southern museums and schools, commissioned by Howard Univ., 1953. Exhibited: Int. Exh., Musée d'Art Moderne, Paris, France, 1955; CGA, 1954; Smithsonian Inst., 1953; American Univ., 1949; Barnet Aden Gal., Wash., D.C.; HCE and Gal. 256, both Provincetown, Mass.; James Gal., N.Y.; Provincetown AA; one-man: Howard Univ.; Barnet Aden Gal.; Hacker Gal., N.Y.; Urban Gal.; Parma Gal., N.Y., 1959, 1960, 1961; East Hampton Gal., N.Y., 1964, 1966; A.M. Sachs Gal., N.Y., 1969. Positions: Editor, New York Element (art newspaper).

SCHWARTZ, WILLIAM SAMUEL—Painter, Lith., S.
880 N. Lake Shore Dr., Apartment 18-B, Chicago, Ill. 60611
B. Smorgon, Russia, Feb. 23, 1896. Studied: Vilna A. Sch., Russia; AIC. Awards: prizes, Detroit, Mich., 1925, 1926; AIC, 1927, 1928, 1930, 1945, Brower Prize, 1963; Union League Club, Chicago, 1959; Oklahoma A. Center, 1939, 1942; Corpus Christi, Tex., 1945; Monticello Col., Godfrey, Ill., 1939. Work: AIC; Encyclopaedia Britannica; Detroit Inst. A.; LC; U.S. Dept. Labor; Phila. A. All.; Dallas Mus. FA; Madison AA; Tel-Aviv Mus., Israel; Biro-Bidjan Mus., Russia; Oshkosh Mus. A.; Montclair A. Mus.; Standard Oil Co.; SFMA; PAFA; Joslyn A. Mus.; Santa Barbara Mus. A.; Henry Gal., Seattle; Denver A. Mus.; Ain-Harod Mus., Israel; Univs., Illinois, Nebraska, Wyoming, Minnesota, Missouri, Chicago; Am. People's Encyclopaedia; State T. Col., De Kalb; State Normal Univ., Carbondale; Monticello Col.; Beloit Col.; Bradley Univ.; libraries of Davenport, Iowa, Glencoe, Ill., Cincinnati, Ohio, Chicago, Ill.; Musée d'Art Juif, Paris; Des Moines A. Center; Little Gallery, Cedar Rapids; Chicago Pub. Schs. Coll.; Chicago Normal College; Northwestern Univ. Law Lib., Chicago; Illinois State Mus.; Southern Methodist Univ., Dallas; Illinois State Mus., Springfield; Evansville Mus. A. & Sciences; Union League, Chicago; Illinois State Historical Library. Exhibited: nationally and internationally, since 1918.

SCHWARZ, HEINRICH—Museum Curator, E., W., L.
Wesleyan University, Davison Art Center, Middletown, Conn. 06457
B. Prague, Czechoslovakia, Nov. 9, 1894. Studied: Univ. Vienna, Ph.D.; Wesleyan Univ., M.A. Member: CAA; AFA; Drawing Soc. (Nat. Comm.); Print Council of America (Bd. Directors). Awards: Austrian Cross of Honor for Science and Art, 1st Class, 1964. Author: "Amicis," Yearbook of the Austrian State Gallery, 1927; "D.O. Hill, Master of Photography," 1931; "Carl Schindler," monograph (in cooperation with F.M. Haberditzl), 1931; "Salzburg und das

Salzkammergut," 1936, 1958 (3rd ed.), and other books. Contributor of scientific articles to European and American magazines. Lectures on Painting and Graphic Arts. Positions: Asst. Albertina, Vienna, 1921-23; Cur., Austrian State Gallery, Vienna, 1923-38; Research Asst., Albright A. Gal., 1941-42; Cur., Paintings, Drawings & Prints, Mus. A., Rhode Island Sch. Des., Providence, R.I., 1943-53; Visiting Prof. & Cur. of Collections, Davison Art Center, Wesleyan Univ., Middletown Conn., 1954-1956; Prof., History of Art, 1956-1962; Visiting L., Wellesley Col., 1952; Mt. Holyoke, 1954, Yale Univ., 1958; Visiting Prof., Columbia University, 1966-1967, 1967-1968. Editorial Advisory Board, Master Drawings.

SCHWARZ, MYRTLE COOPER—Educator, C., W.
Livingston University, Livingston, Ala., 35470
B. Vanzant, Ky., Dec. 10, 1900. Studied: Western Kentucky State Col., A.B.; Univ. Kentucky; Univ. Virginia; Col. of William & Mary; Columbia Univ., M.A., Ed. D. Member: NEA; Oklahoma Edu. Assn.; NAEA; Western A. Edu. Assn;; Nat. Assn. of Curriculum Development; Nat. Assn. of Student Teaching; Assn. of Childhood Edu. International; Honorary Positions: Pres., Art Sect., Va. Educ. Assn.; Memb., Seven Co-operating Universities studying Teacher Training; Memb. Commission of Teacher Training; Assn. Higher Education; Prof. Standards & Development Comm., NEA; Chm., College Teachers of Art, Western AA. Exhibited: Oklahoma AA, 1944-1957; Enid A. Lg., 1944-1947; Philbrook A. Center, 1944-1957; VMFA, 1931-1943; Birmingham Mus. A.; Montgomery Mus. FA.; Springhill Col., Mobile, 1969. Contributor to Virginia Journal of Education; Kentucky Magazine. Positions: Prof. A., Dir. A. Edu., Oklahoma State Univ., Stillwater, Okla., 1947-1965; Wisconsin State Univ., 1965-1966; Livingston (Ala.) Univ., 1966- .

SCHWEITZER, GERTRUDE—Painter
Colt's Neck, N.J. 07722
B. New York, N.Y., 1911. Studied: PIASch.; NAD; Julian Acad., Paris, France. Member: NA; AWS; Wash. WC Cl.; New Jersey WC Soc. Awards: prizes, Phila. WC Cl., 1936; Norton Gal. A., 1946, 1947; Montclair A. Mus., 1947, 1952, 1958; Soc. Four Arts, 1947, 1948, 1950, 1951, 1959; Miami, Fla., 1951; AAPL, 1953, 1956, 1957, 1959; Audubon A., 1959; medals, AAPL, 1934; AWS, 1933; Seton Hall Univ. (and prize). Work: BM; Canajoharie Gal. A.; Toledo Mus. A.; Atlanta AA; Norton Gal. A.; Hackley A. Gal.; Davenport Mun. A. Mus.; Witte Mem. Mus.; Mus. Mod. A., Paris, France; Mus. of Albi, France; Montclair A. Mus., and many private colls. U.S., and abroad. Exhibited: nationally and in Europe at leading galleries, universities, museums and art associations. One-man: U.S.; Milan, Rome, Venice, Italy; Paris, France, 1960-61: Galerie Charpentier; Worth Ave. Gal., Palm Beach; Hanover Gal., London; Galerias Al Cavallino, Venice, Il Naviglio, Milan, L'Obelisco, Rome, and others.

SCHWEITZER, M. R.—Art Dealer, Appraiser, Collector
M.R. Schweitzer Galleries, 958 Madison Ave. 10021; h. 25 E. 86th St., New York, N.Y. 10028
B. Sept. 7, 1911. Member: Charter Member, American Society of Appraisers. Specialty of Gallery: American Painting, 1830-1930; European, 16th to 19th centuries. Field of Research: American Painting by little-known masters, 1830-1930. Collection: American and English 19th century, Spanish and Italian, 17th century.

SCHWINN, BARBARA E. See Jordan, Barbara Schwinn

SCOTT, DAVID WINFIELD—Museum Director
National Collection of Fine Arts, Smithsonian Institution; h. 3016 Cortland Place, N.W., Washington, D.C. 20008
B. Fall River, Mass., July 10, 1916. Studied: Univ. California, Ph.D.; Harvard Col., A.B.; ASL, with John Sloan and others; Claremont Grad. Sch., M.A., M.F.A. Awards: Tiffany Fnd. F., 1937, 1938; Del Amo Fnd. grant, study in Spain, 1951, 1957; Danforth Teacher F., 1955-56. Exhibited: Cal. WC Soc., 1940, 1945-1954; Los A. Mus. A., 1949, 1950; MMA, 1953. Positions: L., Prof. A., Scripps Col., and Claremont Graduate Sch., Claremont, Cal., 1946-63; Chm., A. Faculty, Scripps Col., 1956-63; Pres., Cal. WC Soc., 1952. Asst. Dir., 1963-1964; Director, 1964- , National Collection of Fine Arts, Washington, D.C.

SCOTT, HENRY (EDWARDS) JR.—Painter, Des., L., E., W.
Art Department, University of Missouri at Kansas City; w. 451 Greenway Terr., Kansas City, Mo. 64113; s. South Rd., Chilmark, Mass. 02535
B. Cambridge, Mass., Aug. 22, 1900. Studied: Harvard Univ., B.A., M.A.; ASL; in Italy with Edward Forbes; in New York with George Bridgman. Member: CAA; AAUP. Awards: Sachs F., 1925, Bacon A. Scholarship, 1926-28, Harvard Univ.; prize, Rochester A., 1928. Work: FMA; Univ. Kansas Medical Center; Univ. Kansas City Law Sch.; Amherst Col.; Regency House, Kansas City. Exhibited: Rochester A., 1928; Pittsburgh A., 1930-1934; Amherst Col., 1941; Springfield, Mass., 1942; Boston and Cambridge, Mass., 1947; Mar-

tha's Vineyard, 1947, 1952, 1955, 1963; Kansas City, 1950-1969. Author: "Historical Outline of the Fine Arts," 1936. Conceived & directed stage production of "Giotto's Frescoes of the Nativity," Pittsburgh, 1932-33, Amherst Col., periodically since 1935: Stage des. for Amherst Masquers, 1935-36, Univ. Kansas City Playhouse, 1949-50. Positions: L., Asst., Hd. Tutor, Div. FA, Harvard Univ.. and Radcliffe Col., 1923-26; Instr. A., Asst. to Dir., Mem. A. Gal., Univ. Rochester, 1928-29; Asst. Prof. A., Univ. Pittsburgh, 1929-34; Assoc. Prof. A., & Cur., Amherst Col., 1935-43; Assoc. Prof., Chm. A. Dept., Univ. Missouri at Kansas City, 1947-1964, Prof., 1959- . Memb., Municipal A. Comm., Kansas City, Mo., 1954-1969.

SCOTT, JONATHAN—Painter, T.
P.O. Box 1154, Taos, N.M. 87571
B. Bath, England, Oct. 30, 1914. Studied: Heatherly Sch. A., London; Heymann Schule, Munich; Academie de Belli Arti, Florence. Member: Pasadena Soc. A.; Cal. WC Soc. (Pres., 1960-61); Taos AA. Awards: prizes, Cal. WC Soc., 1955; Pasadena Soc. A., 1942-1944, 1947, 1948, 1952, 1956; A. of So. Cal., Laguna Beach, 1958. Work: Pasadena A. Mus.; Cal. AA; ports. in private colls. Commissioned to paint for U.S. Navy Combat Art Program, 1963, 1964. Exhibited: Cal. WC Soc., 1954-1957; Los A. Mus. A., 1940, 1948, 1949; Sacramento State Fair, 1949, 1950; Los A. County Fair, 1939, 1940, 1950; Laguna Beach, 1955-1957; Santa Barbara A. Mus., 1955 (one-man); Butler Inst. Am. A., 1956; Frye Mus., Seattle, 1958; Saratoga, 1960; McNay AI, San Antonio, 1963 (one-man); Col. of Santa Fe, 1967; Mus. New Mexico, 1967; Taos AA, 1968, all one-man. Musée de la Marine, Paris, 1963, with Navy's "Two Centuries of History" show.

SCRIVER, ROBERT MACFIE (Bob)—Sculptor
Box 172, Browning, Mont. 59417
B. Browning, Mont., Aug. 15, 1914. Studied: Northwestern Univ.; Dickinson (N.D.) T. Col.; Univ. Washington. Member: SC; Soc. Animal Artists; L'International A. Gld.; NSS; Montana Inst. of the Arts; Cowboy Artists of America. Work: Montana Hist. Soc., Helena; Mus. of the Plains Indians, Browning, Mont.; Glenbow Foundation Mus., Alberta, Canada; Cowboy Hall of Fame, Oklahoma City. Exhibited: Audubon A., 1964, 1965; NAD, 1964; Academic A., 1964; Soc. Animal Artists, 1961-1964; Glacier National Park Exh., 1963; one-man: Glendale, Cal., 1961; Northridge, Cal., 1961; Montana Historical Soc., 1968; Whitney Gal. of Western Art, Cody, Wyo., 1969. Specializes in Western and animal sculpture now in the collections of prominent Western Art collectors. Articles in American Artist and True magazine, 1964-1965. Positions: Owner, Dir., Scriver Studio, 1951- , Museum of Montana Wildlife, 1956- , The Bighorn Foundry, 1964, (where Scriver casts his own bronzes by the cire perdue method), all located in Browning, Mont.

SCULL, MR. and MRS. ROBERT C.—Collectors
1010 Fifth Ave., New York, N.Y. 10028*

SCULLY, VINCENT—Scholar, Writer
Orchard Road, Woodbridge, Conn.*

SCURIS, STEPHANIE—Sculptor, T.
Maryland Institute of Art, 116 W. Lanvale St. 21217; h. 928 S. Wolfe St., Baltimore, Md. 21231
B. Lacedaemonos, Greece, Jan. 20, 1931. Studied: Yale Sch. A. & Arch., B.F.A., M.F.A., with Josef Albers. Awards: Winterwitz Award, prize for outstanding work. Alumni award, all Yale Univ.; Peabody Award, 1961-62; Rinehart Fellow, 1961-64. Work: Jewish Community Center, Baltimore; sc., Bankers Trust Co., N.Y.; Cinema I and Cinema II, N.Y. (lobby sculpture); West View Center, Baltimore. Exhibited: MModA, 1962; WMAA, 1964; Art: USA traveling exh., 1958, 1960; New Haven A. Festival, 1958-59, and others. Positions: Instr., Sculpture, Maryland Institute of Art, Baltimore, Md., 1961- .

SECKEL, PAUL B.—Painter, Gr.
12 Van Etten Blvd., New Rochelle, N.Y. 10804
B. Osnabrueck, Germany, July 18, 1918. Studied: London Central Sch. A. & Crafts, London, England; Univ. Buffalo, B.F.A.; Yale Univ., M.F.A. Awards: Emily Lowe Award, 1963. Exhibited: MModA; Audubon A. annuals; Am. Acad. A. & Lets., 1963; Ruth White Gal., N.Y., 1964.

SECKLER, DOROTHY GEES—Critic, T., L.
64 Sagamore Rd., Bronxville, N.Y. 10708
B. Baltimore, Md., July 9, 1910. Studied: T. Col., Columbia Univ., B.S. in A. Edu.; Maryland Inst. A.; N.Y. Univ., and in Europe. Awards: Traveling scholarship, Md. Inst. A., 1931; AFA award for art criticism, 1954. Work: MModA. Co-author: "The Questioning Public," MModA Bulletin, 1949; "Figure Drawing Comes to Life," 1957; Modern Art Section of "Famous Artist's Course," 1953. Contributor of numerous articles to Art News including Artist Paints a Picture, and Can Painting Be Taught? series. Also reviews on ex-

hibitions and monographs. Lectures on Modern Art. Contributor art features to "MD," medical news magazine. Positions: Instr., N.Y. Univ. (part time), 1947-52; L., MModA., 1945-49; Assoc. Ed., Art News and Art News Annual, New York, N.Y., 1950-55; Gallery Ed., Art in America, New York, N.Y., 1955-61; L., Instr., City Col. of New York, 1957-60; L., Instr., Pratt Inst., Brooklyn, N.Y., 1960-61; Special contributor (Fine Arts) to MD, Medical News Magazine, N.Y., 1957-61; Contributor to Encyclopedia of World Art, 1959.*

SECUNDA, ARTHUR—Painter, S., T., W., L.
418-D, West Los Feliz Rd., Glendale, Cal. 91204; h. 1530 Easterly Terr., Los Angeles, Cal. 90026.
B. Jersey City, N.J., Nov. 12, 1927. Studied: N.Y. Univ.; ASL; Academie Grande Chaumiere, Academie Julian, and with L'Hote, and Zadkine, all Paris, France; Institute Meschini, Rome; and in Mexico. Member: ASL (Life). Work: Santa Barbara Mus. A.; Honolulu Acad. A.; MModA. Bibliotheque Royale, Brussels; Mus. FA, Ostende, Belgium; Cal. State Col., Los Angeles; BM. Exhibited: Parrish A. Mus., Southampton, 1951; Guild Hall, East Hampton, 1951; Grace Cathedral, San F., 1958; De Cordova & Dana Mus., 1959; Otis AI, 1961; Brigham Young Univ., 1961; Los A. AA, 1964; Phoenix A. Mus., 1964; Scripps Col., Pomona, 1964; Feigen-Palmer Gal., Los A., 1964; Ward Eggleston Gal., N.Y., 1950; traveling exh., Florence, Italy, 1952; N.Y. City Center Gal., 1954-55; SFMA, 1958; Boston A. Festival, 1959; Oakland A. Mus., 1960, 1964; SFMA annual, 1960; Hunterdon County A. Center, Clinton, N.J., 1960; Cal. State Fair, 1962; Denver A. Mus., 1962; Pasadena Mus. A., 1964; one-man: Design House, Detroit, 1951; N.Y. Pub. Lib. (Branches). 1952; Panoras Gal., 1957; Santa Barbara, 1958, 1961; Ankrum Gal., Los A., 1962; Santa Barbara Mus., 1962; Fresno A. Center, 1963; Palm Springs Mus., 1964; Long Beach A. Mus., 1964; 2-man: (with Harry Sternberg), Brigham Young Univ., Utah State Univ., Salt Lake City A. Center, all in 1961. One-man shows in 1968, 1969: Igor Mead Gal., San F.; Ventura Cal.; Fleischer/Anhalt Gal., Los Angeles; Univ. Cal., Davis; Richard Foncke Gal., Gent, Belgium; Panta Rhei Gal., Antwerp; Roda Langan Gal., Gavle, Sweden; Kunstcentrum Tvenster, Rotterdam, Holland. Author: "Artist of All Time" (Canada, 1965). Positions: Art Reviewer, Santa Barbara News Press, 1959-60; Art Ed., Beverly Hills Times, 1960; Assoc. Ed., Artforum, 1961-62; Contributor to Craft Horizons, Art Voices and others, 1964-65; Instr., Santa Barbara Mus. A. (and Cur. Edu., 1958-60); Santa Barbara City College; Otis AI; UCLA. Publisher & Editor: "Art Object Magazine."

SEDGWICK, JOHN POPHAM, JR.—Scholar, W., E.
Art Department, University of North Carolina; h. 304 Crestland St., Greensboro, N.C. 27401
B. Cambridge, Mass., Jan. 28, 1925. Studied: Williams College, A.B.; Harvard Univ., M.A., Ph.D. Awards: Fulbright Fellowship, Paris, 1951-1952; Ford Fnd. Teaching Intern, Columbia University, 1953-54. Contributor articles to Art News, Encyclopedia Americana, and others. Author: "Art Appreciation," 1959; "Structure and Evolution of the Major Cultures," 1962; "An Illustrated History of Art" (with E. M. Upjohn), 1963. Positions: Taught at Columbia Univ. and Hunter College, N.Y.; Prof. A., University of North Carolina, Greensboro, N.C., 1962- .*

SEEGER, STANLEY, JR.—Collector
Frenchtown, N.J. 08825*

SEFF, MR. and MRS. MANUEL—Collectors
120 East End Ave., New York, N.Y. 10028*

SEGAL, GEORGE—Sculptor
R.F.D. No. 4, Box 323, North Brunswick, N.J. 08902
B. New York, N.Y., Nov. 26, 1924. Studied: N.Y. Univ., B.S. in A. Edu.; Rutgers Univ., M.F.A. Work: MModA; Albright-Knox A. Gal., Buffalo; MModA, Stockholm, Sweden; Mint Mus. A., Charlotte, N.C.; AIC; A. Gal., Ontario, Toronto, Canada; WAC; Nat. Gal., Canada, Ottawa; Newark Mus.; New Jersey State Mus., Trenton. Exhibited: WMAA, 1964, 1966, 1968; AFA, 1961; AIC, 1962; "American Pop Art," Dusseldorf, Stockholm, Copenhagen, The Hague and Ghent, 1963; Sonnabend Gal., Paris, 1963; Sao Paulo Bienal, 1963, 1967; Jewish Mus., N.Y., 1964, 1966; Rochester Mem. A. Gal., 1965; WMA, 1965; Neuendorf Gal., Hamburg, Germany, 1966; AIC, 1966; Los Angeles County Mus., 1967; PMA, 1967; MModA, 1967, 1968; Guggenheim Mus., 1967; 3-man, A. Gal., Toronto, 1967; Albright-Knox Gal., Buffalo, 1967; "Documenta IV," Kassel, Germany, 1968; Helsinki, Finland, 1969; Vancouver (B.C.) A. Gal., 1969; Haywood Gal., London, 1969. One-man: Sidney Janis Gal., N.Y., 1967, 1968; Mus. Contemp. A., Chicago, 1968; Galerie Speyer, Paris, 1969.

SEGY, LADISLAS—Writer, L., T., Cr., Gallery Dir.
Segy Gallery, 708 Lexington Ave. 10022; h. 35 W. 90th St., New York, N.Y. 10024
B. Budapest, Hungary, Feb. 10, 1904. Awards: Hon. Litt. D., Central

State College, Wilberforce, Ohio. Author: "African Sculpture Speaks," 1952, 1955, 1961-1969; "African Sculpture," 1958, 1959, 1960, 1962, 1964, 1966, 1967, 1969. Contributor to Phylon; Midwest Journal; Journal of Negro History; Review of General Semantics; Centennial Review of Arts and Sciences and other periodicals in the U.S. Also to leading anthropological magazines and museum bulletins in Germany, Austria, France, Belgium and Switzerland. Lectures: "African Sculpture and Its Background" and "African Sculpture and Modern Art" (over 250 lectures) to Teachers Col., Columbia Univ., N.Y. Univ., Parsons School of Design, American Committee on Africa, Morgan State College, Univ. Michigan, John Herron A. Mus., Brandeis Univ., Yale Univ., and many others. Private Collection: African, modern French and American art; Mescala sculpture, neolithic stone implements, etc. Specialty of gallery: African Art. Positions: Expert and Consultant on African Art and Dir., Segy Gallery, New York, N.Y.

SEIBERLING, MISS D.—Art Writer
Life Magazine, Time-Life Bldg., New York, N.Y. 10020*

SEIDE, CHARLES—Painter, T., L., W.
Kings Point, Great Neck, N.Y.; h. 1 Washington Square Village, New York, N.Y. 10012
B. Brooklyn, N.Y., May 14, 1915. Studied: NAD. Member: AEA (Nat. Dir. 1953-1954, Bd. Dirs., N.Y. Chap. 1954-1955). Awards: Elliott and Suydam medals; Hallgarten award: Tiffany Fnd., F.; Yaddo Fnd.; prizes, Pepsi-Cola, 1946, 1948; Brooklyn Soc. A., 1950, 1956. Work: FMA, and private colls. Exhibited: Pepsi-Cola, 1946, 1948; PAFA, 1952; Brooklyn Soc. A., 1949-1958; NAD; WMAA; BM; Cooper Union; Riverside Mus., New York City; PMA; Syracuse Mus. A.; WAC; Butler Inst. Am. A.; Des Moines A. Center; Luyber Gal.; Assoc. Am. A.; Contemp. A. Gal.; ACA Gal.; Norlyst Gal.; Laurel Gal.; Artists Gal., 1956 (one-man), and others. Contributor to art and art materials. magazines. Positions: Instr., Brooklyn Mus. Sch. A., 1946-1962; Cooper Union, 1950- ; Dir., Seide Workshops; Great Neck, N.Y.; Tech. Dir., Museum Artists Materials Co., 1949-1960; Dir. Eve Sch. of Art & Architecture, 1966-1968, Assoc. Prof. A., Hd. Dept. A., Cooper Union, New York City, 1968- . Also Instr., Silvermine Col. A., 1966-1967.

SEIDENBERG, (JACOB) JEAN—
Sculptor, P., Des., Photog.
232 Industrial Ave., New Orleans, La. 70120
B. New York, N.Y., Feb. 14, 1930. Studied: BMSch. A., with John Bindrum; Syracuse Univ., Col. of FA. Awards: Scholarship, Syracuse Univ.; prizes, Louisiana State A. Comm. (2); New Orleans AA, 1951, 1953, 1954, 1958; Tiffany Fnd. Grant, 1960; Ball State Univ., purchase award, Arkansas A. Center, Little Rock, 1966. Work: mosaic mural, Motel de Ville; Saratoga Bldg.; sculpture, Simon-Diaz Clinic; James Derham Jr. H.S.; Oil & Gas Bldg.; Int. House, all in New Orleans; Lakewood Country Club, Algiers, La.; St. Rita Catholic Church, Harahan, La.; St. Michael's Church, Biloxi, Miss.; St. Richards Catholic Church, Jackson, Miss.; Philips Area Jr. H.S. and Union Bethel Church, both New Orleans; des. for Louisiana Gettysburg Monument Commission. Exhibited: Riverside Mus., N.Y., 1958; Orleans Gal. Group; Pensacola A. Center, 1959; Delgado Mus. A., 1955 (one-man); New Orleans AA, 1951, 1953, 1954, 1956, 1958, 1959, 1960, 1961; La. State A. Comm., 1951-1954, 1956, 1958, 1959, 1961; Bressler Gal., Milwaukee, 1957; Island A. Colony, Sea Island, Ga., 1957; Village A. Center, N.Y., 1956; Southwestern Louisiana Inst., 1958; Golden Jubilee, New Orleans, 1959; Butler Inst. Am. A., 1961; La. State Univ., 1959; Univ. Indiana (Photographs), 1959; Mortimer Brandt Gal., N.Y., 1962; East Tennessee State Col., 1962; MModA, 1962-63; 44th New Orleans House Trade Mission to the Orient, 1961; DMFA, 1962; Arkansas A. Center, 1963, 1966, 1968; Ball State Univ., 1968; Mobile, Ala., 1968; Baton Rouge Gal., 1968; West Berlin, Germany, 1968; Southeast Mus. Assn. traveling exh., 1964-65; one-man: Delgado Mus. A., 1955, 1963; Orleans Gal., 1959, 1962, 1964; Arkansas A. Center, 1964; Tulane Univ., 1965; Glade Gal., New Orleans, 1969; Middlebury (Vt.) Col., 1969; Washington Irving Gal., N.Y., 1969.

SEIDLER, DORIS—Printmaker, P.
215 Middle Neck Rd.; h. 14 Stoner Ave., Great Neck, N.Y.
B. London, England, Nov. 26, 1912. Studied: with Stanley W. Hayter Member: Phila. Pr. Cl.; Canadian Soc. P. & Etch.; SAGA. Awards: medal and prize, Pr. Cl. of Phila.; Bradley Univ. purchase award; BM, purchase, 1968. Work: PMA; SAM; LC; London (Ont.) Mus. A., Canada; St. Lawrence Univ.; BM; Smithsonian Inst.; USIA. Exhibited: PAFA; BM; LC; Toronto, Canada; Inst. Contemp. A., London; WMAA; AAA Gal., N.Y., and in Canada and Italy; one-man: England (3): Holland; Amsterdam; Grenchen, Switzerland; Redfern Gal., London; Roko Gal., N.Y. Guest Artist, Tamarind Workshop, Los Angeles.

SELDES, GILBERT—Critic
125 E. 57th St., New York, N.Y. 10022*

SELDIS, HENRY J.—Critic
Los Angeles Times, Times-Mirror Square 90053; h. 8921 Appian Way, Los Angeles, Cal. 90046
B. Berlin, Germany, Feb. 23, 1925. Studied: N.Y. Univ., B.A.; Grad. studies, Columbia Univ.; New School for Social Research. Training in Criticism with Donald Bear, Santa Barbara. Awards: Frank Jewett Mather Award, CAA, 1953. Member: CAA; Am. Soc. of Aesthetics and Criticism; Kappa Tau Alpha, hon. Journalism Soc.; Int. Art Critics Assn. Lecturer in art: Univ. California at Santa Barbara, 1955-58; UCLA Extension, 1958-59; Cal. State Col. at Los Angeles, 1967-1969. Many public lectures. Dir., The Image Retained Exh. shown at Municipal Gal., Los A., Cal. PLH, FA Gal. of San Diego and Santa Barbara Mus. A., 1961; Co-author "Sculpture of Jack Zajac," 1961; Dir., Pacific Heritage Exhibition, 1965; Dir., Rico Lebrun Retrospective Exhibition, 1968. Regular contributor to: Art in America; Arts; Christian Science Monitor in addition to Sunday Art Page, Calendar, for Los Angeles Times and twice weekly gallery reviews in the Times. Positions: Art Critic, Santa Barbara News-Press, 1950-58; Art Editor, Los Angeles Times, 1958- .

SELEY, JASON—Sculptor, E.
Art Department, Cornell University; h. 209 Hudson St., Ithaca, N.Y. 14850
B. Newark, N.J., May 10, 1919. Studied: Cornell Univ., B.A.; ASL, with Zadkine; Ecole National Superiore des Beaux-Arts, Paris, France. Awards: Travel grant from U.S. Office of Education for sculpture in Haiti, 1947-1948, 1949; Fulbright Scholarship for France, 1949-1950. Work: MModA; WMAA; Newark Mus. A.; Nat. Gal., Ottawa, Canada; Ontario Gal. A., Canada; Mus. of Univ. Cal., Berkeley; Dartmouth Col.; Everson Mus. A., Syracuse, N.Y.; Larry Aldrich Mus., Ridgefield, Conn.; Cathedral St. Trinite, Port-au-Prince, Haiti. Exhibited: WMAA, 1952, 1953, 1962, 1964, 1966, 1968; MModA, 1961, 1963; Festival of Two Worlds, Spoleto, 1962; Battersea Park Sculpture, London, 1963; Documenta III, Kassel, Germany, 1964; Contemp. Am. Sculpture, Berlin, 1965. Positions: Prof. FA, Hofstra Col., N.Y., 1953-1965; Assoc. Prof. A., and A.-in-Res., N.Y. Univ., 1965-1967; Prof. A., Chm., A. Dept., Cornell Univ., Ithaca, N.Y., 1968- .

SELIG, MR. and MRS. MANFRED—Collectors, Patrons
Empire Children's Wear Co., 2609 First Ave. 98121; h. 803 32nd Ave., S., Seattle, Wash. 98144
Collection: Old and Modern paintings; graphic art.

SELIG, MARTIN—
2360 43rd St. ..., Seattle, Wash. 98102*

SELIGER, CHARLES—Painter, Des., T.
Pictorial Productions, Inc.; h. 616 East Lincoln Ave., Mt. Vernon, N.Y. 10552
B. New York, N.Y., June 3, 1926. Work: MModA; WMAA; Newark Mus. A.; Tel-Aviv Mus., Israel; Mun. A. Mus., The Hague; Iowa State Univ.; Wellesley Col.; Munson-Williams-Proctor Inst.; City of Karlsruhe, Germany; USIS Coll.; Vancouver (B.C.) A. Gal.; SAM; BMA; Vassar Col.; Hirschhorn Coll.; Univ. Southern Illinois; Rose A. Mus., Brandeis Univ., and in private colls. Exhibited: WMAA, 1949-1958; AIC, 1948, 1961, 1963; MModA, 1951; Japan, 1955; Venice, 1948; Carnegie Inst., 1955; Rome-N.Y. Fnd., Rome, Italy, 1961; Toledo Mus. A., 1960; DMFA, 1960; Univ. Illinois, 1965; Munson-Williams-Proctor Inst., 1963-1965; Albright-Knox A. Gal., 1960; Nordness Gal., N.Y., 1960; Smithsonian Inst., 1968; Norfolk Mus. H. Sciences, 1966; St. Paul A. Center, 1966; Am. Acad. A. & Lets., 1966, 1968; one-man: A. Center Sch., Los A., 1949; deYoung Mem. Mus., 1949; Cal. PLH, 1952; Paris, 1950; Italy and Holland; Willard Gal., 1952, 1953, 1955, 1956, 1958, 1959, 1961, 1963, 1968; Otto Seligmann Gal., Seattle, Wash., 1956-1958, 1965-1967; Haydon-Calhoun Gal., Dallas, 1962; Nassau Community Col., Garden City, N.Y., 1966; Retrospective Exh., Wooster A. Center, Ridgefield, Conn., 1969. Positions: Managing Des. Dir., Pictorial Productions, Inc., Mt. Vernon, N.Y., at present.

SELIGMAN, KURT—Painter, printmaker
Sugar Loaf, N.Y. 10981*

SELLA, ALVIN CONRAD—Painter, E.
Department of Art, University of Alabama, University, Ala. 35486
B. Union City, N.J., Aug. 30, 1919. Studied: Yale Sch. A.; ASL, with Brackman, Bridgman; Columbia Univ., Dept. A., with Machau; Syracuse Univ., Col. FA; Univ. New Mexico; and in Mexico, D.F. Awards: First award, 54th Annual Miss. Juried Exh. Member: ASL; AAUP; CAA; F.I.A.L. Work: painting, Briston Iron & Steel Co.; Collectors of Am. Art; Sullins Col. Exhibited: CGA, 1951, 1957, 1960; Toledo Mus. A., 1958; Birmingham Mus. A., 1956; Memphis Mus. A., 1955; Norfolk Mus. A. & Sciences; Virginia Intermont Col., 1949, 1955, 1957; East Tennessee State Col., 1958; Contemp. A. Gal., N.Y., 1945 (one-man), 1947; 1949; Palacio de Bellas Artes, Mexico City,

1946, (one-man); Collectors of Am. A., 1949-1951; PAFA, 1953; Atlanta AA, 1959; Sullins Col., 1959; MMA, 1959; Twentieth Century Gal., Williamsburgh, Va., 1959-60; AFA traveling exh., 1961-62. Recent one-man exhs.: Centenary Col., Shreveport; Lauren Rogers Mus. A., Laurel, Miss.; Municipal A. Gal., Jackson, Miss.; Birmingham Mus. A., 1969. Positions: Hd., Dept. A., Sullins College, Bristol, Va., 1948-61; Prof. A., Univ. Alabama, University, Ala., 1961- . Visiting Prof., Mississippi A. Colony (spring) workshops, 1962-64; Shreveport Art Colony, (La.) 1964-68; A.-in-Res., Summer School of the Arts, Univ. of South Carolina, 1968.

SELLERS, CHARLES COLEMAN—Scholar, Writer
Librarian, Dickinson College; h. 161 W. Louther St., Carlisle, Pa. 17013
Studied: Haverford College, B.A.; Harvard Univ., M.A.; Temple Univ., Litt. D. Author: "Lorenzo Dow," 1928; "Benedict Arnold," 1930; "Charles Willson Peale," 1497; "Portraits and Miniatures by C.W. Peale," 1952; "Benjamin Franklin in Portraiture," 1962; "Charles Willson Peale with Patron and Populace" (Am. Philosophical Soc.), 1969; "Charles Willson Peale," 1969 (Scribner's). Editor, "American Colonial Painting" by W.P. Belknap, Jr., 1959. Positions: Bibliographical Librarian, Wesleyan Univ., Middletown, Conn., 1937-49; Cur., Dickinson College, 1949-56; Librarian, 1956-1968; Librarian, Waldron Phoenix Belknap, Jr., Research Library of American Painting, Winterthur, Del., 1956-59.

SELVIG, FORREST HALL—Writer, Scholar, Editor
140 Greenwich Ave., Greenwich, Conn. 06830; h. 122 E. 82nd St., New York, N.Y. 10028
B. Tacoma, Wash., Jan. 3, 1924. Studied: Harvard Univ., A.B.; Grad. study, A. History, Univ. California, Berkeley. Contributor articles to: Art News, Arts, Art in America. Author, editor of many catalogues and publications on art. Author: "The Nabis and Their Circle," Art News, 1961; "Symbolists and Nabis," Whitney Mus. Annual, 1968. Positions: Museum Asst., San Francisco Museum of Art, 1957; Asst. Curator, Walker A. Center, Minneapolis, 1958-1961; Asst. Director, Minneapolis Inst. A., 1961-1963; Asst. Dir., Gallery of Modern A., N.Y., 1963-1965; Director, Akron A. Inst., 1966-1968; Associate Editor, New York Graphic Society, Greenwich, Conn., 1968- . Other positions: Trustee, Lovis Corinth Memorial Foundation; Member, Urban Design and Fine Arts Commission, Akron, Ohio, 1966-1968.

SELZ, PETER H.—Museum Director, E., Hist., W., L.
University Art Museum, University of California, Berkeley, Cal.
B. Munich, Germany, Mar. 27, 1919. Studied: Univ. Chicago, M.A., Ph.D.; Univ. Paris. Member: CAA; Soc. Arch. Hist. Awards: Fulbright award, Univ. Paris, 1949-50; Univ. Chicago F., 1946-49; Belgian-American Edu. Fnd. F., 1953; Pomona Col., Trustee F., 1957; Order of Merit, Federal Republic of Germany, 1963; honorary doctorate, Cal. Col. A. & Crafts, 1967. Author: "German Expressionist Painting," 1957; "Understanding Modern Art," 1955; "Fifteen Polish Painters," 1961; "Mark Rothko," 1961; "Art Nouveau," 1960; "New Images of Man," 1959; "The Work of Jean Dubuffet," 1962; "Emil Nolde," 1963; "Max Beckmann," 1964; "Seven Decades of Modern Art," 1965; "Alberto Giacometti," 1965; "Directions in Kinetic Sculpture," 1966; "Funk," 1967. Contributor to Art Bulletin; Art News; Art Journal; Arts; Arts & Architecture; School Arts; Penrose Annual and other publications; Editor of "Art in America" and Consultative Com., "Art Quarterly," article "Painting" and others in Encyclopaedia Britannica. Exhs. arranged at Pomona College: Toulouse-Lautrec; Greene & Greene; Leon Golub; Primitive Art of Haiti; California Drawings; The Art of Greece and Rome; German Expressionist Painting; Buckminster Fuller; Modern Religious Art; The Stieglitz Circle, and others. Directed exhs. at Mus. Mod. A., N.Y.: New Images of Man; Art Nouveau; Mark Rothko; Futurism; Graphic Work of Umberto Boccioni; 15 Polish Painters; New Talent Shows; Chagall's Jerusalem Windows; Jean Dubuffet; Emil Nolde; Auguste Rodin; Max Beckmann; Alberto Giacometti; Am. Sculpture Exh., Battersea Park, London, 1963. Dir. exhs. at Univ. Art Mus., Berkeley, on: Directions in Kinetic Sculpture, 1965; Funk, 1967; Richard Lindner, 1969. Selected American contribution to Documenta III, Kassel, 1964. Positions: Asst. Prof. A. Hist., Inst. Des., Univ. of Chicago, 1953-54; Hd., A. Edu. Program, Inst. Des., Illinois Inst. of Tech., 1953-55; Chm. A. Dept. & Dir. A. Gal., Pomona College, Claremont, Cal., 1955-58; Cur., Painting & Sculpture Exhs., Museum of Modern Art, New York, N.Y., 1958-1965; Dir., CAA, 1959-1968; Director, University Art Museum & Prof. Art History, University of California, Cal., 1965- .

SEMANS, JAMES HUSTEAD, M.D.—Patron
Duke University Medical Center 27706; h. 1415 Bivins St., Durham, N.C. 27707
B. Uniontown, Pa., May 30, 1910. Studied: Princeton Univ., A.B.; Johns Hopkins Univ., M.D. Positions: Chairman, Board of Trustees,

North Carolina School of the Arts, 1964- ; Board Member, The Mary Duke Biddle Foundation.

SENNHAUSER, JOHN—Painter, T., Des.
255 W. 84th St., New York, N.Y. 10024
B. Rorschach, Switzerland, Dec. 10, 1907. Studied: in Italy; CUASch. Member: Am. Abstract A.; Nat. Trust for Historic Preservation; Assoc. Memb., Intl. Inst. A. & Let., Zurich; Fed. Mod. P. & S. (Pres., 1967-68). Awards: prizes, WMAA, 1951; Philbrook A. Center, 1951. Work: Guggenheim Museum; WMAA; Philbrook A. Center; Munson-Williams-Proctor Inst. Exhibited: NAD, 1935; PAFA, 1936-1953; Albright A. Gal., 1940; AIC, 1947, 1592, 1953; WMAA, 1948-1955; BM, 1943, 1949, 1951, 1953; Philbrook A. Center, 1951; Guggenheim Mus., 1942-1944; WMA, 1951; CGA, 1953; Univ. Illinois, 1953; Walker A. Center, 1953; Springfield Mus. A., 1952; AFA traveling exh., 1947-1949, 1952, 1954, 1955; Western Assn. A. Dir. traveling exh., 1947-1949, 1955, 1956; Brown Univ., 1954; Univ. Maine, 1955; CAM, 1956; North Carolina Mus. A., 1969; one-man: N.Y., 1936, 1939, 1942, 1947, 1950, 1952, 1956; Zabriskie Gal., N.Y., 1957; Knapik Gal., 1961; Salpeter Gal., N.Y., 1964; Meierhans Art Galleries, Perkasie, Pa., 1968, and many other exhs. nationally, and in Europe, Japan and Canada. Positions: Hd. A. Dept., C.R. Gracie & Sons, New York, N.Y.

SEREDY, KATE—Writer, I.
Montgomery, N.Y. 12549
B. Budapest, Hungary. Studied: Budapest Acad. A. Awards: Newbery medal, 1937. Author, I., "The Good Master"; "Listening"; "The White Stag"; "A Tree for Peter"; "Singing Tree"; "The Open Gate"; "Gypsy", "The Chestry Oak," 1935-1951; "Philomena," 1955; "The Tenement Tree," 1959; "A Brand New Uncle," 1961; "Lazy Tinka," 1962.

SERGER, MRS. HELEN—Art dealer
La Boetie Gallery, 1042 Madison Ave., New York, N.Y. 10021*

SERISAWA, SUEO—Painter, T.
10552 Santa Monica Blvd., West Los Angeles, Cal. 90025
B. Yokohama, Japan, Apr. 10, 1910. Studied: Otis AI; AIC, and with George Barker. Awards: prizes, Los Angeles County Mus., purchase, 1950, 1951; Chaffey Jr. Col., 1954, 1961; medals, PAFA, 1947; Work: San Diego FA Assn.; Santa Barbara Mus. A.; Pasadena AI; Univ. Arizona; Cal. State Fair Coll.; Los A. Mus. A.; MMA; Mus. Mod A., Eliat, Israel; Lytton Savings & Loan, Los Angeles; also in private colls. Exhibited: AIC; Los A. Mus. A.; San Diego FA Soc.; Denver A. Mus.; SFMA; Univ. Illinois; Univ. Nebraska; La Tausca Exh.; Carnegie Inst.; Walker A. Center; Hallmark awards; Int. traveling exh. to Tokyo, Japan; Sao Paulo, Brazil; CGA; AFA traveling exh.; WMAA, 1958; Stanford Univ.; MMA; Cal. PLH; Artists West of the Mississippi; PAFA; Santa Barbara Mus. A.; Mus. Mod. A., Eliat, Israel; FA Gal. of San Diego; Univ. Arizona; Joslyn Mus. A., Omaha; deYoung Mus., San Francisco; Otis A. Inst.; Cal. WC Soc., and others. One-man: Dayton A. Inst.; Hatfield Gal., Los Angeles; Scripps Col.; Occidental Col.; Pasadena Mus. A.; Landau Gal., Los Angeles. Positions: Instr., Painting, Scripps Col., Claremont, Cal., 1949; Kann Inst. A., Beverly Hills, Cal., 1947-51; Dir., Instr., Serisawa Studio, Los Angeles, Cal.

SERRA, RICHARD—Sculptor
319 Greenwich St., New York, N.Y. 10013
B. San Francisco, Cal., 1939. Studied: Univ. California, Berkeley, Santa Barbara, B.A.; Yale Univ., B.A., M.F.A. Exhibited: Yale Univ., New Haven, Conn., 1966; Noah Goldowsky Gal., N.Y., 1967-1969; Purdue Univ., 1967; Ithaca Col., N.Y., 1967; AFA traveling exh., 1968; Galerie Ricke, Cologne, 1968, 1969 (2); John Gibson Gal., N.Y., 1968; Leo Castelli Warehouse, N.Y., 1968; WMAA, 1968, 1969 (2); MMoDA, traveling exh., 1969; Washington Univ., St. Louis, Mo., 1969; New Jersey State Mus., Trenton, 1969; Stedelijk Mus., Amsterdam, 1969; Kunsthalle, Bern, Switzerland, 1969; Guggenheim Mus., N.Y., 1969; Aldrich Mus. Contemp. A., Ridgefield, Conn., 1969; Paula Cooper Gal., N.Y., 1969. One-man: Galleria La Salita, Rome, 1966; Galerie Ricke, Cologne, 1968; Galerie Lambert, Milan, 1969.

SESSLER, STANLEY SASCHA—Painter, E., Et., L.
1126 Manchester Drive, South Bend, Ind. 46615
B. St. Petersburg, Russia, Mar. 28, 1905. Studied: Courtauld Inst. A., Univ. London; Mass. Sch. A. Member: F., Royal Soc. A., London; F., Intl. Inst. A. & Let., Germany; AAUP; Midwestern Col. A. Conference (V. Pres., 1941, Pres. 1942), Academic A.A., Springfield, Mass. Awards: prizes, Hoosier Salon, 1938-41; South Bend, Ind., 1942; Northern Ind. A. Salon, 1952, 1953, 1955, 1958, 1959, 1966, 1967; Michiana Exh., 1950. Work: Univ. Galleries, Univ. Notre Dame; Philbrook A. Mus.; St. James Cathedral, South Bend; Moreau Seminary, Notre Dame, Ind.; port., Indiana Univ.; altar piece, St. Mary's Church, Floyd's Knobs, Ind.; mural, Bu-

chanan (Mich.) Pub. Lib.; Provincial House, St. Edward's Univ., Austin, Tex.; Guerry FA Gal., Sewanee, Tenn.; Columbus Mus. A. and Crafts, Columbus, Ga.; Jewish Community Federation of Cleveland. Exhibited: Hoosier Salon, 1929-1942, 1949-1951, 1969 and traveling exh. in Midwest; Indiana A. Cl., 1939-1942; Northern Ind. A., 1929-1946, 1949, 1952, 1953, 1955, 1961-1965, 1969; Springfield (Mass.) Mus. A., 1965; Ogunquit A. Center; Palm Beach A. Center; Michiana Exh., 1950, 1952; South Bend AA, 1950 (one-man); South Bend Women's Cl., 1951 (one-man); Lansing, Mich., 1958; Champaign, Ill., 1952; Ill. State Fair, 1960; Univ. Gal., Notre Dame, 1954-1961, 1964; Philbrook A. Mus., 1965; Heritage Gal., Chicago, 1965; Nat. Exh. of Realistic A., Springfield, Mass., 1965-1969; One-man: Columbus Mus. of A. & Crafts, (Ga.), 1966; Auburn Univ., (Ala.), 1966; Univ. of the South, Sewanee, Tenn., 1966; St. Edward's Univ., Austin, Tex., 1967; Coppini FA Gal., San Antonio, Tex., 1968. Illus. books for Ave Maria Press, Notre Dame, Ind., 1948-53. Positions: Dir. Dept. A., 1937-60, Prof. A., 1928- , Univ. Notre Dame, Ind.

SETTERBERG, CARL—Painter, I.
45 Tudor City Place, New York, N.Y. 10017
B. Las Animas, Colo., Aug. 16, 1897. Studied: AIC; Chicago Acad. FA; Grand Central Sch. A. Member: ANA; AWS; Audubon A.; All. A. Am.; SI (Life); Soc. Painters in Casein, Knickerbocker A. Awards: Emily Clinedinst Award and Ctf. Merit, SC; NAC; Caroline Arcier prize, Hudson Valley AA; Obrig prize and Ranger Fund purchase prize, NAD; U.S. Air Force Citation; Lena Newcastle award, Watercolor USA award, 1967, and the William Church Osborne award, 1969, AWS; Swedish-American A. Exh., Prize and medal, Swedish Cl., Chicago; American Artist Magazine Medal of Honor; All. A. Am. award, 1966. Work: Air Force Academy, Colo. Springs (12 paintings); U.S. Air Force Acad. Coll.; Columbus (Ga.) Mus. A.; McChord Air Force Base, Wash., D.C.; De Beers Coll., and in private colls. Exhibited: NAD; AWS; Audubon A.; All. A. Am.; Hudson Valley AA; Knickerbocker A.; Swedish American Cl., Chicago; SI; Laguna Beach AA; Birmingham Mus. A.; Tweed Gal., Duluth, Minn.; Norton Gal. A., West Palm Beach; Columbus Mus. A.; Royal Watercolor Soc., London, England; "200 Years of American Watercolor Painting," MMA, 1966-67, and many traveling exhs. in U.S. One-man: SI; Reynolds Gal., Taos, N.M.; Pelham Manor Cl., N.Y. Illustrations have appeared in many national and international magazines.

SEVERINO, D. ALEXANDER—Educator, L.
College of Education, Ohio State University, Columbus, Ohio 43210; h. 6215 Olentangy River Road, Worthington, Ohio 43085
B. Boston, Mass., Sept. 14, 1914. Studied: Mass. Sch. A., B.S.; Boston Univ., Ed.M.; Harvard Univ., Ed.D. Member: NAEA; Nat. Com. on A. Edu., AFA; Western AA; Am. Assn. Col. for T. Preparation; NEA. Awards: F., AIA. Lectures include "Environmental Forces—Some Aesthetic Components, Cincinnati, Ohio, 1969. Positions: Instr., R.I. Col. of Edu., 1938-42, Asst. Prof., 1942-43; Asst. Dean, R.I.Sch.Des., 1946-47; Prof., Chm., Bradford Durfee Tech. Inst., 1947-52; Assoc. Prof., Univ. Wisconsin, 1952-55; Prof., Dir. Sch. F. & App. A., Ohio State Univ., Columbus, Ohio, 1955-1958; Prof. FA, Assoc. Dean, College of Edu., Ohio State Univ., 1958- . Coordinator India/Education Project, 1957- .

SEVIN, WHITNEY—Educator, P., S.
Art Department, Franklin College; h. 275 South Middleton St., Franklin, Ind. 46131
B. Birmingham, Mich., Oct. 9, 1931. Studied: Kalamazoo Col.; Cranbrook Acad. A., B.F.A., M.F.A. Member: AEA; CAA. Awards: prizes, Kalamazoo AA, 1952; Army Photographic Comp., 1956; South Bend AA, 1957 (purchase); Art for Religion, Indianapolis, 1958; Eli Lilly European travel grant, 1959; Indiana A., 1960, 1964; Indiana State Fair, 1960, 1961; Louisville A. Center, 1961 (2). Work: Cranbrook Acad. A.; South Bend AA; Cranbrook Sch. Galleries. Exhibited: Butler Inst. Am. A., 1957, 1958, 1960, 1964; Ball State T. Col., 1957, 1958, 1959, 1962; Provincetown A. Festival, 1958; Columbia Mus. A., 1957; Exh. Momentum, Chicago, 1952, 1953; Michigan A., 1953-1957; Michiana Regional, 1957, 1964; Ind. State Fair, 1960, 1961; Louisville A. Center, 1961, 1964; Religious A. Festival, Duluth, 1964; Duluth A. Center, 1964. One-man: Hampton Inst. Mus., 1964; Va. State Col., Norfolk, 1964; Basil Gal., Duluth, 1964. Included in "Prize Winning Paintings," 1960. Positions: Prof. A., Art Dept., Franklin College, Franklin, Ind.; Prof. A., Chm. Art Dept., Hampton Institute, Hampton, Va., 1964- .*

SEWELL, AMOS—Illustrator
Sturges Highway, Westport, Conn. 60680
B. San Francisco, Cal., June 7, 1901. Studied: Cal. Sch. FA; ASL; Grand Central Sch. A., and with Guy Pene du Bois, Harvey Dunn, Julian Levy. Member: SI. Work: SI. Exhibited: Annual exh. American Illustration; SC; Cambridge (Mass.) Sch. Des.; I., for national magazines and textbooks.*

SEWELL, JACK VINCENT—Museum Curator
The Art Institute of Chicago (3); h. 1350 North Lake Shore Drive, Chicago, Ill. 60610
B. Dearborn, Mo., June 11, 1923. Studied: Univ. Chicago, M.A.; Harvard Univ. Member: Far Eastern Ceramic Group; Japan-American Soc. of Chicago (Dir.); The Cliff Dwellers and Arts Cl. of Chicago. Contributor to Archaeology, AIC Quarterly. Lectures: Indian and Far Eastern Art; The Arts of China; Strength in Delicacy—A Study of Archaic Chinese Bronzes; Sculpture of Gandhara. In charge of complete reinstallation of Oriental Collections in Art Institute, 1958. Positions: Cur., Oriental Art, The Art Institute of Chicago.*

SEXAUER, DONALD R.—Printmaker, E.
Art Department, East Carolina University, Greenville, N.C. 27834
B. Erie, Pa., 1932. Studied: College of William & Mary; Edinboro State Col., Pa., B.S. in A. Edu.; Kent State Univ., M.A. Awards: purchase prizes, Bradley Univ., 1966; Dixie Ann., Montgomery, 1966; Assoc. A. North Carolina, 1966; NAD, 1965. Work: Boston Pub. Library; Mint Mus. A.; Peoria A. Center; Montgomery Mus. FA.; Dayton A. Inst.; Dennison Univ.; Holyoke (Mass.) Mus. A.; Ithaca Col., N.Y.; Butler Inst. Am. A.; Lincoln Univ., Pennsylvania; Smith Col.; and others. Member: Academic A., Springfield, Mass.; Assoc. A. of North Carolina; Print Council of America; Pratt Graphic A. Center; SAGA. Exhibited: Madison Gal., N.Y., 1963; Springfield Mus. FA, 1963, 1964; North Carolina Mus. A., 1963; SAM, 1964, 1965; Portland (Ore.) A. Mus., 1964, 1965; Western Mich. Univ., 1964; Ohio Univ., 1964; Assoc. A. North Carolina, 1964-1967; Jewish Community Center, Richmond, 1964; A. Festival, Jacksonville, 1964; Mint Mus. A., 1964, 1966; Mercyhurst Graphics, Erie, Pa., 1964; SAGA, NAD, 1965-1967, 1969; 32nd Print & Drawing, Wichita, Kans., 1965, 1969; Bradley Univ., 1966; Pratt Graphic Center, N.Y., 1966; Kutztown (Pa.) State Col., 1966; Dixie Ann., Montgomery, 1967, 1968; Albany (N.Y.) Inst. Hist. & A., 1967; Albion Col., 1968; Oklahoma A. Center, 1968, 1969, and others. One-man: Belaire A. Center, Clearwater, Fla., 1965; Rocky Mount (N.C.) A. Center, 1963; Univ. North Carolina Chapel Hill, 1966; Lincoln Univ., 1967; Little Gal., Raleigh, and one-man and others. 2-man: Raleigh, N.C., 1964. Positions: Prof., A. Dept., East Carolina Univ., Greenville, N.C., at present.

SEXTON, LEO LLOYD, JR.—Painter
4575 Aukai Ave., Honolulu, Hawaii 96815
B. Hilo, Hawaii, Mar. 24, 1912. Studied: BMFA Sch. (Charles Cummings traveling scholarship); Slade Sch., London, England. Member: Hawaii P. & S. Lg. Awards: prizes, A. Dirs. Cl. award of Merit; Artists of Hawaii award, Honolulu Acad. A. Work: Honolulu Acad. A. Governors' ports., 1952-58. Floral paintings commissioned, 1964, for the Laurence Rockefeller Maunakea Beach Hotel. Exhibited: Honolulu Acad. A., 1958, 1959; Oakland A. Mus., 1938. Illus. "Mother Goose in Hawaii," 1960.

SEYLER, DAVID WOODS—Sculptor, P., I., Des., E.
2809 Woodsdale Blvd., Lincoln, Neb. 68502
B. Dayton, Ky., July 31, 1917. Studied: Cincinnati A. Acad.; AIC B.F.A.; Univ. Chicago; Univ. Wisconsin, M.S., and with Francis Chapin, Paul Burlin, W. Colescott, Edmund Giesbert, and others. Member: F.I.A.L. Awards: prizes, Syracuse Mus. FA, 1938; Trebilcock prize, 1938; Thomas C. Woods grant, 1959-60. Work: Univ. Chicago; Syracuse Mus. FA; CM; murals, Philippine Island Base, U.S. Navy; Int. des. & windows, Holy Trinity Church & Wesley Fnd. Chapel, Lincoln, Neb.; Sculptor of Centennial medals for State of Nebraska, 1967; Univ. of Nebraska, 1969. Exhibited: nationally and internationally. One-man: AIC, 1944; Loring Andrew Gal., Cincinnati, 1943; Univ. Chicago, 1940; Miller & Paines Gal., N.Y.; Gal. Tournabuoni, Florence, Italy; Univ. Nebraska, 1961; Sheldon Mem. A. Gal., 1964, 1969. Positions: Des., S., Rookwood Pottery, 1936-39; Pres., Dir., Kenton Hills Porcelains, Erlanger, Ky., 1939-45; A. Dir., S. Belvedere Pottery, Lake Geneva, Wis., 1945-49; Prof., A. Dept., Univ. Nebraska, 1949- . Dir. A., Lakewood Arts Consultants, Lincoln, 1969.

SEYMOUR, CHARLES, JR.—
Educator, Mus. Cur., Historian, L.
Yale University, New Haven, Conn.; h. 145 Cliff St., New Haven, Conn. 06511
B. New Haven, Conn., Feb. 26, 1912. Studied: King's Col., Cambridge Univ.; Yale Col., B.A.; Univ. Paris; Yale Univ., Ph.D., and with Henri Focillon. Awards: Guggenheim F., 1954-55. Author: "Notre Dame of Noyon in the 12th Century," 1939; "Masterpieces of Sculpture in the National Gallery of Art, Washington, D.C.," 1949; "Tradition and Experiment in Modern Sculpture," 1949; "Art Treasures for America" (Kress Collection Anthology), 1961; "Italian Sculpture 1400-1500" (Pelican History of Art), 1966; "Michelangelo's David," 1967. Contributor to Gazette des Beaux-Arts, Art

Bulletin. Lectures: Renaissance Sculpture; 19th Century Sculpture, etc. Positions: Instr., Hist. A., Yale Univ., 1938-39; Cur. S., 1939-42, Asst. Chief Cur., 1946-49, NGA, Washington, D.C.; L., Am. Univ., Washington, D.C., 1942; L., Johns Hopkins Univ., Assoc. Prof. Hist. A. and Cur. Renaissance A., 1949-54; Prof. Hist. A., 1954- , Chm., Hist. & A. Dept., 1956-59, Yale University, New Haven, Conn.; Dir., CAA, 1940-42, 1958-61; Dir., Renaissance Soc. of America, 1961-1969; Visiting L., Univ., Colorado, 1958, 1961 (summer session). Baldwin Lecturer, Oberlin, 1964; Visiting Mellon Professor, University of Pittsburgh, 1965.

SHACKELFORD, KATHARINE BUZZELL—Painter, T.
4528 El Camino Corto, La Canada, Cal. 91011
B. Fort Benton, Mont. Studied: Montana State Col.; Univ. California, B.E., and with Nicolai Fechin. Member: Glendale AA; Women Painters of the West; Los A. Mus. Assn. Town & Country FA; Los A. AA. Awards: prizes, Glendale AA, 1953-1955; Women Painters of the West, 1954. Exhibited: Los A. AA; Glendale City Hall; Los A. City Hall; Madonna Festival; Pasadena AI; Sao Paulo, Brazil; Colombo, Ceylon; Singapore; Great Falls (Mont.) Pub. Lib., and others. Lectures: Approach to Portraiture; Art and Religion; Faces and Places Around the World.*

SHACKELFORD, SHELBY—Painter, E., W., I., Gr.
300 Northfield Pl., Baltimore, Md. 21210
B. Halifax, Va., Sept. 27, 1899. Studied: Maryland Inst.; in Paris; & with Marguerite & William Zorach; Othen Frieze, Fernand Leger. Awards: purchase prizes, BMA, 1952, 1956; prize, Jewish A. Center, Balto, 1960; Md. regional, 1962. Work: N.Y. Pub. Lib.; BMA; Morgan Col.; Western Maryland Col. Exhibited: Graphic Exh., N.Y., 1936; 50 Prints of the Year, 1930-1932; BMA, 1944-1946, 1955; Peale Mus. A., 1954, 1955; Jewish A. Center, Balto., 1960; one-man: BMA, 1957; Western Md. College, 1958; Jefferson Place Gal., Wash., D.C., 1958; Scargo Pottery Gal., 1960, 1961; Dennis, Mass., 1962, 1963. Author, I., "Now for Creatures," 1934; "Electric Eel Calling," 1941; I., "Time, Space and Atoms," 1932. Positions: A. Advisor, Friends Sch., Baltimore, Md., 1945-46; A. T., BMA, Baltimore, Md., 1946; Hd. A. Dept., 1948-59; in charge of exhs., 1959-65, St. Timothy's Sch., Stevenson, Md., 1946- . Instr., Adult Edu., BMA, 1954- .

SHAFFER, ELIZABETH DODDS (Mrs. Verl R.)—Painter
100 S. 19th St.; h. 1915 Broad St., New Castle, Ind. 47362
B. Cairo, Ill., Feb. 12, 1913. Studied: Butler Univ., A.B., and with Wayman Adams, Jerry Farnsworth. Member: Indiana A. Cl. Awards: prizes, Indiana State Fair, 1949, 1952, 1954, 1957, 1959 (2) 1966, 1967; Richmond, Ind., 1968; Hoosier Salon, 1951, 1955, 1956, 1960; Indiana A. Cl., 1953, 1954, 1955, 1957, 1960; Michiana regional, 1956. Work: McGuire Hall and MacQuarrie Gal., both Richmond, Ind.; Hoosier Salon Gal., Indianapolis; Inland Container Corp., Indianapolis, and in private colls. Exhibited: Hoosier Salon; Indiana A. Cl.; John Herron AI, 1966-1969; Indiana State Fair; Michiana Regional; Richmond Annual.

SHAFRON, MRS. HAROLD M. See Noronha De, Maria

SHANE, FREDERICK E.—Painter, Lith., E.
Dept. of Art, University of Missouri; h. 205 South Garth St., Columbia, Mo. 65201
B. Kansas City, Mo., Feb. 2, 1906. Studied: Broadmoor A. Acad.; Kansas City AI, and with Randall Davey. Awards: prizes, CAM, 1942, 1943; Springfield Mus. A.; Davenport Mun. A. Gal., and others. Work: Scruggs-Vandervoort-Barney; CAM; William Rockhill Nelson Gal. A.; Nat. Mus. A., Tel Aviv, Israel; Denver A. Mus.; State Hist. Soc. of Missouri; Springfield (Mo.) Mus. A.; IBM; Wilmington (Del.) A. Center; Mus. New Mexico, Sante Fe; Abbott Laboratories; USPO, Eldon, Mo.; State Univ. of N.Y., Oswego, N.Y. Exhibited: AIC; CGA; PAFA; WFNY 1939; WMAA; Pepsi-Cola, 1945; Kansas City AI; Denver A. Mus.; CAM; Assoc. Am. A.; Los A. Mus. A.; Davenport Mun. A. Gal.; Joslyn A. Mus.; one-man: GRD Gal., N.Y.; Assoc. Am. A.; Kansas City AI; Vanguard Gal., St. Louis; Denver A. Mus.; Stendahl Gal., Los A.; Michigan State Col.; Univ. Missouri (retrospective), 1951, 1964; Christian Col., 1964 and Palmer Gal., Kansas City, 1965. Volume of drawings publ., 1964. Positions: Prof. A., Chm. A. Dept., Univ. Missouri, Columbia, Mo., 1958-1967.

SHANE, GEORGE WALKER—Art Critic, P.
Des Moines Register, 715 Locust St. 50304; h. 708 41st St., Des Moines, Iowa 50312
B. Eldon, Iowa, Dec. 8, 1906. Studied: Univ. Kentucky; AIC, and with Louis Bouche. Research on Impressionism in Paris, 1958, under grant from Guivi Malville (Art Patron). Awards: Purchase awards, Des Moines A. Center, 1952; Iowa A. Educators Assn. Work: Joslyn A. Mus.; Davenport Municipal Mus.; Des Moines A. Center; Mulvane A. Center. Positions: Pres., Des Moines Art Forum, 1952-53; Art Critic, Des Moines Register, 1938- .*

SHANKS, BRUCE (McKINLEY)—Editorial Cartoonist
Buffalo Evening News (5); h. 675 Delaware Ave., Buffalo, N.Y. 14202
B. Buffalo, N.Y., Jan. 29, 1908. Awards: Freedoms Fnd. awards, 1952-1955, 1957, 1961, 1963, 1965, 1966; Pulitzer Prize for 1957 editorial cartoon; Christopher award, 1957; "Page One" award, Buffalo Newspaper Gld., 1956, 1959, 1960-1967 (yearly); Grand Award, National Safety Council, 1961 (for 1960 cartoon). Cartoon Citation, All-America Conference to Combat Communism, Wash., D.C., 1964. World reproduction of work through arrangement of exchange with West Berlin syndicate. Work: Cartoons on permanent exh., Dept. Justice and Supreme Court Offices, Washington, D.C. Exhibited: Cartoon exhs., in schools, banks, colleges, etc. Cartoons reproduced in New York Times, Newsweek, U.S. News & World Report, and other newspapers. Also, Time magazine.

SHANNON, PATRIC—Museum Director, P., Des., E.
Oklahoma Art Center, Plaza Circle, Fair Park, 3113 Pershing Blvd. 73107; h. 300 N.W. 17th St., Oklahoma City, Okla. 73103
B. Durant, Okla., May 6, 1920. Studied: Stanford Univ., A.B.; Univ. California, M.A. and with Hans Hofmann. Member: CAA; AAMus. Exhibited: SFMA; Los A. Mus. A.; Oakland A. Mus.; WMAA; DFMA. Positions: Educational Asst. to Director, Oakland A. Mus., 1950-51; Color Consultant, W & J Sloane, San Francisco, 1951-53; Staff Des., Cleveland Playhouse, 1953-54; Color Consultant, Stolte, 1955; Dir., Theatre Arts, El Camino Col., California, 1956-57; Chm., A. Dept., Austin Col., Sherman, Texas, 1957-61; University of California Graduate School (Art History), 1962-1965; Dir., Oklahoma Art Center, Oklahoma City, 1965- . Juror for National Bridge Design Competition for United States Steel Conference, 1967; Juror of regional and national art exhibitions.

SHANNON, MRS. WILLIAM. See Lenney, Annie

SHAO FANG SHENG—Painter, C., Des., T., L.
Route 1, Williamstown, W. Va. 23185
B. Tientsin, China, Sept. 13, 1918. Studied: in China with old master of Peking; Frank Lloyd Wright Fnd. at Taliesen East & West (Fellowship); Fla. Southern College. Member: Nat. Soc. A. & Lets.; Chautauqua AA. Awards: prizes, Chautauqua, N.Y., 1964; Bethany Col., W. Va., 1963; Swaney Gal., New Cumberland, W.Va., 1962; Marietta A. Lg., 1962; Appalachian Corridors Exh.; purchase, Clarksburg A. Center. Work: Norfolk Mus. A. & Sciences; Zanesville AI. Commissioned by the Chinese Government to make paintings of the frescoes in the Cave of the Thousand Buddhas, a IV Century Buddhist cliff sanctuary, in the Gobi Desert. These paintings were on a loan exhibition to the Metropolitan Museum of Art, and were exhibited in one-man shows at the Art Institue of Chicago; and the Zanesville, Ohio, Art Institute (1964). Exhibited: one-man: Gallery at Taliesin, Spring Green, Wis.; AIC; AFA traveling exh.; Norfolk Mus. A. & Sciences; J. B. Speed Mus. A.; San Jose, Cal.; South Bend, Ind.; New Haven, Conn; Bowling Green, Ohio; Manchester, N.H.; Saratoga Springs, N.Y.; Rollins Col., Winter Park, Fla.; Fla. Southern Col.; Tampa AI; Winter Haven AA; Chautauqua, N.Y., 1968; Swaney Gal., New Cumberland, Oglebay Inst., 1968; Bethany Col., 1968; Contemp. A. Gal., Palm Beach, 1968; W. Va. A. & Crafts, 1968; Sunrise A. Gal., Charleston, 1968; MMA; Zanesville AI. Positions: Instr., Fla. Southern Col., Lakeland, Fla.; Chautauqua Summer School, N.Y.

SHAPIRO, DAISY VIERTEL (Mrs. Jack)—Collector, Patron
200 East End Ave., New York, N.Y. 10028
B. New York, N.Y., July 8, 1892. Studied: Painting with Louise Pollet, Alex Redein. Member: Art Collectors Club of America; Friends of the Whitney Museum of American Art. Collection: Contemporary American painting and sculpture.

SHAPIRO, DAVID—Painter, Eng., E., L.
124 Susquehanna Ave., Great Neck, N.Y. 11021
B. New York, N.Y., Aug. 28, 1916. Studied: Educational Alliance Sch., N.Y.; Am. Artists Sch., with Anton Refregier. Awards: Fulbright award, 1951-52, 1952-53; purchase prizes, U.S. Treasury Dept., 1941; BM, 1946; LC, 1950; Springfield Mus. FA, 1957; prizes, Freedom House, 1951; Springfield Mus. FA, 1947; Northwest Pr.M., 1968; SAGA, 1968; Berkshire Mus., 1966, 1967; Oklahoma Pr.M., 1968. Work: BM; Springfield Mus. FA; MMA; PMA; Slater Mem. Mus.; Univ. British Columbia; U.S. Treasury Dept.; Trade Bank & Trust Co., N.Y.; LC. Member: SAGA (Pres.); CAA. Exhibited: PAFA, 1942; BM, 1946-1952; Springfield Mus. FA, 1947, 1955, 1957, 1965; LC, 1946, 1949-1953 1956, 1957; Audubon A., 1948; SAM, 1947, 1950; WMAA, 1951, 1958; SAGA, 1951, 1957, 1964, 1965; Rochester Mem. Mus., 1952; Bradley Univ., 1952; Carnegie Inst., 1952; Galeria Camino, Italy, 1952, 1953; Galeria Enit, Italy, 1952; Riverside Mus., 1954; AFA, 1941, 1946, 1949-1954, 1957, 1958 & "Painters Panorama" 1954-55, 1955-56; Brandeis Univ., 1954; Kansas City, 1954; Munson-Williams-Proctor Inst., 1955; NAD, 1956; Akron

AI, 1958; CGA, 1959; Univ. Virginia, 1960, and others; one-man: Univ. British Columbia, 1948; Vancouver A. Gal., 1949; Ganso Gal., N.Y., 1953; Ann Ross Gal., 1955; Avnet Gal., 1964, 1965; Milch Gal., N.Y., 1958, 1961, 1963; Loring Gal., 1967; Harbor Gal., 1968. Illus., "Hidden Animals," 1945. Contributor article "Visual Design" to Journal of the Royal Arch. Inst. of Canada, 1949. Former Instr., Smith College; Brooklyn College; G.W.V. Smith Mus. A.; Univ. British Columbia; Prof. FA, College of Hofstra Univ., Hempstead, N.Y., 1962- .

SHAPIRO, IRVING—Painter, Des., T., Comm., I., W., L.
8644 North Harding Ave., Skokie, Ill. 60077
B. Chicago, Ill., Mar. 28, 1927. Studied: AIC; Am. Acad. A. Member: AWS; A. Gld. of Chicago. Awards: Ranger award, NAD, 1958; Union League Comp., Chicago, 1955, 1957; North Shore AA, 1958, 1961; Certif. of Merit, AWS, 1962, and others. Work: Univ. Vermont; Grumbacher Coll.; Union Lg., Chicago. Exhibited: AWS, 1958, 1961; Audubon Soc., 1959; Butler Inst. Am. A., 1959, 1960; Union Lg., Chicago, 1955, 1957, 1959, 1961; Springfield, Ill., 1958, 1959, 1961; Welna Gal., Chicago, 1964. Contributor illus. to American Artist magazine; Chicago Tribune. Lectures on Watercolor with demonstrations to art clubs, professional groups, libraries, etc. Instr., watercolor, design, composition, advertising art, American Academy of Art, Chicago. Dir., Northwestern Acad. of Watercolor (Home Study).*

SHAPIRO, SEYMOUR—Painter, T.
31 Walker St., New York, N.Y. 10013
B. Irvington, N.J., May 4, 1927. Studied:.Newark Sch. FA; New Jersey State Teachers Col., B.S. in Edu.; Hunter College, grad. work, M.F.A. Awards: purchase prizes, Newark Mus., 1958, 1961; Newark A. Festival, 1958; prize, Monmouth College Festival FA, 1963; Bamberger's (N.J.), 1966, 1967 (purchase); Ford Fnd. A.-in-Res. Grant, Quincy (Ill.) A. Cl.; Work: Cornell Univ.; Newark Mus. (3); Albright-Knox A. Gal.; Union Carbide Co., Bamberger's, and others. Exhibited: Newark Mus., 1958 (2), 1961, 1965; Stable Gal., N.Y., 1959; traveling exh., AFA, 1960; American Gal., N.Y., 1962; Stryke Gal., N.Y., 1962; Provincetown A. Festival, 1958; Newark Arts Festival, 1958, 1961; PAFA, 1962; Univ. Illinois, 1963; Monmouth (N.J.) Festival, 1963; New Jersey State Mus., 1965; Maryland Inst., Baltimore, 1966; Visual Arts Gal., N.Y., 1966; CM, 1966; PAFA, 1962; PMA, 1965. One-man: Stable Gal., N.Y., 1962, 1969; Castalane Gal., Provincetown, Mass., 1962; Argus Gal., Madison, N.J., 1966; Quincy (Ill.) A. Cl., 1966. Positions: Taught, Maryland Inst. A., Baltimore, Md., 1964-1966.

SHAPLEY, FERN RUSK (Mrs. John)—Museum Curator, W.
National Gallery of Art, Constitution Ave. at 6th St., Northwest 20025; h. 326 A St., Southeast, Washington, D.C. 20003
B. Mahomet, Ill., Sept. 20, 1890. Studied: Univ. Missouri, A.B., A.M., Ph.D.; Bryn Mawr Col. Awards: F., in Archaeology, Bryn Mawr Col.; European Fellowship Grant, 1915; Resident F., Univ. Missouri, 1915-16. Author: "George Caleb Bingham, The Missouri Artist," 1917; "European Paintings from the Gulbenkian Collection," 1950; "Paintings from the Samuel H. Kress Collection: Italian Schools, XIII-XV Century," 1966; "Paintings from the Samuel H. Kress Collection: Italian Schools, XV-XVI Century," 1968; Co-author: "Comparisons in Art," 1957. Contributor articles to Gazette des Beaux-Arts; Art Quarterly; Art in America; American Journal of Archaeology, etc. Positions: Asst. in A. & Archaeology, 1916-17, Asst. Prof. A., 1925, Univ. Missouri; Research Asst., 1943-47, Cur. Paintings, 1947-56, Asst. Chief Cur., 1956-60; Cur. Research, Samuel H. Kress Foundation, 1960- , National Gallery of Art, Washington, D.C.

SHAPLEY, JOHN—Scholar
Howard University 20001; h. 326 A St., S.E., Washington, D.C. 20003
B. Jasper, Mo., Aug. 7, 1890. Studied: Univ. Missouri, A.B.; Princeton Univ., M.A.; Univ. Vienna, Ph.D. Carnegie Medal, 1927. Field of Research: History of Art. Co-author: "Comparisons in Art," 1959. Positions: Pres., CAA, 1923-39; Pres., Byzantine Inst. of America; Formerly Prof. at various universities; Currently, Prof. Emeritus, Catholic University, Wash., D.C. and Prof., Howard University.

SHAPSHAK, RENÉ—Sculptor, W., L., Mus. C.
219 7th Ave. 10011; h. Hotel Chelsea, 222 W. 23rd St., New York, N.Y. 10011
B. Paris, France, Apr. 18, 1899. Studied: Ecole des Beaux-Arts, Acad. Julian, Place des Vosges, Paris, France; Ecole des Beaux-Arts, Brussels; Tate Sch. Art, London. Member: Am. Craftsmens Council; AFA; Int. FA Council; Hon. Life, Am. Int. Acad., Wash., D.C.; Professional Council, N.Y.; Arch. Lg. Awards: Ph.D., St. Andrews, England; Alfaro Medal, 1960; Golden Jubilee Award, Borough Pres., Bronx, N.Y.; Chevalier, Greek Order of St. Dennis

of Zante, 1962; Order of Lafayette, New York-France; L.H.D., Philathea Col. Work: sculpture: Trinity Col. of London; Musée Nationale, Paris; Univ. Mus., Salonika; Bezalel Mus. and School of Art, Jerusalem; Smithsonian Inst.; National Mus., Tel Aviv; Truman Library, Independence, Mo.; Municipal Mus., Paris; Eliezer Ben-Yehuda Mus., Jerusalem; Cecil Rhodes Mus., England; Art Gal. & Mus., Madras, India; Alcoa Co., Pittsburgh; Royal Coll., Denmark and England; South Africa House, London; U.S. Coast Guard, Wash., D.C. and California; Willimantic State Col., Conn.; Internat. Am. Inst., Washington, D.C., private colls., U.S., Canada, South America, Europe, Orient, etc. Many portraits of prominent persons, worldwide. Exhibited: WMAA, 1957; United Nations, 1955; Delgado Mus., 1956-1959; Palais des Beaux-Arts, Paris, 1955; New Art Centre, N.Y., 1962; Chelsea A. Festival, 1963; and many private galleries in New York and Europe. Art lecturer, Donnell and Central Libs., N.Y.; City A. Lg., N.Y., 1960-1965. Mus. Curator, Philathea Col. Mus. of Mod. A., London, Ont., Canada.

SHARP, HAROLD—Cartoonist
3973 Saxon Ave., New York, N.Y. 10063
B. New York, N.Y., Mar. 2, 1919. Studied: NAD; Hunter Col., B.A., M.A.; Columbia Univ. Awards: Ashton Award, Hunter Col. Regular contributor to national magazines and newspapers. Feature panel in Journal of the American Medical Association.

SHARP, MARION LEALE (Mrs. James R.)—Painter
1160 Fifth Ave., New York, N.Y. 10029
B. New York, N.Y. Studied: ASL; and with Lucia Fairchild Fuller. Member: Nat. Lg. Am. Pen Women; Balt. WC Cl.; MMA. Awards: prizes, NCFA, 1946, 1952; Nat. Lg. Am. Pen Women, 1938. Exhibited: PAFA; Pa. Soc. Min. P.; BMA; Nat. Lg. Am. Pen Women; BM; Los A. Mus. A.; All. A. Am.; Grand Central A. Gal.; Soc. Min. P., New York; Detroit A. & Crafts Cl.; Chicago Soc. Min. P.; Governor's Exh., Nassau, Bahamas; Newport AA (one-man); Paris Salon, France.*

SHARRER, HONORE (Mrs. Perez Zagorin)—Painter
208 E. Oakdale Road, Baltimore, Md. 21210
Exhibited: WMAA, 1965*

SHAW, CHARLES GREEN—Painter, I., W., Des.
340 East 57th St., New York, N.Y. 10022
B. New York, N.Y., May 1, 1892. Studied: Yale Univ., Ph.B.; Columbia Univ. Member: Am. Abstract A.; AEA; Century Assn.; Fed. Mod. P. & S.; Nantucket AA. Awards: Nantucket AA, 1958. Work: PMA; BMA; Guggenheim Mus.; WMAA; Detroit Inst. A.; BM; CMA; Lawrence Mus.; Nantucket Fnd.; MModA; MMA; SFMA; BMFA; Newark Mus.; Cal. PLH; Dayton AI; CM; Yale Univ. Gal. FA; Berkshire Mus.; AIC; Rockefeller Inst., N.Y.; DMFA; Rochester Mem. A. Gal.; Akron AI; Munson-Williams-Proctor Inst.; AGAA; Sheldon Mem. A. Gal., Univ. Nebraska; Smithsonian Inst.; CGA; Los A. Mus. A.; Williams Col. Mus.; Wadsworth Atheneum; Chrysler Mus.; PC; WAC; Wichita Mus. A.; Colby Col.; MIT; Syracuse Univ.; NCFA; IBM; Chase Manhattan Bank; Joslyn A. Mus., Omaha; Kalamazoo A. Center; Santa Barbara A. Mus.; Cornell Univ.; and in many university and college colls. Exhibited: AIC, 1943; MModA, 1951, 1957; Paris, France, 1950; Rome, Italy; Tokyo, Japan, 1954; Walker A. Center, 1954; Joslyn A. Mus., 1955; traveling exh., Europe, Int. Assn. of Plastic A., 1956-57; Carnegie Inst., 1945; WMAA, 1946, 1957, 1963, 1964; DMFA, 1963; Lever House, 1963, 1964; Riverside Mus., N.Y., 1964; Univ. W. Va., 1964; Chicago AC, 1938; SFMA, 1938; SAM, 1938; Am. Abstract A., 1937-1958, 1967, 1968; Fed. Mod. P. & S., 1942-1958, 1967, 1968; Inst. Mod. A., Boston, 1945; Hemisfair, San Antonio, 1968; paintings on loan, U.S. Embassies, Berne, Switzerland, Addis Ababa, Ethiopia; one-man exh.: Valentine Gal., 1934, 1938; Gal. Living Art, N.Y., 1938; Art of Tomorrow Mus., 1940; Passedoit Gal., 1945, 1946, 1950, 1951, 1954, 1956, 1957, 1958; Nantucket AA, 1953-1958; BM, 1957; other exhs.: AFA traveling exh., 1955-56; Galerie Pierre, Paris, 1936; Mayor Gal., London, 1936; Berkshire Mus., 1940; Am-British A. Center, 1949 (one-man); 8 x 8 Exh., PMA, 1945; Riverside Mus., 1957, 1958. Recent one-man: Bertha Schaefer Gal., N.Y., 1963, 1964, 1966, 1968; Univ. Louisville, 1963; Southampton A. Gal., N.Y., 1964; Gallery Youmans-Faure, La Jolla, Cal., 1964. Author: "New York Oddly Enough," 1938; "The Giant of Central Park," 1940; & other books. I., "The Milk that Jack Drank," "Black and White," 1944; "It Looked Like Spilt Milk," 1945. Contributor to: national magazines, newspapers, poetry magazines and anthologies, peoms to literary magazines.

SHAW, HARRY HUTCHINSON—Painter, E., L.
501 Sloop Lane, Sarasota, Fla. 33577
B. Savannah, Ohio, Oct. 4, 1897. Studied: Univ. Michigan; Stanford Univ.; Univ. Mexico; PAFA; Ohio State Univ., B.F.A., M.A.; Cleveland Sch. A.; & with Hawthorne, Moffett, Garber, & others. Member: New Orleans AA. Work: Research Studio, Maitland, Fla.; Massillon Mus.; Canton AI; Southwestern La. Inst.; Akron YWCA; Akron Pub.

Lib.; mural, Univ. Michigan; Lafayette (La.) Pub. Lib.; U.S. Embassy, Mexico; Univ. of Americas, Mexico; Mexican-Northamerican Cultural Inst., Mexico; Ford Motor Co.; Mus. Mod. A., Mexico; Smithsonian Inst., & in private colls. in U.S. and abroad. Exhibited: PAFA, 1926; Phila. WC Cl., 1925; Phila. AC, 1926; High Mus. A.; New Orleans AA; Contemp. A., N.Y.; Soc. Indp. A., 1926; Butler AI; Columbus Gal. FA; CM; Florida Gulf Coast Annual, 1969; Midtown Gal., N.Y.; Canton A. Inst.; Montclair (N.J.) A. Mus.; Sarasota AA., Fla., 1964-1969, and others; one-man: London, England, 1962; Torremolinos, Spain, 1961; Paris, 1961; Mexico City, 1964; Longboat AA, 1965; Contemporary A. Gals., N.Y.; Beaumont A. Mus., Tex., 1968; Butler Inst. Am. A.; Canton (Ohio) A. Inst.; Ohio Univ.; Univ. of Southwestern Louisiana; Akron (Ohio) A. Inst.; Mexican Northamerican Cultural Inst. at Mexico City, Guadalajara and Monterrey, 1964-1968. I., "Quest," 1934 (a book of block prints).

SHAW, MRS. HARRY HUTCHINSON. See Allen, Margo

SHAW, KENDALL—Painter, E.
916 President St., Brooklyn, N.Y. 11215
B. New Orleans, La., Mar. 30, 1924. Studied: Tulane Univ., B.S., M.F.A.; Louisiana State Univ.; New School for Social Research, N.Y.; Brooklyn Mus. Sch. Member: CAA. Mus. Contemp. A., Nagaoka, Japan; N.Y. Univ.; Tulane Univ.; Chase Manhattan Bank, N.Y.; and in private colls. Exhibited: Herron Mus. A., Indianapolis, 1964; McNay A. Mus., San Antonio, 1964; AIC, 1965; Mus. Contemp. A., Nagaoka, Japan, 1965; N.Y. Univ., 1965; Contemporaries Gal., N.Y., 1966; Univ. Illinois, 1967; Phoenix A. Mus., 1968; Galerie Simone Stern, New Orleans, 1968; One-man: Orleans Gal., New Orleans, 1960, 1961, 1963; Columbia Univ., Sch. Arch., 1962, 1965; Tibor de Nagy Gal., N.Y., 1964, 1965, 1967, 1968; Colby Col., New London, N.H., 1967; Zella Gal., New Orleans, 1968. Positions: Lecturer, Herbert H. Lehmn College, City College of New York; Parsons School of Design, New York City, at present. U.S. Delegate to Int. Assn. of Plastic Art (UNESCO) Conference, London, 1965.

SHAYN, JOHN—Painter, Des., W., L.
20 E. 67th St., New York, N.Y. 10021
B. Boston, Mass., Jan. 15, 1901. Studied: Boston Univ.; BMFA Sch.; Mass. Normal; ASL. Member: AEA; Seraphim Biblical Art Fnd. of America (Fndr. & Sec.). Exhibited: (1963) Miami, Fla., Chicago, Ill.; Boston, Mass., Great Neck, N.Y. One-man: Newton, Montross, Kleeman, Wildenstein galleries, N.Y. Work: Union of Am. Hebrew Congregations; Berg Fnd.; Frank Lloyd Wright Fnd., Wis. Radio and TV lectures on Bible Art and Symbolism. Author: "True Craftsmanship as Applied to Design." Writer and lecturer on art, Technical and Religious. Inventor, Wax Color Tempera Medium.*

SHECTER, PEARL S.—Painter, L., T.
60 E. 9th St., New York, N.Y. 10003
B. New York, N.Y., Dec. 17, 1909. Studied: Hans Hofmann Sch. A.; Columbia Univ., M.F.A.; New Bauhaus Sch. Des., Ill.; Harvard Univ., graduate study-Fine Arts; Grande Chaumiere, Paris. Member: Int. Soc. of Edu. through Art; CAA; AEA; Experiments in Art & Technology. Awards: Carnegie grant, 1938; gold medal, Lucca, Italy, 1963. Work: sc., metal, jewelry, Miami Univ., Oxford, Ohio; N.Y. Univ.; Ford Fnd., International Relations; sc., Mus. of Natural Hist., N.Y., and in private colls. Exhibited: Tweed Gal. A., Duluth, Minn., 1963; Mus. FA of Houston, 1963; CAM, 1964, 1966; Alice Nash Gal., 1965; Carnegie Int. Center, N.Y., 1965; AEA, 1969; Lehigh Univ., 1967; Litchfield (Conn.) Gal., 1967; Bridgeport Center Gal., Conn., 1967; Indiana Univ., 1966; one-man: Alice Nash, Gal., 1964. Many other exhibitions in prior dates, both group and one-man. Invited by Italian Council of Art to jury Internat. A. Exh., 1963. Positions: Art Lecturer, N.Y. Univ.; Instr., Newton-Harvard A. Center, Newton, Mass., 1962. Art Dir., Little Red School House.

SHEETS, MILLARD OWEN—Designer, P., L.
Claremont, Cal. 91711
B. Pomona, Cal., June, 1907. Studied: Chouinard AI. Member: NA; Cal. WC Soc.; AWS; Soc. Motion Picture A. Dirs. Awards: prizes, AIC, 1938; Cal. State Fair, 1930, 1932, 1933, 1938; Los A. Mus. A., 1932, 1945; P. & S. Cl., 1932; Los A. County Fair, 1928, 1930; Arizona State Fair, 1928-1930; San Antonio, Tex., 1929; Cal. WC Soc., 1927; Hon. LL.D., Notre Dame Univ., 1964; Hon. M.F.A. Otis AI, 1963. Work: MMA; AIC; Los A. Mus. A.; White House, Wash., D.C.; WMAA; BM; SFMA; Dayton AI; CMA; SAM; R.I. Sch. Des.; Witte Mem. Mus.; Mus. FA of Houston; Wood Mem. Gal.; Albany Inst. Hist. & A.; Ft. Worth Mus. A.; San Diego FA Soc.; Hackley A. Gal.; deYoung Mem. Mus.; Univ. Oklahoma; N.Y. Pub. Lib.; Los A. Pub. Lib.; numerous sch. & col.; Des., Home Savings & Loan Bldgs. (12); Scottish Rite Temple, Los A.; Nat. Am. Insurance Bldg., Los A., 1956. Murals, Pomona First Federal Savings & Loan; Interior & exterior of Our Lady of the Assumption Church, Ventura, Cal.; Altar mural, Precious Blood Church, Los A.; annual calendar, United Airlines; mural, Notre Dame Library Tower, 1964; mural, mosaic

dome, National Shrine, Wash., D.C.; mosaic, Detroit Library entrance, 1963; illus., Limited Edition book, 1965. Exhibited: AIC; WFNY 1939; Denver A. Mus.; Faulkner Mem. Gal.; Currier Gal. A.; BMFA; CGA; VMFA; Sao Paulo, Brazil, 1955; WMAA; Carnegie Inst.; CAM; Oakland A. Gal.; Albright A. Gal.; Kansas City AI; Nebraska AA, etc.; one-man exh.: Delgado Mus. A.; Brooks Mem. A. Gal.; Springfield A. Mus.; Rochester Mem. A. Gal.; High Mus. A.; Honolulu Acad. A.; Milch Gal.; Dalzell Hatfield Gal., Los A.; & many others. I., "Sketches Abroad." Positions: Hd. A. Dept., Scripps Col., Claremont, Cal., 1932-35; A., Life magazine, Burma-India front; Balch L., Scripps Col.; Hd., Los Angeles County AI, Los Angeles, Cal., 1953- ; Prof. A., Scripps Col., 1938- . Dir. Otis Art Institute, Los Angeles, Cal., 1955-1962.

SHEETS, NAN (Mrs. Fred C.)—Museum Director, Cr., W., L., P.
401 Northwest 18th St., Oklahoma City, Okla. 73103
B. Albany, Ill., Dec. 9, 1889. Studied: Valparaiso (Ind.) Univ.; & with John Carlson, Robert Reid, Birger Sandzen, Hugh Breckenridge, & others. Member: Oklahoma A. Lg. (Hon.); Kappa Pi (Hon. Life Member); F., Royal Soc. A., London. Awards: prizes, Broadmoor A. Acad., 1924; Kansas City AI, 1924; SSAL, 1929; elected to Oklahoma Hall of Fame for contribution to cultural life of the State. Work: Kansas City AI; Fla. Southern Col.; Springfield (Ill.) Mus. A.; Oklahoma A. Center, 1965; Nat. Cowboy Hall of Fame, 1968; Western Heritage Center, 1968; Oklahoma Univ.; Vanderpoel Coll.; Dallas Mus. FA. Conducted art column, Daily Oklahoman, 1934-1962. Positions: Dir., Oklahoma A. Center, Oklahoma City, Okla. 1935-1965; Hon. Trustee (Life), Oklahoma A. Center.

SHELDON, OLGA N. (Mrs. A. B.)—Collector, Patron
611 N. Madison, Lexington, Neb. 68850
B. Lexington, Neb., Aug. 25, 1897. Collection: Chiefly American art; Works from collection on loan or gift to Sheldon Memorial Art Gallery, University of Nebraska.*

SHELL, MR. and MRS. IRVING W.—Collectors
h. 442 Wellington Ave., Chicago, Ill. 60657; also, 785 Fifth Ave., New York, N.Y. 10022
Collection: Includes works by Emilio Greco, Reg. Butler, Julio Le Parc, Yuichi Inoue, Zubel Kachadoorian, Siqueiros, Morio Hoshi.*

SHEPHERD, DOROTHY G. (Mrs. Ernst Payer)—
Museum Curator
Cleveland Museum of Art, Cleveland, Ohio 44106; h. Giles Rd., Moreland Hills, Ohio .
B. Wellend, Ont., Canada, Aug. 15, 1916. Studied: Univ. Michigan, A.B., M.A.; N.Y. Univ., Inst. FA. Member: CAA; Archaeological Soc. Am.; Am. Research Center in Egypt; Centre Intl. des études des Textiles Anciens, Middle East Institute; Am. Soc. for Aesthetics. Contributor to Arts Orientalis; Bulletin of the Cleveland Museum of Art. Lectures: Islamic Art and Architecture; Art & Architecture of Spain; Islamic and Medieval Textiles; Art of the Ancient Near East. Positions: Monuments Officer, Monuments and Fine Arts Section, SHAEF (Berlin), 1945-47; Cur., Textiles and Near Eastern Art, 1954- . Adjunct Prof., History of Art, Case-Western Reserve University, Cleveland.

SHEPLER, DWIGHT (CLARK)—Painter, I., W., S.
95 Dudley Rd., Newton Centre, Mass. 02159
B. Everett, Mass., Aug. 11, 1905. Studied: BMFA Sch.; Williams Col., B.A. Member: St. Botolph Cl., Boston; Gld. Boston A. (Vice-Pres., 1959-); Boston Soc. WC Painters; F.I.A.L. Work: U.S. Navy; Lawrence A. Mus., Williams Col., Williamstown, Mass.; Dartmouth, England, Mus.; murals, U.S. Naval Acad., Annapolis, Md.; port., U.S. Naval War Col., Newport, R.I.; NAD; mon., Ellsmore Island, for Arctic Inst. North America; habitat backgrounds, Boston Mus. Sc. Exhibited: PAFA, 1936; AIC, 1940; CGA, 1943; Carnegie Inst., 1944; BMFA, 1943, 1951, 1952, 1957, 1958; NAD, 1956; Minneapolis Inst. A., 1943; NGA, 1943-1945; Joslyn A. Mus., 1955; Salon de la Marine, Paris, 1945; MMA, 1945, 1949; Montclair A. Mus., 1941 (one-man); Philbrook A. Center, 1942; one-man exh., Boston, New York, Chicago, etc. I. "Many a Watchful Night," 1944; "The Navy at War," 1943; Life's Picture History World War II, 1950; "The Second World War" (color plates), 1959, & other books. Painting for USS Enterprise V (first nuclear powered aircraft carrier) of the battle between USS Enterprise III and H.B.M. Boxer, 1813 (1961); Contributor to: Sportsman, Country Life, Pageant, Life, Ford Times, & other national magazines.*

SHEPPARD, CARL D., JR.—Educator, Historian
Dept. of Art History, University of Minnesota, Minneapolis, Minn. 55455; h. 342 N. Mississippi Blvd., St. Paul, Minn. 55104
B. Washington, D.C., Jan. 11, 1916. Studied: Western Reserve Acad.; Amherst Col., B.A.; Harvard Univ., M.A., Ph.D. Member: CAA; Soc. Architectural Historians; Am. Inst. Archaeology; Medi-

aeval Acad.; Société Nationale des Antiquaries de France. Co-author, "Looking at Modern Painting" (2nd ed.) 1959-61. Contributor to: Art Bulletin, Speculum, Gazette des Beaux Arts, Art Quarterly and others. Positions: (Teaching: Mediaeval Art, specifically Romanesque and Pre-Romanesque Sculpture)-Prof., Univ. Michigan, Ann Arbor, 1946-49; Univ. California, Los Angeles, 1950-64; Chmn., Department of Art History, Univ. Minnesota, Minneapolis, 1964- .

SHEPPARD, (JOHN) CRAIG—Painter, S., E., I., L.
Art Department, University of Nevada; h. 1000 Primrose St., Reno, Nev. 89502
B. Lawton, Okla., July 22, 1913. Studied: Univ. Oklahoma, B.F.A. (Painting), B.F.A. (Sculpture). Member: AAUP; CAA; Pacific AA; Western Assn. Art Mus. Awards: Fulbright Fellow to Univ. of Oslo, Norway, 1955-56; bronze medal, Denver A. Mus.; silver medal, Midwest Annual; purchase award, Nev. Exh., Reno, 1968, and other prizes and mentions. Work: Musée d'Art Moderne, Paris; BM; Mus. of the Great Plains, Lawton; El Paso Mus. A.; Gilcrease Mus. A., Tulsa; murals, Will Rogers Theatre, Oklahoma City; Business Admin. Bldg., Univ. Oklahoma; Student Union Bldg., Montana State Col., Bozeman and many other murals in private homes in Oklahoma, Nevada, Kansas and Texas. Exhibited: BM, 1961; Stanford Univ., 1958; deYoung Mem. Mus., San F., 1958; Salon de l'Art Libre, Musée de Beaux Arts, both Paris, 1962; Cal. PLH, 1965; Watercolor:U.S.A., Springfield A. Mus., 1968; one-man: Mus. A., Bergen, Norway; Feingarten Gal., Los A.; Gallerie Coard, Paris; El Paso Mus. A.; Philbrook Mus. A., Tulsa; Univ. Nevada, Reno, and other local and regional exhs. Illus. "Horses of the Conquest," 1949; "Life and Death of an Oilman," 1951, both Univ. Oklahoma Press. Lectures: American Indian Art, at Univ. Oslo and Finnish-American Soc., Helsinki. Positions: Instr., Sculpture, Univ. Oklahoma; Inst. of Art, Montana State Col.; Douglas Aircraft Co.; Chm., Art Dept., University of Nevada, 1947-1965. Chmn. Governor's Council of the Arts, Nev., 1963-1968. Bd. of Dir., New A. Gal., 1950-1963.

SHEPPARD, MRS. J. CRAIG. See Jacobson, Yolande

SHEPPARD, JOSEPH SHERLY—Painter, I., T.
1106 Cathedral St., Baltimore, Md. 21201
B. Baltimore, Md., Dec. 20, 1930. Studied: Maryland Inst. A., with Jacques Maroger. Member: All. A. Am. Awards: Emily Lowe prize, 1956, prize, 1963, bronze medal, 1959, all All. A. Am.; Guggenheim Fellow, 1957; John and Anna Stacey Scholarship, 1958; prize, Peale Mus., Baltimore, 1953; Butler Inst. Am. A., 1963, 1967. Work: Univ. Arizona Mus. A.; Butler Inst. Am. A.; Davenport Mus. A.; Western Maryland College; BMA; Columbus (Ohio) Mus. A.; Westmoreland County Mus.; Norfolk Mus. A. & Sciences; Brooks Mem. Mus., Memphis. Murals, Equitable Trust Co., Towson, Md., and Baltimore. Exhibited: All. A. Am., 1954-1965; Springfield (Mass.) Mus. FA; Butler Inst. Am. A., 1956-1964; Laguna Beach (Cal.) AA, 1964; BMA, 1956, 1964, 1965; Peale Mus. A., 1951-1953; CGA frequently. One-man: Butler Inst. Am. A., 1964; Westmoreland County Mus., 1966; Davenport Mun. A. Gal., 1967, Greensburg, Pa., Illus.: Sports Illustrated. Positions: Instr., Painting, Drawing, Maryland Inst. A., Baltimore, Md., 1963- .

SHERMAN, JOHN K(URTZ)—Critic
2502 West 22nd St., Minneapolis, Minn. 54405
B. Sioux City, Iowa, Apr. 19, 1898. Studied: Univ. Minnesota. Positions: A. Ed. & Cr., Music & Drama Cr., Minneapolis (Minn.) Star & Tribune, at present. Author: "Music and Maestros: The Story of the Minneapolis Symphony Orchestra"; "Music and Theatre in Minnesota History"; "Sunday Best: Collected Essays."*

SHERMAN, SARAI—Painter, printmaker
c/o Forum Gallery, 1018 Madison Ave., New York, N.Y. 10021*

SHERMAN, WINNIE BORNE (Mrs. Lee D.)—Painter, L., T.
500 E. 77th St., Apt. 934, New York, N.Y. 10021
B. New York, N.Y. Nov. 10, 1902. Studied: T. Col., Columbia Univ.; CUASch.,B.F.A.; NAD; ASL. Member: Int. Platform Assn.; Nat. Soc. A. & Lets. (Pres., Empire State Chptr., 1968-1970, Nat. A. Chm., 1966-1968); ASL; AWS; AAPL; Catherine L. Wolfe A. Cl. (Pres., 1968-1970); F., Royal Soc. A., London; New Rochelle AA; Nat. Lg. Am. Pen Women (N.Y. City A. Chm.); Hon. Member, Kappa Pi. Awards: prizes, American Artist magazine, 1953; New Rochelle AA; Westchester County Fed. Women's Cl., 1954; Westchester A. & Crafts, 1954; Fla. Southern Col., 1952; New Rochelle Women's Cl., 1954, 1957, and others. Work: Seton Hall Univ. Lib.; Grand Central A. Gal.; Grumbacher Coll.; IBM. Exhibited: AWS, 1933; Grand Central Gal., 1955, 1963-64; AAPL, 1954-1958; NAC, 1955-1959, 1968; 1969; Fifty American Artists, Newton,Gal., 1955-1958 and SC, 1955-1958; Hudson Valley AA, 1953-1955; New Rochelle AA, 1945-1957; Mt. Vernon AA, 1953-1957; Westchester A. & Crafts Gld., 1945-

1958; Burr Gal., 1957-1959; Vendome Gal., 1941, 1942; Ligoa Duncan Gal., 1958; Carnegie Endowment Center, N.Y.; SI; Lever House, N.Y., 1968; one-man: Westchester County Center, 1951; New Rochelle Pub. Lib., 1953; Arch. Lg., N.Y., 1954; Burr Gal., 1957. Lectures: Watercolor Techniques. "Poems in Paint" demonstrations, to women's clubs, TV, art clubs, etc. Positions: A. Instr., City Col. of N.Y., 1960-1964; FA Dept., The High Schools of New York City (Bd. of Edu.), 1961-1967; Instr., Watercolor, Inst. for Retired Professionals, New School, New York City, 1966-1969.

SHERMUND, BARBARA—Cartoonist, Gr., I., P., Comm. A.
901 Ocean Ave., Seabright, N.J. 07761
B. San Francisco, Cal. Studied: Cal. Sch. FA; ASL. Member: SI; Nat. Cartoonists Soc. Contributor to Esquire, New Yorker, and others. Exhibited: Int. Cartoon Exh., Belgium, 1964; San Diego Exposition, 1964; Lytton Center of Visual Arts, Los Angeles, 1965 (on permanent exhibition).

SHERRY, WILLIAM GRANT—Painter, S., T., L.
137 Granada Drive, Corte Madera, Cal. 94925
B. Amagansett, L.I., N.Y., Dec. 7, 1914. Studied: Academie Julian, Paris, France, with Pierre Jerome; The Heatherly Sch. A., London, England, with Ian McNab. Awards: prizes, Laguna Beach Festival A.; purchase prize, Springfield Mus. A.; Fort Lauderdale Mus. A., 1964. Work: Springfield Mus. A., Springfield, Mass. Exhibited: Laguna Beach Festival A., 1949, 1950, 1951; Portland (Me.) A. Mus., 1953-1958; Boston A. Festival, 1956; Art:USA, 1958; Silvermine Gld. A., 1957; Delgado Mus. A., 1958; Colby Col., 1956; Farnsworth Mus. A., 1956-1957; Univ. Maine, 1956-1958; Four Arts Soc., 1960; All. A. Am., 1960; one-man: Univ. Maine, 1958; Maine A. Gal., Wiscasset, 1958; Ringling Mus. A., Sarasota, 1949; Portland (Me.) Mus. A., 1959; Farnsworth Mus. A., 1960; Center St. Gal., Winter Park, Fla., 1964-1969; Corwith Gal., San F., 1965; Dallas North Gal.; Arlene Lind Gal., San F.

SHIBLEY, GERTRUDE—Painter, Gr.
351 W. 24th St., New York, N.Y. 10011
B. New York, N.Y., Dec. 10, 1916. Studied: Brooklyn Col., B.A.; Hans Hofmann; Pratt Inst., Brooklyn, N.Y.; New School, N.Y. Exhibited: Art:USA, 1958; NAWA, 1951, 1952; WMAA; Riverside Mus., N.Y., 1951, 1952, 1954, 1956, 1958; Springfield Mus.; Argent Gal., N.Y.; New School, 1951, 1953, 1955, 1957, 1959; N.Y. Univ.; Artists Gal., N.Y.; James Gal., N.Y.; Roko Gal., N.Y.; Camino Gal., 1961, 1964; Phoenix Gal., 1967, 1968; Hudson Gld., N.Y., 1967, 1968; one-man: Copain Gal., N.Y., 1953; Panoras Gal., 1954, 1958; Phoenix Gal., N.Y., 1965, 1967, 1969; 3-man, Camino Gal., 1962.

SHIKLER, AARON—Painter
44 W. 77th St., New York, N.Y. 10024
B. Brooklyn, N.Y., Mar. 18, 1922. Studied: Tyler Sch. FA., Temple Univ., B.F.A., B.S. in Edu.; M.F.A.; Barnes Fnd.; Hans Hofmann Sch. FA. Member: NA. Awards: Tiffany Fnd., 1957; Ranger Award, 1959; Proctor Prize, 1959, 1961; Clarke Prize, 1962, all New York City. Work: MMA; Mint Mus. A.; Parrish Mus. A., Southampton; NAD; Montclair A. Mus. (N.J.); BM. Contributor to two chapters of "Pastel Painting," by E.L. Sears, 1968. Exhibited: AIC, 1962; NAD, 1959-61, 1963, 1965; Gallery of Modern Art, N.Y., 1965; IBM, 1963; BM; Butler Inst. Am. A., 1959, 1960, 1961; New Britain Mus. A (Conn.), 1964; 9 exhs. at the Davis Galleries, New York.

SHIMON, PAUL—Painter, C.
457 Franklin D. Roosevelt Dr., New York, N.Y. 10002
B. New York, N.Y., Nov. 11, 1922. Studied: ASL, and with Jean Liberte. Awards: Shiva scholarship, 1948; Emily Lowe award, 1954; MacDowell Colony F., summer, 1961. Work: Four drawings purchased by the U.S. Information Agency to be exhibited in four African embassies; Fordham Univ. Mus., New York, on permanent exhibit at the Louis Held Collection, Butler Inst. Am. A., Youngstown, Ohio. Exhibited: Audubon A., 1951, 1956; Soc. Painters in Casein, 1956; Alabama WC Soc., 1948, 1951; Artists Gal., N.Y., 1959; one-man: RoKo Gal., 1946; Tribune, 1950, 1952; Panoras Gal., 1955 (group); N.Y. City A. Center, 1954-1956; Lovisco Gal., 1959, 1961; Art Directions Gal., 1960; Galerie Anjou, 1964; Capricorn Gal., 1967-1969.

SHIPLEY, JAMES R.—Educator, Des.
University of Illinois, Dept. Art, Champaign; h. 27 Greencroft St., Champaign, Ill. 61820
B. Marion, Ohio, Dec. 26, 1910. Studied: Cleveland AI; Western Reserve Univ., B.S.; Univ. Southern California; Inst. Des., Chicago; Univ. Illinois, A.M. Member: Industrial Des. Soc. of Am.; CAA; IDI; Midwest Col. A. Conf. Lectures: "The New Artist"; "The Modern Movement." Positions: Des., General Motors Corp., Styling Section, 1936-39; Prof. Indst. Des., 1939- , Actg. Chm., Dept. A., 1955-56, Hd. Dept. A., 1956- , University of Illinois; Edu. Sec., Am. Soc. Indst. Des., 1957-1961; Vice-Pres., Indst., Des. Edu. Assn., 1957-

58, Pres., 1959-1961; Chm., Program Comm., Mid-west Col. A. Conf., 1958, Vice-Pres., 1960-61; Vice-Pres., Nat. Assn. Schs. of Art, 1960-61, Pres., 1961-63, Chm. Com. on Admissions & Accreditation, 1966-1969; Nat. Educ. Com., Industrial Des. Soc. of Am., 1965-1969; Memb., Visual Arts Comm., Festival of the Americas, Chicago, 1959. Contributor articles to professional journals. Design Consultant to many Illinois firms.

SHIREY, DAVID—Art editor
Newsweek Magazine, 444 Madison Ave., New York, N.Y. 10022*

SHOEMAKER, VAUGHN—Cartoonist, P., L.
Box V, Ocean View & Scenic Dr., Carmel, Cal. 93921
B. Chicago, Ill., Aug. 11, 1902. Studied: Chicago Acad. FA. Member: Nat. Cartoonists Soc.; Nat. Soc. Editorial Cartoonists; Nat. Press Cl. Awards: Pulitzer prize, 1938, 1947; Freedoms Fnd., 1949-1953, 1957; National Headliners award, 1942; National Safety Council grand award, 1945, 1949; Hon. degree, D.Litt., Wheaton Col., Wheaton, Ill. Exhibited: O'Brien Gal., Chicago, 1935, 1936; Marshall Field, 1938; perm. cart. coll., Huntington Lib., San Marino, Cal. Author, I., 7 cartoon books; first telecasting of cartoons, Station W9XAP, Chicago, 1930; TV shows "Over Shoemaker's Shoulder," DBKB, NBC, ABC, 1949, 1950. Positions: Instr., Chicago Acad. FA, 1927-42; Cart., 1922- , Chief Cart., 1925-50, Chicago (Ill.) Daily News; Chief Cart., Chicago Today, 1962; Chicago Tribune-N.Y. News Syndicate, 1963.

SHOKLER, HARRY—Printmaker, P., L., W., T.
Londonderry, Vt. 05148
B. Cincinnati, Ohio, Apr. 25, 1896. Member: Grand Central A. Gal.; Nat. Serigraph Soc.; So. Vermont A. Awards: Friburg traveling scholarship, 1927; purchase prize, Albany Inst. Hist. & A.; prize, Miller A. Center, Springfield, Vt. Work: MMA; Syracuse Mus. FA; PMA; Newark Mus.; Dayton AI; Carnegie Inst.; Munson-Williams-Proctor Inst.; Cincinnati Pub. Lib.; Princeton Pr. Cl.; Lib. Cong. Exhibited: NAD, 1943-1946; Lib. Cong., 1944, 1945; SFMA, 1945; Northwest Pr. M., 1944, 1945; one-man: New York (6); Cincinnati; Syracuse; Princeton Univ.; So. Vermont A. (5); BMA; Springfield, Vt.; traveling exh., circulated by Old Bergen (N.J.) A. Gld. Author: "Artists Manual for Silkscreen Printmaking," 1946, rev. ed., 1961. Lectures: Serigraphy. Positions: Instr., Southern Vermont A. Center.

SHORE, MARY (McGARRITY)—Painter, C., Des., S.
Page St., East Gloucester, Mass. 01930
B. Philadelphia, Pa., Mar. 19, 1912. Studied: CUASch.; AIC. Member: AEA. Awards: Blanche E. Colman A. Fnd., 1966. Work: AGAA, and in private colls. Exhibited: all major New England A. Mus.; traveling exh., MModA, 1963; Northeastern Univ., 1963; de Cordova & Dana Mus., 1963, 1964; Fitchburg A. Mus., 1964; Phila. A. Alliance, 1965; AGAA, 1966; Horizon Gal., Rockport, Mass., 1967-1968; one-man: Lyceum, Havana, Cuba, 1950; Marblehead, Mass., 1953; de Cordova & Dana Mus., 1956, 1957; Boris Mirski Gal., Boston, 1960; Phila. A. All., 1963, 1965; Mirski Gal., 1964; Town Wharf Gal., Blue Hill, Me., 1964; Fitchburg A. Mus., Mass., 1966.

SHORTER, EDWARD SWIFT—Museum Director, P., L.
Columbus Museum of Arts & Crafts, 1251 Wynnton Rd. 31906; h. Folly Hill, River Rd., Columbus, Ga. 31904
B. Columbus, Ga., July 2, 1902. Studied: Mercer Univ., A.B. (Grad.); Corcoran Sch. A.; Fontainebleau, France, and with Wayman Adams, Hugh Breckenridge, and with Andre L'Hote, in Paris. Member: AAPL; Soc. Wash. A.; AEA; SAGA; NAC; SC; Studio Gld.; All. A. Am.; SSAL; Assn. Ga. A.; Columbus AA. Awards: prizes, Assn. Georgia A., 1934; Soc. Wash. A., 1938; Atlanta Gal., 1947; Studio Gld., 1940; Gari Melchers Award for outstanding contribution to advancing American art, awarded by Artists Fellowship and Salmagundi Club, 1965. Work: Montgomery Mus. FA; High Mus. A.; Georgia Mus. A., Athens, Kansas State Mus., Hays, Kans.; Mercer Univ.; Baylor Univ.; Southern Baptist Seminary, Louisville; Washington Mem. Lib., Macon, Ga.; Wesleyan Col., Macon, Ga.; Fed. Housing Project, Columbus, Ga.; First Baptist Church, Columbus. Exhibited: PAFA; CGA; WFNY 1939; SSAL; SFMA; Southeastern AA, 1954; Soc. Wash. A.; Assoc. Georgia A., annually, and others. Positions: Former Instr. Painting, Burnsville, N.C.; Acting Dir., Columbus Mus. A. & Crafts, Columbus, Ga., 1953-55, Dir., 1955- ; Pres., Assn. Georgia A., 1955-57; Columbus AA. Board, Columbus Symphony; Georgia Fine Arts Commission, nominating committee.

SHOTWELL, HELEN HARVEY—
Painter, Pictorial Photog.
Woodstock, N.Y. 12498; also, 257 West 86th St., New York, N.Y. 10024
B. New York, N.Y., Apr. 21, 1908. Studied: painting, with Henry

Lee McFee; Edwin Scott, Paul Pusinas; photography with Flora Pitt Conrey. Member: NAWA; Woodstock AA; F.I.A.L.; Jackson Heights A. Cl.; Fitchburg A. Mus. Work: IBM; Fitchburg A. Mus.; Columbia Univ.; Albert Schweitzer Fnd.; China Inst., N.Y. Exhibited: Dayton AI; Montclair A. Mus.; High Mus. A.; Carnegie Inst.; PAFA; CGA; SFMA; Carnegie Endowment Gal.; WFNY 1939; one-man: Argent Gal.; Fitchburg A. Center; Carolina AA; Shuster Gal., N.Y.; Whaler's Gal., Sag Harbor, N.Y.; photographs shown in international salons, New Zealand, Iceland, India, Spain, South America, U.S.

SHOULBERG, HARRY—Painter, Ser.
112-114 W. 14th St., New York, N.Y. 10011
B. Philadelphia, Pa., Oct. 25, 1903. Studied: Col. of the City N.Y.; Am. A. Sch., and with Sol Wilson, Carl Holty, G. Glintenkamp. Member: AEA; An. Am. Group; Nat. Soc. Painters in Casein; Silvermine Gld. A.; New Jersey Soc. P. & S.; Audubon A. Awards: prizes, Am. Color Pr. Soc.; Bronx, N.Y.; Nat. Ser. Soc.; Parrish Mus.; Gld. Hall, Easthampton, 1953, 1955; New Jersey Soc. P. & S., 1956; Silvermine Gld. A., 1957; Emily Lowe award, 1957; Talens Award, 1966; M. J. Kaplan Mem. Award, 1967; hon. men., Brooklyn Soc. A., 1961; Grumbacher Award, 1964; Peterson Medal, Audubon A., 1965. Work: MMA; BMA; Milwaukee Inst. A., SFMA; Carnegie Inst.; Univ. Wisconsin; Univ. Oregon; State Dept.; Ball State T. Col.; Marshall Col.; U.S. Army; Denver Pub. Sch.; Brooks Mem. A. Gal.; Denver A. Mus.; Univ. State of N.Y.; Tel-Aviv Mus., Israel; Ain-Harod Mus., Israel; G.W.V. Smith Mus.; Norfolk Mus. A.; Univ. Arizona; New Jersey State Col. Exhibited: LC; SAM; Bradley Univ.; NAD; Art: USA, 1958; Audubon A. 1958; New Jersey Soc. P. & S., 1958; "Prize Prints of the 20th Century"; one-man: Modern Age, N.Y., 1945; Nat. Ser. Soc., 1947; Webb Gal., Los A., 1947; Univ. Denver, 1948; Teacher's Center Gal., 1951; Salpeter Gal., 1951; Hudson Gld., N.Y., 1955; Harbor Gal., N.Y., 1968.

SHRYOCK, BURNETT HENRY, SR.—Painter, E., Des.
2010 Wood River Dr., Carbondale, Ill. 62901
B. Carbondale, Ill., Feb. 4, 1904. Studied: Univ. Illinois, A.B.; Am. Acad. A., Chicago; AIC; T. Col., Columbia Univ., M.A. Member: Ill. A. Council; Int. Council of Deans of FA; Arts Com., Ill. Sesquicentennial, 1968. Awards: prizes, CM, 1943; Alabama WC Exh., 1944; La Tausca Pearls Comp., 1946. Work: CAM; Southern Illinois Univ. Exhibited: AIC, 1936, 1938, 1944, 1946; Alabama WC Exh., 1944; Denver A. Mus., 1944, 1945; La Tausca Pearls Comp., 1946; Kansas City AI, 1945; one-man exh.: William Rockhill Nelson Gal., 1946; Jackson, Miss., 1944; CAM, 1943-1945; New Orleans A. & Crafts, 1948. Positions: Asst. Prof. A., 1935-42, Chm. A. Dept., 1942-44, Southern Illinois Univ.; Prof. A. Chm. A. Dept., 1944-1947; Univ. Kansas City, Mo.; Chm., Prof. A., 1950- , Dean, Sch. FA & Prof. A., 1955- , Southern Illinois Univ.

SHUCK, KENNETH MENAUGH—
Museum Director, P.
Springfield Art Museum, 1111 East Brookside Drive; h. 938 Elm St., Springfield, Mo. 65806
B. Harrodsburg, Ky., May 21, 1921. Studied: Ohio State Univ., B.S. in FA, M.A. in FA; Univ. Chile, Santiago, Chile. Member: Midwest Mus. Conference; Missouri State Archaeological Soc.; Missouri Hist. Soc.; AFA; AAMus. Awards: Pan-American Travel Grant, 1950. Exhibited: Denver A. Mus., 1952. Lectures: Painting of Chile, to colleges and art organizations. Positions: Dir., Springfield A. Mus., Springfield, Mo. 1951- . Chm., Visual Arts Committee, Missouri State Council on the Arts.

SHUFF, LILY (Mrs. Martin M. Shir)—Painter, Eng.
465 West End Ave., New York, N.Y. 10024
B. New York, N.Y. Studied: Hunter Col., B.A.; ASL; Brooklyn Acad. FA; Farnsworth Sch. A.; Columbia Univ. Member: Brooklyn Soc. A.; AEA; N.Y. Soc. Women A.; NAWA; Nat. Soc. Painters in Casein; Silvermine Gld. A.; Conn. Acad. FA; New Jersey Soc. P. & S.; Soc. Wash. Pr. M.; Am. Color Pr. Soc.; Hunterdon County A. Center; Audubon A.; Woman Pays Cl. Awards: prizes, Brooklyn Soc. A., 1953, 1957, 1962; New Jersey Soc. P. & S., 1956, medal, 1962; Caravan Gal., 1958; NAWA, 1958, 1959; Conn. Acad. FA, 1956; Barton award, 1957; Grumbacher award, 1960, 1965; Sophia Halpern award, 1960; Pauline Law award, 1958; Painters in Casein, 1957, 1963, 1965, 1966, 1967; Am. Soc. Contemp. A., 1966, 1968; Jersey City Mus., 1969, and others. Work: Pakistan Consulate, N.Y.; Lane Col., N.Y.; James Fenimore Cooper H.S.; Georgia Mus. FA; Yale Univ.; Mueller Coll., Paris, France; LC; MMA; Bezalel Mus., Jerusalem; Norfolk Mus. A.; Butler Inst. Am. A.; Neville Mus., Wis.; MMA; Safed Mus., Israel; Central Oklahoma Mus., and in private colls., U.S. and abroad. Color slides of paintings in university colls. Exhibited: Independents, 1941; Vendome Gal.; NAC; BM, 1943-1958; LC, 1955; Conn. Acad. FA, 1954; Audubon A.; RoKo Gal.; NAD; LC traveling exh., 1954-55; AFA traveling exh.; Brooklyn Soc. A., 1943-1958; NAWA, 1942-1958; N.Y. Soc. Women A., 1944-1958; A. Lg. Am., 1944; Long Island A. Festival, 1946; Hofstra Col., 1945; Argent

Gal., 1944; Van Dieman-Lilienfeld Gal., 1948, 1952; Riverside Mus.; Provincetown A. Festival, 1958; Art:USA, 1958; traveling print shows, U.S. and abroad, 1954-1958; Butler Inst. Am. A.; WMAA; Jersey City Mus.; Silvermine Gld. A.; Smithsonian Inst.; Portland Mus. A.; Sarasota Nat.; Long Island Univ.; SAGA; BMFA; Am. Color Pr. Soc.; Brooklyn Pub. Lib., and others; one-man: Argent Gal., 1947, 1956, 1959-61; Van Dieman-Lilienfeld Gal., 1948, 1952; Girandeau Gal., Paris, 1951; AEA, 1951; WMAA, 1951; Laurel Gal.; DeMotte Gal.; Lotos Cl.; BM; Utica Pub. Lib.; Cortland, N.Y.; Mercersburg (Pa.) Acad.; Freemont Fnd., Mich.; Pack Mem. Gal., N.C.; Charlotte Pub. Lib., N.C.; Purdue Univ.; McPherson Col., Kans.; Conn. State Col.; Regar Mus., Ala.; Mason City, Iowa; State Univ., N.Y.; Thiel Col., Pa.; East Side Gal., N.Y., 1966; traveling exh. through U.S. Mus., 1960-1969, and others. Lectured on Art, Nat. Women's Com., Brandeis Univ., and on TV. Represented in "Prize-winning Paintings, 1967." Positions: Rec. Sec., Nat. Soc. Painters in Casein, 1957-64; Chm. Memb. Jury, NAWA, 1956-58, 1964-66; Bd. Gov., NAWA, 1958-1967; Bd. Gov., N.Y. Soc. Women A., 1956-1968.

SHULMAN, JOSEPH L.—Collector
750 Main Street, Hartford, Conn. 06103; h. 875 Fifth Ave., New York, N.Y. 10021
Collection: Includes works by Modigliani, Picasso, Gris, Valaden, Marini, Metzinger, Laurencin, Pascin, Renoir, Guttuso, Le Corbusier, Bauchant, Matisse, Lipchitz, Fresnay, Hofmann, Gates, Du Fresne, Liberte, Kermelouk, Mirko, Marino, Botkin, Vespianna, Epstein.*

SHUNNEY, ANDREW—Painter
32 Union Square 10003; h. 146 E. 49th St., New York, N.Y. 10017; s. 154 Main St., Nantucket, Mass. 02554
B. Attleboro, Mass., Mar. 12, 1921. Studied: R.I.Sch.Des. Exhibited: Salon d'Automne, Paris; one-man: Kenneth Taylor Gal., Nantucket, Mass., 1959-1961; Palm Beach Gal., 1961, 1963, 1965; Elms Gal., Midland, Tex., 1964; Richelle Gal., St. Louis, 1963, 1968; Hammer Gal., N.Y., 1961, 1963, 1965, 1967, 1969; Galerie Martal, Montreal, Can., 1968.

SHUTE, BEN E.—Painter, T., L.
1262 Peachtree St.; h. 1002 Cardova Dr., Northeast, Atlanta, Ga. 30324
B. Altoona, Wis., July 13, 1905. Studied: AIC; Chicago Acad. FA. Member: Assn. Georgia A.; Nat. Soc. Painters in Casein. Awards: Carnegie Grant, 1948, 1950; Mead Paper Co. award, 1961; Southeastern Annual, 1961; Georgia Artists, 1959; Atlanta WC Cl., 1960. Work: Atlanta AA, and in many private colls. Exhibited: Pasadena AI, 1946; Assoc. Am. A., 1945; AIC, 1929; Cal. PLH; Assn. Georgia A.; Argent Gal., N.Y., 1949; Butler Inst. Am. A., 1957; Atlanta Mead Paper Co. exh., 1958; Atlanta AA, 1958; Telfair Acad. A., 1958 (one-man); BM, 1963. Lectures Contemporary American Painting. Positions: Instr., 1928-43, Hd., FA Dept., 1943- , Atlanta AI, Atlanta, Ga.; Chm., Southeastern Annual Exh., 16 years; Bd. Georgia AA, 1945-1964; Instr., Atlanta School of Art.*

SIBLEY, CHARLES KENNETH—Painter, E.
Norfolk, Va. 23508
B. Huntington, W. Va., Dec. 20, 1921. Studied: Ohio State Univ., B.A.; AIC; Columbia Univ., M.A., State Univ. Iowa, M.F.A. Awards: Tiffany F., 1951; Stern Mem. award, NAD, 1961; Texas AA, 1954. Work: MMA; Rochester Mem. Mus.; North Carolina State Gal.; Norfolk Mus. A.; Ohio Valley States Coll.; Winston-Salem Coll.; Va. State Mus.; Laguna Gloria Mus., Austin, Tex.; Iowa State Univ.; Harvard Univ. Exhibited: MMA, 1950; WMAA, 1953; PAFA, 1954; NAD, 1951, 1953, 1954, 1960-1962; Butler Inst. A., 1961; CGA, 1951, 1953; Carnegie Inst.; Cal. PLH, 1953; High Mus. A., 1954; one-man: Univ. Ohio, 1951; Norfolk Mus. A., 1955; Janet Nessler Gal., N.Y., 1961, 1963; Washington & Lee Univ., 1965. Positions: Instr., Duke Univ., 1949; Texas State Univ., 1952-54; Hd. Dept. A., Old Dominion College, Norfolk, Va.; 1956- .*

SICKMAN, JESSALEE B(ANE)—Painter, T.
1215 Eye St., Northwest (5); h. 3639 Jennifer St., Northwest, Washington, D.C. 20015
B. Denver, Colo., Aug. 17, 1905. Studied: Univ. Colorado, B.A.; Goucher Col.; Corcoran Sch. A. Member: Soc. Wash. A; AEA. Awards: prize, Corcoran Sch. A., 1941; Barney prize, Wash., D.C., 1945. Work: CGA, and in private Colls. Exhibited: Soc. Wash. A., Corcoran Alum. Exh.; Corcoran Biennials; Wash. (D.C.) Pub. Lib. (one-man); CGA (4-man); St. Mary's Seminary, Md. (one-man); Margaret Dickey Gal., Wash., D.C. I., Forum magazine.

SICKMAN, LAURENCE C. S.—Museum Director, L.
901 East 47th St., Kansas City, Mo. 64110
B. Denver, Colo., Aug. 27, 1906. Studied: Harvard Univ., A.B. Member: Chinese A. Soc. of Am.; Assn. for Asian Studies; Am. Ori-

ental Soc.; Japan Soc.; Exec. Com., A. in the Embassies Program, State Dept., 1965. Awards: Harvard-Yenching F., China, 1930-34; Fogg A. Mus., Research F. & Lecturer, 1937-39; Order of Knight Commander of the Polar Star (granted by the King of Sweden to men of Letters and Science), 1968. Contributor to Revue des Arts Asiatiques, Gazette des Beaux-Arts and other art publications. Author (with Soper) "The Art and Architecture of China," London, 1956, 3rd ed., 1968; Editor, "Chinese Calligraphy and Painting in the Collection of John M. Crawford, Jr.," 1962; Editor, The University Prints, Oriental Art, Series O, "Early Chinese Arts," Section II, 1938. Lectures: on Chinese Painting, Sculpture and Ceramics. Positions: Bd. Gov. Ed. "Archives," Chinese Art Soc. of America, 1948- ; Memb. Comm. on Far Eastern Studies, Am. Council of Learned Societies, 1948-53; Bd. Gov., Far Eastern Assn., 1951-53; Bd. Governors, CAA, 1963- ; Pres., Assn. A. Mus. Dirs., 1964-65; currently, Council, AAMus.; Cur. Oriental Art, 1935-45, Vice-Dir., 1946-53, Dir., 1953- , Nelson Gallery of Art, Kansas City, Mo.

SIDER, DENO—Painter, S., C., T., I., L.
17620 Ventura Blvd., Encino, Cal. 91316
B. Norwich, Conn., Mar. 2, 1926. Studied: Norwich Acad., and with Leon Franks. Member: Cal. A. Cl.; Valley A. Gld.; Hollywood AA; Burbank AA; San Fernando Valley A. Cl. Awards: Perkins medal of Conn.; Cranbrook Inst. A. scholarship, 1943; BMFA scholarship, 1943; Professional A. Sch., N.Y. scholarship, 1943; John and Anna Stacey scholarship, 1955, 1956; prizes, Burbank AA, 1954-1964; San Fernando Valley A. Cl., 1954-1964; San Fernando Spring Exh. & Art Festival, 1959-1961; Friday Morning Cl., 1959, 1960; Valley A. Gld., 1960, 1961; Bullocks award, 1964; Madonna Festival award 1963, purchase, 1964; Mattatuck (Conn.) Mus. purchase, 1964; Duncan Vail Gal., 1960; Encino, Cal., 1966; Hollywood Bowl, 1967; Tuaca award, 1969. Exhibited: Burbank AA, 1954, 1955, 1959-1961; Cal. A. Cl., 1953-1964; San Fernando Valley A. Cl., 1954-1965; Burbank A. Cl.; Cal. AA; Valley A. Gld.; Art House, Beverly Hills; Leeds A. Gal., Encino; Art Unlimited, Los Angeles, and others. Demonstrations oil painting, art clubs, women's clubs, Rotary Cl., Del Mar & Madonna Festivals, and others.

SIDERIS, ALEXANDER—Painter
118 East 59th St.; h. Hudson View Gardens, New York, N.Y. 10033
B. Skopelos, Greece, Feb. 21, 1895. Studied: ASL; Julian Acad., Paris, France; & with George Bridgman, Pierre Laurence. Member: AAPL (Vice-Pres. N.Y. Chptr., 1956-58). Awards: gold medal, Knickerbocker A., prize, 1964; prize, AAPL, 1953; NAC, 1961. Work: Amarillo Mus.; Amarillo Col. (Tex.); Wesleyan Col., Macon, Ga.; Greek Church, Phila., Pa.; Church of the Annunciation, Pensacola, Fla.; murals for churches in Salt Lake City, Utah and Newport News, Va., also, Byzantine mural, Greek Cathedral, New York City, 1964, and work in many private colls. Exhibited: NAD, 1938; All. A. Am., 1940-1944, 1957; WFNY 1939; Soc. Indp. A.; Oakland A. Gal.; Argent Gal., 1935 (one-man); NAC, 1955; Knickerbocker A., 1959-1961 and prior; AAPL, 1953; Barbizon Gal., 1954; Vendome Gal., Delphic Studio, 1939 (one-man); Arthur Newton Gal., 1946, 1947, 1949, 1950, 1953, 1961 (one-man) & in Paris, France, 1960 and prior; Hellenic American Union Gal., Athens, Greece, 1968 (one-man).

SIEBER, ROY—Scholar
Fine Arts Department, Indiana University; h. 114 Glenwood East, Bloomington, Ind. 47403
B. Shawano, Wis., Apr. 28, 1923. Studied: New School, B.A.; State Univ. Iowa, M.A., Ph.D. Awards: Ford Fnd. Fellowship, 1958, for research in England and Nigeria. Field of Research: African Art. Taught this subject at universities of Iowa, Wisconsin and Indiana. Positions: Chm., Fine Arts & Humanities Committee, African Studies Assn., 1963-64; Sec., Midwest AA, 1963; Lectures on African Arts to colleges, Peace Corps, etc. Visiting Prof., African Art History, University of Ghana, 1964; Consultant to Ford Foundation, 1960-62; Trustee, Museum of African Art, Washington, D.C.*

SIEGEL, ADRIAN—Painter, Photog.
1907 Pine St., Philadelphia, Pa. 19103
B. New York, N.Y., July 17, 1898. Member: AEA; F., Royal Soc. A. & Sciences, London, England; Phila. A. All.; Woodstock AA. Exhibited: CGA; PAFA; Phila. A. All., and in Tokyo, Japan, Brussels, Belgium; photographs exhibited: MModA; George Eastman House, Rochester, N.Y.; Grand Central Station, N.Y.; PMA; Newark Mus. A.

SIEGEL, IRENE—Printmaker
421 Roslyn Place, Chicago, Ill., 60614
B. Chicago, Ill., Jan. 26, 1932. Studied: Northwestern Univ., B.S.; Univ. Chicago., Grad. Study; Inst. Design, Illinois Institute of Technology, M.S. Member: Art Club of Chicago. Awards: Pauline Palmer prize, 1955, Frank G. Logan prize, 1966, both at AIC; Moholy-Nagy Fellowship, Illinois Inst. Design, 1955; Tamarind

ellowship, Lithography Workshop, 1967. Work: MModA; Los Angees County Mus. A.; Pasadena A. Mus.; LaJolla Mus.; International Bank for Reconstruction and Development, Wash., D.C.; Illinois Bell Telephone Co.; Northern Illinois Univ., DeKalb. Exhibited: Drawings:USA, MModA, 1955; AFA, 1968; Tamarind Prints, MModA, 1969; Chicago Artists & Vivinity, 1955-1968; Drawing Soc. Exh., Mus. FA of Houston, 1965; Los Angeles County Mus., 1968; Soc. Contemp. A., AIC.

SIEGEL, MR. and MRS. JEROME—Collectors
 130 E. 67th St., New York, N.Y. 10021*

SIEGEL, LEO DINK—Illustrator, Cart.
 100 W. 57th St., New York, N.Y. 10019
B. Birmingham, Ala., June 30, 1910. Studied: Univ. Alabama; NAD. Member: SI. I., Saturday Evening Post, Cosmopolitan, Good Housekeeping, Esquire, Playboy, Field & Stream, & other national magazines.

SIEGRIEST, LUNDY—Painter, Gr., T.
 5203 Miles Ave., Oakland, Cal. 94618
B. Oakland, Cal., Apr. 4, 1925. Studied: Cal. Col. A. & Crafts. Awards: prizes, SFMA, 1949; Albert Bender Grant, San F., 1952; Cal. State Fair, 1949, 1951; Oakland A. Gal., 1952, medal, 1954; San F. AA, 1953, 1954; Santa Barbara Mus. A., 1955; Cal. PLH, 1952, 1964; Terry AI, 1952; Richmond (Cal.) A. Center, 1956; Univ. Santa Clara, 1963; deYoung Mem. Mus., 1957, 1964; Santa Barbara A. Assn. 1969. Work: Cal. PLH; Phelan Coll.; Terry AI; Cal. State Agricultural Soc.; SFMA; Santa Barbara Mus. A.; San F. A. Comm.; Denver A. Mus.; Valley A. Center; LC; Oakland Pub. Lib; WMAA. Santa Clara Univ. (Cal.); Col. of the Pacific, Stockton, Cal.; Crown Zellerbach Coll., San Francisco; Hall of Justice, San Francisco. Exhibited: PAFA, 1949, 1950; Univ. Illinois, 1952, 1953, 1955; Audubon A., 1950; Terry AI, 1952; Ft. Worth Mus., 1952; Cal. PLH, 1951, 1952, 1964; SFMA, 1950-1952; Oakland A. Gal., 1948-1952; Cal. State Fair, 1947-1952; Denver A. Mus., 1950, 1953-1955, 1964; Los A. Mus. A., 1949; Colo. Springs FA Center, 1953; DMFA, 1954, 1955; Carnegie Inst., 1955; Sao Paulo, Brazil, 1955; Stanford Univ., 1956; Cal. Painting traveling exh., 1956; AFA traveling exh., 1956, 1957, 1958; Cal. Drawings traveling exh., 1957, WMAA, 1957, 1960; Brussels World's Fair, 1958; VMFA, 1958; Flint AI, 1958; Bolles Gal., San F., 1958; Provincetown A. Festival, 1958; Vancouver (B.C.) A. Gal., 1958. Positions: Instr., Jr. Center of A. & Science, Oakland, Cal. Instr., Civic Arts, Walnut Creek, Cal.

SIEVAN, MAURICE—Painter, T.
 924 West End Ave., New York, N.Y. 10025
B. Ukraine, Russia, Dec. 7, 1898. Studied: NAD; & with Leon Kroll, Charles Hawthorne. Member: CAA; Woodstock AA; Fed. Mod. P. & S.; Provincetown AA. Awards: prize, Queens Botanical Garden Soc., 1949; Audubon A., 1946. Work: Univ. Arizona; Univ. Georgia; MModA.; Chrysler Mus. A.; Butler Inst. Am. A.; Elmira Col., N.Y.; Fla. Southern Col.; BM. Exhibited: Salon d'Automne, Paris, 1931; CGA, 1945; PAFA, 1944, 1946, 1949; Carnegie Inst., 1943-1945; AIC, 1941; BM, 1941, 1953; MMA (AV), 1942; VMFA, 1944; MModA, 1943, 1956, 1965; WMAA, 1943; NAD, 1926, 1938, 1942-1945; AWS, 1941; Minn. State Fair, 1943; deYoung Mem. Mus., 1943; G.W.V. Smith A. Mus., 1944; Tomorrow's Masterpieces traveling exh., 1943-1944; Wadsworth Atheneum, 1944; Inst. Mod. A., Boston, 1945; Bucknell Univ., 1940; Riverside Mus., 1943, 1967-1969; Wildenstein Gal., 1942-1946; Midtown Gal., 1933-1934; Contemporary A., 1939, 1944; Audubon A., 1952, 1953; Jewish Mus., 1948, 1956; Woodstock AA, 1951, 1956, 1968, 1969; Rudolph Gal., 1951, 1956, 1957, 1958; Dayton AI, 1955, 1956; Farnsworth Mus., 1950; AFA traveling exh., 1953-54, 1955-56; Dayton AI, 1949; Nelson Gal. A., 1947; Rochester Mem. Gal., 1946; ACA Gal., 1938, 1946; Gal. Mod. A., 1944; Babcock Gal., 1943, 1944; Mortimer Brandt Gal., 1944-1946; Provincetown AA, 1957, 1958, 1964, 1966, 1967; Cornell Univ., 1961; Art:USA, 1958, 1959; one-man:exh.: Contemporary A., 1939, 1941; Brandt Gal., 1945; Summit (N.J.) AA, 1945, 1952; Passedoit Gal., 1955, 1957; Mint Mus. A., 1955; Salpeter Gal., 1948, 1949, 1951; Barone Gal., 1960; Landry Gal., 1961, 1963; Holland-Goldowsky Gal., Chicago, 1961; HCE Gal., Provincetown Mass., 1961, 1966, 1967; Kaye Gal., 1968, 1969. Positions: Instr., Queens Col., Flushing, N.Y.

SIGISMUND, VIOLET—Painter, Lith.
 1 Sheridan Square, New York, N.Y. 10014
B. New York, N.Y.. Studied: ASL. Member: AEA; ASL; NAWA; Provincetown AA; Woodstock AA; Knickerbocker A. Awards: Knickerbocker A., 1952; Village A. Center, 1961; Silvermine Gld. A., 1960; NAWA, 1963. Exhibited: PAFA, 1940; Telfair Acad. A., 1939; Audubon A., 1947, 1948, 1952, 1960, 1961; Knickerbocker A., 1952, 1953, 1955, 1956-1965; All. A. Am., 1942, 1948, 1964; NAD, 1952, 1962, 1964; Woodstock, N.Y., 1943-1955; Lenox Gal., 1952; ACA Gal., 1947

(one-man); N.Y. City Center, 1953-1961; Provincetown, 1956-1963; Art:USA, 1958; Fairleigh Dickinson Univ., 1959; Village A. Center, 1953-1961; NAWA, 1963-1965; Hyannis, Mass., 1964; NAWA traveling exh. US and Europe, 1964-65.*

SILBERSTEIN, MURIEL ROSOFF (Mrs.)—
 Teacher, Scholar, Patron, Collector
 Institute of Modern Art, 4 W. 54th St., New York, N.Y. 10019;
 h. 144 Clinton Ave., Staten Island, N.Y. 10301
B. New York, N.Y., Sept. 21, 1923. Studied: Carnegie-Mellon Institute of Fine Arts, B.F.A.; Philadelphia Museum, with Hobson Pitman; Institute of Modern Art, with Victor D'Amico and Jane Blano; Staten Island Museum, with Joseph Smith; Art Students League, N.Y.; Cheltenham Art Center, Philadelphia, Pa. Member:Kearsarge Group of Painters. Awards: Staten Island Woman of Achievement Award, 1967. Field of Research: Creative Art Education. Collection: Includes works by Joseph Smith, Freda Mulcahy, William Major, and others. Lectures: "Creative Art Education," Wagner Col., 1967-1968; Graduate Seminar on Art Education, N.Y. Univ., 1969. Positions: Scene designer, Asst. Technical Director, Pittsburgh Playhouse, 1944-1946; Interior display, Gimbel's department store, 1946-1947; Program illustrator, Philadelphia Orchestra children's concert series, 1950-1951; Art supervisor, S.I. Children's Theatre Assoc., 1962- ; Chairman, Art Education Comm., Art Rental and Sales Gallery, S.I. Museum, 1961-1963; Instructor, children's program and teacher education, Institute of Modern Art, MModA, 1963- . Art consultant to Staten Island Mental Health Head Start Program, 1965-1968.

SILINS, JANIS (Mr.)—
 Scholar, Painter
 1258 Chestnut St., Roselle, N.J. 07203
B. Riga, Latvia, June 1, 1896. Studied: Univ. Moscow; Kazan Acad. A.; Univ. Riga, Ph.D.; Univ. Marburg; Univ. Stockholm. Member: Assn. A., Soc. of Historians, both Riga; Prof. Union of A., Munich; Soc. A. Historians, Univ. Würzburg; Hon. Memb., Baltic Inst., Bonn; Orlando AA; Southeastern Mus. Conf. Awards: State award in A. Hist., Riga. Exhibited: widely in Europe and in Winter Park and Orlando, Fla. Author: Monographs: Rudolfs Perle, 1928; Karlis Zale, 1942; Ludolfs Liberts, 1943; other writings, "Latvian Landscape Painting," 1963; "Essays on Art," 1942; "Gailis, a Latvian Landscape Painter," 1948; "Images and Ideas," 1964. Field of Research: Art of the 19th and 20th Centuries; Art of Eastern Europe; Baltic Art; Problems of Art Philosophy. Contributor to many European publications with articles and papers on art and art philosophy. Lectures on Art History. Arranged and catalogued exhs., Rollins Col., "The Arts of Norway," 1957; 8th Annual Fla. A. Group, 1957; Memorial Exh. of Paintings by Leonard Dyer; and many more in U.S. and Europe. Positions: Asst. Prof. A., 1956-1964, Dir., Morse Gal. Art, 1956-61, Rollins College, Winter Park, Fla. Visiting Prof., Univ. Würzburg.

SILKOTCH, MARY ELLEN—Painter, T.
 Hazelwood Pl. (Arbor), Piscataway, N.J. 08854
B. New York, N.Y., Sept. 12, 1911. Studied: Van Emburgh Sch. A., Plainfield, N.J., and with Jonas Lie, Sigismund Ivanowski. Member: AEA; NAWA; AAPL; Plainfield AA; Westfield AA. Awards: prizes, Plainfield AA, 1950 (2), 1952, 1955-1961; AAPL, 1951, 1961; East Orange, N.J., 1952. Exhibited: Plainfield AA, 1948-1961; Paper Mill Playhouse, 1948; AAPL, 1948-1951, 1961, 1969; Edward William Col., Hackensack, N.J., 1969; Atlantic City A. Center, 1969; (one-man) Watchung, N.J., 1968; Montclair A. Mus., 1950, 1958; Irvington Mus. & A. Assn., 1948-1952 (1951, one-man); Raritan Valley AA, 1950-1952; Barrett A. Gal., Plainfield, N.J., 1949 (one-man); Swains, Plainfield, 1951, 1953, 1955, 1956] 1960 (one-man); NAWA, 1959; Westfield AA, 1959, 1967; Bucks County Playhouse, Pa., 1960. Positions: Instr., Van Emburgh Sch., Plainfield, N.J., 1944-1964; Instr., A., Adult Edu., Dunellen, N.J., 1948-57; Bound Brook Adult Edu., 1950-57; North Plainfield, 1951-54; Pres., Plainfield AA, 1952-60; Vice Pres., Academic A., 1967- ; Pres., New Jersey Chptr. AAPL, 1969- .

SILLS, THOMAS—Painter
 240 W. 11th St., New York, N.Y. 10014
B. Castalia, N.C., Aug. 20, 1914. Awards: Copley Fnd. Award, 1957. Work: MModA; WMAA; Brandeis Univ.; Williams College; Finch College; Los A. Mus. A.; Phoenix Mus. A.; Norfolk Mus. A. & Sciences; Fordham Univ.; Syracuse Univ. Sheldon Mem. Mus., Lincoln, Neb.; Phoenix A. Mus.; Norfolk Mus. A. & Sciences; Krannert A. Mus., Univ. Illinois. Exhibited: WMAA, 1960; New Sch. for Social Research, N.Y., 1956-1962; Univ. Colorado, 1959; Stable Gal., N.Y., 1955; Camino Gal., N.Y., 1956; Fairleigh Dickerson Univ., 1964; Dord Fitz Gal., Amarillo, Tex.; Brooklyn Col., 1969; IBM Gal., and traveling, 1967; one-man: Betty Parsons Gal., N.Y., 1955, 1957, 1959, 1961; Bodley Gal., 1963, 1964, 1967; Paul Kantor Gal., Los A., 1962.

SILVERCRUYS, SUZANNE (Mrs. Suzanne Silvercruys Stevenson)—Sculptor, W., L.
 1 West 67th St., New York, N.Y. 10023; h. 3001 E. Camino de Bravo, Tucson, Ariz.
B. Maeseyck, Belgium. Studied: Yale Sch. FA, B.F.A.; & in Belgium, England. Awards: Hon. degree, L.H.D.; Temple Univ., 1942; L.L.D., Mount Allison Univ., Sackville, Canada; Rome Alum. prize, 1928; BAID, 1927; Chevalier Order of Leopold; Officer Ordre de la Couronne; Officer d'Academie de France; Coronation med.; Queen Elizabeth med.; & others. Work: busts, plaques, mem., Louvain Lib.; McGill Univ., Canada; Yale Sch. Medicine; Reconstruction Hospital, N.Y.; First Lutheran Church, New Haven, Conn.; MMA; Duell award for N.Y. Press Photographers Assn.; Rumford (R.I.) Mem.; Government House, Ottawa, Can.; Amelia Earhart Trophy for Zonta Cl.; His Eminence, Cardinal Cushing, Stonehill College, North Easton, Mass.; statue of Padre Kino of Arizona, Statuary Hall, Rotunda, U.S. Capitol, Wash., D.C.; Hon. Joseph W. Martin, Rotunda of old House of Representatives, Wash., D.C.; war mem., Shawinigan Falls, Canada; gold medal, presented by Young Democrats to Jas. Farley; many portrait busts of prominent persons. Exhibited: CGA; BAID; Salon de Printemps, 1931. Author: "Suzanne of Belgium"; "A Primer of Sculpture," 1942.

SILVERMAN, DR. RONALD H.—Educator
 Art Department, Los Angeles State College, 5151 State College Drive, Los Angeles, Cal. 90032*

SIMON, BERNARD—Sculptor, T.
 2231 Broadway; h. 490 West End Ave., New York, N.Y. 10024
B. Russia, Jan. 6, 1896. Studied: Edu. All. & Art Workshop, N.Y. Member: AEA; Silbermine Gld. A.; Brooklyn Soc. A.; Knickerbocker A.; N.J. Soc. P. & S.; Provincetown AA; Cape Cod AA; Lg. of Present Day A. Awards: prizes, AEA; Silvermine Gld. A.; Knickerbocker A.; Audubon A.; N.J. Soc. P. & S. Work: Slater Mem. Mus., Norwich, Conn.; Norfolk Mus. A. & Sciences and in private collections. Exhibited: Audubon A.; Sarasota, Fla.; Silvermine Gld. A.; Shore Gal., Boston; Boston A. Festival; Boston Univ.; one-man: Ruth White Gal., N.Y.; Naples A. Gal., Fla.; Arwin Gal., Detroit; Provincetown Group; Truro A. Center; Lucinda Gal., Tenafly, N.J.; Kornbluth Gal., Fair Lawn, N.J.; Woodstock, N.Y.; ACA Gal., N.Y. (2); Silvermine Gld. A.; East End Gal., Provincetown, Mass. (3); Shore Gal., Provincetown; Provincetown AA.; Hyannis AA. Positions: Instr., MModA; New School for Social Research, N.Y.; Bayonne Art Center.

SIMON, ELLEN R.—Designer, P., C., I., W., Gr., T.
 419 West 119th St., New York, N.Y. 10027
B. Toronto, Canada, Apr. 15, 1916. Studied: Ontario Col. A.; ASL; New Sch. Social Research and with Joep Nicolas, Yvonne Williams. Work: Albertina Coll., Vienna; N.Y. Pub. Lib.; BM; Nat. Gal. of Canada; A. Gal. of Ontario; Stained glass windows in many churches and synagogues in Canada including Waterdown, Ont.; Toronto, Winnipeg, Montreal, Newtonbrook, etc.; Temple Emanuel, Tuscaloosa; Sidney Hillman Mem. window, Hastings-on-Hudson, N.Y.; Church of St. Michael & All Angels, Toronto, 1960-1967; (6 porch windows; other windows: Princeton Univ. Chapel; Holy Family, Narthex, 1966; Adlai Stevenson window in progress), and others. Exhibited: Pasadena AI, 1945 (one-man); Nat. Gal. of Canada; PMA; Albany Pr. Cl.; Mississippi AA; Smithsonian Inst.; N.Y. Pub. Lib.; Picture Loan Co., Toronto; Hart House, Toronto Univ.; Wash. Kiln Cl.; Carnegie Lib., Pittsburgh; Mus. Contemp. Crafts, N.Y.; DMFA; Ontario Soc. Architects, 1961, and others. Author, I., "The Critter Book," 1940; Illus.: "Inga of Porcupine Mine," 1942; "Americans All," 1944; "Music in Early Childhood," 1952. Instr. in stained glass, Riverside Church, N.Y., Arts & Crafts program, 1965- .

SIMON, HOWARD—Portrait Painter, I., Gr.
 Stanfordville, N.Y. 12581
B. New York, N.Y., July 22, 1903. Studied: NAD; Julien Acad., Paris, France. Member: AIGA; Cal. Soc. Et.; Dutchess County AA. Awards: prize, Long Island A. Lg., 1955. Work: MMA; BMA; N.Y. Pub. Lib.; Brooks Mem. A. Gal.; Mills Col.; Little Rock Mus. A.; N.Y. Univ. Gal. of Portraits, Medical Center. Exhibited: 50 Prints of the Year; 50 Books of the Year; Victoria & Albert Mus., London; Int. Pr. M., Los A.; one-man: Smithsonian Inst.; A. Center, N.Y.; Three Arts Gal., Poughkeepsie, N.Y. I., Limited Editions Club, "Lyrics of Francois Villon"; Dickens' "Christmas Stories"; Mark Twain's "The Prince and the Pauper"; "Rabelais," etc. Author: "500 Years of Art in Illustration"; "A Primer of Drawing," 1954; "Watercolor Painting"; Illus.: "Is Anyone Here?"; A. and I: "Climb This Mountain." Positions: Adjunct Prof. A., Port. & Figure Painting, Drawing, N.Y. Univ., Div. General Edu., New York, N.Y., 1947- .

SIMON, MR. and MRS. LEO—Collectors
 983 Park Ave., New York, N.Y. 10028*

SIMON, NORTON—Collector
 Norton Simon Foundation, 100 N. Hudson Ave., Los Angeles, Cal. 90004; h. 1645 W. Valencia Dr., Fullerton, Cal. 92633*

SIMON, SIDNEY—Painter, S.
 95 Bedford St., New York, N.Y. 10014
B. Pittsburgh, Pa., May 21, 1917. Studied: Univ. Pennsylvania, B.F.A.; PAFA; Barnes Fnd., and with George Harding. Awards: Cresson traveling F., PAFA, 1940; Abbey F., 1940; prize, Carnegie Inst., 1941, 1945; Assoc. A. Pittsburgh, 1951; Babcock Mem. Award, 1963; Gold Medal, Century Assn., 1965; F., PAFA, 1960. Member: AEA; CAA. Work: U.S. War Dept., Wash., D.C.; Century Assn.; Walt Whitman H.S., Yonkers, N.Y.; Am. Embassy, Paris, France; MMA; Temple Beth Abraham, Tarrytown, N.Y.; Reproductions and illus.: Life, Look, Vogue, Fortune, Show, Madamoiselle magazines and in leading art publications. Exhibited: NGA; MMA, 1945, 1950, 1961; Assoc. A. Pittsburgh, 1936-1941, 1945; PAFA, 1946-1952, 1960, 1962; PAFA Fellowship Exh., 1959-1969; CGA, 1948, 1950; WMAA, 1950, 1952-1955, 1959, 1962; Colby Col., 1961; BM, 1953; Bowdoin Col., 1952; NAD, 1946, 1960; USIS traveling exh., Europe, 1958; Arch. Lg., 1958, 1961; F., PAFA, 1960-1963; Detroit Inst. A., 1959, 1960; Century Assn., 1960-1969; Vanderbilt A. Gal., Nashville, 1962; MModA, 1962; Chautauqua Inst., 1963; Edu. Alliance Retrospective, American Federation of Arts, 1963, and many others. One-man: PAFA, 1946; Queensland Nat. A. Gal., Brisbane, 1944-45; Nat. Gal. Victoria, Melbourne, Nat. Gal. South Australia, Adelaide; Tokyo, Japan, 1953; Nat. Gal. of New South Wales, Sydney, Australia; Niveau Gal., N.Y., 1949; Grand Central Moderns, 1950, one-man, 1953; Rockland Fnd., 1955; Motel on the Mountain, Suffern, N.Y., 1959; Market Fair, Nyack, N.Y., 1960; Grippi Gal., N.Y., 1963; Pittsburgh Plan for Art, 1965. Positions: Instr., Painting, CUASch, 1946-47; Brooklyn Mus. Sch., 1948-55; Skowhegan Sch. Painting & Sculpture, 1946-58; Parsons Sch. Des., 1962-1963; New Sch. for Social Research, N.Y., 1964-1969; A.-in-Res., Am. Acad. in Rome, 1969-70.

SIMON, SIDNEY—E., Hist., W., L.
 108 Jones Hall, University of Minnesota; h. 2668 Inglewood Ave., South, Minneapolis, Minn. 55416
B. Pittsburgh, Pa., June 13, 1922. Studied: Carnegie Inst., B.F.A.; Harvard Univ., Ph.D. Member: CAA. Awards: Fulbright Research Fellowship, 1959. Collaborated on following exhs.: Gerhard Marcks, Sculptor, 1953; Reality and Fantasy 1900-1954; Expressionism 1900-1955; Sculpture of Theodore Roszak, 1956; Paintings by Stuart Davis, 1957; The 18th Century: One Hundred Drawings by One Hundred Artists, 1961; The 19th Century: 125 Master Drawings, 1962; 20th Century Master Drawings, 1963. Positions: Senior Cur., Walker Art Center, Minneapolis, 1953-59; Assoc. Prof., Dept. Art & Dir., University of Minnesota A. Gal., 1959-1967; Prof., Dept. Art History, 1968- .

SIMONI, JOHN PETER—Educator, P., C., S., W., L., Gal. Dir., Cr.
 Art Department, Wichita State University; h. 1816 Harvard St., Wichita, Kans. 67208
B. Denver, Colo., Apr. 12, 1911. Studied: Colorado State Col. of Edu., B.A., M.A.; Nat. Univ. Mexico; Kansas City AI, with Thomas Hart Benton; Colorado Univ., with Max Beckmann; Ohio State Univ., Ph.D.; Mass. Inst. Tech.; and in Trentino, Italy. Member: AAUP; Am. Soc. for Aesthetics; CAA; Kansas Fed. A.; Southwestern Col. A. Conf. (Pres. 1962-64); Kansas A. Edu. Assn.; Midwest Col. A. Assn.; F.I.A.L. Awards: The Trentino prize, Italy, 1928; Carter prize, Denver, Colo., 1931; Knight Officer, Order of Merit, Republic of Italy for contributions to art, USA-Italy, 1966. Work: Colorado Friends of Art Coll.; reliefs, sc., murals, Southwest-Citizens Fed. Savings & Loan Assn., Wichita; Kansas State Bank, Newton; Fine Arts Center Theatre, Univ. Wichita; East Heights Methodist Church; Citizens Nat. Bank, Emporia, Kans.; sc., Turner Ford Motor Co., Wichita, 1968; Nat. Commercial Bank; painting, Mathewson Intermediate Sch., Wichita; Lahey Mortuary Chapel, Wichita; Yingling Chevrolet Co., Wichita; Rolling Hills Country Cl., Wichita; St. Paul Methodist Church, Wichita. Exhibited: Mulvane Mus. A.; Wichita A. Mus.; Colorado State Col.; Birger Sandzen Mem. Gal., Lindsborg, Kans. (2-man); Univ. Wichita. Contributor book reviews to College Art Journal; Art Critic, weekly column for Wichita Eagle. Lectures: Art Education Today; Italian Renaissance; Art in Religion, etc. Organized and directed the Elsie Allen Art Gallery, Baker Univ. and assembled the Allen Collection of paintings; arranged and catalogued the Bloomfield Collection of paintings for Univ. Wichita, 1956. Positions: Hd. Dept. A. & Gal. Dir., Baker Univ., 1937-55; Prof. A., 1955-57; Chm., Dept. A. & Dir., of the university galleries, University of Wichita, 1957-63; Prof. A., Wichita State Univ., 1964- ; Co-Dir., Univ. Gallery, 1964-1967; Monthly art column, The Baldwin Ledger, 1965- ; Color Consultant, Western Lithograph Co., Wichita, Kans. & Houston, Tex., 1961-63. Des., John Coultis Interiors, 1964- .

SIMONT, MARC—Illustrator, W.
156 E. 39th St., New York, N.Y. 10016; h. West Cornwall, Conn. 06796
B. Paris, France, Nov. 23, 1915. Studied: Academie Julian, Academie Ranson, and with Andre Lhote, Paris, France; NAD. Awards: Tiffany Fnd. F., 1937; Caldecott Award, 1956. Exhibited: SI, 1965. Contributor illus. to: Sports Illustrated; Newsweek; N.Y. Times; American Heritage; Horizon. Author, I., "Polly's Oats," 1951; "The Lovely Summer," 1952; "Mimi," 1954; "The Plumber out of the Sea," 1955; "Opera Souffle," 1951; "The Contest at Paca," 1959; "How Come Elephants," 1965; "Afternoon in Spain," 1965. Illustrator: "The First Story," 1947; "The First Christmas," 1948; "The Happy Day," 1949; "The Big World and the Little House," 1950; "Fish Head," 1954; "A Tree is Nice," 1956; "American Folklore and Legend," 1958; "The 13 Clocks," 1950; "The Wonderful O," 1958; "Mr. Robbins Rides Again," 1958; "Every Time I Climb a Tree," 1968.

SIMPSON, DAVID WILLIAM—Painter, T.
146 Bishop Ave., Point Richmond, Cal. 94807
B. Pasadena, Cal., Jan. 20, 1928. Studied: Cal. Sch. FA, B.F.A.; San Francisco State Col., M.A. Member: San.F. A.; Artists' Comm. Work: Oakland A. Mus.; SFMA; Phoenix Mus. A.; MModA; Storm King A. Center, Mountainville, N.Y.; Golden Gateway Project, San F.; NCFA; Smithsonian Inst.; BMA; PMA; SAM; La Jolla A. Mus. Exhibited: Carnegie Inst., 1961, 1967; MModA, 1963; Los A. Mus. A., 1964; San F. AI, 1953 and later; other exhibitions in Western States and in Europe. Positions: Assoc. Prof. A., Univ. of Cal., Berkeley.

SIMPSON, MAXWELL STEWART—Painter
Old Raritan Rd., Scotch Plains, N.J. 07076
B. Elizabeth, N.J., Sept. 11, 1896. Studied: NAD; ASL, and abroad. Member: Audubon A.; SC; AAPL; P. & S. Soc. New Jersey. Awards: prize, Montclair A. Mus., 1943; silver medal, NAC, 1951; Terry AI, 1952; NAD, 1953; Art Center of the Oranges, 1955, 1958; NAD, Speyer award, 1953; Emily Lowe award, 1958; Grand Nat. Gold Medal, AAPL, 1959; Marine award, Silvermine Gld. A., 1959; N.J. "Artist of the Year" award, 1959; Plainfield AA, 1956; NAC, 1957; SC, 1960, 1962; Springfield Mus. FA, 1963. Work: Newark Mus.; NGA; N.Y. Pub. Lib.; Briarcliff Sch.; Newark Pub. Lib.; Newark Mus.; New Jersey State Mus.; Montclair Mus. A.; Grand Central Gals., and others; mural, Stage House Inn, Scotch Plains, N.J. Exhibited: National Exhs. since 1920. Incl., Paris Salon, 1924; NAD, 1945, 1948, 1949; Los A. Mus. A., 1945; Carnegie Inst., 1941, 1943; Nwbg. Mus.; CGA, 1939; WFNY 1939; WMAA, 1934; GGE, 1939, Montclair A. Mus., 1943, 1944; Riverside Mus., 1944; Newark Mus., 1943, 1952; NAC, 1951; MMA, 1942; BMA, 1934; Pepsi-Cola, 1947; Terry AI, 1952; PAFA; AIC; Albright A. Gal.; Rochester Mem. A. Gal.; AIC; BMFA; MMA; Nat. Univ. Mexico; one-man: Dudensing Gal., 1930, 1932; Artists Gal., 1941; Eggleston Gal., N.Y., 1960, 1961; Gal. 52, South Orange, N.J., 1966, 1968; Grand Central Gal., N.Y., 1967. I., "Aucassin and Nicolete," (50 Books of the Year), 1936.

SIMPSON, MERTON D.—Painter
1063 Madison Ave., New York, N.Y. 10028
B. Charleston, S.C., Sept. 20, 1928. Studied: N.Y. Univ.; CUASch., and with William Halsey. Awards: prizes, Red Cross Exchange Exhibit, France, Japan, 1950; Oakland A. Mus., 1952; Atlanta Univ., 1950, 1951, 1956; Intercultural Cl., 1951; South Carolina Cultural Fund F., 1951; Gibbes A. Gal., 1956. Work: Atlanta Univ.; Howard Univ.; Gibbes A. Gal.; Scott Field Mus., Chicago. Exhibited: Atlanta Univ.; Contemp. A. Gal., N.Y.; Bertha Schaefer Gal., N.Y.; Intercultural Cl., N.Y.; Oakland A. Mus.; Gibbes A. Gal.; MMA; Univ. Michigan; Guggenheim Mus., N.Y., and others; one-man: Kuhar Gal., Charleston; Aden Gal., Wash., D.C.; Barone Gal., N.Y. Permanent exhibition at Merton Simpson Gallery of Primitive and Modern Arts, New York, N.Y.*

SIMS, AGNES—Painter, S., C.
600 Canyon Road, Santa Fe, N.M. 87501
B. Rosemont, Pa., Oct. 14, 1910. Studied: Phila. Sch. Des. for Women; PAFA. Member: Hon. Assoc., Archaeology, School of American Research; AEA. Awards: Am. Philosophical Soc. grant, 1949 (for research and recording of Southwest Indian Petroglyphs); Neosho grant, 1952; Ingram Merrill Fnd. grant, 1960. Work: Mus. New Mexico; Colorado Springs FA Center; Denver A. Mus. Arranged exhibition of reproductions of Southwest Indian petroglyphs, BM, 1953, and Musee de L'Homme, Paris, 1954. Exhibited: one-man: Mus. New Mexico; Colorado Springs FA Center; Santa Barbara Mus. A.; Wash. A. Cl.; Phila. A. All.; Viviano Gal., N.Y.; Boissevain Gal., N.Y.; WAC. Exh. of wall hangings based on Southwest Indian Petroglyphs for USIS at U.S. Embassy, London, England, 1964. Author, I., "San Cristobal Petroglyphs," 1950.

SINAIKO, A(VROM) ARLIE—Sculptor
115 Central Park West, New York, N.Y. 10023
B. Kapule, Russia, Oct. 1, 1902. Studied: Univ. Wisconsin, B.S.; AIC; ASL; Sculpture Center, N.Y., and with Archipenko, Lassaw, Harkavy. Member: AEA; Am. Soc. Contemp. A.; Silvermine Gld. A.; Provincetown AA. Awards: prize, Am. Soc. Contemp. A.; purchase, PAFA. Work: PAFA; Univ. Wisconsin; Evansville Mus. A.; Ein Harod Mus., Israel; N.Y. Univ. Coll.; Lincoln Center for Performing Arts, N.Y.; Phoenix A. Mus.; Int. Synagogue, Kennedy Airport, N.Y.; Chrysler Mus.; Lowe Mus., Miami Univ.; Ringling Mus. A.; Brooks Mem. Mus.; Andrew Dickson White Mus., Cornell Univ.; Arkansas A. Center, Little Rock; Denver A. Mus. Exhibited: PAFA, 1960; Detroit Inst. FA, 1960; Art:USA 1958; Sculpture Center; Provincetown AA; Brooklyn Soc. A.; Univ. Wisconsin; McNay AI, San Antonio; East End Gal., Provincetown; Riverside Mus., N.Y. One-man: Gal. D'Art Faubourg, France, 1962; Bodley Gal., N.Y., 1958-1964; New Gallery, Provincetown, 1960-1962; Fordham Univ., 1965.

SINDLER, MR. and MRS. ALLAN P. (LENORE B.)—Collectors
Cornell University; h. 302 Fall Creek Drive, Ithaca, N.Y. 14850
(Mr. Sindler): B. New York, N.Y., Oct. 24, 1928. Studied: Harvard University, B.A., M.A., Ph.D., Collection: Contemporary graphics, drawings, small sculpture. Positions: Professor of Government, Cornell University.*

SINGER, BURR (Mrs. Burr Lee Friedman)—Painter, Lith.
2143 Panorama Terr., Los Angeles, Cal. 90039
B. St. Louis, Mo. Studied: St. Louis Sch. FA; AIC; ASL, and with Waltar Ufer. Member: Cal. WC Soc. (Vice-Pres., 1958); AEA; Los A. AA; Council All. A. Awards: prize, Marineland Exh., 1955; Los A. County Fair, 1951, 1953. Work: Warren Flynn Sch., Clayton, Mo.; LC; Beverly-Fairfax Jewish Community Center, Los A.; Child Guidance Clinic, Los A. Exhibited: WFNY 1939; GGE, 1939; Denver A. Mus., 1943-1946; Audubon A., 1945; Pepsi-Cola, 1944; Los A. Mus. A., 1940-1945, 1952, 1954, 1955; Cal. WC Soc., 1940-1945, 1953-1958, 1968 and traveling; Fnd. Western A., 1943-1945; Santa Barbara Mus. A., 1952; Greek Theatre, Los A., 1951; LC, 1948; 1950; Phila. Pr. Cl., 1952; Gump's San F., 1952; Cal. State Fair, 1949-1951, 1953; Oakland A. Mus., 1954; Maryhill (Wash.) Mus., 1951; Int. Color Lithog., 1954; Frye Mus. A., Seattle, 1960, 1962; Watercolor:USA, Springfield, Mo., 1964; Cal. WC Soc. Exh., Los A., 1965; A. of Los A. & Vicinity, 1961, 1969; one-man: Chabot Gal., Los A., 1949; Esther Robles Gal., Los A., 1957; Cafe Galeria, Los A., 1958; Comara Gal., 1959; Kramer Gal., Los A., 1963.

SINGER, CLYDE J.—Painter
524 Wick Ave.; h. 210 Forest Park Dr., Youngstown, Ohio 44512
B. Malvern, Ohio, Oct. 20, 1908. Studied: Columbus A. Sch.; ASL, with John Steuart Curry, Kenneth Hayes Miller, Alexander Brook; Research Studio, Maitland, Fla. Member: Columbus A. Lg. Awards: prizes, NAD, 1938; Butler AI, 1938, 1942, 1948, 1953; Portland (Ore.) A. Mus., 1937-1939, 1946, 1951; Canton AI, 1949; medal, AIC, 1935; Ohio State Fair, 1955, 1958, 1967, 1968; Gilcrease Inst. Am. Hist. & Art, 1958. Work: PAFA; Vanderpoel Coll.; Canton AI; Massillon Mus.; Columbus Gal. FA; Butler AI; Wadsworth Atheneum; Research Studio; IBM; Canton Repository; Fla. Southern Col.; Columbus Pub. Sch.; Akron AI; Gilcrease Inst.; Norfolk Mus. A. & Sciences; Art Inst. of Zanesville, Ohio; Capital Univ., Columbus, Ohio; mural, USPO, New Concord, Ohio. Exhibited: PAFA, 1935, 1936-1939, 1941, 1949, 1950; CM, 1935-1940; AIC, 1935-1938; NAD, 1936, 1938, 1953, 1955, 1958; WFNY, 1939; GGE, 1939; Carnegie Inst., 1936-1939, 1946-1948; WMAA, 1936, 1940; CGA, 1937, 1939; VMFA, 1940, 1942; Butler AI, 1937-1969; Columbus A. Lg., 1936-1939, 1941, 1947-1955; All. A. Am., 1957; Denver A. Mus.; Oakland A. Gal.; Milwaukee AI; John Herron AI; Los A. Mus. A.; New Haven Paint & Clay Club; Conn. Acad. FA; SFMA; Colorado Springs FA Center; Dallas Mus. FA; Montclair A. Mus.; BMA; Cal.PLH, and many others. Positions: Asst. Dir., Butler AI, Youngstown, Ohio; A. Cr., Youngstown Vindicator.

SINGER, WILLIAM EARL—Painter, S., W., L.
12897 San Vicente Blvd., "Brentwood," West Los Angeles, Cal. 90049
B. Chicago, Ill., July 10, 1910. Studied: Univ. Chicago; AIC; in Paris; & with Charles Wilimovsky, John Norton. Member: Chicago SA; Cal. WC Soc.; Beaux-Arts Soc., Paris, France; F.I.A.L. Awards: prizes, A. Fair, Chicago, 1933; Davis award, Chicago, 1932; Beaux-Arts Soc., Paris, 1934; Rosenfield award, Chicago, 1940; Denver A. Mus., 1938; Havana, Cuba, 1946; Nat. Sch., 1949; Santa Cruz, 1948; European Grant, Fnd. Internationale des Arts, Paris, Geneva, 1962-63; Israel Govt. Honorarium, 1965; French Government Medal of Honor, 1968; Order of Artes et Lettres, presented by André Malraux, Minister of Culture, France, 1969; Order of Orange

Nassau from the Government of Netherlands, 1969. Work: Grand Rapids A. Gal.; Illinois State Mus.; Scopus Col., Melbourne, Australia; Presidential Palace, Colombia; Israeli Govt.; Am. Embassy, Paris; Cook County Hospital, Chicago; Court House, Foley, Ala.; Univ. Texas; Joslyn A. Mus.; Newark Mus.; Univ. Minnesota; AIC; Lib. Cong.; Univ. Illinois; U.S. Govt.; Libertyville (Ill.) Court House; Biro-Bidjan Mus., Russia; Osaka Mus., Japan; St. Mary's Col., Winnipeg, Canada; Chanute Field Air Base; Bernheim Gal., Paris; Mexico City; Am. Fnd., Mexico City; Thomas Mann Mem., Zurich; Buenos Aires, Argentina; Israel Legation, Copenhagen; Oscar Hammerstein Mem., N.Y.; Gertrude Lawrence Mem., London; American Embassy, London; bronze monument of Vincent Van Gogh for the City of Arles, France, 1968, and others. Exhibited: AIC, 1932-1941; WFNY, 1939; GGE, 1939; Great Lakes traveling exh., 1939; Denver A. Mus., 1938, 1939; Albright A. Gal., 1939; Toronto (Canada) A. Mus., 1938-1939; AIC, 1940 (one-man); Haarlem Mus.. Netherlands: Roval Acad., Brussels; Sao Paulo, Brazil; Bibliotheque Nationale, Paris; Univ. Chicago; Santa Barbara Mus. A.; traveling exh., European capitols, 1951, 1956-57, and 1962-63; South America, 1953. Contributor to: "New Horizons in American Art," MModA; "American Art Today," Nat. A. Soc. Publication: "William Earl Singer" by Andre Blum, Cur., Museum du Louvre, Paris; "Arts & Lettres," publ. by U.S. Govt. Inf. Ofc., Paris; "An American in Paris" by Maximilian Gauthier, Paris, 1962. Lectures: Contemporary Painting & the Old Masters. Author: I., "Paintings of Israel." Invited by State of Israel to paint official portraits of Pres. Weizmann and Prime Minister Ben Gurion. Color consultant, Chicago World's Fair & Brussels International.

SINTON, NELL — Painter
1020 Francisco St., San Francisco, Cal. 94109
B. San Francisco, Cal., June 4, 1910. Studied: San Francisco A. Inst. Member: San Francisco A. Inst. (Bd. Memb.). Awards: Oakland Mus., 1958, 1961. Work: SFMA; Chase Manhattan Bank; Oakland Mus.; Lytton Trust Co., San Jose, Cal. Exhibited: MMA, 1952; Art;USA, 1958; AFA traveling U.S. and Asia, 1958, 1963; Vancouver (B.C.) Gal. A., 1958; San Francisco A. Inst., 1940-1967; Am. Acad. A. & Lets., 1968; Stanford Research Inst., 1958; Los Angeles County Mus., 1961; Univ. Nevada, 1969; one-man: SFMA; Quay Gal., San Francisco, 1965, 1969; Staempfli Gal., N.Y., 1960. Author: Morphologie Autre, 1960; Michel Tapie. Contributor to: Art News; Art Forum; Art International.

SIPORIN, MITCHELL— Painter, E.
300 Franklin St., Newton, Mass. 02158
B: New York, N.Y., May 5, 1910. Studied: AIC; Crane Col., Chicago; Am. Acad. in Rome. Member: AFA; AEA; Brandeis Univ. Creative A. Comm. Awards: medal, PAFA, 1946; AIC, 1947; Guggenheim F., 1946-1947; prizes, AIC, 1942, 1947; Prix de Rome, 1949; Hallmark award, 1950; Nat. Inst. A. & Lets., 1955; first prize, watercolor, Butler Inst. Am. A., 1959; Senior Fulbright award, Italy, 1967. Work: AIC; MMA; WMAA; MModA; Wichita Mus. A.; Smith Col.; Univ. New Mexico; Encyclopaedia Britannica; Univ. Georgia; AGAA; Alabama Polytechnic Inst.; Univ. Arizona; Brandeis Univ.; Cranbrook Acad. A.; FMA; Univ. Iowa; Newark Mus. A.; N.Y. Pub..Lib.; frescoes, USPO, St. Louis, Mo.; Decatur, Ill. Exhibited: WMAA, 1956-1958; AFA traveling exh., 1956-48; AIC; one-man: Downtown Gal., 1938-1942, 1947-1957; MModA, 1942; de Cordoba Mus., 1954; Art U.S.A., The Johnson Coll., 1964-65. Positions: Hd. Dept. Painting, BMFA Summer Sch., 1949; Instr., Drawing, Columbia Univ., New York, N.Y., 1951; Prof. FA, A.-in-Res., 1951-58, Chm. FA Dept., 1956-62, Brandeis University; A.-in-Res., Am. Acad. in Rome, 1966-1967.

SIRENA (Contessa Antonia Mastrocristino Fanara) —
Painter, Gallery Director
1724 Hempstead Turnpike, East Meadow, L.I., N.Y. 11554
B. White Plains, N.Y., Jan. 13, 1924. Member: Academy of Paestum, Salerno (Hon.); Academy of the 500, Rome; Delegate for U.S. for the International Committee on Culture. Awards: Gold Cup, Quadrenale of Rome; Gold Cup, Cultural Center of Naples; Medal of the Vatican; Silver Trophy from the Belgian Committee of Culture; Grand Cross of the Order of St. Constantine. Work: Vatican Museum; Museum of Modern Art, Rome and Milan; Museum of the State of Venice, Trieste; Province of Naples; Museums of: Bologna, City of Bari, Palermo-General Sicilian Region; Assisi, Montecatini, Ministry of Interior, Rome; Museum Revoltella, Trieste; Museum of Rome Town Hall. Exhibited: in addition to above, Van Dieman Lilienfeld Gal., N.Y., 1966; Galeria Internationale, N.Y., 1969 (one-man).

SIRUGO, SALVATORE—Painter
351 W. 24th St., New York, N.Y. 10011
B. Pozzallo, Sicily, Aug. 18, 1920. Studied: ASL; Brooklyn Mus. Sch. A. Member: AEA; ASL (Bd. Cntrol, 1961); Brooklyn Mus. Sch. Alumni; Artists' Club. Awards: Emily Lowe award, 1951; Brooklyn

Mus. Sch. A. Scholarship, 1952; Woodstock Fnd., 1952; Longview Fnd., 1962; Lannan Fnd., 1963. Exhibited: WMAA, 1952; PAFA, 1953; Art:USA, 1958; Provincetown A. Festival, 1958; Contemp. A. Mus., Houston; Howard Wise Gal., Cleveland; Kansas City AI; Woodstock AA; Peridot, Borgenicht, Phoenix Gal., East Hampton Gal., N.Y., Tanager (one-man, 1961), Camino (one-man, 1959) Gals., N.Y. "K" Gal., Woodstock, N.Y. (one-man, 1963); Great Jones Gal., N.Y. (one-man, 1966); Trinity Col.; Univ. Miami; Rutgers Univ.; Columbi Univ.; Univ. So. Illinois; Windham Univ., Vermont; NAD, and others

SISTI, ANTHONY J.—Collector, Patron, Cr., P., T., Art Dealer
469 Franklin St., Buffalo, N.Y. 14203
B. New York, N.Y., Apr. 21, 1901. Studied: Albright A. Sch., Buffalo; Royal Academy, Florence, Italy, under Falice Carena (Doctorate degree); Julien Acad., Paris; Royal Acad., Munich. Awards: prizes, Western New York Exh., Buffalo, 1931, 1946, 1947; Patteran Soc., Buffalo, 1943; Buffalo Soc. A., 1934, 1947. Exhibited: One-man and group exhs., Argent Gal.; MModA; Mus. of the City of New York; Riverside Mus.; Grand Central Gals.; Ferargil Gal.; Howard Univ., Washington, D.C.; Cal. PLH.; also in Ashland, Ohio; Niagara Falls, Ontario, Canada; Niagara Falls, N.Y., and others, 2 one-man exhs., Albright A. Gallery, Buffalo, 1934, 1946. Collection: Old Masters, Impressionists, Modern. Positions: Pres., Patteran Society, 1957; Vice-Pres., I.S.D.A., 1964-1965; Chm., 1st Allentown Exhibition, 1956; Chm., Civic Art Festival, Buffalo, 1965.*

SIVARD, ROBERT PAUL—Painter, Des., Lith.
United States Information Agency (25); h. 3013 Dumbarton Ave., Northwest, Washington, D.C. 20007
B. New York, N.Y., Dec. 7, 1914. Studied: PIASch.; NAD; New Sch. for Social Research; Academie Julien, Paris, France. Awards: prizes, Dept. of State Comp., 1957; CGA, 1956; NAD, 1958; purchase prize, Butler Inst. Am. Art, 1968. Work: murals, Oregon State Capitol; GGE, 1939; WFNY, 1939; Exhibited: Musée d'Arte Moderne, Paris, 1953; Galerie Charpentier, Paris, 1954; CGA, 1956, 1957; Carnegie Inst., 1957; one-man: Galerie Craven, Paris, 1953; U.S. Embassy, Paris, 1954; Midtown Gal., N.Y., 1955, 1958, 1960, 1962, 1964, 1966, 1968; Retrospective Exh., Phila. A. All., 1968. Positions: A. Dir., Fawcett Publ., 1940-42, 1946-48; Dir., Intl. Refugee Organization, Geneva, Switzerland, 1948-49; Dir., Visual Information, U.S. Embassy, Paris, 1951-54; Dir., Exhibits Div., U.S. Information Agency, Wash., D.C., 1958-1967; organized exhibits at U.S. National Exhibition, Moscow, 1959; Milan Triennale, 1960; Sao Paulo Bienale, 1959, 1961, 1963, 1965; Venice Bienale, 1964, and all U.S. Govt. sponsored art exhibits abroad, 1958-1967; Art Director, USIA, 1967- .

SKEGGS, DAVID OTTER—Designer, P., C., Gr., L.
Far Corners, Inc., Akron, Ohio; h. 1854 Orchard Drive, Bath, Ohio 44210
B. Youngstown, Ohio, Feb. 5, 1924. Studied: Denison Univ., A.B.; Iowa State Univ., M.A., and with Hans Hofmann. Member: AEA; Ohio Designer-Craftsmen; American Craftsman Council. Work: Akron AI; Smith Col.; Youngstown Col.; Indiana State T. Col.; Butler AI; Dayton AI; Des Moines A. Center; Joslyn Mus. A.; Nebraska State T. Col.; Sioux City A. Center; U.S. Embassies, abroad; and private colls. Exhibited: Canton AI; Akron AI; Butler AI; CMA; Toledo Mus. A.; Dayton AI; CM; Columbus Gal. FA; Indiana State T. Col.; AIC; Detroit Inst. A.; South Bend AA; Denison Univ.; Kenyon Col.; Massillon Mus. A.; Terry AI; BMFA; Syracuse Mus. FA; Ohio State Univ.; Newark Mus. A.; Bradley Univ.; BM; LC; Phila. Pr. Cl.; Serigraph Gal.; N.Y.; SAM; Newport AA; Wadsworth Atheneum; Los A. Mus.; Colorado Springs FA Center; J.B. Speed Mus. A.; Columbia Gal. FA; Smith Col., Ohio, Iowa State Fairs, and many others. Positions: Asst. Prof. A., 1948-52, Hd. Dept. A., 1952-54, Youngstown Col.; Dir., Sioux City A. Center, Sioux City, Iowa, 1954-1957; Des., Garth Andrew Co., Bath, Ohio, 1961-1965. Skeggs Design Studio, 1960- ; Far Corners, Inc., 1965- .

SKELTON, PHILLIS HEPLER—Painter, Gr., T., L.
543 South College Ave., Claremont, Cal. 91711
B. Pittsburgh, Pa., Dec. 31, 1898. Studied: Univ. So. California, A.B.; Scripps Grad. Col.; Claremont Grad. Sch. M.A., and with Eliot O'Hara, Phil Dike, Millard Sheets, Dong Kingman, David Scott, and others. Member: Nat. Cal. WC Soc.; Riverside AA and A. Gld.; Pasadena Soc. A.; Pomona Valley AA; Awards: AWS, 1954, 1960; Nat. Cal. WC Soc. Work: Victoria (B.C.) A. Gal.; Pasadena A. Mus., and in private colls. Exhibited: Butler AI, 1954; AWS, 1953, 1960; Nat. Cal. WC Soc., 1952-1966; Nat. Orange Show, 1953, 1962; Int. Flower Show, 1955; San Gabriel Valley, 1953-1955; Palos Verdes, 1955; Denver A. Mus., 1954; Nat. Cal. WC Soc. traveling exhs.; All-California A. Exh., 1955, 1960; Santa Fe, N.M.; El Paso, Tex.; Mexico, Canada, Paris, France; Mid-West Museum Circuit; one-man: Pasadena A. Mus., 1954, 1960, 1964; Laguna Beach A. Gal., 1954, 1960; Twenty-Nine Palms, Cal., 1953, 1960 and many regional exhs. Positions: Instr. Children's Classes, Scripps Col., Claremont, 1958-1965.

SKEMP, ROBERT OLIVER—Painter, I.
 32 Hyde Lane, Westport, Conn. 06880
B. Scottdale, Pa., Aug. 22, 1910. Studied: ASL, with Benton, Bridgman, DuMond; Grand Central A. Sch., with Ballinger, Carter; George Luks Sch. A. Member: SI; F.I.I.A.L. Awards: prizes, Outdoor Adv. A., 1952, 1953, 1954, 100 Best Posters, 1937-1954; gold medals, 1951, 1952. Work: Chicago Sch. Bd.; Univ. North Carolina; Wooster Col., Ohio; Miss. State Col. for Women; Reynolds Tobacco Co.; Senate Office Bldg., Wash., D.C.; new Federal Court Bldg., New York City; French Hospital, N.Y.; Rockefeller Univ.; Richmond (Va.) Univ.; Richmond (Va.) Univ.; Jefferson Medical Col., Pa.; Clarion State Col., P.; Lehigh Univ., Pa.; Am. Tel. & Tel. Co.; Gettysburg Theological Seminary; Columbia Univ.; Cornell Univ., and others.; murals, Mormon Pavilion, N.Y. World's Fair, 1964-65, and many others. Exhibited: A. Dir. Cl., Chicago; A. Dir. Cl., N.Y.; Portraits, Inc., Grand Central A. Gal.; Art:USA, 1958. Contributor illus. to national publications.

SKINNER, CLARA (GUY)—Painter, Eng., E.
 "The Hollow," East Hampton, Conn. 06424
B. Chicago, Ill. Studied: Univ. So. California; ASL, (N.Y. and Paris, France). Member: AEA; ASL. Awards: Essex AA, 1964. Work: MMA; SFMA; CMA; Olsen Fnd.; and in private colls. Exhibited: MMoA, 1965; CAM; SAM; Pasadena A. Mus.; BMA; "50 Best Prints of the Year," AFA; Essex AA; New Haven Festival of Arts, and others. Illus., "When Spain Was Young" (Calcott) and children's books. Illus. to New Yorker magazine..

SKINNER, ORIN ENSIGN—Designer, L., W., C.
 9 Harcourt St., Boston, Mass. 02116; h. 37 Walden St., Newtonville, Mass. 02160
B. Sweden Valley, Pa., Nov. 5, 1892. Studied: with Herman J. Butler, Frank von der Lancken. Member: Boston Soc. A. & Crafts (Master Craftsman); Mediaeval Acad. Am.; Newcomen Soc., England; F.I.A.L. Work: stained glass windows, Cathedral St. John the Divine, St. Patrick's Cathedral, N.Y.; St. John's Cathedral, Albuquerque, N.M.; Princeton Univ. Chapel; Browning Mem. Lib., Baylor Univ., Waco, Tex.; St. John the Evangelist Cathedral, Spokane; St. John's Cathedral, Denver; Chapel, U.S. Naval Acad.; Chapel, U.S. Submarine Base, New London, Conn.; Grace Cathedral, San F.; Heinz Mem. Chapel, Univ. Pittsburgh; Daniel L. Marsh Chapel, Boston Univ. Contributor to art, architectural, religious magazines, with articles on Stained Glass. Series of lectures on Mediaeval Crafts, MM. Positions: Pres., Treas., Charles J. Connick Assoc.; Ed., Mngr., "Stained Glass," official publication of Stained Glass Assn. Am., 1932-49; Pres., Stained Glass Assn. Am., 1948-50.

SKLAR, DOROTHY (Mrs. Dorothy Sklar Phillips)—Painter, T.
 6612 Colgate Ave., Los Angeles, Cal. 90048
B. New York, N.Y. Studied: Univ. California at Los A., B.E. Member: NAWA; New Orleans AA; Cal. WC Soc.; Laguna Beach AA; AEA; Alabama WC Soc.; Women Painters of the West; Westwood AA; Nat. Soc. Painters in Casein. Work: Los A. Municipal Coll.; Baptist Univ., Shawnee, Okla.; Westside Jewish Community Center, Los Angeles, and in private collections. Awards: prizes, Ala. WC Soc., 1944-1946; New Orleans AA, 1946, 1950, 1951; Laguna Beach AA, 1945-1947, 1952, 1954, 1957, 1959, 1960; Cal. A. Cl., 1949, 1951, 1953, 1954; Madonna Festival, 1955, 1961; Westwood AA, 1953, 1957; Santa Cruz A. Lg., 1959, 1960; Santa Monica, 1946; NAWA, 1957, 1960; Women Painters of the West, 1958 (3), 1959, 1960; Frye Mus., Seattle, Wash., 1966. Exhibited: Cal. PLH, 1945; Alabama WC Soc., 1944-1956; Delgado Mus. A., 1944-1954, 1957; Gloucester, Mass., 1944-1946; NAWA, 1946-1948, 1957, 1960; Portland A. Lg., 1944-1947, 1953; Denver A. Mus., 1945, 1946, 1950, 1951; Oakland A. Mus., 1945, 1950; Laguna Beach AA, 1944-1958; Santa Cruz A. Lg., 1944, 1946; Santa Paula Chamber of Commerce, 1944-1949; Arizona State Fair, 1946, 1949; Greek Theatre, Los A., 1949-1951; Cal. State Fair, 1949, 1950, 1954-1957, 1960, 1966; Audubon A., 1947, 1958; PAFA, 1953, 1954; Butler Inst. Am. A., 1955, 1958, 1960, 1968; Nat. Orange Show, 1953, 1958; Los A. Mus. A., 1954, 1955; AWS, 1958; Art:USA, 1958; Frye Mus. A., Seattle, 1957, 1958, 1960, 1966; Knickerbocker A., 1956, 1958, 1960; Little Gal., Los A., 1956-1958; Madonna Festival, 1954-1957; Tupperware, 1957; Long Beach Mus., 1960; Nat. Soc. Ptrs. in Casein, 1959, 1960; P. & S. Soc. of New Jersey, 1960; 1967 exhs.: Albany (Ga.) Mus.; Creative A. Gld., Dalton, Ga.; Carnegie Lib., Clarksdale, Miss.; Southwest Tex. State Col.; Univ. Tex., Austin; Oconee County Lib., Walhalla, S.C.; La Salle Col., Phila.; Warder Pub. Lib., Springfield, Ohio; Willimantic (Conn.) State Col.; 1968 exhs.: Univ. of the South Mus., Sewanee, Tenn.; Doak Balch Gal. Mus., Tusculum Col., Tenn.; Elyria Pub. Lib., Ohio; Marshall Univ., W.Va.; Univ. Maine; George Washington Carver Mus., Ala.; Clinton FA Center, Ill.; Watkins Inst., Nashville, Tenn.; one-man: Oklahoma Baptist Univ. Cortland (N.Y.) Lib.; Rutgers Univ.; DeKalb (Ill.) Pub. Lib.; Massillon Mus. A.; Univ. Tennessee; Chabot Gal., Los A., Laguna Beach AA, 1958 (2-man). Positions: Treas., So. Cal. Chptr., AEA, 1951-52; Rec. Sec., Cal. WC Soc.,

1961-62, Treas., 1962-63, V.-Pres., 1963-64. Art Dir., Westside Community Center, Los Angeles, 1965-1968.

SKOURAS, MRS. ODYSSIA A.—Art dealer
 Director, Odyssia Gallery, 41 E. 57th St., New York, N.Y. 10022*

SLATE, JOSEPH (FRANK)—Educator, W., P., L.
 Art Dept., Kenyon College; (mail) Box 417, Gambier, Ohio 43022
B. Hollidays Cove, W.Va., Jan. 19, 1928. Studied: Univ. Washington, B.A.; Yale Univ. Sch. of Art & Architecture, B.F.A., and Yale Grad. Sch.; private study of printmaking, Tokyo. Member: CAA; Yale Arts Assn. Awards: Yale Alumni Fellowship, 1960; Danforth Fellowship, 1968; Carnegie Grant in Writing, 1968- . Contributor to New Yorker, 1962, 1963; essay (with I.L. Child) Art Journal, 1963; illus., The Kenyon Review, 1962, article, 1969. Positions: Chm., A. Dept., Kenyon College, Gambier, Ohio, 1963- ; Chm., FA Div., Kenyon Col., 1968- ; Chm., Mid-Ohio Arts Assoc., 1966-1967; Exec. Com., Kress Fnd. Art History Program, Mid-Ohio Colleges, 1967-1969.

SLATKIN, CHARLES E.—Art Dealer
 Charles E. Slatkin Galleries, 115 E. 92nd St., New York, N.Y. 10028*

SLAUGHTER, LURLINE EDDY—Painter
 Silver City, Miss. 39166
B. Heidelberg, Miss., 1919. Studied: Miss. State Col. for Women, B.S.; Miss. A. Colony Workshops. Member: Miss. A. Colony (Bd. Dirs.); State A. Advisory Com.; Miss AA, Jackson; Tenn. A. Lg.; Nat. Des. Center, N.Y. Awards: prizes, U.S. FA Registry, N.Y., 1966; McComb A. Festival, 1967-1969; Southern Contemp. A. Festival, Greenville, Miss., 1966. Work: Miss. State Col. for Women; Miss. State Univ.; Pine Bluff (Ark.) A. Mus. Exhibited: Nat. Oil Exh., Jackson, 1960, 1963-1967; The Parthenon, Nashville, 1967; Hunter Gals., Chattanooga, 1965; Beaumont Mus., 1966; Delta Annual, Little Rock A. Center, 1965; Panama City, 1966; Artists Registry Exh., Brooks Mem. Mus., Memphis, 1967; Miss. State Univ., 1966; Delta State Col., 1966; Miss. State Col. for Women, 1968; Greenville AA, 1967; LaFont, Pascagoula, 1967, 1969; Greenwood A. Festival, 1969; Univ. Florida, 1967; one-man: Ahda Artzt Gal., N.Y., 1967; Nat. Des. Center, N.Y., 1968, 1969.

SLETTEHAUGH, THOMAS CHESTER—
 Educator, S., P., C., Gr., W., L.
 48 Teaberry Lane, Frostburg, Md. 21532; w. 1010 N. 6th Ave., Columbus, Miss. 39701
B. Minneapolis, Minn., May 8, 1925. Studied: Univ. Minnesota, B.S., M. Edu., with Quirt, Rood, Myers and Hebald; Pa. State Univ., D. Edu. Member: Am. Soc. for Aesthetics; CAA; Eastern AA; NAEA; Western AA; Comm. on A. Education; Assoc. A. of Pittsburgh; Soc. Minn. Sculptors; Pa. State Doctors Soc. Awards: prizes, (sculpture), 1949, 1951; (prints), 1950, 1952, 1954, 1958, all Minneapolis; (pottery), 1958, 1960. Work: In private collections. Interior redesign, St. Peter's Church, Slippery Rock, Pa., 1962; stainless steel sculpture, Mississippi State Col. of Women Admin. Bldg., 1969. Exhibited: Nat. Com. on A. Edu., 1956; Chautauqua AA, 1957, 1958; Wichita Nat. Decorative Arts, 1959; Church Architectural Gld. of America, 1961; Wichita Nat. Graphic Arts, 1963; PAFA, 1964; Minnesota FA Assn., 1949-1959, 1960, 1964; Minneapolis AI, 1948, 1950, 1951, 1954; WAC, 1951, 1957-1960; St. Paul Gal. A., 1956, 1957, 1959, 1960, 1961, 1963; Joslyn Mus. A., 1953, 1954; Assoc. A. of Pittsburgh, 1958-1969; BMA, 1968; Brooks Mem. Mus., 1969; Carnegie Mus., 1957-1969; CGA, 1966, 1968; Univ. Minnesota; Mississippi State Col. for Women, 1969; Peale Mus., 1968; VMFA, 1966; Rochester, A. Center, 1966, 1967; Wichita AA, 1968; Washington County Mus., Hagerstown, Md., 1966, 1968. Contributor to Eastern AA Research Bulletin; Journal of the Alleghenies, and others. Positions: Taught: Univ. Minnesota; Pa. State University; Syracuse University; Prof. A., Hd. Dept. of Art, Frostburg State College, Md.; Prof. & Hd. A. Dept., Dir. A. Gal. and Cur. of Museum Colls., Mississippi State Col. for Women, Columbus, Miss., at present.

SLICK, JAMES NELSON—Sculptor, P.
 287 Cabrillo St., Costa Mesa, Cal. 92627
B. Salt Lake City, Utah, Aug. 26, 1901. Studied: Cornell Univ., Ithaca, N.Y. Awards: 1st prize, Blue Grass Fair, Lexington, Ky., 1964. Work: Sculpture commissions-Nat. Mus. of Racing, Saratoga Springs, N.Y.; Hall of Fame, Saratoga Springs; Santa Anita Park, Arcadia, Cal.; Hialeah Park, Fla.; Keeneland Racing Assn., Lexington, Ky.; Monmouth Park, N.J.; Garden State Park, Hallondale, N.J.; life-sized bronze of horse for Meadowland Park, Pa., 1967; paintings—Irish Derby winner, painted in England; M.F.H. Galway hunt, painted in Ireland.

SLIFKA, MR. and MRS. JOSEPH—Collectors
 870 Fifth Ave., New York, N.Y. 10021*

SLIFKA, ROSE—Editor
"Craft Horizons", 16 E. 52nd St., New York, N.Y. 10003*

SLIVE, SEYMOUR—Scholar, Writer
Harvard University, Fogg Museum 02138; h. One Walker St.
Place, Cambridge, Mass. 02138
B. Chicago, Ill., Sept. 15, 1920. Studied: Univ. Chicago, A.B., Ph.D.
Member: F., American Academy of Arts & Sciences (1964); Hon.
Member, Karel van Mander Society; CAA (Dir., 1958-1962, 1965-
1969); Renaissance Society. Awards: Fulbright Fellowship to the
Netherlands, 1951-52; Guggenheim Fellowship, 1956-57; Hon. De-
gree, A.M., Harvard University (1958); Fulbright Research Scholar,
University of Utrecht, 1959-60; Officer of the Order of the House of
Orange-Nassau, 1962. Field of Research: Seventeenth Century Dutch
Art. Author: Rembrandt and His Critics: 1630-1730 (1953); The
Rembrandt Bible (1959); Catalogue of Frans Hals Exhibition held in
Haarlem (1962); Frans Hals, Das Festmahl der St. Georgs-Schützen-
gild 1616 (1962); Dutch Painting: 1600-1800 (with Jakob Rosenberg)
(1966); Rembrandt Drawings (1965). Positions: Instr., FA, Oberlin
College, 1950-51; Asst. Prof. & Chm. Art Dept., Pomona College,
1952-54; Asst. Prof. FA, 1954-57, Assoc. Prof., 1957-61, Prof. FA,
1961- , Chairman, Dept. FA, 1968- , Harvard University; Exchange
Professor, University of Leningrad, 1961; Ryerson Lecturer, Yale
University, 1962.

SLIVKA, DAVID—Sculptor
107 Bank St., New York, N.Y. 10014*

SLOAN, MR. and MRS. J. SEYMOUR—Collectors, Patrons
180 E. 79th St., New York, N.Y. 10021
Collection: Primarily American art, but also includes works by
Europeans—Moore, Jongkind, Gromaire, Fraser, Matisse.*

SLOAN, ROBERT SMULLYAN—Painter
1412 Arlington St., Mamaroneck, N.Y. 10543
B. New York, N.Y., Dec. 5, 1915. Studied: Col. City of N.Y., A.B.;
N.Y. Univ.; Ecole des Beaux Arts, Paris. Member: Mamaroneck
A. Gld. (Pres.). Awards: Nat. Soldier Exh., 1945. Work: U.S. Trea-
sury Dept.; IBM; Bradford Col.; Am. Flange Co.; Triangle Publ.,
and in private colls. Exhibited: U.S. Nat. Mus.; ASL; BM; Carnegie
Inst.; CGA; AWS, 1957; Portraits, Inc., 1958, and others. One-man:
Leger Gal., White Plains, N.Y., 1955. Contributor to Time, Life,
Coronet and other publications with reproductions of work. Pres.,
Sloan & Roman, Inc., Art Gallery, New York City.

SLOANE, ERIC—Illustrator, W., P., L.
"Weather Hill," Cornwall Bridge, Conn.
B. New York, N.Y., Feb. 27, 1910. Studied: ASL; N.Y. Sch. F. &
Appl. A.; Yale Univ. Sch. FA. Awards: Freedoms Fnd., 1965; Gold
Medal, Hudson Valley AA, 1964. Work: Des. and executed Willett's
Memorial, Am. Mus. Natural History; murals, International Silver
Co., Meriden, Conn.; Morton Salt Co., Chicago; Wings Club, N.Y.,
and many others, Author, I., "Skies and the Artist"; "Our Vanishing
Landscape"; "American Yesterday"; "Seasons of America's Past";
"Book of Storms"; "Clouds, Air and Winds"; "Eric Sloane's
Weather Book," "Return to Taos," "Look at the Sky," "A Rever-
ence for Wood," "Diary of an Early American Boy," "Museum of
Early American Tools," "ABC's of Americana," and others. Con-
tributor to: Look; Life; American Heritage; New Yorker; Field &
Stream; Popular Science; American Artists; Popular Mechanics and
other publications.*

SLOANE, JOSEPH CURTIS—
Educator, Hist., Mus. Dir.
Department of Art, University of North Carolina; h. Morgan
Creek Road, Chapel Hill, N.C. 27514
B. Pottstown, Pa., Oct. 8, 1909. Studied: Princeton Univ., A.B.,
M.F.A., Ph.D. Member: CAA (Sec., 1954-56, Pres., 1956-58).
Awards: Hodder Fellow, Princeton Univ., 1948-49; Fulbright Re-
search grant, France, 1952-53. Author: "French Painting Between
the Past and the Present," 1951; "Paul Marc Joseph Chenavard,"
1962. Contributor to: Art Bulletin; Art Quarterly; Journal of Aes-
thetics and Art Criticism, etc. Lectures: 19th Century French
Painting. Positions: Prof. A., Chm., Dept. of A., & Dir., Ackland
Art Center, University of North Carolina, Chapel Hill, N.C.

SLOANE, MARY (HUMPHREYS)—Painter, W., L.
R.F.D. Bernardston, Mass. 01337
B. New York, N.Y., Aug. 18, 1912. Studied: Wells Col., B.A.; Colum-
bia Univ., and with George Picken. Member: AEA; NAWA; Cape Cod
AA; Provincetown AA; Springfield (Mass.) A. Lg.; AAUW. Awards:
Medal of Honor, NAWA, 1957; silver medal, Springfield A. Lg., 1959;
prizes, Boston A. Festival, 1956; Silvermine Gld. A., 1957; Spring-
field A. Lg., 1958. Exhibited: Boston A. Festival, 1956-1958; Silver-
mine Gld. A., 1956, 1957, 1960; Columbia, S.C., 1957, 1959; NAWA,
1957; Springfield A. Lg., 1956-1961; Cape Cod AA, 1956, 1957; Prov-
incetown AA, 1956, 1957; Hilson Gal., Deerfield, Mass., 1957 (2-

man); de Cordova & Dana Mus., 1958 (2-man); Bay Path Jr. Col.,
1960 (2-man); One-man: Ruth White Gal., N.Y., 1958, 1960, 1962; Am.
Intl. Col., 1959; G.W.V. Smith Mus. A., 1960; Bismarck (N.D.) Junior
Col., 1962; Minot (N.D.) State Teachers Col., 1962; Unitarian Soc.,
Amherst, Mass., 1968; St. Paul's Sch., Concord, N.H., 1969; 2-man:
New Mexico Highlands Univ., 1962; Int. Group, Roland Gibson A.
Fnd., 1968. Author: "Strong Cables Rising," 1942. Lectures on art
colleges, library associations. Positions: Mass. State A. Chm.;
AAUW Art Leader, 9-State Northeast Conf., 1960.

SLOANE, PATRICIA—Painter
79 Mercer St., New York, N.Y. 10012
B. New York, N.Y., Nov. 21, 1934. Studied: on scholarships: R.I.
Sch. Des., B.F.A.; Ohio Univ. Grad. Col.; NAD, with Olinsky; Hans
Hofmann Sch. A.; Dayton AI; Hunter Col., N.Y., M.A., 1968. Mem-
ber: CAA; Am. Soc. for Aesthetics. Awards: Scholastic Art Awards,
1950, 1951 and other regional and national prizes; Teaching F.,
Ohio Univ. Work: MModA Lending Coll.; Andrew Dickson White
Mus., Cornell Univ.; Univ. Notre Dame. Exhibited: Scholastic Art
Award Exh., Carnegie Inst., 1951; Camino Gal., N.Y., 1961 (2-man),
1962 (one-man); Terrain Gal., 1959; Morris Gal., 1958; NAD, 1958;
Village A. Center, 1958; Lower East Side Neighborhood A. Assn.,
1957; Gallery 195, 1957 (3-man); Brata Gal., 1963 (one-man); Prov-
idence A. Cl., 1954; R.I. Artists Annual, 1954; Lush Gal., 1954;
Dayton AI, 1949; Ohio Univ., 1956; Alan Stone Gal.; Purchase (N.Y.)
Annual, 1961; Brooklyn Heights Assn., 1961; Osgood Gal., 1962;
Riverdale YMHA, 1964; Aegis Gal., 1964; Emanu-el Midtown YMHA,
1964; Chelsea Exh., St. Peter's Episcopal Church, 1964; one-man:
Grand Central Moderns, 1968; Fordham Univ.; Univ. Rhode Island,
1968. Book jacket des. & book des. for book publishers, N.Y. Cr.,
"East," a newspaper of the arts. Contributor drawings to "Village
Voice." Author: "Color: Basic Principles and New Directions,"
1968. Contributor to: Arts magazine, Am. Journal of Aesthetics,
Craft Horizons, and others. Gallery lecturer, WMAA. Positions:
Instr., Introduction to the Fine Arts, Ohio Univ., 1956; A. & Crafts,
Jewish Community Center, Providence, R.I.; Instr., Scarsdale
Studio Workshop, 1965- ; Univ. R.I., Community Col. of City Univ.
of New York, N.Y. Univ. Ext., Trenton Junior Col., and others.

SLOBODKIN, LOUIS—Sculptor, W., I., L., T.
209 West 86th St., New York, N.Y. 10024
B. Albany, N.Y., Feb. 19, 1903. Studied: BAID. Member: An Am.
Group; S. Gld.; AIGA; AEA (Bd. Nat. Dirs.). Awards: Caldecott
med., 1943. Work: Madison Square P.O., N.Y.; mem. tower, Phila.,
Pa.; Interior Bldg., Wash., D.C. Exhibited: WMAA, 1935-1944;
PAFA, 1941-1945; WFNY 1939; AIC, 1939-1943; MMA, 1942; S. Gld.,
traveling exh.; An Am. Group, 1939-1946; AIGA, 50 Best Books
Exh., 1944; MMA Illus. Exh., 1944; AV Good-Will Tour, Europe;
AFA traveling exh., 20 Best Children's Books, 1944. Author:
"Magic Michael," 1944; "Sculpture Principles and Practice," 1949;
"Clear the Track," 1945; "First Book of Drawing," 1958, & other
books. I., "Rufus M.," 1943; "Many Moons," 1943; "Tom Sawyer,"
1946; "Robin Hood," 1946; & many others. Contributor to: Maga-
zine of Art, Horn Book. Lectures: Contemporary Sculpture; De-
signing & Illustrating Children's Books. Positions: Hd. S. Dept.,
Master Inst., New York, N.Y., 1934-37; Hd. S. Div., New York City
Art Project, 1941-42; Pres., An Am. Group, 1945-46; Bd. Dir., S.
Gld., 1940-45.

SLOSHBERG, LEAH PHYFER (Mrs. Willard)—
Museum Assistant Director
102 N. Gouverneur St., Trenton, N.J. 08625
B. New Albany, Miss., Feb. 21, 1937. Studied: Mississippi State
College for Women, B.F.A.; Tulane University, M.A. Member:
American Association of Museums. Exhibitions arranged: Burgoyne
Diller Retrospective, 1966; Focus on Light, 1967; Ben Shahn Retro-
spective, 1969. Positions: Curator of Arts, to 1969; Assistant Di-
rector, 1969- , New Jersey State Museum, Trenton, N.J.

SLOTNICK, MORTIMER H.—Painter, Des., Gr., T., L.
43 Amherst Dr., New Rochelle, N.Y. 10804
B. New York, N.Y., Nov. 7, 1920. Studied: City College of New
York; Columbia Univ. Member: All. A. Am.; AAPL; Am. Veterans
Soc. A.; Knickerbocker A.; New Rochelle AA; Westchester AA.
Work: in private colls.; paintings published by Am. A. Group and
Bernard Picture Co., both New York City; Donald Art Co., Port
Chester, N.Y. Exhibited: WMAA; Riverside Museum, N.Y.; Hudson
River Mus.; N.Y. Pub. Lib.; Grand Central A. Gal.; NAC; NAD, and
others. Lectures: History of Art Through Paintings, City College
and Board of Education, New Rochelle, N.Y. Positions: Instr., A.,
Supervisor of Arts for Bd. of Edu., New Rochelle, N.Y.; Lecturer,
Art Dept. Graduate School, City College of New York.

SMALL, AMY GANS—Sculptor, C.
211 E. 51st St., New York, N.Y. 10022; also, Plochman Lane,
Box 307, Woodstock, N.Y. 12498
B. New York, N.Y., Apr. 22, 1915. Studied: Hartford A. Sch.; ASL;

Nat. Park Col., and with Seymour Lipton. Member: AEA; Westchester A. & Crafts Gld.; Sculpture Center, N.Y.; Woodstock AA; The Guild, East Hampton, N.Y. Work: in private colls. Exhibited: The Contemporaries Gal.; Riverside Mus.; AEA; Barone Gal.; RoKo Gal.; Rudolf Gal., Woodstock; Woodstock AA; Krasner Gal. (oneman), 1958; Woodstock Gld. Craftsmen; Selected Artists Gal., N.Y., 1960-61 (one-man); The Guild East Hampton, 1969 (one-man). Positions: Instr., Sculpture, Woodstock Sch. of A., Woodstock, N.Y.

SMART, MRS. J. SCOTT—Collector, Patron, W.
 Beachmere Place, Ogunquit, Me. 03907
B. Springfield, Ill., Feb. 27, 1917. Studied: Oxford University; Wellesley College, B.A.; Columbia University, M.A.; Painting, with Bernard Karfiol. Member: Ogunquit Art Association (Honorary Life); Corporation Member, Institute of Contemporary Art, Boston. Editor and writer: Hamilton Easter Field Art Foundation Collection Catalogue, 1966; "Barn Gallery Associates in Action, 1969" (public relations booklet). Collection: 20th century New England painting and sculpture. Positions: Board Secretary, Program Director, Barn Gallery Associates, Inc., Ogunquit, Me., 1958- ; Program Chairman, Ogunquit Art Association, 1937-1939, 1955-1958; Founding Board of Directors, Treasurer, Ogunquit Chamber of Commerce, 1966-1968, Honorary Life Member, 1968- ; Acquisition Committee, De Cordova and Dana Museum, Lincoln, Mass., 1966- .

SMILEY, RALPH J.—Portrait Painter
 1759 Orchid Ave., Hollywood, Cal. 90028
B. New York, N.Y., July 24, 1916. Studied: ASL; NAD; with George Bridgman, Frank DuMond, Robert Brackman, Dean Cornwell, and others. Member: Los A. AA; Am. Inst. FA; Los A. P. & S. Cl.; Cal. A. Cl.; ASL. Work: ports. in private colls. Exhibited: Los A. AA; Cal. A. Cl.; Audubon A.; NAD; ASL; Los A. P. & S. Cl. Positions: Instr., Drawing, Painting, Hollywood Art Center School.

SMITH, ALVIN—Painter, I., T.
 220 Montgomery St., Brooklyn, N.Y. 11225
B. Gary, Ind., Nov. 27, 1933. Studied: State Univ. Iowa, B.A.; Kansas City AI; Univ. Illinois, M.A.; N.Y. Univ. (painting with Samuel Adler). Awards: purchase prizes, Atlanta Univ., 1961; Dayton AI, 1962. Member: NAEA; Junior Literary Gld. (artist-member); Am. Fed. of Teachers. Work: Atlanta Univ.; Dayton AI. Exhibited: Atlanta Univ., 1961, 1962; Purdue Univ., 1964; Wesleyan Col., 1964; Dulin Gal. A., Knoxville, 1964; Audubon A., 1965; Sioux City A. Center, 1955; Nelson Gal. A., Kansas City, 1957; Dayton AI, 1961, 1962; Toledo Mus. A., 1962; Contemp. A., N.Y., 1962; Ruth Sherman Gal., N.Y., 1965. Illus.: "Fisherman's Choice," 1964; "Shadow of a Bull," 1964; "William Phips and The Treasure Ship," 1965; "The Mystery of the Grinning Idol," 1965; "A Question of Harmony," 1965; "Odyssey of Courage," 1965. Contributor to Arts & Activities Magazine, 1958. Positions: Instr., Art, Kansas City Pub. Schls., 1955-57; Dayton Pub. Schls., 1960-1962; New York City Pub. Schls. (Brooklyn), 1962- .*

SMITH, MRS. BERTRAM—Collector, Patron
 907 Fifth Ave., New York, N.Y. 10021
B. Dallas Texas. Studied: New York Institute of Fine Arts. Collection: Post Impressionist, School of Paris paintings, drawings and sculpture. Positions: Patron, Member of the Painting and Sculpture Acquisitions Committee, the Museum of Modern Art; Secretary of the International Council of the Museum of Modern Art; Trustee, Museum of Modern Art.

SMITH, C. R.—Collector
 510 Park Avenue, New York, N.Y. 10022*

SMITH, DAVID LOEFFLER—Educator, P., W.
 Swain School of Design, 19 Hawthorn St., 02740; h. 122 Hawthorn St., New Bedford, Mass. 02740
B. New York, N.Y., May 1, 1928. Studied: Bard Col., B.A.; Cranbrook Acad. A., M.F.A., and with Hans Hofmann, Raphael Soyer. Awards: Henry Posner prize, Carnegie Inst., 1961. Exhibited: group shows in New York, Boston, Pittsburgh. Series of lectures on American Art, European Art for educational television programs. Contributor articles to American Artist, 1959-1962; Carnegie Magazine, 1960; American Journal, 1963; Quarterly Journal of the Old Dartmouth Historical Society, 1965; Antiques, 1967; Arts Magazine, 1968. Positions: Asst. Prof. A., Actg. Chm. A. Dept., Chatham College, Pittsburgh, Pa. Prof. A., Director, 1962-1966, Dean, Swain School of Design, New Bedford, Mass., at present.

SMITH, EMILY GUTHRIE (Mrs. Tolbert C.)—Painter, T., C., L.
 408 Crestwood Dr., Ft. Worth, Tex. 76107
B. Ft. Worth, Tex., July 8, 1909. Studied: Texas State Col. for Women; Oklahoma Univ.; ASL, with Robert Brackman. Member: Texas FA Assn.; Ft. Worth AA; Taos AA; Dallas AA; MModA. Awards: prizes, West Texas annual, 1953, 1964; Ft. Worth AA, 1955, 1957; Texas FA Citation, Austin, 1959, 1960; Tarrant County Annual,

1960, 1965, 1966; Longview, Tex., 1964 (3), 1968; Chelmont Nat., 1960. Work: DMFA; Ft. Worth A. Center; Lubbock Mus. A.; Lone Star Gas Co.; D.D. Feldman Coll., Dallas; murals, Ft. Worth Savings & Loan Co., 1959; Western Hills Hotel, 1960; mosaic, All Saints Hospital, Ft. Worth; Diamond M Fnd.; U.S. Fed. Loan & Guaranty Co., Longview Tex.; Univ. Texas, Arlington; McLean Jr. High Sch., Ft. Worth. Lecture: "Demonstration of Portrait Painting," to Sherman A. Lg. Exhibited: Retrospective, Fort Worth A. Center, 1966; Weatherford A.A., 1967; Texas Pavilion, Hemisfair, 1968; West Texas Mus., Lubbock, 1968; Tyler Juried A. Exh., 1968; one-man: Lubbock A. Center, 1967; Temple A. Center, 1967; Oxford House Gal., Longview Tex., 1968; Carlin Gal., Ft. Worth, 1968. Positions: Instr. A., Ft. Worth A. Center; Workshop, Ruidoso, N.M., summers, 1966-1968.

SMITH, GARY—Sculptor, P.
 53 Pitt St., New York, N.Y. 10002*

SMITH, GORDON MACKINTOSH—Museum Director
 Albright-Knox Art Gallery 14222; h. 61 Oakland Pl., Buffalo, N.Y. 14222
B. Reading, Pa., June 21, 1906. Studied: Williams Col., A.B.; Harvard Univ. Grad. Sch. A. & Sc.; travel and study in Europe. Awards: Hon. LL.D., D'Youville College, Buffalo, N.Y., 1963. Member: F., Royal Soc. A., London; Assn. A. Mus. Dirs.; AFA; CAA; AAMus. Contributor to Art News. Numerous lectures to art organizations and in museums. Positions: Cur., Berks County Hist. Soc., Reading, Pa., 1935-36; Asst. Regional Dir., WPA, 1936-41; Chief, Plans & Intelligence Div., Camouflage Br., Ft. Belvoir, Va., 1942-44; Projects Specialist, Office Strategic Services, Wash., D.C., 1944-46; Dir., Currier Gallery A., Manchester, N.H., 1946-55; Dir., Albright-Knox A. Gal., Buffalo, N.Y., 1955- .

SMITH, HASSEL W., JR.—Painter
 1293 Hurlbut Ave., Sebastopol, Cal. 95472
B. Sturgis, Mich., Apr. 24, 1915. Studied: Northwestern Univ., Evanston, Ill., B.S.; Cal. Sch. FA. Awards: Abraham Rosenberg Fellowship, 1941-42. Work: Tate Gal., London; Albright-Knox A. Gal.; CGA; CAM; Pasadena Mus. A.; SFMA; N.Y. State Univ. of New York; WMAA; Washington Univ., St. Louis; Dallas Mus. Contemp. A.; Los A. Mus. A. Exhibited: SFMA, 1950, 1962; Washington Univ., Seattle, 1950; WAC, 1950; Cal. Sch. FA, 1952 (2-man); Mus. Contemp. A., Houston, 1956; Los A. Mus. A., 1957; Dilexi Gal., San F., 1960-1964; Albright-Knox A. Gal., 1961; Gimpel Fils Gal., London, 1961; Galerie Laurence, Paris, 1961; Hanover Gal., Zurich, 1961; AIC, 1961; Emmerich Gal., N.Y., 1961-1963; Painters of the Southwest traveling exh., 1962; Painters of the Pacific traveling exh. from Auckland, N.Z., 1962; Carnegie Int., 1962; WMAA, 1962; CGA, 1962; Cal. PLH, 1961-1962 (prize, '62); John Moore's Annual Invitational, Liverpool, England, 1963; Marylhurst Col., Ore., 1964 (2-man); David Stuart Gal., Los A., 1963; Occidental Col., Los A., 1964; oneman: Cal. PLH, 1948, 1953; Labaudt Gal., San F., 1949, 1950; Dilexi Gal., 1956-1958, 1960, 1961; Ferus Gal., Los A., 1956-1962; Reed Col., Portland, Ore., 1959; Gimpel Fils, London, 1960, 1963; Emmerich Gal., N.Y., 1961-1963; Retrospective, Pasadena A. Mus., 1961; Galleria del Ariete, Milan, 1962; Stuart Gal., Los A., 1964; Univ. Minnesota, 1964; Retrospective, San Francisco State Col., 1964; Worth Ryder Mem. Gal., Univ. California at Berkeley, 1964. Positions: Instr., Cal. Sch. FA, San Francisco, 1945-48; San Francisco State Col., 1946-47; University of Oregon, 1948-49; Cal. Sch. FA, 1949-52; Presidio Hill Elem. Sch., San Francisco, 1952-55; Lecturer, Univ. California at Berkeley, 1963-64, 1964-65.*

SMITH, HELEN M. (Mrs. Hueston M.)—Educator, I., P., Des.
 Art Department, Maryville College, 1900 Meramec St.; h. 11447 Clayton Road, St. Louis, Mo. 63131
B. Canton, Ohio, Oct. 19, 1917. Studied: Univ. Melbourne, Australia; Washington Univ., St. Louis, B.F.A., M.A. Art Instruction, Inc. (Certif.); St. Louis Univ. Member: St. Louis A. Gld.; Archaeological Soc. Am.; Oriental Archaeological Soc.; F.I.A.L.; F., Int. Inst. A. & Lets.; Illinois A. Educ. Assn.; 20th Century Cl. Awards: Ruth Kelso Renfrow A. Cl., St. Louis, 1955. Exhibited: St. Louis A. Gld., 1952-1955; Annual Missouri Exh., 1954, 1955; Religious Art Exh., Ladue, Mo., 1954, 1956; Ars Sacra Exh., 1955, 1956, 1967; Collector's Choice, 1955; St. Louis Metropolitan Church Federation, 1956, 1957; 20th Century A. Cl., 1958; Immaculata Church Exh., Richmond Heights, Mo., 1960; Catholic A. Exh., California, 1963; Concordia Seminary, 1962; Liturgical Art, Seattle, 1962 and traveling, 1962-63; Springfield A. Mus., 1962; Servite A. Festival, 1967. One-man: Clayton, Mo., 1954. Illus., "Aghios Kosmos," 1959; illus. for many medical journals and books. Lecturer: Harvard Univ., Yale Univ., Oriental Inst. Archaeology, 1960. Positions: Instr. A., Villa Duchesne, 1953-56; Hd., A. Dept., Maryville College, St. Louis, Mo., 1958-60, Asst. Prof., Art & Archaeology, Dir. A. Dept., 1960-61, Dir., Art & Archaeology Dept., 1961- . Medical Illustrator, St. Louis University Medical Center; Consultant to American College of

Radiology, 1963- . Research Asst. & Med. Illustrator, Dept. of Ophthalmology, Washington Univ., 1964-1968. Asst. Prof., A. Hist., Acting Dir., Audio-Visual Center, and Dir. Instructional Graphics, Southern Ill. Univ., 1968- .

SMITH, HOWARD ROSS—Museum Curator
1010 Green St., San Francisco, Cal. 94133
B. Los Angeles, Cal., Aug. 21, 1910. Studied: Univ. California, M.A.; Cal. Col. A. & Crafts, and with Eugen Neuhaus. Positions: Hd. Dept. A., Univ. Maine, Orono, Me., 1942-49; Cur., Cal. PLH, San Francisco, Cal., 1951-55; Asst. Dir., CAL.PLH, San F., 1955- .

SMITH, JEROME IRVING—Museum Curator, Librarian, W.
Henry Ford Museum, Dearborn, Mich. 48124; h. 17517 Maumee Blvd., Grosse Pointe, Mich. 48230
B. New York, N.Y., Nov. 24, 1910. Studied: Columbia Univ. Member: AAMus.; Special Libraries Assn.; Am. Library Assn.; Detroit Book Club; Founders Soc., Detroit Inst. of Arts. Author: article on New York City in Encyclopedia Americana. Contributor to: Country Life; Antiques; Town & Country; Avocations; Art in America; The Connoisseur & other magazines and newspapers. Positions: Cur., Library Dir. of Publicity, Ed. Bulletin, 2nd Asst. Dir., Mus. of the City of New York, 1933-1951; Dir., Seattle Mus. of History & Industry, 1951-1952; Registrar, 1953-1966, Libr. 1966- , Henry Ford Mus.; Nat. Chm., Museum Librarians—Special Libraries Assn., 1938; Nat. Chm., Registrar's Section, Am. Assn. Museums, 1958.

SMITH, JOHN BERTIE—Painter, E. W., L.
Art Department, Baylor University 76703; h. 2109 Charboneau Dr., Waco, Texas 76710
B. Lamesa, Tex., June 5, 1908. Studied: Baylor Univ., A.B.; Univ. Chicago, A.M.; AIC; Columbia Univ., Ed. D., and with Josef Bakos, Peppino Mangravite. Member: CAA; Midwestern Col. A. Conference (Pres. 1954); Missouri Col. A. Conference (Pres. 1952-54); Southeastern AA; AAUP; AEA; Mid-Am. A.; Nat. A. Edu. Assn.; Texas FA Assn. (Pres., 1959-60); Texas A. Edu. Assn. (Pres., 1969-1971). Awards: scholarship, Univ. Chicago, 1931; Dow scholarship, Columbia Univ., 1936. Work: Denver A. Mus.; Univ. Wyoming; Athens (Tex.) Pub. Lib. Exhibited: Denver A. Mus., 1938, 1939, 1941, 1943, 1945; Colorado Springs FA Center, 1945; AIC, 1931; Mulvane A. Center, 1954; Texas FA Assn. traveling exh., 1958; Texas WC Soc., 1955; one-man: Univ. Colorado, 1945; Mobile A. Gal., 1957; Abilene A. Mus., 1957; Wichita Falls A. Gal., 1958; Texas FA Citation Exh., 1959, 1960. Contributor to Design, School Review and other publications. Editor, Texas Trends in Art Education, 1960-62. Positions: Dean, Kansas City AI, Kansas City, Mo., 1949-54; Hd. Dept. A., Chm. Humanities Div., Hardin-Simmons Univ., Abilene, Tex., 1954-60; Chm. Dept. Art, Baylor University, Waco, Tex., 1960- .

SMITH, JOSEPH A(NTHONY)—Painter, I., T., S.
8 N. Saint Austin Place, Staten Island, N.Y. 10310
B. Bellefonte, Pa., Sept. 5, 1936. Studied: Pratt Inst., Brooklyn, B.F.A. and grad. study; Pa. State Univ. (summer) 1954-58, 1960, 1961. Member: Phila. WC Soc. Awards: prize, AWS, 1967. Work: PAFA; Bloomsburg (Pa.) State Col., and in private colls. Illus.: "Ten Knots on a Counting Rope," 1964; "Hunger Valley," 1964; "Exploring Music," 1965; "Tales of Hans Christian Anderson," 1965; numerous stories in anthologies. Exhibited: PAFA, 1961, 1967, 1969; CAM, 1962; American Art at Mid-Century Exh., Orange, N.J., 1963, 1964, 1965-1968; Central Col., Iowa, 1965; AWS, 1965, 1967, 1969; Pa. State Univ., 1955-1958, 1960, 1962; Janet Nessler Gal., N.Y., 1962; Staten Island Mus., 1962, 1963, 1966; Tuxedo Park, N.Y., 1962-63; CGA, 1962; Springfield (Mass.) Mus. FA, 1962; Sneeds Gal., Rockford, Ill., 1963; Fine Arts Gal., Birmingham, Mich., 1963; Univ. Nebraska, 1963; Univ. South Carolina, 1966; Phila. A. All., 1966; Laguna Beach AA, 1967; Frye Mus., Seattle, 1967; Montgomery (Ala.) Mus. FA, 1967; Canton A. Inst., 1967; Purdue Univ., 1967; Hamline Univ., St. Paul, 1968; Utah Mus., FA, Salt Lake City, 1968; Laguna Gloria Mus., Austin, Tex., 1968; Kalamazoo Inst. A., 1968; one-man: Fleischer Mem. A. Mus., Phila., 1961; Janet Nessler Gal., 1963, 1964; Lehigh Univ., 1964-65; Bloomsburg State Col., 1968; Pratt Institute, 1962, 1964, 1967; Positions: Instr., Art, Pratt Institute, Brooklyn, N.Y., 1961- ; Instr., Painting, Staten Island Museum, 1964.

SMITH, JUSTIN V.—Collector
1121 Hennepin Ave., Minneapolis, Minn. 55403; h. Box 236, Rte. 3, Wayzata, Minn. 55391
B. Minneapolis, Minn., Oct. 25, 1903. Studied: Princeton University, B.A. Collection: Contemporary painting and sculpture. Positions: Board of Directors, Walker Art Center, Minneapolis, Minn., 1936- .

SMITH, LAWRENCE M. C.—Patron, Collector
1707 Benjamin Franklin Pkwy. 19103; h. 3460 School House Lane, Philadelphia, Pa. 19144
B. Philadelphia, Pa., Oct. 4, 1902. Studied: University of Pennsylva-

nia, A.B., LL.D.; Magdalen College, Oxford University, B.A., M.A.; Benjamin Franklin Fellow, Royal Society of Arts. Positions: President, the American Federation of Arts, 1948-1952, now Trustee; Trustee, Philadelphia Museum of Art; Assoc. Trustee, University of Pennsylvania; U.S. National Commission for UNESCO, 1948-1951, 1954-1960; 1962- . Vice-Chairman, 1965. Chairman of the Board, Civic Center Museum, Philadelphia, 1957-1960. Collection: General.

SMITH, LEON P.—Painter, L., E.
Shoreham, L.I., N.Y. 11786
B. Chickasha, Okla., May 20, 1906. Studied: East Central State Col., Ada, Okla., A.B.; T. Col., Columbia Univ., M.A. Awards: Guggenheim F., 1944; Longview award, 1959; Nat. Council on the Arts, 1966; Artist at Tamarind Workshop, Los Angeles, 1968. Exhibited: BM, 1942-1944; AIC, 1943, 1961; WMAA, 1946; Egan Gal., 1946; SFMA, 1944; Telfair Acad. A., 1941; MMA, 1943; Riverside Mus., 1954; Yale Univ. A. Gal., 1956; Carnegie Inst., 1961; Tooth Gal., London, 1961; Zurich, Switzerland, 1961; Chicago A. Cl., 1969; Guggenheim Mus., N.Y., 1961; one-man exh.; New York, 1941, 1943, 1946; Mills Col., N.Y., 1955; Betty Parsons Gal., 1958; 1960; Museo Bellas Artes, Caracas, 1962; Stable Gal., N.Y., 1963; Galerie Muller, Stuttgart, Germany, 1964; Galerie Chalette, N.Y., 1965; Corcoran Gal. A., Wash., D.C., 1965; Ten-year Retrospective Exh., SFMA, Rose Mus., Brandeis Univ., Ft. Worth (Tex.) A. Mus., 1968. Positions: A.-in-Res., Brandeis Univ., Waltham, Mass., 1968.

SMITH, MRS. LOUISE—Collector
907 Fifth Avenue, New York, N.Y. 10021*

SMITH, OLIVER—Painter, C., Des.
s. Pigeon Cove, Mass.; h. 223 Shore Dr., Ozona Shores, Fla. 33560
B. Lynn, Mass., Oct. 1, 1896. Studied: R.I. Sch. Des.; with Charles Hawthorne, and in London, England. Member: Phila. WC Cl.; SC; Clearwater AA; Sarasota AA; Rockport AA; Washington AA. Awards: Tampa Fair; Pinellas County Fair; Rockport AA; Belleair A. Center. Work: Univ. Florida; Gainesville Pub. Lib.; Tarpon Springs, and in many private colls. Stained glass windows, Temple Emanu-El, New York; Princeton Univ. Chapel; Mellon Cathedral, Pittsburgh; Wittenberg Col. Chapel, Springfield, Ohio; Lutheran Church, Miami, Fla., and in many churches over a 35-year period.

SMITH, PAUL J.—Museum Director
Museum of Contemporary Crafts, 29 W. 53rd St., 10019; h. 541 E. 72nd St., New York, N.Y. 10021
B. Sept. 8, 1931. Studied: Art Inst. of Buffalo; School for American Craftsmen. Member: International Council of Museums; National Fulbright Screening Committee on Design; Museum Council of New York; New York State Assn. of Museums. Exhibitions: arranged: Made With Paper; Plastic As Plastic; Object in the Open Air; Fantasy Furniture; Amusements Is; Objects: USA. Positions: Vice Pres., Louis Comfort Tiffany Fnd.; Bd. member, New York State Craftsmen and Artist-Craftsmen of New York; Bd. member, Elder Craftsmen Shop, N.Y.; Bd. member, Haystack Mountain School of Crafts; Director, Museum of Contemporary Crafts, New York, N.Y., at present.

SMITH, PAUL K(AUVAR)—Painter
1039 Stuart St., Denver, Colo. 80204
B. Cape Girardeau, Mo., Feb. 27, 1893. Studied: St. Louis Sch. FA; Denver A. Acad. Member: Gilpin County AA; Denver A. Gld.; Denver A. Mus. Awards: purchase awards: Heyburn, Idaho, 1940, 1951; Gilpin County AA, 1950; Denver A. Mus., 1951, 1956; Central City, 1964; So. Colorado State Col., Pueblo; Colo. State Fair, 1948, 1949, 1954, 1959; prior to 1959—Colorado Springs FA Center; Kansas City, Mo.; New York City; Topeka, Kans.; Santa Fe, N.M.; San Francisco, Cal.; Springville, Utah, Denver Metropolitan Exh., 1956; prizes, Canon City, Colo., 1958, 1969; Gilpin County AA, 1958, 1961; Denver A. Gld., 1937, 1946, 1954, 1960, 1966, 1968, 1969. Exhibited: Joslyn A. Mus., 1939-1958; Denver A. Mus., 1923-1956, 1962-1964; Denver Metropolitan Exh., 1950-1964; 15 Colo. A., 1949-1965; Mulvane A. Center, Topeka, 1956, 1964; Community A. Gal., Denver, 1957; Denver A. Gld., 1934-1958; Gilpin County AA, 1949-1965; Central City, 1962-1964; Lever House, N.Y., 1964 and ten other exhs., 1962-64. One-man: Denver A. Mus.; Pueblo, Colo; Loretto Heights Col., 1958; Sak's Gal., Denver, 1958; Bauer's Cherry Creek Center, 1958, Denver.

SMITH, PAUL ROLAND—Painter, E., Et.
Department of Art, Hamline University 55101; h. 3168 Shoreline Ave., St. Paul, Minn. 55112; also, Box 352, Nisswa, Minn.
B. Colony, Kans., Sept. 12, 1916. Studied: Kansas State Col., B.S.; State Univ. of Iowa, M.F.A., and with James Lechay, Mauricio Lasansky, Stuart Edie, Byron Burford. Member: AEA (Hon. Pres., 1965-1969); CAA; Midwest College A.; AAUP. Awards: prizes, Des Moines Art Salon, Des Moines A. Center, 1953, 1958; Sioux City Re-

gional, 1957, 1959; Minnesota Centennial, St. Paul, 1958; Northeast Iowa Exh., 1961-1964; Grant for European Study, 1961, and other awards and hon. mentions in U.S. Work: Des Moines A. Center; Sioux City A. Center; Wright Mus., Beloit; State Univ. of Iowa; Kansas State Col.; WAC; Mulvane Mus. A. Exhibited: Momentum Exh., Chicago; Art:USA 1958; Ball State Col., 1956, 1957; BM, 1952; Terry AI, 1952; Des Moines A. Center, 1950-1960; Sioux City A. Center, 1955-1960; Nelson Gal. A., 1955, 1956; Joslyn Mus. A., 1957, 1958; Univ. Nebraska, 1958; Univ. Iowa 1958; one-man: Assoc. Am. A., N.Y.; Millikin Univ.; Des Moines A. Center; Central Col.; Blanden Mem. Mus.; Augustana Col.; Beloit Univ.; Luther Col. Author: Art Bibliography, Source Books in Fine Arts; Ed., National Exhibition Calendar, AEA. Contributor to Sketch Book. Lectures: Indian Art; Contemporary Art; Contemporary Collections at Luther Col. FA Festival; Des Moines A. Center; Blanden Mem. Mus., art associations and colleges. Positions: Instr., Painting, Drawing, Humanities, State College of Iowa; Ft. Scott Jr. Col.; Ft. Hayes State Col.; Pres., Central Area Chptr., AEA; Regional Dir., Mid-west Region, AEA; Chm. Dept. A., Prof. A., Hamline University, at present.

SMITH, RALPH ALEXANDER—Scholar, Writer, Educator
College of Education, University of Illinois, Urbana-Champaign, 61801; h. 1708 W. Park Ave., Champaign, Ill. 61820
B. Ellwood City, Pa., June 12, 1929. Studied: Columbia College, A.B.; Teachers College, Columbia University, M.A., Ed. D. Contributor of articles to: Modern Organizations and Behavior: Focus on Schools, 1969; Readings in the Humanities; Concepts and Art Education, 1969; also to: Macmillan Encyclopedia of Education; Educational Theory; The Record; The Educational Forum; Studies in Art Education; Journal of Aesthetic Education; Screen Education (London); Art Education; School Arts; Art Journal and other educational publications. Positions: Editor, (founder) Journal of Aesthetic Education, 1966- ; Editor, Aesthetics and Criticism in Art Education, 1966; Editor, Aesthetic Concepts and Education; Associate Professor, Aesthetic Education, College of Education, University of Illinois, at present.

SMITH, RAY WINFIELD—Collector, Scholar, W., Cr., Patron
Box 43, Dublin, N.H. 03444
B. Marlboro, N.H., June 4, 1897. Studied: Dartmouth College, B.S. Awards: Hon. Doctor of Humane Letters, Dartmouth College, 1958. Member: German Archaeological Institute (Fellow). Author: "History Revealed in Ancient Glass," National Geographic Magazine, Sept., 1964; "Glass from the Ancient World," articles in National Geographic Magazine, and many other publications. Field of Research: Technological research on ancient glass; Egyptian Archaeology (New Kingdom). Collection: Ancient glass. Positions: Former Trustee, Archaeological Institute of America; President, Ray Winfield Smith Foundation, 1955- ; Board of Vistors, BMFA; Council Member, American Association for the Advancement of Science; Former Chairman, International Committee on Ancient Glass; Director, American Research Center in Egypt, 1963-1965. Presently Director, Akhenaten Temple Project; Consultant, Brookhaven National Laboratory; Research Associate, University Museum, Philadelphia, Pa.

SMITH, ROBERT ALAN—Painter, Serigrapher, I.
4840 Grand Ave., Ojai, Cal. 93023
Studied: Chouinard AI, Los Angeles; San Miguel de Allende, Mexico, with Sequeiros. Awards: James Phelan Award, 1961; prizes, Chouinard AI, 1954; Ventura County A. Festival; Purchase Awards: LC, 1960; BMFA, 1960; Univ. North Dakota, 1961; Bradley Univ., 1960, 1962; Pasadena A. Mus., 1960; Woodward Fnd., Wash., D.C. (serigraph purchase for U.S. Embassy, Rio de Janeiro). Exhibited: Los A. Mus. A., 1949, 1960, 1961; Pasadena A. Mus., 1948, 1950, 1953, 1958, 1960, 1962; LC, 1959, 1960; Smithsonian Institution, 1960, 1962; SAM, 1960, 1962; BMFA, 1960, 1961; BM, 1962, 1964; Assoc. Am. A., 1962; United Nations, 1963; Bradley Univ., 1960, 1962, 1964; Dept. of State, 1962; Univ. North Dakota, 1961; Newport AA, 1960; Am. Color Pr. Soc., 1961; Hunterdon County A. Center (N.J.), 1961; Cal. State Fair, 1961; N.Y. World's Fair, 1964; Dickson A. Center, UCLA, 1959; DeCordova & Dana Mus., 1961; USIA exh., Africa, (serigraph purchased by Pan American Airways, Casablanca, Morocco); James Phelan Traveling Exh., 1963-64; American Federation of Arts traveling exh., 1962-1964, 1964-1966. New Media Gal., Ventura, Cal., 1967, 1968; Forum of the Arts Gal., Ventura, 1968; Ryder Gal., Los Angeles, 1967. Serigraphs exhibited in other traveling exhs., nationally. One-man: Pasadena A. Mus., 1959; Santa Barbara Mus. A., 1964; Orr's Gal., San Diego, 1961; Ojai A. Center, 1960; Michel Thomas Gal., Beverly Hills, 1961; Maxwell Gal., San F., 1962; Norton Galleries, St. Louis, 1960; Barnett Bros. Gal., Beverly Hills, 1963; Ventura Pub. Lib., 1964. Work: White House, Washington, D.C., two serigraphs, 1966, (loaned by The National Coll., Smithsonian Inst., Wash., D.C.). I. "Long Ago Elf," 1968 and "Crocodiles Have Big Teeth All Day," 1969, both by Mary Smith (wife). Positions: Asst. Animator, Walt Disney Studios, 1955-58;

Instr., Art and Serigraphy, Ventura College, 1964- ; Instr., Painting. Chouinard Art School, Los Angeles, 1965- .

SMITH, ROBERT C.—Scholar
Glenmoore, Pa. 19343*

SMITH, R(OBERT) HARMER—Painter, Arch. Delineator
231 Wilkinson Ave., Jersey City, N.J. 07305
B. Jersey City, N.J., July 27, 1906. Studied: PIASch.; Yale Univ., B.F.A.; & with Ernest Watson. Member: Hudson Artists; SC; Jersey City Mus. Assn. (Trustee). Awards: Jersey Journal medal, Hudson Artists, 1961. Exhibited: AWCS; Arch. L.; Jersey City Mus. Assn. Contributor to: American Artist, Architectural Record, Pencil Points magazines.*

SMITH, SAM—Painter, E., C., Des., I.
Art Department, University of New Mexico; h. 213 Utah St., Northeast, Albuquerque, N.M. 87108
B. Thorndale, Tex., Feb. 11, 1918. Member: AAUP. Awards: prizes, New Mexico State Fair, 1959, 1960 (2). Work: Albuquerque Pub. Lib.; Abilene Mus. A.; Encyclopaedia Britannica. Exhibited: White House, Pentagon, Nat. Mus., all of Wash., D.C.; Mus. New Mexico traveling exh., 1968-1969; one of four New Mexico artists represented in Eight State Traveling Exhibition, sponsored by Southwestern Fine Arts Commission, 1968-1969; Santa Fe and Taos, N.M.; Biltmore Gal., Los Angeles; Abilene, Ft. Worth and San Antonio, Tex.; CGA, 1949 (one-man); MMA; and in England; Nat. Mus., Mexico, D.F. Illus. "Cowboy's Christmas Tree," 1957; "Life of Frank Grouard," 1958; "George Curry, an Autobiography," 1958; "Roots in Adobe," 1960. Positions: Prof. A., University of New Mexico, 1956- .

SMITH, TONY—Sculptor
c/o Knoedler Gallery, 14 E. 57th St., New York, N.Y. 10019*

SMITH, WALT ALLEN—Sculptor, Des., L., T.
656 North Occidental Blvd., Los Angeles, Cal. 90026
B. Wellington, Kans., Mar. 1, 1910. Studied: La. County AI. Member: Cal. A. Cl.; F.I.A.L.; Otis AI Alumni Assn. (Pres. 1952-62 62). Awards: gold medal, Cal. A. Cl., 1955, prizes, 1958, 1959; gold medal & prize, Nat. Orange Show, 1959; Int. Madonna Festival, 1960, 1961; Pasadena A. Fair, 1960. Work: Cole Co.; Electronic Eng. of California; memorial for the Hungarian Revolution of 1957 commissioned by Baron & Baroness Von Braun de Bellatini, 1957; Civic Center Gal., Scottsdale, Ariz. Work also in private colls. Exhibited: Nat. Orange Show, 1948, 1950, 1959; Cal. Int. 1950, 1956; Cal. Centennial, 1949; Palm Springs, 1955, 1956; Greek Theatre, Los A., 1949, 1950; Los Angeles A. Festival, 1949-1964; Bowers Mem. Mus. 1956-1959; Wilshire Ebell, 1957; Cunningham, Mem. Gal., Bakersfield, 1957; Los A. Mus. A., 1957, 1958, 1959; Descanso Gardens, 1957, 1958-1965; Duncan Vail Gal., 1956-1965; Palos Verdes Lib., 1956, 1957; Florentine Gal., Pacific Palisades, 1956, 1957, 1958; Whittier Gal., 1956, 1957; Pacific Coast Cl., Long Beach, 1958, 1959; Madonna Festival, 1956, 1957, 1959-1965; Cal. A. Cl., 1955, 1956, 1958, 1959; Glendale Lib., 1957; Van De Kamp Wilshire Gal., 1960, 1961; Wilshire Federal, 1960, 1961; Kagel Canyon, 1960, 1961; Santa Barbara A. Festival, 1960, 1961; Am. A. Acad., 1961; Los A. County Arboretum, 1959-1964; John Wesley Branch General Hospital, 1960; Smithsonian Inst., 1963; Vault Gal., Los Gatos, Cal., 1965, and many others. One-man: Guardian Bank, Hollywood, 1964; 2-man: Tanar Gal., Hollywood, 1963; (with K. Tanahashi), Hollywood, 1965. Hollenbeck Culture Center, 1967. Chm., Cal. Artist's Advisory Bd., 1966-1967. Included in "Award Winning Art," 1964. Lectures with demonstrations on Sculpture and Jewelry Design. Judge, Cal. State Fair, 1962, 1964, 1967.

SMITH, WILLIAM ARTHUR—Painter, Lith., I., L.
Windy Bush Road, Pineville, Pa. 18946
B. Toledo, Ohio, Apr. 19, 1918. Studied: Univ. Toledo, and with Theodore J. Keane; Ecole des Beaux Arts, Grande Chaumiere, Paris, France. Member: NA; West Coast WC Soc.; AWS (Bd. Dir., 1954-55); Int. Assn. A. (Vice-Pres. 1966-1969); Audubon A.; Toledo Tile Cl. Awards: medal, AWS, 1948, 1952, prize, 1954, and Grand Prize and Gold Medal, 1965; NAD, 1949, 1951; Cal. WC Soc., 1948; Obrig prize, 1953; Butler AI, 1953; Ranger Fund, 1951; prize & gold medal for "Watercolor of the Year," 1957; Dorne purchase prize, 1958; Pennell Mem. purchase, 1956; SAGA; Hon. deg., M.A., Toledo Univ. 1954; Audubon A., 1969; Ted Kautzy Mem. Award, AWS, 1969. Work: Chrysler Corp.; Fla. Southern Col. MMA; LC; Los A. Mus. A.; mural, Maryland House, 1968. Exhibited: MModA, 1953, 1954; MMA, 1952, 1953; LC, 1953, 1954; DMFA, 1953, 1954; PAFA, 1954; AWS, 1953-1955; NAD, 1953, 1954; Audubon A., 1954, 1956; Phila. WC Cl., 1953; CAM, 1953; one-man: Phila., Pa., 1953; Italy, Greece, Turkey, India, Japan, and others, all 1954; Singapore, Manila, 1955. U.S. Delegate to Int. Conference Plastic Arts, Venice, 1954. Lectures:

American Art, Univ. Santo Tomas, Manila, 1955; Univ. Philippines, 1955; Acad. FA, Athens, Greece, 1954. Rec. Sec., NAD, 1953-55; Pres., 1956-57, Hon. Pres., 1957- , AWS; Memb., Cultural Delegation of P. & S. to the U.S.S.R., 1958. Exec. Committee, Int. Assn. of Art (UNESCO affiliate). Lecture tour to art schools and colleges in Taiwan, Thailand, Viet Nam, Burma, Nepal and Turkey, 1964-65. Contributor articles, Harpers Bazaar.

SMITHSON, ROBERT I.—Sculptor, W., L.
799 Greenwich St., New York, N.Y. 10014
B. Passaic, N.J., Jan. 2, 1938. Studied: ASL. Work: WMAA. Exhibited: Jewish Mus., N.Y., 1966; WMAA, 1966, 1968; Los Angeles County Mus., 1967; Finch Col., N.Y., 1967; Albright-Knox A. Gal., Buffalo, 1968; Mus. Mod. A. and the Tate Gal., London, 1968; Haags Gemeentemuseum, The Hague, 1968; Andrew Dickson White Mus. A., Cornell Univ., 1969; Dwan Gal., N.Y., 1969. Contributor to: Artforum, Art International, Arts magazines. Lectures: Art in the City; Making Art in Yucatan; Minimal Art, at Columbia, Yale, New York universities. Positions: Artist Consultant to Tibbetts, Abbott, McCarthy and Stratton, Architects and Engineers, 1966-1967.

SMUL, ETHEL LUBELL—Painter, Lith., T., L., Gr.
165 West 20th St., New York, N.Y. 10011
B. New York, N.Y., Sept. 11, 1897. Studied: Maxwell Sch. for Teachers; Hunter Col.; Pratt Graphic Art Center; ASL, and with Brackman, Olinsky, Robinson, and others. Member: NAWA; N.Y. Soc. Women A.; Am. Soc. Contemp. A.; AEA; ASL (life). Awards: Prize, NAD, 1968. Exhibited: NAD, 1936, 1952, 1954, 1962-1965; Argent Gal., 1934-1952; LC, 1948, 1949; Carnegie Inst., 1949; Rotary Shows, U.S. and Canada, 1956-1965; Italy, 1946; France, 1949; Everhart Mus. A.; CM, 1952-54; Riverside Mus., 1949, 1952, 1955, 1957; Massillon Mus., 1958, 1960; Neville Pub. Mus., 1958, 1960; Kenosha Pub. Mus., 1958, 1960; Georgia Mus. A., 1958, 1960; Columbia Mus. A., 1958, 1960; Jersey City Mus., 1960. Lectures: Arts and Crafts. Positions: Instr. A., Jr. H.S., New York City; Treas., N.Y. Soc. Women A., 1952, 1953, 1956-1958, Dir., 1959-61; Treas., Am. Soc. Contemp. A., 1961- . Rec-Sec., N.Y. Soc. Women A., 1964, 1965.

SMYTH, CRAIG HUGH—Educator
Institute of Fine Arts, New York University, 1 East 78th St., New York, N.Y. 10021; h. 84 Hillside Ave., Cresskill, N.J. 07626
B. New York, N.Y., July 28, 1915. Studied: Princeton Univ., A.B., M.F.A., Ph.D. Member: CAA. Awards: Fulbright F., 1949-50; ACLS grant, 1958. Author: "The Earliest Works of Bronzino," Art Bulletin 1949. "Mannerism and 'Maniera'," 1963; "The Sunken Courts of the Villa Giulia and the Villa Imperiale," in Essays in Honor of Karl Lehmann, 1964; (with Henry A. Millon) "Michelangelo and St. Peter's I, Notes on a Plan of the Attic as Originally Built on the South Hemicycle," Burlington Magazine, Aug. 1969. Positions: Sr. Mus. Aide, NGA, 1941-42; Dir., Central Art Collection Point, Munich, Germany, 1945-46; Research Asst., L., Frick Collection, N.Y., 1946-49; Asst. Prof., 1950-53, Assoc. Prof., 1953-1957, Prof., 1957- ; Hd. Grad. Dept. FA, Dir., Inst. FA, New York Univ., 1953- ; Teaching Renaissance Painting, Drawing, and Architecture. A. Dir., CAA, 1953-1957, Sec., 1956. Visiting Committee, Dept. of Art & Archaeology at Princeton University. Hon. Trustee, Metropolitan Mus. A., 1968.

SNEED, PATRICIA M. (Mrs. William R., Jr.)—
Art Dealer, Collector
Sneed Gallery 35, 2024 Harlem Blvd., Rockford, Ill. 61103
B. Spencer, Iowa, Oct. 24, 1922. Studied: Drake University, Des Moines, Iowa. Member: AFA; Board of Trustees, Burpee Art Museum, Rockford, Ill. Specialty of Gallery: Contemporary American Art. Collection: Contemporary American art. Positions: Owner and operator, Sneed Gallery 35, 1958- ; President, Board of Trustees, Burpee Art Museum, Rockford, Ill.; An originator of children's art appreciation program, "Show Me a Picture"; Member, Civic Center Commission, Rockford, Ill.

SNELGROVE, WALTER H.—Painter
2966 Adeline St., Berkeley, Cal. 94703
B. Seattle, Wash., Mar. 22, 1924. Studied: Univ. Washington; Cal. Sch. FA; Univ. California, B.A., M.A.; Florence, Italy, Berenson's "I Tatti." Member: San Francisco AA. Awards: prizes, Oakland Mus., 1962; SFMA, 1963; Kelham Mem. Award, Cal. PLH, (2). Work: AFA; Oakland Mus.; Colorado Springs FA Center; Cal. PLH.; Stanford Univ. Exhibited: WMAA, 1965; Carnegie Int., 1966; AIC; VMFA; Albright-Knox A. Gal., Buffalo; Des Moines A. Center; Denver A. Mus.; Santa Barbara Mus. A.; Richmond (Cal.) A. Center; Colorado Springs FA Center; Cal. PLH; Henry A. Gal., Univ. Washington.

SNODGRASS, JEANNE OWENS (Mrs. Charles T.)—
Museum Curator, L., W., Cr., E.
Educational Dimensions, Inc., 3535 Lee Rd.; h. 3715 Avalon Rd., Shaker Heights, Ohio 44120
B. Muskogee, Okla., Sept. 12, 1927. Studied: Art Instruction; Northeastern State Col.; Oklahoma Univ. Member: Oklahoma Museums Assn. (Sec.); Ethno-History Assn.; Tulsa Hist. Soc. (charter). Lectures: American Indian Painting: Its History and Its Artists. From 1955-1968, responsible for 214 exhibitions of Indian Art and Artifacts at Philbrook A. Center; also for Annual American Indian Artists Nat. Competition held at Philbrook. Author: "American Indian Paintings," 1964; Editor, "American Indian Basketry," 1964; "American Indian Painters: A Biographical Directory," 1968 (Mus. of the American Indian, Heye Fnd. N.Y.C. publ.). Positions: Asst. to the Director, Cur., American Indian Art, Philbrook Art Center, Tulsa, Oklahoma, 1955-1968; Admin. Asst. to the President, Educational Dimensions, Inc., 1969- . Juror: Anadarko Indian Expo.; All American Indian Expo.; New Mexico A. Mus. Indian Annual; Scottsdale Indian A. & Crafts Exh.; Bismarck (S.D.) Nat. Indian Competition, 1963; Charlotte (N.C.) Indian Art Show, 1964. Supv. & Juried Inter-Tribal Indian Ceremonials painting exhibit, 1960, 1961. Assoc. on American Indian Affairs and member of their Arts & Crafts Adv. Comm. Consultant: Gilcrease Mus., Tulsa, Okla.; Heard Mus., Phoenix, Ariz.

SNOW, MARY RUTH (Mrs. Philip J. Corr)—Painter
4856 Loughboro Road, Northwest, Washington, D.C. 20016
B. Logan, Utah, Mar. 6, 1908. Studied: Univ. Utah, B.A.; Corcoran Sch. A.; ASL; Otis AI; Grand Central Sch. A., and in Paris, France; Berlin, Germany. Member: Soc. Wash. A., Wash. A. Cl.; NAWA; AEA; Wash. A. Gld.; Wash. WC Cl. Awards: prizes, Soc. Wash. A., 1952; Wash. A., NAWA, 1966. Work: Massillon Mus. A. Exhibited: CGA, 1967 and prior; Soc. Wash. A., 1960 & prior; Wash. A. Cl.; VMFA; MMA; Wash. WC Cl.; PC; Georgetown Gal.; Wash. A. Gld., 1960 & prior; American Univ., Wash., D.C.; Norfolk Mus. A. & Sc.; NCFA; Los A. Mus. A.; NAD; NAWA, 1966-1969 and prior; A. Mart, Georgetown, D.C., 1961; Rockville A. Gal., 1961; Religious Art Exh., Wash., D.C., 1964, 1965; Creative A. Gal., N.Y.; Nat. Acad. A. & Lets.; Pan-American Union; Univs. of Maryland and Utah, and in Germany; Massillon Mus. A., 1969; George Washington Univ., 1967; U.S. State Dept., 1966; U.S. Dept. of Commerce, 1966; Contemp. Gal., Palm Beach, Fla., 1966-1968; One-man: Wash. A. Cl., 1945; Chequire House, Alexandria, 1950; Silver Springs (Md.), A. Center, 1950; Alexandria Pub. Lib., 1945, 1950; Nat. Cathedral School; Colony Gal., Wash., D.C.; Wash. Gal. Mod. A., 1965, 1966; Panoras Gal., N.Y., 1965. Positions: Pres., Soc. Wash. A., Washington, D.C., 1951-1953; Advisor, Bd. Edu., Arlington County, 1951-52; Pres. Wash. A. Gld., 1958-59; Bd. Memb., A. Gld. of Wash., 1960-61; Soc. Wash. A., 1958-59; Community Liaison, Soc. Wash. A., 1961-62.

SNOW, MICHAEL—Painter, S., Film Maker
300 Canal St. 10013; h. 123 Chambers St., New York, N.Y. 10007
B. Toronto, Ont., Canada, Dec. 10, 1929. Studied: Ontario College of Art, Toronto. Awards: Grand Prize, 4th Intl. Experimental Film Festival, Brussels, Belgium, 1968. Work: MModA; Art Gallery of Toronto; Montreal Mus. FA; National Gallery of Canada. Exhibited: Carnegie Inst. Tech., 1958, 1959; 1964; Poindexter Gal., N.Y., 1964; Isaacs Gal., N.Y., 1958-1964; also, 1968 and 1969; Gallery of Modern A., N.Y.; MModA, N.Y.; WMAA, N.Y.

SNYDER, SEYMOUR—Illustrator, Des., Comm. A.
11 East 44th St. 10017; h. 315 East 68th St., New York, N.Y. 10021
B. Newark, N.J., Aug. 11, 1897. Studied: Fawcett Sch. Indst. A., Newark, N.J.; ASL; Grand Central Sch. A. Member: F., AAPL. Illus. & covers for House & Garden, American Home, McCall's; Better Homes & Gardens, & other magazines. Nat. advertising illus. for Westinghouse, General Electric, Nat. Lead Co., Johns-Manville, Dupont, R.C.A., and many others. Lectures, History of Art, High School of Art & Design, New York, N.Y.

SOBY, JAMES THRALL—Writer, Cr.
Brushy Ridge Rd., New Canaan, Conn. 06840
B. Hartford, Conn., Dec. 14, 1906. Studied: Williams Col. Awards: Hon. D.H.L., Williams College, 1962. Author: "After Picasso," 1935; "The Early Chirico," 1941; "Salvador Dali," 1941; "Tchelitchew," 1942; "Romantic Painting in America" (with Dorothy C. Miller), 1943; "Georges Rouault," 1945; "The Prints of Paul Klee," 1945; "Ben Shahn," 1947; "Contemporary Painters," 1948; "Twentieth Century Italian Art" (with Alfred H. Barr, Jr.), 1949; "Modigliani," 1951; "Giorgio de Chirico," 1955; "Yves Tanguy," 1955; "Balthus," 1956; "Modern Art and the New Past," 1957; "Ben Shahn, His Graphic Art," 1957; "Juan Gris," 1958; "Joan Miro," 1959; "Ben Shahn: Paintings," 1963; "Magritte"

(Mus. Mod. A.), 1965. Contributor of articles and criticisms to leading art publications. Positions: Asst. Dir., 1943, Dir., Painting & Sculpture, 1943-45, Trustee, 1943- , Hon. Chm. Committee on the Museum Collections, Member of Executive and Program Committees, Vice-President (1961-), MModA., New York, N.Y.; A. Cr., Saturday Review of Literature, 1946-57; Acting Ed., 1950-51, Chm. Editorial Bd., 1951-52, Magazine of Art.

SOFFER, SASSON—Sculptor, P.
 60 W. 25th St., New York, N.Y. 10010; h. 505 La Guardia Pl., New York, N.Y. 10012
B. Baghdad, Iraq, June 1, 1925. Studied: Brooklyn Col. Member: Experiments in Art & Technology; A. Cl., N.Y. Awards: Ford Fnd. purchase award, 1961, A.-in-Res. grant, 1966. Work: Albright-Knox A. Gal., Buffalo; WMAA; Chase Manhattan Bank; Rockfeller Inst., and in many private collections. Exhibited: Carnegie Inst., 1958, 1961; WMAA, 1962, 1966; Yale Univ. Gal. FA, 1961; NAC, 1958. One-man exhs., U.S. and Denmark; also, Artists Gal., N.Y., 1958; Betty Parsons Gal., N.Y., 1961, 1963; Poindexter Gal., N.Y., 1964; John Daniels Gal., N.Y., 1965; Corpus Christi Mus. FA, 1965; Portland (Maine) Mus. FA, 1966.

SOGLOW, OTTO—Cartoonist
 330 West 72nd St., New York, N.Y. 10023
B. New York, N.Y., Dec. 23, 1900. Studied: ASL, with John Sloan. Member: SI; Cartoonist Soc. Awards: The Highest Award in Cartooning, The "Reuben," 1967. Author, I., "Pretty Pictures"; "Everything's Rosey"; "Wasn't the Depression Terrible"; "The Little King." I., many books. Contributor to: New Yorker, Colliers, Life magazines; syndicated in many newspapers by King Features Syndicate.

SOKOLE, MIRON—Painter, E., W., L., Gr.
 250 West 22nd St., New York, N.Y. 10011; s. Maverick Rd., Woodstock, N.Y. 12498
B. Odessa, Russia, Nov. 20, 1901. Studied: CUASch; NAD. Member: AEA; Audubon A.; Woodstock AA; 23rd St. A. Cl. Awards: prize, medal, NAD. Work: IBM; Upjohn Co.; U.S. State Dept.; VMFA; Butler Inst. Am. A.; Univ. Minnesota; Tel-Aviv Mus. Exhibited: CGA, 1941, 1943, 1958; AIC, 1931, 1932, 1935, 1940-1944; WMAA, 1939, 1943, 1945, 1946, 1948, 1953, 1954; BM; DMFA; Detroit Inst. A., 1959; Dayton AI, 1953; CM, 1958; PAFA, 1940-1942, 1952, 1955, 1957; BMA; Columbus Gal. FA, 1951, 1953, 1957-1960; Carnegie Inst., 1943-1945, 1949; MMA, Birmingham Mus, 1952, 1953; Audubon A., 1952; John Herron AI, 1954; Des Moines A. Center, 1956; Memphis Mus. A., 1956; Butler Inst. Am. A., 1956-1958; Montreal, Canada, 1954; Musée d'Art, Paris; Art:USA 1958; St. Gauden's Mem. Mus., 1958; Springfield Mus. A., 1956; Univs. of Iowa, Alabama, North Carolina, Illinois, Nebraska; Kay Gal., N.Y., 1963, 1964; Norfolk Mus. A. & Sciences, 1965; Woodstock AA, 1965-1967; Copeland Gal., 1967; Collectors Gal., 1968; Southampton Col., 1969; traveling exhs., Miami, Fla., Dayton, Ohio, and others; one-man: Midtown Gal., 1934, 1935, 1937, 1939, 1944, 1951, 1956; Kansas City AI, Nelson Gal. A., and traveling exhs., "Religion in American Art," and others. Positions: Prof. A., Fashion Inst. of Technology, State Univ. of New York.

SOLINGER, DAVID M.—Collector, Patron
 250 Park Ave. 10017; h. 33 E. 70th St., New York, N.Y. 10021
Collection: 20th century paintings and sculpture. Positions: President, Board of Trustees, Whitney Museum of American Art; Trustee, American Federation of Arts.

SOLMAN, JOSEPH—Painter, T., W., L.
 156 2nd Ave., New York, N.Y. 10003
B. Russia, Jan. 25, 1909. Studied: NAD; Columbia Univ. Member: Fed. Mod. P. & S. Awards: Nat. Inst. A. & Lets. grant, 1961, and Childe Hassam purchase award, 1968; portrait prize, NAD, 1969. Work: PC; WMAA; Dayton A. Inst.; Butler Inst. Am. A.; Hallmark purchase, 1958, included in exh. touring Europe; Int. Assn. of Plastic Arts traveling exh. to Europe, 1956. Book on work, "Joseph Solman," publ. 1966. Exhibited: PAFA, 1951, 1952; CGA, 1943, 1945, 1951, 1955; Carnegie Inst.; PMG, retrospective exh., 1949; ACA Gal.; WMAA, 1955. Positions: Instr., Painting, MModA, 1952-54; Pres., Fed. of Mod. Painters & Sculptors, 1965-1967; A. Instr., City Col. of New York, at present.

SOLOMON, ALAN R.—Scholar, Writer
 470 West End Ave., New York, N.Y. 10024
Studied: Harvard College, A.B.; Harvard University Graduate School, M.A., Ph.D. Museum training with Paul Sachs and Jakob Rosenberg. Author: "Robert Rauschenberg"; "Jasper Johns"; (With photographer Ugo Mulas) "New York, The New Art Scene," 1967; numerous articles and catalog texts on New American Art. Positions: Dir., White Museum Art, Cornell University (initiated the

Museum), 1953-1961; Dir., The Jewish Museum, N.Y., 1962-1964 (reorganized Museum and instituted new program in contemporary art); Arranged exhibitions: "Young Italians," Institute of Contemp. A., Boston, 1967; "New York, The Second Breakthrough," Irvine, Cal., 1959-1964; "New York: Painting Since 1945," for the opening of the new Pasadena Museum, Sept. 1969. Assoc. Prof., History of Art, Cornell Univ. to 1962; U.S. Commissioner, XXXII Venice Biennale, 1964; Visiting Prof., Cornell College of Arch., New York program, 1963-67; Visiting Prof., Sch. FA, Univ. California, Irvine, Cal., 1968, and Prof., Chm. Dept. A., Sch. of FA and Dir. of Art Gallery, 1968- ; Dir., Exh. of American Painting, U.S. Pavilion, Expo '67, Montreal.

SOLOMON, HYDE—Painter
 201 E. 28th St., New York, N.Y. 10016
B. New York, N.Y., May 3, 1911. Studied: ASL, sculpture with Zadkine; Art History, with Prof. Meyer Schapiro, Columbia Univ. Work: WMAA; Newark Mus. A.; Slater Mem. Mus., Norwich, Conn.; Wadsworth Atheneum; Munson-Williams-Proctor Inst.; Brandeis Univ.; WAC; Gloria Vanderbilt Mus. purchase fund; Readers Digest Coll.; Mitsui Bank of Japan; Ford Fnd., and others. Exhibited: CGA; Toledo Mus. A.; WMAA annuals; PAFA; Univ. Illinois; Carnegie Inst., 1964; Univ. Nebraska; WAC, 1960; Carnegie Inst., 1967; Peridot Gal., N.Y., 1968; one-man: Poindexter Gal., N.Y., 1967, 1969. Positions: A.-in-Res., Goddard College, 1954-55; Princeton University, 1959-1962.

SOLOMON, RICHARD—Collector
 393 D St. 02210; h. 276 Marlborough St., Boston, Mass. 02116
B. Boston, Mass., May 12, 1934. Studied: Harvard University; Harvard Graduate School of Business Administration. Collection: Contemporary paintings, drawings, sculpture, including works by Vasarely, Warhol, Oldenburg, Nevelson, Rauschenberg, Cesar, Poliakoff, Sonderborg, Trova, Hajdu, Kelly, Higgins, Callary, and others. Positions: Trustee, Institute of Contemporary Art, Boston.*

SOLOMON, MR. and MRS. SIDNEY L.—Collectors
 Abraham & Straus, 422 Fulton St., Brooklyn, N.Y. 11201; h. 1095 Park Ave., New York, N.Y. 10028
(Mrs. Solomon)—B. Boston, Mass., May 15, 1909. Studied: Radcliffe College, A.B.; Simmons College, B.S. (Mr. Solomon)—B. Salem, Mass., Feb. 21, 1902. Studied: Harvard College; Harvard Business School. (Mr. Solomon)—Awards: Retailer of the Year, 1965; Tobe Award for Distinguished Contribution to Retailing, 1965. Collection: Sculpture of the 20th Century to Contemporary and Paintings. Includes, Sculpture: Giacometti, Lipchitz, Marini, Nevelson, Dubuffet, Arp, Chadwick, Calder, Schmidt, Doris Caesar, Trova; Paintings: Sargent, Vuillard, Tomayo, Delaunay, Monet, Matta; Drawings: Many, including Maillol, Archipenko, Degas, Lachaise. Watercolors: Nolde, Marini. Also a collection of Pop Art. Positions: (Mr. Solomon)—Chairman of the Board, Abraham & Straus, Brooklyn, N.Y.

SOLOMON, SYD—Painter, T., Lith.
 1216 First St.; h. 2428 Portland St., Sarasota, Fla. 33581; s. Baiting Hollow Rd., East Hampton, L.I., N.Y.
B. Uniontown, Pa., July 12, 1917. Studied: AIC; Ecole des Beaux Arts, Paris, France. Work: BMA; Delgado Mus. A.; Butler Inst. Am. A.; Birmingham Mus. A.; High Mus. A.; Wadsworth Atheneum; Clearwater A. Mus.; Walter Chrysler Mus. A.; WMAA; Provincetown Mus. A.; Rose Mus., Brandeis Univ.; PMA; Ringling Mus. A.; Guggenheim Mus. A.; Georgia Tech.; Ryder Coll.; Friends of Art, Uniontown, Pa.; Meade Atlanta Painting of the Year Coll.; Sarasota AA; Fla. Southern Col.; Fla. Fed. Arts; Hirshhorn Fnd. Coll.; Adelphi Col.; CM; Univ. Miami Lowe Gal.; Jacksonville Univ., and others. Exhibited: Nationally and internationally; recent exhs.: WMAA, 1963; Univ. Illinois, 1965; New England Annual, Silvermine Gld. A., 1964; Painting of the Year, 1964; AIC, 1967; Fla. State Exh., N.Y. World's Fair, 1964; one-man: Saidenberg Gal., N.Y., 1964, 1966, 1968; Univ. South Florida, 1964; Janice David Gal., 1963; Guild Hall, East Hampton, 1967, and others. Positions: Dir. Faculty, Famous Artists Schools, Inc., Westport, Conn., 1953- ; Visiting Prof. Art, New College, Sarasota, Fla., at present.

SOLWAY, CARL E.—Art dealer
 Director, Flair Gallery, 113 W. 4th St., Cincinnati, Ohio 45202*

SOMMERBURG, MIRIAM—Sculptor, C., Gr., P.
 1825 First Ave., New York, N.Y. 10028
B. Hamburg, Germany, Oct. 10, 1910. Studied: with Friedrich Adler, Richard Luksch, in Germany. Member: Print Council of America; NAWA; Am. Color Pr. Soc.; AEA; Audubon A.; Am. Soc. Contemp. A.; Creative A. Assoc. Awards: Fla. Southern Col., 1952; Village A. Center, 1948, 1949, 1950, 1951, 1957, 1960; Creative A. Gal., 1950; New Jersey P. & S., 1955; silver medal, Knickerbocker A., 1954;

Am. Soc. Contemp. A., 1959, 1962, 1964; Silvermine Gld. A., 1959; NAWA, 1961; Des. in hardwoods awards, Chicago, 1959 (2); medal, Audubon A., 1966. Work: Fla. Southern Col.; Springfield (Mo.) A. Mus.; MMA; Norfolk Mus. A. & Sciences. Exhibited: Fla. Southern Col., 1952; NAWA, 1952-1964; BM, 1951, 1954; Audubon A., 1948-1964; New Orleans AA, 1947, 1949, 1950-1952, 1954, 1955; SAGA, 1947, 1948, 1951, 1959; All. A. Am., 1949; Cal. Soc. Et., 1946; Syracuse Mus. FA, 1945; WMAA, 1951, 1954; Riverside Mus., 1947, 1948, 1953-1958; PAFA, 1954, 1966; N.Y. World's Fair, 1965; BMFA, 1951-1954; Amsterdam, Holland, 1956; Belgium, 1956; Baton Rouge, La., 1957, 1958; Contemporaries, 1956, 1957; Young Am. A., 1955; Silvermine Gld. A., 1958, 1959; Brooklyn Soc. A., 1954-1964; Atlantic City, N.J., 1960; Creative A. Assoc., 1953-1961; Grand Central A. Gal., 1952; Serigraph Gal., 1953; Phila. Pr. Fair, 1960; Village Temple, N.Y., 1960, 1961; Har Zion, Phila., 1960, 1962, 1964; Time & Life Bldg., N.Y., 1957; Jewish Tercentenary traveling exh., 1955; Berlin, Germany, 1954; Burlington Gal., London, 1955; Corinthian Gal., Phila., 1964; USIS traveling exh., South America, 1963-1964; Museums of Buenos Aires and Rio de Janeiro, 1963; Royal Acad. Gal., Edinburgh, Scotland, 1963; Birmingham, England, 1964; Mexico, 1964-1965; India and France, 1965; one-man: Village A. Center, 1950, 1958; Creative A. Gal., 1951; Salpeter Gal., 1953; Kaufman Gal., 1954, 1963; Carl Schurz Fnd., 1955; Union of Hebrew Congregations, N.Y., 1965.

SONENBERG, JACK—Painter, Gr.
128 East 16th St.; h. 217 East 23rd St., New York, N.Y. 10010
B. Toronto, Canada, Dec. 28, 1925. Studied: Ontario Col. A.; Sch. for Art Studies, N.Y., with Lewis Daniel; Washington Univ. Sch. FA, B.F.A., St. Louis, with Fred Conway, Paul Burlin and Fred Becker. Awards: prizes, Bradley Univ., 1956, 1960, purchase; Springfield Mus. FA, 1957; New England Annual, 1962; Tiffany Fnd. award, 1962; St. Paul A. Center, 1964 (purchase); SAGA, 1965; AFA-Ford Fnd. Artist-in-Residence Award, 1966. Work: Bradley Univ.; PMA; MMA; NGA; N.Y. Pub. Lib.; Chrysler Coll.; Syracuse Univ.; Univ. Oklahoma; Washington Univ.; Guggenheim Mus.; BM; Iowa State Col.; St. Paul A. Center; Grand Rapids Mus.; Chase Manhattan Bank; Nat. Gal., Canada. Exhibited: BM, 1953, 1954, 1956, 1958, 1960, 1962; BMFA, 1955; Springfield Mus. FA, 1956, 1957; Pomona, Cal., 1956; PAFA, 1957, 1959, 1960; Butler Inst. Am. A., 1958, 1961; Provincetown A. Festival, 1958; CAM, 1951; WMAA, 1959, 1967, 1968; Detroit Inst. A., 1959-60; Newark Mus., 1960; Krannert A. Mus., 1963; Finch Col. Mus., 1965; Mus. Graphic A., 1966; 4th Internat., USA-Japan-Tokyo, 1967; one-man: Washington Irving Gal., N.Y., 1958; RoKo Gal., 1959, 1961; Feingarten Gal., Los A., 1962, and New York, 1963; Siembab, Boston, 1959; Des Moines A. Center, 1964; Byron Gal., N.Y., 1965, 1968; Hampton Col. Mus., 1966; Grand Rapids Mus., 1968. Positions: Instr., School of Visual Arts, New York, N.Y., 1961. Instr., Pratt Inst., 1968.

SONNENBERG, MR. and MRS. BENJAMIN—Collectors
19 Gramercy Park, New York, N.Y. 10003*

SONNENSCHEIN, HUGO, JR.—Scholar
135 S. LaSalle St., Chicago, Ill. 60603; h. 809 Lincoln Ave., Winnetka, Ill. 60093
B. Chicago, Ill., Feb. 22, 1917. Swarthmore Col.; Lake Forest Col., B.A.; Univ. Virginia Law School, LL.B.; John Marshall Law School, LL.M. Member: (Life) (Sponsor), AIC; MModA; AFA; Am. Bar Associations. Field of Research: Legal Prints and Drawings. Positions: Editor, Chicago Bar Record, 1950-1966; President and Trustee, Library of International Relations, 1966- .

SOPHER, AARON—Painter, Cart., I., P.
500 W. University Parkway, Baltimore, Md. 21210
B. Baltimore, Md., Dec. 16, 1905. Studied: Baltimore Polytechnic Inst.; Maryland Inst. Member: AEA. Awards: prizes, BMA, 1943, 1946; Balt. Evening sun., 1931, 1933, 1943, 1945; CGA, 1953; Peale Mus., 1964. Work: PMG; BM; Dumbarton Oaks Coll.; BMA; Edward Bruce Mem. Coll.; Cone Coll., Balt.; Nelson Gutman Coll., Balt.; AGAA; Walters A. Gal., Baltimore, and others. Exhibited: NAD, 1945, 1946; WMAA, 1942; Lib. Cong., 1943, 1945; BM, 1941; Carnegie Inst., 1943; AIC, 1938, 1940, 1942; Albany Inst. Hist. & A., 1943, 1945; BMA, 1940-1946; Butler Inst. Am. A., 1960, 1961. I., "Rivers of the Eastern Shore," 1944; portfolio 45 drawings, "Maryland Institutions," 1949; "Princess Mary of Maryland," 1956; "People, People," 1956 (poems); "The Hospitalized Child," 1967; "The Bull on the Bench," 1967. Included in "6 Maryland Artists," 1955. Contributor to: Baltimore Sun papers; Harpers; Johns Hopkins magazine; New Yorker; Wall Street Journal; Washington Post, & other publications. Monographs: "Aaron Sopher," by Forbes Watson, 1940; "Aaron Sopher," by Wilbur H. Hunter, Jr., 1960.

SORBY, J. RICHARD—Painter, E., Des.
1618 Fairlawn Ave., San Jose, Cal. 95125
B. Duluth, Minn., Dec. 21, 1911. Studied: Univ. Minnesota; Colo-

rado State Col. Edu., A.B., M.A.; AIC; Mexico City Col.; U.C.L.A.; Univ. Colorado. Member: AEA; East Bay AA, (Vice Pres. 1966-1967). Awards: prizes, Nelson Gal. A., 1955; Denver A. Mus., 1954; Central City, Colo., 1955; Joslyn Mem. Mus., 1956; Univ. Santa Clara, St. Jude Exh., 1966; Cedar City (Utah) Exh., 1966; San Jose A. Lg., 1967, 1968; East Bay AA, 1966; Phoenix (Ariz.), purchase, 1966. Work: Marine Hospital, Carville, La.; Utah State Agricultural Col.; Brigham Young Univ.; Utah State Univ.; Col. of Southern Utah; Rural Electrification Admin.; Nelson Gal. A.; Denver A. Mus.; Joslyn A. Mus.; Kansas State College; Central City, Colo. Exhibited: NGA, 1941; Denver A. Mus., 1937, 1938, 1940, 1941, 1946, 1948-1959; Nelson Gal. A., 1950, 1955; Cal. State Fair, 1964; Art Inst. of San Diego, 1966; Joslyn A. Mus., 1941-1943, 1945, 1954, 1956; PAFA, 1941; Kansas City AI, 1941; Salt Lake City, 1954; Cedar City, Utah, 1948-1969; Oakland A. Mus., 1961; Crocker Gal. A., Sacramento, 1960-64; Fukuokua, Japan & Western Mus. traveling exh. with East Bay AA., 1966-1968; Jack London Square Exh., Oakland, Cal., 1966; Northern Cal. Annual, Sacramento, 1966; F.A. Festival, Salinas, Cal., 1966; Statewide Exh., Santa Cruz, Cal., 1966, 1967; one-man: Denver A. Mus., 1948, 1954; Monterey, Cal., 1961, 1962; Park's Gal., San Jose, 1963; Group 21 Gal., Los Gatos, Cal., 1968; Artell's Gal., Woodside, Cal., 1967; Rosemyer Gal., San Jose, 1967. Positions: Assoc. Prof., Univ. Denver, 1946-1959; Prof. A., San Jose State Col., Cal., at present.

SOUDEN, JAMES G.—Educator, P.
Otis Art Institute, 2401 Wilshire Blvd., Los Angeles, Cal. 90057; h. 6709 Berquist Ave., Canoga Park, Cal. 91304
B. Chicago, Ill., Oct. 14, 1917. Studied: AIC; Univ. Arizona, B.F.A., M.A.; Inst. Des., Illinois Inst. of Technology, M.S. in A. Edu. Positions: Assoc. Prof. A., 1949-1962, Actg. Hd., Art Dept., Univ. Arizona, 1962; Prof. A. & Dean of College, Otis Art Institute, Los Angeles, Cal., 1962- .

SOWERS, MIRIAM (R.) (Mrs.)—Painter
3020 Glenwood Drive, Northwest, Albuquerque, N.M. 87107
B. Bluffton, Ohio, Oct. 4, 1922. Studied: Univ. Miami; AIC. Member: Int. Platform Assn.; Centro Studi & Scambi Internazionali. Awards: prizes, Toledo Mus. A., 1952; New Mexico A. Lg., 1954; Corrales, N.M., 1960; Ouray (Colo.), 1961; New Mexico State Fair, 1967. Work: Lovelace Clinic, Albuquerque; Texas A. & I. Univ.; Houston Baptist Col.; paintings in public & private colls. Exhibited: Akron AI, 1951; Massillon Mus. A., 1951; Ohio State Fair, 1951, 1952; Toledo Mus. A., 1951, 1952; Canton AI, 1952; Dayton AI, 1952; Butler Inst. Am. A., 1952; Montpelier Tri-State, Ohio, 1952; Mus. New Mexico, 1954-1958; New Mexico State Fair, 1954-1961; Botts Mem., 1954, 1955; Sheldon Swope Gal., 1957, 1961; Roswell, N.M., 1957; El Paso Sun Carnival, 1957; Tucson Fiesta, 1958; Blue Door Gal., Taos, 1959, 1961; Little Studio, N.Y., 1959, 1961; Chelmont Nat., El Paso, 1960; Ouray, Colo., 1961; Corrales, N.M., 1960; Jeanes Gal., La Jolla, 1960, 1961; one-man: Atelier Gal., Cedar Falls, Iowa, 1962-1965; Southwestern Gal., Dallas, 1964; Winblad Gal., San F., 1964; N.Y. World's Fair, 1964; Sowers Studio, 1955-1958, 1960; Griegos Lib., 1956; Mus. New Mexico, 1957-61; Unitarian Church, 1958; Texas A. & I. Univ., 1968; Houston Baptist Col., 1968. Positions: Co-Dir., New Mexico, Arizona Reg. Exh., Phoenix, 1967; Dir., Nat. competitions for one-man shows with Art Intimates, 1968-1969. Owner, Symbol Gal. Art, Albuquerque, N.M.

SOYER, ISAAC—Painter, Lith.
108 East 31st St.; h. 122 East 61st St., New York, N.Y. 10021
B. Russia, 1907. Studied: CUASch.; Edu. All. A. Sch., N.Y., and in Paris, France, Madrid, Spain. Awards: prizes, Albright A. Gal., 1944; Audubon A., 1945. Work: WMAA; DMFA; Albright A. Gal.; State T. Col., Buffalo, N.Y.; Tel-Aviv Mus., Israel; Brooks Mem. Mus., Memphis, Tenn.; BM. Exhibited: WMAA, 1966, 1969; CGA; AIC; Milwaukee AI; CM; VMFA; Audubon A.: Akron AI; Cal. PLH; Soc. Four A.; WAC; MModA; PAFA; BM; ACA Gal., N.Y., and others; one-man: Midtown Gal., N.Y.; Phila. A. All.; William Rockhill Nelson Gal. A.

SOYER, MOSES—Painter, T.
70 West 3rd St.; h. 356 West 21st St., New York, N.Y. 10011
B. Russia, Dec. 25, 1899. Studied: CUASch; NAD; BAID; & abroad. Member: An Am. Group. Work: MMA; Newark Mus.; Swope A. Gal.; PMG; Toledo Mus. A.; MModA; BM; Detroit Inst. A.; Everson Mus. A., Syracuse; WMAA; Nat. Inst. A. & Let.; mural, USPO, Phila., Pa. Exhibited: nationally. Books: "Moses Soyer," by Bernard Smith; "Moses Soyer," by Charlotte Willard. Author: "Painting the Human Figure." Illus., "First Book of Ballet."*

SOYER, RAPHAEL—Painter, Gr., E.
88 Central Park W., New York, N.Y. 10023
B. Russia, Dec. 25, 1899. Studied: CUASch; NAD; ASL, with Guy Pene du Bois. Member: Am. Soc. P., S. & Gr.; Nat. Inst. A. & Lets. Awards: Temple gold medal, 1943; bronze medal, CGA, 1943; gold medal, NAD, 1957; gold medal, Nat. Inst. A. & Lets., 1957; prize,

AIC, 1940. Work: WMAA; PMG; MMA; BMA; N.Y. Pub. Lib.; MModA.; AGAA; Columbus Gal. FA; CGA; Buffalo AA; BM, etc.; mural, Kingsessing Postal Station, Phila., Pa. Book: "Raphael Soyer" by Walter Gutman. Author: "A Painter's Pilgrimage," "Homage to Thomas Eakins"; "Fifty Years of Print Making." Positions: Instr., ASL; Am. A. Sch.

SPAETH, ELOISE O'MARA—Collector, Writer
120 E. 81st St., New York, N.Y. 10028
B. Decatur, Ill., June 19, 1904. Studied: Millikin University. Member: U.S. National Commission to UNESCO, 1961- . Author: "American Art Museums and Galleries," 1960, paperback edition, 1966, new ed., 1969; "Collecting Art," 1968. Contributor to art and religious publications. Collection: Contemporary religious art; Antiquities; Contemporary American and European art. Positions: Trustee, 1938-1944, Director, Modern Gallery, 1940-1944, The Dayton Art Institute; Trustee, 1945- , Chairman, Extension Services, 1947-1959, American Federation of Arts; Trustee, 1950- , Chm., Acquisitions Committee, 1962- , Guild Hall Museum; Trustee, Vice-President, Archives of American Art, 1959; Chairman, East Division Archives, 1959; Director, Friends of the Whitney Museum; Member, Smithsonian Institution Fine Art Commission.

SPALDING, PHILIP E.—Museum Official
2411 Makiki Hts. Dr., Honolulu, Hawaii 96822
B. Minneapolis, Minn., Nov. 5, 1889. Studied: Stanford University. Awards: LL.D., University of Hawaii, 1961. Positions: Trustee and Officer, Honolulu Academy of Arts, 1944- .*

SPARK, VICTOR D. —Art Dealer
Victor D. Spark Art Gallery, 1000 Park Ave., New York, N.Y. 10028
B. Brooklyn, N.Y., May 16, 1898. Studied: New York University, B.S. Specialty of Gallery: American and Foreign Paintings; Drawings; works of art; Appraisals of Fine Art. Position: Dir., Victor D. Spark Art Gallery, New York, N.Y.

SPAULDING, WARREN (DAN)—Painter, E., L.
85 Masonic St., Rockland, Me. 04841
B. Boston, Mass., Oct. 7, 1916. Studied: Mass. Sch. A.; Yale Univ. Sch. FA, B.F.A., M.F.A. Member: Maine Coast Artists. Awards: Alice Kimball English F. for foreign travel, Yale Univ., 1949; prizes, U.S. Section FA comp., 1940; St. Louis A. Gld., 1951, 1954, purchase, 1958; Joslyn A. Mus., purchase, 1958. Work: Marine Hospital, Carville, La.; St. Louis A. Gld.; Joslyn A. Mus.; Univ. Maine; Branford Col.; Yale Univ., and in private colls. Exhibitions: 1953-61: CAM; PAFA; Springfield A. Mus.; Boston and Maine A. Festivals; Maine Coast Artists, 1968; A. of the Missouri Valley, Topeka; Am. Graphic A. & Drawing annual, Wichita; Kansas State Col.; Joslyn A. Mus.; Maine A. Gal., 1967, 1968; Univ. Maine (one-man); Northeast Harbor, Me. (one-man) other one-man exhs., 1962-64; Univ. Maine, 1969; Weeden Gal., Boston; The Gallery, Dark Harbor, Me.; Kennebec Valley AA, 1967. Lectures: "Turner & His Time," "The Nature Temple as Domestic Architecture in Britain," and "An Introduction to Style in Art." Studied the Turner Bequest, British Mus., 1965-1966. Positions: Instr., Yale Univ. Sch. FA; A. Dir., The Taft School; Asst. Prof. in Composition, Sch. FA, Washington Univ., St. Louis, Mo.; Dir., The Gallery, Camden, Maine.

SPAVENTA, GEORGE—Sculptor, C., T.
84 E. 10th St., New York, N.Y. 10003
B. New York, N.Y., Feb. 22, 1918. Studied: Leonardo da Vinci A. Sch.; Beaux Art Inst. Des., N.Y.; Academie Grande Chaumiere, Paris, France. Work: Univ. California at Berkeley; Mass. Inst. of Technology. Exhibited: Carnegie Inst., 1949-1950; MModA traveling exh., U.S., 1964-65 and Paris and other European cities, 1965-66. Positions: Instr., Sculpture, New York Studio School, N.Y.*

SPEIGHT, FRANCIS—Painter, T.
Box 13-B, East Carolina College, Greenville, N.C. 27834
B. Windsor, N.C., Sept. 11, 1896. Studied: Wake Forest Col.; Corcoran Gallery of Art; PAFA. Member: NA; Nat. Inst. A. & Lets. Awards: Cresson European traveling scholarships, 1923, 1925; Kohnstamm prize, AIC, 1930; Hallgarten prize, 1930, Altman prizes, 1950, 1953, 1958, Obrig prize, 1955, all NAD; Clark prize and medal, CGA, 1937; Sesnan gold medal, PAFA, 1940; Nat. Inst. A. & Lets., N.Y., grant, 1953; gold medal of honor, PAFA, 1961; Percy Owens award, F. PAFA, 1961; Gold Medal, for Achievement in Art, Awarded by State of North Carolina, 1964; prize, Pa. Nat. Exh., Ligonier Valley, Pa., 1961; Hon. Degrees: D.H.L., Wake Forest College, 1962; D.F.A., College of the Holy Cross, 1964. Work: MMA; BMFA; Toronto Gal. A.; PAFA; Rochester Mem. Gal.; Norton Gal. A.; Butler Inst. Am. A., and in many other museums. Exhibited: Retrospective exh., North Carolina Museum of Art, Raleigh, 1961. Positions: Instr., PAFA, Philadelphia, Pa., 1925-61; Prof. A., Artist-in-Res., East Carolina College, Greenville, N.C., at present.

SPENCER, ELEANOR PATTERSON—Educator, W.
7 rue Fustel de Coulanges, Paris 5, France
B. Northampton, Mass., Jan. 29, 1895. Studied: Smith Col., B.A., M.A.; Radcliffe Col., Ph.D.; Ecole du Louvre, Sorbonne, Paris, France. Awards: Hon. L.H.D., Goucher College, 1967. Member: CAA; Am. Assn. Univ. Prof. Awards: Sachs F., Harvard Univ., 1928-1929, 1929-1930, Fulbright Scholar, Paris, 1962-63; Am. Council of Learned Soc. grant, 1962. Contributor to: Magazine of Art; Gazette des Beaux-Arts; Scriptorium; Burlington Magazine. Positions: Member Bd. of Trustees of Baltimore Mus. A., Walters A. Gal., and The Peale Museum. Prof., History of Art, Goucher College, 1930-1962 (Emeritus); Staff, CASA, Paris, 1964-1966.

SPENCER, HUGH—Illustrator, L.
Pratt St., Chester, Conn. 06412
B. St. Cloud, Minn., July 19, 1887. Studied: Chicago Sch. App. & Normal A.; ASL; N.Y. Evening Sch. Indst. A.; & with Charles Chapman, Arthur Covey. Member: Soc. Conn. Craftsmen; Meriden A. & Crafts; Conn. Botanical Soc. I., Nature & Science Readers & Textbooks (drawings & photographs). Contributor to Natural History and Nature magazines. Pres., Connecticut Botanical Soc., 1963-64.

SPENCER, JEAN—Painter, Des., T.
890 Park Ave., New York, N.Y. 10021; h. 101 Sutton Manor, New Rochelle, N.Y. 10805
B. Oak Park, Ill. Studied: Wellesley Col.; AIC; Grand Central Sch. A., and with Wayman Adams. Member: NAWA; Audubon A.; Portraits, Inc.; Grand Central A. Gal.; Martha's Vineyard AA; All. A. Am.; Audubon A. Awards: medal, Grand Central Sch. A.; prizes, Pen & Brush Cl.; NAWA; Audubon A. purchase prize. Work: portraits, pub. bldgs., Charlottesville, Va.; Sioux Falls, S.D.; Trenton, N.J.; Court House, High Point, N.C.; N.Y. Pub. Lib.; Osteopathic Clinic, N.Y.; House Office Bldg., Wash., D.C.; Fla. Southern Col.; Norfolk Museum A.; Arizona Mus., Dragoon, Ariz. Work in private colls. Exhibited: NAD; All. A. Am.; NAWA; All-Illinois Soc. Painters; NAC; Studio Gld.; Pen & Brush Cl.; Audubon A.; one-man: B. T. Batsford, Ltd., N.Y.; Marshall Field & Co., Chicago; Wilton, Conn.; Creative A. Gal., Charlottesville, Va.; Martha's Vineyard AA; IFA Gal., Wash., D.C.; Grand Central A. Gal. Author: "Fine and Industrial Arts." Positions: Chm. Jury & Jury of Awards, Chm. Entertainment, Memb. Adv. Bd., NAWA; Chm. Pub. Rel., Audubon A.; Treas., All. A. Am.

SPERAKIS, NICHOLAS GEORGE—Painter, Gr.
27 Eldridge St. 10002; h. 3 Weehawken St., New York, N.Y. 10014
B. New York, N.Y., June 8, 1943. Studied: Pratt Inst.; NAD; ASL; Member: SAGA. Awards: purchase prize, Mercyhurst Col., College Point, N.Y., 1964; Am. Acad. A. & Lets. Fellowship, 1969. Work: BM; N.Y. Pub. Library; Chrysler Mus., Provincetown, Mass.; Norfolk Mus. A. & Sciences. Exhibited: Mercyhurst Col., 1964, 1965; BM, 1964, 1966; Chrysler Mus., 1965, 1966; Norfolk Mus. A. & Sciences, 1966; Jewish Mus., N.Y., 1964; Am. Acad. A. & Lets., 1969 (2); Kessler Gal., Provincetown. Positions: Instr., Printmaking and Painting, A. Sch. of the Educational Alliance, New York, N.Y.

SPEYER, JAMES—Museum Curator
Art Institute of Chicago, Michigan Ave. at Adams St., Chicago, Ill. 60603*

SPIDELL, ENID JEAN—Painter, E.
Pratt Institute, 215 Ryerson St., Brooklyn, N.Y.; h. 50 Jackson St., New Rochelle, N.Y. 10801
B. Hampton, N.B., Canada, June 5, 1905. Studied: Parsons Sch. Des.; N.Y. Univ., B.S. in A. Edu.; T. Col., Columbia Univ., M.A.; & with George Pearse Ennis; ASL; Syracuse Ext., Taxco, Mexico. Member: AWS; Int. Soc. Color Council; New Rochelle AA (Pres. 1959-1963, Dir., 1963-). Awards: prize, AV-Am. A. Group design competition, 1943. Exhibited: in member organizations; one-man: New Rochelle Pub. Lib., 1956, 1964; New Rochelle, 1968; Bronxville Pub. Lib., 1964. Positions: Assoc. Prof. A., Chm., Fashion Arts, Pratt Inst., Brooklyn, N.Y., at present; Dir., New Rochelle AA, 1956-59, Pres., 1959-1963.

SPIEGEL, SAM—Collector, Producer of Motion Pictures
711 Fifth Ave., 10022; h. 475 Park Ave., New York, N.Y. 10022
B. Austria, Nov. 11, 1901. Studied: University of Vienna. Awards: Academy Awards, 1951, 1954, 1957, 1959, 1963; The Thalberg Award, 1964. Collection: Modern impressionist art. Positions: Producer of Motion Pictures, including "Tales of Manhattan," "The African Queen," "On the Waterfront," "Bridge on the River Kwai," "Lawrence of Arabia," "Suddenly, Last Summer."*

SPITZER, FRANCES R. (Mrs. A. Luis)—Collector
200 E. 66th St., New York, N.Y. 10021
B. New York, N.Y., Mar. 31, 1918. Studied: Syracuse Univ., B.S. Collection: French Impressionists; Contemporary American.

SPIVACK, SYDNEY SHEPHERD—Scholar
Green Hall, Princeton University, Princeton, N.J. 08540; h. Far Hills, N.J. 07931
Studied: Columbia University, A.M., Ph.D. Member: Fellow, American Sociological Assn.; Fellow, Society for Applied Anthropology. Field of Research: Sociology of Art.*

SPIVAK, MAX—Painter, C., Des., T.
175 Madison Ave., New York, N.Y. 10016
B. Bregnun, Poland, May 20, 1906. Studied: Col. City of N.Y.; ASL; Grande Chaumiere, Paris. Member: Am. Abstract A.; NSMP. Awards: Silver med., Arch. Lg., 1956. Work: BMA; Newark Mus.; mosaic murals, SS "Constitution"; SS "Independence"; Statler Hotel, Los A.; Calderone Theatre, Hempstead; Gen. Wingate H.S., Brooklyn; Cerebral Palsy Sch., N.Y.; Warner-Lambert, Morris Plains, N.J.; Johnson & Johnson, New Brunswick, N.J.; Colgate-Palmolive Research Center, New Brunswick, N.J., 1966; Jr. H.S. 189, Queens, N.Y.; Textile Center, New York, N.Y.; Chas. Pfizer & Co. Research Center, Groton, Conn. Exhibited: WFNY 1939; GGE, 1939; MModA, 1936, 1950; Mortimer Levitt Gal., 1948-1950 (one-man): WMAA, 1948, 1949. Positions: Asst. Prof. A., Bard College, Annandale-on-Hudson, N.Y.; Instr., 2-D Design, Pratt Institute, Brooklyn, N.Y.; 1st V.-Pres., Arch. Lg., 1966-1968; 1st V.-Pres., NSMP.

SPONENBURGH, MARK RITTER—Educator, Hist., S.
Department of Art, Oregon State University, Corvallis, Ore. 97330
B. Cadillac, Mich., June 15, 1916. Studied: Cranbrook Acad. A.; Wayne Univ.; Ecole des Beaux-Arts, Paris, France; Univ. London; Univ. Cairo; degrees, M.A., M.F.A.; F.R.S.A., and others. Member: CAA; Northwest Inst. Sculpture; AAMus. Awards: Cranbrook Acad. A., Scholarship, 1940; Tiffany Fnd. F., 1941; Fulbright F., 1951-53; purchase prizes: Detroit Inst. A.; Portland A. Mus., and others. Work: Detroit Inst. A.; Portland A. Mus.; Univ. Oregon; Mus. Mod. A., Egypt; Pakistan Arts Council. Exhibited: PAFA; Michigan Artists; Oregon Artists; Durand-Ruel and Paris Salon, France; Inst. FA, Cairo; Nat. Gal., Pakistan; One-man: 15 one-man exhs. of sculpture. Contributor to Journals and Periodicals: Arts Quarterly; Museums Journal; Journal of Institut d'Egypte; Revue de Caire; Near East Bulletin; Journal of Near Eastern Studies; Liturgical Arts. Lectures: History & Techniques of Sculpture (Egyptian; N.W. Coast); Folk Arts and Crafts (Egyptian, Nubian, Swati, Pakistani). Exhibitions planned, assembled, arranged and catalogued: "Sculpture of the Pacific Northwest," Univ. Oregon, 1955; "2000 Years of Horse and Rider in the Arts of Pakistan," National College, Lahore, 1959; "Folk Arts of Swat," National College of Arts, Lahore and Karachi, 1961. Positions: Assoc. Prof., Univ. of Oregon, 1946-56; Visiting Prof., Royal College of Arts, 1956-57; Principal & Prof., National College of Arts, Lahore, 1958-61; Prof., Oregon State University, Corvallis, Ore., 1961- .*

SPONGBERG, GRACE—Painter, C., Gr
909 North Rush St., Chicago, Ill. 60611
B. Chicago, Ill., Apr. 25, 1906. Studied: AIC. Member: Chicago Soc. A. Work: Bennett Sch., Byford Sch., Horace Mann Sch., all in Chicago; Mus. Vaxco, Sweden. Exhibited: CM; PAFA; AIC; Joslyn A. Mus.; Chicago Soc. A.; Riverside Mus.; Evanston A. Center; Laguna Beach AA; Oakland A. Gal.; Miami Beach A. Center; Springfield Mus. FA; Grand Rapids, Mich.; LC; SAM.

SPORN, IRVING—Collector, Patron
Irving Sporn and Co., 518 Forest Ave. 04102; h. 88 Beacon St., Portland, Me. 04103
B. New York, N.Y., May 29, 1917. Studied: New York University, B.S.; Columbia University, M.Sc., Ph.D., LL.D. Member: Maine Historical Society; Portland Historical Society. Collection: Pre-Columbian art; Medieval manuscripts; Incunabula; Orientalia; Oceanic art.*

SPRAYREGEN, MORRIS—Collector
N.Y. Stock Exchange, 26 Broadway 10004; h. 812 Park Ave., New York, N.Y. 10021
Collection: Primarily French impressionist and post-impressionist art.

SPRIGGS, EDWARD S.—Museum director, P.
Studio Museum in Harlem, 125th St. and Fifth Ave., New York, N.Y.*

SPRINCHORN, CARL—Painter
c/o Babcock Gallery, 805 Madison Ave. & Jas. Graham & Sons, 1014 Madison Ave.; h. Beaver Dam Rd., Selkirk, N.Y. 12158
B. Broby, Sweden, May 13, 1887. Studied: N.Y. Sch. A.; and with Robert Henri. Member: AEA. Work: PC; FMA; MMA; High Mus.

A.; Univ. Maine; PMA; City of N.Y.; BM; New Britain Mus.; Providence Mus. A.; Am-Swedish Hist. Soc., Phila., Pa., and others. Exhibited: nationally. One-man: WMA; Chicago A. Cl.; and the following galleries: George Hellman, Knoedler, Marie Sterner, Frank Rehn, Ainslie's, Macbeth, and others. 50th Anniversary Exh., Independent Artists, Delaware A. Center, Wilmington, 1960; "Maine Artists" exh., Colby College, 1964.

SPRINGWEILER, ERWIN FREDERICK—Sculptor, C.
121 Springs Drive, Wyandanch, L.I., N.Y. 11798
B. Pforzheim, Germany, Jan. 10, 1896. Studied: Art Craft Sch., Pforzheim; Acad. FA, Munich; asst. to Paul Manship, Herbert Hazeltine. Member: NSS; ANA; Int. Inst. A. & Let.; Conn. Acad. FA; McDowell Colony; Soc. Animal Artists. Awards: prizes, NSS, 1937; NAD, 1938, 1949, Speyer prize, 1959; Sculpture House award, 1959, Academic AA; Locust Valley, L.I., sculpture prizes, 1959, 1960; Arch. Lg., 1949; Medal of Honor, NAC, 1956. Work: Congressional gold medals of George M. Cohan and General W. L. Mitchell; statues, Washington Zoo and Detroit, Mich.; Brookgreen Gardens; reliefs, Washington Zoo, USPO, Chester, Pa., Manchester, Ga. Other works at Norton Mus., Shreveport, La.; Syracuse Univ. Contributor articles to National Sculpture Review. Exhibited: NAD; PAFA; AIC; and other major exhibitions; 150 Years of American Sculpture Exh., Old Westbury, N.Y., 1960.*

SPRUCE, EVERETT FRANKLIN—Painter, E., Gr.
Department of Art, University of Texas; h. 15 Peak Rd., Austin, Tex. 78746
B. Faulkner County, Ark., Dec. 25, 1908. Studied: Dallas AI, & with Olin H. Travis. Awards: prizes, Dallas Mus. FA, 1955; D.D. Feldman Comp., Dallas, 1955; Texas FA Assn., 1942; SFMA, 1940; Texas General, 1945; WMA, 1945; Pepsi-Cola, 1946; La Tausca Exh., 1947; Am. Exh., Brussels, 1950; Ford Fnd. award of Retrospective Exh., circulated nationally by the American Federation of Arts, 1959. Work: U.S. State Dept.; Mus. FA of Houston; Dallas Mus. FA; PMG; Witte Mem. Mus.; MModA; North Texas State T. Col.; Nelson Gal. A.; PAFA; Newark Mus.; MMA; Cal. PLH; Illinois Wesleyan Univ.; Univ. Nebraska; Des Moines A. Center; Colorado Springs FA Center; Mus. FA, Rio de Janeiro; N.Y. Pub. Lib.; Delgado Mus. A.; Ft. Worth A. Center; McNay AI, San Antonio. Portfolio of paintings in color, Blaffer Series, Vol. I, Univ. Texas Press. "Everett Spruce," by John Leeper, publ. 1959 by AFA. Exhibited: CGA, 1939, 1941, 1943, 1945, 1951; MModA, 1942; CM, 1944; Carnegie Inst., 1948, 1949, 1951; Dallas Mus. FA, 1932-1935, 1938-1940; Texas General, 1939-1945; Pepsi-Cola, 1946; Univ. Illinois, 1948, 1950, 1951, 1952; La Tausca Pearls, 1947; Brussels, Belgium, 1950; Bordighera, Italy, 1955; one-man: Hudson Walker Gal., 1939; Levitt Gal., 1945, 1947, 1949, 1953; Dallas Mus. FA, 1933; Witte Mem. Mus., 1943. Positions: Instr., A., 1940-45, Asst. Prof., 1945-52, Prof., 1952-1961, Grad. Prof. of Painting, 1961- , Univ. Texas, Austin, Tex.*

SPURGEON, SARAH (EDNA M.)—Educator, P.
804 1/2 "C" St.; h. 204 East 9th St., Ellensburg, Wash. 98926
B. Harlan, Iowa, Oct. 30, 1903. Studied: State Univ. Iowa, M.A., B.A.; Harvard Univ.; Grand Central Sch. A.; & with Grant Wood, Paul Sachs, & others. Member: Nat. Edu. Assn.; Am. Assn. Univ. Prof.; Wash. Edu. Assn.; Women Painters of Wash. Awards: Carnegie F., 1929-1930; prizes, State Univ. Iowa, 1931; Iowa A. Salon, 1930, 1931. Work: Iowa Mem. Un., Iowa City; mural, Univ. Experimental Sch., Iowa City, Iowa; SAM; Ginkgo Mus., Vantage, Wash.; Henry Gal., Univ. Washington. Exhibited: Kansas City AI; Joslyn Mem.; Cal SE; Des Moines A. Salon; SAM; Gumps, San F., Cal. One-man: Campus Music & Gal., Seattle, 1956-1958. Contributor to: Design, Childhood Education magazines. Positions: Assoc. Prof., Central Washington State Col., Ellensburg, Wash., 1939-42, 1944- .

SQUAREY, GERRY—Painter, T., L.
Main Rd., Waquoit Village, Falmouth, Mass.; w. 15 E. 11th St., New York, N.Y. 10003
B. Sydney, Canada. Studied: Mass. College A., B.S. in Edu.; Hyannis T. Col., M.E.; Boston Univ.; Connecticut Univ.; Hillyer Col. (Prof. Certif.). Member: NAWA; Hartford Soc. Women P.; Conn. WC Soc.; Cape Cod AA; Falmouth A. Gld.; Provincetown AA; Conn. AA; Eastern AA; Conn. Edu. Assn. Awards: prizes, Hartford Soc. Women P., 1950, 1953, 1954; Conn. WC Soc., 1953, purchase, 1958; NAWA, 1953; Cape Cod AA, 1955, 1960; Falmouth A. Gld., 1959, 1960, 1964; N.Y. Comm. on Art, for New York Hospitals, purchase, 1964. Exhibited: NAD; Argent Gal.; Wadsworth Atheneum; Springfield Mus. FA; Yale Univ.; Lyman Allyn Mus. A.; Farnsworth Mus.; Slater Mus. A.; New Britain Mus. A.; Portland Mus. A.; Silvermine Gld. A.; Cape Cod AA; Provincetown AA; Boston A. Festival, 1957; New Britain T. Col., 1958; Central Col. of Conn.; Falmouth A. Gld.; one-man, Cape Cod AA, 1959. Positions: Chm., A. Dept., Hartford Pub. H.S., 1949-61; Instr., Painting, Central Col. of Conn., 1959-61. Exec. Vice-Pres., Cape Cod AA, 1960-64, Dir., 1964- .*

SQUIER, JACK—Sculptor, E.
Art Department, Cornell University; h. 221 Berkshire Rd., Ithaca, N.Y. 14850
B. Dixon, Ill., Feb. 27, 1927. Studied: Indiana Univ., B.S.; Cornell Univ., M.F.A.; Oberlin Col. Work: Cornell Univ.; WMAA; Ithaca Col., N.Y.; Everson Mus., Syracuse, N.Y., and in private colls. Exhibited: Indiana Univ., 1950; Cornell Univ., 1951, 1952; John Herron AI, 1950; Downtown Gal., N.Y., 1952, 1953; Alan Gal., N.Y., 1953-1961, 2-man, 1954, 3-man, 1955; Univ. Minnesota, 1955; MMoDA, 1955-1958; Mus. FA of Houston, 1956; Perls Gal., Los A., 1956; Margaret Brown Gal., Boston, 1956; Tanager Gal., N.Y., 1956; Stable Gal., N.Y., 1956, 1957, 1959-1961; WMAA, 1957, 1958, 1960, 1962, 1964, 1966; AIC, 1957; AFA traveling exh.; Phillips Acad., 1957; Time & Life Bldg., N.Y., 1957; Illinois Bi-annual, 1959-1961, 1963-1965; MMA, 1959; Brussels World Fair, 1959; Galerie Claude Bernard, Paris, 1960; Hanover Gal., London, 1960; Wadsworth Atheneum, 1960; Boston A. Festival, 1961; Carnegie Inst., 1961; New School, N.Y., 1961; Landau-Alan Gal., N.Y., 1967, 1968; Felix Landau Gal., Los Angeles, 1967, 1968; Grand Rapids Mus., 1968; one-man: Cornell Univ., 1952, 1959, 1964; Alan Gal., 1956, 1959, 1961, 1964, Lima, Peru, 1963; Landau-Alan Gal., N.Y., 1966. Positions: Prof. A., Cornell Univ., Ithaca, N.Y., at present.

STAEMPFLI, GEORGE W.—Art Dealer, Collector, Cr.
47 E. 77th St.; h. 40 East 78th St., New York, N.Y. 10021
B. Bern, Switzerland, Dec. 6, 1910. Studied: Erlangen University, Ph.D. Member: AFA; Collection: Contemporary painting and sculpture. Positions: Cur., Museum of Fine Arts, Houston, 1954-1956; Coordinator, Fine Arts Program, Office U.S. Comm. Gen., Brussels World's Fair, Belgium, 1956-1958; President, Staempfli Gallery, N.Y., 1959- .

STAHL, BEN(JAMIN) (ALBERT)—Painter, I., L., T., W.
Siesta Key, Sarasota, Fla. 33581
B. Chicago, Ill., Sept. 7, 1910. Member: Westport A.; SI; AAPL; Fla. A. Comm.; Int. Platform Assn.; Sarasota AA; A. & W. Gld. Awards: prizes, Chicago Gld. Freelance A., 1937; Chicago Fed. Advertising Cl., 1939, 1941; A. Dir. Cl., Chicago, 1943, 1944, 1947, 1948; A. Dir. Cl., New York, 1947, 1952; Chicago Fed. Advertising Cl., 1939-1941; medals, A. Dir. Cl., Chicago, 1943; NAD, 1949. Work: Author, Illus., "Blackbeard's Ghost," publ., 1965 and screen rights sold to Walt Disney. Illus., Anniversary edition of "Gone With the Wind"; Illus., Hall of Fame; New Britain Mus. Am. Art; Albion Col.; Adelphi Col., N.Y.; Duke Univ. Exhibited: AIC. Lectures: Illustration and Methods. Positions: Member, Founding Faculty, Famous Artists Schs., Westport, Conn.; Member, Bd. Advisors, Am. A. Fnd. Fndr., Museum of the Cross, Sarasota, Fla., 1965- .

STALEY, ALLEN—Scholar
Department of Art History, Columbia University, New York, N.Y. 10027
B. St. Louis, Mo., June 4, 1935. Studied: Princeton University, B.A.; Yale University, M.A., Ph.D. Field of Research: Nineteenth-century painting. Co-author (with F. Cummings and R. Rosenblum) "Romantic Art in Britain, Paintings and Drawings 1760-1860," 1968. Positions: Lecturer, Frick Collection, New York, 1962-1965; Assistant Curator of Painting, Philadelphia Museum of Art, 1965-1968; Assistant Curator of Painting, Philadelphia Museum of Art, 1965-1968; Assistant Professor, Department of Art History and Archaeology, Columbia University, New York, 1969- .

STAMATS, PETER OWEN—Collector, Patron
427 Sixth Ave. S.E. 52406; h. 222 Forest Drive S.E., Cedar Rapids, Iowa 52403
B. Cedar Rapids, Iowa, July 20, 1929. Studied: Dartmouth College, B.A.; Université de Bordeaux. Collection: Graphics, modern sculpture. Positions: President, 1959-1960, Director, Cedar Rapids Art Association; Trustee, Cedar Rapids A. Center; Member: Iowa State Arts Council.

STAMATY, STANLEY—Cartoonist, Comm. A., I.
P.O. Box 75, Elberon, N.J. 07740
B. Dayton, Ohio, May 21, 1916. Studied: Cincinnati A. Acad. Member: Nat. Cartoonists Soc.; Magazine Cartoonists Gld.; Art Dirs. Cl. of New Jersey. Contributor to True; Look; Parade; Saturday Review. Illus., books, "Personal Business Law," "Practical Business Psychology," McGraw-Hill Book Co.; "Mathematics," American Book Co.

STAMM, JOHN DAVIES—Collector
666 Fifth Ave. 10018; h. 120 E. 95th St., New York, N.Y. 10028
B. Milwaukee, Wis., May 2, 1914. Studied: New York University, B.S. Collection: Modern American paintings; Lithographs by Lautrec, as well as books, catalogues, magazines and papers pertaining to him. Positions: Wrote catalogue for exhibition of Lautrec

posters and lithographs, Milwaukee Art Institute, Lawrenceville School, the Brooks School, 1965; Wrote introduction to catalogue, exhibition of works by Philip Evergood.*

STAMOS, THEODOROS—Painter, T., L., Des.
East Marion, L.I., N.Y. 11939
B. New York, N.Y., Dec. 31, 1922. Studied: Am. A. Sch., with Simon Kennedy. Member: A. Lg. Am. Awards: F. grant, Nat. Inst. A. & Lets., 1956; Tiffany F., 1951; Intl. prize, Tokyo Biennial, 1961; Brandeis Univ., 1959. Work: MMoDA; MMA; WMAA; AGAA; PMG; Albright A. Gal.; Phoenix A. Mus.; Univ. Nebraska; Univ. Iowa; Cal.PLH; Wadsworth Atheneum; Tel-Aviv Mus.; Walker A. Center; Mus. Mod. A., Rio de Janeiro; Munson-Williams-Proctor Inst.; Univ. Notre Dame; Oklahoma A. Center; Butler Inst. Am. A.; Krannert A. Mus.; Smith Col.; Case Inst.; M.I.T.; Brandeis Univ.; Univ. Mich.; Colorado Springs FA Center; Des Moines A. Center; Brooks Mem. A. Gal.; Phillips Gal.; A. Gal. of Toronto, Canada; CGA; NCFA; AIC; Phoenix A. Mus.; SFMA; Detroit Inst. A.; Vassar Col. Exhibited: Carnegie Inst., 1945, 1947, 1950, 1958; WMAA, 1946-1951, 1955; PAFA, 1947, 1948, 1950, 1951; Univ. Illinois, 1950; Univ. Iowa, 1947, 1948; Univ. Nebraska, 1950; Colorado Springs FA Center, 1948; Cal. PLH, 1949, 1950; MMoDA, 1949, 1951, 1955, and European traveling exh.; Walker A. Center, 1948; AIC, 1947; Soc. Four A., 1950; MMA, 1950; Betty Parsons Gal., 1947-1951; Venice Biennale, 1949; CGA, 1958-59, retrospective exh., 1958; numerous one-man exhibitions including Gimpel Freres, London, 1960; Galleria d'Arte del Naviglio, Milan, Italy, 1961. Illus. "Sorrows of Cold Stones," and book of poems, 1950; executed 5 color lithographic posters, 1964 (commissioned by the List Poster Fund) for exhibition "West Side Artists of New York," Riverside Museum; illus., poem, for special issue of Art in America article "Artists and Poets," 1965. Lecturer, Univ. Alabama, "Why Nature in Art," 1965. Positions: Instr., Black Mountain Col., 1950; Cummington (Mass.) Sch. A., 1952, 1953; ASL, 1961, 1968- ; Columbia Univ., 1969- .

STAMPER, WILLSON Y.—Educator, P., Des., A. Sch. Dir.
924 Pueo St., Honolulu, Hawaii 96815
B. Brooklyn, N.Y., Jan. 5, 1912. Studied: ASL; Cincinnati A. Acad. Member: Hawaii P. & S. Assn. Awards: prizes, scholarship, ASL, 1933-36; CM, 1942; Honolulu Acad. A., 1947, 1948 (3), 1952, 1956; "Artist of Hawaii," 1949; Watumull Fnd. purchase prize, 1946, 1949. Work: CM; MMoDA; Honolulu Acad. A. Exhibited: GRD Gal., N.Y.; Willard Gal., N.Y.; CM, group and one-man exhs.; SFMA; Weyhe Gal., N.Y.; Butler Inst. Am. A.; Columbus Gal. FA; Riverside Mus.; Cincinnati Mod. A. Soc.; Ohio Graphic A. Soc., traveling exh.; Honolulu Acad. A., group and one-man exhs.; Dayton AI; CMA; Taft Mus. A.; Carnegie Inst.; Royal Hawaiian A. Gal., Honolulu; Nassau A. Gal., Bahamas, 1964. Positions: Instr., Tech. Adv., Honolulu Acad. Arts; Fndr., Dir., Honolulu Acad. A. Sch., Honolulu, Hawaii, 1946-1962. Instr., Advanced Painting, at the Academy, 1962- .

STAMPFLE, FELICE—Scholar
33 E. 36th St., 10016; h. 450 E. 63rd St., New York, N.Y. 10021
B. Kansas City, Mo., July 25, 1912. Studied: Washington University, A.B., A.M.; Radcliffe College, Graduate student. Field of Research: Drawings, especially 18th century Italian. Positions: Curator of Drawings and Prints, Pierpont Morgan Library, 1945- ; Editor, Master Drawings (quarterly devoted to study and illustration of drawings), 1963- ; Author of various articles, reviews, exhibition catalogues.

STANCZAK, JULIAN—Painter, T.
6229 Cabrini Lane, Seven Hills, Ohio 44131
B. Borownica, Poland, Nov. 5, 1928. Studied: Uganda, Africa; London, England; Cleveland Inst. A., B.F.A.; Yale Univ., M.F.A. with Albers and Marca-Relli. Awards: prizes, Interior Valley Exh., 1961; CM; Dayton AI, 1963. Work: Dayton AI; Albright-Knox A. Gal.; Larry Aldrich Mus.; Des Moines A. Center; LC; CMA; CM; Herron Mus. A., Indianapolis; BMA; Dartmouth Col. Exhibited: MMoDA, 1965; Riverside Mus., N.Y., 1965; Krannert A. Mus., Univ. Illinois, 1965; Univ. Nebraska, 1965; Austin, Tex., 1965; Fort Worth, 1965; Butler Inst. Am. A., 1961, 1965; CM, 1957-1959, 1961, 1963, 1964; CMA; Dayton AI, 1962, 1963, 1964; Flint Int., Mich., 1966; Carnegie Int., Pittsburgh, 1967; WMAA, 1967; Albright-Knox A. Gal., 1968; one-man: Feingarten Gal., Los Angeles, 1966; Kent State Univ., 1968; Dartmouth Col., 1968; Martha Jackson Gal., N.Y., 1968. Positions: Instr., Cincinnati Art Academy; Painting, Drawing, Cleveland Inst. A.

STANDEN, EDITH APPLETON—Museum Associate Curator
Metropolitan Museum of Art, Fifth Avenue at 82nd St. 10028; h. 295 Central Park West, New York, N.Y. 10024
B. Halifax, Nova Scotia, Canada, Feb. 21, 1905. Studied: Oxford University, B.A. Member: CAA. Field of Interest: European Tap-

estries after 1500. Co-author: "Decorative Art from the S.H. Kress Collection," 1964. Contributor to: Art Bulletin; Metropolitan Museum of Art Bulletin and Journal (1969). Positions: Assoc. Cur. Textiles, Metropolitan Museum of Art, New York, N.Y.

STANKIEWICZ, RICHARD (PETER)—Sculptor, L.
(Mail): Star Route, Huntington, Mass. 01050; h. Worthington, Mass. 01098
B. Philadelphia, Pa., 1922. Studied: Hans Hofmann Sch. FA; and with Fernand Leger, Ossip Zadkine in Paris, France. Member: Intl. Inst. A. & Lets. (Life Fellow). Exhibited: PAFA, 1954; WMAA, 1956; Stable Gal., 1954, 1955, 1960, 1961, 1964, 1965; Univ. Minnesota, 1955; Denver Children's Mus., 1955; Hacker Gal., N.Y., 1953; Hansa Gal., 1953, 1955, 1956, 1957, 1958; Frumkin Gal., Chicago, 1955, 1957; Tanager Gal., N.Y., 1955, 1957; Martha Jackson Gal., N.Y., 1956, 1957; Camino Gal., N.Y., 1956, 1957; Silvermine Gld. A., 1957; James Gal., N.Y., 1957, 1958; WMAA, 1957; Riverside Mus., 1957, 1958; Mus. FA of Houston, 1957; Brata Gal. N.Y., 1958; Rutgers Univ., 1958; MModA, 1958; Carnegie Inst., 1958, 1959-60: VMFA; AIC; AFA traveling exh.; MModA.; Claude Bernard, Paris; WMAA; Carnegie Inst., 1961; Stockholm, Amsterdam, Copenhagen, Sao Paulo, Brazil, 1961, and others; one-man: Hansa Gal., 1953-1958; Frumkin Gal., 1958; Stable Gal., N.Y., 1959-1961; Galerie Neufville, Paris, 1960; Pace Gal., Boston, 1961; Jewish Mus., N.Y., 1964; Rodin Mus., Paris, 1965. Work: WMAA; MModA.; AIC; Albright-Knox A. Gal., Buffalo; WAC; Guggenheim Mus., N.Y., and in private colls. Lectured at Amherst Col., Miami Univ., Smith Col., State Univ. of N.Y. at Albany, Tampa AI, Skowhegan Sch. A. Positions: Prof. A., State Univ. of N.Y. at Albany, 1967- .

STAPP, RAY V.—Educator, C., P., S., Comm. A.
Eastern Illinois University; h. 42 Circle Dr., Charleston, Ill. 61920
B. Norton, Kans., July 10, 1913. Studied: Bethany Col., B.F.A., with Birger Sandzen; Kansas City AI, with Thomas Hart Benton; ASL, with DuMond, Reilly, Trafton; T. Col., Columbia Univ., M.A.; Pa. State Univ., D. Ed. Awards: Jewelry & Sc. prizes, Erie A. Center, 1960. Member: NAEA; Western AA; Illinois A. Edu. Assn. Work: Mem. painting, Farmer's Co-op, Dodge City, Kans. Exhibited: Wichita Dec. Art & Ceramic Exh., 1957; Kansas State Fed. A. traveling exh., 1949-1956; Kansas Des.-Craftsmen Exh., Lawrence, Kans., 1955. Contributor to Arts & Activities. Positions: Instr. A. & A. Edu., Bethany Col., Lindsborg, Kans., 1949-55, Asst. Prof. & Hd. A. Dept., 1955-56; Asst. Prof., 1957-60; Hd. A. Dept., 1960- , Edinboro College, Edinboro, Pa., 1957-1964; Assoc. Prof., Eastern Illinois University, 1964- .

STAPRANS, RAIMONDS—Painter
551 Sutter St., San Francisco, Cal. 94102
B. Riga, Latvia, 1926. Studied: A. Acad., Stuttgart, Germany; Univ. Washington, B.A., with George Le Brun, Archipenko; Univ. California, M.A. Awards: hon. men., Cal. State Fair, 1955; Tucson Festival, 1960. Work: CAL.PLH; Los A. Mus. A.; Santa Barbara Mus. A. Exhibited: Portland (Ore.) A. Mus.; Ross Widen Gal., Cleveland, 1959; Andre Weil, Paris, 1961; O'Hana Gal., London, 1961; St. Etienne Gal., N.Y., 1961; CAL.PLH, 1961, 1963; Maxwell Galleries, San F., 1955-1957, 1959, 1960, 1963, 1967.

STARIN, ARTHUR N(EWMAN)—Painter, I.
Box 135, Royal Oak, Talbot County, Md. 21662
B. Falls Church, Va. Studied: PIASch.; ASL; George Washington Univ., & with C.C. Rosencranz, Eliot O'Hara. Member: Acad. A., Easton, Md.; Baltimore WC Soc.; All. A. Am.; AWS; New Jersey Soc. Arch.; Rehoboth A. Lg. Work: Fla. Southern Col.; Ford Motor Co.; La Salle Col., and in private colls. Exhibited: All. A. Am., 1933-1968; Fla. Southern Col., 1952; traveling exh., Casein Paintings, 1952; AIC; Ferargil Gal.; Vendome Gal.; Wash. WC Cl.; CGA; Newark; Paper Mill Playhouse; A. Center of the Oranges, 1952; Easton (Md.) A. Festival, 1957, 1958; Morris County AA, 1948-1955; Ford Motor Co. Bldg., N.Y. World's Fair, 1964; Wash., D.C., 1964; Maryland Inst., 1962-1964; Easton Acad., 1963; Rehoboth Beach, Md., 1963; AWS; Maryland Federation Arts, Annapolis, 1967. Contributor to architectural magazines. Illus. for Ford Times, 1959- . Lectured NAD; Maryland State Col.; Chestertown Art Assoc.

STARK, GEORGE KING—Sculptor, E.
Art Department, State University College; h. 229 E. 7th St., Oswego, N.Y. 13126
B. Schenectady, N.Y., June 14, 1923. Studied: State Univ. Col., Buffalo, B.S. in A. Edu.; Columbia Univ., M.A.; Univ. Buffalo, Ed. D., in Higher Edu. Member: NAEA; Eastern AA; N.Y. State Art Teachers Assn.; Int. Soc. A. Educators. Awards: prizes, Ceramic Exhs., Everson Mus. A., Syracuse, N.Y., 1956, 1958, 1962; Buffalo Chptr. AIA, Albright-Knox A. Gal., 1957, 1960. Work: IBM; American Art Clay Co.; George Peabody Col., Nashville, Tenn.; State Univ. Col. at Buffalo and Oswego, N.Y.; Lowe A. Mus., Univ. Miami, Fla.; sculp-

ture Mervish Dept. Store Executive Suite, Toronto, Can., 1959; Savoy Hilton Hotel, N.Y.; N.Y. Coliseum, U.S. Rubber Co. display, 1959; Sheraton Palace Hotel, San Francsico; Park-Sheraton Hotel, N.Y.; Prudential Steamship Lines, N.Y.; St. Peter and Paul Church, Williamsville, N.Y. Exhibited: Albright-Knox A. Gal., Buffalo, 1957, 1960; Munson-Williams-Proctor Inst., Utica, N.Y., 1964; Everson Mus., Syracuse, 1965; Rochester Mem. A. Gal., 1966. Contributor articles to: College Art Journal, Arts & Activities, Art Education Journal, School Arts, School and Society. Positions: A. Consultant, Erie County (N.Y.) Edu. & Ext. Bd., 1952-1953; Prof. A. at State Univ. of New York units: New Paltz, 1953-1954; Buffalo, 1954-1964; Oswego, 1964- and Chm. A. Dept., 1968- ; Visiting Prof. A., Albany, 1965; Univ. Miami, Coral Gables, Fal., 1967-1968.

STARK, MELVILLE F.—Painter, E., L.
Zionsville, Pa. 18092; also, 16A School St., Rockport, Mass. 01966
B. Honesdale, Pa., Sept. 29, 1904. Studied: East Stroudsburg (Pa.) State T. Col., B.S.; Univ. Pennsylvania, M.S.; Syracuse Univ.; & with Walter E. Baum. Awards: prizes, Springfield Mus. A.; Knickerbocker A.; Univ. Pennsylvania; Phila. Fidelity Trust Co.; Nat. Soc. Ptrs. in Casein; Woodmere A. Gal., Phila. Work: Reading A. Mus.; Allentown A. Mus.; Lehigh Univ.; Muhlenberg, Cedar Crest, Moravian colleges; Kutztown State T. Col.; Allentown City Hall and School Distr.; City of Bethlehem School Distr.; Lehigh County Court House. Exhibited: PAFA; NAD; Phila. Sketch Cl.; Woodmere A. Gal.; Phila. A. All.; Reading A. Mus.; Scranton A. Mus.; Lehigh Univ.; Springfield Mus. A.; Knickerbocker A.; Univ. Pennsylvania; Nat. Soc. Ptrs. in Casein; Rockport AA; Allentown A. Mus. Positions: Director, Mel Stark Art School & Gallery Bearskin Neck, Rockport, Mass. 01966

STARKS, ELLIOTT ROLAND—Educator, A. Dir.
Wisconsin Union, University of Wisconsin 53706; h. 3509 Gregory St., Madison, Wis. 53711
B. Madison, Wis., Feb. 24, 1922. Studied: Univ. Wisconsin, B.A., M.S. in A. Edu. Member: Madison AA; Assn. of College Unions; Wisconsin Alumni Assn. Author: "Arts and Crafts in the College Union," 1962. Positions: Asst. Prof., Social Ed., Adv. and Dir., Wisconsin Union Gallery, University of Wisconsin.

STARR, MAXWELL B.—Painter, S., T.
54 West 74th St., New York, N.Y. 10023
B. Odessa, Russia, Dec. 6, 1901. Studied: NAD; BAID; N.Y. Univ. Member: Arch. Lg.; NSMP; All. A. Am.; Tiffany A. Gld.; Rockport AA; Audubon A.; AEA; North Shore A. Awards: prizes, NAD, 1919, 1921-1924, med., 1920; Tiffany Fnd. F., 1923-1924; Int. Mural Comp., 1925; Chaloner prize, 1922-1924; medal, BAID, 1922-1924; NAD, 1923. Work: Am. Mus. Numismatics; murals, U.S. Customs Office, N.Y.; Brooklyn Tech. H.S.; USPO, Siler City, N.C.; Rockdale, Tex. Exhibited: NAD; PAFA; All. A. Am.; AIC; WMAA, MModA; BMFA; WFNY, 1939; one-man: Hartwell Gal., Los Angeles, 1947; Bodley Gal., N.Y., 1959, 1961; Collectors' Gal., Wash., D.C. Positions: Founder, Dir., Maxwell Starr Sch. A., New York City and East Gloucester, Mass.*

STASACK, EDWARD ARMEN—Painter, Gr., T.
3503 Paty Drive, Honolulu, Hawaii 96822
B. Chicago, Ill., Oct. 1, 1929. Studied: Univ. Illinois, B.F.A., M.F.A. Member: Cal. Soc. Etchers; SAGA; Honolulu Pr. M.; Hawaii P. & S. Soc.; Boston Pr. M. Awards: Tiffany Fnd. grant, 1957, 1963; Rockefeller Fnd. grant, 1958; prizes, SAGA, 1956, 1957, 1961; Cal. Soc. Et., 1956; Northwest Pr. M., 1957; SFMA, 1958; Grand Prize, Art in Hawaii, 1960; Honolulu Pr. M., 1956-1960; Springfield A. Lg., 1956, 1957; Ball State Col., 1957. Work: Bradley Univ.; Univ. Illinois Student Union; Honolulu Acad. A.; SAM; SFMA; Brick Store Museum; LC; PMA; AGAA; Butler Inst. Am. A.; CM; CGA; San Francisco State Univ.; Free Lib., Philadelphia; Hunterdon A. Center; Univ. Cal., Berkeley; Achenbach Fnd.; Joslyn A. Mus.; Southern Ill. Univ.; Boston Pub. Lib.; Los Angeles County Mus.; Krakow Mus. and Poznan Mus., Poland. Exhibited: LC, 1956, 1957, 1960; Silvermine Gld. A., 1957; Hunterdon County A. Center, 1957, 1958; Albany Print annual, 1957, 1959; Wash. WC Cl., 1957; Brick Store Mus., 1956-1958, 1960; Cal. Soc. Etchers, 1956-1958; Northwest Pr. M., 1957, 1959, 1960; Phila. Pr. Cl., 1956; SAGA, 1956, 1957, 1960; SFMA, 1956, 1960, 1961; Artists of Hawaii, 1956-1960; Honolulu Pr. M.,,1956-1960; Downtown Gal., N.Y., 1960, 1965; IBM Gal., N.Y.; Carnegie Inst., 1964; Am. Acad. A. & Lets., 1965; CGA, 1965; Univ. Illinois, 1961, 1963, 1965; Ljubljana, Yugoslavia Biennal of Prints, 1963; Am. Color Pr. Soc., 1963, 1964; also, Hofstra Univ.; Univ. Cal., Long Beach; MModA, Mexico; Pratt Center for Contemp. Pr. M.; Japan Print Assn.; Smithsonian Inst. and others; one-man: The Gallery, Hawaiian Village, 1957-1959; Univ. Hawaii, 1957; Honolulu Acad. A., 1961, 1969; and others. Positions: Assoc. Prof. A., Chm. A. Dept., Univ. Hawaii, at present; Pres., Honolulu Printmakers, 1959, 1960.

STASIK, ANDREW—Painter, Printmaker
c/o Pratt Graphic Art Center, 39-17 46th St., Long Island
City, N.Y. 11104*

STEADMAN, WILLIAM E., JR.—
Museum Director, E., P., L., Collector
University of Arizona Museum of Art, Tucson, Arizo 85721; h.
3337 Via Golondrina, Tucson, Ariz. 85716
B. Pigeon, Mich., Jan. 31, 1921. Studied: Michigan State Univ., B.A.;
Univ. Arizona, B.F.A.; Yale Univ., B.F.A., M.F.A. Member:
AAMus.; Ohio WC Soc. Collection: English and American Antiques.
Exhibited: one-man: Roswell, N.M.; Grand Central A. Gal., 1955;
New Britain Inst., 1956. Contributor "The Sully Portraits at West
Point," to Antiques Magazine. Lectures. Articles published: An-
tiques Magazine, Design Magazine, "Great of Heart" Ford Times.
Catalogs: "Andrew Wyeth" Foreward; "John Marin" Foreward; "A
Giant in American Art—Thomas Hart Benton" Foreward; "Yankee
Painter-Winslow Homer" Text; "American Painting, 1765-1963" the
Fleischman Collection, Comments; "The Bird in Art" Foreward;
"The Bird in Art" Text, Art Gallery Magazine. Recent publications:
Foreword—"Walt Kuhn, Painter of Vision," "The C. Leonard
Pfeiffer Collection," (Univ. Arizona Mus. Art), "The Gallagher Col-
lection," (Univ. Arizona Mus. Art), "The George Gregson Collec-
tion." Introductions—"Charles Burchfield-His Golden Year,"
"East Side, West Side, All Around the Town" (Reginald Marsh Re-
trospective). Text—"Homage to Seurat," "La Tierra Encantada."
Preface—"Henry Moore." Positions: Instr., A. Hist. & Apprecia-
tion, Connecticut State Teachers College, New Britain, Conn.; Univ.
New Mexico, Roswell, N.M.; West Point, N.Y.; Cur., FA, United
State Military Academy, West Point, N.Y., 1953-57; Dir., Museum of
Fine Arts, Little Point, N.Y., 1953-57; Dir., Museum of Fine Arts,
Little Rock, Ark., 1957-59; Registrar, Avery Brundage Collection
deYoung Mem. Museum, San Francisco, Cal., 1961; Dir., Univ. Ari-
zona Museum of Art, Tucson, Ariz., 1961- .

STEARNS, JOHN BARKER—Educator
Department of Art, Dartmouth College; h. 3 Downing Rd.,
Hanover, N.H. 03755
B. Norway, Me., Feb. 13, 1894. Studied: Dartmouth Col., A.B.;
Princeton Univ., M.A., Ph.D. Member: Am. Philological Assn.;
Archaeological Inst. Am.; Am. Classical Lg.; Classical Assn. of
New England. Author: "Studies of the Dream as a Technical De-
vice," 1927; "The Assyrian Reliefs at Dartmouth," 1953; "Byzan-
tine Coins in the Dartmouth Collection," 1954; "Reliefs from the
Palace of Ashurnasirpal II," 1961. Contributor to Classical Weekly;
Classical Philology; Classical Journal. Positions: Instr., Hist. An-
cient Art, Classical Civilization, Alfred Univ., 1920-21, Princeton
Univ., 1922-24, Yale Univ., 1925-28; Prof., 1928- , Chm., Depart-
ment of Art, 1954- , Dartmouth College, Hanover, N.H. Prof. Emer-
itus, 1961.

STEARNS, THOMAS (ROBERT)—Sculptor, C.
Harmony Hill Farm, Patterson, N.Y. 12563
B. Oklahoma City, Okla., Sept. 4, 1936. Studied: Memphis Acad. A.;
Cranbrook Acad. A.; Acad. FA, Venice, Italy. Awards: Italian Gov-
ernment award, 1960; Fulbright travel grant, 1960; Guggenheim
Fellowship, 1965; Nat. Inst. A. & Lets. Grant, 1965. Work: Cran-
brook Mus. A. Exhibited: Venice Biennale; Brussels Intl., 1961;
Seattle World's Fair, 1962; Mus. Contemporary Crafts, N.Y.;
Czechoslovakia and Italy, 1964; Parke Bernet Gal., N.Y.; Willard
Gal., N.Y., 1964; New Jersey State Mus., 1969; Ringling Mus. A.,
Sarasota, Fla., 1968 (one-man). Guest Designer, Venini (Glass),
Venice, Italy, 1960-62.

STEBBINS, THEODORE E., JR.—Museum Curator, Scholar, Col-
lector, Critic
Yale University Art Gallery, New Haven, Conn 06510; h. 265
Pine Orchard Rd., Branford, Conn. 06405
B. New York, N.Y., Aug. 11, 1938. Studied: Yale College, A.B.;
Harvard University, LL.B., M.A. Awards: Chester Dale Fellowship,
National Gallery of Art, Washington, D.C., 1966-1967. Publications:
"Art Since 1956," exhibition catalogue, Lamont Gallery, Exeter,
N.H.; "Luminous Landscape: The American Study of Light, 1860-
1875," Fogg Museum exhibition catalogue, 1966; "Richardson and
Trinity Church," article in Journal of the Society of Architectural
Historians, 1968; "Martin J. Heade," Whitney Museum, 1969, and
various other articles on 19th and 20th century American art.
Member: Art Collectors Club of America; AFA. Collection: Old
Master Prints; 19th century American landscape and still-life
paintings; contemporary American painting and sculpture. Posi-
tions: Instr., Art History, 1967-1968, Associate Curator of Ameri-
can Art, Yale University Art Gallery, 1968- .

STECHOW, WOLFGANG—Educator
325 West College St., Oberlin, Ohio 44074
B. Kiel, Germany, June 5, 1896. Studied: Univ. Göttingen, Germany,
Ph.D. Member: CAA; Archaeological Inst. Am.; Am. Soc. for Aes-
thetics; Nat. Comm. for the History of Art. Awards: Univ. of Michi-
gan, L.H.D., 1966; Oberlin Col., D.F.A., 1967. Author: "Apollo und
Daphne," 1932, new edition, 1965; "Salomon van Ruysdael," 1938;
"Dutch Landscape Painting of the Seventeenth Century," 1966, sec-
ond edition, 1968; "Northern Renaissance Art, 1400-1600," 1966;
"Rubens and the Classical Tradition," 1968; various museum & ex-
hibition catalogs. Contributor to: Art in America, Art Quarterly,
Art Bulletin, Gazette des Beaux-Arts, & other art magazines. Lec-
tures: Renaissance and Baroque Art; Iconography; Aesthetics. Po-
sitions: Acting Asst. Prof., 1936, Assoc. Prof., 1937-40, Univ. Wis-
consin; Prof. Hist. A., Oberlin Col., Oberlin, Ohio, 1940-1963; Prof.
Emeritus and Lecturer in History of Art, Oberlin College, and
Advisory Curator of European Art, Cleveland Museum of Art, 1964-
1966; Visiting Prof., Univ. Michigan, 1963-64; Ed-in-Chief, Art Bul-
letin, 1950-52. Memb. Com. on Visual Arts, Harvard Univ., 1954-
56; Adv. Council, Dept. of Germanic Languages & Literatures,
Princeton Univ.; Visiting Prof., Williams Col., 1966-1967; Adjunct
Prof., Case Western Reserve Univ., 1967- ; W.A. Neilson Research
Prof., Smith Col., spring 1969; appointed Mellon Prof. of A., Vassar
Col., 1969-1970.

STECZYNSKI, JOHN MYRON—Educator, L., P., C.
Sunnyside Lane, R.F.D. #2, Lincoln, Mass. 01773
B. Chicago, Ill., June 22, 1936. Studied: AIC; Craft Center, Worces-
ter, Mass.; Univ. Notre Dame, B.F.A.; Yale Univ., M.F.A.; Acad.
FA, Warsaw, Poland, and with Umberto Romano. Awards: Woodrow
Wilson F., Yale Univ., 1958; Polish Govt. Grant to Warsaw, 1960;
Chopin FA Cl. award, Butler Inst. Am. Art, 1961; Polish Arts Cl.,
Chicago, prize, 1959; Univ. Illinois, 1953. Work: wood relief panels,
Ursuline Provincialate, Kirkwood, Mo.; wood sculpture, Moreau
Seminary, Notre Dame, Ind.; banners, Little Flower Church, South
Bend, Ind.; St. Mark's Episcopal Church, Worcester, Mass., and
others. Exhibited: BM, 1961 and circulated by AFA; Council of
Polish Cultural Clubs Nat. Exh., 1961; Univ. Notre Dame A. Gal.,
1956-1958; Chicago Arts Exh., 1957, 1958; Polish A. Cl., Chicago,
1958, 1959; Yale Univ. Gal. A., 1960, 1961; Craftsmen of the North-
eastern States, Worcester, Mass., 1963; Craftsmen of the Eastern
States, 1963-64 (circulated by Smithsonian Institution); Christo-
centric Arts Festival, Univ. Illinois, 1964; Prints for Collectors,
Worcester Craft Center, 1964; one-man: Warsaw, Poland, 1961;
Worcester A. Mus., 1961. Lectures: Modern Liturgical Art; Polish
Folk Art; Byzantine Art to clubs, university groups. Positions:
Prof. A., Sch. of the Worcester A. Mus., Worcester, Mass.; Instr.,
A. Hist., BMFA Sch., 1961-1963; Chm., Dept. A., Newton Col. of
the Sacred Heart, Newton, Mass. at present.

STEEL, MRS. RHYS CAPARN. See Caparn, Rhys

STEELE, IVY (Mrs. Henry B., Jr.)—Sculptor, P., T.
456 West Barry Ave., Chicago, Ill. 60657
B. St. Louis, Mo., Apr. 15, 1908. Studied: Wellesley Col., B.A.,
Washington Univ. Sch. FA, St. Louis, and with Todros Geller, Eu-
gene Deutsch; Cosmo Campoli. Member: AEA (V. Pres., 1962-65;
Sec., 1965-1969); Chicago Soc. A. (Dir. 1965- , V.P., 1966-1968,
Pres. 1968); Perspective; A. Cl. of Chicago; Renaissance Soc. of
Univ. Chicago. Work: Sculptures: Covenant Methodist Church,
Evanston, Ill.; Highland Park Hospital, Ill. and in private colls. Ex-
hibited: Oakland A. Mus., 1936; Grand Rapids A. Gal., 1940; Okla-
homa A. Center; AIC, 1935, 1936, 1940, 1944, 1951; Chicago Sculp-
tors, 1944; Univ. Chicago, 1953, 1964; AIA, Chicago, 1959; Devorah
Sherman Gal., 1960, 1965-1969; McKerr Gal., 1961; Feingarten Gal.,
1961-1965; Bresler Gal., Milwaukee, 1961-1965; Ruth White Gal.,
N.Y., 1964, 1965; Illinois Inst. Tech., 1962; Chicago Pub. Lib.,
1964; AIC, 1962-1968; Renaissance Soc., 1948-1969; Nat. Des. Cen-
ter, Chicago, 1967; Univ. Illinois, 1967; Sculptors' Gal., St. Louis,
1968; Studio Gal., Geneva, Ill., 1968-1969. Positions: Instr., Child-
ren's Art, Francis W. Parker School, 1941-44; Hull House, Art
Dept., 1947-56. Instr., Sculpture, Adjunctive Therapy Dept., Mi-
chael Reese Hospital, 1960-1969.

STEFANELLI, JOSEPH—Painter
158 W. 22nd St., New York, N.Y. 10011*

STEG, J(AMES) L(OUIS)—Educator, Pr.M.
Art Department, Newcomb College, Tulane University; h. 7919
Spruce St., New Orleans, La. 70118
B. Alexandria, Va., Feb. 6, 1922. Studied: Rochester Inst. Tech.;
State Univ. of Iowa, B.F.A., M.F.A., with Mauricio Lasansky.
Awards: prizes, Phila. Pr. Cl., 1950, 1964; purchase prizes: BM,
1948, 1952; DMFA, 1953, 1958; LC, 1948; SAM, 1949, 1964; Univ.
Minnesota, 1950; Delgado Mus. A., 1952, 1953, 1955, 1965; 8th Int.
Drawing & Print. Exh., Lugano, Switzerland, 1964. Work: LC; BM;
SAM; FMA; MModA; WMA; DMFA; Carnegie Inst.; N.Y. Pub. Lib.;
PMA; CMA; Munson-Williams-Proctor Inst.; Delgado Mus. A.;
Univs. of: Minn, Neb., Del.; Albion Col.; Princeton Pr. Cl.; **Bezalel**

Mus., Israel; Mus. Mod. A., Sao Paulo, Brazil; Davenport Mus.; Wesleyan Univ.; De Pauw Univ.; Okla. Pr. Soc; IBM Coll.; Pace College; Sweet Briar College; Univ. So. Florida; USIA Coll. Exhibited: nationally and abroad; one-man: Weyhe Gal., 1945; Phila. A. All., 1957; Munson-Williams-Proctor Inst., 1951; Davenport Mus. A., 1958; Orleans Gal., New Orleans; Newcomb A. Gal. Positions: Prof. A., Tulane University, New Orleans, La.

STEIG, WILLIAM—Cartoonist, S.
 East St., Sharon, Conn. 06069
B. New York, N.Y., Nov. 14, 1907. Studied: Col. City of N.Y.; NAD. Work: sculpture, Smith Col.; R.I. Mus. A.; painting, BM. Exhibited: Downtown Gal., and in various group exhibitions. Author, I., Books of Drawings: "The Lonely Ones"; "About People"; "All Embarrassed"; "Till Death Do Us Part"; "Persistent Faces"; "Small Fry"; "The Agony in the Kindergarten"; "The Rejected Lovers"; "Dreams of Glory." Illus., "Listen Little Man." Contributor to the New Yorker and other leading magazines.*

STEIN, HARVE—I., P., L., E.
 P.O. Box 237, Noank, Conn. 06340
B. Chicago, Ill., Apr. 23, 1904. Studied: AIC; Julian Acad., Paris, and with Harvey Dunn. Member: SI (Hon. Life); AWS; Audubon A.; A. Fellowship; AAUP; Appraisers Assn. of Am. Awards: prizes, Cert., Chicago Book Clinic, 1952; Audubon A., 1955; Providence WC Cl., 1956; New Haven P. & Clay Cl., 1957; Providence A. Cl., 1963. Work: U.S. State Dept.; Univ. Minnesota; Brown Univ.; Public Archives, Toronto, Canada; Montclair A. Mus.; N.Y. Pub. Lib; Univ. of So. Mississippi. Exhibited: National watercolor exhs. throughout U.S. Illustrator of many books. Contributor to national magazines. Author article "The Illustrator Explains," American Artist magazine, 1958. Positions: Instr., Painting, Connecticut College, 1946, 1947, 1951; New London A. Students Lg., 1948-1959; Mitchell Col., New London, Conn., summer session, 1955-56. Dir., Stone Ledge Studio Art Galleries, Noank, Conn., 1963- . Prof. Emeritus FA., Rhode Island Sch. Des., 1944-

STEIN, MAURICE JAY —Painter, Comm., Des., S., T.
 Studio 6-A, 969 Park Ave. 10028; h. 969 Park Ave., New York, N.Y. 10028
B. New York, N.Y., Mar. 26, 1898. Studied: Cooper Union A. Sch.; Pratt Institute, Brooklyn; City College of New York; Columbia Univ. Member: F., Royal Soc. A., London; Nat. Soc. A. & Lets. (Treas., 1966-1967); Hon. Member, Catholic FA Assn.; Am. Veterans Soc. A.; Hon. member, Kappa Pi. Awards: Gold Medal, Hunter College, 1962; Grumbacher award, 1961. Work: Series of portraits of professional golfers and other sports figures; work is in Pelham Bay Golf Club, N.Y.; Bobby Jones Golf Club, Sarasota, and others. Exhibited: William Farnsworth Museum of Art, Rockland, Me., 1963, 1964. Founder, Palette Scholarship Award; Instr., Golden Age Group Synagogue, New York City.

STEIN, RONALD—Painter
 76 E. 79th St., New York, N.Y. 10021*

STEIN, WALTER—Painter, I.
 11 Cooper Square, New York, N.Y. 10003
B. New York, N.Y., Nov. 30, 1924. Studied: Cooper Union Sch. A.; ASL; Accademia di Belle Arte, Florence, Italy; N.Y. Univ.; New School for Social Research. Work: FMA; MModA; BMFA; PC; AIC; Yale Univ. A. Gal.; Walter P. Chryster Coll.; MMA. Exhibited: CGA; WMAA; Inst. Contemp. A.; Boston Graham Gal.; Durlacher Bros. Gal.; Vassar Col.; Rhode Island Sch. of Des.; Rosequist Gal., Phoenix, and others. Works Published: Lithographs in "Natural History," Jule Renard, publ. by Dept. of Printing & Graphic Arts, Harvard College, 1960; woodcuts and engravings, "A Common Botany," 1956; author, illus., "Painting," 1945. Illus., "Elegy" by Chidiock Tichborne, 1967, one of AIGA's "50 Best Books of the Year." Illus., "Natural Histories," by Toulouse-Lautrec, Bonnard, Stein, 1967. Positions: Instr., drawing, Cooper Union A. Sch.

STEINBERG, ISADOR N.—Painter, Des., I.
 57 West 69th St., New York, N.Y. 10023
B. Odessa, Russia, June 14, 1900. Studied: Sch. Des. & Liberal A.; ASL; N.Y. Univ.; Grande Chaumiere, Paris, and with John Sloan, Max Weber. Awards: Scholarship, Sch. Des. & Liberal A.; AIGA, 1941; Fifty Books of the Year, 1939. Exhibited: Newark A. Cl., 1935; AIGA Fifty Books of the Year and Textbook Exh., 1939, and others including 1958. Illus., technical and scientific books including Einstein's "Evolution of Physics"; Mayer's "Artist's Materials and Techniques"; "Tools of War"; "Military Roentgenology"; Columbia Viking Encyclopaedia, 1953; Dictionary of Antiques and Decorative Arts, 1957; "Exploring Science," 1958, and others. Wrote, des., executed U.S. Army courses in Botany, Surveying, Lettering, Mechanical Drawing, etc. Positions: L., Sch. Des.; Consultant on book

production & illustration to Pentagon, 1943; former Instr., Adv. Des., Columbia Univ., Extension; Owner, York Studios, New York, N.Y.*

STEINBERG, MRS. MILTON—Art Director
 Brandeis University, Waltham, Mass.; h. 500 E. 77th St., New York, N.Y. 10021
B. New York, N.Y., May 9, 1910. Studied: Hunter College, N.Y.; Butler University, Indianapolis, Ind., B.A. Positions: Executive Director, Brandeis Creative Arts Awards Program.*

STEINBERG, SAUL—Painter, Cart., Des.
 3 Washington Square Village, New York, N.Y. 10012
B. Roumania, June 15, 1914. Studied: R. Politecnico, Milan, Italy. Member: Nat. Inst. A. and Lets., 1968. Work: MModA; MMA; FMA; Detroit Inst. A.; Victoria & Albert Mus., London; murals, Plaza Hotel, Cincinnati; four Am. Export Lines ships. Exhibited: MModA, 1946; Betty Parsons Gal., 1952, 1966, 1968; Sidney Janis Gal., 1952, 1966; Inst. Contemp. A., London, 1952; AIC, 1949; Obelisco, Rome, 1951; New Sch. A. Center, 1967; one-man: Galerie Mai, Paris, 1953; Kunstmuseum, Basel, 1954; Stedelijk Mus., Amsterdam, 1953; Museo de Arte, Sao Paulo, Brazil, 1952; Galerie Blanche, Stockholm, 1953; Hanover, 1954; AFA, 1953-55. Author: "All in Line," 1945; "The Art of Living," 1949; "The Passport," 1954. Contributor to national magazines.

STEINBOMER, DOROTHY H. (Mrs. Henry)—
 Sculptor, C., Des., P., A. Libn., L.
 800 Burr Rd., San Antonio, Tex. 78209
B. Bayonne, N.J., May 27, 1912. Studied: Our Lady of the Lake Col., B.A., M.L.S.; Univ. of the Americas, Mexico City, M.F.A., and with Harding Black; Etienne Ret; Michael Frary; Dan Lutz; Fletcher Martin. Member: CAA; Stained Glass Assn. of Am.; AFA; Am. Craftsmen's Council; Craft Gld. of San Antonio; Texas FA Assn.; FA Adv. Council, Univ. Texas; San Antonio A. Lg. (Pres. 1956-58); Church Architectural Gld. of America; Mexican-American Cultural Exchange Inst. (Pres. 1965). Work: stained glass windows: Jefferson Methodist Chapel, Redeemer Lutheran Church, Northwood Presbyterian Church, Aldersgate Methodist Church, all in San Antonio; St. John Lutheran Church, Temple, Tex.; fused glass hanging Cross, First Presbyterian Church, Midland, Texas; fused glass and metal sc., Holiday Inn, Dallas; screen, McClaugherty Chapel, San Antonio; fused glass sculpture, Medical Center, Houston, and in private colls. Organized two international exhs. (Arch.) for Hemisfair, San Antonio, 1968. Exhibited: Texas FA Assn., 1957 (2-man); Southwest Tex. State College, 1956; A. & M. Col., 1959; Witte Mem. Mus., 1957, 1960; Artisans Gal., Houston, 1960; 4023 Galleries, Dallas, 1961; Craft Gld. of San Antonio, 1962-1965. Numerous studio shows in Southwest of stained glass. Organized Community Arts Forum, San Antonio; organized national "Faith Into Form" exhibition (Church Arch. Gld.) Dallas, 1964. Positions: L., visual arts series, and A. Librarian, St. Mary's Univ., San Antonio, Tex., 1967- .

STEINFELS, MELVILLE P.—Painter, Des., I., E.
 322 Talcott Pl., Park Ridge, Ill. 60068
B. Salt Lake City, Utah, Nov. 3, 1910. Studied: AIC; Chicago Sch. Des. Work: Murals (buon fresco, fresco secco, mosaic, ceramic tile)—Church of the Epiphany, Chicago; Loyola Univ., Chicago; St. Mary's Capuchin Seminary, Crown Point, Ind.; Newman Cl., Ann Arbor; St. Mary Magdalen Church, Melvindale, Mich.; Chapel of Siena Heights Col., Adrian, Mich.; Mary, Seat of Wisdom Church, Park Ridge, Ill.; Holy Ghost Fathers Seminary, Ann Arbor, Mich.; (mosaics) Our Lady of Good Counsel Church, Plymouth, Mich.; Colombiere College, Clarkston, Mich.; St. Gerard's Church, Detroit; St. Michael's Church, Pontiac, Mich.; paintings, in churches in Memphis, Tenn., Detroit, Mich. Positions: A. in Residence, Siena Heights Col., Adrian, Mich., 1945-50. Lectures: Fresco Painting.

STEINITZ, KATE TRAUMAN—Art Curator
 Elmer Belt Library of Vinciana, University of California, Los Angeles, Cal. 90024; h. 11842 Goshen Ave., Los Angeles, Cal. 90049
B. Beuthen, Germany, Aug. 2, 1889. Studied: in Berlin with Kollwitz, Lovis Corinth; Univ. Paris, Grand Chaumiere, Sorbonne, Tech. Hochschule, Hanover, Germany. Member: Am. Soc. for Aesthetics; Los A. County Mus. Assn.; Special Libraries Assn. Mus. Group; Archaeological Inst. Am. Awards: State Dept., Specialists' Div., travel grant to Europe, 1956; Kress Fnd. grant to deliver Lettura Vinciana in Venice, 1969. Works: Hanover, Germany, Mus.; Societe Anonyme, Yale Univ. Exhibited: Berlin, Hanover, Germany; N.Y. Pub. Lib.; WFNY 1939. Contributor to art magazines in the U.S. and abroad. Author: "Leonardo da Vinci's Manuscripts," 1948; "Leonardo da Vinci's Trattato della pittura," Research Monography, 1956; "Kurt Schwitters Erinnerungen & Gespräche," Zurich, Arche, 1963, English edition, 1968. Lectures: Leonardo da Vinci; Modern Art; de-

livered 9th Lettura Vinciana, Venice, 1969. Arranged exhibitions of rare books and exhibitions of da Vinciana, Univ. Southern Cal., Redlands Univ., Los A. Mus. A., Cal. State Exhibitions, UCLA, Los A. Pub. Lib., 1945-1952. Positions: Cur., The Elmer Belt Library of Vinciana, Univ. California, Los Angeles, Cal.; Instr., Italian Renaissance, Pomona College, Claremont, Col., 1958-59, UCLA ext. div.

STEINKE, BETTINA (BLAIR)—Portrait Painter
 Box 933, Taos, N.M. 87571
B. Biddeford, Me., June 25, 1913. Studied: CUASch., with Alpheaus Cole; Phoenix AI, with Gordon Stevenson, Thomas Fogarty. Member: SI; Press Cl. Awards: prize, New Rochelle AA; medal, CUASch. Work: Baldwin Piano Co.; Circus Saints & Sinners Coll.; The Press Box, N.Y.; Pratt & Whitney Co.; United Fruit Co.; Standard Oil Co. of New Jersey; Philbrook A. Center; Baylor Medical Center, Dallas; Kansas Power & Light Co., Topeka; NBC, and many others including work in private colls. Exhibited: Richardson Bros., Winnipeg, Can., 1953-54; SI, 1950; A. Center, Curacao, N.W.I., 1947; Oklahoma City A. Center, 1953, 1968 (one-man); Philbrook A. Center, 1952; Tucson, Ariz., 1951; Reynolds Gal., Taos, N.M., 1955; Blair Gals., Santa Fe, N.M., 1965- ; New Rochelle AA, 1940, etc. Illus., "NBC Symphony Orchestra," 1939 (98 portraits); other books of portraits, 1946, 1948; "The Last War Trail," 1954. Positions: Pres., Harwood Advisory Board, University of New Mexico.

STEINMANN, MR. and MRS. HERBERT—Collectors
 745 Fifth Ave. 10022; h. 9 E. 81st St., New York, N.Y. 10028

STEINMETZ, GRACE TITUS—Painter, E., Gr.
 Box 270, R.D. No.2, Manheim, Pa. 17545
B. Lancaster, Pa., Apr. 17, 1911. Studied: PAFA; Barnes Foundation; Abbott Art Sch.; Millersville State Col., B.S. in Edu.; Univ. Pennsylvania M.S. in Edu. (Science). Member: Nat. Soc. Ptrs. in Casein; F., Royal Soc. A. Awards: prizes, Lancaster County AA, 1953, 1960, 1966, 1967, 1969; Harrisburg AA, 1965; Delaware Valley A. Group, 1965, 1968; Nat. Soc. Painters in Casein, 1969; New Jersey P. & S., 1969; Lancaster Open, 1963, 1965, 1968; juried exh., Lancaster, 1960. Work: Florida Southern College; Millersville State College. Exhibited: Nat. Soc. Ptrs. in Casein, 1963-1965; Quarryville A. Festival, 1965; F., PAFA, 1964; Indiana State Col., 1952; Southeastern Regional, 1960; Harrisburg AA, 1965; Lancaster, 1959-1968; Echo Valley A. Group, 1963-1969; Lancaster County AA, 1936-1969; Frost Gal., N.Y., 1968 (one-man); AWS, 1968; Lancaster Festival A., 1968; Painters in Casein traveling exh., 1963, 1969; Old Bergen A. Gld., 1965, 1969. Positions: Adjunct Prof. Painting, Elizabethtown (Pa.) College.

STELL, H. KENYON—Scholar, Art Admin., Art Historian
 State University College 13045; h. Cosmos Hill Road, Cortland, N.Y. 13045
B. Adams, N.Y., Jan. 22, 1910. Studied: Syracuse Univ., B.F.A. and Graduate Resident Study; N.Y. Univ., M.A. Field of Research: Art and Art History (organized Cortland College art history program). Exhibited: Nassau-Suffolk A. Lg.; Assoc. A. of Syracuse; State Univ. Art Faculty Exhs. Positions: Pres., Huntington T. Assn., 1943-45; A. Chm., N.Y. State T. Col. Faculty Assoc. Conf., Lake Placid, 1950; Dir., N.Y. State Fair A. Show, 1951; Pres., Cortland College Chptr. AAUP, 1952; organizer, Art Exh. Assn. and Annual A. Festival, State Univ. College, 1955, 1956; Recipient of 15-year Citation, NAEA, 1960; Art Show Advisory Comm., N.Y. State Exposition, 1962-1970; juror for exhibitions including Buffalo Soc. Artists, Roberson Mem. Members' Show, Scholastic Awards Exhs., at Syracuse, Rochester and Binghamton, 1955-1965; Chm., College Cultural Comm., 1959-63; Dir.-Organizer, Cortland State Univ. "Art in Western Europe" study program, summer 1963 (group lecturer in National Gallery, London, Rijksmuseum, The Louvre, Glyptotek, Uffizi Gal., Florence and places of art interest in Rome. Mayor's Advisory Com. on Revitalization of Downtown Cortland, 1969. Sabbatical leave for art research in 50 galleries in U.S. and Mexico, 1968. Prof. A., Chm., Art Department, State University College at Cortland, N.Y., 1947-1966; Prof. A. Hist. at present.

STELLA, FRANK—Painter
 84 Walker St. 10013; h. 29 E. 73rd St., New York, N.Y. 10021
B. Malden, Mass., May, 1936. Studied: Phillips Academy; Princeton Univ. Work: MModA; WMAA; Pasadena A. Mus.; Albright-Knox A. Gal., Buffalo; WAC. Exhibited: MModA, 1960; Guggenheim Mus., 1960; CGA, 1963; WMAA, 1964; Venice Biennale, 1964; Seattle World's Fair, 1962.*

STENBERY, ALGOT—Painter, I., T.
 144 Bleecker St., New York, N.Y. 10012
B. Cambridge, Mass., Apr. 24, 1902. Studied: Hartford A. Sch.; BMFA Sch.; ASL; & with Kimon Nicolaides, Frederick Bosley, Albertus Jones. Member: An Am. Group; Audubon A.; SC. Work: MMA; murals, Harlem Housing Project; USPO, Wayne, Mich. Ex-

hibited: PAFA, 1939; WFNY 1939; WMAA, 1945; Walker A. Gal., 1937 (one-man); AWCS., 1966, 1967. Illus., "The Giant"; "Far Country"; "Bridges at Toko-Ri"; "Little Britches"; "The Sojourner"; "Time to Remember"; "Seven Steeples"; also numerous juveniles.

STEPHENS, RICHARD—Painter, Cart., L., T., Comm. A.
 604 Sutter St., San Francisco, Cal. 94402; h. 23 De Sabia Rd., San Mateo, Cal.
B. Oakland, Cal., Dec. 3, 1892. Studied: Univ. California; Scripps Col.; Cal. Col. A. & Crafts; Cal. Sch. FA; Andre L'Hote, Julian Acad., Paris, France. Member: Cal. WC Soc.; A. & A. Dir. Cl.; San F. Advertising Cl. Awards: prizes, San Mateo Fair, 1954, 1960. Work: Scripps Col. Exhibited: Drawing Exh., San F., 1940; Oakland A. Gal., 1930-1940, 1945, 1949; Santa Cruz, Cal., 1940, 1948, 1949; Cal. WC Soc., 1950, 1952; Scripps Col., 1951; Gump's Gal., San F., 1935; Raymond & Raymond, 1933; City of Paris, San F., 1948-1952, 1955; Richmond, Cal., 1953; Sherman & Clay Gal., San Francisco & San Mateo, 1961; Howland Gal., San F., 1961; Winblad Gal., San F., 1964. I., "Glen Warner's Book for Boys," 1932; "Live English." Contributor cartoons to Sunset, College Humor, American Artist, Western Advertising, Judge magazines. Positions: Founder, Instr., Acad. Art, San Francisco, Cal.*

STERLING, MRS. ROBERT—Patron
 14 E. 77th St., New York, N.Y. 10021*

STERN, MR. and MRS. ARTHUR L. (MOLLY S.)—
 Collectors, Patrons
 One Exchange St.; h. 3365 Elmwood Ave., Rochester, N.Y. 14610
(Mrs. Stern)-B. New York, N.Y., Apr. 21, 1913. Studied: Goucher College, A.B. Awards: Phi Beta Kappa, 1934. (Mr. Stern)-B. Rochester, N.Y., Apr. 11, 1911. Studied: Yale University, A.B.; Harvard University, LL.B. Collection: Predominately abstract expressionism. Positions: (Mr. Stern)-President, Board of Managers, 1961-1964, Chairman of Board, 1965- , Member of Board, 1956- , Rochester Memorial Art Gallery; President, 1956-1958, Member Board, 1949- , Chairman of Board, 1958-1960, Rochester Civic Music Association; Chairman, Board of Trustees, Rochester Institute of Technology, 1961- .

STERN, HAROLD PHILLIP—Assistant Museum Director, W., L.
 Freer Gallery of Art, Jefferson Dr. at 12th St., S.W. 20560; h. 2122 Massachusetts Ave., N.W., Washington, D.C. 20008
B. Detroit, Mich., May 3, 1922. Studied: Political Science, B.A., Center for Japanese Studies, M.A., Art History-Japan, Ph.D., University of Michigan. Member: Japan-America Society of Washington; American Oriental Society. Awards: Freer Fellowship, 1950. Author: "Masterpieces of Korean Art," 1957; "Hokusai: Paintings and Drawings in the Freer Gallery of Art," 1960; "Master Prints of Japan," 1969; Co-editor: "Art Treasures from Japan," 1965. Lectures: Ukiyoe; Tokugawa Painting; "Life in 14th Century Japan "; "The Korean Imperial Treasures"; "Japanese Art" to museums, galleries, universities and the Japan Society. Taught Ukiyoe Painting at University of Michigan. Positions: Hon. lecturer, University of Michigan (current); Advisor to two Japanese Government Loan Exhibitions, 1953 and 1965-1966; Advisor on Korean Government Loan Exhibition, 1957-1958; Assistant Director, Freer Gallery of Art, Washington, D.C., 1962- .

STERN, JAN PETER—Sculptor
 14640 Hilltree Rd., Santa Monica, Cal. 90402
B. Berlin, Germany, Nov. 14, 1926. Studied: Syracuse Univ., Col. FA, B.I.D. Work: Smithsonian Inst. (installed on Capitol Mall, Wash., D.C.); Pa. State Univ.; Storm King A. Mus., Mountainville, N.Y.; Atlantic Richfield Coll.; Joseph H. Hirshhorn Coll.; monumental sculptures for: Maritime Plaza, Golden Gateway Center, San F.; Inst. Science & Tech., Univ. of Michigan; Prudential Center, Boston; Random House Bldg., New York, N.Y.; Alcoa Hdqtrs., Chicago; Cardinal Spellman Retreat House, New York. Exhibited: AFA traveling exh., 1965-1966; Mus. Contemp. A., Chicago, 1968; CAM, 1968; Phoenix (Ariz.) Mus. A., 1967; Pennsylvania State Univ., (one-man); N.Y. World's Fair, 1964; New Sch. for Social Research, N.Y., 1960 (one-man); Barone Gal., N.Y., 1960 (one-man); Santa Barbara Mus. A., (one-man). Programs produced about his work by Educational TV, Los Angeles and Boston.

STERNBERG, HARRY—Painter, Gr., T., L., W.
 Rt. 2, Box 1651, Escondido, Cal. 92025
B. New York, N.Y., July 19, 1904. Studied: ASL; & with Harry Wickey. Member: AEA. Awards: Guggenheim F., 1936; Fifty Prints of the Year, 1930; Fine Prints of the Year, 1932-1934; 100 Prints of the Year, 1938; prize, Phila. Pr. Cl., 1942; Assoc.Am.A., 1946, 1947; Audubon A., 1955. Work: MModA; MMA; WMAA; N.Y. Pub. Lib.; Lib. Cong.; FMA; PMA; CMA; BM; AGAA; Univ. So. Cal.;

deYoung Mem. Mus., San F.; New Zealand Mus. A.; Nat. Mus., Tel Aviv; WAC (complete coll. of all Sternberg's prints); Univ. Minnesota (complete coll. of Sternberg's graphics); Victoria & Albert Mus., London, England; Bibliotheque Nationale, Paris, France; murals, USPO, Chicago, Ill.; Chester, Pa.; Sellersville, Pa. Included in "Modern Masters of Intaglio," Queens College, 1964. Exhibited: nationally. One-man: ACA Gal., 1956, 1958, 1960, 1965; Univ. Minnesota, 1957; Gorelick Gal., Detroit, 1958; Brigham Young Univ., 1958; Idyllwild Sch. A., 1958; Gallery Eight, Santa Barbara, 1961; Salt Lake A. Center, 1961; Heritage Gal., Los A., 1964. Group exh., "Drawing: USA," 1964, St. Paul, Minn. Author, I., "Silk Screen Color Printing," 1945; "Modern Methods and Materials of Etching," 1949; "Composition," 1958; "Modern Drawing," 1958; "Woodcut," 1962. Positions: Instr., Graphic A., painting, ASL. Summer Instr., Idyllwild (Cal.) School of Art, 1957, 1958; L. & Workshop, Brigham Young Univ., Provo, Utah, 1958. Dir. & produced art film, "The Many Worlds of Art," 1960.

STERNE, DAHLI—Painter, S.
315 W. 70th St., New York, N.Y. 10023
B. Stettin, Germany, 1901. Studied: Kaiserin Auguste Victoria Acad., B.A.; and in the U.S. with Albert Pels, Ludolf Liberts, Josef Shilhavy. Member: 50 Am. Artists; Nat. Soc. A. & Lets; All. A. Am., AAPL; Wolfe A. Cl.; Hon. Memb., Kappa Pi; F., Royal Soc. A., London, England. Awards: prizes, Grumbacher award, 1952; AAPL, 1955; citation, Okla. AA, 1954; citation, Seton Hall Univ.; gold medal, Ogunquit A. Center, 1957. Work: Oklahoma City A. Center; Evansville Mus. A.; Fla. Southern Col.; Seton Hall Univ.; Gracie Mansion, N.Y.; Hunter Col.; Mount St. Vincent College, N.Y. Exhibited: NAC, 1953-1958; All. A. Am., 1955; 50 Am. Artists, 1955-1958; Grace Pickett traveling exh.; Grumbacher traveling exh.; one-man: New York City. Contributor illus. to Today's Art magazine. Art Dir., exhibitions of Nat. Council of Jewish Women.

STERNE, HEDDA—Painter
179 East 71st St., New York, N.Y. 10021
B. Bucharest, Roumania, Aug. 4, 1916. Studied: abroad. Awards: Tamarind Fellowship, 1967. Work: Univ. Illinois; MMA; MModA; Univ. Nebraska; AIC; U.N. Bldg., New York; WMAA; Carnegie Inst. Exhibited: PAFA, 1947-1952; Carnegie Inst.; MMA; WMAA; AIC; MModA; Santa Barbara Mus. A.; Los A. Mus. A.; Albright A. Gal.; VMFA, SFMA, Vassar Col.; Saidenberg Gal.; Chicago A. Cl.; CGA; Univ. Nebraska; Soc. Contemp. A.; WMA; MModA traveling exh.; Univ. Illinois, and others. Numerous one-man shows, including Sao Paulo, Brazil, 1953; Rome, Italy; San Francisco, Cal., and Betty Parsons Gal., regularly.*

STEVENS, BERNICE A.—Craftsman, T.
Box 564, Gatlinburg, Tenn. 37738
B. Evansville, Ind. Studied: Univ. of Evansville, B.S.; Univ. Tennessee, M.S. in crafts; Gatlinburg Craft Sch.; Ringling Sch. A.; Saugatuck Sch. Painting. Member: Hoosier Craft Gld; AAUW; So. Highland Handicraft Gld.; 12 Des.-Craftsmen. Awards: Delta Kappa Gamma Fellowship, 1955; Ford F., 1955-56. Exhibited: Huntington, W. Va., Nat. Jewelry Exh., 1955, and Rochester, N.Y., 1956, circulated by Smithsonian Inst.; Southern Highlands Handicraft Gld. Fair, 1948-1950, 1959-1969; Evansville Tri-State Exhs., 1940-1956; Hoosier Craft Gld., 1950-1956; Louisville, Ky., 1955; John Herron AI, 1955; Ft. Wayne traveling exh., 1955; Des.-Craftsmen USA, 1960, Plum Nelly Exh. (Ga.), 1963-1969; BMA, 1966. Contributor to School Arts Magazine; Creative Crafts; Ford Times; Handweaver & Craftsman magazines. Included in "Artisans of the Appalachians," 1967; author, chapter on Crafts in "The Southern Appalachian Region," (Univ. Kentucky); contributor to American Girl magazine and author of occasional teen-age stories. Author: guide book of crafts in the Smokies area–"Our Mountain Craftsmen," 1969. Positions: Instr. A. & Crafts, Evansville Pub. Schs., 1927-55; Jewelry, Evansville Col., 1947-55; Jewelry, Cherokee, N.C., summer, 1954-1963; Jewelry, Arrowmont Sch. of Crafts, Univ. Tennessee, summers, 1964-1969. Conducted craft survey of the Southern Highlands for Southern Appalachian Studies, sponsored by Ford Fnd. Education Dir., Southern Highlands Handicraft Gld., 1959-63; Instr. Crafts for the State Department, to youth leaders in Malaya, 1960-61 (3 mos.); studio craftsman and producer (part-owner) for shop of 12 Designer-Craftsmen, Gatlinburg.

STEVENS, DWIGHT ELTON—Designer, P., E.
151 South Willis St., Stillwater, Okla. 74074
B. Sharon, Okla., May 1, 1904. Studied: Oklahoma A. & M. Col., B.S. in Arch.; Cincinnati A. Acad. Member: Nat. Inst. Arch. Edu.; SSAL; AIA; Cal. WC Soc. Awards: prizes in arch. des., national and regional comp.; CM, 1925; Okla. Chapter, AIA, 1954. Exhibited: Denver A. Mus.; Oakland A. Gal.; AWS; SSAL; Oklahoma A; CM; Philbrook A. Center; Cal. WC Soc.; PMA; Dallas Mus. FA; Delgado Mus. A.; Okla. A. & M. Col. (one-man). Positions: Prof. Arch. Des.,

Dept. Arch., Oklahoma State Univ., Stillwater, Okla. Lectures: Gothic Art and Architecture of the Church; "The Student and Design Practices."

STEVENS, EDWARD JOHN, JR.—Painter, Et.
621 Palisade Ave., Jersey City, N.J. 07307
B. Jersey City, N.J., Feb. 4, 1923. Studied: State T. Col., Newark, B.S.; T. Col., Columbia Univ., M.A. Member: AEA; Audubon A.; Phila. WC Cl. Work: WMAA; PAFA; SFMA; Columbus (S.C.) Mus. A.; AGAA; Newark Mus.; Smith Col.; Detroit Inst. A.; SAM; Univ. Washington; Honolulu Acad. A.; Princeton Pr. Cl.; Chappell Mem. A. Gal., Univ. Omaha; Pa. State Univ.; Trenton A. Mus.; AIC; BMFA; Am. Univ.; Phila. Pr. Cl.; BMA; Univ. Alabama; Univ. Delaware; LC. Exhibited: Grand Rapids A. Mus.; BM, 1945, 1946; WMAA; PAFA; SFMA; AGAA; Amherst Col.; Bryn Mawr Col.; Munson-Williams-Proctor Inst.; Soc. Four A.; Phila. A. All.; one-man: Mills Col., 1951; BMA, 1948; Weyhe Gal., 1944-1968. Positions: Instr., Newark Sch. F. & Indst. A., 1947-59; Dir., 1959- .

STEVENS, ELISABETH GOSS—Art Critic
37 Harrison Dr., Larchmont, N.Y. 10538
B. Rome, N.Y., Aug. 11, 1929. Studied: Wellesley Col., B.A.; Columbia Univ., M.A. Positions: Editorial Assoc., Art News, 1964-1965; Art Critic, The Washington Post, 1965; Freelance art critic, 1965- . Contributor to: Art in America; Artforum; Art International; Life; Atlantic Monthly; New York Times.

STEVENS, JOSEPH TRAVIS—Illuminator, Engrosser
1610 Beck Bldg., Shreveport, La.; h. 6305 Southcrest Dr., Shreveport, La. 71109
B. Marietta, Okla., July 18, 1922. Studied: East Central Col., Ada, Okla., B.A. in Edu.; Centenary Col., Shreveport, La. Member: Nat. Soc. A. & Lets.; Prof. Draftsmen's Soc. of Shreveport. Work: William H. Francis Mem., 1957; Charles I. Thompson Mem., 1958; Herman Brown Memorial; Tribute to Schiller, for Chancellor Konrad Adenauer, 1958; Mural. Illumination for St. Andrew's Church, Roswell, N.M.; St. Mark's, Shreveport, 1962; numerous scrolls. Exhibited: Louisiana State Mus. (one-man), 1961; Shreveport A. Show, 1957; Shreveport Library, 1961. Contributor manuscript illuminations to Shreveport Magazine, 1960; Shreveport Times, 1957. Lectures: Neo-Gothic Illuminations, History & Demonstration of Technique.

STEVENS, MAY—Painter
97 Wooster St., New York, N.Y. 10012
B. Boston, Mass., June 9, 1924. Studied: Mass. Sch. A., B.F.A.; ASL; Julian Acad., Paris; Queens Col.; City Col. of N.Y.; Hunter Col. Member: AEA. Awards: prize, Silvermine Gld. A., 1958; Am. Acad. A. & Lets. (purchase). Work: Washington Univ., St. Louis; Jacksonville A. Mus.; N.Y. State Univ., Binghamton; Hampton Col. Mus.; Ball State Univ. Mus.; Schenectady (N.Y.) Mus. Exhibited: N.Y. City Center, 1957, 1958; Art;USA, 1958; Salon d'Automne, Paris, 1951; Salon de Jeunes Peintres, Paris, 1951; BM, 1958; Sch. Visual Arts, 1961, 1965, 1966; Terrain Gal., 1962; PAFA, 1964, 1966; Nat. Inst. A. & Lets., 1964; Obelisk Gal., Wash., D.C., 1965; Silvermine Gld. A., 1956, 1958, 1964; Butler Inst. Am. A., 1959, 1960; AEA (six man) 1960; New York Univ., 1967; Hampton Col. Mus.; Am. Acad. A. & Lets., 1967, 1968; one-man: Galerie Huit, Paris, 1951; Galerie Moderne, N.Y., 1955; ACA Gal., N.Y., 1959; Hudson River Mus., 1960; de Aenlle Gal., N.Y., 1961. Roko Gal., N.Y., 1963, 1968; Mari Gal., Woodstock, N.Y., 1963; AFL-CIC Hdq., Wash., D.C., 1964; Ball State Univ., 1968; Queens Col., N.Y., 1969. Positions: Lecturer, Queens Col., N.Y.; Instr., School of Visual Arts, N.Y.

STEVENS, WILLIAM B., JR.—Museum director
Pennsylvania Academy of the Fine Arts, Broad & Cherry Sts., Philadelphia, Pa. 19102*

STEVENSON, BRANSON GRAVES—Graphic Artist, C., P., L., E.
715 Fourth Ave., North, Great Falls, Mont. 59401
B. Franklin County, Ga., Apr. 5, 1901. Studied: A. Sch., Instituto Nacional, Panama; Col. of Great Falls A. Sch.; & with Roberto Luiz. Member: Montana Inst. A.; Studio 10 of Great Falls. Work: Montana Inst. of the Arts, Helena; Montana Hist. Soc.; State Capitol, Helena, Mont.; mural, Army Air Base, Great Falls, Mont.; "Story of Paper," colored glass mural, in new Public Library, Great Falls, Mont., completed 1967. Exhibited: Univ. Oregon (purchase prize), 1964; Henry Gal., Univ. Wash.; Portland Ceramic Studios; Spokane, Wash.; traveling exh., Germany; Lectures: Graphic Arts Processes, Contributor articles on Ceramic pottery, processes and glazes, to Craft Horizons and Ceramic Age magazines. Positions: Faculty of the Fine Arts, College of Great Falls; Fellow, Memb. Adv. Council, Chm. Permanent Coll., Montana Institute of the Arts; One of Fndrs., Dir., The Archie Bray Fnd., Helena, Mont.; One of the Fndrs., Dir., C. M. Russell Gallery, Great Falls, Mont.

STEVENSON, FLORENCE EZZELL (Mrs. Earle D.)—
 Painter, L., Des., I.
 9411 Longwood Dr., Chicago 20, Ill. 60620
B. Russellville, Ala. Studied: Athens Col.; Tuscaloosa Conserva-
tory of A. & Music; AIC; Chicago Acad. FA. Member: AAPL; SSAL;
All-Illinois Soc. FA; No-Jury Soc. A.; South Side AA; Mun. A. Lg.,
Chicago; Nat. Lg. Am. Pen Women; Chicago A. Cl.; Ridge AA, Chi-
cago; Int. Platform Assn.; The Cordon Alumni Assn., The School of
the Art Institute of Chicago. Awards: medals, All-Illinois Soc. FA,
1936; prizes, South Side AA, 1939; Ill. Fed. Women's Cl., 1940; Nat.
Lg. Am. Pen Women, 1945-1961; Cordon Cl., 1950, 1954, 1959, 1960;
AIC. Work: Rosenwald Coll.; Hanover Col., Indiana; Vanderpoel
Coll.; Mun. Bldg., Russellville, Ala.; Morgan Park H.S., Chicago;
Sutherland Sch., Gage Park Sch., Chicago; Midlothian (Ill.) Sch. Ex-
hibited: AIC; The Parthenon, Nashville, Tenn.; A. Cl. of Chicago;
one-man: Birmingham Pub. Lib.; The Cordon, Chicago, 1960; Drake,
Congress hotels, Chicago; Smithsonian Inst., 1948, 1954; Brooks
Mem. Mus.; Ridge AA; Vanderpoel A. Gal.; Birmingham A. Cl.;
Chicago A. Cl., and others. Paintings on covers of La ReVue
Moderne, Paris; Christian Science Monitor; Art World; Literary Di-
gest, and others. Lectures on art to schools, women's clubs and
groups. Positions: Bd. Dirs., Stevenson & Assoc., Inc.

STEVENSON, MRS. SUZANNE SILVERCRUYS. See Silvercruys,
 Suzanne

STEWART, ALBERT T.—Sculptor
 4215 Via Padova, Claremont, Cal. 91711
B. Kensington, England, Apr. 9, 1900. Studied: BAID; ASL, and with
Paul Manship. Member: NSS; Am. Mus. Natural Hist.; NA. Awards:
silver medal, BAID, 1923; gold medal, NAD, 1927; gold medal,
PAFA, 1928; prizes, NAD, 1931, citation, 1955; Arch. Lg., 1932; Los
A. County Fair, Pomona, 1940, 1949; Chaffey AA, 1951; Pasadena
AI, 1948. Work: MMA; FMA; Reading Mus. A.; tablets, panels, fig-
ures, doors, fountains, etc.: Seamen's Mem., N.Y.; Buffalo (N.Y.)
City Hall; St. Paul City Hall and Court House; St. Bartholomew's
Church, N.Y.; Am. Battle Monument, Thiacourt, France; Cosmopoli-
tan Cl.; Kansas City Mun. Auditorium; Labor Bldg., Wash., D.C.;
Amherst and Williams Colleges; County Court House, Mineola, N.Y.;
White House, Wash., D.C.; County Court House, Los A.; Fort Moore
Mem., Los A.; Pasadena Mus. A.; Mercantile Bank, Dallas, Tex.;
U.S. Mint, San F.; Cal. Inst. Tech.; Scripps Col.; Community Church,
Claremont, Cal., and many other churches throughout California;
USPO, Albany, N.Y.*

STEWART, JARVIS ANTHONY—Educator, P.
 Lyon Hall, Ohio Wesleyan University; h. 61 Westgate Dr.,
 Delaware, Ohio 43015
B. Maryville, Mo., Dec. 28, 1914. Studied: Phillips Univ., Enid,
Okla., B.F.A.; San Miguel Allende, Mexico; Ohio State Univ., M.A.,
Ph.D. Member: Am. Studies Assn.; Columbus A. Lg. Work: Colum-
bus Gal. FA. Exhibited: Art:USA, 1958; Northwest Missouri AA;
Oklahoma AA; Oklahoma State Fair; Ohio State Fair; Columbus A.
Lg., 1945-1957; Exh. Momentum, Chicago; Interior Valley Exh.,
1955; one-man exhs. Positions: Prof. A., Chm., Dept. FA, Ohio
Wesleyan University, Delaware, Ohio, 1953- . Instr., Scuola Vic-
enza, Italy, summer, 1963.

STEWART, JOHN LINCOLN—Scholar, W., Univ. Administrator
 John Muir College, University of California at San Diego &
 La Jolla, Cal.; h. 9473 La Jolla Farms Rd., La Jolla, Cal.
 92037
B. Alton, Ill., Jan. 24, 1917. Studied: Denison Univ., A.B.; Ohio
State Univ., M.A., Ph.D. Awards: Dartmouth Faculty Fellowship,
1962-63; Hon. D.A., Denison Univ., 1964. Field of Research:Con-
temporary American and British Literatures. Author: "John Crowe
Ransom," 1962; "The Burden of Time," 1965. Positions: Provost
and Advisor to the Chancellor for the Arts, Univ. of California;
Asst. Prof., Prof., Dartmouth College, 1949-1964; Assoc. Dir., Hop-
kins Art Center, Dartmouth College, 1962-1964; Prof. and Provost,
John Muir College, University of California San Diego, at La Jolla,
1964- .

STEWART, REBA—Painter, T.
 1506 Park Ave., Baltimore, Md. 21217
B. Hudson, Mich., Aug. 1, 1930. Studied: BMFA Sch. FA; Yale
Univ., Sch. A. & Arch., B.F.A., M.F.A. Awards: Clarissa Bartlett
Traveling Fellowship, BMFA, 1955; prizes, Boston Pr. M., 1955
and the Patrick Gavin Mem. Prize, 1959; Portland A. Festival, 1960.
Work: Commission, IGAS for woodcut of an Edition of 200, 1957;
work in colls. of FMA; BMFA; Brandeis Univ.; Wellesley Col.;
Wheaton Col.; Fitchburg Mus. A.; William Lane Fnd., Leominster,
Mass.; and in private colls. Exhibited: Boston Pr. M., 1954, 1955,
1956, 1958, 1959, 1960; Inst. Contemp. A., Boston, 1955 (5-man);
Boston Pr. M., traveling exh., 1955, 1958-59; Swetzoff Gal., Boston,
1957-1961, 1967; Nat. Graphic Art Exhibition of Japan, Tokyo, 1958;

De Cordova & Dana Mus., 1959; Boston A. Festival, 1955-1962; New
Haven A. Festival, 1960; AIC, 1961; one-man: Swetzoff Gal., 1955,
1958, 1960; Boylston Street Print Shop, Boston, 1956; Yoseido Gal.,
Tokyo, 1957; Gal. Lemon, Tokyo, 1957; Loan Exh. of print through
USIS to Japan, 1957-58; Yamada Contemp. A. Gal., Kyoto, 1958;
Fitchburg (Mass.) 1958; Deerfield Acad., 1961; Paul Schuster Gal.,
Cambridge, Mass., 1968. Positions: Instr., Graphic Arts, Boston
Mus. Sch. FA, 1955-56; Boston Center for Adult Edu., 1955-56;
Des., Drawing, Monticello College, Alton, Ill., 1961-1963; Drawing,
Painting, Des. & Color, Maryland Institute, College of Art, Balti-
more, 1963-1969.

STIEBEL, ERIC—Art dealer
 32 E. 57th St., New York, N.Y. 10022*

STILES, JOSEPH E(DWIN)—Painter, Lith., T., Comm.
 840 S. 7th St., San Jose, Cal., 95112
B. Spring Hill, Kans., Oct. 14, 1931. Studied: Univ. Kansas, B.F.A.;
Univ. New Mexico, M.A.; ASL, and with Louis Bouche, Will Barnet.
Member: AAUP. Awards: prize, Kansas Painters, 1953; Huntington
Hartford Fnd. F., 1960-61. Exhibited: Balt. WC Cl., 1953; CM, 1954;
Terry AI, 1952; Kansas Painters, 1953, 1954, 1960; Missouri Valley,
1953; Friends of Art Biennial, 1958; Wichita AA, 1960; Joslyn A.
Mus., 1960; Air Capitol Annual, Wichita, 1960; Topeka A. Gld., 1960;
Nelson Gal. A., 1958, 1960; one-man: Oklahoma A. Center, 1953;
Baker Univ., 1958; Gal. Guidea, San Francisco, 1961; Birger Sandzen
Gal., 1959. Positions: Instr. Univ. Kansas, 1959-60.*

STILL, CLYFFORD—Painter, T.
 Westminster, Maryland 21157*

STILLMAN, ALEXANDER—Collector, P.
 30 N. La Salle St., Chicago, Ill. 60602; h. Penny Road, Bar-
 rington, Ill. 60010
B. New York, N.Y., Sept. 29, 1914. Studied: Art Institute of Chicago,
M.A. Author: "Mayan Art," 1935. Field of Research: Mayas; Indian
art.*

STILLMAN, E. CLARK — Collector, Scholar
 22 E. 40th St. 10016; h. 24 Gramercy Park, New York, N.Y.
 10003
B. Eureka, Utah, Oct. 24, 1907. Studied: University of Michigan,
A.B., A.M. Field of Reseach: African sculpture; Medieval and
modern book illumination and illustration. Collection: Traditional
Congolese sculpture; Manuscript and printed Books of Hours.

STILWELL, WILBER MOORE—Educator, P., Des., Gr., L., I., W.
 University of South Dakota, Vermillion, S.D. 57069
B. Covington, Ind., Feb. 2, 1908. Studied: Kansas City AI; Kansas
State T. Col., B.S. in Edu.; State Univ. Iowa, M.A. Member: Am.
Assn. Univ. Prof.; South Dakota Edu. Assn. Awards: med., Kansas
City AI, 1933, 1936; National Gallery of Art Medal for "Distinguished
Service to Education in Art," 1966; Gold Medal, AAPL, 1966; prizes,
Oklahoma A. Exh., Tulsa, 1940; Kansas A. Exh., Topeka, 1941. Ex-
hibited: PAFA, 1934; Kansas City AI, 1933, 1936, 1939; Topeka, Kan.,
1939-1941; Missouri A., 1938; Tulsa, Okla., 1940. Lectures: Con-
temporary Art. Co-author, articles for art education and education
magazines. Positions: Prof. A., Univ. South Dakota, Vermillion,
S.D., 1941- . Fndr., Dir., South Dakota Annual H.S. Art Competition.

STIPE, WILLIAM STONE—Painter, E.
 1216 West Jarvis St., Chicago, Ill. 60626
B. Clarinda, Iowa, Nov. 12, 1916. Studied: Univ. Iowa, B.A., M.A.,
BMFA Sch., with Karl Zerbe; Inst. Design, Chicago. Member: AEA.
Awards: prizes, Brick Store Mus.; Wash. WC Cl. Work:
Springfield (Mo.) A. Mus.; Ohio Univ., Athens; Northern Trust Co.,
Chicago; Int. Minerals & Chemical Corp.; Kansas State Col. Exhib-
ited: Brick Store Mus., 1948; Wash. WC Cl., 1949; AIC, 1956; Alan
Gal., N.Y., 1956; Superior St. Gal., Chicago, 1960; AIC, 1961; Univ.
Chicago, 1963 (2-man); Univ. Illinois, 1964; also, NAD, PAFA; Den-
ver A. Mus.; BMFA; Butler Inst. Am. A.; Springfield A. Mus.; Exh.
Momentum, Chicago; Columbia (S.C.) A. Mus.; Univ. Chicago, 1963
(2-man); one-man: Chicago Pub. Lib., 1951; Hotel Sherman, Chicago,
1952; Beloit Col., 1953; Inst. Design, Chicago, 1956; Ruth White Gal.,
N.Y., 1957; AIA, Chicago, 1959; Sherman Gal., Chicago. Positions:
Asst. Prof., Art Dept., Northwestern University, Evanston, Ill.,
1948.

STITES, RAYMOND SOMERS—Educator, Historian, W., L.
 11212 Kenilworth Ave., Garrett Park, Md. 20766
B. Passaic, N.J., June 19, 1899. Studied: Brown Univ., M.A., Ph.B.;
R.I. Sch. Des.; Univ. of Vienna, Ph.D. Member: CAA; Am. Archae-
ological Soc.; Ohio Valley AA. Exhibited: MMA; Denver Archaeolog-
ical Mus.; Dayton AI; Am. Mus. Natural Hist. Author: "The Sculp-
tures of Leonardo da Vinci," 1930; "The Arts and Man," 1940;
"The Self Psychoanalysis of Leonardo da Vinci," 1969. Contrib-

utor to: Art magazines. Lectures: Leonardo da Vinci. Positions: Chm., Dept. A. & Aesthetics, Antioch Col., Yellow Springs, Ohio, 1930-48; Cur. in charge of Edu., Nat. Gal. Art, Washington, D.C., 1948- ; Assisstant to the Director (Educational Services), Nat. Gal. Art, 1968- ; Dir., Culture Films, Inc.

STODDARD, DONNA MELISSA—Educator, W., L., P.
Florida Southern College; h. 925 East Lexington St., Lakeland, Fla. 33801
B. St. Petersburg, Fla., July 1, 1916. Studied: Fla. Southern Col., B.S.; Pittsburgh AI; Pennsylvania State Col., M.A.; N.Y. Sch. Int. Des. Member: Am. Assn. Univ. Women; Fla. Fed. A.; Southeastern AA; Nat. AA; CAA; Southeastern Col. AA.; Fla. Arts Council; Int. Soc. for Edu. Through Art; F., Royal Soc. A., London; AFA; Lakeland A. Gld.; AAUP; Ridge A.A., and many educational associations. Awards: prizes, AAPL, 1951; Am. Culture Award, 1952; Fla. Southern Col., 1942; AAUW, 1951; Grumbacher award, 1953; Miami Woman's Cl. gold medal, 1953; Hon. L.H.D., Philathea Col., London, Ontario, Canada, 1968; Internat. Hon. mem. of Beta Sigma Phi Sorority, 1969. Work: Directed the Fla. Int. A. Exh., 1952; Organized and installed permanent Contemporary art collection of Fla. Southern Col.; contributor to Design magazine; arranges exhibitions for Fla. Southern Col., and other organizations. Positions: Exec. Departmental Officer of A., Fla. Southern Col., Lakeland, Fla., 1940- . WEDU-TV County A. Chm. for Art Auction, 1968-1969.

STODDARD, HERBERT C.—Painter, E.
1267 Second St.; h. 1543 Palmetto Lane, Sarasota, Fla. 33580
B. Brooklyn, N.Y., Aug. 31, 1910. Studied: Univ. Virginia, Col. Arch.; New York Univ., Col. Arch.; Ringling Sch. A., Sarasota. Member: AEA; Fla. A. Group. Awards: prizes, in regional shows, Sarasota AA, Manatee A. Center, Clearwater AI. Exhibited: Sarasota AA at Ringling Mus., 1955-1959; Tampa AI; Fla. State Fair; Soc. Four Arts, Palm Beach; Sarasota AA annuals; Manatee A. Center; Fla. A. Group. Positions: Dir., Sarasota School of Art, 1957- ; Asst. Prof. of Art, New College, Sarasota, Fla.

STODDARD, WHITNEY SNOW—Educator, Scholar, Writer
Williams College; h. Gale Road, Williamstown, Mass. 01267
B. Greenfield, Mass., Mar. 25, 1913. Studied: Williams College, B.A.; Harvard University, M.A., Ph.D., under Professor Chandler Post, Wilhelm Koehler, Paul Sachs. Awards: Advanced Research Fellowship, Fulbright, to France, 1954; Carnegie Grant (France), 1936. Member: CAA; Soc. Architectural Historians; Mediaeval Academy of America. Author: "The West Portals of Saint-Denis and Chartres" (Cambridge: Harvard Univ. Press), 1952; "Adventure in Architecture: Building the New St. John's" (New York), 1958; "Romanesque and Gothic France" (Wesleyan Univ. Press), 1966. Positions: History of Art-Instr., 1938-1943, Asst. Professor, 1943-1948, Assoc. Professor, 1948-1953, Professor, 1953- , Williams College, Williamstown, Mass.

STOFFA, MICHAEL—Painter, T., Cr., L.
102 Elm St., Westfield, N.J.; h. 168 Plainfield Ave., Metuchen, N.J. 08840
B. Hlinne, Czechoslovakia. Studied: Newark Sch. F. & Indst. A.; PAFA, with Walter Stuempfig, Hobson Pittman; ASL, with Robert Philipp, John Grabach, Theodore Benda. Member: New Brunswick A. Center; North Shore AA; South Orange AA; Maplewood AA; Westfield A. Cl.; Rahway A. Center; Cranford Creative A. Group. Awards: Scholarship, Newark Sch. F. & Indst. A.; prizes, Plainfield AA, 1950; New Brunswick A. Center, 1957, 1958; Talens award, 1960; Silverton A. Lg., 1960; Westfield AA, 1963; So. Orange & Maplewood AA, 1964; B'nai B'rith, Metuchen, 1964. Exhibited: ASL, 1957; Old Mill AA, 1957, 1958, 1960, 1961; PAFA, 1951; Rahway A. Center, 1958, 1960, 1961; Cranford AA, 1958, 1960, 1961; Westfield AA, 1958; New Brunswick AA, 1956-1958; Asbury Park, N.J., 1958; Burr Gal., 1958; Crespi Gal., N.Y., 1958; Bennett Col., 1960; New Brunswick A. Center, 1960, 1961; Int. A. Gal., 1960; Hull A. Gal., 1961; Pigeon Cove Gal., Rockport; one-man: Swain A. Gal., Plainfield, 1964; Papermill Gal., Millburn, 1963; Cherry Hill, N.J., 1962. Demonstrations in many art galleries and centers in New Jersey, and N.Y. World's Fair, 1964.*

STOKSTAD, MARILYN—Educator, W.
University of Kansas; h. 808 Mississippi St., Lawrence, Kans. 66044
B. Lansing, Mich., Feb. 16, 1929. Studied: Carleton Col., B.A.; Michigan State Univ., M.A.; Univ. Michigan, Ph.D.; Univ. of Oslo, Norway. Awards: Fulbright award, 1951-52; Rackham award, 1953-54; AAUW, 1954-55; Watkins prize, 1960; Nat. Endowment for the Humanities, 1967-1968; Inst. for Research in the Humanities, Univ. Wisconsin, 1968-1969. Author: "Renaissance Art Outside Italy," 1968. Contributor, Editor, The Register of the Museum of Art of the University of Kansas. Positions: Prof., Chm., Dept. of History of Art, University of Kansas, Lawrence, Kans.

STOLL, MRS. BERRY VINCENT—Collector
3905 Lime Kiln Lane, Louisville, Ky. 40222
B. Louisville, Ky., Feb. 2, 1906. Studied: Bryn Mawr College; Louisville Art School. Collection: Paintings and antiques. Positions: Vice-President, J. B. Speed Art Museum, Louisville, Ky.

STOLL, TONI (Mrs. Herbert)—Painter, T.
64 Johnson St., Highland Park, N.J. 08904
B. New York, N.Y., Nov. 5, 1920. Studied: Syracuse Univ., Col. of FA, B.F.A.; Rutgers Univ. Member: AAPL; New Brunswick A. Center; Hunterdon A. Center; Gld. Creative A.; Fnd. for A. & Sciences. Awards: prizes, AAPL, 1960, 1962 (2); Int. A. Gal., N.Y., 1961; Metuchen A. Fair, 1963. Work: New Brunswick Pub. Lib., and many private colls. Exhibited: AAPL at NAC, 1961, 1962, Smithsonian Inst., 1961, 1963, Maplewood, N.J., 1961; Fairleigh Dickinson Univ., 1962, Drew Univ., 1962, Newark Pub. Lib. 1964, Paramus, N.J., 1960, 1961; Ptrs. & Sc. Soc. of New Jersey, 1961-1963; Hunterdon County AA, 1961-1964; Art Center of the Oranges, 1963; Monmouth Col. Festival of Arts, 1963; Douglass Col., 1964; Gld of Creative A., 1962-1964; New Brunswick A. Center, 1963; Old Queens Gal., New Brunswick, 1964, 1965; Madison Gal., N.Y., 1960; Art Directions Gal., N.Y., 1960; Int. Gal., N.Y., 1961; Eva DeNagy Gal., Province. town, 1962; N.J. Council Charity A. Exh. in Bergen County, Paramus and Paterson, and many other local and regional exhs. One-man exhs. throughout New Jersey, 1958-1964. Judge of the following exhibitions: Raritan Valley AA, 1961; Roebling-Boehm Art Scholarship Comp. for New Jersey, 1962; Spring Conf. Exhib. of Gen. Fed. Women's Clubs, New Brunswick, 1962; Cinema Theatre Children's Exh., Menlo Park, 1964. Teaching private art classes.

STOLOFF, CAROLYN—Painter
232 E. 35th St., New York, N.Y. 10016
B. New York, N.Y., 1927. Studied: Univ. Illinois; Columbia Univ., B.S.; with Xavier Gonzalez, Eric Isenburger, and abroad. Awards: Audubon A. Silver Anniversary Medal of Honor, 1967. Work: Norfolk Mus. A. Exhibited: PAFA; Laurel Gal.; Audubon A.; NAD; Argent Gal.; Contemp. A. Gal.; Ross Gal.; Westchester Gld. A. & Crafts; Arthur Brown Gal.; WMAA; ACA Gal.; New Jersey Soc. P. & S.; Long Island A. Lg.; N.Y. City Center; Krasner Gal., N.Y.; one-man: Dubin Gal., Phila.; Manhattanville Col., Purchase, N.Y. Positions: Asst. Prof. A., Chm. A. Dept., Manhattanville College, Purchase, N.Y., 1961-1965.

STOLOFF, IRMA (Mrs. Charles I.)—Sculptor
46 East 91st St., New York, N.Y. 10028
B. New York, N.Y. Studied: ASL, and with Alexander Archipenko. Member: NAWA; AEA; ASL; Silvermine Gld. A.; Audubon A. Awards: NAWA, 1953; hon. men., P. & S. Soc. of New Jersey, 1959; Catherine L. Wolfe A. Cl., 1969. Work: Norfolk Mus. A. & Sciences; Sheldon Swope A. Gal., Terre Haute, Ind.; Butler Inst. Am. A.; Gibbes A. Gal., Charleston, S.C.; Rose A. Mus., Brandeis Univ. Exhibited: Salons of Am., 1931; Woodstock Gal., 1934; Argent Gal., 1947, 1958; NAWA, 1947-1956, 1960, 1961, 1962, 1964; 1966-1968; NAD, 1950, 1953; New Jersey Soc. P. & S., 1955; Art:USA, 1958; Silvermine Gld. A., 1957, 1959, 1960, 1964; Audubon A., 1960, 1961, 1962; 1965-1969; Lever House, N.Y., 1963, 1964, 1966-1968; Pepsi Cola Gal., N.Y., 1964, and in Paris, France. Work reproduced in many art publications in Mexico, Paris, Rome, and Buenos Aires, 1960; Sculpture Jury, NAWA, 1952-1954, 1955-1957, 1968-1970; Exec. Bd., Audubon A., 1965-1969.

STOLTENBERG, DONALD—Painter, T., Gr.
Setucket Road, Brewster, Mass. 02631
B. Milwaukee, Wis., Oct. 15, 1927. Studied: Illinois Inst. Des., B.S. Member: Boston Printmakers. Awards: prizes, Boston A. Festival, 1956, 1957, 1959; Portland (Me.) Mus. A., 1957 (purchase) Provincetown A. Festival, 1958. Work: BMFA; DeCordova and Dana Mus.; Portland Mus. A.; AGAA. Exhibited: MMA, 1952; AIC, 1957; CGA, 1963; Inst. Contemp. A., Boston, 1957, 1960; Silvermine Gld. A., 1962; DeCordova and Dana Mus., 1962, 1963, 1964; Boston A. Festival, 1955-1965. Positions: Visiting Critic in painting, R.I. School of Design, 1962-1963; Instr., printmaking, De Cordova and Dana Mus., Lincoln, Mass.

STONE, ALEX BENJAMIN—Art Dealer, Collector
4520 Fourth Ave., Moline, Ill. 61265; h. 3223—29th Ave. Ct., Rock Island, Ill. 61201
B. Sczuczyn, Poland, Mar. 14, 1922. Studied: St. John's University; Kansas State University, D.V.M. Member: AFA; MModA; Museum membership, Davenport, Iowa. Specialty of Gallery: 19th century romantic American landscapists; Contemporary American and European prints. Collection: Eclectic-15th century Venetians to 20th century surrealists.

STONE, ALLAN—Art Dealer
Allan Stone Gallery, 48 E. 86th St., New York, N.Y. 10028; h. Northeast Harbor, Me.
B. New York, N.Y., Feb. 5, 1932. Studied: Phillips Acad., Andover,

Mass., B.A.; Harvard Univ., B.A.; Boston Univ., LL.B.; Columbia Univ. Specialty of Gallery: 20th Century American Art.*

STONE, ALLEN—Painter, L.
50-75 42nd St., Long Island City, N.Y. 11104
B. New York, N.Y., Feb. 19, 1910. Studied: NAD, with Sidney Dickinson, Leon Kroll, Raymond Neilson, Ivan Olinsky; ASL, with Maxwell Starr. Member: ASL; Am. Veterans Soc. A.; F. Royal Soc. A., London; F.I.A.L. Awards: prizes, Army Regional Exh., Fla., 1946; Citation, Fla. Southern Col., 1953; Am. Veterans Soc. A., 1957; David Knapp Mem. award; Stuyvesant award. Work: Grumbacher Coll.; Mus. City of New York; Fla. Southern Col.; Burke Fnd.; Grand Central National, N.Y.; Seton Hall Univ., and in private colls. Exhibited: CAA traveling exh.; Laguna Beach A. Center; Soc. Indp. A.; Minnesota State Fair; Minneapolis, Minn.; All. A. Acad., N.Y.; Tallahassee, Fla.; Grand Central A. Gal.; Lynn Kottler Gal.; Mun. Gal., Insel Gal., N.Y., 1958; N.Y. City Center; Barbizon Plaza Gal.; NAD; BM; Fleurs de Lys Gal., N.Y.; Showplace Gal., N.Y. Compiled books on Art Techniques of Famous Present Day Illustrators, 1951; contributor illus. to many national magazines. Lectures and demonstrations, New York and New Jersey. Positions: Instr., Caton Rose Inst. FA, Long Island; Sch. Adv. A., Newark, N.J. Artist, Grumbacher Research Labs., N.Y.*

STONEBARGER, VIRGINIA—Teacher, P.
143 Maple Ave., Hartland, Wis. 53029.
B. Ann Arbor, Mich., Mar. 9, 1926. Studied: Antioch Col., B.A.; Colorado Springs FA Center; ASL; Hans Hofmann; N.Y. Univ. Awards: Scholarship, Colo. Springs FA Center; ASL; N.Y. Univ.; prize, Watertown, Wis., 1958; Milwaukee A. Center, 1960; Danforth Fnd. Fellowship for study for M.F.A. degree in Painting, 1969. Exhibited: Univ. Minnesota, 1954; Art:USA, 1958; ACA Gal., 1951, 1952; Urban Nat. Group, 1953; Women's Cl., Milwaukee, 1961; Milwaukee A. Center, 1959-1961; Univ. Wisconsin, 1959; one-man: Panoras Gal., N.Y., 1960; Bresler Gal., Milwaukee, 1960; Frederick's Gal., Milwaukee, 1965; Y.W.C.A., Waukesha, Wis., 1967; Lakeland Col., Sheboygan, Wis., 1968. Sneed Gal., Rockford, Ill., 1965 (3-man). Positions: A. T., University Lake School, Hartland, Wis., 1959-1962. Instr. painting, Watertown Adult Voc. Sch., Wis., 1967-1968.

STONER, KENNETH F.—Collector, Patron
830 3rd Ave. 10022; h. 200 E. 84th St., New York, N.Y. 10028
B. Collamer, Pa., Aug. 10, 1919. Studied: Pennsylvania State University, B.S.L.A. Collection: Primitive American and China trade; Modern American and European art. Positions: Landscape Architect, Clarke and Rapuano, 1946-1969; Assoc., 1961-1969.

STOOPS, DR. JACK—Educator
10609 Eastborne Ave., Los Angeles, Cal. 90024*

STORM, LARUE—Painter, Gr.
3737 Justison Road, Coconut Grove, Miami, Fla. 33133
B. Pittsburgh, Pa. Studied: Univ. Miami, Coral Gables, Fla., M.A.; ASL, Woodstock, N.Y., and in France. Awards: gold medal, Univ. Miami, 1955; purchase award, Columbia (S.C.) A. Mus., 1959. Work: Columbia A. Mus.; George Peabody Col., Nashville, Tenn.; Lowe Mus. A.; Norton Gal. A., West Palm Beach, Fla. Exhibited: Detroit Inst. A., 1952, 1957; Southeastern Annual, Atlanta, 1950, 1953, 1958, 1961; Mayo Gal., Wellfleet, Mass., 1954; Nat. Mus., Havana, Cuba, 1956; Lyceum Cl., Havana, 1956; Ringling Mus. A., 1955; Soc. Four Arts, 1955-1960; CGA, 1957; Toledo Mus. A., 1957; Norton Gal. A., 1969 (one-man); Lowe Gal. A., 1966 (one-man); Sarasota AA; Fla. State Fair, 1958; Art:USA, 1958; Butler Inst. Am. A., 1958, 1960; Columbia Mus. A., 1965 (one-man); Arnot A. Gal., Elmira, N.Y., 1963 (one-man); El Paso Mus. A., 1965; Jacksonville, Fla., A. Festival, 1964.

STORY, ALA—Staff Specialist in Art, Collector
June Mountain, Great Barrington, Mass.; also 305 Ortega Ridge Rd., Santa Barbara, Cal. 93103
B. Hruschau, Austria, Apr. 25, 1907. Studied: Lycee Wiener Neustadt, Austria; Acad. FA, Vienna; Univ. Vienna. Awards: Hon. M.A., University of California, 1968. Exhibited: Two Collections: Ala Story and Margaret Mallory, Santa Barbara Museum of Art and California Palace of the Legion of Honor, San Francisco, 1966. Publications: "William Merritt Chase," 1964; "Surrealism: A State of Mind," 1965; "Paul Klee," 1967; "Max Weber," 1968; "The Ala Story Print Collection of the Art Galleries, University of California, Santa Barbara," 1967; "The Ala Story Collection of the Santa Barbara Museum of Art," 1967. Collection: German Expressionist and American Contemporary Paintings. Member: Cosmopolitan Cl., New York. Positions: Sec., Galerie des Beaux Arts, London, 1928-30; Sec., Redfern Gal., London, 1930-32; Dir., Wertheim Gal., London, 1932-34; Co-Partner & Dir., Storran Gal., London, 1934-35; Co-Partner & Dir., Redfern Gal., 1935-37; British Art Center, N.Y.,

1938-40; Fndg. Dir. & Pres., American-British A. Center, N.Y., 1940-52; Co-Fndr. & Vice-Pres., Falcon Films (first U.S. Art Documentary color and sound film company), 1947- ; Dir., Santa Barbara Museum of Art, Santa Barbara, Cal., 1952-57. Staff Specialist in Art, University of California at Santa Barbara, 1963- .

STOUT, GEORGE LESLIE—Museum Director
Isabella Stewart Gardner Museum; h. 2 Palace Rd., Boston, Mass. 02115
B; Winterset, Iowa, Oct. 5, 1897. Studied: Grinnell Col.; Univ. Iowa, A.B.; Harvard Univ., A.M.; & abroad. Awards: Carnegie F., Harvard Univ., 1926-1929. Co-Author: "Painting Materials, A Short Encyclopaedia," 1942; Author; "The Care of Pictures," 1948; Ed., "Color and Light in Painting." Contributor to: Technical Studies in the Field of the Fine Arts; Magazine of Art; Mouseion; with articles on conservation, methods of examination, & treatment of works of art. Positions: Fellow for Technical Research, FMA, & L. on Design, Harvard Univ., 1929-33; Hd. Dept. Conservation, FMA, & L. on FA, Harvard Univ., Cambridge, Mass., 1933-47; Consultant & Restorer, Gardner Mus., Boston, Mass., 1934-47; F., Am. Acad. A. & Sciences; F., Int. Inst. for Conservation of Museum Objects; Member, ICOM Comm. for the Care of Paintings, 1948-1954; Dir., WMA, Worcester, Mass., 1947-1954; Cur., Isabella Stewart Gardner Mus., Boston, Mass., 1955- .

STOUT, MYRON STEDMAN—Painter
4 Brewster St., Provincetown, Mass. 02657
B. Denton, Tex., Dec. 5, 1908. Studied: North Texas State Univ., B.S.; Columbia Univ., M.A.; Hans Hofmann Sch. A.; Academia San Carlos, Mexico City. Awards: Nat. Fnd. for the Arts & Humanities, 1966; Guggenheim Fellowship, 1969. Work: BM; Carnegie Inst.; Guggenheim Mus., N.Y.; MModA; Woodward Fnd. Exhibited: WMAA, 1958; Carnegie Inst., 1958; Art:USA, 1959 MModA, 1959; Inst. Contemp. A., Boston, 1959, 1960; AFA, 1960-1961; Jewish Mus., N.Y., 1963; Sidney Janis Gal., N.Y., 1964; Albright-Knox Gal., Buffalo; CGA, 1969, and others.

STRAIGHT, MICHAEL—Collector
3077 N St., Washington, D.C. 20007
B. Long Island, N.Y., Sept. 1, 1916. Collection: 15th, 16th, 17th century French and Italian paintings.*

STRALEM, MR. and MRS. DONALD S.—Collectors
941 Park Ave., New York, N.Y. 10028

STRATER, HENRY—Painter
Shore Rd., Ogunquit, Me. 03907
B. Louisville, Ky., Jan. 21, 1896. Studied: Princeton Univ.; ASL; PAFA; Julian Acad., Paris; Madrid, and with Vuillard in Paris. Awards: prizes, GGE, 1939; Soc. Four Arts, 1947; Palm Beach AI, 1960. Work: J.B. Speed A. Mus.; Univ. Indiana; IBM; Univ. Louisville; Portland Mus. A.; AIC; Detroit Inst. A.; FMA; Princeton Univ. Mus.; Univ. Michigan; Smith Col.; Norton Gal. A.; PMA; Bowdoin Col. Mus.; Ogunquit Mus. A.; Farnsworth Mus. A.; Colby Col. Exhibited: Salon d'Automne, Paris; Whitney Studio Cl.; NAD; J.B. Speed A. Mus.; WMAA; Kansas City AI; PAFA; CGA; Norton Gal. A.; Soc. Four Arts; AIC; BM; WMA; VMFA; CMA; Soc. Indp. A.; one-man: Montross Gal., 1931, 1933, 1934, 1936, 1937, 1939; Speed Mus. A., Louisville, Ky., 1938, 1965; Van Horn Gal., Boston, 1937; Portland Mus. A., 1939, 1952; Laurel Gal., 1952; Univ. Indiana, 1952; Princeton Univ., 1952, 1969; Walker A. Center, 1938, 1952; Louisville A. Cl., 1952, 1962; Univ. Maine, 1952; Farnsworth Mus., 1953; Bowdoin, 1938, 1952; Thieme Gal., Palm Beach, 1961, 1962, 1964, 1967, 1969; Rehn Gal., N.Y., 1961, 1963-1965, 1968; Swope A. Mus., 1965; Kirby A. Center, Lawrenceville, N.J., 1965; Butler Inst., Youngstown, 1966; Norton Gal., W. Palm Beach, 1962, 1967; Heath Gal., Atlanta, 1967. I., "Sixteen Cantos"; "In Our Time"; "Portfolio of 25 Drawings by Henry Strater," 1958; "Henry Strater, Twelve Color Plates," 1961; "Henry Strater, (1896-)," 1961; "Henry Strater (Rehn Gallery) 1967," 46 color plates.

STRAWBRIDGE, EDWARD RICHIE, 2nd.—Painter
8210 Crittenden St., Philadelphia, Pa. 19118
B. Germantown, Pa., Nov. 22, 1903. Studied: PMSchIA; PAFA; Cape Cod Sch. A. Member: AWS; Phila. Sketch Cl.; Phila. WC Cl.; Soc. Western A. Work: PMA; Ford Motor Co., Milpitas, Cal.; Phila. WC Cl.; Univ. Pennsylvania; Germantown Friend's Sch., Phila.; Haverford Col.; Strawbridge & Clothier, Phila., Pa.; Temple Univ., School of Dentistry, Phila., and in numerous private collections on the East and the West Coasts. Exhibited: PAFA; NAD; AWS; All. A. Am., Phila. A. All.; John Herron AI; NAC; Wilmington Soc. FA; SC; Phila. Sketch Cl.; Phila. WC Cl.

STREETER, TAL—Sculptor
Old Verbank School, Millbrook, N.Y. 12545
B. Oklahoma City, Okla., Aug. 1, 1934. Studied: Univ. Kansas,

B.F.A., and Grad. Sch., M.F.A.; Colorado Springs FA Center; Asst. to Seymour Lipton (3 years). Work: Washington (D.C.) Gal. Modern Art; Hopkins A. Center, Dartmouth Col.; Fairleigh Dickinson Univ.; SFMA; Smith Col.; Wadsworth Atheneum, Hartford, Conn.; Oklahoma A. Center; Arkansas A. Center; Great Southwest, Atlanta; N.Y. Univ. Exhibited: WMAA, 1965; Rose A. Mus., Brandeis Univ., 1964; Washington Gal. Mod. A., 1963; N.Y. World's Fair, 1965; Springfield Mus. FA, 1957; Silvermine Gld. A., 1964; Nelson Mus. A., Kansas City, 1961; Larry Aldrich Mus., Ridgefield, Conn., 1968; Inst. Contemp. Art, 1966; Dept. of Cultural Affairs, New York City (Parks Sculptures of the Month) 1968-1969. Author, Director (with E.C. Tefft) films: Bronze Casting of Sculpture (Int. Film Bureau, Chicago); Sculpture from Fire (University Films, Kansas). Positions: Instr., sculpture, 1956-57, design, 1960-61, Univ. of Kansas; Sculptor-in-Res., Int. Artists Seminar, Fairleigh Dickinson Univ., 1962; Visiting-Artist-in-Res., Dartmouth College, 1963; Sculptor-in-Res., Bennett College, Millbrook, N.Y. 1964- .

STREETT, TYLDEN WESTCOTT—Sculptor
307 Mosher St., Baltimore, Md. 21217
B. Baltimore, Md., Nov. 28, 1922. Studied: Johns Hopkins Univ.; St. John's Col.; Maryland Inst. FA, B.F.A., M.F.A., and with Sidney Waugh, Cecil Howard; Asst. to Lee Lawrie, 1956-57. Member: NSS; AEA. Awards: Rinehart Traveling F., 1953, 1954; Louis Comfort Tiffany Fnd., 1956; John Gregory Award, 1962. Work: Kirk-in-the-Hills, Bloomfield, Mich.; Kuwait Embassy, Wash., D.C.; West Point, N.Y.; Roland Park Presbyterian Church, Balto. Md.; Wash. (D.C.) Cathedral; portrait busts of prominent persons. Positions: Dir., Grad. Sch. and Instr. in Sculpture, Maryland Inst., Col. of A., Baltimore, Md.

STRINGER, MARY EVELYN—Educator, P.
Art Department, Mississippi State College for Women; h. Faculty Club, Columbus, Miss. 39701
B. Huntsville, Mo., July 31, 1921. Studied: Univ. Missouri, A.B.; Univ. North Carolina, M.A.; Harvard Univ.; and with Julio De Diego, Clemens Sommer. Member: CAA; Medieval Academy of America; A.A.U.W. Awards: prizes, Meridian, Miss., 1951; Fulbright F., 1955-56; Jackson, Miss., 1951; Danforth Teacher Study Grant, 1959, renewal, 1964-65 for further study, Harvard Univ.; Harvard Traveling Fellow, 1966-1967. Exhibited: Jackson, Miss., 1949-1956; Atlanta, Ga., 1949, 1950; New Orleans A., 1951; 2-man exh., Allison Wells, Miss., 1952, 1954, 1958; one-man, Meridian, Miss., 1955; Norfolk, Va., 1954; Ft. Dodge, Iowa, 1957. Positions: Assoc. Prof. A., Mississippi State Col. for Women, Columbus, Miss., 1947- .

STRISIK, PAUL—Painter, T., L.
10 Main St., Rockport, Mass. 01966
B. Brooklyn, N.Y., Apr. 21, 1918. Studied: ASL with Dumond. Member: All. A. Am.; AWS; Knickerbocker A.; SC; Gld. Boston A.; Academic A.; AAPL; Hudson Valley AA; Rockport AA; North Shore AA; Copley Soc., Boston; AVSA; New England A. Group. Work: Parrish Mus., Southampton; Mattatuck (Conn.) Mus.; Univ. Utah; Percy Whitney Mus., Fairhope, Ala.; Union Carbide & Chemical Co. Exhibited: All. A. Am., 1955-1965; NAD, 1963-1965; AWS, 1963-1965, 1969; SC, 1963-1965; Hudson Valley AA, 1955-1968; Academic A., 1955-1965; AVSA, 1955-1966; Rockport AA, 1955-1967; one-man: Grand Central A. Gal., 1962; Suffolk Mus., 1963; Rockport AA, 1963. Awards: prizes, Rockport AA, 1961, 1963, 1964 (3), 1965, gold medal and award, 1967; Am. Vets Soc. A., medals, 1962, 1964, prize, 1963, 1966; AAPL, 1963 (2), 1964, 1968; Academic A., 1963, 1964; Knickerbocker A., 1963, 1965; Meriden AA, 1962, 1966; North Shore AA, 1962, purchase, 1967; SC, 1964; Hudson Valley AA, 1965, 1968; All. A. Am., 1965; SC, 1965 (2); 1967 (3); AWS, 1969; Copley Soc., 1962; Jordan Marsh awards, 1962, medal, 1967.

STROBEL, THOMAS C.—Painter, Gr., T.
565 W. Lake St., Chicago, Ill. 60606; h. 204 Otis Rd., Barrington Hills, Ill. 60010
B. Bellemeade, Tenn., Sept. 6, 1931. Studied: AIC, B.F.A.; Univ. Chicago, and in Germany. Member: Chicago A. Cl.; North Shore A. Center; Evanston A. Center. Awards: Scholarship, AIC; Fulbright Award for Painting, Dusseldorf, Germany, 1960-61; Gold Medal, Sun Times, Chicago, 1960; Graham Fnd. Grant, 1968-1969, Art & Psychology; prizes, Oak Park (Ill.) A. Festival, 1958; Evanston A. Center, 1959; Highland Park Festival, 1959; purchase prize, State A. Academy, Dusseldorf, Germany. Work: State A. Acad., Germany; Krannert Mus., Univ. Ill.; AIC; Int. Minerals & Chemicals Corp.; IBM Coll.; U.S. Steel Corp., and in private colls. Exhibited: Feingarten Gal., N.Y., 1959 and Cal., 1960; AIC; 1959-1964; Chicago A. Cl., 1964; Ill. State Mus., 1964; Amerika Haus Exh., Munchen, Hamburg, Berlin, Germany, 1961; Galeria Biosca, Madrid, 1963; Albright-Knox A. Gal., Buffalo, 1965; WMA, 1965; CMA, 1965; WAC, 1965; AIC, 1965; one-man: Feingarten Gal., Chi-

cago, 1960; Chicago Pub. Lib., 1961; Fairweather-Hardin Gal., Chicago, 1963; State A. Acad., Dusseldorf, 1960-61; Galeria del Arte Moderno, Madrid, 1963; University Club, Chicago, 1964. Positions: Instr., Painting & Drawing, Northwestern Univ., Chicago, Ill.

STROMBOTNE, JAMES—Painter
Perls Gallery, 350 N. Camden Dr., Beverly Hills, Cal. 90210
B. Watertown, S.D., 1934. Studied: Pomona Col., B.A.; Claremont Grad. Sch., M.F.A. Awards: Art in America award; Honnold Traveling Fellowship, Pomona Col., 1956; Guggenheim Fellowship, 1962-1963; Appointed to Inst. Creative Arts, Univ. California, 1965-1966; Tamarind Fellowship, Lithography, 1968. Work: WMAA; Pasadena A. Mus.; Amon Carter Mus. Western Art; City of Los Angeles; Santa Barbara Mus.; San Diego FA Gal.; La Jolla A. Center; Univ. California at Los Angeles; Pomona Col.; Scripps Col.; Univ. Nebraska, and others. Exhibited: WMAA, 1960-1963; Univ. Illinois, 1961; The Painter and the Photograph, 1964; New School, N.Y., 1964, 1968; Parke Bernet Gals., N.Y., 1963, 1964; Carnegie Int., 1964; AFA, 1964; CGA, 1967; one-man: Studio 44, San Francisco and Coronet-Louvre Gal., Los Angeles, 1956; Frank Perls Gal., Los Angeles, 1956; Frank Perls Gal., Los Angeles, 1958-1964; Redlands Univ. and Univ. California, Riverside, 1960; Pasadena A. Mus. and Nexus Gal., Los Angeles, 1961; Obelisk Gal., Wash., D.C., 1963; David Stuart Gal., Los Angeles, 1965, 1966; Esther Bear Gal., Santa Barbara, 1966; Bertha Schaefer Gal., N.Y., 1967; Mt. San Antonio Col., 1967; San Jose State Col, 1968, and others.

STRUPPECK, JULES—Sculptor, E., W.
Newcomb Art School, New Orleans, La. 70118
B. Grangeville, La., May 29, 1915. Studied: Univ. Oklahoma, B.F.A.; Louisiana State Univ., M.A. Awards: prizes Gal. A., Miami; Bertha Schaefer Gal.; Marine Hospital, New Orleans, La.; Court House, New Iberia, La.; USPO, Many, La. Exhibited: AFA traveling exh., 1941; Bertha Schaefer Gal., 1953; WMAA, 1954; Arch. Lg., 1954; SFMA, 1966. Author: "The Creation of Sculpture"; Contributor to Design magazine. Positions: Prof. S., Newcomb Col., Tulane Univ., New Orleans, La., at present.

STUART, DAVID—Art dealer
807 N. La Cienega Blvd., Los Angeles, Cal. 90046*

STUART, KENNETH JAMES—Art Director
Readers Digest, 200 Park Ave., New York, N.Y. 10017; h. 295 Ridgefield Rd., Wilton, Conn. 06897
B. Milwaukee, Wis., Sept. 21, 1905. Studied: PAFA, and in Paris, France. Awards: SC gold medal and citation, 1960; Certificates of Merit, N.Y. A. Dirs. Club, 1962 (2) and award, 1963; Award of Distinctive Merit, New Jersey A. Dirs. Club, 1962; Citations for Merit, SI (3), 1963; New York Type Dirs. Club award, 1963. Positions: Hd., Illus. & Adv. Dept., Moore Col. A., 1939-1944; Bd. Mngrs., Moore Sch. A., 1944-1956, Phila. Pa.; Art Editor, Saturday Evening Post, Philadelphia, Pa., 1944-1962; Art Director, Readers Digest, 1962- .

STUART, SIGNE NELSON—Painter, T.
1874 Michigan Ave., Salt Lake City, Utah 84108
B. New London, Conn., Dec. 3, 1937. Studied: Univ. Conn., B.A.; Yale-Norfolk A. Sch.; Univ. New Mexico, M.A. Awards: Univ. New Mexico purchase award, 1959; Ford Fnd. purchase award, 1964; Cheney-Cowles Mus., Spokane, 1966. Work: Univ. New Mexico; Roswell Mus. & A. Center; Tacoma A. Center; Col. of Idaho; Jonson Gal., Albuquerque, N.M. Exhibited: Essex AA, 1959, 1960, 1961; Connecticut Artists annual; 1960; El Paso Artists, 1961; Oklahoma A. Center, 1961; Gallery Realities, 1960, 1961; Mus. New Mexico, 1962; Tucson A. Center, 1962; Mid-America Exh., Kansas City, 1962; Denver A. Mus., 1962; Roswell Mus., 1962; Newport AA, 1963; Univ. New Mexico, 1964; SAM, 1964; Reno Regional, 1964; Portland (Ore.) A. Mus., 1964; Salt Lake City A. Center, 1965, 1967; College of Idaho, 1965; Univ. Connecticut, 1965; Molly Barnes Gal., Los Angeles, 1969; 2 man exhs.: Univ. Oregon Mus., 1963; Salem (Ore.) AA, 1964; Univ. Idaho, 1965; Boise Cal., 1966; Yellowstone A. Center, Billings, Mont., 1968-1969; Jonson Gal., Albuquerque, N.M., 1969; one-man: Boise Col., 1967; Phillips A. Gal., Salt Lake City, 1969.

STURTEVANT, HARRIET H.—Painter
35-50 77th St., Jackson Heights, N.Y. 11372
B. Manchester, N.H., May 2, 1906. Studied: Albright A. Sch.; Parsons Sch. Design, New York & Paris. Member: AWS; PB; All. A. Am.; Wolfe A. Cl.; Knickerbocker A. Awards: prizes, Knickerbocker A., 1962, 1964; Long Island A. Lg., 1953, 1964; NAC, 1957, 1963; Wolfe A. Cl., 1957, 1960, 1963; gold medal, 1967; PB, 1955, 1958, 1961, 1963. Exhibited: AWS, 1956, 1961, 1962, 1964; Audubon A., 1954, 1959, 1961; Watercolor: USA, 1962, 1963; NAD, 1963; All. A. Am., 1954-1964; Knickerbocker A., 1958-1964; L.I. Art

Lg., 1953-1956, 1964; NAC, 1954-1964; Soc. Ptrs. in Casein, 1960, 1964; PB, 1955-1965; Wolfe A. Cl., 1954-1965, 1967; Pen & Brush Cl., 1969 (one-man); and others.

SUBA, SUSANNE—Illustrator, Des., P.
 1019 Third Ave., New York, N.Y. 10021
B. Budapest, Hungary. Studied: PIASch. Awards: A. Dir. Cl., Chicago and New York; BM. Work: BM; Mus. City of N.Y.; MMA; AIC; Kalamazoo A. Center. Exhibited: one-man: AIC; Hammer Gal., N.Y.; Kalamazoo A. Center. Illus., "Rocket in My Pocket"; "Told in Germany: Fairy Tales"; Author, I., "The Man With the Bushy Beard;" "Dancing Start. Contributor spot designs, covers to New Yorker magazine. Positions: Instr., Community College, Brooklyn, N.Y.; School of Fine Arts, Notre Dame Univ., Nelson, British Columbia.

SUBLETT, CARL C.—Painter, E.
 2104 Lake Ave., Knoxville, Tenn. 37916
B. Johnson County, Ky., Feb. 4, 1919. Studied: Western Kentucky State Col.; Univ. Tennessee. Awards: Virginia Highlands Festival, 1955; Virginia Intermont Regional, 1959, 1965; Knoxville A. Center, 1955-1959 (purchases); Tenn.-Carolina State Fair, 1958 (purchase); Nashville A. Festival, 1959; East Tennessee Purchase Show, Johnson City, 1959; Wash. WC Cl., 1960; Birmingham AA, 1960; FA Festival, Clarksville, 1960; Watercolor:USA, 1964; Good Living Exh., Oak Ridge, (best in show); Hunter Gal., Chattanooga, 1966; WC Soc. of Alabama, Birmingham; Tenn. WC Comp., 1967; Birmingham Festival of Arts, 1967; Mus. A. & Sciences, Macon, 1969, and others. Work: Mint Mus. A.; Mead Co., Atlanta; East Tenn. State Col.; Nashville A. Gld.; Tenn.-Carolina State Fair Coll.; Ala. WC. Soc.; Knoxville A. Center of the Dulin Gal.; Stephens Col., Columbia, Mo.; Tenn. Botanical Gardens & FA Center; Univ. Tenn. Student Center, and in many private colls. Exhibited: Southeastern Annual, Atlanta, 1954-1958, 1960; Mid-South Exh., Memphis, 1956-58; Virginia Intermont Col., 1949-1960; Wash. WC Cl.; Provincetown A. Festival, 1958; Nashville Festival, 1958-1960; Mississippi AA, 1958, 1959; Painting of the Year, Atlanta, 1958; Painters of the New South, Birmingham, 1959; Butler Inst. Am. A., 1959; PAFA, 1959; Tenn. FA Center, 1960; Portland (Me.), 1960; Smithsonian Inst., 1960; numerous 2 and 4-man exhs., 1959. Other exhs., 1964-1965: Watercolor: USA; Drawing Soc. traveling exh., 1965; Univ. Tennessee, 1964; Dulin Gal., 1964; Southeastern Annual, 1964; represented State of Tennessee in Governor's circuit exh., 1966-67; Hunter Gal., 1966; Birmingham Mus. A.; Art in Embassies Program, 1967; Birmingham Festival of Arts, 1967; Mus. A. & Sciences, Macon, 1969; Mead Corp. traveling exh., 1967. Included in Prize Winning Watercolors, 1964. Contributor to Kingsport Times (editorial art). Positions: Prof. Art, Univ. of Tennessee, Knoxville, Tenn.

SUDLOW, ROBERT NEWTON—Painter, E.
 University of Kansas, Department of Painting, Lawrence, Kans. 66044
B. Holton, Kans., Feb. 25, 1920. Studied: California Col. A. & Crafts, M.F.A.; Univ. Kansas, B.F.A.; Univ. California; Andre L'Hote, Grande Chaumiere, Paris, France. Member: Kansas Fed. A. Awards: prizes, CAM, 1946; Joslyn A. Mus., 1947; Topeka A. Gld., 1947, 1951, 1955-1957; Mulvane A. Mus., 1948; Kansas State Col.; Huntington Hartford F., 1957; Elizabeth Watkins F., 1958. Work: Nelson Gal. A.; Wichita A. Mus.; Kansas State Univ., Manhattan, Kans.; CAM; Joslyn A. Mus.; Mulvane A. Mus.; St. Benedict's, Atchison, Kans.; Baker Univ., Baldwin, Kans.; Stephens Col., Columbia, Mo.; Kansas City Public Library; Kansas State Col. Exhibited: PAFA, Kansas State Col.; Kansas State Col.; Springfield Mus. A.; Univ. California; Ariz. State T. Col.; CAM; Joslyn A. Mus.; Wichita; Colorado Springs FA Center; William Rockhill Nelson Gal. A.; Mulvane A. Mus. Positions: Assoc. Prof., Univ. Kansas, Lawrence, Kans., 1946- .

SUGARMAN, GEORGE—Sculptor
 127 Greene St., New York, N.Y. 10012
B. New York, N.Y., May 11, 1912. Studied: City Col. of New York, B.A.; Atelier Zadkine, Paris, France. Awards: prize, Carnegie Inst., 1961; Longview Fnd. Grant, 1961, 1962; National Arts Council, 1966; Ford Fnd. Grant for Tamarind Lithography, 1965. Work: Mass. Inst. Tech.; WAC; Geigy Chemical Corp., Ardsley, N.Y.; Kunstmuseum, Basel, Switzerland; Museum Schloss Marberg, Leverkusen, West Germany; Museum van der Heydt, Wuppertal, West Germany; Museum Haus Lange, Krefeld, West Germany; Scientific Data Systems, El Segundo, Cal. (out-door sculpture). Exhibited: Carnegie Inst., 1961; Sao Paulo Bienal, 1963; WMAA, 1961, 1964, 1966, 1967, 1969; Seattle World's Fair, 1962; Jewish Mus., N.Y., 1964; AIC, 1966; Los Angeles County Mus., 1967; Foundation Maeght, France, 1968; Venice Biennale, 1968; MMoDA, 1969; one-man: Galerie Schmela, Dusseldorf, 1967; Galerie Ziegler, Zurich, 1967; Fischbach Gal., N.Y., 1968, 1969; Kaiser Wilhelm Mus., Krefeld, West Germany 1969; Kunsthalle, Basel, 1969.

SUGIMOTO, HENRY—Painter, Gr., I., T.
 948 Columbus Ave., New York, N.Y. 10025
B. Los Angeles, Cal. Studied: Cal. Sch. FA; Cal. Col. A. & Crafts, B.F.A. Member: San F. AA; Cal. WC Soc.; Nika AA, Tokyo; Print Council of Am.; Fnd. Western A.; Soc. Wash. Pr. M. Awards: prizes, San F. Lg. A., 1936; Fnd. Western A., 1937; Arkansas State Exh., 1946; med., GGE, 1939; AIGA, 1957 (purchase). Work: Palace Legion Honor; Hendrix Col., Ark.; Univ. Arkansas; Mus. of Uyeno, Tokyo, Japan; Cal. Col. A. & Crafts; & in France. Exhibited: Salon d'Automne, Paris, 1931; Cal.-Pacific Exp., 1935; GGE, 1939; San F. AA; Los A. AA; Fnd. Western A.; Cornell Univ., 1950 (one-man); LC, 1950, 1955; PAFA, 1953; Tokyo, Japan, 1953, 1963; BMFA, 1957; AIC, 1957; Memphis Acad. A., 1957; Univ. Minnesota, 1957; AIGA, 1957; U.S. Nat. Mus., Wash., D.C., 1960; Salon des Artistes Francais, Paris, 1963; one-man: Wakayama, Osaka, Tokyo, Japan, 1963; K. T. Hall, Los Angeles, 1967; Wiener Gal., N.Y., 1968; Galeria International, N.Y., 1967; Nichido Gal., Tokyo, 1969. Illus., "Songs from the Land of Dawn"; "New Friends for Susan"; "Toshio and Tama."

SULLINS, ROBERT M.—Painter, E., Gr.
 167 W. Fifth St., Oswego, N.Y. 13126
B. Los Angeles, Cal., Aug. 31, 1926. Studied: Univ. Wyoming, B.A., M.F.A.; Univ. Illinois; Univ. of Guanajuato, Mex., M.F.A., 1967. Awards: Fulbright Grant, Painting, Paris, France, 1959-60. Work: Univ. Wyoming; Public Schools, Rawlins, Wyo.; State Univ. at Oswego, N.Y.; Dulin Gal., Knoxville; Int. Inst. of Edu., New York City, 1968, and in private collections. Murals: St. Joseph Catholic Church, Rawlins, Wyo. Exhibited: Tri-State Exh., Cheyenne, 1956-1958; Wyoming State Exh., 1958; Omaha, Neb., 1958; Finger Lakes Exh., Rochester, N.Y., 1961, 1963, 1964; Everson Mus. A., Syracuse, N.Y., 1962, 1964; Munson-Williams-Proctor Inst., Utica, 1962-1964; State Capitol, Albany, 1962-1964; N.Y. State Exh., Syracuse, 1962; Wayne State Univ., 1962; Art Collectors Exh., Ann Arbor, 1962; Univ. North Dakota, 1962-1964; Fall River, Mass., 1964, 1965; Macon, Ga., 1965; Bucknell, Pa., 1965; PAFA, 1964; St. Paul, Minn., 1963; El Paso, Tex., 1957; Dulin Gal., Knoxville (purchase prize, 1968); Washington & Jefferson Col., 1968; Las Vegas, Nev.; Purdue Univ.; Munson-Williams-Proctor Inst., Utica, N.Y.; State A. Convocation, Albany, N.Y., 1969; one-man: Univ. Wyoming, 1958; Rawlins, Wyo., 1959, 1960; Lander, Wyo., 1959; State Univ. of N.Y. at Oswego, 1961, 1964; Jason Gal., N.Y., 1966; Univ. Florida, 1966; Aegis Gal., N.Y., 1968. Positions: Prof. A., State Univ. of New York, Oswego, N.Y., 1961- .

SULLIVAN, GENE (Miss)—Art Dealer, P., Des., Comm., I.
 69 W. 55th St., New York, N.Y. 10019
B. Sauquoit, N.Y., Nov. 29, 1900. Studied: N.Y. School Fine & Applied Arts; ASL. Member: Pennsylvania Academy of Fine Arts; American Watercolor Society; Catherine Wolfe Art Club. Awards: Albers Memorial Award, Catherine Wolfe Art Club. Exhibited: American Watercolor Society, 1949, 1955, 1962, 1964, 1968, 1969; National Arts Club, 1956, 1957; Audubon Artists, 1950, 1953; Allied Artists of America; Grand Central Art Gallery, 1956 (one-man) Ferargil Gal. (one-man). Illustrations: American Home, House & Gardens, Parents and Good Housekeeping magazines. Designs for greeting cards: Suncan McIntosh, N.Y., California Artists, Reproducta Company, N.Y.; G. Caspari, N.Y. Positions: Director, Gene Sullivan Gallery, New York, N.Y.

SULLIVAN, MAX WILLIAM—Museum Director, E.
 Everson Museum of Art, 401 Harrison St., Community Plaza, Syracuse, N.Y. 13202; h. 120 Lincklaen St., Cazenovia, N.Y. 13035
B. Fremont, Mich., Sept. 27, 1909. Studied: Western State T. Col., A.B; Harvard Univ., A.M. Member: AIA; University Club; AAMus.; Harvard Cl. Awards: Hon. deg., LL.D., Providence Col., 1950. Positions: Instr., Cranbrook Acad., 1933-35; Instr., A. & Crafts, Middlesex Sch., Concord, Mass., 1935-38; Hd. A. Dept., Groton (Mass.) Sch., 1938-42; Consultant A. Edu., Harvard Sch. of Edu., 1940-42; Dir. Exh. of New England Handicrafts, WMA, 1942-43; Consultant, MMA, 1943-44; Dir. Edu., R.I. Sch. Des., 1944-45, Dean of Sch., 1945-47, Pres. of Corp., 1947-55; Dir., Portland Art Mus., Portland Art Assn., and Mus. A. Sch., Portland, Ore., 1956-1961; Sec., Bd. Trustees, 1957-60; Dir., Everson Mus. A., Syracuse, N.Y., 1961- .

SUMM, HELMUT—Painter, E., L.
 University of Wisconsin; h. 6183 North Lake Dr., Milwaukee, Wis. 53217
B. Hamburg, Germany, Mar. 10, 1908. Studied: Univ. Wisconsin, B.S.; Marquette Univ., M.E.; & with Umberto Romano, Carl Peters, William H. Varnum. Member: Wis. P. & S.; Wis. WC Soc. Awards: prizes, Milwaukee AI, 1945, 1946; Gimbel award, 1951; Wis. State Fair, 1951; De Pere (Wis.) A. Festival, 1955; Milwaukee Journal, 1950, 1954; Wis. P. & S. 1958 and AIA award, 1963; Madison Salon, 1966; Meta-Mold Corp. purchase, 1957; Wis. Woman's Cl., 1958,

purchase; United Community Services, Greater Milwaukee Comp., 1960; Beloit, Wis., 1964; purchase awards: Univ. Wisconsin Green Bay Center,1966 and Fox River Valley Center, 1968; Lakeland Col., 1967. Work: Milwaukee AI; Gimbel Coll.; Murals, St. John's Lutheran Sch., Milwaukee; Home for the Aged, Wauwatosa, Wis. Exhibited: John Herron AI, 1946; Lib. Cong., 1944, 1945; Phila. Pr. Cl., 1945, 1946; Wis. P. & S.; Wis. Salon, 1966; AIC, 1950, 1952; Wis. State Fair; DePere, A. Festival, 1955; Milwaukee Atheletic Cl.; WC Cl., 1956-1958; Milwaukee Jewish Center, 1958, 1964; AWS, 1960 and traveling exh., 1960-61. One-man: St. Norberts, De Pere, Wis., 1957; Milwaukee-Downer Seminary, 1958; Kenosha Pub. Mus., 1961; Milwaukee, 1967; Hardin Gal., 1967; West Side Gal., 1969 (Milwaukee); Wustum Mus., 1969. Positions: Director teaching tours Univ. Wisconsin summers, 1961, 1963, 1965, 1967; Prof. A. & Art Edu., Univ. Wisconsin Sch. of FA, Milwaukee, Wis. Dir., Art Dept. Ext. Div., 1948-1958.

SUMMER, (EMILY) EUGENIA—Painter, E., S.
　　Mississippi State College for Women, Columbus, Miss.; h. 915 Fifth Ave. South, Columbus, Miss. 39701
B. Newton, Miss., June 13, 1923. Studied: Miss. State Col. for Women, B.S.; Columbia Univ., M.A., and with Edwin Ziegfeld, Hugo Robus, Dong Kingman.; Post-grad. study, Cal. Col. A. & Crafts, Oakland. Member: AAUW; Southeastern AA; Miss. AA; Allisons A. Colony; CAA; Am. Craftsmens Council. Awards: Elected to "Hall of Fame," Miss. State Col. for Women, 1945; Miss. AA. purchase prize, 1962, 1968; Mid-South exh., Brooks Gal., Memphis, 1965; First Nat. Bank purchase prize, Municipal Gal., Jackson, 1965. Work: Municipal Gal., Jackson; First Nat. Bank, Jackson. Exhibited: Miss. AA, 1947, 1949, 1951, 1956, 1959-1961, 1962, 1965, 1966, 1968; New Orleans AA, 1952, 1953, 1955; Atlanta AA, 1951, 1952, 1965; Memphis Biennial, 1955; Allisons A. Colony, 1952, 1955, 1956, 1958, 1959, 1960; Atlanta AA, 1952; Brooks Mem. Gal., 1955, 1957, 1961, 1962, 1963, 1965, 1966, 1967, 1968, 1969; Mun. A. Gal., Montgomery, 1952, 1953; Delgado Mus., 1952, 1955, 1960; Mus. FA, Little Rock, 1960, 1963, 1965; Soc. Four Arts, Palm Beach, 1960; Mead Packaging of Atlanta, 1961; AFA traveling exh., 1961; Mun. A. Gal., Jackson, 1962-1968; Hunter Gal., Chattanooga, 1964; Fine A. Center, Little Rock, 1962-1963; Birmingham Mus. A., 1968; Cushing Gal., Dallas, Tex., 1969; Art in Embassies Program (U.S. State Dept.), Rio de Janeiro, 1967-1969. Positions: Assoc. Prof. A., Miss. State Col. for Women, Columbus, Miss., 1949- .

SUMMERFORD, BEN L.—Painter, E.
　　Art Department, American University, Massachusetts & Nebraska Aves., Washington, D.C. 20016; h. 10216 Brown's Mill Rd., Vienna, Va. 22180
B. Montgomery, Ala., 1924. Studied: American Univ., Wash., D.C., B.A., M.A. Awards: Academy of Time Fellowship, 1947; Fulbright Fellowship to France, 1949-50. Work: Watkins Gallery, American Univ.; CGA; PC. Exhibited: Jefferson Place Gal., Wash., D.C., 1961, 1963 (one-man), 1967 (one-man). Lectures extensivley in Baltimore and Washington, D.C. including Nat. Gal. A., 1968 and CGA, 1969. Positions: Prof., Chm. A. Dept., The American University, Washington, D.C.

SUMMERS, CAROL—Graphic
　　523 W. 45th St., New York, N.Y. 10036
B. Kingston, N.Y., Dec. 26, 1925. Studied: Bard College, B.A. Member: Phila. Pr. Cl.; Print Council of America. Awards: Italian Government Study Grant, 1954; Tiffany Fnd. Fellowship, 1955, 1960; Guggenheim Fellowship, 1959. Work: MModA; BM; N.Y. Pub. Lib.; MMA; PMA; BMA; Nat. Gal. FA; LC; Smithsonian Inst.; SFMA; Malmo Mus., Sweden; Kunstmuseum, Basel, Switzerland; Lugano A. Mus.; Grenchen A. Mus., Switzerland; BMFA; New Britain Inst.; WAC; AIC; Cal. PLH; Los A. Mus. A.; Univ. Utah, Nebraska, Kansas, Minnesota, Ohio, Missouri; Cornell Univ.; Victoria & Albert Mus., London; Musée Bibliotheque, Paris; Bradley Univ.; SAM. Positions: Instr., Printmaking: Brooklyn Mus. Sch.; Haystack Mountain School of Crafts; Pratt Graphic A. Center, N.Y.; Hunter College; School of Visual Arts, N.Y.; Univ. Pennsylvania.

SUMMERS, DUDLEY GLOYNE—Painter, I.
　　Glasco Turnpike, R.F.D. 77, Woodstock, N.Y. 12498
B. Birmingham, England, Oct. 12, 1892. Studied: ASL; Garden Sch. A., Boston, and with Douglas Connah, Thomas Fogarty, Charles Chapin, F. R. Gruger. Member: SI; SC; A. Gld., Inc. Exhibited: Grand Central A. Gal.; Albany Inst. Hist. & Art; Expo '67; IBM; County Cl., Poughkeepsie, N.Y. Contributor to Red Book, Country Gentleman and other national magazines. Former Instr., Illus. & Drawing, N.Y. Sch. A.; Van Amburgh Sch. A., Plainfield, N.J.

SUNDERLAND, ELIZABETH READ—Educator
　　College Station, Art Dept., Duke University, Durham, N.C. 27708; h. Willett Rd., Rte. #2, Durham, N.C. 27705
B. Ann Arbor, Mich., June 12, 1910. Studied: Univ. Michigan, A.B.;

Univ. Munich, Germany; Radcliffe Col., A.M., Ph.D. Member: Societe des Amis des Arts de Charlieu (hon.); Mediaeval Acad. Am.; CAA; AAUP; La Diana (Hon.); Francaise d'Archéologie; Académie de Mâcon; Am. Assn. Arch. Historians. Author: "Histoire monumental de l'abbaye de Charlieu," 1953. Contributor to: Art Bulletin; Speculum; College Art Journal; Journal of the Soc. Arch. Hist.; Journal of the Arch. Inst. of Japan; Parnassus; South Atlantic Quarterly, & other publications. Field of Research: Mediaeval Architecture of 8th—11th centuries. Awards: Guggenheim F., 1952-53; Chevalier de la Legion d'Honneur, 1954; Citoyenne d'Honneur de la Ville de Charlieu, France, 1952; Duke Endowment Res. Grant for Italy, 1965-1966, and others. Positions: Instr. FA, Duke Univ., 1941-42; Asst. Prof. FA, Wheaton Col., Norton, Mass., 1942-43; Asst. Prof. FA, Duke Univ., Durham, N.C., 1943-1951, Assoc. Prof., 1951- . Dir., Soc. Architectural Historians; Councillor, Mediaeval Acad. of America.

SUNKEL, ROBERT CLEVELAND—Educator, Scholar
　　Department of Art, Northwest Missouri State College; (mail) P.O. Box 75, Maryville, Mo. 64468
B. Clarksville, Tex., Jan. 19, 1933. Studied: Kilgore Col., A.A.; Texas Christian Univ., B.F.A., M.F.A.; Herron Sch. A., Indianapolis, Ind.; Temple Univ.; Northern Illinois Univ. Awards: Bertram Newhouse award, Ft. Worth, Tex., 1955, and other awards in regional exhibitions. Positions: Council Member, Missouri Art Edu. Assn.; Member, Steering Com., Missouri Col. AA; Instr. A., Henderson State T. Col., 1958-1960; Instr. A., 1960-1963, Chm., Dept. A., 1963- , Northwest Missouri State Col.

SUSSMAN, ARTHUR—Painter
　　69-45 182nd St., Flushing, N.Y. 11365
B. Brooklyn, N.Y., Mar. 30, 1927. Studied: Syracuse Univ., B.F.A.; Brooklyn Mus. Sch. A. Awards: Grant, Oriental Studies Fnd., 1962. Exhibited: one-man: Miami Mus. Mod. Art, 1964; Inst. Cultural Relations, Mexico City, 1961; Artists House, Haifa, Israel, 1964; Malaga, Spain, 1963; Bernard Black Gal., N.Y., 1965.*

SUSSMAN, RICHARD N.—Painter, Gr., Des.
　　2018 Irving Ave., South, Minneapolis, Minn. 55405
B. Minneapolis, Minn., June 25, 1908. Studied: Minneapolis Sch. A.; ASL, with George Grosz; Hans Hofmann. Work: MMA; SFMA; Univ. Minnesota; Minneapolis Inst. A.; Brandeis Univ.; WAC; stained glass windows for churches in many cities of U.S. Exhibited: Palace Legion Honor, 1946, 1948; deYoung Mem. Mus., 1944; SFMA, 1949; Joslyn Mus. A., 1961; Poindexter Gal., N.Y., 1960; WMAA, 1960; one-man: WAC, 1955, 1961, 1962, 1964, 1968; Univ. Minnesota, 1956; Minneapolis Inst. A., 1959, 1964.

SUTHERLAND, SANDY—Painter, T.
　　15 Gramercy Park South, New York, N.Y. 10003
B. Cincinnati, Ohio, Apr. 10, 1902. Member: All. A. Am.; AWS; ASL; Grand Central A. Gal.; Portraits, Inc. Awards: Hoe Medal, Mechanics Inst.; prizes, AWS; Village A. Center; Kenneth Taylor Gal., Nantucket; SC (numerous awards). Exhibited: WMAA; AWS (group and traveling); Audubon A.; All. A. Am.; PAFA; Phila. WC Cl.; MMA; AAPL; SC; Taylor Gal., Nantucket; ASL; Grand Central Gal.; NAC; Portraits, Inc., and others. Author: Illus. article, American Artist magazine, 1963, 1968.

SUTTMAN, PAUL—Sculptor
　　c/o Terry Dintenfass Gallery, 18 E. 67th St., New York, N.Y. 10021*

SUTTON, GEORGE MIKSCH—Painter, I., W., L., Mus. Cur.
　　University of Oklahoma, Norman, Okla. 73069
B. Lincoln, Neb., May 16, 1898. Studied: Bethany Col., B.S.; Cornell Univ., Ph.D. Member: Wilson Ornithologists' Soc.; Arctic Inst. of North America; Cooper Ornithological Soc.; Am. Geographical Soc.; British Ornithologists' Union; Am. Ornithologists' Union; New Zealand Ornithological Soc. I., "Birds of Florida"; "Birds of Western Pennsylvania"; "Guide to Bird Finding"; "The Golden Plover and Other Birds"; "American Bird Biographies"; "Georgia Birds"; "The Seashore Book" (in part), I., the bird section of World Book Encyclopaedia; "Iceland Summer" (won the John Burroughs Award); "Oklahoma Birds." Author, I., "Birds in the Wilderness"; "Eskimo Year"; "Mexican Birds"; and many others. Series of life-size drawings of Mexican birds, reproduced by Fnd. for Neotropical Research. Positions: Prof. Zoology, Univ. Oklahoma, Norman, Okla.

SUZUKI, SAKARI—Painter, Scenic Artist
　　5040 Marine Dr., Chicago, Ill. 60640
B. Iwateken, Japan. Studied: Cal. Sch. FA. Awards: prize, Am. A. Cong., 1936; Terry AI, 1952. Member: United Scenic A. Am. Work: High Mus. A., Atlanta, Ga.; murals, Willard Parker Hospital, N.Y.; scenic paintings: Municipal Opera, St. Louis, 1953-55; Star-

light Theatre, Kansas City, 1956-62, 1964; General Motors, Detroit, for GM's Futurama, N.Y. World's Fair, 1962-63. Exhibited: CGA, 1934; Berkshire Mus.; ACA Gal., 1936 (one-man); CAA Exh.; New Jersey Col. for Women, 1945; Artists Gal., N.Y., 1948, 1951 (one-man); Ogunquit A. Center, 1950, 1951; U.S. Dept. Army, 1951; PAFA, 1952; Mandel Bros., 1955 (one-man).

SVET, M(IRIAM) (Mrs. Dore Schary)—Painter
33 East 70th St., New York, N.Y. 10021
B. Newark, N.J., Apr. 15, 1912. Studied: Faucett A. Sch.; with Carl Von Schleusing, Newark; NAD; ASL, with George Bridgman, Frank V. Dumond. Member: AFA; Los A. AA. Work: Los Angeles City Hall; Brandeis Univ.; Fairleigh Dickinson Col., Teaneck, N.J. Ports. in private colls. Exhibited: One-man: Assoc. Am. A., 1951, 1956; Vigeveno Gal., Westwood, Cal., 1954; Los A. AA (twice yearly); Nessler Gal., N.Y., 1962-1964; Corcoran Rental Gal., Wash., D.C., 1964.

SWAN, BARBARA—Painter, Lith.
808 Washington St., Brookline, Mass. 02146
B. Newton, Mass., June 23, 1922. Studied: Wellesley College, B.A.; BMFA Sch. Member: AEA (Pres. N.E. Chapter). Awards: Albert Whitin Traveling Fellowship from Boston Mus. FA, 1948; F., Mac-Dowell Colony; Grant as Assoc. Scholar, Radcliffe Inst. for Independent Study, 1961-1963. Work: Harvard Univ.; Boston Pub. Lib.; Simmons Col.; Wellesley Col.; Radcliffe Col.; Brandeis Univ.; Colby Col.; Milton Academy; PMA; BMFA; FMA; WMA. Exhibited: Carnegie Inst., 1949; Univ. Illinois; Toledo Mus. A.; BM, 1964; BMFA; Inst. Contemp. A., Boston, 1960; De Cordova & Dana Mus., 1963; Boris Mirski Gal., Boston; Cober Gal., N.Y., 1968. Positions: Instr., Painting & Drawing, Boston Museum School; Wellesley College; Milton Academy; Boston University.

SWAN, MARSHALL W. S.—Educator
U.S. Information Service, Stockholm, Sweden
B. Brockton, Mass., Nov. 10, 1917. Studied: Harvard Univ., A.B., A.M., Ph.D. Member: Soc. for Advancement of Scandinavian Studies. Contributor to: publications of the Bibliographical Soc. of Am., Journal of English Literary History, & other publications; Ed., two vols. of Scandinavian Studies; Lectures on American Painting. Positions: Asst. Prof., Tufts Col., Medford, Mass., 1942-46; Cur., Dir., Am. Swedish Hist. Mus., Philadelphia, Pa., 1946-49; Public Affairs Officer, American Embassy, The Hague, Holland, 1951-55; U.S. Information Service, Milan, Italy, 1955-57. Cultural Attache, American Embassy, Rome, Italy, 1957-58; Public Affairs Officer, American Embassy, Oslo, Norway, 1958-1963; Asst. Chief of Training, United States Information Agency, Washington, D.C., 1963-1966; Public Affairs Officer, American Embassy, Stockholm, Sweden, 1966- .

SWANN, ERWIN—Collector, Patron, Writer
24 W. 55th St., New York, N.Y. 10019; h. R.D. #1, Riegelsville, Pa. 18077
B. New York, N.Y., Dec. 9, 1906. Studied: Univ. Virginia; Univ. Wisconsin. Member: Advisory Council, Dept. of Art History & Archaeology, Columbia University, New York, at present. Collection: French Impressionist Art; Modern European and American Art; Indian and Far Eastern; Original Drawings of Caricature and cartoon artists of the 18th, 19th, and 20th centuries. Founder: The Swann Collection of Caricature and Cartoon.

SWANSON, DEAN—Museum Curator
Walker Art Center, 807 Hennepin Ave. 55403; h. 504 W. Franklin Ave., Minneapolis, Minn. 55405
B. St. Paul, Minn., Sept. 7, 1934. Studied: Univ. Minnesota, B.A., M.A. Exhibitions organized with catalogues: Robert Rauschenberg, 1965; Nicholas Krushenick, 1968; Richard Lindner, 1969. Positions: Teaching Asst., Univ. Minnesota, 1957-1960; Asst. Cur., 1962, Assoc. Cur., 1964, Chief Cur., 1967- , Walker Art Center, Minneapolis, Minn.

SWARZ, SAHL—Sculptor, P., T.
245 Palisade Ave., Cliffside Park, N.J. 07010
B. New York, N.Y., May 4, 1912. Studied: ASL, and with Dorothea Denslow. Member: Sculpture Center. Awards: Am. Acad. A. & Lets. grant, 1955; Guggenheim F., 1955, 1958; Ford Fnd. purchase, 1963. Work: Brookgreen Gardens, S.C.; Ball State T. Col.; Lawrence A. Mus., Williams Col., Williamstown, Mass.; Norfolk Mus. A. & Sc.; WMAA; Federal Courthouse, Statesville, N.C.; Newark (N.J.) Mus.; New Jersey State Mus., Trenton; VMFA; Minneapolis Inst. A.; USPO, Linden, N.J.; equestrian statue, Buffalo, N.Y. Exhibited: nationally since 1934. One-man: Sculpture Center, 1954, 1957, 1960, 1962, 1966; Phila. A. All., 1959; Fairweather-Hardin Gal., Chicago, 1963; Brandeis Univ., 1964. Author: Blueprint for the Future of American Sculpture, 1943; The Sculpture of Ilse Erythropel, 1967. Lecture: "The History of the Clay Club," (Krefeld, Germany), 1968. Positions: Assoc. Dir., Sculpture Center,

New York, N.Y., 1938-1954; Res., Am. Acad. in Rome, 1955-57; Instr., Pratt Institute, Brooklyn, N.Y., 1964-65; Brandeis Univ., 1964-65; Univ. Wisconsin, Madison, 1966; Columbia Univ., 1966- .

SWARZENSKI, HANNS—Educator, Mus. Cur., W.
102 Raymond St., Cambridge, Mass. 02140
B. Charlottenburg, Germany, Aug. 30, 1903. Studied: Univ. Freiburg, Munich, Berlin; Univ. Bonn, Ph.D.; Harvard Univ.; & in Italy. Member: Mediaeval Acad. Am. Author: "The Berthold Missal," Pierpont Morgan Lib., N.Y., 1943; Ed., F. Saxl's "English Sculptures of the XII Century," 1954; "Monuments of Romanesque Art," 1955; "European Masters of the 20th Century," 1957; "Masterpieces of Primitive Art; 1958. Contributor to: Art Bulletin, Gazette des Beaux-Arts, etc. Lectures: Romanesque Art; Illuminated Manuscripts. Positions: Research Asst., Princeton Institute of Advanced Study, Princeton, N.J., 1936-50; Acting Cur., Sculpture, NGA, Washington, D.C., 1943-46; Research F., BMFA, Boston, Mass., 1948- ; Part-time L., Warburg Inst., London Univ., 1950-56; Cur. Dec. Arts & Sculpture, Boston Museum of Fine Arts, 1957- . Lecturer, Harvard University, 1963- .

SWAY, ALBERT—Painter, Gr., I., Indst. Des.
445 East 68th St., New York, N.Y. 10021
B. Cincinnati, Ohio, Aug. 6, 1913. Studied: Cincinnati A. Acad.; ASL. Member: SAGA. Awards: prize, CM, 1939. Work: MMA; Carnegie Inst.; N.Y. Hospital; Pa. State Univ. Exhibited: AIC, 1936-1938; CGA, 1939; PAFA, 1936; GGE, 1939; Paris Salon, 1937; Stockholm, Sweden, 1937-38; WFNY 1939; LC, 1943-1945; Albright A. Gal., 1951; SAGA, 1951-1969; Butler AI, 1940; NAD, 1944; Royal Soc. P., Et., Engravers, London, England, 1954; America Japan Contemp. Print Exh., Tokyo, 1967; one-man: Closson A. Gal., Cincinnati, 1937; Delphic Studios, 1938; Wellons Gal., 1950, 1951. Illus. text books including Lamb's Sectional Histories (New York State); "New York State in Story," Medical illus. for text books including "A Syllabus for Health Visitors" published by The Navajo Tribal Council, Window Rock, Ariz., 1960, and others, 1961, 1968. Illus. educational film strips produced by Our York State, Cooperstown, N.Y., 1950, 1954, 1959, 1967. Exhibit Des., Dept. Public Health, Cornell Univ. Medical College, 1963, 1964; Instr., Drawing & Painting, New York Hospital League, 1963-64.

SWEENEY, JAMES JOHNSON—Museum Director, W.
120 East End Ave., New York, N.Y. 10028
B. Brooklyn, N.Y., May 30, 1900. Studied: Georgetown Univ., Wash., D.C., A.B.; Jesus Col., Cambridge, England; Sorbonne, Paris, France; Univ. Siena, Italy. Awards: Hon. D.F.A., Grinnell Col., 1957; Chevalier Legion d'Honneur, 1955; Hon. degrees 1960-61: L.H.D., Col. of the Holy Cross; L.H.D., Rollins Col.; Arts D., Ripon Col.; D.F.A., Univ. Michigan and Univ. Notre Dame; D.F.A., Univ. Buffalo, 1962; L.H.D., Georgetown Univ., 1963; L.H.D., Univ. Miami, 1968; Art in America Award, 1963. Member: F., Royal Soc. Antiquaries of Ireland (Dublin); Mediaeval Acad. of Am. (Councillor, 1966-); Acad. in Rome, 1962- ; Am. Acad. A. & Lets., 1967- ; Societe Europeene de la Culture; Fed. Internationale du Film d'Art, Paris (Hon. Pres.); Century Assn.; Grolier Cl.; AAMus.; FA Council, Univ. St. Thomas, Houston; Int. Jury VI Biennale, Sao Paulo, 1961; Bd. Dirs., AFA, 1960- ; Bd. Dir., Tamarind Lithography Workshop, Los Angeles; Int. Assn. Art Critics, 1947 (Vice-Pres., 1948-1957, Pres., 1957-1963), and others. Dir. Exhs: "African Negro Art," MModA, 1935; "Joan Miro," 1941; "Alexander Calder," 1943; "Picasso," Art Gallery of Toronto, 1949; "Alfred Stieglitz," 1947; "Twelve American Painters," 1948; Rosc '67, Dublin, 1967; "Signals in the Sixties," Honolulu, 1968; Dir., and commentary, film "Henry Moore," 1948; "Adventures of—," 1957; (with Richard de Rochemont), "The Road to the Olmec Head," 1963; Dir., Va. Biennial Exh., 1950; Installation U.S. Pavillion Bienale, Venice, Italy, 1952; memb. Jury II, Bienale Sao Paolo, 1954; Carnegie Intl. Jury, 1958; "Message on the Plastic Arts," Brussels World's Fair, 1958. Author, co-author or Ed.: "Antoni Gaudi" (with Jose Luis Sert), 1959; "African Folk Tales and Sculpture" (with Paul Radin), 1952; "Alexander Calder," 1951; "Burri," 1955; "The Miro Atmosphere," 1959; "Irish Illuminated Manuscripts," 1965; "Vision and Image," 1968. Positions: L., Salzburg, 1948-49; Dir., Dept. Painting & Sculpture, MModA, 1945-46; Dir., Burlington Magazine, London, 1952- ; Adv. Ed., Partisan Review, 1948- ; Contrib. Cr., New Republic, 1952-53; Exh. Dir., Musée d'Art Moderne, Paris, and Tate Gal., London, 1952; Res. Scholar, Univ. Georgia, 1950-51; memb., W.B. Yeats Mem. Comm., Dublin; memb. Adv. Comm., Arts Center Program, Columbia Univ.; art edu. dept., N.Y. Univ; Bennington Col. Dir., Solomon R. Guggenheim Museum, New York, N.Y., 1952-60; Dir., Museum of Fine Arts, Houston, Tex., 1961-1968, Consultant Director, 1968- ; Gallery Consultant, National Capital Development Commission, Canberra, Australia, 1968- . Lecturer on Fine Arts, Harvard University, 1961; Member, National Council on the Arts, Wash., D.C., 1965- . Visiting Committee Fine Arts, Harvard, 1969- .

SWEENY, BARBARA—Associate Museum Curator
John G. Johnson Collection, Parkway & 25th St., P.O. Box 7646, Philadelphia, Pa. 19101; h. 314 Hathaway Lane, Wynnewood, Pa. 19096
B. Philadelphia, Pa., Apr. 10, 1904. Studied: Wellesley Col., B.A. Compiled catalogue of the Johnson Collection, 1941; revised catalogue Italian Painting, Johnson Collection, 1966. Book of Illustrations of the Johnson Collection, 1953. Positions: Asst. to the Curator, 1931-54, Assoc. Cur., 1954- , Johnson Collection, Philadelphia, Pa.

SWEENEY, FREDRIC—Illustrator, W., Comm.
4576 Cooper Rd., Sherwood Estates, Sarasota, Fla. 33580
B. Holidaysburg, Pa., June 5, 1912. Studied: Cleveland Sch. A. Awards: prize, Cleveland Mus. Natural Hist., 1939 (bird show); Kendall Scholarship, Cleveland Sch. A.; Lithographers & Printers Nat. Award Competition & Exhibit (calendar) 1960, 1961. Exhibited: Sarasota AA; Manatee A. Lg.; St. Petersburg AA. Author, I., "Techniques of Drawing and Painting Wildlife," 1959. Author, I., "Drawing and Painting Birds," 1961; "Painting the American Scene in Watercolor," 1964. Illus: "The First Book of the Seashore"; "The First Book of the American Expansion"; "Naturalist-Explorers"; "Hawk in the Sky"; "The Frightened Hare"; "Weather." Author, Illus., to Sports Afield; Nature Magazine; Ourdoors Magazine; Outdoorsman Magazine. Positions: Adv. A., Cleveland Press, 8 years; Wildlife Calendar Artist, Brown & Bigelow, 20 years; Instr., Ringling Sch. A., Sarasota, Fla., 17 years.

SWENSON, VALERIE—Painter
Shandaken, N.Y. 12480
B. Kansas City, Mo., Apr. 11, 1907. Studied: Kansas City AI; Univ. Kansas, B.F.A. Member: Woodstock Gld. A. & Craftsmen; Exhibited: Woodstock Gld. A. & Craftsmen; exhs., in Chicago, Philadelphia and New York; one-man: Am. Mus. Natural Hist.; Argent Gal., N.Y.; Albany Inst. Hist. & A. Author, I., "A Child's Book of Trees," 1953; "A Child's Book of Reptiles and Amphibians," 1954; "A Child's Book of Stones and Minerals," 1955, "Bees and Wasps," 1959; "The Year," and illustrations for many nature books and magazines.

SWETZOFF, HYMAN—Art Dealer
Swetzoff Gallery, 123 Newbury St., Boston, Mass. 02116*

SWIFT, DICK—Printmaker, P., E.
Art Dept., California State College, Long Beach, Cal.; h. Box 523, Sunset Beach, Cal. 90742
B. Long Beach, Cal., Nov. 29, 1918. Studied: Los A. State Col., B.A.; Claremont Grad. Sch., M.F.A.; Chouinard AI; ASL. Member: Am. Color Pr. Soc.; Los Angeles Pr. Soc. (Pres. 1968-1969). Awards: prizes, Birmingham, Mich., 1962; Long Beach A. Mus., 1962; Univ. Illinois, 1962 (2); FA Gal. of San Diego, 1963; Cranbrook Acad. A., 1966; Los Angeles City, 1967; purchase prizes, Wichita AA, 1963; Okla. Pr.M., 1964; Downey Mus., 1964; Los A. Annual, 1964; Am. Color Pr. Soc., 1965; N.J. State Mus., 1968; Otis A. Inst., 1969; Cal. State Col. Grant for Paris, 1965. (29 awards prior to 1966). Work: San Jose Col.; Univ. Illinois; CM; Drake Univ.; Zanesville AI; Univ. of Redlands; Wichita A. Center; Swope Gal. A.; Downey A. Mus.; Univ. Nevada; PMA; Otis A. Inst.; State Univ., Albany, N.Y.; Lytton Center of Visual A., Los Angeles; Oklahoma A. Center; Victoria & Albert Mus., London; Bibliotheque Nationale, Paris; USIA, State Dept.; Wayne State Col.; Canton A. Inst.; Baylor Univ.; N.Y. Pub. Library and many others. Exhibited: nationally, 1965-1969, including Univ. Oklahoma; Beloit Univ.; State Univ. of N.Y.; Univ. Alaska; Methodist Univ.; Otis AI; CAL.PLH; Los A. Mus. A.; Pasadena Mus. A.; PAFA; SAM; BMFA; Okla. Pr.M.; Am. Color Pr. Soc. and others; one-man: Santa Barbara Mus.; De Ville Gal., Los A.; Hobbs Gal., San F.; Cornell Univ.; Orange County AA; Fullerton AA; St. Benedicts Col., Kansas; Ryder Gal., Los A.; Northwestern Col.; Univ. Mississippi; Univ. Wichita; Adrian Col., Mich.; (over 180 exhs. 1942-1965). Positions: Prof. A., California State College, Long Beach, Cal., 1958- .

SWIGGETT, JEAN (Mr.)—Educator, P.
9275 Briarcrest Dr., La Mesa, Cal. 92041
B. Franklin, Ind., Jan. 6, 1910. Studied: Chouinard AI; Claremont Grad. Sch.; San Diego State Col., A.B.; Univ. Southern California, M.F.A. Member: San Diego A. Gld.; La Jolla A. Center. Work: San Diego FA Soc.; La Jolla A. Center; murals, SS. Pres. Adams; SS. Pres. Jackson; USPO, Franklin, Ind.; Ridpath Hotel, Spokane, Wash.; San Diego County Hospital. Awards: prizes, Hoosier Salon, 1950; San Diego A. Gld., 1950-1960; Cal. State Fair, 1951; Los A. County Fair, 1951. Exhibited: GGE, 1939; Los A. Mus. A., 1935-1941, 1946, 1950; SAM, 1941; San Diego A. Gld., 1948-1960; SFMA, 1936, 1938; Denver A. Mus., 1951, 1952; John Herron AI, 1948-1954, 1957; Hoosier Salon, 1948-1952; Ariz. State Fair, 1950; Cal.

State Fair, 1951, 1952; Albright A. Gal., 1951; Scripps Col., 1958; Bradley Univ., 1952; La Jolla Mus. A., 1966; Jewish Community Center, San Diego, 1966, 1967; FA Gal., San Diego, 1966, 1967; Long Beach Mus. A., 1968; Laguna Beach AA, 1968; Tucson A. Center, 1967; local invitationals, 1962-1965; one-man: San Diego City Col., 1967. I., "California Today," 1937. Des., Art Show, So. California Expo., 1958, 1959; member of jury, 1960. Lectures: FA Gal., San Diego, 1968, 1969, on "Yugoslavian Frescoes" and "Peruvian Crafts," and for private groups. Positions: Instr., A., Univ. So. California, 1940-41; Wash. State Col., 1941-42; Prof., Instr., oil, watercolor, life drawings & composition, Art of Middle America, and Aesthetics, San Diego State Col., San Diego, Cal., 1946- , Chm. A. Dept., 1963- .

SWIRNOFF, LOIS (CHARNEY)—Painter, E., L.
Dept. of Art, Carpenter Center for Visual Art, Harvard University, Cambridge, Mass. 02138; h. 80 Monmouth St., Brookline, Mass. 02146
B. Brooklyn, N.Y., May 9, 1931. Studied: Cooper Union, N.Y.; Yale Univ., B.F.A., M.F.A. with Albers. Member: AEA. Awards: Fulbright Fellowship, to Italy, 1951-52; Assoc. Scholar, Radcliffe Inst. for Independent Study, 1961-62, 1962-63. Work: AGAA; Farnsworth Mus.; Jewett A. Center, Wellesley, Mass.; Radcliffe Inst., Cambridge, and in private colls. Exhibited: Boston A. Festival, 1961-1964; Munson-Williams-Proctor Inst.; CAM; Duveen-Graham Gal., N.Y.; Cooper Union Mus. A.; Yale Univ. Gal. FA; BM; La Jolla Mus. A.; Limited Editions Gal., Los Angeles; one-man: Wellesley Col.; Wheaton Col.; Radcliffe Col. Positions: Prof. A., Univ. Cal., at Los Angeles and Univ. of Southern California, 1963-1968; Visiting Lecturer, Harvard Univ., at present.

SYKES, (WILLIAM) MALTBY—Painter, Gr., E., L.
Art Department, Auburn University; h. 712 Brenda Ave., Auburn, Ala. 36830
B. Aberdeen, Miss., Dec. 13, 1911. Studied: with John Sloan, Wayman Adams, Diego Rivera, Fernand Leger, Stanley Hayter, André L'Hote. Member: NAEA; Phila. Pr. Cl.; Am. Color Print Soc.; Ala. WC Soc.; Birmingham A. Cl.; SAGA; Scarab Cl. Awards: prizes, Ala. A. Lg., 1944, 1945; New Orleans AA, 1937, 1945, 1948, 1949; Ala. State Fair, 1939, 1941, 1958; Birmingham A. Cl., 1941, 1942, 1948, 1949, 1956; Mint Mus. A., 1945; Ala. WC Soc., 1941, 1943; AIGA, 1949; Research grant, Auburn Univ., 1954-55, 1966-1967; Sabbatical award, Nat. Endowment for the Arts, 1966-1967; Mid-South Exh., 1957; Pr. Cl. of Albany. Work: Ala. State Capitol Bldg.; Ala. Dept. Archives & Hist.; Albany Inst. Hist. & A., Montgomery Mus. FA; Univ. Alabama; Section Hist. Properties, Wash., D.C.; MMA; Ala. Col.; Auburn Univ.; Okla. A. & M. Col.; BMA; Birmingham Mus. A.; BM; CM; PMA; Stedelijk Mus., Amsterdam; Tennessee FA Center; the White House Coll., Washington, D.C. Exhibited: Albany Inst. Hist. & A., 1948, 1949, 1951, 1963; AFA, 1950, 1951; AIGA, 1949; Bradley Univ., 1952; BM, 1949-1952, 1966; Carnegie Inst., 1945, 1946; Chicago Soc. Et., 1952; CM, 1952; Delgado Mus. A., 1945-1950; Fla. State Univ., 1964, 1967; Birmingham Mus. A., 1963; Laguna Beach AA, 1948; LC, 1945, 1948-1951; Mint Mus. A., 1944, 1945, 1968; NAD, 1946, 1949; PAFA, 1937, 1950; Phila. Pr. Cl., 1945, 1956, 1963; SAM, 1945, 1946, 1949, 1950, 1952; SAGA, 1951, 1952, 1956, 1962, 1963; L.D.M. Sweat Mem. Mus., 1952; Wichita AA, 1948-1950; Phila. WC Cl.; Wash. WC Cl.; AWS; Salon d'Automne, 1951; BM, 1951, 1952; Int. Color lithog., exh., 1952-1954, 1956; MMA, 1952; U.S. State Dept. European exh., 1955-56, 1963-64; Curator's Choice, 1956; Am. Color Print Soc., 1958, 1963, 1964, 1967; Am. Drawing Biennial, 1969; Japan Pr. Assn., 1967-1969; and others. One-man: Auburn Univ., 1967; Birmingham-Southern Univ., 1967; Huntsville Mus. Assn., 1968; Tennessee FA Center, 1968; Columbus Mus. A. & Crafts, 1968; Springhill Col., 1969. Color engraving distr. by Int. Graphic Arts Soc., 1955, 1958, 1962. Positions: Prof. A., and A.-in-Res., Auburn University, Auburn, Ala., 1942, 1943, 1946- . Sec., Nat. Assn. Schs. of Design, 1958-59.

SYLVESTER, LUCILLE—Painter, W., I., L., T.
200 West 20th St., New York, N.Y. 10011
Studied: ASL; Julian Acad., Paris, France; Hunter Col.; Columbia Univ. Member: Audubon A.; Knickerbocker A. (1st Vice-Pres. 1963-65); Intl. Platform Assn.; Catherine L. Wolfe A. Cl.; ASL (life); AAPL (Fellow); N.Y. Hist. Soc. Awards: gold medal, Knickerbocker A., 1952; Wolfe A. Cl., 1957, 1959. Exhibited: NAD; NAWA; Audubon A., 1959-1969; All. A. Am.; Argent Gal.; ASL; NAC; AEA; Barbizon Little Gallery, 1955, 1959 (one-man); New Jersey P. & S., 1955; Butler Gal., 1955; Churchill Gal., 1957 (one-man); Hudson Gld. Gal., 1958 (2-man); Federal Hall Mus., 1961; Knickerbocker A., 1959-1968; Wolfe A. Cl., 1959-1969; Hammer Gal. (one-man); Sutton Gal., 1963; Fairleigh Dickinson Univ., 1964; Freedom House; Columbia Univ. T. Col.; AAPL, 1968; Int. Platform Assn., 1965, 1967, 1968; Chelsea A. Festival, 1967; Interfaith AA, 1967, 1968; Springville, Utah, Mus. A., 1968; Hudson Valley AA,

968; and others. Contributor to national magazines. Author, I., juvenile books, Series of Historical feature articles, Chelsea-Clinton News, 1968-1969.

SYLVIA, LOUIS—Painter, T.
38 Howland St., South Dartmouth, Mass. 02714
Studied: Swain Sch. Des.; NAD; ASL. Awards: prizes, Mystic AA, 1961-1964; Niantic WC Exh., 1964; Dartmouth Double Award, 1964; Groton A. Festival, 1968; Saybrook (Conn.) A. Festival, 1968. Exhibited: Jordan Marsh Co.; Newman Gal.; Sandjford Mus., Norway; Kendall Mus., Sharon, Mass.; Mystic AA, and others. One-man, South County AA; Findlay Gal., N.Y. Work: murals, South Eastern Savings Bank and 1st Nat. Bank, New Bedford, Mass. Positions: Instr., A., Roosevelt Jr. H.S., New Bedford, Mass., 1958- .

SYMON, GAIL—Painter, E.
c/o Hicks, Cloverly Circle, East Norwalk, Conn. 06855
B. Boston, Mass. Studied: NAD; ASL; Grand Central A. Sch.; Otis AI; Member: Audubon A.; Conn. Acad. FA; Silvermine Gld. A.; New Haven Paint & Clay Cl. Awards: prizes, Silvermine Gld. A., 1945; New Haven Paint & Clay Cl., 1951; Conn. Acad. FA, 1953, 1959. Work: in private colls. Specializes in portraits. Exhibited: Argent Gal.; Montross Gal.; Salpeter Gal.; Babcock Gal.; Macbeth Gal., all in New York City; Riverside Mus.; three one-man exhs., New York City and Silvermine Gld. Positions: Dir., Silvermine College A., New Canaan, Conn., 1950-1963, Dean Emeritus, 1964- . Instr., at present.

SZABO, LASZLO—Portrait Painter, T., L.
795 Elmwood Ave.; h. 103 Lancaster Ave., Buffalo, N.Y. 14222
B. Budapest, Hungary, Aug. 18, 1895. Studied: Royal Acad. A., Budapest; Ecole des Beaux-Arts, Paris, France; ASL. Member: Pan Arts Soc.; Buffalo Soc. A.; Rationalists A. Cl.; Gld. All. A.; Genesee Group; Batavia Soc. A.; F., Royal Soc. A., London; ASL (life); Daubers Cl.; FA Lg. (Pres.). Awards: prizes, Buffalo Soc. A., 1938, 1943, 1946, 1947, 1950-1954; Gld. All. A., 1939, 1940, 1944, 1949, 1950, 1952, 1964, 1967; Pan Arts Soc., gold medal, 1955; Rembrandt prize, 1956, 1960; Diestel & MacDonald prizes, 1957; FA Lg., silver medal, 1958, gold medal, 1963 and 1968, Grumbacher prize, 1964; Gainsborough prize, 1959, Rembrandt prize, 1960, 1967; Talens & Son, Inc. prize, 1961, 1966; Buffalo Symphony Orchestra prize, 1963. Work: Erie County Hall, Buffalo, N.Y.; Niagara Sanatorium, Lockport, N.Y.; Buffalo Consistory, Riverside H.S., Liberty Bank, all of Buffalo; Swope A. Gal.; N.Y. State Hist. Assn., Ticonderoga, N.Y.; N.Y. State Supreme Court, Buffalo; East Aurora Trust Co., and St. John Vianney Seminary, both East Aurora, N.Y.; Domestic Relations Court, Buffalo; Veterans Admin. Hospital, Buffalo; N.Y. State Historical Assn., Ticonderoga, N.Y. Exhibited: Buffalo Soc. A., annually; Gld. All. A.; Albright A. Gal.; Rundall Gal., Rochester; Rationalists A. Cl., traveling exhs. in Rochester, Albany, Binghampton, Auburn, N.Y.; Batavia Soc. A.; Genesee Group; PAFA; Ogunquit A. Center; Sheldon Swope A. Gal.; Daubers Cl. & Cayuga Mus., Auburn, N.Y.; Buffalo Mus. Science; Pan A. Soc.; FA League, Buffalo; one-man: Town Cl., Kowalski Gal., Twentieth Century Cl., Pub. Lib., Shea's Buffalo Theatre, Buffalo Pub. Lib.; YMCA and Williams Gal., all in Buffalo, N.Y.

TADASUKE, KUWAYAMA—Painter
142 Fulton St., New York, N.Y. 10038
B. Nagoya, Japan, Aug. 24, 1935. Studied: ASL; Brooklyn Mus. Sch. Work: MModA; Albright-Knox Gal., Buffalo; Mus. FA of Houston; Chase Manhattan Bank; Columbia Broadcasting Corp.; James Michener Coll.; Krannert Mus., Univ. Illinois; Rose A. Mus.; Brandeis Univ.; Aldrich Mus. Contemp. A.; Lowe Gal., Miami; Univ. Nebraska; Phoenix A. Mus.; BMA; Am. Republic Ins. Co.; Art International; International Minerals; Ohara Mus., Japan; Nagaoka Contemp. A. Mus.; Gutai Mus., Japan. Exhibited: MModA, 1965; Albright-Knox A. Gal., 1965; Krannert Mus., Univ. Illinois, 1965; Nat. Mus. Mod. A., Tokyo, Japan, 1965; 17th Annual "Shusakutan," Tokyo, 1966; Jewish Mus., N.Y., 1966; N.Y. State Fair, 1967. One-man: Kootz Gal., N.Y., 1965 (2); Tokyo Gal., 1966; Gutai Mus., Osaka, 1967; Fischbach Gal., N.Y., 1967, 1969.

TAIT, MRS. TREVOR S. See Lamb, Katharine

TAJIRI, SHINKICHI G.—Sculptor
Kasteel Scheres, Baarlo (Limburg), The Netherlands
B. Los Angeles, Cal., Dec. 7, 1923. Studied: AIC; Academie Grande Chaumiere and with Zadkine, Leger, in Paris, France. Awards: Copley Fnd. Award for Sculpture, Paris, 1959; John Hay Whitney Fnd. Fellowship, 1960, Amsterdam; Gold Medal for Sculpture, Biennale of San Marino, 1963; Mainichi Shibum prize for Sculpture, Tokyo Biennale, 1963. Work: MModA; Carnegie Inst.; Univ. Illinois; Stedelijk Mus., Amsterdam; Boymans Mus., Rotterdam; Gemeente Mus., Arnhem; Palais des Beaux Arts, Leige; Mus. of Göteborg and Stockholm, Sweden; Wuppertal, Germany; Mus. 20th Century Art,

Vienna. Exhibited: Sonsbeek, Arnheim, 1966; Carnegie Int., 1967; Kunsthalle, Berne, 1967; Expo '67, Montreal; Documenta IV, Kassel, 1968; Kunsthalle, Recklinghausen; 1968; one-man: Court Gal., Copenhagen, 1966, 1968; Galerie Krikhaar, Amsterdam, 1967; Galerie Leger, Malmö and Göteberg, 1967; Stedelijk Mus., Amsterdam, 1967; Palais des Beaux-Arts, Brussels, 1968; Univ. of Technology, Eindhoven 1968; Univ. Economics, Tilburg, 1968; Von der Heydt Mus., Wuppertal, 1968; Contact-Wunstrof, Germany, 1968; Kunstverein, Dusseldorf, 1968; Kunsthalle, Basel, 1969; Galerie Espace, Amsterdam, 1969. Positions: Guest Prof., Wekkunstschule, Wuppertal, Germany, 1951-52; Visiting Prof., Minneapolis School of Art, (sculpture), 1964-65.

TAKAEZU, TOSHIKO (Miss)—Ceramic Craftsman, T.
Cleveland Institute of Arts, 11141 East Blvd. h. 11519 Mayfield Rd., Cleveland, Ohio 44106
B. Hawaii, June 17, 1922. Studied: Honolulu Acad. A.; Univ. Hawaii; Cranbrook Acad. A. Awards: Webler award and Artesian purchase award, Mich. Artist-Craftsmen, 1961; Mich. Potters Assn., 1961; Founders Soc. purchase prize, 1958; Butler Inst. Am. A., purchase, 1957, 1959, 1960. Work: CMA; Detroit Inst. A.; Smithsonian Inst.; Albion Col.; Murray State T. Col.; univs. of Michigan, Eastern Michigan, Utah State, Michigan State, Northern Illinois; St. Paul Gal. A.; Butler Inst. Am. A.; Des Moines A. Center; Bangkok Mus., Thailand; Springfield Mus. A.; Cranbrook Mus. A.; Muskegon A. Mus.; Cleveland AA. Exhibited: First Unitarian Church, Cincinnati, 1960; Albright A. Gal., 1960; Akron Inst. A., 1958; Des Moines A. Center, 1960; Texas Christian Univ., 1959; So. Illinois Univ., 1957, 1959; Univ. Michigan, 1960; Milwaukee A. Center, 1959; Louisville A. Center, 1960; Ball State T. Col., 1958; Contemp. Crafts, Columbus, 1958; Murray State T. Col., 1958; Staten Island Mus. Hist. & A., 1958; Univ. Nebraska, 1955; Syracuse Nat., 1951, 1953, 1954, 1956, 1958; Wichita Nat. Dec. A. & Ceramics, 1951-1953, 1955, 1958-1961; St. Paul, 1952; CMA, 1957-1961; Butler Inst.; Miami Nat. Ceramics, 1953, 1955, 1958; Midwest Des. & Wisconsin Des. Craftsmen, 1955; one-man: Cleveland Inst. A., 1961; Clarke Col., 1961; St. Mary's Col., Notre Dame, 1961; AIC, 1960; George Peabody Col., 1961; Mich. State Univ., 1960; Univ. Wisconsin, 1955; Bonnier's, N.Y., 1955; 2-man: Honolulu Acad. A., 1959; Lake Erie Col., 1960; Cleveland Women's Cl., 1958; 3-man: Las Vegas (N.M.) Highlands Univ., 1958, and other exhs. International: Ostend Exh., 1959-61; Brussels Fair, 1958; Intl. Cultural Exchange, 1960. Positions: Instr., Ceramics, Cleveland Institute of Arts, 1956- .*

TAKAL, PETER—Painter, Gr.
116 East 68th St., New York, N.Y. 10021; Saylorsburg, Pa. 18353
B. Bucharest, Roumania, Dec. 8, 1905. Studied: in Berlin; art in Paris. Member: AEA; Am. Color Pr. Soc.; SAGA; Phila. WC Cl. Awards: Boston Pr.M., 1956, 1958; Brooklyn Soc. A., 1957, 1958, 1961, 1962; Phila. Pr. Cl., 1958; Ball State T. Col., 1958, 1964; Silvermine Gld. A., 1959; Pasadena Mus. A., 1962; Providence A. Cl., 1963; Yaddo Fnd., 1961; Tamarind Litho. Workshop, 1963-64; Ford Fnd.-AFA Artist-in-Res., Wright A. Center, Beloit College, Mar. 1965. Work: MMA; WMAA; MModA; BM; deYoung Mem. Mus.; N.Y. Pub. Lib.; PMA; Crocker A. Gal., Sacramento; BMA; Achenbach Graphic Coll.; AGAA; DMFA; LC; John Herron AI; CMA; Mills Col., Oakland; Univ. Maine; Univ. Minnesota; Univ. Wisconsin; deCordova & Dana Mus.; Yale Gal. FA; WAC; NGA; SFMA; Los A. Mus. A.; CAM; Amon Carter Mus., Ft. Worth; AIC; CM; Grand Rapids A. Gal.; PAFA; Pasadena A. Mus.; Wright A. Center, Beloit; U.S. State Dept.; Smithsonian; Univ. California; Michigan State Univ.; R.I.Sch. Des.; AFA; Rochester Mem. A. Gal.; Everson Mus.; Montreal Mus. FA; Carnegie-Mellon Univ., Pittsburgh; Alverthorpe Gal., Jenkintown, Pa.; Royal Mus. A.; Copenhagen; Victoria & Albert Mus., London; 14 museums in Germany; also among recent acquisitions in museum of Stockholm, Zurich and Florence, Italy; and others; also in European museums and collections. Exhibited: SFMA, 1943, 1958; PAFA, 1953, 1959, 1960, 1963, 1965; Norfolk Mus.,A.; WMAA, 1955-1969; BM, 1954-1960; LC, 1955, 1957-1959, 1960; CAM, 1956; Univ. Utah, 1957; Phila. Pr. Cl., 1956-1958; Phila. A. All., 1957; Sweat Mus. A., 1956-1958; Smithsonian Inst., 1956, 1958; Silvermine Gld. A., 1956, 1958; CGA, 1965; Ball State T. Col., 1958, 1961; AWS, 1958; Des Moines A. Center, 1958; Dayton AI, 1958; AFA traveling Exhs., 1955-1960; Oakland A. Mus., 1955, 1958; Pr. Council Am., 1959, 1962, 1963; Contemporaries, 1959, 1960; SAM, 1959; Ringling Mus. A., 1959, and many others; 45 one-man exhs., 1932-1969; MModA, 1956, 1959, 1969, & traveling European, 1961; Inst. Contemp. A., Boston, 1959; one-man traveling exh. throughout U.S., 1957-1959; one-man traveling exh., 9 German Museums, State Dept. traveling exh., 1961-62; Smithsonian Inst., 1959-62; Strozzi Palace, Florence, 1960 (one-man). Recent one-man exhs.; Artists Gal., 1954, Graham Gal., 1955, 1958, The Contemporaries, 1959, 1960, 1962, Weyhe Gal., 1964, 1965, all in New York City; Harriman Gal., Boston, 1964; Everson Mus., Syracuse, N.Y., 1964; Wright A. Center, Beloit, 1965; Intl. group exhs., Salzburg, 1959; Yugoslavia, 1961;

others nationally to 1969. Lectures: Cleveland Mus. A., 1958; Beloit College, 1965; Central Col., Pella, Ia., 1968. Instr. Drawing, Beloit College, Wisconsin, 1965; Central Col., Iowa, 1968. Contributor to: Harper's Bazaar; New World Writing; American Artist; Courrier Graphic, Paris; Bonnier, Stockholm, and others.

TAKEMOTO, HENRY TADAAKI—Craftsman, Lith., S.
c/o 537 North Kenmore St., Los Angeles, Cal.
B. Honolulu, Hawaii, July 23, 1930. Studied: Univ. Hawaii, B.F.A.; Los Angeles County AI, M.F.A. Awards: prizes, Mus. Contemp. Crafts, N.Y., 1958; Los Angeles County Mus., 1959; double purchase prize, Wichita AA, 1959; silver medal, Ostend, Belgium, 1959 (sculpture); bronze medal, Mus. Contemp. Crafts, N.Y., 1960. Work: Smithsonian Inst. Exhibited: Seattle World's Fair, 1962; Ceramic Intl., Prague, 1962; Pasadena A. Mus.; and others. Positions: Instr., Ceramics, Cal. School of Fine Art San Francisco, Cal. Des. & Glaze Chemist, Interpace Corp.; Instr., Ceramics, Scripps College, Claremont, Cal., 1965-1966.*

TALBOT, WILLIAM H. M.—Sculptor
Washington, Conn. 06793
B. Boston, Mass., Jan. 10, 1918. Studied: PAFA; Academie des Beaux Arts, Paris, and with George Demetrios. Member: Fed. Mod. P. & S.; Arch. Lg., N.Y.; Sc. Gld. Awards: Prix de Rome; Cresson Traveling Fellowship, PAFA. Work: WMAA; Bryn Mawr Col.; St. Lawrence Univ.; Earlham Col., Richmond, Ind.; fountains: Fitchburg (Mass.) Library; Missouri Botanical Gardens, St. Louis; fountain memorials: Bryn Mawr Col.; Barnes Hospital, St. Louis. Exhibited: PAFA, 1948, 1966; WMAA, 1949, 1962; Sc. Gld., 1963-1968; Wadsworth Atheneum, Hartford, Conn., 1953, 1966; Mattatuck Mus., Waterbury, Conn., 1967; Wolcott Library, Litchfield, Conn. 1967; St. John's Parish House, Washington, Conn., 1966; AGAA, 1955.

TALLEUR, JOHN—Printmaker, P., E.
University of Kansas; h. 242 Concord Rd., Lawrence, Kans. 66044
B. Chicago, Ill., May 29, 1925. Studied: AIC, B.F.A.; State Univ. Iowa, M.F.A. Member: Print Council of America. Awards: Fulbright F. to France, 1951. Work: MModA; MMA; AIC; Carnegie Inst.; Des Moines A. Center; Joslyn Mus. A.; Univ. Illinois; Univ. California; Univ. Iowa; Bradley Univ. Exhibited: In major national and regional print exhibitions. Positions: Prof., Print-making & Painting, University of Kansas, Lawrence, Kansas.

TAM, REUBEN—Painter, T.
549 West 123rd St., New York, N.Y. 10027; s. Monhegan, Me.
B. Kapaa, Kauai, Hawaii, Jan. 17, 1916. Studied: Univ. Hawaii, Ed. B.; Cal. Sch. FA; Columbia Univ.; New Sch. for Social Research. Awards: prizes, GGE, 1939; Honolulu Acad. FA, 1939, 1941; Honolulu Pr. M., 1940; BM, 1952, 1956; Guggenheim F., 1948. Work: MModA; MMA; BM; IBM; Honolulu Acad. FA; Wichita A. Mus.; Massillon Mus. A.; N.Y. Pub. Lib.; Ft. Worth AA; Univ. Nebraska; Univ. Georgia; Los A. Pub. Lib.; Butler AI; Am. Acad. A. & Let.; Albright A. Gal.; DMFA; Munson-Williams-Proctor Inst.; Newark Mus. A.; Encyclopaedia Britannica: Des Moines A. Center; WMAA; Univ. Illinois; AGAA; NCFA; CGA. Exhibited: VMFA; Carnegie Inst.; PAFA; Los A. Mus. A.; Albright A. Gal.; WFNY 1939; GGE, 1939; BM; MModA; WMAA; Univ. Illinois; MMA; Walker A. Center; AIC; CGA; Boston A. Festival; U.S. State Dept. European Exh.; MModA traveling exh.; AFA traveling exh. One-man: Cal. PLH, 1940; Crocker A. Gal., 1941; Honolulu Acad. FA, 1941, 1967; Downtown Gal., 1945, 1946, 1949, 1952; Alan Gal., 1955, 1957, 1959, 1961, 1964; Phila. A. All., 1954; Landau-Alan Gal., 1967; Portland (Ore.) A. Mus., 1966; Oregon State Univ., 1966. Positions: Instr., Painting, Brooklyn Mus. Sch. A., Brooklyn, N.Y.; Visiting Prof., Oregon State Univ., 1966.

TAMBELLINI, ALDO—Sculptor
c/o Howard Wise Gallery, 50 W. 57th St., New York, N.Y. 10019*

TANIA (SCHREIBER)—Sculptor, P., T.
345 Fireplace Rd., East Hampton, N.Y. 11937
B. Poland, Jan. 11, 1924. Studied: McGill Univ., M.A.; Columbia Univ.; ASL. Work: Rose A. Mus., Brandeis Univ.; N.Y. Univ.; Morgan State Col.; N.Y. Civic Center Synagogue, awarded by A.I.A., 1968; commissioned by N.Y. City for two walls in "Vest Pocket Parks," Brooklyn & Bronx, 1967-1968. Exhibitions: (recent)— SFMA, 1963; Wash. Gal. Mod. A., 1963; Oakland A. Mus.; Univ. Illinois, 1963; Art Dealers Assn. of America; Sarah Lawrence Col.; Flint Inst. A., 1963; Univ. of Virginia, 1964, 1968; World House Gal., N.Y., 1964; WMAA, 1964, 1965; Milwaukee AI, 1965; Univ. Delaware, 1965; Bertha Schaefer Gal., N.Y., 1963, 1964, 1966 (one-man); 2-man: Benson Gal., 1967; N.Y. Univ. Loeb Center, 1964, 1967; Bertha Schaefer Gal., N.Y., 1968; 4-man: MModA., 1969. Positions: Instr., Fundamentals of Des., Drawing, New York University, N.Y., 1963- .

TARNOPOL, GREGOIRE—Collector
47 E. 88th St., New York, N.Y. 10028
B. Odessa, Russia, Feb. 24, 1891. Studied: Academy of Art, Munich, under Prof. Hugo von Haberman; Academy of Art, Petrograd, under Prof. Tchistiakoff; Academy of Art, Copenhagen, under Profs. Rhode & Tucksen. Collection: Modern French art—Impressionists and Ecole de Paris. (From Delacroix to Picasso).

TARR, WILLIAM—Sculptor
42 Graham Rd., Scarsdale, N.Y. 10583
B. New York, N.Y., May 31, 1925. Studied: ASL. Awards: Bundy A. Gal., 1963; Ford Fnd. Purchase Award, 1964. Certificate of Merit, Municipal Art Society, New York City, 1969. Work: AIC. Exhibited: WMAA, 1962, 1964; Stephen Radich Gal., N.Y., 1962; MIT, 1964; Westchester A. Soc., 1965; Flint Inst. A., 1965.

TATMAN, VIRGINIA DOWNING—Teacher, C., P.
Kenosha Technical Institute; h. 2703 73rd St., Kenosha, Wis., 53140
B. Kenosha, Wis., July 5, 1917. Studied: Univ. Wisconsin at Milwaukee. Member: Wisconsin Designer-Craftsmen; Greater Kenosha A. Council (Vice-Pres.). Awards: prizes, Winter A. Fair, Kenosha, 1969; Kenosha AA, 1969. Exhibited: Wisconsin State Fair; annually, Wisconsin Designer-Craftsmen; Milwaukee A. Center annual summer fair, and others; one-man: Kenosha Public Mus. Positions: Former Cur., Kenosha Public Mus.; Instr., Kenosha Technical Inst., at present.

TATSCHL, JOHN—Craftsman, S., E., Gr., L.
Art Department, University of New Mexico; h. 3502 12th St., Northwest, Albuquerque, N.M. 87107
B. Vienna, Austria, June 30, 1906. Studied: T. Col., Vienna; Acad. App. A., Acad. FA, Master Sch. Sculpture, Vienna. Awards: Purchase awards, Roswell Mus. & Mus. New Mexico, Santa Fe; Research Grants, Univ. New Mexico, 1950, 1953; AIA award for Art in Architecture, 1963. Work: Mus. New Mexico, Santa Fe; mural, USPO, Vivian, La.; Monument, Campus, Univ. New Mexico; wood sculpture, Lib., Univ. New Mexico; 10 stained glass windows, St. Michael Church, Albuquerque; Library, Canyon, Tex.; bronze monument and stained glass wall (executed & des., 1962); stained glass windows, Am. Bank of Commerce, Albuquerque; stained glass for churches in Las Cruces, Los Alamos and Albuquerque. Univ. New Mexico campus; fountain, Roswell Museum. Exhibited: regularly in Southwest Exhs., 1946-1956. Positions: Asst. Prof., Park Col., Mo., 1943-46; Prof. A., Univ. New Mexico, Albuquerque, N.M., 1946- ;*

TATTI, BENEDICT—Sculptor, T., P.
214 East 39th St., New York, N.Y. 10016
B. New York, N.Y., May 1, 1917. Studied: ASL; Univ. of State of N.Y.; and with Louis Slobodkin, William Zorach and Ossip Zadkine. Member: Brooklyn Soc. A.; Am. Soc. of Contemp. A., N.Y.; P. & S. Soc. of N.J.; Lg. of Present Day Artists, N.Y. Awards: prizes, Brooklyn Soc. A., 1944; NGA, 1945; Am. Soc. of Contemp. A.; P. & S. Soc. of N.J. Work: Sundial, Dumbarton Oaks, Washington, D.C.; Bison, Tokyo Park, Japan; Monument to D'Aragon, N.Y.; medallions— David Sarnoff, Dwight Eisenhower, Mark Twain. Exhibited: MMA, 1942; NGA, 1945; Brooklyn Soc. A., 1943-1947, 1951; Tribune A. Gal., 1946 (one-man); Audubon A., 1947, 1961; PAFA, 1950, 1954; Arch. Lg., 1950, 1960; Hans Hofmann Sch. A., 1949, 1950; Galerie Claude Bernard, Paris, 1960; Burr Gal., N.Y., 1961; RoKo Gal., N.Y.; one-man: Library Gal., North East Harbor, Maine; Alexander Gal., N.Y. Positions: Raymond Loewy Assoc., 1951- ; Instr., sculpture, Crafts Students League, N.Y.; Instr. A., Board of Edu., N.Y.C. and High School of Art & Design, N.Y.C.

TAUBES, FREDERIC—Painter, Et., Lith., W., L., E., Cr.
Haverstraw, N.Y. 10927
B. Lwow, Poland, Apr. 15, 1900. Studied: Munich A. Acad., with F. von Stuck, M. Doerner; Bauhaus, Weimar, with J. Itten. Member: F., Royal Soc. A., London. Work: SFMA; William Rockhill Nelson Gal.; MMA; San Diego FA Soc.; Santa Barbara Mus. A.; deYoung Mem. Mus.; High Mus. A.; etc. Exhibited: Carnegie Inst., 1936-1946; CGA, 1936-1946; PAFA, 1935-1944; VMFA, 1938-1946; AIC, 1935-1946; 25 one-man exhs. in New York City. Author: "The Technique of Oil Painting," 1941; "You Don't Know What You Like," 1952; "Anatomy of Genius," 1949; "Quickest Way to Paint Well," 1951; "The Mastery of Oil Painting"; "Modern Art Sweet and Sour"; "Pictorial Anatomy of the Human Body"; Collected essays: "The Art and Technique of Portrait Painting," and other books. Former contributing Ed., to: American Artist magazine, with "Taubes' Page"; Former Contributing Ed., Encyclopaedia Britannica: Yearbooks. Positions: Carnegie Visiting Prof. A., A. in Residence, Univ. Illinois, 1940-41; Visiting Prof., Mills Col., Oakland, Cal., 1938; Univ. Hawaii, 1939; CUASch, 1943; Univ. Wisconsin, 1945, and many other universities in Canada and England, 1947-51. Formulator of

Taubes Varnishes and Copal Painting Media. American Ed., The Artist magazine with the Taubes Page as editorial feature, at present.*

TAUCH, WALDINE—Sculptor, P., T., L.
115 Melrose Place, San Antonio, Tex. 78212
B. Schulenberg, Tex., Jan. 28, 1892. Studied: with Pompeo Coppini. Member: F., NSS; Nat. Soc. A. & Let.; Coppini Acad. FA; San Antonio River A. Group; San Antonio Conservation Soc.; AAPL; San Antonio Woman's Cl. (hon.). Awards: Hon. deg., D.F.A., Howard Payne Col., Brownwood, Tex. Work: Witte Mem. Mus.; Wesleyan Col., Macon, Ga.; monument, City Hall Square, San Antonio; Canton, Tex.; Gonzales, Tex.; Bedford, Ind.; Richmond, Ky.; fountain, Pelham Manor, New York, N.Y.; relief, Children's Reading Room, Jersey City Lib.; portrait relief, Howard Payne Col., Brownwood, Tex.; monument, Buckner Boys' Ranch, Burnet, Tex.; fountain group, Kocurek Estate, San Antonio; Baylor Univ. Lib.; bronze "Texas Ranger," Terminal Bldg., Love Field, Dallas, Tex., 1961.

TAULBEE, DANIEL J.—Painter
2706 Nettie St., Butte, Mont. 59701
B. St. Ignatius, Mont., Apr. 7, 1924. Studied: Famous Artists Sch., Westport, Conn.; Michigan State Normal Sch.; Montana State Col. Member: Soc. Animal Artists; Montana Inst. A. Work: in many private collections. Exhibited: Soc. Animal A.; Burr Gal., N.Y.; Farnsworth Mus. A., Rockland, Me.; All-American Indian Days, Sheridan, Wyo.; All-Indian Exh., Philbrook A. Mus., Tulsa, Okla.; 15 one-man shows in Western States, recently at Philbrook Mus. A., Tulsa and Heard Mus., Phoenix. Represented in England, Germany, France, Switzerland and Italy. Specializes in historical Indian and Western art. Illus., "Trail Dust," 1959. Lectures: The Indian of the High Plains.

TAYLOR, BERTHA FANNING—Painter, L., Mus. Cur., W., T., Cr.
434 Pembroke Ave., Norfolk, Va. 23507
B. New York, N.Y., July 30, 1883. Studied: CUASch; Sorbonne, Univ. de Montpelier, Ecole du Louvre, Paris, France; & with Maurice Denis, Georges Desvalliers. Member: CAA; Am. Soc. for Aesthetics; Tidewater A. (Pres. 1954-58). Awards: med., Paris Salon, 1937; PBC, 1942; Medal, Chevalier Palmes Académiques from French Government, 1963, for "outstanding contribution to the cause of French culture." Exhibited: Societe National des Beaux-Arts, Salon d'Automne, Salon des Tuileries, Salon Des Artistes Independants, Musee du Jeu de Paume, Paris, France; Ferargil Gal., 1940; Garden City Community Cl., 1941 (one-man); Harlow Gal., 1944; Sharon, Conn., 1941 (one-man); PBC, 1942, 1944, 1945; regularly, Virginia Beach, and Tidewater A. Festival; also Norfolk Mus. A. Work: St. Peter's Church, Spotswood, N.J.; Norfolk Mus. A.; many portrait commissions. Lectures: in Louvre, Paris, "French & Italian Painting & Sculpture"; in New York Metropolitan Mus., "French Painting"; in Norfolk Art Mus. and Public Library, "General Art History and Art Appreciation," 1945-1969. Author: "Form and Feeling in Painting," 1959; "My Fifteen Years in France," 1968. Positions: L., Louvre Mus., Paris, 1930-39; A.Cr., New York Herald-Tribune's Paris Edition, 1930-32, Cur., The Hermitage Fnd. Mus., Norfolk, Va., 1945-49; Instr., Adult Classes, Norfolk Mus. A., 1950-60; A.Cr., Norfolk Virginian-Pilot, 1953-60.

TAYLOR, CHARLES—Painter
2021 Waverly St., Philadelphia, Pa. 19146
Studied: Graphic Sketch Club (Fleischer Memorial). Member: Phila. WC Cl. (Pres.); Phila. A. All.; AWS; Audubon A.; All.A.Am.; SC. Awards: prizes, Phila. A. All., 1954, 1955; Altman prize, NAD, 1955; Grumbacher award, 1958; American Artist magazine Medal, 1960; AWS, and others. Work: PMA; Montclair A. Mus.; Woodmere A. Gal.; Harcum Col.; NAD; N.Y. Univ. Exhibited: NAD; CGA; AIC; PAFA; AWS; Phila. WC Cl.; Phila. A. All.; Woodmere A. Gal., and others.

TAYLOR, GRACE MARTIN—Painter, Gr., E.
1604 Virginia St. E., Charleston, W. Va. 25311
B. Morgantown, W. Va. Studied: Univ. W. Va., A.B., M.A.; PAFA; Carnegie Inst.; AIC; Emil Bisttram Sch. A.; Hans Hofmann Sch. FA; Ohio Univ.; Davidson Sch. Mod. Painting, and with Fritz Pfeiffer, Blanche Lazzell, William and Natalie Grauer, and others. Member: Am. Color Pr. Soc.; Tri-State AA (Fndr., Bd. Dir.); Creative Arts Festival of W. Va. (Fndr., Bd. Trustees). Awards: prizes, 50 Best Color Prints, 1933; West Virginia AA, 1942, 1945, 1947-1949, 1953-1961, 1967; Va. Intermont Col., 1948; Tri-State Creative AA, 1953-1955; Huntington Gal., 1955, 1960, 1964; Huntington A. Festival, 1966-1968; Hallmark Purchase award, 1953; Charleston A. Gal., 1963. Exhibited: Oakland A. Mus.; Smithsonian Inst.; CGA; MMA; Phila. Pr. Cl.; BM; SFMA; Los A. Mus. A.; NAD; Mint Mus. A.; Provincetown AA; Soc. Four A.; Wash. WC Cl.; AWS; AFA traveling exh.; William & Mary Col.; Ohio Valley WC Exh.; one-man: Ohio Univ.; W. Va. Univ. Author: section in "Preparation and Use of Visual Aids,"

1950. Positions: Hd. A. Dept., Mason Col. Music & FA, 1934-56; Admin. Asst., 1950-53, Dean, 1953-55, Pres., 1955-56, Assoc. Prof., 1956-1968, Morris Harvey College, Charleston, W. Va.; Extension Services, West Virginia Univ., 1967- .

TAYLOR, DR. and MRS. J. E.—Collectors
142 Lodges Lane, Bala-Cynwyd, Penna. 19004*

TAYLOR, JOHN (WILLIAMS)—Painter, Pr. M., T.
Shady, Ulster County, N.Y. 12479
B. Baltimore, Md., Oct. 12, 1897. Studied: ASL, and with Boardman Robinson; also with J. Francis Smith, S. MacDonald-Wright; also study abroad. Member: NA; Woodstock AA. Awards: prizes, Am. Acad. A. & Let., 1948; Paintings of the Year, 1948; BMA, 1939; medals, AWS, 1949; VMFA, 1946; Guggenheim F., 1954; prize, Albany (N.Y.) Inst. Hist. & Art, 1968. Work: mural, USPO, Richfield Springs, N.Y.; other work: VMFA; New Britain Inst.; WMAA; MMA; Canajoharie A. Gal.; Hackley A. Gal.; NAD; ASL; Currier Gal. A.; John Herron AI; Morse Gal. A., Rollins Col. Exhibited: Carnegie Inst., 1941-1950; PAFA, 1948, 1949, 1951, 1952, 1954; VMFA, 1948; Univ. Illinois, 1948, 1949; WMAA, 1943-1946, 1951, 1954, 1955, 1959; AWS, 1949; John Herron AI, 1945, 1946, 1953-1955; NAD, 1945, 1949, 1951, 1952, 1954, 1955, 1957, 1961, 1963; Watercolor USA, 1966-67; Berkshire Art Assn. Annual, 1968. One-man: Macbeth Gal., 1938, 1944, 1950; Milch Gal., 1955, 1963; Am. Acad. A. & Let., 1948. Positions: Visiting Instr., John Herron AI, Indianapolis, Ind., 1950, 1954, 1957, 1960; ASL, Woodstock, N.Y., 1948-51, 1954; Visiting Instr., Pa. State Univ., 1957; Mich. State Univ., 1958; Assoc. Prof. Painting, Tulane Univ., 1958-59. Visiting Prof. Painting, University of Florida, 1960-62; Univ. Washington, 1963.

TAYLOR, JOHN C. E.—Painter, E.
Trinity College, Hartford, Conn.; h. 30 Four Mile Rd., West Hartford, Conn. 06107
B. New Haven, Conn., Oct. 22, 1902. Studied: Yale Univ., B.A., M.A.; Julian Acad., Paris; & with Walter Griffin. Member: FA Comm., City of Hartford; 1957-1966; Rockport AA; North Shore AA; Conn. Acad. FA; SC. Awards: Cooper prize, Hartford, Conn., 1935; New Orleans, 1946; Rockport AA, 1955. Work: New Britain (Conn.) A. Mus., and in private colls.; des. for woodcarvings, Trinity Col. Chapel. Exhibited: CGA, 1935, 1939; Pepsi-Cola, 1946; AV, 1942; Gloucester, Mass.; Hartford, Conn.; Palm Beach, Fla.; San. F., Cal.; Charlotte, N.C.; Boston, Mass.; etc. Lectures on Art History at Loomis School, Windsor, Conn., Conard H.S., West Hartford, and elsewhere. Positions: Hd. FA Dept., 1945-1964, Assoc. Prof., 1952- , Prof., 1956- , Trinity Col., Hartford, Conn.

TAYLOR, JOSHUA CHARLES—Scholar
Department of Art, University of Chicago 60637; h. 5510 Woodlawn Ave., Chicago, Ill. 60637
B. Hillsboro, Ore., Aug. 22, 1917. Studied: Portland Mus. A. Sch.; Reed College, Portland, B.A., M.A.; Princeton Univ., M.F.A., Ph.D. Awards: Quantrell Award, University of Chicago, 1956; Invited to Italy by the Ministry of Education for Research on Futurism, 1960. Author: "William Page: The American Titian" (Univ. Chicago, 1957); "Learning to Look" (Univ. Chicago, 1957, 1961); "Futurism" (Museum of Modern Art, N.Y., 1961); "The Graphic Works of Umberto Boccioni" (Museum of Modern Art, 1961). Field of Research: American Art; 19th and 20th Century Painting and Theory, with concentration on Italy. Positions: Instr., History of Art & Humanities, 1949- ; William Rainey Harper Professor of Humanities and Art, University of Chicago; Trustee, Mus. of Contemporary Art, Chicago; Adv. Bd., Int. Study Center, MModA, N.Y.

TAYLOR, MARIE—Sculptor
4607 Maryland Ave., St. Louis, Mo. 63108
B. St. Louis, Mo., Feb. 22, 1904. Studied: ASL; Washington Univ. Sch. A. Member: Sculptors Gld., N.Y.; Nat. Soc. A. & Lets. Awards: prizes, CAM; St. Louis A. Gld.; NAWA: Six States Exh., Omaha. Work: CAM and in private colls. Altar, St. Paul's Episcopal Church, Peoria, Ill. Exhibited: PAFA; WMAA; Denver Mus. A.; Joslyn Mus. A.; Kansas City AI; Carroll Knight Gal., St. Louis; Brooks Mem. Mus., Memphis; 5 one-man shows, Betty Parsons Gal., N.Y.*

TAYLOR, PRENTISS—Painter, Lith., T., L., I., W.
J 718 Arlington Towers, Arlington, Va. 22209
B. Washington, D.C., Dec. 13, 1907. Studied: ASL, and with Charles Hawthorne, Charles Locke, and others. Member: ANA; A. Gld. Wash.; Soc. Wash. Pr. M. (Pres.); Albany Pr. Cl.; Boston Pr. M.; SAGA; Wash. WC Cl.; Cal. Pr. M.; AEA. Awards: prizes, Greater Wash. Indp. Exh., VMFA, 1943; LC, 1943; Am. A. Group, 1953; NAD, 1954; Boston Pr. M., 1954; VMFA, 1955; CGA; purchase award, DePauw Univ., 1959; Pr. Cl. of Albany, 1967. Work: BMFA; AGAA; Wadsworth Atheneum; N.Y. Pub. Lib.; MMA; WMAA; PMA; BMA; PC; LC; Univ. Virginia; VMFA; Norfolk Mus. A. & Sc.; Gibbes A.

Gal.; SAM; DePauw Univ.; Butler Inst. Am.A.; Boston Pub. Library; Howard Univ.; MModA; PMA; Albany Pr. Cl.; Randolph-Macon Col.; Smithsonian Inst.; Univ. Delaware; Univ. Maine; Valentine Mus., Richmond; Exhibited: WMAA, 1945; VMFA, 1943; Irene Leach Mem., 1945, 1946, 1949-1952; AIC, 1933 and subsequently; PAFA; Phila. Pr. Cl.; CGA, 1949, 1951; Phila. A. All.; LC; A. Gld. Wash.; Rochester Mem. A. Gal.; Carnegie Inst., 1946-1949; Atlanta, Ga., 1957, 1958; Butler Inst. Am.A., 1957; BM; Cal. Soc. Etchers; Wash. WC Soc.; Soc. Wash. Pr. M.; Soc. Wash. A. I., "Scottsboro Limited"; "The Negro Mother." Lectures: Invention and History of Lithography; Art as Psychotherapy; Pissarro; Degas; Cezanne; Characteristics of Current American Prints. Paper, "How Art May Help Reintegrate the Disordered Mind," Am. Psycho. Assn., Chicago, 1960. Positions: Art Therapist, St. Elizabeths Hospital, Washington, D.C., 1943-54; L., Painting, American Univ., Wash., D.C., 1955- .

TAYLOR, RALPH—Painter, T., Gr.
 135 S. 18th St., Philadelphia, Pa. 19103
B. Jan. 18, 1897. Studied: Phila. Graphic Sketch Cl.; PAFA; with Henry McCarter, and abroad. Member: Phila. A. All.; F., PAFA; Phila. Pr. Cl.; Phila. WC Cl.; Woodmere A. Gal. Awards: bronze medal, Phila. A. Week; Cresson traveling scholarship, PAFA, 1922; gold medal, Cape May, N.J., 1949; gold medal, Da Vinci All., 1959; prizes, PAFA, 1952; F., PAFA, 1954; Da Vinci All., 1955; Phila. A. All., 1965. Work: PAFA; F., PAFA; LaFrance Alliance; Graphic Sketch Cl., and in private colls. Exhibited: CGA; NAD; PAFA; Rochester Mem. A. Gal.; All. A. Am.; Phila. A. All.; PMA; Woodmere A. Gal.; Graphic Sketch Cl.; State T. Col., Indiana, Pa.; Butler Inst. Am. A.; Phila. Pr. Cl.; BM traveling exh. prints, 1961; 2 one-man exhs., 1961; Univ. Pennsylvania, 1966 (one-man), and others.

TAYLOR, ROBERT—Writer, Critic
 Boston Herald, 300 Harrison Ave., Boston, Mass. 02118; h. 5 Lookout Court, Marblehead, Mass. 01945
B. Newton, Mass., Jan. 19, 1925. Studied: Colgate Univ., A.B.; Brown Univ. Grad. Sch. Author: "In Red Weather," 1961 (novel). Positions: Art Critic, Boston Herald, 1952- ; Boston Correspondent, Pictures on Exhibit, 1954-59; Visiting Lecturer, Wheaton College, 1960- .*

TAYLOR, ROSEMARY—Craftsman
 34 Rock Rd. West, Green Brook, N.J. 08812
B. Joseph, Ore. Studied: Cleveland Inst. A.; N.Y. Univ. Member: Artist-Craftsmen of N.Y.; New Jersey Des.-Craftsmen; Am. Craftsmen's Council. Awards: Plainfield AA, 1956-1964. Exhibited: New Jersey Des.-Craftsmen, regularly; New Jersey State Mus., Trenton, 1967; Newark Mus. A.; Mus. Nat. Hist.; annually in Craftsmen's Groups; Montclair A. Mus.; Syracuse Mus. FA; Phila. A. All., 1960, 1961, 1967; Plainfield (N.J.) Jewish Community Center, 1961; Newark Pub. Lib.; Morris Jr. Mus.; Hunterdon County A. Center, Gallery 100, Princeton, 1963, 1964; N.Y. World's Fair, 1964; one-man: Rahway A. Center; Paterson State Col., 1964; Alicia Rahm Gal., 1966; Only Originals Gal., 1969; Gal. 100, 1963-1969. Demonstrations of techniques of ceramics. Positions: Instr., Rahway A. Center, 1952-56; Rahway Adult Edu.; privately. Pottery Consultant, McCalls Needlework & Crafts magazine, 1963-1969.

TAYLOR, RUTH P.—Educator, P., Gr.
 277 Washington Ave., Brooklyn, N.Y. 11205
B. Winsted, Conn., Mar. 21, 1900. Studied: PIASch.; ASL, and with George Bridgman, Kimon Nicolaides. Member: NAWA; AM. Soc. Contemp. A.; Pen & Brush Cl. Awards: prize, Riverside Mus., 1956; Grumbacher prize, NAWA, 1961. Exhibited: NAWA, 1935-1965, and traveling exhs.; N.Y. WC Cl., 1936; AWS, 1937, 1951; LC, 1944; BM, 1941-1946, 1952; Argent Gal., 1937-1958; Newark A. Sch., 1938-1945; Brooklyn Soc. A., 1948-1965, and traveling exhs.; P. & S. Soc., New Jersey, 1965; Pen & Brush Cl., 1951-1965, and others. Positions: Instr., Newark A. Sch., Newark, N.J., 1926-45; Asst. Prof., PIASch., Brooklyn, N.Y., 1925-56, Assoc. Prof., 1956- ; 1st Vice-Pres., 1956-58, Rec. Sec., 1958-59; Chm. Com., Am. Soc. Contemp. A., 1965-66; Chm., Watercolor Jury, 1957-59, 1962-63, nominating Com., 1964-65. NAWA.*

TAYSOM, WAYNE PENDLETON—Sculptor, E.
 Fairbanks Hall, Oregon State University; h. 1765 Alta Vista St., Corvallis, Ore.
B. Afton, Wyo., Oct 10, 1952. Studied: Univ. Wyoming; Columbia Univ.; Univ. Utah, B.F.A.; Ecole des Beaux-Arts, Paris; T. Col., Columbia Univ., M.A.; Cranbrook Acad. A. Member: AAUP; Portland (Ore.) AA. Awards: purchase prize, Portland A. Mus., 1956. Work: Portland A. Mus.; ports. in private colls.; architectural sculpture, Medical-Dental Center, 1st Nat. Bank; Ore. State Univ. Mem. Union and Kerr Library, Corvallis; Lane County Courthouse, Eugene, and Masonic Temple. Exhibited: Detroit Inst. A., 1950; Portland A. Mus., 1953-1958, 1962; SAM, 1954-1957; Denver A.

Mus., 1953-1956; San F. AA, 1954-1957; Northwest Sculpture, 1955-1957; Seattle World's Fair, 1962; 2-man, Ore. Ceramic Studio, 1964. Positions: Prof. S., Univ. Oregon, 1951-52; Oregon State University, Corvallis, Ore., 1953- .*

TCHENG, JOHN T. L. (DR.)—Scholar
 109 Tower Pl., Fort Thomas, Ky. 41075
B. Shanghai, China, Sept. 21, 1918. Studied: With Prof. S. C. Chao, Shanghai; With Prof. C. C. Wang, N.Y. Member: (Active) Cincinnati Art Club. Field of Research: Chinese calligraphy.

TEAGUE, DONALD—Painter
 P.O. Box 745, Carmel, Cal. 93921
B. Brooklyn, N.Y., Nov. 27, 1897. Studied: ASL, and in London, England. Member: NA; AWS. Awards: prizes, New Rochelle AA, 1935; SC, 1936; Isador Prize, 1939; AWS, 1939, 1944, 1954, 1955, 1965, Certif. of Merit, 1962, award and Gold Medal, 1964; NAD, 1932, 1947, 1949, 1952, 1959, 1965, Morse Gold Medal, 1962, Certif. of Merit, 1963, Obrig award, 1969; Cal. State Fair, 1952; Soc. Western A., 1952-1954; gold medal, AWS, 1953, silver medal, 1961, Butler award, 1966, Saportes award, 1967, Oehler award, 1968, Lehmann award, 1969; Medal of Honor, American Artists magazine, 1957; prize, Cal. Statewide Exh., 1954, 1955; Madonna Festival, Los A., 1957; Commendation, Senate of State of Cal., 1964. Work: VMFA; Frye Mus. A., Seattle; Cal. State Fair Coll.; U.S. Air Force, Colorado Springs, Colo; Univ. Kansas; Mills Col., Oakland and in many private colls. Exhibited: MMA; NAD; BM; AIC; Toledo Mus. A.; Conn. Acad. FA; Univ. Oregon; Royal WC Soc., London, Tokyo Mus.; Kyoto Mus.; Mus. of W.C., Mexico City, and in Southern and Midwestern museums. Contributor to Sat. Eve. Post; McCalls; Colliers; Woman's Home Companion, American, and other national magazines.

TEDESCHI, PAUL VALENTINE—Painter, E.
 Dogburn Rd., Orange, Conn. 06477
B. Worcester, Mass., Nov. 1, 1917. Studied: Vesper George Sch. A., Boston; AIC; Yale Univ., B.F.A., M.F.A.; Columbia Univ. Member: AFA; CAA; AAUP; Sarasota AA; Silvermine Gld. A. Awards: Silvermine Gld. A., 1958; New Haven Paint & Clay Cl., purchase, 1949. Exhibited: Boston Festival A., 1960; Providence Festival A., 1960; New Haven Festival A., 1960, 1964; Silvermine Gld. A., 1958-1964; Conn. WC Soc., 1957; Conn. Acad. FA, 1960; one-man: Ruth White Gal., N.Y., 1960; Nexus Gal., Boston, 1961; Silvermine Gld. A., 1961; Southern Conn. State Col., 1959. Contributor illus. and articles to The Grade Teacher; The School Executive. Positions: Chm., Art Competition, New Haven Festival of Art, 1960; Consultant, Teacher Edu. Booth at Springfield Expo., 1952; Consultant, "Operation Palette," U.S. Navy Art Show, 1960; Chm., Dept. FA, 1954-55, Asst. Prof. A., 1954-1969, Assoc. Prof., 1969- . Southern Connecticut State College, New Haven, Conn.

TEE-VAN, HELEN DAMROSCH—Painter, I.
 Rte, 1, Box 312, Sherman, Conn. 06784
B. New York, N.Y., May 26, 1893. Studied: N.Y. Sch. Display; & with George de Forest Brush, Jonas Lie. Member: Soc. Women Geographers. Work: murals & museum displays: Berkshire Mus.; Bronx Zoo, N.Y. Exhibited: NAD, 1917; CAM, 1917; CM, 1917; Los A. Mus. A., 1926; Am. Mus. Natural Hist., N.Y., 1925; PAFA, 1923; Gibbes Mem. A. Gal., 1935; Buffalo Mus. Sc., 1935; Berkshire Mus., 1936; Ainslie Gal., 1927; Warren Cox Gal., 1931; Argent Gal., 1941; Soc. Animal Artists, Burr Gal., N.Y., 1961. I., various scientific & juvenile books, including, "Reluctant Farmer," 1950; "Mosquitoes in the Big Ditch," 1952; "Reptiles Round the World," 1957; "The Story of the Platypus," 1959; "Sea Monsters," 1959; "The Story of An Alaskan Grizzly Bear," 1969; Adapted and illus., "The Trees Around Us," 1960; Illus., "Imported Insects" (Talley), 1961; "The Story of a Hippopotamus" (Milotte), 1964; Author, Illus., "Insects Are Where You Find Them," 1963; "Small Mammals Are Where You Find Them," 1967. Contributor to: Forum, Animal Kingdom, Story Parade, & other publications. Positions: A., N.Y. Zoological Soc. Expeditions, Tropical Research Dept., 1922, 1924, 1925, 1927, 1929-1933, 1946.

TEICHMAN, DAVID—Collector
 1120 Fifth Ave., New York, N.Y. 10028*

TEICHMAN, SABINA—Painter
 27 East 22nd St.; New York, N.Y. 10010
B. New York, N.Y. Studied: Columbia Univ., A.B., M.A. Member: AEA; Audubon A.; Provincetown AA; Cape Cod AA. Awards: medal, Westchester Women's Cl., 1946. Work: Carnegie Inst.; Brandeis Univ.; G.W.V. Smith Mus. A.; Tel-Aviv Mus., Israel; SFMA; WMAA; Butler Inst. Am. A.; Mus. of the Univ. of Puerto Rico; Living Arts Fnd. Coll., N.Y.; BMA; BM; Michener Coll., Univ. Texas; FMA; Finch Col. Mus.; Norfolk Mus. A. & Sciences; Smithsonian Inst.; Vatican Mus., Rome; Fairleigh Dickinson Univ.; Nat. Mus., Israel; Michener Coll.; Syracuse Univ.; Swope Gal. A., Phoenix A. Mus.;

Colby College; Univ. Massachusetts. Exhibited: AWS, 1934-1940; NAWA, 1938-1954; N.Y. WC Soc., 1934-1936; Audubon A., 1950, 1952, 1953, 1964-1969; New Sch. for Social Research, 1952; Cape Cod AA, 1953-1955; Provincetown AA, 1949-1955; WMAA, 1956, and Collector's exh., 1958; Art:USA, 1958; Childe Hassam Exh., Nat. Inst. A. & Lets., 1961; Butler Inst. Am. A., 1964; Swope A. Gal., 1965; ACA Gal., Rome, 1965; one-man: Salpeter Gal., 1947, 1949, 1952, 1954; Shore Gal., Boston, 1955; ACA Gal., 1957, 1958-1961, 1963, one-man: ACA Gal., N.Y., 1969.

TELLER, JANE (SIMON)—Sculptor
200 Prospect Ave., Princeton, N.J. 08541
B. Rochester, N.Y., July 5, 1911. Studied: Skidmore Col.; Barnard Col., B.A., and with Aaron Goodelman. Member: New Sculpture Group; S. Gld. Awards: prizes, NAWA, 1960; Phila. A. All. Work: Temple Judea, Doylestown, Pa., 1968. Exhibited: PMA, 1955, 1962, 1965; MModA, 1959; Friends Exh., Phila., 1955, 1956, 1958, 1962; Phillips Mill, New Hope, Pa., 1949-1951, 1953, 1960; Edward Callanan Gal., New Hope, 1956 (one-man); Bertha Schaefer Gal., 1957, 1966; Parma Gal., N.Y., (one-man) 1957, 1962, (2-man) 1959; NAWA, 1960; New Sculpture Group, 1959-1961; Galerie Claude Bernard, Paris, 1960; Holland-Goldowsky Gal., Chicago, 1961; S. Gld., 1961-1968; Phila. A. All., 1962 (2-man); Osgood Gal., N.Y., 1963 (2-man); PAFA, 1964; Riverside Mus., N.Y., 1962; New Hope (Pa). Hist. Soc., 1961, 1962, 1964; WMAA, 1960-1962; Lyman Allyn Mus., A., New London, Conn., 1960; Stable Gal., N.Y., 1959-1961; New Jersey State Museum, 1965-1967; Newark Museum, 1965, 1968.

TEMES, MORT(IMER) (ROBERT)—Cartoonist, Comm. A.
10 Sycamore Dr., Hazlet, N.J. 07730
B. Jersey City, N.J., Apr. 15, 1928. Studied: ASL, with William Mc-Nulty, Robert Hale, and others; N.Y. Univ., B.A. Member: Nat. Cartoonists Soc.; ASL; Magazine Cartoonists Guild. Exhibited: in cartoonists' exhibitions. Work: in many anthologies. Contributor cartoons to national magazines.

TEMPLE, MR. and MRS. ALAN H. — Collectors
11 Paddington Road, Scarsdale, N.Y. 10583*

TENGGREN, GUSTAF ADOLF—Painter, I., Des., Lith.
Dogfish Head, West Southport, Me.
B. Magra Socken, Sweden, Nov. 3, 1896. Studied: Slödförening Skola & Valand Sch. FA, Gothenburg, Sweden. Member: Authors Gld., Inc.; Maine Art Gal. Awards: Herald-Tribune award, 1946. Exhibited: Am.-Swedish Hist. Mus., Phila., Pa., 1945 (Nordfeldt & Tenggren); Am.-Swedish Inst., Minneapolis, 1950 (one-man); Akron AI, 1952; Boothbay Harbor, Me., 1948 (one-man), 1949-1952; WMA; Oklahoma A. Center; AWS; Wash. WC Cl.; Phila. A. All.; Los A. County Fair; Maine A. Gal., Wiscasset, Me., 1957; Boothbay Region A. Gal., Boothbay Harbor, Maine, 1966-1968; Temple Beth El A. Festival, Portland, Maine, 1969; Univ. of Maine, (one-man), 1969. Work: I., "The Tenggren Mother Goose"; "The Tenggren Tell It Again"; "Sing for Christmas"; "Sing for America"; "Tenggren's Cowboys and Indians"; "Pirates, Ships and Sailors"; "Tenggren's Arabian Nights," 1957; "Canterbury Tales," 1961, and others.

TERENZIO, ANTHONY—Painter, E.
University of Connecticut, Storrs, Conn.; h. R.F.D. 2, Storrs, Conn. 06268
B. Settefrati, Italy. Feb. 10, 1923. Studied: PIASch., B.F.A.; Columbia Univ., M.A.; Am. A. Sch., with Raphael Soyer and Jack Levine. Member: Mystic AA. Awards: prizes, Emily Lowe Comp., 1950; Conn. Artists, Norwich, Conn., 1957; Norwich AA, 1960. Work: Syracuse Univ. Exhibited: Terry AI, 1952; Butler Inst. Am.A., 1957; Boston A. Festival, 1958; BM, 1950; Ward Eggleston Gal., 1950, 1958; Springfield A. Lg., 1956; Norwich AA, 1956-1965; Berkshire A. Mus., 1957, 1958; Wadsworth Atheneum, 1959; New Haven A. Festival, 1959; Smith Col. Mus., 1965; Northeastern Univ., Boston, 1963, 1965; Austin A. Center, Trinity Col., Hartford, Conn., 1967, 1969; one-man: Creative A. Gal., N.Y., 1950, 1952; Eggleston Gal., 1958. Work reproduced in "Prize Winning Paintings," 1960. Positions: Prof., Des., Fla. State Univ., 1950-1951; Brooklyn College, 1951-1952; Painting & Drawing, Univ. Connecticut, 1955- .

TERRELL, ALLEN TOWNSEND—Sculptor, P., Ser.
42 Stuyvesant St., New York, N.Y. 10003
B. Riverhead, N.Y., Nov. 2, 1897. Studied: Columbia Univ.; ASL; Julian Acad., Ecole des Beaux-Arts, Fontainebleau, France; & with Charles Despiau. Member: NAC; AWCS; NSS; All.A.Am.; Nat. Trust, England; Nat. Trust for Hist. Preservation, Wash., D.C.; BM; Fontainebleau Assn. Awards: prizes, Ernest Piexotta award, N.Y., 1941; Village A. Center, 1943, 1949, 1954; IBM, 1945; Nat. Ser. Soc., 1950; Medal of Honor, NAC, 1959. Work: York Cl., N.Y.; MMA; Suffolk County (N.Y.) Historical Soc.; Riverhead (N.Y.) Free Library; murals, S.S. America; Aluminum Corp. Am., Garwood, N.J.; modeled Vermilye med., Franklin Inst., Phila. Exhibited: Salon

d'Automne, 1931; NAD, 1932-1934, 1937, 1961, 1962; PAFA, 1933, 1934, 1936; AWS, 1942-1951, 1961, 1962; WMAA, 1954; Grosfeld House, N.Y., 1957; one-man exh.: Decorators' Cl., N.Y., 1939; Stendahl Gal., 1944; Pasadena AI, 1944; Mildred Irby Gal., N.Y., 1953; Village A. Center, 1943, 1955, 1956, 1958. Benefit Exh. for Central Suffolk Hospital, Riverhead, N.Y., 1962.

TERRY, ALICE (Mrs. B. F. Johnson)—Painter, S.
P.O. Box 104, Bearsville, N.Y. 12409
B. New York, N.Y., June 23, 1925. Studied: Pembroke Col., B.A. Work: N.Y. Univ.; Guggenheim Mus. A. Exhibited: Camino Gal., N.Y., 1959; Ellison Gal., Ft. Worth, Tex., 1959-60; Martha Jackson Gal., N.Y., 1960; Fleischmann Gal., N.Y., 1959; David Anderson Gal., N.Y., 1960, 1961; HCE Gal., Provincetown, 1961; Krannert A. Mus., Urbana, Ill., 1961; WMAA, 1954; Fleischmann Gal., N.Y., 1958 (one-man); Albright-Knox A. Gal.; McNay AI, San Antonio; one-man: Hacker Gal., N.Y., 1962; Rose Fried Gal., N.Y., 1963; Univ. Miami Mus., 1965.*

TERRY, DUNCAN NILES—Craftsman, Des.
1213 Lancaster Ave., Rosemont, Pa. 19010; h. 752 Brooke Rd., St. Davids, Pa. 19087
B. Bath, Me., Nov. 6, 1909. Studied: BMFA Sch.; Central Sch. A. & Crafts, London, England; Acad. Moderne, Paris, France; & with Henry Hunt Clark, Fernand Leger. Member: Phila. A. All.; Stained Glass Assn. Am. Awards: Traveling Scholarship, BMFA Sch., 1931-1932. Work: glass murals, panels, etc., Beck's Restaurant, Phila., Pa.; Good Shepherd Home, Allentown, Pa.; Church Good Shepherd, Rosemont, Pa.; Glass Blowers Union Bldg., Phila., Pa.; Ludington Mem. Lib., Bryn Mawr, Pa.; Jefferson Hospital Chapel, Phila.; News-Journal Bldg., Wilmington, Del.; Northminster Chapel, Richmond, Va.; Good Shepherd Lutheran Church, Phila.; St. Michael's Monastery, Oyama, Japan; Riverside Church, N.Y.; other churches & temples in Long Branch, N.J.; Douglas, Ga.; Phila., Pa.; St. Paul, Minn.; Baltimore, Md.; Wayne, Pa.; Bayside, Va.; Tulsa, Okla.; St. Mary's Church, Kittanning, Pa.; Trinity Episcopal Church, Trenton, N.J.; Cathedral of the Incarnation, Garden City, N.Y.; All Saints' Church, Phila., Pa.; St. Paul's Church, Oaks, Pa.; Episcopal Church of the Holy Comforter, Gadsden, Ala. Work installed in churches and other public buildings in 25 states.

TERRY, HILDA (D'ALESSIO) (Mrs. Gregory)—Cartoonist
8 Henderson Place, New York, N.Y. 10028
B. Newburyport, Mass., June 25, 1914. Studied: NAD; ASL. Member: Nat. Cartoonists Soc. Creator of "Teena," King Features Syndicate. Lecturer, Understanding Art Through Cartoon Direction, to universities and clubs. Positions: Assoc. Ed., Art Collectors Almanac; Owner-Dir., Gallery 8, Henderson Place, New York, N.Y. and Trinity Press. A. Dir., Fondiller Corp., Electronic Business Mach.; Dir., Special Effects, Electronic Display, American Information Corp. Cartoon Instr., New York-Phoenix Sch. of A. & Des.

TERRY, MARION (E.)—Painter, E., L.
14080 N. Bayshore Dr., Madeira Beach, Fla. 33708
B. Evansville, Ind., June 4, 1911. Studied: Albright A. Sch.; Buffalo AI; Univ. Buffalo; Cape Sch. A., Provincetown, Mass.; Univ. Florida, and with Xavier Gonzalez. Member: Florida A. Group; Fla. Fed. A.; Pen & Brush Cl.; Village A. Center, N.Y. Awards: prizes, Fla. Fed. A., 1938; Sarasota Nat. Exh., 1951; Fla. Southern Col., 1951; Intl. Exh., Havana, Cuba, 1954; Fla. State Fair, Tampa, 1956, and others in Fla. Work: New York Hospital Coll.; Living War Memorial (476 portraits of every Dade County serviceman who lost his life in World War II); 7 paintings purchased, Commercial Bank, Winter Park, Fla.; 4 paintings, First Nat. Bank, Winter Park, Fla.; City Nat. Bank, Clearwater, Fla.; Honeywell, Inc., Phila., Pa.; University Nat. Bank, Coral Gables; Ford Times. Exhibited: Sarasota, 1951; Terry AI, 1952; Fla. Southern Col., 1952; MMA, 1952; Village A. Center, N.Y.; Creative A. Gal.; Soc. Four A., Palm Beach; Buffalo AI; Fla. A. Group; Fla. Fed. A.; Norton Gal. A.; Blue Dome; Lowe Gal. A., Miami; Provincetown AA; Cape Cod AA; Southeastern Annual; Ford Motor Co. traveling exhs., 1955, 1957-58; Fort Worth, Tex., 1958; one-man: Ferargil Gal., N.Y., 1950, 1952; Buffalo, N.Y.; St. Louis, Mo.; Decatur, Ill.; Cleveland, Ohio; City Hall, St. Petersburg, 1963; Craft Village, St. Petersburg, 1963-64; La Petite Gal., Palm Beach, 1965; Clearwater A. Gal., 1964; Mirell Gal., Miami, 1967. Positions: Instr., YWCA, St. Petersburg, Chamber of Commerce, Madeira Beach, Fla.

TETTLETON, ROBERT LYNN—Painter, E.
Fine Arts Center, University of Mississippi 38677; h. 137 Leighton Rd., Oxford, Miss. 38655
B. Ruston, La., Dec. 23, 1929. Studied: Louisiana Polytechnic Inst., B.A. in A. Edu.; Louisiana State Univ., M.E. in A. Edu.; Special training with Miss Elizabeth Bethea, Louisiana State Univ.; Grad. work at N.Y. Univ. and Univ. Florida. Member: AAUP; NAEA; Southeastern AA; Southeastern Col. A. Conf.; Mississippi A. Edu.

Assn. Exhibited: Brooks Mem. Mus., 1968; traveling exh., Mary Buie Mus., Oxford, Miss., 1968; Fine Arts Assn., Gainesville, Fla., 1961. Contributor to Early Childhood Education Assn. Journal. Positions: Instr., A. Edu. and Painting, Northeast Louisiana State College, Univ. Florida and Univ. Mississippi; Prof. A., Univ. Mississippi, 1964- .

TEWI, THEA—Sculptor
100-30 67th Dr., Forest Hills, N.Y. 11375
Awards: Gold Medal, NAWA, 1969; prizes, Silvermine Gld. A., 1962; P. & S. Soc., New Jersey, 1964, 1966-1968; Knickerbocker A., 1965, 1968; NAC, 1966; Soc. Contemp. A., 1966; Smithtown Annual, N.Y., 1966; Artists-Craftsmen, N.Y., 1967. Work: Smithsonian Inst.; CM; Norfolk Mus. A. & Sciences. Exhibited: Audubon A., 1961, 1968; P.& S. Soc. New Jersey, 1961, 1968; Silvermine Gld. A., 1962, 1964-1966; Knickerbocker A., 1962, 1968; Lg. Present Day A., 1962, 1968; All. A. Am., 1965; Springfield Mus. FA, 1965; NAC, 1966; Smithtown, N.Y. 1966; Soc. Contemp. A., 1966-1968; Artists-Craftsmen, N.Y., 1966-1968; NAWA, 1968, 1969; Int. Biennale of Sculpture, Carrara, Italy, 1969. One-man: Village A. Center, N.Y., 1961; La Boetie Gal., N.Y., 1966, 1968, 1969; Iona Col., New Rochelle, N.Y., 1967; Villency Gal., Roslyn Heights, N.Y., 1968.

TEXOON, JASMINE—Painter, T.
193 Warburton Ave., Yonkers, N.Y. 10701; h. 3523 Riverdale Ave., Bronx, N.Y. 10463
B. New York, N.Y., Sept. 19, 1924. Studied: NAD; ASL; BMSch.A. Work: Holy Cross Church of Armenia; Cardinal Hayes Lib., Manhattan Col.; DAR Coll.; mural, Marian College, Fond du Lac, Wis., 1968; mural, Monastery of Padri Mechitarista, Venice, Italy, 1969. Awards: Prix de Paris, 1962, 1968-69. Exhibited: NAC, 1952, Kottler Gal., N.Y., 1956; Galerie Ars, Florence, Italy; Ligoa Duncan Gal., 1961-1964, 1968, 1969; Raymond Duncan Gal., Paris, 1962, 1968, 1969; Echeverria Gal., N.J., 1962; Burr Gal., N.Y., 1960, 1961; Academy A. Gal., Wash., D.C., 1967; Savannah AA, 1967; Hickory Mus. A., (N.C.), 1967; Jersey City Mus., 1968; Thomson Gal., New York, N.Y., 1968-69 one-man: Burr Gal., 1959. Positions: Instr., Painting, Evander Childs H.S. & P.S. Nos. 7 and 127, Bronx under Bd. Edu., Adult Edu. Program.

TEYRAL, JOHN—Painter, T.
Cleveland Institute of Art, 11141 East Boulevard 44106; h. 2470 Kenilworth Road, Cleveland, Ohio 44106
B. Yaroslav, Russia, June 10, 1912. Studied: Cleveland Inst. A.; BMFA Sch. FA; Grande Chaumiere, Paris; Accademia di Belli Arti, Florence, Italy. Awards: prizes, CMA, 1941-1961; Butler Inst. Am. A., 1944; Ill. State Fair; Fulbright Grant for study in Italy, 1949-1950. Work: CMA; City of Cleveland; Butler Inst. Am. A.; Pepsi Cola Coll.; Montclair (N.J.) Mus. A. Mural, Pres. Garfield Mem., Cleveland, Ohio and portraits of many prominent persons. Exhibited: Carnegie Inst.; MMA; VMFA; CGA; Univ. Nebraska; Munson-Williams-Proctor Inst.; Univ. Illinois; Chautauqua AA, 1963; BMFA; CMA, 1929-1961; Butler Inst. Am. A., and others. Positions: Instr., Painting and Drawing, Cleveland Institute of Art, 1939- .

THACHER, JOHN SEYMOUR—Museum Director
1703 Northwest 32nd St.; h. 1735 32nd St., Northwest, Washington 7, D.C.
B. New York, N.Y., Sept. 5, 1904. Studied: Yale Univ., B.A.; Univ. London, Ph.D. Member: Century Assn; Univ. Cl.; Cosmos Cl.; Assoc. Intl. Inst. for Conservation of Museum Objects; F., Pierpont Morgan Lib.; Grolier Cl. Author: "Paintings of Francisco de Herrara, the Elder," Art Bulletin, '37. Positions: Asst. to Dir., 1936, Asst. Dir., 1940- ; FMA, Cambridge, Mass.; Exec. Officer, 1940-45, Acting Dir., 1945-46, Dir. & Treasurer, 1946- , The Dumbarton Oaks Research Library & Coll., Trustees for Harvard Univ.; Trustee, Assoc. in FA, Yale Univ., 1953- ; Treas., Byzantine Inst., Inc., Washington, D.C.*

THAW, E. V.—Art dealer
525 Park Ave., New York, N.Y. 10021*

THEK, PAUL—Sculptor
c/o Stable Gallery, 33 E. 74th St., New York, N.Y. 10021*

THELIN, VALFRED P.—Painter, L., Des.
190 Shore Rd., Ogunquit, Me. 03907
B. Waterbury, Conn., Jan. 8, 1934. Studied: Layton Sch. A.; AIC; Int. Conf. Center, Konstanz, W. Germany; and in Mexico and Europe. Member: Wis. WC Soc.; Wis. Ptrs. & Sculptors; All. A. Am.; Rockport AA. Awards: prizes, Tucson FA Center, 1960; Highland Park AA, 1962; Mystic (Conn.) A. Festival, 1962; Mead Painting of the Year Exh., Atlanta, 1963; Racine AA, 1963; Gold-Mill Exh., 1963; Proviso A. Exh., 1962; Milwaukee A. Center, 1963; Atlantic City, N.Y., 1964; Winnetka Womens Cl., 1964; Ranger Fund, NAD, 1965; purchase awards: Wisconsin Salon of Art, 1959, 1962; Wisconsin

State Col., La Crosse, 1961, 1962; Oak Park AA, 1961; Bonniwell Exh., Mequon, 1962; Park Forest Exh., 1963; Butler Inst. Am. A., 1964. John Singer Sergeant Award, Springfield Mus.; Jurors' Award for Distinction, Mainstreams USA, Grover A. Center, Marietta, Ohio; Gramercy Award, Nat. Soc. Painters in Casein, Springfield, Ill. (2). Work: Univ. Wisconsin; Phillips Sch., Milwaukee; Milwaukee Western Bank; Wis. State Col.; Oak Park AA; Mt. Sinai Hospital, Milwaukee; Schubert & Assoc., La Crosse; Kenneth Mayer, Architects, Glenview; Milprint, Inc., Milwaukee; Nat. Blvd. Bank, Chicago; Longfellow Jr. H.S., Wauwatosa; Butler Inst. Am. A.; Bruggers, Inc., Los A.; Springfield (Mass.) Mus. FA; Ft. Wayne Mus. A.; State Street Bank, Boston; Marquette Univ.; Randall Architects, N.Y. NAD, and in private colls. Exhibited: Morris Gal., N.Y., 1960; Oklahoma FA Center, 1961, 1964; Las Vegas Art Roundup, 1961; Madison Ave. Gal., N.Y., 1961, 1962; Soc. Four A., Palm Beach, 1963; Red River Annual, Moorhead, Minn., 1964; Grand Forks, N.D., 1964; Wisconsin Heritage, Milwaukee, 1961; Wright A. Center, Beloit, 1962-1964; AIC, 1963, 1964 (rental service); Swedish Cl., Chicago, 1961; Ill. State Fair, 1961, 1963; AWS, 1965, 1968; Audubon A., 1965, 1967; PAFA, 1965, 1968; Chautauqua Annual, 1962-1964: Butler Inst. Am. A. 1963-1968; Cal. WC Soc., 1963, 1964; Watercolor:USA, 1963-1968; Wis. Salon, 1959, 1960, 1962-1964; Wis. Ptrs. & Sculptors, 1961-1965; Wis. Print & Drawing, 1962, 1963; Alfred Strelsin Invitational, 1963; Cranbrook Acad., 1966; SFMA, 1966; Birmingham Mus., 1966; Knickerbocker A., 1966, and others. Numerous one-man exhs. Included in "Prize Winning Graphics, Bk. II," 1964; "Prize Winning Watercolors, Bk. III," 1965, Book V, 1967; "Prize Winning Paintings, Bk. V," 1965.

THIEBAUD (MORTON), WAYNE—Painter, E.
Rosebud Farm, Hood, Cal. 95639
B. Mesa, Ariz,, Nov. 15, 1920. Studied: Sacramento State Col. Member: San F. AI. Awards: prizes, CAL.PLH; Cal. State Fair; (as producer)—First Prize, Art Film Festival, 1956; Golden Reel Film Festival, 1956; "Space" at Cal. State Fair; two Scholastic Awards for "Space" and "Design," 1961; and other awards. Work: MModA; WMAA; LC; Albright-Knox A. Gal.; Washington Gal. Mod. A.; Rose A. Mus., Brandeis Univ.; Wadsworth Atheneum; Cal. State Fair Coll.; mosaic, Municipal Utility Dist. Bldg., Sacramento. Producer of 11 educational motion pictures, distr. by Bailey Films, Hollywood. Author: "Delights" (17 etchings), 1965; "America Rediscovered" (Original etchings), 1963. Exhibited: many museums including Los A. Mus. A., 1963; Oakland A. Mus., 1963; Toronto A. Gal.; Dayton AI; Inst. Contemp. A., Houston; Crocker A. Gal., Sacramento; SFMA; Sao Paulo, Brazil, Biennale, 1968, and in The Hague, Holland, Vienna, Berlin, Hong Kong and South America. One-man: Crocker A. Gal., 1952; Gumps, San F., 1953; Artists' Cooperative, Sacramento, 1954; San Jose State Col., 1955; Sacramento City Col., 1957; deYoung Mem. Mus., 1962; Allan Stone Gal., N.Y., 1962-1964; Galleria Schwarz, Milan, Italy, 1963. Positions: Chm. A. Dept., Sacramento City College, 1951; Guest Instr., San Francisco Art Institute, 1958; Prof. A., University of California at Davis, 1960- ; Prof. A., A.-in-Res., Cornell Univ., 1966; A.-in-Res., Viterbo College, 1969.

THIESSEN (CHARLES) LEONARD—Designer, P., Gr., S., L., T.
Nebraska Arts Council, 1112½ Farnam St., 68102; h. 3042 Stone Ave., Omaha, Neb. 68111
B. Omaha, Neb., May 3, 1902. Studied: Univ. Nebraska; Sch. Royal Acad., Stockholm, Sweden; Heatherley's Sch., London. Member: AEA. Work: Nebraska AA; A. Gld., Lincoln, Neb.; Univ. Omaha; Joslyn A. Mus.; Univ. Nebraska; Kansas Wesleyan Univ., Salina; Alfred East Mem. Gal., Kettering, England; murals, Lincoln Municipal Auditorium, Stewart Theatre, St. Matthews Church, all Lincoln, Neb.; Paxton Hotel, St. John's Episcopal Church, First Covenant Church, all in Omaha; Lodge, Grand Teton Nat. Park, Wyoming; Dundee Presbyterian Church, Omaha; Clarkson Mem. Hospital, Omaha. Lectures: History of Art. Positions: Exec. Dir., Nebraska Arts Council; Art Editor-Reviewer, Omaha World-Herald.

THOM, ROBERT ALAN—Illustrator, P., W., L.
6160 West Surrey Rd., Birmingham, Mich.
B. Grand Rapids, Mich., Mar. 4, 1915. Studied: Columbus (Ohio) Inst. FA; and with Robert Brackman. Member: SI; Bloomfield AA, Birmingham, Mich. (Fndg. Pres.). Work: Parke, Davis Co.; Bohn Aluminum & Brass Corp.; Univ. Mich., College of Pharmacy; Univ. Wis., Col. of Pharmacy; Phila. Col. of Pharmacy; U.S. Pharmacopoeia Hdqtrs., N.Y.; Brookside Sch., Cranbrook; Univ. Maryland; Nat. Assn. Retail Druggists Hdqtrs., Chicago; Nat. Bank, Mexico, Mo.; Standard Accident Ins. Co. Hdqtrs., Detroit; Michigan Bell Telephone Co.; Univ. Utah. Exhibited: Vancouver (B.C.) A. Gal., 1955; Smithsonian Inst., 1955; Oklahoma City A. Center. 1957; Columbus Mus. A., 1957; Georgia Mus. A., Athens; Morehead Planetarium, Univ. North Carolina; Columbia (S.C.) Mus. A., 1958 Sheldon Swope Gal. A., 1958; Lehigh Univ., 1958; Washington County Mus. FA, Hagerstown, Md., 1958; Reading Pub. Mus., 1959; Valen-

tine Mus., Richmond, 1959; Everhart Mus., Scranton, 1959; State
Hist. Soc., Madison, Wis., 1959; Rochester (Minn.) A. Center,
1959; Univ. Minnesota, 1960; Univ. Arkansas Medical Center, 1960;
Dayton Mus. Natural Hist., 1960; Oregon Mus. Nat. Hist., Portland,
1960; Detroit Hist. Mus., 1960; Kansas City Health Fair, 1961;
Acad. of Medicine, Toledo, 1961; Bowers Mem. Mus., Santa Ana,
Cal., 1961; Pioneer Mus., Stockton, 1961; Seattle Hist. Soc., 1961;
McMorran Auditorium, Port Huron, Mich., 1961; History of Phar-
macy and History of Medicine, exh. throughout U.S. and Canada;
History of the State of Michigan, 1963, Michigan Bell Telephone
Co., and many others (all one-man). Article & illus. on Wine Fes-
tival, Burgundy, France, Gourmet Magazine, 1961.*

THOMAS, ALMA WOODSEY—Painter, T., S.
 1530 15th St., N.W., Washington, D.C. 20005
B. Columbus, Ga., Sept. 22, 1896. Studied: Howard Univ., B.S. in
Fine Arts; Columbia Univ., M.A. in A. Edu.; American Univ., Wash.,
D.C. European tour of the Art of Europe under Tyler Sch. FA of
Temple Univ., 1959. Member: Soc. Wash. A.; AFA; CGA; Washing-
ton Gal. Mod. A.; Wash. WC Assn.; AEA. Awards: prizes, Water-
color Community A. Show, Capitol Hill, 1961; Outdoor A. Fair, Dept.
of Commerce, 1959; Howard Univ. Gal. A., 1961. Work: Barnett
Aden Gal. and Howard Univ. Colls. Also in many private colls. Ex-
hibited: Barnett Aden Gal., 1951, 1953, 1954, 1959, 1961, 1963; Du-
pont Theatre Gal., 1954, 1955, 1957, 1960, 1961; Metropolitan Area,
1954, 1955; Soc. Washington A., 1956, 1961, 1963, 1966, 1968, 1969,
and traveling, 1959-60; College of Art, traveling exhs., 1956, 1957,
1959, 1961; Atlanta Univ., 1952, 1954, 1964; CGA, 1955, 1956, 1959,
1960, 1968; American Univ., 1958; Howard Univ., 1958, 1960, 1961,
1963; Int. House, 1959, 1960; Washington WC Exh., 1961, 1962, 1967-
1969; Dept. Commerce A. Fair, 1956, 1959, 1960; Washington Re-
ligious Exh., 1961, 1962; Grace Episcopal Church Religious Exh.,
1962, 1963; Assoc. A. Gal., 1961; Martha Jackson Gal., N.Y. (Bene-
fit Exh.), 1963; Am. Soc. of African Culture Convention, 1962;
George Washington Univ., 1968; Smithsonian Inst., 1968; Lee Nord-
ness Gal., N.Y., 1969; Massillon Mus., 1969; BMA, 1969; The White
House, 1969, and others. One-man: American Univ., 1959; Dupont
Theatre, 1960; College Arts Traveling Service, 1958, 1961; retro-
spective exhs., Howard Univ., 1966 and Bader A. Gal, 1966. Posi-
tions: Vice-President, Barnett Aden Art Gallery, Washington, D.C.,
1943-1965.

THOMAS, ED(WARD) B.—Educator, L., P., W.
 1500 42nd St., E., Seattle, Wash. 98102
B. Cosmopolis, Wash., Nov. 30, 1920. Studied: Columbia Univ.; N.Y.
Univ.; Univ. Washington, B.A., M.F.A. Member: AEA; Pacific AA;
Washington AA; NAEA; Nat. Com. on A. Edu.; AAMus.; Northwest
Pr.M. Awards: prize, for School Telecasts, 1956, Am. Exh. of Edu.
Radio-TV programs, Ohio Univ., and other TV awards. Exhibited:
Nat. Ser. Soc., 1952; SFMA, 1951; SAM, 1951, 1954; regional exhs.
since 1950. Author: Guide to Life's Illuminations Exhibit, Time,
Inc., 1958; "Mark Tobey," 1959. Lectures weekly TV art pro-
grams, Seattle, since 1951; recorded TV series for school use:
"Man's Story"; "Treasure Trips"; "Our Neighbors"; "The Japa-
nese"; Electronic tour of "Masterpieces of Korean Art," 1958; "Van
Gogh," 1959; "Treasures of Japan," 1960, SAM. Editor, Narrator
of film "Chinese Ink & Watercolor," 1961. Positions: Instr., A.
Hist., Cornish Sch., Seattle, 1952-1958; Cur. Edu., 1951-54, Edu.
Dir., 1954-61; Asst. Dir., 1963-1967, Assoc. Dir., 1963-1967, Seattle
Art Museum and Seattle Center Art Pavilion, Seattle, Wash. 1st
Vice-Pres., Pacific AA, 1960-62; Bd. Trustees, All. A. of Seattle,
1959-1962; Arts Advisory Bd., Seattle World's Fair, 1958-62; Sec.,
Fine Arts, Inc., 1962; Vice-Pres., Western Assn. of Art Museums,
1963-64. Visiting Prof., Lecturer in Art, Western Washington State
College, Bellingham, Wash., 1967- .

THOMAS, GEORGE R.—Educator, Ser., L.
 University of New Hampshire; h. 17 Bagdad Rd., Durham,
 N.H. 03824
B. Portsmouth, Va., Dec. 8, 1906. Studied: Univ. North Carolina;
Carnegie Inst., B.Arch.; Columbia Univ. Member: AIA; New Hamp-
shire Soc. Arch.; New Hampshire AA; Council, N.H. Lg. A. &
Crafts. Positions: Hd. Dept. A., Dir. A. Gal., Univ. New Hamp-
shire, Durham, N.H., at present.

THOMAS, REYNOLDS—Painter, Lith., Portraits
 Santa Fe, N.M. (P.O. Coronado Sta.). Also, Box 611, Camden,
 Me.; Saanen, Switzerland 3792
B. Wilmington, Del., Jan. 21, 1927. Studied: PAFA; Univ. of Fine
Arts, Mexico. Member: AFA; Int. A. Gld., Monte Carlo, France.
Awards: prizes, Delaware A. Center, 1956; Thouron prize, PAFA,
1952 and scholarship, 1954. Work: Delaware A. Center; Wilmington
Trust Co.; Northern Trust Co., Chicago; All-American Engineering
Co., Wilmington, Del.; Texas Instruments, Dallas; Farnsworth Mus.;
Garcia Corp., Teaneck, N.J. Exhibited: PAFA, 1953, 1955; Ringling
Mus., Sarasota, 1953; MMA, 1956; Mus. FA, Santa Fe, 1962; Nelson

Gal. A., Kansas City, 1963; Audubon A., 1964; Salon Bosio, Monte
Carlo, 1962; Delaware A. Center, 1952-1961; Phila. A. All., 1953,
1954; PMA, 1955; PAFA, 1951-1955; Farnsworth Mus., Rockland,
Me., 1964; Fairweather-Hardin Gal., Chicago; Palm Beach Gal.,
Fla.; Galleria 88, Rome, Italy; Kennedy Gal., N.Y., 1963; one-man:
Country A. Gal., Long Island, N.Y. (3); Kennedy Gal., N.Y., 1963,
1964; Farnsworth Mus., 1966; Hotel de Paris, Monte Carlo, Amer-
ican Week celebration, 1966. Other exhs. in France, Mexico, Swit-
zerland and Monaco.

THOMASITA, SISTER MARY, O.S.F.—Painter, C., S., Des., E., L.
 Studio San Damiano; h. 6801 N. Yates Rd., Milwaukee, Wis.
 53217
B. Milwaukee, Wis., Feb. 23, 1912. Studied: Milwaukee State T.
Col., B.E.; AIC, B.F.A., M.F.A. Member: Wisconsin P. & S.;
Western AA; Catholic AA; Wisconsin Chptr., AIA (Hon.); Liturgical
Arts Soc.; CAA; Milwaukee AI; Wisconsin A. Edu. Assn. Awards:
prize, Wisconsin P. & S., 1950. Friends of Art, award, Milwaukee,
1965; Governor's Art Award, 1968. Work: sculpture in private col-
lections; wood mosaic panels, Marquette Univ. Mem. Lib.; panels,
St. Cyprian's Convent, River Grove, Ill. Exhibited: AIC, 1944-1947;
Milwaukee AI, 1950, 1952, 1953, 1956; and in New York, Dayton,
Seattle, Dallas, Portland, Madison and many other cities. Contribu-
tor to: Journal of Arts & Letters; Arts & Activities; Liturgical Arts
magazine. Lectures: Contemporary Art; Contemporary Religious
Art, etc. Positions: Exh. Com., Milwaukee A. Center, 1949- ; Bd.
Dirs., Children's A. Program, Milwaukee A. Center, 1955- ; Adv.,
Arts & Activities Magazine, 1955- . Catholic Div., Savage & Conso-
lini University Speakers' Bureau, 1960 (National); Governor's Arts
Council, 1963; Wis. Arts Fnd. & Council, 1965.

THOMPSON, (JAMES) BRADBURY—Designer, Art Dir., Des., E.
 Jones Park, Riverside, Conn. 06878
B. Topeka, Kans., Mar. 25, 1911. Studied: Washburn Univ., A.B.,
1934, D.F.A., 1965. Member: A. Dir. Cl. (1st Vice-Pres.; Exec.
Comm.); SI; AIGA (Bd. Dirs.); Dutch Treat Cl.; Alliance Graphique
International; Westport AA; Nat. Soc. A. Dir. (Representative, 1958-
1964). Awards: Gold T-Square, Nat. Soc. A. Dir., 1950; A. Dir. Cl.
medal, 1945, 1947, 1950 (2), 1955, award, 1946, 1953-1958; Wash-
burn Univ. Distinguished Service Award. Exhibited: Int. Exh. Gr. A.,
Paris, France, 1955, London, 1956; Milan, Italy, 1961, Amsterdam,
1962, Hamburg, 1964; traveling one-man exh., AIGA, 1958. Exh.
Adv. & Editorial A., N.Y., 1943- ; AIGA, 1948- ; Type Dir. Cl.,
1957- ; MModA, 1955; one-man Washburn Univ., 1964; Harvard
Univ., 1965. Designer: "Painting Toward Architecture," 1948;
"Photo-Graphic," 1949; "Abstract Painting," 1951; "Annual of
Advertising Art," 1943, 1954; "Graphic Arts Production Yearbook,"
1948, 1950; "The Fiction Factory," 1955; "Art News Annual,"
1945- ; "Westvaco Inspirations," 1938- ; Christmas editions; West-
vaco Corporation, 1958- ; "Homage to the Book," 1968; "The Qual-
ity of Life," 1968. Author: "The Monalphabet," 1945; "Alphabet
26," 1950. Positions: A. Dir., Capper Publications, 1934-38; A. Dir.,
Rogers, Kellogg, Stillson, Inc., 1938-41; A. Dir., Office War Infor-
mation, 1942-45; A. Dir., Mademoiselle, 1945-59; A. Dir., Living
for Young Homemakers, 1947-49; Des. Dir., Art News and Art News
Annual, 1945- ; Publications A. Dir., Street & Smith Publ., New
York, 1945-59; Consultant, Westvaco Corporation, 1945- ; Famous
Artists Schools, 1959- ; McGraw-Hill Publications, 1960- ; Time-
Life Books, 1964-67; Cornell University, 1965- ; "Harvard Busi-
ness Review," 1964-67; Field Enterprises Educational Corp.,
1964- . Educator: Visiting Critic, Yale Univ., Sch. Art & Archi-
tecture, 1956- ; Bd. Governors, Phila. College of Art, 1956-59.

THOMPSON, DOROTHY BURR (Mrs.)—Scholar, Archaeologist,
 W., L.
 Institute for Advanced Study, Princeton, N.J.; h. 134 Mercer
 St., Princeton, N.J. 08540
B. Delhi, N.Y., Aug. 19, 1900. Studied: Bryn Mawr Col., Ph.D.;
Amer. Sch. Classical Studies, Athens; Radcliffe Col. Member:
Archeol. Inst. Amer.; Classical Assn. of Canada. Awards: Bryn
Mawr European fellowships, 1923, 1925. Field of Research: Minor
Arts; Landscape Architecture; Ancient Private Life. Author:
"Terracottas from Myrina in the Museum of Fine Arts, Boston,"
1934; "Swans and Amber," 1949 (trans. of Greek lyrics); "Troy,
The Terracotta Figurines of the Hellenistic Period," 1963. Con-
tributor: Amer. Journal of Archeol.; Hesperia. Lectures: Greek
art, Roman private life, modern Greece, etc. Positions: Staff of
Agora excavations, Athens, 1931- .

THOMPSON, F. RAYMOND (RAY THOMPSON)—
 Commercial Artist, I., Cart., Des., W.
 1107 Montgomery Ave., Fort Washington, Pa. 19034
B. Philadelphia, Pa., July 9, 1905. Studied: Temple Univ.; PAFA;
Stella Elkins Tyler Sch. Member: Old York Road A. Gld. Exhib-
ited: Old York Road A. Gld. Contributor cartoons to national mag-
azines and trade journals. I., newspaper comics: "Somebody's

Stenog"; "Myra North, Special Nurse"; "Homer, The Ghost." Illus. for many adv. campaigns. Author: "You Can Draw a Straight Line!"; Country Store Coloring Book"; "The Early Days of Steam Coloring Book."

THOMPSON, KENNETH W.—Illustrator, P.
20 West 11th St., New York, N.Y. 10011
B. New York, N.Y., Apr. 26, 1907. Studied: with Eric Pape, H. Ballinger, George Pearse Ennis, Wayman Adams. Member: Nantucket AA; AWS; SI; A. Gld. Awards: prizes, A. Dir., Cl., N.Y., 1947, 1962, 1967 (2), medals, 1947, 1950, 1957, 1961; A. Dir. Cl., Chicago, 1947 (2), 1951, 1953-1958, 1960, 1961 (2), 1962, 1968 (2), medals, 1955, 1956; AIGA, 1962; A. Dirs. Cl., New Jersey, 1963, 1968 (2). Exhibited: AWS, 1936-1945, 1947-1950. Contributor to Life, Colliers, American, Look, and other national magazines. Cartographer for book series: "The Continent We Live On," and, "The West: A Natural History."

THOMPSON, LOCKWOOD—Collector
Union Commerce Bldg. 44115; h. 11901 Carlton Rd., Cleveland, Ohio 44106
B. Cleveland, Ohio, July 4, 1901. Studied: Williams College, A.B.; Harvard University, LL.B. Member: International Council, MModA, 1963- ; Friends of the University Gallery, Ohio State University. Fellow for Life, CMA. Awards: Medaille de Bronze de la Reconnaissance Francaise, 1945. Collection: Contemporary art, beginning with surrealist paintings of the 1930's, with emphasis on European and South American artists. Positions: an organizer and 1st president, Cleveland Society for Contemporary Art, 1961-1963; Member, Advisory Council, CMA; Member, Board of Trustees, Ohio State University, 1938-1943, 1946-1951; President, Board of Trustees, 1964-1965, Member of Board, 1955- , Cleveland Public Library. Chm., Bd. of Ethics for City of Cleveland. Int. Sponsor, Space Ltd., London, England.

THOMPSON, PAUL LELAND—Painter, C., T.
240 W. Front St., Plainfield, N.J. 07060
B. Buffalo, Iowa, May 20, 1911. Studied: Cal. Sch. FA, San Francisco; Corcoran Sch. A., Wash. D.C. Member: AEA; Hunterdon County A. Center; Landscape Cl., Wash., D.C.; Soc. Washington A.; A. Gld. Awards: prizes, Soc. Washington A.; Art Center of the Oranges, East Orange, N.Y., 1957; New Jersey WC Soc., 1964; Plainfield A., 1964; Hunterdon A. Center, Clinton, N.J., 1964, 1965, 1967; Landscape Cl., Wash., D.C.; North Carolina Trailside Mus., 1964; New Jersey State Exhs., Plainfield, 1964, South Orange, 1966, Westfield, 1965 (2), Clinton, 1968. Work: Two murals, Shiloh Baptist Church, Plainfield, N.J.; other work: Marine Ins. Co., Pittsburgh; Fairleigh Dickinson Univ., Rutherford, N.J. Exhibited: Honolulu Acad. A.; SAM; Columbus (Ohio) Gal. FA; CGA; SFMA; Cal. PLH; San Francisco AA; Knoedler Gal., N.Y.; NAD; one-man: Int. Galleries, Wash., D.C.; Swain's A. Gal., Plainfield (4); also exhibited recently at A. Center of the Oranges; Hunterdon County A. Center, Clinton; New Jersey WC Soc.

THOMPSON, RALSTON—Painter, E.
Wittenberg University; h. 254 Circle Dr., Springfield, Ohio 45503
B. Ironton, Ohio, Mar. 28, 1904. Studied: Wittenberg Col., A.B.; Dayton AI; Chicago Acad. FA; Ohio State Univ., M.F.A.; Columbia Univ. Awards: 61 prizes and other awards, 1941-1965. Work: Butler AI; Dayton AI; Ohio Univ.; CM; Procter and Gamble; Federated Stores; Wittenberg Univ.; Columbus Gal. FA; Canton AI; CMA; Bates Col. Exhibited: Nationally and internationally, and one-man exhs., since 1941. Positions: Instr., Ohio State Univ., 1935-41; Dir., Dept. FA, 1941- , Assoc. Prof., 1945-47, Prof., 1947-1969, Wittenberg Univ., Springfield, Ohio, Emeritus.

THOMPSON, SUSIE WASS—Watercolorist
Cape Split, Addison, Me. 04606
B. Addison, Me., July 15, 1892. Member: Kennebec Valley AA. Work: Walker A. Mus., Brunswick, Me.; Library, Northeast Harbor, Me.; Mus. Contemp. A., Wash., D.C.; Maine State Hospital, Augusta; Farnsworth Mus., Rockland. Exhibited: one-man: Stanford Univ. Research Inst., 1957; Bowdoin College, 1957; Northeast Harbor (Me.) Library, 1958; Colby Col., 1959-60; Farmsworth Mus., 1961; Maine State A. Festival, 1960, 1961; Rochester, N.Y. (one-man); Sullivan, Me., 1964 (one-man); Cape Split, Me., and Jonesport, Me., 1966, 1967, both one-man; Hooksett, N.H., 1968, and private exhibitions.

THON, WILLIAM—Painter
Port Clyde, Me. 04855
B. New York, N.Y., Aug. 8, 1906. Member: ANA; SC; Brooklyn Soc. A. Awards: prizes, BM, 1942, 1945; NAD, 1944, 1951, 1954, 1955, 1961. Altman prize, 1969; Dawson Medal, Phila. WC Cl., 1968; SC, 1942; F.. Am. Acad. in Rome, 1947; Dana medal, 1950; Am. Acad. A. & Let. grant, 1951; PAFA, 1952; Audubon A., 1953; Hallmark

1955; Hon. D.F.A., 1957, medal, 1956, Bates College. Work: Bloomington (Ill.) AA; Swope A. Gal.; Farnsworth Mus.; Encyclopaedia Britannica; Toledo Mus. A.; MMA; Butler Inst. Am. A.; Munson-Williams-Proctor Inst. A.; Rochester Mem. A. Gal.; WMAA; BM; John Herron AI; High Mus. A.; Davenport Mun. Gal.; Wilmington Soc. FA; CAL.PLH; PAFA; Honolulu Acad. A.; Dayton AI; Univ. Michigan; Sara Roby Fnd.; Rollins Col.; Atlanta Univ.; Columbus Gal. FA; S.C. Johnson & Son Corp.; Parke Davis Coll.; Michener Fnd.; Bank of New York; Northern Trust Co.; Empire Trust Co.; Vaughn School, Bloomfield Hills, Mich.; Conner Fnd.; Univ. Club, N.Y.; Allied Maintenance Co.; Univ. Miami; CAM. Work is in the collections of 45 major U.S. museums. Exhibited: CGA; PAFA; VMFA; AIC; WMAA; Kansas City AI; Albright A. Gal.; NAD; Toledo Mus. A.; CAL.PLH; Univ. Michigan. Positions: Trustee, Am. Acad. in Rome.

THORNDIKE, CHARLES JESSE (CHUCK)—
Cartoonist, Comm. A., I., W., L.
11660 Canal Drive, North Miami, Fla. 33161
B. Seattle, Wash., Jan. 20, 1897. Studied: Seattle A. Sch.; Univ. Washington; Cal. Sch. FA. Author, I., "Secrets of Cartooning," 1937; "Art of Cartooning," 1938; "Business of Cartooning," 1938; "Drawing for Money," 1490; "Seeing America," 1946; "Arts and Crafts for Children," 1942; "Susie and Sam in Rock City," 1948; "Oddities of Nature," 1950; "New Secrets of Cartooning," 1955. Contributor of "Oddities of Nature" and "World of Tomorrow," Curtis Syndicate, Miami Herald and other newspapers. Lectures: History of Cartooning. Positions: A. Dir., General Motors Acceptance Corp., N.Y.; U.S. Navy (Civil Service), Wash., D.C.; Commentator "Cartoon Club of the Air" (radio), N.Y.

THORNE, THOMAS—Painter, E., L.
Belmede, Williamsburg, Va. 23185
B. Lewiston, Me., Oct. 5, 1909. Studied: Portland (Me.) Sch. F. & App. A.; Yale Sch. FA, B.F.A.; ASL, with Reginald Marsh. Member: CAA; Va. Hist. Soc. Work: Hobart Col., Geneva, N.Y.; murals, H.S., General Hospital, Portland, Me.; James Blair H.S., Williamsburg, Va. Exhibited: PAFA, 1930; N.Y. WC Cl., 1937; VMFA, 1945, 1954, 1961; Boston Soc. Indp. A., 1935-1938; Norfolk Mus. A. & Sciences, 1960, one-man, 1964. Lectures: Modern Painting; (lecture) "William Byrd, Collector," Richmond Antiquarian Soc., 1965. Contributor to Antiques magazine. Positions: Chm. Dept. FA, William & Mary Col., Williamsburg, Va., 1943- .

THORPE, EVERETT CLARK—Painter, Des., E., I., L.
Utah State University; h. 1445 Maple Dr., Logan, Utah 84321
B. Providence Cache, Utah, Aug. 22, 1907. Studied: Utah State Univ., B.S. in Edu., M.F.A.; and with Ralph M. Pearson, Alvin Gittens, Karl Zerbe, George Grosz, Hans Hofmann. Member: Am. Assn. Univ. Prof.; CAA; Utah A., Sciences & Let.; Utah State Inst. FA; Provincetown AA; NSMP. Awards: prizes, Utah State Inst. FA, 1946, 1965, 1967; Terry AI, 1952; Utah State Fair, 1951, 1957, 1958, 1965, 1967, 1968; Intermountain Mural Comp., 1956-1958. Work: Utah State Inst. FA; Logan City Schs. Coll.; Cache County & Tremontan Sch. Coll.; Utah State Capitol; L.D.S. Temple, Bancroft, Idaho, Salt Lake Temple; USPO, Provo, Utah; State Capitol; Utah Hotel; Zion Bank; Dixie Col., and in private colls.; Utah State Col. murals, U.S. Forestry Bldg., Utah; Milton R. Merril Lib.; Bridger-Land State Capitol Bldg. Exhibited: CGA; Denver A. Mus.; Utah State Inst. FA; Utah A. Center; Univ. Utah; Terry AI; Cedar City, Utah; Colo. Springs FA Center; SAM; Los A. Mus. A.; Idaho Col.; Art:USA, 1958; Provincetown, Mass.; Wyoming Univ.; Phoenix Mus. Positions: Prof. A., Utah State Univ., Logan, Utah, 1944- ; A., Deseret News.

THURMAN, SUE (Mrs.)—Museum Director
Institute of Contemporary Art, 100 Newbury St., Boston, Mass. 02116
Positions: Dir., Institute of Contemporary Art, Boston, Mass., 1961- .*

THWAITES, CHARLES WINSTANLEY—Painter, Gr.
Box 4454, Santa Fe, N.M. 87501
B. Milwaukee, Wis., Mar. 12, 1904. Studied: Univ. Wisconsin; Layton Sch. A. Awards: prize, 48 States Comp., 1939; prizes, med., Palace Legion Honor, 1946; Milwaukee AI, 1933, 1936, 1939, 1941, 1943, 1944. Work: Univ. Wisconsin; Univ. Mexico; Marquette Univ.; Milwaukee Fed. Court; Milwaukee County Court; Milwaukee A. Center; murals, USPO, Greenville, Mich.; Plymouth, Chilton, Wis.; Windom, Minn.; Port., Pres. of St. John's College, Annapolis, Md., and Santa Fe, N.M. Exhibited: Carnegie Inst., 1941, 1945; CGA, 1939, 1941; VMFA, 1946; MMA (AV), 1942; AIC, 1930-1932, 1936, 1937, 1940-1942, 1945, 1951, 1952, 1953; PAFA, 1936, 1938; Pepsi-Cola, 1946; SFMA, 1946; Contemporary A. Gal., 1944 (one-man); Kearney Mem. Exh., 1946; Univ. Wisconsin, 1936-1938, 1945; Walker A. Center, 1952; Harwood Gal., Taos, N.M., 1953-1955; Mus.

New Mexico, Santa Fe, 1955, 1956, 1958, 1959, 1961, 1962, 1964, 1968; Nelson Gal. A., 1956; New Mexico Highlands Univ., 1957; Taos Moderns, 1957, 1958, 1959, 1960; Colorado Springs FA Center, 1959; New Mexico A., 1958, 1960; Galeria Escondida, Taos, 1961; Dord Fitz Gal., Amarillo, 1961; Southwest Biennials and Fiesta Annuals, 1966-1968; traveling exhibitions, 1966-1968; Fed. of Rocky Mountain States, Eight States Exh., 1968; Univ. Maryland, 1966; one-man: Mus. New Mexico, Santa Fe, 1957; Stables Gal., Taos, 1957, 1958; St. John's Col., Santa Fe, 1965.

TIBBS, THOMAS S.—Museum Director, L., W.
 La Jolla Museum of Art, 700 Prospect St.; h. 1524 Virginia Way, La Jolla, Cal. 92037
B. Indianapolis, Ind., Aug. 30, 1917. Studied: Univ. Rochester, A.B., M.F.A.; Columbia Univ. Member: CAA; Am. Assn. Mus.; Assn. Mus. Dirs.; F., Royal Soc. A., London. Lectures: General Art History; The Artist, Craftsman in Our Society; Museum Education, etc. Exhibitions arranged: Exhibition 80, 1953; Craftsmanship in a Changing World, 1956; Furniture by Craftsmen, 1957; Contemporary Wall Hangings, 1957; The Patron Church, 1958; Louis Comfort Tiffany Retrospective, 1958; Young Americans Competition, 1958; Finnish Rug Designs & Contemporary Crafts from Museum Collections, 1958; Six Decades of American Painting, 1961. Contributor to Encyclopaedia Britannica; author of numerous exhibition catalogs and contributor to museum catalogs. Lectures for many colleges, universities, museums, art organizations, etc. Positions: Assoc. Dir. Edu.; Rochester Mem. A. Gal., 1947-52; Dir., Huntington Galleries, Huntington, W.Va., 1952-56; Dir., Mus. Contemp. Crafts, New York, N.Y., 1956-60; Dir., Des Moines Art Center, 1960-1968; Dir., La Jolla Museum of Art, La Jolla, Cal., 1968- .

TIFFANY, MARGUERITE BRISTOL—Painter, E., C., L.
 330 East 33rd St., Paterson, N.J. 07504
B. Syracuse, N.Y. Studied: Syracuse Univ., B.S.; T. Col., Columbia Univ., M.A.; Parsons Sch. Des.; and with Emile Walters, William Zorach. Member: NEA; NAEA; Nat. Lg. Am. Pen Women, (N.J. State Pres., 1966-1968); Am. Assn. Univ. Profs.; Assoc. Handweavers (Pres. 1968-1970); Eastern AA; AAPL (Corres. Sec., 1963-1969; N.J. Chptr., Trustee, 1969-1971); Nat. Platform Assn., etc. Exhibited: Montclair A. Mus., 1933-1935, 1937; Paterson A. Lg., annually; Englewood AA; America House, N.Y., 1941, 1942; AAPL, annually; Spring Lake, N.J., annually; Ridgewood AA, 1951-1954; Fair Lawn (N.J.) AA, annually; Ogunquit A. Center, annually; 7 one-man shows, N.Y., 1967-1968; private exh., Oregon, Arizona and Fairbanks, Alaska, 1967. Author: "Industrial Arts Cooperative Service" (pamphlet), 1935. Contributor to education publications. Pub. Dir., for art exhs.; New Jersey Chm. A. Exh., Metropolitan Opera Gld., 1950-58. Lectures on art and travel. Demonstrations to clubs in N.Y. & N.J., 1968-1969. Positions: Past Pres., Montclair A. Mus. A. T. Assn.; Pres., during organization of New Jersey A. Edu. Assn.; Pres., Sec., Paterson A. Lg., 1961-64; Council Memb., Eastern AA, 6 years; Assoc. Prof., State T. Col., Paterson, N.J., 1927-1956; Fairleigh Dickinson Univ., Teaneck, N.J., 1956-64, Rec. Sec., 1960-62, V.Pres., 1962-64, Pres., 1964-66, Nat. Lg. Am. Pen Women.

TIGERMAN, STANLEY—Painter, Des., E.
 664 N. Michigan Ave., Chicago, Ill. 60611; h. 820 Seward Ave., Evanston, Ill. 60202
B. Chicago, Ill., Sept. 20, 1930. Studied: Inst. Design, Chicago; Yale Univ., B. Arch.; M. Arch. Member: Exec. Comm., Yale Arts Assn.; A. Cl. of Chicago; AIA. Awards: Grant, Graham Fnd., 1965; Alpha Rho Chi Medal in Architecture, Yale Univ., 1961. Exhibited: WAC, 1965; B.C. Holland Gal., 1964 (one-man), Chicago; AIC, 1957, 1958, 1963, 1964; Norfolk Mus. A. & Sciences, 1964. Contributor to Architectural Forum; Progressive Architecture; Arts & Architecture; Zodiac (Italy); Casa Bella (Italy). Lectures on Art & Architecture (Optical Systems), Positions: Assoc. Prof., Univ. Illinois, Chicago, 1965- .*

TILLIM, SIDNEY—Painter, Cr., T., L.
 23 E. 20th St., 10003; h. 166 E. 96th St., New York, N.Y. 10028
B. Brooklyn, N.Y., June 16, 1925. Studied: Syracuse Univ., College of Fine Arts, B.F.A. Awards: Yaddo Fnd. Fellowship, 1961. Work: Univ. of Tex., Austin; Weatherspoon A. Gal., Greensboro, N.C.; Mus. A., Ogunquit, Maine. Exhibited: PAFA, 1954; The Painter & The Photograph, national tour, 1964-65; Wadsworth Atheneum, 1964; Silvermine Gld. A., 1964; R.I. Sch. of Des. Mus. A., 1966; Nat. Acad. A. & Lets., 1967; Vassar Col., 1968; Philbrook A. Center, 1969; Oklahoma A. Center, 1969; Milwaukee A. Center, 1969. One-man: New Group Gal., Monterey, Cal., 1952; Cober Gal., N.Y., 1960; Schoelkopf Gal., N.Y., 1965; Robert Schoelkopf Gal., N.Y., 1967; Georgia State Col., Atlanta, 1969; Noah Goldowsky Gal., N.Y., 1969, and in numerous group shows. Contributing editor, "Art Forum," Lectures extensively. Positions: School of Visual Arts, N.Y.; Survey of Art History & Form and Structure, Pratt Institute, Brooklyn, N.Y.; Parsons School of Design, N.Y. Instr., A. Hist., Bennington Col., at present.

TING, WALASSE—Printmaker, P.
 100 W. 25th St.; h. 234 W. 21st St., New York, N.Y. 10011
B. Shanghai, China, Oct. 13, 1929. Work: Stedelijk Mus., Amsterdam; AIC; Detroit Inst. A.; Chrysler Mus., Provincetown, Mass.; Musée Cernuschi, Paris; Silkeborg Kunstmuseum, Denmark; Rockefeller Inst., N.Y.; MModA; Guggenheim Mus.; BMA; Nat. Mus., Jerusalem; PMA; BMFA. Exhibited: Galerie Facchetti, Paris, 1954; Brussels, Belgium, 1956; Galerie Chalette, N.Y., 1957; Martha Jackson Gal., N.Y., 1959, 1960; Lefebre Gal., N.Y., 1963, 1967; J.L. Hudson Gal., Detroit, 1968; Galeries Espace, Amsterdam, 1960, Birch, Copenhagen, 1961, 1966, 1967; Rive Gauche, Paris, Van de Loo, Munich, Smith, Brussels, St. Stephan, Vienna, 1962, Salon deMai, Paris, 1964-1968.

TINKER, EDWARD LAROCQUE—Collector, W., Patron
 550 Park Ave., New York, N.Y. 10021
B. New York, N.Y. Studied: Columbia University, A.B.; New York University, LL.B. Awards: Palmes Academiques, French Government, 1933; Chevalier, Legion of Honour, 1939; Two Medals, French Academy; Hon. Doctor of Laws, Middlebury College, 1949; Hon. Doctor de Filosofia y Letras, University of Madrid; Columbia University medal "For Service"; Award, The Americas Foundation, 1962; Hon. Doctor of Letters, Columbia University, 1963; Knight Commander, Order of Queen Isabella of Spain. Member: Various learned societies and clubs, including The Council on Foreign Relations, Society of American Historians, The American Academy of Political and Social Sciences, The Northwestern Council for Latin American and inter-American Studies; The Pan-American Society, English Speaking Union, Order of Lafayette, American Society of French Legion of Honour. Author: "Lefcadio Hearn's American Days," 1924; "Toucoutou," 1928; Monographs on various facets of Creole life and literature; "Old New Orleans" (in collab. with Mrs. Tinker); Contributed a weekly column to the Sunday Literary Section of the New York Times, "New Editions, Fine and Otherwise." Collection: Prints, paintings and equestrian gear of the Latin cattle riders; Donated his collection, together with books relating to them, to the University of Texas, Austin. Positions: Incorporated The Tinker Foundation, to work for better understanding between the peoples of the New World; Honorary Curator, Hall of the Horsemen of the Americas, University of Texas; Chancellor, American Antiquarian Society, Worcester; Vice-President, Spanish Institute; Vice-President, National Institute of Social Sciences; Board of Managers, American Bible Society; President-Emeritus and Founder, Uruguayan-American Society; Member of the Advisory Council, School of International Affairs, Columbia University; Lectured in Mexico for The Carnegie Endowment for International Peace, 1943; Lectured in Argentina and Uruguay for the Department of State, 1945.*

TIRANA, ROSAMOND (Mrs. Edward Corbett)—Painter
 Mayflower Heights, Provincetown, Mass.; h. 3500 35th St., Northwest, Washington, D.C. 20016
B. New York, N.Y., Jan. 29, 1910. Studied: Swarthmore Col., B.A.; Univ. Geneva, Switzerland (Grad. work); painting with Bernice Cross, E.R. Rankine and Hans Hofmann. Member: AFA. Awards: prizes, Lycee Mooiere, Paris, France, 1924; Virginia Regional Exh., 1959; Washington Post Area Comp., 1959. Exhibited: CGA, 1956-1959, 1966; Provincetown AA, 1957-1965; Warrenton, Va. Area Exh., 1959; Wash. A. Assn., 1958-1960. One-man: Artists' Gal., Provincetown, 1960; Thenen Gal., N.Y., 1962, 1964; Franz Bader Gal., Wash., D.C., 1959, 1963, 1965, 1969; NCFA, "Art for Embassies," 1968, U.S. Embassy, Turkey, 1969. Positions: Foreign Corr., Chicago Daily News, London "Clarion," Milwaukee Leader, 1932-1934.

TOBEY, ALTON S.—Painter, I., T., Hist., L.
 296 Murray Ave., Larchmont, N.Y. 10538
B. Middletown, Conn., Nov. 5, 1914. Studied: Hartford A. Sch.; Yale Sch. FA, B.F.A., M.F.A. Member: AEA (Bd. Dirs.); Lg. of Present Day Artists; Mamaroneck A. Gld.; NSMP; Westchester A. Soc. Work: Murals, Smithsonian Inst.; MacArthur Memorial, Norfolk, Va. (6); Campfield Library, Hartford, Conn.; Project 400, Chadds Ford, Pa. (13); other work in collections of: Norfolk Mus. A. & Sciences; NAD; Wadsworth Atheneum, Hartford; St. Francis Hospital, Hartford; Veterans Administration, Bronx, N.Y.; Hall of Fame, Goshen, N.Y.; New Jersey Medical Center; Hofstra Univ., N.Y.; Reader's Digest Coll.; Elmira (N.Y.) Col., and many private colls. Illustrations for: Life Magazine's "Epic of Man" series—Neolithic, Mycanae, Maya, Shang Dynasty, Sumer and Neanderthal. Cover and contents of one issue of Life's "Russian Revolution" series. Contributed to many other issues. Completed 300 paintings for the "Golden History of the United States" published in 12 volumes for The Golden Books; many portraits and illustrations for Reader's Digest. Exhibited: Riverside Mus., N.Y.; Norfolk Mus. A. & Sciences; PMA; Loeb Center, N.Y. Univ.; Mari Gal. and Collectors Gal., both Woodstock, N.Y.; Iona Col., New Rochelle, N.Y.; West-

chester A. Soc., White Plains, N.Y.; Goshen Hall of Fame; Connect-
icut Acad., Hartford; Yale A. Sch.; Oneida (N.Y.) A. Council; West-
brook Col., Portland, Me.; Willimantic (Conn.) State Col.; Wiscon-
sin State Univ.; Albany Mus., Georgia; Rosenberg Library, Galves-
ton, Texas; Bar Harbor, Me.; Venice, Fla., and others.

TOBEY, MARK—Painter
 c/o Willard Gallery, 23 West 56th St., New York, N.Y. 10019
B. Centerville, Wis., 1890. Studied: with Henry S. Hubbell; Kenneth
Hayes Miller. Member: Nat. Inst. A. & Let. Work: SFMA. Awards:
Grand Intl. prize, Municipality of Venice. Exhibited: Beaux Arts
Gal., London; BM; Cal. PLH; AIC; Colorado Springs FA Center;
Detroit Inst. A.; Durand-Ruel Gal.; Univ. Illinois; Iowa State Univ.;
MMA; Munson-Williams-Proctor Inst.; MModA; Pasadena AI;
Venice Biennale, 1958; Western Washington Fair; WMAA; and many
others. One-man: Chicago A. Cl., 1940, 1946; Contemp. A., N.Y.,
1931; Detroit Inst. A., 1946; M. Knoedler Gal., 1917; Portland A.
Mus., 1945; SFMA, 1945; SAM, 1935, 1942; Willard Gal., 1944, 1945,
1947, 1949, 1950, 1951, 1953, 1954, 1957; WMAA (retrospective),
1951; Berne, Switzerland, 1954; Paris, France, 1954; London,
England, 1954; Retrospective Exh., Kunstmuseum, Mannheim,
Germany, 1961; one-man: Beyeler Gallerie, Basel, Switzerland;
Retrospective Exh., Musée des Arts Decoratifs, Basel, Switzer-
land, 1961.*

TOBIAS, ABRAHAM JOEL—Painter, S., Lith., W., L.
 98-51 65th Ave., Rego Park, L.I., N.Y.
B. Rochester, N.Y., Nov. 21, 1913. Studied: CUASch.; ASL; Rutgers
Univ. Member: Arch.Lg.; NSMP; AEA; Awards: Arch. Lg., 1952.
Work: BM; Los A. Mus.; Howard Univ. Gal. A.; N.Y.Pub.Lib.;
Rochester Pub. Lib.; murals, Midwood H.S., N.Y.; James Madison
H.S., N.Y.; Adelphi Col.; Howard Univ. Lib.; USPO, Clarendon, Ark.;
Beth Israel Hospital, N.Y.; Long Island Jewish Hospital; Domestic
Relations Court, Brooklyn; Polytechnic Inst., Brooklyn; Mosaic mu-
ral, Bd. of Edu., P.S. No. 134, N.Y.; mural, "History of Science,"
Polytechnic Inst. of Brooklyn, 1960. (Contributed article on the Sci-
ence Mural to American Artist magazine Mar. 1969). Received U.S.
patent, 1958, for an artistic process relating to thermoplastic mate-
rials. Work reproduced in Science Digest and Look Magazine, 1968.
Exhibited: MModA, 1939; BM, 1937-1939; SFMA, 1941; ACA Gal.,
1936; Delphic Studios, 1935-1937 (created the concept of the shaped
canvas and introduced this form into American art during the one-
man show at Delphic Studios, 1935.) Adelphi Col.; Arch. Lg.; N.Y.
Mun. A.; one-man exh.: New Sch. Social Research; Everhart Mus.,
1939; Howard Univ., 1938; Delphic Studios, N.Y.; Plastics: USA Eu-
ropean traveling exhs., USIA, 1960-61. Lectures: Mural Painting.
Contributor article "Mural Painting" to American Artist magazine,
1957. Positions: A. Dir., U.S. Army Air Forces, Intelligence Div.,
1944; Strategic Services, 1945; Metropolitan Opera Gld., 1946;
Instr., Howard Univ. Washington, D.C., 1943-46; A. in Residence,
Adelphi Col., Garden City, L.I., 1947-1957.

TOBIAS, THOMAS J.—Collector, Museum Trustee
 20 S. Battery, Charleston, S.C. 29401
B. Charleston, S.C., Nov. 12, 1906. Studied: College of Charleston,
B.S. Awards: Hon. L.H.D., Hebrew Union College, Jewish Institute
of Religion, 1968. Collection: African, Chinese and Japanese masks.
Positions: Trustee, Secretary, Vice-President, 1946-1964, Presi-
dent, 1964-1967, Carolina Art Association, which operates the
Gibbes Art Gallery (a community art gallery), Charleston, S.C.

TODD, MICHAEL—Sculptor, Assemblages
 205 E. 17th St., New York, N.Y. 10003
Exhibited: Pace Gal., N.Y., 1964, 1965; WMAA, 1965; Rigelhaupt
Gal., Boston, 1966; Royal Marks Gal., and Sidney Janis Gal., N.Y.,
1966; Henri Gal., Washington, D.C., 1968; Gertrude Kasle Gal., De-
troit, Mich., 1968; Bennington Col., 1968.*

TOLPO, CARL—Painter, S., W., L.
 25 Oakdene Rd., Barrington, Ill. 60010; also R.R. #2, Stockton,
 Ill. 61085
B. Ludington, Mich., Dec. 22, 1901. Studied: Augustana Col.; Univ.
Chicago; AIC, and with Frank O. Salisbury, London, England; and
with Gutzon Borglum. Member: AAPL. Awards: prizes, Chicago
Nat. Portrait Comp., 1952; Illinois Abraham Lincoln Mem. Comm.,
1955. Work: ports., Augustana Col.; Augustana Hospital, Chicago;
Swedish-Am. Hist. Mus., Phila., Pa.; Mun. Court, City of Chicago;
Inst. of Medicine; John Marshall Law Sch., Chicago; Univ. Illinois
Medical Sch.; mural, Pioneer Room, La Grange (Ill.) YMCA; 9 offi-
cial ports. State Capitol Bldg., Springfield, Ill.; ports. in private
colls.; sculpture, Saddle & Sirloin Cl., Chicago; 2 Lincoln bronze
busts, Lincoln Room, Ill. State Hist. Mus., Springfield; Lincoln
busts, Alfred W. Stern Coll., LC; 25 Heroic Baseball Hall of Fame
Portrait paintings, Chicago, Ill.; Heroic Lincoln monument, Bar-
rington, Ill., Lincoln Museum, Washington, D.C. and Lake County
Courthouse, Waukegan, Ill. Exhibited: 5 one-man exhs., 1938-1944;

NSS, 1967. Contributor "The Fine Use of the Creative Principles,"
Barrington Courier-Review. "My Lincoln Sculpture and the Crea-
tive Order," dedicatory address, 1969, U.S. Dept. of Interior ac-
ceptance of heroic Lincoln sculpture for Lincoln Museum, Washing-
ton, D.C.

TOMLINSON, FLORENCE K. (Mrs. E.B.)—
 Painter, Eng., I., T.
 703 Glenway, Madison, Wis. 53711
B. Austin, Ill. Studied: Colt Sch. A., Madison, Wis.; Univ. Wiscon-
sin, and with Oscar Hagen, Frederic Taubes, and others. Member:
Wis. P. & S.; Nat. Lg. Am. Pen Women; Madison A. Gld.; Madison
AA; F.I.A.L.; AEA. Awards: prizes, Madison A. Gld., 1944-1948,
1969; Nat. Lg. Am. Pen Women, Smithsonian Inst., 1963, 1964, 1968.
Work: Milwaukee AI; mural, Midland Cooperative, Minneapolis,
Minn. Exhibited: LC, 1944, 1945, 1948-49, 1952; Milwaukee AI; La-
guna Beach AA, 1945; NAD, 1942, 1943, 1948; Albright A. Gal., 1943;
Northwest Pr.M., 1946; Madison A. Salon, 1940-1943, 1945, 1955,
1956; Joslyn A. Mus., 1948; Layton A. Gal., 1948; Madison, Wis.,
1949-1952, 1953, 1955; Rochester Mem. A. Gal., 1953; SAGA, 1953;
Bradley Univ., 1952; Madison AA, 1953, 1955, 1958 (one-man), 1960;
Milwaukee A. Center, 1961. Madison Bank & Trust Co., 1954 (one-
man); Janesville, Wis.; Madison, Wis., (both one-man) 1969; Dover
(Del.) State Col., 1967 (one-man). Positions: Pres., Madison A.
Gld., 1945-46, 1946-47; Pres., Madison Chptr., Nat. Lg. Am. Pen
Woman, 1952-1954, State A. Chm., 1955, State Pres., 1966-1968;
Instr. A., Madison Vocational and Adult Sch., 1942-1962.

TOMPKINS, ALAN—Painter, I., Des., E., L.
 11 Milburn Drive, Bloomfield, Conn. 06002
B. New Rochelle, N.Y., Oct. 29, 1907. Studied: Columbia Col., B.A.;
Yale Univ., B.F.A. Awards: Winchester traveling fellowship, 1933-
34. Work: murals, USPO, Martinsville, North Manchester and In-
dianapolis, Ind.; Boone, N.C.; General Electric Co., Bridgeport,
Conn.; Columbia Univ. Cl., N.Y.; Central Baptist Church, Hartford,
Conn. Exhibited: Local and regional exhs. Illus., "Wedding Jour-
ney"; "In the Hands of the Senecas"; also several anthologies and
science books. Positions: Instr., Drawing & Des., L., John Herron
AI, 1934-38; CUASch., N.Y., 1938-43; Indst. Des., General Electric
Co., 1943-46; Columbia Univ., 1946-51; Asst. Dir., Hartford A. Sch.,
Hartford, Conn., 1951-1957; Dir., 1957- . Vice-Chancellor, Univ.
of Hartford, 1960- .

TONEY, ANTHONY—
 Painter, Gr., I., Comm. A., T., W., L.
 16 Hampton Place, Katonah, N.Y. 10536
B. Gloversville, N.Y., June 28, 1913. Studied: Syracuse Univ.,
B.F.A.; T. Col., Columbia Univ., M.A., Ed. D.; Ecole des Beaux-
Arts, Grande Chaumiere, Paris, France. Member: AEA; CAA; Au-
dubon A.; NEA; NSMP; ANA; Int. Inst. A. & Lets. Awards: Hiram
Gee F., Syracuse Univ., 1934; prizes, AEA, 1952, 1593; Univ. Illi-
nois, 1950; Audubon A., 1954, Medal of Honor, 1967; T. Col. Alumni
F., 1953; Ohio Wesleyan, 1953; Emily Lowe award, 1955; prize,
Mickewiecz Comp., 1956; Staten Island Mus. purchase, 1957; Ranger
Fund purchase award, NAD, 1965; Childe Hassam Fund, 1966. Work:
WMAA; Staten Island Mus.; Norfolk Mus. A. & Sciences; T. Col.,
Columbia Univ.; Syracuse Univ.; Univ. Illinois; Norton Gal. A.; mu-
ral, Gloversville (N.Y.) H.S.; Ohio Wesleyan Univ.; Berkshire Mus.
Exhibited: Mortimer Brandt Gal.; CGA; AIC; MModA; Mortimer Le-
vitt Gal.; Audubon A.; Los A. Mus. A.; Nat. Inst. A. & Lets., 1963,
1965, 1967; Montclair A. Mus.; Speed Mus. A.; Univ. Virginia; Grand
Central A. Gal.; Gal. Mod. A., N.Y., 1965; Westchester A. Soc.,
1962 and (6-man) 1965; Syracuse Mus. FA; NAD, 1946-1948, 1950-
1954; Univ. Iowa; Univ. Illinois, 1948, 1950-1952, 1955; WMAA, 1948,
1949-1953, 1955, 1961; AFA traveling exh., 1949, 1956, 1960, 1961;
Carnegie Inst., 1949; PAFA, 1950-1954; Salpeter Gal., 1950; Univ.
Nebraska, 1950, 1952; ACA Gal., 1951, one-man 1949-1964; BM,
1951; Des Moines A. Center, 1951; AIC, 1951; Roswell Mus. A.,
1956; Kansas City AI, 1956; Univ. New Mexico, 1956; Martick Gal.,
Balt., Md., 1955 (one-man); A. Gal., N.Y., 1948; Berkshire Mus. A.,
1957, 1960; Lenox Gal., 1960, 1961; Tyringham Gal. (Mass.), 1958,
1959-1961; Staten Island Mus. Hist. & A., 1958; Univ. So. Illinois,
1959; ACA Gal., N.Y., 1959, 1962, 1967; Detroit, Mich., 1961; one-
man: Wakefield Gal.; Artists Gal.; ACA Gal., Rome, Italy, 1964; New
York, 1968, 1968; Syracuse Univ.; Santa Barbara Mus. A.; Roswell
Mus., N.M.; Berkshire Mus.; Cayuga Mus.; Staten Island Mus. A.; Kan-
sas City AI; Univ. New Mexico; Rochester Inst. Tech.; Garelick Gal.;
Pace College, 1968; Dutchess County Community College, 1968; Ful-
ton Montgomery Col., 1969; Katonah, N.Y., Gal. Positions: Nat. Dir.,
AEA, 1952-56, 1958-59, Sec. N.Y. Chap., 1958-59, N.Y. Delegate,
1958-59, Bd. Memb., 1960-62; Instr., Hofstra Col., 1953-55; New
Sch. for Social Research, 1953- ; Five Towns Music & Art Fnd.; Bd.
Memb., Audubon A., 1958-59. Author: "Creative Learning in Higher
Education"; "Anatomy of Discovery," 1965; "Creative Painting and
Drawing," 1966; Ed., "150 Masterpieces of Drawing"; collaborator
with other artists and a poet, "Tune of the Calliope."

TOOKER, GEORGE—Painter
Hartland, Vt. 05048
B. Brooklyn, N.Y., Aug. 5, 1920. Studied: Phillips Acad., Andover, Mass.; Harvard Univ., A.B.; ASL, with Reginald Marsh, Kenneth Hayes Miller, Harry Sternberg. Member: ANA. Work: WMAA; MMA; Walker A. Center; AIC; MModA; S.C. Johnson & Sons, Inc. Coll.; Sara Roby Fnd. Coll.; Dartmouth Col.; Addison Gal. Am. A. Awards: Grant, Nat. Inst. A. & Lets., 1960. Exhibited: WMAA, 1947-1958, 1961, 1964, 1965, 1967; MMA, 1950, 1952; Carnegie Inst., 1958; Spoleto (Italy) A. Festival, 1958; one-man: Isaacson Gal., N.Y., 1960, 1962; Durlacher Bros., 1964, 1967; Hopkins A. Center, Dartmouth Col., 1967. Positions: Instr., ASL, 1965-1968.

TOPOL, ROBERT M.—Collector
825 Oriental Ave., Mamaroneck, N.Y. 10543*

TORBERT, MEG (Mrs. Donald R.)—Designer
2116 Irving Ave., South, Minneapolis, Minn. 55405
B. Faribault, Minn., Sept. 30, 1912. Studied: Univ. Minnesota, B.S.; Univ. Iowa, M.A. Awards: Carnegie F., 1937. Work: Interiors for Mayo Memorial Medical Center, Minneapolis, Minn. Ed., contributor to Design Quarterly. Instr. Des., Univ. Minnesota to 1949; Cur. Des., Walker Art Center, Minneapolis, Minn., 1950-1962; Freelance designer and consultant for Minnesota Mathematics Film Center, 1965-1968. Freelance designer, writer, consultant, 1969- .

TOULIS, VASILIOS (APOSTOLOS)—Printmaker, P., E.
210 E. 23rd St. 10010; h. 150 E. 18th St., New York, N.Y. 10003
B. Clewiston, Fla., Mar. 24, 1931. Studied: Univ. Florida, B. Des., with Fletcher Martin, Carl Holty; Pratt Inst., B.F.A., with Richard Lindner, Fritz Eichenberg, Jacob Landau, Walter Rogalski. Member: AAUP. Awards: Tiffany Fnd. Grant, 1967 (printmaking). Work: U.S. State Dept., Wash., D.C.; Museo del Arte Moderno, Mexico City; Caravan House, New York City. Commissioned: Portfolio of Prints, Center for Contemp. Printmaking, 1968. Exhibited: PAFA, 1963, 1964; BM, 1966; Museo del Arte Moderno, 1967; Int. Min. Print Exh., 1968; New Paltz Nat. Print Exh., 1968; Phila Pr. Cl., 1961, 1964; Fleischer Mem., Philadelphia, 1966; North New Jersey A. Lg., 1964. Lectures: Seragraphic Printmaking, Univ. Rhode Island, 1967; Seminar, Pratt Inst., Brooklyn, N.Y., 1969. Positions: Hd., Graphic Arts Workshops, Pratt Inst., 1966- ; Advisor, Printmaking, to Director, Hudson River Museum, N.Y.

TOVISH, HAROLD—Sculptor, T., W., L.
164 Rawson Road, Brookline, Mass. 02146
B. New York, N.Y., July 31, 1921. Studied: Columbia Univ.; Zadkine Sch. Sculpture; Grand Chaumiere, Paris. Member: AEA. Awards: prizes, WAC; purchase, 1951; Minneapolis Inst. A., 1953, 1954; Boston A. Festival, 1957, 1958; Boston Inst. Contemp. A., 1958; Grant Nat. Inst. A. & Lets., 1960. Work: sc., Minneapolis Inst. A.; WAC; WMAA; BMFA; AGAA; Univ. Minnesota; drawings: Guggenheim Mus. (also sculpture); Minneapolis Inst. A.; WAC; AIC; PMA. Exhibited: MMA, 1943; WMAA, 1952-1954, 1957, 1960; AIC, 1954, 1960; San F. AA, 1952; Toledo Mus. A., 1948; Boston A. Festival, 1957, 1958; Venice Biennale, 1956; WAC, 1951, 1953, 1955; Denver Mus. A., 1952, 1953; Univ. Illinois, 1959, 1960; MModA, 1959; Carnegie Inst., 1959; Boulder, Colo., 1961; Helsinki, 1959; Ostend & Charleroi, Belgium, 1959; Retrospective: Watson Gal., Wheaton Col., 1967; Guggenheim Mus., 1968; one-man: Dintenfass Gal., N.Y., 1965; Swetzoff Gal., Boston, 1965; AGAA, 1965. Positions: Asst. Prof. Sculpture, New York State Col. of Ceramics, 1947-49; Univ. Minnesota, 1951-54; Instr., S., BMFA Sch., Boston, Mass., 1957- . Sculptor-in-Res., American Acad. in Rome, 1966; Research Fellow, Center for Advanced Visual Studies, Mass. Inst. Technology.

TOWNLEY, HUGH—Sculptor, E.
6 Walley St, Bristol, R.I. 02809
B. West Lafayette, Ind., Feb. 6, 1923. Studied: Univ. Wisconsin; Apprenticed with Ossip Zadkine, Paris; London County Sch. A. & Crafts, London, England. Awards: prizes, Wisconsin Salon A., 1951, 1954; Walter prize, San Francisco Salon A., 1953; Wisconsin P. & S. Soc., 1952, 1956, 1957; Margaret Brown award, Inst. Contemp. A., Boston, 1960, 1961; R.I. A. Festival, 1962, 1963, 1965; Silvermine Gld. A., 1963; Beverly Farms, Mass., 1962, 1963; Berkshire AA, 1961, 1963, 1964. Work: SFMA; WMAA; Milwaukee AI; Munson-Williams-Proctor Inst., Utica; AGAA; FMA; BMFA; Williams Col. Mus.; Kalamazoo A. Center; deCordova & Dana Mus.; Wrexham Fnd., New Haven; Univ. Rhode Island; Pembroke Col., Brown Univ.; Sobin Chemical Co., Boston; Old Stone Bank, Bristol, R.I. Exhibited: MModA, 1955; "Momentum," Chicago, 1952, 1953, 1956, 1957; AIC, 1954, 1964; WMAA, 1957, 1962, 1963; Carnegie Inst., 1958; Univ. Illinois, 1961, 1963; Inst. Contemp. A., Boston, 1960-1962, 1965; New Sch. for Social Research, N.Y., 1962; Wadsworth Atheneum, Hartford, 1965; deCordova & Dana Mus., 1964, 1965; one-man: Galerie Appollinaire, London, 1951; Univ. Wisconsin, 1955; Milwaukee AI, 1957; Swetzoff Gal., Boston, 1958, 1959; Arts

Council, Winston-Salem, 1958; Lyman Allyn Mus., New London, Conn., 1958; Pace Gal., Boston, 1962, 1964, 1965; Pace Gal., New York, 1964; Univ. Connecticut, 1964; Sloan Gal., Valparaiso Univ., 1965; Mitchem Gal., Milwaukee, 1965. Positions: Assoc. Prof., Sculpture & Drawing, Brown Univ.; Asst. Prof., Boston Univ., 1957-61.*

TOWNSEND, MARVIN—Cartoonist, Comm. A.
631 West 88th St., Kansas City, Mo. 64114
B. Kansas City, Mo., July 2, 1915. Studied: Kansas City AI; Col. of Commerce A. Sch. Member: Cartoonists Gld. of Am. Illus.; cartoons for advertising promotions series for local and national firms; Eastman Kodak; Glass Container Inst., etc. Contributor cartoons to: national and trade magazines in the U.S. and Canada. A "Marvin Townsend Collection of Cartoons," Syracuse Univ. Creator of comic strips "Poochie"; "Foxy"; Cubby the Bear"; "Quacker"; "Jane & Joey"; "Julie & Jack"; "Sanitary Sam"; "Meg & Greg"; "Art on the Job"; and industrial safety strip, "Bert" for the Nat. Safety Council; "Floralaffs" cartoon page feature in Florist magazine; "Ali" in Treasure Chest magazine; Florist Telegraph Delivery cartoons, and others. Specializes in cartoon strips for children in various age groups; illus. for humorous articles; commercial art and layout. Special assignment cartoons and illustrations for technical and business articles in trade magzines.

TRAHER, WILLIAM HENRY—Painter, I., L., W.
2331 Niagara St., Denver, Colo. 80207
B. Rock Springs, Wyo., Apr. 6, 1908. Studied: Yale Univ.; NAD. Work: Wyoming design, Container Corp. State Series; reviews and reproductions, N.Y. Times; Christian Science Monitor; Annual of Advertising Art; Gebrauchs Graphik, etc. Rear projection backgrounds, Barter Theatre, "The Virginian." Murals, Jefferson Nat. Expansion Memorial, St. Louis, Mo. Five Panel "Wilderness" mural, Columbia Savings Bank, Pueblo, Colorado. Positions: Chief, Background A., Denver Mus. Natural Hist.; Bd. Trustees, Denver A. Mus., Denver, Colo.

TRAUERMAN, MARGY ANN—Painter, T.
2 W. 67th St., New York, N.Y. 10023
B. Sioux Falls, S. Dak. Studied: Los Angeles City Col., A.B.; State Univ. Iowa, B.F.A.; Am. Acad. A., Chicago; ASL, and with Jacob Getlar Smith. Member: AWS; P. & S. Soc. of New Jersey. Awards: prizes, Texas Annual, 1951; NAWA, 1956; P. & S. Soc. of New Jersey, 1967, 1968. Exhibited: PAFA, 1953, 1961; AWS, 1953, 1957, 1958, 1959, 1960, 1962, 1963, 1968, and traveling exh., 1957; All. A. Am., 1954-1956, 1962; Audubon A., 1958; NAWA, 1956, 1957, 1958; NAD, 1956; Knickerbocker A., 1956, 1957; Nat. Soc. Painters in Casein, 1956; Texas Annual, 1951; Chatham Col., Pittsburgh, 1961 (one-man); P. & S. Soc. of New Jersey, 1967-1969. Positions: Instr., Adv. A., High School of Art & Design, New York City.

TRAVIS, KATHRYNE HAIL—Painter, T.
Drawer T, Ruidoso, N.M. 88345
B. Ozark, Ark., Feb. 6, 1894. Studied: Galloway Col., AIC; Cincinnati Acad. FA; Ohio Mechanics Inst.; Chicago Acad. FA. Member: Kathryne Hail Travis A. Cl., Dallas (Hon.); AAPL. Work: in many private colls. Exhibited: one-man: Los Angeles; Seattle, Wash.; Arkansas; Oklahoma; DMFA; Texas State Fair. Co-Founder, Co-Dir., Dallas AI (later absorbed by Dallas Mus. FA); Dir., Fndr., Gallery of Art & Summer School of Painting (in Ruidoso, N.M.).

TRAVIS, OLIN HERMAN—Painter, Lith., L., E.
8343 Santa Clara Dr., Dallas, Tex. 75218
B. Dallas, Tex., Nov. 15, 1888. Studied: AIC; & with Clarkson, Norton, Walcott, Sorolla. Awards: prizes, SSAL, 1930, 1932. Work: Dallas Mus. FA; Elisabet Ney Mus.; Highland Park Mus.; Hall of State, Dallas, Tex.; Love Field Airport, Tex. Exhibited: Rockefeller Center, N.Y.; GGE, 1939; Texas Centennial; DMFA, 1953; numerous one-man exh.; Chicago, San Antonio, Denver, Dallas, etc. Lectures: Landscape, Portrait Painting. Positions: Founder, Dir., Dallas AI, Dallas, Tex.; Dir., San Antonio (Tex.) AI, 1944-45; Instr., Painting, Austin Col., Sherman, Tex., 1951- ; Painter of backgrounds for Dallas Mus. Natural Hist.; Des., groupings, costumes, backgrounds and color for Southwestern Historical Wax Museum, Dallas, Tex.; Pres., Dallas Soc. for General Semantics.

TREADWELL, GRACE A. (Mrs. Abbot)—Painter, L., T.
35 Knightsbridge Rd., Great Neck, N.Y. 11021
B. West Chop, Mass., July 13, 1893. Studied: BMFA Sch.; ASL; Grande Chaumiere, Paris, France. Member: Pen & Brush Cl.; NAWA; Mississippi AA; AEA. Awards: prizes, Pen & Brush Cl. (8); Miss. AA. Work: Albright A. Gal.; murals, St. Luke's Church, Smethport, Pa.; Madonna, St. Mark's Church, St. George's Episcopal Church, N.Y., and Father Flannigan's Boys Town, Nebraska; triptych & mural in children's ward, Bird S. Coler Hospital, N.Y. Exhibited: BM; High Mus. A.; NAWA; All. A. Am.; Knickerbocker A.; 4 one-man exhs., N.Y.*

TREADWELL, HELEN—Mural Painter, Des.
33 West 67th St., New York, N.Y. 10023
B. Chihuahua, Mexico, July 27, 1902. Studied: Vassar Col.; Sorbonne, Paris, France. Member: NSMP (Pres., 1963-1968); Arch. Lg. (1st Vice-Pres., 1952-1954, 1964-1966; memb. Exec. Com.); Sec., U.S. Comm. of the Int. Assn. of Art; AEA (Bd. Dir.). Awards: special award, mural paintings in Mun. Bldgs., Chile. Work: Hotel mural decorations include, Hotel New Yorker, N.Y.; Hotel Utah, Salt Lake City; Hotel Tourraine, Boston; Hotel Bermudiana, Hamilton, Bermuda; Hotel Southern, Baltimore; Cipango Club, Dallas; Roslyn Country Club, Long Island, N.Y.; Burlington Railway coach panels; S.S. Uruguay; Chase Manhattan Bank, San Juan, Puerto Rico; Brooklyn Savings & Loan Bank, Bensonhurst, L.I.; Marine Midland Trust Co. N.Y.; Valeria Cl., N.Y.; Sun & Surf Cl., Atlantic Beach, L.I.; Guggenheim Dental Clinic for Children, N.Y.; indst. murals: Okonite Cable Co., Passaic, N.J.; Standard Vacuum Oil Co., Harrison, N.Y.; Trinity Ofc. Bldg., N.Y.; mosaic, E. R. Squibb, Miami; mosaics in schools in New York City, Bronx, Brooklyn and Long Island; many murals in private homes and restaurants. Lutheran Church of the Incarnate Word, Rochester, N.Y. Exhibited: one-man: Arthur Newton Gal., 1934; Rockefeller Center, N.Y.; Arch. Lg., 1946, 1949, 1950, 1956; Crespi Gal., 1959; Contemporaries Gal., N.Y., 1965.

TREBILCOCK, PAUL—Painter
44 West 77th St., New York, N.Y. 10024
B. Chicago, Ill., Feb. 13, 1902. Studied: Univ. Illinois; AIC; & in Europe. Member: NA; Chicago AC; Century Assn.; Chelsea AC, London, England. Awards: prizes, ASL, Chicago, 1923; AIC, 1925, 1926, 1928, 1937, med., 1929; Chicago Galleries Assn., 1926; NAD, 1931; Newport AA, 1931. Work: AIC; Albright A. Gal.; Cranbrook Mus.; The Pentagon, Wash., D.C.; IBM; CM; Hunter Gal. A., Chattanooga, Tenn.; U.S. Embassy, London; Universities of: Rochester, Wisconsin, Harvard, Yale, Princeton, Columbia, Johns Hopkins; Northwestern Univ.; Dartmouth, Finch and Pace Cols.; many portraits of prominent persons. Contributor to: American Artist magazine.

TREIMAN, JOYCE WAHL—Painter
712 Amalfi Drive, Pacific Palisades, Cal. 90272
B. Evanston, Ill., May 29, 1922. Studied: Stephens Col., A.A.; State Univ. Iowa, B.F.A. Awards: prizes, Denver A. Mus., 1948; Ill. State Mus., 1948; AIC, 1949-1951, 1953, 1959, 1960; Magnificent Mile, Chicago, 1953; Highland Park, Ill., 1953; Ford Fnd. purchase, 1960; Ball State Col., 1961 (purchase); Tiffany F., 1947; Tupperware A. Fund F., 1955; Pasadena A. Mus., 1962; La Jolla Mus. A., 1962; All-City Show, Los A., 1963, 1964, 1966; Los Angeles Home Show, 1965; Rossmor Exh., 1965; Ford Fnd. A.-in-Res. Grant, 1963; Tamarind Lithography Workshop Fellowship, 1962; L.A. Times, "Woman of Year for Art," 1965. Work: Denver A. Mus.; State Univ. Iowa; Ill. State Mus.; Tupperware A. Mus., Orlando; AIC; Utah State Univ.; Abbott Lab.; Oberlin Col.; Int. Minerals, Minn.; N.Y. and Chicago; Pasadena A. Mus.; Ball State Univ.; Univ. Oregon; Los A. Mus. A.; Univ. Cal., Los Angeles and Santa Cruz; Univ. Oregon. Exhibited: Carnegie Inst., 1955, 1957; MMA, 1950; Univ. Illinois, 1950-1952, 1956, 1961; WMAA, 1951-1953, 1957, 1958, 1962; AIC, 1945-1960; Denver A. Mus., 1943, 1948, 1955, 1958, 1960, 1964; VMFA 1946, 1948; LC, 1954; DMFA, 1954; CGA, 1957; Detroit Inst. A., 1958; PAFA, 1958; Lake Forest Col., 1959; Stanford Univ., 1955; Boston A. Festival, 1960; Ball State Col., 1961; SFMA, 1951; Univ. Texas, 1952; John Herron AI, 1953; Univ. Chicago, 1953; AFA traveling exhs., 1951, 1953, 1955-1958; Downtown Gal., N.Y.; MModA, 1962, 1969; Scripps Col., Cal., 1966; Felix Landau Gal., L.A., 1967; Lytton Center, 1967; Washburn Univ., 1967; Cal. Painters traveling exh., 1968; and many others. One-man: AIC, 1947; Winnetka, Ill., 1949; Fairweather-Garnett Gal., Evanston, 1950; Hewitt Gal., N.Y., 1950; Palmer House, Chicago, 1952; Nelson Gal., Chicago, 1953; Feingarten Gal., 1955; Cliff Dwellers Cl., Chicago, 1955; Fairweather-Hardin Gal., 1955, 1958; Willard Gal., N.Y., 1960; Landau Gal., Los A., 1961, 1964; Forum Gal., N.Y. 1966; Cal. State Col., 1967. Positions; A-in-Res., San Fernando Valley, Cal., 1968; Visiting Artist, Art Center Sch., Los Angeles, 1968.

TREISTER, KENNETH—Painter, S., Des., Arch.
1460 Brickell Ave., Miami, Fla. 33131; h. 3660 Battersea Rd., Coconut Grove, Fla. 33131
B. New York, N.Y., Mar. 5, 1930. Studied: Univ. Florida, B. Arch.; Univ. of Miami. Member: Gld. Religious Architecture; Blue Dome Fellowship; Fla. Sculptural Soc.; Southern Assn. of Sculpture; AIA. Awards: prize, Nat. Ceramic Exh., Lowe A. Gal., 1953; State of Florida A. Comm. for permanent exhibition in Fla. Supreme Court Bldg., Tallahassee, Fla. Work: Norton Gal. A., Palm Beach; Miami Mus. A.; Supreme Court of the State of Florida; bronze Menorah, wood and bronze Ark and sculptured chandelier for Temple Israel of Greater Miami. Exhibited: High Mus. A., Atlanta; Greenwich Gal., N.Y.; Columbus Mus. FA.; Mus. Contemp. A. of Houston; Lowe A.

Gal., Coral Gables, Fla.; Mirell Gal., Miami, one-man: 1964-1967, 1969. Contributor articles to many architectural, school, and building publications.

TRIANO, ANTHONY THOMAS—Sculptor, L., T.
586 Devon St., Kearny, N.J. 07032; also, 501 Main St., Avon-by-the-Sea, N.J. 07717
B. Newark, N.J., Aug. 25, 1928. Studied: Newark Sch. FA and with Reuben Nakian. Awards: purchase award, Newark Mus., 1940, 1961; Montclair Mus., 1956. Work: Newark Mus.; Abbott Lab.; Newark Pub. Lib.; J. L. Hudson Coll.; Hartford A. Fnd.; Patterson State Col.; Galerie Inst., N.Y. Exhibited: Newark Mus., 1955, 1958-1961; Montclair A. Mus., 1952-1956; Trenton Mus.; East Hampton Gld.; one-man: Albert Landry Gal., N.Y., 1960, 1962; Robin & Krueger; Papermill Playhouse; Dimensions in N.J. and eleven others. Positions: Dir., Triano Schools of Fine Art, Kearny and East Orange, N.J.

TRIFON, HARRIETTE—Painter, T., Et., S.
84 Laurel Hill Drive, Valley Stream, N.Y. 11581
B. Philadelphia, Pa. Studied: with Aaron Berkman, Nahum Tschacbasov, Chaim Gross, Michael Ponce de Leon. Awards: City Center, N.Y., 1957; prizes, Birmingham Mus. A., 1954; Long Island A., 1953, 1956 (3); Malverne A., 1954; Nassau A. Lg., 1958. Work: Hewlett-Woodmere Library; Woodward Fnd., Wash., D.C.; Birmingham Mus. A.; Staten Island Mus. A. & Sc.; Jewish Mus. Exhibited: Birmingham Mus. A., 1954, 1956; All. A. Am.; ACA Gal.; Five Towns Music & A. Fnd.; Long Island A. Lg.; Art: USA; N.Y. City Center, 1953-1958; Barzansky Gal., 1955, 1957 (one-man); Hofstra Col., 1956 (one-man); Barzansky Gal., N.Y., 1960 (one-man); Phila. Pr. Cl.; Boston Pr.M.; N.Y. World's Fair, 1964; Assoc. Am. Artists Gal., N.Y.; Small World Gal., 1963 (one-man); Loring Gal., 1965, 1968 (one-man).

TRIMM, H. WAYNE—Illustrator
Sketch Book Farm, Chatham, N.Y.
B. Albany, N.Y., Aug. 16, 1922. Studied: Cornell Univ.; Syracuse Univ.; Augustana Col., A.B.; Kansas State Col.; State Col. of Forestry, M.S. Member: Am. Ornithologists Union; Columbia County A. & Crafts; Hon. Memb. Tuscarora Indian Tribe, 1960; Soc. Animal Artists. Work: dioramas, Springfield Mus. A.; three ecological dioramas for Augustana College, 1967; Movie making for Audubon Screen Tour, 1968-69; CMA; 3 murals, Jug End Barn, S. Egremont, Mass., 1961. Exhibited: American Bird Artists traveling exh., sponsored by Audubon A., 1948; Joslyn Mus. A.; Buffalo Mus. Science, 1950; San Jose State Col., 1951; Erie Mus., 1952; Albany State Col., 1956; Ogunquit, Me., 1960-61; N.Y. Coliseum Sportsman's Show, 1961 (one-man); Syracuse, N.Y. War Mem., 1961 (one-man); Utica Col., 1962 (one-man). Illus., "The Mammals of California and Its Coastal Waters," 1954; "Manual of Museum Techniques," 1948; Collier's Encyclopedia, 1960-61; field paintings for "The Birds of Tikal," 1963-64; "The Birds of Colorado," 1966. Contributor illus. to Audubon Magazine; New York State Conservationist. Lectures: Conservation, and Wildlife Painting; "Alaskan Bowhunting," Positions: Staff Artist, N.Y. State Conservation Dept., Conservation Dept., Conservation Edu. Div., 1953- .

TRIPLETT, MARGARET L.—Educator, P.
Norwich Art School, Norwich, Conn.; h. 1 Prunier Court, Norwich, Conn. 06360
B. Vermillion, S.D., Dec. 30, 1905. Studied: State Univ. Iowa, B.A.; BMFA Sch.; Yale Univ., M.A.; & with Grant Wood. Member: Eastern AA; Nat. Edu. Assn.; Conn. State T. Assn.; Conn. A. Assn.; Conn. WC Soc.; Mystic AA; Nat. Com. on A. Edu. (Council Assoc., 1961-63); NAEA; Norwich AA. Work: Munson-Williams-Proctor Inst., Utica. Exhibited: AWCS, 1940; CM, 1940; New Haven Paint & Clay Cl., 1939; Portland Mus. A., 1939; Iowa A. Salon, 1932-1934, 1938; Joslyn Mem., 1933; Conn. Acad. FA, 1937, 1938; Conn. WC Soc., 1939, 1940, 1949-1951, 1954, 1955, 1957, 1958, 1959, 1961; Mystic AA, 1948-1961; de Cordova & Dana Mus., 1953; Slater Mus. A., 1953-1961; Essex AA, 1960, 1961; one-man: New Britain YWCA, 1953; Audio Workshop, West Hartford, 1955; Eastern Conn. A., 1948-1952; Lyman Allyn Mus., 1958; Mystic AA, 1960. Positions: Instr., A., 1929-43, Dir., 1943- , The Norwich A. Sch., Norwich, Conn.; Pres. Conn. AA, 1954-56; Trustee, Hartford A. Sch., of the Univ. of Hartford, 1956- .*

TRIVIGNO, PAT—Painter, E., L.
Tulane University; h. 1831 Marengo St., New Orleans, La. 70115
B. New York, N.Y., Mar. 13, 1922. Studied: Tyler Sch. A., Temple Univ.; Univ. Iowa; N.Y. Univ.; Columbia Univ., B.A., M.A. Member: CAA; Southeastern Col. AA; MacDowell Colony Assn.; New Orleans AA; F.I.A.L. Awards: prizes, Delgado Mus. A., 1951, 1954, 1957; Am. Acad. A. & Let., 1950, 1951, 1960; Carnegie Univ. grant, 1957-58. Work: Syracuse Univ.; Miami, Fla.; Delgado Mus. A.; Arkansas

Arts Center, Little Rock; Painting, Exec. Offices, The New York Times, 1966; Gulf Bldg., Jacksonville, Fla. Exhibited: WMAA, 1950; Young Painters, USA, 1951; Univ. Illinois, 1950, 1961; PAFA, 1952, 1960; Univ. Nebraska, 1951, 1960; Des Moines A. Center, 1951; Cal.PLH, 1952; Cranbrook Mus. A., 1953; Dayton AI, 1951, 1952; Toledo Mus. A., 1952; Denver A. Mus., 1955, 1957; Birmingham Mus. A., 1952; VMFA, 1952; DMFA, 1954, 1956; Univ. Florida, 1952; Atlanta, Ga., 1952; Norfolk Mus. A., 1954; Delgado Mus. A., 1951, 1953, 1954; Luyber Gal., N.Y., 1950 (one-man); Mus. FA of Houston; Seligmann Gal., N.Y., 1960, 1964 (one-man); Columbia Univ., 1961, 1962 (one-man); AIC, 1961; Detroit Inst. A., 1960; Rose Fried Gal., N.Y., 1969 (one-man); AFA traveling exh., 1961-62; AIC; PAFA. Positions: Prof. A., Hd., Painting & Drawing Div., Tulane Univ., New Orleans, La.

TROCHE, E. GUNTER—Museum Director
 Achenbach Foundation for Graphic Arts, California Palace of the Legion of Honor; h. 2242 Steiner St., San Francisco, Cal. 94115
B. Stettin, Germany, Sept. 26, 1909. Studied: Univ. Vienna; Univ. Munich, Ph.D. Member: Renaissance Soc. Am.; Deutscher Verein fuer Kunstwissenschaft; Roxburghe Cl. of San Francisco. Author: "Italian Painting in the 14th and 15th Centuries," 1935; "Painting in the Netherlands, 15th and 16th Centuries," 1936; many museum catalogs and numerous articles and book reviews in professional magazines. Arranged exhs., "The Printmaker, 1450-1950," 1957; "German Expressionists," 1958, and many other exhibitions. Positions: Asst. Cur., State Museums, Berlin, 1932-36; Cur., Municipal Museum, Breslau, 1936-38; Cur., 1938-45, Dir., 1945-51, Germanic National Museum, Nuremberg, Germany; Dir., Achenbach Foundation for Graphic Arts, California Palace of the Legion of Honor, San Francisco, Cal., at present.

TROMMER, MARIE—Writer, Cr., P., T.
 99 Bay 29th St., Apt. C-3, Brooklyn, N.Y. 11214
B. Kremenchug, Russia, Sept. 29, 1895. Studied: CUASch; Master Inst. of United Arts, and with Douglas Volk, Wayman Adams. Member: Cooper Union Alumni Assn. Awards: prizes, Avalon Poetry Organization, 1959; Explorer Magazine, 1960; 50th Anniversary Honorary Plaque, Cooper Union Alumni Assn., 1964. Work: Corona Mundi, N.Y.; Women's Nat. Inst.; N.Y. Hist. Soc.; Mus. City of N.Y.; N.Y. Pub. Lib.; LC; Long Island Hist. Soc.; Mus. Natural Hist., N.Y.; Theodore Roosevelt House, N.Y.; BM Lib.; and others; books in hand-made covers, Brooklyn Pub. Lib.; Cooper Union Sch. & Mus.; translations from American and British poets into Russian in the collections of: Vassar Col. Library; Colby Col.; Wellesley Col.; Univ. Iowa; Williams Col.; Occidental Col.; Univ. Nevada; LC; Brooklyn Pub. Library, and others. Exhibited: Soc. Indp. A.; All. A. Am.; Salons of Am.; Brooklyn Soc. A.; Brooklyn WC Cl.; Brooklyn Heights Exh., 1955; Women's Int. Exp., 1959-1961.

TROTTER, ROBERT (BRYANT)—Painter, Des., I., T.
 608 W. Princess Anne Rd., Norfolk, Va. 23517
B. Norfolk, Va., Sept. 6, 1925. Studied: Maryland Inst. FA, with Howard Frech, Jacques Maroger; ASL, with Julian Levi, John Carroll. Member: ASL; AEA; Tidewater A.; Maryland Inst. Alumni. Awards: prizes, Ohio State Fair, 1953; G.W.V. Smith Mus., Springfield, Mass., 1954; Delaware A. Center, 1953; Oglebay Inst., Wheeling, W. Va., 1954; Soc. Painters in Casein, 1958; WTAR-TV Anniversary Exh., Norfolk, 1958; Paul Green Award, 1959, Chamber of Commerce award, 1959 and Haycox award, 1959, all Virginia Beach, Va.; Valentine Mus., 1960; Unitarian Church award, 1963; Alfred Khouri Mem. Award, 1964, purchase awards: Irene Leach Mem. Mus., Norfolk, 1957; Massillon Mus., 1957; Montgomery Mus. FA, 1961. Work: Norfolk Mus. A. & Sc.; Massillon Mus.; Humble Oil Co. Coll.; Montgomery Mus. FA; mural and mem. port., St. Agnes Church, Mingo Junction, Ohio; mem. painting, High Street Methodist Church, Franklin, Va.; Seaboard Bank, (Norfolk), 1969; Old Dominion Col., Norfolk Public Schs., Alfred Khouri Coll., 1968; Kaufmann Coll. (Winston-Salem), 1968. Work: included in Prize Winning Paintings, 1961. Exhibited: Ogunquit A. Center, 1951; Butler Inst. Am. A., 1952, 1954, 1956, 1958, 1960; L.D.M. Sweat Mus., 1953; PAFA, 1953; G.W.V. Smith Mus., 1953, 1954; Springfield Mus., 1958; Delgado Mus., 1954; Ball State Col., 1956-1965; Wichita AA, 1959; Norfolk Mus. A.; 1951, 1953, 1954, 1955, 1957-1964; Jersey City Mus., 1952, 1958; Massillon Mus., 1952, 1954, 1957; Canton AI, 1953; VMFA, 1953, 1959; Pa. State T. Col., 1953; Ohio State Fair, 1953, 1954; Ohio WC Soc., 1953; Wilmington A. Center, 1953-1955; Bishop Col., 1954; Va. Beach AA, 1959; Valentine Mus., 1960; Montgomery Mus. FA, 1961, 1965; W. Va. Wesleyan Col., 1962; Mint Mus. A., 1962; Newport AA, 1962; Cooperstown AA 1962; Smithsonian traveling exhs., and others. One-man: Norfolk Mus. A. & Sciences, 1952; Sheppard Mem. Lib., 1954; Vanderbilt Univ., 1957; traveling exhs., Norfolk Mus. A., 1954, 1962, 1964; VMFA, 1953, 1959; Canton AI, 1953, Ohio WC Soc., 1953; Studio Gld., 1954, 1955, 1956; Va. State Col., 1965.

Positions: Hd. A. Dept., College of Steubenville, Ohio, 1952-54; Dir., Studio Sch., Steubenville, 1954-55; Art Dir., U.S. Naval Safety Center, Norfolk, Va. 1955- .

TROVA, ERNEST TING—Sculptor, P.
 6 Layton Terr., St. Louis, Mo. 63124
B. St. Louis, Mo., Feb. 19, 1927. Work: (paintings)- MModA; Tate Gal., London; American Container Corp. (sculpture)- MModA; WMAA; Guggenheim Mus.; CAM. Exhibited: Documenta IV; Los Angeles County Mus.; Guggenheim Mus.; Jewish Mus., N.Y.; Nat. Mus. Modern A., Tokyo.

TROVATO, JOSEPH S.—Painter
 Munson-Williams-Proctor Institute, 310 Genesee St., Utica, N.Y. 13504; h. 12 Hamilton Place, Clinton, N.Y. 13323
B. Guardavalle, Italy, Feb. 6, 1912. Studied: ASL; NAD; Sch. of Related A. & Sciences, Utica, N.Y.; Munson-Williams-Proctor Inst. Sch. A. Awards: Hon., D.F.A., Hamilton College, Clinton, N.Y., 1963. Work: Munson-Williams-Proctor Inst.; Utica College; LC. Exhibited: one-man: Colgate Univ., 1950, 1958; Munson-Williams-Proctor Inst.; Utica Col. of Syracuse Univ., 1954, 1962; Albany Inst. Hist. & A., 1957; E.W. Root A. Center, Hamilton Col., 1961; Everson Mus. A., 1963. Contributor to Art in America. Arranged exhibitions: 50th Anniversary Exh. of the Armory Show, 1963; Charles Burchfield, 1962; Edward Hopper, 1964; Learning About Pictures from Mr. Root, 1965. Organized for the N.Y. State Council on the Arts, "125 Years of New York Painting and Sculpture" exhibition, in celebration of the 125th anniversary of the New York State Fair. Presently compiling definitive catalogue of the paintings of Charles Burchfield and organizing "The Nature of Charles Burchfield," a memorial exhibition to be held at Munson-Williams-Proctor Inst., Buffalo, N.Y., in the spring of 1970. Positions: Asst. to the Director, Munson-Williams-Proctor Inst., Utica, N.Y., 1939- ; In charge of Exhibition Program, Edward W. Root Art Center, Hamilton College, 1958- ; Field Researcher, New York State, Archives of American Art, "The New Deal and the Arts," 1964-65; on leave from Munson-Williams-Proctor Inst. to accept appointment of Visiting Assistant Professor of Art, Hamilton College, Clinton, N.Y., 1965-66; Consultant, New York State Council on the Arts.

TRUBNER, HENRY—Museum Curator
 Seattle Art Museum, Volunteer Park, Seattle, Wash. 98102; h. 9341 Vinyard Crest, Bellevue, Wash. 98004
B. Munich, Germany, June 10, 1920. Studied: Harvard Univ., B.A., M.A. Member: AAMus.; Asia Society; CAA; Japan Society; Oriental Ceramic Society, London. Author: "The Arts of the Han Dynasty," Chinese Art Society of America, Asia House, N.Y., 1961; "The Far Eastern Collection," Royal Ontario Museum, Toronto, 1969. Coauthor: "Art Treasures from Japan," Los Angeles, Detroit, Philadelphia, Toronto, 1965-1966. Contributor to: Archives of the Chinese Art Society; Artibus Asiae; Oriental Art Magazine; Transactions of the Oriental Ceramic Society. Lectures: "Aspects of Han Pictorial Representation," Oriental Ceramic Society, London, 1961; "Japanese Ceramics," symposium on Japanese Ceramics, Detroit Institute of the Arts, 1964; "Japanese Tea Ceremony Ceramics," M.H. deYoung Memorial Museum, San Francisco, 1969. Teaching: The Arts of India, China, Japan, University of Toronto; Graduate Seminar, Far Eastern Art. Positions: Curator of Oriental Art, Los Angeles County Museum, Los Angeles, 1947-1958; Curator of the Far Eastern Department, Royal Ontario Museum and Professor, Department of East Asian Studies, University of Toronto, Toronto, Ontario, 1958-1968; Curator of Asiatic Art, Seattle Art Museum, Seattle, Washington, 1968- .

TRUE, VIRGINIA—Educator, P.
 20 Tee Way, South Yarmouth, Cape Cod, Mass. 02664
B. St. Louis, Mo., Feb. 7, 1900. Studied: John Herron AI, B.A.E.; Cornell Univ., M.F.A.; PAFA; Columbia Univ.; Univ. Colorado. Member: NAWA; CAA; AID; AEA; AAUP; Cornell Cl., N.Y.; AFA; MModA; Chrysler Mus. of A., Provincetown, Mass.; Ringling Mus. of A., Sarasota. Awards: prizes, Denver A. Mus.; Kansas City AI, Rochester Mem. A. Gal. Work: Univ. Colorado; State Col. Agriculture, Ft. Collins, Colo.; Cornell Univ., and in private colls. Exhibited: AWCS; NAWA, Carnegie Inst.; Denver A. Mus.; Kansas City AI, Rochester Mem. A. Gal.; Cornell Univ., retrospective exh., White Mus., 1965; one-man: Cape Cod Conservatory of Music and Art, 1969. Positions: Instr. A., John Herron AI, 1926-28; Univ. Colorado, 1929-36; Prof. A., Cornell Univ., Ithaca, N.Y., 1936-1965; Hd. Dept. Housing & Des., 1945-1965, Emeritus, 1965- ; Instr., Cape Cod Art Assoc., summers, 1968, 1969; Advisory Com., White Mus., Cornell Univ., 1960-1965; Advisory Com., Col. of Arch., Cornell Univ., 1962-1965.

TRUETTLER, WILLIAM—Associate curator
 National Collection of Fine Arts, Smithsonian Institution, Washington, D.C. 20560*

TRUEX, VAN DAY—Painter
c/o Graham Gallery, 1014 Madison Ave., New York, N.Y.
10021*

TRUITT, ANNE (DEAN)—Sculptor
3506 35th St., N.W., Washington, D.C. 20016
B. Baltimore, Md., Mar. 16, 1921. Studied: Bryn Mawr Col., B.A.;
Inst. Contemp. A., Washington, D.C. Exhibited: WMAA, 1968; PMA,
1968; Dayton A. Inst., 1968, 1969; Hemisfair, San Antonio, 1968; Los
Angeles County Mus., 1967; Jewish Mus., N.Y., 1966; Inst. Contemp.
A., Philadelphia, 1965 (7-man); Wadsworth Atheneum, Hartford,
Conn.; FA Gal. of Houston, 1963; Pan American Union, Washington,
D.C., 1956; CGA, 1953, 1955; NCFA, 1954; BMA, 1954; DMFA, 1950;
Minami Gal., Tokyo, 1967; one-man: Emmerich Gal., N.Y., 1963,
1965, 1969; Minami Gal., Tokyo, 1964, 1966; BMA, 1969.

TSCHACBASOV, NAHUM—Painter, Gr., E.
222 West 23rd St., New York, N.Y. 10011
B. Baku, Russia, Aug. 30, 1899. Studied: Lewis Inst.; Armour Inst.
Tech., and in Paris. Member: An Am. Group. Awards: prize,
Pepsi-Cola, 1947. Work: MMA; State Dept., Wash., D.C.; WMAA;
Dallas Mus. FA; Univ. Illinois; Brandeis Univ., Univ. Georgia; Univ.
Alabama; Univ. Nebraska; BM; Tel-Aviv Mus., Israel; PMA; Butler
AI; PAFA; Smith Col.; Jewish Mus.; Stetson Univ., DeLand, Fla.;
Bethune-Cookman Col., Daytona, Fla.; La Jolla A. Center, Cal.; Univ.
Maine, Orono; Glassboro (N.J.) State Col.; Columbus Mus. A.; Wil-
limantic (Conn.) State Col.; Edison Jr. Col., Ft. Myers, Fla.; Car-
negie Pub. Library, Clarksdale, Miss.; Harding Col., Searcy, Ill.;
Menninger Clinic, Topeka, Kans.; Oregon State Univ., Corvallis,
Ore.; Baldwin Wallace Col., Berea, Ohio; Sacramento (Cal.) State
Col.; Mississippi State Col. for Women, Columbus; Wustum Mus. A.,
Racine, Wis.; Debereaux Fnd., Scottsdale, Ariz.; Ulster County Com-
munity Col., Stone Ridge, N.Y., and others. Exhibited: Carnegie
Inst.; AIC; PAFA; CGA; MModA; WMAA; VMFA; Walker A. Center;
MMA; Berkshire Mus.; Rochester Mem. Gal.; Riverside Mus.; Univ.
Indiana; Univ. Illinois; Univ. Iowa; and in Europe; one-man: Galerie
Zak, Paris, 1934; Gallery Secession, 1935; ACA Gal., 1936, 1938,
1940, 1942, 1946; Univ. Texas, 1946; New Orleans A. & Crafts; Vige-
veno Gal., Los A.; 1030 Gal., Cleveland, Ohio; Perls Gal., 1947-48;
John Heller Gal., N.Y., 1951, 1953; Colorado Springs FA Center,
1946; SFMA, 1946; Nelson Gal. A., 1950; Walker A. Center, 1951;
Kansas State Col.; Ohio Univ.; Indiana State T. Col.; Univs. of Mis-
souri, Nebraska, Colorado, Florida, North Carolina; Pa. Col. for
Women; Allegheny Col.; Jewish Mus., and many others throughout
the U.S. Contributor to Art Students League Quarterly; Numero.

TSELOS, DIMITRI THEODORE—Educator, L.
University of Minnesota, Minneapolis, Minn. 55455; h. 1494
Branston St., St. Paul, Minn. 55108
B. Tripolis, Greece, Oct. 21, 1901. Studied: AIC; Univ. Chicago,
Ph.B., M.A.; Princeton Univ., M.A., M.F.A., Ph.D.; N.Y. Univ.; &
abroad. Member: CAA (Mem. Bd.); Am. Soc. Arch. Historians;
Archaeological Inst. Am. Awards: Carnegie F., Princeton Univ.,
1928-1929, 1930-1931; FA F., N.Y. Univ., 1929-1930; Fulbright F.,
Greece, 1955-56, 1963-1964; Contributor to: Am. Journal Archaeol-
ogy, Art Bulletin, Magazine of Art, & other publications. Author:
"Sources of Utrecht Psalter Illustrations." Positions: Instr., Asst.
& Assoc. Prof., N.Y. Univ., New York, N.Y., 1931-49; Prof., Univ.
Minnesota, 1949- . Summer & Collateral Positions: Univ. Southern
California, Swarthmore Col., Columbia Univ., Univ. Pennsylvania,
Vassar Col.; Lectures at: Yale Univ., Walker A. Center, etc.

TSENG YU-ho, BETTY (ECKE)—Painter, T.
3460 Kaohinani Drive, Honolulu 17, Hawaii
B. Peking, China, Nov. 27, 1923. Studied: Fu Jen Univ., Peking,
B.A.; post-grad. at universities in Peking and Hawaii. Member:
Honolulu P. & S. Awards: Rockefeller Scholarship, 1953; Watamull
Fnd. purchase award, 1957; prize, Stanford Univ., 1958. Work:
Honolulu Acad. A.; AIC; Inst. Oriental Studies, Rome; murals,
Catholic Church, Island of Kaui, Hawaii; cemetery, Manoa, Honolulu;
stage des., Juilliard Sch. Music, N.Y.; St. John's Col., Annapolis,
Md. Exhibited: Stanford Univ., 1958; SFMA, 1957, 1963; AFA
traveling exh., Smithsonian traveling exh., 1952-1954; and in Peking,
Shanghai, London, Zurich, Paris, Rome, Hong Kong, San Francisco,
Honolulu, Pasadena, Chicago; recent exhs.: Univ. Illinois, 1958,
1961, 1963, 1965; Honolulu Acad. A., 1959, 1962; WAC, 1960; Down-
town Gal., N.Y., 1960, 1962; Carnegie Inst., 1961, 1964-65; Nat.
Mus. Mod. A., Stockholm, 1963; IBM Gal., N.Y., 1965; "Pacific
Heritage," Los Angeles, San Francisco, Santa Barbara and San
Diego; CGA, 1965; "50 Artists of the 50 States of America,"
Burpee A. Gal., Rockford, Ill., 1965, and others. Contributor
"Seven Junipers of Wen Cheng-ming" (Chinese Art Soc., 1954);
"Hsueh Wu and Her Orchids" (Arts Asiatiques); Note on "T'ang
Yin" (Oriental Art, 1956). Lectures: Chinese Painting; Some Con-
temporary Elements in Chinese Pictorial Art; Some Formal De-

velopments in Chinese Painting. Positions: Instr., Chinese Painting,
Consultant in Chinese Painting, Honolulu Acad. A., Honolulu, Hawaii;
Assoc. Prof., University of Hawaii, 1963- .*

TSUCHIDANA, (HARRY) SUYEMI—Painter, Et.
616 N. Virgil Ave., Los Angeles, Cal. 90004
B. Honolulu, Hawaii, May 28, 1932. Studied: Honolulu Acad. A.; Cor-
coran Sch. A., Wash., D.C. Member: Hawaii P. & S. Lg.; Los A. AA.
Awards: John Hay Whitney F., 1959-60. Work: Phila. Free Lib.;
Honolulu Acad. A. Exhibited: CGA, 1956; Soc. Wash. A., 1956; Co-
lumbia (S.C.) Mus. A., 1959; Art in Hawaii, Honolulu, 1960, 1962,
1963, 1964; Art Assoc., Honolulu, 1961; Gima's Gal., 1963 (one-
man); N.Y. Drawing Soc., Western States Regional, 1965; Contemp.
A. Center of Hawaii, Honolulu, 1966 (one-man). Positions: Instr.,
Kaimuki Community School for Adults, Honolulu.

TSUTAKAWA, GEORGE—Sculptor, P., E.
3116 S. Irving St., Seattle, Wash. 98144
B. Seattle, Wash., Feb. 22, 1910. Studied: Univ. Washington Sch. A.,
B.A., M.F.A., and with Alexander Archipenko. Awards: Design
award, Washington Chptr. A.I.A.; prizes, Santa Barbara Mus. A.,
1959; Denver A. Mus., 1960; SFMA, 1960. Work: Paintings: SAM;
Henry Gal., Univ. Washington; sculpture: Santa Barbara Mus. A.;
Denver A. Mus. Commissions: Fountains: (1960-1968) Seattle Pub.
Library; Renton (Wash.) Center; Lloyd's Shopping Center, Portland,
Ore.; Northgate Shopping Center, Seattle; Sunken Plaza, Kansas City,
Mo.; Pacific Federal Savings & Loan Assn., Tacoma, Wash.; Civic
Mall, Fresno, Cal.; Ala Moana Center, Honolulu; Phi Mu, Univ.
Washington Campus; Hobert Research Center, Troy, Ohio; National
Cathedral, Washington, D.C.; Sch. Pub. Health, Univ. Cal. at Los
Angeles, Minor Clinic, Everett, Wash. Other works: Walnut Relief,
St. Mark's Church, Seattle; U.S. Commemorative Medal for Century
21, Seattle World's Fair; Bronze Gates, Lake City Library, Seattle.
Exhibited: SFMA, 1955, 1958, 1960; Sao Paulo Bienal, 1955; Denver
A. Mus., 1960, 1964; Santa Barbara Mus. A., 1959, 1961, 1966; Int.
A. Festival, Amerika Haus, Berlin, Germany, 1965; deYoung Mem.
Mus., 1965; SAM, annually since 1933; Portland A. Mus., 1955-1960;
Oakland Mus., 1951, 1966; Spokane A. Center, 1954-1957; Vancouver
(B.C.) A. Gal., 1960, 1964; FA Gal. of San Diego, Positions: Instr.,
Sculpture, Drawing Watercolor, Sch. A., Univ. Washington, Seattle,
1946- .

TUBIS, SEYMOUR—Painter, Gr., T., S., Des.
414 Canyon Rd., Santa Fe, N.M. 87501
B. Philadelphia, Pa., Sept. 20, 1919. Studied: Temple Univ.;
PMSch.A.; Hans Hofmann Sch. A.; Grande Chaumiere, Paris,
France; Instituto d'Arte, Florence, Italy. Member: ASL; SAGA.
Awards: SAGA, 1948; Joe and Emily Lowe award, 1950, 1953, 1955;
Newspaper Gld. of N.Y., 1933. Work: Lowe Fnd.; SAGA; MMA; ASL;
LC; Pa. State Univ.; Univ. Arizona; Univ. Calgary, Alberta, Can.;
mural, U.S. Army Signal Corps, Camp Crowder, Mo., and in private
colls. Exhibited: Northwest Pr. M., 1948, 1949, 1967; LC, 1948,
1949; Phila. Pr. Cl., 1948, 1949, 1952; Carnegie Inst., 1948; SAGA,
1948, 1951; Wichita AA, 1948; BM, 1949; PAFA, 1950; Lowe Fnd.,
1951, 1952, 1953, 1955 (last two one-man); MMA, 1953, 1955; River-
side Mus., 1956, 1958, 1960; Lincoln H.S., N.Y., 1957 (one-man);
Art:USA, 1958; N.Y. Pub. Lib., 1958; Royal Soc. P. Et., & Engrav-
ers, London, 1954; ASL, 1950; Taft Sch., Conn., 1953 (one-man);
Hofstra Col., 1953; Assoc. Gal.,Detroit, 1955; MModA, 1960, 1961;
Roosevelt Field, 1960; Carus Gal., N.Y., 1960, 1961; Gld. Creative
A., N.J., 1962 (one-man); Montclair A. Mus., 1962; N.Y. Times Gal.,
1963 (one-man); Mus. FA of New Mexico, 1964; DMFA, 1967; New
Mexico State Lib.; 10 yr. retrospective Col. of Santa Fe, 1969; New
West Gal., Albuquerque, 1969; Gal. Contemp. A., Taos, 1969 (one-
man); Mainstreams, 1968 and others. Formerly taught at ASL, N.Y.;
Great Neck (N.Y.) Bd. of Educ.; N.Y.C. Adult Educ. Program; Rock-
port, Mass. Chm., Dept. FA & Instr., Graphic A., Inst. of Am. In-
dian Arts, Santa Fe, N.M.

TUCHMAN, MAURICE—Museum Curator
Los Angeles County Museum of Art, 5905 Wilshire Blvd.
90036; h. 1922 N. Sycamore Ave., Los Angeles, Cal. 90028
B. Jacksonville, Fla., Nov. 30, 1936. Studied: Col. of the City of
New York, B.A.; Columbia Univ., M.A.; Dissertation for Ph.D. in
progress, "The Life and Work of Chaim Soutine," a monograph and
catalogue raisonne. Awards: Fulbright Scholar, 1960-61. Exhibi-
tions organized: "Van Gogh and Expressionism," 1964; "Peter
Voulkos," 1965; "New York School," 1965; R.B. Kitaj," 1965; "Da-
vid Smith," 1965; "Five Younger California Artists," 1965; "Ed-
ward Kienholz," 1966; "Irwin Price," 1966; "John Mason," 1966;
"American Sculpture of the Sixties," 1967; "Soutine," 1968. (Author
of accompanying catalogues for the preceding exhibitions). Other
publications: "Soutine," Arts Council of Great Britain, 1964; "Sou-
tine's Portraits," Art de France, 1964; "Willem de Kooning," Les
Peintres Celebres, 1964. Positions: Art Editor of Modern Art Sec-

tions: Columbia Encyclopedia, 1962-1964; Curatorial and Lecture Staff, Guggenheim Mus., summer, 1964; Senior Cur., Modern Art, Los Angeles County Museum of Art, 1964- .

TUCKER, CHARLES CLEMENT—Portrait Painter
3621 Arborway Dr., Charlotte, N.C. 28211
B. Greenville, S.C., Sept. 13, 1913. Studied: ASL, with Frank Du-Mond, George Bridgman, Ivan Olinsky. Member: NAC; ASL; Atelier Cl., N.Y.; Gld. Charlotte A.; AAPL; Hudson Valley AA; Int. Platform Assn.; FA Lg. of the Carolinas. Awards: prizes, Council Am. A. Societie, 1966; North Carolina Nat. Bank, 1958, 1959; Charlotte-Mecklenburg, Bi-Centennial "Artist of the Year." Work: Hickory Mus. A.; Winthrop Col., Rock Hill, S.C.; Crossmore Sch., Cross-more, N.C.; Dept. Labor, Raleigh; Presbyterian Synod Home, Montreat, N.C.; Comm. Room of Foreign Affairs, Nat. Capitol, Wash., D.C.; People's Nat. Bank, Rock Hill, S.C.; Bon Marche, Asheville, N.C.; Episcopal Church, Monroe, N.C.; Mint Mus.; Bry-son City (N.C.) Federal Court House; St. Vincent's Col., Latrobe, Pa.; Mars Hill (N.C.) Col.; Catawba Col., Salisbury, N.C.; Newton Federal Court House; North Carolina Nat. Bank, Charlotte. Murals, Officer's Cl., Ft. Meade, Md.; Merchants Assn., Charlotte, N.C.; U.S. Fed. Courtroom, Charlotte, N.C.; Sullivan School, Rock Hill, S.C.; High Point (N.C.) Bank; Monroe H.S., N.C.; Capitol Bldg., Columbia, S.C.; LeRoy School, Jackson, Ala.; Masonic Bldg., Rock Hill, S.C.; Radar Mem. Clinic, Washington, D.C.; Wingate (N.C.) Col. Am. Trust Co., Monroe, N.C.; Johnson Motor Lines and Thurston Motor Lines, Charlotte, N.C., and other banks, schools, hospitals and public buildings. Exhibited: In many other museums and traveling exhs. U.S. and abroad.

TUCKER, MRS. MARCIA—Associate curator
Whitney Museum, 945 Madison Ave., New York, N.Y. 10021*

TUCKER, MRS. NION—Collector
Burlingame Country Club, Hillsborough, Calif. 94010*

TUCKER, PERI (STAUB) (Mrs. Joseph A.)—Writer, Comm. A.
201 Driftwood Lane, Harbor Bluffs, Largo, Fla. 33540
B. Kashau, Austria-Hungary, July 25, 1911. Studied: Columbus Sch. A.; and with Roy E. Wilhelm, Earl C. Van Swearingen. Exhibited: Ohio WC Soc.; Canton, Ohio; Akron, Ohio; Massillon, Ohio. I., "Big Times Coloring Book"; "The Quiz Kids" and other books for child-ren. Art reviews and features, Akron Beacon Journal, 1942-51 and St. Petersburg Times, 1952-1955, art writer 1955-1966, contributor of weekly illustrated art essay, 1969- . Contributed to Craft Hori-zons, 1961. Des., color & furnishings plan for Memorial Civic Cen-ter, Clearwater, Fla., 1960. In charge, Civic Center art exhibitions, 1960- . Inaugurated annual art show for City of Clearwater spring festival, 1961; Arranged exhibition series for St. Petersburg Public Library, 1963. Exh. reviews at Akron, Cleveland, Youngstown Mus., 1942-1951; Exh. reviews and features on visiting art personalities at Clearwater, St. Petersburg, Tampa, Sarasota institutions and uni-versitites, 1955-1966.

TUDOR, TASHA—Illustrator, Port. P., W., Des., Comm. A.
P.O. Route 1, Contoocook, N.H.; h. Webster, N.H. 06473
B. Boston, Mass., Aug. 28, 1915. Studied: BMFA Sch. I., "Pumpkin Moonshine," 1938; "Alexander the Gander," 1939; Author, I., "Snow Before Christmas," 1942; "The White Goose," 1943; "Mother Goose," 1944; "Thistly B," 1949; "The Doll's Christmas," 1950; "Amanda the Bear," 1951; "Edgar Allan Crow," 1953; "A is for Annabelle," 1954, and many others. Creator of the Tasha Tudor Christmas Cards. Exhibited: Currier Gal. A., 1955. Contributor to Horn Book; Parents Magazine; Life magazine.*

TULK, ALFRED JAMES—Mural Painter, P.
210 Upper State St., North Haven, Conn. 06473
B. London, England, Oct. 3, 1899. Studied: Oberlin Col.; Yale Univ., B.F.A.; NAD; ASL; Univ. Guanajuato, Mexico, M.F.A. Member: NSMP; Arch. Lg. Awards: Medal, BAID, 1922. Work: Murals, St. Elizabeth Sch., N.Y.; Culver Military Acad., Culver, Ind.; Good Sa-maritan Hospital, Suffern, N.Y.; Salvation Army Hospital, Flushing, N.Y.; St. Ignatius Loyola, Chicago; Lutheran Church, York, Pa.; Franciscan Monastery, New Canaan, Conn.; Mutual of Omaha Bldg., Hamden, Conn.; Picuris Indian Pueblo, N.M., and many others; mo-saics, State Capitol, Harrisburg, Pa.; SS. Peter and Paul Catholic Church, Indianapolis; St. Joseph's Church, Dunkirk and Richmond Hill, N.Y.; Mary Immaculate Seminary, Northampton, Pa.; Jr. H.S., New York City; stained glass churches in Corpus Christi and Hous-ton, Tex.; Col. of West Africa, Liberia; Univ. Detroit; ports., N.Y. Pub. Lib. Exhibited: one-man: Laredo, Tex.; Stamford and New Ha-ven, Conn.; New York City; Birmingham, Ala.; Hollywood, Bradenton and Sarasota, Fla.

tum SUDEN, RICHARD—Painter, S., Gr., T.
Box 157, Accord, N.Y. 12404
B. New York, N.Y., Dec. 9, 1936. Studied: BM Sch. A.; Wagner Col.,

A.B.; Cooper Union Sch. A.; Hunter Col., N.Y., M.A.; N.Y. Univ. Awards: Art in America, 1964; Yaddo Fnd., 1964. Work: MModA; Larry Aldrich Collection. Exhibited: AIC, 1965; Tibor de Nagy Gal., N.Y.; Hull Col. of A., Great Britain, 1967; Univ. of Cal., Davis, 1968. Positions: Instr., Art History, Hunter College, N.Y.; Special assignment, Board of Education, New York City, to Staten Island Institute of Arts & Sciences.

TUNIS, EDWIN—Writer, I.
R.F.D. 1, Box 78, Reisterstown, Md. 21136
B. Cold Spring Harbor, N.Y., Dec. 8, 1897. Studied: Maryland Inst., and with C. Y. Turner, Joseph Lauber, Hugh Breckenridge. Member: Pen Cl.; Author's Gld. Awards: gold medal, Boys' Cl. of Am., 1956 (for "Wheels"); Edison Fnd. award (for "Colonial Living"), 1957. Work: murals, McCormick & Co., Balt.; Title Guarantee Co., City Hospital, both of Baltimore. Author, I., "Oars, Sails, and Steam," 1952; "Weapons," 1954; "Wheels," 1955; "Colonial Living," 1957; "Indians," 1959; "Frontier Living," 1961 (runner-up for Newbery Medal); "Colonial Craftsmen," 1965, "Shaw's Fortune," 1966.

TURNER, EVAN HOPKINS—Museum Director
Philadelphia Museum of Art, 26th & Parkway 19130; h. 200 W. Willow Grove Ave., Philadelphia, Pa. 19118
B. Orono, Me., Nov. 8, 1927. Studied: Harvard University, A.B., M.A., Ph.D. Awards: Bacon Traveling Fellowship, Harvard Univer-sity, 1952-1953. Positions: Teaching Fellow in Art History, Harvard University, 1950-1952; Lecturer on Art History, Frick Collection, New York, N.Y., 1953-1954; General Curator and Asst. Director, Wadsworth Atheneum, Hartford, Conn., 1955-1959; Director, Montreal Museum of Fine Arts, Montreal, Canada, 1959-1964; Director, Philadelphia Museum of Art, Philadelphia, Pa., 1964- .*

TURNER, GEORGE RICHARD (DICK)—Cartoonist
555 Flamevine Lane, Vero Beach, Fla. 32960; s. R.R. No. 2, Leesburg, Ind. 46538
B. Indianapolis, Ind., Aug. 11, 1909. Studied: DePauw Univ., A.B.; Chicago Acad. Member: Nat. Cartoonists Soc.; Press Cl. Exhibited: Nat. Cartoonists Soc. exhibitions. Cartoon "Carnival" feature ap-pears in some 450 papers.

TURNER, HAMLIN—Painter
193 Atlantic Ave., Marblehead, Mass. 01945
B. Boston, Mass., Nov. 6, 1914. Studied: Harvard Col. Member: Marblehead A. Gld. (Bd. Gov.). Work: General Electric Co., Mass.; Lamont Mus., Exeter, N.H.; Seaboard Life Ins. Co., Miami, Coe Chevrolet Corp., Augusta, Me.; Moses Brown Acad., R.I.; Mass. Inst. Technology; Royal Norwegian Embassy, Brazil. Exhibited: Boston A. Festival, 1953, 1954; deCordova & Dana Mus., 1954; La-mont Gal., Exeter, N.H., 1953; Brookline Pub. Lib., 1953; Long Whart Studios, Boston, 1954, 1955; Neptune Gal., Marblehead, 1955; King Hooper Gal., Marblehead, 1951-1958; Music Theatre Gal., Bev-erly, Mass., 1956-1958; Marblehead A. Gld., 1958-1965; Jordan-Marsh, Boston, 1958; Springfield Mus. A., 1960; Eastern States Exh., 1960; Beverly Farms Exh., 1962, 1963; World House Gal., 1963, 1964; Houghton Lib., Harvard Univ.; Lynn (Mass.) A. Festival, 1964; Marblehead A. Festival, 1963 (prize winner).

TURNER, JANET ELIZABETH—Painter, Gr., E., L.
Chico State College; h. 317 Ivy St., Chico, Cal. 95928
B. Kansas City, Mo., Apr. 7, 1914. Studied: Stanford Univ., B.A.; Kansas City AI; Claremont Col., M.F.A.; T. Col., Columbia Univ., Ed.D. Member: NAD; P. & S. Soc., New Jersey; Cal. WC Soc.; NAWA; Audubon A.; Los Angeles Pr.M. Soc.; Int. A. Gld.; Am. Color Pr. Soc.; SAGA; Boston Pr.M.; NAEA; AAUW; San F. Women A.; Springfield A. Lg.; CAA. Awards: Guggenheim F., 1953; prizes, Texas FA Assn., 1948-1954; Dallas Mus. FA, 1948, 1949, 1951; Southwest Pr. Exh., 1949-1951; Wichita AA, 1950, 1953; NAWA, 1950-1952, 1967; Northwest Pr.M., 1952; Fla. Southern Col., 1952; SAGA, 1952; Boston Pr.M., 1953, 1967; Texas WC Soc., 1953; Spring-field A. Lg., 1955, 1957; Tupperware F., 1956; Cal. State Fair, 1960, 1966, 1967; Audubon A., 1966; Kingsley A. Cl., 1961, and others. Work: Smith Col.; Dallas Mus. FA; Witte Mem. Mus.; Lyman Allyn Mus.; Princeton Pr. Cl.; LC; Wichita AA; Santa Barbara Col.; SFMA; SAM; New Britain Mus.; N.Y. World's Fair, 1964-65; Boston Pub. Lib.; LC; PMA; CMA; Yale Univ.; Fitchburg A. Center; BM; Biblio-theque Nationale, Paris; Victoria & Albert Mus., London. Exhibited: nationally, 1941-1961; one-man: Tokyo, Japan; Jerusalem; group exh.; London, Amsterdam, Rome, etc. Several USIA exhs. abroad. Illus., "The Yazoo," (river series). Positions: Assoc. Prof. A., Chico State College, Chico, Cal.

TURNER, JOSEPH (DR.)—Patron
1150 Park Ave., New York, N.Y. 10028
B. New York, N.Y., Feb. 6, 1892. Studied: Jefferson College, Phila-delphia, B.S., M.D. Field of Interest: Kodachrome photography (non-profit) of works of art, and donating the transparencies to museums and universities.

TURNER, ROBERT C.—Ceramic Craftsman
East Valley Road, Alfred Station, N.Y.
B. Port Washington, N.Y., July 22, 1913. Studied: Swarthmore Col., A.B.; PAFA; Alfred Univ., M.F.A. Member: York State Craftsmen, (Bd. of Trustees, 1965-1968); Am. Craftsmen's Council, (Trustee, 1957-1959); AAUP; ACLU; Am. Ceramic Soc.; Nat. Council on Educ. in the Ceramic A. (Pres., 1968-69). Awards: prizes, Wichita Mus. A., 1949, 1955; Syracuse Mus. FA, 1951, 1954; Finger Lakes Exh., 1957, 1958; silver medal, Cannes, France, 1955; Silver Medal, Int. Exh. Ceramics, Prague, 1962; Ceramic Nat. Exh., Everson Mus., Syracuse, 1966; Ceramics Art, U.S.A., prize, 1966; Craftsmen, U.S.A., award, 1966; Univ. Artists, State Univ., N.Y., prize, 1967. Work: WAC; Syracuse Mus. FA; St. Paul Gal. A.; Univ. Illinois; Utah State Univ.; Los A. County Fair Assn; State Univ. N.Y., Albany; Mus. of Contemp. Crafts, N.Y.; Johnson Coll.; Kansas City A. Inst.; Sheridan Col., Toronto. Exhibited: Los A. County Fair, 1951, 1952; Syracuse Mus. FA, 1947-1949, 1951, 1954, 1956, 1958, 1960, 1962; Wichita Mus. A., 1948, 1949, 1951; Univ. Illinois, 1952; Univ. Wisconsin, 1952; Kiln Cl., Wash., D.C., 1951, 1952; St. Paul Gal. A., 1955, 1957; Memphis Acad. FA, 1957; Utah State Univ., 1957; Scripps Col., 1951, 1957; Maryland Inst. FA, 1958; Mus. Contemporary Crafts, N.Y., 1956-1958; Brussels World's Fair, 1958; Rochester Mem. A. Gal., 1954 (one-man); Finger Lakes Exh., Rochester, 1957, 1958; Univ. Michigan, 1959; Des.-Craftsmen USA, 1960; Int. Cultural Exchange Ceramic Exh., 1960; Ostend Ceramic Int., 1959; Int. Exh., Buenos Aires, 1962. Positions: Instr., Black Mountain Col., 1949-51; Univ. Wisconsin (summer), 1957; Ceramic Specialist, U.S. Aid Program, El Salvador, 1963; Vice-Chm., Design Div., Am. Ceramic Soc., 1962, 1963. Assoc. Prof., Dept. A., State Univ. N.Y. Col. of Ceramics at Alfred Univ., Alfred, N.Y., 1958- .

TUROFF, MURIEL P. (Mrs.)—Craftsman, P., S.
517 Gerona Ave., Coral Gables, Fla. 33146
B. Odessa, Russia, Mar. 24, 1904. Studied: NAD; ASL; Am. A. Sch.; PIASch. Member: Ceramic Lg. of Miami; Arts Council, Miami; Lowe A. Gal.; Blue Dome Fellowship, (Treas. 1965- .); Assoc. Florida Sculptors; AEA; Am. Craftsmen's Council; Greater Miami A. Center; Miami Mus. Modern A.; Center for Democratic Studies. Work: Jewish Mus., N.Y.; Pageant Gal., Miami; Nat. Portrait Gal., Washington, D.C. and ceramic ports. in private colls. Exhibited: Syracuse Mus. FA, 1946; AAUW traveling exh., 1946-47; N.Y. Soc. Ceramic A., 1948-1955; N.Y. Soc. Craftsmen, 1948-1955; Cooper Union, 1956; AFA traveling exh., 1961. Jewish Mus., N.Y., 1957, 1958, 1961; Blue Dome Fellowship, 1965, 1968, 1969; Bacardi Bldg., Miami, 1965; AEA, 1968; Burdine's, Miami, 1968. Author, I., "How to Make Pottery and Other Ceramic Ware," 1949. Positions: Instr., Henry Hudson Day Camp, 1943; Riverdale Neighborhood House, 1942-45; Kingsbridge Veteran's Hospital, 1944-45; Instr., Basic Design, Westchester County Center, White Plains, N.Y., 1958-61; Pres., N.Y. Soc. Craftsmen, 1956-57; Fnd. Memb., Artist-Craftsmen of New York; Chm. of Patrons and Awards, Miami Nat. Ceramic Exh., 1965.

TUTTLE, RICHARD—Painter
c/o Betty Parsons Gallery, 24 W. 57th St., New York, N.Y. 10019*

TWARDOWICZ, STANLEY—Painter, T.
48 Ocean Ave., Northport, L.I., N.Y. 11768
B. Detroit, Mich., July 8, 1917. Studied: Summer Sch. Painting, Saugatuck, Mich.; Skowhegan Sch. Painting & Sculpture, Maine. Awards: Guggenheim F., 1956-57. Work: Milwaukee AI; Los A. Mus. A.; Columbus Gal. FA; Ball State T. Col., Muncie, Ind.; MModA; Newark Mus. A.; Heckscher Mus., Huntington, N.Y.; N.Y. Univ. Coll. Exhibited: WMAA, 1954-1956, 1958, 1964; Guggenheim Mus., 1954; AIC, 1954, 1957, 1961; Carnegie Inst, 1955; Rome-N.Y. A. Fnd., Rome, Italy, 1958; Sao Paulo, Brazil, 1960; Columbus Gal. FA, 1960; Iowa State Univ., 1960; Am. Acad. A. & Lets., 1960; Univ. Nebraska, 1960; "Art in Embassies" (sponsored by MModA), London, Warsaw, 1962-65; one-man: Contemporary A. Gal., N.Y., 1949, 1951, 1953, 1956; Peridot Gal., N.Y., 1958, 1959, 1960, 1961, 1963-1965, 1967, 1968; Dwan Gal., Los A., 1960, 1961. Positions: Instr.,A , Ohio State Univ., Columbus, Ohio, 1946-51; Instr., Hofstra University, L.I., N.Y., at present.

TWIGGS, RUSSELL GOULD—Painter, Ser.
424 South Aiken Ave., Pittsburgh, Pa. 15206
B. Sandusky, Ohio, Apr. 29, 1898. Studied: Carnegie Inst. Awards: prizes, Assoc. A. Pittsburgh, 1942, 1947, 1949, 1953, 1957, 1958, 1959, 1961-1966; Heinz Comp., Pittsburgh, 1955; CM, 1955; Pittsburgh Playhouse, 1955; Nat. Ser. Soc., 1951; Rector, Pa., 1960. Work: MIT; AAUW; Univ. Wisconsin; Carnegie Inst.; Pa. State Coll.; Rochester Mem. A. Gal.; Wadsworth Atheneum; WMAA; Tennessee Wesleyan Co.; Childe Hassam Fund, 1959; N.Y. Univ. Coll.; Allegheny Col.; BM; Alcoa Coll. Exhibited: Carnegie Inst., 1942-1945, 1958, 1961, 1962-1964; PAFA, 1946-1948, 1950; AIC, 1937, 1946,

1947, 1957; Assoc. A. Pittsburgh, annually; Abstract Group, annually; A. & Crafts Center, Pittsburgh, annually; Butler Inst. Am. A., 1953-1955; Colorado Springs FA Center, 1954; Nat. Ser. Soc., 1950-1952; CGA, 1957; Minneapolis Inst. A., 1950; LC, 1952; BM, 1952, 1957; Univ. W. Va., 1952; CM, 1955; MModA, 1956; Univ. Utah, 1957; Am. Acad. A. & Lets., 1958; AFA traveling exh., 1957; Pittsburgh Plan for Art, 1966; Carnegie Int. 1955, 1958, 1961, 1963, 1966; one-man: Pittsburgh Playhouse, 1950; Grand Central Moderns, N.Y., 1955, 1957, 1958, 1960; Allegheny Col., 1957; Schermerhorn Gal., Beloit, Wis., 1959; Pittsburgh Plan for Art, 1962; Univ. Pittsburgh, 1964-65; Carnegie Inst., 1963; retrospective exh., Westmoreland County Mus. A., Greensburg, Pa. 1964.

TWITTY, JAMES—Painter, T.
1600 S. Joyce St., Arlington, Va., 22202
B. Mt. Vernon, N.Y., Apr. 13, 1916. Studied: ASL; Univ. Miami. Awards: prizes, All. A. Am.; Univ. Miami; Soc. Wash. A.; Norton Gal. A., Palm Beach. Work: CGA; Columbia (S.C.) Mus. A.; Lowe Gal. A.; Court of General Sessions, Wash., D.C.; Newsweek Magazine; Federal Deposit Ins. Corp.; Int. Monetary Fund; High Mus. A., Atlanta; Oklahoma A. Center; Lehigh Univ.; Norfolk Mus. A. & Sciences; City of Bethlehem, Pa.; Art in Embassies program; Chesapeake Bay Bridge Authority; Manufacturers Hanover Bank, N.Y.; The White House, Wash., D.C., and others. Exhibited: CGA, 1965, 1966; NAD, 1964; Audubon A., 1962; All. A. Am., 1961-1963; Butler Inst. Am. A., 1963; George Washington Univ., 1967, 1969; Grosvenor Gal., London, 1968; Lehigh Univ., 1967; Edinburgh, Scotland, Festival, 1968; one-man: Janet Nessler Gal., N.Y., 1962; Bader Gal., Wash., D.C., 1963, 1965, 1968; Queens Square Gal., Leeds, England, 1968; Dallas, Tex., 1969; Seligmann Gal., N.Y., 1964, 1969. Positions: Instr., Painting, Corcoran School of Art, Washington, D.C.

TWOMBLY, CY—Painter
Leo Castelli Inc., 4 E. 77th St., New York, N.Y. 10021*

TWORKOV, JACK—Painter, T.
161 W. 22nd St., New York, N.Y. 10011
B. Biala, Poland, Aug. 15, 1900. Studied: Columbia Univ.; NAD; ASL. Awards: Recipient of first William A. Clark Prize, accompanied by the Corcoran Gold Medal, 28th Biennial Exh. of American Painting, 1963. Work: Marine Hospital, Carville, La.; Albright A. Gal.; MMod A; MMA; Santa Barbara Mus. A., Wadsworth Atheneum; Watkins Gal., American Univ.; BMA; New Paltz State T. Col.; WAC; WMAA; Newark Mus. A.; James Michener Fnd.; Washington (D.C.) Gal. Mod. A.; S.J. Johnson & Sons; Union Carbide; Yale Univ. Gal. FA. Exhibited: nationally; Vanguard American Art for Paris, Sidney Janis Gal., N.Y. & Galerie de France, 1952; European Traveling exh., sponsored by Foreign Council of Museums of Modern Art, 1958; Documenta II, Kassel, Germany, 1959; USIA Yugoslavia Exh., 1961; one-man: Egan Gal., 1947, 1949, 1952, 1954; BMA, 1948; Stable Gal., 1957, 1958, 1959; WAC, 1957; Holland-Goldowsky Gal., Chicago, 1960; Univ. Mississippi, 1954; Castelli Gal., N.Y., 1961, 1963; Newcomb Col., 1961; Yale Univ. Gal. FA, 1963; WMAA, 1964 and traveling for a year to 5 museums; Kasle Gal., Detroit, 1969. Positions: Leffingwell Prof. of Painting (Emeritus) & Chm. A. Dept. of the School of Art and Architecture, Yale University, New Haven, Conn., 1963-1969.

TYSON, MRS. CHARLES R. —Collector
6910 Wissahickon Ave., Philadelphia, Pa. 19119*

TYSON, MARY (Mrs. Mary Thompson)—Painter
20 W. 11th St., New York, N.Y. 10011
B. Sewanee, Tenn., Nov. 2, 1909. Studied: Grand Central Sch. A.; and with George Pearse Ennis, Howard Hildebrandt, Wayman Adams and others. Member: AWCS; Pen & Brush Cl.; East Hampton Guild Hall; Nantucket AA. Work: Nantucket AA; Nantucket Fnd.; Amherst Col., and in private colls. Exhibited: Baltimore WC Cl.; AGAA; BM; Phila. WC Cl.; AWCS; Montross Gal.; Morton Gal.; Harlow Gal.; Nantucket AA, 1952-1961; Pen & Brush Cl., 1961, one-man 1968, 1969; NAC; Lobster Pot and Gallery 5, Nantucket. Awards: Pen & Brush Cl., 1961-1963, 1966.

TYTELL, LOUIS—Painter, Gr.
50 1/2 Barrow St., New York, N.Y. 10014
Studied: Col. of City N.Y., B.S.S.; T. Col., Columbia Univ., M.A.; NAD; Skowhegan Sch. Painting & Sculpture. Awards: prize, Gr. Des., 1951; New Sch., 1954; N.Y. City Center, 1954; Brooklyn Soc. A., 1954, 1962; Tiffany Fnd. Fellowship, 1962; prize, Am. Soc. Contemp. A., 1966; Nat. Inst. A. & Lets., Grant, painting, 1967. Work: LC. Exhibited: NGA; Detroit Inst. A.; WMAA; Carnegie Inst.; MModA, 1943; Walker A. Center, 1944; Pepsi-Cola, 1945; PAFA, 1949, 1966; Bradley Univ., 1951, 1952; SAGA, 1951, 1952, 1953, 1954; BM, 1951, 1952, 1954; LC, 1952, 1954; AFA traveling exh., 1952; NAD, 1956, 1962, 1966, 1968; Silvermine Gld A., 1962; N.Y. World's Fair, 1964; Int. Drawing Comp., Potsdam, N.Y., 1960; RoKo Gal.,

N.Y., 1961, one-man, 1962, 1965, 1968; Nat. Inst. A. & Lets., 1967; Skowhegan Sch. Painting & Sculpture, 1966, 1967, 1968; New Sch., N.Y., 1968; Smithsonian Inst., traveling exh., 1968-1969. Positions: Chm. A. Dept., High School of Music & Art, New York, N.Y.; Assoc. Prof. A., City Col. of New York, 1967, 1968.

UCHIMA, ANSEI—Graphic-Printmaker
 664 W. 163rd St., New York, N.Y. 10032
B. Stockton, Cal., May 1, 1921. Member: SAGA; Am. Color Print Soc.; Japan Print Assn. Awards: prizes, Silvermine Gld. A., 1964; SAGA, 1965; Guggenheim Fellowship, 1962-1963. Work: AIC; Rijksmuseum, Amsterdam, Holland; Honolulu Acad. A.; N.Y. Public Lib.; LC; PMA; NGA; Arts Council of Great Britain; MMA; BM; Print Editions: Intl. Graphic Arts Soc., 1957, 1960, 1961, 1964, 1965; N.Y. Hilton Hotel 1961. Exhibited: BM Natl. Print Exh., 1960, 1962, 1964; PAFA, 1963, 1965; Sao Paulo Intl. Biennale, 1955; Tokyo Intl., 1957, 1960; Grenchen Intl. Print Triennial, 1958, 1961. Positions: Instr., Printmaking, Beloit College, Wisconsin; Pratt Graphic A. Center, N.Y.; Sarah Lawrence College; Bronxville, N.Y.; Columbia Univ., N.Y.

UDEL, MRS. JOAN ERBE. See Erbe, Joan

ULIN, DENE (MRS.)—Fine Arts Consultant, Collector
 27 E. 65th St., New York, N.Y. 10021
B. Detroit, Mich., Sept. 6, 1930. Studied: Connecticut College for Women; Chicago Art Institute. Author: Occasional articles for magazines. Collection: Contemporary art. Personal Collection and representative artists shown: J. Walter Thompson Company, New York City; Neiman-Marcus, Dallas; Salcowitz, Houston; Hall's Kansas City; Cooper Union Museum, New York City; Tiffany's windows, New York City; Joan Rivers Show, NBC-TV, 1969. Positions: Adviser to purchasers of the fine arts, in relationship with 40 N.Y.C. galleries and dealers, for paintings, sculpture, drawings; Exclusive agent in the U.S. for William Accorsi (toy sculpture) and Luba Krejci (lace constructions).

ULLMAN, GEORGE W.—Collector, Patron, W.
 4642 N. 56th St., Phoenix, Ariz. 85018
B. New York, N.Y., Feb. 2, 1880. Studied: in France. Author: "Captive Balloons." Collection: French furniture and paintings, Louis XV and Louis XVI periods.*

ULLMAN, HAROLD P.—Collector
 12001 San Vicente Blvd., Los Angeles, Cal 90049; h. 800 Woodacres Rd., Santa Monica, Cal. 90402
B. Chicago, Ill., Jan. 30, 1899. Studied: University of Michigan, School of Engineering. Collection: Rouault Graphics. Positions: Board Member, Los Angeles County Museum, 1959-1964; Board Member, Pasadena Art Institute Art Acquisitions, 1965- .*

ULLRICH, B. (Mrs. Murray G. Zuckerman)—Painter, Lith., Photog.
 2206 44th Ave., San Francisco, Cal. 94116
B. Evanston, Ill. Studied: Northwestern Univ., B.A.; AIC, B.F.A.; Univ. Chicago, M.A. Member: AEA; San Francisco Women A.; Bay Area Photographers; Friends of Photography. Work: Univ. Arizona; Chicago, Pub. Lib.; AEA Midwest Color Slide Coll.; Color reproduction of painting "Mardi Gras" in American Heritage (frontispiece), Feb. 1965. Exhibited: MMA, 1943; Carnegie Inst., 1941, 1943, 1944; WFNY, 1939; AIC, 1937, 1950; SFMA, 1939-1941; SAM, 1940; Denver A. Mus., 1940; Central America traveling exh., 1941; U.S. Govt. traveling exh., 1940-1941; Riverside Mus., 1940; San Diego FA Soc., 1940; Cal. WC Soc., 1938-1940; AEA, 1953-1969; Renaissance Soc., 1953-1964; Chicago Artists, 1958; Detroit Inst. A., 1940, 1944; George Eastman House, Rochester, N.Y. (photog.), 1960; McCormick Place, Chicago, 1962-63; Monroe Gal., 1964; San Joaquin Mus., Stockton, Gal., 1966; Western Assn. of A. Mus. Traveling Exh., 1966-1969; San Francisco Art & Library Comm. Traveling Exh., 1967-1969; Bay Area Photographers Exhibitions in: San Francisco A. Festivals, 1967-1968; K.N.E.W. Gal., Oakland, 1967; Cellini Gal., San Francisco, 1967; Crown Zellerbach Gal., San Francisco, 1967, 1968; "Preview '68" traveling exh., California, 1968; one-man: SFMA, 1940; G Place Gal., Wash., D.C., 1944.

UMLAUF, CHARLES—Sculptor
 Department of Art, University of Texas; h. 506 Barton Blvd., Austin, Tex. 78704
B. South Haven, Mich., July 17, 1911. Studied: AIC; Chicago Sch. Sculpture. Member: Texas Assn. Col. T.; Texas FA Assn.; Texas WC Soc. Awards: Scholarship, AIC; Guggenheim F., 1949; Ford Fnd. purchase, 1960; prizes, AIC, 1937, 1938, 1943; Oakland A. Mus., 1941; Texas Annual, 1942-1944, 1946-1949, 1951-1953, 1959, 1963; Texas FA Assn., 1948-1950, 1952, 1954, 1957, 1959, 1963, 1964; Okla. A. Center, 1963; The Mrs. Lyndon Johnson award for bronze "Madonna and Child," Tex. FA Assn., 1964; Syracuse Mus. FA, 1948; Univ. Illinois, 1957; Lubbock, Tex., 1957; City of Dallas Love

Field monument, 1959; Witte Mem. Mus., 1960. Work: Witte Mem. Mus.; McNay Mus. A.; DMFA; Mus. FA of Houston; Ft. Worth A. Center; MMA; Santa Barbara Mus. A.; Wichita Mus. A.; Love Field entrance, Dallas; Ft. Worth Children's Mus.; IBM; Liturgical A. Soc.; Univ. Illinois; Des Moines A. Center; El Paso Mus. A.; Okla. A Center; Louisiana State Univ.; Texas FA Assn., Southwest Life Ins. Co., Dallas; Southwestern Savings Assn., Houston; and in private colls. Bas-reliefs: USPO, Morton, Ill.; Paulding, Ohio; Baptist Student Center, Univ. Tex.; Christian Church, Austin; fountain groups: Cook County Hospital, Lane Tech. H.S., both Chicago; Love Field, Dallas; entrance, Witte Mem. Mus., San Antonio; crucifix, Shrine of St. Anthony, San Antonio; St. Mark's Church, Burlington, Vt.; Susan B. Allen Mem. Hospital, Eldorado, Kans.; Stonebridge Priory, Lake Bluff, Ill.; churches in Sioux Falls, S.D., Austin, Tex., San Antonio, Tex., Dallas, Tex., and others. Liturgical A. Soc.; merchandise Mart, Chicago. Other recent work at Faculty Chapel, St. Mary's Univ., San Antonio, 1962; Our Lady of the Lake Convent, San Antonio, 1961, 1962; Bus. Admin. Bldg., Univ. Texas, 1962; Academic Center, Univ. Tex., 1963; lobby, Phillips Petroleum Bldg., Bartlesville, Okla., 1964; St. Luke's Methodist Church, Houston, 1966; Pioneer Gas Co. & First Nat. Bank, Lubbock, Tex., 1968; First Federal Savings & Loan Assn., Austin, 1968. Exhibited: AIC, 1936-1941, 1943, 1955; Oakland A. Mus., 1941, 1946, 1949; SFMA, 1941, 1946, 1957; PAFA, 1946-1948, 1950, 1951, 1954, 1962, 1966. WMAA, 1946-1948, 1950, 1951, 1953, 1956; Denver A. Mus., 1948-1950, 1952, 1955, 1956; Syracuse Mus. FA, 1948-1950, 1958; Kansas State Col., 1958; Univ. Illinois, 1953, 1957; Int. Religious Biennale, Salzburg, 1958 and touring 1958-59; Columbus Gal. FA, 1949; Dayton AI, 1950; Munson-Williams-Proctor Inst., 1951; Nat. Soc. A. & Lets., 1950, 1954, 1955; Newark Mus., 1956; AFA traveling exhs., 1957, 1958; Ft. Worth A. Center, 1957, 1958, 1959; DMFA, 1958, 1959, 1960; 28 one-man exhs. 3-man, Firestone Lib., Princeton Univ., 1960; Oklahoma A. Center, 1960; Nat. Gal., Adelaide, So. Australia, 1962; Krannert Mus., Univ. Illinois, 1959, 1963; Mulvane A. Mus., 1964; Louisiana State Univ., 1964; Newman Fnd., Univ. Illinois, 1964. J. B. Speed Mus., 1965; Washington, D.C., 1968; San Antonio, 1968. Positions: Prof. A., Univ. Texas, Austin, Tex.

UNDERWOOD, PAUL A.—Scholar
 Dumbarton Oaks Research Library, 1703 32nd St., N.W., Washington, D.C. 20007*

UNTERMAN, RUTH—Painter, Gal. Dir., T.
 Ontario East Gallery, 235 E. Ontario St., Chicago, Ill. 60611; h. 1235 Ridge Ave., Evanston, Ill. 60202
B. Oak Park, Ill., May 23, 1920. Studied: Univ. Illinois, B.S.; Ill. Inst. Tech., Inst. of Design, M.S. in A. Edu. Member: AEA, Chicago Chpter. (Bd. Dirs.); Chicago Soc. A. Awards: prizes, New Horizons, 1960; Evanston A. Center, 1960; Art Directions, New York City, 1961 (purchase); North Shore A. Lg., 1962. Exhibited: "5 Chicago Artists," Assoc. A. Gal., Wash., D.C., 1962; Art Directions, N.Y., 1961 (2-man); Ill. Inst. Tech, 1960; Deerfield H.S., 1962; Hillel Fnd., Northwestern Univ., 1962, 1964. Positions: Adv. Com., Bernard Horwich Jewish Community Center, Chicago, 1963-65; Dir., Co-Owner, Ontario East Gallery, Chicago, Ill.*

UNTERMYER, JUDGE and MRS. IRVING—Collectors
 960 Fifth Ave., New York, N.Y. 10021*

UNWIN, NORA SPICER—Printmaker, I., W.
 Pine-Apple Cottage, Old Street Rd., Peterborough, N.H. 03458
B. Surbiton, Surrey, England, Feb. 22, 1907. Studied: Royal Col. A., Kingston Sch. A., London. Member: ANA; Royal Soc. P., Et. & Engravers, London; SAGA; Boston WC Soc.; Cambridge AA; New Hampshire AA; Boston Pr.M.; Albany Pr. Cl.; Awards: SAGA, 1951; Boston Soc. Indp. A., 1952; NAWA, 1953; New Hampshire AA, 1952; NAD, 1958; Fitchburg A. Mus., 1965; Boston Soc. WC Painters, 1965; CAA, 1967; Albany Pr. Cl., 1967. Work: British Mus.; Victoria & Albert Mus., London; LC; Boston Pub. Lib.; N.Y. Pub. Lib.; Ft. Worth A. Mus.; Cal. State Lib.; MMA; Fitchburg A. Mus.; Lawrence Mus., Williams Col. Exhibited: Royal Acad., Royal Soc. P., Et. & Engravers, London, 1931-1969; Bibliotheque Nationale, Paris, 1951; Salon de Mai, Paris, 1952; LC, 1950-1952; Phila. Pr. Cl., 1950, 1951; MMA; NAD; WMA; SAGA, 1950-1969; Currier Gal. A.; Springfield Mus. FA; Univ. New Hampshire A. Center; NAWA, 1952; Boston Pr.M.; Boston Soc. Indp. A.; one-man: Currier Gal. A.; Boston Pr.M., 1954; Fitchburg A. Mus., 1955, 1966; Albany Pr. Cl., 1955; Boston Atheneum; Univ. New Hampshire; Holman's Print Shop, Boston; Grafton, Vt., 1960, 1969; Sharon A. Centre, N.H., 1960, 1965; Thorne A. Gal., Keene, N.H., 1966; Weeden Gal., Boston, 1964, and in other cities, 1967-1969. Author, I., "Round the Year"; "Lucy and the Little Red House"; "Doughnuts for Lin"; "Proud Pumpkin"; "Poquito," 1959; "Two Too Many," 1962; "The Way of the Shepherd," 1963; "Joyful the Morning," 1963; "The Midsummer Witch," 1966. Numerous children's books illus. for American and English publishers.

UPJOHN, EVERARD MILLER —Educator, W., L.
Columbia University, West 116th St.; h. 29 Claremont Ave., New York, N.Y. 10027
B. Scranton, Pa., Nov. 6, 1903. Studied: Harvard Univ., B.A., M.Arch. Member: Athenaeum, N.Y.; CAA; Soc. Arch. Historians. Author: "Richard Upjohn, Architect and Churchman," 1939; "History of World Art," rev. ed. (with Paul S. Wingert & J. G. Mahler), 1958; "Highlights, An Illustrated History of Art," (with John P. Sedgwick). Contributor to Art Bulletin, Encyclopaedia Americana, Encyclopaedia Britannica. Advisor on Art & Architecture, Grolier Encyclopedia. Lectures: The Gothic Revival. Positions: Asst. Prof. FA, Univ. Minnesota, 1929-35; Prof. FA, Columbia Univ., New York, N.Y., at present. Matthews Lecturer, MMA, 1941-42, 1960.*

URBAN, REVA —Painter, S., Lith.
845 8th Ave., New York, N.Y. 10019
B. Coney Island, N.Y., Oct. 15, 1925. Studied: ASL. Awards: Carnegie Scholarship, ASL.; Yaddo Fnd. Fellowship, 1960; Tamarind Lithography Workshop Ford Fnd. Grant, 1963. Work: Univ. Mus., Univ. California, Berkeley; Finch Col. Mus., N.Y.; Univ. Southern Illinois; AIC; MModA; Fine Arts Gal., San Diego; Alverthorpe Gal., Jenkintown, Pa.; Benjamin and Dorothy Smith Fnd., California; Grunwald Graphic Arts Fnd., Univ. California at Los Angeles. Exhibited: Carnegie Int. Exh., 1958; Inst. Contemp. A., Boston, 1958, 1959; USIA traveling exh. to Europe, 1958-1959; Salzburg, Austria, 1959; Columbus (Ohio) Gal. FA, 1959; CGA, 1959; Univ. Colorado, Boulder, 1958, 1950; Univ. Southern Illinois, 1960; BMFA Sch., 1962; Duke Univ., 1962; Documenta III, Kassel, Germany, 1964; "Seven Decades- 1895-1965" Crosscurrents in Modern Art, 1966; one-man: Peridot Gal., N.Y., 1958, 1960; Gres Gal., Washington, D.C., 1961 and Chicago, 1962; Grippi & Waddell Gal., N.Y., 1965; Jason Gal., N.Y., 1965.

USUI, MRS. BUMPEL. See Pratt, Frances

UZIELLI, GIORGIO—Collector
120 Broadway 10005; h. 1107 Fifth Ave., New York, N.Y. 10028
B. Florence, Italy, June 5, 1903. Studied: University of Florence, Doctor of Law. Collection: Aldine Editions; First Editions of Dante; Paintings and Bronzes.

VACCARO, NICK DANTE—Painter, E., Gr.
Visual Arts Dept., University of Kansas; h. 535 Kansas St., Lawrence, Kans. 66044
B. Youngstown, Ohio, Apr. 9, 1931. Studied: Univ. Washington, B.A.; Univ. California, Berkeley, M.A. Member: Kansas State Fed. A. Awards: prizes, SFMA, purchase, 1958; Mus. FA of Houston, 1961; DMFA, purchase, 1962; Montgomery Mus. FA. Work: San F. AA; DMFA; Montgomery Mus. FA; Univ. California, Berkeley; Fairway Motor Hotel, McAllen, Tex.; Youngstown Univ. Exhibited: Butler Inst. Am. A., 1956, 1959, 1966; Oakland Bay Printmakers, 1958; SFMA, 1958; Honolulu Acad. A., 1959; LC, 1960; San F. Annual, 1960; CAL.PLH, 1961; SAM, 1957, 1958; DMFA, 1961-1963; Ringling Mus. A., Sarasota, 1961; Oklahoma A. Center, 1961, 1966; Delgado Mus. A., New Orleans, 1961, 1963; Denver A. Mus., 1962; Mulvane A. Center, 1964; Springfield A. Mus., Mo., 1966-1968; Wichita A. Mus., 1966-1968; Univ. of Kansas, Lawrence, 1966-1969; El Paso Mus. of Al, 1966-1967; Nelson Gal., Atkins Mus., Kansas City, Mo., 1964-1966; Purdue Univ., 1966; Canton A. Inst., Ohio, 1966. One-man: Wichita Univ., 1966; Jewish Comm. Center, Kansas City, Mo., 1968. Positions: Instr., Dept. Art, University of Texas, Austin, 1960-61; Asst. Prof., Sch. of Architecture, Univ. Texas, 1961-63; Prof., Chm., Dept. of Drawing and Painting, University of Kansas, Lawrence, Kans., 1963-1967.

VACCARO, PAT(RICK) (FRANK)—Serigrapher, T.
3 Oak Dr., Poland, Ohio 44514
B. New Rochelle, N.Y., Jan. 15, 1920. Studied: Ohio State Univ.; Youngstown Univ., B.S. in A. Edu. Member: Boston Pr. M.; Am. Color Pr. Soc.; Hunterdon County A. Center, Clinton, N.J.; P. & S. Soc. of N.J.; Christian A. Gld., Chicago. Awards: prizes, Butler Inst. Am. A., 1954, 1955, 1967, 1968; BMFA, 1954; Canton AI, 1957; purchase awards: USIS (3); Peoria A. Center, 1961; Jersey City Mus.; Lawton, Okla.; Anniston, Ala.; Colby, Kansas, 1967; U.S. FA Registry, Nat. Des. Center, N.Y., 1968; Am. Color Pr. Soc., 1969; Symbol A. Gal., 1968. Work: Butler Inst. Am. A.; Farnsworth Mus. A.; Wellesley Col.; USIS, for embassies abroad; Canton AI; and in private colls. Exhibited: Int. Ser. Soc., 1954, 1955; Northwest Pr. M., 1954; Wash. WC Cl., 1954-1956; Soc. Indp. A., Boston, 1953, 1954, 1956-1958; MModA, 1954; Exchange Exh., Italy, 1954-1957; Butler Inst. Am. A., 1947, 1956-1960, 1966-1968; Smithsonian Inst.; Am. Color Pr. Soc., 1957, 1958, 1961, 1966-1969; Wash. Pr. M., 1956-1958; Boston Pr. M., 1959, 1960, 1966-1969; Audubon A., 1960, 1968; Hunterdon County A. Center, 1959, 1966-1969; Honolulu Pr. Exh., 1959; P. & S. of New Jersey, 1959, 1966, 1967; Oklahoma Pr. M., 1958; Butler Inst. Am. A., 1959 (5-man); Oakland A. Center,

1966-1969; Color Graphics, Grenchen, Switzerland, 1966, 1967; Old Bergen Gld., N.J., traveling exh., 1966, 1967; Springfield A. Lg., 1968; The Gallery, Barnegat Light, N.J., 1968; Union Carbide Gal., N.Y., 1968; one-man: Canton AI, 1959; Butler Inst. Am. A., 1958; Aalst, Belgium, 1967; Nat. Des. Center, N.Y., 1968; Christian A. Gld., Chicago, 1968; Albuquerque, N.M., 1968; Union City, N.J., 1968; Westfield, N.J., 1968; Stone-Brandel Gal., Chicago, 1968; Cuyahoga Falls, Ohio, 1969; one-man exhs. in Pennsylvania, Colorado and New York. Positions: Faculty of Youngstown State Univ. and Youngstown Public Schools.

VAIL, ROBERT WILLIAM GLENROIE—
Former Museum Director, E., Cr., W., L.
2505 Wisconsin St., Northeast, Albuquerque, N.M. 87110
B. Victor, N.Y., Mar. 26, 1890. Studied: Cornell Univ., B.A.; Lib. Sch., N.Y. Pub. Lib.; Columbia Univ; Univ. Minnesota. Award: Hon. degree, Litt. D., Dickinson Col.,1951; L.H.D., Clark Univ., 1953; N.Y. Hist. Soc. Gold Medal for Achievement in History, 1960. Author: "The Voice of the Old Frontier"; "Knickerbocker Birthday: A Sesquicentennial History of the New York Historical Society," 1954; "The Case of the Stuyvesant Portraits," 1958; many monographs. Ed., Sabin's Dictionary of Books on America. Position: Librarian, N.Y. State Lib., 1940-44; Dir., N.Y. Hist. Soc., 1944-1960; Assoc. in Hist., Columbia Univ., New York, N.Y.; Rosenbach lectures in Bibliography, Univ. Pennsylvania.*

VALIER, BIRON—Painter, Pr.M.
P.O. Box 9012 John F. Kennedy Sta., Boston, Mass. 02114
B. West Palm Beach, Fla., Mar. 13, 1943. Studied: Yale Univ., M.F.A.; Cranbrook Acad. A., B.F.A.; Univ. Arkansas; summers and part-time: ASL; Norton Gal. & Sch. A.; Florida State Univ.; Mexico City Col. Awards: Butler Inst. Am. A. (purchase), 1966; prizes, Florida State Fair FA Exh., 1966, 1968; Palm Beach A. Gld., 1965; Palm Beach A. Inst., 1965, 1967. Exhibited: NAD; SAGA; Woodstock AA, N.Y.; Butler Inst. Am. A.; Denver A. Mus.; Jacksonville Mus. A.; Ringling Mus. A.; Lowe A. Gal., Univ. Miami; Montgomery Mus. FA; Louisiana State A. Comm.; Telfair Acad. A. & Sciences; Dulin A. Gal.; High Mus. A.; Kalamazoo Inst. A.; Detroit Inst. A.; Cranbrook Acad. A. Mus.; Young Printmakers, 1967, and others. Three-man: Norton Gal. & Sch. A., West Palm Beach, 1969.

VALLEE, JACK (LAND)—Painter
1216 Northeast 50th St., Oklahoma City, Okla. 73111; also Monhegan Island, Me. 04852
B. Wichita Falls, Tex., Aug. 23, 1921. Studied: Midwestern Univ.; ASL, with Reginald Marsh, Howard Trafton, Frank DuMond. Member: All. A. Am.; Wash. WC Cl.; Kennebec (Me.) AA; AWS; NAC; Assn. Oklahoma A. Awards: prizes, Emily Lowe award, 1958; Southwest Am. Exh., purchase, 1959; Silvermine Gld. A., 1960; Eastern States Exh., Springfield, Mass., 1960; Oklahoma Nat. Print & Watercolor Exh., Oklahoma City, 1960; Oklahoma A., 1961; Texas watercolor annual, San Antonio, 1961; Conn. Acad. FA, 1964; Philbrook A. Center, 1963; Berkshire AA, 1961 (purchase); Ogunquit A. Center, 1962; McDowell Colony Fellowship, 1963; Okla. A. Festival, 1962-1964; Watercolor: USA, 1964. Work: Springfield Mus. A.; Univ. Oklahoma; Oklahoma A. Center; Berkshire Mus., Pittsfield, Mass.; Holyoke Mus. A.; Lehigh Univ.; Liberty Nat. Bank & Trust, Okla. City. Exhibited: All. A. Am., 1959-1964; AAPL, 1959-1963; AWS, 1958, 1960, 1961, 1964, 1965; Audubon A., 1959; PAFA, 1960; Peoria A. Center, 1961; Butler Inst. Am. A., 1961, 1962; Oklahoma Pr.M., 1956-1965; S.W. American Exh., 1959-1961; Springfield Mus. A., 1959-1964; Silvermine Gld. A., 1959-1963; Texas WC annual, 1961; Wash. WC Cl., 1960, 1961, 1959-1964; Oklahoma A., 1957-1961; P. & S. of New Jersey, 1960, 1961; N.Y. City Center, 1964; Conn. Acad. FA, 1959-1965; DMFA, 1963, 1964; De Cordova & Dana Mus., 1963; Holyoke Mus. A., 1964; Knickerbocker A., 1959-1965; Maine State A. Festival, 1961, 1962; Mississippi AA, 1963, traveling, 1963-64; N.Y. State Expo., 1964; N.Y. World's Fair, Okla. Exh., 1964; PAFA, 1961; Philbrook A. Center, 1956-1965; Staten Island Mus., 1963; Watercolor:USA, 1962-1964; and many others nationally. One-man: Bodley Gal., N.Y., 1959; Cox Gal., Boston, 1959; Highgate Gal., N.Y., 1962; Banfer Gal., N.Y., 1963; Little Gal., Detroit, 1964; Fisher Gal., Wash., D.C., 1965, 1968; Lehigh Univ., 1965; Okla. A. Center, 1951, 1962; Univ. Okla. A. Gal., 1967; Sartor Gal., Dallas, 1954; Phila. A. All., 1964; Holyoke Mus., 1964, 1968; and others.

VALLEE, WILLIAM—Painter, I., Comm. A., Des., Gr.
P.O. Box 4-502, Anchorage, Alaska 99501
B. South Paris, Me., June 18, 1934. Studied: Univ. of Alaska. Member: Alaska A. Gld.; Alaska WC Soc.; Am. Soc. of Photogrammetry; F., AAPL. Awards: prizes, Anchorage Fur Rendezvous, 1963; Easter A. Festival, Palmer, Alaska, 1963; Alaska A. Gld.-Artist of the Month, 1963 (one-man exh. during the month). Work: in private collections. Exhibited: Anchorage Fur Rendezvous, 1963; Easter A. Festival, 1963; Alaska Festival of Music & Art, 1963, 1964; one-man: Anchorage Petroleum Club, 1963; Anchor Galleries, 1963 (Art-

ist of the Month). Positions: Treas., Soc. of Alaskan A., 1963; Pres., Chm., Alaska A. Gld,, 1964; Sec., Alaska International Cultural A. Center, 1964- ; Pres., Alaska WC Soc., 1963- . Contributions to the Fine Arts in Alaska: Instituted, in cooperation with AAPL, New York, the first American Art Week, 1963; Co-Founder, Alaska-International Cultural Arts Center which is to become a Museum, Art Colony and Art Educational Center; Bd. Dirs., Co-Founder of Anchorage Community Art Center which has offered the first educational school of art in Alaska for painters (affiliated with City of Anchorage & Recreation Department); Pres., Chm. Bd., Alaska Map Service, Inc.

VALTMAN, EDMUND—Cartoonist
Hartford Times, 10 Prospect St., Hartford, Conn. 06101
B. Tallinn, Estonia, May 31, 1914. Studied: Tallinn A. Sch. Member: Assn. of American Editorial Cartoonists; Nat. Cartoonists Soc.; Conn. Acad. FA; Archives of American Art. Exhibited: Trinity Col., Hartford, 1966. Work: Univ. Southern Miss.; State Historical Soc. of Mo.; Harry S. Truman Library, Independence, Mo.; Lyndon B. Johnson Library, Austin, Tex. Awards: Pulitzer Prize, 1961.

van AALTEN, JACQUES—Painter
522 Madison St., New Orleans, La. 70116
B. Antwerp, Belgium, Apr. 12, 1907. Studied: NAD; ASL, with Nicolaides; Grande Chaumiere, Paris, France. Member: NSMP; New Orleans AA; Rockport AA. Awards: Suydam Medal, N.Y., 1930; Tiffany Scholarship, 1930. Work: State of Louisiana Coll., Capitol Bldg., Baton Rouge, La.; Fresco mural, Textile H.S., N.Y.; numerous portraits including portrait of Pope Pius XII in Vatican Collection, 1955. Exhibited: NAD; WMAA; BAID; Rockport AA, 1962-1964; Arch. Lg.; Soc. Independent A.; Detroit Inst. A.; Delgado Mus. A., 1958, 1959; Old State Capitol, Baton Rouge, La., 1960; one-man: Gallery Circle, New Orleans, 1960; Le Petit Theatre du Vieux Carre, New Orleans, 1961; Norton Gal. A., Palm Beach, 1963; Rockport AA, 1964.

VAN ARSDALE, DOROTHY THAYER (Mrs.)—Chief of
Traveling Exhibitions
Smithsonian Institution, Washington, D.C. 20560; h. 7615 Elba Rd., Alexandria, Va. 22306
B. Malden, Mass., Jan. 14, 1917. Studied: Simmons Col., B.S. Positions: Chief, Traveling Exhibitions, Smithsonian Institution, Washington, D.C.

VAN ATTA, HELEN U.—Collector
4850 Preston Rd., Dallas, Tex. 75205
B. Midland, Tex., Mar. 3, 1914. Collection: Contemporary American Art.

VAN BERG, SOLOMON—Collector
88 Central Park West, New York, N.Y. 10023*

VAN BUREN, RAEBURN—Illustrator, Cart., L.
21 Clover Dr., Great Neck, N.Y. 11021
B. Pueblo, Colo., Jan. 12, 1891. Studied: ASL. Member: Cartoonists Soc.; SI (Life); A. & W. Soc. Exhibited: SI. Contributor of: illus. to Saturday Evening Post, New Yorker, Life, Esquire, & other magazines. Syndicated comic strip, "Abbie an' Slats." "Cartoonist of the Year," B'nai B'rith, Phila., Pa., 1958. Lectures: Comic Strip Art.

VAN BUREN, RICHARD—Sculptor
c/o Bykert Gallery, 24 E. 81st St., New York, N.Y. 10019*

van der MARCK, JAN—Museum Curator, Writer
Walker Art Center, 1710 Lyndale Ave., South 55403; h. 2821 East Lake of Isles Blvd., Minneapolis, Minn. 55408
B. Roermond, The Netherlands, Aug. 19, 1929. Studied: Univ. of Nijmegen, The Netherlands, A.B., M.F.A., Ph D.; Univ. of Utrecht, post-graduate study; Columbia Univ., New York, post-graduate study. Awards: Fellowships from Netherlands Organization for Pure Scientific Research, 1954-55; Rockefeller Fnd., 1957-59. Contributor of articles to Museum Journal, 1960, 1961; Art International, 1963, 1964. Catalogues and/or monographes on: Willem Reijers; Jaap Wagemaker; Jacques Lipchitz; Mark Brusse; Robert Indiana; Richard Stankiewicz; Rik van Bentum; Richard Randell; Bram van Velde; Charles Biederman; "The Californians" and "New Art of Argentina." Cooperated: Art Since 1950, Seattle, 1962; United States Exhibition, VII Bienal do Museu de Arte Moderna, Sao Paulo, Brazil, 1963. Author: "Romantische Boekillustratie in Belgie," 1956; "Neo-Realisme in de Schilderkunst" (Amsterdam), 1960; Pays-Bas in Bernard Dorival (ed.) "Peintres Contemporains" (Paris), 1964. Positions: Cur., Municipal Museum, Arnhem, The Netherlands, 1959-1961; Asst. Dir., Dept. Fine Arts, Seattle World's Fair, 1961-1962; Curator, Walker Art Center, Minneapolis, Minn., 1963- .*

VAN DER POEL, PRISCILLA PAINE (Mrs.)—
Educator, P., Cart., L.
Hillyer Art Gallery; h. 58 Paradise Road, Northampton, Mass. 01060
B. Brooklyn, N.Y., Apr. 9, 1907. Studied: Smith Col., A.B., A.M.; ASL; British Acad. in Rome & with Frank DuMond, George Bridgman, Sherrill Whiton, & others. Member: CAA; AAUP; Northampton Hist. Assn.; Cosmopolitan Cl.; Smith College Faculty Cl. Exhibited: Studio Cl., Tryon Mus., Northampton, Mass., 1936-1945; Lectures: Modern Art, etc. Positions: Instr. A., 1935-39, Asst. Prof. A., 1939-45, Assoc. Prof. A., 1945-60, Prof., 1959- , Chm. Dept. A., 1954-1958, Actg. Chm., summer, 1959, 1961, Smith Col., Northampton, Mass.; Pres., Faculty Arts Council, 1958-; Vice-Pres., Faculty Cl., 1960-61, Pres., 1961-62.

VAN DERPOOL, JAMES GROTE—Educator
570 Park Ave., New York, N.Y. 10021
B. New York, N.Y., July 21, 1903. Studied: MIT, B. Arch; Am. Acad. in Rome (Research); Atelier Gromort of Ecole des Beaux-Arts (Research) Paris; Harvard Univ., M.F.A. Member: AIA; Soc. Arch. Historians (Nat. Pres., 1955-57); Royal Soc. A., London, England (Hon. life & Benjamin Franklin F.); Nat. Trust for Historic Preservation; Am. Scenic & Historic Preservation Soc. (Trustee); CAA; Renaissance Seminar; Century Assn.; Grolier Cl.; St. Nicholas Soc., N.Y. (Historian) 1958-1968; Holland Soc. Awards: Phi Beta Kappa (Hon.); Life F., Royal Soc. A., London; George McAneny Medal for 1965. Author: "History of Avery Library," 1954; "History of Historic St. Lukes, Smithfield, Va." Contributor of many articles to art and architectural publications; articles to Encyclopaedia Britannica and Collier's Encyclopaedia. Lectures on Renaissance Architecture and American Architectural subjects. Positions: Arch. Ed., Columbia Encyclopaedia (2nd edition); Assoc. Prof., Hist. Arch., Univ. Illinois, 1933-39; Hd. A. Dept., Prof. Hist. A. Univ. Illinois, 1939-46; Prof. Arch., Columbia Univ., New York, N.Y., 1946- . Bd. Dirs., Am. Mus. of Immigration, 1948- . Trustee, Columbia Univ. Press, 1959-1962; Ulster County Hist. Soc.; Historic St. Luke's; Adv. Bd., Hawthorn Press, 1962-1967; Wyckhoff House; Acting Dean, School of Architecture, Columbia Univ., 1959-60; Prof. Emeritus Hist. of Architecture, Columbia Univ. (on leave); Exec. Dir. Emeritus, Landmarks Preservation Commission for New York City, 1962-1965; Advisory Board, National Trust for "Lyndhurst" 1965-1968, and for "Kingsland" and for "Dyckman House." Vice-Chm., Int. Fund for Monuments.

VANDER SLUIS, GEORGE—Painter, E.
Art Department, Syracuse University, Syracuse, N.Y. 13210; h. 4132 Onondaga Blvd., Camillus, N.Y. 13031
B. Cleveland, Ohio, Dec. 18, 1915. Studied: Cleveland Inst. A.; Colorado Springs FA Center. Awards: Fulbright Fellowship to Italy, 1951-1952. Work: Rochester Mem. Mus.; Syracuse Univ.; Colgate Univ.; Everson Mus.; State Univ. at Cortland; N.Y. Univ.; Colorado Springs FA Center; State Univ. at Albany; Munson-Williams-Proctor Inst., Utica, N.Y.; General Electric Corp., Syracuse; Kalamazoo A. Center; Hamline Univ., St. Paul. Exhibited: CGA, 1947, 1957; PAFA, 1953; WMAA, 1954, Fulbright Painters, 1958; Univ. Nebraska, 1957, 1960; Minneapolis Inst. A., 1957; Univ. Illinois, 1961; Chautauqua, N.Y., 1959-1968; State Exposition, Syracuse, N.Y., 1966; The White House, Wash., D.C., 1966; Mus. Contemp. Crafts, N.Y., 1968, and others. One-man: 1947-1961: Univ. Nebraska; Syracuse Univ.; Everson Mus.; Rochester Mem. Mus.; Jacques Seligmann Gal., N.Y. Recent one-man: CM, 1962; Royal Marks Gal., N.Y., 1962-1964; Munson-Williams-Proctor Inst., 1963; Lowe A. Center, Syracuse Univ., 1966; Krasner Gal., N.Y., 1968 (2). Positions: Prof., Painting and Drawing, Syracuse Univ., N.Y., at present.

VAN DE WIELE, GERALD—Painter, Gr.
801 West End Ave., New York, N.Y. 10025
B. Detroit, Mich., 1932. Studied: AIC; Black Mountain Col., North Carolina. Awards: Na. Council on the Arts Grant, 1968. Work: BMA; Borg Warner Corp., Chicago; Singer Mfg. Co.; Owens Corning Fiberglass Corp.; Coca Cola Co.; and in private colls. Exhibited: Contemp. A. Soc., Chicago, 1957; AIC, 1957; Wells St. Gal., Chicago 1957; Exh. Momentum, 1957; Dain/Schiff Gal., N.Y., 1960; Albright-Knox A. Gal., Utica, N.Y., 1963; American N.Y., 1963; Leo Castelli Gal., N.Y., 1963; Riverside Mus., N.Y., 1964, 1966; Pace Gal., Boston, 1964; Goddard/Riverside, 1966; Peridot Gal., N.Y., 1968; traveling exh., Smithsonian Inst., 1968; Illinois Wesleyan Univ., Bloomington, 1968; one-man: Wells St. Gal., Chicago, 1967; Leo Castelli Gal., N.Y., 1963; Periodt Gal., N.Y., 1969.

VAN DYK, JAMES—Painter, E.
811 N. 19th St., Philadelphia, Pa. 19130
B. Los Angeles, Cal., June 23, 1930. Studied: ASL; Yale School of Fine Arts, B.F.A., M.F.A. Member: Hon. Member, Tau Sigma Delta (Architectural Hon. Soc.). Awards: prizes, Silvermine Gld. A., 1958; New Haven Festival A., 1958; Yale Univ. purchase award, 1958.

Work: Joslyn Mus. A.; Yale Univ. Gal. FA; MModA; Northeast Regional Lib., Philadelphia. Exhibited: "Young Americans," 1962 and "Recent Paintings," 1962 both MModA; Inst. Contemp. A., Boston, 1962; De Cordova & Dana Mus., 1962; WAC, 1963. Illus., "Book of Isaiah," 1958. Positions: Instr., Graphics and Painting Yale University; Asst. Prof., Graduate School of Fine Arts, University of Pennsylvania at present.*

VAN HOESEN, BETH (Mrs. Mark Adams) —Printmaker, P.
 3816 22nd St., San Francisco, Cal. 94114
B. Boise, Idaho, June 27th, 1926. Studied: Stanford Univ., B.A.; Fontainebleau, Julian Acad., Grand Chaumiere, Paris; San Francisco State Col.; San F. AI; and in Mexico. Member: San F. Women A.; San F. AI; Cal. Soc. Pr. M. Awards: prizes, San F. Women A., 1959, 1960, 1968; San F. Art Festival, 1961; Cal. Soc. Et. 1961, 1965; San F. AI; Pasadena Mus. A., 1964. Work: Achenbach Fnd. for Graphic A.; Oakland A. Mus.; SFMA; BM MModA; Pasadena Mus. A.; Victoria & Albert Mus., London; AIC; Smithsonian Inst. Exhibited: San F. AI annuals to 1962; Cal. Soc. Etchers annuals to 1965; PAFA, 1963, 1965; SFMA, 1962, 1965, 1967; BM, 1962, 1968; Northwest Printmakers, 1962, 1963; Pratt Graphic A. Center, 1964; Pasadena Mus. A., 1964; AFA traveling exh. "Images of Women"; USIA "American Intaglia" exh. (traveling, and many other exhibitions nationally in prior dates; one-man: deYoung Mus., 1959; SFMA, 1959; Achenbach Fnd., Cal. PLH, 1961; Santa Barbara Mus. A., 1963; Hansen Gal., San Francisco, 1966; Landau Gal., Los Angeles, 1967. Author: "The Nude Man," limited ed. itaglio book, 1965.

VAN HOOK, DAVID H.—Painter, L., Mus. Cur.
 Columbia Museum of Art, Bull & Senate Sts.; h. 939 Brantley Dr., Columbia, S.C. 29210
B. Danville, Va., Dec. 25, 1923. Studied: Univ. South Carolina, with Edmund Yaghjian. Member: Gld. South Carolina A.; AAMus.; Southeastern Mus. Conf. Awards: purchase prize, Gld. South Carolina A., 1961; Honor Award, Columbua Mus. A., 1959; Rose Talbert Award, Charleston, S.C., 1954. Work: Columbia Mus. A.; Univ. South Carolina, 1961; Clemson (S.C.) Univ. Exhibited: Dallas, Texas, 1956; New Orleans, 1955; 2nd Calhoun Life Biennial, Columbia, 1959; Southeastern Annual Atlanta, 1955, 1961; Gld. South Carolina A., 1953-1964; Jacksonville, Fla., 1964; Charleston, S.C., 1964; Columbia, S.C., and Clemson, S.C., both 1964. Arranged exhibition: "Hawaiians in New York, " 1960. Positions: Registrar, 1951-58, Asst. to Director, 1958-60, Cur. Exhibits, 1961- , Columbia Museum of Art, Columbia, S.C.

VAN LEYDEN, ERNST OSCAR MAURITZ—Painter, S.
 Montfort-L'Amaury, Seine et Oise, France
B. Rotterdam, Holland, May 16, 1892. Studied: Roterdam Academie; St. Martin's Sch. A., London; Kunstgewerbe Schule, Berlin. Awards: med., Exp. in Brussels, Paris, Amsterdam, The Hague; prizes, Venice, Italy, 1932; Los A. Mus. A.; Tamarind Lithograph Workshop Fellowship, 1967. Work: Tate Gal., London; Lisbon Mus., Portugal; Boymans Mus., Rotterdam and in other museums in Europe; also, WMAA; Albright-Knox A. Gal.; Larry Aldrich Mus.; BM; in museums throughout Europe. Exhibited: Los A. Mus. A.; Santa Barbara Mus. A.; San Diego FA Soc.; Syracuse Mus. FA; SFMA; Santa Barbara Mus. A., Guggenheim Mus., N.Y.; Stedelijk Mus., Amsterdam; recent one-man exhs.: Galerie International d'Art Contemporain, Paris, 1962; Andrew-Morris Gal., N.Y., 1963; Anderson-Mayer Gal., Paris, 1964; Martha Jackson Gal., N.Y., 1965; extensively in Europe. Creator special glass-tile technique for murals.

VAN LEYDEN, KARIN ELIZABETH—Painter, Des., I., Muralist
 Montfort-L'Amaury, Seine et Oise, France
B. Charlottenburg, Germany, July 23, 1906. Member: Royal Soc. Mural P., Great Britain. Work: in many museums throughout Europe; mural commissions in U.S.A. Exhibited: Marie Sterner Gal., 1938; Nierendorf Gal., 1940; Bonestell Gal., 1946; Syracuse Mus. FA, 1941; San Diego FA Soc.; Santa Barbara Mus. A.; Los A. Mus. A.; SFMA; Felix Landau Gal., Los A., 1953; Galleria Inez Amour, Mexico City, 1953; Venice Biennale, 1956; Galleria Bevalacqua La Masa, Venice, 1960; Bertha Schaefer Gal., N.Y., 1964, 1965 and extensively in Europe, including Paris, France, 1950; Vallauris, France, 1951.

VANN, LOLI (Mrs. Oscar Van Young)—Painter
 2293 Panorama Terr., Los Angeles, Cal. 90039
B. Chicago, Ill., Jan. 7, 1913. Studied: AIC, and with Sam Ostrowsky. Awards: prizes, Los.A. Mus. A.; Chaffey Col.; Madonna Festival, Los. A. Work: Hollenbeck H.S., Los A.; Chaffey Col.; archives of Venice and Sao Paulo, Brazil. Exhibited: AIC; Carnegie Inst.; Cal.PLH; SFMA; Santa Barbara Mus. A.; Denver A. Mus.; Chaffey Col.; Oakland A. Mus.; Los A. Mus. A.; Fnd. Western A.; Los A. AA; Pasadena AI; Laguna Beach AA; La Jolla A. Center; MMA; SAM; Los A. County Fair; Cal. State Fair; Palos Verdes, Cal.; Santa

Monica Pub. Lib.; CGA; Nat. Orange Show; Scripps Col.; Cowie Gal., Los A., 1958 (one-man); Glendale Pub. Lib., 1960 (one-man).

VAN VEEN, STUYVESANT—Painter, Gr., I., W., L., E
 Art Department, City College of New York; h. 320 Central Park West, New York, N.Y. 10025; s. North Quaker Hill, Pawling, N.Y. 12564
B. New York, N.Y., Sept. 12, 1910. Studied: City Col. of N.Y.; PAFA; NAD; ASL; N.Y. Sch. Indst. A.; with Daniel Garber, Thomas Benton, and others. Member: NSMP; AEA; McDowell Alum. Assn.; Nat. Soc. Painters in Casein; Am. Soc. Contemp. A.; AWS. Awards: prizes, McDowell Cl., 1936; Ohio Valley Exh., Athens, Ohio, 1945, 1946; Wright Field Army A., 1945; State Army A. Exh., 1945; Childe Hassam Fund purchase award, Am. Acad. A. & Lets., 1961; Am. Soc. Contemp. A., prize 1967; Silvermine Gld., 1968. Work: N.Y.-Hist. Soc.; Ohio Univ.; N.J. State Mus.; MMA; Archives Am. A.; Cincinnati Hist. Soc.; Newark Mus.; Syracuse Mus. A.; Norfolk Mus. A. & Sciences; N.Y. State Univ., New Paltz; Univ. Minnesota; N.Y. Pub. Lib ; Living Arts Fnd.; Ohio Univ.; Smithsonian Col.; Lincoln Center Lib. of Performing Arts; CM, and in private colls.; murals, panels, etc.; USPO, Pittsburgh, Pa.; Fordham Hospital; Queens Pub. Lib.; Seagram Corp.; Juvenile & Domestic Relations Court, Phila., Pa.; Wright-Patterson Air Base, Dayton, Ohio; P.S. #8, Bronx, N.Y., Grace Lines; Allan House, Cincinnati, and others. Exhibited: Carnegie Inst.; AIC; MModA; WMAA; CGA; PAFA; BMFA; BM; CAM; Minneapolis Inst. A.; Syracuse Mus. FA; NGA; BMA, all from 1929 to present.USIA Exh. "Plastics USA," Russia; Staten Island Mus. A. & Hist.; Albright-Knox A. Gal.; AWS; Arch. Lg.; CM; NAD; NSMP. One-man exhs., 1928-65, nationally, ACA Gal., 1968. Illus.: El Capitan Veneno; The Fairy Fleet; The Rebel Mail Runner; Garibaldi; The Young Peoples Book of Presidents; The Art of Making Dances. Contributor to Fortune, Sat. Review, Nation magazines. Mural Consultant, Intl. Fair Consultants, Inc. Positions: Instr., Supv., Cincinnati A. Acad., 1946-49; Faculty, A. Dept., City Col. of N.Y., 1949-1965, Asst. Prof. A., 1965- . Honorary Bd. Dirs., N.Y. Chapter, AEA. Pres., Bd. Dirs., Artists' Technical Research Inst.; Pres., MacDowell Colonists, 1967- .

VAN WOLF, HENRY—Sculptor, P.
 5417 Hazeltine Ave., Van Nuys, Cal. 91401
B. Regensburg, Bavaria, Apr. 14, 1898. Studied: in Europe. Member: P. & S. Cl., Los A.; Fndr., Past Pres., Valley A. Gld.; F., Am. Inst. FA; Fed. Internationale de la Medaille; NSS; Dir., Council of Traditional Artists Soc. Awards: prizes, Cal. A. Cl., 1948, 1950, 1952; P. & S. Cl., 1948-1955; Ebell Cl., 1949, 1965, 1966; Los A. City A. Exh., 1949, 1950, 1966; A. of the Southwest, 1950, 1951, 1953, 1954; Cal. Int. Flower Show A. Exh., 1951; Greek Theatre, Los A., 1962; sculpture exh., sponsored by NSS, New York, 1962; Los A. Tower Galleries, 1963; Valley A. Gld., 1948, 1949, 1962, 1963, 1965, 1966; Am. Inst. FA, 1962. Work: USPO, Fairport, N.Y.; Red Hook Housing Project, N.Y.; Wall Mem., Hollywood; Inglewood Cemetery, Inglewood, Cal.; Cal. A. Cl. Medal; Prof. A. Gld. Medal; war mem. for German-American Lg. of Los Angeles; bronze statue of Ben Hogan, Golf Writers' Assn. of Am.; mem. port., Los A., Cal.; bronze mem. bust, Einstein Mem. Fnd.; bronze doors, Episcopal Church, Encino, Cal.; bronze Madonna, St. Timothy Church, West Los Angeles; Lincoln bust, Van Nuys H.S.; bust of James Madison for James Madison H.S., North Hollywood; sc. group, Garden Grove (Cal.) Community Church; Lincoln bust for Lincoln Bank, Van Nuys; figure, First Methodist Church, San Fernando; figure, Civic Center, Van Nuys; Beethoven Monument, Torrance, Cal.; Edison Mem. Basrelief, Lankershim; Elm. Sch., No. Hollywood, Cal., and many others. Exhibited: in Europe, 1921-28; BM, 1932; All. A. Am., 1936, 1937; Arch. Lg., 1937; Springfield Mus. A., 1938; Cal. A. Cl., 1944-1952; P. & S. Cl., 1948-1952; A. of the Southwest, 1950, 1951; Los A. A. Exh., 1947-1950; Int. Contemp. Religions Sculptured Medals, Rome, Italy, 1963; Int. Exh. Contemp. Sculptured Medals, in Athens, Greece, 1966 and Paris, 1967, and others.

VAN YOUNG, OSCAR—Painter, T., L., Lith.
 2293 Panorama Terr., Los Angeles, Cal. 90039
B. Vienna, Austria, Apr. 15, 1906. Studied: Acad. FA, Odessa, Russia; Los Angeles State Col., B.A., M.A., and with Todros Geller, Emil Armin. Member: AWS; F., Int. Inst. A. & Lets.; Cal. WC Soc.; Los A. AA. Awards: prizes, AIC; Cal. WC Soc.; Lewis Award of Merit; Chaffey Col.; Walnut Creek (Cal.) Festival, 1951; Cal. State Fair. Work: Los A. Mus. A.; Archives, Sao Paulo, Brazil; Chaffey Col., Ontario, Cal.; Santa Barbara Mus. A.; Frye Mus. A., Seattle; Los A. City Hall. Exhibited: AIC; NAD; VMFA; Cal.PLH; Oakland A. Gal.; San F. AA; Santa Barbara Mus. A.; Denver A. Mus.; San Diego FA Soc.; Los A. Mus. A., 1941-61; Cal. State Fair; Los A. County Fair; Cal. WC Soc., 1953-1961; Nat. Orange Show, 1958; Scripps Col., 1958; Los A. County AI, 1958; one-man: Vigeveno Gal.; Los A. Mus. A.; SFMA; Pasadena AI, 1951; Santa Barbara Mus. A.; Cowie Wilshire Gal., Los A.; Los A. Annual, 1968. Positions: Instr., Pasadena City College, at present.

VAN YOUNG, MRS. OSCAR. See Vann, Loli

VARGA, MARGIT—Writer, P.
 Bridgehampton, N.Y. 11932
B. New York, N.Y., May 5, 1908. Studied: ASL, with Boardman Robinson, Robert Laurent. Work: Springfield (Mass.) Mus. FA; MMA; Univ. Arizona; IBM Coll.; PAFA. Exhibited: R.I. Sch. Des.; Nebraska AA: Cranbrook Acad. A., 1940; Dallas Mus. FA; AIC; Central Illinois Exp., 1939; CGA; VMFA; WMAA, 1951; Univ. Illinois, 1951; Carnegie Inst.; Pepsi-Cola. Author: "Waldo Peirce," 1941; "Carol Brant," 1945; Co-Author: "Modern American Painting," 1939; Ed., "America's Arts & Skills" (book). Contributor to: Magazine of Art; Studio Publications; Life magazine. Positions: Asst. A. Dir., Life magazine, New York, N.Y., 1936-61; A. Consultant, Time, Inc., 1961- .

VARGAS, RUDOLPH—Sculptor, Des.
 3661 Whittier Blvd. 90023; h. 1074 North Herbert Ave., Los Angeles, Cal. 90063
B. Mexico, Apr. 20, 1904. Studied: San Carlos Acad. FA, Mexico City. Work: many wood carvings for churches in U.S. Bronze Memorial to Albert Pyke, 1961. Cherry wood carved Madonna for Gallery of Art, Vatican, Rome, Italy; Crucifix and seven figure carvings, Santa Teresita Hospital, Duarte, Cal.; bronze portrait of Father Felix J. Penna, founder of Don Bosco Technical Inst. Positions: Sculptor for advertising and movie studios. Now working for the "Disney World" in Orlando, Florida, sculpturing the "37 Presidents of the United States."

VARGO, JOHN—Painter, Gr., E., I.
 Lowe Art Center, Syracuse University, Syracuse, N.Y. 13210; h. 6319 Danbury Dr., Jamesville, N.Y. 13078
B. Cleveland, Ohio, Aug. 9, 1929. Studied: Cleveland Inst. A. Awards: purchase prizes, CMA, 1955, 1957, 1958; N.Y. State Exh., Syracuse, 1964; Merit Citation, SI, 1959, 1960; Merit Award, Cleveland A. Dirs., 1954; prize, Rochester-Finger Lakes Exh., 1966. Work: CMA; Munson-Williams-Proctor Inst., Utica, N.Y.; Syracuse Univ. Mural: "The Erie Canal," Syracuse, 1960. Exhibited: Illustrators, 1959, 1960; Watercolor: USA, 1962, 1963; AWS, 1964; Northwest Pr. M., 1964; Butler Inst. Am. A., 1967; Am. Color Print Soc., Philadelphia, 1967; CMA, 1951-1958; Syracuse Regional, 1959-1965; Utica Artists, 1960, 1961, 1963, 1966-1968; Rochester-Finger Lakes Exh., 1960, 1961, 1964, 1966; N.Y. State Exh., Syracuse, 1962, 1964, 1967; Art Faculty, Syracuse Univ., 1959-1968. Positions: Prof. A., Illustration (Chm. of Program), Watercolor, Printmaking, Syracuse University, at present.

VARIAN, ELAYNE H. (Mrs. John)—
 Museum Curator, Hist., T., W., L.
 Finch College Museum of Art, 62 E. 78th St. 10021; h. 16 W. 9th St., New York, N.Y. 10011
B. San Francisco, Cal. Studied: University of Chicago, M.A.; Art Institute of Chicago. Member: American Association of Museums; International Council of Museums; College Art Association; National Trust for Historic Preservation; National Trust (England). Contributor to Art in America; Arts magazine. Lectures: Contemporary Art History; Museology; Operation of Small Museums, etc. Exhibitions arranged: Twentieth Century Italian Art from the Carlo F. Bilotti Collection; Rene Bouche; Documentation; Jan Cybis; Jacques Kaplan's Private Collection; Hans Richter; The Josephine and Philip A. Bruno Collection; Art From Belgium; Energy Sculpture; Art in Jewelry; Contemporary Watercolors from Sweden; Art in Process, and others. Positions: Assistant to the President, Duveen Brothers, Inc., 1962-1963; Exec. Director, Village Art Center, 1964-1966; Advisor, New York State Council on the Arts, 1967-1969; Consultant, Everson Museum of Art, Syracuse, N.Y., 1969; Member, Mayor Lindsay's Citizens Advisory Committee, New York, 1967-1969; Director & Curator, The Contemporary Wing, Finch College Museum of Art, New York City, at present.

VASS, GENE—Painter, S., Gr.
 159 Mercer St., New York, N.Y. 10012
B. N.Y., July 28, 1922. Studied: Univ. of Buffalo, BFA. Work: MMoD A; Guggenheim Mus.; WMAA; Albright-Knox A. Gal.; BMA; AIC; Southern Illinois Univ.; Sheldon Mem. A. Gal.; Chase Manhattan Bank, and others. Exhibited: Norfolk Mus., 1957; CGA, 1959; Albright-Knox A. Gal., 1956-1959; Univ. of Illinois, 1961; Nebraska AA, 1961; AIC, 1961; MMoD A traveling exh. to Canada, Finland and U.S.A., 1961-1962; Carnegie Inst., 1958-1959; 1964-1965; WMAA, 1962, 1965; Syracuse Univ., 1967; Des Moines A. Center, 1967.

VASSOS, JOHN—Painter, Des., I., Cr., W., L.
 54 West 55th St., New York, N.Y. 10019; h. Comstock Hill, Norwalk, Conn. 06850
B. Greece, Oct. 23, 1898. Studied: Robert Col., Constantinople; Fenway A. Sch., Boston; BMFA Sch.; ASL; N.Y. Sch. Des. Member: Silvermine Gld. A. (Pres.); IDI; Phila. A. All. Awards: prizes,

Silvermine Gld. A., 1950; Electrical Manufacturing award, 1941; AIGA, 1927; 50 Best Books of the Year (des. & typography), 1951; Silver Medal, IDI, 1961; medal, American Packaging; the Paidea Award, Hellenic Univ. Club of New York, 1963; The Cross of the Golden Phoenix from the Government of Greece by order of King Constantine II, 1964. Work: Athens (Greece) Mus.; Athens Pub. Lib.; murals, Radio-TV Station, Phila., Pa.; Conadado Beach Hotel, Puerto Rico; United Artists Theatre, Los A.; Skouras Theatres, N.Y.; mosaic mural, entrance of the Military Electronic Center, Van Nuys, Cal., 1960; mural, RCA Electronic Center, Palm Beach, 1961. Des., U.S. Trade Fair pavilions at Karachi, Pakistan and New Delhi, India; re-designed Rivoli Theatre, N.Y.; Des., electronics bldg., Dominican Republic, U.S. Trade Fair, Designing the aesthetic concept of RCA's new Electronic Transistorized Data Processing Computing System. Developed historical complex for the city of Norwalk, Conn.—Town House, Governor Finch House, and the Old School and recreated Yankee Doodle House with terraces & gardens. Exhibited: A. Center, N.Y., 1928; N.Y Pub. Lib., 1930; Toledo Pub. Lib., 1931; New Sch. for Social Research, 1934; Riverside Mus., 1937; Montross Gal., 1938; Warwick Gal., Phila., 1941; Silvermine Gld. A., 1950-1952; Syracuse Univ. Lib. designated section for manuscripts and paintings. I., Oscar Wilde's Trilogy; Grey's Elegy; "Kubla Khan." Author, I., "Phobia," 1934. Contributor to art and design magazines. Chm. Bd., Industrial Designers Society of America, 1965 (a newly created Society, merging the Am. Soc. Indst. Des. and Indst. Des. Inst.); Advisory Council of Columbia Sch. Gen. Studies.

VELARDE, PABLITA—Painter, I., L., W.
 805 Adams St., Northeast, Albuquerque, N.M.
B. Santa Clara Pueblo, N.M., Sept. 19, 1918. Studied: U.S. Indian School, Santa Fe, with Dorothy Dunn. Member: A. Lg. New Mexico; Nat. Lg. Am. Pen Women; Inter-Tribal Indian Ceremonial Assn.; Louvre, Paris (Life). Awards: Palmes Academique, French Government, 1955; prizes incl. grand prizes, Gallup Ceremonial, Gallup, N.M., 1955, 1959; Nat. Lg. Am. Pen Women, 1955; Philbrook A. Center, 1953, 1955, 1956-1959; Mus. New Mexico, Santa Fe, 1958, 1959; New Mexico State Fair, 1959 (2); purchase awards, Philbrook A. Center, 1949; Denver A. Mus., 1954; M. H. deYoung Mus., San F., 1955; Mus. New Mexico, 1957, 1958. Work: murals, Maisel Bldg., Albuquerque, 1940; Bandelier Nat. Monument Mus., N.M., 1946; Foote Cafeteria, Houston, 1957; Western Skies Hotel, Albuquerque, 1958. Exhibited: Univ. California, Berkeley, 1945; Philbrook A. Center, 1949, 1953, 1956-1959; Oakland A. Mus., 1952; Denver A. Mus., 1954; deYoung Mem. Mus., 1955; James Graham & Sons, N.Y., 1955, 1956; Santa Fe Rodeo Exh., 1955; Chapell House, Denver, 1955; Smithsonian Inst., 1955; Santa Fe Fiesta, 1957, 1958; Mus. New Mexico, 1957-1959, 1961; Nat. Lg. Am. Pen Women, 1958, 1959; Cal. PLH, 1958; Gallup Ceremonial, 1959; Stanford Univ., 1959; one-man: Philbrook A. Center, 1955; Mus. New Mexico, 1957, 1958; Desert A. & Crafts, Tucson, 1957; Albuquerque Pub. Lib., 1957, 1959; Enchanted Mesa, Albuquerque, 1958, 1960, 1961; Anadarko Expo., 1958; Lockett's Gal., Tucson, 1958; Vaughn's Town & Country Shop, Phoenix, 1958. Exhs. 1960-61: Smith Col, San Jose, Cal., 1960; Univ. New Mexico, 1960; Santa Fe Fiesta, 1960; Desert House, Tucson, 1960, 1961; Prospect Lib., Albuquerque, 1961. Traveling Exhs.: Mus. New Mexico; Philbrook A. Center. Illus., (Cover) "Indians of Arizona" by Kenneth M. Stewart; Author, I., "Old Father, the Story Teller," 1960. Painting demonstrations for KOB-TV, Albuquerque.*

VERMES, MADELAINE—Craftsman
 315 E. 65th St., New York, N.Y. 10021
B. Hungary, Sept. 15, 1915. Studied: Alfred Univ.; Craft Students Lg.; Greenwich House Potters. Member: Artist-Craftsmen of N.Y.; Nat. Lg. of Am. Pen Women; York State Craftsmen. Work: Cooper Union Mus.; Museo International delle Ceramiche, Faenza, Italy. Exhibited: Syracuse Mus. FA; Mus. Natural Hist., 1954; Cooper Union Mus., 1955-1957; Barbizon-Plaza Gal., 1954; AEA 1955; Willow Gal., 1955 (one-man); Miami Nat. Ceramic exh., 1956; Artist-Craftsmen of N.Y., 1957; The Coliseum, N.Y., 1957; A. Lg. of Long Island, 1958; Brentano's, N.Y., 1957 (one-man); Int. Ceramic Arts, Smithsonian Inst.; Phila. A. All.

VERSHBOW, MR. and MRS. ARTHUR (CHARLOTTE)—Collectors
 54 Bishopsgate Rd., Newton Centre, Mass. 02159
(Mrs. Vershbow)—B. Boston, Mass., June 12, 1924. Studied: Radcliffe College, A.B. (Mr. Vershbow)—B. Boston, Mass., Mar. 22, 1922. Studied: Massachusetts Institute of Technology, B.S., M.S. Collection: Prints, particularly works by Redon, Piranesi, Callot; Illustrated books, specially 15th to 17th centuries.

VICENTE, ESTEBAN—Painter
 88 East 10th St.; h. 36 Gramercy Park East, New York, N.Y. 10003
B. Segovia, Spain, Jan. 20, 1906. Studied: Escuela de Bellas Artes de San Fernando, Madrid, B.A. Awards: Tamarind Fellowship,

1962. Work: BMA. Exhibited: WMAA, 1950, 1955, 1956; Nebraska AA, 1951; Carnegie Inst., 1952, 1955; Cal. PLH, 1953; Sidney Janis Gal., 1951-52; Galerie de France, Paris, 1952; Univ. Illinois, 1952; Egan Gal., N.Y., 1955 (one-man); Seattle World's Fair, 1962. Visiting Prof. A., Univ. Cal., Berkeley, 1954-55.*

VICKREY, ROBERT REMSEN—Painter
 c-o Midtown Galleries, 11 East 57th St., New York, N.Y. 10022
B. New York, N.Y., Aug. 20, 1926. Studied: Yale Univ., B.A.; ASL; Yale Sch. FA, B.F.A., and with Kenneth Hayes Miller, Reginald Marsh. Member: AWS; Audubon A. Awards: Edwin Austin Abbey Mural Fellowship, 1949, and prize; American Artist magazine citation, Audubon A., 1956; AWS, 1956; NAD, 1958; Fla. Southern Col., 1952; Hallmark award, 1955. Work: WMAA; Museu de Arte Moderna, Rio de Janeiro; Fla. Southern Col.; Parrish A. Mus., Southampton; Delgado Mus. A.; DMFA; Sara Roby Fnd.; Munson-Williams-Proctor Inst., NAD; Atlanta Univ.; Butler Inst. Am. A.; Lakeland (Fla.) Mus.; Atlanta AA; Herron Mus. A.; VMFA; Wichita A. Mus.; Gal. of Modern Art; Rutgers Univ.; Am. Acad. A. & Lets.; Philbrook A. Center; New Britain Mus. Am. A.; Swope A. Gal.; Birmingham Mus. A.; Joslyn Mem. Mus.; Spelman Col.; MMA; Newark Mus.; Norfolk Mus. A. & Sciences; Mattatuck Mus.; Wake Forest Univ.; Syracuse Univ.; Gibbes A. Gal., Charleston, S.C.; Canajoharie Library; CGA; Brooks Mem. Gal.; Colorado Springs FA Center; Finch Col., N.Y.; I.B.M.; Sperry Rand Corp. Time magazine covers; book jackets. Exhibited: WMAA, 1951, 1956-1958; CGA, 1950; Audubon A., 1949-1952, 1956, 1957; AWS, 1952, 1956; NAD, 1949-1951, 1956-1958; Fla. Southern Col., 1952; MMA, 1952; Santa Barbara Mus. A., 1956; CMA, 1956; Butler Inst. Am. A., 1956, 1958; Mus. FA of Houston, 1956; Springfield Mus. A., 1956; AIC, 1956, 1957; DMFA, 1956; Memphis Mus. A., 1956; Univ. Nebraska, 1956; Denver A. Mus., 1957; Columbus (Ohio) Gal. FA, 1957; PAFA, 1952, 1957; Columbia (S.C.) Mus., 1957; Grand Rapids A. Gal., 1957; Ft. Worth, 1957; Des Moines A. Center, 1958; Davison A. Center, Wesleyan Univ., 1966 (one-man); Midtown Gal., N.Y., 1969 (one-man).

VIERTHALER, ARTHUR A.—Craftsman, E., Des., W., L.
 University of Wisconsin, Department of Art, Madison, Wis.; h. Rt. #1, Waunakee, Wis. 53597
B. Milwaukee, Wis., Sept. 15, 1916. Studied: Milwaukee State T. Col., B.S.; Univ. Wisconsin, M.S. Awards: prizes, Wisconsin State Fair, 1950-1952; Wisconsin Des-Craftsmen, 1950; Madison AA; Mississippi River Exh., 1961; Midwestern Jewelry USA Exh. Work: many jewelry commissions, religious articles, etc. Exhibited: Wichita Dec. A., 1949-1954; Des-Craftsmen traveling exhs., 1954-1955; Huntington Gal., 1955; Smithsonian Inst., traveling exh., 1955-1960; St. Paul Gal. A., 1955; Midwestern Des., 1953; Milwaukee Des., 1948-1954; Wisconsin State Fair, 1949-1955; Madison AA, 1948-1950. Contributor to Midwestern Designer Craftsmen. Lectures: "Pre-Historic Design"; "Contemporary Design"; "Natural Phenomena of Design Elements in Minerals"; "Gemstones," "Mining for Gemstones," etc. Positions: A.T., Madison Pub. Schs.; Prof., Dept. Edu., Univ. Wisconsin, Madison, Wis.

VIESULAS, ROMAS—Painter, Et., Lith.
 1432 Beech Ave., Melrose Park, Pa. 19126
B. Lithuania, Sept. 11, 1918. Studied: Univ. Vilnius, Lithuania; Ecole des Arts et Metiers, Germany; Ecole des Beaux-Arts, Paris. Member: SAGA; Phila. Pr. Cl.; Audubon A. Awards: French Govt. Grant, 1949; Guggenheim F., 1958, 1964, 1969; Tamarind Fellowship, 1960; PMA, 1958; Collins prize, 1957; Lea prize, 1960; Rosenwald prize, 1960; P. & S. of New Jersey, 1958; Kovner prize, 1960; Conn. Acad. FA, 1955; Audubon Patrons; Hunterdon County A. Center, N.J., 1961; Fleishers Mem. Fnd., 1961; purchase prizes, BM, 1962, 1968; State Univ., N.Y., 1968; SAM, 1968; Eyre Medal, 1961, and others, 1963-1968. Work: MMA; MMoDA; NGA; LC; N.Y. Pub. Lib.; PMA; Phila. Pr. Cl.; CM; AIC; WAC; Univ. Nebraska; Boston Pub. Lib.; La Jolla A. Center; Albion Col.; Harvard Univ. Lib.; Univ. Cal.; Portland (Ore.) A. Mus.; Riverside Mus., N.Y.; Rosenwald Coll.; USIA; AGAA; SAM; BM; NCFA; Brooks Mem. Mus.; Harvard Univ.; and others U.S. and abroad; Musee d'Art et d'Histoire, Geneva; Bibliotheque Nationale, Paris. Murals, Holy Cross Church, Chicago. Exhibited: Salon Nat. Indp., Paris, 1950; Int. Graphic Arts Exh., Yugoslavia, 1959, 1961; France & Amsterdam, 1960-61; Munich, Germany, 1958; Nat. Gal., Ottawa, 1960-61; Honolulu, 1960; CM, 1954, 1956, 1958, 1967; MMoDA, 1956, 1959; NGA, 1959; BM, 1959; BMFA, 1955, 1956, 1959; Los A. Mus. A., 1959; WMAA, 1959; PMA, 1955, 1959, 1961; AIC, 1952, 1959; Wadsworth Atheneum, 1959; Brooks Mem., 1959; BM, 1958, 1960; Phila. Pr. Cl., 1953-1961; LC, 1954-1957; PAFA, 1957, 1961; CAM, 1959; Smithsonian Inst., 1957; DMFA, 1959, 1960; Portland A. Mus., 1954, 1955, 1961; Nat. Philatelic Mus., 1954; Oberlin Col., 1961; New Britain Mus. Am. A., 1961; Santa Barbara Mus., 1960; Oakland A. Gal., 1953; SAM, 1961, VMFA, 1958; Audubon A., 1956-1961; Weyhe Gal., N.Y., 1960, 1968; Contemporaries, N.Y., 1954, and many others;

numerous universities and colleges including the universities of Iowa, Michigan, Alabama, North Carolina, Georgia, Oklahoma, Texas, Syracuse, Illinois State, Delaware, etc. Traveling exhs., SAGA, 1960-61, Europe; AFA, 1958-1961. One-man: N.Y. Pub. Lib., 1956; Nat. Hall, Boston, 1957; Panoras Gal., N.Y., 1957 (2-man); CM, 1967; Weyhe Gal., N.Y., 1968; Coral Gables, Fla., 1969; Herron Mus., 1967; Pa. State Univ., 1967; Pensacola, Fla., 1967; Temple Univ., 1966 and many others; Paris, France, 1959; Grabowski Gal., London, 1960, and others. Portfolios: "Dainos" (lithographs), 1959; "Toro Desconocido," 1960. Positions: Prof., Chm., Dept. Printmaking, Tyler Sch. A., Temple Univ., Philadelphia, Pa., at present.

VIGTEL, GUDMUND—Museum Director
 The High Museum of Art, 1280 Peachtree St., N.E. 30309; h. 2082 Golf View Dr., N. W., Atlanta, Ga. 30309
B. July 9, 1925. Studied: Grunewald's Studio, Stockholm, Sweden; High Mus. Sch. A.; Univ. Georgia, B.F.A., M.F.A. Positions: Admin. Asst., Corcoran Gallery of Art, Washington, D.C., 1954; Asst. to the Director, 1957, Asst. Director, 1961-1963, Director, 1963- , The High Museum of Art, Atlanta, Ga.

VIRET, MARGARET M. (Mrs. F. I.)—Painter, T., L.
 294 Northeast 55th Terr., Miami, Fla. 33137
B. New York, N.Y., Apr. 18, 1913. Studied: Terry AI; Miami A. Sch.; Univ. Miami, and with O'Hara, Roure, Sellier, Amoroso, Gonzalez and others. Member: Miami Palette Cl. (Fndr.); Miami A. Lg. (Charter Memb., Past Pres.); Fla. Fed. A.; AAPL; Miami Springs A. Gld. (Hon.); Coral Gables A. Cl.; Lowe A. Gal. (Sec.); Arts Council of Dade County; Fla. Arts Comm.; Fla. Adult Edu. Assn. Awards: Miami Beach A. Center, 1953; Miami Woman's Cl., 1959; Dade County Exh., 1960, 1962; Fla. Fed. Women's Cl.; Coral Gables A. Cl., 1963; Miami Beach Woman's Cl., 1964; Miami A. Lg., 1960; Mayor's Award, Miami Beach, for the advancement of art, 1969. Work: Mayfair Art Theatre, Miami; Miami Woman's Cl.; Fla. Fed. Women's Cl.; Tampa A. Mus., and in private colls. Exhibited: AAPL, 1950-1965; Norton Gal. A., West Palm Beach, 1958; Fla. Fed. A., Tampa, 1952-1965; Jacksonville Mus., 1958; Sarasota A. Mus.; Daytona Beach A. Center; Lowe Gal. A.; Playhouse A. Gal.; YWCA Exhs.; Poinciana A. Festival; Chamber of Commerce exhs.; Roney Plaza A. Festival; Soc. Four Arts, Palm Beach, 1965-1969. Lectures, Religion in Art to women's clubs. Positions: State A. Dir., Fla. Fed. Women's Cl. (6 yrs.); A. Dir., Mayfair A. Theatre, Miami, 1958- ; Vice-Pres., Fla. Fed. A., 1957-1959; Asst. State Dir. (Fla.) AAPL, 1957- . Arranges one-man exhibits for Mayfair Art Theatre, 1958- . Instr. Art, Dade County Dept. of Adult Education.

VISSON, VLADIMIR—Exhibition Director
 Wildenstein Gallery, 19 E. 64th St. 10021; h. 315 E. 68th St., New York, N.Y. 10021
B. Kiev, Russia, Dec. 5, 1904. Studied: Sorbonne, Paris, Faculte de Lettres. Positions: Director of Exhibitions, Wildenstein Gallery, New York, N.Y., 1945- .

VIVIANO, CATHERINE—Art Dealer
 Catherine Viviano Gallery, 42 E. 57th St., New York, N.Y. 10022*

VODICKA, RUTH KESSLER—Sculptor
 97 Wooster St. 10012; h. 33 East 22nd St., New York, N.Y. 10010
B. New York, N.Y. Studied: City Col., N.Y.; Sculpture Center; New Sch., N.Y., and with O'Connor Barrett, ASL, and George Grosz. Member: S. Gld.; Audubon A.; NAWA; CAA; Am. Soc. Contemp. A. Work: Norfolk Mus.; Montclair State Col.; Grayson County State Bank, Sherman, Tex.; Temple of Jewish Community Center, Harrison, N.Y., and in private colls. Awards: prizes, NAWA, 1954, 1957, 1963; NAD, 1955; Audubon A., 1957, 1960; Silvermine Gld. A., 1957, 1958; Brooklyn Soc. A., 1959, 1962; Ptrs. & Sc. of New Jersey, 1962, 1963. Exhibited: Sculpture Center, N.Y., 1949-1953; Phila. A. All., 1951, 1952, 1954; de Cordova & Dana Mus., 1951; SFMA, 1952; Texas traveling exh., 1952; WMAA, 1952-1956; NAD, 1952, 1955; PAFA, 1953, 1954, 1958; Audubon A., 1954-1965; Arch. Lg., 1956, 1964; Am. Jewish traveling exh., 1954, 1955; AIC, 1954; Burlington Gal., London, England, 1955; S. Gld., 1955-1965; AFA traveling exh., 1957-58; Riverside Mus., 1954, 1958, 1959, 1961, 1962, 1967; CGA, 1955; Albright A. Gal., 1955; CMA, 1955; Galerie Claude Bernard, Paris, 1960; Detroit Inst. A., 1958; DMFA; Abilene Mus. A.; Speed Mus. A.; Museo des Belles Artes, Buenos Aires, Argentina, 1963; Mexican traveling exh., 1964-65; Cultural Festival, New York City, 1967, 1969; Bd. of Edu. traveling exh., 1964-1969; one-man: Assoc. Am. A., 1956; Sunken Meadow Gal., Long Island, 1957; Krasner Gal., N.Y., 1959; Angeleski Gal., N.Y., 1962; Mari Gal., Woodstock, N.Y., 1962; Mar: Gal., Larchmont, N.Y., 1967; Roosevelt Field, N.Y., 1960; New Gal., Provincetown, Mass., 1961; Art Film: "Demonstra-

tion of Steel Welding" for SFMA, 1952; "Sculptress Works With Blowtorch," 1956 (Voice of America newsreel). Positions: Instr. S., Queens Youth Center, Bayside, L.I., N.Y., 1953-56; Emmanuel Midtown YMHA, 1966- .

VOGEL, DONALD—Printmaker, T.
2830 Grand Concourse, New York, N.Y. 10458
B. Poland, Dec. 24, 1902. Studied: Parsons Sch. Des.; Columbia Univ., B.S., M.A. Member: SAGA. Awards: prizes, AV, 1943; Northwest Pr.M., 1943, 1946; Munson-Williams-Proctor Inst., 1943; LC, 1950. Work: SAM; Pa. State Univ.; MMA; Munson-Williams-Proctor Inst.; SAGA; LC. Exhibited: SAGA, 1948-1952; NAD, 1948, 1949; Carnegie Inst., 1948; LC, 1948, 1951; Northwest Pr.M., 1948, 1949; PAFA, 1949; J.B. Speed Mem. Mus., 1950; Flint Inst. A., 1950; Wichita AA, 1950; BM, 1950; AFA traveling exh., 1950; Royal Soc. P., Et. & Engravers, 1954; Cal. Western Univ., San Diego, 1960; Pratt Graphic A. Center, 1964. Contributor to Print Collector's Quarterly; Le Revue Moderne; American Prize Prints of 20th Century, and others. Positions: Instr., High School of A. & Des., New York, N.Y.

VOGEL, EDWIN C.—Collector
654 Madison Ave., 10021; h. Sherry Netherland Hotel, 781 Fifth Ave., New York, N.Y. 10022
B. New York, N.Y., Sept. 21, 1883. Studied: Columbia College, A.B.; New York Law School, LL.B. Collection: French impressionist and post-impressionist paintings; Chinese porcelain; English 18th century furniture. Positions: (Hon.) Chairman, Advisory Council, Department of Art History and Archaeology, Columbia University, 1961-1969.

VOLLMER, RUTH—Sculptor
32 Union Square 10003; h. 25 Central Park West, New York, N.Y. 10023
B. Munich, Germany. Member: Am. Abstract A.; Sculptors Gld. Work: MModA; N.Y. Univ. NCFA; Smithsonian Inst.; Riverside Mus., N.Y.; Oklahoma A. Center. Work commissioned for exhibition at the Museum of Modern Art, N.Y.: "Art in Progress," 15th Ann. Exh., 1944; "Element of Stage Design" toured the U. S., 1947-1950; "Children's Holiday Carnival of Modern Art," 1949-1960; "International Samples Fair," Milan, Barcelona (U.S. Dept. Commerce), 1957; "Children's Creative Center," U.S. Pavilion, Brussels World's Fair, 1958. Exhibited: Univ. Colorado, 1961; Bundy A. Gal., Waitsfield, Vt., 1963; Am. Abstract A., 1963-1969; Sculptors Gld., 1964-1969; WMAA, 1964; Betty Parsons Gal., N.Y., 1959, 1960, 1963, 1969; One-man: Betty Parsons Gal, 1960, 1963, 1966, 1968.

von BOTHMER, DIETRICH FELIX—Museum Curator, E., W., L., Scholar
The Metropolitan Museum of Art, Fifth Ave. and 82nd St. 10028; h. 48 E. 83rd St., New York, N.Y. 10028; also, Centre Island Rd., Oyster Bay, N.Y. 11771
B. Eisenach, Germany, Oct. 26, 1918. Studied: Friedrich-Wilhelm Universität, Berlin; Wadham College, Oxford University (Diploma in Classical Archaeology); Univ. California, Berkeley; Univ. Chicago; Univ. California, Ph.D. Awards: Guggenheim Fellow, 1967. Member: Archaeological Inst. America; Society for the Promotion of Hellenic Studies (London); Deutsches Archäologisches Institut (Berlin); Vereinigung der Freunde Antike Kunst (Basel). Author: "Amazons in Greek Art," 1957; "Ancient Art from New York Private Collections," 1960; "An Inquiry into the Forgery of the Etruscan Terracotta Warriors," 1961; "Corpus Vasorum Antiquorum" U.S.A. fasc. 12, The Metropolitan Museum of Art fasc. 3 (1963). Frequent contributor to: Bulletin of The Metropolitan Museum of Art; American Journal of Archaeology; Antike Kunst; Journal of Hellenic Studies; Archäologischer Anzeiger; Revue du Louvre, and others. Lectures on ancient art for museums and societies in New York, Dayton, Omaha, Boston, etc., both privately and for the Archaeological Inst. of America. Arranged exhibition: Ancient Art from New York Private Collections, The Metropolitan Museum of Art, Dec. 1959-Feb. 1960. Positions: Book Review Editor, American Journal of Archaeology, 1950-1957; Part-time teaching, New York Univ. Inst. of Fine Arts; Chm., American Committee for the Corpus Vasorum Antiquorum; Curator, Greek and Roman Art, The Metropolitan Museum of Art, New York, N.Y., at present.

VON DER LANCKEN, GIULIA—Painter, T.
80 Greenridge Ave., White Plains, N.Y.
B. Florence, Italy. Studied: Royal Acad. FA, Florence, Italy with Rivalta, Caloshi, Fattori, Burchi; in Venice with Hopkinson Smith. Awards: Diplome of Honor, Acad. FA, Florence, Italy; prizes, Oklahoma State Art Exhibit; Westchester Outdoor Exh. (hon. men.); prize, (port.) White Plains Woman's Cl., 1964, 1965; Tulsa AA.; Yonkers AA, 1965. Exhibited: Florence, Italy; Rochester A. Cl.; Chautauqua AA; Oklahoma City A. Center; Philbrook A. Center;

Delgado Mus. A.; NAD; Washington WC Cl.; N.Y. WC Cl.; Westchester A. & Crafts; Hudson Valley AA; one-man: Tulsa A. Gld.; Philbrook A. Center; Harrison, N.Y., 1965. Author: "Music as a Stimulus to Creative Art."*

VON GROSCHWITZ, GUSTAVE—Museum Director, T., L.
University of Iowa Museum of Art, Iowa City, Iowa 52240
B. New York, N.Y., Apr. 16, 1906. Studied: Columbia Univ., A.B.; N.Y. Univ., M.A. Awards: F., CAA, 1945-46. Contributor to leading art magazines. Lectures on contemporary painting and sculpture. Positions: Assoc. Dir., Univ. Iowa Museum of Art, Iowa City, at present.

von RIEGEN, WILLIAM—Cartoonist, I., P., T.
230 Grant Ave., Dumont, N.J. 07628
B. New York, N.Y., Dec. 11, 1908. Studied: ASL, with George Bridgman. Member: SI; ASL; Nat. Cartoonists Soc. Exhibited: MMA; SI; Louvre, Paris, France, and in many traveling exhs. of cartoons throughout U.S. Illus. "Professional Cartooning," 1950; "Ever Since Adam and Eve," 1955. Contributor cartoons and illustrations to Sat. Eve. Post; Look; Readers' Digest; Esquire; New Yorker; True; Argosy; Reader's Digest Humor Book; Saturday Review; Ladies Home Journal; Good Housekeeping; Christian Science Monitor; King Features. Cartoons, "Twenty-Five Years of Cartooning," Sat. Eve. Post; Esquire's "Cartoon Album"; New Yorker 1955-1965 Album; Best Cartoons of the Year 1965, 1967, 1968; True Cartoon Parade, and other national magazines. Included in Best Cartoons 1964. Positions: Instr., ASL, part-time; PIASch.

VON SCHLEGELL, DAVID—Sculptor, T.
173 Christopher St., New York, N.Y. 10014
B. St. Louis, Mo., May 25, 1920. Studied: Univ. Michigan; ASL. Awards: Nat. Council on the Arts grant, 1968; purchase prize, Carnegie Int. Exh., 1968. Work: AGAA; MIT; Cambridge, Mass.; WMAA; R.I.Sch.Des., Providence; Carnegie Inst. Exhibited: WMAA, 1964, 1966, 1968; Los Angeles County Mus. A., 1961; The Jewish Mus., New York City, 1967. Positions: Instr., Sculpture, Univ. of California at Santa Barbara, 1968; School of Visual Arts, New York City, 1969.

VON SCHNEIDAU, CHRISTIAN—Painter, S., W., L.
920½ South St. Andrews Place, Los Angeles, Cal. 90019
h. 1023 Emerald Bay, Laguna Beach, Cal. 92651
B. Smaland, Sweden, Mar. 24, 1893. Studied: Acad. FA, Sweden; AIC, and with J. Wellington Reynolds, Charles Hawthorne, Richard Miller and others. Member: P. & S. Cl., Los A.; Cal. A. Cl.; Scandinavian-Am. A. Soc.; Swedish Cl., Los A.; Desert A. Center, Palm Springs; Bakersfield, Kern River Valley Art Assns.; Laguna Beach AA; Cal. WC Soc.; Los A. AA; Fairbanks (Alaska) A. Gld.; Indp. A. Lg., Chicago. Awards: prizes, AIC, 1912-1916; Minnesota State Fair, 1915; Swedish Am. Exh., Chicago, 1917; Provincetown, Mass., 1920; Southwest Mus., 1921; Pomona State Fair, 1925, 1927; Morton Mem. Hall, Phila., 1928; Creative Arts Cl., Los A., 1931; Los A. Mus. A., 1939; Scandinavian Am. A. Soc., 1940, 1941, 1943, 1945; Soc. Western A., 1947; Swedish-Am. A. Portrait Comp., 1951; P. & S. Cl., Los A., 1945, 1947, 1950-1952; Gardena H.S., 1951; Friday Morning Cl., 1951, 1952; Laguna Beach AA, 1959-60 (5); Grumbacher award, 1968; medals, Cal. State Fair, 1919, 1920; Scandinavian-Am. A. Soc., 1939, 1940; GGE 1939; Gold Medal & 1st prize, Kern Valley AA. Work: portraits, murals, in numerous theatres, churches, hotels and clubs throughout the U.S. and abroad; 3 murals finished 1968 for Chapel of California Hospital. Exhibited: nationally. Also in Fairbanks, Anchorage, Kotzebue and Juneau, Alaska. Positions: Dir., Von Schneidau Sch. A. Los Angeles, Cal., and Palm Springs, Cal.; Prof. A., Business Men's AI, Los Angeles. Instr., Portrait Painting, Bakersfield AA and Cunningham Mem. Mus.

VON WICHT, JOHN—Painter, Gr., Des.
43 Hicks St.; h. 51 Poplar St., Brooklyn Heights, N.Y. 11201
B. Malente-Holstein, Germany, Feb. 3, 1888. Studied: Darmstadt-Bauhaus Sch.; Berlin Acad., Germany. Member: Fed. Mod. P. & S.; Audubon A.; Am. Abstract A.; SAGA; Am. Soc. Contemp. A.; Inst. Int. des Arts et Lettres. Awards: prizes, Am. Soc. Contemp. A., 1945, 1948, 1950, 1952-1954, 1957, 1960, 1961, 1964, 1968; North Shore AA, 1951; Audubon A., 1952-1955, medal, 1958; BM, 1950, 1951 (purchase), 1955, 1958, 1960 (purchase); 1964 (purchase), 1968 (purchase); Phila. Pr. Cl., 1953 (purchase), 1954, 1957, 1968 (purchase); SAGA, 1954, 1968; Riverside Mus., 1958, 1964; Boston A. Festival, 1958; Art:USA 1959; Ford Fnd. purchase, 1960; Potsdam Pr. (purchase) 1968. Grant for stencil printing, Chapelboro Fnd., Boston, 1967-1968. Work: Nat. Mus., Stockholm; Musée Nationale d'Art Moderne, Paris; MMA; WMAA; LC; Riverside Mus.; PMA; BMFA; BM; Kansas State Col.; John Herron AI; CM; de Cordova & Dana Mus.; Univ. Illinois; Bradley Univ.; MModA; Yale Univ. Gal.; BMA; Chrysler Mus.; Jewish Mus., N.Y.; Liege Mus.,

Belgium; Museo d'Arte Contemporains, Madrid; Cornell Univ.; Minneapolis Univ. Mus., and many others. Murals, mosaics, stained glass: in many cities of U.S. and Canada. Exhibited: nationally and internationally. One-man: Artists Gal., N.Y., 1944; Univ. Cal. at Los A., 1947; Mercer (Ga.) Univ.; Kleemann Gal., 1946, 1947; Passedoit Gal., N.Y., 1950-1952, 1954, 1956, 1957, 1958; John Herron AI, 1953; Carl Schurz Mem. Fnd., 1954; Robles Gal., Los A., 1959 (Retrospective); Santa Barbara Mus., 1959 (Retrospective); Pasadena Mus. A., 1959; Bertha Schaefer Gal., N.Y., 1960, 1961, 1962, 1964, 1967; Barcelona, Spain, 1961, and in Paris, 1959; Liege, 1959; Madrid, 1959; Brussels, 1959; Barcelona, 1960; Galerie Neufville, Paris, 1962; San Juan, Puerto Rico, 1963; one-man traveling exh., U.S.A., 1963-64; Galerie Leonhart, Munich, 1964, and others. Positions; Instr., Painting, ASL, 1951, 1952 (summers); color lithography, John Herron AI, Indianapolis, Ind., 1953.

von WIEGAND, CHARMION (Mrs. Joseph Freeman) — Painter, W.
 333 E. 34th St., New York, N.Y. 10016
B. Chicago, Ill. Studied: Barnard Col.; Columbia Univ.; N.Y. Univ. Member: Am. Abstract A. (Pres. 1951-1953); Le Salon des Realities Nouvelles, Paris. Work: Acquired 1961-1969: Carnegie Inst.; MModA; WMAA; N.Y. Univ. Col.; Newark Mus. A.; SAM; Univ. Notre Dame; Cornell Univ.; Container Corp. of America; Michener Col., Univ. Texas, Austin; Joseph Hirshhorn Col., Washington, D.C.; Geigy Chemical Corp. Awards: prizes, Religious Art Exh., Cranbrook Acad. A., 1969. Exhibited: MMA, 1951; WMAA, 1955; CGA, 1955; Sidney Janis Gal., N.Y., 1964; MModA, 1964; Marlborough-Gerson Gal., N.Y., 1964; Albright-Knox A. Gal., Buffalo, 1968; Berlin, Germany, 1968; AFA traveling exh., 1969, and in Paris, Rome, Copenhagen, Munich, Tokyo, Bochiem, Germany. One-man: Rose Fried Gal., 1947; Saidenberg Gal., 1952; John Heller Gal., 1956; Dusanne Gal., Seattle, Wash., 1955; Retrospective, Howard Wise Gal., N.Y., 1961 and (one-man) in 1965; Univ. Texas, Austin. Contributor to Journal of Aesthetics; Yale Review; Encyclopaedia of Arts, Art News; Arts Yearbook, The Arts, and others.

VORIS, MARK — Educator, P., Des.
 2626 East Lee St., Tucson, Ariz.
B. Franklin, Ind., Sept. 20, 1907. Studied: Franklin Col.; AIC; Instituto Allende, Mexico; Univ. Arizona and with Paul Dougherty. Member: Palette & Brush Cl.; Tucson FA Assn.; Ariz. Edu. Assn.; Ariz. A. Edu. Assn. Exhibited: Stanford Univ.; de Young Mem. Mus.; Cochise Col.; Univ. Arizona; Tucson A. Center. Positions: Prof., A. Dept., Col. FA, Univ. Arizona, Tucson, Ariz.; Actg Hd. Dept. A., 1962-63.*

VOULKOS, PETER — Sculptor
 1306 3rd St., Berkeley, Cal. 94710; h. 354 63rd St., Oakland, Cal. 94618
B. 1924. Exhibited: WMAA, 1964.*

VRANA, ALBERT — Sculptor
 3891 Little Ave. 33133; h. 3685 St. Gaudens Rd., Coconut Grove, Fla. 33133
B. Cliffside, N.Y., Jan. 25, 1921. Studied: Univ. Miami and in Europe. Member: Sculptors of Florida. Award: Tiffany Fnd. grant, 1963. Work: sc., Atlanta AA; arch. sc., Miami Beach Pub. Lib.; exterior sc., Hope Lutheran Church, Miami and Professional A. Center, Miami; exterior sc., Fed. Office Bldg., Jacksonville. Exhibited: Lowe Gal. A., one-man touring USA, 1963-65; Fla. State Univ., 1963; Univ. Oklahoma, 1964; Mt. Vernon Seminary, Washington, D.C., 1965; Cayuga Mus. A., Auburn, N.Y., 1965; Columbia (S.C.) Mus. A.; Univ. North Carolina; Columbus (Ga.) Mus. A.; Hunter Gal., Chattanooga, Tenn. One-man: A.C.A. Gal., N.Y., 1966; Berenson Gal., Miami, 1968, 1969. Positions: Former Instr., Sculpture Dept., Art Institute of Miami, and Miami-Dade Jr. Col. Summer sessions, Penland Sch., N.C.

VYTLACIL, VACLAV — Painter, E.
 Sparkill, N.Y. 10976
B. New York, N.Y., Nov. 1, 1892. Studied: AIC; ASL; Royal Acad., Munich; Hans Hofmann Sch. A., Munich. Member: Am. Abstract A.; Fed. Mod. P. & S. Work: PAFA; AIC; MMA; Rochester Mem. Mus.; Montclair (N.J.) A. Mus.; Colorado Springs FA Center; WMAA; PC; Gallatin Coll., Philadelphia, and others. Exhibited: nationally, including Carnegie Inst.; CGA; PAFA; U.S. State Dept. exh., London; AIC; Am. Abstract A.; SFMA; Fed. Mod. P. & S.; Feigl Gal., N.Y.; Rochester Mem. Mus. (one-man); BMFA (one-man), etc. Author: "Egg Tempera Painting and Oil Emulsion." Positions: Taught painting and drawing: Univ. California; California Col. A. & Crafts, Oakland; Univ. Georgia; Minneapolis Inst. A.; AIC, and others. Instr., ASL, New York City, 1928-1935, 1942, 1945-1969.

WAAGE, FREDERICK O. — Educator, Scholar
 Department History of Art, Cornell Univ.; h. 103 Comstock Rd., Ithaca, N.Y. 14850
B. Philadelphia, Pa., Oct. 7, 1906. Studied: Univ. Pennsylvania,

B.A.; Princeton Univ., M.A., M.F.A., Ph.D. Member: CAA; Archaeological Inst. Am. Author: Numismatic Notes and Monographs, No. 70, N.Y.; "Antioch on the Orontes," Vol. IV, Pt. 1, Princeton, 1948; "Prehistoric Art," Dubuque, 1967. Contributor to: American Journal Archaeology, Antiquity, Hesperia magazines. Positions: Instr. Archaeology, 1935-1938, Asst. Prof. Hist A. & Archaeology, 1938-1941, Assoc. Prof. 1941-1945, Prof., 1945- , Chm., Dept. FA, 1942-1960, Cornell Univ., Ithaca, N.Y. Visiting Lecturer in Art, Elmira College, Elmira, N.Y., 1952-1958; Lecturer in Art, Ithaca College, N.Y., 1958- .

WAANO-GANO, JOE — Painter, Des., I., W., L.
 8926 Holly Place, Los Angeles, Cal. 90046
B. Salt Lake City, Utah, Mar. 3, 1906. Studied: Univ. So. California; Los A. Acad. FA; Lukits Acad. FA; Hanson Puthuff Sch. FA. Member: AAPL; Soc. P. & S.; A. of the Southwest; Valley Prof. A. Gld.; F., Am. Inst. Fine Arts; Southwest AA; Cal. A. Cl. Awards: prizes, Hermosa, Cal., 1953; Soc. P. & S., Greek Theatre, Los A., 1953, 1954, 1956, 1958; A. of the Southwest, 1953, 1954, med., 1955, 1958, 1961, 1964; Friday Morning Cl., 1954-1957, 1960, 1961, 1963; medals, Chicago, 1933; Indian Center, Los A., 1953-1956, 1962; Madonna Festival, Los A., 1952; med., Cal. A. Cl., 1958; special award, Int. Flower Show, 1957. Work: Gardena H.S.; murals, Los A. General Hospital; Sherman Indian Inst., Riverside, Cal.; Western Airlines Offices, San F.; Rapid City, S.D. Exhibited: Nationally and internationally. One-man: Los A. Mus. A., 1940; Los A. City Col., 1941; Southwest Mus., Los A., 1943, 1946, 1951, 1955; Havenstrite FA Gal., 1945, 1953, 1958; La Casa, Beverly Hills, 1948; Walt Disney Studio Gal., Burbank, 1951; Woman's Cl. of Hollywood, 1952, 1956; Glendale Lib., 1952, 1964; Bowers Mem. Mus., 1943; Mt. San Antonio Col., 1953; Tuesday Cl., Glendale, 1954, 1957, 1964; Bank of America, Studio City, Cal., 1961; Laguna Beach, 1961; Wilshire Fed. Savings, Los A., 1959, 1962; Beverly-Hilton Hotel, 1963; Indian Festival, LaGrande, Ore., 1963; Beverly Hills Hotel, 1964; Univ. Cl., Los A., 1954, 1963; Mt. View Gal., Altadena, 1955; Int. Flower Show, 1957. Lectures: Art of the American Indian; Mural and 3D Painting. Author: "Southwestern Indian Art"; four "How Come" books for children; "Swift Eagle" (all illustrated). Des., Indian Council Fire Honor Award, presented annually since 1933 to "Greatest Living American Indian."

WACHSTETER, GEORGE — Illustrator
 85-05 Elmhurst Ave., Elmhurst, L.I., N.Y. 11373
B. Hartford, Conn., Mar. 12, 1911. Work: N.Y. Pub. Lib. (theatre coll.); U.S. Steel Coll., and work in private colls. Illus.: "NBC Book of Stars." Positions: Regular contributor illus. and caricatures, drama page, Herald Tribune, N.Y., 1941-50; N.Y. Times, 1942-1950 and Times TV artist, 1950-1951; drama artist, 1956-1963 and TV pictorial magazine cover artist for Journal-American, 1958-1963; drama artist, N.Y. World-Telegram, 1964-1966. Other positions: Caricaturist for U.S. Steel "Theatre Guild on the Air," 1945-1963; promotional illustrations for CBS, ABC and RCA television net works; syndicated feature illustrations for Hallmark TV drama series, 1964- ; many works for leading advertising agencies. Posters, promotional illus. for theatrical and motion picture productions 1936 to date.

WADDELL, RICHARD H. — Art Dealer
 Waddell Gallery, 15 E. 57th St. 10022; h. 12 E. 76th St., New York, N.Y. 10021
B. New York, N.Y. Studied: Amherst College, B.A.; Columbia University, M.S. Specialty of Gallery; Generally avant-garde, with emphasis on European artists, mainly sculptors.

WADE, JANE — Art dealer
 45 E. 66th St., New York, N.Y. 10021*

WADSWORTH, FRANCES L(AUGHLIN) (Mrs. R. H.) —
 Sculptor, P., L.
 "Mulgrave," Day St., Granby, Conn. 06035
B. Buffalo, N.Y., June 11, 1909. Studied: Albright A. Sch.; in Italy and France and with Gutzon Borglum, Charles Tefft, John Effl, Antoinette Hollister. Member: Nat. Lg. Am. Pen Women; Conn. Acad. FA; Hartford A. Cl. (Pres.); F.I.A.L. Awards: prizes, Nat. Lg. Am. Pen Women, 1956-1958. Work: sc. portraits, Univ. Virginia; Kingswood Sch., Hartford; American Sch. for the Deaf, West Hartford; bronze portrait, Pres. John F. Kennedy, Governor's Office, State Capitol, Hartford; garden sc., Inst. of Living, Hartford; St. Catherine's Sch., Richmond, Va.; Aetna Life Ins. Co., Hartford; Alice Cogswell Monument, Missouri School for the Deaf, Fulton, Mo.; Monument, Tower Square, Hartford, Conn., 1966; bronze, Broadcast House, Hartford; bas reliefs, South Congregational Church, Hartford; monuments, Thomas Hooker Monument, Hartford; Gallaudet Monument, Hartford; mural, Institute of Living. Exhibited: Nat. Lg. Am. Pen Women, 1956, 1958; Conn. Acad. FA, 1930, 1931, 1932,

1956, 1957, 1958; Conn. Soc. Women Painters, 1930, 1931, 1932, 1956-1958; NSS, 1967. Demonstrations and lectures on sculpture techniques.

WAGNER, RICHARD—Painter
306 5th Ave., S.; h. 600 14th Ave., S., Naples, Fla. 33940
B. Trotwood, Ohio, June 18, 1923. Studied: Antioch Col., Ohio; Manchester Col., Indiana; Dayton A. Inst.; Univ. Colorado, B.F.A., M.F.A. Member: Grand Central A. Gal., N.Y. Work: Denver A. Mus.; LC; Univ. Colorado; DeCordova & Dana Mus., Lincoln, Mass.; Mt. Holyoke Col.; Rochester Mem. Gal.; Dartmouth Col. Exhibited: Grand Central A. Gals., 1958, 1959, 1961, 1963, 1966, 1969; Shore Gal., Boston, 1959, 1962; LC, 1953; PAFA, 1955; Carnegie Int., 1959; MModA, 1960; Boston A. Festival, 1958, 1960, 1962; Currier Gal., 1964; DeCordova & Dana Mus., 1957, 1958; Jefferson A. Festival, New Orleans, 1969. 37 one-man exhs. in the last 16 years. Contributor Illus. to: Ford Times, Christian Science Monitor, New York Times Book Reviews. Positions: Instr., A., Dartmouth Col., 1953-1966, Chm. Dept. A., 1964-1966. Dir. of own gallery and instr., A. Sch. at Wagner Studios, Naples, Fla., and Telluride, Colo., at present.

WALD, SYLVIA—Painter, Printmaker
405 East 54th St., New York, N.Y. 10022
B. Philadelphia, Pa. Studied: Moore Inst. A. Member: AEA; Nat. Ser. Soc.; AFA. Awards: prizes, MModA., 1941; LC, 1944; NAWA, 1949; Serigraph Gal., 1948, 1949, 1950; BM, 1951, 1954 (purchase); Phila. Pr. Cl., 1960, purchase award, 1969; Print Council, 1960, 1963 (purchase); prize, Pratt Inst. miniature exh., 1968. Work: Howard Univ., Allen R. Hite Mus., J.B. Speed Mem. Mus.; Ball State T. Col.; Assn. Univ. Women; N.Y. Pub. Lib.; MMA; Princeton Univ.; Univ. Nebraska; Munson-Williams-Proctor Inst.; Nat. Gallery, Canada; Bibliotheque Nationale, Paris; Victoria & Albert Mus., London; Univ. Iowa; U.S. State Dept.; PMA; MModA; BM; North Carolina Mus. A., Raleigh, 1969, WMAA, 1969; U.S. Army; LC; works purchased by a company to be loaned to USIS for distribution to U.S. Embassies, 1966-1968. Exhibited: Carnegie Inst., 1941; WMAA, 1941, 1950, 1955; PMA, 1941; AIC, 1941; PMG, 1942; MMA, 1942, 1953; PAFA, 1949; MModA, 1941; BM, 1949-1952, 1958; LC, 1952; Univ. Chile, 1950; Smithsonian Inst., 1954; Univ. So. California, 1953, 1954; Japan, Germany, Austria, 1950-51; Norway, 1951; Israel, 1949; Salzburg, 1952; The Hague and Amsterdam, Holland; Switzerland, 1953; France, 1954; Italy, 1955; Sao Paulo, Brazil, 1954; Copenhagen, 1964, 1965; Athens, Greece, 1964; Ball State T. Col., 1964; Brooks Mem. Gal., 1964; Prize-Winning Am. Prints touring exhs., 1961-62; MMA European traveling exh., 1955-56; Univ. Illinois, 1958; Mexico City, 1958; "American Prints Today," European traveling exh., 1957-58; one-man: ACA Gal., 1939; Univ. Louisville, 1945; Kent State Col., 1945; Serigraph Gal., 1946, 1951; Allen Hite Mus., 1948; Grand Central Moderns, 1957; Sherman Gal., Chicago, 1960; Briarcliff (N.Y.) Library, 1969; New Sch. for Social Research, N.Y., 1968; The Book Gal., N.Y., 1969, and numerous traveling exhibitions.

WALDMAN, PAUL—Painter
71 Greene St., New York, N.Y. 10012
b. Erie, Pa., Aug. 1, 1936. Studied: BMSch. A.; Pratt Inst., Brooklyn. Awards: Ford Fnd. Grant, 1965. Work: N.Y. Univ. Coll.; Singer Corp.; Colby Col.; Mount Holyoke Col.; Newark Mus.; Rutgers Univ.; State Univ. of N.Y., Stony Brook, L.I.; Univ. Massachusetts; Johns Hopkins Univ.; White Mus.; Cornell Univ.; Finch Col., N.Y.; MModA; BM; Fairleigh Dickinson Univ.; FMA; Los Angeles County Mus.; Hirshhorn Coll.; Muss. Inst. Tech.; Cal. PLH; Nelson-Atkins Mus.; Smithsonian Inst.; R.I. Sch. Des. Mus.; Colgate Univ.; Univ. California, Berkeley. Exhibited: Art in America, 1961; Allan Stone Gal., N.Y., 1961; BM, 1966; Western Assn. A. Mus., traveling, 1966; Arkansas A. Center, 1966; Nelson Gal., Kansas City, 1966; Univ. Kentucky, 1966; Ithaca Col. Mus., 1967; Fla. State Univ., 1966; Finch Col. Mus., 1966, 1967 (circulated by AFA), 1968; Bianchi Gal., N.Y., 1967; Stable Gal., N.Y., 1967; N.Y. Univ., 1967; Smithsonian Inst. traveling, Germany, 1967, France, 1968; Univ. North Carolina, 1967; WMAA, 1967; Kent State Univ., 1968; Newark Mus., 1968; Kansas City A. Inst., 1967; one-man: 1963, 1965; Barnard Col., 1962; Louis Alexander Gal., N.Y., 1962 (2); Gal. Mod. A., Wash., D.C. 1963, 1964; Brandeis Univ., 1964; Wadsworth Atheneum, Hartford, 1964; Byron Gal., N.Y., 1964; Univ. Colorado, 1964; Knoedler Gal., 1965; Visual Arts Gal., 1955, 1968; Albrecht Mus., St. Joseph, Mo., 1966; Bennett Col., 1965. Positions: Instr., Painting, Brooklyn Mus., Sch., June, 1963—(inc. summer school) and Jan. 1966; N.Y. Community Col., Oct.-May, 1963; Greenwich A. Center, Jan.-June, 1963.

WALDRON, JAMES M. K.—Museum Curator, P., T.
Reading Museum and Art Gallery, 500 Museum Road, Reading, Pa.; h. 23 South 7th Ave., West Reading, Pa. 19602
B. Hazleton, Pa., Sept. 3, 1909. Studied: Kutztown State T. Col., B.S; Tyler Sch FA, Temple Univ., M.F.A. Member: Int. Inst. of Conser-

vation; Eastern AA; NAA; NEA; Pa. State Edu. Assn. Awards: Kutztown State College General Alumni Assn. Citation, 1961. Work: Reading Mus. & A. Gal.; mural, Baptist Church, Reading. Exhibited: Berks A. All., 1948, 1957 (both one-man); Kutztown State T. Col.; Reading Mus. & A. Gal. A. Ed., of the Pa. Art Education Bulletins, 1955, Harrisburg; Illus. for the Berks County Historical Review. Lectures: History of Painting. Arranged 31 regional, annual exhibitions for Reading Museum and Berks County. Positions: A. T. & Supv., West Reading School Dis., 22 yrs.; part-time instr., Kutztown State T. Col., 8 yrs.; Cur. Fine Arts, Reading Museum & Art Gallery, Reading, Pa., at present.

WALINSKA, ANNA—Painter, T.
310 Riverside Dr. 10025; h. 875 West End Ave., New York, N.Y. 10025
B. London, England. Studied: Andre L'Hote and at Grand Chaumiere, Paris; NAD; ASL. Member: NAWA; Am. Soc. Contemp. A.; Audubon Soc. Awards: prizes, NAWA, 1957, 1968; Silvermine Gld. A., 1957; Am. Soc. Contemp. A., 1960 (2). Work: Newark Mus.; Riverside Mus., N.Y.; Jewish Mus., N.Y.; Tel-Aviv Mus.; mus. of Safad and the Sholom Asch Mus., Bat-Yam, Israel, and in private colls., U.S. and abroad. Numerous portrait commissions. Exhibited: PAFA, 1963; CMA; MMA; MModA, 1956; BMA, 1959, 6-man, 1958; Riverside Mus., N.Y., 5-man, 1965; other exhs., in England, France, Japan, Israel, Burma and U.S.A. One-man: Jewish Mus., 1957 (retrospective); Gres Gal., Wash., D.C., 1958; Monede Gal., 1961. Illus., "The Merry Communist"; "The Gate Breakers," 1963. Positions: Instr., Painting & Drawing, Master Institute of United Arts, New York, N.Y., 1957- .

WALKER, HERBERT BROOKS—
Sculptor, P., Gr., Mus. Dir., W., L.
Walker Museum, Fairlee, Vt. 05045
B. Brooklyn, N.Y., Nov. 30, 1927. Studied: ASL; Yale Sch. FA, B.F.A. Member: ASL (Life). Awards: prize, New England Regional, 1963. Work: Stony Brook Mus. A., N.Y.; MModA (photos); LC; Barbados Mus.; Yale Art Coll.; paintings, photos, Orinoco Mining Co., Venezuela; paintings, documentary film, Gahagan Dredging Co. portraits, paintings and sculpture in private collections U.S., South America, and Europe. Exhibited: Stony Brook Mus., 1952; MModA (80 photographs for exhibit on Antonio Gaudi), 1958, traveling exh., 1962; Jordan Marsh, Boston, 1960; Newbury, Vt., 1961-1963; Walker Mus., Fairlee, Vt., 1960-65; Barbados Mus., 1955, and others. Lectures: New Sch. Soc. Research, N.Y., 1964; The Cooper Union, N.Y., 1967; Dartmouth College, 1968. Positions: Hd., Materials Aid Production, Iranian Oil Refinery, Abadan, 1957-59; Cultural Advisor, State PTA, Vermont, 1963-64; Founder, Owner, Walker Museum, Fairlee, Vt., 1960- ; Exec. Committee, Yale Arts Assn., 1969.

WALKER, HERSCHEL CAREY—Collector
510 Park Ave., New York, N.Y. 10022*

WALKER, HUDSON D.—Collector, Art Specialist
Walker & Ebeling, 18 East 48th St., New York, N.Y. 10017; h. 40 Deepdene Rd., Forest Hills, N.Y. 11375
B. Minneapolis, Minn., June 17, 1907. Studied: Univ. Minnesota; FMA, Harvard Univ. Positions: Dir., Marsden Hartley Exh. MModA, 1944; Selected Annual Exh. Contemporary American Paintings, Walker A. Center, 1943, 1944, 1946; Pres., AFA, 1945-48, Trustee, 1944- , Sec. 1962- ; Chm. Exec. Com., Comm. for a N.Y. State Art Program, 1946; Treas., Artist's Com., Nat. Council of Am-Soviet Friendship, 1944-47; Member, U.S. Nat. Comm. for UNESCO, 1946-48; Exec. Dir., Artist's Equity, N.Y., 1947-51; Exec. Dir., Artist's Equity Fund, 1951-58; Trustee, Print Council of America; Trustee, IGAS; Chm., AFA 50th Anniversary Development Committee; Friends of the Whitney Mus. Am. A.; Trustee, Provincetown AA; Trustee & Vice-Pres., T.B. Walker Fnd., Minneapolis, Minn.; Memb. Art Advisory Committee, Colby College.

WALKER, JAMES ADAMS—Educator, P., W., Ser.
Kent State University, Warren, Ohio 44481; h. 8778 Gull Rd., Richland, Mich. 49083
B. Connersville, Ind., Jan. 24, 1921. Studied: Western Mich. Univ., B.S.; Columbia Univ., M.A.; Mich. State Univ., M.F.A.; Univ. Mich. Arch. Sch.; East Carolina Col.; Claremont Grad. Sch. Member: Hoosier Salon; Mich. Acad. Sci., A. & Lets. (Chm. FA Sect. 1965-67). Awards: prizes, Mich. Acad. Sci., A. & Lets., 1966; Hoosier (Indianapolis) Salon, 1966-1968; Butler (Youngstown, O.) Inst. Am. A., 1967, 1968; Canton (O.) Inst. A., 1968; Flint (Mich.) Inst. A., 1966; Canton (O.) Jewish Community Center, 1968. Work: Grand Rapids A. Gal., Albion (Mich.) Col.; Franklin (Ind.) Col.; Mich. (E. Lansing) Educ. Assn. Hdqrs.; Indiana Univ.; Saginaw (Mich.) Mus.; Mich. Tech. Univ.; Upjohn Pharm. Co.; Canton (O.) A. Inst.; Butler Inst. Am. A. Exhibited: All-Ohio Graphics and Ceramics Exh., 1966; Henry Ford Community Col., 1967; Massillon (O.) Mus., 1967; Tokyo & Kagoshima, Japan, 1967, and others. Positions:

Cr., Instr., East Carolina Col.: A. Consultant, Greenville, N.C.
Pub. Schs., 1949-55; Instr., Northern H.S., Flint, Mich., 1956-66;
Asst. Prof. A., Trumbull Branch, Kent State Univ., Warren, O.,
1966- .

WALKER, MORT—Cartoonist
 Greenwich, Conn. 06830
B. Eldorado, Kans., Sept. 3, 1923. Studied: Missouri Univ., A.B.;
Washington Univ., St. Louis. Member: Nat. Cartoonists Soc. (Past
Pres.); A. & Writers Assn. Work: Permanent coll. of work, Syra-
cuse (N.Y.) Univ. Exhibited: MMA, 1951. Awards: Billy De Beck
award, Nat. Cartoonists Soc., 1953; Banshee award, 1955 as "Out-
standing Cartoonist of the Year." Author: "Beetle Bailey & Sarge";
"Beetle Bailey & Friends"; "Fall Out Laughing, Beetle Bailey";
"Trixie"; "Sam's Strip Lives!?" I., many cartoons in book col-
lections, text and humor anthologies. Creator, I., "Beetle Bailey";
"Hi and Lois"; "Sam's Strip," King Features Syndicate. Editor,
Nat. Cart. Soc. Album.

WALKER, DR. and MRS. PHILIP—Collectors
 115 Sargent Road, Brookline, Mass. 02146*

WALKER, RALPH—Collector
 101 Park Ave., New York, N.Y. 10017*

WALKER, ROBERT MILLER—Educator
 212 Elm Ave., Swarthmore, Pa. 19081
B. Flushing, N.Y., Dec. 10, 1908. Studied: Princeton Univ., B.A.,
M.F.A.; Harvard Univ., Ph.D. Member: CAA; Soc. Arch. Histor-
ians; Phila. Pr. Cl. (V. Pres.); Am. Archaeological Soc.; Print
Council of Am. (Bd. Dirs.); Renaissance Soc. of America. Contribu-
tor to Art Bulletin. Positions: Instr., Williams Col., Williamstown,
Mass., 1936-38; Prof. FA, Chm., FA Dept., Swarthmore Col., Pa.,
1941- .*

WALKEY, FREDERICK P.—Museum Director
 De Cordova Museum, Sandy Pond Road; h. Trapelo Rd., Lin-
 coln, Mass.
B. Belmont, Mass., May 29, 1922. Studied: Duke Univ.; BMFA Sch.
A.; Tufts Col., B.S. in Ed. Member: AAMus.; AFA. Position: Exec.
Dir., De Cordova Museum, Lincoln, Mass.*

WALLACE, DAVID HAROLD—Writer, Museum Curator
 Harpers Ferry, W.Va. 25425; h. 9 W. Third St., Frederick,
 Md. 21701
B. Baltimore, Md., Dec. 24, 1926. Studied: Lebanon Valley College,
B.A.; Columbia University, M.A., Ph.D.; additional graduate study,
Edinburgh University. Co-author (with George C. Groce): "The
New-York Historical Society's Dictionary of Artists in America,
1564-1860," 1957; Author: "John Rogers, the People's Sculptor,"
1967. Positions: Asst. Editor, N.Y. Historical Society, 1952-1956;
Chief Curator, Independence National Historical Park, Philadelphia,
Pa., 1957-1968; Asst. Chief, Branch of Museum Operations, National
Park Service, 1968- .

WALSH, W. CAMPBELL—Sculptor, P., Des.
 40 West 13th St., New York, N.Y.; h. 31-35 Crescent St.,
 Astoria, L.I., N.Y. 11202
B. Altoona, Pa., Oct. 22, 1905. Studied: Pa. Mus. & Sch. Indst. A.;
PAFA, and with George Harding, muralist and Henry McCarter,
painter. Member: NSMP (Treas., 1963-66); Arch. Lg. of N.Y.;
AEA. Awards: prizes, Municipal AA, N.Y., 1938; Ohio Univ., 1948.
Work: Ohio Univ.; mosiacs, Providence Hospital, Holyoke, Mass.;
St. Peters & Pauls Cathedral, Phila., Pa.; St. Stanislaus Novitiate,
Lenox, Mass.; St. John the Evangelist, Silver Spring, Md.; Boys
Town (Neb.) School; St. Tomas More, Chicago; Meadowbrook Nat.
Bank, Merrick, L.I.; murals, Bishop Clarkson Hospital, Omaha and
Bishop Clarkson Nurses' Home (sculpture); First Nat. City Bank,
N.Y.; fresco, St. Cecelia Cathedral, Omaha; St. Mary's Seminiary,
Baltimore; Most Holy Rosary, Syracuse, N.Y.; painting, Lady in the
Retreat, Mt. Kisco, N.Y.; sculpture, St. Mary's Cathedral, Trenton,
N.J. Exhibited: CGA; PAFA; VMFA; Carnegie Inst.; NAD; Rocke-
feller Center; WMAA. Arch. Lg. (NSMP), 1961.*

WALTER, MAY E.—Collector, Patron
 923 Fifth Ave., New York, N.Y. 10021
Collection: Twentieth century masters, includes cubism, futurism.
Positions: Art Advisory Council, University of Notre Dame; Secre-
tary, trustee, member of Executive Committee, American Crafts-
man's Council. Member of Collector's Club of America. Patron:
New York University Art Collection; Notre Dame University; Cornell
University.

WALTER, VALERIE HARRISSE—Sculptor
 202 East 31st St., Baltimore, Md. 21218
B. Baltimore, Md. Studied: Maryland Inst.; ASL; Notre Dame of

Maryland and with Ephraim Keyser, Augustus Lukeman. Awards:
prize, CGA, 1934; prize, Capitol Hill Assn., 1961. Work: CGA;
Unitarian Church, Baltimore; Baltimore Zoo; Philadelphia Zoo;
Aeronautical Ministry, Rome, Italy; Notre Dame Col. of Maryland;
SAM; Hispanic Mus., N.Y.; Lord Collection, Johns Hopkins Univ.;
fountains, and decorative pieces. Exhibited: NSS; NAD; Paris Salon;
CGA; BMA; PAFA; Detroit Inst. A.; SFMA; Capitol Hill Assn.,
Wash., D.C., 1961.

WALTON, HARRY ARCHELAUS, JR.—Collector
 White Oak Dairy, Covington, Va. 24426
B. Covington, Va,, Sept. 24, 1918. Studied: Lynchburg College,
Lynchburg, Va., A.B.; University of Virginia; Columbia University.
Member: Fellow, Pierpont-Morgan Library; Virginia Bibliographical
Society; Manchester (England) Bibliographical Society; (Life) Brit-
ish Humanist Association, London. Author: many translations and
studies relating to the source material below. Collection: Includes
illuminated manuscripts, incunabulae, literary manuscripts, early
Bibles, fine bindings, Aldinae, master drawings and other primary
source materials.

WALTON, MARION (Mrs. Marion Walton Putnam)—Sculptor
 49 Irving Pl., New York, N.Y. 10003
B. New Rochelle, N.Y., Nov. 19, 1899. Studied: ASL; Grande Chau-
miere, Paris, and with Antoine Bourdelle; Borglum Sch. Sculpture.
Member: S. Gld.; AEA. Work: Univ. Nebraska; WFNY, 1939; private
colls. U.S., France and Sweden. Exhibited: WMAA; MMA; MModA;
BM; Newark Mus.; AIC; BMA; WMA, Wash., D.C.; SFMA; San Diego,
Cal.; Lincoln, Neb.; Paris, France; PAFA; Carnegie Inst.; Weyhe
Gal. (one-man); Dallas Mus. FA; Los A. Mus. A.; Paris, France.
Instr., Sculpture, Sarah Lawrence Col., 1949-50. Continued creative
work in Rome, Paris and New York, 1962-65.*

WALZER, MARJORIE SCHAFER—Sculptor, P.
 18 Dogwood Lane, Westport, Conn. 06880
B. New York, N.Y., July 3, 1912. Studied: ASL, with Kuniyoshi,
Bouche, and others; Silvermine Gld. A., with Albert Jacobson, Julius
Schmidt. Awards: Soc. Connecticut Craftsmen ceramics award,
1965 (2); Hartford, Ridgebury and Stamford, Conn. Member: Silver-
mine Gld. A.; Conn. Crafts; N.Y. Soc. Ceramic A. Exhibited: WMA,
1955; N.Y. Ceramic A., 1955; Silvermine Gld. A., 1955, 1961 (one-
man), 1969 (one-man); Conn. Crafts, 1954, and traveling exh., 1961;
Smithsonian Inst. traveling exh., 1955-56; Georg Jensen, N.Y., 1960;
Boston A. Festival, 1961; Eastern States Exh. with Smithsonian Inst.
tour following, 1964; N.Y. World's Fair, 1965; Soc. Conn. Craftsmen,
1965; AFA, 1969; Paint & Clay Cl., New Haven, Conn., 1968; First
Nat. Bank, New York, N.Y., 1969. Judge, N.Y. Artist-Craftsmen Exh.,
1960-1961. Consultant, Raymond Loewy-William Snaith Assoc., to
establish pottery workshop in Puerto Rico, 1962-65.

WANG, YINPAO (Harry Wang)—
 Painter, Des., T., W., L.
 306 Ninianne Blvd.; h. 306 Emmons Drive, Princeton, N.J.
 08540
B. Suchow, China, Mar. 11, 1908. Studied: Chao Tung Univ., China,
B.A.; Univ. Pennsylvania, M.A. Member: F., Royal Soc. A., London,
Nat. Soc. Int. Des., Phila. A. All.; Nat. Soc. A. & Lets.; Nat. Press
Cl., Wash., D.C. Awards: prizes, Grumbacher award, 1955; Wood-
mere A. Gal., 1961; AID Int. Design Award, 1961, 1963; Int. Plat-
form Assn. Special Award, 1967; Hon. Citizen Key to City of Harris-
burg, Pa., 1964. Work: Henry Ford Mus., Dearborn, Mich., Detroit
Inst. A.; Gracie Mansion, N.Y.; Mus. Immigration and Naturaliza —
tion, New York. Exhibited: Chinese Nat. AA Exh., 1925-1946; Paris
Contemp. Chinese Painting exh., 1930; Chungking, 1944; Hunter Col.,
N.Y.; Grand Central Gal., 1955-1965; China Inst., N.Y., 1956;
Grumbacher traveling exh., 1956-1965; one-man: ASL, 1938; Kun-
ming, 1945; Shanghai, 1946; N.Y. Pub. Lib., 1947; Minnesota State
Shanghai, 1946; N.Y. Pub. Lib., 1947; Minnesota State Art Gal.,
1955; China Soc. of America, N.Y., 1955; Meier & Frank Co., Port-
land, Ore., 1956; Gracie Mansion, 1956; Crocker Gal., Sacramento,
1957; Detroit Inst. A., 1958; Woodmere A. Gal., Phila., 1960; Werbe
Gal., 1961; Ward Eggleston Gal., N.Y., 1964; Gal. 64; N.Y. World's
Fair, 1964; Columbia Univ., 1967; Shaffer Gal., 1966. Contributor
to Today's Art; Design Magazine; Upholstering Industry; N.Y.
World-Telegram and others. Lectures: History, Appreciation and
Techniques of Chinese Art. Positions: Prof., Kwansi Univ., China;
Lecturer, China Institute in America, New York, N.Y.; ASL, N.Y.;
Dir., Nat. Soc. Int. Des. (Pa Chaptr.); Vice-Pres., Chinese A. Cl.,
N.Y.; Editor, Peking Pictorial, China; Fndr, Peking A. Soc.; Pres.,
Harry Wang & Co.

WARBURG, EDWARD M. M.—Collector
 730 Park Avenue, New York, N.Y. 10021*

WARD, ELEANOR (Mrs.)—Art Dealer
 Stable Gallery, 33 E. 74th St., New York, N.Y. 10021*

WARD, LYLE E.—Painter, E., L., Gr.
Art Department, The College of the Ozarks, Clarksville, Ark. 72830
B. Topeka, Kans., 1922. Studied: Kansas City Art Institute, B.F.A., M.F.A., and with Miron Sokole, William McKim, and Wallace Rosenbauer. Member: CAA; MCAC. Awards: Arkansas A. Center, 1963, 1965; Little Rock A. Festival, 1960, 1962. Work: Univ. Okla. A. Mus.; Ark. A. Center; Kansas City A. Inst.; Nelson Gal., Kansas City; and in private collections. Exhibited: BM, 1951; CGA, 1959; Butler Inst. Am. A., Youngstown, Ohio, 1959, 1960; Soc. of Four Arts, Palm Beach, Fla., 1966; Missouri Valley A., Topeka, Kans., 1954-1962; New Orleans AA, 1956; Brooks Mem. A. Gal., Memphis, Tenn., 1958, 1962, 1964; Delta Exh., Little Rock, 1958, 1960-1962, 1964-1966; Nelson Gal., Kansas City, 1959, 1960, 1962, 1964; Okla. City A. Center, 1960; DMFA, 1961; Little Rock A. Center, 1961, 1965; Kansas State Col., Pittsburg, Kansas, 1963; Masur Mus. A., Monroe, La., 1965, 1966; Arkansas A. Center, 1966. One-man: Kansas City A. Inst., 1951-1960; Univ. Ark., 1959 (2); Superior St. Gal., Chicago, 1960; Reis Gal., Ft. Smith, Ark., 1962; Kansas State Col., 1963; Encounter Gal., Oklahoma City, 1965; Arkansas A. Center. 1966. Position: Chm., A. Dept. of the Col. of the Ozarks, Clarksville, Ark.

WARD, LYND (KENDALL)—Lithographer, Eng., I., W., L.
Lambs Lane, Cresskill, N.J. 07626
B. Chicago, Ill., June 26, 1905. Studied: T. Col., Columbia Univ., B.S.; & in Germany. Member: NA; SAGA (Pres., 1953-59); SI. Awards: Zella de Milhau prize, 1947; LC, 1948; NAD, 1949, John Taylor Arms Mem. Prize, 1962; Caldecott medal, for "The Biggest Bear," 1953; Samuel F. B. Morse Gold Medal, 1966. Work: Lib. Cong.; Newark Mus.; MMA; Montclair A. Mus. Exhibited: Am. A. Cong.; WFNY 1939; NAD; John Herron AI; Lib. Cong. Novels in woodcuts: "God's Man," 1929; "Madman's Drum," 1930; "Song Without Words," 1936; "Vertigo," 1937; & others. Contributor of: articles on book illustration to Horn Book; American Artist and other magazines.

WARDLAW, GEORGE M.—Painter, S., C., E.
Department of Art, University of Massachusetts; h. Webster Court, Amherst, Mass., 01002
B. Baldwyn, Miss., Apr. 9, 1927. Studied: Memphis Acad. A., B.F.A.; Univ. Tennessee; Memphis Univ.; Univ. Mississippi, M.F.A. Work: (Crafts, metal) U.S. State Dept. Exhibited: AGAA, 1949; Jacques Seligmann Gal., N.Y., 1949; Bertha Schaefer Gal., N.Y., 1952; MMA, 1952; Univ. Illinois, 1953, 1955; Brooks Mem. Gal., 1954; Delgado Mus., 1954; Louisiana State Univ., 1956; St. Paul Gal. A., 1957; Mus. Contemp. Crafts, N.Y., 1957; Memphis Acad. A., 1958; Woodstock AA, 1959, 1960; Portland Mus. A., 1959-1961; Betty Parsons Gal., N.Y., 1960, 1961; Skidmore Col., 1960, 1962; Schenectady Mus. A., 1961; Feigen Gal., 1963; Allan Stone Gal., 1963, 1964; AIC, 1963; Silvermine Gld. A., 1964; Lending Lib., MModA; R.I. Sch. Des., 1965; Northeastern Univ., Boston, 1965; Smith Col., 1967; One-man: State Univ. of N.Y. at New Paltz, 1959; Betty Parsons Gal., 1960; Skidmore Col., 1964; Yale Summer Sch. of Music and Art, 1965-1968; 2-man, Yale A. Gal., 1966; 3-man: Univ. Mississippi, 1955; Allan Stone Gal., 1963; 4-man: Wadsworth Atheneum, Hartford, 1964. Traveling Exhs.: AFA, 1949, 1957; Smithsonian Inst., 1953, 1955; Europe and Far East, U.S. State Dept., 1952. Positions: Instr., Jewelry & Silver-smithing, Univ. Mississippi, 1951-54; Louisiana State Univ., 1954-55; Painting, Sculpture, Des., State Univ. of N.Y. at New Paltz, 1955-63; Prof., Exec. Officer, Dept. Art and Instr., Painting, Yale Univ., New Haven, Conn., 1964-1968, Dir., Yale Summer Sch., 1967-1968; Assoc. Prof. & Dir., Grad. A. Programs, Univ. Massachusetts, Amherst, Mass., 1968- .

WARHOL, ANDY—Painter, S., C., Des., Gr., I.
Leo Castelli Gallery, 4 E. 77th St., New York, N.Y. 10021
Studied: Carnegie Inst. Technology. Member: Film Co-op. Exhibited: MModA, 1962; Swan Gal., Los A., 1962, 1965; Sidney Janis Gal., N.Y., 1962, 1964, 1965; Guggenheim Mus., 1963, 1966; Washington Gal. Mod. A., 1963; Nelson Gal. A., Kansas City, 1963; Sonnabend Gal., Paris, 1963, 1967; Oakland A. Mus., 1963; ICA, London, 1963; Moderna Museet, Stockholm, 1964; Louisiana Mus., Denmark, 1964; Stedelijk Mus., Amsterdam, 1964; Salon de Mai, Paris, 1964; Rose A. Mus., Brandeis Univ., 1964; ICA, Phila., 1964; Morris Int. Gal., Toronto, 1964; U.S. Plywood Corp., 1964; Univ. New Mexico A. Gal., 1964; Rochester Mem. Gal., 1964; Portland (Ore.) Mus., 1964; WMA, 1965; Palais des Beaux Arts, Brussels, 1965; Hamburger Kunstkabinett, Hamburg, Germany, 1965; American Embassy, Paris, 1965; Univ. Texas, 1966; R.I. Sch. of Design, 1966; New Sch. A. Center, 1967; Pollock Gal., 1968; Leo Castelli, 1968.*

WARK, ROBERT RODGER—Museum Curator, Hist.
Henry E. Huntington Library & Art Gallery, San Marino, Cal.; h. 1540 Laurel St., So. Pasadena, Cal. 91103
B. Edmonton, Canada, Oct. 7, 1924. Studied: Univ. Alberta, B.A.,

M.A.; Harvard Univ., A.M., Ph.D. Member: CAA. Author: Sculpture in the Huntington Collection; French Decorative Art in the Huntington Collection; Sir Joshua Reynolds, Discourses on Art (Ed.); Rowlandson's Drawings for a Tour in the Post Chaise; Rowlandson's Drawings for the English Dance of Death; Isaac Cruikshank's Drawings for Drolls; Early British Drawings in the Huntington Collection 1600-1750. Contributor to Burlington Magazine; Warburg & Courtauld Journal; Art Journal; Art Quarterly; Art Bulletin; Huntington Library Quarterly. Positions: Instr., FA, Harvard Univ., 1952-54; History of Art, Yale Univ., 1954-56; Cur., Art Collections, Henry E. Huntington Library & Art Gallery, San Marino, Cal., 1956; Lecturer, in Art, California Institute of Technology, 1960- .

WARNEKE, HEINZ—Sculptor, E.
1063 31st St., N.W., Washington, D.C. 20007; s. The Mowings, East Haddam, Conn. 06423
B. Bremen, Germany, June 30, 1895. Studied: Bremen & Berlin Acads. Member: NA; F., NSS; Conn. Acad. FA.; New England Sculptors Soc.; F., Int. Inst. A. & Lets. Awards: prizes, St. Louis A. Gld., 1925, 1926; AIC, 1930; prizes, med., Wash. AA, 1943; med., PAFA, 1935. Work: Brookgreen Gardens, S.C.; AIC; Univ. Nebraska; AGAA; CGA; Univ. Virginia; Pa. State Univ.; reliefs, mem., groups, etc.; Masonic Temple, Ft. Scott, Kan.; Medical Soc., St. Louis, Mo.; Nat. Cathedral, Wash., D.C.; Public Accounting Bldg., Wash., D.C.; YMCA, City Hall, both in St. Louis; Office Postmaster-General, Wash., D.C.; Interior Bldg., Wash., D.C.; Fairmount Park, Phila., Pa.; Prodigal Son, Bishop's Garden, Nat. Cathedral, Wash. D.C.; Pulpit, Columns and Pews in Trinity Church, Upperville, Va.; Elephant Group, Philadelphia Zoo; War Memorial Chapel, Nat. Cathedral, Wash. D.C.; Mountain Lion mascot, Penna. State Univ.; Wildcat mascot, Roberts High School, Pottstown, Pa.; portrait plaque of Allen Dulles, C.I.A. Bldg., Langley, Va. Exhibited: Westbury, L.I., N.Y., Boston, Chicago, Pittsburgh, St. Louis, San Francisco, Paris, etc.; one-man: Berlin, New York, Philadelphia, New London, Conn., Wash., D.C. Positions: Head, Sculpture Dept., Corcoran Gal. A., & George Washington Univ. (retired).

WARNER, HARRY BECKER, JR.—Critic, W.
The Herald-Mail Company, 25-31 Summit Ave.; h. 423 Summit Ave., Hagerstown, Md. 21740
B. Chambersburg, Pa., Dec. 19, 1922. Author: "All Our Yesterdays," 1969. Positions: Art Critic, Hagerstown, (Md.) Morning Herald, 1943- .

WARREN, FERDINAND E.—Painter, Gr.
227 E. Hancock St., Decatur, Ga. 30030
B. Independence, Mo., Aug. 1, 1899. Studied: Kansas City AI; Tiffany Fnd.; Grand Central Sch. A.; ASL. Member: NA; Audubon A.; SC; Am. Veterans Soc. A.; AWS. Awards: prizes, NAD, 1935; All. A. Am., 1939; SC, 1938, 1940, 1942, 1944, 1947; AWS, 1948; Audubon A., 1950; Southeastern AA, 1951; Butler AI, 1954; medals, Midwestern A.; AWS, 1950; Tiffany Fnd. F., 1925-26. Work: MMA; BM; Rochester Mem. A. Gal.; NAD; New Britain Mus. A.; Maxwell House Coll.; Univ. Georgia Mus.; Butler AI; Currier Gal. A.; Atlanta AA, and in private colls. Exhibited: NAD; All. A. Am.; Brooklyn Soc. A.; Randolph-Macon Woman's Col.; AIC; PAFA; CGA; VMFA; Carnegie Inst.; NAC; SC; Audubon A.; BM; Berkshire A. Center; Illinois Wesleyan Univ.; Bucks County AA; Dallas AA; Walker A. Center; R.I. Sch. Des.; N.Y. Bd. Edu.; Montclair A. Mus.; John Herron AI; Am. Veterans Soc. A.; Springfield AA; Univ. Nebraska; Nat. Inst. A. & Let.; Toledo Mus. A.; Farnsworth Mus. A.; MMA; one-man: Kansas City, Mo.; 2-man: Milch. Gal., N.Y., and many others. Positions: Instr. A., Resident A., Univ. Georgia, 1950-51; Hd. Dept. A., Agnes Scott Col., Decatur, Ga., at present.

WARREN, MRS. GEORGE HENRY—Collector
53 E. 66th St., New York, N.Y. 10021
B. Oakland, Cal., Jan. 29, 1897. Awards: Legion of Honor, France. Collection: Cubist and Abstract Art.

WARREN, JEFFERSON T.—Museum Director
Vizcaya-Dade County Art Museum, Miami, Fla. 33136
B. Louisville, Ky., Oct. 4, 1912. Studied: Univ. Minnesota, B.A., M.A., and in Europe. Member: AAMus.; Southeastern Mus. Conference; Archaeological Inst. America. Contributor to museum publications and to Grolier Universal Encyclopedia. Lectures: "Vizcaya" and "Fashions in Steel," in Fla., Mass., and New York. Positions: Former Cur. & Exhibits Des., Minneapolis Pub. Lib. Museum, 1946-1957; Dir., John Woodman Higgins Armory, Worcester, Mass., 1957-1962; Superintendent, Mus. Div., Dade County Park & Recreation Department and Director, Vizcaya Art Museum, 1962- .

WARREN, L. D.—Cartoonist
Cincinnati Enquirer 45201; h. 1815 William Howard Taft Rd., Cincinnati, Ohio 45206
B. Wilmington, Del., Dec. 27, 1906. Positions: Cart., Cincinnati Enquirer.

WARSHAW, HOWARD—Painter, E.
Art Department and College of Creative Studies, University of California at Santa Barbara; h. 250 Toro Canyon Rd., Carpenteria, Cal. 93013
Member: F., Inst. of Creative Arts, Univ. Cal. Work: murals, Dining Commons, Univ. Cal., Santa Barbara; Revelle College, Univ. Cal., San Diego; Santa Barbara Pub. Lib.; Wyle Research Co. & Laboratory, El Segundo, Cal. Five covers designed for The Center Magazine. Other work in the collections of Carnegie Inst.; PAFA; Los A. Mus.; Santa Barbara Mus. A.; Mus. of the City of Auckland, N.Z.; U.S. Navy Coll. Lecturer: Univ. Faculty Lecture Series "Non Verbal Communication," given on all campuses of Univ. California, 1965. Positions: U.S. Navy Combat Artist, Japan, Okinawa, (summer) 1964; Prof. A., Univ. of California at Santa Barbara, at present.

WARSINSKE, NORMAN GEORGE—Sculptor, C.
4515 52nd N.E., Seattle, Wash. 98105
B. Wichita, Kans., Mar. 4, 1929. Studied: Univ. Montana, B.A. in Journalism; Univ. Washington, B.A. in art. Also studied in Darmstadt, Germany. Member: Am. Craftsmens Council. Work: Iron mural, Univ. Unitarian Church, Seattle; Iron sculpture, Honolulu; Hawaii; Bronze fountain, King County Medical Bldg., Seattle; Bronze mural, Pilgrim Lutheran Church, Bellevue, Wash. Exhibited: Santa Barbara Int. traveling exh.(Metal), 1962; Northwest Annuals 1958-1960, 1963, 1965, 1966; one-man: Yellowstone A. Gal., 1967; Northwest Craft Center, 1968. Positions: Instr., Drawing, Univ. of Washington, 1957, 1958; Member, Seattle Municipal Art Commission, 1964-1968; President, Northwest Craft Center, 1965- .

WASEY, JANE (Mrs. Jane Wasey Mortellito)—Sculptor
178 East 75th St., New York, N.Y. 10027
B. Chicago, Ill., June 28, 1912. Studied: in Paris, with Paul Landowski; in New York with Simon Moselsio, John Flanagan, and in Connecticut with Heinz Warneke. Member: S. Gld.; NSS; Audubon A; NAWA; N.Y. Ceramic Soc. Awards: prizes, Lighthouse Exh., N.Y., 1951; NAWA; Gld. Hall, East Hampton, L.I., 1949-1956; Arch. Lg., 1955; Parrish Mus., Southampton. Work: WMAA; PAFA; Univ. Nebraska; Univ. Arizona; CAM; Univ. Colorado. Exhibited: WMAA; MMA; AIC; PMA; Syracuse Mus. FA; CM; CAM; Burlington Gal., London; PAFA; Nebraska AI; Univ. Colorado; Audubon A; one-man: Montross Gal., 1934; Delphic Studio, 1935; Philbrook A. Center, 1947; Contemporaries, 1954; Kraushaar Gal., 1955; Mus. Natural History, N.Y., 1958.*

WASHBURN, GORDON BAILEY—Gallery Director
Asia House Gallery, 112 E. 64th St. 10021; h. 163 E. 81st St., New York, N.Y. 10028
B. Wellesley Hills, Mass., Nov. 7, 1904. Studied: Deerfield Acad.; Williams Col., A.B.; FMA, Harvard Univ. Member: CAA; Assn. A. Mus. Dir.; AAMus. Awards: Guggenheim F., 1949-50; Chevalier, Legion of Honor, 1952; Hon. degree, M.F.A., Williams Col., 1938; D.F.A., Allegheny Col., 1959; D.F.A., Univ. Buffalo, 1962; Hon. D.F.A., Washington & Jefferson College, 1968. Author: "Master Drawings," 1935, "Master Bronzes," 1937 both Albright Gal. A.; "Old and New England," 1945, " Isms in Art Since 1800," both R.I. Sch. Des.; "French Painting 1100-1900," 1951; "Pictures of Everyday Life-Genre Painting in Europe, 1500-1900," both Carnegie Inst. (latter, 1954); "1955 Pittsburgh International Exhibition of Contemporary Painting," 1955; Television kinescopes on film: series entitled "Looking at Modern Art with Gordon Washburn," 1955-56; "American Classics of the Nineteenth Century," Carnegie Institute, 1957; "The 1958 Pittsburgh International Exhibition of Contemporary Painting & Sculpture," Carnegie Institute, 1958; "Restrospective Exhibition of Paintings from Previous Internationals," Carnegie Institute, 1958; "Structure and Continuity in Exhibition Design" included in The Nature and Art of Motion, 1965; various articles for periodicals, national and international, as well as regular contributions to Carnegie Magazine, the journal of Carnegie Institute. Lectures cover all periods of art history. Exhibitions arranged: Pittsburgh International (triennially); French Painting 1100-1900, Carnegie Inst.; Pictures of Everyday Life-Genre Painting in Europe, 1500-1900, Carnegie Inst.; "American Painting in the 1950's" (a catalogue) for the American Federation of Arts, 1968; 3 exhibitions per year, 1962-1969, Asia House Gallery, New York. Positions: Dir. Albright A. Gal., Buffalo, N.Y., 1931-42; Dir., Mus. A. Rhode Island Sch. Des., 1942-49; Dir., Dept. FA, Carnegie Inst., Pittsburgh, Pa., 1950-1962; Dir., Asia House Gallery, New York, N.Y., 1962- .

WASHINGTON, JAMES—Sculptor
1816 26th Ave., Seattle, Wash. 98122*

WASSER, PAULA KLOSTER—Writer, P.
1519 Marigold Road, Livermore, Cal. 94550
B. Hatton, N.D. Studied: Univ. Minnesota; Minneapolis Sch. A.;
Univ. North Dakota, B.S.; Stanford Univ., M.A.; Chouinard AI; ASL; Univ. So. California, and with Dan Lutz, Carlos Merida, Jean Charlot, Frank McIntosh. Member: Sierra Club; California Roadside Council, and other conservation groups and civic clubs. Awards: prizes, Arizona State Fair, 1930, 1931; Fellow, Int. Inst. A. & Lets. (F.I.A.L.). Exhibited: Phoenix FA Assn.; Tucson FA Festival; Arizona A. Gld.; Arizona State Fair; one-man: Desert Sch. A., Scottsdale, 1950; Phoenix Little Theatre, 1951; Univ. Nevada, Reno, 1958. Author: "The Arizona State College Collection of American Art," 1954; compiled brochures of College Collection, 1950-1952, 1955-1956, 1959-1960, 1960-1961, 1962-1963. Co-Author: A Guide for the Improvement of the Teaching of Art in the Schools of Arizona. Contributor to American Homes magazines; Design; Bulletin of Dept. A., Nat. Edu. Assn. Positions: A. T., Jr. H.S., Grand Forks, N.D., 1923-25; Supv. student art, State T. Col., Valley City, N.D., 1926-27; Actg. Hd., Dept. A., 1928-31, Hd., 1933-54, Arizona State Univ., Tempe; Cur., American Collection, Ariz. State Univ., Tempe, Ariz., 1950-1964; Prof. A., 1949-1964; Prof., Emeritus, Curator, Emeritus, 1965- .

WASSERMAN, ALBERT—Portrait Painter, Des., T.
34-24 82nd St., Jackson Heights, N.Y. 11372
B. New York, N.Y., Aug. 22, 1920. Studied: ASL, with Charles Chapman; NAD, with Sidney Dickinson. Member: All. A. Am.; New Jersey P. & S. Soc.; AEA; ASL; AWS. Awards: Pulitzer Scholarship, NAD, 1940, Obrig prize, 1941; All. A. Am., 1941, 1944; Munroe prize, Ogunquit A. Centre, 1952. Exhibited: NAD, 1940-1942; All. A. Am., 1941, 1942, 1947-1969; Audubon A., 1953; AWS 1950-1969; New Jersey P. & S. Soc., 1949-1969; Hagerstown Mus. A., 1958; Ogunquit A. Center, 1941-1962. Positions: Instr., Portrait & Still Life, Jackson Heights A. Cl.; ASL; The National Art League.

WASSERMAN, JACK—Scholar, E.
University of Wisconsin 53211; h. 2715 N. Lake Dr., Milwaukee, Wis. 53211
B. New York, N.Y., Apr. 27, 1921. Studied: N.Y. Univ., B.A.; N.Y. Univ. Inst. Fine Arts, M.A., Ph.D. Awards: Fulbright Award, 1952; Samuel S. Fels Fund Award, 1959 for research in Italy; Fellow, Royal Soc. Arts, London. Field of Research: Renaissance and Baroque Art and Architecture. Contributor of articles to: Marsyas; Art Bulletin; Journal of the Society of Architectural Historians; Burlington Magazine; Review of Howard Hibbard, "The Architecture of the Palazzo Borghese" to the Journal of the Soc. of Arch. Historians; Author: "Italian Drawings," a catalogue of an exhibition in connection with a Michelangelo Symposium at University of Wisconsin-Milwaukee; book length monograph on the sixteenth century Roman architect Ottaviano Mascarino, publ. 1966 by Accademia di San Luca in Rome. Positions: Ed. Bd., Marsyas, 1950; member of a unit from N.Y. Univ. for excavations on Samothrace, Greece, 1950; Area Chm., Committee to Rescue Italian Art; Professor & Chmn. of Dept. of Art History & Curator of the Art History Gallery, University of Wisconsin-Milwaukee, at present.

WATFORD, FRANCES (Mrs. B. E.)—Painter, T.
106 Montezuma Ave., Dothan, Ala. 36301
B. Thomasville, Ga., Sept. 6, 1915. Studied: Hilton Leech Sch. A.; Sarasota Sch. A.; Ringling Sch. A. Member: Ala. A. Lg.; Ala. WC Soc.; Dothan-Wiregrass A. Lg. (Fndr. & Exec. Bd.). Awards: Loveman, Joseph and Loeb purchases awards, 1958, 1961; Award of Merit and Fitzpatrick Mem. Award, 1963; Armistead Award, 1960, all Ala. A. Lg.; Dothan-Wiregrass A. Lg., 1961, 1962, 1965, 1966, 1968 (2); Malone Award, 1962; prizes, 1961, 1962, 1965, all Ala. WC Soc.; Diplome d'Honneur, Vichy, France, 1964; Ala. A. Lg., 1966; Birmingham (Ala.) Festival of A., 1966. Work: Birmingham Mus. A.; Montgomery Mus. FA. Exhibited: Ala. WC Soc., 1951, 1953, 1954, 1959, 1961, 1962; Miami National, 1962; Biennale, Vichy, France, 1964; Southeastern Annual, Atlanta, 1958; Drawing Soc., Atlanta, 1965; Dixie Annual, 1960-1966; Hunter Gal., Chattanooga, 1960, 1963; Jacksonville Annual, 1963; Ala. A. Lg., 1951-1965; Dothan-Wiregrass A. Lg., 1962-1965; Madison Gal., N.Y., 1960; Pensacola Interstate Fair, 1963; Chattahoochee Valley AA, 1964; one-man: Dothan, Ala., 1961, 1964; Montgomery Mus. FA, 1961; Columbus (Ga.) Mus. of A. & Crafts, 1966; Traveling exhs., Ala., Fla., Ga., Tenn., La.; 4-man traveling exh., 1962-63. Positions: Dir., Frances Watford Sch. A., and the Attic Gallery, Dothan, Ala.

WATKINS, FRANKLIN C.—Painter, T.
237 Oceana Dr., Harvey Cedars, N.J. 08008
B. New York, N.Y., Dec. 30, 1894. Studied: Univ. Virginia; Univ. Pennsylvania; PAFA. Member: NA; Nat. Inst. A. & Let.; Am. Philosophical Soc. Awards: prizes, Carnegie Inst., 1931; AIC, 1938; GGE 1939; med., Paris Salon, 1937; CGA, 1938, 1939; prizes, med., PAFA, 1941, 1942, 1944. Work: PAFA; MMA; WMAA; PMA; MModA; CGA; PMG; Smith Col.; Courtauld Inst., London; murals, Rodin Mus., Phila.

WATKINS, LOUISE LOCHRIDGE (Mrs. Frank J.)—Museum Director, T., L.
George Walter Vincent Smith Art Museum, Springfield, Mass. 01103; h. 56 Wenonah Rd., Longmeadow, Mass. 01106
B. Springfield, Mass., July 6, 1905. Studied: Skidmore Col., B.S. Member: AAMus.; Springfield A. Lg., Springfield Photographic Soc. (Hon.); State Com. on Art Curriculum for Massachusetts Schools, 1968- ; Mass. Gld. of Craftsmen. Contributor to Museum Bulletin. Lectures: Decorative Arts; History of Cloisonne; History of Enameling; Chinese Jades; etc. Organized the Springfield Color Slide Int. Exh. Positions: Instr., 1936-38, Asst. to Dir., 1938-50, Dir., 1951- , George Walter Vincent Smith A. Mus., Springfield, Mass.; Sec-Treas., New England Museum Assoc., 1950-1960.

WATROUS, JAMES S.—Painter, E., C., W.
2809 Sylvan Ave., Madison, Wis. 53705
B. Winfield, Kan., Aug. 3, 1908. Studied: Univ. Wisconsin, B.S., M.A., Ph.D. Member: NSMP; CAA. Awards: Ford F., 1954-55. Work: murals, Webcrafters, Inc., Madison, Wis.; mosaic murals, Commerce bldg., Univ. Wisconsin (2); Chemical Eng. Bldg., Washington Univ., St. Louis; exterior arch. sculpture, State of Wisconsin Bar Assn. Bldg.; exterior mosaic arch. decoration, Dean Clinic, Madison, Wis.; Social Science Bldg., Univ. Wisconsin. Author: "The Craft of Old-Master Drawings," 1957. Positions: Prof. 1939- , Chm. Dept. A. Hist., 1953-1962, Oskar Hagen Prof. Art History, 1964- , Chairman, Division of Humanities, 1965-1968, Univ. Wisconsin, Madison, Wis.; Chairman, University of Wisconsin Arts Council, 1966-1968; Pres., Midwest Col. A. Conf., 1960; Bd. Dirs., CAA, 1960-62; Nat. Com., Drawing Society, Inc. Pres., College Art Assn., 1962-64.

WATSON, ALDREN AULD—Illustrator, Des., Gr., Ed.
Putney, Vt. 05346
B. Brooklyn, N.Y., May 10, 1917. Studied: Yale Univ.; ASL, with George Bridgman, Charles Chapman, Robert Brackman, William Auerbach-Levy, and others. Member: Author's Gld. Awards: prize, Domesday Book Illustration Comp., 1945. Work: mural, S.S. President Hayes; Thos. Crowell Co. offices (1964); illus. books in libraries in U.S., Canada, Europe and private colls. Contributor to Encyclopaedia Britannica; Time magazine war maps, 1941; articles to Horn Book; Printing & Graphic Arts; maps for text & trade books. Exhibited: SI annuals, Fifty Books Shows. Illus., "Grimm's Fairy Tales," 1940; "Shakespeare's Sonnets," 1942; "Cavalleria Rusticana," 1952; "Walden," 1942; Kipling's "Jungle Books," 1946; "Gulliver's Travels"; "Hunting of the Snark," 1954; "Red Badge of Courage," 1953; "Whose Birthday Is It?," 1954; "When Is Tomorrow?," 1955; "What Does A Begin With?," 1956; "Fairy Tale Picture Book," 1957; "Arabian Nights Picture Book," 1958; "Sugar on Snow," 1964; "Henry's Dog Henry," 1964; "Katie's Chickens," 1965; "Just Right," 1968; "Our Terrariums," 1969; "Carol to a Child," 1969, as well as 125 other books including trade, juvenile, text and educational books. Author, I., "My Garden Grows" (juvenile, 1962); "Hand Bookbinding," 1963, rev. ed. 1968; "The Village Blacksmith," 1968. Biographical chapter in "Forty Illustrators and How They Work." Co-author (with Ernest Watson) "Watson Drawing Book," 1964. Designer photo type faces for book & advertising. Official NASA artist, Apollo 8, 1968.

WATSON, (JAMES) ROBERT (JR.)—Painter
741 Santa Barbara Rd., Berkeley, Cal. 94707
B. Martinez, Cal., Feb. 28, 1923. Studied: Univ. California; Univ. Illinois; Univ. Wisconsin, with Frederick Taubes. Awards: prizes, Cal. State Fair, 1956; San F. A. Festival, 1958. Work: Toledo Mus. A.; Mills Col., Oakland, Cal.; St. Mary's Col., Orinda, Cal.; Gardena H.S.; Costa Mesa H.S.; Vallejo H.S.; Cal. PLH. Exhibited: NAD, 1955; Univ. Illinois, 1955; Cal. PLH, 1952; Cal. State Fair, 1952, 1955; San F. Art Festival, 1951-1954; one-man: Hammer Gal., N.Y., 1958; Cowie Gal., Los Angeles, 1958-1965; Maxwell Gal., San Francisco, 1958-1965; André Weil, Paris, 1959, 1963; O'Hana Gal., London, 1963, 1965; Denver, 1963, 1965; Arwin Gal., Detroit, 1965.*

WATTS, ROBERT M.—Sculptor, L., E.
Rutgers University, New Brunswick, N.J. 08903; studio: 80 Wooster St., New York, N.Y. 10012
B. Burlington, Iowa, June 14, 1923. Studied: Univ. Louisville, B.M.E.; ASL; Columbia Univ., A.M. Member: ASL (Life); AAUP. Awards: Univ. Research Council Grants, Rutgers Univ., 1961-1967; Carnegie Corp. Grant, 1965. Exhibited: (Objects, Assemblage, Constructions, etc)—Martha Jackson Gal., N.Y., 1960; traveling exh. sponsored by Moderna Museet, Stockholm, 1961; MModA, 1961; traveling exh. to DMFA, SFMA, 1962; Fluxus Int. Festival, 1962-63-U.S.A., Scandinavia, France, Italy, England, Japan and Canada; MModA traveling exh., U.S., 1963-64, 1967, 1968; Washington Gal. Mod. A., 1963; Smolin Gal., N.Y., 1963; Kornblee Gal., N.Y., 1963; Rolf Nelson Gal., Los A., 1963 (3-man); Musee d'Art Moderne, Paris, 1963; Albright-Knox A. Gal., 1963; Dwan Gal., Los A., 1964; Bianchini Gal., N.Y., 1964, 1967; Leo Castelli Gal., N.Y., 1964;

Milan,, 1964; Center Americain des Artists, Paris, 1964; PVI Gal., 1964; WMAA, 1965; Byron Gal., 1965; weekly series at Cafe Au Go Go, N.Y., 1964-65; R.I. Sch. Des., 1966; Fischbach Gal., N.Y., 1966; Sonnabend Gal., Paris, 1966; Inst. Contemp. A., Boston, 1965, 1966; Madrid, 1966; Avant-Garde Festival, N.Y., 1966, 1967; Janis Gal., N.Y., 1966; Arts Council, Philadelphia, 1967; N.J. State Mus., Trenton, 1967, 1968; Stockholm, 1966; Guggenheim Mus., 1968; Rutgers Univ., 1968; Ricke Gal., Germany, 1968; Milwaukee A. Center, 1968; Univ. Cal., San Diego, 1969; SFMA, 1969; Univ. Cal., Santa Cruz, 1968-1969. One-man: Douglass Col. A. Gal., 1953, 1957; Univ. Alabama, 1957; Grand Central Moderns, N.Y., 1961, 1962; Delcorte Gal., N.Y., 1958; Bianchini Gal., N.Y., 1966; Ricke Gal., Germany, 1966; Stein Gal., Italy, 1967, Illus.: "American Indian Sculpture," 1949 and "The Sculpture of Negro Africa," 1950, both by Paul Wingert; "The Tsimshian: Their Arts and Music," 1951. Contributor to Fluxus I & II, 1964, 1965; The International Avant-Garde, vol. 5, 1964; also contributor to N.Y. Times Literary Supplement, 1964. Positions: Assoc. Prof., Sculpture & Experimental Workshop, Rutgers University, at present. Consultant, Arts Council of America; Carnegie Study Group, Univ. Cal., Santa Cruz, 1968-1969.

WAUGH, COULTON—Painter, E., L., Cart.
R.R. 2, Box 133, Newburgh, N.Y. 12550
B. Cornwall, England, Mar. 10, 1896. Studied: ASL; & with George Bridgman, Frank DuMond. Member: Grand Central Gal. Work: Davenport Mun. A. Gal.; Toledo Mus. A.; Syracuse Univ., Coulton Waugh Coll.; Cooperstown AA. Exhibited: 7 one-man exhs., New York, 1935-1968. Contributor to: Yachting, Fortune, Boys' Life, American Artist magazines; Encyclopaedia Britannica. Author, I., comic strip, "Dickie Dare," Assoc. Press, 1934-1943 and 1949-1957; news feature, "Junior Editors," Assoc. Press, 1962- . Author, "The Comics," 1947. Positions: Instr., A., Adult classes, Bethlehem A. Center, 1955-57; A.T., Cornwall (N.Y.) Central Sch., 1957-59; Instr. A., Orange County Community College, 1959-1962; Cur., Storm King A. Center, Cornwall, N.Y., 1961-1962; Cartoon Advisor, Art Instruction Schools, Minneapolis, Minn., 1964- .

WAXMAN, MRS. BASHKA PAEFF. See Paeff, Bashka

WAYNE, JUNE—Lithographer, P., W., L.
1108 N. Tamarind Ave., Los Angeles, Cal. 90038
B. Chicago, Ill., Mar. 7, 1918. Member: Int. Platform Assn. Awards: Named "Woman of the Year," 1952, for Meritorious Achievement in Modern Art, by the Los Angeles Times; numerous prizes for printmaking and painting. Work: Achenbach Fnd. for Graphic Arts, San Francisco; AIC; CM; Grunwald Fnd. for Graphic Arts, UCLA; Houghton Library, Cambridge, Mass.; La Jolla Mus. A.; LC; Long Beach Mus. A.; Los Angeles County Mus.; MModA; Nat. Gal. A., Rosenwald Coll.; Newberry Library, Chicago; N.Y. Public Library; Pasadena A. Mus.; PMA; FA Gal. of San Diego; Santa Barbara Mus. A.; Smithsonian Inst.; WAC; Wilkie Fnd., Des Plaines, Ill.; Phila. Pr. Cl.; Columbia (S.C.) Mus.; Clark Library, Los Angeles; Amon Carter Mus., Ft. Worth, Tex.; Dudley Peter Allen Mem. Mus., Oberlin Col.; Univ. of California, at Santa Barbara; Univ. Minnesota Library; Univ. New Mexico; Northwestern Univ.; DePauw Univ.; Cal. State Col.; Iowa State Univ. Also work in the Bibliotheques Royale de Belgique, Brussels; Bibliotheque Nationale de France, Paris. Exhibited: Los Angeles County Mus., 1950, 1951; Univ. Illinois, 1951, 1953, 1954; Colorado Springs FA Center, 1951, 1957; AIC, 1951, two-man, 1952; Cal. PLH, 1952; Sao Paulo, Brazil, 1955; WMAA, 1955; Strasbourg, France, 1956; Tate Gal., London, 1956; Grunwald Fnd. for Graphic Arts, 1957, 1962; Smithsonian Inst. traveling exh., 1957-1958; NCA, 1958; Print Council of Am., 1959; Pasadena A. Mus., 1959, 1960; Marion Koogler McNay Mus., San Antonio, 1959; Musée National d'Art Moderne, Paris, 1959; Museo de Bellas Artes, Caracas; Tokyo, Japan, 1961; Smithsonian Inst., 1964; four-man: Cal. State Col., Fullerton, 1964; Long Beach Mus. A., 1965; CM, 1968; Downey (Cal.) Mus., 1969; San Diego Nat. Prints, 1969; MModA Tamarind Exh., 1969. One-man: Santa Barbara Mus. A., 1950, 1953, 1958; SFMA, 1950; Pasadena Mus. A., 1952; The Contemporaries Gal., N.Y., 1953; La Jolla A. Center, 1954; deYoung Mus. A., 1956; Achenbach Fnd., 1958; Los Angeles County A. Mus., 1959; Phila. A. All., 1959; Univ. New Mexico, 1968; FAR Gal., N.Y., 1969. Contributor to Arts & Architecture, Artist's Proof, and other publications. Positions: Bd. Dirs., Grunwald Graphic Arts Fnd.; Pres., Stone Circle Fnd.; Nat. Com., U.S. State Dept. for Art in Embassies Program; Member, Chancellor's Advisory Committee in Art Management (UCLA); Founder, Director, Tamarind Lithography Workshop.

WEAVER, MR. and MRS. HENRY G.—Collectors
204 Cloverly Road, Grosse Pointe Farms, Mich. 48236*

WEAVER, JOHN BARNEY—Sculptor
12408 Stafford Lane, Bowie, Md. 20715
B. Anaconda, Mont., Mar. 28, 1920. Studied: AIC, and with Albin Polasek. Member: Montana Inst. A. Award: Albert B. Kuppen-

heimer Scholarship, 1941. Work: sculpture, Hist. Soc. of Montana, Helena; "Charles M. Russell," Statuary Hall, Wash., D.C.; "Sam Mitchell," Capitol, Helena, Mont.; figure group, Carroll College, Helena, Mont. War Mem., Butte, Mont.; figures, St. Luke's Church, River Forest, Ill.; College Inn, Hotel Sherman, Chicago; dec. fig., Episcopal Youth Center, Helena; dec. sc., Univ. Montana; port. busts of many military and government persons; Battleship North Carolina Mem., Wilmington; life size figures of Miss Rose Cleveland, Mrs. John F. Kennedy, Mrs. Lyndon B. Johnson in "Hall of First Ladies," Bldg. of Science and Industry, Smithsonian Inst.; sculpture exhs., Natural History Bldg., Smithsonian Inst.; museum exhibits and diorama, Mont. Hist. Soc., Helena; "Grandfather Mountain," North Carolina. Exhibited: AIC, 1947; Old Northwest Territory Exh., 1947; Denver A. Mus., 1948; Wisconsin P. & S. Soc., 1951; SAM; Chicago Renaissance Soc.; Milwaukee AI; Salon of Art, Wisconsin; Bowie Col., Gailsville, Md., and others. Positions: Instr., Sculpture & Figure Drawing, Layton School of Art, Milwaukee, 1946-51; Sculptor & Diorama Artist, Hist. Soc. of Montana Museum, 1955-61; Smithsonian Institution, Wash., D.C., 1961- . Instr. Sc., Bowie State Col., Bowie, Md.*

WEBB, AILEEN OSBORN (Mrs. Vanderbilt) — Patron
 29 W. 53rd St. 10019; h. 347 E. 72nd St., New York, N.Y.10021
B. Garrison, N.Y., June 25, 1892. Awards: Doctor of Fine Arts, California College of Arts and Crafts, June 1960; Sustaining Members Award, Junior League of the City of New York, 1963; Trail Blazer Award, New York Chapter, National Home Fashions League, 1964. Positions: Chairman of the Board, American Craftsmen's Council; President, World Crafts Council; President, America House, New York, N.Y.*

WEBER, ALBERT JACOB — Painter, E.
 Las Animas, Galilea, Mallorca, Spain; h. 1106 Lincoln St., Ann Arbor, Mich. 48104
B. Chicago, Ill., July 10, 1919. Studied: AIC, B.F.A.; Mexico City College, M.A.A. Member: Ann Arbor AA. Awards: prizes, Butler Inst. Am. A., 1960, 1961 (purchase); AIC, 1948; Carnegie Inst., 1949; Gr. Rapids A. Gal., 1958; Print Exh. Gal., Chicago, 1958; Butler Inst. Am. A., 1959 (purchase), 1961 (purchase); Exh. Graphic A. & Drawing, Olivet Col., Olivet, Mich., 1962 (purchase). Exhibited: Ala. WC Soc., 1946 and traveling, 1947; AIC, 1948; AWS, 1948; Phila. Pr. Cl., 1949, 1960; BM, 1949, 1950, 1958; LC, 1949; Joslyn Mem. Mus., 1949; Evanston A. Center, 1949; Carnegie Inst., 1949; PAFA, 1950, 1952, 1959, 1960; Mexico City, 1951; USIA, Mexico City, 1951; Madrid and Santander, Spain, 1953, 1954; Univ. Michigan, 1956, 1958, 1959, 1967, 1969; Detroit Artists Market, 1956, 1957, 1960; Wichita AA, 1957, 1960; Soc. Wash. Pr. M., 1957, 1960; South Bend AA, 1957; Scarab Cl., Detroit, 1957; Bloomfield AA, 1957, 1967; Forsythe Gal., Ann Arbor, 1957, 1958; Butler Inst. Am. A., 1957, 1959; Chicago Soc. A., 1957; Detroit Inst. A., 1957, 1960, 1966; Grand Rapids A. Gal., 1958; Print Exh. Gal., Chicago, 1958-1960; Ill. State Fair, 1958, 1959; AFA traveling Exh., 1958-59, 1959-60; Ann Arbor AA, 1958; Riverside Mus., 1959; Silvermine Gld. A., 1958; one-man: Mexico City, 1952; Cromer & Quint Gal., Chicago, 1953; Battle Creek, Mich., 1957; Forsythe Gal., 1959; Univ. Michigan, 1961; Angeleski Gal., N.Y., 1961; 2-man: Univ. Michigan, 1956; Print Exh. Gal., 1958. Positions: Instr., Mexico City College; Prof., Dept. A., University of Michigan, 1955-1969.

WEBER, HUGO — Painter
 797 Greenwich St., New York, N.Y. 10014
B. Basel, Switzerland, 1918. Studied: Apprenticeship with Ernst Suter, Switzerland and with Gimond, Maillol and Arp in France. Work: AIC; CM. Exhibited: AIC, 1947, 1949, 1951, 1953; Toledo Mus. A., 1947; Salon des Realities, Paris, 1948, 1958, 1959; Guggenheim Mus., 1955; Neuchatel, Winterthur, Berlin, 1956, 1957, 1958; Galerie Creuze, Paris, 1957; Galerie Arnaud, Paris, 1957; Charleroi, Belgium, 1958; Kunsthaus, Zurich, 1960; Salon de Mai, Paris, 1961; American Acad., Paris, 1961; one-man: AIC, 1951; Colorado Springs FA Center, 1951; Galerie 16, Zurich, 1952; Inst. Design, Chicago, 1952; Galerie Parhass, Wuppertal, Germany, 1952; Allan Frumkin Gal., Chicago, 1953, 1955; Betty Parsons Gal., N.Y., 1953, 1955, 1959; Galerie Hutter, Basel, 1953; American University, Beirut, Lebanon, 1954; Holland Gal., Chicago, 1961; Gres Gal., Chicago, 1962. Films by the Artist: "Vision in Flux," 1951; "Process Documentation by the Painter," 1954*

WEBER, IDELLE — Painter, S.
 35 Sidney Place, Brooklyn Heights, N.Y. 11201
B. Chicago, Ill. Studied: Scripps Col., Claremont, Cal.; Univ. California at Los Angeles, B.A., M.A.; ASL. Work: Albright-Knox A. Gal., Buffalo. Exhibited: Guggenheim Mus., 1964; Wadsworth Atheneum, 1964; WMA, 1964, 1965; MModA, 1962; Recent Drawings:USA, 1956; Milwaukee AI, 1965; Contemp. A. Assn. Houston, 1963; Gallery of Modern Art, N.Y., 1965; Byron Gal., N.Y., 1964, 1965; Ohio Univ., 1965; St. Paul Gal. A., 1961-62; Norfolk Mus. A., 1966; Westmore-

land County Mus., (Pa.), 1966; Winthrop Col., 1967; Univ. Wyoming, 1967; Japan Cultural Forum, Nov. 1966-July, 1967; Auburn College, 1968; Mississippi State Univ., 1968; Asheville-Biltmore College, (N.C.), 1968; Purdue Univ., 1968; Central Connecticut State College, 1968; West Virginia Univ., 1968; Ball State Univ. A. Gal., 1968; Ohio Northern Univ., 1968; Joslyn A. Mus., Omaha, 1968; Everhart Mus. A., Scranton, Pa., 1969; Salem College, No. Carolina, 1969; Univ. Akron, 1969; Heckscher Mus. A., Huntington, N.Y., 1969; Ringling Mus. A., Sarasota, Fla., 1969; one-man: Bertha Schaefer Gal., New York, N.Y., 1963, 1964.

WEBER, JOHN — Art dealer
 Dwan Gallery, 29 W. 57th St., New York, N.Y. 10019*

WEBSTER, DAVID S. — Assistant Museum Director
 Shelburne Museum, Shelburne, Vt. 05482

WEBSTER, LARRY — Designer, P., Photog.
 14 Beacon St., Boston, Mass. 02108; h. 116 Perkins Row, Topsfield, Mass. 01983
B. Arlington, Mass., Mar. 18, 1930. Studied: Mass. Col. Art, B.F.A.; Boston Univ., M.S. in Communication Arts. Member: AWS; All. A. Am.; Boston Soc. WC Ptrs.; Soc. of Printers, Boston; Rockport AA; Gld. of Boston A.; Nat. Soc. A. Dirs. Awards: AWS, 1963, 1967; Stephans prize, All. A. Am., 1963; Academic AA, 1963; Watercolor: USA purchase award, 1962; Rockport AA, 1960, 1962, 1964; Bronze Medal of Honor, NAC, 1966, Silver Medal of Honor, 1968; Obrig prize, NAD, 1967; Silver Medal of Honor, AWS, 1968. Work: Grand Rapids A. Mus.; De Cordova & Dana Mus., Lincoln, Mass.; Davenport Mun. Gal.; Springfield Mus., Springfield, Mo. Exhibited: AWS, 1961-1964; Watercolor: USA, 1962, 1963; All. A. Am., 1963, 1964; Boston A. Festival, 1961-1964; New England Exh., De Cordova & Dana Mus., 1962. Positions: Vice-Pres., Art Director, Graphic Designer, Thomas Todd Co., Boston, Mass., 1956- .

WECHSLER, HERMAN J. — Writer, Art Dealer, Collector
 746 Madison Ave. 10021; h. 333 Central Park West, New York, N.Y. 10025
B. New York, N.Y., Aug. 21, 1904. Studied: New York University, B.S.; Harvard University, M.A.; Ecole du Louvre, Paris; student with Paul J. Sachs, John Shapley, Adolf Goldschmidt, Meyer Shapiro, and others. Author: Pocket Books of — "Old Masters"; "Gods and Goddesses in Art and Legend"; "Lives of Famous French Painters." "Introduction to Prints and Printmaking"; "Great Prints and Printmakers," 1968. Specialty of Gallery: Graphic Art of 19th and 20th Centuries. Positions: Founder, President and Director, FAR Gallery, New York, N.Y., 1934- .

WECHTER, VIVIENNE THAUL — Painter, E., L.
 Fordham University 10058; h. 4525 Henry Hudson Parkway, New York, N.Y. 10071
B. New York, N.Y. Studied: Jamaica Teachers Col.; N.Y. Univ.; Columbia Univ.; Sculpture Center, N.Y.; ASL; Pratt Graphic A. Center. Member: AAUP; AEA (Bd. Dirs.); Am. Soc. Contemp. A. Awards: Grumbacher and Granick awards, Am. Soc. Contemp. A.; New Jersey Soc. Ptrs. & Sculptors; Childe Hassam Exh., Am. Acad. A. & Lets. Work: Norfolk Mus. A. & Sciences; N.Y. Univ. Medical Center; Fordham Univ.; Fairleigh Dickinson Univ.; Salem Methodist Church; Phoenix Mus. A.; Ohio State Univ.; St. Xavier's Col., Chicago; CGA; Mus. F.A., Houston and Ft. Worth; Jewish Mus., N.Y.; Riverside Mus., N.Y.; Southampton Col., N.Y. Exhibited: Art:USA; Provincetown AA; Silvermine Gld. A.; Audubon Soc.; Springfield Mus. FA; New Jersey Soc. Ptrs. and Sculptors; Am. Acad. A. & Lets.; Am. Soc. Contemp. A.; Cornell Univ.; Waterloo (Iowa) Mus. A. Illus., cover design and interior pages in "Park of Jonas," book of poetry by Alfeo Marzi, 1965. Author: "Art in the 60's" foreward in catalog, "Five Museums Come to Fordham Univ.," 1968; "Art on College Campuses," foreward in catalog,"Fordham in the Arts," 1968. Lectures on art to art societies; French Painting of 19th and 20th Centuries to French Club, Fordham University. Positions: Creator & Moderator, University Roundtable, weekly broadcast on the arts, WFUV-FM; Prof. FA and Artist-in-Residence, Fordham University, 1964- .

WEDDIDGE, EMIL — Lithographer, P., E., Des., L.
 870 Stein Rd., Ann Arbor, Mich. 48103
B. Ontario, Canada, Dec. 23, 1907. Studied: Michigan State Normal Col., B.S.; Univ. Michigan, M. Des.; ASL, with Morris Kantor, Emil Ganso. Member: Phila. Pr. Cl.; Am. Color Print Soc.; Michigan WC Soc.; AFA; Int. Platform Assn.; Pr. Council of America. Awards: prizes, Detroit Inst. A.; Friends of Mod. A., Grand Rapids, Mich., 1950; LC, 1950; Am. Color Pr. Soc., 1950, 1954, 1957; South Bend AA, 1957; AFA, 1957; Am. Connoisseur Selection, 1953; Rackham Research Grant; Tamarind Fellowship, 1961-1962; Bloomfield AA, 1961; Int. Platform Assn., 1968. Work: Univ. Michigan; Grand Rapids Mus. A.; Detroit Inst. A.; Univ. Maine; Smithsonian Inst.; Chrys-

ler Corp.; Parke Davis Co.; MMA; BM; CM; N.Y. Pub. Lib.; Grace Dow Mem. Lib.; Univ. Kentucky; Saginaw Mus. A.; LC; Western Canada A. Circuit; AFA; Bradford Jr. Col.; Univ. North Carolina; Edinboro T. Col.; Albion Mus. A.; Rosenwald Coll.; Pontoise Mus., France; Bibliotheque Nationale, Paris; murals, Mich. Consolidated Gas Co. Exhibited: Nationally and internationally. One-man: Contemporaries Gal., N.Y., 1953; Farnsworth Mus., 1955; NGA, 1955; Grace Dow Mem. Lib., 1955; Jackson AA, 1957; Edinboro State T. Col., 1957; Grand Rapids, 1958; Miami Univ., 1958; Univ. North Carolina, 1958; Bradford Jr. Col., 1958; South Bend A. Center, 1958; Women's City Cl., Detroit, 1956; Horace Rackham Bldg., Detroit, 1956, 1958; Galerie Herbinet, Paris, France; Park Gal., Detroit; South Bend AA, and many others. Positions: Prof., Printmaking & Des., Univ. Michigan, Ann Arbor, Mich.

WEDIN, ELOF—Painter
 3512 James Ave., Minneapolis, Minn. 55412
B. Sweden, June 28, 1901. Studied: AIC; Minneapolis Inst. A. Awards: prizes, Minnesota State Fair, 1953, 1954, 1957; Minneapolis Inst. A., 1954; Women's Cl. Minneapolis, 1956; WAC, 1958. Work: Minneapolis Inst. A.; Univ. Minnesota; Minneapolis Women's Cl.; Dayton Co., Minneapolis; Smith Col.; murals, USPO, Litchfield, Minn.; Mobridge, S.D. Exhibited: Los A. Mus. A., 1945; Texas Centennial, 1936; Minneapolis Inst. A., 1937; GGE 1939; AFA traveling exh., 1954, 1958, 1960-61; Colorado Springs FA Center, 1954; St. Paul A. Gal., 1955; European traveling exh., 1961; Twin City Area Artists, 1961; WAC, 1963; one-man: WAC, 1954, 1962; Univ. Minnesota A. Gal., 1968; retrospective, Am.-Swedish Inst., Minneapolis, 1956, 1963; Bethel Col., 1957; Winona Pub. Lib., 1957; Kilbride Gal., Minneapolis, 1958, 1961, 1964.

WEEKS, JAMES (DARRELL NORTHRUP)—Painter
 2333 Jones St., San Francisco, Cal. 94133
B. Oakland, Cal., Dec. 1, 1922. Studied: Cal. Sch. FA; Hartwell Sch. Design; and in Mexico City. Award: Rosenberg Fellowship, 1951. Work: CGA; Howard Univ.; SFMA; AFA. Exhibited: CGA; AIC; Carnegie Inst., 1964; Univ. Iowa, 1965; Los A. Mus. A.; Landau Gal., Los A., 1964; Poindexter Gal., N.Y., 1961, 1963; SFMA; Cal. PLH; deYoung Mem. Mus.; Oakland A. Mus.; and in Cleveland and Kansas City. Positions: Instr., Painting, Drawing, California School of Fine Arts, San Francisco; and California College of Arts & Crafts, Oakland, Cal.*

WEEKS, LEO ROSCO—Painter, I.
 7 Glenwood Rd., Fanwood, N.J. 07023
B. La Crosse, Ind., June 23, 1903. Studied: Am. Acad. A., Chicago, and with Glen Sheffer. Member: All-Illinois Soc. FA; Assn. Chicago P. & S.; Hoosier Salon; Palette & Chisel Acad., Chicago; Westfield (N.J.) AA. Awards: prizes, Palette & Chisel Acad., 1943, 1944, 1956, 1958; Hoosier Salon, 1948; All-Illinois Soc. FA, 1946, 1950, 1952, 1960. Work: Pub. Schs., Cairo, Herrin, Downers Grove, Rock Island, Ill.; in private colls., U.S. & Central America. Exhibited: Hoosier Salon; Palette & Chisel Acad.; All-Illinois Soc. FA; Chicago P. & S.; Westfield (N.J.) AA; Union Jr. Col., Cranford, N.J. and others. I. "Penny Wise," 1942 and other children's books. Illus. and Asst. A. Dir., for Popular Mechanics Magazine, 1943-1968.

WEEMS, KATHARINE LANE—Sculptor
 825 Fifth Ave., New York, N.Y. 10021; s. Manchester, Mass. 01944
B. Boston, Mass., Feb. 22, 1899. Studied: BMFA Sch., and with Charles Graffy, Anna Hyatt Huntington, Brenda Putnam. Member: NA; Nat. Inst. A. & Let.; NAWA; NSS; Arch. Lg.; Pen & Brush Cl.; Gld. Boston A.; AAPL; Assoc. A., Inc.; Conn. Acad. FA; North Shore AA. Awards: Medal, Sesqui-Centennial Exp., Phila., 1926; Boston Tercentenary Exh., 1930; prizes, PAFA, 1927; Paris Salon, 1928; Nat. Assn. Women P. & S., 1928; Grand Central A. Gal., 1929; NAD, 1931, 1932, 1960, 1963; NSS, 1960; gold medal, NAC, 1961; Arch. Lg., 1942; NAWA, 1946; gold medal, AAPL, 1963; bronze medal, Wolfe Art Club, 1969. Work: BMFA; Reading Mus.; PAFA; Brookgreen Gardens, S.C.; BMA; carvings, bronzes, doors, Inst. Biology, Harvard Univ.; S.; fountain, Boston, Mass., medals, U.S. Legion of Merit; U.S. Medal for Merit; Fincke Mem. Medal, Groton Sch.; Goodwin Medal, MIT.; Mus. of Science, Boston (40 bronzes in permanent coll.). Exhibited: NAD 1969; Wolfe Art Club, 1969; Nat. Acad. A. & Let., etc.

WEESE, MYRTLE A.—Painter
 10652 Poplar, Loma Linda, Cal. 92354
B. Roslyn, Wash., Oct. 30, 1903. Studied: Los Angeles County AI, and with George Flower, Ejnar Hansen. Member: Scandinavian-Am. Soc.; Am. Inst. FA; Las Artistas A. Cl.; Prof. A. of Los Angeles. Awards: prizes, Friday Morning Cl., 1955, 1964; Sierra Madre Exh.; Duncan Vail Gal., L.A., 1960; Brea Women's Cl., 1961 (2); Los Angeles, 1961; Las Artistas, 1961; gold medal, Greek Theatre, Los A., 1961. Work: paintings, and ports. in private collections. Ex-

hibited: One-man: Bowers Mem. Mus., Santa Anna; Greek Theatre, Los A.; Sierra Madre City Hall; Los Angeles City Hall; Women's Cl. (2 one-man); Descanso Gardens, 1961; Sierra Madre, 1967.

WEHR, PAUL ADAM—Illustrator, Comm. A., Des.
 6038 Allisonville Rd., Indianapolis, Ind. 46220
B. Mt. Vernon, Ind., May 16, 1914. Studied: John Herron AI, B.F.A. Member: Indiana A. Cl. Awards: prizes, Indiana State Fair, 1940, 1941; Indiana A., 1942, 1944, 1951, 1956; Hoosier Salon, 1943, 1944, 1969; A. Dir. Cl., Chicago, 1945; first award, Indiana Sesquicentennial Design Comp., Seal and Commemorative Stamp, 1965. Work: Herron AI; covers for Popular Mechanics magazine. Exhibited: PAFA, 1940, 1943; Advertising A. Exh., N.Y., 1945; A. Dir. Cl. Chicago, 1945, 1954; Hoosier Salon, 1943, 1944; Indiana A., 1937, 1942, 1943; Indiana AC, 1944; Indiana State Fair, 1936, 1940, 1941. Illus. Collier's, Coronet, Red Book magazines. Positions: Hd., Commercial A. Dept., John Herron AI, Indianapolis, Ind., 1937-45; I., Stevens, Gross Studios, Inc., Chicago, Ill. Covers for Sports Afield; Coronet; Country Gentleman magazines.

WEIDENAAR, REYNOLD H(ENRY)—Printmaker, P., T.
 341 Atlas Ave., S.E.; h. Morton House, 72 Monroe Ave., Grand Rapids, Mich., 49502
B. Grand Rapids, Mich., Nov. 17, 1915. Studied: Kansas City AI. Member: NA; Phila. Pr. Cl.; Phila. WC Cl.; SAGA; AAPL; F., Soc. Western A.; AWS; All. A. Am.; Michigan Pr. M.; Michigan Acad. Sc., A. & Let.; North Shore A.; Springfield A. Lg., and many other organizations. Awards: Guggenheim F., 1944; Tiffany Fnd. scholarship, 1948; prizes, Detroit Inst. A., 1946, 1949, 1953; Bridgeport A. Lg., 1947, 1949, 1953, 1954; George Walter Vincent Smith Mus., 1948; Conn. Acad. FA, 1948; Delgado Mus. A., 1948; Norton Gal. A., 1948; New Jersey P. & S. Soc., 1948; Fla. Fed. A., 1949-1951, 1953; SAGA, 1950; Cal. Soc. Et., 1950; Audubon A., 1950; Oakland A. Gal., 1951; Providence A. Cl., 1951; Springfield Mus. A., 1952; Chicago Soc. Et., 1951; Clearwater Mus. A., 1951, 1952; Fla. Southern Col., 1952; Brick Store Mus., 1953; Dallas Pr. Soc., 1954; NAD, 1954; Mich. Artists, 1960; Soc. Western A., 1962; AAPL, 1962; John Taylor Arms award, Michiana Exh., 1962; Cooperstown (N.Y.) AA, 1962; gold medal, A. Lg. of Long Island, 1964, and many others. Work: PMA; BMFA; Norfolk Mus. A. & Sc.; Brooks Mem. Mus.; L.D.M. Sweat Mem. Mus.; Nat. Gal., New South Wales; Liverpool, England, Pub. Lib.; CMA; Oklahoma A. & M. Col.; N.Y. Pub. Lib.; Carnegie Inst.; CM; DMFA; MMA; Pa. State Univ.; WMA; LC; U.S. Nat. Mus.; Detroit Inst. A.; Nelson Gal. A.; Hackley A. Gal. Exhibited: Bradley Univ., 1952; Oakland A. Gal., 1948-1951; SAGA, 1948-1952, 1953, 1954; PAFA; Audubon A., 1948-1952, 1954, 1955; Northwest Pr. M., 1948-1952; NAD, Mus. A., 1954; Wichita AA, 1954; New Orleans AA, 1948-1952, 1954, 1955; Wash. WC Cl., 1955; Portland 1948-1951, 1954, 1955; Detroit Inst. A., 1948-1951, 1954, 1955, 1957; Phila. Pr. Cl., 1949, 1952; Chicago Soc. Et., 1948-1952; LC, 1951; Butler Inst. Am. A., 1957, 1958; AWS, 1957; traveling exh., Am. Prints, 1951; Old Bergen A. Gld. traveling exh.; one-man: Hamline Gal., 1948; Albany Inst. Hist. & A., 1948; Fla. Southern Col., 1950; Miami A. Center, 1950; Okla. A. & M. Col., 1950; Wustum Mus. A., 1950, 1952; Univ. British Columbia, 1951; Wesleyan Univ., 1952; and others. Contributor to Design Magazine; Art Material Trade News. Illus. "Great Lakes Shipwrecks and Survivals," 1960; "Michigan," 1965. Positions: Hd. Dept. Life Drawing, Kendall Sch. Des., Grand Rapids, Mich.

WEIDNER, ROSWELL THEODORE—Painter, Lith., T.
 612 Spruce St., Philadelphia, Pa. 19106
B. Reading, Pa., Sept. 18, 1911. Studied: Barnes Fnd.; PAFA. Member: Phila. WC Cl.; Int. Inst. for Conservation of Hist. & Artistic Works; AEA; Phila. A. All. Awards: F., PAFA; Cresson traveling scholarship, PAFA, 1936; Granger Mem. prize, F., PAFA, 1960; Dawson Mem. prize, PAFA, 1964. Work: Reading Mus. A.; MMA; LC; PAFA; Pa. State Col.; PMA; Univ. Pa.; Conn. State Library, Hartford. Exhibited: PAFA, to 1969; NAD; CGA; Pepsi-Cola; Phila. Sketch Cl.; Phila. A. All.; Kutztown State T. Col.; PMA; Woodmere A. Gal.; one-man: PAFA, 1948, 1965; Reading Mus., 1960; Terry AI, 1956; Phila. A. All., 1962; Peele House, Phila., 1965; William Penn Mem. Mus., Harrisburg, Pa., 1966. Positions: Instr., Painting & Drawings, PAFA, Philadelphia, Pa.; Pres., F., PAFA, 1957- .

WEIL, MR. and MRS. RICHARD K.—Collectors
 6372 Forsyth Blvd., St. Louis, Mo. 63101*

WEILL, ERNA—Sculptor, C., T.
 886 Alpine Dr., Teaneck, N.J.
B. Germany. Studied: Univ. Frankfurt, Germany. Member: N.Y. Soc. Artist-Craftsmen; Bergen A. Gld.; Modern A. Gld.; AEA; Com. on A. Edu. Awards: prizes, Int. Exh. Women's Art, 1946, 1947; Grant, Mem. Fnd. for Jewish Culture. Work: Tel-Aviv Mus., Israel; Bezalel Mus., Jerusalem; Hebrew Univ., Jerusalem; Georgia State Mus., Athens; Hyde Park Lib.; Jewish Mus., N.Y.; Birmingham Mus.

A.; House of Living Judaism, N.Y.; Fairleigh Dickinson Univ.; Rutgers Univ.; Center for the Study of Democratic Insts.; N.Y. Pub. Lib.; arch. sc., Teaneck Jewish Center; Temple Har-el, Jerusalem; White Plains Jewish Center; ports. of prominent persons in private colls. Exhibited: BM, 1951; Village A. Center, 1948-1954; Mus. Natural Hist., N.Y.; N.Y. Soc. Craftsmen; N.Y. Soc. Ceramic A.; Jewish Mus., N.Y., 1953, 1955; AEA; Montclair A. Mus.; Newark Mus.; Montclair T. Col., 1964; N.Y. World's Fair, Jersey pavillion; Jersey City Mus.; Lever House; one-man: Carlebach Gal., N.Y., 1951; Schoeneman Gal., N.Y., 1957; Fairleigh Dickinson Univ., 1965. Contributor to Design, School Arts magazines; covers for "Library Journal" and "N.J. Education Review," 1969. Lectures: Religious Art; Ceremonial Objects. Positions: Instr., S., Ceramics, BM, 1942-43; Forest Hills, N.Y. and Teaneck, N.J. Community Centers; and privately.

WEILL, MR. and MRS. MILTON—Collectors
65 West 54th St., New York, N.Y. 10019*

WEIN, ALBERT W.—Sculptor, P., Des., E.
5450 Encino Ave., Encino, Cal. 91316
B. New York, N.Y., July 27, 1915. Studied: Maryland Inst.; BAID; NAD; Grand Central Sch. A. Member: F., Am. Acad. in Rome; F., NSS; Arch. Lg.; All. A. Am.; F., Huntington Hartford Fnd.; F., Int. Inst. A. & Lets.; Soc. Motion Picture A. Dirs. Awards: prizes, Prix de Rome, 1947, 1948; Tiffany Fnd. grant, 1949; Hudson Valley AA, 1948; Medallic Art Co., 1949; Ecclesiastical S. Comp., 1950; NSS, 1942, 1946; Mun. A. Comm., 1938; BAID, 1934; Arch. Lg., 1944. Work: Gramercy Park Mem. Chapel, N.Y.; USPO, Frankfort, N.Y.; Eugene Higgins Mem., Woodlawn Cemetery, N.Y.; Memorial Cemetery, Los Angeles; Brookgreen Gardens, S.C.; medal for Soc. Medalists; medallion, Am. Inst. of Commemorative Art.; Des. for Steuben Glass Co., presentation bowl for Pres. Trujillo, Dominican Republic, among others. Jewish Mus., N.Y., bronze portrait plaque of Hon. Abba Eban; bronze ext. sc., and art work for altar, Temple Akiba, Culver City; stained glass windows, Temple Beth El, Riverside, Cal.; bronze wall sc., Temple Beth David, Temple City, Cal.; bas-relief panels, Univ. Wyoming Sci. Center; sc., St. Michael's Episcopal Church, Anaheim, Cal.; bronze sc., Hillside Memorial Park, Los Angeles; Memorial to Six Million, Los Angeles; Cuffee Medal, Am. Negro Com. Soc.; William Ellery Channing Medal, Hall of Fame. Exhibited: Cal. PLH; Syracuse Univ.; NAC; A.I.A. Arts in Architecture exh., Los A.; Pittsburgh Plan for Art; NAD; MMA; Arch. Lg.; WMAA; SFMA; Jewish Mus., N.Y.; Mun. A. Gal.; one-man: Argent Gal., 1951; Cowie Gal., Los A., 1957, 1958; Manhattan Gal., Pasadena, 1959; Canton AI, 1961; Ross Widen Gal., Cleveland, 1961; Michel Thomas Gal., Beverly Hills, 1962; Heritage Gal., Los A., 1965, 1967-1969. Positions: Visiting Prof. of A., Univ. of Wyoming, 1965-1967.

WEINBERG, ELBERT—Sculptor, Printmaker
Via Appia Antica 20, Rome, Italy
B. Hartford, Conn., May 27, 1928. Studied: Hartford A. Sch.; R.I. Sch. Des., B.F.A., with Waldemar Raemisch; Yale Univ., M.F.A. Awards: Prix de Rome, 1951; Guggenheim F., 1959; Nat. Inst. A. & Lets., 1968. Work: MMoA; Jewish Mus., N.Y.; Brandeis Univ.; Colgate Univ.; Fed. Reserve Bank, Atlanta; Reynolds Aluminum Award; White Plains Jewish Community Center; AGAA; Yale Univ. A. Gal.; wall, lobby of 405 Park Ave., N.Y.; Menorah Synagogue; dec., children's ward, Warm Springs (Ga. Polio Fnd.) Exhibited: WMAA, 1957, 1958, 1960, 1964; one-man: Providence (R.I.) A. Center, 1951, 1954; Grace Borgenicht Gal., 1958, 1960; Boris Mirski Gal., Boston, 1963. Positions: Asst. Instr., R.I.Sch.Des. & Yale Univ.; S., and Des., Cooper Union A. Sch., New York, N.Y., 1956-1959.

WEINER, ABE—Painter, T., L.
1636 Denniston Ave., Pittsburgh, Pa. 15217
B. Pittsburgh, Pa., Nov. 5, 1917. Studied: Carnegie Inst. Tech., Col. of FA; and with Robert Gwathmey, Clarence Carter, Samuel Rosenberg, A. Kostellow. Member: Assoc. A. Pittsburgh. Awards: prizes, Assoc. A. Pittsburgh, 1941, 1945, 1958, 1959, special exh., 1953; Carnegie Inst., 1950; Three Rivers A. Festival, Pittsburgh, 1968, purchase. Work: Chatham Col., Pittsburgh; 100 Friends of Art, Pittsburgh; Latrobe H.S., Latrobe, Pa.; mural, Alcoa Room, Duquesne Cl., Pittsburgh, and other work in private colls. Exhibited: Carnegie Inst., 1946-1949, Carnegie Int., 1950; MMA, 1953; Assoc. A. Pittsburgh, 1941-1964; Butler Inst. Am. A., 1946, 1950; Carnegie Nat. & Int., traveling exh., 1948-1950; Contemp. A. Soc., Chicago, 1947; one-man, Ivy Sch. Professional A., 1968. Lectures: Contemporary Painting. Positions: private instruction; Asst. Dir., Ivy School of Professional Art, all Pittsburgh.

WEINER, EGON—Sculptor, E., L.
835 Michigan Ave., Evanston, Ill. 60432
B. Vienna, Austria, July 24, 1906. Studied: Sch. A. & Crafts, Acad.

FA, Vienna. Member: F., Int. Inst. A. & Lets. (Life); Mun. A. Lg., Chicago (Dir. 1961-64); Am. Soc. for Church Architecture; MModA.; Hon. F., Am-Scandinavian Fnd.; Nat. Inst. A. & Lets. (Adv. Council, 1968-1970). Awards: prizes, Grand Prix, Paris, 1925; Blumfield award, Vienna, 1932-34; Mun. A. Lg., Chicago, 1948, gold medal, 1969; Syracuse Mus. FA, 1949; AIA, 1955, Citation, 1962; Mus. Science & Indst., Chicago, 1955; Roosevelt Univ., Chicago, 1956; medals, AIC, 1949 prize, 1959; Oakland A. Mus., 1945, 1951. Work: Syracuse Mus. FA; Augsburg Col., Minneapolis; Augustana Col., Rock Island, Ill.; groups, reliefs, figures, Church of St. Augustin, Vienna; Salem Church, Chicago; windows (6) Standard Cl., Chicago; figure, Concordia Col., Ft. Wayne, Ind.; Chicago Airport; Glencoe, Ill.; Amalgamated Meatcutters Union Bldg., Chicago; St. Paul Church, Mt. Prospect, Ill.; "Pillar of Fire," Fire Academy, Chicago, 1962; Univ. Wis., 1963; bronze relief, Presbyterian Church, La Grange, Ill., 1964; bronze fig., new Science Bldg., North Park Col., Chicago; Gary (Ind.) Public Library; American Church, Oslo; bronze, Marina City, Chicago; portrait busts, Sen. William Benton, for Encyclopaedia Britannica, Chicago; Dr. Eric Oldberg for Illinois Research Hospital, Chicago; sculpture in coll. of the Vatican. Other work: des. for marble cemetery monument to Mayor Baeck, Salzburg, 1960; fig., American Embassy, Oslo; Exhibited: AIC, 1940-1964; PAFA, 1941, 1947, 1949-1951; Oakland Mus. A., 1942, 1945, 1946, 1948-1951; Univ. Chicago, 1943, 1945, 1960; Syracuse Mus. FA, 1948-1951, 1958; Portland (Ore.) A. Mus., 1948; CAM, 1949; Assoc. Am. A., Chicago, 1949; MMA, 1951; A. Center, Chicago, 1954; Religious Art exh., Minneapolis, 1957; Denver Mus. A., 1958; Northwestern Univ., 1961; Am. Embassy, Oslo, 1960; Int. Religious Exh., Salzburg, 1962; Seattle World's Fair, 1962; N.Y. World's Fair, 1964-65; one-man: AIC; Renaissance Soc., 1947; Illinois Inst. Tech., 1949; Univ. Illinois, 1951; Lawrence Col., 1951; Palmer House, Chicago, 1955; Davenport Mun. A. Gal., 1958, 1963; Augustana Col., 1958; AIA, 1958; McKerr Observatory Gal., Chicago, 1961; Univ. Valparaiso, Ind., 1959; Concordia Col., Chicago and Nevada, 1960; Bloomington, Ill., 1961; Conrad Gal., Chicago, 1965. Contributor to American-German Review; Frontiers; Figure magazines. Lectures, U.S. and abroad. Positions: Prof. S. and Life Drawing, AIC, Chicago, Ill. Visiting Prof. A., Augustana Col., 1956. Edu. Consultant for film on the Del Prado Mus., Madrid, Spain, 1969, for Int. Film Bureau, Chicago. Roundtable discussion at the 100th Anniversary Celebration of Frank Lloyd Wright, in Oak Park, Ill., in connection with the portrait bust of Mr. Wright, which the artist completed in 1969.

WEINER, MRS. SAMUEL—Collector
737 Park Ave., New York, N.Y. 10021*

WEINER, TED—Collector
2601 Ridgmar Plaza 76116; h. 4808 Westridge St., Fort Worth, Tex. 76116; also, 1021 Capistrano Ct., Palm Springs, Cal. 92262
B. Forth Worth, Tex., Mar. 9, 1911. Awards: West Texas Chamber of Commerce Cultural Award in appreciation for contributions to the cultural functions of the area. Collection: Contemporary Paintings and Sculpture, including works by Henry Moore, Maillol, Marino Marini, Modigliani, Lipchitz, Picasso, Callery, Voulkos, Chadwick, Noguchi, Calder, Laurens, Marcks, de la Fresnaye, de Stael, Tamayo, Parker Kline. Positions: Member Board of Directors of Forth Worth Art Association; Fort Worth Symphony Orchestra; Van Cliburn International Competition Foundation; Palm Springs Desert Museum; Palm Springs Cultural Committee; member, Art Commission, City of Fort Worth. Sponsor, Experimental Art Class, Fort Worth Museum of Science and History.

WEINGAERTNER, HANS—Painter
11 Maple St., Belleville, N.J. 07109
B. Kraiburg, Germany, Sept. 11, 1896. Studied: Royal Acad., Munich, Germany and with Ludwig Klein, Moritz Hyman. Member: Audubon A.; New Jersey WC Soc. Awards: prizes, Montclair A. Mus., 1949, 1950; Bamberger purchase, 1964. Work: Newark Mus.; Rutgers Univ.; Jefferson H.S., Elizabeth, N.J., and in many private colls., U.S. and Germany. Exhibited: AIC; CGA; Newark Mus. (one-man show); Seton Hall (one-man show) 1967; Carnegie Inst.; VMFA; Montclair A. Mus.; New Jersey State Mus.; Pa. State T. Col.; PAFA; WMAA; NAD; Am. Acad. FA; AWS; New Jersey WC Soc. Positions: Instr., Fine Arts & Anatomy, Newark Sch. F. & Indst. A., Newark, N.J.

WEINGARTEN, HILDE (Mrs. Arthur Kevess)—Printmaker, P.
140 Cadman Plaza West, Brooklyn, N.Y. 11201
B. Berlin, Germany. Studied: ASL; Cooper Union (Grad.). Member: AEA (Bd. Dirs.); NAWA; Lg. of Present Day A.; P. & S. Soc. of New Nersey; Contemp. A. of Brooklyn. Work: Bezalel Nat. Mus., Israel and private colls. Exhibited: CGA; BM; Phila. A. All.; Phila. Pr. Cl.; Albright-Knox Gal., Buffalo; Rochester Mem. Gal.; Bradley Univ.; CMA; SAM; Denver A. Mus.; DMFA; Riverside Mus., N.Y.; Bezalel Mus., Israel; Osaka, Japan; Art:USA, 1958, N.Y.; ACA Gal.,

N.Y.; Mari Gal., Woodstock, N.Y.; Paul Kessler Gal., Provincetown, Mass.; Loeb Student Center, N.Y. Univ.; Donnell A. Library, N.Y.; Old Bergen Guild, New Jersey traveling exh.; and others. One-man: Hicks St. Gal., Brooklyn, 1962, 1968; Contemp. A., N.Y., 1963, 1966. Graphics reproduced in "The Tune of the Calliope," 1958; "German Folksongs," 1968.

WEINHARDT, CARL J(OSEPH) JR.—Museum Director
Art Association of Indianapolis, Herron Museum of Art, 110 E. 16th St., Indianapolis, Ind. 46202
B. Indianapolis, Ind., Sept. 22, 1927. Studied: Harvard College, A.B.; Harvard Grad. Sch. of Edu., M.A.; Grad. Sch. of Arts & Sciences, Harvard University, M.F.A.; L.H.D., Christian Theological Seminary, 1968. Member: CAA; Soc. Architectural Historians; Municipal A. Soc., N.Y.; Assn. A. Mus. Dirs. Awards: Phi Beta Kappa, Harvard Univ.; Travel Grants from MMA, 1955-1960; Lotos Club of New York Award of Merit, 1964. Contributor of articles to: Metropolitan Museum Bulletin; Minneapolis Inst. Arts Bulletin; Art in America; Sat. Review (articles on photography). Author: "Domestic Architecture of Beacon Hill, 1800-1850" (The Bostonian Soc., 1958). Arranged exhibitions: "18th Century Design" (MMA, 1960); "The Mc-Millan Collection" (Minn. Inst. A., 1962); "Four Centuries of American Art," 1963; "Tchelitchew," "Corinth" and "Marsh" (Gallery of Modern Art, N.Y.). Positions: Instr., Boston Architectural Center, 1954-55; Columbia Univ., 1957-59; Assoc. Cur., Metropolitan Museum of Art; Dir., Minneapolis Inst. Arts to 1963; Dir., The Gallery of Modern Art, N.Y., 1963-1965; Dir., Art Association of Indianapolis (which operates the John Herron Museum and School of Art), Indianapolis, Ind., 1965- .

WEINMAN, ROBERT ALEXANDER—Sculptor
37 East 28th St., New York, N.Y. 10016; h. Cross River Road R.D. 1, Bedford, N.Y. 10506
B. New York, N.Y., Mar. 19, 1915. Studied: NAD. Member: F., NSS (Sec., 1961-64, 1st V.P., 1965-68): Awards: prizes, NSS, 1952; Saltus award, 1965. Work: Brookgreen Gardens, S.C.; Our Lady Queen of Martyrs Church, N.Y.; U.S. Military Acad., West Point, N.Y.; bronze doors, Armstrong Lib., Waco, Tex.; medals, series of 12 for Nat. Collegiate Athletic Assn.; Am. Arbitration Assn.; Am. Chemical Soc.; Airmen's Mem., Tulsa, Okla.; figures, Mary Immaculate Seminary, Northampton, Pa.; sc. entrance, Our Lady of Perpetual Help, Richmond Hill, N.Y.; Stations of the Cross, Chapel, Manhattanville College, Purchase, N.Y.; medals, Crusade for Freedom; Studebaker 100th Anniversary; Helms Athletic Fnd.; Int. Golf Assn.; Canada Cup Medal; Immaculate Conception; Nash Conservation Award medal; A.I.A. President's Medal; trophies; Sports magazine award; Int. Golf Low Score Trophy; sc. dec., Fed. Reserve Bank, Buffalo, N.Y., and others. Exhibited: NAD; PAFA; Albany Inst. Hist. & A.; NAC; NSS.

WEINSTEIN, MR. and MRS. JOSEPH—Collectors, Patrons
450 7th Ave. 10001; h. 211 Central Park West, New York, N.Y. 10024
Mr. Weinstein: New York, N.Y., Nov. 13, 1899. Studied: Harvard University. (Mrs. Weinstein): Simmons College. Collection: Picasso, Cezanne, Renoir, Rouault, Soutine, Max Weber, Balcomb Greene, Rodin, Zogbaum, Zorach and others. Also included in the collection: African Sculpture.

WEINTRAUB, JACOB D.—Art dealer
992 Madison Ave., New York, N.Y. 10021*

WEISGARD, LEONARD—Illustrator, Des., L., T., W.
Roxbury, Conn. 06783
B. New Haven, Conn., Dec. 13, 1916. Studied: PIASch.; & with A. Brodovitch. Awards: prizes, Caldecott award, 1947; AIGA awards; SI awards. Work: MModA Children's Coll. Exhibited: MModA; MMA; AIGA, 1958; & in many libraries. Author: numerous children's books, 1936-1946; "Silly Willy Nilly," publ. in Near East. Author, I., "Treasures to See," 1957; "Mr. Peaceable Paints," 1957; I., "First Days of the World," 1959; "First People in the World," publ. in Persian, 1958; "When I Go to the Moon," 1961; "Where Does the Butterfly Go in the Rain?," 1961; "The Athenians," 1964; "The Beginnings of Cities," 1969. Contributor to: New Yorker, American Home, Ladies Home Journal, & other magazines. Lectures: "Primitive Art Forms in Relation to Children's Books"; "How to Illustrate a Child's Book"; "Creativity" lectures at Danbury State Teacher's College, 1964. Other lectures, Oneonta State Univ.; Ohio Univ. Des. for San Francisco Ballet Co.; children's greeting cards, United Nations. Positions: A. Consultant, Field Edu. Enterprises, 1958; Consultant with Boston Univ. seminar Television and the Child, 1958.

WEISGLASS, MR. and MRS. I. WARNER—Collectors
475 Park Ave., New York, N.Y. 10022*

WEISMAN, WINSTON R.—Educator, W., Art Historian
Department of Art History, Pennsylvania State University, University Park, Pa.; h. 525 Glenn Road, State College, Pa. 16801
B. New York, N.Y., Feb. 3, 1909. Studied: Ohio Univ., B.A., Ph.D.; N.Y. Univ., Inst. FA, M.A. Member: CAA; Soc. Architectural Hist. (Dir. 1965). Awards: Carnegie Fnd. Scholarship; F., Am. Council of Learned Soc. Research grant; Am. Philosophical Research grant (2). Graduate lecturer, Univ. Pennsylvania Inst. FA; Concora Lecturer, Northwestern University. Many contributions to: Architectural Review; Journal of the Soc. of Arch. Hist.; Catholic Art Quarterly; College Art Journal, Journal of the Am. Inst. Arch.; American Heritage; N.Y. Times Sunday Magazine; Art Bulletin, etc. Field of Research: History of Commercial Architecture. Positions: Hd. Art History Dept., Pennsylvania State Univ., University Park, Pa. 1953- ; Dir., Center for the Study of Renaissance and Baroque Art, Pennsylvania State University, 1966.

WEISMANN, DONALD LeROY--Educator, P., Cr., L., W.
Department of Art, Div. Comparative Studies & Humanities Research Center, University Texas 78712; h. 405 Buckeye Trail, Austin, Tex. 78746
B. Milwaukee, Wis., Oct. 12, 1914. Studied: Wisconsin State Col., B.S.; Univ. Minnesota; Univ. Wisconsin, Ph.M.; St. Louis Univ.; Harvard Univ.; Ohio State Univ., Ph.D. Member: AAUP; CAA; Am. Studies Assn.; Texas FA Soc. Awards: Carnegie FA Scholarship, Harvard Univ., 1941; prizes, Wis. P. & S., 1934, 1936; Wis. Mem. Gal., 1937; Ky.-Ind. Exh., J. B. Speed Mus. A., 1953; DMFA, 1955-1957 (purchase); Butler Inst. Am. A., 1957 (purchase); D. D. Feldman Exh., 1955, 1956, 1957, 1958 (purchase); other purchase prizes, Southwest Am. A., 1961; Chrysler Mus., 1959; Columbia (S.C.) Mus. A., 1961; Longview (Tex.) purchase prize, 1968; Univ. Research Inst. Award, Italy, 1961-62; Bromberg Teaching Excellence Award, 1965. Work: mural, Illinois Centennial Bldg. Exhibited: Nationally and internationally, 1934-1969. Contributor to College Art Journal; Midwest Review; New Mexico Quarterly; Southwestern Art; Texas Quarterly; New Republic; Christian Scholar; New Catholic Encyclopedia; Cronache Culturali (Florence, Italy). Author: "Some Folks Went West," 1960; "Jelly Was the Word," 1965; "Language and Visual Form," 1968; "An Introduction to the Visual Arts," 1969. Produced TV Videotape series "Mirror of Western Art" for National Educational Television, 1960; also, "The Visual Arts." Ford Foundation, 1961. Lectures: Aesthetics; 19th & 20th Century Painting, Assembled, catalogued exhs.: Ulfert Wilke Retrospective Exh., Univ. Kentucky. FA Gal.; Victor Hammer Retrospective, Univ. Kentucky. Positions: Asst. Prof., Illinois State Normal Univ., 1940-42, 1946-48; Prof., Wayne Univ., 1949-51; Prof., Hd. A. Dept., Univ. Kentucky, 1951-54; Prof., Chm., Dept., A., Univ. Texas, 1954-58, Grad. Prof., A. Hist., 1958-64, Univ. Prof. in the Arts, 1964- , Chm., Dir. Comparative Studies, 1967- . Austin, Tex. Special Consultant, USIS, Florence, Italy, 1961-62. Member, Nat. Council on the Arts, Presidential Appt., 1966-1972.

WEISS, LEE (ELYSE C.)—Painter
106 Vaughn Court, Madison, Wis. 53705
B. Inglewood, Cal., May 22, 1928. Studied: Cal. Col. A. & Crafts. Member: AEA; AWS; Cal. Nat. WC Soc.; Phila. WC Soc.; Wis. P. & S.; Wis. WC Soc. Awards: Medal of Honor, Knickerbocker A., 1964; prizes, grand prize and 2 purchase awards, Madison A., 1963; John Singer Sargent Mem. Award, Springfield Mus. A., 1965; AWS Lowe Award, 1966; Ranger Fund purchase, NAD, 1967; AWS traveling 1966-1967, 1969-1970; Watercolor: USA purchase, 1966; John Marin Mem. Award, 1967; Winslow Homer Mem. Award, 1968; Ill. Regional, 1964, 1965; Wustum Mus., Racine, 1966-1968; Union Lg., Chicago, purchase, 1967; Loomis Mem. Award, Waterloo, Iowa, 1968. Other prizes, 1959-62. Exhibited: AWS, 1964-1967, 1969; PAFA, 1965, 1968; NAD, 1965, 1967, 1969; All. A. Am., 1964; Denver A. Mus., 1964; Knickerbocker A., 1964, 1965; Wash. WC Soc., 1964; Butler Inst. Am. A., 1964, 1966, 1967; Miss. AA, 1965; Watercolor:USA, 1964, 1965, 1966; Union Lg., Chicago, 1965, 1967, 1969; Grand Rapids Mus., 1963, 1964; SFMA, 1960; Ill. State Fair, 1964, 1965, 1966, 1968; Wis. State Fair, 1963, 1964; Wis. Salon of Art, 1965, 1967; Madison A., 1963, 1965; WAC, 1960; The White House, 1969; Cal. Nat. WC Soc., 1965-1967; traveling exh.; Audubon A., 1966, 1967, 1969; Marquette Univ., 1968; Milwaukee A, Center, 1965, 1967; Int. WC Exh., San Diego, 1967; one-man: Cal. PLH, 1962; Minneapolis Inst. A., 1963; Univ. Wisconsin, 1963; Rochester A. Center, 1964; Distelheim Gal., Chicago, 1963, 1964; Forsythe Gal., Ann Arbor, 1962, 1964, 1966, 1968; Saginaw Mus. A., 1964; WAC, 1960; Milwaukee AI, 1965. Bergstrom A. Center, 1968; Davenport Mun. Mus., 1967; Bader Gal., Wash., D.C., 1966, 1968, 1969; Gilman, Chicago, 1968; Kenosha Pub. Mus., 1965; Naples, Fla., 1969, and others. Work: Davenport Mus.; George Washington Univ.; Hickory (N.C.) Mus.; NAD; Springfield (Mo.) Mus.; U.S. Dist. Court, Wash., D.C.; Wustum Mus. FA, Racine, and others.

WEISSMAN, POLAIRE—Executive Director
Costume Institute, Metropolitan Museum of Art, Fifth Ave. at 82nd St., New York, N.Y. 10028

WEITZMAN, MR. and MRS. J. DANIEL—Collectors
45 Sutton Place South, New York N.Y. 10022*

WEITZMANN, KURT—Scholar
McCormick Hall, Princeton University; h. 30 Nassau St., Princeton, N.J. 08540
B. Almerode, Germany, Mar. 7, 1904. Studied: Universities of Muenster, Wurzburg, Vienna and Berlin (Ph.D. Univ. Berlin). Author of 11 books and about 70 articles. Field of Research: Late Classical, Early Christian, Byzantine and Western Medieval Art. Awards: Doctor honoris causa, Univ. Heidelberg, 1967; L.H.D., Univ. Chicago, 1968. Member: Board of Scholars, Dumbarton Oaks, Harvard University, Washington, D.C.; Fellow, Medieval Academy of America; Member, American Philosophical Society, Philadelphia; Academy of Science, University of Göttingen; Permanent Member, Institute for Advanced Study, 1935- , Princeton University. Five expeditions to Mount Athos; five expeditions to Mount Sinai for the study of Byzantine Art. Positions: Assoc. Prof., 1945-1950, Prof., 1950- , Art and Archaeology, Princeton University, Princeton, N.J.

WELCH, JAMES HENRY—Collector
James Welch Hammond Organ Studios, 308 W. Tusc. Parkade Bldg. 44702; h. 114 48th St. N.W., Canton, Ohio 44709
B. Cleveland, Ohio, June 21, 1931. Studied: Western Pa. Horological Institute, Pittsburgh, Certified Watchmaker; College of Wooster, B.A. Member: National Association of Watch and Clock Collectors. Collection: 17th, 18th and early 19th century decorative watches, including enamel automaton repousse, and complicated watches, some of historical interest; Small collection of 18th century English musical clocks; American paintings—Hudson River, 19th century portraits and still lifes; British 19th century landscapes and portraits; French Barbizon School landscapes. Positions: President, Ohio Valley Chapter, National Association of Watch and Clock Collectors, 1964-1965.*

WELCH, LIVINGSTON—Sculptor, P.
c/o Shuster Gallery, 536 Third Ave., New York, N.Y. 10016
B. New Rochelle, N.Y., Aug. 8, 1901. Studied: Hunter Col., N.Y. Work: Notre Dame Univ. Mus.; Casanova Col. Exhibited: one-man shows in New York since 1961 including World House Gal., 1962-1965; Shuster Gal., N.Y., 1965-1969; Caravan Gal., N.Y., 1956; Wellons Gal., N.Y., 1948.

WELCH, MR. and MRS. ROBERT G.—Collectors
540 Terminal Tower 44135; h. 16800 S. Woodland, Cleveland, Ohio 44120*

WELCH, STUART CARY—Scholar, Mus. cur.
Fogg Art Museum, Quincy St. & Broadway, Cambridge, Mass. 02138*

WELLER, ALLEN STUART—Educator, Cr., W., L.
110 Architecture Bldg., University of Illinois; h. 412 W. Iowa St., Urbana, Ill. 61801
B. Chicago, Ill., Feb. 1, 1907. Studied: Univ. Chicago, Ph.B., Ph.D.; Princeton Univ., A.M.; Indiana Central College, LL.D. Member: CAA (Bd. Dir.); Nat. Assn. Sch. Art (Bd. Dir.); Midwestern College A. Conf.; Soc. Arch. Historians. Awards: Carnegie F., 1927-28; Princeton Univ. F., 1928-29; Bureau of Univ. Travel F., 1929; Legion of Merit, 1945. Author: "Francesco di Giorgio, 1439-1501," 1942; "Abraham Rattner," 1956; "Art U.S.A. Now," 1962; "The Joys and Sorrows of Recent American Art," 1968. Contributor articles and reviews to art magazines. Book review Ed., College Art Journal, 1949-57; Chicago correspondent, Art, 1952-58. Positions: Ass. Prof., Univ. Missouri, 1929-42, Assoc. Prof., 1946-47, Prof. A., 1947- , Hd. A. Dept., 1948-54, Dean, Col. F. & App. A., 1954- ; Director, Krannert A. Museum, 1964- , Univ. Illinois, Urbana, Ill.; Visiting Prof. Hist. A., Univ. Minnesota, 1947, Univ. Colorado, 1949, Univ. California, 1950, 1953, Univ. Rhode Island, 1963, Aspen Inst. for Humanistic Studies, 1963, Oregon State Univ., 1968. Member, Illinois Arts Council; Advisory Board and Chairman, Humanities Comm., Field Educational Enterprises.

WELLIVER, NEIL—Painter, T., Cr.
516 Woodland Terr., Philadelphia, Pa. 19104
B. Millville, Pa., July 22, 1929. Studied: PMCol. A.; Yale Univ., with Albers, Diller, Brooks, Relli. Awards: Morse Fellowship, 1960-61. Exhibited: AFA traveling exh., 1960, 1968; Stable Gal., N.Y., 1959; NAC, 1959; MModA; Frumkin Gal., N.Y., 1967; Vassar Col. Mus., 1968; WMAA; PAFA; Univ. Illinois; Colby Col.; Brandeis Univ.; Yale Univ.; one-man: Phila., Pa., 1953; Boston, Mass., 1959; Stable Gal., 1964, 1966; Tibor de Nagy Gal., N.Y., 1968, 1969;

Swarthmore Col., Wilcox Gal., 1966. Positions: Critic, Painting, CUASch., 1954-57; Yale University, New Haven, Conn., Univ. Pennsylvania. Contributor to: Art News; Craft Horizons; Perspecta. Work featured in Art News, "Welliver's Travels," 1968.

WELLS, CHARLES—Sculptor
c/o FAR Gallery, 746 Madison Ave., New York, N.Y. 10021*

WELLS, FRED N.—Executive Director
Nebraska Art Association, Sheldon Memorial Art Gallery 68508; h. 1235 Piedmont Road, Lincoln, Neb. 68510
B. Lincoln, Neb., Aug. 12, 1894. Studied: Univ. California at Berkeley; Univ. Nebraska, A.B. Awards: Sigma Delta Chi Honorary Journalistic Fraternity. Positions: Chm., Nebraska State Capitol Murals Commission, 1951-1965; Pres., Nebraska Art Assn., 1963-1964, Executive Secretary at present; Treas. and Director, Nebraska Arts Council.

WELLS, JAMES LESESNE—Painter, Lith., Eng.
1333 R St., Northwest, Washington 9, D.C.
B. Atlanta, Ga., Nov. 2, 1902. Studied: Lincoln Univ.; T. Col., Columbia Univ., B.S., M.A.; NAD, and with Frank Nankivell. Member: AFA; Wash. WC Cl. Awards: medal, 1931, prize, 1933, Harmon Fnd.; Wash. Artists, 1957; Wash. WC Cl., 1959; Smithsonian Inst., 1961; purchase award, AFA, for Talladega College, Ala., 1964. Work: PMG; Valentine Mus. A.; Thayer Mus. A.; Univ. Kansas; Hampton Inst.; Howard Univ.; Lincoln Univ.; IBM. Exhibited: Soc. Wash. Printmakers, 1962, 1963, 1964; Wash. WC Cl., Smithsonian Inst., 1962; CGA, 1963; Har Zion Temple, Phila., Pa., 1964, and many other exhs. in prior dates; one-man: Barnett Aden Gal., 1950, 1960; Graphic Div., Smithsonian Inst., 1962. Positions: Assoc. Prof. A., Howard Univ., Washington, D.C.*

WENGENROTH, STOW—Lithographer
717 Main St., Greenport, N.Y. 11944
B. Brooklyn, N.Y., July, 1906. Studied: ASL; Grand Central A. Sch.; & with George Pearse Ennis, John Carlson. Member: NA; Nat. Inst. A. & Let.; Providence WC Cl.; Conn. Acad. FA; SC; Prarie Pr. M.; SAGA; Smithsonian FA Comm. Awards: prizes, Phila. Pr. Cl., 1937, 1939; SC, 1937; AV, 1942; Northwest Pr. M., 1943; Conn. Acad. FA, 1943, 1946; Mint Mus. A., 1944; med., Phila. WC Cl., 1933, 1943; Audubon A., 1945, 1955; A. Fellowship med., 1944. Work: Syracuse Mus. FA; BMA; AGAA; Lib. Cong.; N.Y. Pub. Lib.; WMAA; Denver A. Mus.; Milwaukee AI; Los A. Mus. A.; SAM; FMA; BMFA; PAFA; MMA; Carnegie Inst.; Albany Inst. Hist. & A.; complete coll. of prints in Wiggin Collection, Boston Public Library. Exhibited: nationally. Position: Trustee, Tiffany Foundation.*

WERNER, ALFRED—Critic, Writer, Lecturer
230 W. 54th St. 10019; h. 453 Hudson St., New York, N.Y. 10014
Studied: University of Vienna; New York University Institute of the Fine Arts. Member: International Association of Art Critics. Awards: Professor Honoris Causa, conferred by the Austrian Government, 1967. Author: Twenty books published including works on Modigliani, Pascin, Chagall, Barlach. Contributor to Arts Magazine, Art Journal, American Artist, Kenyon Review, Antioch Review. Lectures: History of Modern Art, at Guggenheim Museum, Museum of Modern Art, National Gallery of Art, Jewish Museum. Positions: Instructor, Art History, Wagner College and City College, N.Y. U.S. Correspondent: Pantheon (Munich); Die Kunst und das Schöne Heim (Munich).

WERNER, DON(ALD) (L.)—Painter, Des.
Hudson River Museum, 511 Warburton Ave., Yonkers, N.Y. 10701; h. 65 W. 92nd St., New York, N.Y. 10025
B. Fresno, Cal., Feb. 2, 1929. Studied: Chouinard A. Inst., Los Angeles; Fresno State Col., B.A. Member: Gallery 84, New York. Awards: Fresno A. Center. Work: Murals, Dan River Mills, New York, N.Y.; Wellington-Sears, New York, N.Y.; other work Fresno A. Center. Exhibited: Hudson River Mus., 1965; Gallery 84, 1967-1970. Des., special display props for Seventeen and Better Homes & Gardens magazines. Exhibitions arranged and catalogues produced: "Art in Westchester," from private collections, 1969; Herbert Bayer and Ingerborg Ten-Haeft "Two Visions of Space"; Robert Hatton Monks "An American in Flanders," 1970. All installations at Hudson River Museum. Positions: Display Dir., (11 years), Seventeen Magazine; Instr., Watercolor, Collage, Assemblage, Museum Designer, Hudson River Museum, New York City, at present.

WERNER, NAT—Sculptor
225 E. 21st St., New York, N.Y. 10010
B. New York, N.Y., Dec. 8, 1910. Studied: Col. City of N.Y., B.A.; ASL; & with Robert Laurent. Member: S. Gld. Work: Lyman Allyn Mus.; WMAA; Hirshhorn Coll.; James Madison H.S., N.Y.; N.Y. Engineering Soc.; USPO, Fowler, Ind. Exhibited: WMAA, 1936-1946;

PAFA, 1942, 1943, 1945, 1946; AIC, 1942, 1943; MMA, 1941; MModA; ACA Gal., 1938, 1941, 1942, 1944, 1946, 1950, 1952, 1956, 1960, 1962; SAG Gal., 1965 (all one-man exh.). Lectures: Contemporary Sculpture.

WERTH, KURT—Illustrator
645 West 239th St., New York, N.Y. 10063
B. Leipzig, Germany, Sept. 21, 1896. Studied: State Acad. for Graphic Arts, Leipzig. Work: Museum of Art, Leipzig. Exhibited: one-man exhibitions, Leipzig and Berlin. Illus.: "Merry Miller," 1952; "Tailor's Trick," 1955; "The Year Without a Santa Claus," 1957; "Tony's Birds," 1961; "Honker Visits the Island," 1962; "A Tiger Called Thomas," 1963; "Meet Miki Takino," 1963; "Hear Ye of Boston," 1964; "Isabelle and the Library Cat," 1966; "Hear Ye of Philadelphia," 1967; "Miranda's Dragon," 1968; "The Bright and Shining Breadboard," 1969. Author, I., "The Monkey, the Lion, and the Snake," 1966; "The Cobbler's Dilemma," 1967; "King Thrushbeard," 1968.

WERTHEIM, MRS. MAURICE—Collector
43 East 70th St., New York, N.Y. 10021*

WESCHLER, ANITA—Sculptor, P.
510 La Guardia Place, 10012; h. 136 Waverly Place, New York, N.Y. 10014
B. New York, N.Y. Studied: Parsons Sch. Des.; ASL, with Zorach; PAFA, with Laessle. Member: NAWA; Arch. Lg.; Fed. Mod. P. & S.; S. Gld.; Audubon A.; Artist-Craftsmen of N.Y. Awards: medal, Montclair A. Mus.; Soc. Wash. A.; SFMA; Medal of Honor, Audubon A., 1963; prizes, Friends of Am. A., Grand Rapids, Mich.; F., McDowell Colony; F., Yaddo Fnd.; prize, AFA traveling exh., 1951; NAWA, 1952; F., PAFA, 1957. Work: WMAA; Univ. Nebraska; Amherst Col.; ASL; Norfolk Mus. A. & Sc.; Tel-Aviv Mus.; Turkish All.; USPO, Elkin, N.C., and in private colls. Author: "Nightshade," volume of poetry. Exhibited: MMA; WMAA; MModA; BM; AIC; PAFA; PMA; Carnegie Inst.; AFA traveling exh.; SFMA; S. Gld.; Am. Acad. A. & Lets.; Fed. Mod. P. & S.; Silvermine Gld. A.; Newark Mus.; Audubon A.; Art: USA, 1958, and others; one-man: Assoc. Am. A.; Weyhe Gal.; Hudson Park Branch, N.Y. Pub. Lib.; Robinson Gal.; Levitt Gal.; Suffolk Mus.; S. Gld., 1969 (3-man), and others; 20 one-man traveling exhs.; translucent paintings in fiber glass and plastic resin, 1956. Positions: Exec. Bd., Sculptors Gld. and delegate to I.A.A.

WESCOTT, PAUL—Painter
Heathcliff, West Chester, Pa. 19380; Friendship, Me. 04547
B. Milwaukee, Wis., Apr. 12, 1904. Studied: AIC; PAFA. Member: NA; PAFA (life); Chester County AA (life, Dir.); Phila A. All.; AFA; Wilmington Soc. FA; Portland Mus. A. (life). Awards: Cresson traveling scholarship, Toppan prize, PAFA, 1930, Lambert Fund, 1943; NAD, Ranger Fund, 1953, Obrig prize, 1954; Palmer prize, 1956, 1965, 1967; Andrew Carnegie prize, 1969, Altman prize, 1959; Butler Inst. Am. A., 1959 (purchase); Portland Mus. A., 1959; prize, Art: USA, 1958; Huston Prize, Miami, 1963; Medal, Phila. Sketch Club. Work: PAFA; NAD, etc. Exhibited: MMA; PAFA; NAD; PMA; BMA; CGA; AIC; Detroit Inst. A.; Toledo Mus. A.; CAM; Butler Inst. Am. A.; Farnsworth Mus. A.; Phila. A. All.; Portland Mus. A., and others. Positions: Instr., Dir., A. & Crafts, The Hill Sch., Pottstown, Pa., 1933-52.

WESSELMANN, TOM—Painter
c/o Sidney Janis Gallery, 15 E. 57th St., New York, N.Y. 10022
B. Cincinnati, Ohio, Feb. 23, 1931. Studied: Hiram College; Univ. Cincinnati, B.A.; Art Acad. of Cincinnati; Cooper Union A. Sch., N.Y. Work: Albright-Knox Z. Gal.; Univ. Nebraska; MModA; WMAA; Brandeis Univ.; WMA; N.Y. Univ. Coll.; Washington Univ., St. Louis; Atkins Mus. FA, Kansas; DMFA; Suermondt Mus., Aachen Germany. Exhibited: Judson Gal., N.Y., 1959, 1960; Dwan Gal., Los A., 1962, 1964; Finch Col. Mus., N.Y., 1962, 1966, 1968; Sidney Janis Gal., N.Y., 1962, 1964, 1967; Landau Gal., Los A., 1962; MModA, 1962 (2), 1965-1968, traveling exh. 1966, 1968; Pace Gal., Boston, 1962, 1964; Tanager Gal., N.Y. 1962; Albright-Knox Gal., 1963, 1966, 1968; Brandeis Univ. (Kootz Gal.), 1963 and (Rose A. Mus.), 1963; Contemporary A. Assn., Houston, 1963; Contemp. A. Center, Cincinnati, 1963; Morris Gal., Toronto, 1963, 1964; Univ. Mich., 1963; Nelson Gal., A., Kansas City, 1963; Oakland A. Mus., 1963; Galerie Saqqarah, Gstaad, 1963, 1965; Sonnabend Gal., Paris, 1963-1966; Wash. Gal. Mod. A., 1963; AIC, 1964, 1966; Bianchini Gal., N.Y., 1964, 1966; Univ. British Columbia, 1964; Carnegie Inst., 1964, 1967; Davison A. Center, Wesleyan Univ., 1964; Dayton AI, 1964; Des Moines A. Center, 1964; Rochester Mem. Gal., 1964; Mirvish Gal., Toronto, 1964; Moderna Museet, Stockholm, 1964; Portland A. Mus., 1964; Poses Inst., Brandeis Univ., 1964; City Galerie, Zurich, 1965; Fort Worth A. Center, 1965; Milwaukee A. Center, 1965; Hamburg, Germany, 1965; Brussels, Belgium, 1965; Sch. Visual Arts, N.Y., 1965; WMAA, 1965 (2), 1966-1968; WMA, 1965; A. Gal. of Toronto,

1965, 1966; Larry Aldrich Mus. Contemp. A., Conn., 1966; Inst. Contemp. A., Boston, 1966-1968; CMA, 1966; N.Y. Univ., 1966, 1968; R.I. Sch. Des., 1966, 1967; Museo de Art, Moderno, Mexico City, 1966; Ithaca Col. Mus. A., 1967; AFA, N.Y., 1967, 1968; Univ. Colorado, 1967; Georgia Mus., Univ. Georgia, 1967; Detroit Inst. A., 1967; Cologne, Germany, 1967; Sao Paulo, Brazil, 1967; David Stuart Gal., Los Angeles, 1969; Vancouver A. Gal., Canada, 1969; A. Gal. of Ateneum, Helsinki, Finland, 1969; Winnipeg A. Gal., Canada, 1969, and many others. One-man: Tanager Gal., N.Y.; 1961; Green Gal., N.Y., 1962, 1964, 1965; Sidney Janis Gal., N.Y., 1966, 1968; Galerie Ileana Sonnabend, Paris, 1966; Galerie Gian Enzo Sperone, Torino, Italy, 1967; Gal. 12, Minneapolis, Minn., 1969; Mus. Contemp. A., Chicago, 1969; DeCordova Mus., Lincoln, Mass., 1969.

WESSELS, GLENN ANTHONY—Painter, W., L., E.
Art Department, University of California, Berkeley, Cal. 94704; h. 1601 La Vereda Road, Berkeley, Cal. 94709
B. Capetown, South Africa, Dec. 15, 1895. Studied: Cal. Col. A. & Crafts, B.F.A.; Univ. California, B.A., M.A.; & in Paris, France; Munich, Germany. Member: San F. AA; AAUP. Awards: prize, SAM; San F. AA, 1956; Oakland A. Mus., 1957; Univ. California Inst. for Creative Art Grant to Italy, 1964-65. Work: SFMA; Univ. California; SAM; Washington State Col.; Oakland A. Mus. Exhibited: Oakland A. Mus., 1935, 1957; San F. AA, 1935-1956; SAM; Santa Barbara Mus. A., 1946 (one-man); deYoung Mem. Mus., San F., 1959; San Jose State Col., 1961; Univ. Nevada, Reno & Las Vegas, 1962; Univ. Cal. at Davis, 1963; Univ. Cal. at Berkeley, 1964; Mills Col., Oakland, 1965. Author, I., Correspondence manuals in drawing & painting (Univ. California Extension Div.), 1945, 1946. Contributor to Encyclopedia Americana, 1946. Lectures: Modern Art; Art History & Art Appreciation. Positions: Instr., California Col. A. & Crafts, Berkeley, Cal., 1930-1940; Mills Col., Oakland, Cal., 1932; Assoc. Prof. FA, Washington State Col., Pullman, Wash., 1940-1956; Assoc. Prof. A., Univ. California, Berkeley, Cal., 1946-50; Prof., 1951-1963, Emeritus, 1964- ; Prof., 1968- , Bd. of Trustees, 1967- , Cal. College of A. & Crafts, Berkeley; Bd. of Dirs., Oakland Museum, 1968- and Chm. Acquisitions Committee, 1969- .

WEST, CLIFFORD BATEMAN—Painter, T., Lith.
225 Lone Pine Road, Bloomfield Hills, Mich. 48013
B. Cleveland, Ohio, July 4, 1916. Studied: Cleveland Sch. A.; Adams State T. Col., Alamosa, Colo., B.A.; Colorado Springs FA Center; Cranbrook Acad. A., M.A.; & with Boardman Robinson, Arnold Blanch, & others. Awards: Prix de Rome, 1939; prize, Flint Inst. A.; Nat. Religious Art Show; Cine Golden Eagle Award for film "Harry Bertoia's Sculpture"; Mich. Academy of A., Sci., & Ltr., 1969. Work: Massillon Mus. A.; Iowa State T. Col.; Cranbrook Mus. A.; murals, Rackham Mem. Bldg., Detroit; Alamosa (Colo.) Nat. Bank; City Bank, Detroit; Casa Contenta Hotel, Guatemala; Veterans Mem. Bldg., Detroit, Fox & Hounds Inn, Detroit; Colo. State Hist. Soc., Denver. Exhibited: AIC, 1937, 1939, 1943-1945; MMA (AV), 1942; Detroit Inst. A., 1937, 1938, 1940-1945, 1955; CMA, 1934, 1937; Butler AI, 1938, 1943, 1946, 1955; Massillon Mus. A., 1953, 1954; Denver A. Mus., 1937, 1939, 1943; Milwaukee AI, 1946; Little Gal., Birmingham, Mich., 1961. Lectures: Art in Education; Design in Photography; Design & Compositions. Produced, filmed, and directed 12 films on Renaissance Sculpture and Architecture; 2 on Edvard Munch; 2 on Carl Milles; 1 on Arnold Blanch and 1 on Harry Bertoia. Positions: Co-founder and Pres. of Ossabaw Island Project Foundation, a working location for creative people in all the disciplines. Pres. of O.I.P. Films, Bloomfield Hills, Mich.

WEST, LOWREN—Painter, I.
300 Riverside Drive, New York, N.Y. 10025
B. New York, N.Y., Feb. 28, 1923. Studied: PIASch.; Hans Hofmann Sch. FA; Columbia Univ. Awards: NAC, 1962. Exhibited: NAC, 1960, 1962; MModA, 1960; Stable Gal. (Ariz.), 1963; Riverside Mus., 1964; Art in America Exh., 1967-1969; Monogram A. Gal., N.Y., 1967. Contributor illus. to New Yorker magazines; Fortune; Graphis. Graphic designs for General Electric, Westinghouse and Life magazine.

WEST, WALTER RICHARD—Painter, T.
Bacone College, Muskogee, Okla. 74401
B. Darlington, Okla., Sept. 8, 1912. Studied: Bacone Col.; Univ. Oklahoma, B.F.A., M.F.A.; Univ. Redlands, Cal.; Tulsa Univ. Awards: prizes, Kansas City, Mo.; Philbrook A. Center, Nat. Indian Exh., 1949, 1950, 1955, 1960, 1964 (2); Citation, Indian A. & Crafts Bd., Dept. Interior, 1960; Hon. D.H.L., Eastern Baptist College, 1963. Work: William Rockhill Nelson Gal. A.; U.S. Dept. Interior, Wash., D.C.; Chappell A. Gal., Pasadena, Cal.; Phoenix Indian H.S.; USPO, Okemah, Okla.; Bacone Col.; James Graham & Son, N.Y.; NGA. Exhibited: Kansas City, Mo., 1937; Tulsa, Okla., 1938; Dept. Interior, Wash., D.C.; Chappell Gal. A., 1941; Am. Indian A. Exh., Philbrook A. Center, 1946, 1949, 1950, 1955; one-man: Univ. Redlands, 1952,

1965; Esquire Theatre Gal., Chicago; Oshkosh Pub. Mus.; Bacone Col.; Telfair Acad. A.; Philbrook A. Center, 1955; Tulsa, 1957; Eastern A. & M. Col., Wilburton, Okla., 1958; Oakbrook, Ill. 1965. I. "The Cheyenne Way," 1941; "The Thankful People," 1950; "Tales of the Cheyennes," 1952; "Indian Legends," 1963. Lectures: "Art of the North American Indians"; "Indian Art," especially own series of religious interpretations. Work reproduced in Life International, 1959. Positions: Hd. A. Dept., Bacone Col., Muskogee, Okla., 1947- .*

WEST, WILBUR WARNE — Educator
 Armstrong Hall of Fine Arts, Cornell College; h. 324 South Third St., West, Mount Vernon, Iowa 52314
B. Indiana, Mar. 10, 1912. Studied: Ohio State Univ., B.S., with Arthur Baggs, Edgar Littlefield; Columbia Univ., M.A.; Woodstock, N.Y. Member: NAEA; Western AA; Northern Indiana A.; AAUP; CAA. Awards: Midland Gal., 1935; Scholarship, AIA, 1946. Exhibited: Nat. Ceramics Exh.; Butler Inst. Am. A.; Midland Gal., South Bend; Hoosier Salon; Northern Indiana A.; Columbus A. Lg.; Indiana State Fair; Akron AI; Kent Univ.; Des Moines A. Center; Cornell Col. A. Gal. Lectures: Art & Architecture of Europe; Design Today. Position: Hd., A. Dept., Gallery Dir., Cornell College, Mount Vernon, Iowa. Co-ordinator, Foreign Study Programs.*

WESTERMANN, H(ORACE) C(LIFFORD) JR.—Sculptor
 1254 Taylor St., San Francisco, Cal. 94108
B. Los Angeles, Cal., Dec. 11, 1922. Studied: AIC. Awards: Tamarind Fellowship, 1968. Work: in many leading private collections. Exhibited: MModA; WMAA; and other exhibitions in New York City; Chicago; Oakland, Cal.; Hartford, Conn.; San Francisco; Flint, Mich.; Los Angeles; Houston, Tex., and others.*

WESTERMEIR, CLIFFORD PETER—Educator, W., L., P., I.
 1703 Columbine Ave., Boulder, Colo. 80302
B. Buffalo, N.Y., Mar. 4, 1910. Studied: Buffalo Sch. FA; PIASch; N.Y. Sch. F. & App. A.; Univ. Buffalo, B.S.; Univ. Colorado, Ph.D. Awards: prizes, The Patteran, 1939, 1940. Work: Albright A. Gal.; many portraits. Exhibited: Albright A. Gal., 1937-1943; AWCS, 1939; Syracuse Mus. FA, 1941; Boulder, Colo.; & in Paris, London; one-man: Denver, Colo., 1950; Santa Fé, N.M., 1950; Tucson, Ariz., 1958. Contributor to: Britannica Junior; Encyclopaedia Britannica. Author: "Man, Beast and Dust: The Story of Rodeo," 1947; Author, I., "Trailing the Cowboy," 1955; "Who Rush to Glory," 1958. Positions: Instr., Buffalo Sch. FA, 1935-44; Univ. Buffalo, 1935-44; Univ. Colorado, 1944-46; Asst. Prof. A., St. Louis Univ. & Maryville Col., St. Louis, Mo., 1946- ; Prof., Univ. Arkansas, Fayetteville, Ark., 1952- ; Guest L., Univ. Texas, 1954. Guest Lecturer, Univ. Colorado, 1957, 1959. Prof., Univ. of Colorado, Boulder, Colo., 1964- .

WESTON, HAROLD — Painter
 282 Bleecker St., New York, N.Y. 10014; s. St. Huberts, N.Y. 12943
B. Merion, Pa., Feb. 14, 1894. Studied: Harvard, A.B. Member: Fed. Mod. P. & S. (Pres. 1953-57); Intl. Assn. A. (U.S. delegate 1954, 1957, 1960, 1963 & 1966, Vice Pres. 1960-1961, Pres. 1962-1963, Hon. Pres. 1963-); U.S. Committee IAA (Vice Pres. 1954-57, Liaison Officer, 1957-61, Pres. 1961-67, Hon. Pres. 1967-); Nat. Council on the Arts & Government (Vice Chm., 1954-1960, Chm. 1960-); F., World Acad. of Art & Science; Hon. member, SAGA; Hon. member Nat. Soc. Mural Painters; A. Consultant in Europe for USIA 1957-1958. Awards: prize, award, Am. Soc. Contemp. A. 1964; Harold Weston Manuscript Coll., established at Syracuse Univ. 1964. Work: London War Museum; Rochester Mem. A. Gal.; PAFA; P.C., Wash., D.C.; Yale Univ. Gal. of A.; General Services Admin. Bldg.; SFMA; Columbia Univ. Lib.; MModA; FMA; Smithsonian Inst.; CGA; Evansville (Ind.) Mus. A. & Sciences; WMAA; Butler Inst. Am. A.; N.Y. Univ.; Oakland A. Mus.; Syracuse Univ. A. Mus.; Norfolk Mus. A. & Sciences; Portraits Coll., Princeton Univ.; Purdue Univ.; BM; Fordham Univ.; Adirondack Mus., Blue Mt. Lake, N.Y.; Everson Mus., Syracuse; Pa. Hist. Soc.; Am. Univ., Wash., D.C.; Munson-Williams-Proctor Inst., Utica, N.Y. Exhibited: one-man: 11 New York and 29 others; group exhs., USA over 100, Europe 9. Fed. Mod. P. & S. 1966; PAFA 1967; Mus.; N.J. State Mus., Trenton; Fed. Mod. P. & S., 1968.

WETHEY, HAROLD EDWIN—Educator, L., W.
 2009 Morton Ave., Ann Arbor, Mich. 48104
B. Port Byron, N.Y., Apr. 10, 1902. Studied: Cornell Univ., A.B.; Harvard Univ., M.A., Ph.D. Member: CAA; Hispanic Soc. Am.; Soc. Arch. Historians; Acad. de S. Fernando; Soc. Peruana Historia; Academia Nacional de Ciencias de Bolivia; Acad. Am. Franciscan History. Awards: F., Rockefeller Fnd., 1944-1945; Sheldon F., Harvard Univ., 1932-1933; Paris Scholarship, Inst. Int. Edu., 1931, 1934; Guggenheim F., 1949; Fulbright F., to Italy, 1958-59; Fellowships, Am. Council of Learned Societies, 1936, 1963-64; Russel Lec-

tureship, Univ. Michigan, 1964-65 (major award for distinguished accomplishment in research); Distinguished Faculty Achievement Award, Univ. of Michigan, 1968. Author: "Gil de Siloe and His School," 1936; "Colonial Architecture and Sculpture in Peru," 1949; "Alonso Cano, Painter, Sculptor and Architect," 1955; "Alonso Canor Pintor," 1958; "Arquitectura virreinal del Alto Peru," 1961; "El Greco and His School," 1962; "El Greco y su escuela," 1967; "Titian, The Religious Paintings," 1969. Contributor to: Encyclopaedia Britannica; Thieme-Becker's "Kunstler-Lexikon"; Art Quarterly; Art Bulletin; Gazette des Beaux-Arts; Burlington magazine; Encyclopedia Americana; Encyclopedia of World Art; New Catholic Encyclopedia; Dizionario biographico degli italiani. Contributing Ed., Handbook of Latin-American Studies, 1946-59. Editor: "History of Spanish Painting," by C. R. Post, Vol. XIII, 'The Schools of Aragon and Navarre in the Early Renaissance,' 1966; Vol. XIV, 'The Later Renaissance in Castile,' 1966. Lectures: Spanish and Latin American Art; Italian Renaissance and Baroque Art. Positions: Instr., Asst. Prof., Bryn Mawr Col., 1934-38; Washington Univ., St. Louis, Mo., 1938-40; Assoc. Prof., 1940-46, Prof., 1946- , Univ. Michigan, Ann Arbor, Mich. Visiting Prof., Univ. of Tucuman, Argentina, 1943; Univ. Mexico, summer 1960, (U.S. Dept. State). Memb. Ed. Bd. College Art Bulletin, 1965- .

WEXLER, GEORGE—Painter, E.
 17 Apple Rd., New Paltz, N.Y. 12561
B. Brooklyn, N.Y., Jan. 18, 1925. Studied: CUASch.; New York Univ., B.A.; Michigan State Univ., M.F.A. Awards: prizes, Albany Inst. Hist. & Art, 1963, 1964; State Univ. of New York Arts Fellowship, 1966, 1967. Work: Chrysler Mus. A.; Grand Rapids A. Gal.; Michigan State Univ. Murals, Eastland Shopping Center, Detroit (3); T. H. Chapman Co., Milwaukee (2). Exhibited: Silvermine Gld. A., 1961; PAFA, 1961; Chautauqua A. Annual, 1960; Int. Drawing Exh., Potsdam, N.Y., 1960; Provincetown A. Festival, 1959; Bradley Univ., 1952; Detroit Inst. A., 1951-1955; Momentum, Chicago, 1954; Albany Inst. Hist. & Art, 1958, 1963, 1964, 1965, 1966; N.Y. Univ., 1962; New School for Social Research, 1962; American Gal., N.Y., 1964; one-man: Angeleski Gal., N.Y., 1961; Karlis Gal., Provincetown, 1960; Fleischman Gal., N.Y., 1959; Polari Gal., Woodstock, N.Y., 1959, 1961; Albany Inst. Hist. & Art, 1966; Univ. of Maine, 1968. Positions: Prof. Painting, Drawing & Design, Michigan State Univ.; State University, College of Edu., New Paltz, N.Y.

WEYHE, M. E.—Art dealer
 794 Lexington Ave., New York, N.Y. 10021*

WHEELER, CLEORA CLARK—Designer, Illuminator, W., L.
 1376 Summit Ave., St. Paul, Minn. 55105
B. Austin, Minn. Studied: Univ. Minnesota, B.A., Ctf. Adv. Engineering Drafting; N.Y. Sch. F. & App. A. Member: Am. Soc. Bookplate Collectors & Des.; Nat. Lg. Am. Pen Women. Awards: prizes, Minn. A. Soc., 1913; Nat. Lg. Am. Pen Women, 1942, 1950; Achievement Award, Kappa Kappa Gamma, 1952. Work: LC; Yale Cl., N.Y.; Minnesota State Hist. Soc.; Minneapolis Inst. A.; St. Paul Pub. Lib.; Minneapolis Pub. Lib.; Los A. Pub. Lib.; Am. Lib. in Paris; Huntington Lib., San Marino, Cal.; Libraries of: Brown, Columbia, Harvard, Minnesota, Princeton, Stanford, Rochester and Yale Universities; Bryn Mawr, Mills, Monmouth, Mt. Holyoke, Radcliffe, Smith, Vassar, Wellesley and Wells colleges; Pub. Lib., City of Liverpool, England; Am. Assn. Univ. Women, Hdqtrs., Wash., D.C.; brass wall plaque, Minn. Chapter House Lib., Kappa Kappa Gamma; Univ. Virginia Lib. Exhibited: annually 1916-1925, Am. Bookplate Soc.; Avery Lib., Columbia Univ.; Grolier Cl.; Bookplate Assn. Int. Exh., 1926, 1931-1936; N.Y. Times Book Fair, 1937; Northwest States Book Fair, Minneapolis, 1940; Boston Book Fair, 1940; Nat. Lg. Am. Pen Women, 1936, 1938, 1940, 1944, 1946, 1948, 1950, 1952, 1954, 1956, 1960, 1962, 1964, 1966; U.S. Nat. Mus., 1946, 1948, 1950, 1952, 1954, 1956, 1960, 1962; Minn. State A. Soc.; St. Paul Inst.; Minneapolis Inst. A.; AAUW, St. Paul Branch, 1958. Numerous one-man exhs., including Univ. Minnesota, 1956. Author series 6 articles on bookplates, Minnesota Medicine magazine, 1957 and chapter on Insignias in national History of Kappa Kappa Gamma. Lecturer on Bookplates. Positions: Nat. Lg. Am. Pen Women: Br., Cor. Sec., 1936-38; Br., 1st Vice-Pres., 1938-40; Br., Pres., 1940-42; Minnesota State Pres., 1942-44; Nat. Chm., Des., 1944-46; Minn. State Publ. Chm., 1946-48; Nat. Chm., Heraldic Art, 1954-56, 1964-66.

WHEELER, MONROE—Director Museum Exhibitions
 Museum of Modern Art, 11 W. 53rd St., New York, N.Y. 10019; h. "Hay-meadows," Rosemont, N.J. 08556
B. Evanston, Ill., Feb. 13, 1900. Studied: France, England and Germany. Awards: Chevalier, French Legion of Honor, 1951, in recognition of his "outstanding services to the cause of French contemporary art in the United States." Director of the following Museum of Modern Art Exhibitions: Modern Bookbinding by Professor Ignatz Wiemeler, 1935; Modern Painters and Sculptors as Illustrators,

1936; Prints of Georges Rouault, 1938; Britain at War, 1941; 20th Century Portraits, 1942; Airways to Peace, 1943; Modern Drawings, 1944; Chaim Soutine, 1950; Georges Rouault Retrospective, 1953; Textiles and Ornaments of India, 1956; The Last Works of Henri Matisse, 1961; Bonnard and His Environment, 1964. Author, or Co-author of the Museum of Modern Art's publications for the above exhibitions. Positions: Co-founder and partner of publishing firm of Harrison of Paris, 1930-1935; Dir., American Section, Salon International de Livre, Paris, 1932; Chairman, Committee on Publications, Office of the Coordinator of Inter-American Affairs, 1940-1945; Member, Publications Committee, UNESCO, Paris, 1949; Trustee, The Grolier Club; Vice-Pres., and Trustee, New York Genealogical and Biographical Society; President and Trustee, International Graphic Arts Society; Life Member, French Institute in the United States; former Trustee, American Institute of Graphic Arts; Member, Advisory Board for Research and Graduate Education of Rutgers University. Positions with the Museum of Modern Art, New York, N.Y.: Chairman, Library Committee, 1935; Member, Advisory Committee, 1937; Membership Director, 1938; Director of Publications, 1939- ; Director of Exhibtions, 1940- ; Trustee, 1945-1966, Hon. Trustee for life, 1966- ; Chm. Comm. on Drawings and Prints, 1967- ; Trustee, Ben Shahn Foundation, 1969- .

WHEELER, ROBERT G.—Historian, L., W.
 Henry Ford Museum, Dearborn, Mich. 48120; h. 24111 Meridian Rd., Grosse Ile, Mich. 48138
B. Kinderhook, N.Y., Sept. 20, 1917. Studied: Syracuse Univ.; Columbia Univ.; N.Y. State Col. for Teachers. Member: AAMus.; Midwest Conf., AAMus.; AFA. Contributor to Antiques Magazine; American Collector; New York Hist. Soc. Bulletin; New York History; N.Y. Sun; N.Y. World-Telegram & Sun. Lectures: 17th, 18th and 19th Century Arts & Crafts of the Hudson Valley. Positions: Pres., Northeastern Conf., AAMus., 1953-54; 1967-1968; Instr., Am. A. Hist., A. Appreciation, Russell Sage Col., Albany Div., 1950-56; Asst. Dir., 1947-49, Dir., 1949-56, Albany Inst. Hist. & A., Albany, N.Y.; Dir. Research & Publ., Sleepy Hollow Restorations, Tarrytown, N.Y., 1956-1968; Director of Crafts, Henry Ford Museum 1968-1969; Vice-President, Henry Ford Museum, 1969- .

WHINSTON, CHARLOTTE (Mrs. Charles N.)—Sculptor, P., Gr.
 2 Tudor City Place, New York, N.Y. 10017
B. New York, N.Y. Studied: N.Y. Sch. F. & App. A.; NAD; CUASch.; ASL, and with George Luks, George Maynard and others. Member: NAWA; Pen & Bruch Cl.; N.Y. Soc. Women A.; ASL; AEA; New Jersey P. & S. Soc.; Knickerbocker A.; Brooklyn Soc. A.; Audubon A.; All. A. Am.; Nat. Soc. Painters in Casein; Lg. Present Day Artists. Awards: prizes, scholarship, N.Y. Sch. F. & App. A., 1915; prizes, CUASch., 1921; AAPL, 1947; Yonkers AA, 1948; New Rochelle Women's Cl., 1948, 1951; State T. Col., Indiana, Pa., 1949; Westchester Fed. Women's Cl., 1949; Pen & Brush Cl., 1960, 1961, 1965, 1966, 1967, 1968; Ptrs. In Casein, 1965; medals, City Col., N.Y., 1916; NAD, 1917; Pen & Brush Cl., 1948; Argent Gal., 1957; Church of the Covenant, 1958; silver medal, Seton Hall Univ., 1958; gold medal, Catholic A. Soc., 1958; Am. Soc. Contemp. A., 1966; NAWA, medal of honor, 1969. Work: Norfolk Mus. A.; Seton Hall Univ.; exterior mural, Ave. of the Americas (44th-45th Sts.), N.Y.; Riverside Mus., N.Y.; Wis. State Univ.; Smith Col. Exhibited: Paris, France; Amsterdam, Holland; Antwerp and Brussels, Belgium; Napels, Italy; Athens and Salonika, Greece; NAWA, 1946-1969; Pen & Brush Cl., 1946-1969; State T. Col., Indiana, Pa., 1947-1954; Audubon A., 1947-1969; All. A. Am., 1959-1969; Westchester A. & Crafts Gld., 1944-1955; Yonkers AA, 1944-1951; Soc. Indp. A., 1943, 1944; Hudson Valley AA, 1948-1951; AAPL, 1947-1951; New Jersey P. & S., 1951-1969; Norlyst Gal., 1945, 1946; Contemp. A., 1945-1947; Brooklyn Soc. A., 1957-1969; Nat. Soc. Painters in Casein, 1958-1969; N.Y. Soc. Women A., 1958-1969; P. & S. of New Jersey, 1957-1969; AEA, 1950-1953; WMAA, 1951; Knickerbocker A., 1955-1969; Tokyo, 1960; one-man: Contemp. Cl., White Plains, N.Y., 1947; Pen & Brush Cl., 1949, 1955; Engineering Women, N.Y., 1950. Positions: Pres., 1959-1961, Treas., 1961-1964, Adv. Com., NAWA; Dir., Nat. Soc. Painters in Casein; Rec. Sec., 1954-1956, Asst. Treas., Pen & Brush Cl.; Dir., N.Y. Soc. Women A. Official in many other art organizations, to 1969.

WHIPPLE, ENEZ (Mrs.)—Art Director
 Guild Hall of East Hampton, East Hampton, N.Y. 11937
Positions: Dir., Guild Hall, East Hampton, N.Y.*

WHITAKER, FREDERIC—Painter, W.
 6453 Camino del Teatro, La Jolla, Cal. 92037
B. Providence, R.I., Jan. 9, 1891. Member: NSMP (Hon.); NAC; SC; All. A. Am.; Am. Inst. FA; Council of Am. A. Soc.; Am. Veterans Soc. A.; and many others. Awards: 100 prizes throughout the U.S. Work: permanent Coll. of MMA; BMFA and 32 other museums. Positions: Pres. (1949-56) AWS; Member Council (1952-64), NAD, Vice-Pres. (1956-57); Audubon A. (Founder, 1943, Pres., 1943-46),

New York, N.Y.; Vice-Pres., AAPL; Contributing Ed., American Artist magazine. Author: "A Guide to Better Painting"; "Whitaker on Watercolor"; 75 articles on prominent artists in American Artist.

WHITAKER, MRS. FREDERIC. See Monaghan, Eileen

WHITAKER, IRWIN (A.)—Educator, C.
 Art Department, Michigan State University; h. 1545 Cahill Dr., East Lansing, Mich. 48823
B. Wirt, Okla., Oct. 19, 1919. Studied: San Jose State Col., B.A.; Claremont Col., M.F.A. Member: Nat. Council on Educ. for Ceramic A. Work: Detroit Inst. A. Exhibited: Many national and regional craft exhibitions. Author: "Crafts and Craftsmen," 1967. Positions: Prof., Ceramics, Southern Oregon College, 1949-50; Michigan State Univ., East Lansing, Mich. 1950- .

WHITCOMB, JON—Portrait Painter
 8 Circle Rd., Darien, Conn. 06820
B. Weatherford, Okla. Studied: Ohio Wesleyan Univ.; Ohio State Univ., A. B. Positions: Faculty, Famous Artists School, Westport, Conn.

WHITE, CHARLES WILBERT—Painter, Gr., T., L.
 6263 Annan Way, Los Angeles, Cal. 90042
B. Chicago, Ill., Apr. 2, 1918. Studied: AIC; ASL; Taller de Grafica, Mexico. Member: AEA; Nat. Conf. Artists. Awards: AIC Scholarship, 1937; Nat. Scholastic award, 1937; Am. Negro Expo., 1940; Rosenwald Fellowship. 1942, 1943; Alford award, Atlanta Univ., 1946, popular award, 1953; Atlanta Univ. purchase awards, 1946, 1949, 1951; Nat. Inst. A. & Lets. Grant, 1952; John Hay Whitney Fellowship, 1955. Work: Atlanta Univ.; Howard Univ.; Fisk Univ.; Tuskegee Inst.; Hampton Inst.; Newark Mus.; WMAA; AFA; Am. Acad. A. & Lets.; IBM; LC; and in private colls. U.S. and abroad. Exhibited: 1938-1964: AIC; Howard Univ.; LC; Smith Col. Mus.; Inst. Contemp. A., Boston; Atlanta Univ.; BMA; Newark Mus.; BM; SFMA; WMAA; Am. Acad. A. & Lets.; MMA; Smithsonian Inst.; and others abroad. One-man: Barnett Aden Gal., Wash., D.C., 1947; ACA Gal., N.Y., 1947, 1949, 1951, 1953, 1958, 1961; Pyramid Cl., Phila., 1954; Univ. So. Cal., 1958; Heritage Gal., Los A., 1964; Occidental Col., 1964; Univ. of Judaism, Los A., 1964.*

WHITE, DORIS ANNE—Painter
 Rte. 1, Jackson, Wis. 53037
B. Eau Claire, Wis., July 27, 1924. Studied: Univ. Berne, Switzerland; AIC. Member: ANA; AWA; Cal. WC. Soc.; Phila. WC Soc.; All. A. Am.; Knickerbocker A. Awards: prizes, Madison Salon of Art, 1958; Wisconsin State Fair, 1959, 1960; First Wisconsin Nat. Bank, 1959; Nat. Lg. Am. Pen Women, 1960; Mattie Jarrott Scholarship, 1960; Butler Inst. Am. A., purchase, 1960, 1961, 1963, 1964; Wayne Univ., 1960; Knickerbocker Artists, purchase, 1961, 1963; Wisconsin P. & S. Gimbel award, 1961; Illinois State Fair, 1961; AWS, gold medal, 1963, prizes, 1964, 1965, 1966, 1967; NAD, 1963, and purchase; All. A. Am., 1962; Soc. Four Arts, 1963; Lowe Gal., purchase 1963; WAC, 1963 (purchase); Univ. North Dakota, purchase, 1962; Watercolor:USA purchase, 1964; Union League, Chicago purchase, 1962. Exhibited: AWS, 1958-1969; Cleveland Inst. A., 1968; Bergstrom A. Center, Neenah, Wis., 1968; Wis. State Fair, 1961; Wash. WC Cl., 1961; Wright A. Center, Beloit, 1960; Burpee Gal., Rockford, 1960; First Nat. Bank, Minneapolis, 1960; Madison Salon of Art, 1957, 1958, 1960, 1963, 1964; Wis. P. & S., 1956-1958, 1960, 1961; PAFA, 1963, 1965; AIC, 1963; Knickerbocker A., 1961-1963; Okla. Pr. M., 1963; Miami Univ., 1963; All. A. Am., 1962, 1963; Audubon A., 1964; NAD, 1962-1969; Butler Inst. Am. A., 1960-1965; Wayne State Univ., 1960; WAC, 1963, 1964; Ill. State Fair, 1962-1964; Springfield Mus. A., 1963; Phila. A. All., 1963 and others; one-man: Mount Mary Col.; Jewish Alverno Col.; Panoras Gal., N.Y.

WHITE, IAN McKIBBIN—Museum Director
 California Palace of the Legion of Honor, Lincoln Park, San Francisco, Cal. 94121; h. 2 Lagunitas Rd., Ross, Cal. 94957
B. Honolulu, Hawaii, May 10, 1929. Studied: Harvard College, B.A. in Architecture; Graduate School of Design, Harvard University; University of California at Los Angeles. Member: Municipal Art Society of New York (member Board of Directors 1966); Victorian Society in America (Advisory Committee). Commissions: Frieda Schiff Warburg Sculpture Garden, Brooklyn Museum, 1966; Designed the Peary-Macmillan Arctic Museum for Bowdoin College, 1967. Contributor to Curator magazine. Exhibitions designed for the Brooklyn Museum: "Haiku in a Japanese Garden," (Brooklyn Botanic Garden), 1960; "Japanese Ceramics," 1961; "The Nude in American Painting, 1961; "Gold of the Andes," 1963; "Techniques of Painting," (6 case circulating exhibit) 1963; "American Painting/The Fraad Collection," 1964; American Art/The Goldstone Collection," 1965; "Paintings from the Hirshhorn Collection," 1965. Positions: Administrative Assistant and Designer, Brooklyn Botanic

Gardens, 1959-1960; Assistant Superintendent, 1961-1963, Superintendent, 1963-1964, Assistant Director, 1964-1966, Brooklyn Museum; Director, California Palace of the Legion of Honor, San Francisco, Cal., at present.

WHITE, LAWRENCE EUGENE—Educator, C.
George Pepperdine College, 1121 West 79th St. 90044; h. 11508 Tarron Ave., Los Angeles, Cal. 90047
B. Abilene, Tex., Dec. 2, 1908. Studied: Abilene Christian Col., B.A.; Univ. So. California, M.A. Member: Pacific AA; NAEA. Author: "Art for the Child," 1950. Positions: Instr., Abilene Christian College, 1932-36; Prof. A., Chm. Dept. A., George Pepperdine College, Los Angeles, Cal.

WHITE, LEO (F.)—Cartoonist
Patriot-Ledger, 13 Temple Place, Quincy, Mass. 02169; h. 168 Strasser Ave., Westwood, Mass. 02090
B. Holliston, Mass., Apr. 8, 1918. Studied: Sch. Practical A., Boston; Evans Sch. Cartooning, Cleveland. Creator of "Hockey Stars," Toronto (Ont.) Telegram News Service; "TV Starscramble," Columbia Features, N.Y.; "Little People's Puzzle," United Features, N.Y. Positions: Sports & Editorial Cartoonist, Patriot-Ledger, Quincy, Mass.

WHITE, NELSON COOKE—Painter, W.
Rte. 2 Newshore Rd., Waterford, Conn. 06385
B. Waterford, Conn., June 11, 1900. Studied: NAD; & with Henry Cooke White. Member: Conn. Acad. FA; Lyme AA. Exhibited: NAD; AWCS. Author: "The Life and Art of J. Frank Currier," 1936; "Abbott H. Thayer—Painter and Naturalist," 1951. Contributor to: Art in America; Art & Archaeology. Positions: Trustee, Lyman Allyn Mus., New London, Conn.; (Emeritus) Wadsworth Atheneum, Hartford, Conn.

WHITE, ROGER LEE—Painter, E., Gr.
Oklahoma City University, Oklahoma City, Okla. 73106
B. Shelby, Ohio, Nov. 27, 1925. Studied: Miami Univ., Oxford, Ohio, B.F.A.; Univ. Denver, M.A.; Univ. Colorado (grad. study), and with Jimmy Ernst, Mark Rothko. Member: Assn. of Oklahoma A.; Oklahoma Pr. M. Soc. (Exec. Bd.). Awards: prizes, Jackson, Miss., 1955; Memphis, Tenn., 1955; Oklahoma A. Center, 1956-1958, 1960; Philbrook Mus., Tulsa, 1956-1960; Midwest Biennial, Omaha, 1959. Work: Miami Univ.; Jackson, Miss., A. Center; Okla. Pr. M. Coll. Exhibited: Columbia (S.C.), 1957; Jackson, Miss., 1955; Delgado Mus., 1955-1957; Oakland A. Mus., 1955; SAM, 1956; Oklahoma Nat. Prints & Watercolor Exh., 1960, 1961; Colorado Springs FA Center, 1959; Columbus, Ohio, 1946; DMFA, 1956-1958; Denver Mus. A., 1953, 1954; Nelson Gal. A., Kansas City, 1955; Memphis, Tenn., 1955; Newport, R.I., 1954; Omaha, 1958; Santa Fe, N.M., 1956, 1957; Mulvane A. Mus., 1955-1957; Philbrook A. Center, 1956-1961; Oklahoma A. Center, 1956-1961; Univ. Oklahoma, 1958 (one-man); Contemp. Am. A. Exh., 1963; Southwest P. & S., Houston, 1963; Nelson Gal. A., Kansas City, 1964. Positions: Chm., Dept. A., Oklahoma City University, Oklahoma City, 1956- .*

WHITE, RUTH—Art Dealer
Ruth White Gallery, 42 E. 57th St. 10022; h. 401 E. 74th St., New York, N.Y. 10021
B. New York, N.Y., May 25, 1911. Studied: Privately and with Kurt Seligmann. Specialty of Gallery: Contemporary paintings, sculpture and graphics.

WHITEHEAD, JAMES L.—Museum Director
Franklin D. Roosevelt Library, Hyde Park, N.Y. 12538; h. 50 Spackenkill Rd., Poughkeepsie, N.Y. 12603
B. Demopolis, Ala., Feb. 21, 1913. Studied: Birmingham Southern College, A.B.; Vanderbilt Univ., M.A.; Univ. Pennsylvania, Ph.D. Member: AAMus. Positions: Asst. Archivist, F. D. Roosevelt Lib., Hyde Park, N.Y., 1941-43; Asst. to the Dir., Minnesota Hist. Soc., 1949-50; Dir., Staten Island Institute of A. & Sciences, Staten Island, N.Y., 1951-1961; Asst. to the President, Pratt Institute, Brooklyn, N.Y., 1961-1964; Director, Monmouth Museum, Red Bank, N.J., 1964-67; Curator of Museum, Franklin D. Roosevelt Library, Hyde Park, N.Y. 12538, 1967- .

WHITEHILL, FLORENCE FITCH (Mrs. Herman)—Painter
7 Peter Cooper Rd., New York, N.Y. 10010
B. Hillsdale, N.Y., Sept. 8, 1903. Studied: Mass. Col. A., Boston; Grand Central Art Sch., N.Y. Member: Wash. WC Cl.; New Haven Paint & Clay Cl.; Academic A., Springfield; F., Fifty Am. Artists; Catherine L. Wolfe A. Cl.; Nat. Lg. Am Pen Women (A. Chm. 1958-62, NYC Branch A. Chm., 1965-66, State A. Chm., 1965); F., Royal Soc. A., London; Contemp. A. Cl, Greenwich, Conn.; AAPL. Awards: prizes, AAPL, 1952; Catherine Wolfe A. Cl., 1953, 1954, 1957, 1968; Nat. Lg. Am. Pen Women, 1958 (2), 1959 (2), 1967, 1968; Newbold

Morris Award, 1964. Work: New-York Hist. Soc.; East Hampton Hist. Soc.; Tamassee (S.C.) School. Exhibited: NAWA, 1944-1948; All. A. Am., 1944, 1952; Ogunquit A. Center, 1947, 1948, 1952, 1955; AAPL, 1953, 1967, 1969; Nat. Lg. Am. Pen Women, 1958-1969; Catherine Wolfe A. Cl., 1949-1969; P. & S. of New Jersey, 1945-1947; New Haven Paint & Clay Cl., 1946-1948, 1950-1953, 1955; Portland (Me.) Soc. A., 1947, 1948; Wash. WC Cl., 1947, 1954-1956; Academic A., 1955-1958, 1967; NAC, 1954, 1955, 1957-1961; Fifty American Artists, 1955-1965; Contemp. A. Cl., 1964, 1966, 1969; Guild Hall, East Hampton, 1949, 1950, 1953-1956; one-man: Squirrel Island, Me., 1949, 1950; New York, 1958, 1960; Fifty Am. A., 1969.

WHITEHILL, WALTER MUIR—Museum Director, W., E.
Boston Athenaeum, 10½ Beacon St., Boston, Mass.; h. 44 Andover St., North Andover, Mass. 01845
B. Cambridge, Mass., Sept. 28, 1905. Studied: Harvard Univ., A.B., A.M., Univ. London, Courtauld Inst., Ph.D.; & in Spain, France, Ireland. Member: Mass. Hist. Soc.; Am. Antiquarian Soc.; Hispanic Soc. Am.; CAA; Mediaeval Acad. Am.; etc. Awards: D. Litt., Univ. New Brunswick, 1959; LL.D., Washington & Jefferson Col., 1959; L.H.D., Northeastern Univ., 1961; L.H.D., Univ. of Delaware, 1967; Merrimack Col., 1968; Hon. member, Boston Society of Architects. Author: "Spanish Romanesque Architecture of the Eleventh Century," 1941; "The East India Marine Society and the Peabody Museum of Salem, a Sesqui-Centennial History," 1949; "Boston Public Library, a Centennial History," 1956; "Boston, A Topographical History," 1959; "Dumbarton Oaks," 1967 & other books. Contributor to: art & educational journals & bulletins, with articles concerning mediaeval Spanish art. Positions: Asst. Dir., 1936-46, Trustee, 1950- , Peabody Mus., Salem, Mass.; Dir. & Libn., Boston Athenaeum, Boston, Mass., 1946- ; Memb. Faculty, Peabody Mus., Harvard Univ., 1951- ; Senior Tutor, Lowell House, Harvard Univ., 1952-1956; Trustee, Boston Mus. FA, 1953- ; Editor, Am. Acad. A. & Sc., 1954-1957. Lecturer, Harvard Univ., 1956-57; Lowell Inst., 1958.

WHITESIDE, FORBES J.—Scholar
Art Department, Oberlin College, Oberlin, Ohio 44074*

WHITMAN, ROBERT—Painter
c/o Pace Gallery, 9 W. 57th St., New York, N.Y. 10019*

WHITMEYER, STANLEY H.—Educator, Des., P., W., L.
School of Art & Design, Rochester Institute of Technology; h. 51 Kron St., Rochester, N.Y. 14619
B. Palmyra, Pa., Feb. 14, 1913. Studied: Rochester Inst. Tech.; N.Y. State Univ. T. Col., B.S. in Ed.; Syracuse Univ., M.F.A. Member: N.Y. State A. T. Assn.; Eastern AA; NAEA; Rochester A. Cl.; Rochester A. Council. Awards: Grad. Scholarship, Syracuse Univ., 1944; Outstanding Alumni, 1968, State University College at Buffalo; Citation 1968 by New York State Art Teachers Association. Exhibited: Rochester Mem. A. Gal.; Olean, N.Y.; Albright A. Gal.; Harrisburg, Pa.; Honolulu Acad. A.; Bevier & Rundel Gal. Contributor to School Arts, Design, Everyday Art, Torch magazines. Positions: Prof., Dir., Sch. of A. & Design, Rochester Inst. Tech., Rochester, N.Y. Vice-Pres., Arts Council of Rochester.

WHITMORE, COBY—Painter, I.
414 Baynard Cove Club, Hilton Head Island, S.C. 29982
B. Dayton, Ohio, June 11, 1913. Work: The Pentagon, Wash., D.C.; U.S. Air Force Acad.; New Britain (Conn.) Mus. Am. A.; Syracuse Univ.; Soc. of Illustrators; also McCalls, Ladies Home Journal, and various British and European publications.

WHITNEY, MR. and MRS. JOHN HAY—Collectors
163 E. 63rd St., New York, N.Y. 10021
Position: (Mr. Whitney) Vice-President, National Gallery of Art, Smithsonian Institution, Washington, D.C.*

WICK, PETER ARMS—Scholar, Collector
Houghton Library, Harvard University, Cambridge, Mass. 02138; h. 35 W. Cedar St., Boston, Mass. 02114
B. Cleveland, Ohio, May 17, 1920. Studied: Yale University, B.A., B. Arch.; Institute of Fine Arts, New York University; Fogg Art Museum, Harvard University, M.A. Field of Research: Prints and drawings. Author: "Prendergast Watercolor Sketchbook"; "Jacques Villion: Master of Graphic Art," Exhibition Catalogue, BMFA; Honoré Daumier Anniversary Exhibition Catalogue, BMFA, 1958; "A Summer Sketchbook by David Levine," 1963. Collection: Prints and Drawings. Positions: Assistant Cur., Dept. of Prints and Drawings, BMFA, 1962-1964; Director, Print Council of America, 1965; Governor, Gore Place, Waltham-Watertown, Mass., 1965; Asst. Director, Fogg Art Museum, Harvard University, Cambridge, Mass., 1966-1967; Houghton Library, Harvard University, Cambridge, Mass. at present.

WIDSTROM, EDWARD FREDERICK—Sculptor
21 Lydale Pl., Meriden, Conn. 06450
B. Wallingford, Conn., Nov. 1, 1903. Studied: ASL; & with Arthur Lee, William Zorach. Member: Conn. Acad. FA; New Haven Paint & Clay Cl.; NSS; AAPL; Kent AA; Meriden A. & Crafts Assn; Hudson Valley AA; Springfield Acad. A.; Wallingford A. Lg. Awards: prizes, Meriden A. & Crafts Assn., 1937, 1946, 1950, 1967; Classic A., 1959-1961; New Haven Paint & Clay Cl., 1960; Academic A., 1960; Hudson Valley AA, 1961, 1967, 1968; Conn. Acad. FA, 1961; Springfield Acad. A., 1960; Council Am. A. Soc., 1964. Work: port. relief, port.bust, St. Stephen's Sch., Bridgeport, Conn.; Meriden A. & Crafts Assn.; Stoddard Mun. Bldg., Meriden; Presidents of the U.S., Washington to Johnson, Int. Silver Co.; New Haven Paint & Clay Cl. Exhibited: NAD, 1940, 1953, 1955, 1961-1964; PAFA, 1939, 1940; Fairmount Park, Phila., 1940; Conn., Acad. FA, 1934-1961; New Haven Paint & Clay Cl., 1939-1962; Meriden A. & Crafts Assn., 1936-1969; Cayuga Mus. Hist. & Art, 1941 (one-man); AAPL, 1960; NSS, 1959-1969; Kent (Conn.) AA, 1959-1969; Academic A., 1960-1965; Meriden Savings Bank, 1962 (one-man); AAPL, 1960, 1968; Springfield Acad. A., 1960-1968; Hudson Valley AA, 1961, 1967-1969.

WIEGAND, ROBERT—Painter
16 Greene St., New York, N.Y. 10013
B. Mineola, N.Y., May 15, 1934. Studied: Albright A. Sch., Buffalo, N.Y., State Univ. at Buffalo, B.S. in A. Edu.; N.Y. Univ. Grad. Sch. Member: Ptrs. & Sc. Soc. Awards: Cowper award, Sisti Galleries, Buffalo, 1957. Works: mural, N.Y.C. Dept. of Parks, 1968. Exhibited: Albright-Knox A. Gal., 1957; Knoedler Gal., N.Y., 1958; Riverside Mus., N.Y.; Staten Island Mus.; 10 Downtown, N.Y.C., 1968; BM, 1968; MModA, 1969; and over 30 other group shows, 1957 to date. One-man: six shows, 1957-1966. Contributor to Art Voices, 1965. Positions: Instr., Painting, Staten Island Academy, N.Y.

WIEGHARDT, PAUL—Painter, E.
School of the Art Institute of Chicago, Chicago, Ill.
B. Germany, Aug. 26, 1897. Studied: Sch. FA, Cologne, Germany; Bauhaus, Weimar, with Klee; Acad. FA, Dresden, Germany. Work: Albright A. Gal; Barnes Fnd., Merion, Pa.; Berkshire Mus.; PC; Rosenwald Coll.; Jenkintown, Pa.; Smith Col. Mus., and in private colls. Exhibited: Salon d'Automne, Salon des Tuileries, Salon des Independants, Paris, France; French Group, Exposition Nationale, Paris; AIC; PAFA; LC; Soc. Contemp. A., Chicago; Stanford Univ.; Univ. Illinois; Salon d'Automne, 1947-1955; one-man, 1941-58: Berkshire Mus.; Harvard Univ.; St. Paul A. Gal.; PC; Knoedler Gal.; Springfield Mus. FA; AIC; Illinois Inst. Tech.; Syracuse Univ.; Milwaukee AI; Osthaus Mus., Hagen, West Germany; Univ. Arizona; 1020 A. Center, Chicago, and others. Positions: Prof., AIC, Chicago, Ill., 1946-1963; Instr., Evanston A. Center (Ill.), 1948- ; Instr., Dept. Arch., Ill. Inst of Tech., Chicago, 1950- .*

WIER, GORDON D. (DON)—Designer, P., T., I.
717 Fifth Ave., New York 22, N.Y.; h. 201 E. 21st St., New York, N.Y. 10010
B. Orchard Lake, Mich., June 14, 1903. Studied: Univ. Michigan, A.B.; Chicago Acad. FA.; Grand Central Sch. A.; and with J. Scott Williams. Awards: Inst. Graphic Arts Certificate of Excellence, 1950, 1951. Work: Detroit Inst. A.; Musees Royaux d'Art et d'Histoire, Brussels; J. B. Speed Mem. Mus., Louisville, Ky.; and in the private collections of H. M. Baudouin I, King of the Belgians; Their Majesties, King Frederick IX and Queen Ingrid of Denmark; Chancellor Konrad Adenauer, Germany; President Morales, Honduras; H.I.H. Crown Prince Akihito, Japan; Their Serene Highnesses Prince Rainier III and Princess Grace, Monaco; H.M. Queen Ratna Rajya Lakshmi Devi Shah, Nepal; The Rt. Hon. Sir Winston Spencer Churchill, United Kingdom. Exhibited: Balt. WC Cl.; Delaware River AA; Society of Decorators; 2 one-man exhs., Bridgeport, Conn. Illus.; "Aventures par la Lecture," 1932; "The Victors," 1933. Positions: Instr., Grand Central Sch. A., 1928-35; Designer, Steuben Glass, 1945-49; Designer, Corning Glass Works and Steuben Glass, 1949-50; Designer, Steuben Glass, 1950-51; A. Dir., Steuben Glass, 1952- .*

WIESE, KURT—Illustrator, W.
R.D. 1, Frenchtown, N.J. 08825
B. Minden, Germany, Apr. 22, 1887. Studied: abroad. Member: Phila. WC Cl.; Hunterdon County A. All. Work: Author, I., "The Chinese Ink Stick"; "Liang and Lo"; "Karoo the Kangaroo"; "Ella, The Elephant"; "The Rabbit's Revenge"; "The Parrot Dealer"; "Fish in the Air"; "The Dog, The Fox and The Fleas"; "Happy Easter"; "The Cunning Turtle"; "The Groundhog and His Shadow"; "Rabbits Bros. Circus"; "A Thief in the Attic," and other books. Illus. over 300 children's books.

WIESENBERGER, ARTHUR—Collector, Patron
61 Broadway, New York, N.Y. 10006; h. Old Mill River Rd., Pound Ridge, N.Y. 10576
B. New York, N.Y. Studied: Columbia College, B.A. Member:

(Life) MMA; (Patron) PMA; WMAA. Collection: Abstract painting; Impressionist painting; Tibetan painting; Tibetan and Indian sculptures. Positions: Member, Advisory Council, Dept. of Art and Architecture, Columbia University.*

WIGGINS, BILL—Painter
711 West 8th St., Roswell, N.M.
B. Roswell, N.M., Sept. 24, 1917. Studied: Abilene Christian College; Am. Univ., Shrivenham, England, with Francis Speight. Member: AEA. Work: Roswell Mus. & A. Centre. Exhibited: Newport, R.I., 1954; Mus. New Mexico, 1952, 1958, 1960; Low Ruins Springs Nat. Exh., Tubac, Ariz., 1965; Fifth Nat. A. Exh., Tyler, Tex., 1968; Southwest A. Exh., Mus. of Southwest, Midland, Tex., 1968, 1969; Mainstreams '68, Marietta Col. (Ohio); one-man: Roswell Mus., 1951, 1955, 1957, 1960; Odessa (Tex.) College 1955; Midland (Tex.) Women's Cl., 1955; Midland Inst. FA, 1959, 1964; Artesia (N.M.) Pub. Lib., 1959; Mus. New Mexico, 1960; Eastern New Mexico Univ., Portales, 1969. Positions: Instr., Roswell Museum & A. Center, 1955-1963.

WIGHT, FREDERICK S.—Educator, Gal. Dir., W., P.
Art Galleries, University of California 90024; h. 456 North Bundy Drive, Los Angeles, Cal. 90049
B. New York, N.Y., June 1, 1902. Studied: Academie Julian, and others, Paris, France; Univ. Virginia, B.A.; Harvard Univ., M.A. Author: Van Gogh, 1953; Goya, 1954; John Marin, 1955; Morris Graves, 1956; Hans Hofmann, 1957; Arthur G. Dove, 1958; Richard Neutra, 1958; Modigliani, 1961. New Art in America (co-author), 1957; Looking at Modern Paintings, 1957. Work: Los A. Mus. A.; Roswell Mus. A. Exhibited: one-man: deYoung Mem. Mus., 1956; Pasadena A. Mus., 1956; Fine Arts Gal., San Diego, 1960; Esther Robles Gal., 1960; Long Beach Mus. A., 1961. Positions: Asst. Dir., Inst. Contemp. A., Boston; Dir., Art Galleries, 1953- , Chm. Dept. Art, 1963-1966, Univ. California at Los Angeles.

WILDE, JOHN—Painter, E.
Department of Art, University of Wisconsin, Madison, Wis.; also, R.F.D. No. 1, Evansville, Wis. 53536
B. Milwaukee, Wis., Dec. 12, 1919. Studied: Univ. Wisconsin, B.S., M.S. Work: AIC; PAFA; Univ. Nebraska; Marquette Univ.; Santa Barbara Mus. A.; WMAA; Wadsworth Atheneum; Carnegie Inst.; WAC; WMA; de Beers Coll., Johannesburg, S. Africa; Milwaukee War Memorial; Detroit Inst. A.; St. Paul A. Gal., Nat. Inst. A. & Lets.; NCFA. Exhibited: CGA, 1953; PAFA, 1940, 1946, 1947, 1950-1960; WMAA, 1952-1957, 1958, 1960, 1961, 1963; MMA, 1950, 1952, 1957; AIC, 1941, 1947, 1948, 1950-1953; VMFA, 1948; Univ. Illinois, 1948, 1952, 1953, 1955, 1957, 1959, 1961, 1963; Walker A. Center; Milwaukee AI; NAD; Butler Inst. Am. A.; Denver A. Mus.; A. Festival, Spoleto, Italy; AFA, 1964-65; Gal. Mod. A., N.Y., 1965; Art: USA, auspices of USIA, England, Italy, Austria, Germany, Japan, Spain, etc.; Mus. Mod. A., Paris, France; one-man exhs., Retrospective Milwaukee Art Center, 1967. Positions: Instr., Dept. A. Edu., 1948-50, Asst. Prof. 1950-55, Assoc. Prof., 1955-59, Prof., 1959- , Chm. Dept. A. & A. Edu., 1960-1962, appointed Alfred L. Sessler distinguished Prof. of Art, 1969, Univ. Wisconsin, Madison, Wis.

WILDENHAIN, FRANS RUDOLF—Ceramic Craftsman, P., S., T.
School for American Craftsmen, Rochester Institute of Technology, 65 Plymouth Ave., South, Rochester, N.Y.; h. 6 Laird Lane, Pittsford, N.Y. 14534
B. Leipzig, Germany, June 5, 1905. Studied: Bauhaus, Weimar, Germany. Awards: prizes, Int. Exp., Paris, 1939; Exh., Los A., 1949 (2); Wichita AA, 1951; Rochester Mem. A. Gal., 1951 (2), 1953 (2), 1954 (2), 1955, 1956 (2), 1958, 1960, 1961, 1963, 1964; Univ. Rochester, 1953, 1963; Albright A. Gal., 1952, 1954, 1957, 1958, 1964; St. Paul A. Gal., 1955; Miami Nat., 1957, 1958; Syracuse Mus. FA, 1957, 1964; Guggenheim F., 1958. Work: Stedeljik Mus., Amsterdam; Boymans Mus., Rotterdam; Stoke-Upon-Trent, England; Mons, Belgium; Faenza and Milan, Italy; Portland A. Mus.; SAM; Scripps Col.; BMA; Everson Mus., Syracuse; Indianapolis AA; AIC; Rochester Mem. A. Gal.; Univ. Illinois; Univ. Michigan; Univ. So. Illinois; St. Paul A. Gal.; Munson-Williams-Proctor Inst. Ceramic Murals: Strasenburgh Laboratories, Rochester; Nat. Library of Medicine, Wash., D.C.; Summit Hospital, N.J. Exhibited: MMA, 1929; SFMA, 1949; deYoung Mem. Mus., 1948; Portland A. Mus., 1949; San Diego A. Gal.; AIC; Walker A. Center; Des Moines A. Center; VMFA; Univ. California; Univ. California at Los A.; Dallas Mus. FA; Ft. Worth AA; Henry Gal., Seattle; Wichita AA; BMA; Syracuse Mus. FA, 1952, 1954, 1955, 1956, 1958, 1960, 1962, 1964; Rochester Mem. A. Gal., 1951-1965; Univ. Illinois, 1953, 1955, 1956, 1957; BM, 1953, 1961; Albright A. Gal. 1954-1960, 1964; Nebraska AA, 1955; America House, N.Y., 1955; Ceramic Int., Cannes, France, 1955; Ostend, 1959; Prague, 1962; Miami Nat., 1957, 1958; Mus. Contemp. Crafts, 1956, 1962-1964; Brussels Fair, 1958; and many others. Contributor of ceramic designs to Art & Architecture, House Beautiful, Crafts Horizons, Ceramic Monthly, American Artist, Fortune, and

other publications. Positions: Prof., Ceramics, Sch. for Am. Craftsmen, Rochester Inst. Tech., Rochester, N.Y. at present.

WILDENHAIN, MARGUERITE—Ceramist
Haystack Mountain School of Crafts, Deer Isle, Maine 04627*

WILDENSTEIN, DANIEL —Art Historian, Art Dealer
19 E. 64th St. 10021; h. 11 E. 64th St., New York, N.Y. 10021
B. Verriéres-le-Buisson (Seine) France. Studied: Sorbonne, Paris, Licencié ès Lettres. Specialty of Gallery: Old Masters, French 18th century paintings, drawings, sculpture, 19th century French paintings. Positions: Group sec. French Pavilion, World's Fair, 1937; Director (with the Late Georges Wildenstein) Arts, weekly French newspaper and also Gazette des Beaux-Arts, 1951- ; Director, activities, Musée Jacquemart-Andre, Paris, and Musée Chaalis, Institut de France, Paris; Vice-Pres., 1943-1963, Pres. & Chm. of Board, 1963-1968; Chm. of the Board, 1968- , Wildenstein & Company, New York, N.Y.

WILDER, MITCHELL A(RMITAGE)—Museum Director, E.
Amon Carter Museum, 3501 Camp Bowie Blvd., Fort Worth, Tex. 76107
B. Colorado Springs, Colo., Aug. 19, 1913. Studied: McGill Univ., Montreal, Canada, A.B.; Univ. California, Berkeley. Author: "Santos' Religious Folk Art of New Mexico." Positions: Dir., Amon Carter Museum, Fort Worth, Texas, at present.

WILEY, WILLIAM T.—Painter
Muri Beach, Sausalito, Cal. 94965*

WILFORD, LORAN FREDERICK—Painter, T.
Ringling School of Art, Sarasota, Fla. 33578
B. Wamego, Kan., Sept. 13, 1893. Studied: Kansas City AI, and with Charles Wilimovsky, George Pearse Ennis. Member: AWS; Audubon A.; SC; Sarasota AA; Bradenton A. Lg.; Royal Soc. A., London. Awards: prizes, AWS, 1929, 1932, 1961, 1962; Phila. WC Cl., 1931; SC, 1930, 1953; Audubon A., 1945; Sarasota AA, 1954, 1959, 1961, 1965; Bradenton A. Lg., 1965; Ft. Lauderdale, Fla., 1954. Work: Toledo Mus. A.; N.Y. Pub. Lib.; Atlanta Art Assn. Galleries: murals, Holmes Pub. Sch., Darien, Conn.; Springfield A. Mus., Springfield, Mo., and in many private colls. Exhibited: Carnegie Inst.; CGA; NAD; PAFA; GGE 1939; Audubon A.; AWS; Palm Beach, Fla.; Ft. Lauderdale, Fla.; MMA, 1966. One-man. Huntsville Art Center & Mus., 1969. Positions: Instr., Ringling Sch. A., Sarasota, Fla.

WILKE, ULFERT S.—Painter, E., Mus. Dir.
Museum of Art, University of Iowa; h. 21 Lakeview Circle, Iowa City, Iowa 52240
B. Bad Toelz, Germany, July 14, 1907. Studied: in Germany; Paris, France; Harvard Univ.; State Univ. Iowa, M.A. Member: CAA. Awards: Albrecht Durer prize, Germany, 1928; Delgado Mus. A., 1944; Ky.-Ind. Exh., 1951-1957; Soc. Four Arts, Palm Beach, 1944, 1946; Va. Intermont Col., 1951; medal, Army Art Comp., 1945; Guggenheim F., 1959-60, 1960-61. Work: Hanover Mus., Germany; Univ. Iowa; Univ. Louisville; Univ. Illinois; Stanford Univ.; Mills Col.; Univ. Kentucky; Wadsworth Atheneum; Carnegie Inst.; AGAA; Dayton AI; Joslyn Mem. Mus.; PMA; Chase Manhattan Bank; Phoenix Mus. A.; North Carolina Mus. A.; SFMA; N.Y. Univ.; Columbia Univ.; CMA; WMAA; Bezalel Mus., Jerusalem; Los Angeles County Mus., and in private colls. Exhibited: Berlin Acad., 1930, 1931; MMA, 1952; AIC, 1944; Guggenheim Mus., N.Y., 1954; BM, 1955, 1957; VMFA, 1958; deYoung Mus., 1959; Kraushaar Gal., N.Y., 1960; Smithsonian Inst. traveling exh.; Howard Wise Gal., N.Y., 1965 and 3-man 1965; Kalamazoo Inst. A., 1964 (2-man); Martha Jackson Gal., N.Y., 1964; MModA, 1965; Newark Mus., 1966; Berne, Switzerland, 1965; Nat. Inst. A. & Lets., 1965; Dayton A. Inst., 1965. 1966-1967; N.J. State Mus., Trenton, 1966, 1967; Inst. Contemp. A., Boston, 1966; Tokyo, Japan, 1967; N.Y. Univ., Loeb Center 1967; Simone Stern Gal., New Orleans, 1968 (2-man); more than 30 one-man exhs., U.S. and Germany; one-man, Kyoto, Japan, 1958. Illus. "The Best of De Maupassant"; "Music To Be Seen," 1956; "Fragments From Nowhere," 1958. Lectures: under auspices of Assn. of Am. Colleges. Positions: Dir., Kalamazoo Inst. A., 1940-42; Dir., Springfield (Ill.) AA, 1946; Asst. Prof., Univ. Iowa, 1947; Assoc. Prof., Univ. Louisville, 1948-61, Prof., 1961-1962; (On sabbatical leave, Japan, 1958, Rome, Italy, 1959-61); Visiting Prof., A. in Res., Univ. Georgia, 1955-56; Univ. British Columbia, 1961; Asst. Prof., 1962-1964; Assoc. Prof., 1964-1967, Rutgers Univ.; Dir., Art Museum, Univ. Iowa, Iowa City, 1968- .

WILKINS, RUTH S.—Museum Curator
Everson Museum of Art, 401 Harrison St. 13202; h. 219 Standist Dr., Syracuse, N.Y. 13224
B. Boston, Mass., Nov. 20, 1926. Studied: Wellesley Col., B.A. Organized and catalogued: 22nd Ceramic National Exh., 1962; 9th-15th Syracuse Regional A. Exhs., 1961-1967; 23rd Ceramic National

Exh., 1964, 22nd-25th exhs., 1962-1968. Editor of Publications: "American Painting from 1830;" "Chinese Art from the Cloud Wampler and other Collections." Post Standard "Woman of Achievement in the Arts" award, 1968. Positions: Former Admin. Asst., Everson Museum of Art, Syracuse, N.Y.; Cur., Collections, Everson Mus. Art, Syracuse, N.Y., at present.

WILKINSON, CHARLES K.—Museum Curator
Brooklyn Museum, Eastern Parkway & Washington Ave., Brooklyn, N.Y. 11238*

WILLARD, CHARLOTTE—Writer, Critic, Scholar
340 E. 63rd St., New York, N.Y. 10021
B. Miscolz, Hungary, Oct. 27, 1914. Studied: New York University; Columbia University Graduate School; New School for Social Research. Author: "Moses Soyer," Monograph; "What Is a Masterpiece?". Contributor to Art in America. Field of Research: Renaissance- for "The Story Behind the Paintings." Positions: Managing Editor "Seventeen," 1944-1946; Exec. Editor, "Junior Bazaar," 1946-1947; Asst. Editor, "Look," "Flair." Author major article on Willem deKooning, Look magazine, May 27, 1969. Art Critic, New York Post, 1964-1969. Currently freelance. Elected member of International Art Critics Circle, 1968.

WILLE, O. LOUIS—Sculptor, T., P., A. School Dir.
The Tyrol, Box 422, Aspen, Colo. 81611
B. St. Paul, Minn., Apr. 27, 1917. Studied: Univ. Minnesota, B.A., M.A. Exhibited: Kraushaar Gal.; Sculpture Center, N.Y.; Walker A. Center; Minneapolis Inst. A.; Univ. Minnesota; Syracuse Mus. FA; Denver A. Mus.; Blue Door Gal., Taos, N.M.; Springville (Utah) A. Gal. Positions: Dir., Aspen A. Sch., Aspen, Colo.

WILLENBECHER, JOHN—Sculptor
c/o Feigen Gallery, 24 E. 81st St., New York, N.Y. 10028*

WILLET, HENRY LEE—Craftsman, W., L.
10 East Moreland Ave., Philadelphia, Pa. 19118; h. Willow Wadi Farm, Ambler, Pa. 19002
B. Pittsburgh, Pa., Dec. 6, 1899. Studied: Princeton Univ.; Univ. Pennsylvania, and in Europe. Awards: medal, Phila. A. & Crafts Gld.; Phila. A. All.; Doctor of Art, Lafayette Col., 1951; Citations, West Point Military Acad., 1960; Pa. Mus. Col. of Art, 1960; Hon. L.H.D., Geneva Col., Pa., 1966; Hon. L.H.D., Ursinus Col., Pa., 1967; Conover Award, Church A. Gld. Member: AFA; (Hon.) AIA; Arch. Lg.; F., Stained Glass Assn. Am.; PAFA; Fairmount Park Assn.; Am. Soc. for Church Architecture; Fellow, Royal Soc. Arts, London, England; Gld. for Religious Architecture. Work: stained glass windows, Nat. Cathedral, Wash., D.C.; U.S. Cadet Chapel, West Point, N.Y.; Westminster Presbyterian Church, Detroit; Princeton Univ. Chapel; Chicago Theological Seminary; Grosse Pointe (Mich.) Mem. Church; Westwood Community Church, Los A., Cal.; all window, Nat. Presbyterian Church Center, Wash., D.C.; Univ. Presbyterian Church, Seattle, Wash.; Mich. State Univ. Chapel; Bryn Mawr Presbyterian Church, Pa.; Montview Church, Denver, Colo.; Highland Park Presbyterian Church, Dallas; Robinson Sch., Puerto Rico; Westminster Church, Buffalo, N.Y.; sculpture, glass facade, The Church Center at The United Nations; 5400 glass panels for the Hall of Science, N.Y. World's Fair; all glass in the Millar Chapel and Vail Chapel, Northwestern Univ. and many others. Exhibited: in leading U.S. galleries, Exh. of Am. Stained Glass, U.S. Dept. Commerce, World Trade Fair, Poznan, Poland, 1958. Lecturer with traveling exh. "New Work in Stained Glass," at museums & colleges. "Gold" Process window illus. in Life magazine, 1955. Co-author, "Stained Glass," Encyclopaedia Americana. Contributor to Architectural Forum, Stained Glass Quarterly, Religion in Life, and other magazines. Positions: Chm., Bd., Willet Stained Glass Studios; Past Pres., 1942-44, Stained Glass Assn. Am.

WILLIAMS, BEN F.—Museum Curator, P.
North Carolina Museum of Art; h. 2813 Mayview Road, Raleigh, N.C. 27607
B. Lumberton, N.C., Dec. 24, 1925. Studied: Corcoran Sch. A., with Eugen Weisz; George Washington Univ., A.A.; Univ. North Carolina, A.B.; Columbia Univ., Paris Extension, Ecole du Louvre; Netherlands Inst. for Art History (10th Summer Course); ASL. Member: AAMus.; Southeastern Mus. Conf.; CAA. Awards: prizes, Southeastern Annual, 1947; North Carolina A., 1947; Wash. Soc. A., 1947; Wash. A. Fair, 1946; Ronsheim Mem. award, Corcoran Sch. A., 1946. Work: Atlanta AA; North Carolina Mus. A.; Greenville (N.C.) Civic A. Gal.; Duke Univ.; Knoll Assoc., N.Y. Exhibited: CGA; PC; Atlanta AA; VMFA; Jacques Seligmann Gal.; Virginia Intermont, Bristol, Va.; Weatherspoon Gal., Greensboro; Person Hall Gal., Chapel Hill, N.C.; Asheville A. Mus.; AFA traveling exhs. Contributor articles on 19th Century American Painting & Sculpture to North Carolina Museum of Art Bulletin; North Carolina Historical Review. Assisted with exhibitions "Rembrandt and His Pupils";

"E. L. Kirchner"; Arranged exhs.: "Francis Speight-Retrospective"; "Sculptures of Tilmann Riemenschneider"; "Carolina Charter Tercentenary Exhibition"; "Young British Art"; "North Carolina Collects"; the retrospectives for Josef Albers, Hobson Pittman, Jacob Marling, Victor Hammer, Feodor Zakharov, Henry Pearson, and the collections of the North Carolina Museum of Art. In charge of Annual North Carolina Artists' Exhibition. Positions: General Cur., North Carolina Museum of Art, Raleigh, N.C.

WILLIAMS, GARTH MONTGOMERY—Illustrator, S., P., W., Des.
Apartado Postal 123, Guanajuato, Gto., Mexico
B. New York, N.Y., Apr. 16, 1912. Studied: Westminster Sch. A.; Royal Col. A., London, England. Member: A.R.C.A.; F.I.A.L. Awards: Prix de Rome, 1936. Illus.: "Stuart Little"; "Little Fur Family"; "Wait 'Til the Moon is Full"; "Charlotte's Web"; "Little House Books" (8); "Tall Book of Make Believe"; "Cricket in Times Square"; "The Rescuers"; "The Friendly Book"; "Mr. Dog"; "Sailor Dog"; "Animal Friends"; "Baby Animals"; "Elves and Fairies"; "Amigo"; "Gingerbread Rabbit"; "Bianca"; "The Turret"; "Bread and Butter Indian"; "Bedtime for Francis," 1960; "Bianca in the Salt Mines"; "Push Kitty," 1968; "Tucker's Country," 1969. Author, I., "Benjamin Pink," 1951; "The Rabbits Wedding," 1958.

WILLIAMS, GERALD—Craftsman, L., W.
(Mail)—R.F.D. 1, Goffstown, N.H. 03045; h. Dunbarton, N.H. 03301
B. Asansol, India, Jan. 5, 1926. Studied: Cornell Col., Mt. Vernon, Iowa. Member: Lg. of New Hampshire A. & Crafts; Potters Gld. of New Hampshire; American Craftsmen's Council; Boston Soc. A. & Crafts (Trustee). Awards: prizes, Fitchburg A. Exh., 1962, 1964; Selected by Am. Assn. of Museums for Soviet Exchange Program, 1965, 1966. Work: Fitchburg A. Mus.; ceramic mural, Mt. Sunapee Ski Lodge, 1964; mosaic plaques, St. Anselm's Coll., 1955; Syracuse Univ. Mus.; Johnson Wax Coll. of Am. Crafts; wall plaques, Nashua and Laconia, N.H. Exhibited: Syracuse National Ceramic Exh., 1954, 1968; Wichita Ceramics, 1956; Young Americans, 1956; Am. Craftsmen's Mus., 1956; Brussels, 1958; Ostend Int., 1960; New Delhi, 1960; South America (State Dept. traveling exh.), 1964; Lg. of N.H. A. & Crafts, annually; Potters Gld. of New Hampshire; Fitchburg Mus. A.; Victoria & Albert Mus., London, 1966; Expo '67; Art in Embassies, 1967; Mass. and New England Crafts Exhs., 1968; BMFA Sch., 1968; Flint Mus. A., 1969; Nashua (N.H.) Art Sciences Center, 1969; Boston A. Festival, and others. One-man: De Cordova & Dana Mus., 1953; Univ. of New Hampshire, 1964; Sharon A. Center, 1966, Colby Jr. Col., 1967, Univ. of New Hampshire, 1969; Weiss Gal., Cleveland, 1967; L'Atelier Gal., Iowa, 1969. Author: "Textiles of Oaxaca," 1964 (a booklet published in connection with the exhibition "Textiles of Oaxaca"). Conducts illustrated lectures on India and Mexico. Collected, prepared and arranged the exhibition "Textiles of Oaxaca" and circulated for showing in U.S. museums. Positions: Instr., Sculpture, Currier Art School, Manchester, N.H.; Pottery, Dartmouth College (Hopkins A. Center), Hanover, N.H.; Pottery, Sharon (N.H.) A. Center; Worcester Craft Center, 1967; Willimantic (Conn.) State T. Col., 1968; Cortland (N.Y.) Univ., 1969.

WILLIAMS, GLUYAS—Illustrator Cart., W.
Sylvan Ave., West Newton, Mass. 02165
B. San Francisco, Cal., July 23, 1888. Studied: Harvard Univ., A.B. Work: Lib. Cong. Exhibited: BMFA, 1946. Author: "The Gluyas Williams Book," 1929; "Fellow Citizens," 1940; "The Gluyas Williams Gallery," 1957. I., "Daily Except Sunday," 1938; "People of Note," 1940; "Father of the Bride," 1949; all books by Robert C. Benchley. Contributor to: New Yorker magazine.

WILLIAMS, HERMANN WARNER, JR.—Historian, W., L., Cr., E.
Corcoran Gallery of Art, 17th St. & New York Ave. 20005; h. 3226 Woodley Rd., Northwest, Washington, D.C. 20008
B. Boston, Mass., Nov. 2, 1908. Studied: Harvard Col., A.B.; Harvard Univ., M.A.; Univ. London, Ph.D.; N.Y. Univ. Member: AAMus.; CAA; AFA; Assn. A. Mus. Dir. Co-Author: "William Sidney Mount, 1807-1868," 1944; Author: "The Civil War," 1961; "American Genre Painting," in progress. Contributor to: Burlington Magazine; MMA Bulletin; Life; Encyclopaedia Britannica & art magazines. Lectures: Contemporary American Painting. Positions: Asst. Cur., Renaissance Art, BM, 1936; Asst. Cur., Painting, MMA, 1936-46; Chief Hist. Properties Section, War Dept., 1945-46; Asst. Dir., CGA, Washington, D.C., 1946-47; Dir., 1947-1968, Emeritus, 1968- ; Consultant to the Board, 1968- .

WILLIAMS, HIRAM—Painter
Art Department, University of Florida; h. 2804 N.W. 30th Terr., Gainesville, Fla. 32601
B. Indianapolis, Ind., Feb. 11, 1917. Studied: Pennsylvania State Univ., B.S., M. Edu. Member: AAUP. Awards: prizes, Wilmington

A. Center, 1952 (2), purchase, 1953; D.D. Feldman Exh., Dallas 1956-1959; Texas State Fair, 1957; Texas FA Soc., 1959; Research Grant, Univ. Research Inst., of the Univ. Texas, Austin, 1958. Work: MModA, CGA; Michener Coll., Univ. of Texas; PAFA; Wilmington A. Center; Ringling Mus. A.; Johnson Wax Co. Coll.; WMAA; and in private collections. Exhibited: Wilmington Art Center, 1952, 1953; Donovan Gal., Phila., 1953; Texas FA Soc., 1955, 1957, 1959; Beaumont, Texas, 1956; New Orleans, 1956; Texas Graphics, Dallas, 1956; D.D. Feldman Exh., 1956, 1958, 1959; Texas State Fair, 1956, 1957; Mus. of Contemp. A., Houston, 1961; MModA, 1962; CGA, 1963, 1965; Carnegie Inst., 1964; WMAA, 1960; PAFA, 1963, 1964; one-man: Texas FA Soc., 1959; Cushman Gal., Houston, 1960; Nye Gal., Dallas, 1964; Chapman Kelley, Dallas, 1965; Nordness Gal., N.Y., 1961-1963; 2-man: Laguna Gloria Mus., Austin, 1957; Witte Mus. A., San Antonio, 1957. Positions: Instr. Advanced Painting, Univ. California at Los Angeles, Univ. Texas, Univ. So. Cal.; University of Florida, Gainesville, Fla., at present.

WILLIAMS, LEWIS W., II—Educator, Hist.
Art Department, Beloit College; h. 647 College St., Beloit, Wis. 53511
B. Champaign, Ill., Apr. 24, 1918. Studied: Univ. Illinois, B.F.A., M.F.A.; Univ. Chicago, Ph.D. Member: CAA. Lectures: History of Art—American, Modern and Renaissance. Awards: Teacher of the Year, Beloit College, 1966. Positions: Prof. A., Beloit College, Beloit, Wis., 1955- . Other teaching: Univ. Missouri, 1948-50, summer, 1961; Univ. Illinois, 1950; Northwestern Univ., 1953-55; Univ. Illinois, 1966.

WILLIAMS, MARY FRANCES—Educator, Mus. Cur.
Art Department, Randolph-Macon Woman's College; h. 239 Westmoreland St., Lynchburg, Va. 24503
B. Providence, R.I., Apr. 26, 1905. Studied: Radcliffe Col., B.A., M.A., Ph.D. Member: CAA; Arch. Historians; Archaeological Inst. Am.; AAUW; AAUP; Lynchburg A. Cl.; Lynchburg FA Center. Contributor reviews of exhibitions local newspapers. Author: Catalogue of Randolph-Macon Woman's College collection of American Painting. Positions: Asst. Prof. A., Hollins Col., 1936-39; Mt. Holyoke Col., 1939-43; Northwestern Univ., 1951-52; Assoc. Prof. A., State T. Col., St. Cloud, Minn.; Prof. A., Chm. Dept. Art, Curator, Randolph-Macon Woman's Col., 1952- ; Member, Va. State A. Commission, 1956- ; Virginia Commission on The Arts and Humanities, 1968- .

WILLIAMS, NEIL—Sculptor
60 Grand St., New York, N.Y. 10013
Exhibited: WMAA, 1965.*

WILLIAMS, WARNER—Sculptor, Des., L., T.
Geodesic Dome Studio, Culver, Ind. 46511
B. Henderson, Ky., Apr. 23, 1903. Studied: Berea Col.; Herron AI; AIC, B.F.A. Member: Chicago AC; NSS; Chicago AA; Hoosier Salon. Awards: prizes, AIC, 1941; Herron AI, 1929; Hoosier Salon, 1928, 1930, 1931, 1932, 1937, 1942; North Shore AA, 1939; City of Chicago award, 1938. Work: mem., bas-reliefs, etc.; Court House, Frankfort, Ky.; Berea Col.; Indiana Univ.; City Church, Gary, Ind.; Purdue Univ.; Bradwell Sch., Chicago; Francis Parker Sch., Chicago Univ. Pittsburgh; Ball Mem., Indiana State Col.; McCormick Mem., Northwestern Univ. Medical Sch., Chicago; Peck Recreational Area, Detroit; Hektoen Mem., Hektoen Clinic, Chicago; port., Cardinal Stritch Tomb, Chicago; Saint Cabrini Shrine, Chicago; Knute Rockne Mem., Voss, Norway; Thomas Masaryk Mem., Chicago. Other work 1964-69: Hippocrates tablet, Univ. Michigan Medical Center; Maimonides Mem., Univ. Ill., Univ. South Dakota, College of Pharmacy, Phila., Beth-el Hospital, Brooklyn, N.Y.; William Lear Mem., Lear, Inc., Grand Rapids; Charles Mather tablet, Culver Auditorium; Norwegian Mem., Chicago River Bridge; Queen Maria Theresa comm. medal for Societe Commemorative de Femmes Celebres; Edison Commemorative medal; State of Indiana Sesquicentennial medallion; Dr. Albert Schweitzer bas-relief for Bok Tower, Fla.; Athletic medal for Culver Educ. Fnd.; 50th ann. medal for 500-mile speedway race; bust of Dr. George Gruenfelder; St. Vincent de Paul medallion for DePaul Univ.; Arthur Schmitt mem, Univ. Chicago, and others. Contributor to: Design magazine. Positions: A. in Residence, Culver Military Acad., Culver, Ind., 1940-1968.

WILLIAMS, WHEELER—Sculptor, P., L.
15 West 67th St., New York, N.Y. 10023; also, Madison, Conn.
B. Chicago, Ill., Nov. 3, 1897. Studied: Yale Univ., Ph.B.; Harvard Univ. Sch. Arch., M. Arch.; Ecole des Beaux-Arts, Paris, France. Member: NA; NSS; Arch. L.; F., Am. Inst. FA; FA Fed. N.Y.; Mun. A. Soc., N.Y.; AAPL (Pres.); Am. Veterans Soc. A. Awards: prize, NAD, 1936; gold medal, NAC, 1956; AAPL, 1957; med., Paris Exp., 1937, and others. Work: San Diego FA Soc.; Brookgreen Gardens, S.C.; Four A. Gal., Palm Beach, Fla.; Norton Gal. A., West Palm Beach, Fla.; AIC; Hackley A. Gal.; Chapel, West Point; U.S. Naval

Acad., Annapolis; over-entrance, Parke Bernet Gal., N.Y.; bust of Clifford Holland, entrance to Holland Tunnel, N.Y.; Am. Battle Monument, Cambridge, England; statue of Sen. Taft, Taft Memorial Carillon, Wash., D.C.; garden facade, Brooks Mem. A. Gal., Memphis, Tenn.; bust of Othmar Ammann, Des. & Engineer of George Washington Bridge, N.Y.; other major works 1962-1965: "Pioneer Mother of Kansas," Liberal, Kans.; Bust of Admiral Hewitt, U.S. Naval Acad.; "Muse of the Missouri Fountain," Kansas City; bronze bust of Admiral Luis de Florez, U.S. Naval Training Center, Port Washington; many architectural & monumental works, portrait busts, relief, medals, garden sculptures, ecclesiastic statues, throughout U.S., South Africa, & Canada. Exhibited: Salon des Artistes Francais, 1923-1927; Salon d'Automne, Paris; PAFA; AIC; WFNY, 1939; NAD; GGE, 1939; Palace Legion Honor; NSS, etc.; one-man exh.: Ferargil Gal.; Arden Gal, Guild Hall, East Hampton, L.I., N.Y.; Soc. Four A.; etc. Lectures: Garden Sculpture; Portrait Sculpture; Methods & Techniques. Author: Monograph on Sculpture, 1947.*

WILLIS, MRS. ELIZABETH BAYLEY—Collector
Agate Point, Bainbridge Island, Wash. 98110
B. Somerville, Mass., May 9, 1902. Studied: University of Washington, A.B.; Studied with Lyonel Feininger, Mark Tobey, Morris Graves. Collection: Contemporary costumes and textiles of India, Mingei (Folk arts of Japan—textiles and pottery), collections now at the University of Washington; Costumes and textiles of Southeast Asia and Tibet, now at the Smithsonian Institution and Burke Memorial, Washington State Museum, Seattle; Ming and Ch'ing paintings (private collection). Positions: Cur., Henry Gallery, Univ. of Wash., 1946-1947; Associate, Willard Gallery, N.Y., 1943-1946; Cur., SFMA, 1947-1949; Acting Asst. Director, California Palace of Legion of Honor Museum, 1949-1951; Consultant, UN Technical Assistance, Handicrafts, 1952-1958; Adviser, Government of India, handloom textile industry, 1955-1957; Research, India and Northeast Frontier Arts and Textiles, 1959-1964; Surveys of handicrafts for UN: Formosa, Vietnam, India, Morocco. Research consultant on Decorative Arts.

WILLSON, ROBERT—Sculptor, C., P., E.
Art Department, University of Miami, Coral Gables, Fla. 33146; h. 7955 S.W. 126th Terr., Miami, Fla. 33156
B. Mertzon, Tex., May 28, 1912. Studied: Univ. Texas, B.A.; Univ. of Mexico and Univ. de Bellas Artes, M.F.A.; Advanced study with Orozco and others. Member: CAA; AAUP; AAMus.; Int. Council of Mus.; Florida Craftsmen; Florida Sculptors, and others. Awards: National Scholarship to Corning Museum of Glass, 1956; Univ. Miami Art Grant to Italy in Glass Sculpture, 1964; prizes, Lowe A. Gal.; Nat. Ceramic Exh., Miami. Work: Painting, Nat. Mus. of Art, Auckland, N.Z.; Witte Mem. Mus.; sculpture, Univ. Miami; glass sculpture in the collections of: Museo Correr, Venice, Italy; Nat. Italian Glass Mus., Murano; Corning Mus. of Glass, N.Y.; Carrain Glass Coll., Padova, Italy; Norton Gal. A., West Palm Beach; Harmon Gal., Naples, Fla., and in private colls. Exhibited: SFMA; Nat. Ceramic Exh., Syracuse, N.Y.; Nat. Ceramic, Miami; Texas Sc.; Fla. Sculptors; Fla. State traveling exh.; Texas Ceramic Exh.; glass sculpture: (group exhs.) Fucina degli Angeli Mus., Venice, 1967, 1968, 1969 (with Picasso, Leger, Braque, and others) Adria Gal., N.Y., 1968; U.S. tour including Ringling A. Mus., Sarasota, Mus. FA of Houston, Lakeview A. Center, Norton Gal. A., West Palm Beach, Corning Mus., Miami A. Center and others, 1969-1971. One-man: invited by City of Venice, Galeria Becilacqua la Masa, San Marco, 1964; Museo Correr Venice, 1969. Editor, Des., "Samuel Kress Collection in Miami," Univ. Miami Press, 1961; Author, Ed. (catalog, color) "Renoir to Picasso 1914," Univ. Miami, 1963. Originator, Curator, Editor of Catalog for "3500 Years of Colombian Art," exhibition at Univ. Miami, 1962. Author: "Art Concept in Clay," 1968 (college textbook on art history of ceramics), articles of glass sculpture in College Art Journal, 1966, 1969. Positions: Prof. A., Instr. in Glass, Ceramics and Enamels, University of Miami, Coral Gables, Fla., at present.

WILMETH, HAL TURNER—Educator, Gal. Dir., L., P.
Dominican College, San Rafael, Cal.; h. 96 Half Moon Rd., Novato, Cal. 94947
B. Lincoln, Neb., July 9, 1917. Studied: Kansas City AI, B.F.A.; Drury Col.; Univ. Nebraska; Univ. Chicago, M.A.; in Italy, and with Thomas Hart Benton, Ulrich Middeldorf, Roberto Longhi. Member: AAUP; AFA; No. Cal. Renaissance Soc., Italy-America Soc.; CAA. Awards: Vanderslice scholarship, Sch. Des. scholarship, Kansas City AI, 1937-38; Fulbright F., 1949-50, 1950-51. Work: Univ. Oklahoma, and in private colls. Positions: Instr., Kansas City AI, 1938-40; Instr., 1948-51, Asst. Prof. A. Hist., 1951-54, Univ. Nebraska; Dir., Gump's Gal., San F., 1954-60; Assoc. Prof., Dean of Students, Com. for Academic Admin., Cal. Col. A. & Crafts, Oakland, Cal., 1955-60; Univ. California Ext. Div., 1958-59; San Francisco State Col., 1960-61; Prof. A. Hist., Chm. Dept., Dominican Col., San Rafael, Cal., 1961- .

WILNER, MARIE (SPRING)—Painter
1248 White Plains Road, New York, N.Y. 10473
B. Paris, France, July 24, 1910. Studied: Hunter Col., B.A.; ASL; New Sch. for Social Research, N.Y. Member: Royal Soc. A., London (Life); Lg. Present Day A.; Kappa Pi; AAPL; NAWA; AEA; A. Lg. of Long Island; Nat. Soc. A. & Let.; Int. Platform Assn.; Int. A. Gld., Monaco; Centro Studi e Scambi Internationali; Leonardo da Vinci Soc. Awards: prizes, Ross Exh., Newark, N.J.; Village A. Center; Seton Hall Univ.; gold medal, AAPL, 1964; prizes, P. & S. Soc.; NAWA, 1963; Chevalier of the Société d'Encouragment au Progrès and Bronze Medal of Honor, 1968; Médaille de Bronze de Saint Luc, Haute-Académie Int. de Lutèce à Paris, 1968; Bronze Medal, Third Biennale Delle Regioni, Ancona, Italy, 1968. Work: Norfolk Mus. A.; N.Y. Univ.; Lowe Gal. A., Coral Gables, Fla.; Richmond (Ind.) AI; Evansville Mus. A.; Seton Hall Univ.; Birmingham (Ala.) Mus. A.; Sholem Asch Mus., Israel; LC; Georgia Mus. A.; Safad Mus., Israel; Tweed Gal., Univ. Minn.; Community Col., N.Y.; LaSalle Col., Pa.; and in France. Contributor article to "Physician's Wife" magazine; article & cover to Design. Exhibited: PAFA, 1957; Knickerbocker A., 1954, 1956, 1957; Chautauqua AA, 1958; Collectors of Am. A., 1955-1957; P. & S. Soc. of New Jersey, 1955-1957; NAWA, 1956, 1957 and traveling exhs.; AAPL, 1956, 1957, 1964; Seton Hall Univ., 1957; Peabody Inst., Balt.; Md.; Irvington A. Mus. Assn., 1952, 1953; Hudson Valley AA, 1953; Parke-Bernet Gal., 1957; Barzansky Gal., 1956; Bodley Gal., 1957; A. Lg. of Long Island; Hyannis AA, 1956; Riverside Mus.; Soc. Am. P. & S.; Pietrantonio Gal., N.Y., 1964 and prior; IBM; Creative Cl.; Creative Artists Assn.; Butler Inst. Am. A., 1961; Parrish Mus., Southampton, 1961; Salon de L'Art Libre, Paris, 1961; Brussels Int.; Hirschl & Adler Gal., N.Y.; several N.Y. group traveling exhs. to Europe, Asia, U.S. and South America; Ogunquit A. Center, 1961; Int. A. Festival, Saint-Germain des Prés, 1968; XV Int. Exh. Contemp. A., Rome, 1969; Palme d'Or des Beaux-Arts, Monaco, 1969; Int. Exposition, Charleroi, Belgium, 1968, 1969, and others. One-man: Cayuga Mus., 1961; Galerie Renoir, Belgium, 1961; Galerie Raymond Duncan, Paris, 1962; Mus. A., Science & Indst., Bridgeport, Conn.; Norval Gal., N.Y.; Gal. St. Placide, Paris; Deauville, 1964; Revel Gal., N.Y., 1963; Evansville Mus., 1965; Irving Gal., Milwaukee, 1964; Hazleton (Pa.) AA, 1965; Swope Mus. A., Terre Haute, 1965; Univ. Del., 1966; LaSalle Col., Phil., 1966-1968; N.Y. Univ., 1966; Oliva Gal., Southampton, 1966; Pietrantonio Gal., N.Y., 1966, 1969; Dickson Gal., Wash., D.C., 1968, 1969; Bohmann's Gal., Stockholm, 1968; Raymond Duncan Gal., Paris, 1967, 1968; Rioboo Nueva Gal., Buenos Aires, 1969; Tweed Gal., Univ. Minn., 1969. Positions: Cultural Advisor, Int. A. Gld., Monaco, 1969.

WILSON, BEN—Painter, T.
Vail, N.J.; h. 596 Broad Ave., Ridgefield, N.J. 07657
B. Philadelphia, Pa., June 23, 1913. Studied: Col. City of N.Y., B.S.S.; NAD; & with Karl Anderson, Leon Kroll, George Eggers. Member: Soc. Indp. A.; Hetero A. Group; Assoc. Artists of N.J.; Modern Artist Gld.; Vectors. Awards: prize, Col. City of N.Y., 1933; med., NAD, 1932; Noyes prize, Montclair A. Mus., 1958, Skinner prize, 1959, 1963; Ford Fnd. Grant, 1965. Work: Everhart Mus., Scranton, Pa.; Fairleigh Dickinson Univ., Edwards Col., Hackensack; Norfolk Mus. A. & Sciences. Exhibited: Audubon A., 1945, 1951; PAFA, 1946, 1955; Pepsi-Cola, 1946; Norlyst Gal., 1945; Riverside Mus., 1942; Am.-British A. Center, 1943; Soc. Indp. A., 1944; Newark Mus., 1952, 1955, 1958, 1961; New Sch. Social Research, 1952; Phila. A. All., 1955; DMFA, 1955; CMA, 1955; Albright A. Gal., 1955; CGA, 1955; Montclair A. Mus., 1956, 1969; YMHA, 1957; Art: USA, 1958, World's Fair, 1965; Lever House, N.Y., 1966; Jersey City Col, 1967; Chemical Bank—N.Y. Trust Co., N.Y., 1967; New Mexico State Univ., 1968; Edward Williams Col., N.J., 1968; Philharmonic Hall, N.Y., 1969; Trenton Mus., N.J., 1969; one-man: Galerie Neuf, 1946; Artists Gal., 1949; Rutgers Univ., 1949; Salpeter Gal., 1950, 1952, 1955, 1957; Highgate Gal., Montclair, N.J., 1959; New York, 1959; Galerie A. G., Paris, France, 1959; Fairlawn Lib., 1960; Granite Gal., N.Y., 1964; Spectrum Gal., N.Y., 1966; Bloomfield Col., N.J., 1968; Ridgefield Pub. Lib., N.J., 1968. Lectures: Modern Art, N.Y. Univ. Sch. Gen'l Edu., 1962; Artist-in-Res., Everhart Mus., Scranton, Pa. July 1965. Article, "Critique of Cobra," in Artists Proof, 1966.

WILSON, CHARLES BANKS—Painter, Lith., I., W., E., L.
100 North Main St.; h. 110 B St., Northeast, Miami, Okla. 74354
B. Miami, Okla., Aug. 6, 1918. Studied: AIC. Member: F.I.A.L. Awards: prizes, AIC, 1939; Laguna Beach AA, 1945; NAD, 1942, 1945; Mint Mus. A., 1944; BM, 1943; Wichita AA, 1945; Joslyn A. Mus., 1954; Hendrix Col., 1946; Chicago Soc. Et., 1939; LC, 1953, 1954; Philbrook A. Center, 1945, 1952, 1954, 1955, 1961; Springfield A. Mus., 1945. Work: Abbott Laboratories Coll.; Taggert Coll., Glasgow, Scotland; MMA; Gilcrease Inst.; Ford Motor Co.; Teton Nat. Park, Jackson Lake Lodge; many portraits, including Thomas Hart Benton, Thomas Gilcrease, Will Rogers and others. Commissioned by the Oklahoma House and Senate to do four life size por-

traits of notable Oklahomans—Will Rogers, Sequoyah, Sen. Robert Kerr and Jim Thorpe, for the rotunda of the Oklahoma State Capitol Bldg., the last one installed, 1968; work in many private colls. Exhibited: 1939-1958: Oakland A. Mus.; AIC; U.S. Dept. Interior; Denver A. Mus.; Laguna Beach AA; NAD; Mint Mus. A.; BM; Texas FA Assn.; LC; SAM; SFMA; AIGA; PAFA; DMFA; Joslyn A. Mus.; Philbrook A. Center; Oklahoma A. Center; Crocker Gal. A., Sacramento; Assoc. Am. A.; Univ. Kansas; Nelson Gal. A.; CGA; CAM; Hendrix Col.; NGA; Gilcrease Inst.; Okla. A. & M. Col.; Rochester Pr. Cl.; Minneapolis Inst. A.; Colorado Springs FA Center; Cal. PLH; Carnegie Inst.; Mus. FA of Houston; Delgado Mus. A., and in many others throughout U.S. 1960-61: paintings exh. in Europe & Asia, circulated by USIA. One-man: Philbrook A. Center; Oklahoma A. Center; Springfield Mus. A.; Univ. Tulsa; Smithsonian Inst.; Gilcrease Inst.; N.Y. World's Fair, 1964-65; Tulsa Lib.; Tri-State Fair, Amarillo, Tex., and others. Illus., State sch. text "Oklahoma, Our Home," 1955; "Whispering Wind," 1955; Author: "Indians of Eastern Oklahoma"; "Indians," 1964; color film: "Indians in Paint," 1955. Other illus.: "Henry's Lincoln," 1945; "Treasure Island," 1948; "The Mustangs," 1952; "The Texas Rangers," 1957; "On the Chisholm Trail," 1958; "The History of Geronimo," 1958; Author, I., "Ten Little Indians," 1957, and others. Contributor articles to Coronet, Colliers magazines; United Newspapers Magazine Corp.; U.S. Dept. Interior; Daily Oklahoman; regularly, watercolors to Ford Times magazine. Paintings used on Will Rogers Calendars, 1959, 1960, 1966 nationally publ. by Shaw-Barton Co. Lectures: Book Illustration, to Kansas, Illinois, & Ohio State Convention of School Librarians, Pittsburgh, Kans. & Cleveland, Ohio, Springfield, Ill. Positions: Hd., Div. A., Northeastern Oklahoma A. & M. Col., Miami, Okla., 1948-1961.

WILSON, EDWARD N.—Sculptor, E., Des.
Department Art & Art History, State Univ. of New York, Binghamton, N.Y. 13901
B. Baltimore, Md., Mar. 28, 1925. Studied: Univ. Iowa, B.A., M.A. Member: CAA; AFA; Assoc. A. of No. Carolina. Awards: Carnegie Grant, 1952; BMA; Ceceile Gal., N.Y., 1959; Howard Univ., purchase, 1961; State Univ. of N.Y. Fellowships, 1966, 1968. Work: Howard Univ.; Duke Univ.; State Univ. of N.Y., Binghamton, and in private colls. Exhibited: Art:USA, 1958; Univ. Iowa, 1951, 1954; North Carolina A., 1955, 1962; Maryland A., 1956, 1962; Duke Univ., 1956; Silvermine Gld. A., 1959; Chapel Hill A. Gal., (N.C.), 1959; Detroit Inst. A., 1959; Ceceile Gal., N.Y., 1959; PAFA, 1960; Woman's Col., Univ. No. Carolina, 1960-61; Howard Univ., 1961; Mint Mus., 1962; Munson-Williams-Proctor Inst., Utica, N.Y., 1965, 1968; Oakland A. Mus., 1967; FA Gal., San Diego, 1967; Univ. Cal., Davis, 1966; UCLA, 1966; Minneapolis Inst. A., 1968; High Mus. A., Atlanta, 1969; Everson Mus. A., Syracuse, N.Y., 1969. Commissions: Duke Univ., 1966; John F. Kennedy Memorial (Park and Sculpture), Binghamton, N.Y., 1966-1969. Illus. for College and University Business, Vol. 23, 1957; critical mention, La Revue Moderne des Arts, Paris, 1960; American Negro Art, London, 1960. Positions: Instr. A., 1951-53, Actg. Chm., 1953-54, Chm., Dept. Art, 1955-1964, North Carolina College, Durham, N.C. Assoc. Prof. A., State Univ. of New York, Binghamton, N.Y., 1964-1966, Prof. A., 1966- , Chm. Dept. A. and A. History, 1968- .

WILSON, JANE—Painter, E.
1974 Broadway; h. 317 W. 83rd St., New York, N.Y. 10024
B. Seymour, Iowa, Apr. 29, 1924. Studied: Univ. Iowa, B.A., M.A. Awards: Louis Comfort Tiffany Grant, 1967. Work: MModA; WMAA; Wadsworth Atheneum, Hartford; N.Y. Univ.; Rockefeller Inst.; Herron Mus. A.; Chase Manhattan Bank; Singer Coll.; Uris Corp. Exhibited: MModA., 1957-1959, 1961, 1964, 1965, (Embassies Program, 1967-1968); WMAA, 1963, 1968; CGA, 1963; Mass. Inst. Tech., 1962; PAFA, 1964; Gal. Mod. A., N.Y., 1965; AFA, 1963, (Embassies Program, 1967-1968); Univ. Nebraska, 1964; Mulvane A. Center, Topeka, 1964; Landau Gal., Los A., 1962, 1965; Esther Bear Gal., Santa Barbara, 1963, 1964; N.Y. World's Fair, 1964; Parke Bernet Gal., N.Y., 1964; Parrish Mus. A., Southampton, 1965; New York Parks Comm., 1967; Smithsonian traveling exh., 1968; Newport Festival of A., 1968; Univ. of Iowa, 1969; Finch Col. (N.Y.), 1969; one-man: Graham Gal., N.Y., 1968, 1969. Positions: Instr., Art History, Pratt Institute, 1967-1969.

WILSON, RALPH L.—Collector
301 21st N.W., Canton, Ohio 44709*

WILSON, SOL—Painter, Printmaker
200 West 72nd St., 10023; h. 530 West 113th St., New York, N.Y. 10025; s. 495 Commercial St., Provincetown, Mass.
B. Vilno, Poland, Aug. 11, 1896. Studied: CUASch; NAD; BAID; & with George Bellows, Robert Henri. Member: ANA; AEA; Cape Cod AA; Provincetown AA; Audubon A. Awards: prizes, Am. Red Cross, 1942; AV, 1943; Pepsi-Cola, 1944; Audubon A., 1947, 1949, 1963;

Medal of Honor, 1959; CGA, 1947; Carnegie Inst., 1947; Am. Acad. A. & Let., 1950; Cape Cod AA, 1953, 1954, 1956; Nat. Soc. Painters in Casein, 1955; NAD, 1958, Carnegie prize, 1966. Work: Telfair Acad.; Lincoln H.S., N.Y., Brooklyn Col.; BM; Am. Red Cross; LC; WMAA; Butler AI; WMA; BMA; Delgado Mus. A.; MMA; Newark Mus.; Univ. Minnesota; SAM; CAM; USPO, Delmar, N.Y.; Westhampton, N.Y.; Living Arts Fnd., N.Y.; Nebraska AA; Bezalel and Ain Harod Museums, Israel; Blanden Mem. Mus.; Ball State Univ.; N.Y. Univ. Coll.; Syracuse Univ.; Mary Washington Col.; Norfolk Mus. A. & Science; Prudential Life Ins. Coll., New Jersey; Provincetown AA; Brandeis Univ.; Smithsonian Inst.; Wisconsin State Univ. Exhibited: NAD, 1938, 1940, 1945, 1946; PAFA, 1934, 1935, 1940, 1945; Carnegie Inst., 1943-1946; WMAA, 1945; CGA, 1935, 1943, 1945; AIC, 1935, 1943, 1945; VMFA, 1942, 1944, 1946; Critics Choice, N.Y., 1945; Nebraska AA, 1945, 1946; Lib. Cong., 1944; Univ. Iowa, 1945, 1946; CAM, 1939; Pepsi-Cola, 1944, 1945; etc.

WILSON, TOM MUIR—Graphic Designer, E.
2524 Grand Ave. S., Minneapolis, Minn. 55405
B. Bellaire, Ohio, Dec. 6, 1930. Studied: Rochester Inst. Tech.; M.F.A.; Cranbrook Acad. A., B.F.A.; West Virginia Inst. Tech. Awards: prizes, Phila. Pr. Cl., 1961; AIA award (sculpture), 1956; Photography published in Art in America, 1961. Exhibited: Boston A. Festival, 1961; Chatham Col., Pittsburgh, 1961; Lancaster, Pa., 1960; Photography Exh., George Eastman House, Rochester, N.Y., 1963; Western New York Annual, Buffalo, 1963; 1964; Art of Two Cities, Minneapolis, 1965; one-man: Rochester, N.Y.; Wheeling, W. Va., 1957, 1959, 1961; Source Gal., Boston. Positions: Prof. A., Instr., Photography and Graphic Design, Minneapolis School of Art; Photography, Rochester Inst. Tech.; Sculpture & Des., Nazareth Col., Rochester; Designer, Exhibit Galleries, George Eastman House Museum of Photography, 1961-62; Freelance photographer and Graphic Designer, New York, Rochester and Minneapolis, 1961- .*

WILTON, ANNA KEENER. See Keener, Anna Elizabeth

WINCHESTER, ALICE—Writer, Editor
Antiques Magazine, 551 Fifth Ave.; h. 249 E. 48th St., New York, N.Y., 10017
B. Chicago, Ill., July 26, 1907. Studied: Smith College, A.B. Awards: Hon. L.H.D., Russell Sage College, 1966; Smith College Medal, 1968. Author: "How to Know American Antiques," 1951; Co-author: "American Primitive Painters," 1954; Co-editor: "The Antiques Book"; "The Antiques Treasury"; "Living with Antiques," and other books. Editor, Antiques Magazine, 1938- .

WINDFOHR, MR. and MRS. ROBERT F.—Collectors
1900 Spanish Trail, Fort Worth, Tex. 76107
Position: (Mr. Windfohr) Chm. Board, Fort Worth Art Center, Fort Worth, Texas.*

WINER, DONALD ARTHUR—Museum Curator, P., C., E.
William Penn Memorial Museum, Harrisburg, Pa. 17108
B. St. Louis, Mo., Oct. 26, 1927. Studied: Univ. Missouri, B.S., M.A. Member: AAMus., Pa. Gld. of Craftsmen. Exhibited: group and one-man exhibitions. Arranged exhibitions: Dixie Annual 1959; American Jewelry Today 1963; William Singer, Pa. Impressionist 1967; Edwin W. Zoller Memorial, 1968. Positions: Edu. Cur., Springfield A. Mus., Springfield, Mo., 1954-1957; Dir. Edu., Brooks Memorial Art Gallery, Memphis, Tenn., 1957-1959; Dir., Montgomery (Ala.) Museum of Fine Arts, 1959-1962; Dir., Everhart Museum, Scranton, Pa., 1962-1966; Cur. of Fine Arts, William Penn Memorial Museum, Harrisburg, Pa., 1966- .

WINES, JAMES—Sculptor, T.
389 Broome St. 10013; h. 60 Greene St., New York, N.Y. 10012
B. Oak Park, Ill., June 27, 1932. Studied: Syracuse Univ. Sch. A. Awards: Prix de Rome, 1956; Pulitzer Fellowship, 1953; Guggenheim Award, 1962; Ford Fnd. Grant, 1964. Work: Albright-Knox Gal., Buffalo; AIC; CMA; Currier Gal. A.; Los A. Mus. A.; Nelson Gal. A., Kansas City; Stedelijk Mus., Amsterdam; Syracuse Univ.; WAC; WMAA. Monumental sculptures for Hoffmann-La Roche Bldg., Nutley, N.J. Exhibited: WMAA, 1958, 1960, 1962, 1964; MModA, 1959; AIC, 1959-1963; PAFA, 1961, 1964; Carnegie Inst., 1961; New School, N.Y., 1961, 1964; Sao Paulo Bienale, 1963; Ten American Sculptors, WAC, 1964. Positions: Instr., Sculpture, New School, N.Y., 1963; School of Visual Arts, New York, N.Y., 1963-1965.

WINGATE, ARLINE (Mrs. Clifford Hollander)—Sculptor, C.
23 East 74th St., New York, N.Y. 10021; also, East Hampton, N.Y.
B. New York, N.Y., Oct. 18, 1906. Studied: Smith Col.; in Europe, and with Alexander Archipenko. Member: Fed. Mod. P. & S.; NAWA; S. Gld.; Arch Lg. Awards: prizes, NAWA, 1945; Amelia Peabody award, 1956; Easthampton Gld. Hall, 1958. Work: Nat.

Mus., Stockholm, Sweden; Parrish Mus., Southampton, N.Y.; Guild Hall, East Hampton, N.Y.; Hirshhorn Coll.; Newark Mus.; Ghent Mus., Belgium; Syracuse Univ. Mus.; Birmingham Mus. A.; Norfolk Mus. A. & Science; J. Walter Thompson Co. Exhibited: NAC; NAWA; PAFA; BM; Wadsworth Atheneum; Smith Col.; Syracuse Univ. Mus.; WMAA; AIC; Riverside Mus.; SFMA; BMA; Fairmount Park, Phila.; MMA; one-man (2), Midtown Gal., N.Y.; Burlington Gal., London; Museo des Belles Artes, Buenos Aires; Petit Palais, Paris, France, and Ghent Mus., Belgium.

WINGERT, PAUL STOVER—Educator, W., L.
Department of Art History and Archaeology, Columbia University; h. 5900 Arlington Ave., Riverdale, N.Y. 10471
B. Waynesboro, Pa., Nov. 13, 1900. Studied: Columbia Col., A.B.; Columbia Univ., M.A., Ph.D.; Univ. London; Sorbonne, Paris, France. Member: CAA; Am. Ethnological Soc.; Polynesian Soc.; Am. Anthropological Assn.; F., Am. Assn. for Advancement of Science; F., Royal Anthropological Inst.; F., Italiana di Antropologiae Etnologia. Awards: Wenner-Gren grant to South Seas, 1952; Guggenheim F., 1955. Author: "The Sculpture of William Zorach," 1938; "An Outline Guide to the Art of the South Pacific," 1946; "American Indian Sculpture," 1949; "The Sculpture of Negro Africa," 1950; "Art of the South Pacific Islands," 1953; "Primitive Art," 1962, 1965. Co-author: "Arts of the South Seas," 1946; "History of World Art," 1949, 2nd ed. rev., 1958; "The Tsimshian: Their Arts and Music," 1951. Contributor articles and reviews to Art Bulletin; Am. Anthropologist; Transactions of New York Academy of Sciences; College Art Journal; Art Digest; Book of Knowledge; Records of the Auckland (N.Z.) Inst. & Museum; Sat. Review, and others. Exhs. on Primitive Art, organized or supervised: "Arts of the South Seas," MModA (with Ralph Linton, Rene d'Harnoncourt), 1946; "African Negro Sculpture," deYoung Mem. Mus., 1948; "Prehistoric Stone Sculpture of the Pacific Northwest," Portland (Ore.) A. Mus., 1951; "Melanesian Art," War Mem. Mus., Auckland, N.Z., 1952; "South Pacific Art," 1953; "African Sculpture," BMA, 1954; "Oceanic Art," BMA, 1955-56 (with Douglas F. Fraser), and other exhs. Positions: Cur. FA & Archaeology, 1934-1942, Instr., 1942-1949, Asst. Prof. FA & Archaeology, 1949-54, Assoc. Prof. FA & Archaeology, 1954-58; Prof., 1958- , Columbia Univ., New York, N.Y.*

WINKEL, NINA—Sculptor, L.
185-36 Galway Ave., St. Albans, L.I., N.Y. 11412
B. Borken, Germany, May 21, 1905. Studied: in Germany. Member: S. Center; S. Gld.; F. NSS; Intl. Platform Assn.; ANA. Awards: medal, NAD, 1945, Samuel F. B. Morse Medal, 1964; Avery award, 1958, 1959; Medal, NSS, 1967. Work: mem. Seward Park H.S., N.Y.; monument, Charlotte, N.C.; historical wall panels, Hanes Milling Co., New York City; commissioned for sculptural group for City of Wiesbaden, Germany. Exhibited: NAD, 1945-1969; PAFA, 1958 and prior; Nebraska AA, 1946; S. Center, 1944 (one-man), 1948-1952, 1958 (one-man), 1968 (one-man); Newark Mus., 1944; Fairmount Park, Phila., Pa.; WMAA, 1954; Univ. Notre Dame, 1955 (one-man) and prior; Detroit Inst. A., 1958. Lecturer, art treasures and antiquities in Europe. Trustee, Keene Valley Library, Keene Valley, N.Y., 1966- .

WINOKUR, JAMES L.—Collector, Patron
2818 Smallman St. 15222; h. 5625 Darlington Rd., Pittsburgh, Pa. 15217
B. Philadelphia, Pa., Sept. 12, 1922. Studied: University of Pennsylvania, B.S. in Economics. Member: Term Member, Museum of Art Committee, and Fellow of the Museum of Art, Carnegie-Mellon University; Board of Governors, Pittsburgh Plan for Art. Collection: Cobra Paintings, Drawings and Sculpture including Carl-Henning, Pedersen, Jorn, Corneille, Lucebert, Ubac, Reinhoud and others; 20th Century American Paintings, Drawings and Sculpture including Kane, Feininger, Dove, Wines, Sam Francis, etc.; Prints from Old Masters to the 20th Century.

WINSEY, A. REID—Painter, I., Cart., W., E., L.
609 Ridge Ave., Greencastle, Ind. 46135
B. Appleton, Wis., June 6, 1905. Studied: Univ. Wisconsin, B.S., M.S.; Yale Univ.; Am. Acad. A., Chicago; & with Elmer Taflinger, Thomas Hart Benton. Awards: Nat. Fnd. for Humanities grant (for African Art Syllabus). Member: African Studies Assn.; Fellow, Royal Anthropological Inst.; Indiana AC; Indiana Fed. AC; Chicago SE. Work: Layton A. Gal.; Wis. General Hospital, Madison, Wis.; Central Nat. Bank, Greencastle, Ind.; A. Edu. Bldg., Madison, Wis.; Atwater Training Sch., New Haven, Conn. Exhibited: Wis. Salon. Author, I., "Freehand Drawing Manual"; "Drawing Simplified." Contributor to: School & Art magazines. Positions: Hd. Dept. F. & App. A., De Pauw Univ., Greencastle, Ind., 1935- . Conducts art tours to Europe each summer, for college credit. Bd. Dirs., Hoosier Salon.

WINSHIP, FLORENCE SARAH—Illustrator, W., Des.
1111 Oxford Rd., Deerfield, Ill. 60015
B. Elkhart, Ind. Studied: Chicago Acad. FA; AIC. Member: Children's Reading Round Table, Chicago. I., 1940-1961; "ABC Picture Book"; "Sounding Rhymes"; "Counting Rhymes"; "Woofus"; "Miss Sniff"; "Sir Gruff"; "What Happened to Fluffy"; "Roosty"; "See It"; "Snowball"; "Lady, the Little Blue Mare"; "Poppyseed," "Mimi"; "The Night Before Christmas"; "Clip Clop"; "Mother Goose"; "Gingerbread Man"; "Sleepy Puppy"; "Hildy's Hideaway," and other books for children.

WINSTON, MRS. FISHER. See Atkin, Mildred Tommy

WINTER, CLARK—Sculptor
College of Fine Arts, Carnegie Institute of Technology; h. 202 W. Swissvale Ave., Pittsburgh, Pa. 15218
B. Cambridge, Mass., Apr. 4, 1907. Studied: Harvard Univ., A.B.; Indiana Univ., M.F.A.; Fontainebleau Acad. A.; Cranbrook Acad. A.; ASL. Member: AEA; Soc. Sculptors (Pres.); Abstract Group. Awards: prizes, Oakland A. Mus.; Mid-America A.; Wichita AA; Western Pa. Soc. Sculptors, 1956-1960; Assoc. A. Pittsburgh; Fla. Int. Exh. Work: Pittsburgh Hilton Hotel, Am. Needlecraft Co., N.Y., and in private colls. Exhibited: MMA; PAFA; Audubon A.; Sculpture Center, N.Y.; PMA; WMAA; Carnegie Inst. (one-man); Carnegie Col. FA (one-man); Kansas City AI (one-man); SFMA; Westmoreland County Mus. Positions: Instr., Indiana Univ., 1947-49; Hd. Sc. Dept., Kansas City AI, 1949-53; Visiting Assoc. Prof., Univ. California, Berkeley, 1953,55; Assoc. Prof., Col. FA, Carnegie Inst., Pittsburgh, Pa., 1955- .*

WINTER, LUMEN MARTIN—Painter, S., Des., Lith., L.
36 East 23rd St., New York, N.Y. 10010; h. 30 Evergreen Ave., New Rochelle, N.Y. 10804
B. Ellery, Ill., Dec. 12, 1908. Studied: Cleveland Sch. A.; NAD; Grand Central Sch. A.; BAID. Member: Arch. Lg. (Vice-Pres); NSMP (Vice-Pres.); AWS; SI; New Rochelle AA. Awards: prize, CM, 1944; New Rochelle, N.Y.; Ohio Univ. (purchase);Ranger award, NAD, 1965; Special award, NAC, 1965; Petersen award, 1969, and awards in numerous competitions. Work: LC; Mus. Contemp. A., Dallas; murals, Michigan Union H.S., Grand Rapids; Fed. Bldg., Hutchison, Kans.; Friars Cl., Cincinnati; East Brooklyn Savings Bank; Park Sheraton Hotel, Wash., D.C.; Washington County Mus., Md.; Wilmington (Del.) Col.; The Vatican, Rome; LC; Univ. Notre Dame; mosaic with marble bas-relief and monument, Church of St. Paul the Apostle, N.Y.; mosaic, AFL Hdqtr. Bldg., Wash., D.C.; bronze figure, White Plains, N.Y.; mosaic and fresco, Southland Center, Dallas, Tex.; Stations of the Cross, Our Lady of Good Counsel College, White Plains, N.Y.; wood carving, Higgins Mem. Room, Nat. Bar Assn., Wash., D.C.; Venetian glass & gold mosaic mural, Lobby, Park-Sheraton Hotel, N.Y.; 12 sc. figures, Astor Home for children, Rhinebeck, N.Y.; figure of St. Francis, Marceline, Mo.; figure, exterior sc., Stations of the Cross and two murals, Cathedral Col., Elmhurst, N.Y.; sc. and mosaics, Union Central Life Ins. Co., Cincinnati, Ohio; bas-relief, Nat. Wildlife Fed. Hdqtr., Wash., D.C.; mosaic mural, U.S. Air Force Acad.; ceramic mural, Sheraton Towers, Chicago. Exhibited: CM; Grand Rapids A. Gal.; Butler AI; SAM; BM; PAFA; AIC; Detroit Inst. A.; Wilmington Mus. FA; Cincinnati A. Cl.; SAGA; Alabama WC Soc.; Salons of America; Univ. Ohio; AWS; Arch. Lg.; SC; one-man: Hackley A. Gal.; Grand Rapids Pub. Lib.; Brown Gal., Cincinnati; Bonestell Gal.; Center Gal., N.Y.; A.F.I. Gal., N.Y.; Argent Gal.; Salpeter Gal.; Galerie Internationale, N.Y. Co-author, "Story of Leonardo de Vinci's 'Last Supper' "; Articles about Lumen Martin Winter, American Artist Magazine, 1950, 1952, 1959, 1966.

WINTER, RUTH—Painter
98-50 67th Ave., Rego Park, N.Y. 11374
B. New York, N.Y., Jan. 17, 1913. Studied: N.Y. Univ., B.S., M.A.; ASL. Member: Mahopac A. Lg.; NAWA. Awards: prize, NAWA, 1957; Mahopac A. Lg., 1959. Exhibited: Art: USA, 1958; Provincetown A. Festival, 1958; City Center, N.Y., 1956-1960; Argent Gal., 1957; Silvermine Gld. A., 1957, 1958, 1959, 1961; Orange, N.J., 1957; Gallery 15, 1958, 1959; Mahopac A. Lg., 1959; NAWA, 1959-1962, 1968; NAD, 1960; BM, 1960; Knickerbocker A., 1960; Ruth Sherman Gal., N.Y., 1960; Lever House, N.Y., 1963, 1967, 1968; Denker & Simon A. Gal., L.I., N.Y., 1963, 1964. Participated in Ethical Culture Soc. art auction, 1966.

WINTERNITZ, EMANUEL—Scholar, Museum Curator, W.
Metropolitan Museum of Art, Fifth Ave. at 82nd St. 10028; h. 350 Central Park West, New York, N.Y. 10025
B. Vienna, Austria, Aug. 4, 1898. Studied: Univ. Vienna, LL.D; studied music with various teachers in Vienna. Awards: Guggenheim Fellowship for Research, 1946; American Council of Learned

Societies Fellowship for Research, 1962; American Philosophical Soc. grant, 1969. Member: American Musicological Soc. (Council member, 1956-1958, Chm., N.Y. Chapter, 1960-1962); CAA; Int. Phenomenological Soc.; Music Library Assn.; Soc. for Ethnomusicology; Raccolta Vinciana, Milan (1962). Author: "Musical Autographs from Monteverdi to Hindemith," 1955; "Musical Instruments of the Western World," 1967; "Musical Instruments and Their Symbolism in Western Art," 1967. Contributor of articles to many professional publications including Harvard Educational Review, Burlington Magazine, American College Dictionary, Journal of the Warburg and Courtauld Institutes; Musical Quarterly, Commonwealth of Music; Journal of American Musicological Soc.; Am. Philosophical Proceedings, and others; also to numerous journals and museum bulletins. Positions: Lecturer, Fogg Museum, and many U.S. universities and other museums, 1938-1941; Lecturer, Columbia University, 1947-1948; Visiting Prof., Yale University School of Music, 1949-1960, Rutgers University, 1961- ; Prof. of Music, City Univ. of New York, 1968- ; joined the Metropolitan Museum of Art, 1942, Curator of Musical Instruments, and Musical Collection, 1949- , reorganized the Crosby Brown Collection of Musical Instruments.

WINTERS, DENNY (Miss)—Painter, C., I., T., Gr.
Rockport, Me. 04856
B. Grand Rapids, Mich., Mar. 17, 1907. Studied: AIC; Chicago Acad. FA. Awards: prizes, Denver A. Mus., 1941; Guggenheim F., 1948; SFMA, 1941; purchase award, Butler Inst. Am. Art, 1964. Work: PMA; SFMA. I., "Full Fathom Five"; "Savage Summer." Jacket des., "Wilderness River." Exhibited: MMoDA; AIC, 1936, 1937, 1945; PAFA, 1940, 1941; SFMA, 1939-1943; Carnegie Inst., 1945, 1946; Los A. Mus. A., 1939-1945 (one-man 1944); SFMA, 1943 (one-man); Perls Gal., 1942; Levitt Gal., 1945 (one-man); Rehn Gal., 1953, 1954, 1957, 1962 (all one-man); Univ. Maine, 1951, 1959, 1962 (one-man); Riverside Mus., 1954; Northeast Harbor, Me., 1960; Maine A. Gal., Wiscasset, 1960; Rehn Gal., N.Y., 1961; Detroit Inst. A., 1960; PAFA, 1960; Phila. A. All., 1963 (one-man); Grand Rapids A. Mus., 1964 (one-man); Colby Col., 1964.

WINTERSTEEN, MRS. JOHN—Collector
1425 Mt. Pleasant Rd., Villanova, Pa. 19085
B. Philadelphia, Pa., June 16, 1903. Studied: Smith College, B.A. Awards: Distinguished Daughter of Pennsylvania, 1964; Hon. L.H.D., Ursinius College, 1965; Hon. D.F.A., Villanova University, 1967; D.F.A., Wilson College and Moore College of Art, 1968. Collection: 19th and 20th Century French Painting and Sculpture; French Impressionist and Post-Impressionist Paintings, including 15 paintings by Picasso and Matisse's "Lady in Blue." Positions, Affiliations: President, 1964-1968, Board of Governors, 1947-1964 and Trustee, Women's Committee, Philadelphia Museum of Art; Hon. Chairman, 1966 Conference at Philadelphia of the National Trust for Historic Preservation; Board of Governors, Philadelphia Museum of Art College of Art, 1955-1964; Chairman, Philadelphia Art Festival, 1967; Organized and was first Chairman of Visitors Committee for the Art Museum of Smith College, 1951; Advisory Council Member of the Museum of Art of Princeton University, 1958- ; Member Visiting Committee of the Design and Visual Arts Department, Harvard University, 1964- ; Hon. Chairman, Philadlephia Friends of the American Museum in Britain; Board of Trustees, 1965- , and Board of Managers, 1968, Moore College of Art. Appointed by the Mayor as a member of the Philadelphia Art Commission (only woman member); Charter Member, Philadelphia Center for the Performing Arts; on Mayor's Committee for 1976 Bicentennial Observation and of 1976 World's Fair Committee. Many other civic, art and state positions.

WISE, HOWARD—Art Dealer
50 W. 57th St. 10019; h. 110 W. 13th St., New York, N.Y. 10011
B. Cleveland, Ohio, Nov. 6, 1903. Studied: Clare College, Cambridge University, England, B.A. (Honors): Western Reserve University; Cleveland Institute of Art. Specialty of Gallery; Kinetic and Light Art. Positions: Established Howard Wise Gallery of Present Day Painting and Sculpture, Cleveland, Ohio, 1957; Director, Howard Wise Gallery, New York, N.Y., 1960- .

WITTENBORN, GEORGE—Art dealer
1018 Madison Ave., New York, N.Y. 10021*

WITTKOWER, RUDOLF—Educator, Hist., W., L.
400 West 118th St., New York, N.Y. 10027
B. Berlin, Germany, June 22, 1901. Studied: Univ. Munich; Univ. Berlin, Ph.D. Member: Soc. Arch. Historians; Renaissance Soc. of Am.; Archaeological Inst. of Great Britain and Ireland; F. Am. Acad. A. & Sciences; Accademia di Belli Arti, Venice; Accademia dei Lincei, Rome; F., British Acad., 1958; Hon. F., Warburg Inst., London, 1958; Foreign Memb., Max-Planck Gesellschaft, Gottingen. Awards: Serena Medal, British Acad., 1957; Banister Fletcher Prize, 1959. Author: "British Art and the Mediterranean," 1948; "Architectural Principles in the Age of Humanism," 1949, "The Drawings of Car-

racci," 1952; "The Artist and the Liberal Arts," 1952; "Gian Lorenzo Bernini," 1955; "Art and Architecture in Italy, 1600-1750," 1958; "Born Under Saturn," 1963; "The Divine Michelangelo," 1964. Editor: "Studies in Architecture"; "Columbia University Studies in Art History and Archaeology." Contributor to Art Bulletin; Burlington Magazine; Warburg and Courtauld Inst. Journal; Archaeological Journal, etc. Positions: Bibliotheca Hertziana, Rome, 1923-33; Warburg Inst., Univ. London, 1934-56; Prof. Hist. A., Univ. London, 1949-56; Prof., Columbia Univ., New York, N.Y., 1956-1969. Kress Foundation Professor, National Gallery, Washington, D.C., 1969-1970.

WITTMANN, OTTO—Museum Director
Toledo Museum of Art, Monroe at Scottwood 43601; h. 2516 Underhill Rd., Toledo, Ohio 43615
B. Kansas City, Mo., Sept. 1, 1911. Studied: Harvard Col., 1933, grad. study, 1937-38, Carnegie Scholar, summer, 1937. Member: Assn. A. Mus. Dirs. (Pres. 1961-62); AAMus., (V. Pres., 1963-1966); CAA (Dir., 1964-); Intermuseum Conservation Assn; Intl. Inst. for Conservation; National Arts Accession Committee U.S. Embassies; Ohio Arts Council; American Society of French Legion d'honneur; Archeology Institute of America; Society Architectural Historians; Verein der Freunde Antiker Kunst; Sponsor, National Trust School, Attingham, Shropshire, England; Phi Kappa Phi Honor Society; Awards: Knight, Order of Orange-Nassau; Officer, Order of Arts & Letters (France); Chevalier, Legion d'Honnour, (France); Honorary degree, LL.D. University of Toledo; D.F.A., Hillsdale (Michigan); D.F.A., Bowling Green, (Ohio). Contributor to Art News; Art Quarterly; College Art Journal; Museum News; American Quarterly & numerous museum publications. Positions: Cur. Prints, Nelson Gal. A., Kansas City, Mo., 1933-1937; Prof. A. Hist., Skidmore Col., 1938-1940; Asst. Dir., Portland (Ore.) Mus. A., 1941; Sec-Treas., AAMus. Dirs., 1958-1961; Pres., AAmus Dirs., 1961-1962; Pres., Intermuseum Conservation Assn., 1956-1957; Presidential appointee, National Council on the Arts, 1965; Secretaire General, ICOM, Comité pour Musées du Verre; Editorial Consultant, Art Quarterly Gazette des Beaux Arts; Asst. Dir., 1946-1953, Assoc. Dir., 1953-1959, Dir., 1959, Toledo Museum of Art.

WOELFFER, EMERSON—Painter, Pr. M.
475 Dustin Dr., Los Angeles, Cal. 90065
B. Chicago, Ill., July 27, 1914. Studied: AIC; Inst. Des., Chicago, B.F.A. Awards: Tamarind Lithography Workshop Fellowship, 1961; Guggenheim Fellowship, 1967-1968; Raymond Speiser Mem. Award, PAFA, 1968; U.S. State Dept. Grant to Turkey, 1965. Work: AIC; WMAA; MMoDA; Univ. Illinois, La Jolla A. Mus.; Pasadena A. Mus.; Los Angeles County Mus.; North Carolina State Mus., Raleigh; Delgado Mus. A., New Orleans; Washington (D.C.) Gal. Mod. A.; Univ. California at Los Angeles A. Gals., and in many private colls. U.S. and abroad. Exhibited: Mass. Inst. Tech., 1952, 1958; Paul Kantor Gal., Los Angeles, 1953; Mus. Contemp. A., Houston, 1957; WMAA, 1962; Amon Carter Mus., Ft. Worth, 1962; Los Angeles County Mus., 1964, traveling to WAC and A. Gal. of Toronto; one-man: AIC, 1951; Poindexter Gal., N.Y., 1958, 1961; Int. Gr. Exh., Germany, France, Italy and Spain, 1958; Paul Kantor Gal., Los Angeles, 1960; Primus Stuart Gal., Los Angeles, 1961; La Jolla Mus. A., 1961; Retrospective Exh. (1946-1962) Pasadena A. Mus., 1962; Gal. 16, Graz, Austria, 1965. Positions: Instr., Colorado Springs FA Center, 1950; Instr., Chouinard A. Inst., Los Angeles, 1959; Visiting Prof., Painting, Univ. Southern California, 1962 (summer).

WOLF, BEN—Painter, Cr., W., I., T., L., Gr.
4618 Pine St., Philadelphia, Pa. 19143
B. Philadelphia, Pa., Oct. 17, 1914. Studied: with Carl H. Nordstrom, Justin Pardi, Hans Hofmann. Member: Phila. WC Cl.; Phila. Sketch Cl.; Franklin Inn; AEA; AAUP; Phila. A. All.; Phila. Pr. Cl. Exhibited: PMA, 1955; other exhibitions, 1962-65; FAR Gal., N.Y.; Little Gal., Phila.; Newman Gal., Phila.; East End Gal., Provincetown; Golden Anniversary Exh. of Provincetown AA, circulated by AFA; one-man: Santa Barbara Mus. A., 1947; Minnesota State Fair, 1947; Mus. New Mexico, Santa Fe, 1949; Babcock Gal., 1950; Delgado Mus. A., 1950: Bijou Theatre, N.Y., Cyrano Exh., 1950; Carriage House, Phila., 1955; Phila. A. All., 1959; Newman Gal., Phila., 1960; Karlis Gal., 1960; East End Gal., 1961, both Provincetown. I., "Memoirs of C. N. Buck," 1941; "The King of Golden River," 1945. Contributor to "Art in the Armed Forces," 1944; "G.I. Sketch Book," 1944; Life magazine, Art Digest, Child Life magazines. Author: monograph on Raymond Jonson, in "Artists of New Mexico," Univ. New Mexico Press; monograph on Morton Livingston Schamberg, Univ. Pennsylvania Press. Contributor to: Art in America; National Observer; Pa. Magazine of History and Biography; Phila. Bulletin; numerous exhibition catalogs. Positions: Assoc. Ed., Art Digest, 1944-47; Assoc. Ed., Picture on Exhibit, 1947; A. Cr., Santa Fe New Mexican, 1948-49; Panelist, Provincetown AA, 1959, 1961; Asst. Prof., PMA Col. A., at present (on leave).*

WOLFE, ANN (Mrs. Ann Wolfe Graubard)—Sculptor, W., L., T.
4035 Lyndale Ave., South, Minneapolis, Minn. 55409
B. Poland, Nov. 14, 1905. Studied: Hunter Col., B.A.; in Paris,
with Despiau. Member: Soc. Minnesota S.; F.I.A.L. Awards:
prizes, Soc. Wash. A., 1945; Minn. State Fair, 1949; Minneapolis
Inst. A., 1951; Minneapolis Woman's Cl., 1954. Work: Col. City of
N.Y.; Mus. A., Jerusalem; Nat. Mus., Korea; Children's Hospital,
St. Paul; Hamline Univ.; Colgate Univ.; Hartt Col., Univ. Hartford;
Mt. Zion Temple, St. Paul; Univ. Minnesota. Exhibited: All. A.
Am., 1936; AGAA, 1942; A. Gld. Wash., 1942-1945; Soc. Wash. A.,
1944, 1945; WMA, 1940, 1946; Walker A. Center, 1948, 1953, 1956-
1961; PAFA, 1951; Minneapolis Inst. A.; Sc. Center, N.Y., 1953,
1961; Minn. State Fair, 1956-1961; Rochester A. Center; Kraushaar
Gal.; St. Paul Gal. A., 1956-1961; Int. S. Int., 1949; one-man: WMA,
1939; Grace Horne Gal., 1940; Whyte Gal., Wash., D.C., 1946; Ham-
line Univ., 1951; Minn. State Fair, 1951; Walker A. Center, 1955;
World Gal., St. Paul, 1954; Minneapolis Inst. A., 1964; Adele
Bednarz Gal., Los A., 1966; Stewart-Verde Gal., San F., 1966. Art
publications reviewer, Worcester (Mass.) Telegram & Minneapolis
Tribune. Instr. S., Jewish Community Center, Minneapolis, Minn.

WOLFF, ROBERT JAY—Painter, E., Des., W., L.
Brooklyn College of the City University of New York, Brook-
lyn, N.Y.; h. New Preston, Conn. 06777
B. Chicago, Ill., July 27, 1905. Studied: Yale Univ.; & in Paris,
with Georges Mouveau. Awards: prizes, AIC, 1933, 1934. Mem-
ber: Int. Platform Assn. Work: Guggenheim Mus.; BM. Exhibited:
Am. Abstract A., 1938-1950; one-man exh.: Quest & Kuh Gal., Chi-
cago; Reinhardt Gal., Nierendorf Gal., Kleemann Gal., Guggenheim
Mus., 1952; Saidenberg Gal., 1954, 1955, N.Y., Borgenicht Gal.,
1956, 1958; also group exh. U.S. and abroad. Author, I., "Elements
of Design," 1945. Author-Des. books about color for children:
"Seeing Red," "Feeling Blue," "Hello Yellow!" 1967-68. Con-
tributor to: art magazines; "Vision and Value Series, Vol. 1, The
Education of Vision," 1965. Positions: Dean, Hd. Painting & S.
Dept., Inst. Des., Chicago, Ill., 1939-42; Hd., Graphic Dept., U.S.
Naval Training Aids Development Center, 1943-45; Prof. A.,
1946- ; Chm. A. Dept., 1946-64; Hd. Grad. A. Program, 1964- ,
Brooklyn Col. of the City Univ. of N.Y., Brooklyn, N.Y.; Visiting
Bemus Prof. of Design, Sch. of Architecture, Mass. Inst. Tech.,
1961. Visiting Lecturer, Grad. Sch. Des., Harvard Univ., Cam-
bridge, Mass., 1961.

WOLFSON, SIDNEY—Painter, S.
Salt Point, N.Y. 12578
B. New York, N.Y., June 18, 1914. Studied: ASL; Cooper Union A.
Sch.; Pratt Institute, N.Y. Work: WMAA; Colgate Univ.; N.Y.
State Univ. at Stony Brook; Wadsworth Atheneum, Hartford. Ex-
hibited: Carnegie Inst., 1962; WMAA, 1962; St. Thomas Univ.,
Texas, 1963; Basel, Switzerland, 1960; Berkshire Mus. Retrospec-
tive, 1960; Bennington Col. Retrospective, 1963. Other one-man
exhs.: Bennett Col., 1966; The Contemporaries Gal., N.Y. (sculp-
ture), 1967; I.B.M. Gal., N.Y. (painting), 1969. Positions: A.-in-
Res., Creative Arts Acad., N.Y., 1968.

WOLINS, JOSEPH—Painter, T.
44 East 21st St. 10010; h. 183 East 98th St., New York, N.Y.
10029
B. Atlantic City, N.J., Mar. 26, 1915. Studied: NAD, with Leon
Kroll, Gifford Beal, Ivan Olinsky. Member: Brooklyn Soc. A.; AEA.
Work: MMA; Norfolk Mus. A. & Sciences; Ein Harod Mus., Israel.
Exhibited: Univ. Illinois, 1948; Pepsi-Cola, 1948; WMAA, 1949-1951,
1953; Silvermine Gld. A., 1956; MMoMA, Sao Paulo, Brazil, 1960,
1962; CGA, 1947; Toledo Mus. A., 1946; Municipal Gal., N.Y., 1939;
New School, N.Y., 1940; PAFA; Norfolk Mus. A. & Sciences, 1963;
Smithsonian Inst. Traveling Exh., 1965; Butler Inst. Am. A., 1965;
Smithsonian Drawing Exh., 1965; one-man: Contemp. A. Gal., N.Y.,
1947, 1949, 1952, 1954, 1956; Bodley Gal., N.Y., 1959; Silvermine
Gld. A., 1960; Agra Gal., Wash. D.C., 1967; B'nai B'rith Mus., Wash.
D.C., 1967. Positions: Instr., Painting, Hodson Center, N.Y., 1945;
Community Center, Valley Stream, N.Y., 1952; South Shore Com-
munity Center, 1953-57; Westchester Workshop, 1954; North Shore
A. Workshop, 1959; BM, 1961; Long Beach (N.Y.) Adult Edu. Sch.,
1962- .

WOLLE, MURIEL SIBELL (Mrs. Francis Wolle)—
Educator, W., L., P.
Fine Arts Department, University of Colorado; h. 763 16th
St., Boulder, Colo. 80302
B. Brooklyn, N.Y., Apr. 3, 1898. Studied: N.Y. Sch. F. & App. A.;
N.Y. Univ., B.S. in A. Edu.; Univ. Colorado, M.A. Member:
Boulder A. Gld.; Colorado Edu. Assn.; The Westerners; Colo. State
Hist. Soc.; Montana State Hist. Soc.; Colo. Authors Lg. Awards:
prizes, Kansas City, AI, 1932, medal, 1934; NAWA, 1934; Spring-
field (Mo.) AA; Norlin medal, Univ. Colorado, 1957; Laureate Key,

Delta Phi Delta, 1958; Denver Woman's Press Club; Robert L.
Stearnes Medal, 1966. Work: Denver A. Mus.; Springfield AA.
Exhibited: Denver A. Mus., 1928-1944; Boulder A. Gld., 1927-1965;
NAWA, 1932-1941; Kansas City AI, 1932-1938; Joslyn A. Mus.,
1932-1940. Author, I., "Ghost Cities of Colorado," 1933; "Cloud
Cities of Colorado," 1934; "Stampede to Timberline," 1949; "Mon-
tana Pay Dirt," 1963; "The Bonanza Trail," 1953. Contributor to
The Mining Journal, The Mining World, Colorado Quarterly, The
Brand Book, and other publications. Lectures: Ghost Towns of
Colorado. Positions: Instr. A., Texas State Col. for Women, 1920-
23; N.Y. Sch. F. & App. A., 1923-26; Hd. Dept. A., 1928-47, Prof.,
Dept. FA, Univ. Colorado, Boulder, Colo., 1936-1966, Prof.
Emeritus, 1966- .

WOLSKY, MILTON LABAN—Illustrator, P., C., L.
5804 Leavenworth St., Omaha, Neb. 68106
B. Omaha, Neb., Jan. 23, 1916. Studied: Univ. Omaha; AIC; ASL,
and with Julian Levi, Hans Hofmann. Member: SI; AWS; Int. Inst.
A. & Lets.; Omaha Artists-Art Dirs.; Assoc. Omaha A. Awards:
1st award & purchase, Governor's Art Show, 1964. Work: Air
Force Hist. Fnd.; producing, at present a series of Cities of the
Northern Plains, appearing in Time magazine for the Northern Nat-
ural Gas Co.; editorial and advertising illus. in national magazines.
Exhibited: AWS, 1950, 1953; Joslyn Mus. A., 1938-1942, 1955, 1958,
1960; Mid-west Exh., 1957, 1964; U.S. Air Force Art Exh., Smith-
sonian Inst., 1960; WAC, 1963; Colo. Springs FA Center, 1963.
One-man: Joslyn A. Mus., 1961; Rochester A. Mus., Minn., 1961;
Blanden Mem. Gal., Ft. Dodge, Iowa, 1961. Author: "Basic Ele-
ments of Painting." Guest lecturer, Joslyn A. Mus.

WONG, FREDERICK—Painter
45 E. Broadway, New York, N.Y. 10002; h. 315 Riverside Dr.,
New York, N.Y. 10025
B. Buffalo, N.Y., May 31, 1929. Studied: Univ. New Mexico, B.F.A.,
M.F.A. Member: AWS, All. A. Am. Awards: prizes, AWS, William
Church Osborn award, 1962, Ranger Purchase Fund, 1961; Honolulu,
Hawaii, 1960; Butler Inst. Am. A., 1960; Silvermine Gld. A., 1963;
All. A. Am., 1964. Work: Atlanta AA; Chas. Pfizer, Inc.; Reading
(Pa.) Mus. A.; Illus. for Time/Life Books; Butler Inst. Am. A.;
Lehigh Univ. Exhibited: Audubon A., 1965; All A. Am., 1964; AWS,
1960-1969; traveling exh., 1960-1962; Springfield, Mo., 1963; Los
A. Mus. A., 1959; Philbrook A. Center, Tulsa, 1963, 1964, 1969;
Marietta Col., (Ohio), 1969; Butler Inst. Am. Art, 1968; American
Univ., Wash., D.C., 1959; Lehigh Univ., 1963, 1964; one-man: Mi
Chou Gal., N.Y., 1956, 1959, 1962, 1963, 1965; Fairleigh Dickinson
Univ., 1963; Lehigh Univ., 1965; Kenmore Gal., Phila., 1964, 1965,
1967; Jones Gal., La Jolla, Cal., 1968; Newport AA, 1965. Posi-
tions: Instr., Form & Structure, Gen'l. Drawing, Pratt Institute,
Brooklyn, N.Y., 1966-67, 1968-69.

WONG, JASON—Museum Director, W., L.
Long Beach Museum of Art, 2300 E. Ocean Blvd., Long Beach,
Cal. 90803
B. Long Beach, Cal., May 12, 1934. Studied: Univ. California at Los
Angeles, A.B.; California State Col., Long Beach, M.A. Member:
AAMus.; Western Assn. A. Mus.; CAA. Lectures: 20th Century
American Art; The 20th Century Perspective-Abstraction; Aesthe-
tics and the New Freedom; The Post-War Aesthetic: The 1950's;
given at Long Beach City College Extension. Contemporary Art, at
Crocker A. Gal., Sacramento, 1968. Exhibitions arranged: "7 De-
cades of Design," 1967; "Arts of Southern California," annual
series sponsored by Los Angeles County; Annual Southern California
(juried) Exhibitions. Positions: A. Dir., Audiorama Corp. of Amer-
ica, Hollywood, Cal., 1964; A. Dir., Quest International, 1965; Con-
ducted art discussions on radio weekly broadcasts, 1966-1967;
Juried: New Mexico State Fair Art Show, Albuquerque, 1966; Kings-
ley Annual at Crocker A. Gal., Sacramento, Cal., 1967; California
State Fair Art Show, 1969; Arizona State Fair Exh., 1969. Dir.,
Long Beach Museum of Art, at present.

WONNER, PAUL (JOHN)—Painter
131 Hermosillo Rd., Santa Barbara, Cal. 93103
B. Tucson, Ariz., Apr. 24, 1920. Studied: Cal. Col. A. & Crafts,
Oakland; Univ. California, Berkeley, M.A., M.L.S. Work: Guggen-
heim Mus.; SFMA; NCFA, Washington, D.C.; Oakland Mus.; Joseph
H. Hirshhorn Fnd.; S.C. Johnson Co. Coll.; Reader's Digest Coll.,
N.Y. Exhibited: Guggenheim Mus., 1954; Carnegie Inst., 1958, 1964;
WMAA, 1959; AIC, 1961, 1964; Univ. Illinois, 1961, 1963, 1965;
MMoMA, 1962, and others. One-man: deYoung Mem. Mus., San F.,
1955; Felix Landau Gal., Los A., 1959, 1960, 1962, 1963, 1965, 1968;
Santa Barbara Mus. A., 1960; Cal. PLH, 1961; Poindexter Gal.,
N.Y., 1962, 1964; Waddington Gal., London, 1965; Landau-Alan Gal.,
N.Y., 1967. Positions: Instr., Painting, Univ. California at Los An-
geles, 1963-64. Instr., Otis Art Inst., Los Angeles, 1966-1968.

WOOD, (JAMES) ART(HUR) JR.—Cartoonist
U.S. Independent Telephone Assn., 438 Pennsylvania Bldg., Wash., D.C. 20004; h. 7008 Tilden Lane, Rockville, Md. 20852
B. Miami, Fla., June 6, 1927. Studied: Washington & Lee Univ., B.A. Member: Nat. Cartoonists Soc.; Assn. Am. Editorial Cartoonists; Nat. Press Cl. Awards: Freedoms Foundation awards: 1953, 1954, 1958, 1959, 1960; Christopher Award, 1954; Golden Quill Award, 1960, 1962. Work: Drawings, LC; permanent coll. of all cartoons at Alderman Library, Univ. Virginia; also in the colls. of Univ. Akron, The William Allen White Fnd. Coll. and Univ. Kansas. Exhibited: cartoons: Nat. Coll. of the Cartoonists Soc., 1958-1961; Brussels World Fair, 1958; Int. Cartoon Exh. "The Great Challenge," 1959-60; one-man: Pittsburgh Press Cl., 1959. Lectures: The American Cartoon; The Political Cartoon in a Changing World, for art galleries, civic groups, journalism schools, etc. Positions: Editorial Cart., Richmond News Leader, 1950-56; Political Cart., Pittsburgh Press, 1956-1963; Cartoonist for 'The USITA' and other telephone publications, at present; Dir., National Center of the Cartoon and Graphic Arts, Sigma Delta Chi; Dir. of Information, U.S. Independent Telephone Assn., Washington, D.C.

WOOD, HARRY EMSLEY, JR.—Educator, L., P., S., Cr., W.
Art Department, Arizona State University, Tempe, Ariz. 85281; h. 104 Vista del Cerro, Tempe, Ariz. 85281
B. Indianapolis, Ind., Dec. 10, 1910. Studied: Univ. Wisconsin, B.A., M.A.; Ohio State Univ., M.A., Ph.D.; Accademia dei Belli Arti, Florence, Italy, with Ottono Rosai; and with John Frazier, Provincetown, Mass.; Emil Bisttram, Taos, N.M. Member: CAA; NAEA; Pacific AA; Am. Soc. for Aesthetics; Arizona Representative of Art Councils of America, 1965- . Awards: purchase prize, A. Gld., 1959. Work: murals, Great Central Ins. Co., Peoria, Ill.; Memorial Union, Arizona State University, Tempe; Phoenix A. Mus. Many portraits of prominent persons. Author: "Lew Davis, 25 Years of Painting in Arizona," 1961. Exhibited: Phoenix & Tucson annuals, 1961; one-man: Columbus, Ohio, 1941; Peoria, Ill., 1944; Decatur, Ill., 1945; Galesburg, Ill., 1946; Beloit, Wis., 1947; Illinois State Mus., 1949; Florence, Italy, 1950; Indiana A. Retrospective, John Herron, AI, 1953; Arizona A., Tucson, 1956, 1957; Phoenix A. Mus., 1961. Positions: Prof. A., Illinois Wesleyan, Bloomington, 1942-44; Dean, Col. of FA, Bradley Univ., Peoria, 1944-50; Chm. A. Dept., Arizona State University, Tempe, Ariz., 1954- ; Pres., Pacific AA, 1958-60; Pres., Ariz. A. Edu. Assn., 1954-55. Nat. Council, NAEA, 1958-62; Professional lecturer on art, Boasberg-Hoyt Lecture Bureau, Cleveland. Dir. Sedona (Ariz.) A. Center of Ariz. State Univ. Summer Session. Vice-Pres., Research & Development, Visual Impact Materials, Inc., 1965- ; Senior Member, Wood & Stout Assoc., 1963- .*

WOODHAM, JEAN—Sculptor
48 Cheese Spring Rd., Wilton, Conn. 06897
B. Midland City, Ala., Aug. 16, 1925. Studied: Alabama Polytechnic Inst., B.A.; Sculpture Center, N.Y.; Univ. Illinois. Member: AEA; NAWA; Sculptors Gld.; Audubon A.; Arch. Lg., N.Y. Awards: F., Univ. Illinois, 1950; NAWA, 1956, 1959, 1960, 1961, 1962, Medal of Honor, 1966, Lorne Mem. prize, 1966; New England Annual, 1956-1958, 1959, 1960 (2); New Canaan Exh., 1960, 1961, 1963; Rowayton A. Center, 1963; Audubon A., 1958, 1961, 1964, medal, 1962; Conn. Acad. prize, Wadsworth Atheneum, 1967. Work: Massillon Mus. A.; Temple Israel, Westport, Conn.; Nuclear Ship "Savannah"; Norfolk Mus. A.; Int. Bank for Reconstruction & Development, N.Y.C.; Jewish Community Center, Harrison, N.Y.; fountain sculpture, Ala. State Col., Montgomery; Flintkote Headquarters Bldg., White Plains, N.Y. Exhibited: PAFA, 1950, 1954; Audubon A., 1951, 1960-1967; NAWA, 1951-1967; London, England, 1954; Syracuse Mus. FA, 1948, 1952; N.Y. Soc. Ceramic A., 1951-1955; Sculpture Center, N.Y., 1947-1949, 1951; John Heller Gal., 1954; BMFA; CM; High Mus. A.; Montgomery Mus. FA; New England Annual, 1956-1960; Barone Gal., N.Y.; Stuttman Gal.; Sculptors Gld., 1959, 1960-1964, 1967, annuals, Lever House, N.Y., 1959-1968; Riverside Mus., N.Y.; Norfolk Mus.; Mus. Mod. A., Rio de Janeiro; Vera Cruz, Mexico City, Guadalajara, Monterey, Mexico; N.Y. World's Fair, 1964; Arch. Lg., N.Y., 1966; New Haven Festival A., 1966; Conn. Acad. FA, 1967; Mattatuck Mus., 1967; Stamford Mus., 1968; and others. One-man: Ala. Polytechnic Inst., 1950; Univ. Illinois, 1952; Silvermine Gld. A., 1955; Wesleyan Univ., Middletown, Conn.; Stuttman Gal., 1959; Rive Gauche Gal., Darien, Conn., 1962, 1966; Wilton Lib., 1963; New Canaan Lib., 1963; Mattatuck Mus., Waterbury, Conn., 1968. Positions: Treas., Sculptors Gld., 1960-65, Exec. Bd., 1966-1967; Chm., Sc. Jury, NAWA, 1965-66, Juror, 1960, 1961, 1963, 1964; Juror, Audubon A., 1964. Instr., sculpture, Stamford Mus., 1967- .

WOODNER, IAN—Collector
39 W. 67th St., New York, N.Y. 10023*

WOODRUFF, HALE ASPACIO—Painter, E., L.
22 East 8th St., New York, N.Y. 10003
B. Cairo, Ill., Aug. 26, 1900. Studied: John Herron AI; Academie Moderne, Paris; Harvard Univ.; and in Mexico. Awards: prizes, Harmon Fnd., 1926; Diamond Jubilee Exp., Chicago, 1940; High Mus. A., 1940; Hon. D.F.A., Morgan State Col., Baltimore, Md., 1968. Work: Newark Mus.; Howard Univ.; Atlanta Univ.; murals, Talladega Col., Ala.; Golden State Mutual Life Ins. Co., Los A., Cal.; Atlanta Univ. Lib. Exhibited: VMFA; High Mus. A.; Assn. Georgia A.; BMFA; Los A. Mus. A.; AIC; John Herron AI; BMA; WMAA, 1954; one-man: Bertha Schaefer Gal., 1953, 1954, 1958; Univ. Southern Ill., 1956; Hampton Inst., 1957; Eastern Michigan State Col., 1956; Univ. North Carolina, 1955. Lectures, auspices of Assn. Am. Colleges. Positions: Prof. Emeritus, N.Y. Univ.

WOODS, GURDON G.—Educator, S., L.
160 Robles Dr., Santa Cruz, Cal. 95060
B. Savannah, Ga., Apr. 15, 1915. Studied: Copley Soc., Boston; ASL. Member: Art Assn., San F. AI; Regional A. Council of the San Francisco Bay Area; Bohemian Cl., San F. Awards: prizes, NAD, 1944; San F. A. Festival (purchase) 1950, 1961; San F. AA, 1952, 1954; Chapelbrook Fnd. Research Grant, 1965-1966; Creative Arts Inst. Grant, 1968; Wells Fargo award, 1954; sculpture prize, Richmond A. Center, 1953. Work: in private colls. Fountain, des. for ceramic tiles & eleven reliefs, IBM Bldg., San Jose, Cal.; Aluminum fountain, Paul Masson Winery, Saratoga. Exhibited: Riverside Mus., N.Y., 1945; Sao Paulo, Brazil, 1955; San F. AA, annuals; WMAA; NAD; Denver A. Mus., 1952, 1953, 1958; Erik Locke Gal., San F., 1958, 1959; Richmond & Walnut Creek, Cal., annuals, 1949-1955; Stevenson Col. and Crown Col., Univ. Cal., Santa Cruz, 1968. Positions: Member, San Francisco A. Comm., 1954-55; Dir., San Francisco Art Inst., San Francisco, Cal., 1955-64; Dir., College of the San Francisco Art Institute, 1955-1966; Assoc. Prof., Univ. California, Santa Cruz, Chm., Bd. of Studies in Art, 1966- . Lecturer, Pacific AA, 1959; Univ. Cal. Ext. 1959-60.

WOODS, SARAH LADD (Mrs. Thomas C.)—Patron, Collector
2475 Lake St., Lincoln, Neb. 68502
B. Lincoln, Neb., May 8, 1895. Studied: Wellesley College, B.A.; University of Nebraska. Awards: Hon. degree, L.H.D., University of Nebraska, 1969. Collection: Contemporary American art—Thomas C. Woods Collection in Sheldon Gallery, Univ. of Nebraska. Positions: Patron, President, 1940-1942, Trustee, Nebraska Art Association.

WOODS, WILLIS FRANKLIN—Museum Director, P., T.
The Detroit Institute of Arts, 5200 Woodward Ave. 48202; h. 18318 Oak Dr., Detroit, Mich. 48221
B. Washington, D.C., July 25, 1920. Studied: Brown Univ., A.B.; American Univ.; Univ. Oregon. Member: Am. Assn. Mus. Dir.; AAMus.; AFA; CAA. Position: Mngr., Watkins Mem. Gal., 1946-47; Asst. Dir., CGA, 1947-49; Dir., Norton Gal. & Sch. A., West Palm Beach, Fla., 1949-1962; Dir., The Detroit Institute of Arts, 1962- ; Pres., Fla. A. Group, 1951-52; Chm. Southern A. Mus. Dir. Assn., 1954-55; Pres., Fla. Fed. A., 1954-56. Instr., Art Appreciation, Palm Beach Jr. College, 1959-1962; Editorial Bd., The Art Quarterly, 1962- ; Member, Bd. Trustees: Society of Arts & Crafts, 1962- ; Archives of American Art, 1962- ; Detroit Adventure, Exec. Comm., 1962- ; Etruscan Foundation, 1963- ; Detroit Artists Market, 1964- .

WOODWARD, STANLEY—Painter, Et., W., I., T.
27 South St., Rockport, Mass. 01966
B. Malden, Mass., Dec. 11, 1890. Studied: BMFA Sch.; PAFA. Member: Gld. Boston A.; AWS (Life); Int. Platform Assn.; Wash. WC Cl.; Conn. Acad. FA; Boston Soc. WC Painters; SAGA; Audubon A.; All. A. Am.; Rockport AA; North Shore AA; SC; F.I.A.L. Awards: prizes, NAD, 1925; AWS, 1927; Balt. WC Cl., 1927; Springfield A. Lg., 1928; Stockbridge AA, 1931; New Haven Paint & Clay Cl.; Rockport AA, 1940, 1948, 1955, 1959, 1960, 1965; Wash. WC Cl., 1940; North Shore AA, 1941, Gordon Grant Mem. prize, 1967; AAPL, 1962; Meriden AA, 1950; Springfield Academic A., 1959; medals, Boston Tercentenary, 1930; Jordan Marsh, Boston, 1949, 1959, 1967. Work: BMFA; Bowdoin Col.; Converse Mem. Gal., Malden, Mass.; Ft. Worth Mus. A.; Ball State T. Col.; New Haven, Conn.; Amherst Coll.; Wheaton Coll.; Washington County Mus., Hagerstown, Md.; BM; Vanderpool Coll.; Holyoke A. Mus.; Framingham (Mass.) Lib.; Wilton (N.H.) Lib.; Wellesley Hills Lib.; Springville (Utah) A. Mus.; Lehigh Univ. A. Mus. Exhibited: PAFA; CGA; AIC; BMFA; CAM; NAD; Pepsi-Cola. Author: "Adventure in Marine Painting," 1948; "Marine Painting in Oil and Water Color," 1961; "The Sea," 1969. Illus. to Collier's and Ford Times magazines. Contributor: "Color and Painting Methods," American Artist magazine. Positions: Instr., Woodward Outdoor Painting Sch., 1935- . Instr., Laguna Beach Sch. A. & Des., 1963.

WOODY, (THOMAS) HOWARD —Sculptor, E., L.
Art Department, University of South Carolina; h. 433 Arrow-wood Rd., Columbia, S.C. 29210
B. Salisbury, Md., Sept. 26, 1935. Studied: Richmond Prof. Inst., B.F.A.; East Carolina Univ., M.A.; Univ. Iowa; AIC; Kalamazoo A. Center; Univ. Kentucky. Member: Southern Assn. Sculptors (Pres.); Nat. Sc. Center (Bd. Member); Nat. Sc. Conf. (Bd. Member); CAA; Southeastern Col. A. Conf.; Gld. South Carolina A.; South Carolina Craftsmen. Awards: prizes, South Carolina Sculptors, purchase; Southern Sculptors, 1967; South Carolina Craftsmen; Atlanta Festival of Sculpture. Work: Columbus (Ga.) Mus. A. & Crafts; Georgia Southern Col.; Gibbes A. Gal., Charleston; North Carolina Nat. Bank, Winston-Salem; Pembroke State Col.; Western Carolina Univ. Exhibited: Southern Sculptures, 1965-1968; Nat. Sc. Exh., 1969; Small Southern Sculptures; Contemp. Sculpture; Atlanta Festival, 1968, 1969; Art in Embassies Program; Smithsonian Inst., traveling exh. of sculpture; one-man: Asheville Mus. A.; Columbia (S.C.) Col.; Montgomery Mus. FA; Murray State Univ., Kentucky; Pembroke State Col.; Roanoke FA Center, Va.; Univ. South Carolina; Western Carolina Univ.; three-man: VMFA. Positions: Assoc. Prof., Head A. Dept., Pembroke State Col., N.C., 1962-1967; Assoc. Prof., Sculpture, Univ. South Carolina, Columbia, 1967- .

WOOLFENDEN, WILLIAM E.—Art Administrator
Archives of American Art, The Detroit Institute of Arts, 5200 Woodward Ave. 48202; h. 16187 Westbrook St., Detroit, Mich. 48219
B. Detroit, Mich., June 27, 1918. Studied: Wayne State Univ., B.A., M.A. Field of Research: American Art. Positions: Asst. Cur., American Art, 1945-1948, Dir., Education, 1950-1960, The Detroit Institute of Arts; Asst. Dir., 1960-1963, Exec. Dir., 1963-1964, Dir., 1964- , Archives of American Art.

WORCESTER, EVA—Painter, S., W., L.
80 Sunningdale Drive, Grosse Pointe Shores, Mich. 48236
B. Erie, Mich., June 9, 1892. Studied: BMFA Sch.; and with Eliot O'Hara, Hobson Pittman, Emile Gruppe, Margaret F. Browne, and others. Member: Michigan WC Soc.; Grosse Pointe A.; Desert A. Center, Palm Springs, Cal.; Copley Soc., Boston; Chicago A. Cl.; Michigan A.; Pen & Brush Cl.; Int. Platform Assn.; NAWA; Fed. Am. A. Awards: prizes, Grosse Pointe A., 1955; Nat. Lg. Am. Pen Women, 1953. Work: War Mem. Coll., Detroit; Grosse Pointe Garden Center; Nat. Fed. Women's Cl., Boston; Lobby, Detroit TV-Radio Station Bldg., and in private colls. Exhibited: Nat. Lg. Am. Pen Women, 1953, 1954; Detroit Inst. A., annually; Mich. Acad. A. & Lets.; Thieme Gal., Palm Beach, 1963; NAD, 1965; one-man: Copley Gal., Boston, 1952; Washington Gal., Miami Beach, 1954; Detroit War Mem., 1956; Palm Springs, Cal., 1957, 1958, 1968, 1969; Galerie Bernheim, Paris, France, 1959-60; Desert Mus., Palm Desert, Cal., 1963.

WORMLEY, EDWARD J.—Designer
450 E. 52nd St., New York, N.Y. 10022
B. Oswego, Ill., Dec. 31, 1907. Studied: AIC. Member: F., IDSA; Arch. Lg.; F., AID. Awards: AID, 1950, 1951; MModA, 1950-1952; Elsie De Wolfe Award, AID, 1962. Exhibited: MModA, 1947-1954; Arch. Lg., 1947-1949; BMA, 1951; Akron AI; R.I. Sch. Design, 1948; Albright-Knox A. Gal., 1947; Dayton AI. Lectures on Furniture Design, Modern Design, Harvard Univ., John Herron AI, BMA, Parsons School of Design, Pratt Institute, School of the Art Institute of Chicago. Positions: Visiting Consultant and Lecturer, Cornell University, 1955; Board of Directors, American Craftsmen's Council; America House, Inc.; International Graphic Arts Society; Virginia Mills, Inc.; Industrial Furniture, Textile and Interior Designer; Design Director, Dunbar Furniture Corporation, 1931-1942, 1947 to present.*

WORTH, PETER JOHN—Educator, S., Des.
Department of Art, Woods Bldg., University of Nebraska; h. 3515 Van Dorn St., Lincoln, Neb. 68506
B. Ipswich, England, Mar. 16, 1917. Studied: Ipswich Sch. A.; Royal Col. A., A.R.C.A. Member: CAA; Egypt Exploration Soc., London. Work: Denver A. Mus.; Joslyn A. Mus. Exhibited: SFMA, 1950; Wakler A. Center, 1951, 1952, 1956; AIC, 1951; Denver A. Mus., 1952, 1953, 1955-1957, 1960-1963; Nelson Gal. A., 1950, 1953, 1954, 1957. Positions: Prof. A., & Hist. of Art, Univ. Nebraska, Lincoln, Neb.

WORTHAM, HAROLD—Art Consultant, P.
Serrano 63, Madrid 6, Spain
B. Shawnee, Okla., Jan. 24, 1909. Studied: Yard Sch. FA, Wash., D.C.; ASL; San Fernando Acad. Bellas Artes, Madrid. Awards: prizes, Metropolitan A. Exh., Wash., D.C., 1936; Madrid Acad. FA, 1952, 1953. Member: F., Int. Inst. A. & Lets.; British Inst.; Inst. Cult. Hispanica. Exhibited: Washington, D.C., 1936-1949; one-man: Rosenberg Lib., Galveston, Tex., 1942, 1953; Casa Americana, Ma-

drid, 1952; Prado Salon, 1959; Galeria Fortuny, 1964. Contributor to Spanish periodicals. Positions: Consultant on Conservation of Paintings. At present under contract to the Spanish Government on the conservation of its artistic patrimony (Zurburan, Murillo, etc.): Museo de Santa Cruz (Toledo), Museo de Pontevedra, Monasterio de Nuestra Señora de Guadalupe, et al. Also consultant on restoration and conservation to galleries, museums and private collectors. Staff member, Instituto de Conservacion de Espana, Madrid.

WRAY, DICK—Painter
3510 Mt. Vernon St., Houston, Tex. 77006
B. Houston, Tex., Dec. 5, 1933. Studied: Univ. Houston. Work: Ford Fnd. purchase, Albright-Knox Gal., Buffalo, 1962; Mus. FA of Houston, 1963. Exhibited: Mus. Contemp. A., Houston, 1961; Southwest Painting & Sculpture, Houston, 1962; Univ. Michigan, 1964; Hemisfair, Houston, 1968; MModA, "Homage to Lithography," 1969.

WRIGHT, BARTON ALLEN—Museum Curator, I.
Museum of Northern Arizona, Box 1389; (mail) P.O. Box 176, Flagstaff, Ariz. 86001
B. Bisbee, Ariz., Dec. 21, 1920. Studied: Univ. Arizona, B.A., M.A. Member: Am. Archaeological Soc.; Western Mus. Conf.; AAMus.; I., "Ventana Cave," 1950; "Upper Pima of San Cayetano del Tumacacori," 1956; "Master of the Moving Sea," 1958; "Throw Stone," 1960; "Column South," 1960; "This is a Hopi Kachina," 1962; "Age of Dinosaurs," 1968. Contributor to Ceramic Series; Plateau; Kiva; American Antiquities. Arranged: Junior Indian Art Show; Hopi Craftsman; Navajo Craftsman; 1957— "Tattletale Bones"; 1958— "Timber"; "Shonto, A. Contemporary Navajo Community," 1959; "Hi-Q," meteorological exhibit, 1960; "The Way of Words," 1962; "The Harvey Collection," 1963; "Salvage Archaeology," 1965; "The Rio de Flag," 1966; "The Recent Land," 1968. Murals in Babbitt Bros., Inc., bldgs. in Flagstaff, Ariz. Positions: State Archaeological Asst., Town Creek Indian Mound, N.C., 1949-51; Archaeologist, Amerind Fnd., Dragoon, Ariz., 1952-55; Cur. A. & Exhibits, Mus. Northern Arizona, Flagstaff, Ariz., 1955-58; Cur. of Museum, 1959- .

WRIGHT, MR. & MRS. C. BAGLEY—Collectors
311 Occidental Ave. S., Seattle, Wash. 98104*

WRIGHT, CATHARINE MORRIS (Mrs. Sydney L.) —
Painter, W., L., Gr.
Fox Hill, Jamestown, R.I. 02835
B. Philadelphia, Pa., Jan. 26, 1899. Studied: Moore Inst. A., and with Henry B. Snell, Leopold Seyffert. Member: NA; AWS; Phila. WC Cl. (V.-Pres.); All. A. Am.; Audubon A.; Newport AA; Authors Lg. Am. Awards: prizes, PAFA; NAD; Newport AA; Germantown A. Lg.; Silvermine Gld. A., 1955; All. A. Am.; medal, Springside (Pa.) Sch.; (Hon.) D.F.A., Moore College of Art, 1959. Work: PAFA; Allentown Mus.; Moore Inst. A.; New Britain AI; Woodmere A. Gal.; Univ. Pennsylvania; Pa. State Col.; PMA; NAD. Exhibited: PAFA, 1918- ; CGA, 1921-1941; NAD, 1930-1952, 1964; AIC, 1921-1942; Carnegie Inst.; All. A. Am.; Audubon A.; Newport AA, 1918-1946; Woodmere A. Gal.; Phila. A. All.; one-man: Syracuse Mus. FA; New Britain AI; deCordova Mus.; PAFA; Fitchburg (Mass.) Mus. A.; Mt. Holyoke Col. Contributor to Scribners, Story Parade, Sat. Eve. Post, Atlantic Monthly magazines. Positions: Founder, Instr., Fox Hill Sch. A., Jamestown, R.I. Author: "The Simple Nun"; "Seaweed Their Pasture"; "The Color of Life," 1957.

WRIGHT, JAMES COUPER—Painter, T., L.
4 Lida Lane, Pasadena, Cal. 91103
B. Kirkwall, Orkney Islands, Scotland, Mar. 21, 1906. Studied: Edinburgh Col. A., Scotland, D.A.; in Europe (scholarship). Member: Cal. WC Soc.; Pasadena Soc. A.; AWS. Awards: 54 awards for watercolors. Work: SFMA; Oakland A. Mus.; Santa Barbara Mus. A.; Los A. Mus. A.; Pasadena A. Mus.; San Diego FA Gal. Exhibited: Nationally and with numerous one-man exhibitions. Positions: Instr., Pasadena City College; summer at Los Angeles Harbor.

WRIGHT, LOUIS BOOKER—Historian, W.
Folger Shakespeare Library, 201 East Capitol St. 20003; h. 2915 Foxhall Road, Northwest, Washington, D.C. 20009
B. Greenwood, S.C., Mar. 1, 1899. Studied: Wofford Col., A.B.; Univ. North Carolina, M.A., Ph.D. Member: Mod. Language Assn.; Am. Hist. Assn.; Am. Antiquarian Soc.; Am. Philosophical Soc.; Grolier Cl.; Colonial Soc. of Mass.; Mass. Hist. Soc. Awards: Guggenheim F., 1928-29, 1930. Author: "Middle-Class Culture in Elizabethan England," 1935; "The First Gentlemen of Virginia," 1940; "Culture on the Moving Frontier," 1953; "The Cultural Life of the American Colonies," 1957; "Shakespeare for Everyman," 1964; "The American Heritage History of the Thirteen Colonies," 1967; "The Arts in America: The Colonial Period," in collaboration with George Tatum and others, 1966. Contributor to many learned journals. Lectures: British and American colonial history. Posi-

tions: Prof., Am. Hist., Bibliography, Research Methods: Univ. North Carolina, Emory Univ., Univ. Michigan, Univ. Washington, UCLA, and others; Memb. Permanent Research Group & Chm. Comm. on Fellowships, Huntington Lib., 1932-48; Dir., Folger Shakespeare Library, Washington, D.C., 1948-1968, Emeritus, 1968.

WRIGHT, RUSSEL—Industrial Designer, Writer
221 E. 48th St., New York, N.Y. 10017; h. Garrison, N.Y. 10524
B. Lebanon, Ohio, Apr. 3, 1904. Studied: Cincinnati Acad. A.; ASL; Princeton Univ.; Columbia Univ. Sch. of Architecture; N.Y. Univ. Sch. of Architecture. Awards: Tiffany Award for sculpture; Soc. of Indst. Designers Inst., for industrial design; Trail Blazer Awards (2) 1951 for best work in upholstery fabric and for table service; Mus. Mod. A., "Good Design" awards, 1950, 1953 with European traveling exhibition, 1952-53; special medal, Soc. Indust. Designers for work as President. Author: "Easier Living" and contributor of articles to home magazines. Design of Dragon Rock: experimental home and arboretum using native materials on mountain Garrison-on-Hudson 1960; design of Chinese gourmet restaurant Shun Lee Dynasty 1966; closed design office 1967; consultant on master planning to National Park Service 1968; citation from First Lady's Beautification Committee and award from Mayor of Washington for plan and direction of Summer in the Parks, a program of education and recreation in 44 parks in the District of Columbia 1968. Commission of U.S. Technical Aid Mission to five Far Eastern countries, 1956-1960. Founder, of American Society of Industrial Designers (now ASID/IDA) and President, 1952-53.

WRIGHT, STANLEY MARC—Painter, T., L.
Stowe, Vt. 05672
B. Irvington, N.J., May 24, 1911. Studied: PIASch.; Tiffany Fnd., and with Jerry Farnsworth. Member: SC; AAPL; Audubon A.; Am. Veterans Soc. A. Awards: Montclair A. Mus., 1947, 1948, 1951; Fleming Mus. A., 1950-1964; Newark Mus., 1946; Jersey City Mus. A., 1948; Spring Lake, 1947, 1948; SC, 1953; Ogunquit A. Center, 1953, 1958; Newbury A. Center, 1953-1964; Irvington A. & Mus. Assn., 1946; Milburn-Short Hills, 1947, 1948; Newark A. Cl., 1946-1948; SC, 1952. Work: mural, Newark Airport. Exhibited: MMA, 1942; NAD; Audubon A., 1949-1964; NAC, 1949, 1950; All A. Am.; CGA; Grand Central A. Gal.; New Hope, Pa.; Provincetown, Mass.; SC, 1949-1964; Montclair A. Mus.; Newbury A. Center, 1953-1964; Ogunquit, 1953-1960; Fleming Mus., 1950-1964; Wash. Congressional Cl.; Silvermine Gld. A.; Wood A. Gal., and others. One-man: 1962-1964: Fleming Mus.; Hanover Galleries; Wood A. Gall. The Art Colony. I., "Creation of Man." Positions: Instr., Newark Sch. FA; Wright Sch. A.

WRIGHT, MR. and MRS. WILLIAM H.—Collectors
12921 Evanston St., Los Angeles, Cal. 90049
Collection: Modern paintings and watercolors; Pre-Columbian sculpture, mostly from Colima, Mexico.*

WRIGHTSMAN, CHARLES BIERER—Collector
First City National Bank Bldg., 1021 Main St., Houston, Tex. 77002; h. Palm Beach, Fla. 33480*

WRISTON, BARBARA—Museum Art Historian, W.
The Art Institute of Chicago, Michigan at Adams St. 60603; h. 260 E. Chestnut St., Apt. 3406, Chicago, Ill. 60611
B. Middletown, Conn., June 17, 1917. Studied: Oberlin Col., B.A.; Brown Univ., M.A. Contributor to various periodicals and on decorative arts and American architecture, including Journal of the Soc. of Arch. Historians, Bulletin, AIC, etc. Positions: Museum Asst., Museum of Art, Rhode Island Sch. Design, 1939-1944; Lecturer to the Schools, Museum of Fine Arts of Boston, 1944-1961; Officer and Dir., including President, Soc. of Architectural Historians, 1952-1965; Hd., Dept. of Museum Education, The Art Institute of Chicago, 1961- ; Chm., the United States Committee on Education and Cultural Action of the International Council of Museums, 1966- ; Member of the United States Committee for the International Council of Monuments and Sites.

WUERMER, CARL—Painter
c/o Grand Central Art Galleries, The Biltmore Hotel, Vanderbilt Ave. & 43rd St., New York, N.Y. 10017; h. Woodstock, N.Y. 12498
B. Munich, Germany, Aug. 3, 1900. Studied: AIC; ASL; & with W. J. Reynolds. Member: A. Fellowship, Inc.; All. A. Am. Awards: prizes, AIC, 1927; NAD, 1928; Grand Central A. Gal., 1929, 1945; Springfield (Mass.) A. Lg., 1928; Buck Hill Falls (Pa.) AA, 1943; Carnegie Inst., 1949; Jasper Cropsey award, Hudson Valley AA, 1958. Work: Mun. Coll., Chicago; Buck Hill AA; IBM Coll.; Amherst Col.; Mun. Coll. City of Chicago; Encyclopaedia Britannica Coll. Exhibited: nationally; one-man exh.; Anderson Gal., Chicago, 1925, 1926; AIC, 1928; Grand Central A. Gal., 1930, 1934, 1938, 1943,

1947, 1948, 1953, 1956, 1966 (one-man); O'Brien A. Gal., Chicago, 1931. Positions: Vice-Pres., A. Fellowship, Inc.

WUNDER, RICHARD P.—Museum Director
Cooper-Hewitt Museum of Design, Smithsonian Institution, 3rd Ave. at 7th St., 10003; h. 45 East End Ave., New York, N.Y. 10028
B. Ardmore, Pa., May 31, 1923. Studied: Harvard Univ., A.B., M.A., Ph.D. Member: AAMus.; College AA; Furniture Hist. Soc. of Great Britain; Nat. Trust for Historic Preservation; Société de l'Histoire de l'Art Francais, France; Soc. of Arch. Historians; Soc. of Arch. Historians of Great Britain; Walpole Soc., Great Britain. Awards: John Thornton Kirkland traveling fellowship, Harvard Univ. Author: "Extravagant Drawings of the 18th Century from the Collection of the Cooper Union Museum," 1962; "Architectural and Ornamental Drawings of the 16th to the Early 19th Centuries in the Collection of the University of Michigan Museum of Art," 1965; " "Frederic Edwin Church," 1966; "17th and 18th Century European Drawings,"1966. contributed articles to Cooper Union Museum Chronicle. Positions: Advisory Com., Mus. of Am. Folk A. and Archives of Am. A. Editorial Bd., "Art Quarterly"; Dir., Drawing Soc.; Bd. of Trustees, Mus. of Graphic Art; Advisory Com., Resources Council, Inc.; Faculty Advisory Com., U. S. Dept. of Agriculture Grad. Sch. Faculty Advisory Com.; Smithsonian Inst.; Editorial Bd., Smithsonian Journal of History; Editorial Policy Com., Smithsonian Press. Director, Cooper-Hewitt Museum of Design, Smithsonian Institution, New York, N.Y.

WUNDERLICH, RUDOLF G.—Art Dealer
Kennedy Galleries, Inc., 20 E. 56th St., New York, N. Y. 10022; h. Boxwood House, Ossining, N. Y. 10562
B. Tarrytown, N. Y., Nov. 13, 1920. Studied: New York University. Specialty of the Gallery: Early American 18th, 19th and 20th Century Paintings, Drawings, and Watercolors; also Western Americana and Old and Modern Master Prints.

WURTZBURGER, MRS. ALAN—Collector
Timberlane, Pikesville, Md. 21208*

WYATT, WILLIAM STANLEY—Painter, T., Gr., I., L.
City College of New York, 139th & Convent Sts.; h. 177 River Rd., Grand View-on-Hudson, N.Y.
B. Denver, Colo., Sept. 20, 1921. Studied: Columbia Col., B.A.; Columbia Univ., M.A.; AIC; BM Sch. A., with Tamayo; Dept. FA & Archaeology, Columbia Univ. under Meyer Shapiro, Julius Held and Millard Meiss. Member: AAUP; CAA; Am. Mus. Natural Hist. Awards: Distinction in Illustration, Assn. of American Alumni Magazines, 1958. Work: Mexican-North American Cultural Inst., Mexico City; State Univ. of New York, and in many private collections. Exhibited: New York Pub. Lib., 1955; Barnard Col., 1958; Barzansky Gal., N.Y., 1957; New York State Capitol, 1962; Rockland Fnd., N.Y., 1960; Palmer House Gals., Chicago, 1961; The Gallery, Denver, 1961; one-man: Columbia Univ., 1958, 1959 (2); Yankton (S.D.), 1958; City Col., Baruch Sch., 1961; Montana State Univ., Missoula, 1961; Regis Col., Denver, 1961; Rockland Community Col., 1961; Clarksville Gal., West Nyack, N.Y., 1962; The Collectors Gal., Mexico City, 1962. Illustrated: "Poems of Verlaine," 1958; "Poems of Baudelaire," 1960 (Peter Pauper Press); "20th Century Views" series 60 titles; "Essays for a Scientific Age," 1964, cover design, "The Fall" by Camus 1964 and "North American Trees" by Platt, 1965, all for Prentice Hall Publ. Co. Contributor illus. and cartoons to: N.Y. Times; N.Y. Herald-Tribune; Harpers; Newsweek; Columbia Alumni News and others. Lectures: Modern Art and Survey of Art History, Art Education Project, New York Public Library. Positions: Asst. Prof., Hd. A. Dept., Waynesburg (Pa.) Col., 1949-1951; Lecturer, Columbia Univ. Sch. Painting & Sculpture, 1952-1960; Instr. Sch. Gen. Studies, 1952-1956, Lecturer in Drawing, 1956-1959, and in Art Dept., 1956-1961, Instr., Departmental Rep., Baruch School, 1961-1962, City College of New York; Consultant in organizing art department, and instructor, Rockland Community College, 1961-1962.*

WYCKOFF, SYLVIA SPENCER—Painter, E.
Syracuse University; h. 705 East Molloy Rd., Syracuse, N.Y. 13211
B. Pittsburgh, Pa., Nov. 14, 1915. Studied: Syracuse Univ., B.F.A., M.F.A. Member: Nat. Lg. Am. Pen Women; AAUP; All. A. Syracuse; Daubers Cl., Syracuse; NAWA; Assoc. A. Syracuse; Sigma Chi Alpha (Hon. A. Edu.). Awards: prizes, Assoc. A. Syracuse, 1943; Onondaga Historical Exh., 1945; Nat. Lg. Am. Pen Women, 1948; Gordon Steele Memorial Award for Painting. Exhibited: NAWA; Eight Syracuse Watercolorists, 1943-1952; Assoc. A. Syracuse; Daubers Cl.; Munson-Williams-Proctor Inst., 1969 & prior; Nat. Lg. Am. Pen Women; Lowe A. Center, Syracuse; Syracuse Mus. FA.; Rochester Mem. A. Gal., 1969; Faculty Show, Univ. Syracuse, 1968; Cooperstown, N.Y., 1968; Assoc. A., Syracuse, 1968. Positions: Assoc. Prof. A., Syracuse Univ., Syracuse, N.Y., 1942- .

WYETH, ANDREW NEWELL—Painter
Chadds Ford, Pa. 19317
B. Chadds Ford, Pa., July 12, 1917. Studied: with N.C. Wyeth. Member: NA; Audubon A. (Dir.); Phila. WC Cl. (Dir.); AWCS; Nat. Acad. A. & Let.; Am. Acad. A. & Let. Awards: prize, Wilmington (Del.) Mus. A.; Butler AI; award of merit med. & prize, Am. Acad. A. & Let., 1947; PAFA; Carnegie Inst.; medal, AWS; Hon. degree, D.F.A.; Harvard Univ., 1955; Colby Col., 1955; Dickinson Col., 1958; Swarthmore Col., 1958. Work: MMA; BMFA; AIC; BMFA; MModA; Canajoharie A. Gal.; Univ. Nebraska; AGAA; New Britain Mus.; Butler AI; Wilmington Mus. A.; Lincoln Mus., England. Exhibited: AIC (one-man); MModA; Brussels Fair, 1958; PAFA, 1947; traveling shows: Japan, India (AFA), 1954; Germany, Switzerland, England, 1955-56; Italy, 1958. Positions: Memb. FA Com. for Smithsonian Inst.*

WYETH, HENRIETTE (Mrs. Peter Hurd)—Painter
San Patricio, N.M.
B. Wilmington, Del., Oct. 22, 1907. Studied: Normal A. Sch., Boston, Mass.; PAFA, and with N. C. Wyeth. Awards: prizes, 4 firsts, Wilmington Soc. FA; PAFA, 1935. Work: Wilmington Soc. FA; Roswell Mus. A.; New Britain (Conn.) Mus. A.; Lubbock Mus. A.; Texas Tech. Col.; portraits in private collections. Exhibited: Carnegie Inst.; AIC; MMA; Roswell Mus. A.; New York City, and others.

WYMA, PETER EDWARD—Cartoonist
3431 Mitchell Rd., St. Clair, Mich. 48079
B. Chicago, Ill., Apr. 16, 1922. Studied: School of Visual Arts, N.Y. Member: Nat. Cartoonists Soc. Awards: Best published cartoon of the Year, 1950, 1951, Sch. of Visual Arts. Work: Daily cartoon panel, General Features Syndicate; "Senator Caucus," Washington Evening Star and others; Freelance cartoons to all major publications.

WYMAN, WILLIAM—Ceramic Craftsman, P., S., Des.
9 Iron Hill St., East Weymouth, Mass. 02189
B. Boston, Mass., June 13, 1922. Studied: Mass. Col. A., B.S.; Columbia Univ., M.A. and at Alfred Univ. Member: Am. Craftsmen's Council; AAUP. Awards: Des Moines A. Center; DeCordova Mus., Lincoln, Mass.; Mass. Assn. Craftsmen; Ceramic Nat. Exh., Syracuse, N.Y.; R.I. Festival Arts; Smithsonian Inst.; Am. Craftsmen's Council. Work: ceramic monument, Weymouth H.S., 1965; collections of: Des Moines A. Center; St. Paul Gal. A.; Univ. Iowa; Univ. Minnesota; Mus. Contemp. Crafts; Lee Nordness Gal., N.Y.; Everson Mus. A.; Hamline Univ.; Smithsonian Inst.; Mass. Col. A. Alumni; Weymouth H.S.; AGAA; S. C. Johnson Coll. of American Crafts. Exhibited: Work exhibited in every major ceramic exhibition, nationally and internationally, since 1952, including—MMA; Mus. Contemp. Crafts; Inst. Contemp. A., Boston; Brussels Worlds Fair; Ostend, Belgium, World Ceramic Exh.; N.Y. Worlds Fair; Munich, Germany; WMA; Alfred Univ., N.Y.; Victoria and Albert Mus., London; Lee Nordness Galleries, N.Y., and others. Workshops and lectures at many universities, colleges and art organizations, nationally and in Canada. Positions: Operates the Herring Run Pottery, East Weymouth; Instr., Ceramics and Sculpture, BMFA Sch., Boston, at present.

WYNNE, ALBERT GIVENS—Painter, E., Des., Gr.
Colorado College 80903; h. Rt. 1, Black Forest, Colorado Springs, Colo. 80908
B. Colorado Springs, Colo., Jan. 3, 1922. Studied: Univ. Denver; Iowa Wesleyan Col., B.A.; State Univ. of Iowa, M.A., and with S. Carl Fracassini, Boardman Robinson, James Lechay, and others. Awards: prizes, A. Exh., Anchorage, Alaska; Des Moines A. Center. Exhibited: Indiana, Pa., 1948; Wash. WC Cl., 1953; Virginia Intermont Col., 1953; Fur Rendezvous, Anchorage, Alaska, 1955, 1956; Alaska Contemp. A., 1956; Iowa A., 1957, 1958, 1960, 1961; Joslyn A. Mus., 1958, 1962; WAC, 1958; Butler Inst. Am. A., 1958; Sioux City, Iowa, 1959; CGA, 1961; AFA traveling exh., 1961-62; Colorado Springs Faculty, 1960; Roswell, N.M., 1962; Colo. Springs, 1962; Denver A. Mus., 1962; one-man: Iowa Wesleyan Col., 1950, 1957; Mel Kohler Des. Studio, Anchorage, Alaska, 1955; Mt. Pleasant, Iowa, 1959; Design Center, Denver, 1962; Colo. Springs FA Center, 1962; El Pueblo Mus., Pueblo, Colo., 1964; Colo. Woman's Col., Denver, 1964. Positions: Honoraria Instr., Univ. Colorado, Colo. Springs FA Center, 1963- .*

YAGHJIAN, EDMUND—Painter, E., L.
1510 Adger Rd., Columbia, S.C. 29205
B. Armenia, Feb. 16, 1904. Studied: R.I. Sch. Des., B.F.A.; ASL. Member: CAA; AFA; Southeastern AA; ASL; AAUP. Awards: prizes, So. Carolina State Exh., 1946, 1947, 1949; Southeastern Annual, 1947; Gld. South Carolina A., 1954, 1955; Columbia A. Gld., 1955; Hunter Gal., 1960; Gibbes A. Gal., 1961; purchase, Winston-Salem State Fair, 1963; Univ. of S.C., 1967. Work: West Point Mus.; Norfolk Mus. A.; N.Y. Pub. Lib.; Duke Univ.; Ossining (N.Y.) Mus.; Mont-

pelier, Vt.; High Mus. A.; Clemson (S.C.) Univ.; Gibbes A. Gal.; Furman Univ.; Finkel Gal.; Gallery Two; Mint Mus.; Galerie Fontainbleau; Pittsburgh Plan for Art; So. Vermont Art Center; numerous H.S. and Hospitals. Exhibited: CGA, 1936, 1939; 1945; PAFA, 1934, 1936, 1939, 1941, 1943, 1949, 1951, 1953; NAD, 1934, 1936; MMA, 1942; WMAA, 1936, 1939, 1942; Carnegie Inst., 1936, 1941, 1945; Birmingham Mus. A. Gld. South Carolina A., 1956, 1957; BMA; Butler AI; one-man: Kraushaar Gal.; Gibbes A. Gal.; Telfair Acad.; Columbia Mus. A.; Florence Mus. A.; Univ. Missouri; Univ. South Carolina; ASL; Converse Col.; Galerie Fontainbleau, 1964; Madison Gal., 1963; Chaffee Mus., 1963; Finkel Gal., 1963; Ligoa Duncan Gal., 1965. One-man: Mint Mus.; Gallery Two; Atlanta AA., 1966; Galerie Internationale, 1967; So. Vermont Art Center; AGBU Gal., 1968; Florence (S.C.) Mus., 1969. Positions: Hd. A. Dept., Univ. South Carolina, Columbia, S.C., 1945- , A.-in-Res., Univ. S.C., 1966.

YATER, GEORGE DAVID—Painter, I., W.
Truro, Mass. 02666; also Frederiksted, St. Croix, V.I.
B. Madison, Ind., Nov. 30, 1910. Studied: John Herron AI; Cape Sch. A., with Henry Hensche. Awards: Traveling scholarship, John Herron AI, 1932; Scholarship, Cape Sch. A.; prize, Hoosier Salon, 1931; 1946, 1954, 1956; Indiana State Fair, 1930; Indiana AA, 1936, 1953; Cape Cod AA, 1953, 1960, 1961, 1967, 1968; DePauw Univ., purchase, 1959; Falmouth A. Gld., 1961. Work: Paper Mill Playhouse; Ford Motor Co.; N.Y.-New Haven & Hartford Railroad Coll.; Indiana Univ. DePauw Univ.; Chrysler A. Mus.;Provincetown A. A. Exhibited: NAD; PAFA; AWS; Inst. Mod. A., Boston; Univ. Illinois; Currier Gal. A.; Provincetown AA; Indiana AA; Hoosier Salon; Indiana State Fair; Lyme AA; Butler AI; Cape Cod AA; Key West A. & Hist. Soc.; Henry Ford Mus.; Detroit Inst. A.; deCordova & Dana Mus.; Sarasota AA; Seligmann Gal.; Ringling Mus. A.; Chrysler A. Mus., Provincetown; Stuart Gal., Boston; Paper Mill Playhouse; Dennis (Mass.) A. Center; Portland (Me.) A. Mus.; USIA exhs. to Asia, Middle East, Europe, South America; one-man: Babcock Gal., 1936, 1939; Grace Horne Gal., Boston, 1941; Hanover Col., 1939; 1950; Provincetown AA, 1950; Madison, Ind., 1950; Key West A. & Hist. Soc. 1952, 1953; Cape Cod AA, 1952-1960; A. & Crafts Cal. Wellfleet, Mass.; Frederiksted, St. Croix, and others. Illus. for Ford Times; Lincoln-Mercury Times; New England Journeys; articles and photographs for Rudder; Motor Boating, Yachting; Popular Photography, etc. Positions: Dir., Provincetown AA, 1947-61; Dir., Sarasota AA, 1955-1956.

YEKTAI, MANOUCHER—Painter
231 E. 76th St., New York, N.Y. 10021
B. Tehran, Iran, Dec. 21, 1922. Studied: in Paris. Work: MModA; Union Carbide, N.Y., and others. Exhibited: WAC, 1960; Carnegie Inst., 1961; MModA, 1962; AIC, 1962, among other exhibitions, U.S.A.; one-man: Borgenicht Gal., N.Y., 1951, 1952, 1954; Assoc. Am. A., 1956; Poindexter Gal., N.Y., 1957, 1959, 1960, 1962, 1964; Anderson-Mayer Gal., Paris, 1963; Gumps, San Francisco, 1963, 1964; Felix Landau Gal., Los A., 1963; Feingarten Gal., Chicago, 1963; Gertrude Kasle Gal., Detroit, 1966-1968; Huber Gal., Zurich, 1964; Benson Gal., Bridgehampton, N.Y., 1966.

YEPEZ, DOROTHY—Museum Director, Cur., E., W., L., P., S.
Gallery-Museum, Dorothy Yepez Galleries, Bloomingdale Rd., Saranac Lake, N.Y. 12983; h. 301 E. 64th St., Apt. 3-J, New York, N.Y. 10021
B. Philadelphia, Pa., Feb. 22, 1918. Studied: Univ. Pennsylvania; Temple Univ., Phila., Pa.; N.Y. Univ.; Cooper Union, N.Y.; New Sch. for Social Research, N.Y., and privately. Member: AFA; Am. Edu. Theater Assn.; Nat. Council on the Arts & Government; Essex-Clinton County Council on the Arts (charter member); Arts Center Committee on Henry St. Settlement, N.Y.; Historical Soc., Washington Heights, N.Y.; Arts Committee, Central Presbyterian Church, New York City. Exhibits at Pen & Palette annual exhibitions, Saranac Lake, N.Y.; Yepez Galleries; work in coll. of the Saranac Lake Free Library. Lectures: schools, churches, civic and women's organizations. Conducts a series known as Professional Theater for Students, a Summer Gallery-Museum Program.

YOAKUM, DELMER J.—Painter, Des., Ser.
Paramount Studios, Hollywood, Cal.; h. 4614½ W. 64th St., Inglewood, Cal. 90302
B. St. Joseph, Mo., Dec. 6, 1915. Studied: Kansas City AI; Jepson AI; Chouinard AI, and with Henry Lee McFee, Herbert Jepson, Phil Dike, Rico LeBrun, Richard Haines, and others. Member: AEA; Cal. WC Soc.; Los A. AA; Los A. Mus. Assn.; South Bay AA; Motion Picture Scenic A. Awards: prizes, Newport Harbor purchase, 1954; Cal. WC Soc., 1954, 1959 purchase; Santa Monica, 1948, 1949; medal, Oakland A. Mus., 1949; purchase, Wiseburn Sch., Hawthorne, Cal., 1957; prize, Frye Mus. A., Seattle, 1958, 1961, 1963; Las Vegas, Nev., 1959, 1963; Inglewood AA, 1960, 1961, 1962, 1964. Work: Painted Grand Canyon Diorama, Disneyland, Anaheim, Cal., 1959; Newport (Cal.) H.S.; San Diego FA Soc. Exhibited: But-

ler AI, 1953, 1945, 1956, 1958; Denver A. Mus., 1953, 1954; Los A. Mus. A., 1946, 1948-1950, 1952, 1954-1958; Oakland A. Mus., 1949, 1950, 1952, 1954; Los A. AA., 1946-1949, 1951-1953; Univ. Wash., 1954; Arizona State Fair, 1948; Nat. Orange Show, 1949, 1952, 1964; Newport Harbor, 1952-1955; PAFA, 1957; Frye Mus. A., 1958, 1959, 1962-1964; Cal. WC Soc., 1954, 1956-1964; and traveling exhs.; Chaffey Annual, Ontario, Cal., 1959; Ringling Mus. A., 1959 60; Long Beach, 1959-60; traveling exh., Mexico, 1959-62; Santa Monica AA, 1959 (5-man); Stockton, Cal., 1957; Univ. So. Cal., 1957; Pasadena A. Mus., 1957, 1958; Cal. PLH, 1958; traveling exh., Cal. WC Soc., 1954, 1957, 1958-1961; Inglewood A. Lg., 1962-1965; VMFA, 1963-1965; Richmond A. Center, 1963; Las Vegas A. Lg., 1962, 1963; Cal. State Fair, 1962-1964; Tucson A. Center, 1964; Miracle Mile, Los A., 1965; Municipal A. Gal., Los A., 1965; Dulin Gal., Knoxville, 1964.*

YOCHIM, LOUISE DUNN—Painter, S., T., W., C., Lith., L.
 228 North La Salle St., Skokie, Ill.; h. 9545 Drake Ave., Evanston, Ill. 60203
B. Jitomir, Ukraine, July 18, 1909. Studied: AIC, M.A.E.; Univ. Chicago. Member: NAEA; Western A. Edu. Assn.; Chicago Soc. A.; F.I.A.L.; Renaissance Soc. A. Awards: prizes, Chicago Soc. A., 1953; Am. Jewish A. Cl., 1947, 1954, 1955, 1958. Exhibited: AIC, 1935-1937, 1941, 1942, 1944; Detroit Inst. A., 1945; Chicago FA Gal., 1945; Univ. Chicago, 1946, 1962; Todros Geller Gal., 1947, 1951-1955; Riverside Mus., 1951; Kansas City, Mo., 1948; Terry AI, 1952; Des Moines A. Center, 1955; Cromer & Quint Gal., Chicago, 1954, 1955; Werbe Gal., Detroit, Old Orchard Fair, Skokie, Ill.; Evanston A. Center; Spearfish, N.D.; Rapid City, N.D.; Springfield Mus. A., 1959, 1961; Assoc. A. Gal., Wash., D.C., 1961; Northwestern Univ., 1960, 1963; McCormick Place Gal., 1963; Contemp. Gal., 1962; Sun-Times Gal., Chicago, 1960; Mandel Bros., 1953-1955, 1957; Univ. Club of Chicago, 1966; 8 one-man exhs., Chicago, 1947, 1951, 1952, 1957, 1960; one-man: Chicago T. Col., 1964; Covenant Cl., 1964; First Federal Gal., 1962; Nat. Design Center, Marina City, 1965; McKerr Gal., 1962; Rosenstone Gal., Bernard Horwich Center, Chicago, 1968. Work: in private colls. Author: "Building Human Relationships Through Art," 1954; "Perceptual Growth in Creativity," 1967; Ed., "Art in Action," for Chicago Pub. Schs., 1969. Contributor articles and reviews to Sentinel magazine. Positions: Instr. A., Chicago H.S., 1935-50; Acad. FA, Chicago, 1952; Supv. A., Dist. 6, Chicago Pub. Schs., at present; Instr., Chicago T. Col., 1953, 1961-62; Wright Jr. Col., 1952, 1953. Lectures on Art Education.

YORK, JAMES—Art dealer
 70 E. 56th St., New York, N.Y. 10022*

YOUNG, JOSEPH LOUIS—Mural Painter, S., C., Gr., E., L.
 Art in Architecture, 8422 Melrose Ave.; h. 7917½ West Norton Ave., Los Angeles, Cal. 90046
B. Pittsburgh, Pa., Nov. 27, 1919. Studied: Westminster Col., New Wilmington, Pa., A.B.; BMFA Sch.; ASL; Cranbrook Acad. A.; MIT; mosaics in Rome with Gulio Giovanetti. Member: NSMP; F., Int. Inst. A. & Lets.; Watts Towers Committee. Awards: Guest, Am. Acad. in Rome, 1951-52; Abbey scholarship for mural painting, 1949-50; F., BMFA Sch., 1951-52; F., Huntington Hartford Fnd., 1952-53; Hon. LL.D., Westminster Col., New Wilmington, Pa., 1960; Syracuse Univ. Mss. Coll. Work: murals, QM Headquarters, Miami Beach, Fla.; Baptist Church, Manchester, Conn.; Courtyard Silversmiths, Boston; BMFA Sch.; Temple Emanuel, Beverly Hills, Cal.; Don Bosco Tech. H.S., San Gabriel, Cal.; cantilevered mural (mosaic) Los Angeles Police Facilities Bldg.; Southland Shopping Center, Los A.; Texaco Bldg., Los A.; bas-relief mosaic murals, Shalom Mem. Park, Palatine, Ill.; Math. Bldg., Univ. Cal. at Los Angeles; sc., Temple Sinai, Westwood, Los Angeles; mosaics, Nat. Shrine of Immaculate Conception, Wash., D.C, and many more works in churches, chapels, parks and buildings. Exhibited: Arch. Lg., 1951; Butler AI, 1948; Nat. Army Exh., 1945; one-man: Falk-Raboff Gal., Los A., 1953; 10 year retrospective Art in Architecture, Palm Springs Desert Mus., 1963; Carnegie-Mellon Univ. Mus.; BMFA; Los Angeles County Mus.; SFMA, and others. Author: "Bibliography of Mural Painting in USA," 1946; "A Plan for Mural Painting in Israel" (for Ministry of Education of the State of Israel); "A Course in Making Mosaics," 1957; "Mosaics: Principles and Practice," 1963. Work subject of prize winning documentary film with sound and color, "The World of Mosaic." Contributor of articles to AIA Bulletin of Southern California. Lectures (with slides): The History of Architectural Mosaics; Murals for Contemporary Architecture, etc. Positions: Dir., Pittsburgh office of Stewart Howe Alumni Service, 1941-42; Radio News Analyst, United Press Assn., N.Y., 1942-43; Special Services, AAF, 1943-46; Chm., Exh., BMFA Sch.; 1950-51; Instr., BMFA Sch., 1950-51; Senior Editorial Assoc., Creative Crafts Magazine; Guest Lecturer for Italian Govt., 1959; Designer, 400th Anniversary Michelangelo Mem. Exh., Int. Design Center, Los Angeles, 1964; Founder, Dir., Mosaic Workshop, Los Angeles, Cal. Founding Chm. and A.-in-Res., Dept. Arch. Arts, Brooks Inst. Sch. FA, Santa Barbara, 1968- .

YOUNG, MAHONRI SHARP—Museum Director
 Columbus Gallery of Fine Arts, East Broad St., Columbus, Ohio 43215; h. Lancaster Rd., Granville, Ohio 43023
B. New York, N.Y., July 23, 1911. Studied: Dartmouth Col., A.B.; Univ. Paris; N.Y. Univ., Inst. FA. M.A. Member: Assn. A. Mus. Dir. Author: "Old George," 1940. Contributor to American Scholar; Art News; Apollo. Positions: Instr., A. Dept., Sarah Lawrence Col., 1941-50; Chm. A. Dept., Sarah Lawrence Col., 1948-50; Actg. Dir., Community A. Program, Munson-Williams-Proctor Inst., Utica, N.Y., 1951-53; Dir., Columbus Gal. FA, Columbus, Ohio, 1953- .

YOUNG, PETER—Painter
 c/o Goldowsky Gallery, 1078 Madison Ave., New York, N.Y. 10021*

YOUNG, WEBB—Painter
 702 Canyon Rd.; h. 540 Camino Rancheros, Santa Fe, N.M. 87501
B. Covington, Ky., Sept. 2, 1913. Studied: AIC, with Gerald Cassidy; Famous Artists Schs. Exhibited: Mus. New Mexico, Santa Fe, regularly; traveling exhs., Taos AA, Santa Fe A. Gal. Contributor covers to New Mexico Magazine; 20 booklet covers for Nat. Park Service's Monuments; creator Air Corps 188th Fighter Squadron's symbol; New Mexico State Tourist Bureau's Vacation Map; State Game & Fish Dept.'s illus. fishing map; contributor to Ford Times. Author: "Student Steps to Water-Color Painting." Specializing in The New Mexico scene.

YOUNG, WILLIAM THOMAS (TOM)—Painter, Et., Lith., E., L.
 Department of Art, Auburn University, Auburn, Ala. 36830
B. Huntington, W. Va., Oct. 7, 1924. Studied: Univ. Cincinnati; Univ. Alabama, B.F.A., M.A.; Ohio State Univ.; Univ. So. California; Columbia Univ.; John Herron AI; Chouinard AI; Hans Hofmann Sch. FA; Cincinnati Acad. A. Member: Comm. on A. Edu. Awards: prizes, Scholarship, John Herron AI, 1940; Alabama WC Soc., 1954; Staten Island Mus. Hist. & A., 1955; N.Y. City Center Gal., 1956. Work: Univ. Alabama; Army Air Force Base, Okla. (mural); Univ. So. Ill. Mus.; Wagner Col., Staten Island; mural, Hayden Publ. Co., N.Y., 1963; work in numerous private colls. Exhibited: Alabama WC Soc., 1949; PMA, 1950; BM, 1950; Canton A. Mus., 1951; Birmingham, 1953, 1954; N.Y. City Center, 1956, 1957; Wagner Col., 1957, 1959; CM, 1946; Mich. State Univ., 1947; Montgomery Mus. FA, 1950; A. Lg. of Long Island, 1954; Pietrantonio Gal., N.Y., 1956, 1959; Artzt Gal., N.Y., 1959; Nonagon Gal., N.Y., 1958 (5-man); Univ. So. Illinois, 1960; Brata Gal., N.Y., 1960; Toronto, Canada, 1960; Kansas City AI, 1960; Kauffman Gal., 1956; Tanager Gal., 1957; Davida Gal., 1957; March Gal., 1957, 1958, 1959, 1960; Marino Gal., 1958, and many others; one-man: Univ. Alabama, 1948-1950, 1961; Jackson Mun. A. Mus., 1961; Little Rock A. Center, 1961; Brata Gal., N.Y., 1962; Univ. So. Illinois, 1961; Univ. Mississippi, 1961; Allison's A. Colony, Way, Miss., 1961. Positions: Instr., A., Univ. Alabama, 1949-50; Prof. A. Alabama State Col., 1950-52; Prof. A., Chm. A. Dept., Wagner College, Staten Island, N.Y., 1953-1969; Prof. A., Hd., Dept. A., Auburn Univ., Auburn, Ala., 1969- . Juror, annual Staten Island Mus. Exh., 1964; and for 14th annual Festival of Arts, Birmingham Art Mus., 1965; Dir., special seminars "Exploring Art in New York," 1964-1969.

YOUNGERMAN, JACK—Painter
 123 Fulton St., New York, N.Y. 10038
B. Louisville, Ky., Mar. 25, 1926. Studied: Univ. North Carolina; Univ. Missouri, A.B.; and in Paris. Work: Reynolds Bldg., Richmond, Va.; Chase Manhattan Bank, N.Y.; MModA. Exhibited: Carnegie Inst., 1958, 1961; CGA, 1959; and group shows in Paris; MModA., 1959; Guggenheim Mus., 1961; Musée d'Art Moderne, Paris, 1961. One-man: Betty Parsons Gal., N.Y., 1958, 1960, 1961, 1965; Retrospective exh., WMA, 1965; Byron Gal., N.Y., 1965.*

YOUNGERMAN, REYNA ULLMAN—Painter, L. T.
 3000 Prairie Ave., Miami Beach, Fla. 33140
B. New Haven, Conn., June 26, 1902. Studied: Yale Sch. FA, B.F.A.; ASL; & with Wayman Adams, Alexander Brook, Jerry Farnsworth. Member: Conn. Acad. FA; Blue Dome F.; Fla. A. Group; Sarasota AA; NAWA; AEA (Pres. Florida Chptr.); Open Forum Speaker's Bureau, Boston; Miami WC Soc.; Des.-Dec. Gld.; New Haven Paint & Clay Cl.; Brush & Palette Cl.; Meriden SA; F.I.A.L.; Palm Beach A. Lg.; Conn. WC Soc. Awards: F., Tiffany Fnd., 1926-1927; prizes, New Haven Paint & Clay Cl., 1942; Meriden SA, 1934, 1945, 1946; Miami A.; Blue Dome Fellowship; Pan-American portrait award; AAPL; Lowe Gal.; Conn. Acad. FA; Yale Sch. FA; Fla. Painters Group; medal, Beaux-Arts (4). Work: Tiffany Fnd.; Superior Court, New Haven, Conn. Exhibited: NAWA, 1932-1946; BMFA; Morgan Mem.; Avery Mus.; Yale Gal. FA; NAD; Conn. Acad. FA; New Haven Paint & Clay Cl.; Brush & Palette Cl.; Copley Soc., Boston; Ogunquit A. Center; Palm Beach A. Lg.; Ft. Lauderdale, Fla.; Norton Gal. A. (one-man); Soc. Four A.; Miami A. Center; Barzansky Gal.; Butler AI; Argent Gal.; Audubon A.; Mayo Hill Gal., Wellfleet; Pro-

vincetown A. Gal.; Sarasota AA; Lowe Gal. A.; Rockport A. Gal.;
Hartford Atheneum; Montreal, Canada; PAFA; Oelschlager Gal.,
Chicago; Worth Ave. Gal., Palm Beach (one-man); Miami Mus. Mod.
Art; Nationale Palazio des Artes, Cuba, and others. Positions:
Chm., City of Miami Beach Music & Art Board; Leader, Brandeis
Art Appreciation Study; Chm. Miami Beach Art Festival.

YOUNGLOVE, RUTH ANN (Mrs. Benjamin Rhees Loxley)—Painter,
C., L.
 1180 Yocum St., Pasadena, Cal. 91103
B. Chicago, Ill., Feb. 14, 1909. Studied: Univ. California at Los A.,
B.E.; & with Orrin White. Member: Cal. WC Soc.; Pasadena SA; A.
Assoc.; Laguna Beach AA.; Palm Springs Desert A. Awards:
prizes, Los A. County Fair, 1937-1941. Exhibited: Pasadena SA,
1959-1961; Laguna Beach AA, 1956-1961; Los Angeles City Hall,
1957, 1960; Greek Theatre, 1957; Friday Morning Cl., 1956, 1958;
Pasadena Pub. Lib., 1958, 1960; Pasadena Soc. A., 1957; Santa
Paula, 1955, 1957, 1958, 1959-1961; Long Beach, 1963; Whittier,
1964; So. Pasadena, 1964; Tujunga, 1964; Newport Harbor, 1954,
1955; Pasadena, 1955, 1961 (one-man); Pasadena Folk Dance Group,
1945-1964; Desert Gal., 1960-61; Chicago, 1961; Des Moines, 1961;
Bakersfield, Cal., 1960. Lectures: Landscape Painting. Positions:
Patron Chm., Pasadena Soc. A., 1954-61.

YRISARRY, MARIO—Painter
 297 Third Ave., New York, N.Y. 10010
B. Manila, P.I., 1933. Studied: Queens Col., N.Y., B.A.; Cooper
Union, N.Y. Work: Aldrich Mus. Contemp. A., Ridgefield, Conn.;
Connecticut Community Col. A. Collection, and in private colls. Ex-
hibited: Fleischman Gal., N.Y., 1958; March Gal., N.Y., 1959; Gal-
eria Escindida, Taos, N.M., 1969; MModA, Art in Embassies, Tokyo,
1962, Abidjan, 1966, Prague and Brussels, 1967; Preston Gal., N.Y.,
1963; Silvermine Gld., 1964; Inst. Contemp. A., Boston; Contempor-
aries, N.Y., 1965; Park Place Gal., 1967; Drew Univ., N.J., 1967;
Bennington Col., Vt., 1967; Univ. So. Illinois, 1967; Graham Gal.,
N.Y., 1967; 4th Int. Exh. Young Artists, Tokyo, 1967; Georgia Mus.
A., Athens, 1967; U.S. Dept. Commerce, Australia, 1967-1968;
Mannheim, West Germany, 1969; Castelli Warehouse, N.Y., 1969;
O.K. Harris Gal., N.Y., 1969; one-man: Udinotti Gal., Tempe, Ariz.,
1960; Thompson Gal., Provincetown, Mass., 1961; Graham Gal.,
N.Y., 1964, 1965, 1967; Galerie Gunar, Dusseldorf, W. Germany,
1967; Obelisk Gal., Boston, 1969.

YUNKERS, ADJA (Mr.)—Painter, Lith., Eng., L., I., T.
 217 E. 11th St., New York, N.Y. 10003
B. Riga, Latvia, July 15, 1900. Studied: Leningrad, Berlin, Paris,
London. Awards: Guggenheim F., 1949-1950, 1954-1955; prize, BM,
1952; Ford Fnd. grant, 1959-60 and Ford Fnd. Visiting Artist, Ha-
waii; Bronze medal, AIC, 1961; Tamarind Workshop Fellowship, Los
Angeles, 1961. Work: In 46 museums U.S. and abroad including
MModA; MMA; N.Y. Pub. Lib.; BM; PMA; Phila. Pr. Cl.; BMA;
FMA; BMFA; WMA; Springfield Mus. A.; Colorado Springs FA Cen-
ter; NGA; CGA; WAC; Bibliotheque Nationale, Paris; Bibliotheque
Royale de Belgique, Brussels; Johannesburg A. Gal., South Africa;
Mus. Mod. A., Sao Paulo, Brazil, and in private coll. Exhibited:
MModA, 1949; Int. Print Exh., Paris, 1949; Contemp. Am. Gr. A.,
Germany, 1950-1952; Int. Print Exh., Paris, 1949; Contemp. Am. Gr.
A., Germany, 1950-1952; Int. Print Exh., Paris, 1951-1952; Int.
Print Exh., Switzerland, 1951-1952; Galeria Buchholz, Madrid, 1952;
one-man: Kleeman Gal.; CGA; Smithsonian Inst., Phila. A. All.; AIC;
Colorado Springs FA Center; Pasadena AI; SFMA; Ministry of In-
formation, Lisbon; Mus. Mod. A., Madrid, 1955; Paris, London,
Basel, Florence, Rome, Berlin and New York; Retrospective Exh.,
BMA, 1960; Emmerich Gal., N.Y., 1961. Positions: Ed., Publ.,
"Ars-Portfolio," Stockholm, Sweden, 1942-45, and Albuquerque,
N.M., 1952- ; Faculty, New Sch. for Social Research, New York,
N.Y., 1947-1956; Cooper Union, New York, N.Y. 1957-1964; Visiting
Critic, Art Dept., Columbia University, 1967-1969.

ZABARSKY, MELVIN J.—Painter
 65 Pine St., Norton, Mass. 02766
B. Worcester, Mass., Aug. 21, 1932. Studied: WMA Sch. A.; Ruskin
Sch. Drawing & FA; Boston Univ., B.F.A.; Univ. Cincinnati, M.F.A.
Member: AEA. Awards: Ford Fnd. grant, 1969; Wheaton Col. Re-
search grant, Italy, 1967; prize, Boston A. Festival, 1962; Certif. of
Achievement, in the Fine Arts, Boston Univ., 1964. Work: MModA.;
DeCordova & Dana Mus.; Ein Harod Mus.; Israel, and private colls.
Exhibited: Nat. Inst. A. & Lets., 1963; Drawing Soc. Exh., 1965; XXI
Biennial of Am. Drawing, 1965; De Cordova & Dana Mus., 1963-1968;
Boston Univ., 1969; Inst. Contemp. A., 1969, Boston; Ringling Mus.
1969; Portland (Me.) Mus., 1969; Currier Gal., 1969; Trago Gal.,
Boston, 1969 (one-man); Wheaton Col. (one-man) 1969. Boston A.
Festival, 1962, 1964; Boris Mirski Gal., Boston, 1962 (one-man);
Marion A. Center, 1963 (2-man); Wheaton College, 1964 (2-man);
Seven Boston Painters, Smith Mus., Springfield, Mass., 1964. Posi-
tions: Instr., Painting, Swain Sch. Design, New Bedford, Mass.;
Assoc. Prof., Painting, Wheaton College, Norton, Mass.

ZABRISKIE, VIRGINIA M.—Art Dealer
 699 Madison Ave. 10021; h. 145 E. 35th St., New York, N.Y.
 10016
B. New York, N.Y., July 15, 1927. Studied: N.Y. Univ., B.A.; Inst.
Art & Archaeology, Paris, France; Ecole du Louvre, Paris, France;
N.Y. Univ., Institute of Fine Arts. Specialty of Gallery: Contempo-
rary American sculpture and painting, estates and works by earlier
American artists. Presents regular exhibitions. Contributor arti-
cles and reviews on American Art to Contact; Pictures on Exhibit.
Positions: Lecturer, Louvre Museum, Paris, 1950; Owner-Director,
Zabriskie Gallery, New York, N.Y., 1954- .

ZACHARIAS, ATHOS—Painter
 141 Copeces Lane, Springs, East Hampton, N.Y. 11937*

ZADOK, MR. and MRS. CHARLES—Collectors
 40 Central Park South, New York, N.Y. 10019*

ZAHN, CARL F.—Designer
 Boston Museum of Fine Arts, 479 Huntington Ave., Boston,
 Mass. 02115; h. 30 Standish Rd., Wellesley Hills, Mass. 02181
B. Louisville, Ky., Mar. 9, 1928. Studied: Harvard College, A.B.
Exhibited: 50 Books of the Year, 1960-1968; Design and Printing for
Commerce, 1960-1964; Typomundus 20, 1965; "Communication by
Design," Andover, Mass., Inst. Contemp. A., Boston, Manchester,
N.H. and Providence, R.I. Positions: Graphics Designer, Boston
Museum of Fine Arts, Boston, Mass. Vice-Pres., AIGA, 1968-1969;
Instr., graphic design, School of the Mus. FA, Boston, 1968-1969.

ZAJAC, JACK—Sculptor, P., Gr.
 Pizza del Biscione 95, Rome, Italy; h. 741 Miramar, Clare-
 mont, Cal. 91711
B. Youngstown, Ohio, Dec. 13, 1929. Studied: Scripps College,
Claremont, Cal.; Am. Acad. in Rome. Awards: Prix de Rome,
1954; Am. Acad. A. & Lets. Grant; Guggenheim Fellowship. Work:
MModA; Los A. Mus. A.; PAFA; Milwaukee AI; Nelson Gal. A.,
Kansas City; Univ. Nebraska. 10 acquatints illustrating Dante's
Ante Purgatorio, Racolin Press, 1964. Exhibited: MModA, 1959,
1962; Carnegie Inst., 1959-1964, WMAA, 1959 and others.*

ZALSTEM-ZALESSKY, MRS. ALEXIS—Collector
 Cloud Wald Farm, New Milford, Conn. 06776*

ZAMITT, NORMAN—Sculptor
 c/o Landau Gallery, 702 La Cierega, Los Angeles, Cal. 90069.
Guggenheim Fellow, 1968.

ZECKENDORF, MRS. GURI—Collector
 1100 Park Ave., New York, N.Y. 10028*

ZEISLER, RICHARD SPIRO—Collector, Patron
 767 Fifth Ave. 10022; h. 980 Fifth Ave., New York, N.Y. 10021
B. Chicago, Ill., Nov. 28, 1916. Studied: Amherst College, B.A.;
Harvard University, Post-grad. work. Member: Fellow, The Pier-
pont Morgan Library, 1964- ; International Council of the Museum
of Modern Art, Exec. Comm., and co-chairman of Library Overseas
Program, 1967- . Collection: 20th century European painting. Po-
sitions: Chairman, Art Advisory Committee, Mount Holyoke College,
1964- ; Chairman, Visiting Committee, Fine Arts Department, Am-
herst College, 1964-1965, Advisory Commission, Creative Arts
Awards, Brandeis University, 1958- .

ZELENSKI, PAUL J.—Painter
 Art Department, University of Connecticut; (Mail) Box 141,
 Storrs, Conn.
B. Hartford, Conn., Apr. 13, 1931. Studied: Cooper Union A. Sch.;
Yale Univ., B.F.A.; Bowling Green State Univ., M.A. Member:
Texas Men of Art; Mystic AA; Contemp. New England A. Awards:
prizes, Texas FA Assn., 1960, 1961; Conn. WC Soc., 1963; Plaza 7
Exh., Hartford, Conn., 1964; Norwich AA, 1964, 1965. Work: Fort
Worth, Texas, A. Center; Archives of Mus. Mod. A., Sao Paulo,
Brazil. Exhibited: Ball State Univ., 1960-1963; PAFA; Texas FA
Assn., 1958-1961; Texas Annual 1960, 1961; Boston A. Festival,
1957, 1959, 1961-1963; New England Art, 1963, 1965, 1967; Univ.
Massachusetts, 1963; Amel Gal., N.Y., 1964, 1966; Plaza 7 Exh.,
Hartford, 1964; Conn. WC Soc., 1961, 1963; Oklahoma Annual, 1959,
1960; Mystic AA, 1962-1968; Dixie Annual, 1960, 1961; Jordan
Marsh, Boston, 1963-1968; Portland, Me., 1961; Fort Worth A. Cen-
ter, 1960; de Cordova & Dana Mus., 1964, 1965; Sun Festival, El
Paso, 1959-1960; Inst. Contemp. A., Boston, 1964-1969; Silvermine
Gld. A., 1967, 1968; Inter-Collegiate A. Faculty Exh., New Canaan,
Conn., 1967; Temple Israel, Waterbury, Conn., 1967, 1968; New
Haven A. Festival, 1966-1968; Slater Mem. Mus., Norwich, Conn.,
1965-1968; Berkshire Annual, Pittsfield, Mass.; Springfield Mus.
FA, 1968; Wadsworth Atheneum, Hartford, Conn.; New Britain Mus.;
Trinity Col., Hartford, 1967, 1968; 3-man: Mystic AA, 1967; Nexus
Gal., Boston, 1966, and others. One-man: Nexus Gal., Boston; Univ.

Connecticut. Positions: Assoc. Prof. A., Design, Color, Drawing, Painting, University of Connecticut, Storrs, Conn., at present.

ZERBE, KARL—Painter, E.
1807 Atapha Nene, Tallahassee, Fla. 32301
B. Berlin, Germany, Sept. 16, 1903. Studied: in Germany and Italy. Member: AEA; CAA; SAGA. Awards: John Barton Paine award, Richmond, Va., 1942; Blair award, Chicago, 1944; Harris award, Chicago, 1946; Carnegie Inst., 1949; PAFA, 1947, 1949, 1951; Citation, Boston Univ. 1957; D.F.A., Fla. State Univ., 1963. Work: Nat. Inst.; A. & Let.; MMA; WMAA; BM; Albright A. Gal.; AIC; Butler AI; CAM; Cranbrook Acad. A.; FMA; Harvard Univ.; Ft. Worth AA; John Herron AI; Los A. Mus. A.; MIT; Munson-Williams-Proctor Inst.; Newark Mus.; New Britain AI; PMG; R.I.Sch. Des.; San Diego FA Gal.; VMFA; Walker A. Center; Tel-Aviv Mus.; Univ. Georgia, Illinois, Iowa, Nebraska, Minnesota, Oklahoma, Rochester, Washington; IBM; Des Moines A. Center, and others. Exhibited: nationally, including MModA, 1963; Rio de Janeiro; Art:USA (Johnson Coll.), traveling exh., 1962-1965; one-man: Harvard Univ., 1934; Berkshire Mus., 1943, 1947; AIC, 1945, 1946; Phila. A. All., 1949, Munson-Williams-Proctor Inst., 1950; Inst. Contemp. A., Boston, 1951; Currier Gal. A., 1951; MIT, 1952; BMA, 1952; deYoung Mem. Mus., 1952; Colorado Springs FA Center, 1952; Retrospective Exh., Ford Fnd., 1960. Positions: Hd., Dept. Painting, BMFA Sch., Boston, Mass., 1937-54; Prof. A., Fla. State Univ., Tallahassee, Fla., 1954- ; Pres., AEA, 1957-59.

ZEREGA, ANDREA PIETRO de—Painter, E., L.
2908 M. St., Northwest, Washington, D.C. 20007
B. De Zerega, Italy, Oct. 21, 1917. Studied: Corcoran Sch. A., with Richard Lahey, Hobart Nichols, Mathilde Mueden Leisenring; in Italy, with Dr. Gaspare Biggio; Tiffany Fnd. Member: A. Gld. Wash.; Soc. Wash. A.; Wash. WC Cl.; SSAL; Landscape Cl. Wash.; Corcoran Alum. Assn.; Georgetown A. Group; Third Order Secular of St. Francis of Assisi, Mt. St. Sepulchre Fraternity. Awards: F., Tiffany Fnd., 1938; prizes, Wash. A., 1940; Soc. Wash. A., 1942; Times Herald Exh., 1943; Landscape Cl., 1945; BMA, 1952; medals, Soc. Wash. A., 1945; Landscape Cl., 1944, 1946, 1952, 1953; Religious Art Exh., Wash., D.C., 1958. Work: PMG; Barnett Aden Gal.; Tiffany Fnd.; Butler Inst. Am. A.; Toledo Mus. A.; Concrete-mosaic "The Way of the Cross," Chapel of the Holy Spirit, Ursuline Acad., Bethesda, Md.; stained glass windows and "The Way of the Cross," Church of the Epiphany, Georgetown, Wash. D.C., 1965; and in private colls. U.S. & abroad. Exhibited: CGA; PAFA; Carnegie Inst.; NAD; MMA; VMFA; Va. Acad. FA; PMG; Ferargil Gal.; Wash. A. Cl.; Univ. Kentucky; Catholic Univ. of Am.; BMA; Minn. State Fair; Richmond AA; Brooks Mem. A. Gal.; Currier Gal. A.; Vassar Col.; Muehlenberg Col.; J. B. Speed Mem. Mus.; Munson-Williams-Proctor Inst.; U.S. Nat. Mus.; Barnett Aden Gal.; Franz Bader Gal., Wash., D.C.; Univ. Illinois; Graham Gal., N.Y., 1961; USIA traveling exh. to Europe, 1959; one-man: Wash. Pub. Lib.; Catholic Univ. of Am.; Whyte Gal.; Playhouse Gal., Wash., D.C.; CGA, 1952 (retrospective); Bader Gal., Wash., D.C., 1960, 1964. Positions: Dir., Studio San Luca, Georgetown, D.C.; Chm., A. Dept., Marymount Col., Arlington, Va.*

ZEVON, IRENE—Painter, Gr.
222 West 23rd St., New York, N.Y. 10011
B. New York, N.Y., Nov. 24, 1918. Studied: Tschacbasov Sch. A. Member: NAWA. Awards: prize, NAWA, 1957. Work: Cal. State Lib.; Butler Inst. Am. A.; DMFA; LC; Univ. Georgia Mus.; Univ. Maine; CAM; Wesleyan Col.; Glassboro State Col.; Columbus Mus. A. & Crafts; Menninger Clinic; Stetson Univ.; La Jolla A. Center; Oakland (Ind.) City Col.; Columbus Pub. Lib., Clarksdale, Miss.; Edison Jr. Col., Ft. Myers, Fla.; Harding Col., Searcy, Ill.; Oregon State Univ., Corvallis, Ore.; Bethune Cookman Col., Daytona Beach, Fla.; Baldwin Wallace Col., Berea, Ohio; Sacramento State Col., Sacramento, Cal.; Mississippi State Col. for Women, Columbus, Miss.; Topeka Pub. Lib., Topeka, Kans.; Pensacola Art Center, Fla.; Wustum Art Mus., Racine, Wis.; St. Xavier Col., Chicago, Ill.; Devereux Fnd., Scottsdale, Ariz., and in many private colls. Exhibited: Stamford (Conn.) Mus. A. Center; New Britain Mus. Am. A.; Averett Col., Danville, Va.; Maryville (Tenn.) Col.; Mercer Col., Macon, Ga.; Massillon Mus. A.; Rockford (Ill.) AA; Kenosah (Wis.) Pub. Mus.; St. Louis Pub. Lib.; Long Island Univ.; NAD, and in other galleries and museums. One-man: Kottler Gal., N.Y., 1959; Hudson Gld., N.Y., 1959; Univ. Maine, 1960; Wesleyan Col., 1960; Mary Buie Mus., Oxford, Miss.; Lauren Rogers Lib. & Mus., Laurel, Miss., 1960; Eastern Ky. State Col., Richmond, 1960; 1961: Allis A. Lib., Milwaukee; Glassboro State Col., N.J.; Georgia Mus. A.; Cal. State Lib.; Miss. Southern Col., Hattiesburg; Miss. State Col. for Women, Columbus; Columbus Mus. A. & Crafts; Carnegie Pub. Lib., Clarksdale, Miss.; Neville Pub. Lib., Green Bay, Wis.; Mount Union Col., Alliance, Ohio; Willimantic State Col., Conn.; Joplin (Mo.) Jr. Col.; Columbus (Ohio) Pub. Lib.

ZIBELLI, THOMAS A. (TOM ZIB)—Cartoonist
167 East Devonia Ave., Mt. Vernon, N.Y. 10552
B. Mt. Vernon, N.Y., Oct. 28, 1916. Studied: Grand Central A. Sch.; Commercial Illustration Studios. Exhibited: OWI Exh., Am. FA Soc., N.Y., 1943, 1944; El Paso, Tex., 1945. Contributor cartoons to Best Cartoons of the Year, 1947-1956 inclusive; Best From Yank; "Honey, I'm Home"; "You've Got Me on the Hook"; "But That's Unprintable"; "Teensville, USA"; "You've Got Me in the Nursery"; "Lady Chatterly's Daughter," etc. Also, cartoons to Colliers; Look; Sat. Eve. Post; Ladies Home Journal; American; This Week; Argosy and many other national magazines. Cartoon illus. for book, "Why Not?," 1960-61. Freelance adv. cartoons & filmstrip illus.

ZIEGFELD, EDWIN—Scholar, Writer
Teachers College, Columbia University 10027; h. 62 Morton St., New York, N.Y. 10014
B. Columbus, Ohio, Aug. 15, 1905. Studied: Ohio State University, B.S., B.S. in Edu.; Harvard University, M.L.A.; University of Minnesota, Ph.D. Awards: Outstanding Achievement Award, University of Minnesota, 1956; Award for Distinguished Service to Art and Education, National Gallery of Art, Washington, D.C., 1966. Co-Author: (With Ray Faulkner and Gerald Hill) "Art Today," 1941, rev. ed. 1949, 5th ed. (with Faulkner), 1969; "Art for Daily Living," (With E. Smith), 1944; "Art and Education," a Symposium (Editor), 1953; "Art for the Academically Talented Student," 1962. Positions: President, National Art Education Association, 1947-1951; Council Member, National Committee on Art Education, Museum of Modern Art, N.Y., 1948-1951 and 1953-1956; President, International Society for Education through Art, 1954-1960. Chairman, Art Education Department, Teachers College, Columbia University, New York, N.Y., at present.

ZIEMANN, RICHARD CLAUDE—Printmaker, T.
15 Maple St., Chester, Conn. 06412
B. Buffalo, N.Y., July 3, 1932. Studied: Albright A. Sch.; Yale Univ., B.F.A., M.F.A. Studied: painting with Albers and Brooks; printmaking with Peterdi and drawing with Chaet. Member: SAGA. Awards: Fulbright Grant to the Netherlands, 1958-1959; Nat. Inst. A. & Lets. grant, 1966; Tiffany Fnd. Grant, 1960-1961; prizes, Boston A. Festival, 1958; Smithsonian Inst., 1963; Boston Printmakers, 1965; NAD, 1965; Hunterdon A. Center, 1965; Ohio Univ., 1965; Wichita AA, 1965, 1967 (purchase); Wesleyan Col., 1964 (purchase); BM; 1958 (purchase); others, Silvermine Gld. A., 1950; Northwest Printmakers, 1950, 1965; SAGA, 1961, Buell Mem. prize, 1966, Bermond purchase award, 1968; Pratt Graphic A. Center, 1966; Conn. Acad. A., 1967; Wadsworth Atheneum, 1967; Fall River (Mass.) AA, 1967; PMA, 1968; Providence A. Cl., 1968; purchase prizes: Oklahoma A. Center, 1966; Kutztown (Pa.) State Col., 1966; LC, 1966; N.Y. State Univ., Potsdam, 1967; Manchester (N.H.) Inst. A. & Sciences, 1968; Dulin Gal., Knoxville, 1968; Western Michigan Univ., Kalamazoo, 1968; Medal of Honor, Audubon A., 1966. Work: Brooklyn Mus.; Silvermine Gld. A.; SAM; De Cordova & Dana Mus.; Attleboro Mus. A.; UCLA Mus.; Univ. Michigan; Univ. Kentucky; Yale Univ. Gal. FA; NGA; LC; Arts Council of Pakistan; Univ. So. Illinois; USIA; Wesleyan Col.; Ohio Univ.; U.S. Embassy, Moscow; Oklahoma A. Center; CM; PMA; Everson Mus. A.; Minneapolis Inst. A.; Univ. Massachusetts. Edition of Prints for IGAS, 1958, 1960, Yale Univ. Alumni, 1960 and for Pan American Airlines, 1962. Exhibited: De Cordova & Dana Mus., 1961; "American Prints Today" touring exh. to 24 museums, 1962-63; Paris Biennale, 1963 and to most major print exhibitions (1958-1965). Also, Creative Print Making, USIA, 1963; Graphic Arts:U.S.A., Yale Univ., 1964, R.I. Sch. Des., 1965. One-man: Tomac Gal., Buffalo, 1966; Springfield Col., 1966; Allen R. Hite A. Inst., Univ. Louisville, 1967; Alpha Gal., Boston, 1967; Univ. Conn. A. Gal., 1968. Positions: Asst. Prof. A., Hunter College, N.Y. 1966; Printmaking, Yale Summer School, 1966-1967; Asst. Prof. A., Lehman Col., N.Y., at present. Supervisor of Graphic Workshop in "Graphic Arts U.S.A.," exh., toured the Soviet Union, 1963-64.

ZIGROSSER, CARL—Museum Curator, W., Cr.
6347 Wayne Ave., Philadelphia, Pa. 19144
B. Indianapolis, Ind., Sept. 28, 1891. Studied: Columbia Univ., A.B. Member: Phila. A. All.; Phila. Pr. Cl. Awards: Guggenheim F., 1939, 1940; Phila. A. All. Achievement Medal, 1959; Hon. Litt. D., Temple Univ., 1961. Author, Ed., "Twelve Prints by Contemporary American Artists," 1919; "The Artist in America," 1942; "John B. Flannagan," 1942; "Kaethe Kollwitz," 1946; "Lithographs by Toulouse Lautrec," 1946; "The Book of Fine Prints," 1948; "Caroline Durieux," 1949; "Masterpieces of Drawing in America," 1950; "Ars Medica," 1959; "The Expressionists: A Survey of their Graphic Art," 1957; "Mauricio Lasansky," 1960; "Misch Kohn," 1961; "Prints: Thirteen Essays on the Art of the Print," 1962 (editor & contributor); "Multum in Parvo," 1965; "Original Prints and Their Care," 1965; "Medicine and the Artist," 1969; "Prints and Drawings of Käthe Kollwitz," 1969, and other books. Contributor to: Print Collector's Quarterly, Print Connoisseur, Creative Art,

Twice a Year, Magazine of Art, & other publications. Consultant in Graphic Art of the XVIII-XX Centuries for the Carnegie Study of the Arts of the United States. Exhibition: "Curatorial Retrospective," PMA, 1964. Positions: Dir., Weyhe Gal., New York, N.Y., 1919-40; Cur., Prints & Drawings, PMA, Philadelphia, Pa., 1941-1964, Emeritus, 1964- . Trustee, Solomon R. Guggenheim Fnd., 1951- ; Vice-Dir., PMA, 1955-1963. Vice-Pres., Print Council of America, 1956- .

ZILZER, GYULA—Etcher, Lith., P., Des.
 27 West 96th St., New York, N.Y. 10025
B. Budapest, Hungary, Feb. 3, 1898. Studied: Royal Acad. A., Budapest; Hans Hofmann Sch. A., Munich; Royal Polytechnic Univ., Budapest; Academie Colorossi, Paris. Awards: Int. Exh., Moscow, 1927 (purchase); Int. Exh., Bordeaux, France, 1927; Scholarship, French Govt., 1928. Work: Graphische Cabinet, Munich; Mus. Mod. A., Budapest; ports., U.S. District Court for the Southern Dist. of N.Y.; graphics: MModA; N.Y. Pub. Lib.; MMA; Los A. Mus. A.; San Diego FA Center; Luxembourg Mus., Paris; Musee de l'art d'Occident, Pushkin Mus., Moscow; Bezalel Mus., Israel; Bibliotheque Nationale, Paris; Exhibited: In Europe, 1925-1930; AIC, 1932-1937; one-man: Galerie Billiet, Paris, 1926; Kunst zaal Van Leer, Amsterdam, Holland, 1931; Bloomsbury Gal., London, 1931; Mellon Gal., Phila., 1933; New Sch. for Social Research, N.Y., 1933; Assoc. Am. A., 1937; Los A. Mus. A., 1943; deYoung Mem. Mus., San F., 1927; FA Gal. of San Diego; Art of Today Gal., N.Y., 1957; Commerford Gal., N.Y., 1961; Theodor Herzl Inst., N.Y., 1963; Racz Gal., Detroit, 1965; Marion Koogler McNay AI, San Antonio, Tex., 1968. Illus., "The Mechanical Man," 1961; "Kaleidoscope" (lithography album); Illus., Edgar Allan Poe (Paris) Production Des. & A. Dir., for major films, Hollywood, Cal., 1938-48; Cinerama, 1958.

ZIMMERMAN, ALICE E.—Craftsman
 "Skyhigh," P.O. Box 564, Gatlinburg, Tenn. 37738
B. Mount Vernon, Ind. Studied: DePauw Univ., B.M.; Columbia Univ., M.A.; Universal Sch. Crafts; AIC; Ringling Sch. A.; Univ. Tennessee Craft Workshop; Craft Study Tour of Scandinavia; San Miguel de Allende, Mexico; Univ. Tennessee. Member: Am. Craftsmens Council; Delta Kappa Gamma; Kappa Pi; Southern Highland Handicraft Gld. Exhibited: Am. Jewelry & Related Objects Exh., 1955, 1956, 1958; Louisville A. Center, 1955; Indianapolis Hobby Show, 1954; Southern Highlands Handicraft Gld., annually; Am. Craftsmens Council, 1959; World Agricultural Fair, New Delhi, India, 1958-60; Tri-State Annual, 1950-1958; Univ. Minnesota, Tweed Gal.; Wilmington College; McClung Mus., Knoxville, Tenn., 1963-1969; BMA, 1966. Contributor to School Arts magazine. Lectures with slides on various crafts. Produced set of craft slides in connection with Ford Fnd. sponsored Survey of the Southern Appalachian Studies, 1959. Reproductions of the artist's jewelry used in various recent books on jewelry-making, including "Artisans of the Appalachians," 1967. Tour of duty with USIS in Fed. States of Malaya, 1960-61, assisting in instruction & establishing craft workshops. Positions: Instr., Hanover H.S., 1928-33; Reitz H.S., 1934-58; Univ. of Evansville, Ind., 1947-58. Juried (with Bernice A. Stevens) Mid-States Craft Exh., Evansville, Ind., 1963, 1968. Producer and Part-owner of 12 Designer Craftsmen Shop, Gatlinburg, Tenn.

ZIMMERMAN, PAUL WARREN—Painter, E.
 200 Bloomfield Ave., W. Hartford; h. 257 Victoria Rd., Hartford, Conn. 06114
B. Toledo, Ohio, Apr. 29, 1921. Studied: John Herron AI, B.F.A. Awards: prizes, Indiana AA, 1945, 1947-1949, 1951, 1955, 1957, 1959; Mary Milliken F., John Herron AI, 1946; Springfield A. Lg., 1949, 1954, 1958, 1960; Butler Mus. Am. A., 1950; Conn. Acad. FA, 1950, 1959, 1961, Sage-Allen award, 1964, prize, 1963, Best of Show, 1968, 1969; Silvermine Gld. A., 1951, 1953, 1954; Conn. WC Soc., 1952-1954, 1959, 1964; Norwich AA, 1953, 1955, 1956, 1959; Mystic AA, 1960, 1961; NAD, 1954, 1956, B. Altman prize, 1967 and 1969, Salmagundi prize, 1962; Boston A. Festival, 1954, members prize, 1964; Berkshire A. Festival, purchase prize, 1959, McGinnis award, 1961; Hoosier Salon, 1955; Chautauqua, N.Y., 1955; Essex AA, 1952, 1955, 1958. Work: Wadsworth Atheneum; deCordova & Dana Mus.; NAD; Mus. FA of Houston; New Britain Mus. Am. A.; Mattatuck Mus. A.; Springfield Mus. FA; Berkshire Mus.; PAFA; Univ. Notre Dame; Lehigh Univ.; United Aircraft Corp.; Chase Manhattan Bank; First Nat. Bank, New Haven, Conn., and in private colls. Exhibited: PAFA, 1946, 1949-1969; CGA, 1948; NAD, 1952, 1959, 1960, and others to 1969; Butler AI, 1947-1955, 1961; Pasadena AI, 1946; Conn. Acad. FA, 1946-1952; Springfield A. Lg., 1947-1952; Univ. Illinois, 1948, 1961; Indiana AA, 1945-1955, 1959; Hoosier Salon, 1950-1954; Silvermine Gld. A., 1951, 1952; Essex AA, 1948, 1952; Conn. WC Soc., 1947-1960; Univ. Nebraska, 1959, 1960; Berkshire A. Festival, 1959, 1960; New Haven A. Festival, 1960; Boston A. Festival, 1959-1961; Dayton A. Inst.; Columbus Gal. FA; Milwaukee A. Inst.; Univ.

Miami; Am. Acad. A. & Lets.; Wadsworth Atheneum, and many others. One-man: Wellons Gal., 1953; Design Assoc., Hartford, 1951; deCordova & Dana Mus., 1955; Shore Gal., Boston, 1958; Jacques Seligmann Gal., 1958, 1960, 1962, 1964, 1968; Wesleyan Univ., 1958; Phila. A. All., 1959; Gettysburg Col., 1959; Portland Mus. A. 1959; G.W.V. Smith Mus., 1960; Munson Gal., New Haven, 1962; Scott Richards Gal., Chicago, 1963; Lehigh Univ., 1965; Verle Gal., Hartford, 1964, 1966; Naples (Fla.) Gal., 1967, 1968 Hunter Gal., 1966, Chattanooga, and others. Positions: Assoc. Prof., Hartford A. Sch. of the Univ. of Hartford, Hartford, Conn., 1947- .

ZIOLKOWSKI, KORCZAK—Sculptor
 Crazy Horse, Custer, S.D. 57730
B. Boston, Mass., Sept. 6, 1908. Studied: Rindge Tech. Sch. Member: NSS. Awards: prize, WFNY 1939. Work: mem., portrait busts, statues, figures, etc.; SFMA; Symphony Hall, Boston; Vassar Col.; WFNY 1939; SFMA; granite port. of Wild Bill Hickok, Deadwood, S.D.; West Hartford, Conn.; Chief Sitting Bull. Assisted Gutzon Borglum on Mount Rushmore Nat. Mem., South Dakota; now engaged on equestrian figure of Crazy Horse, Chief of the Dakota Indians, at Custer, S.D. (project requested by Sioux Indian Chiefs. Equestrian fig. to be 563 ft. high by 641 ft. in length). Positions: Pres. Bd., Crazy Horse Mem. Fnd.

ZIPKIN, JEROME R.—Collector
 475 Fifth Ave. 10017; h. 1175 Park Ave., New York, N.Y. 10028
B. New York, N.Y. Studied: Princeton University. Collection: Contemporary Paintings and Sculpture.

ZIROLI, NICOLA—Painter, C., Gr., E., L.
 1111 McHenry St., Urbana, Ill. 61801; s. East Boothbay, Me. 04544
B. Montenero, Italy, May 8, 1908. Studied: AIC. Member: Audubon A; AAUP; AWS; Nat. Soc. Painters in Casein; Awards: prizes, Wash. Soc. A., 1934; AIC, 1938, 1939, 1948, 1955; Springfield (Mo.) A. Mus., 1945, 1946, 1956; Decatur A. Center, 1945, 1946; Ohio Univ., 1946; Mint Mus. A., 1946; Chicago Newspaper Gld., 1946; State T. Col., Indiana, Pa., 1947, 1948; Mississippi AA, 1952, Ohio Valley, 1952, 1954; Magnificent Mile, Chicago, 1952, 1955; Springfield, Ill., 1952, 1954; Audubon A., 1953, 1955, 1956; Butler AI, 1955, 1956; AIC, 1955; Evansville (Ind.) Mus. A., first prize & purchase; Soc. Four A., Miami, 1962; Knickerbocker A., 1962; El Paso Mus. A. (2), 1962; Springfield State Fair (Ill.), 1963; Marina City, Chicago, 1965; medals, San F. AA, 1939; Audubon A., 1947; Nat. Soc. Painters in Casein, 1957. Work: Springfield Mus. A.; IBM; Vanderpoel Coll.; Chicago Pub. Lib.; MMA; WMAA; Univ. Minnesota; Univ. Nebraska; Washburn Univ.; Pa. State T. Col.; Ill. State T. Col.; Ohio Univ.; Mulvane Mus.; Butler AI; Slater Mem. Mus., Norwich, Conn.; Delgado Mus. A., New Orleans, La. Exhibited: Albany Inst. Hist. & A.; Albright A. Gal.; Cal. PLH; Carnegie Inst.; AWS; Dayton AI; Syracuse Mus. FA; Miami Mus. Mod. A.; Smithsonian Inst.; Norton Gal. A., West Palm Beach; Des Moines A. Center; Kansas City AI; AIC; CM; CMA; CGA; Denver A. Mus.; Detroit Inst. A.; Los A. Mus. A.; MMA; Milwaukee AI; Mint Mus. A.; NAD; WMAA; Oakland A. Gal.; VMFA; Audubon A.; Univ. Ohio; PAFA; Toledo Mus. A.; A. Gal., Toronto; SFMA; Phila. WC Cl.; Grand Rapids A. Gal.; Terry AI; Ill. State Mus.; Mississippi AA; Witte Mem. Mus.; Kansas City AI; and many other museums and galleries.

ZISLA, HAROLD—Painter, E., Des., L., Mus. Dir.
 South Bend Art Center; h. 1230 Dennis Dr., South Bend, Ind. 46614
B. Cleveland, Ohio, June 28, 1925. Studied: Cleveland Inst. A.; Western Reserve Univ., B.S. in Ed., A.M. Exhibited: CMA, 1948; South Bend Michiana, 1955, 1956; John Herron A. Mus., 1962-63; Fort Wayne A. Mus., 1965; Kalamazoo AI, 1963; Lafayette A. Center, 1965. Positions: Instr., Indiana Univ. Ext. (South Bend), 1955; South Bend A. Center, 1953- ; Dir., & Bd. member, South Bend A. Center, South Bend, Ind., 1957- ; Bd., Assn. of Prof. Artists of Indiana; Asst. Prof., Asst. Chm. Dept. Art, Indiana Univ. at South Bend, 1966- .

ZOELLNER, RICHARD CHARLES—Painter, Gr., I., L., E.
 University of Alabama, University, Ala.; h. 14 Guilds Wood, Tuscaloosa, Ala. 35401
B. Portsmouth, Ohio, June 30, 1908. Studied: Cincinnati A. Acad.; Tiffany Fnd. Member: SSAL; Ala. A. Lg.; Birmingham A. Cl.; Am. Assn. Univ. Prof.; Southeastern Col. A. Conference; SAGA. Awards: prizes, Indiana Soc. Pr. M., 1944; Northwest Pr. M., 1945; Ala. A. Lg., 1945; Ala. WC Soc., 1946; Delgado Mus. A., 1950, 1955; Ala. State Fair, 1951; PAFA; BM, 1955. Work: LC; La. Polytechnic Inst.; SAM; Government House, V.I.; BM; Univ. Chattanooga; Univ. Mississippi; Univ. Alabama; PAFA; PMA; Birmingham A. Mus.; VMFA; murals, USPO, Portsmouth, Georgetown, Medina, Cleveland, Ohio; Mannington, W. Va. Exhibited: LC, 1943, 1945; PAFA; AIC, 1941, 1942; WFNY 1939; SAM, 1944; SFMA, 1944; Dayton AI,

1942, 1943; CM, 1941-1943, 1952; Intermont Col., 1944; SSAL, 1945; Carnegie Inst., 1949; Albany Inst. Hist. & A., 1949; High Mus. A., 1949-1951; Delgado Mus. A., 1950; SAGA, 1950-1952; BM, 1949-1952, 1955; Birmingham Mus. A., 1954 (one-man); Bradley Univ., 1955. Positions: Prof. A., Univ. Alabama, University, Ala., at present.*

ZONA, (RENALDO)—Painter, S.
 c/o East Hampton Gallery, 22 W. 56th St., New York, N.Y. 10019; h. 40 Turtle Cove Lane, Huntington, N.Y. 11743*

ZORNES, (JAMES) MILFORD—Painter, I., Comm. A., T., W., L.
 P.O. Box 24, Mt. Carmel, Utah 84755
B. Camargo, Okla., Jan. 25, 1908. Studied: Pomona Col.; Otis AI; and with Chamberlin, Sheets. Member: ANA; Cal. WC Soc.; AWS; San Diego FA Soc.; West Coast WC Soc.; Pasadena Soc. A. Awards: Tuthill prize, 1938; prizes, MMA, 1941; Bombay, India, 1944; Pomona Col., 1931, 1946; Los Angeles County Fair, 1933, 1936; San Diego FA Soc., 1937; Arizona State Fair, 1950; American Artist magazine Medal of Honor (AWS Exh.), 1963; purchase awards, Los Angeles City Exh., 1963, 1964. Work: MMA; Los A. Mus. A.; San Diego FA Soc.; Butler AI; White House Coll., Wash., D.C.; Glendale H.S.; Beverly Hills H.S.; Univ. Cal. Library; NAD; LC; U.S. War Dept.; Los Angeles County Lib.; Newport Beach H.S.; Pomona Col.; murals, USPO, El Campo, Tex.; Claremont, Cal. Exhibited: MMA; Western Fnd. A.; Los A. Mus. A.; San Diego FA Soc.; AWS; CGA; AIC; Denver A. Mus.; CMA; Riverside Mus.; BM; NAD; PAFA; CM; Toledo Mus. A.; Bombay AA, India; Pomona Col.; Butler AI; Oklahoma A. Center; Cowie Gal., Los Angeles; Brooks Gal., London; Laguna Beach Mus.; Santa Barbara Mus. A.; Gal. of Modern Masters, Wash., D.C., and many others. Illus., "Manual of Southern California Botany," 1935; "Palomar," 1952. Contributor to Ford Times. Positions: Instr., Pomona Col., 1946-50; A. Dir., Padua Hills, 1955-1967; Riverside A. Center, 1957-1968; Summer Workshop, 1965- .

ZOX, LARRY—Painter, T.
 535 Broadway, New York, N.Y. 10012
B. Des Moines, Iowa, May 31, 1936. Studied: Oklahoma Univ.; Drake Univ.; Des Moines A. Center. Awards: Guggenheim Fellowship, 1967. Work: Am. Republic Ins. Corp., Des Moines; Des Moines Register & Tribune; Des Moines A. Center; J. L. Hudson Co., Detroit, Mich; Kasmin Gal., London; Joseph Hirshhorn Coll.; WMAA; Oberlin Col., Oberlin, Ohio; CBS, New York City; Tate Gal., London; MModA. Exhibited: American Fed. A., N.Y., 1963; AFA traveling exh., 1963-1965; MModA, 1964; Albright-Knox Gal., Buffalo, 1964; Washington (D.C.) Gal. Mod. A., 1964; Weatherspoon Gal., Univ. North Carolina, Greensboro, 1965; Gal. Mod. A., N.Y., 1965; WMAA, 1965, 1966, 1967, 1968; BMFA, 1966; AIC, 1965; Long Island Univ., Brooklyn, 1966; Kornblee Gal., N.Y., 1966; Guggenheim Mus., 1966; Trinity Col., Hartford, Conn., 1967; Riverside (Cal.) Mus., 1968; Kent State Univ., Ohio, 1968. One-man: Kornblee Gal., N.Y., 1964, 1965, 1966 (2); J. L. Hudson Co., Detroit, 1967; Galerie Ricke, Cologne, Germany, 1968; Colgate Univ., 1968. Positions: A.-in-Res., Cornell Univ., 1961; Univ. North Carolina, Greensboro, 1967; Sch. Visual Arts, N.Y., 1967-1968; Juniata Col., Huntingdon, Pa., 1968; Dartmouth Col., Hanover, N.H., 1969 (winter).

ZUCKER, JACQUES—Painter
 44 West 77th St., New York, N.Y. 10024
B. Radom, Poland, June, 1900. Studied: Julian Academie, Grande Chaumiere, Paris, France. Work: Mus. Mod. A., Paris, France; Tel-Aviv Mus., Israel; Helena Rubinstein Mus., Tel-Aviv; Bezalel Mus., Jerusalem, and in leading art colls. in U.S.A. and abroad. Exhibited: MMA. Carnegie Inst.; PAFA; AIC; Smith Col.; Springfield Mus. A.; Inst. Mod. A., Boston; WMA; WMAA; BM; Assoc. Am. A.; Bignou Gal.; Wadsworth Atheneum; Yale Univ., Dudensing Gal.; Ferargil Gal.; Reinhardt Gal.; Wildenstein Gal.; Tel-Aviv Mus., 1950; Galerie Andre Weil, Paris, Milch Gal., N.Y., 1952, one-man, 1955; Schoneman Gal., N.Y., 1959, 1964 (one-man); Petrides Gal., Paris, 1960 (one-man); 28 other one-man shows. Lecture, demonstration of drawing, N.Y. Pub. Lib., 1957. Articles and biographies in Coronet, Esquire, Menorah Journal and in foreign language periodicals.

ZUCKER, PAUL—Educator, Cr., W.
 227 East 57th St., New York, N.Y. 10022
B. Berlin, Germany, Aug. 14, 1888. Studied: Univ. Berlin and Munich; Inst. Tech., Berlin and Munich, Ph.D. Member: CAA; Am. Soc. Arch. Historians; Am. Soc. for Aesthetics. Awards: prizes, Architectural Comp., Germany, 1933; Arnold W. Brunner Scholarship, AIA, 1953. Author: "Stage Setting at the Time of the Baroque"; "Stage Setting at the Time of the Classicism"; "Architecture in Italy at the Time of the Renaissance"; "American Bridges and Dams"; "Styles in Painting," 1950, 1962 (paperback edition); "Town and Square—From the Agora to the Village Green," 1959, 1968; "Fascination of Decay: Ruins—Relic, Symbol, Ornament," 1968 (awarded Rossi Prize, Cooper Union, 1968). Ed., "The Music Lover's Almanac" (with William Hendelson); "New Architecture and City Planning, A. Symposium." Positions: Adjunct Prof., Cooper Union, New York, N.Y., 1938-1964; Instr., New Sch. for Social Research, New York, N.Y.

ZUCKERMAN, MRS. MURRAY G. See Ullrich, B.

ZWICK, ROSEMARY G.—Painter, S., C., Ser.
 1720 Washington St., Evanston, Ill. 60202
B. Chicago, Ill., July 13, 1925. Studied: State Univ. Iowa, B.F.A.; AIC. Member: Am. Craftsmen's Council; Renaissance Soc., Chicago. Awards: Village of Oak Park School, 1958; Chicago Art, Esquire Theatre, 1950. Work: 2 animal figures, Wonderland Shopping Center, Livonia, Mich.; relief, Motorola Company, 1961; Crow Island Sch., Winnetaka, Ill. Exhibited: Ceramic Nat., Syracuse Mus. A., 1951, 1952, 1956, 1962; Wichita AA, 1952, 1959, 1960, 1961; CM, 1950, 1954; BM, 1951; LC, 1952; Nat. Serigraph, 1950; Indiana Univ., 1961; Univ. California, 1953; AIC, 1947-1950, 1952, 1954, 1956, 1966; AIC art rental (juried) 1953-1965, 1967-1969; Midwest Des.-Craftsmen, 1957; Wash. Printmakers, 1964; Wichita AA, 1966; Illinois State Mus., 1966, 1967; Lakeview Center for A., Peoria, 1967-1968; one-man: Esquire Little Gal., 1950; Contemp. A. Gal., 1950; Chicago Pub. Lib., 1953, 1963; Ruth Dickens Gal., 1951; Findlay Gal. (N.Y. & Chicago), 1956; Park Gal., Detroit, 1958; Palmer House Gal., 1962; Mundelein Col., 1964; Chicago T. Col., 1965; Nat. Col. Educ., Evanston, 1966; Bloomington AA, 1967; A. Hendler Assoc., Houston, 1969. Positions: Co-owner, 4 Arts Gallery, Evanston, Ill.

CANADIAN BIOGRAPHIES

CANADIAN ABBREVIATIONS

AA Mtl—Art Association of Montreal (Museum of Fine Arts), Montreal
AG—Art Gallery
AG Tor—Art Gallery of Toronto
Alta—Alberta
ARA—Associate of the Royal Academy (England)
ARCA—Associate of the Royal Canadian Academy
BC—British Columbia
CAC—Canadian Arts Council
Can—Canada, Canadian
CAS, Mtl—Contemporary Arts Society, Montreal
CGP—Canadian Group of Painters
CNE—Canadian National Exhibition (annual), Toronto
CPE—Canadian Society of Painter-Etchers and Engravers (formerly CSPEE)
CSGA—Canadian Society of Graphic Art
CSPWC—Canadian Society of Painters in Water Colour
Dom—Dominion (of Canada)
Eng—England

FCA—Federation of Canadian Artists
Man—Manitoba
MPQ—Musée de la Province de Québec, Quebec City
Mtl—Montreal
N.B.—New Brunswick
NGC—National Gallery of Canada, Ottawa
N.S.—Nova Scotia
OCA—Ontario College of Art, Toronto
OSA—Ontario Society of Artists
P.E.I.—Prince Edward Island
P.Q.—Province of Quebec
R—Royal
RA—Royal Academy (or Academician)
RCA—Royal Canadian Academy (or Academician)
RCAF—Royal Canadian Air Force
RSBA—Royal Society of British Artists (England)
Sask.—Saskatchewan
SSC—Sculptors' Society of Canada
Tech.—Technical
Tor.—Toronto

CANADIAN BIOGRAPHIES

*A Biographical Directory of Canadian paint-
ers, sculptors, museum directors, writers, etc.*

ADAMS, GLENN NELSON — Painter
 1445 Painter Circle, Montreal 9, P.Q.
B. Montreal, P.Q., Jan 24, 1928. Studied: McGill Univ.; Montreal
Mus. FA; Mount Allison Univ., Sackville, N.B., under Alex Colville
and L.P. Harris. Work: Montreal Mus. FA; Canadian Industries,
Ltd.; Montreal Star. Exhibited: Banfer Gallery, 1963, 1964; Galerie
Agnes Lefort, 1964; Montreal Mus. FA, 1964.*

ADAMS, IRVINE C(LINTON) — Painter
 R.R. No. 1, Summerland, B.C.
B. Swan Lake, Man., Sept. 2, 1902. Studied: with H. Faulkner Smith.
Awards: Fla. Int. A. Exh., Grumbacher award, 1952; Hon. Mention,
Paris Salon, 1963; Mention, Diablo AA. Exh., California, 1963.
Work: in private collections. Exhibited: Fla. Int. Exh., 1952; Pastel
Soc., London, 1957, 1960; Summer Salon, R.I. Galleries, London,
1959, 1961, 1963; Royal Soc. of British Artists, 1962; Paris Salon,
1957, 1958, 1960, 1963, 1964; Diablo AA., 1963; AWS, 1964; One-man:
in British Columbia.*

ALDWINCKLE, ERIC — Painter, Gr.
 80 Elm Ave., Toronto, Ont., Canada*

ALFSEN, JOHN MARTIN — Painter
 154 Main St., Markham, Ont., Canada*

ALLEN, RALPH — Painter, Gr., E., Mus. Dir.
 Art Centre, Queen's University, Kingston, Ont.
B. England, 1926. Studied: Sir John Cass Sch. A. and Slade Sch. FA,
London, England. Member: OSA. Honours: Jessie Dow award, Mon-
treal, 1959; Canada Council Scholarship, 1959; Baxter award, To-
ronto, 1960; Canada Council Senior Fellowship, 1968. Work: Nat.
Gal. Canada; Art Gal. of Toronto; Queen's Univ.; mural, Queen's
Park, Toronto, and in private colls. Publication: Catalogue of Per-
manent Collection of Paintings, Drawings and Sculpture, Agnes
Etherington Art Centre, 1968 (267 illustrations). Lectures: On
Daniel Fowler, Kingston, Ont. and at NGC, Ottawa, 1965. Exhibited:
one-man: Montreal, 1960; Kingston, 1960; Ottawa, 1964; Kingston,
1967; Toronto, 1968. Positions: Assoc. Prof. A., Queen's University,
Kingston, Ont.; Director, Agnes Etherington Art Centre.

ALTWERGER, LIBBY (MRS.) — Painter, Gr., T.
 526 Dovercourt Rd., Toronto 173, Ont.
B. Toronto, Canada, July 13, 1921. Studied: Ontario Col. A., with
Carl Schaeffer. Member: Canadian Gr. A. Soc.; CSPWC; CPE, 1963.
Awards: Lieut. Gov. General's Medal, 1959; Mary Dingham Scholar-
ship, 1958; O'Keefe Scholarship, 1956; Grand Prix Gold Medal, In-
ternational Feminine Culturelle, Vichy, France, 1963; Sterling Trust
award for a lithograph, 1965. Exhibited: RCA, 1960; OSA, 1961; one-
man: Pascall Gal., Toronto, 1964; Sonneck Gal., Kitchener, 1968.
Positions: Instructor, drawing, Ryerson Polytechnical School.

AMAYA, MARIO — Museum Curator
 The Art Gallery of Ontario, Grange Park, Toronto 2B, Ont.
B. New York, N.Y., Oct. 6, 1933. Studied: Brooklyn College, B.A.;
London University Extension course in Fine Arts at the National
Gallery, London, England. Awards: Cassandra Foundation Award,
New York, 1968. Author: "Art Nouveau," 1967; "Pop as Art,"
1965; "Tiffany Glass," 1966. Contributor to Encyclopaedia Brittan-
ica;London Vogue; Holiday magazine; Sunday Times Colour Supple-
ment; The Director; Art in America; The Spectator; New Republic
Founding Editor, Art and Artists Magazine, London; Associate Edi-
tor, "About the House," magazine on the friends of Covent Garden.
Exhibitions arranged: Institute of Contemporary Arts for the British
Board of Trade under the auspices of the Institute, New York, 1968;
at Palacio Strozzi, Florence, Italy "Ten British Galleries." Cata-
logue written for the above. Positions: Chief Curator, The Art Gal-
lery of Ontario, Toronto, at present.

ANDERSON, RONALD TRENT — Painter, Pr.M., E.
 Nova Scotia College of Art, 6152 Coburg Rd.; h. 3000 Olivet
 St., Apt. 402, Halifax, N.S.
B. Madison, Wis., Oct. 10, 1938. Studied: Univ. Wisconsin, B.S. in
A. Edu., M.S. in A., M.F.A. Awards: purchases: Dalhousie Univ.,
1967; Illinois Midwest A. Fair, 1966; Madison AA, 1964 and other
awards, 1962, 1966; other prizes, Wisconsin Salon of Art, 1961,
1963; Milwaukee A. Center, 1961; Merit Award, Wisconsin Pr. M.,
1963. Exhibited: Dalhousie Univ., 1967; Illinois State Fair, 1967;
Mequon, Wis., 1967; Illinois Midwest A. Fair, 1966; Madison AA,
1964, 1966; Wisconsin Salon A., 1961, 1963; Milwaukee A. Center,
1961; Wisconsin Pr. M., 1963; Mtl. Mus. FA, 1968; Watercolors:
USA, Springfield, Mo., 1962, 1964, 1965; Wisconsin Pr. M., Smith-
sonian Inst., Washington, D.C., 1962; Nat. Drawing & Sculpture Exh.,
Muncie, Ind., 1962, 1963; Nat. Drawings & Prints, Athens, Ohio,
1963; Illinois State Mus., Springfield, 1965, 1967; Union Lg. Chicago,
Nat. Des. Center, 1967; one-man: Arts Unlimited Gals., Milwaukee,
1964; Bradley Univ., 1966. Work: Dalhousie Univ., Halifax; Univ.
Wisconsin; Madison A. Center; Park Forest (Ill.) A. Center, and in
many private collections U.S. and Canada. Positions: Graduate
Teaching Fellowship, Univ. Wisconsin, 1961-1963; A. Instr., Bloom
Township H.S., Chicago Heights, 1963-1967; Asst. Prof., Hd. A. Edu-
cation Dept., Nova Scotia College of Art, 1967- .

ANDREWS, SYBIL (MORGAN) (MRS.) — Painter, Gr., T.
 2131 South Island Highway, Willow Point, Campbell River, B.C.
B. Bury St. Edmund's, England, Apr. 19, 1898. Studied: Heatherley
Sch. FA, London, and with Boris Heroys. Member: CSPEE. Honour:
G.A. Reid award, CSPEE, 1951. Work: Victoria & Albert Mus., Lon-
don; Leeds Mus., England; Dublin Mus.; Los A. Mus. A.; Mass. Soc.
A.; Nat. Gal., South Australia. Exhibited: "200 Years of British
Graphic Art," Prague, Bucharest, Vienna, 1936; Buenos Aires, 1954;
Cal. Pr. M.; and in Great Britain, Canada, U.S.A., South Africa,
Australia, China.

ANNAND, ROBERT WILLIAM — Painter
 Old Barns, Colchester County, Nova Scotia
B. Truro, N.S., Nov. 5, 1923. Studied: Mount Allison Univ.; Ontario
Col. A.; and in Mexico. Awards: Maritime Exh., Beaverbrook A.
Gal., Fredericton, N.B., 1960. Work: NGC. Exhibited: 1st and 2nd
Atlantic Award Exhs., Dalhousie A. Gal., Halifax, 1967; one-man:
Dalhousie A. Gal., 1957; St. Mary's Univ., Halifax, 1967; Province
House, Halifax, 1964.

ARBUCKLE, FRANKLIN — Painter, I.
 278 Lawrence Ave. E., Toronto, Ont., Canada*

ARCHAMBAULT, LOUIS — Sculptor
 278 Sanford Ave., St. Lambert, P.Q.
B. Mtl., Apr. 4, 1915. Studied: Univ. Mtl., B.A.; Ecole des Beaux-
Arts de Montreal. Honours: Les Concours Artistiques de la Prov-
ince de Quebec, 1948, 1950; Canadian Govt. Overseas Award, 1953-
54; Canada Council Fellowships, 1959, 1962, 1969; R.A.I.C. All. A.
medal, 1958; Service Medal, Order of Canada, 1968; Elected R.C.A.,
1968. Work: Musée de la Province; AG Tor.; NGC; Museo Inter-
nazionale della Ceramica, Faenza, Italy; Ottawa City Hall; Toronto
Sun Life Bldg.; Ottawa Airport; Toronto International Airport; Mon-
treal Place des Arts; Can. Imperial Bank of Commerce, Montreal;
Queens Park, Toronto; and others. Exhibited: Int. Sc. Exh., London,
1951; Venice Biennale, 1956; Milan, 1954, 1957; Canadian Pavilion,
Brussels World's Fair, 1958; Carnegie Int., 1958; Expo '67, Mtl.;
Canadian Pavilion and Art Plaza, Expo '67; NGC, 1967; Hemisfair,
San Antonio, Tex., 1968; Int. Sc. Exh., Legnano, Milan, 1969.

ARISS, HERBERT JOSHUA — Painter, S., T.
 770 LeRoy Crescent, London, Ont.
B. Guelph, Ont., Canada, Sept. 29, 1918. Studied: Ontario Col. of A.;
Ontario Col. Education. Member: Western A. Lg.; OSA; CGP; Can.

Soc. Painters in Watercolor; CSGA. Awards: CAC Senior Fellowship, 1960-1961; Honour award, Canadian Soc. Painters in Watercolor, 1964. Work: NGC; AG Ont.; St. Johns(N.B.) A. Gal.; London (Ont.) AG; Vancouver AG; Calgary AG; Winnipeg AG; Sarnia AG; Univ. Western Ont.; Ont. Government Bldg., Toronto; Beck Mem. Secondary Sch.; Huron & Erie Bldg., Chatham; Joan Labatt Co., London. Exhibited: CGP, 1955; NGC, 1955; CSPWC, 1953-1955, 1962-1965; OSA, 1953, 1954, 1962-1965; Western A. Lg., 1948-1955; Canadian Biennial, regularly; Calgary Graphics, 1962-1965; CSGA, 1962-1965; AG Hamilton, 1950, 1951, 1955; AG Ont., 1961; Alberta Col. A., 1963; Edmonton AG, 1964; 20/20 Gal., London; Univ. Western Ont.; Guelph Univ. Illus., Educational books. Positions: Hd. A. Dept., H.B. Beal Tech. & Comm. H.S., London, Ont.; Doon Sch. FA.

ARMSTRONG, WILLIAM WALTON — Painter
222 Hospital St., Montreal, Que., Canada*

AYRE, ROBERT HUGH—Writer, Cr.
5745 Cote St. Luc Rd., Montreal 254, Que.
B. Napinka, Man., Apr. 3, 1900. Honours: Can. Drama Award 1942; Canada Council travel grant (Paris, London, Italy), 1962. Contributor: various periodicals and yearbooks. Art in Canada. Author: "Mr. Sycamore" (novella); "Sketco, the Raven" (Indian legends); short stories. Position: A. Cr., Montreal Star.

AZIZ, PHILIP — Painter, Des.
50 Dewson St., Toronto, Ont., Canada*

BAND, CHARLES S.—Collector, Patron
2 McKenzie Ave., Toronto, Ont.
B. Thorold, Ont., Dec. 14, 1885. Studied: Upper Canada College. Awards: Officer d'Academie, French Government. Collection: Canadian paintings, drawings, sculpture. Positions: Past President, Art Gallery of Toronto.

BANFIELD, A. W. F. — Educator
National Museum of Canada, Elgin & Albert Sts., Ottawa, Canada*

BARBEAU, MARIUS — Writer, Mus. Wkr.
260 MacLaren St.; National Museum of Canada, Ottawa, Ont. B. Ste-Marie, Beauce Co., P.Q., Mar. 5, 1883. Studied: Univ. Laval, LL.L.; Oxford, B.A.; Univ. de Paris. Honours: Fellow, R. Soc. of Can. 1916; Pres., Am. Folklore Soc. 1917-18; Doctor honoris causa, Univ. Mtl. 1935; Member Washington Acad. of Sciences 1936; Hon. Fellow, Oriel Col., Oxford 1941; Gold Medal, ACFAS, Quebec 1946; D. Litt., honoris causa, Oxford Univ., 1953. Author: "Totem Poles of the Gitksan"; "Cornelius Krieghoff, Pioneer Painter of America"; "Saintes Artisanes"; "Totem Poles of Canada"; "Alaska Beckons"; "L'Arbes des Rêves"; Le Rêve de Kamalmouk"; "Le Merveilleuse Aventure de Jacques Cartier"; "Alouette"; "Quebec, ou survit l'ancienne France"; "Haida Myths"; "The Tree of Dreams"; "Totem Poles, I and II"; "Haida Carvers"; "Medicine Men"; "Roundelays-Dansons a`la Ronde";*

BATES, MAXWELL—Painter, Gr., W., Arch.
931 Lakeview Ave., Victoria, B.C.
B. Calgary, Alta., Dec. 14, 1906. Studied: Provincial Inst. Tech. & A.; BMSch., with Max Beckmann; and with Abraham Rattner. Member: CGP; CSPWC; CSGA; F.I.A.L.; Alberta Soc. A.; ARCA; Associate Member, B.C. Soc. FA. Honours: CSPWC, 1957; Minneapolis, Minn., 1958; Winnipeg A. Gal., 1957 (purchase); CSGA, 1960. Work: NGC; AG Tor.; Winnipeg A. Gal.; Norman Mackenzie A. Gal., Regina; Calgary All. A. Centre; Auckland (N.Z.) A. Gal.; London (Ont.) A. Mus. Other work: Bldg., and interior furnishings in marble, bronze, oak, etc., by A. W. Hodges Friba and Maxwell Bates (Archs.), St. Mary's Cathedral, Calgary, Alta., Canada. Exhibited: NGC, 1930, 1931, 1953, 1955, 1959, 1961, and traveling exh., 1958-1959; Int. Biennial of Lith., Cincinnati, Ohio, 1958; Phila. Pr. Cl., 1958; Biennial Exh. A., Minneapolis, Minn., 1958; AFA traveling exh., 1959; Canadian Art, Mexico City, 1960; Biennial Prints, Tokyo, 1960; Coloured Graphics, Grenchen, Switzerland, 1961; one-man: Manchester, England, 1934; London, 1938; Vancouver A. Gal., 1947; Queen's Univ., 1950; Manitoba Univ., 1956; Retrospective exh., Norman Mackenzie A. Gal., Regina, Winnipeg & Edmonton, 1960-61; Victoria A. Gal., 1966; Winnipeg A. Gal., 1968; Calgary A. Gal., 1969.

BAYEFSKY, ABA—Painter, Pr.M.
7 Paperbirch Dr., Don Mills, Ont.
B. Toronto, Ont., Apr. 7, 1923. Studied: Central Tech. Sch., Toronto. Member: ARCA (Council member); CSGA; CSPWC; CGP. Awards: French Government Scholarship, 1947; purchase prize, CSPWC, 1952; J.W.L. Forster Award, OSA, 1957; Canada Council Grant (to India), 1958; Centennial Citation, Tor., 1967. Work: NGC;

Nat. Gal. of Victoria, Melbourne, Australia; AG Ontario; Hamilton AG; LC; Hebrew Univ., Jerusalem; Beaverbrook Mus.; MMA; Hart House, Univ. Tor., and many other public collections. Royal Canadian Air Force Official war artist; mural, Northview Colliate, Tor.; Tapestry, Synagogue Ont.; mural, Ont. Government Bldg. Exhibited: All major Canadian Art Society exhs. 17 one-man shows. I.: Portfolio of 18 lithographs, "Tales from the Talmud," 1963; "The Ballad of Thrym," privately printed, 1965; Portfolio of colour blockprints, "Indian Legends," 1968; "Rubaboo," 1962. Positions: Instr., Ontario College of Art, 1956- .

BEAMENT, COMMANDER HAROLD—Painter, Des.
183 St. Paul St., East, Montreal 127, P.Q.
B. Ottawa, July 23, 1898. Studied: Osgoode Hall, Tor.; OCA. Member: RCA. Honours: Jessie Dow Prize, AA Mtl. 1935. Work: War Records NGC; Dominion Archives, Ottawa; A. Gal., London, Ont.; MPQ; AA Mtl.; A. Gal., Hamilton, Ont. Commissions: offical war artist with R. Can. Navy 1943-46; des. current 10¢ stamp (Eskimo) for Canadian Govt. Exhibited: RCA 1922; NGC 1926-33; Wembley, 1924, 1925; Paris 1927; S. America 1929; S. Dominions 1936; Coronation 1937; Tate 1938; WFNY 1939; War art, NG London, NGC 1945, '46; OSA. Teaching: AA Mtl. 1936; N.S. Col. A. Positions: War Artist, Royal Canadian Navy; Hon. Treas., 1958, Pres., 1964-1967, RCA.

BEAMENT, T(HOMAS) H(AROLD)—Painter, C., Pr.M., T.
449 Elm Ave., Montreal 217, Que.
B. Montreal, Que., Feb. 17, 1941. Studied: Fettes Col., Edinburgh, Scotland (Crerar Scholarship); Ecole des Beaux-Arts, Mtl. and Post-Grad. in Graphics; Belli Arti, Rome, (Italian Government Scholarship); Sir George Williams Univ., M.A. in A. Edu. Member: CPE. Awards: Bronfman purchase award, Mtl. Mus. FA, 1963; Anaconda Merit Award, 1965; Canada Council Scholarship Grant, 1966; Province of Quebec Grant, 1966; prize, Canada Crafts, 1967. Work: Mtl. Mus. FA; Musee d'Art Contemporain, Mtl.; Musee de Quebec; London (Ont.) AG; Confederation Centre, Charlottetown, P.E.I.; murals, Holiday Inn, Mtl., 1966; 6 banners, Nesbitt Thomson Co., Mtl., 1968; Quebec Pavilion, Osaka, Japan, 1969. Exhibited: Royal Canadian Academy, 1961-1963, 1965-1967; CPE, 1965-1969; Calgary Graphics, 1966; Batiks, Design Gal., Toronto, 1968; Rome, Italy, 1964; Paris Biennale (rep. Canada), 1966; Poland, 1967; Northwest Pr.M., 1967; Mtl. Mus. FA, 1961, 1963; one-man: Galerie Irla Kert, Mtl., 1965; Concours Artistiques de Quebec, 1966-1968;Galerie Place Royale, Mtl., 1966; 1940 Gal., Mtl., 1968; Canadian Gld. of Crafts, 1968.

BELL, R. MURRAY—Collector
321 Bloor St. East 5; h. 134 Forest Hill Rd., Toronto 195, Ont. Studied: Univ. Alberta; Osgoode Hall Law School, Toronto. Collection: Chinese ceramics, with special interest in blue and white Chinese procelain.

BELLEFLEUR, LEON—Painter, Eng.
417 St-Joseph Blvd. W., Montreal, Que.
B. Montreal, Que., Feb. 8, 1910. Studied: Ecole des Beaux-Arts, Mtl.; Ecole Normale, Mtl. Member: Assn. Prof. A. of Quebec. Awards: prizes, Jessie Dow Award, 1950; Commonwealth Award, Vancouver; Guggenheim award, 1960. Work: NGC; AG Tor.; Musee de la Province du Quebec; Musee d'Art Contemporain, Mtl. Exhibited: Sao Paulo, Brazil, 1950, 1953; Spoleto, Italy, 1960; retrospective: NGC, London (Ont.) Mus., Mtl. Mus. Contemp. A., 1968. Many other exhibitions in Europe, U.S., Japan, Mexico and Canada.

BENTON, MARGARET PEAKE—Miniature and Portrait Painter
Wesley Ave., Niagara-on-the-Lake, Ont.
B. South Orange, N.J. Studied: OCA under Sir Wyly Grier and Archiblad Barnes. Member: Min. P. S. & Gravers, Wash., D.C. Honour: For best painting, Miniature Painters', Sculptors', Gravers' Soc., Wash., D.C., 1962. Work: portraits, Wesley Bldg., Tor.; North Tor. Collegiate Inst.; Nurmanzil Psychiatric Centre, Lucknow, India; King's Col., Halifax, N.S.; PMA; PAFA; murals, St. John's Garrison Church Tor.; miniatures: Queen Elizabeth's private collection. Exhibited: OSA, 1933; PAFA 1940, 1941, 1943, 1945-1951; Washington A. Cl., 1943, 1945-1947, 1951-1968; RCA 1938-1940, 1942, 1948, 1949; Royal Acad. A., London, 1950. Instr., Painting, Niagara-on-the-Lake H.S., 1960-61.

BENY, WILFRED ROLOFF — Painter, Et., L., Eng., Photographer
432 13th St. South, Lethbridge, Alta.; also, Lungotevere 3-B Rome, Italy
B. Medicine Hat, Alta., Jan. 7, 1924. Studied: Banff Sch. FA; Univ. Tor., B.A., B.F.A.; State Univ. Iowa, M.A., M.F.A.; Columbia Univ.; N.Y. Univ. Inst. FA. Honours: F., Univ. Iowa; Guggenheim F., 1952; Centennial Medal, 1967; Canada Council Fellowship, 1968; Gold Medal, Int. Book Fair, Leipzig, 1968 for "Japan in Colour." Work:

St. Hilda's Col., Univ. Tor.; Univ. Iowa; FMA; MModA; BM; N.Y. Pub. Lib.; Yale Univ.; CM; Wesleyan Univ.; NGC; A. Gal. Toronto; Oslo Mus., Norway; Bezalel Mus., Jerusalem; Redfern Gal., London, and others; (U.S.A.) FMA; Yale Univ. Gal. FA; BM; MModA, and others. Exhibited: CSPWC 1942-1944; OSA 1943-1945; AA Mtl. 1945; Nat. Print Show, Wichita, Kans. 1946; Phila. Print Cl., 1946; Milan, Italy, 1952; Weyhe Gal., N.Y., 1947; Palazzo Strozzi, Florence, 1949; Knoedler Gal., 1951; Merano, Vicenza, Italy, 1951; SFMA; AIC; LC; Carnegie-Mellon Univ.; DMFA, and others. One-man: Hart House, Univ. Tor., Eaton College, Tor.; Univ. Iowa 1946; Libraire Paul Morihien, Paris, 1952; Florence, Italy, 1949; Knoedler Gal., N.Y., 1951, 1954; A. Gal., Toronto, 1954; Robertson Gal., Ottawa, 1954; Waldorf Gal., Montreal, 1954; Contemp. Gal., N.Y., 1955; Western Canada Circuit, 1955; Barozzi Gal., Venice, 1967; Ten year retrospective exh. (photographs), Gal. Mod. A., New York City, 1968, and in France. Author-Photographer, "A Time of Gods," publ. London, 1962 in 8 Language editions; "Pleasure of Ruins," for which Rose Macauley's text was adapted, chosen by Time-Life Int. Book Soc. for the United States; "To Everything There Is a Season," number one on Canada's best seller list, 1967.

BICE, CLARE —Painter, Mus. Cur.
1010 Wellington St.; Williams Memorial Art Gallery and Museum, London, Ont.
B. Durham, Ont., Jan. 24, 1909. Studied: Univ. West Ont., B.A.; ASL; Grand Central Sch. of A., N.Y. Member: OSA. Honours: RCA; OSA, LL.D. (Hon.); Canadian Govt. F., 1953. Exhibited: OSA, 1940- ; CNE 1938-58; WFNY 1939; Western Ont. Exh. 1940-58; NGC Army Art Exh. 1944. Author, Illus.; "Jory's Cove"; "Across Canada"; "The Great Island," 1954; "A Dog for Davie's Hill," 1965; "Hurricane Treasure," 1965; also I. of other children's books. Contributor articles on art to Canadian Art, etc. Positions: Cur., Williams Memorial Art Gallery, London, Ont. Pres., Canadian Art Museum Director's Organization 1966-68; Pres., Royal Canadian Academy, 1967- .

BIELER, ANDRE —Painter, E., L., Eng.
R.R. #1, Glenburnie, Ont.; Dept. of Art, Queen's University, Kingston, Ont.
B. Lausanne, Switzerland, Oct. 8, 1896. Studied: ASL; Ecole du Louvre, Paris, under Maurice Denis; Switzerland under Ernest Biéler. Member: RCS; OSA, CGP, CSPWC, CSGA, FCA. Honours: Pres. FCA 1942-4; Vice-Pres. CGP 1943; ARCA; Forster award, OSA, 1957; Hon. LL.D., Queens University, 1969. Work: NGC; MPQ; AA Mtl.; AG Tor.; Winnipeg AG; Hart House, Univ. Tor.; Queen's Univ.; Aluminum Co. of Canada; mural, East Mem. Bldg., Ottawa; Edmonton A. Gal; Windsor AA, 1955; Mus. FA, Montreal, 1952; Art Collection Soc., Kingston; mosaics, Chalmer's Church Hall, Kingston; Frontenac Tile Co., Kingston, and others. Exhibited: Int. WC, Chicago; Brooklyn; Coronation 1937; Tate 1938; Chicago 1939; WFNY 1939; Addison 1942; Yale 1944; Rio 1944, '46; DPC 1945; UNESCO 1946; BMFA, 1946; VMFA, 1949; Contemp. Can. Art, 1950; Brazil, 1950; SFMA, 1956; One-man: Mtl. 1924; '26, '45; Paris 1936; Ottawa, 1954; Kingston, 1954, 1955, 1960, 1966; Mus. FA, Montreal, 1952; Retrospective, Queen's Univ., 1963; San Miguel de Allende, Mexico, 1964, Glenburnie, Ont., 1964, and others. Contributor: Kingston Conference Proceedings 1941; Maritime Art; Canadian Art, Lectures: Spanish, Mexican, Canadian art on tour of E. Canada; "Modern Art," Windsor and Ottawa. Positions: Emeritus Prof. FA, Queen's Univ., Kingston, Ont. 1963- ; Dir. Etherington Art Centre.

BINNING, BERTRAM CHARLES —Painter, E., Mus. Cur.
2968 Mathers Crescent, West Vancouver; University of British Columbia, Vancouver, B.C.
B. Medicine Hat, Alta., 1909. Studied: Vancouver Sch. A.; ASL; Univ. Oregon; in London under Henry Moore, Ozenfant and Meninsky. Member: FCA; British Columbia Soc. FA; CSGA; CGP; ARCA. Honours: medal, Vancouver, 1951; Carnegie Scholarship, 1936, 1951. Work: NGC; AG Tor.; Hart House, Univ. Tor.; Vancouver A. Gal. Exhibited: British Columbia Soc. A., 1932-1945; British Columbia Soc. FA, 1935-1946; OSGA, 1941-1946; CGP, 1943, 1944; Rio 1946; BMFA, 1949, 1955; AG Tor., 1949; NGA, 1950; Canadian Biennial, 1954; Venice Biennale, 1954; Sao Paulo, Brazil, 1953; PC (3 Canadians), 1955; Valencia, Venezuela, 1955; Milan Triennial, 1957. Positions: Assoc. Prof. A., Univ. British Columbia, and Cur. FA Gal., Univ. British Columbia.*

BLOORE, RONALD LANGLEY —Educator, P.
York University, Toronto 12, Ont.
B. Brampton, Ont., May 29, 1925. Studied: Univ. Toronto; N.Y. Univ.; Washington Univ., M.A.; Courtauld Inst., Univ. London. Work: In major Canadian public and private colls. Murals: Montreal Int. Airport; Confederation Center, Charlottetown, P.E.I. Positions: Assoc. Prof., Oriental and Modern Art, York Univ., Toronto, Ont.

BOGGS, JEAN SUTHERLAND —
Museum Director, Scholar, Educator, W.
The National Gallery of Canada, Elgin & Albert Sts., Ottawa 4, Ont., Canada
B. Negritos, Peru, June 11, 1922. Studied: Univ. Toronto, B.A.; Radcliffe College, A.M., Ph.D. Member: College Art Association (Vice-Pres.); Association of Art Museum Directors; Canadian Art Museum Directors Organization; Canadian Museums Association; American Association of Museums. Awards: Hon. D. University, Calgary, 1967; LL.D., Laurentian University, Sudbury, 1967; LL.D., University of Toronto, 1967. Contributor to Art Bulletin, Art News, National Gallery of Canada Bulletin, Canadian Art, Connoisseue, Massachusetts Review, Burlington Magazine, and others, 1955-1967. A contributions to "Man and His World" catalogue of the International Fine Arts Exhibition, Expo '67. Exhibitions Arranged: "Delacroix," 1962-1963 collaborating with Lee Johnson and William Withrow on arrangement of exhibition and editing the catalogue; "Picasso and Man," 1964, complete direction; "Canaletto," colaboration with W. G. Constable on arrangement of exhibition, editing catalogue, all at The Art Gallery of Toronto; "Drawings by Degas," City Art Museum, St. Louis, Mo., 1967, complete direction. Field of Research: 19th and 20th Century Art. Author: "Portraits by Degas", 1962; "Picasso and Man," catalogue of an exhibition, Art Gallery of Toronto, 1964; "Edgar Hilaire Germain Degas," Los Angeles County Museum catalogue, 1958; "Drawings by Degas," City Art Museum, St. Louis, Mo., 1967. Positions: Assistant Professor of Art, Skidmore College, 1948-1949, Mount Holyoke College, 1949-1952, University of California, Riverside, 1954-1962; Curator, The Art Gallery of Toronto, 1962-1964; Steinberg Professor of the History of Art, Washington University, 1964-1966; Director, The National Gallery of Canada, Ottawa, (June) 1966- .

BORNSTEIN, ELI —Educator, P.
Dept. Art, Univ. of Saskatchewan, Saskatoon, Sask., Canada*

BOUCHARD, LORNE —Painter
4070 Jauron St., Montreal 9, P.Q.
B. Montreal, P.Q., Mar. 19, 1913. Studied: Drawing, in Montreal with W.M. Barnes; Ecole des Beaux-Arts, Montreal. Member: RCA; Montreal A. Cl. Work: Montreal Mus. FA; in private colls. Canada, U.S.A., Australia, Switzerland, and England. Exhibited: Mtl. Mus. FA, 1960 and prior; RCA traveling colls, 1957-1958, and group, 1960; CNE exh., Toronto, 1958; OSA; Seagram's "Cities of Canada" world circuit; Hamilton, London, Ont.; 4-man, London, Ont., 1962; 2-man, Mtl. Mus. FA, 1962; one-man: Montreal; Klinkhoff Gal., 1959-60, 1962-1964, 1966, 1968.

BOYD, JAMES —Printmaker, Des., T.
550 O'Connor St., Ottawa, Ont.
B. Ottawa, Ont., Dec. 16, 1928. Studied: ASL, with Will Barnet, Bernard Klonis; NAD, with Robert Phillip; Contemporaries Graphic A. Centre. Member: CSGA; F.I.A.L. Awards: prize, Nat. Print Exh., Vancouver, 1961. Work: Toronto Telegram Coll.; Nat. Gal. Canada; McMaster Univ.; murals, Canadian Tourist Bureau, Chicago; N.Y. World Trade Fair —Canadian Section, 1958. Exhibited: CSGA, 1955-1961; SAGA, 1956, 1961; Isaacs Gal., 1961; Nat. Print. Exh., Vancouver, B.C., 1961; "Winnipeg Show," 1957, 1958; Minneapolis, 1958; one-man: Loranger Gal., Ottawa, 1956; Robertson Gal., Ottawa, 1958. Positions: Instr., Graphic A., Ottawa Municipal A. Centre, 1957-1961; Port. and Vignette Engraver-Bank Notes —1946-1952; Exh. Des., Canadian Section, Brussels World's Fair, 1958. Graphic Des., C.B.C.-TV., 1961.*

BOZICKOVIC, ALEX —Painter, Pr. M.
12 Deerford Rd., Apt. 805, Willowdale 427, Ontario, Ont.
B. Sarajevo, Yugoslavia, July 8, 1919. Studied: Univ. Belgrade, Academie FA, B.F.A. Awards: prizes, Chicago, Ill., 1966; Gallery Boheme, Copenhagen, 1955. Work: Mus. FA, Rijeka, Yugoslavia; City of Bremen, West Germany. Murals: Zopas Company, Rome, Italy; City Hospital, Bremen; City-Bauamt, Bremen. Exhibited: AIC, 1960; Old Orchard Festival, Chicago, 1959-1967; one-man: Rome, 1952; Copenhagen, 1955; Bremen, 1956; New York City, 1957; Chicago, 1963-1965; Los Angeles, 1962; Milwaukee, 1963 and Toronto, Can., 1968. Positions: Instr., Painting and Printmaking, Americana Art Center, Northfield, Ill., at present.

BRAITSTEIN, MARCEL —Sculptor
1061 Richelieu N., St. Hilaire, P.Q.
B. Charleroi, Belgium, July 11, 1935. Studied: Ecole des Beaux-Arts, Mtl.; Instituto de Allende, San Miguel de Allende, Mexico. Member: Quebec Sculptors Assn. Awards: prizes, Quebec Province A. Comp., 1959; Mtl. Mus. FA, 1961; Canada Council Grant for travel and work in Europe, 1961-1962. Work: AG Tor.; Mtl. Mus. FA; Winnipeg AG; Confederation Centre, Charlottetown, P.E.I.; monument to Rt. Hon. Arthur Meighen, Ottawa, 1969; Firemen's

Bank, Mtl. Exhibited: Young Contemporaries, London, Ont., 1960-1963; Mtl. Mus. FA, 1961, 1965; national exhs, since 1959; Mexico, 1961; Bundy A. Gal., Vermont, 1966, and others. One-man: Brussels, Belgium, 1960; Mexico, 1961; Montreal, 1961, 1963, 1965. Positions: Instr., Advanced sculpture, Mtl. Mus. FA, 1963-1965; Sculpture, Ecole des Beaux-Arts, Mtl., 1965- .

BRANDTNER, FRITZ—Painter, C., Des., Gr.
 4840 Plamondon Ave., Montreal 252, P.Q.
B. Danzig, July 28, 1896. Studied: Danzig Acad. under F. A. Pfuhle. Member: CGP; CSPWC; F.I.A.L. Honours: prizes, AA Mtl., 1946; Canadian Olympic Comp., 1948; Comp. for des. of commemorative 5-cent piece, 1950; Canada Council Visual Arts award for 1968-1969. Work: Central Station, Mtl.; Bell Telephone Co., Berkeley Hotel, Trans-Canada Airlines, Mtl.; Can. Nat. Railways, Boston; Hotel Vancouver; Bishop's Col., Lennoxville, P.Q.; NGC; AG Tor.; Vancouver AG; Hart House, Univ. Tor.; Can. Nat. Railways, St. Johns, Newfoundland. Exhibited: S. Dominions 1936; Gloucester 1939; WFNY 1939; Addison 1942; Yale 1944; DPC 1945; Elmira, N.Y., 1946; Rio 1946; Phila. WC Cl., 1946; Vancouver AG; Winnipeg AG; CSGA; CSPWC; CGP; Sao Paulo, Brazil. Lectures, radio talks. Positions: A. Master, Miss Edgar's and Miss Cramp's Sch., Mtl., 1944-1966; L., McGill Univ., 1947-1956; Dir., Observatory A. Centre, Univ. New Brunswick Summer Sch., 1949-53.

BRIANSKY, RITA (PREZAMENT)—Etcher, P.
 4832 Wilson Ave., Montreal 253, P.Q.
B. Grajewa, Poland, July 25, 1925. Studied: Montreal Mus. FA, with Jacques de Tonnancoeur, Eldon Grier; Ecole des Beaux-Arts; ASL, N.Y., with Corbino, Sternberg, Bosa and Vytlacil. Member: CSGA; CPE. Honour: prize, Montreal Mus. FA, 1949; Burnaby, B.C., 1961, 1963; Canada Council Grant 1962, 1967; purchase award, St. Joseph's T. Col., Montreal. Work: AG Hamilton; Burnaby A. Soc.; New Brunswick Mus.; St. Joseph's T. Col.; Thomas More Inst., Montreal; McMaster Univ.; Willistead A. Gal.; Vancouver A. Gal.; Can. Nat. R.R., Executive Train; Reader's Digest, Montreal; Alberta Col. A. Illus., anthology of children's stories, and other work reproduced in Canadian Art and UNICEF Engagement Calendar, 1966. Exhibited: CSGA, 1958-1961; Montreal Spring Shows, 1945-1962; Upstairs Gal., Toronto (one-man), 1959; Women's Int., Vichy, France, 1960; Int. Prints, Tokyo, 1960; Exh. Prints, Burnaby (B.C.) A. Soc., 1961, 1963; Phila. A. All., 1965; United Nations, N.Y., 1965; one-man: Montreal Mus. FA, 1958, 1960; Elca London Studio, Montreal, 1963, 1965; Gallery Pascal, Toronto, 1964, 1966, 1969; Artlenders, Montreal, 1964; Alice Peck Gal., Burlington, Ont., 1964; Glynhyrst Arts Council, Brantford, Ont., 1965; West End A. Gal., Montreal, 1967. Various group shows, 1949-1969.

BRIEGER, PETER H.—Educator, Historian
 University of Toronto; 51 Woodlawn Ave., West, Toronto 5, Ont.
Positions: Prof. Hd. Dept. A. & Archaeology, Univ. Toronto, Toronto, Ont.*

BROOMFIELD, ADOLPHUS GEORGE—Painter, Et., Textile Des., L.
 232 Isabella Ave., Cooksville, Ont.; 1179 King St., W., Toronto, Ont.
B. Tor., Aug. 26, 1906. Studied: OCA under F. S. Haines, J. W. Beatty, A. Lismer and J. E. H. MacDonald. Member: ARCA; CSPEE; OSA; Ont. Inst. Painters. Honours: ARCA; prize, RCAF exh. 1944. Work: RCAF; Sarnia AG; Nat. Defense Col., Ottawa; Canada Wire & Cable Coll., Toronto; War Collection, Nat. Gallery, Ottawa. Exhibited: CSGA 1928-1938; CNE 1930-1938, 1958; OSA 1930-1945, traveling exhs., 1955-1958; CSPEE 1935-1939; RCA 1935-1945, 1960; Nat. Gal., Ottawa, 1960; NG London war art 1944; AG Tor.; AG Mtl.; Ottawa, Ont.; traveling exhs. of OSA, RCA; University Loan Exhibitions.

BROWNHILL, HAROLD—Painter, Et., Lith., Cart., I.
 6322 Norwood St., W. 22, Halifax, N.S.
B. Sheffield, England, July 12, 1887. Studied: Sheffield Col. A., with Cook, Jahn. Member: (Hon., and Past Pres.) Nova Scotia Soc. A. Honour: several certifs., South Kensington Bd. Edu. Exhibited: Nova Scotia Traveling Exh., 1952; Nova Scotia Soc. A., 1933-1936, 1948-1955. Cart., Yorkshire Telegraph & Star; Halifax Herald & Evening Mail; Halifax Chronicle Herald, 1968.

BUCHANAN, DONALD WILLIAM—Critic, W.
 460 Crestview Rd., Ottawa, Ont.
B. Lethbridge, Alta., Apr. 9, 1908. Studied: Univ. Tor., B.A.; Univ. Oxford (Eng.). Author: "James Wilson Morrice," 1937; "This is Canada," 1945; "Canadian Painters," 1946; "The Growth of Canadian Painting," 1950; "Alfred Pellan," 1960; "A Nostalgic View of Canada," 1964. Contributor to Canadian Art, Studio, Univ. Toronto Quarterly, Canadian Geographical Journal, and others. Positions: Former Assoc. Dir., National Gallery of Canada, Ottawa, Ont.; Consultant, Canadian Corp. for 1967 World Exh., Mtl.*

BUSH, JACK—Painter
 1 Eastview Cres., Toronto, Ont.
B. Tor., Mar. 20, 1909. Studied: OCA; RCA classes. Member: CSPWC; OSA; Painters Eleven. Honours: Pres. CSPWC; Rolph Clark Stone purchase prize, OSA exh., 1946; J. W. L. Forster award, OSA, 1952; CNE, 1957; CAC Senior Fellowship for study in Europe and N.Y., 1962; Grand Award, Mtl. Mus. FA, 1965; Guggenheim Fellowship, 1968. Exhibited: Canadian Artists Exh., Riverside Mus., N.Y., 1956; Fifteen Canadian Painters—U.S. tour, 1963-1964; Post Painterly Abstraction, Los A., 1964; Bennington Col., 1964; Mtl. Mus. FA, 1965; Sixth Biennial Canadian Painting, Ottawa, 1965; SFMA, 1965; Nine Canadians-Inst. Contemp. A., Boston, 1967; NGC, 1967, 1968; Represented Canada at Sao Paulo, Brazil, 1967; Carnegie Int., 1967; Expo '67; NGC, 1968 traveling to Europe; Canada Council Exh., Edinburgh Festival, Scotland, 1968. One-man: Roberts Gal., 1949, 1952; Park Gal., 1958, 1959, 1961; Elkon Gal., N.Y., 1962-1964; Waddington Gal., London, 1965-1967; Emmerich Gal., N.Y., 1966, 1967; David Mirvish Gal., Toronto, 1966-1968; Galerie Godard-Lefort, Mtl., 1969; 5-man, Scarborough Col., Tor., 1968. Contributed article to Art International, Feb., 1965. Positions: Visiting Artist, Mich. State Univ. Art Dept., Spring, 1965; Cranbrook Acad. A., Bloomfield Hills, Mich., 1968.

CAISERMAN-ROTH, GHITTA (Mrs. Max W.)—Painter
 5 Bellevue St., Montreal, Que., Canada*

CAMPBELL, ROSAMOND SHEILA—
 Painter, Des., Cart., Comm., I., T.
 Clifton Royal, King's County, N.B.
B. Bareilly, India, Mar. 25, 1919. Studied: Adelaide Sch. FA, Australia; Melbourne Gallery Painting Sch.; Central Sch., London, England, with John Farleigh; Regent St. Polytechnic, London, England, with Auerbach. Member: Maritime AA; Saint John A. Cl. Honours: prizes, Maritime AA, purchase, 1957, 1958, 1961; Saint John Exh., 1958-1961. Work: in colls. in Nova Scotia, Prince Edward Island and New Brunswick. Exhibited: Maritime AA, 1957-1961; Dalhousie Univ., 1961; New Brunswick Mus., 1957, 1958; Saint John Pub. Lib., 1959; one-man: Adelaide, Melbourne, Victoria, Australia; London, England; Halifax, N.S.; Acadia Univ., Wolfville, N.S. Illus. children's books for leading publishers, London and Australia. Lectures on art. Positions: Free lance artist; display director, New Brunswick Museum.

CARTER, DAVID GILES—Museum Director, Hist., W., L.
 Montreal Museum of Fine Arts 109; h. 49 Rosemount Ave., Westmount 217, P.Q.
B. Nashua, N.H., Nov. 2, 1921. Studied: Princeton Univ., A.B.; Harvard Univ., M.A. (Grad. Sch. A. & Sc.); N.Y.U. Inst. FA. Member: CAA; Medieval Acad. of America; FSA; Mus. Dirs. Assn.; AAMus.; Center for Romanesque Studies; AFA; Arms & Armor Cl. of America; Arms & Armour Soc. (Britain); The Grolier; AAMD; CAMDO (Pres. 1968-). Awards: Grace Tilton prize, Princeton Univ., 1944; Museum F., MMA, 1951; Brussels Art Seminar F., 1952; Gold Medal of Culture, Italian Ministry of Foreign Affairs, 1962. Contributor to: Art Bulletin; Speculum; John Herron A. Mus. Bulletin; Museum Notes (Rhode Island School of Design); Musees Royaux des Beaux-Arts, Brussels (Bulletin) Vie des Arts, L'Oeil. Lectures: Northern Renaissance and Baroque Art to museum and college audiences. Exhibitions and Collections arranged: "Turner in America" (print section only); "The Young Rembrandt and His Times," 1958, San Diego FA Gal.; "Dynamic Symmetry," 1961, Currier Gal. A. and Dartmouth College; "The Clowes Collection," 1959, Indianapolis; "El Greco to Goya," 1963, Indianapolis and Providence; The Weldon Collection, 1964, Providence; "Images of the Saints," 1965 (with E.P. Lawson and W. J. Johnston), Montreal; "Masterpieces from Montreal," 1966 (8 U.S. museums); "The Painter and the New World," 1967, Montreal; "Rembrandt and His Pupils," 1969; Montreal and The Art Gallery of Ontario, Toronto, and many others. Positions: Cur. Asst., Dept., Painting, MMA, 1952-54; Cur., Paintings & Prints, John Herron AI, Indianapolis, 1955-59; Visiting Lecturer, Indiana Univ., 1958-59; Dir., Museum of Art, Rhode Island School of Design, Providence, R.I., 1959-1964; Dir., Montreal Mus. FA, 1964- .

CHAMBERS, JOHN—Painter
 1336 Wilton St., London, Ont., Canada*

CHIARANDINI, ALBERT—Portrait Painter
 72 Bowerbank Dr., Willowdale, Ont.
B. Udine, Italy, Sept. 30, 1915. Studied: Ontario Col. A. Member: F.I.A.L.; Ontario Soc. A. Work: Univ. Toronto and in private colls. Exhibited: Hamilton A. Gal., 1952, 1954-1956, 1960, 1961; Victoria, B.C., 1957; OSA, 1938, 1962, 1964, 1966; RCA, 1948, 1963, 1968; Kitchener-Waterloo, 1964; Edmonton Gal., 1968; St. John, Newfoundland, 1963. Positions: Instr., Ontario Col. of A., Northern Secondary School, at present.

CHICOINE, RENE — Painter, T., Cr.
Ecole des Beaux-Arts, 125 Sherbrooke West, Montreal, P.Q.
B. Montreal, 1910. Studied: Beaux-Arts, Mtl. Work: Musee de
Quebec; Court House, Mtl. Exhibited: since 1928. Positions: Instr.,
Ecole des Beaux-Arts, Montreal.*

CLARK, (MRS.) PARASKEVA — Painter
56 Roxborough Dr., Toronto 5, Ont.
B. St. Petersburg, Russia, Oct. 28, 1898. Studied: under S. Zaiden-
berg, V. Schoukhaeff, C. Petrov-Vodkin, and at Leningrad Acad. of
Arts 1918-21. Honours: Hamilton, Ont., 1948; purchase prize, Win-
nipeg A. Gal., 1954; Purchase Award, AG Hamilton, 1964. Member:
CSPWC; RCA. Work: NGC; AG Ontario; Napler AG, New Zealand;
Dalhousie Univ. Commissions: war records of women's divisions
armed forces 1945; Winnipeg AG, Man; Assumption Univ., Windsor;
AG Hamilton; Univ. Toronto, Hart House; Victoria Col., Univ. To-
ronto. Exhibited: S. Dominions 1936; Coronation 1937; Tate 1938;
Great Lake Exh. 1938-9; Gloucester 1939; Int. WC, Chicago 1939;
WFNY 1939; Addison 1942; Yale 1944; Hackley A. Gal., 1955; Rio
1944; DPC 1945; CGP; CSPWC; New Zealand, 1958; PAFA 1949;
BMFA 1949; NGA, Wash., D.C. 1950; Sao Paulo, Brazil, 1951; Retro-
spective, Victoria Col., Univ. Toronto, 1952; Festival of Britain,
1951; WAC, 1958; AG Tor., 1953 (2-man); AA Mtl., 1955-56 (2-man);
Macdonald Col. (one-man); Hart House, Univ. Toronto, 1956 (one-
man); Roberts AG, Tor.

COLLIER, ALAN CASWELL — Painter
115 Brooke Ave., Toronto, Ont., Canada*

COLVILLE, ALEXANDER— Painter, Gr.
P.O. Box 253, Sackville, N.B.
B. Toronto, Ont., Aug. 24, 1920. Studied: Mount Allison Univ. with
Stanley Royle, B.F.A. Work: New Brunswick Mus.; NGC; AG Tor.;
AG Hamilton; London (Ont.) A. Mus.; Saskatoon A. Centre; MModA;
Lord Beaverbrook Coll., and private colls. in U.S. and Canada. Ex-
hibited: Tate Gal., London, 1964; Venice Biennale, 1966; Bologna
Biennale, 1967; "Menschenbilder," Darmstadt, 1968; Canadian Bien-
nial, 1968; one-man: Hewitt Gal., N.Y., 1953, 1955; Banfer Gal.,
N.Y., 1963; Marlborough Fine Art (London) Ltd., 1969.

COOKE, EDWY FRANCIS—Museum Director, E., P.
Dept. of Fine Arts, Sir George Williams University; h. 3455
Cote des Neiges, Montreal, P.Q.
B. Toronto, Ont., Mar. 10, 1926. Studied: Univ. Toronto, B.A.; Univ.
Iowa, M.F.A. Member: CSPWC; Canadian Museums Assn.; Univer-
sities A. Assn. of Canada; CAA. Honour: Canada Council grant for
overseas research, 1958. Work: AG Tor.; London (Ont.) Mus. A.;
Beaverbrook AG, Fredericton, N.B.; Sir George Williams Univ.,
Mtl.; Loyola Col., Mtl.; Norman Mackenzie A. Gal., Regina, Sask.
Exhibited: Extensively in Canada, 1944-58 with RCA; CGP; CSPWC;
CSGA; Mtl. Mus. A.; NGC; OSA; Can. Nat. Exh., etc. One-man: Hart
House, Univ. Toronto, 1947, 1952; London (Ont.) A. Mus., 1955. Art
Centre, Univ. of New Brunswick, 1962. Positions: Instr., Drawing &
Painting, A. Workshop, 1951-59; AG Tor., 1951-59; Univ. Toronto,
1954-59; Cur. Lee Collection, Hart House, Univ. Toronto, 1953-59;
L., Hist. of Art, Univ. Toronto, 1952-59; Hd., Dept. FA, Univ. New
Brunswick, Fredericton, N.B., 1959-1964; Dir., Beaverbrook A.
Gal., Fredericton, N.B., 1959-1964; Assoc. Professor, Dept. of FA,
Sir George Williams Univ., Mtl., 1964-1969; Dir., Sir George Wil-
liams Collection of Art and the Art Galleries, 1966- , Prof. FA,
1969- .

COPE, DOROTHY (Mrs. C. A.) — Painter
840 Evelyn Drive, West Vancouver, B.C.
B. Vancouver, B.C., Sept. 5, 1915. Studied: Vancouver A. Sch.
Member: B.C. Soc. A.; CSPWC. Honour: Winnipeg Show, 1957
award; Diploma of Honour, Intl. Salon, Vichy, France, 1961. Work:
Vancouver A. Gal. Exhibited: B.C. Annual, 1938-1958; B.C. Soc.
A., 1949-1958; CSPWC, 1954-1958; Winnipeg Show, 1956-1958; OSA,
1958; Montreal Spring Show, 1958; "100 Years of British Columbia
Art," 1958; Toronto A. Gal., 1959 (4-man); one-man: The New De-
sign Gal., 1962.*

COSGROVE, STANLEY — Painter
309 Ave. du Coteau, La Tuque, P.Q.
B. Montreal, Dec. 23, 1911. Studied: Beaux-Arts, Mtl.; AA Mtl.,
and with Orozco in Mexico. Member: A.R.C.A. Honours: medal,
Beaux-Arts, Mtl.; traveling scholarship in Quebec; Govt. F.,
France, 1953. Work: NGC; Vancouver A. Gal.; MModA, New York;
Winnipeg A. Gal. Exhibited: Yale 1944; DPC 1945; Rio 1946;
UNESCO 1946; Montreal Mus. FA; Quebec Pronvincial Mus.; Nat.
Gal., Ottawa; one-man: Beaux-Arts 1939; AA Mtl., 1944; Mexico
1943; Quebec 1939; Dominion Gal., 1949; Retrospective Exh., Mon-
treal Mus. FA, 1961.*

COUGHTRY, JOHN GRAHAM— Painter, S.
832 Yonge St., Toronto, Ont.
B. St. Lambert, Que., June 8, 1931. Studied: Montreal Sch. A. &
Des.; Ontario Col. A. Honours: Eaton traveling scholarship, To-
ronto, 1953; prizes, Winnipeg Nat. Exh., 1957, 1962; Montreal Mus.
FA, 1958; Vancouver AG, 1962; AG Tor., 1963. Work: Toronto A.
Gal.; Winnipeg A. Gal.; NGC; MModA; Albright-Knox AG; Detroit
Inst. A. Sc. relief, Beth David Synagogue, Toronto. Exhibited: Gug-
genheim Mus., N.Y., 1958; Carnegie Inst., 1958; 2nd Biennial Cana-
dian Art, 1957; WAC, 1958; major Canadian exhibitions, 1957-1958.
Venice Biennale, 1960; Sao Paulo Biennale, 1959; Commonwealth
Exh., London, 1962; Dunn Int. Exh., Tate Gal., London, 1963; Gug-
genheim Int., N.Y., 1964; Vancouver AG, 1962; AG Tor., 1963; one-
man: The Isaacs Gal., Toronto, 1967, 1969.

COULING, GORDON — Educator, P.
Department of Fine Art, Wellington College, University of
Guelph; h. 5 Simpson Way, Guelph, Ont.
B. Guelph, Ont., Nov. 21, 1913. Studied: Onatraio Col. A., Toronto;
N.Y. Univ. Member: Canadian Assn. of Univ. Teachers; CAA. Work,
Murals, Metropolitan United Church, Toronto; Trinity United
Church, Kitchener; St. Joseph's Hospital, Guelph; stained glass, in
churches in Vancouver, Kitchener and Guelph. Positions: Lecturer
and Assistant Professor in Art, Macdonald Institute, Ontario Agri-
cultural College, 1949-1965; Associate Professor and Chairman,
Department of Fine Art, Wellington College, University of Guelph,
1965- .

COURTICE, RODY KENNY (Mrs.)—Painter, T.
Rosedale Court-204, 30 Elm Ave., Toronto 5, Ont.
B. Renfrew, Ont., Aug. 30, 1895. Studied: OCA, Tor.; AIC; in Paris,
France, and London, England; Also studied with Hans Hofmann.
Member: CSGA; CSPWC; OSA; CGP; Heliconian Cl.; RCA. Work:
various public and private colls. Exhibited: Nationally and inter-
nationally.

CRAWFORD, CATHERINE BETTY—Painter, Gr.
342 Thames St., South, Ingersoll, Ont.
B. Ingersoll, Ont., Feb. 5, 1910. Studied: Univ. Toronto, B.A.; Art
with Gordon Payne, F. H. Varley, Carl Schaeffer and others. Mem-
ber: CSPEE. Honour: purchase award, Western A. Lg., London,
1960; 1st prize, watercolor, Western Fair, 1962. Work: CSPEE;
Lending Lib. Canadian Art, London, Ont. Exhibited: CPE, 1951-
1965; traveling exhs., CPE; Retrospective show of Canadian Print-
making, Toronto, 1958; Western Ontario exhs. since 1945; 3-man
show, London A. Mus., 1948, 2-man, 1953; traveling exhs., Western
Ontario A., 1949, 1955, 1957. Positions: Lib., Cur. Exhibits, Public
Lib., Ingersoll, Ont. *

CRYDERMAN, MACKIE (Mrs.) — Painter, Gr., Des., C., T.
12 Chalmers Ave., London 24, Ont.
B. Dutton, Ont. Studied: Winnipeg Sch. A., with Franz Johnston; On-
tario Col. A.; Artisans Gld., Detroit, with Arthur Neville Kirk: Gld.
of All. Arts & Crafts; Soc. Arts & Crafts, with Sarkis Sarkisian, and
privately with Francis de Erdly. Member: CPE. Honour: prize,
Western Fair, 1955. Work: Medway H.S.; H. B. Beal Tech. Sch., and
in private colls. Scenery and sets for London Little Theatre, Domin-
ion Drama Festival, 1949; murlas & decor, Park Towers Club, Lon-
don, Ont., 1961. Exhibited: RCA, 1938, 1939, 1941, 1944, 1945; OSA,
1940-1943; CSPWC, 1942, 1943; Contemp. Canadian A., 1950; CPE,
1956-1965; Canadian Nat. Exh., 1956; Western A. Lg., 1936-1969;
Hamilton A. Gal.; traveling exhs.; London (Ont.) A. Gal., 1957; Expo
'67; Mtl. Mus. FA. Positions: Instr. A., summer school, Univ. West-
ern Ontario, 1946; Dept. Edu., Ontario, 1947, 1948; Dir. A., H. B.
Beal Tech & Commercial H.S., London, Ont., 1927- . Bd. Governors,
Fanshawe Col. Applied A. & Tech., London, Ont.

CYOPIK, WILLIAM — Painter
Welland, Ont., Canada*

DAGYS, JACOB —Sculptor, T.
78 Chelsea Ave., Toronto 9, Ont.
B. Lithuania, Dec. 16, 1905. Studied: Kaunas A. Col., Lithuania,
and sculpture with Prof. Zikaras. Member: Sculptors Soc. of Can-
ada. Work: in churches and in private colls. Exhibited: Lithuanian
exh. of Artists Soc., 1934-39; Sc. Soc. of Canada, Montreal, 1953,
Toronto, 1958, 1961, Quebec, 1960; Montreal annual exh., 1954, 1957,
1959; Colour and Form Soc., Toronto, 1953-1965; RCA, 85th Annual
Exh., Mtl, 1964-1965; 2-man: Detroit, 1967; Chicago, 1968; one-man:
Toronto, 1967. Group shows in Toronto, Hamilton and Chicago, 1967-
1968. Album of Dagy's sculptures and paintings published 1967.

DALE, WILLIAM SCOTT ABELL—Educator, L. W.
University of Western Ontario, London; h. 401 Huron St., Lon-
don 24, Ont.
B. Toronto, Ont., Sept. 21, 1921. Studied: Trinity Col., Toronto,

B.A.; Univ. Toronto, M.A.; Harvard Univ., Ph.D. Member CAA; Mediaeval Acad. America; Royal Soc. Arts, London. Contributor: Art Bulletin, Canadian Art, Burlington Mag. Positions: Lecturer, FA, Carleton Col., Ottawa, 1951-1955; Research fellow, Dumbarton Oaks Research Library, Washington, 1956-1957; Cur., AG Tor, 1957-1959; Dir., Vancouver AG, 1959-1961; Research Asst. and Research Cur., 1950-1957, Asst. Dir., 1961-1966, Deputy Dir., 1966-1967, National Gallery of Canada; Chm., Dept. FA, University of Western Ontario, 1967- .

DALY, KATHLEEN (Mrs. George Pepper)—Painter, Gr., W.
 441 Walmer Rd., Toronto 10, Ont.
B. Napanee, Ont., May 28, 1898. Studied: OCA; Grande Chaumiere, and with Rene Pottier in Paris, France; Univ. Toronto. Member: RCA; OSA; Zonta Cl.; CGP; Heliconian Cl. Work: AG Tor.; Canadian Embassy, Copenhagen; Women's Union, Univ. of Toronto; Victoria Lib., Tor. Univ.; legislative bldg., Edmonton; London (Ont.) A. Mus. NGC; London Pub. Library & Mus.; Lord Beaverbrook A. Gal.; Dept. Northern Affairs, Ottawa; Banff Sch. FA; Banff Library, Archives of the Canadian Rockies. Exhibited: OSA from 1926; RCA 1928-1961; Buenos Aires 1930; CGP 1932-1961; S. Dominions 1936; Coronation 1937; Tate 1938; WFNY 1939; Rio 1944, CSGA; CSPEE; CNE; AA Mtl.; Vancouver AG; Pratt Lib., Baltimore, Md.; Hart House, Univ. Tor.; Banff Sch. FA, 1958; Lets., Eskimo portraits, A. & Lets. Cl., Toronto, 1961 (one-man). Illus. "Kingdom of Saguenay," by M. Barbeau. Contributor articles to Globe & Mail magazine.

DAOUST, SYLVIA—Sculptor
 2105 Bord du Lac, Dorval, P.Q.
B. Mtl., May 24, 1902. Studied: Beaux-Arts, Mtl. Member: Royal Canadian Acad. A.; SSC. Honours: 1st prize (exaequo) Willingdon Arts Competion 1929; Prov. of Quebec scholarship to Europe 1929; RCA, 1951; Canadian Govt. scholarship, France, 1955-56; medal, Royal Arch. Inst. of Canada, 1961. Work: MPQ; Collège St.-Laurent; Mtl., Monastère St. Benoît-du-lac; Univ. Mtl.; port. busts, monuments, in several chapels and churces, Mtl.; mon., "Frère Marie-Victorin," Botanical Gardens, Mtl. Commissions: Int. Bus. Machines; Portraits for Can. Bar Assn.; and Gov't Quebec. Exhibited: NGC; MPQ; AG Tor.; AA Mtl.; RCA since 1930; Tate 1938; Rio 1946; Albany 1946; N.Y. 1946; Expo. Religious Art, Rome, 1950. Position: Instr., Ecole des Beaux-Arts, Mtl.*

deGARTHE, WILLIAM E. Painter, S.
 Peggy's Cove, Halifax County, N.S.
Studied: Mount Allison Univ.; Montreal Mus. FA; in Rockport and Gloucester, Mass.; in Rome, Paris & New York. Member: Nova Scotia Mus. FA; Maritime AA; Nove Scotia Soc. A.; Moncton A. Soc.; F.I.A.L.; Montreal Indp. AA.; Am. A. Prof. Lg.; Longboat A. Center, Fla. Work: Nova Scotia Mus. FA; Barbados Mus., Bridgetown, B.W.I. Exhibited: Canadian traveling exhs.; Hamilton; Maritime AA; Nova Scotia Soc. A.; Royal Soc. of Marine Painters, London, England. One-man: Halifax, N.S.; Moncton, N.B.; Fredericton, N.B.; Barbados, B.W.I. (3 one-man); Montreal, 1960; Toronto, 1964; Longboat Key Art Center, Fla., 1965, all one-man exhs. Author, I., "This Is Peggy's Cove," 1956.

del JUNCO, EMILIO—Collector, Patron, Architect, Art Dealer
 Morris International Gallery, 130 Bloor St., W.; h. 196
 Roxborough Drive, Toronto 5, Ont.
B. Havana, Cuba, July 29, 1915. Studied: School of Architecture, Univ. Havana; Kungliga Konstakademi, Stockholm, Sweden; Private studies with Dean J.L. Sert, Harvard University. Specialty of Gallery: Contemporary art. Collection: Contemporary art. Positions: Lecturer and critic, Sch. Architecture, Univ. Toronto, 1961-1964; Promotion and organization of exhibitions in Cuba, Sweden, U.S. and Canada; Donor of paintings to MModA, Guggenheim Mus., AG Tor, 1947-1965.*

de PEDERY-HUNT, DORA—Sculptor, Des.
 88 Walker Ave., Toronto 7, Ont.
B. Budapest, Hungary, Nov. 16, 1913. Studied: Royal Sch. Appl. A., Budapest, M.A. Member: ARCA; SSC, (Past Pres.); OSA. Honours: Canada Council Award, 1958; OSA, sculpture award, 1963; Nat. Council of Jewish Women, 1966; Uno-a-Erre, Arezzo, Italy, purchase, 1964-1966; Can. Government's Centennial medal, 1967. Work: NGC; A. Gal., Toronto; A. Gal. of Ont.; Dept. External Affairs, Ottawa; Mus. of Contemp. Crafts, Charlottetown; figures, medals, ports., drawings, arch. sculpture, Liturgical Art: Cabinet of Medals, The Hague; Cabinet of Medals, Brussels. Exhibited: All major group shows in Canada. Biennial of Christian A., Salzburg, 1964; Internat. Exh. of Contemp. medals, The Hague, and Rome, 1963, Athens, 1966, Paris, 1967, Prague, 1969; Can. Religious Art Today, Regis Col., Toronto, 1963, 1966; Can. Pavillion, Expo'67. One-man: Laing Gal., Toronto, 1959-1967; Robertson Gals., Ottawa, 1962; Dorothy Cameron Gal., Toronto, 1965; A. Gal., Memorial Univ., St. John's, 1966; Douglas Gal., Vancouver, 1966; Wells Gal.,

Ottawa, 1967; Erindale Col., 1968; The Art Lenders, Montreal, 1968. Positions: Can. Rep. of the Federation Internationale de la Medaille, Paris.

DE TONNANCOUR, JACQUES G. —Painter, T.
 211 Walnut Ave., St. Lambert, P.Q.
B. Mtl., Jan. 3, 1917. Studied: Collège Brébeuf; Beaux-Arts Mtl.; AA Mtl. under G. Roberts. Honours: Brazilian govt. scholarship to Rio de Janeiro 1945-1946; 2nd Prize, Quebec Annual Art Competition, 1964. Canada Council Fellowship, 1958, medal, 1968. Work: NGC; AG Tor.; murals, Dow Planetarium, Mtl., 1967; Université de Montreal, 1968. Exhibited: Addison Gal. 1942; Yale 1944; Rio 1944, '46; DPC 1945; UNESCO; one-man (15), Mtl.; Retrospective Exh., Vancouver A. Gal., 1966; Musée d'Art Contemporain, 1967. Lectures: Can. art. Author: "Roberts." Positions: Instr. Beaux-Arts, Mtl.

DEUTSCH, PETER ANDREW —Painter
 20 Skipton Court, Downsview, Toronto, Ont.
B. Trnava, Czechoslovakia, July 31, 1926. Studied: Univ. St. Andrew's, Scotland, B.Sc. Work: NGC; A. Inst. of Ontario; Laurentian Univ., Sudbury, Ont.; A. Gal., Mount Allison Univ., Sackville, N.B.; Rothmans A. Gal., Stratford, Ont. Exhibited: Univ. Waterloo, Ont., 1965; Gal. Moos, Toronto, 1965; Canadian Biennial, 1965-1966; Laurentian Univ., 1965; Univ. Toronto, 1966; Scarborough Col., 1966; A. Gal., Hamilton, 1966; Winnipeh Biennial, 1966, 1968; OSA, 1967; Ontario Centennial, 1967; RCA, 1967, 1968; Galerie du Siecle, Mtl., 1968; A. Gal. Queens Univ., Kingston, 1968; one-man: Ruth Sherman Gal., N.Y., 1964, 1965; Southampton East, N.Y., 1966; Gal. Moos, Toronto, 1965, 1968.

DINGLE, ADRIAN —Painter
 830 Upper Middle Rd., Mississauga, Ont.
B. Barmouth, Wales, Feb. 4, 1911. Studied: Goldsmiths' Col. Sch., London, and with J. W. Beatty. Member: OSA (Pres. 1967-1970); RCA; A. & Let. Cl., Toronto; F.I.A.L. Work: AG London (Ont.); Huron Col.; Univ. Cl., Toronto; NGC; Ontario Cl., Toronto; Dominion Steel, Hamilton, Ont.; Royal Bank of Canada. Exhibited: RCA, 1934-1968; OSA, 1934-1968; London (England) Port Soc., 1936; Sydney, Australia, 1955; Nat. Gal. New South Wales. Illus., covers, MacLean's magazine; Mtl. Standard. Positions: Instr., Doon Sch. FA, summer, 1952-54; Book illus., Macmillan and Ryerson Publs., fictional and educational; Instr., Schneider Sch. FA, Actinolite, Ont., 1963-1964.

DRUMMOND, ARTHUR A.—Painter, I.
 Orono, Ont.
B. Toronto, Ont., May 28, 1891. Studied: Ontario Col. Art; Privately under W.M. Cutts, J.W. Beatty, C.M. Manley, and others. Member: Amer. Watercolor Soc.; Formerly founder member CSGA. Work: In public and private collections in Canada and the U.S., also in England, Norway, Japan, Australia, Turkey, South Africa, Portuguese West Africa, Bermuda, and elsewhere. Exhibited: RCA; Ont. Soc. Artists; Can. Nat. Exh.; Amer. Watercolor Soc.; Mtl. A. Assn.; and others. Position: Illustrator, Canadian Home Journal.

EMERY, CHARLES ANTHONY—Museum Director, E., W., L., C.
 The Vancouver Art Gallery, Vancouver, B.C.
B. Farnborough, England, April 30, 1919. Studied: Pembroke College, Oxford. Contributor of articles and reviews to Art International, Studio, arts/canada, and other art, architectural and literary periodicals in America and Europe. Broadcaster, lecturer and critic. Positions: Formerly Professor of Art History, University of Victoria, B.C. Arts Advisory Panel, Canada Council; Canadian Committee, ICOM; Canadian Art Museum Directors Organization; Director, The Vancouver Art Gallery 1967 to present.

ETROG, SOREL—Sculptor, P., Pr. M.
 229 Yonge St.; h. 155 Balliol St., P.H. 2, Toronto, Ont.
B. Jassy, Roumania, Aug. 29, 1933. Studied: Inst. Painting & Sculpture, Tel-Aviv; BM Sch. A. Work: AG Tor.; Mtl. Mus. FA; Musee d'Art Contemporain, Mtl.; NGC; Boymans Mus., Rotterdam, Holland; Kroeller-Meuller Mus., Otterlo, Holland; Museo d'Arte Moderna, Legnano, Italy; Museo Internazaionale d'Arte Contemporanea, Florence, Italy; MModA; Guggenheim Mus., N.Y.; FMA; Smith Col. Mus.; Los Angeles County Mus.; Univ. Notre Dame; Tel-Aviv Mus., Israel; Univ. Cal. at Los Angeles A. Gal.; Musee d'art Moderne, Paris; AIC; Israel Mus., Jerusalem; Mus. Mod. A., Haifa, Israel; Kuntsmuseum, Basel, Switzerland, and many others, U.S. and Canada. Exhibited: Mus. Tel-Aviv, 1957; Ten Years of Israel Artm Jerusalem, Tel-Aviv and Haifa, 1958; Mus. Mod. A. Haifa, 1958; AG Tor., 1960; CNE, Tor., 1960; Guggenheim Mus., N.Y., 1962; Art In Canada Exh., Bordeaux, France, 1962; Fifteen Canadian Artists, traveling, U.S., 1963-1965; Carnegie Int., 1964, 1967; Denver Mus. A., 1965; DMFA, 1965; Venice Biennial, 1966; Legnano, Italy, 1966; Expo '67; Retrospective (1958-1968), Palazzo Strozzi, Florence, Italy, 1968; travel-

ing exh., Ontario Colleges organized by AG Tor., 1968-1969; one-man: Tel-Aviv, 1958; Gallery Moos, Tor., 1959, 1961, 1963, 1964, 1967; Dominion Gal., Mtl., 1963; Rose Fried Gal., N.Y., 1963, 1968; Pierre Matisse Gal., N.Y., 1965; Hudson Gal., Detroit, 1965; Felix Landau Gal., Los Angeles, 1965; Galerie Dresdnere, Mtl., 1965; Benjamin Gal., Chicago, 1966; Galeria Pagani, Milan, 1966; Galerie Springer, Berlin, 1967; Dartmouth Col., Hanover, N.H., 1967; Dominion Gal., 1967; Georges Moos, Geneva, 1968; Staempfli Gal., N.Y., 1968, and others.

EVELEIGH, HENRY—Painter, Des., E.
1239 Green St., Montreal, P.Q.
B. Shanghai, July 26, 1909. Studied: Slade Sch., London, Member: Contemp. A.Soc., Mtl. Honours: prizes. Slade Sch., 1933, 1934; Can. A. Dir. Cl.; UN Poster Comp., 1947. Work: AA Mtl. Exhibited: New English Contemp. A. Soc., London Group; Addison 1942; Yale 1944; DPC 1945; Rio 1944, 1946; Albany 1946; one-man: numerous one-man exhs., Mtl., 1944-51. Positions: Prof., Ecole des Beaux-Arts, Montreal, P.Q., 1947- .*

FARLEY, LILIAS MARIANNE—Painter, S., T., Des.
1109 Fifth Ave., Whitehorse, Yukon Terr., Canada
B. Ottawa, Ont., May 2, 1907. Studied: Vancouver A. Sch.; Univ. British Columbia. Member: Northwest Inst. Sculpture; British Columbia Soc. A.; Sculptors Soc. of Canada; FIAL (Life). Honours: prizes, IBM (purchase); Vancouver A. Gal. Work: IBM; and in private colls. Murals, Hotel Vancouver (B.C.); Federal Bldg., White Horse; color plates for Dept. Indian Affairs, Ottawa; bronze details, Hotel Vancouver; Post-office, Vancouver, B.C. Exhibited: RCA, 1937, 1938, 1940; Sc. Soc. of Canada, 1942-1958; Northwest Inst. Sc., 1956-1958; British Columbia Soc. A., annually; Vancouver A. Gal., 1958; one-man: Vancouver A. Gal., 1945; Univ. British Columbia, 1958. Positions: Instr., A., Whitehorse Secondary Sch.*

FENWICK, KATHLEEN M.—Museum Curator, Ed.
35 Cooper St., Ottawa, Ont.
B. London, England, June 17, 1901. Studied: Oxford Univ.; Julian Acad., Grande Chaumiere, Paris; Goldsmiths' Col., Univ. London; Victoria & Albert Mus.; British Mus. Honours: Hon. LL.D., Univ. Toronto, 1966; Service Medal, 1968 Order of Canada; Centennial Medal, 1967. Work: NGC. Contributor to many NGC publications. Organized numerous exhibitions for NGC. Lectures on prints and drawings. Author: (with A.E. Popham), "European Drawings in the Collection of the National Gallery of Canada," 1965. Positions: Asst. Ed., Canadian Art, 1943-59; Adviser, Canadian Delegation UNESCO, First A., General Conference, Paris, 1946; Chm., Arts & Experimental Category, Canadian Film Awards, 1959-1963; Cur., Emeritus, Prints and Drawings, National Gallery of Canada, Ottawa, Ont.; Member, Foreign Advisory Council, Mus. Gr. A., N.Y., 1965; Member, Canadian Eskimo Arts Council, 1968- ; Director, "Man and His World," International Fine Arts Exhibition, Expo '67, Montreal.

FILIPOVIC, AUGUSTIN—Sculptor, P., T., L., Cr.
585 Markham St., Toronto, Ont.
B. Davor Croatia, Yugoslavia, Jan. 8, 1931. Studied: Artistical Lyceum, Acad. FA, both Zagreb; Acad. FA, Rome, Italy. Member: OSA; Sc. Soc. of Canada. Awards: Prize of Rome, 1958; La Mostra d'Arte, Lazio, 1952. Work: Palazzo Braschi, Galleria di Arte Moderne, Rome; A. Gal. Toronto; sc. mural, Colonial Tower, Toronto; Fort William, Ont. Library; Croatian Church, Toronto. Exhibited: La Mostra d'Arte of Lazio, Rome, 1952, 1955; Intl. Gal., Rome, 1956; Via Margutta, Rome, 1957, 1958; Stockholm, 1958; Gallery Moos, Toronto, 1960, 1961, 1965; A. Gal., Hamilton; La Forte Galleria, Mtl., 1965; one-man: Palazzo delle Esposizione, Rome, 1954; Palazzo Marignoli, Rome, 1956; San Sebastianello, 1959. Contributor to Canadian Art magazine. Lectures, History of Contemporary Art; Modern Sculpture, Drawing & Painting. Positions: Instr., Central Tech. Sch., Toronto; Guest lecturer, Univ. Toronto.*

FOX, CHARLES HAROLD—Craftsman
18 Caldwell Ave., Kentville, N.S.
B. Clarks Harbour, N.S., Jan. 15, 1905. Honours: prizes, Canadian Nat. Exh., Toronto, 1951, 1953, 1955; Nat. Exh., St. John, N.B., 1957; Montreal, 1961. Work: Commissioned by Gov. of Nova Scotia to execute jewelry as a gift to Princess Elizabeth and the Duke of Edinburgh, 1951. Exhibited: Jewelry exhibited: Crafts Exh., NGC, 1957; Brussels World's Fair, 1958; Expo '67; International Exh., by Dept. of External Affairs, Ottawa, 1966, 1968.

FOX, WINIFRED GRACE—Craftsman, P., I., Des.
18 Caldwell Ave., Kentville, N.S.
B. Avondale, N.S., Nov. 26, 1909. Studied: Mount Allison Univ., Sch. FA, ASL, with George Bridgman. Member: Nova Scotia Soc. A. Honours: prizes, Canadian Nat. Exh., Toronto, 1951, 1953, 1955; Nat.

Exh., St. John, N.B., 1957; Montreal, 1961; purchase award and the painting presented to Province of New Brunswick; Work: des. and executed gift of jewelry for Princess Elizabeth and the Duke of Edinburgh as gift of the Province of Nova Scotia, 1951; St. John (N.B.) Mus.; Centennial permanent Coll., Nova Scotia. Exhibited: Montreal AA; New Brunswick, 1957; Nova Scotia Soc. A., annually; Maritime and Nova Scotia traveling exhs.; Jewelry exhibited: NGC, 1957; Brussel's World's Fair, 1958; Expo '67; International Exh., by Dept. of External Affairs, Ottawa, 1966, 1968. One-man: Zwickers A. Gal., Halifax, N.S.; Acadia Univ., Wolfville, N.S.; Atlantic A. Gal., Halifax. Illus. "We Keep a Light"; "The Flowing Summer." Positions: Des., Dept. Handcrafts, Nova Scotia Provincial Government, 1945-1960.

FRANCIS, HAROLD CARLETON—Painter, Eng., Comm.
548 Kininvie Drive, London, Ont.
B. Culloden, Ont., Feb. 19, 1919. Studied: ASL, with Robert Brackman. Member: CSPEE; F.I.A.L. Exhibited: CSPEE, 1949-1961; CSGA, 1943, 1944, 1953; Canadian Nat. Exh., 1957; Hamilton A. Gal., 1954, 1960; Western Ontario Exh., 1942-1965. Contributor articles and illus. to Canadian Forum.

FRANCK, ALBERT JACQUES—Painter, Rest.
90 Hazelton Ave., Toronto 5, Ont.
B. Middleburg, Holland, Apr. 2, 1899. Member: OSA; CSPWC. Awards: purchase awards, Canadian Council; Univ. Western Ontario. Exhibited: RCA; OSA; CSPWC; CSGA, all annually.*

FREIFIELD, ERIC—Painter, E., L.
Ontario College of Art; h. 48 Eccleston Drive, Toronto 16, Ont.
B. Saratov, Russia, Mar. 13, 1919. Studied: St. Martin's Sch., London, England; ASL, with Robert Beverly Hale. Member: CSPWC; CSGA (Past Pres.); A. & Lets. Cl., Toronto; RCA. Awards: prizes, Alberta Soc. A., 1937; CSGA, 1957; Carnegie Trust Fund Scholarship, Edmonton, 1937; Queens Univ., Traveling Fellowship, 1941; Canada Council Senior Arts Fellowship, 1961, Toronto. Work: Univ. Alberta; A. Gal. of Vancouver; Hart House, Univ. Toronto; St. Michael's Col., Univ. Toronto; and in many private colls. Exhibited: New English A. Cl., London, England, 1938; Kingston, 1941; CSPWC, 1947, 1948, 1950, 1953, 1957-1960; CSGA, 1954-1959; Royal Canadian Acad., 1952, 1958, 1960; A. Gal., Toronto, 1950; Brooklyn Mus., New York, 1959; one-man: Brook St. Gal., London, England, 1939; Vancouver A. Gal., 1940; Vancouver Sch. A., 1941; Ontario College of Art, 1947; Mus. FA, Edmonton, 1952; Hart House A. Gal., Univ. Toronto, 1958; Rodman Hall, St. Catharines, 1966; A. & Lets. Cl., Toronto, 1966; Edmonton A. Gal., 1967; Brantford A. Gal., 1967; A. Gal. of Vancouver, 1968; Univ. of Manitoba, Winnipeg, 1969; Saskatoon A. Gal., 1969; A. Gal. of Hamilton, 1969. Lectures: Artistic Anatomy; Contemp. Am. Painting, in art colleges and associations. Positions: Prof. A., Instr., Figure drawing, Anatomy, Watercolor Painting, Ontario College of Art, Toronto, Ont. Pres., Canadian Soc. Graphic A., 1958-59.

GAGE, FRANCES M.—Portrait Sculptor
60 Birch Ave., Toronto 7, Ont.
B. Windsor, Ont., Aug. 22, 1924. Studied: Ontario Col. A.; ASL; New York; Ecole des Beaux-Arts, Paris, France. Member: Sculptors Soc. of Canada. Awards: Royal Soc. of Canada Scholarship to France; numerous art school prizes. Work: Crest, Ontario Hydro. Seaway, Cornwall; Metro Road Bridges; fountain head, Cancer Hostel, Toronto; fountain, Albright Gardens, London, Ont.; figure & reliefs, Prov. Inst. of Trades Bldg., London, Ont.; Kitchener-Waterloo AG; Rothmans of Canada; Univ. Western Ont. Medical Sch.; Medical Sciences Bldg., Toronto; Univ. Guelph; bronze, Prince Arthur, Toronto; many portraits. Exhibited: Royal Canadian Acad.; Sculptors Soc. of Canada, 1956, 1958, 1960, 1961; Ontario Soc. A., 1951, 1953, 1954, 1957, 1958, 1960, 1961.

GAUTHIER, JOACHIM GEORGE—Painter
184 Ranleigh Ave., Toronto 12, Ont.
B. North Bay, Ont., Aug. 20, 1897. Self-taught; later studied under Frank Carmichael, Tor. Member: CSPWC; OSA; ARCA. Work: In private collections.*

GILLING, LUCILLE—Printmaker
178 Alfred Ave., Willowdale, Ont.
B. Hamilton, Mo., Sept. 28, 1905. Studied: Kansas City AI; N.Y. Sch. F. & Appl. A.; Queens Univ., Kingston, Ont.; and in Europe. Member: CPE. Awards: Sterling Trust Award, CPE exh., 1960; Anaconda Award for Merit, 1968. Work: The Nat. Lib. of Canada; Ministere des Affaires Culturelles du Quebec; Montreal Mus. of FA; Toronto Central Lib.; McGill Univ.; Sir George Williams Univ.; Univ. of Western Ontario; Univ. of St. Michael's Col.; Scarborough Pub. Lib.; Univ. of Windsor; Windsor Pub. Lib.; Anaconda American Brass; Ohio State Univ.; Victoria and Albert Mus.; London; in U.S.A.: Buffalo and Erie County Lib.; Wayne State Univ.; Northern Illinois

Univ.; Univ. of Texas, Phoenix Pub. Lib. Exhibited: CPE, 1956-1969; CSGA, 1958, 1959, 1961, 1964; Canadian Nat. Exh., 1957-1969; Rodman Hall, St. Catherines, Ont., 1964. One-man: Symbol Gal., Albuquerque, New Mexico, 1968; Pascall Gal., Toronto, 1966; Dorothy Butchart Gal., Leith, Ont., 1966; Sabot Gal., 1969; two and three-man: Sonneck Gal., Kitchener, Ont., 1967. Published two portfolios of etchings based on "Canterbury Tales," and "Don Quixote," 1968.

GLYDE, HENRY GEORGE—Painter, E.
R.R.1, Port Washington, B.C.
B. Luton, England, June 18, 1906. Studied: Hastings Sch. of A. and Science; R. Col. A., London. Honours: RCA. London, England; Senior Fellowship, Canada Arts Council, 1958-1959. Member: Canadian Soc. Gr. A. Work: AG Tor.; Edmonton AG; NGC. Exhibited: R. Brit. Artists, London; RA, London RCA; OSA; CSGA, etc. Teaching: Instr. Borough Polytechnic, London; Croydon Sch. of A.; High Wycombe Sch. of A.; head of art dept., Prov. Inst. of Technology and A., Alta. Positions: Prof. FA, Emeritus, Univ. Alberta, and Banff Sch. FA.

GOETZ, PETER—Painter, T.
University of Waterloo; 784 Avondale Ave., Kitchener, Ont.
B. Siberia, Russia, Sept. 8, 1917. Studied: Waterloo Col.; Doon Sch. FA with F. H. Varley. Member: CSPWC; OSA; Western A. Lg.; F.I.A.L.; OSA. Honours: Western Fair, 1963-1964; Quebec Nat. Exh., 1964. Work: in various public bldgs. Exhibited: CSPWC; RCA; OSA; Montreal Mus. FA; A. Gal. Hamilton; Winnipeg Exh.; NG traveling exh.; Quebec Nat. Exh.; CNE; Western A. Lg.; Western Fair; Victoria and Vancouver, B.C.; Halifax; one-man: Doon Sch. FA, 1956-1965. Positions: Instr. FA, Preston High-Western Ont. Adult Education Groups.

GOLDHAMER, CHARLES—Painter, T., Lith.
1 Brule Gardens, Toronto 3, Ont.
B. Philadelphia, Pa., Aug. 21, 1903. Studied: OCA. Member: CSPWC (Past Pres.); OSA; CSGA; CSPEE; A. & Letters Cl., Tor. Honours: Adamson prize for life drawing, OCA. Work: AG Tor.; Hart House, Univ. Tor.; War Records NGC. Commissions: official war artist with RCAF 1943-6. Exhibited: RCA 1928-39; OSA 1930-9; CSGA 1928-39; CSPWC 1930-9; S. Dominions 1936; Coronation 1937; Tate 1938; Gloucester 1939; WFNY 1939; War Art 1946 NGC. Author: "Lithographs of Ontario" portfolio. Contributor: Canadian Art. Lectures: Lithography. Positions: Dir. A., Central Tech. Sch., Tor. since 1928.

GRANDMAISON, NICKOLA DE—Painter
125 Cave Ave., Banff, Alta.
B. Russia, Feb. 24, 1892. Studied: St. John's Wood Sch. of A., London. Honours: ARCA; medal, Int. Bus. Machines exh., NY 1939. Work: portraits, Manitoba Law Soc. Exhibited: RCA 1943; Los A. Mus. A., 1959; Orange County, Cal., 1959; Acad. Science, San F., 1960; Eaton's College Street Exh., Toronto, 1960; Great Falls, Mont., 1961. Indian portraits on permanent exhibition at: Woolaroc Mus. A., Bartlesville, Oklahoma; Nat. Mus. of Canada, Ottawa; Glenbow Fnd. of Calgary, Alta.

GRIFFITH, JULIUS—Painter, Gr.
102 Hillsdale Ave., West, Toronto 7, Ont.
B. Vancouver, B.C., Apr. 21, 1912. Studied: Vancouver Sch. A., with MacDonald, Varley; Central Sch. A. & Crafts, London, England, with Noel Rooke, John Farleigh. Member: CSGA; CSPWC (Sec.). Honour: Prize for best watercolour, St. Catharine's, Ont., 1962; Centennial Medal, 1967. Work: British War Artists Coll.; AG Hamilton; Carleton Col., Ottawa; A. Gal., Toronto; Nat. Gal. of Canada. Exhibited: 1st Biennial Print Show, Tokyo, 1957; Brooklyn Mus., N.Y., 1960; one-man: Picture Loan Soc., Toronto, 1954, 1956, 1958; Illus., "River For My Sidewalk," 1953.

GROVES, NAOMI JACKSON (Mrs.)—Writer, L., P.
2896 Highfield Crescent, Ottawa 14, Ont.
B. Montreal, Canada. Studied: Rannows A. Sch., Copenhagen; Sir George Williams Col.; McGill Univ., B.A., M.A.; Heidelberg, Berlin and Munich Univs.; Radcliffe Col., A.M., Ph.D. Member: Ernst Barlach Gesellschaft; Harvard Visiting Com. for FA. Honours: Gov. General's gold medal, McGill Univ., 1933; traveling F., Canadian Fed. of Univ. Women, 1936-37. Exhibited: one-man: Radcliffe Col., 1939; Wheaton Col., 1942; McMaster Univ., 1953; Mtl. Mus. FA. Contributor articles and illus. to: FMA Bulletin; Geographic Quarterly; Canadian Art; Art News and others. Lectures: "Ernst Barlach as Sculptor, as Dramatist"; "Barlach in America," 1964; "The Group of Seven, Another Look," 1969, at the Nat. Gal. of Canada. Author: "The Transformations of God," Hamburg 1962; "A.Y.'s Canada," Toronto, 1968. Positions: L., McGill Univ., 1933-36, Wheaton Col., 1940-42, Carleton Col., 1943-45; Asst. to Dir., NGC, 1942-43; Assoc. Prof. in charge of FA, McMaster Univ., 1951-58; Consultant, NGC, 1963-1964.

GUITÉ, SUZANNE—Sculptor, T.
Perce Art Center, Perce, Que.
B. Perce, Que., Dec. 10, 1926. Studied: Inst. Design, Chicago, with Moholy Nagy, Archipenko, Brancusi; Belle Arte, Firenze, Italy. Member: Sculptors Soc. of Canada. Awards: prize, Quebec Provincial Exh., 1954. Work: Quebec Provincial Mus. Exhibited: Montreal Spring Exh., 1961; Quebec Outdoor Show, 1960. Positions: Fndr., Dir. classes, Perce Art Center, Perce, Que., 1955- .

HAGAN, (ROBERT) FREDERICK—Printmaker, E., P.
53 Lundys Lane, Newmarket, Ont.
B. Tor., May 21, 1918. Studied: OCA; ASL; & with George Miller, N.Y. Member: CSGA; CSPEE; OSA. Exhibited: RCA; OSA; CSPWC; CGP; LC; CM; NGC. Work: Mural, Oakville Centennial Library. Teaching: Res. Artist, Pickering College, Newmarket, Ont., 1942-6. Positions: Instr., Drawing & Printmaking, OCA, Toronto, Ont., 1946- .

HALL, JOHN A.—Painter, E., Eng., I., Des.
10 Kilbarry Rd.; University of Toronto, Toronto, Ont.
B. Toronto, Ont., Oct. 10, 1914. Studied: Ontario Col. A. Member: CSGA; OSA. Honour: CAC Senior Artists' Award, 1963. Work: AG Tor.; murals in porcelain enamel on steel panels; Delhi, Port Colborne, and Simcoe, Ont.; Expo '67, Montreal. Exhibited: CGP; CSPWC; OSA; RCA; CSGA; WFNY 1939; Yale Univ., 1944; Rio, 1944, '46. Illustrated: "Spirit of Canadian Democracy," 1945; "These English"; "The Grandmothers"; "Glooscap's Country"; "Nunny-Bay 3"; "The Road Across Canada." Positions: Assoc. Prof. in Visual Communications, Dept. of Architecture, Univ. Toronto. Exhibition Design: Canadian Nat. Exh.; Canadian Furniture Mart.; Canadian Pavilion, Brussels; private practice. Instr., AG Tor.; Instr., Painting, Teachers' Summer Courses in Art, Ontario Dept. Education.

HANES, URSULA ANN—Sculptor
39 Roxborough St., West, Toronto 5, Ont.
B. Toronto, Ont., Jan. 18, 1932. Studied: Cambridge Sch. A., England; ASL; Columbia Univ.; Univ. Toronto, and in Italy and England. Member: OSA; Royal Canadian Acad. A.; Sculptors Soc. of Canada (Pres., 1964-1966). Honour: prize, New England Soc. A., 1953. Work: port bust, Stratford Shakespearian Festival Theatre, Ontario; fountains, Sheridan Nurseries, Toronto; Clarke Irwin Publ. Co., Toronto; Welland, Ont.; Toronto, Ont.; exterior wall, Welland County Hospital, Ont.; Bas-relief murals, lobby, Temple Sinai, Toronto; Cedarbrook Sch., Toronto. Exhibited: Royal Canadian Acad. A., 1955, 1957, 1958, 1959-1964; Canadian Nat. Exh., 1955, 1957, 1958; Sc. Soc. of Canada, 1955, 1958, 1965; New England Soc. A., 1953; Stratford Festival Exh., 1955, 1957, 1964; Young Canadian Contemporaries, 1957; Ontario Soc. A., 1954, 1955, 1957-1964.

HANSON, JEAN—Painter, Des., Gr.
1193 Sarta Road, Oakville, Ont.
B. Toronto, Ont., Sept. 27, 1933. Studied: Ontario Col. A. Member: OSA; CSPWC. Exhibited: CSPWC, 1955-1968; AG Hamilton, 1955-1963; Chapellier Gal., N.Y., 1953; Smithsonian Inst., 1956, 1962-1963; NGC traveling exh., 1955; Montreal Mus. FA, 1956; Western Exh., London, Ont., 1956-1958; Canadian Nat. Exh., 1956; Monsanto Canadian A. Comp., 1957; OSA, 1957; Royal Ontario Mus., 1958; CSPWC traveling exhs., 1959, 1960; Boutique Gal., Stratford, Ont., 1960; Toronto Outdoor Exh., 1961; Oakville Women's Cl., 1961; Winnipeg, Man., 1961; A. Gal., Toronto, 1961; OSA, 1957, 1963-1967; Willistead AG, Windsor, Ont., 1961; Winnipeg Biennial, Winnipeg AG, 1962; RCA, Toronto AG, 1963; CSPWC Group Show, Hart House, Univ. Tor., 1963; North Truro AG, Cape Cod, Mass., 1963; Hart House, Univ. Tor. Group Show, 1964; one-man: Upstairs Gal., Toronto, 1961.

HARLEY, HARRY GEORGE—Cartoonist
5 Grand Ave., Grimsby, Ont.
B. St. Catharines, Ont., Feb. 22, 1929. Studied: Ontario Col. A.; St. Catharines Collegiate Inst.; Univ. Toronto. Member: Magazine Cart. Gld. Contributor cartoons to: Medical Economics; Argosy; Wall Street Journal; King Features Syndicate (Laff-A-Day); Cavalier; Medical Tribune; Modern Medicine; Look, Better Homes & Gardens, Financial Post, Parade; Design Engineering; Canadian Machinery; Purchasing Week; Modern Purchasing, Modern Power and Engineering, Medical Post, and other publications.

HARRIS, LAWREN—Painter
4760 Belmont Ave., Vancouver 8, B.C.
B. Brantford, Ont., Oct. 23, 1885. Studied: Univ. Tor. & in Germany & France. Member: Group of Seven; CGP; FCA. Honours: Pres. FCA 1945; LL.D., Univ. B.C.; LL.D., Univ. Toronto, 1951; LL.D., Univ. Man.; Medal Award, CAC, 1962. Work: NGC; AA Mtl.; AG Tor.; Detroit Inst. of A.; Williams AG, London, Ont. Exhibited: all important Can. Exh.; Wembley 1925; Paris 1927; Group of Seven

1936; S. Dominions 1936; Coronation 1937; West Coast Exh. NGC 1937; Tate 1938; WFNY 1939; Addison 1942; Rio 1944; Yale 1944; DPC 1945; Albany 1946; one-man: Retrospective, NGC, Ottawa, and Vancouver, B.C., 1963. Contributor: Canadian Art; Can. Review of Music and Art. Lectures: Democracy and Art; Abstract Painting. Positions: Trustee, NGC, 1948-1963.

HARRIS, LAWREN PHILLIPS—Painter, T.
Mount Allison University, Sackville, N.B.
B. Toronto, Oct. 10, 1910. Studied: BMFA and with his father, Lawren S. Harris, Toronto. Member: OSA; CGP; RCA. Honour: Canadian Govt. Overseas F., 1957-58; Hon. Fellow, Nova Scotia Col. of A. Work: War Records, NGC. Commissions: official war artist with Can. Army 1943-6; Prize, Atlantic Awards Exh., 1967. Exhibited: S. Dominions 1936; OSA from 1936; RCA from 1938; CGP from 1938; Great Lakes Exh., Buffalo 1938-9; WFNY 1939; CSGA 1939-41; War Art 1945, '46 NGC; Teaching: Instr. N. Vocational Sch., Tor., 1938-40; Trinity College Sch., Port Hope, Ont., 1940-1. Positions: Head, Dept. FA, Mount Allison Univ., Sackville, N.B.

HEBERT, JULIEN—Sculptor, Des., E.
1651 Sherbrooke St., West; 4211 Westhill Ave., Montreal, P.Q.
B. Rigaud, Can., Aug. 19, 1917. Studied: Ecole des Beaux-Arts, Mtl.; Univ. Montreal; and with Zadkine, Paris, France. Member: Assn. Canadian Indst. Des.; Interior Dec. Soc. of Quebec; Sculptors Soc. of Canada. Honours: Des. awards, Nat. Indst. Des. Council and others, 1953-1958. Exhibited: Milan Triennale, 1954, Intl. and Canadian Section; Design exhs., Canada and abroad. Teaching: Hist A., Ecole des Beaux-Arts, Mtl.; furniture des., Inst. of Appl. A., Mtl.*

HELLER, JULES—Educator, W., Gr.
York University, Downsview, Toronto, Ont.; h. 64 Admiral Rd., Toronto 5, Ont.
B. New York, N.Y., Nov. 16, 1919. Studied: Arizona State Univ., B.A.; Columbia Univ., M.A.; Univ. Southern California, Ph.D. Exhibited: in major group exhibitions since 1947. Lecturer and art juror. Author: "Problems in Art Judgment"; "Printmaking Today"; numerous articles published. Positions: Exec. Editor, Impression 1957-58; Hd., Dept. Fine Arts, Univ. Southern California, 1958-1961; Director, School of the Arts, The Pennsylvania State University, 1961-1963; Dean, College of Arts & Architecture, Pa. State Univ., 1963-1968; Dean, Faculty of Fine Arts, York Univ., Toronto, 1968- .

HERBERT, JOHN D.—Administrator
Canadian Museums Association, Royal Ontario Museum, Univ. of Toronto, 100 Queen's Park, Toronto 5, Ont., Canada*

HILTS, ALVIN—Sculptor
605 Oshawa Blvd. N., Oshawa, Ont.
B. Newmarket, Ont., Apr. 2, 1908. Studied: in Mexico; and with Frances Loring. Member: Sculptors Soc. Canada (Pres. 1956-1958). Work: War mem., Newmarket; churches in Timmins, Kirkland Lake, Newmarket; and in private colls. Exhibited: RCA, 1954-1956; Sculptors Soc., 1948, 1953, 1958; NGC; AG Toronto; Vancouver A. Gal.; AG Hamilton. Teaching: Sculpture, Pickering Col., Newmarket; Oshawa Collegiate & Vocational Sch.

HOLGATE, EDWIN HEADLEY—Painter
Morin Heights, P.Q.
B. Allandale, Ont., Aug. 19, 1892. Studied: AA Mtl.; Paris under Lucien Simon, & others. Member: Group of Seven 1931-3; CGP; FCA. Honours: RCA 1935. Commissions: murals, Château Laurier Hotel, Ottawa; official war artist, RCAF 1943-4. Work: NGC; MPQ; Sarnia AG; AA Mtl.; Le Havre, France. Exhibited: Wembley 1925; NGC West Coast Exh. 1927; Paris 1927; S. Dominions 1936; Group of Seven Exh. 1936; Coronation 1937; Tate 1938; WFNY 1939; Yale 1944; Rio 1944, '46; DPC 1945; NGC War Art 1945, '46; UNESCO 1946; CGP; RCA; one-man: AA Mtl. 1933; Scott Gal., Mtl. 1937; Dom. Gal., Mtl. 1946. Illustrator: "Other Days, Other Ways," etc. Teaching: Instr., AA, Mtl.; wood engraving, Ecole des Beaux-Arts, Montreal.*

HOLMES, REGINALD—Painter, Ser., Lith., T.
Vancouver Art School, 590 Hamilton St., Vancouver, B.C.; h. 570 15th St., West Vancouver, B.C.
B. Calgary, Alta., Oct. 4, 1934. Studied: Vancouver A. Sch., and with Jack Shadbolt. Member: Fed. Canadian A.; CPE; Western Pr. M. Honour: A.E. Grauer award, Vancouver, 1958. Exhibited: CPE, 1956-1958; Western Pr. M., 1957; Contemp. A., 1958, 1959, 1960; British Columbia A., 1956-1958; British Columbia Pr. M., 1956, 1957; British Columbia Centennial, 1958; Victoria A. Gal., 1958; Vancouver A. Gal., 1958; Bernaby, B.C.; British Columbia Soc. A., 1961; one-man: Hart House, Univ. Toronto, 1957; New Design Gal., 1961. Teaching: Painting, Graphic Arts, Vancouver (B.C.) Art School. Vice-Pres., Fed. Canadian Art, B.C.*

HOO, SING (Sing Hoo Yuen)—Sculptor, T.
139 Livingstone Ave., Toronto, Ont.
B. Canton, China, Feb. 2, 1909. Studied: OCA; Slade Sch., London. Member: OSA; RCA; R.C.A.; SSC; F.I.A.L. Commissions; exhibits of marine life of six geological periods, 1934-9. Exhibited: CNE 1932-40, 1956, 1957; OSA from 1932; RCA from 1938; sculptors Soc. 1957, 1958; Nat. Gal., Ottawa, 1960; A. Gal., Toronto, 1961. Lectures: Oriental and Occidental A.

HORNE, (ARTHUR EDWARD) CLEEVE—Painter, S.
181 Balmoral Ave., Toronto, Ont.
B. Jamaica, B.W.I., Jan. 9, 1912. Studied: in England with D. Dick; OCA; and in Europe. Member: RCA; A. & Let. Cl., Toronto; OSA; SSC. Honour: R.A.I.C. Allied Arts award, 1963. Work: Alexander Bell mem., Brantford, Ont.; war mem., Law Soc. of Upper Canada; NGC; Shakespeare Mem., Stratford, Ont.; work covers portrait painting, architectural sculpture, memorials, and art consultation related to architecture. Exhibited: NGC; RCA since 1928; OSA 1939; SSC since 1935. Positions: A. Consultant, Imperial Oil Bldg., Toronto; Canadian Imperial Bank of Commerce, 1961-63; Queen's Park Project, Ontario Government-1966-1969; A. Adv., Ontario Hydroelectric Power Comm.; St. Lawrence Seaway Power House Project, 1957-1958.

HORNYANSKY, NICHOLAS—Etcher, Des., T.
44 Westmoreland Ave., Toronto 4, Ont.
B. Budapest, Hungary, Apr. 11, 1896. Studied: Acad., Budapest; with Porcaboeuf, in Paris. Member: OSA; RCA; CSPEE; A. & Letters Cl., Empire Cl., Tor.; Am. Color Pr. Soc. Honours: G. A. Reid award, 1955; Sterling Trust Award purchase, 1960; Am. Color Pr. Soc., Phila., Pa., 1959. Work: NGC; Royal Ont. Mus., Tor.; Musee Plantain, Antwerp; Budapest Mus.; Mercier Mem. Hall, Malines, Belgium; Mus. New Mexico; Parliament, Budapest; LC; PMA. Exhibited: OSA 1933-1958; PAFA 1934; S. Dominions 1936; LC 1945-1954; RCA; CSPEE; WFNY 1939; Buenos Aires; Univ. Maine, 1952; Royal Etchers Soc., London, England; Tokyo; Osaka, Japan. Positions: Instr., Printmaking, Etching, OCA, Toronto, Ont. (retired).*

HUBBARD, ROBERT HAMILTON—Museum Curator, Historian, L.
National Gallery of Canada, Ottawa 4, Ont.
B. Hamilton, Ont., June 17, 1916. Studied: McMaster Univ., B.A.; Inst. d'art et d'archéologie, Paris; Musées Royaux, Brussels; Univ. Wisconsin, M.A., Ph.D.; LL.D., Mount Allison Univ., 1965. Member: CAA; AAM; Fellow, Royal Soc. of Canada. Contributor: Canadian Art; Art Quarterly; Architectural Review; Journal Royal Architectural Int. of Canada; Connoisseur; Everyman's Encyclopaedia, and other publications. Author: "European Paintings in Canadian Collections," 1956-1962 (2 vols.); and catalogues of NGC Collections: Vol. 1 (Older Schools), 1957; Vol. 2 (Modern European Schools), 1958; Vol. 3 (Canadian Schools), 1960; Anthology of Canadian Art, 1960; "The Development of Canadian Art," 1963; "Tom Thomson," 1962; "Rideau Hall," 1967; (Ed.) "Scholarship in Canada, Achievement and Outlook," 1968. Lectures: Canadian Art. Teaching: history of art, Univ. Toronto 1945-6; Carleton Univ., Ottawa 1944-52. Positions: Chief Cur., National Gallery of Canada.

HUGHES, EDWARD JOHN—Painter
Box 173, Shawnigan Lake, B.C.
B. North Vancouver, B.C., Feb. 17, 1913. Studied: Vancouver Sch. A. Honours: Vancouver Sch. A. scholarships; Emily Carr scholarship, 1947; Canada Council Fellowship, 1958, award, 1963, 1967; R.C.A., 1969. Work: NGC; AG Tor.; AG Vancouver; Dominion Gal., Mtl.; Hart House, Univ. Toronto; Brock Hall, Vancouver; Univ. New Brunswick; AG Victoria, and others.

HYDE, LAURENCE—Engraver, P., Comm., W.
1050 Graham Blvd., Montreal 304, P.Q.
B. London, England, June 6, 1914. Studied: Central Tech. Sch., Tor. Member: CSGA. Work: NGC; AG Vancouver; LC; AG Tor. Exhibited: CSGA; OSA; CSPEE; WFNY 1939; Rio 1946. Author: "Southern Cross" (novel in wood engravings, chosen as one of "Best Western Books," 1952); "Under the Pirate Flag," 1965; "Captain Deadlock," 1967; Des. seven stamps for Canadian Postal Dept. Contributor to Canadian Arts; Canadian Geographic Magazine. Illus., "The Ottawa," by W. E. Greening, 1961; History of the Bank of Montreal," 2 vols., 1967. Positions: Producer-Dir., Nat. Film Bd. of Canada.

JACKSON, ALEXANDER YOUNG—Painter
c/o McMichael, Kleinburg, Ont.
B. Montreal, P.Q., Oct. 3, 1882. Studied: Monument National, Mt.; AIC; Acad. Julian, Paris, under J. P. Laurens. Member: CGP; Group of Seven (orginal) OSA; A. & Letters Cl., Tor. Honours: RCA (resigned 1933); LL.D., Queen's Univ.; C.M.G. 1946. Work: Tate, London; Springfield (Ill.) AA; Wellington Gal., New Zealand; NGC; AG Tor.; AA Mtl.; MPQ, etc. Commissions: official war artist with Can. Army in France 1917-18. Exhibited: Can. War Memorials

1923, '24; Wembley 1925; West Coast Exh., NGC 1927; Paris 1927; S. Dominions 1936; Group of Seven Exh. 1936; Coronation 1937; Tate 1938; WFNY 1939; Addison 1942; Rio 1944; Yale 1944; DPC 1945; Albany 1946; UNESCO 1946. Author and Illustrator: "The Far North" 1928 "Banting as an Artist," 1943; "A Painter's Country," 1958. Contributor: Canadian Art magazine.

JONES, JACOBINE—Sculptor
209 Davy St., Niagara-on-the-Lake, Ont.
B. London, England. Studied: Regent St. Polytechnic, and under H. Brownsword, London; and in Denmark. Member: RCA; SSC. Honours: gold medal, Regent St. Polytechnic. Work: Kelvin Mus., Glasgow; Confederation Life Bldg., Toronto; Trinity Col. Chapel; St. John's Convent, Willowdale, Ont.; NGC; Bank of Canada, Ottawa; York Township Bldg.; Bank of Nova Scotia, Tor.; figures, Our Lady of Mercy Hospital, Tor.; Archives Bldg., Tor.; Mother House of Sisters of St. Joseph, Tor.; Morrisburg, Ont.; General Hospital, Tor.; Newmarket, Ont.; Crippled Children's Center, Tor.; Hamilton A. Gal.; Ryerson Inst., Tor.; St. Mark's Church, Niagara-on-the-Lake; Church of St. John The Evangelist, Thorold, Ont.; South African Embassy, Ottawa. Exhibited: Liverpool 1929; RA 1930; Paris Salon 1932; RCA from 1932; AA Mtl., 1934; Tate 1938; WFNY 1939; Waterloo, Ont.; Hamilton, Ont.; 1966-1969: Montreal, Hamilton, and St. Catharines; one-man: Rodman Hall A. Centre, St. Catharines, 1969. Former Dir., Sculpture & Ceramics, Ontario Col. of A., 1951-1956. Lectures on Sculpture.

KAHANE, ANNE—Sculptor
3794 Hampton Ave., Montreal 261, P.Q.
B. Vienna, Austria, Mar. 1, 1924. Studied: CUASch., N.Y. Member: ARCA. Honours: prizes, Concours Artistiques, Quebec, 1956; Unknown Political Prisoner Award, England, 1953. Work: Expo '67; NGC; Provincial Mus., Quebec; AG Toronto; Winnipeg A. Gal.; Vancouver A. Gal.; Montreal Mus. FA; Winnipeg Int. Airport; Place des Arts, Mtl. Exhibited: Canadian Pavilion, Brussels World Fair, 1958; Venice Biennale, 1958; Carnegie Inst., 1958. "300 Years of Canadian Art," National Gallery of Canada, 1967; "Sculpture 67," Centennial Exh. of Sculpture, Toronto.

KANEE, BEN (DR.)—Collector
3195 Granville St., (9); h. 6449 Cedarhurst, Vancouver 13, B.C.
B. Melville, Sask., Oct. 12, 1911. Collection: Canadiana-Group of Seven and contemporary West Coast artists; British works, including drawing by Augustus John and drawing and oil by R. Dunlop; Sculpture by Rodin, Valentine and Maillol; Canadian art-including works by Turner, Cox and Oesterle; Graphics, including works by Picasso, Chagall, Miro, Renoir, Bonnard, Vlaminck, Villon, Moore, Dali, Uchima, Braque and Albers; Canadian Eskimo carvings and prints, Haida Indian carvings including a Totem Pole by Bill Reid; Antiquities-Etruscan, Luristan bronze, early Hebrew art, Pre-Columbian and early Peruvian art. Positions: Chairman, Permanent Collection Committee, 1963- , Vice-President, 1965- , Vancouver Art Gallery.

KARSH, YOUSUF—Writer, Photographer
Karsh Studio, 130 Sparks St.; h. "Little Wings," Prescott Highway, R.R. 2, Ottawa, Ont.
B. Mardin, Armenia-in-Turkey, Dec. 23, 1908. Awards: Hon. LL.D., Queens University, Kingston, Ont, 1960, Carleton University, Ottawa, Ont., 1960; Hon. L.H.D., Dartmouth College, 1963, Ohio State University, 1965; Hon. LL.D., Mount Allison Univ., Sackville, N.B., 1968; Hon. D.C.L, Bishops Univ., Lennoxville, Que., 1969; Can. Centennial medal; Service medal of the Order of Can. Exhibited: Expo '67; CGA, Wash., D.C, 1968-1969; Mus. FA, Montreal; BMFA; Corning Mus., N.Y.; Greensboro Lib. Gal., N.C. Author, Photographer of the following books: "Faces of Destiny," 1946; "Portraits of Greatness," 1959; "In Search of Greatness," 1962; With Bishop Filton J. Sheen "This is the Mass," "These are the Sacraments," "This is Rome," "This is the Holy Land"; With J.B. Frank, "The Warren Court," 1964; "Karsh Portfolio"; article, "Saturday Review," 1969. Karsh photograph of Sir Winston Churchill on commemorative Canadian stamp. Lectures extensively. Visiting Prof. of Photography, Sch. of FA, Ohio Univ., Athens. Photographic Adviser, Theme Pavilion, Expo '70, Osaka, Japan.

KOPMANIS, AUGUSTS A.—Sculptor
19 Millbrook Crescent, Toronto 6, Ont.
B. Riga, Latvia, Mar. 17, 1910. Studied: Acad. FA, Riga, Latvia. Member: Sculptors Soc. of Canada; OSA; F.I.A.L. Exhibited: Montreal Mus. FA, 1954-1960; Winnipeg Show, 1956, 1957, 1958; RCA, 1957-1961; Sculptors Soc., 1958, 1960, 1961; Open Air Exh., Montreal Parks Dept., 1958; Colour & Form Soc., 1953-1964; Western Ontario Exh., 1956, 1957, 1960, 1964; Hamilton, Ont., 1957, 1958, 1960, 1961, 1963, 1964, 1965; OSA, 1956, 1958, 1959, 1961, 1962, 1964; CNE, 1958, 1959; Windsor A. Gal.,1958, 1960, 1961; Garden Sculpture Show, Toronto, 1961; Confederation AG and Mus.,

Charlottetown, P.E.I.: 1964; NGC, 1963; Albert White Gal., Tor., 1962, 1965; one-man: Toronto Upstairs Gal., 1959, 1961. Illus., "Season in Latvian Folk Songs,"1956.*

KORNER, JOHN—Painter
5816 Kingston Rd., Vancouver 8, B.C.
B. Novy Jicin, Czechoslovakia, Sept. 29, 1913. Studied: with Othon Friesz, Victor Tischler in Paris. Member: ARCA; CGP; British Columbia Soc. A. Honours: Winnipeg Show, 1956, 1957, 1961; British Columbia Centennial award, 1958; Vancouver AG, 1960. Work: NGC; Museums of: Toronto, Montreal, Seattle, Fredricton, Vancouver, Winnipeg, London, Windsor, Univ. of British Columbia; Univ. of Kingston, and others. Murals in Vancouver and Palm Springs, Cal. Exhibited: Canadian Biennials; Seattle World's Fair; traveling exhs. to England, India, Australia, Africa under auspices of Nat. Gal. of Canada; also, SFMA; Portland Mus. A.; Minneapolis, Minn. Contributor to Canadian Art. Positions: Instr., Drawing & Painting, Vancouver School of Art, 1953-1958; University of British Columbia, 1958-1961.

KRAMOLC, THEODORE MARIA—Painter, Gr., Des.
40 Bucksburn Rd., Rexdale, Ont.
B. Yugoslavia, Mar. 27, 1922. Studied: Ont. Col. A., and in Yugoslavia. Member: Int. Inst. Arts and Letters; CPE; S.G.A. Work: AG Tor.; AG Hamilton; NGC. Exhibited: One-man: Picture Loan Society, Toronto, 1962, 1964, 1967; Victoria Col., Univ. Tor., 1963; Civic Mus., Manitowoc, Wisc., 1964; Pollock Gal., 1969, Toronto; Nat. Gal. Biennale, Exh. of Prints and Drawings, 1966.

LATNER, ALBERT J.—Collector, Patron
111 Davisville Ave.; h. 245 Warren Rd., Toronto 7, Ont.
B. Ontario, Can., April 25, 1927. Studied: Univ. of Toronto, B.A. Collection: Paintings; Modern Art; Primitive Sculpture. Positions: Pres., Greenwin Construction Co., 1954- .

LEMIEUX, JEAN PAUL—Painter
2008 Dickson, Sillery, P.Q.
B. Quebec, Nov. 18, 1904. Studied: Beaux-Arts, Mtl.; Acad. Colarossi, Paris. Honours: prizes, Quebec Provincial Painting; AA Mtl., 1934, 1951; Govt. Overseas Award, 1954-55; Companion of the Order of Canada, 1968; Doctorate, Naval Univ., Quebec, 1969. Member: RCA. Work: Painting chosen for Coll. of Queen Elizabeth; AG Tor.; MPQ. Exhibited: AA Mtl. 1931, 1934, 1938, 1941; RCA 1934, 1940, 1942; Addison Gal., 1942; Yale 1944; DPC 1945; Albany 1946; UNESCO 1946; CGP, 1951; Palais Montcalm, Quebec, 1953 (one-man); Sao Paulo, Brazil, 1957; Brussels World's Fair, 1958; Canadian Nat., 1957; Mexico City, 1958; Australian Tour of Canadian Painting, 1957; Carnegie Inst., 1958; Univ. of British Columbia, Vancouver, 1958 (one-man); Venice Biennale, 1960; Warsaw, 1962; Tate Gal., London, 1963; Traveling Can. Exh. organized by MModA, 1963; Musée Galliera, Paris, 1963; Retrospective Exh., Mtl. and Ottawa, 1967. Contributor: Canadian Art Magazine. Lectures: Can. Art, Blake, Gauguin. Teaching: Beaux-Arts, Mtl., 1933-4; Ecole du Meuble, Mtl. 1935-6. Positions: Instr. Beaux-Arts, Quebec.

LENNIE, BEATRICE—Sculptor, Des., P., I., T., L., C.
4011 Rose Crescent, West Vancouver, B.C.
B. Nelson, B.C., June 16, 1906. Studied: Vancouver Sch. A.; Cal. S Sch. FA., and with H. Tauber, Frederick Varley, Ralph Stackpole. Member: British Columbia Soc. A.; Sculptors Soc. of Canada; Puppeteers of Am.; Northwest Inst. of Sc.; Vancouver A. Cl. Work: on public buildings and in private colls. U.S. and Canada. Port. busts, plaques, fountains, panels, figs., Patullo Bridge, New Westminster, B.C.; Federal Bldg., Vancouver; Shaughnessy Military Hospital; Acad. of Medicine; Vancouver Hotel; Vancouver Labor Temple; Ryerson Mem. Centre; Holy Family Hospital, and others. Exhibited: NGC; Sculptors Soc.; RCA; Vancouver A. Gal.; AG Toronto; Mtl. AA; Seattle, Puyallup, Wash.; San Francisco, Cal. Cartoons to Vancouver Daily Province.*

LEWIS, STANLEY—Sculptor, Gr., T., L.
7153 Waverly; h. 4145 Blueridge Crescent, Apt. 37, Montreal 109, Que.
B. Montreal, Que., Mar. 28, 1930. Studied: Montreal Mus. FA Sch.; Instituto de Allende, San Miguel, Mexico, and in Florence, Italy. Member: SSC. Awards: prizes, Provincial Art Comp., 1959; Quebec Art Comp., 1960. Work: Sc., Instituto de Allende, San Miguel, Mexico. Exhibited: Mtl. Mus. FA; Winnipeg A. Gal.; A. Gal., Hamilton; Quebec Provincial Mus. Technical Adviser, "The Agony and the Ecstasy," 1961. One-man: City of Montreal, retrospective stone-cut sc. exh., 1968; Montreal, multi-coloured stone-cut prints exh., 1968; Island of Santorini, Greece, sc. exh., 1969. Contributor to Canadian Jewish Review, 1953. Lectures:Techniques of Marble Carving of Michelangelo, at Mtl. Mus. FA and Thomas More Inst. Positions: Instr., Modeling, McGill Univ. Sch. Arch., 1952; Instr., Modeling & Drawing, Montreal Mus. FA, 1955-56; Instr., Lithography, In-

stituto de Allende, San Miguel, Mexico, 1955. Instr., sculpture & stone-cut printing, The Saidye Bronfman Art Centre, Montreal, 1967- .

LINDNER, ERNEST — Painter, Gr.
414 9th St. E., Saskatoon, Sask., Canada
B. Vienna, Austria, May 1, 1897. Studied: Acad. Applied Art, Vienna, Member: CSGA; CPE. Honour: Print of the Year, Toronto, 1944; prize, NGC, 1968; Canada Council Grant, 1959. Work: Canadian Industries, Ltd.; IBM; Grand Central Gal., N.Y.; Royal Ontario Mus., Tor.; Hart House Collection, Tor.; Sir George Williams Univ. Coll.; Beaverbrook A. Gal., Fredericton, N.B.; Winnipeg A. Gal.; NGC; Norman Mackenzie A. Gal., Regina; Acad. Applied A., Vienna. Exhibited: NGC; 1968 and prior; Montreal Mus. FA; Winnipeg Show, bi-annually; CSGA; CPE; CSPWC; Saskatchewan Arts Board Exh.; OSA annual; Mendel A. Gal., Saskatoon. Included in "Canadian Drawings and Prints," by Paul Duval, 1952. Positions: Hd., Art Dept., Technical Collegiat Inst., Saskatoon, 1936-1962.

LOCHHEAD, KENNETH CAMPBELL — Educator, P.
School of Art, University of Manitoba, Winnipeg, Man.
B. Ottawa, Ont., May 22, 1926. Studied: PAFA; Barnes Fnd. Honours: O'Keefe Award, 1950; Dow Award, 1963; Robinson Award, Mtl. Mus., 1964. Work: Mural decoration for Regina Branch, Canadian Legion; Gander, Newfoundland Int. Airport; Other work in numerous public collections throughout Canada. Exhibited: In major Canadian art galleries through NGC and Western Can. Art Circuit exhibits; Contemp. Can. Painters Exh., for circulation, Australia, 1957; Canadian Pavilion, World's Fair, 1958; Utrecht Central Mus., 1958; Groningen Mus., 1958; Fine Arts Mus., Mexico City, 1960; Saskatchewan Arts Board exhs.; NGC biennial exhs.; Norman Mackenzie AG., 1961; NGC exh. to Warsaw, 1961-1962; NGC, 1961; Los A County Mus., 1964; one-man: Regina Col., 1953; Robertson AG, 1953; Sask. House Summer Festival, 1961; David Mirvish Gal., Tor., 1964; Lefort Gal., Mtl., 1965; Design Gal., Vancouver, 1965; Positions: Assoc. Prof. A., Sch. A., Univ. Manitoba, Winnipeg, 1964- ; Dir., Sch. A., Univ. Saskatchewan, Regina, 1950-1964.*

LONGSTAFFE, JOHN RONALD — Collector
19 New Bridge St., London, E.C. 4, England; h. 63 St. Georges Road West, Bickley, Kent, England
B. Toronto, Ont., Apr. 6, 1934. Studied: University of British Columbia, B.A., LL.B. Collection: Contemporary Canadian Art. Positions: President, Vancouver Art Gallery Association, 1966-1968; Vice-Chairman, National Museums of Canada, 1968-1969.

LUZ, VIRGINIA — Painter, T.
Central Technical School; 113 Delaware Ave., Toronto 4, Ont.
B. Toronto, Ont., Oct. 15, 1911. Studied: Central Tech. Sch. Member: OSA; CSPWC. Work: Huron Col.; Canadian Dept. External Affairs; J.S. McLean Collection; London A. Mus., and in private collections. Exhibited: CGP, 1945-1953; CSPWC, 1947-1965; CNE; Canadian Women A., 1947 (N.Y.); Canadian Tour, 1948-1949; OSA, 1945-1965; AG Hamilton, 1952-1965; 2-man: Toronto, 1951, 1952; 3-man: London, 1954. Positions: Instr., Illus., Central Technical School, Toronto, Ont. Executive Council, OSA, 1965-1966.*

MacAULAY, JOHN ALEXANDER, Q.C. — Collector
941 Somerset Bldg. (1); h. 1125 Wellington Crescent, Winnipeg 9, Manitoba
B. Morden, Manitoba, May 29, 1895. Studied: University of Manitoba; Manitoba Law School. Cellection: Impressionist and post-impressionist art; Works of the Barbizon school; English paintings; Canadian paintings. Positions: President, Winnipeg Art Gallery, 1950-1958; Trustee, NGC, 1952-1956; Past President, Canadian Bar Association; President, Board of Governors, League of Red Cross Societies, Geneva, Switzerland; Senior member, legal firm, Aikins, MacAulay and Company.*

McCARTHY, DORIS JEAN — Painter, T., L., C., Des.
Central Technical School, Toronto, Ont.; h. 1 Meadowcliff Drive, Scarborough 712, Ont.
B. Calgary, Alta., July 7, 1910. Studied: OCA; Central Sch. A. & Crafts, London, England. Member: ARCA; OSA (Pres. 1964-1967); CSPWC; Ont. Assn. Teachers of A. & Crafts; Prof. A. of Canada. Work: AG Ontario; Victoria Univ.; Pickering Col.; Huron Col.; London, Ont., A. Mus. Commissions:mural, Earlscourt Lib., Tor.; Creche St.-Aidans Church, Tor. Exhibited: with all major society exhs. in Canada since 1931 and numerous one-man exhibitions. Positions: Asst. Head, A. Dept., Instr., Drawing & Painting, Central Technical School, Toronto, Ont., 1932- .

MACDONALD, GRANT — Painter, I., T.
"Tarquin," Lakeshore Rd., Kingston, Ont.
B. Montreal, Que., June 27, 1909. Studied: OCA; ASL; Heatherley's A. Sch., London, Eng. Member: RCA; OSA. Honours: medal, A.

Dir. Cl., Tor., 1952. Work: Redpath Lib., McGill Univ.; Hart House, Univ. Toronto; AG Tor.; Queen's Univ.; Kingston Collegiate Inst.; Art Collection Soc., Kingston, Ont. many portraits, 1940-52; also in galleries, schs., univs., libraries and private collections, Canada, U.S.A. and England. Exhibited: OSA 1949, 1951-1955, 1966, 1967; Canadian Nat. Exh., Tor., 1949-51; CGP 1950, 1952; CSGA 1947, 1950-1952; RCA 1949, 1951-1955, 1967; AA Mtl., 1941-1944, 1949, 1953-1955, 1968; A. Dir. Cl., Tor., 1951, 1952; AG Hamilton 1949, 1951, 1953-1955, 1967, 1968; AA Kingston 1948-1955, 1967, 1968; Vancouver A. Gal., 1952-1955. One-man: Wells Gal., Ottawa, 1966; Kingston A. Centre, (retrospective), 1966; Roberts Gal., Tor., every two years since 1941. Illus., "Shakespeare for Young Players," 1942; "Haida," 1946; "Behind the Log," 1947; "Jimney Cricket," 1927; "Sunshine Sketches of a Little Town," 1948; "A Masque of Aesop," 1952; "Renown at Stratford"; "Twice Have the Trumpets Sounded," and others. Positions: Instr., Figure Drawing, Queen's Univ., Kingston, Ont., Summer school, 1948, 1952, 1953, 1964, 1965.

MacDONALD, MANLY — Painter
4 Rosedale Rd., Toronto 5, Ont.
B. Point Anne, Ont., Aug. 15, 1889. Studied: OCA; Albright A. Sch.; BMFA. Member: RCA; Ontario Inst. Painters. Honours: Painting presented by City of Toronto to Her Majesty Queen Elizabeth, 1959. Work: NGC; A. Mus. London, Ont.; Union Carbide Co., Toronto; series of paintings, Abitibi Power & Paper Co.; St. Lawrence Seaway Authority; paintings: Ontario Highway Dept.; City of Tokyo, Japan; Granite Club of Toronto; also in private collections, Canada, U.S.A. and abroad. Exhibited: Can. War Memorials NGC 1923, '24; Wembley 1924; WFNY 1939; Rio 1944; RCA; Ont. Inst. of Painters Exh.*

MacDONALD, THOREAU — Illustrator, P., Des.
Thornhill, Ont.
B. Tor., Apr. 21, 1901. Studied: under his father, J. E. H. MacDonald, but largely self-taught. Work: NGC, AG Tor. Exhibited: Wembley 1925; Paris 1927; Coronation 1937; Tate 1938; WFNY 1939. Illustrator: "Maria Chapdelaine" 1938, and about 50 other books. Author: "The Group of Seven," and books on pioneer subjects, buildings and farming.*

McEWEN, JEAN (Mr.) — Painter
580 Davaar St., Montreal, P.Q.
B. Montreal, P.Q., Dec. 14, 1923. Member: RCA. Awards: Quebec Art Competition, 1962; Jessie Dow Award, Mtl. Spring show, 1964. Work: MModA; WAC; Albright-Knox Gal.; Ottawa Mus.; Toronto Mus.; Mtl. Mus. FA; Vancouver Mus.; Quebec Mus.; Mural, Toronto Airport; Plase des Arts, Mtl., 1967; Stained Glass Window, Sir George Williams Univ., 1966. Illustrator: "Le Pain Quotidien," poems by Michel Beaulieu, 1964. Exhibited: Dunn Int. Exh., Tate Gal., London, 1963; one-man: Martha Jackson Gal., N.Y., 1962; Gallery Moos, Tor., 1963, 1965, 1967, 1969; Gal., Mtl., 1963; Anderson Mayer Gal., Paris, 1964; Gal. Godart-Lefort, Mtl., 1962, 1964, 1966, 1969.

McGEOCH, LILLIAN JEAN — Painter, Des., T.
King Georges Road, Toronto 18, Ont.
B. Sundridge, Ont., Jan. 17, 1903. Studied: Ontario Col. A. Member: Nova Scotia Soc. A.; Women's A. Assn., Toronto; Hamilton AA. Honour: Award of Merit, Etobicoke AA, 1960. Work: Nova Scotia Soc. A.; Maritime AA; Dept. Edu., Halifax. Exhibited: Nova Scotia Soc. A.; Maritime AA; Women's A; Port Credit A. Group, 1961; Etobicoke AA, 1960, 1961; Peel County Exh., 1961; one-man: Halifax, 1960; Toronto, 1957; Toronto Lyceum Club, 1960; Gallery in the Kingsway, Tor.; Richview Library, 1968, 1969; Women's A. Assn., Tor., 1969. Positions: Vice-President, Women's Art Assoc., 1965.

MACKAY, DONALD CAMERON — Educator, P., Et., I.
Nova Scotia College of Art; 5883 Inglis St., Halifax, N.S.
B. Fredericton, N.B., Mar. 30, 1906. Studied: Nova Scotia Col. A.; Dalhousie Univ.; Academie Colorossi, Paris; Chelsea Sch. A., London and with Arthur Lismer. Member: Maritime AA (Pres.); Nova Scotia Soc. A. (Pres.); CSGA; F., Royal Soc. A.; Canadian Conf. of the Arts (Vice-Pres.); Canadian Soc. Edu. through Art (Pres.). Honours: Research Fellowships awarded by Canada Council and by British Council, bronze medal, Art of the Western Hemisphere Exh., 1940; silver medal, Royal Inst. Canadian Architects, 1955. Work: NGC; Nova Scotia Mus. FA; T. Col., Nova Scotia; IBM; N.Y. Pub. Lib.; AIC. Murals, Halifax Mem. Lib.; port., Dalhousie Univ. Exhibited: RCA; CSPWC; CSPEE; CSGA; Canadian Art Exh.; Maritime AA; Nova Scotia Prov. Painters; Nova Scotia Soc. A.; Chelsea A., London, England; one and two-man exhs., Halifax, London and Toronto. Author: "Master Goldsmiths and Silversmiths of Nova Scotia," 1948; I., "Warden of the North"; "History of Nova Scotia"; "Story of Newfoundland"; "Story of Nova Scotia"; "Highlights of Nova Scotia History"; "Tales of the Sea." Contributor to Journal of Education; Dalhousie Review; Dictionary Canadian Biography and most Canadian young people's publications. Positions: Special Lec-

turer in FA, Dalhousie Univ.; Prof. A., Nova Scotia Dept. Edu.; Vice-Principal, 1938-45, Principal, Nova Scotia College of Art, Halifax, N.S., 1945- ; Official War Artist, Royal Canadian Navy, 1939-1945.

MANAREY, THELMA (Mrs. C. H.) — Painter, Gr.
12026 93rd St., Edmonton 18, Alta.
B. Edmonton, Alta., May 2, 1913. Studied: Univ. Alberta; Univ. Washington (summer); Banff Sch. FA. Member: Alberta Soc. A.; Edmonton A. Cl.; CPE; Focus Group. Work: Edmonton Pub. Sch. Coll. Honours: Banff Sch. FA scholarship, 1955; Banff Sch. FA purchase award, 1956; purchase, Red River Exh., Winnipeg, 1965; prize, Visual Arts Exh., Edmonton, 1967. Exhibited: Nat. Ser. Soc., N.Y., 1956; CPE, Toronto, 1956-1958; "Critic's Choice," Point-Claire, P.Q., 1966; Winnipeg Biennial, 1966; All-Alberta, 1969. One-man: 7 one-man exhs.

MANN, VAUGHAN — Painter, Ser., W., L., T.
Box 1, R.R. 1, Oyama, B.C.
B. Moose Jaw, Sask. Studied: Columbia Univ., N.Y., B.S. Member: CPE; Nat. Ser. Soc., N.Y. Work: Royal Ontario Mus. Exhibited: CPE, 1954, 1955, 1957; Moose Jaw, Sask., 1956, 1961, 1967; (one-man); Kelowna, B.C., 1956 (one-man); Vancouver A. Gal., Calgary, Alta.; Nelson, B.C., 1960 (one-man). Author: "Picture Apprecia-tion—Elementary School"; "Picture Appreciation—Junior High School." Lecturer for Univ. British Columbia Extension Dept., and for Saskatchewan Univ. Summer School; Dir., A., Teacher's College, Saskatchewan.

MARTIN, BERNICE FENWICK (Mrs. Langton) — Painter, Gr.
150 Millwood Rd., Toronto 295, Ont.
B. Shelbourne, Ont., July 7, 1912. Studied: Ont. Col. A., Univ. Tor.; Univ. Calgary, Alta.; Toronto Tech. Schs., and with J. W. Beatty, Frank Carmichael, P. C. Sheppard. Member: CPE; FIAL (Life); Chm., Presentation Pr. Com., Soc. Canadian Painter-Etchers & En-gravers. Honours: 4 prizes, Can. Nat. Exh. Work: Paintings and prints in public buildings and private collections, in Canada and abroad. Exhibited: Vancouver FA Gal., 1958-1961; London FA Gal., 1959-1965; Kitchener-Waterloo FA Gal., 1959-1965; Mtl. Mus. FA, 1964; CPE traveling shows, 1959-1965; North York Public Library, 1960, 1962, 1964; Salada Tea House, Can. Nat. Exh., 1963; Hamilton FA Gal., 1960, 1965; Toronto Public Library, Central, 1961; Royal Ont. Mus., Tor., 1959, 1961. RCA; Que. Mus. FA; Vancouver FA Gal.; Victoria FA Gal.; Winnipeg FA Gal.; AG Ont.; CPE traveling show, 1959-1968; AA Mtl.; Royal Ont. Mus.; Que. FA Gal.; FA Gal. of Hamilton; North York Pub. Lib.; O'Keefe Centre; Sch. Arch., Univ. Tor.; Tor. City Hall; London FA Gal.; Kitchener-Waterloo FA Gal.; Tor. Central Pub. Lib.; "Centennial Operation. Ont. Art '67;" exh. & traveling show; Expo '67; CNF, FA Gal., 1963, 1968; one-man: Eaton's FA Gal.; Beaches Pub. Lib., Scarborough; Towne Cinema; Gld. All.A.; Casa Loma, and many studio exhs. Lectures & demonstrations on colored Block Printing.

MARTIN, JOHN — Painter, Des., C., Gr., I., T., L.
Swan St., Ayr, Ont.
B. Nuneaton, England, Aug. 1., 1904. Studied: Nottingham Sch. A.; Slade Sch. A., London. Member: CSPWC; ARCA; A. & Letters Cl., Tor.; A. Dir. Cl., Tor.; CPE; OSA; CGP; N.S. Soc. Artists. Honours: Needham prize, England, 1916; prize, CPE, 1936; Reid prize, Tor., 1943, 1944; purchase, A. Gal., 1957; purchase, AG Ham-ilton, 1958; Senior Fellowship, Canada Council; Citation, Amer. Soc. Local History, 1963. Work: Nuneaton A. Cl.; Leicester AG; London Mus. A.; Ontario Hist. Soc.; Sarnia, Hamilton AG; Royal Ontario Mus. Author: "A Guide to Waterloo"; "Paths of History in Perth and Huron." Exhibited: RCA 1935-1952; OSA 1930-1952; CPE 1934-1946; Sarnia AG 1933-1935, 1939, 1941, 1942; CSPWC 1940-1952; Vancouver AG 1950, 1952; London AG 1950-1952. Lec-tures: Industrial and Social Design; History of Art. Positions: Dir. Des., OCA, 1945-52; Tillsonburg A. Soc., 1949-54; Lecturer, Art Inst. of Ontario, 1954- ; A. Dir., Ridley Col., St. Catharines, Ont.; Dir., Instr., Dundas A. Assn., 1964- .*

MARTIN, LANGTON — Printmaker, P., C.
150 Millwood Rd., Toronto 7, Ont.
B. Toronto, Ont., May 15, 1903. Studied: Ont. Col. A.; Univ. Tor., and with J.W. Beatty, Peter C. Sheppard. Member: CPE; F.I.A.L. Awards: Canadian Nat. Exh., 1953, leathercraft. Work: Prints in collections in Canada, U.S., Africa, Europe, and Asia. Exhibited: CPE traveling shows, 1954-1966; Royal Ont. Mus.; Hamilton AG; Kitchener-Waterloo AG; North York Public Li-brary; Mtl. Mus. FA, 1964, 1967; Expo '67; Salada Tea House, Cana-dian Nat. Exh., 1963, 1968; Univ. Toronto, 1966.

MASSE, GEORGES SEVERE — Painter, T., L.
1593 Marie-Claire, LaSalle, Que.; 5655 Cote St-Luc Rd., Montreal, P.Q.
B. Montreal, P.Q., Aug. 10, 1918. Studied: Mtl. Mus. FA Sch., with

Sherriff-Scott; Bauff Sch. FA, with Frederic Taubes. Honours: prize, Mtl. FA, 1938. Author: "The Art of Painting Today," 1965. Exhibited: Mtl. Mus. FA, 1942, 1944, 1946, 1947, 1955; Royal Cana-dian Acad., 1948, 1958; Quebec A. Festival, 1951; AG Hamilton, 1948, 1949, 1951, 1952, 1954, 1955; Quebec Provincial Exh., 1956, 1957; Victoria A. Gal., 1957, 1958; one-man: Montreal. Positions: Scientific Illus., Univ. Montreal, 1941; Instr., Montreal Mus. FA, 1942-43; Dir. own Art School, 1944- ; Pres., Ind. A. Assn., 1961-1965; Pres., Group 80, 1969-1970.

MASSON, HENRI — Painter, T.
70 Spruce St., Ottawa, Ont.
B. Namur, Belgium, Jan. 10, 1907. Studied: Athénée Royale, Brus-sels; Ottawa AA. Member: CGP; CSPWC; CSGA. Honours: LL.D., Assumption Col., Windsor, Ont., 1955. Work: NGC; MPQ; AG Tor.; Hart House, Univ. Tor.; Vancouver AG; Winnipeg AG; etc.; Caracas (Venezuela) Mus.; Vinadelmar (Chile). Exhibited: WFNY 1939; Addi-son Gal. 1942; Intl. WC Exh., Brooklyn 1942; Yale 1944; Rio 1944, '46. DPC 1945; Phila. WC Cl., 1946; UNESCO 1946; Wash., D.C., 1951; Sao Paulo, Brazil; one-man: Toronto, Eaton Gal., 1945-6; Ottawa, Little Gal. 1944-6; Mtl., Art Francais 1946; AA Mtl., 1953; Winnipeg, Ottawa, Robertson Gal., etc. Positions: Instr., children's classes, NGC, 1948-50; Instr., Queen's Univ. Summer Sch., 1948-52; Banff Sch. FA, 1954; Instr., Doon Sch. FA, 1960-1964.*

MAY, HENRIETTA MABEL — Painter, T.
1495 Balfour Ave., Vancouver, B.C.
B. Montreal, P.Q. Studied: AA Mtl. under Wm. Brymner; Paris. Member: CGP; FCA; B.C. Soc. A.; Fndr.-Memb., Beaver Hall Group; Fndr.-Memb., Canadian Group of Painters. Honours: ARCA; Jessie Dow prize, AA Mtl. 1915, '18; Mtl. Women's Cl. prize 1919. Work: NGC Musée de la Province de Quebec; AA Mtl.; Brandon Hospital; Regina Pub. Lib.; AG Tor.; Vancouver AG Beaverbrook A. Gal., N.B.; Paintings in public buildings in Santa Fe, New Mex., Ottawa, Ont. Exhibited: RCA since 1913; Can. War Memorials NGC 1923, '24; Wembley 1925; Paris 1927; Buenos Aires 1930; CGP since 1933; S. Dominions 1936; Coronation 1937; Tate 1938; WFNY 1939; Rio 1944; DPC 1945; AA Mtl.; Beaver Hall Grp., Mtl. Positions: Supv. children's classes, National Gallery of Canada and Instr. Elmwood School, Rockcliffe, Ottawa.*

MELVIN, GRACE WILSON — Painter, Des., T., I., L.
6212 Balaclava St., Vancouver 13, B.C.
B. Glasgow, Scotland. Studied: Glasgow Sch. A. Member: British Columbia Soc. A.; CSGA; Canadian Fed. A.; Canadian Group of Painters. Honours: Traveling scholarship, Glasgow Sch. A.; prize, Winnipeg Show, 1956. Work: NGC; Victoria Gal. A.; Queen's Ar-chives, London; Canadian Engineers "Book of Remembrance" (2 World Wars) now in St. Paul's Cathedral, London, England; Calgary A. Gal. Illus., "The Indian Speaks," and other books. Exhibited: CGP, 1954, 1958; British Columbia Centennial, 1958; British Colum-bia Soc. A., 1953-1958, 1967 Glenbow Fnd., Calgary; British Colum-bia Soc. Graphic A., 1946-1958; Winnipeg Show, 1956, 1957, 1966; exhibited in major Canadian exhibitions, 1964-1965; one-man: Van-couver A. Gal.; Victoria A. Gal., 1968; Univ. British Columbia, etc. Positions: Hd. Dept. Des., Vancouver Sch. A., 1934-52, and other teaching positions prior. Staff, Glasgow Sch. A., Scotland.

MILLER, H. McRAE — Sculptor, Des., Comm. A., T., P.
R.R. #2, Range 6, Ste. Agathe des Monts, P.Q.
B. Montreal, Que., 1897. Studied: ASL, N.Y. under John Sloan; Beaux-Arts, Mtl., under Alfred Laliberte; and with C. W. Simpson, F. S. Coburn. Member: F., F.I.A.L. Honours: ARCA 1944; SSC 1948; RCA, 1955. Work: NGC; Quebec Provincial Mus. Commis-sions: portrait sc., Quebec Provincial Mus. Exhibited: RCA 1927-1930, 1936-1951, 1955, 1958, 1959; RCA, Quebec & Winnipeg, 1960; Mtl. Mus. FA 1927-1930, 1935-1945; NGC, 1950. Positions: Past Pres., SSC, 1955-56.

MITCHELL, JOCELYN TAYLOR. See Taylor, Jocelyn

MOCHIZUKI, BETTY — Painter
175 Livingstone Ave., Toronto 10, Ont.
B. Vancouver, B.C., Oct. 31, 1929. Studied: Ontario Col. of Art. Member: CSPWC; CSG. Honour: C. W. Jefferys Award in graphic art, 1962. Work: Univ. Toronto; Dept. External Affairs. Exhibited: CSPWC, 1954-1960; CSG, 1956, 1958, 1959; Western Ontario Exh., 1956; Vancouver A. Gal., 1956-1961; Toronto A. Gal., 1956, 1958, 1960, 1961; Norman Mackenzie Gal., 1958; Women's Committee Show, London, Ont., 1959; Sarnia Pub. Lib., 1961; Kitchener-Water-loo A. Gal., 1967; Agnes Etherington A. Center, 1964, 1967; one-man: Picture Loan Soc., 1955, 1958, 1960; Univ. Toronto, Victoria Col., 1967.

MOLINARI, GUIDO — Painter, S.
1611, Visitation; h. 3516 Northcliffe, Montreal, Que.
B. Montreal, Que., Oct. 12, 1933. Studied: Sch. A. & Des., Mtl. Mus.

FA. Member: ARCA. Awards: prizes, Mtl. Mus. FA., 1962, 1965; Royal Canadian Academy, 1964; Venice Biennial, 1968; Guggenheim Fellowship, 1967. Work: Guggenheim Mus., N.Y.; MModA; Kunstmuseum, Basel, Switzerland; NGC; AG Tor.; Mus. Contemp. A., Mtl.; Mtl. Mus. FA; Vancouver AG; Edmonton AG; York Univ. AG, Tor.; Canada Council Coll., Ottawa. Exhibited: Guggenheim Int., 1964, and exhs., in 1965, 1967; Venice Biennial, 1968; Edinburgh, 1968; Musee d'Art Moderne, Paris, 1968; MIT, 1968; Washington Mus. Mod. A., 1967; Boston Inst. Contemp. A., 1967; Biennial of Canadian Art, Ottawa, 1968; Sculpture '67, Tor.

MORISSET, GERARD — Educator, W., Mus. Cur.
 1104 Rue Raymond-Cosgrain, Quebec, P.Q.; Museum of the Province of Quebec, Quebec, P.Q.
B. Cap-Santé, P.Q., Dec. 11, 1898. Studied: L. en Loi, Univ. Laval; diplomé, Ecole du Louvre, Paris. Member: Fellow, Royal Soc. of Can.; Attaché hon. des Musées nationaux de France. Honours: medal, Royal Soc. of Canada, 1954. Author: "Peintres et Tableaux"; "Coup d'Oeil sur les Arts en Nouvelle-France"; "Paul Lambert"; "Vie et oeuvre du Frére Luc"; "Francois Ranvoyzé"; "La Peinture Traditionelle au Canada francais," etc. Contributor: Revue populaire; Monde Francais, Voix du Canada (Radio). Positions: Cur., Provincial Mus.*

MORRIS, KATHLEEN MOIR— Painter
 79 Windsor Ave., Westmount, Montreal 217, Que.
B. Montreal, P.Q., Dec. 2, 1893. Studied: AA Mtl. Member: GGP. Honours: ARCA 1929; Willingdon A. Comp., 1930. Work: NGC; Mtl. Mus. FA; Hart House, Univ. Tor.; A. Gal., Hamilton; Mackenzie King Mus.; Canadian Legation, Paris, France. Exhibited: Wembley 1924, 1925; RCA since 1914; OSA 1921-1923; Paris 1927; Buenos Aires 1930; S. Dominions 1936; Coronation 1937; Tate 1938; WFNY 1939; Rio 1944; Corcoran Gal.; Brussels, Belgium; Canadian Cl., N.Y., 1950; Festival of Britain, 1951; RCA exh., Toronto, Ottawa (numerous) and Halifax; South Africa, 1957; one-man: Mtl. Mus. FA, 1939; Montreal A. Cl., 1956, 1962 (2-man).

MOULD, LOLA FROWDE (Mrs. William) — Painter, Des.
 15 Amelia St., Sydney, N.S.
B. Sydney, N.S., Dec. 3, 1908. Studied: Mount Allison Univ.; New England Sch. Des., Boston; N.Y. Sch. Des. Member: Maritime AA; Nova Scotia Soc. A.; Dept. Edu. Curriculum Research for Art; F.I.A.L; Int. Soc. Edu. through Art. Work: mural, Sydney Bank of Montreal; Miner's Mus., Cape Breton, N.S. and many private collections. Exhibited: Dalhousie Univ.; Maritime AA; Nova Scotia Dept. Edu. traveling exhs; Nova Scotia Soc. A.; in Sydney Maritimes Cape Breton; Lord Beaverbrook Gal., Fredericton, N.B.; Montreal; Boston, Mass.; New York; One-man shows in New York and Sydney and Halifax, N.S. Organized Children's Annual Art Fair for City of Sydney, Taught children's art classes.

MOWAT, ALEXANDER SUTHERLAND — Educator, P.
 2 Studley Ave., Halifax, N.S.
B. Bonnybridge, Scotland, Feb. 19, 1905. Studied: Edinburgh Univ., M.A., B. Ed. Member: Nova Scotia Soc. A. (Pres.); Maritime AA (Treas.). Exhibited: Nova Scotia Soc. A.; Maritime AA, both regularly. Positions: Prof. Edu., Dalhousie Univ., Halifax, N.S.*

MUHLSTOCK, LOUIS — Painter
 3414 Sainte-Famille St., Montreal, P.Q.
B. Narajow, Poland, Apr. 23, 1904. Studied: Mtl.; in Paris under L.-F. Biloul. Member: CSGA; CGP; FCA; CAS Mtl. Work: NGC; AG Tor.; MPQ; A. Mus., London, Ont.; Mtl. Mus. FA; Winnipeg AG; Edmonton AG; Hart House, Univ. Tor.; Victoria Col.; McGill Univ. Exhibited: Paris Salon 1930, 1931; S. Dominions 1936; Coronation 1937; WFNY 1939; Gloucester 1939; Am-British A. Center, N.Y., 1940; Addison 1942; Yale 1944; DPC 1945; Pio 1946; UNESCO 1946; CGP; CSGA; BMFA 1949; NGA, Wash., D.C. 1950; Intl. Gr. Exh., Lugano, 1954; Sao Paulo, Brazil, 1954; NGC, 1955; Carnegie Inst., 1955; one-man: Mtl. Mus. FA 1951, 1954; Western Canada Circuit, 1950; numerous other one-man exhs., Montreal, Toronto and Western Canada.*

MURPHY, ROWLEY WALTER —
 Painter, Stained Glass Des., I., T., W., L.
 230 Glen Rd., Toronto 5, Ont.
B. Toronto, Ont., May 28, 1891. Studied: OCA; PAFA under J. Pennell, Henry McCarter, Joseph Pearson, H. H. Breckenridge, and others. Member: OSA; ARCA; Canadian Soc. through Art; F., PAFA; Fed. Canadian A.; AG Tor.; Great Lakes Hist. Soc., Cleveland; Ont. Inst. Painters. Honours: ARCA; 1st prize drawing, Tor. 1929; Lea Prize, PAFA; Cresson European scholarship, PAFA 1913-14; Victory Loan Poster prize, Ottawa 1940. Work: NGC War Records: PAFA; London Mus. A.; Maritime Mus. Canada, Halifax; Maritime Mus. of Upper Canada, Toronto; Ontario Village Mus., Morrisburg; Historical Mus., Toronto; Royal Canadian Navy, London; Hamilton AG; R. Can. Yacht Cl. Commissions: official war ar-

tist with R. C. Navy 1943-4; Paintings, Can. Bank of Commerce 1946; Stained Glass, Bryn Athyn Cathedral, Pa.; Meaford, Ont.; 2 series of plates of Historic Vessels of the Great Lakes and Canadian Historical Vessels; murals, Bd. Room, Toronto Harbour Comm.; Mural Decorations, Mus. of the River, Morrisburg, Ont., 1964-65. Illus. historical articles "Inland Seas," Cleveland: "The Telescope," Detroit on La Salle's Griffon; Illus. "The Griffon" by C. H. J. Snider; Historical Illus. for Toronto-Dominion Bank and Imperial Bank of Canada, etc. Exhibited: PAFA 1913-5; '17-8; AFA 1913; OSA from 1918; RCA from 1926; War Art 1945 NGC; 1958: Toronto, Hamilton, Montreal, Halifax, Vancouver; CSG; Great Lakes Exh., London, Ont.; Royal Canadian Yacht Club, Tor. Author and Ill.; "The Welland Canals"; "Ghosts of the Great Lakes." Illus.: "War Log of the Nancy"; "Ship-Shore News," Toronto; "Memories of the 3rd Welland Canal," Inland Seas, Cleveland. Contributor: Can. Art; Imperial Oil Fleet News, etc. Official designer for full-sized replica of La Salle's "Griffon." Lectures: Navy Art. Positions: Instr., Hamilton and Tor. Tech. Schs.; des. of camouflage, R.C.N. 1941-2; Instr. OCA from 1927; Ontario Dept. Edu., 1931- ; Instr., Artists' Workshop, Tor.; Instr., Figure Drawing, MacDonald Hall, Guelph, Ont.

NAKAMURA, KAZUO — Painter, S.
 30 Old Mill Dr., Toronto 9, Ont.
B. Vancouver, B.C., Oct. 13, 1926. Studied: Central Tech. Sch., Toronto. Member: CSGA; CSPWC; CGP. Honours: prize, Intl. Exh., Lugano, Switzerland, 1956. Work: Hart House, Univ. Toronto; Lord Beaverbrook A. Gal.; Dept. External Affairs; AG Toronto; NGC; MModA; Winnipeg AG; Victoria Col., Tor.; Univ. Western Ont., London; Lugano Collection, Lugano, Switzerland; Hallmark Collection, U.S.; Univ. Cl. of Mtl. Exhibited: Painters Eleven, Riverside Mus., N.Y., 1956; Intl. Exh., Switzerland, 1956; Smithsonian traveling exh. of Canadian Abstract Art, 1956-57; Canadian Art traveling exh., Australia, 1957; Mexico City, 1958; Canadian Contemp. Painting, 1958; DMFA, 1958; Netherlands, Germany, 1959; Yugoslavia traveling exh., 1959; AFA traveling exh., 1959-60; BM, 1959; Hallmark, 1960; Canadian Art traveling exh., Mexico, 1960-61; Paris Biennial, 1961; Canadian Art traveling, Poland, 1961-62; Central Africa, 1962; MModA, 1962-1963; Albright-Knox Gal., Buffalo, 1962; London, England, 1963; World Show, New York, 1964.*

NEDDEAU, DONALD FREDERICK PRICE— Teacher, P., Des., Gr.
 21 Sherwood Ave., Toronto 12, Ont.
B. Toronto, Ont., Jan. 28, 1913. Studied: Ontario Col. A., and with J. W. Beatty, Franklin Carmichael, Archibald Barnes. Member: OSA; CSPWC; Canadian Gld. Potters; A. & Let. Cl., Toronto; F.I.A.L.; Canadian Craftsmen's Assn.; Ontario Craft Fnd. Honours: scholarship, Ontario Col. A., 1935, Rous and Mann award, 1936. Exhibited: RCA, 1936, 1948, 1951, 1954-1961; OSA, 1942, 1944-1948, 1951-1965; traveling exhs., 1944-48, 1951-1965; CSPWC, 1943, 1948-1965; traveling exhs., 1949-1965; CSPWC & Cal. WC Soc. Exh., 1950-1958; CGP, 1955, 1956, 1958, 1961, One-man: London, 1959; Kitchener, 1960; Toronto, 1960; New York, 1961. Positions: Instr. A., Central Tech. Sch., Toronto, Ont., 1948-1965; Pres., CSPWC. Dir., Ontario Federation for Films on Art.

OESTERLE, LEONHARD — Sculptor
 27 Alcina Ave., Toronto 4, Ont.
B. Bietigheim, Germany, Mar. 3, 1915. Studied: With Fritz Wotruba in Zurich, Switzerland, and art college in Zurich..Member: OSA; RCA; SSC. Work: State Gal., Stuttgart; London AG; Kitchener-Waterloo AG; NGC; Col. McLaughlin Collegiate Inst., Oshawa, Ont.; St. Augustin Col., Tor.; Erindale Col, Univ. Tor. Also in private collections in Germany, Switzerland, Canada, U.S.; one-man: Roberts Gal., Tor.; Hart House, Univ. Tor.; Erindale Col.; Dunkelman Gal., Tor.; Waddington Galleries, Mtl.; House Sol, Georgetown. Positions: Instr., Sculpture, Ontario Col. A., Tor., 1963-1968.

OGILVIE, WILLIAM ABERNETHY— Painter
 P.O. Palgrave, Ont.
B. Cape Province, South Africa, Mar. 30, 1901. Studied: Johannesburg, with Erich Mayer; ASL, New York, with Nicolaides. Member: Canadian Group of Painters; CSPWC. Honours: Canada Council Fellowship, 1957-58; Italy; Official Canadian War Artist, 1943-45 M.B.E. Work: NGC; A. Gal., Toronto; A. Gal., London; A. Gal., Hamilton; Winnipeg A. Gal.; Edmonton A. Gal. mural, Chapel of Hart House, Univ. Toronto. Exhibited: NGC; Southern Dominions; Rio de Janeiro; UNESCO; Tate Gal., London, England; Brussels, Belgium, etc. Special Lecturer, Dept. A. & Archaeology, Univ. Toronto. Positions: Dir., Sch. FA, Montreal Mus. FA, 1938-41; Drawing & Painting, Ontario College of Art, 1947-55.

PANABAKER, FRANK S.— Painter
 Ancaster, Ont.
B. Hespeler, Ont. Studied: OCA; Grand Cent. Sch. of A. and ASL, N.Y. Honours: ARCA; Jessie Dow prize, AA Mtl. 1930. Work: AG

Tor.; Thomson Gal., Owen Sound, Ont.; A. Gal., Hamilton; A. Gal., London, Ont. Exhibited: NAD 1929; Allied Artists of Am.; RCA; OSA; CNE; Salmagundi Cl., N.Y.; Canadian Painting Exh., London, England, 1955. Author: "Reflected Lights," 1957.

PECK, TREVOR F. — Collector
 1500 Sherbrooke St., W.; h. Two Westmount Square, Montreal, P.Q.
B. Montreal, P.Q., Apr. 30, 1914. Studied: McGill University, B.Arch. Collection: Modern painting and sculpture; Primitive African sculpture.

PEHAP, ERICH K. — Painter, Gr., Des., I., T., L.
 14 Ozark Crescent, Toronto 6, Ont.
B. Viljandi, Estonia, Apr. 10, 1912. Studied: in Europe. Member: CSGA; Estonian A. Assn., Toronto; Int. A. Gld.; F.I.A.L. Honours: Estonian Govt. Ministry of Edu. award, 1940, 1941. Work: Estonian Nat. Mus.; AG Hamilton. Exhibited: extensively in Europe; AG Hamilton, 1950, 1961, 1962, 1965, 1967; AA Mtl., 1950, 1954, 1957, 1961, 1967; CPE, 1952, 1962-1967; CSGA, 1951-1955, 1957-1968; Western Ont. Exh., 1950; Willistead AG, Windsor, 1951, 1952, 1964; RCA, 1954, 1961, 1962, 1968; Manitoba Soc. A., 1954; OSA, 1955; Colour & Form Soc., 1952-1954, 1956, 1959-1961; Estonian A. Exh., Mtl., 1951-1955, 1960, 1962, 1965-1968; Soc. Estonian A., Tor., 1955-1969; New Canadian A. Exh., 1951, 1952; Riverside Mus., N.Y., 1960; Vancouver AG, 1961; Tor. Outdoor A. Exh., 1961-1963; Thirteen Estonian Artists, Tor., 1963; Hunterdon County A. Centre, 1963; O'Keefe Centre for the Performing Arts, Tor., 1962; Exh. Estonian Art, Tor., 1964; Don Mills V.A.A., 1959, 1960, 1961; Baltic Painters, Tor., 1963, 1968; 5th Rodman Hall Ann. Exh., 1965; Bergdon Gal., Tor., 1967; Estonian A. Exh., Detroit, 1967; Estonian Group of A. of Can., AA Mtl., 1967; Exh. of Estonian A., Cleveland, 1968; Laurentian Univ. AG, 1968; Tor. Nat. Exh. AG, 1968; one-man exhs., Estonia, Stockholm, Sweden, Toronto, Can., and others. Illus., A. Poldmaa "Selected Poems," 1942; "The Country Life," album of 12 linoleum engravings; 10 prints in "New Direct Method," album, 1961.

PELLAN, ALFRED — Painter
 649 Bᵈ des Mille Isles, Ville d'Auteuil, Cte Laval, P.Q.
B. Quebec, P.Q., May 16, 1906. Studied: Beaux-Arts, Quebec; Beaux-Arts, Paris. Honours: Bourse de la P.Q. to Europe 1926-1930; premier prix d'art mural, Paris 1935; Bourse de recherche de la Societe Royale du Canada en France, 1952-53; Senior F. award, Canada Council, 1958; Companion of the Order of Canada, 1967; Nat. Film Board "Voir Pellan," 1969; Ph.D., Univ. Ottawa, 1969. Work: Grenoble Mus.; NGC; MPQ; Montreal Mus. FA; AG Ontario; Musée Nationale d'art Moderne, Paris. Commissions: Murals, Can. Embassies in Rio de Janeiro and Paris; City Centre Bldg., Montreal; Lord Beaverbrook AG; AG Hamilton; AG Edmonton; Kitchener-Waterloo AG; Winnipeg Airport; Place des Arts, Mtl;; Ecole Saint Patrice, Granby; Nat. Library and Archives, Ottawa; Dalhousie A. Gal.; Willistead A. Gal., Windsor. Work is subject of numerous monographs. Exhibited: Retrospectives: Musée National d'art Moderne, Paris, 1955; City Hall, Mtl., 1956; NGC, Mtl. Mus. FA, Le Musée de la Province de Québec, AG Tor, 1960-1961; Group shows: Muzeum Narodowe W Warszawie, Poland, 1963; Spoleto Festival, Italy, 1963; "Fifteen Canadian Artists," organized by the Can. Advisory Com., Canada Council, MModA, for circulation in the U.S., 1963; Musée Galliera, Paris, 1963; Tate Gal., London, 1964; and many countries abroad. One-man: Galerie Libre, Mtl., 1963; Kitchener-Waterloo AG, 1964; Rodman Hall, St. Catherines, Ont., 1964; Roberts Gal., Tor., 1964; Winnipeg A. Gal., 1968; Musée d'Art Contemporain. Illus.: "Voyage d'Arlequin" by E. de Grandmont, 1946; "Les Iles de la Nuit" by A. Grandois 1944. Contributor: illus. in Fortune, Time, Le Canada, Regards, Amérique Française, Almanach des Arts de Paris, Journal des Beaux-Arts de Paris, etc.

PEPPER, MRS. GEORGE. See Daly, Kathleen.

PIERCE, ELIZABETH R. (Mrs. Vernon L.) — Painter
 R.R. #1, Yarmouth, N.S.
B. Brooklyn, N.Y. Studied: Columbia Univ. Ext.; ASL, with John Steuart Curry, Richard Lahey, Anne Goldthwaite. Member: NAWA; Women's Inst. for Nova Scotia; Lg. of Long Island; ASL; Yarmouth Arts and Crafts Centre; Yarmouth A. Soc. Awards: prizes, Douglaston A. Lg., 1946; Women's Int. Expo., 1947; A. Lg. Long Island, 1950; Kew Forest AA, 1954 (med.). 1955. Work: Queensboro Pub. Lib., Jamaica Br.; P.S. 131, Brooklyn; A. Lg. Long Island, and in private colls. Exhibited: BM; ASL; Jersey City Mus.; NAD Galleries; Douglaston A. Lg.; A. Lg. of Long Island; Nat. Mus., Wash., D.C.; Argent Gal.; Creative Gal.; Hudson Valley AA; NAC; Riverside Mus.; Pen & Brush Cl.; traveling exh. Nova Scotia Paintings, 1962-1963; N.S. Festival of the Arts, Tatamagouche, 1963; N.S. Soc. Artists, Halifax, 1964. Positions: Dir., A. Lg. Long Island, 1954-57; Instr., Adult Edu., Yarmouth, Nova Scotia Dept. Edu., 1959-1968;

Pres., Yarmouth A. Centre, 1961-62; Fine Arts Com., Yarmouth County Agricultural Soc., 1962-1965.

PINSKY, ALFRED — Painter, Lith., T.
 4072 Northcliffe Ave., Montreal 28, P.Q.
B. Montreal, P.Q., Mar. 31, 1921. Studied: Mtl. Mus. FA, and with Anne Savage. Member: CSGA. Honours: scholarship, Mtl. Mus. FA, 1938-39. Exhibited: CSGA; CGP; Mtl. Mus. FA. Positions: Assoc. Prof. FA, Chm., Dept. FA, Sir George Williams Univ.; Author of critical reviews of exhibitions for CBC, Mtl.*

PLAMONDON, MARIUS GERALD — Sculptor, E., C.
 1871 Sheppard Ave., Quebec 6, P.Q.
B. Quebec, P.Q., July 21, 1919. Studied: Ecole des Beaux-Arts, Quebec, and in France and Italy. Member: Sculptors Soc. of Canada; Stained Glass Assn. of Am. Honours: Scholarship to Europe, 1938-40; Royal Glass F., 1955-56. Work: stone carvings, stained glass, for numerous churches, university buildings, hotels and hospitals. Exhibited: nationally and internationally. Positions: Pres., Ecole des Beaux-Arts, Quebec. Pres., SSC, 1959-61; Vice-Pres., Int. Assn. Plastic Arts (UNESCO).

PREZAMENT, JOSEPH — Painter, Gr., T.
 4832 Wilson Ave., Montreal 253, P.Q.
B. Winnipeg, Man., Jan. 3, 1923. Studied: Winnipeg Sch. A., with Lemoine Fitzgerald; Montreal Mus. FA, with Arthur Lismer; Montreal A. Sch., with Ghitta Caiserman, Alfred Pinsky. Member: CSGA. Honour: Purchase award, St. Joseph's T. Col., 1967. Work: Thomas More Inst., Mtl. Exhibited: AG Toronto, 1950; Mtl. Mus. FA, 1954-1958; CSGA, 1957, 1958, 1960, 1961; Royal Canadian Acad, 1958; A. Gal., Hamilton; Nat. Print Exh., Burnaby B.C., 1961; Toronto Central Lib., 1960; one-man: Galerie Libre, Mtl., 1960; Artlenders, Mtl., 1968.

ROBERTS, (WILLIAM) GOODRIDGE — Painter
 355 Lansdowne Ave., Montreal, P.Q.
B. Barbados, B.W.I., Sept 24, 1904. Studied: Beaux-Arts, Mtl.; ASL. Member: CGP; CSGA; CSPWC; CAS Mtl.; RCA; Eastern Group. Honours: prize, Quebec Provincial, 1948; Mtl. Mus. FA 1948, 1956; R. Can. Air Force 1952; Canadian Govt. Overseas F., 1953-54; Winnipeg AG, 1957; LL.D., Univ. New Brunswick, 1960; Glazebrook Award, 1959. Work: NGC; Mtl. Mus. FA; Vancouver A. Gal.; Winnipeg A. Gal.; Bezalel Mus., Israel; MPQ; AG Tor.; Edmonton Mus.; AG Hamilton. Commissions: official war artist, RCAF 1943-45. Exhibited: WFNY 1939; Addison Gal. 1942; Rio 1944, 1946; War Art 1944; NG London; Yale 1944; NGC; DPC 1945; UNESCO 1946; Sao Paulo, Brazil 1951, 1953; Venice, Italy 1952; Carnegie Inst. 1952, 1955; Valencia Intl. 1955; Mexico City, 1958; Brussels, 1958; Tate Gal., London, 1964; one-man: A. Cl. Mtl., 1932, 1939, 1941; Ottawa 1933, 1938; Hart House, 1933, 1938, 1951; Queen's Univ., 1934, 1935; AA Mtl. 1940, 1942; Beaux-Arts, Mtl. 1940, 1942; McGill Univ. 1942, 1945; Dominion Gal. Mtl., 1943, 1945, 1948-50, 1952, 1953, 1955; Galerie Creuze, Paris, 1954; Vancouver AG 1943; College Brebeuf, Mt., 1943; Scott Gal., Mtl. 1943, 1945; Mtl. Mus. FA, 1951. Positions: Res. A., Univ. New Brunswick, 1959-60.*

ROBERTS, THOMAS KEITH (TOM) — Painter
 1312 Stavebank Rd., Port Credit, Ont.
B. Toronto, Ont., Dec. 22, 1909. Studied: Central Tech. Sch.; Ontario Col. A. Member: RCA; OSA. Honours: Rolph, Clarke, Stone, Ltd., purchase award, 1949, Toronto. Work: NGC; Seagram Coll.; Canadian Bank of Commerce; Univ. Club, Toronto; series of paintings for Rio Tinto Mining Co.; in banks, insurance companies, etc., Canada; paintings, Ford Motor Co., Ltd., Coll.; in private colls. in U.S., Canada, England, India, etc. Exhibited: RCA, since 1931; OSA; 1929-1969; Mtl. Mus. FA, 1932-1969; Canadian Nat. Exh., 1931-1969; numerous traveling exhs.; annual one-man exhs. in Toronto, Windsor, Hamilton and Winnipeg.

ROBERTS, WILLIAM GRIFFITH — Painter, T.
 The Ontario College of Arts, The Grange, Toronto, Ont.;
 114 Court St. South, Milton, Ont.
B. Nelson, B.C., July 25, 1921. Studied: Ontario Col. A.; Vancouver Sch. A. Member: OSA; RCA (Assoc.). Honours: Monsanto Award, Montreal, 1958; CSPWC, 1960; Forrester award, 1964. Work: Calgary A. Council; AG Winnipeg; NGC; London, Ont. AG; AG Tor.; Hart House, Tor.; Univ. Western Ont.; Mural, Upper Canada Village, Ont. Exhibited: Canadian Biennial, 1959, 1961, 1963; One-man shows, 1962-1965. Positions: Resident Artist, Univ. Western Ont., 1963-1964.*

SALTMARCHE, KENNETH CHARLES —
 Museum Director, P., W. Cr., L.
 995 Chilver Rd., Windsor, Ont.
B. Cardiff, Wales, Sept. 29, 1920. Studied: OCA; ASL, N.Y. Posi-

tions: Director, Willistead Art Gallery, Windsor, Ont., 1946- ; Pres., Ontario Assn. of Art Galleries, 1968- .

SCHAEFER, CARL FELLMAN — Painter, T., Lith.
157 St. Clements Ave., Toronto, Ont.
B. Hanover, Ont., Apr. 30, 1903. Studied: OCA; Central Sch. of A. and Des., London. Member: ARCA; CGP; F., Int. Inst. A. & Lets.; CSPWC; CSGA; RCA. Honours: Guggenheim Fellow 1940-1; Coronation medal Elizabeth II, 1953; Pres. CSPWC 1937-9; Can. Centennial Medal, 1967. Work: Hart House, Univ. Toronto; NGC; AG Tor.; A. Gal., Hamilton; Queens Univ.; Pickering Col.; Dalhousie Univ.; Dept. External Affairs; Upper Canada College, Toronto; Univ. College; English Electric Co., London, England. Commissions: official war artist with RCAF 1943-6; Ser. ptgs. for Canada Packers; Rodman Hall, Univ. Western Ont.; AG Vancouver, B.C.; Memorial Univ., St. Johns, Newfoundland; Rodman Hall, St. Catherines, Ont.; Royal Bank of Canada Collection, Tor.; Maple Leaf Milling Co. Collection, Tor.; Rothmans Ltd. of Can.; Glenyrst A. Council, St. Catharines, Ont.; T. Eaton Co. of Can.; Sir Geo. Williams Univ., Mtl.; Exhibited: OSA; CSGA; Group of Seven; CGP, annually; Int. Exh. of Wood Eng., Warsaw, etc., 1933, '36; S. Dominions 1936; Coronation 1937, R. Scot. Soc. PWC, Edinburgh 1938-9; Tate 1938; Great Lakes Exh., Buffalo 1938-9; WFNY 1939; Gloucester 1939; 18th Int. WC Exh. Chicago 1939; 38th Phila. WC 1940; Am. WC Soc. and N.Y. WC 1941; Phila. WC & Print 1941; 11th Int. Biennial, Brooklyn 1941; AIC 1941; Addison Gal. 1942; Senate 1943; United Nations Print Exh. Phila. 1943; Yale 1944; War Art NG London, 1944, '45; War Art NGC 1945, '46; DPC 1945; Art of United Nations, San Francisco 1945; N.Y. 1945; Rio 1946; UNESCO 1946; Phila. WC Cl., 1946; RCA CSPWC (all Canadian exhs. through 1961); Vancouver AG, 1956-1958, 1966; Australia & New Zealand, 1948; Queen's Univ., BMFA 1949; PAFA 1949; NGA, Wash., D.C., 1950; Sao Paulo, Brazil, 1952; German Indst. Fair, Berlin, 1952; Canadian Exh., London, England, 1955; New Zealand, 1955; Canadian-Am. joint traveling exh., 1955-56; First Canadian exh. painting to Asia, India, Ceylon, Pakistan, etc., 1955; Can. Rep., Hallmark Awards, 1957; A. Gal., Toronto, 1949-50, 1959, 1965; A. Gal., Hamilton, 1958, 1959, 1961, 1966-1968; DMFA, 1958; Mexico City, 1960; AG Greater Victoria, B.C., 1965; Commonwealth Arts Festival, England, 1965; Confederation A. Gal., Charlottestown, P.E.I., 1966; AG Ont., 1966, 1967; NGC, 1967, 1968; Sarnia A. Gal., 1967; Montreal Mus. FA, 1967; T. Thomson Mus. Gal., Owens Sound, 1968; Cal. of D. Duncan A. Gal., Windsor, 1968; J.S. McLean Col. A. Gal., Ont., 1968; St. Catharines Gal., 1968; London A. Mus., 1969; one-man: Hart House 1951; Canadian Cl., N.Y., 1948; VMFA 1949; AG Tor., 1954 (2-man retrospective); Upper Canada Col., 1957; Roberts Gal., Tor., 1963, 1966; MacIntosh Gal., Univ. Western Ont., London, 1964. Positions: Hd. Dept. Drawing & Painting, Ontario Col. A., Toronto, 1955- .

SCOTT, LLOYD (EDWARD WILLIAM) — Illustrator
Main St., East, Beaverton, Ont.
B. Foam Lake, Sask., Jan. 22, 1911. Studied: Ontario Col. A. (Assoc. degree). Member: CSPEE (Assoc.); F.I.A.L. Exhibited: OSA, 1937; CSPEE, 1950, 1951. Illus.: "The Great Adventure," 1950; "Pirates and Pathfinders," 1954; "Salvador, The Horse That Joined the Mounties," 1957; "My First History of Canada," 1958; "Adventurers from the Bay," 1962; "Danger in the Coves," 1962; "The Scarlet Force," 1963, and other books. Contributor illus. to The Beaver, Magazine of the North.*

SCOTT, (Mrs.) MARIAN D. — Painter
451 Clarke Ave., Westmount, Montreal, P.Q.
B. Mtl., June 26, 1906. Studied: AA Mtl.; Beaux-Arts, Mtl.; Slade Sch., London. Member: CGP. Work: Bezalel Mus., Israel; Vancouver A. Gal.; AA Mtl.; AG Tor.; NGC; Musée de Quebec; Mtl. Mus. FA; A. Gal. of Windsor. Beaverbrook A. Gal. (N.B.). Commissions: "Endocrinology" in McGill Univ. Medical Bldg.; mural, "Tree of Life," chapel of General Hospital, Montreal; Thomas More Inst. Coll. Exhibited: CNE; OSA; RCA; NGC 1936; CGP from 1939; WFNY 1939; Addison Gal. 1942; Yale 1944; Sao Paulo, Brazil, 1951, 1953; Rio 1944, '46; Grand Central Gal. 1945; DPC 1945; DMFA, 1958; one-man: Grace Horne Gal., Boston 1941; Galerie Camille Hébert, Montreal, 1964; 2-man, Mtl. Mus. FA and AG Tor., 1953-1955; Queens Col.; Dominion Gal., Montreal 1956, 1958; Laing Gal., Toronto 1960; Gal. Libre, Mtl., 1966.

SEGUIN, TUTZI HASPEL — Painter, C., Ser., T., L.
43 Camberwell Rd., Toronto, Ont.
B. Bucharest, Romania, Oct. 14, 1911. Studied: Romanian Acad. Art. Member: FCA; AG Tor. Honours: gold medal, CNE 1938; Intl. award in Graphics, Women's Intl. Art Organization, Vichy, France. Commission: church mural, Tor. 1942. Exhibited: Bucharest Salon 1934-7; RCA 1938; CSPWC from 1944; CSGA 1944, '46; one-man: A. Cl., Tor., 1943, '45, '46. Specializing in enamel on copper. Demonstrations and lectures to groups and on TV. Posi-

tions: Dir., Muskoka Workshop, Summer School of Fine Arts & Crafts; Dir., Art Activities, Camp Rockwood.*

SHADBOLT, JACK LEONARD — Painter, T.
461 North Glynde St., Vancouver, B.C.
B. Shoeburyness, England, Feb. 4, 1909. Studied: Euston Road Group, London; Andre Lhote, Paris; ASL, N.Y. Honours: Canadian Govt. F., France, 1957; Carnegie Intl. award, 1958. Work: AG Tor.; NGC; Mtl. Mus. FA; SAM; Vancouver A. Gal.; Victoria A. Centre; AG Hamilton; Winnipeg AG; BM; Seattle A. Mus.; Mtl. A. Mus.; Smith Col. A. Mus.; Mills College; Univ. B.C.; Hart House, Tor.; Edmonton Int. Airport, mural; Charlottetown Mem. Centre, mural. Other work in private collections. Exhibited: represented frequently in Canadian traveling exhs.; Sao Paulo, Brazil, 1953; Caracas, Venezuela, 1953; Valencia, Venice, Venezuela, 1955; Carnegie Inst., 1955; Seattle World's Fair, 1962; Tate Gal., London; one-man: Toronto, Montreal, Winnipeg, Vancouver, Canada; also, New York, Seattle, San Francisco; Brussels World's Fair, 1958; Mexico City, 1958. L., Writer, in Canada, on contemporary art problems. Positions: Hd., Drawing & Painting Section, Vancouver Sch. A., Vancouver, B.C.*

SMITH, GORDON — Painter, E., S., Gr.
Fine Arts Department, University of British Columbia;
Apt. 302, 2085 Bellevue Ave., West Vancouver, B.C.
B. Brighton, England, June 18, 1919. Studied: Winnipeg Sch. A.; Vancouver Sch. A.; California Sch. FA; Harvard Summer Sch. Member: British Columbia Soc. A.; CSPEE; ARCA; CGP. Honours: Canadian Biennial, 1956; Canada Council Senior Fellowship, Study Abroad, 1960-61. Work: NGC; AG Toronto; AG Winnipeg; London (Ont.) Mus. A.; Hart House, Univ. Toronto; Univ. British Columbia; AG Vancouver; Queen Elizabeth Theatre, Vancouver; Queen's Univ., Kingston, Ont. Exhibited: Guggenheim Mus., N.Y., 1957; Mexico City, 1958; Canadian Biennial, 1955, 1957, 1963; Sao Paulo, Brazil, 1961; Canadian Exhibition, Warsaw, Poland, 1962; World's Fair, Seattle, Wash., 1963; one-man: Hart House, 1957; AG Vancouver, 1957; Laing Gal., Toronto; Agnes Lefort Gal., Mtl., 1963; New Design Gal., Vancouver, 1964. Positions: Assoc. Prof. A., Univ. British Columbia, Vancouver, B.C.*

SMITH, JOHN IVOR — Sculptor
7370 Somerled Ave., N.D.G., Montreal 29, Que.
B. London, England, Jan. 28, 1927. Studied: McGill Univ., B.Sc.; Mtl. Mus. F.A. Sch. A. & Des., under Jacques de Tonnancour, Eldon Grier, Arthur Lismer. Member: SSC. Honours: prizes, Quebec Provincial Comp., 1956, 1959; Winnipeg Show, 1959, 1960, 1961; Grand Award, Montreal Spring Exh., 1960; Vancouver Contemporary Exh., 1961; Canada Council Fellowship 1957 (forfeited). Work: Quebec Provincial Mus.; Winnipeg A. Gal.; Edmonton A. Gal.; Toronto A. Gal.; London A. Gal.; Allied Arts Centre, Calgary; Rodman Hall Arts Centre, St. Catharines; Imperial Bank of Commerce Collection; Queen's University; Sir George Williams University; McMaster University. Exhibited: One-man show, Isaacs Gallery, Toronto; Montreal Spring Exhibition, 1956, 1957, 1960-1965; Winnipeg Show 1959-1965; Women's Committee exh., Toronto, 1958-1960 and Montreal 1959-1963; OSA, 1959; Nat. Outdoor Sculpture Show, 1960; Quebec Provincial Exh. 1956-1965.*

SNOW, JOHN (HAROLD THOMAS) — Lithographer, P.
915 18th Ave., Southwest, Calgary, Alta.
B. Vancouver, B.C., Dec. 12, 1911. Member: CSGA. Honour: prize, CSGA, 1957, 1959, 1961; Jessie Dow award, Mtl. Mus. FA, 1962; Winnipeg show, graphics award, 1961; member: ARCA. Work: NGC; Victoria and Albert Mus., London, England. Exhibited: Int. Biennial Exh. Prints, Tokyo, 1957; Canadian Biennial, 1957, 1959; Int. Biennial, Color Lithography, Cincinnati, 1958; Inter-Am. Biennial, Mexico City, 1958; Royal Inst. British Artists, London, 1960, 1967, 1968; Can. Watercolours, Drawings & Prints, 1964; Royal Academy, London, England, 1963; Royal Scottish Acad., 1966, 1969; Canadian Prints & Drawings, Canadian Gov't. Pavilion, Expo 1967; Pratt Graphic Art Center, N.Y., 1962; Dorothy Cameron Gal., Ltd., Tor.; Pascal Gal. Tor.; Salon des Beaux Arts, 1969.

SURREY, PHILIP HENRY — Painter, W.
478 Grosvenor Ave., Montreal 217, P.Q.
B. Calgary, Alta., Oct. 8, 1910. Member: CSGA. Honours: prize, Montreal, 1953; Winnipeg, 1959; purchase, NGC, 1967. Work: AG Tor.; Mtl. Mus. FA; Musée de Quebec; Bezalel Mus., Jerusalem; NGC; AG Hamilton; A. Gal., London; NGC; Canadian Embassy, Mexico City. Exhibited: NGC; AG Hamilton; A. Gal., London; Sir George Williams Univ.; Winnipeg AG; Canadian Embassy, Mexico City. WFNY 1939; Addison Gal., 1942; Yale 1944; DPC 1945; Rio 1946; Montreal Mus. FA, 1957; London AG, 1963; one-man: Watson Gal., Montreal, 1951; Roberts Gal., Toronto, 1953; Montreal Mus. FA, 1955, 2-man, 1961; Stratford (Ont.) Festival, 1961; Jerrold Morris

Int. Gal., Tor., 1964. Positions: Sec., Int. Plastic Arts Assn. (UNESCO), 1958-60. Instr., Drawing & Painting, Sir George Williams Univ., 1965- .

SWINTON, GEORGE—Painter, Et., Lith., E., W., L.
 University of Manitoba, School of Art; 191 Yale Ave., Winnipeg 9, Man.
B. Vienna, Austria, Apr. 17, 1917. Studied: Univ. Vienna; McGill Univ., B.A.; Montreal Sch. A. & Des.; ASL, N.Y. Member: CSGA; Can. Eskimo Arts Council. Honour: prizes, Winnipeg Show, 1954, 1957, 1960; Phila. Pr. Cl., 1951; Canada Council Senior Fellow, 1959-60; purchase prizes, Canadian Biennials; Hamilton Winter Exh., 1963; Canada Centennial Medal, 1967. Work: Smith Col. Mus.; Winnipeg A. Gal., Israeli Mus. FA; NGC; Queen's Univ.; Calgary A. Centre; AG Hamilton; Beaverbrook AG; Univ. London AG; NGC; Vancouver AG; Confederation A. Centre, Charlottetown; Mount Allison Univ.; Etherington A. Centre, Kingston; MacIntosh Mem. Library, London, Ont. Exhibited: Graphic Arts Today, 1952; Boston Pub. Lib., 1952; NGC, 1955; DMFA, 1958; Canadian Biennial; CGP; Winnipeg Show; CSGA; One-man: 30 one-man exhs. Retrospective exh., Winnipeg A. Gal., 1960, 1968. Contributor articles to Queen's Quarterly; Colliers Encyclopaedia; Canadian Art. Author (with Donald Buchanan), "What Is Good Design?". Author: "Contemporary Eskimo Carving," 1965. Lectures: NGC, 1964; MMA, 1964; Mtl. AG, 1965; Regina and Saskatoon A. Gals., 1965; Univ. British Columbia, Lakehead Col., 1964; N.C.A.E., Chicago, 1963. Positions: Cur., Saskatoon A. Centre, 1947-49; Instr., Smith Col., 1950-53; Queen's Univ., 1953-54; Prof. and Director of Exhibitions, Univ. Manitoba Sch. A., Winnipeg, Man., 1954- .

SYLVESTRE, GUY—Editor, Cr., W., L.
 1870 Garden River Dr., Ottawa, Ont.
B. Sorel, P.Q., May 17, 1918. Studied: College Ste-Marie, Mtl.; Univ. Ottawa, L.Ph., M.A. Member: FCA; Societe des ecrivains canadiens; Canadian Lib. Assn.; Royal Soc. of Canada Académie canadienne francaise. Editor: Gants du ciel, 1943-46; Anthologie de la poesie canadienne, 1943, 1958; Co-editor, la Nouvelle Revue canadienne. Author: "Poetes Catholiques de la France contemporaine," 1944; "Sondages," 1945; "Impressions de theatre," 1950; "Panorama des lettres canadiennes francaises," 1964; "Ecrivains canadiens," 1964; "Un siécle de littérature canadienne," 1967. Contributor to numerous art and educational publications. Positions: National Librarian, National Library, Ottawa.

TAYLOR, FREDERICK (BOURCHIER)—Painter, S.
 Apartado Postal No. 101, Calle de Diez de Sollano y Dávalos No. 49, San Miguel de Allende, Gto., México.
B. Ottawa, Ont., July 27, 1906. Studied: McGill Univ., B. Arch.; Byam Shaw Sch. Drawing, Painting & Des.; London, England; London County Council Central Sch. A. & Crafts; Goldsmith's Col. A., Univ. London. Member: RCA; CSPEE; CSGA. Honours: McGill Univ., Delta Upsilon Mem. Scholarship, 1930. Work: Prints & drawings: NGC; Dominion Archives, Ottawa; AG Hamilton; London (Ont.) A. Mus.; McGill Univ.; paintings: Beaverbrook A. Gal., Fredericton, N.B.; Bezalel Mus., Jerusalem; IMB; McGill Univ.; McCord Mus., Mtl.; Montreal Mus. FA; AG Ontario; Bonar Law Lib., Fredericton; Algoma Ore Properties; Algoma Steel Corp.; Brewing Corp. of Am.; Canadian Breweries, Ltd.; Canadian Corporations, Ltd.; Canadian Ingersoll-Rand; Canadian Railways; Distillers Corp.; Dominick Corp.; Dominion Govt. of Canada; Henry Birks & Sons; Kerr Steamships; Dow Brewery; Sun Life Assurance Co.; Royal Ontario Mus., Tor.; Sir George Williams Univ., Mtl.; Canadian Industries, Ltd., Mtl.; Commissions for the Government of Canada & for many major industrial corporations in Canada and U.S., and others. Exhibited: prints and drawings in all major shows in Canada since 1932; paintings, prints and drawings in Canadian exhs., since 1937; exh. widely in U.S., Canada, Mexico and abroad. One-man: Montreal, Toronto, Ottawa; Instituto Nacional de Bellas Artes, San Miguel de Allende, Mexico, 1967. Positions: Formerly instr., Sch. Arch., McGill Univ. Exec. Comm., Canadian Arts Council, 1952-53; Council Memb., RCA, 1955-57.*

TAYLOR, JOCELYN (Jocelyn Taylor Mitchell)—
 Painter, C., Des., T.
 R.R. 1, Streetsville, Ont.
B. Toronto, Ont., May 29, 1899. Studied: Central Tech. Sch.; Ontario Col. A.; ASL, N.Y. Member: Heliconian Cl., Toronto; CSPWC; OSA. Exhibited: RCA; OSA; CSPWC, all from 1949 to present; ceramics, Montreal and Toronto, 1955; Int. Salon, Vichy, France, 1961. Illus., "The School Theatre," 1925; "Creative Theatre," 1929; "Pirates and Pathfinders," 1947; "Living Latin," 1950. Positions: Asst. to Dir., 1919-21, Tech. Dir., 1925-26, Hart House Theatre, Univ. Toronto; Instr., N.Y. Univ., 1931-43; Instr. A., Central Tech. Sch., Toronto, Ont. 1946-1965.

THORNE, GORDON KIT—Painter, Et., Lith., T., Comm. A., Des.
 742 Broughton St., Vancouver 5, B.C.
B. Stanway, England, Aug. 21, 1896. Studied: Goldsmith's Sch. A., Univ. London, England. Member: British Columbia Soc. A. (Assoc.); Fed. Canadian A.; CPEE, Western A. Circle (Vice-Pres.); life memb., Vancouver Mus. Assn. Work: Vancouver Pub. Mus. & A. Assn. Gallery; Murals, Queen Elizabeth Theatre; Centennial Mus. Work in many leading hotels and in private homes. Exhibited: CPEE, 1952-1956; Fed. Canadian A. traveling exh., 1956-1958; Western A. Circle, and others; Vancouver A. Gal.; retrospective exh., Vancouver City Mus., 1958; one-man: New Richmond A. Gal., B.C. Book, "Strolling and Sketching, 10 Original Lithographs," 1968-1969.

THORNE, M. ART—Painter, T.
 40 Delisle Ave., Toronto 7, Ont.
B. Devon, N.B., Nov. 15, 1909. Studied: Ontario Col. A., Assoc. degree, with John Alfsen, George Pepper, Gustav Hahn, Emanuel Hahn; ASL, N.Y., with Vytlacil, Marsh, Kantor. Member: A. & Lets. Cl. Toronto; Casa Loma, Toronto. Work: murals, British American Oil Co., Toronto; Casa Loma, Toronto. Exhibited: CSGA, 1944; Candian Younger A., 1948-1950; Nova Scotia Soc. A., 1944, 1945; Rochester Mus. A. & Sc., 1949; Royal Ontario Mus., 1948; AG Toronto, 1948; YM-YWHA Toronto, 1954, 1956; Int. Cinema, 1954, 1956; Queen Elizabeth Bldg., Toronto, 1957; Royal York Hotel, 1958, Northwood Golf & Country Cl., 1960, Robert Simpson Co., 1961-1963; Forest Hill A. Centre, 1967 (one-man), all Toronto. Positions: Art Dir., Forest Hill Art Club, Toronto.

TINNING, G. CAMPBELL—Painter
 1509 Sherbrooke St. West, Apt. 73, Montreal 109, Que.
B. Saskatoon, Sask., Feb. 25, 1910. Studied: ASL; Eliot O'Hara Sch., Maine. Member: ARCA. Honour: Twice recipient of Jessie Dow prize for watercolour, Mtl. Mus. FA. Work: mural, Jenkins Valve Co., Lachine, Que.; mural dec., President's Lounge, Head Office, Bank of Montreal; mural, offices of Stikeman & Elliott, Mtl. Commissions: official war artist with Can. Army 1943-6; Hotel de Champlain, Montreal; Canadian Pacific Railroad Co.; murals, Ritz Carlton Hotel, Montreal. Exhibited: Expo '67, Montreal.

TOLGESY, VICTOR—Sculptor
 90 Kirby Rd., Ottawa 14, Ont.
B. Miskolc, Hungary, Aug. 22, 1928. Honours: Canada Council Grant, 1957; First prize, Nat. Gal. Canadian Sculpture Show, 1962; Canada Council Senior Fellowship, 1965; sculpture prize, RCA, 1967. Work: NGC; Willistead Mus., Windsor, Ont.; Waterloo Univ.; Brandon Univ.; and in private colls. Steel sc., Expo '67; Hungarian Freedom Monument, Toronto and several architectural works in Canada. Exhibited: Brussels World's Fair, 1958; Canadian Conf. Arts, Toronto, 1961; NGC First Canadian Outdoor Sculpture Show, 1962; Winnipeg shows, 1961, 1962, 1964, 1966, 1968; Sculpture '67, Toronto; one-man: Ottawa, 1953, 1956, 1957, 1962, 1964, 1966; Toronto, 1965.

TOUSIGNANT, CLAUDE—Painter, S.
 3684 St. Laurent, Montreal 130, Que.; h. 4874 Cote des Neiges #306, Montreal 247, Que.
B. Montreal, Que., Dec. 23, 1932. Studied: Sch. A. & Des., Mtl.; Academie Ranson, Paris. Member: Artistes Professionels de Mtl. Awards: prizes, Salon de la Jeune Peinture, 1962; Centennial Exh., 1967. Work: NGC; Phoenix (Ariz.) A. Mus.; Aldrich Mus. Contemp. A., Ridgefield, Conn.; York Univ.; Canadian Council; Vancouver AG; Canadian Industries; Mtl. Mus. FA; Sir George Williams Univ.; Mus. Contemp. A., Mtl. and Que., and others. Exhibited: Guggenheim Mus., N.Y., 1965; Canada Art, Paris, Rome and Brussels; Lausanne, Switzerland, 1968; MIT; Washington Gal. Mod. A.; many other group exhs., and 13 one-man shows. Positions: Instr., Des., School of Art & Design, Montreal, Canada; Pres., Claude Tousignant, Inc.

TOWN, HAROLD BARLING—Painter, S., Des., I., W.
 25 Severn St., Studio 4; h. 9 Castlefrank Crescent, Toronto 5, Ont., Canada
B. Toronto, Can., June 13, 1924. Studied: Ontario Col. of Art. Member: Assoc. RCA; Hon. Memb., Toronto A. Dirs. Club; Canadian Group of Painters. Awards: Arno prize, Sao Paulo, Brazil, 1957; Int. Exh. Drawings and Prints, Lugano, Switzerland, 1958; Fellowship, Instituto de Cultura Hispanica, Madrid, Spain, 1963; Medal, Montreal A. Dirs. Club, 1963; Grand Prix, A. H. Robinson Award, Montreal Mus. FA, 1963; Merit Award, RCA; prize, Minera Santa Barbara, 1963; Woemn's Committee, Toronto Art Gal., 1963; Santiago, Chile, 1963; LL.D, Honoris Causa, York Univ., Toronto, 1966; Centennial Medal, Canada, 1967; Medal of Service of the Order of Canada, 1969. Work: Stedelijk Mus., Amsterdam; Tate Gal., London; Mus. Mod. A., Sao Paulo, Brazil; Museo de Arte Contemporaneo, Santiago, Chile; Galleria d'Art di Villa Ciani, Lugano, Switzerland; MModA; Guggenheim Mus.; BM; CMA; Detroit Inst. A.; NGC; A. Gal., Toronto; Montreal Mus. FA; Vancouver A. Gal.; Mackenzie A.

Gal., Regina; Hamilton, Edmonton, Winnipeg and Victoria Art Galleries; Beaverbrook A. Gal.; A. Gal of London, Ont.; Univ. Toronto; Queen's Univ., Kingston; Univ. British Columbia; Vancouver Univ. Coll.; Sir George Williams Univ., Mtl.; Imperial Oil Coll., Toronto; Albirght-Knox A. Gal.; MMA; Hirshhorn Coll., Wash., D.C.; Canadian Council Coll., Ottawa; Telegram Bldg., Toronto; Toronto Int. Airport; Queens Park Complex, Toronto. Exhibited: MModA, 1962, traveling 1963; Guggenheim Mus., 1963 (2); Dunn Int. Exh., Fredericton, N.B. and Tate Gal., London; Graphik 1963, Albertina Mus., Vienna, 1963; Bonino Gal., N.Y., 1963; Morris Int. Gal., Toronto, 1963; Santiago, Chile, 1963; Buffalo, N.Y., 1963; Lima, Peru, 1964; Tate Gal., 1964; Arte de America y Espana, Rome, Milan, Berlin and Paris, 1964; Venice Biennale, 1964; Seventh Biennial of Canadian Painting; NGC, Ottawa; Montreal Mus. FA; De Marco Gal., Edinburgh; Print Biennale, Bradford, England, 1968-1969; Canada 101, Edinburgh Festival, 1968, and others in U.S., Canada and abroad. One-man: Morris Gal., N.Y., 1962; Fairleigh Dickinson Univ., Madison, N.J., 1963; St. Chaterine's Art Council, 1963. Designed banner for Founders Col., York Univ., and sets & costumes for "House of Arteus," Nat. Ballet Co. of Canada. Contributor articles and illus. to Globe & Mail, Toronto; Canadian Art; Macleans Magazine; Chatelaine; and other publications. Regular columnist, "Toronto Life" magazine. Auth. & I., "Enigmas," 1964; I., "Love Where the Nights are Long," 1962.

TRAVERS, GWYNETH (Mrs. C. H.) — Printmaker
234 Albert St., Kingston, Ont.
B. Kingston, Ont., Apr. 6, 1911. Studied: Queen's Univ., B.A. Member: CPE; Artists' Workshop, Kingston. Honours: prizes, Quebec Nat. Comp., 1958; Reid Award, CPE, 1958; Expo. Provincial de Quebec, 1958, 1959, 1960-1964, 1965; Winnipeg Show, 1960. Work: NGC; Acadia Univ.; A. & Lets. Cl., Toronto; CPE; Queen's Univ., Kingston; Winnipeg AG; Montreal Mus. FA. Exhibited: Can. Nat. Exh., 1957, 1958; Winnipeg Show, 1958, 1959, 1960, 1964; CPE, 1956-1968; Expo. Provincial, 1958-1964; Kingston AA, 1948-1968; NGC, 1959; Ont. Soc. Gr. A., 1961; Western Ontario Exh., 1959-1961; A. Gal., Hamilton, 1960-1964; 2-man, Agnes Etherington A. Center, Queens Univ., 1964; "9 Kingston Artists," traveling show, 1967-1969.

VALIUS, TELESFORAS — Engraver, Lith., E.
84 Pine Crest Road, Toronto 9, Ont.
B. Riga, Latvia, July 10, 1914. Studied: Sch. A., Kaunas, Lithuania, and in Paris, France; Ontario Col. of Educ., Univ. Toronto. Member: CSGA; CSPEE; Am. Color Pr. Soc.; F.I.A.L.; Lithuanian A. Inst. Honours: prizes, CSGA, 1958; Royal Ontario Mus., 1958; Sterling Trust Award, CPE, at Royal Onatrio Mus., 1961; Can. Centennial Silver Medal, 1967. Work: AG London (Ont.), and in museums in Lithuania; Mus. FA., Montreal; A. Inst. of Ontario. Exhibited: Lithuanian A. Soc., 1937-1942; in Germany, Austria, France, Belgium, Argentina, New Zealand; CSGA, 1953-1955, 1957, 1958, 1964; NGC, 1954-1956, 1958; Montreal Mus. FA, 1954, 1955, 1957; Rochester Mem. A. Gal., 1953; Chicago, 1956, 1958; New York, N.Y., 1958, 1960; Am. Color Pr. Soc., Tokyo, 1961; CPE, 1962-1964, 1966-1968; Abstract Art, '62, Tor., 1962; Ann. Color Print Soc. Exh., Philadelphia; Canadian Religious Art Exh., Toronto, 1963; AG, Hamilton, 1963; AG Mtl., 1964; London Art Mus., 1964; Print Cl., Philadelphia, 1964; Am. Color. Pr. Soc., Phila., 1966, 1967, 1968, 1969; Agnes Etherington Art Center, Kingston, 1964; Mus. FA, Mtl., 1964; Soc. Can. A., Toronto, 1968; Lithuanian Inst. of A., Chicago, 1969; one-man: Paris, France, 1959; New York, N.Y., 1960; Toronto Pub. Lib., 1961; Galerie des Beaux Arts, Paris, 1964. Positions: Pres., CPE, 1962-1964; Pres., CSGA, 1964-1965. Instr., etching, Central Tech. Sch., Toronto, 1960- . Instr., Winston Churchill Coll. Inst., Scarboro, 1967- .

VICKERS, GEORGE STEPHEN — Educator
Dept. of Fine Art, Univ. of Tor., Toronto, Ont.; 31 Rosedale Rd., Toronto, Ont.
B. St. Catharines, Ont., Dec. 19, 1913. Studied: McMaster Univ., B.A.; Harvard Univ., A. M. Author: "Art and Man," (with P. H. Brieger and F. Winter) 3 vols., 1964. Contributor: Art Bulletin, Burlington Magazine. Honours: Junior Fellow, Harvard, 1939-42. Positions: Prof., Univ. Tor.; Council Memb., Chm., Dept. Fine Art, Univ. Toronto; Trustee, Nat. Mus. of Canada.

WALSH, JOHN STANLEY — Painter, I., W.
142 52nd Ave., Lachine, P.Q.
B. Brighton, England, Aug. 16, 1907. Studied: London Central Sch. A., London, England. Member: Can. WC Soc.; Can. Soc. Gr. A. Work: Montreal Mus. FA; Toronto A. Mus. Exhibited: AWS, 1961; CSPWC; Can. Soc. Gr. A.; RCA; numerous one-man exhs., Montreal, New York and Toronto. Contributor articles and illus. to American Artist; New York Times; Esquire; Harper's Bazaar; Field & Stream; Argosy; Family Circle; Women's Day; Good Housekeeping, etc. Lectures on Watercolor Painting.

WATSON, SYDNEY H. — Painter, E., Des.
2 Nesbitt Dr., Toronto 5, Ont.
B. Toronto, Ont., 1911. Member: CSPWC; OSA; Academican Des., RCA; CGP; Canadian Handicraft Gld. Honours: A. Dirs. Medal, 1956; Government of Canada Centennial Medal, 1967. Work: Hart House; NGC; murals, Head Office, Imperial Oil Co. Bldg.; Chapel, Toronto General Hospital; Bank of Montreal, Toronto Office; Canadian Imperial Bank of Commerce, Mtl.; Excelsior Life Ins. Co., Tor.; wall paintings, Chapel of Trinity College School, Port Hope; Ecclesiastical deocrations, Chapel of Upper Canada College, and Church of the Redeemer, Toronto; Lever Brothers, Toronto; North York General Hospital, Toronto; Chapel, Anglican Church Ltd., Toronto; Commemoration, Univ. Ave. Armouries, Toronto; Medal des., Royal Canadian Acad. A.; exterior dec., Lash Miller Bldg., Univ. Toronto; Queen's Park Project, Govt. of Ontario. Exhibited: many Canadian Society Exhs., traveling under auspices of Nat. Gal. Canada, exhibiting in England, United States, Australia and New Zealand. Positions: Art Master, Lakefield Prep. Sch., 1940-44; Staff, Ontario College of Art, 1946; Principal, Ontario College of Art, 1955- .

WHEELER, ORSON SHOREY — Sculptor, T., L.
1441 Drummond St., Montreal, P.Q.
B. Barnston, P.Q., Sept. 17, 1902. Studied: Bishop's Univ., B.A.; RCA classes, Mtl.; Cooper Union, N.Y.; BAID, N.Y.; NAD, and in Europe. Member: SSC; Honours: RCA; Dominion Govt. Centennial Medal, 1967. Commissions: bust, Can. Pacific Railways; Jacobs mon., Mtl.; Supreme Court, Ottawa; Morril mon., and Hackett mon., Stanstead, P.Q.; bust, Court House, Mtl.; Bishop's Univ., P.Q.; Montreal Children's Hospital; Mtl. Mus. FA; Provincial Archives, Quebec; King's Col., Halifax, N.S.; Robinson Residence for Retired Teachers, Cowansville, Quebec. Sculpture for Dow Chemical of Canada, Ltd. and in private colls, in Canada & U.S. Exhibited: AA Mtl., 1928 and from 1932-1946, 1948, 1949, 1952, 1957; RCA, 1931-1953, 1955, 1958, 1959, 1961; Tate 1938; WFNY 1939; NAD 1940; SSC; Smith Col. 1945; Ottawa, 1950; Quebec City 1951, 1960; Mtl. Mus. FA, 1952-1957; has made over 50 scale models of world famous buildings to illus. history of architecture. Models exhibited Mtl. Mus. FA, 1955. TV Film: "Quebec Arts '58" produced by C.B.C. French version "Madones et Abstractions" shown at Brussels World's Fair, 1958. Positions: Lecturer in FA, Sir George William Univ. from 1931; Chm. Permanent Coll., Can. Handicrafts Gld., 1944-1964, Co-Chm., 1964- . Sessional Lecturer in Arch., McGill Univ., 1949- ; Treas., SSC, 1952-1967.

WHITEHEAD, ALFRED — Painter, E., L.
52 Havelock St., Amherst, N.S.
B. Peterborough, England, July 10, 1887. Member: Nova Scotia Soc. A. Honours: Doctor of Music, McGill Univ.; LL.D., Mount Allison; F.R.C.O., London, England; NSA. Exhibited: Montreal Spring Exhs., 1942-1947; Nova Scotia Soc. A., 1948, 1949, 1952-1958; Maritime AA; RA (London); Royal Soc. British Artists (London); Pastel Soc. (London); One-man: Mount Allison Univ., 1951; Amherst, N.S., 1952; Dalhousie Univ., 1961; Univ. New Brunswick, 1962. Netherwood Col., Rothesay, N.B., 1956, 1957. Positions: Dean, Music, Mount Allison Univ., Sackville, N.B., 1947-53; Emeritus, 1953- .

WOODS, REX NORMAN — Illustrator, P., Des., Comm.
707 Eglinton Ave., West, Toronto 10, Ont.
B. Gainsborough, England, July 21, 1903. Studied: Gainsborough Sch. of Sc. & A.; Ontario College of Art. Member: SI, N.Y.; Canadian Authors Assn.; Nat. Soc. A. Dir. Commissions: posters for Gen. Motors; Canadian War Savings; posters, adv. illus., MacDonald Tobacco Co.; Canadian Breweries, Ltd.; Hudson's Bay Co. Contributor to Maclean's magazine, and others. Represented in Canadian Historical Coll. of Confederation Life Assn., Toronto, 1956- . Crysler Hall Mus., Upper Canada Village; painting, "Fathers of Confederation" in Parliament Buildings, Ottawa, 1969.

ZACKS, SAMUEL JACOB — Collector, Patron
200 Bay St. (1); h. 400 Walmer Rd., Toronto, Ont.
B. Kingston, Ont., Apr. 29, 1904. Studied: Queens University, Kingston, Ont., B.A.; Harvard University Graduate School. Awards: Lockhead Scholarship, 1925; Weizmann Institute of Science Medal of Merit, 1966; Honorary Fellow, Oxford University, 1969. Collection: European and American Sculpture; Contemporary Canadian painting (many works donated to Queens University); Paintings of the School of Paris; Impressionist paintings and drawings; African sculpture; Eskimo art; Pre-Columbian art; Grecian, Egyptian sculpture. Positions: Chairman, Exhibition Committee, 1962-1966, Member, Inner Executive Com., 1963- , Member, International Council of Art, President, 1966-1968, Art Gallery of Ontario, Member, International Council, Museum of Modern Art, N.Y.

GEOGRAPHICAL
INDEX

ABBREVIATIONS

Adv. Des.—Advertising Designer
Arch.—Architect
Arch. Des.—Architectural Designer
Arch. Hist.—Architectural Historian
Art.—Artist
Art Cent. Dir.—Art Center Director
Art E.—Art Educator
Art Ed.—Art Editor
Art Lib.—Art Librarian
Art Publ.—Art Publicist
Art Sch. Dir.—Art School Director
Art Soc. Dir.—Art Society Director

Bk. Bndr.—Bookbinder
Bkp. Des.—Bookplate Designer

C.—Craftsman
Call.—Calligrapher
Cart.—Cartoonist
Carto.—Cartographer
Cer. C.—Ceramic Craftsman
Cer. Des.—Ceramic Designer
Chief Exh. Div.—Chief Exhibits Division
Comm. A.—Commercial Artist
Cons. A. Dir.—Consulting Art Director
Cr.—Critic
Cur. Collections—Curator of Collections

Dean E.—Dean of Education
Des.—Designer
Dir.—Director
Dir. Rest.—Director of Restoration

E.—Educator
Ed.—Editor
Ed. of Publ.—Editor of Publications
Eng.—Engraver
Et.—Etcher

Fash. I.—Fashion Illustrator
Flm. Mk.—Film Maker
Form. Mus. Dir.—Former Museum Director

Gal. Dir.—Gallery Director
Gr.—Graphic Artist
Gr. Des.—Graphic Designer

Hist.—Historian

I.—Illustrator
Ill.—Illuminator

Indst. Des.—Industrial Designer
Indst. I.—Industrial Illustrator

L.—Lecturer
Lib. Dir.—Library Director
Libr.—Librarian
Lith.—Lithographer

Mar. P.—Marine Painter
Med. I.—Medical Illustrator
Min. P.—Miniature Painter
Mur. P.—Mural Painter
Mus. A.—Museum Associate
Mus. Admin.—Museum Administrator
Mus. Asst. Dir.—Museum Assistant Director
Mus. Assoc. Cur.—Museum Associate Curator
Mus. Cons.—Museum Conservator
Mus. Consult.—Museum Consultant
Mus. Cur.—Museum Curator
Mus. Des. Exh.—Museum Designer of
 Exhibitions
Mus. Dir.—Museum Director
Mus. L.—Museum Lecturer
Mus. Off.—Museum Officer
Mus. Prep.—Museum Preparator
Mus. Res. F.—Museum Research Fellow
Mus. Rest.—Museum Restorer
Mus. Res. & Pro. Asst.—Museum Research
 & Program Assistant
Mus. Sec.—Museum Secretary
Mus. Staff A.—Museum Staff Artist

P.—Painter
Pack. Des.—Package Designer
Por. P.—Portrait Painter
Pr.—Painter
Pr. M.—Printmaker

S.—Sculptor
Sc. Des.—Scenic Designer
Ser.—Serigrapher
Supv.—Supervisor

T.—Teacher
Tex. Des.—Textile Designer
Theat. Des.—Theatrical Designer
Typ.—Typographer
Typ. Des.—Typographic Designer

W.—Writer

GEOGRAPHICAL INDEX

ALABAMA

Auburn

Sykes, (William) Maltby—P., Gr., E., L.
Young, William Thomas—P., Et., Lith., E., L.

Birmingham

Ellis, George Richard—Mus. Cur.
Howard, Richard Foster—Mus. Dir.
Hulsey, William Hansell—Collector.
Jacobs, Jay Wesley—Por. P.
Kennedy, Doris Wainwright—P.

Brindidge

Godwin, Robert Lawrence—P., S., T.

Dothan

Watford, Frances (Mrs. B. E.)—P., T.

Huntsville

Hudson, Ralph M.—E., Des., P., W., L., Comm. A.

Livingston

Schwarz, Myrtle Cooper—E., C., W.

Mobile

Altmayer, Jay P.—Collector.
Blackburn, Lenora W. (Mrs. Willis C.)—Collector.

Montgomery

Brooks, Louise Cherry (Mrs.)—Collector, Ceramist

Tuscaloosa

Brough, Richard Burrell—E., P., Des., Comm., A., I.
Richardson, Jeri (Pamela)—S., E.
Zoellner, Richard Charles—P., Gr., I., L., E.

University

Sella, Alvin Conrad—P., E.

ALASKA

Anchorage

Appel, Keith Kenneth—P., Pr.M., E.
Kohler, Mel(vin) (Otto)—E., Int. Des.
Vallee, William—P., I., Comm. A., Des., Gr.

Palmer

Machetanz, Fred—P., Pr.M., I., L., W.
Machetanz, Sara (Mrs. Fred)—W.

ARIZONA

Camp Verde

Dyck, Paul—P., L.

Flagstaff

Danson, Edward B.—Mus. Dir., W.
Salter, John Randall—S., P., Des.
Wright, Barton Allen—Mus. Cur., I.

Phoenix

Bergamo, Dorothy Johnson—P., Lith., T., L.
Coze, Paul (Jean)—P., W., I., L., E., S.
Datus, Jay—P., T., W.
Greenbowe, F(rederick) Douglas—P.
Jacobson, Arthur R.—P., Gr., E.
Pritzlaff, Mr. and Mrs. John Jr.—Collectors.
Ullman, George W.—Collector, Patron, W.

Scottsdale

Curtis, Philip C.—P.
Goo, Benjamin—S., Des., E.
Hack, Patricia Y. (Mrs. Phillip 3.)—Art Dealer.
Hack, Phillip S.—Collector.
Harris, Robert George—I., Comm. A., P., L.
Keane, Bill—Cart.
Lang, Margo Terzian (Mrs. J.M.)—P.
Manning, Reg(inald) (West)—Cart., W., Des., L.
Ruskin, Lewis J.—Collector, Patron

Tempe

Harter, Tom J.—E., P., Des., I.
Wood, Harry Emsley, Jr.—E., L., P., S., Cr., W.

Tucson

Bolster, Ella S. (Mrs. H. G.)—C., L.
Edgerly, Beatrice (Mrs. J. Harvard Macpherson)—P., Lith., I., T., Cr., W.
Haas, Lez (L.)—P., E.
Hay, Dorothy B. (Mrs. John L.)—P., Et.
Hyslop, Alfred John—E., S.
Loney, Doris Howard (Mrs. Boudinot S.)—P., L., Gr.
McMillan, Robert W.—E., P., L.
Pleasants, Frederick R.—Collector, Patron, W., Scholar.
Silvercruys, Suzanne (Mrs. Suzanne Silvercruys Stevenson)—S., W., L.
Steadman, William E., Jr.—Mus. Dir., E., P., L., Collector.
Voris, Mark—E., P., Des.

ARKANSAS

Clarksville

Ward, Lyle E.—P., E., L., Gr.

Eureka Springs

Freund, Harry Louis—P., E., I.

Fayetteville

Reif, Rubin—P., Gr., Des., Comm. A., E., C.

Little Rock

Graham, Bill (William Karr)—Cart.

Marianna

Govan, Francis Hawks—Ed., P., C., Des., L.

Morrilton

Rockefeller, Mr. and Mrs. Winthrop—Collectors

CALIFORNIA

Altadena

Baker, George P.—S., T.
Green, David (Oliver) (Jr.)—S., Des., E., L.

Arcadia

Kushner, Dorothy Browdy—P., C., T.
Roysher, Hudson (Brisbine)—Des., C., E., L.

Belvedere

Ludekens, Fred—I., Des.

Berkeley

Bischoff, Elmer Nelson—P., E.
Blos, May—I., C., P.
Blos, Peter W.—P., E., Gr.
Cahill, James Francis—Mus. Cur., E.
Chipp, Herschel Browning—E., Mus. C., W., L., Cr.
Davis, Jerrold—P.
Giambruni, Tio—S.
Harris, Lucille—P., Et., Des.
Kasten, Karl—P., E., Et.
Loran, Erle—P., E., W.
Miyasaki, George Joji—P., Gr., E.
Nelson, Lucretia—E., P.
Prestini, James—S., E., Des., C.
Raffael, Joseph—P.
Reichek, Jesse—Pr.M., Des., P., E.
Ruvolo, Felix—P., E.
Selz, Peter H.—Mus. Dir., E., Hist., W., L.
Snelgrove, Walter H.—P.
Watson, (James) Robert (Jr.)—P.
Wessels, Glenn Anthony—P., W., L., E.

Beverly Hills

Bensinger, B. Edward III—Collector.
Brown, Harry Joe, Jr.—Collector, W., Cr.
Chamberlain, Wesley—Pr.M.
D'Agostino, Vincent—P.
Factor, Donald—Collector, Ed.
Greene, Lucille Brown (Mrs. Roy)—P., T., W., L.
Halff, Robert H.—Collector.
Kantor, Paul—Art Dealer.
Perls, Frank (Richard)—Art Dealer, Collector.
Strombotne, James—P.

Big Sur

Bowman, Dorothy (Louise) (Mrs. Howard Bradford)—Ser., P.

Bolinas

Harris, Paul—S.
McDowell, Barrie—S.
Okamura, Arthur—P.

Burbank

Riley, Art(hur Irwin)—P., Des., Cart., I.

Burlingame

Lilienthal, Mr. and Mrs. Philip N., Jr.—
 Collectors

Cambria

Paradise, Phil—P., Lith., Ser., T., L., S.

Canoga Park

Souden, James G.—E., P.

Capistrano Beach

Partch, Virgil Franklin—Cart., I., Comm.,
 L., W.

Cardiff-by-the-Sea

Louden, Orren R.—P., W., L.

Carlsbad

Hagen, Ethel Hall—P., C., T.

Carmel

Adriani, Bruno—Collector, Scholar, W.
Dooley, Helen Bertha—E., L., P.
Huth, Hans—Former Mus. Cur., W., L.
Huth, Marta—P.
Lagorio, Irene R.—P., Gr., Des., C., L.
Laycox, (William) Jack—P., I., Des.
Oehler, Helen Gapen (Mrs. Arnold J.)—P.,
 L., T.
Shoemaker, Vaughn—Cart., P., L.
Teague, Donald—P.

Carmel Valley

Ketcham, Henry King—Cart.
Parker, Alfred—I.

Carpenteria

Warshaw, Howard—P., E.

Cathedral City

Johnson, Katharine King (Mrs. Norman F.)
 —P.

Chico

Turner, Janet Elizabeth—P., Gr., E., L.

Claremont

Ames, Arthur Forbes—P., C., Des., E.
Ames, Jean Goodwin—Des., P., C., E.
Benjamin, Karl Stanley—P.
Blizzard, Alan—P., E.
Dike, Phil(ip) (Latimer)—P., Des., C., E.,
 Gr.
Dorman, Margaret—Gal. Dir., P., S., T., I.,
 L.
Hueter, James W.—S., P., T.
Sheets, Millard Owen—Des., P., L.
Skelton, Phillis Hepler—P., Gr., T., L.
Stewart, Albert T.—S.
Zajac, Jack—S., P., Gr.

Corona del Mar

Brandt, Rex(ford)—P., I., W., L., T., Des.
Delap, Tony—S., E.
Hall, George W.—S.

Corte Madera

Potter, G. Kenneth—P., T., L., Gr., S.
Sherry, William Grant—P., S., T., L.

Costa Mesa

Garver, Thomas H.—Mus. Dir., W., L.
Slick, James Nelson—S., P.

Daly City

Pearson, Louis—S.

Davis

Baird, Joseph Armstrong, Jr.—E., W., L.
Nelson, Richard L.—E., P., L.

El Segundo

Grauel, Anton C.—S.

Encino

Hoowij, Jan—P.
Hubenthal, Karl S.—Cart.
Love, Rosalie Bowen—P., T.
Sider, Deno—P., S., C., T., I., L.
Wein, Albert W.—S., P., Des., E.

Escondido

Sternberg, Harry—P., Gr., T., L., W.

Fresno

Bitters, Stan—S.
Brewer, Donald J.—E., W., Cr., L.
Musselman, Darwin B.—P., E., L.
Odorfer, Adolf—Cer.C.—E.
Pickford, Rollin, Jr.—P., Des., I., T.

Fullerton

Ivy, Gregory Dowler—E., Des. Coordinator,
 P.
Simon, Norton—Collector.

Greenbrae

Irwin, John—Publisher, Ed.

Hillsborough

Tucker, Mrs. Nion—Collector.

Hollywood

Asmar, Alice—P., Des., T., L., Gr.
Band, Max—P., W., S., L.
Hockney, David—Lith.
Houser, Vic(tor) Carl—S., W., L., P., Des.,
 T.
Janss, Ed—Collector.
Paval, Philip—P., C.
Rose, Barbara—Cr.
Ruscha, Edward Joseph—P., Des.
Scarpitta, Nadja—S., L., W., T., P.
Smiley, Ralph J.—Por. P.

Hood

Thiebaud (Morton), Wayne—P., E.

Inglewood

Yoakum, Delmer J.—P., Des., Ser.

La Canada

Shackelford, Katharine Buzzell—P., T.

Lafayette

Schnier, Jacques—S.

Laguna Beach

Armstrong, Roger—P., Cart., W., L., T.
Blacketer, James (Richard)—P., Des., T.
Carmichael, Jae (Jane Grant Giddings)—P.,
 Gr., T., L.
Frankel, Charles—S.
Frankel, Dextra—S., C., Gr., Mus. Dir.
Interlandi, Frank—Cart., P.
Kauffman, Robert Craig—P., T.
Scheu, Leonard—P., T., Lith., L.
Von Schneidau, Christian—P., S., W., L.

La Jolla

Brach, Paul (Henry)—P., Lith., E.
Ellison, J. Milford—T., P., L., Gr.
Levy, Beatrice S.—P., Gr., T.
Mason, Roy Martell—P.
Monaghan, Eileen (Mrs. Frederic Whitaker)
 —P.
O'Hara, (James) Frederick—Pr. M., P., E.
Schapiro, Miriam—P., Pr.M., Des.
Stewart, John Lincoln—S., W., Univ. Admin-
 istrator
Tibbs, Thomas S.—Mus. Dir., L., W.
Whitaker, Frederic—P., W.

La Mesa

Swiggett, Jean (Mr.)—E., P.

Livermore

Wasser, Paula Kloster—W., P.

Loma Linda

Weese, Myrtle A.—P.

Long Beach

Hay, Velma (Messick)—P.
Messick, Benjamin Newton—P., Lith., Et.,
 T., L.
Wong, Jason—Mus. Dir., W., L.

Los Angeles

Anderson, Andreas Storrs—E., P.
Aron, Kalman—P.
Asher, Dr. and Mrs. Leonard—Collectors.
Berg, Phil—Collector, Patron.
Blankfort, Dorothy (Mrs. Michael)—Collec-
 tor.
Blankfort, Michael—Collector.
Bloch, E. Maurice—E., L., Mus. Cur. &
 Dir., W., P.
Blum, Shirley Neilsen—S., E.
Blumberg, Ron—P., T.
Brice, William—P., E.
Broderson, Morris—P.
Brody, Mr. and Mrs. Sidney F.—Collectors.
Burkhardt, Hans Gustav—P., E., Gr.
Chuey, Robert Arnold—P., T.
Cremean, Robert—S.
Crutchfield, William Richard—Pr.M., P.,
 Des., I., T., W.
Darricarrere, Roger Dominique—S., C.,
 Des., E.
Davidson, J. Leroy—Scholar.
Davis, Ronald—P.
Dimondstein, Morton—S., P., Gr., T., L.
Donahue, Kenneth—Mus. Dir.
Drudis, Jose—P., L.
Eloul, Kosso—S., Gr.
Ewing, Edgar—P.
Fenci, Renzo—S., E.
Finch, Keith—P.
Finkelstein, Max—S.
Foulkes, Llyn—P., E.
Francis, Sam—P.
Frazier, Charles—S.
Freed, Ernest Bradfield—Et., Eng., P., E.
Gibson, George—P., Des., I., L.
Gray, David—S.
Hammersley, Frederick—P.
Hansen, Robert (William)—P., S., E.
Hatfield, Mrs. Ruth—Art dealer.
Jarvaise, James J.—P.
Kent, Sister Corita—Ser., E.
Kester, Lenard—P., Des., Gr., I., T., L.
Kienholz, Edward—S.
Landau, Felix—Art Dealer
Lauritz, Paul—P., T., L.
Leeper, John P.—P.
Letendre, Rita (Rita Letendre-Eloul)—P.,
 Gr.
McLaughlin, John—P.
Mason, John—S.
Natzler, Gertrud—Cer.C.
Natzler, Otto—Cer.C.

Nelson, Rolf G.—Gal. Dir., P., S., Gr.
Ohrbach, Jerome K.—Collector.
Peake, Channing—P.
Peck, Edward—Director University Galleries, E.
Price, Kenneth—Lith., S.
Price, Vincent—Collector, W., L., Actor
Quinn, Noel—P., Des., E., I., Gr.
Reeves, J. Mason, Jr.—P.
Robles, Esther Waggoner—Art Dealer, Collector, L.
Ross, Kenneth—Mus. Dir., Cr., L.
Saturensky, Ruth—P., T., L.
Schwaderer, Fritz—P.
Secunda, Arthur—P., S., T., W., L.
Seldis, Henry J.—Cr.
Silverman, Dr. Ronald H.—E.
Singer, Burr (Mrs. Burr Lee Friedmann)—P., Lith.
Sklar, Dorothy (Mrs. Dorothy Sklar Phillips)—P., T.
Smith, Walt Allen—S., Des., L., T.
Steinitz, Kate Trauman—Art Curator
Stoops, Dr. Jack—E.
Stuart, David—Art dealer
Takemoto, Henry Tadaaki—C., Lith., S.
Tsuchidana, (Harry) Suyemi—P., Et.
Tuchman, Maurice—Mus. Cur.
Vann, Loli (Mrs. Oscar Van Young)—P.
Van Young, Oscar—P., T., L., Lith.
Vargas, Rudolph—S., Des.
Waano-Gano, Joe—P., Des., I., W., L.
Wayne, June—Lith., P., W., L.
White, Charles Wilbert—P., Gr., T., L.
White, Lawrence Eugene—E., C.
Wight, Frederick S.—E., Gal. Dir., W., P.
Woelffer, Emerson—P., Pr.M.
Wright, Mr. and Mrs. William H.—Collectors.
Young, Joseph Louis—Mur.P., S., C., Gr., E., L.
Zamitt, Norman—S.

Malibu

Brown, William Theo(philus)—P., T.
Getty, J. Paul—Collector, W.
Rivas, Paul George—P., Gal. Dir., T., Cr., L., W., Et.

Manhattan Beach

Crown, Keith (Allan) Jr.—P., E., L.

Mendocino

Bothwell, Dorr—P., Gr., T., L.

Mill Valley

Anderson, Jeremy Radcliffe—S., E.
Lederer, Wolfgang—Des., I., E.
O'Hanlon, Richard Emmett—S., L., E.
Riegger, Hal—C., E., S.

Millbrae

Nepote, Alexander—P., E., L.

Montclair

Ruben, Richards—P., T., Ser.

Montecillo-Del Mar

Herman, Vic—P., Cart., I., Des., W.

Monterey
Bradford, Howard—Ser., P., T.
Dedini, Eldon—Cart.

Morgan Hill

Freimark, Robert—P., Gr., T., W.

North Hollywood

Hulett, Charles Willard—P., T., I.
Mesches, Arnold—P., T., L.

Northridge

Dentzel, Carl Schaefer—Mus. Dir., W., L.

Novato

Wilmeth, Hal Turner—E., Gal. Dir., L., P.

Oakdale

Ayling, Mildred S.—P., L.

Oakland

Beasley, Bruce—S.
Cornin, Jon—P., E., Des.
Hartman, Robert—P., E.
Logan, Maurice—P.
Martin, Fred—P.
Neumeyer, Alfred—E., W.
Paris, Harold Persico—S., Gr., E.
Schoener, Jason—P., C., S., E.
Siegriest, Lundy—P., Gr., T.
Voulkos, Peter—S.

Ojai

Dominique, John A.—P.
Johnson, Frances G.—P.
Johnson, Wesley E.—P., T.
Smith, Robert Alan—P., Ser., I.

Orange

Boaz, William G.—E., S., P.
Partin, Robert (Edwards)—P., E.

Pacific Palisades

Campbell, Richard Horton—P.
Chesney, Lee (R., Jr.)—Graphic-Printmaker, P., E.
Longman, Lester D.—E., L., W.
Macdonald-Wright, Stanton—P., W., L.
Portanova, Joseph Domenico—Portrait Sculptor, Indst. Des.
Treiman, Joyce Wahl—P.

Palm Desert

Rahr, Frederic H.—Collector, Patron.
Rich, Frances—S., E., L.

Palo Alto

Ackerman, Gerald Martin—Scholar, W.
Farmer, Edward McNeil—P.
Lazarevich, Emil—S.
Lobdell, Frank—P., E.

Pasadena

Coplans, John (Rivers)—Mus. Cur.
Edmondson, Leonard—P., Et., E.
Levy, Hilda—P., Ser.
Wright, James Couper—P., T., L.
Younglove, Ruth Ann (Mrs. Benjamin Rhees Loxley)—P., C., L.

Pebble Beach

Lewis, Jeannette Maxfield (Mrs. H. C.)—Et., Eng., P.

Petaluma

McChesney, Robert Pearson—P.

Piedmont

Johnson, Doris Miller (Mrs. Gardiner)—P., T.
Mills, Paul Chadbourne—Mus. Cur.

Point Richmond

Simpson, David William—P., T.

Redwood City

Bowman, Richard—P., Gr.
Defenbacher, Daniel S.—Des., E., W., L.

Richmond

De Forest, Roy Dean—P.
Haley, John (Charles)—P., S., E.
Pinkerton, Clayton—P., T.

Ross

White, Ian McKibbin—Mus. Dir.

Sacramento

Kent, Frank Ward—P., Mus. Dir., W., L.
Marcus, Irving E.—P., Gr., E.

San Bernardino

Harrison, Robert Rice—E., W., L.

San Carlos

Long, Stanley M.—P.

San Diego

Albrizio, Humbert—S.
Beach, Warren—Mus. Dir., P.
Jackson, Everett Gee—E., P., I.
Kilian, Austin—E., P., Des., L.
Lopez, Rhoda LeBlanc—C., T., S., Des., L.

San Francisco

Acton, Arlo C.—S.
Adams, Mark—P., Des.
Anargyros, Spero—S.
Asawa, Ruth (Lanier)—S., Gr.
Axton, John T. III—P.
Beetz, Carl Hugo—Lith., P., E., W.
Bolles, John—Art Dealer
Brandon, Warren Eugene—P., T., W.
Church, Robert M.—E., Mus. D.
Clark, G. Fletcher—S.
Conner, Bruce—I.
Cox, E. Morris—Collector.
Fitch, George Hopper—Collector, Patron.
Frankenstein, Alfred Victor—Cr., W., L., T.
French, Palmer Donaldson—W., Cr.
Fried, Alexander—Cr.
Garth, John—P., W., L., Cr., T., Gr., I., S.
Gutmann, John—E., P., Gr.
Haas, Elise S. (Mrs. Walter A.)—Collector, Patron
Hack, Howard E.—P., Gr.
Harvey, Robert Martin—P.
Hinkhouse, Forest Melick—Art Consultant
Hoover, Herbert—Gal. Dir.
Howard, Robert Boardman—S., P., C., T.
Howe, Thomas Carr—Mus. Dir.
Ivey, James Burnett—Cart.
Jonniaux, Alfred—Por. P.
Kaller, Robert Jameson—Art Dealer, W., Cr.
Keith, David Graeme—Mus. Cur.
Kingsbury, Robert David—S., C.
Koblick, Freda—S., T.
Kussoy, Bernice (Helen)—S.
Leighton, Thomas C.—Por. P., T., L.
Lindstrom, Charles Wesley—Mus. Cur., T., L., P., Des.
Lindstrom, Miriam B. (Mrs. Charles W.)—Mus. Cur., E., W., L.
Loberg, Robert Warren—P., T.
McGregor, Jack R.—Mus. Dir.
Miller, Mrs. Robert Watt—Patron.
Mundt, Ernest Karl—S., W., L., E.
Nadaline, Louis E.—P.
Newman, L. James—Art Dealer
Nordland, Gerald John—Mus. Dir., Cr., W., L.
Post, George (Booth)—P., E.
Proom, Al(bert E.)—P., Des.
Rambo, James I.—Mus. Cur.
Reichman, Fred—P.
St. Amand, Joseph—P.
Sinton, Nell—P.
Smith, Howard Ross—Mus. Cur.
Staprans, Raimonds—P.

Troche, E. Gunter—Mus. Dir.
Ullrich, B. (Mrs. Murray G. Zuckerman)—
 P., Lith., Photog.
Van Hoesen, Beth (Mrs. Mark Adams)—
 Pr. M., P.
Weeks, James (Darrell Northrup)—P
Westermann, H(orace) C(lifford), Jr.—S.

San Jose

French, James C.—Mus. Cur., W., L.
Hunter, John—P., Pr. M.
Schnittmann, Sascha S.—S., W., L., E.
Sorby, J. Richard—P., E., Des.
Stiles, Joseph E(dwin)—P., Lith., T.,
 Comm.

San Juan Capistrano

Honeyman, Robert B., Jr.—Collector.

San Mateo

Stephens, Richard—P., Cart., L., T.
 Comm. A.

San Pedro

Christensen, Gardell Dano—P., S., W.,
 Des.

Santa Barbara

Backus, Standish, Jr.—P., I., Des., Gr.
Bartlett, Paul—P., T.
Dole, William—P., E.
Dorra, Henri—E., Form. Mus. Dir.
Fenton, Howard—P., E.
Frame, Robert (Aaron)—P., T.
Gebhard, David—Mus. Dir., E.
Ludington, Wright S.—Collector, P.
Lutz, Dan—P., T.
Mallory, Margaret—Collector.
Moir, Alfred Kummer—Scholar, E.
Morse, Mrs. McLennan—Collector, Photographer.
Story, Ala—Staff Specialist in Art, Collector.
Wonner, Paul (John)—P.

Santa Cruz

Auvil, Kenneth William—Ser., E., W.
Woods, Gurdon G.—E., S., L.

Santa Monica

Andrews, Oliver—S., E.
Bongart, Sergei—P., T., L.
Diebenkorn, Richard—P.
Haines, Richard—P., E., Lith., Des.
Johnston, Ynez—P., Et., S.
Kayser, Stephen S.—E., W., L.
Mullican, Lee—P., S., E.
Phillips, Gifford—Collector, W.
Stern, Jan Peter—S.
Ullman, Harold P.—Collector.

Sausalito

McWhorter, Arthur A., Jr.—P., T.
Wiley, William T.—P.

Sebastopol

Schulz, Charles Monroe—Cart.
Smith, Hassel W., Jr.—P.

South Laguna

Jones, John Paul—P., Et.

South Pasadena

Matson, Victor (Stanley)—P.
Wark, Robert Rodger—Mus. Cur., Hist.

Stanford

Eisner, Elliot Wayne—Scholar.
Eitner, Lorenz—Scholar, W., Art Historian
Elsen, Albert Edward—Scholar, Collector,
 W., E.

Faulkner, Ray (Nelson)—E., W., Mus. Dir.
Mendelowitz, Daniel Marcus—P., E., W.

Stinson Beach

Hudson, Robert H.—S.

Stockton

Gilbert, Arthur Hill—P.
Gyermek, Stephen A.—Mus. Dir., P., E., C.
Reynolds, Richard (Henry)—E., S., Des., P.,
 Cr., W., L.

Studio City

Block, Irving Alexander—P., E.
Jensen, Eve—P.
Reep, Edward—P., T., Lith., L.

Sunnymead

Banister, Robert Barr—E., P., C., Gr., W.

Sunset Beach

Swift, Dick—Pr. M., P., E.

Sylmar

Gebhardt, Harold—S., E.

Tarzana

Kendall, Viona Ann (Mrs. Giles A.)—P.,
 Gr., T.

Topanga

Gill, James (Francis)—P., S., Gr.

Torrance

Everts, Connor—P.

Trinidad

Groth, Bruno—S.

Twentynine Palms

Hilton, John W.—P., W., L.

Van Nuys

Van Wolf, Henry—S., P.

Venice

Bengston, Billy—P.
Falkenstein, Claire—S.
McCracken, John (Harvey)—S., T.

Ventura

Herron, Jason (Miss)—S., W., L.
Koch, Gerd—P., S., Gr., T., Des.
Koch, Irene Skiffington—P., S., T.

Vista

Anderson, Brad(ley) J.—Cart.

Walnut Creek

Dennis, Charles H.—Cart.
Eaton, Myrwyn L.—E., P., L., W.
Laycox, (William) Jack—P., I., Des.

West Covina

Cross, Watson, Jr.—P., E., L.

West Los Angeles

Daves, Delmer—Collector.
Penny, Aubrey J(ohn) R(obert)—P.
Serisawa, Sueo—P., T.
Singer, William Earl—P., S., W., L.

COLORADO

Aspen

Bayer, Herbert—P., Des.
Wille, O. Louis—S., T., P., A. Sch. Dir.

Boulder

Black, Wendell H.—E., Pr. M., P.
Drewelowe, Eve—P., S.
Geck, Francis Joseph—E., Des., W., L., P.
Matthews, Eugene Edward—P., E.
Megrew, Alden Frick—E., Hist.
Neher, Fred—Cart.
Pneuman, Mildred Young (Mrs. Fred A.)—
 P., Gr.
Westermeir, Clifford Peter—E., W., L., P.,
 I.
Wolle, Muriel Sibell (Mrs. Francis Wolle)—
 E., W., L., P.

Colorado Springs

Bartlett, Fred Stewart—Mus. Dir., T., W.
Wynne, Albert Givens—P., E., Des., Gr.

Cory

Kloss, Gene—Et., P.

Denver

Bach, Otto Karl—Mus. Dir., P., Cr., E., W.,
 L., C.
Billmyer, John Edward—C., E., P., L.
Hansen, Frances Frakes—E., P., Des.
Kirkland, Vance Hall—E., P.
Smith, Paul K(auvar)—P.
Traher, William Henry—P., I., L., W.

Estes Park

Samuelson, Fred B.—P., E.

Gardner

Fleming, Dean—S., P., E., Cart., L.

Golden

Deaton, Charles—S., Des.

Grand Junction

Redden, Alvie Edward—E., P.

Gunnison

Julio, Pat T.—E., C., Gr.

Silverton

Pozzatti, Rudy O.—P., Gr., I., E.

CONNECTICUT

Bethel

Farris, Joseph G.—Cart., P.
Huntington, Anna Hyatt (Mrs. Archer M.)—
 S.

Bloomfield

Tompkins, Alan—P., I., Des., E., L.

Branford

Stebbins, Theodore E., Jr.—Mus. Cur.,
 Scholar, Collector, Cr.

Bridgewater

Clymer, John F.—P., I.
Evergood, Philip—P., Gr., W., L., Des., I.

Brookfield

Beall, Lester Thomas—Indst. Des., P., I.

Byram

List, Vera G.(Mrs. Albert A.)—Patron, Collector, Publisher

Cannondale

Lipman, Jean—W., Ed., L.

Chester

Killam, Walt—P., Gr., T., C.
Spencer, Hugh—I., L.
Ziemann, Richard Claude—Pr. M., T.

Clinton

Reimann, William P(age)—S., E., C.

Cornwall Bridge

Gray, Cleve—P., W., Gr., Cr.
Sloane, Eric—I., W., P., L.

Cos Cob

Kane, Margaret Brassler—S.

Darien

MacLean, Arthur—P., Comm.
Neilson, Katharine B(ishop)—E., L., W.
Newman, Ralph Albert—Cart., W.
O'Hara, Dorothea Warren—Potter, P., W.
Ray, Ruth (Mrs. John Reginald Graham)—
 P., Comm. A., L.
Whitcomb, Jon—Por. P.

East Hampton

Skinner, Clara (Guy)—P., Eng., E.

East Norwalk

Broudy, Miriam L.—P.
Garbaty, Marie Louise (Mrs. Eugene L.)—
 Collector, Patron
Symon, Gail—P., E.

Falls Village

Fransioli, Thomas (Adrian)—P., Gr.
Lathrop, Dorothy P(ulis)—I., W., Eng., P.
Lathrop, Gertrude K.—S.

Gaylordsville

Schmid, Richard—P.

Glenbrook

Arthur, Revington—P., E., Gr., L.

Granby

Wadsworth, Frances L(aughlin) (Mrs. R. H.)
 —S., P., L.

Greenwich

Barrie, Erwin S.—P.
Baruch, Mr. and Mrs. Joseph M.—Collec-
 tors
Brown, W(illiam) F(erdinand) II—Cart., I.,
 W.
Gimbel, Mrs. Bernard F.—Collector, Patron
Hirshhorn, Joseph H.—Collector
Kaep, Louis J.—P.
Laughlin, Mortimer—P.
Mellon, Mrs. Gertrude A.—Collector
Ochtman, Dorothy (Mrs. W. A. Del Mar)—
 P.
Walker, Mort—Cart.

Hamden

Keller, Deane—E., P.

Hartford

Behl, Wolfgang—S., T.
Elliott, James Heyer—Mus. Dir.
Ferguson, Charles B.—Mus. Dir., P., Gr.,
 E., L.
Huntington, John W.—Collector, Patron,
 Arch.
Valtman, Edmund—Cart.
Zimmerman, Paul Warren—P., E.

Ivoryton

Bendig, William C.—P., T.
Jensen, Leo—S., P.
Jensen, Pat—P., S.

Kent

Breasted, James H(enry), Jr.—L., Hist.
Howard, Len R.—C., Des.
Nelson, George Laurence—P., Lith., L.

Lakeville

Blagden, Thomas P.—P., T.
Hubbard, Earl Wade—P., W., L.

Litchfield

Caesar, Doris—S.
Landeck, Armin—Et., Eng., Lith.
Purves, Austin—Mur. P., S., C.

Lyme

Hardin, Adlai S.—S.

Madison

Bauermeister, Mary—P., S.
Williams, Wheeler—S., P., L.

Mansfield Center

Forman, Kenneth W.—P., Gr., E.
Knobler, Lois Jean—P.
Knobler, Nathan—P., E., S.

Meriden

Widstrom, Edward Frederick—S.

Middletown

Frazer, John Thatcher—P., E., Flm. Mk.
Green, Samuel M.—E., P.
Limbach, Russell T.—Lith., Et., P., E., W.
Risley, John—S., Des., E.
Schwarz, Heinrich—Mus. Cur., E., W., L.

Milford

Johnson, Lester F.—P.

Mt. Carmel

Catlin, Stanton L.—Mus. Dir., L., W.

Mystic

Bates, Gladys Edgerly—S.
Bates, Kenneth—P.

New Canaan

Barton, August Charles—Des., P., E., L.
Cavalli, Dick—Cart.
Eberman, Edwin—Des., E., P.
Ernst, Jimmy—P., E.
Johnson, Philip—Collector, Arch.
Lamb, Adrian—Por. P.
Margolies, Ethel Polacheck—P.
Saxon, Charles D.—Cart.
Soby, James Thrall—W., Cr.

New Fairfield

Austin, Darrel—P.
Nevelson, Mike—S., C.

New Hartford

Ballinger, Harry Russell—P., T., W., L.

New Haven

Albers, Anni—Des., C., E., W., L., Gr.
Albers, Josef—P., Gr., Des., E., L., W.
Chaet, Bernard R.—P., E.
Chase, Alice Elizabeth—E., L., W.
Fussiner, Howard Robert—P., Gr., T., W.,
 L.
Gute, Herbert Jacob—P., E.
Jensen, Lawrence N.—P., E., W., L.
Kubler, George—E., W., L.
Lee, George Joseph—Mus. Cur.
Rannit, Aleksis—E., Hist., Cr., W.
Ritchie, Andrew C.—Mus. Dir., L., W.
Seymour, Charles, Jr.—E., Mus. Cur.,
 Hist., L.

New London

Lukosius, Richard—P., E.
McCloy, William Ashby—E., P., Et.
Mayhew, Edgar De Noailles—E., Mus. Dir.,
 L., W.

New Milford

Zalstem-Zalessky, Mrs. Alexis—Collector

New Preston

Wolff, Robert Jay—P., E., Des., W., L.

Newington

Martin, G(ail) W(ycoff)—P., E., Gr.

Newtown

Danes, Gibson—E., L., Cr.
Getz, Ilse—P.
Lougheed, R(obert) E(lmer)—P., Comm., I.
Schnakenberg, Henry—P.

Niantic

Dennis, Roger Wilson—P., Lith., T., Con-
 servator

Noank

Brackman, Robert—P.
Stein, Harve—I., P., L., E.

Norfolk

Kelemen, Pal—W., Hist., E.

North Haven

Tulk, Alfred James—Mur. P., P.

North Sterling

Holden, R(aymond) J.—I., P., Comm. A.

Northford

McClusky, John—P.

Norwalk

Chappell, Warren—I., Des., Gr.
Lovell, Tom—I.
Pellew, John C.—P.
Vassos, John—P., Des., I., Cr., W., L.

Norwich

Radin, Dan—P., C., T.
Triplett, Margaret L.—E., P.

Old Greenwich

Salter, Stefan—Book Des., T.

Old Lyme

Chandler, Elisabeth Gordon—S.
Hilles, Susan Morse (Mrs. Frederick W.)—
 Collector, Patron
Ingle, Tom—P., T., L., Cr.
Loftus, John—P.
Nason, Thomas W.—Eng., Et., I., P.

Old Saybrook

Endrich, Frederick C, Jr.—S., Eng., T., P.

Orange

Davies, Ken(neth) (Southworth)—P., E.
Tedeschi, Paul Valentine—P., E.

Redding

Eliscu, Frank—S.

Redding Ridge

Ridabock, Ray(mond)—P., T.

Ridgebury

Ross, Alex—I., P.

Ridgefield

Drummond, Sally Hazelet—P.
Nitsche, Erik—Des., I.
Perlin, Bernard—P., I.

Riverside

Decker, Richard—Cart., Comm., Des., I.
Nevell, Thomas G.—Indst. Des., W.
Thompson, (James) Bradbury—Des., Art
　　Dir., Des., E.

Rowayton

Johnson, Crockett—P., W., I.
Nonay, Paul—P., T., L.
Peterdi, Gabor—P., Et., Eng., L., T.

Roxbury

Calder, Alexander—S., P., I.
Ericson, Dick—Cart., W., I., L.
Weisgard, Leonard—I., Des., L., T., W.

Salisbury

Osborn, Elodie Courter (Mrs. Robert C.)—
　　Scholar, Collector, W.
Osborn, Robert Chesley—Cart., P., I., W.,
　　T., L.

Sharon

Steig, William—Cart., S.

Sherman

Blume, Peter—P.
Tee-Van, Helen Damrosch—P., I.

Simsbury

Cowing, William R.—P., T., L.

South Britain

Phillips, Irving W.—Cart., I.

South Kent

Aymar, Gordon Christian—Por. P.

South Norwalk

Frasconi, Antonio—P., Gr., Des., T., I.
Koch, Robert—E., W., L.
Lasker, Joseph Leon—P.
Low, Joseph—Gr., Des.

Southport

Benton, William—Collector

Stamford

Bushmiller, Ernest Paul—Cart.
Connolly, Jerome—P., I.
Hausman, Fred S.—P., Des., Collector
Ogg, Oscar—Des., W., L., T., Cr.
Schanker, Louis—Pr. M., E., P., S.

Storrs

Crossgrove, Roger Lynn—P., E.
Gregoropoulos, John—P., T.
Kiley, Robert L.—P., Gr., E.
Terenzio, Anthony—P., E.
Zelenski, Paul J.—P.

Thompsonville

Fitzsimmons, James Joseph—P.

Uncasville

Cuming, Beatrice—P., T.

Voluntown

Caddell, Foster—P., T., I., Lith.

Warren

Gray, Francine du Plessix—W.

Washington

Porter, Priscilla Manning—C., T., W., L.
Talbot, William H. M.—S.

Waterford

White, Nelson Cooke—P., W.

West Cornwall

Mangravite, Peppino—P., E., Lith., W.
Simont, Marc—I., W.

West Hartford

Taylor, John C. E.—P., E.

West Redding

Briggs, Austin—Collector, I.
Giusti, George—Des., Consultant

Weston

Bleifeld, Stanley—S., P., Gr., T.
Rand, Paul—Des., P., E., I., Cr., W., Typog.

Westport

Besser, Leonard—S., P., T., Gr.
Cherner, Norman—Des., P., L., I., W.
Cowan, Wood—Cart., W., I., L.
Cumming, George Burton—Ed. Art Bks, T.,
　　L., W.
Daugherty, James Henry—P., Lith., W., I.,
　　L.
Dohanos, Stevan—I., P., Gr.
Fisher, Leonard Everett—P., I., Author
Fogel, Seymour—P., Muralist, S., W., L.
Gramatky, Hardie—I., P., W., L.
Hurd, Justin G.—Cart.
Johnson, Edvard Arthur—P., T., Des.
Lopez-Rey, Jose—E., W., L.
Olsen, Herb(ert) (Vincent)—P.
Price, Garrett—I.
Rabut, Paul—I., Des., P.
Reindorf, Samuel—P., Eng.
Rosendale, Harriet—P.
Sewell, Amos—I.
Skemp, Robert Oliver—P., I.
Walzer, Marjorie Schafer—S., P.

Wilton

Darrow, Whitney, Jr.—Cart.
Lipman, Howard W.—Collector
Mayhall, Dorothy A.—Mus. Dir., S.
Prins, Benjamin Kimberly—I.
Purdy, Donald Roy—P.
Stuart, Kenneth James—Art Dir.
Woodham, Jean—S.

Woodbridge

Crosby, Sumner McKnight—E.
Geiger, Edith R.(Mrs. Arthur)—P.
Lytle, William Richard—P., E., Et., L.
Scully, Vincent—S., W.

Woodbury

Broderson, Robert—P.
Leighton, Clare—Eng.

DELAWARE

Newark

Allen, Margaret Prosser—E., P.
Gowans, Alan—E., W.
Homer, William Innes—E., W., L.

Wilmington

Geesey, Titus Cornelius—Collector, Patron
Haskell, Harry G., Jr.—Collector
Montgomery, Charles Franklin—Mus. E.
St. John, Bruce—Mus. Dir.

Winterthur

Morse, John D.—W., Ed., E.

DISTRICT OF COLUMBIA

Adams, William Howard—Art Admin., Pa-
　　tron, Collector
Bader, Franz—Gal. Dir., Collector
Barefoot, Carl—Ed.
Berkowitz, Leon—P.
Biddle, James—Preservationist, Patron,
　　Collector, W.
Bingham, Lois A.—Art Admin., L.
Bookatz, Samuel—P.
Breeskin, Adelyn Dohme (Mrs.)—L., For-
　　mer Mus. Dir., A. Consult.
Breitenbach, Edgar—Chief, Print Division
Brown, J(ohn) Carter—Mus. Dir., L., W.,
　　Cr.
Bullard, Edgar John, III—Mus. Cur.
Campbell, Dorothy Bostwick—P., S., Ce-
　　ramist
Campbell, William P.—Mus. Cur.
Carter, Albert Joseph—Mus. Cur., T.
Chieffo, Clifford Toby—P., E., Ser.
Cogswell, Margaret P.—Mus. Admin.
Cooke, Hereward Lester, Jr.—Mus. Cur.,
　　W., P.
Cott, Perry Blythe—Mus. Cur.
D'Arista, Robert—P., E.
Davis, Douglas M.—Cr., W.
Davis, Gene—P.
Davis, Robert Tyler—Mus. Asst. Dir., E.,
　　W.
Deak-Ebner, Ilona (Ilona E. Ellinger)—E.,
　　P., L.
de Weldon, Felix Weihs—S., P., T., L.
Eisenstein, Julian—Collector
Ettinghausen, Richard—Mus. Cur., W., L.,
　　Hist.
Ferriter, Clare (Mrs. John T. Hack)—P., T.
Finley, David Edward—Former Mus. Dir.
Fontanini, Clare—E., S., Des., W., L.
Gilliam, Sam, Jr.—P., T.
Glenn, Amelia Neville (Mrs. C. Leslie)—
　　Patron
Haden, E(unice) (Barnard)—P., I., L., W.
Hecht, H(enry) Hartman, (Jr.)—Collector,
　　Asst. Mus. Dir., Patron, L.
Heller, Lawrence J.—Collector
Howland, Richard Hubbard—Hist., Mus. D.,
　　L., E.
Isham, Sheila Eaton (Mrs. Heyward)—P.,
　　Lith.
Jones, Lois Mailou (Mrs. Vergniaud Pierre-
　　Noel)—P., Des., E., Comm. A.
Jones, Thomas Hudson—S.
Kainen, Jacob—Mus. Cur., Et., Lith., P., W.
Knox, Katharine McCook (Mrs.)—Art Hist.,
　　Collector
Kreeger, David Lloyd—Collector, Patron
Lawson, Edward Pitt—Asst. Exhibitions
　　Admin.
Lazzari, Pietro—P., S.
Lowe, Harry—Mus. Cur., L., E., Des., P.
MacAgy, Douglas—Art Admin., W., E., Mus.
　　Dir., L.
McGrath, Kyran M.—Association Dir.
Mehring, Howard William—P., T.
Millsaps, Daniel Webster, III—W., P., Des.,
　　Gr.
Montague, Ruth DuBarry—P., L., T., W., I.
Moore, E. Bruce—S.
O'Hara, Eliot—P., Gr., W., L., T.
Perlmutter, Jack—P., Lith., E.
Phillips, Marjorie—Mus. Dir., P.
Pierce, Delilah W.(Mrs.)—E., P.
Pope, Annemarie H. (Mrs. John A.)—Con-
　　sult., Traveling Exhib.
Pope, John Alexander—Mus. Dir.
Porter, Dr. James A.—E.
Quandt, Russell Jerome—Mus. Art Rest.
Rennie, Helen Swell—P., Des.

Richman, Robert M.—Mus. Dir., W., Cr., E.
Rood, John—S., P., W., L., E.
Ross, Marvin Chauncey—Mus. Cur., W., E., L.
Safford, Ruth Perkins—P.
Sawyer, Alan R.—Mus. Dir., L., W.
Schlaikjer, Jes Wilhelm—Port. P., I., T.
Scott, David Winfield—Mus. Dir.
Shapley, Fern Rusk (Mrs. John)—Mus. Cur., W.
Shapley, John—S.
Sickman, Jessalee B(ane)—P., T.
Sivard, Robert Paul—P., Des., Lith.
Snow, Mary Ruth (Mrs. Philip J. Corr)—P.
Stern, Harold Phillip—Asst. Mus. Dir., W., L.
Straight, Michael—Collector
Thacher, John Seymour—Mus. Dir.
Thomas, Alma Woodsey—P., T., S.
Tirana, Rosamond (Mrs. Edward Corbett)—P.
Truettler, William—Assoc. Cur.
Truitt, Anne (Dean)—S.
Underwood, Paul A.—Scholar
Warneke, Heinz—S., E.
Wells, James Lesesne—P., Lith., Eng.
Williams, Hermann Warner, Jr.—Hist., W., L., Cr., E.
Wright, Louis Booker—Hist., W.
Zerega, Andrea Pietro de—P., E., L.

FLORIDA

Atlantic Beach

Roberds, Gene Allen—Pr. M., S., E.

Cantonment

Carey, John Thomas—E., Hist.

Clearwater

Holder, Charles Albert—P., T.
Lillie, Ella Fillmore (Mrs. Charles D.)—Lith., P., Ser.
Pachner, William—P., T.

Clermont

Amateis, Edmond—S., E., W., I.

Cocoa Beach

Adams, Robert David—Des., P., T., I., Comm., L., S.

Coconut Grove

Freundlich, August L.—E., Gal. Dir., L., W., P.
Treister, Kenneth—P., S., Des., Arch.
Vrana, Albert—S.

Coral Gables

Turoff, Muriel P. (Mrs.)—C., P., S.

Daytona Beach

Koch, Berthe Couch—P., E., S., Gr., W., L.
Koch, M. Robert—C., E., Gr., L.

DeLand

Messersmith, Fred Lawrence—P., E.

El Dora

Leeper, Doris—P., S.

Fort Lauderdale

Bessemer, Auriel—P., E., I., W., L.
Hope, Henry Radford—E., Art Hist.

Gainesville

Craven, Roy C., Jr.—P., E., Des., S., W., L.
Holbrook, Hollis Howard—E., P., Des., I., L.
Holbrook, Vivian Nicholas—P.
Kerslake, Kenneth Alvin—Pr. M., E.
Williams, Hiram—P.

Jacksonville

Adams, (Moulton) Lee—P., I., L.
Hicken, Russell Bradford—Mus. Dir., E., L.

Jupiter

Connery, Ruth (McGrath)—P., T.

Lakeland

Herold, Don G.—Mus. Dir., L., T.
Stoddard, Donna Melissa—E., W., L., P.

Lantana

Houser, James Cowing, Jr.—P., E.

Largo

Tucker, Peri (Staub) (Mrs. Joseph A.)—W., Comm. A.

Madeira Beach

Terry, Marion (E.)—P., E., L.

Marathon

Leake, Gerald—P.

Miami

Bergling, Virginia C.—W.
Charles, Clayton (Henry)—S., E., P., L.
Draper, Robert Sargent—Art Dealer, P., W., L.
Gerard, Allee Whittenberger (Mrs.)—P., T.
Massin, Eugene Max—P., E.
Randolph, Gladys Conrad (Mrs. Paul H.)—P., W.
Storm, Larue—P., Gr.
Viret, Margaret M. (Mrs. F. I.)—P., T., L.
Warren, Jefferson T.—Mus. Dir.
Willson, Robert—S., C., P., E.

Miami Beach

Gains, Jacob—P., Gr.
Gaston, Marianne Brody—P., Comm., I., Des., Gr., S.
Hoff, Syd—Cart.
Leiferman, Silvia W.—P., S.
Paul, Boris DuPont—P., E., Mus. Cur., Cr., W., L.
Rosenblum, Sadie—P., Et.
Schein, Eugenie—P., T.
Youngerman, Reyna Ullman—P., L., T.

Naples

Wagner, Richard—P.

North Miami

Thorndike, Charles Jesse—Cart., Comm. A., I., W., L.

Orange Park

Hunt, (Julian) Courtenay—P., T.

Orlando

Crane, Roy(ston) (Campbell)—Cart., W.

Osprey

Buzzelli, Joseph Anthony—P., Lith., Ser., C., T., L., Enamelist

Ozona Shores

Smith, Oliver—P., C., Des.

Palm Beach

Dame, Lawrence—Cr., W.
Goldman, Albert Martin—P.
Gordon, John—Mus. Dir.
Hensel, Hopkins—P.
Koni, Nicolaus—S., P., C., T., L.
Levin, Mrs. Isadore (Jeanne L.)—Collector, Patron, Art.
Plimpton, Russell—Mus. Dir.
Wrightsman, Charles Bierer—Collector

Pensacola

Giles, Charles—E., P., L., W., Cr.
Newton, Earle Williams—Mus. Dir., Collector, Hist., E.

Ponte Vedra Beach

Greacen, Nan (Mrs. Rene B. Faure)—P.

Port Charlotte

Randall, Ruth Hunie (Mrs.)—E., C., W.

Port Salerno

Hutchinson, James Frederick, II—P., S. Mus. Cur., Cart., L.

St. Augustine

Calkin, Carleton Ivers—E., P., L.

St. Petersburg

Crane, James—E., P., Cart.
Failing, Frances E(lizabeth)—P., T.
Goldberg, Norman L. (Dr.)—Hist., W., L.
Heitland, W. Emerton—P., E., T., L.
Hill, Polly Knipp (Mrs. George S.)—Et., Eng., P., L.
Hodgell, Robert Overman—Pr. M., E., P., I., C., Des.
Malone, Lee H. B.—Mus. Dir., T., L.

Sarasota

Allen, Margo (Mrs. Harry Hutchinson Shaw)—S., P., L., W.
Barber, Muriel V. (Mrs. J. S. Barber, Sr.)—P., C., S., T., Cr.
Farnsworth, Jerry—P., T.
Floethe, Richard—I., Des., Gr., T., L.
Hoppes, Lowell E.—Cart.
Kelsey, Muriel Chamberlin—S.
Kimbrough, Verman—E.
Lane, Bent (Mrs. Clayton Lane)—P., C., W., L., E.
Leech, Hilton—P., T.
Oehlschlaeger, Frank J.—Art Dealer
Parton, Nike—P., S., C.
Posey, Leslie Thomas—S., T., C., L.
Remsen, Helen Q.—S., T.
Rogers, Meyric Reynold—Mus. Cur., E., W., L.
Rowland, Elden—P., T.
Saunders, Guy Howard—P., Des., T.
Sawyer, Helen (Mrs. Helen Sawyer Farnsworth)—P., Lith., T., W.
Shaw, Harry Hutchison—P., E., L.
Solomon, Syd—P., T., Lith.
Stahl, Ben(jamin) (Albert)—P., I., L., T., W.
Stoddard, Herbert C.—P., E.
Sweney, Fredric—I., W., Comm.
Wilford, Loran Frederick—P., T.

South Miami

Bailey, James Arlington, Jr.—P., Rest.

Stuart

Mosley, Zack T.—I., Cart.

Tallahassee

Bosch, Gulnar Kheirallah—Art Hist.
Deshaies, Arthur—Pr. M.
Johnson, Ivan Earl—E., Cr., W., L.
Kuhn, Marylou—E., P.
Zerbe, Karl—P., E.

Glenview

Barnett, Earl D.—Des., P., Comm. A.

Highland Park

Arenberg, Albert L.—Collector
Esserman, Ruth (Mrs. Norman)—P., E.
Flax, Serene (Mrs. Don)—P.
Hokin, Edwin E.—Collector
Lazard, Alice A.—P.
Schulze, Franz—E., Cr.

Hinsdale

Larsen, Ole—P., Comm., I.

Hubbard Woods

Ludgin, Earle—Collector

Kenilworth

Cunningham, Charles C.—Mus. Dir., Collector, Scholar, W.

Lake Bluff

MacAlister, Paul (R.)—Des., C., L., W., Mus. Dir.

Lake Forest

Judson, Sylvia Shaw—S., C.
Lockhart, James Leland—I., P., W.
Mills, George Thompson—E.
Mullen, Buell (Mrs. J. Bernard)—P., Muralist, L.

Libertyville

Holland, Daniel E.—Cart.

Macomb

Loomer, Gifford C.—E., P., S.

Normal

Hoover, F. Louis—E., Ed., W.

Northbrook

Eitel, Cliffe Dean—Des., P., I., Gr.

Northfield

Glass, Henry P(eter)—Des., E.
Iervolino, Joseph A.—Art Dealer, Collector
Iervolino, Paula—Gal. Dir., Collector

Park Ridge

Steinfels, Melville P.—P., Des., I., E.

Peoria

Boardman, Jeanne (Mrs. Lester Knorr)—P., C.
Knorr, Lester—S., P., C., E.

Ringwood

Pearson, James E.—S., T., P., C.

Rock Island

Stone, Alex Benjamin—Art Dealer, Collector.

Rockford

Paulin, Richard Calkins—Mus. Dir., T., Gr., C.
Sneed, Patricia M. (Mrs. William R., Jr.)—Art Dealer, Collector.

Roselle

Martyl (Martyl Schweig Langsdorf)—P., Muralist, T.

Skokie

Shapiro, Irving—P., Des., T., Comm., I., W., L.

Springfield

Bealmer, William—E.

Stockton

Tolpo, Carl—P., S., W., L.

Urbana

Bradshaw, Glenn R(aymond)—E., P., W.
Britsky, Nicholas—P., E.
Creese, Walter Littlefield—E.
Doolittle, Warren Ford, Jr.—E., P.
Gallo, Frank—S.
Schultz, Harold A.—P., L., E.
Weller, Allen Stuart—E., Cr., W., L.
Ziroli, Nicola—P., C., Gr., E., L.

Winnetka

Alsdorf, James W.—Collector, Patron
Maremont, Adele H. (Mrs. Arnold H.)—Collector
Maremont, Arnold H.—Collector
Mayer, Robert Bloom—Collector
Pattison, Abbott—S., P.
Sonnenschein, Hugo, Jr.—Scholar

Wood Dale

Mason, Alice F. (Mrs. Michael L.)—Lith., P., L., T.

INDIANA

Bloomington

Engel, Harry—P., E., L.
Hoffa, Harlan—Scholar
McGarrell, James—P., Gr., T.
Markham, Ronald—P.
Rouse, Mary Jane Dickard—Scholar
Sieber, Roy—Scholar

Culver

Williams, Warner—S., Des., L., T.

Elkhart

Gilbert, Clyde Lingle—P., Comm. A., Des., C., Gr.

Evansville

de Jong, Hubert—Collector, Patron
Eilers, Anton Frederick—Por. P., Indst. Des., T.
Gumberts, William A.—Collector, Patron, Cr.
Knecht, Karl Kae—Cart., W.
Osborne, Robert Lee—E., P., Des., S., L.

Fort Wayne

Bonsib, Louis William—P.
Kruse, Donald—Et., T.

Franklin

Sevin, Whitney—E., P., S.

Greencastle

Meehan, William D.—Des., P., T.
Winsey, A. Reid—P., I., Cart., W., E., L.

Indianapolis

Block, Amanda Roth (Mrs.)—P., Gr.
Boyce, Gerald Gladwin—E., P., C., L.
Brucker, Edmund—P., E.
Clowes, Allen Whitehill—Collector, Patron, Mus. Admin.
Davis, Harry Allen—P., E.
Eiteljorg, Harrison—Collector, Patron, Sponsor
Goth, Marie—Por. P.
Herrington, Arthur W. and Nell Ray—Collectors, Patrons
Mattison, Donald Magnus—P., E.

Mess, Evelynne B. (Mrs. George Jo)—P., Et., T., C.
Rauch, John G.—Collector
Rubins, David Kresz—S., T.
Wehr, Paul Adam—I., Comm. A., Des.
Weinhardt, Carl J(oseph), Jr.—Mus. Dir.

Lafayette

Farrell, Bill John—C., Gal. Dir.

Michigan City

Harbart, Gertrude F. (Mrs. Frank)—P., T.

Muncie

Griner, Ned—E., C.
Nichols, Alice Welty—E., P., Gal. Dir., Des., L.

New Castle

Shaffer, Elizabeth Dodds (Mrs. Verl R.)—P.

Notre Dame

Lauck, Anthony (Rev.)—S., E., W., P., Cr., L.

Reelsville

Peeler, Richard E.—C., S., E.

Richmond

Kempton, Elmira—P., E.

St. Mary-of-the-Woods

Esther, Sister (Newport)—E., P., L., W.

South Bend

Holmes, Mr. and Mrs. Paul J. (Mary E.)—Collectors
Howett, John—Mus. Cur., T., Hist., Lith., W., L.
Sessler, Stanley Sascha—P., E., Et., L.
Zisla, Harold—P., E., Des., L., Mus. Dir.

Terre Haute

Lamis, Leroy—S.
Porter, Elmer Johnson—E., P.

Vincennes

Beard, Marion L. Patterson (Mrs. Francis E.)—E., P., L.

West Lafayette

Beelke, Ralph G.—E.
Revington, George D., III—Collector

IOWA

Ames

Davis, Alice—E., P.

Burlington

Schramm, James S.—Collector, Patron.

Cedar Falls

Campbell, Marjorie Dunn—E., P.
Henrickson, Paul Robert—E., P., Gr., W.
Herrold, Clifford H.—E., C.
Page, John Henry, Jr.—Et., P., E.

Cedar Rapids

Kocher, Robert Lee—P., E., Gal. Dir.
Stamats, Peter Owen—Collector, Patron.

Davenport

Rochow, Elizabeth Moeller (Mrs. A. M.)—Mus. Dir., P., E.

Des Moines

Good, Leonard—E., P., Cr., L., W.
Kawa, Florence Kathryn—P., T.
Kirsch, Dwight—Art Consultant, P., E., W.,
　L.
Kirschenbaum, Jules—P., Gr., E.
Ruhtenberg, Cornelis—P.
Shane, George Walker—Art Critic, P.

Fort Dodge

Halm, Robert J.—P., Gr., E.

Iowa City

Cuttler, Charles David—Hist., P., E.
Edie, Stuart Carson—P., E.
Fracassini, Silvio Carl—P., E., C.
Lasansky, Mauricio—P., Gr.
Lechay, James—P., E.
Patrick, Joseph—P.
Von Groschwitz, Gustave—Mus. Dir., T.,
　L.
Wilke, Ulfert S.—P., E., Mus. Dir.

Mt. Vernon

West, Wilbur Warne—E.

Waterloo

Alling, Clarence (Edgar)—Mus. Dir., T., C.
Held, Alma M.—P., T.

KANSAS

Emporia

Eppink, Helen Brenan (Mrs. N. R.)—P., Ed.
Eppink, Norman R.—E., P., Gr.
Hall, Rex Earl—P., E.

Hays

Moss, Joel (Dr.)—P., E., S., C.

Lawrence

Berger, Klaus—E., W.
Carey, James Sheldon—E., C.
George, Walter Eugene, Jr.—Arch. Des.,
　E., Cr., W., L.
Larsen, Erik—E., Cr., W., L.
Stokstad, Marilyn—E., W.
Sudlow, Robert Newton—P., E.
Talleur, John—Pr. M., P., E.
Vaccaro, Nick Dante—P., E., Gr.

Lindsborg

Bashor, John William—P., E., C., Gr.

Manhattan

Helm, John F., Jr.—E., P., Gr., L., Cr.

Topeka

Hunt, Robert James—P., Gr., T.

Wichita

Adlmann, Jan Ernst von—Mus. Dir., Des.
Bernard, David E.—Graphic Printmaker,
　E., S.
Bosin, F. Blackbear—P., Comm., Des.
Dickerson, William J.—P., Lith., T.
Garnsey, Clarke Henderson—E., P., L.
Kiskadden, Robert M(organ)—P., E.
Kurdian, H(aroutiun)—Collector, Patron,
　W., Scholar, Art Dealer
Simoni, John Peter—E., P., C., S., W., L.,
　Gal. Dir., Cr.

KENTUCKY

Berea

Haggart, Winifred (Watkins)—E., P.
Pross, Lester Fred—E., P.

Fort Thomas

Tcheng, John T. L. (Dr.)—Scholar.

Lexington

Freeman, Richard B.—E.
Petro, Joseph (Victor) Jr.—P., I.

Louisville

Covi, Dario A.—E., Mus. Dir.
Kohlhepp, Dorothy Irene—P.
Kohlhepp, Norman—P., Lith., S.
Nay, Mary Spencer (Mrs. Lou Block)—P.,
　Gr., E.
Page, Addison Franklin—Mus. Dir., T.
Stoll, Mrs. Berry Vincent—Collector.

Mt. Sterling

Bush, Lucile Elizabeth—E., P.

Murray

Eagle, Clara M.—E., C., Des., Ser.

LOUISIANA

Baton Rouge

Boyer, Mrs. Richard C.—Collector, Patron.
Broussard, Jay Remy—Mus. Dir., P.
Cavanaugh, Tom—P., E.
Dufour, Paul Arthur—P., Gr., E.
Durieux, Caroline (Mrs.)—Lith., P.
May, William L.—Collector.
Sachse, Janice R.—P.

Lake Charles

Holcombe, R. Gordon, Jr. (Dr.)—Collec-
　tor, Patron.

New Orleans

Byrnes, James Bernard—Mus. Dir.
Davis, Mr. and Mrs. Walter—Collectors.
Emery, Lin (Miss)—Sculptor.
Fulton, W. Joseph—Mus. Dir., E., W.
Kohlmeyer, Ida (Mrs. Hugh)—P., E.
Lamantia, James Rogers, Jr.—Collector,
　Arch.
Seidenberg, (Jacob) Jean—S., P., Des.,
　Photog.
Steg, J(ames) L(ouis)—E., Pr. M.
Struppeck, Jules—S., E., W.
Trivigno, Pat—P., E., L.
van Aalten, Jacques—P.

Ruston

Bethea, F. Elizabeth—E., P.

Shreveport

Mann, Mr. and Mrs. T. B.—Collectors.
Morgan, Arthur C.—S., E., W., L.
Morgan, Gladys B. (Mrs. Arthur C.)—P., T.
Stevens, Joseph Travis—Ill., Engrosser.

Slidell

Dunbar, George B.—P., T.

MAINE

Addison

Thompson, Susie Wass—Watercolorist.

Bangor

D'Amico, Augustine A.—Collector, Patron.

Boothbay Harbor

Eames, John Heagan—Pr. M., P.

Bristol

Klebe, Charles Eugene—P., I.

Brunswick

Beam, Philip Conway—E., Administrator
Hammond, Ruth Evelyn (Mrs. Edward S.)—
　P., T., W.

Cape Elizabeth

Meissner, Berniece (Mrs. Leo)—
Meissner, Leo—Eng., P.

Cape Neddick

Kuhn, Brenda—Patron.
Laurent, Robert—S., E., Collector.

Cape Porpoise

Bacon, Peggy (Brook)—P., Gr., I., Cart.,
　W.

Castine

Ortman, George—P., S., Gr., T., L.

Cushing

Langlais, Bernard—S.

Deer Isle

Merritt, Francis Sumner—P., T., Lith.,
　Des., L., W.
Wildenhain, Marguerite—Ceramist.

East Boothbay

Rockwell, Frederick (F.)—S., P.

Harborside

McCloskey, Robert—I., W.

Kennebunkport

Deering, Roger (L.)—P., L., T.

Monhegan Island

Gussow, Alan—P., Gr., T.
Vallee, Jack (Land)—P.

Northwest Harbor

Stone, Allan—Art Dealer

Ogunquit

Hallam, Beverly (Linney)—P., E., L.
Ritter, Chris—P.
Smart, Mrs. J. Scott—Collector, Patron, W.
Strater, Henry—P.
Thelin, Valfred P.—P., L., Des.

Orono

Hartgen, Vincent Andrew—E., P., Mus.
　Dir.

Port Clyde

Thon, William—P.

Portland

Dole, George—Cart., P.
Muench, John—P., Gr., E.
Pancoast, John—Mus. Dir.
Sporn, Irving—Collector, Patron.

Rockland

Hadlock, Wendell Stanwood—Mus. Dir.,
　L., E.
Spaulding, Warren (Dan)—P., E., L.

Rockport

Winters, Denny (Miss)—P., C., I., T., Gr.

Searsport

Peirce, Waldo—P., I., W.

Skowhegan

Cummings, Willard Warren—P., T.

South Harpswell

Etnier, Stephen Morgan—P.

Stonington

Muir, Emily—P., Des., C., S., W., L.

West Southport

Tenggren, Gustaf Adolf—P., I., Des., Lith.

Waterville

Carpenter, James M.—E.

Winter Harbor

Browne, Syd—P., Lith., Et., T.

MARYLAND

Baltimore

Coplan, Kate M.—Exh. Des.
Crosby, Ranice (Mrs. Jon C.)—Med. I., E., I.
Embry, Norris—P., Gr.
Erbe, Joan (Mrs. Joan Erbe Udel)—P.
Ford, John Gilmore—Collector, Art Dealer
Gallagher, Edward J., Jr.—Collector
Gray, Christopher—E.
Hartigan, Grace—P.
Hill, Dorothy Kent—Mus. Cur.
Hoffman, Harry Zee—P., T.
Ireland, Richard Wilson—P.. T.. I., Gr.
Katzen, Lila—S., P., T., L.
King, Edward S.—Res. A., E.
Klitzke, Theodore E.—E., L.
Kramer, Reuben Robert—S., T.
Maril, Herman—P., T.
Martin, Keith Morrow—P., E.
Martinet, Marjorie D.—P., E.
Miner, Dorothy—Mus. Cur., L., W.
Oppenheimer, Selma L.—P.
Parkhurst, Charles Percy—Mus. Dir., E., Hist.
Quisgard, Liz Whitney—P., S., T., Cr.
Rembski, Stanislav—P., W., T., L., Cr.
Rosen, Israel, (Dr.)—Collector
Rosenthal, Gertrude—Mus. Cur., E.
Scuris, Stephanie—S., T.
Shackelford, Shelby—P., E., W., I., Gr.
Sharrer, Honore (Mrs. Perez Zagorin)—P.
Sheppard, Joseph Sherly—P., I., T.
Sopher, Aaron—P., Cart., I., P.
Stewart, Reba—P., T.
Streett, Tylden Westcott—S.
Walter, Valerie Harrisse—S.

Bethesda

Jackson, Vaughn Lyle—P., Comm., Des., I.

Bowie

Weaver, John Barney—S.

Bozman

Ernst, James A.—P., E., L.

Cheverly

Mansfield, Richard Harvey—Cart., L., T.

Chevy Chase

Asher, Lila Oliver—P., Des., T., S., Gr.
Fern, Alan M.—Mus. Cur., Hist., W.

Frederick

Wallace, David Harold—W., Mus. Cur.

Frostburg

Slettehaugh, Thomas Chester—E., S., P., C., Gr., W., L.

Garrett Park

Stites, Raymond Somers—E., Hist., W., L.

Garrison

Leake, Eugene Walter, Jr.—P., E., L.

Hagerstown

Roberts, Clyde H.—P., T.
Warner, Harry Becker, Jr.—Cr., W.

Lanham

Christensen, Erwin Ottomar—Mus. Cur., E., W., L.

Linthicum Heights

Paul, Bernard H.—C.

Pikesville

Wurtzburger, Mrs. Alan—Collector.

Potomac

Bolton, Mimi Dubois—P., L., T.

Reisterstown

Tunis, Edwin—W., I.

Rockville

Wood, (James) Art(hur), Jr.—Cart.

Silver Spring

Cohen, Harold Larry—E., Des., I.
Karaberi, Marianthe—S., P., L.
Levitine, Dr. George—Scholar.

Talbot County

Starin, Arthur N(ewman)—P., I.

Westminster

MacDonald, William Allan—E.
Still, Clyfford—P., T.

MASSACHUSETTS

Allston

Lillie, Lloyd—S.

Amherst

Grillo, John—P.
Hendricks, James (Powell)—P., E.
Matheson, Donald Roy—Pr. M., P., E., Form. Mus. Dir.
Morgan, Charles Hill—E., Mus. Dir.
Norton, Paul F.—E., Hist.
Roskill, Mark Wentworth—Scholar, W., Cr., E.
Wardlaw, George M.—P., S., C., E.

Andover

Dalton, Frances L.—P., T.
Hayes, Bartlett Harding, Jr.—Mus. Dir., E., L., W.

Arlington

Bakanowsky, Louis J.—E., S., Arch.
Dahill, Thomas Henry, Jr.—P., T., L.
Rosenberg, Jakob—Mus. Cur., E., W.

Belmont

Reynolds, Joseph G., Jr.—Des., C., L., W.

Bernardston

Sloane, Mary (Humphreys)—P., W., L.

Beverly

Broudo, Joseph David—E., C., P., L.

Boston

Brown, Judith—S.
Cabot, Hugh—P., W.
Capp, Al—Cart.

Clift, John Russell—I., P., T., Gr., Comm.
Coletti, Joseph Arthur—S., L., W.
Cormier, Robert John—P., L., T.
Cox, Jan—P.
Cox, J(ohn) W(illiam) S(mith)—P., T.
Crite, Allan Rohan—P., I., L., W., C.
Driscoll, Edgar Joseph, Jr.—Cr., W.
Erdman, R. H. Donnelley—Collector, Patron, Arch.
Fillman, Jesse R.—Collector.
Gibran, Kahlil—S.
Hunter, Robert Douglas—P., I., L.
Kanegis, Sidney—Art Dealer.
Light, Robert MacKenzie—Art Dealer.
Mirski, Boris—Art Dealer.
Mongan, Agnes—Mus. Dir., W., Cr., L.
Peabody, Amelia—S.
Pezzati, Pietro—Por. P.
Pinardi, Enrico Vittorio—S., P., E., L.
Pride, Joy—P., Des., T., L.
Robb, Mr. and Mrs. Sidney R.—Collectors.
Rowlands, Tom—P.
Rubington, Norman—P., S.
Saltonstall, Nathaniel—Collector.
Schwartz, Henry—P., T.
Solomon, Richard—Collector.
Stout, George Leslie—Mus. Dir.
Swetzoff, Hyman—Art Dealer.
Thurman, Sue (Mrs.)—Mus. Dir.
Valier, Biron—P., Pr. M.
Wick, Peter Arms—Scholar, Collector.

Boylston

La Rocco, Anthony—C.

Brewster

Stoltenberg, Donald—P., T., Gr.

Brighton

Burnett, Calvin—Gr., P., T., W.

Brookline

Ablow, Joseph—P., E., L., W.
Barron, Harris—S.
Barron, Ros—P.
Carmack, Paul R.—Cart.
Hibel, Edna—P.
Kramer, Jack N.—P., E.
Little, Nina Fletcher (Mrs. Bertram K.)—Collector, Scholar, W.
Pineda, Marianna (Packard Tovish)—S.
Swan, Barbara—P., Lith.
Swirnoff, Lois (Charney)—P., E., L.
Tovish, Harold—S., T., W., L.
Walker, Dr. and Mrs. Philip—Collectors.

Cambridge

Agoos, Herbert M.—Collector.
Arnheim, Rudolf—E., W.
Burwash, Nathaniel—S.
Cone, Jane Harrison (Mrs.)—Cr.
Constable, William George—Mus. Advisor, A. Hist.
Coolidge, John Phillips—Mus. Dir.
Cox, Gardner—P.
Deknatel, Frederick Brockway—Scholar.
Feininger, T. Lux—P., T.
Freedberg, Sydney Joseph—Scholar, W.
Garvey, Eleanor—Assoc. Cur.
Hanfmann, George M. A.—Mus. Cur., Hist., E.
Hyde, Andrew C.—Mus. Dir.
Kepes, Gyorgy—P., Des., E., W.
Kitzinger, Ernst—Scholar
Kuhn, Charles L.—Mus. Cur.
Lent, Blair—I., Gr., P., W., Des.
Mazur, Michael—Pr. M., S.
Neuman, Robert S(terling)—P., E.
Noble, Verrill Ruth—Des,, W.
Paeff, Bashka (Mrs. Bashka Paeff Waxman)—S., L.
Piene, Otto—S.
Plaut, James S.—Mus. Consult.
Preusser, Robert Ormerod—P., E., L., W.

Rabb, Mr. and Mrs. Irving W.—Collectors.
Rathbone, Perry Townsend—Mus. Dir.
Rosenthal, Nan (Mrs. Otto Piene)—W.
Rowland, Benjamin, Jr.—E., W., P., L.
Schroeder, Eric—Mus. Cur., P.
Slive, Seymour—Scholar, W.
Swarzenski, Hanns—E., Mus. Cur., W.
Welch, Stuart Cary—Scholar, Mus. Cur.

Cape Cod

Beneker, Katharine—Museologist, Des.
 Exh., P.
True, Virginia—E., P.

Chatham

Orr, Elliot—P.

Cheshire

Blake, Leo B.—P., T., L., I.

Chestnut Hill

Saltonstall, Elizabeth—Lith., P., T.

East Gloucester

Liszt, Maria—P.
Shore, Mary (McGarrity)—P., C., Des., S.

East Weymouth

Wyman, William—Cer. C., P., S., Des.

Edgartown

Graves, Maitland—P., T., W.

Falmouth

Brouillette, T. Gilbert—Art Dealer, Con-
 sult.-Res.
Squarey, Gerry—P., T., L.

Fitchburg

Harris, Mrs. Mason Dix—Mus. Dir.

Gloucester

Aarons, George—S.
Demetrios, George—S.
Duca, Alfred Milton—P., S., E., Des., W.,
 L.
Gage, Harry Lawrence—Typ. Des., W., P.,
 L., Gr.
Hammond, John Hays, Jr.—Mus. Dir.
Hancock, Walker (Kirtland)—S., T.
Jeswald, Joseph—P.

Harwich Port

Gilbertson, Charlotte—P., Gr.

Hingham

Reardon, M(ary) A.—P., Et., Lith., I.

Holden

Levenson, Minnie G. (Mrs.)—E.

Huntington

Nagler, Edith (Kroger)—P., I., T., W.

Lenox

Hatch, John Davis—Mus. Admin., A. Hist.

Lexington

Cascieri, Areangelo—E., P.
Loehr, Max—Scholar, Mus. Cur.

Lincoln

Steczynski, John Myron—E., L., P., C.
Walkey, Frederick P.—Mus. Dir.

Longmeadow

Robinson, Frederick Bruce—Mus. Dir., E.,
 L.

Watkins, Louise Lochridge (Mrs. Frank J.)
 —Mus. Dir., T., L.

Lunenberg

Lane, William H.—Collector

Marblehead

Chamberlain, Samuel—Et., Lith., W., E.,
 L., Des.
Taylor, Robert—W., Cr.
Turner, Hamlin—P.

Montague

Kamys, Walter—P., E.

Natick

Geller, Esther (Shapero)—P.

New Bedford

Frauwirth, Sidney—Collector.
Smith, David Loeffler—E., P., W.

Newbury

Marx, Robert Ernest—P., Gr., E.

Newton

Bahm, Henry—P.
Dergalis, George—P., Cr., L., T.
Hicken, Philip Burnham—P., Ser., T., L.
Siporin, Mitchell—P., E.

Newton Center

Abeles, Sigmund M.—S., E., Gr., L.
Cobb, Ruth (Mrs. Lawrence Kupferman)—P.
Glaser, Samuel—Collector, Arch.
Kupferman, Lawrence—P., E.
Shepler, Dwight (Clark)—P., I., W., S.
Vershbow, Mr. and Mrs. Arthur (Charlotte)
 —Collectors

Newton Upper Falls

Grippe, Florence—C., P., S., Des.
Grippe, Peter—S., Gr., P.

Newtonville

Dahl, Francis W.—Cart.
Halberstadt, Ernst—P., S., Photog.
Polonsky, Arthur—P., E., I.
Reynolds, Douglas Wolcott—P., E., L.
Skinner, Orin Ensign—Des., L., W., C.

Norfolk

Orr, Forrest (Walker)—P., I.

North Andover

Whitehill, Walter Muir—Mus. Dir., W., E.

North Brookfield

Neal, (Minor) Avon—Pr. M., W., L.
Parker, Ann—Pr. M., W., L.

North Truro

Allen, Courtney—I., S., C.

Northampton

Baskin, Leonard—S., Gr., T.
Chetham, Charles—Mus. Dir.
Cohen, H. George—P., Des., E., L.
Jules, Mervin—P., Gr., I., L., E.
Offner, Elliot—S., Typ., E.
Larkin, Oliver—E., W., Cr., L.
Van Der Poel, Priscilla Paine (Mrs.)—E.,
 P., Cart., L.

Northboro

Jewell, Kester D.—Mus. Admin.

Norton

Zabarsky, Melvin J.—P.

Pepperell

Cooney, Barbara (Mrs. C. Talbot Porter)—
 I., W.

Pigeon Cove

Banta, E(thel) Zabriskie (Smith)—P., T., C.

Pittsfield

Henry, Stuart (Compton)—Mus. Dir., P.,
 Des.

Provincetown

Corbett, Edward M.—E., P.
Daphnis, Nassos—P.
Forsberg, James—P., Gr.
Freborg, Stan(ley)—P., S.
Hensche, Henry—P., L., E.
Jensen, Marit—P., Ser.
Kaplan, Joseph—P.
Knaths, (Otto) Karl—P.
Malicoat, Philip C.—P.
Moffett, Ross E.—P.
Stout, Myron Stedman—P.

Rockport

Andrus, Vera—P., Lith., W., T., L., I.
Callahan, Jack—Por. P., T.
Cordich, John—P.
Davidson, Allan A.—P., W., L., S.
Gabin, George J.—P., T.
Gellman, Beatrice (McNulty) (Mrs. William
 C.)—P., S., T., W., L.
Hibbard, A(ldro) T(hompson)—P., T.
Martin, Roger (H.)—P., Gr., I., Des.
Morrell, Wayne Beam, Jr.—P., W., L.
Murphy, Gladys Wilkins (Mrs. Herbert A.)
 —P., C., Des., Pr. M.
Murphy, Herbert A.—Arch., P., C.
Nicholas, Thomas Andrew—P.
Parsons, Kitty (Mrs. Richard H. Recchia)—
 P., W.
Pearson, Marguerite S.—P., T.
Recchia, Richard H(enry)—S.
Ricci, Jerri—P.
Schlemm, Betty Lou—P., L.
Stark, Melville F.—P., E., L.
Strisik, Paul—P., T., L.
Woodward, Stanley—P., Et., W., I., T.

Salem

Dodge, Ernest Stanley—Mus. Dir., W., L.

Sharon

Brewington, Marion Vernon—Mus. Dir., W.

Sherborn

Pickhardt, Carl E., Jr.—P., Et., Lith., T.,
 L.

Shrewsbury

Graziani, Sante—P., Des., T.

South Dartmouth

Sylvia, Louis—P., T.

South Egremont

Haupt, Erik Guide—Por. P.

South Hadley

Cogswell, Dorothy McIntosh—E., P., L.
DeLonga, Leonard A.—S., P., E.
Hayes, Marian—E., L.
Rox, Henry—S., E., I., Comm. A.

South Harwich

Sahrbeck, Everett William—P., Des.

Springfield

Rose, Iver—P.

Stockbridge

Cresson, Margaret French—S., W.
Rockwell, Norman—I.

Sudbury

Aronson, David—

Swampscott

Fitzpatrick, Frank G.—Collector.

Swansea

Doyle, Edward A.—Arch. I., P., Des.

Topsfield

Webster, Larry—Des., P., Photog.

Tyringham

Picken, George—P., Et., Lith., E.

Vineyard Haven

Berresford, Virginia—P.

Waltham

Keyes, Bernard M.—Por. P.

Wellesley

McAndrew, John—Scholar, W., E., Collector, L.
Zahn, Carl F.—Des.

West Medford

Perrin, C(harles) Robert—P., Des., Cart., I., L.

West Newton

Williams, Gluyas—I., Cart., W.

Westboro

Bissell (Charles) Phil(ip)—Cart., I.

Westwood

Philbrick, Margaret Elder (Mrs.)—Gr., P., I.
Philbrick, Otis—P., Lith., E., Gr.
White, Leo (F.)—Cart.

Williamstown

Bloedel, Lawrence Hotchkiss—Collector.
Faison, S(amson) Lane, Jr.—E., W., L., Cr.
Hamilton, George Heard—Mus. Cur., E.
Rudolph, Prof. and Mrs. C. Frederick—Collectors
Stoddard, Whitney Snow—E., Scholar, W.

Worcester

Dresser, Louisa—Mus. Cur., L., W.
Farber, George W.—Collector.
Hovsepian, Leon—P., Gr., L., T.
Kurwacz, William—C.
Rich, Daniel Catton—Mus. Dir., W., L.
Riley, Chapin—Collector.

Worthington

Stankiewicz, Richard (Peter)—S., L.

MICHIGAN

Ada

Collins, Kreigh—I.

Albion

Bobbitt, Vernon L.—P., E.

Ann Arbor

Eisenberg, Marvin—Scholar, T.
Gooch, Donald B.—Des., I., E., P., Comm.

Iglehart, Robert L.—E.
Kamrowski, Gerome—P., E.
La More, Chet Harmon—S., P., Gr., E.
McClure, Thomas F.—S., E.
McMillan, Constance—P., I., T.
Reider, David H.—Des., E., Photog.
Sawyer, Charles Henry—Mus. Dir., E.
Weber, Albert Jacob—P., E.
Weddidge, Emil—Lith., P., E., Des., L.
Wethey, Harold Edwin—E., L., W.

Birmingham

Fredericks, Marshall M.—S.
Harris, Paul Stewart—Mus. Dir., W., L.
Malbin, Lydia Winston (Mrs. Barnett)—Collector, Patron.
Michaels, Glen—S., P.
Thom, Robert Alan—I., P., W., L.

Bloomfield Hills

Coppin, John Stephens—P.
DeLawter, Mr. and Mrs. Hilbert H.—Collectors, Patrons.
Grotell, Maija—C., T.
Mitchell, Wallace (MacMahon)—Mus. Dir., P.
Schmidt, Julius—S.
West, Clifford Bateman—P., T., Lith.

Dearborn

Nelson, Hans Peter—Indst. Des., E., I., C.

Detroit

Barron, Mrs. S. Brooks—Collector.
Bostick, William Allison—P., C., Cart., I., Lith., L., E., W.
Broner, Robert—Et., Eng., P., E., Cr.
Driver, Morley (Brooke Lister)—Collector, W., Cr.
Elam, Charles Henry—Mus. Cur.
Gaines, Natalie Evelyn—S.
Landry, Albert—Art Dealer, Gal. Dir.
Sarkisian, Sarkis—E., P.
Woods, Willis Franklin—Mus. Dir., P., T.
Woolfenden, William E.—Art Admin.

East Lansing

Brainard, Owen D.—E., P., Ser., L., W.
Church, C. Howard—E., P., Gr., S.
Henricksen, Ralf Christian—P., E.
Jungwirth, Irene Gayas (Mrs. Leonard D.)—P., E., L., C.
Whitaker, Irwin (A.)—E., C.

Flint

Davidek, Stefan—P.
Hodge, G. Stuart—Mus. Dir., Cur., P., Et.

Grand Rapids

Forslund, Carl V., Jr.—P.
Inslee, Marguerite T. (Mrs. Charles)—Collector, P.
McBride, Walter H.—Mus. Dir., C.
Mast, Gerald—P., E., Gr., Des.
Perkins, Mabel H.—Collector.
Weidenaar, Reynold H(enry)—Pr. M., P., T.

Grosse Ile

Wheeler, Robert G.—Hist., L., W.

Grosse Pointe

Smith, Jerome Irving—Mus. Cur., Libr., W.

Grosse Pointe Farms

Krentzin, Earl—S., C.
Weaver, Mr. and Mrs. Henry G.—Collectors.

Grosse Pointe Shores

Worcester, Eva—P., S., W., L.

Highland Park

Binai, Paul Freye—P., E.
Brose, Morris—S., T.
Midener, Walter—S., C., T.

Huntington Woods

Morris, Donald F.—Art Dealer, Collector.

Kalamazoo

Greaver, Hanne—Graphics.
Greaver, Harry—Mus. Dir., P., Gr.
Kemper, John Garner—E., Des., L., W., P.

Lansing

Leepa, Allen—P., E., W.

Mackinac Island

Cater, Harold Dean—Hist., W., E., L.

Marquette

Harrison, Cleobelle—E.

Mt. Morris

Ferguson, Edward R., Jr.—P., Gr.

Okemos

Alexander, Robert Seymour—Indst. Des., E., P.
Brauner, Erling B.—E., P.
Ippolito, Angelo—P.
Love, Paul—Mus. Cur., E.

Richland

Walker, James Adams—E., P., W., Ser.

St. Clair

Wyma, Peter Edward—Cart.

MINNESOTA

Excelsior

Nash, Katherine (Mrs. Robert C.)—S., E., L.

Mankato

Artis, William Ellisworth—E., C., S., Gr., L., P.

Minneapolis

Amberg, H. George—W., E., L.
Arnold, Richard R.—Des., P., E.
Berlind, Robert Elliot—P., T.
Clark, Anthony Morris—Collector, Mus. Dir., Scholar.
Couch, Urban—P., E., L.
Dayton, Bruce B.—Collector
Fossum, Syd(ney) (Glenn)—P., Gr., E., L.
Friedman, Martin L.—Mus. Dir.
Granlund, Paul Theodore—S., T.
Hendler, Raymond—P., S., E.
Herstand, Arnold—P., Gr., E.
Israel, Robert—P., Des., T.
Justus, Roy Braxton—Cart.
Larkin, Eugene—Pr. M., E.
McCannel, Mrs. Malcolm A. (Louise W.)—Collector.
Morris, Edward A.—P., Comm., I.
Munzer, Aribert—P., T.
Myers, Malcolm Haynie—P., Et., Eng.
Preuss, Roger—P., I., W., L.
Quick, Birney MacNabb—P., E.
Rowan, Herman—P., E.
Rudquist, Jerry J.—P., E.
Saltzman, William—P., E., S., Des.
Sherman, John K(urtz)—Cr.
Simon, Sidney—E., Hist., W., L.
Sussman, Richard N.—P., Gr., Des.
Swanson, Dean—Mus. Cur.
Torbert, Meg (Mrs. Donald R.)—Des.

van der Marck, Jan—Mus. Cur., W.
Wedin, Elof—P.
Wilson, Tom Muir—Gr. Des., E.
Wolfe, Ann (Mrs. Ann Wolfe Graubard)—
 S., W., L., T.

Nisswa

Smith, Paul Roland—P., E., Et.

Red Wing

Biederman, Karel Joseph—S., W., Hist.

St. Paul

Bobleter, Lowell Stanley—P., E., Gr., L.,
 W., Des.
Boese, Alvin William—Res., Collector.
Caponi, Anthony—S., E.
Celender, Donald D.—P., S. Hist.
Gayne, Clifton Alexander, Jr.—E.
Grey, Mrs. Benjamin Edwards—Patron,
 Collector.
Hastie, Reid—E., P., W., L.
Leach, Frederick Darwin—E., P., Lith.,
 Eng., L., Cr.
Lein, Malcolm E.—Mus. Dir.
Le Sueur, Mac—P., L.
Myhr, Dean Andrew—Arts Admin.
Niemeyer, Arnold M.—Collector, Patron.
Niemeyer, Trenton A.—Art Dealer, Collec-
 tor, Patron.
Rahja, Virginia Helga—E., P., S., C., Gal.,
 Dir.
Sheppard, Carl D., Jr.—E., Hist.
Tselos, Dimitri Theodore—E., L.
Wheeler, Cleora Clark—Des., Ill., W., L.

Wayzata

Sachs, Samuel II—Mus. Chief Cur., Scholar,
 W., L.
Smith, Justin V.—Collector.

Winona

Murray, Floretta—E., P., S.

MISSISSIPPI

Bay St. Louis

Kimbrough, Sara Dodge—P., T.

Cleveland

Norwood, Malcolm Mark— E., P., C.

Columbus

Dice, Elizabeth Jane—E., C., P.
Nichols, Edward Edson—P., E.
Stringer, Mary Evelyn—E., P.
Summer, (Emily) Eugenia—P., E., S.

Hattiesburg

Ambrose, Charles Edward—P., E., S.

Jackson

Horton, Jan (Mrs.)—P.
Hull, Marie Atkinson (Mrs. Emmett J.)—P.,
 T.

Meridian

Casteel, Homer, Jr.—P., S., Lith.

Oxford

Hamblett, Theora—P.
Rowland, Mrs. Herron—Mus. Dir.
Tettleton, Robert Lynn—P., E.

Silver City

Slaughter, Lurline Eddy—P.

Steens

Frank, David—C., P., T.

Summit

Barnes, Halcyone D.—P.
Dawson, Bess Phipps—P., T.

MISSOURI

Cape Girardeau

Bedford, Helen De Wilton—E., C.

Clayton

Collins, William C.—P., T.

Columbia

Larson, Sidney—P., Mus. C., E., I., W.
McKinin, Lawrence—E., P., C.
Shane, Frederick E.—P., Lith., E.

Kansas City

Benton, Thomas Hart—P.
Clare, Stewart (Dr.)—Res. A., Des., E., L.,
 W.
Dowling, Daniel Blair—Cart.
Hall, Joyce C. (Mrs.)—Collector.
James Frederic—P.
McKim, William Wind—Lith., P., T.
Neufeld, Paula—P., T.
Roth, James Buford—P., Conservator.
Scott, Henry (Edwards) Jr.—P., Des., L.,
 E., W.
Sickman, Laurence C. S.—Mus. Dir., L.
Townsend, Marvin—Cart., Comm. A.

Kirksville

Morton, Richard H.—E.

Kirkwood

Arnold, Newell Hillis—S. C., E.
Reinhardt, Siegfried Gerhard—P., Des., T.,
 L.

Maryville

Sunkel, Robert Cleveland—E., Scholar.

St. Charles

Eckert, William Dean—E., P., Gr.

St. Joseph

Hartley, Harrison Smith—P., I., L.

St. Louis

Bauer, William—P., I., Gr.
Betsberg, Ernestine (Mrs. Arthur Osver)—
 P.
Buckley, Charles Edward—Mus. Dir.
Conway, Fred—P., E., L.
Duhme, H. Richard, Jr.—S., E.
Gerdine, Mrs. Leigh—Collector
Hudson, Kenneth Eugene—E., P.
Jones, Howard (William)—S., P.
May, Morton David—Collector, Patron
Newman, Beatrice D.—Collector, Re-
 searcher.
Osver, Arthur—P.
Pulitzer, Mr. and Mrs. Joseph, Jr.—Col-
 lectors.
Quest, Charles F.—P., Gr., E., L.
Quest, Dorothy (Johnson) (Mrs. Charles F.)
 —Por. P., T., L.
Smith, Helen M. (Mrs. Hueston M.)—E., I.,
 P., Des.
Taylor, Marie—S.
Trova, Ernest Ting—S., P.
Weil, Mr. and Mrs. Richard K.—Collectors.

Springfield

Albin, Edgar A.—E., P., L., W.
Caggiano, Vito—E., Art Admin.
Shuck, Kenneth Menaugh—Mus. Dir., P.

Warrensburg

Ellis, Edwin Charles—E., Gr.

Webster Groves

Boccia, Edward Eugene—P., C., E.

MONTANA

Billings

Morrison, Robert Clifton—Pr. M., T.
Ralston, J(ames) K(enneth)—P., I., S., W.

Browning

Scriver, Robert Macfie—S.

Butte

Lochrie, Elizabeth—P., S., E., L.
Taulbee, Daniel J.—P.

Great Falls

Stevenson, Branson Graves—Gr., C., P.,
 L., E.

Miles City

Masterson, James W.—P., S.

Missoula

Dew, James Edward—E., P., C.
Hook, Walter—E., P., S., C.

NEBRASKA

Fremont

Hopkins, Lin (Mr.)—P., Et.
Hopkins, Ruth Joy (Mrs.)—P.

Lexington

Sheldon, Olga N. (Mrs. A. B.)—Collector,
 Patron.

Lincoln

Geske, Norman Albert—Mus. Dir., E., L.
Laging, Duard Walter—Art Hist., E.
Lux, Gladys Marie—I., P., C., Gr.
Seyler, David Woods—S., P., I., Des., E.
Wells, Fred N.—Executive Dir.
Woods, Sarah Ladd (Mrs. Thomas C.)—Pa-
 tron, Collector.
Worth, Peter John—E., S., Des.

Omaha

Bisgard, J. Dewey (Dr.)—Collector, Patron.
Blackwell, John Victor—Scholar, E.
Gregg, Richard Nelson—Mus. Dir., W., L.,
 E.
Hammon, Bill J.—S., P., C., Des., Gr., I.
Hill, Peter—P., E.
Kingman, Eugene—Mus. Dir., P., Lith.
Lubbers, Leland Eugene, S. J.—S., P.,
 Scholar, W.
Merriam, John F.—Trustee.
Thiessen (Charles) Leonard—Des., P., Gr.,
 S., L., T.
Wolsky, Milton Laban—I., P., C., L.

Shelby

Duren, Terence Romaine—P., I., L.

Wayne

Lesh, Richard D.— E., P.

NEVADA

Las Vegas

Myer, Peter Livingston—P., C., Gr., S. T.

Reno

Jacobson, Yolande (Mrs. J. Craig Sheppard)—S., L., Cr.
Sheppard, (John) Craig—P., S., E., I., L.

NEW HAMPSHIRE

Campton

Drerup, Karl—C., P., E., Gr.

Concord

Barrett, Thomas R.—P., T.
Chandler, John William—E.
Gibson, Roland—Collector, E., Art Admin.
Hoffmann, Lilly E.—C., Des., T.

Dublin

Smith, Ray Winfield—Collector, Scholar, W., Cr., Patron.

Dunbarton

Williams, Gerald—C., L., W.

Durham

Hatch, John W(oodsum)—P., E.
Thomas, George R.—E., Ser., L.

Exeter

King, Roy E(lwood)—S., T.
Lyford, Cabot—S., T.

Hanover

Boghosian, Varujan—S., E.
Lathrop, Churchill Pierce—E., Gal. Dir., L.
Stearns, John Barker—E.

Keene

Lourie, Herbert S.—P., E.

Manchester

Eshoo, Robert—P., T.
Hutton, William—Mus. Dir.

Mason

Jones, Elizabeth Orton—I., W., P., Gr.

Meredith

Montana, Bob—Cart.

Petersborough

Dombek, Blanche—S.
Unwin, Nora Spicer—Pr. M., I., W.

Portsmouth

Reopel, Joyce—S., Gr.

Potter Place

Eaves, Winslow Bryan—S.

Sunapee

Livingstone, Biganess (Mrs. Melvin)—P., E., L.

Tamworth

Olds, Elizabeth—P., Gr., I., W.

Waterville Valley

Rey, H(ans) A(ugusto)—I., W., Lith., Cart., L.

Webster

Tudor, Tasha—I., Por. P., W., Des., Comm. A.

NEW JERSEY

Atlantic Highlands

Crawford, William H.—Cart., S., I., L.

Avon-by-the-Sea

Triano, Anthony Thomas—S., L., T.

Bayonne

Gary, Jan (Mrs. William D. Gorman)—P., Gr.
Gorman, William D.—P., Gr.
Grasso, Doris Elsie—P., S., T.

Belleville

Weingaertner, Hans—P.

Blairstown

Lenney, Annie (Mrs. William Shannon)—P., T., L.

Bloomfield

Schwacha, George—P., T., L.

Bloomingdale

Angelini, John Michael—P., Des.

Cape May

Gilmore, Ethel (Mrs. Charles J. Romans)—P., Gr., T.
Romans, Charles John—P., T., C.

Chatham Township

Huntley, Victoria Hutson—Lith., P., L.

Cherry Hill

Cataldo, John William—Scholar, Gr., W., S.

Chester

Sandol, Maynard—P.

Cliffside Park

Swarz, Sahl—S., P., T.

Clifton

Rossi, Joseph—P., Des., T., L.

Colt's Neck

Schweitzer, Gertrude—P.

Convent

Moore, Fanny Hanna (Mrs. Paul)—Collector, Patron

Cresskill

Lamb, Katharine (Mrs. Trevor S. Talt)—Des., P., C.
Mayen, Paul—Des.
Radoczy, Albert—P., T.
Smyth, Craig Hugh—E.
Ward, Lynd (Kendall)—Lith., Eng., I., W., L.

Dover

Johnson, Avery F.—P., I., T.
Kearns, James—S., P., Gr.

Dumont

von Riegen, William—Cart., I., P., T.

East Brunswick

Bloom, Don(ald) S.—P., T., L.
Bradshaw, Robert George—E., P.
Cantor, Robert Lloyd—E., Des., C., Cr., W., L.
Maris, Valdi S. (Mr.)—P., T., Cr., S.

East Orange

Mueller, George Ludwig—P.

Elberon

Stamaty, Stanley—Cart., Comm. A., I.

Elizabeth

De Nagy, Eva—P.

Englewood

Bell, Enid (Mrs. Enid Bell Palanchian)—S., C., T., I., W., L.
Casarella, Edmond—Gr., P., S., T., Comm.
Cicero, Carmen Louis—P.
Grushkin, Philip—Des., T., Call., L.
Romano, Clare (Ross)—P., Pr. M., T.
Ross, John—Pr. M., E., Gr., Des.

Fair Lawn

Kaufman, Stuart—P., L.
Quanchi, Leo—P.
Schwab, Eloisa (Rodriguez)—P.

Fanwood

Weeks, Leo Rosco—P., I.

Far Hills

Dillon, C. Douglas—Patron, Collector.
Spivack, Sydney Shepherd—Scholar.

Finesville

Kozlow, Sigmund—P.

Flanders

Konrad, Adolf Ferdinand—P., T., L.

Frenchtown

Anusziewicz, Richard J.—P.
Seeger, Stanley, Jr.—Collector.
Wiese, Kurt—I., W.

Gladstone

Duvoisin, Roger A.—I., W.

Glen Gardner

Hunt, Kari (Mrs. Douglas M.)—S., L., W.

Glen Ridge

Kato, Kay—Cart., I., L., P.
Macdonald, Herbert—P., T., L.

Green Brook

Taylor, Rosemary—C.

Hackensack

Copeland, Lawrence G.—C., Des., E.

Hampton

Colker, Ed.—P., Gr., E.
Mordvinoff, Nicolas—P., I., W.

Harvey Cedars

Watkins, Franklin C.—P., T.

Hasbrouck Heights

Perham, Roy Gates—P., L.

Hawthorne

Calcia, Lillian Acton—E.

Hazlet

Temes, Mort(imer) (Robert)—Cart., Comm. A.

de Hellebranth, Elena Maria—P., T., L.,
 W., I.
Robbins, Hulda D(ornblatt)—P., T., Ser.

Warren

Gregory, Waylande—S., Des., W., L., P.

Washington Crossing

Ring, Edward A.—Collector, Art Dealer,
 Patron

Watchung

Bolley, Irma (Saila)—P., Des.

Wayne

Notaro, Anthony—S.

Weehawken

Groshans, Werner—P.

West Orange

Hunter, Graham—Cart., Comm., I., W.
Schaffer, Rose (Mrs. Jacob)—P., Gr., T., L.

Westfield

Hanan, Harry—Cart.

Westwood

Saslow, Herbert—P.

Wyckoff

Bengert, Elwood G.—Stained Glass Des., P.

NEW MEXICO

Abiquiu

O'Keefe, Georgia—P.

Albuquerque

Adams, Clinton—P., Lith., E.
Antreasian, Garo Zareh—P., Lith., E., L.
Coke, Van Deren—E., Mus. Dir., Photogra-
 phy, Cr.
Harman, Fred—I., Cart., P.
Jonson, Raymond—P., Gal. Dir.
Kerr, James Wilfrid—P., L.
Smith, Sam—P., E., C., Des., I.
Sowers, Miriam (R.) (Mrs.)—P.
Tatschl, John—C., S., E., Gr., L.
Vail, Robert William Glenroie—Former
 Mus. Dir., E., Cr., W., L.
Velarde, Pablita—P., I., L., W.

Hobbs

Easley, Loyce (Mrs. Mack)—P., T.

Las Cruces

Mannen, Paul William—P., E., L., W.

Montezuma

Du Jardin, Gussie (Mrs. Elmer Schooley)—
 P., S., Gr.
Roper, Jo—S.
Schooley, Elmer Wayne—P., Pr. M., T.

Ranchos de Taos

Cook, Howard—P., Gr., E., S.
Dasburg, Andrew Michael—P., T.
Latham, Barbara—P., Gr. I.

Roswell

Wiggins, Bill—P.

Ruidoso

Travis, Kathryne Hail—P., T.

San Patricio

Hurd, Peter—P., W.
Meigs, John (Liggett)—P., W., L., Des.
Wyeth, Henriette (Mrs. Peter Hurd)—P.

Santa Fe

Bacigalupa, Andrea—P., C., Muralist
Boyd, E. (Miss)—W., Mus. Cur., P., L.
Dutton, Bertha P.—Mus. Dir., E., W., L.
Ellis, Fremont F.—P.
Keener, Anna Elizabeth (Anna Keener
 Wilton)—P., Gr., E.
Longley, Bernique—P.
Montoya, Geronima Cruz (Po-Tsu-Nu)—P
 T.
Naumer, Helmuth—P.
Newberry, Clare Turlay—I., W., P.
Scholder, Fritz—P.
Sims, Agnes—P., S., C.
Thomas, Reynolds—P., Lith., Portraits
Thwaites, Charles Winstanley—P., Gr.
Tubis, Seymour—P., Gr., T., S., Des.
Young, Webb—P.

Silver City

McCray, Dorothy (Mrs. Francis)—Pr. M.,
 P., E.

Taos

Boyer, Jack K.—Mus. Dir., Cur.
Egri, Ted—S., P., L., T.
Ray, Robert Donald—P., Gr., S.
Reed, Doel—Et., P., E., L.
Scott, Jonathan—P., T.
Steinke, Bettina (Blair)—Por. P.

NEW YORK

Accord

tum Suden, Richard—P., S., Gr., T.

Albany

Rosen, Hy(man) (Joseph)—Editorial Cart.
Schafer, Alice Pauline—Et., Eng.

Alfred

Randall, Theodore A.—E., S.

Alfred Station

Turner, Robert C.—Cer. C.

Almond

Phelan, Linn Lovejoy—C., Des., T.

Altamont

Cowley, Edward P.—E., P.
Frinta, Mojmir Svatopluk—Scholar, W.

Ardsley-on-Hudson

Griggs, Maitland Lee—Collector.

Armonk

Ehrman, Frederick L.—Collector.
Gressel, Michael L.—S.
Heyman, Mr. and Mrs. David M.—Collec-
 tors.

Au Sable Forks

Kent, Rockwell—P., Gr., W., I., L.

Auburn

Kimak, George—P., Gr., T., L.
Long, Walter Kinscella—Mus. Dir., P., S.,
 Des., T., L.

Bearsville

Klitgaard, Georgina—P., Gr.
Terry, Alice (Mrs. B. F. Johnson)—P., S.

Bedford

Weinman, Robert Alexander—S.

Binghamton

Lindsay, Kenneth C.—Art Hist., W., L.
Martin, Keith—Mus. Dir., P., E.
Wilson, Edward N.—S., E., Des.

Blauvelt

Hoyt, Whitney F.—P.
Leber, Roberta (McVeigh)—C., T.
Plummer, John H.—Cur., E.

Bronx

Allen, Patricia (Patricia Burr Bott)—P., S.,
 Gr., W., L.
Fastove, Aaron (Fastovsky)—P., I.
Filtzer, Hyman—S., Rest.
Jennewein, C. Paul—S.
Kassoy, Bernard—P., T., Cart.
Texoon, Jasmine—P., T.

Bronxville

Levinson, Fred (Floyd)—Indst., Adv. Des.,
 Cart.
Mawicke, Tran—I., P.
Mayers, John J. (Dr.)—Collector.
Poucher, Elizabeth Morris—S., Gr.
Rojankovsky, Feodor Stepanovich—I.
Seckler, Dorothy Gees—Cr., T., L.

Brooklyn

Anderson, Lennart—Pr. M., T.
Albert, Calvin—S., E.
Baumbach, Harold—P.
Beerman, Miriam—P.
Bidner, Robert D. H.—P., Des.
Birillo, Ben—S.
Bothmer, Bernard V.—Mus. Cur., Vice
 Dir., E., W., L.
Buechner, Thomas E.—Mus. Dir.
Cadmus, Paul—P., Et.
Carrel, Claudia—P., S., Gr.
Castellon, Frederico—P., Gr., S., E., I.
Cramer, A(braham)—Cart., Comm., P.
d'Andrea, Albert Philip—E., S., P.
Dubin, Ralph— P., T., Gr.
Duncalfe, W. Douglas—P., E., Des., L.
Fein, Stanley—P., Cart., Des.
Fife, Mary E. (Mr. Edward Laning)—P., T.
Fjelde, Paul—S., E.
Gluckman, Morris—P.
Grado, Angelo John—P., Des.
Grebenak, Dorothy (Mrs. Louis)—C.
Gurr, Lena—P., Ser., Lith., Woodcut.
Hasen, Burt(on)—P.
Johnson, J. Stewart—Mus. Cur.
Jones, Nell Choate—P.
Kaye, George—E.
Kipniss, Robert—P., Et., Lith.
Kish, Maurice—P.
Konzal, Joseph—S.
Kottler, Lynn—Art Dealer.
Krukowski, Lucian—P., E.
Kupferman, Murray—P., C., T., S., Des.
Leff, Rita—P., Pr. M.
Le Roy, Harold M.—P., W., L.
Leventhal, Ethel S.—P., Et.
Lieberman, Meyer F.—P., Gr., T.
Lucchesi, Bruno—S., T.
Machlin, Sheldon (Merritt)—S., Photog-
 Journalist, Gr.
McNeil, George—P., E.
Mandelbaum, Dr. and Mrs. Robert A.—Col-
 lectors.
Marans, Moissaye (Mr.)—S., L., T.
Mayhew, Richard—P., I.
Megargee, Lawrence A.—Animal I.
Menken, Marie—P., C.
Morse, Jennie Greene (Mrs. Henry W.)—E.,
 Des., P., C.
Odate, Toshio—S.
Peck, Augustus—E.

Pierotti, John—Cart.
Pollaro, Paul—P., E., L.
Ranson, Nancy Sussman (Mrs.)—P., Ser., L.
Read, Helen Appleton (Mrs.)—Gal. Dir., W., Scholar, Cr.
Reich, Nathaniel E.—P.
Rhoden, John W.—S.
Richmond, Frederick W.—Collector, Patron.
Riley, Olive—E.
Rohm, Robert—S.
Rose, Dorothy—P.
Rubin, Irwin—P., Des., E.
Scharff, Constance (Kramer)—P., Pr. M.
Schneider, Noel—S.
Schucker, Charles—P., E.
Shaw, Kendall—P., E.
Smith, Alvin—P., I., T.
Taylor, Ruth P.—E., P., Gr.
Trommer, Marie—W., Cr., P., T.
Weingarten, Hilde (Mrs. Arthur Kevess)— Pr. M., P.
Wilkinson, Charles K.—Mus. Cur.

Brooklyn Heights

Von Wicht, John—P., Gr., Des.
Weber, Idelle—P., S.

Buffalo

Berger, Jason—P.
Burkhart, Dr. Robert C.—E.
Cuthbert, Virginia (Mrs. Philip C. Elliott)— P., T., L.
Elliott, Philip Clarkson—P., E., W., L.
Goodman, James—Art Dealer.
Hatchett, Duayne—S., E.
Johnson, Charlotte Buel—Art Hist., E., W.
Knox, Seymour H.—Patron.
Levick, Mr. and Mrs. Irving (Mildred)— Collectors.
Moore, Ethel—Art Ed.
Shanks, Bruce (McKinley)—Editorial Cart.
Sisti, Anthony J.—Collector, Patron, Cr., P., T., Art Dealer.
Smith, Gordon Mackintosh—Mus. Dir.
Szabo, Laszlo—Por. P., T., L.

Buskirk

Goossen, Eugene C.—Cr.

Camillus

Vander Sluis, George—P., E.

Carmel

Lee, Robert J.—P., I., Cart.
Parker, Robert Andrew—P.

Cazenovia

Ridlon, James A.—E., P., S., Et.
Sullivan, Max William—Mus. Dir., E.

Chappaqua

Fagg, Kenneth S.—S., P., I.
Reibel, Bertram—Wood Eng., Gr., S.

Chatham

Johansen, Anders D.—P.
Trimm, H. Wayne—I.

City Island

Borghi, Guido Rinaldo—P., S., T.

Clinton

Baldwin, John L.—Dir.
Palmer, William C.—P., L., E.
Penney, James—P.
Root, Mrs. Edward W.—Collector.
Trovato, Joseph S.—P.

Cooperstown

Jones, Louis C.—Mus. Dir.

Keck, Sheldon—Conservator.
Rath, Frederick L., Jr.—Hist., Mus. Dir., L., W.

Corning

Perrot, Paul N.—Mus. Dir.

Cortland

Stell, H. Kenyon—Scholar, Art Admin., Art Hist.

Croton-on-Hudson

Biddle, George—P., Gr., W., C., S., L.
Ettenberg, Eugene M.—Bk. Des., T., W., L., Cr.
Gropper, William—P., Lith., W.

Demarest

Racz, Andre—P., Gr., E., W., L.

Dobbs Ferry

Borgatta, Isabel Case—S., L.
Borgatta, Robert E.—P., E., S.
Butler, Joseph Thomas—Mus. Cur., W., L.
Lissim, Simon—P., Des., E., I., L.
Rothschild, Lincoln—S., P., W., E., L.

Eagle Bridge

Bittleman, Arnold (Irwin)—P.

East Chatham

Lehman, Irving G.—S., P., C., Gr.
Rickley, George Warren—S., E., W., L., Cr.

Elmira

Fox, Roy C.—Et., Eng., P.

Essex

Douglas, Edwin Perry—P.

Fairport

Peters, Carl W.—P., T.

Fayetteville

Goodnow, Frank A.—P., E.
Pollock, Merlin F.—P., E.

Freeville

Kahn, (H.) Peter—E., P., Gr., Des.

Garrison

Locke, Charles Wheeler—P., Gr., Cart., I.
Wright, Russel—Indst. Des., W.

Geneva

Bate, Norman Arthur—Et., W., I., E., P.

Gloversville

Schulman, Jacob—Collector.

Grand View-on-Hudson

Hader, Elmer (Stanley)—I., W., P.
Wyatt, William Stanley—P., T., Gr., I., L.

Groton

Colby, Victor—E., S.

Harrison

Neustadter, Edward L.—Collector, Patron.

Hastings-on-Hudson

Begg, John (Alfred)—S., P., Des.
Bohnert, Rosetta (Mrs. Herbert)—P., W., T., L.
Freedman, Maurice—P.
Lipchitz, Jacques—S.
Nemec, Nancy—Gr., P.

Haverstraw

Taubes, Frederic—P., Et., Lith., W., L., E., Cr.

Highland

Krevolin, Lewis—C., Des., T.

Holland

Blair, Robert N.—P., S., Gr., E., I.

Holland Patent

Christiana, Edward I.—P., T.

Hopewell Junction

Frazier, Paul D.—S., T.

Hyde Park

Benney, Robert—P., I., W., L.

Interlaken

Cleary, Fritz—S., Cr.

Ithaca

Atwell, Allen—P., E.
Brittiah, W. Lambert—E.
Daly, Norman David—P., E., S., Des.
Evett, Kenneth Warnock—P., E.
Grippi, Salvatore (William)—P., E.
Hoyt, Dorothy (Dillingham)—P., Int. Des.
Leavitt, Thomas Whittlesey—Mus. Dir.
Mahoney, James Owen—P., E.
Poleskie, Stephen F., Jr.—Pr. M., P.
Seley, Jason—S., E.
Sindler, Mr. and Mrs. Allan P. (Lenore B.) —Collectors.
Squier, Jack—S., E.
Waage, Frederick O.—E., Scholar.

Jamesville

Vargo, John—P., Gr., E., I.

Katonah

Askin, Arnold Samuel—Collector.
Baur, John I. H.—Mus. Dir., L., W.
Giobbi, Edward Gioachino—P., Gr.
Lipinsky De Orlov, Lino Sigismondo—Mus. Dir., P., Et.
Roesch, Kurt (Ferdinand)—P., Et., Eng., T., I.
Samerjan, George E.—Des., P., T., L., S.
Toney, Anthony—P., Gr., I., Comm. A., T., W., L.

Kenmore

Czurles, Stanley A.—E., P., W., L., Des.

Larchmont

Gross, Alice—S.
Richard, Betti—S.
Stevens, Elisabeth Goss—Art Cr.
Tobey, Alton S.—P., I., T., Hist., L.

LONG ISLAND

Albertson

Madsen, Viggo Holm—P., T., Gr., W.

Amagansett

Gwathmey, Robert—P., Ser., T.

Astoria

Halbers, Fred—Et., P.
Walsh, W. Campbell—S., P., Des.

Baldwin

Carter, Granville W.—S.

Bayside

Feldman, Lilian—P., T.

Goldstein, Milton—Et., P., T., L.
Niemann, Edmund E.—P.

Bethpage

Paddock, Denis—Collector.

Bridgehampton

Benson, Emanuel—E., W., Cr., L.
Prohaska, Ray—P., E.
Varga, Margit—W., P.

Cedarhurst

Lichtenberg, Manes—P., T.

Centerport

Fasbender, Walter—Mus. Executive Dir.
Lewicki, James—I., E., P., Des.

Deer Park

Ames, Lee J.—I.

East Hampton

Borgzinner, Jon—W., Cr.
Brooks, James—P., T.
deKooning, Willem—P.
De Pauw, Victor—P., W.
Ferren, John—P., S., Des., Gr., T.
Fine, Perle—P., W., Gr., L., E., Cr.
Johnson, Buffie—P., Gr., E., W., L.
Krasner, Lee—P.
Lassaw, Ibram—S., L.
Leiber, Gerson A.—P., Pr. M.
Levi, Julian (E.)—P., T., Lith.
Little, John—P.
Ossorio, Alfonso A.—P., S., Collector.
Rosenberg, Harold—W.
Tania (Schreiber)—S., P., T.
Whipple, Enez (Mrs.)—Art Dir.
Wingate, Arline (Mrs. Clifford Hollander)—
 S., C.
Zacharias, Athos—P.

East Marion

Stamos, Theodoros—P., T., L., Des.

East Meadow

Sirena (Contessa Antonia Mastrocristino
 Fanara)—P., Gal. Dir.

Elmhurst

Berkon, Martin—P., T.
Wachsteter, George—I.

Elmont

Rogers, John—P., T., L.

Flushing

Bergere, Richard—I., P., Comm.
Cornell, Joseph—S.
Friedensohn, Elias—P., T.
Gilbert, Creighton—Art Hist., W., E.
Johnson, Clifford Leo—Cart.
Mieczkowski, Edwin—P.
Pincus-Witten, Robert—S., Cr.
Reiss, Lee (Mrs. Manuel)—P.
Rosenthal, Seymour—Lith., P.
Sussman, Arthur—P.

Forest Hills

Catan-Rose, Richard—P., T., Et., Lith., S.,
 L., I.
Lombardo, Josef Vincent—E., P., W., L.
Tewi, Thea—S.
Walker, Hudson D.—Collector, Art
 Specialist.

Franklin Square

Indiviglia, Salvatore—P., T., Comm., I., L.

Freeport

Lariar, Lawrence—Cart., I., W., Ed., S.
Rowan, Frances—P., Gr., T.

Glen Cove

Paris, Jeanne C.—Cr., Collector.

Glen Head

Kerr, E. Coe, Jr.—Art Dealer.

Great Neck

Beck, Margit—P., T., L.
Berne, Gustave Morton—Collector.
Cohen, Wilfred P.—Collector, Patron.
Filmus, Tully—P., L., T.
Housman, Russell F.—E., Mus. D., P.
Pomerance, Leon—Collector, W., Patron.
Reiner, Mr. and Mrs. Jules—Collectors,
 Patrons.
Richmond, Lawrence—Collector.
Roston, Arnold—Des., P., E., W., Patron,
 Collector.
Seidler, Doris—Pr. M., P.
Shapiro, David—P., Eng., E., L.
Treadwell, Grace A. (Mrs. Abbot)—P., L.,
 T.
Van Buren, Raeburn—I., Cart., L.

Greenport

Wengenroth, Stow—Lith.

Hempstead

Hornung, Clarence Pearson—Des., I., W.

Hicksville

Landy, Jacob—E., L.

Hollis

Burchess, Arnold—P., E.

Huntington

Engel, Michael (Martin) II—P., Des., Lith.,
 W.
Hopkins, John Fornachon—P., E.
Zona, (Renaldo)—P., S.

Jackson Heights

Freund, Tibor—P., Arch.
Schmeidler, Blanche J.—P., Gr., Des., C.,
 L.
Sturtevant, Harriet H.—P.
Wasserman, Albert—Pr. P., Des., T.

Jamaica

Eliasoph, Paula—P., Gr., W., L., T.
Jonynas, Vytautas K.—P., Des., Gr., T.
Krigstein, Bernard—P., I., T., Gr.
Lloyd, Tom—S.

Jamaica Estates

Kessler, Edna L.—P., Int. Des.

Kew Gardens

Albee, Grace (Thurston) (Arnold) (Mrs.
 Percy F.)—Eng., L.
Knapp, Sadie Magnet—C., P., S., Gr.,
 Enamelist.

Kings Point

Avnet, Lester—Collector, Art Patron.
Rath, Hildegard—P., T., Gr., W., L., Ser.
Schimmel, Norbert—Collector.
Schulhof, Mr. and Mrs. Rudolph B.—Collec-
 tors.

Levittown

Schachter, Justine Ranson—P., Des., I.

Locust Valley

Lippold, Richard—S., E., Des.
Rogalski, Walter—Pr. M., T., L.

Long Island City

Davison, Robert—P., Des., Comm.
De Rivera, Jose—S.
Gussow, Roy—S., E., Des.
Lerner, Abram—Mus. Dir.
Noguchi, Isamu—S.
Stasik, Andrew—P., Pr. M.
Stone, Allen—P., L.

Manhasset

Harvey, Jacqueline—P.
Paley, Mr. and Mrs. William S.—Collectors.
Preston, H. Malcolm—P., E.

Melville

Glarner, Fritz—P.

Merrick

Cariola, Robert—P., S., Gr., T.

Mill Neck

Marks, Mrs. Laurence M.—Trustee.

Northport

Twardowicz, Stanley—P., T.

Oyster Bay

Howell, Douglass (Morse)—P., Et., Eng.,
 Hist., W., L.

Plainview

Liberi, Dante—P., S., I.

Plandome Manor

Miller, Barse—P., E.

Port Washington

Guggenheim, Harry Frank—Collector, Pub-
 lisher, W.
Kleinholz, Frank—P., T., Des., Gr., L.
Ronay, Stephen R.—P.

Rego Park

Aronson, Irene—Des., P., Gr., T., I., W.
Tobias, Abraham Joel—P., S., Lith., W., L.
Winter, Ruth—P.

Rockville Centre

Day, Robert James—Cart.

Roosevelt

Landau, Jacob—P., Gr.

Roslyn

Kenny, Thomas Henry—P., Lith.

Roslyn Estates

Pall, Dr. & Mrs. David B.—Collectors.

Roslyn Heights

Donneson, Seena—P., Gr.

Sag Harbor

Billings, Henry—P., Des., I., W.
Bolotowsky, Ilya—P., T., S., W., L.
Brook, Alexander—P.
Knee, Gina (Mrs. Alexander Brook)—P., Gr.
Schwartz, Aubrey—Pr. M., S.

Sagaponack

Georges, Paul—P.

St. Albans

Winkel, Nina—S., L.

Sands Point

Barnet, Howard J.—Collector.
Richter, Horace—Collector.

Sea Cliff

Mellow, James R.—Cr.

Setauket

Koch, John—P.

Shelter Island

Donato, Louis Nicholas—P., Des., T.

Shoreham

Smith, Leon P.—P., L., E.

Southampton

Alajalov, Constantin—P., I.
Porter, Fairfield—P., E., Cr., W., L.
Rivers, Larry—P.

Stony Brook

Kaprow, Allan—Scholar, Art.

Thomaston

Schreck, Michael—P., S., L., T.

Valley Stream

Hart, Allen M.—P., T.
Trifon, Harriette—P., T., Et., S.

Wainscott

Porter, (Edwin) David—P., Lith., W., L., S.

Wantagh

Glaser, David—P., Des., Comm., I., Ser.

Water Mill

Brandt, Grace Borgenicht—Art Dealer, Collector.
Jackson, Lee—P.

Westbury

Cronbach, Robert M.—S., E., L.

Whitestone

De Cesare, Sam—P., S., C., T., I.

Williston Park

Baum, William—P.

Woodhaven

Csoka, Stephen—P., Gr., E.

Woodmere

Brodey, Stanley C.—P.

Woodside

Fax, Elton Clay—I.

Wyandanch

Springweiler, Erwin Frederick—S., C.

NEW YORK STATE
(Cont.)

Mamaroneck

Gumpel, Hugh—P., T.
Kent, Norman—Eng., P., W., L., Bk. Des.
Lekberg, Barbara (Hult)—S.
Sloan, Robert Smullyan—P.
Topol, Robert M.—Collector.

Middletown

Ericson, Beatrice—P.
Parker, Roy D.—P.

Mill Brook

Bachrach, Gladys Wertheim—P.
Della-Volpe, Ralph—P., Gr., E., L.
Streeter, Tal—S.

Millerton

Helck, C. Peter—I., P., G., T.

Monsey

Mesibov, Hugh—P., E., Gr., L., C.

Montgomery

Seredy, Kate—W., I.

Monticello

de Hoyos, Luis—Collector

Mount Kisco

Jones, Amy (Mrs. Owen Phelps Frisbie)—
 P., I., T., L., Gr., S.
Laskey, Dr. and Mrs. Norman F.—Collectors.

Mount Vernon

Fenton, John Nathaniel—P., Et.
Gilchrist, Agnes Addison (Mrs. John M.)—
 Arch. Hist., W., L.
Seliger, Charles—P., Des., T.
Zibelli, Thomas A.—Cart.

New City

Corcos, Lucille—P., I., Des.
Poor, Henry Varnum—P., C., S., E., W.

New Paltz

Bohan, Peter—S., Art Gal. Dir.
Kammerer, Herbert Lewis—S.
Munsterberg, Hugo—S., W., Collector.
Wexler, George—P., E.

New Rochelle

Beling, Helen (Mrs. Lawrence R. Kahn)—S.,
 T., L.
Conant, Howard S.—E., W., L., P.
Kinghan, Charles R.—P., Comm., I., T.
Lantz, Michael—S.
Liljegren, Frank—P., T.
Mallary, Robert—S., P., Gr., E.
Meizner, Paula—S., T.
Mochi, Ugo—Animal A., I., L.
Montlack, Edith—P., T.
Schaeffler, Lizbeth—S., C., P., T., Comm.
Seckel, Paul B.—P., Gr.
Slotnick, Mortimer H.—P., Des., Gr., T., L.
Spencer, Jean—P., Des., T.
Spidell, Enid Jean—P., E.
Winter, Lumen Martin—P., S., Des., Lith.,
 L.

New York City

Aach, Herbert H.—P., E., W., L.
Abramovitz, Mr. and Mrs. Max—Collectors.
Abrams, Harry N.—Publisher, Collector.
Abrams, Ruth—P.
Acquavella, Nicholas—Art Dealer.
Adams, Alice (Gordy)—S., C., T.
Addams, Charles—Cart.
Adler, A. M.—Art Dealer.
Adler, Samuel M.—P., E., L.
Adrian, Barbara—P.
Agostinelli, Mario—P., S.
Agostini, Peter—S.
Ahlskog, Sirkka—C., T., S.
Akston, Joseph James—Collector, Art Patron, Publisher.
Alcalay, Albert—P.
Alcopley, L.—P., Gr., Des., I., W., L.

Aldrich, Larry—Collector, Patron.
Alloway, Lawrence—Mus. Cur.
Alonzo, Jack J.—Art Dealer, Collector.
Alston, Charles Henry—P., S., T.
Altschul, Arthur Goodhart—Collector, Patron.
Amen, Irving—Eng., P., S.
Amino, Leo—S., Des., T.
Anderson, Doug—I., Comm. A.
Anderson, John—S.
Andre, Carl—S.
Andrews, Benny—P., S., T., I.
Angel, Rifka—P.
Anspach, Ernst—Collector.
Antonakos, Stephen—S.
Apostolides, Zoe—P.
Arakawa, Shusaku—P.
Arnason, H. Harvard—Art Hist.
Arnest, Bernard Patrick—P.
Arnhold, Mrs. Hans—Collector.
Aronson, Boris—P., Des., S., Gr., I., W., C
Aronson, Joseph—Des., W.
Artschwager, Richard—P., S.
Ascher, Mary G. (Mrs. David)—P., C., Gr.,
 L.
Ashton, Dore—Cr., W., E., L.
Atkin, Mildred Tommy (Mrs. Fisher Winston)—P.
Ault, Lee Addison—Collector, Publisher,
 Art Patron.
Avedisian, Edward—P., T.
Avlon-Daphnis, Helen—P., T.
Azuma, Norio—Ser.
Baber, Alice—P.
Bageris, John—P., E.
Baker, Charles Edwin—Ed., Hist., W.
Baker, Richard Brown—Collector.
Baker, Mr. and Mrs. Walter C.—Collectors.
Bannard, William Darby—P.
Baranik, Rudolf—P.
Bareiss, Walter—Collector.
Barile, Xavier J.—P., Gr., I., T., L.
Barker, Walter—P., S.
Barnes, Robert M.—P., E.
Barnet, Will—P., T., Gr.
Barrett, Oliver O'Connor—S., I., E., W.
Barr-Sharrar, Beryl—P., E., W.
Bartle, Annette—P., Comm., I.
Barton, John Murray—P., Gr., L.
Barzun, Jacques—E., W., Hist., Cr., L.
Baskerville, Charles—P.
Bass, Mr. and Mrs. John—Collectors, Patrons.
Battcock, Gregory—W., Cr.
Bauman, Lionel R.—Collector.
Bean, Jacob—Mus. Cur.
Bearden, Romare Howard—P.
Beck, Rosemarie (Phelps)—P., T.
Becker, Martin—Collector.
Becker, Maurice—P., Cart.
Beckmann, Hannes—P., T., L.
Beinecke, Frederick William—Collector.
Beineke, J. Frederick (Dr.)—Collector.
Beline, George—P., S.
Bell, Clara Louise (Mrs. Bela Janowsky)—
 P.
Bell, Leland—P.
Bellamy, Richard—Art Dealer.
Benn, Ben—P., T.
Benton, Fletcher—S.
Bensing, Frank C.—Por. P., I., Des.
Ben-Zion—P., Gr., T.
Bergen, Sidney L.—Art Dealer.
Berger, Samuel A.—Collector.
Bergman, Mr. and Mrs. Louis B.—Collectors.
Berkman, Aaron—P., T., L., W.
Bernstein, Theresa F. (Mrs. William
 Meyerowitz)—P., Et., Lith., T., W., A.
 Hist.
Bettmann, Otto L.—Gr. Hist.
Bianco, Pamela (Ruby) (Mrs. Georg T. Hartmann)—I., P., Lith., W.
Bileck, Marvin—Et., Eng., I., T.
Bingham, Mrs. Harry Payne—Collector.

Findlay, David—Art Dealer.
Fingesten, Peter—S., E., W., L.
Finkle, Mr. and Mrs. David—Collectors.
Fischbach, Marilyn Cole (Mrs. Herbert)—
 Art Dealer, Collector.
Fischer, John—P., S.
Fisher, Ethel—P., Et., Lith.
Fishko, Bella (Mrs.)—Art Dealer.
Fleischman, Lawrence A.—Collector, Pa-
 tron, Art Gal. Dir.
Flexner, James Thomas—W., Cr., L.
Floch, Joseph—P.
Folds, Thomas McKey—E., L., Des., Cr.
Forakis, Peter—P., S.
Ford, Charles Henri—P., Photographer,
 W., Flm. Mk.
Forst, Miles—P., Gr. E.
Forsyth, William H.—Mus. Assoc. Cur., W.
Fosburgh, James Whitney—P., E., W., L.
Foster, Hal—Cart., P.
Fox, Milton S.—P., Lith., T., W., L.
Francis, Muriel Bl—Collector.
Franck, Frederick S. (Dr.)—P., I., Gr., W.
Frank, Helen—P., Des., I.
Frank, Mary—S.
Frankenthaler, Helen (Motherwell)—P.
Fraser, Douglas (Ferrar)—Scholar.
Frater, Hal—P.
Freedman, Doris Chanin (Mrs.)—Collector,
 Admin.
Freedman, Robert J.—Collector.
Freeman, Margaret B.—Mus. Cur., W.
Freeman, Mark—Lith., T., P.
Freilich, Ann (Ann F. Schultz)—P., E.
Freilich, Michael Leon—Art Dealer, Col-
 lector.
Freilicher, Jane—P.
French, Jared—P., S.
Frick, Miss Helen Clay—Lib. Dir.
Fried, Michael—Cr.
Fried, Rose—Gal. Dir.
Friedman, B(ernard) H(arper)—W., Patron,
 Collector.
Fromer, Mrs. Leon—Collector.
Frumkin, Allan—Art Dealer.
Fuller, Sue—P., S., Gr., E., W., L.
Gahman, Floyd—P., Et., L., C., Gr., E.
Garbisch, Edgar William and Bernice
 Chrysler—Collectors, Patrons.
Gardiner, Robert D. L.—Collector.
Garrett, Stuart Grayson, Jr.—P., E.
Gary, Dorothy Hales—Collector, Patron,
 Cr., Gal. Dir.
Gasparo, Oronzo Vito—P.
Gates, John Monteith—Arch. Des.
Gaucher, Yves—P.
Geber, Hana—S., L., T.
Gechtoff, Sonia—P., E.
Geisel, Theodor Seuss—I., Des., Cart., W.
Geist, Sidney—S.
Gekiere, Madeleine—P., E., I.
Gelb, Jan—P., Et., T.
Geldzahler, Henry—Mus. Cur.
Genauer, Emily—Cr., W., L.
Gerardia, Helen—P., Gr.
Gerdts, William H.—Mus. Cur., T., Hist.,
 W., L.
Gerst, Mrs. Hilde W.—Art Dealer.
Ghent, Henri—Asst. Mus. Dir., W. Collec-
 tor.
Gikow, Ruth—P., I., Ser.
Gilvarry, James—Collector.
Ginsburg, Max—P., T., I.
Glasgall, Mrs. Henry W.—Collector.
Glickman, Maurice—S., P., T., W.
Glincher, Arnold B.—Art Dealer.
Glinsky, Vincent—S., Et., T., Lith., P.
Glueck, Grace H.—W.
Goff, Lloyd Lozes—P., I., Gr., W., E.
Gold, Fay—P.
Goldberg, Michael—P.
Goldberger, Mr. and Mrs. Edward—Col-
 lectors, Patrons.
Goldin, Leon—P., Lith., E.
Goldowsky, Noah—Art Dealer.
Goldschmidt, Lucien—Art Dealer.

Goldstone, Mr. and Mrs. Herbert—Col-
 lectors.
Goldwater, Robert—Mus. Admin., W., Cr.,
 L., E.
Gollin, Mr. and Mrs. Joshua A.—Collec-
 tors.
Golub, Leon (Albert)—P., Gr., E.
Gonzalez, Xavier—P., S., L.
Goodelman, Aaron—S.
Goodman, Estelle—S.
Goodnough, Robert—P.
Goodrich, Lloyd—Mus. Dir., W., L.
Gorchov, Ron—P.
Gordon, Martin—Art Dealer.
Gordon, Russell—P.
Gorsline, Douglas Warner—P., I., W., T.,
 Ser.
Gottlieb, Abe—Collector, Patron.
Gottlieb, Mrs. Abe—Collector, Patroness.
Gottlieb, Adolph—P.
Goulet, Lorrie (Mrs. Lorrie deCreeft)—S.,
 P.
Grace, Charles M.—Collector.
Graham, James—Gal. Dir.
Graham, Robert C.—Collector, Patron, Art
 Dealer.
Grausman, Philip—S., T.
Graves, Morris—P.
Greenberg, Clement—W., Cr., P., L.
Greene, Balcomb—P., E.
Greenspan, George—Collector.
Greenwald, Charles D.—Collector, Patron.
Greenwald, Dorothy Kirstein—Collector.
Greer, David—Art Dealer.
Grier, Harry Dobson Miller—Mus. Dir.
Grooms, Red—P.
Gross, Chaim—S., T.
Gross, Sidney—P.
Grosvenor, Robert—S.
Groth, John—P., I., T., Gr.
Grotz, Dorothy (Mrs. Paul)—P.
Grube, Ernst J(oseph)—E., W.
Gruppe, Karl H.—S.
Guerrero, Jose—P.
Guion, Molly—Por. P.
Gusten, Theodore J. H.—Executive Dir.
Guy, James—S., P.
Haber, Leonard—Collector, Scholar, Des.
Habergritz, George—P., S., T., C.
Hackenbroch, Yvonne Alix—Scholar, W.
Hacklin, Allan—P.
Hadzi, Dimitri—S.
Hahn, Stephen—Art Dealer.
Hale, Nathan Cabot—S., T., W., L.
Hale, Robert Beverly—Mus. Cur., E., P.,
 W., L.
Halpern, Nathan L.—Collector.
Hammer, Victor J.—Art Gal. Dir.
Handler, Professor and Mrs. Milton—Col-
 lectors, Patrons.
Hare, David—S.
Harkavy, Minna—S.
Harmon, Lily—P.
Harnett, Mr. and Mrs. Joel William—Col-
 lectors.
Harris, Margo Liebes—S.
Harriton, Abraham—P., T.
Hartford, Huntington—Collector, Patron, W.
Hartl, Leon—P.
Hartwig, Cleo—S., T.
Haskell, Douglas—Cr., W.
Haupt, Mrs. Enid—Collector.
Hausman, Dr. Jerome—E.
Hayes, David Vincent—S.
Hayter, Stanley William—P., Gr., T., W., L.
Hayward, Peter—P., S.
Hazen, Mr. and Mrs. Joseph H.—Collectors.
Heeramaneck, Nasli M.—Collector, Patron,
 Art Dealer.
Heil, Joseph H.—P., Gr.
Heilemann, Charles Otto—Comm. A., I.,
 Des., P., E.
Heiloms, May—P., L.
Heineman, Bernard, Jr.—Collector.
Heinz, Mr. and Mrs. Henry J., II—Collec-
 tors.

Held, Al—P.
Held, Julius S.—Scholar, Collector.
Held, Philip—P., Ser., T.
Heliker, John Edward—P., E.
Helioff, Anne—P.
Heller, Ben—Collector.
Heller, Dorothy—P.
Heller, Goldie (Mrs. Edward W. Greenberg)
 —Collector, Advertising.
Hendricks, Geoffrey—E., P., Gr.
Henselman, Casper—Collector.
Hermanos, Maxime L.—Collector.
Herring, Mr. and Mrs. H. Lawrence—Col-
 lectors.
Hess, Emil John—P., S.
Hess, Thomas B.—Executive Editor, W.,
 Cr.
Hesse, Eva—S.
Heusser, Eleanore Elizabeth—P., T.
Higgins, Thomas J., Jr.—Cart.
Hightower, John B.—Administrative Execu-
 tive
Hildebrand, June Mary Ann—Pr. M., T., P
Hill, (James) Jerome—P., Lith.
Hillsmith, Fannie—P., Et., Eng., C.
Hinman, Charles—P.
Hios, Theo(dore)—P., Gr.
Hirsch, David W.—Cart.
Hirsch, Hortense M. (Mrs. Walter A.)—
 Patron
Hirsch, Joseph—P., Lith.
Hirschfeld, Albert—Caricaturist, I., W., Gr.
Hirschl, Norman—Art Dealer
Hitchcock, Henry-Russell—Hist., Cr.
Hobson, Katherine Thayer—S.
Hoff, Margo—P.
Hoffmann, Arnold, Jr.—P., Des., I.,
 Comm. A.
Hoie, Claus—P.
Hollerbach, Serge—P., I.
Hollister, Paul, Jr.—P., W.
Holton, Leonard T.—Cart., I., W.,
 Comm.
Hooker, Mrs. R. Wolcott—Collector,
 Patron.
Hoopes, Donelson F.—Mus. Cur., W., L.
Hopkins, Budd—P.
Hopkins, Peter—P., Des., Et., I., W., T., L.
Horch, Nettie S. (Mrs.)—Mus. Dir.
Horowitz, Mr. and Mrs. Raymond J.—Col-
 lectors.
Horowitz, Saul—Collector.
Horwitt, Will—S.
Houghton, Arthur A., Jr.—Museum Presi-
 dent
Hovell, Joseph—S., T.
Hoving, Thomas—Mus. Dir.
Howat, John K.—Mus. Cur.
Howe, Nelson Scott—P., Des., T.
Howell, Hannah Johnson (Mrs. Henry W.,
 Jr.)—Art Lib.
Howell, Marie (W.)—Des., C., T.
Hultberg, John Phillip—P.
Humphrey, Ralph—P.
Hunter, Sam—Mus. Dir., W., L.
Husted-Andersen, Adda—Metal Craftsman,
 Des., T.
Hutton, Leonard—Art Dealer
Huxtable, Mrs. Ada Louise—Cr.
Indiana, Robert—P., S., Ser., L.
Inman, Pauline Winchester (Mrs. Robert G.)
 —Gr., I.
Inokuma, Genichiro—P.
Insley, Will—S., P., W., T.
Iolas, Alexandre—Art Dealer
Irwin, Mr. and Mrs. John N., II—Collectors.
Irwin, Robert—P.
Isaacs, Betty Lewis—S.
Isaacson, Robert L.—Art Dealer.
Isenburger, Eric—P.
Ittleson, Henry, Jr.—Collector.
Jachmann, Kurt M.—Collector.
Jackson, Martha Kellogg—Collector, Art
 Dealer
Jackson, Ward—P., S., W., L.
Jacobs, David—S.

Rogers, Leo M.—Collector.
Rohlfing, Christian—Mus. Admin.
Roir, Irving—Cart.
Rojtman, Mr. and Mrs. Marc B.—Collectors.
Roller, Marion—S.
Romano, Emanuel Glicen—P., I., T.
Romano, Umberto—P., Lith., S., T., L.
Rome, Harold—Collector, P. W., Composer.
Rosati, James—S., E.
Rose, Hanna Toby—Mus. Cur. of E.
Rose, Herman—P., Et., T., L.
Roseman, Aaron—P.
Rosenberg, Alexander—Art Dealer.
Rosenberg, Saemy—Art Dealer.
Rosenblatt, Adolph—P., Lith., S.
Rosenblum, Robert—Scholar, W., Cr., E.
Rosenborg, Ralph M.—P.
Rosenhouse, Irwin Jacob—Lith., Des., I., P.
Rosenquit, Bernard—P., Et.
Rosenthal, Mrs. Alan H.—Collector.
Rosenthal, Bernard—S.
Ross, Alvin—P., E.
Ross, Charles—S.
Ross, Mrs. Walter—Collector, Patron.
Roszak, Theodore J.—S.
Rotan, Walter—S.
Roth, Frank—P.
Rothko, Mark—P.
Rousseau, Theodore, Jr.—Mus. Cur.
Rubin, Mr. and Mrs. Harry—Collectors.
Rubin, Lawrence—Art Dealer, Collector.
Rubin, William—Mus. Cur., W.
Ruda, Edwin—P.
Ruskin, Mickey—Collector.
Ruta, Peter—Ed.
Ryerson, Margery Austen—P., Et., Lith., W., I.
Ryman, Robert—P.
Sachs, A. M.—Art Dealer.
Saidenberg, Daniel—Collector, Art Dealer.
St. Clair, Michael—Art Dealer.
Saint-Phalle, Niki De—S., P.
Sainz, Francisco—P., C., Des., Gr., L.
Salemme, Autorino Lucia—P.
Salz, Samuel—Art Dealer.
Samaras, Lucas—S.
Sampliner, Mr. and Mrs. Paul H.—Collectors.
Sander, Ludwig—P.
Sanders, Joop—P., E.
Sandler, Irving Harry—Cr., W.
Sarnoff, Mr. and Mrs. Robert W.—Collectors.
Saul, Peter—P.
Saunders, Raymond (Jennings)—P.
Savage, W. Lee—P.
Saypol, Mr. and Mrs. Ronald D.—Collectors.
Scaravaglione, Concetta—S., T.
Scarpitta, Salvatore—S.
Schab, William H.—Art Dealer.
Schaefer, Bertha—Art Dealer.
Schaefer, Henri-Bella (Mrs. H. Bella De Vitis)—P., T.
Schang, Frederick, Jr.—Collector.
Schapiro, Meyer—E.
Scharff, William—P.
Schlemowitz, Abram—S.
Schneebaum, Tobias—P.
Schneider, Jo Anne—P.
Schoelkopf, Robert J., Jr.—Art Dealer.
Schoen, Mr. and Mrs. Arthur Boyer—Collectors, Patrons.
Schoener, Allon Theodore—W., Cr., Exh. Consult.
Scholz, Janos—Collector, Scholar, W.
Schorr, Justin—P., E.
Schrag, Earl—P., Pr. M., T., L., I.
Schreiber, Georges—P., Lith., Des.
Schroyer, Robert McClelland—Des., I., T.
Schueler, Jon R.—P., T., L.
Schuller, Grete—S.
Schulte, Mr. and Mrs. Arthur D.—Collectors.

Schwabacher, Alfred—Collector.
Schwabacher, Ethel K.—P., W., Cr., L.
Schwartz, Eugene M.—Collector, Patron.
Schwartz, Manfred—P., T., L., W.
Schwartz, Marvin David—Mus. Cur.
Schwartz, Therese—P.
Schweitzer, M. R.—Art Dealer, Appraiser, Collector.
Scull, Mr. and Mrs. Robert C.—Collectors.
Seff, Mr. and Mrs. Manuel—Collectors.
Segy, Ladislas—W., L., T., Cr., Gal. Dir.
Seiberling, Miss D.—Art W.
Seide, Charles—P., T., L., W.
Seldes, Gilbert—Cr.
Selvig, Forrest Hall—W., Scholar, Ed.
Sennhauser, John—P., T., Des.
Serger, Mrs. Helen—Art Dealer.
Serra, Richard—S.
Setterberg, Carl—P., I.
Shapiro, Daisy Viertel (Mrs. Jack)—Collector, Patron.
Shapiro, Seymour—P., T.
Shapshak, René—S., W., L., Mus. Cur.
Sharp, Harold—Cart.
Sharp, Marion Leale (Mrs. James R.)—P.
Shaw, Charles Green—P., I., W., Des.
Shayn, John—P., Des., W., L.
Shecter, Pearl S.—P., L., T.
Shell, Mr. and Mrs. Irving W.—Collectors.
Sherman, Sarai—P., Pr. M.
Sherman, Winnie Borne (Mrs. Lee D.)—P., L., T.
Shibley, Gertrude—P., Gr.
Shikler, Aaron—P.
Shimon, Paul—P., C.
Shirey, David—Art Ed.
Shotwell, Helen Harvey—P., Pictorial Photog.
Shoulberg, Harry—P., Ser.
Shuff, Lily (Mrs. Martin M. Shir)—P., Eng.
Shulman, Joseph L.—Collector.
Shunney, Andrew—P.
Sideris, Alexander—P.
Siegel, Mr. and Mrs. Jerome—Collectors.
Siegel, Leo Dink—I., Cart.
Sievan, Maurice—P., T.
Sigismund, Violet—P., Lith.
Sills, Thomas—P.
Simon, Bernard—S., T.
Simon, Ellen R.—Des., P., C., I., W., Gr., T.
Simon, Mr. and Mrs. Leo—Collectors.
Simon, Sidney—P., S.
Simpson, Merton D.—P.
Sinaiko, A(vrom) Arlie—S.
Sirugo, Salvatore—P.
Skouras, Mrs. Odyssia A.—Art Dealer.
Slatkin, Charles E.—Art Dealer.
Slifka, Mr. and Mrs. Joseph—Collectors.
Slifka, Rose—Ed.
Slivka, David—S.
Sloan, Mr. and Mrs. J. Seymour—Collectors, Patrons.
Sloane, Patricia—P.
Slobodkin, Louis—S., W., I., L., T.
Smith, Mrs. Bertram—Collector, Patron.
Smith, C. R.—Collector.
Smith, Gary—S., P.
Smith, Mrs. Louise—Collector.
Smith, Paul J.—Mus. Dir.
Smith, Tony—S.
Smithson, Robert I.—S., W., L.
Smul, Ethel Lubell—P., Lith., T., L., Gr.
Snow, Michael—P., S., Flm. Mk.
Snyder, Seymour—I., Des., Comm. A.
Soffer, Sasson—S., P.
Soglow, Otto—Cart.
Sokole, Miron—P., E., W., L., Gr.
Solinger, David M.—Collector, Patron.
Solman, Joseph—P., T., W., L.
Solomon, Alan R.—Scholar, W.
Solomon, Hyde—P.
Solomon, Mr. and Mrs. Sidney L.—Collectors.
Sommerburg, Miriam—S., C., Gr., P.

Sonenberg, Jack—P., Gr.
Sonnenberg, Mr. and Mrs. Benjamin—Collectors.
Soyer, Isaac—P., Lith.
Soyer, Moses—P., T.
Soyer, Raphael—P., Gr., E.
Spaeth, Eloise O'Mara—Collector, W.
Spark, Victor D.—Art Dealer.
Spaventa, George—S., C., T.
Sperakis, Nicholas George—P., Gr.
Spiegel, Sam—Collector, Producer of Motion Pictures.
Spitzer, Frances R. (Mrs. A. Luis)—Collector.
Spivak, Max—P., C., Des., T.
Sprayregen, Morris—Collector.
Spriggs, Edward S.—Mus. Dir., P.
Staempfli, George W.—Art Dealer, Collector, Cr.
Staley, Allen—Scholar.
Stamm, John Davies—Collector.
Stampfle, Felice—Scholar.
Standen, Edith Appleton—Mus. Assoc. Cur.
Starr, Maxwell B.—P., S., T.
Stefanelli, Joseph—P.
Stein, Maurice Jay—P., Comm., Des., S., T.
Stein, Ronald—P.
Stein, Walter—P., I.
Steinberg, Isador N.—P., Des., I.
Steinberg, Mrs. Milton—Art Dir.
Steinberg, Saul—P., Cart., Des.
Steinmann, Mr. and Mrs. Herbert—Collectors.
Stella, Frank—P.
Stenbery, Algot—P., I., T.
Sterling, Mrs. Robert—Patron.
Sterne, Dahli—P., S.
Sterne, Hedda—P.
Stevens, May—P.
Stiebel, Eric—Art Dealer.
Stillman, E. Clark—Collector, Scholar.
Stoloff, Carolyn—P.
Stoloff, Irma (Mrs. Charles I.)—S.
Stoner, Kenneth F.—Collector, Patron.
Stralem, Mr. and Mrs. Donald S.—Collectors.
Suba, Susanne—I., Des., P.
Sugarman, George—S.
Sugimoto, Henry—P., Gr., I., T.
Sullivan, Gene (Miss)—Art Dealer, P., Des., Comm., I.
Summers, Carol—Gr.
Sutherland, Sandy—P., T.
Suttman, Paul—S.
Svet, M(iriam) (Mrs. Dore Schary)—P.
Sway, Albert—P., Gr., I., Indst. Des.
Sweeney, James Johnson—Mus. Dir., W.
Sylvester, Lucille—P., W., I., L., T.
Tadasuke, Kuwayama—P.
Takal, Peter—P., Gr.
Tam, Reuben—P., T.
Tambellini, Aldo—S.
Tarnopol, Gregoire—Collector.
Tatti, Benedict—S., T., P.
Teichman, David—Collector.
Teichman, Sabina—P.
Terrell, Allen Townsend—S., P., Ser.
Terry, Hilda (D'Alessio) (Mrs. Gregory)—Cart.
Thaw, E. V.—Art Dealer.
Thek, Paul—S.
Thompson, Kenneth W.—I., P.
Tillim, Sidney—P., Cr., T., L.
Ting, Walasse—Pr. M., P.
Tinker, Edward Larocque—Collector, W., Patron.
Tobey, Mark—P.
Todd, Michael—S., Assemblages
Toulis, Vasilios (Apostolos)—Pr. M., P., E.
Trauerman, Margy Ann—P., T.
Treadwell, Helen—Mur. P., Des.
Trebilcock, Paul—P.
Truex, Van Day—P.
Tschacbasov, Nahum—P., Gr., E.
Tucker, Mrs. Marcia—Assoc. Cur.

Turner, Joseph (Dr.)—Patron.
Tuttle, Richard—P.
Twombly, Cy—P.
Tworkov, Jack—P., T.
Tyson, Mary (Mrs. Mary Thompson)—P.
Tytell, Louis—P., Gr.
Uchima, Ansei—Gr.-Pr. M.
Ulin, Dene (Mrs.)—Fine Arts Consult., Collector.
Untermyer, Judge and Mrs. Irving—Collectors.
Upjohn, Everard Miller—E., W., L.
Urban, Reva—P., S., Lith.
Uzielli, Giorgio—Collector.
Van Berg, Solomon—Collector.
Van Buren, Richard—S.
Van Derpool, James Grote—E.
Van De Wiele, Gerald—P., Gr.
Van Veen, Stuyvesant—P., Gr., I., W., L., E.
Varian, Elayne H. (Mrs. John)—Mus. Cur., Hist., T., W., L.
Vass, Gene—P., S., Gr.
Vermes, Madelaine—C.
Vicente, Esteban—P.
Vickrey, Robert Remsen—P.
Visson, Vladimir—Exhibition Dir.
Viviano, Catherine—Art Dealer.
Vodicka, Ruth Kessler—S.
Vogel, Donald—Pr. M., T.
Vogel, Edwin C.—Collector.
Vollmer, Ruth—S.
von Bothmer, Dietrich Felix—Mus. Cur., E., W., L., Scholar.
Von Schlegell, David—S., T.
von Wiegand, Charmion (Mrs. Joseph Freeman)—P., W.
Waddell, Richard H.—Art Dealer.
Wade, Jane—Art Dealer.
Wald, Sylvia—P., Pr. M.
Waldman, Paul—P.
Walinska, Anna—P., T.
Walker, Herschel Carey—Collector.
Walker, Ralph—Collector.
Walter, May E.—Collector, Patron.
Walton, Marion (Mrs. Marion Walton Putnam)—S.
Warburg, Edward M. M.—Collector.
Ward, Eleanor (Mrs.)—Art Dealer.
Warhol, Andy—P., S., C., Des., Gr., I.
Warren, Mrs. George Henry—Collector.
Wasey, Jane (Mrs. Jane Wasey Mortelliot)—S.
Washburn, Gordon Bailey—Gal. Dir.
Watts, Robert M.—S., L., E.
Webb, Aileen Osborn (Mrs. Vanderbilt)—Patron.
Weber, Hugo—P.
Weber, John—Art Dealer.
Wechsler, Herman J.—W., Art Dealer, Collector.
Wechter, Vivienne Thaul—P., E., L.
Weems, Katharine Lane—S.
Weill, Mr. and Mrs. Milton—Collectors.
Weiner, Mrs. Samuel—Collector.
Weinstein, Mr. and Mrs. Joseph—Collectors, Patrons.
Weintraub, Jacob D.—Art Dealer.
Weisglass, Mr. and Mrs. I. Warner—Collectors.
Weissman, Polaire—Executive Dir.
Weitzman, Mr. and Mrs. J. Daniel—Collectors.
Welch, Livingston—S., P.
Wells, Charles—S.
Werner, Alfred—Cr., W., L.
Werner, Don(ald) (L.)—P., Des.
Werner, Nat—S.
Werth, Kurt—I.
Wertheim, Mrs. Maurice—Collector.
Weschler, Anita—S., P.
Wesselmann, Tom—P.
West, Lowren—P., I.
Weston, Harold—P.
Weyhe, M. E.—Art Dealer.
Whinston, Charlotte (Mrs. Charles N.)—S., P., Gr.

White, Ruth—Art Dealer.
Whitehill, Florence Fitch (Mrs. Herman)—P.
Whitman, Robert—P.
Whitney, Mr. and Mrs. John Hay—Collectors.
Wiegand, Robert—P.
Wier, Gordon D.—Des., P., T., I.
Wildenstein, Daniel—Art Hist., Art Dealer.
Willard, Charlotte—W., Cr., Scholar.
Willenbecher, John—S.
Williams, Neil—S.
Wilner, Marie (Spring)—P.
Wilson, Jane—P., E.
Wilson, Sol—P., Pr. M.
Winchester, Alice—W., Ed.
Wines, James—S., T.
Winternitz, Emanuel—Scholar, Mus. Cur., W.
Wise, Howard—Art Dealer.
Wittenborn, George—Art Dealer.
Wittkower, Rudolf—E., Hist., W., L.
Wolins, Joseph—P., T.
Wong, Frederick—P.
Woodner, Ian—Collector.
Woodruff, Hale Aspacio—P., E., L.
Wormley, Edward J.—Des.
Wunder, Richard P.—Mus. Dir.
Yektai, Manoucher—P.
Yepez, Dorothy—Mus. Dir., Cur., E., W., L., P., S.
York, James—Art Dealer.
Young, Peter—P.
Youngerman, Jack—P.
Yrisarry, Mario—P.
Yunkers, Adja (Mr.)—P., Lith., Eng., L., I., T.
Zabriskie, Virginia M.—Art Dealer.
Zadok, Mr. and Mrs. Charles—Collectors.
Zeckendorf, Mrs. Guri—Collector.
Zeisler, Richard Spiro—Collector, Patron.
Ziegfeld, Edwin—Scholar, W.
Zevon, Irene—P., Gr.
Zilzer, Gyula—Et., Lith., P., Des.
Zipkin, Jerome R.—Collector.
Zox, Larry—P., T.
Zucker, Jacques—P.
Zucker, Paul—E., Cr., W.

Newburgh

Jackson, Hazel Brill—S., Eng.
Waugh, Coulton—P., E., L., Cart.

North Sales

Kipp, Lyman—S.

Nyack

Dahlberg, Edwin Lennart—P., I.

Olcott

Penney, Charles Rand—Collector.

Old Chatham

Coates, Robert M.—W., Cr.
Kratina, K. George—S.

Orangeburg

Costigan, John Edward—P.
Der Harootian, Koren—S., P.

Ossining

Rothschild, Herbert M.—Collector, Patron.
Wunderlich, Rudolf G.—Art Dealer.

Oswego

Saunders, Aulus Ward—E., P.
Stark, George King—S., E.
Sullins, Robert M.—P., E., Gr.

Patterson

Stearns, Thomas (Robert)—S., C.

Peekskill

Levine, Seymour R.—Collector.

Pelham Manor

Callan, Elizabeth Purvis—P., Comm., T., L.

Piermont

Davidson, Morris—P., W., L., T.

Pine Plains

Becker, Charlotte (Mrs. Walter Cox)—I., P., Comm., W.

Pittsford

Wildenhain, Frans Rudolf—Cer. C., P., S., T.

Pleasantville

Handville, Robert Tompkins—P., I., L.
Menconi, Ralph Joseph—S.

Port Chester

Blattner, Robert Henry—Des., I., T., P., W., L.
Reichman, Gerson—Collector.

Poughkeepsie

Forman, Alice—P., Des.
Havelock, Christine Mitchell—E.
Nochlin, Linda (Pommer)—Scholar, Cr., W.
Piccirilli, Bruno—S.
Pickens, Alton—P.
Rubenstein, Lewis W.—P., E., Gr.
Whitehead, James L.—Mus. Dir.

Pound Ridge

Guggenheimer, Richard H.—P., T., W., L.
Parker, Harry S. III—Mus. E.
Sachs, James H.—Collector, Patron.
Wiesenberger, Arthur—Collector, Patron.

Purchase

Goldsmith, Mr. and Mrs. C. Gerald—Collectors, Patrons.

Red Hook

Lax, David—P., E., Lith.

Riverdale

Bishop, Isabel (Mrs. Harold G. Wolff)—P., Et.
Burgard, Ralph—Dir. of Arts Councils.
Carmel, Hilda—P., C.
Hnizdovsky, Jacques—P., Eng.
Lane, Alvin S.—Collector.
Menkes, Sigmund—P.
Rifkin, Dr. and Mrs. Harold—Collectors.
Wingert, Paul Stover—E., W., L.

Rochester

Avery, Ralph H.—P., Comm. A.
Barschel, H(ans) J(oachim)—Gr. Des., Photog., W.
Brennan, Harold James—E., C., L., W.
Christensen, Hans (Jorgen)—C., Des., T.
Herdle, Isabel C.—Asst. Mus. Dir.
Menihan, John C.—P., Lith., Ser., L., Des.
Newhall, Beaumont—Mus. Dir.
Prior, Harris King—Mus. Dir., E.
Stern, Mr. and Mrs. Arthur L. (Molly S.)—Collectors, Patrons.
Whitmeyer, Stanley H.—E., Des., P., W., L.

Rye

deCreeft, Jose—S., T.
Drew, Joan—Pr. M., S., L.
Morgan, Frances Mallory—S.
Schmid, Elsa (Mrs. J. B. Neumann)—Mosaic A.

Salt Point

Wolfson, Sidney—P., S.

Saratoga Springs

Baruzzi, Peter B.—P., E., L.
Pardon, Earl B.—E., C., S., P.

Saugerties

Fite, Harvey—S., E., L., W.

Scarsdale

Arbeit, Arnold A.—P., E., C., I., S., W., L.
Bernstein, Sylvia—P.
Callisen, Sterling—E.
Goldsmith, Morton Ralph—Collector, Patron.
Johnson, Cecile Ryder—P.
Kaufman, Irving—P., E., W., L.
Kearl, Stanley Brandon—S.
Kizer, Charlotte E.—C., P., T.
Lerner, Alexander—Collector.
Morgan, Barbara Brooks (Mrs.)—Photographer, P., Gr., W., L.
Ries, Martin—Asst. Mus. Dir., P., S., Gr., T., W., L.
Schutz, Anton—Et., Ed.
Tarr, William—S.
Temple, Mr. and Mrs. Alan H.—Collectors.

Scottsville

Meyer, Fred(erick) Robert—P., S., Des., E., Flm. Mk.

Selkirk

Sprinchorn, Carl—P.

Shady

Ruellan, Andree—P., Lith., Et.
Taylor, John (Williams)—P., Pr. M., T.

Shandaken

Swenson, Valerie—P.

South Nyack

Breger, Dave—Cart.

Sparkill

Vytlacil, Vaclav—P., E.

Spencertown

Knight, Frederic C.—P., E.

Stanfordville

Simon, Howard—Por. P., I., Gr.

Staten Island

Bernstein, Gerald—P., Form. Mus. Cur., T., Rest.
Mulcahy, Freda—P., Mus. Cur.
Salerno, Charles—S., E.
Silberstein, Muriel Rosoff (Mrs.)—T., Scholar, Patron, Collector.
Smith, Joseph A(nthony)—P., I., T., S.

Stony Point

Dienes, Sari—P., Gr., Des., T., S.

Suffern

Pousette-Dart, Richard—P., T.

Sugar Loaf

Seligman, Kurt—P., Pr. M.

Syracuse

Bakke, Larry—P., E., W.
Burke, E. Ainslie—P., T., Lith.
Detore, John E.—P.

Kerfoot, Margaret (Mrs. M. W. Jennison)—P.
Mack, Rodger A.—S.
Marshall, John Carl—C.
Ochikubo, Tetsuo—P., Gr., E., Des.
Schmeckebier, Laurence E.—E., L., Cr., W., S.
Wilkins, Ruth S.—Mus. Cur.
Wyckoff, Sylvia Spencer—P., E.

Tappan

Lo Medico, Thomas G.—S.
Nickford, Juan—S.

Tarrytown

Hull, John R.—E.
Rockefeller, Governor Nelson Aldrich—Collector, Patron.

Troy

Mochon, Donald—E., P., Mus. Dir.

Upper Nyack

Howard, John L(angley)—P., I., T.
Phillips, Blanche (Howard)—S.

Utica

Dwight, Edward H.—Mus. Dir.
Loy, John Sheridan—E., P.
Moshier, Elizabeth Alice—E., P., C., Des., L., W.
Murray, William Colman—Collector, Patron.
Pribble, Easton—P., T., L.

Valley Cottage

Greene, Stephen—P., E.
Heaton, Maurice—C.

Voorheesville

O'Connor, Thom—Lith.

Warwick

Ostuni, Peter W.—S., P., E.

Wassaic

Durchanek, Ludvik—S., P.

Westchester

Hammond, Natalie Hays—P., W., Mus. Dir.

White Plains

D'Amico, Victor—Art E.
FeBland, Harriet—P., C., T.
Nickerson, Ruth (Jennie Ruth Greacen)—S., L.
Von der Lancken, Giulia—P., T.

Wingdale

Bolomey, Roger (Henry)—S., P., E., L.

Woodstock

Angeloch, Robert (Henry)—P.
Chavez, Edward—P., S., C., Gr., E.
Crampton, Rollin—P., T.
Crist, Richard—P., I., W.
de Diego, Julio—P., Gr., I., C., T.
Faggi, Alfeo—S., L.
Fortess, Karl Eugene—P., Lith., L.
Greenwood, Marion—P., Lith., T.
Guston, Philip—P.
Hart, Agnes—P., T.
Laufman, Sidney—P., T.
Lee, Doris—P., Gr., I.
Loomis, Lillian (Anderson) (Mrs.)—P.
Ludins, Eugene—P.
Magafan, Ethel—P.
Martin, Fletcher—P., Gr., I., E., L.
Mattson, Henry (Elis)—P.

Neustadt, Barbara (Mrs. Gunther Meyer)—Gr., I., L.
Petersham, Maud Fuller—I., W.
Pike, John—I., P., T.
Plate, Walter—P., T.
Plath, Iona (Mrs. Jay Alan)—Tex. Des., W.
Refregier, Anton—P.
Schuster, Carl—W., Scholar.
Small, Amy Gans—S., C.
Summers, Dudley Gloyne—P., I.
Wuermer, Carl—P.

Yonkers

Sarff, Walter—P., Des., I., Comm. Photog.

Yorktown Heights

Kaupelis, Robert John—P., E.

NORTH CAROLINA

Asheville

Bunker, Eugene Francis, Jr.—E., C., P., S.
Gray, Robert W.—E., C.
Gray, Verdelle (Mrs. Robert W.)—C., Des.
Lee, Cuthbert—Por. P.

Blowing Rock

Moose, Philip Anthony—P., E., L.

Chapel Hill

Foushee, Ola Maie (Mrs. John M., Sr.)
Howard, Robert A.—S., E.
Kachergis, George—P., E.
Ness, (Albert) Kenneth—P., E., Des.
Schlageter, Robert—Mus. Dir.
Sloane, Joseph Curtis—E., Hist., Mus. Dir.

Charlotte

Dalton, Harry L.—Collector.
Franklin, Ernest Washington, Jr. (Dr.)—Collector.
Gatewood, Maud F.—P.
Gebhardt, Ann Stellhorn (Mrs. Bruce)—P., E.
Kortheuer, Dayrell—Por. P., T., Cons., Landscape P.
Tucker, Charles Clement—Por. P.

Durham

Hall, Louise—E.
Mueller, Earl George—Scholar, Cr.
Patrick, Ransom R.—E., P., Hist., Des., Comm., L., Cr.
Semans, James Hustead, M.D.—Patron.
Sunderland, Elizabeth Read—E.

Franklin

Raveson, Sherman Harold—P., Des., Typ. A. Dir., W., Ed.

Greensboro

Carpenter, Gilbert Frederick—P., E.
Clarke, Ruth Abbott (Mrs.)—P., E.
Sedgwick, John Popham, Jr.—Scholar, W., E.

Greenville

Crawley, Wesley V.—S., E.
Gordley, Metz T.—P., C., E.
Gray, Wellington B.—E., P., C., Des.
Jacobson, Leon—P., E., Gr.
Sexauer, Donald R.—Pr. M., E.
Speight, Francis—P., T.

Hendersonville

Hagglund, Irv(in) (Arvid)—Cart.

Raleigh

Bier, Justus—Mus. Dir., W., L.

Bier, Senta Dietzel (Mrs. Justus Bier)—E., W., Cr.
Cox, Joseph H.—P., E.
Williams, Ben F.—Mus. Cur., P.

Webster

Morgan, Lucy Calista—C., T., W.

Wilmington

Howell, Claude Flynn—P., E., L.

Winston-Salem

King, Joseph Wallace (Vinciata)—P.

NORTH DAKOTA

Grand Forks

Nelson, Robert Allen—P., E., Pr. M.

OHIO

Akron

Drumm, Don—S., C.
Kitner, Harold—P., E., Cr.

Athens

Kortlander, William Clark—P., Hist.

Bath

Skeggs, David Otter—Des., P., C., Gr., L.

Beachwood

Gund, George—Collector, Patron, W.

Berea

Cosla, O. K. (Dr.)—Collector, W.

Canal Winchester

Craig, Eugene—Cart., L.

Canton

Welch, James Henry—Collector.
Wilson, Ralph L.—Collector.

Cincinnati

Adams, Philip Rhys—Mus. Dir., L., W.
Barnett, Herbert Phillip—E., P., L.
Bauer-Nilsen, Otto—S.
Cornelius, Francis DuPont—Cons., P.
De Forest, Julie Morrow (Mrs. Cornelius W.)—P.
Driesbach, Walter Clark, Jr.—S.
Fabe, Robert—P., E.
Fischer, Mildred (Gertrude)—C., Des., P., E.
Grooms, Reginald L.—E., P.
Hanna, Katherine—Mus. Dir.
Haswell, Ernest Bruce—S., W., L., T.
Hayes, Robert T.—P., Des.
Healy, Marion Maxon (Mrs. Rufus Alan)—P., Et., Lith.
Knipschild, Robert—P., T.
Longacre, Margaret Gruen (Mrs. J. J., IV)—Et., Lith., L., P., C.
Moscatt, Paul N. J.—P., T., Et.
Rice, Harold R.—E., Cr., W., Gr., L.
Solway, Carl E.—Art Dealer.
Warren, L. D.—Cart.

Cleveland

Bickford, George Percival—Collector, L.
Chiara, Alan R.—P., Des., T.
Cooney, John—Mus. Cur.
Dubaniewicz, Peter Paul—P., T., L.
Hornung, Dr. Gertrude Seymour (Mrs. Robert M.)—E., Hist., Patron, Collector, W.
Jankowski, Joseph P.—P., E., C., I.

Kowalski, Raymond A.—P., Des., T., Art Dir.
Lee, Sherman Emery—Mus. Dir., Cur.
McVey, Leza S. (Mrs.)—Cer. S.
McVey, William M.—S., E., L.
Miller, Leon Gordon—Des., P., Gr., S.
Morse, A. Reynolds—Collector.
Putnam, Mrs. John B.—Collector.
Rawski, Conrad Henry—E., L., W.
Takaezu, Toshiko (Miss)—Cer. C., T.
Teyral, John—P., T.
Thompson, Lockwood—Collector.
Welch, Mr. and Mrs. Robert G.—Collectors.

Cleveland Heights

Henning, Edward B.—Mus. Cur., Scholar, W.
Rappaport, Maurice I.—Collector, Cr., Art Dealer.

Columbus

Barkan, Manuel—Scholar, W., E.
Dailey, Joseph Charles—P., Des., Ser., C., T.
Gatrell, Marion Thompson—P., Gr., E.
Gatrell, Robert M.—P., Gr., E.
Hewett, Edward Wilson—P., E.
McWhinnie, Harold James—Pr. M., T., W.

Cuyahoga

Flint, Leroy W.—E., P., L., S.

Dayton

Clark, Mark Alan—Mus. Cur.
Colt, Priscilla C.—Mus. Cur., W., L.
Colt, Thomas C., Jr.—Mus. Dir.
Evans, Bruce Haselton—Mus. Cur., W.
Glover, Donald Mitchell—Cur. of Education, L.
Haswell, Mr. and Mrs. Anthony—Collectors.
Ostendorf, (Arthur) Lloyd, Jr.—P., W., I., Hist., Comm.
Pinkney, Helen Louise—Mus. Cur., Libr.

Delaware

Getz, Dorothy—E., S.
Stewart, Jarvis Anthony—E., P.

East Cleveland

Jeffery, Charles Bartley—C., T.

Euclid

Bates, Kenneth Francis—C., T., L., W.

Findlay

Fowler, Mary Blackford (Mrs. Harold N.)—S., P., W.

Gambier

Slate, Joseph (Frank)—E., W., P., L.

Gates Mills

Clague, John (Rogers)—S., T.

Granville

Young, Mahonri Sharp—Mus. Dir.

Kent

Novotny, Elmer Ladislaw—P., E.
O'Sickey, Joseph Benjamin—P., Des., E.

Lebanon

Koepnick, Robert Charles—S., T.

Moreland Hills

Shepherd, Dorothy G. (Mrs. Ernst Payer)—Mus. Cur.

Oberlin

Arnold, Paul B.—E., P., Gr.

Artz, Frederick B.—Scholar, W., Collector.
Bongiorno, Laurine Mack (Mrs.)—E.
Buck, Richard David—Mus. Cons., L.
Stechow, Wolfgang—E.
Whiteside, Forbes J.—Scholar.

Oxford

Fulwider, Edwin L.—P., E., Gr., Des.

Painesville

McGee, Winston Eugene—E., P.

Parma

Jergens, Robert Joseph—P., E.

Poland

Butler, Joseph G.—Mus. Dir., E., P.
Dennison, Dorothy D. (Butler)—P., Lith.
Vaccaro, Pat(rick) (Frank)—Ser., T.

Rocky River

Kuekes, Edward D.—Cart.

Sandusky

Brown, Dan(iel) Q(uilter)—Cart., P.

Seven Hills

Stanczak, Julian—P., T.

Shaker Heights

Snodgrass, Jeanne Owens (Mrs. Charles T.)—Mus. Cur., L., W., Cr., E.

Springfield

Morgan, Helen Bosart (Mrs. J. W.)—S., T.
Thompson, Ralston—P., E.

Toledo

Bruner, Louise (Mrs. Raymond A.)—Cr., W., L.
Draper, Line Bloom (Mrs. Glen C.)—P.
Saunders, John Allen—Cart., W., L.
Wittmann, Otto—Mus. Dir.

Worthington

Severino, D. Alexander—E., L.

Wyoming

Gross, Mr. and Mrs. Merrill Jay—Collectors, Patrons, Consult.

Yellow Springs

Metcalf, Robert Marion—Stained Glass Des., P., E., L.
Milder, Jay—P., S., Gr., T.

Youngstown

McDonough, Dr. John Joseph—Collector, Patron.
Singer, Clyde J.—P.

OKLAHOMA

Bartlesville

Patterson, George W. Patrick—P., Mus. Dir., Des., Hist., W.

Miami

Wilson, Charles Banks—P., Lith., I., E., W., L.

Muskogee

West, Walter Richard—P., T.

Norman

Bavinger, Eugene A.—P., T.

Corsaw, Roger D.—Cer. C., E.
Henkle, James Lee—S., Indst. Des., P., T.
Olkinetzky, Sam—Mus. Dir., P., E.
Sutton, George Miksch—P., I., W., L., Mus.
 Cur.

Oklahoma City

McChristy, Quentin L.—P., Des., Gr., I.
Patterson, Patty (Mrs. Frank Grass)—P.,
 C., T., L., W.
Shannon, Patric—Mus. Dir., P., Des., E.
Sheets, Nan (Mrs. Fred C.)—Mus. Dir., Cr.,
 W., L., P.
White, Roger Lee—P., E., Gr.

Stillwater

McVicker, J. Jay—P., S., Gr., E.
Stevens, Dwight Elton—Des., P., E.

Tulsa

Allen, Clarence Canning—P., Des., I., W.,
 L.
Allen, Loretta B. (Mrs. Clarence)—P.,
 Des., Comm., I., T.
Broadd, Harry Andrew—E., P., L., A. Hist.
De Vinna, Maurice (Ambrose, Jr.)—Cr., E.
Gussman, Herbert—Collector, Patron.
Hogue, Alexandre—P., Lith., W., E.
Humphrey, Donald G.—Mus. Dir.
O'Meilia, Philip Jay—P., T., I.
Packer, Clair Lange (Mr.)—P., W., I.,
 Comm., Cart., Des.

OREGON

Corvallis

Gilkey, Gordon Waverly—Pr. M., E., W., L.
Gunn, Paul James—E., P., Gr.
Jameson, Demetrios George—P., Gr., E.
Levine, Shepard—P., E., Lith., L., W.
Sandgren, Ernest Nelson—P., Lith., E.
Sponenburgh, Mark Ritter—E., Hist., S.
Taysom, Wayne Pendleton—S., E.

Eugene

Cochran, George McKee—P., Cart., I., W.,
 L.
Kutka, Anne (Mrs. David McCosh)—P.
Lanier, Dr. Vincent—E.
McCosh, David (John)—P., E.
McFee, June King—Scholar, W.

Gearhart

Klep, Rolf—I., Comm. A., Des.

Gresham

de Graaff, Mr. and Mrs. Jan—Collectors,
 Patrons.

Lake Oswego

Rosenberg, Louis Conrad—Et., I., Arch.

Portland

Givler, William Hubert—P., Et., Lith., T.
Goodwin, Alfred—Collector.
Griffin, Rachael—Mus. Cur., Cr., E., W., L.
Halvorsen, Ruth Elise—P., C., Des., W.
Hardy, Thomas Austin—S., T., Lith.
Heidel, Frederick (H.)—P., E.
Johanson, George E.—P., Gr., T.
Kennedy, Leta M.—C., Des., Gr., L., E.
Littman, Frederic—S.
McLarty, William James—P., E., Gr., L.
Morris, Carl—P.
Morris, Hilda (Mrs. Carl)—S.
Newton, Francis John—Mus. Dir.

Salem

Hall, Carl A.—P., Gr., Cr., T.

PENNSYLVANIA

Abington

Cartledge, Rachel H.—P.
McGarvey, Elsie Siratz (Mrs. James P.)—
 Mus. Cur., E.

Allentown

Berman, Dr. Muriel M. (Mrs. Philip)—Col-
 lector, Patron, L.
Berman, Philip—Collector, Patron.
Dreisbach, C(larence) I(ra)—P., Des., T., L.
Hoffman, Richard Peter—P.
Moller, Hans—P.

Ambler

Lee, Manning de Villeneuve—P., I.
Willet, Henry Lee—C., W., L.

Arcola

Mitchell, Henry (Weber)—S.

Bala-Cynwyd

Taylor, Dr. and Mrs. J. E.—Collectors.

Barto

Bertoia, Harry—S., Des., P., C.

Bethlehem

Quirk, Francis J.—P., E., L., Dir. Exh.

Blue Bell

Martino, Giovanni—P.

Boalsburg

Bogart, George A.—P., E.

Bryn Athyn

Ewald, Louis—P., Des.

Bryn Mawr

Pittman, Hobson—P., L., Cr., T.

Camp Hill

Bartlett, Robert W.—P., Des., Comm., I.

Carlisle

Sellers, Charles Coleman—Scholar, W.

Chadds Ford

McCoy, John W. (II)—P., T.
Wyeth, Andrew Newell—P.

Chambersburg

Harris, Josephine Marie—E.

Cheyney

Kamihira, Ben—P.

Chester Springs

Hartt, Frederick—Scholar.

Coopersburg

Riu, Victor—S.

Cornwall

Quinn, Henrietta Reist (Mrs. Thomas
 Sydney Quinn, Jr.)—Collector, P.

Doylestown

Bye, Ranulph (de Bayeux)—P., E.

Duncansville

Atkyns, (Willie) Lee (Jr.)—P., T., Gr., S.,
 L., I., E.

East Greenville

Askew, R. Kirk, Jr.—Art Dealer. Collector.

Easton

Higgins, (George) Edward—S.
Salemme, Antonio—S., P., T., L.
Salemme, Martha—P.

Elkins Park

Berenstain, Stanley—Cart., W.
Goodman, Sidney—P., Gr.

Fort Washington

Thompson, F. Raymond—Comm. A., I..
 Cart., Des., W.

Gibsonia

de Coux, Janet—S.
Osby, Larissa Geiss—P., T.

Glenmoore

Jacobs, Harold—P., S.
Smith, Robert C.—Scholar.

Glenside

Gundersheimer, Herman S(amuel)—E., W..
 L.

Greensburg

Chew, Paul Albert—Mus. Dir.
Irvin, Sister Mary Francis—P., E., Gr.

Harrisburg

Winer, Donald Arthur—Mus. Cur., P., C., E.

Haverford

Lloyd, Mrs. H. Gates—Collector, Patron.

Havertown

Gasparro, Frank—S., T.

Huntingdon Valley

Meltzer, Arthur—P., C., L.

Indiana

Kipp, Orval—P., E., Gr., I., L.
Reynolds, Ralph William—E., P.

Jenkintown

Brown, Bo (Robert Franklin)—Cart.
Cain, James Frederick, Jr.—Pr. M., Mus.
 Cur.
Rosenwald, Lessing Julius—Collector, Pa
 tron, W.

Kempton

Hesketh—S.

Kingston

Colson, Chester E.—P., E.

Kutztown

Quirk, Thomas Charles, Jr.—P., T.

Lancaster

Carson, Sol Kent—P., E., Pr. M.
Kermes, Constantine John—P., Pr. M., Des.
Kern, Arthur (Edward)—P.
Lewis, Harold—P., E.

Lansdale

Falter, John—I.

Lemont

Altman, Harold—Et., P., E.

Ligonier

Cornelius, Marty (Miss)—P., E., I., Cr., L., W.

Malvern

Agha, Mehemed Fehmy—W.
Kramrisch, Stella (Dr.)—Mus. Cur., E., Cr., L.

Manheim

Steinmetz, Grace Titus—P., E., Gr.

Meadville

Fugagli, Alfonso—P.

Mechanicsville

Coiner, Charles T.—P., W., L., Des.

Media

Berd, Morris—P., E.
Hildebrandt, William Albert, Jr.—P., S., Gr., E., I.
House, James (Charles), Jr.—S., E.

Melrose Park

Flory, Arthur L.—Gr., P., T., I.
Sabatini, Raphael—P., S., E., Gr., L.
Viesulas, Romas—P., Et., Lith.

Merion Station

Robb, David M.—E.

Narberth

Donohoe, Victoria—Cr.

New Britain Township

Leon, Dennis—S., T., Cr.

New Hope

Cheney, Sheldon—W., Cr.
Harbeson, Georgiana Brown (Mrs. Frank Godwin)—P., Des., C., T., L.
Leith-Ross, Harry—P., Comm. A., W.
McClellan, Robert John—P., C., Gr., W., I., L.
Rosin, Harry—S., T.

Newtown Square

Martino, Antonio P.—P.
Roberts, Gilroy—Eng., S.

Ottsville

Rudy, Charles—S., E.

Paoli

Esherick, Wharton—S., Des., C., Gr.

Penn Wynne

Angelo, Emidio—Cart., P., Flm. Mk.

Philadelphia

Andrade, Edna (Wright)—P., Des., Ser., E.
Bechtle, C. Ronald—P., L.
Benson, Gertrude A.—Art Cr., Feature W., Ed.
Bernstein, Benjamin D.—Collector.
Blackburn, Morris—P., Gr., T., L.
Blai, Boris—S., E.
Bookbinder, Jack—P., Lith., E., L., W.
Campbell, Malcolm—Scholar.
Cramer, Richard Charles—P., E.
Culler, George D.—E., P., Gr.
de Angeli, Marguerite Lofft—I., W.
Dillon, Mildred Murphy (Mrs. James F.)—Pr. M., Et., Ser., R.
Drabkin, Stella (Mrs.)—P., Mosaicist, Gr., Des.
Emerson, Edith—P., I., L., W., Mus. Cur., T.

Etting, Emlen—P., Des., I., E., W., L.
Fenton, Beatrice—S.
Ferris, Edythe (Mrs. Raymond H.)—P., Gr., T., W., L.
Field, Richard S.— Asst. Cur.
Fine, Stan(ley) M.—Cart.
Gardiner, Henry Gilbert—Mus. Cur.
Gill, Frederick James—P., T., L.
Gold, Albert—P., Gr., I., E., W., L.
Grafly, Dorothy (Mrs. Charles Hawkins Drummond)—W., Cr., L.
Graham, Frank P.—Mus. Admin.
Groff, June—Des., P., Ser.
Hathaway, Calvin S.—Mus. Cur.
Havard, James Pinkney—P.
Hawthorne, Jack Gardner—E., L.
Hood, (Thomas) Richard—Gr., Des., E.
Horter, Elizabeth Lentz—P., Et.
Howard, Humbert L.—P.
Hutton, Dorothy Wackerman—Et., Lith., P.
Hutton, Hugh M.—Cart.
Inverarity, Robert Bruce—Des., Mus. Dir.
Jones, (Charles) Dexter (Weatherbee), III—S.
Kaplan, Jerome—Pr. M., E.
Kidder, Alfred, II—Assoc. Mus. Dir.
Klein, Esther M. (Mrs. Phillip)—W., Patron, Collector.
Le Clair, Charles (George)—P., E., L.
McIlhenny, Henry P.—Collector.
Maitin, Samuel (Calman)—P., Gr., T.
Makler, Hope—Art Dealer.
Mangione, Patricia Anthony—P.
Marceau, Henri—Mus. Cur.
Marzano, Albert—P., Des., Ser.
Merrick, James Kirk—P., T., I., W., L., Mus. Dir.
Moskowitz, Shirley (Mrs. Shirley Edith Moskowitz Gruber)—P., S., Gr., T., L.
Nelson, Leonard L.—P., T., Gr., S.
Paone, Peter—Pr. M., P.
Pease, David—P., T.
Perkins, G. Holmes—E.
Pitz, Henry C.—P., I., E., W.
Potamkin, Meyer P.—Collector.
Pretsch, John Edward—Cart., Comm. A., P.
Price, John M.—Art Dir., Des., Cart., Flm. Producer.
Reinsel, Walter—P., Des.
Remenick, Seymour—P.
Richardson, Constance (Coleman) (Mrs. E. P.)—P.
Richardson, E(dgar) P(reston)—E., W., L.
Riggs, Robert—Lith., I., P.
Siegel, Adrian—P., Photog.
Smith, Lawrence M. C.—Patron, Collector.
Stevens, William B., Jr.—Mus. Dir.
Strawbridge, Edward Richie, 2nd.—P.
Taylor, Charles—P.
Taylor, Ralph—P., T., Gr.
Turner, Evan Hopkins—Mus. Dir.
Tyson, Mrs. Charles R.—Collector.
Van Dyk, James—P., E.
Weidner, Roswell Theodore—P., Lith., T.
Welliver, Neil—P., T., Cr.
Wolf, Ben—P., Cr., W., I., T., L., Gr.
Zigrosser, Carl—Mus. Cur., W., Cr.

Phoenixville

Hopkins, Kendal Coles—P., T.

Pineville

Smith, William Arthur—P., Lith., I., L.

Pittsburgh

Arkus, Leon Anthony—Mus. Dir.
Beaman, Richard Bancroft—E., Des., P.
Cantini, Virgil D.—S., C., E.
Gabriel, Robert A.—S., E.
Gardner, Robert Earl—Gr., E., P., C.
Gruber, Aaronel Deroy—S., P.
Hanna, Boyd—I., Eng.
Hovey, Walter Read—E., Scholar, Collector.
Kalinowski, Eugene M.—P., T., S.

Karn, Gloria Stoll— P., Et.
Katz, Joseph M.—Collector, Patron.
Koerner, Henry—P., W., L.
Lepper, Robert Lewis—S., E., P.
Lieb, Leonard—P., T. Gr.
Muller-Munk, Peter—Des.
Rice, Norman Lewis—E., Gr., P.
Rosenberg, Samuel—P., E.
Rosenbloom, Charles J.—Collector.
Twiggs, Russell Gould—P., Ser.
Weiner, Abe—P., T., L.
Winokur, James L.—Collector, Patron.
Winter, Clark—S.

Plymouth Meeting

Pitz, Molly Wood (Mrs. Henry C.)—P., T.

Point Pleasant

Drewes, Werner—P., Gr.

Pottstown

Ihlenfeld, Klaus—S.

Quakertown

Keyser, Robert—P., T.
Papashvily, George—S.

Radnor

Clifford, Henry—Mus. Cur.

Ridgway

McCloskey, Eunice LonCoske—P., W., L.

Riegelsville

Swann, Erwin—Collector, Patron, W.

Rushland

Rosenwald, Mrs. Barbara K.—Collector.

St. Davids

Terry, Duncan Niles—C., Des.

Scranton

Ellis, Carl Eugene—Mus. Cur., Assoc. Mus. Dir., T., L.

Selinsgrove

Bucher, George Robert—E., P., Des., L., S., I.
Putterman, Florence—P., Pr. M., Collector, Patron.

Sewickley

Oliver, Henry, Jr.—Collector.

Sharon

Dunn, Nate—P., T.

Souderton

Hallman, H. Theodore, Jr.—C., T., P.

State College

Dickson, Harold Edward—E., W.
Enggass, Robert—Scholar, W.
Ferguson, Thomas Reed, Jr.—E., P.
Hyslop, Francis Edwin, Jr.—E.
McCoy, Wirth Vaughan—P., E., L.
Mattil, Edward L.—W., Scholar, T.
Montenegro, Enrique—P., E.
Weisman, Winston R.—E., W., Art Hist.

Sunbury

Karniol, Hilda—P., T.

Swarthmore

Walker, Robert Miller—E.

Titusville

Herpst, Martha (Jane)—Por. P., T.

Uniontown

Leff, Jay C.—Collector.

University Park

Beittel, Kenneth R.—E.

Valley Forge

Rainey, Froelich—Mus. Dir., E., W., L.

Villanova

Wintersteen, Mrs. John—Collector.

Warrington

Keene, Paul F.—P., E.

Wayne

Cooke, Donald Ewin—Des., I., Comm., L., W.
Hoffman, Edward Fenno, III—S.
Key, Ted—Cart., W.

West Chester

Jamison, Philip—P.
Wescott, Paul—P.

West Reading

Poole, Earl L(incoln)—Form. Mus. Dir., I., Gr., S., P., E.
Waldron, James M. K.—Mus. Cur., P., T.

Wynnewood

Gill, Sue May (Mrs. Paul)—Por. P., S., T.
Maxwell, John—P.
Merriam, Ruth (Mrs. John W.)—Cons., Collector, W.
Sweeny, Barbara—Assoc. Mus. Cur.

York

Case, Andrew W.—E., P., L.

RHODE ISLAND

Bristol

Knowlton, Daniel Gibson—C., Des., T.
Townley, Hugh—S., E.

Coventry Center

Mays, Maxwell—I., W., P., Des.

Edgewood

Casey, Elizabeth T.—Mus. Cur.

Jamestown

Wright, Catharine Morris (Mrs. Sydney L.)—P., W., L., Gr.

Kingston

Cain, Jo(seph) (Lambert)—P., E., Lith.

Little Compton

Hubbard, Robert—S.

Newport

Kerr, John Hoare—Scholar, Cr., W., Collector, Art Admin.
Nesbitt, Alexander John—Des., E., W., L.

North Kingstown

Loring, Paule Stetson—Watercolorist, Des., Cart., I.

Peace Dale

Eichenberg, Fritz—Pr. M., Eng., Lith., I., T., W.

Providence

Bush-Brown, Albert—W., E., L.
Day, Martha B. Willson (Mrs. Howard D.)—Collector, Miniaturist.
Downing, George Elliott—E., P.
Feldman, Walter—P., Gr., E.
Franklin, Gilbert A.—S., E., L.
Goto, Joseph—S.
Gourley, Hugh J. III—Mus. Cur.
Licht, Frederick—Art Hist.
Morin, Thomas Edward—S.
Peers, Gordon Franklin—P., E.
Robbins, Daniel J.—Mus. Dir., E., Hist.

Wakefield

Leete, William White—P., E.

Westerly

Day, Chon (Chauncey Addison)—Cart.

SOUTH CAROLINA

Anderson

Holcombe, Blanche Keaton (Mrs. Cressle Earl)—P., T.

Charleston

Halsey, William Melton—P., T., L., I., S.
Hirsch, Willard—S., T.
Karesh, Ann (Bamberger)—P., S., Des.
McCallum, Corrie (Mrs. William Halsey)—P., T., L., I., Gr.
Tobias, Thomas J.—Collector, Mus. Trustee.

Columbia

Bardin, J(esse) (Redwin), Jr.—P., C., T.
Craft, John Richard—Mus. Dir.
Ledyard, Walter William (Dr.)—Collector, S.
Mitchell, Dana Covington, Jr. (Dr.)—Collector.
Van Hook, David H.—P., L., Mus. Cur.
Woody, (Thomas) Howard—S., E., L.
Yaghjian, Edmund—P., E., L.

Greenville

Blair, Carl Raymond—P., T.
Bopp, Emery—E., P., S., Des.
Coburn, Bette Lee (Mrs. Marvin)—P.
Gustafson, Dwight Leonard—E., Des.
Koons, Darell John—P., E.

Hilton Head Island

Whitmore, Coby—P., I.

Lexington

Flinsch, Harold, Jr.—Collector, Patron, Cr.

Southern Pines

McNett, Elizabeth Vardell (Mrs. W. B.)—P., Med. I., T., Gr.

Spartanburg

Cook, August—E., P., Eng.
Du Pre, Grace Annette—Por. P.

SOUTH DAKOTA

Aberdeen

Holaday, William H., Jr.—E., P., C., Gr.

Custer

Ziolkowski, Korczak—S.

Sioux Falls

Eide, Palmer—E., P., S.

Yankton

Janssen, Hans—E., Mus. Cur., L., C.

Vermillion

Howe, Oscar—P., E.
Stilwell, Wilber Moore—E., P., Des., Gr., L., I., W.

TENNESSEE

Chattanooga

Cress, George Ayres—P., E.

Clarksville

Bryant, Olen Littleton—S.

Gatlinburg

Stevens, Bernice A.—C., T.
Zimmerman, Alice E.—C.

Knoxville

Ewing, Charles Kermit—E., P., L.
Sublett, Carl C.—P., E.

Memphis

Anthony, Lawrence K.—S., P., E.
Cloar, Carroll—P., Lith.
Goodman, Benjamin—Patron.
Knowles, Richard H.—P., E.
Lehman, Louise Brasell (Mrs. John)—P.
Moss, Morrie Alfred—Collector, Patron.
Rust, Edwin C.—S., E.

Nashville

Brumbaugh, Thomas B.—E., L.
Driskell, David Clyde—P., E., Gr., L.
Jarman, Walton Maxey—Collector.

Sewanee

Barrett, H. Stanford—P., E.

TEXAS

Addison

Murchison, John D.—Collector.

Arlington

Joyner, Howard Warren—E., P., L., Des.
Rascoe, Stephen Thomas—P., E.

Austin

Beitz, Lester U.—P., I., W.
Brezik, Hilarion, C.S.C.—P., I., Exhibit Dir.
Davis, Marian B.—E., Gal. Dir.
Fearing, Kelly—P., Et., E., W., L.
Forsyth, Constance—Et., Lith., P., E.
Goodall, Donald B.—E., Mus. Dir., Cr., L.
Guerin, John William—P., E.
Hatgil, Paul Peter—E., Des., C., S.
Hirsch, Richard Teller—Mus. Cur., W., L.
Kelpe, Paul—P., E.
Milliken, Gibbs—P., E.
Salinas, Porfirio—P.
Spruce, Everett Franklin—P., E., Gr.
Umlauf, Charles—S.
Weismann, Donald LeRoy—E., P., Cr., L., W.

Bay City

Bess, Forrest Clemenger—P., L.

Beaumont

Boughton, William Harrison—P., T.

Clint

Herring, Jan(et) (M.)—P., L., T., C.

Commerce

McGough, Charles E.—E., Gr., P., Des., Comm.

Corpus Christi

Cain, Joseph A.—P., E., Cr., W.

Dallas

Bond, Roland S.—Collector.
Bromberg, Mr. and Mrs. Alfred L.—Collectors.
Bywaters, Jerry—Fine Arts Center Director., E., W., P., L.
Dozier, Otis—P., Lith.
Harris, Leon A., Jr.—Collector, Patron, W., L.
Marcus, Edward S.—Collector.
Marcus, Stanley—Collector, Patron.
Mauzey, Merritt—Lith., W., P., I.
Meadows, Algur H.—Patron.
Mudge, Edmund Webster, Jr.—Collector.
Rueppel, Merrill C.—Mus. Dir.
Travis, Olin Herman—P., Lith., L., E.
Van Atta, Helen U.—Collector.

El Paso

Kolliker, William A.—P., Des., Comm., I., T., L.
Lea, Tom—P., I., W.
Massey, Robert Joseph—P., Et., S., E., L.

Fort Worth

Bomar, Bill—P.
Brown, Richard F(argo)—Mus. Dir.
Cantey, Sam III—Collector.
Chumley, John Wesley—P.
Fuller, Mr. and Mrs. William Marshall—Collectors.
Johnson, Mrs. J. Lee, III—Collector, Patron.
Kalbfleisch, Robert S., Jr.—Scholar, Collector, P.
Richards, Karl Frederick—E., P., E., W.
Smith, Emily Guthrie (Mrs. Tolbert C.)—P., T., C., L.
Weiner, Ted—Collector.
Wilder, Mitchell A(rmitage)—Mus. Dir., E.
Windfohr, Mr. and Mrs. Robert F.—Collectors.

Houston

Adler, Sebastian Joseph, Jr.—Mus. Dir.
Boynton, James W.—P., Lith.
Brochstein, I. S.—Collector.
Chillman, James, Jr.—E., L., Mus. Dir., W.
Collins, Lowell Daunt—P., E., L., Gr., S., I.
De Menil, John—Collector.
Hudson, Mrs. Cecil B.—Collector.
John, Grace Spaulding—P., I., W.
Love, Jim—S.
Montebello de, Guy-Philippe Lannes—Mus. Dir.
O'Neil, John—P., E.
Wray, Dick—P.

Huntsville

Ahysen, Harry Joseph—P., Gr., L., E.
Breitenbach, William J.—P., E.
Geeslin, Lee Gaddis—P., Gr., E.

Kingsville

Kercheville, Christina (Mrs.)—P.

Longview

Elias, Harold John—P., C., Des., I., L.

Lubbock

Gibbons, Hugh James—P., E.
Howze, James Dean—E., P., Gr. Des.
Kreneck, Lynwood A.—Pr. M., P., E.

Nacogdoches

Schlicher, Karl Theodore—E., P., W.

Robstown

Rutland, Emily (Mrs.)—P.

San Angelo

Schmidt, Stephen—Mus. Dir.

San Antonio

Fuchs, Sister Mary Tharsilla—E., P.
Lee, Amy Freeman—P., Cr., L., W., T.
Leeper, John Palmer—Mus. Dir.
Naylor, Alice (Mrs. James K.)—P., Lith., T.
Pace, Margaret Bosshardt (Mrs. David E.)—Des., P., S., E., C.
Roney, Harold Arthur—P., T., L.
Steinbomer, Dorothy H. (Mrs. Henry)—S., C., Des., P., A. Libn., L.
Tauch, Waldine—S., P., T., L.

Waco

Smith, John Bertie—P., E., W., L.

UTAH

Logan

Lindstrom, Gaell—P., C., E.
Reynolds, Harry Reuben—P., C., E.
Thorpe, Everett Clark—P., Des., E., I., L.

Midvale

Olsen, Don—P.

Mt. Carmel

Zornes, (James) Milford—P., I., Comm. A., T., W., L.

Provo

Andrus, J. Roman—E., Lith.
de Jong, Gerrit, Jr.—E., W.

Salt Lake City

Dunn, O. Coleman—Collector.
Fausett, Lynn—P.
Friberg, Arnold—I., P., Des.
Stuart, Signe Nelson—P., T.

VERMONT

Barre

Gaylord, Frank—S., P., T., L.

Barton

Baker, Anna P.—P., Gr.

Bennington

Adams, Pat—P., E.
Longo, Vincent—P., Gr.

Charlotte

Aschenbach, Paul—S.

Dorset

Bley, Elsa W.—P., T.
Calfee, William H.—S.
Fausett, (William) Dean—P., Et., Lith.
Jackson, Beatrice (Humphreys)—P.

Fair Haven

Robinson, Robert Doke—Educator, P., E.

Fairlee

Walker, Herbert Brooks—S., P., Gr., Mus. Dir., W., L.

Hartland

Christopher, William R.—P., C., T.
Tooker, George—P.

Londonderry

Shokler, Harry—Pr. M., P., L., W., T.

Manchester Depot

Lucioni, Luigi—P., Et.

Middlebury

Healy, Arthur K(elly) D(avid)—P., Arch., W., L.
Reiff, Robert Frank—P., E.

Norwich

Sample, Paul—P.

Pawlet

Connaway, Jay Hall—P., T., L.

Putney

Watson, Aldren Auld—I., Des., Gr., Ed.

Royalton

Nash, Ray—W., E., L., Cr.

Rutland

Johnson, Katherine King (Mrs. Norman F.)—P.

St. Johnsbury

Finck, Furman J.—P., T., W.

Shaftsbury

Olitski, Jules—P., E.

Shelburne

Emerson, Sterling Deal—Mus. Dir.
Webster, David S.—Asst. Mus. Dir.

South Pomfret

Penney, Bruce Barton—P.

South Royalton

d'Aulaire, Edgar Parin—P., Et., Lith., W.
d'Aulaire, Ingri Mortenson Parin—W., I., Lith., P.

South Shaftsbury

Noland, Kenneth—P.

Stowe

Wright, Stanley Marc—P., T., L.

Warren

Carpenter, Harlow—Mus. Dir.

West Townsend

Brodie, Gandy—P., T., Des., C., L.

Weston

Landon, Edward—Ser., S., W.

Woodstock

Gyra, Francis Joseph, Jr.—P., I., T., L.

VIRGINIA

Alexandria

Bailey, Worth—Mus. Cur., E., Des.
Chapman, Howard Eugene—Des., Cart., A. Dir.

Connaway, Ina (Mrs. Charles E.)—P., S., Gr., E.
Day, Horace Talmage—P., E.
Dorn, Charles Meeker—Art Association Executive, Scholar, W.
Jamieson, Mitchell—P., T.
Myers, Denys Peter—Mus. Dir., E., L., W.
Richards, Jeanne Herron—Et., Eng., Lith.
Rose, Ruth Starr—P., Lith., Ser., L., T., Des., I.
Sanborn, Herbert J.—Lith., L.
Sandground, Mark B., Sr.—Collector, Patron.
Van Arsdale, Dorothy Thayer (Mrs.)—Chief of Traveling Exhibitions.

Arlington

Bier, Elmira—Assistant to Mus. Dir.
Fenical, Marlin Edward—P., Comm. A., I., W.
Genders, Richard Atherstone—P.
Harlan, Roma Christine—Por. P.
McGowin, Ed(ward) (William) (Jr.)—S.
Reed, Paul—P.
Richardson, Gerard—P., Des., I.
Taylor, Prentiss—P., Lith., T., L., I., W.
Twitty, James—P., T.

Blacksburg

Carter, Dean—S., E.

Bristol

Cooke, C. Ernest—E., W., Cr., L., P.

Charlottesville

Barbee, Robert Thomas—P., Gr., E.
Clark, Eliot (Candee)—P., W., L., E., Cr.
Priest, Hartwell Wyse—Pr. M., P.

Covington

Walton, Harry Archelaus, Jr.—Collector.

Falls Church

Jackson, Virgil V.—Cart., I., P., Des., Comm.
Owens, Winifred (Whitebergh)—P., W., L.

Hollins College

Ballator, John R.—P., E., Lith.

Lexington

Junkin, Marion Montague (Mr.)—P., E.

Lynchburg

Williams, Mary Frances—E., Mus. Cur.

McLean

Anderson, Gwen(dolyn) (Orsinger)—P., T., C., L.
Beggs, Thomas Montague—Fine Arts Consultant, P.
Greenly, Colin—S.

Middleburg

Bowman, Jean—Por. P., I., T.

Norfolk

Behl, Marjorie—P.
Caldwell, Henry Bryan—Mus. Dir.
Matson, Elina (Mrs. Mathew Augustus)—C.
Matson, Greta (Mrs. Alfred Khouri)—P., Lith., T.
Porter, Doris (Mrs. Donald J. McLean)—P., L., T., S.
Sibley, Charles Kenneth—P., E.
Taylor, Bertha Fanning—P., L., Mus. Cur. W., T., Cr.
Trotter, Robert (Bryant)—P., Des., I., T.

Powhatan

Binford, Julien—P., S., E.

Richmond

Apgar, Nicolas Adam—P., Lith., T.
Brown, James M. III—Mus. Dir.
Gaines, William R.—Museum Program Director, P.

Sweet Briar

Barton, Eleanor Dodge—E.

Upperville

Mellon, Paul—Collector.

Vienna

Gonzales, Carlotta (Mrs. Richard Lahey)—P., S., T., I.
Lahey, Richard (Francis)—P., Gr., E., L.
Summerford, Ben L.—P., E.

Williamsburg

Graham, John Meredith, II—Director of Collections.
Roseberg, Carl Andersson—S., Eng., E., I.
Thorne, Thomas—P., E., L.

WASHINGTON

Anacortes

McCracken, Philip—S.

Bainbridge Island

Willis, Mrs. Elizabeth Bayley—Collector.

Bellingham

Loggie, Helen A.—Et., Draughtsman.

Ellensburg

Spurgeon, Sarah (Edna M.)—E., P.

Kent

Pierce, Danny—P., Et., Eng., W.

La Conner

Anderson, Guy—P.

Maryhill

Dolph, Clifford R.—Mus. Dir.

Olympia

Haseltine, James—Arts Administrator, L., W., E., Gr., P.
Haseltine, Maury—P., E., Gr., C.

Pullman

Monaghan, Keith—E., P.

Seattle

Alps, Glen E.—E., Gr.
Banks, Virginia—P.
Brazeau, Wendell Phillips—E., P., Gr.
Bush, Beverly—P., S.
Celentano, Francis M.—P.
Chase, Doris Totten—S., P., L.
Du Pen, Everett George—S., E.
Eckstein, Joanna—Collector, Patron.
Fuller, Richard Eugene—Mus. Dir.
Gonzales, Boyer—P., E.
Grossman, Fritz—E.
Hamill, Mildred—P., C.
Hauberg, Mr. and Mrs. John—Collectors.
Herard, Marvin T.—S., C., E.
Hixon, William—E., P.
Hopkins, Robert E.—S.
Horiuchi, Paul—P.
Johnson, Pauline B.—W., E.
Kahn, Barry—P., S., T.
Kirsten, Richard Charles—P., Gr.
Kohn, Gabriel—S.
Levine, Reeva (Anna) Miller (Mrs.)—Por. P., Des., C., T., L., I.

Maki, Robert Richard—S., T.
Mason, Alden C.—P., E.
Maytham, Thomas Northrup—Associate Museum Director.
Monsen, Dr. & Mrs. Joseph—Collectors.
Moseley, Spencer—E.
Peck, James Edward—Des., P., C., T.
Portmann, Frieda (Bertha) (Anne)—E., P., S., Gr., W., C.
Rising, Dorothy Milne—P., T., L.
Rogers, Millard Buxton—Art Historian.
Selig, Mr. and Mrs. Manfred—Collectors, Patrons.
Selig, Martin
Thomas, Ed(ward) B.—E., L., P., W.
Trubner, Henry—Mus. Cur.
Tsutakawa, George—S., P., T.
Warsinske, Norman George—S., C.
Washington, James—S.
Wright, Mr. and Mrs. C. Bagley—Collectors.

Tacoma

Achepohl, Keith—Et., T.
Chubb, Frances Fullerton—E., P.

Vancouver

Hansen, James Lee—S.

WEST VIRGINIA

Charleston

Keane, Lucina Mabel—E., P., S., I., L.
McNamara, Raymond—Gr. Pr. M., E,, P.
Taylor, Grace Martin—P., Gr., E.

Huntington

Christian, Stephan L.—Art Patron.
Polan, Lincoln M. (Dr.)—Collector.
Polan, Nancy M. (Mrs. Lincoln M.)—P.

Morgantown

Moss, Joe Francis—P., S., Des., E.

Williamstown

Shao Fang Sheng—P., C., Des., T., L.

Westminster

Frudakis, Evangelos W(illiam)—S., T., C.

WISCONSIN

Appleton

Brooks, Charles M., Jr.—E.

Beloit

Boggs, Franklin—P., E., S.
Ishikawa, Joseph—Mus. Dir., L., W.
Williams, Lewis W., II—E., Hist.

Evansville

Wilde, John—P., E.

Green Bay

La Malfa, James Thomas—S.

Hartland

Stonebarger, Virginia—T., P.

Jackson

White, Doris Anne—P.

Kenosha

Faulkner, Kady B.—P., Et., Lith., Ser., E.
Tatman, Virginia Downing—T., C., P.

Madison

Bohrod, Aaron—P.

Butts, Porter Freeman—E., W.
Byrd, D. Gibson—P., E.
Colescott, Warrington—P., E.
Logan, Frederick M.—E., L., W,, P.
Lotterman, Hal—P., T.
Maryan, Hazel Sinaiko—P., S., Collector.
Meeker, Dean Jackson—Pr. M., Muralist.
Starks, Elliott Roland—E., A. Dir.
Tomlinson, Florence K. (Mrs. E.B.)—P., Eng., I., T.
Watrous, James S.—P., E., C., W.
Weiss, Lee (Elyse C.)—P.

Mequon

Atkinson, Tracy—Mus. Dir.

Milwaukee

Borhegyi de, Stephan—Mus. Dir., E., W.
Bradley, Mrs. Harry Lynde—Collector.
Colt, John N.—P., E.
Davis, John Harold—Collector, Illus., P., Des., T.
Flagg, Mr. and Mrs. Richard B.—Collectors.
Green, Edward Anthony—P., Des., Gr., E., Mus. Cur.
Grotenrath, Ruth (Mrs. Ruth Grotenrath Lichtner)—P., Ser., Eng., C., Des., T.
Key, Donald—Cr.
Lewandowski, Edmund D.—P., E.
Lichtner, Schomer—P., C., Des., Ser., T.
Luntz, Irving—Art Dealer, W., Collector.
Melamed, Abraham (Dr.)—Collector, Patron.
Meredith, Dorothy L(averne)—P., C., E.
Pick, John—University Art Administrator, W.
Revor, Sister Mary Remy—E., Des., C., W., L.

Rosenberg, Pierce—Collector.
Schaefer, Josephine M.—P., T.
Schellin, Robert—P., C., E.
Schinneller, James A.—E.
Summ, Helmut—P., E., L.
Thomasita, Sister Mary, O.S.F.—P., C., S., Des., E., L.
Wasserman, Jack—Scholar, E.

Oshkosh

Behncke, Ethel Bouffleur (Mrs. Nile J.)—E., Des., L.
Behncke, Nile Jurgen—Mus. Dir., P.

Platteville

Ross, James Matthew—P., Et., E.

Racine

Jerry, Sylvester—Mus. Dir., P.

Ripon

Breithaupt, Erwin M., Jr.—E., P.

Stoughton

Grilley, Robert L.—P., E.

Verona

Littleman, Harvey Kline—Glass Sculptor, C., E.

Waukesha

Penkoff, Ronald Peter—E., Pr. M., P.

Waunakee

Vierthaler, Arthur A.—C., E., Des., W., L.

WYOMING

Cody

Meyers, Robert William—I.

Jackson

Hagen, Grant O.—P.

Laramie

Boyle, James M.—E.
Deaderick, Joseph—P., E., Et., S., Des.
Evans, Richard—P., E., Gr.
Mueller, Henriette W. (Mrs.)—P., Des., Gr., E., S.
Russin, Robert I.—S., E., L., W.

Sheridan

Martinsen, Ivar Richard—E., P.

PUERTO RICO

Rio Piedras

Balossi, John—E.

VIRGIN ISLANDS

Christiansted

Baringer, Richard E.—P., Des., Arch.

Frederiksted

Irvin, Rea—P., I., Cart.
Yater, George David—P., I., W.

CANADIAN INDEX

ALBERTA

Banff

Grandmaison, Nickola De—P.

Calgary

Snow, John (Harold Thomas)—Lith., P.

Edmonton

Manarey, Thelma (Mrs. C. H.)—P., Gr.

Lethbridge

Beny, Wilfred Roloff—P., Et., L., Eng., Photographer.

BRITISH COLUMBIA

Campbell River

Andrews, Sybil (Morgan) (Mrs.)—P., Gr., T.

Oyama

Mann, Vaughan—P., Ser., W., L., T.

Port Washington

Glyde, Henry George—P., E.

Richmond

Reid, (William) Richard—P.

Shawnigan Lake

Hughes, Edward John—P.

Summerland

Adams, Irvine C(linton)—P.

Vancouver

Binning, Bertram Charles—P., E., Mus. Cur.
Cope, Dorothy (Mrs. C. A.)—P.
Emery, Charles Anthony—Mus. Dir.. E., W., L., C.
Harris, Lawren—P.
Holmes, Reginald—P., Ser., Lith., T.
Kanee, Ben (Dr.)—Collector.
Korner, John—P.
Lennie, Beatrice—S., Des., P., I., T., L., C.
May, Henrietta Mabel—P., T.
Melvin, Grace Wilson—P., Des., T., I., L.
Shadbolt, Jack Leonard—P., T.
Smith, Gordon—P., E. S., Gr.
Thorne, Gordon Kit—P., Et., Lith., T., Comm. A., Des.

Victoria

Bates, Maxwell—P., Gr., W., Arch.

MANITOBA

Winnipeg

Lochead, Kenneth Campbell—E., P.

MacAulay, John Alexander, Q.C.—Collector.
Swinton, George—P., Et., Lith., E., W., L.

NEW BRUNSWICK

Clifton Royal

Campbell, Rosamond Sheila—P., Des., Cart., Comm., I., T.

Sackville

Colville, Alexander—P., Gr.
Harris, Lawren Phillips—P., T.

NOVA SCOTIA

Amherst

Whitehead, Alfred—P., E., L.

Halifax

Anderson, Ronald Trent—P., Pr. M., E
Brownhill, Harold—P., Et., Lith., Cart., I.
Mackay, Donald Cameron—E., P., Et., I.
Mowat, Alexander Sutherland—E., P.

Kentville

Fox, Charles Harold—C.
Fox, Winifred Grace—C., P., I., Des.

Old Barns

Annand, Robert William—P.

Peggy's Cove

deGarthe, William E.—P., S.

Sydney

Mould, Lola Frowde (Mrs. William)—P., Des.

Yarmouth

Pierce, Elizabeth R. (Mrs. Vernon L.)—P.

ONTARIO

Ancaster

Panabaker, Frank S.—P.

Ayr

Martin, John—P., Des., C., Gr., I., T.. L.

Beaverton

Scott, Lloyd (Edward William)—I.

Don Mills

Bayefsky, Aba—P., Pr. M.

Grimsby

Harley, Harry George—Cart.

Guelph

Couling, Gordon—E., P.

Ingersoll

Crawford, Catherine Betty—P., Gr.

Kingston

Allen, Ralph—P., Gr., E., Mus. Dir.
Bieler, Andre—P., E., L., Eng.
MacDonald, Grant—P., I., T.
Travers, Gwyneth (Mrs. C. H.)—Pr. M.

Kitchener

Goetz, Peter—P., T.

Kleinburg

Jackson, Alexander Young—P.

London

Ariss, Herbert Joshua—P., S., T.
Bice, Clare—P., Mus. Cur.
Chambers, John—P.
Cryderman, Mackie (Mrs.)—P., Gr., Des., C., T.
Dale, William Scott Abell—E., L., W.
Francis, Harold Carleton—P., Eng., Comm.

Markham

Alfsen, John Martin—P.

Milton

Roberts, William Griffith—P., T.

Mississauga

Dingle, Adrian—P.

Newmarket

Hagan, (Robert) Frederick—Pr. M., E., P.

Niagara-on-the-Lake

Benton, Margaret Peake—Min. and Por. P.
Jones, Jacobine—S.

Oakville

Hanson, Jean—P., Des., Gr.

Orono

Drummond, Arthur A.—P., I.

Oshawa

Hilts, Alvin—S.
Luke, Alexandra (Margaret Alexandra Luke McLaughlin)—P.

Ottawa

Banfield, A. W. F.—E.
Barbeau, Marius—W., Mus. Wkr.
Boggs, Jean Sutherland—Mus. Dir., Scholar, E., W.
Boyd, James—Pr. M., Des., T.
Buchanan, Donald William—Cr., W.
Fenwick, Kathleen M.—Mus. Cur., Ed.
Groves, Naomi Jackson (Mrs.)—W., L., P.
Hubbard, Robert Hamilton—Mus. Cur., Hist., L.
Karsh, Yousuf—W., Photographer.
Masson, Henri—P., T.
Sylvestre, Guy—Ed., Cr., W., L.
Tolgesy, Victor—S.

Palgrave

Ogilvie, William Abernethy—P.

Port Credit

Roberts, Thomas Keith—P.

Scarborough

McCarthy, Doris Jean—P., T., L., C., Des.

Rexdale

Kramolc, Theodore Maria—P., Gr., Des.

Streetsville

Taylor, Jocelyn (Jocelyn Taylor Mitchell)—P., C., Des., T.

Thornhill

MacDonald, Thoreau—I., P., Des.

Toronto

Aldwinckle, Eric—P., Gr.
Altwerger, Libby (Mrs.)—P., Gr., T.
Amaya, Mario—Mus. Cur.
Arbuckle, Franklin—P., I.
Aziz, Philip—P., Des.
Band, Charles S.—Collector, Patron.
Bell, R. Murray—Collector.
Bloore, Ronald Langley—E., P.
Brieger, Peter H.—E., Hist.
Broomfield, Adolphus George—P., Et., Textile Des., L.
Bush, Jack—P.
Clark, (Mrs.) Paraskeva—P.
Collier, Alan Caswell—P.
Coughtry, John Graham—P., S.
Courtice, Rody Kenny (Mrs.)—P., T.
Dagys, Jacob—S., T.
Daly, Kathleen (Mrs. George Pepper)—P. Gr., W.
del Junco, Emilio—Collector, Patron, Arch., Art Dealer.
de Pedery-Hunt, Dora—S., Des.
Deutsch, Peter Andrew—P.
Etrog, Sorel—S., P., Pr. M.
Filipovic, Augustin—S., P., T., L., Cr.
Franck, Albert Jacques—P., Rest.
Freifield, Eric—P., E., L.
Gage, Frances M.—Por. S.
Gauthier, Joachim George—P.
Goldhamer, Charles—P., T., Lith.
Griffith, Julius—P., Gr.
Hall, John A.—P., E., Eng., I., Des.
Hanes, Ursula Ann—S.
Heller, Jules—E., W., Gr.
Herbert, John D.—Admin.
Hoo, Sing (Sing Hoo Yuen)—S., T.
Horne, (Arthur Edward) Cleeve—P., S.
Hornyansky, Nicholas—Et., Des., T.
Kopmanis, Augusts A.—S.
Latner, Albert J.—Collector, Patron.
Luz, Virginia—P., T.

MacDonald, Manly—P.
McGeoch, Lillian Jean—P., Des., T.
Martin, Bernice Fenwick (Mrs. Langton)—P., Gr.
Martin, Langton—Pr. M., P., C.
Mochizuki, Betty—P.
Murphy, Rowley Walter—P., Stained Glass Des., I., T., W., L.
Nakamura, Kazuo—P., S.
Neddeau, Donald Frederick Price—T., P., Des., Gr.
Oesterle, Leonhard—S.
Pehap, Erich K.—P., Gr., Des., I., T., L.
Schaefer, Carl Fellman—P., T., Lith.
Seguin, Tutzi Haspel—P., C., Ser., T., L.
Thorne, M. Art—P., T.
Town, Harold Barling—P., S., Des., I., W.
Valius, Telesforas—Eng., Lith., E.
Vickers, George Stephen—E.
Watson, Sydney H.—P., E., Des.
Woods, Rex Norman—I., P., Des., Comm.
Zacks, Samuel Jacob—Collector, Patron.

Welland

Cyopik, William—P.

Willowdale

Bozickovic, Alex—P., Pr. M.
Chiarandini, Albert—Por. P.
Gilling, Lucille—Pr. M.

Windsor

Saltmarche, Kenneth Charles—Mus. Dir., P., W., Cr., L.

QUEBEC

Dorval

Daoust, Sylvia—S.

Lachine

Walsh, John Stanley—P., I., W.

La Tuque

Cosgrove, Stanley—P.

Laval

Pellan, Alfred—P.

Montreal

Adams, Glenn Nelson—P.
Armstrong, William Walton—P.
Ayre, Robert Hugh—W., Cr.
Beament, Commander Harold—P., Des.
Beament, T(homas) H(arold)—P., C., Pr. M., T.
Bellefleur, Leon—P., Eng.
Bouchard, Lorne—P.
Brandtner, Fritz—P., C., Des., Gr.
Briansky, Rita (Prezament)—Et., P.
Caiserman-Roth, Ghitta (Mrs. Max W.)—P.
Chicoine, Rene—P., T., Cr.
Cooke, Edwy Francis—Mus. Dir., E., P.
Eveleigh, Henry—P., Des., E.
Hebert, Julien—S., Des., E.
Hyde, Laurence—Eng., P., Comm., W.
Kahane, Anne—S.
Lewis, Stanley—S., Gr., T., L.
McEwen, Jean (Mr.)—P.
Masse, Georges Severe—P., T., L.
Molinari, Guido—P., S.
Morris, Kathleen Moir—P.
Muhlstock, Louis—P.
Peck, Trevor F.—Collector.
Pinsky, Alfred—P., Lith., T.
Prezament, Joseph—P., Gr., T.
Roberts, (William) Goodridge—P.
Scott, (Mrs.) Marian D.—P.
Smith, John Ivor—S.
Surrey, Philip Henry—P., W.
Tinning, G. Campbell—P.

Tousignant, Claude—P., S.
Wheeler, Orson Shorey—S., T., L.

Morin Heights

Holgate, Edwin Headley—P.

Perce

Guité, Suzanne—S., T.

Quebec

Morisset, Gerard—E., W., Mus. Cur.
Plamondon, Marius Gerald—S., E., C.

St. Hilaire

Braitstein, Marcel—S.

St. Lambert

Archambault, Louis—S.
De Tonnancour, Jacques G.—P., T.

Ste. Agathe des Monts

Miller, H. McRae—S., Des., Comm. A., T., P.

Sillery

Lemieux, Jean Paul—P.

Westmount

Carter, David Giles—Mus. Dir., Hist., W., L.

SASKATCHEWAN

Regina

Nulf, Frank A.—P., E.

Saskatoon

Bornstein, Eli—E., P.
Lindner, Ernest—P., Gr.

YUKON TERRITORY

Whitehorse

Farley, Lilias Marianne—P., S., T., Des.

FOREIGN INDEX

AUSTRALIA

St. Georges

Samstag, Gordon—P., T.

ECUADOR

Quito

Mitchell, Eleanor—Fine Arts Specialist & Libr.

ENGLAND

Essex

Howard, Charles—P.

Herefordshire

Creo, Leonard—P., S., Gr.

Kent

Longstaffe, John Ronald—Collector.

FRANCE

Antibes

Budd, David—S., P.

Arles

Kerkovius, Ruth—P., Gr.

La Garenne-Colombes

Moskowitz, Ira—Et., Lith., P.

Montfort-L'Amaury

Van Leyden, Ernst Oscar Mauritz—P., S.
Van Leyden, Karin Elizabeth—P., Des., I., Muralist.

Paris

Barr, Roger Terry—S., P., E., Gr., I., L.
Fink, Don—P.
Koenig, John Franklin—P., Pr. M.
Levee, John Harrison—P., Lith., Eng.
Loeb, Albert—Art Dealer.
MacIver, Loren—P.
Spencer, Eleanor Patterson—E., W.

INDIA

New Delhi

Morley, Grace L. McCann—Mus. Dir., L., W., Cr., E.

ITALY

Camaiore

Jackson, Harry—P., S.

Florence

de Tolnay, Charles—E., W.
Fonelli, J. Vincent—S., P., Arch. Des.
Puccinelli, Raymond—S., P., E., L., W.

Genoa

Lionni, Leo—P., Des., E., Cr.

Rome

Berman, Eugene—P., Des., Sc. Des., Gr., I.
Hebald, Milton Elting—S., C., T.
Kachadoorian, Zubel—P.
Leong, James Chan—P.
Pepper, Beverly—S., P., Gr.
Perry, Charles Owen—S., Arch. & Indst. Des.
Richter, Gisela Marie Augusta—Mus. Cur., W., L., C.
Weinberg, Elbert—S., Pr. M.

Subiaco

Congdon, William—P.

Venice

Guggenheim, Peggy (Mrs.)—Collector, Patron.

MEXICO

Guanajuato

Williams, Garth Montgomery—I., S., P., W., Des.

Mexico City

Gordon, Maxwell—P.

Oaxaca

Rosenthal, Doris—P., Lith., Des., T.

Scheier, Edwin—Ceramist, E., S., P.
Scheier, Mary—Ceramist, Des., C., E., P.

San Miguel de Allende

Dickinson, William Stirling—E., P., W., L.
Pinto, James—P., T., S.
Pratt, Dudley—S.
Taylor, Frederick (Bourchier)—P., S.

MOROCCO

Marrakech

Landau, Rom—S., E., W., L.

NETHERLANDS

Baarlo

Tajiri, Shinkichi G.—S.

SPAIN

Barcelona

Narotzky, Norman (David)—P., Gr., Cr.

Madrid

Wortham, Harold—Art Consult., P.

Mallorca

Hare, Channing—P.

SWEDEN

Stockholm

Swan, Marshall W. S.—E.

SWITZERLAND

Geneva

Ghez, Oscar (Dr.)—Collector.

Locarno

Hulbeck, Beate—P.

VENEZUELA

Caracas

Neumann, Hans—Collector.

OBITUARIES

OBITUARIES
1966-1969

ALAN, JAY—Cartoonist; d. July 17, 1965, age 58, in Woodstock, N.Y. See WWAA 1966

ARNO, PETER—Cartoonist; d. Feb. 22, 1968, age 64, in Portchester, N.Y. See WWAA 1966.

BACH, RICHARD F.—Educator; d. Feb. 16, 1968, age 80, in New York City. See WWAA 1966.

BALDWIN, HARRY II—Painter; d. N.D. in Makawao, Maui, Hawaii. See WWAA 1962.

BEALL, LESTER—Illustrator; d. June 20, 1969, age 66, in New York City. See WWAA 1966.

BELLINGER, LOUISA—Curator; d. Nov. 12, 1968, in Hamden, Conn. See WWAA 1966.

BERHARD, MRS. RICHARD J.—Collector; d. N.D., in New York City

BIEBEL, FRANKLIN M.—Museum Director; d. N.D., in New York City. See WWAA 1966.

BLAIR, STREETER—Painter; d. Nov. 4, 1966, age 78, in Beverly Hills, Cal. See WWAA 1966.

BLANCH, ARNOLD—Painter; d. Oct. 23, 1968, age 72. See WWAA 1966

BLISS, MRS. ROBERT WOODS—Collector; d. Jan. 17, 1969, in Washington, D.C. See WWAA 1966.

BLOCH, JULIUS—Painter; d. Aug. 1966, age 78, in Philadelphia, Pa. See WWAA 1966.

BOARDMAN, NELL—Painter; d. Feb. 28, 1968, age 73, in New York City. See WWAA 1966.

BOHNERT, HERBERT—Portrait Painter; d. Aug. 19, 1967, in Hastings-on-Hudson, N.Y. See WWAA 1966.

BORSTEIN, YETTA—Painter; d. 1968, in Norfolk, Va.

BOUCHE, LOUIS—Painter; d. Aug. 7, 1969, age 73, in Pittsfield, Mass. See WWAA 1966.

BOURDELL, PIERRE VAN PARYS—Sculptor; d. July 6, 1966, age 63, in Oyster Bay, N.Y. See WWAA 1966.

BRITTAIN, MILLER G.—Painter; d. Jan. 1968, age 56, in Saint John, N.B., Canada. See WWAA 1966, Canadian section.

BURLIN, PAUL—Painter; d. Apr. 1969, age 83, in New York City. See WWAA 1966.

CHANIN, ABRAHAM L.—Lecturer; d. N.D., in New York City. See WWAA 1966.

CHERNEY, MARVIN—Painter; d. 1966, age 41, in New York City. See WWAA 1966.

CHOUINARD, MRS. NELBERT—Educator; d. July 9, 1969, age 90, in Pasadena, Cal. See WWAA 1962.

CLEAR, CHARLES V.—Museum Consultant; d. N.D., in Jensen Beach, Fla. See WWAA 1966.

COLEMAN, RALPH P.—Painter; d. Apr. 3, 1968, age 76. See WWAA 1966.

COSGRAVE, J. O'HARA, II—Illustrator; d. May 9, 1968, age 61, in Pocasset, Mass. See WWAA 1966.

CROCKWELL, DOUGLASS—Commercial Artist; d. Nov. 30, 1968, age 64, in Glens Falls, N.Y.

DATZ, A. MARK—Painter; d. N.D., age 79, in New York City. See WWAA 1962.

DEAN, ERNEST WILFRID—Painter; d. N.D, in Collingwood, Ont, Canada. See WWAA 1966, Canadian Section.

DEHN, ADOLF—Graphic Artist; d. May 19, 1968, age 72, in New York City. See WWAA 1966.

DEFRANCESCO, ITALO I.—Educator; d. May 25, 1967, age 66, in Kutztown, Pa. See WWAA 1966.

DEINES, E. HUBERT—Engraver; d. July 2, 1967, age 73. See WWAA 1966.

DIRKS, RUDOLPH—Cartoonist; d. 1968, age 91. See WWAA 1966.

DIXON, FRANCIS S.—Painter; d. Jan. 6, 1967, age 87, in New York City. See WWAA 1962.

DOI, ISAMI—Painter; d. N.D., in Hawaii. See WWAA 1966.

DUPONT, HENRY F.—Museum Curator; d. Apr. 14, 1969, in Wilmington, Del.

ENGEL, MICHAEL M.—Art Publicist; d. Apr. 25, 1969, age 75, in New York City. See WWAA 1966

EPSTEIN, ETHEL S.—Collector; d. N.D., in New York City. See WWAA 1966.

FAULKNER, BARRY—Painter; d. N.D.

FAWCETT, ROBERT—Illustrator; d. Apr. 13, 1967, age 64, in Ridgefield, Conn. See WWAA 1966.

FEELEY, PAUL—Painter; d. June 12, 1966, age 52, in Bennington, Vt. See WWAA 1966.

FEIGIN, DOROTHY—Painter; d. July 12, 1969, age 67, in New York City. See WWAA 1962.

FIELDS, MITCHELL—Sculptor; d. Oct. 6, 1966, age 65. See WWAA 1966.

FISHER, REGINALD—Writer; d. July 26, 1966, age 60. See WWAA 1966.

FLEISCHMANN, ADOLF R.—Painter; d. 1969, age 67, in Germany. See WWAA 1966.

FLEISCHMANN, JULIUS—Collector, d. N.D., in Cincinnati, Ohio. See WWAA 1966.

FLIEGEL, LESLIE—Painter; d. Dec. 1968, age 56. See WWAA 1966.

FOOTE, JOHN, JR.—Painter; d. Nov. 20, 1968. See WWAA 1966.

FORBES, EDWARD W.—Museum Director; d. March, 1969, in Cambridge, Mass. See WWAA 1962.

FRANKLE, PHILIP—Painter; d. Nov. 8, 1968, age 55. See WWAA 1966.

FRANKLIN, CLARENCE—Collector; d. Feb. 16, 1967, age 82. See WWAA 1966.

FRASER, LAURA G.—Sculptor; d. Aug. 13, 1966, age 77, in Norwalk, Conn. See WWAA 1966.

FREY, ERWIN F.—Sculptor; d. Jan. 10, 1967, age 75, in Columbus, Ohio. See WWAA 1966.

FRIEDLAENDER, WALTER—Art Historian; d. Sept. 6, 1966, age 93, in New York City. See WWAA 1966.

FRIEDLANDER, ISAC—Engraver; d. Aug. 23, 1968, age 78, in New York City. See WWAA 1962.

FROELICH, PAUL—Painter; d. N.D. See WWAA 1966.

GARBATY, EUGENE L.—Collector; d. Sept. 6, 1966, age 66. See WWAA 1966.

GATCH, LEE—Painter; d. Nov. 10, 1968, age 66, in Trenton, N.J. See WWAA 1966.

GILRIN, THEODORE H.—Painter; d. Mar. 11, 1967, age 52, in Los Angeles, Cal.

GRAY, HAROLD—Cartoonist; d. May 9, 1968, age 74, in La Jolla, Cal. See WWAA 1962.

GREATHOUSE, WALSER S.—Museum Director; d. Dec. 16, 1966, age 64. See WWAA 1966.

GREENE, J. BARRY—Painter; d. Oct. 5, 1966, age 74. See WWAA 1966.

GREEN-FIELD, ALBERT—Art Publicist; d. N.D. See WWAA 1966.

GRIGAUT, PAUL L.—Museum Curator; d. March, 1969, age 64, Richmond, Va. See WWAA 1966.

GUSTAVSON, LEALAND—Illustrator; d. July 21, 1966, age 67, in Westport, Conn.

HAMMER, VICTOR KARL—Painter; d. July 10, 1967, age 85, in Lexington, Ky. See WWAA 1966.

HANLEY, T. EDWARD—Collector; d. Apr. 9, 1969, age 75, Bradford, Pa. See WWAA 1966.

HARE, MICHAEL MEREDITH.—Scholar; d. Aug. 30, 1968, age 59, in Smithtown, N. Y. See WWAA 1966.

HARRIS, MARGIE COLEMAN—Painter; d. N.D. See WWAA 1966.

HARVEY, JAMES V.—Painter; d. July 15, 1965, age 46, in New York City. See WWAA 1966.

HAUSMANN, MARIANNE PISKO—Painter; d. N.D., in Denver, Colo.

HECHT, ZOLTAN—Painter; d. 1968, age 78.

HERING, HARRY—Painter; d. Apr. 13, 1967, age 80, in New York City.

HERVES, MADELINE—Painter; d. Aug. 24, 1969, age 64, in Newtown, Mass.

HEYL, BERNARD CHAPMAN—Scholar; d. N.D.

HILER, HILAIRE—Painter, d. N.D.

HILL, GEORGE SNOW—Painter; d. Feb. 3, 1969, age 71, in St. Petersburg, Fla.

HILL, HOMER—Illustrator; d. N.D.

HILLMAN, ALEX L.—Collector; d. 1968, age 67, in Boston, Mass.

HOCKADAY, HUGH—Painter; d. May 7, 1968, age 76, in Lakeside, Mont.

HOFFMAN, ARNOLD—Painter; d. Aug. 21, 1966, age 80, in New York City. See WWAA 1966.

HOFFMAN, MALVINA—Sculptor; d. July 10, 1966, age 81, in New York City.

HOLLOWAY, H. MAXSON—Museum Director; d. Aug. 12, 1966, age 59, in Troy, N.Y. See WWAA 1962.

HOPPER, JO N.—Painter; d. Mar. 6, 1968, in New York City.

HORD, DONAL—Sculptor; d. June 30, 1966, age 64, in San Diego, Cal.

HUMPHREY, JACK WELDON—Painter; d. Mar. 23, 1967, age 66, in Saint John, N.B., Canada. See WWAA 1966 Canadian Section.

HUNTINGTON, A. MONTGOMERY—Designer; d. Dec. 6, 1967, age 83.

JACKSON, MARTHA—Gallery Director; d. July 3, 1969, age 62, in Los Angeles, Cal. See WWAA 1966.

JECT-KEY, DAVID—Painter; d. N.D., in New York City. See WWAA 1966.

KATZMANN, HERBERT—Painter; d. N.D., in New York City. See WWAA 1966.

KEFAUVER, NANCY—Advisor on Fine Arts; d. Nov. 20, 1967, age 56, in Washington, D.C. See WWAA 1966.

KIESLER, FREDERICK J.—Architect; d. 1966, age 76, in New York City.

KING, FRANK—Cartoonist; d. June 24, 1969, age 86, in Winter Park, Fla.

KIRKBRIDE, EARLE R.—Painter; d. Aug. 15, 1968, age 77. See WWAA 1966.

KLETT, WALTER CHARLES—Illustrator; d. Dec. 1966, age 69, New York City.

KOSA, EMIL J., JR.—Painter; d. Nov. 4, 1968, age 65, Los Angeles, Cal.

LANGSNER, JULES—Art Writer; d. Oct. 1967, age 56, in Los Angeles, Cal.

LASSEN, BEN—Painter; d. 1968.

LAUNOIS, JOHN RENE—Photographer; d. N.D.

LEHMAN, ROBERT—Collector; d. Aug. 9, 1969.

LENTINE, JOHN—Painter; d. N.D.

LILIENFIELD, KARL—Scholar; d. Aug. 22, 1966, age 85, in New York City.

LOWE, EMILY—Painter; d. Dec. 19, 1966, age 71, in New York City.

LYMAN, JOHN—Painter; d. May 26, 1967, age 79, in Montreal, Canada. See WWAA 1966. Canadian Section.

LYTTON, BART—Collector; d. June 29, 1969, age 56, in Los Angeles, Cal.

McHUGH, JAMES FRANCIS—Collector; d. May 22, 1968, age 74, in Beverly Hills, Cal.

McNETT, WILLIAM BROWN—Illustrator; d. Jan. 25, 1968, age 72, in Los Angeles, Cal.

MANSHIP, PAUL—Sculptor; d. N.D.

MATTERN, KARL—Painter; d. Jan. 18, 1969, age 76, in Des Moines, Iowa.

MAUNSBACH, GEORGE ERIC—Painter; d. N.D.

MESS, GEORGE JO—Painter; d. 1962.

MORE, HERMON.—Museum Director; d. Dec. 1, 1968; age 81, in Long Branch, N.J.

MORRIS, DUDLEY—Painter; d. Jan. 8, 1966.

MURCH, WALTER—Painter; d. Dec. 11, 1967, age 60, in New York City.

NAGEL, STINA—Painter; d. Mar. 24, 1969, age 71, in New York City.

NASON, GERTRUDE—Painter; d. N.D.

NEFF, JOSEPH—Collector; d. June 19, 1969, age 65, in New York City.

OERI, GEORGINE—Critic; d. July 14, 1968, age 54.

OZENFANT, AMEDEE—Painter; d. May 4, 1966, age 80, in Cannes, France.

PAINE, ROBERT T.—Museum Curator; d. 1965, in Boston, Mass.

PARKER, THOMAS—Former Art Federation Director; d. Jan. 22, 1967, age 62, in Alexandria, Va.

PARRISH, MAXFIELD—Painter; d. N.D.

PARSONS, ERNESTINE—Painter; d. July 30, 1967, age 83, in Colorado Springs, Colo.

PARSONS, LLOYD HOLMAN—Painter; d. Feb. 1968, age 75.

PEETS, ORVILLE—Painter; d. Apr. 17, 1968, age 84, in Lewes, Delaware.

PERKINS, PHILIP R.—Painter; d. Dec. 21, 1968, age 54.

PETERSON, JANE—Painter; d. N.D. in New York City. See WWAA 1966.

PHILLIPS, DUNCAN—Museum Director; d. N.D. See WWAA 1966.

PIERCE, GARY—Painter; d. Mar. 16, 1969, age 68, in Tucson, Ariz.

POLLACK, VIRGINIA MORRIS—Sculptor; d. N.D.

PRESSER, JOSEF—Painter; d. Apr. 14, 1967, age 58, in Paris, France.

PRIEST, ALAN—Museum Curator; d. 1968, age 70.

QUATTROCCHI, EDMONDO—Sculptor; d. Oct. 17, 1966.

RANEY, SUZANNE BRYANT—Printmaker; d. May 4, 1967.

REBAY, HILLA—Painter; d. Sept. 27, 1967, age 77, Greens Farms, Conn.

REINHARDT, AD F.—Painter, d. 1967, age 54.

RENIER, JOSEPH EMILE—Sculptor; d. Oct. 8, 1966, age 79.

REYNARD, GRANT T.—Painter; d. Aug. 13, 1967, age 80, in New York City.

RIPLEY, ALDEN LASSELL—Painter; d. Aug. 29, 1969, age 73, in Lexington, Mass. See WWAA 1966.

RORIMER, JAMES J.—Museum Director; d. N.D.

ROWE, GUY—Painter; d. Aug. 25, 1969, age 75, in Huntington, Long Island, N.Y.

RUSSELL, HELEN CROCKER—Collector; d. N.D.

SALTER, GEORGE—Book Designer; d. Oct. 31, 1967, age 70. See WWAA 1966.

SARDEAU, HELENE—Sculptor; d. Mar. 23, 1968, age 69, Croton-on-Hudson, N.Y.

SCHMITZ, CARL LUDWIG—Sculptor; d. May 13, 1967, age 67.

SCHOLLE, HARDINGE—Museum Director; d. May 8, 1969, age 73, in San Mateo, Cal.

SEIBEL, FRED O.—Cartoonist; d. June 18, 1968, age 82, in Richmond, Va. See WWAA 1962.

SHAHN, BEN—Painter; d. Mar. 14, 1969, age 70, in New York City.

SHOENFELT, JOSEPH FRANKLIN—Painter; d. Oct. 14, 1968, age 50.

SHOPEN, KENNETH—Painter; d. Nov. 13, 1967, age 65, in Norwich, Vt.

SILVERMAN, MEL—Painter; d. Sept. 16, 1966, age 35.

SKILES, CHARLES—Cartoonist; d. Feb. 14, 1969, age 58.

SKINAS, JOHN CONSTANTINE—Painter; d. Nov. 20, 1966, age 42, in New York City.

SKLAR, GEORGE—Animal Painter; d. Jan. 6, 1968, age 63.

SNELGROVE, GORDON WILLIAM—Educator; d. N.D.

SOLES, WILLIAM—Sculptor; d. Apr. 17, 1967, age 53.

SONED, WARREN—Painter; d. July 9, 1966, age 55, in Miami, Fla.

SORENSEN, JOHN HJELMHOF—Cartoonist; d. Apr. 5, 1969, age 46.

SOZIO, ARMANDO—Painter; d. Oct. 23, 1966, age 69.

SPAETH, OTTO—Collector; d. Oct. 8, 1966, age 69, in New York City.

SPRUANCE, BENTON—Lithographer; d. Dec. 6, 1967, age 63.

STARKWEATHER, WILLIAM—Painter; d. May 14, 1969, age 89, New Haven, N.Y.

TAKIS, NICHOLAS—Painter; d. Mar. 1965

THOMPSON, BOB—Painter; d. June 4, 1966, age 26, in Rome, Italy. See WWAA 1966.

TURNER, HARRIET FRENCH—Painter; d. Dec. 7, 1967, age 81, in Roanoke, Va.

UHLER, RUTH PERSHING—Painter; d. N.D.

VAIL, LAURENCE—Collagist; d. 1968, age 77, in France.

VAN DER ROHE, LUDWIG M.—Architect; d. Aug. 17, 1969, age 83, in Chicago, Ill.

VAN ROSEN, ROBERT E.—Industrial Designer; d. Nov. 17, 1966, age 62.

VARLEY, FREDERICK H.—Painter; d. Sept. 8, 1969, age 88, in Toronto, Canada.

VELSEY, SETH M.—Sculptor; d. Apr. 12, 1967, age 64.

VON JOST, ALEXANDER—Painter; d. Jan. 11, 1968, age 80.

VON FUEHRER, OTTMAR F.—Painter; d. 1967, age 67.

WALKER, EVERETT—Educator; d. Sept. 15, 1968, age 64, in New York City.

WALKER, HENRY BABCOCK, JR.—Collector; d. 1966, age 54, in Evansville, Ind. See WWAA 1966.

WEISBECKER, CLEMENT—Painter; d. N.D.

WEST, PENNERTON—Painter, d. June 29, 1965, age 52.

WHARTON, JAMES PEARCE—Educator; d. July 5, 1963, age 70.

WHITE, EUGENE B.—Painter; d. Jan. 14, 1966, age 53.

WILSON, ORME—Patron; d. 1966, age 61.

YOST, FRED—Painter; d. 1968, age 80.

ZOGBAUM, WILFRID—Sculptor; d. N.D.

ZORACH, MARGUERITE—Painter; d. June 1968, age 80, in Brooklyn, N.Y.

ZORACH, WILLIAM—Sculptor; d. Nov. 15, 1966, age 79.

OPEN
EXHIBITIONS

OPEN EXHIBITIONS
NATIONAL AND REGIONAL

These exhibitions are open to all artists unless otherwise noted. Asterisk () denotes no answer received to questionnaire.*

ALABAMA

DIXIE ANNUAL, Montgomery, Ala. Annual: March; travels to one to three museums in area. Drawings, prints, water colors, gouaches, only. (Matted). March; Open to artists of 13 states of Ala., Ga., La., Fla., Miss., Tenn., Va., S.C., N.C., Ark., Mo., Ky., Texas; fee $3.00; 3 works per artist; maximum 5' x 5'; Prizes, Museum purchases; jury. Entries and entry cards due Feb. For further information write Registrar; Montgomery Museum of Fine Arts, 440 S. McDonough St., Montgomery, Ala. 36104.

CALIFORNIA

SAN FRANCISCO ART INSTITUTE, Annuals: all fine arts media except photography. Open to all artists. Fee. Jury awards. For further information write San Francisco Museum of Art, Civic Center, San Francisco, Cal.*

SANTA CRUZ ART LEAGUE. Annual: Oil, water color, pastel—March. Open to all residents of California. Fee $1.50 each entry, two of each category may be submitted but only one of each hung if passed by jury. Jury, awards announced on entry blanks. For further information write Santa Cruz Art League, 526 Broadway, Santa Cruz, Cal. 95060.*

CONNECTICUT

CONNECTICUT ACADEMY OF FINE ARTS, Hartford. Annual: oil, tempera, sculpture, etchings, drypoint, lithographs, woodblocks. Open to all artists. Fee $5 for one, $5 for black and whites. For further information write Louis J. Fusari, Sec., P.O. Box 204, Hartford, Conn. 06101.*

NEW HAVEN PAINT AND CLAY CLUB. Annual: oil, water color, black and white, sculpture—March. Open to all artists. Jury, awards; fee $3 for each non-member entry. Entry due February. For further information write New Haven Print and Clay Club, New Haven, Conn.*

SILVERMINE GUILD OF ARTISTS, INC., New Canaan, Conn. NATIONAL PRINT EXHIBITION—Biennial. Open to all artists; all print media except monotypes—March. 3 works per artist allowed; jury; fee; purchase prizes. For further information write Exhibition Secretary, Silvermine Guild of Artists, Inc., 1037 Silvermine Rd., New Canaan, Conn. 06840.
NEW ENGLAND EXHIBITION OF PAINTING AND SCULPTURE—Annual. Open to artists of the six New England States, New York, New Jersey and Pennsylvania. June. Fee: $6 per entry; jury; more than $5,000 in cash awards. For further information write to address above.

DISTRICT OF COLUMBIA

LIBRARY OF CONGRESS, PRINTS AND PHOTOGRAPHS DIVISION, Washington D.C. 20540. NATIONAL EXHIBITION OF PRINTS—Biennial: all fine print media—May-August. Open to printmakers of U.S.A. Original prints in all media, black and white or color, exclusive of monotypes, drawings, photographs or prints colored after printing. No fee. Jury, purchases for the J. & E. R. Pennell Collection. Entries due Feb. 1971. For further information write Prints and Photographs Division, Library of Congress, Washington, D.C. 20540.

MINIATURE PAINTERS, SCULPTORS & GRAVERS SOCIETY OF WASHINGTON, D.C. Annual: all media—April-May. Open to all miniature artists (International Show). Jury, awards; fee $2 for local entries; $3 for out-of-town entries plus postage for return of work. Entry due April, send to National Collection of Fine Arts, 10th and Constitution Ave., N.W., Washington, D.C. 20560. For further information write Mary Elizabeth King, 1518 28th St., Washington, D.C. 20001.*

SOCIETY OF WASHINGTON ARTISTS, Washington, D.C. Annual: oil, sculpture—November-December. Open to artists in Washington and area. Jury; awards; fee $2 per single entry, $3 for two entries, $4 for three entries. For further information write Mr. Melvin D. Buckner, 800 Emerson St., N.W., Washington, D.C. 20011.*

FLORIDA

SARASOTA ART ASSOCIATION SOUTH COAST ART SHOW. Annual: all media—Spring. Open to artists of coastal states, Va. through Texas. Fee $5, non-resident membership. Jury, awards. For entry blanks write Sarasota Art Association, P.O. Box 1907, Sarasota, Fla.*

GEORGIA

ATLANTA UNIVERSITY ANNUAL EXHIBITION OF PAINTINGS, SCULPTURE AND PRINTS BY NEGRO ARTISTS. Annual: oil, gouache, watercolor, pastel, sculpture, tempera, lithograph, wood or linoleum block, etchings, pen or pencil drawings—April. Open to Negro artists (not necessarily residing in U.S.). Two entries in each category. Oil-no limit, prints: 12" x 15", 18" x 22", 20" x 26". No fee. Jury, awards, Entries due March 2. For further information write Miss Norah McNiven, Dir., Dept. of Public Relations, Atlanta University, Atlanta, Ga. 30314.

SOUTHEASTERN EXHIBITION, Atlanta, Ga. Annual: All painting media including watercolor—Fall. Open to artists living in Alabama, Florida, Georgia, Louisiana, Mississippi, North Carolina, South Carolina, Tennessee and Virginia (warehouse handling fee $5). Jury, awards, purchases. Entries due early Fall. Write: Southeastern Annual, High Museum of Art, 1280 Peachtree St., N.E., Atlanta, Ga. 30309.*

ILLINOIS

ART INSTITUTE OF CHICAGO. Biennial: Mixed media, not over 7' in any dimension or weigh over 2,000 pounds.—March 13-April 18, 1971. Open to artists, over 18, U.S. citizens, living within 100 miles of Chicago. Jury, awards; fee none. Entries due Dec. 1970. For further information write Painting and Sculpture Dept., The Art Institute of Chicago, Michigan at Adams, Chicago, Ill. 60603.

DECATUR ART CENTER. ANNUAL CENTRAL ILLINOIS ART EXHIBIT. Limited to two-dimensional work only. Open to all artists within 150 miles of Decatur, including Missouri, Indiana and Iowa. Entries due by January 15th for February opening. Jury, awards. Fee $4. For information write to Marvin L. Klaven, Decatur Art Center, 125 N. Pine St., Decatur, Ill. 62522.*

ROCKFORD ART ASSOCIATION, ILL. ANNUAL JURIED ROCKFORD & VICINITY EXHIBITION: oil, watercolor, sculpture, graphic arts—March. Open to artists of Northern Illinois, & Southern Wisconsin, exclusive of Chicago and Milwaukee. Fee $2 plus $5 dues if not a member of the Rockford Art Association. Jury, awards; entries due Feb. 13 through 18, entry cards same dates. For further information write to Rockford Art Association, 737 N. Main St., Rockford, Ill. 61103.

INDIANA

BALL STATE UNIVERSITY, Muncie. Annual: Drawing and small sculpture (not to exceed 150 lbs. and no dimension more than 36".)—May 1 - June 15. Open to all artists. Fee $2, one work per artist; jury, awards. Entries due April 1; entry cards same date. For further information write Dr. Alice W. Nichols, Art Gallery, Ball State University, Muncie, Ind. 47306.

EVANSVILLE MUSEUM OF ARTS AND SCIENCE. Annual. MID-STATES ART EXHIBITION. Nov. Painting, prints, collages, sculpture, mobiles, watercolor, graphic arts. Open to artists within a 200 mile radius of Evansville. Two entries in any combination of categories; fee: $3 per work, limit of 2 works. Jury, awards. Entries due in Oct. For further information write Art Committee, Evansville Museum of Arts and Science, 411 Southeast Riverside Dr., Evansville, Ind. 47713.

MID-STATES CRAFT EXHIBITION. Annual-Feb. Ceramics, textiles, silver and metal work and miscellaneous (wood, enamel, glass, etc). Open to artists within a 200-mile radius of Evansville. Fee: $2 for three objects or less; jury; awards. Entries due in Jan. For further information write The Craft Committee, at above address.

INDIANAPOLIS MUSEUM OF ART. Biennial: YOUNG PRINT-MAKERS:—Feb.-Mar. Open to all artists. Four works per artist, 24" x 30" matted. Fee: $2; jury; awards.

AMERICAN DRAWING SOCIETY REGIONAL—Nov-Jan. Drawings in any medium. Open to artists living or working in Illinois, Indiana, Iowa, Michigan, Minnesota, Missouri, Ohio and Wisconsin. Jury. Entries due Nov.

INDIANA PRINTS/DRAWINGS/WATERCOLORS. State Exhibition: May-June. Open to any artist in Indiana. Four works per artist. Fee: $2; jury; awards. Entries due mid-April. For further information on these three exhibitions write Mrs. William D. Lovell, Registrar, Indianapolis Museum of Art, 110 E. 16th St., Indianapolis, Ind. 46202.

HOOSIER SALON, Indianapolis. Annual: all media—January-February. Open to Indiana artists, native or by residence in the state for one year minimum. Fee $7.50; jury, awards $4,000-$5,000. Entry due January 12-17th. For further information write Hoosier Salon Patrons Association, 610 State Life Bldg., Indianapolis, Ind. 46204.*

MICHIANA REGIONAL ART EXHIBITION, South Bend, Ind. Biennial: Phase I, Ceramics, Nov.; Phase II, Avant-Garde, painting and sculpture—Mar.; Phase III, Watercolor—May. Open to artists in Michigan and Indiana, or former residents. Jury; awards; Fee, $5 (limited to 2 entries). Entries due a month in advance of each Phase. For further information write South Bend, Indiana 46601.

IOWA

SIOUX CITY ART CENTER. Annual: (Fall Show), oil, encaustic, collage, polymers, varnished caseins, tempera—October. One man jury, up to $1200 in purchase and cash awards; no fee. Open to residents of Iowa, Nebraska, Minnesota, South Dakota. For further information write Director, Sioux City Art Center, 617 Douglas St., Sioux City, Iowa 51101.*

KANSAS

WICHITA ART ASSOCIATION, INC.—KANSAS WATERCOLOR SOCIETY—Nov.-Dec. Transparent watercolors; open to Kansas artists. Fee: $5; jury; awards; limit of 3 works. Entries due Oct. 25. For further information write Wichita Art Association, Inc., 9112 E. Central, Wichita, Kan. 67206.

KENTUCKY

LOUISVILLE ART CENTER REGIONAL BIENNIAL CRAFT SHOW. April-May. Crafts: ceramics, enamels, glass, metal, wood, etc. Open to artists in Illinois, Indiana, Kentucky, Missouri, Ohio, Tennessee, Virginia and West Virginia. Jury; awards; Fee: $2 per entry (limited to 3). For further information write to Mrs. Harold Walton, Louisville School of Art, 2111 S. First St., Louisville, Ky. 40208.

LOUISIANA

ISAAC DELGADO MUSEUM OF ART, New Orleans. Annual. Format varies each year. Generally focus on contemporary painting or sculpture or prints and drawings by regional or national artists. No fee; jury, purchase awards. Spring of each year. For further information write Artists' Annual, Isaac Delgado Museum of Art, Lelong Ave., City Park, New Orleans, La. 70119.*

MAINE

OGUNQUIT ART ASSOCIATION. Annual: all media—July-August. Open to members. Jury (for new members). Fee, annual membership $15. Entry due June. For further information write Ogunquit Art Association, Ogunquit, Me.*

PORTLAND MUSEUM OF ART. Annual: oil, watercolor, sculpture—July. Jury. Fee $3.50. For further information write Exhibitions Secretary, Portland Museum of Art, 111 High St., Portland, Me.*

MARYLAND

WASHINGTON COUNTY MUSEUM OF FINE ARTS, Hagerstown. CUMBERLAND VALLEY ARTISTS. Annual: oil, tempera, gouache, watercolor, sculpture, graphics—April. Open to artists resident or former residents of Cumberland Valley area. No fee; jury, awards. Entry due March. For further information, see below.*

CUMBERLAND VALLEY PHOTOGRAPHIC SALON. Annual: 16 x 20 inches, mounted black and white or colored prints—November.

Jury, awards (3 each class). Open to residents and former residents. Entry due October. For further information on these two exhibitions write Washington County Museum of Fine Arts, Box 423, Hagerstown, Md.*

MASSACHUSETTS

SPRINGFIELD ART LEAGUE. ANNUAL FALL REGIONAL JURY EXHIBITION—November-December. Oil, watercolor, casein, pastel, gouache, prints, drawings and sculpture. Fee $5 (dues). Open to New England States only. Entry cards and work—Nov. For further information write James J. Fitzsimmons, P.O. Box 1702, Springfield, Mass.*

SPRINGFIELD ART LEAGUE. ANNUAL SPRING JURY EXHIBITION—March-April. Oil, watercolor, casein, pastel, gouache, drawings, sculpture. Open to all artists. Jury; Fee $5 non-members. For further information write James J. Fitzsimons, P.O. Box 1702, Springfield, Mass.*

MICHIGAN

MICHIGAN ARTIST-CRAFTSMEN EXHIBITION, Detroit—Biennial, next 1971. Ceramics, metal, wood, textiles, plastics.—January-February. Open to all Michigan craftsmen. Fee $3 per artist; jury, awards; maximum of 5 works per artist. Entries and cards due Jan.

MICHIGAN ARTISTS EXHIBITION, Detroit—Biennial, next 1970. Painting (any media), sculpture, prints, drawings, photos. Open to all Michigan artists. No fee; jury, awards. Entries and cards due April. For further information on these two exhibitions write Samuel J. Wagstaff, Curator of Contemporary Art, Detroit Institute of Arts, 5200 Woodward Ave., Detroit, Michigan. 48202.

MINNESOTA

WALKER ART CENTER, Minneapolis. Biennial: painting, sculpture—Fall of alternate years, next in 1970. Open to artists of Minnesota, Wisconsin, Iowa, North and South Dakota. No fee; jury, awards. For further information write Biennial of Painting & Sculpture, Walker Art Center, 1710 Lyndale South, Minneapolis, Minn. 55403.*

NEBRASKA

JOSLYN ART MUSEUM, Omaha. MIDWEST BIENNIAL. Painting, sculpture, graphics, crafts. Open to artists and designer-craftsmen in Arkansas, Illinois, Louisiana, Montana, New Mexico, Texas, Colorado, Iowa, Kansas, Minnesota, Missouri, Nebraska, Oklahoma, North and South Dakota, Wyoming. Jury, awards; fee $4. Held in even-numbered years, late winter or spring. 11th Midwest Biennial dates, Feb. 8-Mar. 15, 1970. Entries due by Jan. 9, 1970. For further information write Midwest Biennial, Joslyn Art Museum, Dodge at 24th St., Omaha, Neb. 68102.

NEW JERSEY

NEW JERSEY WATERCOLOR SOCIETY, Morristown. Annual: watercolor, casein, tempera, pastel—Nov.-Dec. Open to all present or former residents of New Jersey. Fee $5 for non-members, $3 for members (1 or 2 entries); jury; awards. Entries due Nov. 1. For further information write Mrs. Nat Lewis, 51 Overlook Rd., Caldwell, N.J. 07006.

HUNTERDON ART CENTER, Clinton. NATIONAL PRINT EXHIBITION. Annual: Apr.-May. All print media except monotype, Open to all printmakers. Fee $5 for 2 prints; members $3 for 2 prints. Awards; jury. Entry cards and work due Mar. For further information write Director, Hunterdon Art Center, Clinton, N.J. 08809.

HUNTERDON ART CENTER, Clinton. NEW JERSEY STATE-WIDE EXHIBITION. Annual: Oil, watercolor, sculpture—June-July. Open to all New Jersey artists and those born in the state. $3 each for 2 works. Jury, awards. Entry cards and work due May. For further information write Director, Hunterdon Art Center, Clinton, N.J. 08809.

PAINTERS AND SCULPTORS' SOCIETY OF NEW JERSEY, Jersey City. Annual: oil, watercolor, casein, pastels, graphics, sculpture—March. Open to all artists of U.S. and Canada. Jury, awards (cash and medals); fee $5. Entry due February at Jersey City Museum. For further information write Painters and Sculptors Society of New Jersey, Jersey City, N.J.*

NEW MEXICO

MUSEUM OF NEW MEXICO, Santa Fe. BIENNIAL: New Mexico Biennial and Southwestern Biennial, held alternate years—April-May. All media painting, sculpture. Jury, awards. Works selected for traveling exhibition. (Biennial open to artists of South-Southwest) For further information write Dr. Delmar Kolb, Director, Museum of New Mexico, P.O. Box 2087, Santa Fe 87501.*

FIESTA SHOW. Biennial: Painting, drawing, printmaking, sculpture (all media). Aug.-Nov. Open to New Mexico artists. No fee; awards; 3 works per artist. For further information write to Museum of New Mexico, P.O. Box 2087, Santa Fe, N.M. 87501.

TRAVELING EXHIBITIONS circulated in New Mexico and nationally. For further information write Curator, Traveling Exhibitions, Museum of New Mexico, P.O. Box 2087, Santa Fe, N.M. 87501.*

NEW YORK

ALLIED ARTISTS OF AMERICA, INC., New York City. Annual: oil, watercolor, casein, polymer, pastel, sculpture—October-November. Open to American artists. Jury, awards; fee $5. Entry due October. For further information write Raymond T. Maher, 14 Duchess Ct., Freehold, N.J. 07728.

AMERICAN WATERCOLOR SOCIETY, New York City. Annual: watercolor, pastel, casein—April. Jury, awards; fee $5 for each (limit, two, not to exceed 34" x 42" framed). Entry due March. Open to all artists. For further information write American Watercolor Society, 1083 Fifth Ave., New York, N.Y. 10028.

ART DIRECTORS CLUB, New York City. Annual Exhibition of Advertising and Editorial Art and Design. Open to advertising or editorial materials. Fee $2.00 per proof. $7.50 each TV film. Spring. Entries due December; jury, medals and certificates. For further information write The Art Directors Club, 642 Fifth Ave., New York, N.Y. 10017.*

ARTISTS OF THE UPPER HUDSON, Albany, N.Y. Annual: watercolor, oil, sculpture, pastel, no prints—Spring. Open to all artists living within 100 miles of Albany. Jury, purchase prize plus cash awards; fee $2 for maximum of 2 entries. Entry due May. For further information write Albany Institute of History & Art, 125 Washington Ave., Albany, N.Y. 12210.

AUDUBON ARTISTS, New York City. Annual: oil, watercolor, graphics, sculpture—January-February. Open to all artists. Jury, awards; fee $5; one entry per artist. Entry due January. For further information write Secretary, Audubon Artists of America, 1083 Fifth Ave., New York, N.Y. 10028.

BRONX ARTISTS GUILD, New York City. Annual: all media—April. Jury. Fee $1 per entry, limit 2. For further information write Alice Conklin, Sec., Bronx Artists Guild, 1582 Lurting Ave., Bronx, N.Y. 10461.*

EVERSON MUSEUM OF ART OF SYRACUSE & ONONDAGA COUNTY, Syracuse, N.Y. CERAMIC NATIONAL EXHIBITION. Biennial: Ceramics—November-December. Open to potters and enamelists, in the U.S. & Canada. Jury, awards and purchase prizes in excess of $2,500. Fee. Work selected for traveling exhibition which is circulated for two years. For further information write Everson Museum of Art, 407 James St., Syracuse, N.Y. 13203.*

HUDSON VALLEY ART ASSOCIATION, White Plains, N.Y. Annual: All media—May. Open to all artists in traditional works. Jury, awards; fee for non-members, $6, limit one. Entry due April. For further information write Paul de Tagyos, Pres., 30 Eastchester Rd., New Rochelle, N.Y. 10801.

KNICKERBOCKER ARTISTS, New York City. Annual: oil, casein, watercolor, graphics, sculpture—April. Open to all artists. Fee $5; jury, awards. Entry due April 5. For further information write Thea Krebs, Sec., 150 E. 69th St., New York, N.Y. 10021.*

NATIONAL ACADEMY OF DESIGN, New York City. Annual: oil, sculpture, watercolors, graphics—February-March. Open to all artists. Jury; awards; no fee. Entry due February. For further information write National Academy of Design, 1083 Fifth Ave., New York, N.Y. 10028.

NATIONAL ASSOCIATION OF WOMEN ARTISTS, New York City. Annual: Graphics, oil, watercolor, miniature, sculpture—April-May. Jury, awards. Entry due April. For further information write National Association of Women Artists, 156 Fifth Ave., New York, N.Y. 10010.*

NATIONAL SOCIETY OF PAINTERS IN CASEIN, New York City. Annual: Casein and plastic water media only—March. Open to all artists. Fee $5; jury, medals, approx. $1,000 in awards. Entries due March. For further information write Howard Mandel, 285 Central Park West, New York, N.Y. 10024.

PRINT CLUB OF ALBANY, N.Y. Two open National Print Exhibitions. Biennial. NATIONAL PRINT EXHIBITION—Nov., entries due Sept. SMALL PRINT EXHIBITION—Dec., entries due Oct. All print media except monotypes. Open to all printmakers residing in the U.S.A. Jury, awards, fee $4 for each. Limit of four. For further information write Alice Pauline Schafer, 33 Hawthorne Ave., Albany, N.Y. 12203.

SOCIETY OF AMERICAN GRAPHIC ARTISTS, New York City. Annual: Open to all printmakers. All prints except monotype. Jury, awards; fee $5, limit one (30" maximum). For further information write Society of American Graphic Artists, 1083 Fifth Ave., New York, N.Y. 10028.

YONKERS ART ASSOCIATION, Yonkers, N.Y. Annual: all media. April. Open to members only. For information write Membership Chm., Yonkers Art Association, c/o Hudson River Museum, 511 Warburton Ave., Trevor Park, Yonkers, N.Y. 10071.*

OHIO

ALL-OHIO PAINTING AND SCULPTURE EXHIBITION, Dayton. Biennial, next in 1970. Painting, sculpture—February-March. Open to artists born or residing in Ohio or who formerly resided in Ohio for a period of five years. Jury, awards; no fee; limit, two in either media or total of three. Entry due January. For further information write Mark A. Clark, Registrar, Dayton Art Institute, 405 Riverview Ave., Dayton, Ohio 45401.

ALL-OHIO GRAPHICS AND CERAMICS EXHIBITION, Dayton. Annual: Etchings, lithographs, blockprints, silk screen; monotypes, any fine print in black and white or color may be submitted. No work produced by photo-mechanical means accepted. Nov.-Dec. Jury, awards. Entry due November. For further information write Mark A. Clark, Registrar, Dayton Art Institute, 405 Riverview Ave., Dayton, Ohio 45401.*

BUTLER INSTITUTE OF AMERICAN ART, Youngstown. Annual (Midyear Show): Oil, watercolor—July-September. Open to artists of the United States. Jury, awards; fee $2. Entry due June. For further information write Secretary, The Butler Institute of American Art, 524 Wick Ave., Youngstown, Ohio 44502.

CANTON ART INSTITUTE. Annual: oil, watercolor, drawings, prints, ceramics, enamel, sculpture and photographs—October. Open to artists of Northeast Ohio. Jury, awards, purchases; fee $3. For further information write Canton Art Institute, 1717 Market Ave., North Canton, Ohio 44714.*

ULTIMATE CONCERNS: OHIO UNIVERSITY, Athens, Ohio. Annual: All print and drawing media except monoprint. Open to all artists. Fee $2. Jury; purchase awards; entry due early March. Write: Ultimate Concerns, School of Painting & Allied Arts, Ohio University, Athens, Ohio 45701.*

OKLAHOMA

OKLAHOMA ART CENTER, Oklahoma City. EIGHT STATE EXHIBITION OF PAINTING AND SCULPTURE—Annual. Sept.-Nov. Open to residents of Arkansas, Colorado, Kansas, Louisiana, Missouri, New Mexico, Texas and Oklahoma. Painting and sculpture. Fee: $3; jury; purchase awards. Entries due by Aug.

NATIONAL PRINT AND DRAWING EXHIBITION—Annual: May. Open to any resident of the United States. Prints and drawings. Fee: $4; jury.

OKLAHOMA BIENNIAL—Jan. Painting, sculpture, crafts, any media. Open to residents of Oklahoma. Fee: $3; jury, awards. For further information on these three exhibitions, write Oklahoma Art Center, Fair Park, Plaza Circle, 3113 Pershing Blvd., Oklahoma City, Okla. 73107.

PENNSYLVANIA

AMERICAN COLOR PRINT SOCIETY, Philadelphia, Pa. Annual: all print media in color—March. Open to all printmakers working in color. Fee $2.75; jury, awards. Entry due February. For further information write Caroline M. Murphy, Treas., 2022 Walnut St., Philadelphia, Pa. 19103.*

PENNSYLVANIA ACADEMY OF THE FINE ARTS, Philadelphia. Annual: oil, sculpture—January-February. Open to American artists. No fee. Jury, awards. For further information write The Pennsylvania Academy of the Fine Arts, Broad & Cherry Sts., Philadelphia, Pa. 19102.*

RHODE ISLAND

ART ASSOCIATION OF NEWPORT. Annual: oil, watercolor, prints, drawings, small sculpture—July. Open to all American artists. Jury, awards; fee $2. Entry due early June. For further information write Mrs. Paul C. Rogers, Exec. Sec., Art Association of Newport, 76 Bellevue Ave., Newport, R.I. 02840.*

PROVIDENCE ART CLUB. OPEN DRAWING SHOW—MONOCHROMATIC. All media; work must have been done in last two years—Nov. Annual. Open to all artists; jury; fee: $2; awards, $100-$50. Entry due Nov. For further information write Mrs. Rohn Truell, Providence Art Club, 11 Thomas St., Providence, R.I. 02903.

TENNESSEE

BROOKS MEMORIAL ART GALLERY, Memphis. MIDSOUTH EXHIBITION. Annual: March. Paintings, drawings, sculpture, prints. Open to artists residing within 250 miles of Memphis. Jury; awards. For further information write Mid-South Exhibition, Brooks Memorial Art Gallery, Overton Park, Memphis, Tenn. 38112.

MISSISSIPPI RIVER CRAFT SHOW. Sponsored by the Memphis
Branch of the A.A.U.W. Open to craftsmen residing within the
ten mid-continent states bordering the Mississippi River.*

TEXAS

TEXAS ANNUAL OF PAINTING AND SCULPTURE. Annual: Octo-
ber-November, then on circuit. Open to Texas artists. No fee;
jury, awards. Entry due September.*

DALLAS COUNTY PAINTING, SCULPTURE, DRAWING. Annual:
May-June; oil, pastel, sculpture, drawing. Open to artists of
Dallas County. Jury, awards; no fee. Entry due April.*

SOUTHWESTERN EXHIBITION OF PRINTS AND DRAWINGS, Dallas.
Biennial: prints, drawings except monoprints—Oct.-Nov. Open
to residents of Texas, Oklahoma, Louisiana, New Mexico, Colo-
rado, Arizona, Arkansas. Jury, awards. Entry due October;
limit two works.

TEXAS CRAFTS EXHIBITION. Annual: textiles, ceramics, metal,
wood, bookbinding—November-December. Open to Texas
craftsmen; jury, awards. Fee $3. Entry due November. For
further information on these four exhibitions write Dallas Mu-
seum of Fine Arts, Dallas, Texas 75226.*

VERMONT

SOUTHERN VERMONT ART CENTER, Manchester. Annual: Fall.
All media. Open to all members and associate artists, plus a
number of invited. Fee $5; limit of 2; jury; entries due Sept.
For further information write: Director, Southern Vermont Art
Center, Manchester, Vt. 05254.

VIRGINIA

INTERMONT REGIONAL, Bristol, Va. Annual: oil, watercolor,
drawing, graphics—April. Jury, awards. Open to artists of
Virginia, West Virginia, Kentucky, Tennessee, Ohio, North Caro-
lina, Georgia, Alabama and District of Columbia. Fee $2 for
oils, $1 for other media. Entry due March. For further infor-
mation write Prof. Ernest Cooke, Virginia Intermont College,
Bristol, Va.*

IRENE LEACHE MEMORIAL EXHIBITION, Norfolk. Biennial: all
media of painting, drawings; pastels not acceptable.—Mar.-
Apr. Open to artists residing in Virginia, North Carolina, West
Virginia, Maryland, Delaware and Wash., D.C., and natives of
those states. Jury; $2,000 in cash awards; fee $2 per painting,
limit of three. Entry and cards due Jan. For further informa-
tion write Irene Leache Memorial Exhibition, Norfolk Museum,
Norfolk, Va. 23510.

VIRGINIA MUSEUM OF FINE ARTS, Richmond. Three Biennial Ex-
hibitions. Open to natives and residents of Virginia and those
former residents who lived in Virginia for five years. VIRGINIA
CRAFTSMEN—Mar.-April. Personally designed crafts in
metal, textile, wood, ceramics and leather. Jury; awards; limit
of 3 works.

VIRGINIA DESIGNERS—Jan.-Feb. Magazine and newspaper ad-
vertisements, brochures, folders, catalogues, programs, post-
ers, etc. Fee: $3; jury; awards; limit of 10 panels; entries by
Nov.

VIRGINIA PHOTOGRAPHERS—Oct.-Nov. Monochrome and
color photographic prints and color transparencies. Fee: $3 for
non-members, members free; jury; awards; entries by Aug.;
limit 8 prints and 8 transparencies. For further information
write Virginia Museum of Fine Arts, Boulevard and Grove Aves.,
Richmond, Va. 23221.

WASHINGTON

NORTHWEST PRINTMAKERS EXHIBIT, Seattle. Annual: All fine
print media, not including monotypes—February-March. Open
to all artists of fine print media. Jury, awards; fee $2. Entry
and cards due Jan. For further information write Secretary,
Seattle Art Museum, Volunteer Park, Seattle, Wash. 98102.*

WEST VIRGINIA

ANNUAL REGIONAL EXHIBITION 180, Huntington. All media—
May. Open to artists above high school age, living within 180
miles of Huntington in Ohio and Kentucky, and all of West Vir-
ginia. Jury, awards; fee. Entry due April. For further infor-
mation write Exhibition 180, Huntington Galleries, Huntington,
W.Va. 25701.

WISCONSIN

WISCONSIN PAINTERS AND SCULPTORS. Annual: oil, water-
color, pastel, sculpture (no prints or drawings)—May-June.
Open to all artists of Wisconsin 21 years of age and over. Fee
$3; no fee for members of Milwaukee Art Center; jury,
awards. See address below.*

WISCONSIN DESIGNER-CRAFTSMEN. Biennial. Open to all crafts-
men of Wisconsin over 21 years of age. All media—March.
Jury, award; fee $5 per artist, limit of three. Entry due Jan.
For further information on these two exhibitions write Anne K.
Donovan, Admin., Milwaukee Art Center, 750 N. Lincoln Memor-
ial Drive, Milwaukee, Wis.

WISCONSIN SALON OF PRINTS AND DRAWINGS, Madison. Annual:
prints and drawings only—November-January. No fee; jury,
awards. Open to Wisconsin artists. Entry due November. For
further information write Joan Kurlan, Chairman, Wisconsin
Union Gallery Comm., 800 Langdon St., Madison, Wis. 53706.